0058374

DATE DUE	
OCT 2 5 1996	
DEC 1 0 1996	
MAY 1 2 1997	

BRODART, INC. Cat. No. 23-221

Chinese Ivories
from the Shang to the Qing

Chinese Ivories
from the Shang to the Qing

An exhibition organized by

The Oriental Ceramic Society

jointly with

The British Museum

24 May to 19 August 1984
in Oriental Gallery II

Exhibition Committee

Peter Fawcett *Chairman*

Craig Clunas

Derek Gillman

Colin MacKay

John Da Silva

Arthur Reynolds

Colin Sheaf

William Watson

Roderick Whitfield

Catalogue

Craig Clunas

Peter Fawcett

Derek Gillman

James Watt

William Watson *Editor*

© 1984 Oriental Ceramic Society

ISBN 0 903421 22 4

Designed by James Shurmer

Produced for the Oriental
Ceramic Society by
British Museum Publications Ltd,
46 Bloomsbury St, London WC1B 3QQ
Distributed by Sotheby Publications, Philip Wilson
Publishers Ltd, Russell Chambers, Covent Garden,
London WC2E 8AA
Set in Monophoto Apollo
and printed in Great Britain by
Jolly & Barber Ltd, Rugby

Front cover: Cat. no. 75

Drawings on pages 17, 19, 21 and 23 by Wendy C. M. Ho

Contents

Foreword

It is a tradition of the Oriental Ceramic Society that every four or five years its members present a major exhibition to the public. On this occasion we are honoured by our Patron the Duke of Gloucester who so kindly offered to open the exhibition. Often the assistance of museums is sought to fill out part of an exhibition which pieces in the possession of the Society's members do not fully cover. The maintenance of close links with museums is a chief aim of the Society, and in the present exhibition particularly the loans made by museums have proved to be indispensable. We are deeply indebted to the British Museum for joining us as partner in this enterprise, enriching the exhibits with choice pieces from its own store, offering the use of its splendid gallery, and not least affording us the cooperation of Mr Lawrence Smith, Keeper of the Department of Oriental Antiquities, and members of his staff.

There could not have been an exhibition without the contribution made from our members, for whose enthusiastic support we are most grateful. We thank no less those members whose ivory carvings are not shown, through lack of space or through the need to represent, as evenly as possible, the whole development and scope of the art. These omitted pieces, their photographs and attached information have been most valuable in our research. Lord Thorneycroft and the other Trustees of the Victor Sassoon Chinese Ivory Trust are major contributors

Some three years ago Chinese ivories were chosen as the theme of our major exhibition because the study of this subject called for revision and reassessment. It is the purpose of the exhibitions to define areas of uncertainty as well as to summarize established fact, and in this respect the ivories are a particularly topical study. The viewer and reader must indulge our hesitations and omissions, and deal kindly with what may prove to be our errors. To our knowledge, we may say, they have not before been afforded such an opportunity to learn and judge through a special exhibition. The paper read to us by R.S.Jenyns in 1953 launched the subject in the Society, and much has been built upon it. The majority of the exhibits are of the Ming and Qing periods, ivories of earlier times being exceedingly rare, and somewhat unaccountably so. The Shang period enjoys the advantage of excavation, and the few artistic ivories unearthed are eloquent of the period style as demonstrated over the whole range of Shang art. But it is not well understood why so little ivory should be found in excavation on Zhou and Han sites, plain or carved, or survive in tombs or temple collections of the Tang, Song and Yuan periods. It is a sign of lively study in the Chinese decorative arts that controversy should exist over the dating of objects. Ivory is no exception in this, and so it is right to record some differing views. For example, conclusion regarding the triple Buddhist images No.14 is specially critical, one author defending a Yuan date while others would assign the pieces to the later Ming. The date placed in the catalogue, '14th–16th century', comprehends the extremes, and future study must refine this dating. Only exceptional cases give rise to such divergence. The vast export of Chinese carved ivories that took place in the nineteenth century has inevitably meant that the majority of pieces collected in the west belong to this late phase of the art. It was a main concern of the organizers to do strict justice

to this more standardized, in a measure more vulgarised, material by placing its best product in perspective with superior earlier work.

The historical import of the carvings for us occidentals is a leading theme in the introductory essays. A large rôle is assigned to Luso-Hispanic demand for Christian subjects, a theme dealt with here more fully perhaps than in previous writing; we have been delighted to include an instrument (No. 161) now in the possession of Jesuit Fathers, whose order was so influential at the Ming and Qing courts; we have enthusiastically noted the realities of trade and commerce, the names of ships which brought the carvings to Europe; and it has been pleasing to include among the exhibits items which featured in the first catalogue of the British Museum. Happily, from one point of view, the carving of ivory in present-day China is much reduced, and the threat which the trade in ivory to China and other places once held over the very survival of the elephant (especially the African elephant) is also lessened, and by Customs control will ideally be removed altogether. Before the Second World War as much as 200 tons of ivory would be landed in London in a single year. Now it is otherwise, and those who are concerned by the unnecessary slaughter of elephants must value the work of the Fauna and Flora Preservation Society.

We are grateful to many scholars. In the British Museum Jessica Rawson of the Department of Oriental Antiquities, and Neil Stratford and Tim Wilson of Medieval and Later Antiquities earn our thanks. In the Victoria and Albert Museum Rose Kerr, Carolyn Hopkins, Tim Miller, Joe Earle, Malcolm Baker and Paul Williamson have at various times given their advice. Christian Jörg of the Groningen Museum and Beatriz and Jose Pintado of Mexico City have also made valuable contributions. For their scientific information we are beholden to Dr R. Burleigh of the British Museum's Research Laboratory, who has done prompt and meticulous work for us, to Dr Juliet Jewell of the Natural History Museum and to Dr M. Pollard of the Research Laboratory for Archaeology and the History of Art in the University of Oxford. Miss Jean Rankine, Deputy Director of the British Museum, presided benevolently over the practical arrangements in her museum. Ron Wallom and Christopher Date energetically helped with the exhibition organization. Anita MacConnell and Jane Insley also gave their help.

The resources of the Oriental Ceramic Society are limited, and we acknowledge with gratitude the financial support of the Sassoon Trust, of an anonymous donor, and of Olaf Kier, C.B.E., who has borne the cost of the loan of the Danish ivories. Messrs Thompson Quarrell have regularly put their library and office facilities at the disposal of the members of the Exhibition Committee, who have of course been the architects of this whole venture. We acknowledge a chief debt to the lenders of the ivories for the photographs they so promptly supplied to us. The photographic services of the British Museum, the Victoria and Albert Museum, and the Metropolitan Museum of New York have come generously to our aid, and similar assistance was kindly afforded by Messrs Christie, Manson and Woods Ltd and by Messrs Sotheby Parke Bernet. Finally we thank the authors of this catalogue, who have spent so many hours in research. If this exhibition achieves its purpose in extending the knowledge and understanding of Chinese ivory carving, the merit will be theirs. We recall gratefully too our pleasurable co-operation with the design and editing staff of British Museum Publications.

Peter Fawcett *Chairman of the Exhibition Committee*
William Watson *Editor*

Chronological Table

Neolithic age	*c.* 7000–1600 BC
Shang dynasty	1600–1027 BC
Zhou dynasty	1027–221 BC
Western Zhou	1027–771 BC
Eastern Zhou	770–221 BC
Qin dynasty	221–207 BC
Han dynasty	206 BC–220 AD
Six Dynasties	220–589 AD
Three Kingdoms	220–265 AD
Western Jin dynasty	265–316 AD
Eastern Jin dynasty	317–420 AD
Northern and Southern dynasties	420–581 AD
Sui dynasty	581–618 AD
Tang dynasty	618–906 AD
Five Dynasties	907–960 AD
Song dynasty	960–1279 AD
Liao (Khitan) dynasty	916–1125 AD
Jin (Jürchen) dynasty	1115–1234 AD
Yuan dynasty	1279–1368 AD
Ming dynasty	1368–1644 AD
Qing dynasty	1644–1911 AD

Prolegomena to Ivory Carving

Elephants

Three species provided the Chinese carver with ivory. Although it has been extinct in China for some 20,000 years, *Elephas primigenius*, the mammoth, was the source of substantial quantities of ivory from time to time.[1] There was *Elephas maximus* or *indicus*, the Indian elephant, with sub-species extending to China and South-East Asia, and thirdly *Loxodonta africana*, the African elephant, of which there were also various races.

The elephant died out gradually in China, receding to the south and south-east, particularly Yunnan. It is thought that elephants were uncommon in the Tang epoch and rare by the Song dynasty. Therefore nearly all the ivory in this exhibition must have been imported into China, and it is only some of the earliest pieces which were probably made of indigenous ivory. The Chinese had to obtain their ivory, like their jade, from abroad. The later Chinese might have had some knowledge of the elephant in various ways. Although it had become extinct in China, its tradition lived on in works of art, in literary texts and in memories rekindled by the occasional incursions of herds from the south. There were elephants almost continuously at the imperial court. Mammoth remains were sometimes discovered, especially in the north. Meanwhile tusks were regularly imported. This was hardly enough to make the elephant familiar. It is significant that whereas Chinese artists excelled at other animal forms, they failed to master the elephant for lack of observation. The Indians on the other hand were able to reproduce in Ganesha the quintessence of an elephant, using only a semi-zoomorphic form.

Tusks

The most highly modified of all mammalian teeth are those of the elephant. Tusks are developed from one pair of continuously growing upper teeth which are incisors and not canines. The tusk grows from the skull, so that the tip is the oldest part. It develops in two directions. Firstly cones of new dentine or ivory form between the pulp and the ivory; they gradually lengthen the tusk, cone upon cone. Secondly the base of each cone is wider than the one before, so that the girth of the root of the tusk also increases all the time. This necessitates a wider socket, and remarkably enough the whole head of the elephant grows with its tusks.

A tusk may be considered in two parts. The root, which is of course embedded in the head, takes up about one-third of the length of the tusk; its principal characteristic is a conical cavity occupied by the soft pulp. Secondly there is the main tusk, which is solid but for a minute, so-called 'nerve' hole.

Tusks are covered with an uneven cement, enamel or rind, about 1.6mm thick except at the working tip, where it is worn off; raw tusks can be unattractive. Tusks vary with the species, sex and individual animal. The elephant usually leads with his right tusk; for this and other reasons tusks are often asymmetrical. The Indian Ganesha (*Ekadanta*) is often shown

with only one tusk. The African savannah bull may carry tusks up to three metres long, weighing over fifty kilos each, whereas the forest variety have shorter, straighter tusks. The Indian male is less well-endowed and some may have none at all, as in Ceylon. Tusks are not essential, but they have a role in sexual selection and in defence. African cows have smaller tusks, whilst Indian females have none, or mere 'tushes'; yet the cows live successfully. Indeed a tuskless bull will usually overcome an ordinary male because of his stronger trunk.[2] There are sometimes representations of elephants with six tusks in Buddhist art.[3] While no such species is known,[4] there was a bunodont mastodon with four tusks,[5] and it is conceivable that skeletons came into Chinese hands.

Tusks are strong, but like jade they will break if dropped on a hard surface. They deteriorate if temperatures vary abruptly, and tusks which are very old or which have been badly tended give stale ivory and much wastage. Some Chinese carvers allege they can distinguish tusks (and rhinoceros horns) taken from beasts freshly killed; they claim this 'blood ivory' is pink against the light[6] and that it has a transparent surface layer.

When it comes to carving, the hollow root has its limitation but, like bamboo, it provides a natural brush pot. As for the main tusk, it may have some cracks and its tip is only scrap ivory for toggles and the like. The 'nerve' is seldom central and it can leave an awkward hole which requires a plug. This is the origin of 'spot' in billiard balls. This solid part of the tusk may have a rapidly diminishing diameter; the carver must also meet this challenge and to appreciate his response an understanding of ivory is needed. Small amorphous lumps of ivory may form inside the pulp cavity as a pathological condition; such excrescences may be known as 'elephant pearls'.

Ivory

	Hardness	Appearance of tusk	Principal Origin	Comments
African Savannah	Soft	Large	East Africa, South Africa, Senegal	White ivory
African Forest	Hard	Smaller straighter and browner	Parts of West Africa	Best ivory, especially female. Some hard ivory may have come out of Zanzibar
Indian	Soft	Bulls only. None at all in Ceylon	India	White ivory. Smells when cut. Polishes less well
S. E. Asian	Hard	Bulls only	Burma, Siam, Indochina, China (extinct)	Somewhat similar to Indian

	Hardness	Appearance of tusk	Principal Origin	Comments
Mammoth	Soft and often stale	Very large and strongly curved	Northern Asia and elsewhere (extinct)	

Specimens of ivory differ, but an average chemical composition is:

Calcium Phosphate Ca_2PO_4	64	%
Organic matter (mainly collagen)	24	%
Water	11.15	%
Calcium Carbonate $CaCO_3$	0.10	%
Traces of other elements	0.75	%
	100.00	%

The proportion of collagen is 18%, so that it is hardly surprising that in a hot dry environment ivory should tend to collapse. As it dries, the formation cones and the growth rings separate until the piece disintegrates. Other properties of ivory are:

Specific Gravity	1.70/1.92
Index of Refraction	1.56
Resistivity at 22°C	2×10^8 ohm-cm
Hardness (Moh)	$2\frac{1}{2}$

The virtues of ivory are attributable not only to its constituents but also to its construction. The dentine is formed by a multitude of minute tubes, as little as 0.0169 mm in diameter and wonderfully ordered, so that when a tusk is observed in cross-section these tubes may be discerned starting from the centre in two systems. One system curves clockwise and the other anticlockwise. The two systems intersect, forming the very characteristic pattern of diamonds or lozenges, which diminish gradually towards the centre of the tusk. This engine-turned, decussating appearance is peculiar to ivory and makes it readily identifiable. The lozenges tend to be fainter in Indian ivory, while in mammoth ivory they have some different angles because of the curvature of the tusk (Fig. 1). However, in practice it is seldom possible to distinguish them. This is disappointing since the other teeth of the various species are totally different and readily distinguishable. Nor is there any distinction between male and female ivory, which is also regrettable because female ivory is virtually always African. Less visible and quite different from the pattern of tubes are the concentric growth rings or 'lines of Owen'.[7]

The construction may be complex, but it is admirable. Ivory is strong, uniform, resilient, enduring, pliable and stable. Pieces seldom split or splinter. It is superior to the teeth of other animals and to boxwood; there is no substance so satisfactory for carving. Its virtues and versatility are illustrated by the wide variety of objects made from it, such as woven mats, billiard balls, filigree fans, fish hooks, mallets, rulers, furniture, combs and the shafts of howdahs. Moreover, because of its composition and build, ivory will take a polish on all its surfaces. It then becomes unctuous and one of the tactile materials of China like nephrite, lacquer and silk. The polish of a Ming piece often seems to have increased with age, attaining

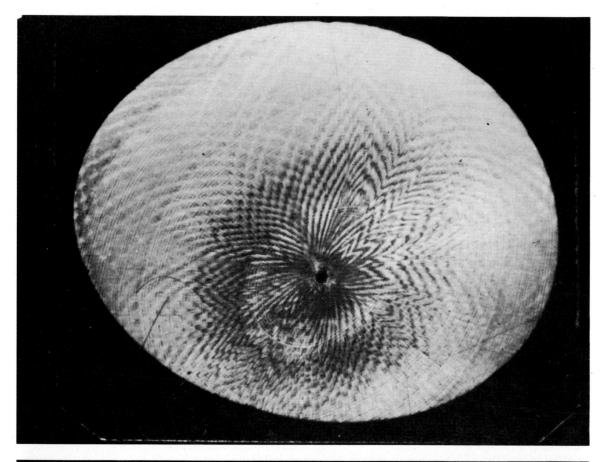

Fig. 1 An African elephant tusk. (*Above*) transverse cross-section; (*Below*) longitudinal cross-section. The widths of the segments photographed are 4 cm and 5 cm respectively. Courtesy of the Pitt Rivers Museum.

a vitreous patina. The surface of ivory is such that it is unsurpassed for painting or writing.[8] A criterion for ivory carvers is their ability to appreciate and exploit these properties of tusks and ivory.

Carving

The tools for ivory and wood carving are similar. The tusk is cut into pieces by a saw with a rather stiff blade. The rind is obdurate[9] and even the ivory calls for frequent lubrication with water, sometimes merely by dipping the saw in a bucket from time to time.[10] The pieces of tusk cannot be worked until the enamel is removed. A grinding stone may be used. The Chinese and Japanese are reputed to have heated and cooled the tusk repeatedly until the enamel cracked off.[11] Percussion with a hammer may also be employed. However these procedures may leave the ivory with cracks. We have seen in Upper Burma the rind removed simply with a chisel. The carver marks his piece with ink. He then proceeds to carve it with chisels, files, gouges, knives, a bow drill and other tools.[12] Polishing may be with a moist bamboo skin. A soft friable block is rubbed on the index and thumb of the left hand; the piece is then rubbed against these two fingers. Finally it is burnished with a cloth.[13]

The Colour of Ivory

The natural colour of growing ivory is mainly determined by the species and its diet. Thus Indian ivory is whiter than African, which is creamy white for animals feeding in the savannah, more brown for those in the Congo forests and rose tinted in the bamboo forests. The colour of dead ivory may be governed by its hardness, its age, exposure to light and environmental factors. Some West African ivories are reputed to retain their pristine pallor into old age. Certainly many old ivories are white, but this could be attributable either to the nature of the ivory, or to its history since it was carved. Some ivories have greater chromatic mutations than others and many specimens do not change evenly; there are sadly monochromatic pieces but most display a gradation of tonal values, so subtle as to constitute one of the main appeals of old ivory. Many oils are readily absorbed by ivory and they accentuate the grain and the colours; pipes and boxes used for opium are beautiful examples with cream, imperial yellow through oranges to an infinity of browns. Paint from the blade of a hacksaw may be sufficient to impregnate ivory. Oil from the human body and hands imparts colour, as may be seen on Assam arm bangles, or the side of a pendant worn against the body; but there are always disconcerting exceptions.

There is some disagreement as to the effect of light upon ivory, but the better opinion seems to be that it is only a bleaching agent. Sunlight blanches ivory, as some collectors have discovered to their cost, but there is no information as to the intensity required.[14] The fronts of statues are usually lighter, presumably because they are more exposed to light. Ming statues were often painted; yet beneath the paint the ivory is often surprisingly mellowed. It may be that it was so before it was painted over, or that some component of the paint affects the ivory, or simply that it matures gradually despite the exclusion of light.

The artistic colouring of ivory employs paint or stain. The Tang period ivories preserved at Nara in Japan are painted in several colours. A coat of pigment or gold may be laid on an underlay of lacquer or some other medium superimposed on the ivory. Adherence is poor so that although many pieces were painted, few retain their colour, despite attempts on some pieces to provide a key by criss-cross cuts. Stain penetrates the ivory and it is more persistent

but the choice of colour is smaller. The piece may be fumigated, boiled briefly (tea imparts its colour) or soaked in a solution.[15] There is no room here for a list of the chemicals used but they are not unusual: mercuric sulphide (HgS) for red,[16] malachite ($CuCo_3Cu[OH]_2$) for green and so on. More often than not, Ming figures have a beige hem to their robes which is probably caused by some oil-based pigment or undercoat.

Dating

The date proposed for ivories included in this exhibition are the fruit of art-historical study which draws on knowledge of the other Chinese arts, on the implications of archaeological contexts, on aspects of intellectual history and on the records of commerce. Judgment by connoisseurs and historians goes far towards a general dating of the carving, although in particular cases there can be much doubt. Scientific methods of dating the material, as distinct from its artistic treatment, have proved of interest where bone has been excavated from early sites which long antedate any of the items exhibited or described in this catalogue. Unfortunately there appear to be no instances of the useful application of the available scientific techniques to artistic ivories. These techniques however promise well for the future, always supposing they can be resorted to without unacceptable damage to the artistic work. The appearance, weight and tactile qualities of ivory are some indication of age to those who have long worked with it. Scientific tests which have shown to be useful in determining the age of at least ancient bone and ivory include notably the following:

1. Elemental analysis.
2. Radiocarbon.
3. Analysis of work on the ivory by the use of the scanning electron microscope to examine worked surfaces.[17]
4. Amino-acid racemization.

Thermoluminescence dating has been tried without success on other organic materials such as fossil bone and it is doubtful whether it can be usefully applied to ivory at all.

It may be helpful to consider very briefly some of these methods. Elemental analysis is based simply on the gradual decay of the collagenous material and its partial replacement by inorganic salts. Loss of protein is due to various factors such as hydrolysis or biological attack and it is dependent on temperature, pH and moisture. The percentages below, culled from the analyses of Baer, Jochsberger and Indictor (1977), illustrate the loss with age of carbon, hydrogen and nitrogen, but the increase in ash and fluorine.

	Ash	C	H	N	F
Modern Elephant ivory (Africa)	53.32	16.25	3.51	5.52	0.04
Elephant ivory believed to be 9th century BC	86.4	2.78	0.73	0.53	0.09
Elephant ivory believed to be 19th–18th century BC	93.07	0.87	0.25	0	0.3

Although fluorine concentrations increase with time and can be measured by spectrometry, this method has not been found very helpful with ivories. Racemization may depend on the site conditions. This is an analysis of the rate of change of structural alteration and interplay, which depends on external factors including environment and temperature in the history of

the piece. Conventional radiocarbon techniques are discouraging for ivory carvings because they require samples of 50–100 g. However the new accelerator method only needs a few milligrams of ivory.[18]

Materials similar to Ivory

There should be no difficulty in distinguishing ivory visually from other substances, provided the characteristic pattern can be seen. However if the specimen be poor, recognition may become a problem, for example with pieces artificially coloured or extensively decorated and etched, such as Japanese *netsuke*, or those which are small or very old. There are deceptive imitations of ivory used convincingly in the reproduction of French seventeenth-century crucifixes, but as yet simulated Chinese ivories do not seem to have attracted the same attention and skill. Other materials comparable to ivory in appearance or in employment are:

Artificial Plaster of Paris. Celluloid, which often has the longitudinal lines; it burns readily, unlike ivory. Modern plastics.

Bone Including the ribs of sea cows such as *Halicore dugong*.

Horn and antler

Walrus upper canines Up to a metre in length with a crystalline layer of grey dentine. Good material.

Sperm whale and other marine teeth Referred to vaguely as 'marine ivory'.

Narwhal teeth The single white twisted 'unicorn' sword tooth. It can be more than two metres long, but it is hollow and narrow.

Hippopotamus canines The canines are large, white and curved; they are exceptionally hard and therefore were once used for dentures.

Various mammalian teeth Rhinoceros, wild boar, bear, none of which attains any size.

Helmeted hornbill (Rhinoplax vigil) The casque of the large beak of the cock, unctuous, very pale orange with a vivid red rind. Of exceptional value.

Vegetable ivory Nuts, usually the American *Phytelephas macrocarpa*. It soon acquires a rather dirty greyish appearance.

Fossil ivory True ivory but sometimes so degraded that it is difficult to identify, e.g. odontolite, which has the appearance of turquoise.

Many of these substances only occur in pieces suitable for small carvings and the better among them are more expensive than ivory.

PETER FAWCETT

Notes

1. As much as 20 tons reached the London market in 1900.

2. U Toke Gale, *Burmese Timber Elephant*, Rangoon, 1974.

3. Such as the celebrated bronze elephant in the Wan Nian Temple on Mount Omei weighing about 62 tons and 7.4m high which was begun in 980 in the reign of Tai Zhong. It is painted white and harnessed; upon its back Buddha Puxian is seated.

4. Because of a deformity a bull may sometimes be found with several tusks. Musée de Paléontologie in Paris possesses interesting specimens.

5. The Tetrabelodon of the Upper Miocene age (some 11 to 15 million years ago) which roamed in China, India and Europe. It bore a pair of tusks in the upper jaw and another pair in the lower jaw. In the Buddhist story Queen Kasi 'was brought the skull' of an elephant with six tusks, belonging of course to her former husband, the future Buddha. The origin of this six-tusked elephant could be imaginary, or some deformed specimen, or the Tetrabelodon.

6. See reference to bamboo forest ivory below.

7. Sir Richard Owen, 'On the Ivory & Teeth of Commerce', *Journal Royal Society of Arts*, 1856.
T. K. Penniman, *Pictures of Ivory and other Animal Teeth, Bone & Antler*, Pitt Rivers Museum, Oxford, 1952.

8. Xu Beihong's galloping horse and a long inscription may apparently be drawn on a piece of ivory 3 × 6mm, which is little more than a grain of rice in size. (*China Reconstructs*, February 1983, pp. 58–59.)

9. The rind is 4 on Moh's scale.

10. This method is used every three or four years to 'tip' working elephants, that is to saw off the tip of the tusk; it will by then have lost its enamel. This increases the supply of tips for toggles and small carvings. U Toke Gale *op. cit*.

11. This process was used for extracting minerals such as jadeite.

12. For Indian and Japanese tools (plates and text) see Kunz, pp. 256–278 and illustrations A de C. Sowerby, 'China's Ivory Carving Industry', China Journal, 1936, pp. 151–154. (Reproduced Warren E. Cox.)

13. C. I. A. Ritchie, *Ivory Carving*, Arthur Barker, 1969.

14. Piano keys were commonly bleached in diluted hydrogen peroxide and then exposed to sunlight for 1 to 7 days. G. F. Kunz, *Ivory and the Elephant in Art, Archaeology and in Science*, Doubleday & New York, 1910, p. 251.

15. Pieces displayed in a cabinet, where the lining was fixed with a rubber solution, turned a vivid orange. Tests revealed sulphur impregnation. F. J. Cooper, *The Museums' Journal*, No. 1, p. 23 (1939) and No. 6, p. 168 (1955).

16. Described by Warren E. Cox, *Chinese Ivory Sculpture*, Bonanza, 1946, p. 110 as 'mercury chloride', which would not seem correct.

17. The determination of nitrogen sorption isotherms on surfaces more recently cut, which is still a very uncertain method.

18. Carbon 14. The new method is undergoing development at Oxford University and also at half-a-dozen laboratories outside Britain.

Pre-Ming Ivory Carving

The earliest finds

The earliest known carved ivories of a non-utilitarian nature have been found at the Hemudu site in Zhejiang, a dating to 5000 BC making it one of the earliest known neolithic sites in China.[1] One of the several remarkable things about this well-preserved site is the occurrence of a large number of decorated pottery objects, bones, wood and ivory. The twenty-odd ivory objects all came from the fourth, lowest, layer. Some of them, such as the 'butterfly-shaped' perforated plaques, are similar in shape and decoration to bone objects. The most notable feature of the decoration is a 'split representation' of a bird (Fig. 1) which is also found on similar bone objects, but in this case with the profiles of the bird's head sometimes turned outward. The decoration is executed in thin incised line and includes concentric circles, often with drilled depressions or perforations in the centre. In the case of the present piece, the set of concentric circles is surrounded on the outside with a flame-like frame, described by the excavators as 'a pair of birds facing the sun'.[2] It may be noted that carvings in ivory at Hemudu are closest in style to those of bone, although 'butterfly-shaped' plaques occur also in stone and wood. The jades of Hemudu, limited to simple rings and arcs, have little in common with the ivory objects in form or decoration.

The Shang dynasty

The ivory finds at Shang sites at Anyang are not as numerous and as varied as artefacts of bone or jade, but are nevertheless significant and relatively more plentiful than finds from archaeological sites of later historical periods. At the royal tomb 1001 at Xibeigang in Anyang, ivory finds include fragments of a bowl and a cylindrical 'vessel' (lacking a base which may have once existed) and fragments of handles and ornamental parts carved in the form of horns and other parts of animals. These are generally decorated with carved animal motifs on a ground of 'thunder' spirals.[3] Most notable among the smaller ivory carvings are the 'animal teeth' (oblong flat plaques with one of the longer sides slightly curved and a saw-tooth edge on the opposite side) and bottle-shaped horns which are probably finial ornaments. Of the over one hundred hair-pins removed from tomb 1001, most are of bone and a few are of jade, stone and ivory. The ivory hair-pins are nearly all of the simplest design, i.e. without an ornamental top, with the exception of one piece which has a flat plaque-like top shaped like the Chinese character for sheep or ram, *yang*. In the excavation report this piece is described as 'probably ivory'. No. 4 in the present exhibition is exactly of this shape.

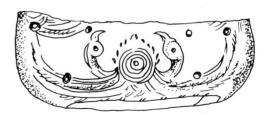

Fig. 1 Line drawing of carved ivory object from Hemudu.

Li Chi, in his study of the hair-pins from the pre-1937 excavations of Shang sites in Anyang,[4] classified them into eight major types. All of them, with the exception of the 'ram-top' type discussed above, have been found in the recently excavated tomb no. 5, the tomb of Fu Hao, in Anyang.[5] The Fu Hao finds perhaps confirm Li Chi's dismissal of the 'ram-top' type as the crudest of the ornamented hair-pins (hence not prepresented in the burial chamber of a royal tomb), but negates his hypothesis, based on evidence available to him, that the various designs may have some relation to the social class of the wearers. It is also interesting to note that whereas the hair-pins of tomb 1001 were nearly all recovered from the filling of the tomb, the several hundred bone hair-pins from the Fu Hao tomb were nearly all found in a 'wooden casket' in the central part of the burial chamber. The 'casket' contained also the three major ivory objects in the Fu Hao burial.

A pair of large ivory-handled beakers and a ewer are among the most spectacular finds from the Fu Hao tomb. They are elaborately carved all over and the pair of beakers are inlaid with turquoise to highlight the primary decorative patterns. The beakers are shaped like a bronze *gu* but with a very large handle extending to the full height of the vessels (Fig. 2). The decorative schemes on the body of the beaker follow the classification formulated by Kao Ch'u-hsün,[6] for all the large bone vessels found in tomb 1001 at Xibeigang. The schematic drawing of the decoration on one of the large *gu* from tomb 1001 is reproduced in Fig. 3 for comparison. The surface is divided into four horizontal bands. The uppermost and bottom registers are decorated by masks. The narrow band above the bottom register is occupied by a frieze of *kui* dragons, horizontal cicadas all pointing in the same direction. The second register, the main decoration, is dominated by a mask with antler-like horns, and issuing from the mouth of the mask is a triangular pattern with a pair of inverted *kui* dragons on either side. This vertical grouping of patterns is repeated three times around the sides of the beaker. The large handles are shaped like birds at the top, and the lower part is decorated on either side with a vertical *kuei* dragon, the body of which is also joined to an animal head in high relief.

Fig. 4 illustrates the most complex design found on the several large *gu*-shaped bone beakers from tomb 1001. In this piece, the triangular pattern below the main mask on the second register is occupied by another mask which in turn extends to another triangular pattern. One notable feature of this decoration, common to all decoration on ivory and bone articles of any size, is the liberal use of long curved and hooked flanges which extend from the masks or profiles of animals and birds. These flanges form the horns of the masks or animal profiles or plumage in the case of patterns suggesting birds. The effect is one of ambiguity between representation of masks and animal forms on the one hand and geometric patterns, based on parts of animal forms, on the other hand. It may as readily be said that the animal forms are made up of geometric elements, as that the animal forms are dissolved into curvilinear pattern.

There is also an ambiguity in the treatment of the masks, which often combine human and animal characters. The masks in nearly all ivory carvings of the Shang period have human eyes, adapted to the form of the oracle-bone character for *mu* (eye), rather than the alternative convention of a rectangle with rounded corners and a central slit. In this respect a *taotie* in the British Museum (No. 4) is exceptional, although it may be argued that this piece is an ivory substitute for jade, as there are a large number of small jade carvings in the form of this small mask. There are however a few masks on bronzes and jades with obvious animal horns combined with conventional human eyes.

The similarity of decoration found on Shang bronzes and ivories arises from a shared stock of motifs. The main difference is that the arrangement so often found on bronzes, in which

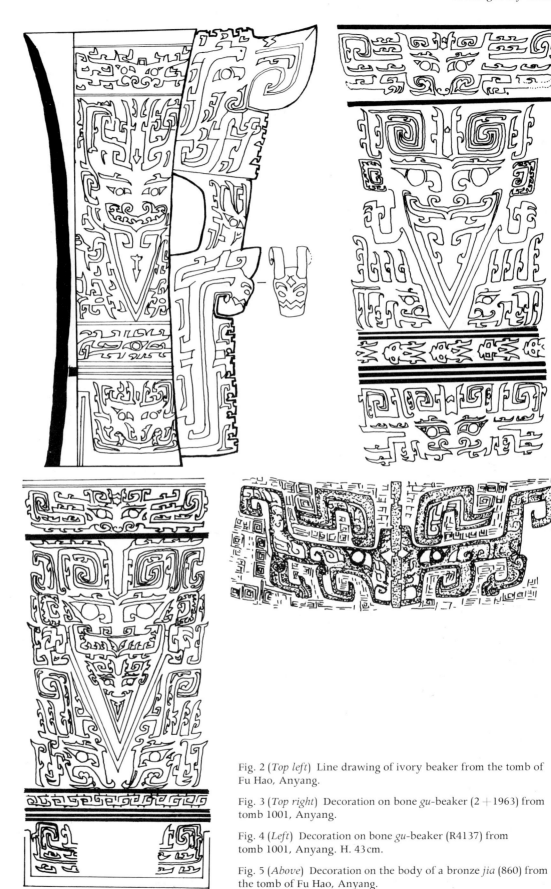

Fig. 2 (*Top left*) Line drawing of ivory beaker from the tomb of Fu Hao, Anyang.

Fig. 3 (*Top right*) Decoration on bone *gu*-beaker (2 + 1963) from tomb 1001, Anyang.

Fig. 4 (*Left*) Decoration on bone *gu*-beaker (R4137) from tomb 1001, Anyang. H. 43 cm.

Fig. 5 (*Above*) Decoration on the body of a bronze *jia* (860) from the tomb of Fu Hao, Anyang.

the mask is made up of two confronting *kui* dragons on either side of a raised flange (Fig. 5), never occurs on ivories. The mask on ivories is always a coherent face, which occurs on carvings of other materials such as jade and bone, but more rarely on bronzes. Further, the main features of the masks on the bronzes from Anyang, i.e. the pair of confronting *kui* dragons, are distinct from the background, which is made up of a pattern of square spirals, and in this way the mask is more discreet and coherent; whereas the masks on ivory vessels lack this contrasting background, the patterns which make up the rest of the decorated surface being either geometric elements extending from the mask itself or made up of other animals and birds. Consequently the ivory decoration, although coherent in design, appears more diffused or dissolved, and the split masks on bronzes, made up of two animal profiles, are coherent and forceful.

The difference in materials will however explain much if not all of the apparent differences in the decorative style. The raised central flange separating the two halves of the mask on bronzes would be difficult to achieve on ivories, but it seems to be a technical necessity on bronzes. And when there is an attempt to decorate the ground on ivory pieces, such as No. 1 and No. 7 in this exhibition, the area is usually not extensive enough to create an impression of a distinct mask on a spiral ground. The only exception appears to be a piece in the Musée Guimet.[7] It is interesting to observe that when *kui* dragons appear on ivories, they are placed a little pace apart on either side of the triangular pattern or follow each other head to tail in a continuous band around the sides of the vessel. They are never placed head to head to make up a *taotie* mask. What is said above of the characteristics of the decoration on ivories from Anyang applies in a large degree to the decorations on jade and stone vessels, at least those with a narrow body. In the case of large jade and stone carvings there are often two distinct profile bodies coming out on either side of a coherent frontal mask.

The decorative style of Shang ivories corresponds totally to bone carvings, except in one respect. It has been well observed that the motifs of the decorations on the opposite side of a certain type of spatulae are always different even if the general scheme of the motifs is similar.[8] Thus if a dragon appears on a certain area on one side of the spatula, a different type of dragon or a phoenix occupies the equivalent position on the other side. The same would apply to the more geometric patterns. A square spiral on one side would be matched by eye patterns on the other. This phenomenon is not found on small jade or ivory carvings where the same pattern appears on both sides of a piece if it is carved on both sides.

The Zhou dynasty

The piece from the Musée Guimet, No. 8, is one of the few pieces of early ivory that can be dated with any certainty to the Western Zhou period. The treatment of the bird motif, with the repeated use of curved lines forming spirals, is similar to jade carvings of the same period. There have been very few finds of ivories on excavated sites of either the Western or Eastern Zhou periods. One great exception is the recently published site at Qufu in Shandong province, capital of the state of Lu.[9] The excavation was carried out mainly at the burial grounds of the ancient city of Qufu, covering almost the entire Zhou period. From the Eastern Zhou burials a considerable number of important ivory objects were found, including a string of ivory beads and a comb of the early Eastern Zhou period, and in other Eastern Zhou burials all manner of personal ornaments and elaborately carved ivory plaques and finials, archer's thumb rings, and two back-scratchers with the hands carved in great detail, the finger nails long and the palms covered with curvilinear pattern. The handle ends of the back-scratchers

are carved in the form of dragon heads (Fig. 6). Evidently the carving techniques at this time were sufficiently advanced for treating ivory in the same manner as wood and to give them decorative patterns that one finds also on lacquerware of the same period. Also this is the beginning of the use of ivory finials in the form of dragon heads similar to those made in gilt bronze and jade, a tradition which was to last for nearly two thousand years. The exhibition included two bone pieces of the late Eastern Zhou period (Nos 9 and 10) which represent two of the most common objects of bone and ivory of the period.

The very existence of ivory objects of the Zhou period raises the intriguing question of the source of the material. If the climate in north China was warm enough for elephants down to the late Shang period, it was highly unlikely that it remained so for another eight hundred years to the end of the Zhou. The find of ivory objects in north China would thus indicate trade with south China where elephants have been known to exist down to perhaps as late as the fourteenth century. By the time of the Warring States, ivory was known to come from the south. The *Zhanguo ce* relates a conversation of the fourth century BC between the Chu king, Huai Wang, and Zhang Yi in which the king said that: 'gold, pearls, rhinocerous (horns) and elephant (tusks) are produced in the state of Chu'.[10] In the *Huainan Zi* (second century BC) it is recorded that the First Emperor of Qin 'had the advantage of rhinoceros horns, ivory, kingfisher feathers and pearls from Yue'—an area including Guangdong and north Vietnam. The finds of wooden models of ivory tusks and rhinoceros horns in the Mawangdui Tomb no. 1 in Changsha, and pottery models of the same in early Western Han burials in Guangzhou also show the value set on ivory and rhinoceros horn.[11] Considering the large volume of trade with merchants from the South Seas reaching Guangzhou from the third century BC on through the entire Han period, it is likely that ivory was already an important item of import from Vietnam, and perhaps also from India.

The Han dynasty and the Six dynasties

There is sadly little material relating to the elephant or ivory in the Han period, either in literature or as objects. The official histories record trade in ivory and elephants sent as tributes from the south, and apart from the models already mentioned, there has not been direct or indirect evidence for ivory from the many Han excavations in China. The reason for this may be that ivory was still a relatively scarce commodity used mainly for the ornamental parts of furniture and chariots, such as would not find their way into burials; and perishability

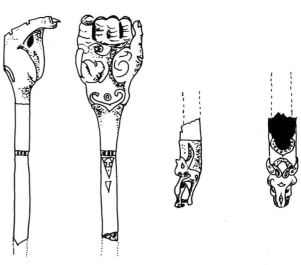

Fig. 6 Drawing of the two ends of a back-scratcher from the site of the city of the Lu state at Qufu.

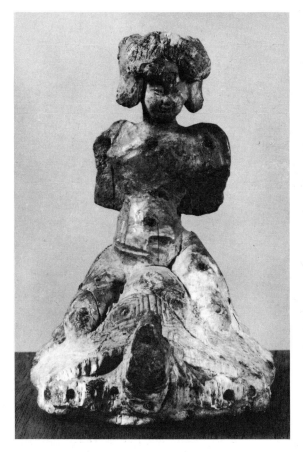 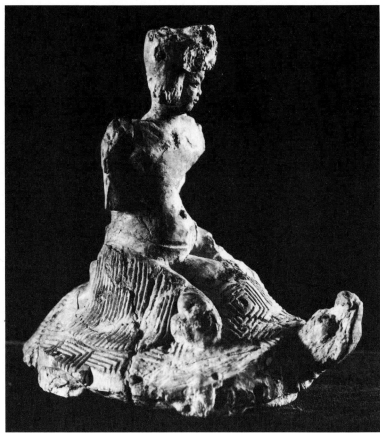

of the material must also be a factor contributing to the scarcity of extant ivories from all early periods.

One of the most important archaeological finds of carved ivory of the period is that from a Western Han tomb near Nanchang in Jiangxi province. Eight pieces of ivory were found of which four are annular discs of the *bi* type with 'grain' pattern on one side and the other side plain; and one is of the *yuan* type (the central opening relatively larger than that of the *bi*); another is a bracelet of hexagonal cross-section similar to a large number of known pieces of agate of the Warring States period. The remaining three pieces are all associated with a bronze sword: a scabbard chape, a scabbard slide and a pendant in the forms of a dancing figure found by the side of the sword. All these pieces have counter-parts in jade and other hardstones. The dancer-pendant, of which a well-known example in jade is in the Asian Art Museum of San Francisco, is particularly interesting as this is perhaps the first time that a pendant of this type has been found in a context which suggests its use as an ornament for a sword. A report of November 1983 speaks of the recent discovery, in the city of Guangzhou, of the tomb of the second king of Nan Yue, a southern Chinese kingdom of the early Western Han Period with its capital in Guangzhou. The discovery was hailed as of equal archaeological importance to that of the tomb of Liu Sheng, Prince Jing of Zhongshan, and his wife at Mancheng and of the tombs of the family of the Marquis of Dai at Changsha. Among the objects discovered, which number over one thousand, are bronzes, iron objects, pottery, lacquer, jade and hardstones, gold and silver textiles, bamboos, and ivories, the detailed descriptions of which have yet to be announced.[11a]

The history of ivory in China during the period of the Six dynasties is more interesting than that of the preceding era, even if extant examples are equally scarce. There is a curious

Fig. 7 Figure of a female seated on a tortoise with blue stone or paste inlay. H. 10.8 cm. 5th or 6th century AD. Charles B. Hoyt Collection. Museum of Fine Arts, Boston.

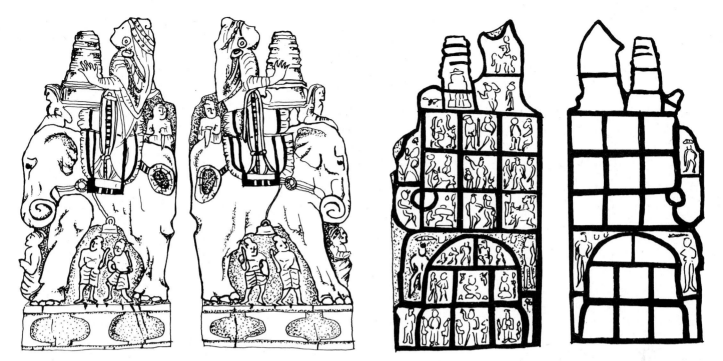

Fig. 8 An ivory travelling shrine. H. 15.9 cm.
The drawings show the outer and inner sides of each half.
The elephant carries a reliquary in the form of a stupa.
The inner surfaces are divided into compartments containing trinities of images, and other scenes of Buddhist story not easily identifiable (not all these scenes could be drawn).
Property of the Gansu Cultural Properties Administration.

ivory carving in the Museum of Fine Arts, Boston, which represents a female figure seated on a tortoise. Both the figure and tortoise have inlays of a blue stone or paste, now mostly lost (Fig. 7). This carving can be tentatively dated to the Southern Dynasties on account of the somewhat unusual head-gear of the female figure, which finds a parallel in certain pottery female figures surviving from Eastern Jin and Southern Dynasties tombs near Nanjing.[12] The tortoise, with head raised, serving as a pedestal or vehicle would have been a familiar sight in the Nanjing area, as the rulers of the Southern Dynasties were inveterate builders of grand cemeteries with monumental stone sculptures of fabulous animals and steles with tortoise pedestals. Stone steles with tortoises even became a common theme in *Wu ge*, the folk-songs of the Nanjing Southern Dynasties.

Given the considerable traffic between southeast China and countries in Indo China and the Malaysian peninsula during the Six dynasties period, there should have been no shortage of ivory, even if little of it has survived to this day. This is also the time of the earliest mention in Chinese literature of ivory carvings of Buddhist subjects. In 484 AD the Indian monk Nāgasena who was sent by the King of Funan, Jayavarman, to request Chinese intervention in this country's dispute with Linyi (Campa). Nāgasena brought with him gifts of various treasures including an image quoted by Laufer as an 'elephant', carved out of white sandalwood, and two ivory pagodas. In 529 and 530 the countries of Panpan and Dandan (in the northern part of the Malayan peninsula and closely related to Funan) respectively sent embassies to the court of Liang dynasty with gifts including ivory carvings of images and pagodas. In his biography the rebellious general, Hou Jing (died 552), is said to have made a habit of wearing an ivory comb.

The most remarkable record of an ivory object in this period is that of the supposed discovery, during the Datong era (534–545) in the county of Shangyin, of an ivory sculpture of an animal. It is described as made of two halves, the inner surfaces of which are carved with Buddhist images, twelve on one side and fifteen on the other.[13] In structure and form, this sculpture is closely similar to an ivory Buddhist travelling shrine belonging to the Gansu Cultural Properties Administration (Fig. 8).[14] This diptych is proposed to be Chinese work

of the late seventh century, possibly manufactured in Changan, a copy of an original from the Gandharan-Jibin area in which Chinese elements are included.[15] Features such as the base of the external sculpture and the treatment of the lotus seats for the Buddha images on the interior of the piece point to early Tang China for the date and provenance of the piece. This ivory sculpture is not only the most important and interesting piece of Chinese ivory carving of the Tang period known to us today but it also represents an excellent example of the eclecticism characteristic of most of the arts in the metropolitan areas of early Tang China. Fortunately we are able to include in this exhibition another piece of about the same period and embodying an equally eclectic style: No. 11, an ivory stand in the Cleveland Museum of Art, which is the subject of another detailed study.[16] Through the study of the lotus throne and other decorative elements of this stand, and by comparing various iconographic elements with Indian proto-types, this piece also is established as work of the mid-seventh century, and possibly also a product of Changan.

The Tang dynasty

Other ivory or ivory-inlaid objects of Tang China are known, of which the most common is the comb-back, No. 12 in this catalogue, a well-known piece in the collection of the Museum of East Asian Art in Berlin. Again, the iconographical elements on this comb-back may be traced to Indian and Central Asian origins (see discussion in the catalogue entry for this piece). It may be of interest to note that the *paiban* (clapper), the percussion instrument held by the seated figure in the centre of this comb-back, was sometimes also made of ivory in both the Tang and Song periods. The Song author Yu Wenbao tells the anecdote in which the poet Su Dongbo asked one of his assistants to compare his poetry to that of Liu Yong's. The reply was: 'Liu Yong's *ci* should be sung by teenage girls holding a red (stained) ivory clapper, but yours must be sung by a big man from Guangxi, beating on a large iron sheet.'[17] The use of clappers, perhaps of ivory, can be seen in the painting of the *Night Revels of Han Xizai* attributed to the tenth-century artist Gu Hongzhong.

The Shōsōin in Nara houses several ivory musical instruments of the Tang period, including vertical and transverse flutes. There is also an elaborately carved pipa plectrum of red ivory.[18] Other musical instruments, gaming and chess boards and boxes in the Shōsōin have ivory inlays and there is also a pair of dice for the game *shuanglu*. Presumably all such articles must have been used in China, but as there is no imperial treasury in China going back to the Tang period none of these objects have survived there except for a few rulers excavated from Tang tombs and collected by late Qing scholars interested in weights and measures. A study of the Chinese foot-measure has listed a number of Tang ivory rulers in Chinese and Japanese collections, the ones in China all archaeological finds during relatively recent periods and those in Japan preserved from Tang times in temples and the Shōsōin.[19] Ivory rulers have been recovered also from Han and Song tombs, but those of Tang are the most numerous and the most fully decorated.

The term red ivory in Tang and Song times did not necessarily mean 'painted' or 'stained' red. The elephant tusks from the districts Chaozhou and Xunzhou in the eastern part of present day Guangdong province were described in the Tang period as small and red in colour 'most suitable for making *hu*'.[20] The *hu* is a ceremonial tablet held by senior officials during formal audiences at court. According to Tang records only officials of the fifth rank and above were permitted to use *hu* of ivory, other ranks being confined to bamboo and wood. In the Shōsōin are ivory *hu* answering to contemporary Tang descriptions and con-

firming the record that the *hu* carried by Tang officials is rounded at the top and square at the lower end.[21] In certain ceremonial dress ivory hair-pins were prescribed.[22]

Probably one of the largest uses of ivory during the Tang and Song periods was that of making decorative fittings and finials for large ceremonial carriages called the *lu*. This is a tradition going back to the beginning of the Han dynasty when five types of carriages were made in accordance with the brief mention in the *Zhou li* (one of the books of rites collated and in part written in the late Zhou period) that the Emperor used five carriages, which were decorated respectively with jade, gold ivory, leather and wood to be used on different state occasions.

The Tang emperors' attitude to these stately carriages is typical of their reaction to most classical tradition attributed to Zhou times. The emperors tolerated the existence of the carriages, but did not take to them. Gaozu (618–626), the first emperor, preferred to be carried in a chair on the way to perform state ceremonies. This practice continued to the time of Xuanzong (712–755), who compromised by driving in the *lu* to the ceremony but returned on horseback, and thus began the tradition of Tang emperors riding among the imperial guards on state occasions. Even however if the imperial *lu*-carriages were put on display rather than to actual use, princes and officials of the highest rank who were permitted ivory carriages (jade and gold carriages being reserved for the emperor) actually rode on them. The tenth century Arab geographer Marsudi, in discussing ivory from east coast of Africa, also noted the use of ivory palanquins in China by royal personages and officials of high rank.[23]

The Song and Yuan dynasties

The Song emperors took quite opposite views from their Tang counterparts regarding ancient rites, and were careful to perform state ceremonies correctly. The Song History contains a large section on the five *lu*-carriages, recording discussion as to the proper design and the details of the various parts. During the Southern Song period the state carriages measured nineteen *chi* (about 20 ft) in height and the length of the axle was over fifteen chi (over 16 ft).[24]

Given the lavish use of ivory for ornamenting carriages and horse fittings during the Song period, it would still be difficult to account for the almost total absence of any ivory object which can be dated with certainty to any part of the three centuries of the dynasty, especially as there was an active overseas trade with ivory producing countries throughout this period. Twelfth-century writers on overseas trade like Zhou Qufei and Zhao Rugua knew of the origin of different types of ivory and the manner of capture of elephants.[25] There are numerous records preserved in the Song History, the *Song huiyao* and other historical writings dealing with 'tribute' from foreign countries in which ivory is one of the main items. The number of tusks and their total weight are sometimes recorded. It may be of interest to note that among the foreign countries sending tributes of ivory to the Song court is the central Asian state of Khotan. This is perhaps testimony to the success of the Khotanese as traders in central Asia. The *Song huiyao* lists an ivory workshop under the office of Wensi Yuan which administered altogether thirty-two workshops for the production of finer articles of daily and ceremonial use for the palace and officials. Presumably it produced such items such as ivory pomanders mentioned incidentally in the *Zhu Fanzhi*.[26]

The story of ivory in the Liao and Jin states of north China is not more exciting than that for the Song, although there is at least one reported find of an ivory comb in a Liao tomb.[27] The Liao and Jin courts also followed half-heartedly the use of Chinese state carriages, the Jurchens

having the additional advantage of having captured Northern Song court accoutrements for their own use. The Jin History records the regulations forbidding commoners to use precious material such as gold, jade, ivory, rhinoceros horn, glass and agate for utensils or for horse trappings and sword and knife hilts and scabbards.

The Yuan History describes the *lu*-carriages in great detail, specifying the exact form of decorations and finials in jade and ivory, etc. Most of the finials are in the form of dragon or *chi*-dragon heads – which reminds one that the jade carving of a dragon's head in Yuan style formerly in the Gure collection may well be one of such finials.[28] Decorative finials of various precious materials can also be seen in the wall paintings of the Taoist temple, Yongle Gong, preserved from the Yuan period. The Yuan design for the ivory carriage included whole chairs of ivory. Nevertheless, it is doubtful whether the Yuan court ever made their own ivory carriage according to their specifications. It is recorded that in the year 1321, the emperor Yingzong ordered the construction of the five *lu*, and in the same year the jade carriage was completed, but work on the other four was abandoned before completion.[29]

In the Yuan bureaucracy the ivory workshop was once again a part of the *Jiangzuoyuan* as in Tang times. In this workshop ivory decorative plaques such as those of jade from the Yuan period must have been made. The plaque in the Metropolitan Museum (No. 13 in this exhibition) with *chi*-dragons carved in detail and high relief may possibly be a survivor from this period, although a Ming date cannot be ruled out. In any case, the *chi*-dragon motif which became popular during the Yuan dynasty (as a revival of a favourite motif of the Han), and appeared frequently on lacquerware, porcelain and jade carvings of this time, continued to be used through the Ming period but in progressively simpler forms. The early fourteenth century saw the beginning of many artistic styles and decorative motifs (or new treatment of old motifs) that was to last for the next two dynasties. This also applied to the areas of Taoist and Buddhist art, both of which flourished in the Yuan period with some official encouragement and aided by the rapid spread of popular Taoism and Buddhism. Given the relatively large number of ivory carvings of Buddhist and Taoist figures in the Ming period, it is tempting to look for the origin of their styles and iconography in the Yuan period by analogy with the development of late Buddhist and Taoist painting and sculptures in other media. Attribution of ivories of this class to the Yuan period remains however speculative. Two items of this exhibition, the Buddhist triad (No. 14) and the Taoist immortal (No. 15), display sufficient characteristics of the Yuan style to suggest a tentative date of fourteenth century, but in the opinion of some conform more closely to the style of figures made in the later Ming (*v.* p. 107 below).

It is also likely that the demand for ivory in the Yuan palace workshop was comparatively small in relation to the total quantity of imported ivory. The Yuan court was in some ways prodigal in its lavishness, but the style of the Mongols was different from the Han Chinese. Beyond making decorative plaques (especially for belts) and other personal ornaments, it is unlikely that there was too much palace demand for dainty objects such as pomanders and finely decorated musical instruments. As noted above, the plan for the building of an ivory carriage in 1321 was abandoned. Lack of real interest and the growing unrest in the country probably contributed to the abandonment of official patronage. There would then be proportionately a greater amount of ivory available for making objects of popular appeal for the commercial market, and Taoist and Buddhist figures may have been included in this category.

JAMES C. Y. WATT

Notes

1. The Zhejiang Cultural Properties Administration and Zhejiang Provincial Museum, 'Excavations (first Season) at Hemudu in Yuyao County, Chekiang Province', *Kaogu xuebao*, 1978, no.1, p.39 (Chinese).
Hemudu Archaeological Team, 'Excavations of Second Season at Hemudu Site in Zhejiang Province', *Wenwu*, 1980, no.5, p.1 (Chinese).
Mu Yongkang, 'On Hemudu Culture', *Proceedings of the First Annual Meeting of the Chinese Archaeological Society*, Wenwu Press, Peking, 1979, p.97 (Chinese).

2. Hemudu Archaeological Team, *op.cit.* caption to Fig.6.

3. Liang Ssŭ-yung & Kao Ch'u-hsün, *Hou Chia Chuang* (The Yin-Shang Cemetery Site at Anyang, Honan), Vols I and II: HPKM1001, Institute of History and Philology, Academia Sinica, Taipei, 1962.

4. Li Chi, 'Eight Types of Hairpins and the Evolution of their Decorative Patterns', *Bulletin of the Institute of History and Philology*, Academia Sinica, Taipei, Vol.XXX (1959).

5. The Institute of Archaeology, Chinese Academy of Social Science, *Tomb of Lady Hao at Yinxu in Anyang*, Peking, 1980.

6. Note 5 above, pp.266–279.

7. Jenyns, S. & Watson, W., *Chinese Art, the Minor Arts* II, New York, 1965, pl.108.

8. Glum, P., 'Rain Magic At Anyang?', *Bulletin of the Museum of Far Eastern Antiquities*, no.54 (1982), cf p.258, Stockholm.

9. The Shandong Institute of Archaeology, etc., *Qufu luguo gucheng* (The Ancient City of the Lu State at Qufu), Qinan, 1982.

10. Crump, J. I. (trans.), *Chan-kuo Ts'e*, Oxford, 1970, pp.240–242.

11. Hunan Provincial Museum and Institute of Archaeology, Academia Sinica, *Changsha mawangdui Yihao Han mu*, Peking, 1973, Vol.1, p.120.
The Guangzhou Cultural Properties Administration & the Municipal Museum of Guangzhou, *Guangzhou Han mu*, Peking, 1981, Vol.I, p.128, pl.XXV, 9.

11a. Regarding the Han pieces mentioned see Jiangxi Provincial Museum, 'The Western Han cemetery in the Eastern Suburbs of Nan-Ch'ang', *Kaogu Xuebao*, 1976, no.2, pp.171–186, pls VI, VII. The *Guangming ribao* of 11 November reports briefly the discovery of the tomb of the second king of Nan Yue. Chen Mengjia in his article 'A Reconstruction of the Han Dynasty calendar based on the Han slips' (Kaogu xuebao, 1965, no.2), and J. Needham in his *Science and Civilisation in China*, vol.3, pp.303–5, discuss the Chinese diviner's plate, of which at least one catalogued example was made of ivory. The author thanks Wu Tung, Diane Nelson and Denise Leidy for bringing archaeological reports of Han sites to his notice.

12. *Jiangsu sheng chutu wenwu xuanji*, Peking, 1963, Fig.142.
See also other figures from Eastern Jin and Southern Dynasties published by the Nanjing Museum in Kaogu, 1983, no.4, pl.V.7 and figs6, 8 on p.332.

13. *Liang Wudi's Edict on an Ivory Image* (538), collected in *Guang hongming ji, juan* 15, to be found in the *Taishō Tripitaka*, Vol.25, book no.2103, pp.203–4. This obscure piece of information was first brought to the notice of art historians by Omuna Seigei in his Shina Bijutsu-shi, Choso-hen, Tokyo, 1915. The previous references are to the dynastic histories: *Nanqi shu* 58, *Liang shu* 54.

14. Gu Tiefu, 'On the Xiangya Zhaoxiang'.
Yen Wenru, 'On the Xiangya Zhaoxiang', *Wenwu cankao ziliao*, 1955, no.10, pp.80, 81. Gu notes the similarity between the Gansu piece and that described in Liang Wudi's Edict of 538 AD.

15. Soper, A. C., 'A Buddhist Travelling Shrine in an International Style', *East and West*, New Series, Vol.15 (1965), pp.211–225.

16. Lerner, M., 'A Seventh-century Chinese Buddhist Ivory', Bulletin of the Cleveland Museum of Art, LV, no.9 (1968), p.295ff.

17. Yu Wenbao, *Chui jian lu*.

18. cf *Tang shu* 21, where ivory plectrums are mentioned.

19. Yang Kuan, *Zhongguo lidai chidu kao* (The Foot-measure in Chinese History), Shanghai, 1957.

20. Liu Xun, *Ling biao lu yi*. This passage on ivory from South China was often quoted in cyclopaediae of the Song and later periods. Song writers also described the ivory from Campa as 'small and reddish in colour'.

21. cf *Jiu Tang shu* 25; *Tang huiyao* 33.

22. *Xin Tang shu* 24.

23. Masudi, *Muruj al-Dhabah wa Ma'adin al-Jawbar*, French tr. *Les Prairies d'Or* by C. B. de Meynard and P. de Courteille. Paris, 1861–77, Vol.III, p.8. Berthold Laufer referred to this passage in his pioneering work *Ivory in China*, Chicago, 1925.

24. *Song shi* 149.

25. Hirth, F. & Rockhill, W. W., *Chau Ju kua*, St Petersburg, 1911, pp.117–18, and p.232.

26. *Ut sup.*, p.232. In the Chinese characters (Xiangnang) for pomander, or scent holder, there is a misprint of *die* for *nang*.

27. Jin Fengyi, 'The Liao Dynasty Tomb at Qianchuanghu Village in Chaoyang County, Liaoning Province', *Wenwu*, 1980, no.12, p.17, fig.27.

28. Arts of the Sung Dynasty, *Transactions of the Oriental Ceramic Society*, Vol.32 (1959–60), Cat.no.280.

29. *Yuan shi* 78.

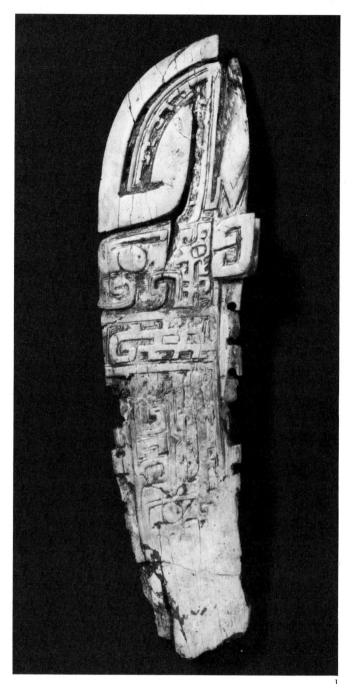

1

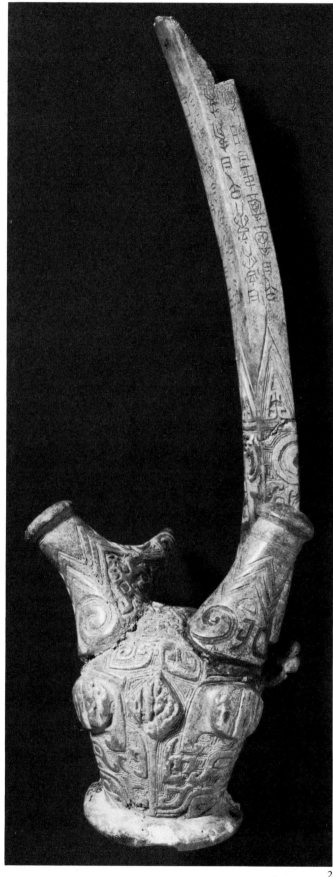

1. Handle

L. 24 cm Colour plate 1

12th–11th century BC

British Museum. Raphael Bequest. OA 1945.10–17.216

This is a relatively large piece of carved ivory surviving from the Shang period. The large surface has enabled the carver to employ a two-tiered scheme of decoration which closely parallels that of bronze vessels of the same period. The two 'flanges with hooks' extending upwards from the eye in the lowest part of the ivory are amongst the most common motifs found on carved ivories of this time.

2

2. Carved antler

L. 27.5 cm

12th–11th century BC

British Museum. 1911.6–15.1

One of the most complex pieces of antler-bone ivory carvings of the Shang period. One of the shorter arms of the antler has been worked into a head with a 'bottle horn' and the longer arm is decorated with a serpent pattern in parallel with a band of cicadas, both terminating in a triangular pattern. Smaller pieces of ivory carved in the form of similar bottle horns have been found on Shang sites. The inscription carved on this piece appears to be a latter-day addition, and the text is generally held to be spurious.

3. Fragment of bone vessel

W. 5.25 cm

12th–11th century BC

British Museum. OA 1952.10–29.7

Ivory bowls have been found at Shang sites with decorations on the surface similar to bronze and jade vessels of the same type. In this case it is the lozenge pattern which is another major motif of Shang art, appearing besides the *taotie* mask.

4. Bone hair-pin

L. 10.3 cm

12th–11th century BC

British Museum. Given by Mrs S. Howard Hansford in memory of her husband. OA 1973.6–20.2

There are eight broad categories of bone, ivory and jade hair-pins from Shang sites at Anyang and this piece represents one of the standard types. It is known as the 'ram-head' type from the resemblance of the head to the Chinese character for sheep or ram, *yang*.

5. Bone fish and ear-pick

L. 8.5 cm; L. 5.7 cm

12th–11th century BC

British Museum. Eumorfopoulos Collection, OA 1937.4–16.78, and Raphael Bequest, OA 1945.10–17.65

Small fish pendants like the first part of this piece, usually jade, are among the most numerous finds from Shang sites at Anyang. In some instances, the tail of the fish extends to a spatula with a slanted cutting edge at the end. In the case of this bone piece the spatula ends in a scoop suggesting that it might have been used as an ear-pick.

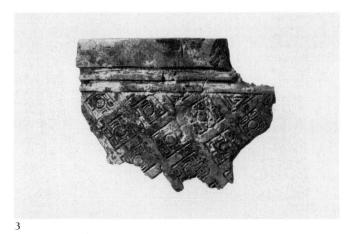

3

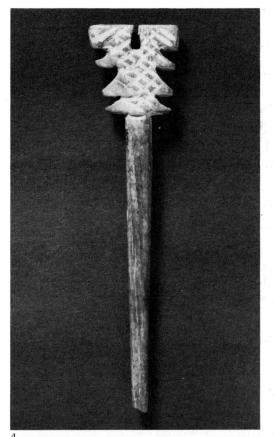

4

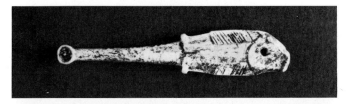

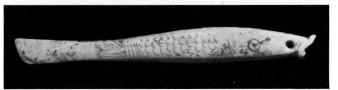

5

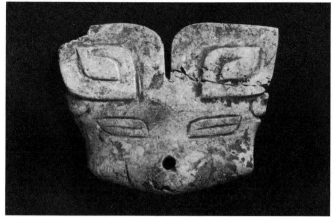

6

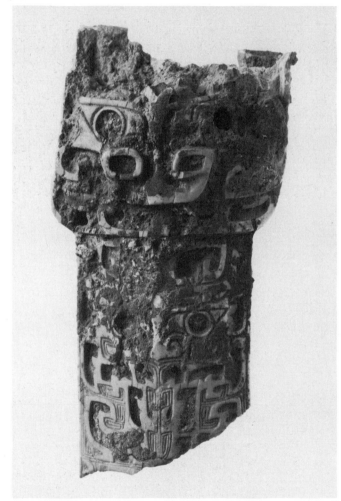

7

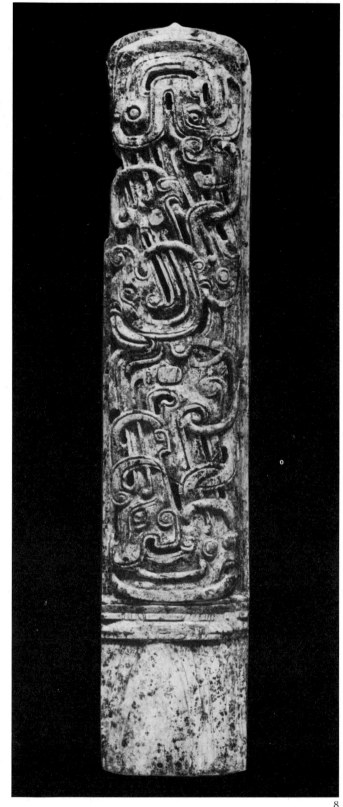

8

6. Taotie mask

W. 5.8 cm

13th–11th century BC

British Museum. Seligman Bequest. OA 1973.7–26.118

Small jade masks are often found at Shang sites at Anyang, all perforations either at the back or through the mask itself for attachment as ornaments for larger objects such as chariot fittings. This piece is an ivory equivalent of the bronze.

7. Fragment of an ornament

L. 12 cm

13th–11th century BC

Fitzwilliam Museum. Raphael Bequest. O.29–1946

This piece resembles the stone 'foot-shaped' vessels from Anyang, but with more elaborate decoration. The nostrils and eyes of the upper mask may have held turquoise inlays. The lower part combines an explicit mask and a triangular pattern below the mouth in which the total decorative pattern is diffused. The lower part of the fragment suggests an owl, or a frog, whose stylised images occur in the Shang repertoire.

8. Handle

L. 15.9 cm

10th century BC

Musée Guimet. MA 2117

The treatment of the dragons on this piece is very similar to the decoration of a jade piece in the British Museum and others excavated from Western Zhou sites in China. Compared with the jade the decoration is more intricate as softness of the material allows, and in higher relief, but the design is not more complex. On the jade piece the main motif is the bird or combination of birds and dragons, whereas the decoration of this ivory piece is composed of only dragons.

9. Archer's thumb-ring (bone)

L. 4.5 cm

5th–4th century BC

Field Museum of Natural History, Chicago. Given by Mrs E. Sonnenschein. No. 235881

In both form and size, this thumb-ring is very similar to the jade and bone thumb-rings found in Eastern Zhou tombs at the Zhongzhoulu site in Luoyang, Henan province. Archery played a central part in the life of the aristocracy in China throughout the Zhou dynasty. The formal archery contest almost always followed an important hunt and was also an integral part of a number of state occasions, especially the royal feast. The literature of the Zhou period often referred to the accessories of the archery contest or ceremony, such as the thumb-ring and the bracer. Zheng Xuan (127–200 AD) commenting on the *Yi li* (section on Xiang-she-li), seems to imply that ivory was the standard material used for archer's

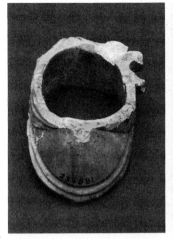
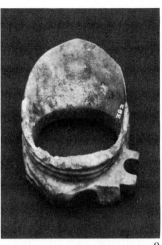

9

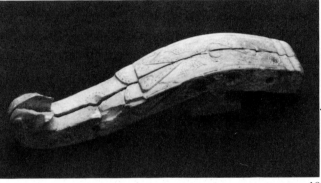

10

thumb-rings in Zhou times. Archaeological evidence indicates that bone and jade thumb-rings were at least as common.

10. Garment hook (bone)

L. 8.6 cm

4th–3rd century BC

Field Museum of Natural History, Chicago. No. 235103

This garment hook is made of two parts; on the inside of each half are three drilled holes to receive the dowels holding the two parts together. Ivory examples of this type in the Fogg Museum of Art and the Musée Guimet show more elaborate and finer carving, which was enhanced by turquoise or paste inlay now missing. This bone example retains some residues of the original green paste inlay. Similar hooks are in the collections of the Nelson Gallery, Kansas City, and in the Museum of Fine Arts, Boston. The green inlay has been identified as malachite by X-ray diffraction analysis by Pamela England at the Research Laboratory of the Museum of Fine Arts, Boston. 'The coarse nature of the inlays would suggest that this is a ground-up mineral.' The orange-red substance in the grooves of the carved decoration was identified as minimum, red lead Pb_3O_4.

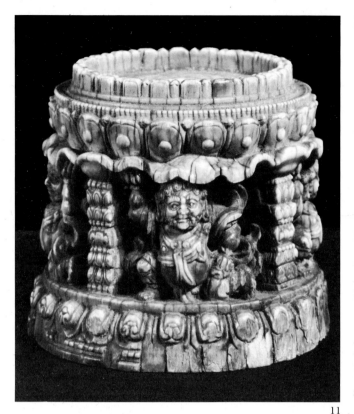

11

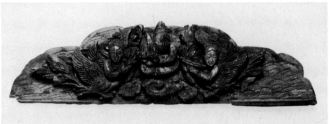

12

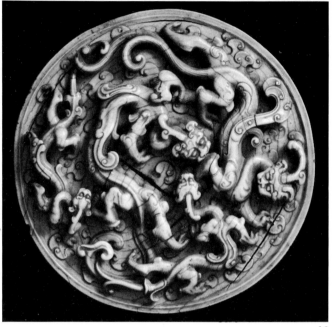

13

11. Pedestal for a Buddhist image

H. 7.8 cm, Diam. (base) 8.9 cm

7th century AD

Cleveland Museum of Art. 68.70. Gift of Mr and Mrs Frederick M. Mayer

The iconographical elements in this piece, while typical of Chinese sculpture of the second half of the 6th century, are of an Indian or West Asian origin. The four dwarfs supporting the upper part of the pedestal resemble *yakshas* but here seem to do service as *Lokapāla*.

The shape of stamens and the disposition of a sash have been taken to indicate a date in the second half of the 7th century; but the argument rests on comparison with stone sculpture where these features may have been adopted a little later than their appearance in softer media.

Published: Lerner, M., 'A seventh-century Chinese Buddhist ivory', *Bulletin of the Cleveland Museum of Art*, LV no. 9 (1968), p. 295 ff.

12. Comb back

W. 10 cm

8th–9th century AD

Museum für Ostasiatishe Kunst, Berlin. Inv. No. 1977–22

The decoration in high relief on this piece consists of a pair of *kinnari* holding offerings on either side of a seated musician holding a *paiban* (clapper). The *paiban* was a common percussion instrument in the imported music of the Tang period,

especially in the musical accompaniment to performances known as *shan yue*. It was often played with the transverse flute and the waist drum. These instruments are seen together on a set of jade plaques (for a belt) in the collection of the Museum of Fine Arts, Boston.

The body of the sinicised *kinnari* is given the same treatment as a phoenix of the middle or late Tang, with the plumage of the tail more resembling a plant scroll than the feathers of a bird.

13. Circular plaque (not exhibited)

Diam. 11.5 cm Colour plate 1

14th–15th century AD

Metropolitan Museum of Art, New York. Purchase, Rogers Fund, 1919, 19.190 AB

The *chi*, or *chi-hu-long* (*chi*-tiger-dragon), became a popular decorative motif in the Yuan period. It is mentioned as one of the chief decorative elements for the state carriages and it appears frequently on fourteenth-century ceramics and carved lacquer. Doubt hovers however over the date of this piece, which has been attributed to times from Song to Qing. The long narrow neck and the raised line down the back and along the branching tail, such as appear on the dragons of the

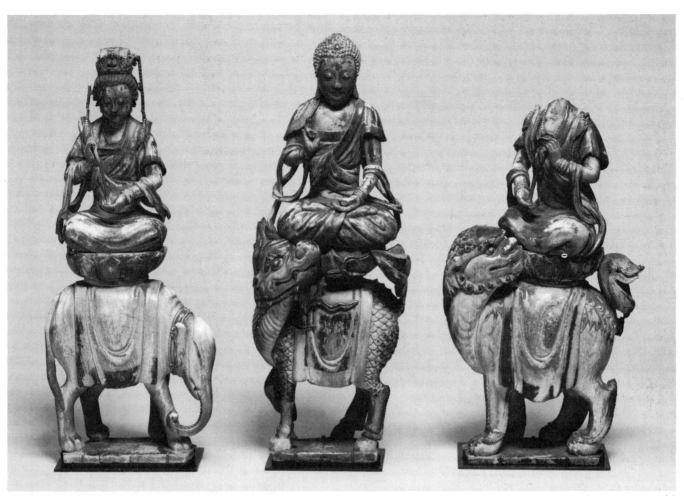

14

plaque, are features of 14th-century *chi*, yet the possibility of archaism of somewhat later date cannot be finally excluded.

Published: Jenyns, S. & Watson, W., *Chinese Art, the Minor Arts II*, New York, 1965, p.181. For porcelain and lacquer with similar *chi* dragon decoration cf. Lee, S. E. & Ho, W. K., *Chinese Art under the Mongols*, Cleveland, 1968, nos 80, 81 and 293.

14. Śākyamuni triad

Puxian: 22.2 cm

Śākyamuni: 23.5 cm

Wenshu: 19.7 cm

14th–16th century AD

Metropolitan Museum of Art, New York. Purchase, Fletcher Fund, 1934, 34.26.1–3

The triad consists of the Buddha, Śākyamuni riding a *qilin*, flanked by the Bodhisattva Puxian (Samantabhadra) and Wenshu (Mañjuśrī) mounted respectively on elephant and lion. Scholars' opinions on the date of this piece have differed widely, ranging from the late Song to the middle Ming. In support of a Yuan date similarities to some temple columns in the Honolulu collection may be cited: the Mañjuśrī compares

closely in the two works, and details of the lion, though not the stance, correspond. The liberal use of strings of beads, as seen in the ivories, is characteristic of the 14th-century Bodhisattva images of south China, and to a lesser extent the beads deck the Mañjuśrī of the Honolulu column. The *qilin* as vehicle of Śākyamuni Buddha is unorthodox to say the least, but understandable in the context of late Yuan and early Ming Buddhist and Taoist art, when mutual borrowing was becoming increasingly common. A cautious dating, in spite of the Yuan indications, would place the images only broadly between the 14th and the 16th centuries. The images were originally polychromed and gilded, and the workmanship is as fine as the ivory carving of any period.

15. Taoist figure

H. 31.7 cm

14th century AD

Cleveland Museum of Art. 64.368. John L. Severance Fund

The stance of the figure, with the belly well forward, and the treatment of the robes, with girdle tied high up the waist and the long tassels coming down in front, and the attention given to the collars of the inner garment, exposed like an amice, are all characteristic of figure painting of the Yuan period as seen

15

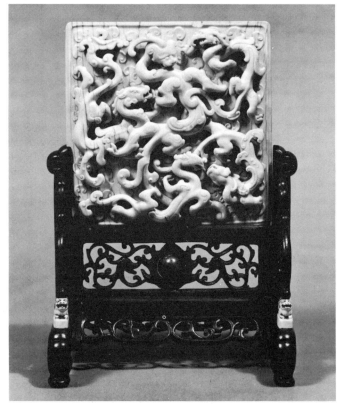

16

on the wall paintings of the story of Lu Dongin in the temple of Yongle Gong. The same features continued right through the Ming periods, but the treatment became increasingly stiff and mannerised. Although a southern Song date is not impossible, a Yuan date argued for it may be more appropriate. Only the head and feet are of ivory, the rest is loquat wood, and the missing hands might well have been carved from ivory also. Perforations above the mouth and on the chin are for the attachment of a beard, now missing.

Published: Lee, S. E., 'Kleinkunst: Two Early Chinese Wood Sculptures', *Archives of Asian Art*, XX, 1966–67, pp. 66–69.

16. Plaque, carved with *chi* dragons

H. 11.1 cm

14th–17th century

The Irving Collection

As with the circular plaque of similar style, No. 13, this finely-carved object has generated a certain amount of discussion as to dating. In favour of an attribution to the Yuan or early Ming dynasty can be adduced the parallels with carved lacquers possibly of that date, and with ceramics decorated in underglaze blue which are securely datable to the first appearance of this particular form of archaistic subject matter in the fourteenth century. There seems to have been a resurgence of the style in the seventeenth century, exemplified by illustrated books like the albums of letter papers emanating from the Ten Bamboo Studio. The current state of research favours a wide dating.

Ming and Qing Ivories: figure carving

The Study of Ivories

Most ivory figure carvings of the Ming and Qing periods depict transcendent beings from China's religious traditions, both Daoist and Buddhist, and from the official and popular cults. Although the gods, immortals and other beings are all known in other media, prior to the Ming dynasty ivory was not commonly used to make these images. From the late sixteenth century onwards, an ivory figure carving industry grew in Fujian province, stimulated by outside influences and a sympathetic economic climate. For the first century or so of production, it remained a local phenomenon but then spread out to other centres during the Qing dynasty.

The industry developed on the western part of the Fujian coastline at Zhangzhou, a city which might be seen as a sixteenth-century equivalent of twentieth-century Hong Kong. Fujian freed itself of central government regulations restricting overseas trade, and Zhangzhou merchants and gentry more or less did as they wished during the late Ming, acting as entrepreneurs, middlemen and traders, actively looking for foreign capital. Fruitful contacts were established with the Spanish, who had conquered the nearby Philippine Islands.

The Europeans had their own tradition of elephant-ivory figure carving, which had flowered in Paris in the mid-thirteenth century. A great number of Christian votive images were produced in ivory during the Gothic period, and these continued to be employed in churches long after manufacture had ceased in about AD 1400 (Fig. 1). When the Iberians came to the East they commissioned ivory images in Gothic style to decorate their altars. The Spanish market images made at Zhangzhou stimulated also the production of a large series of figures in Chinese taste, with auspicious symbolism, made as pleasing ornaments for the most part. The evidence for this industry is provided by both Chinese and Spanish documentation, which combined gives a far more convincing picture of the context in which Ming figures were made than theories which try to link such objects with the names of recorded carvers.[1]

Ivory figures in the Chinese domestic taste from Zhangzhou can usually be recognized by their stylistic features, as can some of the Sino-Spanish images of the Virgin; in particular the following – a strong sense of line in the carving, for many of them appear to have followed woodblock prints, both Spanish and Chinese; the edges of folds in robes and tunics are rounded off; borders on the garments are often coloured with paint, or more rarely with lacquer, these pigments leaving a stain when rubbed away; the eyes, nose and mouth are frequently quite close together in relation to the whole surface of the face, lending the expression an air of concentration. In addition, some have acquired a yellow or brownish patina through age and handling. A typical image is shown in Fig. 4.

These Zhangzhou carvings were followed in the later Qing and twentieth century by other figures, which were loosely based upon the Fujian style, but made in various parts of the country. Several centres have been cited for these figure carvings, including Canton, Peking, Shanghai and Amoy.[2] There were also export figures made in the eighteenth century at Canton alongside other ivory objects for the European market. To see how the industry

began, we may consider the historical setting and the activities of the Iberians as they came into Asian waters during the sixteenth century in search of 'Christians and Spices'.

The Development of the Industry

Only a few years after the Portuguese had discovered the route east round the Cape of Good Hope, de Albuquerque, who conquered Malacca in 1511, made his first contact with the Chinese, establishing excellent relations with the junk-masters trading in the Malayan straits.[3] Pushing on to China, which they reached in 1513, their fortunes were initially good, but they were then humiliatingly expelled from Canton in 1521–22, after the piratical exploits of Simão de Andrade soured Sino-Portuguese relations. For the next thirty years they flitted from harbour to inlet, engaged in a 'hit and run' smuggling trade with the coastal Chinese in Guangdong,, Fujian and Zhejiang provinces, sometimes in conspiracy with, and sometimes fleeing from the local authorities.[4]

Meanwhile, in India the merchants and missionaries had established an important base at Goa, a port on the west coast, from which they controlled their Asian commerce in spices and other commodities, including ivory, building up there a prosperous entrepôt with Portuguese-style architecture, both secular and ecclesiastic. Many ivories which originated in Goa are still to be found in Portuguese collections, some fine examples of which were included in a recent exhibition in Lisbon.[5] Colonial carvings were needed to help equip churches and hospices, to fire the hearts of Europeans, native Christians and potential converts alike. Church decoration played its part in the evangelical campaign to spread Christianity across Asia.

The Portuguese missionaries were naturally not satisfied with merely India and south-east Asia, and wanted to bring China too into the Christian fold. In the late 1550's, after the Chinese had finally allowed the Lusitanians a foothold on the mainland proper, in Guangdong at *Amaao* (called Macao by the Portuguese), the missionaries flooded in. One of the first names for Macao was *povoação do Nome de Deos na China*, 'Settlement of the Name of God in China'.[6] A letter of 1570, written by Gregorio Goncalves, *presbitero secular* to the Spanish ambassador in Portugal, described Macao as a settlement of about five thousand Christian souls, with three churches, a hospital for the poor and a house of the Santa Misericordia (a charitable Brotherhood). Like their brethren in Goa, these Christians, and particularly the evangelising missionaries, needed images for their churches. Some, or indeed many of them, may have been brought directly from Goa, either colonial images made in India, or European originals. From about 1560 the Portuguese stayed put at Macao, for as their trade was now legitimised they had no further need to deal stealthily with the locals; they gave up visiting other parts of the south coast, leaving such activity in the hands of Japanese pirates, *wakō*, who sometimes included disaffected Chinese merchants.[7]

There are Christian ivories in Portuguese collections which clearly were made in China, and this might suggest an industry based in Macao or Canton. The Portuguese were certainly commissioning objects from the Chinese, as we know from the armorial and monogrammed underglaze blue decorated porcelain made for them at Jingdezhen.[8] But if Macao did have an image-making industry, there is no record documenting it; in any case, commissioned ivory Christian images would more likely have been produced upriver at Canton, a large city where carvers could readily have been found to do the work. Knowing that Canton was a major centre of export ivory work in the middle and late Qing, we should nevertheless beware of projecting the industry further backwards in time.

Portugal was not however the only European presence in Asian waters during the late sixteenth century, nor was the Pearl River estuary a commercial oasis on a coastline otherwise deserted of foreign trade. Its Iberian neighbour Spain, finally got a stake in what was then the most lucrative trade in the world, when galleons carrying merchant adventurers and missionaries crossed the Pacific to the Philippines in 1565. The two countries, Portugal and Spain, had divided up their intended areas of world exploration and conquest in 1494 under the Treaty of Tordesillas. After a series of clashes in the early sixteenth century over the demarcation line in the East, the Emperor Charles V of Spain relinquished his claim on the Spice Islands. Some two decades later the Spanish were diverted by their discovery of vast silver mines in Mexico and Peru, and when they decided to make another serious bid for a share of the Eastern market they had the financial backing to challenge Portuguese supremacy. As with the Portuguese years earlier, the Manila galleons brought not only European commerce but also the church. One after the other, the mendicant orders and Society of Jesus arrived from Acapulco, the Augustinians in the vanguard in 1565, the Discalced Franciscans in 1578, the Jesuits in 1581, the Dominicans in 1587 and the Augustinian Recollects in 1606.[9]

In 1580 Portugal fell under the suzerainity of Spain and King Felipe II promised his new subjects that the Spanish would keep to the Philippines and not threaten Portuguese interests at Macao. This policy of appeasement was not so limiting as it appears, for the Spanish had already begun to build up excellent commercial contact with China itself, not by visiting it, but via the Fujian Chinese who came to them.

The Chinese were not long in reacting to the presence of the new conquerors of Luzon. A narrative by Fernando Riguel, the Philippine governor's notary, dispatched from Mexico on 11 January 1574, described an early encounter:

'A year ago there came to the port of this city three ships from China, and to the neighbouring islands five more. Those which came here brought merchandise such as is used by the Chinese, and such as they bring here ordinarily. The distance from the mainland is not great, the voyage lasts about eight days . . .'

For the natives of the Philippines they brought

'large earthenware jars, common crockery, iron, copper, tin, and other things of that kind.'

For the chiefs they brought

'a few pieces of silks and fine porcelain; but these goods are not especially of the common.'

For the Spaniards however they brought

'some fine ware and other articles, which they readily sold, since we who are here have plenty of money, and the Chinese need it. They were so delighted that they will surely return in six or seven months, and will bring a great abundance of many very fine articles. They brought specimens of many kinds of goods peculiar to their country, in order to arrange the price at which they can be sold – such as quicksilver, powder, pepper, fine cinnamon, cloves, sugar, iron, copper, tin, brass, silks in textiles of many kinds and in skeins, realgar, camphor, various kinds of crockery, luscious and sweet oranges; and a thousand other goods and trifles quite as many as the Flemings bring. Moreover they brought images of crucifixes and very curious seals made like ours. The cause of this unusual visit is that freedom and passage to their own country were given to some Chinese who were slaves among us; those people spread the news of this settlement, where they could come with safety and trade freely; accordingly they came with the ship and goods to which we have already referred.'[10]

With a good eye for profit, the Chinese on the mainland and those in Luzon supplied the Spaniards with fine daily and luxury commodities, as well as religious images, in return for silver bullion from the Americas.

As the word of business opportunity got about, thousands of Chinese from Zhangzhou in Fujian flooded to Luzon to capitalise on the new market, many settling there.[11] The Fujianese population became so large in the 1580s that a Chinese quarter was set up – the Parian, 'market-place'. It was an appropriate name, for the Chinese, who had been dealing there for years, increasingly dominated local business, the crafts industry and even agriculture, improving productivity with traditional Chinese skills.[12]

The Fujianese presence on Luzon was, by and large, welcomed by the Spanish, who could draw upon the commercial and artistic skills of not only the local Chinese but also of their fellow townsmen on the mainland.[13] In 1590, Bishop Salazar wrote to the King of Spain:

'The handicrafts pursued by the Spaniards have all died out, because people buy their clothes and shoes from the Sangleys (Chinese), who are very good craftsmen in Spanish fashion, and make everything at a very low cost. . . . They are so skilful and clever that, as soon as they see any object made by a Spanish workmen, they reproduce it with exactness. What arouses my wonder most is, that when I arrived no Sangley knew how to paint anything; but now they have so perfected themselves in this art that they have produced marvellous work with both the brush and chisel, and I think that nothing more perfect could be produced than some of their ivory statues of the Child Jesus which I have seen. This opinion is affirmed by all those who have seen them. The churches are beginning to be furnished with the images which the Sangleys made and which we greatly lacked before; and considering the ability displayed by these people in reproducing the images which come from Espana, I believe that soon we shall not even miss those made in Flanders.'[14]

In the 1580s, therefore, the Chinese were supplying much religious imagery for the Spanish, including ivory. The term 'Sangley' which from the seventeenth century was used by the Spanish to cover all Chinese, including those resident in the Philippines, referred in the sixteenth century particularly to the traders who came in from the Fujian ports.[15] Salazar's text thus implies that the ivories commissioned for colonial churches in the Philippines were actually made in Fujian. This is supported by current work on sixteenth- and seventeenth-century Spanish documentation which suggests that woodblock printed breviaries, illustrated with holy figures, and brought by the missionaries from Mexico, were sent over to the mainland to serve as models for Sino-Christian ivories.[16] Certainly a major ivory industry grew up to cater for Spanish needs, as attested by the numbers of such figures which still survive in Mexican collections.

The Fujianese came to Manila, both because they were good businessmen and because the province was the only one in which the gentry-sponsored merchants were free of the Ming interdict on travelling overseas. They received quasi-official sanction to sail abroad in 1567, after an appeal by the Fujian governor, who pleaded that military interference was increasing real piracy at the expense of trade. The previous official attitude had been hardened by the activities of Portuguese, Japanese and Chinese smugglers. In the 50s Wang Shizhen, who took responsibility for the coastal defences of Zhejiang, had railed against 'criminal merchants and sly people of Fujian and Zhejiang, who seeing the fat profits to be made, secretly traded with foreigners in prohibited goods'.[17] By the 1570s, this line had given way to a relaxed *laissez faire* attitude under which the Fujianese could travel abroad without fear of reprisals. Fujian officials and local gentry were often tied up with the merchants in these overseas

ventures. The Zhangzhou gazetteer for 1628 recorded that 'the men of Zhangzhou often build great vessels and trade with foreign countries far away. Those of moderate means pool their capital; and it also happens that those of means lend money for the purpose.'[18]

The city of Zhangzhou was one of the three great ports on the Fujian coast, the others being Quanzhou and the provincial capital Fuzhou. Zhangzhou's historical role in coastal trade has been obscured by the later development of nearby Xiamen (Amoy), formerly a military garrison in the Dragon River estuary. Xiamen expanded from the seventeenth century on, whilst the older, long established port receded in importance as its river silted up and it was no longer viable for large vessels to travel twenty-five miles upstream.

In the Ming however Zhangzhou had special relations with Luzon. The Ming History starts its chapter on Luzon: 'Luzon is situated in the southern seas, from Zhangzhou it is very close indeed'.[19] The *Ming Shan cang*, a private history of the Ming written by the Fujianese scholar He Qiaoyuan (1558–1630), noted the close links between Zhangzhou and Luzon.[20] The first Ming official market to deal with Sino-Philippine trade was set up in Fuzhou in 1492, but then Haicheng, a district in Zhangzhou prefecture, halfway between Zhangzhou town and Xiamen, developed its own tax station run by the coastal defence force. Yuegang market in Haicheng was so busy during the Wanli period that the provincial army picked up taxes amounting to 20,000 taels per annum from the commodities passing through it.[21]

Only by understanding the close links between the Spanish and Zhangzhou merchants, both in Luzon and at home in Fujian, is it possible to appreciate how Zhangzhou came to be the centre of ivory figure production in the late sixteenth and seventeenth centuries. Late Ming and Qing dynasty gazetteers for Zhangzhou prefecture were published in the years 1573, 1628, 1715, 1777 and 1877. The 1573 gazetteer makes no mention of ivory amongst the local produce of the prefecture, either in Zhangzhou city, or any of the other districts in the area.[22] The 1628 gazetteer however includes the following paragraph in the 'local produce' chapter, under the section on manufactured goods (reproduced almost *verbatim* in the 1715 edition):

'Ivory carving: elephant ivory can no longer be found in the prefecture, and is wholly traded by those who come into the port markets. Zhang [zhou] people carve it into immortals and that sort of thing, supplying them for the purpose of providing pleasure. Their ears, eyes, limbs and torso are all lifelike. Exceptionally skilful work comes from Haicheng. Ivory chopsticks, ivory cups, ivory belt-plaques and ivory fans are also to be had.'[23]

The figures were in existence by 1591, the date of the preface to Gao Lian's *Zun sheng ba jian*, in which the author wrote: 'In Fujian ivory is carved into human form, the workmanship of which is fine and artful; however one cannot put them anywhere, or give them as a decent present.'[24] The literati snobbism does at least tell us that the figures were circulating by the last decade of the sixteenth century. The Fujian ivory immortals and other domestic-market figures were made in response to the Sino-Spanish market in Christian figures; to follow the steps in this process, we must look at the similarity between Gothic images of the Virgin and Ming Chinese images of Guanyin.

From Bishop Salazar we know that Spanish conquistadors and missionaries brought to the Philippines sculpture from both Spain and Northern Europe. In addition they had much illustrated printed material in late Medieval style, which they were using in their liturgy and evangelical campaigns. With these two sources, they started to commission Christian ivory figures from nearby Zhangzhou which imitated the Gothic ivory images still circulating in Europe. This was a viable commercial proposition given the amount of ivory coming into

 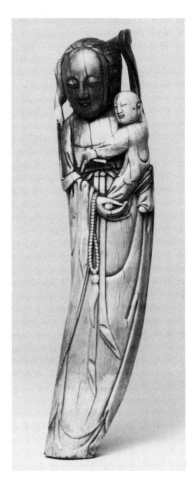

China.[25] Some of them, including the images of the Virgin, issued from Chinese hands with their costume carved in as linear a fashion as the prints from which they were copied. Images of the Virgin were greatly favoured, as can be seen from the account of the Philippines written by the Jesuit Father Pedro Chirino in 1604, which relates how a certain Father Antonio Sedeno had sought out Chinese artists and hired them for a programme of ecclesiastical decoration, to the end that 'almost all the churches in the island were adorned with images, nearly all of which were of the Mother of God'.[26]

Religious ivory carvings from Zhangzhou were obviously executed for profit. The carvers then saw the opportunity of even greater returns than those offered by the Spanish at Manila, and expanded into a wider consumer market. They recognised in the images of the Virgin and Child enough of Guanyin to realise that the Christian images could serve as models for domestic ivory carvings. The similarity between the two deities had been recognised twenty years before:

'In the city of Cantão [Canton]... I saw an oratory high from the ground very well made, with certain gilt steps before it, made of carved work, in which was a woman very well made with a child about her neck, and it had a lamp burning before it. I suspecting that to be some show of Christianity, asked of some laymen whom I found there, and of some of the idol's priests who were there, what that woman signified and none could tell it me, nor give me any reason for it... It might well be the image of Our Lady, made by the ancient Christians that Saint Thomas left there, or by their occasion made, but the conclusion is that all is forgotten. It might also be some heathen image.'[27]

(Left to right)

Fig. 1 Virgin and Child (no. 38), probably German, by the so-called Master of Kremsmünster, late 14th century AD. In the late Ming period, Fujianese craftsmen were commissioned by the Spanish to replicate images such as this.

Fig. 2 Virgin and Child, Sino-Spanish. Ming dynasty, about AD 1580–1644. Courtesy of the Hispanic Society of America.

Gaspar da Cruz, a Portuguese Dominican friar who travelled within South China in the winter of 1556, saw an image of what was almost certainly the *songzi* Guanyin, 'Guanyin who gives (male) children', and thought that it might be the Mother of God bearing the Infant Christ. This was a manifestation of the compassionate Bodhisattva that appealed especially to women supplicants. Da Cruz was, of course, projecting what he hoped to see, but to one European at least, the images of the Virgin and Child and the *songzi* Guanyin were interchangeable.[28]

Whereas da Cruz had looked at a maternal image of Guanyin and recognised the Virgin and Child, the Chinese, it appears, looked at the Sino-Spanish Gothic style ivories of the Virgin and Child and recognised the *songzi* Guanyin. It is unlikely to have been the case that Zhangzhou craftsmen were naïve and believed that the Spanish actually worshipped Guanyin, although it may have been so: rather that they liked the idea of a Guanyin image carved in the unusual material of ivory.

By removing the cross from the rosary and replacing it with a tassel, by emptying the Infant's hand of the orb or dove and adding a few Chinese details, such as a high collar and arching Buddhist scarf, the Virgin was neatly transposed into the *songzi* Guanyin. It has been thought that Philippine ivory Virgins look Chinese because they were based upon images of Guanyin;[29] in fact the opposite is true. Fujian ivory figure models were successful and popular precisely because of their novelty value and foreignness, which appealed to a south Chinese community busily engaged in overseas trade. It was a parallel situation to that of seventeenth and eighteenth-century Europe, when Chinese figures were valued for their exotic charm and suggestion of wealth on the part of those who could afford to buy them. Through the booming maritime trade the province was immensely wealthy in the period 1570–1620,[30] and ivory, vulgar though it may have been to scholars such as Gao Lian, was an expensive material. In the atmosphere of burgeoning growth and prosperity, sinicised Western ivories, a luxurious novelty, must have appealed to the *nouveaux riches* whether merchants or gentry.

The 'Gothic' Guanyins were not the only form borrowed from the Christian range of icons. The so-called 'medicine ladies' were likewise adapted from overseas art (Fig. 7). The subject matter of these little models of naked or semi-naked reclining women appears to set them apart from other late Ming figures. Most western texts describe them as 'medicine ladies' or 'doctor's models', following an account of them written in 1936:

'To overcome the difficulties that such reticence naturally placed in the way of physicians called to diagnose and treat sick ladies, the former had the ivory carvers make them small figures of nude women in repose showing in intimate detail every organ. One of these figures would be taken to the bedside of the patient, who would put her hand through the folds of the curtains that hid her from the physician's view and touch the exact spot on the figure that was causing her trouble. The physician would then feel his patient's pulse, ask a few innocuous questions, make his diagnosis and give her a prescription. . . . Some of these little ivory figurines are extremely beautiful, but they are not easy to come by, since native curio dealers display considerable reticence in showing them to customers.'[31]

But this explanation is doubtful. Apart from its diagnostic absurdity (their minute size and awkward articulation), there seems to be no mention of any such species of object in texts on medicine.

Beyond their connection with the Zhangzhou group, these figurines illustrate the process by which alien prototypes were borrowed, sinicised and put onto the domestic market. Considering the apparent transposition of the Virgin and Child into the *songzi* Guanyin, it

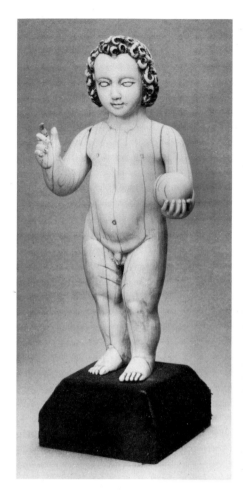

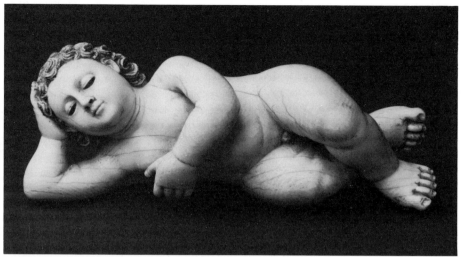

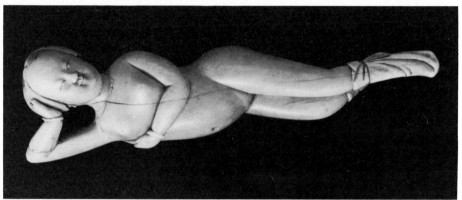

seems no less likely that the prototypes for the 'medicine figures' were ivory carvings of the infant Christ (Figs 5 and 6). The sleeping versions of the Holy Child may have been originally imported into the Philippines from Goa, in which case they would have been executed from ivory originals.[32]

To Chinese eyes, this image, holy as it was to Christian sensibilities, can never have been more than a robust male child (usually with one hand thrown up behind the head and one knee raised). The Chinese may not have ever realised that the figure was meant to represent a child, for unlike Chinese infants who have their heads shaved, models of Christ and St John often have a full head of hair. European inventories of the eighteenth century frequently misunderstood Chinese export figures.[33] Conversely, the chubby naked body that we encounter in European images of angels, seraphim, cherubim and holy infants, was a tradition unknown in China. Odd as they must have thought them, the Chinese lost no time in adapting these 'little men' to their own purpose, retaining the pose but changing the sex.

As ladies, suggestive in repose, sometimes coyly draped with a chemise, they could now be used as erotic toys (Nos 128–30 and 133), easily concealed in a hand or sleeve. They were carved with some sort of foot covering, for in Chinese erotica ladies are usually shown with socks or shoes over their bound feet, this binding itself having erotic appeal.[34] Often, as Sowerby says, the carving was 'intimate', so it was hardly surprising that 'native curio dealers display considerable reticence in showing them to customers.' It may be that those same antique dealers were responsible for confecting the 'medicine lady' story in order to sell their mild pornography to prudish westerners. It is recorded by the Ming scholar Shen Defu

Fig. 5 (*Far left*)
The Holy Child (no. 42), Sino-Spanish. Ming dynasty, about AD 1580–1644.

Fig. 6 (*Above top*)
The Holy Child asleep (no. 43), probably Indo-Portuguese, 16th-17th century AD.

Fig. 7 (*Above*)
Erotic female image (no. 129), Ming dynasty, about AD 1580–1644. Small erotic models of reclining naked or semi-naked ladies appear to be based upon Christian figures of the infant Holy Child or St John.

(1578–1642) that ivory carvers in Fujian 'made small figures of pairs in sexual congress which were of high artistic quality.'[35] Explicitly erotic ivories were collected by Europeans in China.[36]

In style the so-called 'Sino-Portuguese' Christian ivories are indistinguishable from those that we have identified as coming from Zhangzhou, and must now be recognised as made in the context of Sino-Spanish trade. Zhangzhou mechants, entrepreneurial as they were, may have shipped them down to Macao themselves, or they may have been sold by the Spanish. Despite royal injunctions that the two countries leave each other alone in the East, the Portuguese traded in the Philippines and occasionally the Spanish travelled to Macao. As the church and commerce were the *raisons d'être* for both countries there, it is easy to conclude that the Portuguese simply bought them off the Spanish when they visited Manila.[37]

Figures in the Domestic Taste

Ivory figures made at Zhangzhou also included stellar gods, gods of official, semi-official and popular cults, immortals and attendants. Certain Guanyin types and the erotic ladies were based on foreign models, but the others were drawn purely from domestic sources. Once it was intuited that figures carved into ivory were not only novel, but might actually sell in the home market, it cannot have been long before projected profit stimulated the production of a variety of familiar deities and spirits. The Zhangzhou gazetteers tell us that they were made for 'pleasure', which concords with the fact that few of them are serious devotional images.[38]

If, in order to understand better the significance of the whole Zhangzhou output, we survey the figures that we are able to identify, we see that most of them have some sort of auspicious import. A number of the figures are impossible to name, either because their attributes have been broken away, or because we are too distant from south Chinese popular religion of the late sixteenth and seventeenth centuries to be sure of their context. However we can recognize the general categories sufficiently well to know that these figures encode a series of personal and social targets common to many individuals in Imperial China – long life, official position, wealth, happiness and male progeny.

Different divinities or supernatural beings had 'responsibility' for these: 'responsibility', however, only partly sums up the rôle that gods played in daily life. Buddhist divinities, such as the *songzi* Guanyin, were directly responsible for helping people, and a woman might give birth to a son after praying to Guanyin to end a period of barrenness. But in the case of indigenous religious spirits (*shen*), direct intercession on a particular problem was only part of the religious process. The supplicant also aimed at creating a good working relationship with the *shen*, wherein benefits flowed freely to the family, clan or village at large. The *shen* were expected to keep evil spirits away and look after the living to the limit of their ability. In return, they were perfumed, fed and wined in sacrifices at temples and at home. The system therefore ran parallel with worshipping ancestors, who were likewise supposed to afford protection and bring happiness.

These deities played an important part in the daily life of the individual. The ceremonies enacted in homes and temples were paralleled in county, prefectural, provincial and imperial capitals at increasingly grand sacrifices and ceremonies. The masters of ceremonies for such sacrifices were likewise more and more important: magistrates, prefects, governors, and at the top, the emperor himself.

In Ming and Qing China native religious cults can be divided into two categories, official

and popular, with the official cults organized by the civil service bureaucracy and the popular cults by the Daoist church.[39] Ivory figures depict divinities from each category. The cults were not always as strictly delimited as conservative Confucians would have liked, and the emperors themselves sometimes encouraged non-official 'heterodox' cults in the face of stony-faced censure from their ministers. In 1488 the newly enthroned Hongzhi emperor, Zhu Yutang, was memorialised by a Supervising Secretary in the Ministry of Rites to cease sacrificing to a group of Daoist deities he deemed unworthy of such respect. These included the Dipper Asterism (discussed below under *Wen Chang*), the God of Thunderbolts, the Celestial Master Zhang Ling, the God of Emoluments Zitong Dijun, and the Gods of Golden and Jade Gates; Hongzhi, remembered as a distinctly pro-Confucian monarch, nevertheless retained them all.[40]

Two important gods who straddled both cults were Guandi and Wen Chang. Both appear as ivory images. Wen Chang ('Literary Glory') was incorporated in the Qing official sacrifices despite murmurings from some quarters, who thought that students of the classics should get on with their work without the help of divine patrons. Each god 'looked after' a section of Chinese society; Guandi, the deified military hero Guan Yu, was patron of not only the military but also the merchants,[41] and Wen Chang of literary men. Guandi even had a literati aspect, when placed in *Wenwu miao*, 'Temples of Literature and the Martial Arts'.[42] Another patron of merchants was Mazu, protectress of sailors, but in the sea-faring town of Zhangzhou, her cult may have been taken too seriously for her to be turned into an object for entertainment. Certainly few of the ivories are recognisably Mazu, who is usually shown as a regal, manly looking deity,[43] unless perhaps some of the matronly figures represent her rather than Guanyin.[44]

A further class of transcendent being shown in ivory is the stellar god. Stellar gods belong to the enormous body of star lore which grew alongside Chinese interest in astronomy and astrology. By Han times, star worship was already firmly established in state ceremonial; star gods were also the object of official worship in the provinces.[45] 'Embodied stars' which became widely popular included not only Wen Chang (θ Ursa Major, a white double), but also Longevity God Shou Xing, Emoluments God Lu Xing and Happiness God Fu Xing.

During the Tang, poets used the potent and pregnant language of star imagery to great effect. Li Bai wove images about his own relations with the planet Venus and the moon and even characterised himself as the Wine Asterism (a small group of stars in Leo). His conviction in his starry destiny was carried into later legend, helped on by the Tang poets, Li He, Pi Rixiu and Zheng Gu.[46] Long after the intoxication of Daoist alchemy had worn off from Chinese intellectual life, the literary tradition retained the images of stellar divinities, so that stories and plays continually incorporated them into their fabric.

Yet another class of being shown in ivory were *xian*, immortals, well-established in Chinese religious myth by the Western Han dynasty. The stories of the Queen Mother of the West and her meetings with Chinese sovereigns apparently have their origins in early agricultural and fertility festivals.[47] Daoism became an organised religion with a recognized founder, the Celestial Master Zhang Daoling, in the second century AD; Daoist immortals who roamed the clouds and mountain paradises of the 'earthly' sphere were regarded, however, as inferior to the most sublime of beings, the *zhenren* or 'perfected men' who domiciled themselves in the highest heavens.

Immortality was taken very seriously by early Daoists. The potent ingredients used in Six Dynasties elixirs reflect a fierce determination by adepts to purify their bodies that took some of them deliberately to the gates of death, in a suicidal alchemy known as 'liberation by

means of a corpse'.[48] The widespread passion for alchemy faded after the Tang, when Confucianism regained its integrity as a major philosophical power. In the Yuan drama, well known immortals, drawn from history and myth, were used as *dramatis personae* to give a fantastic and auspicious dimension to plays. The *Ba xian*, the Eight Immortals, are thought to have been united through this medium. Although the concept of the immortal was born in early myth and religion and matured in the millennial atmosphere of the Southern Dynasties and periods of Daoist fervour at the Tang capital Chang'an, by the Ming they were stock figures whose significance was largely symbolic. The *Ba xian* represented all types of person, old, young, male, female, androgynous, rich, poor, beautiful and ugly. They stood for the warming thought of a happy and fulfilled old age.

In the theatre stellar gods and immortals were often depicted as figures of fun. A rather noisy mode of drama with a chorus, the Yiyang, developed in the early sixteenth century, spreading from Jiangxi province to Peking, Nanjing, Hunan, Fujian, Guanxi and Guangdong provinces. It was a popular theatre which appealed to a wide strata of society, its language based upon local village dialects and its music a long way from the elegant Kunqu drama. Whilst the Kunqu was mainly seen in Suzhou in the late sixteenth century, reaching Zhejiang in the early seventeenth, in Yiyang Ming drama was carried right across the south.[49] The following passage, translated by William Dolby from an early Ming *zaju* play *Meeting of Immortals* by Zhu Youdun, gives a good idea of the immortals' later role. Within the play, four *xian*, Han Xiang, Zhang Guo, Lan Caihe and Li Yue disguise themselves as itinerant entertainers to give a *yuanben* performance at a birthday party; here two of them have adopted the theatrical classification of *fumo*, 'assistant man' and *jing*, 'adjutant'.

JING Let us now proclaim the cast and bill, just run through all the lot:
FUMO Lan Caihe claps castanets of sandalwood in his hand,
JING Han Zhongli bears the True Words so all may know and understand.
FUMO Iron-Crutch Li blows his fife with skipping whistle and skirl,
JING White Jade-Toad flutters in dance, sleeves and skirts a-whirl.
FUMO Master Han Xiang reels off lines, flawless flowers of wonder,
JING Zhang Guolao pounds his drum with booms like peals of thunder.
FUMO Imperial Uncle Cao great songs in mighty tones resounding sings,
JING Gaffer-god Xu leisurely strums, caressing his dulcimer strings.
FUMO Dongfang Shuo is learning the player's comic arts,
JING And Lü Dongbin is director to run them through their parts.
FUMO Immortals one and all, perform their play upon this stage
JING To wish you a thousand autumns, a merry life and ripe old age.[50]

The desire for a secure long life was a recurrent theme in Chinese literature, philosophy and allegory. Respect for age was enshrined in the hierarchical structure of the clan, where the eldest had executive control, and formalised in the second most important Confucian relationship, of son to father. The Eight Immortals, the stellar god of longevity, the Queen Mother of the West, all symbolised the hope of reaching a hoary untroubled old age. The original quest for personal immortality may have been partly stimulated by a need to escape the terrible series of wars in the late Zhou, but in later times, immortality had become by and large a cipher for attaining a good age. Even in this century, good wishes are still offered with the phrase *wan sui*, 'ten thousand years'.

In the late Ming, some wealthier elements of the population carried on the search for the elixir. A profusion of long-life motifs, stellar gods, deer, talismanic trees, pine and cranes

appear on Jiajing (mid-sixteenth-century) lacquer and porcelain, reflecting the emperor's own taste for the everlasting. He spent a large sum of state revenue procuring the ingredients for his drugs, as well as indulging in more recherché Daoist practices. The Italian Jesuit Matteo Ricci wrote that when the Jesuit fathers first lived in Peking, around 1600, alchemy was all the rage amongst the educated classes.[51] At a more mundane level, the desire for long life, wealth, happiness, progeny and position was graphically set down in the popular print. Cheap woodblock prints were used in a number of festivals: for example on a woman's fiftieth birthday, she was given images of the Queen Mother of the West, a symbol of longevity and fecundity.[52] The Queen Mother of the West, the Eight Immortals and Shouxing were also brought into birthday celebrations through the performance of plays like 'Meeting of Immortals'. The rich costumes of the players and the associations of the characters contributed to the festive and auspicious air of such occasions. It might be that many of the ivory images were in fact made as birthday presents.[53]

Deities and spirits who held out possibilities for improving one's lot were an ever-present fact of life in Ming dynasty Fujian. A Spanish friar, Martin de Rada, who was allowed to visit Fujian in 1575, a couple of years or so after the Sino-Spanish trade effectively began, wrote in his *Relation*:

'So great was the number of idols which we saw everywhere we went that they were beyond count, for each house has its own idols besides the multitudes which they have in temples and in special houses for them. . . . With all that, the one which they hold as the true God is the Heaven, for all the others they consider to be merely intercessors through whom they pray to Heaven (which they call Thien) to grant them health, wealth, dignity, or a prosperous voyage.'[54]

Ivory figures of immortals and the like were *ruyi*, 'wish-fulfilling' objects. Essentially for pleasure they combined the rather crass and luxury novelty of ivory with the desire to surround oneself with lucky objects and images which brought to fruition all the best things in life.

Prototypes for Figures in the Domestic Taste

The source for the style of the domestic market figures appears to be prints, just as it was in the case of the Christian ivories. But before looking at Ming printing, we shall briefly survey three-dimensional material in wood, clay, metalwork and porcelain, which have some stylistic relationship to ivory, to assess the range of possible sculptural prototypes available in China at that time.

An idea of Ming wooden temple sculpture is given by the polychromed attendant (Fig. 8), perhaps from north China, who would have flanked some important popular deity in a temple *tableau*. Sculpture of the Ming period is generally rather robust in appearance, an almost unconscious rule-of-thumb in dating problematic material. Unfired clay (*su*) was also widely used to make large-scale images, important examples from both the Song and the Ming surviving at the Jinci temple, Taiyuan (Fig. 9). For small images however, it was rather fragile, and fired earthenware was much preferred. Although few of the excavated Ming tomb models are stylistically close to the ivories (No. 82), glazed earthenware and stoneware tilemakers' figures sometimes do have similar features (Fig. 10). Roof ridge figures, although they proliferated on late Ming architecture, were unlikely to be source material, by virtue of their inaccessibility.

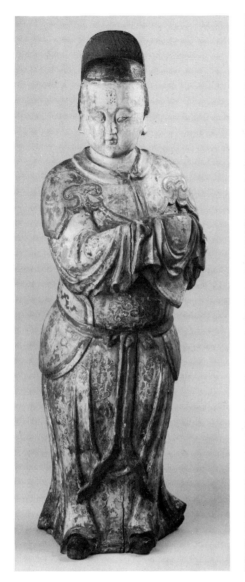
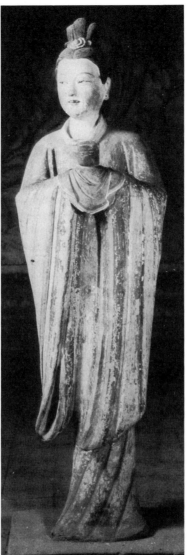
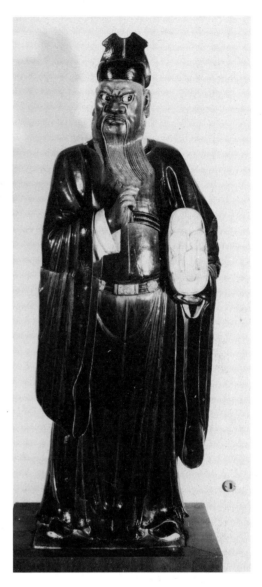

(Left to right)

Fig. 8 Attendant figure from a temple, polychromed wood. Ming dynasty, 15th-16th century AD, British Museum.

Fig. 9 Attendant female figure at the Jinci, Shanxi province, painted unfired clay. Ming dynasty, 16th century AD.

Fig. 10 Attendant figure to a Judge of Hell, glazed stoneware. Ming dynasty, 16th century AD, British Museum.

In metalwork, some bronzes are similarly modelled, for example a series of immortals represented by No. 79. A silver model of Shou xing, excavated from a Suzhou tomb dated to 1613, indicates that luxury versions of these divinities existed in other materials.[55] In porcelain, models of Shou xing and the Ba xian decorated both in underglaze blue and overglaze enamels were made at Jingdezhen during the Wanli period (No. 83).

Whilst each medium had its own modelling tradition and idiosyncracies, there were also features which were shared between different media, such as conventions for robe folds. Above this, the craftsmen of the day would have been well aware that the most comprehensive contemporary source for figure studies were illustrated printed books.

The boom in vernacular and semi-vernacular fiction of the sixteenth and seventeenth centuries both led to, and fed upon a corresponding growth in the printing industry. Works with military, supernatural or pious interest were produced alongside literary masterpieces. The readership for this fiction was by no means homogenous, although obviously it had to be literate. A recent study proposed a working average percentage for literacy in pre-modern China of about five per cent of the population, divided into three levels, highly literate, fully literate and semi-literate.[56] Whilst it was only the highly literate (those who had studied for

the higher civil service degrees) who could manage the sophisticated prose of classics like the Jinping mei, it is probably the case that those popular works written in a mixture of formulaic classical Chinese and simple vernacular appealed to quite a wide mixture of the fully and semi-literate, including the less well educated gentry and their wives.

The publishing centre with the largest share of this market was Jianyang, a district in central Fujian, famous for its printing since the Song dynasty.[57] During the Wanli period, two towns in Jianyang, Masha and Shulin, churned out many pot-boilers for an undemanding readership. Printed books were never cheap in the absolute sense, but these Fujian texts were considerably less expensive than the luxurious editions produced at the same time in Huizhou, Anhui province or Suzhou, Jiangsu province. Amongst the novels published in Jianyang during the Wanli period were a series of illustrated hagiographical novels, thirteen of which are listed in a recent work.[58] They include the lives of the following supernatural beings: Zhong Kui (the Demon Queller), Bodhidharma, the Eight Immortals of the Upper Cave and Guanyin of the Southern Seas. With Jianyang so near, this sort of reading must have been readily consumed in wealthy Zhangzhou, diffusing not only stories, but also pictures of their fantastic subjects.

Hagiographical works also existed which brought together many different transcendents in one volume. One such book, the *Lie xian quanzhuan*, a selection of biographies of spirits and immortals published at Xi'nan, Jiangsu around 1600, is fortunately accessible. With text edited by Wang Shizhen accompanying the illustrations, the *Lie xian quanzhuan* gives us one dated view of the late Ming manner of illustrating popular immortals (Figs 11–14).

Deprived of the technique of washes, wood block prints make maximum use of the very clean and mobile line which runs throughout the history of Chinese graphic arts. Figures are rendered with great economy and subtlety, a few lines rendering the sweep of a robe in the wind. The skills of figure drawing are not an invention of the Wanli block-makers; the success of these prints lies in their use of a linear technique developed in painting and prints over centuries. The animated actions of the characters owes something to Chinese dance and theatre; many of the most invigorating scenes in late Ming prints show the participants swinging their arms and sleeves, twisting their bodies and turning their heads in a truly dramatic fashion. This is especially appropriate when the texts illustrated are plays them-selves or stories also performed in the theatre. The distinctive linear carving of the Zhangzhou ivories seems to derive from this source; with many illustrated books in circulation, it would make sense for ivory carvers (or their patrons) to select their models from these up-to-date and readily available printed popular divinities and immortals. With Christian prints pro-viding the source material for the Christian ivories, it was only natural that for the domestic market, the Chinese should turn to their own sophisticated printed 'pattern-books'.

A final word should be said about the dating of the Zhangzhou group. The initial production might be put somewhere around the year 1580. Gao Lian's acerbic comment of 1591 indicates that Fujian ivories had been known for at least a little while. Riguel's pleasant surprise at the crucifixes delivered to Manila in 1574 likewise suggests that a few years would need to pass before mutual commercial exploitation between China and Spain was fully underway. When production ceased is more problematic. Zhangzhou was one of the towns affected by the anti-rebel military strategy of the late 1650s and early 1660s. The whole coastline of Fujian was disrupted as Qing troops evacuated large bodies of the populace in an attempt to cut the support of the loyalist forces under Coxinga (Zheng Cheng'gong).[59] After the rebels in Taiwan were finally pacified in 1683, the province slowly recovered, but whilst it continued to trade overseas, the halcyon days of opportunism and profit seen in the late sixteenth and earlier

Figs. 11–14
Woodblock printed
illustrations of
various immortals,
from the *Lie xian
quanzhuan*, AD 1600.
Courtesy of the
School of Oriental
and African Studies,
London University.

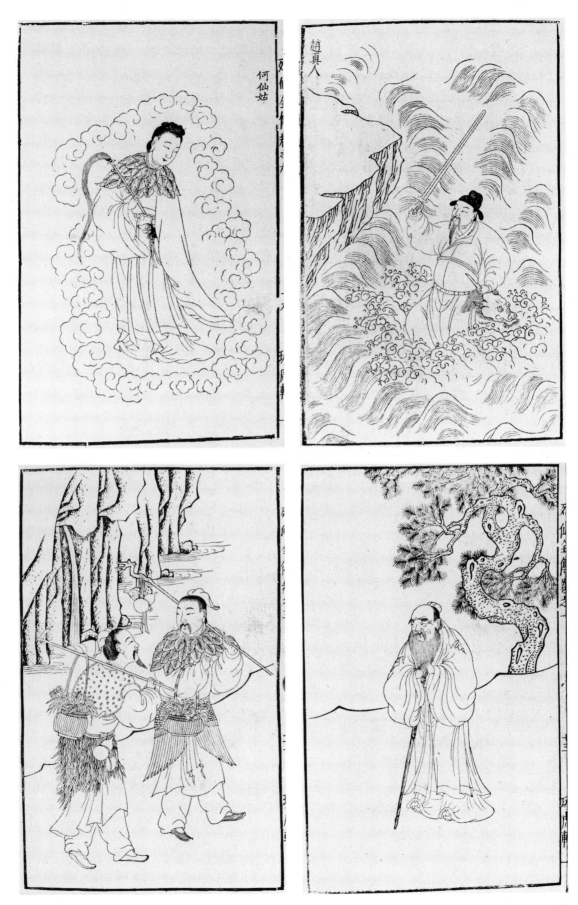

seventeenth century were over.[60] Zhangzhou itself declined in importance, and although Zhangzhou histories of the nineteenth century continue to tell of the ivories carved there, this is probably due to the customary repetition of local histories, which compile a stock of old facts.[61] Few of the Zhangzhou ivories fall stylistically into the post-Kangxi period.

With the growth of the export trade at Canton, ivory was carved into all sorts of novelties and trinkets for the Dutch, English and other East India companies. Canton, a centre of enamelling, surely accounts for the splendid enamelled copper figures with ivory heads, in the Mottahedeh Collection (No. 135). Fine, sharply carved figures like the reclining Li Bai and young girl (Nos 139 and 140) were probably also made there, perhaps with a nod to Zhangzhou work of a century earlier. Some of the Zhangzhou domestic-taste ivories were themselves exported to Europe, finding their way into important collections like Schloss Ambras and the Royal Danish Kunstkammer (No. 131).[62]

As datable ivory figures are so scarce, the dating of individual pieces in this exhibition has inevitably rested on personal judgment. Certain figures, such as the 1655 embracing couple from the Kunstkammer, have proved useful milestones, and so have one or two datable figures in the blanc-de-chine of Dehua. These porcelain figures make an interesting footnote to Zhangzhou ivory carving. Produced in the adjacent prefecture (Quanzhou), they first appear around 1600.[63] Studies in the history of Chinese art have shown that the relatively inexpensive ceramic medium often copied more costly materials, such as silver, bronze and lacquer.[64] It is therefore almost unavoidable to conclude that Dehua, whose sixteenth-century production had hitherto been chiefly censers and bowls, began to copy the more expensive figures from neighbouring Zhangzhou ony a few years after they came on to the market. The ivory coloured glaze on late Ming blanc-de-chine was perhaps induced to resemble the natural colour of the tusk.[65]

During the seventeenth and eighteenth centuries, Dehua sent endless models of Guanyin off its production lines. It now appears that Europe, the destination of so many of these Chinese 'idols', was ultimately, if unwittingly, responsible for bringing them into existence.

DEREK GILLMAN

Notes

1. Lucas, S. E., in *The Catalogue of Sassoon Chinese Ivories*, Country Life, London, 1950, vol. 3, gives a list of eight Ming carvers to whom he accredits ivory figures. A similar list, based on a Ming source, appears in Li Fang, *Zhong'guo yishujia zhenglue*, Peking, 1914, juan 5, p. 3, but there, and in a recent survey by Zhou Nanquan of Ming and Qing carvers, 'Ming Qing zhuo yu, diaoke gongyi meishu ming jiang', *Gugong Bowuyuan yuankan*, 1983, 1, p. 82, there is no indication that their output was anything other than desk objects and baubles.

2. Jenyns, R. S. and Watson, W., *Chinese Art, The Minor Arts*, London, 1965, vol. II, p. 181; Laufer, Berthold, *Ivory in China*, Chicago, 1925, p. 77.

3. Boxer, C. R., *Fidalgos in the Far East, 1550–1770*, Oxford University Press, Hong Kong, 1968, p. 2.

4. Boxer, C. R., *South China in the Sixteenth Century, Being the narratives of Galeote Pereira, Fr. Gaspar da Cruz, O.P., Fr. Martin de Rada, O.E.S.A. (1550–1575)*, Hakluyt Society London, 1953, pp. xxi–xxiv.

5. *Portuguese Discoveries and Renaissance Europe*, 17th Council of Europe Exhibition, Lisbon, 1983.

6. Boxer, C. R., *Fidalgos*, pp. 3–4.

7. Boxer, C. R., *South China*, pp. xxx–xxxvi.

8. Le Corbeiller, C., *China Trade Porcelain: Patterns of Exchange, Additions to the Helena Woolworth McCann Collection in the Metropolitan Museum of Art*, New York, 1974, pp. 12–15, for three examples of Portuguese market ware.

9. Phelan, J. L., *The Hispanization of the Philippines, Spanish Aims and Filipine Responses*, Madison, 1959, p. 32.

10. Blair, E. H. and Robertson, J. A. (ed.), *The Philippine Islands*, Taibei, 1962, reproduction of the Cleveland 1903–1909 edition, vol. 3, 1569–1576, pp. 243–245. The crucifixes could have been modelled after either Spanish or Portuguese originals. One of the Chinese rescued by the Spanish commander Miguel Lopez de Legazpi from the Filipino tribesmen at Mindoro had subsequently gone to Canton, where he was warned off the Spanish by their Lusitanian rivals, but nevertheless chose to ignore Portuguese advice.

11. He Qiaoyuan, *Ming Shan cang*, Taibei, 1971, facsimile of the 1640 edition, vol. 20, p. 6205. He Qiaoyuan probably was responsible for the error passed onto the *Ming*

Shi that Luzon was taken by the Portuguese rather than the Spanish. This is discussed by Zhang Weihua, *Ming Shi Folangji Lüsong Helan Yidaliya si zhuan zhushi, A Commentary of the four chapters on Portugal, Spain, Holland and Italy in the History of the Ming dynasty*, Harvard-Yenching monograph series, no. 7, Peiping, 1934, pp. 78–80. He Qiaoyuan, and the Ming Shi, misleadingly suggest that mass immigration of Chinese occurred before the Spanish arrived; Spanish sources indicate that large-scale immigration started from about 1584 onwards, cf. Blair and Robertson, *op. cit.*, vols. 6, 7, *passim*.

12. Phelan, J. L., *op. cit.*, p. 11.

13. Periodically mutual distrust led to violent action. The worst event happened in 1603 when a party of eunuchs searching for gold arrived on Luzon and the Spaniards, fearing a Chinese invasion, started an anti-Chinese campaign; the Chinese were provoked into retaliation and the subsequent rioting led to the deaths of over 20,000 Chinese inhabitants. See He Qiaoyuan, *op. cit.*, vol. 20, pp. 6206–6207 and Phillips, G., 'Early Spanish Trade with Chin Cheo (Chang Chao)', *China Review*, vol. XIX, no. 4, Shanghai, 1891, pp. 249–254.

14. Blair, E. H. and Robertson, J. A. (ed.), *op. cit.*, vol. 7, 1588–1591, p. 226. Ivory has been erroneously translated as 'marble'; another translation, in which ivory is correctly given, appears in Felix, Alfonso (ed.), *The Chinese in the Philippines*, vol. 1, 1570–1770, Manila 1966, pp. 119–132.

15. Boxer, C. R., *South China*, p. 260, n. 2.

16. Spanish invoices and commissions relating to ivory carving will be published by Beatríz Sanchez Navarro de Pintado in 1984, in a catalogue accompanying the exhibition *Oriental Christian Ivories in Mexico*, to be held in Mexico City.

17. Elvin, M., *The Pattern of the Chinese Past*, London, 1973, pp. 222–224.

18. Elvin, M., *ibid.*, p. 224.

19. *Ming Shi*, Xinhua shudian edition, Peking, 1974, vol. 28, juan 323, p. 8370. The *Ming Shi* also noted, based on the *Ming Shan cang*, that Fujian people went to Luzon because it was both near and wealthy.

20. He Qiaoyuan, *op. cit.*, vol. 20, p. 6205.

21. Chang, T'ien-Tse, *Sino-Portuguese Trade from 1514 to 1644, A Synthesis of Portuguese and Chinese Sources*, Leiden, 1934, p. 95 and Zhang Weihua, *op. cit.*, p. 81.

22. Luo Qingxiao and Xie Bin (ed.), *Zhangzhou Fuzhi*, Taibei, 1965, facsimile of 1573 edition; juan 1, pp. 15–16.

23. Yuan Yesi and Liu Tinghui (ed.), *Zhangzhou Fuzhi*, 1628, juan 27, p. 3, and Wei Litong (ed.), *Zhangzhou Fuzhi*, 1715, juan 27, p. 5. I am deeply grateful to Joe Earle of the Victoria and Albert Museum for his very great kindness in visiting the Naikaku Bunko in Tokyo on my behalf, and using up his own valuable research time to check up on the relevant chapters in both the 1628 edition of the *Zhangzhou Fuzhi* and He Qiaoyuan's local history of Fujian province, the *Min Shu*. In the 1715 edition, the sentence referring to Haicheng has been deleted.

24. Gao Lian, *Zun sheng ba jian*, in Xie Guozhen, *Ming dai shehui jingji shi liao xuan bian*, Fujian, 1980. I am grateful to Craig Clunas for bringing this passage to my attention.

25. See pages 128–131.

26. Blair, E. H. and Robertson, J. A. (ed.), *op. cit.*, vol. 12, 1600–1604, pp. 229–230.

27. Boxer, C. R., *South China*, p. 213.

28. This phase in the history of the Guanyin cult may have been influenced by Christianity. Cf. Soper, A. C., *Literary Evidence for Early Buddhist Art In China*, Artibus Asiae Supplementum XIX, Ascona, 1959, pp. 150–157.

29. Ferrão de Travares e Tavora, B., *Imaginaria Luso-Oriental*, Lisbon, 1983, p. 16.

30. Wills, J. E. Jn., 'Maritime China from Wang Chih to Shih Liang', in Spence, J. D. and Wills, J. E. Jn. (ed.), *From Ming to Ch'ing, Conquest, Region, and Continuity in Seventeenth Century China*, New Haven and London, 1979, pp. 213–215.

31. Sowerby, A. de C., 'Chinese Tinted Coloured and Lacquered Carved Ivory in the Frank Lewis Hough Collection', *China Journal*, Shanghai, September, 1936, p. 130.

32. Obregon, G., 'Artistic Aspects of the Philippine Trade', *Artes de Mexico*, 1971, no. 143, p. 112, and de Pintado, Beatríz Sanchez Navarro, 'Ivory Carvings', *Artes de Mexico*, 1976, no. 190, p. 98. Obregon suggests that the sleeping Infants were modelled on sleeping Buddhas from Bamiyan.

33. The section of the Dresden Inventory drawn up for Augustus the Strong which lists Dehua figures is reproduced in Donnelly, P. J., *Blanc de Chine*, London, 1969, pp. 338–341. *Songzi* Guanyin images are listed as 'dolls with babes-in-arms'.

34. Van Gulik, R. H., *Sexual Life in Ancient China*, Leiden, 1961, pp. 216–222.

35. Van Gulik, *ibid.*, p. 319.

36. Sowerby, A. de C., *op. cit.*, pp. 130–1, with reference to the Hough Collection.

37. For records of Portuguese visits to the Philippines, see Blair, E. H. and Robertson, J. A. (ed.), *op. cit.*, various volumes, in particular vol. 8, 1591–1593, pp. 174–196, for the documents from the investigation into trade with Macao carried out at the request of Governor Dasmarinas: an example is the testimony of Captain Poyatos: 'the Portuguese of the city of Macan trade and hold business communication with the Spanish inhabitants of this city and of these islands; and that much gain and profit has come and comes to them, and that they have not met, and never will meet any injury for coming to trade in these islands.' (p. 180.)

38. See however Nos 120 and 125.

39. Feuchtwang, S., 'School-Temple and City God', in Wolf, A. P., *Studies in Chinese Society*, Stanford, 1978, pp. 103–118.

40. Liu Ts'un-yan, 'The Penetration of Taoism into the Ming Neo-Confucianist Elite', *T'oung Pao*, 57, Leiden, 1971, pp. 44–49. The memorial, by Zhang Jiugong, was endorsed by the Minister himself, Zhou Hongmu.

41. Keith Stevens, who has carried out extensive research into Hong Kong and Taiwanese temple images, has pointed out to me that Guandi is there regarded principally as a *zhong shen*, God of Loyalty, rather than God of War, as he is usually called in Western writing.

42. Feuchtwang, S., *op. cit.*, p. 106.

43. An early Ming print of Mazu is reproduced in Wang Bomin, *Zhong'guo banhua shi*, Shanghai, 1961, pl. 26; and an illustration to the Jianyang novel *Tainfei niangma zhuan* appears in A. Ying, *Zhong'guo lanhuan tuhua shi'hua*, Peking, 1957, pl. 16.

44. For the origins of the Mazu legend, and its subsequent development in the Ming and Qing, cf. Li Xianzhang, 'Sankyō sōjin daizen to Tempi jōboden o chūshin to suru Boso densetsu no kōsatsu' *Tōhō shūkyō*, 11, pp. 61–82 and 'Boso densetsu no gensho keitei', *Tōyō gakuhō*, 39, pp. 76–108.
39, pp. 76–108.

45. Schafer, E., *Pacing the Void, T'ang Approaches to the Stars*, Berkeley, 1977, p. 221.

46. Schafer, E., *ibid.*, pp. 123–125.

47. Loewe, M., *Ways to Paradise, The Chinese Quest for Immortality*, London, 1979, pp. 119–126.

48. Strickmann, M., 'On the Alchemy of T'ao Hung-Ching', in Welch, Holmes and Seidel, Anna (ed.), *Facets of Taoism*, New Haven and London, 1979, pp. 136–8.

49. Mackerras, C., 'The Growth of Chinese Regional Drama in the Ming and Ch'ing, *University of Hong Kong Journal of Oriental Studies*, vol. 9, 1971, pp. 67–78.

50. Dolby, W., *A History of Chinese Drama*, London, 1976, pp. 24–25.

51. *China in the Sixteenth Century: The Journals of Matthew Ricci: 1583–1610*, trans., Gallagher, L. J., S. J., New York, 1953, pp. 90–92.

52. Doré, H., *Recherches sur les Superstitions en Chine*, vol. IX, pp. 491–2.

53. van Gulik, R. H., 'The "Mango" Trick in China, An Essay on Taoist Magic', *The Transactions of the Asiatic Society of Japan*, Third Series, vol. 3, December, 1954, Tokyo, p. 129.

54. Boxer, C. R., *South China*, p. 304.

55. *Wenwu*, 1975, 3, p. 55.

56. Idema, W. L., *Chinese Vernacular Fiction, The Formative Period*, Leiden, 1974, pp. 99–102.

57. Wu Kuang-Ch'ing, 'Ming Printing and Printers', *Harvard Journal of Asiatic Studies*, vol. 7, 1942–1943, pp. 232–236.

58. Dudbridge, G., *The Legend of Miao-shan*, Oxford, 1978, p. 53. Dr Dudbridge presents an admirable account of the way in which the Miaoshan cult developed from its early twelfth century origins at the Xiangshan temple, Linru xian, Henan province; see below, p. 53.

59. Maritime trade was prohibited in 1655 and the economic structure of the province disrupted. Haicheng was lost to Qing troops in 1656. The anti-loyalist evacuation programme is covered by J. E. Wills Jn., in *Pepper, Guns and Parleys, The Dutch East Indies and China, 1662–1681*, Berkeley and Los Angeles, 1975, pp. 16–17.

60. Wills, J. E. Jn., *Maritime China*, p. 231.

61. Li Weiyu (ed.), *Zhangzhou Fuzhi*, 1806 revision of 1777 edition, juan 6, p. 4; Shen Dingyuan and Wu Lianxun (ed.), *Zhangzhou Fuzhi*, Tainan, 1965 facsimile of 1877 edition, juan 39, p. 2; both of these have the same passage about ivory carving, heavily edited from the 1715 edition.

62. Two Zhangzhou figures of standing immortals are preserved in Schloss Ambras; unfortunately they are not amongst the inventoried material.

63. The earliest datable figures (including the British Museum Cai Shen, No. 117) are discussed by Donelly, *op. cit.*, pp. 130–139.

64. The influence on ceramics of Tang and Liao metalwork and Song and Yuan lacquer is discussed by J. Rawson in *The Ornament on Chinese Silver of the Tang Dynasty*, British Museum Occasional Paper, no. 40, London, 1982, in particular pp. 20–23.

65. Dehua porcelain stone is very low in iron, and can therefore be fired in an oxidising atmosphere, which will induce a warmer colour in the glaze without losing the whiteness. My thanks to Nigel Wood for clarifying this point. An analysis of the body was presented by Guo Yanyi *et. al.*, at the 1982 Shanghai Conference on the scientific and technological aspects of Chinese ceramics, the papers from which will shortly be published. Dehua glazes are also discussed by Watt, J., *Te Hua Porcelain*, Chinese University of Hong Kong, Hong Kong, 1975, Introduction.

Manifestations of Guanyin

The Bodhisattva Avalokiteśvara, in China Guanyin, an abbreviation of Guanshiyin, 'the Bodhisattva who Hears the Cries of the World', has appeared to earthly devotees in a variety of manifestations. These have special and appropriate names which are used in divers contexts: prayers, texts, paintings, prints, oral stories, plays and vernacular fiction.

Besides the basic form 'Guanshiyin', popular manifestations have been *Dabei*, a glorious thousand-eye and thousand-armed Tantric vision; the *nanhai* (southern seas) Guanyin, who sits in serene contemplation on Mount Potalaka off the southern coast of India; the *baiyi* Guanyin (white-robed) Guanyin, a robed female manifestation, apparently introduced from Tibet in the eighth century; the *shuiyue* (water-moon) Guanyin, who gazes at a reflection of the moon, an image for the insubstantiality of the material world, his head surrounded by a moon-like nimbus; and Miaoshan, the mythologized secular face of a Chinese maiden who eventually was transfigured into *Dabei*.

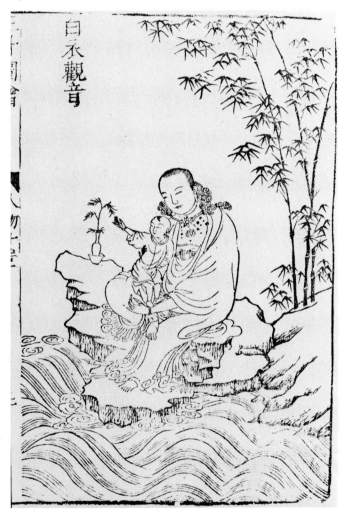

Fig. 15 Woodblock printed illustration of the *baiyi* Guanyin holding a child, from the *San cai tu hui*, AD 1609. Courtesy of the School of Oriental and African Studies, London University.

The name *songzi* (child-giving) Guanyin which has been extensively employed in the text above, is a generic name which describes not so much a particular manifestation as a quality ascribed to the Bodhisattva in the Lotus Sutra. Guanyin can grant children in any manifestation, but of course it was natural that the female manifestations would push to the fore for this role. The white-robed Guanyin, perhaps originally the Tantric White Tara female aspect of Avalokiteśvara, was merged with the water-moon Guanyin, and from the Southern Song dynasty it was common to see a white-cloaked female Guanyin seated meditating by the waterside (the most celebrated image of this version is the Mu Qi triptych in the Daitokuji, Kyoto). This conflation formed the basis for one type of the *songzi* Guanyin, and the Ming encyclopaedia *San cai tu hui*, compiled by 1609 by Wang Qi (fl. 1565–1614), shows the *baiyi* Guanyin seated on a bank with a child on her lap (Fig. 15).

Such illustrations coloured Ming ideas about the *nanhai* Guanyin, who likewise was shown as a young woman, sometimes carrying a child, walking over water or riding a sea-dragon. The *nanhai* Guanyin had always been a saviour of souls in peril of shipwreck and there was thus good reason for showing him/her about on the water. Both the forementioned versions of Guanyin qualify as *songzi* Guanyin. The womanly image of Guanyin was further developed by the Miaoshan myth, which added a patina of youthful feminine beauty to the nexus of beliefs surrounding the Bodhisattva.

Zhangzhou ivories almost invariably show a female manifestation of Guanyin, often holding a child because of the auspicious sentiments discussed in previous pages, but sometimes alone with one or several attributes, a scroll, sceptre and rosary. The hair-styles, loops and *chignons* derive from printed illustration and were presumably at sometime in the Ming a fashion amongst ladies of means. Images of female immortals, such as He Xiangu of the Song tale, resemble Guanyin insofar as they were drawn from the same source, printing, where the ideal of female beauty was rather stereotyped.

17. Figure of white-robed Guanyin holding a *ruyi*-sceptre

H. 15.2 cm

Ming dynasty, about AD 1580–1644

Asian Art Museum of San Francisco. The Avery Brundage Collection, B62 M49

18. Figure group, polychromed wooden bodies with ivory heads and hands: Guanyin holding a child

H. 19 cm

Ming dynasty, about AD 1580–1644

Fitzwilliam Museum, Cambridge University. Given by Cecil Byers, 0–29 1938

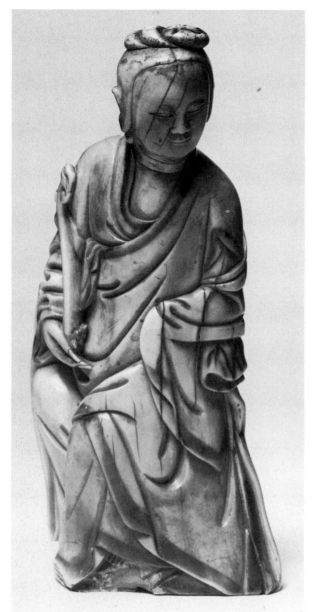

17

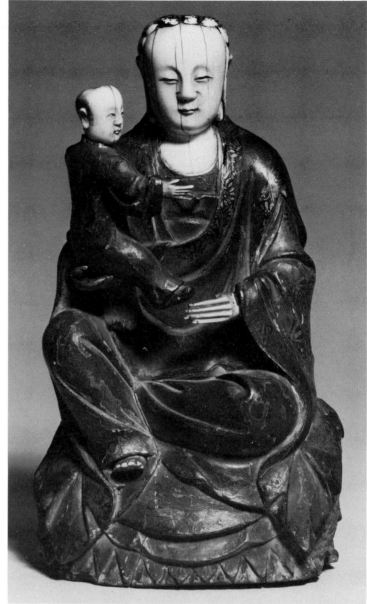

18

In this group, ivory as a new medium for figure carving dovetails with established techniques in wood carving for temples and domestic altars. From the illustration to the *San cai tu hui* shown on p. 53, it can be seen that this model is based upon the white-robed Guanyin tradition, although here this connection is obscured by the vivid coloration.

19. Figure of white-robed Guanyin holding a scroll

H. 10.5 cm

Ming dynasty, about AD 1580–1644

Museum of Far Eastern Antiquities, Stockholm. Collection of King Gustav VI Adolf, HM 2637; ÖM 1192/74

20. Figure of Guanyin holding a child, with a rosary looped on her wrist

H. 26.3 cm

Ming dynasty, about AD 1580–1644

Victoria and Albert Museum. 274–1898

21. Figure of white-robed Guanyin with Bodhisattva jewellery, with a later ivory stand

H. 9.2 cm

Ming dynasty, about AD 1580–1644

The Irving Collection

The Bodhisattva is seated in the *rājalīla* pose of royal ease, one of the seated postures often used in Chinese Buddhist

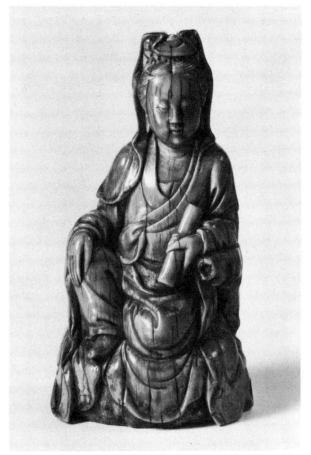

19

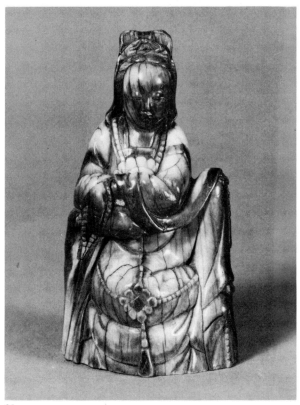

21

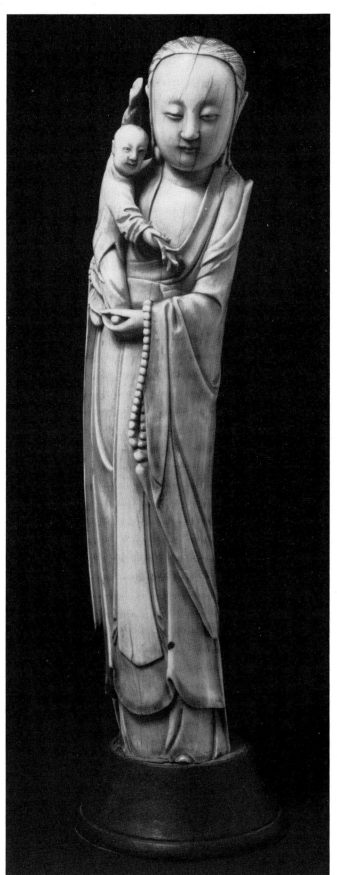

20

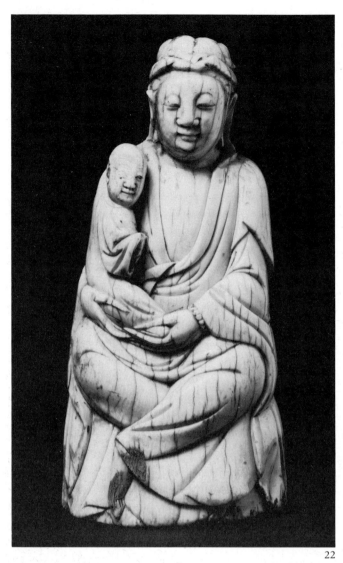

22

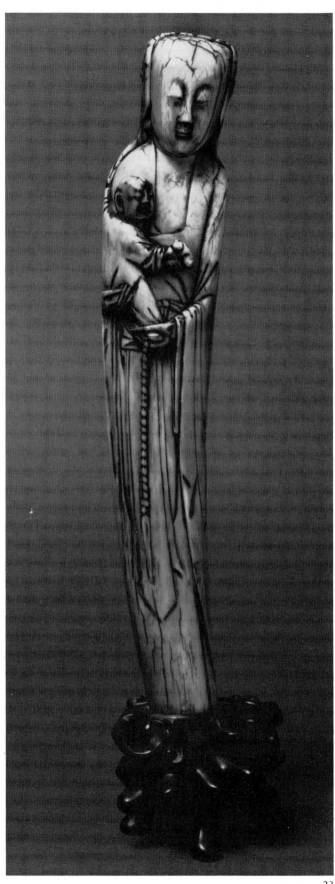

sculpture to suggest Guanyin at rest on Mount Potalaka. From the Song period onwards Guanyin was sometimes shown in a variant of this position, with one leg pendant. The beading represents the rich jewellery worn by Bodhisattvas, lavishly described in Buddhist sutras to conjure up visions of gem-like paradises into which the good and faithful would be reborn.

22. Figure of white-robed Guanyin holding a child

H. 15.2 cm

Ming dynasty – Qing dynasty, 17th century AD

Victoria and Albert Museum. A 28–1934

23. Figure of Guanyin holding a child, with a rosary in her hand

H. 24 cm

Ming dynasty, about AD 1580–1644

Phillip N. Allen

23

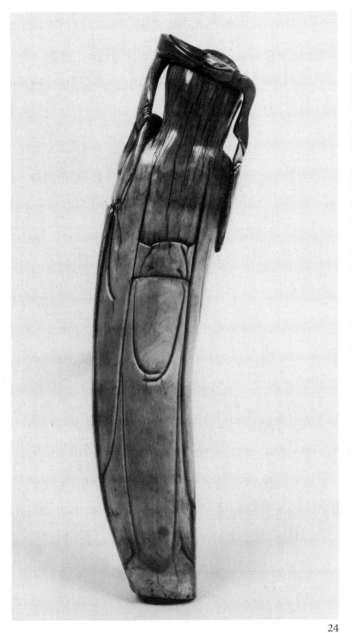

24

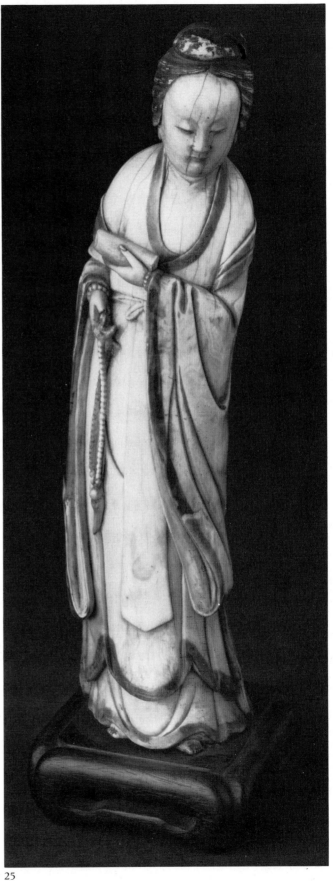

24. Figure of Guanyin holding a child, wearing a high arched scarf and rosary

H. 26 cm Colour plate 1

Ming dynasty, about AD 1580–1644

Private Collection

25. Figure of Guanyin holding a scroll and rosary

H. 23.6 cm

Ming dynasty, about AD 1580–1644

British Museum. Ernest Marsh Bequest, OA 1945.4–20.2

Exhibited: International Exhibition of Chinese Art, Royal Academy, 1935–6

25

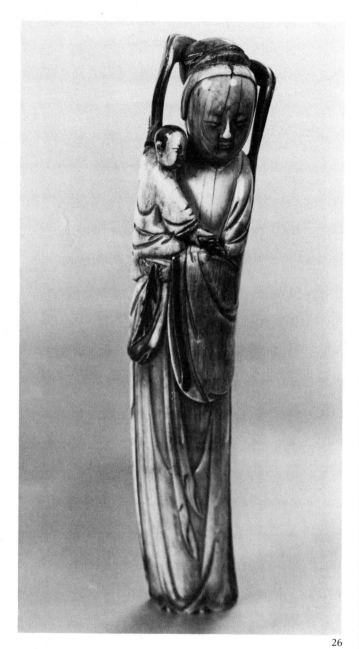

26

27. Figure of Guanyin holding a child, gilt lacquered

H. 32 cm

Ming dynasty, about AD 1580–1644

Victoria & Albert Museum. A.15–1935

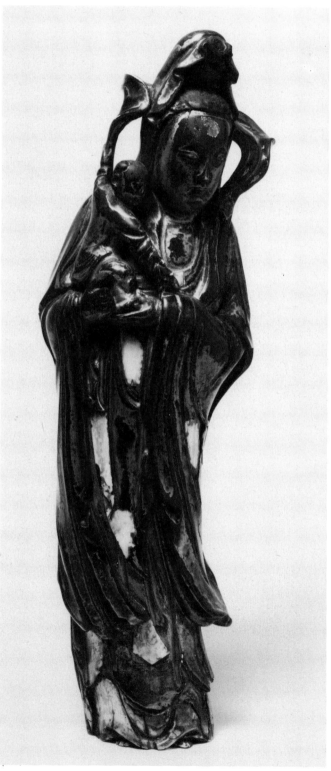

26. Figure of Guanyin holding a child, wearing a high arched scarf

H. 21 cm

Ming dynasty, about AD 1580–1644

Private Collection

The flying scarf worn by many ivory Guanyin and some Daoist immortal images has its origins in Buddhist art of the Six Dynasties, imported into China through Central Asia. Such scarves completed the dress of both Bodhisattva and the flying heavenly beings known as *apsarases*. In Wei Buddhist art, these were used to great effect, shaped as they then were by the sinuous linear rhythms of indigenous Chinese art, particularly by the cloud-scrolls amongst which *apsarases* were often placed.

27

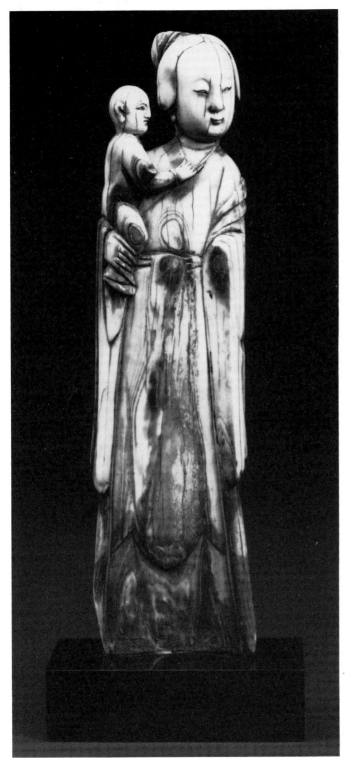

28. Figure of Guanyin holding a child

H. 17 cm

Ming dynasty, about AD 1580–1644

Private Collection

The head of the child is a replacement.

29. Figure of white-robed Guanyin holding a child with a scroll, a folded over lotus leaf at her left side

H. 19.5 cm

Ming dynasty, about AD 1580–1644

Mr Che Ip

The petal-shaped bodice worn just underneath the robe at the breast derives from a pleated undergarment seen on Buddhas and Bodhisattvas from the 6th century onwards.

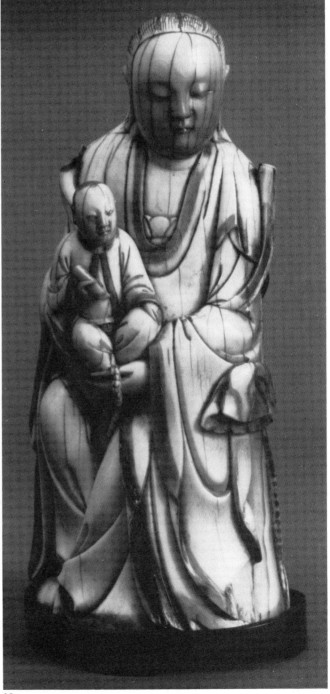

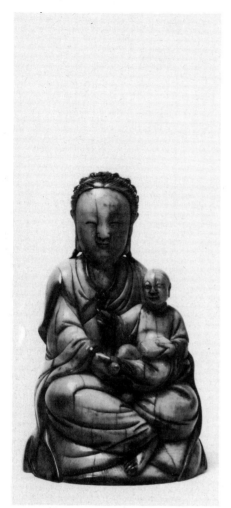

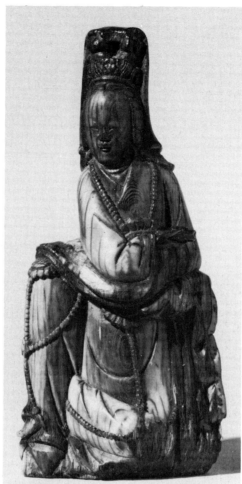

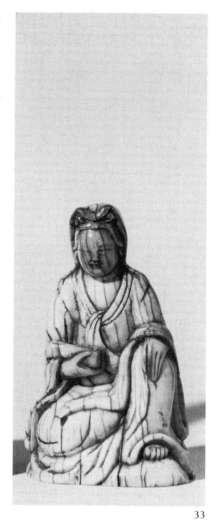

30

32

33

30. Figure of white-robed Guanyin holding a child with a book and lotus

H. 8.3 cm

Ming dynasty, about AD 1580–1644

Sir Victor Sassoon Trust, T 24. On loan to the Victoria and Albert Museum

31. Figure of Guanyin holding a child

H. 23 cm

Ming dynasty, about AD 1580–1644

Private Collection

32. Figure of white-robed Guanyin with Bodhisattva jewellery

H. 12.5 cm

Ming dynasty, about AD 1580–1644

Private Collection

The model is essentially the same as No. 21, but on the crown of this slightly larger figure there was originally an image of the

Buddha Amitabha, of whom Guanyin is an emanation. This has been gouged away, presumably by Christians in order to convert the Guanyin into a Madonna. Such iconoclasm is not unexpected considering the dialogue between the Spanish at Manila and the Chinese at Zhangzhou, which stimulated such images as these in the first place.

33. Figure of white-robed Guanyin holding a book

H. 7.5 cm

Ming dynasty, about AD 1580–1644

Private Collection

34. Figure of Guanyin holding a rosary and scroll

H. 28.1 cm

Ming dynasty, about AD 1580–1644

British Museum. Eumorfopoulos Collection, OA 1937.4–16.205

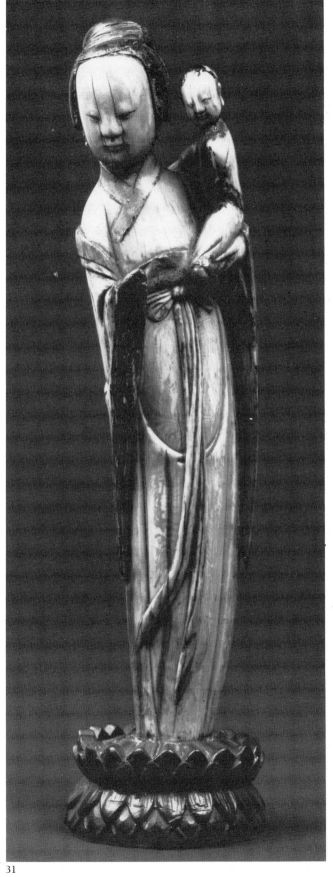

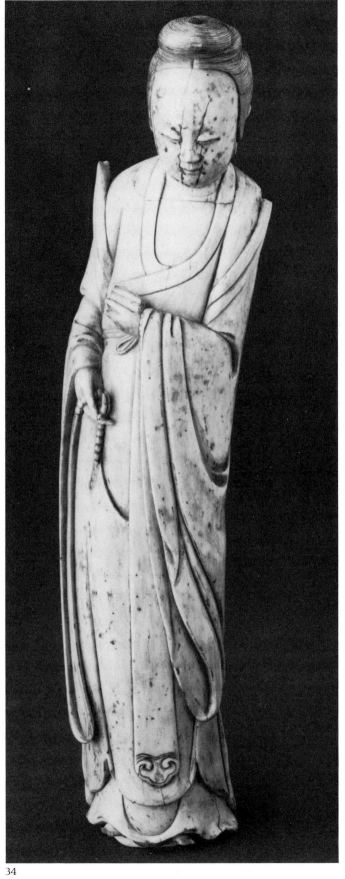

31

34

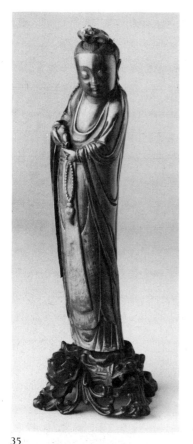

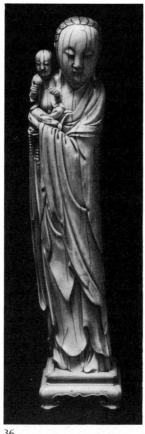

35 36

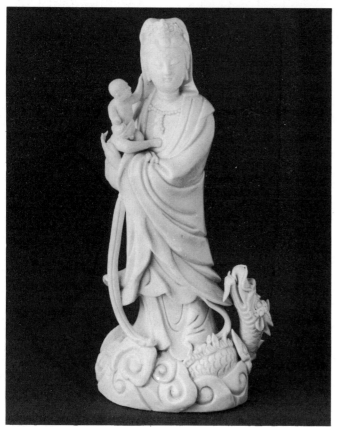

37

35. Figure of Guanyin holding a double-gourd flask and rosary

H. 27 cm (with stand)

Ming dynasty, about AD 1580–1644

British Museum. Given by Miss L. S. David, (formerly J. J. Joass Collection), OA 1952. 12–19.10

36. Figure of Guanyin, holding a child

H. 33.7 cm

Ming dynasty, about AD 1580–1644

Sir Victor Sassoon Chinese Ivories Trust, 117/740

37. Porcelain figure, Guanyin holding a child, riding on a water dragon

H. 24.5 cm

Dehua, Fujian province

Ming dynasty, 17th century AD

British Museum, Donnelly Bequest, OA 1980.7–28.19

Ivories for the Spanish Christian market

Ivories made for the Spaniards at Manila are numerous, but lie outside the scope of the present exhibition, except insofar as they provide the rationale for the original existence of Zhangzhou figure carvings. The background to this cultural exchange has occupied a good part of the main text, and thus it is only necessary to note here the range of objects known to have been produced. In addition to images of the Crucifixion, the Madonna and the Holy Infants Christ and St John, there were also saints and angels, all carved in the round. Plaques carved in low relief directly copied the woodblock printed sources from Mexico and Europe which also served as models for figure carving; finally there were heads and hands made for insertion in non-ivory bodies.

38. Figure group of the Virgin and Child, surface much damaged and no traces of paint

H. 20 cm (Fig. 1)

Probably German, by the so-called Master of Kremsmünster, late 14th century AD

British Museum. M&LA 56.6–23.148

The statuette is included in the exhibition as an outstanding representative of a class of votive sculpture in ivory extremely popular in Europe, particularly in the 14th century. For whatever reason, European elephant ivory production virtually ceased from around 1400 onwards until it was revived in the Baroque period. However Gothic images like this continued to be employed in churches long after the 14th century. There

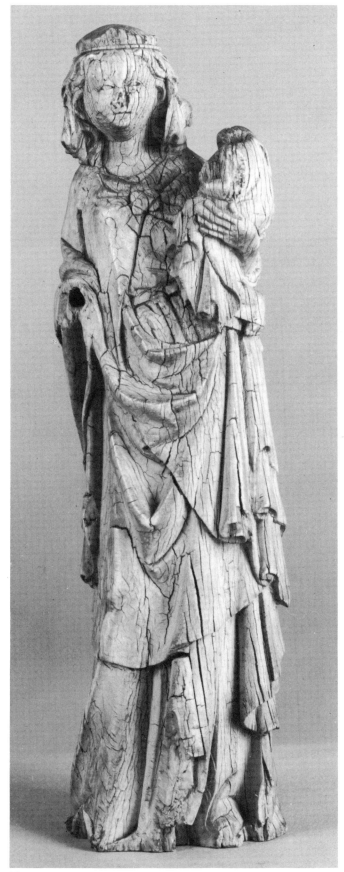

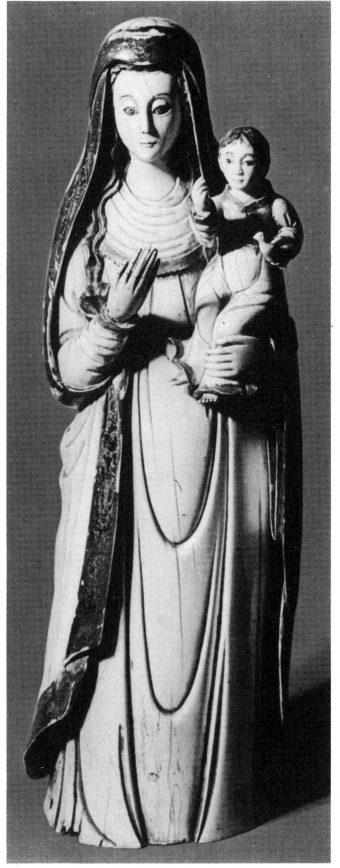

38

39

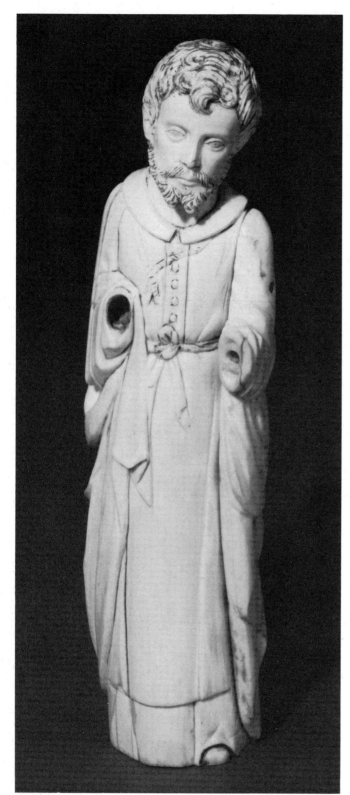

40

is therefore every reason to think that groups like this one are the ultimate models for the Sino-Spanish Christian images.

Published: Dalton, O. M., *Catalogue of the Ivory Carvings of the Christian Era in the British Museum,* London, 1909, no. 332.

39. Figure group of the Virgin and Child, the hems lacquered and gilt

H. 36 cm (Fig. 3)

Ming dynasty, about AD 1580–1644

José Maria Jorge

Exhibited: Portuguese Discoveries and Renaissance Europe, 17th Council of Europe Exhibition, Lisbon, 1983.

This robustly carved model is a fine example of Chinese ivory carving executed for Western patrons. Although it has been previously regarded as Sino-Portuguese, and naturally so as it has been preserved in Portugal, it was made at Zhangzhou in the context of the Sino-Spanish trade. It may have been taken to Macao by Zhangzhou merchants seeking to capitalise on the Portuguese market, but it is more probable that it was purchased by Portuguese visiting Manila.

Published: Ferrão de Tavares e Tavora, B. *Imaginária Luso-Oriental*, Lisbon, 1983, p. 16.

40. Figure of St Joseph

H. 19.2 cm

Ming dynasty, about AD 1580–1644

British Museum. Given by the Rev. J. Chester, M&LA 84.10–17.2

Published: Dalton, *op.cit*, no. 550.

41. Figure of a Christian saint, possibly St Dominic

H. 18 cm Colour plate 2

Ming dynasty, about AD 1580–1644

Private Collection

The left hand holds a (?) missal upon which a bird is perched.

42. Figure of the Holy Child holding an orb

H. 22.9 cm (Fig. 5)

Ming dynasty, about AD 1580–1644

Mrs Rafi Y. Mottahedeh

Pigment still remains on the face and lips. The reverse is incised with a partly legible Chinese four-character inscription (the last two characters perhaps referring to Jesus). Votive images depicting the naked Christ Child were commonly commissioned by both the Spanish at Manila and the Portuguese at Goa.

Published: Howard, D. and Ayers J, *China for the West,* London and New York, 1978, Vol. 2, No. 685; Bowie, T., *East-west in Asia*, Fig. 200, Bloomington and London 1966.

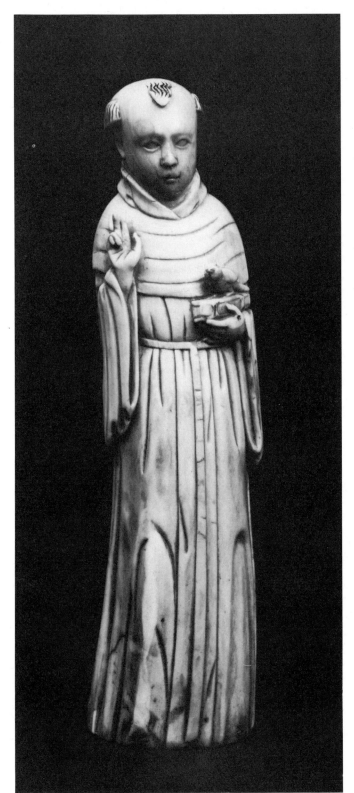

41

43. Figure of the Holy Child asleep

H. 14.3 cm (Fig. 6)

Probably from Goa

16th–17th century AD

British Museum. OA 1981.6–5.1.

Models of sleeping Child served as prototypes for Chinese figures of reclining naked females (Nos 128–131, 133). The sleeping Child image in ivory may have been originally imported into Manila from the Portuguese colony at Goa in India, where many such figures were made. Nevertheless, Sino-Spanish examples are also known, preserved in Mexican collections.

Daoist Immortals and other Adepts

The band of Eight Immortals, the *Ba xian*, brought together as a dramatic convention in the Yuan dynasty is usually made up of the following: Lü Yan, called Dongbin (male), Han Xiangzi (male), Zhang Guo (male), Lan Caihe (male/androgynous), He Xiangu (female), Zhongli Quan (male), Li Tieguai (male) and Cao Guojiu (male). As to these eight, there are grounds for believing that three were historical persons, one more may have been, one has a very ancient ancestry in mythology, and the other three are composite legends.

Lü Yan was a Tang poet who, having failed the metropolitan examinations in the second half of the ninth century, gave up the quest for an official career and worldly rewards in favour of his own metaphysical search. His poems are concerned with alchemy and straddling the heavens:

'Let me but have a staff of power on the true and perfect road–
How then would I trouble to worship the moon or tread the altar of stars'[a]

Han Xiangzi was a distant nephew of the great Confucian statesman and writer Han Yü (AD 768–824), and is referred to in one of Han Yü's poems written in 799/800. This shadowy figure was skilled in Daoist lore and had prognosticated Han Yü's future at a time when the latter had fallen from official favour. Later Daoists apparently superimposed this man's talents onto a better known nephew Han Xiang, in order to show that even a celebrated Confucianist could take advice from a Daoist mage.

Zhang Guo was another historical Daoist; his talents were sufficiently appreciated for him to be called to the court of Tang Xuanzong (reigned AD 713–756) where he was probably instrumental in converting the emperor to Daoism. As well as being a master of breathing techniques, he was a capable star-reader who understood the relation of the Five Planets to human destiny. Some of the surviving books on astrology attributed to him may be authentic.

[a] Schafer, E. H., *Pacing the Void*, p. 229

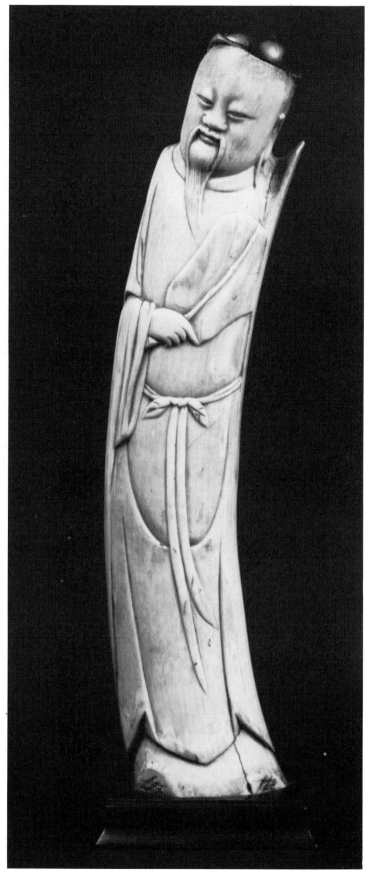

44

45

Lan Caihe may have existed. His legend parallels the rich stories circulated about the eccentric seventeenth-century painter Zhu Da, who ran about market places dragging his robes in the dust. Lan Caihe sang and begged in public places making an exhibition of himself, one day apparently just leaping up and away into the void. Whether he really lived or not, his life, like Zhu Da's, is a celebration of inspired or 'divine' madness. A single Tang poem is attributed to him. Lan (Ch. 'blue') supposedly always wore an indigo shirt; in later stories and pictures he can be represented as a hermaphrodite.

He Xiangu belongs to a very old Chinese tradition of divine sylphs, stemming from the shamanistic origins of indigenous religion. This particular ethereal fairy is first introduced in collectanea of the Song period, where her apotheosis is placed in the eighth century AD. Of all the stories relating to the Eight Immortals, that which refers to He Xiangu gaining the power of flight by ingesting crushed mica is the most explicit allusion to contemporary Daoist practice and aspiration.

Historical sources for the other three characters are still unidentified, if they exist.

The Eight Immortals and other adepts are sometimes shown wearing feather or leaf clothes, the latter a ready form of rustic waterproofing depicted in the arts as suitable dress of peasants hurrying through the rain in landscape. Daoist immortals were seen as rustic beings, living amongst mountains, but the real purpose of feathered capes, stoles and skirts was esoteric. From Han times, Daoist adepts had worn such dress to signify their desire to rise away from the grip of earth and to walk freely across the cosmos. Han brick reliefs show fantastic feathered beings, whose potency in Chinese imagination persisted in the adepts' arcane costume.

44. Figure of He Xiangu holding a mortar and pestle, horn cap

H. 20 cm

Ming dynasty, about AD 1580–1644

Private Collection

Mortar and pestle was used for crushing ingredients to go into elixirs of immortality; in He Xiangu's case mica was the preferred drug.

45. Figure of Zhongli Quan holding a fan, restored wood cap

H. 21.6 cm

Ming dynasty, about AD 1580–1644

Private Collection

The omission of one arm, leaving only a curling flange, is not uncommon on Zhangzhou ivories. The remaining hand usually holds an identifying attribute, making the other iconographically redundant; the truncation is presumably due to the size and shape of the tusk.

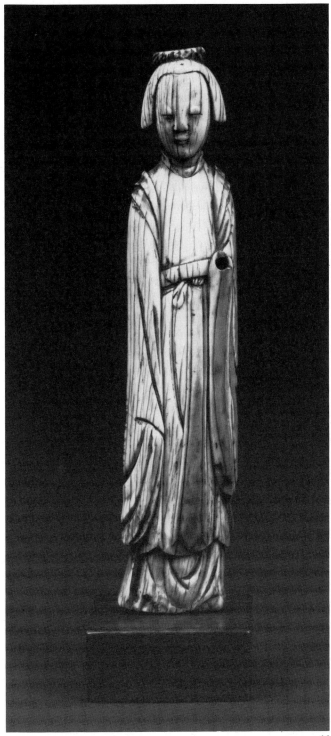

46

46. Figure of female immortal, probably He Xiangu

H. 15 cm

Ming dynasty, about AD 1580–1644

Private Collection

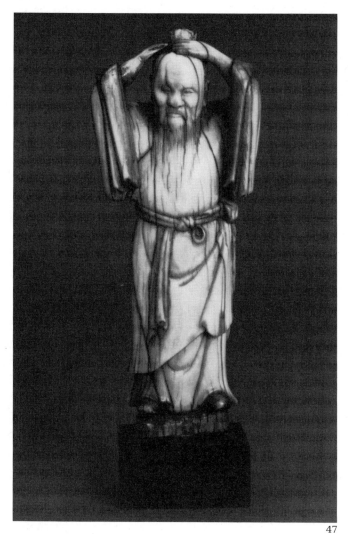

47

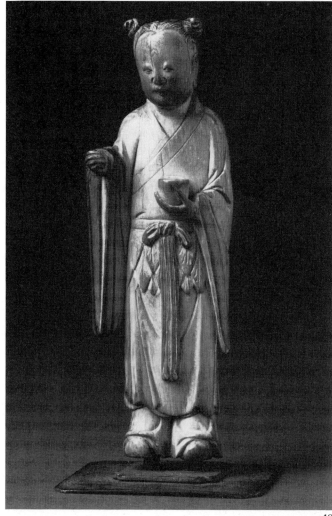

48

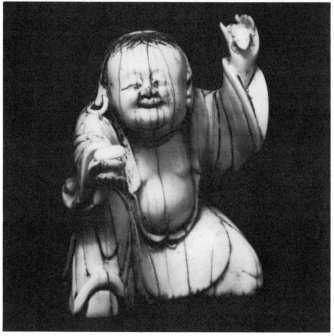

49

47. Figure of a Daoist immortal fixing his cap with a hair-pin

H. 11.5 cm

Ming dynasty, about AD 1580–1644

Mr Che Ip

Lucas calls this model Zhang Daoling, the First Celestial Master and founder of religious Daoism, but comparison with the *Lie Xian quanzhuan* suggests that it represents Dong Wang Gong, consort to the Queen Mother of the West.

48. Figure of a Daoist immortal, possibly Han Xiangxi, wearing a feather or leaf skirt and holding a mortar

H. 12 cm

Ming dynasty, about AD 1580–1644

Dr E. Widmaier

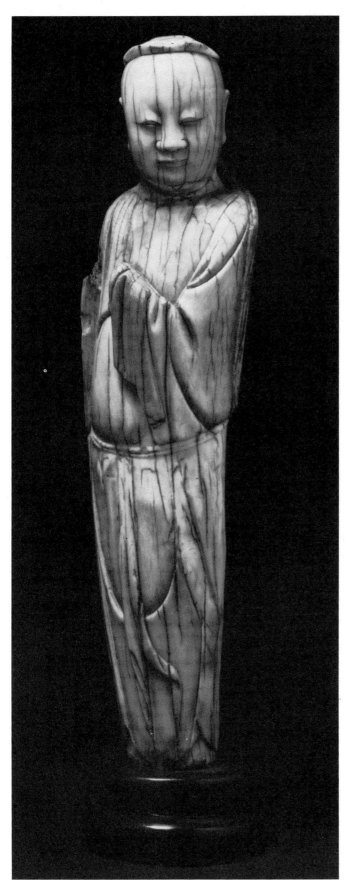

50

49. Figure of Liu Hai holding a three-legged toad and a box

H. 8.6 cm

Ming dynasty, about AD 1580–1644

Sir Victor Sassoon Trust, T48

The three-legged toad carried by Liu Hai, an immortal associated with wealth, has its origins in mythology of the late 1st millennium BC. A compilation of philosophical ideas known as the *Huainanzi*, assembled by a group of nobles and intellectuals of the 2nd century BC, refers to the dynamic relationship between the toad which lives in the moon and the moon itself, wherein the moon gains in brightness as it feeds upon the beast. In another tradition, the toad devours the moon, thus causing eclipses. Early ideas on the nature of the cosmos and its unearthly inhabitants were developed and improved upon in the climate of cosmogenic speculation characteristic of the Han. The sun was inhabited by a three-legged bird, and so the moon's tenant was reduced by one leg to correspond. Both lunar creatures, the hare and the toad, were linked with the concept of immortality.

50. Figure of Han Xiangzi wearing a ribboned cap

H. 22.9 cm

Ming dynasty, about AD 1580–1644

Sir Victor Sassoon Trust, X590

His flute is missing.

51. Figure of Han Xiangzi

H. 26 cm

Ming dynasty, about AD 1580–1644

Private Collection

His flute is missing, and the cap restored.

52. Figure of a Daoist immortal with wooden body, ivory head and hand, and horn cap

H. 25.5 cm

Ming dynasty, about AD 1580–1644

Museum für Ostasiatische Kunst, Berlin. Given by Frau G. von Scharfenberg, 1967–15

Like the Guanyin with a polychromed wooden body (No. 18) this piece has only its extremities in ivory; however the addition of a cap in horn, a desirable material both for medicines and carving, suggests that it is not a cheap version of a wholly ivory image, but rather an alternative. The fold of the robe below the tied belt drops into the U-shape familiar from comparable ivory pieces, and the painting of the border echoes the pigmentation of Zhangzhou ivories; there can be little doubt that these were made in the same workshops. Compare the immortal from the Cleveland Museum of Art (No. 15.), which is similarly constructed.

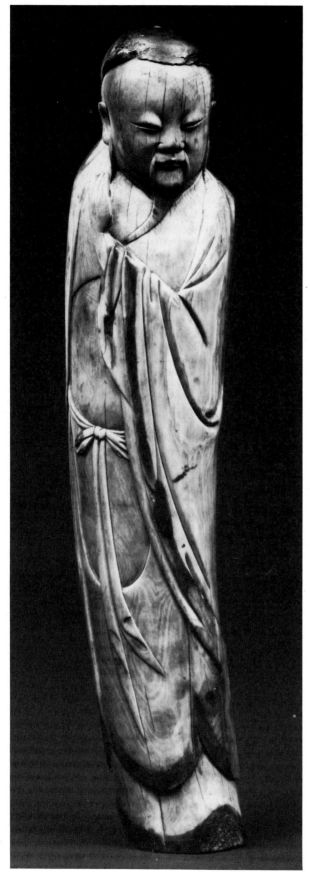

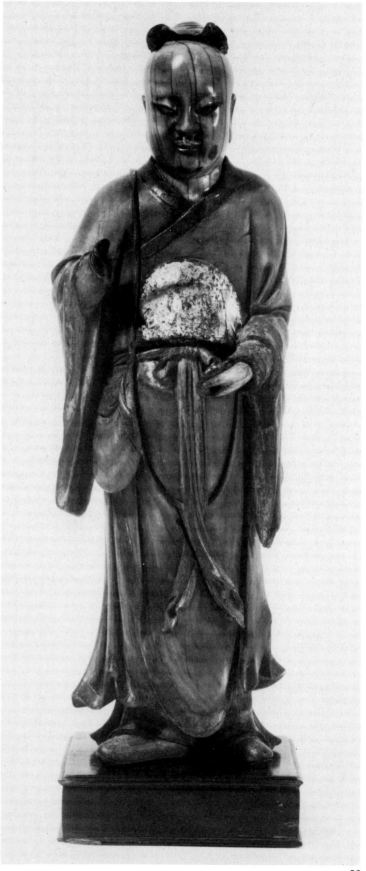

51

52

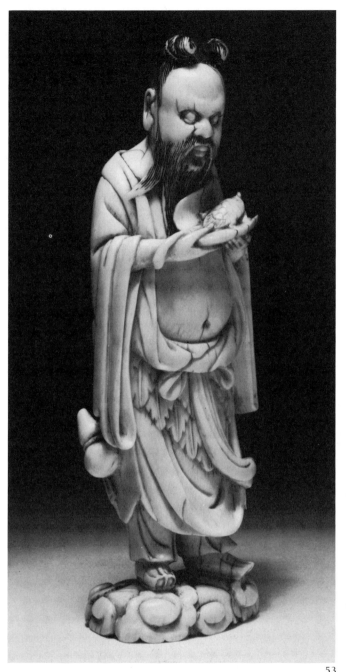

53

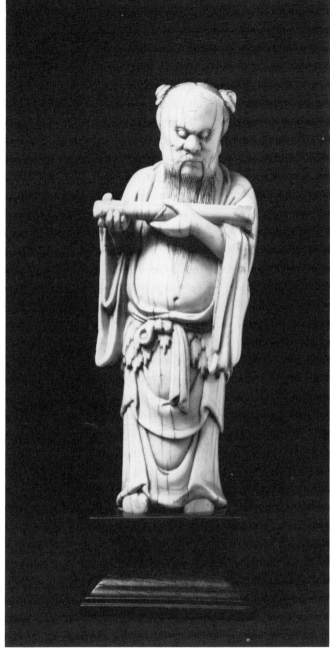

54

53. Figure of Zhongli Quan wearing a feather or leaf skirt, slung with a double gourd elixir flask and holding a fan and tortoise, standing on a cloud-scroll base

H. 14.7 cm Colour plate 3

Ming dynasty, about AD 1580–1644

Victoria and Albert Museum. FE. 4–1977

The tortoise was yet another symbol of longevity, and was invoked in birthday congratulations through the phrase *gui ling*, 'age of the tortoise', a reference to the long life-span of the reptile. From the Yuan onwards *gui* became a taboo word in some parts of the country because of an insalubrious sexual connotation, but in the south it continued to be used as an auspicious emblem.

54. Figure of Zhongli Quan wearing a feather or leaf skirt and holding a scroll

H. 11.5 cm

Ming dynasty, about AD 1580–1644

Sir Victor Sassoon Chinese Ivories Trust, X 1427

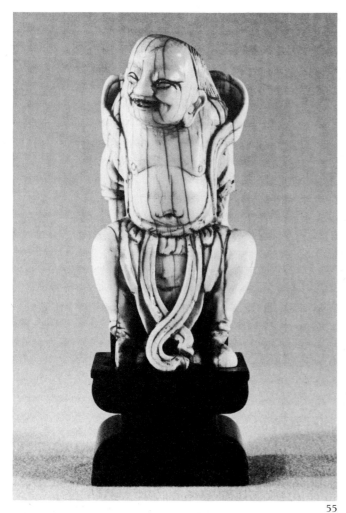

55

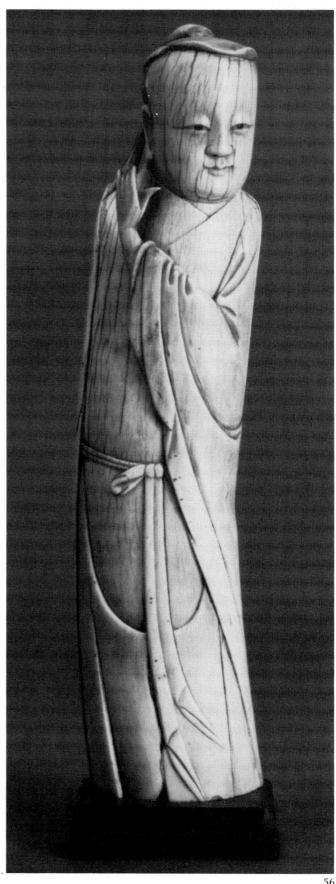

55. Figure of a Daoist adept dressed in a loose tunic and coiling scarf

H. 8.9 cm

Ming dynasty, about AD 1580–1644

Winchester College, Duberly Collection

This may have formed part of the support for a vessel.

56. Figure of Han Xiangzi wearing a ribboned cap

H. 26.5 cm

Ming dynasty, about AD 1580–1644

Mr Che Ip

His flute is missing.

56

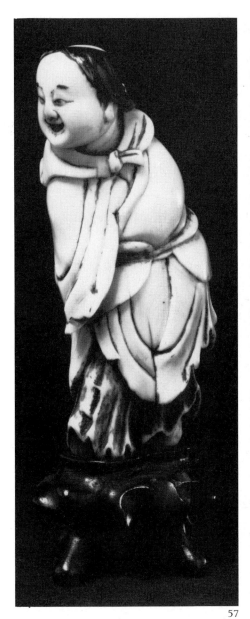

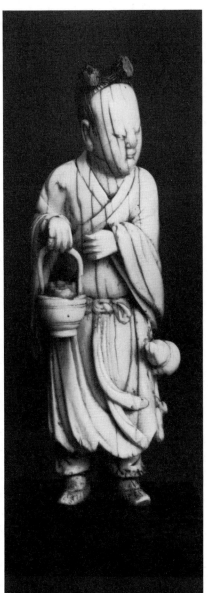

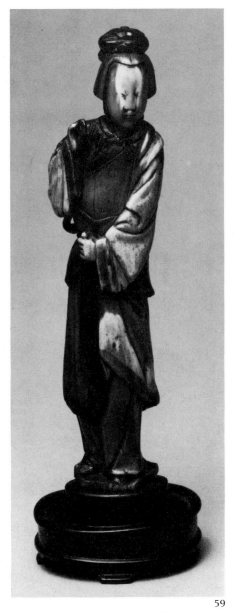

57

58

59

57. Figure of a Daoist adept wearing a cape, tunic and apron

H. 11.1 cm

Ming-Qing dynasty, 17th century AD

Sir Victor Sassoon Chinese Ivories Trust T7. On loan to the Victoria and Albert Museum.

His hair and trousers are tinted respectively black and red. In the cape, generous tunic (as opposed to traditional flowing robe) and round face, the modelling is similar to the Mottahedeh figures of Dutchmen (No. 134). The bedraggled appearance and manic grin are conventions used to depict the Divine Fool, as for example the inspired Tang dynasty monks Han Shan and Shi De.

58. Figure of Lan Caihe, with a double-gourd elixir flask and a basket of flowers

H. 12 cm

Ming dynasty, about AD 1580—1644

Mr Che Ip

59. Figure of a female immortal, probably He Xiangu, wearing a feather or leaf cape

H. 13.4 cm

Ming dynasty, about AD 1580—1644

Sir Victor Sassoon Chinese Ivories Trust, T 40. On loan to the Fitzwilliam Museum, Cambridge University

Her right hand holds what is probably the stem of a lotus, attribute of He Xiangu.

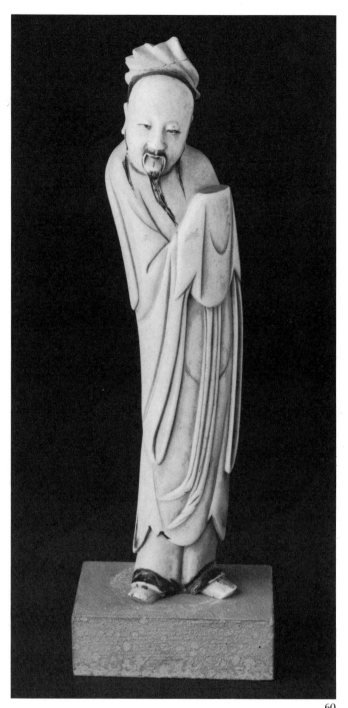

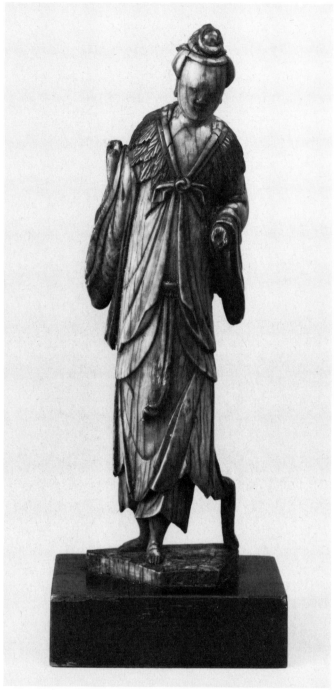

60

61

60. Figure of an immortal holding up an offering cloth

H. 23.2 cm

Ming dynasty, about AD 1580–1644

British Museum, Eumorfopoulos Collection. OA 1937.7–16.166

The object originally proffered by this immortal is now missing. Offerings have been presented on special kerchiefs since early times. The eight attendant statues in the 16th century

Water-mother (*shuimu*) Hall at the Jinci, Shanxi province (see Fig. 9), all hold their gifts in this way (*cf. Jinci*, Peking 1981, pl. 73).

61. Figure of a female immortal, probably He Xiangu, wearing a feather or leaf cape

H. 15 cm

Ming dynasty, about AD 1580–1644

Private Collection

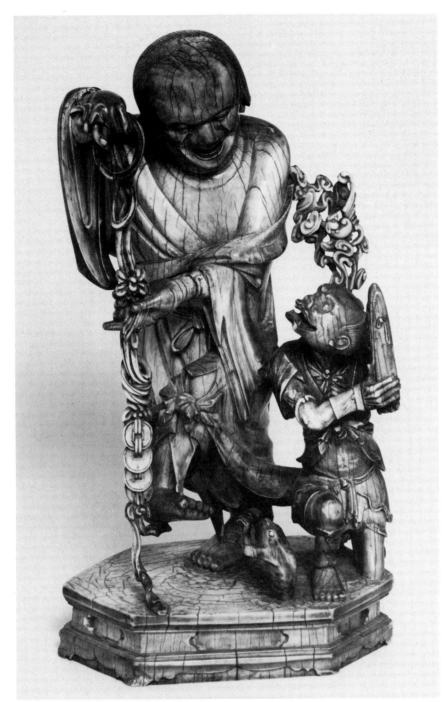

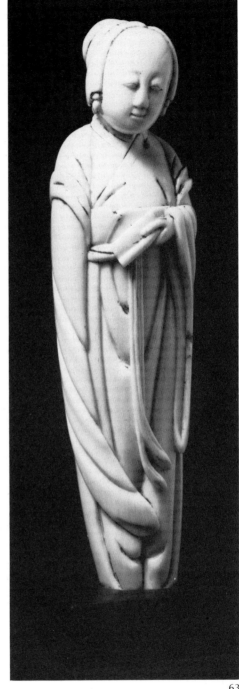

62

63

62. Figure group Liu Hai with a string of cash and his three-legged toad, accompanied by a demon

H. 27.3 cm

Ming dynasty-Qing dynasty, 17th century AD

Asian Art Museum of San Francisco. The Avery Brundage Collection, B60 S72

The group is laden with auspicious symbols: a string of Chinese money (wealth), a three-legged toad (immortality) and a bat (happiness). The sharp edges, attention to detail and pierced work indicate a slightly later date than the great body of Zhangzhou figures.

63. Figure of a female immortal holding a book

H. 17.2 cm

Ming dynasty, about AD 1580–1644

Sir Victor Sassoon Chinese Ivories Trust, T2. On loan to the Victoria and Albert Museum

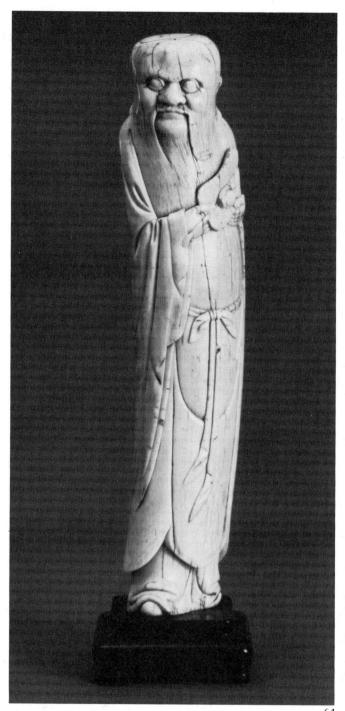

64

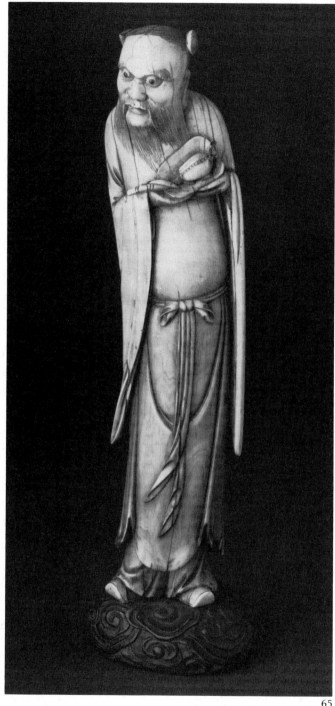

65

64. Figure of Zhongli Quan holding a fan and tortoise

H. 27 cm

Ming dynasty, about AD 1580–1644

Mr Che Ip

65. Figure of Zhongli Quan holding a fan and tortoise

H. 29.8 cm (with stand)

Ming dynasty, about AD 1580–1644

British Museum. Given by Miss L. S. David (formerly J. J. Joass Collection). OA 1952.12–19.8

Exhibited: Burlington Fine Arts Clubs, Exhibition of Chinese Art, 1915, International Exhibition of Chinese Art, Royal Academy, 1935–6.

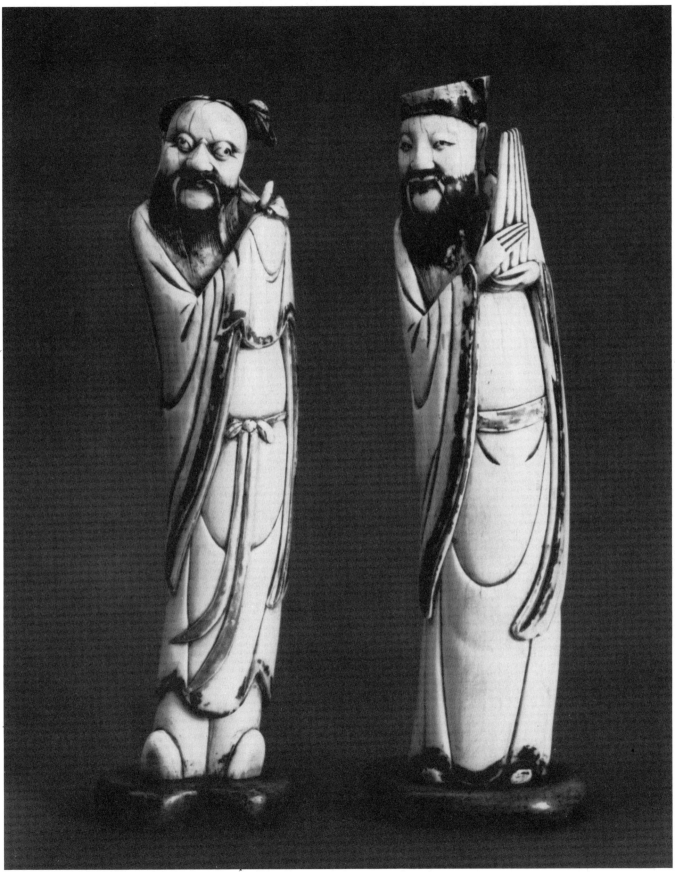

66. Two figures from a set of the *Ba Xian*, Zhongli Quan with a tortoise and probably Cao Guojiu with *sheng* pipes

H. 25.7 cm Colour plate 3

Ming dynasty, about AD 1580–1644

Mr Che Ip

These vividly coloured figures demonstrate very clearly the residual staining from paint used to decorate the borders of robes and highlight the incised folds. In the present case a considerable amount of the original pigmentation survives, the dark edges and linear crevices on the pale cream ground making a striking parallel with the conventions of contemporary woodblock prints, from which ivory iconography and style seem to have been drawn (see Figs 11–14). The identification of the immortal with the *sheng* is a little uncertain, for canonically only He Xiangu should carry this musical instrument; however here the arrangement of pipes is rendered so like a flat court *hu* sceptre (Cao Guojiu's emblem) that Cao seems the most appropriate attribution.

67. Figure of Zhongli Quan wearing a feather or leaf skirt and holding out a scroll

H. 11.5 cm

Ming dynasty, about AD 1580–1644

Mr Che Ip

In Buddhist art, scrolls are held by divinities such as Guanyin to represent Buddhist teaching; the Indian originals of such objects were palm-leaf books, but in China these were transformed into the native equivalent, a scroll of silk or paper wrapped about a wooden roller. Indigenous Chinese deities and saints, such as stellar gods, Daoist immortals and learned adepts are sometimes shown examining scrolls on which the *yin-yang* diagram is illustrated. This diagram sums up the most fundamental cosmic process through which the world is brought into being, the interaction of the male, light, active *yang* principle with the female, dark, passive *yin* principle. The *yin-yang* diagram was only one amongst many created by both Daoist and neo-Confucian metaphysicians, but it is the one most commonly seen in decorative art. The scroll carried here by Zhongli Quan may thus contain just such a picture; or it may stand for the pieces of calligraphy with a hundred versions of the long-life character, *shou*, which were given to older people on their birthdays. The latter possibility is encouraged by the likelihood that many ivory images were themselves birthday gifts.

68. Figure of He Xiangu holding a mortar and pestle

H. 24.5 cm

Ming dynasty, about AD 1580–1644

British Museum. Ernest Marsh Bequest, OA 1945. 4–20.3

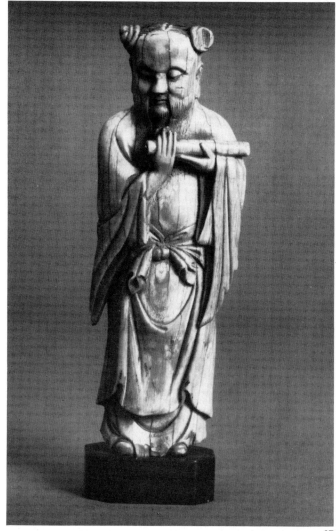

67

69. Figure of Han Xiangzi holding a flute

H. 17.3 cm

Ming dynasty, about AD 1580–1644

British Museum. Given by Miss L. E. S. David (formerly J. J. Joass Collection). OA 1952. 12– 19.7

The flute is a replacement.

Published: Jenyns, R. S., and Watson, W., *Minor Arts*, Vol. 2, No. 123

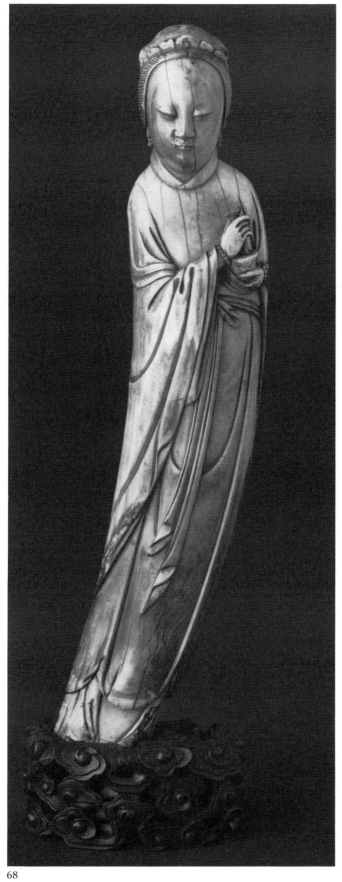

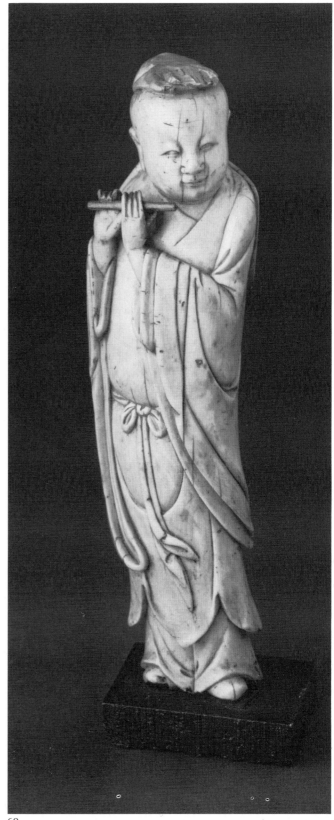

68

69

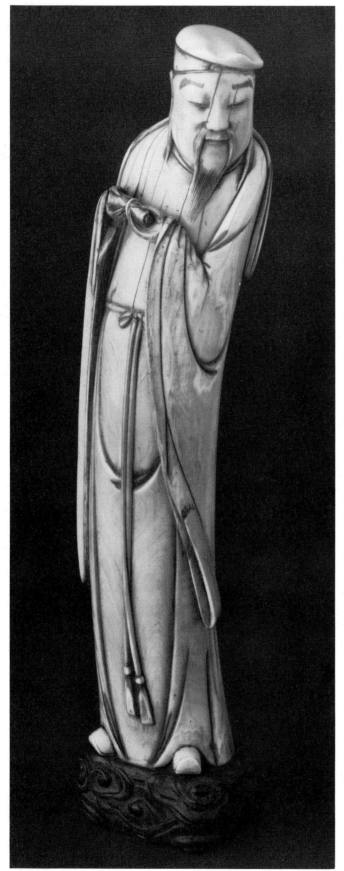

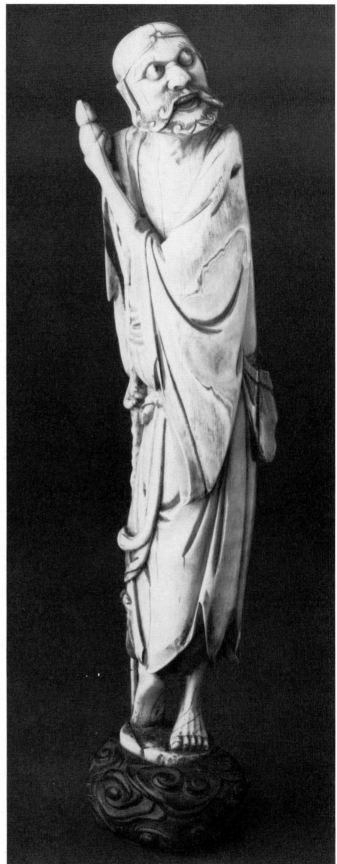

70

71

70. Figure of Zhang Guo holding a scroll

H. 30.5 cm (with stand)

Ming dynasty, about AD 1580–1644

British Museum. Given by Miss L. E. S. David (formerly J. J. Joass Collection). OA 1952. 12–19.9

Published: Jenyns, R. S. and Watson, W., *Minor Arts*, Vol. 2, No. 124

Exhibited: Burlington Fine Arts Club, Exhibition of Chinese Arts, 1915; International Exhibition of Chinese Art, Royal Academy, 1935–6.

71. Figure of Li Tieguai with satchel, double-gourd elixir flask and crutch

H. 29 cm (with stand) Colour plate 2

Ming dynasty, about AD 1580–1644

British Museum. Given by Miss L. E. S. David (formerly J. J. Joass Collection). OA 1952.12–19.6

Although there are several legends telling how the immortal Li Tieguai came to be a crippled and ugly beggar, the prevalent one is as follows. The learned mage was in the habit of leaving his body and betaking his purified soul on celestial missions; on one occasion he entrusted his attendant with his apparently lifeless physical body until his return, but this fellow was called to his mother's sickbed, and believing that his master had been away too long to be credible, and that he had abandoned his corporeal body for good, burned it. When Li finally did return, his pure soul was homeless, and finding only the corpse of a recently deceased beggar he had no alternative but to inhabit that. He is therefore shown as a lame bearded apparition, with wild bulging eyes emphasising his ugliness.

Exhibited: Burlington Fine Arts Club, Exhibition of Chinese Art 1915; International Exhibition of Chinese Art, Royal Academy, 1935–6.

72. Figure of an immortal, probably Cao Guojiu, Lü Dongbin or Zhang Guo

H. 19.1 cm

Ming dynasty, about AD 1580–1644

Asian Art Museum of San Francisco. The Avery Brundage Collection, B60 S475

The whole surface has been coated with a thin layer of black pigment, perhaps lacquer.

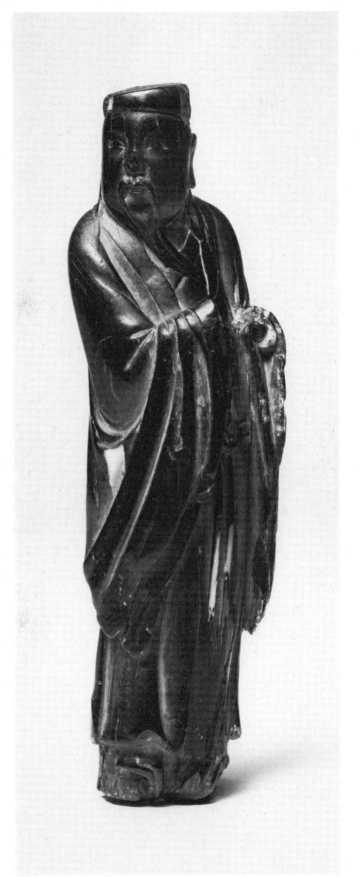

72

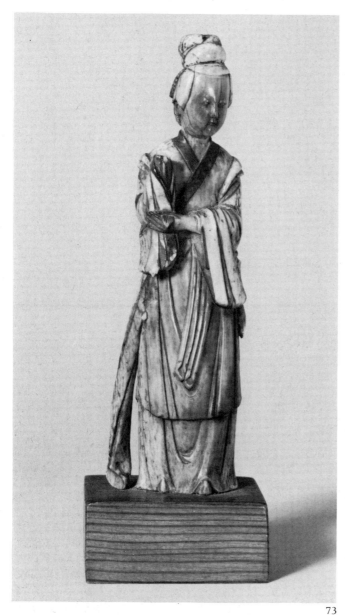

73

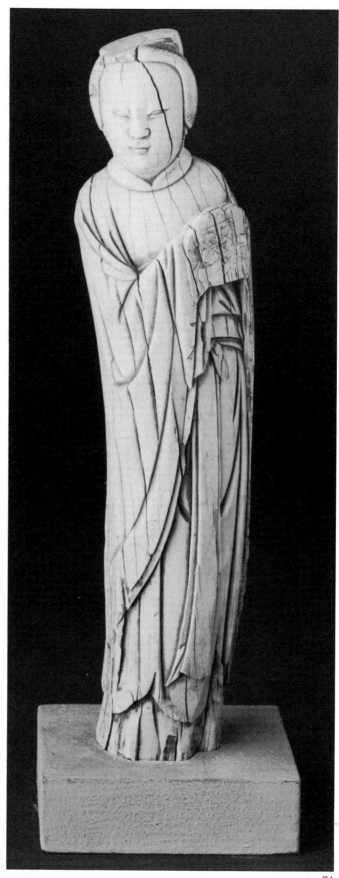

73. Figure of a female immortal, possibly He Xiangu

H. 13 cm

Ming dynasty, about AD 1580–1644

Private Collection.

74. Figure of a female immortal holding up an offering cloth

H. 23.5 cm

Ming dynasty, about AD 1580–1644

British Museum, Eumorfopoulos Collection. OA 1937.7–16.165

The left side has been damaged; both the sleeve and front of the offering cloth have been broken away.

74

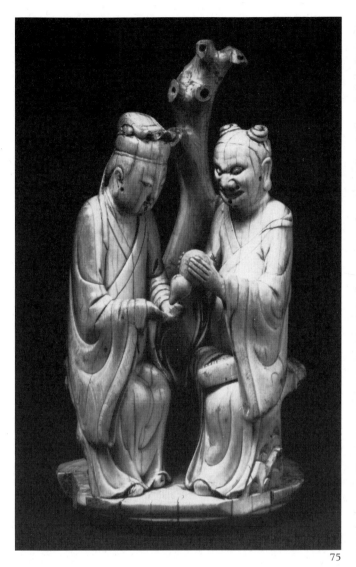

75

75. Figure group, Bian Qiao and Chang Sangjun seated beneath a stumpy tree

H. 14 cm Colour plate 2

Ming dynasty, about AD 1580–1644

Sir Victor Sassoon Chinese Ivories Trust, T 51. On loan to the Victoria and Albert Museum

Bian Qiao, a Warring States physician originally from Mao, in present day Hebei, was given secret formulas by Chang Sangjun which enabled him to acquire great skill. He specialised in taking the pulse, and also had a profound understanding of the five viscera. He settled in the state of Lu, and was thence known as the 'Physician of Lu'; this model shows him receiving an elixir from Chang Sangjun.

76. Figure of Lü Dongbin

H. 26.7 cm

Qing dynasty, 19th–20th century AD

Sir Victor Sassoon Chinese Ivories Trust, 247/120

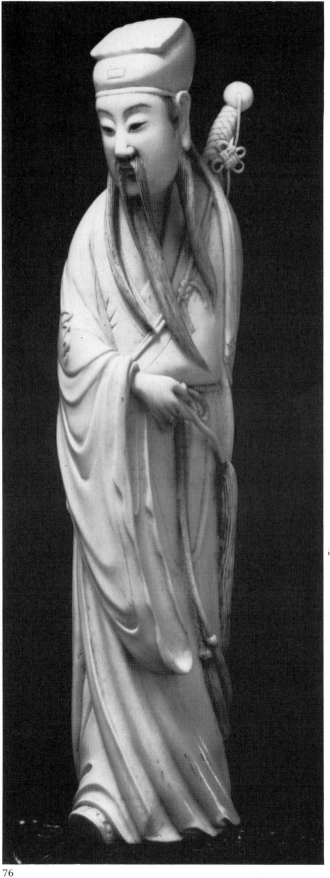

76

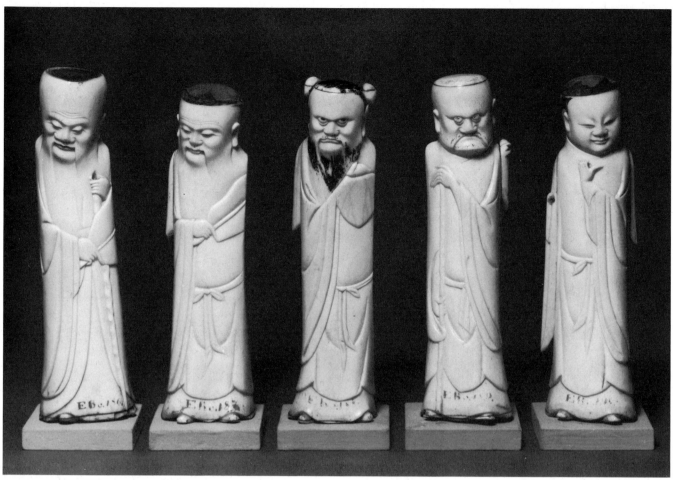

77

77. Five bone figures, Shou xing, stellar god of longevity, and four immortals

H. about 17 cm

Qing dynasty, 17th century. Probably Fujian province

Nationalmuseet, Copenhagen. Kunstkammer Collection, EBc 186, EBc 187, EBc 188, EBc 189, EBc 190

These five figures appear in the 1690 Kunstkammer inventory as 'Four Indian idols of ivory' and 'An East Indian idol carved out of ivory', the latter separate figure being the Han Xiangzi. They are in fact made of bone, but the similarity of the two materials makes the mistake understandable. The immortals are Han Xiangzi, Li Tieguai, Zhongli Quan and, with the fan, probably Lü Dongbin or Zhang Guo. The treatment of the robes and all-round modelling is in lower relief than in earlier Zhangzhou carvings although the general style is essentially unchanged.

78. Wooden figure of an immortal holding a scroll

H. 20 cm

Ming dynasty, about AD 1580–1644

Private Collection

The surface has been coated with a thin layer of black pigment, in the same fashion as immortal No. 72. Although there is no direct evidence that such wooden figures as these were also made in Zhangzhou, the style is so similar to ivory carvings of immortals that it is hard to think otherwise. Added to which is the knowledge that wooden bodies were made with ivory heads and hands.

79. Bronze figure of an immortal, probably Zhang Guo or Lü Dongbin

H. 25.4 cm

17th–18th century AD

British Museum, Franks Collection. OA 83.10–20.1

This figure belongs to a series of bronzes which, like the Zhangzhou ivories, display very strong linear rhythms and a bearing which indicates a source in woodblock prints. The present poor state of knowledge concerning the chronology of Ming and Qing dynasty temple and domestic figural bronzes, many of which do survive, makes it difficult to offer any concrete solution to the problem of how fluent bronzes like this and similarly modelled ivories are related.

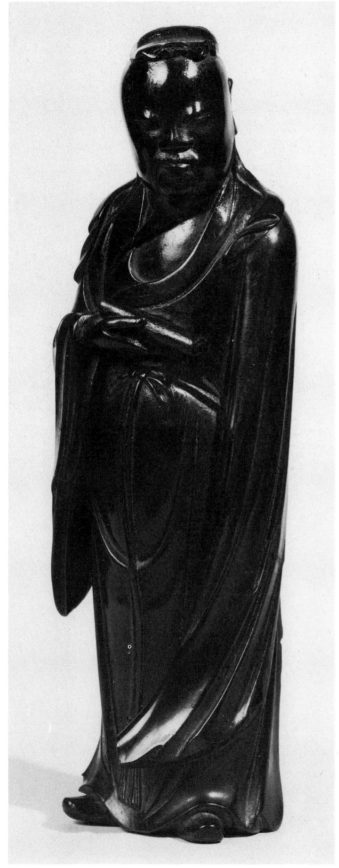

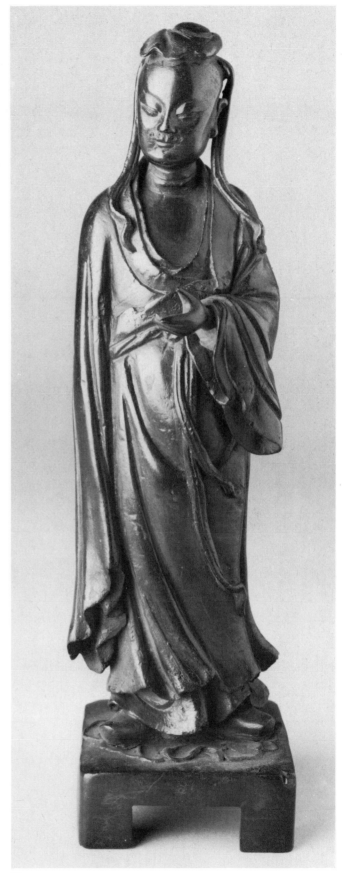

78

79

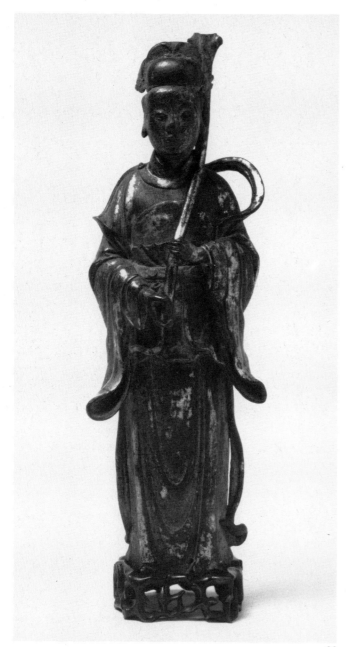

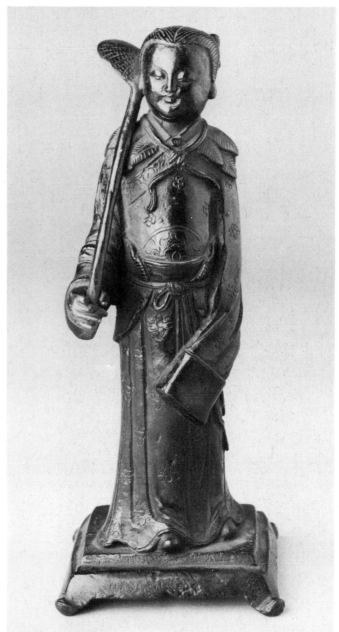

80

81

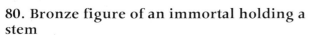

80. Bronze figure of an immortal holding a stem

H. 17.3 cm

17th century AD

Victoria and Albert Museum. M360–1912

81. Bronze figure of He Xiangu carrying a lotus leaf

H. 20.4 cm

17th–18th century AD

British Museum. Given by Miss L. E. S. David (formerly J. J. Joass Collection) OA 1952.12–19.17

Unlike the preceding bronzes, this He Xiangu is stiffer and more tubular than an ivory equivalent, however the number of elements which it shares with ivory models, the feather/leaf cape, the half-turned torso and simple line serve to remind us that there was a stylistic pool for figure characterisation which was common to large and small sculpture, murals, paintings and prints.

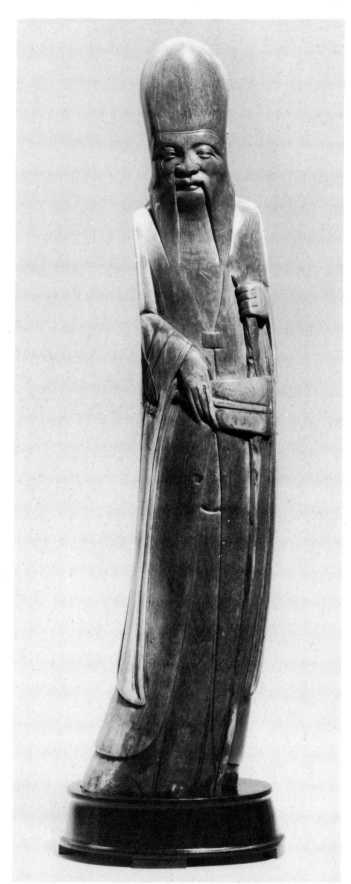

fruited once in every three thousand years. Dongfang Shuo, mage and courtier to Han Wudi, tried to make off with these peaches, and he too is one of the fruit-bearing immortals.

87. Figure of a longevity god or an immortal holding a fan and staff

H. 30 cm

Ming dynasty, about AD 1580–1644

Private Collection

The back bears a spurious four-character Xuande mark, *Xuande dingwei* year (AD 1427).

88. Figure of a longevity god or an immortal holding a (?) fan

H. 15.2 cm

Ming dynasty, about AD 1580–1644

Asian Art Museum of San Francisco. The Avery Brundage Collection, B81 M2

89. Figure of a longevity god or an immortal seated on a deer and holding a scroll in his left hand

H. 7 cm

Ming-Qing dynasty, 17th century AD

Private Collection

This model has suffered a great deal of wear, especially about the face, presumably from its being of a size that is easily carried and toyed with. The deer often shown with Shouxing in pictures is rarely carved in ivory, for on the scale on which these figures are normally made it would have to be abbreviated and contorted to fit across the width of the tusk. In a miniature like this piece there is no problem.

90. Figure of a longevity god or an immortal holding a fan

H. 23 cm

Ming dynasty, about AD 1580–1644

Private Collection

The top of the head, which is sheared off, probably once took a cap of the type worn by the similarly carved, but wooden figure No. 99. Although thus denuded, the high forehead and lined brow indicate that it is supposed to represent Shouxing or one of the other longevity beings. In the rest of the modelling however there is little to distinguish it from the Zhongli Quan formula seen on figures like Nos 64 and 65.

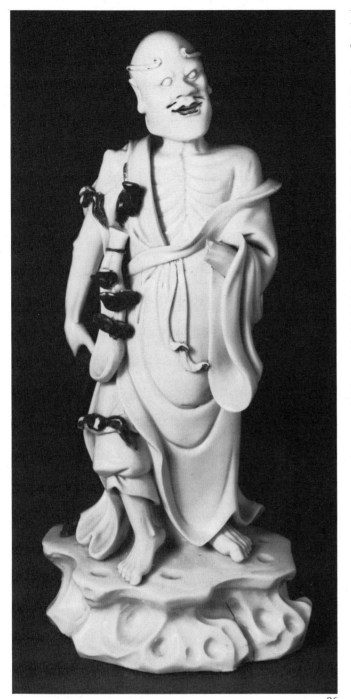

86

86. Porcelain figure, Li Tieguai

H. 24.2 cm

Dehua, Fujian province

Ming dynasty, 17th century AD

British Museum. OA F7+

The reverse has two impressed seal marks, one of the potter He Chaozong, and the other a commendation mark reading *qianli miantan* 'despite a thousand *li* separation, we converse face-to-face'.

Longevity-Bestowing Deities and Immortals

Shouxing, stellar god of longevity, is shown in paintings, prints and three-dimensional models as a hoary sage with a massive cranium (of at least partly phallic origin), a long beard and benevolent expression, usually holding a staff and sometimes accompanied by a deer or a crane, both themselves symbols of long life. The asterisms with which he was originally matched lay probably within the first and second lunar lodgings, *jiao* (the horn) and *kang* (the gullet), but star gods have been so widely used and confused in popular legend, that he is also linked with that very powerful constellation the Northern Dipper. The Three Stars, signifying longevity, rank and happiness, are sometimes placed together in the heavens and sometimes sent to opposite sides of the sky. Another celestial band over which a longevity star presides has five members, who are supposed to reside in the southern heavens, and were probably created to parallel the Five Planets, arbiters of human destiny. Shouxing was portrayed in anthropomorphic form from at least as early as the Tang dynasty.

In addition to Shouxing himself, there are several other long-life deities and immortals with which he can be confused. The similarity between Shouxing and these other figures highlights the stereotyping common in Chinese religious and semi-religious art, and it is often only from the context that a figure can be identified. Attributes like a peach, a staff (indicating great age), a deer, a full beard and bald head were glyphs for age itself, and could be put on any appropriate figure with religious or mythical association. The other beings include Laozi (or Lao jun), the mythical founder of the quietist thinking known as 'philosophical' Daoism, apocryphal author of the late Eastern-Zhou classic *Daode jing*; his disciple Wang Ni; Ancestor Peng (Peng Zu), a Methuselah-like immortal who stayed upon the earth for a fantastic length of time; his disciple Duke Green Bird (Qing Niao Gong). In the *Lie xian quanzhuan*, a book purporting to describe all immortals, Duke Green Bird is shown with a deer, and could be confused for Shouxing if it were not for the accompanying caption.

Longevity-beings frequently carry a peach or branch of peaches, a fruit and a tree which have psycho-sexual symbolism. One method of purifying the physical body and creating a more permanent self was through sexual practices requiring restraint on behalf of the male. Such ideas form a background to the more exoterically auspicious symbolism of long-life gods and immortals.

The peach was a particular emblem of the Queen Mother of the West, Xi Wang Mu, who presided over a jewel-like paradise in the Kunlun Mountains. Han myth relates that the Queen visited the emperor Wu (r. 140–86 BC) and gave him five magic peaches, which he enjoyed so much that he then determined to plant their seeds. The Queen was amused at his desire for this rare ambrosia and told him that the trees only

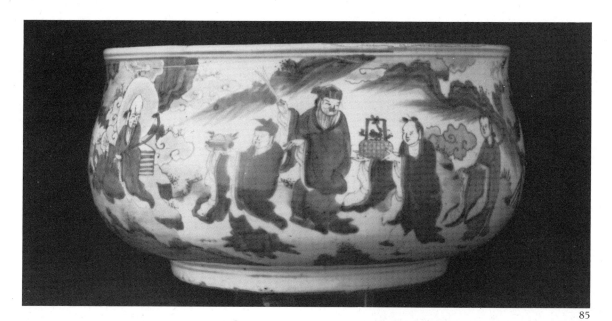

85

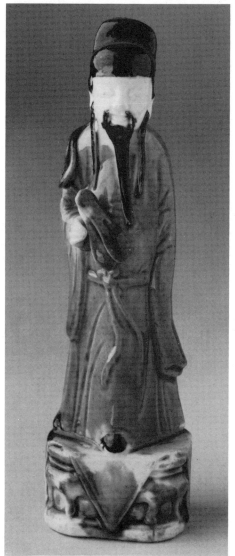

emperor had developed an appetite for the means of attaining immortality; during his reign long-life symbols and other auspicious emblems such as the *Ba xian* and stellar gods decorated Jingdezhen porcelain in both enamels and underglaze blue. Figure models such as this, and the Shouxing were presumably offered as luck-bringing presents in the same way that ivory figures appear to have been.

84. Porcelain figure of Cao Guojiu

H. 13.9 cm

Jingdezhen, Jiangxi province. Qing dynasty, Kangxi (AD 1662–1722) period

British Museum, OAF503+

Jingdezhen porcelain immortals of the Qing dynasty, which were exported to Europe in very great quantities, are usually more naturalistic than those of the late-Ming Wanli period. This may be due to even greater influence of prints at the factories, or to the influence of the figure-model boom in neighbouring Fujian province, in ivory and Dehua porcelain, both of which drew their inspiration from prints.

85. Porcelain censer, decorated in underglaze blue with the Eight Immortals visiting Shou xing

H. 14.8 cm, Diam. 29 cm

Jingdezhen, Jiangxi province. Ming dynasty, dated Tianqi *yichou* year (AD 1625)

Private Collection. On loan to the British Museum

This subject is known as *Ba xian yang Shou*, 'The Eight Immortals looking up at the stellar god of longevity', a common one in popular woodblock prints of the late Ming, and one appropriate to an anniversary. Until recent times children were given caps with silver badges depicting these figures to wear on their birthdays.

84

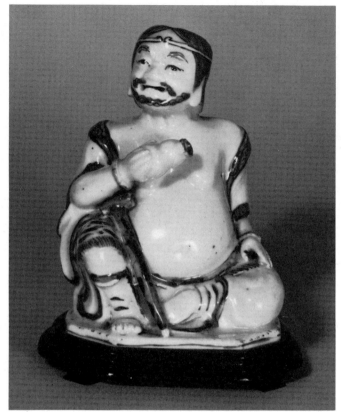

83

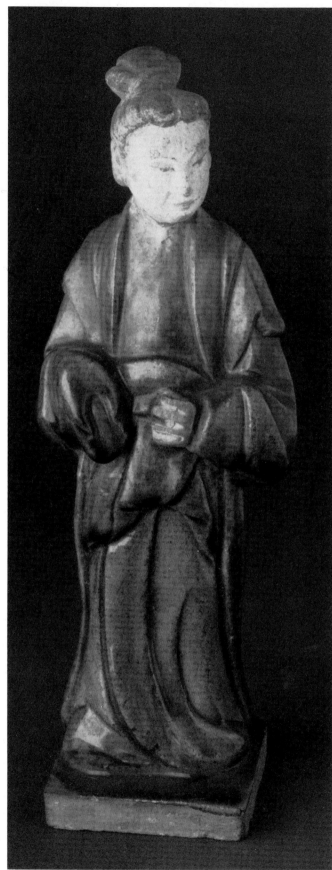

82

82. Earthenware funerary model of a lady attendant, decorated with green lead glaze

H. 20.2 cm

Ming dynasty, AD 1368–1644

British Museum. OA 1937.7–16.112

This small tomb image, made to bring comfort to and show respect for the deceased, is modelled with a few economical ridges in the clay which adequately suggest the flow and movement of a bulky silk dress. The success in Chinese figure representation from early times lies greatly with the long, cleanly cut robes and skirts, sweeping hems and trailing sleeves, as worn by the gentry, the folds and creases of which could be neatly rendered with the elegant calligraphic line basic to much of Chinese art. As seen even in modest figures, the merit of ivory carving depends partly on this graphic method of reproducing dress.

83. Porcelain figure of Li Tieguai holding his crutch, decorated in underglaze blue

H. 15.5 cm

Jingdezhen, Jiangxi province. Ming dynasty, Wanli (AD 1573–1619) period

Private Collection

Jingdezhen, the main porcelain producing centre in Yuan to Qing China, turned out models of immortals and Shouxing from the second half of the 16th century onwards. The Jiajing

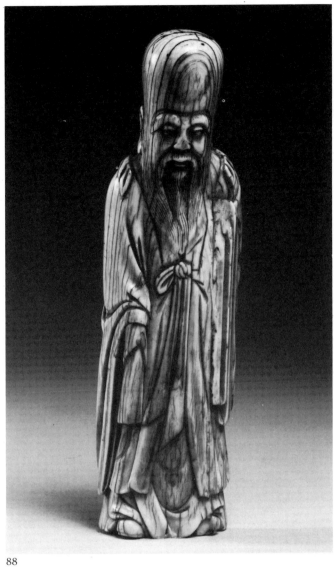

88

89

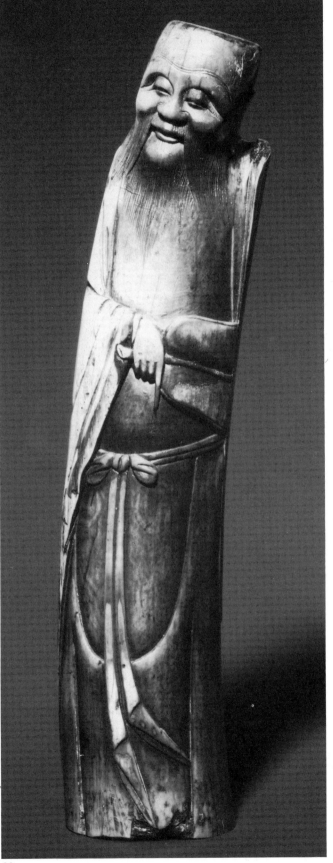

90

91

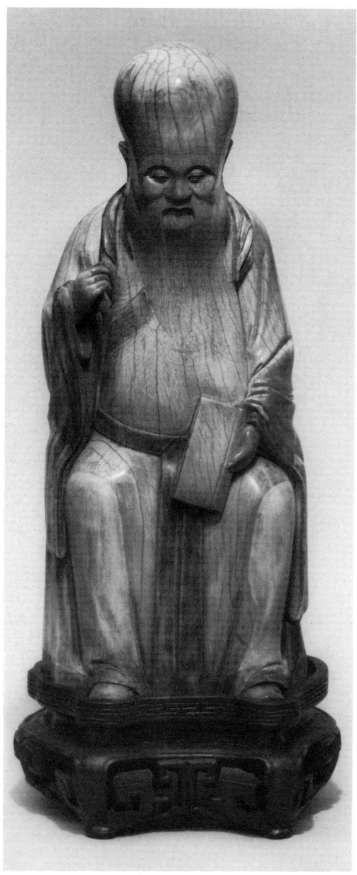

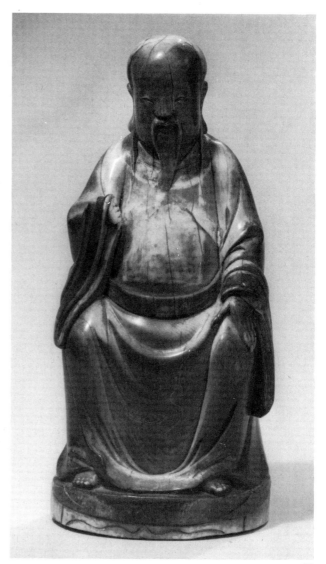

92

91. Figure of Shou xing seated with a book in his left hand, a flower stem in his right

H. 23.3 cm Colour plate 4

Ming dynasty, about AD 1580–1644

Metropolitan Museum of Art. Bequest of Rosina H. Hoppin, 1965, Alfred W. Hoyt Collection, 65.86.135

92. Figure of a seated stellar god or immortal

H. 14.7 cm

Ming dynasty, about AD 1580–1644

Metropolitan Museum of Art. Bequest of Rosina H. Hoppin, 1965, Alfred W. Hoyt Collection, 65.86.125

Were it not for the bare feet of this scholarly looking deity, he would be read as Wen Chang, god of the *literati*, however it is almost inconceivable that a patron god would be shown unshod.

91

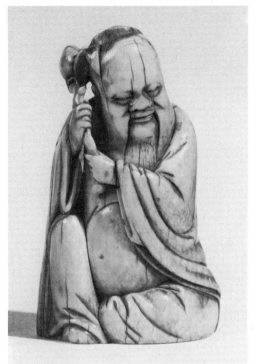

93

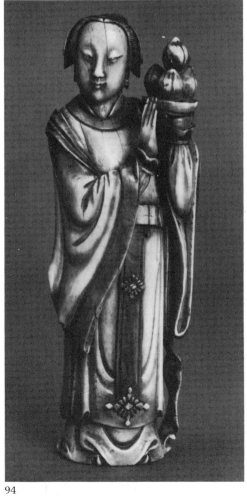

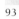

94

95

93. Figure of a longevity god or immortal carrying a peach spray

H. 10 cm

Ming dynasty, about AD 1580–1644

Private Collection

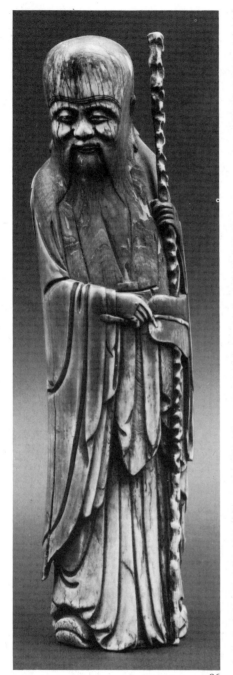

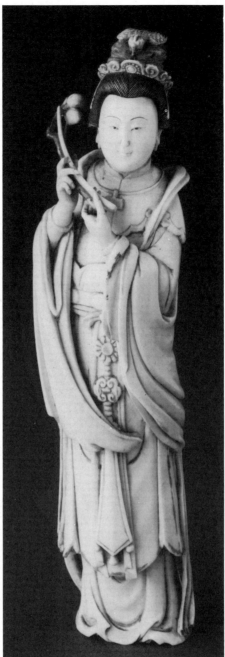

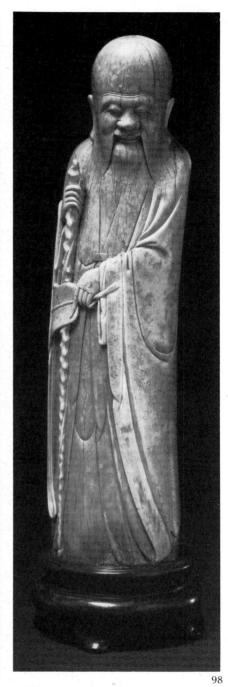

96

97

98

94. Figure of a peach-bearing immortal, perhaps attendant on Xi Wang Mu

H. 14 cm

Ming-Qing dynasty, 17th century AD

Mr Che Ip

This, and the waiting maid (No. 95), may represent Dong Shuangcheng, one of the Queen Mother's bearers; this identity is supported by comparison with a Dehua porcelain group of Xi Wang Mu and lady-in-waiting No. 102. Many immortals and gods carry peaches, particularly in printed illustration, He Xiangu being only one among others who can claim the

fruit as an attribute. As the peaches are held up like an offering, the figure may simply be intended as an anonymous bringer of congratulatory wishes.

95. Figure of a peach-bearing immortal, perhaps attendant on Xi Wang Mu

H. 16.8 cm

Ming dynasty, about AD 1580–1644

British Museum. Given by Miss. L. E. S. David (formerly J. J. Joass Collection). OA 1952. 12–19.11

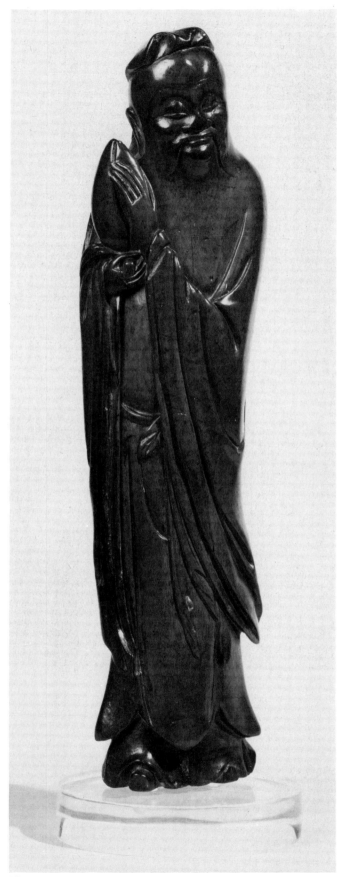

99

96. Figure of a longevity god or immortal holding a staff and fan

H. 32.4 cm

Ming dynasty, about AD 1580–1644

Cleveland Museum of Art. 40.691. Bequest of James Parmelee

The wrap-around beard always seen on figures of the longevity gods is ultimately derived from the false whiskers worn as one of the stage conventions denoting an elderly person. Such conventions were very important in a theatre that allocated characters to particular rôle types, such as old, young, official, warrior, matron, etc.

97. Figure of Xi Wang Mu wearing a phoenix head-dress and carrying a *hu* sceptre and peach spray

H. 19.4 cm

Qing dynasty, probably Kangxi (AD 1662–1722) period

British Museum. Sloane Collection, OA SL.84

Sloane Collection objects entered the British Museum in 1753, many having been acquired by Sir Hans Sloane from other earlier collections. This ivory, which retains much of its polychromy on the hair and head-dress, is stylistically quite different from most other credibly early ivory figures. The carving is altogether sharper and carried out in high relief, with clear gaps for instance under the swept-over sleeves, between the fingers, and through the peach spray. In these respects it resembles the figure group of Liu Hai and a demon, with cash, clouds and a bat (No. 62). The style of both these pieces prompts the thought that rather than reflecting a late phase in Zhangzhou carving, they may represent early export carving executed at Canton and based upon tried and tested Fujian figures.

98. Figure of a longevity god or immortal holding a staff and fan

L. 28.9 cm

Ming dynasty, about AD 1580–1644

Sir Victor Sassoon Chinese Ivories Trust, 164/166

99. Wooden figure of a longevity god or immortal holding a huge peach

H. 21.5 cm

Ming-Qing dynasty, 17th century AD

Private Collection

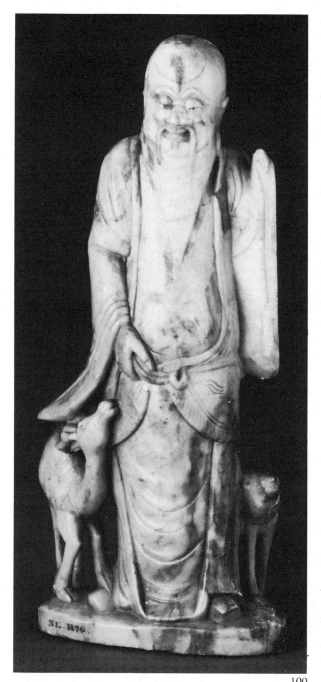

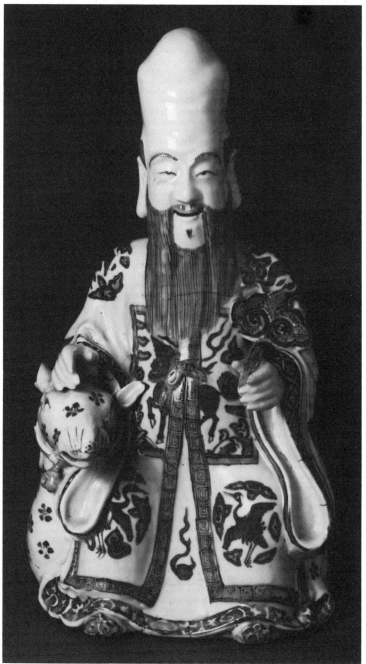

100

101

100. Soapstone figure of Shouxing, with a deer and crane

H. 22.4 cm

Fujian province. Qing dynasty, 17th-early 18th century AD

British Museum. Sloane Collection, OA SL.1176

Soapstone was extensively quarried in Fujian province, and from the 17th century onwards, many carvings in this material were made for the export market. In addition to longevity gods such as this, which are similar to ivory figures, crude images of the *nanhai* Guanyin were made in forms already popularised in Dehua porcelain.

101. Porcelain figure of Shouxing seated on a deer, holding a *ruyi* sceptre, decorated in underglaze blue

H. 33.6 cm

Jingdezhen, Jiangxi province. Ming dynasty, Wanli (AD 1573–1619) period

British Museum. Franks Collection, OA F1472

The phallic symbolism associated with the massive cranium of the stellar god is well displayed in this immodest porcelain model.

PLATE 1

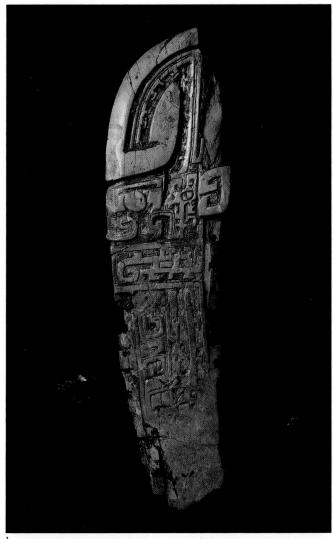

1

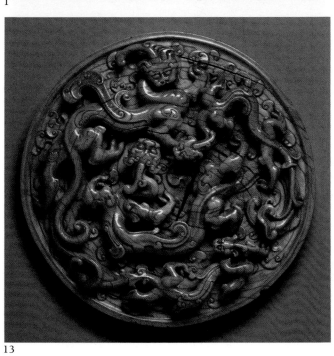

13

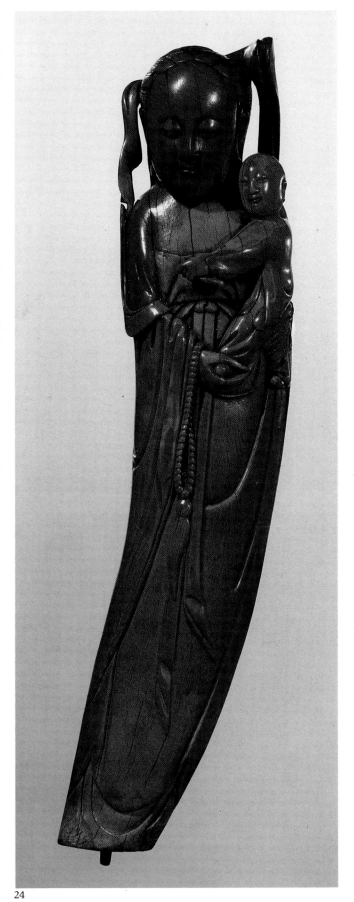

24

PLATE 2

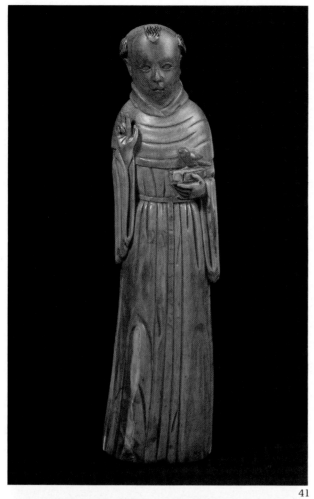

41

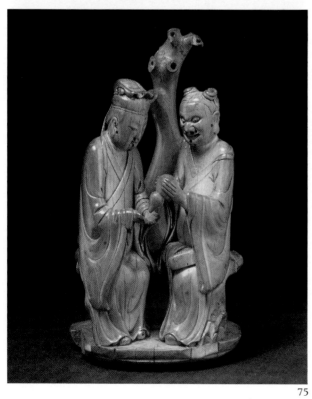

75

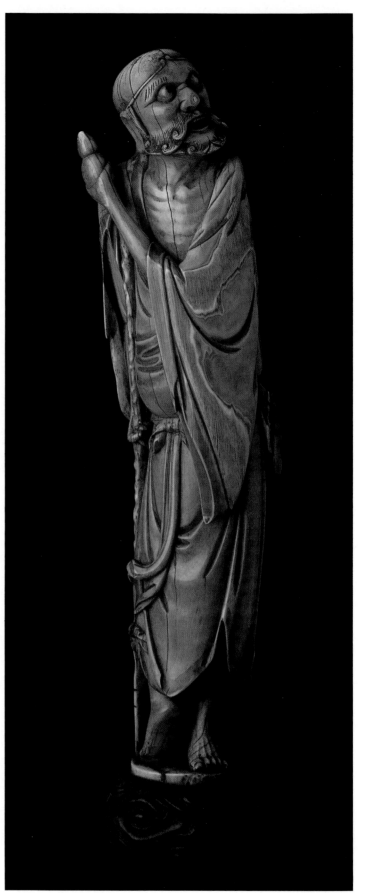

71

PLATE 3

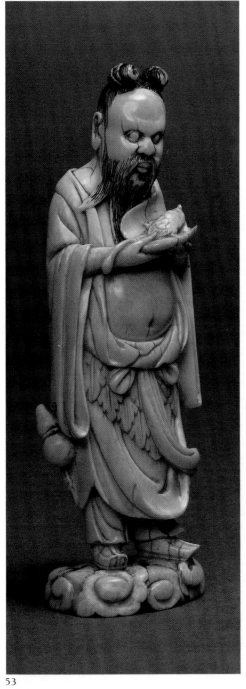

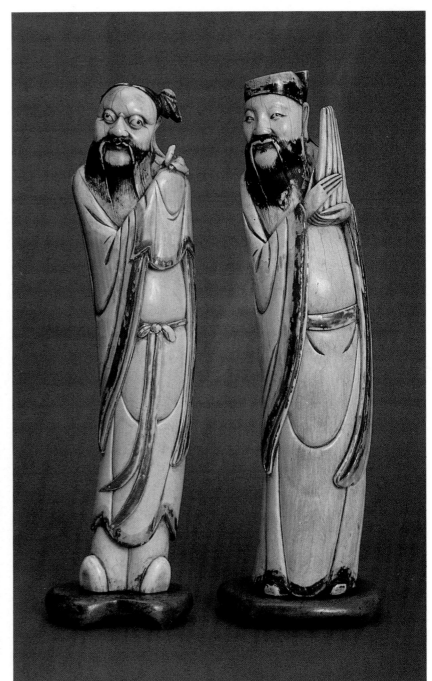

53

66

PLATE 4

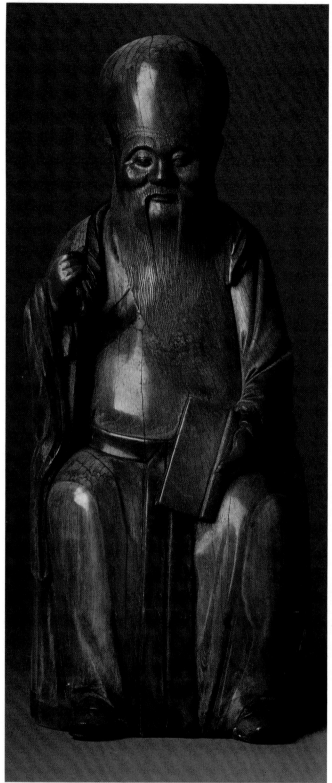

91

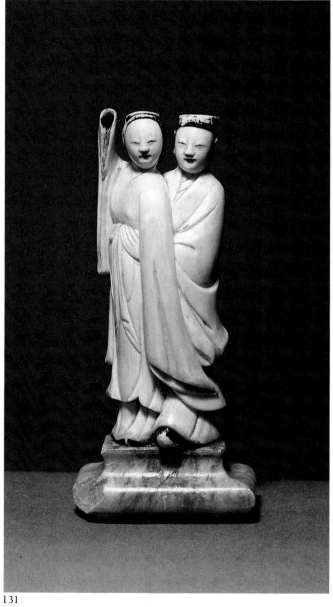

131

PLATE 5

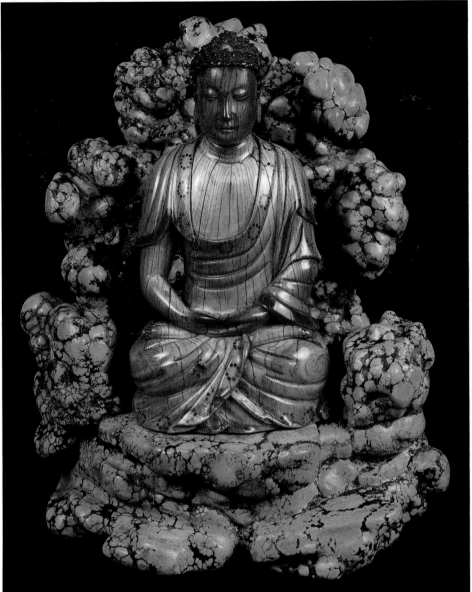

120

142

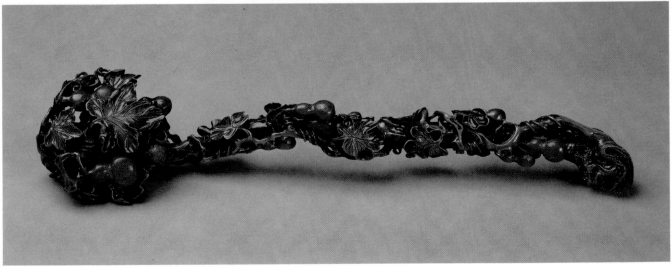

160

PLATE 6

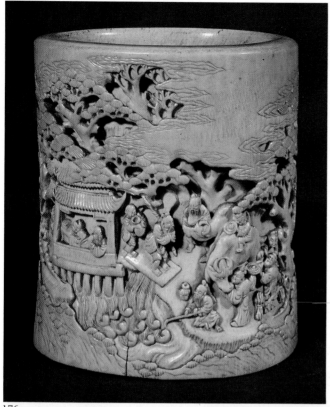

176

180

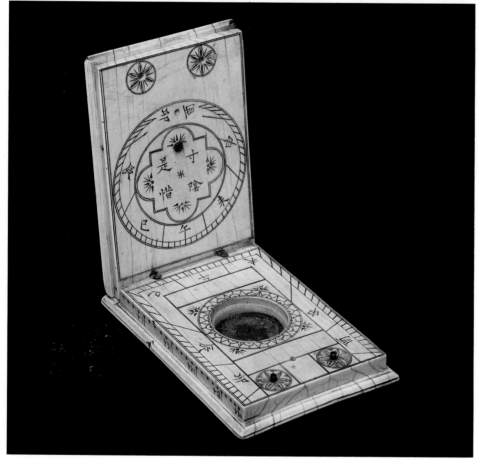

161

PLATE 7

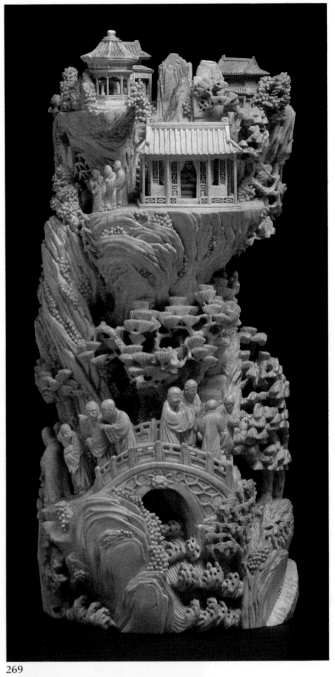

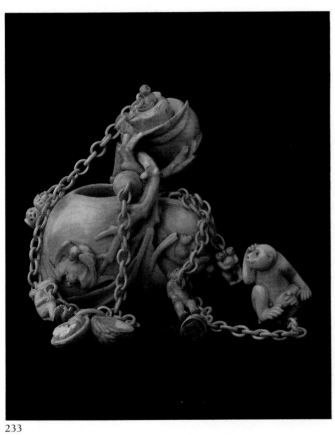

233

269

239

PLATE 8

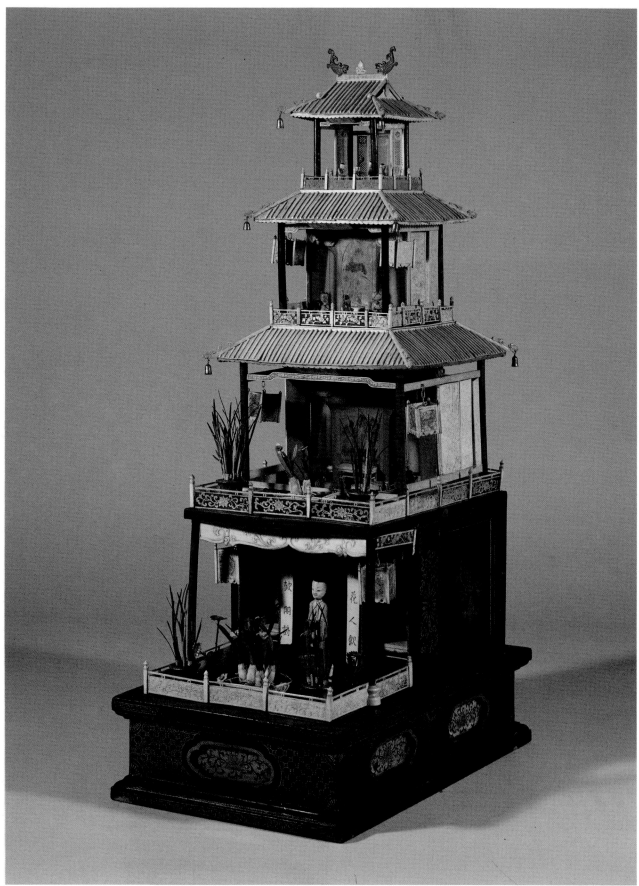

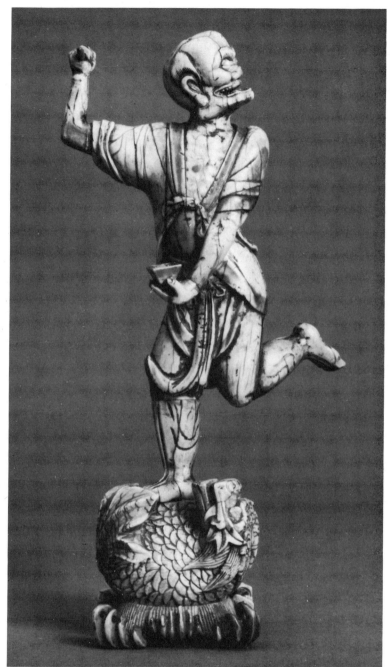

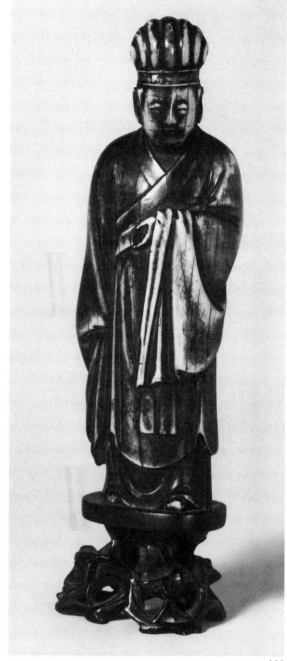

107

108

107. Figure of the stellar god Kui xing standing on a dragon-carp

H. 21 cm

Ming dynasty, about AD 1580–1644

Mr Che Ip

The image of Kui xing is a collation drawn from several aspects of the Chinese experience, star-mysticism and astronomy, the twilight world of imps and demons, respect for the written character and the fondness for punning. The character *kui* is the name of an asterism in the Northern Dipper and is made up of the character for demon (*gui*) and for a dipper, or bushel measure (*dou*). The *gui* character has at its lower right an element which curves upwards: the Kui xing image is therefore a pictorial pun of a demon with its right leg kicking upwards, a bushel measure in one hand. The *kui* asterism is twinned with Wen Chang, and is also seen as a literary man's stellar correspondence. The stellar god Kui xing, despite having such a grotesque appearance, appeared besides Wen Chang in temples and was also worshipped for success in examinations. In his right hand he holds a writing brush, and he rides upon a dragon-carp, itself alluding to the myth that carp who leap the Dragon Gate Falls in Henan province are transformed into dragons, an allegory for successful civil service candidates.

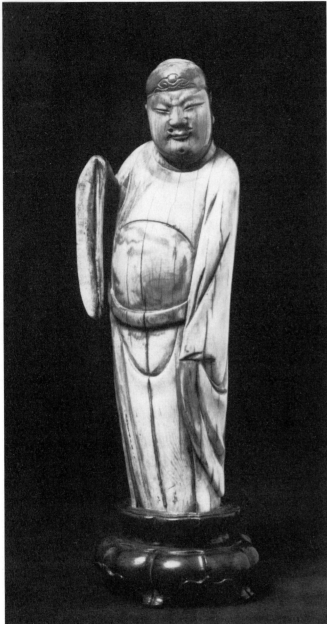

105

105. Figure, possibly Wen Chang, with the right arm raised

H. 12.1 cm

Ming dynasty, about AD 1580–1644

Sir Victor Sassoon Chinese Ivories Trust, 158/889. On loan to the Victoria and Albert Museum

The right hand is missing. Like the Dehua porcelain figure of Guan Yu (No. 118) which this ivory model resembles in its design, it was intended that hair should be stuck into the apertures bored into the upper lip, cheeks and chin. Putting real hair on a carved image was thought to bring it more to life, not aesthetically so much as spiritually.

106. Figure, possibly Wen Chang

H. 21 cm

Ming dynasty, about AD 1580–1644

Private Collection

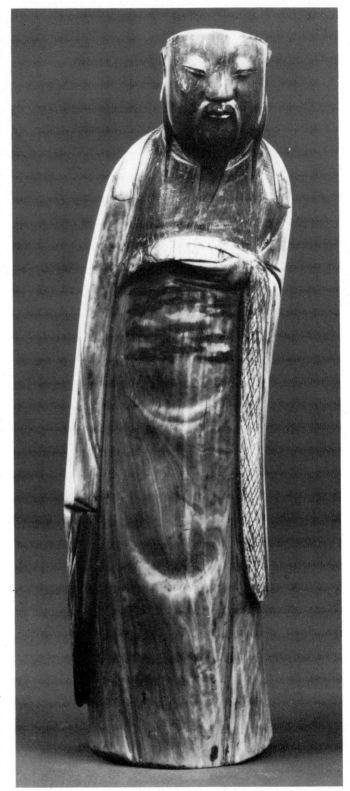

106

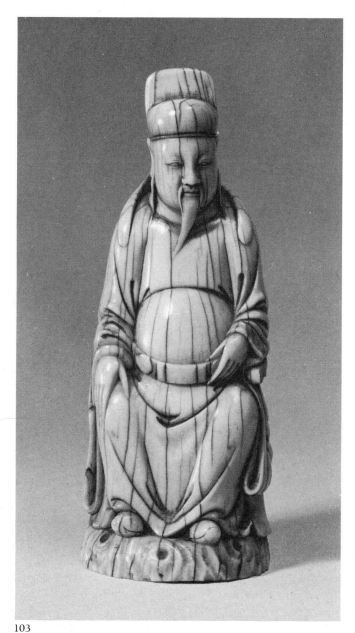

103

103. Figure of Wen Chang seated on a domed base

H. 13.5 cm

Ming dynasty, about AD 1580–1644

Museum of Far Eastern Antiquities, Stockholm. Collection of King Gustav VI Adolf, HM 217, OM 1195/74

Exhibited: Arts of the Ming Dynasty, Oriental Ceramic Society, 1957, no. 373.

104. Figure of Wen Chang seated on a throne

H. 13 cm

Ming dynasty, about AD 1580–1644

Private Collection

The rear of the throne is painted with a flower spray.

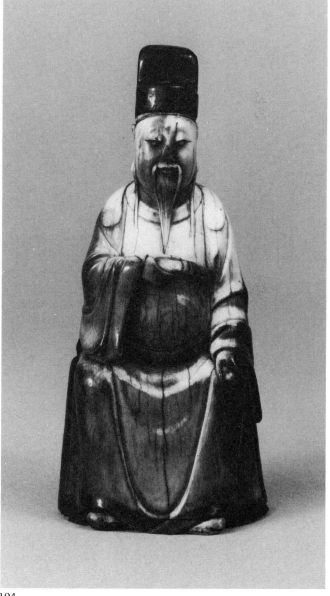

104

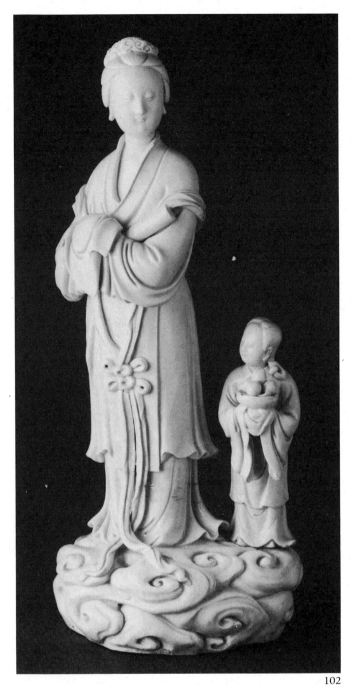

102

102. Porcelain figure group, Xi Wang Mu with a maid-in-waiting holding a dish of peaches, standing on a cloud

H. 37.9 cm

Dehua, Fujian province. Ming dynasty, early 17th century AD

British Museum. Franks Collection, OA F 678

Xi Wang Mu usually wears a phoenix in her tiara, as she does on the figure No. 97; but in this case the goddess appears to be based more on the Zhangzhou images of Guanyin than she does on accurate printed sources.

Patron Gods

Of the two commonly seen patron gods carved in ivory, Wen Chang and Guandi, the former is the harder to identify, for he is usually depicted as an anonymous *literatus* wearing the voluminous gown of the Ming scholar, but with no further personal attributes. The stereotyped vision of the ideal scholar has very ancient antecedents in Chinese pictorial art. The donors who fill the lower register of Dunhuang banner paintings are such well-dressed gentlemen. Formal images of the archetypal *literatus* were more suited to hieratic art and persisted in the tradition of ancestor portraits, where stereotyping fitted in well with the intention and aims of the genre – to recreate the individual, whatever his personal foibles, in terms of the perfect Confucian official. Despite the changes in men's fashion over the centuries, the overall impression of such images is that they were remarkably consistent.

Wen Chang ('Literary Glory'), the god of the *literati*, took on the appearance of his 'clients' in much the same way that heavenly ministers were given the appearance of their earthly counterparts. Wen Chang looks like the sort of scholar that examination candidates hoped one day to become, powerful, respected, with a stipend and tax allowances. Originally a stellar correspondence to the scholars on earth, affirming the place of that class in the grand cosmic order, in later times he was worshipped for success in the civil service examinations and symbolised the path to social acceptance and material rewards.

Guandi was the apotheosis of a historical general who lived in the late second to early third centuries AD. Guan Yu was one of the heroes of the Three Kingdoms period, who supported the Han pretender Liu Bei in his bid to continue the Han state in Shu (present-day Sichuan province). The oath of everlasting loyalty sworn by Liu Bei, Guan Yu and Zhang Fei in the Peach Orchid is a Chinese shorthand for loyalty, trust and sincerity. The saga of the struggle for succession following the collapse of the Han dynasty in AD 220 entered cultural life in a variety of forms, the historical narrative, the oral tale, the drama and the fully-blown Ming novel. The story tradition is known as *San Guo zhi yan yi*, 'The Romance of the Three Kingdoms'. The valiant general Guan was enfeoffed by Song and Yuan monarchs and finally deified by the Wanli emperor in 1594. This followed a custom of honouring the worthy and valued after they were deceased in the hope that they would exert a benevolent influence on state affairs, in return for their elevated rank and sacrifices. It was a practice contiguous with ancestor worship. Guan Yu, or Guandi (the god Guan) as he now was became Protector of the empire and a talisman of the armed forces. At the popular level, Guandi was appreciated as a symbol of loyalty and trust, having laid down his life for those principles, and therefore became a patron of merchants and an emblem of good faith in business transactions.

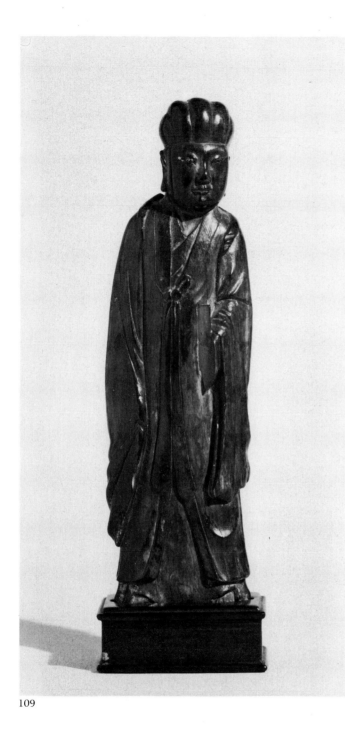

109

108. Figure of a deity wearing a lobed official hat

H. 13.5 cm

Ming dynasty, about AD 1580–1644

Private Collection

The lobed hats seen on high officials and deities in Ming paintings and prints, which clearly were worn in state life, as evidenced by the gold funereal model of such head-gear in the British Museum, have their origins in one of two sartorial traditions. Either they came from the lobed hats made to imitate the sort of high-looped hair-styles worn by gentlemen in the Han and Six Dynasties period, or they derive from the *yuanyou guan*, 'far-wandering hats' sported by royal scions since ancient times. *Yuanyou guan* have strong mystic overtones, and like feather capes and skirts, were probably originally put on by those who wished to project themselves beyond terrestrial horizons; the connection between such esoteric apparel and the court may stem from the officially sponsored star worship of the Han dynasty.

109. Figure of a deity wearing a lobed official hat

H. 13.5 cm

Ming dynasty, about AD 1580–1644

Private Collection

The attribute once held in the left hand is now broken away.

110. Figure of Guandi seated on a round-backed chair

H. 27.9 cm

Ming dynasty, about AD 1580–1644

Asian Art Museum of San Francisco. The Avery Brundage Collection, B60 S299

The posture taken by Guandi, one leg thrown up on to the other knee and one hand firmly grasping his long whiskers, belongs to the repertory of exaggerated gestures of Chinese theatrical tradition. In the same way that characters can be immediately recognized as they come onto the stage by their costume, and in the case of male rôles, by their beards, so a particular pose is struck to identify and amplify the emotional state of the moment. This is a very decisive type of movement, fully in keeping with the resolute hero Guan. Another such pose is seen in the stoneware image of a Judge of Hell, Fig. 10.

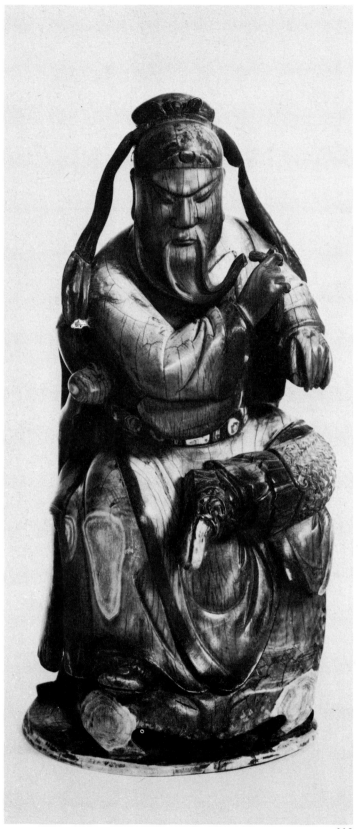

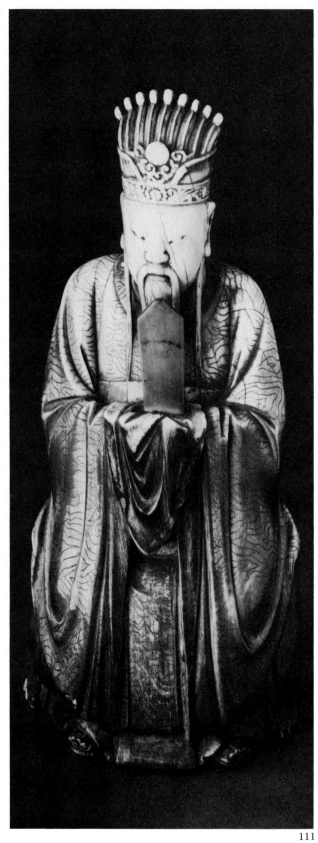

110

111

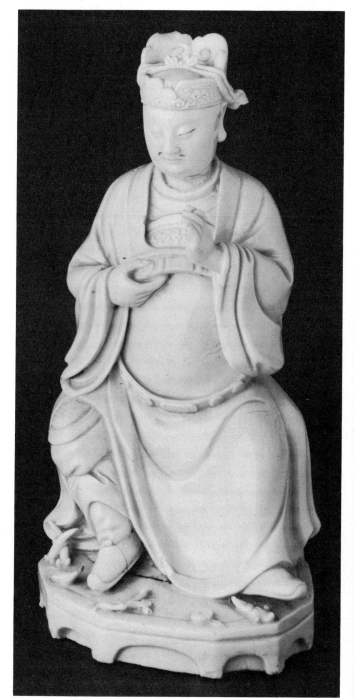

117

117. Porcelain figure of Cai shen, god of wealth

H. 26.2 cm

Dehua, Fujian province. Ming dynasty, dated Wanli *gengxu* year (AD 1610)

British Museum, OA 1930.11–13.1

This Cai shen is a yardstick by which to date early 17th century blanc-de-chine figure models, and is also useful as a comparative piece against which to date contemporary ivories made at Zhangzhou, the neighbouring prefecture.

118. Porcelain figure of Guandi

H. 29.3 cm

Dehua, Fujian province, Ming dynasty, early 17th century AD

British Museum, Eumorfopoulous Collection, OA 1938. 5–24.27

Datable by means of the preceding figure, this Guandi copies the style laid down in Zhangzhou ivories. Dehua models must have often followed woodblock originals, but the folds in this figure's full robes seem to be in direct imitation of an ivory (compare with No. 105).

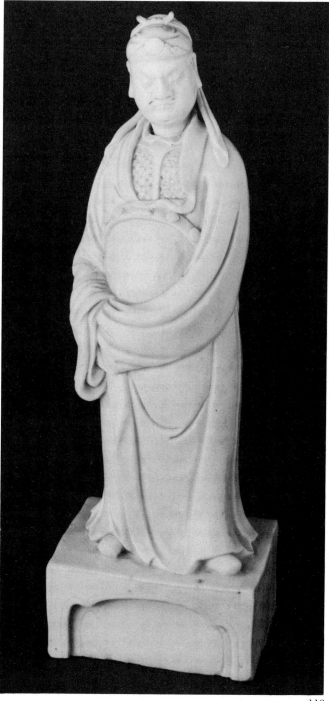

118

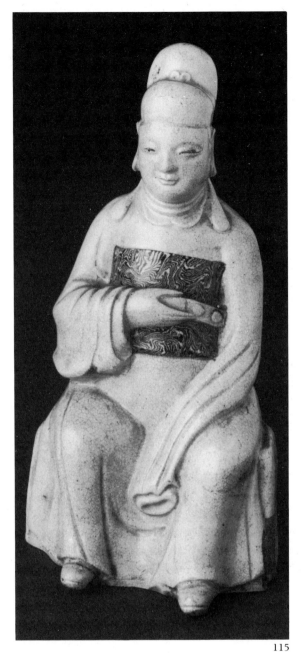

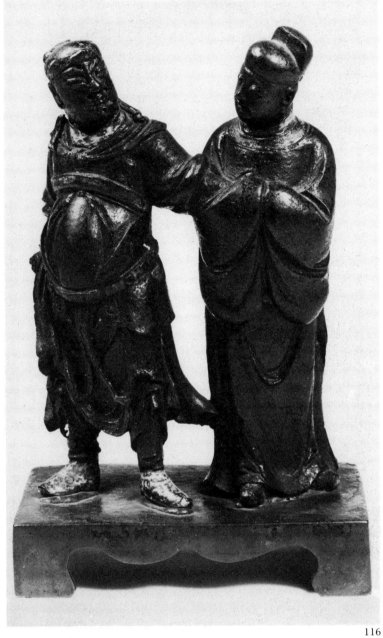

115

116

115. Stoneware figure of Wen Chang decorated in brown and ochre glazes

H. 17.6 cm

Possibly from Jizhou, Jiangxi province. Ming dynasty, dated Wanli *ding you* year (AD 1597)

The reverse inscribed: 'modelled by Chen Wencheng'

British Museum, Eumorfopoulos Collection. OA 1936. 10–12.284

116. Bronze figure group, Wen Chang and Guandi

H. 22 cm

Ming dynasty, 16th–17th century AD

Musée Guimet, given by M. Gaston Migeon, Inv. Eo, No. 1465

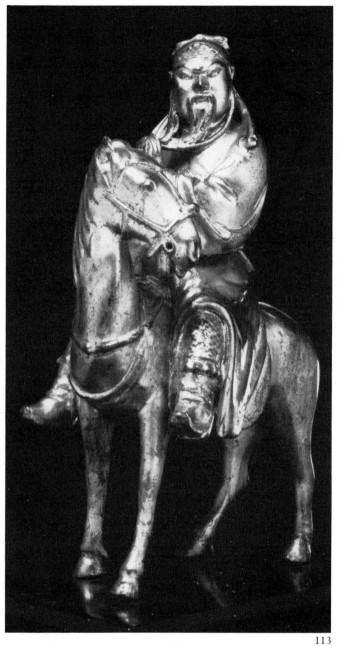

113

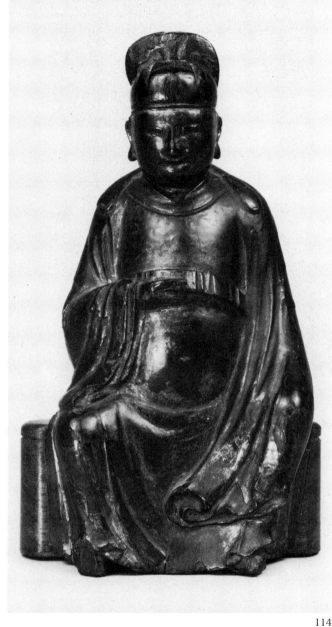

114

113. Figure group, Guandi mounted on his horse *Chi Tu* (Red Hare), gilt lacquered

H. 16.5 cm

Ming dynasty, about AD 1580–1644

Sir Victor Sassoon Chinese Ivories Trust, 149/2

This well-known carving of Guandi and Red Hare brings a fourth animal model into the exhibition, adding to the elephant, *qilin* and lion (see No. 14). The gilt lacquer is in a very good state and was probably applied during the Qing period, perhaps to imitate gilt bronze, a medium in which Guandi mounted groups are common.

Published: Jenyns, R. S, Chinese Carvings in Elephant Ivory, *T.O.C.S.*, 1951–1953, vol. 27, pl. 14.

114. Gilt lacquered wooden figure of Wen Chang

H. 18 cm

17th–18th century AD

Private Collection

This and the succeeding model, No. 115, show the Wen Chang formula in different media.

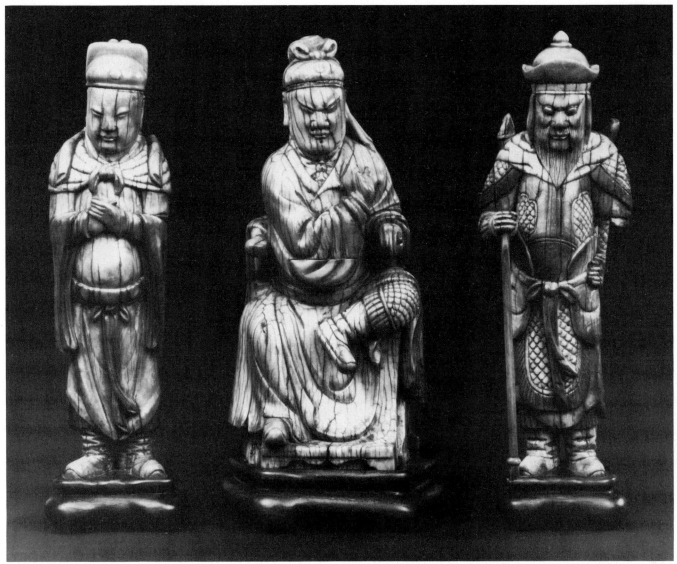

111. Figure of a deity, with traces of red paint

H. 20.5 cm

Early 20th century AD

British Museum. OA 1952, 12–19.5.

Given by Miss L. E. S. Davis (formerly J. J. Joass Collection)

This carving is one of a series of modern fakes which cleverly simulate Ming originals. The manufacturing process seems to have been as follows: the figure was carved in the sixteenth to seventeeth century manner and then 'cooked' to give it age cracks, and in this case the appearance of calcification, then either painted or lacquered; finally it was polished down in selected places, particularly the face, to obscure its unavoidably modern aspect and to give it an even greater air of antiquity. Here, on those areas which have only been partially polished, such as the hat band, the carving is very weak and quite inferior to that on genuinely early pieces. The pair to this is known, a female goddess also exhibited in 1935–6 (No. 2931) but its present whereabouts is unknown.

112. Figure group, Guandi and his attendants Guanping and Zhou Cang

H. all about 14 cm

Ming dynasty, about AD 1580–1644

Private Collection

As well as being a patron of merchants, Guandi also found himself a place in the type of literati shine known as *wenwu miao*, 'temples of literature and the martial virtues'; these temples might be patronised by merchants who wanted to earn more social kudos than they would by merely sponsoring Guandi temples. Guandi is here attended by his standard bearer Zhou Cang, and his adopted son Guanping dressed as a scholar. *Wenwu miao* were often built in conjunction with a private school set up to train candidates for the examinations.

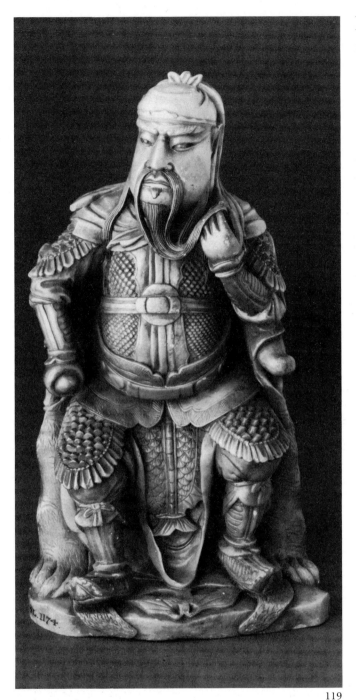

119

119. Soapstone figure of Guandi

H. 25.1 cm

17th–18th century AD

British Museum. Sloane Collection, OA SL.1174

This soapstone image of Guandi bears traces of the influence of woodblock prints designed by the late Ming painter, Chen Hongshou (1599–1652), whose mannered portraits lengthened the proportions of the body and drew out the eye-lines, emphasising the linear elements of the figure to impart his pictures an 'archaic' atmosphere.

Buddhist Figures

In proportion to the number of Daoist immortals and gods, the divine beings of Buddhism are relatively scarce in ivory with the exception of the Bodhisattva Guanyin. The reasons for this have already been set forth above: the main interest of ivory figure carving lay in the auspicious symbolism intrinsically associated with particular types of supernal being.

Buddhas and Bodhisattvas were not included in the repertory of popular deities who brought about long life, rank and worldy happiness, but were rather part of a much greater cosmic drama in which the individual soul was a minute fleck, reborn again and again over a span of eons until it finally reached perfection. Much the most sought after aim of the ordinary Chinese Buddhist believer was to be reincarnated in one of the paradises on high, particularly the Western Paradise of the Amitābha Buddha, where souls emerged, cleansed, from the buds of lotus flowers. This desire was the major difference setting Buddhist deities apart from indigenous *shen* in the popular consciousness, for the former were concerned with the after-life and the latter with rewards in this one.

Apart from the Bodhisattva Avalokiteśvara (Guanyin) discussed above, and Maitreya, the Buddha of the future, who was often shown in later days as a fat smiling monk seated in the vestibules of temples, the important Buddhist deities were remote, august beings, all-powerful and all-embracing. The forms in which they were depicted in Ming and early Qing temple statuary derived either from mature Tang imagery of the seventh to eighth century, or from the lamaistic Buddhism introduced into China with the Mongol invasion of the thirteenth century. Both these sculptural traditions were foreign in origin, and their style and iconography were distinct from native convention, as seen for example on representations of the stellar god Wen Chang.

As the Buddhas, such as Śākyamuni, Amitābha, Vairocana, and the Bodhisattvas Mahāsthāmaprāpta, Samantabhadra and Mañjuśrī held out the promise not only of marvellous elysian regions for the good and faithful, but also terrible hells for the back-sliders, they were approached with much greater reverence than native *shen*, and were not treated in as rumbustious a fashion as sometimes reported for the latter. Thus it is not surprising that the somewhat lightweight medium of ivory only rarely features Buddhas seated in meditation. A handsome exception is the image in *dhyānāsana* (No. 120). (Gaspar da Cruz tells of images being thrown into the water, burned or trodden underfoot, after giving poor predictions when lots were thrown to indicate the course of events.)

After the ivory figure-carving business had spread out from Zhangzhou to other parts of the country and the original context of 'wish-fulfilment' had been left behind, many additions were made to the original categories of immortals and patron gods. The Buddhist Lohan became especially popular from the middle Qing to the twentieth century, possibly because the five hundred different representations

of Lohan gave workmen ample opportunity to display the intricate carving techniques that were becoming fashionable. The market must have also been stimulated by the advent of many Europeans taking advantage of the treaty concessions forced on the Chinese in two Opium Wars. Several large collections contain many images made to exploit this new clientèle, pieces which often use a greater amount of the tusk than was the case in the Ming period.

120. Figure of a Buddha seated in *dhyānāsana* in a later detachable grotto of turquoise matrix

H. 17 cm; cave H. 24 cm Colour plate 4

Ming dynasty, about AD 1580–1644

Private Collection. Formerly Spencer Churchill Collection

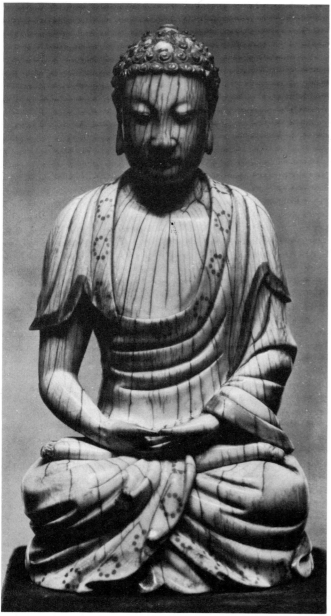

120

The overall appearance of this Buddha, who may be the historical Buddha Sākyamuni or the Amitābha Buddha, is similar to the central figure in the Metropolitan trinity, No. 14. The hands lightly touch each other in the attitude of meditation, and the bearing is introspective. Despite previous speculation over its early age, the carving and pigmentation leave no doubt as to its identity as a Zhangzhou ivory. Only the stippled rosettes are unusual.

Published: International Exhibition of Chinese Art, Royal Academy, 1935–1936, London. Jenyns, R. S., 'Chinese Carvings in Elephant Ivory', *T.O.C.S.*, 1951–1953, vol. 27, pl. 15. Jenyns, R. S. and Watson, W. *Minor Arts* vol. 2, no. 120.

121. Figure of a Buddha seated in *dhyānāsana*, on a lotus base supported on a hexagonal plinth

H. 15 cm

Provenance uncertain. Qing dynasty, AD 1644–1911

Sir Victor Sassoon Chinese Ivories Trust, T. 42. On loan to the Victoria and Albert Museum

The Buddha holds a diamond club, *vajra*, in his right hand. This and the lamaistic style of rendering the figure derived from Nepalese and Tibetan prototypes, suggests that it might date from the 18th century, a period when lamaistic beliefs were prevalent in China, sponsored by the foreign Manchu court. The image has been burnt, leaving a charred patch at the front and extensive cracking.

122. Figure of a Lohan asleep

H. 10.5 cm

Possibly Zhangzhou. Qing dynasty, 17th–early 18th century AD

Mr Che Ip

This carving bears some resemblance to soapstone carvings of Lohan and monks which can be securely dated to the 17th and 18th centuries, such as those in the 1690 and 1737 inventories of the Royal Danish Kunstkammer, and those in the pre-1753 Sloane Collection at the British Museum (No. 126). The holes on the top of the crown are novitiate's initiation marks, burned into the scalp by lighted piles of incense.

123. Figure of Bodhidharma holding his shoe

H. 32.5 cm

Qing dynasty, 19th–20th century AD

Sir Victor Sassoon Chinese Ivories Trust, 193/178.

Bodhidharma was the first Chinese patriarch and honoured as the founder of contemplative Chan Buddhism (Zen). This carving embodies a legend about the 6th century monk in which he appeared after his death carrying one shoe – when his coffin was opened it was found to be empty, but for the other shoe.

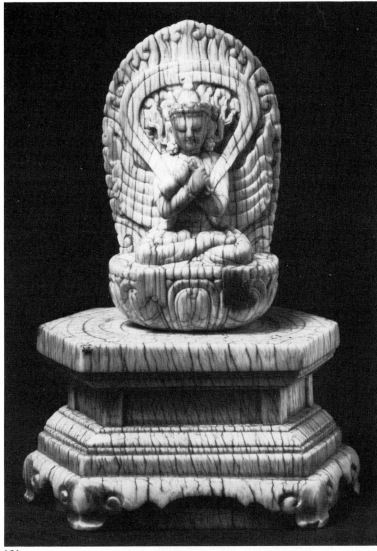

121

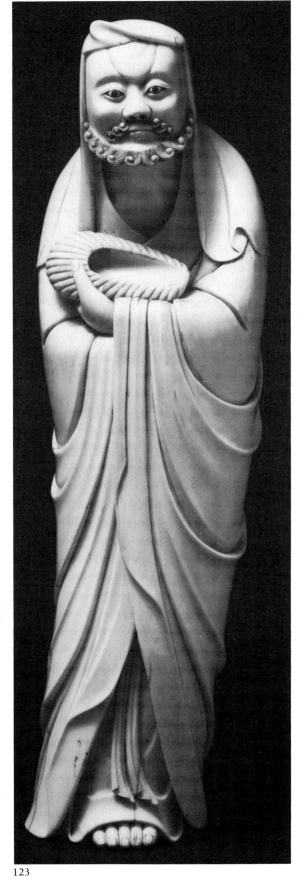

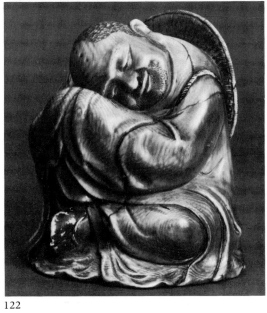

122

123

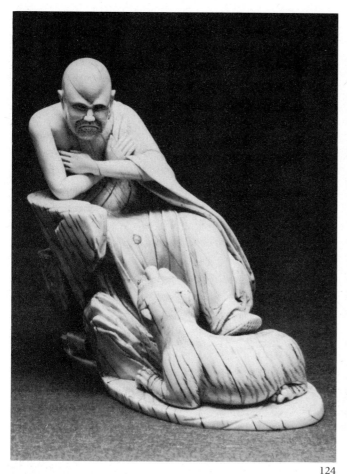

124

124. Figure of the Eighteenth Lohan with his tiger

L. 15.2 cm

Qing dynasty, AD 1644–1911

Collection of Mrs and Mr Donckerwolcke, Ghent

The eighteenth of the so-called 'historical' disciples of the Buddha Śākyamuni, he confronts a reclining tiger. The tiger is an attribute of this Lohan, but the overriding image is that of the Buddhist saint who quells wild animals with his perfect serenity; a convention which has its origins in Chan Buddhist art of the 9th and 10th centuries, initiated by masters such as Guanxiu (AD 832–912) and Shi Ke (10th century).

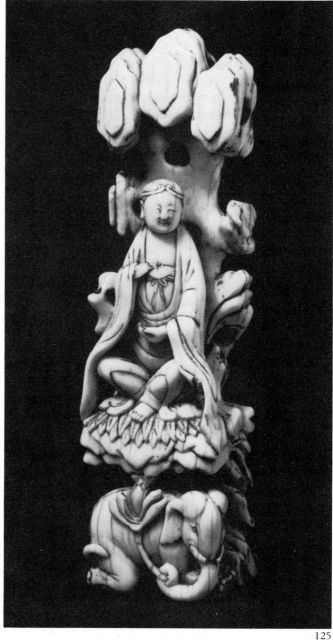

125

125. Figure of Samantabhadra mounted on an elephant

H. 15.2 cm

Ming-Qing dynasty, 17th century AD

Sir Victor Sassoon Chinese Ivories Trust, T1. On loan to the Victoria and Albert Museum

The rocky grotto represents Emei mountain, the Chinese home of the Bodhisattva. The hard stone surface is covered with a mat of leaves, fashioned in the same way as the feather or leaf capes worn by Daoist immortals. It is conceivable that this piece is one of three, which together form a trinity of the Buddha, Mañjuśrī and Samantabhadra, like the Metropolitan Museum examples No. 14.

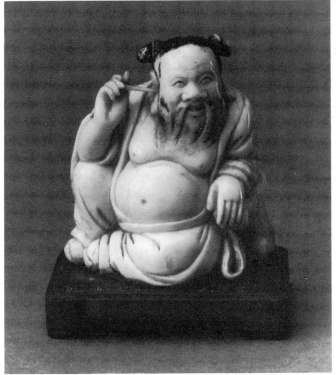

126

126. Figure of the Thirteenth Lohan seated picking his ear

H. 6 cm

Ming-Qing dynasty, 17th century

Nationalmuseet, Copenhagen. Kunstkammer Collection, EBc192

This small reclining image of the Thirteenth Lohan appears in the earliest inventory, drawn up in 1674 and dating from the time when the Royal Danish Kunstkammer was sited at the Royal Copenhagen Palace. The figure is called 'A small East Indian idol of ivory'. In the subsequent inventory of 1690 it is 'A small seated idol of ivory'.

Published: Hornby J., 'China', in Dam-Mikkelsen, Bente & Lundbaek, Torben, (ed.), *Ethnographic Objects in the Royal Danish Kunstkammer 1650–1800.* Copenhagen 1980; pp.181–183

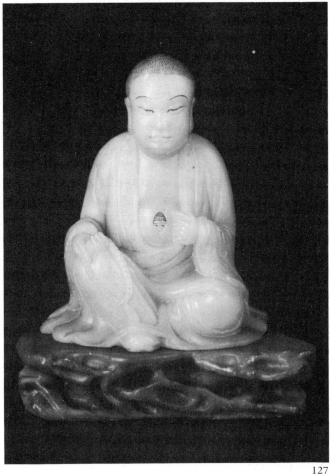

127

127. Soapstone figure of the 145th Lohan

H. 7.9 cm

Qing dynasty, 17th–early 18th century AD

British Museum. Sloane Collection, OA SL 2003

The Lohan Wudaxiang, one of the five hundred Buddhist 'saints', opens up his chest to reveal a Buddha in his heart cavity. This small soapstone captures the exotic flavour of Lohan images, which became so popular in later ivory production. Larger temples often erected a 'Five Hundred Lohan Hall' in which these extraordinary beings were ranged about central Buddha or Bodhisattva statues. Compare the ivory Lohan, No. 122.

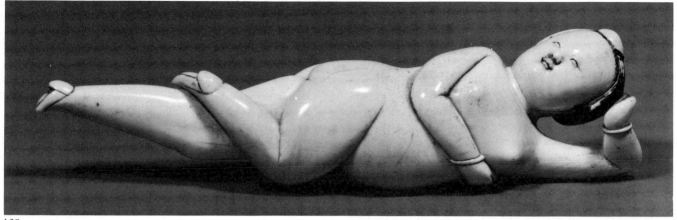

128

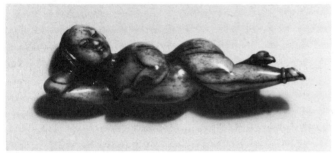

130

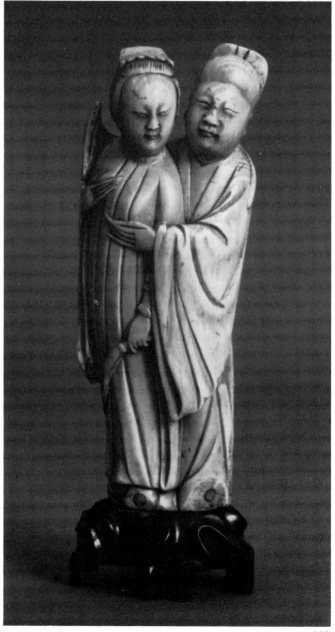

Erotica

Besides the ladies already discussed above (p. 41), there exist also groups which depict a man and woman embracing. One of these is highly important to the dating of Zhangzhou figures, as it is listed in a mid-seventeenth century inventory. The inventory took the form of a catalogue published posthumously by the Danish doctor, naturalist, collector and museologist Ole Worm (1588–1654), to record his collection of wonders and curiosities. Worm held the chair of medicine at the University of Copenhagen and carried his taxonomic approach over to his collection, which he housed in the *Museum Wormianum*. The catalogue was published in 1655. The value of the group (No. 131) lies in the indication it gives of the styles current at this time.

128. Erotic figure of a reclining lady

L. 16.2 cm

Ming dynasty, about AD 1580–1644

The Irving Collection

129. Erotic figure of a reclining lady

L. 13.1 cm (Fig. 7)

Ming dynasty, about AD 1580–1644

Sir Victor Sassoon Chinese Ivories Trust, 205/1322. On loan to Liverpool Museum

132

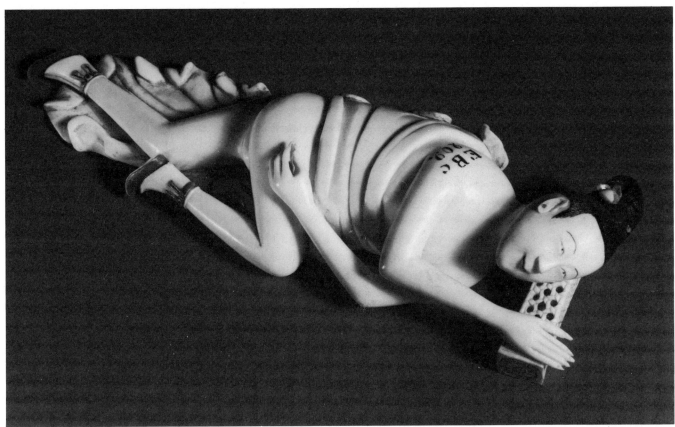

133

130. Staghorn erotic figure of a reclining lady

L. 7 cm

Ming dynasty, about AD 1580–1644

Private Collection

131. Figure group of a man and woman embracing

H. 11 cm Colour plate 5

Ming-Qing dynasty, before AD 1654

Nationalmuseet, Copenhagen. Kunstkammer Collection (formerly Museum Wormianum), EBc191

The Worm Catalogue records: 'Statue of ivory, five inches high, made in China, showing a man in Chinese attire embracing a woman of the same nationality. She raises one hand as if to box him on the ear. With regard to headdress, clothing, shoes and faces it is a quite skilful rendering of Chinese'. To Worm this carving was of interest for what it said about Chinese dress and costume of the time. With some knowledge of Chinese etiquette however, it is clear that the group would have been quite beyond the pale in polite society; women of rank only ventured outside in curtained palanquins – an embrace such as this in public was simply lewd. The intention is made even clearer in the following group where the 'scholar's' hands rest on the woman's breast.

Published: Hornby, J., as cited at No. 126, p. 181.

132. Figure group of a man and woman embracing

H. 12 cm

Ming dynasty, 17th century

Mr Che Ip

133. Erotic figure of a reclining lady

L. 15 cm

Canton, Guangdong province. Qing dynasty, Kangxi (AD 1662–1722) or Yongzheng (AD 1723–1735) period

Nationalmuseet, Copenhagen. Kunstkammer Collection, EBc209

Inventoried in 1737 as 'A small ivory image in a box, which shows how the Chinese women sleep; same was brought from China in 1732'. The carving arrived on the *Kronprins Christian* from Canton in 1732, demonstrating that such figures were still being made well into the 18th century, and now at the cosmopolitan trading port of Canton, which was also responsible for many other novelties and toys in ivory.

Published: Hornby, J., p. 183.

Export and Miscellaneous Figures

The seventeenth century saw the dramatic rise of Dutch power in the East. Before the northern Protestants were able to dominate the Chinese and Japanese sea routes they had to reduce the power of the Portuguese, both in India and on the China–Japan run. This they did in the early years of the seventeenth century, removing the *fidalgos* from most of their Asian entrepots, and then in June 1622 launching an attack on Macao itself, which was successfully rebuffed. The Dutch fleet turned to the Penghu Islands (Pescadores) which lie between Fujian and Taiwan, and occupied them in the same summer, ignoring the fact that they were Chinese sovereign territory. From this base they tried to upset the Sino-Spanish trade by piratical interceptions of Chinese junks out from Fujian, by doing 'as much damage as possible to the Chinese'. In 1624 the Chinese navy retaliated and drove the intruders back to Taiwan, where they stayed for the next forty-odd years. Taiwan however became a very useful station for Dutch interests and a great deal of trade was carried out with the mainland. It is very likely that the Zhangzhou group of an embracing couple collected by Ole Worm (No. 131) was originally purchased by Dutch merchants operating out of that island. The Dutch were themselves driven out of Taiwan by Zheng Cheng'gong (Coxinga) when he retreated from the advancing Qing army in 1662. Trade had been interrupted by the war of succession a few years before this, but now it became sporadic. It was re-opened in about 1683, the year in which Zheng was finally defeated, but in many respects it echoed the late Ming Sino-Spanish trade, with Chinese vessels sailing out to Batavia in Indonesia, carrying the goods that the Europeans required.

The Dutch therefore were active in the Chinese export market for over fifty years during the seventeenth century and for over thirty of these they were just off the Fujian coast. This helps to explain how non-religious Zhangzhou ivories came into early north European collections such as the Museum Wormianum and Schloss Ambras.

134. Two figures of Dutch merchants carrying *ruyi* sceptres

H. both 7.9 cm

Qing dynasty, 17th century AD

Mrs Rafi Y. Mottahedeh (formerly H. R. Norton and Frederick Mayer collections)

The costume reflects a European style of the second half of the 17th century, in particular of Holland, France and England during about 1660–1670. The sleeves of the flaring coats descended to the elbows, as shown here, but the lacey sleeves of the shirt should come down to the wrists. Underneath was worn a sleeveless waistcoat of the same length as the coat, known in England as a Persian vest; the belt was worn either over or under the outer garment – both alternatives being

134

134

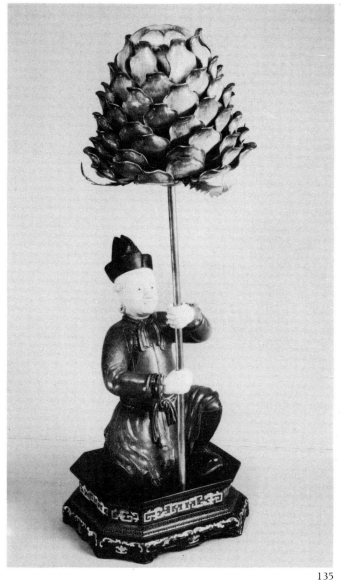

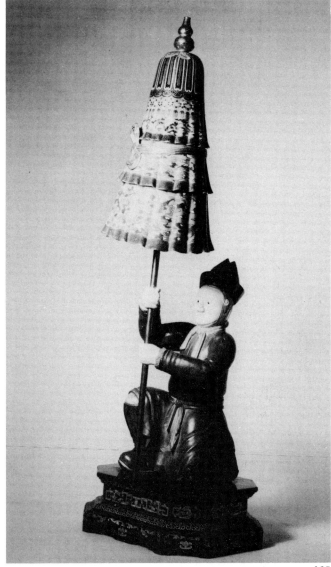

135

135

shown on these two figures. The painting, in red and black with traces of blue and green, picks out the patterning on the boots. In the 17th century Dutch sea captains were considered to be amongst the trendsetters in mens' fashion.

Published: Howard, D. and Ayers, J., *China for the West.* Vol. 2, No. 684

135. Two figures with wooden bodies, ivory heads and hands, enamelled copper attributes

H. 71.2 cm and 76.3 cm

Probably Canton, Guangdong province. Qing dynasty, 18th century AD

Mrs Rafi Y. Mottahedeh (formerly in the collection of H.M. Queen Mary)

These two figures belong to a set of eight, each bearing one of

the Eight Buddhist Emblems, probably originally of tantric origin, but widely used in Qing decorative arts as auspicious symbols. The two carried here are a lotus flower with numerous petals and an umbrella, tied around the centre with a gold ribbon. The format, wood bodies with ivory appendages, has been encountered before, in the standing immortal in Berlin and the seated Guanyin in the Fitzwilliam Nos 52 and 18. This set was probably manufactured at Canton, which was not only the main foreign trading port in the 18th century but also a centre of enamelled copper wares for the European market. Both the features and the hair-styles are European, the scrolls at the temples representing wig-curls, but the costume is basically Chinese: long gowns buttoning up diagonally at the right shoulder.

Published: International Exhibition of Chinese Art, Royal Academy, 1935–1936, Howard D. and Ayers J., Vol. 2, no. 688

136

136. Figure group, Chi She suckling her mother

H. 7.3 cm

Qing dynasty, 17th–early 18th century AD

British Museum. Sloane Collection, OA SL.1004

An image of filial piety, the younger woman offers her breast to her aged mother. Classic Chinese images of filial piety were popular in Japanese netsuke, and indeed this small model has been drilled in the manner seen on toggles, with two holes through the base of the mother's chair.

137. Figure group, an elderly man and young boy

H. 13.5 cm

Provenance uncertain

Qing dynasty, 18th–19th century AD

Mr Che Ip

137

138. Figure of a scholar reclining against a bolster

L. 5.5 cm; H. 4.5 cm.

Ming dynasty, about AD 1580–1644

Private Collection

Possibly Li Bai (AD 701–762), one of China's greatest poets. Li lived a very bohemian life, addicted as he was to the call of the wine vat. In his poems he identifies himself with the Wine Asterism, and wine haunted even his death for, in legend at least, he drowned whilst clutching at the reflection of the moon. He is thus often depicted laying drunkenly against a vat. It might otherwise represent Zhang Zhihe, another 8th century wine addict and cosmologist.

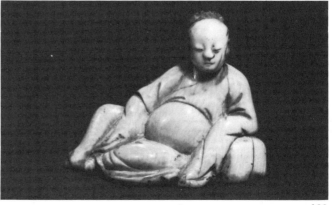

138

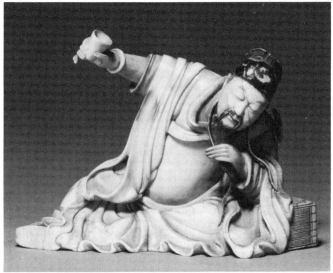

139

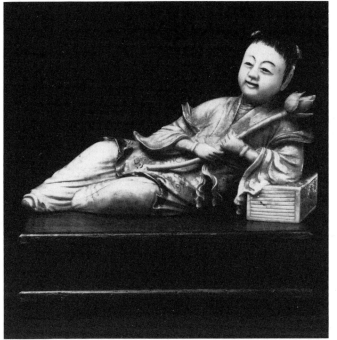

140

139. Figure of a scholar reclining against a fascicle of books

L. 9.2 cm

Possibly Canton, Guangdong province. Qing dynasty, 18th century AD

Fitzwilliam Museum, Cambridge University. Mrs C. Goetze Bequest 0.26–1951

Like the preceding figure, Li Bai or Zhang Zhihe.

140. Figure of a young girl holding a lotus, reclining on a fascicle of books

L. 11.4 cm; H. 7 cm

Possibly Canton, Guangdong province. Qing dynasty, 18th century AD

Sir Victor Sassoon Chinese Ivories Trust, X 900

Similarly modelled to the preceding figure, No. 139, this may represent He Xiangu. Both fall into the category of small vividly coloured figure models made for export to the West, which includes porcelain models decorated in *famille verte* and *rose* enamels.

141. Figure of a European holding a staff

H. 8.4 cm

Qing dynasty, 18th century AD

Mrs Rafi Y. Mottahedeh

Howard and Ayers note that the medallion hung from the chain about his neck displayed what was possibly intended for a device of the Dutch East India Company; if this is the case, then the figure is presumably a Company official.

Published: Howard D. and Ayers J., Vol. 2, no. 686.

141

Ming and Qing Ivories: useful and ornamental pieces

Ivory and the 'Scholars' Taste'

The idea of 'scholars' taste' has been a much-used one in western studies of Chinese decorative art over the last fifty years. It arose as a tool with which students in Europe and America could distance themselves from earlier western enthusiasms for things Chinese, and attempt to define those objects which were esteemed by the Chinese themselves. As such, it was perhaps a useful concept. However, as our understanding of Ming and Qing society has deepened it has become clear that it is unwise to speak of 'scholars' as a homogenous, unchanging body of united taste and sensibility. Pre-modern China contained many élites, divided not only by their differing degrees of access to political and economic power, but by geographical and educational factors. This perception is only gradually beginning to inform studies of China's decorative arts, where still all too often an idealised 'scholars' taste' is invoked to lend a patina of elevated tone to those objects which the author may find personally pleasing. This is particularly true if an object is characterized by restraint in the decoration, or if by its function it is associated with the manipulation of brush and ink.

This catalogue, concentrating as it does on one material only from among the many employed by Chinese craftsmen, allows us to step back from generalities and turn to what individual Chinese, some of whom were esteemed by contemporaries as scholars and men of taste, actually said about ivory and its use. When we do so, a much more complex picture emerges, where exact contemporaries of similar educational and class background may disagree on matters of taste, where ivory may be fashionable for one kind of object but avoided for another, and where what was denounced by the arbiters of the late Ming comes to be highly praised by the antiquarians of the late Qing.

Ivory was never a 'canonical' material in Ming and Qing China. It played little part in either ritual or poetic metaphor. No treatises were devoted to its history or to its literary resonances. It thus lacked the corpus of moral allusions attached to bamboo, with its air of unaffected rusticity and antique simplicity, and the vast body of lore surrounding jade, which though it too was a luxury import from distant lands was hallowed by its associations with the ritual observances of High Antiquity. Significantly, both bamboo and jade had a body of literature devoted to them in the Ming and Qing. Lacking these broader associations, ivory was appreciated largely for what it was, an expensive, aesthetically pleasing and easily worked material. There is little evidence that any great importance was attached in the early Ming at least to that 'faithfulness to the material' which might attract us to ivory objects today. Rather it was a vehicle for cunningly wrought and intricate toys. From the very beginning of the dynasty, the *Ge gu yao lun* of 1388 gives one of the earliest accounts of those concentric ivory balls, called *gui gong qiu*, 'devils' work balls', which so fascinated Europe, and of which No. 266 is a later example.[1] From an early sixteenth-century source, Dai Guan's 'Notes from the Pavilion of Washing the Hat-Strings' comes another view of ivory as a suitable material for meticulous but frivolous complexity, an almost untranslatable idea covered by the Chinese adjective *qiao*. He writes:

activities is given in *Ming gong shi*, 'A History of the Ming Palaces', a late-Ming synopsis by Lü Se of a longer work, *Zhuo zhong zhi* by Liu Ruoyu (1541– ?), a court eunuch of the Wanli period. It reads:

'They acquire and manage all screens, ornaments and utensils used in the Imperial Presence. There is a Buddha workshop and other workshops. They manufacture (*zao ban*) all hardwood couches, tables, cupboards and shelves set in the Imperial Presence, as well as dice, chess pieces, dominoes and combs of ivory, *huali*, *baitan*, *zitan*, ebony, *jichimu*, and dishes, boxes and fan handles of inlaid, incised and carved lacquer.'[17]

The description of the staffing of the *Yu yong jian* in the same source, though it only mentions administrators, makes it sound like a modest operation. It is legitimate to speculate whether full-time ivory carvers were maintained to make dice and combs all through the Ming dynasty or whether, as would more nearly coincide with known Ming practice, craftsmen were occasionally required to fulfil corvée obligations by producing for the court.

The situation in the Qing period is rendered more complex by the greater quantity of information, though this has been subject to varying interpretation. Work done in recent years by Chinese scholars with access to unpublished archival material is beginning to allow a revision of past confusion, and a clearer picture is emerging of central government involvement in craft production. This involvement was a flexible one, varying in commitment over the years, and makes it clear we must jettison the simplistic version found in older European textbooks of workshops established, producing at full tilt for a number of years, then abolished.

Such a simplified picture, which has enjoyed surprising longevity, is almost entirely the creation of Stephen W. Bushell. It is closely bound up with ivory carving, as it is following his discussion of a wrist-rest in the Victoria and Albert Museum (No. 151) that Bushell launches into a much quoted but rarely scrutinized passage:

'The style of carving of the piece just described is like that of the Imperial Ivory Works founded within the palace at Peking towards the end of the 17th century in connection with the Kung Pu, the official "Board of Works". It is on record that the emperor K'ang Hsi established, in 1680, a number of factories, *tsao pan chu*, and brought up practised craftsmen for the various branches of work from all parts of the empire.'

Bushell then lists 27 types of workshop, with ivory carving as No. 14, and concludes, 'These ateliers, which lasted for a century or more, were closed one by one after the reign of Ch'ien Lung, and what remained of the buildings was burned down in 1869.'[18]

Two of Bushell's errors can be disposed of immediately. He makes it seem as if *zaobanchu* 'Office of Manufacture' was the name given to each of his 27 workshops, rather than referring to the whole. He also attaches it to the Ministry of Works, though it was actually an organ of the Imperial Household Department, *Nei wu fu*.[19] He gives no source for his account, but there can be no doubt that his list of workshops at least is taken from the 1818 edition of *Da qing hui dian shi li*, 'Collected Statutes with Precedents of the Great Qing', a standard administrative compendium. There is here a problem however. The Chinese text reads: 'As originally laid down (*yuan ding*), the *zaobanchu* was to prepare workers and workshops to manufacture items to be supplied to the Inner Court. The various workshops were. . . .'[20] The text then lists what may be taken, by punctuating rather differently from Bushell, to be not 27 but 31 separate workshops, with the *yazuo* 'Ivory Workshop' still being fourteenth in the list. The real mystery lies in the date when this is supposed to have happened. There is no

by the playwright and collector Kong Shangren (1648–1718). The Fujian author Xie Zhaozhe (1567–1624) remarks with disfavour in his *Five Collected Miscellanies* on the use of ivory handled brushes.[9] One late Ming writer on seals does allow ivory for private seals, but another early Qing author from Shanghai closes his discussion of suitable materials for seal carving by saying, 'Rhinoceros horn and ivory are not worth considering'.[10] On the other side, ivory and rhinoceros horn are explicitly praised as suitable for decorating the ends of scroll rollers by Zhou Jiazhou, author of the leading late Ming monograph on all aspects of scroll mounting.[11]

There is no evidence that ivory was an innately *ya*, 'elegant', material, as bamboo was. Indeed there is evidence to the contrary. In one of the most notorious chapters of the sixteenth-century erotic extravaganza, *The Golden Lotus*, musical accompaniment is provided by red-stained ivory clappers (perhaps looking rather like No. 235) in a scene where ivory chopsticks blend with silver and gold utensils, miniature porcelain tables and refined, exotic viands to give an atmosphere of total sensual indulgence.[12] The style here is flashy, expensive and vulgar. We see something of this prejudice carried on into Qing, when court regulations prescribed ivory chopsticks for 'Chinese feasts' but forbade them at 'Manchu feasts' where the dynastic conviction that Manchu customs were plainer and more morally elevating prevailed.[13]

By the eighteenth and nineteenth centuries, when the majority of the objects shown here were carved, the very concept of 'elegance' had become vulgarised, ivory was more freely available and more freely employed. The indigent but sensitive Shen Fu, early nineteenth-century author of *Six Records from a Floating Life*, thought it quite natural to use ivory chopsticks.[14] Gu Lu's account of Suzhou in the Jiaqing and Daoguang reigns mentions one street in which: 'there are more than ten shops selling things like bone and ivory hairpins and ornaments, knobs, earpickers, bone and ivory staffs, dice and ivory dominoes of every colour.'[15] It is into this context of quiet, late Qing domesticity that the majority of the objects in this exhibition fall. Almost all are the products of anonymous craftsmen, working for a clientèle whose modest style of living was far from the austere elegance of that dictated by arbiters such as Wen Zhenheng.

Imperial Workshops of the Ming and Qing

The concept of the 'imperial piece', a type of object of manifest stylistic significance and pre-eminent quality of execution, has on the whole not been helpful to the study of China's decorative arts. It is based on an assumption, so pervasive it has never been defended, that the Ming and Qing emperors were able to bring under their immediate control all the finest craftsmen in every medium. The argument then runs that the finest surviving objects must possess imperial workshop provenances, and this body of high-quality work is then invoked to bolster the existence throughout a period of centuries of such workshops.

And yet the actual evidence for the activities and production of imperial workshops in the Ming and Qing is fragmentary and hard to interpret. On investigation disquieting facts emerge to challenge the image of palace craftsmen as the paragons of skill. The Qianlong emperor was known to hold the view that in many cases the jade carvers of Suzhou surpassed those of the workshops in his own palace.[16] It is necessary to take a hard look at the whole concept of 'an imperial workshop', before hastening to ascribe any pieces, be they ivories or not, to such a source. The meagre evidence of the Ming period can be quickly repeated. Responsibility for the supply of craft objects seems to have rested with a eunuch-staffed office called the *Yu yong jian*. A presumably reliable and contemporary account of their

great-great-grandson of Wen Zhengming. He was a younger brother of the important late Ming official Wen Zhenmeng (1574–1636). He lived in Suzhou, and was renowned as a lute player, painter and calligrapher in his own day, though he never achieved high rank. His treatise vibrates with his exquisitely tuned sensibilities, and with the self-righteousness of an arbiter of style. His highest praise is *ya*, 'elegant', and no condemnation is more damning than *su*, 'vulgar'. This all-important contrast between *ya* and *su* is never defined and never defended. As with matters of style and fashion in all cultures and ages, something either has it, or it hasn't.

When we look closely at chapter seven of the text, entitled 'Vessels and Utensils' for some sign of ivory objects, it is the absence of this material that is immediately striking. Wrist-rests, brush rests, table screens and brush-pots are all described in some detail, with meticulous attention paid to matters of proportion, material and decoration which would escape us today. In none of these entries is ivory included as an acceptable material. When it is mentioned for the first time, it is specifically condemned: Wen is talking about *bichuan*, 'brush boats', those rectangular high sided trays of which no. 275 is a porcelain example. He says:

'One can use *zitan* wood, ebony or finely inlaid bamboo.
Only they must not be made of jade or ivory.'[5]

We can be fairly sure that ivory brush trays existed in the late Ming, though apparently none has survived. We can also be sure that in some 'scholarly' circles at least they were entirely *su*. Wen is similarly dismissive of the use of ivory for the manufacture of fan handles. It *is* used, he allows, in Suzhou, but then Suzhou fans are vulgar, and not as elegant as those produced in Sichuan.[6] However ivory is not totally beyond the pale, as he does allow its use for the carving of seals, disallowing instead porcelain in this context.

If we now turn to a rather similar text, the *Remainders from Investigations* (attributed to Tu Long (1542–1605) but possibly by Xiang Yuanbian (1525–1590)), the complexity attendant on talking about vanished patterns of taste becomes apparent at once. The format of this rather earlier work parallels that of Wen Zhenheng, with chapter four devoted to 'Implements and Papers for the Studio'. The parallel is continued in that it is *only* under the heading 'Brush trays' that ivory is mentioned at all. The similarity then ends, for what this text says is as follows:

'Brush trays. There are those of *zitan* wood or ebony finely inlaid with bamboo strips which are very delicate. Some make them of jade or ivory, which are also fine.'[7]

This passage reappears with identical wording in the work of another contemporary, Gao Lian, whose 'Notes on the Elegant Enjoyment of Pleasurable Idleness' mentions ivory only here and in the context of ivory inlaid rulers, which it dismisses.[8] What are we to make of this? The three (or four) authors shared a common class and emotional background and lived in the same lower Yangtze region. Could the thirty or so years between Tu Long and Wen Zhenheng be sufficient for ivory and jade brush trays to fall drastically out of fashion? We do not as yet know, but a lot more investigation in a variety of sources will be necessary before we can replace unsound blanket pronouncements with a sharper awareness.

There is no doubt that sixteenth- and seventeenth-century accounts generally mention ivory only rarely. The important *Random Accounts of Idle Emotions* (*Xian qing ou ji*) of 1671 by the bon viveur, dramatist and novelist Li Yu (1611–?1680) never alludes to it in the course of a long discussion of how to furnish and equip an elegant studio. Nor does the *Xiang jin bu*

'Hua Yunzhao of Wuxi used to possess a 'devils' work' ivory gourd, big as a longan fruit, containing several tens of objects all made of ivory and of a fineness and delicacy such that they cannot be enumerated. One took a little bowl of black horn large as a five-piece coin, then tipped all the objects in the gourd into it so that black and white were clearly contrasted. On the bowl were characters reading: Made by so-and-so in such-and-such a month of such-and-such a year. The incised characters were only as big as a sesame seed so that only a young person with sharp eyes could read them. In the gourd was a pagoda, broad as a grain of rice and of seven storeys. Each storey had a ring attached, which was fastened to a bucket which was fastened to linked rings like fetters, each link as big as a hemp seed in diameter. The other objects such as scissors, lute, lamp stand, mirror case, incense burner and vase were all like a hemp seed but exact in execution. When people played with them, if they breathed in the least bit heavily then the pieces would fly up in the air. There was an ivory rod, carved with cranes calling, and when everything was jumbled up and could not be separated this was used to sort them out. Han Fei Zi states that the King of Yan gathered ingenious artificers, one of whom claimed he could carve a washing monkey with the point of a needle. Now on seeing this I believe that such skills can exist.'[2]

This is not only a remarkably accurate description of the type of toy represented by Nos 231–233, it also delineates a whole approach to the material, one which coexisted with and sometimes dominated a more straightforward treatment of ivory down to this century.

In the mid-Ming period, ivory seems to have remained restricted in use to relatively small objects, perhaps reflecting difficulties of supply. We see this in Gao Lian's 'Eight Discourses on the Art of Living' of 1591, where he enumerates seven carvers from earlier in the dynasty, 'who were all able to carve scroll cases, incense boxes, fan pendants, hairpins and toggles in horn, ivory, incense wood and *zitan* wood, variously curious and ingenious, surpassing the men of old.'[3] The words for 'curious and ingenious', *qi qiao*, again carry these connotations of slightly meretricious gimmickry which are rarely far away from discussions of the subject by Ming authors. There is however evidence, if not exactly contemporary, of the popularity of ivory fan pendants in the most august of sixteenth-century circles. Gao Shiqi's 'Notes Made During Court Recess' of 1684 is a generally well-informed series of notes on sites of historical interest within the imperial palace. Gao was familiar with eunuchs' accounts of Ming palace custom, and with storehouses untouched since the fall of the dynasty, and he mentions that among the presents habitually given by the Jiajing emperor in his later years to favoured officials were 'fan pendants in the shape of Immortals, of crystal or ivory'.[4] The Jiajing emperor's particular interest in Taoism is well documented so his choice of subject matter is scarcely surprising. What remains dubious is whether such ivory trinkets would have been judged elegant by all the emperor's contemporaries.

There is a considerable late Ming and early Qing literature devoted to the good life and how to lead it, dealing with the arrangement of dwellings, of furniture and even with the details of implements for enjoying incense, calligraphy and painting. These texts are precise snapshots of the tastes of their owners, with all the idiosyncrasies that implies. The close attention they pay to incense burners, wrist-rests, water droppers and table screens allows us a glimpse of the sixteenth- and seventeenth-century élite interior as prescribed by some of its most sensitive inhabitants. When it comes to ivory, they can reveal some surprises. Perhaps the model example of this sort of guide to living graciously is the *Treatise on Things that Matter* by Wen Zhenheng (1585–1645). Wen had all of the characteristics and enjoyed the style of living for which 'the scholars' taste' has become an overworked shorthand. He was a

mention of Bushell's '1680', only a rather vague term which suggests that the compilers of the 1818 *Statutes*, normally precise about dates, were in the dark themselves. The confusion is compounded if we check the Guangxu period edition of the *Statutes*, frustratingly precise about details of administration and accounting, maddeningly vague about dates, craftsmen or products. Then we read that in Kangxi 32 (1693), 'The *zaobanchu* established workshops',[21] though it is obvious from the immediately preceding discussion that palace craftsmen, organised in some form, did exist prior to this date. On the interpretation of all this we can only trust those contemporary Chinese scholars whose access to primary source materials preserved in the Qing archives in Peking allows them to see beyond the confining systematization of the *Statutes*.

Yang Boda's study of Qing jade carving shows us that at one stage there were in fact two *zaobanchu*. The earliest was established in the vicinity of the Yang Xin Dian, 'Palace of the Culture of the Mind', in the north-western corner of the palace, probably in the Shunzhi reign. In early Kangxi, claims Yang, another workshop was set up beside the Wu Ying Dian, 'Palace of Martial Valour', in the south-west.[22] The two were united in Kangxi 47 (1708), and operated from the Wu Ying Dian site, though the name '*Yang Xin Dian zaobanchu*' confusingly clung to the organisation throughout the dynasty. The location is confirmed by the maps in a 1788 account of Peking, which show the *zaobanchu* occupying part of the courtyard behind the Wu Ying Dian in the south-west of the 'Great Within'.[23] It is unclear exactly when imperial workshops in general were established, but it is clear that the year 1680, nowhere mentioned in Chinese sources as particularly significant, can no longer be upheld as the year of their foundation.

How many *zuo*, or distinct workshops, were there at any one time? Again the evidence is confusing. Bushell's 27 can be shown to be based on a misreading of the Chinese, but is the 1818 *Statutes* total of 31 any more trustworthy? One Chinese researcher into the archival sources has specifically said that it is not. Chong Zhang's essay, 'Workshops and Craftsmen of the *zaobanchu*' counts 42 workshops prior to Qianlong 23 (1758), one of them being a *yazuo* or 'Ivory Workshop.[24] Drastic amalgamation in that year reduced the number to 13, with no independant *yazuo*. In Qianlong 48 (1783) the number was expanded to 15, where it remained till the Guangxu period reduction to 14. Chong lists the 61 separate types of craftsmen active in the Guangxu period, and reveals that ivory carvers, together with jade carvers, painters, rubbers, mounters and roller makers, came under the *Ruyi guan*. This appears to have functioned as a sort of design office. It did not, as Bushell thought, make *ruyi*. Bushell's mistake, repeated by some subsequent authors, was to see the *Statutes* list as once-and-for-all, when in fact it describes a process. It seems reasonable to assume that such ivory carving as was carried out in palace workshops was done by members of an independent *yazuo* until 1758, and thereafter by carvers attached to the *Ruyi Guan*.

A closer focus still is obtained through the very recent work of Zhou Nanquan, whose 'Noted Jadeworkers and Carvers of the Ming and Qing' draws on the 'Clear Registers of the Various Workshops', manuscript account books preserved in archives in Peking, as well as on a variety of published literature. Zhou gives details of 21 known *zaobanchu* ivory carvers of the years between 1731 and 1790. This list is perhaps incomplete. It does not, for example, mention the famous and flamboyant Du Shiyuan, who is discussed below, nor You Xibei who was reputedly summoned to court in the Kangxi reign.[25] It nevertheless seems likely that the 'imperial ivory workshop' was a sporadic, small-scale affair with few carvers (perhaps as few as one or two at any given time) and very little going on. The chances of any surviving piece of ivory carving, regardless of its high quality, having a palace provenance fall accordingly.

In only a few cases can names of palace carvers and objects plausibly from their hand be linked. Several from Peking are illustrated by Zhou Nanquan. Others are in the Palace Museum, Taiwan. None of the objects in this exhibition has a sure connection with palace craftmanship, though the sleeping mat, No. 236 and the openwork box No. 190 seem possible candidates.[26]

The above excursion into administrative history is necessary to lay another of the ghosts attributable to Bushell, that of 'the palace style'. He makes much of the supposed contrast between court and Canton styles, the latter characterized by the dominance of technical trickery over artistic feeling. But the fact is that a substantial number of the *zaobanchu* ivory carvers *were* Cantonese, established craftsmen with mature styles who may have spent only a short time in Peking. Nor was a summons to the palace invariably a welcome honour, as we see from the story of Du Shiyuan as told in the early nineteenth century *General Chats from the Garden of Clogs* by Qian Yong. Qian tells how in the early Qianlong period Du was known as 'a devil craftmen', famed for his ability to carve Su Shi's excursion to the Red Cliff on a peach pip, but also for his addiction to drink;

'Gaozong heard of his fame and summoned him to an audience, lavishly rewarding him with gold and silks but abruptly removing his supply of drink. Shiyuan spent all of his days locked up in the palace in deep depression, wishing to leave but unable to do so. Pretending to be mad he once entered the Yuan Ming Yuan and cut down a piece of purple bamboo in the garden, topped and tailed it to make a flute and sat at the top of a large pine tree blowing on it. The guards were astonished and made a report of all the circumstances. Gaozong said, "I think this man is crazy" and ordered him to be sent away. He returned to Suzhou and gave himself over to drink as before.'[27]

Even carvers less mercurial than Du Shiyuan did not spend their lives from childhood romantically immured in the palace, learning a distinctive 'imperial' style. To take another example, Huang Zhenxiao from Canton entered the *zaobanchu* in 1739. Yet Zhou Nanquan illustrates an extremely fine brushpot from his hand dated 1738, i.e. it is a piece from his own workshop.[28] This alone would demonstrate the pointlessness of trying to isolate 'palace pieces' by quality or style. The palace was served by some of the best people but not by *all* of the best people. They had mature styles of their own and may have returned to their homes and their private customers after a time.

As an illustration of both these points the case of the Cantonese Yang Youqing is instructive. He entered the *zaobanchu* in 1771 and is known to have died there in 1790.[29] He was the only ivory carver to die in harness, suggesting that the others either retired or returned home. Again uniquely he was succeeded by his son Yang Xin, summoned from Canton where he was presumably maintaining the family workshop. This rarity of family succession meant a constant influx of new blood which mitigated against the formation of a 'palace style'. Such a thing did not exist. The products of the *zaobanchu* had status and were desired. This was true of ivories as of everything, as we see from the eighteenth century novel *Hong lou meng* (*The Dream of the Red Chamber*) where ivory note tablets of 'palace manufacture' (*gong zhi*) are a coveted gift from an Imperial Concubine to her young relatives.[30] But it is the status of the giver rather than the pre-eminence of the craftsmen which imparts glamour and desirability to the objects.

Imperial actions could, however, have an influence on the work of craftsmen other than by directly employing them. Here is Qian Yong again:

'Although the craft of carving exists everywhere, it is most flourishing and most ingenious in Ningguo, Huizhou [both in Anhui] and Suzhou. In the Qianlong period the emperor Gaozong made six Southern Progresses, and travelling palaces were built at all the famous cities of Jiangsu and Zhejiang, all filled with ornaments, carved screens on stands of ivory, *zitan* or *huali* woods, bronze bibelots, ceramic or jade vessels decorated with dragons and phoenixes, clouds and waves, patterns both archaic and foreign, all so curiously wrought that each piece involved hundreds and hundreds of craftsmen. It was said that carving flourished ever increasingly from this time.'[31]

Several points emerge from this interesting passage. Firstly, the term *diaoke*, 'carving', itself: it covers all small-scale work in jade, ivory, woods and to a lesser extent bamboo. Ivory carving is never viewed by Ming and Qing sources as a subject separate from the generality of *diaoke*. Hence there is scarcely such a thing as 'an ivory carver'. There are only carvers in general working in a variety of materials, The Zhu lineage of Jiading, renowned chiefly as bamboo carvers occasionally worked in ivory, though no plausible example can be produced. These carvers, makers of brushpots, boxes and bibelots, are on the whole different from the producers of the figure carvings discussed above. There is no evidence for a named carver producing figures.

Qian allows us to expand the known number of sites at which ivory was carved in the Qing. In addition to Peking and Canton we now have two places in Anhui and the great craft centre of Suzhou. Of the 21 named palace carvers between 1731 and 1790, 11 came from Canton, 9 from unknown birthplaces and 1 from Nanjing. The bibulous Du Shiyuan hailed from Suzhou. Hardly surprisingly, the craftsmen in ivory as in so many other materials clustered round their clientèle in the capital and in the prosperous cities of the lower Yangtze. But there were other centres of activity, one of them being Zhangzhou in Fujian as we have seen. The evidence from Zhangzhou, deriving as it does from a local gazetteer, is rather more interesting than the formulaic tales of near miraculous miniaturisation favoured by the early Republican compilation, Li Fang's *Brief Biographies of Chinese Artists*.[32] Further research in such material will doubtless lengthen the list of areas where carving workshops were active.

Technique and Subject Matter

The tools of the Ming and Qing ivory carver can have differed little from those of the worker in bamboo or wood, and were noteworthy mainly for their simplicity. Saws and rasps for initial roughing out, knives and files for finer work were crude to the point that observers assumed some secret process was employed to allow the material to be softened. This pervasive myth finds its most confident expression in the early Republican writer Xu Ke: 'The nature of ivory is hard, yet those who make objects of it can carve landscapes and figures as fine as a hair. First they cut it into sections with a saw, and allow vinegar to soak into the grain, whereupon it becomes soft as beancurd. After carving is completed they boil it in an infusion of scouring rush and it becomes hard as before'.[33] No such magic formula in fact exists, and the illustrations to W. Cox's *Chinese Ivory Sculpture* show that it was with skill, patience and simple tools that effects were achieved. These effects were varied, with a repertoire of techniques to parallel those achieved in jade, lacquer or any other carved medium.

The first technical factor to be taken into consideration is the constraint imposed by the shape of the unworked ivory tusk. Most ivory objects are small, or else elongated following

the natural curve. There is some parallel here with bamboo, and as we have seen the same carvers often worked in both materials, but ivory is solid and a better medium for sculpture. The simplest form of decoration of an ivory object is of course a simple polish, with the material left to acquire a patina through age and handling. In the Qing, totally plain objects included brush-pots (Nos 170 and 171), bowls (No. 205) and vases (No. 209), the latter in particular recalling the forms of monochrome glazed porcelains.

Perhaps the next simplest technique of decoration is scratch incising, where thin incisions are inked or lacquered in to form a picture. The Sloane thumbring and the brush-pots (Nos 239 and 181) are examples of this, perhaps a relatively late form of decoration arising in the 18th century. This is reversed, the ground being inked in and the design reserved in white, on the table screen (No. 162) and brush-pots (Nos 182 and 183). This style of decoration was practised in Tang China, as the ivory rulers preserved in the Shōsōin show, but there is no evidence of continuity between the Tang and the eighteenth century, and the Japanese term *bachiru* does not appear in Chinese sources. With the exception of this, and of the incision of inscriptions, most of the other techniques to be considered are variations of relief carving. In Chinese terms they are *yang ke*, as opposed to *yin ke*.

Low relief carving, the ground recessed and the design then rising to the level of the initial surface, appears on the seventeenth-century brush-pot (No. 176). A more extreme form of the same thing is seen on No. 178, where the 'ground' is deeply sunk into the section of ivory to allow the figure carvings to stand out proud, almost carved in the round and with much use of undercutting. Like many ivory carvers' effects, it seems to have its origins in bamboo working, in this case in the technique of *xian di shen ke*, 'sunken ground deep carving', identified by Wang Shixiang as being an innovation of the early Qianlong period.[34] True relief carving, where the ground is entirely recessed, appears on objects of various types, such as the brush-pot with playing children (reminiscent of carved lacquer) and particularly on the undersides of wrist-rests of eighteenth–nineteenth century date. The close-grained nature of ivory, greater than that of bamboo, allows here a degree of undercutting and a delicacy of carving not available to the bamboo carver. It also allows the use of piercing, rare on bamboo, but seen here at its most precise on the box from San Francisco (No. 190). Turning to the subject matter of ivory decoration, we are faced with the fact that by the eighteen and nineteenth centuries when the majority of the objects in this catalogue were produced, the decorative repertoire had undergone enormous expansion. The floral scrolling on the ivory clapper (No. 235), one of the few Ming objects shown here, is firmly linked to that on textiles, ceramics and lacquer of the same period. Such connections with the common currency of decoration continued into the Qing. Brush-pot No. 179 parallels eighteenth-century carved lacquers, while the table screen (No. 162) has its roots in the single sheet coloured woodblock prints of later eighteenth-century Suzhon, also the source of so much porcelain painting in enamels. Also part of the common currency of Qing decoration is the manipulation of elements drawn from the art of the Warring States and Han periods. These element were transmitted through the medium of published collections such as *Xi qing gu jian* of 1749, and are visible on objects such as No. 149. With Nos 207 and 208 not only the decoration but the form of the vessel draws inspiration from archaic bronzes.

However, by the eighteenth century the wide availability of printed manuals of painting style, of which *The Mustard Seed Garden* remains the best known, gave to craftsmen in many materials access to 'high art'. With Zhe school and Wu school reduced to a set of formulae such distinctiveness as they had ever had was eroded, and the art of an élite made the common property of craft workers of less exalted social status. Thus on the incised brush-pot

No. 180 the simple, one-sided composition has its line of descent from Song painting through the Zhe school and its reproductions in woodblock print, while the deserted hut is a clichéd allusion to the painting of Ni Zan. Such distinctions and artistic lineages have by this late date become meaningless, as the huge storehouse of style, motif and area of allusion is ransacked, combined and recombined in the late Qing decorative synthesis.

Ivory as an Inlay Material

Ivory played an important part in Chinese decorative art as a material for inlay since Shang times, and it may well be that a high proportion of the importation of ivory ended up as decorative detailing on objects chiefly made of something else. There is literary testimony to its use in this way from the mid-Ming dynasty, as well as a number of actual pieces which illustrate the texts. Objects inlaid with ivory could be large and impressive. Gaspar da Cruz, who spent some months in Canton in 1556, remarks on the large testered beds which dominated the Ming interior, and notes: 'I being in Cantam, there was a very rich one made wrought with ivory, and of a sweet wood which they call Cayolaque, and of sandalwood, that was priced at four hundred crowns'.[35]

No piece of major Ming furniture with ivory inlay survives, probably because the timbers used were softwoods relatively vulnerable to time and decay. However a group of lacquered boxes inlaid with bone (No. 282), of early seventeenth-century date, may give an idea of the style involved. We do not yet know enough about the development of this furniture type through the early Qing, but sufficient pieces survive from the early nineteenth century on to suggest its continuous existence from the late Ming. One of the finest surviving pieces of ivory inlaid furniture is the bed, now in the Oriental Museum, Durham, traditionally associated with Lancelot Dent, one of the leading British merchants of the years leading up to the First Opium War. By Dent's time, this distinctive type, in which the inlay stands out in low relief, seems to have been a speciality in Ningpo. An English observer of the 1840s is quite categorical on this point:

'There were beds, chairs, tables, washing-stands, cabinets and presses, all peculiarly Chinese in their form, and beautifully inlaid with different kinds of wood and ivory, representing the people and customs of the country, and presenting, in fact, a series of pictures of China and the Chinese. Every one who saw these things admired them, and, what was rather strange, they seem peculiar to Ning-po, and are not met with at any of the other five parts, not even in Shang-hae.'[36]

To return to the late Ming: the whole topic of inlay work from that time on is inseparable from the name of Zhou Zhu, the eponymous inventor of a technique of fixing semi-precious stones and other coloured materials, ivory being one of them, to a variety of surfaces. This 'Zhou work' (*Zhou zhi*) is frequently referred to in Ming and Qing writings, but it is almost impossible to untangle fact from fiction in the accounts given of its founder. He may even be a convenient fiction himself, a product of the Chinese tendency to attribute craft styles to individual, named culture heroes. One of the earliest references to this shadowy figure appears in Gao Lian's 'Eight Discourses on the Art of Living' of 1594, and is tantalisingly brief. In the course of a discussion of inlaid lacquer Gao remarks, 'Modern inlay work is seen everywhere. There is a vast gulf between it and Zhou's early work. Its value is also low'.[37] The implications are that Zhou (no given name is here recorded) was active some time earlier than the 1590s, and that his work was well enough known to need no further gloss.

In the Qianlong period, when polychrome inlay was a much practised art. Wu Qian (1733–1813) added some details in his 'General Notes from Miyang', including the sort of story often gathered round the name of a great craftsman:

'In the time of Ming Shizong (1522–66), Zhou Zhu was expert at the manufacture of inlaid caskets, boxes and such like, of a surpassing quality. These were known at the time as "Zhou inlay". He was a client of Yan Song (1480–1565). On Yan's disgrace his goods were all sequestered and entered the Palace. Thus extremely few pieces are still in circulation'.[38]

But what was 'Zhou work'? What does it look like? The clearest description is found in Qian Yong's *General Chats from the Garden of Clogs*, dated 1838:

'The method of Zhou work is unique to Yangzhou. In the late Ming there was a man named Zhou, who created the style, hence the name. The method is to take gold, silver, gemstones, pearls, coral, dark green jade, *feicui* jade, crystal, agate, tortoiseshell, clam shell, lead, coloured pine, mother-of-pearl, ivory, 'secret wax' and 'sinking incense'. They are carved into landscapes, figures, trees, pavilions, flowers, birds and animals, then inlaid into objects of *zitan* wood, *huali* wood or lacquer. Large objects can be screens, tables, chairs, window frames and book cabinets. Small ones included brush rests, tea utensils, inkstone cases and book caskets. The five colours are jumbled up, beggaring description. These are indeed strange trinkets unknown from ancient times. In the Qianlong period people like Wang Guoshen and Lu Ang were skilled at this trick. Nowadays Ang's grandson Kuisheng is still capable of it'.[39]

The same source goes on to describe how in 1817 over two hundred leaves of window lattice in this garish polychrome inlay were installed in one of the palaces of the Yuan Ming Yuan, though it seems clear from Wu's tone that he did not consider the style particularly elevated or refined. It does seem to have been fashionable in the eighteenth century however, as a variety of surviving pieces show. Wood is the most common ground, with ivory one of the most frequently employed materials due to its softness and the ease with which it can be carved. Much rarer is the type represented by a brush-pot from the Sassoon collection (No. 184), where the ground itself is of ivory.

Sources of Elephant Ivory in Ming and Qing China

The origins of the raw elephant ivory which found its way to the carvers' workshops of Ming and Qing China cannot be considered in isolation from the general currents of trade which brought a variety of exotic luxury goods to China's ports. The subject is one where a plethora of romantic and arcane geographical information can all too easily be used to obscure the basic picture and where a concentration on the undoubtedly thrilling story of European trade and discovery in east Asia can mask the fact of China's overwhelming dependence for its supply of ivory on trade routes which remained at this period in the hands of indigenous Asian traders. Thai, Malay, Chinese and Indian merchants have left no voluminous records to parallel those of the Dutch or English East India Companies, but there can be little doubt that the bulk of China's overseas trade remained in their hands until the coming of steam navigation. The fullness and detail of the European sources, some of which will be employed below, must not blind us to this.

Chinese sources too must be subject to certain reservations in their use. Geographical treatises show a tendency to copy information from each other, particularly when dealing

with exotic foreign products. Lists of such goods can retain a conventionalised form, as can be seen even in the writings of the great early Qing polymath Gu Yanwu, whose *Tian xia jun guo li bing shu* (preface dated 1662) lists sappan wood, pepper, rhinoceros horn and ivory as the chief products of the 'Great Western Ocean' countries of Thailand and Cambodia.[40] This list would have been perfectly comfortable to a Tang dynasty writer on exotica a thousand years earlier, and is used here more to make a point about the foreignness of such countries than as a precise observation.

That said, there are certain generalisations which can be made about the Chinese literature on foreign trade, which does reflect to an extent changing circumstances and changed Chinese perceptions of the world. The first of these is that textural evidence clearly shows a remarkable 'forgetting' of the existence of Africa as a source of ivory between the Yuan and late Ming periods. The well-known thirteenth-century Song dynasty account of foreign trade, *Zhu fan zhi* by Zhao Rugua, is clearly aware that the Arabs, through the coast of east Africa, had access to a source of ivory which provided larger and better coloured patterned tusks than those of south-east Asia.[41] The same perception is visible in *Dao yi zhi lüe*, *A Brief Account of the Island Barbarians* of 1349 by Wang Dayuan, probably a native of Quanzhou in Fujian province, and certainly a traveller himself with personal experience at his command. In addition to well-attested sources of ivory such as Jiaozhi (modern northern Vietnam), various states of modern Vietnam and Kampuchea, Thailand and the Malay Peninsular, Wang mentions 'Jiajiangmenli' and 'Cengyaoluo', which the modern commentator Su Jiqing identifies with present-day Madagascar and Zanzibar respectively.[42] The 1388 edition of *Ge gu yao lun*, *The Essential Criteria of Antiquities*, in the very first years of the Ming dynasty still differentiates between inferior ivory from relatively accessible sources such as Jiaozhi and the only partly-sinicized province of Guangxi and longer thicker tusks from the Southern Barbarians (*Nan Fan*), by which it is likely Africa is meant, since the term Western Barbarians (*Xi Fan*) covers south-east Asia.

The astonishing and much-discussed expeditions of Zheng He and his fleet, which actually reached the coast of Africa in 1421/22 can have had little real effect on the availability of African ivory in China. Ma Huan, the most reliable contempory chronicler of these voyages, did not visit Africa himself, and so has nothing to say on the products of that country, contenting himself with conventionally noting that in Zhancheng (Champa, modern central Vietnam) 'elephants' tusks are very abundant' and that Thailand is also a source of supply.[43] The memory of Zheng's expeditions was never totally lost, but an eschewal of these costly enterprises by the Ming state led to a distinct lessening of interest in far-flung parts by geographical writers. Nevertheless such writing did take place, and much of it was directly associated with the practicalities of foreign trade. One of the most useful guides to the world and its wares as seen from late Ming China was published in 1617 in 12 *juan* and entitled *Dong xi yang kao*, *An Investigation of the Eastern and Western Oceans*. Its author Zhang Xie (*c*. 1574–*c*. 1640) was a native of Fujian with personal experience of trading voyages overseas, and wrote at the instigation of Fujian officials who wished a permanent record of his knowledge. He does share a common reverence for literary sources, and even lists Japan as a source of ivory on the basis of the Song dynastic history, but in general he is a reliable witness to the trading entrepots where ivory was to be obtained; Vietnam, Cambodia, Thailand, Sumatra, the Malay Peninsula and Java.[44] It is important, of course, to remember that Zhang's list makes no distinction between those regions where elephants lived and ivory was available at its source, and those where it was merely transhipped. He lists Malacca, in his day in Portuguese hands, though ivory was in no sense a 'product' of this cosmopolitan

trading centre. This is a common characteristic of Chinese sources, as we shall have cause to note again.

The *Dong xi yang kao* contains an interesting account of the rates of taxation of foreign goods entering the port of Quanzhou as of 1589, with the following entry: 'Ivory: that made up into utensils is taxed at 1 silver *liang* per 100 *jin*. That not made up into utensils pays 5 silver *qian* per 100 *jin*.'[45] Zhang has no further comment on these tantalising 'utensils', which could have been as basic as plain chopsticks, and may well have come from other Chinese ports, rather than workshops overseas.

By the early seventeenth century, the intervention of Portuguese, then Dutch ships in the long distance transport of goods, particularly luxury goods, throughout Asia had to an extent altered the position with regard to China's ivory supplies. The routes from Mozambique to Goa, and from Goa to Macao and Canton may have brought Indian and African ivory to Chinese workshops in slightly greater quantities than hitherto. The Dutch traveller Linschoten certainly mentioned it as one of the items which Portuguese ships found it worth bringing to Canton in the 1590s, stating: 'Looking glasses, Ivorie bones and all kinde of Christall and Glasse are well sold there.'[46] Roughly contemporary is a Portuguese memorandum of around 1600, which includes ivory in a list of goods regularly carried between Goa and China, with the detail, 'Ivory is sold to the Chinese at 50 taels the picul for the white and straight kind.'[47] The price here is significant as, taken together with other admittedly sporadic early seventeenth-century evidence, it suggests why ivory remained a relatively unimportant item of European import to China. Quite simply, it was not profitable enough. It was a good speculation when porcelain was cheap, as Jan Pietersz Coon explained from Batavia on 6 October 1616: 'The elephant tusks we have all traded with the Chinese, and mostly for porcelains, to wit, flat wares, the tusks reckoned at 55 and 60 reals per picul (62.5 kilos) and the porcelain for half the price they were formerly bought at.'[48]

But the ruthless economic efficiency of the Dutch East India Company opposed any commodity which in 1636 was costing 60–65 taels per picul in 'Cambodja', yet was saleable to Chinese traders on Taiwan in 1638 at only 60 taels for the same weight. The profits were nil.[49] The Dutch seem to have lost interest at that point, contenting themselves with noting the activities of Chinese merchants in buying ivory in Thailand and Cambodia. Other Europeans, though, seem to have persevered. The Portuguese, whose early prosperity had been founded on the long distance carrying trade, were observed by the Englishman Nicholas Buckeridge carrying quantities of ivory from east Africa to India in 1653.[50] A proportion of this may well have been re-exported to China, though the existence of such a route cannot be conclusively proved.

Europeans remained well aware that ivory was a precious material which the Chinese were eager to obtain. It was suitable for inclusion in presents, such as the five pieces of ivory included in the gifts brought by a Dutch embassy of 1685 to the Kangxi emperor, attested by both Dutch and Chinese sources.[51] At least part of the point of such a diplomatic mission was to display to the Chinese goods which could be supplied in greater quantities if trade was permitted, but it is not reasonable to assume that in the case of ivory the Dutch were eager to sell great amounts of it, as they omitted it from their presents to the emperor on the embassies of 1655–57, 1666–68 and their much later last embassy in 1794–95. If European traders shied away from ivory as a commodity in the seventeenth and eighteenth centuries, their south-east Asian competitors did not. The Thais could provide tame elephants as diplomatic gifts in 1667,[52] but were also described by a censor's report from Amoy in the early 1680s as a principal source of ivory. Regardless of China's several impositions of a 'closed shoreline'

policy, Thai junks were able in the late seventeenth century to supply exotica to most parts of the south-east Chinese littoral.[53] Ivory was in theory a Thai royal monopoly from the reign of King Narai (c. 1656–1688), but the kings could farm their monopolies, often to Chinese merchants, to maximise their incomes. That it was Thai and Chinese junks, not East Indiamen, which brought most of China's ivory is shown by surviving Chinese records of the cargoes arriving at Canton between 1715 and 1720. Silver bullion of course predominates, but ivory is not mentioned at all, and was either wholly absent or else present in such small

quantities as to be not worth recording.[54] There is sporadic evidence in the unpublished archives of the Dutch East India Company that English traders occasionally brought some ivory to Canton in the years c. 1760–1790,[55] but nothing to suggest that the growing presence of European traders in Chinese waters meant a greatly increased availability of ivory to the Chinese carver.

Mid-Qing Chinese sources, such as Chen Lunqiong's *Hai wai wen jian lu, Record of Things Heard and Seen Overseas*, of 1730 and Yang Bingnan's *Hai lu, Record of the Seas* (after 1820) continue to locate the major sources of ivory on the Malay-Thai peninsula at Songkhla and at Pattani.[56] These are both points of shipment as well as centres of production. In the reign of Rama I (1782–1809) Ligor was another such centre, while at the same period Thais traded ivory to Saigon, Faifo and Hue for re-export, casting retrospective doubt on the position of Vietnam as a primary source.[57] An English observer in 1826, Captain Henry Burney, specifically notes that Chinese traders living at Trang and Pattani were involved in the shipment of luxury products including ivory to Bangkok for eventual transport to China.[58]

The coming of the steamship altered the situation fundamentally in the nineteenth century, as did European imperialism in Africa, which opened up new sources of African ivory. The traditional junk trade of south-east Asia declined, along with Arab and Indian carrying trade across the Indian Ocean, though neither has entirely disappeared to this day. Increased supplies of ivory coincided with increased integration of China's craft producers into world markets, as they turned out toys, fans, card cases and sewing tools for the western market. By 1863 'the best and largest part' of China's ivory still came from Thailand, but a quantity was also coming from east Africa via Bombay. The same source remarks on the variation in quality of ivory pieces: 'The tusks should be chosen without flaws, solid, and white; for if cracked or broken at the point, or decayed inside, they are less valuable. The largest and best weighs from 5 to 8 a picul, and decrease in size up to 25 in a picul; a large sound tusk often sells for $300 and upwards.'[59]

The above discussion should not allow us to forget that ivory was and remained a minor item in China's overseas trade. The meticulous import statistics of late nineteenth-century Consuls-General do not take notice of it. Nevertheless the persistence with which this purely decorative material found its way to Ming and Qing China must in the end tell us something about its attractiveness and desirability to Chinese carvers and to their customers over this considerable period.

CRAIG CLUNAS

Notes

1. David, Sir Percival, *Chinese Connoisseurship*, London, 1971, p.133.

2. Dai Guan (*jinshi* of 1508), *Zhuo ying ting bi ji, juan* 3, quoted in Xie Guozhen, *Mingdai shehui jingji shiliao xuanbian*, 3 Vols, Fujian Renmin Chubanshe, 1980–81, I, pp.314–315.

3. Gao Lian, *Zun sheng ba jian, juan* 14, quoted in Xie Guozhen, I, p.320.

4. Gao Shiqi, *Jin ao tui shi bi ji*, Beijing Guji Chubanshe, 1980, p.146.

5. Wen Zhenheng, *Chang wu zhi*, Congshu Jicheng, vol.1508, Shanghai, 1935, p.50.

6. Wen Zhenheng, p.57.

7. Tu Long, *Kao pan yu shi*, Congshu Jicheng, vol.1559/1, Shanghai, 1935, p.76.

8. Gao Lian, *Yan xian qing shang jian*, Meishu Congshu, vol.15, Shanghai, 1947, *san ji, dishi ji*, pp.229 & 226.

9. Xie Zhaozhe, *Wu za zu*, Guoxue Zhenben Wenku, Shanghai, 1935, *juan* 12, p.146.

10. Gan Yang Xu Fu, *Yin zhang ji shuo*, Meishu Congshu, vol.4, Shanghai, 1947, *chuji, diba ji*, pp.160–161. Ye Mengzhu, *Yue shi bian*, Shanghai, Guji Chubanshe, 1981, p.164.

11. van Gulik, R. H., *Chinese Pictorial Art as viewed by the Connoisseur*, Serie orientale Roma XIX, Rome, 1958, p.310.

12. Mote, F. M., 'Yuan and Ming' in Chang, K. C. ed., *Food in Chinese Culture*, Yale University Press, 1977, p. 251.

13. Spence, J., 'Ch'ing' in Chang, K. C. ed., p. 284.

14. Shen Fu, *Six Records of a Floating Life*, translated by Leonard Pratt and Chiang Su-hui, London, 1983, p. 48.

15. Gu Lu, *Tong qiao yi zhuo lu*, Shanghai, Guji Chubanshe, 1980, p. 157.

16. Torbert P. M., *The Ch'ing Imperial Household Department; a study of its organisation and principal functions 1662–1796*, Harvard East Asian Monographs 71, Harvard University Press, 1971, p. 170.

17. Liu Ruoyu, *Ming gong shi*, Beijing, Guji Chubanshe, 1981, p. 33. An abbreviated version of this passage appears in *Ming shi*, Zhonghua Shuju, 1974, *juan* 74, p. 1819.

18. Bushell, S. W., *Chinese Art*, 2 Vols, HMSO, 1905, I, p. 116.

19. Torbert, p. 45.

20. *Qin ding da qing hui dian shi li* 1818 ed., *juan* 917, p. 14b. Howard Hansford S., gives the *juan* number incorrectly in 'The Ch'ing Dynasty Jade', Transactions of the Oriental Ceramic Society 35, 1963–64, p. 38.

21. *Qin ding da qing hui dian shi li* Guangxu ed., *juan* 1273, p. 4b.

22. Yang Boda, 'Qingdai gongting yuqi', *Gugong bowuyuan yuankan*, 1982, 2, pp. 49–61, p. 50.

23. Wu Changyuan, *Chen yuan zhi lüe*, Beijing, Guji Chubanshe, 1981.

24. Quoted from *Zhonghua zhoubao*, II.19, p. 8, by Peng Zeyi, *Zhongguo jindai shougongyeshi ziliao*, 4 Vols, Beijing, Sanlian Shuju, 1957, I, pp. 148–149.

25. Li Fang, *Zhonguo yishujia zhenglüe*, Tianjin, 1915, *juan* 3, p. 17b.

26. Zhou Nanquan, 'Ming qing zhuoyu, diaoke gongyi meishu mingjiang', *Gugong bowuyuan yuankan*, 1983. 1, pp. 79–87; *Masterpieces of Chinese Miniature Crafts in the Palace Museum*, Taibei, 1971, Nos 23–27; *Masterpieces of Chinese Writing Materials in the Palace Museum*, Taibei, 1971, Nos 38–40.

27. Qian Yong, *Fu yuan cong hua*, 2 Vols, Zhonghua Shuju, 1979, I, pp. 324–325.

28. Zhou Nanquan, p. 85 & pl. 8.

29. Zhou Nanquan, p. 85.

30. Cao Xueqin/Gao E, *Hong Lou Meng*, 4 Vols, Renmin Wenxue Chubanshe, 1972, I.

31. Qian Yong, p. 324.

32. e.g. Li Fang, *Zhonguo yishujia zhenglüe, juan* 3, p. 17a. The story about Du Shiyuan carving Su Shi's Red Cliff Excursion on a peach stone appears as a cliché in several sources.

33. Xu Ke, *Qing bi lei chao*, Shanghai, 1918, Vol. 17, *bi* 45, p. 74, 'Scouring rush', *mu zei* in Chinese, is *Equisetum hiemale L.*

34. Wang Shixiang/Wan-go Weng, *Bamboo Carving of China*, China House Gallery, New York, 1983, p. 36.

35. Boxer, C. R., *South China in the Sixteenth Century*, Hakluyt Society, London, 1953, p. 125.

36. Fortune, R., *Three Years Wandering in the Northern Provinces of China*, John Murray, London, 1847, p. 89.

37. Gao Lian, *Zun sheng ba jian, juan* 14, quoted in Xie Guozhen, I, p. 319.

38. Wu Qian, *Miyang congbi*, quoted in Zhu Qiqian, *Qi shu*, Peking, 1957, p. 65a.

39. Qian Yong, I, p. 322.

40. Gu Yanwu, *Tian xia jun guo li bing shu, ce* 26, 'Fujian', quoted in Xie Guozhen, II, p. 134.

41. Hirth, F. and Rockhill, W. W., *Chau Ju-kua: His Work on the Chinese and Arab Trade in the twelfth and thirteenth Centuries, entitled Chu-fan-chï*, Imperial Academy of Sciences, St Petersburg, 1911, p. 232.

42. Wang Dayuan and Sun Jiqing, *Dao yi zhi lüe shi*, Zhonghua Shuju, 1981, pp. 297 & 358.

43. Ma Huan, *Ying yai sheng lan 'The Overall Survey of the Ocean's Shores (1433)*, translated by Mills, J. V. G., Hakluyt Society, Cambridge University Press, 1970, pp. 81 & 106.

44. Zhang Xie, *Dong xi yang kao*, Zhonghua Shuju, 1981, pp. 13–126.

45. Zhang Xie, p. 141

46. Burnell, A. C. and Tiele, P. A. eds., *The Voyage of John Huyghen van Linschoten to the East Indies*, 2 Vols, Hakluyt Society, London, 1885, I, p. 151.

47. Boxer, C. R., *The Great Ship from Amacon; Annals of Macao and the Old Japan Trade, 1555–1640*, Lisbon, 1959, p. 183.

48. Volker, T. *Porcelain and the Dutch East India Company*, Leiden, 1954, p. 27.

49. I am most grateful to Dr C. A. J. Jörg for supplying this and other information from W. P. Coolhaas, *Generale Missiven van Gouverneurs-Generaal en Raden aan Heeren XVII der Verenigde Ostindische Compagnie*, series Rijks Geschiedkundige Publicatien: The Hague, 1960–1975, Part I, p. 593 and pp. 706–707.

50. Margarite Ylvisaker, 'The Ivory Trade in the Lamu Area, 1600–1870', *Paideuma 28 Mitteilungen zur Kulturkunde*, 1982 p. 221.

51. Vixseboxse, J., *Een Hollandsch Gezantschap naar China in de Zeventiende Eeuw (1685–1687)*, Leiden, 1946, p. 120. Wang Shizhen, *Chi bei ou tan*, 2 Vols, Zhonghua Shuju, 1982, I, p. 81.

52. Wang Shizhen, I, p. 65.

53. Sarasin Viraphol, *Tribute and Profit: Sino- Siamese Trade 1652–1853*, Harvard East Asian Monographs 76, Harvard University Press, 1977: pp. 43–44.

54. Lü Jian, 'Tan Kangxi shiqi yu xi ou de maoyi', *Lishi Dang'an*, 1981, 4, p. 114.

55. Personal communication from Dr C. A. J. Jörg, quoting reports of 4/1/1765, 14/1/1784 and 31/12/1788.

56. Quoted in Cushman, J. W. & Milner, A. C., 'Eighteenth and Nineteenth Century Chinese Accounts of the Malay Peninsula', *Journal of the Royal Asiatic Society (Malaysian Branch)*, LII.I, Vol. 235, 1979, pp. 1–56, pp. 48–49.

57. Viraphol, pp. 174 & 203.

58. Viraphol, p. 215.

59. Williams, S. W., *The Chinese Commercial Guide*, Hong Kong, 1863, p. 91.

Writing accessories and other ornaments

142. Brush, carved in openwork with squirrel and vine design

L. 15 cm Colour plate 5

First half of 17th century

Sir John and Lady Figgess

An ivory brush carved in openwork is illustrated in *Masterpieces of Chinese Writing Materials in the National Palace Museum* (Taipei 1971) pl. 3, where it is given a Qing date. Here the parallels with brushes in carved red lacquer such as No. 276 combine with the late Ming motif of squirrels and vines to suggest a rather earlier date. This piece, unusually for a Chinese ivory, has been preserved in Japan. The sixteenth century connoisseur Xiang Yuanbian (see No. 152) dismisses ivory as a suitable material for brush handles in his *Jiao chuang jiu lu*, along with a long list of other materials, preferring plain bamboo.

143. Brush-rest, a figure under a pine tree, ivory and wood

L. 7.3 cm

17th century

Asian Art Museum of San Francisco B70 M13

The carving here is closely related to that of figures in the round and this seems to be one of the earlier of the writing accessories.

144. Brush-rest, carved with pine trees and figures

L. 6.7 cm

C. 1650–1750

Private Collection

The three old men examining a scroll beneath a pine tree wreathed in *lingzhi* fungus may be the Three Stars of Longevity, Happiness and Wealth, but the iconography is typically generalised.

145. Brush-stand

L. 25 cm

19th century

Mrs J. Barrow

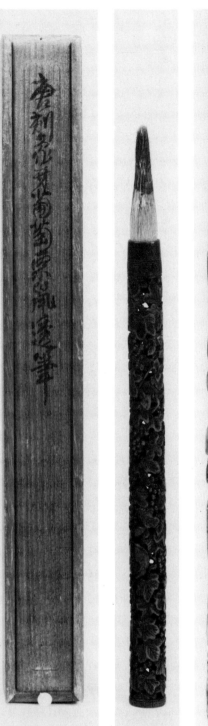
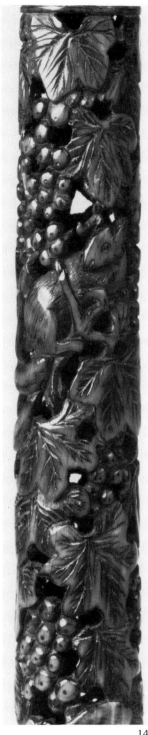

142

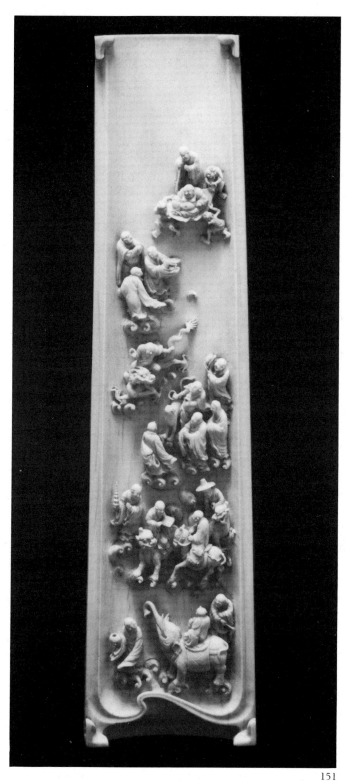

151

151

151. Wrist-rest, carved with a design of 'The Eighteen Lohan Crossing the Sea'

L. 25.5 cm

Second half of 18th century

Victoria and Albert Museum 1074–1871

The concave side of the wrist-rest (*bige*) allows a considerable thickness of ivory for very high relief carving which is here utilised to the full. It is possible that such ornate rests were not in fact used but inserted in stands for display as table screens. The subject matter is a common one for the period, associated with the name of Du Shiyuan among other carvers (cf. Qian Yong p. 325). The reverse is carved with geese in low relief and an inscription reading, 'Inscription on the Eighteen Lohan, Responders to the Truth, Possessors of the Precious Likeness and the Mighty Countenance, Flower-garlanded inhabitants of the Six-Thousand Dharma-realms contained in a grain of Millet. Carved by Xianglin'. The name of the carver is otherwise unrecorded. Compare the composition of No. 46 in *Masterpieces of Chinese Writing Materials in the National Palace Museum* (Taipei 1971), and of No. 23 in *Masterpieces of Chinese Miniature Crafts in the National Palace Museum*.

Published: Bushell 1904, I, p. 103.

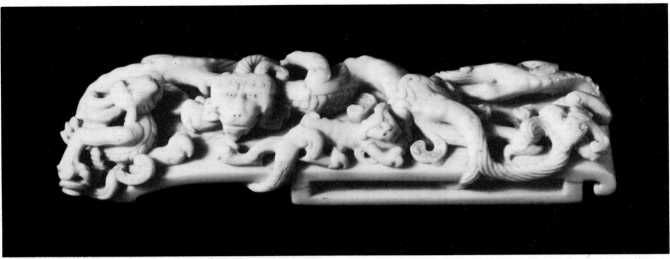

149

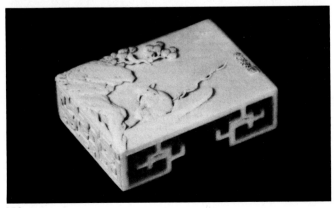

148

149. Sword slide, carved with *chi* dragons

L. 10.3 cm

18th century

Sir Victor Sassoon Chinese Ivories Trust 864/1016

This copy of a Han dynasty sword slide, much more elaborately carved than any of the jade originals, could have served as a brush or ink rest, or simply as a pleasantly tactile object to have to hand.

150. Rest for an ink cake, carved with an angler in a boat

L. 4.5 cm

Early 18th century

Sir Victor Sassoon Chinese Ivories Trust T39

This finely carved example of a *mochuang*, or ink-cake rest, can be compared with those illustrated as Nos 38 and 39 in *Masterpieces of Chinese Writing Materials in the National Palace Museum* (Taipei 1971). However the style of the low-relief carving and the form of the characters *Xihuang* in the lower right corner have no connection with the known work of the 17th century bamboo carver Zhang Xihuang and the attribution to him is undoubtedly spurious.

150

146

147

146. Model of a table

L. 38 cm

Possibly 17th century

Mr and Mrs Gerald Godfrey

This unusual model of a *pingtou an* preserves the general lines of the original table but is much too squat. Its lowness suggests it may have been used as a type of wrist rest.

147. Brush or ink-cake rest

L. 20.2 cm

Qing dynasty

Private Collection

148. Figure of a *qilin*

L. 8.3 cm

Early 19th century

Sir Victor Sassoon Chinese Ivories Trust

Lucas draws attention to the legend that a *qilin* appeared at the birth of Confucius and vomited 'precious writings'. The style of the beast here recalls some of the mythological subject matter on enamelled porcelain of the Jiaqing and Daoguang periods.

Published: Sassoon Catalogue No. 934.

136

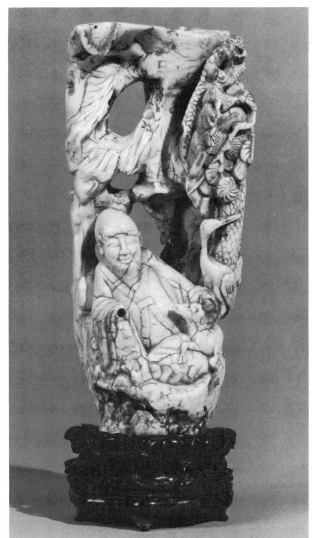

145

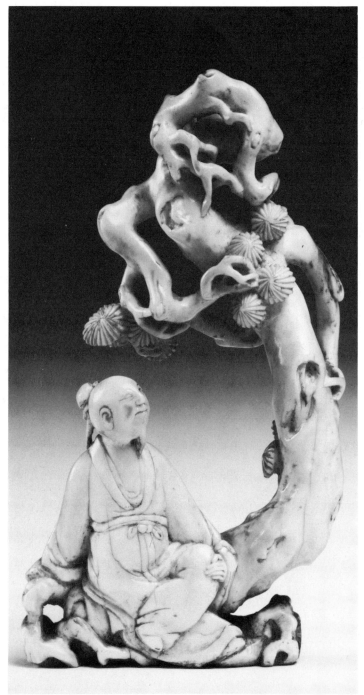

143

144

152

152. Wrist-rest, carved with crayfish and waterplants

L. 28.9 cm

18th century

The Cleveland Museum of Art 77.9 Edmund L. Whittemore Fund

152

This much-published object carries inscriptions linking it with two of the most important figures in the cultural circles of 16th-century Suzhou. The concave side is inscribed 'Treasured and Enjoyed in the Tian Lai Pavilion' and carries an incised seal, 'Secret Plaything of Molin.' The Tian Lai Pavilion was the studio, and Molin the *hao*, of Xiang Yuanbian (1520–1590), collector, connoisseur and probable author of *Kao pan yu shi*, discussed on p. 120 above. The reverse is signed by Wen Peng (1498–1573), eldest son of Wen Zhengming. In view of his fame, Xiang Yuanbian was a popular target for spurious attributions, and there can be little doubt that this piece must be dated in accordance with the style of carving to the mid-Qing. As we have seen, Ming sources do not mention ivory as a material suitable for wrist-rests, nor is the subject matter acceptable as part of the Ming repertoire.

Published: *International Exhibition of Chinese Art* (Royal Academy of Arts 1935–36) no. 2947. *Arts of the Ming Dynasty* (OCS 1957) no. 366. Jenyns, R. S. and Watson, W., *Chinese Art: the Minor Arts II* (Oldbourne Press, London 1965) p. 197.

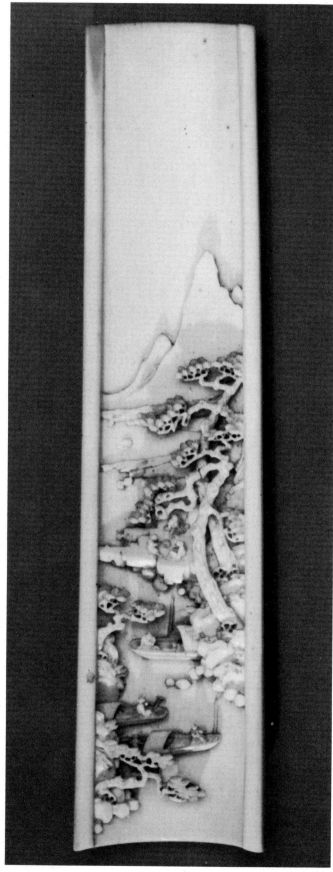

153

153

153. Wrist-rest, carved with a mountainous landscape

L. 22.9 cm

18th century

Private Collection

The reverse carved with rocks, birds and butterflies in low relief.

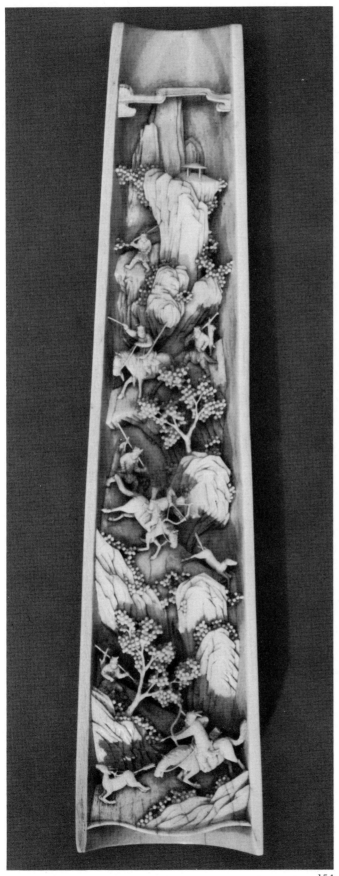

154

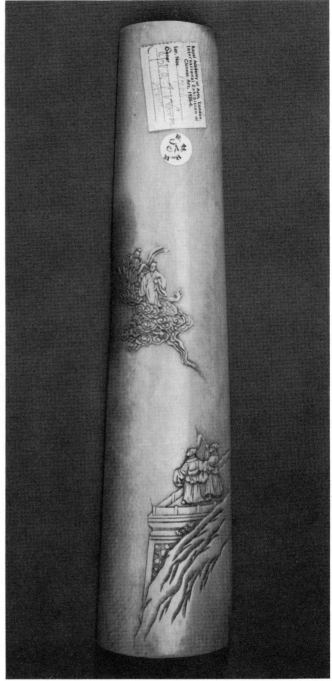

154

154. Wrist-rest, carved with a hunting scene

L. 28 cm

18th century

Private Collection

On the reverse, two figures look up from a terrace at a male and female deity mounted on a dragon and a phoenix. Here again there is a distinct difference between the type of decoration on each side.

Published: *Arts of the Ch'ing Dynasty* (OCS 1963–64) no. 447.

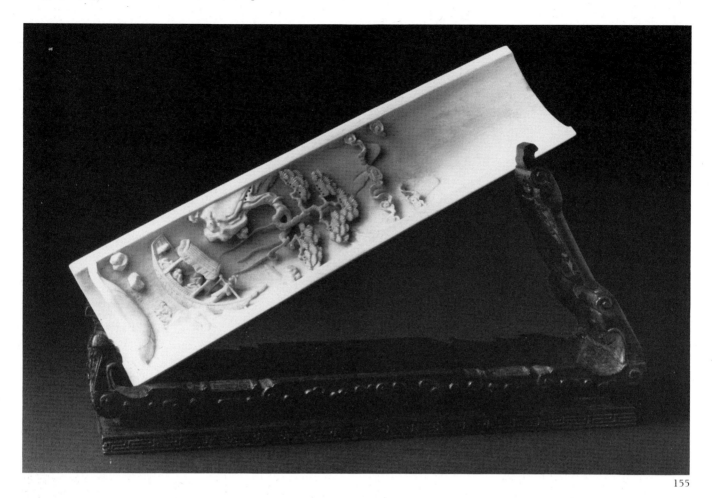

155

155. Wrist-rest, carved with Su Dongpo's visit to Red Cliff

L. 19.9 cm

18th–19th century

Sir Victor Sassoon Chinese Ivories Trust 559/111

The Red Cliff Excursion (see No. 174) is frequently mentioned in Qing sources as the subject of *tours de force* of intricate carving, and is a more common part of the decorative repertoire than most of the scenes appearing on Sassoon Collection wrist-rests. The reverse is carved with *kui* dragons in low relief.

Published: Sassoon Catalogue No. 559.

156. Table-screen, carved with the Four Luminaries

H. 9.8 cm

18th century, the wood frame later

Sir Victor Sassoon Chinese Ivories Trust 919/15

The Four Luminaries of Mount Shang were a group of semi-mythical recluses believed to have lived in the period of turmoil surrounding the fall of the Qin dynasty.

Published: Sassoon Catalogue No. 919.

157. Wrist-rest, incised with banquet scene and calligraphic inscription

L. 22.2 cm

Dated 1888

Sir Victor Sassoon Chinese Ivories Trust T45

The text is a shortened version of Li Bai's prose essay, 'Feasting by Night in the Garden of Peaches and Plums', source of the famous line, 'This floating life is like a dream, how brief is our pleasure'. The inscription carries a cyclical date *wuzi*, which can be read as 1888 on the basis of the late-Qing style of painting here copied, and on the basis of the late-Qing fondness for miniaturised calligraphy which reached its apogee with the early 20th-century carver Yu Shuo. The inscription, which like the picture is rubbed with red ink, is dedicated to an unidentified Run Zhifang and signed Zhao Qing.

158. *Hu* court tablet

L. 54 cm

Sir Victor Sassoon Chinese Ivories Trust 896/1064

Court tablets of ivory, carried by officials while actually in the imperial presence, were used at least as early as the Tang period. In the Ming dynasty they were plain but for a single

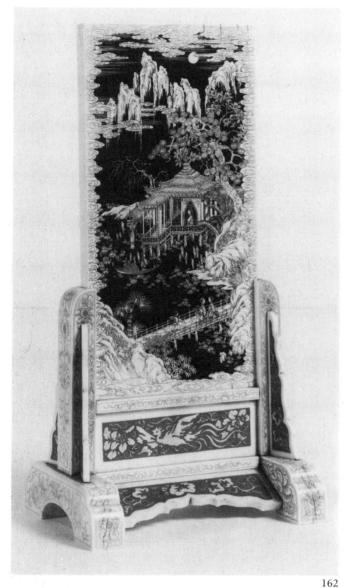

162

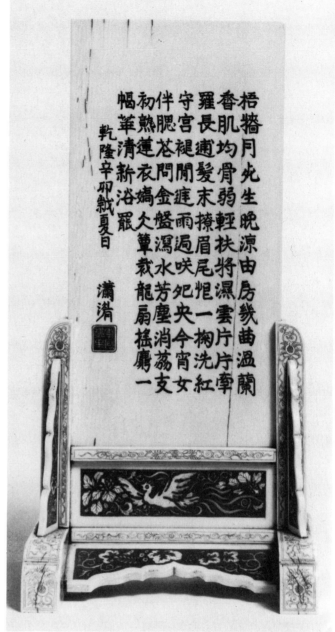

162

162. Table screen, incised with a scene of lakeside pavilions

H. 23 cm

Dated 1771

Ashmolean Museum, Oxford

This is the finest example in the exhibition of the technique of reserving decoration in white against a black or (in the case of the stand) red ground. The garbled poetic inscription on the reverse is signed *Xiaomen* and dated to the *xin mao* year of Qianlong, equivalent to 1771.

Published: Arts of the Ch'ing Dynasty (OCS 1963–64) no. 442. Jenyns, R. S. and Watson, W., *Chinese Art; the Minor Arts II*, p. 162.

character denoting the category of the official concerned. They were preserved by court doorkeepers and collected only on entering the palace, it being an offence to retain them as they gave access to restricted areas. Nevertheless through the sixteenth century there were complaints that their distribution was only laxly supervised (*Ming Shi, juan* 68 p.1665). They were no longer used at court in the Qing, but were a popular antiquarian curiosity and almost certainly continued to be manufactured.

159. *Hu* court tablet

L. 48.1 cm

Mrs Gloria L. H. Kuo

160. *Ruyi*, carved with foliage and gourds

L. 28 cm Colour plate 5

18th century

Private Collection

The *ruyi*, or 'as you please', began as an aristocratic pointer and back-scratcher in the centuries following the fall of the Han dynasty. By the Qing it had become a purely decorative form particularly suitable as a gift.

161. Tablet sundial and calendar

L. 10.4 cm Colour plate 6

Dated 1638

Stonyhurst College

This rare relic of the German Jesuit missionary and astronomer Johann Adam Schall von Bell (1592–1666) was bought by Walter C. Hillier from 'a small huckster's stall' in Seoul in 1890 (*The Stonyhurst Magazine* X, October 1906). It is a pocket sundial and calendar, also incorporating a compass and display of the phases of the moon, modelled on a Nuremberg style of instrument of the first half of the seventeenth century. The top is inscribed *bai you ri yue gui*, 'portable daily and monthly sundial'. The base is inscribed *ji xi Tang Ruowang zhi*, 'made by Tang Ruowang from the extreme west', and *Chongzhen wu yin sui*, a date equivalent to 1638. Tang Ruowang was the Chinese name adopted by Schall von Bell, active in Peking from 1623 in disseminating European scientific ideas among the Chinese élite. This unpretentious but extraordinary testimony to his activities may have been a gift for a friend. Ivory calculating rods used by the Kangxi emperor himself in his studies with Schall's successors are illustrated in Yan Dunjie, 'Gugong suo cang Qingdai jisuan yiqi', *Wenwu* 1962.3 pp.19–20), while an ivory ruler of Jiajing date is also preserved in the Palace Museum, Peking. See Ju Zhai, 'Gu chi kao' *Wenwu cankao ziliao* 1957, 3 p.28.

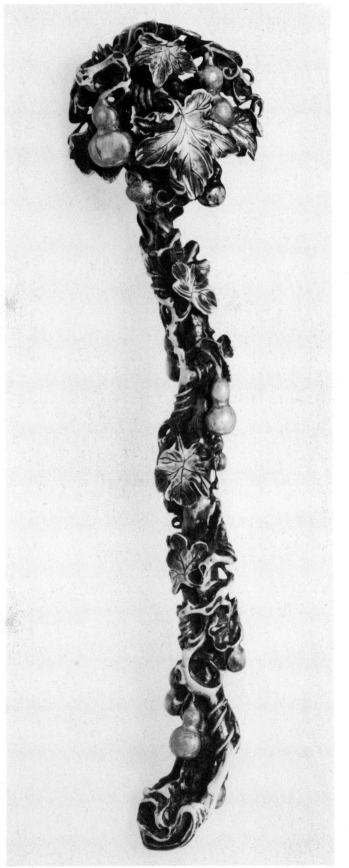

160

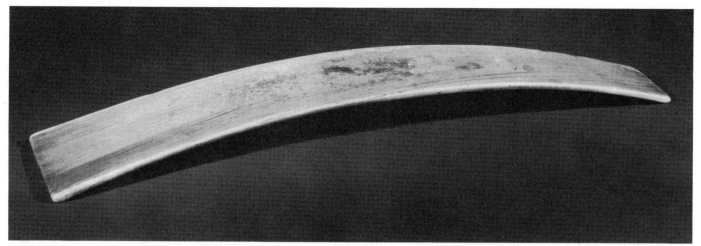

159

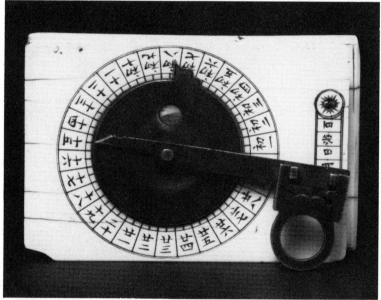

161

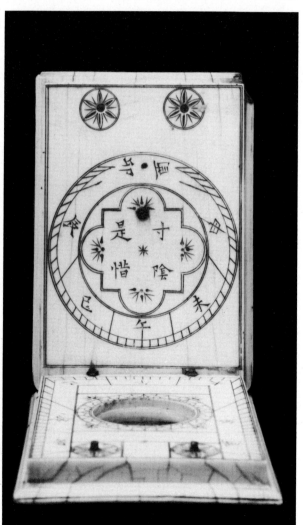

161

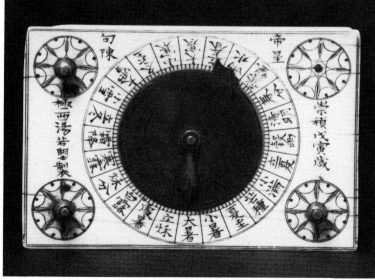

161

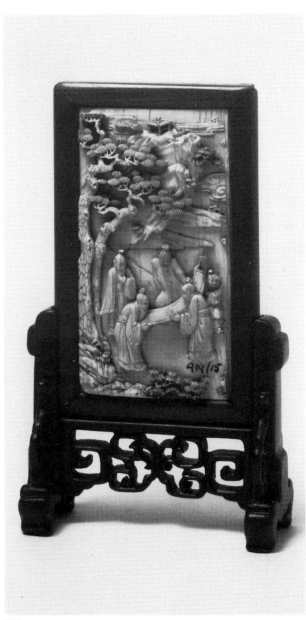

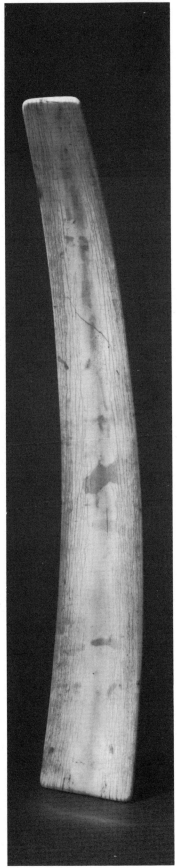

156

157

158

163

163. Table-screen panel, inlaid with a dragon and *lingzhi* fungus

H. 13.3 cm

18th–early 19th century

Fitzwilliam Museum, Cambridge

The reverse bears a couplet signed *Zi'ang*, the *hao* of the Yuan artist Zhao Mengfu, but this must be judged to be spurious on stylistic grounds.

Published:*International Exhibition of Chinese Art* (Royal Academy of Arts 1935–36) no.1020. Jenyns, R. S., 'Chinese Carvings' p.52. Jenyns, R. S. and Watson, W., *Chinese Art; the Minor Arts II*, p.182.

164. Plaque, carved with two boys

H. 23.5 cm

Cleveland Museum of Art 77.65. Gift of Mr and Mrs Arthur Holden

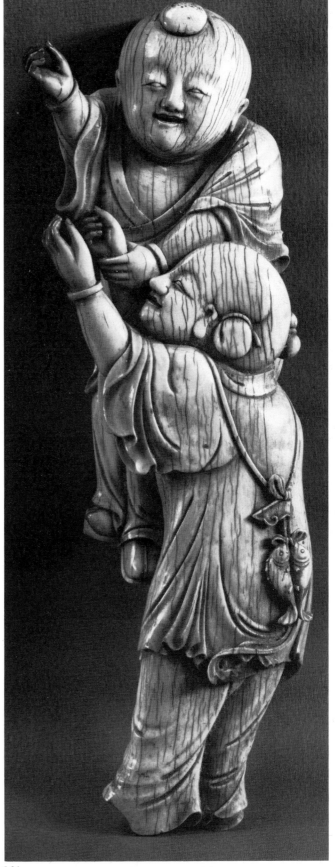

164

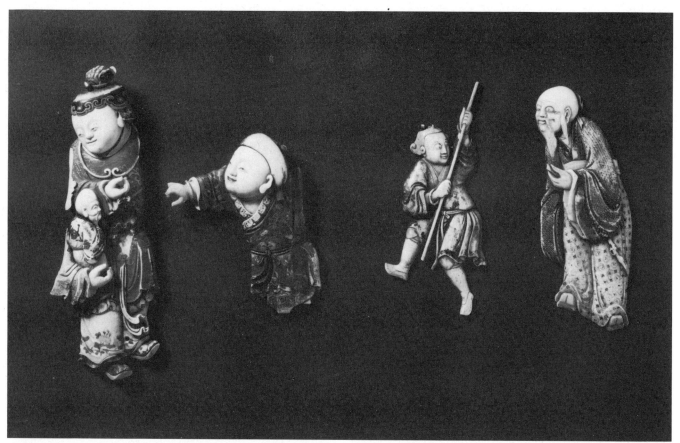

165–168

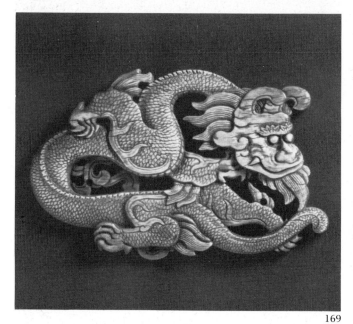

169

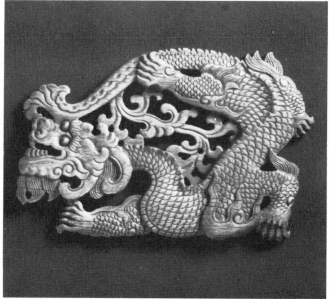

169

165. An old man, appliqué panel from a screen

H. 13.2 cm

18th–early 19th century

British Museum OA 6616

166. Boy with oar, appliqué panel from a screen

H. 12.5 cm

18th–early 19th century

British Museum OA 6617

167. Woman, appliqué panel from a screen

H. 16.5 cm

18th–early 19th century

British Museum OA 6516

168. Boy, appliqué panel from a screen

H. 10 cm

18th–early 19th century

British Museum OA 6515

The last two appliqué figures are traditionally said to have been looted from the Yuan Ming Yuan palace complex in 1860.

169. Pair of plaques, carved with dragons

L. 10.9 cm

16th century

British Museum

Brush-pots

The brush-pot, in Chinese *bitong*, gradually supplanted other methods of storing writing brushes from the mid-sixteenth century, and is found in all the media of Ming and Qing craftsmanship; ceramic, lacquer and jade. Bamboo and ivory with their natural circular sections are obvious materials for the making of these pieces. The maximum diameter of the tusk kept ivory pots well below the size of those in bamboo and other materials, and they tend to be comparatively tall and slim in proportion. The entire repertoire of decorative techniques was deployed on the surface of Qing ivory brush-pots.

170. Plain brush-pot

H. 11.8 cm

Qing dynasty

Mr and Mrs J. Lobel

171. Plain brush-pot

H. 10.8 cm.

Qing dynasty

Private Collection

170

171

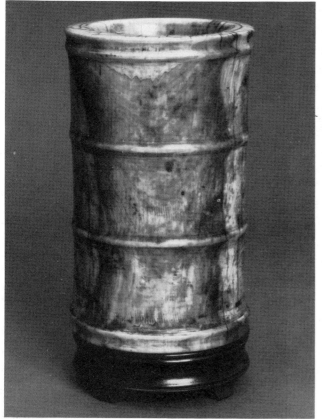

172

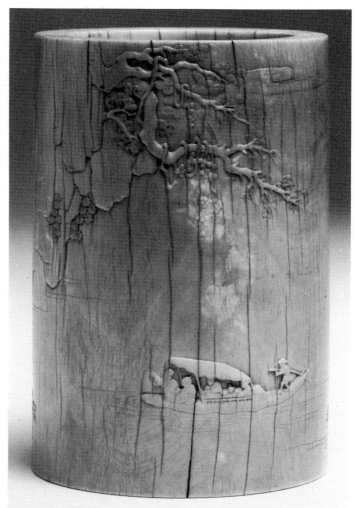

174

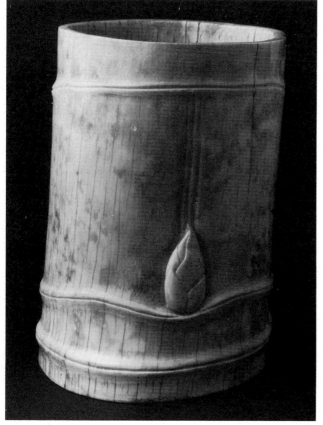

173

172. Brush-pot, carved as a segment of bamboo

H. 13.75 cm

Qing dynasty

Mr Che Ip

173. Brush-pot, carved as a segment of bamboo

H. 14.9 cm

18th–19th century

Sir Victor Sassoon Chinese Ivories Trust

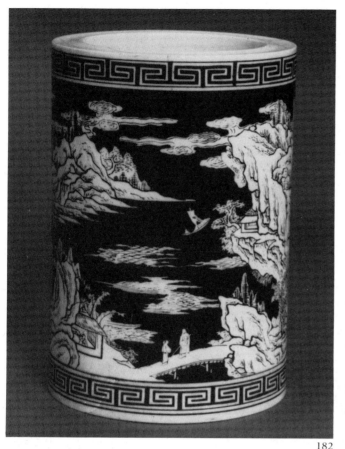

182

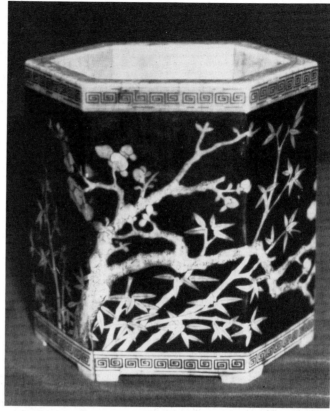

183

182. Brush-pot, with landscape scene reserved against a black ground

H. 13 cm

First half of 18th century

Dr Che Ip

183. Brush-pot, with design of bamboo and prunus

H. 14 cm

18th century

Mr and Mrs Gerald Godfrey

184. Brush-pot, inlaid with mother-of-pearl, amber, wood, steatite, malachite, lapis lazuli and other minerals

H. 12 cm

Second half of 18th–early 19th century

Sir Victor Sassoon Chinese Ivories Trust

This rather crude but eye-catching pot represents a late continuation of the *Zhou zhi* technique centred on Yangzhou (see p. 127). A wrist-rest decorated in the same technique on the upper surface is No. 34 in *Masterpieces of Chinese Miniature Crafts in the National Palace Museum* (Taipei 1971).

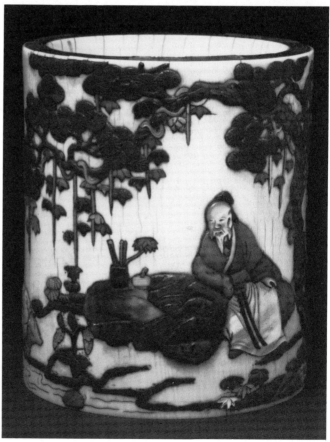

184

178. Brush-pot or matchpot

H. 12.7 cm

Mid-19th century

Victoria and Albert Museum 1068–52

Possibly acquired from The Great Exhibition, and described in C. Alabaster's 1872 *Catalogue of Chinese Objects in the South Kensington Museum* as 'made for the foreign market, but modelled after the vases which stand on the tables of Chinese scholars to hold the pencils or brushes with which they write'.

179. Brush-pot, carved with children playing

H. 9.2 cm

Dated 1774

Sir Victor Sassoon Chinese Ivories Trust X572

A four line *jueju* poem incised at the top of one side reads:

'By Jasper Terrace a full Moon reveals the Palace of Vasty Chill.
Judging the plum blossoms there is aided by the pale light of dawn.
On earth below a new world of silver is spread out,
With the railings of the pavilion turned as if to jade.'
In the *jiawu* year of Qianlong (1774)

The poem, a description of a night of brilliant moonlight, has no connection with the subject of the carving, but such incongruity is by no means unknown on Qing objects of this type.

180. Brush-pot, incised with landscape scene

H. 13 cm Colour plate 6

Late 17th–18th century

Private Collection

The incised decoration of a page-boy approaching a deserted hut is almost a clichéd allusion to the style of painting associated with Ni Zan. The calligraphic inscription on the other side is a couplet of seven-character lines which does relate to the scene, describing the contrast between the distant peaks and the cliff in the foreground.

181. Brush-pot, incised with figures in a landscape

H. 12.7 cm

18th century

Sir Victor Sassoon Chinese Ivories Trust

The majority of brush-pots have a base composed of a separate piece of ivory let into the tubular body, but in this instance the whole object is carved from a single piece.

Published: Sassoon Catalogue No. 683

180

181

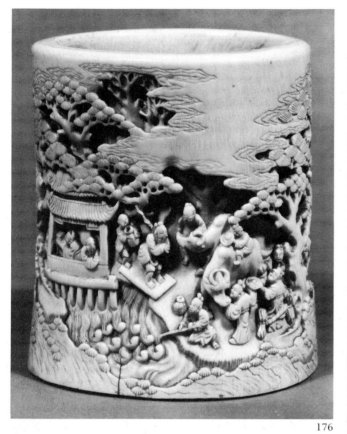

176

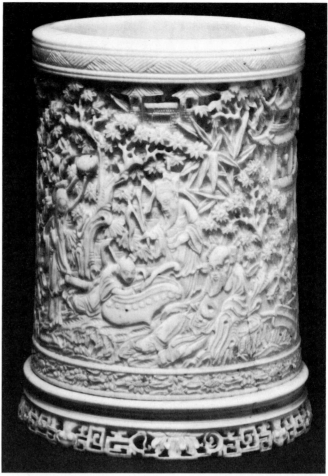

178

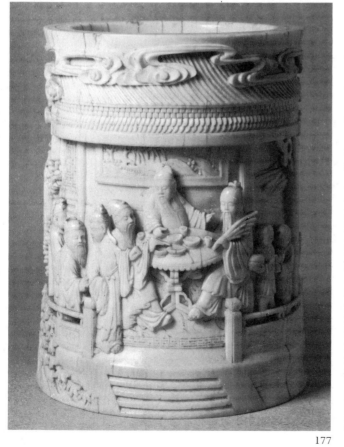

177

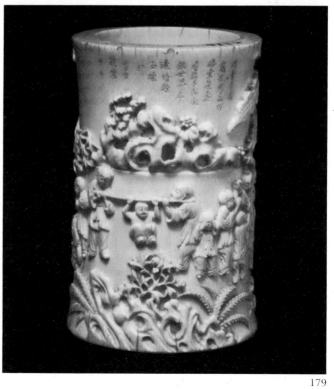

179

174. Brush-pot carved with Su Shi's excursion to Red Cliff

H. 10.9 cm

1647 or 1707

Asian Art Museum of San Francisco B62 M54 A,B

The poet and statesman Su Shi (1036–1101) wrote two rhapsodies, *fu*, in 1082 to record his impressions of visits to what he believed to be the site of the Battle of Red Cliff in 208 AD. These two *fu*, with their prose surfaces, have remained among the best known and most often alluded-to pieces of Chinese literature. The subject also passed into the decorative arts, appearing frequently on Ming and Qing porcelain and bamboo carving. Here the particularly fine low relief treatment of the subject is notable for its sympathetic use of areas of uncarved ivory to suggest the vast reaches of the river. An inscription carries the cyclical date *dinghai*, probably to be read as 1647 or 1707.

175. Brush-pot, carved with birds and flowers

H. 23.8 cm

Possibly 17th century

Sir Victor Sassoon Chinese Ivories Trust 678/511

The crude low relief carving on this unusually tall piece recalls the rather perfunctory painting on some late Ming porcelain, and can be compared with that on the bowl No. 203, where the decoration is cut into the material.

Published: Sassoon Catalogue No. 645

176. Brush-pot, carved with a scene of rural life

H. 13 cm Colour plate 6

First half of 18th century

The Irving Collection

177. Brush-pot, carved with a dinner party

H. 12.6 cm

Late 18th–First half of 19th century

Museum of Far Eastern Antiquities, Stockholm OM 1203/74

The crisp-edged vertical cutting of the ivory, the rather formulaic and repetitive features and the prominent use of a late type of round dining table suggest a date for this piece not earlier than the mid-Qing.

Published:Chinese Art from the Collection of H.M. King Gustaf VI Adolf of Sweden (British Museum 1972) no. 172

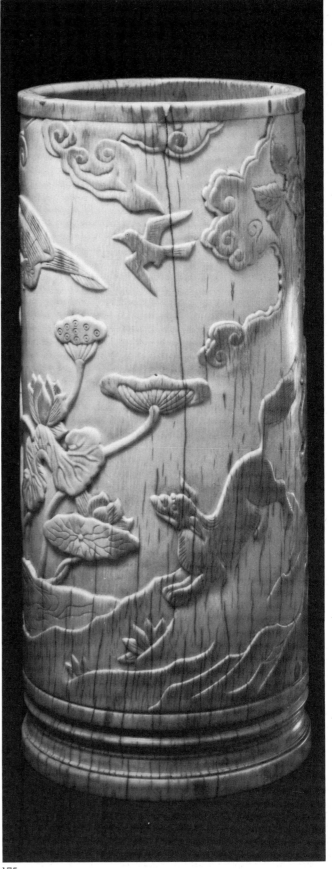

175

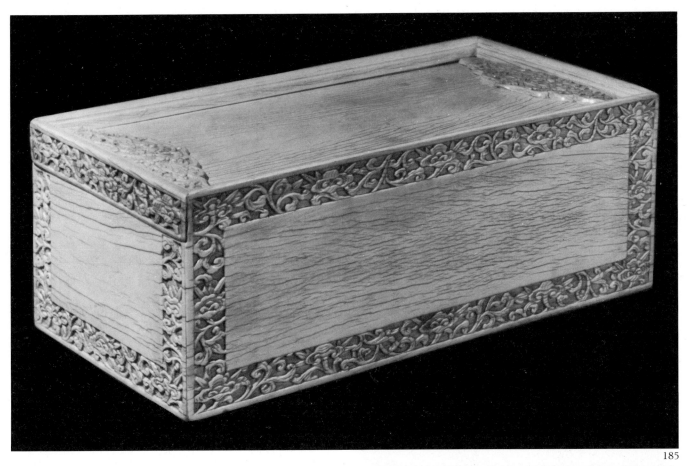

185

Boxes

The majority of ivory boxes are naturally small and round, possibly used for cosmetics or for seal vermilion. Occasionally more ambitious rectangular forms were attempted.

185. Rectangular box with sliding lid, carved with fungus scrolls

L. 25.5 cm

Late 16th–17th century

Mr and Mrs J. Lobel

In form and proportion this box cannot be related to any purely Chinese type, and it may have been intended for export to the Islamic world, particularly as the decoration eschews any figural representation. A possible prototype for the shape can be found in Isnik ceramic pen cases from the second half of the sixteenth century (Victoria and Albert Museum 203–1885).

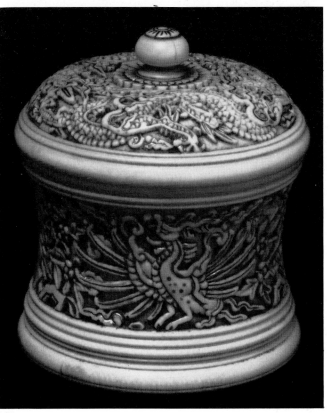

186

186. Box, carved in low relief with dragons, phoenixes and animals

H. 9.5 cm

Second half of 17th century

Victoria and Albert Museum 2564–1856

This and the succeeding piece belong to the same group as Nos 200 and 201, which can be assigned to the third quarter of the 17th century on the basis of the Copenhagen inventories for 1674. Like them, it shows traces of gilding and of a brown pigment over a decorative scheme which may have been intended for markets in south-east Asia. Both boxes also have screw-on lids, not common on Chinese objects. Compare Hornby, J., *China*, p. 182.

187. Box, carved in low relief with *qilin* and phoenixes

H. 8.9 cm

Second half of 17th century

Mr Marcus Linell

188. Box, carved with lotus, peony and plum flowers

Diam. 5 cm

17th–18th century

Mr Che Ip

The skilful low relief carving on this piece recalls to an extent that of Ming objects in carved red lacquer, but appears rather flatter. There are also stylistic similarities to objects moulded in Dehua porcelain and to bamboo carvings such as that illustrated as No. 27 in Wang Shixiang/Wan-go Weng, *Bamboo Carving of China*, China Institute in America 1983.

189. Box, carved in the form of a melon

L. 11.1 cm

18th century

The Cleveland Museum of Art 70.138. Gift of Lois Clarke

190. Box, carved in openwork

L. 15.3 cm

18th century

Asian Art Museum of San Francisco B62 M48

This seems a possible candidate for attribution to a palace workshop of the Qianlong period, on the basis of similar examples of openwork preserved in both Peking and Taipei. See Zhou Nanquan, 'Ming Qing zhuo yu, diaoke gongyi meishu mingjiang' *Gugong bowuyuan yuankan* 1983.1 pl. 7 for a box signed 'Li Juelu'. An unsigned example is No. 30 in *Masterpieces of Chinese Miniature Crafts in the National Palace Museum* (Taipei 1971).

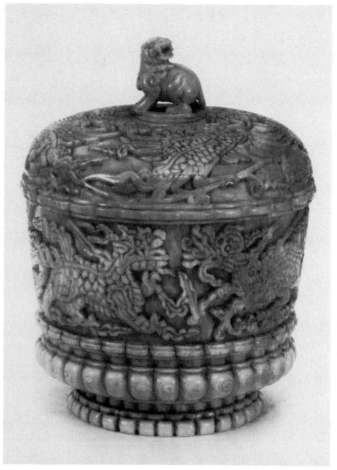

187

188

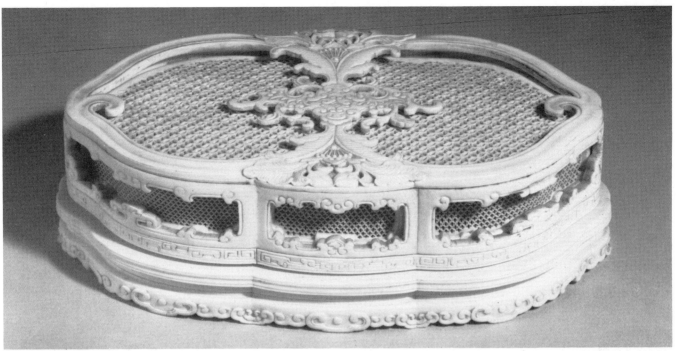

190

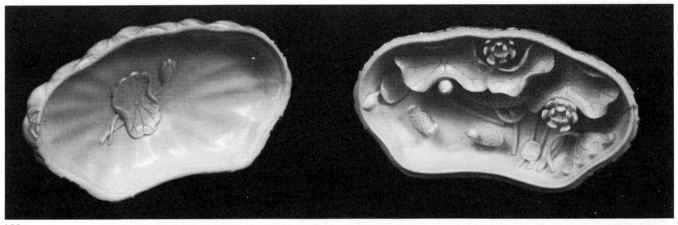

189

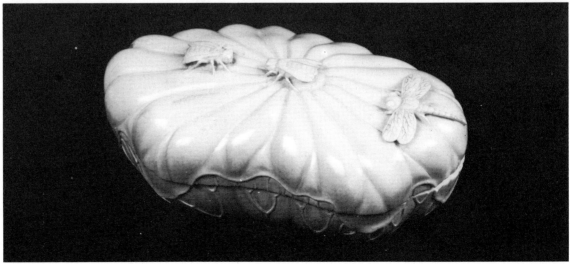

189

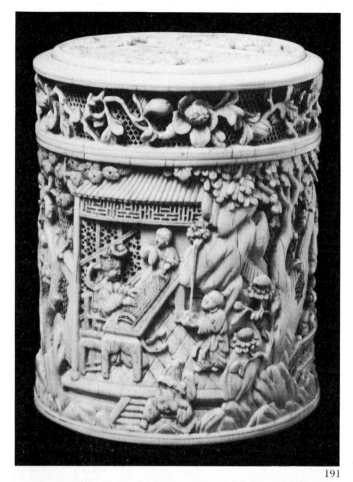

191

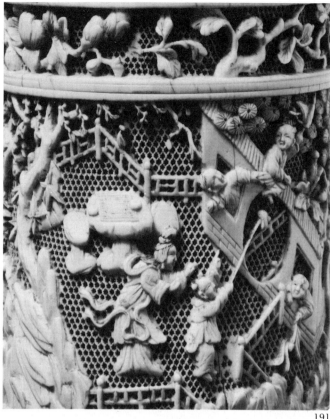

191

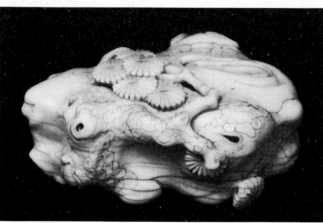

192

191. Box, carved with women and playing children

H. 12 cm

Late 18th–19th century

Sir Victor Sassoon Chinese Ivories Trust

There are traces of polychrome on the relief carving, which is set off by a ground of openwork. A crude four-character Qianlong mark is incised on the base, but the box may well be of later date.

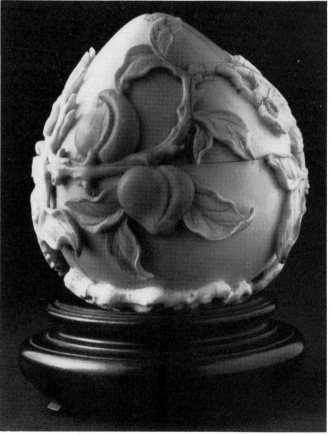

193

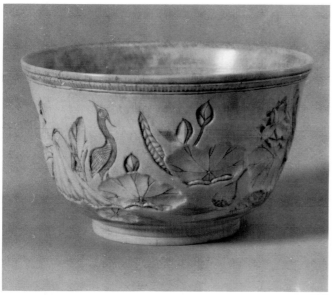

203

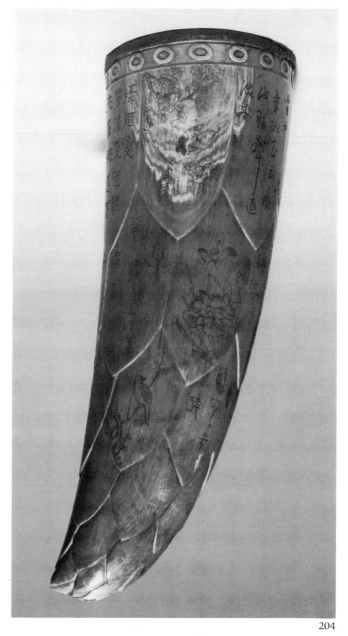

204

203. Cup

H. 5.4 cm

Possibly 17th century

Museum of Far Eastern Antiquities, Stockholm OM 1203/74

Compare the brush-pot No. 175.

204. Cup, carved as a bamboo shoot with incised birds and flowers

H. 22.9 cm

First half of 18th century

Asian Art Museum of San Francisco B62 M56

The incising of the decoration is relatively crude and even naive, but the Sloane Collection thumb ring (No. 239) provides proof of the existence of such a technique in the first half of the Qing dynasty. This piece is also noteworthy in that it accepts the natural curve of the tusk rather than ignoring it in the course of the carving.

205. Plain bowl

Diam. 11 cm

Qing dynasty

Private Collection

206. Cup, curved as a half peach with bats and *ruyi*

L. 9.8 cm

18th century

Sir Victor Sassoon Chinese Ivories Trust

The interior has been lacquered gold, and the exterior shows traces of red and green pigment.

207. Vessel in the form of an archaic bronze *yi*

L. 10 cm

18th century

Private Collection

This and the next piece are examples of the interpretation by ivory carvers of the forms and decoration of pre-Han bronzes and jades. Imperially sponsored compendia of bronze patterns such as *Qin ding xi qing gu jian* of 1749 may have been the sources from which craftsmen worked, though the decoration here is in the nature of an interpretation of bronze motifs. Traces of red pigment are visible on the outside of the body.

Published: *Arts of the Ch'ing dynasty, Transactions of the Oriental Ceramic Society 1963–64)* No. 443. Jenyns, R. S. and Watson, W., *Chinese Art: the Minor Arts II*, p. 198.

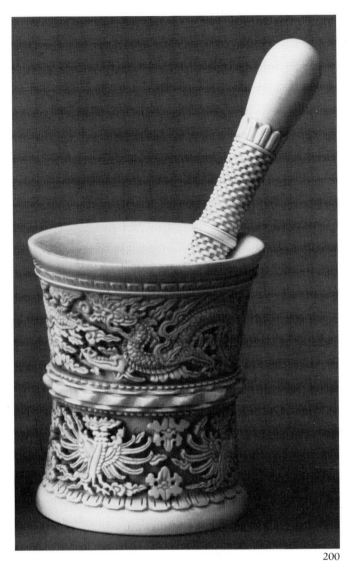

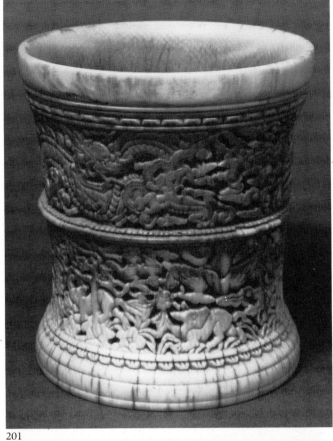

201

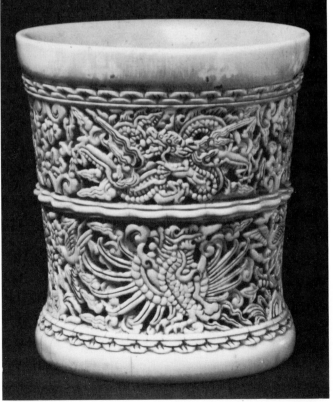

202

200

201. Mortar

H. 13 cm

Third quarter of 17th century

Phillip N. Allen

A traditional provenance states that this piece was looted during the Peninsular War from a convent in Portugal, where it was used for pounding aromatic gums, and was in the possession of R. North in 1835.

202. Mortar

H. 9.8 cm

Third quarter of 17th century

Sir Victor Sassoon Chinese Ivories Trust T43

197

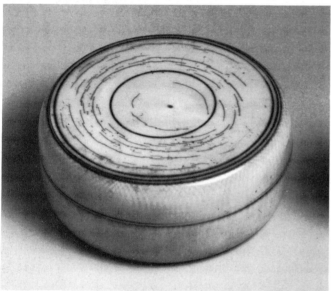

198

199

197. Round box, carved in low relief with archaistic scrolls

H. 2 cm

First half of 19th century

Private Collection

The decoration here recalls that on veneered bamboo boxes attributed to the Daoguang reign, such as No. 181 in Ip Yee and Tam, L.C.S., *Chinese Bamboo Carving, Part I*, Hong Kong Museum of Art 1978. This and the preceding piece demonstrate the survival of elements from the Qianlong period revival of interest in archaic decoration into the later part of the Qing dynasty.

198. Plain box

H. 3 cm

Qing dynasty

Private Collection

199. Plain box

H. 3 cm

Qing dynasty

Private Collection

Vessels

As with the bamboo which was probably the carvers' other main raw material, the form of the raw tusk constrains the shapes which can be achieved. In some cases such as the vase No. 209, where the inspiration is a ceramic form, the curve of the uncut tusk is ignored. This is also true of the archaistic group. Occasionally, as with No. 204, the curve is incorporated into the form of the finished piece, but in general ivory, whether stained or uncoloured is treated simply as an easily carved material to be bent to the carver's purposes.

200. Mortar and pestle

H. *of mortar* 11 cm, L. *of pestle* 18 cm

Third quarter of 17th century

Nationalmuseet, Copenhagen, Ethnographic Collection EBc42a, EBc42b

Inventoried in Copenhagen in 1674 with two associated boxes similar to Nos 186 and 187, this mortar is part of a group which is not visibly related to any other type of 17th-century Chinese object. Yet though the overall effect may appear rather strange, individual elements such as the dragons here striding round the upper band of decoration are well within the Chinese repertoire.

Published: Hornby, J., *China* p. 183

192. Box, carved as a section of pine trunk

L. 7.5 cm

18th century

Sir Victor Sassoon Chinese Ivories Trust

Compare No. 279, a similar box in bamboo signed by the 18th century carver Deng Fujia.

Published: Sassoon Catalogue No. 939

193. Box, carved as a peach with foliage

H. 7.9 cm

18th–19th century

Sir Victor Sassoon Chinese Ivories Trust

Published: Sassoon Catalogue No. 943

194. Foliated box

H. 4.5 cm

18th–19th century

Sir Victor Sassoon Chinese Ivories Trust

The scene on the lid shows the Stars of Happiness and Longevity surrounded by children. The base of the interior is carved with a curled-up dog in low relief, while the base of the exterior is in the form of a chrysanthemum. The rounded lobing of the body recalls the fabric-core lacquers of the later Qianlong period.

Published: Sassoon Catalogue No. 938

195. Hexagonal box, carved with a cricket

H. 2.8 cm

19th–early 20th century

Sir Victor Sassoon Chinese Ivories Trust T21

Possibly for transporting a singing or fighting cricket.

196. Ink-stone case

L. 14 cm

19th century

Sir Victor Sassoon Chinese Ivories Trust

194

195

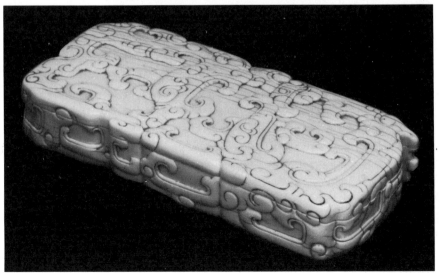

196

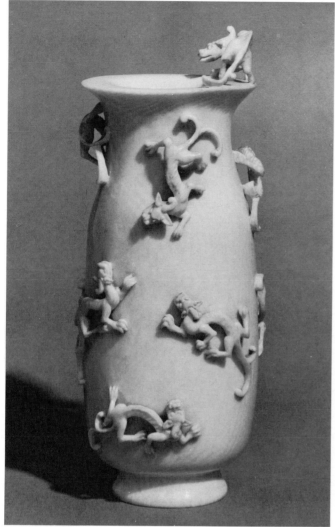

212

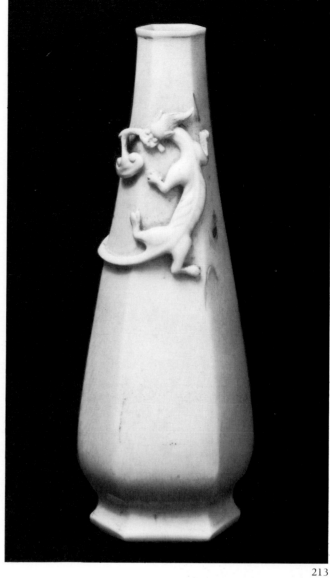

213

212. Vase, carved with *chi* dragons

H. 12.7 cm

18th century–19th century

Mrs L. M. F. Carson

The piece is marked *Da Qing Qianlong yu zhi*, but there is no firm evidence that such a mark was ever added to ivory carvings, and it may well be a later addition.

Published: *The Animal in Chinese Art*, Arts Council of Great Britain/Oriental Ceramic Society, 1968, no. 94.

213. Vase, carved with a *chi* dragon and *lingzhi* fungus

H. 13.7 cm

18th century

Sir Victor Sassoon Chinese Ivories Trust

209

210

211

208. Vessel in the form of an archaic bronze *he*

H. 20.1 cm

18th century

Sir Victor Sassoon
Chinese Ivories
Trust 538/1578

209. Vase

H. 20 cm

Early 18th century

Mr and Mrs J. Lobel

210. Vase

H. 10.1 cm

18th century

Mr and Mrs J. Lobel

211. Vase

H. 11.5 cm

18th century

Private Collection

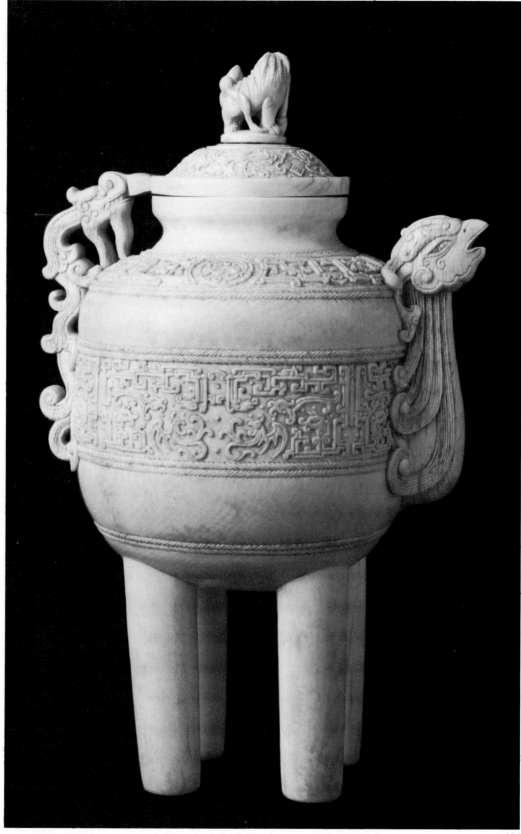

208

205

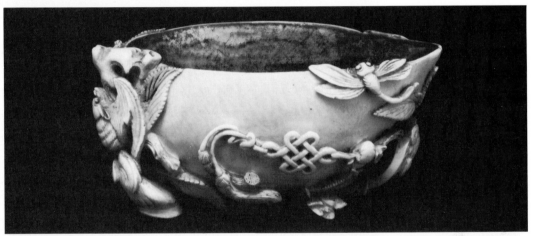

206

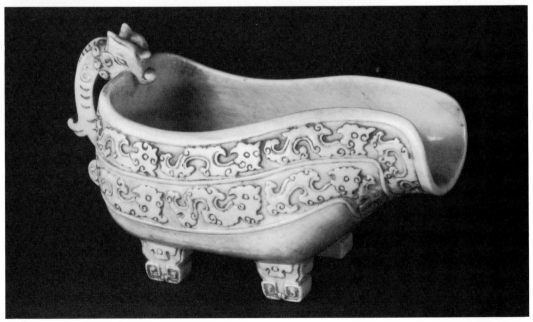

207

214

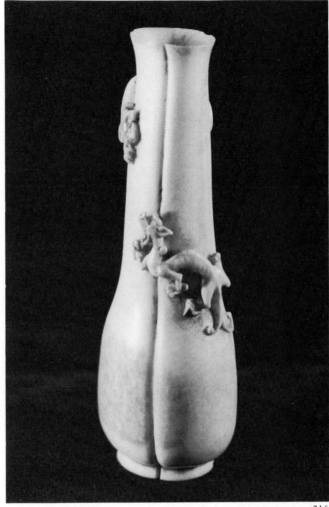

216

215

214. Lobed vase

H. 10.8 cm
18th century
Sir Victor Sassoon Chinese Ivories Trust T46

215. Lobed vase, wood with traces of paint or lacquer

H. 11.5 cm
18th century
Private Collection

216. Lobed vase, carved with two *chi* dragons

H. 12 cm
18th century
Professor P.H. Plesch
Published: *The Scholar's Desk* (OCS 1979), No. 90.

217

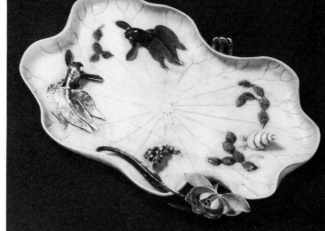

218

217. Tray, stained ivory carved as a lotus leaf

L. 15.2 cm

First half of 19th century

Sir Victor Sassoon Chinese Ivories Trust 826/822

In the Qing dynasty ivory was occasionally stained with a form of verdigris, either to simulate jade as in No. 247 or as here to give a naturalistic effect. The front of the leaf is carved with a tiny snail and three-legged toad, and the reverse carries two characters *Shiyuan*, for the carver Du Shiyuan. Such a signature is unlikely to be genuine.

218. Tray, carved in the form of a lotus leaf with shells and reptiles

L. 19.1 cm

First half of 19th century

Victoria and Albert Museum 2565–'56

Described by C. Alabaster in 1872 as 'A good specimen of the old school of ivory carving which appears to be now extinct ... although the taste displayed in tinting the ivory has been and still is by some as much questioned as was the introduction of the practice of tinting marble among our sculptors'. The shells and reptiles here are naturalistically painted in an effect similar to an ivory oyster shell illustrated as no. 31 in *Masterpieces of Chinese Miniature Crafts in the National Palace Museum* (Taipei 1971).

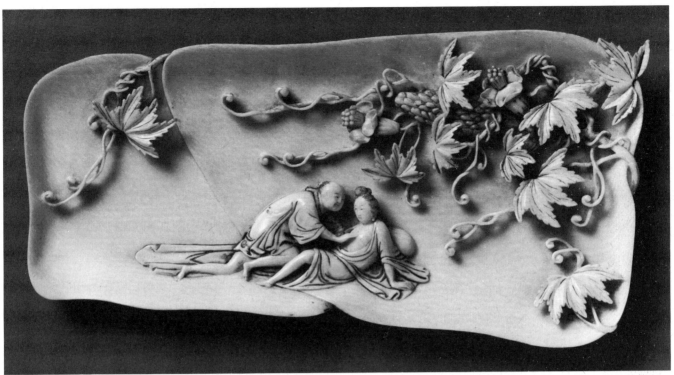

219

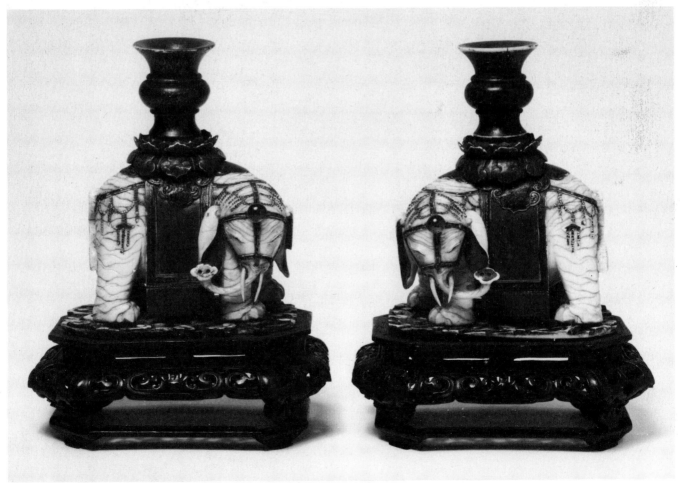

220

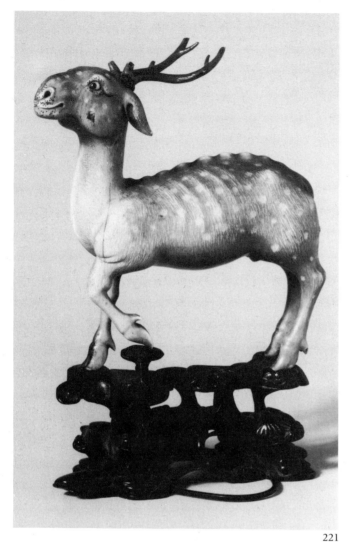

221

219. Tray, carved with an erotic scene, traces of pigment

L. 17.9 cm

19th century

Private Collection

220. Pair of vases, carved and painted as elephants

H. 28 cm

19th century

Sir Victor Sassoon Chinese Ivories Trust X1127/8

Vases in this form, designed to hold dried flowers or emblems such as *ruyi* carved in ivory and other materials, were fashionable from the Qianlong period. Some of the finest examples are in cloisonné enamel on metal, and on a considerably grander scale than these diminutive pachyderms.

221. Figure of a stag, naturalistically coloured

H. 13 cm

Late 18th–early 19th century

Private Collection

This figure recalls the animal models in porcelain which formed a considerable part of Chinese ceramic exports to Europe.

Seals

The monograph on ceremonial in the Ming official history is categorical that 'all imperial and official seals are of jade, gold or silver'. (*Ming shi juan*, 68, pp. 1657–1663). This practice seems to have been continued under the Qing, as a number of preserved official jade and silver seals show. In both dynasties, the use of ivory appears to have been restricted to personal seals for use on less formal occasions.

Given the ease and frequency with which seal legends in a soft material like ivory were recut, it seems wise to leave aside consideration of the more obscure inscribed texts and examine the decoration of the pieces here displayed. The majority are carved with dragon knops in a very conservative style induced by the cultural importance of seals and the popularity of genuine early examples as collectors' items.

222. Seal, carved rhinoceros horn with a dragon knop

H. 7.2 cm

Early Ming dynasty, 14th–15th century

Museum of Far Eastern Antiquities, Stockholm OM 1223/74

Long thought to be an example of carving in mammoth ivory, and frequently exhibited as such, this has recently been shown by scientific examination to be carved in rhinoceros horn. Its purely traditional provenance to an unidentified nephew of the first Ming emperor can also be discounted, but it remains on the basis of its carving one of the finer examples of such miniature craftsmanship.

Published: *International Exhibition of Chinese Art* (Royal Academy of Arts London 1935–36) No. 2939. Jenyns R. S. 'Chinese carvings' p. 53. Jenyns R. S. and Watson W. *Chinese Art; the Minor Arts II* p. 186. *Chinese Art from the Collection of H.M. King Gustaf VI Adolf of Sweden* (BM 1972) No. 169.

223. Seal, carved with a snarling tortoise knop

H. 3.7 cm

17th–18th century

Museum of Far Eastern Antiquities, Stockholm, OM 1222/74

224. Seal, carved with a lion knop

H. 4.5 cm

17th–18th century

Private Collection

225. Seal, carved with a rabbit knop

L. 5.7 cm

18th century

Winchester College. The Duberly Collection.

226. Seal, carved with a ram knop

L. 4.2 cm

18th–19th century

Private Collection

224

226

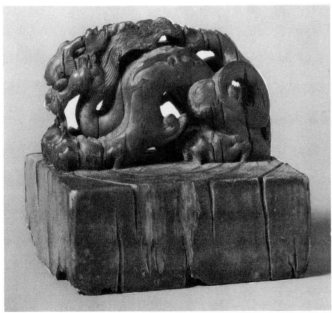

222

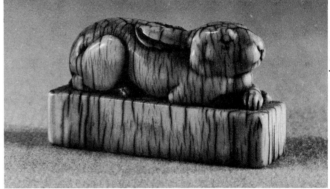

225

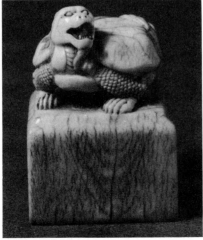

223

227. Seal, carved on the knop with lions and foreigners

L. 8.3 cm

18th–19th century

Sir Victor Sassoon Chinese Ivories Trust 829/897

The inscription, *Jai Yong hou zhang*, 'Seal of the Marquis Jia Yong' is a typical example of the sort of spurious attribution often added to a letter seal. Marquis Jia Yong was a title conferred on Li Guohan, a Chinese general in the service of the Manchus in the conquest period. An ivory seal would be a very unlikely vehicle for an official title of this type.

Published: Sassoon Catalogue No. 829

228. Seal, carved on the knop with an elephant and attendant

H. 7.6 cm

19th century

Sir Victor Sassoon Chinese Ivories Trust

The inscription, *Shao zai zhi zhang* 'Seal of the Shao Zai' (an archaic title for the Vice-presidents of the Board of Civil Office) is spurious.

Published: Sassoon Catalogue No. 832

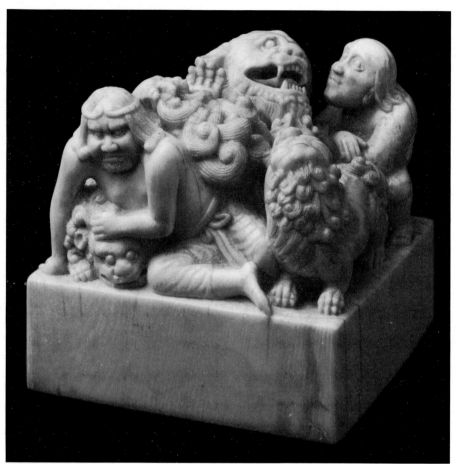

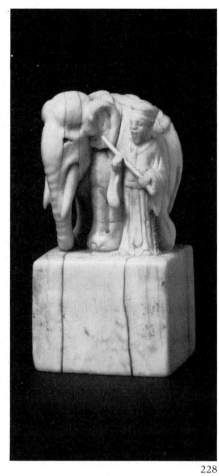

227

228

227

229. Seal, carved with a hawk knop

H. 3.5 cm (not illustrated)

First half of 19th century

Private Collection

On one side is the inscription, 'Done for Ziyong by Zhuoren'. Zhuoren may be the *hao* of the Suzhou seal carver Li Mougong, or may simply be a self-deprecating appelation 'foolish man'. The actual seal inscription is a seven-character line of verse, 'The one I think fondly of is beyond the green mountains'.

Published: *In Scholar's Taste* (Sydney L. Moss Ltd. 1982) No. 138

230. Seal case, carved with archaistic dragons

H. 6 cm (not illustrated)

Early 19th century

Ip Yee

This miniature case, possibly for a bronze seal, is carved from a single piece of ivory, the two sections being linked but movable.

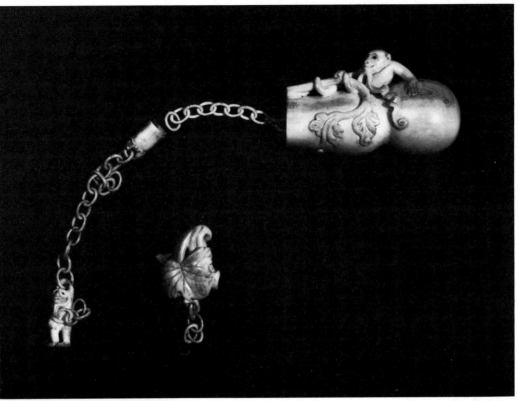

231

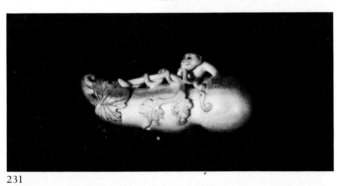

231

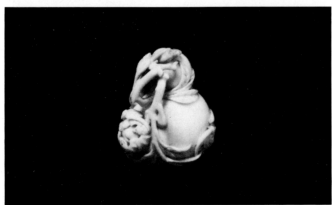

232

231. Group of miniature seals in a gourd

H. 4.3 cm

18th–19th century

Private Collection

This and the following two objects are among the most ingenious of the toys produced by Chinese ivory carvers, the equivalent for the domestic customer of the concentric balls beloved by 19th century Europe. As we have seen, such objects are described in an early 16th century text, though no early examples survive. The entire piece, case, chains and the objects on them, is carved from a single piece of ivory.

232. Group of monkeys in a miniature peach carved with bats

H. 3.2 cm

18th–19th century

Sir Victor Sassoon Chinese Ivories Trust 892/1095

There is a typical late Qing rebus at work here in the decoration, with the homophones *hou* 'monkey' and 'nobleman' as well as the familiar *fu* 'bat' and 'happiness'. The combination of monkeys and peaches also recalls the heaven-storming monkey Sun Wukong, hero of *Journey to the West*, and the combination of such felicitous allusions would make these objects suitable as presents on birthdays or other occasions.

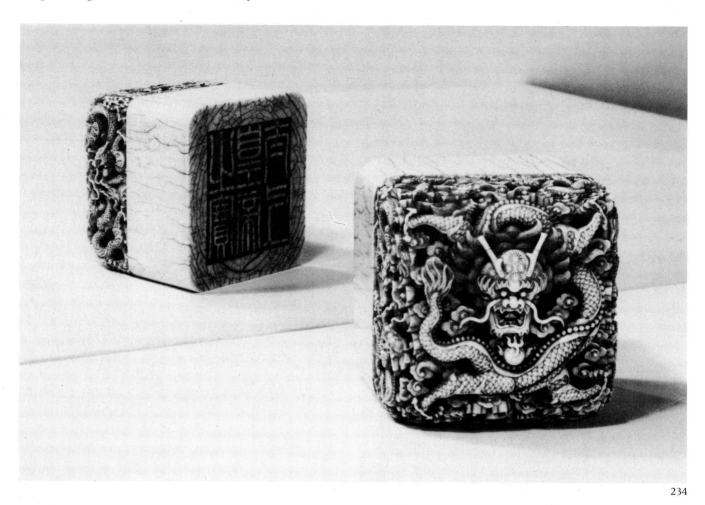

234

233. Group of monkeys in two peaches carved with bats

L. 5.5 cm Colour plate 7

18th–19th century

Private Collection

The chain here carries a number of other objects as well as the tiny monkeys

234. Seal, carved with a dragon among clouds

L. 8.9 cm

Early 20th century

Ashmolean Museum, Oxford

This seal bears the impressive inscription, *Tai Shang Huang Di zhi bao*, 'Treasure of the Supreme Sovereign', this being the title assumed by the Qianlong emperor after his abdication in 1795. This legend is recorded as one of the imperial collection seals, where 'treasure' applies to the painting rather than to the seal itself, in Victoria Contag & Wang Chi-ch'üan, *Maler- und Sammler-Stempel aus der Ming- und Ch'ing-Zeit* (Commercial Press, Shanghai 1940) p. 585 No. 70. A very similar seal with identical inscription appears as Lot 210 in *Fine Chinese Ceramics and Works of Art*, Sotheby's, London July 15th 1980. Neither seal seems likely to be exactly what it purports to be. Imperial seals were not made of ivory, jade or silver being the preferred material, and indeed a Yongzheng period collection seal of silver appears as Lot 67 in *Fine Chinese Ceramics and Works of Art*, Sotheby's, New York 8th November 1980. An oval ivory seal of similar decoration to the present example, but claiming to be that of the Jiaqing emperor, is in the University of Malaysia Museum, Kuala Lumpur (UM.56.1). The most charitable interpretation of this group of seals is that they are genuine Qing dynasty objects recut with pretentious inscriptions to aid a sale. The less charitable, and on balance more likely, is that they are modern fakes. In this context the late Dr J. W. H. Grice, long resident in China between the wars, is illuminating. In 'Faking and Selling Chinese Antiques', *Country Life* 29 July 1954 he writes: 'One man and his sons specialised in making large square seals surmounted with beautifully executed intertwined imperial dragons, which they artificially stained and cracked to give the necessary look of age'. He goes on to describe the theatricals with which such supposedly purloined treasures were palmed off on 'the wealthy American tourist'.

Published: *Arts of the Ch'ing Dynasty* (OCS 1963–64) No. 445. Jenyns, R. S. and Watson, W., *Chinese Art: the Minor Arts II*, p. 198.

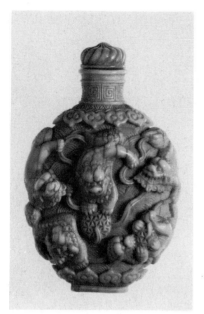

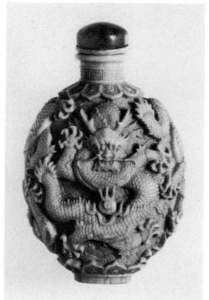

243

244

245

243. Snuff-bottle, carved with lions

L. 6.8 cm

About 1800

From the Burghley House Collection

The base has a four-character Qianlong seal mark

244. Snuff-bottle, carved with dragons

H. 7.1 cm

About 1800

From the Burghley House Collection

The base has a four-character Jiaqing mark

245. Snuff saucer, incised with a horseman

Diam. 5.2 cm

18th–19th century

Private Collection

246. Purse, carved with dragons

H. 7.4 cm

18th century

Asian Art Museum of San Francisco B81 M45

This problematical object might at first sight appear to belong to the same class of imitations as No. 234, but the bands of low relief carving of archaistic dragons link it with the archaistic vessels such as Nos 207 and 208, and a Qianlong period date does seem acceptable.

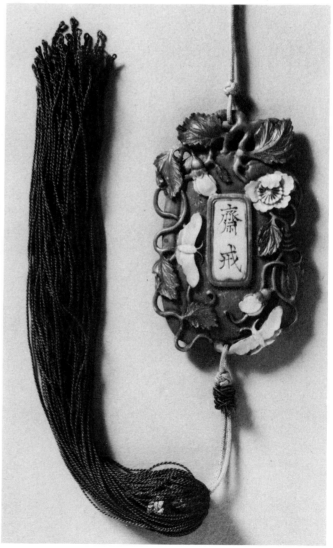

247

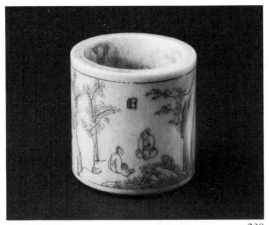

239

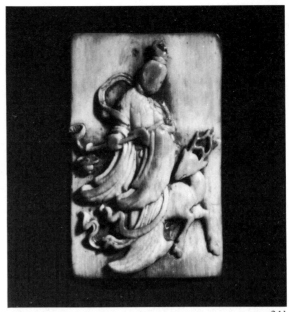

241

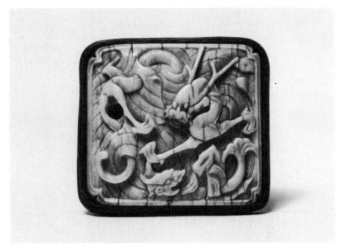

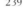

240

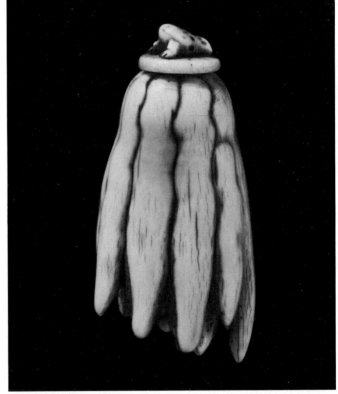

242

239. Thumb ring, incised with a landscape scene

H. 3.1 cm Colour plate 7

Early 18th century

British Museum, Sloane Collection SL 1512

This piece, datable by inventory to before 1753, is an important benchmark in establishing a chronology of incised ivory decoration.

240. Belt plaque, carved with a dragon among waves

L. 5.1 cm

First half of 19th century

Sir Victor Sassoon Chinese Ivories Trust

241. Belt buckle, carved with a woman and deer

H. 6.6 cm

18th–early 19th century

Private Collection

242. Snuff bottle, carved and coloured as a *foshou* citrus fruit

L. 9 cm

19th century

British Museum, Raphael Bequest OA 1945–10–17 345

236

236

237

238

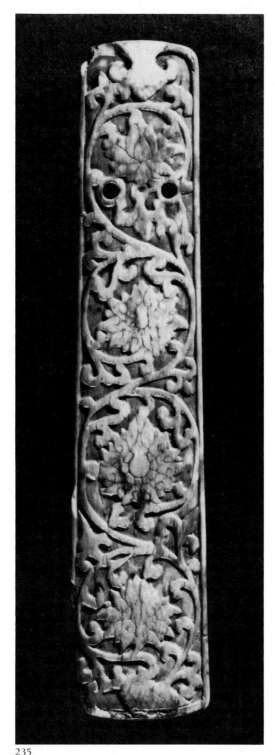

235

Personal Adornment and Toys

Ivory was little used in the manufacture of jewellery in China, but was a material frequently employed in the making of the paraphernalia of snuff taking and cricket-fancying. Small offcuts from larger objects were fashioned into toggles *(zhuizi)* or pendants for fans, though the toggles never seem to have approached the delicacy and inventiveness of the Japanese netsuke.

235. Clapper, carved with lotus scroll

L. 18 cm

15th–16th century

Michel Duchange, Paris

This piece, which retains traces of red pigment, calls to mind the red ivory clappers which accompany music in Chapter 27 of the 16th-century novel *Jin ping mei*. The low relief scrolling can be dated by analogy with contemporary textiles, lacquer or ceramics, and makes this one of the few convincingly early Ming ivory carvings.

236. Sleeping mat, woven from strips of ivory

L. 255 × 170 cm

Possibly early 18th century

British Museum, Department of Ethnography 1974. As 19.1

According to Zhou Nanquan, 'Xiangya xi', *Gugong bowuyuan yuankan* 1980.2 p. 96, five woven ivory mats were manufactured in Peking in the Yongzheng period by unnamed Cantonese craftsmen. Two of these have remained in the palace to the present day, and one is illustrated in *Exhibition of Treasures of Imperial Palace*, Hong Kong 1981, pl. 14. One was discovered in the 1960s in Shandong, having left the palace at the time of its occupation by European troops in 1900. The other two are untraced, but it may be that this example, acquired in China by Dr J. W. H. Grice, is one of the same group.

237. Ring, formed of four interlocking dragons

Diam. 5.3 cm

Song-Ming dynasty

A. S. Reynolds

238. Jade ring, formed of four interlocking dragons

Diam. 5 cm

Song-Ming dynasty

A. S. Reynolds

An almost identical piece in the Seattle Art Museum is illustrated as No. 202 in James Watt, *Chinese Jades from Han to Ch'ing*. The state of knowledge of such objects still does not allow of a precise dating.

246

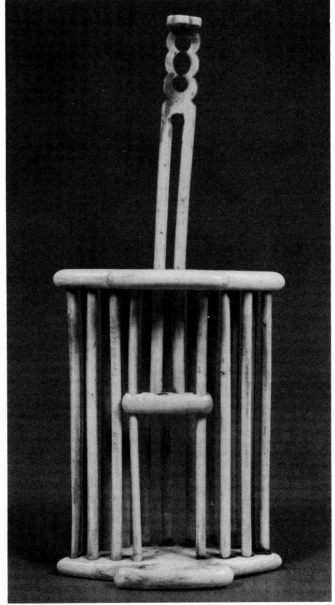

248

247. Abstinence plaque, stained ivory

L. 6.8 cm

19th century

British Museum. OA 1983.6–1.1

Such plaques were made in a variety of materials in the Qing period. They carry the Chinese inscription *zhai jie* and the Manchu *bolgomi targa*, both meaning 'fasting', to indicate that the wearer is making a religious fast.

248. Cage for transporting a fighting cricket

L. 9 cm

Late 19th–early 20th century

V. Dulany Hyman

249. Container for a singing cricket

L. 12 cm

Late 19th–early 20th century

V. Dulany Hyman

In the shape of a moulded gourd

250. Toggle, an ivory ball with an eagle's claw set in silver

L. 3.5 cm

Qing dynasty

Private Collection

251. Three toggles, standing boys

H. 5.2–5.3 cm

Qing dynasty

Private Collection

252. Three toggles, kneeling boys

L. 4.2–4.4 cm

Qing dynasty

Private Collection

The form is an ancient one, seen on ceramic pillows from north Chinese kilns of the Song period.

253. Six toggles, pine stumps and prunus blossoms

H. 3.1–5.2 cm

Qing dynasty

Private Collection

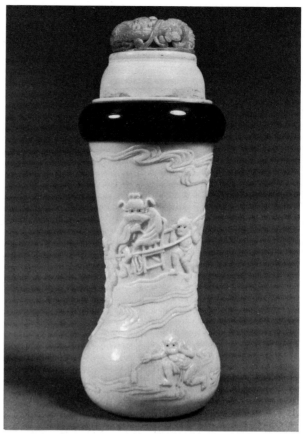

249

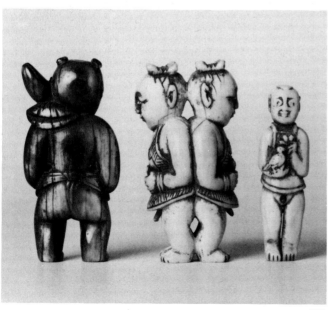

251

250

254. Five toggles, monkeys

H. 3–4.7 cm

Qing dynasty

Private Collection

255. Three toggles, in the form of various types of drum

L. 2.9–3.2 cm

Qing dynasty

Private Collection

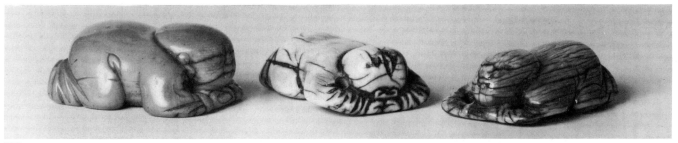

252

253

254

255

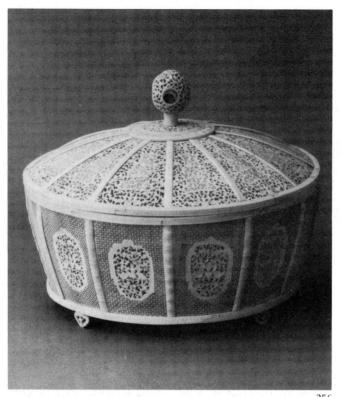

256

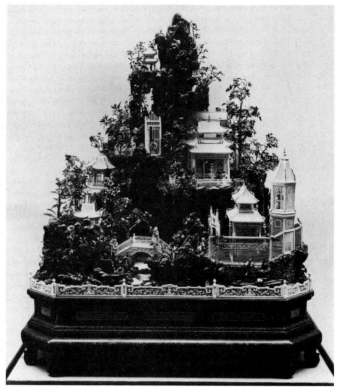

259

Pieces for the Western Market

From the early eighteenth century carvings in ivory formed a minor but influential part of the export of Chinese craft products through the port of Canton. Fans, caskets, small card cases, jewellery and elaborate mechanical models were the principal commodities. Many visitors to China, William Hickey and John Barrow among them, wrote admiringly of Chinese skill in the eighteenth century, though by the nineteenth century European incomprehension of Chinese aesthetic criteria had conquered amazement at their cunning artifices. European inventories are of great help in dating export ivories, and in recalling types of object of which no exemplar survives, such as the ivory flowers mentioned in a Swedish inventory of Drottningholm Palace in 1777.

256. Box, carved in openwork

Diam. 25 cm

Middle of 18th century

National Museum of Denmark, Ethnographic Collection EB 2595

This piece entered the Royal Danish Kunstkammer from the estate of Queen Sophia Magdalena in 1772, and displays the intricate piercing used on both export and domestic ivories in the mid Qianlong period

Published: Hornby, J., *China* p. 184.

257. Model of a summerhouse, ivory with soapstone and lacquered wood

H. 82 cm Colour plate 8

Middle of 18th century

National Museum of Denmark, Ethnographic Collection EBc219

Acquired by the Danish crown in 1762 from the estate of Olfert Fas Fischer, this mechanical toy with moving musicians and rotating ship models shows the re-export of clockwork toys from Canton to Europe. The lacquer painting is in a distinctively Cantonese style also seen on export furniture.

Published: Hornby, J., *China* p. 206.

258. Model of a boat, with clockwork engine

L. 69 cm

About 1800

Victoria and Albert Museum A.6–1936, bequeathed by A. J. Hall

Ship models seem to have been a particularly popular souvenir of Canton, judging by the frequency of their survival in English country houses. Several mechanical examples are illustrated in Hornby, J., *China*. Placards on the boat's sides show it as belonging to a *jiangjun*, the military official known to Europeans as the 'Tartar General'. The donor's grand-father, Richard Hall (1764–1834) served the Honourable East India Company as chief super-cargo at Canton until his return to England in 1803.

263

263. Painted mirror with ivory figures

L. 38 cm

From *c.* 1750

Mrs Rafi Y. Mottahedeh

The various ivory elements here have no original association with the glass painting, but have been gathered from several sources in both export and domestic taste. The collage was probably assembled in the early nineteenth century.

264. Fan, pierced and painted ivory

L. 26 cm

Early 18th century

Victoria and Albert Museum 2249–1876, given by Sir Matthew Digby Wyatt and Lady Wyatt

Wedge-shaped fans of this type are the earliest known form of Chinese export pattern. The decoration bears a close resemblance to that on contemporary porcelain in so-called 'Chinese Imari' style.

Published: Julia Hutt, 'Chinese fans and fans from China', *Fans from the East* (Debrett/V & A 1978) p. 32.

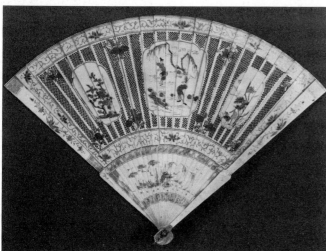

264

265. Fan, pierced ivory with monogram MD

L. 25.3 cm

Late 18th century

Victoria and Albert Museum 2248–1876. Given by Sir Matthew Digby Wyatt and Lady Wyatt

This very open brisé fan successfully combines a European neo-classical medallion with diapers in the Chinese taste. The crisp, sharp-edged carving on the guards is very typical of export ivories. Sir Matthew Digby Wyatt, donor of this and the preceding object, was for many years Art Referee to the South Kensington Museum, and played a key role in the formation of its collections. An associate of Henry Cole and Owen Jones, he was first Cambridge Slade Professor of Fine Art.

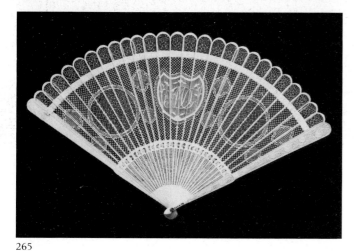

265

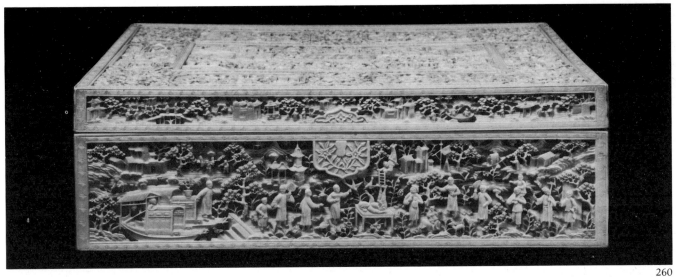

260

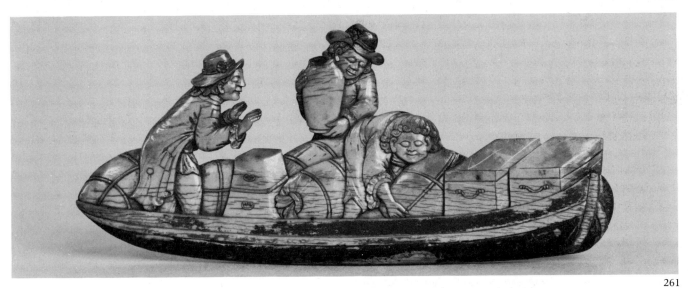

261

262. Box, carved with a western woman in low relief

H. 7.4 cm

Late 18th century

Mrs Rafi Y. Mottahedeh

The source of the decoration possibly lies in an English engraving, since the same scene has been identified in a glass painting of similar date.

Published: Howard and Ayers II p. 662

262

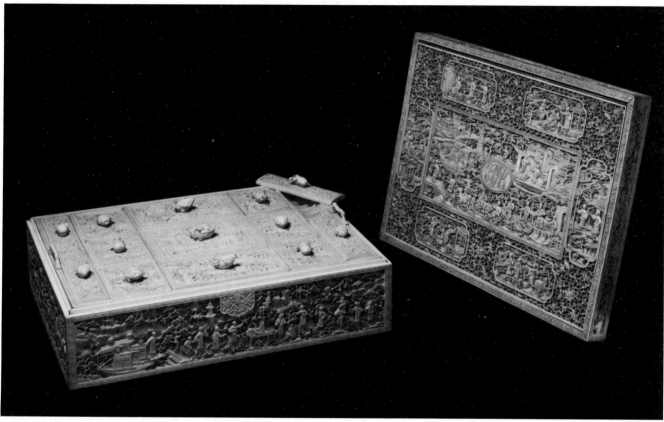

260

259. Model of a Buddhist temple, ivory on a composition base with mother of pearl, semi-precious stones and metals

L. 85.1 cm, H. 104.2 cm

About 1800

Victoria and Albert Museum I.S.9347

This imposing model of a temple, with monks receiving fashionable visitors, was once in the museum of the Honourable East India Company and has a traditional association with Josephine Bonaparte. An unsubstantiated story has it that the piece was destined for her when captured by a British ship.

Published: Bushell (1904) I p. 105.

260. Workbox

L. 35.7 cm

About 1790–1800

Victoria and Albert Museum 1796–1892, bequeathed by Mrs A. M. Ingle

The very crowded figural decoration with unusual subjects such as musicians, jugglers and lion dancers is related to that on Cantonese export lacquers. The very high relief carving is cut back to a translucent ground. The interior is fitted with a removable tray divided into thirteen compartments, some with hinged lids. All these carry knobs in the form of various fruits. The lid and one side carry the monogram CSB.

261. Plaque, painted ivory showing Dutchmen loading goods

L. 16 cm

First half of 18th century

Culturgeschiedenis van de Nederlanders overzee C.N.O.

This plaquette probably once formed part of a box or small screen, or a mirror such as No. 263. The hull of the small boat is painted red and blue in the Dutch colours and may represent Dutch merchants loading their small amounts of private trade goods.

Published: Jorg, C. J. A., *Porcelain and the Dutch China Trade* (Martinus Nijhoff, The Hague 1980) p. 54. Rissink, W. G. F. C., 'Een ivoren plaquette van Chinese makelij'.

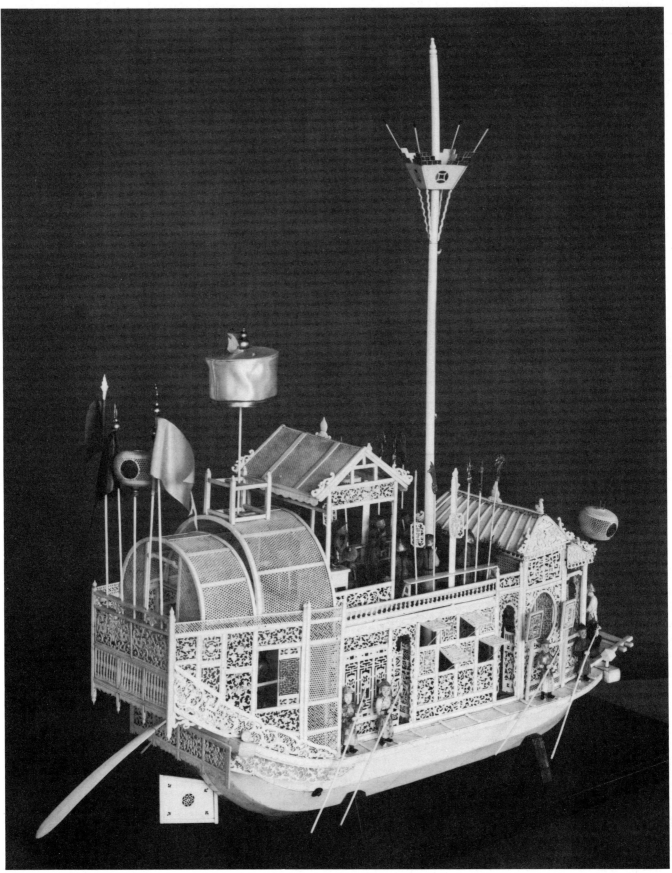

258

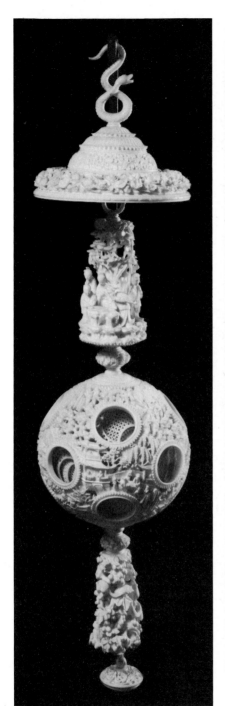

266

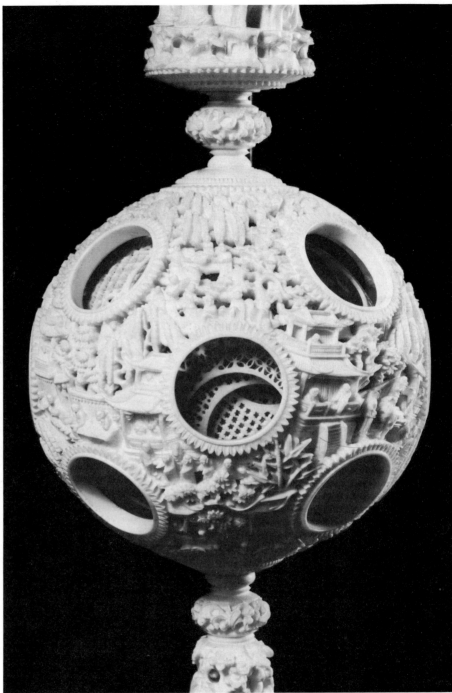

266

266. Pendant of concentric balls

H. 45.7 cm

Early 19th century

Victoria and Albert Museum 380–1872

'Devil-work Balls' are mentioned in *Ge gu yao lun* of 1388, though no early examples survive. The carving of concentric balls was practised in Europe from around 1500, but the skill was particularly associated in the western mind with China. In 1872 C. Alabaster wrote in his *Catalogue of Chinese Objects* *in the South Kensington Museum*, 'for deep and delicate carving there is no foreign work equal to or even approaching the fan sticks and small jewel boxes to be bought in the Hong Kong and Canton shops, and the art of cutting ball within ball, as the Chinese are fond of doing, has not even been attempted by Europeans.' In his minute recommending purchase, Matthew Digby Wyatt called this, 'the finest ball of its kind I ever saw and contains *at least* 18 concentric carved balls (I never saw more than 14) all of great fineness and spirit.'

267

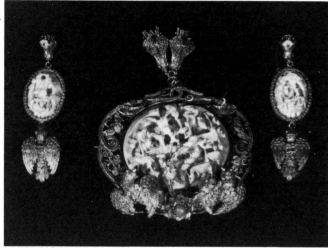

267

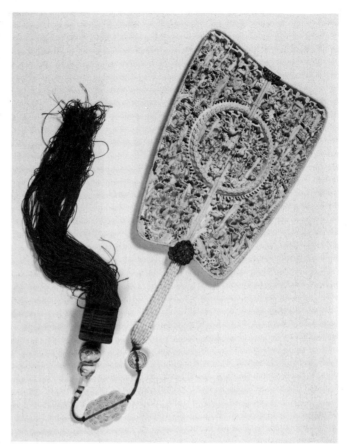

268

267. Parure and box, ivory with gold filigree

L. of box 12 cm

About 1820–1830

Mrs J. P. W. Martin

The brooch and earrings are each composed of a deeply undercut ivory plaque set in ornate gold filigree. The brooch also bears a single carnelian bead. The central cartouche of the box has been left plain to allow a monogram to be added later. A bracelet which may be from the same workshop is No. 166 in Forbes, H. A. C. Kernan, J. D. and Wilkins, R. S. *Chinese Export Silver 1785 to 1885* (Milton, Massachusetts 1975).

268. Fan, incised and openwork carving

L. 48.3 cm

Late 19th century

Sir Victor Sassoon Chinese Ivories Trust X1585

This impressive *tour de force* is one of a pair, designed solely for display or for the western tourist market rather than for use. The carved side shows the Royal Mother of the West and

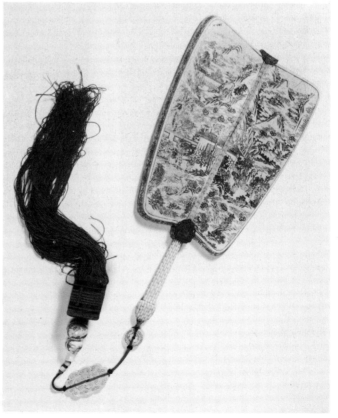

268

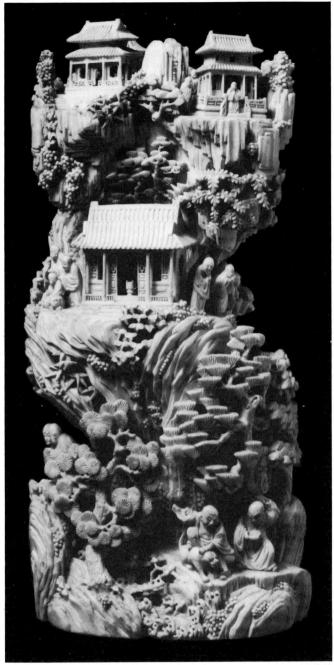

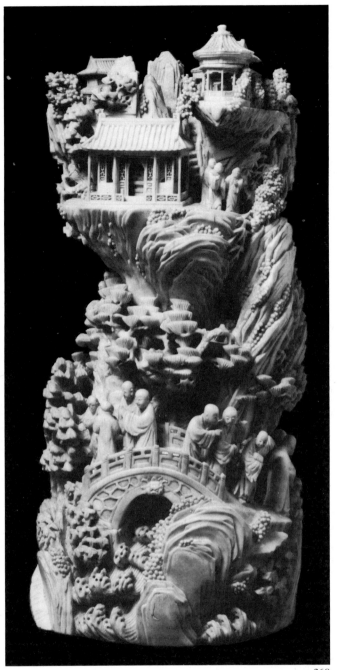

269

269

the Royal Duke of the East with a pantheon of deities. The incised side, decorated in the style of Shanghai periodical literature of the late 19th century shows a scene from a heroic novel, possibly the *Shuihu zhuan*. Such incongruous juxtapositions of decorative subject are common on late pieces of this type.

269. Model of a monastery

H. 31.1 cm Colour plate 7

Late 19th–early 20th century

Sir Victor Sassoon Chinese Ivories Trust 902/585

Lucas identifies this scene with the monastery of Tiantai Shan in Zhejiang province, home of the Buddhist sect of the same name. He also identifies the famous 'Stone Bridge' as being visible on one side. It is thus typical of a large number of pieces in the Sassoon Collection which exhibit very precise subject matters from Chinese history or literature which are but rarely found elsewhere in the Chinese decorative arts. It seems possible that objects with such precise but rare allusions were in a sense 'carved to order' for inclusion in the collection.

Published: Sassoon Catalogue No. 902.

270

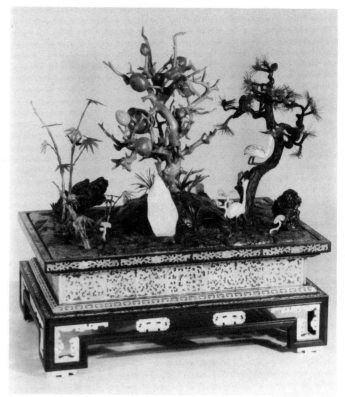

271

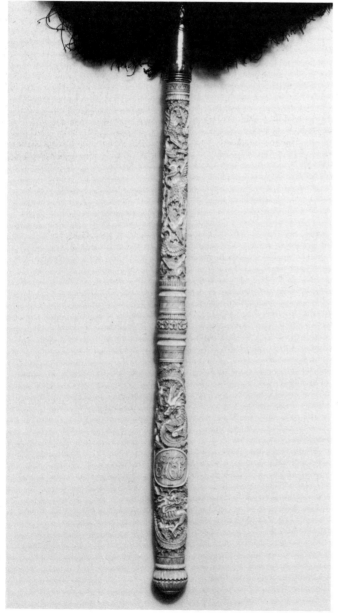

270

270. Parasol

L. 72.5 cm

Middle of the 19th century

Private collection

The stick, which can be dismantled for packing, is carved with the initials AES.

271. Miniature garden, various materials

L. 42 cm

18th century

National Maritime Museum. W 34–1

This typical example of a type of miniature landscape garden popular in the Qianlong period is executed in carved wood and ivory, mother of pearl, coral, malachite and rose quartz. It carries a traditional but unverified provenance stating that it was gift to Commodore Anson, when he visited Canton and Macao in 1742–43 during a circumnavigation of the globe.

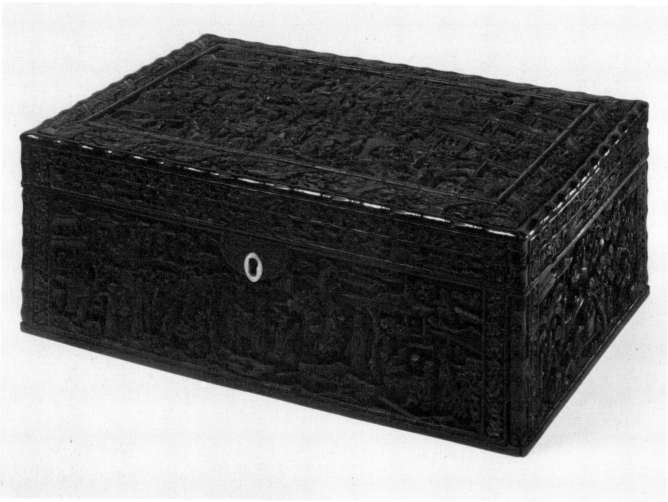

281

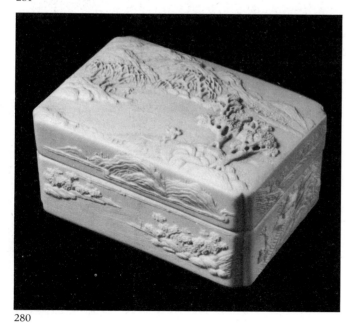

280

280. Box, unglazed porcelain moulded with landscape scene

L. 9.2 cm

Daoguang mark and period (1821–1850)

Victoria and Albert Museum 146–1905

281. Workbox for the Western market, carved tortoiseshell

L. 25.7 cm

Early 19th century

Victoria and Albert Museum 636–'77

282. Box, lacquered wood inlaid with bone

L. 76.4 cm

First half of 17th century

Fitzwilliam Museum Cambridge

Wang Shixiang has suggested that this distinctive flanged form of document box was designed to fit between the parallel carrying poles of a sedan chair.

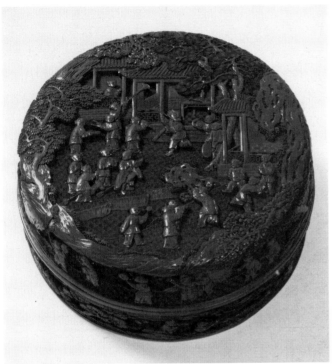

278

279

279

275. Brush-tray, porcelain printed in underglaze blue

L. 31 cm

Wanli period (1573–1619)

Victoria and Albert Museum

276. Brush, carved red lacquer

L. 23 cm

Late 16th–early 17th century

Victoria and Albert Museum FE.48 & A–1974, given by Sir Harry and Lady Garner

277. *Ruyi*, carved bamboo

L. 47 cm

18th century

Victoria and Albert Museum FE.21–1976

278. Box, carved red lacquer

H. 7 cm, Diam. 15 cm

18th century

Victoria and Albert Museum W.97–1911

279. Box, bamboo carved as a segment of pine trunk

L. 11.4 cm

18th century

Victoria and Albert Museum W.338–1910

Signed *Yongji*, the *hao* of the Qianlong period Jiading carver Deng Fujia.

275

276

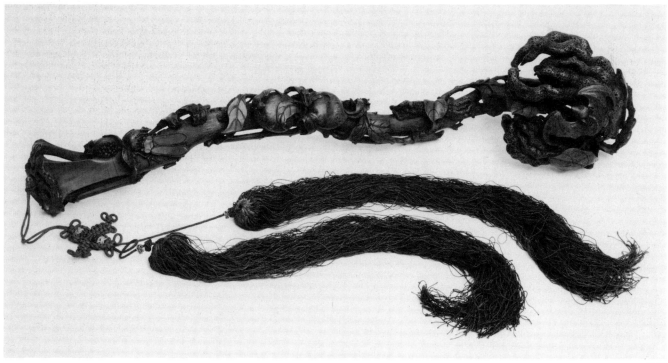

277

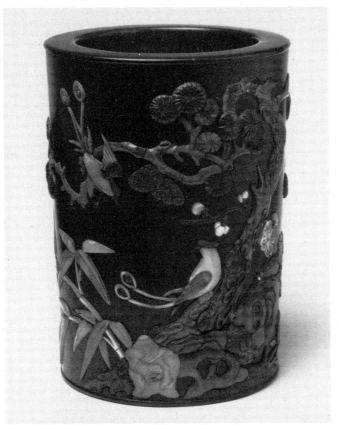

272

273

274

Comparative pieces

272. Brush-pot, zitan wood with inlay of semi-precious stones

H. 12.7 cm

Late 18th–early 19th century

Victoria and Albert Museum 2159–'55

273. Brush-pot of unglazed porcelain with calligraphic inscriptions

H. 12.1 cm

Early 19th century

Victoria and Albert Museum 839–1883

274. Brush-pot of unglazed porcelain with moulded figure of Dongfang Shuo

H. 14.3 cm

Late 18th–early 19th century

Victoria and Albert Museum 29–1883

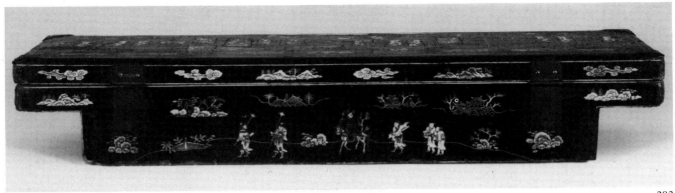

282

283

283. Tools

L. of tool on left 15 cm

Mr Che Ip

A set of nineteen tools recently used for ivory carving by Li Jiaren, a native of Nanking. Most of them were improvised by the carver himself, and have now been replaced by modern equivalents. Mr Li is the grandson of a carver of bamboo and wooden roots who moved to Shanghai a century ago and there found his experiment in ivory so well received by the European community that he took ten pupils into his workshop to meet the demand for his work. Mr Li's grandfather, Li Zhenjin, was one of these. The work, in 'Shanghai style', was inventive, specialising in landscapes, seals and legendary figures.

Chinese Glossary

The names of books are placed with those of their authors when these are known

Ama Ao 阿媽澳

A Ying 阿英

bachiru 撥鏤

Baiyi Guanyin 白衣觀音

Ba xian yang shou 八仙仰壽

Bian Qiao 扁鵲

bichuan 筆船

Cao Guojiu 曹國舅

Chang Sangjun 長桑君

Chang wu zhi 長物志

Chen Lunqiong: Hai wai wen jian lu
陳倫炯海外聞見錄

Chen yuan zhi lüe 宸垣識略

chi tu 赤兔

Chui Jianlu 吹劍錄

da bei 大悲

Dai Kuan: Zhuo ying ting biji 戴冠濯纓亭笔記

Da Qing hui dian shi li 大清會典拾禮

Dao yi zhi lüe 島夷誌略

Deng Fujia 登孚嘉

diaoke 彫刻

Dong Shuangcheng 董雙成

Dong xi yang kao 東西洋考

Du Shiyuan 杜士元

fumo 副末

Fu xing 福星

Gan yang xu fu 甘暘旭炅

Gao Lian: Zun sheng ba jian 高濂遵生八箋

Gao Shiqi: Jin ao tui shi biji 高士奇金鰲退食筆記

Ge gu yao lun 格古要論

Gongzhi 宮製

Guanshiyin 觀世音

Guan Ping 關平

guigongqiu 鬼工球

guiling 龜齡

Gu Lu 顧祿

Gu Yanwu: Tianxia junguo libing shu
顧炎武天下郡國利病書

Hai Cheng 海登

Han Shan 寒山

Han Xiangzi 韓湘子

He Qiaoyuan 何喬遠

He Xiangu 何仙姑

Jiangzuoyuan 將作院

Jianyang 建陽

Jia yong hou zhang 嘉勇侯章

jing 淨

jiao 角

Jinci 晉祠

Jinpingmei 金瓶梅

ji xi Tang Ruowang zhi 極西湯若望製

kang 亢

Kong Shangren: Xiang jin bu 孔尚任享金簿

Kunqu 崑曲

Lan Caihe 藍采和

Liexian quanzhuan 列仙全傳

Li Fang: Zhongguo yishujia zheng lüe
李放中國藝術徵略

Li He 李賀

Li Tieguai 李鐵枴

Li Xianzhang 李獻璋

Liu Bei 劉備

Liu Hai 劉海

Liu Tinghui 劉庭蕙

Li Weiyu 李維鈺

lu 輅

Luo Qingxiao 羅青霄

Lu xing 祿星

Lü Yan 呂喦

Masha 麻沙

Mazu 媽祖

Ming gong shi 明宮史

Ming Qing zhoyu diaoke gongyi meishu mingjiang
明清琢玉彫刻工藝美術名匠

Ming shi Folangji Lüsong Helan Yidaliya si zhuan zhushi
明史佛郎機呂宋和蘭意大理亞四傳注釋

196

	
Miyang cong bi	米陽叢筆
mochuang	墨床
Mu Qi	牧溪
Neiwufu	內務府
Peng Zu	彭祖
Pi Rixiu	皮日休
Qian Yong	錢泳
qiao	巧
Qing bai lei chao	清稗類鈔
qi qiao	琦巧
Quanzhou	泉州
Ruyi guan	如意館
San cai tu hui	三才圖会
Shao zai zhi zhang	少宰之章
Shen Defu	沈德符
Shen Fu: Fu sheng liu ji	沈復浮生六記
Shi De	拾德
Shi qingniao Gong	十青鳥公
Shou xing	寿星
shuimu	水母
shulin	書林
Tai shang Huang Ti zhi bao	太上皇帝之寶
Tianfei niangma zhuan	天妃娘媽傳
Tong qiao yi zhuo lu	桐橋倚棹錄
Tu Long	屠隆
Wang Bomin	王伯敏
Wang Dayuan: Dao yi xhi lüe	汪大淵島夷誌略
Wang Ni	王𡵉
Wang Qi	王圻
Wang Shixiang	王世襄
Wang Shizhen	王世貞
Wei Litong	魏荔彤
Wen Chang	文昌
Wenwu miao	文武廟
Wen Zhengheng	文震亨
Wu Changyuan	吳長元
Wu Lianxun	吳聯薰
Wu Qian	吳騫
Wu za zu	五雜俎
Xiandi shenke	陷地深刻
Xianglin	鄉林
Xiang Yuanbian: Kao pan yu shi	項元汴考槃餘事
Xie Guozhen: Ming dai shehui jingji shiliao xuanbian	謝國楨明代社会経济史料選編
Xie Zhaozhe	謝肇淛
Xin'an	新安
Xi Qing gu jian	西清古鑑
Xi Wangmu	西王母
Xu Ke	許柯
Ya	雅
Yang Bingnan: Hai lu	楊丙南海錄
Yang xin dian	養心殿
Yan xian qing shang jian	燕閒清賞箋
Ye Menzhu	葉夢珠
Yin zhang ji shuo	印章集說
Yiyang	弋陽
Yongji	用吉院本
yuanben	
Yuan Yesi	袁業泗
Yue shi bian	閱世編
Yu Wenbau	俞文豹
yu yong jian	御用監
zao ban chu	造辦處
zhai jie	齋成
Zhang Fei	張飛
Zhang Guo	張果
Zhang Weihua	張維華
Zhang Xihuang	張希黃
Zhang Zhihe	
Zheng Chenggong	鄭成功
Zheng Gu	奠谷
Zhenren	貞人
Zhongguo banhua shi	國中版画史
Zhongguo lianhuan tuhua shi hua	中國連環圖画史話
Zhong Kui	鍾馗
Zhongli Quan	鍾離權
Zhou Cang	周倉
Zhou Jiazhuo: Zhuanghuang zhi	周嘉冑裝潢志
Zhou Nanquan	周南泉
Zhou zhi	周製
Zhou Zhu	周柱
Zhu Da	柴奢
zhuizi	墜子
Zhu Youdun	朱有燉
Zitong Dijun	梓潼帝君

Select Bibliography

Reference to more specialised literature, particularly to technical studies and to historical sources, are placed in the notes following the introductory matter, on pages 16, 27, 50 and 132.

BAILEY, L.L. 'Old Chinese Ivories', *Apollo* XLIII (1946) p.63f

BARROW, J. *Travels in China: Peking to Canton*, London 2nd Edition 1806 *cf.*p.308

BACHHOFER, L. 'Eine Chinesiche Elfenbeinfigur', *Pantheon* 5 (1930) Munich

BISHOP, C.W. 'The Elephant and its ivory in Ancient China', *Journal of the American Oriental Society* XLI (1921) p.290

BOODE, P. 'Chinese Writing Accessories', *Transactions of the Oriental Ceramic Society* I (1948)

BOXER, C.R. *South China in the Sixteenth Century*, Hakluyt Society, London 1953

— *The Great Ship from Amacon: Annals of Macao and the Old Japan Trade*, Lisbon 1959

— *Fidalgos in the Far East, 1550–1770*, O.U.P. Hong Kong 1968

BUNAG, G.E. 'An Introduction to Philippine Colonial Carvings in Ivory', *Arts of Asia* July–August 1983 p.94 (Hong Kong)

BURLINGTON FINE ARTS CLUB *Catalogue of a Collection of Objects of Chinese Art*, London 1915

BUSHELL, S.W. *Chinese Art*, London 1905

CAMMAN, S. *Substance and Symbol in Chinese Toggles*, University of Pennsylvania 1962

CHANG T'ien-Tse *Sino-Portuguese Trade from 1514 to 1644*, Leiden 1934

CLAYTON, H. *The Conservation of Ivory & Bone*, South African National War Museum, Johannesburg Sept 1971

COLYER, Sir Frank 'Abnormal Tusks of Elephants', *Journal of the Bombay Natural History Society* Nov 1970

COMSTOCK, H. 'Heirlooms of the SCHUYLER family (Chinese carved ivory puzzle balls)', *Connoisseur* XCVII (1936) p.40

COOPER, F.J. 'Ivory discoloured by rubber', *The Museums Journal* No.1 (1939). p.23; No. 6 (1955) p.168

COX, W.E. *Chinese Ivory Sculpture*, New York 1946

DAVID, Sir Percival *Chinese Connoisseurship*, London 1971

DE PINTADO, Beatriz S.N. 'Ivory Carvings', *Artes de Xexico* 190 (1976)

DONNELLY, P.J. *Blanc de Chine*, London

FELL, H.G. 'Carved Chinese Picture Panels', *Connoisseur* 1937

FERRÃO DE TAVARES E TAVORA B. *Virgens Sino-Portuguesas de Marfim*, Guimarães 1979

GUILLAUME, G. 'La femme dans l'art chinois d'après les statuettes de terre cuite et d'ivoire du Musée Cernuschi', *L'art et les Artistes* 5 XXXV p.78

HARADA, J. *English Catalogue of Treasures in the Imperial Depository*, Shōsōin, Imperial Household Museum, Tokyo 1932

HIRTH, F. & ROCKHILL, W.W. *Chau Ju-kua: His work on the China Arab Trade in the twelfth and thirteenth centuries entitled CHU-FAN-CHI*, St. Petersburg 1911

HORNBY, J. *China*, in Dam-Mikkelsen, Bente and Lundback, Torben (ed.), *Ethnographic Objects in the Royal Dutch Kunstkammer 1650–1800*, Copenhagen 1980

HOWARD, D. & AYERS, J. *China for the West*, 2 vols. Sotheby Parke Burnett 1978

JENYNS, R.S. & WATSON, W. *Chinese Art: The Minor Arts*, London 1965

IP Yee & TAM, C.S. *Chinese Bamboo Carving Part I*, Hong Kong Museum of Art 1978

IRONS, J.N. *Carving of the Old China Trade*, Hong Kong 1983

JENYNS, R.S. 'Chinese Carvings in Elephant Ivory', *Transactions of the Oriental Ceramic Society* 27 (1953) p.37

KRYUKOVA, I.A. *Rez'ba po slonovoi kosti v kitaiskoy narodnoy respublike*, Moscow 1957

KUNZ, G.F. *Ivory and the Elephant in Art, in Archaeology, and in Science*, New York 1926

LAUFER, B. *Ivory in China*, Field Museum of Natural History, Chicago 1925

LEE, S.E. 'Two Early Chinese Ivories', *Artibus Asiae* XVI (1953) p.257

LEIBBRAND, R. 'Old Ivory of China', *China Journal* XIV (1931) p.288

LERNER, M. 'A Seventh Century Chinese Buddhist Ivory', *Bulletin of the Cleveland Museum of Art* Nov 1968

LI Fang *Zhongguo yishujia zhenglue*, Tianjin 1915

LUCAS, S.E. The Sassoon Chinese Ivories, 3 vols. *Country Life* London 1950 (Reviews: W. Cohn in *The Burlington Magazine* XCV (1953) p.55; S.H. Hansford in *Country Life* CIX (1951) p.1622; W. Watson in *Studio* CXLII (1951) p.58)

LYDEKKER, R. 'Mammoth Ivory', *Annual Report of the Smithsonian Institute* 1899, (1901). p.361

MASKELL, A. *Ivories*, London 1904, 1966

MASPERO, H., GROUSSET, R. & LION, L. *Les ivoires religieux et médicaux chinois*, Paris 1939

MOLINIER, E. 'Les ivoires', *Histoire générale des arts appliqués à l'industrie*, Paris 1896

NA Chih-liang 'Chinese Ivory Carvings', *Bulletin of the National Palace Museum*, Taipei Vol. 4 No. 5 (Nov/Dec 1969)

NESS, A.R. 'Continuously growing teeth', *Discovery* Nov (1960) p.488

OBREGON, G. 'Artistic Aspects of the Philippine Trade', *Artes de Mexico* 143 (1971)

PENNIMAN, T.K. *Pictures of Ivory and other Animal Teeth Bone & Antler*, Pitt Rivers Museum, Oxford 1952

PRIEST, A. 'Three Chinese Ivories', *Bulletin of the Metropolitan Museum of Art*, XXX (1935) p.8

RIDDELL, S. *Dated Chinese Antiquities*, London 1979

SALMONY, A. 'Archaic Chinese Bone Carvings: YIN period', *Fine Arts* XX (1933) p.21

SARASIN VIRAPHOL *Tribute and Profit: Sino-Siamese Trade 1652–1853*, Harvard East Asia Monographs 76, Harvard University Press 1977

SASSOON CATALOGUE *v*. LUCAS S.E.

SOWERBY, A. DE C. 'Chinese Ivory Carving. Ancient and Modern', *China Journal*, XXI (1934) p.53

— 'On the trail of Ivory', *China Journal* XXV (1936) p.139

— 'The Ivory Producing Animals', *China Journal* XXV (1936) p.160

— 'Chinese tinted coloured and lacquered carved ivory in the Frank Lewis HOUGH collection', *China Journal* XXV (1936) p.126

SUNAMOTO ETSUJIRŌ *ZŌ* (Elephants), Osaka 1931–2

TARDY *pseud*. (Henri Gustave Eugène L'Engellé) *Les Ivoires*, Paris 1966

TORBERT, P.M. *The Ch'ing Imperial Household Department*, Harvard East Asian Monographs 71, Harvard University Press 1971

WANG Shi-xiang & WENG Wan-go *Bamboo Carving of China*, China House Gallery, New York 1983

WATSON, W. *Chinese Ivories: The Grice Collection*, The Graves Art Gallery, Sheffield 1958

WILLIAMSON, G.C. *The Book of Ivory*, London 1938

WILLS, G. (Cyril Staal) *Ivory*, London 1968

YETTS, W.P. 'Two Exhibitions of Chinese Objects Yamanaka Galleries', *The Burlington Magazine* LI (1921) p.318

— 'Ivory Statuettes from Hong Kong', *Liturgical Arts* XXI (1953) (New York)

— *Manchu pleasure-barges. A Ch'ien Lung ivory miniature*, Illustrated London News CLXXXIX (1936) p.77

— *The Care of Ivory*. Conservation Pamphlet No. 9, Victoria & Albert Museum 1971

YLVISAKER, M. 'The ivory trade in the Lamu area, 1600–1870', *Paideuma: Mitteilungen zur Kulturkunde* 28 (1982) (Wiesbaden)

ZHOU Nanquan 'Ming Qing zhuoyu diaoke gongyi meishu ming jiang', *Gugong bowuyuan yuankan* 1 (1983). p.82

Lenders to the Exhibition

Phillip N. Allen

Mrs Joan Barrow

Mrs L. M. F. Carson

Che Ip

Mrs and Mr Donckerwolke

Michel Duchange

Sir John and Lady Figgess

Mr and Mrs Gerald Godfrey

V. Dulany Hyman

Ip Yee

The Irving Collection

José Maria Jorge

Ms Gloria L. H. Kuo

Marcus Linell

Mr and Mrs J. Lobel

Mrs J. W. P. Martin

Mrs Rafi Y. Mottahedeh

Professor P. H. Plesch

A. S. Reynolds

The Asian Art Museum of San Francisco.
The Avery Brundage Collection

The Ashmolean Museum, Oxford

The British Museum

The Cleveland Museum of Art

Culturgeschiedenis van de Nederlanders
overzee C.N.O.

The Field Museum of Natural History,
Chicago

The Fitzwilliam Museum, Cambridge

The Metropolitan Museum of Art

The Museum of Far Eastern Antiquities,
Stockholm

Museum für Ostasiatische Kunst, Berlin

The National Museum of Denmark

The Sir Victor Sassoon Chinese
Ivories Trust

The Victoria and Albert Museum

Winchester College.
The Duberly Collection

Biographical Dictionary of Dance

Barbara Naomi Cohen-Stratyner

A Dance Horizons Book

SCHIRMER BOOKS
A Division of Macmillan Publishing Co., Inc.
NEW YORK

Collier Macmillan Publishers
LONDON

Schirmer Books
A Division of Macmillan Publishing Co., Inc.
866 Third Avenue, New York, N. Y. 10022

Collier Macmillan Canada, Inc.

Printed in the United States of America

printing number
1 2 3 4 5 6 7 8 9 10

Library of Congress Cataloging in Publication Data

Cohen-Stratyner, Barbara Naomi.
 Biographical dictionary of dance.

 "A Dance Horizons book."
 Includes bibliographical references.
 1. Dancing—Biography. I. Title. II. Series.
GV1785.A1C58 1982 793.3'092'2 [B] 81-86153
ISBN 0-02-870260-3

This book is dedicated to the

continuing memory of Cecilia Spivakowsky Cohen, 1917 to 1980,

whom I love and miss.

Preface

The more than 2,900 figures profiled in this book span the last four centuries of dance history in Europe and the Americas, embracing a wide range of dance and theatrical genres, from the *opéra-ballet* to the Broadway musical, from the burlesque striptease to the television variety show. While the emphasis quite naturally falls on performers and choreographers, also included are dance impresarios and entrepreneurs as well as a number of composers and artists whose contributions have greatly enriched the dance. Throughout, there are names that will be instantly recognizable to even the most casual dance enthusiast—Rudolf Nureyev, Fred Astaire, Serge Diaghilev, Claude Debussy. Others will be more familiar to students of the dance and to scholars—Antony Tudor, Ida Rubinstein, Marius Petipa, Thoinot Arbeau.

Still others, however, may prove unknown to virtually everyone. There is Geneva Sawyer, for example, about whom little can be divined except that her work as a movie choreographer at the Fox studios included devising dance steps for Shirley Temple. There is Hollis Edwards, a black American tap dancer whose talents in the 1920s and 1930s were favorably compared with those of Bill ''Bojangles'' Robinson but who, unlike Robinson, happened to be a midget. There is Lady Constance Stewart-Richardson, a Scottish peeress, radical suffragist, and interpretive dancer of the early twentieth century who concluded her life by teaching dance to factory workers. And there are other surprises.

Most entries, of course, are not in the way of curiosities. There is a generous sampling of significant contemporary and historical talents, many of whom have until now been simply overlooked, undervalued, or forgotten. But whether they are amusing oddities, awesome legends, or hold the middle ground, each of the dance figures discussed has made a discernible contribution to the performing arts. By bringing them together I have sought only to democratize the pantheon—and in doing so, if possible, to lend a greater legitimacy to the variety of dance forms that, without the support of sophisticates, have nonetheless engaged generations of untutored audiences.

In researching the farflung exploits of so many greater- and lesser-known dancers of different periods, I relied extensively on an enormous compilation of primary sources, including theater programs, annals, posters, advertisements, contracts reproduced in trade papers, and even receipts and cancelled checks. For biographies of contemporaries, I frequently augmented these materials with personal interviews of the subjects themselves, as well as my own observations from the scores of dance, theater, and film events I have attended over the years. I also took advantage of the largely unpublished findings of many noted authorities, such as those of Ivor Guest, Lillian Moore, and Marian Hannah Winter in ballet history, and Sally R. Sommer and Sally Banes in the history of modern and postmodern dance. In sum, these diverse resources served to help compile the unusually thorough lists of choreographic credits that appear at the close of many entries, to correct occasional longstanding misattributions, and to recover several forgotten pieces by celebrated choreographers, among them George Balanchine and Charles Weidman.

Limitations of space, unfortunately, have seldom allowed me to cite references. For many biographies, however, I do append a bibliography of relevant analytic and historical studies for further reading. Also, I have tried to list dancers' and choreographers' own writings about their work whenever they exist.

As with all reference volumes, this book was created with a set of ground rules. A work of limitless substantive and chronological scope would be the ideal, but one must accept the realities of space restrictions and unavoidable time gaps. Only works presented at live performances on or before December 31, 1980 are included herein. Works created for filmed or taped media and released in 1980 or 1981, and, of course, obituary notices from 1981 and early 1982 are also listed.

To facilitate reading and obviate the need for cross-referencing, entries are arranged alphabetically by professional name; real names are cited in the text. All biographical and professional information in the entries was verified through three independent sources. Such data is missing or qualified only when appropriate verification could not be obtained. Dates are included for every work in each choreographer's listing. Within text, however, dates are provided only for verified created roles. Translations are given only for titles or technical phrases in Slavic, Germanic, Scandinavian, and Asian languages, which are not proper or geographical names.

Few of the biographies in this book could have been realized without the facilities of the New York Public Library's Performing Arts Research Center, the Center's Dance Collection, and its Billy Rose Theater Collection; the staffs of each were tremendously helpful in checking facts, tracking down files, and recommending dancers for inclusion. I extend my gratitude to Collection curators Genevieve Oswald, Paul Myers (now retired), and Dorothy Swerdlove, to Center administrators Thor Wood and Richard Buck, and to their assistants. My thanks also to the Library's pages, who patiently endured my persistent monopolization of their time.

The curators of the Margaret Herrick Library of the Academy of Motion Picture Arts and Sciences in Los Angeles were especially solicitous concerning the many dancers and choreographers who have worked in the movies. Too numerous to mention by name are the librarians across the country who assisted me in tracing leads and verifying facts, and the archivists of private collections who sifted through decades of programs and press releases to locate credits and to check the spelling of names.

Many of my research assistants on this project have since returned to performing and choreographing. Among them, I pay affectionate tribute to Karen Davidov, who helped me greatly on the contemporary-ballet biographies, to Susan Jacobson, Susan Reiter, and Linda S. Bandy. Carole Pipolo typed the manuscript, purged it of a host of grammatical errors, and was untiring in her willingness to cope with the very real problem of my dyslexia. On the editorial side, Eileen DeWald of Macmillan was a model of sympathy, critical intelligence, and perseverance.

Lastly, I must acknowledge my indebtedness to Al Pischl of Dance Horizons. A friend for many years, he launched me on this extraordinary assignment as biographer-at-large for the dance community.

Barbara Naomi Cohen-Stratyner
New York City
May 1982

A

Abarca, Lydia, American ballet dancer; born January 8, 1951 in New York City. Abarca was trained at the Harkness House Ballet School by Leon Fokine and Patricia Wilde, and at the school of the Dance Theatre of Harlem, under Arthur Mitchell and Karel Shook.

A charter member of Mitchell's Dance Theatre of Harlem, she became famous for her performances in the company's revivals of George Balanchine's *Concerto Barocco, Agon, Serenade, Allegro Brillante,* and *Bugaku.* Her technical brilliance and elegant line have been revealed in her appearances in the duets from the New York City Ballet repertory—Jerome Robbins' *Afternoon of a Faun* and William Dollar's *The Combat.*

During the company's off-seasons, Abarca has performed on Broadway in Billy Wilson's *Bubbling Brown Sugar* (international company) and in Bob Fosse's *Dancin'* in the 1980 replacement cast; her film appearances include the comedy, *A Piece of the Action,* and the musical extravaganza, *The Wiz* (MGM, 1977), in which she danced around the World Trade Center to Louis Johnson's choreography.

Abbott, Loretta, American modern and theatrical dancer; Abbott does not believe that biographical information is relevant to her performances. Trained in New York by Syvilla Fort and Thelma Hill, she has performed in many modern dance companies and concert groups and has made a reputation for herself on Broadway. Abbott has performed in works by Donald McKayle (both in his company and in the Alvin Ailey Dance Theatre), Louis Johnson, Fred Benjamin, George Faison, creating the role of the "Young Girl" in his *Poppy* (1971), Rodney Griffin, appearing in his *Not in Your Hands . . .* (1977) and *Misalliance* (1972), and Eleo Pomare, dancing his solo, *Woman's Blues.* She has appeared in almost every work in the large repertory of the Ailey company, but is probably best known for her role in his *Blues Suite.* Her noncompany performances in Ailey works included parts in his *Reidaiglia* for Swedish television and his Broadway musical *La Strada* (1969), for which she served as dance captain.

Equally at home on the theatrical stage as in concerts, she has been seen and applauded in *Peer Gynt* (1969), *Purlie* (1970), *Two Gentlemen of Verona* (1972), *Raisin* (1973), and Off Broadway musicals, *St. Joan and the Microphone* (1976) and *Holy Moses and the Top Ten* (c.1977). She has danced on film in *The Wiz* (1977), with choreography by Johnson, and in the audition scene in *Voices* (MGM, 1978), and has choreographed dance sequences for television.

Works Choreographed: CONCERT WORKS: *The Spark of Faith* (1979).

TELEVISION: *Good Times* (CBS, 1976, "Rent Party" episode).

Abbott, Merriell, American theatrical dance director and entrepreneur; born c.1893 in Chicago; date and place of death unverified, it is possible that she is still alive. Abbott was a student of Andreas Pavley and Serge Oukrainsky in Chicago and served as their teaching assistant. The niece of Barney Balaban (head of the Balaban and Katz theater chain), she became a Prolog director in her twenties, staging precision acts for the Paramount/Publix circuit, which was then based in Chicago. The Merriell Abbott Girls were an acrobatic precision team, integrating sommersaults, handstands, arabian rolls, and splits into the usual split-second teamwork. She also staged dance routines for a more conventional female chorus of precision dancers and directed line work for a male team in the late 1920s.

She became the director of entertainment and staff choreographer for The Palmer House, a major Chicago hotel, in 1933, eventually serving in those capacities for the entire chain of Hilton hotels. For the cabarets and floor shows in the hotels, she staged acrobatic teams, exhibition ballroom work, and variety entertainments based around vocalists and bands. Her school in Chicago became a center for study and employment in the Midwest just as the Fanchon-sponsored studios did in California.

The number one troupe of Merriell Abbott Dancers can be seen in their acrobatic routines in two Jack Benny vehicles, *Man About Town* (Paramount, 1939) and *Buck Benny Rides Again* (Paramount, 1940).

Able, Will B., American eccentric theatrical dancer and comedian; born November 21, 1926 in Providence, Rhode Island; died November 11, 1981 on tour in St. Louis, Missouri. After moving to New York City, Able studied various dance techniques with Leon Wills (acrobatics), Josephine Lavoie (Spanish and eccentric), and the faculty of the School of American Ballet. At six-foot-six and the possessor of one of the country's best hitch kicks, Able was quickly booked as an eccentric dancer in the last gasps of vaudeville and in Broadway shows. A year after playing The Palace for the first of many times, Able made a national reputation as the dour "Pennsylvania Dutch" in Tamiris' *Plain and Fancy* (1955). For the next twenty-five years, he danced in musicals, such as *All American* (1962) and *Coco* (1969), traveling vaudeville shows, including the *Folies Burlesques*, and his own nightclub acts. Since the mid-1970s, he has managed and starred in a burlesque retrospective show, *Baggy Pants and Co.,* bringing the genre's jokes, strippers, and dance routines to a new and appreciative audience.

Able has also proven that he can be a talented comedian with both feet on the ground—especially on television. His best-remembered continuing role was "Hanigan" on *The Phil Silvers Show* (CBS, 1955–1959), but he has been seen on scores of single episodes on other popular sitcoms.

Abrahamowitsch, Ruth, German concert dancer; born 1907 in Halle-auf-Saale, Germany; died April 1, 1974 in Warsaw, Poland. Abrahamowitsch was trained at the Mary Wigman school in Dresden and performed in Wigman's troupe from 1923 to 1928. From 1927 to 1933, she performed with the Berlin Stadtischeoper (Municipal Opera) in works by Lizzie Maudrik, among them her *Legend of Joseph* (1930), in which she was acclaimed as a character dancer.

With George Groke, also a former Wigman student with the Stadtischeoper, she performed in a series of recitals in Berlin and abroad. They each won awards at the International Solo Dance Festival in Warsaw, sponsored by the magazine *Muzyka,* in January 1933. Within a few months, they were forced to leave Germany to avoid political persecution.

Traveling to Canada and the United States during the war, they gave concerts in New York in 1935. All of her known works were performed at these recitals although they date from 1932; among the best received were her *Salome* (1933), her entry for the festival, *Dance after a Picture by Pisanello* (1934), and *Jeanne d'Arc* (1935). Abrahamowitsch, who performed as Ruth Sorel Abrahamowitsch in New York and as Ruth Sorel in Canada, taught in Montreal before returning to Warsaw after the war.

Works Choreographed: CONCERT WORKS: *Salome* (1933); *Dance after a Picture by Pisanello* (1934); *Jeanne d'Arc* (1935); *Death Lament* (1935); *Conjurer* (1935, co-choreographed with George Groke); *Diabolic Figure* (1935); *Sillouettes Exchanges* (1935); *A Pair of Lovers at Evening's Rest* (1935); *Mea Culpa* (1948).

Abramova, Anastasia, Soviet ballet dancer; born June 30, 1902, possibly in Moscow. Abramova was trained at the Moscow school of the Bolshoi Ballet by Vassili Tikhomirov and Alexander Gorsky. A member of the Moscow Bolshoi throughout her performing career, she was assigned principal roles in much of the company's repertory. Unique among her colleagues, Abramova was acclaimed in both revivals of the Fokine repertory, notably his *Carnaval* and the early Soviet ballets, such as Tikhomirova and Lashchilin's *The Red Poppy* (1927). She also danced in many works by Kasyan Goleizovsky created for the Bolshoi in the later 1920s and early 1930s, among them his *Kreisler Valse, Sequidilla, Prelude,* and *Grotesque.*

Achille, Mme. Fanny Soulier, French nineteenth-century ballet dancer performing in the United States after 1827. The dancer, whose maiden name is not known, was born in Lyon in 1797; died after 1880 in New York City. Trained in Lyon, she married M. Achille there and emigrated with him to the United States in 1827.

They made their debuts at the Bowery Theater in March of that year, following Mlle. Hutin-Labasse and preceding Mme. Celeste. She performed there in Claude Labasse's version of *The Deserter* and in a kind of Pas des Déèses with her husband, Hutin-Labasse, and Celeste in one grande divertissement.

In 1829, possibly after the death of her husband, she toured with Mme. Caroline Ronzi-Vestris in a

version of *The Marriage of Figaro*, as "Cerubino"; it is not certain whether this performance was danced or sung.

After retiring from the stage in 1830, Mme. Achille taught ballroom dance forms in New York for over fifty years.

Ada May, American theatrical dancer and actress; born Ada May Weeks, March 8, 1900 in Brooklyn, New York; died April 24, 1978 in New York City. Ada May, who used both of her first names on stage and Ada May Weeks in film, was trained by Malvina Cavallazzi at the school of the Children's Ballet of the Metropolitan Opera, where she danced in *Parsifal* and *Aida* (c.1912). After leaving the Met, she studied theatrical techniques at the Ned Wayburn Studio of Stage Dancing in New York.

Wayburn staged a vaudeville act for her and Fred Nice, Jr. which used their ballet training and eccentric/comedy dance abilities. They also worked together in *Miss Springtime* (1916), in a ballet whirlwind act that used costumes based on those designed for *Schéhérazade* by Bakst. Her other Broadway successes included *Round the Map* (1915), the Ziegfeld *Midnight Frolic of 1916, Fancy Free* (1918), *The O'Brien Girl* (1921), *Lollipop* (1924), and Ziegfeld's extravagant musical *Rio Rita* (1927), staged by Albertina Rasch. In London, she was featured in the Cochran 1930 and 1931 *Revues*.

As Ada May Weeks, she worked in dramatic plays and films after 1932. Her last known performance was in Charles Chaplin's film, *Monsieur Verdoux* (UA, 1947), although she may have joined her Metropolitan Children's Ballet and Broadway colleague, Queenie Smith, in playing grandmothers on television before her death in 1978.

Adair, Tom, American ballet dancer; born c.1940 in Venus, Texas. After local training, Adair moved to New York to continue his studies at the Ballet Russe de Monte Carlo school, joining the company in the early 1960s. While he was cast in classical ballets and divertissements, such as the Balanchine/Danilova excerpts from *Raymonda*, Adair was also assigned character roles even in his early career. In the American Ballet Theatre from 1963, he played character roles in *Giselle, Swan Lake*, and David Lichine's

Graduation Ball, and dramatic dance roles in Antony Tudor's *Dark Elegies* and *Jardin aux Lilas*. As well as his expert portrayals of "Von Rothbart" and "The General," he was known for the exactitude and realism of his characterization of the "Bartender" in Jerome Robbins' *Fancy Free*, a role that can be thrown away but in his hands was memorable.

Adam, Adolphe Charles, French nineteenth-century composer; born July 24, 1802 in Paris; died there May 3, 1856. Trained by Boeidieu at the Conservatoire de Musique in Paris, he specialized in opera-comique and ballet scores. He was a founder of the short-lived Théâtre Nationale (1847), and himself a professor at the Conservatoire.

In his best known work, *Giselle* (1841), and his other works, Adam showed a remarkable ability to differentiate tunes within musical sequences by gender, age, and place of national origin. In the second act of *Giselle*, for example, he followed the original libretto and created different variations for the two soloist Wilies, making them into individuals. Adam's ballet scores include *La Jolie Fille Du Gand* (1839), *Le Corsaire* (1856), *Orfa* (1852), *Le Diable à Quatre* (1845), and *Les Mohicans* (1837)—all for the Paris Opéra.

Adama, Richard, American ballet dancer and choreographer working in Europe after the mid-1950s; born August 8, 1928 in Long Beach, California. Adama was trained by Bronislava Nijinska who was then teaching in the Los Angeles area. She recommended him for positions in the Original Ballet Russe and the Grand Ballet du Marquis de Cuevas in the late 1940s.

He joined the Vienna State Opera in 1955, performing in works by Dimitrije Parlić and Erika Hanka and creating a major role in Yvonne Georgi's *Agon* (1958). Later he danced for Georgi in the Hanover Ballet, in her *Hamlet*, and *Passacaglia No. 1*, and staged a production of *Giselle* there in 1961. After performing in Bremen in the late 1960s, he returned to Hanover and became the director of the ballet in 1970. Adama is known for his versions of romantic ballets based on their original scores, among them his *Giselle*, and *La Sylphide* (1964).

Works Choreographed: CONCERT WORKS: *Giselle* (1961); *Platée, ou Junon Jalousé* (1962); *The Legend of Joseph* (1962); *La Sylphide* (1964).

Adamova, Adela, Italian ballet dancer working in Argentina; born in 1927 in Turin. Trained locally by Michel Borovski, she left Italy to become a member of the Teatro Colón in Buenos Aires. Associated with the works of Margarete Wallmann there, she was cast in feature roles in her *Offenbachiana, Aubade, Saloman,* and *La Boutique Fantasque,* among many others. She was also acclaimed for her performances in the company's productions of *Les Patineurs, Apollon Musagète* (by Adolf Bolm), *The Nutcracker,* and *The Sleeping Beauty.*

In the mid-1950s, she was invited to dance at the Teatro alla Scala (at which Wallmann was ballet master), reviving her Argentine roles. Since returning to Buenos Aires, she has worked as an actress and vocalist.

Adams, Carolyn, American modern dancer; born August 6, 1943 in New York City. Adams received early training from Nelle Fisher and the faculty of the Martha Graham school. While attending Sarah Lawrence College, she studied with Bessie Schoënberg and spent her junior year abroad in Paris where she worked with Karin Waehner, a former student of Mary Wigman.

She has been associated throughout her career with the company of Paul Taylor. Since 1965, when she first worked with him, she has performed in most of the touring repertory and has created roles in his *Post Meridian* (1966), *Orbs* (1966), *Lenyo* (1967), *Public Domain* (1968), *Big Bertha* (1971), *Esplanade* (1975) and *Le Sacré du Printemps* (1980), among many others.

Adams, David, Canadian ballet dancer working in Canada and England; born November 16, 1928 in Winnipeg, Manitoba, Canada. After local training, Adams accepted a scholarship to continue his studies at the school of the Sadler's Wells Ballet.

He graduated into the company in 1946, performing featured roles in *Coppélia,* Celia Franca's *Khadra,* and Andrée Howard's *Assembly Ball.* With the Metropolitan Ballet in its last season of existence, he was featured in *Spectre de la Rose, Swan Lake,* and John Taras' *Designs for Strings.*

A founding member of the National Ballet of Canada, 1951 to 1961, he danced in the company's revivals of works by Antony Tudor, among them, *Jardin aux Lilas, Offenbach in the Underworld,* and *Gala Performance,* and in the classics, including *Giselle, The Nutcracker, Swan Lake,* and *Coppélia.* Returning to England, Adams joined the London Festival Ballet, 1961–1969. He served as Director of Ballet for All, a touring company, but returned to performance with the Royal Ballet in 1970.

Works Choreographed: CONCERT WORKS: *Barbara Allen* (1961).

Adams, Diana, American ballet dancer; born March 29, 1926 in Stanton, Virginia. Adams received her early training from her mother, Emily Hadley; she later moved to New York to study with Edward Caton and Antony Tudor.

Adams appeared in two Broadway musical comedies, *Oklahoma!* and *One Touch of Venus,* before she joined Ballet Theatre in 1943. In her seven years in the company, she created the role of "Cybele" in Tudor's *Undertow* (1945), and performed featured roles in his *Romeo and Juliet, Dim Lustre, Numbus,* and *Jardin aux Lilas.* She also created roles in Agnes De Mille's *Fall River Legend* (1948) and Michel Fokine's revival of *The Firebird* (1945). Her featured roles in the company included "Myrthe" in *Giselle* and the female leads in George Balanchine's *Theme and Variations.*

Adams joined the New York City Ballet in 1950, remaining with that company until her retirement in the mid-1960s. She created a large number of roles in that company, in, among other works, Frederick Ashton's *Picnic at Tintagel* (1952), Jerome Robbins' *The Pied Piper* (1957), Todd Bolender's *The Filly* (1953), and Tudor's *Lady of the Camilias* (1951) and *La Gloire* (1952). For Balanchine, she created roles in his *La Valse* (1951), *Opus 34* (1954), *Ivesiana* (1954), *Episodes* (1959), and *Liebeslieder Waltzes* (1960), among others. In 1957, she appeared in the premiere of *Agon,* creating, with Arthur Mitchell as partner, the central duet—many consider this the single most

important, influential, and innovative movement sequence in all of twentieth-century dance.

Appearing as a ballet dancer in two films, she worked with Gene Kelly in his *Invitation to the Dance* (MGM, 1954) and partnered Danny Kaye in Michael Kidd's satire of Russian ballet that forms the climax of *Knock on Wood* (Paramount, 1954).

Addison, Errol, English ballet and theatrical dancer; born 1901 in Heaton, England. After early training with Lila Fields and Alfred Haines, Addison became a student of Enrico Cecchetti in his London school.

He was a member of the (Leonid) Massine–(Lydia) Loupokhova Company in the 1922–1923 season, but spent more of his career in stage work. Like so many Cecchetti protégés, Addison was tremendously influential in the theatrical forms of ballet technique. In fact, Addison and many American Cecchetti students were the innovators of the eccentric ballet tap techniques; he and his partner Iris Kirk-White performed in many cabarets, nightclub acts, cine-varieties shows, and West End musical comedies, especially in the early 1930s. He also worked in the acrobatic ballet style with partner Gladys Godby, notably in *Wake Up and Dream* (1930).

When he retired from performance, Addison returned to the more conventional applications of Cecchetti technique. He served as a company teacher for the Royal Ballet and its affiliated school from 1954 to 1963 and for the Ballet Rambert, from 1964 to his retirement ten years later.

Addor, Ady, Brazilian ballet dancer; born c.1935 in Rio de Janeiro. Trained at the school of the Teatro Municipal, she performed with the ballet company there for much of her career. After dancing in the corps, she danced in the ad hoc company of Aurel Milloss in Sao Paulo in 1953.

Returning to the Teatro Municipale, she became associated with the ballets of Leonid Massine, especially his *Gaité Parisienne, Les Présages, Le Beau Danube,* and *La Boutique Fantasque.* After Igor Schwekoff taught at the theater on a guest ballet master basis, she returned with him to New York, where she joined the American Ballet Theatre. There too, she danced in Massine works, but added parts in

David Lichine's *Graduation Ball,* Agnes De Mille's *Rodeo,* and *Fall River Legend,* Antony Tudor's *Pillar of Fire* to her personal repertory. She performed with Ballet Theatre from 1957 to 1961, with a season spent touring with Alicia Alonso. In the mid-1960s, she returned to Brazil to teach.

Adelaide, American vaudeville and theater ballet and exhibition ballroom dancer; born Mary Dickey, c.1884; died 1959. At first a baby acrobatic dancer, La Petite Adelaide, as she was billed, did a ballet specialty act from the age of seven, having received training from a Mme. Kruger and a Mme. Fransioli. She later studied with Elisabetta Menzelli, c.1910 to 1920.

A biography of La Petite Adelaide is a history of the uses of toe techniques in American theatrical dance. In her solo act and Broadway musicals, c.1887 to 1910, the four-foot-five dancer performed variations of a doll act in which, after she was unwrapped, she stepped from a box or carton and danced. When the novelty wore off by 1907, she performed the act on horseback—on point on horseback—at the Hippodrome. In her musicals, *Lady Slavey* (1900), *The Babes and the Baron* (1904–1906), *The Orchid* (1907), and *Up and Down Broadway* (1910), she danced on tables, inside hampers, and on top of drums. It should be noted that her publicity releases claimed that she worked in unstructured, unstuffed shoes.

In 1911, while starring in *Katie Did,* La Petite Adelaide met dancer J.J. Hughes (c.1881–1941) and formed a dance team with him. They worked in Europe first, where they were "discovered" by Melville Ellis and imported to New York for the Shubert Brothers. For the next twelve years, they performed together on Broadway and on the Keith circuit in vaudeville. Their shows included the *Passing Show of 1912,* in which they performed a pantomime/dance, *The Spark of Life,* and a whirlwind one-step, *Monte Christo Jr.* (1914), and Ned Wayburn's *Town Topics* (1915). Their vaudeville acts, which they co-choreographed, ranged from playlets, such as *Chantecleer* (1911), to cultural surveys, like *The Dancing Divinities, Birth of a Dance,* and *Classics of an Age* (1917); from straightforward harlequinades, as in their *Pier-*

rot and Pierrette (1914) to political pageants like *The Garden of the World* (1917), in which "Civilization" danced with "Peace."

Adiarte, Patrick, Filipino-American theatrical dancer; born c.1944 in New York City. Adiarte studied with Paul Draper, Luigi, and with Valentina Pereyaslavec. He made his professional debut in 1951 as the youngest prince in Jerome Robbins' *The King and I.* After three years in the show, he grew into the principal child's part, "Prince Chulalungkon," which he also played in the film version. As the teenager in *Flower Drum Song* (1958), directed by Gene Kelly and choreographed by Carol Haney, he did his big numbers, "Chop Suey" and "The Other Generation." Kelly hired him to partner him in his television special, *Dancing Is a Man's Game,* while Adiarte was in the New York production.

Adiarte choreographed a television series in Italy at age eighteen, and returned to the United States to serve as principal dancer for *Hullabaloo* (NBC, 1965–1966), before switching to dramatic roles.

Works Choreographed: TELEVISION: *Summer Follies* (RAI, 1961–1962).

Adorée, Renée, French theatrical and film dancer and actress; born Renée de la Fonte, September 30, 1898 in Lille, Belgium; died October 5, 1933 in Tujunga, California. Adorée was born on tour with her parent's circus. By the age of ten, she was a veteran performer with the troupe as a toe dancer, horseback dancer, and acrobat. She left the circus to perform with another traveling company and was in Brussels when World War I broke out. After fleeing to England, she emigrated to the United States. Her Broadway appearances were curtailed by the 1919 Equity strike but she was seen by enough people as a specialty dancer in *Oh, Uncle!, Oh, What a Girl* (where she introduced "The Rocker," a popular fox trot), *The Magic Melody* and *The Dancer,* to be offered a contract by Fox Film Corp. Although Adorée is best known for her performance as the heroine of the war epic, *The Big Parade* (MGM, 1925), she appeared frequently as a decadent French dancer in her other pictures, which included *Made in Heaven* (Goldwyn Productions, 1921), *On Ze Boulevard* (Columbia,

1929), *Parisian Nights* (Gothic/R.C., 1925), and *The Pagan* (MGM, 1929).

Adorée retired from pictures in 1929 with the tuberculosis that would kill her at age thirty-five.

Adret, Françoise, French ballet dancer and choreographer; born August 7, 1920 in Versailles. Adret studied ballet with Mme. Roussane, Nora Kiss, and Victor Gsovsky in Paris and the South of France. It is not certain whether Adret danced with the Roland Petit Ballets de Paris before becoming its ballet master in 1948. After touring with that troupe, she began almost twenty years of working as ballet master and choreographer for a variety of European companies, including the Netherlands Opera (c.1951–1958), the Warsaw Opera, and the Nice Opera (1960–1964). She staged opera divertissements as well as her own modern ballets in each company, but did not have full artistic control over repertory until she formed her own Ballet-Théâtre Contemporain in Paris and Angiers.

Works Choreographed: CONCERT WORKS: *La Conjuration* (1948); *Oui ou Non* (1949); *Terrian Vague* (1950); *Apollon Musagète* (1951); *Billard* (1951); *Il Ritorno* (1952); *Quatre Mouvements* (1952); *Le Canape* (1953); *Le Rêve de Veronique* (1954); *Les Deux Panthères* (1955); *Pour un Corps de Ballet* (1955); *Orphée* (1955); *Le Sanctuaire* (1956); *Le Photographe* (1956); *Phêdre* (1957); *Repetto* (1957); *Suspense* (1958); *Otello* (1958); *Barbaresques* (1960); *Mayerling* (1961); *Claire* (1955); *Nice Party* (1962); *Idylle* (1962); *L'Affiche* (1962); *Concerto Grosso* (1962); *Gordana* (1962); *Maquettes* (1962); *Resurrection* (1963); *Le Tricorne* (1963); *Quatre Tempéraments* (1963); *Le Manteau Rouge* (1963); *Pièces à Danser* (1963); *Le Mandarin Merveilleux* (1965); *La Belle au Bois Dormant* (1966); *Cinderella* (1967); *Les Forains* (1967); *Incendio* (1967); *Aquathemes* (1968); *Eonta* (1969); *Requiem* (1970); *La Follia di Orlando* (1972); *7,pour 5* (1973); *Zykws* (1973).

Aglié San Martino, Filippo, Conte, Italian seventeenth-century *ballo* organizer and possibly choreographer; born 1604 possibly in Savoie; died August 1, 1667. The nephew of Ludovico Aglié San Martino and himself a celebrated diplomat, Aglié San Martino was attached to the court of Victor Emmanuel I

of Savoie (or Savoy), then a duchy including what is now Savoie (France), Turin, and most of the Piedmontale region of Italy. He was a favorite of the Duchess Maria Christina and organized many spectacles and pageants for her court.

Although his place in history and much of his poetry is known, the scarce information on Aglié San Martino's dance works, and on whether he actually choreographed them, all comes from the same source—a French Jesuit, Charles François Ménéstrier (1631–1705) who was an expert on court and religious ceremony. Two of his major works, *Traité des Tournois, Joustes, Carrousels et des autres Spectacles Publics* (Lyon, 1669) and *Des Représentations en Musiques Anciennes et Modernes* (Lyon, 1701) describe Aglié's balli. The occasional balli, with their national, topical, and mythological allusions, are fascinating and deserve as much study as the French and Florentine court tourney and masques.

Works Choreographed: CONCERT WORKS: *Bacco trionfatore delle Indie* (1624); *La Forza dell' Amore* (1626); *Circe cacciata dai suoi Strati* (1627); *Gli Amanti idolatri del loro sole* (c.1630); *Gli Habitori de Monti* (1631); *La Verita nemica dell' Apparenza sollevata dal Tempo* (1634); *Il Balletto degli alchemisti* (1640); *La Fenice rinnovata* (1644); *Dono de Re dell' Alpi à Madama Reale* (1645); *L'Oriente geurrico e festaggante* (1645); *Il Tabacco* (1650); *Il Gridelno, o Ballet du Griseldis* (1653); *Lisimaco* (1681).

Agoust Family, French jugglers and theatrical dancers. The patriarch of the family, Henri Laurent Agoust, was a French popular entertainer who became associated with the Alhambra Theatre in London as ballet master and performer when that theater was still a foreign outpost of French pantomime. He lasted into the Alhambra's tenure as an English ballet/pantomime house long enough to produce *The Revolt of the Daughters* there in 1894. Quarreling with the management, however, he left the theater and set his children up in a juggling act that in contemporary descriptions sounds simply impossible. His children—Emmanuel, Alfred Laurent, Georges, and Louise—and Alfred's wife, Dora, toured together from the early 1900s to the mid-1910s, in England, France, Eastern Europe, and the United States.

Since they were playing in San Francisco during the earthquake, and everything in that city was analyzed in detail in each survivor's memoirs, we have good descriptions of their most celebrated act, *A Jolly Supper at Maxim's.* As it began, two waiters at the august Paris restaurant were setting a table, throwing plates, silverware, and glasses to each other before they landed magically in place on the table. Then an elderly military gentleman and his young date enter the room and are seated at the table. They are served by the mad waiters, who played with their food before it landed on the table in front of them. Just as the audience was applauding the waiters, the date began to juggle rolls, peas, fruit, and her filled dishes. This final gag, with the stylish Parisian lady giving in to temptation and juggling, was repeated in many of the family's acts, notably in Louise Agoust's solo piece, *Mme. Foulard,* in which she began to make up her face and ended up juggling her cosmetics and powder puffs. The family toured together for most of the individual members' careers—only Louise and Emile, a son of one of the Agoust brothers, had careers on their own. Louise's solo acts were popular for many years on the Orpheum circuit in the United States after the family retired as a unit in France.

Agoust, Emile, French ballet master and theatrical dancer; born 1839 in Neuilley, France; date and place of death uncertain. A member of the Agoust family of jugglers and dancers, he toured with his parents and grandfather (possibly grand-uncle), Henri Laurent Agoust, and danced in his productions at The Alhambra Theatre, London. He was a ballet master at the Alhambra himself in 1910, creating the *Ballet of 1830.* He moved to New York in 1912 when that production was purchased whole by the Shubert Brothers to be presented as Act II of *The Passing Show of 1912.* He remained in the United States, at first working as the dance partner for Irene Bordoni and then with an act of his own.

His dance act with Simone de Beryll (Alice Porrier) was characterizational pantomime. They included *"Mon Ami"* (1913), *The First Affair* (revived for De Beryll in 1913), *Ma Cherie* (1914), *The Galatine Snake* (1914), and *The Temptation of Adam and Eve,* which had the distinction of being legally

deemed "objectionable." Returning to France after the end of World War I, he served as a ballet master for three Paris cabarets—the Moulin Rouge, the Follies Mariguy, and Folies-Bergère.

Ahonen, Leo, Finnish ballet dancer also working in the United States; born June 19, 1939 in Helsinki. Ahonen was trained at the Kirov School in Leningrad and at the Scandinavian School of Ballet. He made his professional debut with the National Ballet of the Netherlands, but soon moved to Canada to dance with the Royal Winnipeg Ballet. He performed there in works by Brian MacDonald, among them the dramatic *Rose Latulipe* and the ridiculous comic *Pas d'Action*, and in the company productions of European ballet classics, ranging from *Les Patineurs* to Kirsten Ralov's revival of *Napoli*. Ahonen moved to the San Francisco Ballet, where he also taught, but still guested on the East Coast with Soili Arvola, most frequently with The Eglevsky Ballet. He served as ballet master of the Houston Ballet during its years of change from a small local troupe into a national company, but left to form his own troupe, The New Texas Ballet.

Works Choreographed: CONCERT WORKS: *Daydream* (1967).

Aiello, Salvatore, American ballet dancer and teacher; born February 26, 1944 in Herkimer, New York. Aiello was trained at the Chris Elenor School locally and with Lillian Seasley in nearby Schenectady, performing for her in the Tri-City Ballet. After moving to New York City to attend Juilliard, he entered the Harkness scholarship program and Ballet. He joined the Royal Winnipeg Ballet in 1971, performing in its contemporary repertory of works by Oscar Araiz, Norbert Vesak, and John Neumeier. Although he left to perform for Neumeier in the Hamburg State Opera Ballet, he returned to Winnipeg to serve as associated artistic director and regisseur. Still associated with the contemporary works, he appeared in Araiz' *Rite of Spring*, Vesak's *What to Do 'Till the Messiah Comes*, and Michael Smuin's *Pulcinella Variations*. He has also choreographed for the company.

Aiello returned to the United States in 1980 to become associate director and ballet master of the

North Carolina Dance Theatre, resident company of the North Carolina School of the Arts.

Works Choreographed: CONCERT WORKS: *Solas* (1976); *Reflections* (1978); *Journey* (1979); *Clowns and Others* (1980).

Aikens, Vanoye, American modern dancer; born c.1925 in Atlanta, Georgia. Educated at Morehouse College, he studied with Syvilla Fort and Katherine Dunham, dancing in the company of the latter through much of his career.

Among the many works in which he partnered Dunham in her own choreography were *Nanigo, L'Ag'Ya, Rites of Passage*, the shows *Tropical Revue, Bal Negre*, and *Concert Varieties*, and the films, *Casbah* and *The Bible* ("Sodom and Gomorrah" section). He also danced in two films made in Italy in the 1960s, *The Revolt of the Slaves* and *Cleopatre*, before retiring from dance to act and teach in Europe.

Ailey, Alvin, American modern dancer and choreographer; born January 5, 1931, in Rogers, Texas. Ailey moved to Los Angeles in 1942 to study with Lester Horton; and continued his training with Hanya Holm, Charles Weidman, Martha Graham, Jane Dudley, Anna Sokolow, and Karel Shook.

Ailey joined the Lester Horton Dance Theatre in 1953; after Horton's death in 1953, he remained with the company as choreographer, creating his earliest works, *La Creacion du Monde, According to St. Francis, Mourning Morning*, and *Work Dances* (all 1954). In 1958, Ailey presented his first recital with a group that would become the nucleus of his company, variously called the Alvin Ailey Dance Theatre and City Center Dance Theatre. Ailey has served as artistic director of the company from its founding to 1979–1980, when he took a medical leave of absence. Most of Ailey's works have been created in Horton and traditional modern dance techniques. He participated in the Ballet Theatre Workshop concerts, and has also choreographed pieces for the Robert Joffrey Ballet—*Feast of Ashes* (1962) and *Labyrinth* (1963); its successor the City Center Joffrey Ballet—*Mingus Dances* (1971); the Harkness Ballet—*Ariadne* (1965), *El Amor Brujo,* and *Macumba* (both 1966), and *Yemanja* (1967), and American Ballet Theatre, for

which he created *The River* (1970) and *Sea Change* (1972).

Ailey has also used his company to promote the revivals of works by Horton, among them *The Beloved* and *Liberian Suite*, and by Donald McKayle, Talley Beatty, and Pearl Primus; the company has also commissioned new works by many young choreographers, notably among them, Rael Lamb, George Faison, Jr., and Dianne McIntyre.

Ailey has performed extensively on television, especially on the variety shows of the late 1950s, in musical comedies and dramatic shows, and appeared in films, among them, Jack Cole's *Lydia Bailey* (Columbia, 1952).

Ailey is probably the best known American choreographer in many areas of the world. He and his company have toured extensively on both commercial and state department–sponsored circuits. He, and the success of his company, have been responsible for many young dancers, especially Japanese, and African and European blacks, coming to the United States to work.

Works Choreographed: CONCERT WORKS: *According to St. Francis* (1954); *La Creacion du Monde* (1954); *Mourning Morning* (1954); *Work Dances* (1954); *Ariette Oubliée* (1958); *Blues Suite* (1958); *Cinco Latinos* (1958); *Ode and Homage* (1958): *Sonera* (1959); *Mistress and Manservant* (1959); *Gillespiana* (1960); *Knoxville: Summer of 1915* (1960); *Revelations* (1960); *Hermit Songs* (1961); *Modern Jazz Suite (Three for Now, Reflections in D Light, Gillespiana)* (1961); *Roots of the Blues* (aka *Jazz Piece*) (1961); *Been Here and Gone* (1962); *Feast of Ashes* (1962); *The Blues Ain't* (1963); *Labyrinth* (aka *Ariadne*) (1963); *Light* (1963); *My Mother, My Father* (1963); *Rivers, Streams, Doors* (1963); *The Twelve Gates* (1964); *1 Amor Brujo* (1966); *Macumba* (1966); *Yemanja* (1967); *Masekela Langage* [sic] (1968); *Quintet* (1968); *Gymnopedies* (1970); *The River* (1970); *Streams* (1970); *Archipelago* (1971), two versions, each premiered this year; *Choral Dances* (1971); *Cry* (1971); *Flowers* (1971); *Mary Lou's Mass* (1971); *The Mingus Dances* (1971); *Myth* (1971); *The Lark Ascending* (1972); *Love Songs* (1972); *Sea Change* (1972); *Shaken Angels* (1972); *A Song for You* (1972); *Hidden Rites* (1973); *The Mooche* (1975), stage version; *Black, Brown and Beige* (1976); *Pas de "Duke"* (1976); *Praise God and Dance* (1976); *Three Black Kings* (1976); *Passage* (1978); *Shigaon* (1978); *Memoria* (1979); *Phrases* (1980).

OPERA: *Miss Julie* (1966); *Antony and Cleopatra* (1966); *Mass* (1971); *Lord Byron* (1972).

THEATER: *African Holiday* (1960); *Jericho Jim Crow* (1964); *La Strada* (1969).

Akesson, Birgit, Swedish concert dancer and ballet choreographer; born 1908 in Malmo, Sweden. Akesson was trained by Mary Wigman and performed with her concert group until the mid-1930s. She had a concert and recital career of her own in the 1940s and early 1950s; unfortunately not many titles are extant from this period, and few of them have verifiable dates.

In 1957, Akesson began to choreograph for the Royal Swedish Ballet, creating *Sisyphus* for that company; other works there include *The Minotaur* (1958), *Rites* (1960), *Icaros* (1963), and *Nausikaa* (1966). Although celebrated for those mythological ballets, she also created abstract works for the company, among them *Minor seconds, Major sevenths* (c.1960) and *Play for Eight* (1962). Akesson directed the Stockholm Choreographic Institute from 1964 to 1968.

Works Choreographed: CONCERT WORKS: *L'Oeil: Sommeil en rêve* (c.1953); *Movement from Dances Without Music* (1954); *Moon* (1955); *Rain* (c.1955); *Sisyphus* (1957); *The Minotaur* (1958); *Rites* (1960); *Minor seconds, Major sevenths* (1960); *Play for Eight* (1962); *Ikaros* (1963); *Nausikaa* (1966).

OPERA: *Aniara* (1960).

Alban, Jean-Pierre, English ballet dancer; born 1936 in Cairo, Egypt; died January 15, 1973 in London. After training in Berlin and Paris, he joined the London Festival Ballet with which he performed for over eighteen years. Originally best known for classical roles in the company's productions of David Lichine's *Graduation Ball* and Harald Lander's *Etudes*, he later took character roles in Jack Carter's *The Witch Boy*, as the "Conju' Man" and the Festival Ballet's *Schéhérezade*.

Alban retired from the Festival Ballet in early January 1973, and committed suicide a week later.

Albert, François Décombe, *dit*, French nineteenth-century ballet dancer and choreographer; born François Albert Décombe, April 15, 1787 or 1789 in Bordeaux, France; died July 18, 1865 in Fontainebleu. It is not known with whom Albert studied locally; the legend that he stopped his training at age ten, returning to ballet only after seeing Gaetan Vestris dance cannot be verified. It should be remembered, however, that Bordeaux was a center of experimental dance activity in France at the end of the eighteenth century, and that, before the age of ten, Albert may have studied with, or been otherwise influenced by, Jean D'Auberval there. It is known that, as a performer with the Théâtre de la Gaîté in Paris, he studied with Jean-François Coulon.

Albert made his Paris Opéra debut in 1803, dancing with that company, intermittently, for an extraordinary thirty-two years. The partner of both Lise Noblet and Marie Taglioni, he transcended the transition from the *ballet d'action* and the Romantic era by creating roles in Pierre Gardel's *Paul et Virginie* (1806) and Philippe Taglioni's *La Fille de Marbre* (1845), and most of the ballets in between. His choreography too revealed the Opéra philosophical shift; his Paris ballets range from *Le Séducteur du Village, ou Claire et Mectal* (1818) to *La Jolie Fille de Gand* (1842) and *La Mañola* in 1860.

Most of Albert's choreography was created for companies in London, among them the King's Theatre (1821–1837), an emigré center of French ballet, and the Royal Italian Opera at Covent Garden, 1847. His English ballets include *Alcide* (1821), *Cendrillon* (1822, later restaged for the Paris Opéra), *The Fair Sicilian* (1834), *Le Corsaire* (1837), and *l'Odalisque* (1847).

Although the foremost professional ballet dancer of his time, there is evidence that Albert was also involved in the burgeoning movement to legitimize the study of social dance techniques. His published dance manual, *l'Art de la Danse à la ville et à la cour, manuel à l'usage des maîtres à danser, des mères de famille et maîtresses de pension* (1834), considered dance as a domestic as well as performing art.

Works Choreographed: CONCERT WORKS: *Le Séducteur du Village, ou Claire et Mectal* (1818); *Oehone et Paris* (1821); *Finette et l'Éveillé* (1821); *Alcide* (1821); *Cendrillon* (1822); *Daphnis et Céphise* (1830); *Une Heure à Naples* (1832); *l'Anneau Magique* (1832); *Amynthe et l'Amour* (1832); *The Fair Sicilian* (1834); *Le Corsaire* (1837); *La Jolie Fille de Gand* (1842, performed in Italy as *Beatrice di Gand*); *Don Sébastien de Portugal* (1843); *l'Odalisque* (1847); *La Reine des fées* (1847); *La Bouquetière de Venise* (1847); *La Mañola* (1860).

Albertieri, Luigi, Italian ballet dancer teaching in the United States after 1910; born c.1860 in Rome; died August 25, 1930 in New York City. After working as a singer and comic with a children's troupe in Northern Italy, Albertieri became a student and protégé of Enrico Cecchetti. He traveled and performed with Cecchetti in London, dancing in Manzotti's *Excelsior*, and St. Petersburg.

After his first visit to New York, to perform with the Metropolitan Opera in 1895, Albertieri worked in London until 1902, dancing in Drury Lane pantomimes, staged by John D'Auban and Carlo Coppi, and in Empire Theatre spectacles, choreographed by Katti Lanner.

Albertieri emigrated to the United States in 1910, remaining there until his death. He served as ballet master for the Chicago Lyric Opera (1910 to 1913), The Century Opera in New York (1914), and the Metropolitan Opera (1913 to 1927), before opening his own school. Well known as one of the only European teachers unprejudiced against theatrical dancers, if not the theatrical techniques, Albertieri taught his Cecchetti to many important performers and choreographers, among them, Rosina Galli, ballerina of the Met, Albertina Rasch, a soloist at the Century who became one of Broadway's most important dance directors, swimmer Annette Kellermann, concert dancer Margaret Severn, and the Marmein sisters.

Bibliography: *The Art of Terpsichore* (New York: 1923).

Albrecht, Angele, German ballet dancer known for her performances for Béjart's Ballet du XXième Siècle; born December 13, 1942 in Freiburg. Trained in Munich by Lula Von Sachnovsky, she attended classes at the Royal Ballet School in London in 1959. Featured in the classics at the Hamburg Opera Ballet during the 1960s, she was applauded for her perform-

ances in the company's productions of *Swan Lake, Les Sylphides,* George Balanchine's *Apollo, Four Temperaments* and *Palais de Cristal* and Janine Charrat's *Abraxas.*

Since 1969, she has been a member of Maurice Béjart's company, creating roles in his *Ni Fleurs Ni Coronnes* (1968), *Actus Tragicus* (1969), *Nijinsky, Clown of God* (1971), *Beaudelaire* (1972), *I Trionfi* (1973), and *Pli selon pli* (1975), among many others. Featured in his *Messe pour le temps present, Bhakti, Sacre du Printemps, Les Vainqueurs* and *Romeo and Juliet,* she has developed a personal notation system to record his works which have been exhibited as art work in New York and Europe.

Aldous, Lucette, English ballet dancer; born September 26, 1938 in Auckland, New Zealand. After early training at the Frances Sculley School in Sydney, Australia, Aldous attended the Royal Ballet School from 1955 to 1957.

As a member of the Ballet Rambert in London from 1957 to 1963, she performed in revivals of Antony Tudor's *Gala Performance, Dark Elegies,* and *Jardin aux Lilas,* and in John Cranko's *Variations* and *La Reja.* Switching to the London Festival Ballet for the 1963 to 1966 seasons, she was featured in the company's productions of *Giselle, Les Sylphides, Swan Lake,* and *The Nutcracker.* She also performed the classics in the touring company of the Royal Ballet (1966 to 1970), notably in *Coppelia* and Kenneth Macmillan's *Concerto.*

Aldous returned to Sydney in 1971 to perform with the Australian Ballet. With that company, she has performed soubrette roles in Robert Helpmann's production of the ballet of *The Merry Widow* and in Rudolf Nureyev's revival of *Don Quixote.* In both productions, she has toured extensively in America and Europe. Her performance as "Kitri" in *Don Quixote* was repeated in Nureyev's film version.

Alenikoff, Frances, American modern dancer and choreographer; born August 20, 1920 in New York. Alenikoff received professional training in ballet from Julia Barashkova, in African and Haitian dance from Syvilla Fort and Walter Nicks of the Katharine Dunham School, and in modern dance technique from Lester Horton, Mary Anthony, and Paul Sanasardo. She participated in composition workshops with Doris Humphrey, Anna Sokolow, Louis Horst, and Horton.

There is no evidence that Alenikoff performed in any choreographer's works before forming her Aviv Theatre of Dance and Song in 1959, although she has since participated in Part VIII of Kei Takei's *Light.* She has worked in multimedia creation since 1968, integrating movement with films, slides, and verbal and musical scores. As a choreographer, she has worked almost exclusively for her own companies, but in association with a wide range of visual artists, poets, and composers. Her works have been filmed in documentaries and she has herself created photomontages for exhibit.

Works Choreographed: CONCERT WORKS: *Legend of Caupolican* (1953); *Cycle* (1956); *Incantation* (1956); *Dolorosa* (1956); *L'Histoire du Soldat* (1957); *Reflections* (1957); *Song* (1957); *Nightfear* (1957); *Two Sorrows* (1957); *Requiem* (1959); *Variations* (1959); *Cocoon* (1959); *And the Desert Shall Rejoice* (1959); *Sabbath Bride* (1959); *Debka* (1959); *Morning in Galilee* (1959); *Medley* (1961); *To the Desert* (1961); *Festivals* (1961); *Oriental Dance* (1961); *In the Vineyard* (1961); *Reminiscences* (1962); *Ozi* (1962); *Polyanka* (1962); *Jig* (1962); *From the Sea* (1962); *Charleston* (1963); *Shango* (1963); *Pavane* (1964); *Interior Journey* (1967); *Translations, Territories and Refractions* (1967); *Gospel Songs, U.S.A.* (1967); *In Memoriam . . . The Letter* (1967); *In the Courtyard* (1967); *Utopia or Oblivion* (1967); *Near the Wall of Lion Shadows* (1968); *Your Mouth of Salt* (1968); *Lens* (1968); *Territories and Refractions* (1968); *Process* (1969); *Frekoba . . . Take One (Incubus)* (1969); *Salt* (1969); *Episodes on the Edge* (1969); *Health Notes: Skin Layers and Body Parts* (1969); *Square Zucchini* (1970); *The One of No Way* (1970); *Apples on Eden's Expressway* (1970); *In the Salt Range* (1971); *Square Zucchini #2* (1971); *Rope* (1971); *Obsidian* (1972); *Litanies* (1972); *Walking* (1972); *Rope #2* (1973); *Belle* (1973); *Seaweed on Ochre* (1973); *Pavana* (1973); *Terns in Place* (1973); *Invitation to Nausicaa* (1973); *Pomegranate* (1973); *Notes for a Moon Calendar* (1974); *Flutewind* (1974); *Fingers* (1974); *I Don't Want to Kiss Your Mouth of Salt* (1974); *Moon of the Break Up of Ice* (1974); *Suite* (1974); *Zero Sum* (1975); *Fresh Water-Earth*

Jar (1976); *Duad* (1976); *Sign Language & Hiero-glyphs* (1976); *Copely Square* (1976); *Lavender #1* (1976); *Fossil Folio: Artifacts, Relic, Safari, Nostalgia, Frames, Tribe, Dyad, Myth, Jam, Fetish* (1977); *Cryptics* (1977); *Memoirs* (1977); *Lavender #2* (1978); *Midnight on the Last Overland Express* (1978); *Scratchings* (1978); *Line Drawings* (1978); *Siren* (1978); *Twice* (1979, co-choreographed with Susan Mosakowski); *Footnotes* (1979); *Eggroles* (1979); *Quartet* (1979); *Interface* (1980, co-choreographed with Susan Mosakowski); *Life/Lines* (1980).

THEATER WORKS: *Zaide* (1957); *Josephine Baker Show on Broadway* (1964); *Joan and the Devil* (1978).

FILMS: *Incubus* (Frekoba) (Independent, 1969); *Alenka* (Independent, 1969); *Shaping Things—A Choreographic Journal* (Independent, 1977).

Alexander, Claire, American film dancer and actress; born 1898; died November 16, 1927 in Alhambra, California. Alexander was a member of the Mack Sennett Bathing Beauties, a group of contract ingenues who appeared in Sennett's comedies for Triangle Studios. She was known as a flapper in those films and frequently danced on screen. Like Joan Crawford and Clara Bow, she could often be found doing the Charleston or Black Bottom on a table in a party or crowd scene in Sennett movies. Alexander got out of the Bathing Beauties chorus line as the ingenue heroine of the Vitaphone serials about "Jerry." From 1914 to 1917, she appeared in *Jerry's Big Mystery, Jerry's Brilliant Scheme, Jerry's Triple Alliance, Jerry's Romance, Jerry's Best Friend* and many others, as well as challenging Pearl White as the heroine of Pathé's *The Fatal Sign*.

Alexander, Dorothy, American ballet and concert dancer and choreographer; born April 22, 1904 in Atlanta, Georgia. After local dance classes from a Mrs. Dan Noble, she continued her studies with Mikhail Fokine, Bronislava Nijinska, Hanya Holm, Lucille Marsh, Tatiana Chamié, Irma Duncan, and Yeichi Nimura in New York and at the Nicholas Legat studio and the school of the Sadler's Wells Ballet in London.

Associated throughout her career with the development of ballet schools and companies in the South, and especially in her native Atlanta, she re-turned there in 1922 to form her first studio, La Petite Ecole de Dance. Now the Atlanta School of Ballet, the Petite Ecole trained dancers for her concert group (c.1929) and Dance Art Group (c.1935), which became the Atlanta Civic (1941–) and Atlanta Ballet (1967–). She choreographed for the companies, for her solo and duet programs and for the Atlanta bicentennial presentations of 1933, using over three thousand performers.

Not only is Alexander considered responsible for the founding and survival of the Atlanta Ballet, but she is credited with contributing to the development of the regional ballet movement in the United States, organizing the first Festival in 1956 and serving as National Association for Regional Ballet (NARB) president for many terms.

Works Choreographed: CONCERT WORKS: (Note: unfortunately, specific dates could not be determined for all of Alexander's works.) *A Benefit Bridge Party; Alley Tunes; Careers; Dance of Drama; Death and the Ballerina; Enchanted Princess; Esther; Ghost of a Clown; Gypsy Fire; Gypsy Interlude; Hadassah; Heirs of All Ages; In and Yo; Kasperle; Krazy Kat; Leadership; The Little Fairy Who Couldn't Dance; Le Longo de Rene; Magic Castanets* (co-choreographed with Elizabeth Sterling); *Marble Moods; Oenone; Pagan Puritan; Pierrot's Song; Snow Toward Evening; Vague Night* (all late 1920s–1930s); *Americana Suite* (co-choreographed with Hildegarde Bennett and Hilda Gumm); *Amelia and the Green Umbrella; Classical Suite; Dance Panorama; Dance of the Hours; The Flight of Fancy* (co-choreographed with Gumm); *Friends; Generations; Little Black Sambo; Masquerade Suite* (co-choreographed with Gumm); *Polka; Poppy Seed Cake; Rali Ka Mela* (Fair at Rali); *Sir Archibald; Southern Roses; The Swan and the Skylark; Travelogue* (with assistance from Bill Black and Willis Parkins); *Valse Classique; Valse Moderne; War Poems; Woman in War* (late 1940s); *Designed for Love; Fireworks Suite* (1956); *Green Altars* (1958); *Le Jongleur de Notre Dame; Twelve Dancing Princesses* (late 1950s, co-choreographed with Gumm); *Deo Gratias; Prologue* (co-choreographed with Robert Barnett, Carl Ratcliff, and Merrilee Smith); *Soliloquy* (1963); (late 1960s).

Alexander, Rod, American theatrical dance and television choreographer; born Rod Alexander Burke,

January 23, 1920 in Colorado. Raised in Hollywood where he studied with Theodore Kosloff, Alexander worked for Jack Cole at Columbia Studios. He danced in *The Heat's On* (Columbia, 1943) for Cole and in Charles Walters' *Ziegfeld Follies* (MGM, 1946), before moving to New York.

After dancing in featured roles in two musicals, Tamiris' *Inside U.S.A.* (1948), partnering Valerie Bettis, and her *Great to Be Alive* (1950), he teamed up with Bambi Linn to work on television. Their comedy dance acts on early variety shows were innovative and extremely popular. Doing their own choreography, they appeared on Max Liebman's *Your Show of Shows* (NBC, 1952-1954), *Max Liebman Presents* (NBC, 1954-1956 and CBS, 1960-1961), and *The Arthur Godfrey Show* (CBS, 1949-1959), *The Arthur Murray Show* (NBC, 1953-1955), and *The Steve Allen Show* (NBC, 1956-1958), as well as guest shots of other shows.

Alexander returned to film briefly in the late 1950s to choreograph *Carousel* (1956) and *The Best Things in Life Are Free* (1956) for Twentieth-Century Fox. His later stage credits include *Shinbone Alley* (1956), the touring American Dance Jubilee (1958 for the Cultural Exchange Program), and a Japanese musical, *Asphalt Girl* (1964).

Works Choreographed: THEATER WORKS: *Shinbone Alley* (1956); *Thirteen Daughters* (1961); *Asphalt Girl* (Japan, 1964).

FILMS: *Carousel* (Twentieth-Century Fox, 1956); *The Best Things in Life Are Free* (Twentieth-Century Fox, 1956).

Alexander, Rolf, German ballet dancer; born c.1918. Alexander was trained in the Essen Folkwangschule by Kurt Jooss and Sigurd Leeder, joining the Jooss Ballet in 1935. Celebrated in Western Europe, the United States, and England—to which the company emigrated during World War II—for his portrayal of the title role in Jooss' *The Prodigal Son,* he also appeared in the company's productions of his *The Big City, A Spring Tale,* and *The Green Table,* becoming one of the first performers after its creator to portray "Death." Among the many works in which he created roles were Jooss' *The Manor* (1943) and *Pandora* (1944), and Leeder's *Sailor's Fancy* (1943). Alexander remained in England until 1951, appearing in and coaching dance for musical films and was also acclaimed in the principal dance role in Tamiris' *Annie Get Your Gun* in its 1947 London production.

In 1951, he returned to Essen to perform with the reunited Jooss Ballet and to teach at the Folkwangschule.

Alexander, Ross, American theatrical and film dancer and actor; born July 27, 1907 in Brooklyn, New York; died January 2, 1937 in the Los Angeles area, California. Ross' Broadway credits were primarily roles in melodramas, especially those in Blanche Yurka's Henry Hewett Repertory Theatre, but when he accepted a contract from Warner Brothers/First National/Vitaphone in 1933, he was transformed into a popular song-and-dance man. Although he was still cast in straight roles, most notably as "Demetrius" in the all-star Max Reinhardt *Midsummer Night's Dream* and with Errol Flynn in *Captain Blood,* he was best known for his work in the many Warner Brothers musicals. He lost Ruby Keeler to another man in Busby Berkeley's *Flirtation Walk* (1934) and in Bobby Connolly's *Ready, Willing and Able* (1937), but won the heroine as juvenile lead of *Going Highbrow* (1935), *Shipmates Forever* (1935), and *We're In The Money* (1934). His best remembered dance number was in the Connolly film, in which he sang "Too Marvelous for Words," but his tapping and special dance styles were excellent in each assignment.

Tragically, Alexander is best remembered for his manner of death, not for his film work. A little more than one year after the suicide of his wife, dancer Aleta Freed, he shot himself. Their deaths were for many years cited as the moral examples of the dangers of Hollywood to young actors, much in the way that Janis Joplin and Jimi Hendrix are cited to young people today.

Alf, Fé, German concert dancer, working in the United States after 1931; born c.1910 in Germany; Alf first received dance training from Kurt Jooss in Hamburg, c.1922. She entered the Mary Wigman school in 1929, performing in *Totemal* in Munich that year. In 1931, she moved to New York as assistant to Hanya Holm, then the director of the Wigman school here.

Alf opened her own studio in 1933 and performed as a concert dancer until 1939, when she seems to

have retired. Although celebrated for her performances in George Bockman's solo *Suite for Woman* (1937), she danced primarily in her own works, notably among them, *Duet for Clarinet and Dancer* (1937), *Cycle of the City* (1933–1937), and *Rhapsodic Dance* (1933). In 1938, however, she joined with Bockman, William Bales, Sybil Shearer, Kenneth Bostock, and Eleanor King to form a cooperative group, the Theatre Dance Company. The troupe was not able to book enough concerts and soon merged with Jack Cole's nightclub act. Although her fellow members returned to their dance careers, Alf does not seem to have performed after 1939, preferring to teach in the New York area.

Works Choreographed: CONCERT WORKS: *Cycle of the City (Girl in Conflict, Slavery, Degradation)* (1933); *Summer Witchery* (1933); *Chorale* (1933); *Dance Song* (1933); *In Great Joy* (1933); *Rhapsodic Dance* (1933); *Reverie* (1935); *Functional Dance* (1935); *Promenade* (1935); *Upon the Death of the Loved Ones* (1935); *Combat* (1935); *Birds and Man* (1935); *Presage to Conflict, Perpetual Drive* (added to *Cycle of the City*) (1937); *Triadic Progression* (1937); *Duet for Clarinet and Dance* (1937); *Sola* (1937).

Alfred, Julian, American dance director; born Julian Alfred Polachek, c.1890; died December 8, 1927 in New York City. It is not sure whether Alfred was born in New York or immigrated to the United States as a child. He performed in vaudeville and on Broadway in the early Jerome Kern musical *The Girl from Utah* (1914) before becoming known as a coach and choreographer. Much of his time was spent staging dance acts for vaudeville, but he also choreographed at least three Broadway musicals. Two were tremendously successful, if old-fashioned, extravaganzas— the circus backstage musical *Poppy* (1923) and the fifteenth-century French aristocratic Hungarian operetta, The *Vagabond King* (1925). His last show, *Twinkle-Twinkle*, was a more conventional musical comedy, typical of 1926.

Works Choreographed: THEATER WORKS: *See-Saw* (1919); *Poppy* (1923); *The Vagabond King* (1925); *Twinkle-Twinkle* (1926); vaudeville acts (1920–1927).

Algaroff, Youly, Soviet ballet dancer working in Western Europe; born March 28, 1922 in Simferpol.

Trained by Boris Kniaseff, he made his debut at the Opéra Ballet de Lyon before moving to Paris to dance with the Ballets des Champs-Elysées. He left that troupe to perform for Serge Lifar in his Nouveaux Ballets de Monte Carlo in 1946, dancing in his *Apollon Musagète*. Returning to the Champs-Elysées, he was featured in Roland Petit's *Le Rendez-vous, La Fiancée du Diable* and *Les Amours de Jupiter*, Janine Charrat's *Jeu de Cartes* and Leonid Massine's *Le Peintre et son Modele*, in the male title role. Algaroff also appeared with the Grand Ballet du Marquis de Cuevas and the Paris Opéra Ballet, creating roles in Lifar's *Cinéma* (1953) and *L'Oiseau de Feu* (1954), and performing in his *Phèdre* and Harald Lander's *Printemps à Vienne*.

After retiring from performance, he has become an impresario and concert manager.

Algeranoff, Harcourt, English ballet dancer; born Harcourt Essex, c.1903 in London, England; died April 7, 1967 in Robinvale, Australia. After early training from an unnamed school in London, Algeranoff studied with many of the Russian dancers in residence there, including Anna Pruzina, Nicholas Legat, and Pierre Vladimiroff; it is not known, however, how long he trained with each. As a member of the Anna Pavlova touring companies, he continued his studies with Ivan Clustine, Laurent Novikoff, and Anatole Oboukoff; on her Oriental and American tours, he also worked with Matsumoto Fijima and Uday Shankar. As the principal character dancer in the companies after Serge Oukrainsky decided to remain in the United States, Algeranoff partnered Pavlova in *Russian Dance, Oriental Impressions*, and *La Péri*.

Following Pavlova's death, Algeranoff performed in New York and London with the first Ballet Russe de Monte Carlo company, Olga Spessivtseva's Australian tour, the (Alicia) Markova/(Anton) Dolin Company and the Original Ballet Russe, in which he danced in Leonid Massine's *Les Presages* and *Les Femmes de Bonne Humeur*, and in Mikhail Fokine's *Carnaval, Coq d'Or*, and *Petroushka*, with "The Blackamoor" in the latter as his best known role. After a season with the International Ballet in London, in works by Mona Ingelsby, Algeranoff returned to Australia where he worked with the Borovansky Ballet, the North Western Ballet Society, and a small

touring company of his own. Algeranoff retired in 1959, remaining in Australia to teach and coach.

Works Choreographed: CONCERT WORKS: *Coppélia* (1959, after Nicholas Sergeev).

Algeranova, Claudie, English ballet dancer; born Claudie Leonard, April 24, 1924 in Paris. Raised in London, she was trained at the Cone-Ripman School, starting in her adolescence. As Claudie Leonard, she joined Mona Ingelsby's International Ballet where her roles included "The Glove Seller" in Leonid Massine's *Gaité Parisienne*, a controversial "Giselle," "Prayer" in Nicolas Sergeev's *Coppélia*, and a principal role in *For Love or Money*, by her then husband, Harcourt Algeranoff.

They emigrated to Australia to work with the Borovansky Ballet, but she soon became more involved in a separate career with the Australian Children's Theatre. Algeranova returned to Europe in the late 1950s to perform and teach in state opera ballets in Lucerne and Graz, eventually becoming ballet master of the Bavarian State Opera in Munich.

Algo, Julian, German concert and ballet dancer and choreographer working in Sweden after the 1930s; born December 9, 1899 in Ulm; died May 24, 1955 in Stockholm. Trained in ballet by Eugenia Eduardova and in concert dance by Rudolf von Laban, he worked with Yvonne Georgi in her companies in Gera and Hanover in the mid-1920s. Ballet master himself in Duisberg from the late 1920s to 1930, he was named to that position with the Royal Swedish Ballet in 1931, remaining there until his death. He staged productions of the Diaghilev repertory, although it is unsure from whom he learned the works, and created new ballets, among them *Prima Ballerina* (1934), *Vision* (1945), and a version of *Sylvia* that combines the original romanticism with staging techniques based on Laban's mass movements.

Works Choreographed: CONCERT WORKS: (Unfortunately, this list does not include the complete repertory of his ballets.) *Prima Ballerina* (c.1934); *Orpheus in the City* (aka *In Town*) (1935); *Casanova* (1937); *La Taglioni* (c.1943); *Vision* (1945).

Allan, Maud, Canadian interpretive dancer working in Europe from 1903; born 1883 in Toronto, Canada; died October 7, 1956 in Los Angeles, California. Al-

lan, who was raised in San Francisco, became involved in the local Greek revival movement while studying art and music. She made her performing debut in Vienna, 1903, probably on a concert tour.

Although many of her works were visualizations of the piano repertory, her best known solo, *The Vision of Salome*, was created to commissioned music. That controversial work, based partially on art works, was primarily responsible for Allan's reputation in Europe and the United States. Created in 1908 for performance in London, according to current research, her *Salome* brought her fame as an erotic dancer, not an interpreter of culture.

Allan toured frequently, performing in India (1913), Southeast Asia (1913, 1923), South America (1919–1920), and the United States. Although her first attempt to tour North America was aborted when she became a pawn in the so-called "Class Act War" between rival vaudeville booking agencies, her later tours were tremendously successful. Compared frequently to Isadora Duncan, Allan was considered more reliable by entrepreneurs and may have been booked to replace Duncan's cancelled performances.

Still misinterpreted, Allan has been largely considered either a kind of secondary Isadora Duncan or a classier Gertrude Hoffman. Probably the most straightforward of the early twentieth-century interpretive dancers, she performed visualizations of music without the pseudoethnic or national overtones of most. Although she did have a school in England from 1928, Allan does not have a direct link with choreographers of the present.

Works Choreographed: CONCERT WORKS: *Vision of Salome* (1908); *Valse in A Minor, Mazurka in G Sharp Major, Mazurka in B Flat* (1908); *Spring Song* (1908); *Valse Caprice* (1908); *Arabian Dance* (1908); *Melody in F* (1909); *Peer Gynt Suite* (Morning, Ase's Death, Anitra's Dance, Dance of the Gnomes) (1909); *Le Roi s'Amuse* (1909); *Sarabande and Gavotte* (1910); *Beautiful Blue Danube Waltz* (1910); *l'Après-midi d'une Faune* (1916); *Eight* (Chopin) *Preludes; Moment Musical* (1916); *Nair, the Slave* (1916); *Am Meer* (By the Sea) (1916); *Barcarole* (1916); *Pavanne* (1916); *Reverie* (1916); *Gopak* (1916); *Valse Triste* (1916).

Allard, Marie, French eighteenth-century ballet dancer; born August 17, 1742 in Marseilles; died Jan-

uary 14, 1802 in Paris. After training and an early career in Marseilles and at the Comédie-Francaise, Allard made her debut at the Paris Opéra in 1761. In her twenty-one years with the Opéra, she was celebrated for her demicharacter roles in works by Jean-Georges Noverre, notably his *Les Petites Riens*, Maximilien Garden, among them *Phaon* (1778) and *Echo et Narcisse* (1780), and the Lavals, père et fils, including their *Erosine* (1765), *Thétis et Pélée* (1765), and *Aeglé* (1770). Her final performance was in the pastorale, *Laura et Petrarque*, in 1780.

The mistress of Gaetan Vestris, she was the mother of Auguste, called Vestr'Allard.

Allen, April, American film and television dancer; born in the 1950s in Houston, Texas. The elasticity of the American theatrical media is frequently stretched to include new forms of dance, absorbing them into commercial productions. Allen is considered one of the star performers of a contemporarily popular new technique—theatrical roller skating. Her dance training came in class with Patsy Swaze locally, Brian Foley in Toronto, and Bob Banas in New York. A former competitive skater and ten-time National Artistic Roller Skating Champion, she has adapted her talents to the requirements of film and television, with appearances in *Skatetown, USA* (Columbia, 1979), *Dancin'* (CBC–Montreal, 1980 special), talk shows, each network's sports magazine, and specials in Canada, Brazil, and Argentina.

Allen, Deborah, American modern and theatrical dancer; born January 16, 1950 in Houston, Texas. Trained locally at the school of the Houston Ballet and at the Ballet Nacional de México, Allen continued her training while attending Howard University.

While dancing with George Faison's Universal Dance Experience, she performed on Broadway in *Purlie* (1971), Off Broadway in his *Ti-Jean and His Brothers* (1972 at The Public Theatre) and assisted him on the short-lived *Via Galactica* (1973). She has also appeared on Broadway as "Beneatha Younger" in *Raisin* (1973), in *Truckload* (1975), in *Ain't Misbehavin'* (1980 cast), and in the recent revival of *West Side Story*, winning critical praise and audience adoration as "Anita."

Allen has acted in nonmusical production on stage, in film, and on television, most notably as "Mrs. Alex Haley" in the second series of *Roots*.

Allen, Gracie, American vaudeville dancer and comedienne; born July 26, 1906 in San Francisco, California; died May 27, 1964 in Hollywood, California. Allen was a dancer in vaudeville before teaming up with George Burns. She danced in her own original act and in the popular Burns and Allen act, working first as an Irish jigger (in the female version that resembled a soft shoe). The Burns and Allen dance segment was introduced in vaudeville and was seen in their films and television show (CBS, 1950–1957) and heard on radio. Derived from a minstrel show specialty, it consisted of a soft shoe or tap dance, performed in a straight line across the stage. After eight bars, Burns would say "Stop the music," and they would do a joke. After he said "Professor, please," to signal the conductor, they would dance to the other side of the stage for eight bars. In a conventional sixty-four-bar song, they would fit in eight jokes. This *schtik* was so well known in vaudeville that they were able to use it in their radio show, even though no one outside of the studio audience could see them dance. Members of the home audience heard Burns' orders and the jokes separated by eight bars of music and supplied the dance steps from their imagination.

Allen's comedy soon became more important to the act than her considerable dance skills. She had a magnificent sense of timing and could answer a question, make a statement, or act in a way that seemed perfectly logical to her but ridiculous to Burns and the audience. Every person who saw one of their films for RKO or Paramount, notably *Damsel in Distress* (RKO, 1937) with Fred Astaire, recognized lines or situations that could elicit a "Gracieism" and laughed in anticipation at the joke itself and Burns' reaction. It is a wonderful part of the syndication system of television programming that the modern audience can still see the Burns and Allen shows, albeit at four in the morning, and can still laugh at her "Gracieisms."

Allen, Sarita, American modern dancer; born November 2, 1954 in Seattle, Washington. A member of

the Alvin Ailey Repertory Workshop from the early 1970s, she graduated into the senior company after dancing in Ailey's Duke Ellington concert for CBS' *Festival of the Lively Arts for Young People*. In the Ailey Dance Theatre, she has created major roles in his *The Mooche* (1975), Jennifer Muller's *Crossword* (1977), and Rael Lamb's *Butterfly* (1978). Among the many works in which she was assigned featured roles are Ailey's *Hidden Rites, Night Creature, Streams, The Lark Ascending*, and *Three Black Kings*, George Faison's *Gazelle* and *Suite Otis*, Donald McKayle's *Blood Memories*, and James Truitte's *Liberian Suite*.

Alonso, Albert, Cuban ballet dancer and choreographer; born May 22, 1917 in Havana, Cuba. The younger brother of Fernando Alonso, he studied with Nicolas Yavorsky in Havana and with Olga Preobrajenska and Stanislas Idzikowski in Paris.

From 1935 to 1939, Alonso performed with the Ballet Russe de Monte Carlo in Europe, with featured roles in revivals of Leonid Massine's *La Boutique Fantasque, Soleil de Nuit, Les Femmes de Bonne Humeur*, and *Le Tricorne*, and in the company production of *Aurora's Wedding*; in Ballet Theatre from 1944 to 1945, he performed in Jerome Robbins' *Fancy Free*.

Alonso is best known for his work in Cuba, in the Ballet of the Sociedad Pro-Arte Musical during the 1940s and in the Ballet Nacional in the 1960s and 1970s. After dancing for Yavorsky with the Sociedad Pro-Arte in his *Le Beau Danube, Prince Igor*, and *Coppélia*, Alonso staged over twenty ballets for the company, among them, *Los Preludios* (1942), *Sombras* (1946) and *Alicia en el Reino de las cartas* (1948). He has choreographed also for the touring Ballet de Alberto Alonso (c.1960), the Experimental Company of the Musical Theatre of Havana (from 1962 to 1965), the Ballet Nacional, where he staged the celebrated *Un retablo para Romeo y Juliet* in 1970, and the company of el Teatro Radiocentro y CMQ Television. Considered the foremost abstract choreographer in Cuba, he is also celebrated for the vehicles that he staged for Alicia Alonso, revealing both her pure classical technique and her ability to create characterizations, as in his *Carmen Suite* (1970) and *Retablo para Romeo y Juliet*.

Works Choreographed: CONCERT WORKS: *Los Preludios* (1942); *Concerto* (1943); *Forma* (1943); *La Hija de General* (1943); *Rascacielos* (1943); *Sinfonía* (1943); *El Mensaje* (1944); *Sombras* (1946); *Antes del Alba* (1947); *Alicia en el reino de las cartas* (1948); *Mozartiana* (1950); *Aria* (1951); *Orfeo* (1951); *Serenata* (1951); *Sueno Infantil* (1951); *El alardoso* (1953); *La enganadora* (1953); *La Guagua* (1953); *El parque* (1953); *El solar* (1953); *Linum* (1953); *Nocturnos* (1953); *Juana Revolico* (1954); *Tambo* (1954); *Voragine* (1954); *Al ritmo del bongo* (1955); *Bembe* (1955); *El bombin de Barreto* (1955); *En los tiempos de arbuerlita* (1955); *La Havana de noche* (1956); *La mujer de Antonío* (1956); *Rapsodia Negra* (1956); *Volo como Natias Perez* (1956); *El Caballeero de la Rosa* (1957); *El petardo* (1957); *La Rebambaramba* (1957); *Arabasco* (1958); *Petit Ballet* (1958); *Cimarron* (1960); *Estudios ritimicos* (1962); *La Rumba* (1964); *Espacio y movimiento* (1966); *Carmen Suite* (1967); *El Guije* (1967); *Conjugación* (Conjugación Primera) (1970); *Errantes* (1970); *Un retablo para Romeo y Juliet* (1970); *Diogenes ante el tonel* (1971); *A Santiago* (1972); *Viet Nam: La Lección* (1973).

Alonso, Alicia, ballet dancer and choreographer whom many consider personally responsible for the maintenance of ballet in Cuba; born Alicia Ernestine de la Caridad Hoyo, December 21, 1921 in Havana, Cuba. Originally trained at the Sociedad Pro-Arte Musical in Havana, notably by Nicolas Yavorsky, Alonso moved to New York to attend the School of American Ballet where she worked with Muriel Stuart and George Balanchine.

After performing three seasons with the Sociedad Pro-Arte, including her first "Swanilda" in 1935, Alonso worked on Broadway in *Stars in Your Eyes*, staged by Carl Randall. She then danced with Ballet Caravan for a season before joining Ballet Theatre, in which she repeated her Caravan role of "The Mother/The Mexican Sweetheart" in Eugene Loring's *Billy the Kid*. Her exceptionally brilliant technique and devastating stage presence brought her prominence in Ballet Theatre's large repertory of classical pas de deux and revivals; her *Giselle*, especially, and *Swan Lake* were considered among the best in the history of the company. Alonso also performed to great acclaim in the company's newer

works, creating roles in Antony Tudor's *Goya Pastoral* (1940), *Undertow* (1945), and *Shadow of the Wind* (1948), Michael Kidd's *On Stage* (1945), Bronislava Nijinska's *Schumann Concerto* (1951), and George Balanchine's *Theme and Variations* (1947).

Alonso never gave up her links to Cuba, returning to the Sociedad Pro-Arte for annual performances in which she danced the premieres of works by Alberto Alonso, *Forma* (1943), *La Hija de general* (1943), *Sombras* (1946), and *Antes del Alba* (1947). She also worked with the Agrupacíon La Silva de la Havana, for which she choreographed *La Tinaja* (1942).

Her own company, Ballet Alicia Alonso (1948–1959), produced ballets in Cuban theaters and on television. She choreographed works for this group also, among them her *Ensayo Sinfónica* (1950), *Lidia* (1951), and *El Pillete* (1952). From 1959 to the present, she has been the prima ballerina, ballet master, director, and, for Cuba and the rest of the world, the image of the Ballet Nacional de Cuba.

In that company, she has performed her own versions of the classic repertory, notably her *Giselle*, and new commissioned works, among them, Alberto Alonso's *La Carta* (1965) and *Un retablo para Romeo y Juliette* (1969).

It is hard to describe Alonso's importance to the dance community. Her own courage and determination have kept a company alive—whether the artistic vision of the group is contemporarily popular is irrelevent. She represents the ability of one dancer to affect her art.

Works Choreographed: CONCERT WORKS: *La Condesita* (1942); *La Tinaja* (1942); *Ensayo Sinfónica* (1950); *Lidia* (1951); *El Pillette* (1952); *Narciso y Eco* (1955); *La Carta* (1965); *El Circo* (1967).

Alonso, Fernando, Cuban ballet dancer; born December 17, 1914 in Havana, Cuba. After local studies with Nicolas Yavorsky at the Ballet School of the Sociedad Pro-Arte Musical, Alonso continued his training in New York with Mikhail Mordkin, Leon Fokine, Anatole Vilzak, and Edward Caton.

Alonso performed briefly with the Ballet Mordkin (1938) and Ballet Caravan (1939) before joining Ballet Theatre as a charter member. In his eight years in Ballet Theatre, Alonso created roles in many works by Antony Tudor, including his *Goyescas* (1940) and *Undertow* (1945), and George Balanchine, among them, *Waltz Academy* (1944) and *Theme and Variations* (1947). He also performed in Tudor's *Jardin aux Lilas, Gala Performance*, and *Romeo and Juliet*, and in the revivals of Mikhail Fokine's *Carnaval, Les Sylphides,* and *Petroushka*.

Returning to Cuba permanently in 1948, he began a continuing association with the companies of his then wife Alicia Alonso, companies which evolved into the Ballet Nacional de Cuba. He has served as ballet master of the Ballet Alicia Alonso (1948 to 1956) and of the Ballet Nacional (1959 to 1975) and has been director of the school of the Ballet Nacional since 1961. He created roles in many of the works by his brother Alberto, among them his *Sombras* (1946) and *Antes del alba* (1947), and has himself choreographed three ballets for the Agrupacíon La Silva in 1942, and the Ballet Alicia Alonso.

Works Choreographed: CONCERT WORKS: *Pelleas y Melisanda* (1942); *Casañuecas* (1953) *Divagaciones* (1957).

Alston, Richard, English modern dancer and choreographer; born October 30, 1948 in Stroughton, England. Trained at the London School of Contemporary Dance, he joined its company, the Contemporary Dance Theatre, in 1970. He has choreographed for this company since then, except for the 1975 season, when he was in New York studying with Merce Cunningham.

Among the many works that he has staged for the Contemporary Dance Theatre are *Nowhere Slowly* (1970) and *Headlong* (1975). He has also choreographed for the Scottish Theatre Ballet and for his own company, Strider (c.1972–1975).

Works Choreographed: CONCERT WORKS: *Nowhere Slowly* (1970); *Windhover* (1972); *Tiger Balm* (1972); *Combines* (1972); *Balkan Sobranie* (1972); *Headlong* (1975); *Connecting Passages* (1977); *Behind the Piano* (1979).

Alton, Robert, American theater and film dance director; born Robert Alton Hart, January 28, 1902 in Bennington, Vermont; died June 12, 1957 in New

York. Alton moved to New York in 1918 to study ballet with Louis Chalif, later working with Mikhail Mordkin from the early 1920s to 1929.

Alton made his professional debut in the road company of the musical *Take It From Me*; on that tour, he met his future dancing partner (and later, wife), choreographer Marjorie Fielding. Returning to New York, they entered the 1922 *Greenwich Village Follies* as a dance team, later performing as a featured act in vaudeville and in the Marx Brothers' musical, *I'll Say She Is* (1924).

Alton staged Prologs for the Paramount Theaters in Brooklyn and Manhattan before returning to Broadway as a dance director. His first choreography credit was for *Hold Your Horses*, featuring Joe Cook and Harriet Hoctor (1933). He staged another twenty-five Broadway shows, among them, *Hooray for What?* (1937), Olsen and Johnson's popular *Hellzapoppin'* (1938), *Me and Juliet* (1953), and four musicals featuring Ethel Merman, including *Anything Goes* (1934) and *Dubarry was a Lady* (1939). One of his best remembered shows was Rodgers and Hart's *Pal Joey* (1940), which provided Gene Kelly with his most important stage role. Alton and Fielding staged aquacades and water ballets in the late 1930s and 1940s for, among others, the Casa Manaña, Fort Worth, Texas, and the 1939 New York World's Fair.

Alton served as dance director and director for eighteen feature films; most were backstage musicals, among them, *Bathing Beauties* (MGM, 1944), *Ziegfeld Follies* (MGM, 1946), *Easter Parade* (MGM, 1948), the last Astaire and Rogers film, *The Barclays of Broadway* (MGM, 1949), and two popular composer biographies, *Words and Music* about Rodgers and Hart (MGM, 1948), and *'Til the Clouds Roll By* about Jerome Kern (MGM, 1946).

Works Choreographed: THEATER WORKS: *Hold Your Horses* (1933); *Life Begins at 8:40* (1934); *Anything Goes* (1934); *Thumbs Up* (1934); *Ziegfeld Follies of 1934, Parade* (1935); *Ziegfeld Follies of 1936, The Show is On* (1936); *Hooray for What?* (1937); *Between the Devil* (1937); *Hellzapoppin'* (1938); *Leave it to Me* (1938); *One for the Money* (1939); *Streets of Paris* (1939); *Too Many Girls* (1939); *Dubarry was a Lady* (1939); *Two for the Show* (1940); *Higher and Higher* (1940); *Panama Hattie* (1940); *Pal Joey* (1940); *Early to Bed* (1943); *Laffing Room Only* (1944); *Hazel Flagg* (1953); *Me and Juliet* (1953); *The Vamp* (1955).

FILMS: *You'll Never Get Rich* (Columbia, 1941); *Two-Faced Woman* (MGM, 1942); *Bathing Beauties* (MGM, 1944); *Ziegfeld Follies* (MGM/Loew's, 1946); *'Til the Clouds Roll By* (MGM, 1946); *Merton of the Movies* (MGM, 1947, also directed); *The Pirate* (MGM, 1948); *Easter Parade* (MGM, 1948); *Words and Music* (MGM, 1948); *The Barclays of Broadway* (MGM, 1949); *Annie Get Your Gun* (MGM, 1950); *Pagan Love Song* (MGM, 1950, also directed); *Show Boat* (MGM, 1951); *The Belle of New York* (MGM, 1952); *Call Me Madam* (Twentieth-Century Fox, 1953); *White Christmas* (Paramount, 1954); *There's No Business Like Show Business* (Twentieth-Century Fox, 1954); *The Girl Rush* (Paramount, 1955).

Alum, Manuel, American modern dancer and choreographer; born January 23, 1943 in Arezibo, Puerto Rico. Alum studied modern dance in Chicago with Neville Black in 1958–1959, and in New York with Martha Graham in 1961. He also has ballet training with Mia Slavenska and Margaret Black. In 1962, Alum began to study modern dance with Paul Sanasardo, becoming a member of his company in 1963, and, in 1969, its assistant artistic director.

Alum created roles in Sanasardo's *Excursions* (1966), *Cut Flowers* (1966), *An Earthly Distance* (1966), *The Animal's Eye* (1966), and *Footnotes* (1970). While a member of the company, he began to choreograph works for himself, among them his celebrated solo *The Cellar*, in 1967. Since the formation of his own company in 1973, he has created works for it and for both ballet and modern dance companies, among them Dance Theatre of Harlem (*Moonscapes*, 1973), Ballet Rambert (*Escaras*, 1974), and the Israeli group Bat-Dor, for which he has staged *Juana* (1973) and *Ilanot* (Young Trees) (1974).

Alum's work was basically within the traditional modern dance format but with a strong emphasis on solo characterizations and gestural movement. In 1978–1979, however, he accepted a residency in Japan and his artistic vision shifted to a small degree.

Since that time, his work has been involved in discerning the differences between culture in Japan and in the United States, as seen by a cultural alien of both.

Works Choreographed: THEATER WORKS: *Familial Trio* (1963); *Nightbloom* (1965); *The Offering* (1966); *Storm* (1966); *The Cellar* (1967); *Fantasia* (1967); *Palomas* (1968); *Overleaf* (1969); *Era* (1970); *Roly Poly* (1970); *Sextetrahedron* (1972); *Woman of Mystic Body, Pray for Us* (1972); *Deadline* (1973); *East to Nijinsky* (1973); *Juana* (1973); *Moonscapes* (1973); *Steps—a Construction* (1973); *Escaras* (1974); *Ilanot* (Young Trees) (1974); *Yemaya* (1974); *B.B.B.* (*Bowery Bicentennial Celebration*) (1976); *El Tango* (1976); *Together* (1976), originally a section of *Escaras; Dream REM #51177* (1978); *On the Double* (1978); *Untitled* (1979).

Alvarez, Anita, American modern and theatrical dancer; born 1920 in Tyrone, Pennsylvania. Trained at the Neighborhood Playhouse by Martha Graham, she danced for Graham from 1934 to 1941, creating roles in her *Celebration* (1934), *Horizons* (1936), and *American Lyric* (1937). During the 1930s Alvarez also performed with the Theater Union Dance Group as one of the constituent members of the New Dance League.

A veteran of four summers at Camp Tamiment, Alvarez danced on Broadway from the time she left Graham. She was a solo or specialty dancer in *Something for the Boys* (1942), *Allah Be Praised* (1943), *One Touch of Venus* (1944), and *A Connecticut Yankee in King Arthur's Court* (1943 revival), before being cast in her best part, "Susan Mahoney" in *Finnian's Rainbow* (1947). In this Michael Kidd show, her character was a deaf mute who communicated only through dance. Alverez also worked on Broadway in *Gentlemen Prefer Blondes* (1950) and on film in *Tars and Spars* (Columbia, 1945).

Alvarez, Carmen, American theatrical dancer; born July 2, c.1936 in Hollywood, California. Raised in Providence, Rhode Island, she studied dance there with Annette Van Dyke and Eva Handy Hall. Moving to New York, she continued her ballet training with Margaret Craske and Anatole Vilzak, and her jazz work with Peter Gennero, Matt Mattox, and Luigi.

Alvarez was a member of the corps de ballet of the Radio City Music Hall before making her Broadway debut in Bob Fosse's *The Pajama Game* (1954). After working in her first of eight Miliken Shows (generally considered the most prestigious of all industrials), she was cast as "Moonbeam McSwine" in Michael Kidd's *Li'l Abner* (1956), repeating that dance characterization in the film version (Paramount, 1959). She succeeded Chita Rivera as "Anita" in Jerome Robbins' *West Side Story* (c.1958) and stood by for her in Gower Champion's *Bye Bye Birdie* (1960). Among her many other Broadway musical credits are *The Yearling* (1965), *The Apple Tree* (1966), *Zorba* (1968), *Look to the Lillies* (1970), and the 1970 revival of *Irene*. Her Off Broadway career includes participation in the hit revue *The Decline and Fall of the Entire World as Seen through the Eyes of Cole Porter* (1965).

On television, she has danced in most of the variety shows, from *Arthur Murray's Dance Party* (NBC, 1961) and *American Bandstand* (Syndicated, 1961), to *The Ernie Kovacs Show* (NBC, 1962).

Alvienne, Claude M., American ballet teacher; born c.1869, possibly in New York; died April 23, 1946 in New York City. Although Alvienne's own training cannot be verified, he was considered the foremost teacher of ballet to theatrical dancers of the 1910s and 1920s. Among his many students were the Astaires, the Dooleys, and students at Harvard College where he staged *Hasty Pudding Shows*, and at Princeton University where he staged *Triangle Club Shows*. Alvienne's importance to the development of ballet as a theatrical medium is enormous since, for many years, he was one of only three classical ballet teachers who would accept theater performers—adults or children—into his classes. The others, incidentally, were Luigi Albertieri and Louis Chalif.

Amati, Olga, Italian ballet dancer; born January 19, 1924 in Milan. Trained at the school of the Teatro alla Scala, by Cia Fornaroli, Paula Gurssiani, and Ettorina Muzzacchelli, she spent most of her career in the company. A member of the La Scala Ballet from

1942 to 1956, she performed leading roles in Aurel Milloss' *Le Creature di Prometo, Folli e Viennesi,* and *Evocazioni,* Margarete Wallmann's *L'Ucello di fuoco,* and the company productions of George Balanchine's *Ballet Imperial,* Leonid Massine's *Gaité Parisienne,* and *Giselle* and *Swan Lake.* She also danced for Milloss in his chamber company of 1945, with roles in his *Allucinazioni* and *L'Isola eterna.*

Amati has taught in Rome since her retirement.

Ames, Jerry, American tap dancer and teacher; born Jerome Abrams, c.1930 in Maspeth, Queens. After local training Ames crossed the East River to study with Jack Stanley in Manhattan. Although he appeared in a Broadway show, *Are You With It?* (1945), and on most of the television shows broadcast from New York in the 1950s, he is best known for his concert work. He participated in both of the major tap revival revues of the recent renaissance, *Tap Happening* (1969) and *The Hoofers* (1970) and has presented recitals of his own student company. Ames has also co-authored a textbook on the technique, *The Book of Tap* (New York: 1976) with Jim Siegelman.

Amiel, Josette, French ballet dancer; born November 29, 1930 in Vanves, France. Trained at the Conservatoire Nationale de Paris, she entered the Paris Opéra in 1949. Featured in the company's productions of the classics, among them *Giselle* and *Swan Lake,* she created roles in Serge Lifar's *Chemin de Lumière* (1957) and the Venusberg divertissement for *Tannhauser* (1956). A favorite partner of Flemming Flindt in the company and in guest appearances, she was featured in the premieres of his *La Leçon* (1963), *Symphonie de Gounod* (1964), and *Le Jeune Homme à Marier* (1965).

Anastos, Peter, American ballet dancer and choreographer; born 1948 in Schenectady, New York. After some ballet training with the Ballet North in upstate New York, he moved to New York City to work in magazine production and continued his studies with Wilson Morelli, Vera Nemtchinova, and Elizabeth Anderson-Ivantzova. He performed briefly with the Trocodero Gloxinia Ballet before splitting from that organization to form his own company with Natch Taylor, the Le Ballet Trockadero de Monte Carlo. Unlike the original company, which is concerned with reconstructing classics from the historical past, the Trockadero de Monte Carlo bases its repertory on satires of the classics, many of them staged by Anastos, who performed as Olga Tchikaboumskaya.

While Anastos' pointe technique may not be up to the standards set by his colleagues in the all-male company, his choreography is adored by his audiences. Whether they like satires of the Diaghilev repertory, such as the ultra-Egyptian *Cheopsiana* (1978), or imitations of the New York City Ballet, as in his *Go for Barocco* (1974), or *Yes, Virginia, Another Piano Ballet* (1977), they like the Trock. In a strange way, this travesty company devoted to in jokes has become very popular with audiences outside the dance world in New York, thanks, at least partially, to the troupe's appearance on the Shirley MacLaine special, *Where Do We Go From Here?* (CBS, 1977).

Anastos has branched out from his company to create works for conventional troupes, among them *Fête Diverse* (1978) for the Eglevsky Ballet on Long Island, and *Simulcast* for Harry (1979), co-choreographed with Senta Driver. He is the choreographer-in-residence for the Garden State Ballet, New Jersey, and has staged a *Nutcracker* for the company.

Works Choreographed: CONCERT WORKS: *Don Quixote* (1974); *Siberiana* (1974); *Go for Barocco* (1974); *Walpurgis Nacht* (1975); *The Nutcracker* (I) (1975); *Pieriana* (1976); *Ecole de Ballet* (1976); *Les Biches* (1976); *Isadora Dances* (1977); *Giselle, Act II* (1977); *Yes, Virginia, Another Piano Ballet* (1977); *Cheopsiana* (1978); *Dragonfly* (1978); *Fête Diverse* (1978); *Simulcast* (1979, co-choreographed with Senta Driver); *The Nutcracker* (II) (1980).

Anchutina, Leda, American ballet dancer; born c.1920 in Irkustk, Siberia. A student of Mikhail Fokine in New York, Anchutina became one of George Balanchine's earliest pupils in America, at the School of American Ballet.

In his American Ballet, in concert, and at the resident company of the Metropolitan Opera, she created roles in many of his early abstract works, among them, *Serenade* (1934), *Reminiscence* (1935), *The Bat*

(1936), *Jeu de Cartes* (1937), and *Le Baiser de la Fée* (1937). She also performed in the first season of the Ballet Caravan, a company of Balanchine students, dancing in Lew Christensen's *Pocohontas* (1936) and William Dollar's *Air and Variations* (1936). With Dollar, she worked with the Radio City Music Hall as a première danseuse, notably in the specialty *The Three Glass Hearts* (1939).

Married to André Eglevsky, she has taught at his company in Long Island, and has directed it since his death. Among their many pupils are Patricia McBride, Sean Lavery, and Fernando Bujones.

Andersen, Ib, Danish ballet dancer working in the United States after 1979; born December 14, 1954 in Copenhagen. After ballroom dance lessons as a child, he entered the school of the Royal Danish Ballet where he studied with Vera Volkova, just before her death, Hans Brenaa, and Kirsten Ralov. He made his debut as an aspirant (or apprentice to the company) in the revival of Rudi van Dantzig's *Monument for a Dead Boy* in 1973, later performing in the company productions of John Neumeier's *Romeo and Juliet, Swan Lake, The Nutcracker,* and *Giselle.* His roles in the contemporary repertory included "D'Artagnan" in Flemming Flindt's *The Three Musketeers,* and "The Youth" in Glen Testley's *Sacré du Printemps,* while in the Bournonville works, he was assigned featured solos in *Napoli, La Sylphide, Konservatoriet, Flower Festival in Genzano,* and *Kermesse in Bruges.*

Andersen joined the New York City Ballet in the early 1980 season. Successfully adapting himself to the Balanchine style, he has created the principal male role in Balanchine's *Ballade* (1979) and *Davidsbundlertanze* (1980), performed in *Symphony in C,* and *Apollo.*

Andersen, Werner, Danish ballet dancer; born August 7, 1929 in Copenhagen. Trained at the school of the Royal Danish Theatre, he performed with the Royal Danish Ballet for much of his career.

Joining the company in 1948, he created roles in Harold Lander's *Rhapsody* (1959), and in Frederick Ashton's *Romeo and Juliet* (1955), with featured parts in the company revivals of Bournonville's *La Ventana, La Sylphide, Konservatoriet,* and *From Siberia to Moscow,* and in Balanchine's *Symphony in C, Serenade,* and *Night Shadow,* as "The Poet." Noted for his performances in the classical repertory, he also worked in dramatic ballets by Birgit Cullberg, including her *Miss Julie* and *Moon Reindeer,* and Roland Petit.

Anderson, Claire, American film dancer and actress; born c.1896 in Detroit, Michigan; died March 23, 1964 in Venice, California. After dancing in vaudeville locally, Anderson was "discovered" by Triangle Studios as Blanche Sweet's replacement in deep-focus shots in an unfinished film. She received a contract from Triangle on the basis of her work as Sweet and became one of the Mack Sennett Bathing Beauties. Although they appeared occasionally as a precision line in promotional filmstrips and newsreels, the Bathing Beauties were basically a stock company of ingenues capable of acting in the Keystone Kop or other comedy series. Anderson was used as a social dancer at first, appearing in the backgrounds of dozens of films, but soon became a featured performer, billed as "successor to Olive Thomas." Among her most successful Triangle films were *Cinders of Love* (1916), *The Lion and the Girl* (1916), and *His Baby Doll* (1917). In 1920, she left the studio and freelanced as a dramatic actress and comedienne, most notably in *The Yellow Stain* (Fox Film Corp., 1922) and *The Clean-Up* (Universal, 1923).

She should not be confused with the Pittsburgh-born Claire Anderson who appeared on Broadway in the 1940s.

Anderson, Cynthia, American ballet dancer; born September 23, 1956 in Pasadena, California. Trained in California by Jonathan Watts and Evelyn Le Mone, she moved to New York to enter the Joffrey II company and to continue her studies with Maggie Black. Anderson graduated into the City Center Joffrey Ballet, the parent company of her original group, in 1976 and has appeared with it ever since. She has been cast in new works by resident choreographers Robert Joffrey and Gerald Arpino, including the former's *Postcards* (1980) and the latter's *Suite Saint-Saens* (1979), and revivals by guests, most no-

tably Jiri Kylian, for whom she danced in *Return to the Strange Land.*

Anderson-Ivantzova, Elizabeth, Soviet ballet dancer and teacher; born c.1893 in Moscow; died November 10, 1973 in New York City. Trained at the Moscow school of the Imperial Ballet, she performed with the Bolshoi Ballet during the 1910s, with "Aurora" as her best role.

She emigrated to the United States with the 1924 tour of the Chauve-Souris, remaining in New York until her death. Her studio was considered one of the most disciplined in the dance world, since she taught a very strict class based on her own studies with Vassili Tikhomirov.

Anderson, John Murray, English exhibition ballroom dancer, director, dance director, and producer, working in the United States after 1912; born September 20, 1886 in St. John's, Newfoundland; died January 30, 1954 in New York. Anderson, who grew up in Europe, studied acting at the Beerbohm Tree Academy of Dramatic Art and dance with Louis (Hervé) D'Egville in London.

In 1912, Anderson worked as an exhibition ballroom dancer in New York and opened a school there. After his only stage appearance, in a revival of *The Beggar Student* (1913), he performed at Shanley's with his new partner, and future wife, Genevieve Lyon. With Lyon, he modeled for the illustrations and instructions for the dance manual, *Social Dancing of Today,* by Troy and Margaret Kinney, published in 1914.

Anderson staged pageants and society entertainment in New York, including the opening of the first Horn and Hardart's restaurant, before moving west with his tubercular wife. After schools and performances in Phoenix, Flagstaff, Bisbee, and Denver, they returned to New York, where he produced the historical pageant *Terpsichore* (December 1915). During World War I, he served with the Bureau of Public Information, writing propaganda songs, plays, and motion picture scenarios.

In 1919, after producing nightclub revues at Rector's and the Palais Royale, Anderson produced and staged the first of six editions of *Greenwich Village Follies,* considered by many the most innovative revue series of the 1920s. These *Follies* reflected their contemporary art movements, both American and European, and used many tableaux and pantomime ballets, based on Oscar Wilde stories.

Anderson's other theatrical ventures involving dance include his directorship of the Prolog division of Paramount-Publix Theatre, which announced in 1926 that the production of Prologs was "the most important development in dance since the opening of the Imperial Theatre of Russia." His units, among them *The Grecian Urn, The Beethoven (Moonlight) Sonata, Sea Chanties,* and the *Bughouse Cabaret,* were choreographed by Boris Petroff, Paul Oscard, and Jack Partington. He also served as director of the Radio City Music Hall, producing four Prologs there. As a result of his Prolog activity, he was hired by Universal Studios to direct films—he is only credited with one motion picture, *King of Jazz* (1930), although he was under contract for at least fourteen years.

By the time Anderson retired, he had staged over thirty-four shows, over sixty Prologs, seven circus editions, two dozen nightclub revues (mostly for Billy Rose–owned cabarets), two films, and had written over sixty songs.

Bibliography: Anderson, John Murry. *Out Without My Rubbers* (New York: 1954).

Andersson, Gerd, Swedish ballet dancer; born 1932 in Stockholm. Trained privately by Lilian Karina and at the School of the Royal Swedish Ballet, she graduated into the company in 1948. Although she has been successful in her portrayals of the classical heroines, most notably "Swanilda" in the company production of *Coppélia,* she has become associated with the creation of works by contemporary choreographers. Among those pieces in which she has been received with most acclaim are Janine Charrat's *Abraxas* (1951), "Miss Julie" in Birgit Cullberg's ballet of that name, Antony Tudor's *Echoes of Trumpets* (1963), and Brian Macdonald's *Ballet Russe* (1966).

Anderton, Elizabeth, English ballet dancer; born May 28, 1938 in London. Trained at the Sadler's

Wells School on the first C.W. Beaumont Scholarship, she graduated into the Sadler's Wells company in 1955. In that company and its descendant, the Royal Ballet, she performed featured roles in the revivals of the classical repertory and parts in contemporary works. She has been associated with the major choreographers of the developing English ballet and has created roles for each, for example, "Johanna" in John Cranko's *Sweeney Todd* (1959), "The Gypsy" in Frederick Ashton's *Les Deux Pigeons* (1961), and a major role in Antony Tudor's *Knight Errant* (1968).

Anderton assisted Robert Helpmann on many projects including serving as his assistant with The Australian Ballet.

Andreae, Felicity, English ballet dancer and writer; born in 1914 in Southampton. Andreae, one of the first students at the Royal Academy of Dancing, had been previously trained by Phyllis Bedells, Tamara Karsavina, and Elsa Brunelleschi. For six months in 1936, she studied in Paris with Mathilde Kschessinska, and performed with Leon Woizikovski at the Opéra Comique. Andreae was probably the last member of that unique breed—the English freelance ballerina. She appeared with the Camargo Society and Vic-Wells Ballets occasionally in the 1930s, participated in what is believed to have been Antony Tudor's first work for television in 1937, and worked extensively with the Entertainment National Service Association (ENSA). She also performed with the Old Vic Company (for many years, the principal Shakespearean company in England), with a theatre in Yorkshire and with that uniquely British form, the Fol-de-Rol Concert party. Andreae is also known as a writer for television and print on the dance and the author of the series and book *Ballet for Beginners* (BBC, 1952, published in London 1953).

Works Choreographed: THEATER WORKS: *Tuppence Coloured* (1927); "weathervane dance" only.

Andréani, Jean-Paul, French ballet dancer; born 1929 in Rouen. Andréani was trained at the School of the Paris Opéra, graduating into the company in the mid-1940s. His studies with Gustave Ricaux and Serge Peritti prepared him for principal roles in the company's productions of the classics, among them Serge Lifar's *Romeo et Juliette* (1955) and Vladimir Bourmeister's *Swan Lake*. In his thirty years in the Opéra, Andréani was also applauded in the Opéra's contemporary repertory, especially in ballets by Serge Lifar, including his *Blanche-Neige* (1951) and *Grand Pas* (1953), and in the pieces that George Balanchine revived in the late 1950s, such as the *Gounod Symphony* and *Palais de Cristal*.

Andréani was the older brother of Xavier Andréani (1932–1954), also a member of the Opéra, who was tragically killed in a traffic accident on his way to a ballet engagement.

Andreyanova, Yelena Ivanovna, Russian nineteenth-century ballet dancer; born July 13, 1816 in St. Petersburg; died October 26, 1857 in Anteuil, France. Trained at the school of the Imperial Ballet in St. Petersburg, Andreyanova made her Maryinsky Theater debut in 1837.

During her short career, she performed at the Maryinsky, becoming the company's first "Giselle" in 1842, but also worked at the Paris Opéra, c.1845, and La Scala, c.1846. Her other featured roles included "the Abess" in Phillipe Taglioni's *Robert le Diable* and the leading female role in his *Salterello*.

Angiolini, Gasparo, Italian eighteenth-century ballet dancer and choreographer in Italy, Vienna, and Russia; born February 9, 1731, in Florence; died February 6 (7), 1803 in Milan. Trained by his father, Francesco, Angiolini performed in Venice at the Teatros San Moise (1747) and San Cassiano (1750), before moving to Vienna to work for Frantz Anton Hilverding. For the remainder of his career, Angiolini commuted between the traditional itinerancy of the Italian opera ballet choreographer and positions in Vienna and St. Petersburg inherited from Hilverding.

The latter portion of his career may prove to be more important historically since he, with predecessor Hilverding and successor Charles LePicq, introduced the innovations of the late eighteenth century—ballet d'action choreography and radicalized ballet technique—to Russia and maintained them in the popular and court theaters of Austro-Hungary.

The first, and most prolific, Vienna period lasted from 1757 to 1766; after succeeding Hilverding as ballet master in 1759, Angiolini staged many ballets and opera divertissements for the Burgtheater and Kärntnerthor, among them, *Don Juan* (1761), *Semiramide* (1765), and the original production of Whilhelm Christoph Gluck's *Orpheus e Eurydice* in 1762.

Angiolini's Russian career began in 1766 when he succeeded Hilverding as ballet master to the Imperial Theaters of St. Petersburg and, briefly, Moscow, serving also as choreographer for court festivals staged for the coronation of Catherine II. His tenures in St. Petersburg, 1766–1772, 1776–1779, and 1782–1786, enabled him to create a large repertory of works, among them *Préjugé vainen* (Prejudice Conquered) (1768), *L'Orphano della China* (1776), *Thésée et Ariadne* (1778), and two early works of European chinoiserie, *Les Chinoises en Europe* (1767) and *L'Orphano della China* (1776).

Between tenures in Russia and Austro-Hungary, Angiolini served as ballet master for opera theaters in the republics and kingdoms that then made up ununified Italy; he created works for the following: Teatro San Benedetto (Venice) from 1772, Teatro Reggio (Turino) from 1757, and Teatro alla Scala from 1773. Works created for La Scala included *Il Diablo a Quatro* (1782), *Il Suffi e lo Schiavo* (1782), and *Cupid e Psyche* (1789).

Angiolini was the cousin (or, possibly uncle) of choreographer Pietro Angiolini, who succeeded him as ballet master at La Scala. Gasparo's own son, also named Pietro, was an artist whose importance in the importation of European scene-painting techniques into the Russian theater is now being investigated.

Works Choreographed: CONCERT WORKS: *Ballo di Contadini* (1757); *Ballo di Nazioni Diversi* (1757); *Ballo de' Caratteri con Giuoco della Gatta Cieca* (1757); *Soldati e Vivandiere* (1757); *La Scoperta Dell' America da Christoforo Columbo* (1757); *La Départ d'Enée, ou Didone Abbandonaatée* (1760); *Don Juan* (1761); *Alessandro* (1762); *Flore et Zéphire* (1764); *Seriramide* (1765); *Les Chinoises en Europe* (1767); *Zabavy o sviatkakh* (1767); *Préjugé vainen* (Prejudice Conquered) (1768); *L'Amicizia alla Prova* (1782); *L'Arte Vinta dalla Natura (1773); La Caccia*

d'Enrico IV (1773); *Il Disertore Francese* (1773); *Il Sacrifice di Dircea* (1778); *L'Orphano della China* (1776); *Thésée et Ariadne* (1778); *Lo Scorrimento d'Achille* (1779); *La Morte di Cleopatre* (1780); *Attila* (1781); *Gli Scherzi* (1781); *Mascherata* (1781); *Lauretta* (1781); *Despina e Ricciardetto* (1781); *Il Castigo de' Bonzi* (1781); *Il Solimano Secondo* (1782); *Il Suffi e lo Schiava* (1782); *Il Trionfo d'Amore* (1782); *Tasso in Creta* (1782); *La Vendetta Spiritosa* (1782); *Il Diablo a Quatro* (1782); *Il Geni Riuniti* (1782); *Divertimento Campestre* (1788); *Cupid e Psyche* (1789); *Dorina e l'Uomo Selvatico* (1789); *La Nozze de' Sanniti* (1789); *Fedra* (1789); *Sargine* (1790); *Il Vincitori de' Giuochi Olimipici* (1790); *Il Tutore Sorpreso* (1790); *Alzira, ossia Gli Americani* (1791); *Tito, o la Parteza di Berenice* (1792).

OPERA: *Orpheus e Eurydice* (1762).

Angiolini, Giuseppina, Italian nineteenth-century ballet dancer; born c.1800, possibly in Milan; the details of Angiolini's death are not certain. Believed to have been the daughter of the choreographer Pietro Angiolini, she was trained at the school of the Teatro alla Scala in Milan. She appeared there in ballets by her father and by Domenico Rossi, c.1813 to 1820, but also danced at the theaters in Cremona, Sinigalia, the Teatro Reggio in Turin, and both the La Scala and Canobbiano in Milan in the 1810s and 1820s. After she was married to Antonio Cortesi, c.1824, she appeared as Guiseppina Angiolini-Cortesi at the Teatro Reggio as prima ballerina and as director of the ballet school attached to the theater. Although she performed in the works by many other choreographers, she remains best known for her work in the early ballets of Cortesi, among them, *Il Castello del Diavolo (1826), Don Chisciotte* (1827), and *Aladino* (1827).

Angiolini, Pietro, Italian eighteenth–nineteenth-century ballet dancer and choreographer; born 1746 in Florence; died 1830 in Milan. The nephew or cousin of Gasparo Angiolini, Pietro may have studied with him or with his own parents, also Italian performers. Although he may have made his debut earlier, perhaps in a northern European court theater, his earli-

est extant credits come from his association with choreographer Guiseppe Banti, with whom he performed in Sienna (from 1770) and in Florence (from 1776).

In the early 1780s, Angiolini performed with the ballet company of the Teatro San Benedetto in Venice, during which time he married Caroline Pitrot, a dancer with the company. They both went to London in 1785 (and, probably, in 1783) to work with Charles LePicq, a colleague of Gasparo Angiolini from Vienna and his successor in St. Petersburg.

Pietro Angiolini's first known tenure as ballet master was in the 1788 season at the Teatro Filodrammatica in Cremona. Within three seasons, he was established as a choreographer on the Lombardy-Piedmonte opera house circuit, working at Bologna (from 1789), Milan's Teatro alla Scala (regularly from 1790), Venice's Teatro la Fenice (from 1803), and the Teatro Reggio in Turino, after 1818. Although current research seems to prove that his major works were created for La Scala and then produced for the other opera houses, this cannot be verified. The works themselves seem to divide evenly between the two thematic categories of the Italian ballet d'action (as influenced, through Gasparo Angiolini or Charles LePicq, by Frantz Anton Hilverding)— romantic pastorales or massive stagings of incidents from Roman or local Italian history, such as *Castor e Pollux* (1788) and *Il Triomfo di Vitallio Massimino e la Distruzione di Pompejano* (1803). Angiolini also seems to have been influenced by the early nineteenth-century revival of interest in the Crusades and Europe's relationship with Arabia; his works include *Rinaldo ed Armida* (1790) and *Haroun-al-Raschid* (1823).

Works Choreographed: *Castor e Pollux* (1788); *Le Donne mal Accorte, ossia l'Avvendutezza Ricompensata* (1788); *Il Disprezzo Vendicato dal Disprezzo* (1789); *Argent Fait Tout* (1790); *Rinaldo ed Armida* (1790); *Le Morte d'Attila* (1803); *Il Trionfo di Vitellio Massimino e la Distruzione di Pompejano* (1803); *Upsaldo e Valwane* (1806); *Ercole ed Acheloo* (1807); *Achille in Sciro* (1808); *Ippolito ed Asseli, ossia la sposo Fedele* (1811); *Igor ed Olga* (1811); *l'Amore Fuor di Stagione* (1816); *Emma ed Iglido* (1816); *Almaric ed Elisene* (1817); *Abenhabet, ossia l'Eroe di Granata* (1818); *Lubin e Lilla* (1818); *Timur-Kan* (1820); *Haroun-al-Raschid* (1823); *La Fedelta Combattuta* (1826).

Anisimova, Nina, Soviet ballet dancer and choreographer; born January 27, 1909 in St. Petersburg. Trained at the Leningrad Choreographic Institute, by Agrippina Vaganova, she performed with GATOB in Vassili Vainonen's *Flames of Paris,* c.1932.

Anisimova began to choreograph in the late 1930s, creating works for the theaters in Perm, Ufa, and the Leningrad Maly. In 1964, she was invited to Copenhagen to stage a production of *Swan Lake* but her works have not in general been seen in the West.

Works Choreographed: CONCERT WORKS: *Les Noces Andaleuse* (1936); *Gayane* (1942); *Song of the Crane* (1944, with Safiullin); *Schéhérézade* (1950); *Ivushka* (1957).

Annabelle, American theatrical performer, considered the first featured dancer in films; born Annabelle Whitford Moore, July 6, 1878 in Chicago, Illinois; died there December 1, 1961. The step-daughter of the manager of vaudeville houses in Philadelphia and the Midwest, she made her professional debut as a skirt dancer on point at the Chicago Columbian Exposition of 1893, billed as "The Peerless Annabelle." She appeared in the Fairy Ballet sequences of those productions which form the transitions among spectacles, English pantomime, and musical comedy in the 1890s and early 1900s, among them *The Beauty and the Beast* (1901) and *Mr. Bluebeard.* She was dancing in the latter as "Stella, Queen of the Fairies" during the 1903 Iroquois Theatre fire in Chicago. She also appeared in Olga Nethersole's company as a soubrette and worked as a specialty ballet dancer on roof gardens, c.1897 to 1903.

Annabelle appeared in the chorus of the first three Ziegfeld *Follies*, becoming known for her personifications of the iconographies of contemporary illustrators—she was known as the "Nell Brinkley Girl" and as "The [Charles Dana] Gibson Girl." Her last known theatrical performance was in the 1912 production, *The Charity Girl.*

Her dance specialties were preserved in almost a dozen short films for the Edison Company between 1894 and 1900. They included her *Butterfly, Fire, Serpentine, Skirt,* and *Sun Dances.* Although she was

not the first person to dance on film—by almost thirty years—she was one of the first to be billed as a featured dancer. She was best remembered, however, for her theatrical career, and on her eightieth birthday was fêted by the newspapers of her native Chicago as a great American performer.

Ann-Margaret, Swedish-born American film and television dancer and actress; born Anna Olsen, April 28, 1941 in Stockholm. She was raised in Wilmette, Illinois, where she studied dance and music. Engaged to dance in Las Vegas, she performed frequently on television and in clubs before making her screen debut in *State Fair* (Twentieth-Century Fox, 1962).

Best known now as an actress, she became famous for her song and dance performed on a treadmill at the beginning and end of *Bye Bye Birdie* (Columbia, 1962), also dancing in the nightclub scene of that film. Other related credits included her next film, *Viva Las Vegas* (MGM, 1964), Vegas engagements, and television appearances on variety shows, notably Jack Benny and Bob Hope specials on NBC, the filmed version of *Dames at Sea* (NBC, 1971, special), and her own variety shows, most recently *Rockette: A Holiday Tribute to the Radio City Music Hall* (NBC, 1978) and *Hollywood Movie Girls* (ABC, 1980).

Ansermet, Ernest, Swiss conductor associated with the Diaghilev Ballet Russe; born November 11, 1883 in Vevey; died February 20, 1969 in Geneva. A student of Ernest Bloch, among other composer/teachers, he conducted in Switzerland before being engaged by Serge Diaghilev as principal conductor for the Ballet Russe company. He toured extensively with the company from 1915 to 1923, working principally with pick-up orchestras in Western Europe and North and South America. Ansermet also conducted on the United States and Canada tour of the Ballet Russe that was directed by Valslav Nijinsky and is believed to have been responsible for the hiring of Flore Revalles as the troupe's mime for that season. Among the many scores that he conducted for Diaghilev and Nijinsky were the premieres of Igor Stravinsky's *L'Histoire du Soldat* (1918), *Chant du Rossignol* (1920), *Pulcinella* (1920), *Renard* (1922), and *Les Noces* (1923), and Serge Prokofiev's *Chout* (1923); other ballets that he conducted frequently were *Les Sylphides*, Richard Strauss' *Till Eulenspiegel* (for the American tour), and *Schéhérézade*. Ansermet is also celebrated as a promoter of the music of Stravinsky with his own L'Orchestre de la Suisse Romande, founded in 1918.

Antheil, George, American composer; born July 8, 1900 in Trenton, New Jersey. Antheil trained at the Sternborg Conservatory and with Ernest Bloch. His first dance-related work was his score for the *Ballet Méchanique* (1925) for a collaboration with Fernand Leger. Other dance scores include *Fighting the Waves* (1929), which may never have been choreographed, *Songes* (Dreams) for George Balanchine (1935), and the bull-fighting dramatic ballet by Eugene Loring, *Capital of the World* (1953, premiered as a television production). Antheil is also known for his jazz-derived symphonic works and for his film scores, most notably for the controlled schmaltz of *Make Way for Tomorrow.*

Anthony, Mary, American modern dancer and choreographer; born c.1920 in Newport, Kentucky. Moving to New York in the early 1940s, she became a student of Hanya Holm; she later served as her assistant and danced in her *Orestes and the Furies* (1943). Anthony also studied with Martha Graham at her New York studio and with Louis Horst.

Anthony taught from the early 1950s, becoming one of the most acclaimed teachers of composition in the dance world. She danced infrequently but did perform for John Butler in his *Three Promenades with the Lord* and *Frontier Ballad* (both 1955). During the 1950s she began to choreograph for her own company in New York and for the commercial theater in Rome, where she staged *Voltare pro Venere* (1950), *Passa d'Oppo* (1955), and a long-running television variety show. The construction of her works is their most cogent element, proving her theories on formal composition. Her pieces are frequently dramatic and tend to involve universal characters rather than specific individuals.

Works Choreographed: CONCERT WORKS: *Chaconne* (1949, co-choreographed with Joseph Gifford); *Genesis* (1949); *Giga* (1949); *Songs* (1956); *Threnody* (1956); *The Purification* (or *Ritual of Puri-*

fication) (1957); *Blood Wedding* (1958); *The Catbird Seat* (1958); *At the Hawk's Well* (1963); *Gloria* (1967); *Antiphon* (1968); *In the Beginning: Adam* (1969); *In the Beginning: Adam and Eve* (1970); *A Ceremony of Carols* (1971); *Cain and Abel* (1971); *Seascape* (1975); *Tryptich* (c.1979); *Lady of the Sea* (1980).

THEATER WORKS: (all productions in Italy) *Voltare pro Venere* (1950); *Barbanera* (1953); *Passa d'Oppo* (1955).

TELEVISION: *Canzonissima* (RAI, 1960–1962).

Antonio, Spanish concert dancer; born Antonio Ruiz Solar, November 4, 1921 in Seville. Trained from the age of five by Manuel Real, called Realito, he made his debut at age eight with his cousin, Rosario, in the act "Los Charalillas Sevillanos." They toured together from 1929, when they really were little kids from Seville, to 1953, performing regular seasons in England, France, North and South America, and Spain. In the United States, they appeared in MGM's *Ziegfeld Girl* (1941), in the Judy Garland Mexican specialty number in *Hollywood Canteen* (1944), and in *Pan-Americana* (1945).

Splitting from Rosario in 1953, Antonio formed his own company under the sponsorship of Sol Hurok. He toured Western Europe and the Americas for a decade, with seasonal bookings for his "electrifying Spanish ballet" and guest appearances for himself that included performances of Leonid Massine's *Le Tricorne* and *Capriccio Espagñol* with the Teatro alla Scala in 1953.

He filmed the latter for Spanish television in 1974. Since he was reportedly jailed for blasphemy in that year, a particularly fanatical one late in the Franco regime, it is not known whether the show was ever broadcast.

Antonio's choreography credits date from his solo career after 1953. Since the titles of works have been verified, but specific dates for them cannot be checked, they are listed by season.

Works Choreographed: CONCERT WORKS: *Zapateado* (1946); *The Disdainful Segovian, Allegro de Concerto, Cana, Andeluza, Sorongo Gitano, Homage a Manual de Falla, Farruca, Sequidillas, Fandagos de Huelva* (c.1950–1953); *Serranad de Vejer* (1953); *Viva Navarra* (1954); *Sortilegio de los Collares* (1954); *El Mirabra, Spanish Sonata, Anda Ja-*

leo, Verdiales, Sacromonte, Por Soleares, Fandango por Verdeales, Seguiryras Gitana (c.1955); *Fantasia Galicia, La Taberna del Toro* (1956); *Triana* (1956); *Le Tricorne* (1956); *Paso a Cuatro, Jugando al Toro* (1960); *Variations on a Spanish Rhapsody* (1960); *La Noce de Luis Alonso, Romeo, Retablo Castellano, Suite of Sonatas, Estampa Flamenco* (1968).

THEATER WORKS: *Billy Rose's Concert Varieties of 1945* (Caprice Espagñol, Dansa Ritual del Fuego, Canasteros di Triana) (1945).

Antonio, Juan, Mexican modern dancer and choreographer working in the United States; born May 2 in the mid-1940s in Mexico City. Trained locally at the school of the Instituto de Bellas Artes and of the Ballet Folklorico de Mexico, he moved to New York in the mid-1960s. He spent a busy year dancing in the concert companies of Anna Sokolow, Pearl Lang, Gloria Contreras, José Limón, Carmen de Lavalade, whom he partnered in Alvin Ailey's *Reflections in D*, and Glen Tetley, for whom he danced in *Ziggurat, Mythical Hunters,* and *Embrace Tiger, Return to Mountain.*

In 1967, he became a member of the newly formed Louis Falco Company, remaining with Falco to the present as associate director. Among the many works in which he created roles are Falco's *Timewright* (1969), *Caviar* (1970), *Ibid* (1971), *Soap Opera* (1972), *Avenue* (1973), *Storeroom* (1974), and Jennifer Muller's *Rust-Giacometti Sculpture Garden* (1971) and *Tub* (1973). He has worked with Falco restaging productions for other companies and assisted Julie Arenal on her choreography for the Broadway play, *Indians* (1969).

Most of Antonio's choreography has been created for the Falco troupe, although he staged *Exchange* (1973) for the Dance Circle of Boston, *Memorias* (1979) for the Ballet Nacional de España, and works for student companies in Philadelphia and New York. He has done Mexican-derived pieces, among them *Day of the Dead* (1971), *Memorias*, and the television work *Latin Dance in New York* (1978), but also creates abstractions on contemporary relationships.

Works Choreographed: CONCERT WORKS: *Huescape* (1968); *Day of the Dead* (1971, in collaboration with Erin Martin); *One Day Wonder* (1972); *Exchange* (1973); *First Base* (1974); *I Remember* (1975);

B-Mine (1976); *Tric-Trac* (1977); *Coasting* (1978); *Image* (1979); *Memorias* (1979); *Tournament* (1980).

TELEVISION: *Latin Dance in New York* (German unidentified television network, 1978, special).

Apinée, Irena. Latvian ballet dancer working in Canada; born c.1930 in Riga. Apinée emigrated to Canada in the early 1950s after early training at the school of the Riga Opera Ballet. She performed with the National Ballet of Canada from 1954, appearing in the company's productions of *The Nutcracker, Les Sylphides,* and other classics. In 1956, she switched to the Chiriaeff company, Les Grands Ballet Canadiens where she danced in the works of Ludmilla Chiriaeff and Nicholas Zverev. With her partner, Jury Gotchalk, she spent a season with the American Ballet Theatre in New York, dancing in George Balanchine's *Theme and Variations* and the company's *Coppélia.* They also appeared at the Radio City Music Hall in that season, and returned frequently for guest shots in the mid-1960s. They both worked with the short-lived Montreal Ballet but returned to Les Grands Ballets Canadiens after its demise. Apinée's strength and precision and the humor that she brought to characterizations made her valuable to all of the companies with which she worked.

Appel, Peter, Dutch ballet dancer and choreographer; born September 8, 1933 in Surabaya, Java. Trained at the Kennemer Studio in Haarlem and by Olga Preobrajenska, he joined the Netherlands Ballet in 1953. Among his roles in that company were "Cassio" in Serge Lifar's *The Moor of Venice,* and principal parts in Leonid Massine's *Les Présages,* George Balanchine's *The Four Temperaments,* and Sonia Gaskell's *Rhythms.* After dancing in Gaskell's Dutch National Ballet, the London Festival Ballet, and the Basel Opera Ballet, with which he performed in Orlikowsky's *Swan Lake* in 1963, he became ballet master of the Hamburg State Opera Ballet. He then served as director of the ballet at the Cologne Opera, c.1969 to 1971 and director of the Cologne Institute for Stage Dancing before returning to Hamburg in 1972.

Appleyard, Beatrice, English ballet dancer; born 1918 in Maidenhead, England. Trained by Ninette De Valois, Tamara Karsavana, and Bronislava Nijinska, she performed in two Ashton theater works, *Pomona* and *High Yellow,* before becoming a charter member of the Vic-Wells Ballet. There, she danced in many new works by De Valois and Frederick Ashton, including his *The Lord of Burleigh* (1931) and *Les Rendezvous* (1933) and her *The Haunted Ballroom* (1934), *Danses Sacrées et Profanes, The Scorpions of Ysit* (1932), and *Casse Noisette.*

She taught in London and in Ankara, Turkey after 1951.

Works Choreographed: CONCERT WORKS: *The Sleeping Beauty* (1950); *Fête Champêtre* (1954).

Araiz, Oscar, Argentinean ballet dancer and choreographer; born December 1940 in Bahia Blanca, Argentina. Araiz began his dance studies late, at the age of sixteen. This training came in modern dance, with Dore Hoyer (Wigman technique) and Renate Schottelius (Limón technique), and in ballet at the school of El Teatro Argentino in La Plata. Araiz made his professional debut as a dancer in the 1958 season of El Teatro Argentino.

In 1963, Araiz founded his own company, The Oscar Araiz Dancers, in Buenos Aires; this troupe was reorganized as El Ballet de Hoy in 1965. Araiz' early choreography for them included *El Canto de Orfeo* (1964) and *Ebony Concerto* (1965). In 1968, his company was incorporated into El Teatro Municipale San Martin, and Araiz was named artistic director of the new ballet company, 1968 to 1975. During this time he choreographed and performed in many works, among them, *Esceñas* (1964), *Coloquois* (1971), and *Adagietto* (1971). He began work on his cycle of works by Gustave Mahler that included the *Adagietto, Lieder* (1975), and two works created for other companies, *Mahler 4: "Eternity Is Now"* (Royal Winnipeg Ballet, 1976) and *Song of the Wayfarer* (Paris Opéra, 1977).

In 1974, Araiz became choreographer-in-residence of the Royal Winnipeg Ballet; this company revived many of his South American works, including *Esceñas* and *Adagietto,* and commissioned *Mahler 4.* Araiz's works have also been revived by many European companies, among them, the Paris Opéra, the Hamburg and Munich State Opera Ballet Companies, and the Royal Swedish Ballet. The City Center

Joffrey Ballet in New York, revived his *Romeo y Julia* in 1977 and premiered his *Heptagon* in 1978.

Works Choreographed: CONCERT WORKS: *Ritos* (1963); *El Canto de Orfeo* (1964); *La Gorgona y La Manticora* (1964); *Esceñas* (1964); *La Pazzoa Senile* (1965); *Ebony Concerto* (1965); *Le Sacre du Printemps* (1966); *Sinfonia India* (1967); *The Miraculous Mandarin* (1967); *Deserts* (1967); *Sinfonia* (1968); *Magnificat 1969* (1969); *Romeo y Julia* (1970); *In Gaddo da Vida* (1970); *Love Affair* (1971); *Coloquios* (1971); *Cantabile a Duo* (1971); *Adagietto* (1971); *Halo* (1975); *Lieder* (1975); *Mahler 4: "Eternity Is Now"* (1976); *Songs of a Wayfarer* (1977); *Heptagon* (1978).

Arbatova, Mia, Latvian ballet dancer of importance to the development of ballet in Israel; born c.1910. Raised in Riga, she was trained at the school of the Opera Ballet and continued her studies in Paris with Olga Preobrajenska. An opera ballet tour led her to Palestine in 1934, but after she returned to Riga, she was forced to go to London where she joined the Ballet Russe de Monte Carlo, and New York, where she danced with the Mikhail Mordkin Ballet, before receiving a travel permit. When she settled in Palestine in 1938, she taught ballet at Gertrude Krauss' studio and worked with the opera. Her involvement with the Hagana in the late 1940s led her into political cabaret work in Tel Aviv and performances with the Habimah Theatre.

Arbatova's persistence in teaching ballet in Israel finally developed into her participation in the formation of the Israel Classical Ballet in 1968.

Arbeau, Thoinot, French sixteenth-century priest and writer on dance; born Jehan Tabouret, c.March 17, 1519 or 1520 in Dijon; died July 29, 1595 in Langres. Arbeau was trained in ecclesiastical law in Paris before becoming attached to the Cathedral of St. Mammès in Langres. At the time that his dance manual, *Orchésographie*, was published in 1589, he was the vicar-general of the Langres bishopric. The work was written as a Socratic dialogue, then considered the correct form for teaching law, the arts, and ecclesiastic knowledge. Arbeau taught dance steps, music, and forms to "his former student, Capriol," while preaching on social, moral, and physical functions of the art form. The importance of the work lies in its inclusion of both popular and court dances and in the simplicity of its technical instructions. It is indeed possible to learn an Allemande, a Branle, or a Gavotte from the manual.

The *Orchesography* is currently available in two translations. The Cyril W. Beaumont edition of 1925, with musical notation translated into the contemporary system, was reprinted in 1965 by Dance Horizons, Brooklyn, New York. The 1948 translation by Mary Stewart Evans was reprinted by Dover Books in 1967 with additional notes by Julia Sutton and a set of dance instructions in Labanotation by Sutton and Mireille Backer.

Archibald, William, Trinidanian modern dancer and playwright working in the United States; born 1919 in Trinidad, British West Indies; died December 27, 1970 in New York City. A member of a literary family, Archibald was trained in botany in Trinidad before moving to New York in 1937 to study with Doris Humphrey and Charles Weidman. As a Humphrey/Weidman dancer from 1937 to 1941, he participated in the first years of the Bennington School of Dance and created roles in her *Passacaglia and Fugue in C Minor* (1938) and his *Opus 51* (1938) and *On My Mother's Side* (1940), among other works.

Archibald had a successful career as a theatrical dancer concurrent with his modern one and appeared in *One for the Money* (1939), *Two for the Show* (1940), *All in Fun* (1940), *Laffing Room Only* (1944), and *Billy Rose's Concert Varieties* (1945). Although none of his shows was staged by Weidman, he frequently appeared with fellow Humphrey/Weidman dancers, among them Nadine Gae in the first two revues, and Beatrice Seckler, with whom he had a successful Roxy Theatre engagement. His other Broadway show was a result of his summers at the Tamiment Camp. In the *New Faces of 1942,* he first performed a part to which he would return occasionally throughout his career, creating the title role in Imogene Coca's liberated version of the *Afternoon of the Faun.* Even after he became known as an author, he danced it with her on *Your Show of Shows* (NBC, 1950, episode).

He had previously written short stories before his first Broadway authorship credit was received for

Carib Song (1945), a musical for the Katherine Dunham Dancers. The best remembered of his many credits were both suspense thrillers—the play *The Innocents* (1950), based on Henry James' *The Turn of the Screw,* and the Hitchcock film, *I Confess.*

Arden, Donn, American nightclub and extravaganza dance director known as "Mr. Extravaganza"; born c.1919 in St. Louis, Missouri. Arden studied dance with Robert Alton before that choreographer left St. Louis for New York and Hollywood. As an adolescent, he won second prize in a Charleston competition, losing to Ginger Rogers, and moved to Los Angeles, where he was trained at the Fanchon and Marco-sponsored studio. He was a featured dancer at the Lookout House cabaret in Cincinnati, when he began staging acts for dancers at age eighteen.

Arden worked in the Midwest and in armed services musicals until 1948 when he was invited to stage revues at the Lido in Paris. He remained there until 1966, creating successful extravaganzas employing elaborate scenic effects, lavish decorations, and practically naked show girls moving up and down his signature staircase systems. He created similar shows, although with "a family feeling," for the Desert Inn in Las Vegas, Nevada, after 1950, becoming a staff choreographer there in 1966 with *Hello, America!* which showed the San Francisco earthquake, the sinking of the Titanic, and the explosion of the Hindenburg. His other American assignments include the Latin Quarter cabaret in New York in the early 1960s, the 1943, 1968, and 1969 *Holiday on Ice* shows, and the shows at the ill-fated MGM Grand Hotel in Las Vegas, where he staged the extremely popular *Hallelujah Hollywood* (1978–1981).

Works Choreographed: THEATER WORKS: *Revues at the Lido* (Paris, 1948–1966); revues for the Desert Inn (1950, 1959, 1966, 1974); revues for the Latin Quarter (1962–1964); *Hallelujah Hollywood!* (1978–1981); *Holiday on Ice* (1943, 1968, 1969).

Arenal, Julie, American modern dancer and theatrical choreographer; born 1942 in New York City. Trained at Bennington College and the American Dance Festival summer school, Arenal studied with and worked for Anna Sokolow for many years. She served as her assistant for the first seasons of the famed Lincoln Center Repertory Theatre in the mid-1960s, and at the Juilliard School. Arnal also appeared in works by Sophie Maslow, in concert, and at the annual Festival of Lights, in works by John Butler, José Limón, and Kazuko Hirabayashi.

In 1968, she became the choreographer of the season's most successful Broadway musical, *Hair,* which Sokolow had staged in its original Public Theatre production. For the next few years, she staged productions of the show in Los Angeles, San Francisco, London, Yugoslavia, and Stockholm, as well as the many national and road companies traveling around the United States. Her later Broadway credits include *Indians* (1970), which many considered one of the best movement pieces to hit New York, and Richard Peaslee's *Boccacio* (1975); she staged *Hair* composer Galt MacDermot's *Isabel's a Jezebel* (1970) in London, and a new production of *Funny Girl* in Tokyo (1980). Arenal has remained most active Off Broadway, working on Tom Eyen's *2008 ½* at the Truck and Warehouse Theatre in 1974 and staging dances and movement for many New York Spanish-language companies, notably, *I Took Panama* for the Puerto Rican Traveling Theatre (1977), and *The Sun Always Shines for the Cool* for The Family (1979). Her films have included *King of the Gypsies* (Paramount, 1978) and *Soup for One* (WB, 1981).

Between theater projects, Arenal has worked occasionally in the concert field throughout the 1970s. She has contributed two pieces to the Ballet Hispanico de Nueva New York, *Fiesta* (1972) and *A Puerto Rican Soap Opera* (1973), and works for the San Francisco Ballet, and the Ballet Nacional de Cuba (1978). She teaches dance and movement for actors at the H/B Studio and the Puerto Rican Traveling Theatre.

Works Choreographed: CONCERT WORKS: *Fiesta* (1972); *A Puerto Rican Soap Opera* (1973); *A Private Circus* (1975); *An Afternoon of Music and Dance* (1976); *The Referee* (1977); *El Arbito* (1978).

OPERA: *La Novela* (1975).

THEATER WORKS: *This Side of Paradise* (1962); *Hair* (1968, also productions abroad and in the United States to 1973); *Indians* (1970); *Isabel's a Jezebel* (London, 1970); *Siamese Connection* (1971); *Gun Play* (1971); *Hunger and Thirst* (1972); *Butter-*

finger's Angel (1974); 2008 ½ (1974); Boccacio (1975); I Took Panama (1977); The Sun Always Shines for the Cool (1979); Funny Girl (Tokyo, 1980).

FILM: King of the Gypsies (De Laurentiis/Paramount, 1978); Four Friends (Filmways Pictures, Inc., released 1981); Soup for One (WB, released 1981).

TELEVISION: Gypsy Fever (ABC, 1978, special).

La Argentina, Argentinian dancer specializing in Spanish classical and folk dances; born Antonia Mercé, September 4, 1888 in Buenos Aires; died July 20, 1936 in Bayonne, France. Trained originally in Ballet technique by her parents who, after 1890, were attached to the Teatro Royal in Madrid. Prima ballerina of the Madrid Opera House from 1902 to 1908, she left pure ballet to study and perform Spanish classical and folk dance. Known for her work with castanets, she became world famous as the principal Spanish dancer of her time. She toured constantly, performing in Europe, the United States, South America, and the Orient. From her New York premiere in 1917, she made biannual trips to the continent.

Much of her choreography credits date from 1927 to her death in 1936, but it is not certain whether she performed someone else's works before then, or simply did not receive her due credits.

Works Choreographed: CONCERT WORKS: El Amor Brujo (1926); Bolero (1927); Juerga (c.1929); La Vide Breve (c.1929); La Corrida (c.1929); Goyescas (c.1929); Danzas No. 5 (c.1929); La Garerana (c.1929); La Gitana (c.1929); Andalusian Serenade (1930); Au Temps de Velasquez (c.1931); Madrid 1890; (1934); Alegrias Solera (1934); Zapatadeo (1934); Sacro Monte (1934); Polo Gitano (1935); Suite of Dances from the Argentine (1935); Suite of Andalusian Dances (1935); El Amor Brujo (II) (1936).

La Argentinita, Argentinian specialist in Spanish dance forms; born March 3, 1895 in Buenos Aires; died September 24, 1945 in New York City. Unlike La Argentina, La Argentinita did not have a classical ballet background. She received her training in Span-ish dance from gypsies, in whose folk styles she specialized. With a reputation in Spain for her performances in bulerias, alegarias, and cuadros flamenco, she was invited to New York to appear in the International Revue of 1930. After this unsuccessful presentation, she returned to Spain to collaborate with Federico Garcia-Lorca on the Madrid Ballet and his chamber productions. She choreographed works for herself in concert throughout the 1930s until the outbreak of the Spanish Civil War, when, after Garcia-Lorca's execution, she emigrated to the United States. Known originally for her performances in the many New York benefit dance concerts for Spanish Civil War refugees and victims, she worked as a concert dancer and in conjunction with ballet and theatrical productions until her death in 1945. Among her better received projects were a performance with Leonid Massine of his Le Tricorne for Ballet Theatre in 1942, a collaboration with him on Capriccio Espagñol (1939), and many tours and recitals with José Greco and guitarist Carlos Montoya under Sol Hurok's sponsorship.

Works Choreographed: CONCERT WORKS: El Amor Brujo (1933); Les Rues de Cadiz (1935); Vedowa Scaltra (c.1936); La Romería de los Cornudos (c.1936); Mazurka of 1890 (c.1937); Café de Chintas (c.1937); Goyecas (c.1939); Capriccio Espagñol (1939, co-choreographed with Leonid Massine); El Huyano (c.1939); Jote de Alcaniz (c.1939); L'Espagnolade (1940); Tacita de Plata (1940); La Vernbena de la Paloma (1940); Segovianos (1940); Zapateado (1940); Bolero (1940); The Dance of Luis Alonso (1940); Pictures of Goya (1943, co-choreographed with Pilar Lopez).

Argyle, Pearl, South African ballet dancer who worked in London; born Pearl Wellman, November 7, 1910 in Johannesburg, South Africa; died January 29, 1947 in New York City. Trained by Marie Rambert, she made her professional debut with the Rambert Dancers (later Ballet) in 1926, with featured roles in Fokine's Les Sylphides and Carnaval, and Susan Salaman's Le Rugby.

With the Ballet Club after 1927, she created roles in the early works of the developers of the English ballets—Frederick Ashton, Ninette De Valois, An-

drée Howard, and Antony Tudor. She performed in the premieres of Ashton's *Capriol Suite* (1930), *A Florentine Picture* (1930), *La Péri* (1931), *Façade* (1931), *The Lady of Shalott* (1931), *The Lord of Burleigh* (1931), *Les Masques* (1933), *Valentine's Eve* (1935), *Le Baiser de la Fée* (1935), and *Siesta* (1936). For Antony Tudor, she danced in *Atalanta of the East* (1933), *The Planets* (1934), and *The Descent of Hebe* (1935); Ninette De Valois cast her in her *Bar aux Folies Bergère* (1934), while Andrée Howard chose her for parts in *Cinderella* (1935) and *Mermaid* (1935). In this prolific period, she also danced in George Balanchine's works in the London season of Ballets '33.

Argyle performed in the West End in Charles B. Cochran's *Ballyhoo* of 1933 and *Midnight Cabaret* of 1934. Discovered by London Films, she was cast in the lead of *That Night in London* (1935).

Ari, Carina, Swedish ballet dancer; born April 14, 1897 in Stockholm; died December 24, 1970 in Buenos Aires, Argentina. Trained at the school of the Royal Swedish Ballet, she continued her studies in Copenhagen under Mikhail Fokine. Ari is best known for her performances with the Ballets Suedois, through the lifespan of that innovative company. She appeared in most of the repertory of ballets by Jean Borlin, among them his *Dangsille, Danse pour les Ciseaux, and Les Maries de la Tour Eiffel.*

As choreographer for the Opéra Comique in Paris, she created her own ballets, such as *Sous-Marine* (1925) and *Les Valses de Brahms* (1933), and danced in works by Serge Lifar. She lived in South America in the latter years of her life but maintained connections with Swedish dance through a series of scholarships and awards.

Works Choreographed: CONCERT WORKS: (It is very unfortunate that we have been unable to verify a more complete listing of Ari's works.) *Sous-Marine* (1925); *Les Valse de Brahms* (1933).

Armitage, Karole, American postmodern dancer and choreographer; born Madison, Wisconsin. After early studies at the North Carolina School of the Arts, Armitage continued her training under Bill Evans at the University of Utah and with Viola Far-ber at the Merce Cunningham studio in New York City. She performed with the Geneva Opera Ballet in the 1973–1974 season, but returned to New York to join the Cunningham company in 1975. Among the many works in which she performed in her five years with the troupe were revivals of his *Summerspace* and *Winterbranch,* his continuing series of *Events,* and his new repertory works, *Rebus* (1976), *Travelogue* (1977), *Torse* (1976), and *Signals* (1976). She began to present concerts of her own choreography while in the Cunningham troupe. Her works have been extremely well received in New York performances and cited for their imaginative uses of props to define both place and attitude, and for their ingenious systems of movement and structures.

Works Choreographed: CONCERT WORKS: *Do We Could* (1979); *Objectstacle* (1980); *The The* (1980).

Armitage, Merle, American dance publicist and concert manager; born 1893 in Mason City, Iowa. Trained as an engineer, Armitage wrote and worked as a book designer before becoming a concert and tour manager in the Los Angeles area. He directed public and press relations for the Diaghilev Ballet Russe, writing most of the pun-filled *Ballet Russe Courier,* and performed the same functions on the Anna Pavlova tours to the West Coast. In the 1930s, he sponsored performances of the Ballet Caravan and the Martha Graham Dance Company (both of which were managed by Francis Hawkins); he seems to have been connected to the Hurok tour route, although he was not himself a booking agent.

Armitage's books on dance-related subjects include *Martha Graham* (1937), *Accent on Life* (c.1971), and *Dance Memoranda* (1947)—all self-designed and published. Although for many years all of his works were out of print, Da Capo recently republished his *Martha Graham* in paperback.

Armour, Thomas, American ballet dancer and teacher; born March 7, 1909 in Tarpon Springs, Florida. After local training with his mother, Ines Noel Armour, he accompanied her to Paris where he continued his studies with Olga Preobrajenska and Lubov Egorova. He appeared with three Russian ballets in Paris, of Ida Rubinstein, Bronislava Nijinska, and

Leon Woizikowsky, before returning to the United States in 1939. A member of the Ballet Russe de Monte Carlo until leaving for military service, he performed in Frederick Ashton's *Le Diable s'Amuse,* George Balanchine's *Jeu de Cartes,* and Leonid Massine's *Vienna—1814, Rouge et Noir,* and *Nobilissima Visione,* as "The Beggar."

He was unable to continue his performance career after demobilization and for many years dropped out of dance completely. In 1951, however, he became principal teacher and artistic director of the Miami Civic Ballet (now Miami Ballet) and the Miami Conservatory. A popular instructor in his own classes and in regional ballet festivals, his students include Ted Kivett, and Patricia and Coleen Neary.

Armour, Toby, American postmodern dancer and choreographer; born September 27, 1936 in New York City. Trained at the Martha Graham school and the Merce Cunningham studio, she studied and performed with James Waring in his Living Theater workshops. She took his works, among them, *Moonlight Sonata* (1974), *Intrada,* and *Phrases,* to Paris as a solo recital, while studying ballet with Lubov Egorova. Her performance credits include Remy Charlip's *Clearing* (1967) and *Frames of Reference* (1969), and John Herbert McDowell's *Dance in Two Rows (Version III)* (1970).

Armour has choreographed since the early 1960s, creating dances for the Judson Dance Theater performances, for her solo concerts, for cooperative recitals such as the Dancing Ladies concert of 1972, and for her company in Boston, The New England Dinosaur. She maintains some of the Waring repertory in the Dinosaur concerts, and helped to organize the Judson Memorial for him. She has recently returned to solo concerts, dancing in Aileen Passloff's *Variations on an Original Theme* and her own *Bagatelles* and *Epilogue for an Endless Dance* in a 1979 piano recital.

Works Choreographed: CONCERT WORKS: *Solo* (1962); *Godmother* (1962); *Last News of a Morning Cruise* (1963); *Group Work* (1964); *The Three-Cornered Whale* (1964); *Solo* (1965); *Duet* (1965); *Tango Family* (1965); *Fragments of a Minor Murder* (1966); *Largo* (1967); *Runway* (1967); *Reveries of a Solitary Walker* (1967); *Relámpago* (1967); *Props* (1968);

Quartet (1968); *Anti-Matter* (1968); *Visions at the Death of Alexander* (1968); *Pastorale* (1969); *Brick Layers* (1970); *Abalone Co.* (1970); *Interlope* (1970); *Ethnic Dance* (1971); *Holiday Time at Stanley Brown's* (1971); *Ruby Turnpike* (1971); *Solo* (A Time for Silence and Watching) (1971); *Dinosaur Love* (1972); *Social Dancing* (1972); *Heads* (1973); *Elliptic Spring* (1973); *Where the Wild Things Are* (1973); *Black Breakfast* (1974); *Heads cont.* (1974); *Adagio* (1975); *Walrus and Carpenter* (1975); *Moongarden* (1975); *Owl and Pussycat* (1975); *Genesis* (1975); *Fragments of Garden* (1975); *Overture* (1976); *Bogue March* (1976); *Window Nocturnes* (1976); *Romantic and Animal Meditations* (1976); *Hup* (1977); *Mayday* (1977); *Ark* (1978); *March* (1978); *E.U.S.* (1979); *Bagatelles* (1979); *Epilogue for an Endless Dance* (1979); *Oum Khalsoum* (1980); *Oompah* (1980).

Arnold, Becky, American postmodern dancer and choreographer; born September 21, 1936 in Blossten, Indiana. Trained originally by Bernice Peterson, an early Hanya Holm dancer, Arnold studied at Eugene Loring's American School of Dance, taking classes in modern dance and jazz. Moving to New York in the early 1960s, she performed for Helen Tamiris, dancing in her *Women's Song* and *Memoirs* (both 1960) and *Arrows of Desire* (1963), and studying with her and with Daniel Nagrin.

Arnold performed in the premiere of Yvonne Rainer's *Continuous Project Altered Daily,* the 1966 work which is considered the touchstone of the postmodern dance movement. A founding member of The Grand Union, she performed with that improvisational company for two years.

Now living in the Boston area, Arnold choreographs for her own company, but has also contributed a work to the Ballet for Cambridge company. One work, *Solo Dance and Film* (1977), included her own choreography for solo performance, her film work and a rare performance of Rainer's *Trio A.*

Works Choreographed: CONCERT WORKS: *Motor Dance* (1975); *Bonaja Transit* (1976); *Solo Dance and Film* (1977); *Dancing Fats* (1978); *Encounters* (1980).

Arnold, Bené, American ballet dancer; born 1953 in Big Springs, Texas. Arnold's career has been connected in many ways with the development of dance

in the West by the Christensen Brothers—William, Lew, and Harold. After studies with each, she joined the San Francisco Ballet in 1950. She danced in William's productions of *Coppélia, Swan Lake* (originally *Prince Siegfried*), and in both his and Lew's productions of *The Nutcracker,* but was best known for her portrayal of "The Bearded Lady" in Lew Christensen's *Jinx.* She served as ballet master of the San Francisco Ballet from 1960 to 1963, when she moved to Utah to serve in the same capacity for Ballet West, directed by William Christensen.

Arnold, Malcolm, English composer; born October 21, 1921 in Northampton. The British melodist has worked in all available media of the twentieth century from live orchestral scores to music for radio, television, and film. Although he is probably best known for his score for the popular film *Bridge on the River Kwai,* he is celebrated for his contributions of the revitalized English ballet through his music for Frederick Ashton's *Homage to the Queen* (1935) and *Rinaldo and Armida* (1955), and Robert Helpmann's *Elektra* (1963).

Arnst, Bobbe, American theatrical dancer and singer; born c.1909 in New York City. The daughter of actress Billie Arnst, she was a baby performer in film and on the Southern vaudeville circuit. She made her Broadway debut at fifteen in the *Greenwich Village Follies of 1924.*

As a vocalist and musical comedy dancer, Arnst worked consistently through the 1920s. She toured with the Ted Lewis Band, personifying his signature tune, "Isn't She a Pretty Thing?" and returned to Broadway with the revues *A la Carte* and *Le Maire's Affairs* (both 1927). She introduced the song "How Long Has This Been Going On?" in *Rosalie* and began a series of performances as the comic lead in musical comedies, among them *Simple Simon* (1930), *Whoopee* (1928), and *I Married an Angel* (1938).

Her secondary career as a dance satirist brought her roles in Kaufmann and Hart's plays *The Fabulous Invalid* (1938), with its imitations of Broadway figures, and *You Can't Take It With You,* in the role of "Essie Sycamore," the disaster-prone student ballerina who does the entire show falling off point. She also did her imitations and satirical act in clubs in

New York through the 1930s and early 1940s, adding pieces on exotic dancers, jivers, and tappers.

von Aroldingen, Karin, German ballet dancer associated with George Balanchine's New York City Ballet from 1962; born July 9, 1941 in Greiz, Germany. Trained in Berlin, von Aroldingen joined the Frankfurt Opera Ballet in 1959. In her three seasons with that company, she performed in the Tatiana Gsovsky productions of *The Sleeping Beauty* (1960) and *The Seven Deadly Sins* (1962), as the "Dance Anna." Lotte Lenya, who re-created her original role as the "Vocal Anna," recommended her to Balanchine for whom she has performed ever since.

Dancing almost entirely in the Balanchine repertory, von Aroldingen's featured roles include parts in *Serenade, Apollon Musagète, Concerto Barocco, Western Symphony,* both the "Emerald" and "Ruby" sections of *Jewels,* the second pas de deux in *Agon* and, perhaps her most celebrated characterization, "The Siren" in his *Prodigal Son.* Among the many Balanchine works in which she has created roles are *Who Cares?* (1970), *PAMTGG* (1971), the acrobatic first duet in *Stravinsky Violin Concert* 1972), *Variations pour un Porte et un Soupir* (1974), *Kammermusik No. 2* (1978), *Vienna Waltzes* (1978), and Schumann's *Davidbundlertanze* (1980). The latter three ballets demonstrate her unique range of performance abilities: in the *Kammermusik,* she has to dance an extraordinarily dense pattern of steps very quickly to an unusual rhythmic pattern in a canon form, while in the *Vienna Waltzes,* her duet with Sean Lavery is totally romantic. In the last recent work, the romantic duet has disintegrated into her partner's madness, but the choreography is almost as dense as in the *Kammermusik,* and she must demonstrate the emotional situation without facing the audience.

Aronson, Boris, Russian-American theatrical designer; born October 15, 1900 in Kiev. Aronson was trained at the State Art School in Kiev, where he worked under constructivist innovator Alexandra Exter. He emigrated to the United States in the early 1920s and worked for the Yiddish Art and Schildkraut Theatres, creating sets and costumes for Yiddish language theater in New York. From 1932,

when he did his first Broadway show, he has become recognized as America's finest and most consistently creative theatrical designer. His mobile sets for *A Little Night Music*, for example, for an opening forty years after his Broadway debut, were magnificent and seemed to replace dance in the musical comedy.

He has worked occasionally in dance productions throughout his American career. His Yiddish language experience (for productions staged primarily by Lillian Shapiro) led to connections with the concert dance world, but he also worked extensively in ballet. From Eugene Loring's *The Great American Goof* (1940) to Mikhail Baryshnikov's *Nutcracker* of 1977, he was frequently engaged by the American Ballet Theatre to design its productions, but he also did sets and costumes for the New York City Ballet (Jerome Robbins' *Ballade,* 1952), and The Eliot Feld Ballet, returning to his Yiddish theater roots for *The Tzaddik* (1974).

Arova, Sonia, Bulgarian ballet dancer working primarily in England and the United States; born June 20, 1927, in Sofia, Bulgaria. Originally trained at the school of the Bulgarian State Opera Ballet under Anastos Petroff, Arova moved to London as an adolescent and enrolled at the Cone-Ripman School. She has also studied in Paris with Serge Lifar and Olga Preobrajenska, and with Vera Volkova.

During the 1940s and early 1950s, Arova performed with a number of companies in London and Paris, among them the International Ballet, the Metropolitan Ballet, with which she created a role in John Taras' *Design with Strings* in 1948, the Ballet Rambert, in which she danced "Odette/Odile" in *Swan Lake,* the London Festival Ballet, and Le Ballet des Champs-Elysées. From 1955 on, she has performed mostly in the United States—first, as a member of Ballet Theatre, with which she re-created her role in *Design with Strings* and performed the "Lucille Grahn" role in *Pas de Quatre,* both in 1955. For most of the remainder of her performing career, Arova danced with the Ruth Page Ballet and its successor, Page's Chicago Opera Ballet. With this company, she was featured in Page's *Camille* and *Die Fledermaus,* and partnered Rudolph Nureyev in his American debut, dancing the Don Quixote Pas de Deux with the Chicago Opera Ballet, in March 1962. Arova also performed with the National Ballet,

Washington, in works by her then husband, Job Sanders, among them, *Bachianas Brasileiras.*

Arova served as ballet mistress of the Norwegian National Ballet from 1966 to 1970. Returning to the United States, she has served as director of the San Diego Ballet and Ballet Alabama.

Arpino, Gerald, American ballet dancer and choreographer; born January 14, 1928 on Staten Island, New York. After early training in Seattle, Washington, with Mary Ann Wells (while he was serving in the U.S. Coast Guard), Arpino returned to New York to study modern dance (Graham technique) with May O'Donnell and Gertrude Schurr, and ballet with Margaret Craske, Antony Tudor, Alexandra Fedorova, and Muriel Stuart.

Arpino's early dance jobs included performing with the May O'Donnell Concert Group, appearing on Broadway in *Annie Get Your Gun,* and tours of South America with the Ballets Russes concert group of Nana Gollner and Paul Petroff in 1951 and 1952.

As a dancer and choreographer, Arpino's career has been associated with the various companies directed by Robert Joffrey. He danced in Joffrey companies between 1956 and 1964, when he retired from performance, creating roles in, among others, his *Persephone* (1952) and Arpino's own *Ropes* (1961); he also performed featured roles in Balanchine's *Pas de Dix* and *Square Dance* in their Joffrey productions, and served as premier danseur for the New York City Opera from 1955 to 1961.

Although some of Arpino's earliest choreography was created for concert groups or performances at the Choreographers' Workshop, much of his repertory was produced for and by the Robert Joffrey Ballet Concert, The Robert Joffrey Ballet, its apprentice group, and the extant City Center Joffrey Ballet Company. Arpino has also choreographed for the popular Off Broadway production of *Jockeys* in 1977.

Works Choreographed: CONCERT WORKS: *Pas de Deux to Ravel, Partita for Four* (1961); *Ropes* (1961); *Undine* (1962, later titled *Sea Shadow); Incubus* (1962); *The Palace* (1963); *Viva Vivaldi* (1965); *Design for Dreaming* (1966); *Olympics* (1966); *Nightwings* (1966); *Arcs and Angels* (1967); *Cello Concert* (1967); *Elegy* (1967); *The Clowns* (1968); *Secret Places* (1968); *Fanfarita* (1968); *A Light Fantas-*

tic (1968); *Animus* (1969); *Trinity* (1969); *The Poppet* (1969); *Solar Wind* (1970); *Confetti* (1970); *Valentine* (1971); *Reflections* (1971); *Kettentanz* (1971); *Chabriesque* (1972); *Sacred Grove on Mount Tamalpais* (1973); *Jackpot* (1973); *The Relativity of Icarus* (1974); *Drums, Dreams and Banjos* (1975); *Touch Me* (1977); *Orpheus Times Light* (1977); *Suite Saint-Saens* (1979).

THEATER WORKS: *Jockeys* (1977).

Arshansky, Michael, Ballet dancer, mask maker and make-up artist; born c.1896, died June 30, 1978 in New York City. Arshansky made his American performance debut with the Mikhail Mordkin Ballet, on the Keith vaudeville circuit in 1926 and 1927, appearing in his *Aziade* and the divertissement *Wanyka-Tanyka*. Best known for his work with the two City Center–based companies, he served as both mask maker and director of pantomime for the New York City Opera in the 1950s, during the period in which the pioneers of American modern dance served as its ballet masters. Director of make-up and masks for the New York City Ballet for more than thirty years, he also appeared in mime roles in Balanchine ballets, among them ''The Father'' in *The Prodigal Son* (revival), ''Drosselmeyer'' and the ''Grandfather'' in *The Nutcracker,* ''Cassandre'' in *Harlequinade* (1965), ''Pulcinella's Father'' in *Pulcinella* (1972), and ''The Burgomeister'' in *Coppélia* (1974).

Arthur, Charthel, American ballet dancer; born October 8, 1946 in Los Angeles, California. After local training from Eva Lorraine and Bronislava Nijinska, Arthur moved to New York to study at the American Ballet Center, school of the City Center Joffrey Ballet.

A member of the Joffrey company since becoming an apprentice in 1965, Arthur has performed in almost every work in the repertory. Her brilliant technique and ability to assume the performance styles required by different choreographers have won her featured roles in the company revivals of Mikhail Fokine's *Petrouchka,* Kurt Jooss' *The Green Table,* Leonid Massine's *Le Beau Danube,* and Jerome Robbins' *Interplay.* Her seemingly blank face was put to use in her characterizations of the bland heroines of John Cranko's *Pineapple Poll* and Ruthanna Boris' *Cakewalk,* both revived for the company.

Among the Gerald Arpino works in which she has performed are his *Trinity, Cello Concerto,* and *Viva Vivaldi!;* she has danced for Joffrey himself in the revival of his *Pas des Déèsses* and the premiere of *Remembrances.*

Asafiev, Boris, Soviet composer; born July 29, 1894 in St. Petersburg; died January 27, 1949 in Moscow. Asafiev studied composition with Rimsky-Korsakof and Anatole Liadnov, but spent most of his early adult life writing music criticism and analyses under the name Igor Glebov. When he returned to composition in the early 1930s, he became the creator of three of the most important and long-lasting scores of the Soviet repertory—*Flames of Paris* (1932), *The Fountains of Bakhshisarai* (1934), and *The Prisoner of the Caucausus* (1938).

Asakawa, Hitomi, Japanese ballet dancer working in Europe; born October 13, 1948 in Kochi, Japan. Asakawa was trained with the Nishino Ballet and school. Since the mid-1960s, she has been a member of the Ballet du XXième Siècle in Belgium. She has become a valued member of Maurice Béjart's company there and has been assigned principal roles in his *Bhakti* (1970), in which she played ''Siva'' and *Romeo and Juliet,* in the leading female role.

Asakawa, Takako, Japanese modern dancer and choreographer, working in the United States from 1960; born February 23, 1938, in Tokyo, Japan. After studies in Japan at the Komadori school, Asakawa came to New York with the revue *Holiday in Japan.* She remained in New York to study at the Martha Graham School of Contemporary Dance.

Askawa joined the Graham Company in 1962, performing with it until 1979. Among the Graham works in which she has created roles are *Cortege of Eagles* (1976), *Archaic Hours* (1969), and *Adorations* (1975). While in the company, she also danced in the ad hoc company of fellow Graham dancer, Yuriko, performing in her *Wind Drum* and other works (1965). Asakawa also performed briefly with the Alvin Ailey Dance Theater, dancing in Ailey's *Revelations* and Talley Beattey's *Congo Tango Palace* and *The Road of the Phoebe Snow.*

In 1970, Asakawa and her husband, David Hatch Walker, formed a company, Asakawalker, through

which to perform their works in recital. Although they choreograph for each other and create roles in each other's pieces, the works are not collaborative, each stages his or her own works uniquely. Among the works that Asakawa has contributed to the company repertory are *Reflection of Romance* (1977, *Opalescence* (1978), *Eclipse* (1973), and *Fantasy II* (1972).

Works Choreographed: CONCERT WORKS: *Fantasy II* (1972); *Eclipse* (1973); *Ambrosia* (1974); *Reflections of Romance* (1977); *Opalescence* (1978).

Asensio, Manola, European ballet dancer; born May 7, 1946 in Lausanne, Switzerland. Asensio was trained in Milan at the school of the Teatro alla Scala, but returned to Geneva's Grand Théâtre to make her first mark on the dance world. She spent seasons with Het Nationale Ballet and the New York City Ballet before joining the Harkness Youth and adult Ballets. She remained with those troupes from 1969 to 1972, winning acclaim for her performances in the contemporary repertory, most notably in Ben Steveson's *Bartok Concerto* and *Three Preludes,* Brian MacDonald's *Firebird,* and Vincente Nebrada's *Sebastien*. At the death of the Harkness, she moved to England to dance with the London Festival Ballet. Her exquisite technique and musicality have enabled her to switch back to the classical repertory, with principal roles in the company productions of *The Nutcracker, The Sleeping Beauty,* and *Giselle,* and in Ronald Hynd's new plotted works, *La Chatte* and *The Sanguine Fan.*

Ashley, Frank, Jamaican modern dancer and choreographer working in the United States; born in Kingston, Jamaica. Trained locally by Ivy Baxter, he performed with the National Dance Theatre of Jamaica before accepting a scholarship to the Martha Graham School in New York City. In the city, he appeared in modern dances in a number of companies, among them, Helen McGehee's *Ceremonies of Remembrance* (1969), Yuriko's *Celebrations, Dances for Dancers,* and the two *Events* (1970 and 1971), and Eleo Pomare's *Blues for the Jungle, Black on Black, Radiance of the Dark,* and *Les Desemamorades*. His own choreography in the United States has been created primarily for his company in resi-

dence at the Henry Street Settlement, where he serves as director of dance. In that capacity, he teaches class, works with actors and directors at the Settlement's New Federal Theatre, and presents company concerts. Whether the political drama of *Garvey* (1976) or the introspective abstractions of his current works, his dances have proven extremely popular with his audience and with critics alike.

Works Choreographed: CONCERT WORKS: *Eyes Don't See* (1966); *The Birds* (1970); *If Not Now—When?* (1970); *Maiden Voyage* (1971); *West Indian Hello* (1972); *Vivachi* (1972); *Vakako* (1973); *Rock-Steady Suite* (1973); *The Game* (1974); *Manipulation* (1974); *Garvey* (1976); *Threshold of a Hope* (1976); *Dirty Blues* (1977); *Things Fall Apart* (1977); *Crossovers* (1977); *Outer Limits–Inner Journeys* (1978); *Time of Day* (1979); *Dance of Praise* (1980); *Magnificat* (1980).

THEATER WORKS: *The Mystery of Phyllis Wheatley* (1976); *Birdland* (1978).

Ashley, Merrill, American ballet dancer; born Linda Merrill, in 1950 in St. Paul, Minnesota. Raised in Rutland, Vermont, Ashley moved to New York as an adolescent to study at the School of American Ballet.

Graduating from the New York City Ballet in 1966, she has become one of the company's most popular dancers. Her extraordinarily brilliant technique and developing stage presence and personality have been applauded in many works in the George Balanchine repertory, among them his *Square Dance, Divertimento No. 15, Symphony in C, Tchaikovsky Piano Concerto* and *Tchaikovsky Suite No. 3*. She has created roles in his *Requiem Canticles II* (1972, for the Stravinsky Festival), *Coppélia* (1974), *Cortège Hongrois* (1973), *Ballo della Regina* (1978), and *Ballade* (1980). Her non-Balanchine featured roles have included parts in Jerome Robbins' *In the Night* and Jacques d'Amboise's *Saltarelli*.

Ashmole, David, English ballet dancer; born October 31, 1949 in Cottingham, Yorkshire. Ashmole was trained at the Royal Ballet School, graduating into the company in 1968. He performed in the Royal Ballet until the mid-1970s, taking the great classical and romantic leads, including a well-received "Prince Siegfried," "Colas," "Florimund," and "Solar."

He was also, however, adept in the contemporary repertory and known especially for his ability to bring life into smaller roles, such as "Nenvolio" in Kenneth Macmillan's *Romeo and Juliet*. Ashmole's other appearances in the repertory include work in Frederick Ashton's *The Two Pigeons, Daphnis and Chloe, Enigma Variations, Monotones,* and *Scenes de Ballet.*

In the mid 1970s, Ashmole switched to the touring company of the Royal Ballet with its more contemporary repertory and chamber concert format. He has performed in Ashton works, most notably in his *Les Rendezvous,* but has also danced in newer pieces such as Peter Wright's *Summertide.*

Ashton, Frederick, English ballet dancer and choreographer generally considered the most important creative influence in Great Britain; born September 17, 1904 in Guayaquil, Ecuador. Raised in England, he studied with Leonid Massine (c.1924), and Marie Rambert. He began to choreograph for her, creating his first ballet, *The Tragedy of Fashion, or The Scarlet Scissors,* in a revue called *Riverside Nights,* 1926, later dancing with the (Vera) Nemchinova/(Anton) Dolin Ballet (c.1927), and the Ida Rubinstein Ballet's London season (c.1928).

Ashton participated in two organizations—the Ballet Club and the Camargo Society—that contributed tremendously to the development of ballet in England. With his choreographic colleagues, among them Antony Tudor, Ninette De Valois, Andrée Howard, and Susan Salaman, he created a large repertory of works of the groups' occasional concerts. As a dancer, he performed in the premieres of Howard and Salaman's *Our Lady's Juggler* (1930), Howard's *Cinderella* (1935), and his own *Capriol Suite* (1930), the solo *Suadad do Bresil* (1930), *Mazurka des Hussars* (1930), *La Péri* (1931), *Façade* (1931), *Mercury* (1931), *The Lady of Shalott* (1931), *The Lord of Burleigh* (1931), *Foyer de Danse* (1932), and *Mesphisto Valse* (1934). Dancing only through the 1930s, he worked with the Vic-Wells and Sadlers' Wells Ballets, dancing in his own *Nocturne* (1936) and in De Valois' *Barabau* (1936), and *Le Roi Nu* (1938).

One of England's most prolific choreographers, he created over sixty works for the above companies and the Royal Ballet, serving as its director from 1963 to 1970. Although critics and fans argue for hours to choose his "best work," it is generally agreed that his Façade (1931), *Les Patineurs* (1937), *La Fille Mal Gardée* (1960), and *Jazz Calendar* (1968) are among the most successful of his humorous pieces, while the two *Monotones* (1965 and 1968) and *Symphonic Variations* (1946) are among the best of the abstractions. Ashton has also choreographed or restaged full-evening works for the English audience, among them a *Sleeping Beauty,* a *Swan Lake, Marguerite and Armand* (1963) for Fonteyn and Nureyev, and *A Month in the Country.* Although in the 1930s and 1940s, he was able to create up to ten ballets a season, in recent years he has slowed down into a semiretirement, emerging to create occasional pas de deux and solos, including the very popular *Five Brahms Waltzes in the Manner of Isadora Duncan* (1976) for Lynn Seymour, *The Dance of the Blessed Spirits* (1978) for Antony Dowell, *Etude* (1977) for the film *The Turning Point,* and *Rhapsody* (1980).

Ashton had a successful career in revue choreography in the 1930s, creating incidental interpolated dances for London shows such as *The Ballyhoo of '32, The Flying Trapeze* (1935), *The Town Talks* (1936), and *Running Riot* (1938). In general, he staged only ballets for the shows, leaving the tap routines to others. His films were primarily dance oriented, among them, *The Tales of Hoffman* (1951) and *The Story of Three Loves* (1953), both for Moira Shearer, and the Royal Ballet's *Tales of Beatrix Potter* (1971). His other earlier film credits were for dance sequences staged for the Rambert Dancers in the early days of British sound film.

As an opera choreographer, he had the fortune to participate in Virgil Thomson's *Four Saints in Three Acts* (1934), and in the premieres of two major works by Benjamin Britten—the comic *Albert Herring* (1947) and his last opera, *Death in Venice* (1973). He also worked on the standard repertory at the Vic-Wells and Royal Opera, such as *La Traviata, Faust,* and *Die Fledermaus.*

Works Choreographed: CONCERT WORKS: *A Tragedy of Fashion* (1926); *Suite de Danses* (1927); *Argentine Dance* (1927); *Nymphs and Shepherds* (1928); *Leda* (1928); *Capriol Suite* (1930); *Saudad do Brésil* (1930); *Mazurka des Hussars* (1930); *Pomona*

(1930); *A Florentine Picture* (1930); *La Péri* (1931); *The Dance of the Hours* (1931); *Foxhunting Ballet* (1931); *Façade* (1931); *Mercury* (1931); *Regatta* (1931); *The Lady of Shalott* (1931); *A Day in a Southern Port* (aka Rio Grande) (1931); *The Lord of Burleigh* (1931); *Pompette* (1932); *Foyer de Danse* (1932); *Les Masques* (1933); *Pavanne pour une Enfant Défunte* (1933); *Les Rendezvous* (1933); *Mephisto Valse* (1934); *Pas de deux classique* (1934); *Valentine's Eve* (1935); *In a Venetian Theatre* (1935); *Le Baiser de la Fée* (1935); *Siesta* (1936); *Apparitions* (1936); *Nocturne* (1936); *Perpetuum Mobile* (1937); *Harlequin in the Street* (1937); *Les Patineurs* (1937); *A Wedding Bouquet* (1937); *Horoscope* (1938); *The Judgement of Paris* (1938); *Harlequin in the Street* (1938 version); *Cupid and Psyche* (1939); *Devil's Holiday* (1939); *Dante Sonata* (1940); *The Wise Virgins* (1940); *The Wanderer* (1941); *The Quest* (1943); *The Sleeping Beauty* (1946, by Nicholas Sergeyev after Marius Petipa, Ashton contributed dances to this production and subsequent revivals); *Symphonic Variations* (1946); *Les Sirènes* (1946); *Valses Nobles et Sentimentales* (1947); *Scènes de Ballet* (1948); *Don Juan* (1948); *Cinderella* (1948); *Le Rêve de Léonor* (1949); *Illuminations* (1950); *Daphnis and Chloe* (1951); *Tiresias* (1951); *Casse-Noisette* (The Kingdom of Snow and the Kingdom of Sweets only) (1951); *Picnic at Tintagel* (1952); *Vision of Marguerite* (1952); *Sylvia* (1952); *Le Lac des Cygnes* (1952, choreographed by Nicholas Sergeev, revised by De Valois with additions by Ashton); *Orpheus* (1953); *Homage to the Queen* (1953); *Rinaldo and Armida* (1955); *Variations on a Theme by Purcell* (1955); *Madame Chrysanthème* (1955); *Romeo and Juliet* (1955); *La Péri* (1956); *Birthday Offering* (1956); *The Beloved* (1956); *La Valse* (1958); *Ondine* (1958); *Scene d'amour from "Raymonda"* (1959); *La Fille Mal Gardée* (1960); *Giselle* (1960, after Coralli and Perrot, revised by Marius Petipa, reproduced by Nicholas Sergeyev, additional choreography by Ashton and Tamara Karsavina); *Les Deux Pigeons* (1961); *Poème Tragique* (1961); *Persephone* (1961); *Marguerite and Armand* (1963); *The Dream* (1964); *Monotones* (1965); *Monotones (II)* (1966); *Sinfonietta* (1967); *Jazz Calendar* (1968); *Enigma Variations* (1968); *Lament of the Waves* (1970); *The Creatures of Prometheus* (1970); *Meditation from "Thais"* (1971); *Siesta* (1972); *The Walk to Paradise Garden* (1972); *Fashion Show* (1974); *Scene Dansante* (1975); *Brahms-Waltz* (1975); *A Month in the Country* (1976); *Five Brahms Waltzes in the Manner of Isadora Duncan* (1976); *Hamlet—Prelude* (1977); *Tweedledom and Tweedledee* (1977); *Explosion Polka* (1977); *Orpheus: The Dance of the Blessed Spirits* (1978); *Salud d'Amore* (1979); *Rhapsody* (1980).

OPERA: *Four Saints in Three Acts* (1934); *Albert Herring* (1947); *Death in Venice* (1973).

THEATER WORKS: *Riverside Nights* (1926); *Jew Süss* (1929, "A Tragedy of Fashion" only); *Marriage à la Mode* (1930); *A Masque of Poetry and Music: "Beauty, Truth and Rarity"* (1930); "Follow Your Saint" performed as a separate work in 1931, 1932 and 1936, "Dances on a Scotch Theme" performed as a separate work in 1931; *A Kiss In Spring* (1930); *The Cat in the Fiddle* (1932, "The Passionate Pilgrim" only); *Ballyhoo* (1932, ballets only); *High Yellow* (1932, as assistant to Buddy Bradley); *Magic Nights* (1932, co-choreographed with Bradley) *How D'You Do?* (1933, ballets only); *After Dark* (1933, ballets only); *Gay Hussar* (1933, comedy dances arranged by Charles Brooks); *Nursery Murmurs* (1933, ballets only); *Jill Darling!* (1934, "I'm Dancing with a Ghost" only); *The Flying Trapeze* (1935, all dances except those for Jack Buchanan and "Angel on Horseback"); *Round About Regent Street* (1935, co-choreographed with J. Sherman Fisher); *The Town Talks* (1936, "The Hat" only); *Home and Beauty* (1937); *Floodlight* (1937, ballets only); *Running Riot* (1938, ballets only); *A Midsummer Night's Dream* (1945); *c.1830* (1971, choreography of the Fifth Song only); *World of Harlequin* (1973, co-choreographed with Ninette de Valois); *Tonight at 8:30* (1973).

FILMS: *Dance Pretty Lady* (British International, 1932); *Escape Me Never* (British and Dominion Pictures, 1935); *The Tales of Hoffman* (London Films, 1951); *The Story of Three Loves* (MGM, 1953); *Tales of Beatrix Potter* (EMI Films, 1971); *A Turning Point* (Twentieth-Century Fox, 1977, Etude only).

Bibliography: Vaughan, David. *Frederick Ashton and His Ballets* (London and New York: 1977).

Asmus, Harry, American ballet dancer and choreographer; born c.1930 in Carroll, Iowa; died March 24,

1977 in Dover, Delaware. Trained by Vincenzo Celli, he danced with the Mia Slavenska company before joining Ballet Theatre in the late 1940s. Best known for his performances in Antony Tudor's *Gala Performance* and *Shadow of the Wind,* he also danced in Frederick Ashton's *Les Patineurs,* George Balanchine's *Theme and Variations,* and the company productions of *Giselle* and *Swan Lake.*

He worked with the Ballet Nacional de Venezuela during the 1960s, returning to the United States to teach at the June Taylor School in New York. He joined the faculty of the Marion Tracy Studio in Dover, Delaware, and served as director of the Dover Ballet Theatre School and company from 1974 until his unsolved murder in 1977.

Works Choreographed: CONCERT WORKS: *Continuum* (1956); *Spring Poem* (1957); *Isabella* (1957); *Ballinade* (1957); *Celestiana* (1958); *Innocents* (1965); *España* (1967) *And Four* (1967).

Asquith, Ruby, American ballet dancer; born c. 1910, possibly in Portland, Oregon. A student of Willam Christensen in Portland, she replaced Mignon Lee in the Christensen Brothers act in vaudeville. With the other members of the double adagio team (at that point, one other female, and Lew and Harold Christensen), she joined the Albertina Rasch musical, *The Great Waltz* (1935), and the newly formed School of American Ballet. After performing with the American Ballet in George Balanchine's works for the company and the Metropolitan Opera, she and the Christensens became charter members of the Ballet Caravan, a touring company troupe made up of American Ballet dancers. She appeared in almost all of the company's repertory and created roles in William Dollar's *Air and Variations* (1936), Eugene Loring's *Yankee Clipper* (1937) and *Harlequin for President* (1936), Erick Hawkins' *Show Piece* (1937) and Lew Christensen's *Charade* (1939), and *Promenade* (1936), among others.

Asquith became a principal dancer with William Christensen's San Francisco Ballet in the early 1940s, appearing in his *Now the Brides* (1941), *Winter Carnival, Sonata Pathétique* (1943), *Blue Plaza* (1945), and as "Odette" in his 1944 *Prince Siegfried*, an early full-length *Swan Lake*. After retiring from performance, she joined her husband, Harold Christen-

sen, on the faculty of the school of the San Francisco Ballet.

Astafieva, Serafina, Russian ballet dancer and teacher; born 1876 in St. Petersburg; died September 13, 1934 in London. Astafieva, one of the most influential teachers of Russian classical ballet technique, was herself trained at the St. Petersburg school of the Imperial Ballet by Christian Johnansson. After performing with the Maryinsky Theater, she joined Diaghilev's Ballet Russe in 1909, dancing principal roles in Fokine's *Cléopâtre* and *Khovantchina*. She performed on a tour as a concert dancer in the mid-1910s, doing solo ballet dances based on bird and serpent imagery and, according to English publicity releases, on the theories of Leo Tolstoy.

As a teacher, Astafieva practically created the English ballet, training Anton Dolin, Alicia Markova, Margot Fonteyn, and many others.

Works Choreographed: CONCERT WORKS: *Indian Bird Fantasy* (1915); *Supplication* (1916); *Serpent* (1916); *The Peacock* (1916); *The Pursuant* (1916).

Astaire, Adele, American theatrical dancer; born Adele Austerlitz, September 10, 1898, in Omaha, Nebraska; died January 25, 1981 in Arizona. With her younger brother Fred, she was brought to New York to study with Claude Alvienne and work in vaudeville. Their first act, written and produced by Ned Wayburn, was a skit in which they imitated "adult life," and danced. Because of their youth, they were not allowed to work in New York, so by the time they first worked on Broadway in 1917, they had done the Wayburn act for ten years and were veterans of vaudeville.

As a dance act, Adele and Fred Astaire worked in *Over the Top* (1917), *The Passing Show of 1918,* the operetta *Apple Blossoms* (1919), *The Love Letter* (1921), *For Goodness Sake* (1922), *The Bunch and Judy* (1922), the Gershwins' *Lady, Be Good* (1924, New York; 1926, London), their *Funny Face* (1927, New York; 1928, London), *Smiles* (1930), and *The Band Wagon* (1931). Although she worked alone as a juvenile and vocalist, introducing "Fascinating Rhythm" in *Lady, Be Good*, she more frequently worked with her brother in their eccentric dance acts—movements and patter songs, as in *The Bunch*

and Judy and *Funny Face,* and walkarounds in *The Band Wagon*—and their exhibition ballroom work, interpolated into every show.

Astaire retired in 1932. There are those who still consider her to have been her brother's finest partner.

Astaire, Fred, American tap dancer extraordinaire; born Frederick Austerlitz, May 10, 1899 in Omaha, Nebraska. Astaire and his older sister, Adele, were brought to New York as children to receive dance training and go into vaudeville. They studied with Claude Alvienne and Ned Wayburn, the latter only long enough to purchase a dance act, but could not perform in New York because of the Gerry Society restrictions on child performers. After doing their act on the Keith-Orpheum circuit, they returned to New York as finished specialty dancers to enter *Over the Top* (1917). They worked together on Broadway in *The Passing Show of 1918, For Goodness Sake* (1922), the Gershwins' *Lady, Be Good* (1925) and *Funny Face* (1927), *Smiles* (1930), and *The Band Wagon* (1931), among other, less successful shows. As popular as they were in New York, their London reputations were even greater.

After Adele retired, following the close of *The Band Wagon,* he performed with Claire Luce in *The Gay Divorcee* (1932). For much of his film career, his search for a perfect partner was a frequent publicity theme; many members of the audience and the professionals, however, believed that he could dance with anyone and make her, or him, look wonderful. The partnership with Ginger Rogers was the most successful in number of films produced and in the production of an ideal of dance. The work with Eleanor Powell brought him a tap dancer who was almost his equal, while the films with Rita Hayworth gave him a marvelous ballroom partner. He also danced with three tall women in the 1950s and 1960s—Lucille Bremer, who never really developed a motion picture personality, Cyd Charisse, wonderful in *The Band Wagon,* and Barrie Chase, with whom he worked on television.

It is unfortunate that critics who adhere to the auteur theory of films should find it necessary to promote the idea that Astaire choreographed all of the dances that he performed in his movies. There are two major problems with this theory—the most obvi-

ous is that in the Hollywood film industry a credit is something very definite, very important, and very much a point of law. When a dance director, actor, or anyone else stages a dance routine, he, she, or they demand and receive a credit. The other difficulty with the theory that Astaire staged his routines is that it diminishes his accomplishments. To say that he could perform in his own routines is admirable, but to be able to perform so brilliantly in dances staged by so many other imaginations is magnificent. So, to augment the latter, it is necessary to say that he danced in the choreography of Dave Gould, who won the first dance director Oscar for "the Carioca," Harry Losse, a concert dancer with Denishawn lineage, Bobby Connolly, Charles Walters, and ballet choreographers Eugene Loring, Michael Kidd, and Roland Petit, as well as Hermes Pan, who developed from an RKO staff dance assistant to a world-famous Hollywood choreographer in his thirty years in the business. Much of those thirty years was spent on films starring Astaire, Rogers, or both.

Astaire's dance numbers can be divided roughly into four categories—exhibition ballroom romances, tap competitions, solos, and solos with props. The most frequently performed was the first type, danced with each of his female partners; the dances were based on conventional exhibition ballroom styles, in turn based on social dance work. They involved a single format, with the meeting, duet work, breaks apart and pulls together, and a final symmetrical or tandem series of movements. Among Astaire's examples in this style are the famous love duets with Ginger Rogers, such as "Cheek to Cheek" and "Night and Day," which are exquisitely beautiful from their openings, in which one touch from Astaire spins her into his arms, to the finales in which they simply sit.

The tap competition numbers were also danced with Rogers, as well as with his other partners. With Rogers and Powell especially, these numbers, based on minstrel formats, presented an alternating series of tap flurries, each dancer trying to beat out the other. At their best, these numbers can be magnificent with true communication between the dancers. A personal favorite is the "Let Yourself Go" number from *Follow the Fleet* in which the Astaire-Rogers competition is set in a dance hall with "real" inter-couple competitions. Another is the "Shorty George" with Rita Hayworth, with Astaire working

close to the floor to make his style compatible to hers.

The solos were just that—a chance to see Astaire dance, occasionally with a "schtik," such as the "fireworks dance" in *Holiday Inn,* but more frequently just alone before a camera. The solos with props are among his greatest accomplishments. He could not only dance with anyone, but with anything—the coat tree in *Royal Wedding,* the wall in that underrated film, or the drum set in *Easter Parade.*

It would be difficult to overestimate Astaire's influence. He represents tap, theater, and ballroom dance to much of the world, and perfection in performance to everyone. To be like Fred Astaire is to follow the film image of sophistication—and to have a talent and work to perfect it.

Bibliography: Astaire, Fred. *Steps in Time* (New York: 1959); Green, Stanley and Burt Goldblatt. *Starring Fred Astaire* (New York: 1973).

Astolfi, Luigi, Italian nineteenth-century ballet dancer and choreographer working in the Italian states and in Portugal; the details of Astolfi's birth and death are not certain. After making his debut in 1817 with the ballet company of the Teatro San Benedetto di Venerzia, he moved to Lisbon where he was employed at the Teatro Real de San João from 1823 to 1824 and from 1839 to 1840. He had the traditional itinerant career of a successful Italian choreographer in the years before the unification of the country. Among the many opera houses at which he worked were the Teatro Filarmonica in Verona, the Kartnerthotheater in Vienna, the Carlo Felice in Genoa, the Grande in Trieste, the Eretrino in Venice, and the Regio in Turin.

Works Choreographed: CONCERT WORKS: *As Habitantes do Tejo na Acclemacao do S. João Sexto* (1823); *A Duqueza d'Osimo* (1824); *Annibal em Capua* (1824); *Fayel* (1825); *O Triunfo de Berenice* (1825); *Branca de Rossi, ou O Exemplo do amor conjugal* (1826); *La Schiava sultana* (1827); *Mathilde, Herzogin* [Marquessa] *di Spoleto* (1829); *Panurge auf der Laterneinisel* (1829); *The Maskenball* (1829); *Caesar in AEypten* (1829); *St. Clair, oder Der Verbante suf die inse* (1829); *Gabriele von Vergy* (1829); *La Scimia riconoscente* (1830); *Il Colonell di Calatraca, ossia I Prigioniere di amore* (1831); *Allessan-*

dro principe di Salerno, ossia I due fratelli rivali (1831); *Defalo e Procri* (1831); *Giovanni di Calaid* (1832); *Le Sette reclute* (1832); *Pizzare in Quito* (1833); *I Minatori di Salerno* (1833); *Buondelmonte* (1834); *Ildebrando duca di Spoleto* (1835); *Emma ed Igildo* (1835); *Il Maestro del villaggio* (1836); *Giovanni Baldesio gonfaloniere maggiore di Cremona detto Launino della Pappa* (1837); *Belisario* (1837); *As Nove Recrutas, ou A Festa de Baile com Marscara* (1837); *Mancino* (1838); *Una Lezione alle moglie* (1838); *Il Faluto notturno* (1838); *Il Furioso* (1838); *La Bella Persiana* (1838); *Erkoff, ou O Boyardo em Madrid* (1839); *Os Portuguezes em Tanger* (1839); *Ruggero di Napoli* (1841); *La Rosa magica* (1841); *Il Consiglio di reclutaizione* (1842); *Oscar d'Alva* (1842); *Zoraide* (1842); *Floreska* (1843); *Pandora* (1843); *L'Orfano per assassino* (1843); *Spiritna* (1843); *La Giovane militare* (1845); *Le Pillole del diavole* (1846); *Alma, ossia La Figlia del Fuaco* (1846); *La Figlia dell'oro* (1847); *Gentile di Fermo* (1847); *Il Proscritto lombardo* (1848); *L'Independenza siciliana* (1848); *La Sollevazione dell Fiandre* (1851); *Boemondo* (1851).

Atanasoff, Cyrile, French ballet dancer; born June 30, 1941 in Pueaux-Seine. Atanasoff, whose first name is also spelled Cyril and Cyril-Ivan, was trained at the School of the Paris Opéra and graduated into the company in the late 1950s. He was at first considered a specialist in the nineteenth-century repertory and was one of the dancers chosen to perform a pas de deux and divertissement program at Jacob's Pillow in 1962, but soon became associated with the Opéra's contemporary repertory. He was cast in the company's productions of pieces by Maurice Béjart, (among them his *La Damnation de Faust,* Michael Descombey (including his *Sarraceña* [1964], and *Bacchus et Ariadne*), John Butler (in his *Intégrales and Amériques,* both 1973) and Roland Petit, for whom he danced in *Notre-Dame de Paris* (1965) and *Nana* (1976). Atanasoff has guested in both his classical and modern roles.

Athenos, Cleo, American modern dancer; Athenos is the first in alphabetical listing of an extraordinary group of performers for whom, tragically, no verified biographical information can be provided. The dancer/members of the three pioneering troupes of

the traditional American modern dance, the Martha Graham company, the (Doris) Humphrey/(Charles) Weidman Concert Group, and the Tamiris dancers, and their colleagues in the concert dance contributed tremendously to the development in the genre and its works. Their importance should not be diminished simply because contemporary historians have been unable to locate them or the details of their lives. Athenos and her colleagues are therefore, listed and given entries in this biographical directory. It is hoped that in future editions, actual biographies can be discovered, proven, and included.

Athenos was a student at the Humphrey/Weidman Studio in New York and, possibly at the Denishawn school here when those choreographers were directing it. As a member of the Concert Group, she appeared in many of the most important early works by Humphrey and Weidman including those in which the choreographers developed and extended their technical and gestural vocabularies and their senses of structure. Among her many credits were roles in Humphrey's *Air for the G String, Life of the Bee* (1929), *Water Study* (1931), *Concerto in A Minor* (1931), *Drama of Motion* (1931), *The Shakers, The Pleasures of Counterpoint* (1932), *Dionysiac* (1932), and *La Valse* (1933) and in Weidman's *The Conspirator* (1929), *The Happy Hypocrite* (1931), *Piccali-Saldati* (1931), *Candide* (1933), *Farandole* (1933), and *Bacchanale* (1933).

Atlas, Consuelo, American modern dancer, born Consuelo Baraka, in 1944 in West Medford, Massachusetts; died November 23, 1979 in Boston. Like so many of her black colleagues from the area, Atlas was trained at the Elma Lewis School of Fine Arts in Boston, continuing her studies at the Boston Conservatory of Music under Jan Veen. A member of the Alvin Ailey Dance Theatre from 1966 to 1972, she created roles in Ailey's *Quintet* (1968) and *Myth* (1971), Kelvin Rotardier's *Child of the Earth* (1971), and Miguel Godreau's *Circle of the Sunconcious* (1969). Her featured roles in the company included major dance performances in Ailey's *Blue Suite, Streams, Flowers,* and *Revelations;* Talley Beatty's *Congo Tango Palace* and *The Black Belt;* Lucas Hoving's *Icarus;* Joyce Trisler's *Dance for Six* and *Journey;* and the strong dramatic portrayal of the inhibited woman of Lester Horton's *The Beloved.*

Atlas retired to teach in the Boston area in the early 1970s. She held popular classes in community schools and the Cambridge area academic halls of Radcliffe, Tufts, and Wellesley. With her husband, Henry Atlas, she directed and taught for the Impulse Dance Company until her tragically early death at the age of thirty-five.

Attles, Joseph, American theatrical performer; born April 7, 1905 on St. James Island, Charleston, South Carolina. Attles' professional biography serves as a guide to the theatrical possibilities of the theater in the twentieth century. He made his Broadway debut in the *Blackbirds of 1928* and later appeared in the 1929 and 1934 Broadway editions and in the 1936 London one. Since Lew Leslie included a musical adaptation of the popular DeBose Hayward play in the 1929 edition, Attles was actually the first person to sing "Porgy," although not in the Gershwins' version. After performing in the Paul Robeson vehicle, *John Henry* (1940), and the musical comedy version of *La Belle Hélène* (1944), Attles was forced to leave the theater and work for the Pullman railway cars. But in 1952, he returned to entertainment, as the "Sportin' Life" of the international company of the Gershwins' *Porgy and Bess,* touring Europe for four years. He remained in Europe to manage Bricktop's Rome nightclub, but returned to New York for Agnes De Mille's rare failure, *Kwamina* (1961) and a string of plays, among them Langston Hughes' *Tambourines to Glory* (1963) and *Jerico Jim Crow* (1964), and productions of the early Lincoln Center Repertory Company and the Negro Ensemble Company. When these activities could not guarantee him financial survival, he opened a luncheonette in the Bronx, but came back to Broadway once again to sing and dance in *Bubbling Brown Sugar* (1973), along with fellow "Sportin' Life" Avon Long. Attles also tours with a one-man show dedicated to the poetry of Paul Lawrence Dunbar.

Auber, François Daniel Esprit, French eighteenth-century composer; born January 29, 1782 in Caen; died May 13, 1871 in Paris. A student of Maria Luigi Cherubini, Auber was considered a master of both comic and "Grand" opera, creating both for the Paris Opéra. Each of his many operas included a ballet sequence, in the tradition of the time. Among the

best known of his operas—in terms of ballet—were *Le Dieu et la Bayadere* (1830, choreographed by Filippo Taglioni), *Gustave III* (1833, staged by Taglioni), and *La Muette di Portici* (1828). That opera, also known as *Masaniello*, provided the finest mime role for ballerinas of the nineteenth century, that of "Fenella"; it was the specialty of the touring dancers of that century in the United States from Celeste to Pavlova, who filmed the role in 1916.

Audran, Edmond, French ballet dancer; born 1919; died July 1951 in Lyons. Audran, whose family owned the Studio Wacker, was trained by Lubov Egorova and performed with her Ballet de Jeunesse. After military service, he joined the Nouveau Ballet de Monte Carlo during Serge Lifar's tenure as director, dancing in his *A la Mémoire d'un Héro* (1947), *Mephisto Valse*, and *Romeo et Juliette*. Audran's short career was also celebrated for his partnering of his wife, Ludmila Tcherina, and of Moira Shearer in the English films *The Red Shoes* and *Tales of Hoffmann*. He died shortly after an automobile crash outside of Lyon.

Audy, Robert, American tap dancer and teacher; born in Grand Rapids, Michigan. After local training with Ollie Wood and Alyce Hogan, he moved to New York to take ballet classes with Mme. Alexandra Federova-Fokine, Francis Cole, and Mia Slavenska and modern dance forms with Jane Dodge and Syvilla Fort. His tap style was created over years of work and studies with Roye Dodge, Ernest Carlos, Dave Morgenstern, Francis Cole, and Paul Draper. Audy has performed extensively in New York and across the country and has presented master classes in almost every city that has a dance studio. He is also a very popular teacher in Paris. His two textbooks, while they claim to "teach yourself to tap," only make his classes in New York more popular; they do bring the American art form to young dancers elsewhere.

Bibliography: Audy, Robert. *How to Teach Yourself to Tap* (New York: 1976); *How to Teach Yourself Jazz Dancing* (New York: 1978).

Augusta, Mlle., Bavarian ballet dancer best known for her performances in the United States during the nineteenth century; born Augusta Fuchs, c.1806 in Munich; died February 17, 1901. Augusta, who also performed as Augusta, Countess of St. James, was trained in Munich but sent to Paris to continue her studies with François Albert. She was in the corps de ballet of the premiere of *l'Orzie* in 1831, but is only listed as a solo dancer for the 1835 season.

Whatever her qualifications, she was a tremendous success in America as "the famous French ballerina," Mlle. Augusta. After her debut at the Park Theatre, New York in *Les Naiades* in 1836, she toured intermittently for ten years. She reached north to Montreal, south to Havana, and west to the Mississippi circuit from St. Louis to New Orleans. Her repertory included the standard works of the Romantic era—*La Bayadère, La Sylphide*, and *Giselle*, as well as divertissements. She was New York's first "Giselle," but followed Mme. Céleste, as the first to perform *La Bayadère* in this country. Like Céleste, Augusta's best role was "Fenella" in *La Muette di Portici*, considered the most difficult and most impressive mime role of the century.

Although she lived into the next century, she retired by 1850, returning to Europe. She should not be confused with Augusta Maywood, her American-born contemporary and rival in many of the same roles, or with Augusta Rabineau, who was her pupil.

Augustyn, Frank, Canadian ballet dancer; born January 27, 1953 in Hamilton, Ontario. After early training locally, he continued his studies at the school of the National Ballet of Canada.

Graduating to the company in 1970, he has become known for his performances in the company's productions of the classics. He has danced the male leads in *The Sleeping Beauty*, playing both "Florestan" and "the Blue Bird," *The Nutcracker, Swan Lake, Les Sylphides, Giselle, Coppélia*, and *La Fille Mal Gardée*. His partnership with Karen Kain in those ballets has brought new recognition to both dancers.

Aumer, Jean, French eighteenth-century ballet choreographer; born April 21, 1774 in Strasbourg, France; died July 1837 in Saint-Martin-en-Bosc. A student of Jean D'Auberval in Bordeaux, Aumer followed the innovative choreographer to London in 1791 to perform with his company at the King's Theatre.

Unlike most of his contemporaries in Europe, Aumer's career was not carried out under the authority of the Paris Opéra; he made his debut there as a dancer in Louis-Jacques Milon's *Pygmalion* (c.1798) but left the company after three seasons. His short tenure as its Maitre de Ballet was not until 1826–1831 during the transition from the *ballet d'action* to Romanticism.

From 1802 to 1806, Aumer served as Maitre de Ballet for the Théâtre de la Porte Saint-Martin, a fascinating theatrical organization that produced melodramas and popular entertainments, rather than operas. Aumer staged revivals of D'Auberval's *La Fille Mal Gardée* and *Annette et Lubin*, and choreographed ballets, among them *Jenny, ou le Mariage Sécret* and *Les Deux Créôles* (both 1806) and fight scenes for melodramas.

After the suppression of the Porte-Saint-Martin company in 1807, Aumer worked at the court theater of Jérôme Bonaparte's short-lived Duchy of Westphalia. Unfortunately, little material is extant from the Kassel court; two titles of Aumer works are known—*Les Amours d'Antoine et de Cléôpatre* and *Cléôpatre en Tarso* (both produced in 1808)—but it is not known whether the works (possibly a single work) were created for Kassel or revived for the theater.

Following the collapse of the Duchy, Aumer moved to Vienna, where he served as ballet master for the Teater an der Wein and the Hofoper, from 1815 to c.1822. Many of his best known works were created in Vienna, among them *Aline, Reine de Golconda* (1818) and *Les Pages du Duc de Vendôme* (1815), excerpts from which were performed in the United States by touring ballet companies throughout the nineteenth century. His prolific period as Maître de Ballet at the Paris Opéra before retirement produced some of the most important works of the early Romantic period, including *La Somnambule* (1827), *La Tyrolienne* (1827), and *La Belle au Bois Dormant* (1829), to music by Louis Herold.

Works Choreographed: CONCERT WORKS: *Echert, premier Roi d'Angleterre, ou la Fin de l'heptarchie* (1802); *Rosina et Lorenzo* (1805); *Jenny, ou le Mariage Sécret* (1806); *Les Deux Créôles* (1806); *Les Amours d'Antoine et de Cléôpatre* (1808?); *Cléôpatre en Tarso* (1808?), may be same work as *Les Amours d'Antoine; Les Pages du Duc de Vendôme* (1815); *Aline, reine de Golconda* (1818); *Emma, oder die Heimlich Ehe* (the secret marriage) (1820), may be revival of *Jenny; Alfred le Grand* (1822); *La Somnambule* (1827); *Astolphe et Joconde* (1827); *Lydie* (1828); *La Belle au Bois Dormant* (1829); *La Tyrolienne* (1829); *Manon Lescaut* (1830).

OPERA: *Guillaume Tell* (1829); *La Muette de Portici* (1829).

Auric, Georges, French composer; born February 15, 1899 in Lodève. After studies at the Paris Conservatory and the Scuola Cantorum, he became a protégé of Erik Satie. As the youngest member of Les Six, he contributed to the collaborative score for Jean Cocteau's *Les Mariés de la Tour Eiffel* in 1921. His successful secondary career as a dance composer actually began with a stage production of Molière's *Les Fâcheux* in 1924. He revised his score for the Bronislava Nijinska ballet of *Les Fâcheux* for the Diaghilev Ballet Russe and was given a further commission for Leonid Massine's *Les Matelots* (1925), and George Balanchine's *La Pastorale* (1926). Later ballet scores include Balanchine's *La Concurrence* (1932), Serge Lifar's *Phedre* (1952) and Massine's *Bal de Voleurs* (1960).

Austin, Debra, American ballet dancer; born July 25, 1955 in Brooklyn, New York. Trained at the School of American Ballet, Austin joined the New York City Ballet in 1971.

In her nine years with the company, Austin performed in most of the repertory, creating roles in John Clifford's *Bartòk No. 3* (1974), Jacques D'Amboise's *Sinfonietta* (1975), and Jerome Robbins' *Chansons Madécasses,* choreographed for the Ravel Festival in 1975. Her outstanding elevation and magnificent leaps across the stage in *Divertimento No. 15* and *Symphony in C* were recognized by George Balanchine, who tailored a solo in his *Ballo della Regina* to her abilities in 1979.

Austin left the New York City Ballet in 1980 to join the Geneva Opera Ballet, directed by fellow NYCB alumna Patricia Neary.

Aveline, Albert, French ballet dancer and choreographer; born 1883 in Paris; died February 3, 1968 in Anvières, France. Trained at the school of the Paris Opéra, Aveline made his debut there in 1909.

Throughout his long career, Aveline was associated with the Opéra as a dancer, and as ballet master from 1917 on. The principal danseur noble of the company, he was best known as the constant partner of Carlotta Zambelli, dancing with her in works by Josef Hanssen, Leo Staats, Ivan Clustine, and himself. He also staged works for her, among them the revival of *Les Deux Pigeons* in 1923.

Known for his revivals, he staged productions of *Les Indes galantes* in 1952, as well as such original ballets as *La Grisi* (1935), *Un Baiser pour rein* (1936), and *Jeux d'Enfants* (1941).

Works Choreographed: CONCERT WORKS: *La Grisi* (1935); *Un Baiser pour rein* (1936); *Elvire* (1937); *Les Sauntons* (1938); *Le festin de l'araignée* (1939); *Jeux d'Enfants* (1941); *La Grande Jatte* (1950); *Les Indes galantes* (1952, original prologue); *L'Aiglon* (1952).

Avian, Bob, American theatrical dancer and choreographer; born December 26, 1937 in New York City. Avian made his Broadway debut when the national company of *West Side Story* opened the celebrated musical's second New York run in 1960. After returning to the road with the tour of *Carnaval*, he moved back to New York to appear in one of the unluckiest streaks of musicals in any gypsy's life—*No Where to Go But Up* closed in one week. *Zenda* didn't even make it to its New York opening, and *Jennie* struggled to make ten weeks. Not surprisingly, Avian began to work extensively in television, where he became one of the medium's most employable dancers. One source has estimated that he appeared in more than a third of all production numbers taped in New York between 1964 and 1968 on all three networks.

Avian is best known currently as the co-choreographer of *A Chorus Line* (1975), still billed as "the best thing that ever happened to Broadway." He also worked with Michael Bennett to co-stage the Katherine Hepburn vehicle *Coco* (1969) and the innovative *Ballroom* (1978). Although he still works with the many *Chorus Line* companies and casts, he has moved into production of musicals and no longer performs.

Av-Paul, Annette, Swedish ballet dancer; born in 1944 in Stockholm, Sweden. Av-Paul, who also performed as Annette Wiedershelm-Paul, received her early training from her mother, a specialist in Dalcroze-type movement classes for children. A graduate of the school of the Royal Opera House, she performed with the Opera Ballet and the Royal Swedish Ballet from 1962 to 1972.

Associated with Antony Tudor, director of the latter company in 1963 and 1964, she has performed to great acclaim in his dramatic and abstract works, among them *Echoes of Trumpets* (1963) and revivals of *Pillar of Fire* and *Undertow*. She created emotionally affecting roles in Birgit Cullberg's *Salome* (1964) and performed in her *Medea*, but also danced in the company's productions of the classics, *Les Sylphides, Swan Lake*, and *The Sleeping Beauty*. Her performances in works by Brian Macdonald, including his *While the Spider Slept* and *Song Without Words*, led her to engagements with the Harkness Ballet and the Royal Winnipeg Ballet of which he served as artistic director in the 1960s and 1970s. With those groups, she performed principal roles in his *Rose la Tulipe, Firebird, Tchaikovsky*, and *Zealous Variations*.

Avrahami, Gideon, Israeli dancer working in England from the mid-1960s; born October 31, 1941 in Tel Aviv, Israel. Trained in Tel Aviv by Gertrud Kraus and a member of both the Lyric Theatre and the Batsheva Dance Company, Avrahami left Israel to perform with the Ballet Rambert in London.

With the Rambert from 1967 to 1974, he performed in Norman Morrice's *Pastorale Variés, The Empty Suit*, and *Spindrift*; in Christopher Bruce's *There was a Time*; and in John Chesworth's *Pawn to King 5*. After playing "Diaghilev" in the television production about Nijinsky, *God of the Dance* (BBC, 1975), he became director of the East Midland Mobile Arts company outside of London (1977). He has since choreographed for that troupe.

Works Choreographed: CONCERT WORKS: *Full Circle* (1972).

Avril, Jane, French popular dancer of La Belle Epoche; born Jeanne Richepin, June 1868 in Montmartre; died January 16, 1943 in Paris. It is unlikely that Avril had any formal training in dance other than children's classes.

Although she made her actual debut as a member of a team of Belles à cheval at The (Paris) Hippo-

drome, she became famous for her next employment as a specialty dancer at the Moulin Rouge. Her act, a solo, was basically an improvised waltz, called La Mélanite after her own nickname. It was in this dance, not in the Can-Can Quadrille, that she became known throughout Europe—through descriptions in the press, and through the magnificent posters of Henri Toulouse-Lautrec.

Avril did not stay at the Moulin Rouge throughout her career; she also brought her act to the Jardin de Paris season of the Théâtre des Champs-Elysées (1894), at the Folies-Bergère (1897), in London in her only known performance in the Quadrille (with La Eglantine, Cléopâtre, and La Gazelle), at the Paris Exposition of 1900, and at Le Bal Tabarin (1909). Between those engagements, she participated in at least one legitimate theatrical production, playing "Anitra" in Lugne-Poé's presentation of *Peer Gynt* at his Nouvelle Theatre.

Azito, Tony, American modern and theatrical dancer; born July 18, 1948 in New York City. After studying with her at the Juilliard School, Azito performed for Anna Sokolow as a dancer and narrator, most notably in her *Short Lecture and Demonstration of the Evolution of Ragtime as Presented by Jelly Roll Morton*. During the last ten years, he has become celebrated as a member of New York–based avant-garde theater companies, among them The Medicine Show (in its first years as an outgrowth of the Open Theatre) and various productions of the Cafe La Mama. His performances in that theater's *C.O.R.F.A.X. (Don't Ask)* in 1974 and the continuing *Cotton Club Revues* were especially acclaimed. A genuine star of Off Off Broadway, the nearest that Azito has come to conventional commercial theater is in his Broadway appearances in the Brooklyn Academy of Music's production of Kurt Weill's *Happy End* and the New York Shakespeare Festival's revivals of *The Threepenny Opera* and Gilbert and Sullivan's *Pirates of Penzance*.

It is difficult to describe Azito's performance style and its impact on an audience. He manages to transform his unique body into each characterization and personality, and reinvents it into superhuman shapes. Directors, and through them, audience members seem to get fixated on parts of his body —Richard Forman in *Threepenny Opera* on his hands and Wilford Leech in *C.O.R.F.A.X.* and *Pirates* on isolations of his legs and torso—but he retains a sense of the entire shape through each characterization.

B

Babilée, Jean, French ballet dancer and choreographer; born Jean Gutmann, February 2, 1923 in Paris. He was trained at the school of the Paris Opéra Ballet by Boris Kniaseff, Alexander Volinine, and Victor Gsovsky, later performing briefly with the company.

With Les Ballets des Champs-Elysées from 1945 to 1950, he created roles in Jeanine Charrat's *Jeu de Cartes* (1945), David Lichine's *La Rencontre* (1948) and *La Création* (1948), and his most celebrated role, the "Young Man" in Roland Petit's *Le Jeunne Homme et la Mort* (1946). Returning to the Opéra in 1952, he performed in Harald Landers' *Hop-Frog* (1952) and in the company productions of *Giselle* and *Spectre de la Rose*. He formed his own troupe, Ballets Jean Balibée, in 1955, creating new ballets, such as *Balance à Trois* (1955), and reviving his *Divertimento* (1954) and *l'Amour et son Amour* (1948).

In the 1960s and 1970s he performed with the Maurice Béjart Ballet in his *La Reine Verte* (1963) and in the Ballet du XXième Siècle, creating a role in *Life* (1979). He also worked in the various Roland Petit companies. He also choreographed for companies in Marseille and Strasbourg.

With his own and other companies, Babilée was perceived as the ideal French dancer of the twentieth century, bringing an intelligence and humanity to his roles in intellectual and symbolic ballets, in which he frequently represented "Everyman," "Life," and all of humanity.

Works Choreographed: CONCERT WORKS: *L'Amour et Son Amour* (1948); *Til Eulenspeigel* (1949); *Divertimento* (1954); *Balance à Trois* (1955); *l'Histoire du Soldat* (1967); *Danses en Mi Majeur* (1973).

Baccelli, Giovanna, Italian ballet dancer working in London; born 1753 in Venice; died May 7, 1801 in London. It is not known where Baccelli received her training and early experience.

Celebrated in London for her work with the King's Theatre, Baccelli performed there from 1772 to 1783. Among her best known featured roles were parts in M. Simonet's *La Polonaise favorite* (1772) and in Jean-Georges Noverre's *Les Amans surpris* (1780),

Médée et Jason (1781), *Les Amans réunis* (1782), and the revival of *Les Petites Reins* in 1781.

In 1782, Baccelli made her Paris Opéra debut; her roles there included featured parts in Gardel's *Ninette à la Cour.*

Bach, Johann Sebastien, German eighteenth-century composer; born c.March 21, 1685 in Eisenach, Saxe-Weimar; died July 28, 1750 in Leipzig. Discussing Bach only in terms of dance is rather like describing Shakespeare as a writer who influenced television. His active contribution to dance production lies in the piano suites of six French and six English dances, which memorialize the rhythms and structures of then contemporary dances, such as the Courrante, Gigue, Branle, and Allemande. Although the revival of interest in Bach's enormous canon is generally attributed to concerts sponsored and conducted by Felix Mendelssohn in the late 1810s, contemporary choreographers, caught up in French and Italian Romanticism, did not use his scores. Since the 1930s, however, almost every choreographer in ballet and traditional modern dance has adopted Bach as principal composer and mentor in formal composition. The ballets based on Bach run a gamut that would have been inconceivable to the composer, from the formalism of Balanchine's 1941 masterpiece, *Concerto Barocco* (double violin concerto in D minor), to the lush neoromanticism of Roland Petit's 1946 *Le jeune homme et la mort* (C minor Passacaglia). The neoclassical approach to Bach is the one most frequently employed by choreographers in ballet techniques, such as Jerome Robbins, Benjamin Harkavy, Mikhail Fokine, Bronislava Nijinska, and Janine Charrat, and in modern dance, among them Doris Humphrey, Charles Weidman, Anna Sokolow, and Paul Taylor.

Baclanova, Olga, Soviet theatrical dancer and actress working in the United States; born c.1899 in Moscow; died September 6, 1974 in Vevey, Switzerland. After training there, Baclanova became a member of the Moscow Art Theatre, where she danced and sang in productions by Nemirovich-Danchenko. When the

Theatre was imported into the United States by Morris Gest, she was tremendously successful in New York as the heroine of *Carmencita and the Soldier*. She remained in the United States and toured with Gest's production of Max Reinhardt's *The Miracle*, alternating in the principal role of "The Nun" with Diana Manners. During the Los Angeles engagement of *The Miracle*, she was "discovered" by the casting office of Paramount/Famous Players-Laskey Studios, where she was offered a contract in 1926. Baclanova is unquestionably best known as the languorous "normal" ballerina in Tod Browing's classic horror film *Freaks* (MGM, 1932), but also appeared in dance roles in melodramas, such as *The Street of Sin* (Paramount, 1928), and in musicals, like *Cheer Up and Smile* (Fox Film Corp., 1930) and *Broadway Brevities* (Fox Film Corp., 1935, short subject).

Baclanova returned to Broadway and cabaret work in the late 1930s, also starring in a popular radio show in the 1940s.

Bacon, Faith, American theatrical dancer and striptease artist; born 1909 in Los Angeles; died September 27, 1956 in Chicago, Illinois. Trained by Albertina Rasch in Los Angeles and New York, she made her Broadway debut in the 1925 edition of *Artists and Models*, as a model. Although she was still an adolescent, she appeared as a naked show girl (probably in flesh tights) in the 1926 through 1930 editions of *Earl Carroll's Vanities* and the last Florenz Ziegfeld edition of the *Follies* (1931).

She billed herself as a concert dancer from 1932 to 1935, performing interpretive dance works in recitals, none of which, unfortunately, is known by title. In 1935, however, she went on the burlesque wheel as a strip-tease artist. Her most popular works were created between that year and 1939, when she headlined the World's Fair Congress of Beauty in New York. These pieces—among them, *Bird of Paradise, Dance of the Living Orchids* and *The Afternoon of a Faun*—were also performed in Prologs on the Paramount/Publix circuit, so it must be assumed that she either did different versions of her repertory for different audiences, or that she never stripped all the way down. It should be noted that her *Afternoon of a Faun* was unrelated to Mikhail Fokine's; although her costume was similar to the original's, it

was made with individual leaves and grapes, which were picked off one by one by a trained fawn.

Badings, Henk, Dutch composer; born January 17, 1907 in Bandoengs, Java. The celebrated Dutch orchestral and chamber music creator began to work in collaboration with ballet choreographers in the mid-1950s when he did the first of many scores for Yvonne Georgi. Apart from his Georgi works, *Electronic* (1957), *Evolution* (1958), and *Woman of Andros* (1960), he has also composed on occasion for Jan Zielstra (1956) and has allowed Rudy van Dantzig and Jonathan Taylor to reuse scores for their *Jungle* (1961) and *Diversities* (1966), respectively.

Bagnold, Lisbeth, American modern dancer; born October 10, 1947 in Bronxville, New York. Bagnold studied dance locally at the Steffi Nossen studio before continuing her training while attending the University of California at Los Angeles under Gloria Newman and Penny Levitt-Stephens. While at UCLA, she also worked under Gus Solomons, Valerie Bettis, for whom she danced in *On Ship* (1971), José Limón, and Alwin Nikolais. She moved to New York to take classes at the Nikolais (Murray) Louis studio and joined the former's company in 1971. She has appeared in almost all of Nikolais' group works created between 1972 and 1978, including his celebrated *Grotto* (1973) and in the company's repertory. Bagnold also teaches for Nikolais at the New York studio and at the school which he sponsors in France. She recently began to choreograph for her own recitals.

Works Choreographed: CONCERT WORKS: *Quiescence* (1980).

Bailey, Bill (I), American tap dancer; born May 25, 1878 in Richmond, Virginia; died November 25, 1949. Bailey, who should not be confused with other tap dancers of that name, was a protégé of Bill Robinson and his manager Marty Forkins. Bailey made his debut in 1908 as a member of Robinson's vaudeville act, and stood by for him in a number of revues. He appeared with Robinson in many films for Twentieth-Century Fox, with and without Shirley Temple, among them *The Little Colonel* (1935), *In Old Kentucky* (1935), *The Littlest Rebel* (1935), *Dimples*

(1936), *Rebecca of Sunnybrook Farm* (1938), *Just Around the Corner* (1938), and *Stormy Weather* (1943).

Using "Bill Bailey Won't You Please Come Home" as his theme song, he was a headliner on the black vaudeville circuits throughout his solo career, but retired to teach just before his death.

Bailey, Bill (II), American tap dancer; born 1912 in Newport News, Virginia; died December 12, 1978 in Philadelphia. This Bill Bailey, the older brother of singer Pearl Bailey, was also a Bill Robinson protégé, working in the Bojangles' "tapologuist" style of talking to the audience while dancing. He replaced Robinson in the 1937 Cotton Club act, and imitated him in the Broadway musical *Banjo Eyes* (1941). Other Broadway credits include George Balanchine's *Cabin in the Sky* (1940), repeating his role in the film version, and *Zanzabarian Nights* (1944).

Bailey appeared frequently with his sister, and worked as a tap-percussionist with all the major black bands of the 1930s and 1940s, among them the Count Basie and Duke Ellington Orchestras. He retired in 1946 to become a minister, but returned to the concert stage occasionally for benefit performances with the Basie and Miles Davis groups. During the 1950s and early 1960s, he became a favorite on *The Ed Sullivan Show*, performing almost annually on that popular television variety show.

Bill Bailey (II) should not be confused with his predecessor, who probably adopted the name from the famous song, or with a white dancer who left the New York stage to open a Cotton Club bar in Singapore.

Bailey, Frankie, American theatrical dancer known as "The Girl with the Million Dollar Legs"; born Francesca Walters, May 29, 1859 in New Orleans; died July 8, 1953 in Los Angeles, California. Bailey was the best known chorus dancer in turn-of-the-century burlesque and the featured performer of the Weber and Fields Music Halls, c.1896 to 1912. Among the many productions in which she appeared were *Whirl-i-gig* (1899), *Fiddle-Dee-Dee* (1900), *The Ginger Bread* (1905), and *Hokey-Pokey* (1912). In each, she led the chorus dressed in an elaborate head dress, a tunic or military *cuirass*, boots, and tights—

revealing the glory of her legs to the appreciative audience. She retired from the stage in 1916 but appeared frequently in films as a mother, maid, or townswoman until the 1940s.

Bailey's continuing reputation is based on more than the publicity campaign that accompanied her performances for Weber and Fields. Despite her age—she was in her forties during the peak of her success—she did have spectacular legs and was able to parlay them into a career.

Bailin, Gladys, American modern dancer and choreographer; born February 11, 1930 in New York City. Trained at the Henry Street Settlement House, she became a student of Alwin Nikolais when he joined the faculty there. A Nikolais company member since 1948, she performed in all of his television works and many of the stage presentations, among them *Totem* (1959), *Stratus and Nimbus* (1961), *Imago* (1963), and *Galaxy* (1965). Bailin also performed in the companies and recital groups of fellow Nikolais dancers, Bill Frank, Beverly Schmidt-Blossom, and Murray Louis. As a charter member of the Louis troupe, she created roles in his *Signal* (1960), *Facets* (1962), *Chorus I* (1966), *Family Album* (1954), and *Junk Dances* (1964). She frequently danced in duets with Don Redlich, notably in his *Alice and Henry* (1967) and *Couplet* (1967), and performed in his pieces, *Air Antique* (1966) and *Slouching Towards Bethlehem* (1969).

Bailin has choreographed occasionally for concerts shared with Redlich, Louis, and other Nikolais dancers. She has taught at the New York University School of the Arts and at the Nikolais/Louis Dance Theatre Lab.

Works Choreographed: CONCERT WORKS: *Quiet Vision* (1954); *Five Ladies* (1954); *Interlude* (1954); *Persistent Memory* (c.1956); *Harlequinade* (c.1956); *Prelude and Courante* (1957); *Warrior* (1957); *Flight* (1957); *Sentinel* (1957); *Evensong* (1957); *Suite* (Walking, Sitting, Running) (1957); *Koto* (1957); *Helix* (1957); *Riff* (1957); *Amaranth* (1957).

THEATER WORKS: *The Oldest Trick in the World* (1965).

Baker, Josephine, American entertainer working primarily in France; born June 3, 1906 in St. Louis,

Missouri; died April 12, 1975 in Paris. The name of Baker's social dance teacher in St. Louis cannot be verified; from descriptions of classes in other Mississippi port cities, it is unlikely that she was taught any musical comedy dance work. Baker made her professional debut in *Shuffle Along*, the celebrated Sissle and Blake musical comedy of 1921. After dancing in the Plantation Club (New York's) Plantation Revue in 1924, she returned to Broadway in Sissle and Blake's *The Chocolate Dandies* (1924), which, like *Shuffle Along*, had been on the road before its New York opening.

Baker first performed in Paris in 1925 in *La Revue Nègre* at the Théâtre des Champs-Elysées. Her success in that show was so overwhelmingly great that she was hired to perform as a specialty dancer with the Folies Bergère, which she did intermittently until the mid-1950s. Her act was basically a series of dances in the French jazz hot style; although she was best known for her costuming, there is no doubt that she was an excellent dancer with a great shimmy. The costume did become celebrated and a part of the French iconography—the association with the bananas of her outfit was so pervasive that a banana flan was renamed for her.

Her shows alternated between New York and Paris—she was not popular in London—with *La Créole* (Paris 1935), the *Ziegfeld Follies of 1936* (New York), *Paris Sings Again* (closed out of New York, 1947), *Mes Amours* (Paris, 1958), and her own show, *Josephine Baker and Her Company*. Her films were all French and included *La Revue des revues* (1927), *La Folie du Jour* (1927), *Zou-Zou* (1934), and *Princesse Tam-Tam* (1935).

Bibliography: Baker, Josephine. *Une Vie des Toutes les Couleurs* (Paris: 1926); *Les Memoires de Josephine Baker* (Paris: 1927); *Voyages et Adventures* (Paris: 1931).

Baker-Scott, Shawneequa, American modern dancer and choreographer; born in the Bronx, New York. Baker-Scott was trained at the eclectic New Dance Group under Donald McKayle, Jean-Léon Destiné, Hadassah, Sophie Maslow, Jane Dudley, William Bales, Muriel Maning, and Asadata Dafore. She appeared with the companies of many of her teachers including McKayle, for whom she danced in *Legendary Landscape* and *And Her Name Was Harriet*

(1952). Her performances with the Eleo Pomare company include roles in *Les Desenamorades* and *Blues for the Jungle* (1966).

A popular teacher at Ron Pratt's Alpha Omega Studio, Baker-Scott has found time to choreograph for herself and other dancers, many of whom perform her works in their solo programs.

Works Choreographed: CONCERT WORKS: *Every Mother's Child* (1975); *Insights: Tribute to Tap Dancers* (1975); *Inner Corners of the Soul* (1975); *Bittersweet* (1975); *Crossroads* (1975); *Keeper of the Flame* (1975); *Johnstown: Profile of the Reverend James Jones* (1979).

Bakst, Léon, Russian theatrical designer; born Lev Rosenberg, May 10, 1866 in Grodno; died December 28, 1924 in Paris. Originally a painter and graphics designer, he worked on many projects directed by Serge Diaghilev, among them the *Mir Iskusstva* (The World of Art), the Annals of the Imperial Theaters, and the exhibits of Russian art produced in Paris. His reputation rests securely on his work for Diaghilev's Ballet Russe, among them *Cléopâtre* (1909), *Schéhérazade* (1910), unquestionably his best known work, *Narcisse* (1911), *Le Dieu Bleu* (1912), *L'Apres midi d'un Faun* (1912), *La Legende de Joseph* (1914), *Les Femmes de bonne humeur* (1917), and *The Sleeping Princess* (1921, revival). He also created designs for Ida Rubinstein's *Le Martyr de Saint-Sébastien* (1911), and for Gertrude Hoffman, including a black and white gown, billed as a "Cubist costume" in her 1911 *Broadway to Paris*.

Bakst's reputation was extraordinarily wide ranging. He appeared in cartoons in London and Cole Porter lyrics in New York, and many styles of domestic designs were named after him for their color schemes, since, as Porter said, "To show how much our tempers have been taxed, [Ma] just had our bathroom done over by Bakst."

Bibliography: Levinson, André. *Léon Bakst* (Paris: 1927); Spencer, Charles. *Léon Bakst* (London: 1973).

Balanchine, George, Ballet dancer and ballet and theater choreographer, the major ballet figure of the twentieth century; born Georgi Balanchivadze, January 22, 1904 in St. Petersburg. The son of a Georgian composer, he was trained at the school of the Impe-

rial Ballet/State Academy of Dance, graduating into the GATOB in 1921. He did his first choreography for the Evenings of Young Ballet in 1922, under constructivist choreographer Kaslan Goleizovsky. In 1924, he, Tamara Geva, and Nicholas Efifmov toured Germany with an ad hoc company, the Soviet State Dancers; they auditioned for Diaghilev while in Western Europe. A choreographer for the Ballet Russe from 1925 until Diaghilev's death in Venice in 1929, he fit into the constructivist theme in the impresario's current tastes. Two works from his Ballet Russe tenure are considered among the masterpieces of the twentieth-century repertory: *Apollon Musagète* (1928, currently titled *Apollo*) and *Prodigal Son* (1929). Each emphasizes a defined specific movement which is unique in choreography, with bodies serving as shapes and not dancers working as personalities.

After Diaghilev's death, he contributed works to the repertories of the Paris Opéra, the Royal Danish Ballet, and the Ballet Russe de Monte Carlo of René Blum, before becoming the director of Les Ballets 1933, for which he staged *Les Songes, Mozartiana,* and the premiere of *The Seven Deadly Sins.*

In 1934 he accepted the invitation of art critic and writer, Lincoln Kirstein, to direct the School of American Ballet and its company, the American Ballet, which was in residence at the Metropolitan Opera. His first American ballet, still the signature piece of the company, was *Serenade* (1934), an abstract work that has become progressively more abstract with each revision. That company existed until 1942. During the war, Balanchine created occasional works for benefits and for the Ringling Brothers and Barnum and Bailey Circus, and staged pieces for the Ballet Russe de Monte Carlo, among them, *Danses Concertantes* (1944) and *La Somnambula* (1946). He and Kirstein were reunited in 1946 with the Ballet Society—a private, performance-by-subscription company which commissioned his *The Four Temperaments* (1946), another work that has become increasingly abstract in the passing years, *Divertimento* (Haieff) (1947), and the American premiere of the Paris Opéra's *Symphony in C,* to share programs with orchestral concerts.

That organization evolved into the New York City Ballet, the company with which he has been associated ever since, and for which he has created most of his next ninety-four works. He has choreographed almost continuously since the founding of the institution creating from two to five new ballets a year. They range from "good for the company" to masterpieces with no apparent order. Although every member of the enormous City Ballet audience has a personal favorite, certain ballets seem to be generally adored. These include *The Nutcracker* (1954), which provides a good part of the company's income but includes segments of choreographic beauty to offset its pure theatricality, and the most uncompromisingly abstract ballets: *Agon* (1957), which has been called the dance masterpiece of the postwar era, *Episodes Part I* (1959), and the trio from the 1972 Stravinsky Festival, *Symphony in Three Movements, Stravinsky Violin Concerto,* and *Duo Concertante,* works which from all reports were created together in less than a week.

Although it has been said that one cannot write about Balanchine without a paragraph per bar of music, one can generalize somewhat about his choreography. He has created some abstractions in plotted ballets, among them, *The Nutcracker, A Midsummer Night's Dream* (1962), *Harlequinade* (1965), the controversial *Don Quixote* (1966), and *Coppélia* (1974), co-choreographed with Alexandra Danilova. Each of these, however, includes a lengthy section of abstract ballet set in rigid hierarchical structures. These hierarchies are also visible in his other works—it is one of the last vestiges of his Imperial Theater education. One can always see the status of a performer within each ballet by his or her position on stage. In works as seemingly disparate as *Symphony in C, Episodes* (1959), *Liebeslieder Walzer* (1960), *Bugaku* (1963), the *Stravinsky Violin Concerto* (1972), and *Union Jack* (1976, his tribute to Great Britain for the American bicentennial), the audience can see the visualized hierarchy.

In all works from the fairy tale *Nutcracker* and *Coppélia,* to the abstractions, one can find the flash of choreographic brilliance and wit, irreverently known to the company regulars as the "Balanchine double whammy." It can be a streak of humor, as in movements that sneak into the duet of *Rubies* (*Jewels,* Part II, 1967), or a shock or terror, as he uses in *La Valse* (1951). That ballet is terrifying long before the "Death figure" enters—the three women who open the work are brittle sophisticates who renew the cruelty of that cliché. It is interesting that the

gesture he chose to depict quickly their frailty and short span of beauty—sweeping arms that break at the wrist—is the same chosen by José Limón to characterize the "Iago" figure in *The Moor's Pavanne.* The gesture Balanchine chose for "Death's" selection of the victim is unique: he brings her black gloves that she dons with the sweeping arm of the three women, an enormous gesture that fills the stage with a simple pedestrian movement. The "Whammy" can open the ballet, as it does with a streaking diagonal of dancers in *Symphony in Three Movements,* or close it, as he does with the literally off-beat kick-line in *Stars and Stripes* (1958).

Balanchine uses what is both the largest and the most controlled movement vocabulary in the contemporary dance. He expanded the potential of movement within the ballet technique by freeing the body from the straight back and level hips of the conventional, symmetrical nineteenth-century style. Each unusual step is used for controlled effect; they attract the audience's attention or lead the audience's eyes to a particular point or angle on stage. It is not just that Balanchine produces more than other choreographers, or works in more different styles; it is that he still takes more chances than any other creative genius. In a period when most choreographers find a style and work within its confines forever, and at an age when most septuagenarians would be happy to rest on their laurels, Balanchine is willing to experiment with whole works, structures, and individual movements. The opening of *Serenade,* with the double diamond of women performing the same movements, breaking down a basic ballet port de bras into a language of its own, the fantastic speed of *Square Dance* (1957), so enthralling that the original trick of having the steps called seems peripheral now, the stark romances of *Meditation* (1963) and the "Man I Love" duet in *Who Cares?* (1970), the shock of the two duets in *Chaconne* (1976), one emotional and adolescent, one formal and quickly aging—all are chances and choices that are recognizable as uniquely Balanchine.

It was previously said that Balanchine's early works for Diaghilev—*Agon, Episodes,* and the Stravinsky works—are masterpieces of the twentieth century. It is possible that two of his most recent works will join them in that distinction. They are the *Kammermusik*

No. 2 (1978), which uses a vocabulary similar to that of *Episodes,* but with a speed associated with the Baroque works and a structure that is more formal than most, and the *Schumann's Davidsbundlertanze* (1980), a controversial work in the lineage of *Liebeslieder Walzer,* with social occasions and dance forms becoming humanized, and then, frightening. The waltzes are individualized and the forthcoming revelations about the personae on stage depicted in movements, stage patterns, pace, density of steps—everything perceivable except facial expression and words.

As pleasant as it could be to discuss Balanchine's ballets for a dozen pages, it is important to remember that he had a very successful career as a musical comedy and film choreographer. After contributing dance numbers to *Wake Up and Dream* (1929) and (C.B.) *Cochran's 1930 Revue,* he staged whole musicals on Broadway. These include the 1935 Shubert Brothers' *Ziegfeld Follies*; three Rogers and Hart musicals: *On Your Toes* (1936), *Babes in Arms* (1937), and *The Boys from Syracuse* (1938); the operettas *Rosalinda* (1942, after *Der Fledermaus*), *The Merry Widow* (1943), *Song of Norway* (1944), and *The Chocolate Soldier* (1947); the Harriet Hoctor revue *Dream with Music* (1944); and the Ray Bolger vehicle *Where's Charley?* (1948), among many others. Unlike many contemporary ballet-dancers-turned-Broadway-choreographers, he did not insist on inserting a dream ballet in each show, but stayed within the feel and vocabulary of the script and score.

Balanchine's first film was an English melodrama about a sculptor who tries to chop off the hands of his pianist-wife's lover; in it he danced with Anton Dolin and Tamara Toumanova in an interpolated scene. His American film career was considerably less successful than his live-theater one, although that may have been because of his refusal to move to Hollywood. He contributed two extensive dance sequences to *The Goldwyn Follies* in 1938, using the American Ballet corps and Vera Zorina; one is a jazz versus ballet version of *Romeo and Juliet,* the other a water nymph ballet that resembles *La Valse* in many ways. His "Slaughter on Tenth Avenue" was revised for the film of *On Your Toes* in 1939, for Zorina and Eddie Albert.

Balanchine's influence on the ballet is incalculable. He has taught composition by example to the same

extent that Louis Horst did by active lecturing, pushing American dancers in every technique into a recognition of structure and form, whether they decide to use them or not. He has opened up the ballet technique and rescued it from direct competition with the modern dance. His ideals of abstract ballets requiring precision of choreography and performance have been transmitted to all dancers and have raised the standards of performance accordingly. It should be reiterated that his influence is not limited to those who have worked with him but extends to the whole world of dance.

The following list of works by Balanchine is complete to December 31, 1980. It does not include the half-dozen ballets that he plans to create for the 1981 Tchaikovsky Festival, so contains only 150 concert works. An ongoing research project, directed by Nancy Reynolds, will soon result in a more complete chronology of Balanchine's work.

Works Choreographed: CONCERT WORKS: *La Nuit* (c.1922); *A Poem* (c.1922); *Valse* (c.1922); *Marche Funebre* (c.1923); *Le Chant du Rossignol* (1925); *Bardeau* (1925); *Romeo and Juliet* (1926); *La Pastorale* (1926); *Jack-in-the-Box* (1926); *The Triumph of Neptune* (1926); *La Chatte* (1927); *Apollon Musagète* (1928); *The Gods Go-a-Begging* (1928); *Aubade* (1930); *Jack and Jill* (1930); *Josephslegende* (1931); *Le Bourgeois Gentilhomme* (1932); *La Concurrence* (1932); *Cotillon* (1932); *Les Songes* (1933); *Mozartiana* (1933); *Fastes* (1933); *Les Valses de Beethoven* (1933); *Serenade* (1934); *Alma Mater* (1934); *Reminiscence* (1935); *Dreams* (1935); *Transcendence* (1935); *Concerto* (I) (1936); *The Bat* (1936); *Orpheus et Eurydice* (1936); *Magic* (1936); *Le Baiser de la Fée* (1937); *The Card Party* (1937); *Hobo* (1937); *Balustrade* (1941); *Ballet Imperial* (now entitled *Tchaikovsky Piano Concerto No. 2*) (1941); *Concerto Barocco* (1941); *Divertimento* (Rossini) (1941); *Fantasie Brasileria* (1941); *Pas de Trois for Piano and Two Dancers* (1942); *Circus Polka* (1942); *Danses Concertantes* (1944); *Pas de Deux* (The Sleeping Beauty) (1945); *Elegie* (1945); *La Somnambula* (occasionally called *Night Shadow*) (1946); *Raymonda* (1946, co-choreographed with Alexandra Danilova); *The Four Temperaments* (1946); *Renard* (1947); *Divertimento* (Haieff) (1947); *Palais de Cristal* (1947, performed as *Symphony in C*); *Symphonie Concertante* (1947); *Theme and Variations* (1947); *The Triumph of Bacchus and Ariadne* (1948); *Orpheus* (1948); *Pas de Trois Classique* (1948); *The Firebird* (1949); *Bourée Fantasque* (1949); *Pas de Deux Romantiques* (1950); *Jones Beach* (1950, co-choreographed with Jerome Robbins); *Mazurka* (1950); *Sylvia Pas de Deux* (1950); *Trumpet Concerto* (1950); *La Valse* (1951); *Capriccio Brillante* (1951); *A la Françaix* (1951); *Tyl Eulenspiegel* (1951); *Swan Lake* (Act II) (1951); *Caracole* (1952); *Bayou* (1952); *Scotch Symphony* (1952); *Metamorphoses* (1952); *Harlequinade Pas de Deux* (1952); *Concertino* (1952); *Valse Fantasie* (1953); *Opus 34* (1954); *The Nutcracker* (1954); *Western Symphony* (1954); *Ivesiana* (1954); *Roma* (1955); *Pas de Trois* (1955); *Pas de Dix* (1955); *Jeux d'Enfants* (1955, segments choreographed by Barbara Milberg and Francisco Moncion); *Allegro Brillante* (1956); *Divertimento No. 15* (1956); *A Musical Joke* (1956); *Square Dance* (1957); *Agon* (1957); *Gounod Symphony* (1958); *Stars and Stripes* (1958); *Waltz Scherzo* (1958); *Native Dancers* (1959); *Episodes* (Part I only) (1959); *Pan America* (*Columbia, Mexico, Cuba*) (1960); *Tchaikovsky Pas de Deux* (1960); *The Figure in the Carpet* (1960); *Momentum Pro Gesualdo* (1960); *Donizetti Variations* (1960); *Liebeslieder Walzer* (1960); *Modern Jazz Variants* (1961); *Electronics* (1961); *Valses et Variations* (1961); *A Midsummer Night's Dream* (1962); *Bugaku* (1963); *Movements for Piano and Orchestra* (1963); *Meditation* (1963); *Tarantella* (1964); *Clarinade* (1964); *Pas de Deux and Divertissement* (1965); *Harlequinade* (1965); *Don Quixote* (1965); *Variations* (1966); *Brahms-Schoenberg Quartet* (1966); *Trois Valses Romantiques* (1967); *Jewels* (Emeralds, Rubies, Diamonds) (1967); *Glinkiana* (1967); *Metastases and Pithoprakta* (1968); *Requiem Canticles* (I) (1968, note 1972 work to same music by Robbins); *Who Cares?* (1970); *Tchaikovsky Suite No. 3* (includes *Theme and Variations* as movement no. 4) (1970); *Concerto for Jazz Band and Orchestra* (1971, co-choreographed with Arthur Mitchell); *PAMTGG* (1971); *Lost Sonata* (1972); *Symphony in Three Movements* (1972); *Stravinsky Violin Concerto* (1972); *Divertimento from "Le Baiser de la Fée"* (1972); *Scherzo à la Russe* (1972); *Duo Concertant* (1972); *Pulcinella* (1972, with Jerome Robbins); *Choral Variations of Bach's "Von Himmel Hoch"*

(1972); *Cortège Hongrois* (1973); *Variations pour une Porte et un Soupir* (1974); *Sonatine* (1975); *Scheherezade* (1975); *Le Tombeau de Couperin* (1975); *Pavane* (1975); *Tzigane* (1975); *Gaspard de la Nuit* (1975); *Rapsodie Espagnole* (1975); *The Steadfast Tin Soldier* (1975); *Chaconne* (1976); *Union Jack* (1976); *Etude for Piano* (1977); *Vienna Waltzes* (1977); *Ballo della Regina* (1978); *Kammermusik No. 2* (1978); *Le Bourgeouis Gentilhomme* (1979, with Jerome Robbins); *Walpurgisnacht* (1979); *Ballade* (1980); *Schumann's Davidsbundlertanze* (1980).

OPERA: *L'Enfant et les Sortileges* (1925); *The Rake's Progress* (1953).

THEATER WORKS: *Wake Up and Dream!* (1929, interpolated dance sequence); *Cochran's 1930 Revue; Ziegfeld Follies* (1936, interpolated dance sequences); *On Your Toes* (1936, including "Slaughter on Tenth Avenue," also performed as separate ballet); *Babes in Arms* (1937); *I Married an Angel* (1938); *The Boys from Syracuse* (1938); *Keep Off the Grass* (1940); *Louisiana Purchase* (1940); *Cabin in the Sky* (1940); *The Lady Comes Across* (1942); *Rosalinda* (1942); *What's Up?* (1943); *Dream with Music* (1944); *Song of Norway* (1944); *Mr. Strauss Goes to Boston* (1945); *The Chocolate Soldier* (1947, revival); *Where's Charley?* (1948); *Courtin' Time* (1951).

FILMS: *Dark Red Roses* (British Sound Film Productions/British Independent Exhibitors, Distributors, 1929); *The Goldwyn Follies* (Samuel Goldwyn Productions, 1938); *On Your Toes* (1st National/WB, 1939); *I Was an Adventuress* (Twentieth-Century Fox, 1940); *Star Spangled Rhythm* (Paramount, 1942).

TELEVISION: *Noah and the Flood* (CBS, 1962 special).

Bibliography: Balanchine, George and Francis Mason. *Balanchine's Complete Stories of the Great Ballets* (Garden City, N.Y.: 1954, 1977, 1982); Kirstein, Lincoln. *The New York City Ballet* (New York: 1973); Koegler, Horst. *Balanchine und das moderne Ballett* (Hanover: 1964); Reynolds, Nancy. *Repertory in Review* (New York: 1977); Taper, Bernard. *Balanchine* (New York: 1963).

Baldina, Alexandra Maria, Russian ballet dancer working in the United States after the 1910s; born September 27, 1885 in St. Petersburg; died September 6, 1977 in Hollywood. Baldina was trained at the school of the Imperial Ballet in St. Petersburg, graduating into the Maryinsky Ballet in 1903. She transferred to the Bolshoi Ballet in Moscow, however, within the year. After many roles with the Russian companies, including the principal parts in revivals of Petipa's *Esmeralda* and Ivanov's *Nutcracker*, and creating the "ballerina of the Prelude" role in Mikhail Fokine's *Les Sylphides* (1909 version), Baldina joined the Diaghilev Ballet Russe. There, she performed in the Fokine repertory and became involved with Theodore Kosloff, Moscow-born dancer of the Maryinsky Ballet.

For the next fifteen years, Baldina, Kosloff, his brother Alexis, and the latter's wife, Juliette Mendez, toured and performed in England and the United States. They moved to America first to work as a quartet on the Orpheum circuit in 1910, in Theodore Kosloff's versions of Petipa, Gorsky, and Ivanov. They joined up with Gertrude Hoffman's Saison des Ballets Russe company for its 1911 Winter Garden seasons in New York and lengthy tour. For Hoffmann, they danced in the Diaghilev repertory, including versions of *Schéhérezade, Les Sylphides* and *Cléopâtre* credited to Kosloff. Soon after the tour ended, they returned to Europe briefly to perform in Tamara Karsavina's Coliseum Theatre season in London.

The family Kosloff's next American tour involved the two Kosloffs and their wives as principals and a company that included Anatole Bourman and Natasha Rambova. Baldina and Theodore Kosloff returned from Los Angeles, where he worked in film from 1915, to New York to perform on Broadway in *The Passing Show of 1915, The Awakening, Maid in America,* and other Shubert Brothers productions.

Baldina taught in the Los Angeles area from the late 1910s to her retirement in late 1977. For many years she and the family taught at the franchised schools that her husband set up across the country but she opened a private studio after his death in 1956.

Bales, William, American modern dancer and choreographer; born June 27, 1910 in Carnegie, Pennsylvania. After studies in Pittsburgh with Frank Eckl, Bales attended Carnegie Institute of Technology as a

drama major. Moving to New York in 1934, he took classes at the Humprey/Weidman studio, joining the Concert Group in 1935. In the company, he created roles in Doris Humphrey's *New Dance* (1935), *With My Red Fire* (1936), *Passacaglia, and Fugue in C Minor* (1938) and *Theatre Piece* (1936), co-choreographed with Charles Weidman. Before continuing the usual career development of a Humphrey/Weidman dancer through group and solo recitals to choreography, Bales performed with the Radio City Music Hall Ballet (c.1937) and at the Tamiment Encampment, playing Broadway with the camp's *Straw Hat Revue* in 1940.

As a concert dancer, Bales shared a Dance Observer-sponsored recital with Graham company members Sophie Maslow and Jane Dudley in 1942. Within the year, they had formed a company, the Dudley-Maslow-Bales Dance Trio, that lasted until 1954. Most of Bales' choreography was created for that group, either collectively, as for *As Poor Richard Says . . .* (1943), collaboratively with Dudley, or alone. Many of his best known works were solos, among them, *To a Green Mountain Boy* (1942), *Adios* (1943), and *Impromptu* (1950).

Bales is as important to American modern dance as an educator and curriculum-developer as he is as choreographer. Among the schools at which he has taught are Bennington College (1940s), New York University (1952), the Juilliard School (1962-), and the State University of New York's Performing Arts college at Purchase, at which he developed the dance program as its first chairperson (1967–1975).

Works Choreographed: CONCERT WORKS: *Il Combattimento* (1941, co-choreographed with Nona Shurman); *Bach Suite* (1942, with Jane Dudley and Sophie Maslow); *To a Green Mountain Boy* (1942); *Black Tambourine* (1942); *Es Mujer* (1942); *As Poor Richard Says . . .* (1942, with Jane Dudley and Sophie Maslow); *Peon Portraits* (Field Hands, Adios) (1943, variously premiered); *Sea Bourne* (1945); *Furlough* (1945, with Jane Dudley); *Three Dances in a Romantic Style* (Presto, Moderato, Grazioso) (1948); *Judith* (1949); *Impromptu* (1950); *The Haunted Ones* (1951).

Balin, Edmund, American theatrical dancer and choreographer also working in England; born in the mid-1920s in Lawrence, Massachusetts. Balin began his professional training with the Army Air Corps Special Services division and continued it after attending college in New York with classes from Jack Potteiger, Igor Schwetzoff, and Nanette Charisse. He performed in Jerome Robbins' *High Button Shoes* (1947), Michael Kidd's *Arms and the Girl* (1950), and Donald Saddler's *Wonderful Town* (1953), on which he assisted, as well as an estimated 150 television variety series and specials. Like many of his colleagues, Balin began his choreographic career as the reproducer of Broadway show routines in London; he served in that capacity for *Wonderful Town* in London and for the national company of *A Tree Grows in Brooklyn* before receiving his own live theater assignments on Broadway for *By Hex* (1956) and *Kaleidoscope* (1957). Balin also staged dances for television in the 1950s, most notably for the *Armstrong Circle Theatre* and *Voice of Firestone* in the United States and for the *Cross Canada Hit Parade* for the CBC.

Balin, who was known as "the king of the industrials" in the 1960s and 1970s and is credited with introducing that commercial theatrical form to England, has worked extensively in recent years as a nightclub and cabaret act creator.

Works Choreographed: THEATER WORKS: *By Hex* (1956); *Kaleidoscope* (1957); *Half a Sixpence* (London, 1963); dozens of industrials; cabaret acts.

TELEVISION: *Armstrong Circle Theatre* (fifty-three episodes of series, NBC, 1950–1957); *Voice of Firestone* (three episodes, ABC, c.1954–1962); *One Touch of Venus* (NBC, 1955, special); *Cross Canada Hit Parade* (CBC, 1958–1959).

Ballard, Michael, American modern dancer; born in the 1940s in Denver, Colorado. Ballard reportedly began his dance training at the University of Colorado in an effort to get out of taking Freshman Phys. Ed. Liking it, he transferred to the University of Utah which had a ballet program directed by Willam Christensen and a modern dance program that featured many guest lectures and master classes from New York–based choreographers. He began to work with one of the guests, Alwin Nikolais, and accepted his invitation to study with him in New York after graduation.

Ballard was a member of the Nikolais troupe for many years in the 1960s and 1970s, dancing in his *Imago* (1963), *Somniloquys* (1966), *Proximities, Intersection,* and *Trend* among many others. When fellow Nikolais dancer, Murray Louis, formed his own company, Ballard performed with him, creating major roles in his *Figura* (1978), *Afternoon* (1978), *Scheherezade* (1974), and *November Dances* (1980).

With writer Kitty Cunningham, Ballard created a book of memoirs, published during the 1981 season, that describes in humorous and horrifying detail the life of the contemporary modern dancer.

Bibliography: Cunningham, Kitty. *Conversations with a Dancer* (New York, 1980).

Ballon, Domenico, Italian ballet choreographer of the late eighteenth century; researchers have been so frustrated trying to determine some sort of biographical data, training, or performance history for Ballon, that at least some of them have begun to believe that the name was a pseudonym. Although from 1778, when he was a demicaractère dancer at the Teatro San Benedetto in Venice, to 1797, his activities can be determined and charted, I cannot hazard a guess about his earlier life.

From 1782 to 1797, he served as ballet master and choreographed ballets for theaters throughout the Lombardy-Piedmontale area of North Italy. His historical and mythological ballets were created for the Teatro da San Agostino in Genoa, di San Benedetto in Venice, Communale in Bologna, Nuova in Padua, and Reggio-Ducale in Turin, the major theaters in the cultural capitals of un-unified Italy. Many of his works were specifically suited to the individual theatres, unique in a period when both works and choreographers traveled so widely. Ballets about the sources of wealth were presented in Venice, the trading center of the world at that time, while at least one piece about the only foreign ruler in Paduan history, *La Morte di Ezzelino III* (1794), was produced at the Teatro Nuovo there.

Works Choreographed: CONCERT WORKS: *Ino e Temisto* (1782); *Gli' Eccessi delle Gelosia, ossia la Morte d'Attalik* (1783); *Lauretta, ossia la Pastorella in ceinto* (1784); *Festa Militare* (1785); *Igor Primo, ossio Olga incoronata dai Russe* (1785); *Il Trionfo del Gustavo re di Svezia* (1786); *Il vinciti generoso* (1786); *La Passaggiata di Napoli* (1786); *La Conquista del Perù, ossia Amazille Tedesco* (1787); *La Vedowa ingegnosa, ossiavo la Bizzarrie del bel sesso* (1787); *Sardanapolis, Re degli Assiri* (1788); *Il Cavalier benefico* (1788); *Olimpia e Cassandro, ossia la Morte di Allessandro vendicata* (1789); *l'Incoronazione di Vladisoa, re di Polonia in re d'Ungaria* (1791); *Angelica e Witor* (1791); *I Due cacciatori e la venditrici de latte* (1791); *l'Americano in Europa* (1791); *Orfeo e Eurydice* (1791); *Il Cid firenze* (1791); *l'Incendio di Cartagihe* (1792); *Il Sommanbolo* (1792); *Atille Veneziano* (1793); *Le Convulsioni* (1793); *Geofreddo nell'Isola di Armida* (1794); *I Veniziani a Constantinopoli, ossia Alessio Comneno* (1794); *Una Mascherata* (1794); *Finta Sciocca* (1794); *La Morte de Ezzelino III, tiranno di Padua* (1794); *Il Geloso in gabbia* (1795); *I Matrimoni all'azzardo* (1796); *Ino e trentini* (1797); *Gengis-kan in Corea* (1797).

Ballou, Germaine, American theatrical dancer and teacher of ballet and modern dancer; born Germaine Douglas, December 14, 1899 in Seattle, Washington. After local training at the Douglas Dancing School, she and her younger sister, Ann, moved to Los Angeles to study at the Denishawn School there from 1920 to 1927. Ballou paid for her classes by working as a milliner and seamstress at the Fanchon and Marco West Coast Deluxe Theater chain costume shops and by appearing in films as an exotic dancer and extra. Among her many screen credits were Denishawn-type numbers in the Javanese Greta Garbo vehicle, *Wild Orchids* (MGM, 1929), *The Persian Market* (Metro, 1924), and *Lives of the Bengal Lancers* (Paramount, 1935).

In 1981, Ballou celebrated her sixtieth year of teaching. She and her sister directed studios in Los Angeles, Hollywood, and Manhattan Beach from 1921 on. They taught Denishawn work until the 1960s, when Ballou began training her students in Cecchetti ballet technique. They also presented lecture-demonstrations and recitals in the Los Angeles area in the costumes that Douglas brought back from the Denishawn Oriental tour.

Balon, Jean, French eighteenth-century ballet dancer and choreographer; born 1676 in Paris; died there in

1739. Although he made his debut in Chantilly, most of Balon's career was associated with the Academies Royal de Musique, and with private performances. He took featured dance roles in Pecourt's *Les Saisons* (1695) and *Jeu de cartes* (1700) at the Opéra and danced in the Grands Nuits de Sceaux season in the Spring of 1715. His choreography for the Opéra included *L'Inconnue (1720) and Les Caractères de la danse,* in which Marie Camargo made her debut in 1728.

Works Choreographed: CONCERT WORKS: *L'Inconnue* (1720); *Les Eléments* (1721); *Les Caractères de la danse* (1728); *Horace* (1730).

Balough, Buddy, American ballet dancer; born in Chicago, Illinois. Trained at the Ballet Theatre School, Balough worked with its sponsoring company throughout his career.

In Ballet Theatre, he created roles in Alvin Ailey's *Sea Change* (1970) and Eliot Feld's *A Soldier's Tale* (1971), and performed in most of the company revivals of the classics. A short dancer with fine technique and an exceptional stage personality, Balough made his biggest hit as the "First Sailor" in Jerome Robbins' *Fancy Free.* Plagued with injuries, Balough retired early from ballet performance after working briefly with Dennis Wayne's Dancers. In 1980, he joined the Broadway cast of *A Chorus Line* and dropped the last two letters of his surname.

Bankoff, Ivan, Russian theatrical ballet and exhibition ballroom dancer working in the United States; born Jonas Ledermann, c.1893 in Leningrad. Trained at the school of the Imperial Theaters (not necessarily as a ballet dancer), he was hired to understudy Mikhail Mordkin as Anna Pavlova's partner on the 1911 tour of the United States. Alternatively, he was a Russian circus performer who came to the United States with the Samarian Aerialist Ballet in 1908 to play the Orpheum circuit. It is also possible that both stories are true and that he was hired in America to stand by for Mordkin.

However he came, he entered vaudeville in 1913 in a characterizational exhibition ballroom act with Girlie Lola on the Keith and Orpheum circuits, and also worked as a boxer before entering the United States Army in 1916. Following his discharge, he re-turned to vaudeville in a new act with Mlle. Phoebe. This routine, including songs and a comedy monologue as well as the dance numbers, was more successful, and they were hired to perform on Broadway in *The Girls in the Air* (1919) and the *Greenwich Village Follies of 1920.* He was a *Follies* regular for a number of editions but by 1922 he had switched partners again. With his new partner, Beth Cannon, he introduced his most popular act, *The Dancing Master.* In it, he "taught" her both ballet and social dances and performed a unique solo, a *kazatke* on toe on tap. For the next eight years, they were headliners on American circuits and in European cabarets, with his solo, their *Dancing Master* sketch, and a series of characterizational dances, including a famous Apache number and a gambling act in which he played craps on the floor while haphazardly lifting her into impossible adagio poses in a satire of dream ballets.

Banks, Margaret, Canadian ballet dancer and film and television choreographer; born 1924 in Vancouver, British Columbia. After studying locally with June Roper, Banks moved to London to continue her training with Ursuala Moreton at the Vic-Wells Company.

Returning to North America, she performed with Ballet Theatre in New York for six seasons. As well as dancing in the company revivals of Mikhail Fokine's *Les Sylphides, Carnaval,* and *Petrouchka,* she created roles in George Balanchine's *Waltz Academy* (1944), David Lichine's *Fair at Sorochinsk* (1943), and Bronislava Nijinska's *Harvest Time* (1945). Leaving ballet for Broadway, she was featured in Jerome Robbins' *Look Ma, I'm Dancing* (1948) about a ballet company.

Banks has been associated with television dance since the development of prime time in the late 1940s. Her Broadway experience led her to engagements on the *54th Street Revue* (CBS, 1949–1950), one of the earliest hour-long variety shows, and on Max Liebman's *Your Show of Shows* (NBC, 1949–1954) and many of his specials. She served as dance director for many episodes of the long-running *Dinah Shore Show* (NBC, 1956–1963) which began as a monthly series, then went weekly, and finally was a series of specials. Banks has also staged dances for many vari-

ety specials, for competitions and for awards ceremonies, including a two-year engagement for the Academy Awards.

Moving to Hollywood with television production, she served as assistant choreographer or camera dance assistant for many films staged by Jack Cole, Nick Castle, Hermes Pan, Charles O'Curran, and Jerome Robbins, for whom she worked on *West Side Story* (Twentieth-Century Fox, 1962). Her solo credits seem to be for comedies and dramas, among them, the Shirley MacLaine version of *The Children's Hour,* and *Two for the Seesaw.*

Works Choreographed: FILM: *The Children's Hour* (UA, 1962); *Two for the Seesaw* (UA, 1962).

TELEVISION: *The Dinah Shore Show* (NBC, 1956–1963, including runs as monthly and weekly series and specials).

Banks, Marilyn, American modern dancer, born in the mid-1950s in Brooklyn, New York. Banks was trained by her uncle Chuck Davis at the John F. Kennedy Community Center in Brooklyn, and at the Juilliard School. She has performed with Davis frequently over the last eight years, appearing in his *Yarabi, Isicathulo, Ritual,* and *Moln Yanee,* among many other original works and stagings of folk rituals. In her years with the Alvin Ailey Dance Theatre, she has danced in the troupe's wide-ranging repertory, with parts in Rael Lamb's *Butterfly,* and Ailey's *Memorials, Cry,* and *Night Creatures.* She has also emerged as the company's comedienne, and has brought delight to audiences in George Faison's *Suite Otis* and *Tilt* in gloriously shaded portraits of contemporary characters.

Banti, Giuseppe, Italian eighteenth-century ballet dancer and choreographer; flourished 1767 to 1793; date and place of both birth and death are uncertain.

The best known member of a celebrated northern Italian family of dancers, Banti performed and choreographed at many of the theaters of the area. He worked in Pistoia, staging *Diane e Atteone* (1769) for the theater there, the San Carlo in Naples, creating *La Pastorella Liberata* (1772), the San Pietro in Trieste, the Ducale in Parma and the Teatro Reggio in Turin, where he choreographed many of his most fa-

mous works, among them *La Constanza conjugale* (1789) and *Il trionfo improviso* (1789). At La Scala in Milan from 1793 to 1796, he created many ballets, among them *Il Mastino della Scala* (1793) and *La Contadina Astuta* (1793). His last known place of employment was the Teatro San Moisé in Venice, from 1796.

Works Choreographed: CONCERT WORKS: *Diane e Atteone* (1769); *La Pastorella liberata* (1777); *La Constanza conjugale* (1789); *La Fiera di Singaglio* (1789); *Il Gastaldo burlato* (1789); *Il trionfo improviso* (1789); *Feste in occassione delle pace* (1789); *Mastino della Scala* (1793); *La Contadina Astuta* (1793).

Barbarina, La, the most celebrated Italian ballet dancer of the eighteenth century; born Barbara Campanini in 1721 in Parma, then a Farnese Duchy; died June 7, 1799 in Barschau, Silesia, Prussia. A student and protégé of Antonio Rinaldi (called Faussan or Fossani), she made her Paris Opéra debut in 1739, dancing with him in *Les Festes de Hebé.* Among her other ballets at the Opéra were *Zaide, La Reine de Grenade,* and *Les Fêtes grecques et romans,* none of which was credited to choreographers.

After performing at Versailles with a troupe from the Comédie-Française, she was invited by English impressario John Rich to perform at his Covent Garden and Lincoln's Inn Fields theaters. In London, she performed in *Mars and Venus,* possibly John Weaver's version, and *Catone in Utica* (1744). In 1744, she accepted an engagement at the court theater of Frederick, Crown Prince, in Berlin. Although she had to be brought to Berlin under force, she performed at the theater for two years, notably as the "statue of Galatea" in Jean Barthélemy Lany's restaging of *Pygmalion* in 1745.

La Barbarina retired at the end of the decade after ten years of performing. That she is still known as the great Italian dancer of the preromantic ballet is a tribute to her technique and style, as evidenced through contemporary descriptions and illustrations.

Barber, Samuel, American composer; born March 9, 1910 in West Chester, Pennsylvania. The somewhat conservative lyrical composer has been associated

with dance performance since the mid-1940s. He wrote two peices specifically for productions—*Medea* for Martha Graham (1946, now performed as *Cave of the Heart*) and *Souvenirs*, choreographed by Todd Bolender for the New York City Ballet in 1955. The latter is just one of the many choreographers who have used Barber's existing music for dance works, as he did with the "Capricorn" *Concerto for Chamber Orchestra* (1944, staged 1955). John Neumeier used that work for his *Separate Journeys* in 1968. Alvin Ailey has made use of many Barber scores, among them incidental dances for his *Knoxville: Summer of 1915* (1948, staged 1960), *Hermit Songs* (1953, staged 1961), and *Antony and Cleopatra* (1966).

Barbieri, Margaret, South African ballet dancer working in England; born March 2, 1947 in Durban. The great-great-niece of Enrico Cecchetti, she was trained locally at the Iris Manning and Brownie Sutton, and in London at the school of the Royal Ballet.

A member of the Royal Ballet from 1965, she has been featured as "Swanilda" in *Coppélia,* and in roles in John Cranko's *Pineapple Poll,* Peter Wright's *El Amor Brujo,* and the company production of *Giselle.* She has created roles in Antony Tudor's *Knight Errant* (1968), Joe Layton's *O.W.* (1972), Ronald Hynd's *Charlotte Brontë* (1974), and David Drew's *Sacred Circles* (1974).

Barclift, E. Nelson, American modern and theatrical dancer; born c.1920 in Richmond, Virginia. After theatrical training, he studied at the Doris Humphrey/Charles Weidman Studio in New York. He continued his training in the 1940s under Dorothy Bird, Martha Graham, and the staff of the Albertina Rasch studio. As a student at the Bennington School of the Dance, he created roles in Humphrey's *With My Red Fires* (1936) and Weidman's *Quest* (1936). He entered theatrical work through concert work, performing in Benjamin Zemach's *The Eternal Road* in 1937, but continued in conventional musicals, such as *Right This Way* (1938) and military revues, among them *This Is the Army,* which he co-choreographed with Robert Sidney. His most celebrated (or infamous) production was Orson Welles' direction of Michael Todd's *Around the World in Eighty Days* (1946), considered one of the great financial disasters of Broadway history. Moving to Hollywood, he began to write songs for films, gradually getting out of dance work.

Works Choreographed: THEATER WORKS: *This Is the Army* (1942, co-choreographed with Robert Sidney); *Yea Furlo* (1944); *Around the World in Eighty Days* (1946).

Bardin, Madeleine, French ballet dancer; born c.1920 in Paris. Trained at the school of the Paris Opéra, she spent most of her French performing career with the company. Associated there with the ballets of Serge Lifar, she appeared most memorably in his *Les Mirages, La Péri, Le Chevalier et la demoiselle,* and *Guignol et Pandore.* She left the Opéra in 1956 to appear in Cyril Richard's production of *La Périchole* in New York City and decided to remain here.

Bari, Lynn, American film dancer and actress; born Marjorie Fisher, December 18, 1920 in Roanoke, Virginia. Bari made her film debut as a member of the dance chorus in *Dancing Lady* (MGM, 1933), with choreography by Sammy Lee. She appeared in a number of musical films, mostly for Paramount and Fox, before switching her career focus to dramatic roles. In some, such as *Search for Beauty* (Paramount, 1934), produced by Fanchon, and the *George White Scandals* (Fox Film Corp, 1935), she was cast as a show girl, since her five-foot-six was tall for motion pictures. In others, among them *Music is Magic* (Fox Film Corp, 1935), *Sing and Be Happy* (Twentieth-Century Fox, 1937) and the famous adolescence musical *Pigskin Parade* (Twentieth-Century Fox, 1936), she tapped. After she stopped dancing in pictures, she became one of Hollywood's most popular "other women," vamping the "husbands" of long-suffering contract women at Fox and Universal until the late 1950s. She returned to show business after fifteen years of retirement to join the touring cast of *Follies* in 1973.

Bari, Tania, Dutch ballet dancer associated with the companies of Maurice Béjart; born July 5, 1936 in

Rotterdam, the Netherlands. Trained in Paris by Nora Kiss and Victor Gsovsky, she joined her first Béjart troupe, Le Ballet de l'Etoile, in 1955. In 1960, she moved with him to Brussels to become a charter member of the Ballet du XXième Siècle. In the two companies, she has created roles in his *Sacre du Printemps* (1959), *Sonate à Trois* (1957), *Ninth Symphony* (1964), *Mathilde* (1965), *Bhakti* (1968), and *Les Vainqueures* (1969). Bari retired in 1973. Her clean performance style, elegant line, and cool delivery made her seem, to many, the ideal Béjart dancer.

Barnard, Scott, American ballet dancer; born October 17, 1943 in Indianapolis, Indiana. Barnard studied tap and acrobatics locally with Beverly and John Black as a child; at Butler University, he was inspired by George Verdak and Margaret Saul to begin ballet lessons. On graduation from Butler in 1966, Bernard moved to New York, where he studied ballet with Scott Douglas, Richard Englund, and Robert Joffrey.

After a brief apprenticeship with the City Center Joffrey Ballet, Barnard joined the company in the Spring of 1968, remaining with the company until 1979, when he retired to become its ballet master and choreographic assistant. Among the works in which he created roles were Gerald Arpino's *The Clowns* (1968), *Confetti* (1970), *Kettentanz* (1971), and *Chabriesque* (1972). He performed featured roles in Arpino's *Olympics, A Light Fantastic,* and *Viva Vivaldi,* and in the company revivals of Bournonville's *Konservatoriet* and *William Tell Variations* and Kurt Jooss' *The Green Table.*

Barnett, Robert, American ballet dancer and choreographer; born May 6, 1925, in Okanogan, Washington. After local tap dance study and service in the Navy, Barnett used his G.I. Bill money to train with Bronislava Nijinska in New York. He performed briefly with the Original Ballet Russe on tour before joining the New York City Ballet in 1950.

A popular dancer with the company for nine seasons, Barnett is best remembered for the exceptional jumps and sense of comedy that led George Balanchine to create featured roles in *The Nutcracker* (Candy Cane section) in 1954 and *Stars and Stripes* in 1958. Other roles created for Barnett in the company

are in Jerome Robbins' *Ballade* (1952), Todd Bolender's *Souvenirs* (1955), and Francisco Moncion's section of *Jeux d'Enfants* (1955). Barnett also performed in the company premieres of Frederick Ashton's *Illuminations* (1950), as "The Dandy," and in the *Picnic at Tintagel* (1952), as "Merlin."

Barnett left the New York City Ballet to join The Atlanta Ballet, one of the largest of the established ballet companies outside of New York. As performer and as artistic director from 1963, he has staged ballets for the company, among them, a full-length *Sleeping Beauty* (1968), *Joey and Friends,* to music by John Lennon and Paul McCartney (1969), and *Glinkadances* (1972).

Works Choreographed: CONCERT WORKS: *The Sleeping Beauty* (1968); *Joey and Friends* (1969); *Bach Impressions* (1970); *Schubert Fifth Symphony* (1970); *Bacchic* (1970); *Glinkadances* (1972); *Lumenesque* (1976); *Peasant Dances* (1976).

Barnett, Robert Morgan, American modern dancer and choreographer; born c.1950 in the Adirondack Mountains, in upstate New York. Barnett joined Pilobolus in its first season while he was a student at Dartmouth College. He has choreographed whole company collective works for Pilobolus as well as pieces with its male contingent and with Martha Clarke. In 1979, he and Clarke co-founded Crownest with French choreographer Felix Blaska, for which they continue to co-create works. Robert Morgan Barnett should not be confused with the ballet dancer and choreographer Robert Barnett.

Works Choreographed: CONCERT WORKS: *Anaendron* (1971, choreographed by Pilobolus); *Walklyndon* (1971, choreographed by Pilobolus); *Geode* (1971); *Ocellis* (1972, co-choreographed with Moses Pendleton, Michael Tracy, and Jonothan Wolken); *Pilobolus* (1972, choreographed with Pendleton, Wolken, and then members Lee Harris and Stephen Johnson); *Aubade* (1973, co-choreographed with Martha Clarke); *Monkshood Farewell* (1974, choreographed by Pilobolus); *Terra Cotta* (1974, co-choreographed with Clarke); *Untitled* (1975, choreographed by Pilobolus); *Ciona* (1975, choreographed by Pilobolus); *Solos from The Eve of Samhain* (1977); *Molly's Not Dead* (1978, choreographed by Pilobolus); *Haiku* (1979, co-choreographed with Clarke and Fe-

lix Blaska); *The Garden of Villandry* (1980, co-chore-ographed with Clarke and Blaska).

Baron, Emilie, French nineteenth-century ballet dancer; born Marie Pescaline Dreville, c.1834, possibly in Paris; died November 19, 1852 in St. Louis, Missouri.

When she made her debut at Thomas Placide's Théatre des Variétés in 1849, she was billed as the "première danseuse du Theatre de la Nation, Paris"; this status cannot be verified. With Placide for three years, she performed in his productions of *Le Fête de Terpsichore, La Statue vivante, Le Carnaval de Venise, Giselle, The Living Fountain,* and *Robert le Diable,* as "the Abess." A suit she brought against Placide sheds an interesting light on her concept of her status as a dancer: in 1851, she sued him for forcing her "as an artiste in ballets and fairy scenes" to dance a polka comedy. By winning the case, she delineated the difference between a ballet dancer and a specialty dancer.

Baron was burned fatally in 1854 during a performance in St. Louis. As was tragically common during this period, Baron's death was due to an accident involving gas lighting.

Baronova, Irina, Soviet "Baby ballerina," working in the West after the mid-1920s; born 1919 in Russia. Raised in Rumania and France, she was trained in Paris by Olga Preobrajenska.

After dancing with the Paris Opéra, she joined the Ballet Russe de Monte Carlo, creating roles in Leonid Massine's *Les Présages* (1933), *Beach* (1933), *Choreartium* (1933), *Union Pacific* (1935), and dancing in his *Le Beau Danube.* As one of the three "Baby Ballerinas," she was also cast in the company productions of the classical pas de deux and in Bronislava Nijinksa's *Les Cent Baiser.*

An early star of Ballet Theatre, then billed as "the finest in Russian ballet," she danced in the premiere of Mikhail Fokine's *Bluebeard* (1941) and brought her glorious stage presence and ideal technique to *Coppélia, La Fille Mal Gardée,* his *Petrouchka, Swan Lake, Princess Aurora,* and Antony Tudor's *Gala Performance,* as the "Italian Ballerina."

Leaving the ballet, she performed on Broadway in *Follow the Girls* (1944), a wartime musical about a burlesque star, and in Hollywood in Ernst Matray's *Florian* (MGM, 1940).

Barra, Ray, American ballet dancer; born Raymond Martin Barallobre, January 3, 1930, in San Francisco, California. Trained by Harold and Lew Christensen at the school of the San Francisco Ballet, Barra graduated into the company as an adolescent.

Joining the American Ballet Theatre from 1953 to 1959, Barra participated in many of the Ballet Theatre Workshop performances of new works, with parts in Katherine Litz's *The Enchanted* (1956), Herbert Ross' *Paean* (1957), Enrique Martinez's *The Mirror* (1958), and Kenneth Macmillan's *Winter Eve* (1957). In the company itself, he performed in their revivals of the classics and was assigned a featured role in Birgit Cullberg's *Miss Julie.*

From 1959 to 1966, Barra performed with the Stuttgart Ballet, creating roles in John Cranko's *Romeo and Juliet* (1962), *Swan Lake* (1963), *The Firebird* (1964), and *Eugene Onegin* (1965), as well as Kenneth Macmillan's *Las Hermanas* (1963) and *Song of the Earth* (1965).

Barreau, Pierre, Haitian modern dancer working in the United States; born August 30, c.1953 in Haiti. Raised in New York after 1965, Barreau was trained at the Juilliard School, where he studied with Anna Sokolow and Daniel Lewis, among others. He appeared in Sokolow's *Come, Come Travel with Dreams* in the 1974 student recital before he joined the Contemporary Dance System (now, the Daniel Lewis Repertory Dance Company), where he continued to perform in her works, among them *Rooms, Ballade, Lyric Suite, Dreams,* and *Moods* (1975). Among the many other works in which his versatile performance strength has been seen in that company, dedicated to the preservation of pieces by Sokolow, Doris Humphrey, José Limón, and company members, are Humphrey's *Nightspell,* Limón's *The Exiles* and *The Waldstein Sonata,* and Lewis' *Beethoven Trio, There's Nothing Here of Me but Me* (1980) and *First They Slaughtered the Angels* (1974). Barreau has also performed with the Raymond Johnson company in his *Black Dance* and *Sugar Cane* and in the troupe's revivals of pieces by James Waring, among them *Mazurka* and *Scintilla.*

Barret, Dorothy, American concert dancer; born c.1918 in the Bay area of California. The real name of Barret, who used her married name professionally, is not known. She was trained at the University of California at Berkeley by Louise La Gai and did her earliest known choreography there for a pageant, Parthneia. After moving to New York, she continued her studies with Chester Hale, Ella Dagnova, Albertina Rasch (all of whom worked in the theater but were European-trained in ballet), Pierre Vladimiroff and George Balanchine at the School of American Ballet and Martha Graham, Hanya Holm, and the staff of the Humphrey/Weidman studio, receiving one of the most varied dance educations possible. Barret performed in Felicia Sorel's and Senia Gluck-Sandor's Dance Centre company, dancing in his *El Amor Brujo* and *Petrouchka,* and gave five known recitals while in New York. Unfortunately, those five concerts represent the total of her known creative works.

Works Choreographed: CONCERT WORKS: *In Limbo (Search for the Dead, Migration)* (1938); *Little Attitudes* (1938); *Provocation-Timidity-Willfullness* (1938; these may be subtitles for *Little Attitudes*); *The Evolution of the Modern Dance* (1940, lecture-demonstration); *Spring Fever* (1941); *Secret of the Dead* (1941); *She Stood . . .* (1941); *Museum Pieces (Blue Fresco of Knossus, Stele, East Indian Figures)* (1941); *Two Perspectives of My Art* (1941, may be secondary title for lecture-demonstration of 1940); *Farewell Performance* (1942); *Like a Childe* (1942); *Two Personalities of My Aunt* (1942); *In a World I Never Made* (1942); *Prelude to Action* (1942); *Ariadne Leads the Way* (1944); *Epitaph* (1944); *Saturday Afternoon* (1944); *At the Sound of Sinatra* (1944); *Flirtation Waltz* (1944).

The Barrys, American whirlwind dance team; the original Barrys were Fred Barry and his wife Elaine (died January 30, 1948). After her death, he performed with Susan Graves, an ex-Rockette, for three years.

Barry was a chorus dancer in *Roberta* when he began to work in acrobatics. He met his future wife, a former Chester Hale student and member of the Capitol Theater Ballet, when both were in the large ballet chorus of Albertina Rasch's *The Great Waltz* (1934). They performed together for thirteen years, developing their unique combinations of ballet, acrobatics, and whirlwind turns over a series of tours and theatrical appearances on Broadway in *Priorities of '42, Mexican Hayride* (1944), and *Up in Central Park* (1945). Many of their longest engagements were in cabarets and supper clubs in New York and Los Angeles.

Barstow, Edith, American theatrical ballet dancer and theater and television choreographer; born 1907 in Astabula, Ohio; died January 6, 1960 in Sarasota, Florida. Raised in Tacoma, Washington, she performed with her family on the Pantages vaudeville and Prolog circuit from the age of ten. By her late adolescence, she was touring in theaters and cabarets with her younger brother, Richard, in a toe tapping and exhibition ballroom act. They worked on the Balaban and Katz circuit in the Midwest with Merriell Abbott and joined with her to stage shows at the Palmer House, Chicago. The Barstows also toured throughout the world in Adele and Fred Astaire vehicles, playing, for example, in *Funny Face* in Australia.

She retired from the late 1930s until the end of World War II, but was reunited with her brother to stage ten editions of the *Ringling Brothers and Barnum and Bailey Circus,* 1949 to 1960, and dozens of industrial shows. She choreographed musical numbers for many successful early television shows, including the *Colgate Comedy Hour* when it was hosted by Eddie Cantor (NBC, 1950–1954), *Garroway at Large* (NBC, 1949–1954) and *Milton Berle's Texaco Star Theater* (NBC, 1948–1955).

Works Choreographed: THEATER WORKS: *Ringling Brothers and Barnum and Bailey Circus* (1949–1960 editions, co-staged with Richard Barstow); *General Motors Motorama* (1952–1955); industrials.

TELEVISION: *Texaco Star Theater* (NBC, 1948–1955); *Garroway at Large* (NBC, 1949–1954); *Colgate Comedy Hour* (NBC, 1950–1954); *The Buick Circus Hour* (NBC, 1952–1953); *Nothing But the Best* (NBC, 1954); *The Frankie Laine Show* (CBS, 1955–1956).

Barstow, Richard, American theatrical dancer and choreographer; born 1908 in Astabula, Ohio; died May 2, 1981 in New York City. Raised in Tacoma, Washington, he followed his sister Edith into the fam-

ily vaudeville act. Although born with a club foot, he became an eccentric toe dancer, specializing in toe tapping, long-distance toe dancing, Russian toe work, and the walking-down-the-staircase trick that was popularized by Bessie Clayton and Mazie King in the 1900s. He and Edith toured through the 1920s and 1930s on the vaudeville and Prolog circuits of America and in European cabarets and music halls, where they were known as the "second Astaires."

He did a solo act at the Radio City Music Hall in 1939 but was reunited with Edith after his military service. Known as "The Industrial Ziegfelds," they staged cabaret acts, ice shows for Belita, industrials, and editions of the Ringling Brothers and Barnum and Bailey circus (1949–1960). While his sister created musical numbers for television shows, he staged legitimate shows on Broadway and cabaret revues for Olsen and Johnson and the larger New York and Chicago hotels. After her death, he remained with the circus, staging annual editions until 1977, and directed shows at the Latin Quarter in New York (1964–1966). He had a brief film career, during which he choreographed *The Girl Next Door* (Twentieth-Century Fox, 1953), *New Faces* (Twentieth-Century Fox, 1954), and the first musical version of *A Star Is Born* (WB, 1954), with Judy Garland, and also staged Garland's live acts in the late 1960s.

Although he announced his retirement at age seventy, he took a job choreographing and directing the Jones Beach production of *Annie Get Your Gun* in 1978.

Works Choreographed: THEATER WORKS: *Barefoot Boy with Cheek* (1947); *Jerkzbezerk* (1947); *New Faces of 1952; This was Burlesque* (1961, and occasional revisions); *Annie Get Your Gun* (1978, revival); industrials including the General Motors *Motorama* (1952–1955); club acts (including The Palmer Hotel, 1949–1952, and The Latin Quarter, 1964–1966); the *Ringling Brothers and Barnum and Bailey Circus* (1949–1960, co-choreographed with Edith Barstow; 1960–1977, solo); *Judy Garland Live at the Palace* (1967).

FILM: *The Girl Next Door* (Twentieth-Century Fox, 1953); *New Faces* (Twentieth-Century Fox, 1954); *A Star Is Born* (WB, 1954).

Barta, Karoly, Hungarian ballet dancer and choreographer; born May 8, 1936 in Bekesczba, Hungary.

Trained at the State Institute of the Hungarian Ballet, he performed in Budapest with the Hungarian Opera Ballet, the Folk Ensemble of the Ministry of the Interior, and the Bihari company.

He moved to the United States in 1958, working first for Ruth Page's Chicago Opera Ballet. He also danced at the Radio City Music Hall in the mid-1960s when Marc Platt was ballet master, and on television in *Polka-Go-Round* (ABC, 1959). Barta worked in Washington in the mid-1960s and returned after teaching at the University of Birmingham, Alabama, for many years. He currently serves as director of Ballet Dance for Washington, Inc., in the nation's capital.

Works Choreographed: CONCERT WORKS: *Folk Fun* (1963); *Rossini's Toy Shop* (1968); *Adagio and Two Fugues* (1968); *Three Dvorak Dances* (1968); *Guitar Concerto* (1970); *Eight Russian Folk Songs for Orchestra* (1970); *La Gazza Ladra* (1973); *Faust Ballet* (1973).

Barté, Leon, theatrical ballet dancer working in the United States; born c.1900, possibly in the United States, possibly in France. Barté was trained in the United States by the staff of the Pavlova company, which he joined in America in the late 1910s. It is not known where or under which scholarship program he joined the company. After returning to New York, he continued his training under Chester Hale, Ella Dagnova, and Joyce Coles (all former Pavlova dancers) at the Capitol Theater free ballet school and performed there with Hale's Capitol Theater Ballet. From the mid-1920s to the early 1930s, he performed in the two most popular theatrical formats employing dance—revues and Prologs. He appeared on Broadway in revues, including the *Artists and Models* (1925 and 1926 editions) and the celebrated *Straw Hat Revue* of 1939, in which he partnered Imogene Coca in her Water Sprite satire. Between these engagements, he was a staff Prolog ballet danseur at the Capitol, the Roxy and the Radio City Music Hall where he partnered Patricia Bowman, Hilda Eckler, and (Leda) Anchutina. Barté's other performance credits include a successful trio act with Jean Myrio and Desha (Podgorsky). Since both Bowman and Desha were Mikhail Fokine students, it is possible that he also worked with Fokine in New York.

Bartho, Catarina, Italian, Russian, or possibly American theatrical ballet dancer working in New York; neither Bartho's birth nor death dates are verifiable. According to her own publicity releases, Bartho was born in St. Petersburg, trained at the school of the Imperial Theater in Moscow and with Enrico Cecchetti, and had performed at the Maryinsky Theater before moving to the United States in 1894. In that year, she made her American debut as a Russian dancer with David Henderson's American Extravaganza Company in New York.

From 1896 to 1903, Bartho worked as a specialty dancer in roof garden theaters, among them, Koster and Biel's, The Casino Roof, and The Victoria Roof. Billed as the "Queen of the Toe Dancers," she appeared as both a skirt dancer and a conventional ballet technician. Among her acts were a toe dance, jumping on and off tables (incredibly, this was a traditional act for ballet dancers at roof theaters), and a point-work Can-Can. Bartho performed an eccentric toe dance on a railroad track (or, more probably, on a montaged film) for a 1903 motion picture, *Speedway* (American Mutoscope and Biograph Co., 1903). Not surprisingly, Bartho retired in 1904 with acute rheumatism.

Bartholin, Birger, Danish ballet dancer and choreographer; born May 1, 1900 in Odense. Bartholin studied privately with Mikhail Fokine when he was in residence in Copenhagen. On Fokine's suggestion, he moved to Paris to continue his training under Nicolas Legat, Lubov Egorova, and Alexander Volinine. During the 1920s and 1930s, he performed ballet works with a variety of short-lived companies based in Paris, among them Bronislava Nijinska's ballets for Ida Rubinstein, revivals of the Diaghilev repertory in the (Vera) Nemtchimova/(Anatole) Oboukhoff Ballet de Monte Carlo (with which he danced in *Coppélia* and *Les Sylphides*), and Les Ballets de Boris Kniaseff. In the latter troupe, he was cast in Kniaseff's personal versions of the classics, notably his *Les Sylphides*, which followed the old pattern of including five men, and in his original works, among them *Au Temps Des Tartares*. Bartholin also participated in editions of C.B. Cochran's annual London revues and appeared as "The Spielmann" in the London production of Max Reinhardt's *The Miracle*.

Bartholin returned to Copenhagen in the early 1930s to give a solo recital of works by Egorova and Nijinsky; the titles of these pieces are not known but it is likely that the former staged her version of *Petrouchka* for him. After his London seasons, he went back to Denmark to form a small company for which he staged *Rhapsody in Blue* and *Marriage à la Mode* (both c.1933). The chamber troupe was shelved for a few years while he danced with the Blum Ballet Russe, notably in George Balanchine's *Aubade* and Fokine's *Don Juan*, and taught for Egorova's Ballet de la Jeunesse, but in 1938 he formed a new company in Denmark. Most of his extant works were created for this troupe or for the Royal Danish Ballet in the 1950s, but he also served as ballet master for the Finnish National and Norwegian Ballets.

Bartholin's school in Copenhagen may have had a more lasting influence than his choreographic work, since, unfortunately, most has been lost.

Works Choreographed: CONCERT WORKS: *Rhapsody in Blue* (c.1933); *Marriage à la Mode* (c.1933); *Symphonie Classique* (1940); *Les Bronzes* (1940); *Romeo and Juliet* (1941); *Infante* (1942, full title possibly *Pavanne pour une Infante Defuncte)*; *Trois Images* (1942); *The Lion Tamer* (c.1944); *L'Aigrette* (1953); *Parisiana* (1953); *La Jeunesse* (1958); *The Shadow* (1960).

Bartik, Ottokar, Czechoslovakian ballet dancer and choreographer working in the United States; born c.1885 in Czechoslovakia; died July 27, 1936 in Prague. Trained in Prague and Milan, he was hired by Guilio Gatti-Cazazza to perform at the Metropolitan Opera in New York in 1908. He remained in the United States until the early 1930s, dancing at the Met (1908–1930), choreographing there, staging incidental dances for plays and melodramas, and teaching private classes in ballet, interpretive dancing, and tableaux. His best known works for the opera house were his version of the Polovtsian Dances from *Prince Igor* (1915), his *Dance in Place Congo* (1918), performed without an opera around it, and his skating ballet from *Le Prophète* (1928).

Works Choreographed: CONCERT WORKS: *Dance in Place Congo* (1918).

THEATER WORKS: *The Prodigal Son* (1924, incidental dances for Laurette Taylor production).

Bartók, Belá, Hungarian composer; born 1881 in Nagyszentmiklós, Austro-Hungary (now Roumania); died September 26, 1945 in New York City. Although he composed two scores specifically for ballet composition, Bartók's greater importance to dance may lie in his analyses and collections of Hungarian folk dance music and rhythms (c.1905–1940). Of the two commissioned scores, *The Wooden Prince* (1914) was choreographed by Otto Zobisch for the Budapest State Opera, while his *Miraculous Mandarin* was written for Hans Steinbach at the Opera Ballet in Cologne. The latter score has been staged by many later choreographers in Western Europe, among them Todd Bolender, Flemming Flindt, Alfred Rodrigues, and Werner Eck.

Bartolomici, Luigi, French ballet and popular dancer also working in London; born c.1760, probably in or around Paris; died March 18, 1800 in London. Bartolomici was a member of an Italian theater performing family presenting commedia dell'arte in Paris and harlequinades in London in the late 1700s. He moved to London to dance in James D'Egville's ballets and harlequinades at the Drury Lane Theatre, presumably having met or worked with him in Paris. Shortly after appearing in *The Happy Stratagem* there, however, he was killed under mysterious circumstances. Bartolomici, one of the few dancers to find a place in English common law, was one of the first victims of "police brutality," and his killing was one of the test cases to determine whether police action that results in a death can be considered manslaughter. It may say more about the relative status of foreign performers to native policemen than about the facts in the case that the "bobby" was found innocent and released.

Barton, James, American theatrical, eccentric dancer, and comic; born November 1, 1890 in Glouchester, New Jersey; died February 19, 1962 in Mineola, New York. Barton grew up in vaudeville touring with his father, who had been the Interlocutor with the Primrose and West Minstrel Show, and his singer mother, Clara Barton. He made his debut in *The Silver King* (1892) with his mother and began a progression of roles in a series of *Uncle Tom's Cabins*, growing from "Topsy" to "George" (the hero) to "Simon Legree." He worked in stock company until 1915 when he took a job as principal comic in *Twentieth Century Maids* on the Columbia burlesque wheel. After four years, Barton, who was then billed as "Box Bar Bennie," was hired to play a small part in the *Passing Show of 1919*. During rehearsals, however, the Equity strike was called and the producers shut down the theaters in a lock-out. Replacing Ed Wynn in an Equity benefit show, he literally stopped the show and became an overnight sensation. When the *Passing Show* had its Broadway run, he was featured.

Barton's first Broadway career was the one that involved dance performances. His specialty was the drunk dance—an acrobatic character number that was a throwback to Vernon Castle's silly-ass Englishman act. Barton fell down stairs, over scenery, people, and feet for twelve years from the 1919 *Passing Show* to *Sweet and Low* (1930). He was principal comic in *The Last Waltz* (1921), the *Mimic World of 1921* (a midnight matinee concurrent with *The Last Waltz*), *The Rose Girl* (1923), *Dew Drop Inn* (1923), the *Passing Show of 1924*, *Artists and Models*, *Ziegfeld's American Revue* (1926), and, a personal favorite, *The Rose of Stamboul* (1922), in which he sang a tribute to Anna Pavlova, "Why Do They Die at the End of a Classical Ballet?"

"The Man with Funny Feet," as he was billed, moved into more mature roles in the late 1930s, appearing in *Knickerbocker Holiday*, *Bright Lights of 1944* (1943), and *Paint Your Wagon*. His best known later performances, however, were in straight roles—as "Jeeter" in the long-running *Tobacco Road* (occasionally from 1934 to 1939), and as "Hickey" in *The Iceman Cometh*.

Baryshnikov, Mikhail, Soviet ballet dancer working in the United States after 1974; born January 27, 1948 in Riga, Latvia. Trained at the Riga Choreographic School and the Vaganova School with Alexander Pushkin, he performed with the Kirov Ballet from 1966 to 1974. Among his featured parts in the Kirov were the title roles in Oleg Konstantin Sergeev's *Hamlet* and Leonid Ĭakobsen's *Vestris* (1969), and principal roles in the company's productions of *The Sleeping Beauty*, *The Nutcracker*, *Coppélia*, and *Don Quixote*.

Baryshnikov defected to Canada during the summer of 1974, performing that season with the Na-

tional Ballet of Canada and the American Ballet Theatre. He joined Ballet Theatre in 1974, dancing with the company until 1978 and becoming artistic director in 1980. His Ballet Theatre roles included parts in *Coppélia, Swan Lake, Giselle*, George Balanchine's *Theme and Variations*, Twyla Tharp's *Push Comes to Shove* (1976), John Butler's *Medea*, and John Neumeier's *Hamlet Connotations* (1976). He also performed a large repertory of pas de deux, with Gelsey Kirkland and Natalia Makarova, and guested with companies in Canada, England, and the rest of America. He was a member of the New York City Ballet for a season, but was unable to handle the density and pace of George Balanchine's choreography. He was cast almost exclusively in roles associated with Edward Villella, among them male leads in *Theme and Variations, The Prodigal Son*, and *Tarantella*, but performed in two premieres—Jerome Robbins' *Opus 19* and *The Four Seasons* (both 1979). He has restaged productions of the full-length classics for Ballet Theatre, among them, *The Nutcracker* (1976) and *Don Quixote* (1978).

Baryshnikov is the catalyst and hero of the most successful and omnipresent publicity campaign in the recent history of dance. In the same week in 1975, he appeared on the covers of both *Time* and *Newsweek* and, like a Hollywood starlet of the 1930s and 1950s, is regularly mentioned in gossip columns. Publicity releases on him—published as gossip *and* as news— mention his appearances as apocalyptic happenings. Interestingly, some of his publicity campaigns, as well as repertory, were derived from Villella's—his claim that he could jump so high in a 1979 performance at the White House that the top of his head would hit a chandelier was practically copied from Villella's 1961 recital. His appearance in the film, *A Turning Point* (Twentieth-Century Fox, 1977), in the juvenile role, and on television in Ron Field's *Baryshnikov on Broadway* (ABC, 1980, special) added to his reputation.

Works Choreographed: CONCERT WORKS: *The Nutcracker* (1976); *Don Quixote* (1978).

Basquette, Lina, American theatrical ballet dancer and child film star; born April 19, 1908 or 1909 in San Mateo, California. Basquette was trained by her step-father, silent film dance director Ernest Belcher.

Her professional debut at the age of six or seven was at an industrial show for Victrolas at the 1915 International Exposition and was followed by more than two dozen films and stage credits—all before her twentieth birthday.

Within two years after her debut, she was the star of a series of two reelers produced by the Star Featurette Company; these films—such as *Little Manauna's Triumph* (1917), *The Caravan* (1917), and *Amelita's Friend* (1918)—each featured a short dance sequence. Billed as "The Baby Pavlova," she also appeared in feature films as a child ballerina.

In 1922, she made her New York debut as a ballet specialty dancer in the *Ziegfeld Follies* of that year. She also performed in the next edition of the *Follies*, in the Ziegfeld musical, *Louie the Fourteenth* (1925), in the revue *Le Maire's Affairs* of 1927 and in straight plays.

Returning to film in the mid-1920s, Basquette became a dramatic actress of high repute. By the time she had been named a W.A.M.P.A.S. Baby Star of the Future in 1928, she had amassed a list of credits that stretched over two pages of type—at twenty years old. Although her career continued for a number of years, "the Baby Pavlova" did not remain a ballet dancer.

Batchelor, Michael, Venezuelan ballet dancer working in England; born April 25, 1957 in Caracas. The son of an airline executive, Batchelor began his dance training in Puerto Rico and continued in Frankfurt before entering the school of the Royal Ballet in England, 1973. He has been a member of the Royal Ballet since 1974, and has created roles in Kenneth Macmillan's *Mayerling* (1978) and *Fin du Jour* (1979) and Frederick Ashton's *Rhapsody* (1970). His celebrated featured roles include "Benvolio" in Macmillan's *Romeo and Juliet* and parts in his *Elite Syncopations* and Ashton's *Scénes de Ballet*.

Works Choreographed: CONCERT WORKS: *Ego* (1977).

Bates, Clayton "Peg-Leg," American tap dancer; born 1908 in Fountain Inn, South Carolina. Bates, who lost his left leg in an accident at the age of ten, had an eccentric flash act on the black and white vaudeville circuits, tapping with his good leg and bal-

ancing on his peg. He made his debut in a local amateur show at the Liberty Theater and worked in black stock companies as an adolescent. He toured with Eddie Leonard's *Dashing Dinah* troupe (c.1926 to 1928), winding up at the Lafayette Theatre in New York. His appearance in the *Blackbirds of 1928* brought him to Paris where he did twenty-two weeks at the Moulin Rouge. Returning to New York, he was a headliner at the Paradise and Connie's Inn, and at the opening of the Club Zanzibar in 1944, and the star of the *Bronze Follies* of 1946. Bates toured with the Count Basie Orchestra and with the Ink Spots during the 1950s, appearing at the Radio City Music Hall frequently in the end of that decade.

His unique act included many of the traditional steps of the eccentric dancer, including high kicks, done with both legs, and leaps, reaching, according to contemporary reports, to five feet off the ground.

Battle, Hinton, American theatrical dancer; born November 29, 1956 in Neubraeche, Germany. Raised in Washington, D.C., Battle was trained at the Jones/Haywood School there and made his first appearances with their Capitol Ballet. He received a scholarship to the School of American Ballet in New York but instead of pursuing a career in ballet, he made his Broadway debut at age sixteen as "The Scarecrow" in *The Wiz*. His eccentric dance in that successful show made him a popular Broadway performer.

Although he has made guest performances with ballet and modern dance companies—among them the Dance Theatre of Harlem and Otis Sallid's New Art Ensemble—he has concentrated on theatrical appearances. Following *The Wiz*, he went into the national company and Broadway cast of Bob Fosse's *Dancin'*; and is known to millions of television viewers as the man doing the split over the show's title in the logo and commercial. In late 1980, he was given a major dance role in the Duke Ellington revue, *Sophisticated Ladies* (opened 1981). In that popular show, staged by Henry Le Tang and Donald McKayle with Michael Smuin, he gets to perform his split leap, articulated taps, and slow jazz fouétées.

Bauer, Margaret, Austrian ballet dancer; born May 24, 1927 in Vienna. Trained at the school of the Vi-

enna State Opera Ballet, she performed with the company intermittently from its reorganization in 1945 to her retirement in 1971. She was equally dramatically celebrated for her performances in the classic roles of "Giselle" and "Odette/Odile" and in contemporary ballets by Erika Hanka, among them her *Homeric Symphony*, in which she played the blind "Nausicaa," and her *Classical Symphony*.

Bauman, Art, American modern and postmodern choreographer; born December 22, 1939 in Philadelphia. After attending George Washington University, he studied at the Juilliard School under Anna Sokolow and José Limón, among others. Although his background at Juilliard prepared him for formal composition in choreography, and his earliest works were created in that mode, he soon became involved in nonformal construction of dances.

A brilliant collagist of movement, sounds, and visuals, he has created his works in very disparate methods over his professional life. Originally, he presented pieces that required manipulation of images in live performance, film, and decor—in *Dialog* (1967), for example, the performer is seen in a synchronized dance of live choreographed movement, filmed pedestrian movement, and in a still photograph. He dissected and reassembled dance structures to create new imagistic works.

In the early 1970s, however, he became involved in improvisational techniques of dance creation. He has been able to mesh the two methods (which he may not consider disparate at all) into choreographic processes involving game work, collaging of available and prepared materials, and strict improvisation. One of the most influential teachers of the 1970s, he has taught formal classes at Bennington and at the Dance Theatre Workshop, which he co-founded, and workshops across the country.

Works Choreographed: CONCERT WORKS: *Journal* (1962); *The Time of Singing* (1963); *Desert Prayer* (1963); *Barrier* (1963); *Break Forth into Joy* (1963); *Nocturne* (1963); *Errands* (1966); *Periodic* (1966); *Burlesque/Black & White* (1967); *Dialog* (1967); *Relay* (1968); *Chances* (1968); *Sketches for Nocturne* (1969); *Approximately 20 Minutes* (1970); *Processional Hymn, Sermon, Sanctus and Recessional* (1970); *Dancing in Central Park* (1971); *Untitled Im-*

provisations with the Dance Theatre Workshop group; *Materializations* (1971); *Dancing in the Cathedral* (1972); *A Dance Concert for Radio* (1972); *You Are Here* (1972); *A Movement Project* (1972); *Dances for Women* (1973); *A Piece About Pieces* (1973); *Mute Piece* (1973, co-improvised and choreographed with Antony La Giglia); *The Return* (1975); *Untitled Improvisations* (1973 to present).

Bausch, Pina, German ballet dancer and choreographer; born July 27, 1940 in Solingen. Bausch was trained at the Essen Folkwangschule by Kurt Jooss, Hans Zullig, and Lucas Hoving. She traveled to New York to expand her training with classes from Antony Tudor, José Limón, Paul Taylor, and Paul Sanasardo. After her return to Essen, she staged a few works for the student company before becoming ballet master of the Wuppertal State Opera Dance Theatre in 1973. Although she has done some experimental work for interpolated dance sequences in opera productions, notably in a 1972 *Tannhauser* and a 1974–1975 cycle of Gluck operas, she is best known (or more controversial) for her concert ballets. Her evenings of works by Stravinsky in 1975 and by Kurt Weill in 1976 were especially experimental, with the most discussion engendered by the productions of Weill's *Seven Deadly Sins* and the work set to songs from *Happy End* and named after its only lyrical song, *Furchtet euch Nicht* (Do not fear) (1976). She has been compared to Anna Sokolow in her personal presence and in the awe and loyalty that she inspired in her company of dancers/actors/vocalists.

Works Choreographed: CONCERT WORKS: *In the Winds of Time* (1969, German title unavailable); *Nachnull* (beyond zero) (1970); *Action for Dancers* (1972); *Fritz* (1974); *Adagio/Five Lieder* (1974); *Ich Bring' dich um die ecke* (I Carry You around the Corner) (1974); Stravinsky program (*Wind von West, Tango, Zweite Fruhling* [The Second Spring]); *Sacre du Printemps* (1975); Weill program (*Seven Deadly Sins, Furchtet euch Nicht*) (1976); *Braubart* (translated full title reads: *Braubard, on Listening to a Tape Recording of Bela Bartok's Opera, Duke Bluebeard's Castle*) (1977), *Komm, Tanz mit Mir* (Come, Dance with Me) (1977); *Kontaktof* (1978); *Er Ninmt se du der hand* (1978); *Sit Down and Smile* (German title unavailable) (1978); *Legend of Chastity* (1980); *Bandoleon* (1980).

OPERA: *Renate Wandertans* (Renate emigrates) (1978).

Bayard, Sylviane, French ballet dancer also working in Germany; born October 8, 1957 in Bergerac, France. Bayard was trained locally by Desha Delteil, an American who in her youth had been a student of Mikhail Fokine. After further work with Rosella Hightower, she joined the Stuttgart Ballet in 1974. She has won acclaim in the company's "old" repertory of full-length ballets and divertissements by John Cranko, but has also been applauded in new works commissioned to expand its scope. Among those credits are roles in William Forsythe's *Flore Subsimplici* and Rosemary Halliwell's *Mirage*, both premiered in a New Choreographers' recital in 1979.

Bayer, Josef, Austrian composer; born March 6, 1862 in Vienna; died there March 12, 1913. Trained at the Vienna Conservatory under Bruckner, he served as violinist, and from 1885 as director of ballet music for the Vienna Court Opera. Because of his staff position, he composed primarily operettas and ballets, creating the latter in collaboration with Josef Hassreiter, the Court Opera's ballet master. His best remembered works are *Die Puppenfee* (1888), which was for many years in the standard repertory of ballerina-based companies, *Sonne und Erde* (1889), *Tanzmarchen* (1893), and *Rouge et Noir* (1892). Divertissements from his exotic *Der Goldasoka* were frequently used by interpretive dancers in the 1910s.

Baylis, Lilian Mary, English impresario; born May 9, 1874 in London; died there on November 25, 1937. Baylis made her professional debut with the family act, The Gypsy Revelers, performing in England and in South Africa, after 1891. Returning to London, she worked with her aunt, Emma Cohns, the manager of the Old Victoria Coffee and Music Hall. After Cohn's retirement in 1898, Baylis managed the theater, better known as the Old Vic, until her death in 1937. Originally a music hall with occasional Biograph showings, it was transformed into a ballet and opera theater. Then, after the Sadler's Wells was

built, the new theater housed the Vic-Wells Ballet and the Old Vic housed productions of Shakespeare. Her connection with Ninette De Valois, director of the ballet company, dated to the establishment of a dance sequence in one Shakespeare play.

For the last years of her life, Baylis would sit in her theaters watching Gielgud, Richardson, Redgrave, and Olivier switching off roles with each other in one and Frederick Ashton, Antony Tudor, and Ninette De Valois judiciously sharing dancers and rehearsal time in the other.

Baylis, Nadine, English theatrical designer; born June 15, 1940 in London. Baylis was trained at the Centre School of Art, traditionally the school that promoted collaboration between a designer and director or choreographer. She has frequently worked with choreographer Glen Tetley, designing his works for the Ballet Rambert and other troupes, among them his *Embrace Tiger and Return to Mountain* (1968), *Field Figures* (1970), *Rag Dances* (1971), and *Gemini* (1973). Her other Rambert assignments have included Norman Morrice's *That Is the Snow* (1971) and Christopher Bruce's *There Was a Time* (1973) and *Ancient Voices of Children* (1975). She has also worked on theatrical productions in London and the United States.

Bays, Frank, American ballet dancer; born c.1950 in Bristol, Virginia. Trained at the Ballet Russe School with Perry Brunson, Bays performed with the First Chamber Dance Company from 1972.

In that company, he danced in company director's Charles Bennett's *Schubert, Opus 159*. Joining the City Center Joffrey Ballet, he has danced in most of the company repertory, including Joffrey's own *Nightwings*. Among his other featured roles are parts in José Limón's *The Moor's Pavanne*, Gerald Arpino's *Viva Vivaldi!*, Leonid Massine's *Le Tricorne*, Frederick Ashton's *Façade*, and Kurt Jooss' *The Green Table*.

Beard, Dick, American ballet dancer; born c.1920. A student of Antony Tudor and Margaret Craske, Beard joined Ballet Theatre in the 1945–1946 season. Among his many roles with the company were

"Paris" in Tudor's *Romeo and Juliet* and a "Lover-in-Experience" in his *Pillar of Fire*, and appearances in his *Jardin aux Lilas* and the premiere of Michael Kidd's *On Stage* (1945). He joined the New York City Ballet in 1947, appearing in most of the Balanchine repertory and creating roles in Jerome Robbins' *Age of Anxiety* (1950). Beard disregarded the conventions of the time and left ballet to enter vaudeville, touring for the remainder of his professional life with an acrobatic dance team, The Three Cabots.

Beaton, Cecil, English designer and photographer; born January 14, 1904 in London; died January 18, 1980.

As a ballet designer, Beaton is best known for his work for Frederick Ashton, creating decor for his *Les Sirenes, Marguerite et Armand* (1963), *Picnic at Tintagel* (1952), and *Swan Lake* (1952). His stage designs include *My Fair Lady* (1956) with its famous black and white Ascot Gavotte scene; among his films are *Gigi* (MGM, 1958), *My Fair Lady* (WB, 1964), and *On a Clear Day You Can See Forever* (Paramount, 1970, co-designed with Arnold Scarsi).

Bibliography: Beaton, Cecil. *The Strenuous Years* (London: 1973); *The Restless Years* (London: 1976); *The Parting Years* (London: 1978).

Beatty, Patricia, Canadian modern dancer and choreographer; born May 15, 1936 in Toronto. Beatty was trained in ballet locally by Gladys Forrester and Gwynneth Lloyd before attending Bennington College in Vermont. Introduced there to American modern dance, she studied at the Martha Graham School in New York and worked with Pearl Lang in the early 1960s. After returning to Toronto to become one of Canada's most influential modern dance teachers, she founded the New Dance Group there in 1966. It merged with the concert group of fellow Graham students David Earle and Peter Randazzo in 1967 to become the Toronto Dance Theatre. She serves as an artistic director and company teacher for the group, which is considered the stronghold of American traditional modern dance forms in Canada. Beatty has also choreographed for the Dance Theatre; her *Hot and Cold Heroes* (1970) and *Harold Morgan's Delicate Equilibrium* (1974) have been singled out as es-

pecially interesting combinations of the Graham technique and her own sense of theatricality and contemporary vision.

Works Choreographed: CONCERT WORKS: *Momentum* (1967); *Flight Fantasy* (1967); *Against Sleep* (1969); *First Music* (1969); *Study for a Song in the Distance* (1970); *Hot and Cold Heroes* (1970); *Rhapsody in the Late Afternoon* (1972); *Los Sencillos* (1972); *Harold Morgan's Delicate Equilibrium* (1974); *The Reprieve* (1975); *Seastill* (1979); *Lessons in Another Language* (1979, as Essay on Spanish Ideas); *Skyling* (1980).

Beatty, Talley, American modern dancer and choreographer; born c.1923 in New Orleans, Louisiana. Beatty was trained by Katharine Dunham, in whose company he performed from 1940 to 1946. Among the many works in which he danced for her were the *Tropical Revue* (1943) and *Rites de Passage* (1941), which many consider his greatest role. He has also studied with Martha Graham and Aubrey Hitchins, both in New York.

As a freelancer, he performed in Lew Christensen's *Blackface* (1947) for the Ballet Society, in Syvilla Fort's *Procession and Rite*, and in Emily Parham's *Legend* and *Trajectories* (both 1958). He was the performer in Maya Deren's *A Study of Choreography for the Camera* (Independent Production, 1945) and partnered Pearl Primus in Tamiris' 1946 revival of *Show Boat*.

Beatty has choreographed since 1948, when he created a concert of dances for recital. Until the mid-1960s, he worked primarily for his own companies, creating many of his best known works, such as *The Road of the Phoebe Snow* (1959) and *Come and Get the Beauty of It Hot* (1960), both of which are now included in the repertory of the Alvin Ailey Dance Theatre. He has also choreographed works specifically for the Ailey company, notably *The Black District* (1968), and for the Boston Ballet, Birgit Cullberg Ballet in Stockholm, Bat-sheva company in Israel, the Inner City Dance Company of Watts, Los Angeles, and New York's Ballet Hispanico.

His many imaginative and successful theatrical productions have included the original New York production of Genet's *The Blacks* in 1961, the 1968 revival of *House of Flowers*, and many presentations of Vinnette Carroll's Urban Arts Corps, among

them *Bury the Dead* (1971), *Croesus and the Witch* (1971), *Your Arm s Too Short to Box with God* (1977), and *But Never Jam Today* (1978).

Works Choreographed: CONCERT WORKS: *Jim Crow* (1948); *Blues* (1948); *Sonatina* (1948); *Rural Dances of Cuba* (1948); *Southern Landscape* (1949); *Dances of the Mulatress from the North* (1950); *The Passionate Power St. Claire* (1950); *Region of the Sun* (1950); *Tone Poem* (1950); *Void* (1950); *Fire on the Hill* (1951); *Hamsin* (1958); *Introduction, Entrance and Dance of the Gloao* (1958); *The "Way Out" East St. Louis Toodleoo* (1958); *Nobody Came* (1959); *The Road of the Phoebe Snow* (1959); *Oh! Moonlight, Oh! Starlight* (1959); *Toccata* (1959); *Field Calls and Work Songs* (1959); *Come and Get the Beauty of It Hot* (1960); *Come and Get the Beauty of It Hot* (revised) (1962); *Look at all Those Lovely Red Roses* (1962); *Danse au Nouveau Cirque Paris 1897* (1963); *The Migration* (1964); *Powers of Six* (1964); *Montgomery Variations* (1967); *The Black Belt* (1968); *The Black District* (1968); *A Wilderness of Mirrors* (1968); *Antigone* (1969); *L'Histoire d'un Petit Voyage* (1969); *Bring My Servant Home* (1970); *Poeme de l'Extase* (1972); *Caravanserai* (1973); *Cathedral of Heaven* (1973); *Tres Cantos* (1975); *The Nymphs are Departed* (1975).

THEATER WORKS: *Parranda-Afro-Cuban dance* (1954); *The Blacks* (1961); *Ballad for Bimshire* (1963); *House of Flowers* (1968, revival); *Billy Noname* (1970); *Don't Bother Me, I Can't Cope* (1970); *Ari* (1971); *Bury the Dead* (1971); *Croesus and the Witch* (1971); *Your Arms Too Short to Box with God* (1977); *But Never Jam Today* (1978).

Beauchamp, Pierre-François, French ballet theorist and choreographer; born in Versailles, 1636; died c.1705 in Paris. A member of a musicians' family, Beauchamp was named Superintendent of Ballets to the King soon after 1650. His duties to Louis XIV were twofold; he produced ballets (in the old use of that word—they were actually court masques), and codified the technique which is now considered standard to ballet. Inventor of a notation system, he is generally credited with having codified the five basic positions and, therefore, the necessity of turn-out in the ballet technique.

Because the court registers credited ballets to the authors of their librettos, it is difficult to determine

which works Beauchamp staged and which he simply supervised. The list below is short since it includes only those works with which he was officially credited.

Beauchamp was the director of the Académie Royale de Musique and, as such, instituted his codified positions in all ballets produced at the Paris Opéra. His tenure at the Opéra paralleled that of Jean-Baptiste Lully for whose scenarios and music he provided dance steps.

Works Choreographed: CONCERT WORKS: *Ballet d'Alcidiane* (1658); *Ballet de la Jeunesse* (1686); *Le Triomphe de l'Amour* (1687).

THEATER WORKS: *Poquelin* (1664).

Beaugrand, Léontine, French ballet dancer of the Romantic era; born April 26, 1842 in Paris; died there May 25, 1925. Trained by Mme. Dominique, Beaugrand made her Paris Opéra debut in Marie Taglioni's *Le Papillon* in 1860. Among her noted roles in her twenty-year career at the Opéra were the peasant pas de deux in *Giselle*, "Swanilda" in Saint-Léon's *Coppélia* after Bozzachi's death, and principal parts in Saint-Léon's *Diavolina* (1864) and Louis Mérante's *Gretna Green*. Beaugrand retired from performance in 1880.

Beaumont, Ralph, American theater, film, and television dancer and choreographer; born Ralph Bergendorf, March 5, 1926 in Pocatello, Idaho.

Beaumont made his Broadway debut in the revue, *Inside U.S.A.* (1948), following that appearance with roles in *Shangri-la* (1956), in which he also assisted choreographer Donald Saddler, *The Body Beautiful* (1958), and Michael Kidd's *Can-Can*, in which he partnered Gwen Verdon. He performed in films for Warner Brothers, notably as a specialty dancer in *April in Paris, She's Back on Broadway* and Kidd's *The Bandwagon* (all in 1952), the latter on loan to MGM. Before beginning to choreograph on his own, he also performed as dance captain and assisted the choreographers for many television variety shows, among them the *Milton Berle, Ray Bolger, Sid Caesar, Imogene Coca*, and *Ed Sullivan Shows*.

He received his first solo choreographic credit for the City Center revival of *Wonderful Town* in 1958, later staging revivals of *Pal Joey* and *Guys and Dolls* for that theater. His original productions include

Saratoga (1959), *The Yearling* (1965), and *Babes in the Wood* (1964) on Broadway; *The Most Happy Fella* and *Enrico* in London; and *Rinaldo in Campo* (1962) in Rome. He has done television variety shows in the United States and Italy and a single film, *Myra Breckenridge* (Twentieth-Century Fox, 1970).

Since the mid-1970s, Beaumont has served as production administrator and developer of musical projects for the Centre Theatre Group at the Ahmanson Theatre, Music Center of Los Angeles, where he has staged dances and movement for productions of many plays.

Works Choreographed: THEATER WORKS: *Saratoga* (1959); *The Most Happy Fella* (London, 1960); *Rinaldo in Campo* (Rome, 1961); *Babilonia* (Rome, 1962); *Enrico* (Rome, 1962); *Gentlemen Prefer Blondes* (London, 1962); *Babes in the Wood* (1964); *The Yearling* (1965); *A Funny Thing Happened on the Way to the Forum* (Los Angeles revival, 1972).

FILM: *Myra Breckenridge* (Twentieth-Century Fox, 1970).

TELEVISION: *Senore Della Ventura* (RAI, 1962); *The Jack Paar Show* (NBC, 1963).

Beck, Hans, Danish ballet dancer and choreographer at the turn of the twentieth century; born May 31, 1861 in Haderslav, Denmark; died June 10, 1952 in Copenhagen. Trained at the school of the Royal Danish Ballet, Beck made his debut a few days before the death of August Bournonville, 1879. Associated with Bournonville's repertory as a dancer, when he was named ballet master from 1894 to 1915 he maintained the Bournonville works. While no one doubts that Beck saved the ballets, opinions differ as to whether this was a positive artistic decision. In recent years, with the Bournonville centennial rousing interest in his works, historians celebrate Beck for his decision; in 1915, however, he was released from the directorship of the company for keeping the Ballet conservative and based in the nineteenth century.

Beck's own choreography was created for the Royal Danish Ballet during his tenure there. His most popular ballet is *The Little Mermaid* (1909), created for Ellen Price.

Works Choreographed: CONCERT WORKS: *Coppélia* (1896); *The Little Mermaid* (1909); *Pierrette's Veil* (1911).

Becker, Bruce, American modern dancer; born May 28, 1944 in New York City. Becker was trained at the High School of Performing Arts where he studied with May O'Donell and Norman Walker, in each of whose companies he later danced. After graduation, he appeared with the Tamiris-Nagrin troupe (Tamiris was his aunt), and in Walker's company, with which he danced in *Tronfo di Afrodite* (1967) and *Eloges* (1967). He also performed in Walker's works with the Bat-Sheva company in Tel Aviv, notably in his *Baroque Concerto No. 5,* as well as Norman Morrice's *Percussion Concerto* and *Rehearsal . . .* , and Glen Tetley's *Mythical Hunters* and Moise Efrati's *Ein-Dor.*

In 1972, he and Jane Kosminsky formed the 5 by 2 company in order to present concerts of duets by both historically important and contemporary choreographers. Now 5 by 2 Plus, with a larger company and enormous repertory, they perform in chamber works by Tamiris, Walker, Nagrin, José Limón, Merce Cunningham, Anna Sokolow, and James Waring, as well as Becker's own *Clarion* (1978) and *Just Another Dance* (1978). The troupe is well known and popular across the country in performances and in frequent residencies, in which company members teach repertory and technique suitable to each choreographer. In 5 by 2 performances and in solo appearances at conferences and festivals, Becker is in the forefront of promoting a living archive of modern dance in university troupes and professional company repertories.

Works Choreographed: CONCERT WORKS: *Suite Richard* (1977); *Clarion* (1978); *Just Another Dance* (1978); *Grove* (1980); *Angles of Incidence* (1980).

Becker Theodore, Lee, American theatrical dancer; born August 13, 1933 in New York. Trained at the High School of Performing Arts and the Ballet Theatre School, she continued her training with Mikhail Mordkin, Nanette Charisse, and Donald McKayle. She made her Broadway debut in *Gentlemen Prefer Blondes* in 1949, and went from it into Jerome Robbins' *The King and I* (1951). After touring with the (Mia) Slavenska/(Frederick) Franklin Ballet, she was cast in John Murray Anderson's *Almanac* (1953). She assisted Peter Gennaro on *Seventh Heaven* (1953) and entered the cast of Bob Fosse's *Damn*

Yankees (1955), *The Unicorn* (1955), and *Livin' the Life* (1957). Playing "Anybodys," the female member of the Jets, she danced in Robbins' *West Side Story* (1957). After performing in *Tenderloin* (1960), she restaged Robbins' choreography for *Oh Dad, Poor Dad, Mama's Hung You in the Closet and I'm Feeling So Sad* in London and a production of *West Side Story* in Israel.

As a choreographer, she worked on episodes of three New York variety series of the 1950s—*The Steve Allen Show* (NBC, 1955), *The Ed Sullivan Show* (CBS, 1958), and *Ford Star Time* (CBS, 1959)—and two filmed in Hollywood, *The Tony Ambrose* Show (CBS, 1962) and *The Perry Como Show* (NBC, 1963).

In 1976, working as Lee Theodore, she founded The American Dance Machine, a company that performs dance routines from Broadway shows in concert. Billed as "the living museum of American show dancing," the troupe specializes in works of living choreographers but also runs a school that teaches historical techniques. So far, the only original choreography done for the Dance Machine has been Paul Draper's *Tap in Three Movements for Ten Dancers* (1980), the rehearsals for which were shown on a PBS special.

Beckett, Keith, English theater and ballet dancer; born May 11, 1929 in Bletchkey, Buckinghamshire, England. Trained in childhood by Vera Todd in Wembley, he was granted a scholarship to study at the Cone-Ripman School.

After working in the West End in the English production of *High Button Shoes* and the last C.B. Cochran show, *Tough at the Top* (1949), he joined the London Festival Ballet, 1950 to 1956 and 1957 to 1972. A gifted comedy and character dancer, he played "The Mad Hatter" in the premiere of Michael Charnley's *Alice in Wonderland* (1953) and the title role in Mikhail Fokine's *Petrouchka.* His abstract ballet credits include Harald Lander's *Etudes* and David Lichine's *Graduation Ball* and *Concerti.*

Becque, Don Oscar, American concert dancer; born c.1910 in Oklahoma. During travels with his family he studied in Paris with Leo Staats and Carlotta Zambelli and in London with Enrico Cecchetti. In

the United States he worked with Veronine Vestoff and Mikhail Mordkin in New York and studied Delsarte expression under Mabel Ellsworth Todd in Provincetown. After attending the University of Chicago, he moved to New York to perform as a recitalist. Although Becque is best remembered for his tenure as director of the strife-ridden Dance Program of the Federal Theatre Project, Works Progress Administration (1935–1937), he was considered an important concert dancer during the late 1920s and 1930s. His experimental abstractions included works based on geometric shapes in his 1928 recital and pure music visualizations in the late 1930s and 1940s.

Becque became more involved in theater work than dance in the late 1940s but retained contact through his school (founded 1928), at which he taught "creative expression" for actors, dancers, and teachers. Apart from his work in pedagogy and therapeutic uses of dance, he worked extensively in movement analysis and body mechanics for industry.

Works Choreographed: CONCERT WORKS: *Dances Based on Geometric Units* (1928); *Dance Suite* (c.1929); *Phases (Prelude, Introduction, Beginning, Idyll, Diversion, Conflict and Solution, Closing)* (1933); *Evocation* (1933); *Four Dance Pieces* (1933); *Impressions* (1933); *Southern Roses* (1939); *One Lives But Once* (1939); *Eline Kleine Nachtmusik* (1939); *First [Shostakovich] Symphony* (1939); *Trio for Dancers* (1940); *Concerto Royaux* (1940); *Sonate à tre-E meneur* (1940); *Landler Variations* (c.1940); *El Salon Mexico* (c.1940).

Bedells, Phyllis, English theatrical ballet dancer; born August 9, 1893 in Bristol. After early training from Theodore Gilmer in Nottingham, Bedells moved to London to study with Malvina Cavallazzi at the free school of The Empire Theatre. In London, she also took classes with Alexander Genée, Nicholas Legat, Enrico Cecchetti, and Adolf Bolm.

Bedells worked as a pantomime specialty dancer from 1906, when she made her debut as the "First Oyster" in *Alice in Wonderland,* to 1914 when she succeeded Adeline Genée and Lydia Kyasht as première danseuse of the Empire Theatre, where she had done small solos. She was with the Empire when it presented ballets, such as Espinosa's *The Dancing Master,* and when it ran revues. Throughout the 1910s and 1920s, she performed her standard bravura ballet technique in productions at London's major theaters—the Alhambra, the Empire, the Duke of York's and the Royal Albert Hall, where she played in *Hiawatha* every summer from c.1927 to c.1934.

Apart from her theatrical ventures, Bedells had a successful ballet career, partnering Anton Dolin in a season at the Coliseum in 1926–1927. Instrumental in the founding of the Royal Academy of Dancing, she directed the West of England Academy in Bristol. Bedells retired formally in 1935.

Works Choreographed: CONCERT WORKS: *Claire de Lune* (c.1926); *Ballade* (1931).

Bibliography: Bedells, Phyllis. *My Dancing Days* (London: 1954).

Bederkhan, Leila, Persian interpretive dancer working primarily in Western Europe; born c.1903 in Kurdistan (currently, as then, disputed territory belonging to Iraq and/or Iran). Bederkhan, who claimed to have been the granddaughter of the Emir of Kurdistan, was raised in Egypt after the Turkish invasion of her homeland. When Egypt and Turkey began their own conflict in 1917, she was exiled (as a Turk) to Switzerland, where she first studied music. She made what is believed to have been her professional debut in 1926 in Vienna, after abortive medical studies. From then until 1939, she was a popular performer of native and interpretive dances in Austria, France, the United States, and especially Italy, where she settled for many years. Although she appeared almost entirely in her own works, she was cast as the exotic specialty dancer in the Teatro alla Scala (1934) production of *Belkis, Reine de Saba* in Milan.

Works Choreographed: CONCERT WORKS: The following solos remained in Bederkhan's repertory throughout her performing career and were created between 1926 and 1931: *Snake; Heirogliphe; Bridal Song; Profane; On the Island; Kurdistani Dances.*

Beethoven, Ludwig Van, German composer; born December 1, 1770 in Bonn; died March 26, 1827. Although Beethoven only wrote two scores specifically for dance performance, later choreographers have frequently used his music. Of the two scores, the *Ritterballett* (choreographed for Habich in Bonn in 1791) was quickly forgotten as music and as a dance

work, but *The Creatures of Prometheus* (1801) has been more successful. The early version by Salvatore Viganó was well received at the Vienna Hofteater, and later productions were done by Andreas Pavley (1910), Serge Lifar (1929), Aurel Milloss (1933), and Elsa Marianne von Rosen (1958), among many others. Scores of dances have been made to Beethoven concert works, ranging from Anna Pavlova to Jerome Robbins. Both Ruth St. Denis and Ted Shawn adapted Beethoven scores for their own uses—Shawn for *Dance of Greeting* and *Variations on a Theme of Diabelli*, and St. Denis for the *Sonata Pathétique,* designed to be performed with a player piano. The entire range of American ballet and modern dance choreographers have followed the examples of Denishawn, Pavley and Serge Oukrainsky, and Pavlova—among the best known such works are Robbins' *Four Bagatelles;* Paul Taylor's *Orbs* and *Piece Period*; José Limón's *Orfeo* and *Waldstein Sonata;* Iva Kitchell's *Something Classic;* and James Waring's marvelous *32 Variations in C minor.* Beethoven scores have also been favorite choices of Western European ballet choreographers in the twentieth century, such as Maurice Béjart, who staged the *9th Symphony* in 1964, Hans Van Manen, known for his *Grosse Fuge* (1971) and *Adagio Hammerklavier* (1973), and Kurt Jooss, whose late *Party at the Manor* was staged to the "Spring" Sonata in 1953.

Béjart, Maurice, French ballet dancer and choreographer generally considered one of the most innovative and influential in Europe; born January 1, 1927 in Marseilles. Trained at the school of the Marseilles Opera Ballet, he continued his studies in Paris with Leo Staats, Lubov Egorova, and Nora Kiss, and in London with Vera Volkova.

As a dancer with the Marseilles Opera Ballet, he was featured in roles in the classics, and he was in the International Ballet, London. During the early 1950s, he performed and choreographed for the Royal Swedish Ballet, and the Ballets de l'Etoile in Paris, before founding his own Ballet Theatre du Maurice Béjart in 1957. Moving to Brussels, he began the Ballet du XXième Siècle in 1960 for which he has choreographed until the present.

Outstandingly popular with his audiences, Béjart

has meshed an academic and fairly conservative movement vocabulary with a very personal intellectual and philosophical content. Unquestionably a European choreographer, he is more involved in communicating an idea and its cultural milieu to the audience than in revealing a new or ingenious combination of movements in time. His repertory educates his audience both in French literary philosophies, as seen in his verbally derived works, and in Eastern spiritualities. He has also created large-scale nonbiographical works that depict different elements of a person's real life or perceived persona, as in his *Wagner, ou l'Amour Fou* (1965), *Beaudelaire* (1968); and *Nijinsky, Clown of God* (1971). It should be noted however that in New York, which is an island of abstractionists in the world, Béjart's reception has frequently been disappointing.

As befits an intellectual and verbal choreographer, he has been profiled in many books and articles.

Works Choreographed: CONCERT WORKS: *Taming of the Shrew* (1954); *Voyage au coeur d'un enfant* (1955); *Symphonie pour un homme seul* (1955); *Voila l'Homme* (1956); *Le Parfum de la Dame en Rouge* (1956); *Le Balayeur* (1956); *Le Cercle* (1956); *Dualité* (1956); *Le Teck* (1956); *Tanit, ou Le Crepuscule des Dieux* (1956); *Haut Voltage* (1956); *Prométhée* (1956); *Sonate à Trois* (1957); *Pulcinella* (1957); *Chapeaux* (1957); *Concerto* (1957); *L'Étranger* (1957); *Etudes Rhythmiques* (1958); *Juliette* (1958); *La Voix* (1958); *Orpheus* (1958); *Fanfares* (1959); *Equilibre* (1959); *Sacré du Printemps* (1959); *La Belle au Boa* (1960); *The Merry Widow* (1960); *Tales of Hoffman* (1961); *The Seven Deadly Sing* (1961); *Divertimento* (1961); *Gala* (1961); *Pieces pour Orchestre* (1961); *Les Quatre Fils Aymon* (1961); *Bolero* (1961); *Bacchanale* (from *Tannhauser*) (1961); *À la Recherche de Don Juan* (1962); *Les Noces* (1962); *The Journey* (1962); *Suite Viennoise* (1962); *Serenade* (1963); *Damnation of Faust* (1964); *Ninth Symphony* (1964); *Variation pour une porte et un soupir* (1964); *Venusberg* (1965); *Erotica* (1965); *Mathilde* (1965); *L'Art de la Barre* (1965); *Renard* (1965); *Wagner, ou l'Amour Fou* (1965); *Les Oiseaux* (1965); *Romeo and Juliet* (1966); *Cygne* (1966); *Cantates* (1966); *Messe pour le Temps Present* (1967); *Webern Opus 5* (1967); *Soirée Comédie: Aubade* (1967); *Nuit Ob-*

scure (1968); *Baudelaire* (1968); *Bhakti* (1968); *Ni Fleurs, ni Couronnes* (1968); *A la Récherche de . . .* (1968); *Actus tragicus* (1969); *Nomos Alpha* (1969); *Les Vainqueurs* (1969); *Concert de Danse: Lettera Amorosa* (1969); *Four Last Songs* (1970); *Serait-ce le mort?* (1970); *Bach Sonata* (1970); *The Firebird* (1970); *"Comme la Princesse Salomé est belle ce soir"* (1970); *Les Fleurs du Mal* (c.1971); *Song of the Wayfarer* (1971); *Nijinsky, Clown of God* (1971); *Offrande Choréographique* (1971); *L'Ange Heurtebise* (1972); *Stimmung* (1972); *Farah* (1973); *Ah! Vous Dirai-je, Maman?* (1973); *Le Marteau sans Maître* (1973); *Improvisation sur Mallarmé III* (1973); *Tombeau* (1973); *Golestan* (1973); *Seraphita* (1974); *Rose Variations* (1974); *Per la Dolce Memoria di Quel Giorna* (1974); *Ce que l'amour me dit* (1974); *Acqua Alta* (1975); *Les Chants d'Amour et de Guerre* (1975); *Notre Faust* (1975); *Pli Selon Pli* (1975); *Rhapsodie* (1975); *Heliogabale* (1976); *La Molière Imaginaire* (1976); *Isadora* (1976); *V. Come* (1977); *Petrouchka* (1977); *Amor di Poeta* (1978); *Spectre de la Rose* (1978); *Gaite Parisienne* (1978); *Mahler* (1978); *Duo* (1979); *Life* (1979); *Bolero* (new version, 1979); *Leda* (1979).

Bibliography: Livio, Antoine. *Béjart* (Lausanne: 1969). Christout, Marie-François. *Béjart* (Paris: 1972).

Belcher, Ernest, English/American film dance director; born 1883 in London; died February 24, 1973 in Los Angeles. Belcher studied ballet in London with Louis Hervé D'Egville, Alexander Genée, and Francesca Zanfretta; he also partnered and studied with East Indian dance specialist Roshanara in London. From 1902 to 1909, Belcher was a principal danseur at the Alhambra Theatre, London. After two seasons in Paris, he returned as an exhibition ballroom dancer, specializing in the tango, at the Royal Club, London.

Belcher immigrated to the United States in late 1915, moving to Los Angeles. After freelancing briefly, he founded the Celeste School of Dance there in May 1916. This school supplied dancers for films and the film Prologs which Belcher produced for Grauman and Loew's theaters. Belcher also supplied ballet precision troupes and adagio teams for Fanchon and Marco's West Coast Deluxe Theater chain productions, and produced ballets for concerts at the Hollywood Bowl from 1923 to 1936.

Belcher's extensive career as a film dance director took off in 1918, when he staged Carol Dempster's dances for D.W. Griffith's *Broken Blossoms,* and lasted to the end of the silent era. Since he was on staff at independent studios in this period, he was not given on-screen choreography credits for more than 75 percent of his films. He worked for most of the major studios and directors, among them, Griffith, Mack Sennett, Cecil B. de Mille, and Thomas H. Ince. Although most of his films have disappeared, three motion pictures from the 1920s were rereleased with rerecorded sound in 1930 and have been preserved—*The Girl of the Golden West* (First National, 1923), *The Merry Widow* (MGM, 1925), and *The Phantom of the Opera* (Universal, 1925, reissued 1929).

His film work involved staging current and historical social dance scenes, especially for Mack Sennett comedies, and coaching solo specialties for male and female actors playing dancers within the context of their movies, as in, for example, *The Spanish Dancer,* with Pola Negri (Famous Players-Laskey, 1923). He also choreographed "show-within-a-show" sequences in many films, ranging from the exotic nautches in *Salome vs. Shenendoah's* fantasy scenes (Paramount/Mack Sennett, 1919), *The Christian* (Goldwyn, 1923), and *The Temple of Venus* (Fox, 1923), to the reconstructions of the Paris Opéra ballets seen onstage during scenes in *The Phantom of the Opera* (Universal, 1925). He staged dances for three early sound era musical revues—*General Crack* (WB/Vitaphone, 1929), *The Pirate's Revue* (MGM, 1929), and *Radio Revels* (RKO, 1930)—but was replaced by the Broadway choreographers who flooded Hollywood after 1929.

Belcher is also known as the teacher and coach of many film performers. In the silent and early sound eras, he trained, among others, Beth Beri, Mary Pickford, Pola Negri, Ramon Navarro, and Shirley Temple. Later students included Nanette Fabray, Matt Mattox, and Belcher's step-daughter Lina Basquette, daughter Marjorie Champion, and former son-in-law Gower Champion.

Works Choreographed: THEATER WORKS: Prologs for Grauman's Million Dollar Theater, Los Angeles (1918); Prologs for The California Theater, Los Angeles (1921); Prologs for the Loew's Theater chain of West coast houses (1922–1927).

FILM: (Note: this listing includes only credited choreography and dance direction.) *Ragtime Texas Tommy* (Selsoir Motion Picture Company of London, 1912); *Toy Soldiers* (Universal, 1916); *We Can't Have Everything* (Famous Players-Laskey, 1918); *Don't Change Your Husband* (Famous Players-Laskey, 1918); *Broken Blossoms* (D.W. Griffith Independent Productions, 1919); *Salome vs. Shenandoah* (Paramount/Mack Sennett Studios, 1919); *The Furnace* (Real Art Picture Corp., 1920); *Johnny Be Good* (Real Art Picture Corp., 1920); *A Small Town Idol* (Mack Sennett Studios, 1921); *Mother O'Mine* (Famous Players-Laskey, 1921); *Heroes of the Streets* (WB, 1922); *Crossroads of New York* (Mack Sennett Studios, 1922); *The Blind Bargain* (Samuel Goldwyn Productions, 1922); *Doubling for Romeo* (Samuel Goldwyn Productions, 1923); *The Christian* (Samuel Goldwyn Productions, 1923); *The Spanish Dancer* (Famous Players-Laskey, 1923); *The Temple of Venus* (Fox Film Corp., 1923); *Her Reputation* (Thomas H. Ince, Inc., 1923); *The Girl of the Golden West* (First National, 1923); *The Gold Diggers* (WB, 1923); *Souls for Sale* (Samuel Goldwyn Productions/Cosmopolitan Pictures, 1923); *Beau Brummel* (WB, 1924); *The Merry Widow* (MGM, 1925); *The Phantom of the Opera* (Universal, 1925); *Twinkletoes* (First National, 1926); *General Crack* (WB/Vitaphone, 1929); *The Pirate's Revue* (MGM, 1929); *Radio Revels* (RKO, 1930).

Belda, Patrick, French ballet dancer; born 1943, possibly in Paris; died in an automobile accident, February 7, 1967 in Brussels, Belgium. Belda was trained in Paris by Nora Kiss. At the age of twelve, he made his debut in the child's part in Maurice Béjart's *Voyage au Coeur d'un Enfant* (1955); from then until his death, he was associated with Béjart's companies and works.

As a member of his Ballet Théâtre de Paris, 1957 to 1960, Belda created roles in his *Pulcinella* (1957), *l'Etranger* (1957), *Haut Voltage* (1957), *Etudes rhythmitiques* (1958), *Orphée* (1958), *Concertino* (1958), *Thème et Variations* (1959), *La Mégère Apprivoisée* (1959), and *Le Sacré du Printemps* (1959). Moving with Béjart to Brussels to perform in the Ballet du XXième Siécle in 1960, he danced in the premieres of *Signes* (1960), *Boléro* (1960), *Les Quatre fils Amyon* (1961), *Le Temps* (1961), *Fiesta* (1964), *Mathilde* (1965), *l'Art de la Barre* (1965), *Variations pour une Porte et un Soupir* (1965), *Roméo et Juliette* (1965), as "Mercutio," *l'Histoire du Soldat* (1966), in the title role, and *Cygne* (1966).

He had collaborated with Béjart on one work—*Divertimento* (1961)—and had contributed two more to the company at the time of his death.

Works Choreographed: CONCERT WORKS: *Divertimento* (1961, co-choreographed with Maurice Béjart); *Adhérences pour Daphné* (c.1964); *Pierre et le Loup* (c.1966).

Belfiore, Liliana, Argentinian ballet dancer working in Europe; born October 12, 1952 in Buenos Aires. Belfiore was trained locally at the school of the Ballet de Teatro Colón. After dancing with the Ballet Festio Argentino and the Ballet Contemporena, she joined the Colón troupe and was acclaimed for her performances in its productions of *Daphnis et Chloe, Firebird, Cinderella, Giselle,* and *Swan Lake.* The principal roles in those classics of the European repertory became her most celebrated when she joined the London Festival Ballet in 1976. In that company, and as a freelance Rudolf Nureyev partner, her technique and outstanding stage presence were applauded in *Les Sylphides, Conservatoire, Etudes,* the classics, and a repertory of pas de deux. Belfiore left London in 1980 to teach and form a company in New York City.

Belin, Alexandre, French-Canadian ballet dancer; born April 3, 1948 in Mulhouse, France. Raised in Quebec, he was trained at the school of Les Grands Ballets Canadiens, rising from apprentice to company member by 1966. Belin is best known for his performance in the works of Fernand Nault, notably his Carl Orff trilogy of *Carmina Burana, Catulli Carmina,* and *Aphrodite,* and his rock opera, *Tommy.* His portrayal of the title role in that celebrated record-turned-live-production won him acclaim in Canada and the United States.

Belita, Maria, English figure skater and Hollywood dancer; born Gladys Lyne Jepson-Turner, October 25, 1923, in Garlogs, England. A professional skater from the age of four, Belita received ballet training from Anton Dolin and performed briefly with him. The star of the British *Opera on Ice* show, she appeared for four years in the American editions of *Ice Capades,* 1939 to 1943.

Those performances led to a contract with Monogram Studios, a B-film production company for which she was their answer to Sonje Henie. Her Monogram films took her from figure skating, as she did in *Silver Skates* (1943) and *Lady, Let's Dance* (1946) to the more traditional forms of jazz dance. She appeared in the "Ring Around the Rosy" section of Gene Kelly's *Invitation to the Dance* (MGM, 1954) and worked with Fred Astaire in *Silk Stockings* (MGM, 1957) before retiring from the screen.

Bella, Antoinetta, Italian ballet dancer of the late nineteenth century; born January 17, 1863; the date and place of Bella's death are not certain. Bella was trained in Turin, by Vautier, and in Milan at the school of the Teatro alla Scala.

Expert at the combination of bravura technique and mime skills that were necessary in Italian ballet spectacles, Bella performed in the premieres of Luigi Manzotti's *Sieba* (Turin, 1878) and *Excelçior* (Milan, 1881); it is not certain whether her move to La Scala was precipitated by his.

Bella toured the East Coast of the United States in 1884, performing in native and imported spectacle productions that were tremendously popular there.

Belsky, Igor, Soviet ballet dancer and choreographer; born March 28, 1925 in Leningrad. Trained at the Leningrad Choreographic School, he entered the Kirov Ballet in 1943. Among his roles there were principal parts in Lev Iacobsen's *Shuraleh* (1950) and Konstantin Sergeev's *Path of Thunder* (1959). He began to choreograph for the Kirov, contributing *Coast of Hope* (1959) and the *Leningrad Symphony* (1961) to that company, and continued with the Leningrad Maly Opera Ballet from 1963 to 1972. He returned to the Kirov as director from 1972 to 1977, but was replaced and assigned to teach at the Rimsky-Korsakov Conservatory.

Works Choreographed: CONCERT WORKS: *Coast of Hope* (1959); *Leningrad Symphony* (1961); *The Little Humpbacked Horse* (1963); *Swan Lake* (1965); *The Nutcracker* (1969).

Ben-David, Ehud, Israeli modern dancer; born c.1939; died April 5, 1977 in Natanya. A member of the Karmon Folk Dancers before he began his formal modern dance training with Gertrude Krauss, Ben-David was chosen to be a student member of Anna Sokolow's Lyric Theatre in 1962. He joined the Batsheva company at its inception and performed progressively larger roles in its repertory of Israeli and American works in, among others, Jerome Robbins' *Moves,* Martha Graham's *Embattled Gardens,* Glen Tetley's *Mythical Hunters,* and Moise Efrati's *Sin Lieth at the Door.* He created roles in Graham's *Dream* (1974) and Sokolow's solo *Poem* (1975). Ben-David was killed in a traffic accident at the age of thirty-eight.

Benedict, Gail, American theatrical dancer; born in Storm Lake, Iowa. After working extensively in regional theater, Benedict hit Broadway with principal roles in the celebrated dance-filled flops, *Don't Step on My Olive Branch* and *Dr. Jazz.* Her more recent credits, however, have included the original cast of Bob Fosse's *Dancin'* in which she was acclaimed for her ability to dance his diverse techniques and individual style. Her dancing has been seen more recently in Gower Champion's *42nd Street* (where she also serves as the standby "Peggy Sawyer") and in the backstage and musical films *The Fan* and *The Best Little Whorehouse in Texas.*

Benesh, Rudolf and Joan, English dance notators; Rudolf born January 16, 1916 in London; died there May 3, 1975; Joan born Joan Rothwell, March 24, 1920 in Liverpool. Rudolf Benesh was an artist who, with his wife, Joan, developed the system of notation that bears their name. It was copyrighted in 1955, codified for teaching in 1956, and included in the English dance syllabus after 1957. It is now the standard notation system for all dance written down in England, and the medium of teaching at the Royal Academy of Dancing and the Rambert School.

Benesh choreologists also work in the United States, Europe, and Israel.

Unlike Labanotation, which notates every movement in each part of the body, the Benesh system works best with a dance that uses a set movement vocabulary. It is particularly well suited to ballet notation and is most frequently used for that purpose.

Bibliography: Benesh, Rudolf and Joan. *Introduction to Benesh Dance Notation* (London: 1956).

Benjamin, Fred, American modern dancer and choreographer; born September 6, 1944 in Boston, Massachusetts. Benjamin was trained locally at the Elma Lewis School for the Arts. After high school, he moved to New York to continue his studies at the American Ballet Theatre School and with Talley Beatty. His training at the Clark Center for the Performing Arts led him to a faculty position there, which he still holds.

After the move to New York, he danced on Broadway in the black cast of Gower Champion's *Hello Dolly* (with Pearl Bailey in the title role) and in Michael Bennett's *Promises, Promises.* His concert appearances include work for Talley Beatty, notably in his *Pretty Is Skin Deep . . . Ugly Is to the Bone* (1977), and danced in an engagement as guest artist in Alvin Ailey's *Ailey Celebrates Ellington* (WCBS, November 28, 1974). Although he has choreographed for Off Broadway productions, most notably at the AMAS Repertory Theatre, he has concentrated on creating a repertory for his own company. Benjamin's popular work has been described both as activist and as abstractions. Although some pieces are very personal statements on contemporary life, he also creates universal pieces on movement and choreographic processes.

Works Choreographed: CONCERT WORKS: *Jazz Suite* (1968); *A Tale of Four Women* (1969); *New Fantasy* (1969); *902 Albany Street* (1970); *Movin'* (1970); *A Time Remembered* (1970); *Our Thing* (1971); *Mountain High* (1971); *Prey* (1972); *Parallel Lines* (1972); *Two Plus One* (1972); *Personal Testimony* (1972); *Vein Melter* (1973); *Concupiscence* (1973); *Dealing with the Facts and the Pain* (1974); *From the Mountain of the Moon* (1974); *Ceremony* (1974); *Travels Just outside the House* (1975); *Come into my Life* (1976); *Metamorphosis* (1977); *Echoes of an Era* (1977); *The End Game* (1977); *Magic Journey* (1977); *Merry Christmas, Anna* (1978); *A Woman's Lament* (1978); *Crossroads* (1978); *Left over Wine* (1979); *The Wait* (1979); *Feeling Old Feelings* (1980); *Euphoria* (1980); *Another Time, Another Place* (1980); *Firepower* (1980); *Still* (1980); *After the Rain* (1980); *Desert Hush* (1980).

THEATER WORKS: *Bubblin' Brown Sugar* (1975, pre-Broadway production); *It's So Nice to be Civilized* (1979).

Bennett, Barbara, American exhibition ballroom dancer and actress; born 1911 in Palisades, New Jersey. The youngest daughter of famed actors Richard Bennett and Adrienne Morrison, Bennett was trained at the Denishawn schools in New York and Mariardel, Peterborough, New Hampshire, where she was featured in the premiere of Ruth St. Denis' *Cupid and Psyche* (1923). Soon after making her Broadway debut with her father in *The Dancer,* she became the latest partner of Maurice Mouvet, then the most celebrated exhibition ballroom dancer of the day. She toured Europe with him for two seasons before returning to the United States to work in film. Her best known film was the transitional sound musical, *Syncopation* (RKO, 1929), made just before her retirement in 1929.

Bennett, Charles, American ballet dancer; born April 8, 1934 in Wheaton, Illinois. Bennett began his dance training with Bentley Stone in Chicago and made his professional debut with the Ruth Page-Stone Chicago Opera Ballet. A member of Ballet Theatre from 1955 to 1958 he appeared in the company's productions of *Swan Lake* (the Dolin version) and in Antony Tudor's *Romeo and Juliet,* David Lichine's *Graduation Ball,* George Balanchine's *Theme and Variations,* and Kenneth Macmillan's *Winter's Eve* (1957) and *Concerto* (1958).

In 1960 he and two other former Ballet Theatre dancers, Lois Bewley and William Carter, formed a trio for performances at the Casals Festival in San Juan. While all three were dancing in the New York City Ballet, they formalized the trio into the First Chamber Dance Quartet (adding Nadine Revene). In the First Chamber Dance Company, with a varying number of members, Bennett has danced with

Bewley, William Carter, and Nadine Revene, Janice Grohman, Lisa Bradley, and Marjorie Mussman, and with Michael Uthoff who occasionally appeared with the troupe. He has performed in almost every work in the repertory, including their first success, Bewley's *Pi²*, a satire of Balanchine's electronic abstractions that delighted the knowing New York audiences at a number of concerts. The repertory also includes works by Anna Sokolow and José Limón, revivals of classical pas de deux and divertissements, and Bennett's own *Albioni Adagio* (1974), *Ridotto* (1978), and *Schubertiade* (1978).

Now in permanent residency in the Pacific Northwest, the company presents regular seasons in Seattle, Washington, and appears in college bookings and concerts throughout the area in the United States and Canada.

Works Choreographed: CONCERT WORKS: *Impresiones Intimas* (1964); *Vincent* (1964); *Albioni Adagio* (1974); *Visitations* (1976); *Quartet in D Minor* (1978); *Quartet #7 in F Sharp Minor* (1978); *Ridotto* (1978); *Schubertiade* (1978).

Bennett, Dave, American theater and film dancer and choreographer; it is not known which of the four Dave Bennetts in vaudeville this was, but it is likely that he was born c.1895 in or around New York City, and died c.1933 on the West Coast.

The Dave Bennett of this entry can be traced back to 1910 only, at which time he played a dog in the Adelaide and Hughes version of the popular vaudeville act, *Chanticleer,* on the Keith circuit. He appeared in the 1912 and 1913 editions of the *Passing Show* and may have worked for other Winter Garden musicals produced by the Shubert Brothers. It is almost certain that, between 1912 and 1915, he became an assistant to Edward Royce, then the resident dance director for the theater. In 1915 and 1917, he received dance direction credits for two Princess Theater musicals, dialogue-directed by Royce—*Very Good Eddie* (1915) and *Leave It to Jane* (1917). Most of the Princess productions did not have choreography credits at all so it cannot be determined whether he worked on other shows there.

His next verified credits were from 1923 to 1925 and include solo engagements on the *André Charlot Revue of 1924* and the original production of *Rose Marie* (1924). He also staged the Gertrude Hoffmann vehicle, *Hello, Everybody* (1923), sharing credit with her, Mikhail Fokine, and Adolf Bolm, and the first production of *Sunny* (1925), with additional credits assigned to Alexis Kosloff, Julian Mitchell, and John Tiller. Since both shows had ballet numbers, it can be assumed that Fokine, Bolm, and Kosloff did them; Tiller received an automatic titular credit on all Tiller Girl troupe routines. Mitchell's status on the shows is puzzling since he was at the end of his career then.

After another unexplainable gap in time, Bennett was among the Broadway choreographers hired to work in Hollywood after the sound era began. Following the usual apprenticeship/audition period in which he was assigned to short subjects, he staged dances for three Paramount musicals, notably Elsie Janis' production of *Paramount on Parade* (1930), considered one of the most innovative early sound and color films of the transition era.

Works Choreographed: THEATER WORKS: *Very Good Eddie* (1915); *Leave It to Jane* (1917); *André Charlot's Revue of 1924; Rose Marie* (1924); *Hello, Everybody* (1923, additional credits assigned to Gertrude Hoffmann, Mikhail Fokine, and Adolf Bolm); *Sunny* (1925, additional credits assigned to Alexis Kosloff, John Tiller, Julian Mitchell); *Jig Saws* (1933, San Francisco).

FILMS: *Let's Go Native* (Paramount, 1930); *Paramount on Parade* (Paramount, 1930); *Safety in Numbers* (Paramount, 1930); short subjects in the Pathé Mini-Musical series (c.1929).

Bennett, Evelyn, American theatrical dancer; born c.1905, possibly in the New York metropolitan area. A protégé of Gus Edwards, she toured for many years with his Kiddie Cabaret, partnered in one number by Eddie Cantor, George Jessel, and Walter Winchell. She went into a tap act on the Pacific circuit at age thirteen and then headlined in a solo dance flash act for three years in Pantages theaters. In 1922, she returned to New York as specialty feature dancer in *The Clinging Vine,* which success she followed with *Lollipop* (1924), *Suzanna* (1924), and *Merry-Go-Round* (1927). Appropriate to her original success as an Eva Tanguay imitator, she was noted for her exuberance and wild abandon in her eccentric act. Her great success came in her two solo numbers in *Ameri-*

cana (1928)—"Tabloid Papers" and "Why D'ya Roll Those Eyes."

Bennett, Joe, American theatrical dancer and actor; born c.1940 in New York City. Trained at the High School of Performing Arts, Bennett made his professional debut as "Action" on the 1960 national tour of Jerome Robbins' *West Side Story*. He also played that role in the 1964 New York revival, but switched to "Riff" for the Australian and European tours of the 1960s. Bennett became a frequent performer in nightclubs in the United States and South America, including the Copacabana in Rio de Janeiro, in films, among them, the Elvis Presley vehicle, *Viva Las Vegas,* in Vegas and Reno cabarets and on television. He is on Broadway as "Zach," the on-stage choreographer of *A Chorus Line,* after playing in national tours.

Bennett, Michael, American theatrical choreographer and director; born Michael DiFighlia, c.1943 in Buffalo, New York. Trained locally with Miss Dunne's Stars of Tomorrow troupe, he made his Broadway debut as a dancer in *Subways are for Sleeping* (1961). After performing in two cult musicals, *Here's Love* (1963) and *Bajour* (1964), he made his choreographic debut in *A Joyful Noise* (1966).

Working steadily on Broadway after that, he staged dances for *Henry, Sweet Henry* (1967), *Promises, Promises* (1968), his first hit, *Coco* (1969), in which he taught Katherine Hepburn to dance, the Stephen Sondheim musical *Company* (1970), his *Follies* (1971), for which Bennett won the first of his many Tony awards, and *Seesaw* (1974), co-choreographed with Grover Dale and dancer Tommy Tune.

Bennett choreographed, conceived, and directed his next show, *A Chorus Line* (1975). This production, created over months of rehearsals at the Public Theater, has become one of the world's most successful musicals. For Bennett, who actually co-choreographed the show with Bob Avian, it was a logical successor to his work on the Sondheim shows; movement is so integrated into the plot's action that it cannot be divided into musical numbers. One routine seems to be an exception, the celebrated finale "One" performed in silver glitz top hat and tails.

This routine, however, is both the theme and basis of the show's movement, providing the opening of both *A Chorus Line* (when it is titled "Six, Seven, Eight") and of the show for which the audition is held; in between, it provides movement motifs for the choreographer, "Zack," and his assistant, "Larry," to teach to the auditioning gypsies.

His next show, *Ballroom* (1978), based on a television drama that had been staged by Marge Champion, was not as successful. Although as well structured as *A Chorus Line,* it did not attract an audience. Bennett had also directed straight plays, and staged dances for one film; an extended contract with Universal Studios will soon augment his motion picture credits. He has also worked extensively on television, primarily on New York–taped variety shows of the mid-1960s.

Works Choreographed: THEATER WORKS: *A Joyful Noise* (1966); *Henry, Sweet Henry* (1967); *Promises, Promises* (1968, London, 1969); *Coco* (1969); *Company* (1970); *Follies* (1971, also co-directed show); *Seesaw* (1973, received solo credits for directing show, shared choreography credit with Grover Dale and Tommy Tune); *A Chorus Line* (1975, received solo credit for directing show, shared choreography credit with Bob Avian, also received conception credit with the authors); *Ballroom* (1978, co-choreographed with Bob Avian).

FILM: *What's So Bad about Feeling Good?* (Universal, 1968).

TELEVISION: Scattered episodes of the following: *Hullabaloo* (NBC, 1965–1966); *Hollywood Palace* (ABC, 1964–1970); *The Ed Sullivan Show* (CBS, c.1968–1971).

Bennett, Tracy, American ballet dancer; born February 22, 1951 in Salt Lake City, Utah. Trained by William Christensen in Salt Lake City, Bennett performed briefly with his University of Utah Ballet and Ballet West. He moved to New York in the early 1970s to attend the School of American Ballet, from which he joined the New York City Ballet.

Although Bennett has performed in much of the company's enormous repertory, notably in Balanchine's *Tchaikovsky Piano Concerto* and *Momentum pro Gesualdo,* he has been associated primarily

with the works of Jerome Robbins. From *Watermill*, which in 1972 provided him with his first major role, he has danced in the first performances of Robbins' *Ma Mere l'Oye* (1975), *Dybbuk Variations* (1974), its revision *Suite of Dances* (1979), and *Opus 19—The Dreamer* (1979). Bennett has also danced roles in two works by company member Richard Tanner—*Concerto for Two Solo Pianos* (1971) and *Octuor* (1972)—and performs in his small concert group.

Benois, Alexander, Russian theatrical designer and artist; born May 3, 1870 in St. Petersburg; died February 9, 1960 in Paris. A law student descended from a line of artists and architects, he was a member of the staff of *Mir Iskusstva* (The World of Art), the periodical co-founded by Serge Diaghilev, and worked on the Exhibit of Russian Art in Paris, 1907. His first theatrical designs for Diaghilev were during the impressario's short tenure at the Imperial Theatre, on *Sylvia* and *Cupid's Revenge* (both 1901). He also worked for him on the *Boris Gudunov* for Fyodor Chaliapin in 1908, and on most of the early repertory of the Ballet Russe, notably Mikhail Fokine's *Le Pavillon d'Armide* (1907), *Les Sylphides* (1909), *Giselle* (1910), *Petroushka* (1911), and *Le Rossignol* (1914).

Benois designed ballets for the Ida Rubinstein company, among them, *La Bien-aimée* (1928) and *Les Valses* (1929), for the Ballet Russe de Monte Carlo, including Lichine's *Graduation Ball* (1940), and for the various Ballet du Marquis de Cuevas and the London Festival Ballet.

His niece, Nadia Benois, created costumes for many productions of the Ballet Rambert, notably Andrée Howard's *Lady into Fox* (1939). His son Nicola was staff designer for many years at the Teatro alla Scala, Milan.

Bibliography: Benois, Alexander. *Reminiscences of the Russian Ballet* (London: 1941); *Memoirs* (London: 1960).

Benserade, Isaac, French seventeenth-century librettist; born 1612, Lyons-la-Forêt; died October 19, 1691 in Paris. A poet with links to the French court of Louis XIV through the sponsorship of the Cardinal de Richelieu, he was the librettist for many of the ballets de cour produced during the second half of the nineteenth century. His explicit libretti give many clues to the staging and mise-en-scène of these works, although they do not reveal the name of the choreographer, if any. His structures, with constructions of social dances, characterizational pieces, grotesqueries and parades, and processionals are fascinating to read. Many were based on mythological themes or on elements of nature, but always as transformed through the vision of the microcosm of the court— the king always representing the highest element in any group, with relative stratifications moving down through the court and the rest of the world. In his most prolific periods, 1651-1656 and the early 1680s, he created dozens of librettis and worked with Lully to realize them.

Although only the most heavily endowed libraries have copies of the libretti—even the published editions—there are two good texts on the ballet de cour which are still available: Silin's *Benserade and his Ballet de cour* (London: 1940), and Marie-Françoise Christout's *Le Ballet de Cour de Louis XIV* (Paris: 1967), which includes a detailed analysis of the court hierarchy.

Bentley, Muriel, American ballet dancer; born c.1920 in New York City; Bentley received her early training with Ivan Tarasoff, Maria Yakovleva, Vescheslav Swoboda, and Leon Fokine, later attending the school of the Metropolitan Opera Ballet. After an engagement with the José Greco touring company, she joined the corps of the Metropolitan Opera Ballet in 1938, and that of the Fokine Ballet in its Lewisohn Stadium concerts that summer.

For more than fifteen years, Bentley performed with Ballet Theatre, creating dramatic and comedic roles in Antony Tudor's *Pillar of Fire* (1942) and *Shadow of the Wind* (1948), and Agnes De Mille's *Tally-Ho* (1944) and *Fall River Legend* (1948), playing the "Stepmother." Celebrated for her humorous portrayals in the works of Jerome Robbins, then a Ballet Theatre dancer/choreographer, she created roles in his early *Interplay* (1945) and *Fancy Free* (1944), as "The Brunette," the girl with the handbag.

Bentley worked for Robbins on Broadway, playing "Anita" in the replacement cast of *West Side Story*

(c.1958). Following that engagement, she became a member of his Ballets: U.S.A. in 1959, performing in his *The Concert, Moves,* and *Events,* before retiring.

Bérain, Jean-Louis (père), French seventeenth-century theatrical designer; born 1637 in Bar-le-Duc; died 1711, possibly in Paris. Bérain and his son seem to form a history of French theatrical design philosophy and of the very meaning of the word "ballet." The elder Bérain was costume designer for both performances at the court of Louis XIV and for the forerunner of the Paris Opéra. He was an iconographist, integrating elements from a visual vocabulary known and understood by the audience, into a set silhouette based on the French seventeenth-century concept of Roman armour. His cuirasse, hose, shoes, and head dresses for the king, especially, represented him as the high point of the iconographic system—the sun, lion, or god, depending on the theme of the *ballet du cour.*

Bérain, père, remains best known for the work, *Le Triomphe de l'Amour* (1681), which was a particularly elaborate series of masques and aftermasques. The existence of the designs for this work in the Opéra archives, the Biblioteque Nationale, the Archives Nationale, and the Victoria and Albert Museums, in London, have meant that the masque has been studied in detail by scholars of Baroque art forms.

Bérain, Jean-Louis (fils), French seventeenth-century theatrical designer; born 1674; died 1726. Trained at his father's studio, along with a generation of French designers, he worked with him to create *ballet du cour* productions in the late 1680s. Unlike his father, however, he concentrated his work on productions for the Academie Royale de Musique, predecessor of the Paris Opéra. He formed a triumvirate with composer André Campra and the still anonymous choreographer to create almost a score of operas and opera/ballets at the turn of the century, among them the literary and mythological works, *Trancrède* (1702), *Les Muses* (1703), *Iphégénie en Tauride* (1704), *Télémaque* (1704), and *Alcine* (1705).

Bérard, Christian, French artist and theatrical designer; born c.1902 in Paris; died there February 13, 1949. In the sixteen years that he worked with ballet projects, Bérard contributed to many productions that are now considered perfect examples of artistic and aesthetic ideals of the time. He was superb at manipulating the overlarge scale of decors that choreographers such as Leonid Massine and Roland Petit preferred as an artistic choice but could also create simple frames for *Cotillion* (1932) and *Mozartiana* (1933) by George Balanchine. His Massine sets for *Symphonie Fantastique* (1936), *Seventh Symphony* (1938), and *Clock Symphony* (1938) brought him to the attention of both European and American audiences and critics and led to a period in American graphics in which his influence could be seen in everything from billboards to gloves. Bérard served as co-director and founder of the Ballets des Champs-Elysées with Roland Petit and Boris Kochkno, and designed sets and costumes for Petit's early success, *Les Forains* (1945), and David Lichine's *Rencontre* (1948).

Beretta, Catarina, Italian ballet dancer of the nineteenth century; born 1839 in Milan; died there in January 1911. Trained at the school of the Teatro alla Scala, she spent much of her life associated with that theater.

Frequently cast in the works of Pasquale Borri, she danced for him in his *Fiamella* (1866) and *Rodolfo* (1858). She was also featured in the premieres of Lucien Petipa's *Rilla, ossia la Fête di Provence* (1855), Paul Taglioni's *Léonilda* (1869), and Hyppolyte Monplaisir's *Brahma* (1870).

After serving briefly as a regisseur at the Maryinsky Theater in St. Petersburg in 1877, presumably during a tour performance there, Beretta returned to La Scala to teach. Among her many students were Pierina and Ria Teresa Legnani and Marie Giuri.

Berg, Henry, American ballet dancer; born April 4, 1938 in Chicago, Illinois. Trained by Lew and Harold Christensen, he made his debut with the touring Ballet Alicia Alonso before joining the San Francisco Ballet in 1962. He appeared in many works by Christensen, including his *Jinx, Concert Music for Strings and Brass Instruments, Fantasma,* and *Divertissement d'Auber.* A member of the City Center

Joffrey Ballet since 1967, he repeated his role of "The Equestrian" in *Jinx* and appeared in Gerald Arpino's *Konservatoriet, Reflections,* and *Viva Vivaldi,* and in the *"Wouldn't It Be Nice"* section of Twyla Tharp's *Deuce Coupe I.*

Bergese, Micha, German modern dancer and chore-ographer working in England; born in the mid-1940s in Munich, Germany. Raised in Berlin, he supported himself by teaching ballroom dance for three years before accepting a scholarship to the London School of Contemporary Dance. He has danced and choreo-graphed for the London Contemporary Dance The-atre throughout the 1970s, performing in Robert Co-han's *Masque of Separation* and co-creating *Night Watch* with him, Siobhan Davies, and Robert North (1977).

 Works Choreographed: CONCERT WORKS: *Outside In* (1971); *Hinterland* (1974); *Da Capo al Fine* (1975); *El Amor Brujo* (1976); *Nema* (1976); *Night Watch* (1977, co-choreographed with Robert Cohan, Siobhan Davies, and Robert North); *Eighteen Fifty-Nine-Second Pieces* (c.1977); *Changes* (1979); *Solo Rider* (1979); *Scene/Shift* (1979).

Bergsma, Deanne, South African ballet dancer; working in England; born Deanne Harrismith, 1941 in Pretoria. Trained by Marjorie Sturman in Johan-nesburg, she continued her ballet studies at the school of the Royal Ballet.

 A member of the Royal Ballet from 1959, she cre-ated roles in Frederick Ashton's *Enigma Variations* (1968) and in Ray Powell's *One in Five* (1968). Her other performances in which she has been applauded by audiences in England and on tour included Glen Tetley's *Field Figures,* Ashton's *Daphnis and Chloe, Ondine, Swan Lake, The Firebird,* and *The Sleeping Beauty,* in which she danced as "The Lilac Fairy."

 Bergsma is also known throughout the world of opera for her mimed portrayal of "the Polish Mother" in the premiere of Benjamin Britten's opera *Death in Venice* (1973).

Beri, Beth, American interpretive and theatrical dancer; born c.1904 in the Los Angeles, California area. Beri, who made it a policy to state that she had *not* studied with Ted Shawn and Ruth St. Denis in Los Angeles, toured with her interpretive dance act on the Keith and Orpheum circuits from 1918 to 1921. Billed as "the most beautiful dancer in the world," she did pieces based on specific works of music (mostly by Chopin) and on elements of nature; her version of *Spring Song* was also admired. Beri's Broadway roles were as the interpretive dancer in shows that featured other dancers in the more con-ventional theatrical forms. *Kid Boots,* for example, starred Eddie Cantor and ballerina Mary Eaton, when it opened on New Year's Eve of 1922, while *Jack and Jill* (1923) included dances by Clifton Webb (then in the transition between his exhibition ball-room and his eccentric dancer careers) and Ann Pen-nington.

Beriosova, Svetlana, Lithuanian ballet dancer work-ing in England for most of her career; born Septem-ber 24, 1932, in Kaunas, Lithuania. After early train-ing with her father, Nicholas Beriosoff, she attended the School of American Ballet and the Vilzak-Schol-lar studios in New York, and later continued her classes with Olga Preobrajenska in Paris.

 After performing with the Grand Ballet de Monte Carlo in 1947, she joined the (London) Metropolitan Ballet. With that short-lived company, she created roles in John Taras' *Designs with Strings* (1948) and Frank Staff's *Fanciulla delle Rose* in the same year.

 In the Sadler's Wells Theatre Ballet (1950–1952) and Sadler's Wells Ballet, she performed in company productions of *Swan Lake* and *Les Sylphides,* while creating roles in John Cranko's *Pastorale* (1950), *The Shadow* (1953), *Prince of the Pagodas* (1957), and *Antigone* (1959). Noted for her dramatic dance per-formances coupled with brilliant technique, she fre-quently danced in works by Frederick Ashton, among them, his *Rinaldo and Armida* (1955), *A Birthday Offering* (1956), *Persephone* (1961), and *Enigma Variations* (1968). Her work in ballets by Kenneth Macmillan has taken her from technical bravura to dignified character portrayals and has in-cluded *Le Baiser de la Fée* (1960), in the title role, *Diversions* (1961), *Images of Love* (1964), and *Ana-stasia* (1971 version), in which she played the "Tsa-rina."

 Beriosova retired in 1975.

Berke, Dorothea, American theatrical dancer and choreographer; born Dorothea Schlesinger, c.1900, in the Chicago area. A student of Merriell Abbott, Berke appeared in a vaudeville dance act as an adolescent before beginning to work in Prologs. A ballet specialist, she worked at The Capitol Theater in the early 1920s, the beginning of that theater's flirtation with the theatrical uses of that technique. By 1925, however, she had returned to Chicago as a dance director, and eventually, director of dance for the Balaban and Katz theater chain. Unlike the chain's rival, the Paramount/Publix linkage that stretched across the country, Balaban and Katz theaters booked Prologs and presentation acts in the Chicago/Cicero/Evanston/Joliet area only. The chain had a far-reaching effect, however, since it was in these theaters that the Sam Ash policy of having a performer-as-emcee introducing each act was developed.

When the chain was absorbed into the Paramount/Publix empire (which itself merged into the Fanchon and Marco chain), Berke worked with touring performers, staging acts that could fit into presentations at the Capitol, Paramount, Palace, or Roxy. Associated through many years with soprano Grace Moore, she staged most of her personal tour acts and her operetta revivals, most notably *The Dubarry* production of 1932. Berke retired in the late 1930s.

Berkeley, Busby, American film and theatrical dance director; born, Busby Berkeley William Enos, November 29, 1895 in Los Angeles, California. The son of actors in West Coast stock theater companies (touring groups in which a new play was performed each week), Berkeley first worked as a performer in straight, nonmusical plays; in fact, he has claimed that he never studied dance or music. Berkeley served as an assistant entertainment officer in the U.S. Army during World War I; returning to the United States, he made his New York theatrical debut in the play, *The Man Who Came Back* (1918), performing with his mother in stock. He also directed in stock, receiving his first choreographic experience. After touring as "Mme. Lucy" in *Irene,* he moved to New York to work as a Broadway musical comedy dancer and singer.

Busby Berkeley made his debut as a dance director in *A Connecticut Yankee* (1927), beginning a long professional relationship with Richard Rogers and Lorenz Hart. Next, he performed in and staged their *Present Arms* (1928), premiering the song "You Took Advantage of Me." Soon he was considered a member of the Broadway "Big Four" group of young choreographers and show doctors (the others were Bobby Connolly, Seymour Felix, and Sammy Lee). He staged a total of nine Broadway shows, returning to New York in 1971 to supervise the *No No Nanette* revival for Ruby Keeler. Berkeley's work for the chorus in *The International Revue* (1930) brought him to the attention of Eddie Cantor who recommended him for the dance director job on the film version of his vehicle, *Whoopee.*

Berkeley's first film assignments were primarily for Cantor vehicles co-produced by Samuel Goldwyn for United Artists, among them *Palmy Days* (1931) and *Roman Scandals* (1933). During his first three years in Hollywood, he also did South Sea nautches for RKO's *Bird of Paradise* (1932) and staged Prologs for Fanchon and Marco's West Coast Deluxe Theater chain. In 1933, Berkeley's best remembered film was released—*42nd Street*. This film, featuring Ruby Keeler, Dick Powell, Ginger Rogers, and Una Merkel, was the first of the backstage extravaganzas that he staged for Warner Brothers, First National Pictures, and Vitaphone. In these films, among them, *Footlight Parade* (about Prolog production), *Dames,* and the *Gold Diggers* series, he used the techniques that are now considered his trademarks—manipulation of black and white shadings, innovative uses of decor and lighting effects, film reversals, animation effects applied to dance staging, and, especially, his signature overhead camera angles.

Although he staged over fifty motion pictures, Berkeley is best known for his work on four variations of the backstage film genre: the Cantor vehicles with their dream sequences and vaudeville turns; the so-called Warner Brothers musicals (i.e., *42nd Street* and the *Gold Digger* films); the Esther Williams undersea ballets of the 1950s; and the Judy Garland/Mickey Rooney films of the 1940s. Since the two latter film groups were produced by MGM and many film clips of his work were included in that studio's

That's Entertainment movies, Berkeley may soon be as well remembered for his color films. Currently, however, it is the black and white Warner Brothers films that are best known—as cinema, and as representation of American art deco design.

Berkeley is unique in American film as the only nonperforming dance director to have popular acclaim and general recognition. He has been the subject of many museum and cinema revival house film festivals in the United States and throughout Europe.

Works Choreographed: THEATER WORKS: *A Connecticut Yankee* (1927); *Present Arms*)1928); *Good Boy* (1928); *Rainbow* (1928); *Hello Daddy* (1928); *The Street Singer* (1929, also directed and co-produced); *9:15 Revue* (1930); *The International Revue* (1930); *Sweet and Low* (1930); *Ideas* for Fanchon and Marco's Deluxe West Coast Theater chain; *No No Nanette* (1971); also industrials and cabaret acts.

FILMS: *Whoopee* (Goldwyn Prods./United Artists, 1930); *Palmy Days* (Goldwyn Prods./United Artists, 1931); *Flying High* (MGM, 1931); *Night World* (Universal, 1932); *Bird of Paradise* (RKO, 1932); *Kiki* (United Artists, 1932); *The Kid From Spain* (Goldwyn Prods./United Artists, 1932); *Roman Scandals* (Goldwyn Prods./United Artists, 1933); *42nd Street* (WB/Vitaphone, 1933); *Gold Diggers of '33* (First National/Vitaphone, 1933); *Footlight Parade* (WB, 1933); *She Had to Say Yes* (First National/Vitaphone, 1933, also directed); *Dames* (WB/Vitaphone, 1934); *Fashions of '34* (First National, 1934); *Wonderbar* (First National, 1934); *Stars over Broadway* (WB, 1935); *In Caliente* (First National, 1935); *Gold Diggers of '35* (First National/Vitaphone, 1935); *I Live for Love* (WB, 1935, also directed); *Bright Lights* (First National, 1935); *Stage Struck* (First National, 1936); *Gold Diggers of '37* (First National, 1937); *Varsity Show* (WB, 1937); *The Singing Marine* (WB, 1937); *Hollywood Hotel* (First National, 1937); *The Go-Getter* (Cosmopolitan Pictures/WB, 1937); *Gold Diggers in Paris* (WB, 1938); *Men are Such Fools* (WB, 1938); *The Garden of the Moon* (First National, 1938); *Comet over Broadway* (First National, 1938); *Broadway Serenade* (MGM, 1939); *Babes in Arms* (MGM, 1939); *Fast and Furious* (MGM, 1939, also directed); *Forty Little Mothers* (MGM, 1940); *Strike Up the Band* (MGM, 1940, also directed); *Lady Be Good* (MGM, 1941); *Babes on Broadway* (MGM, 1941); *Born to Sing* (MGM, 1942); *For Me and My Gal* (MGM, 1942, also directed); *Girl Crazy* (MGM, 1943); *The Gang's All Here* (Twentieth-Century Fox, 1943); *Cinderella Jones* (First National, 1946, also directed); *Take Me Out to the Ball Game* (MGM, 1949, also directed); *Two Weeks of Love* (MGM, 1950); *Call Me Mister* (Twentieth-Century Fox, 1951); *Two Tickets to Broadway* (RKO, 1951); *Million Dollar Mermaid* (MGM, 1952); *Easy to Love, Small Town Girl* (MGM, 1953); *Rose Marie* (MGM, 1954); *Jumbo* (MGM, 1962, Berkeley received credit as second unit director, terminology which usually refers to the stager of crowd scenes, but it is generally believed that he staged the scenes involving circus performance).

Berlin, Irving, American songwriter; born Israel Baline, May 11, 1888, in Temun, Russia. Raised in New York City, he became a lyricist and composer in the early 1910s, and spent fifty years creating shows and individual songs. Shows that he contributed to or wrote completely included *Watch Your Step* (1914), one of the first revues to be cast with a variety of specialty dancers, *Stop! Look! Listen!* (1915), in which Joseph Santley introduced "The Girl I Love Is on a Magazine Cover" to Marion Davies, the overproduced Ziegfeld and Dillingham *Century Girl* (1916), *The* [George M.] *Cohan Revue* (1917), the World War I *Yip, Yip, Yahank* (1918), the *Ziegfeld Follies of 1919* and *1920,* his own *Music Box Revues of 1921* to *1924,* the Marx Brothers' *Coconuts* (1925), the *American Revue* [Follies of 1927], *Face the Music* (1932), *As Thousands Cheer* (1933), *Louisiana Purchase* (1940), staged by George Balanchine, World War II's *This is the Army* (1942), *Annie Get Your Gun* (1946), *Miss Liberty* (1949), *Call Me Madam* (1959), and *Mr. President* (1962). In those fifty years, the position of dance sequences within shows and individual songs changed drastically; Berlin was able to adapt to every shift, from the complex montage of routines that went into a 1910s revue scene to the second act opener dance numbers of *Annie Get Your Gun* and *Call Me Madam*. Because he wrote hundreds of topical songs, he included references to

dance in many of his works; the interrelations between "That Mysterious Rag" and the Erik Satie score for *Parade* were balanced by his dozens of songs about one-steps, tangoes, and Cuban rhumbas. His "Sadie" and "Becky" songs reveal the liberating jobs in twentieth-century dance. It is impossible to make generalizations about Berlin's songs. He wrote pattersongs and glorious ballads, intensely patriotic numbers such as "God Bless America," and sardonic ones about unemployment after armistices. Berlin was the most versatile songwriter in the Tin Pan Alley of the twentieth century—one who spoke for, to, and about life here.

Berman, Eugene, Russian theatrical designer working in the United States; born November 4, 1899 in St. Petersburg; died December 4, 1972 in Rome. Berman's association with the dance came after he emigrated to the United States in the mid-1930s. His first major designs are not seen in the repertory, they were the costumes for George Balanchine's *Concerto Barocco* (1941), which is now performed without iconographic decor in white leotards. Although his most controversial costumes, for the 1946 Ballet Theatre *Giselle,* have also been discarded with a new artistic policy, the exquisite set pieces and costumes for Antony Tudor's *Romeo and Juliet* (1963) can still be seen in the active American Ballet Theatre repertory.

Berman's contributions to the dance were analyzed in Allison Delarue's "The Stage and Ballet Designs of Eugene Berman," in *Dance Index* (Volume V, no. 2).

Bernadelli, Fortunato, Nineteenth-century choreographer of Italian origin working in Western Europe and Russia; the details of Bernadelli's birth and death cannot yet be verified, but it is probable that he was born before 1795 and died after 1830. He was a member of the large Bernardelli/Bernadelli clan of Italians working in Western Europe, and may have toured with a family branch troupe, but his activities cannot be verified before 1812 when he received his first extant choreography credit for a production of the Kobler Family company, I Groteschi. He was married to Nanette Kobler (second daughter of Josef Kobler, a "Mechanical Artist" and shadow theater producer), who had performed in Vienna as a child in the Teater an der Wein, but was then a member of her family troupe; it is not known when they were married, but he was presumably at least engaged to her when he joined I Groteschi.

Bernadelli's professional life is more easily understood than his unknown biography. He staged works for the Kobler troupes from 1812 to 1818 when he and his wife went to Russia. A remarkably versatile performer, he played "Mme. Simone," the elderly character *travestie* role, in the Kobler's version of *La Fille Mal Gardée* (Das Übelgehü Teater Mädchen, 1813), but the hero "Colin" in his own version, *Jeanette et Colin* (1818). In Russia, he was appointed premier danseur as well as ballet master, and appeared in Ivan Valberkh's *Raoul Barbe Bleu* and *Les Brigands* and in Adam Glushkovsky's folk-derived works.

His ballets for the Kobler family and the Maryinsky Ballet ranged from pieces about automatons of various degrees of anthromorphism, such as *La Flûte Enchantée* (1818) and *Les Poupées Méchaniques* (1818), to works based on the legends of the Crusades, in a curious parallel to the national ballets of the Italian theaters.

Works Choreographed: CONCERT WORKS: *Abzara und Zegry* (1812); *Doppel-Duell* (1813); *Das Übelgehü Teater Mädchen* (1814, after D'Auberval's *La Fille Mal Gardée*); *Jeanette et Colin* (1818, possibly a version of the above); *La Flûte Enchantée, ou les Danseurs Involuntaires* (1818); *Les Poupées Méchaniques* (1818); *La Fête du Mois de Mai dans la Ville de Trevise* (1818); *La Ruse, ou la Mort Simulée d'Arlequin* (1818); *Le Double-Duell* (1819 revival); *Le Rendez-vous Nocturne* (1819); *La Jardinière* (1819, a version of *Das Lüstige Garten-Mädchen,* a Kobler Family production not credited to Bernadelli); *Les Lingères et les Ramoneurs* (1819); *L'Amour de Mars et Vénus* (1819); *Raoul, Roi d'Espagne* (1819); *L'Ennemi Mystérieux, ou la Fôret Noire* (1820); *L'Homme Vert, ou la Poursuite Inapportune* (c.1825); *Richard, Coeur de Lion, en Palestine* (1829); *La Mort D'Atilla, Roi des Huns* (1829); *Le Tambour Magique, ou Suite de la Flûte Enchantée* (1829); *La Fête des Roses à Salency* (1829).

That's Entertainment movies, Berkeley may soon be as well remembered for his color films. Currently, however, it is the black and white Warner Brothers films that are best known—as cinema, and as representation of American art deco design.

Berkeley is unique in American film as the only nonperforming dance director to have popular acclaim and general recognition. He has been the subject of many museum and cinema revival house film festivals in the United States and throughout Europe.

Works Choreographed: THEATER WORKS: *A Connecticut Yankee* (1927); *Present Arms*)1928); *Good Boy* (1928); *Rainbow* (1928); *Hello Daddy* (1928); *The Street Singer* (1929, also directed and co-produced); *9:15 Revue* (1930); *The International Revue* (1930); *Sweet and Low* (1930); *Ideas* for Fanchon and Marco's Deluxe West Coast Theater chain; *No No Nanette* (1971); also industrials and cabaret acts.

FILMS: *Whoopee* (Goldwyn Prods./United Artists, 1930); *Palmy Days* (Goldwyn Prods./United Artists, 1931); *Flying High* (MGM, 1931); *Night World* (Universal, 1932); *Bird of Paradise* (RKO, 1932); *Kiki* (United Artists, 1932); *The Kid From Spain* (Goldwyn Prods./United Artists, 1932); *Roman Scandals* (Goldwyn Prods./United Artists, 1933); *42nd Street* (WB/Vitaphone, 1933); *Gold Diggers of '33* (First National/Vitaphone, 1933); *Footlight Parade* (WB, 1933); *She Had to Say Yes* (First National/Vitaphone, 1933, also directed); *Dames* (WB/Vitaphone, 1934); *Fashions of '34* (First National, 1934); *Wonderbar* (First National, 1934); *Stars over Broadway* (WB, 1935); *In Caliente* (First National, 1935); *Gold Diggers of '35* (First National/Vitaphone, 1935); *I Live for Love* (WB, 1935, also directed); *Bright Lights* (First National, 1935); *Stage Struck* (First National, 1936); *Gold Diggers of '37* (First National, 1937); *Varsity Show* (WB, 1937); *The Singing Marine* (WB, 1937); *Hollywood Hotel* (First National, 1937); *The Go-Getter* (Cosmopolitan Pictures/WB, 1937); *Gold Diggers in Paris* (WB, 1938); *Men are Such Fools* (WB, 1938); *The Garden of the Moon* (First National, 1938); *Comet over Broadway* (First National, 1938); *Broadway Serenade* (MGM, 1939); *Babes in Arms* (MGM, 1939); *Fast and Furious* (MGM, 1939, also directed); *Forty Little Mothers* (MGM, 1940); *Strike Up the Band* (MGM, 1940, also directed); *Lady Be Good* (MGM, 1941); *Babes on Broadway* (MGM, 1941); *Born to Sing* (MGM, 1942); *For Me and My Gal* (MGM, 1942, also directed); *Girl Crazy* (MGM, 1943); *The Gang's All Here* (Twentieth-Century Fox, 1943); *Cinderella Jones* (First National, 1946, also directed); *Take Me Out to the Ball Game* (MGM, 1949, also directed); *Two Weeks of Love* (MGM, 1950); *Call Me Mister* (Twentieth-Century Fox, 1951); *Two Tickets to Broadway* (RKO, 1951); *Million Dollar Mermaid* (MGM, 1952); *Easy to Love, Small Town Girl* (MGM, 1953); *Rose Marie* (MGM, 1954); *Jumbo* (MGM, 1962, Berkeley received credit as second unit director, terminology which usually refers to the stager of crowd scenes, but it is generally believed that he staged the scenes involving circus performance).

Berlin, Irving, American songwriter; born Israel Baline, May 11, 1888, in Temun, Russia. Raised in New York City, he became a lyricist and composer in the early 1910s, and spent fifty years creating shows and individual songs. Shows that he contributed to or wrote completely included *Watch Your Step* (1914), one of the first revues to be cast with a variety of specialty dancers, *Stop! Look! Listen!* (1915), in which Joseph Santley introduced "The Girl I Love Is on a Magazine Cover" to Marion Davies, the overproduced Ziegfeld and Dillingham *Century Girl* (1916), *The* [George M.] *Cohan Revue* (1917), the World War I *Yip, Yip, Yahank* (1918), the *Ziegfeld Follies of 1919* and *1920,* his own *Music Box Revues of 1921* to *1924,* the Marx Brothers' *Coconuts* (1925), the *American Revue* [Follies of 1927], *Face the Music* (1932), *As Thousands Cheer* (1933), *Louisiana Purchase* (1940), staged by George Balanchine, World War II's *This is the Army* (1942), *Annie Get Your Gun* (1946), *Miss Liberty* (1949), *Call Me Madam* (1959), and *Mr. President* (1962). In those fifty years, the position of dance sequences within shows and individual songs changed drastically; Berlin was able to adapt to every shift, from the complex montage of routines that went into a 1910s revue scene to the second act opener dance numbers of *Annie Get Your Gun* and *Call Me Madam*. Because he wrote hundreds of topical songs, he included references to

dance in many of his works; the interrelations between "That Mysterious Rag" and the Erik Satie score for *Parade* were balanced by his dozens of songs about one-steps, tangoes, and Cuban rhumbas. His "Sadie" and "Becky" songs reveal the liberating jobs in twentieth-century dance. It is impossible to make generalizations about Berlin's songs. He wrote pattersongs and glorious ballads, intensely patriotic numbers such as "God Bless America," and sardonic ones about unemployment after armistices. Berlin was the most versatile songwriter in the Tin Pan Alley of the twentieth century—one who spoke for, to, and about life here.

Berman, Eugene, Russian theatrical designer working in the United States; born November 4, 1899 in St. Petersburg; died December 4, 1972 in Rome. Berman's association with the dance came after he emigrated to the United States in the mid-1930s. His first major designs are not seen in the repertory, they were the costumes for George Balanchine's *Concerto Barocco* (1941), which is now performed without iconographic decor in white leotards. Although his most controversial costumes, for the 1946 Ballet Theatre *Giselle,* have also been discarded with a new artistic policy, the exquisite set pieces and costumes for Antony Tudor's *Romeo and Juliet* (1963) can still be seen in the active American Ballet Theatre repertory.

Berman's contributions to the dance were analyzed in Allison Delarue's "The Stage and Ballet Designs of Eugene Berman," in *Dance Index* (Volume V, no. 2).

Bernadelli, Fortunato, Nineteenth-century choreographer of Italian origin working in Western Europe and Russia; the details of Bernadelli's birth and death cannot yet be verified, but it is probable that he was born before 1795 and died after 1830. He was a member of the large Bernardelli/Bernadelli clan of Italians working in Western Europe, and may have toured with a family branch troupe, but his activities cannot be verified before 1812 when he received his first extant choreography credit for a production of the Kobler Family company, I Groteschi. He was married to Nanette Kobler (second daughter of Josef Kobler, a "Mechanical Artist" and shadow theater producer), who had performed in Vienna as a child in the Teater an der Wein, but was then a member of her family troupe; it is not known when they were married, but he was presumably at least engaged to her when he joined I Groteschi.

Bernadelli's professional life is more easily understood than his unknown biography. He staged works for the Kobler troupes from 1812 to 1818 when he and his wife went to Russia. A remarkably versatile performer, he played "Mme. Simone," the elderly character *travestie* role, in the Kobler's version of *La Fille Mal Gardée* (Das Übelgehü Teater Mädchen, 1813), but the hero "Colin" in his own version, *Jeanette et Colin* (1818). In Russia, he was appointed premier danseur as well as ballet master, and appeared in Ivan Valberkh's *Raoul Barbe Bleu* and *Les Brigands* and in Adam Glushkovsky's folk-derived works.

His ballets for the Kobler family and the Maryinsky Ballet ranged from pieces about automatons of various degrees of anthromorphism, such as *La Flûte Enchantée* (1818) and *Les Poupées Méchaniques* (1818), to works based on the legends of the Crusades, in a curious parallel to the national ballets of the Italian theaters.

Works Choreographed: CONCERT WORKS: *Abzara und Zegry* (1812); *Doppel-Duell* (1813); *Das Übelgehü Teater Mädchen* (1814, after D'Auberval's *La Fille Mal Gardée*); *Jeanette et Colin* (1818, possibly a version of the above); *La Flûte Enchantée, ou les Danseurs Involuntaires* (1818); *Les Poupées Méchaniques* (1818); *La Fête du Mois de Mai dans la Ville de Trevise* (1818); *La Ruse, ou la Mort Simulée d'Arlequin* (1818); *Le Double-Duell* (1819 revival); *Le Rendez-vous Nocturne* (1819); *La Jardinière* (1819, a version of *Das Lüstige Garten-Mädchen*, a Kobler Family production not credited to Bernadelli); *Les Lingères et les Ramoneurs* (1819); *L'Amour de Mars et Vénus* (1819); *Raoul, Roi d'Espagne* (1819); *L'Ennemi Mystérieux, ou la Fôret Noire* (1820); *L'Homme Vert, ou la Poursuite Inapportune* (c.1825); *Richard, Coeur de Lion, en Palestine* (1829); *La Mort D'Atilla, Roi des Huns* (1829); *Le Tambour Magique, ou Suite de la Flûte Enchantée* (1829); *La Fête des Roses à Salency* (1829).

Bernard, Karen, American postmodern dancer and choreographer; born September 14, 1948 in Boston, Massachusetts. As a child and adolescent, Bernard studied dance with her father and art at the Boston Museum School. She moved to London in 1969, where she continued her training at the School of Contemporary Dance there, and to New York in 1972, where she began studies in modern dance at the Merce Cunningham, with Barbara Lias, and Erick Hawkins studios and in contact improvisation with David Woodberry. She has also worked in kinesiology and ideokinesiology in New York. Always involved in the collaborations between performance and plastic arts, Bernard worked with David Tremlette on a continuing conceptual project in London in 1972 and has performed and taught with the Art Bus, a mobile workshop in New York City.

Bernard has choreographed since 1974, frequently in collaboration with other dancers, composers, and artists. She uses repetition ingenuously and has shown an extraordinary ability to use performance spaces to full and frequently surprising advantage.

Works Choreographed: CONCERT WORKS: *OMMA I* (1974, in collaboration with Angela Capinagro); *OMMA II* (1975, in collaboration with Capinagro); *Chip Shot (Foam Rubber, Skating, Minus Plus Minus, Burlap Bags)* (1977); *Jumprope* (1977); *Second Wind* (1977); *Off the Wall (Section I, Corner)* (1977); *Cannard (Fourth Wind, As Yet Untitled)* (1978, in collaboration with composer Michael Canick); *Interphase* (1979); *Diptych* (1979); *Dance Stretch (Nine Thoughts, Broken Sense)* (1980, solo and group versions premiered this year).

Bernd, John, American postmodern dancer and choreographer; born May 8, 1953 in Lincoln, Nebraska. After studies with Dimitra Sundeen Beber at Antioch College and twelve years as a competitive swimmer, Bernd moved to New York to continue his training in the Alexander technique and in dance with Merce Cunningham, Viola Farber, and Dan Wagoner at the Cunningham Studio. Although he has performed with The House, in Meredith Monk's *Quarry* and *Venice/Milan,* most of his dance work has been appearances in his own solos and in collaborative choreography with Tim Miller. The latter material is performed under the generic title LIVE BOYS, a suitable description for the creations of the innovative members of the newest generation of postmodernists.

Works Choreographed: CONCERT WORKS: *A Personal Landscape* (1978); *Some Things for Some People* (1979); *Notes on Beach* (1979); *Evidence* (1980); *From One Place to Another* (1980); LIVE BOYS (1980–, continuing collaboration with Tim Miller).

Berners, Lord, English composer; born Gerald Hugh Tyrwitt-Wilson, Lord Berners, September 18, 1883 in Arley Park, Bridgenorth, Shropshire; died May 19, 1950 in London. After a less than completely successful early career in which he was known as a miniaturist, Berners received great acclaim with his commissioned work for the Diaghilev Ballet Russe, George Balanchine's *The Triumph of Neptune* (1926). He later created music for Balanchine's *Luna Park* ballet in the 1930 C.B. Cochran's revue. Most of his later scores, however, were for two early choreographers of the British ballet—Susan Salaman, for whom he wrote *Le Boxing* and *Waterloo and the Crimea* (1931), and Frederick Ashton for whom he composed *A Wedding Bouquet* (1937), *Cupid and Psyche* (1939), and *Les Sirènes* (1946). He also designed and wrote the scenario for *A Wedding Bouquet,* based on works by Gertrude Stein.

Bernson, Kathryn, American postmodern dancer and choreographer; born September 7, 1950 in Los Angeles. After ballet training from Carmelita Maracchi and David Lichine, she attended Bennington College in Vermont where she studied modern dance, choreography, and improvisation with Judith Dunn and Martha Wittman. Since moving to New York she has revived her ballet work under faculty members of the New York School of Ballet and the Manhattan School of Dance, and has taken modern and post modern dance classes with Merce Cunningham and Viola Farber.

Bernson has performed and choreographed in collaboration with Stormy Mullis since the mid-1970s, creating a large repertory of works that frequently involve scripts and sound scores. Their works reflect the interest in improvisatory partnering that many

contemporary choreographers have shown but they have enhanced this theme though the sharing of contact with graphic visual elements and the verbal and sound scores with which they work. She has also taught extensively in technique classes at many universities and in the interdisciplinary programs at art schools, including that at the Pratt Institute in Brooklyn, New York.

Works Choreographed: CONCERT WORKS: *House Dances* (1972); *Carl Takes a Bow* (1973); *Irene and the Chicken* (1973); *The Fying Zucchinis* (1974); *Real Costumes* (1974); *Prospect Park* (1975, co-choreographed with Stormy Mullis); *Walking and Talking* (1975, co-choreographed with Mullis); *New York, New Jersey* (1976); *True Stories* (1977); *Ladder/ Mother of Three* (1977, co-choreographed with Mullis); *Otterduck Pond* (1978, co-choreographed with Mullis); *Double Gestures* (1979, in collaboration with Mullis and visual artist Susan Share); *Bugs* (1980, co-choreographed with Mullis).

Bernstein, Leonard, American conductor and composer; born August 25, 1915 in Lawrence, Massachusetts. Bernstein's musical training included work in composition with Walter Piston and in conducting with Frantz Reiner and André Koussevitsky. Since his debut as substitute conductor of the New York Philharmonic (of which he was assistant conductor) in November 1943, he has been recognized as one of America's most influential and popular orchestra leaders.

Bernstein's connection to dance probably began with Koussevitsky, who introduced both *Petrouchka* and *Sacre du Printemps* in concert, among many other dance scores. He has composed specifically for dance, primarily in collaboration with choreographer Jerome Robbins, creating the ballets *Fancy Free* (1944), *Facsimile* (1946), and *Dybbuk Variations* (1974, now *Suite of Dances*). and the musicals *On the Town* (1944), *Wonderful Town* (1953), and *West Side Story* (1957) for him. Among his many other theatrical ventures have been *Candide* (1956, revised 1974), *1600 Pennsylvania Avenue* (1976) and *MASS* (1971), which was choreographed by Alvin Ailey.

The Berry Brothers, American flash tap and acrobatics dance act; this act consisted of Annanias J. Berry (born c.1912 in New Orleans, Louisiana; died 1951), James J. Berry (born c.1915 in New Orleans; died January 28, 1969 in New York City) and Warren J. Berry (born c.1918 in Denver, Colorado). Trained by their father and by Henri Wessels, the elder two Berrys made their dance debuts together in an amateur dance act called A Miniature (Bert) Williams and (George) Walker in 1925 in Hollywood—more than a dozen years after Walker's death and the end of that extraordinary team. James appeared briefly in the black child slot in the Hal Roach *Our Gang* comedies (replacing "Sunshine Sammy" Morrison), but for most of their careers, he and Annanias worked together in Hollywood and New York. In 1929, they became a staple flash act for the Cotton Club (uptown) and Duke Ellington Orchestra; they worked at the club for four and a half years and returned there and to the Downtown Cotton Club regularly until the early 1940s. In 1938, they were booked with the Nicholas Brothers, their only peers in acrobatic tap, in a competition format. The Berry Brothers also worked on the white club and theater circuits, however, and performed frequently at the Copacabana (c.1929–) and "Roxy" Rothafel's Roxy Theater and Radio City Music Hall. They were most often engaged with jazz vocalists and orchestras, and toured frequently with Count Basie, Cab Calloway, Jimmy Dorsey, and Ella Fitzgerald. The elder Berry died in 1951. The youngest dropped out of performing completely, but James J. remained connected to tap and jazz dance (while holding other jobs) and served as a co-director and founder of Mura Dehn's Afro-American Folk Dance Theatre.

The classic Berry Brother act was formulated in 1936. Annanias had retired briefly in 1934 and had been replaced by his youngest brother, but two years later, he returned and created the trio act. While only a member of the audience at the 1938 joint booking could accurately compare them to the Nicholas Brothers, most sources considered them equals, with the Berrys having a more complex, denser act. Other groups did tap work and acrobatics based on splits, but the Berry trio could create more complicated tumbling combinations than the Nicholas duo. The Berrys, whose acts were not enhanced (or limited) by the Nicholas' image of sophistication, also used more props and straightforward strutting. Their cane dance, which involved soft shoe work, juggling, ac-

robatics, and struts, was considered a classic. Although their routines were mauled in other pictures, the Berry trio can be seen to great advantage in a single film, *You're My Everything* (1949), staged for Twentieth-Century Fox by Nick Castle, who (with and without his partner Geneva Sawyer) was credited with the dance direction for most of the Hollywood black act interpolations of the 1940s.

Berry, Ken, American tap dancer and comedian; born November 3, 1933 in Moline, Illinois. After local studies and a European tour with the Horace Heidt troupes, Berry moved to Hollywood to continue his training with Al White and Louis DaPron. He made his television debut in *Talent Patrol* (ABC, c.1954), as the result of an Army competition, later appearing in nightclubs in Hollywood and Las Vegas.

A popular comedian, Berry has rarely tapped on television. Since many of his television appearances are either in rural comedies, as in *The Andy Griffith Show* and its spinoff, *Mayberry R.F.D.*, or in dramatic roles, he has not been able to interpolate his tap specialties into his acting jobs. He played the choreographer of *The Alan Brady Show* on *The Dick Van Dyke Show* (CBS, 1961–1965), but did not dance frequently on the air.

As a tap dancer, Berry is currently best known for his thirty-second specialty numbers on Kinney Shoe commercials (c.1978 to 1981).

Bessmertnova, Natalia, Soviet ballet dancer; born July 19, 1941 in Moscow. Trained at the School of the Bolshoi Ballet in Moscow, she has been associated with the Bolshoi Ballet throughout her distinguished career. Equally adept at creating characterizations in the Russian and Soviet classics, she has performed "Odette/Odile," "Swanilda," and "Giselle," and "Masha," "Juliet," and "Phrygia." She created the female title role in Kasyan Goleizovsky's *Leili and Medsjhnun* (1964) and principal parts in two major ballets by her husband Yuri Grigorovich—*Ivan the Terrible* (1975) and *Angara* (1976).

Bessy, Claude, French ballet dancer; born October 20, 1932 in Paris. Trained at the school of the Paris Opéra, she performed with the company for most of her professional life. She has created roles in many works by Serge Lifar, among them *Les Noces Fantastiques* (1955), *Chemin de Lumière* (1957), *Septuor* (1950), *Daphnis et Chloe* (1958), and *Pas et Lignes* (1958), and danced in his *Phèdre, l'Atlantide,* and *Le Chevalier Errant.* After dancing in his *Invitation to the Dance* (MGM, 1954), she created the female role in Gene Kelly's *Pas de Dieu* (1960) at the Opéra. She has also performed in the company's productions of the classics and in Harald Lander's *Etudes,* revived for the Opéra when he was ballet master.

Bessy retired in 1975.

Works Choreographed: CONCERT WORKS: *Flash Ballet* (1960); *Chlorinda et Tancredi* (1960); *Les Fourmis* (1966).

Beswick, Bob, American modern dancer; born November 11, 1945 in San Francisco, California. Beswick has studied and worked with a variety of choreographers representing all phases of American traditional modern dance, ranging from Merce Cunningham and James Waring to Gladys Bailin, Murray Louis, and Alwin Nikolais. After performing with the Repertory Dance Theatre of Utah in 1967, he joined the Nikolais company. He has performed in most of the large group works, such as *Tent, Tower,* and *Scenario* (1971), and in Nikolais' reformulated works, including the Mantis sequence from *Imago* and the duet from *Somniloquy.*

Works Choreographed: CONCERT WORKS: *see thru* (1975); *wish cotton was a monkey* (1975, in collaboration with Mickey McLaughlin).

Bettis, Valerie, American modern dance and theatrical choreographer; born 1920 in Houston, Texas. Bettis received her early dance training locally—ballet from Rowena Smith and Wigman technique from Tina Flade. In 1937, she moved to New York to study with Hanya Holm, also spending summers at the Perry-Mansfield Camp in Colorado working in and teaching Holm technique. While in New York, Bettis also studied with Nanette Charisse and Aubrey Hitchins.

Bettis first appeared as a Holm dancer in the augmented dance group that performed *Trend* at its New York premiere, 1937. She joined the regular company, Hanya Holm and Dance Group, for its 1938 tour, performing in *Dance of Introduction, Metro-*

politan Daily, and Dance Sonate, from 1938 to 1940. On layoff, she appeared in Bill Maton's industrial show, Railroads on Parade, at the 1939 World's Fair in New York.

From 1941, Bettis' career was split between her choreography for her own modern dance group and her theatrical performances and staging. She first choreographed for herself in solo concerts and recitals shared with other young dancers; in 1942, for example, she shared a recital with Sybil Shearer and Erick Hawkins. Her days of searching for inexpensive performance spaces were not forgotten; in 1946, she became a founding member of the Choreographers' Workshop.

Bettis' work is typified by her imaginative use of the spoken word and her employment of characterizational gestures. Many of her works were based on poems and novels. Of these, The Desperate Heart (1943), a solo based on a poem by John Malcolm Brinin, and As I Lay Dying, after the William Faulkner novel, are the best known.

Bettis appeared in and choreographed many Broadway and Off Broadway productions, among them the Lee Strasberg production of Peer Gynt in 1951 and Ulysses in Nighttown in 1958. She became nationally known as a dancer for her portrayal of "Tiger Lily" in Inside U.S.A. (1948), choreographed by Helen Tamiris, and later performed in Great to Be Alive (1950). She also worked extensively in film, working primarily on Rita Hayworth films for Columbia Pictures, including Affair in Trinidad (1952), Salome (1953), and Let's Do It Again (1953), in all of which she also performed. Bettis choreographed many series and specials for early television, among them the Paul Whiteman Goodyear Revue (ABC, 1949), An Evening with Richard Rodgers (NBC, March 4, 1951), and Omnibus (CBS, March 29, 1953). She also worked on television as a straight actress in many dramatic specials and series.

Works Choreographed: CONCERT WORKS: Theme and Variations (1941); Triptych (1941); City Streets (1941); Country Lane (1941); Study (1942); Southern Impressions (1942); Salute (1942); And the Earth Shall Bear Again (1942); The Desperate Heart (1943); Italia Speaks (1943); Prairie Born (1943); Suadeas do Brazil (1943); Daisy Lee (1943); A Mellow Bit of Rhythm (1943); Lullaby (1944); Caprice (1944); And Dreams Intrude (1944); Virginia Overture (1944); Theatrics (1945); Fact and Figures (1945); Dramatic Incident (1945); Yerma (1946); Five Abstractions in Space (1946); Tocatta for Three (1946); Rondel for a Young Girl (1946); Virginia Sampler (1947); Status Quo (1947); In Transit (1947); Figure '47 (1947); As I Lay Dying (1948); Domino Furioso (1948); It is Always Farewell (1949); Desert Flame (1950); Museum of Modern Art (1950); A Streetcar Named Desire (1952); The Golden Round (1955); Circa '56 (1956); The Past Perfect Hero (1958); The Closed Door (1959); Early Voyages—Other Voices, Other Loves (1960); He Who Runs (1964); Invention of Darkness (1964); Songs and Processions (1965); Leap (1973); Scene for Piano and Tape (1973); Lament (1973); Something for Kitty Genovese (1973); The Corner (1975); Next Day (1978).

THEATER WORKS: Glad to See You (1944, closed in Philadelphia on pre-Broadway tour); Beggar's Holiday (1946); Peer Gynt (1951); Two on the Aisle (1951); Ulysses in Nighttown (1958, 1959 in London).

FILM: Affair in Trinidad (Columbia, 1952, also appeared in film); Salome (Dance of the Seven Veils sequence only) (Columbia, 1953); Let's Do It Again (Columbia, 1953, also appeared in film); Athena (MGM, 1954).

TELEVISION: The Paul Whiteman's Goodyear Revue (ABC, 1949); An Evening with Richard Rodgers (NBC, 1951, special, also appeared on show); NBC Comedy Hour (1951); Omnibus (CBS, March 29, 1953, special on Gershwin, staged first television production of Gershwin opera 135th Street); Our Town (NBC, 1955, special); l'Histoire du Soldat (PBS Sunday Showcase special, 1967).

Bewley, Lois, American ballet dancer and designer; born c.1936 in Louisville, Kentucky. Bewley studied ballet locally with Lilas Courtney and in New York with Igor Schwezoff. For the first five years of her professional life, she performed with a large number of companies and groups, among them the Ballet Russe de Monte Carlo (c.1955–1957), Ballet Theatre, in which she created roles in Kenneth Macmillan's Winter Eve (1957) and Concerto (1958), Alicia Markova's 1958 tour group, and Jerome Robbins' Ballets: U.S.A. before joining the New York City

Ballet in 1960. In the latter company she appeared in works by George Balanchine and Jerome Robbins but was best known for her work in two comic ballets by Todd Bolender—*Souvenirs* and *Creation of the World.*

In 1960 she and fellow Ballet Theatre/City Ballet members, Charles Bennett and William Carter, formed a trio for performances at the Pablo Casals Festival in Puerto Rico. Their 1961 New York debut was enhanced by the company's most popular piece, her *Pi-r²*, which included satires of almost every dance that the knowledgeable audience had ever seen. She performed with the various groups formed by Bennett, Carter, and herself (the First Chamber Quartet, the First Chamber Dance Company, etc.) through the 1960s, creating works for the members of the troupe. After years of choreographing and designing for ballet and opera companies, she returned to performance in 1976 with the first of a series of one-woman shows in New York. Billed as "The Return of Lois Bewley," the recitals presented her in ten ballets that she had created and designed. In 1980, however, she did retire to concentrate on her design work in opera transparencies and costumes for fashion and streetwear.

Works Choreographed: CONCERT WORKS: *Pi-r²* (1961); *Inner Obstacle* (1961); *Part II and Five Songs* (1964); *Visions Fugitifs* (1968); *Part II* (1968); *Qualcosa di Carino* (1968); *Children of Darkness* (1973); *The Return of Lois Bewley (Concerto Grosso, Emily Jane, Quatro Toriadillas, Quartet No. 3 for Strings and Electronic Tape, Prologue, MCP, Waltz, Sally Mae, Untitled, Epilogue)* (1976); *Six Dances* (1978); *Letters from Composers* (1978); *Covenant* (1978); *Close Encounters* (1978); *Three Songs of Henri Duparc* (1978).

Bey, Hannelore, German ballet dancer; born November 6, 1941 in Leipzig. Bey was trained at the Dresden School of Gerd Palucca and at the Leningrad Choreographic Institute. After dancing in Palucca's Dresden State Opera Ballet, she joined the Berlin Comic Opera in the People's Republic of Germany. She has performed in the principal roles of the company's Soviet-influenced productions of the nineteenth-century classics and in newer neoromantic ballets by Tom Schilling, including his *La Mer, Cin-*derella (1968), *Ondine* (1970), and *Romeo and Juliet* (1973).

Bias, Fanny, French ballet dancer of the early Romantic era; born 1789 in Paris; died there September 6, 1825. Trained at the school of the Paris Opéra, Bias spent most of her short career with that company.

Considered a demi-caractère dancer, she was noted for her *pointe* work. Among her roles were parts in Milon's *Clari* (1820), and the company revivals of Jean Aumer's *Les Pages du Duc de Vendôme* and François Décombe Albert's *Cendrillon*, as a "Wicked Stepsister." She performed at the King's Theatre, London, during the 1821 season, at which time André Jean-Jacques Deshayes was serving as ballet master.

Bias died in 1825 after an intermittent illness of two years; the cause of her death is lost in time behind the euphemism "female disease."

Bigottini, Emilie, French ballet dancer of the early nineteenth-century; born April 16, 1784, in Toulouse; died April 28, 1858 in Paris. Bigottini, whose father was a well-known harlequin, was the sister-in-law of Louis-Jacques Milon, with whom she studied ballet. She performed in his works, notably in *Pygmalion*, at the Théâtre de l'Ambigu-Comique, before making her Paris Opéra debut in 1801.

Famed as an actress, as well as a dancer, she created many roles at the Opéra, among them "Virginie" in Pierre Gardel's *Paul et Virginie* (1806) and roles in Milon's *Nina* (1813) and *Clari* (1820). She also danced in his *Alfred Le Grand* (1822) and in the company revivals of Jean Aumer's *Aline, Reine de Golconde* and D'Auberval's *Le Page inconstant.*

Bigottini retired in December 1823. It is said that on the night of her retirement benefit, she spoke on stage for the first time, taking an acting role in a comedy.

Biles, Richard, American modern dancer and choreographer; born February 25, 1943 in Chicago, Illinois. Trained originally in folk dance forms, Biles studied at the (Bentley) Stone/(Walter) Camryn School of ballet in Chicago, the University of Wisconsin, where he worked under Louise Kloepper,

Anna Nassif, Don Redlich and Mary Fee, and at the (Alwin) Nikolais/(Murray) Louis Dance Theatre Lab in New York. He has performed in the Nikolais company, most notably in the BBC television staging of *Relay* (1971) and in the troupes of Nikolais/Louis dancers, Gale Ormiston, Phyllis Lamhut, and Luise Wykell. Biles has choreographed nineteen works for his own company which presents concerts in and around New York City, and has also found time to teach at studios and universities throughout the area and to work as an assistant to legendary dance publicist Isadora Bennett.

Works Choreographed: CONCERT WORKS: *Quintumbcyclrhomp* (1974); *Loci* (1974); *The Celebrants* (1975); *Pendulum* (1975); *Fluxion* (1975); *Harlequin-Ade* (1975); *The Pale* (1976); *Black & White Dances* (1977); *Solo in Three Parts* (1977); *Venus on the Half-Shell* (1977); *Gemini* (1977); *Trio from Pendulum* (1977); *Puppet Dance* (1977); *Turn-Styles* (1979); *The Rider* (1979); *Sojourn* (1979); *Tracings* (1980); *Pauses* (1980); *And Things That Go Bump In The Night* (1980).

Billings, Jack, Canadian theatrical dancer and film choreographer working in England; born c.1920. Although Billings worked briefly as a dance director for the American Monogram Studios shortly before its demise, he was best known for his work on English film musical comedies of the early 1950s, during the renaissance of the British motion picture industry. He was an expert at staging what are known as domestic musicals, in which "normal" people break into song in response to domestic happenings, such as *Happy Go Lovely* (Excelsior, 1951) and *Harmony Lane* (Dial, 1953). He also did musical numbers for 1950s television and his dance group, The Jack Billings Trio, was one of the most popular acts on the many BBC variety shows.

Works Choreographed: FILM: *Springtime* (British National, 1946); *Mystery at the Burlesque* (Monogram, 1956); *Happy Go Lovely* (Excelsior, 1951); *Harmony Lane* (Dial, 1953).

Bines, David, American ballet dancer and theatrical production manager; born c.1910, probably in New York City. Trained by Alexis Kosloff, he appeared with his troupe in the late 1920s, partnering Xenia

Maclenova in his *Princess Enchantée* and divertissements.

Bines worked with the Publix theater chain out of Chicago in the early 1930s and moved back to New York as dance director of the newly established Paramount/Publix chain (1933–1936). He staged precision lines for units at the Paramount Theatre in New York and for road troupes, but when the chain became a part of the Fanchon and Marco chain in California, he moved to the Keith circuits, where he served as dance director for the vaudeville chain's single attempt at a touring unit, the series of *Follies Comiques* of 1936 and 1937. After a period of two seasons creating *Vanities* units for musician/entrepreneur Dave Apollon, he returned to Keith as production manager of the combined Radio-Keith-Orpheum theater chain and its cornerstone, The Palace. As production manager (i.e., presentation act director) and resident director of The Palace, he staged acts for almost every major star in America, among them, Danny Kaye, Judy Garland, and Sophie Tucker, all of whose television appearances he co-produced. He also arranged acts for RKO Chain theaters and promotional tours for the studio's films in the 1950s. Shortly before retirement in the mid-1960s, he became manager of the Stardust Hotel in Las Vegas.

Biracree, Thelma, American ballet and concert dancer; born c.1903 in Buffalo, New York. Biracree was educated in Rochester, New York, where she became an integral part of the dance and music community. She attended the Eastman School of Music, studying with Enid Knapp Botsford and with Martha Graham, then on the faculty. As a member of Graham's first concert group, she appeared in the premieres of her *Dance Languide* (1926), and other early works. After trips to the West Coast and Europe to continue her training with Theodore Kosloff and Mary Wigman, respectively, she returned to Rochester where she directed the ballet program at the conservatory. She participated in the realization of many new American scores, most notably by Howard Hanson and Walter Piston.

Birch, Patricia, American modern dancer and theatrical choreographer; born in Scarsdale, New York.

Trained at the School of American Ballet, the Perry-Mansfield Camp, and the Martha Graham School, Birch joined the Graham company in 1950. As a performer Birch did her first major roles in *Letter to the World*, as "Young Love," in 1954, and created the role of "Joan, the Maid" in *Seraphic Dialogues* in 1954. She currently serves the company as rehearsal director. During the 1950s and early 1960s, she also performed in Eleanor King's *Brandenburg No. 2* at a 1950 Choreographers' Workshop recital, and began to work in the theater. She worked for Agnes De Mille in her City Center revivals of *Brigadoon, Carousel*, and *Oklahoma* (1957–1958), for Valerie Bettis' production of *Domino Furioso* (1961) and for Jerome Robbins, playing "Anybody's" in the 1959 replacement cast of *West Side Story*.

Birch received her first choreographic credit in 1956, for the Phoenix Theater production of *The Carefree Tree*, but did not work regularly on Broadway until 1967. Since then, she has become one of the best known and respected dance directors in theater, having created spectacular musical numbers for *Grease* (1972), *Over Here* (1964), *Music Is* (1976), *Zoot Suit* (1979), and *Really Rosie* (1980). Birch is equally celebrated for her unspectacular, totally integrated movement sequences for Hal Prince productions, among them, *A Little Night Music* (1973), considered by many one of the most integrated musicals of all times, the revival of *Candide* (1974), and *Pacific Overtures* (1976).

After a brief tenure at United Artists working on *The Wild Party* (1966), Birch returned to Hollywood to work on the film version of *Grease* (Paramount 1978), one of the most successful films ever. Her other motion pictures range from the rock spectacle *Sgt. Pepper's Lonely Heart's Club Band* (Paramount 1979) to the beautiful homage to social dance, *Roseland* (Merchant-Ivory, 1977). The choreographer of PBS' *The Electric Company* since its premiere, Birch also staged the 1978 Academy Awards presentations for television.

Works Choreographed: THEATER WORKS: *The Carefree Tree* (1956); *You're a Good Man Charlie Brown* (1967); *Up Eden* (1968); *Fireworks* (1969); *The Me Nobody Knows* (1969); *The Prime of Miss Jean Brodie* (1969, tango sequence only); *F. Jasmine Adams* (1971); *Grease* (1972); *The Real Inspector Hound* and *After Magritte* (1972); *A Little Night Music* (1973); *Candide* (1974 revival); *Over Here* (1974); *Diamond Studs* (1975); *Truckload* (1975); *Pacific Overtures* (1976); *Music Is* (1976); *They're Playing Our Song* (1978); *Zoot Suit* (1979); *Bread and Circus* (1980); *Sidewalkin'* (1980, also directed); *Gilda Radner—Live From New York* (1980); *Really Rosie* (1980, also directed).

FILM: *The Wild Party* (UA, 1966); *Roseland* (Merchant-Ivory, 1977); *Grease* (Paramount, 1978); *A Little Night Music* (New World Pictures, 1978); *Sgt. Pepper's Lonely Heart's Club Band* (Paramount, 1979).

TELEVISION: *The Electric Company* (PBS, 1972–); *Academy Awards Presentation* (ABC, 1978, special).

Birch, Peter, American theater dancer and television choreographer; born 1923, possibly in New York City. A student at the Fokine school in New York, Birch became a member of the Fokine Ballet in 1936, performing in the corps of the *Polovtsian Dances*. He was a specialty dancer at the Radio City Music Hall, working in a personal tap/ballet and Spanish form, before returning to conventional ballet in Lisa Gardinier's Washington National Ballet, c.1939.

Birch was a featured dancer in many of Agnes De Mille's most successful musical comedies of the 1940s, including her *Oklahoma* (1943), *One Touch of Venus* (1943), *Carousel* (1945), and *Gentlemen Prefer Blondes* (1949). He also danced in Antony Tudor's "Success Story" number in *Hollywood Pinafore* (1945) and in George Balanchine's *Dream with Music* (1944). Birch toured in a series of concerts sponsored by conductor Andre Kostelanetz, dancing with Viola Essen and Edward Caton.

His major television choreographic credit was as dance director for *Jane Frohman's U.S.A. Canteen* (CBS, 1952–1955). This was a difficult project since the star was still recovering from a crippling plane accident and had to be supported to stand or dance and the chorus was made up partially of untrained servicemen. He left television choreography for direction in 1955 to work on a new children's show on CBS. From the first episode in 1955 to the present, it is estimated that Birch has directed over seven thousand editions of the adventures of Captain Kangaroo and Mr. Greenjeans.

Works Choreographed: TELEVISION: *Jane Frohman's U.S.A. Canteen* (CBS, 1952–1955).

Bird, Bonnie, American modern dancer; details of Bird's biography unavailable. Trained originally at the Cornish School in Seattle, Washington, she moved to New York and studied with Martha Graham at the Neighborhood Playhouse. Bird joined the Graham concert group, performing in the premieres of *Celebration* (1934), *Integrales* (1934), *American Provincials* (1934), *Course* (1935), *Panorama* (1935), *Horizons* (1936), and *Chronicle* (1936).

Graham's assistant teacher at her own studio and the Bennington School of Dance, Bird retired from performing to head the dance department at the Cornish School, where she trained Merce Cunningham, among many others. She has taught at all of the major summer schools of dance and at many universities, among them Smith College, Reed College, and New York University. Bird's only known works were created for the Choreographer's Workshop, of which she was an early member.

Works Choreographed: CONCERT WORKS: *The Only Jealousy of Emer* (1949).

Bird, Dorothy, Canadian modern and concert dancer; born on Vancouver Island, British Columbia. Trained originally at the Cornish School in nearby Seattle, Washington, she moved to New York to study with Martha Graham at the Neighborhood Playhouse. A member of the Graham company from 1931 to 1937, she made her debut in *Primitive Mysteries* (1931), a fitting beginning to any career. Other Graham works in which she danced include *Bacchanale* (1931), *Ceremonials* (1931), *Tragic Patterns* (1933), *American Provincials* (1934), *Course* (1935), *Marching Song* (1935), *Panorama* (1935), *Horizons* (1936), and *Chronicle* (1936).

Bird performed on Broadway in musical comedies from 1937 to 1947, with roles in Agnes De Mille's *Hooray for What?* (1937), the *Straw Hat Revue* (1939, from material created at Tamiment during the previous summer), Albertina Rasch's *Lady in the Dark* (1941), *Around the World* (1946), and *Park Avenue*, later that season. While working on Broadway, Bird maintained a career as a concert dancer, sharing recitals with Mirium Blecher and Si-Lan Chen in 1938 and 1947, and with José Limón and Beatrice Seckler in 1945 in which she created a role in his *Concerto*. Her known choreography was all done for these recitals. Bird also taught extensively at the Graham school, the School of American Ballet, and the Rasch Studio.

Works Choreographed: CONCERT WORKS: *Opening Dance* (1938); *Nostalgic Portrait* (1938); *Credo* (1938); *The World Owes Me a Living* (1938); *Songs of the Hill Country* (1945); *New Thoughts on Olden Themes* (1947); *Woman by the Sea* (1947); *Incantations* (1947).

THEATER WORKS: *Beggar on Horseback* (1939, co-choreographed with Mirium Blecher a dance sequence to replace "A Kiss in Xanadu" from production).

Bishop, Kelly, American theatrical dancer and actress; born February 28, 1944 in Colorado Springs, Colorado. Bishop, who also performed as Carole Bishop, was raised in Denver, where she studied ballet with Dimitri Romanoff. After further training at the San Francisco Ballet school, she moved to New York City to try out for the American Ballet Theatre and, failing the audition, to dance with the Radio City Music Hall corps de ballet. For ten years after appearing in Michael Kidd's *Wonderworld* (at the 1964 World's Fair), she worked almost constantly in cabaret shows in Las Vegas or on Broadway in *Golden Rainbow* (1968, as performer and dance captain), Michael Bennett's *Promises, Promises* (1968), Ron Field's *On The Town* (1971 revival), and *Rachel Lily Rosenbloom*. In 1975, she was cast as the original "Sheila," the wise-cracking chorus gypsy motivated, and paralyzed, by the memory that "Everything was Beautiful at the Ballet." It is pointless to speculate to what extent Bishop's own life story became the lyrics of the monologue, but "Sheila" too found her life changed by a Ballet Theatre audition.

Bishop won the featured performer Tony award for her characterization, but left the show after its Los Angeles run. Since then she has acted in small-scale musicals, such as *Vanities* and the 1978 *Piano Bar*, in television series, among them Norman Lear's rock *Faust, A Year at the Top*, and in films.

Bishop, Will, The Second, English theatrical dancer; born c.1870, possibly in London; died November 24, 1944 in London. The son of the Will Bishop who had been star comic of the London Pavillion, he was a child clog dancer in the company of Tom Ward and began to participate in the clogging competitions of 1883 and 1884 won by Dan Leno. By 1892, he was the new Champion Clog Dancer of England.

Bishop was best known for his eccentric dance performances at the Empire Theatre, London. He was a frequent participant in the Empire shows, appearing in the English dance sequences of the theater's productions, among them, *The Girl I Left Behind Me* (1893), *On Brighton Pier* (1894), the celebrated presentation *The Press* (1898), and *Round the Town Again* (1899). Although all of the above were staged by Katti Lanner, it is likely that he interpolated his own specialty acts into the productions. He also performed in the long-running musical, *The Beauty of Bath*, at the turn of the century.

Although he continued to perform as a dancer in music halls, he served as a director of pantomimes at the Coliseum Theatre, London, until World War I.

Bissell, Patrick, American ballet dancer; born December 1, 1957 in Corpus Christi, Texas. After early training in ballet and tap in Toledo, Ohio, Bissell studied at the National Academy of Dance in Illinois, the North Carolina School of the Arts, and the School of American Ballet. After the SAB workshop recital, he was invited to join the American Ballet Theatre.

A tall dancer with surprisingly mature stage presence, Bissell was cast into the principal roles in Ballet Theatre's growing repertory of revivals of the full-evening classics, among them *Swan Lake* and *La Bayadère*. He also performed leading roles in *Don Quixote, The Nutcracker,* Glen Tetley's *Voluntaries* and *Contredanses,* Antony Tudor's *Tiller in the Fields,* and John Meehan's *Adagio for Strings.*

Bissell was dropped from Ballet Theatre on the first day of the Winter 1980 season.

Bjørn, Dinna, Danish ballet dancer and choreographer; born Dinna Bjørn Larsen, February 14, 1947 in Copenhagen. The daughter of Niels Bjørn Larsen, she was trained at the school of the Royal Danish Ballet, where he taught with Edite Frandsen. A member of the Royal Danish Ballet since 1964, she made her first success in Jerome Robbins' *Afternoon of a Faun* but became noted for her performances in the revived works of August Bournonville, notably *Kermesse in Bruges, La Sylphide, La Ventana, Far From Denmark,* and *A Folk Tale.* She taught Bournonville technique and in recent years has toured with her father in a lecture-demonstration of his ballet and mime work.

Works Choreographed: CONCERT WORKS: *Eight plus One* (1970); *Anatomic Safari* (1971); *The Butterfly Mask* (1975).

Bjørnsson, Fredbjørn, Danish ballet dancer and mime; born September 10, 1926 in Copenhagen, Denmark. Trained at the Royal Ballet School by Harald Lander and Vera Volkova, Bjørnsson later studied with Martha Graham in New York while teaching at the American Ballet Center, c.1956.

A member of the Royal Danish Ballet from 1945 to the present, Bjørnsson was featured in many works by Harald Lander, among them, *Slaraffenland* (Cockaigne) and *Morning, Noon and Night,* and in Leonid Massine's revivals of *Le Beau Danube* and *Symphonie Fantastique.* His best known parts, however, were in the company's revivals of the ballets of Auguste Bournonville: *Far from Denmark, A Folk Tale, Napoli, La Ventana, Kermesse in Bruges,* and others. Bjørnsson created roles in the company's productions of *Idolon* (Frank Schauffus, 1952), *Kurtisanen* (The Courtesan) by Borge Ralov (1953) and *Dorene* (The Door) by Kristen Ralov (1962), and was noted for his performances in Balanchine's *Four Temperaments.*

Celebrated currently as a mime in the Bournonville repertory, he has choreographed for the company, among them, *Bag Taeppet* (Behind the Curtain) (1957), and has taught widely in Europe and the United States.

Works Choreographed: CONCERT WORKS: *Bag Taeppet* (Behind the Curtain) (1957); *Bergensiana* (1957); *Lykke paa Rejse* (Bon Voyage) (1959).

Blache, Alexis, French nineteenth-century ballet dancer and choreographer working in Russia; born François Alexis Scipion Blache, 1792, in Marseilles; died c.1852 in Bordeaux. The son of Jean-Baptiste

Blache, he was born in Marseilles where his father was ballet master at the Grand Théâtre. Unfortunately, very little is known about the life or early career of either Alexis or his brother Frédéric-Auguste, although it has been postulated that they performed for their father in Bordeaux, and at the Théâtre de la Porte-Saint-Martin in Paris.

The majority of Blache's known works were created while he was in residence in St. Petersburg. These include *Don Juan* (1832), which may have been created for a French company as many as ten years earlier, *Amadis of Gaul, or the Page and the Sorceress* (1833, Russian title unavailable), and *Fil'-bert, ili Maken'kit Matros* (The Little Sailor) in 1834. He served as ballet master of the Grand Théâtre, Bordeaux, in 1840, and may have remained in that capacity until his death in 1852.

Works Choreographed: CONCERT WORKS: *Don Juan* (1832); *Amadis of Gaul, or the Page and the Sorceress* (1833, Russian title unavailable); *Amur v Derevne, ili Krylatoe Ditia* (Love in the Country, or the Winged Child) (1833); *Don Quixote* (1834); *Fil'-bert, ili Maken'kit Matros* (The Little Sailor) (1834); *Venetsianskiia Zabavy, ili Den'Karnavala* (probably a version of *Carnaval in Venice*) (1834); *Zoraida, ili Mavry Grenady* (Zoraide, the Woman of Spain) (1834); *Les Grecs* (1840).

Blache, Frederic-Auguste, French nineteenth-century ballet and popular entertainment dancer and choreographer; born 1791 in Marseilles; death date unknown. The son of Jean-Baptiste Blache and older brother of Alexis Blache, he was born in Marseilles where his father served as ballet master at the Grand Théâtre. His life and much of his career remain a mystery.

This Blache was known for his work in the popular theaters of Paris. He succeeded his father as ballet master of the Théâtre de la Porte-Saint-Martin from the winter of 1821–1822 until c.1826. The works that he created for that theater, now associated with the name of Charles Mazurier, dancer and acrobat, for whom they were staged, include *Polichinel-vampire* (1823) and *Milon de Crotone* (1824). His *Jocko, le Singe du Brésil* (1825), created for Charles Mazurier and Joseph Mazilier, has earned the dubious distinction of being the most plagiarized work in the nine-

teenth century. In the United States, especially, almost every European acrobatics or ballet troupe that toured the country performed a version of *Jocko*, either on stage or on tightrope.

Two other Parisian popular theaters are known to have employed Frédéric-Auguste Blache as ballet master. He staged two works for the Théâtre de l'Ambigu-Comique, *La Landwer* (1828) and *Cocambo* (1829), designed for Gabriel Ravel of the famous family of acrobats. He also staged one work, *Le Noveau Robinson*, for the ill-fated Théâtre Nautique that floated in the Seine.

Works Choreographed: CONCERT WORKS: *Polichinel-vampire* (1823); *Jean-Jean* (1824); *Milon de Crotone* (1824); *Jocko, le Singe du Brésil* (1825); *La Landwer* (1828); *Cocambo* (1829); *Le Noveau Robinson* (1824).

Blache, Jean-Baptiste, French nineteenth-century ballet dancer and choreographer; born May 17, 1765 in Berlin; died January 24, 1834, in Toulouse, France. Trained locally and in Paris by François Deshayes, Blache had a short career as a dancer at the Paris Opéra, from 1781 to 1786.

Blache's career as a choreographer began in Montpelier (c.1787) and in Marseilles in the 1790s. He succeeded Jean D'Auberval at the Grand Théâtre, Bordeaux, where he created his best works, *Mars et Vénus* (1809, revived for the Paris Opéra in 1826) and *Almaviva et Rosina*, the 1806 ballet of the *Barber of Seville* story which included an early example of a mirror act.

Returning to Paris, he staged ballet-pantomimes for the Théâtre de la Porte-Saint-Martin, among them *L'Amour au Village* (1821), before reviving *Mars et Vénus* for Lise Noblet and François Décombe Albert of the Paris Opéra. Blache retired in 1827.

Works Choreographed: CONCERT WORKS: *Les Meuniers* (1787); *Almaviva et Rosine* (1806); *Mars et Vénus* (1809); *L'Amour au Village* (1821); *La Laitière Polonaise, ou la Fille fugitive* (1825).

Blacher, Boris, German composer; born January 6, 1903 in Newschang, China; died January 30, 1975 in Berlin. Blacher combined studies in architecture and mathematics with traditional musical training to cre-

ate a compositional style that involved both tonality and aleatoric rhythm structures. Among his many orchestral works were scores for ballets for Western European choreographers. These included Victor Gsovsky's *Hamlet* (1950), Jens Keith's *Chiarina* (1950), Janine Charrat's *The First Ball* (1950), Erika Hanka's *The Moor of Venice* (1955), and Tatiane Gsovsky's *Tristan* (1965). Music from his opera *Romeo and Juliet* (1943), *Rosamunde Floris* (1960), and *200,000 Taler* (1965, technically a *singspiel*, not an opera), have also been staged for ballet performance.

Black, Phil, American tap teacher and choreographer; born in Brooklyn, New York. Black was trained by Ernest Carlos, whose protégé he became, PeeWee Williams, Charlie Morrison of the Katharine Dunham Studio, and ballet teacher Vincenzo Celli. He has choreographed many commercials, industrial shows for oil companies, and television shows, including the highly acclaimed *Tap Dance Kid*, but is equally well known for his nightclub work. As well as serving as staff dance director for New York area cabarets, he has staged club acts for Goldie Hawn (at the 1964 World's Fair), Barbara McNair, Peter Palmer, Gregg Burke, Irene Cara, and situation comedy actors Eddie Mekka and Danielle Brisbois.

Black has taught in New York since the 1950s, when he worked at the Carlos studio. Among his hundreds of students are members of the casts of almost every Broadway show of the last dozen years, including Mekka, Burke, Cara, Brisbois, Terri Garr, Priscilla Lopez, Gelsy Kirkland, and Arthur Mitchell.

Works Choreographed: TELEVISION: *The Tap Dance Kid* (ABC, 1977, children's special).

The Blackburn Twins, American tap dance team; born Ramon and Royce Blackburn, in the 1920s in the New York City area. The Blackburns were choir boys before beginning to tour with their tandem act. They did their sophisticated dances in films, including MGM's *Words and Music* and Warner Brothers' *Working Her Way Through College*, television, and on Broadway, with specialty dance status in *Music in the Air* (1932) and *Sons O'Fun* (1941), which co-starred sibling teams Jean and Jane Statler, Doris and Beverly Miller, and Gloria and Grace Chrystal.

They also toured in nightclubs and cabarets in their duo act and in a trio with a series of blonde vocalists, among them Janet Blair, Martha Stewart, Vivian Blaine, and Patti Page.

Blair, David, English ballet dancer; born David Butterfield on July 27, 1932, in Halifax, Yorkshire; died in London, April 1, 1976. Trained at the Sadler's Wells Ballet School, Blair joined the company in 1947. He created roles in many early works of John Cranko, among them *Pineapple Poll* and *Harlequin in April*, both in 1951.

Blair joined the Royal Ballet in 1953, where he became noted for his performances in the classical repertory, notably as "Colas" in *La Fille Mal Gardée*, and in the works of Frederick Ashton, among them *Daphnis and Chloe, The Birthday Offering, Variations on a Theme by Purcell*, and the 1961 production of *The Nutcracker*.

Since 1965, Blair was also well known for his revivals of the classical repertory for American companies, including the productions of *Swan Lake* (1967) and *Giselle* (1968) for American Ballet Theatre. He was named director of the Norwegian Ballet in 1976, but died before assuming the position.

Blair, Pamela, American theatrical dancer; born December 5, 1949 in Arlington, Virginia. Trained at the National Academy of Ballet, she made her Broadway debut in Michael Bennett's *Promises, Promises* in 1968. After the one performance of *Wild and Wonderful* in 1971, she began a string of musical comedy performances in successful shows, with parts in *Sugar* (1972), *Seesaw* (1973), staged by Bennett, Grover Dale, and Tommy Tune, and *A Chorus Line*. As "Val" in the original 1975 cast, she worked with Bennett to create and perform in that celebration of gypsy life.

After dancing and singing in various productions of *A Chorus Line,* she appeared in the short-lived *King of Hearts* (1978) and the long-running *Best Little Whorehouse in Texas* (1979), staged by Tune.

Blake, Laurence, American ballet dancer; born November 15, 1955 in Roanoke, Virginia. Blake was trained at the North Carolina School of the Arts, where he performed with Agnes De Mille's Heritage

Dance Theater and the school's own company. He moved to New York in 1976 to study at the American Ballet Center and perform with the Joffrey II (1976) and City Center Joffrey Ballet (1977–). Blake has performed in the latter company's large repertory of contemporary ballets by Gerald Arpino in which he presents nineteenth-century technique in modern formats, among them *Suite Saint-Saens* and *Kettentanz*, and in revivals of works by mid-twentieth-century English choreographers, including Frederick Ashton's *Jazz Calendar* and John Cranko's *Brouillards*.

Bland, Hubert, American ballet dancer; born December 1, 1920 in Minneapolis, Minnesota. Originally trained as an artist in Minnesota, Bland moved to New York and began studies in ballet with Leon Fokine, Alex Yakovleff, Theodore Kosloff, and Mikhail Mordkin.

He performed with the Mordkin Ballet, creating a role in his *The Goldfish* (1937), and became a charter member of Ballet Theatre, an outgrowth of the Mordkin group. In Ballet Theatre, he created the role of "An Opium Addict" in Eugene Loring's *The Great American Goof* (1940) and performed featured roles in the works of Leonid Massine, notably in his *La Boutique Fantasque* and *Aleko*, and in the company's *Giselle, Petrouchka*, and *Aurora's Wedding*.

Blangy, Hermine, French ballet dancer of the Romantic era who performed in Germany, Austria and the United States; born c.1820 or earlier; died c.1865 in New York. Blangy was trained at the school of the Paris Opéra and performed there from 1835 to 1842, notably in Philippe Taglioni's *La Sylphide* (after 1838), Joseph Mazillier's *Le Diable Amoureux* (creating a major role in 1840) and in *Giselle*, as "Myrthe." It should be noted that although she performed the role of "Giselle" frequently in Europe and based much of her American reputation on that presentation, she did not play it at the Opéra; she was given the second female role of "Myrthe, Queen of the Willis."

After a season at the Theater Royal in Munich, Blangy began the first of three tours of the United States. She made her debut at Niblo's, New York, in *The Vengeance of Diana*, also performing *Asmodeus* there, and in Philadelphia and Boston, where she was

extraordinarily popular. In her next tour, she played both the East Coast and the Mississippi circuit with the Ravel family troup in *Giselle* and *La Sylphide*. Her final tour added *La Vivandière, l'Illusion d'un Peintre*, and *La Fille de Marbre* to the repertory.

Returning to Europe, she produced her own version of *Giselle* at the Vienna Hofteater; this may have been the one that she presented in the United States. Blangy retired from performance shortly after her return.

Although little known now, Blangy was one of the most important Romantic ballerinas to tour the United States, bringing both repertory and the aesthetic concepts of that artistic moment.

Blank, Carla, American postmodern dancer and choreographer; born in Pittsburgh, Pennsylvania. Blank attended classes at the Martha Graham and Merce Cunningham studios and studied with Anna Sokolow, Donald McKayle, Richard Thomas, and Ann Halprin. Her participation in the composition classes that James Waring directed at the Living Theater led to her work with the Judson Dance Theater. Since 1965, she has worked in collaboration with Suzushi Hanayagi in New York, the Bay area of California, where she lives, and in Japan. Her imagistic collages have been highly acclaimed on both coasts.

Works Choreographed: CONCERT WORKS: *Turnover* (1963); *Untitled Duet* (1964); *Film-Dance Collage* (1964); *Second Variance* (1965); *Untitled Chase* (1965); *Spaced* (1965, in collaboration with Suzushi Hanayagi); *Litany* (1965, in collaboration with Hanayagi); *Black* (1966); *Wall St. Journal* (1966, in collaboration with Hanayagi); *Sidelights* (1966, in collaboration with Hanayagi); *Work* (1969, in collaboration with Hanayagi); *With Son* (1972, in collaboration with Hanayagi); *Ghost Dance* (1973, in collaboration with Hanayagi); *Shadow Dance* (1973, in collaboration with Hanayagi); *Crowd* (1974, in collaboration with Hanayagi); *Feast Day* (1974); *Peas & Beans* (1975); *The Lost State of Franklyn* (1975, in collaboration with Hanayagi); *Everybody's Independent & Grand National Spirit Show* (1976); *Animuls* (1976, in collaboration with Hanayagi); *Trickster Today* (1977, in collaboration with Hanayagi); *Moving Lab* (1978); *Kore at Eleusis* (1979); *Kitchen Cabinet* (1980, in collaboration with Jody Roberts).

Blankshine, Robert, American ballet dancer; born December 22, 1948 in Syracuse, New York. Blankshine studied ballet with Olive McCue in Rochester, New York, before moving to New York City to accept a Ford Foundation grant for the School of American Ballet. After taking classes with William Griffith and Lillian Moore at the American Ballet Center, he joined the apprentice group of its sponsor, the City Center Joffrey Ballet.

A charter member of the Joffrey Company, he created roles in Gerald Arpino's *Viva Vivaldi!* (1965), *Olympics* (1966), *A Light Fantastic* (1968), and *The Clowns* (1968), and performed featured roles in Joffrey's *Gamelan* and Glen Tetley's *Games of Noah*, before leaving the country in 1968.

From 1969 to 1974, Blankshine worked in Western Europe as a freelancer and as a member of the Berlin and Frankfurt Ballets. In the latter company, he was associated with the works of Alphonso Catá, in whose *Perspectives, Verklarte Nacht,* and *Ragtime* he danced. Blankshire returned to the United States in 1975 to join the Los Angeles Ballet.

Blasis, Carlo, Italian ballet dancer, choreographer, and teacher of the nineteenth century; born November 4, 1797 in Naples; died January 15, 1878 in Carnobbio, Italy, Blasis was trained in Marseilles by Pierre Gardel and in Bordeaux by Jean D'Auberval, before moving to Paris to continue his lessons with Gardel.

Although he performed in Paris and London, at the King's Theatre, he was associated with the Teatro alla Scala throughout his career. As ballet master and as director of the school that it sponsored, Blasis formulated both the choreographic and performance style of that company which, for the remainder of the century at least, was one of the most influential in the world of music. Apart from his indirect influence, through his many books and dance manuals, he directly trained many dancers, among them Fanny Cerito, Carolina Rosati, and Augusta Maywood, as well as "Les Pleiades de Danse," a group of soloists at La Scala.

The steps and especially the positions that he codified in his books were considered standards for performance for many years—directly, as references to his texts, as in the 1905 formulations of Frederick Zorn, and indirectly through his students and their trainees, among them Enrico Cecchetti the major figure of the twentieth-century Italian technique. The pose that he called "The Attitude" can be found correctly interpreted in almost every ballet choreographed in the last 150 years, and incorrectly visualized (without knowledge of foreshortening) in the texts of many early twentieth-century American teachers, among them Ned Wayburn and Sergei Marinoff.

Blasis' choreography has proved less important and less enduring than his technical theories. Most of his ballets were created for La Scala, but others were choreographed for theaters in Moderna (*Leocadia,* 1833), Florence (*Le Galanterie parigine,* 1853) Venice (*Hermosa,* 1851), Verona (*Il foletto,* 1854), and London, where he worked for the Covent Garden and Drury Lane opera houses.

Works Choreographed: CONCERT WORKS: *Il finto feudaterio* (1819); *Pandora* (1827); *Leocadia* (1833); *Gli intrighi amoresi* (1834); *L'Equivoco comico* (1835); *Una notte de carnevale* (1845); *Gli amori di Adone e Venere* (1835); *Elina* (1835); *La scaltera fattoressa* (1836); *Cambio di conscrito* (1838); *Assedio di Faenza* (1839); *Pas villageous* (1847); *Flore et Zéphyr* (1847); *The Pretty Sicilian* (1847); *The Spanish Galantries* (1847); *La pléiade di Terpsichore* (1847); *La Salamandrina* (1847); *Gli amori di una stella* (1847); *La nimfa Eco* (1849); *Le due zingare* (1849); *Hermosa, o la danzatrice spegnulo* (1851); *Cagliostro* (1852); *Il prestigiatore* (1852); *Manfredo, o Disperazione e illusione* (1853); *Le gelosie, ovvero la prove delle amonti* (1853); *Il figli prodige* (1853); *Raffaello e la formarino* (1853); *Il folletto* (1854); *Lodowiska* (1854); *Faust* (1856); *Fiorina* (1856); *A diabrina* (1857); *Galateia* (1857); *Dolca* (1857); *La danzatrice veneziana* (1858); *Diavolina* (1858); *Meteor* (1862); *Due giorni a Venezia* (1862); *Orfa* (1862); *Pigmalione e Galatea* (1863).

Blaska, Felix, French ballet dancer and choreographer also working in postmodern companies in the United States; born May 8, 1941 in Goeml, the Soviet Union. Blaska was trained by Yves Brieux and at the Paris Conservatoire. He performed as a ballet dancer with the Grand Ballet du Marquis de Cuevas, and the Ballet de Roland Petit (1961–1969). Follow-

ing the latter engagement, during which he first experimented with choreography, he founded his own company, based in Paris and Grenoble. He was enjoying the career of a French modern ballet choreographer with guest engagements across the continent and his own troupe, but left in 1979 to work in the United States with Crows' Nest, a trio collaborative formed with Robert Morgan Barnett and Martha Clarke. Both had been with Pilobolus (and Clarke also had had a successful career in the Sokolow company and as a freelancer) but the Crows' Nest productions are equally shaped by Blaska's style. They have done trio choreography, but he has also worked collaboratively just with Clarke to create the popular company repertory.

Works Choreographed: CONCERT WORKS: *Octandre* (1966); *Les Affinités electives* (1966); *Danses Concertantes* (1968); *Equivalences* (1968); *Sensemaya* (1969); *Electro-Bach* (1969); *Ballet pour Tam-Tam et Percussions* (1970); *Deuxième Concerto* (1970); *Sonate pour deux Pianos et Percussions* (1971); *Le Poème electronique* (1973); *Arcana* (1973); *Trois Pièces pour le Clarinet* (1973); *In White and Black* (1973); *Contre* (1973); *Homahe Ya Sin* (1973); *Spectacle Berio* (1974); *Les Improvisations* (1975); *La Marquesa de Solana* (1979, co-choreographed with Martha Clarke); *Haiku* (1979, co-choreographed with Clarke and Robert Morgan Barnett); *The Garden of Villandry* (1980, co-choreographed with Clarke and Barnett).

Blecher, Miriam, American modern dancer and choreographer; born 1909 in New York; died September 19, 1979 in Los Angeles. Like so many concert dancers of the 1930s, Blecher received her dance training at the Neighborhood Playhouse at the Henry Street Settlement House in the dance program headed by Martha Graham and Louis Horst. She also studied Wigman technique with Hanya Holm and Hans Weiner (Jan Veen) in New York in the early 1930s.

Blecher's short career as a concert dancer and choreographer occurred entirely between 1934 and 1940. An activist member of the New Dance League and American Dance Association, she created solo works for recitals shared with her fellow League members, Si-lan Chen, Lily Mehlman, and Anna Sokolow.

Among her best remembered works are the *Three Dances to Poems* (1934), *East Side Sketches: The Bum* (1937), the fantasizing *Me and Robert Taylor* (1937), and the series of *Masks*—of Wealth, of War, and of Hatred (1938). *Van de Lubbe's Head*, a League work with which she is generally credited, is typical of her anti-Fascist works, inspired by the encroaching war. Blecher left New York in 1940 with her playwright husband, George Sklar; in Los Angeles, where they remained, she worked in dance therapy with the elderly of various local ethnic groups.

Works Choreographed: CONCERT WORKS: *Awake* (1934); *The Disenchanted* (1934); *Three Dances to Poems* (1934); *Harvest Song* (1937); *Advance Scout—Lincoln Battalion* (1937); *Two Jewish Songs* (*In the Shop, In the Field*) (1937); *East Side Sketches* (*The Bum, Me and Robert Taylor*) (1937); *Opening Dance* (1938); *Negro Poems* (1938); *Letter to the President* (1938); *Masks* (*Of Wealth, Of War, Of Hatred*) (1938); *Austria—The Day After* (added to *Jewish Songs*, 1939).

THEATER WORKS: *Beggar on Horseback* (1939, segment co-choreographed with Dorothy Bird).

Bliss, Arthur, English composer; born August 2, 1891 in London; died there March 27, 1975. Influenced by the compositional styles of Stravinsky and *Les Six*, Bliss joined the forefront of the British avant-garde in music. Although his scores for ballet were created in the chronological middle of his long career, he returned to his avant-garde roots to create startling symphonic pieces. His best remembered works for dance were created for the pioneers of native British ballet—Robert Helpmann's *Miracle in the Gorbals* (1945) and *Adam Zero* (1946), and Nanette de Valois' *Checkmate* (1937), probably his most memorable score.

Bliss, Herbert, American ballet dancer; born 1923 in Kansas City, Missouri; died April 18, 1960 in San Mateo, California. After seeing a Ballet Caravan performance while training at the Kansas City Conservatory of Music, Bliss moved to New York to study at the School of American Ballet. After performing in two operettas choreographed by George Balanchine, *Rosalinda* (1942) and *Song of Norway* (1944), and in

the Ballet Russe de Monte Carlo, Bliss joined Ballet Society and became a charter member of the New York City Ballet.

In the ten years between the forming of the Ballet Society and his retirement in 1956, Bliss created roles in many works by Balanchine. Among these were his *The Triumph of Bacchus and Ariadne* (1948), *Orpheus* (1948), *La Valse* (1951), *Opus 34* (1956), *Western Symphony* (1954), *Ivesiana* (1954), and *Divertimento No. 15* (1956). He also danced in the works of many of his fellow dancers, among them Jerome Robbins' *Age of Anxiety* (1950), *The Pied Piper* (1951), and *Quartet* (1954); Todd Bolender's *Capricorn Concerto* (1948) and *Souvenirs* (1955); Fred Danieli's *Punch and the Child* (1947); and Ruthanna Boris' *Cakewalk* (1951) and *Kaleidoscope* (1952).

Blitzstein, Marc, American composer and lyricist; born March 2, 1905 in Philadelphia, Pennsylvania; died January 22, 1964 in Port-du-France, Martinique. A student of Nadia Boulanger and Arnold Schoenberg in Europe, Blitzstein returned to the United States to write for the political theater. His shows, which have been preserved in the repertories of opera companies, ranged from settings of existing plays, such as *Regina* (1949 after *The Little Foxes*) and *Juno* (1958), to translations of topical musicals of other eras, as was his celebrated version of *The Threepenny Opera* (1954). These shows, and the labor opera, *The Cradle Will Rock* (1936), used integrated movement rather than dance sequences per se. Anna Sokolow staged *Regina* and Agnes De Mille worked on *Juno*, his most conventional production, but most of his shows were produced without choreographic credits or formal dance numbers. Of his ballet scores, *The Guests* (1949) for Jerome Robbins made the greatest success with its portrait of a segregated society expressed through the metaphor of a social gathering.

Blomdahl, Karl-Birger, Swedish composer; born October 19, 1916 in Växjö. A pioneer of electronic music techniques through the Royal Academy of Music and the national radio network. Blomdahl has worked closely with contemporary Swedish choreographers. Birgit Akesson choreographed three ballets

to his scores—*Sisyphus* (staged 1954), *Minotaur* (1957, staged 1958), and *Play for Eight* (1962). His scores are best known to American dance audiences through Lucas Hoving's popular *Aubade* (1963).

Blondell, Joan, American film dancer and comedienne; born August 30, 1906 or 1909 in New York City; died December 25, 1979 in Los Angeles. The daughter of vaudevillians Kathryn Cain and the original "Katzenjammer Kid," Edward Blondell, she was born into the proverbial trunk and made her stage debut at the age of three. After years with a stock company, she hit Broadway in *The Trial of Mary Duggan* (1927) and *Maggie the Magnificent* (1929), in which she was featured with a young actor and hoofer, James Cagney. They worked together in *Penny Arcade* (1930) and were both hired for its film version, called *Sinner's Holiday* (WB, 1930). She returned to Broadway in 1943 after thirteen years in film, and more than fifty movies, to appear in Gypsy Rose Lee's *The Naked Genius*. Her most memorable Broadway appearance of the 1950s was as "Aunt Cissie" in *A Tree Grows in Brooklyn*, although she appeared in straight plays for decades after that. Most of her frequent television work was dramatic, although she delighted audiences with her comedy performances.

Although New York theater goers may honor her for her stage appearances, the world adores her for her film work. The "Dizz-whiz-kid" of Warner Brothers' musicals, comedies, and melodramas, she made over one hundred pictures, playing smart alecky or sophisticated career women, many of whom were ex-vaudevillians. She is best remembered now for her roles in the Busby Berkeley musicals for Warner Brothers and Vitaphone, since they have been so successfully revived. Although she missed *Forty-Second-Street,* she appeared in *Footlight Parade* (WB, 1933), *Gold Diggers of 1933* (WB, 1933), *Dames* (WB, 1934), and *Gold Diggers of 1937* (First National, 1936). In each, she was the catalyst for the plot, and frequently the only one in the theater who understood it; in each, she regaled the audience with her unique style of performances—straight out like a second-generation vaudevillian but with a bittersweet edge of maturity. Her musical numbers in the pictures, among them the very strange "Swan Lake of

the Laundry Room'' in the second *Gold Diggers* and the incomparable ''Forgotten Man'' in the first, are among the best simple routines that Berkeley ever staged—not typical of his work, perhaps, but perfectly suited to hers.

Blondy, Nicholas Michael Balthassare, French ballet dancer and teacher; born 1677 in Paris; died there August 13, 1747. The nephew and student of Pierre Françoise Beauchamp, Blondy was associated throughout his career with the Academie Royale de Musique, progenitor of the Paris Opéra.

After his debut in 1691, he became the regular partner of Françoise Prévost, then reigning ballerina of the company. A danseur noble, he was assigned leading roles in Pécour's *Apollon Législateau* (1711), in Jean Balon's *L'Inconnu* (1720), and in the Laval's *Les Fêstes de Thalie* (1714).

Ballet master from 1729, he taught Marie Camargo, considered by some her sponsor in the Opéra, and Frantz von Weyer Hilverding, innovator in the *ballet d'action* style.

Works Choreographed: CONCERT WORKS: *Les Amours des dééesses* (1730); *Les Voyages de l'Amour* (1736).

Bluebell, Miss, English precision line choreographer; born Margaret Kelly, 1925 in England, possibly in or near London. Trained at the London Tiller School, she performed with a Tiller precision team until she was eighteen. She ran her first line of dancers that year, dubbing them The Bluebells. They were hired by the Folies Bergère in Paris, beginning a long association between her English companies and French cabaret theaters. She provided precision teams for the Lido in Paris from 1946 to at least 1959, and for Las Vegas hotels after that, presumably through Lido dance director Donn Arden, now called ''Mr. Extravaganza'' in Vegas.

Miss Bluebell, who should not be confused with Margaret Kelly, ''the Blonde bombshell of burlesque,'' was one of the most imaginative of the English line choreographers. Although more restrictive than her American counterparts, she used many more routines than the pure Tiller stagers and included both different techniques and new and more imaginative formations in her work.

Blum, Anthony, American ballet dancer; born March 3, 1938 in Mobile, Alabama. Trained locally, Blum moved to New York to study with Aubrey Hitchins and at the School of American Ballet. He performed on television (in Max Liebman specials, staged by James Starbuck) and in the 1958 revival of Agnes De Mille's *Brigadoon*, before joining the New York City Ballet in 1963.

In his years in the company, Blum created a large number of roles in works by ballet masters Balanchine and Robbins, and by his fellow dancers. These include Francisco Moncion's *Les Biches* (1960), Jacques D'Amboise's *The Chase* (1963) and *Irish Fantasy* (1964), and John Clifford's *Stravinsky Symphony in C* (1968), *Fantasies* (1969), *Tchaikovsky Suite #1* (Reveries) (1969), *Kodály Dances* (1971), and *Bartok #3* (1974). For Jerome Robbins he created roles in his most acclaimed works of the last decade—*Dances at a Gathering* (1969) and *The Goldberg Variations* (1971). Blum's performances in the premieres of Balanchine works include *Clarinade* (1964), the Élegie section of *Tchaikovsky Suite No. 3* (1970) and *Choral Variations on Bach's ''Von Himmel Hoch,''* created for the Stravinsky Festival of 1972. His many featured roles were primarily in the Balanchine repertory, among them the Sanguinic section of *The Four Temperaments, Agon, Allegro Brillante, Symphony in C,* and *Divertimento No. 15.*

Blum, Réné, French impresario and critic; born March 13, 1878 in Paris; died September 28, 1942 in the German concentration camp at Auschwitz, Poland. Like Serge Diaghilev, Blum was a curator and editor before managing a ballet company. He had co-edited the literary journal *Gil Blas* and served as its art critic, co-founded Le Club des Amis du Septième Art, and had organized art exhibitions, among them La Section d'Or (1912) and l'Exhibition des Arts-Décoratifs (1925). His other activities include writing a critical study of playwright Tristan Bernard, and sponsoring the publication of Proust's *A la Recherche du Temps Perdu.*

Blum had managed the casino at Le Touquet and was serving as director of comedy and operetta at the Théâtre of the Monte Carlo Casino when Diaghilev's death in 1929 stranded his company. As head of the resident theater, he took over the management of the

company, later renaming it the Ballet Russe de Monte Carlo. He also served as director of Les Ballets de Monte Carlo, under Mikhail Fokine, and of the Ballet Russe de Monte Carlo, under Leonid Massine. Tragically, he decided to return to France while the companies were touring the United States. He was arrested on December 12, 1941 and sent to the French camps at Compeigne and Drancy. He was transferred to Auschwitz, possibly as a political prisoner, on September 23, 1942 and died there within the week.

Boardman, Diane, American modern dancer and choreographer; born c.1950 in Brooklyn, New York. Boardman began studying with Murray Louis, Phyllis Lamhut and Gladys Bailin at the Henry Street Settlement and Louis/(Alwin) Nikolais Lab at the age of five. Her later training has ranged from ballet techniques with Wilson Morelli to jazz with Lynn Simonson and Horton modern dance from James Truitte. She was a member of the Lamhut company from 1971 to 1977, appearing in her *Hearts of Palm, Extended Voices, Country Mozart, Conclave, Brainwaves,* and many other works while freelancing in concerts of work dances by Nikolais, and Louis, with whom she did *Junk Dances* in 1980. With her own company (1971–), she has performed in her group dances at many New York theaters and in residencies across the country. Her works combine the imagination and wit of Lamhut with experiments in structures and scoring.

Works Choreographed: CONCERT WORKS: *Love Story* (1971); *Player Piano Piece* (1972); *Oolite* (1974); *Baguette* (1974); *Misc.* (1974); *Cambiozoan* (1975); *Phase II, III, IV* (1975); *Set Up* (1977); *Fusion [Ffuusiioon] Fission* (1977); *Dynamis* (1978); *Bellodonna* (1979); *Man Made* (1979).

Bockman, George, Jr., American modern dancer and choreographer; born 1909 in Boston, Massachusetts; died November 20, 1979 in New York. Bockman studied Wigman technique with Hans Weiner (Jan Veen) in Boston before moving to New York to attend the Pratt Institute to continue his art training. In New York, he took time out from Pratt to assist Martha Graham in her dance class at the Neighborhood Playhouse.

Bockman began to study at the (Doris) Humphrey/(Charles) Weidman Studio in 1934, possibly after working with Weidman in the Experimental Unit of the New Dance League. Joining the Concert Group in 1935, he created roles in Humphrey's *New Dance* (1935) and *Passacaglia and Fugue in C Minor* (1938), in Weidman's *Opus 51* (1938), and in their collaborative *Theatre Piece* (1936).

His choreographic career was unique for the period since, although working through the concert dance movement as a recitalist, he did not choreograph entirely for himself. In fact, his best known work was the series of solos, *Suite for Woman,* created for Fé Alf in 1937. Much of the remainder of his works, c.1937 to 1939, were created for Alf or for their fellow members of the short-lived cooperative group of Humphrey/Weidman dancers—the theatre Dance Company, consisting of William Bales, Kenneth Bostock, Eleanor King, and Sybil Shearer. Along with the group, he performed in nightclubs with the Jack Cole company. On Broadway, he danced in Albertina Rasch's *Lady in the Dark* (1941), Jerome Robbins' *High Button Shoes* (1947), and Tamiris' *Up in Central Park* (1945).

Retiring from performance in the early 1950s, Bockman spent the remainder of his life as a staff art director and set designer for NBC television in New York and Los Angeles, working for variety shows and news programs.

Works Choreographed: CONCERT WORKS: *Suite for Woman (Renascent Figure, Modern Patterns: Show Girl, Street Girl, Shop Girl, Dance Girl, Precursor)* (1937); *Vignettes* (1937); *Nearly a Beginning* (1937); *Little New York Barn Dance* (1938); *Biography of a Hero* (1939).

Bodenwieser, Gertrud, Austrian modern dancer and choreographer; born 1886 in Vienna; died 1959 in Sidney, Australia. Bodenwieser was a professor at the State Academy of Music and Drama in Vienna c.1921 to 1938, when she formed a troupe of dancers to perform her constructivist group works. A part of the German modern dance movement associated with von Laban, Wigman, and Palucca, there is no evidence that she studied with them. Most of the group's performances were in Austro-Hungary or Germany, but they attracted wide recognition on

tours to London (1927) and Italy (1932), with her choreography, notably the group piece, *The Daemon Machine, or Dance of Work* (1932), in which the dancers became dehumanized cogs of machinery.

Bodenweiser emigrated to Australia after 1938, teaching and forming a new performance group in Sidney. Although she retained her constructivism and personal style, there is some evidence that she softened in Australia and created lighter works.

It should be noted that, although a Bodenwieser Archives has been founded recently in Sidney, there is very little hard data on her choreography. The list below, unfortunately, represents less than half of her creative output.

Works Choreographed: CONCERT WORKS: *The Daemon Machine, or Dance of Work* (1923); *An Exotic Orchestra* (1927); *The Swinging Bells* (1927); *Viennese Waltzes* (1927); *Le Ore Solenne* (1932); *Dances to Modern Music* (1932); *Bacchanale* (c.1933); *Waltzes of Delirium* (1933); *Cain and Abel* (1936); *Lucifer* (1936); *Narcissus* (c.1936); *Visions from Painters* (c.1944); *Cinderella of Old Vienna* (c.1945).

Bogdanov, Konstantin, Russian ballet dancer of the nineteenth century; born c.1809 in Moscow; died there in 1877. Bogdanov was trained at the Moscow school of the Imperial Theatres, but spent time in St. Petersburg continuing his studies with Charles-Louis Didelot. Associated with the Moscow Bolshoi throughout his career, he was the principal character dancer there for many years and performed the first "Gurn" in that country. His portrayal of the second male lead, the peasant lover rather than the sophisticated one, in Taglioni's *La Sylphide*, is considered typical of his specialty and ideal for the genre.

Bogdanov served as régisseur for the Bolshoi from 1839 and also ran a private ballet studio. He retired in 1849 to coach his daughter Nadezhda (1836–1897) in her twenty-year career, in Moscow, St. Petersburg, and Paris.

Bogomolova, Ludmilla, Soviet ballet dancer; born March 25, 1932 in Moscow. Trained at the Bolshoi school, she performed with the Ballet throughout her career. She created featured roles in Mikhail Lavrosky's *Pages of Life* (1961) and in Alexander Lapauri's *Lieutenant Kijé* (1963). Her other featured roles included "Kitri" in the company's production of *Don Quixote,* the title role in Lavrosky's *Fadetta,* and a major part in Asaf Messerer's *Spring Waters.*

Bolender, Todd, American ballet dancer and choreographer; born February 17, 1919 in Canton, Ohio. Bolender studied modern dance with Hanya Holm and Fransiska Boas before beginning his training in ballet with Chester Hale. A student at the School of American Ballet, he worked under Anatole Vilzak and George Balanchine.

Joining the American Ballet in 1936, he performed at the Metropolitan Opera in George Balanchine's *The Bat* and *Jeu de Cartes.* He toured with the Ballet Caravan, a cooperative company formed by American Ballet dancers, dancing in the premieres of Lew Christensen's *Filling Station* (1938) and in Eugene Loring's *Billy the Kid* (1938), as the original "Alias," and *City Portrait* (1939), repeating those roles in Loring's Dance Players company. He also participated in two other additional ad hoc companies associated with the School of American Ballet and its students—the New Opera Company, a one-day organization that commissioned Balanchine's *Ballet Imperial* (1942, now called *Tchaikovsky Piano Concerto*), and the American Concert Company, another cooperative group for which he choreographed *School Suite* and *Mother Goose Suite* (1943).

After dancing with the (Catherine) Littlefield Ballet in her *Cafe Society* and *Aurora's Wedding,* and in Ballet Theatre just long enough to injure his ankle, Bolender performed on Broadway in Balanchine's *Rosalinda* (1942) and *Merry Widow* (revival) and Leonid Massine's *Fredericka* (1943). A charter member of Ballet Society and its descendant, the New York City Ballet, he created roles in Balanchine's *Four Temperaments* (1946), with the "Phlegmatic" solo, *Renard* (1947), *Divertimento* (Haieff) (1947), *Symphonie Concertante* (1947), *Metamorphosis* (1952), *Ivesiana* (1954), and *Agon* (1957), leading the Sarabande. He also danced in the premieres of Jerome Robbins' *Age of Anxiety* (1950), *The Pied Piper* (1951), *Fanfare* (1953), and the company premiere of *The Concert* (1956).

A choreographer for the Ballet Society and City Ballet, he added many works to their repertories, among them, *Zodiac* (1947), *Capricorn Concerto*

(1948), *The Miraculous Mandarin* (1951), *The Filly* (1953), *Souvenir* (1955), *At the Still Point* (1955), *Creation of the World* (1960), and *Serenade in A* and *Piano-Rag-Music* for the Stravinsky Festival in 1972. *At the Still Point,* created originally for the Mark Ryder/Emily Frankel Dance Duo, is probably his most popular work. This beautiful character study of lonely people meeting was performed by Melissa Hayden and Jacques D'Amboise in the City Ballet, and has been revived for literally scores of companies in the United States and abroad, most recently the Alvin Ailey American Dance Theatre.

Ballet master of opera ballets in Cologne (1963–1966) and Frankfurt (1966–1968), Bolender has staged works for companies in Germany, Turkey, and the United States.

Works Choreographed: CONCERT WORKS: *School Suite* (1943); *Mother Goose Suite* (1943); *Musical Chairs* (1945); *Commedia Balletica* (1945); *Zodiac* (1947); *Capricorn Concerto* (1947); *Variations* (1947); *Seraglio* (1949); *The Image and the Heart* (1949); *The Miraculous Mandarin* (1953); *The Filly* (1953); *At the Still Point* (1955); *Souvenirs* (1955); *Masquers* (1957); *Whirligig* (1958); *Games* (1958); *Creation of the World* (1961); *The Glow Worm* (1963); *Serenade No. 9* (1963); *Theme and Variations* (1963); *Kontraste* (1964); *Le Baiser de la Fée* (1965); *Time Cycle* (1966); *The Nutcracker* (1966); *Donizettiana* (1967); *Serenade in A* (1972); *Piano-Rag Music* (1972); *Elektra* (1973); *Dance 1, Dance 2* (1974).

THEATER WORKS: *Stop the World* (1964, Köln); *Show Boat* (1971, Vienna; 1974, Geneva); *Helden! Helden!* (Arms and the Man) (1972, Theater an der Wein); *Cry for Us All* (1970, New York); *Kiss Me, Kate* (1963); *My Fair Lady* (1967); *Man of La Mancha* (1971); Ankara State Opera, Drama, and Dance.

OPERAS: New York Metropolitan: *Die Soldaten* (1964).

Bolger, Ray, American eccentric dancer on stage and in film; born January 10, 1904 in Dorchester, Massachusetts. It is not certain whether Bolger had any formal dance training, although in later interviews he claimed to have made his debut in a Delsarte recital.

After performing in vaudeville, he made his Broadway debut in *The Merry World* (1926), following that show with *Heads Up!* (1929) and the George

White *Scandals* of 1931. His act, an eccentric tap or soft shoe that built up in speed and scale until he was dancing triple time with his long legs flailing (under perfect control) up to his ears, was perfected in the *Scandals,* the traditional home for eccentric acts. He alternated between films and Broadway musicals for twenty years, rising to stardom in *Life Begins at 8:40* (1934), in which he danced a one-man version of a championship boxing match; *On Your Toes* (1936), in which he danced George Balanchine's *Slaughter on Tenth Avenue* until the cops came to rescue him; his *Keep off the Grass* (1940), *By Jupiter* (1942), and *Three to Make Ready* (1946), in which he introduced the song that became his theme, "The Old Soft Shoe." His other theme music, "Once in Love with Amy," sung directly to the audience (who usually sang it right back) was in *Where's Charley?* (1958). Bolger returned to Broadway in the 1960s in *All American* (1962) and *Come Summer* (1969).

Although he had produced two-reelers for himself in the mid-1920s, he is best known for the movie musicals that he made for MGM in the late 1930s. After his debut in *The Great Ziegfeld* (1936), he danced in the Eleanor Powell vehicle *Rosalie* (1937) and the Jeannette MacDonald film *Sweethearts* (1938). His next film, *The Wizard of Oz* (1939), made him a star and his "Scarecrow" a part of American culture. The cinema classic also preserved the best example of his eccentric act in the "If I Only Had a Brain" number in which, as a straw scarecrow, he uses all of his loose-limbed, boneless dance tricks. Reunited with Judy Garland in *The Harvey Girls* (1946), he interpolated his version of a waltz into a party scene.

The star of two series on television, *Where's Raymond* (ABC, 1953–1954) and *The Ray Bolger Show* (ABC, 1955–1956), he has appeared on many variety shows and situation comedies.

Bolm, Adolf, Russian ballet dancer and choreographer working in the United States after 1916; born September 25, 1894 in St. Petersburg; died April 16, 1951 in Hollywood, California. Son of the concert master of the Maikhailovsky (French language) Theatre in St. Petersburg, he was trained at the school of the Imperial Ballet there by Platon Karsavin and Nicholas Legat. Although he was a member of the Maryinsky Theatre from 1904 to 1911, he danced

there very seldom. He studied with Enrico Cecchetti in Turin in the summer of 1905, took a troupe to Western Europe in 1908, in which Anna Pavlova did her first *Swan Lake,* and danced at the Empire in London with Lydia Kyasht later in 1909—all before leaving the Maryinsky for the Diaghilev Ballet Russe in its first season.

Bolm's Ballet Russe tenure was notable for the number of ballets in which he created roles. He performed the principal character roles in Mikhail Fokine's *Polovtzian Dances* from Prince Igor, *Petroushka, Daphnis and Chloe, Thamara,* and *Cléopâtre.* After spending part of the spring of 1910 at the Empire, dancing his own *Danses Idylles: Fantasie Chorégraphique,* he returned to the Ballet Russe to dance and to stage movement for Diaghilev's opera productions of *Khovantcha* (1913) and *Une Nuit de Mal* (1914). He toured to the United States with the Ballet Russe in 1916, sharing Nijinsky's roles with Alexander Gavrilov, and decided to stay in the country.

His first company here was the Ballet Intime, a cooperative touring venture with Japanese concert dancer Michio Ito and Roshanara, an Englishwoman who performed Indian dances, and a corps de ballet that included Blanche Talmud and Mary Eaton. He worked on the Otto Kahn circuit of opera houses—the Metropolitan (1917) and the Chicago (1919–1927)—and on Prologs at the Mark Strand and Rialto theatres. His Allied Arts company in Chicago (1924–1927) not only produced ballets and a school, but also sponsored Tamara Karsavina's only American tour. In Los Angeles from 1928 intermittently to his death, he staged new works, taught and choreographed for an unlikely quartet of films produced by Gregory Rattoff, among them, the marvelously terrible *roman à clef, The Mad Genius,* (WB, 1931), which, as its publicity releases stated emphatically, was *not* about Diaghilev and Nijinsky. What the movie was about was John Barrymore remaking "Svengali" in a backstage ballet environment, but it did allow Bolm to create a *Ballet Méchanique,* which he later produced for live performance as *The Iron Foundry.* He served as ballet master to the San Francisco Ballet from 1932 and of Ballet Theatre from 1942 to 1945.

Bolm had a tremendous influence on ballet in America as a choreographer, as a teacher, and as a person. Among the many dancers whom he trained

were choreographers Ruth Page, Walter Camryn, and James Starbuck, and teachers Josephine and Hermine Schwartz (currently in Dayton, Ohio), Thalia Mara, and Jorg Fasting. His liberality made him a more important influence than many of his Russian colleagues. Unlike them, he wrote about the importance of Native American and immigration dances, and of modern dancers to the development of ballet.

Works Choreographed: CONCERT WORKS: *Les Fetes d'Hébé* (1912); *Assyrian Dance* (1917); *Danse Macabre* (1917); *Gopak* (1917); *The White Peacock* (1917); *Petrouchka* (1919); *The Birthday of the Infanta* (1919); *Divertissements for the Ballet Intime (Papillon, Chanson triste, fantasie Chinoise, Bal masqué, Puss in Boots, Prelude, Op 23, No. 5)* (1920); *Pavanne* (1920); *Prelude* (1920); *Mazurka* (1920); *Dream of Love* (1920); *Etude, Opus 25, No. 9* (1920); *Humoresque* (1920); *Krazy Kat* (1920); *Suggestions diaboliques* (1922); *The Rivals* (1924); *Little Circus* (1924); *Elopement* (1924); *El Amor Brujo* (1924); *Bach Cycle (Danse Noble, Lament, Consideration)* (1925); *Parnassus au Montmartre* (1926); *La Fa Harmony* (1927); *Tragedy of the Cello* (1927); *Vision Mystique* (1927); *Alt-Wein* (1928); *Apollon Musagète* (1928); *Allecchinata* (1928); *Pavanne pour une Enfante Défunte* (1928); *Lament (II)* (1935); *Javanese Court Dance* (1937); *Peter and the Wolf* (1940); *The Firebird* (1945).

THEATER WORKS: *Miss 1917* (1917 Autumn Leaves sequence only).

FILMS: *The Mad Genius* (WB, 1931); *The Affairs of Cellini* (Twentieth-Century Pictures, 1934); *The Men in Her Life* (Columbia, 1941); *The Corsican Brothers* (UA, 1942).

Bologna, John Peter, Italian dancer, choreographer, and scenic technician for harlequinades in England; born 1775 in Genoa; died 1846 in Glasgow. Bologna came to England with his father, Pietro, a descendent of Simone de Bologna of the Gelosi commedia troupe, at the age of twelve. From 1792 to 1807, he performed in and staged harlequinades, or spectacle-pantomimes, for the three leading theaters of London—the Sadler's Wells, the Royal Circus, and the Covent Garden.

Among the best known productions in which he participated were *Medea's Kettle, or Harlequin Removed* (1792), *Niobe, or Harlequin's Ordeal* (1797,

his first featured "Harlequin" appearance), *Harlequin's Tour* (1801, his first credit as a "machinist" or scenery designer and technician), *Harlequin and Mother Goose* (1806), which he performed with James Byrne, and *The Fates, or the Harlequin's Holiday* (1819), considered his last major production. In 1810, he obtained a license to present fireworks in London, although it is not known if he ever presented such an exhibition. From 1819, he taught dance in Edinburgh and Glasgow.

Works Choreographed: THEATER WORKS: *Harlequin's Tower* (1801); *Rinaldo Rinaldi* (1801); *Harlequin in his Element* (1801); *Edward and Susan* (1802); *The Fates, or the Harlequin's Holiday* (1819).

Bologna, Pietro, Italian slack-rope and harlequinade performer; born c.1750 in Genoa; died c.1814 in London. Bologna, descended from Simone de Bologna, the "Harlequin" of the Gelosi troupe of commedia players, was the father of John Peter Bologna.

He brought his family to England in 1786 as the Italian company booked into Sadler's Wells. Primarily a slack-rope performer, he also tumbled and played the "Pantalon-father" character in harlequinades. Among the productions in which he performed at the Wells and the Royal Circus were *The Prophecy* (1797), *Harlequin Highlander* (1798), *The Sorceress of Strozzi* (1802), *The Flying Island of Laputa* (1807), and *Imogen, Princess of Britain* (1807), as "Cymbeline."

Bond, Sheila, American theatrical dancer; born Sheila Phyllis Berman, March 16, 1928 in New York City. Trained at the Professional Children's School in New York, Bond made her professional debut during the one-week run of *Let Freedom Sing* on Broadway, October 1942. Although her next two shows were equally unsuccessful, even with Jack Cole's baseball dance in *Allah be Praised,* she became famous in her fourth, *Street Scene* (1947), in which she danced the "Moon-Faced, Starry-Eyed" duet with Danny Daniels in Anna Sokolow's celebrated choreography.

She and Daniels were reunited for *Make Mine Manhattan* in 1948, staged by Hassard Short. Among her other notable Broadway appearances were *Wish You Were Here* (1952), for which she was awarded a Tony, and *Damn Yankees* (1955), choreographed by

Bob Fosse. Bond also appeared on television frequently during the 1950s when variety shows were filmed in New York. Her ten guest shots on *The Ed Sullivan Show* from 1947 to 1955 made her one of the most popular dancers on television, with appearances on the *Arthur Murray Show* (NBC, 1952), *The Jack Paar Show* (NBC, 1957), and many dramatic series, among them *Schlitz Playhouse* (CBS, 1952) and *Playhouse 90* (CBS, 1956–1958).

Bonfanti, Maria, Italian ballet dancer working in the United States after 1866; born February 16, 1845 in Milan; died January 25, 1921 in New York. Bonfanti was trained privately by Carlo Blasis in Milan. After her debut in *Roberto, il Diavolo,* she danced at the Teatro alla Scala for two seasons. She then performed in London, at the Covent Garden with the Italian Opera Company there, and in Madrid at the Teatro Royale in the company's production of *La Muta di Portici.*

From 1866 until 1894, Bonfanti performed in the United States. She made her debut at Niblo's Gardens Theater in *The Black Crook*, one of the spectacles which was performed in different productions throughout the latter part of the nineteenth century. Her first transcontinental tour, which took her to San Francisco, included *The Black Crook* and *The White Faun* in its repertory. Returning to New York in 1871, she picked *The Naiad Queen,* the Julia Turnbull/George Washington Smith vehicle, up for the company. After a trip to Italy, she toured to California with new productions—*Damon and Pythias, The Robbers,* and *Belphagor; Sardanopolus,* based on the La Scala production, was added in 1878.

Bonfanti also performed with other troupes, among them the Kiralfy Brothers, for whom she danced in *Around the World in Eighty Days* (1878), and the Abbey Hickey company, where she did *Humpty-Dumpty.* She stopped touring long enough to be named prima ballerina of the Metropolitan Alcazar Opera in New York, 1882, dancing *Sylvia.* From then until 1891, she alternated tours with the Kiralfys and the spectacle *The Twelve Temptations,* with tenures at the Metropolitan Opera House, New York (1885–1886).

In 1894, she opened a studio in New York where she taught until 1916. While teaching, she staged dances for Bessie Clayton, (c.1910). Bonfanti's im-

portance to the development of ballet technique and the spectacle format is now being investigated by historian Barbara M. Barker in an as yet unpublished manuscript.

Bonnefous, Jean-Pierre, French ballet dancer and choreographer working in the United States after 1970; born April 25, 1943 in Bourg-en-Bresse, France. Trained at the school of the Paris Opéra, Bonnefous performed there from 1959 to 1970. Among the works in which he was seen at the Opéra were Maurice Béjart's *Damnation of Faust, Webern Op. 5,* and Roland Petit's *Notre Dame de Paris.* He danced in the first movement of *Symphony in C* when its creator, George Balanchine, restaged it for the Paris Opéra, leading to his engagement to dance with the New York City Ballet.

He has danced in almost every work by Balanchine in that company's repertory, including *Symphony in C, Orpheus* in the title role, *La Valse, Agon, Tchaikovsky Pas de Deux,* and *Scotch Symphony.* Although celebrated for his purity and simplicity of performance and technical attack, he has danced as a Broadway hoofer in *Who Cares?* and as a Pearly King in the middle section of *Union Jack* (1976), partnering his wife, Patricia McBride. Among the other Balanchine works in which he has created roles are the *Stravinsky Violin Concerto* (1972), *Cortège Hongrois* (1973), *Sonatine* (the opening dance of the Ravel Festival in 1975), and *Vienna Waltzes* (1978). Noted for his performance in Jerome Robbins' *Dances at a Gathering* and *In the Night,* Bonnefous performed in the premieres of his *An Evening's Waltzes* (1973) and *Four Bagatelles* (1973).

Bonnefous has choreographed ballets since 1976, contributing works to the company repertory, to the School of American Ballet workshops, to John Curry's ice show in 1979 and to a chamber touring group which he directs.

Works Choreographed: CONCERT WORKS: *Nuit d'Eté* (1976); *Hayden Concerto* (1976); *Brandenberg Concerto* (1978); Pas Degas section of *Tricolore* (1978); *Quadrille* (1978); *Waltzes and Polka* (1978); *Madrigal* (1979); *Ice Moves* (1979); *Poulenc Pas de Deux* (1980); *Aubade* (1980).

Borchsenius, Valborg, Danish ballet dancer; born Valborg Jorgensen, c.1872 in Copenhagen; died there in 1949. Borchsenius entered the school of the Royal Danish Ballet in 1879; it has been frequently stated that she played one of "Nora's" children in the premiere of Ibsen's *A Doll's House* in that year. As an adult, she partnered Hans Beck in the Bournonville repertory, most notably in his *La Sylphide.* Like Beck, she helped to maintain the Bournonville repertory after she retired to teach in 1918.

Borde, Percival, Trinidanian dancer and choreographer active in the American anthropological modern dance; born c.1924 in Trinidad; died September 3, 1979 in New York City. Borde was trained at the Queens' Royal College annex in the British West Indies and performed in independent research in Afro-Caribbean dance forms before coming to the United States in 1958. A protégé of Pearl Primus, and later her colleague and husband, he was presented in New York recitals as a member of the field of modern dance involved with the preservation and study of popular dance forms of the Caribbean and Africa. He was lead dancer of the Primus troupe for over twenty years and taught with her at their New York studio and in countless residencies at performing arts centers across the country and in Africa. His own lecture-demonstration group, The Talking Drums, toured for two decades. For many years before his death he was both Professor of Dance at the New York University School of the Arts and a member of the Black Studies faculty at the State University of New York at Binghamton. Borde had a successful second career as a theatrical choreographer with the Negro Ensemble Company in New York. His movement patterns for dramatic plays were as exciting as his dance numbers for musical shows there. Borde died during a performance with the Primus company.

Works Choreographed: THEATER WORKS: *Man Better Man* (1969); *Akokawe* (1970); *Harangues* (1970).

Borg, Conny, Swedish ballet dancer and choreographer; born 1939 in Stockholm. Borg was trained at the school of the Royal Swedish Ballet, becoming a member of the company in the early 1960s. After performing in company productions of the classics and in Birgit Cullberg's *Medea,* he became director of a company in Gothenburg in 1967. After three seasons

there, he co-founded the New Swedish Ballet with Ulf Gadd, creating a principal role in Gadd's *The Miraculous Mandarin* (1970). Since 1972, he has served as ballet master of the Mälmo Stadtteater. Much of Borg's choreography has been created for the New Swedish Ballet and the company in Mälmo.

Works Choreographed: CONCERT WORKS: *Rittornell* (1966); *IAAEAO* (c.1969); *Swan Lake* (1974); *Cinderella* (1975).

Boris, Ruthanna, American ballet dancer and choreographer; born March 17, 1918 in Brooklyn, New York. Boris received her early training as a child at the Metropolitan Opera's School of Ballet, where she worked with Guiseppe Bonfiglio, Margaret Curtis, and Rosina Galli. For six years (c.1934–1940) she studied ballet, Spanish dance forms (with Helen Veola), and at the three major studios of American traditional modern dance (Graham, Humphrey/Weidman, and Holm) concurrently. In 1934, she also became a founding student at the School of American Ballet, one of Balanchine's first pupils in America.

Boris performed with the American Ballet, Balanchine's early company, and with its collateral group, the Ballet Caravan, a touring troupe of dancers who performed each other's works; Boris danced in the entire repertory of the troupe's first two seasons, notably in the title role of Lew Christensen's *Pocohontas* (1936), before leaving for a part in Agnes De Mille's Broadway production, *Hooray for What.* After additional work on Broadway, and at the Radio City Music Hall, Boris returned to the Metropolitan Opera (1937–1942).

As a ballerina with the Ballet Russe de Monte Carlo, Boris performed principal roles in *Spectre de la Rose,* Balanchine's *Serenade,* and the *Paquita* and *Bluebird* pas de deux, while choreographing two works—*Cirque de Deux* (1947) and *Quelques Fleurs* (1948). As a guest artist with the New York City Ballet, Boris performed in the works that she choreographed for the company—*Cakewalk* (1951), her most frequently revived ballet, *Kaleidoscope* (1952), and *Will o' the Wisp* (1953).

Boris' later works were created primarily for the Boris-(Frank) Hobi Concert Company that toured in 1954 and 1955 and for the Royal Winnipeg Ballet, with which she danced in 1956 and 1957. More recent

ballet pieces have been commissioned by the Eglevsky Ballet, the Houston Ballet, and San Francisco Bay area companies. A very popular teacher and administrator of school programs, Boris has taught since 1965 at the University of Washington, at Seattle.

Works Choreographed: CONCERT WORKS: *Cirque de Deux* (1947); *Quelques Fleurs* (1948); *Cakewalk* (1951); *Kaleidoscope* (1952); *Will o' the Wisp* (1953); *Sonata* (1954); *Roundelay* (1954); *Le Jazz Hot* (1955); *Pasticcio* (1957); *The Comedians* (1957); *Wanderlings* (1957); *Six to One* (1962); *Themes and Variations* (1966); *Tape Suite* (1974); *Rag Time: Homage to Scott Joplin* (1975); *Four All* (1980).

Borlin, Jean, Swedish ballet dancer and choreographer; born March 13, 1893 in Haernösand, Sweden; died December 6, 1930 in New York City. Trained at the ballet school of the Royal Opera House of Stockholm with Gunhild Rosém and with Mikhail Fokine, he danced with the Royal Opera Ballet from 1905 to 1918, most notably in the company revivals of Fokine's *Cléopâtre, Schéhérézade,* and *Le Dieu Bleu.*

Rolf de Maré sponsored his solo recital in Paris in 1920 and built the Ballet Suédois around his repertory. He created his most celebrated works for this troupe, among them, *Les Mariés de la Tour Eiffel* (1921) to a Jean Cocteau libretto, *L'Homme et son Désir* (1921), *La Création du Monde* (1923), and *Relâche* (1924). His ballets used music by the members of Les Six, including Darius Milhaud, Germaine Taliaferre, Arthur Honnegger, Georges Auric, and François Poulenc—individually and, for the Cocteau, together—Debussy and Cole Porter, who created *Within the Quota* in 1923. Borlin's pieces were also noted for his imaginative sense of designs in a futurist total theater.

Following the dissolution of the Ballet Suédois, Borlin toured with a solo recital program in North and South America and Europe. The details of his death are still confusing; it is believed that he died of complications to the jaundice that he contracted in Brazil.

Works Choreographed: CONCERT WORKS: *Siamese Dance* (1919); *War Dance* (1919); *Jeux* (1920); *Iberia* (1920); *La Nuit de Saint-Jean* (1920); *Maison de foux* (1920); *Le Tombeau de Couperin* (1920); *El Greco*

(1920); *Derviche* (1920); *Les Vierges Folles* (1920); *La Boite à Joujoux* (1920: *L'Homme et son Désir* (1921); *Les Maries de la Tour Eiffel* (1921); *Dansgille* (1921); *Skating Rink* (1922); *Valse de Dame Kobold* (1923); *Anitra's Dance* (1923); *Danse Celeste* (1923); *Danses Grecques, Arabe et Tzigane* (1923); *Hallinger* (1923); *Le Marchand d'Oiseaux* (1923); *Oxdansen* (1923); *Within the Quota* (1923); *Offertunden* (1923); *La Creation du Monde* (1923); *Le Porcher* (1924); *La Giarra* (1924); *Le Tournois Singulier* (1924); *Le Roseau* (1924); *Relâche* (1924); *The Swineherd* (1924); *Harlequin* (c.1924); *Lakem* (1924); *La Sculpture Negre* (1924); *Devant le Mort* (1924); *Dervish* (c.1925).

Borne, Bonita, American ballet dancer; born 1952 in Los Angeles, California. Trained at the School of American Ballet, she graduated into the New York City Ballet in 1971. In ten years with that company, Borne seems to have appeared in every ballet in the period of both expansion and maintenance of repertory.

She has performed in works by the company's many member-choreographers, creating roles in Richard Tanner's *Concerto for Two Solo Pianos* (1971) and Lorca Massine's *Four Last Songs* (1971) and by its ballet masters, John Taras, Jerome Robbins, and George Balanchine, for whom she has danced in *Apollo, Concerto Barocco, Chaconne, Divertimento No. 15*, and many other works.

Borri, Pasquale, Italian ballet dancer and choreographer of the Romantic era; born 1820 in Milan; died April 29, 1884 in Desio. Borri was trained by Carlo Blasis of the Teatro alla Scala, making his debut with the company in 1840.

Considered the major link between Blasis' technical training and the French philosophies of the Romantic era, Borri is generally considered the most influential nineteenth-century choreographer in Italy. Although he was associated with La Scala throughout his career, Borri also danced and choreographed at the Teatro la Fenice in Venice, performing in Viotti's *Nozze di Bacco e Ariana* in 1843, at the Teatro Grande in Trieste (1848), Her Majesty's Theatre, London (1860–1863), and the San Carlo in Naples, where he did Salvatore Taglioni's *Olfa* in 1853. His

most important tenures were at the Hofteater in Vienna, (from 1844 to 1848, 1854, 1858, and 1878 to 1880) where he first choreographed and at La Scala, c.1840 to 1880 (intermittently employed). Among his more influential works were *Rübezahl* (1848), which is considered his first, *La Viandiera* (1852), one of the standards of the Romantic repertory, *Fiamella* (1864), *Fiametta* (1866) and *Stella, o la Vita parigina* (1870).

Works Choreographed: CONCERT WORKS: *Rübezahl* (literally turnip-figure) (1848); *La Ninfa dell'acqua* (1849); *Betty, la Vivandiera* (1852); *Gisella* (1852); *Violetta* (1854); *Carita* (1856); *Die Gaukerin* (The Juggler) (1856); *Redowa* (1856); *Rodolfo* (1858); *Carnevals Abenteurer in Paris* (An Adventure in Paris at the Carnaval) (1858); *Die Wette* (The Wager) (1859); *Die Kamnfager in London* (possibly misrecorded title meaning either The Swept Room or The Battle) (1859); *Gabriella, la Fioreia* (1859); *Mirabella, or la Perle dell'Adriatico* (1860); *Adelina* (1860); *Bremen* (1861); *L'enfant del' armé* (sic—from original program of Her Majesty's Theatre, London) (1863); *Jotta, oder Kunst und Liebe* (Art and Love) (1864); *Fiamella* (1864); *Lolla, or Amore e Arte* (1864, probably a revision of Jotta); *Lola Montes* (1865); *Emma* (1866); *Fiametta, oder Die Macht der Hölle* (The Power of Hell) (1866); *Stella, or la Vita parigina* (1870); *Uriella* (1870); *Le Dea del Valhalla* (1870); *Eletta, o Tenebre e luce* (1872); *Dyellen, oder Die Torrista in Indien* (1879); *Der Stockin Eisen* (The Iron Cane) (1880).

Bortoluzzi, Paolo, Italian ballet dancer; born May 17, 1938 in Genoa, Italy. Bortoluzzi received his early training from Ugo dell'Ara and performed for him in his Compania del Balletto Italiano, 1956 to 1960. He also studied with Leonide Massine at Nervi and danced in a revival of his *Choreatum* and *Le Bal de Voleur.*

Bortoluzzi has been associated with Maurice Béjart's Ballet du XXième Siècle since 1960, and has created roles in many of his works, among them, Beethoven's *Ninth Symphony* (1966), *Nomos Alpha* (1969), *Bolero* (1960), *Fanfares* (1963), *Baudelaire* (1968), and *Bhakti* (1968). Since the early 1970s, he has also worked as a guest artist with American Ballet Theatre, performing in *Spectre de la Rose, La*

Sylphide, Coppélia, Giselle, and Antony Tudor's *Pillar of Fire*.

Works Choreographed: CONCERT WORKS: *Suite en Si Mineur* (1961); *Introduction et Allegro* (1963); *La Valse* (1965); *Siegfried Idyll* (1965, part II of Béjart's *Wagner ou l'Amour fou*); *l'Orage* (1968).

Bosch, Aurora, Cuban ballet dancer; born c.1940 in Havana, Cuba. Trained by Alicia Alonso and José Parés, Bosch has been associated with the Ballet Nacional de Cuba throughout her performing career.

Alonso taught her many of her most famous roles, including *Coppélia,* which she has performed in Cuba and with the Ballet Classico de México. Among Bosch's other celebrated roles with the company are the title part in John Fealy's *Antígona* and the leading female part in Mendéz' *Tarde en la siesta*. A prize winner at two Varna competitions, Bosch currently teaches at the school of the Ballet Nacional.

Boschetti, Amina, Italian ballet dancer and choreographer of the mid–nineteenth century; born 1836 in Milan; died December 31, 1881 in Naples. Trained by Carlo Blasis, she made her Teatro alla Scala debut in 1848, at age twelve. For the next sixteen years, she performed at La Scala, with featured roles in works by Paul Taglioni, including his *Flik e Flok*, Pasquale Borri, Salvatore Taglioni, and Giuseppe Rota, for whom she created roles in his last ballet, *La Maschera,* (1865) and in many of his other "azioni mimodanzati."

Boschetti is known to have choreographed solos for herself, but her only credited full-length ballet was to have been premiered on the day of her death, December 31, 1881. Its first performance at the Teatro San Carlo di Napoli was given in early 1882.

Works Choreographed: CONCERT WORKS: *Il Vello d'Ore* (1882).

Bosl, Heinz, German ballet dancer; born November 24, 1946 in Baden-Baden; died June 12, 1975 in Munich. Bosl was trained at the school of the Bavarian State Opera Ballet by Michel De Luty and Gustav Blank, graduating into the company in 1962. In his thirteen years of professional life, he performed the heroic roles of the classical ballet, including "The Poet" of *Les Sylphides*, "Jean" in *Raymonda*, and

"The Prince Charming" of *The Sleeping Beauty*, and of the contemporary repertory, most notably in John Crako's *Romeo and Juliet, Swan Lake*, and *Eugene Onegin*. His repertory also included roles in Harald Lander's *Etudes*, Birgit Cullberg's *Medea*, and Flemming Findt's *Three Musketeers*.

Bosl's fatal illness was described as leukemia and a viral infection. He died shortly after entering a Munich hospital.

Bouquet, Louis René, French eighteenth-century theatrical designer; born 1717; died 1814. As was the custom of his period, Bouquet served on the staffs of the court productions and at the Paris Opéra. He was the "Dessinateur en chef de l'Opéra" from 1759 until the closing of the theaters during the French Revolution, but had previously worked with the Opéra Comique where he created designs for the 1754 revival of Jean-Georges Noverre's *Les Fêtes Chinoises*. Bouquet also worked with Noverre at the court theaters of Stuttgart and Ludwigsberg (Duchy of Wurtenberg), notably on the productions of his *Médée et Jason* (1762), *La Mort d'Hercule* (1762), *L'Enlévement de Prosperine* (1766), and *Phyrrus et Polixene* (1766).

Bouquet also serves as "Dessinateur en chef des habit (technically, a costume or uniform that can be used for identification) du Roi pour fêtes, spectacles et cérémonies" from 1764 until the revolution. In this capacity he was responsible for creating costumes that fulfilled the iconographic system of Louis XVII at performances at Versailles, Choisy, and Fontainbleu.

Bourman, Anatole, Russian ballet dancer working in the United States since the late 1910s; born c.1898, possibly in St. Petersburg; died in November 1962. Bourman was trained at the St. Petersburg school of the Imperial Ballet, graduating into Maryinsky Ballet in 1905. In the Maryinsky and the Diaghilev Ballet Russe, of which he was a charter member, he was frequently cast in the works of Mikhail Fokine, and there is some evidence that he may also have been in the premiere of Vaslav Nijinsky's *Sacre du Printemps*.

Bourman had preceded the Ballet Russe to America, and joined former Diaghilev colleague Theodore

Kosloff in the tour that he organized in 1913–1914. The company, one of many known as the Imperial Russian Dancers, consisted of the elder Kosloff and his wife Bolshoi ballerina Alexandra Maria Baldina, Alexis Kosloff and his wife, Juliette Mendez, and Natascha Rambova, who was then known as a ballet specialty dancer. He partnered Rambova in Kosloff's original ballets and revivals of the Diaghilev repertory. It is not known whether Bourman traveled as far as Los Angeles with the troupe, although most of its members remained there for a time and became involved in film work.

In the 1920s, he began to work in the new industries requiring ballet training—prologs and film. Like so many of his Diaghilev and Pavlova colleagues, he was able to gain a job as ballet master of one of the major New York or Los Angeles prolog theaters (in his case, the Mark Strand), and to persuade its owner to install a school for him to train dancers. The Mark Strand School (like others, on the theater roof) was second only to the Chester Hale's Capitol Theater school in training its theatrical precision dancers with pure Cecchetti technique. Bourman's Prologs for the Mark Strand featured "bits of ballets," as a trade publication called them—short excerpts from the standard repertory or original choreography, lasting from three to five minutes. He performed in them with his wife Mme. Klemova (Klementovich in Diaghilev credits), and his trained corps.

When the Prolog industry died in the late 1930s, Bourman moved his studio to New England, becoming a respected teacher in Hartford, Connecticut and Springfield, Massachusetts before his death in 1962. Although now best known for his book on Nijinsky, he was an important member of a linkage system between the Russian ballet and the American concert and theater stage.

Bibliography: Bourman, Anatole. *The Tragedy of Nijinsky* (New York: 1936).

Bourmeister, Vladimir, Soviet ballet dancer and choreographer; born July 15, 1904 in Vitebsk; died March 6, 1971 in Moscow. Trained at the Lunsrcharsky Theater Technicum in Moscow, he spent much of his career with the Moscow Art Theatre, or the Stanislavsky and Nemirovich-Danchenko Music Theatre, as it was retitled after 1939. He performed

as a character dancer in both the ballet company and the theatrical productions.

Best known as a choreographer, Bourmeister created many works for the company. Among the best known were his *Jeanne d'Arc* (1957), *Scheherezade* (1944), and versions of *Swan Lake* (1953 and 1965) using the original Tchaikovsky score. The latter work was very controversial when it was first performed in Paris in 1956.

Works Choreographed: CONCERT WORKS: *Le Corsaire* (1931); *Straussiana* (1941); *The Merry Wives of Windsor* (1942); *Lola* (1943); *Scheherezade* (1944); *Carnaval* (1946); *La Esmeralda* (1950); *Swan Lake* (1953); *The Cost of Happiness* (1956); *Jeanne d'Arc* (1957); *The Snow Maiden* (1961); *Swan Lake* (Act II only) (1965); *The Lonely White Sail* (1970).

Bournonville, Antoine, French early nineteenth-century ballet dancer who performed in Sweden and Denmark after the 1780s; born May 19, 1760 in Lyon, France; died 1843 in Copenhagen, Denmark. Raised in Vienna where his sister performed with the Court Theater, Bournonville was trained by Jean-Georges Noverre, then ballet master. He performed in Kassel, Paris, and London before accepting an engagement in Stockholm at the court of Gustave III, in 1782. After ten years there, he was traveling through Copenhagen when he heard that the king had been assassinated—an incident that provided the impetus for Verdi's *Un Ballo in Machera* and Taglioni's *Le Bal Masqué*.

Deciding to remain in Denmark, Bournonville worked there at the Royal Theater until 1823 as a dancer and as ballet master, succeeding his mentor Vincenzo Galleotti. Among his roles in that company were in Galleotti's *La Reine de Golconda, L'Orpheline de la Chine, Romeo and Juliet*, and *Lagertha*, in which his son August made his debut in 1813.

Bournonville, August, Danish ballet dancer and choreographer, considered one of the most important of the nineteenth century; born August 21, 1805 in Copenhagen; died there November 30, 1879. Bournonville was trained by the ballet masters of the Royal Danish Ballet, his father, Antoine, and Vincenzo Galleotti. To continue his studies in Paris with Auguste Vestris, he performed with the Paris Opéra

from 1826 to 1828, dancing Milon's *Nina* with Lisa Noblet. He partnered Eugénie Lecompte in London at the King's Theatre, in Anatole's *Hassan et le Calife* and *Phyllis et Mélibe*, both in 1828.

Returning to Copenhagen, where he remained for the rest of his career, he danced in works by Galleotti, among them his *Celebration*, and staged his own ballets. He staged a total of sixty-one known works, some based on Paris Opéra standards or the traditional mythological themes, but some based on the history of Denmark and Scandinavia. Because he had the full facilities of the ballet and theater school, he could create milieu for the dances—not just a pair of dancers on stage, but soloists in the midst of a carefully choreographed crowd scene that filled the whole stage. His best known works were created in this style, among them *Napoli* (1842) and *Kermesse in Bruges* (1851), but include pas de deux divertissement that can be and frequently are performed as separate entities.

It is hard to judge the impact of Bournonville in his time since his works have been carefully preserved by the Royal Danish Ballet. On one hand, they are entities that can stand careful scrutiny, but they are also more than a century old and cannot compare to the enormous vocabulary of movement that modern choreographers employ. By insisting that he is a "choreographer for all time," modern historians and critics are denying his position as a choreographer of his time.

The Bournonville centenary in 1979 may have stimulated the interest in his works. Revivals of his full-length, full-stage pieces were done in Denmark while programs of pas de deux and divertissements were staged for companies around the world. It may take another hundred years before historians and critics can accept their personal interest in Bournonville and their pleasure in his works as a recognition of his historical importance without feeling that they have to excuse him.

Works Choreographed: CONCERT WORKS: *Gratiernes Hyldning* (Celebration of the Graces) (1829); *Sovngaengersken* (La Sonnumbula) (1829); *Soldat og Bonde* (Soldier and Peasant) (1829); *Hertungen af Verdomes Pager* (Les Parges du Duc de Vendôme) (1830, after Aumer); *Paul og Virginie* (Paul and Virginie, Les Deux Créoles) (1830, after Aumer);

Victors Bryllup eller Faedreene-Arnen (Victor's Wedding, or the Ancestral Home) (1831); *Faust* (1832); *Veteranen eller det Gaestfrie Tag* (The Veteran) (1833); *Romeo og Giulietta* (1833); *Nina, elle den Vanviyyige af Kaerlighed* (Nina, ou la Folie de l'Amour) (1834); *Tyrolierne* (1835); *Valdemar* (1835); *Silfiden* (La Sylphide) (1836); *Don Quixote ved Camachos Bryllup* (At Camarcho's Wedding) (1837); *Hertha's Offer* (1838); *Fantasiens ø eller fra Kinas Kyst* (The Island of Fantasy) (1838); *Festen i Albano* (1839); *Faedrelandes Muser* (The National Muses) (1840); *Toreadoren* (1840); *Napoli* (1842); *Polka Militaire* (1842); *Erik Menveds Barndom* (The Childhood of Erik Medved) (1843); *Bellman eller Polksdansen paa Gronalund* (Bellman, or the Polkas at Gronalund) (1844); *En Børnefest* (The Children's Party) (1844); *Hamburger Dans* (1844); *Kirsten Piil eller To Midsummerfasten* (Kirsten, or The Two Midsummer's Eve Festivals) (1845); *Rafael* (1845); *Polacca Guerriera* (1846); *Den Nye Penelope eller Foraarsfesten i Athenana* (The New Penelope, or The Festival of Spring in Athens) (1847); *Maritana* (1847); *Den Hvide Rose eller Sommeren i Bretagne* (The White Rose, or Summer in Brittany) (1847); *Sondags Echo* (Sunday Echo) (1848); *Gamle Minder eller en Lterna Magica* (Old Memories, or The Magic Lantern) (1848); *Konservatoriet* (1849); *De Uimodstaaelige* (The Irresistable) (1850); *Psiche* (1850); *Kermessen i Bruge* (1851); *Zulma eller Krystalpaladset* (Zulma, or the Crystal Palace) (1852); *Brudefearen i Hardanger* (Wedding in Hardanger) (1853); *Et Folkesagn* (performed as A Folk Tale) (1854); *La Ventana* (1854); *Abdallah* (1855); *Den Alvorlige Pige* (The Serious Maid) (1856); *I Karpatherne* (In the Carpathian Mountains) (1857); *Blomsterfesten* (Flower-festival) *i Genzano* (1858); *Fjeldstuen elle Tyve Aar* (The Mountain Cottage, or the Twenty Years) (1859); *Fjernt fra Denmark eller et Costumebal Ombord* (Far from Denmark, or A Masked Ball on Board) (1860); *Valkirien* (1861); *Pontemolle et Kunstnergilde i Rom* (An Artist's Guild in Rome) (1866); *Thrymskviden* (The Legend of Thrym) (1868); *Cort Adeler i Venedig* (Curt Adeler in Venice) (1870); *Bouquet Royal* (1870); *Liveagerne paa Amager* (The King's Volunteer [Brigade] at Amager) (1871); *Udfaldet i Classens Have* (Udfaldet from the Classen Park) (1871); *Et Eventyr i Billeder* (A Visual

Fairy Tale) (1871); *Mandarinens Døtre* (The Daughters of the Mandarin) (1873); *Weyses Minde* (in Memoriam) (1874); *Farvel til det Gamle Theater* (Farewell to the Gamelteater) (1874); *Arcona* (1875); *Fra det Forrigne Aarhundrede* (From the Last Century) (1875); *Fra Siberien til Moskau* (From Siberia to Moscow) (1876).

Boutilier, Joy, American modern dancer and choreographer; born September 30, 1939 in Chicago, Illinois. Boutilier was trained at the Henry Street Settlement studio of Alwin Nikolais and Murray Louis. She performed in each one's concert group in the mid-1960s, most notably in the premiere of Nikolais' *Sanctum*, and shared recitals with Louis and company members Phyllis Lamhut and Bill Frank. A *New York Times* critic dubbed her "the most creative young modern dance choreographer in town" in the most prolific period of her work, 1968–1971. Her *Homunculus* (1968) was especially well received in New York at her first solo concert, for its innovative uses of space and limitation on movement.

Works Choreographed: CONCERT WORKS: *In Grandma's House* (c.1967); *Homunculus* (1968); *Sortilegy* (c.1968); *Lines of Lewis Carroll* (1968); *Bazooka* (1968); *A Sequel to her Visit* (1971); *Colony* (1971).

Bovington, John, American concert dancer; born June 19, 1890 in Buffalo, New York; died June 29, 1973 in Norwalk, California. An economist and linguist, Bovington became interested in dance performance while teaching sociology at the Keio University, Tokyo from 1920 to 1922. Further training in Oriental dance in Java led to a recital at the Arts' Students' League in New York in 1924. At some time between that date and his next concert in New York, 1928, both he and his wife, Jeanya Marling, worked or studied at the International Theater in Moscow.

A true concert dancer, most of Bovington's works were created for his solo recitals, 1924 to 1937. These short characterizational studies called dance monodramas were performed live or with filmed backgrounds; one solo, *Underground Printer*, was filmed and shown at a recital in 1936. All the pieces combined the movements and breathing techniques of the Orient with the political philosophy of the 1930s.

An organizer of the Dance Congress of 1936 and the American Dancers Association, Bovington may be the only person ever blacklisted by the charge that he was a professional dancer. His firing from a job as Principal Economic Analyst to the Office of Economic Warfare, by the Congressman (Martin) Dies Committee, considered a classic of judicial injustice, was accompanied by a flood of old photographs of Bovington and Marling in scant Javanese costume that were "leaked" to the press.

Works Choreographed: CONCERT WORKS: *Sleep* (1928); *Fermentation* (1928); *Breathings* (1928); *Mother of Three* (1930); *Evolution of Power* (1930); *Balance* (1930); *The Contemporary Siva* (1930); *The Worker Jew* (1930); *Dance Poems of New Russia* (*Worker of Factories, Rhapsody Diplomatic, Panorama of Shock Workers, Collectivizing Peasant, Vanya in his Park*) (1934); *Poem Dances of All Nations* (*Siva, Hitlerian Fantasy, Ancient Rice Worker, Two Songs*) (1934); *Stages in a Struggle* (1936); *Portraits of a Changing World* (*Red Army Speaks, the Peasant Comes of Age, Underground Printer, Evolution, Legend of a Rice Worker, Somnambulist*) (1936).

Bovt, Violette, American ballet dancer working in the Soviet Union; born May, 1927 in Los Angeles, California. Raised in Moscow, she attended the Bolshoi school there from 1935. Bovt performed with the Stanislavsky and Nemirovich-Danchenko Theatre in the 1950s and 1960s, creating roles in A. Chichinadze's *Don Juan* (1962) and *The Wood Fairy* (1960), and in Nina Grishina's production of *Le Corsair*. She was also known for her performances in the principal roles in the classics, notably in Bourmeister's *Swan Lake* and the company's version of *Carnaval*.

Works Choreographed: CONCERT WORKS: *Star Fantasy* (1963, co-choreographed with Nina Grishina).

Bow, Clara, American silent film dancer and actress; born July 29, 1905 in Brooklyn, New York. The "It" girl was trained locally, possibly by William Pitt Rivers. She won her first film contract in a beauty contest, then went on to make films about contemporary life as seen in Hollywood. Her dance ability—her

Charleston and wild Black Bottom—were an integral part of her characterizations. Among her best remembered films were *Dancing Mothers* (1926), *Kid Boots,* (1926), *The Wild Party* (1929), and *Love Among the Millionaires* (1930), all for Paramount/Famous Players-Laskey Studios. She was most celebrated for her central role in the film, *It* (Famous Players-Laskey, 1927), based on the novel by Elinor Glyn, who wrote that *It*, or sex appeal, could be obtained only through dancing.

Bowden, Sally, American postmodern dancer and choreographer; born in the late 1940s in Dallas, Texas. After local training as a child at the Dolly Dinkle Studio, Bowden attended the Boston University School of Fine and Applied Arts, where she studied theater. Her professional dance training in New York included work with Martha Graham, Paul Sanasardo, Merce Cunningham, and ballet teachers Mia Slevanska, Maggie Blake, and Melissa Hayden. She began to choreograph while a member of the Sanasardo company but did not become interested in her present medium, improvisation, until she left the troupe. She first worked in solo performance, in which she adapted herself and her vocabulary to the place in which she appeared; these works are, therefore, titled *Sally Bowden dances at* In the mid-1970s she worked within the improvisatory format in series of performances at a single loft space (a format which the spaces in New York have increasingly made possible) in *Five Wednesdays at Nine* (over 1975) and the marvelous *Wonderful World of Modern Dance: or the Amazing Story of the Plié* (over 1976), which expanded both her vocabularies and the theatricality of the format. Although she has occasionally returned to preset choreography, most notably in *The Potato Piece* (1975) and *The Ice Palace* (1973), both of which used language as well as movement, she has worked improvisationally with herself as soloist and with groups for her New York seasons and in frequent residencies at universities, museums, and colleges outside of the city.

Works Choreographed: CONCERT WORKS: *Woodfall* (1966); *Continuum* (1967); *Three Dances* (1969); *Continuum II* (1969); *Continuum . . . nocturnal* (1969); *Opening Dance* (1971); *Rondo* (1971); *Piece* (1971); *Sally Bowden Dances at the Village View Community Center* (1971); *Sally Bowden Dances at the Trust* (1971); *Sally Bowden Dances at Bird S. Coler Hospital* (1972); *Sally Bowden Dances at the Cubiculo* (1972); *Sally Bowden Dances at Tears* (1972); *Sally Bowden Dances at the Construction Company Dance Studio* (1972); *Sally Bowden Dances and Talks at the New School* (1972); *The Black Ballet* (1973); *Sally Bowden and David Schiller Dance* (1973); *Sally Bowden Dances at the Laight Street Studio* (1973); *Crossover* (1973); *The Ice Palace* (1973–1974); *Sally Bowden Dances at Clark Center* (1974); *Sally Bowden Dances and Roy Berkeley Sings* (1974); *The Universe on the Head of a Pin* (1974); *The Spiral Thicket* (1975); *White River Junction* (1975); *Five Wednesdays at Nine* (1975); *Crossings* (1975); *The Wonderful World of Modern Dance: or The Amazing Story of the Plié* (1976); *Wheat* (1976–1977); *Kite* (1978); *The Potato Piece* (1978); *Voyages* (1978); *Night Dances* (1979); *It Just Happens* (1979); *Morningdance* (1979); *Trails* (1979); *Catch as Catch Can* (1979); *Clearing* (1980); *Crescent* (1980); *Essays* (1980); *The Walking Chime Blues* (1980); *Carvings* (1980).

Bowman, Patricia, American Prolog and ballet company dancer; born December 12, 1904 in Washington, D.C. After training with Lisa Gardinier locally, Bowman moved to New York at age fourteen to study with Mikhail Fokine. Her primary teacher continued to be Fokine throughout his lifetime, although in 1932–1933, she studied with Lubov Egorova in Paris and with Margarete Wallmann in Berlin.

Bowman's career was unique in many ways. The last of the great Prolog ballerinas, she experimented with company-format ballet, but chose to remain in variety theater. Associated throughout her early life with the theaters of S. L. ("Roxy") Rothafel, she served as prima ballerina for his Roxy Theater, New York (c.1928–1931), where she partnered Leonid Massine, then ballet master. She moved with "Roxy" to the Radio City Music Hall in 1932, performing in its Prolog's ballet numbers, staged by Florence Rogge, for sixteen years; she was partnered for many of those seasons by Paul Haakon, who, like her, chose variety over the more conventional ballet company route. Bowman's theater career also included work at other Prolog theaters, among them

the Boston Metropolitan (1935–1938) and the Boston Capitol (1938), and Broadway shows. Her first Broadway appearance was in the first of George White's *Scandals* (1919); she also performed in the first of Billie Burke's *Ziegfeld Follies* (1934), produced by the Shuberts, and in musicals, *Calling All Stars* (1934) and *Rhapsody* (1944). In London, she performed in the stage and film versions of *O-Kay for Sound* (stage 1936; Gainsborough Studios, 1937).

Bowman made her classical format debut in Toronto in a spring 1936 concert of the Toronto Symphony Orchestra. Her ballet company career, however, was concentrated primarily into 1939–1940, when she appeared with the Fokine Ballet, the Mordkin Ballet, and its offshoot, Ballet Theatre, in its premier season. For Mikhail Mordkin, she created the title role in his version of *Giselle*, and roles in *Voices of Spring* and *The Goldfish*. For Fokine, she created the solos *Tennis* and *Persian Angel* and performed *The Dying Swan*. As a member of the charter Ballet Theatre company, she performed featured roles in Anton Dolin's one-act *Swan Lake*, his *Quintet* (1940), and Fokine's *Carnaval*. She also had a featured role (possibly the Ballerina of the Prelude) in the 1940 production of *Les Sylphides*; for Ballet Theatre's fifteenth anniversary concert in 1955, she performed that role again.

Although Bowman had a brief career as a concert dancer, she was better known, after retirement from performance, as a teacher—running a New York studio from 1941 to 1977. Bowman also had an extensive career on radio, performing with *Roxy's Gang* shows in the 1930s, and on television. She performed on televised specials from Rothafel theaters in 1931 and 1939 and on a televised ballet class given by Mikhail Mordkin on NBC in May 1939. In 1951, she hosted a thirteen-week series, *The Patricia Bowman Show*, on CBS.

Works Choreographed: CONCERT WORKS: *Beat Me, Daddy, Eight to the Bar* (1942); *Grande Valse Brilliant* (1950); *Chit Chat Polka* (1950); *Air* (1950); *The Penguin* (1950).

Boyce, Johanna, American postmodern dancer and choreographer; born May 10, 1954 in Hanover, New Hampshire. Boyce considers her studies with Simone Forti, Dana Reitz, and Elaine Summers important to her artistic development. She has choreographed in the New York area since 1978 working frequently with untrained dancers. She uses pedestrian movements in a unique and extraordinarily interesting manner, bringing the audience's focus to individual movements as performed by single dancers or groups. Her *Out of the Ordinary*, a dance for ten, uses tasks and props to bring focus to relationships among people and between performers and their found properties. Boyce has recently begun to work with film and in collaboration with composers.

Works Choreographed: CONCERT WORKS: *New Dances (Pas, Styles, Tracings, Trans Forms, Ghost Dance,* and *Its How You Play the Game)* (1979); *New Choreography: Untitled Work in Progress* (1980); *Heavy Hand* (1980, in collaboration with composer Ray Shatterkird); *Out of the Ordinary* (1980); *A Weekend Spent, Filming It* (1980, in collaboration with filmmakers John Schabel and Holly Fisher).

Boyle, John, American tap dancer and film dance director; born in the 1890s, probably in West Virginia; died c.1950 in Los Angeles. It is unlikely that Boyle had any formal dance training since, according to James Cagney, he spent his childhood working in the coal mines. He somehow became an eccentric, machine-gun, tap dancer in vaudeville, where he was seen by Jack Donahue, then the foremost lanky tapper on Broadway. He joined the faculty of Donahue's studio, teaching Eleanor Powell and the Capps family, among many others, and trained precision tap lines for Broadway shows, most notably *Boom-Boom* (1929), which for some reason billed the Donahue Girls and Boyle Girls as separate specialty acts.

He taught in New York until the mid-1930s, when he moved to Hollywood to coach dancers for film work. His best known pupil was James Cagney, whose routines he staged in *Something to Sing About* (Grand National, 1937) and *Yankee Doodle Dandy* (WB, 1942). The unsuccessful *Something to Sing About* is his only extant performance on film—in a triple-time tap trio with Cagney and Harland Dixon. He was a staff dance director for Universal, Monogram, and Columbia, and ran studio schools for each studio.

Boyle's style of dance has been preserved through

Cagney and Powell. He worked very close to the floor, with little upper torso movement, but produced clean, articulated taps at an incredible pace. His machine-gun tapping ranged from triple time, with three distinct sounds per movement, to quadruple time, which even with the fuzzy sound systems of the Grand National movie, can be heard clearly in *Something to Sing About*, and seen in his protégé's films.

Works Choreographed: THEATER WORKS: *Boom-Boom* (1929).

FILM: *Something to Sing About* (Grand National, 1937); *Yankee Doodle Dandy* (WB/First National, 1943, co-credited with Le Roy Prinz and Seymour Felix); *Spotlight Scandals* (Monogram, 1943); *Bowery to Broadway* (Universal, 1944); *Melody Parade* (Universal, 1944); *My Best Gal* (Republic, 1944); *Sumbonnet Sue* (Monogram, 1945); *High School Hero* (Monogram, 1946); *Mary Lou* (Columbia, 1948); *Ladies of the Chorus* (Columbia, 1949).

Bozzacchi, Giuseppina, Italian nineteenth-century ballet dancer associated with the Paris Opéra throughout her short career; born November 23, 1853, in Milan; died seventeen years later on November 23, 1870 in Paris. After local studies, Bozzacchi emigrated to Paris with her family in 1862. She studied there with Mme. Dominique-Venettoza and, under the sponsorship of Emile Perrin, made her debut at the Paris Opéra in what was to be her only role, "Swanilda."

Swanilda, the leading female role in Arthur Saint-Léon's *Coppélia, ou la Fille aux yeux d'email*, is considered the most important role of the late Romantic era. Bozzacchi was chosen to create this role in its first performances in May 1870.

Giuseppina Bozzacchi died of small pox, exacerbated by the deprivations of the German siege of Paris, on her seventeenth birthday, six months after her Opéra debut.

Brabants, Jeanne, Belgian ballet dancer and choreographer; born January 25, 1920 in Antwerp, Belgium. After early training from Lea Daan, she continued her studies with Kurt Jooss and Sigurd Leeder in modern dance composition and techniques, and with Olga Preobrajenska in ballet. She also worked under Ninette De Valois at the Royal Ballet School in London.

Although she performed from 1939 to the 1950s, she is best known as a choreographer and company director in Belgium. She has created works for the Dance Ensembles Brabants, the Royal Netherlands Theatre, the Royal Flemish Opera and her own Ballet Van Valaanderen (of Flanders), founded in 1969. She has also taught at many schools in the low countries, including the school of the Royal Flemish Opera, now the resident school of her company.

Considered the catalyst of the modern Belgian ballet, she has been of tremendous importance in the development of contemporary dance in all of the Lowlands.

Works Choreographed: CONCERT WORKS: *De Reiskameraad* (1961); *Arabesque* (1964); *Clair de Lune* (1964); *Rhapsody* (1968); *Jury* (1968); *Presto, Viva Lento* (c.1971); *Salve Antverpia* (1974); *Poèma* (c.1975); *Grand Hotel* (1977); *Ulenspiegel de geus* (1977); *Nostalgie* (1979).

Bradford, Billy, American vaudeville and theatrical dancer and writer; born Bradford Ropes, c.1906; died November 21, 1966 in Wolleston, Massachusetts. Bradford made his professional debut in a Gus Edward's *School Days* act in the late 1910s. He toured with Edwards for a season as a specialty soft-shoe dancer before moving to New York to enter musical comedy. For the next dozen years he commuted between the male choruses of Broadway and engagements as a dance partner in vaudeville and Prologs. A regular on the Keith circuit, he appeared in one Boston theater in so many acts "assisting" so many female performers that he was dubbed "omnipresent and indestructible."

While it is likely that Bradford's Broadway credit claims were exaggerated, it is known that he appeared as a dancer in a number of Ned Wayburn feature acts, presentation acts, and at least one edition of *Ned Wayburn's Gambols* (1929).

Bradford is the creator of the best known chorus of all time, but it was not a feat of choreographic skill. Under his real name, he was the author of the celebrated lost novel that became the basis of the classic film and currently popular musical comedy, *Forty-Second Street*. With the success of the film, he

moved to Hollywood to work as a story editor and script writer. Among his other dance-related works are the novel, *Stage Mother*, and the films, *Go Into Your Dance* (First National, 1935), *Sing Dance, Plenty Hot* (Republic, 1940) and the *Hit Parade of 1941* (Republic, 1940).

Bradley, Buddy, American theatrical and film dance director working in England; born Clarence Bradley Epps, July 25, 1913 in Epps, Alabama. Bradley, who claimed to have no formal training, made his professional debut in a revue staged by dancer/choreographer Leonard Harper in 1926, possibly at the Apollo Theater, New York, at which Harper would soon become a resident director. He performed in Harper revues and on the black and white vaudeville circuits before moving to London, where he would remain for most of his professional life.

As a choreographer and teacher, Bradley has been partly responsible for popularizing American jazz dance in the English theater, film, and television. Although not the first American to try to introduce tap and jazz dance in England, his London school (1933–1967) has successfully trained most of the dancers appearing in American and native musical comedies and on television variety shows. Bradley's English shows included revues both staged for C.B. Cochran and self-produced, and musical comedies. He is especially remembered for the shows and films that he staged for Jessie Matthews, among them *Evergreen* (stage: 1930, film: Gaumont Pictures, 1934) and Cochran's *1931 Revue*. As well as staging live shows in the American dance style, he used the techniques in his early English sound musical films, especially in the radio backstage comedies *On the Air* (British Lion Pictures, 1934) and *Radio Parade of 1935* (British & Dominion Film Corp., 1935).

Bradley, and the troupe trained at his school known as The Buddy Bradley Dancers, appeared frequently in London carbarets and music halls. They were also featured on many mid-1950s British television variety shows, including Parnell's *Star Time* (BBC, 1958), *Show Window* (BBC, 1959), and *The Henry Caldwell Show* (ATV, 1959).

Works Choreographed: THEATER WORKS: *Evergreen* (1930); *Cochran's 1931 Revue* (1931); *Hold My Hand* (1931); *Words and Music* (1932); *Mother of Pearl* (1933); *Happy Weekend* (1934); *Anything Goes* (1938); *All Clear* (1939); *Lights Up* (1940); *Sauce Tartare* (1943, choreographed and produced revue); *Sauce Piquante* (1950, choreographed and produced revue).

FILM: *The Little Damozel* (British & Dominion Film Corp., 1933); *Evergreen* (Gaumont Pictures, 1934); *On the Air* (British Lion Pictures, 1934); *Two Hearts in Waltz Time* (Nettleford-Fogwell Picture Corp., 1934); *Brewster's Millions* (British & Dominion Film Corp., 1935); *Radio Parade of 1935* (British & Dominion Film Corp., 1935).

Bradley, Grace, American theatrical and film dancer; born c.1914 in Brooklyn, New York. Bradley made her debut as an adolescent in the W.C. Field's vehicle, *Ballyhoo* (1930) and followed that unsuccessful start with *The Third Little Show* (1931) and *Strike Me Pink* (1933). Although none of those shows had long runs, her redhaired beauty and graceful dance work made her reputation.

She was offered a film contract as a vamp in Harold Lloyd comedies, and was cast as dancing seductresses in a long series of Paramount musicals and melodramas, among them, *Come In Marines* (1934), *She Made Her Bed* (1934), *The Gilded Lily* (1935) and *Stolen Harmony* (1935). On loan to other studios, she made *Red-Head* (Monogram, 1940), *Dangerous Waters* (1936), and *Romance on the Run* (Republic, 1937). After her marriage to actor William Boyd, best known as "Hopalong Cassidy," she cut down on her vamping and returned to straight musical comedies, such as *There's Magic in Music* (Paramount, 1941). Although known now only to aficionados of the last Late Shows, Bradley was second only to Jean Harlow as a dancing vamp. Her appearance in *She Made Her Bed*, especially, is an indictment of the Hollywood view of woman and dance; in the James M. Cain plot, she represents evil and demonstrates it through her dance work.

Bradley, Lisa, American ballet dancer; born 1941 in Elizabeth, New Jersey. Bradley received her ballet training from Fred Danieli, at his School of the Garden State Ballet, and at the School of American Ballet in New York; she has also studied modern dance with Joyce Trsiler.

After performing with the Garden State Ballet in her adolescence, Bradley joined the Joffrey company of the 1960s, called the City Center Joffrey Ballet after 1966. There, she created roles in many works with Gerald Arpino, among them, his *Sea Shadow* (1936), *Incubus* (1962), *Viva Vivaldi!* (1965), *Nightwings* (1966), and *Secret Places* (1968), as well as Joffrey's own *Gamelan* (1962).

Her featured roles with the Joffrey company included Balanchine's *Square Dance*, in the revival of the original version, and *Pas de Dix*, Arpino's *Partita for Four*, Marc Wilde's *The Glass Heart*, and Jerome Robbins' extraordinary *Moves*, performed in silence. She worked with the First Chamber Dance Company from 1967, notably in Lois Bewley's *Death and the Maiden* (1974) and *Quartet in D Minor*, and with the New York City Opera.

From 1972 to 1976, Bradley was a permanent guest artist with the Hartford Ballet, directed by Michael Uthoff, a fellow former Joffrey dancer. She created roles in three of his major works there, *Quartet* (1968), *Aves Mirabiles* (1973), and *Primavera* (1975), while making guest performances with other companies, notably the Joffrey and the Royal Winnipeg Ballet. A dramatic dancer with delicate and precise ballet technique, her guest appearances range from the classic repertory to José Limón's *The Moor's Pavanne* and George Balanchine's *Apollo*.

Brady, Eileen, American ballet dancer; born during the 1950s; trained at the American Ballet Center, Brady performed with the Joffrey II company, creating a role in Lawrence Rhodes *Four Essays* (1971). Graduating to the City Center Joffrey Ballet, she danced in the premiere of Twyla Tharps' *As Time Goes By* (1973) and in the company revivals of Frederick Ashton's *Façade* and *The Dream* and Leonid Massine's *Parade*, as one of the "Acrobats."

Brae, June, English ballet dancer; born June Baer, 1917 in Ringwood, England. After studies with George Goncharov in China, Brae continued her training at the Sadler's Wells Ballet School, in London, and with Nicholas Legat in Paris.

After performances with Marie Rambert, possibly in film, Brae joined the Vic-Wells Ballet in 1935. In that company, she created roles in many of the most important works in the developing English Ballet, among them, Frederick Ashton's *Nocturne* (1936), *A Wedding Bouquet* (1937), and *Cupid and Psyche* (1939) and Ninette De Valois' *Checkmate* (1937), playing "The Black Queen." She danced "The Lilac Fairy" in the 1939 *The Sleeping Princess* and was also featured in the stagings of *Coppélia* and *Swan Lake*.

With the Sadler's Wells Theatre Ballet and Ballet after a brief retirement, she created roles in Robert Helpmann's *Adam Zero* (1946) and Andrée Howard's *Assembly Ball* (1946). Her featured roles included parts in De Valois' *The Haunted Ballroom*, Ashton's *Harlequin in the Street*, Howard's *La Fête Etrange*, and the company's celebrated production of *Les Sylphides*.

Braggiotti Sisters, Italian-American interpretive dancers; Berthe, Francesca, and Gloria were born in Florence, c.1895–1905; Berthe died c.1925 in Boston. Members of a large musical family, the Braggiottis were raised in Florence where they studied with a Mlle. La Roche. In the United States after the early 1920s, they spent summers at Mariarden, the Denishawn encampment in Peterborough, New Hampshire, where Francesca and Gloria appeared in St. Denis' *Cupid and Psyche* (1923). They both took classes with Luigi Albertieri in New York; Gloria also studied at the Ned Wayburn Studio for Stage Dancing there.

Berthe and Francesca ran a school in Boston while performing in prologs there. After Berthe's death, Gloria became a member of the faculty and act. It is possible that all three gave recitals, although programs exist only for Francesca, who gave concerts in 1925 and 1931 as a soloist and in 1928 as part of the Denishawn Lewisohn Stadium program, where she appeared in St. Denis' *The Lamp* (1928).

Neither of the two sisters remained in dance after the mid-1930s. Gloria became a journalist, serving as fashion editor of the old *New York Evening Post*, while Francesca moved back to Italy where she became a star of film epics.

Works Choreographed: CONCERT WORKS: (Note: all credited to Francesca Braggiotti.) *Frangrences* (1925); *Liebeslieder Waltzer* (1928); *Souvenir* (1931); *Skirt Fantasy* (1931); *Study in Shadows* (1931); *Two*

Songs with Dance (1931); *Isolde: Her Grief and Ecstacy* (1931, also performed as *Liebestod*).

Bibliography: Braggiotti, Gloria. *Born in a Crowd* (New York: 1957).

Brandeaux, Pal'mere, American burlesque and cabaret dance director; born in 1899 in Lawton, Oklahoma; died May 22, 1965 in New York City. Brandeaux's first professional experience was in a vaudeville dance act with a female partner named Dore Daudet. They had an "ultrasophisticated" exhibition ballroom act, which was denigrated by critics probably since they had never seen a real Apache, Hesitation, or one-step. After moving to Chicago and New York for coaching, they transformed their act into a comedy eccentric dance act, satirizing the forms that they had previously adopted. The latter format was much more successful and led to engagements in many of the Shubert Brothers' revues of the 1920s, including the *Artists and Models of 1924* and *1927* and *The Passing Show of 1925*..

It is not known how Brandeaux became known as a expert on burlesque, but by 1939 he had become the resident dance director on the Republic Studios' series of films about that art form. He also worked at Universal as a coach and at the Educational Pictures studio (of Hal Roach) before a plane crash in Toronto left him in a wheelchair for the rest of his life. Owing partly to the rehabilitation innovations of World War II, he was able to work for more than twenty years after the accident. He became a dance director and designer at the Minsky Theaters, the Follies Theatre in Los Angeles, the Copacabana, and the Earl Carroll Hollywood cabaret—all of which featured burlesque acts. He also designed on the short-lived Dumont network in the early 1950s.

Works Choreographed: THEATER WORK: Club acts for the Minsky Theater, Follies Theatre, Los Angeles, Casino Theater, Toronto, Copacabana, New York (1935-1955); *This was Burlesque* (1961).

TELEVISION: *Star Time* (Dumont, 1950-51, also designed show.)

Branitzka, Nathalie, Russian ballet dancer; born 1909 in St. Petersburg; died March 8, 1977 in New York. Trained in St. Petersburg by Vaganova and in Paris by Lubov Egorova, she performed in Berlin with Vera Trefilova and Pierre Vladimioff (c.1925). She danced in Boris Kniaseff's company in Paris (c.1930) before joining the De Basil Ballet Russe de Monte Carlo from 1932 to 1940. Associated with the works of Leonid Massine, she appeared in his *Choreartium, Jeux d'Enfants, Beach*, and *Scuola di Ballo*, as well as Mikhail Fokine's *Carnaval* and *Les Sylphides*.

Retiring from performance in 1940, she immigrated to the United States to teach.

Braun, Eric, Austrian ballet dancer performing in the United States from the 1940s; born c.1924 in Vienna, Austria; died October 27, 1970, in Highland Park, Illinois. Training originally at the school of the Vienna Opera Ballet, Braun came to the United States to study with Bronislava Nijinska.

Joining Ballet Theatre in 1945, Braun remained with the company until his retirement in 1956. Among the many roles that he danced in those eleven years were "Alain" in *La Fille Mal Gardée*, the "Boy in Green" in Frederick Ashton's *Les Patineurs*, the "Lead Cadet" in David Lichine's *Graduation Ball*, and both the "First" and "Third Sailors" in Jerome Robbins' *Fancy Free*.

After leaving Ballet Theatre, Braun moved to the Chicago area where he staged industrial shows and taught at the North Shore Academy of Dance. Braun died of a heart attack in October 1970, while teaching a ballet class there.

Brayley, Sally, English ballet dancer working in Canada and the United States from the 1950s on; born 1937 in London, England. Trained originally in Toronto, Canada, by Celia Franca and Betty Oliphant, she continued her studies in New York at the school of the Metropolitan Opera, with Margaret Craske and Antony Tudor, and with Lillian Moore and William Griffith of the American Ballet Center.

After an apprenticeship with the National Ballet of Canada, Brayley joined the ballet company attached to the Metropolitan Opera in New York. Dancing for the Met for four years, she appeared in Tudor's ballets, *Echoing of Trumpets* (1966), and *Concerning Oracles*, in many operas, among them, *La Perichole*, and, in the celebrated *Dance of the Hours* sequence, the revival of *La Gioconda*. In her last two years of

performing, Brayley danced with the City Center Joffrey Ballet, in Gerald Arpino's *Viva Vivaldi!* and *Elegy*, and with the New York City Opera, in *Prince Igor* and *Manon*.

As Sally Brayley Bliss, she has served as associate director of the Joffrey II Company from 1970 to 1974, and as director from 1975 to the present. She has choreographed two works for the company, *Pas de Deux* (1971) and *Dies und Das* (1973), but acts primarily as an administrator.

Breaux and Wood, American theatrical and film dancers and choreographers; Marc Breaux, born c.1925 in Louisiana, and Dee Dee Wood, whose birth date cannot be verified, began to work together as choreographers after many years as Broadway dancers. Breaux was trained by Charles Weidman and Lee Sherman before meeting Wood while both were dancing on the Stan Kenton show, *Music 55* (CBS, Summer 1955). After performance credits in *Kiss Me Kate* (1948), *Ballet Ballads* (1948), and *Catch a Star* (1955), they danced in and assisted choreographer Michael Kidd on his industrial *Motorama*, and Broadway smashes, *Li'l Abner* (1956) and *Destry* (1959). After Wood restaged Kidd's dances for the film of *Li'l Abner*, they moved to Hollywood where they have become successful dance directors for a string of extraordinarily popular films, including two of the all-time money makers, *Mary Poppins* (Buena Vista, 1964) and *The Sound of Music* (Argyle/Twentieth-Century Fox, 1965). They worked together consistently in films, but Breaux has done one Broadway show alone.

Works Choreographed: THEATER WORKS: *Do-Re-Mi* (1960); *Subways Are for Sleeping* (1961); *Minnie's Boys* (1970, Breaux only).

FILM: *Li'l Abner* (Paramount, 1959, choreographed by Wood after Michael Kidd); *Mary Poppins* (Buena Vista, 1964); *The Sound of Music* (Argyle/Twentieth-Century Fox, 1965); *The Happiest Millionaire* (Buena Vista, 1967); *Chitty Chitty Bang Bang* (UA, 1968).

Bremer, Lucille, American film dancer; born c.1922 in Amsterdam, New York. Bremer had been a Rockette, working under Florence Rogge and Leon Leonidoff, before she was offered a contract from MGM in the early 1940s. Although announced as the next "dancing star in the Hollywood constellation," she appeared in only four films with dance sequences in them.

After debuting in *Meet Me in St. Louis* (1944), in which she waltzed, she was cast in the first of two films with Fred Astaire. In *Yolanda and the Thief* (1945), a Vincente Minnelli fantasy choreographed by Eugene Loring, she had two dance numbers with Astaire, the most notable of which is the famous dream sequence performed on a spiraling dance floor with long veils. In *Ziegfeld Follies* (1945), an unmanageable compilation film featuring most of MGM, she danced twice with Astaire in choreography credited to him and Charles Walters. Both these routines included dream sequences—always a feature of Hollywood choreography, but one that was especially associated with her films. In both, she is a wealthy woman who dances with and then spurns Astaire, returning to him only in his dream. The first number actually works best since it is set at a ball and allows the dancers to work with Astaire's favored exhibition ballroom style; the second, better known, sequence, the famous "Limehouse Blues," was celebrated in its time but grates now with its pseudo-Chinoiserie. Bremer's last dance film was another MGM compilation, built around a biography of Jerome Kern—*Till the Clouds Roll By* (1946), choreographed by Robert Alton.

Brenaa, Hans, Danish ballet dancer and choreographer; born October 9, 1910 in Copenhagen. Trained at the school of the Royal Danish Ballet, he graduated into the company in 1928. Best known for his work in the company's many productions of the nineteenth-century classics, he created a major role in Harald Lander's contemporary ballet *Etude* (1948) and was featured in Frederick Ashton's staging of *Romeo and Juliet*. He has choreographed original works and revived the ballets of Bournonville and Petipa for the company.

Works Choreographed: CONCERT WORKS: *Aurora's Wedding* (1949, co-choreographed with Lubov Egorova after Marius Petipa); *Far from Denmark* (1956, with Niels Bjørn Larsen after Bournonville); *Harlequinade* (1958, after Petipa); *Moods* (1964); *William Tell Variations* (1967, after Bournonville);

La Sylphide (1967, co-choreographed with Flemming Flindt after Bournonville); *Konservatoriet* (1969, after Bournonville); *La Sylphide* (1973, with Frank Schaufuss after Bournonville).

Breuer, Peter, German ballet dancer; born October 29, 1946 in Tegernsee, West Germany. Trained by Viktor Gsovsky, he joined the Munich State Opera Ballet in 1961. From 1965 to 1974, he was a featured dancer with the Dusseldorf opera ballet of Erich Walter, for whom he performed in *Baiser de la Fée, The Four Seasons, Sacré du Printemps, Kalevala, L'Orfeo,* and *The Legend of Joseph.* His work in the principal roles of the classical repertory brought him many guest engagements as "Siegfried" and "Albrecht" with the London Festival Ballet, American Ballet Theatre, and German companies. With the Berlin Opera Ballet from 1974, he played the male title role in the Boyarchikov production of *Romeo and Juliet* and learned featured parts in George Balanchine's *Serenade, Apollo,* and *Four Temperaments.*

Brewster Twins, American dance team; born c.1918. Barbara and Gloria Brewster, whole real names were Naomi and Ruth Stevenson, were awarded film contracts in the late 1930s and appeared in a number of musicals with their tandem act. They were frequently placed on either side of the female star vocalist, as they were for Simone Simone in the exceptionally romantic "May I Drop a Petal in Your Cup of Wine?" number in *Josette.* Although Gloria dropped out of dance after her marriage to Claude Stroud (of the Stroud Twins) and worked with him on radio, Barbara had a solo career on Broadway in the late 1930s and early 1940s. Her most memorable appearance was as a specialty dancer and embodiment of the title in the George Jessel/Sophie Tucker vehicle, *High Kickers* (1941).

Brexner, Edeltraud, Australian ballet dancer; born June 12, 1927 in Vienna. Brexner was trained at the school of the Vienna State Opera Ballet and graduated into the company in 1944. She has been associated throughout her career with the works of Erika Hanka, for whom she danced in *Titus Feuerfuchs* (1950) and *Abraxas* (1953), *Giselle, Joan von Zarissa, Romeo and Juliet,* and *Turandot,* among many others. After retiring from the Opera, she taught at her alma mater but took out time to perform at the annual celebrations of Austrian heritage in New York City.

Brian, Donald, Canadian musical comedy performer and exhibition ballroom dancer; working in the United States; born February 17, 1877 in St. John's, Newfoundland; died December 22, 1948 in Great Neck, New York. Raised in Boston, Brian was trained there in pedestal and tap dancing by an English championship clogger resident in New England. After a short career as a boy soprano and a longer one as a peripatetic tenor, Brian worked with a series of stock companies in Boston, Connecticut, and Hoboken, New Jersey. He actually made his Broadway debut during the run of *Three Little Lambs* in early 1900 but began his long period of constant employment in 1902 when he joined the replacement cast of *Florodora,* at the New York Theater Roof Garden. He created the principal male roles in sixteen musical comedies and appeared in half a dozen more. He was the original "Henry Hapgood" in George M. Cohan's *Little Johnny Jones* (1904) and the "Tom" in his *45 Minutes from Broadway,* but was remembered best for two operettas. Brian was the first American "Danilo" and introduced "Maxim's" and both the "Gold and Silver" and "Merry Widow" waltzes. Fourteen years later, he was "Bumerli" in *The Chocolate Soldier,* while in between he sang and danced in *The Dollar Princess* (1909), *The Siren* (1911), *The Girl from Utah* (1914), and *The Girl Behind the Gun* (1918). Brian also appeared in two silent melodramas, feature films and in a number of Broadway Brevity short subjects for Vitaphone/First National.

Brian's career had a slight twist in the 1910s. He extrapolated dance numbers from his successful shows and published work notes for them in syndicated papers. The theatricalized social dances included "The Merry Widow Waltz" (which was actually a ladler), copyrighted in 1911, "The [Dollar] Princess Waltz" (1911), "The Siren Waltz Caprice" (1911), and the "Girl from Utah Cakewalk" and "Fox Trot" (both 1915). Most of the dances were actually glides and one-steps to be performed with the woman standing in front and slightly to the side of her partner or with the participants facing each

other, hands raised above their heads and lips meeting in a prolonged kiss.

Brianza, Carlotte, Italian nineteenth-century ballet dancer, known as the first "Aurora" in *The Sleeping Beauty*; born 1862 in Milan; died 1930 in Paris. Trained by Carlo Blasis in Milan, she performed frequently at the Teatro alla Scala, notably in Josef Hanssen's *La Maladetta* in 1875.

Brianza was, however, best known for her performances on tour—across Europe and to the East Coast of the United States—and in St. Petersburg. She first worked there at the Arcadia Theater, in a production of Manzotti's *Excelsior,* which for many years was Milan's chief export. Joining the Maryinsky Theater for a series of annual performances from 1889, she created roles in Lev Ivanov' *The Tulip of Haarlen,* Marius Petipa's *Kalkabrino,* and, her most celebrated part, "Aurora," the title role in *The Sleeping Beauty* (1890).

She returned to Italy in 1891 to teach, later opening a studio in Paris. Her appearance as "Carabosse," the wicked fairy in Diaghilev's London revival of *The Sleeping Beauty* in 1921, is believed to have been her last public performance.

Brice, Elizabeth, American theatrical dancer and actress; born Bessie Shaler, c.1885 in Findlay, Ohio; died January 25, 1965 in Forest Hills, New York. After local training in Delsarte elocution and social dance, Brice made her Broadway debut in the chorus of *A Chinese Honeymoon* in 1906. She worked steadily as a dancer and actress in progressively larger roles in *Nearly a Hero* (1906), *The Belle of New York* (1908), *Mlle. Mischief* (1908), *The Mimic World* (1908), *The Motor Girl* (1909), and *The Jolly Bachelor* (1910). In 1910, she formed a partnership with Charles King for exhibition ballroom and musical comedy performance in vaudeville and on Broadway. They danced together in *The Sun Princess* (1911), *A Winsome Widow* (1912), *Tantalizing Tommy* (1912), *Watch Your Step* (1914), and *Miss 1917,* as well as tours of the Keith and Orpheum circuits. Brice also worked in the World War I equivalent of USO tours as female star of Will Morissey's *Toots Suite* (1918-1919). She retired after fifteen years of performing.

Brice, Fanny, American comedienne; born Fannie Borach, October 29, 1891 in New York; died May 29, 1951 in Los Angeles. Although only the most myopic balletomane would consider it her major accomplishment, Brice was the most important dance satirist of the early twentieth century. With no formal training, Brice made her debut at thirteen as an amateur at Keeney's Theater, Brooklyn, singing "When You Know You're Not Forgotten by the Girl You Can't Forget." She worked for many years in Burtwig and Simon burlesque shows until, in 1910 according to tradition, she was discovered by Florenz Ziegfeld, Jr. while singing "Sadie Salome, Go Home" in their *Transatlantic Revue.*

Brice performed in eight Ziegfeld *Follies*—(1910, 1911, 1913, 1916, 1917, 1920, 1921, and 1923), as well as his *Midnight Frolics* of 1919. Among her best known characterizational songs were the "Sadie" and "Becky" series about girls from the Lower East Side who wanted to be dancers: "Sadie" wanted to be an exotic "Salome" but was "Egyptian in all but her nose," while Becky, her younger sister who started life as a nautch-er "from Babylon" (Long Island) decided to become a ballerina and "had it over Madame Pavlova," until she was sent back to the chorus of a Shubert show. Her other dance-derived satires included "Countess Dubinsky, who now strips for Minsky," in the Shubert's *Follies of 1934,* a daughter of "an original member of the original Florodora Sextette" in the *Ziegfeld Follies of 1920,* and, in the 1916 edition's take-off of the Ballet Russe, Vaslav Nijinsky, whose "Fantastical style beats the Castles a mile." There is no evidence that the *Swan Lake* satire shown in her film biography *Funny Girl* ever took place, but she did include a "Dying Swan" imitation in her vaudeville act in the early 1920s.

Before retiring from the stage to work in radio, Brice performed in both Shubert productions of the *Follies,* in 1934 and 1936, and in two Billy Rose revues (*Sweet and Low,* 1930, and *Crazy Quilt,* 1931), and in the *Music Box Revue of 1924.*

Bridgeman, Art, American postmodern dancer and choreographer; born April 7, 1950 in Minneapolis, Minnesota. Bridgeman began his dance training at Tufts University under Griselda White. He worked

briefly with Hanya Holm and Nancy Hauser in Minneapolis before moving to New York City. Since 1976, he has become one of the most highly regarded freelance modern and postmodern performers, with credits from Nancy Meehan, the three choreographers of the Nimbus troupe (Erin Martin, Jack Moore, and Alice Tierstein), Irene Feigenheimer, and Linda Tarnay. His work with Harry Streep's Third Dance Company has brought him to special critical attention for his clarity and strength of movement. He has done collaborative choreography with Tarnay and with fellow Nimbus and Streep dancer, Myrna Packer.

Works Choreographed: CONCERT WORKS: *July 20th, Jefferson Gorge, Vermont* (1978, in collaboration with Myrna Packer); *Beginning Sphere* (1978, in collaboration with Linda Tarnay); *Going the Distance* (1979); *One More Time* (1980).

Brill, Patti, American film dancer and theater personality; born Patricia Brilhante, March 8, 1923 in San Francisco; died January 16, 1963 in the Los Angeles area of California. Brill also performed as Patsy Paige. Raised in Los Angeles with her theatrical family, she appeared in films as a child, probably as an Ernest Belcher Movie Tot. After dancing in *Lilies of the Field* (First National/WB, 1929) and *The Vagabond Lover* (RKO, 1929), she took ten years off to complete her schooling, reemerging as a Universal Studio contract adolescent. She was the specialty dance lead in *Mad About Music* (1938) and the Deanna Durbin vehicle *1000 Men and a Girl* (1939), before switching to freelancing as a performer. She danced in *Best Foot Forward* (MGM, 1940), *Star Spangled Rhythm* (Paramount, 1942), Gypsy Rose Lee's *Lady of Burlesque* (UA, 1943), and *Music in Manhattan* (RKO, 1944), before becoming a staple of two series of disparate films—the Paramount comedies about "Henry Aldrich" (1941–1944) and the RKO thrillers starring "The Falcon" (1943–1947).

Brill worked as a performing emcee (or "Sam Asher" in the theatrical jargon) in Special Services and USO shows during World War II. In that capacity, she became a West Coast star in *Meet the People* (1940), *It's a Great Day,* and the *Wheelchair Revue.* In the latter (a company of paraplegic veterans, their nurses, and Special Service personnel) she became

nationally known. Brill also worked on early television, emceeing the innovative *Let There Be Stars* (ABC, 1949).

Brisson, Carl, Danish theatrical dancer and vocalist; born Carl Pedersen, December 24, 1895 in Copenhagen; died there September 26, 1958. A former welterweight boxing champion of Europe, he had an acrobatics act with his brother in Denmark. In 1916, he and his sister-in-law, Tilly Willard of the Willard Sisters act, made their exhibition ballroom debut in Copenhagen. Known as the "Astaires of Europe," they became extremely popular in Scandinavia and Western Europe. Brisson opened a cabaret in Copenhagen where he danced and produced club acts, such as *Hullo, America* (1917), *ZigZag* (c.1918), and *Brisson's Blue Blondes* (c.1919).

He made regular visits to London after 1921, appearing in music halls and as "Danilo" in the 1923 revival of *The Merry Widow.* Among his many English show appearances were *Cleopatra* (1925) as a specialty dancer, *The Apache* (1972), and *The Wonder Bar* (1930), while his many British films included Alfred Hitchcock's *The Manxman* (British International, 1929), *The Prince of Arcadia* (Littleford-Fogwell, 1933), and *Two Hearts in Waltz Time* (Littleford-Fogwell, 1934).

In the United States from 1934, he appeared in films, such as *Murder at the Vanities* (Paramount, 1934) and *All the King's Horses* (Paramount, 1935), and danced on Broadway in Sigmund Romberg's *Forbidden Melody* (1936). In nightclubs after 1943 he did his signature song, "Cocktails for Two," but did not dance much, in keeping with his title, "Elder Statesman of Glamour." Freedom of movement must have been important to him, however, since he was a pioneer in the use of a hand-held microphone.

Britton, Donald, English ballet dancer; born 1929 in London. After early studies at the Maddocks School, Bristol, he attended the Sadler's Wells School in London. Britton performed with the Sadler's Wells Ballet and Theatre Ballet throughout his career with a large number of roles in both classical and contemporary repertory. He created featured parts in Kenneth Macmillan's *Danses Concertantes* (1955) and *The Burrow* (1958) and in John Cranko's *Sweeney*

Todd (1959). His additional roles range from "Rake" in Ninette De Valois' *The Rake's Progress* and "The Boy" in Andrée Howard's *La Fête Etrange* to the ridiculous "Captain Belaye" in Cranko's *Pineapple Poll.*

Britton retired to teach at the Royal Ballet School and the Arts Educational Trust, and has also taught in France.

Brock, Karena, American ballet dancer; born September 21, 1942 in Los Angeles, California. Brock studied ballet with David Preston while attending Texas Christian University and continued her training with Dorothy Perkins, David Lichine, and Tatiana Riabouchinska.

After performing as an adolescent with the Ballet Celeste, in San Francisco, and the Dutch National Ballet, Brock joined the Ballet Theatre, with which she danced until 1979. Among the many ballets in which she created roles during those sixteen years are Eliot Feld's *Eccentrique* (1971) and Dennis Nahat's *Momentum* (1969), *Mendelssohn Symphony* (1971), and *Some Times* (1972), as well as the company premiere of his *Ontogeny.* She participated in many productions of the Ballet Theatre Workshop, including Richard Wagner's *Beatrice* (1964), Enrique Martinez' *Balladen der Liebe* (1965), Fernand Nault's *Bitter Rainbow* (1964), Robert Gladstein's *Way Out* (1970), Steven-Jan Hoff's *Lilting Fate* (1969), and Tomm Rudd's *Polyandrion* (1973). Brock was also acclaimed for her work in demicharacter roles in the company's revival of the classics, notably *Coppélia, La Bayadère,* and *Raymonda.*

She currently serves as artistic director of The Savannah Ballet.

Bronner, Cleveland, American ballet, theater, and concert dancer and choreographer; born c.1875 in Detroit, Michigan; died November 9, 1968 in Norwalk, Connecticut. It is easy at first to think of Bronner's career as an anomaly of American popular entertainment, an untrained ballet dancer staging and designing spectacular works based on legends and mythologies of exotic or fabulous worlds. But, on further consideration, it is Bronner's choice of technique that is unique; in other ways, he is remarkably similar to Ruth St. Denis and Ted Shawn.

He worked in stock as an adolescent but did not study either art or dance. From all available evidence, it seems that Bronner simply set himself up with a vaudeville act that got progressively more elaborate and artistic. By 1918, his feature acts featured himself as danseur, two female performers (including his wife, Ingrid Solfeng), and a light show of effects. His 1918 act, *Dream Fantasies,* brought him to the attention of J.J. Shubert, who put him on a nonexclusive contract to provide ballet sequences for the *Passing Shows of 1920* and *1923,* and the *Midnight Rounders* (a midnight matinee show on the Century Theater roof). The ballets ranged from *The Princess Beautiful* (in *Make It Snappy,* 1923), about the aftermath of a human sacrifice, to the Egyptian *Ballet of the Pyramids,* to his most innovative abstraction, *A Fantastic Conception of 24 Hours.*

Bronner and Solfeng retired from the entertainment industry in the early to mid-1920s. In an interview in 1918, he complained that his name would soon be forgotten and that his artistic conceptions would be lost forever. It is sad, but his prediction has come true, and his works, whatever their artistic merit, are forgotten.

Works Choreographed: THEATER WORKS: *Ballet of the Pyramids* (1917, vaudeville feature act); *Dream Fantasies* (1918, vaudeville feature act); *A Fantastic Conception of 24 Hours* (from *The Midnight Rounders,* 1920); *The Temple of Tannit* (from the *Passing Show of 1920*); *The Princess Beautiful* (from *Make It Snappy,* 1923).

Brooke, Tyler, American theatrical dancer; born Hugo Hansen in 1889 in Bay Ridge, Brooklyn; died March 2, 1943 in Hollywood, California. Trained by William Pitt Rivers in Brooklyn, he made his professional debut in the chorus of *The Air King* in 1899. Capable of playing suave sophisticates and juveniles, he worked constantly on Broadway from 1912 to 1925, appearing in *The Rose Maid* (1912), *Oh, I Say* (1913), *Very Good Eddie* (1915), *So Long Letty* (1917), *Angel Face* (1920), and *No, No, Nanette.* He moved to Hollywood in the mid-1920s where he appeared in Hal Roach comedies. Under contract to Twentieth-Century Fox in the 1930s, he was cast in *Alexander's Rag Time Band, Little Old New York* (1940), *Poor Little Rich Girl* (1936), and *Tin Pan Al-*

ley (1940). Brooke committed suicide after two years of unemployment.

Brooks, Louise, American concert and theatrical dancer and film star; born 1906 in Cherryvale, Kansas. Reportedly without previous dance training, Brooks joined the Denishawn school in Los Angeles after having seen Ruth St. Denis perform at a local theater. In her two seasons of touring with the Denishawn Concert group, she danced in two music visualizations—*Revolutionary Etude* and *Sonata Tragica*—and in two larger works, St. Denis' *The Spirit of the Sea* (1923) and Ted Shawn's *The Feather of the Dawn,* later that season.

Instead of accompanying them on the Denishawn tour of India and Asia, she moved to New York to perform on Broadway. She danced in the George White *Scandals* of 1924, then, after an engagement at the Café de Paris in Paris, performed in Ziegfeld's *Louie the 14th* (1925). Her first films were made at the Paramount Studio in Astoria, New York during that run. Following her appearance in the *Ziegfeld Follies* of 1925, she left for Hollywood to concentrate on films.

A brunette with a world-famous bob, Brooks played typical American young women in her silent films, notably in *The American Venus* (1926), *The Show Off* (MGM, 1931), and *The Canary Murder Case* (1929) (for Paramount). After she went to Germany to play the title role in Ernst Pabst' film of *Lulu,* however, she found that she could not return to the Hollywood studios. She made attempts at two dance-related comebacks—in an adagio team with Dario in 1934 and in the chorus of a musical, *When You're in Love* (Columbia, 1936), staged by Leon Leonidoff. Her loss to films is inestimable.

Brooks, Roman, American modern dancer; born July 5, 1950 in Milington, Texas. Brooks attended the Harlan-Compton College and began his professional dance training with Eugene Loring. After working with the Dance Theatre of Harlem in its contemporary repertory of works by Geoffrey Holder, Louis Johnson, and its director Arthur Mitchell, he joined the Alvin Ailey American Dance Theatre, where he has been cast in principal roles in Ailey's most popular work, *Revelations,* and in his new *Phases* and *Memoria,* as well as Kathryn Posin's *Later That Day* (1980) and Todd Bolender's dramatic *The Still Point.*

Brown, Beverly, American modern dancer and choreographer; born in the late 1940s in Effingham, Illinois. Brown began her dance training at Carlton College with Nancy Hauser and spent her summers in Colorado working with Hanya Holm. When she moved to New York, she took classes with Alvin Ailey, Holm, Merce Cunningham, the faculty of the American Ballet Center, and Erick Hawkins. Brown first became known for her extraordinarily powerful and clear performances with the Hawkins company, appearing in many of the choreographers "classics," among them revivals of *Eight Clear Pieces, Here and Now with Watchers,* and the premiere of *Classic Kite Tails* (1972). While in the company, she performed with the concert groups of her colleagues, including early recitals by Rod Rogers and Anthony La Giglia. She formed a cooperative company with other Hawkins dancers, including most of the cast of *Classic Kite Tails* (Nada Reagan Diachenko, Natalie Richman, Lillo Way, and others), called the Greenhouse Ensemble, and presented her own works in group concerts. She has had a personal company since 1976, when she founded her own Dancensemble.

Brown also works within a form that she calls Theatre for Bodies and Voices—a group of performers who work with the visual and audible elements of performance. She has said that the impetus for her shift in choreographic style came from working with composer Eleanor Hovda who included vocal sounds by Brown in her score for her *Fire Fall* (1974). She now works most frequently in a solo/duet program with Roger Tolle, but also does a tremendous amount of teaching and residencies with a sextet company.

Works Choreographed: CONCERT WORKS: *Stone Drift* (1970); *Ruth's Journey* (1970); *Whelk Woman* (1970); *Cloudspeed* (1971); *Season of Earth Hush* (1973); *Body Music* (1973); *Fire Fall* (1974); *Glympses of When* (1974); *Foothills* (1974); *Life in a Drop of Pond Water* (1975); *Wedding Gift* (1976);

The Reason Why: Dragonfly (1976); *Voices of the Becalmed* (1976); *Balada* (1978); *Awakening* (1978); *Drums and Dancers* (1978); *Mosaic* (1979); *Footprints* (1980); *Attic Antics* (1980); *Vuelta* (1980).

THEATER WORKS: *Popolvuh* (1978).

Brown, Carolyn, American modern dancer and choreographer; born 1927, Fitchburg, Massachusetts. Brown first studied dance with her mother, Marion Rice, who directed a Denishawn school in Fitchburg. After college, she moved to New York to enter the Juilliard School where she studied ballet with Antony Tudor and Margaret Craske, performing in Tudor's *Excercise Piece* (1953). She also studied modern dance with Merce Cunningham.

Brown joined Merce Cunningham and Dancers in 1952, remaining with that innovative company for twenty years. From *Septet* (1953), choreographed at the Black Mountain College session during which the theories of chance dance were formulated, to 1972, she created roles in more than half of Cunningham's works. Among these are *Fragments* (1953), *Suite for Five* (1956), *Labyrinthian Dances* (1957), *Summerspace* (1958), *Gambit for Dancers and Orchestra* (1959), *How to Pass, Kick, Fall and Run* (1960), *Winterbranch* (1965), *Scramble* (1967), *Rainforest* (1968), *Canfield* (1969), *Tread* (1970), and *TV Rerun* (1972). Brown has also created roles in works by John Cage (*Theater Piece,* 1960) and Robert Rauschenburg (*Pelican,* 1963).

Brown has choreographed since 1965; her first work, *Balloon,* was created for Barbara Lloyd and Steve Paxton to perform at the First New York Theatre Rally, May 11, 1965, an evening of premieres by the founders of the postmodern dance movement. Her works have been choreographed for university groups, for the Manhattan Festival Ballet (*Car Lot,* 1968) and Ballet Théâtre Contemporain, Angiers, France (*Balloon II,* 1976), and for her group, the Among Company. She has also worked in film, creating *House Party* (1974) and *Dune Dance* (1975) in that medium.

Works Choreographed: CONCERT WORKS: *Balloon* (1965); *Car Lot* (1967); *West Country* (1970); *Zellerbach Maul* (1971); *As I Remember It* (1972); *Bunkered for a Bogie* (1972); *Synergy I, or, Don't Fight It,* *Bertha* (1973); *Port de Bras for Referees* (1973); *House Party* (1974); *Synergy II* (1974); *Cicles* (1975); *Balloon II* (1976); *Serious Song* (1977); *Duetude* (1977).

FILM: *House Party* (Independent, 1974); *Dune Dance* (Independent, 1975).

Brown, Earle, American composer; born 1926 in Lunenberg, Massachusetts. Brown's work with John Cage in the early 1950s brought him into the group of composers working in electronic, aleatoric and free-form music that gathered around the Merce Cunningham Dance Company, where Cage was musical director. Although his scores have been used by other choreographers, most notably Jack Moore in *4 Elements in 5 Movements* and his then-wife Carolyn Brown's *Carlot,* he is best known in the heliocentric dance world for his music for Cunningham pieces. Two of these, *Galaxy* (1956) and *Springweather and People* (1955), are in the company's current performance repertory.

Brown, Jessica [I], American theatrical ballet dancer; born c.1895. Brown made her theatrical debut as the specialty dancer and leader of the ballet in the Hanlon Brother's extravaganza, *Superba,* on tour in 1907. She worked as a toe dancer for four years, with the exception of a tour with Carter de Haven when she replaced the ailing Flora Parker, performing to pizzicato polkas and popular songs. In 1911, she was featured on a Sunday evening "Concert" (a performance called a sacred concert to avert the Sunday Blue Laws) in her ballet set to the popular "I'd Rather Two-Step than Waltz." Appearing on the program was pianist and songwriter, Bert Kalmar, doing a ragtime parody of the same song. They met while arguing over prior rights to the music, and were married shortly thereafter.

Brown toured with Kalmar for five years in a series of feature acts which he composed and she scripted and designed. They included *Nurseryland* (1916–1917) and an untitled act on which she danced a toe specialty (to Chopin), a Highland fling and an eccentric ragtime toe dance set to "Moving Man Don't Take My Baby Grand." Brown retired in the late 1910s, when Kalmar settled in New York to write

songs and shows with Harry Ruby. She was portrayed by Vera-Ellen in the MGM biopic of Ruby and Kalmar's professional lives, *Three Little Words.*

Brown, Jessica [II], American theatrical dancer; born c.1900 in Buffalo, New York. Brown was trained in Delsarte elocution and interpretive dance in Buffalo. After moving to New York she won her first chorus job by lying about prior experience with Ned Wayburn, then known as the "King of the Chorus." She was cast in the chorus of his *Ziegfeld Midnight Frolic of 1918* (history does not tell us what Wayburn said at their first meeting), and followed it with progressively larger dance roles and specialties in *Gloriana* (1918), *The [George M.] Cohan Revue* (1918), *Come Along* (1919), *A Lonely Romeo* (1919), *Cinderella on Broadway* (1920), *The Girl From Home* (1920), the *Midnight Rounders of 1921,* the *Ziegfeld Follies* of 1921 and 1922, and the *Frolics* of 1922. Her dance specialties ranged from social dance forms to tap work, but she was best known for her eccentric steps in the "legomania" style, in which high kicks were at the premium. Brown was considered second only to Evelyn Law in her ability to kick her foot up to her ear and beyond.

Brown retired from performance to marry the Lord of Northesk, Eleventh Earl of Glenesk, becoming the original of every rumor and fable about a Ziegfeld girl marrying royalty. The marriage failed, but she did not continue her career.

Brown, Karen, American ballet dancer; born October 6, 1955 in Okmulgee, Oklahoma. After moving to New York to prepare for a career in dance, she studied at the American Ballet Center and the school of the Dance Theater of Harlem. A member of the latter company since 1973, she has been seen in many works in the large eclectic repertory. Her graceful presence and strong technical grounding make her identifiable in the company's productions of works by choreographers from George Balanchine to Geoffrey Holder.

Brown, Kelly, American ballet and theatrical dancer; born September 24, 1928 in Jackson, Mississippi; died March 13, 1981 in Phoenix, Arizona. After

studying with his mother and sisters, who together ran the Taylor School of Dancing in Jackson, he continued his training with Bentley Stone and Walter Camryn at their studio in Chicago, and with Carmelita Maracci in Los Angeles. He made his professional debut with the Chicago Civic Opera Ballet in works by Stone, Camryn, and Ruth Page.

Brown was a member of Ballet Theatre after 1948, featured in works by contemporary American choreographers. Among his best remembered roles were "Pat Garrett" in Eugene Loring's *Billy the Kid,* and parts in Jerome Robbins' *Interplay* and *Fancy Free,* and Agnes De Mille's *The Harvest According* and *Rodeo.* He danced for De Mille on Broadway too, appearing in her *Goldilocks* (1958) and in revivals of *Brigadoon, Oklahoma,* and *Carousel.* His other major theater credits include roles in *Shinbone Alley* (1957) and *From A to Z* (1960) on Broadway, revues and prologs at the Radio City Music Hall, and the shows *That's Life* and *Joyride* in Hollywood live presentations. He performed frequently on television broadcast from New York in the 1950s and from Los Angeles in the 1960s, partnering Carol Lawrence on a number of specials including the *Bell Telephone Hour Almanac* (NBC, 1963, special).

Despite a long career in so many phases of dance, Brown is best known for a single role—the villainous leader of the townsmen in Michael Kidd's *Seven Brides for Seven Brothers* (MGM, 1954). Other film appearances include the juvenile lead in *Daddy Long Legs* (Twentieth-Century Fox, 1955), and a part in Gower Champion's *The Girl Most Likely* (RKO, 1957).

Both of Brown's daughters, Leslie Browne and Elizabeth Laing, dancers with Ballet Theatre, were trained at his Phoenix School of Ballet.

Brown, Martin, Canadian exhibition ballroom and theatrical dancer and playwright working in the United States; born c.1885 in Montreal, Canada; died February 14, 1936 in New York City. Brown spent most of his performing career on Broadway, appearing as a juvenile and specialty dancer in musical comedies such as *The Girl Behind the Counter* (1907), *The Motor Girl* (1909), *Up and Down Broadway* (1910), *He Came From Milwaukee* (1910), the

Ziegfeld Follies of 1913, and *Dance-land* (1914). He frequently worked as a partner to one or more of the Dolly Sisters, notably in a vaudeville act with Jansci.

After health problems, Brown began to work as a playwright, creating melodramas about the position and function of the artist in society and the battles between the sexes. His best known work, *The Cobra,* provided Judith Anderson with her first Broadway starring role.

Brown, Mary Jane, American tap dancer and teacher; born May 13, 1917 in Syracuse, New York. The daughter of a vaudeville house manager, she picked up tap techniques from performers playing her parents' Syracuse theater, among them Pat Rooney II, who taught her the waltz clog, Eleanor Powell, Hal Le Roy, and Bill Robinson. She performed with her family's act after 1929, went solo at age fifteen and then joined her older brother, Bob, for a new act. Her brother, who later became a cartoonist, sketched famous dancers, such as Astaire or Robinson, and then staged imitations of the star for himself and his sister.

After he retired, she went on the road with a solo act that consisted of dance specialties, such as rollerskate tap work, jump rope tapping with a time step (instead of the usual waltz clog), and imitations of Le Roy, Powell, Robinson, and Rooney. She spent the late 1930s touring with big bands, among them, Bob Crosby, Wayne King, and the Dorsey Orchestra, where she did a challenge rhythm number with percussionist Gene Krupa. In New York she replaced Ann Miller in the George White *Scandals of 1940* on Broadway and on the road, and played New York clubs such as Leon and Eddie's, Café Society, and the Greenwich Village Inn. Brown appeared frequently on early television variety shows, most memorably on Milton Berle's *Texaco Star Theatre.*

After expanding her formal training in ballet with Mme. Anderson-Ivantzova and Spanish work with Angel Cansino, she opened a ballet studio in the Bronx. She has been a popular tap teacher at the International Dance School since 1969.

Brown, Trisha, American postmodern choreographer; born November 25, 1936 in Aberdeen, Washington. Brown first studied dance—acrobatics, tap, ballet, and musical comedy dancing—locally as an adolescent with Marion Hageage. Later, she attended Mills College, spending summers at the Connecticut College School of Dance, studying composition with Louis Horst and dance with José Limón and Merce Cunningham. After graduation, she taught for two years at Reed College. In the summer of 1959, she participated in Ann Halprin's summer workshop, at which she worked with task dance and improvisation. During the next year, she moved to New York, where, with fellow Halprin students Simone Forti and Yvonne Rainer, she took Robert Dunn's composition class at the Merce Cunningham studio.

The Dunn classes produced the group of dancers and choreographers who formed the Judson Dance Theater, among them, Rainer, Forti, Steve Paxton, David Gordon, Douglas Dunn, Lucinda Childs, and Meredith Monk. At Judson, Brown created roles in Rainer's *We Shall Run, Terrain, Diagonal,* and *Solo Section* (1963), Paxton's *Words Words* (1963) and *Section of a New Unfinished Work* (1966), Deborah Hay's *City Dance* (1963) and *Victory 14* (1965 at the first New York Theater Rally). Brown also choreographed works for Judson concerts, among them *Lightfall, Trillium, Chanteuse Excentrique Americaine* (1963), *Rulegame 5* (1965), and *A String* (1966).

In 1968, Brown began creating "equipment pieces," task dances that were dependent on what Sally Banes called "external support systems." These pieces involved moving up a wall (*Planes,* 1968), for example, or walking down the side of a building (dance of the same name, 1970). In 1971, however, anothr variation of the task dance arose in Brown's choreography—accumulation pieces in which each performer adds to a system of gestures, sounds, or words in turn. Currently, Brown is also choreographing task dances based on the formation of lines by the performers using props or simply their bodies. Among these works are the series of *Structured Pieces* (1973–1975), *Locus* (1975), *Solo Olos* (1976), and *Line Up* (1977).

Brown was a member of the Grand Union improvisation group of choreographers through the company's tenure from 1970 to 1976. As the works created

by the Grand Union were communal and improvisational, they are not included in her chronology.

Brown now choreographs for her group. Trisha Brown and Dancers. Members of this company have included dancers Elizabeth Garren, Terry O'Reilley, Steve Paxton, Wendy Perron, and Mona Sulzman.

Works Choreographed: CONCERT WORKS: *Structured Improvisations* (1961, with Simone Forti and Dick Levine); *Trillium* (1962); *Two Improvisations of the Nuclei for Simone by Jackson Maclow, Improvisation on a Chicken Coop Roof, Chanteuse Excentrique Americaine* (also called *Falling Solo with Singing*); *Lightfall* (1963); *Target, Rulegame* (1964); *Motor, Homemade* (1965); *A String (A Piece of String on Three Parts including Motor, Homemade and Inside)* (1966); *Skunk Cabbage, Salt Grass and Waders, Medicine Dance* (1967); *Planes, Snapshot, Falling Duet, Ballet, Dance with the Duck's Head* (1968); *Yellow Belly, Skymap* (1969); *Man Walking Down the Side of the Building, Leaning Duets, Clothes Pipe, The Floor of the Forest, and Other Miracles, Etc., Stream* (1970); *Walking on the Wall, Leaning Duets II, Falling Duet II, Rummage Sale, Accumulation, Roof Piece* (1971); *Accumulation (55"), Primary Accumulation, Theme and Variations* (1972); *Woman Walking Down a Ladder, Accumulation Pieces* (including *Accumulation with Talking*), *Group Accumulation I, Group Primary Accumulation, Roof Piece II, Group Accumulation II, Structured Pieces I* (1973); *Figure 8, Split Solo, Drift, Spiral, Pamploma Stones, Structured Pieces II* (1974); *Locus, Structured Pieces III, Pyramid* (1975); *Solo Olos* (including *4321234* and *Sticks*) (1976); *Line Up* (including *Spanish Dance*) (1977); *Water Motor, Splang* (1978); *Glacial Decoy* (1979).

Brown, Vida, American ballet dancer; born 1922 in Oak Park, Illinois. After dancing with the Chicago Opera Ballet, Brown joined the Ballet Russe de Monte Carlo where she was featured as the "cowgirl" in Agnes De Mille's *Rodeo* and the "Goose Girl" in *Igrouchki.*

Brown joined the New York City Ballet in 1950, serving as ballet master after 1954. Among the many George Balanchine ballets in which she appeared were *Mazurka from "A Life for the Tsar"* (1950)

and *La Valse* (1951), in which she portrayed one of the three women who perform the second and seventh waltzes. She also performed in the premiere of Antony Tudor's *Lady of the Camilias* (1951), as "Prudence." Since retiring from dancing, Brown has worked as a freelance restager for Balanchine ballets.

Browne, Leslie, American ballet dancer; born in New York City. Raised in Phoenix, she received her first training from her parents, Ballet Theatre alumni Kelly Brown and Isabel Mirrow. After studying at the School of American Ballet, she performed briefly in the corps of the New York City Ballet.

Browne was cast as the female juvenile lead in the Herbert Ross film, *A Turning Point* (Twentieth-Century Fox, 1977), as a result of the illness of Gelsey Kirkland. This role led to her admittance into Ballet Theatre, and roles in Mikhail Baryshnikov's *The Nutcracker* and Antony Tudor's *Jardin aux Lilas*. Participation in a second Ross film, *Nijinsky* (Twentieth-Century Fox, 1980) delayed her progress within the company so, for such a well-known dancer, she has performed in surprisingly few ballets.

Bruce, Betty, American theatrical ballet and tap dancer; born May 2, 1921 in Brooklyn, New York; died July 18, 1974 in New York City. Bruce was trained at the Metropolitan Opera Ballet's children's classes.

After she grew to five-foot-seven, she had to leave the Metropolitan Opera Ballet, although she later appeared as Paul Haakon's partner in the Fokine Ballet's *Scheherazade*. After a tour with Albertina Rasch's concert group of tall dancers where she combined conventional ballet with toe tapping, she decided to concentrate in theatrical dance forms. Bruce quickly became an articulate and stylish eccentric tap dancer, popular in clubs in New York and across Europe. She was hired by George Balanchine to appear as a featured dancer in his *Boys from Syracuse* (1938), notably in the tap ballet trio that he choreographed for her, George Church, and Heidi Vosseler, "The Shortest Day of the Year." For seven years she performed almost constantly on Broadway, appearing in featured dance roles in *Too Many Girls* (1939), *Keep Off the Grass* (1940), *High Kickers* (1941),

Something for the Boys (1943), and Tamiris' *Up in Central Park* (1945). She also did personal appearances as a tap dancer at the Radio City Music Hall, the Strand Theatre Roof, and other presentation houses.

Bruce returned to Broadway after acting on television to play the twirler stripper in the celebrated "Gotta Have a Gimmick" number in Jerome Robbins' *Gypsy,* both on stage (1959) and in the film version (Twentieth-Century Fox, 1962).

Bruce, Christopher, English ballet dancer and choreographer; born October 3, 1945 in Leicester, England. Trained at the Rambert School, he has been associated with that company throughout his career as a dancer and choreographer.

Celebrated for his performances in the works of Glen Tetley, he has taken featured roles in his *Embrace Tiger Return to Mountain, Praeludium, Pierrot Lunaire,* and *The Tempest* (1979), in which he created the role of "Prospero." His other appearances included parts in Louis Falco's *Tutti-Frutti* and the title role in the reconstruction of Vaslav Nijinsky's *l'Après-midi d'un Faune.*

Bruce has created much of his choreography for the company of which he has been associate choreographer from 1972 and associate director since 1975.

Works Choreographed: CONCERT WORKS: *Georg Frideric* (1969); *Living Space* (1969); *Black Angels* (1970); *Wings* (1970); *for those who die as cattle* (1972); *Duets* (1973); *There Was a Time* (1973); *Weekend* (1974); *Unfamiliar Playground* (1974); *Ancient Voices of Children* (1975); *Promenade* (1976); *Girl with Straw Hat* (1976); *Cruel Garden* (1977); *Echoes of a Night Sky* (1977); *Night with Waning Moon* (1979); *Sidewalk* (1980).

THEATER WORKS: *Joseph and the Amazing Technicolor Dreamcoat* (1977).

Brugnoli, Amalia, Italian ballet dancer of the early nineteenth century; born c.1808 in Milan; the date and place of her death are uncertain. The daughter of Guiseppina Brugnoli, "prima grotesca ballerina," she was trained at the school of the Teatro alla Scala and danced there as a child. She joined her mother in the company in 1817, making her debut as an adult in Salvatore Viganò's *Prometheus.* Although she performed in Vienna in the early 1820s, her career was based in northern Italy, at La Scala and the Teatro San Carlo in Naples, where she first performed on point, c.1820. At the Teatro Reggio in Turin in 1823, she was cast in Pietro Angiolini's *Haroum-al-Raschid,* while in 1826, she created an important role in Louis Henry's *Dircea* at La Scala. Considered a rival of Fanny Elssler because both combined the ability to work on point with a sensuality foreign to the ethereal Romantic heroines, she was tremendously popular in Vienna, Elssler's home base.

She does not seem ever to have performed at the Paris Opéra, although she and her husband Paolo Samego did a short season at the Théâtre des Bouffes in Paris in 1832. She was very successful, however, in London that year, especially in the ballet, *Une Heure à Naples.*

While it seems unnecessary to get involved in a posthumous rivalry on the first dancer to work on point, it is interesting that Brugnoli's abilities were demonstrated in both the conventional opera ballets and Romantic works and in the popular theater.

Bruhn, Erik, Danish ballet dancer; born Belton Evers, October 3, 1928 in Copenhagen. Bruhn, who is generally considered one of the best classical technicians of the twentieth century, was trained at the school of the Royal Danish Ballet and with Vera Volkova and Stanislaus Idzikovsky.

As a member of the Royal Danish Ballet, from 1947, he created roles in the works of fellow dancers Borge Ralov, (*Kurtisanen,* 1953), and Birgit Bartholin (*Parisiana,* 1954). He was best known, however, in the classical tests of male dancers—"Siegfried" in *Swan Lake,* "Albrecht" in *Giselle,* and "James" in *La Sylphide,* and in the Bournonville repertory.

In the American Ballet Theatre on and off from 1950 to the mid-1970s, he participated in many Ballet Theatre workshops, creating roles in the early versions of Kenneth Macmillan's *Journey* (1957), Job Sander's *The Careless Burgers* (1957), Enrique Martinez's *La Muerte Enamorada* (1957), and Herbert Ross' *Tristan* (1958). In the company proper, however, he was generally cast in the classical leads, becoming known as one of the great "Albrechts" of

modern times. His next roles were not created until just before his retirement, when he danced in the premieres of two works by John Neumeier—*Epilogue* (1975), a pas de deux with Natalia Makarova, and *Hamlet Connotations* (1976), playing "Claudius."

A popular guest artist, he performed in *Giselle* with literally scores of ballet companies during his career. He also staged revivals of the classics, especially of Bournonville's *La Sylphide,* for many companies, including Ballet Theatre.

The director of the Swedish Ballet from 1967 to 1971, he has served in an advisory capacity for many ballet schools and emerging companies. Considered an expert on Bournonville technique, he co-authored a textbook with dancer/author Lillian Moore, published in London, 1967.

Works Choreographed: CONCERT WORKS: *Concertette* (1953); *Festa* (1957); *Duet* (1959); *Romeo and Juliet pas de deux* (1967); *Scottish Fantasy* (1965).

Brunson, Perry, American ballet dancer and teacher; born c.1934 in Chattahoochee, Florida; died April 30, 1981 in Seattle, Washington. After local training, Brunson moved to New York to continue his studies at the Schollar-Vilzak studio. He performed with the Ballet Russe de Monte Carlo from 1955, appearing in Leonid Danielian's *Sombreros*, Antonio Cobos' *The Mute Wife*, George Balanchine's *Raymonda Variations*, Leonid Massine's *Le Beau Danube* and *Gaite Parisienne*, and the company productions of *Coppélia* and *Swan Lake*. He worked as a ballet master for various companies from a young age, and from 1961 to 1964, served in that capacity for the Ballet Russe de Monte Carlo. After teaching at the schools and apprenticeship programs of the American Ballet Theatre School, the City Center Joffrey Ballet, and the Harkness Ballet, he moved to Seattle, where he taught with the First Chamber Dance Group and the Pacific Northwest Ballet. Brunson's talents included the ability, not only to teach ballet technique, but to enable each individual dancer to work through the strictures of conventional postures and steps onto his or her own body. For this reason, he was in special demand with young companies and the apprentice groups of the Joffrey and Harkness schools.

Bryant, Dan, American minstrel show comic and dancer; born May 9, 1833 in Troy, New York; died April 10, 1875 in New York City. He made his professional debut at the Vauxhall Gardens, New York, in the 1845 benefit for his older brother, Jerry, as a specialty jig dancer with the Ethiopian Operatic Brothers and went on to a successful career in early minstrelsy. This form should not be confused with the highly structured theatricalized chorus pieces of later years. The Ethiopian Operatic Brothers and the Bryants' own minstrel troupes presented Irish sketches, songs, dance numbers, satires on contemporary "high culture" theater forms, and the traditional racial slurs, in a sequence of five or six short scenes. Most of Bryant's personal specialties—the jig, the shuffle, and the drunk act—could be presented in either the Irish or black personae.

Bryant died in his early forties. He was given a unique posthumous tribute when eleven of the city's largest theaters gave simultaneous benefit performances for his family.

A grandson, also named Dan Bryant, had a short career as a juvenile and tenor for the Shubert Brothers' operetta season of 1913, appearing most successfully in *Liebe Augustin* and *The Beggar Student*.

Bubbles, American tap dancer and theatrical performer; born John Sublett, February 19, 1902 in Louisville, Kentucky. Sublett performed with Ford Lee Washington from 1909 to 1953 in the popular act Buck and Bubbles. They danced together on Broadway in the *George White Scandals of 1920*, and *Ziegfeld Follies of 1921, Laugh Time* (1943), and *Carmen Jones* (1944); although both were in the cast of the opera *Porgy and Bess*, they did not work together—Sublett, as "Sportin' Life," electrified the audience with his performance of the Gershwins' songs, "Ain't Necessarily So" and "There's a Boat Dat's Leaving Soon for New York."

Buck and Bubbles also were seen in films—both studio feature films, such as *Varsity Show* (WB, 1937), *Cabin in the Sky* (MGM, 1943), and *A Song Is Born* (RKO, 1948), and in shorts for Pathé and Universal, among them the *Laugh Jubilee* series. They also worked the black vaudeville and theater circuits, playing the Apollo frequently with their tap act.

Buchanan, Jack, Scottish theatrical dancer and choreographer, born April 2, 1891 in Helensburgh, Scotland; died October 20, 1957 in London. Buchanan, who claimed to have no formal training, was the preeminent song and dance man on the English stage and in early sound films; frequently compared to Fred Astaire, he had the same ability to shape both songs and movements to fit his body, performance style, and personality. He danced in over twenty-five shows, choreographing and/or directing many of them, including his first major hit, *Tonight's the Night* (1915), and *André Charlot Revues of 1924 and 1925, Sunny* (1926, London only), the Jessie Matthews-Claude Newman shows *Wake Up and Dream* and *Stand Up and Sing* (1929, 1931), and *The Flying Trapeze* (1935).

He starred in many of the earliest English sound musical films, notably *Man of Mayfair*, and in three American transition period revues, *Paris* (First National, 1926), *Monte Carlo* (MGM, 1926), and *The Show of Shows* (WB, 1929). His appearance in *The Band Wagon* (MGM, 1953), as the musical version of Orson Welles who introduced "That's Entertainment," gave audiences a chance to see him go through a soft shoe number with Fred Astaire, allowing us to compare their ways with a top hat and cane.

Works Choreographed: THEATER WORKS: (Note: Buchanan was credited with choreographing or directing [without any choreography credit given] the following London shows): *Tonight's the Night* (1915); *Bubbly* (1917); *Round the Map* (1917); *Tails Up* (1918); *Jumble Sale* (1920); *Faust on Toast* (1921); *A to Z* (1921); *Battling Butler* (1922); *André Charlot's Revue of 1924; Toni* (1924); *Boodle* (1924); *The Charlot Revue of 1926; Sunny* (1926); *That's a Good Girl* (1928); *Wake Up and Dream* (1929); *Stand Up and Sing* (1931); *Mr. Wittington* (1934); *The Flying Trapeze* (1935); *Between the Devil* (New York, 1937); *Waltz Without End* (1942); *It's Time to Dance* (1943); *Fine Feathers* (1945).

Buck, American tap dancer and theatrical performer; born Ford Lee Washington, October 16, 1903 in Louisville, Kentucky; died February 1955 in New York City.

Washington performed in the tap act Buck and Bubbles for almost fifty years with John "Bubbles" Sublett. Their dancing was applauded in the *George White Scandals of 1920*, the *Ziegfeld Follies of 1921*, and *Carmen Jones* (1944), the Broadway version of *Carmen*, set in a cotton mill in the deep South. They each performed in the original cast of *Porgy and Bess*, but did not interpolate their act into that opera. Extremely popular on the black vaudeville circuit, they were among the best received tap act to play the Apollo Theater, the hub of the Theater Owners' Booking Association wheel, known euphemistically to performers as "Tough on Black Acts."

Their act, or at least a shortened, simpler version of it, can be seen in four films—*Varsity Show* (WB, 1937), *Cabin in the Sky* (MGM, 1943), *Atlantic City* (Republic, 1944), and *A Song Is Born* (RKO, 1948). They starred in a short subject, *Buck and Bubbles' Laugh Jubilee*, but few prints of that film are extant.

Buglisi, Jacquelyn, American modern dancer; born February 19, 1951 in New York City. Buglisi was trained at the High School of Performing Arts and at the Martha Graham School of Contemporary Dance. Before joining the Graham company in 1977, she appeared in the companies and concert groups of many of Graham's former dancers, among them Pearl Lang, with whom she made her debut. As a freelancer, Buglisi danced in major works in a variety of troupes, among them Mary Anthony's *Threnody*, Ross Parkes' *Tides* (for the Anthony company), Joyce Trisler's controversial *Four Temperaments*, and Manuel Alum's *Era* and *Ilanot*. Buglisi's assignments with Graham have ranged from revivals of her classics to the new works of recent years, such as her *Owl and the Pussy Cat* and *Flute of Pan* (both 1978).

Bujones, Fernando, American ballet dancer; born March 9, 1955 in Miami, Florida. Raised in Miami and in Havana, Cuba, he received early training from Alicia Alonso, but usually credits his studies with Zaida Cecilia Méndez as his most important influence. Bujones later studied at the School of American Ballet in New York and performed as a adolescent with the (André) Eglevsky Ballet in Long Island.

Bujones has been a member of the American Ballet Theatre since 1972, currently performing on a "guest

135

artist'' basis. He has performed in works by modern choreographers, notably Alvin Ailey's *The River* and *Sea Change*, and Antony Tudor's *Undertow* and *Shadowplay*. Bujones is better known, however, as one of the very few contemporary American dancers to base his career primarily on classic revivals and pas de deux. He is noted for his performances in principal roles in *Don Quixote, La Bayadère, Swan Lake, Giselle*, and *La Sylphide*, and has also taken the leads in George Balanchine's *Theme and Variations*, Harald Lander's *Études*, and in Mary Skeaping's revival of *The Sleeping Beauty*, as ''Florimund'' and as the ''Enchanted Bluebird.''

Since 1974, when he won a gold medal at the Varna competition, he has been one of the most frequently employed guest-appearance makers in the dance world and has performed with most of the established and ad hoc ballet companies.

Bull, Richard, American modern and improvisational dancer and choreographer; born c.1930 in Detroit, Michigan. Bull worked as a pianist and accompanist while taking dance classes with Maxine Hunt, Erick Hawkins, Alwin Nikolais, Mary Anthony, Martha Graham (for whom he frequently played), Pearl Lang, and Merce Cunningham. He began to work within improvisatory dance forms in 1960 while teaching at New York University and formed his first company, the New York Chamber Dance Group, shortly thereafter. While directing the dance program at the State University of New York at Brockport (one of the larger performance programs in the SUNY system), he revived his company and presented improvisatory programs including the popular *Five Variations on ''Ten Cents a Dance,''* He left Brockport in 1978 on sabbatical (and did not return) to create a new improvisational company with dancers Peentz Dubble and Cynthia Novack; the Improvisational Dance Ensemble presents almost monthly performances. In the late 1970s, however, Bull began to freeze works that were improvised in rehearsal into a repertory of existing pieces, among them *Recursion* (1980), *Monkey Dance* (1980), and *Blue Meter* (1981), each of which still changes during each presentation.

Works Choreographed: CONCERT WORKS: (Note: all works created after *Feedback* [1974] were co-cre-ated with the members of the Improvisational Dance Ensemble.) *Conversations* (1965); *Three*Place*One* (1965); *Suite Teens* (1965); *How to Solve it* (1966); *Progress Report* (1966); *Imitations I & II* (1967); *Revelations* (1967); *Chiaroscuro* (1967); *War Games: Strategies, Tactics, Diversions and Delights* (1968); *Thirteen Ways of Looking at a Blackbird* (1968); *Phorion* (1968); *Sanctuaries* (1968); *Mr. Blue* (1969); *People/Places/Things* (1969); *Analogues I & II* (1969); *Action Music II* (1969, section of evening-length work by Tom Johnson); *Body Count* (1969); *Gallery* (1970); *The Centering Dance* (1970); *Making and Doing* (1970); *Domus* (1970); *Sing-Along Sun King* (1970); *The Bacchae* (1971); *The Hartwell Building can Dance* (1971); *Cousin Caterpillar* (1971); *Bedtime Story* (1972); *L'Histoire du Soldat* (1972); *Octandre* (1972); *Armistice* (1972); *Cycles* (1972); *In a Plastic Garden* (1972); *Hartwell Dances Again* (1972); *Five Handball Court Dances* (1972); *Introductions are in Order* (1972); *The Haircut: A Documentary Dance* (1972); *Space Games* (1972); *Suite Teens* (1972, revised); *One Hand, Two Hands, Mouth* (1972); *The Gentle Dance* (1973); *Command Performance* (1973); *The Dance that Describes Itself* (1973, short work-in-progress version); *Celebration City* (1973, co-directed by Jonathan Atkin); *9.16666666666666666666* (1973); *Opera Scenes* (1973); *The Many Dances One Dance Dance* (1973); *Medieval Dances* (1974, co-directed by Dianne Woodruff); *The Dance that Describes Itself* (1974); *Hamburger (American Ritual, Part I)* (1974, directed by Duvid Smering); *Bowling for Dollars (American Ritual, Part II)* (1974, directed by Duvid Smering); *The Centering Dance* (1974, revised); *The Barn Dance at 20 Adams Street: A Utilitarian Dance Event* (1974); *Variations on ''The Barn Dance at 20 Adams Street''* (1974); *The Walking Dance* (1974); *Small Step, Giant Leap* (1974); *Feedback* (1974); *Overload* (1974); *Eight Dorian Dances* (1975); *The Counting Dance* (1975); *Thank You, Masked Man* (1975); *Visions* (1975); *The Tourist* (1975); *Etudes* (1975); *Its Gonna Rain* (1975, later performed as *The Cosmic Egg*); *Just Improvising* (1975); *Masked Music* (1975); *A Jazz Dance* (1976); *I'm On My Way I and II* (1976); *Jesus' Blood* (1976); *The Longest Dance* (1976, co-choreographed with Cynthia Novack only); *Bicentennial Vaudeville* (1976); *The Greek Dances*

(1976, various dates during three week period); *Five Variations on "Ten Cents a Dance"* (1976); *Ambience* (1977); *The Dance That Describes Itself* (1977); *The Dance That Explains Itself* (1977); *Loft Dance* (1977); *Local New* (1977); *Interactions* (1978); *The Smithsonian Dances* (1978); *The Conspirators* (1978); *Crossovers* (1978); *Story Dance* (1978); *Making Contact* (1978); *Trilogy* (1979); *Prologue* (1979); *Slow Blues* (1979); *Solo Set* (1979); *Telltale* (1979); *Cityscape* (1979); *In This Place* (1979); *Suite* (1979); *La Parole* (1979); *Groupdance* (1979); *Recursion* (1980); *Three Sets (Strolling, Monkey Dance, Didactic Dalliance, Water Wheel)* (1980); *Relay: An Environmental Dance Work* (1980); *Onagainoff* (1980); *Soundings* (1980); *My Story* (1980); *The Sounding Wall: Ten Etudes and Fantasia* (1980); *Touring Dance* (1980); *Relay* (1980).

Bulnes, Esmée, English ballet dancer and teacher in Argentina and Italy; born c.1900 in Rock Ferry, Cheshire. Bulnes based her teaching on her own training from Enrico Cecchetti, Bronislava Nijinska, Lubov Egorova, and Boris Romanoff. She went to Buenos Aires in 1931 to perform, teach, and assist Mikhail Fokine, then the ballet master at the Teatro Colon. She remained there long after Fokine returned to the United States and taught at the Teatro Colon until the late 1940s, when she joined the faculty of the school of the Teatro alla Scala in Milan. Her classes there were so popular and successful at training dancers that she was appointed director of the ballet company and school at the center of opera activity in Italy in 1954. After eight years, however, she returned to the school as its director. Bulnes is considered one of the most influential teachers in Italy, responsible for maintaining the Cecchetti technique that was defined throughout the dance world as "Italian ballet."

Burdick, William, American ballet dancer, choreographer, and expert on historical movement; born December 6, 1925 in Fort Worth, Texas. Although he had some local training, he began his professional dance studies in California while a Navy medical technician. After working there with Sergei Temoff and La Viva del Curo, he moved to New York to study at the Anatole Vilzak/Ludmilla Schollar studio and the School of American Ballet. He was a student of Margaret Craske and Antony Tudor at the Metropolitan Opera Ballet School and a member of Ballet Theatre. He made his professional debut with the San Francisco Russian Opera and performed for the Radio City Music hall ballet after arriving in New York. Among his other engagements in New York were in Charles Weidman's choreography for the New York City Opera (1948-1949), Hanya Holm's work for *Kiss Me Kate* (1950) and Ballet Theatre (1951-1954), where he danced in Jean Babilée's *L'Amour et Son Amour* and William Dollar's *Constancia*, as well as company productions of the classics. His modern dance experience dates from his participation in the student companies of Doris Humphrey, Merce Cunningham, and José Limón at the American Dance Festivals of 1954 and 1957. He can still be seen in the festival films of Limón's *The Traitor* and Humphrey's *Ritmo Jondo, Felipe el Loco,* and *The Shakers.* He performed with the Metropolitan Opera Ballet (1955-1966) as dancer and mime, but returned to the modern field to perform with Elizabeth Keen in her *Quilt* (1971).

Burdick's performances prepared him for a successful career as a choreographer and teacher—a career that he followed most notably at Adelphi University where he has taught since 1973. Since 1960, however, Burdick has become recognized as an expert on period dance and social movement and has been invited to coach and stage segments of many plays. He has worked as a movement specialist with the Metropolitan Opera, the American Stratford Festival, the International Mime Festival, the Acting Company (of students and graduates from the Juilliard School), and his own Dances of Court and Theatre.

Works Choreographed: CONCERT WORKS: *In a Mozart Manner* (1958); *At Point of Family* (1958); *Tender Fallacy* (1958); *The Weather of the Heart* (1958).

Burgmüller, Friedrich, Austrian nineteenth-century conductor; born c.1804 in Regensburg; died 1874 in Paris. Although most musicologists consider Friedrich Burgmüller the least important member of his family of composers, he is known by students of the Romantic era for his scores for the Paris Opéra. He was considered an expert at integrating exotic and

folk tunes into the conventional rhythms of ballet music, most notably in *La Péri* (1843) for the Jean Coralli and the peasant pieces in *Lady Henriette* for Joseph Mazilier and the pas de deux interpolated into the first act of *Giselle*.

Burke, Cameron, American modern and theatrical dancer; born 1953 in Portland, Maine; died May 30, 1978, en route between New York City and Fire Island, New York. A wrestler in high school, Burke was introduced to dance in a "ballet for jocks" program sponsored by the school district. He dropped out of athletics in order to continue his study of dance at Skidmore College and in New York studios. He took classes with Louis Falco, Lar Lubovitch, and Manuel Alum, performing for each choreographer in 1978. After dancing in Central Park for the film of *Hair* (released in 1979), he joined with dancer Deborah Zalkind to create a program of satirical duets, generically called *The Kat's Pajamas* (1977). Their performances in theaters and cabarets made them popular among audiences who recognized their allusions to adolescence in the 1960s. He was cast as "Slick Dude," the lead dancer in the celebrated Aggie scene in Tommy Tune's *Best Little Whorehouse in Texas* in 1978 and began to take acting lessons. Burke was killed by an intoxicated hit-and-run driver while cycling to the popular Fire Island resort on his Monday off.

Burke, Dan, American vaudeville dancer; born c.1848 in Providence, Rhode Island; the details of Burke's death, c.1918, are not certain. Burke made his professional debut in a tandem act with his older brother in the John Murray Railroad Circus, c.1855. He appeared in vaudeville steadily for over forty years, but took time off from his touring to perform as a member of the Theatre Comique company, Harrigan and Hart's repertory troupe, and Haverly's Minstrels. He taught both performers and society amateurs while with Harrigan and Hart.

Burke's vaudeville acts were divided between his solo specialties and his group pieces. The former featured soft shoe and an exhibition high kicking cakewalk that he claimed to have invented. The latter, called "feature acts" in the jargon of the time, were a series of acts for himself and four female dancers—

Dan Burke and His School Girls (c.1905-1910), . . . *and His Wonder Girls* (1910-1917), and *The Old Master, or When the Clock Strikes Nine* (1917-). The first one was simply a male soloist surrounded by a female precision chorus, in the pattern of the Ned Wayburn feature acts that were minivariety shows based around a headliner. *The Wonder Girls* act included some visual effects, including a prop canoe that was "paddled" onto the stage, and a finale that was banned in Sioux City. In it, the dancers lay down on their backs behind a xylophone and kicked out a tune. This was not the first time that this type of act was performed, but it was certainly the best publicized. The final act had a romantic plot about a London nineteenth-century ballet master who sends his latest prodigy off to her opening night but stays home to dream about her mother. It was very successful and brought Burke a tremendous amount of publicity as a dance veteran.

Burke, Dermot, American ballet dancer; born January 8, 1948 in Dublin, Ireland. Raised in Miami, Florida, Burke studied tap, jazz dance, and gymnastics locally, and ballet with Edith Royall, in whose regional company he made his performing debut. Burke moved to New York to study at the American Ballet Center, official school of the City Center Joffrey Ballet.

Burke joined the Joffrey company in 1966, remaining with that company until 1972, and returning as a guest artist in 1974. Among the works in which he created roles in that company are Gerald Arpino's *Secret Places* (1968), *A Light Fantastic* (1968), *Animus* (1969), and *Trinity* (1971), Remy Charlip's *Differences* (1968), Joseph Layton's *Double Exposure* (1972), and Marc Wilde's *The Glass Heart* (1968). He has also performed in featured roles in company productions of Todd Bolender's *The Still Point*, John Cranko's *Jeu des Cartes*, the revival of Fokine's *Petroushka*, Arpino's *Sea Shadow, Olympics,* and *The Clowns,* and Joffrey's own *Astarte*.

Burke has worked frequently as a freelance ballet guest artist, especially with the Eglevsky Ballet, Long Island, New York, with which he has performed the male principal roles in *Cinderella* and *The Sleeping Beauty* in their 1974 and 1975 seasons. In 1975, he created the role of "Scaramouche" in Edward Villel-

la's *Harlequin: A Patchwork of Love*, choreographed for the CBS television broadcast series, *Festival of the Lively Arts for Young People.*

Burns, Louise, American modern dancer; born June 14, 1949 in Florida. Trained by Betty Jones at the University of Hawaii, she continued her studies in New York with Peter Saul, Viola Farber, and Merce Cunningham. A member of the Cunningham company in 1970 and since 1976, she has appeared in *Events* and in many repertory works, among them, *Sounddance, Signals, Squaregame, Summerspace, Changing Steps, Exchange, Fractions* (1978), *Torse,* and *Travelogue* (1977). Burns has also performed in the concerts of fellow Cunningham dancers, most notably Mel Wong's recitals.

Burnside, R.H., Scottish theatrical director and "Veteran of Everything"; born Richard Hubber Thorne Burnside, August 13, 1870 in Glasgow; died September 14, 1952 in Metuchen, New Jersey. The son of the manager of the Glasgow Gaiety and actress Margaret Thorne, he made his stage debut as a child. At twelve, he moved to London to join Edward Terry's troupe, working concurrently as a call boy for the Gilbert and Sullivan productions at the Savoy. Six years later, he emigrated to the United States as tour director for Lillian Russell's American tour.

A songwriter, librettist, designer, and producer, he directed shows at the Hippodrome in New York from 1908 to 1922. There is no evidence that he contributed to the choreography of the shows but he was best known for a single staging effect, used in many productions in the 1910s—lines of up to sixty-four dancers marched into the massive Hippodrome pool in the center of the performing area; they literally walked into the pool and never reemerged. Among his most successful Hippodrome productions, that took full advantage of the theater's unique stage, pool, and scale, were *The Big Show* (1916), *Cheer Up* (1917), *Happy Days* (1919), and his most famous, *The War of the Worlds* (1918).

Burnside also staged Barnum and Bailey circuses, Buffalo Bill and Pecos Bill Wild West Shows, hundreds of pageants, and the Philadelphia Sesquicentennial in 1926. In the 1940s, after retiring from pro-

duction, he founded a Gilbert and Sullivan company in New York, which he ran until his death.

Burr, Marilyn, Australian ballet dancer; born November 20, 1933 in Sydney, Australia. Trained by Leon Kellaway, she joined the National Ballet of Australia in 1949. After three seasons, she moved to London to study with Audrey de Vos and to perform with the New Ballet and London Festival Ballet. In the latter, she created a role in the company production of Kenneth Macmillan's *Concerto* and danced featured roles in the classics, Nicholas Beriosoff's *Esmeralda* (1954), and Vladimir Bourmeister's *The Snow Maiden.*

Emigrating to the United States, she joined the National Ballet, Washington, D.C., where she danced from 1966 to 1970. She danced in that company's productions of *Swan Lake, The Sleeping Beauty, Coppélia,* and *La Fille Mal Gardée.*

Burra, Edward, English artist and theatrical designer; born c.1905 in London. There is a strange tradition in the dance in which new companies most often hire graphic or plastique artists rather than professional designers to create decor and costumes for their first seasons. Burra, a well-respected experimental painter, was engaged to design early works by the innovators of the early English ballet, including Frederick Ashton's *Rio Grande* (1932) and *Don Juan* (1948), and Ninette De Valois' *Barabau* (1936) and *Don Quixote* (1950).

Burrows-Fontaine, Evan, English concert dancer; born, according to her own publicity, in London on January 1, 1900. Although Burrows-Fontaine claimed to have been trained personally by Emile Jaques-Dalcroze (if true, it could mean that she was a piano student of his), nothing can be verified about her education, professional background, or nationality.

She first performed in the United States on a Denishawn tour, dancing her own solos, *Danse Egyptienne* and *Syvillia,* and works by Ted Shawn, *Ta-Toa, Chinese Minuet, Dance Modern,* and *Waltz—Al Fresco and Lu-Lu Fado.* She was already important enough then for the credits to read "Ted Shawn, assisted by Evan Burrows-Fontaine." Fol-

lowing the Denishawn engagement, she performed in vaudeville for many years, notably in a joint tour with Gertrude Hoffmann and interpretive dancer Lady Mary Constance Stewart-Richardson.

Her period of greatest popularity was in the 1920–1921 seasons when she made a hit on Broadway in the *Ed Wynn Carnival* (1920), dancing on a mobile sphinx, and worked at Club Maurice. Following a breach-of-promise suit against Cornelius Vanderbilt Whitney, she seems to have retired from performance.

Bush, Noreen, English ballet and theatrical dancer and teacher; born 1905 in Nottingham; died August 7, 1977 in London. Originally trained in Nottingham by her mother Pauline Bush, she continued her studies in London with Edouard Espinosa.

After performing in West End musicals and operettas, reportedly among them, *The Last Waltz* (1923), *Our Nell* (1924), and *Betty in Mayfair* (1952), she founded a school with her husband, tap dancer Victor Leopold. Renamed The Bush-Davies School in 1939, after merging with the school of Marjorie Davies, it became a successful studio of ballet and general dance. In 1929, Bush became the Head Scholarship Teacher at the Royal Academy of Dancing, with which she served for over forty years.

Butler, Ethel, American modern dancer; the details of Butler's birth cannot be verified. As a student at the Neighborhood Playhouse, Butler worked under Blanche Talmud, Louis Horst and Martha Graham, in whose company she performed from 1933 to 1945. As such, she participated in the premieres of some of Graham's most important pieces of the middle period of her creativity, among them *Integrales* (1934); *American Provincials* (1934); *Panorama* (1935); *Horizons* (1936); *Chronicle* (1936); *American Lyric* (1937); *American Document* (1938); "*Every Soul Is a Circus . . .*" (1939); *Letter to the World* (1940); *Punch and Judy* (1941); and *Deaths and Entrances* (1943). After retiring from performance, Butler taught for Graham and at her own studio in the Washington, D.C. area. Among her students there was choreographer Jan van Dyke.

Butler, John, American modern dancer and choreographer; born September 29, 1920 in Memphis, Tennessee. Trained at the Martha Graham School of Contemporary Dance, he performed briefly with her company, creating a featured role in her *Deaths and Entrances* (1943). He also worked on Broadway, playing the "Dream Curley" in Agnes De Mille's *Oklahoma* in a replacement cast, and on television, where he received a first choreography credit for "The Rooftop Ballet" sequence on a *Kate Smith Show* (NBC, 1951). In 1951, he choreographed what is still his best known production, the original broadcast of the Menotti opera, *Amahl and the Night Visitors* for the NBC Opera Theatre. Throughout the 1950s and 1960s he was employed creating dances for religious programming on WCBS-New York, and the educational networks.

In 1955, he founded the John Butler Dance Theatre, out of the Johnny Butler Dancers from television. Many of his works were created for this troupe before he decided to freelance.

He has also choreographed for the Metropolitan Opera Ballet troupe, the Nederlands Danse Theatre, doing his popular *Carmina Burana* there in 1962, the Pennsylvania Ballet, the Harkness Ballet, and the New York City Opera. A prolific opera choreographer, he has set dances for new operas by Menotti and for the standard repertory of *La Traviata, Aida,* and *Der Fledermaus.*

Works Choreographed: CONCERT WORKS: *Masque of the Wildman* (1953); *Malocchio* (1953); *The Brass World* (1954); *Three Promenades with the Lord* (1954); *Frontier Ballad* (1955); *The Unicorn, the Gorgon and the Manticore* (1956); *Seven Faces of Love* (1957); *Triad* (1958); *The Glory Folk* (1958); *Unquiet Graves* (1958); *The Letter and the Three* (1958); *In the Beginning* (1959); *Album Leaves* (1959); *The Sibyl* (1959); *Turning Point* (1960); *Ballet Ballads* ("Willie the Weeper") (1961); *Hypnos* (1961); *Portrait of Billie* (1961); *Letter to a Beloved* (1961); *Alone* (1962); *Sebastien* (1963); *Catalli Carmina* (1964); *Ceremonial* (1964); *Chansons de Bilitis* (1965); *After Eden* (1966); *Villon* (1966); *Aphrodite* (1967); *The Captive Lark* (1967); *Touch of Loss* (1967); *Landscape for Lovers* (1967); *A Season in Hell* (1967); *Ceremony* (1968); *The Initiate* (1968); *Labyrinth* (1968); *Encounters* (1969); *The Minotaur* (1970); *Journeys* (1970); *Itinéraire* (1970); *Tragic Celebration* (1972); *Moon Full* (1972); *Night Sound* (1972); *Black Angel* (1973); *Trip* (1973); *Integrales*

(1973); *Kill What I Love* (1973); *Puppets of Death* (1974); *Cult of Night* (1974); *Medea* (1975); *Facets* (1976); *Othello* (1976); *Three* (1977); *Icarus* (Iceballet) (1977); *Les Doubles* (1978); *The Commitment* (1979).

OPERA: *The Consul* (1950); *The Unicorn, the Gorgon and the Manticore* (1957); *Nausicaa* (1961); *Sebastien* (1963).

THEATER WORKS: *The Beast in Me* (1963).

TELEVISION: *The 54th Street Revue* (CBS, 1949–1950); *The Kate Smith Show* (NBC, 1951–1952); *Amahl and the Night Visitors* (NBC Opera Theater, December 1951); *Adventure* (CBS, December 1954, special); *The Merry Widow* (Omnibus, CBS, April 1955); *Camera Three* (CBS, 1956, special); *Look Up and Live* (CBS, December 1958, special); *Lamp Unto My Feet* (CBS, November 1962, special); *Bell Telephone Hour* (CBS, November, 1963, special); *Creative America* (CBS, March 1963); *Ceremony of Innocence* (CBS, September 1964, special); *Five Ballets of the Five Senses* (NET, October, 1967).

Butsova, Hilda, English ballet dancer; born Hilda Boot, c.1897 in Nottingham, England; died March 21, 1976 in White Plains, New York. Trained at the Stedmans Academy, she continued her studies under Alexander Volinine and Enrico Cecchetti. As a Stedmans student, she had appeared in Christmas pantomimes before age thirteen when she joined the Diaghilev Ballet Russe for its London season.

Invited to join the touring Anna Pavlova company on the basis of her Ballet Russe performances, she remained with her until 1926, returning in 1928. She served as Pavlova's understudy, but was also given principal roles in the works that the great ballerina did not wish to perform, or could not fit into an evening's schedule. In a typical recital from 1915 to 1926, the audience saw Pavlova in a pas de deux and in a large group piece, and saw Butsova as ballerina in the opening work. She also performed in the touring companies of Mikhail Mordkin, in the United States in 1927, dancing in his *Swan Lake* and in divertimenti, and of Anton Dolin in England.

Settling in the United States in 1930, she returned to the Capitol Theater, where she had been a guest artist briefly in 1926. This New York Theater was the first house on the largest East Coast Prolog circuit and, when she began working there in 1930, was directed by former Pavlova company member Chester Hale. Butsova was one of the Pavlova dancers who worked with him at the theater, along with Ella Dagnova and Joyce Coles.

She retired to teach in the mid-1930s. Celebrated as a coach of the Russian classical repertory, she participated in teachers' training courses and dance master conventions even after ending her formal teaching career.

Byrne, James, English Harlequinade performer and choreographer; born 1756 in London; died there on December 4, 1845. The son of a pantomime performer at the Haymarket Theatre, London, Byrne performed there as a child. It is likely that he was quite short since he was still billed as "Master Byrne" at the age of twenty-six.

At twenty-one he was given his first assignment as a ballet master for the Sadler's Wells Theatre (1775–1776). During the next season, he led a troupe at the Haymarket Theatre that included the D'Egville family. They and the entire Byrne family worked together again at Covent Garden after 1783 along with dancer and "Columbine," Lucia Rossi (c.1780–1845), in *Médee and Jason* (1784) and *The Beggar's Opera* (1788).

In 1796, Byrne and Rossi, along with their son Oscar, performed in Philadelphia and New York in a series of Harlequinades, among them *The Origins of Harlequin* in which the year-old Oscar made his debut. On his return to London, he revolutionized the performance of the "Harlequin" character by adding both acrobatics (which he may have picked up from Alexander Placide who was his competition in New York) and an extended vocabulary of movements and poses. He also changed the costume to the black half-mask and particolored tunic which is now associated with the "Harlequin" character. The first production with the new "Harlequin," *Harlequin Amulet* (1801, at the Drury Lane), is considered by some the most important single performance in English pantomime history.

A prolific choreographer and director of Harlequinades, Byrne had a tremendous influence on the two major "Clowns" of the period—Joseph Bologna and Joseph Grimaldi. His innovations were maintained throughout the height on the English

Harlequinade era and can be seen today in Christmas pantomimes.

Works Choreographed: THEATER WORKS: *The Picture of Paris* (1790); *Oscar and Malvina* (1791); *Harlequin's Music* (1792); *The Governor* (1793); *The Shipwreck* (1793); *Harlequin's Chaplet* (1793); *Harlequin and Faustus* (1793); *Dermot and Kathlane* (1793); *The Travelers in Switzerland* (1794); *Hercules and Omphale* (1794); *Margo and Dago* (1794); *The Tythe Pig* (1795); *The Poor Soldier* (1796); *The Origins of Harlequin* (1796); *Jocket and Jenny* (1800); *The Nuptials* (1800); *The Magic Flute or Harlequin Champion* (1800); *The Animated Statue* (1800); *Blue Bells of Scotland* (1800); *Sir Francis Drake and the Iron Arm* (1800); *Harlequin Amulet* (1800).

Byrne, Oscar, English nineteenth-century ballet and Harlequinade dance director; born c.1795 in London; died in St. Pancras, London, September 4, 1867. The son of the celebrated "Harlequin" James Byrne and Lucia Rossi, the younger Byrne made his professional debut at the age of one in the Philadelphia performances of *The Origins of Harlequin.* He worked with his parents at the Drury Lane Theatre, appearing as a child in the performance of *Harlequin Amulet* (1800), that is considered a turning point in the development of the English pantomime.

He performed in Harlequinades and ballets at the Drury Lane, Covent Garden, the King's Theatre, and the Haymarket before 1820, when he formed his own troupe. That company did pastoral ballets and entr'actes for the His Majesty's Servants troupe of Edmund Kean in the 1820s and 1830s, among them, *Les Villageois Suisse* (1823). It is likely that the Byrne family troupe remained with the Kean for many years, since Charles Kean appointed Byrne as his company teacher and ballet master when he established his own company at the Princess Theatre. When Kean and Ellen Tree opened the theater in 1850, Byrne was the master of deportment, charged with teaching period movement, etiquette, and social dance to the company, which, at that time included the young Terry children. Richard Flexmore, a "clown" in the Bologna family troupe, was the "dances and action" choreographer, and Charles LeClerq was an emeritus dance director. Byrne staged dances within Kean's famous Shakespeare productions and pastorales for LeClerq's daughter, Charlotta, then a ballet dancer but soon to become a major Shakespearean actress. His best-remembered production was the 1856 *Midsummer Night's Dream,* featuring Ellen Terry as "Puck," from which sketches and a single daguerreotype remain, but he also worked on Kean's *Richard II* (1857) and *The Tempest* (1857), and a number of harlequinades. Retiring in 1858 to open a social dance academy, he was replaced by John Cormack, the unknown dance director who was himself followed by John D'Auban.

Byrne's importance lies in his continuation of his father's commedia traditions and in his work with the younger Kean. He was one of the first choreographers to be associated with a director who cared about period accuracy and was, therefore, one of the first to limit his movement vocabulary to correct and unanachronistic gestures and dances. It is unfortunate that he worked in a period in which dance directors were not always credited; therefore, only his Kean credits can be verified.

Works Choreographed: CONCERT WORKS: *Les Villageois Suisse* (1823).

THEATER WORKS: *Bombasto Furioso* (1852); *The Merry Wives of Windsor* (1852); *Henry VIII* (1852); *Macbeth* (1853); *Harlequin Cherry and Fair Star* (1853); *Sardanapolus* (1853); *Harlequin and the Miller and his Men* (1854); *Harlequin and Bluebeard* (1855); *Harlequin and the Merry Magpie* (1856); *Harlequin in Fairy Paradise* (1856); *Faust and Marguerite* (1856); *A Midsummer Night's Dream* (1856); *Aladdin and his Wonderful Lamp* (1857); *The Tempest* (1857); *Harlequin and the White Cat* (1857).

C

Caccialanza, Giselle, American ballet dancer; born September 17, 1914 in San Diego, California. After early ballet training in California, notably from Giavanna Rosi, Caccialanza moved to Milan to study with Enrico Cecchetti, the major teacher of Italian technique in the early twentieth century. She worked with him from 1925 to 1928; their correspondence was printed in *Dance Perspectives,* no. 45 (1971).

Returning to the United States, she studied briefly with Luigi Albertieri, another Cecchetti protégé, before going to work for Albertina Rasch as a member of her dance troupes. After touring with Rasch, she joined the American Ballet, the new company formed for George Balanchine.

In the companies formed of American Ballet members and alumni—the American Ballet, the Ballet Caravan, and the Ballet Society—Caccialanza created roles in many of Balanchine's most important early works. From the waltz section in *Serenade* (1934), his first American ballet, to the *Divertimento* (Haieff) (1947), the works included *Alma Mater* (1934), *La Baiser de la Fée* (1937), *Ballet Imperial* (1941), *Divertimento* (Rossini) (1941), and *Four Temperaments* (1946). With the Ballet Caravan, a cooperative company of Balanchine dancers, she performed in the premieres of Eugene Loring's *Harlequin for President* (1936), William Dollar's *Promenade* (1936), Douglas Coudy's *The Soldier and the Gypsy* (1936), and *Charade* (1939) by Lew Christensen.

Before retiring to teach and coach, Caccialanza danced for Christensen, by then her husband, with the San Francisco Ballet where he still serves as artistic director.

Cachat, Beth, American modern dancer and choreographer; born February 18, 1951 in Cleveland, Ohio. Cachat's studies have included acting work at college, ballet classes from Margaret Craske protégés Janet Panetta and Diana Byer, and training in modern forms from Rael Lamb, Louis Falco, Merce Cunningham, and Viola Farber. Although she has performed in the works of contemporary choreographers, notably in pieces by Kathryn Bernson and Martha Wiseman, she has primarily presented her own works in concert in and around New York City. Her creations have received critical acclaim for their interesting experimentations with performance space and with systems of movement.

Works Choreographed: CONCERT WORKS: *Intervals* (1977); *My Grandfather's Nose* (1977); *Mooncalf* (1977); *The Stuffed Owl* (1977); *Blue* (1978); *We Have Seen Her* (1978); *The Knuklebone Players* (1978); *Long Division* (1978); *Mirage* (1979); *Elegy* (1979); *Rocky Mountain Suite* (1979); *Would You Like to Take a Walk* (1980); *Wind Chimes* (1980).

Cage, John, American composer and theorist; born September 15, 1912 in Los Angeles, California. Cage's musical training included studies with Henry Cowell and Arnold Schoenberg. As a member of the faculty of the Cornish School of Music in Seattle, he composed an early aleatoric (chance) structure work for Syvilla Fort, *Bacchanale,* and first worked with Merce Cunningham, then a student there. Much of his composition for dance has been done for works choreographed by Merce Cunningham, although other dancers have used his extant scores for their ballet, modern, or postmodern pieces.

Like most people credited with a cultural revolution, Cage created two new formulations, both of which had enormous impacts on choreography. He expanded the uses of conventional instruments by ''preparing'' them—attaching sound-producing items to moving parts so that each fingering process produced two or more noises. He also used unconventional parts of instruments to create new orchestrations—the backs of stringed instruments, the sides of percussion ones, and, as in a series of art songs, the lid of a piano. These expansions of the conventional orchestra had an equivalent in the use of pedestrian, or everyday, movements in dance choreography by the early postmodernists.

Cage's second innovation was the development of aleatoric structure—actually worked out over a number of years but culminating in a series of projects for the Black Mountain College summer workshops of the 1950s. In aleatorism, the structure of a work of music or dance is not predetermined by accompanying elements, such as plot or score. For Cage, this can

result in collages of music assembled for a single performance; for Cunningham, it has coalesced into the Event format, in which elements from the repertory are divested of their formats and assembled by chance methods into each individual event.

Because of their methods of creation, it cannot truly be said that Cage composed scores for Cunningham to choreograph. Much of his music, however, has been created to be performed concurrently with a Cunningham dance, among many, *Antic Meet* (1958), *Field Dances* (1963), *Second Hand* (1970), and *Un Jour ou deux* (1973). Not only does Cage perform his music for Cunningham presentations, either on a prepared instrument or on the instrument board of tape recorders, but he also appears as a recognizable figure in spoken-word scores. His puns can be heard in the scores for many works ranging from serious lectures on music to well-remembered gags about the indeterminacy of the New York City subway system.

Cage's writings on music, dance, and creation of works can be found in his books and compilations of his essays. His pieces on the Cunningham tours, and theories on food consumption, can be located in old *Ballet Reviews.*

Bibliography: Cage, John. *Silence* (New York: 1961); *A Year from Monday* (New York: 1967).

Cagney, James, American tap dancer and actor; born July 17, 1899 in New York City. Without dance training, he made his debut in vaudeville in a female impersonation act, *Every Sailor* (c.1919). He went from chorus boy to specialty dancer during the Broadway run of *Pitter Patter* (1920), then returned to vaudeville as a member of Madge Miller and Her Boy Friends. He toured with Parker, Rand, and Leach, replacing Leach (Cary Grant), until he joined Lew Field's *Ritz Girl of 1922,* and *Snapshots of 1923,* which brought him back to New York. After acting in his first play, *Outside Looking In* (1925), he played "Roy Lane, song and dance man," in George Abbott's *Broadway* (1926) in the replacement cast. He was a tap specialist in the *Grand Street Follies of 1928,* and danced as a policeman in the 1929 edition, which led to the part that led to a contract with Warner Brothers.

For many years, Cagney's Hollywood career was schizophrenic. He spent half his time in the gangster films and melodramas that rightly made him famous as a great actor. His musical films, however, were also popular. The best of these include *Footlight Parade* (WB, 1933), a Busby Berkeley film about Prolog production that began as a biopic of Fanchon and Marco and ended up as an allusion to Chester Hale. As "Chester Kent," Cagney spent most of the film trying to produce three original Prologs in a weekend, finally performing his own tap specialties in the end of the last reel. *Something to Sing About* (Grand National, 1935) is a personal favorite since in it he danced with Johnny Boyle and Harland Dixon, tap dancers who could better his machine-gun style and who coached him on the film. His best known role, apart from *The Public Enemy,* was as "George M. Cohan" in the very fictionalized biography of the writer/producer. For Cagney, the film concentrated on Cohan's vaudeville and Broadway performing career and included a reconstruction of his performances in *Little Johnny Johnson* ("I'm a Yankee Doodle Dandy"), and as a Franklin Delano Roosevelt in *I'd Rather Be Right.*

Cahan, Cora American modern dancer; born February 26, 1940 in Brooklyn, New York. After studies with Gertrude Shurr and Margaret Craske as a child, Cahan was trained at the High School of Performing Arts by May O'Donnell and Norman Walker, and at the Juilliard School where she participated in the composition classes of Louis Horst. Although she danced with the companies of Helen Tamiris for whom she appeared in *Memoire,* and Pearl Lang, for whom she was partnered with Eliot Feld in *Rites* (1958), she spent most of her dance career in the companies of her two mentors. She was given O'Donnell's own roles in revivals of her *Suspension* and was cast in major parts of *Brandenburg Concerto No. 5, Pelleas and Melisande,* and *Dance Sonata.* Cahan performed with Walker for ten years creating the leading female roles in almost every work choreographed in the period between 1961 and 1971. Walker's talent for creating characterizational duets with emotional content imbued into the support work was augmented by Cahan's dramatic ability and, to many people, his work in that period has never been equaled. Among their best remembered

duets were *Meditation of Orpheus* (1964), *The Testament of Cain, The Chanter* (1965), and *Elogés* (1967).

Cahan began teaching in the 1950s at her alma mater and also served as professor of dance at the University of Cincinnati in the mid-1960s. She currently works as administrator of the Eliot Feld Ballet and choreographs occasionally for the New York Shakespeare Festival and Public Theater.

Works Choreographed: THEATER WORKS: *Iphigenia* (1971).

Caldwell, Bruce, American ballet dancer; born August 25, 1950 in Salt Lake City, Utah. The image of ballet dancers in contemporary culture is one of youngsters dedicating their lives to the art in a progression of roles as they age into adolescence. The image has been transformed through the popularity of the Christmas ballet, *The Nutcracker,* and now people believe that every "Clara" will grow up to be the "Sugar Plum Fairy" and each "Drosselmeyer's Nephew" (or the young nutcracker) into a "Prince" and "Cavalier." Bruce Caldwell is one of the few dancers for whom this has become reality. A student throughout his life of Willam Christensen and Bene Arnold, he made his debut as "Drosselmeyer's Nephew" in the 1962 revival of Christensen's *Nutcracker.* In the next eleven years, he matured from children's chorus to auxiliary to apprentice to corp member to soloist to principal, with classical cavalier roles in the company's enlarged production of the Christmas ballet. His other adult credits include principal parts in the company's *La Fille Mal Gardée, Swan Lake,* and *Coppélia,* John Butler's *Carmina Burana,* Lew Christensen's *Con Amore,* and George Balanchine's *Symphony in C.*

Calloway, Northern, J., American theatrical and television dancer and actor; born c.1952 in New York City. Calloway was trained at the High School of Performing Arts. He first became widely known as the "Leading Player" in the London and New York productions of Bob Fosse's *Pippin,* the most important dance and personality role in that show. He has appeared in musicals, such as *Salvation* (1969) and *The Me Nobody Knows* (1970), and in dramatic roles with the Lincoln Center Repertory company and independent Broadway productions. Calloway is best known, however, for his continuing performance as "David" on the popular Children's Television Workshop production, *Sesame Street* (PBS, 1970–).

Calzada, Alba, Puerto Rican-American ballet dancer; born January 28, 1945 in Santurce. After training in Spanish classical dance from Maria Therese Miranda and in ballet from Ana Garcia and Juan Anduze, she accepted a scholarship from the Institute of Culture to continue her studies at the American Ballet Center and the American Ballet Theatre School in New York. Calzada performed in the Ballet de San Juan in the mid-1960s, with featured and principal roles in the company's repertory of classical revivals, including its *Les Sylphides, Giselle, Swan Lake,* and *Coppélia.* In 1968, she returned to the mainland to join the Pennsylvania Ballet, in which she repeated her triumphant role in the valse solo of *Les Sylphides* and learned new solos in that troupe's Balanchine repertory, most notably its productions of *Scotch Symphony Serenade, Four Temperaments,* and *Symphony in C.* She also performed in dramatic roles in its revivals of Antony Tudor's *Jardin aux Lilas* and Benjamin Harkavay's *Madrigalesco* and *Time Past Summer,* becoming recognized as one of America's finest characterizational ballerinas.

Camargo, Marie Anne De Cupis, French eighteenth-century ballet dancer and contemporary symbol of dance; born April 1710 in Brussels; died April 29, 1770, in Paris. Camargo performed with the opera ballets of Brussels and Rouen before moving to Paris to study with Balthassare Blondi. She made her Paris Opéra debut in May 1726, creating the female lead in Jean Balon's *Les Caractères de la Danse.* For the remainder of her career (1726 to 1734 and 1740 to 1751), she was associated with the Paris Opéra. Ballets in which she performed featured roles include *Les Fêtes Venitiennes, Hypermnestre,* and *Pyramus et Thisbe,* all of which were staged during the period when choreographers were not credited, and A.B. Laval's *Zélisca* (1746), *l'Année galant* (1747), and *Daphnis et Chloe* (1747).

Camargo's reputation has been built on an incident in her Opéra career, and on the contemporary

views of her technique and delicate style. It involved her shortening of her costume skirt and panniers in order to free her feet for performance. It is not sure whether this incident actually took place or whether it was an apocryphal recognition of the reforms in costuming that were being imposed on the Opéra by its choreographers and performers. It is, however, appropriate that the story is told about Camargo who used her feet inordinantly in performance, doing *batterie* work that could not be seen in the traditional costume. The story is also appropriate to Camargo since she was an early example of celebrity-marketing techniques, lending her name to styles of shoes, wigs, and garments.

Cameron Sisters, American tandem dance team; Dorothy Cameron (died April 15, 1958) and Madeleine Seitz were teamed at the Ned Wayburn Studios in New York City. They first worked together in a vaudeville act that Wayburn staged for them on the Keith circuit in 1912, but were cast in Broadway musicals by 1914, when they appeared as the twin exotic dancers, ''Zillah and Jezirah,'' in *Miss Simplicity.* They worked on film, in Kalem's *Maxim's at Midnight* (1915) and on stage in Wayburn's *Town Topics of 1915, So Long Letty* (1916) and at the Capitol Theater in their extraordinary range of dance styles. Within the tandem format of mirror and opposition poses, they worked in conventional ballet, toe tapping, eccentric, and acrobatic ballet, Russian eccentric work, Russian tap dancing, acrobatic dance, and exhibition ballroom forms. Their 1921 feature act *A Study in Rhythm,* for example, included segments in each of the above techniques, plus the interpretive *Narcissus,* the toe-tapping Point Center Waltz and the unique two-woman Cameron fox trot.

Although Dorothy Cameron retired in the late 1920s, Seitz-Cameron, who was married to actor William Gaxton, appeared as a specialty dancer in *Hit the Deck* (1927) and *Follow Thru* (1929), and as a comedienne with him.

Campbell, Sylvester, American ballet dancer also working in Europe; born January 22, 1938 in Oklahoma. Raised in Washington, D.C., he was trained at the Jones-Hayward school there. After his debut with the New York Negro Ballet in 1956, he moved to Europe where he found company positions and guest

engagements for the next twelve years. He was a member of Het Nationale Ballet of the Netherlands for much of that time, becoming known for his flawless work in the classical repertory and for his dramatic performances in contemporary pieces such as Ronald Hynd's *Baiser de la Fée* and Michel Descombey's *Symphonie Concertante.* When he returned to the Western hemisphere to join the Royal Winnipeg Ballet in 1972, he remained associated with the contemporary European repertory, with roles in works by Georges Skibine, Brian MacDonald, and John Neumeier, as well as the classics. Campbell returned to the United States in 1977 to join the Maryland Ballet, a medium-sized, well-reputed company with an eclectic repertory.

Campra, André, French eighteenth-century composer; born in the late fall of 1660 in Aix-en-Provence; died July 29, 1744 in Versailles. One of the most prominent musicians and composers of his day, Campra served as director of music (conductor and composer-in residence) for the Cathedral of Notre Dame de Paris in the late 1690s and of the Paris Opéra in the 1710s and 1720s. His twenty-five scores served as a bridge between opera and ballet (as we now use those terms), creating a transition from dance as an adjunct to literature to dance as a servant to music. Three works, *L'Europe galante* (1697, premiered as an anonymous work), *Le Carnaval de Venise* (1699), and *Tancrede* (1702), became standards of the eighteenth- and nineteenth-century repertories; versions of the carnival in Venice plot were choreographed as late as 1900.

Camryn, Walter, American ballet dancer and choreographer; born 1903 in Helena, Montana. Raised in farm and grazing country, Camryn did not begin his dance studies until he was twenty-four and a graduate of agriculture college. After working with Alexandra Maximova, he trained with and performed for the various successive directors and ballet masters of the various Chicago area ballets, among them Adolf Bolm, Laurent Novikoff, Muriel Stuart, and Bentley Stone. He was a principal dancer with the Chicago Opera Ballet, the Federal Theatre Project, the (Ruth) Page/Stone Ballet and Page's concert troupes, while directing the Chicago Children's Theatre.

Camryn's choreographic efforts are divided

among his concert solos, dating from the late 1930s and early 1940s, his dance shows for children and his conventional ballets for the Page/Stone Ballet and the students of the Stone/Camryn School. His best known works include the American pieces *Casey at the Bat* (1939) and the tribute to medicine shows, *Dr. Eli Duffy's Snakeroot* (1942), children's ballets, *Hansel and Gretel* (1954) and *Alice in Wonderland* (1951), and abstractions, *In My Landscape* (1960) and *A Sense of Wonder* (1967). With his Chicago colleagues, he has been a major influence in the Midwest, training dancers and choreographers for works around the world.

Works Choreographed: CONCERT WORKS: *Ditties* (1935); *That Daring Young Man* (1939); *Hot Afternoons Have been in Montana* (1939); *Dr. Eli Duffy's Snakeroot* (1942); *Set of Three* (1942); *Songs of Yesteryear* (1942); *The Singing Yankees* (1942); *The Shooting of Dan McGrew* (1942); *Symphony in C Minor* (1944); *Krazy Kat* (1948); *Like a Weeping Willow* (1949); *Alice in Wonderland* (1951); *Hansel and Gretel* (1954); *Trio Variations* (1956); *In My Landscape* (1960); *A Sense of Wonder* (1967); *Carnival Dances* (1967); *Cumberland Gap Suite* (c.1970).

Cannon, Thomas, American ballet dancer; born during the 1910s in the Philadelphia area; died January 21, 1977 in Miami, Florida. A student of Caroline Littlefield, Cannon was associated through much of his career with the company of her daughter, Catherine. As principal male dancer of the Littlefield Ballet, he created the roles of "Daphnis" in her *Daphnis and Chloe* (1936), "The City Slicker" in her *Barn Dance* (1937), and "The Bluebird" in her version of *Aurora's Wedding*. He also danced in her *Café Society, Fête Champêtre, Classical Suite,* and opera ballets. On a freelance basis, he danced with the Chicago Grand Opera Ballet and the Ballet Russe de Monte Carlo.

After retiring from performance, Cannon staged dances for opera companies in Philadelphia, Hartford, Connecticut, and the greater Miami area, where he retired in 1976. From the available illustrations, it is obvious that Cannon was a tremendously gifted *danseur noble* and an articulate performer. It is unfortunate that the Littlefield Ballet never got the reception that it needed to be recognized as a major American ballet company.

Cansino, Eduoardo, Spanish classical and exhibition ballroom dancer working in the United States after the 1910s; born 1895 in Madrid; died December 24, 1968 in Pompano Beach, California. The son of Antonio and Carmen Cansino, he toured with his sister, Elisa, on the Keith vaudeville circuit from 1911 to 1915, remaining in the United States throughout his professional life. He had an act with his next youngest brothers, The Dancing Cansinos, until the depression put a damper on the vaudeville business.

In late 1929 he moved to Los Angeles with his wife, ex-Ziegfeld dancer Volga Haworth, and daughter, Marguerita, to open a studio on Hollywood Boulevard. He staged dances for films made by Warner Brothers and Fox Films, and choreographed Prologs for the Cathay Theatre and for the Fanchon and Marco chains. An expert at theatricalizing tangos, he created cabaret acts for clubs in Tijuana and Agua Caliente that featured his young daughter, who was discovered by the studios and renamed Rita Hayworth. He managed studios in Hollywood and Oceanside, California, and Laredo, Texas, until retiring in the 1950s.

One of Cansino's early films has been preserved. *Dante's Inferno* (Fox Films, 1935) is a fascinating example of the studio sneaking material through the Hays production code and includes a modern sequence, with a background of tango dancers, a carnival, with barely seen circus acts, and a chiaroscura scene in the Kingdom of the Shades that is still cited as one of the studio's best orgies.

Works Choreographed: FILMS: *Golden Dawn* (WB, 1930); *Under a Texas Moon* (WB, 1930); *Dante's Inferno* (Fox Films, 1935); *The Loves of Carmen* (Columbia, 1948).

Cansino Family, three generations of Spanish classical and exhibition ballroom dancers in the United States in the twentieth century. The family patriarch, Antonio Cansino, was an Andalusian dancing master and performer associated through much of his career with the Teatro Real de Madrid and the Teatro Duque de Sevillia. He and his partner/wife, Carmen, had seven children, all of whom became dancers themselves—Elisa, Eduoardo, Angel, Paco, José, Antonio II, and Rafael. Elisa (1895–?) toured with Eduoardo on the Keith circuit of American vaudeville, then returned to Spain to teach. Her son, Ga-

briel (1913–1963), moved to California to teach for Eduoardo in Los Angeles and at his own studio in San Francisco. Angel (1896–?) joined Elisa and Eduoardo to become The Dancing Cansinos, remaining in New York to teach. José (1897–?) had a dance act, Danse Revue Espagnol, for over twenty years (1905–1931) with Toria de Aragon and two of his own pupils. Antonio II had a tango act with his wife, Catarina. Rafael (1897–1948) appeared in films throughout the 1930s and taught in Eduoardo's studio in Hollywood; at his death, he managed an exhibition ballroom school in San Francisco. I have been unable to find specific dates or information about Paco.

The seven members of the second generation toured so extensively that they were all in the same place only twice between 1925 and 1945—holding reunions in Seville and Los Angeles. Although Eduoardo became the best known teacher and José the most famous performer of that generation, all members of the family had an important influence on dance in the United States—Spanish, other ethnic forms, and exhibition ballroom work.

Cantor, Eddie, American theatrical dancer, singer, and comic; born Isidore Itzkowitz, January 31, 1892 in New York City; died October 10, 1964 in Hollywood, California. While Cantor is generally considered one of the foremost comedians and vocalists of the American stage, film, radio, and television, his dance skills are frequently ignored. His act as a young performer, on Broadway and in his early films, employed a tremendous amount of dance and stylized movement. He has even been credited with the development of the "jazz hand," the outstretched fingers and flared wrists that are associated with Broadway and television dance of the 1950s.

His character in revues and musicals was that of a young man emerging very slowly from puberty and discovering women, alcohol, and culture. He spent his first *Follies* playing Bert Williams' son (in blackface), being put down by the comic who called himself "the great loser." In the 1919 *Follies,* the Prohibition edition, he became a star singing "You Don't Need the Wine to Have a Wonderful Time When They Still Make Those Beautiful Girls" and "You'd Be Surprised." His dance satires included participa-

tion in the Ballet Russe numbers in the 1917 *Follies,* and a personal favorite, the song from the 1918 edition, "But After the Ball Was Over . . . Johnny made up for lost time," in answer to the "Anyone can learn to dance at home" type ads.

Cantor's early films, staged by Busby Berkeley, allowed him to do his solo dance act and surrounded him with female choruses. Since the revival of interest in early Berkeley films, it has been easier to see the 1930s Cantor movies, *Roman Scandal* (UA, 1933), *Whoopee* (Samuel Goldwyn, 1930), *Kid Millions* (UA, 1934), *Palmy Days* (UA, 1931), and *The Kid from Spain* (UA, 1932), than to locate his later ones for RKO.

Caperton, Harriette, American exhibition ballroom dancer; born c.1913 in Richmond, Virginia. Known as the "Debutante Dancer," Caperton had local training in social dance and etiquette before she formed a team with Earl Vernon Biddle (c.1905–1939). They toured together for four years on Prolog and presentation act circuits, most notably appearing at the Capitol Theater, New York, in 1932 and 1933. She left Biddle to join a partnership with Charles Columbus, whose long-time colleague in a three-person act, Nelson Show, had recently died. Columbus, who was considered one of the great exhibition and adagio dancers of the 1930s, staged an act for them that included exhibition waltzes and fox trots in the style that we now associate with Astaire and Rogers, and adagio dances focusing on his extraordinary ability to maintain her in gravity-defying positions in rhythm and in conjunction with accompanying music. Their best known dance was a waltz sequence that began with a conventional flirtation dance and ended as an elaborate gymnastic routine. Their work can be better compared to the exhibition and competition routines of ice skaters Tai Babilonia and Randy Gardner than to contemporary dancers. After touring with Columbus from 1935 to 1941 to theaters and clubs, Caperton retired from performance.

Capps, Kendall, American soft shoe expert; born October 3, 1903 in St. Louis, Missouri. A member of The Capps Family, the Orpheum circuit's answer to the Seven Little Foys, he performed in vaudeville as a

child; in 1921, he left the family act to organize a band.

As the male lead of Capps and Savoy, he performed on the Orpheum circuit from 1922 to 1924, when they teamed up with the Lloyd Ibach's troupe. He made it to Broadway in 1925, when he joined the *Greenwich Village Follies* of that year as lead dancer. His appearance in that last regular edition of the famed "intellectual's Follies" brought him bookings with the Paramount/Publix Prologs circuit where he danced for forty weeks. An engagement with MacIntyre and Heath's *Heddin' South* led to his best show part—the juvenile/dance lead in *Boom-Boom* (1928), a Jeannette MacDonald vehicle in which he danced with two different precision teams, trained and provided by Jack Donohue and John Boyle. His reception in this flop was so great that after two seasons on the Paramount/Publix circuit, he followed Donohue and Boyle to Hollywood to dance and coach.

Capp's act, which was unique in its day, but is now associated with MGM performers of the 1930s, was an eccentric soft shoe, known in the jargon as a "flash flush." His ability to maintain a beat while flinging his legs around in stunts was combined with an exceptional versatility of footwork, forcing the audience to try to watch both his support and working legs.

Cappy, Ted, American theater and television choreographer; born June 9, 1920 in Brooklyn, New York; died February 22, 1979 in New York City. Cappy studied ballet with Aubrey Hitchins and modern dance with Hanya Holm. During World War II, he served in the Special Services unit of the Armed Service, appearing in *This Is the Army* (1942), and serving as assistant choreographer on the filmed version (WB, 1943).

Cappy is well known for two disparate forms of choreography; he is famous for the spectacular tap numbers staged for industrials, including the *Miliken Shows* of 1960 and 1961, commercials and musicals during the 1960s. Equally celebrated for his ability to stage dances for straight plays, his work on *Ring Around the Moon* (1950) and *Idiot's Delight* (1951) was subtle and completely integrated into the script and action. He also worked on the revue *Two on the Aisle* (1951) and the whimsical operetta *Three Wishes for Jamie* (1952).

Throughout the 1950s, Cappy worked extensively on television variety shows, among them, *Kate Smith Presents* (NBC, 1954), *The Guy Mitchell Show* (ABC, 1958), and a series of *Sid Caesar* specials.

Works Choreographed: THEATER WORKS: *Ring Around the Moon* (1950); *Idiot's Delight* (1951, revival); *Two on the Aisle* (1951); *Remains to be Seen* (1951); *Three Wishes for Jamie* (1952); *Hit the Deck* (1960, revival); *To Broadway with Love* (1964, New York World's Fair); *Anything Goes* (1972, revival); industrial shows.

TELEVISION: *Salute to America* (NBC, 1951, special); *Kate Smith Presents* (NBC, 1954); *Sid Caesar Presents* (NBC, 1955); *Sid Caesar's Hour* (NBC, 1955, 1956, 1957, specials); *The Guy Mitchell Show* (ABC, 1957–1958); *Sid Caesar-José Ferrer Spectacular* (NBC, 1959); *O'Halloran's Luck* (NBC, 1961, special); commercials.

Caras, Steven, American ballet dancer and photographer; born October 25, 1950 in Engelwood, New Jersey. Trained at the School of American Ballet, Caras performed with the (André) Eglevsky Ballet Company on Long Island before joining the New York City Ballet.

Noted for his dancing in the works of Jerome Robbins, Caras has performed in his *Scherzo Fantastique,* created for the 1972 Stravinsky Festival, the 1971 revival of *The Concert,* and the recent *Opus 19: The Dreamer* (1979). He has also been acclaimed for his work in George Balanchine's *Who Cares?* which depends on exact timing performed with Broadway gypsies' wide smiles.

Known as a photographer of dancers, Caras has exhibited both his studio portraits and action shots.

Cardus, Ana, Mexican ballet dancer working in Europe after the 1960s; born May 8, 1943 in Mexico City. Cardus was trained in Mexico City by Nelsy André and Serge Unger, later performing with Unger's Ballet Concierto de Mexico until 1960.

Cardus has performed in European companies since 1960, with the Ballet International du Marquis de Cuevas in pas de deux derived from the classics for two years, and in the Stuttgart Ballet. In the latter

company, under John Cranko, she created roles in his *l'Estro Armonico* (1963), *Onegin* (1965), *The Interrogation* (1967), and *Quatre Images* (1967), and in Kenneth Macmillan's *Song of the Earth* (1965). She performed in many other Cranko works, among them *Romeo and Juliet, Firebird,* and *Coppélia,* and in George Balanchine's *Allegro Brillante.*

In 1972, she joined a troupe organized for Carla Fracci, again performing pas de deux. Her work in that troupe with choreographer Louis Gai led to an engagement with the Hanover State Opera, for which he served as ballet master. She has since created roles in his *Pulcinella* (1971), *The Stone Flower* (1973), and *Hamlet* (1974).

Carey, André Isidore, Swedish early nineteenth-century ballet dancer working in Italy; born c.1800, possibly in Stockholm; details of death uncertain. The patriarch of the Carey family of dancers performed in Stockholm in the early 1820s but relocated to Milan where he became a principal *danseur noble* of the Teatro alla Scala. A staple in the ballets of Gaetano Galzerani and Gaetano Gioja, he created roles in the former's *La Straniera* (1829), *Jefte* (1828), and *Il Maldeicent* (1828), and in the latter's *Le Nozze de Bacco* at the Teatro Di San Carlo in 1829. He toured as far east as Moscow in the late 1830s in Gioja's repertory, making his Moscow debut in 1838.

Carey was the father of Charles Philippe August Edouard (1824–1873) and Isidore Camile Gustave (c.1817–1870), and grandfather of Léontine and Fanny Carey.

Carey, Edouard, Swedish nineteenth-century ballet dancer working in Italy; born Charles Philippe August Edouard Carey, 1824, possibly in Stockholm; died 1873. The younger son of André Isidore Carey, he also made his reputation in performances at the Teatro alla Scala in Milan. Among the many ballets there in which he created danseur roles were Antonio Monticini's *Ildegonda* (1843), Antonio Cortesi's *Gisella, ossia le Willi* (1843, an early Italian production of the French classic), and Luigi Astolfi's *Zampa* (1850). He became especially well-known for his heroic portrayals of the protagonists in Astolfi's extravagant historical pageant/ballets for La Scala.

Carey, Gustave, Swedish nineteenth-century ballet dancer and choreographer; born Isidore Camile Gustave Carey, c.1817, possibly in Stockholm; died October 26, 1881 in Copenhagen, Denmark. Raised in Milan where his father, André Isidore Carey, was a *danseur noble* with the Teatro alla Scala, he became a member of that company himself in the 1840s. From c.1846 to 1854, he was cast in the principal roles in new ballets by Giovanni Casati, Antonio Monticini, Augusto Hus, Luigi Astolfi, and Filippo Taglioni. Among his best known repertory at La Scala and other Italian theaters were Astolfi's *La Figlia dell' Oro* (1847, Teatro La Fenice, Venice), Taglioni's *Azema di Granata* (1846) and *Isaura, ossia la protetta delle fate* (1856, Teatro San Carlo), Monticini's *Leila de Granata* (1847, Teatro Canobianno, Milan) and *Otello* (1846), and Hus' *Don Sebastiano, re di Portagallo* (1847, Teatro Regio, Turino), *Gustavo III* (1846), and *Ester d'Angaddi* (1847). He played the protagonist in almost every ballet by Vasati, including *Manon Lescaut* (1846), *Le figlie della guerra* (1845), *Abd-el-Kader* (1846), *Il Diavolo a quattro* (1846), and *Shakespeare* (1846).

He staged a few works in Italy before returning to the Scandinavian lands, notably an 1855 revival of *Shakespeare* for the Teatro San Carlo, but his best known production remained his revival of *Giselle* for the Royal Danish Ballet in 1862. His years in Copenhagen brought him into contact with August Bournonville; his influence on that choreographer has led to his rediscovery by present historians in this period of Bournonville's centenary.

Gustave Carey's son, Edouard, not to be confused with his brother of that name, predeceased him; it is not known whether he lived long enough to pursue a career in dance. His daughters, however, Léontine and Fanny, were well-known performers in the Pantomime Theatre at the Tivoli Gardens (c.1865 to 1880). Their dance acts seem to have been tandem pieces, performed in mirroring techniques, but this may be a false perspective created by photographic rather than choreographic posings.

Carlisle, Kevin, American modern dancer and theatrical and television choreographer; born December 24, 1935, in Brooklyn, New York. Trained at the

Juilliard School from which he graduated in 1954, Carlisle served as assistant to Doris Humphrey, then head of its Dance Theater, from 1954 to 1956. During the late 1950s, he performed at many modern dance concerts, among them the series of recitals organized by Fred Berk (1958-1959), and the Chanukkah Festivals staged by Sophie Maslow (c.1957-1959). During the summer of 1958, he played "Enoch Snow, Jr." in the revival of *Carousel* staged for the U. S. Pavillion at the Brussels World Fair.

Carlisle's first recital was shared with television choreographer Bob Hamilton, although it is not certain whether he had performed for him at that time. The works performed at the February 1960 92nd Street Y concert included *Divertimento for Dancers, Jazz Andante, The Joy of Dancing,* and *Pas de Deux 60,* co-choreographed with Edward Villela. Dancers in his company for that concert included Villela and choreographer Larry Fuller; the entire male cast of his *Part-Time Invention,* staged for the Juilliard Dance Ensemble in 1964, is now choreographing—Raymond Cook, Larry (Lar) Lubovitch, Dennis Nahat, and Lance Westergard.

Although Carlisle is remembered as a modern dancer, he is best known as a choreographer for Broadway, for concerts and cabarets, and for television. His Broadway shows have included *Love Match* (1967), *The Happy Time* (1968), *Hallelujah, Baby!* (1967), *Her First Roman* (1968), and the magic spectacle *Blackstone* (1980). He has staged concert and cabaret acts for almost every recording artist around, from George Burns to Joey Heatherton to Liberace and a group called Billy Thundercloud and the Chieftones. Many of the singers for whom he stages live acts also employ him to choreograph their television specials, among them, Nancy Dessault and Barry Manilow for whom he has staged all of his variety appearances. Among Carlisle's more than forty other specials are the *Junior Miss Pageants* (1974-1978), and Grammy, Oscar, and Tony awards ceremonies. Carlisle has also staged specials for Canadian and European television networks, including circus and ice show presentations for Belgian and German stations and the award-winning film of the Modern Jazz Quartet tour for French broadcast.

As well as specials, Carlisle has staged dances for many variety series for both network and syndication. Graduating from dancer to choreographer on the *Garry Moore Show* (CBS, c.1965-1966), he has created musical numbers for *That Was the Week That Was* (NBC, 1965), *The Dean Martin Show* (NBC, 1965-1966), *The Show of the Week* (CBS, Toronto, 1964-1966), *COS* (ABC, 1976-1977) and *Sha Na Na* (Syndicated, 1978-), among many others.

Works Choreographed: THEATER: *Hallelujah Baby!* (1967); *Love Match* (1967); *The Happy Time* (1968); *Her First Roman* (1968); *Blackstone* (1980); many cabaret acts (c.1974-).

TELEVISION: *The Garry Moore Show* (CBS, 1965-1966); *That Was the Week That Was* (NBC, 1964-1965); *The Show of the Week* (CBS, Toronto, 1964-1966); *The Dean Martin Show* (NBC, 1965-1966); *Coliseum* (CBS, 1967-); *What's It All About World* (CBS, 1969); *COS* (ABC, 1976-1977); *The Peter Marshall Show* (Syndicated, 1977); *Sha Na Na* (Syndicated, 1978-); *Solid Gold* (Syndicated, 1980-); specials, award ceremonies, and telethons (c.1973-).

Carlson, Carolyn, American modern dancer and choreographer working in France after 1974; born March 7, 1943 in Oakland, California. Trained at the University of Utah, she moved to New York to work with Alwin Nikolais, who had presented master classes on campus. She performed with the Nikolais company in the late 1960s and early 1970s creating roles in his *Galaxy* (1966), *Somniloquy* (1967), *Limbo* (1968), and *Echo* (1969), among many others. She also performed with the troupe of fellow dancer, Murray Louis, appearing in the premiere of his *Junk Dances* in 1966.

A frequent visitor in Paris with the Nikolais and Louis companies, she was invited to direct the Groupe de Recherche Théâtres of the Paris Opéra in 1974. She has created works for that company since the mid-1970s using her own vision of composition and the ballet training of her dancers.

Works Choreographed: CONCERT WORKS: *Exchange* (1967); *I* (1968); *O* (1968); *Wanderings* (Sermon, duet, anthem, hymn) (1968); *Running* (1971); *Red-Shift* (1973); *Densité—2.65* (1973); *Les Foux d'Or* (1973); *L'Or des Foux* (1973); *Il y a juste un instant* (1974); *Sablier Prison* (1974); *Wind, Water and*

Sand (1976); Human, called Being (1977); The Beginning, The End (1977); This, That and the Other (1977).

Bibliography: Delahaye, Guy, and Lé-Anh, Claude. Carolyn Carlson (Paris, 1978).

Caron, Leslie, French ballet dancer and actress; born 1931 in Paris. Daughter of American theatrical ballet dancer, Margaret Petit, Caron began to dance at the age of ten, studying at the Conservatoire Nationale de la Danse in Paris.

Caron made her professional dance debut with Les Ballets des Champs-Elysées in 1949, appearing as the "Sphinx" in David Lichine's La Rencontre. With that company, she also performed featured roles in Roland Petit's Les Forains, Jannine Charrat's Jeu de Cartes, and Auriel Milloss' Le Portrait de Don Quichote. After performing in American films, Caron danced with Petit's Les Ballets de Paris as a guest artist, appearing as "The Lady" in Deuil en 24 Heures (1954), a ballet created for her by Petit.

In 1951, Caron was selected by Gene Kelly as his co-star in An American in Paris (MGM, 1951). She partnered Fred Astaire in Daddy Longlegs (Twentieth-Century Fox, 1955) in dance sequences created for her by Petit. Caron's other films involving dance are Glory Alley (MGM, 1952), The Story of Three Loves— "The Jealous Lover" sequence only (MGM, 1953), Lili (MGM, 1953), The Glass Slipper (MGM, 1954), Gaby (MGM, 1956), and Gigi (Twentieth-Century Fox, 1958). She has also appeared in many nondance films—American, English, Italian, and French—and on the Paris and London stage in dramatic roles.

Carpenter, Freddie, Australian theatrical dancer and choreographer also working in the United States and England; born c.1910 in Australia. Carpenter was raised in New York City, where he studied ballet with Mikhail Mordkin and tap with Buddy Bradley and possibly Billy Pearce. He was discovered by John Murray Anderson, who cast him in Prologs for the Paramount/Publix circuit and his Almanac revue on Broadway (1929). Carpenter emigrated to England (where most of his career followed) with Sophie Tucker as a specialty dancer in her act, Follow a Star. Although he returned to New York briefly to tap dance in I'd Rather Be Right in 1937, he moved back to London to stage musical numbers for Ivor Novello's operetta, The Dancing Years (1939). After World War II, during which he staged shows for the RAF servicemen and ENSA tours, he became known as the last person in theatrical history to be a successful choreographer specializing in pantomimes. Although most English theaters (outside London) present Christmas pantomimes every year, most use local directors or imported choreographers. Carpenter, as dance director for Howard and Wyndham Productions, became almost a factory of pantomime presentation, creating shows for theaters in London, Liverpool, and, most notably, the Glasgow Alhambra, where one of the few pantos created after 1900, A Wish for Jamie, was premiered in 1960. Carpenter is also known for his productions of Broadway musicals and comedies in Australia and has been responsible for the local debut presentations of How to Succeed in Business Without Really Trying and A Funny Thing Happened on the Way to the Forum in the 1960s.

Works Choreographed: THEATER WORKS: Maritza (c.1937); Bobby, Get Your Gun (c.1938); The Dancing Years (1939); Pantomimes for Howard and Wyndham Productions (c.1953–1970), including A Wish for Jamie (1960) and A Love for Jamie (1963).

Carroll, Danny, American theatrical performer; born Daniel Lichtenberger, May 30, 1940 in Maspeth, Queens, New York. Trained at the High School of Performing Arts, he made his professional debut as a soloist at the Radio City Music Hall in 1956. Within the year he had been cast as "Tommy" (the male juvenile lead) in Oona White's The Music Man, in which he won wide acclaim in the "Shipoopie." Carroll's career has been split between club engagements as a tap dancer or master of ceremonies and work in musical shows. In the former category, he has been a headliner at the Copacabaña, the Latin Quarter, and the Versailles, while his credits in the latter include roles in the national companies of Funny Girl (as "Eddie," the tap dance lead), Once Upon a Mattress, and By the Beautiful Sea. His per-

formances on Broadway itself have involved dance specialty and comedy speaking roles in *Flora, the Red Menace* (1965), *George M!* (1968), *Billy* (1969), and Michael Bennett's *Ballroom* (1978).

Carroll, Earl, American theatrical entrepreneur, songwriter and choreographer; born September 16, 1893 in Pittsburgh; died January 17, 1948 in New York. Originally a songwriter, Carroll was Ned Wayburn's production assistant on shows at the Winter Garden Theater, New York, from 1909 to 1912. He left Wayburn after a fight that made headlines in the trade papers, and went into vaudeville as a singer and dancer.

After writing shows for Broadway, among them *So Long Letty* (1916) and *Daddy Dumplings* (1920), he began to produce a series of revues known as *Earl Carroll's Vanities.* The Broadway editions ran from 1923 to 1936, with one *Sketchbook Revue* in 1929 and a *Hollywood Vanities* in 1940. The *Vanities* were usually described in negative comparisons to the *Follies* and *Scandals;* they did not have music as good as the *Scandals,* and did not employ comedians as funny as the *Follies.* What the *Vanities* had were show girls, the very tall nondancers who "draped the stage undraped" in all editions. Choreographed by George Hale, the shows had considerably less dancing in them than the other revues, but one edition did feature Jessie Matthews (1927, in her *Charlot Revue* act) and another starred comic dancer Ray Dooley. Unlike his rival, George White, Carroll himself did not dance in the *Vanities.*

Moving to California in 1938, he opened a club in Hollywood. He produced two stage revues in Los Angeles—the 1940 edition of the *Vanities* and *From Broadway to Hollywood*—and served as production associate for Twentieth-Century Fox. Among the dance acts performing in the shows were the adagio team who became the parents of Los Angeles Ballet director, John Clifford. Two films were made about the *Vanities*—one from Republic Studios, 1945, directed by Joseph Santley, and *Murder at the Vanities* (1934), staged by Edward Prinz.

Carroll, Elisabeth, French ballet dancer working in the United States after the early 1950s; born Elisa-beth Plister in Andresy, France. After studies with Julie Sedova and Marika Besobrasova in Cannes, Carroll performed with the Monte Carlo Opéra Ballet.

A member of the American Ballet Theatre from 1954 to 1961, Carroll created roles in Birgit Cullberg's *Lady from the Sea* (1960) and Dania Krupsa's *Points on Jazz* (1961). She was assigned featured roles in *Giselle, Swan Lake*, and the company's productions of David Lichine's *Graduation Ball*, probably her best known solo role.

She later performed with The Robert Joffrey Ballet and the Harkness Ballet, notably in Brian Macdonald's *Time Out of Mind* and *Canto Indio.*

Carroll currently teaches at Skidmore College in upstate New York.

Carroll, Nancy, American film dancer and actress; born Ann LaHiff, November 19, 1905 in New York City; died August 6, 1965 in Nyack, New York. Carroll and her sister, Terry, made their joint debuts at an amateur night at the Orpheum 86th Street Theatre in New York. She first performed on Broadway in the *Passing Show of 1923*, as "The Beautiful and the Damned" in one of the elimination picture sequences, and later appeared in the *Passing Show of 1924, Topics of 1924*, and *Mayflower* (1925).

After moving to the West Coast, she appeared in staged productions there of *Nancy* (1926), *Chicago* (c.1927), and two editions of Carter De Haven's *Hollywood Music Box Revue*, staged by Larry Ceballos.

One of the best comediennes in film for over twenty years, she danced in many of her pictures. For example, she did Charlestons in *Ladies Must Dress* (Fox, 1927), *Hot Saturday* (Paramount, 1933), and *The Dance of Life* (Paramount, 1929), to define the modernity and moral attitudes of her character. Theatrical routines were integrated into her performances in *Abie's Irish Rose* (Paramount, 1928), *Chicken à la King* (Fox, 1928), *Child of Manhattan* (Columbia, 1933), and Ceballos' *Transatlantic Merry-Go-Round* (Reliance/UA, 1934). Her best remembered dances were probably the tap specialties in *Paramount on Parade*, a compilation film featuring musical numbers from most of the studio's contract players; her dance in an enlarged shoe is frequently

seen in excerpts to represent the period style of production.

Carter, Jack, English dancer and choreographer; born August 8, 1923 in Swindon, Wiltshire. Trained at the school of the Sadler's Wells Ballet, he danced with the Wells briefly, with the Original Ballet Russe, Ballet Rambert, and with Molly Lake's Continental Ballet (c.1946). With the Ballet de Lagelander in Amsterdam in the mid-1950s, he premiered his best known work, *The Witch Boy* (1956). Since then, he has been known entirely as a choreographer of ballets. His earliest works were primarily literary or biographical, among them *The Life and Death of Lola Montez* (1954), and *Adeline Plunkett in Paris* (1953). Later works have been more abstract, with a wider range of influences. Although most of his ballets have been created on a freelance basis, he is generally associated with the repertories of the Ballet Rambert and the London Festival Ballet, where he served as artistic director from 1965 to 1970.

Works Choreographed: CONCERT WORKS: *Fantasie* (1946); *Stagione* (1950); *l'Homme et sa Vie* (1951); *The Four Seasons* (1952); *Adeline Plunkett in Paris* (1953); *Psalmus Tenebrae* (1953); *Impromptu for Twelve* (1954); *The Life and Death of Lola Montez* (1954); *Love Knots* (1954); *Paysage Triste* (1954); *Shadows of the Past* (1954); *The Witch Boy* (1956); *London Morning* (1959); *Sonata da Manara* (1959); *Improvisations* (1962); *Grand Pas des Fiancées* (1962); *Agrionia* (1964); *Beatrix* (1966); *Cage of God* (1967); *The Unknown Island* (1969); *Pythoness Ascendent* (1973); *Three Dances to Japanese Music* (1973); *Shykemei* (1975); *Lulu* (1976).

TELEVISION: *Living Image* (BBC, 1951); *Journey into Melody* (NBC, March 9, 1958, special).

Carter, William, American ballet and modern dancer; born 1936 in Durante, Oklahoma. Raised in Dallas, Texas, and Los Angeles, California, he studied tap and acrobatics, ballet with Carmelita Maracchi and Christine De Vore, and Spanish dance with Teodoro Morco and Manolo Vargas.

In his first tenure with Ballet Theatre (1957–1961), he was a corps member with featured roles in George Balanchine's *Theme and Variations* and Jerome Robbins' *Fancy Free* and *Interplay*. He left the company to join the First Chamber Dance Quartet (1960–1971), where he performed in his own *Bach Capriccio* and Lois Bewley's *Part II* and *Five Songs*. During his membership in the Quartet, he danced with the New York City Ballet, notably in Balanchine's *Liebeslieder Walzer*.

Carter rejoined Ballet Theatre as a featured character dancer, performing principal roles in Agnes De Mille's *Rodeo*, Eugene Loring's *Billy the Kid*, playing "Pat Garrett," and John Neumeier's *Hamlet Connotations*, as "The Ghost of Hamlet's Father." The versatile Carter danced in Dennis Nahat's abstract *Ontogeny* and tapped with him in De Mille's *Texas Fourth*.

During his ballet career, Carter has participated in performances of two other styles of dance—traditional modern, in the companies of Martha Graham and Pearl Lang and Spanish forms in gala and guest performances. His revival of the Miller's Dance from Massine's *Le Tricorne*, for one, was a high point of the 1975 ABT gala. As a modern dancer, again specializing in character roles, he has worked with Graham, in her *Clytemnestra, Appalachian Spring, Diversion of Angels, Night Journey*, and *Letter to the World*, and for Pearl Lang, notably in her *Cantigas Ladino* and *The Possessed*.

Works Choreographed: CONCERT WORKS: *Allegory* (1963); *Summer Pergola* (1963); *Bach Capriccio* (1964); *Of Silent Doors and Sunsets* (1977); *Such Sweet Thunder* (1978); *Canciones Espagnoles Antiguas* (1979).

FILM: *In a Rehearsal Room* (Independent Production, 1976).

Cartier, Diana, American ballet dancer; born July 6, 1939 in Philadelphia, Pennsylvania. Cartier was trained by Antony Tudor in Philadelphia and New York, working with him in the Metropolitan Opera Ballet. A student also at the American Ballet Center, she graduated into the Robert Joffrey Ballet in 1960. A charter member of the City Center Joffrey Ballet, she has performed for Joffrey throughout the 1960s and 1970s. Among the many ballets in which she has been featured are Lew Christensen's *Con Amore*, John Cranko's *Jeu de Cartes* and *Pineapple Poll*, Flemming Flindt's *The Lesson*, Frederick Ashton's *Façade*, Antony Tudor's *Offenbach in the Under-*

world, Kurt Jooss' *The Green Table*, and Alvin Ailey's *Feast of Ashes*. Her sense of comic timing was exploited in the company revival of Ruthana Boris' *Cakewalk*, while her line and technique were seen in Bournonville's *Konservatoriet* and Gerald Arpino's *Viva Vivaldi*.

Cartier, Jacques, American concert dancer; born c.1907 at sea. The son of an American diplomat, Cartier was born onboard a ship en route to Calcutta, where his father was stationed. He also lived in Japan during his childhood before returning to the United States to attend school. He made his theatrical and professional debut in *A Fantastic Fricassee* (1922), and worked as a specialty dancer in revues such as the *Ziegfeld Follies of 1923*, the *Greenwich Village Follies of 1923*, and *The Manhatters*, Prologs at the Capitol Theater and the operetta, *Golden Dawn* (1927), in which he introduced his best known solo, "Congo Voodoo Dance." Cartier repeated that piece, performed in full body paint and an elaborate head dress on the top of a giant drum, in the film, *King of Jazz* (Universal, 1930), in *Whoopee* (UA, 1931), and in many of his recitals.

Cartier appeared in more films, including the Gloria Swanson vehicles, *My American Wife* and *Queen Kelly*, and in the *Ziegfeld Follies of 1924*, but from the early 1930s he was primarily concerned with his career as a concert dancer. He presented two types of pieces in his recitals—short solo based on national or ethnic characterizations and full-evening dance dramas in which he played up to twelve different people by changing costumes and gestures. The former were danced in concerts in New York's recital halls from the early 1930s until 1936, when he did his first long work, *Proud Heritage*, a story about a Hopi man who is taken to Europe as a "noble savage."

Works Choreographed: CONCERT WORKS: *Dances of the Hopi* (1931); *Plaza de Toros* (1931); *Legenda* (1931); *To a Lady on a Balcony* (1931); *Garrotin* (1931); *From Eastern Theatres (A Japanese Actor, General Fu Hunts Dragons, Dance of Prince Rader)* (1931); *Vienna* (1931); *Harlemite* (1931); *Dominica* (1931); *Legends of the Southwest (Mescali Dance of the Hopi Indians, Legend of the Snow God, Blanket Dance of the Hopi Indians, Comanche Dance of the War Drum)* (1931); *An Eastern Actor* (1931, possibly

the same as *A Japanese Actor*); *Three Poets (Walt Whitman, Pierre Louys, Countee Cullen)* (1931); *Fada Fiesta* (1934); *Dance at Night* (1934); *Sevillanos* (1934); *Love Song—Dance to Beatrice* (1934); *City Song* (1934); *Portraits for the Theatre (Ganjiro as the God Futen, Borgia, Royal Rehearsal)* (1934); *Salutation* (1935); *Buffoonery* (1935); *Tragic Processional* (1935); *Gesthsemane* (1935); *Lazarus* (1936); *Prologue—The Fallen Lucifer* (1936); *Proud Heritage* (1936); *The Grand Monarch* (1937); *Son of the Dragon* (c.1942); . . . *The Noble Czar* (c.1945); *Cavalcade* (1948); *Figure of Fire* (1949).

Caryll, Ivan, Belgian musical theater composer working in England and the United States; born Felix Tilken, 1860 in Liège, Belgium; died November 29, 1921 in New York. Caryll was one of the most successful musical comedy composers of the early twentieth century, creating over thirty works for production in London (1894-1911) and New York (1911-1921). His musicals were plotted with conventional distribution of roles and songs among juvenile leads, secondaries, and comic specialties, but many of his individual songs are still known. Among his most popular and memorable productions were *Little Christopher Columbus* (1893), *The Shop Girl* (1894), *A Runaway Girl* (1896), *The Girl from Kay's* (1902, New York, 1914 as *The Belle of Bond Street*), *The Duchess of Dantzic* (1903), *The Earl and the Girl* (1903), *The Cherry Girl* (1903), *The Pink Lady* (1911), *Oh! Oh! Delphine* (1912) and *The Girl Behind the Gun* (1918).

Casado, Germinal, Moroccan ballet dancer associated with the works of Maurice Béjart; born August 6, 1934 in Casablanca. Originally an art student, he received his dance training from Nicholas Zverev and Victor Gsovsky. After dancing briefly with the Grand Ballet du Marquis de Cuevas, he joined Béjart in his Ballets de l'Etoile in Paris.

He has been Béjart's collaborator as a dancer, creating roles in *Roméo et Juliette* (1958), *Sacre du Printemps* (1959), and *Ninth Symphony* (1964), and as a designer, working on *Les Oiseaux* (1965), *Renard* (1965), and *Nuit Obscure* (1968). Among the many other Béjart works in which he has performed are *Messe Pour le Temps Présent, Prométhée, Bhakti,*

Thèmes et Variations, and *Divertimento* (co-choreographed with Patrick Belda). Since retiring, he has worked as a director in Western Europe.

Works Choreographed: CONCERT WORKS: *Le Concile Musical* (c.1977); *Fauré Requieme* (c.1978).

Casati, Giovanni, Italian nineteenth-century ballet dancer and choreographer; born 1811 in Milan; died there July 20, 1895. Trained at the school of the Teatro alla Scala by Armand Vestris, he performed there in the 1820s.

He staged ballets throughout northern Italy during the 1840s and 1850s. His known works were created primarily for La Scala, but were also staged at the Teatro la Fenice in Venice (*Madamigella d'Alençon*, 1852), and the Teatro di San Carlos in Naples, where he staged *Shakespeare, ovvero Il sogno* [dream] *di una notte d'estate*, in 1855, and the Teatro Comunale in Bologna, for which he choreographed *La Girisette del 1700*. Among his La Scala credits were *Iselda di Normandia* (1846), *Saltimbanco* (1852), and the ballet divertissements for the premieres of Verdi's *Luisa Miller* (1851) and *Atilla* (1846).

Works Choreographed: CONCERT WORKS: *Adone nell'isola di Ciprigna* (1842); *Don Giovanni di Mantua* (1843); *Il Profeta velate del Korosan* (1843); *Iselda di Normandia* (1846); *Abd-el-Kadie, ovvero la Vivandiera francesce* (1846); *La Duchese di Mazzarino* (1846); *Nadila, ovvero l'arpa portentosa* (1850); *Madamigella d'Alençon* (1852); *Le Figlie delle guerra* (1854); *Shakespeare, ovvero Il sogno di una notte d'estate* (1855); *La schiava* (1856); *La Grisetta del 1700* (1861).

OPERAS: *Atilla* (1846); *Luisa Miller* (1851).

Casella, Alfredo, Italian composer; born July 25, 1883 in Turin; died March 5, 1947 in Rome. A child prodigy and student at the Paris Conservatory, Casella's first involvement in music for the theater came from his connection with the Societa Nazional di Musica, co-sponsored by Gabriel Annunzio. He wrote two works specifically for the stage in his first compositional style, *Il Convento Veneziano* (1912, not choreographed for public performance until Jean Borlin's version in 1924) and *Il Giaro*, staged by Nicola Guerra in 1925. Two works of his later period of neoclassicism were also used as dance scores—

Scarlattiana (1926) was choreographed by Bronislava Nijinska as *Les Comediens* in 1932 while his *Paganiniana* (1942) was staged by Aurel Milloss as *La Rosa del sogno* a year later.

Casey, Susan, American ballet dancer; born in Buffalo, New York. Casey has received ballet training from Leon Danielian of the Ballet Theatre School and from Vincenzo Celli. After a season with the New York City Opera, under Robert Joffrey, she joined American Ballet Theatre in 1965.

With that company, for which she now serves as regisseur, she created roles in Michael Smuin's *Pulcinella Variations* (1968) and *The Catherine Wheel* (1971) and performed in his *Gartenfest*, Eliot Feld's *At Midnight*, Agnes De Mille's *Fall River Legend*, and the company's revivals of *Coppélia, Swan Lake*, and *The Sleeping Beauty*.

Cassidy, Tim, American theatrical dancer; born March 22, 1952 in Alliance, Ohio. Cassidy was trained at the University of Cincinnati's extensive arts program before making his Broadway debut in the 1974 revival of *Good News*. After extensive regional and national companies work, he undertook a difficult assignment in Michael Bennett's *A Chorus Line*: he served as understudy for four very different characters—"Frank," "Bobby," "Greg," and "Don" —before becoming the permanent "Bobby." Although he danced in other large-scale productions, among them the Douglas Fairbanks, Jr. musical *Out on a Limb* (1978), the film of *Hair*, and a number of Shirley MacLaine television specials, he has worked most often in his own club act.

Castelli, Victor, American ballet dancer; born October 9, 1952 in Montclair, New Jersey. Trained originally by Fred Danieli, director of the Garden State Ballet, Castelli continued his studies at the School of American Ballet, while performing with Danieli's company and the (André) Eglevsky Ballet.

With the New York City Ballet throughout the 1970s, Castelli's stage presence and expansive movements have been used by all three company ballet masters. His created roles in the works of Jerome Robbins range from *Watermill* (1972), his first major role, to *Scherzo Fantastique* (1972), and *Une Barque*

sur l'Ocean (1975). Castelli also created roles in John Taras' *Concerto for Piano and Winds* (1972) and in Balanchine's *PAMTGG* (1971) and *Union Jack* (1976), his American bicentennial tribute to Great Britain. His featured roles range from the drama of Balanchine's *The Prodigal Son* to the comedy of the ''In the Inn'' section of his *Ivesiana*.

Castle, Irene, American exhibition ballroom dancer; born, Irene Foote, April 7, 1893 in New Rochelle, New York; died, January 25, 1969 in Eureka Springs, Arkansas. Irene Castle studied theatrical dance techniques and, one may assume, social dance forms, with Rosetta O'Neill, a protegé of the Dodworth Family and herself one of New York's best known teachers.

Castle made her professional debut as a member of the replacement cast of *The Summer Widowers*, after her marriage to Vernon Castle, then a comic with the Lew Fields company. Their exhibition ballroom specialty act was introduced in Paris, either in the show *Enfin . . . Une Revue* (1912) or in their cabaret act at the Café de Paris. Their success in Paris was followed by engagements in New York's Café de l'Opéra, where they performed as part of a floor show, demonstrating new steps and old specialties. Frequently, at Café de l'Opéra and on tour, they were placed on bills with other famous dance teams; especially frequent was the co-featuring of the Castles with Maurice Mouvet and his then-partner Florence Walton. The real or invented rivalry between the two teams added to the popularity of both, so that by 1914 each team had acquired wide general recognition—unique at that time for exhibition dance acts, which had tended to have only local bookings.

The Castles' career as an exhibition team was exceptionally successful. They performed in Broadway shows, among them *The Sunshine* (1913) and *Watch Your Step* (1914), and on film. Not only did they make a motion picture that featured them as a dance team, *The Whirl of Life* (Cort Films, 1915), but they also commissioned films of their dances and distributed eight of these as a vaudeville specialty act.

Castle House, which was both their school/cabaret and their business venture, also published dance manuals and music, as well as franchising the Castles' names. Their agent, Elizabeth Marbury, arranged for the production (or, at least, rebaptizing) of Vernon Castle shoes and cigars, and Irene Castle hats and hosiery. Irene Castle, considered one of America's best-dressed women from 1915 on, also wrote (or endorsed) fashion designs and sewing patterns through the *Ladies Home Journal* (which adopted the Castles as the symbol of dance as a proper moral influence) and Butterick Patterns. She popularized both her own designs for afternoon dance frocks and Lucile (Lady Duff-Gordon)'s performance costumes. Castle's identity as a fashion innovator, especially of bobbed hair and split skirts over contrasting slips, was enormous during her professional career and has continued to this day.

When Vernon Castle enlisted in the British Royal Flying Corps in December 1914, Irene Castle began her solo career. She appeared on Broadway in the ill-fated Dillingham and Ziegfeld revue, *Miss 1917*, with Bessie McCoy Davis and Elsie Janis, and then embarked on a successful career in film serials. She performed in over a dozen single features and serials between *Patria* (Pathé, 1917–1918) and *Broadway After Dark* (Warner Brothers, 1924).

Castle returned to vaudeville in 1922, after the death of Vernon in 1918, touring the United States and England with partner Billy Reardon. Although she retired in 1924, she performed briefly at a Celebration of Dance staged at the Chicago World's Fair, 1939, partnered by Alex Fisher. After retirement, Castle, better known as an antivivisectionist activist, acted occasionally in the Chicago and Miami areas.

Castle, Nick, American film and television dance director; born March 21, 1910 in Brooklyn, New York; died August 28, 1968 in Los Angeles. Castle, who claimed to have had no formal dance training, made his performing debut in vaudeville, c.1930. He toured in a dance flash act in vaudeville and Prologs in the United States and Europe.

Castle was hired by Twentieth-Century Fox as a dance coach in 1935. At first he worked with Geneva Sawyer on a series of juvenile musical comedies for Fox's contract children (among them, Shirley Temple), receiving his first solo dance direction credit in 1937 for Fox's *One in a Million*. His best known films include *Swanee River* (Twentieth-Century Fox, 1939), co-choreographed by Sawyer and Cotton Club

resident-director Clarence Robinson, and *Royal Wedding* (MGM, 1951) with Jane Powell and Fred Astaire, source of the famed "All the World to Me" routine in which Astaire danced on the ceiling.

Castle staged dances for many television variety shows during the 1960s, including *The Judy Garland Show* (CBS, 1963), the first season of *Laugh-In* (NBC, 1968), and *The Jerry Lewis Show* (NBC, 1966–1968), on which he was working at the time of his death.

Works Choreographed: THEATER WORKS: *Heaven on Earth* (1948).

FILM: *Little Miss Broadway* (Twentieth-Century Fox, 1937, co-choreographed with Geneva Sawyer); *Love and Hisses* (Twentieth-Century Fox, 1937, with Sawyer); *One in a Million* (Twentieth-Century Fox, 1937); *Hold That Co-Ed* (Twentieth-Century Fox, 1938, with Sawyer); *Rascals* (Twentieth-Century Fox, 1938); *Rebecca of Sunnybrook Farm* (Twentieth-Century Fox, 1938); *Sally, Irene and Mary* (Twentieth-Century Fox, 1938); *Straight, Place and Show* (Twentieth-Century Fox, 1938); *Everything Happens at Night* (Twentieth-Century Fox, 1938, ice skating sequences only); *Swanee River* (Twentieth-Century Fox, 1939); *Down Argentine Way* (Twentieth-Century Fox, 1940, with Sawyer); *Orchestra Wives* (Twentieth-Century Fox, 1942); *Hit Parade of 1943* (Republic Pictures, 1943); *Stormy Weather* (Twentieth-Century Fox, 1943, with Sawyer and Clarence Robinson); *Royal Wedding* (MGM, 1951); *Red Garter* (Paramount, 1954); *Anything Goes* (Paramount, 1956, ballets by Roland Petit, title dance by Ernie Flatt); *State Fair* (Twentieth-Century Fox, 1962).

TELEVISION: *The Judy Garland Show* (CBS, 1963); *The Andy Williams Show* (NBC, 1963–1966); *The Jerry Lewis Show* (NBC, 1967–1968); *Rowan and Martin's Laugh-In* (NBC, 1968).

Castle, Vernon, English/American exhibition ballroom dancer; born Vernon Blythe, May 2, 1877 in Norwich, England; died February 15, 1918 on the Fort Worth, Texas U.S. Army airfield, during a training mission. It is not certain whether Castle had any training in dance.

Castle emigrated to the United States in 1907 and quickly became a member of Lew Field's comedy "repertory company." As the "second banana," or fall guy to Field's elaborate gags, Castle performed highly physical comedy in many Broadway musicals, among them, *The Orchid* (1907), *The Girl Behind the Counter* (1907), and *Old Dutch* (1909). In many Fields' shows, he played English drunks whose perilous descents down staircases and around prop furniture became his trademarks. Performing as "Souseberry Lushmore," and similar characters in Fields' shows, *The Midnight Sons* (1909) and *The Summer Widowers* (1910), Castle frequently partnered Lotta Faust in her Spanish ballroom dance specialties.

In May 1911, Castle married Irene Foote. While they continued to perform in Fields' shows, they became internationally famous as an exhibition ballroom team, helping to popularize the one-step, Tango, Maxixe, and The Walk. Although they danced together in *The Henpecks* (1911) in New York and London, their career as a specialty dance act is generally dated from performances in Paris in *Enfin . . . Une Revue* (1912) and at the Café de Paris.

When the Castles returned to New York in early 1913, they performed their dances in the traditional outlets—at society functions, private dances/lessons, and as interpolated specialty acts in Broadway shows and vaudeville. With their agent Elizabeth Marbury, however, the Castles added a professional and economic dimension to dance as a performance specialty. They sold dances, and their services as teachers and performers, promoting specific items—The Castle Walk, The Castle Hesitation, and so on—with appropriate music scores by James Reese Europe, costumes, and, to a certain extent, modes and philosophies of social behavior.

Vernon Castle retired in December 1914 to join the British Royal Flying Corps, although the act, Mr. and Mrs. Vernon Castle, continued to play *on film* in vaudeville houses until 1916. He returned to the United States as a flight instructor in 1917 and was killed in a flight accident in February of the next year.

Vernon Castle appeared in performance films made by Castle House and distributed as a vaudeville specialty. He also appeared in one feature film, *The Whirl of Life* (Cort Films, 1915), for which he received performance and story credit. Although not stated specifically on extant title cards, it can be assumed that he, or he and Irene Castle, were responsi-

ble for and credited with choreography of their dance routines.

Caswell, Maude, American acrobatic dancer of the early twentieth century; born c.1880 in Sacramento, California. Caswell made her debut in combination shows touring the Midwest in the mid-1890s, but soon developed her own act for the Proctor vaudeville circuit. In her performances, she did splits, rollovers, arabians, and similar impossible feats in one of three characterizations—the American Girl (dressed in a Charles Dana Gibson or Nell Brinkley bathing suit, depending on the season), The Athletic Girl (dressed in Gibsonlike sports clothes), or The Acrobatic Girl (wearing a "Yama-Yama" outfit). After three years on the Proctor circuit, she took her act to Europe where she worked constantly for nine years. Her annual engagements of the Théâtre des Folies-Marigny in Paris were especially successful. In 1909, she returned to the United States as a class act on the William Morris circuit before retiring in 1911.

Catá, Alfonso, Cuban-born ballet dancer and choreographer working in the United States and Europe throughout his career; born October 3, 1937 in Havana. Raised in the New York area, he was trained at the School of American Ballet. He danced with the Frankfurt Ballet and the Grand Ballet du Marquis de Cuevas before beginning to choreograph in the early 1970s. The success of his works for the Frankfurt company led to a season in New York called "Ballet on Broadway," sponsored by actor Dustin Hoffmann. Catá remained in the city to teach and choreograph with the Puerto Rican Dance Theater here. In 1980, he was named artistic director of the Maryland Ballet.

Works Choreographed: CONCERT WORKS: *Nuit de Mai* (1970); *Transfigured Night* (1973); *Ragtime* (1974, co-choreographed with Kent Stowell); *Perspectives* (1974); *In the Present* (1974); *Baroque Variation* (1975); *Coppélia* (1975); *The Golden Broom and the Green Apple* (1975); *Scharaden* (1975); *Sweet Carmen* (1975); *The Seasons* (c.1977).

Catanzaro, Tony, American modern, theatrical, and ballet dancer; born November 10, 1946 in Brooklyn,

New York. Trained at the High School of Performing Arts in New York, from which he graduated in 1964 with highest honors in modern dance, Catanzaro performed with many of the foremost companies in New York, among them, Norman Walker, for whom he danced in *The Night Chanter* (1965), Paul Sanasardo, for whom he created a major role in *Laughter After All* (1964), and Pearl Lang. In Lang's group, he performed featured roles in her *Piece of Brass, Prayer for a Dead Bird,* and *Persephone.*

As a member of the Harkness Youth Ballet, and its successor, the second Harkness company, Catanzaro developed into a classical ballet dancer, noted for his pure technique and dramatic style. He danced with the City Center Joffrey Ballet, 1970 to 1973, with major roles in the premieres of Joe Layton's *Double Exposure* (1972), Margo Sappington's *Weewis* (1971), and the company revival of Leonid Massine's *Le Beau Danube.* He has been associated for many seasons with The Boston Ballet, dancing with the group in 1969 and 1970, 1973 to 1976, and 1977 to the present, and serving as director of the Boston Ballet Ensemble. For that company, he staged *Sailin' Aweigh* (1980) as part of the Boston City Jubilee 350.

Works Choreographed: CONCERT WORKS: *Sailin' Aweigh* (1980).

Caton, Edward, American ballet dancer and choreographer; born April 3, 1900 in St. Petersburg, Russia; died October 22, 1981 in New York City. Caton received private training in St. Petersburg from Ivan Clustine and Alfred Bekefi and in Moscow with Mikhail Mordkin, Alexander Volinne, and Laurent Novikoff; the last two recommended him to Anna Pavlova who hired him to join her company. After dancing for her in *Krakoviak* and *Das Pupperfee,* among other divertissements, he joined the Chicago Civic Opera Ballet, founded by Andreas Pavley and Serge Oukrainsky, also formerly of the Pavlova troupe.

After dancing with the Littlefield Ballet, in Catherine Littlefield's *Sleeping Beauty* (1936) and *Home Life of the Gods* (1938), and with the Mordkin Ballet, in his *Voices of Spring* (1938), Caton became a charter member of Ballet Theatre in 1940. A character dancer in that company, he performed in the company premieres of Anton Dolin's *Quintet* and Antony Tudor's *Gala Performance,* as well as in Tu-

dor's *Romeo and Juliet* and Adolf Bolm's *Peter and the Wolf*.

Caton served as ballet master for the Metropolitan Opera Ballet, also performing as principal mime, and for the International Ballet du Marquis de Cuevas. A popular freelance teacher, he directed the Aegis Universal Dance Company.

Works Choreographed: CONCERT WORKS: *Dances from The Bartered Bride* (1936); *Sebastien* (1945); *Lola Montez* (1946); *Tryptich* (1952); *L'Histoire du Soldat* (1955); *Fêtes Champêtre* (1962).

THEATER WORKS: *Sadie Thompson* (1943).

Catterson, Pat, American modern and tap dancer and choreographer; born February 20, 1946 in Indianapolis, Indiana. Catterson first studied with her parents who were an exhibition ballroom team and ran a dance studio. While attending Northwestern University in Evanston, Illinois, she studied modern forms with Judith Scott and jazz with Gus Giordano, spending summers at the American Dance Festival working with Yvonne Rainer and James Cunningham. Her tap studies have continued in New York under Copasetics Charles Cook and Honi Coles.

The training as it augmented her ideas, resulted in a style that one critic called postmodern tap. The technique of casually bravura tap work is available to her, but her formats are unconventional, using Rainer's pedestrian movements and Cunningham's montages as structural elements. She sets her pieces to the rhythmic classics—Bach and Scott Joplin—or to montages of sounds. Most of her work has been in solo form, although some pieces, among them *Serial II* (1975) and *Does Anybody Else Remember the Banana Man?* (1972) can expand to fit up to fifteen dancers. She frequently uses slides of films as an element, expanding the dimensions of what is usually a grounded technique.

Works Choreographed: CONCERT WORKS: *Green Hibiscus* (1966); *Rituals* (1967); *Rip Rig & Panic* (1967); *Unseen* (1967); *The Case for the Nude Cello Player* (1968); *Side Two* (1968); *(5 = 1) = (1 = 5)* (1968); *Tubes* (1968); *Ground Row* (1969); *This Door Swings Both Ways* (1970); *Epilogue to Bleeker to West 80th* (1970); *Bleeker to West 80th* (1970); *Warm-Up for Judson Church* (1970); *Like as Not* (1971, in collaboration with Douglas Dunn); *Roof Piece* (1971); *Yvonne Rainer's Trio A Backwards* (1971); *I Will I Will I Will I Will* (1971); *Post Roof Piece* (1971); *Shoes and Hair in White II* (1972); *Does Anybody Else Remember the Banana Man?* (1972); *The Relay* (1972); *Purple* (1972); *Biographies* (1972); *Previews and Flashbacks* (1973); *Someone Old New Borrowed Blue (Raindance, "Nothing At All," She Said, Entrance, Hold To and Have)* (1973); *Yes No Noisy Show (Well, It's Been a Thrill a Minute, No Sweeping Exits or Offstage Lines, A Falling Laugh)* (1975); *Serial II* (1975); *Serial I* (1975); *The Bleeding Stage: Scene Two* (1975); *The Bleeding Stage: Scene One* (1975); *No Mere Emotional Attachment . . . A Good Long Term Working Relationship* (1977); *One Must Always Fight the Motion of the Waves or It Will Put You to Sleep Forever* (1977); *Beginners' Routine* (1978); *Keepsake* (1978); *Please, Just Take It One Life at a Time* (1979); *Traditional (Drumming, Soft Shoe, Rag)* (1979); *Modern Interpretive* (1979); *Stripped* (1979); *Stripped* (1980); *Betty Jean* (1980); *Wanda* (1980); *Fred* (1980); *Gael* (1980); *Brahms (Intermezzo/Duet, Intermezzo/Solo, Rhapsody/Trio and Solo)* (1980).

Cavallazzi, Malvina, Italian ballet dancer and teacher working in London and New York; born c.1852 in Italy; died 1924 in Ravenna, Italy. Trained at the school of the Teatro alla Scala in Milan, she may have performed with the company.

After her London debut in 1879, she joined the (Col. Charles) Mapleson Opera Troupe in New York, also dancing with his Italian Opera in London intermittently until 1884. That year, she joined the Metropolitan Opera of New York as their prima ballerina.

From 1888 to 1899, Cavallazzi performed mime and character roles at the Empire Theatre, London, working primarily *en travestie*, as "Antony" in *Cleopatra* (1889) and "Dantès" in *Monte Christo* (1896), for·example. The other ballets by Katti Lanner in which she performed were *A Dream of Wealth* (1889), *Cécile, Dolly* (both 1890), *Orfeo* (1891), and *Versailles* (1892).

Cavallazzi, who had run a school in London, was invited to direct the school of the Metropolitan Opera Company in 1909. In her four years with the Met, her students included Eva Swain, Maria Gambarelli,

and Queenie Smith. Cavallazzi retired from performance and teaching in 1914.

Ceballos, Larry, English film choreographer working in the United States after 1927; born 1888 in London, England; died September 1978 in Los Angeles, California. A member of the celebrated family of acrobats, Ceballos made his debut at the age of two in his parents' circus act. It is not certain whether he had stage performance experience, aside from his circus training, before 1927, when he moved to Los Angeles to accept a job offer from Fanchon (Wolff) to the West Coast Deluxe Theater Prolog chain.

Ceballos worked for the Fanchon and Marco Prolog production firm for three years, staging their *Ideas* (as the Prologs were known), for precision troupes, solo vocalist, and dancers and, following Fanchon's preferences, teams of adagio dancers.

When the silent film production ended in the late 1920s, Ceballos was one of the stage directors hired to choreograph for the new sound musicals. He directed the dances for many films—both feature-length and short subjects—between 1928 and 1931, for Warner Brothers and First National Pictures. Some of these, among them *The Show of Shows* (WB, 1929) and the John McCormick vehicle *Smiling Irish Eyes* (First National, 1929) are among the most interesting of the early sound musicals, employing both the new techniques of film sound editing and the staging innovations developed by Fanchon. His shorts for Vitaphone/First National—in their Miniature Revue series—are especially creative uses of both film and dance; *Under the Sea*, released in 1929, uses different gauges of gauze over the camera lens manipulated to synchronize with the sound and movement editing. It is unfortunate that the only one of Ceballos' films readily available for current viewing is the fairly conventional version of *No, No, Nanette* (First National, 1930).

Although Ceballos staged films throughout the 1930s, only a few titles are extant. This is in part because he began to work for some of the less successful studios, for example, the short-lived Reliance Films, and in part because musical films were frequently eliminated from cinema catalogues. Apart from a single musical comedy, which died during its pre-Broadway tryout—Lerner and Loewe's early

Life of the Party (1942)—no credits can be found for him after 1940.

Works Choreographed: THEATER WORKS: *The Girl from Cook's* (London, 1927); Prologs for the West Coast DeLuxe Theater Chain (Fanchon and Marco Productions, 1927–1929); *Life of the Party* (1942, pre-Broadway tour).

FILM: *The Singing Fool* (First National, 1928); *Sally* (First National, 1929) *The Show of Shows* (WB, 1929); *Honky Tonk* (WB, 1929); *The Gold Diggers of Broadway* (Vitaphone/WB, 1929); *Hold Everything* (WB, 1929); *On with the Show* (WB, 1929); *Smiling Irish Eyes* (First National, 1929); *Paris* (First National, 1929); *Golden Dawn* (WB, 1930); *Going Wild* (First National, 1930); *No, No, Nanette* (First National, 1930); *Mlle. Modiste* (released in England as *Kiss Me Again*) (First National, 1931); *Sitting Pretty* (Paramount, 1933); *Transatlantic Merry-Go-Round* (Reliance Films, 1934); *The Music Goes 'Round* (Columbia, 1936); *One Night in the Tropics* (Universal, 1940); Vitaphone/First National Miniature Revues (1929–1930 short subjects)—known titles: *Under the Sea, The Crystal Cave Revue, The Roof Garden Revue, Hello Baby*.

Ceballos, Réné, American theatrical dancer; Ceballos was trained at the Ballet Russe de Monte Carlo school and studied and performed with the City Center Joffrey Ballet. Her jazz teachers include Betsy Haug and Jo Jo Smith. She has performed in cabarets everywhere from Madrid to Cairo and Beirut as a singer and/or dancer, but is best known for her work in unusual American theatrical productions. She toured with the Spanish international company of *Jesus Christ Superstar* and the European troupe of *Hair* before returning to New York to dance in the dance hits of the 1970s—*A Chorus Line,* staged by Michael Bennett and Bob Avian, and Bob Fosse's *Dancin'* (1978). She is considered expert at Fosse's style with its combination of blatant sexuality and cool, isolated movements.

Cecchetti, Enrico, Italian ballet dancer and choreographer working in Russia between 1887 and 1902, considered the most important teacher of ballet technique of the modern era; born June 21, 1850, in Rome; died November 13, 1928, in Milan. The son of

Cesare Cecchetti and Serafina Casagli, he made his debut at age five in a Genoa production of Rota's *Il Giocatore;* Lillian Moore and later historians have documented his family's tour of the United States with the Ronzani troupe. Eventually, at age thirteen, he received formal training from Giovanni Lepri in Florence.

Cecchetti toured with his parents for many seasons in Italy, but made his formal debut at La Scala in 1870 in Alessandro Bori's *La Dea del Valsalla.* He performed in the first London production of *Excelsior* in 1885, and created roles in Manzotti's *Amor* (1886), *Rolla* (1887), and *Narenta* (1887) at La Scala.

In the summer of 1887, Cecchetti did his first performances in St. Petersburg at the Acadia Theater. After performing *Excelsior* and Manzotti's *Sieba* and his own *Le Pouvoir de l'Amour*, he was invited to stay as premier danseur and teacher at the Imperial Theater. Making his Maryinsky debut in Lev Ivanov's *The Tulip of Haarlem,* he danced in a revival of Jules Perrot's *Catarina* and, in his most celebrated performance, in *La Belle au Bois Dormant* as both the witch "Carabosse" and the "Bluebird" in the difficult Act III variation.

Although the Russian positions did not end Cecchetti's touring performances—he danced in Katti Lanner ballets in London in 1887–1888 and 1891–1892 and taught in Italy and at the Imperial Ballet, Warsaw—his Russian affiliation was to prove the most important element in his reputation as a teacher. Returning to St. Petersburg after his Polish tenure, he became the personal teacher for Anna Pavlova and maître de ballet for the Diaghilev Ballet Russe—intermittently (and, it seems, occasionally concurrently) for a total of fifteen years.

The Cecchetti technique was taught to Pavlova and her company and to the Diaghilev dancers over this period. This method and style of performing the ballet vocabulary was derived from the work of Carlo Blasis (as Cecchetti had learned it from Lepri) and therefore is sometimes called the "Italian technique"; Cecchetti had, however, developed it after his fifty years of touring and watching dance across Europe and in America.

Since he taught in London from 1918 to 1923, it has been said that the Cecchetti technique was most influential in the English ballet. Certainly, the British Cecchetti Society and the textbooks of technique published by C.W. Beaumont have kept the style alive in England, but both Italy and the United States can make claims to genuine Cecchettiism. Teaching in Milan from 1923 until his death, he trained the generations of dancers who performed at La Scala and across Italy in the 1930s through 1950s and who are now themselves running ballet schools.

Cecchetti's influence in America is more diffuse. Two of the major Cecchetti-trained ballet teachers have lived in the United States since the late 1930s— Muriel Stuart, a Pavlova company member, and Margaret Craske, who co-authored the Beaumont texts—and have trained hundreds of dancers through the School of American Ballet, and the Metropolitan Opera Ballet and the Manhattan School of Ballet, respectively. An almost serendipitous Cecchetti influence emerged in the 1920s and 1930s in the popular theater and in Prologs, when a number of American former Pavlova company and Ballet Russe dancers returned to New York and Hollywood. Many of them, notably Chester Hale, Ella Dagnova, Beatrice Collenette, and Alexander Oumansky, worked and taught in the motion picture palaces, such as the Palace, the Capitol, and the Roxy, each of which ran free ballet schools in order to attract women into their corps. There is no reason to believe that the genuine Cecchetti training that these dancers received was less "accurate" than that taught at more conventional ballet schools.

Cecchetti, major teacher and influence that he was, has not been considered an important choreographer. His known works were primarily created for the Imperial Theater in Warsaw (c.1902), although he was also credited with one ballet for the Pavlova company, *La Flute enchantée.*

Works Choreographed: CONCERT WORKS: *A Villa to be Sold* (divertissement performed before *Excelsior*) (1885); *Le Pouvoir de l'Amour* (1887); *After the Ball* (Polish or possibly French original title unavailable) (1902); *Piplet* (1902); *Eva* (1902); *Flora's Awakening* (Polish or possibly French title unavailable) (1902); *La Flute enchantée* (1913).

Bibliography: Beaumont, C.W., *A Manual of the Theory and Practice of Theatrical Dancing* (London:

1922); *Enrico Cecchetti* (London: 1929); Celli, Vincenzo. "Enrico Cecchetti." *Dance Index 7.* (July 1946).

Celeste, Mme., French nineteenth-century ballet dancer known for her work in the United States and England; born Celeste Keppler in 1811 in Paris; died there in 1882. Although she was trained at the school of the Paris Opéra, it is not certain whether she made an official debut with the Opéra.

Touring the United States, or, at least, the East Coast and Mississippi circuit, Celeste is thought to have done the first *La Sylphide* in the country. She was also celebrated for her performance of *La Cachucha* (c.1835), and her mime roles of "The Wild Arab Boy" in *The French Spy* (1834) and "A Dumb Arab Boy" in *The Siege of Corinth* (1837).

Moving to London in 1843, she leased the Adelphi Theatre, becoming one of England's first actress-managers. Considered the first woman to perform "Harlequin" (1850), she produced both harlequinades and straight plays in her sixteen years with the theater; she too eventually shifted from dance and mime to Shakespeare, appearing as "Katherine of France" in her production of *Henry V.*

Mme. Celeste (Keppler-Elliot) should not be confused with Mlle. Celeste (Williams) who toured further into the United States, reaching California on one route, and also managed her own career—the younger, less important, Celeste Williams was probably not a ballet-trained dancer.

Celli, Vincenzo, Italian ballet dancer and teacher working frequently in the United States; born c.1901 in Salerno. Celli emigrated to Chicago as a child and studied eurythmics and music at the famous Hull House settlement. He worked as an actor in Chicago and New York, most notably with the Washington Square Players, and participated in productions staged by Adolf Bolm, including *Salome* and *Coq d'Or* in New York, and the *Birthday of the Infanta* in Chicago. In 1919, he returned to Italy to study with Rafael Grassie and Enrico Cecchetti. He made his Italian debut in Biancifiori's revival of *Excelsior* for the Teatro del Verme and danced with Nicola

Guerra's troupe at the Turin Teatro Reggio. He was engaged by the Teatro alla Scala to partner Cia Fornaroli in *Mahit,* Leonid Massine's *Belkis* and *Regina de Saba,* and Max Terpis' *The 1001 Nights.* As Cecchetti's assistant, he taught Serge Lifar in London and partnered Olga Spessivtseva in private performances (c.1932).

Celli left La Scala following the Fascist takeover of Italy and returned to Chicago (c.1937) where he organized a small company. He moved to New York to serve as ballet master for the Original Ballet Russe two years later and has taught in New York City ever since. Among his scores of students in major companies were many of the first generation of native ballet stars, including Lupe Serrano, Maria Tallchief, and Royes Fernandez.

Cerri, Cecilie, Italian ballet dancer performing in England, Italy, and Austria; born February 11, 1872 in Turin; died January 17, 1931 in Vienna. Trained by a Mme. Legrain in Turin, she performed at the Teatro Reggio there as an adolescent. Her early Italian career also included tenures in Milan, probably at the Teatro Canobianno, and in Florence, where she performed in Manzotti's *Rolla.*

After dancing in St. Petersburg in 1892—possibly on tour or as a guest artist—she was hired by Carlo Coppi, another Manzotti alumnus, to work at the Alhambra Theatre, London. Among her many roles there were principal parts in his *Ali Baba* (1894), *Barbe Bleu* (1895), *Titania* (1895), and *Beauty and the Beast* (1898).

After returning to Italy to perform at the Teatro alla Scala, notably in Pratesi's *Bacco e Gambrinus* (1904), she moved to Vienna to become a member of the ballet of the Court Opera. Although best remembered for her roles in interpolated opera solos, she also danced in the ballets of Josef Hassreiter, including his *Puppenfee.* She taught at the school of the Vienna Court Ballet from 1907 to 1919, where she is believed to have trained choreographers Albertina Rasch and Margarete Wallmann.

Cerrito, Fanny, Italian ballet dancer, one of the most celebrated ballerinas of the Romantic era; born May

11, 1817 in Naples; died May 6, 1909 in Paris. After studies at the school of the Royal Theaters of Naples, Cerrito made her debut there in the Teatro de Fondo in Giovanni Galzerani's *l'Oroscopo* in 1832. Traveling to Rome with Galzerani, she appeared in his *Tre Giobbi di Demasco* (1832) before returning to Naples to make her debut at the Teatro di San Carlo. She made her reputation in that theater performing in works of Galzerani and Salvatore Taglioni and participating in a rivalry with Carlotta Grisi.

Over the next twenty years, Cerrito toured the opera houses and theaters of Europe performing in Romantic-era ballets created for her by Jules Perrot and Arthur Saint-Léon to whom she was married (c.1845 to 1851). Performing at Her Majesty's Theatre, London, La Scala, and the Paris Opéra, she created roles in Perrot's *La Double Cachucha* (1842), *Ondine, ou la Naïde* (1843), *Zélia* (1844), *Lalla Rookh* (1846), and *Les Éléments* (1847). She participated in all three of the occasional works that Perrot choreographed for the available great ballerinas of the Romantic era, depending on who happened to be in London at the time—a pas de deux performed with Fanny Elssler (1843), *Pas de Quatre,* for Marie Taglioni, Carlotta Grisi, and Lucile Grahn (1854), and *Le Jugement de Paris* (Pas des Déèsses) with Taglioni, Grahn, and Arthur Saint-Léon (1846).

After her marriage to Saint-Léon, Cerrito created roles across Europe in his *Tartini, il Violista* (1848), *l'Anti-Polkista, ed i Polkamia* (1848), *Le Violon du Danse* (1849), *Stella* (1850), and *Pacquerette* (1851). Other ballets in which she performed include Joseph Mazilier's *Orfa* (1852), Henri Desplaces' *Eva* (1855) and *La Brésilliene* (1857), and Perrot's *Armida* (1855), in which she made her Bolshoi debut. Cerrito retired in 1857.

Unique among the female stars of the Romantic ballet, Cerrito choreographed ballets for herself that remained in the company repertories; although both Taglioni and Fanny Elssler were credited for a ballet each, they were occasional works. Her best known works were *La Vivandière ed il Postiglione* (1843) and *Gemma* (1854).

Works Choreographed: CONCERT WORKS: *Der Soldat und die Marketenderein in Steichmahn* (pas de deux, possibly an early version of *La Vivandière*

ed il Postiglione) (1841); *Amors Zögling* (The Pupil of Cupid) (1841); *Alma, ou la Fille de Feu* (1842, co-choreographed with Jules Perrot); *Il Lago delle Fate* (1843); *L'Allieva d'Amore* (1843); *La Vivandière ed il Postiglione* (full-length work) (1843); *Rosida, ou les Mimes de Syracuse* (1845); *Gemma* (1854).

Bibliography: Guest, Ivor. *Fanny Cerrito* (London: 1956).

Chabukiani, Vakhtang, Soviet ballet dancer and choreographer; born March 12, 1910 in Tiflis, the Georgian Soviet Socialist Republic. Trained there by Maria Perrini, he took evening classes at the Leningrad Choreographic Institute, graduating into the GATOB. An athletic dancer with tremendous stage presence, he was cast as the hero and representative of the New Russia in Jacobson and Vainonen's *The Golden Age* (1930), Vainonen's *Flames of Paris* (1932) and *Partisan Days* (1937), and Lopoukhov's *Taras Bulba* (1940).

Returning to his native Tiflis (by then spelled Tbilisi), he headed the Georgian State Ballet from 1958 to 1973, when he ran foul of a bureaucracy. Most of his ballets were choreographed for this company.

In 1977, as the result of his reported involvement in an arson attempt at the Paliashuili Opera House, he was sentenced to work in the Ukraine staging ice ballets.

Works Choreographed: CONCERT WORKS: *The Heart of the Hills* (1938); *Laurencia* (1939); *Sinatle* (1947); *Gorda* (1949); *Othello* (1957); *The Demon* (1961); *Etude* (1961).

Chadman, Christopher, American theatrical dancer and actor; born Kenneth Brown, c.1949 in the Bronx, New York. Trained at the High School of Performing Arts, he made his Broadway debut in *Darling of the Day* in 1968. Although his next show, *Jimmy* (1969), lasted only a little longer than his first, his later shows have included many of the most successful of the decade. He has been cast in *The Rothschilds* (1970), *Applause* (1970), where he spoke his first lines on stage, Bob Fosse's *Pippin* (1972), his *Chicago* (1975), the Margo Sappington revival of *Pal Joey* (1976), and Fosse's *Dancin'* (1978). Although that revue has no official stars, he appears more than

any other male dancer and is considered—by the audience, at least—the principal performer in the show, most especially in the "Dancing Man" number.

Chaffee, George, American ballet dancer and collector of dance materials; born c.1920 in Oakland, California. Chaffee's dance education included classes with George Balanchine, Anatole Oboukhov, and Pierre Vladimiroff as one of the early students at the School of American Ballet in New York, with Lubov Egorova, Olga Preobrajenska, and Stanislas Idzikowski in their European studios, and courses at the Mary Wigman school in Dresden. After returning to the United States, he performed with the Fokine Ballet of 1936 through 1938, the Mordkin Ballet of 1938, and the Metropolitan Opera Ballet (c.1939–1941). In the latter company, he partnered Lillian Moore, a colleague in both dance and collecting, whose archives of American materials would almost rival his European one.

Although Chaffee formed a chamber ballet company and was acclaimed as a teacher, he is best known for his lecture-demonstrations and exhibits on the continuing importance of French Romanticism to the dance. A Francophile of the highest order, he performed with the French Folklore Society and served with the Cultural Office of the New York Consulate in promoting the acquisition of French nineteenth-century art and archives for American institutions. His own collection, which is considered one of the best in this country, was frequently on exhibition in New York's museums and galleries. Chaffee also wrote collages, rather than essays, for *Dance Index,* in its time the most innovative dance periodical with a flexible format that attracted some of this country's most experimental graphic designers. Most of his studies in American and French romantic iconography were designed by Joseph Cornell.

Works Choreographed: CONCERT WORKS: *Piccolini* (1951); *Reverie* (c.1958); *Annabel-Lee* (1959); *Vignettes* (1959); lecture-demonstrations of Romantic ballet, Romantic preclassic ballet, and preclassic forms (c.1945–1953).

Bibliography: "American Lithographs of the Romantic Ballet." *Dance Index* (February 1942); "American Music Prints of the Romantic Ballet." *Dance Index* (December 1942); "The Romantic Ballet in London." *Dance Index* (September–December 1943); "Three or Four Graces." *Dance Index* (September–November 1944).

Chagall, Marc, Russian artist and theatrical designer; born July 7, 1887 in Vitebsk. The world-famous exponent of "poetic cubism," a personal style in which recognizable folk or legendary elements are fractured into cubistic structures, is known for his designs on paper, canvas, stained glass, and tapestry but has also created art for the theater. Active in dance during his residency in the New York area (during World War II), he created scenery and costume designs for Leonid Massine's productions of *Aleko* (1942) and *The Firebird* (1949). The designs for the latter have also been used in the New York City Ballet 1972 revival of George Balanchine's version. Other dance designs include a production of that popular Stravinsky score for Adolf Bolm (1945) and *Daphnis and Chloe* for Serge Lifar (1958) and Georges Skibine (1967). He was one of the major artists working in the theater given an issue of *Dance Index* (November of 1945).

Chaib, Elie, Lebanese modern dancer working in the United States; born July 18, 1950 in Beirut. After local studies and work with the Beirut Dance Ensemble, he moved to New York to continue his training at the American Ballet Center and the studios of Martha Graham and Merce Cunningham. Chaib has been a member of the Paul Taylor company since 1973, appearing in almost all of the troupe's large repertory. He has been able to adapt easily to the traditional modern dance technique that Taylor uses and has won audience acclaim to his performances of the choreographer's *Polaris, Airs, Runes, Esplanade,* and other works.

Chakiris, George, American film dancer and actor; born September 16, 1934 in Norwood, Ohio. Raised in Long Beach, California, he was trained at Eugene Loring's American School of Dance in Hollywood. Chakiris danced in the chorus of a number of musical films, most notably, in the sword dance in *Brigadoon* (MGM, 1954), the male quartet surrounding Rose-

mary Clooney in *White Christmas* (Paramount, 1955) and Loring's *Meet Me in Las Vegas* (MGM, 1956) before being cast as "Riff" in the London production of Jerome Robbins' *West Side Story.*

Despite his success in the role of the leader of the Jets, Robbins and the studio cast him as "Bernardo," the head Shark in the 1961 film from Twentieth-Century Fox. His dancing was seen in the gym and rooftop celebration scenes, as well as at the rumble. Considered a prime example of the "Oscar curse," he won the 1961 Academy Award for the film, but has not been cast in a musical film since. He has emerged as one of the finest young actors of his generation in American films and British television and live theater.

Chalif, Louis Hervé, Russian ballet dancer teaching in New York after 1907; born 1876 in Odessa, Russia; died 1948 in New York. Chalif was trained at the school of the Imperial Theater in Odessa by Tomas Nijinsky, father of Vaslav and Bronislava, and by Charles Cherer-Bekefi, father of Theodore, Maria, and Julie. Graduating in 1893, he performed with the ballet company of the Imperial Theater there.

In 1904, Chalif emigrated to the United States to perform at the Metropolitan Opera as a character dancer. In 1907, he opened the first of his Normal Schools of Dancing. These schools, the last of which was housed in the balconied building that still stands across from Carnegie Hall, sponsored classes in Russian (i.e., ballet), Grecian (i.e., interpretive), and theatrical dance forms, and published textbooks in each technique. The Chalif School also published a series of over five hundred dances in his own notation, using words, with music and costume designs.

Despite the similarity in their names, there is no evidence that the Hervé Chalif family of ballet teachers were related to the Hervé D'Egville clan.

Chalon, Alfred Edward, Swiss painter and illustrator working in England; born 1780 in Geneva; died 1860 in London. Although best known for his depictions of Romanticism, Chalon's earliest dance lithographs were caricatures of performers at His Majesty's Theatre (later, Her Majesty's) in the 1820s and 1830s. His drawings of members of the D'Egville clan, now in the collection of The Victoria and Albert Museum in London, are classics of satirical art.

Chalon's "serious" artwork was strictly in the traditions of the English Romantic portraiture; it rated him membership in the Royal Academy, despite his theatrical inclinations. His lithographs of French Romantic ballerinas—among them Pauline Duvernay, Louise Fleury, and Carlotta Grisi—were based on sketches made at London and Paris theaters and were published in both cities. His best known works are the illustration of Jules Perrot's *Pas de Quatre,* which depicts the individualities of each dancer, and his albums of lithographs of Marie Taglioni—six on *La Sylphide* and six on national solos.

Bibliography: Chafee, George. "Three or Four Graces." *Dance Index* (September–November 1944).

Chamie, Tatiana, Russian ballet dancer working in the United States from the mid-1930s; born in Odessa, Russia; died November 18, 1953. Raised in Paris, she studied with Olga Preobrajenska and Lubov Egorova.

Chamie joined the Diaghilev Ballet Russe in the early 1920s, and created roles in three new works—Bronislava Nijinska's *Les Biches* (1924), George Balanchine's *The Triumph of Neptune* (1926), and Leonid Massine's *Cimarosiana* (1926). Following Diaghilev's death in 1929, she performed in the Russian Opera Ballet, a short-lived company formed with Prince Zeretelli, and with Les Ballets de Boris Kniaseff (c.1931).

Chamie was associated with the works of Leonid Massine in two companies called the Ballet Russe de Monte Carlo. Among the works in which she performed to great acclaim were his *Contes Russes, Beach, Vienna - 1814, Rouge et Noir,* and *Bacchanale,* as well as George Balanchine's *La Concurrence.*

She retired in 1943 to open a studio but returned to choreograph for the Monte Carlo troupe. Her enormous collection of performance and casual photographs of the Ballet Russe company are currently a major part of the archives of the Dance Collection, The New York Public Library.

Works Choreographed: CONCERT WORKS: *Le Petite Sirène* (1938); *Birthday* (1949); *Prima Ballerina* (1950); *Chez Maxime* (1951).

Champion, Gower, American exhibition ballroom dancer, theatrical and television dancer and choreographer; born June 22, 1921 in Geneva, Illinois; died August 25, 1980, in New York City, a few hours before the opening of his final hit, *42nd Street.* Champion studied with Ernest Belcher in Los Angeles before making his professional dance debut in supper clubs in 1936, as a member of the dance team of Gower and Jeanne (Tyler). This team performed together until 1942, when Champion entered the U.S. Coast Guard. In 1943 and 1944 he appeared in the servicemen cast of *Tars and Spars.*

In 1946, Champion formed a dance team with Marjorie Belcher, entitled Gower and Belle for a year, then, Marge and Gower Champion. As a team, they performed on television on variety shows from 1948 through 1966, and on their own show, a situation comedy telecast on CBS for the 1957 season only. The team performed in seven films, all but one for MGM; among them were *Mr. Music* (Paramount, 1950), *Show Boat* (MGM, 1951), *Give a Girl a Break* (MGM, 1953), and *Three for the Show* (Columbia, 1955). In addition, Champion appeared in *'Til the Clouds Roll By* (MGM, 1946) and *The Girl Most Likely* (RKO, 1956).

Champion first choreographed for Broadway in 1948, for *Small Wonder;* it is possible, however, that he staged the Marge and Gower Champion specialties in their film and television appearances. Champion's Broadway shows have included some of the most successful musical comedies in recent history, among them, *Bye Bye Birdie* (1960), *Carnival* (1961), *Hello Dolly* (1964), and *I Do! I Do!* (1966). He is also considered one of Broadway's most successful show doctors, and has won both choreography and direction Tony awards for *Bye Bye Birdie, Hello Dolly, The Happy Time* (1968), and the posthumous *42nd Street.*

Works Choreographed: THEATER WORKS: *Small Wonder* (1948); *Lend an Ear* (1948); *Make a Wish* (1951); *Bye Bye Birdie* (1960, also directed); *Carnival* (1961, also directed); *Hello Dolly* (1964, also directed); *Three Bags Full* (1966, also directed); *I Do! I Do!* (1966, also directed); *The Happy Time* (1968, also directed live and filmed sequences); *Prettybelle* (1971, closed out of town); *Sugar* (1972, also di-

rected); *Irene* (1973, revival); *Mack and Mabel* (1974); *42nd Street* (1980, also directed).

Champion, Marjorie, American exhibition ballroom and theater dancer and choreographer; born, Marjorie Belcher, September 2, 1925 in Los Angeles. Champion studied ballet with her father, Ernest Belcher, and tap with Nick Castle in Los Angeles. In New York after the 1940s, she studied ballet with Vincenzo Celli and modern dance (Wigman technique) with Hanya Holm.

Billed as Marjorie Belcher or Marjorie Belle, she appeared in Prologs and concert works choreographed by her father in Los Angeles in the 1930s and made her vaudeville debut with The Three Stooges' act in 1939. Arriving in New York in 1940, she performed in two pre-Broadway tryouts, before making her Broadway debut as a dancer in *What's Up?* (1943).

In 1946, she formed an exhibition ballroom team with former Belcher student, Gower Champion, entitled "Gower and Belle"; after their marriage (1947-1973), they were billed as Marge and Gower Champion. As a team, they performed extensively on television between 1947 and 1966, dancing on almost every variety show from the *Milton Berle Show* on; in 1957, they played "themselves" on a situation comedy on CBS.

As a dance model for animators, Champion worked for the Walt Disney Studios from 1937 to 1940; she was the model for "Snow White," the "Blue Fairy" in *Pinocchio* (RKO, 1940) and various roles in *Fantasia* (RKO, 1940). As a dance team, the Champions appeared in seven films, notable among these was the 1951 remake of *Show Boat.* In 1966, Champion appeared as an actress in *The Swimmer* (Columbia, 1966).

While teaching acting and dance at the Mafundi Institute in Los Angeles, Champion has staged the dances for television specials, *The Queen of the Stardust Ballroom* (CBS, 1974), and *When the Circus Came to Town* (CBS, broadcast delayed to 1981).

Works Choreographed: TELEVISION: *The Queen of the Stardust Ballroom* (CBS, 1974); *When the Circus Came to Town* (CBS, broadcast delayed to 1981).

Chappell, William, English ballet dancer, theatrical choreographer, and costume designer born September 27, 1908 in Wolverhampton, England. Trained at the school of the Ballet Rambert, he graduated into the company in the early 1930s. In that company, the Ballet Club and the Camargo Society, he created roles in many works by the trio of choreographers who stocked the early English ballet—Frederick Ashton, Antony Tudor, and Ninette De Valois. He performed in the premieres of Ashton's *Nymphs and Shepherds* (1928), *Leda* (1928); *Capriol Suite* (1930); *Façade* (1931); *Mercury* (1931); *Pavanne pour une Enfante Defunte* (1933), *A Day in a Southern Port* (1931), *The Lord of Burleigh* (1931), and the musical comedy, *High Yellow* (1932, co-choreographed with Buddy Bradley). He also danced in the first performances of Tudor's *Cross-Garter'd* (1931), *Lysistrata* (1932), and *The Planets* (1934), and in De Valois' *Job* (1931), *The Rake's Progress* (1935), *Checkmate* (1937), and *The Jar* (1934).

Despite his success in the developing ballet field, Chappell began working extensively in revues and musicals, among them *Cochran's 1932 Revue, Kiss in the Spring* (1932), *The Merry Widow* (1943), *4,5,6* (1948), and *A la Carte* (1948). He also designed many productions—both ballets, including among them Ashton's *Les Rendez-vous* (1937) and *Les Patineurs* (1937), De Valois' *Cephalus and Procris* (1931), and Tudor's *The Judgement of Paris* (1938).

He choreographed West End revues and musicals also. Among his most successful productions were *Swing Back the Gate* (1952), *High Spirits* (1953), and the revue *At the Lyric* (1953). He has also directed many productions, including one of England's first jazz musicals, *Expresso Bongo* (1958), *Cockee* (1970), and *Travesties* (1974).

Works Choreographed: THEATER WORKS: *A la Carte* (1948); *The Lyric Revue* (1951); *The Globe Revue* (1952); *High Spirits* (1953); *Going to Lyric* (1954); *Expresso Bongo* (1958); *Living for Pleasure* (1959); *On the Avenue* (1961); *So Much to Remember* (1963).

Charisse, Calliope, Greek interpretive dancer and matriarch of the Charisse family of ballet and theatrical dancers and teachers; born c.1880 in Greece; died September 6, 1946 in the United States. Charisse was trained by a Duncan-inspired performer teaching in Athens. After touring in Greece as a dancer with a unique mix of ballet and Duncanesque movement, Charisse left the country for Paris at the outbreak of World War I. She staged an act for herself and her eleven children with which she performed at a number of benefits in France for American soldiers and their dependents. This enabled her to emigrate to the United States with her family; she and the ten oldest made their debuts at the Hippodrome in 1923 and toured extensively on the Keith circuit. The children, dressed in signature chitons with shoulder-length hair, became extremely popular across the country but eventually each dropped out of the act to follow individual careers.

Shortly before her death, Charisse gave a concert with some of the younger children at which she presented works that seem to be within the Greek revival genre.

Works Choreographed: CONCERT WORKS: *Rebecca* (c.1941); *Pastorale* (c.1941); *Danse Antique* (1941); *Unknown Soldier* (1941); *Diana* (1941); *Orpheus* (c.1941); *Three Graces* (c.1941); *Minuet* (c.1941); *Afternoon of a Faun* (c.1941); *Greece* (c.1941); *Matin* (c.1941, possibly choreographed as early as 1926).

Charisse, Cyd, American film dancer; born Tula Ellice Finklea in 1923 in Amarillo, Texas. She was trained by Adolf Bolm, Nico Charisse, who became her first husband, and Bronislava Nijinksa, making her debut as Felia Sidorova in the Ballet Russe de Monte Carlo, c.1939.

Charisse made her first films for release in 1943. Her earliest musical, *Something to Sing About* (Grand National Pictures, 1943), featured tap dancers Johnny Boyle and Harland Dixon, who may have coached her in their tap techniques. Her best remembered films were made for MGM; throughout the 1940s and 1950s she partnered Gene Kelly and Fred Astaire alternately. She came to prominence in a dance number interpolated into *Singing in the Rain*'s film-within-a-film, "Gotta Dance," in which she danced with Gene Kelly in a 1920s slink and a very 1940s dream sequence. *The Band Wagon,* her next major film, was choreographed by Michael Kidd for Fred Astaire; their numbers together include a so-

cial dance, and a marvelous show-within-a-show called "Girl Hunt" in which she played three different seductresses. She did use her ballet training in some films, among them *The Unfinished Dance* (1947), a remake of the French *Mort du Cygne, The Band Wagon* (1954), *Meet Me in Las Vegas* (1956), which includes a Sleeping Beauty and a Tennis Ballet, and *Silk Stockings* (1957), the musical film of *Ninotchka.*

Charisse also performed on television variety shows and acted in dramatic series. She retired from film in 1967, returning to performance on television in the early 1970s. In many ways, she represents the 1940s and 1950s to film viewers—the concept of movement and the ideal of women. Her presence in a film, through accidents of time, brings it into the present, into the modern vision of dance.

Charisse Family, Greek family of performers and teachers working in the United States. The eleven children of Calliope Charisse emigrated with her to the United States in 1923, after having performed as a family troupe in Athens and Paris. Apart from Nico, whose entry follows, six of the family had dance careers outside of the family troupe. Katerina (Kitty, Kathryn) taught for many years in New York and Los Angeles as Mme. Kathryn Etienne. Pierre enjoyed considerable success in an exhibition ballroom act with his wife, Renée, in the 1940s. Helen taught in Indianapolis until the early 1960s. André, who later became a noted actor, performed with the Edwin Strawbridge company and the Mikhail Mordkin Ballet while serving as ballet master of the Claude Alvienne studio in New York. His Broadway dance credits include roles in *Hold Your Horses* (1933), *Revenge with Music* (1934), *Parade* (1935), *At Home Abroad* (1935), and two shows in which he worked with Paul Haakon, *Death in the Afternoon* and *The Show Is On.* Rita also performed with the Mordkin Ballet and became a charter member of Ballet Theatre. Always interested in jazz forms, she worked with Lee Sherman (a Weidman dancer who choreographed extensively in the United States and Italy) and with Margaret Kelly (Miss Bluebell). Nanette Charisse taught in the New York area through most of her career. As the principal ballet teacher at the New York University School of the Arts, she has trained and become an important influence on many ballet, modern, and postmodern dancers and choreographers.

Charisse, Nico, Greek-American ballet and jazz teacher; born 1904 in Greece; died April 14, 1970 in Las Vegas, Nevada. Charisse, who was considered one of the great dance coaches of Hollywood, was the son of Calliope Charisse, matriarch of a family of dancers and teachers who emigrated from Greece to the United States in 1914. He was trained by his mother and by the staff of the San Francisco Ballet, of which he was a member in the 1930s. His best known pupil was his one-time wife, Cyd Charisse, but he also trained Ava Gardner, Paulette Goddard, Sarah Churchill, Gene Nelson, and the children of many Hollywood celebrities, including Liza Minelli. Although he left his staff position at MGM after his divorce, he remained in Hollywood and opened a studio near the studios.

Charles, Paul, American theatrical performer; born July 29, 1947 in New York City. Charles was trained at the Quintano School, then the center of child performer education in New York. He made his professional debut as an adolescent in the 1960 City Center revival of *The King and I,* and followed it with an adult performance in the 1963 revival of *Best Foot Forward,* and a role in the most infamous flop of the decade, *Kelly.* The versatile performer had a wide range of theatrical experience throughout the next ten years, including parts in the play *Royal Hunt of the Sun,* Michael Bennett's first musical, *A Joyful Noise* (1966), *La Strada,* and the national tours of *Gypsy, West Side Story,* and *Oklahoma.* In *A Chorus Line,* in which he was featured in the late 1970s, he was reunited with Bennett.

Charlip, Remy, American postmodern and theatrical dancer, choreographer, director, and designer; born January 10, 1929 in Brooklyn, New York. While working as an artist and graphics designer, Charlip studied at the New Dance Group Studio, at Juilliard with Antony Tudor and Margaret Craske, and with Merce Cunningham at his studio in the Living Theatre building. He was a member of the Cunningham company for eleven years, c.1950 to 1962, creating

roles in his *Minutiae* (1954), *Suite for Five in Space and Time* (1956), *Antic Meet* (1958), *Aeon* (1961), and many others.

Charlip's artistic creations have been produced for children and adults. As a choreographer, director, writer, and illustrator, his award-winning books and shows for the Paper Bag Players (1958–1965) have been successful and well received. He had done choreography for the traditional outlets of the postmodern era, among them, the Black Mountain College in 1951, the Judson Dance Theater, Sarah Lawrence College dance students, and companies including the London Contemporary Dance Theatre, the Scottish Theatre Ballet, the Taller de Danza Contemporanea in Caracas, and his own Remy Charlip Dance Company (1977–). He has also produced Air Mail Dances. In that genre, he provides pictures or illustrations of moving bodies and lets the performer process the figures into a dance. Since 1972, when he did *Instructions from Paris* for Nancy Green, to the present, he has created dozens of these instruction manual/dances for individuals and groups. In the listing of choreographed works, they are identified by the name of the commissioning performer.

He worked frequently for theater productions in the 1950s through the early 1970s. He staged incidental dances for productions at the Living Theatre, among them the celebrated *Man Is Man* (1962), the Judson Poets Theater (winning an "Obie" for *A Beautiful Day*, 1965), La Mama, and the National and Little Theaters of the Deaf. He frequently designed sets and/or costumes, directed, and wrote music for these productions.

Works Choreographed: CONCERT WORKS: *Falling Dance* (1951); *Crosswords for Cunningham Company* (1952); *Exquisite Corpse #1* (1953); *Exquisite Corpse #2* (1954); *Obertura Republicana* (1956, with Paul Taylor, Marian Sarach, James Waring, and David Vaughan); *December* (1964); *April* (1964); *Dance for Boys* (1965); *April and December* (1965); *Meditation* (1966); *Theater Songs of Al Carmines* (1966); *The Sneaker Players* (1966); *The Tinguely Machine Mystery* (1966); *Etude* (1967); *Between the Black and the White There Is a Rainbow* (1967); *Sneaker Players* (1967); *Clearing* (1967); *An Evening of Dances, Plays, and Songs* (1967); *I Am My Beloved* from *Song of Songs* (1967, with Aileen

Passloff); *Concrete Rainbow* (1967); *Celebration of Change* (1967); *Dr. Kheal* (1968); *Differences* (1968); *Meditation* (II) (1968); *Green Power* (1968, with Ken Dewey); *Sneaker Players (II)* (1968); *Homage à Loie Fuller* (1969); *Happy Is the Man in Whose Hand Line A Meets Line B* (1969, with Burt Supree and June Ekman); *Dark Dance* (1969); *Under Milkwood* (1970); *The Book is Dead* (1971); *Dance* (1972); *Instructions from Paris (for Nancy Green)* (1972); *Quick Change Artists* (1973); *The Moveable Workshop* (1973); *Thinking of You Thinking of Me* (1974); *Le Cahier Vierge* (1974); *Arc en Ciel* (1974); *Mad River* (1974); *If I Were Freedom* (1976); *Tiempo Azul* (1976); *Faces and Figures Found on the Wall Below the Barre Made by the Students in Madame Franklin's Ballet Studio on the Top Floor of the Teatro Municipal in Caracas, Venezuela (for Juan Monson)* (1976); *The Woolloomooloo Cuddle* (1976); *Instructions from Guatamala (for José Ledezma)* (1976); *Part of a Larger Landscape* (1976); *Instructions to New York (for Eva Karczag)* (1976); *Glow Little Glow Worm Glisten Glisten (for Remy Charlip)* (1976); *Danza Por Correo (for José Ledezma)* (1976); *Opening* (1977); *A Week's Notice* (1977); *Ball* (1977); *Balls* (1977); *Art of the Dance* (1977); *Imaginary Dances* (1977); *Travel Sketches* (1977); *Painting Flying (for Remy Charlip)* (1978); *A Tree Blossoms at a Woman's Touch (for Jeannette Lentvaar)* (1978); *El Arte de la Danza (for José Ledezma)* (1978); *I Am My Beloved* from *Song of Songs* (II) *(for Ronald Dabney and Jeannette Lentvaar)* (1978); *Lilace Garden (for Idella Packer and Karen Bean)* (1979); *Six Mail Order Dances for Forty People in Six Open Spaces in Maine* (1979); *250 Dances on a Diagonal with 250 Guest Towels* (1979); *Lilac Garden* (1980); *Green Again* (1980); *Alone Some, Twosome (for Ronald Dabney and Sheila Kaminsky)* (1980); *Red Towel Dance (for Barbara Roan)* (1980); *Foo Doomyo (for Richard Zelens)* (1980); *Los Palos Grandes (for Abelardo Gameche and Eduardo Ramones)* (1980); *Twelve Contradances (for Ronald Dabney and Lance Westergard)* (1980); *Happy, Happy, Happy We* (1980); *Every Little Movement; Hommage to Del Sarte (for David Vaughan and Al Carmines)* (1980); *Waves* (1980, with Toby Amour); *Dance on a Floor (for Toby Amour)* (1980); *39 Chinese Attitudes (for Nancy*

Lewis) (1980); *Our Lady of the In Between (for Toby Amour)* (1980); *Glowworms* (1980, with Bruce Hlibok); *Do You Love Me Still?* (1980).

THEATER WORKS: *Drama in Ex Libre* (1949, also designed show); *Dr. Faustus Lights the Lights* (1951); *Dialogue Between the Manikan and the Young Man* (1951); *Cut-Ups* (1959, also designed and directed show); *Scraps* (1960, also designed, directed, and wrote play); *Tonight We Improvise* (1960); *Group Soup* (1961, also designed, directed, and wrote show); *Fortunately* (1962, also directed, designed, and wrote show); *Man is Man* (1962); *Patter for a Soft Shoe Dance* (1964, directed show only); *Leonce and Lena* (1964); *Sing Ho! For a Bear* (1964); *A Beautiful Day* (1965, also directed show); *Jonah* (1966, also designed show); *More, More, I Want More* (1966); *Variety Show* (1967); *A Re-examination of Freedom* (1967, also designed show); *I Ching Poem for Johnny* (1967); *Bertha* (1967, also designed show); *Well . . . Actually* (1967, co-choreographed with James Waring and John Herbert McDowell); *Sayings of Mao Tse Tung* (1968); *Celebration* (1968); *Untitled Play* (1968); *Spring Play* (1969); *The Red Burning Light* (1969); *Biography* (1970); *Faces* (1970); *Secrets* (1971); *Mystery Play* (1973).

TELEVISION: *Glowworm* (WGBH, 1979, special); *Meet* (WGBH, 1979, special); *Dance in a Bed* (WGBH, 1979, special); *Match* (WGBH, 1979, special); *Etude* (WGBH, 1979, special).

Charlot, André, English theatrical impressario of the 1920s and 1930s; born July 26, 1882 in Paris; died May 20, 1956 in Woodlawn, California. Charlot was known for his musical comedies and especially for the revues that he produced in the 1920s. Unlike Florenz Ziegfeld, Jr. he used very few performers in each production and eschewed large choruses. Like Ziegfeld and his other American colleagues, however, he employed many choreographers on each show, hiring different people to stage the ballets, the dance numbers, and the specialties. Among the many choreographers who worked for him were Harry Pilcer, Frederick Ashton, Jack Buchanan, and Buddy Bradley.

Charlotte, German ice dancer working in the United States; born Charlotte Oelschlagel, c.1899 in Berlin; date and place of death (after 1948) uncertain. "The Genée, Pavlova and Irene Castle of the Ice" was an amateur skating champion before joining the staffs of the Berlin Admiralspalast and Wintergarten in her late adolescence. Charles Dillingham saw her in Berlin and hired her for the (New York) Hippodrome, where he was then producer. He and director R.H. Burnside were always on the search for new performers with talent that could be featured in their theater, which included an ice rink, a swimming pool, a system of traps and elevators that has never been matched and a conventional stage. They put her in the "Flirting at St. Moritz" number of their *Hip, Hip, Hooray* (1915) and surrounded her with a skating chorus and three pairs of ice tandem teams. Her own solos were considered extremely challenging for the period in which women skaters did not leave the ground; she did some leaps, but specialized in tracings (movement patterns around the rink) and in theatrical and ballet movements on the ice, among them a very clean arabesque, a hitch kick, pirouettes and a turn that she performed holding the blade of the skate of her working leg in back of her, very much like the specialty turn that won the 1981 World Skating Champion her title.

When she was not working at the Hippodrome, Charlotte was engaged in dinner clubs and cabarets, as if she were an exhibition ballroom team. Her longest engagement was at the Terrace Garden (roof theater) of the New Hotel Morrison in Chicago (1917), but she also did one-week bookings across the country.

In *Get Together* (1922), Charlotte's third Hippodrome show, after *Hip, Hip Hooray* and *The Big Show* (1916), she worked with the Fokine Ballet, skating a short sequence from *Les Sylphides* as a preview of their scene. She married the Fokine Ballet conductor, Anselm Goetzl, and traveled with the troupe, but there is no evidence that she danced with the company on a conventional stage.

After Goetzl's death in 1924, Charlotte returned to Europe where she performed for almost a dozen years in cabarets and winter gardens with partner Irving Brokaw. She was appearing in Prague at the time of the German occupation, and spent the war years in hiding and camps. She was discovered in a refugee camp for stateless persons in the invasion of Ameri-

can news media during the Nuremburg War Trials in the late 1940s and recognized as the internationally famous ice skater. She can still be seen in her only motion picture, *Charlotte* (Commonwealth Pictures, 1919–1920, five-part serial), and in newsreel films broadcast during the brief histories of skating shown during news coverage of contemporary skating competitions.

Charmoli, Tony, American theater and television dance director; born in Mountain Iron, Montana. Charmoli spent his G.I. Bill education funds on acting classes at the American Theatre Wing and dance lessons at the Jacob's Pillow summer school. He danced on Broadway in *Make Mine Manhattan* (January 1948) and *Love Life* (October 1948) before beginning to work on television. Although he has staged musicals and revues in New York and Los Angeles, he is best known for his choreography on the newer medium.

Charmoli's first successful television show was *Your Hit Parade* (NBC, 1950–1958), a weekly variety series that required him to create a new dance number each week for each of the top ten tunes. Since many of the songs stayed on the charts for months at a time, he had to use all of his ingenuity to come up with new dance ideas for the same old songs. He had a similar assignment on ABC's *Stop the Music* (1954–1956), in a game show format, but branched out on *The Gale Storm Show* (CBS, 1956–1959), a situation comedy about a cruise ship social director. On that well-remembered show, he occasionally danced with the star as one of the ship's entertainers. His later successful variety shows included *The Dinah Shore Chevy Show* (NBC, 1957–1962), *The Danny Kaye Show* (CBS, 1963–1967), with its eccentric dancer star, specialty chorus, and habit of featuring little baby ballerinas, *The Julie Andrews Show* (ABC, 1972–1973), and various *Sonny and Cher* and *Cher* shows, on CBS in the 1970s. He has also staged dances for award ceremonies, variety specials ranging from the 1962 *Rainbow of Stars* with the Rockettes and skater Dick Button to Cher's infamous special with Bette Midler, and, during the mid-1950s, was responsible for the *Longines Wittenauer Thanksgiving and Christmas Shows*.

Works Choreographed: THEATER WORKS: *Ankles Away* (1958); *Laughs and Other Events with Stanley*

Holloway (1960); *Cabaret at Folies-Bergère* (Las Vegas, 1961); *Eddie Fisher at the Winter Garden* (New York Concert, 1962); *Dumas and Son* (Los Angeles, 1967).

FILM: *What's the Matter with Helen?* (Filmways, 1971); *Best of Friends* (unreleased as of December 1980).

TELEVISION: *Your Hit Parade* (NBC, 1950–1958); *Stop the Music* (ABC, 1954–1956); *Oh, Susannah (The Gale Storm Show)* (CBS, 1956–1959); *The Dinah Shore Chevy Show* (NBC, 1957–1963); *The Longine Wittenauer Thanksgiving and Christmas Specials* (various networks, 1955–1958); *Rainbow of Stars* (NBC, 1962, special); *The Danny Kaye Show* (CBS, 1963–1967); *The Julie Andrews Show* (ABC, 1972–1973); *Cher* (CBS, 1975).

Charnley, Michael, English ballet dancer and choreographer also working in musical comedies; born 1927 in Manchester, England. Charnley was trained by Kurt Jooss at Dartington Hall, and at the school of the Sadler's Wells Ballet. He danced with Jooss' company after the German refugee choreographer was released from English internment, and with the Sadler's Wells.

Charnley's theatrical career began in the United States, with an appearance in Tamiris' *Inside U.S.A.* (1947). He staged dances for West End productions, including *A Girl Called Joe* (1955) and *The Ballad of Dr. Crippen* (1961), and for both English and American television shows. Although he was ill in the late 1950s, he worked as staff dance director for the Casino de Paris in 1958.

Works Choreographed: CONCERT WORKS: *No Lips for Comfort* (1951); *Bagatelle* (1951); *Moviementos* (1952); *Symphony for Fun* (1952); *Alice in Wonderland* (1953); *Homage to the Princess* (1956); *Hence in Solitude* (1960); *Black Rainbow* (1960).

THEATER WORKS: *A Girl Called Joe* (1955); *Cinderella* (1955); *A Girl a Day* (1959); *The Ballad of Dr. Crippen* (1961); productions for the Casino de Paris (c.1958).

TELEVISION: *Dance Contrasts* (BBC, 1952); *Roof Top Rendezvous* (BBC, c.1955).

Charrat, Janine, French ballet dancer and choreographer; born July 24, 1924 in Grenoble, France.

Trained in Paris with Jeanne Ronsay, Olga Preobrajenska, Lubov Egorova, and Alexandre Volinine, she made her debut as "Rose Souris," the child dancer in the film *La Mort du Cygne*. As an adult, she performed in the Soirée de la Danse series of recitals, 1941 to 1944, and with Roland Petit's Ballets des Champs-Elysées. She also danced with the Nouveau Ballet de Monte Carlo in 1946, in Serge Lifar's *Prière*, before forming her own company, Ballets de France de Janine Charrat. There, she danced in many of the works that she created for the troupe, among them *Les Algues* (1953), *Concerto* (1947), and *Le Massacre des Amazones* (1951).

She performed until an accident destroyed her dance career; in a horrible revival of the gaslight tragedies of the Romantic era, her costume caught fire during a television rehearsal. After she recovered, she became director of the Geneva Ballet during the 1960s, later opening a studio in Paris.

Works Choreographed: CONCERT WORKS: *Jeux de Cartes* (1944); *Tabou* (1945); *Légende de la Licorne* (1945); *Guernica* (1945, co-choreographed with Roland Petit); *Concert No. 3* (1947); *Theme and Variations* (1948); *A Dame Miroie* (1948); *Allegro* (1948); *L'Ame Heureuse* (1948); *La Femme et son Ombre* (1948); *La Nuit* (1949); *Herodiade* (1949); *Abraxas* (1949); *A Summer's Day* (1950); *Le Massacre des Amazones* (1951); *Concerto à Grieg* (1951); *L'Etrangère à Paris* (1951); *Heracles* (1953); *Les Algues* (1953); *La Valse* (1955); *The Seven Deadly Sins* (1956); *La Dryade* (1956); *Le Jouer de Flute* (1956); *Diagrammes* (1957); *Les Lieux* (1957); *Arlequin* (1958); *La Chimère* (1958); *Dominos* (1958); *Catherine Segurane* (1960); *Roi David* (1960); *Electre* (1960); *Tu auras nom . . . Tristan* (1963); *Pour le Temps Présent* (1963); *Alerte . . . puis 21* (1963); *L'Enfant et les Sortilèges* (1964); *La Répétition de Phaedre* (1964); *Paris* (1964); *Cycle* (1965); *Rencontres* (1965); *Au Mendiant du Ciel* (1968); *Persephone* (1968); *Up to Date* (1968); *Orphée* (1968); *Firebird* (1969); *Les Collectionneurs* (1972); *Hyperprism* (1973); *Offrandes* (1973); *Dia Chronies* (1979).

Chase, Alison, American modern dancer, choreographer, and teacher associated with Pilobolus; born in Eolia, Missouri. Chase studied dance while a student at Washington University (St. Louis), the University of California at Los Angeles, and the studios of Murray Louis and Mia Slavenska. Although, as the modern dance teacher at Dartmouth College, she was the major influence on the founders of Pilobolus, Moses Pendleton and Jonathan Wolken, she did not actually perform with the troupe until its second season. She now dances in all but the all-male works and does both solo and collaborative choreography with Pendleton, with the company's other first female Martha Clarke, and with the full group. Despite her ballet training and traditional modern dance pedagogy, Chase is considered one of the inventors of Pilobolus' movement vocabulary with its abstract and characterizational acrobatics.

Works Choreographed: CONCERT WORKS: (Note: all works credited to Pilobolus were choreographed by the company's entire membership at the time of creation.) *Walklyndon* (1971, choreographed by Pilobolus); *Two Bits* (1973, co-choreographed with Martha Clarke); *Pilea* (1974); *Monkshood* (1974, choreographed by Pilobolus); *Alraune* (1975, co-choreographed with Moses Pendleton); *Untitled* (1975, choreographed by Pilobolus); *Ciona* (1975, choreographed by Pilobolus); *Lost and Found* (1976, co-choreographed with Pendleton); *Lost in Fauna* (1976, choreographed with Pendleton); *Shizen* (1977, choreographed with Pendleton); *Moonblind* (1978); *Molly's Not Dead* (1978, choreographed by Pilobolus); *A Miniature* (1980); *The Detail of Phoebe Struchton* (1980, choreographed with Pendleton).

Chase, Arline, American theater and film dancer; born 1900; died April 19, 1926 in Sierra Madre, California. Chase was trained in New York, possibly in either the Ned Wayburn or William Pitt Rivers studios, before making her successful featured debut in the Jerome Kern musical *Leave It to Jane* (1918). Although she did exhibition ballroom work in that Princess Theatre show, she worked as a ballet dancer in two Wayburn Midnight matinees, the late-night roof-garden revues, *Century Revue* of 1920 and the *Ziegfeld Midnight Frolic* of 1921.

Discovered in the latter, she moved to Hollywood to become a Mack Sennett Bathing Beauty. She appeared as a social dancer in the backgrounds of Sennett films, but soon was given larger roles in his comedies. After two years working for Sennett, tuberculosis forced her to retire.

Chase, Barrie, American film dancer and actress, best known as Fred Astaire's last dance partner; born 1934 in King's Point, Long Island, New York. Raised in Los Angeles, she studied with Adolf Bolm and Maria Bekefi performing in *Scaramouche* as a child. Before becoming known as a performer, Chase assisted Jack Cole on two films for MGM in 1957—*Les Girls* and *Designing Woman*. Under contract to Twentieth-Century Fox, she appeared in a number of films, most notably as the philosophy student who stripped her way through college in *Mardi Gras* (1958).

At some point while demonstrating dances for Cole, Chase was seen by Fred Astaire who hired her as his partner for seven television appearances (1958–1968). She was his last dance partner on screen, and, many think, one of the best. Tall, like Cyd Charisse, with a red ponytail, she looked like a stretched-out Carol Haney, with elongated legs and isolating shoulders. Chase performed with Astaire in *An Evening with Fred Astaire* (NBC, October 17, 1958), *Another Evening with Fred Astaire* (NBC, November 4, 1959), *Astaire Time* (NBC, September 28, 1960), *Think Pretty* (NBC, October 22, 1964), two episodes of *Hollywood Parade* (NBC, January 22 and April 4, 1966), and *The Fred Astaire Show* (NBC, February 7, 1968).

Chase, David, American modern dancer; born June 18, 1948 in Mill Valley, California. Chase studied with a variety of teachers in jazz, ballet, and modern dance techniques, among them Walter Nicks, Karel Shook, and the faculties of the American Ballet Center and the Martha Graham School. He has performed in the modern ballets of Norbert Vesak, the lyrical abstractions of Kazuko Hirabayashi and Mary Anthony, including the latter's *A Ceremony of Carols* (1974). A member of the Martha Graham Company in the 1970s, he has appeared in her revivals of her repertory classics, such as *Letter to the World, Deaths and Entrances*, and *Phaedra*, and in the works of her renaissance, among them, *Lucifer*.

Chase, Lucia, American ballet dancer, founder and co-director of American Ballet Theatre; born 1907 in Waterbury, Connecticut. Chase received her professional dance training from Mikhail Mordkin, making her performing debut in his ballet, 1938 to 1940. In that company, she created the role of "The Fisherman's Wife Turned Queen" in *The Goldfish* (1939) and performed "Lise," her most celebrated role, in *La Fille Mal Gardée*.

A charter member of Ballet Theatre, Chase created many roles, among them the "Eldest Sister" in Antony Tudor's *Pillar of Fire* (1942), "The Nurse" in his *Romeo and Juliet* (1943), and "Polyhymnia" in his *Undertow* (1945). In the Agnes De Mille repertory, she created roles in her *Tally-Ho* (1944) and performed in the company premiere of *Three Virgins and a Devil* in 1941, but is best known for a role that she took on later in her career, that of the "Stepmother" in her *Fall River Legend*. Although admired for her dramatic performances, Chase was also noted for her classical ballet technique as the ballerina of the Prelude in *Les Sylphides*.

Appointed co-administrative director of Ballet Theatre in 1945, she retained that position until 1980 when she was replaced by Mikhail Baryshnikov. Although she had been criticized for overemphasizing the Russian repertory for their many defectors, Ballet Theatre was noted during Chase's tenure for its dancer/choreographers-in-residence, among them, over the years, Jerome Robbins, Herbert Ross, Eliot Feld, Michael Smuin, and Dennis Nahat.

Chauviré, Yvette, French ballet dancer; born April 22, 1917 in Paris. Trained at the school of the Paris Opéra, and with Boris Kniaseff, she has performed with the Opéra for much of her career.

After joining the company in 1937, she created roles in Serge Lifar's *David Triomphant* (1937), *Alexandre le Grand* (1937), *Ishtar* (1941), *Joan de Zarissa* (1942), *Le Chevalier et la Demoiselle* (1941), and *Suite en Blanc* (1943). Returning after a season with the Ballet de Monte Carlo, dancing for Lifar in his *Dramma per Musica* and *Nauteos*, she danced in the premieres of his *Les Mirages* (1947) and *l'Ecuyère* (1948), also dancing in his productions of the classical repertory. Touring with the Opéra, she became celebrated throughout the world for her elegance and stylish technique, especially in the double characterization of *Swan Lake*.

She performed with the Opéra until 1957, creating roles in later Lifar works including his *Rondo Cappriccioso* (1954) and *l'Indécise* (1957), and currently teaches at the school.

Chauviré was featured in the film *La Mort du Cygne* (1937), released in the United States as *Ballerina*.

Works Choreographed: CONCERT WORKS: *Le Cygne* (1954); *La Péri* (1955).

Chaya, Masazumi, Japanese modern dancer working in the United States since the early 1970s; born February 21, 1947 in Uamaguchi, Japan. After studying classical ballet locally, he was cast in dramatic and musical roles on Japanese television before moving to the United States in the early 1970s. He performed with the Ballet Repertory Company (Ballet Theatre II), notably in José Limón's *La Malinche*, before joining the Alvin Ailey Dance Theatre in 1972. He has performed in nearly all of the company's large repertory, creating roles in John Butler's *According to Eve* (1972), Jennifer Muller's *Crossword*, and the 1974 version of Ailey's own *Feast of Ashes*. Among his many company credits are roles in Ailey's *Hidden Rites, The Lark Ascending, Streams,* and *Night Creature*, Butler's *Carmina Burana*, Talley Beatty's *The Road of the Phoebe Snow*, George Faison's *Suite Otis*, Joyce Trisler's *Dance for Six*, Pearl Primus' *The Wedding*, Donald McKayle's *Blood Memories*, and James Truitte's *Liberian Suite.*

Checker, Chubby, American popular recording artist and performer; born Ernest Evans, October 3, 1941 in Philadelphia, Pennsylvania. Checker, whose professional name was an allusion to contemporary singer Fats Domino, became a dance creator appearing on television to plug a series of recordings based on "The Twist." The original song (by Hank Balland and the Midnighters) had been recorded in 1956, but on recommendation from Dick Clark, Checker presented his own version, which Clark introduced on his *American Bandstand*. Checker and his Twist were tremendously successful and, for the first time since the Charleston, a song managed to create its own dance fad. Checker did two more Twists—"Let's Twist Again, Like We Did Last Summer" and "The Peppermint Twist" (named for a nightclub)—and three songs based on other dances, "The Fly," "The Class," and "The Hucklebuck," and appeared in a number of films aimed at adolescents in the United States and England.

The Twist itself was a solo dance, like the Charleston and most forms introduced through mass media, and as Checker did it, was surprisingly nonsexual. It was probably based on the movements left over from the hula hoop craze that preceded it, but was considered a unique new dance. It was instantly satirized and ripped off, but became a symbol of the pre-Beatles era in native American popular music.

Chen, Si-Lan, Chinese concert dancer also working in the Soviet Union and the United States; born in the mid-1910s in the British West Indies. Chen lived in London as a child and studied at the Stedman Academy before returning with her family to China, where she worked under celebrated actor Mei-Lan Fang. In Moscow during the early 1930s, she studied plastique with Kasyan Goleizovsky and became an expert at the folk forms of the Uzbec and Turkistani areas. She gave her first recital in Moscow in 1930; unfortunately titles do not exist for that concert.

Soon after she emigrated to the United States, she began to give recitals and become involved with the concert dance movement as a member of the New Dance League. Most of her extant titles date from that period of work, as does her vital importance as the prime link between Goleizovsky's experiments and the American concert dance. Chen remained in the United States and worked occasionally as a dancer, but spent much of her life in other media.

Her memoirs will soon be published as edited by Sally Banes. They should add a tremendous amount to our understanding of the interdependencies of the arts in this century.

Works Choreographed: CONCERT WORKS: (This list probably represents less than a tenth of Chen's output. It is hoped that her book will include a complete chronology of her works.) *Landlord on a Horse* (1938); *Shanghai Sketches (Empty Bowl, Rickshaw, Partisan)* (1938); *Satiric Suite (Esthete, De Luxe, Espanola, Patriotic Matriarch)* (1938); *Two Chinese Women (Peach Blossom Lady, Boat Girl)* (1938); *Chinese Student-Dedication* (1938); *Death from the Skies* (1939); *In Conquered Nanking* (1939); *Uzbec Dance* (1939).

Cherer-Bekefi Family, Hungarian family of character dancers in Russia and the United States. Alfred and Charles Cherer-Bekefi were the sons of a Budapest physician. Both studied music and plastique lo-

cally before receiving training in classical ballet and national dances. After touring Russia in the 1880s with his brother, Alfred performed for fifteen years with the Bolshoi Ballet before moving to St. Petersburg to teach. Charles also performed at the Bolshoi, but retired from performance to become ballet master of the Odessa Municipal Opera. He later moved to St. Petersburg to rejoin his older brother and taught at his studio.

Three of Charles' children became dancers in Western Europe and the United States. Theodore, who performed here as Sherer Bekefi (without a first name), came to the United States as Adeline Genée's partner in her first American tour. An exceptional dancer, he partnered Anna Pavlova, Harriet Hoctor, and Tamara Karsavina (both in Europe and on her American tour in 1924). He returned to Russia briefly but left again in the early 1920s to dance in European revues before settling in San Francisco. Maria Cherer-Bekefi was raised in St. Petersburg and trained by her father and uncle. After attending the school of the Imperial Ballet there, she performed briefly with the Maryinsky Ballet. She participated in one of Adolf Bolm's tours to Berlin where she was hired by Simeon (brother of Morris) Gest to move to New York to perform in his brother's production of Max Reinhardt's *The Miracle*. Hired originally as the specialty dancer of the Czardas, she also performed the major female roles of "The Madonna" and "The Nun." She remained in the United States as an actress in theater and film. Her younger sister, Julia, was a member of the Maryinsky. Although she is known to have emigrated to the United States, and performed with her brother in the *Greenwich Village Follies of 1921*, it is not known whether she had an independent career.

Chesworth, John, English ballet dancer and choreographer; born 1930 in Manchester, England. Trained at the Rambert School, he graduated into the company in the early 1950s, becoming associate director in 1970 and co-director in 1974. As a performer, he was cast in both repertories of the company—in the revivals of the classics, such as *Coppélia* and *Don Quixote*, and of the early British ballets, *Les Masques* by Frederick Ashton, and Antony Tudor's *Jardin aux Lilas,* and in the contemporary ballets that filled the roster in the late 1950s and 1960s. In the latter style, he created roles in Norman Morrice's *Two Brothers* (1958) and *Hazaña* (1959) and in Glen Tetley's *Ziggurat* (1967) and *Rag Dances* (1971).

Chesworth has choreographed for the company since 1966, with his works being in the contemporary ballet genre. He has also produced the BBC presentations on the company, including the filming of *Sideshow* (Bertram Batell, 1977) and *Dancers*, about the Rambert (BBC, 1978).

Works Choreographed: CONCERT WORKS: *Time Base* (1966); *Tic-Tack* (1967); *Pawn to King 5* (1968); *H* (1968); *Four According* (1970); *Games for Five Players* (1971); *Pattern for an Escalator* (1972); *Project 6354/9116 Mk 2* (1974).

Chevalier, Maurice, French music hall, theater, and film performer; born September 12, 1888 in Ménilmontant, a suburb of Paris; died January 2, 1972 in Paris. Originally an acrobat at the Cirque d'Hiver, he began to sing professionally in the first years of the century. His first important dance performances were presented as Mistinguett's partner in her celebrated Apache, *La Valse Renversant*, at the Folies Bergère. He appeared with her for almost ten years (exclusive of his military service) at the Folies Bergère and replaced the team of Gaby Deslys and Harry Pilcer in *Laissez le Tomber*. Although Mistinguett was also known as a singer, their Apache had a major influence on theatricalized ballroom work in both Paris and New York, where such plotted dances became popular.

Performing in French music halls and cabarets throughout his career, Chevalier became famous around the world for his appearances in American musical films. From his first, *Innocents of Paris* (Paramount, 1929, staged by Fanchon and Le Roy Prinz), to his prolific last years in *Gigi* (MGM, 1958) and *Can-Can* (Twentieth-Century Fox, 1960), Chevalier was an extraordinarily popular dancer, actor, and vocalist. His most important dance appearances occurred toward the beginning of his career, with parts satirizing his own specialty in the "Origins of the Apache" number in *Paramount on Parade* (1930) and his romantic performance in Albertina

Rasch's *The Merry Widow* (MGM, 1934)—both of which were directed by Ernst Lubitsch. In his over forty films and many personal appearances and concert tours, Chevalier became the representative of French popular entertainments to audiences around the world.

Childs, Lucinda, American postmodern dancer and choreographer; born 1940 in New York City. Childs studied at the studios of Hanya Holm and Helen Tamiris before attending Sarah Lawrence College. There she took the celebrated composition classes of Bessie Schönberg. She was continuing her dance training at the Merce Cunningham studio when she became involved in the composition workshops that evolved into the Judson Dance Theatre. She created original works of her own, including *Pastime* and *Minus Auditorium Equipment and Furnishings* (1964), a title that could be considered a theme for the movement, and also danced in her colleagues' pieces, notably, James Waring's *Double Concerto* (1964), Judith Dunn's *Acapulco* (1963), artist Robert Morris' famed happening *Waterman Switch* (1965), and Elaine Summers' *Country Houses* (1963).

She choreographed steadily until 1968, when she began a four-year hiatus. During that obviously productive time, she formulated a new style of choreography—new, at least, to the audience, although one can now find its roots in her Judson work. Her later pieces are based around paths on stage and movement formulas, rather than structural shapes. Her choice of steps became drastically limited, and in many ways more interesting; her uses of stage and negative space fascinate the audience and critics alike.

Apart from her own choreography, she has participated in two productions with avant-garde director/writer Robert Wilson—his grand opera, *Einstein on the Beach* (1976), in which she performed and contributed her own solo, and *I Was Sitting On My Patio This Guy Appeared I Thought I Was Hallucinating* (1977), a language piece in the form of a classical pas de deux. The collaboration with Wilson sparked a work with its composer Philip Glass that resulted in *Dance 1-5* (1979), which some critics described as her most important work, and which audi-

ence members called "devastatingly effective." Their uses of varied repetitions of elements and phrases are similar; the elements that each brought to the production were augmented and defined by the other's participation.

Works Choreographed: CONCERT WORKS: *Pastime* (1963); *Three Piece* (1963); *Minus Auditorium Equipment and Furnishings* (1963); *Egg Deal* (1963); *Cancellation Sample* (1964); *Carnation* (1964); *Street Dance* (1964); *Model* (1964); *Geranium* (1965); *Screen* (1965); *Museum Piece* (1965); *Agriculture* (1965); *Vehicle* (1966); *Untitled Trio* (1968); *Untitled Trio* (II) (1973); *Particular Reel* (1973); *Checkered Drift* (1973); *Calico Mingling* (1973); *Duplicate Suite* (1975); *Reclining Rondo* (1975); *Congeries on Edges for 20 Obliques* (1975); *Mix Detail* (1976); *Radical Courses* (1976); *Transverse Exchanges* (1976); *Cross Words* (1976); *Figure Eights* (1976); *Melody Excerpt* (1977); *Plaza* (1977); *Interior Drama* (1977); *Katema* (1978); *Work in Progress with Philip Glass* (1978, an earlier version of *Dance 1-5*); *Dance 1-5* (1979).

OPERA: *Einstein on the Beach* (1976, Solo: *Character on Three Diagonals,* Act I, scene I, only).

THEATER WORKS: *I Was Sitting On My Patio This Guy Appeared I Thought I Was Hallucinating* (1977).

Chiriaeff, Ludmilla, Latvian ballet dancer and choreographer associated with the development of classical ballet in French-speaking Canada; born 1924 in Riga, Latvia. Raised in Berlin, she studied with Mikhail Fokine and Alexandra Nicolaieva. She performed with the Ballet Russe de Monte Carlo (De Basil) while continuing her training in Paris, but soon returned to the Berlin State Opera.

After dancing with companies in Switzerland—the Lausanne Municipal Theatre and Les Ballets des Artes in Geneva—Chiriaeff emigrated to Canada to form Les Ballets Chiriaeff in the early 1950s, known as Les Grands Ballets Canadienne after 1957. While creating a large repertory for the company and training its dancers, she found time to choreograph short ballets for the French-language Canadian Broadcasting Corporation (c.1952–1955).

Works Choreographed: CONCERT WORKS: *Jeu de Cartes* (1954); *Pierre et le Loup* (1954); *Pulcinella*

(1954); *Nuit sur le Mont Chauve* (1955); *Kaleidoscope* (1955); *Les Ruses d'Amour* (1955); *Variations sur un Theme Enfantin* (1955); *Les Noces* (1956); *L'Oiseau Phoenix* (1956); *Les Clowns* (1956); *Bagatelle* (1956); *Suite Canadienne* (1957); *Carnaval des Animeaux* (1957); *Scherzo Capriccioso* (1957); *Variation en Blanc* (1958); *Etude* (1959); *Farces* (1959); *Cinderella* (1962); *Danses Symphonique* (1956); *Jeux d'Arlequins* (1963).

Chopin, Frederic, Polish nineteenth-century composer; born February 22, 1810 in Zelazowa, Poland; died October 17, 1849 in Paris. Chopin wrote only concert music but has become one of the most frequently choreographed of all composers. His orchestral works have been used by Bronislava Nijinska and William Dollar (each of whom staged a ballet to the Piano Concerto in F minor), and many others, but his piano pieces have proven the most useful for choreographers. The classic use of Chopin is, of course, Mikhail Fokine's *Les Sylphides* (1909), which was originally titled *Chopiniana*. The standard *Sylphides* performed today uses eight pieces, the four solos (usually Valse in G flat major, op. 70, no. 1, Mazurka in D major, op. 33, no. 2, Mazurka in C major, op. 67, no. 3 and Prélude in A, op. 38, no. 7), the pas de deux (to the Valse in C sharp minor, op. 70, no. 3) and two framing pieces. It has also been performed to other valses and mazurkas and, in an early Fokine and a standard Theodore Kosloff version, included four more divertissements, including one for four men.

Although Chopin has been used by almost every choreographer with occasional Romantic tendencies (with the possible exception of George Balanchine), his works for piano are currently associated with the creations of Jerome Robbins. He staged a satirical ballet to some well-known pieces, *The Concert* (1956), to show the reactions of an audience to hearing Chopin. Robbins is, however, better known for a trio of serious works—*Dances at a Gathering* (1969), *In the Night* (1970), and *Other Dances* (1976). These works, for ten dancers, three couples, and a pas de deux respectively, use almost a third of Chopin's complete piano output. The sequences range from lyrical to pseudoethnic to intensively dramatic and

are all popular. Robbins' taste in music, and that of his imitators, has been canonized in the Peter Anastos work for the Ballet Trockadero de Monte Carlo—*Yes Virginia, Another Piano Ballet.*

Chouteau, Yvonne, American ballet dancer; born March 7, 1929 in Vinita, Oklahoma. Chouteau was trained locally by Dorothy Perkins, in Los Angeles by Ernest Belcher and Adolf Bolm, and in New York at the Vilzak-Schollar studio and the School of American Ballet.

She joined the Ballet Russe de Monte Carlo in the 1943–1944 season, as one of the company's Native American "baby" ballerinas. In the company for fourteen years, she was noted for the strength of her bravura technique and stage presence. She was cast in works by Leonid Massine, including his *Gaité Parisienne, Seventh Symphony,* and *Le Beau Danube,* by George Balanchine, among them his *Ballet Imperial* and *Mozartiana,* and by fellow dancer Ruthanna Boris, performing in her *Cirque de Deux* and *Quelque Fleurs.* While with the Ballet Russe, she appeared on television in pas de deux on *Omnibus,* the *Bell Telephone Hour,* and *Your Show of Shows.*

Since the 1960s, she and her husband, Miguel Terekhov, have been artists-in-residence at the University of Oklahoma and directors of the Oklahoma City Civic Ballet. In 1967, she was reunited with the other Native American stars of the Ballet Russe in *The Four Moons,* presented at the Oklahoma Indian Ballerina Festival, with Moscelyne Larkin and Maria and Marjorie Tallchief. She has staged original works and classical ballets for her Oklahoma troupe.

Works Choreographed: CONCERT WORKS: *Prayer* (c.1954); *Ballet Brillante* (c.1967); *La Bayadère* (c.1967, co-choreographed with Miguel Terekhov).

Christensen, Harold, American ballet dancer and teacher; born December 25, 1904 in Brigham City, Utah. Like his older and younger brothers, Harold Christensen was trained by his uncle, Lars Peter Christensen, but decided to attend West Point instead of traveling to New York to continue his studies with Stefano Mascango.

After leaving the military academy, he taught for his older brother in Ogden, Utah. Within a year,

however, he moved back to New York to replace Willam in the brothers' vaudeville act, partnering Ruby Asquith whom he later married. The act went into the Albertina Rasch musical, *The Great Waltz,* and, after its tour, into the new School of American Ballet, where all studied with George Balanchine. He performed in Balanchine's works with the American Ballet in recital and at the Metropolitan Opera and became a charter member of the Ballet Caravan, a cooperative touring company for Balanchine students. In the latter, he created roles in Eugene Loring's *Harlequin for President* (1936), Douglas Coudy's *Folk Dance* (1937), and his brother, Lew's, *Pocohontas* (1936) and *Charade* (1939), while dancing in the remaining repertory.

He performed with the San Francisco Opera Ballet, then directed by his oldest brother, but retired in 1946 to direct the school of the San Francisco Ballet. Among the scores of dancers whom he trained are Paula Tracy, Cynthia Gregory, and Terry Orr, of Ballet Theatre, Conrad Ludlow, Kent Stowell, and Suki Schorer of the New York City Ballet, and Michael Smuin, who returned to the company as its co-director in 1975.

Christensen, Lew, American ballet dancer and choreographer; born May 9, 1909 in Brigham City, Utah. The youngest of his generation of Christensen brothers, he was trained locally by his uncle, Lars Peter Christensen, and by Stefano Mascagno, whom the family had persuaded to settle in Utah. He worked with his brother, Willam, and later, Harold, in an adagio vaudeville act. The troupe joined the 1935 Albertina Rasch musical, *The Great Waltz*; since Rasch choreographed toe precision lines for tall women, it was almost inevitable that the six-foot Christensens would work for her. After touring with that show, they joined the new School of American Ballet, where he became involved with the choreography of George Balanchine.

Christensen created roles in Balanchine's *The Bat* and *Orpheus and Eurydice* (both 1936) with the American Ballet, but became famous for his performance in the title role of his *Apollo,* revived in 1937. With the Ballet Caravan, a company of American Ballet members, he danced in Eugene Loring's

Harlequin for President (1936), William Dollar's *Promenade* (1936), Erick Hawkins' *Show Piece* (1937), and was the first "Pat Garrett" in Loring's *Billy the Kid* (1938). He also choreographed for the Caravan, creating his first ballets, *Pocohontas* (1936) and *Charade* (1939), for the company. The war put an early end to his dance career, although he performed in the Ballet Society—a Balanchine company of 1947—in the premieres of his *Four Temperaments, Renard, Divertimento* (Haieff), and *The Triumph of Bacchus and Ariadne,* and in the first American performance of *Symphony in C.*

Ballet master of the Ballet Society and its descendent, the New York City Ballet, he moved to San Francisco to direct the Ballet there, replacing his brother, Willam, who had returned to Utah. Sole director until 1975, he has created a tremendous amount of choreography for his company, including the popular *Emperor Norton* (1957), *Divertissement d'Auber* (1963), *Lucifer* (1965), and *Three Movements for the Short-Haired* (1968). He has taught many dancers at the school of the San Francisco Ballet, among them, Cynthia Gregory, Terry Orr, Harold Lang, Scott Douglas, and Michael Smuin, who returned to the Bay area to co-direct the company.

Works Choreographed: CONCERT WORKS: *Encounter* (1936); *Pocahontas* (1936); *Filling Station* (1938); *A Midsummer Night's Dream* (1938); *Charade or The Debutante* (1939); *Pastorella* (1941); *Jinx* (1942); *Black Face* (1947); *Story of a Dancer (Prelude to Performance)* (1949); *Balletino (Vivaldi Concerto)* (1949); *Le Gourmand* (1951); *American Scene* (1952); *Con Amore* (1953); *Pas de Trois from Swan Lake* (1953); *The Festival (Heuriger)* (1953); *The Dryad* (1954); *A Masque of Beauty & the Shepherd* (1954); *The Nutcracker* (1954); *Renard* (1955); *The Tarot* (1956); *Emperor Norton* (1957); *The Lady of Shallott* (1958); *Beauty and the Beast* (1958); *Caprice* (1959); *Divertissement d'Auber (Pas de Trois)* (1959); *Sinfonia* (1959); *Danses Concertantes* (1959); *Danza Brillante* (1960); *Esmerelda Pas de Deux* (1960); *Variations de Ballet* (1960); *Original Sin* (1961); *St. George and the Dragon* (1961); *Shadows* (1961); *Jest of Cards* (1962); *Nothing Doing Bar* (1962, revision); *Prokofiev Waltzes* (1962); *Diver-*

tissement d'Auber (1963, full ballet); Fantasma (1963); Bach Concert (1963); Dance Variations (1963); The Seven Deadly Sins (1964, revision); Life—A Pop Art Ballet (1965); Lucifer (1965, Concert music for Strings and Brass); Pas De Six (1966); Symphony in D (1967); Il Distratto (1967); The Nutcracker (1967); Three Movements for the Short-Haired (1968); The Magical Flutist (1968); Airs de Ballet (1971); Tingeltangeltanze (1972); Cinderella (1973, in collaboration with Smuin); Don Juan (1973); Stravinsky Pas de Deux (1976); Ice Maiden (1977); Scarlatti Portfolio (1979).

Christensen, Willam, American ballet dancer and choreographer; born William Farr Christensen in 1902 in Brigham City, Utah. The oldest of the dancer sons of Christian Christensen, he was trained by his uncle, Lars Peter Christensen. Later in New York, he continued his studies with Luigi Albertieri, Juliette Mendez, and Laurent Novikoff.

With his brother, Lew, he formed a double adagio team vaudeville act, one member of which was Mignon Lee, to whom he was married for many years. He left the tour to join the San Francisco Opera Association as ballet master and school director for Serge Oukrainsky in 1937. During the next season, he became director of the company that would become the San Francisco Ballet. There, he staged a full-length Coppélia, based on his memories of earlier productions but including much original choreography, a complete Swan Lake, with Lew as "Siegfried," and a partial Nutcracker and many shorter repertory works. Dancers that he trained include Scott Douglas, Harold Lang, Janet Reed, choreographers James Starbuck and Oona White.

In 1946, he accepted a position with the University of Utah and moved to Salt Lake City. He established a ballet department there, and a company attached to it. As the Ballet West (after 1968), it has become one of the most important companies between the coasts.

Works Choreographed: CONCERT WORKS: Chopinade (1935); Bolero (1936); Coeur de Glace (1936); Bach Suite (1938); Romeo and Juliet (1938); Coppélia (1939); Swan Lake (1940); Winter Carnival (1942); Sonata Pathetique (1943); Amor Espagnole (1944); Triumph of Hope (1944); Le Bourgeois Gentilhomme (1944); The Nutcracker (1944); Blue Plaza (1945); Pyramus and Thisbe (1945); Doctor Pantalone (1947); Nothing Doing Bar (1950); Les Maîtresses de Lord Byron (1951); Le Chasseur Maudit (1953); The Nutcracker (II) (1955); Cinderella (1970).

Christopher, Patricia, American modern dancer; born c.1934 in San Francisco, California. In her studies at Mills College, the Juilliard School, and the American Dance Festival, Christopher received training in modern dance techniques from José Limón, Doris Humphrey, Pauline Koner, Martha Graham, and Hanya Holm. While teaching at Juilliard (from 1964), she performed in the companies and concert groups of a wide variety of modern dancer-choreographers who had themselves been students of the above pioneers. The tall, graceful, and strong Christopher brought her performance talents and presence to appearances for over fifteen years, among them Ruth Currier's Quartet, The Antagonists, Becoming, and Dangerous World, Pearl Lang's Night Flight, Shirah (1960), Appassionata (1962), and And Joy Is My Witness, Lucas Hoving's Strange, to Wish Wishes No Longer (1962), Wall of Silence, Suite for a Summer Day (1962), Has the Last Train Left? and Icarus (1963), and Yuriko's Tragic Memory (1966), Five Characters (1967), and Automaton (1968), among many other individual pieces. She has also taken the Doris Humphrey parts in revivals of her works sponsored by the Limón company, the American Dance Festival and repertory companies, since she resembles that choreographer so in performance.

Chritchfield, Lee, American film and vaudeville dancer; born c.1909 in the Los Angeles area of California. Chritchfield was a charter student of Ernest Belcher at his Los Angeles school and made her debut as a Belcher "Tot." By her eighteenth year, she was a veteran of films (staged by Belcher), live theater, vaudeville, and Prologs, with what seems now to have been a lifetime contract with Fanchon and Marco's West Coast Deluxe Theaters. Although her career was not unusual for a Belcher student, her dancing specialty remains a shining example of the lengths to which a dancer had to go to be unique. Chritchfield was a star on the Marimbaphone, a

combined marimba and xylophone (created by Edward Mills) that was enlarged and rearranged so that she could dance on top of it. She was not the first to tap dance on a xylophone, but she was certainly the only dancer who, within one act, did a waltz clog, a tap number, a flower ballet, and a varsity drag on the instrument.

Chryst, Gary, American ballet dancer; born November 28, 1949 in La Jolla, California. Raised in New York City, Chryst attended the High School of Performing Arts, studying modern dance with Cora Cahan, Gertrude Schurr, and Norman Walker, ethnic dance with Matteo, jazz with Jaime Rogers and Lester Wilson, and ballet with Margaret Black and Yurek Lazowski.

After graduation from PA, Chryst became an apprentice with the City Center Joffrey Ballet, joining the company in 1968, after dancing for Joffrey with the New York Opera Ballet corps. Among the roles that he created in the company were Gerald Arpino's *Eleges* (1967) and *Trinity* (1969) and Margo Sappington's *Weewis* (1971). Among his best known featured roles were the title role in Fokine's *Petroushka,* and parts in Kurt Jooss' *The Big City* and *The Green Table* and Leonid Massine's *Parade,* in all of which he performed lead roles in the first Joffrey company performances. Chryst's protrayals of "The Pimp" in *The Green Table* and "The Conjuror" in *Parade* led to his status as one of America's two or three great native character dancers. He also performed featured roles in Jerome Robbins' *Interplay, Moves,* and *New York Export: Opus Jazz.*

Chryst, who had performed in national companies of Broadway musicals in 1968, left the Joffrey Ballet to join the replacement cast of Bob Fosse's *Dancin',* in the so-called male ballet lead.

Chujoy, Anatole, Latvian dance encyclopedist and editor working in the United States; born 1894 in Riga; died February 24, 1969 in New York City. Educated in the arts and in law at the Universities of Riga, Warsaw, and Petrograd, he emigrated to the United States in the early 1920s. He was a contributor to the *American Dancer* magazine and became founding managing editor of *Dance Magazine* when it was created in 1936. He founded *Dance News* in 1942 to be a newspaper for dancers and members of the audience.

Among his many works on dance is his crowning achievement—the first *Dance Encyclopedia,* published originally in 1949. A second edition, revised with his *Dance News* successor, P.W. Manchester, was published in 1967, and reprinted without revisions in 1977. His *The New York City Ballet* (New York: 1953) was one of the first analytical studies of a company repertory. He also translated and edited works for publication in the United States, introducing many by excerpting chapters in *Dance News.*

Bibliography: *Ballet* (New York: 1936), out of print; *Dance Encyclopedia* (New York: 1949, rev. 1967); *The New York City Ballet* (New York: 1953), reprinted 1967; articles on dance in many encyclopedias, including the *Enciclopedia della Spetaccolo.*

Church, George, American theatrical ballet and tap dancer; born October 8, 1914 in Woroneco, Massachusetts. Church was a boxer, semipro baseball player, and wrestler when someone gave him a ticket to the Ballet Russe de Monte Carlo tour performance in nearby Springfield, Massachusetts for his twenty-first birthday. Very soon thereafter he applied at the local ballet school to begin lessons. The teacher, Anatole Bourman, gave him free ballet classes in exchange for sweeping the studio and, after two years, sent him to New York to study with Mikhail Fokine. Church worked in the ballet corps of Prologs theaters at first, most notably at the Capitol and the Radio City Music Hall, and also teamed up with Natacha Natova in an adagio act.

George Balanchine, recognizing the advantages of a tall, athletic American with flawless Russian training, cast him into the *Ziegfeld Follies of 1936* and *The Boys from Syracuse* (1938) in a memorable trio with Betty Bruce and Heidi Vosseler. Church was given two of the most memorable dance "heavy" roles in all of musical comedy—the murderer in the *Slaughter on Tenth Avenue* sequence in Balanchine's *On Your Toes* (1936), and the dream sequence "Jud" in Agnes De Mille's *Oklahoma* (1943)—in each, he won personal acclaim with both his dancing and his dramatic abilities. Apart from an additional

Broadway show, *Hold Onto Your Hats* (1940), Church worked at the Radio City Music Hall and other presentation houses before being drafted in the middle of the *Oklahoma* run. An injury during his military career damaged his back badly, and it was not until 1958 that he was able to return to the strenuous dancing necessary on Broadway. He appeared in his old role in the 1958 revival of *Oklahoma* and was cast by De Mille into *110 in the Shade* (1963), opening the second act with a tap solo.

When not dancing, Church acted in film and on television.

Ciceri, Pierre-Luc-Charles, French nineteenth-century theatrical designer; born August 18, 1782, Saint-Cloud; died August 22, 1868 in Ste.-Cléron. Rising to the position of chief "decorator" of the productions of the Paris Opéra, Ciceri was responsible for designing all scenic elements, theatrical effects, and lighting (which was not then considered a unique design element), and the mise-en-scène of each production. His tenure lasted from the late works of Pierre Gardel and André-Jean Jacques Deshayes through the ballets of Filippo Taglioni. Although it is difficult to determine which ballets he designed and which he received credit for as head of the design department, it is likely that he actually created the decor for Charles-Louis Didelot's *Flore et Zéphyre* (1815), Gardel's *Proserpine* (1818), François Albert's *Cendrillon* (1823), for which he designed the look of Cinderella that most people still think is the period in which she "should" have lived, Jean Aumer's *La Somnambule* (1827), *Astolphe et Joconde* (1827), and *La Belle au Bois Dormant* (1829), and Jean Mazilier's *Le Diable à Quatre* (1845). His many works for Taglioni include his *Robert le Diable* (1832), *La Fille du Danube* (1836), and *La Laitière Suisse* (1832).

Ciceri is remembered today as the chief interpreter of the Romantic era in scenery and effect. He was responsible for Taglioni's *Les Sylphides* (1832, 1836, 1859 productions) and for Coralli's *Giselle* (1841 and subsequent revivals). In these, his design philosophy, now known as "romantisisme naturaliste," combined the artistic and painterly processes associated with landscape work with the dimensionality and perspective manipulation used in theatrical construc-tion. The second acts of both ballets were set in stylized landscapes, with enough natural tree and rock formation to look real but with so much internal and visible perspective focusing that it manipulated the audience's line of vision. The first acts of both rely on the same techniques, but manipulate architectural elements.

Ciceri has been credited with the development of lighting for the stage. Since this innovation caused so many fires, it is debatable whether it should be celebrated, but there is no question that the controllable, soft lighting could be designed more accurately and handled for subtlety. It is believed that he was also responsible for designing the flying effects used in most of his Romantic ballets, and that he renovated the "disappearances" and trap work for the ballets, ranging from the fairy-tale works for Aumer to the "naturalist" ballets of Taglioni and Coralli.

Ciceri was the nephew (or possibly second cousin) of Charles Ciceri (born c.1770 in Milan), who after an eventful life as a landscape surveyor, infantryman, and merchant in Paris, Santo Domingo, Bordeaux, and the Bahamas, became one of the first professional theatrical designers in the United States. Charles Ciceri arrived in Philadelphia in early 1794 (after being shipwrecked off the Bahamas) and was engaged to be principal scenic artist for the Southwark Theatre, Philadelphia. That theater's company, headed by Hallam, moved to New York's Park Theatre after Philadelphia's infamous summer yellow-fever epidemic. Ciceri was credited with over a score of designs for Park Theatre melodramas, harlequinades, and pageants from 1794 to 1807, among them the original New York *Tammany, or The Indian Chief* (1794), *Blue Beard* (1802), *The Fourth of July, or The Temple of American Independence* (July 4, 1799), and the American premieres of most of the Shakespearean plays (1798–1806). He returned to Paris in 1807, where he forthwith became confused with his nephew. It is believed that he died in Milan, but it is not known whether he was working there at the time.

Cicierska, Margaret, American modern dancer and choreographer; born in New York City. Cicierska was trained at the Juilliard School by, among many others, Anna Sokolow, for whom she danced for

many years. Among the many works by Sokolow in which she danced in the years from 1965 to 1969, were *Lyric Suite, Time + 7, Déserts, Tribute to Martin Luther King,* and *Steps of Silence.* She began choreographing for her own troupe in the early 1970s and has produced a large canon of works in a modern mode that are noted for their imaginative uses of movement and shapings on the limitations of performance spaces. Apart from her abstract works and her theater pieces, Cicierska frequently includes Sokolow solos in her company concerts.

Works Choreographed: CONCERT WORKS: *Seascape* (1970); *Birthspace* (1970); *Harriet* (1971); *Solo: A Dance for Two* (1973); *Drifts* (1974); *Vacuum* (1974); *Glass* (1975); *Walking* (1975); *The Shoppers* (1975); *Walking on Gravel* (1975); *Impromptu* (1975); *Conquest of Mexico* (1976); *Bugs Bunny* (1976).

THEATER WORKS: *Earthlight* (1971); *Footsteps* (1976).

Cieplinski, Jan, Polish ballet dancer and choreographer; born 1900 in Warsaw; died April 17, 1972 in Brooklyn, New York. Trained at the Warsaw School of the Imperial Ballet, he became a member of that company upon graduation. It is believed that he created works for the Ballet as early as 1924, although titles have not been verified. Cieplinski spent the 1920s and 1930s in guest performances with Western European companies during time off from the Polish troupe. Among his many Western tenures were performances with the Anna Pavlova tour of c.1923, and the Diaghilev Ballet Russe (c.1925–1927). He staged ballets for the Royal Swedish Ballet (1927–1931), and Budapest State Opera Ballet (c.1932–1935), including productions of *The Firebird* (1926, probably after Fokine) and *Pulcinella* (1926) for the former, and *Les Trois Miracles du Pauvre Pêcheur* (1933) for the latter. During the German occupation of his native land, he danced with many of the emigré companies in England and the Western hemisphere, among them the Anglo-Polish Ballet (c.1941) and the Ballet di Teatro Colòn. He returned to Eastern Europe after the war and staged ballets for the Budapest State Opera but moved to London in 1950 and New York in 1958. His New York studio was a popular school for ballet and theatrical dancers through the 1960s.

Works Choreographed: CONCERT WORKS: *The Firebird* (1926, possibly after Fokine); *Pulcinella* (1926); *Les Trois Miracles du Pauvre Pêcheur* (1933); *The Birthday of the Infanta* (1947); *Legende de Josef* (1968).

Cilento, Wayne, American theatrical dancer; born August 25, 1949 in the Bronx, New York. Raised in Westchester County, he was a physical education student at the State University at Brockport when he discovered dance. After studying every style of dance available, he made his Broadway debut in Michael Bennett's *Seesaw* (1973). He appeared in the 1973 revival of *Irene,* the Off Broadway *Rachel Lily Rosenbloom and Don't You Ever Forget It,* and the 1974 *Miss American Pageant* before playing "Mike" in the unforgettable *A Chorus Line.* A member of the workshop that Bennett put together to create the show, and the original cast, he introduced the song, "I Can Do That," the first of the gypsies' monologues. In his tale of discovering dance by watching his older sister's ballet classes, he sang a cliché, but one which is unquestionably true for many male dancers. As always in a Bennett show, the effect of the song's lyrics was augmented by the movements, ending in a spectacular jump, and the exultant shout "That, I Can Do."

After two and a half years as "Mike," he toured with Liza Minelli's vehicle, *The Act* (1977), before appearing in Bob Fosse's *Dancin'* (1978). Despite Fosse's insistence that it was a no-star show, Cilento was nominated for a well-deserved Tony award for best featured performer in a musical.

As a choreographer, Cilento is responsible for many of the mini-musicals that grace the television commercials for Dr. Pepper.

Ciocca, Giovanna, Italian nineteenth-century ballet dancer also performing in the United States; born c.1825, probably in Milan; the details of Ciocca's death are not certain. Trained by Carlo Blassis in the early 1840s, Ciocca performed at the Teatro alla Scala in Milan before accepting an invitation to appear at the Park Theatre, New York City. After the Park Theatre engagement, in which she danced in *Giselle* (with Hermine Blangy in the title role), *Diana and Endymeon,* and *The Magic Flute,* she switched

to the Bowery Theatre, New York, where she became involved in a rivalry with Julia Turnbull, with whom she shared roles and partner, George Washington Smith. After her La Scala partner, Giovanni Neri, arrived in New York, she performed almost exclusively with him, at the Bowery, at the Broadway Theatre where she performed in *La Jolie Fille du Gand* in 1850, and on tour with various French families and troupes. In 1851, for example, they performed in *Giselle* and *L'Illusion* [*or Delire*] *d'un Peintre* with Leon Espinosa, Charles Hilariot, and their family companies.

Little is known for certain about Ciocca's career after her return to Europe.

Cisneros, Evelyn, American ballet dancer; born c.1955 in Long Beach, California. Cisneros' training and performances have all been a product of her association with the San Francisco Ballet. A company member since 1977, she has performed in featured roles in a wide variety of ballets by co-artistic director Michael Smuin, among them *Scherzo, Mozart's C Minor Mass, Romeo and Juliet,* and *Medea.* Her appearances as ''Miranda'' in his *The Tempest* (1980) won her national acclaim through touring performances and the PBS broadcast of early 1981. Her quick but lyrical movements and extraordinary balance made her work in that ballet, and especially in its central pas de deux, the personification of ''Miranda's'' exclamation, ''Oh, Brave New World.''

Clark, Cheryl, American theatrical dancer; born December 7, 1950 in Boston, Massachusetts. Clark was raised and trained in Kansas City before moving to New York to accept a scholarship at the Harkness Ballet. After further studies at New York University, she was cast in Bob Fosse's *Pippin* (1972) and *Chicago* (1975). She spent nine months playing ''Cassie'' in the Australian company of *A Chorus Line* before being engaged in that role in the Broadway production of Michael Bennett's celebrated musical. As ''Cassie,'' she has the only dance solo, ''The Music and the Mirror,'' and is the focus of one of the show's most dramatic plot lines.

Clark, Dick, American nondancing arbiter of taste in contemporary social dance; born November 30, 1929

in Mount Vernon, New York. Originally a radio disc jockey, Clark hosted a television show on WFIL-TV, Philadelphia, in the early 1950s that featured dance numbers by the members of the audience. The program was picked up by ABC, broadcast for one season in prime time, and has been on the air continuously every Saturday afternoon since 1957. Dances and steps premiered on *The American Bandstand,* like the records that he promoted, were popularized throughout the country within weeks. The dance fads, and even the names of local Philadelphia high schools, became common elements of life for teenagers from Maine to Georgia, from New York City to the California shore. No television show has ever come close to the *Bandstand* in its impact on a dance form, even if the show's dance taste was fairly conservative for many years. All of the disco shows now on the air are copies of the *Bandstand* format, but lack its general appeal.

Clark himself has branched out since the popularity of the show. A producer of prime-time specials aimed at the youth market, he presents programs of nostalgia for the olden days of the 1960s. He also writes a syndicated column for adolescents, or ''teenagers'' in the phrase popularized by the show, and produces films and cable television programming.

Clarke, Helen, American exhibition ballroom and theatrical dancer; born c.1897 in Omaha, Nebraska. Raised in New York City, she was a frequent participant in the dance competitions in the Mark Strand Theater Roof Garden, where she was discovered by Elizabeth Marbury in 1915. Marbury had recently been at odds with her clients, Irene and Vernon Castle, and had just become the manager of the Princess Theater, New York. Her discovery of Clarke, whom she put under a seven-year personal service contract, solved both of her problems: she could show the Castles that she could book any other exhibition ballroom dancer in their places and could engage Clarke for Princess Theater shows while she was developing as a performer. With Quinten Tod as her partner, Clarke appeared in many of the most memorable Princess shows, among them *Nobody Home* (1915), *Very Good Eddie* (1915), *Love O' Mike* (1917), in which she worked with Tod and Clifton Webb in a dance trio, *Oh, My Dear* (1918), and *La, La Lucille*

(1919). She also worked in the clubs as Marbury's client, specializing in Hesitations and one-steps and charm.

Clarke, Mae, American theatrical dancer; born August 16, 1907 in Philadelphia, Pennsylvania.

After a short career locally, Clarke made her New York debut as a specialty dancer on the Mark Strand Roof Garden in 1924. She took progressively larger roles in four Broadway musicals—*Sitting Pretty* (1924), *Gay Paree* (1925), *The Noose* (1926), and *Manhattan Mary* (1927)—in dance numbers that ranged from a stylized cake-walk in the Dixie musical, *Gay Paree,* to a Charleston in *Manhattan Mary.*

In 1929, Clarke left the live theater for a successful film career. One of the first dancers to metamorphose into a serious actress, she was featured in *The Public Enemy* (WB, 1931), starring ex-hoofer James Cagney, and *Frankenstein* (RKO, 1931). Her last known film appearance was in 1967 in *Thoroughly Modern Millie.*

Clarke, Martha, American modern dancer and choreographer; born June 3, 1944 or 1948 in Baltimore, Maryland. Clarke was trained at the Juilliard School and performed in the companies of two of her teachers there. With Lucas Hoving's concert group, she danced in *Suite for a Summer Day* (1962), while for Sokolow, she appeared in *Session for Six* (at Juilliard), *Lyric Suite, Time + 7,* and *Dreams.* After dropping out of performance briefly, she joined Pilobolus while living in Hanover, New Hampshire, seat of Dartmouth College. As a member of the semicollective acrobatic troupe from 1973 to 1979, she performed in many of the group's large scale works, in duets co-created with Robert Morgan Barnett and in dramatic solos that revealed the Sokolow influence. Since 1979 she, Barnett, and French choreographer Felix Blaska have worked together in a chamber company called Crowsnest. She still creates solos for that company's repertory and works in collaboration with both of her colleagues.

Works Choreographed: CONCERT WORKS: *Two Bits* (1973, co-choreographed with Alison Chase); *Aubade* (1973, co-choreographed with Robert Morgan Barnett); *Terra Cotta* (1974, co-choreographed with Barnett); *Monkshood* (1974, choreographed by Pilo-

bolus); *Ciona* (1975, choreographed by Pilobolus); *Untitled* (1975, choreographed by Pilobolus); *Vagabond* (1975); *Grey Room* (1977); *Wakefield* (1977); *Nachturn* (1979); *Fallen Angel* (1979); *La Marquese de Solana* (1979, co-choreographed with Felix Blaska); *Haiku* (1979, co-choreographed with Barnett and Blaska); *The Garden of Villandry* (1980, co-choreographed with Barnett and Blaska).

Clarke, Paul, English ballet dancer; born August 10, 1947 in Byfleet; died September 12, 1976 in London. Trained at the School of the Royal Ballet, he graduated into the company in 1964. Associated throughout his short life with the company's repertory of contemporary ballets, he was cast in major roles in Joe Layton's *The Grand Tour* (1971) and *O. W.* (1972), and Kenneth Macmillan's *Ballade* (1973). In the London Festival Ballet from 1973, he danced the title role in Brian Moreland's *The Prodigal Son* (1974). He danced featured roles in each company's productions of the romantic classics, notably in *The Sleeping Beauty* and *Giselle.*

Clarke, Thatcher, American ballet and theatrical dancer; born April 1, 1937 in Springfield, Ohio. Clarke was trained by Richard Kimble in Springfield and spent summers at the School of American Ballet in New York City. After moving to New York, he joined the Metropolitan Opera Ballet in 1954 and the Ballet Russe de Monte Carlo shortly thereafter. His roles in that company and in Ballet Theatre, with which he danced in the early 1960s, included "Benno," "Hilarion," and the "Bluebird," with "The Peruvian" in Leonid Massine's *Gaité Parisienne,* considered his most notable part. He also danced with the San Francisco Ballet in the 1950s and early 1960s, appearing primarily in works by Lew Christensen, among them his *Variations de Ballet, Original Sin,* and *Caprice.*

Clarke had a secondary career in the theater and was engaged in the choruses of Harry Asmus' productions in summer stock, the film of *Carousel,* choreographed by Rod Alexander, the Radio City Music Hall, and the Broadway casts of Hanya Holm's *My Fair Lady* (1956), Herbert Ross' *The Gay Life* (1961), and Carol Haney's *Bravo Giovanni* (1962). He has also worked with opera companies across the United

States staging productions of the traditional repertory and of new works, including Henze's *Boulevard Solitude* at the Santa Fe Opera in 1964.

Clauss, Heinz, German ballet dancer; born February 17, 1935 in Mettingen, Germany. Trained locally at the Stuttgart State Opera Ballet School, he performed with its sponsoring company from 1951 to 1957, dancing featured roles in *Coppélia, Firebird,* and *Cinderella.* He also performed the classical repertory with the Zurich State Opera, from 1957 to 1959.

In 1959, however, Clauss was hired to perform with the Hamburg State Opera at the time when George Balanchine was in residence to restage his *Serenade, Concerto Barocco, The Four Temperaments, Symphony in C, Pas de Dix,* and *Apollo.* The title role in the latter provided Clauss with his most celebrated part in the ballet repertory.

Returning to Stuttgart to perform for then company director John Cranko, he created roles in his *Eugene Onegin* (1967), *Presence* (1968), *Taming of the Shrew* (1969), *Brouillards* (1970), *Poème d'extase* (1970), *The Seasons* (1971), and *Traces* (1973). Clauss has served as director of the school of the Stuttgart Ballet since 1976.

Clayden, Pauline, English ballet dancer; born 1922 in London. Trained by Grace Cone, she performed with the Royal Opera House, Covent Garden in interpolated dance numbers in the opera presentations of the 1938 season, with the London Ballet and its outgrowth, the combined Ballet Arts and Ballet Rambert (c.1940). With the Sadler's Wells Ballet from 1942 to 1956, she created roles in Ninette De Valois' *Prometheus* (1943) and Frederick Ashton's *Cinderella* (1948) and appeared in most of the company's revivals of the nineteenth-century classics. Her "Bluebird" variation in *The Sleeping Beauty* and her "Giselle" were especially praised for her delicate technique and characterizations.

Clayton, Bessie, American theatrical ballet dancer; born c.1878 in Philadelphia, Pennsylvania; died 1948 in Long Branch, New Jersey. Clayton was trained by George Washington Smith and his son, Joseph C. Smith, in their studio in Philadelphia. She made her New York debut in *A Trip to Chinatown* in 1891, in the specialty dancer plot of that long-running spectacle. Soon after, she joined the Weber and Field company, working in their comedies until 1904. Clayton, who worked with unblocked shoes, was small and blonde and did what was basically a standard eccentric toe act, similar to that done by La Petite Adelaide and Mazie King.

After a stint in vaudeville, she was cast as a specialty dancer in a series of Broadway musicals, among them *The Belle of Mayfair* (1906) and *Hip! Hip! Hooray!* (1907). She did a pointe-work exhibition ballroom act in the comedy *Kickette de Lingerie* (1907), one of many satires of *The Merry Widow* playing in New York, and a toe-folk routine in her vaudeville act, *Danse des Nations* (1908), which was a traditional melting pot dance specialty. After playing the *Ziegfeld Follies of 1909,* staged by her estranged husband, Julian Mitchell, she sailed for Europe where she worked until 1913. There, she was in *Vive Paris* (1910, at l'Olympia), *Le Clere* [*sic*] *de Lune* (1912) at the Alhambra Theatre, London, and a production in Vienna, where she performed the staircase dance—piqué-turning casually down a flight of stairs on stage—that would become her trademark in her later career. The dance, choreographed for her originally by Vincenzo Romeo, was interpolated into the Act I finale of the *Passing Show of 1913* in New York, staged by Mitchell's archrival, Ned Wayburn, who denigrated it somewhat by having the female chorus repeat the dance after her. She returned to vaudeville with an act that fit into the new tradition (after Adelina Genée) of a female dancer's specialty including an entire review of the history of the art form—*The Dances of Yesterday, Today and Tomorrow,* before retiring after 1915.

Cleare, Ivy, American ballet dancer; born March 11, 1948 in Camden, Maine. Raised in a variety of localities in New England, she began her dance studies with Russel Fratto in Norwalk, Connecticut. After continuing her training at the School of American Ballet and performing small parts in *The Nutcracker* season of the New York City Ballet, she became a member of the apprentice group of what was soon to become the charter City Center Joffrey Ballet company. She appeared in almost all of the repertory of

the new company, including Gerald Arpino's *Viva Vivaldi!*, Robert Joffrey's *Pas des Déeses* (as "Fanny Cerrito") Anna Sokolow's *Opus '65,* Gloria Contreras' *Moncayo I,* and Ruthanna Boris' *Cakewalk,* as "Hortense, Queen of the Water Lilies." Cleare remained with the company for many of its successful early seasons with principal roles in many works in the steadily growing Arpino canon of ballets. She retired to enter the field of dance management.

Clemente, René, American theatrical dancer; born July 2, 1950 in El Paso, Texas. After dance and dramatic training in the state university system, Clemente auditioned and was engaged for his first professional role. That part, "Paul" in *A Chorus Line,* is considered one of the most difficult to dance, sing, and act of any on Broadway since "Paul" not only serves as the focus of one of the show's plots, but must also dance better than anyone else on stage. His on-stage accident is the impetus for the show's best known song, "What I Did for Love." Despite its rigour, Clemente has appeared in that role for more than four years.

Cliff, Laddie, English actor, comic, and choreographer; born September 3, 1891 in Bristol; died December 8, 1937 in Montana, Switzerland. Cliff made his debut in 1897 as a child performer in a music hall in the Shetland Isles, appearing in London in 1900 in pantomimes. After touring in Australia, presumably with a music hall troupe, he worked on the Keith vaudeville circuit in the United States. A soft shoe artist who performed Carter De Haven parts in London, he danced in *His Little Widows* (1919), *Jig-Saw* (1920), and the 1924 edition of *The Co-Optimists.*

Although he soon left dance for comedy, Cliff remained a frequent freelance choreographer for shows. His credited shows include *Wild Geese* (1920) for Jack Buchanan, *Primrose* (1924), and *Over She Goes* (1936), which he also produced.

Works Choreographed: THEATER WORKS: *Wild Geese* (1920); *Primrose* (1924); *Sporting Love* (1934, also produced); *Over She Goes* (1936, also produced).

Clifford, Jack, American exhibition ballroom dancer and actor; born c.1885 in San Francisco, California;

died November 10, 1956 in New York City. Clifford is one of the more interesting figures in the dance world of the early twentieth century. In between his many theatrical performances, he found time to become involved or implicated in four suspicious, unsolved deaths—five, if one counts the murder of Stanford White by Harry Thaw over Clifford's dance partner, Evelyn Nesbit. In addition, although Joseph Santley played many thugs in film, Clifford is certainly the only exhibition ballroom dance star to become a staple villain of Western films and serials. Not surprisingly, there are hazy areas in Clifford's life, but it is likely that he did work as a prize fighter in San Francisco before moving to New York to make it as an exhibition ballroom and staff dancer. True to Hollywood tradition, he was discovered by Florenz Ziegfeld, Jr. and Charles Dillingham in 1911 while a staff dance instructor at Shanley's. He dumped his then-partner Hazel Murray (who sued him for breach of promise and recovery of his formal dancing clothes, among other things) and performed with Ziegfeld's protégé Irene Weston in his *A Winsome Widow* (1912). In 1913, however, he left Weston to tour for almost four years with Evelyn Nesbit Thaw (as she was then billed) in a combination pantomime, interpretive dance, and exhibition ballroom act on the Keith circuit. Although his marriage to Nesbit lasted until 1920, the partnership did not, and while she was working with Eugene Strong (who was eventually co-respondent in their divorce), he toured with Miriam Wills in their extremely popular *Jasper Junction* dance and comedy act.

Clifford had managed to save enough money from his various tours to purchase a camp (resort) in the Adirondacks of upper New York State, and may have retired there during the lost years of his life (1922, when the tour with Wills ended, to 1925). In the latter years, however, he emerged as a leading man in Pathe films, most notably *Sweet Adeline* (1926). He worked in motion pictures steadily from 1925 to 1950. It is not known why he was not featured in the early sound musicals, since he was only in his forties when the era of dancing films hit its peak in the early 1930s, but it may have simply been that he was finding success and financial rewards in other fields. It is estimated that he made over forty feature films (mostly Westerns), at least that many

short subjects and hour-long "Saturday Cs" (third features) and hundreds of serials, including the many episodes of *The Sky Raiders,* in which he starred.

Clifford, John, American ballet dancer and choreographer; born June 12, 1947 in Los Angeles, California. Clifford, whose parents were cabaret performers, studied ballet locally with Kathryn Etienne, Irina Kosmorova, David Lichine, Eugene Loring, and Carmelita Maracchi. He performed with the New York City Ballet as a child, playing "The Nutcracker" during their Los Angeles tour. He also performed on television during the 1960s on, among others, *The Danny Kaye Show* (CBS) and *The Dinah Shore Show* (NBC).

After attending the School of American Ballet for two summer seasons, Clifford joined the New York City Ballet in 1967. He created many roles in that company, among them, Balanchine's *Glinkiana* (1968), *Tchaikovsky Suite #3* (1970), *PAMTGG* (1971), *Lost Sonata* (1972), and *Variations Pour une Porte et un Soupir* (1974), Robbins' *Dances at a Gathering* (1969), *Goldberg Variations* (1971), and *An Evening's Waltzes* (1973), and Jacques D'Amboise's *Tchaikovsky Suite #2* (1969). He also performed featured roles in much of the Balanchine repertory, including parts in *Rubies* (*Jewels*, movement II), *Stars and Stripes, Ivesiana, Four Temperaments,* and *Harlequinade.*

Clifford left the New York City Ballet to become artistic director and choreographer-in-residence for the newly founded Los Angeles Ballet in 1974. For this company, he has choreographed many new ballets, and has restaged the eight ballets that he had created for the New York City Ballet, among them, *Fantasies, Reveries* (1969), *Sarabande and Danse* (1970), *Kodály Dances* (1971), and *Symphonie in E Flat* for the 1972 Stravinsky Festival.

Works Choreographed: CONCERT WORKS: *Stravinsky Symphony in C* (1968); *Fantasies* (1969); *Prelude, Fugue and Riffs* (1969); *Reveries* (1969); *Sarabande and Danse* (1970); *Kodály Dances* (1971); *Symphonie in E Flat* (1972); *Bartok #3* (1974); *Les Amants* (1974); *The Red Back Book* (1974); *Symphony* (Saint-Saens) (1974); *Von Suppe Boufe* (1974); *Dvořák Serenade* (1975); *Prokofiev Violin*

Concerto (1975); *Rachmaninoff Suite* (1975); *Serenade in A* (Stravinsky) (1975); *Sitar Concerto* (1975); *Zolotoye Concerto* (1975); *Introduction and Allegro* (1976); *Rhapsody in Blue* (1976); *Das Himmlische Leben* (1977); *Rococco Variations* (1978); *Transcendental Etudes* (1978); *The Nutcracker* (1979); *La Fête d'Rameau* (1980).

TELEVISION: *The Brothers Grimm* (CBS, 1978, special); *A Special Gift* (ABC, 1979, special).

Clouser, James, American ballet dancer and choreographer; born c.1935 in Rochester, New York. Trained in music and dance at the Eastman School in Rochester, he continued his dance studies in New York at the Ballet Theatre School, under Edward Caton, Anatole Vilzak, and Leon Danielian. After dancing for Danielian in summer stock, he joined Ballet Theatre, remaining in the corps until 1959 when he switched to the Royal Winnipeg Ballet. There, he performed in Agnes De Mille's *The Bitter Weird,* Peter Darrell's *The Mayerling,* Robert Moulton's *Brave Song* and *The Beggar's Opera*, and in Brian MacDonald's *The Darking, Prothalamion,* and *Aimez-vous Bach?*

Ballet master of the company in the 1960s, he currently freelances as a choreographer and as an artistic director of the smaller American and Canadian troupes. Among his better known works are his *Recurrence* (1961), for the Royal Winnipeg Ballet, and the Texas pieces—*Allen's Landing* (1975) and *Charlie Rutledge: A Cowboy Dreams of Heaven* (1975)—both created for the Houston Ballet when he was its artistic director. He has also worked extensively on television, on variety series such as *Swing-Along* (CBC, c.1961–1963), and on religious and cultural specials.

Works Choreographed: CONCERT WORKS: *Recurrence* (1961); *The Little Emperor and the Mechanical Court* (1962); *Danse Bohème* (1963); *Coppélia* (1963); *The Land of Snow* (1963); *Quartet* (1964); *Tribute* (1964); *Sylvia Variations* (1965); *Out of Lesbos* (1966); *Riel* (1966); *Heart of Shame* (1967); *Joie* (1967); *Blanck* (1967); *The Space, The Sound, The Soul, The Scene* (1968); *The Water is Wide* (1970); *Baledire* (1970); *Carmina Burana* (1974); *Con Spirito* (1974); *Allen's Landing* (1975); *Charlie Rutledge: A*

Cowboy Dreams of Heaven (1975); *Caliban* (1976); *Gershwin Song Book* (1977); *Rasputin—the Holy Devil* (1978); *The Texas Dancer* (1979).

TELEVISION: *Swing-Along* (CBC, 1961–1963); *Tocatta* (CBC Camera Three, 1965, special); *Etude in White* (CBC Camera Three, 1965); *More About Eve* (CBC, 1967, special).

Clustine, Ivan, Russian ballet dancer and choreographer; born August 18, 1862 in Moscow; died November 21, 1941 in Nice, France. Trained at the Moscow Bolshoi School, he joined the company after graduating in 1878.

Moving to Paris in 1903, Clustine opened a school there. In 1909, he was named ballet master of the Paris Opéra at the end of Léo Staat's short tenure. He created four ballets for the company—*La Roussalka* (1911), *Les Bacchantes* (1912), *Philotis, Danseuse de Corinthe* (1914), and *Hansli, le Bossu* (1914)—the first three for Carlotta Zambelli.

Leaving the Opéra in 1914, Clustine joined Anna Pavlova as ballet master to her various touring companies; he remained with her until her death in 1931, coaching her pick-up dancers and creating over forty divertissements for her. These works included choreographed social dances like the *Pavloviana* (1914) and *Gavotte Pavlova* (both 1914), ethnic characterizations, such as the Egyptian *Pas de Deux* (1914), the *Spanish Dances* (1915), and the *Assyrian Dance* (1917), and revisions of the Russian standard repertory, among them *Giselle* (after Marius Petipa) and *Chopiniana* and *Tambourine* (after Fokine). It is generally believed, although it cannot be proven from film company records, that Clustine staged the dances for the Pavlova film of *The Dumb Girl of Portici* (Universal, 1916).

Following Pavlova's death, Clustine reopened his Paris school, teaching there for ten years until he died in 1941.

Works Choreographed: CONCERT WORKS: *Zvezdy* (1898); *Cinderella* (1899); *Le Corsair* (1903, after Mazilier); *Halte de Cavalerie* (1903); *La Roussalka* (1911); *Les Bacchantes* (1912); *Amarilla* (1912); *Philotis, Danseuse de Corinthe* (1914); *Giselle* (1913, co-choreographed with Anna Pavlova after Marius Petipa); *Pas de Trois* (1913); *Chopiniana* (1913, after Fokine); *Gavotte* (1913); *Egyptian Pas de Deux* (1914, after Fokine); *Danse Rustique* (1914); *Scène Dansant* (1914); *Anitra's Dance* (1914); *Petit Danse Russe* (1914); *The Awakening of Flora* (1914, after Petipa and Lev Ivanov); *New Gavotte Pavlova* (1914); *The Pavloviana* (1914); *Minuet* (1914); *Raymonda* (1914, after Petipa); *Russian Dance* (1915); *Snowflakes* (1915); *Spanish Dances* (1915); *Orpheus* (1916); *La Péri* (1917, co-choreographed with Hubert Stowitts); *Visions* (1917, after Petipa); *Assyrian Dance* (1917); *Egyptian Ballet* (1917); *Noir et Blanc* (1917); *Valse Triste* (1917); *The Enchanted Lake* (Schubertiana) (1917); *Fairy Tales* (1918, after Petipa); *Danses des Fleurs* (1918, after Saint-Léon); *The Last Song* (1918); *Minuet II* (1918); *Pierrot* (1919); *Serenade* (1919, after Serge and Nicolas Legat); *The Lorelei* (1919); *Christmas* (1920, co-choreographed with Pavlova and Alexander Volinine); *Tambourine* (1920, after Fokine); *Minuet III* (1920); *The Fauns* (1921); *Russian Dance II* (1921); *Dionysius* (1921); *Ajanta's Frescoes* (1923); *The Romance of a Mummy* (1925); *Polka Incroyable* (1928).

FILM: *The Dumb Girl of Portici* (Universal, 1916, not credited on film print).

Cobos, Antonia, American concert dancer and ballet choreographer; born Phyllis Nahle, c.1920 in New York. It is not certain whether Cobos had ballet training before she moved to Barcelona to study Spanish classical forms. She gave her first solo recital in Paris in 1938—only one of the dozen works presented there remained in her repertory, the *Spectral Minuet*.

She continued to present recitals of Spanish dance, a fairly common genre for solo concerts, but is best known for the three ballets that she created in the 1940s and early 1950s. Her first, *The Mute Wife* (1944), was a popular addition to the repertory of the Ballet International and provided Francisco Moncion with one of his first principal roles. Her later works were presented by the Ballet Russe de Monte Carlo—*Madroñas* (1948) and *The Mikado* (1954)—which also sponsored the revival of *The Mute Wife*.

Coca, Imogene, American theatrical dancer and satirist; born c.1909 in Philadelphia, Pennsylvania. Coca

was the daughter of a Keith circuit conductor and of Sadie Brady, a vaudeville dancer who was once an assistant of The Great Thurston, World's Greatest Magician. She made a series of debuts in various genres, and first danced in vaudeville at age nine. Although she continued to perform in vaudeville, notably with one of the last Nelson Show and Charles Columbus acts (c.1927), she moved to New York to become one of Broadway's most popular chorus dancers, with nonroles in *When You Smile* (1925), *Bubbling Over* (1926), *Queen High* (1928), and *Shoot the Works* (1931). Her first dance satire acts were introduced into the *Garrick Gaieties* of 1930 and the *New Faces* of 1934, but she became famous—for the first of many times—for the imitations that she inserted into *The Straw Hat Revue* (1939). That show, which was actually a compilation of acts developed at the Tamiment Camp, included her "Codfish Ballet," a take-off on the water nymph sequence that Balanchine staged for Vera Zorina in *The Goldwyn Follies*, "The Souse-American Way," based on Carmen Miranda, and her first swan queen. Coca performed on Broadway intermittently over the next forty years, tending more toward plotted works rather than revues. Among her best known shows were *Tonight at 8:30* (1940), *The Girls in 509* (1958), *A Thurber Carnival* (1961), literally hundreds of national tours, and the recent *On the Twentieth Century* (1979).

She is, of course, best known for her participation in the magnificent classic of early live television, *Your Show of Shows* (NBC, 1950–1954). On that weekly series, and on many of her larger productions, she repeated some of her dance satires, including her most famous one—"The Afternoon of a Faun," a ballet of role reversal in which she, as "The Nymph," chased and caught "The Faun" (William Archibald).

Cochran, Charles Blake, "England's Greatest Showman," and theatrical producer; born September 25, 1872 in Sussex; died January 31, 1951 in London. Cochran was one of the most prolific and diverse producers in English theatrical history, as the presenter of more than fifty shows. He produced primarily original works, although he was also known as the sponsor of the West End revivals of Broadway musicals such as *Little Nellie Kelly* and *Anything Goes*, and of new works by Americans like Rogers and Hart and Cole Porter. He is most memorable as the producer, and some say inventor, of the British musical comedy and revue forms of the 1920s and 1930s. In terms of dance alone, Cochran was responsible for the important influence of the American tap coach Buddy Bradley who staged *Evergreen* (1930), and the continuing tradition of interpolating ballet numbers into both revues and plotted musicals. Among the dancers whom he hired as choreographers were George Balanchine, Anton Dolin, and Leonid Massine (who contributed many short works to the Cochran revues) and Agnes De Mille, whose work on *Nymph Errant* (1933) brought her her first reputation for theatrical staging.

Cochran's memoirs of his long producing career lasted, appropriately enough, over four autobiographies: *Secrets of a Showman* (London: 1925), *I had Almost Forgotten* (London: 1932), *Cock-a-Doodle-Doo* (London: 1941), and *A Showman Looks On* (London: 1945).

Cocteau, Jean, French poet, novelist, and librettist; born July 5, 1889 in Maison-Lafitte; died October 11, 1963 in Milly-le-Forêt. Cocteau's participation in dance production began in 1912 with his collaboration on the libretto for Mikhail Fokine's *Le Dieu Bleu*, a pseudo-Siamese ballet for Vaslav Nijinsky. His later Diaghilev works included *Le Train Bleu* (1924) for Bronislava Nijinska and *Parade* (1917) for Leonid Massine, with its references to the French circus and American film culture. That innovative work is currently in the repertory of the City Center Joffrey Ballet and the Metropolitan Opera—two productions within ten blocks. He also wrote the scenarios for Darius Milhaud's *Le Bouef sur le Toit* (1920), for the Fratelli Brothers acrobats, *Les Mariés de la Tour Eiffel* (1946) for Jean Borlin, and *L'Amour et son Amour* (1948) for Jean Babilée, and designed productions for Serge Lifar and Marianne von Rosen. His surrealist films did not involve dance performance directly, although allusions to his *La Belle et la Bête* (1946) can be found in many later productions of that section of Ravel's *Ma Mere l'Oye* by French and American choreographers.

Bibliography: Bonalumi, Louis. *Les Oeuvres Complêtes de Jean Cocteau* (Lausanne: 1946), in-

cludes bibliography of plays, essays, and librettos, filmography, and discography; Steegmuller, Francis. *Jean Cocteau* (Boston: 1970).

Coe, Kelvin, Australian ballet dancer; born 1946 in Melbourne, Australia. After studies with Rex Reid, Coe joined the Australian Ballet, with which he remains associated. Noted for his classical technique and partnering ability, he has performed in Rudolf Nureyev's revivals of *Raymonda* (1965, after Petipa) and *Don Quixote* (1971). He created a major role in Robert Halpmann's *Sun Music* (1968) and has performed in his *The Display* and in Frederick Ashton's *Les Deux Pigeons* and, playing "Oberon," his *The Dream.*

Cohan, George M., American theatrical performer, writer, director, and producer; born, according to his own reports, on the fourth of July, 1878 in Providence, Rhode Island; I am enough of a patriot to refuse to doubt the date, but there is ample evidence to show that he was born on July 3; died November 5, 1942 in New York City. The son of Jeremiah (Jerry) Cohan and Nellie Costigan, he performed with his parents' act, *Four of a Kind*, through his adolescence. For thirty years, he starred in, directed, produced, and wrote vehicles for himself. He managed his own theaters, causing a sensation on Broadway, and, in conjunction with Sam Harris, produced a minstrel show in the 1910s. Billed as "The Man Who Owned Broadway," he was considered a great performer who would use any trick to get and hold onto an audience.

Although it is easy enough to determine what he wrote, for whom he wrote it, and with whom he was feuding at the time, it is remarkably difficult to find any information on his dance style. When working with his sister, Josephine (c.1901–1909), he used exhibition ballroom dances in his shows and augmented them with some eccentric dance steps, but since both were short, he did not use high kicks or large gestures. After her death, he tended to dance alone on stage, or as the only male framed with a chorus of women. There is no real evidence that his style was similar to that created for James Cagney who portrayed him in *Yankee Doodle Dandy*. That film, co-staged by LeRoy Prinz and Seymour Felix with Johnny Boyle (who was Cagney's personal dance coach and the best tap teacher in the country), was, of course, built around Cagney's style, which was machine-gun tapping, but used Cohan's poses, including his signature strut with his torso bent forward. Interestingly, Cagney's version of the dock scene in *Little Johnny Jones* (the scene in which he sings, "Give My Regards to Broadway") filmed with moving cameras is probably closer to Cohan's stage production than his own static sound film of the show, made for First National in 1929.

Cohan's silent films may give us a better picture of his dancing, since they are not tappedover and are not slowed down for contemporary projectors. His pictures for Famous Players/Jessie L. Laskey especially are useful tools, most notably his *Broadway Jones* (1926), *The Phantom President* (1923), and *Seven Keys to Baldpate* (1925).

Surprisingly, it has been possible to verify the claims of only one dancer that he was in fact taught routines by Cohan. Georgie Tapps, who was a featured dancer in Cohan's last show, *I'd Rather Be Right* (1937), learned many of his dance routines during rehearsals. Since, however, Tapps' own personal style is so strong and so individual, it is not possible to determine exactly how many steps, combinations, and transitions are his and how many Cohan's.

Writing about Cohan in terms of his dancing only is a bit like analyzing Fred Astaire's films for the way he smokes, but despite the many works on his life and accomplishments, his performance style has never really been studied. He has been the subject of dozens of books, ranging from dissertations on theatrical economics to studies of his rhythmic schemes, and the basis for a musical comedy, *George M!* (1968), in which he was portrayed by another highly individual performer, Joel Gray.

Bibliography: Cohan, George M., *Twenty Years on Broadway* (New York: 1925); McCabe, John, *George M. Cohan: The Man Who Owned Broadway* (New York: 1973); Morehouse, Ward, *George M. Cohan, The Prince of the American Theatre* (Philadelphia: 1943).

Cohan, Josephine, American theatrical performer; born 1876 in Providence, Rhode Island; died July 12, 1916 in New York City. The daughter of Jerry and

Nellie Cohan, she joined her younger brother, George M., in the family act, *Four of a Kind*, at the age of seven. The only member of the family who was considered a specialty dancer, rather than a comic who moved, she was the female lead in almost all of the George M. Cohan/Sam Harris productions during her lifetime, among them *The Governor's Son* (1901), *Running for Office* (1903), and *The Yankee Prince* (1908), in which the whole family performed. Her non-Cohan shows included *The Rogers Brothers in Paris* (1904), one of the most successful in that long line of comedy vehicles, and acts for her and her husband, Fred Niblo, among them *Friday the 13th* (1906), *A Friend of the Family* (1907), and *The Fortune Hunter* (1912).

Cohan spent the 1913–1914 season touring Asia with her husband but was too ill to return to the stage when they reached New York. When she died at the age of forty, she was described as having been ill for three years. Most of the contemporary descriptions called her the most talented performer in the family and, therefore, in the business.

Cohan, Robert, American modern dancer and choreographer working in London after the mid-1960s; born 1925 in New York City. Trained by Martha Graham at her New York school, he performed with her company from 1946 to 1957 and from 1962 to 1969. A talented dancer with enough power and stage presence to partner Graham, he performed in most of the company's continuing repertory. Among the many works in which he created roles are *Diversion of Angels* (1948), *Canticle for Innocent Comedians* (1952), *Ardent Song* (1963), *A Time of Snow* (1968), *Lady of the House of Sleep* (1968), and *Cortège of Eagles* (1969). He has taken major parts in the revivals of *Appalachian Spring* (playing ''The Rivalist'' in 1950), *Letter to the World*, and many others. During company lay-offs, and in his five-year absence, he danced on Broadway in Donald Saddler's *Shangri-la* (1956) and taught extensively across the United States and in Israel.

Cohan has choreographed since the 1960s. In August of that year, he shared a recital with Matt Turney, also of the Graham troupe, which presented early solos and duets. Since 1967, he has staged works for the London Contemporary Dance Theatre, for which he serves as artistic director. He is considered one of the most important modern choreographers in England and a major factor in the continuance of the Graham influence there.

Works Choreographed: CONCERT WORKS: *The Pass* (1960); *Quest* (1960); *Vestiage* (1960); *Streams* (1960); *Praises* (1960); *Sky* (1967); *Hunter of Angels* (1967); *Eclipse* (1967); *Quintet* (1969); *Side Scene* (1969); *Cell* (1969); *X* (1970); *Consolation of the Rising Moon* (1971); *Stages* (1971); *People Alone* (1972); *People Together* (1973); *Mass* (1973); *Waterless Method of Swimming Instruction* (1974); *Class* (1975); *Stabat Mater* (1975); *Masque of Separation* (1975); *Nympheas* (1976).

Cohen, Frederick, German composer associated with the works of Kurt Jooss; born 1904 in Bonn; died March 9, 1967 in New York City. Trained at the Leipzig Conservatory, he became a conductor at a series of German opera theaters, specializing in operetta and dance production. He served as musical director of the Yvonne Georgi company in Hanover (c.1924), and in that capacity at the Folkwand School and Tanztheater in Essen, of which Kurt Jooss was director. He escaped from Germany with Jooss to England, but emigrated to the United States in the mid-1940s. He taught composition, piano, and an opera performance workshop at Juilliard from 1946 until his death, and also participated in the summer workshops at the Black Mountain College, which became an early home of the American aleatoric structure movement.

As a composer, Cohen is best known for his ballets for Jooss, among them, *Suite* (1929), *The Prodigal Son* (1933), *The Mirror* (1935), and *A Spring Tale* (1939). He arranged music for many other ballets, including *A Ball in Old Vienna* (1932, after Josef Lanner), *Seven Heroes* (1933, after Henry Purcell), and *Johann Strauss, Tonight* (1935). Like Jooss, he remains celebrated for his work on *The Green Table* (1932), which has been recorded and included in concert programs of nondance orchestras. His importance as a member of the German composers-in-America was reinforced a week before his death with the 1967 revival of *The Green Table* for the City Center Joffrey Ballet.

Cohen, Ze'eva, Israeli modern dancer and choreographer working in the United States; born August 15,

1940 in Tel Aviv. Cohen studied modern dance technique locally with Gertrude Krauss and Rena Gluck; work with Anna Sokolow at the Lyric Theatre, Tel Aviv, brought Cohen an American-Israel Cultural Foundation grant to study at the Juilliard School, where she trained with Sokolow and José Limón. Cohen also studied ballet in New York with Richard Gibson.

As a student at Juilliard, Cohen performed in many works by Limón and Sokolow, including her *Odes* (1964) and *Ballade* (1965), which she performed in American Dance Theater concerts. She also performed as a member of the Anna Sokolow Dance Company in Israel (1961–1963) and the United States (1963–1968), dancing featured roles in her *Dreams* and *Rooms*; the solo, "Escape," from *Rooms* is still in Cohen's repertory.

Cohen became a member of the Dance Theater Workshop in 1966, performing works by Jeff Duncan, among them *Resonances* (1969), and by Deborah Jowitt. In 1971, she formed a one-woman company, Ze'eva Cohen Solo Dance Repertory. She performs her own works and solos or solo excerpts by choreographers including Kei Takei (*Talking Desert Blues*, 1972), James Waring (*Rune for a Green Star* and *32 Variations in C Minor*, both 1973), and Sokolow. Works that she has choreographed for herself include *Three Landscapes* (1966), *Ring of Silence* (1976), *Listen II*, and *Song* (both 1977); her *Seed*, choreographed for her to perform while pregnant in Spring 1974, was actually performed by another dancer when her daughter was born prematurely.

Cohen has taught dance for actors at the HB Studio in New York and has choreographed a musical play, *Mod Donna,* for the New York Shakespeare Festival in 1970.

Works Choreographed: CONCERT WORKS: *Three Landscapes* (1966); *Suite* (1967); *Passage* (1971); *Cloud Song* (1971); *Wadi* (1973); *Seed* (1974); *Ring of Silence* (1976); *Goat Dance* (1976); *Rainwood* (1977); *Listen II* (1977); *Song* (1977); *Scherzo* (1978); *Portrait for Two* (1979); *Wilderness, Swamps and Forest* (1979).

THEATER WORKS: *Mod Donna* (1970).

Colby, Christine, American ballet, jazz, and theatrical dancer; born February 27, c.1950, in Cincinnati, Ohio. As a student at the school of the Cincinnati Ballet (University of Cincinnati Conservatory), she was trained by James Truitte and David McLain. Other studies included ballet work with Gerald Arpino and Suzanne Farrell, modern dance with Bella Lewitsky, Cora Cohan, Lucas Hoving, and Thelma Hill, and jazz with Jo Jo Smith and Luigi. She danced with the Cincinnati Ballet, but since moving to New York has worked with the companies of her jazz instructors. A former Rockette and soloist with *Disney on Parade*, Colby was engaged as a principal in Bob Fosse's *Dancin'* on Broadway. Fosse's versatility allows her to use each of her former techniques in the show, as well as tap work, gymnastics, and ham-boning.

Cole, Jack, American concert, theater, and film dancer and choreographer; born J. Ewing Cole, April 27, 1914 in New Brunswick, New Jersey; died February 16, 1974 in Los Angeles. In New York, Cole studied modern dance with Ruth St. Denis and Ted Shawn, ballet with Luigi Albertieri, and ethnic forms with La Meri and Mei Lan-Fang. He performed as a Denishawn Dancer under his real name and as Jack Cole from 1930 to 1932, creating roles in Shawn's *Group Dance for Male Ensemble* (1930), *Job* (1931), and *Workers' Songs of Middle Europe* (1931). A charter member of Shawn's Ensemble of Men Dancers, he performed in that group's first concert only. He left Denishawn to join the (Doris) Humphrey/(Charles) Weidman Dance Group in 1932, making his Broadway debut as a Weidman dancer in *The School for Husbands* (1933). Although Cole's dance style, with its combined influences of Orientalia and jazz, are generally believed to have been developed for his work with Shawn, he was originally believed to be, like Weidman, a dance satirist.

For most of his career, Cole, again like Weidman, kept his concert dance company alive by integrating his and their specialties into Broadway revues and musical comedies. From *Caviar* in 1934 to *The Man of La Mancha*, his last show to reach Broadway, Cole staged musical numbers for over a dozen shows, performing in more than half himself.

Although Cole served as dance director for most of the major Hollywood studios, he is most associated with Columbia Studios, where he ran the famous Dance Workshop from 1944 to 1948. He staged both

inauthentic exotic numbers for Hollywood films, such as *Kismet* (MGM, 1944), *The Thrill of Brazil* (Columbia, 1946), and *David and Bathsheba* (Twentieth-Century Fox, 1951), and conventional jazz and tap sequences, as in *Les Girls* (MGM, 1957). He became well known for his sensual solos for Rita Hayworth, especially in the "Put the Blame on Mame" strip in *Gilda* (Columbia, 1946), and Marilyn Monroe, for whom he staged dances in *Gentlemen Prefer Blondes* (Twentieth-Century Fox, 1953) and *Some Like It Hot* (Paramount, 1959).

From 1939, when he performed on an RCA promotional short subject, Cole and his dance groups appeared regularly on television variety shows. Although he never took a staff choreography job on television, he became a semiregular performer on many series and special broadcasts throughout the 1950s and early 1960s. His most frequent appearances with his dance group were on the 1948–1950 and 1955–1959 seasons of *The Perry Como Show* (NBC), Bob Hope specials throughout the 1950s (NBC), and various Sid Caesar vehicles, among them, *Your Show of Shows* (NBC, 1950–1954) and *Sid Caesar Invites You* (ABC, 1958).

Cole is best remembered for his own performance style on Broadway and as a concert dancer. He was also an influence on the group of dancers in the Columbia Workshop; among the members of that group were Rod Alexander, Carol Haney, and Gwen Verdon.

Works Choreographed: THEATER WORKS: *Caviar* (1934); *Thumbs Up* (1934); *May Wine* (1935); *Keep 'Em Laughing* (1942); *Something for the Boys* (1943); *Allah Be Praised* (1944); *Bonanza Bound* (1947, closed out of town); *Alive and Kicking* (1950, only musical numbers involving his dance group); *Kismet* (1953); *Jamaica* (1957); *Candide* (1959, London revival); *Donnybrook* (1961, also directed); *Kean* (1961, also directed); *A Funny Thing Happened on the Way to the Forum* (1962, first pre-Broadway version only); *Zenda* (1963, closed out of town); *Foxy* (1964); *The Man of La Mancha* (1965).

FILM: *Moon Over Miami* (Twentieth-Century Fox, 1941); *Old King Cole* (Paramount, 1942, short subject); *Cover Girl* (Columbia, 1944, co-choreographed with Gene Kelly and Seymour Felix); *Tonight and Every Night* (Columbia, 1945, co-choreographed with Val Raset); *Eadie Was a Lady* (Columbia, 1945); *The Jolson Story* (Columbia, 1945, co-choreographed with Joseph Lewis); *Tars and Spars* (Columbia, 1946); *Gilda* (Columbia, 1946); *The Thrill of Brazil* (Columbia, 1946); *Down to Earth* (Columbia, 1947); *On the Riviera* (Twentieth-Century Fox, 1951); *David and Bathsheba* (Twentieth-Century Fox, 1951); *Meet Me After the Show* (Twentieth-Century Fox, 1951); *The Merry Widow* (MGM, 1952); *Lydia Bailey* (Twentieth-Century Fox, 1952); *Gentlemen Prefer Blondes* (Twentieth-Century Fox, 1953); *The Farmer Takes a Wife* (Twentieth-Century Fox, 1953); *Three For the Show* (Columbia, 1955); *Gentlemen Marry Brunettes* (UA, 1955); *Les Girls* (MGM, 1957); *Designing Woman* (MGM, 1957, also had speaking part in film); *Some Like It Hot* (Paramount, 1959); *Let's Make Love* (Twentieth-Century Fox, 1960).

Cole, Kay, American theatrical dancer and film actor; born Kay Colomines, January 13, 1948 in Miami, Florida. Raised in Los Angeles, she began to act in television and film as a young child. After appearing as a "Mouseketeer," she left Hollywood to tour as "Amaryllis" with the national company of *The Music Man*. She performed in New York in the early 1960s, with roles on Broadway in *Bye Bye Birdie* (1960), and Anthony Newley's *Stop the World, I Want to Get Off* and *The Roar of the Greasepaint, the Smell of the Crowd* (1965), and Off Broadway in the 1963 revival of *Best Foot Forward*. For ten years after the late 1960s, she alternated between New York live theater and West Coast films and television, with memorable appearances in the musicals *Hair* (1968), *Jesus Christ Superstar* (1971), *Words and Music* (1974), and *A Chorus Line* (1975), in which she was the original "Maggie." Cole returned to Hollywood and television acting after the Los Angeles run of that still-popular Michael Bennett show.

Coles, Joyce, South African theatrical ballet and exhibition ballroom dancer working in England and the United States from the mid-1910s; born c.1904 in Cape Town, South Africa. Emigrating to England at age six, Coles was trained in both ballet and exhibi-

tion ballroom work by Louis Hervé D'Egville (II) in London. At fourteen, she joined the Anna Pavlova company then performing in London, remaining with them until 1923. She danced in the corps of *Raymonda, Snowflakes*, and *Giselle*, and received professional training from Enrico Cecchetti.

Coles left the company while on an American tour, deciding to stay in the United States. Her first performing job here was as the partner of Simon Karaveff in his ballet vaudeville act (c.1924). In 1926, she replaced Maria Gambarelli as ballerina at the Roxy Theater. In 1927, she rejoined fellow Pavlova alumnus Chester Hale, then the ballet master of the Capitol Theater in New York, as his assistant and as principal ballet soloist for his programs. Both the Roxy and the Capitol were Prolog theaters, in which four programs of feature films and variety acts were presented each day. Although Hale choreographed dance numbers for both his ballets, which performed in traditional Cecchetti-based technique, and for his precision troupe, which worked in toe tapping and acrobatics, there is no evidence that Coles worked on anything but the traditional ballet routines.

Leaving the Capitol when Hale began a two-year stay in Hollywood, Coles took a featured dance role in the Broadway production of *The Dubarry* (1932). She then returned to London to partner Georges Fontana (replacing Marjorie Moss) in his celebrated exhibition ballroom act. When they toured the United States, she once again left to remain in America, dancing with the various Max Rabinoff-sponsored New York Opera companies, among them, the Cosmopolitan Opera and the Hippodrome Opera until her retirement in the late 1930s.

Coll, David, American ballet dancer; born 1947 in Chelsea, Massachusetts. Raised in Alameda, California, he studied ballet there at the School of the San Francisco Ballet, later performing with that company.

Coll was a charter member of Eliot Feld's American Ballet Company in 1969. He created a major role in Feld's *Intermezzo* (1969), becoming famous in that role in the abstract work with his duets with Christine Sarry. He performed in Feld's *Meadowlark* for his company and in other works of his, *Eccentrique* and *A Soldier's Tale* (both 1971) in American Ballet Theatre. Always noted for his work in the ballets of American choreographers, he was celebrated for his performances in Jerome Robbins' *Fancy Free* and in Dennis Nahat's *Mendelssohn Symphony*. It would be a mistake to associate him completely with new choreography however, since he also danced frequently in the company's revivals of classics, notably in *Coppélia, Swan Lake, Giselle*, and the *Divertissements from* [Bournonville's] *Napoli*.

Collenette, Beatrice, American or English ballet dancer working in the United States; born c.1903. Collenette was one of the English students of Anna Pavlova and Ivan Clustine and performed with the Pavlova company in Europe and on tour in the late 1910s. After dancing with her in the United States, she left the tour to work on Broadway as a specialty interpretive and ballet dancer in the style that is now associated with Harriet Hoctor. She appeared in two shows, *See-Saw* (1920) and *Little Billy* (1921) and in vaudeville on the Keith circuit. Collenette settled in the Los Angeles area where she directed a ballet studio. She was one of the theatrical ballet dancers who taught Cecchetti technique to performers with the Fanchon and Marco production companies and also coached dance for Hollywood studios. It has been suggested that she merged her studio with that of Ernest Belcher, but this cannot be verified.

Collier, Lesley, English ballet dancer; born March 13, 1947 in Orpington, Kent, England. After local studies at the Irene Ayres School of Dancing, Collier continued her training at the Royal Academy of Dancing.

Performing with the Royal Ballet throughout her career, Collier has created roles in Frederick Ashton's *Jazz Calendar* (1968) and *Enigma Variations* (1968) and in Kenneth Macmillan's *The Four Seasons* (1975) and the 1971 version of his *Anastasia*. She has also performed the title role in that full-length ballet, and has been featured in his *Manon* and in Jerome Robbins' *Dances at a Gathering*. Collier danced the role of "Hunca Munca" in Ashton's film, *Tales of Beatrix Potter* (EMI, 1970).

Collins, Charles, American theatrical dancer; born January 7, 1904 in Frederick, Oklahoma. Collins en-

tered show business in the traditional path of the 1920s—he won a Charleston competition and was offered a role in a Prolog tour. After appearing as a replacement chorus boy in a Paramount/Publix unit, he moved to Los Angeles to work in Fanchon and Marco productions.

Moving East with a Fanchon "Idea," he was cast in the Shuberts' *Artists and Models of 1927*. Collins was hired from that show to perform in London as "England's favorite American." He appeared there in *That's A Good Girl* (1928), *Coo-ee* (1929), and *The Co-Optimists of 1929*, before returning to New York to do *Ripples* (1930). In that show he met and married Dorothy Stone and became a member of the celebrated "Stepping Stones," the second generation of actors in the Fred Stone family. He worked with his wife for the remainder of their careers, dancing in *Smiling Faces* (1932), *As Thousands Cheer* (1934), *Stop Press* (1935, London), *Sea Legs* (1937), *Hooray for What* (1938), *The Life of the Party* (1944), *Sari* (1945, Los Angeles), and the 1945 revival of *The Red Mill*.

Collins starred in a 1935 musical film, *The Dancing Pirate* (RKO). Although he received excellent reviews and was favorably compared to Fred Astaire, he did not remain in films. It is difficult to locate a print of the film but it is worth seeing—for Collins' charm and dance style and for the only extant example of a Robert Edmond Jones Technicolor design.

Collins, Janet, American ballet dancer; born March 2, 1917 in New Orleans, Louisiana. Raised in Los Angeles, California, she received ballet training from Carmelita Maracchi, Mia Slavenska, Adolph Bolm, Carlotta Tamon, and Dorothy Lyndall, and studied Spanish forms with Angel Cansino and modern dance with Lester Horton. She received a scholarship to study composition with Doris Humphrey, after her first solo recital in 1947.

Collins has had a complex career because she is one of the most versatile dancers in the country. Her first work was as a theatrical dancer with the Hall Johnson Chorale's productions of *Run Little Chillun* (1940 in Los Angeles) and *Mikado in Swing*; she has also performed on Broadway in *Out of This World* (1950), to Hanya Holm's choreography, and in the

1946 Jack Cole film *The Thrill of Brazil* for Columbia Pictures.

She was a staple on early television variety shows, such as *The Admiral Broadway Review* (NBC and Dumont, 1949), *This Is Show Business* (CBS, 1951), and the *Paul Draper* and *Jack Haley* Shows. Concurrently, she was the principal dancer at the Metropolitan Opera, performing in Zachary Solov's divertissements for *Aida, La Gioconda,* and *Samson et Delila*. She has also had an extensive and varied teaching career, at the School of American Ballet, where she taught modern dance, and in her work with handicapped children.

A concert dancer with Horton and briefly with Katharine Dunham, she had solo recitals in the 1940s and 1970s, and has choreographed many operas. From her first recital at the 92nd Street "Y" in 1947, many solos remain; she has created group works for her students at Manhattanville College in the mid-1960s.

Works Choreographed: CONCERT WORKS: *Blackamoor* (1947); *Eine Kleine Nachtmusik* (1947); *Spirituals* (1947); *Protest* (1947); *Après le Mardi Gras* (1947); *Juba* (1949); *Three Psalms of David* (1949); *Moi l'Aimé Toi, Chère* (1951); *The Satin Slipper* (1960); *Genesis* (1965); *Cockfight* (1972); *Birds of Peace and Pride* (1973); *Song* (1973); *Fire Weaver* (1973); *Sunday and Sister Jones* (1973).

Collins, Lottie, English nineteenth-century popular entertainer; born c.1866, probably in London; died May 21, 1910 in London. Throughout the history of dance and popular culture, there are performers who become famous for a single specialty. Despite the efforts of numerous historians to prove otherwise, one such performer seems to have actually performed only that specialty. Lottie Collins, who was a little known music hall and pantomime dancer, introduced a song into the Christmas presentation of the elderly *Dick Wittington and His Cat* (a pantomime old enough to allow for numerous interpolations) in November 1891 at the Tivoli Theatre, London. For the remainder of her short life, that song, "Ta-ra-ra-Boom-De-ia" was her specialty and ticket to immortality. She interpolated it into the Gaiety Theatre presentation of the musical spectacle *Cinder-Ella*

Up-Too-Late later in 1891 and brought it to the United States on a tour in 1892. The act itself was a solo for Collins, dressed in a short pink dress with black stockings and petticoats, with her celebrated hat, lined with an enormous star. She sang the piece, which had four or five topical verses that changed with performances and political events, and did a can-can that was generally described as "uncontrolled," with its high kicks flailing out "without any sign of a spinal column." Despite her continuing popularity in London, her first performances of "Ta-ra-ra-Boom-De-ia" in New York were blasted, partially because of the set of topical verses relating to her having been held at Ellis Island for an epidemic scare. She returned to London to national adoration, dying there at age forty-four. Collins was the mother of José Collins, musical comedy performer and a star of Broadway and the West End from 1908 to 1927.

Colton, Richard, American ballet dancer; born October 4, 1951 in New York City. After three years at the High School of Performing Arts, Colton won widespread critical acclaim in his performances in the annual graduation concert. He continued his training at the American Ballet Theatre School and the American Ballet Center, resident school of the City Center Joffrey Ballet. He actually made his professional debut with the James Waring concert group, which mixed ballet dancers with members of the Judson group of avant-gardists. Colton appeared in many of Waring's large-scale works from the late 1960s and early 1970s, among them *At the Cafe Fleurette* (1968). He joined the more conventional City Center Joffrey Ballet in 1972, and performed in many works by its resident choreographer Gerald Arpino and the guesting Twyla Tharp. After five years of *Chabriesque, Viva Vivaldi,* and pas de deux, he left the Joffrey for Tharp's company. There, he has been seen in *The Bix Pieces, Sue's Leg,* and *When We Were Very Young,* among the troupe's large repertory.

Columbus, Charles, American theatrical and exhibition ballroom dancer; born c.1905. Trained by Louis Chalif, he made his Broadway debut in 1926, partnering Beatrice Lillie in the musical *Oh, Please.* Although he followed it with other appearances, including the popular *Hullo, Paris* (1930), he left Broadway to form a unique dance trio with fellow Chalif students Nelson Snow (c.1900–1935) and Harriet Hoctor. For five years they toured with their exceptionally popular class act which involved ballet, exhibition ballroom work (in twos), and three-person adagio routines. Their pas de trois were probably fairly conventional using the ballet terre-à-terre steps that were most frequently seen in theatrical contexts, but their adagios were spectacular. Even in a period in which mere throws and lifts were considered dull and many Prolog stagers used simultaneous teams on stage to enliven the proceedings, Columbus, Hoctor, and Snow were thought of as the "flash act team supreme." Each man was able to support the woman easily in any position and to transport her across the stage, in rhythm, while Hoctor (still the best known acrobatic ballet dancer of all time), could maintain a back bend, fish, or split for an inordinate amount of time and performance space. When she was elsewhere, they toured with Florence O'Denishawn who interpolated one of her exotic solos in the act.

After Snow's death, Columbus formed an exhibition ballroom team with Harriette Caperton, "The Debutante Dancer." Although theirs was a particularly acrobatic act, they also did conventional ballroom work. They worked primarily in clubs and hotels but also performed on Broadway in *Frederika* (1937). Following her retirement and his military service, he worked as dance director of the Fred Astaire Studios in the United States and Canada. He performed occasionally, most notably at the Plaza in New York, where he partnered Imogene Coca in 1954, but spent most of his time teaching and maintaining the standards of the studio franchise system.

Combes, Jean, French ballet dancer and choreographer; born November 10, 1904 in Paris. Trained at the school of the Paris Opéra, he continued his studies under Lubov Egorova and Nicola Guerra. Little can be verified about his performance career, but it is believed that he made his debut in the Grand Théâtre de Bordeaux and worked with troupes in Vichy, Marseilles, Rouen, where he was named ballet master in 1936, and Aix-le-Bains. He was associated with the Ballet de Monte Carlo in the late 1930s and became

ballet director of the Strasburg Opera from 1945 to the late 1950s. Since he has been described as an exceptionally prolific choreographer, it must be assumed that we have just been unable to verify the titles of all of his works. Those listed below were created for the Strasburg company, where his literary ballets were extremely popular.

Works Choreographed: CONCERT WORKS: *Paul et Virginie* (1956); *Le Roi Midas* (1957); *Bacchus et Ariadne* (1958); *Cinderella* (1959); *Le Cid* (1960); *La Belle Epoque* (1960).

Comelin, Jean-Paul, French ballet dancer and choreographer; born September 10, 1936 in Vannes, France. After early training from Giselle Charrieau, he continued his studies at the Paris Conservatoire des Beaux-Art with Ives Brieux, Gérard Mulys, and Mona Gaillard. He returned with Gaillard to the Algiers Opera and performed in her *Les Préludes*, *Un Américain à Paris*, and *Le Festin de l'Araignée* (all 1958–1959).

After two seasons with the Paris Opéra Ballet, dancing in *Giselle*, Harald Lander's *Etudes*, and Serge Lifar's *Suite en Blanc*, Comelin spent a few years each at the Festival Ballet, the Marseilles Opéra Ballet, and the Hamburg State Opera. After emigrating to the United States in 1966, Comelin has served as dancer and choreographer-in-residence for the National Ballet, Washington (1966–1969), the Pennsylvania Ballet (1969–1972), the Sacramento Ballet (1972–1974), and the Milwaukee Ballet (1974–1980). Many of his ballets date from the last tenure, among them, his *Daphnis and Chloe* (1976), *Diversions* (1975), *Florestan* (1980), and his popular version of *The Nutcracker*.

Works Choreographed: CONCERT WORKS: *Daughters of Morning* (1969); *In the Mists* (1974); *The Seasons* (1975); *Diversions* (1975); *Sonate a Tre* (1975); *Daphnis and Chloe* (1976); *Seventh Symphony* (1976); *The Nutcracker* (1977); *Opus 19* (1978); *Shostakovitch Piano Concerto No. 2* (1978); *Coppélia* (1978); *Florestan* (1980).

Compson, Betty, American film actress and dancer; born Eleanor Lucimme Compson, March 18, 1897 in Beaver City, Utah; died April 18, 1974. Compson made her professional debut in vaudeville as a dancer/violinist and spent the next ten years working in local theaters, in stock companies, and in a series of touring musical tap shows, among them *The Shadow Girls* (1915), in which she danced in a chorus line. Compson appeared in more than thirty two-reel pictures before getting her break in *The Miracle Man* at Universal. She divided her screen time between romances, in which she played hard-working Cinderellas, and thrillers, in which she played dancers in the throes of espionage, war, and/or illicit love. In many of the latter, she danced with Theodore Kosloff, who was, like her, under contract to Paramount in the 1920s. He partnered (and seduced) her in *The Green Temptation* (Paramount, 1922), *Beggar on Horseback* (Paramount, 1925), and *The Great Gabbo* (Sono-Art, 1929). Her other dance appearances included *Always the Woman* (Samuel Goldwyn Productions, 1922, remade in sound by Tiffany, 1929), in which she played a reincarnation of the queen of the Nile, *Woman to Woman* (Lew Selznick Productions, 1924), in which she did a wild Apache, and *New Lives for Old* (Paramount, 1925) and *Love Me and The World Is Mine* (Universal, 1928), in both of which she played theatrical dancers.

Compton, Betty, Canadian musical comedy dancer and actress on Broadway; born Violet Halling Compton, 1907 on the Isle of Wight, Great Britain; died July 12, 1944 in New York City. Raised in Canada, she made her professional debut in a touring company of *Abie's Irish Rose*. After two unsuccessful Broadway shows—*Merry Merry* (September 1925) and *The City Chap* (October 1925)—Compton became one of New York's favorite musical comedy dancers and actresses. It should be noted, incidentally, that in the latter flop, she shared specialty dancer status with Pearl Eaton and George Raft. Compton's next five shows were unquestionably successful artistically, and most enjoyed long runs. She was featured in *Americana* (1926) and the Gershwins' *Oh, Kay!* (1926), partnered Fred Astaire in "My One and Only" in *Funny Face* (1927) and sprang to stardom in *Hold Everything* (1928) and *Fifty Million Frenchmen* (1929).

Despite her talents and popularity, Compton re-

mains best known for her romance with "Gentleman" Jimmy Walker, mayor of New York. Although his forced retirement was not related to their relationship—it was due to an accusation of tax manipulation—when he left the country she followed, to the detriment of her career. She made a film in England, *The Richest Girl in the World* (WB-England, 1935), but did not perform in the West End. She taught dance in Florida briefly following her divorce from Walker in 1941, but her early death at thirty-seven ended any impact she might have had on American dance training.

Although Compton's existence was alluded to frequently in the Broadway musical *Fiorello* (1959), she did not appear on stage. Compton was, however, a major character in *Jimmy* (1969), in which she was played by Anita Gillette.

Conde, Felisa, American modern dancer; born c.1920. Trained at the Humphrey/Weidman Studio, she joined the company in 1946. Associated primarily with the works of Charles Weidman, she performed in his *A House Divided* (1946), *And Daddy Was a Fireman* (1946), *Flickers* (1948), *Fables for Our Time* (1947), and *Lynchtown* (1947).

After the dissolution of the Humphrey/Weidman Group, Conde performed in cabaret and on television with Peter Hamilton, also of the Group. She danced in the Choreographers' Workshop premieres of his *Italian Concerto* (1950).

In the early 1950s, Conde joined the John Butler Dance Theatre, working with the choreographer in concert and with the New York City Opera. Among her roles in Butler works are *The Shepherd's Dance*, from *Ahmal and the Night Visitors* (1953), *The Brass World* (1954), and *The Parliament of Heaven* (1958), partnered in all by Glen Tetley.

Condé, Hermes, American ballet dancer; born October 7, 1948 in the Bronx, New York, Condé was trained at the School of American Ballet.

A member of the New York City Ballet through the 1970s, Condé is best known for his performances in ballets by Jerome Robbins. He created roles in his *Watermill* (1972), *Dybbuk* (1974), and its revisions, *Dybbuk Variations*, and *A Suite of Dances, Chansons Ma-*

décasses (1975), and *Opus 19: The Dreamer* (1978). Condé has also performed in George Balanchine's *Tombeau de Couperin* and in his *Symphony in C*, with roles in most of the company's large repertory.

Conley, Sandra, English ballet dancer; born October 24, 1943 in Hatfield. After studies with Stella Wallace at the Sutton School, she continued her training at the Royal Ballet School. Although her debut was with the touring company of the Royal Ballet, she graduated into the senior troupe in the early 1970s. Known for her dramatic portrayals of women trapped by their own emotions and by social rituals, she has been cast in prominent roles in the more stylized nineteenth-century classics and in the contemporary works, among them, Frederick Ashton's *Creatures of Promentheus* and *A Month in the Country*, Geoffrey Cauley's *Symphonie Pastorale* (1979 in the Touring Company), and Kenneth Macmillan's *Anastasia* and *Isadora*.

Connolly, Bobby, American theater and film dance director; born 1896; died February 29, 1944 in Encino, California. Originally an industrial engineer, Connolly became a protégé of dance director Ned Wayburn, who had also been trained as an engineer. His first credits date from the period in which Wayburn retired so it seems likely that he took on projects from him.

A versatile dance director, Connolly staged operettas, among them *The Desert Song* (1926) and *The New Moon* (1928), musical comedies about contemporary life, including *Good News!* and *Funny Face* (both 1927), and revues, such as the *Ziegfeld Follies of 1931* (Ziegfeld's last) and *1934* (the Shubert Brothers' first), and the *Ballyhoo of 1932*.

He made the transition to film very easily and quickly. His first films were made in New York studios, *Moonlight and Pretzels* (Universal, 1933) and *Take a Chance* (Paramount, 1933), so he avoided the apprenticeship period to which most of the "Big Four" of Broadway dance directors were subjected in Hollywood. Although he was both prolific and creative, very few of his films are known at the present time. The exceptions are, however, world-famous—*Broadway Melody of 1940* (MGM) with

Eleanor Powell and Fred Astaire in the extraordinary "Begin the Beguine" tap number, *For Me and My Gal* (MGM, 1942), which began the Gene Kelly/Judy Garland partnership, and the film which is generally considered the best known and remembered in the world, *The Wizard of Oz*. His job on that film included the two big dance numbers, the complex circular Munchkin medley of songs that open the Oz sequences and the "Merry Old Land of Oz" scenes just inside the Emerald City, and such unusual tasks as choreographing movement patterns for the winged monkeys and dog soldiers. The yellow brick road walk, alternating *sashées*, is known by generations of filmgoers. Even if all of his Broadway shows and many of his films were forgotten, Connolly would be remembered forever for his work on that movie.

Works Choreographed: THEATER WORKS: *Kitty's Kisses* (1926); *Honeymoon Lane* (1926); *The Desert Song* (1926); *Judy* (1927); *Good News!* (1927); *Funny Face* (1927); *The New Moon* (1928); *Treasure Girl* (1928); *Follow Thru* (1929); *Spring Is Here* (1929); *Show Girl* (1929); *Sons o'Guns* (1929); *Flying High* (1930); *Princess Charming* (1930); *America's Sweetheart* (1931); *Ziegfeld Follies of 1931*; *Free for All* (1931); *East Wind* (1931); *Hot-Cha!* (1932); *Ballyhoo of 1932* (1932, also directed); *Take a Chance* (1932); *Melody* (1933); *Ziegfeld Follies of 1934* (also directed).

FILM: *Moonlight and Pretzels* (Universal, 1933); *Take a Chance* (Paramount, 1933); *Flirtation Walk* (First National, 1934); *Sweet Adeline* (WB/Vitaphone, 1934); *Broadway Hostess* (WB, 1935); *Go Into Your Dance* (First National, 1935, also performed in film); *Stars over Broadway* (WB/Vitaphone, 1935, co-choreographed with Busby Berkeley); *Sweet Music* (WB, 1935); *Cain and Mabel* (Cosmopolitan, 1936); *Coleen* (WB, 1936); *The Singing Kid* (First National, 1936); *The King and the Chorus Girl* (WB, 1937); *Ready, Willing and Able* (WB, 1937); *Swing Your Lady* (WB, 1937); *Fools for Scandal* (WB, 1938); *Honolulu* (MGM, 1939); *The Wizard of Oz* (MGM, 1939); *Two Girls on Broadway* (MGM, 1940); *Broadway Melody* (MGM, 1940); *For Me and My Gal* (MGM, 1942); *Ship Ahoy* (MGM, 1942).

Connor, Laura, English ballet dancer; born 1946 in Portsmouth. After local training from Mavis Butler, she attended the Royal Ballet School in London. A member of the Royal Ballet since 1965, Connor has been cast in many roles that exploit her youth and delicacy. Her combination of simplicity and unquestioned technique have made her a popular favorite in ballets by Jerome Robbins, most notably his *Dances at a Gathering*, and by Frederick Ashton, including his *La Fille Mal Gardée*. Her roles in the company's classical repertory include variations in white acts of nineteenth-century French and Russian ballets such as *Giselle*, *Swan Lake*, and *La Bayadère*.

Conover, Warren, American ballet dancer; born in Philadelphia, Pennsylvania. Trained by Peter Conlow and at the School of the Pennsylvania Ballet, Conover performed with the company before moving to New York.

After dancing for a season with the short-lived Harkness Ballet, notably in Rudi van Dantzig's *Monument for a Dead Boy* (1969 revival), and the Eglevsky Ballet, Conover joined American Ballet Theatre, with which he still performs. Conover became well known for two very different roles—the lead in the *Monument for a Dead Boy*, restaged for Ballet Theatre, and "Alain," the comic role in *La Fille Mal Gardée*. He created roles in works by the company's choreographers-in-residence, Dennis Nahat's *Mendelssohn Symphony* (1971) and Eliot Feld's *A Soldier's Tale* and *Eccentrique* (both 1971), and by guest creators, Alvin Ailey's *Sea Change* (1972), and Lar Lubovitch's *Scherzo for Massah Jack* (1973) and *Three Essays* (1974).

Conrad, Karen, American ballet dancer; born August 18, 1919 in Philadelphia, Pennsylvania; died July 24, 1976 in Atlanta, Georgia. Trained locally by Catherine Littlefield and Alexis Dolinoff, Conrad performed with the Littlefield Ballet from 1935 to 1938, notably as the "Fairy of Song" in her first American production of *The Sleeping Beauty*, 1937.

Conrad spent two seasons with the (Mikhail) Mordkin Ballet, created the role of "The Flirt" in his *Voices of Spring* (1938) and danced in his revivals of *Giselle*, *Les Sylphides*, and *Aurora's Wedding*. A

charter member of Ballet Theatre, she created roles in Anton Dolin's *Capriccioso* (1940) and *Romantic Age* (1942), and took featured roles in the American premieres of Antony Tudor's *Gala Performance* and *Jardin aux Lilac*.

Conrad, and her husband, Pittman Corry, left Ballet Theatre to found and direct the Southern Ballet in Atlanta, Georgia, where she taught until her death.

Constant, Marius, French composer and conductor; born February 7, 1925 in Bucharest. Although he has written music for other choreographers, most prominently for Maurice Béjart, Constant is best known for his collaboration with Roland Petit. He has conducted for a number of Petit companies and has written scores for his *Contre-pointe* (1956), *Cyrano de Bergerac* (1956), *Paradise Lost* (1967), *24 Preludes* (1967), and *Nana* (1976).

Constantine, Tony, American modern and theatrical dancer and actor; born in New York City. Constantine studied ballet with David Howard and Patricia Wilde, modern forms with Louis Falco, Chase Robinson, and Twyla Tharp, and jazz with Luigi. His concert appearances have included performances with Manual Alum, Kazuko Hirabayashi, Louis Falco, most notably in his *Collisions*, and the New York City Opera ballet's *Fledermaus* waltzes. On Broadway, he leapt as a "Shark" in the 1979–1980 revival of *West Side Story* and danced in *Gotta Go Disco* (1977). Constantine has made many films as an actor and dancer, among them Tharp's *Hair*, Bob Fosse's *All That Jazz*, and the rock film *The Rose*.

Consuelo, Beatriz, Brazilian ballet dancer also working in Western Europe; born c.1930 in Porto Alegre, Brazil. After local studies with Toni Seitz, she moved to Rio de Janeiro to continue her training under Nina Verchinina and Tatiana Leskova. She appeared with the Teatro Municipal from 1949 to 1953, with principal roles in the director's stagings of *Giselle*, *Les Sylphides*, *Princess Aurora*, and *Swan Lake* (Act II). With the Grand Ballet du Marquis de Cuevas from 1953 until its disbandment in 1958, she appeared in revivals of Leonid Massine's *Gaîté Parisienne* and *Le Beau Danube*, and that company's *Les Sylphides* and

The Sleeping Princess. Her strong technique and charming performance style were also seen in contemporary works by Georges Skibine and Serge Lifar. When the company dissolved, she joined Serge Golovine's troupe in Geneva as company teacher.

Contreras, Gloria, Mexican ballet dancer and choreographer; born Carmen Gloria Roeniger, November 15, 1934 in Mexico City. Originally trained in Mexico City by Nelsy Dambre, Contreras performed with her company before moving to New York to continue her studies at the School of American Ballet.

She has choreographed for many companies: the Ballet Nacional, the Ballet Classico de México and Ballet de Camara in Mexico, and the New York City Ballet, City Center Joffrey Ballet, and her own Dance Group in New York. Since 1970, she has served as ballet master for the Taller Coregráfico de la Universidad Nacional Autómono de México and has staged ballets for her students there.

Works Choreographed: CONCERT WORKS: *The Wise and Foolish Virgins* (1959); *Moncayo* (1959); *Serenata Concertante, Ocho for Radio, Dueto* (1960, sections of *Pan America*, for which George Balanchine and Francisco Moncion also staged ballets); *Planos* (1963); *Homanago a Revueltas* (1963); *Vitalitas* (1961); *Paratelas y piezas* (1966); *Sonata* (1966); *The Death of a Hunter* (1967); *Isostasy* (1968); *Adagio and Allegro* (1968); *Dances for Women* (1970); *Diana and Actaeon* (1970); *Interludia* (1970); *Opus 32* (1970); *Agua Ferte* (1970); *Eiona* (Bhakti) (1971).

Conway, Carol, American modern dancer and choreographer; born in the late 1940s in Cincinnati, Ohio. Conway began dance studies as a child in Fort Thomas, Kentucky, and took professional training from Gus Giordano (jazz), Charles Kelly (acrobatics), Andre Bernard (ideokinesis), and modern dance techniques from Martha Graham, José Limón, and Erick Hawkins. She performed for Hawkins from 1969 to 1974, most notably in his *Classic Kite Tails* (1972), and co-founded a cooperative company of Hawkins dancers, the Greenhouse Dance Ensemble. Most of her choreography, however, has been created for her own troupe, established in 1974. She has been acclaimed for her imaginative uses of abstract

movement patterns in her concert works and in the opera, *Paul* (1975). Conway's company also sponsors six New Choreographers' recitals each year and participates in New York–area festivals of new works.

Works Choreographed: CONCERT WORKS: *Two* (1970); *One Three* (1970); *Treasure Between* (1973); *Animato* (1973); *Wind* (1973, second version, 1974); *Duelle* (1974); *Product of the Sides* (1974, revised 1975, 1980); *Red Right Returning* (1975); *Together Passing* (1975); *Bagging at the Bottom* (1976); *QN 152* (1977); *Arrow* (1977); *Not Together, Not Apart* (1978); *The Woman's Dance* (1979); *Ramblin'* (1980); *Primaries* (1980).

Cook and Brown, American tap and comedy team; Charles "Cookie" Cook and Ernest "Brownie" Brown have worked together since meeting in Chicago in 1929. Each had performed in vaudeville before combining their talents into their unique combintation of tap, eccentric, and Russian dancing (a form of tap acrobatics based on the kazatskza). They performed as the dance specialists in the act, Garbage and His Two Cans, but soon worked only as a duet, primarily with orchestras. They appeared with Ben Bernie's band at the celebrated College Inn (Chicago, 1930), and danced with Duke Ellington, Count Basie, and Cab Calloway's groups. The act was interpolated into *Kiss Me Kate* (1948, choreographed by Hanya Holm) in the "Too Damn Hot" number performed by chorus boys and valets.

Cook and Brown, both charter members of The Copasetics, has participated in many of the lecture-demonstrations and master classes presented in the renaissance of tap in the late 1970s. Cook especially has been lauded as a teacher with The Changing Times company and its By Word of Foot series of classes.

Cook, Bart, American ballet dancer; born June 7, 1950 in Ogden, Utah. Trained by Willam Christensen in Salt Lake City, Cook performed in his University of Utah Ballet and Ballet West. Moving to New York to study at the School of American Ballet, Cook joined the New York City Ballet in 1971.

Unique for his seemingly disparate abilities to perform Balanchine's dense patterns of small movements cleanly and legibly and to dance his largest movements sweeping his arms, legs, and torso to the floor, Cook has taken a large number of featured roles in the Balanchine repertory. Celebrated for his performances in *The Four Temperaments*, the second duet in *Stravinsky Violin Concerto*, and *Square Dance*, into which Balanchine inserted a new solo for him, Cook has created roles in his *Vienna Waltzes* (1978), and *Union Jack* (1976). After dancing in his *Watermill* (1972), Cook has performed feature roles in many new ballets by Jerome Robbins, among them, *Scherzo Fantastique* (1972), his first major solo, *An Evening's Waltzes* (1973), *The Dybbuk* (1974), and *The Four Seasons* (1979). He has also created roles in many works by fellow company members Jacques D'Amboise—*Sinfonietta* (1975) and *Sarabande et Danse II* (1975)—and Peter Martins, dancing in his *Sonate di Scarlatti* (1979) and touring with his concert group. Partnering Gelsey Kirkland, Sara Leland, Patricia McBride, and Merrill Ashley, Cook has made a unique place for himself in the company.

Cook, Raymond, Australian ballet and modern dancer and expert on reconstruction through Labanotation; born in Currajong, Townsville, Australia. Cook studied ballet locally with Ann Roberts, continuing his training with Charles Lisner and the staff of the Borovansky Ballet school. After dancing with the Australian Ballet (formerly the Borovansky company) in *Swan Lake* and David Lichine's *Graduation Ball*, he moved to New York to expand his dance horizons. Although he continued to teach and choreograph in ballet techniques, he made two major discoveries in New York—the career possibilities of Labanotation and the artistic potential of traditional American modern dance. He attended class at the Juilliard School, where he studied with José Limón and Anna Sokolow and performed in each one's works, among them his *Concerto in D Minor* and her *Session for Six* in what is now known as "The Golden" original cast of which every member now directs his or her own company. Concurrent to his performance work at Juilliard, he progressed through the hierarchy of certification at the Dance Notation Bureau, becoming a certified notator (and reconstructor) in 1967.

Cook has successfully divided his time between teaching and choreographing and directing in both countries. He has created dances for companies at Dartmouth, where he teaches, and for the North Queensland Ballet, where he served as acting director in the early 1970s. He has reconstructed works by Doris Humphrey, Charles Weidman, José Limón, and Anna Sokolow for companies around the world and has supervised the training of notators and reconstructors for the future.

Works Choreographed: CONCERT WORKS: *Land of Tears* (1966); *Dance Suite* (1966); *The Hollow Crowd* (1968); *Sinfonietta* (1969); *The Creature* (c.1969); *Genesis 3* (1970); *Tangle* (1972); *Send Us a Dove* (1972); *Mystical World* (1973).

Cook, Sheri, American ballet dancer also working in Canada; born January 10, 1953 in Fort Riley, Kansas. Cook's studies across the United States and Canada included work with Georges Skibine, Natalia Krasskova, Vera Volkova, Arnold Spohr, and the faculty of the National Ballet Academy in Illinois. She made her professional company debut with the Pittsburgh Ballet Theatre (now Ballet) in 1971, but soon moved to Spohr's Royal Winnipeg Ballet. Her wide range of performance credits there includes roles in the company's revivals of the full-length classics and parts in the more contemporary repertory. She has been applauded in Kurt Jooss' tragic *Green Table*, Brian MacDonald's satirical *Pas d'Action*, Michael Smuin's abstract and humorous *Pulcinella Variations*, Agnes De Mille's comic *Rodeo*, and John Neumeier's dramatic *Pictures*, among many other ballets.

Cook, Will Marion, American composer; born January 27, 1869 in Washington, D.C.; died June 19, 1944 in New York City. Cook was trained at Oberlin as a musician. While touring with a variety of orchestras, including his own group, Cook created a series of musical comedies for production on Broadway. His first (or at least the first to reach Broadway) was *Clorindy, or the Origin of the Cakewalk* (1898) which was one of the earliest attempts to integrate the choreography of a show into its plot. Although the show did not describe the origins of the social dance, it allowed the dance sequences (cake-walk and otherwise) to be slipped into the progression of the show. Although he contributed music to *The Casino Girl* (1900), which is remembered primarily as the show into which the original English Pony Ballet was interpolated, he is best known for his music for the early black musical comedies, *Jes Lak White Folks* (1899), *In Dahomey* (1902), *In Abyssinia* (1906, frequently called *Abyssinia*), *In Bandana Land* (1907), and *In Darkland* (1914).

Cooke, Philip (II), English eighteenth-century ballet dancer; born c.1730 in London; died there September 9, 1755. The son of Philip Cooke (I), a performer and dancing master in London, Cooke (II) made his theatrical debut at his father's benefit night (a concert at which the beneficiary was given a percentage of the gross), in 1739. After studying in France, probably with Louis Dupré, he performed for two years with the Paris Opéra (c.1740–1742). On his return to London, he joined the company of French dancers at Covent Garden, where he became known for his performances in national and occupational divertissement, such as *A Dutch Skipper*, *Les Matelots Francais*, *The Peasant Dance*, and *The Dutch Dance*. In later years there he also appeared in the newer style of mythological ballets, including early productions of *Comus* and *Orpheus and Eurydice*. Cooke died at age twenty-five; his father, who was still teaching in London, survived him.

Coolidge, Elizabeth Sprague, American pianist and art patron; born October 29, 1864 in Chicago, Illinois; died November 4, 1953 in Cambridge, Massachusetts. One of the most important sponsors of the arts in the 1930s and 1940s, Sprague was the founder of the Berkshire Festival in Massachusetts and, through the foundation named for her, the Coolidge Sprague Quartet, a prize and a series of concerts at the Library of Congress, Washington, D.C. Among the works of importance to dance that were commissioned for and premiered at these concerts were Igor Stravinsky's *Apollon Musagète* (1928, choreographed by Adolf Bolm), Paul Hindemith's *Herodiade* (1944), Aaron Copland's *Appalachian Spring* (the best known work from the series and the only one still in the conventional concert repertory, 1944) and Carlos Chavez's *Dark Meadow* (1946). The latter

three were choreographed by Martha Graham for the Washington performances. Although Bolm's *Apollo* was successful at its premiere, George Balanchine's version of a few weeks later is now much better known.

Cooper, Rex, American ballet dancer; born in the 1920s in Forest, Mississippi; died October 26, 1970 in Jackson, Mississippi. As a track star in Mississippi, he began to study locally at Miss Susie Taylor's School of the Dance. After moving up to New York, he continued his training under Elisabeth Anderson-Ivantzova and Antony Tudor. He was a member of Ted Shawn and His Men Dancers briefly and performed in Edward Strawbridge's company from 1939 to 1941. It was, however, his tenure with ballet companies that won him wide recognition. As a member of Ballet Theatre, he created the mime role of the sardonic "Bartender" in Jerome Robbins' *Fancy Free* (1944) and appeared in character roles in the company's productions of the nineteenth-century classics and the Mikhail Fokine and Leonid Massine repertories. A member of the Alicia Markova/Anton Dolin chamber company in 1946 and 1947, he was cast in Bronislava Nijinska's *Fantasia* and Dolin's *The Lady of the Camilias*, as "Germont."

Cooper also had a successful career on Broadway, with roles in the Agnes De Mille musical, *Gentlemen Prefer Blondes*, and on television appearing in the broadcast of *Whoopee* on NBC. He and his wife, Albia Kavan, were appointed directors of the Jackson Ballet in Mississippi, and built that small regional troupe into an important company.

Coppi, Carlo, Italian mime working in England as a pantomime and ballet-spectacle choreographer after 1891; born c.1840 to 1845 in Milan; died c.1915 in England or Italy. Trained at the ballet school of the Teatro alla Scala, he was a principal dancer/mime at the theater in the 1870s and early 1880s, and performed there in Luigi Manzotti's ballet-spectacles, among them, his *Excelsior* (1881), *Sieba* (1882, revival), and *Amore* (1886). He restaged those works for the Teatro Reggio in Turin and the Teatro Constanzi in Rome, c.1881 to 1886.

Coppi moved to London in the early 1890s to work at the Alhambra Theatre, then the most innovative producer of pantomimes and spectacles. From *Oriella*, in 1891, to *Brittania's Realm*, his patriotic work of 1902, Coppi staged nineteen ballets for the theater. They ranged from traditional pantomimes, such as *Aladdin* (1892), *Rip Van Winkle* (1896), and *Santa Claus* (1901), to national dance pageants, like his *Gathering of the Clans* (1895) and *In Japan* (1902), which was revived for La Scala, and his tribute to his adopted country for the Jubilee year, *Victoria and Merrie England* (1897). While in England, he worked with Henry Irving on at least two of his productions at the Lyceum Theatre, *Robespierre* and *Faust* (c.1895).

Returning to La Scala in 1902, he restaged *In Japan* (as *Nel Giappone*) and choreographed a new work, *La Canzone del Filo*, in 1904. As he was an important element in the importation of Italian ballet technique and spectacle production to England, it is unfortunate that so little research has been done on Coppi. A major link between Manzotti and the English theater, Coppi could prove to be a vital cog in the history of musical theater production.

Works Choreographed: CONCERT WORKS: *Oriella* (1891); *Temptation* (1891); *On the Ice* (1892); *Don Juan* (1892); *Aladdin* (1892); *Ali Baba and the Forty Thieves* (1894); *Titania* (1895); *The Gathering of the Clans* (1895); *Blue Beard* (1895); *Donnybrook* (1896); *Rip Van Winkle* (1896); *The Tzigane* (1896); *Babes in the Wood*, (1897, co-choreographed with John D'Auban); *Victoria and Merrie England* (1897); *Beauty and the Beast* (1898); *Jack and the Beanstalk* (1899, co-choreographed with D'Auban): *Inspiration* (1901); *Gretna Green* (1901); *Santa Claus* (1901); *In Japan* (1902); *Brittania's Realm* (1902); *La Canzone del Filo* (1904).

Coppini, Antonio, Italian nineteenth-century ballet dancer and choreographer; born 1806; died October, 1888. Coppini was trained with his brother Giuseppe and sister Carolina, making his own debut in Venice in 1838. He performed and choreographed there and in Bologna, Florence, and Rome, also staging his works in Mantua, Genoa, and Pergola. Most of his ballets were based on historical themes, but some of his later works seem to be involved with pageantry as a method of demonstrating national themes, among them *L'Espozione di Londra* (1865) and *Il Taglio*

dell'istmo di Suez (1871). His works are interesting precursors to the productions that his son, Ettore, did for Imre Kiralfy in the United States in the 1880s.

Works Choreographed: CONCERT WORKS: *Lucrezia degli Obizzi* (1843); *Il conte Pini* (1843); *Fontana d'amore* (1845); *Il Principali rivali* (1845); *Il Figglio figgitivo* (1845); *A Il Figlio Bandito* (1849); *Albina, ossia I Pescatori di Calabria* (1851); *Zuleika* (1852); *Isaura, o La Bellazza fatale* (1852); *Il Diavolo zoppo* (1853); *Saltimbanco* (1855); *Adelaide di Borgogna* (1855); *Una sfida al bersaglio* (1855); *Giovanni da Prodida* (1855); *Francesca da Rimini* (1856); *Violetta* (1857); *Le Due gemelle* (1863); *L'Avventuriera e Don Cesare di Bazan* (1863); *Firenze* (1865); *L'Esposizione di Londra* (1865); *Il Taglio dell'istmo di Suez* (1871); *La Polvere e la Spada* (1871); *Guilio di Valois* (c.1873).

Coppini, Ettore, Italian nineteenth-century ballet dancer and choreographer, also working in the United States; born 1845, probably in Pergola; died February 7, 1935 in Milan. The son of Antonio Coppini, he and his brothers Achille and Cesare performed in his father's ballets and in those of Luigi Manzotti; in fact, restaging ballets by Manzotti seems to have been a family tradition. Ettore appeared in his *Amor Sports* and *Rolla* at the Teatro alla Scala and restaged productions of them in Milan, Turin, Berlin, and Naples. As principal mime at La Scala, he performed in the Milan premiere of Josef Hassreiter's *La Fata dell Bambole* (1904) and in a 1906 revival of *Coppélia*.

Coppini also worked with Imre Kiralfy, serving as ballet master of his extravaganzas in the United States and England. Although only three credits for his productions can be verified, it is possible that he participated in as many as nine Kiralfy historical pageants between 1880 and 1900. He retired in 1905 in Milan to teach.

Works Choreographed: THEATER WORKS: *The Fall of Babylon* (1880, Buffalo, New York); *Christopher Columbus, or the Discovery of America* (1892, for a tour of the Barnum and Bailey Circus); *China, or the Relief of the Legations* (1901, London).

Coquillard-Albrier, Albertine, French nineteenth-century ballet dancer; born c.1810, probably in Paris; died there February 20, 1846. Coquillard-Albrier and her younger sisters, Fifine and Victorine, were trained at the school of the Paris Opéra. Although later and contemporary authors have described her association with the Opéra as little more than an accommodation address, she was a member of the company from the mid-1830s and a *coryphée* from 1838. Her most important role was in Aumer's *Les Pages du Duc de Vendôme,* which she performed at the Opéra and in London in 1840. After leaving Paris to be in Naples with Eduoard Carey, "the Hercules of the North," she returned but died young.

Coralli, Jean, French nineteenth-century ballet dancer and choreographer; born January 15, 1779 in Paris; died there May 1, 1854. Coralli, whose parents were members of the Théâtre-Italien company in Paris, was trained at the school of the Paris Opéra. Although he danced and choreographed for theaters in Vienna, London, and Milan, he continues to be best known for his work at the Paris Opéra.

Shortly after his performing debut at the Opéra, Coralli left France to join the company of Sébastien Gallet at the King's Theater, London (1802–1803). He then worked in Vienna, where he staged his earliest extant ballets, *Les Abericérages et les Zégris* (1806) and *Die Inkas*, and *Hélène et Paris*, in 1807. After following the traditional itinerant choreographer's route to theaters in Lisbon and Marseilles, he served as ballet master at La Scala (c.1809–1824).

Returning to Paris in 1825, he staged works for the Théâtre de la Porte-Saint-Martin (1825–1830) and the Paris Opéra (1831–1848). One of the most important choreographers of the French Romantic ballet, many of his works became standards of the nineteenth-century repertory, among them, *Le Diable Boiteux* (1836), *La Tarentule* (1839), and *La Péri* (1843). *Giselle,* co-choreographed with Jules Perrot in 1843, remains in the repertory of most current ballet companies and is considered the classic of the Romantic ballet.

Works Choreographed: CONCERT WORKS: *Les Abericérages et les Zégris, ou les Tribes Ennemiés* (1806); *Die Inkas* (1807); *Hélène et Paris* (1807); *Le Calife Généreux* (1808); *Armide* (c.1815); *La Neige* (c.1815); *La Finacée de Sarnen, ou le Retour au Chalet* (c.1815); *l'Amour et l'Hymen au Village* (1815);

Irene deificato (1815); *M. de Pourceagnac* (1826); *Faust* (1826); *Les Artistes* (1829); *La Tempête* (1931); *l'Orgie* (1831); *La Tentation* (1832); *Ali Baba, ou les 40 Voleurs* (1833); *Don Juan* (1834); *Les Fêtes à Versailles* (1837); *Le Diable Boiteux* (1836); *La Chatte Métamorphosée en Femme* (1837); *Stradella* (1837); *La Tarnetule* (1839); *Le Lac des fées* (1839); *Les Matyrs* (1840); *La Reine de Chypre* (1841); *Giselle* (1841, co-choreographed with Jules Perrot); *La Péri* (1843); *Un Bal sous Louis XIV* (1843); *Eucharis* (1844); *Marie Stuart* (1844); *l'Etoile de Séville* (1845); *David* (1846); *l'Ame en Peine* (1846); *Ozai, ou l'Insulaire* (1847); *Belisa, ossia la Nuova Claudina* (1854).

Cordua, Beatrice, German ballet dancer; born March 12, 1943 in Hamburg. Cordua was trained at the school of the Hamburg State Opera Ballet. Shortly before her debut with the Hamburg company, she attended classes at the Royal Ballet School in London. Since her debut in Hamburg in 1959, she has performed with the state ballets there, in Cologne, Frankfurt, and again in Hamburg; in each, she has been associated with the works of American John Neumeier. Among the large number of Neumeier full-length ballets and divertissements in which she created major roles in these companies were his *Firebird* (1970), *Rondo* (1970), *Romeo and Juliet* (1971), *Daphnis and Chloe* (1971), and *Sacre du Printemps* (1972).

Corelli, Juan, Spanish ballet dancer and choreographer for television; born November 1, 1934 in Barcelona. Corelli was trained locally by Josette Isard and in Paris by Olga Preobrajenska. After an accident during his engagement at the Liceo Opera in Barcelona, he returned to class work, studying in London under Harold Turner and Stanislav Idzikowski.

Although he danced with the Grand Ballet du Marquis de Cuevas intermittently from 1955 to 1958, he has become best known for his choreography on television. He has staged ballets on Radio-Télévision Française since 1958. Unfortunately, exact dates have not been verified for these presentations.

Works Choreographed: CONCERT WORKS: *Pierre et le Loup* (1960); *The Bronze Venus* (1962); *Othello* (1964); *Romeo and Juliet* (1972).

TELEVISION: (Note: all productions for Radio-Télévision Française.) *Concerto de Aranjuez* (1958); *Combattino di Tancredi e Clorinda* (1959); *L'Empereur de Chine* (1959); *Le Chant du Rossignol* (1960); *Carmina Burana* (c.1960); *Til Eulenspeigel* (c.1961); *Héro et Leandre* (c.1961); *Le Diable et le Kermesse* (c.1962); *The Miraculous Mandarin* (c.1962); *Ballet Cruel* (c.1962); *Nocturne Pour Une Inconnue* (c.1963); *Etrange Nuit* (1963); *Jeux* (c.1963); *A Midsummer Night's Dream* (c.1964); *Harold in Italie* (1964); *La Carouse du Saint-Sacrament* (c.1965); *Orphée* (c.1965); *The Prince and the Beggar* (c.1966).

Corey, Arthur, American theatrical dancer; born October 3, 1900 in Atlanta, Georgia. Corey was trained by Jean Van Vlissenden in interpretive dance technique outside Chicago, Illinois, and continued his studies with Andreas Pavley in the mid-1920s. After making his professional debut at a social private benefit in his most celebrated act, *Egyptian Caprice*, or *Le Slave d'Or* (painted with gold leaf and glycerine), he performed on Broadway in *It's Up to You* (1921), *Spice of 1922* (co-starring with Delores "The White Peacock"), *Sparkles of 1926*, in which he performed his *Aurora Boralis* specialty which sounds like a Lois Fuller dance with black-light effects, and the *Earl Carroll Vanities of 1926*. His vaudeville acts included *Painted Redskins*, a tribute to native American culture, *The Jewel Box*, *Burmese Fancy*, *Temptation*, *Two Wooden Shoes*, which may have been staged by the Dutch-born Pavley, and *Machinery*, his expressionist homage to the industrial age. *Aurora Boralis* and *Egyptian Caprice* were also performed on his Keith-Orpheum circuit tours.

Corey is the author of a series of articles and a privately published biography of Pavley, called *Danse Macabre*. His gold paint act, and especially a photograph of him making up his back while checking himself in a full-length mirror, inspired many works of art, most notably Paul Cadmus' *The Acrobats*, which uses an almost identical pose.

Corey, Winthrop, American ballet dancer also working in Canada; born 1947 in Washington, D.C. Corey was trained locally in the school of the National Ballet. His work with National Ballet choreog-

raphers led him to the Royal Winnipeg Ballet, where he also performed in works by Norbert Vesak and Brian MacDonald. A member of the National Ballet of Canada since the early 1970s, he has been seen in almost every role of that company's large and eclectic repertory, from the Celia Franca productions of the classics to John Neumeier's rewrites of literary ballets. The role for which his dramatic and performing talents were most acclaimed was a "Catalion" in the latter's *Don Juan*.

Corio, Ann, "The Girl with the Epic Epidermis"; born c.1920 in Hartford, Connecticut. Corio made her theatrical debut in an edition of the Earl Carroll *Vanities*, but became famous as a headliner in burlesque. She worked frequently at The Old Howerd Theatre, Boston (known as The Palace of burlesque) in her solo act, which was once billed as "How to undress with finesse." Corio also acted in straight plays; her reading of the classic line from *White Cargo*, "I am Tondelayo," won her a film contract and the similarly exotic female leads in *Swamp Woman* (1941), *Jungle Siren* (1942), *Sarong Girl* (1943), *The Sultan's Daughter* (1944), and *Call of the Jungle* (1944), all for Producers' Releasing Corporation and Monogram Studios.

Corio's greatest fame, however, came later in her life. From 1962 to the present, she toured with her revue, *This Was Burlesque*, introducing that art form to audiences around the country. Each edition features comics who revive the classic routines of burlesque and strip-tease artistes who recreate their own specialties. In 1979, she opened a new revue called *Big Bad Burlesque* in New York.

Bibliography: Corio, Ann. *This Was Burlesque* (New York: 1968).

Corkle, Francesca, American ballet dancer; born August 2, 1952 in Seattle, Washington. Originally trained by her mother, Virginia Ryan Corkle, she continued her studies at the American Ballet Center, school of the City Center Joffrey Ballet.

Part of the so-called "Seattle-connection" of Washington-born dancers in the Joffrey company, Corkle has spent almost her entire performing career with it. Noted equally for her precision of attack and

surprisingly lyrical movements, Corkle has performed featured roles in most of the company's repertory, notably in their revival of the original version of George Balanchine's *Square Dance*, with the caller, and of Ruthanna Boris' *Cakewalk*. Among the Ballets in which she has created roles are Gerald Arpino's *Kettentanz* (1971) and *Confetti* (1970), Joffrey's own *Remembrances* (1974), in the female dance lead, and his *Postcards* (1980).

Cornelys, Teresa, Italian dancer and singer, known as a stager of balls in London; born Teresa Imer, c.1723 in Venice; died August 19, 1797 in the Fleet Street Gaol, London. She grew up in her father's commedia dell'arte troupe (for which Carlo Goldoni wrote libretti and plays) and probably made her debut with it. After her marriage to dancer Angelo Pompetai, she moved to Vienna, where he was a member of the Court theater. She performed with him as a singer (from descriptions, a contralto) and as a dancer, specializing in pastoral comedies. Although she made her English debut as a vocalist in the King's Theatre 1746 season of operas by Wilhelm Christof Gluck, she did not settle in London until after working in Beyreuth and Flanders, where Charles, Prince of Lorraine, had appointed her "directrice des spectacles en Flendres" (then the Austrian Netherlands).

When she returned to London (as the wife of Cornelis di Rigerbosm from whom she took her professional name), she began a new career as the director of a series of subscription balls and masquerades. These events were private parties (invitation by membership on the subscription list) at which she staged overt performances and concerts and arranged enough "spontaneous" activity to keep the guests/audience amused. The balls frequently were arranged around a theme, in imitation of masques, and attracted most of the aristocracy and cultural elite. Her concerts, which did not involve dance, were conducted at one time by Johann Christian Bach. Unfortunately, the excellence of her musical programs garnered her the rivalry of Covent Garden which, like the Paris Opéra in Paris, protected its monopoly over the enjoyment and entertainment of the London audience. She was brought up on charges of running a

"disorderly house," for which euphemism she was tried and convicted. She later ran what seems to have been a social service institution, arranging balls for pay until she was imprisoned for bankruptcy in 1797. She died in prison before her release could be arranged.

Cornfield, Ellen, American modern dancer; born March 26, 1948 in Washington, D.C. After ballet training as an adolescent, Cornfield studied Martha Graham technique with David Wood at the University of California at Berkeley. She worked with Merce Cunningham and Carolyn Brown when his company was in residence at Berkeley, moving to New York to continue her studies in 1972.

Cornfield has been a member of the Cunningham company since the mid-1970s. She has performed in his *Events* and in repertory works, creating roles in his *Westbeth* (1975), *Torse* (1976), and *Travelogue* (1977). Like most Cunningham dancers, she has begun to choreograph on her own, presenting works in performance for the first time in 1980.

Works Choreographed: CONCERT WORKS: *Performance No. 1* (1980); *Three Times 3* (1980).

Coronado, Jose, Mexican modern dancer and choreographer working in the United States since 1965; born during the 1940s in La Paz, Mexico. Trained at the Instituto Nacional de Bellas Artes in Mexico City under Guillermo Arriaga and Ana Merida, he graduated into the company and worked with the visiting Anna Sokolow. The Ballet Folklorico, with which he danced next, gave him a scholarship to the Martha Graham school. While in New York, he also studied with Vincenzo Celli, Hector Zaraspe, and at the American Ballet Center. He danced with the Sokolow company, in her *Lyric Suite* and *Odes*, and in the Contemporary Dance System, of which Sokolow was choreographer-in-residence, in her *Steps of Silence* and Daniel Lewis' *And First They Slaughtered the Angels* (1975), and *Razoumavsky* (1975).

Coronado has directed a company since 1973, presenting a solo created for him by Sokolow, *Baile*, and his own choreography. His works frequently deal with ritual, with an imagery system that seems to be based in folk Catholicism. He adds children to his company for some works—a seven-year-old girl portraying "Mary" in *Seata* (1973) and a young boy dreaming the *Vigil* (1975)—limiting others to his small troupe. Audiences have become fascinated by his imaginative uses of red flowers as props, representing actual or spiritual rape and, in *The Rose Wound* (1973), the stigmata.

Works Choreographed: CONCERT WORKS: *Seata* (1973); *Sanse Sacre* (1973); *The Rose Wound* (1973); *Suite en Verde* (1973); *Three Pieces for Ellen* (1973); *In a Bed of Faded Roses* (1974); *So Was/So Is/So Be* (1974); *Fugitive Vision* (1974); *Almas* (c.1974); *Vigil* (1975); *Mujeres* (1975); *Silences* (1975); *Beautiful Dreamer* (1975); *Corrida* (1975); *From the Steeples and the Mountains* (1975); *The Eagles Are Dying* (1975); *Sanza Mexicana: The Post Card* (1976); *Deer Dance* (1977); *Four Preludes and One Etude* (1977); *Non Omnis Moriar* (1977); *Rape* (1980); *Diptyche Liturge* (1980); *Tango for Joan Pilauka* (1980); *Preludes for Robert Pierce* (1980); *Les Offrandes Oubliées* (1980).

Correia, Don, American theatrical dancer; born in the late 1940s or early 1950s in San Jose, California. Correia is one of the most recognized Broadway dancers of the present time, from his work on television specials and in comments. He has become associated with the development of the American theatrical song through his appearances on the television salutes to Richard Rogers and Irving Berlin and his live participation in New York cabaret and Broadway revues dedicated to Frank Loesser. In his more conventional credits, Correia could be seen as "Mike" ("I Can Do That"), the athlete who discovered art through his sisters' dance classes, in *A Chorus Line*, and as featured dance partner in the nightclub acts of female stars Sandy Duncan, Shirley MacLaine, Ann-Margaret, and Goldie Hawn.

Corry, Carl, American ballet dancer; born March 31, 1955 in Atlanta, Georgia. The son of Pittman Corry and Karen Conrad, he was trained at the school of their Southern Ballet of Atlanta. After moving to New York, he continued his studies with Margaret Craske. Corry performed with the Joffrey II troupe after 1976 and the parent company, the City Center Joffrey Ballet since 1978. In the 1980 season, his technical skill and growing maturity were recognized

by the company's resident and guest choreographers. He was cast in new ballets by Robert Joffrey (*Postcards*, 1980), Moses Pendleton (*Relache*, 1980), and Cho San Goh (*Momentum*, 1979).

Cortesi, Antonio, Italian nineteenth-century ballet choreographer; born December 1796 in Pavia, Lombardy; died April 1879 in Florence. Cortesi was the son of Margherita Reggina and Giuseppe Cortesi, both of whom were celebrated for their performances in the works of Onorato and Salvatore Viganó in the theaters of the Italian city-states. Antonio Cortesi performed in many of those theaters, with his family in his father's *Catterina di Coluga* (1814 in Padua) and alone, in Venice, Padua, Verona, and Florence before beginning a tenure at the Teatro San Carlos in Lisbon.

Cortesi's first original choreography dates from his return from Portugal and his tenure as ballet master and director of the ballet school at the Teatro Reggio in Turin. He worked the circuit of theaters in un-unified Italy, bringing extant and creating new works to each in its turn at the Carneval, Primavera, or other seasons. It is not certain whether the gift that he showed for absorbing the aesthetic themes of other countries derived from early travels with his family or from growing up in Pavia which was variously part of Spain, France, and Austro-Hungary. He is best known now for his productions of works associated with the Paris Opéra, among them Filippo Taglioni's *La Sylphide* (1841, La Scala), Coralli's *Giselle* (1843) and Albert's *Beatrice* (or *La Jolie Fille*) *de Gand* (1845). Cortesi was, however, a prolific choreographer in the two genres then popular in Italian theaters—the last gasps of pastoral romances and the early days of Italian national works based on historical themes. It seems from contemporary evidence that he was equally successful at creating popular ballets about *nozze*, *matrimonio*, and *sogno* as he was at depicting the lives, and, dramatically, the deaths of kings and countries.

Works Choreographed: CONCERT WORKS: (Note: it is likely that Cortesi restaged each of the following at least once, and frequently five or six times.) *Oreste* (1826); *Il Castello del diavolo, ossia La Fiera* (1826); *Chiara di Rosemberg* (1826); *I Pazzi per progetto* (1826); *Con Chisciotte, ossia le Nosse di Gamascio*

(1827); *Aladinao* (1827); *William Wallace* (1827); *Ines di Castro* (1827); *Alceste* (1827); *Zaira* (1827); *M. Jaquinet* (1828, this ballet may have been titled *Mister Jaquinet*); *Adelasia in Italia* (1828); *L'Orso ed il Bassà* (1828); *Antonio Foscarini* (1828); *Otto giorno di matrimonio, ossia La Luna di miele* (1829); *Il Pranzo alla fiera, ossia Don Desiderio direttore del pique-nique* (1829); *I Crociati a Damasco* (1829); *Merope* (1829); *Gugliermo Tell* (1829); *Ismelda de' Lambertazzi* (1831, also performed as *Ismelda e Bonifacio*); *Tosca* (1832); *Il Velocidero di Parigi* (1832); *L'Ultima giorno di Missolunghi* (1833, also performed as *La Presa di Missolunghi*); *Le Piccole Danaidi* (1834); *La Vera Somnambula* (1834); *Gismonda* (1836, also *Gismonda da Mendrisio*); *Masianello* (1836, also performed as *l'Ultimo giorno di Pompei*); *Marco Visconti* (1836); *L'Arrivo della dilogenza* (1837); *Gli Spiriti assassini* (1837); *Il Passaggio delle Beresina* (1837); *La Silfide* (1837); *Il Ratto delle venete dis Domingo* (1838); *Il Rinnegato, ossia La Battaglia di Navarino* (1838); *I Figlie di Edoardo IV* (1838); *Nabucodonosor* (1838); *Le Furberie di Frontino* (1839); *L'Ebrea di Toledo* (1841); *Mazappa* (1841); *Astuzia contro astuzia, ossia Il Matrimonio per Scommessa* (1841); *Os Doudos por projecto* (1842); *Procida* (1842); *Gisella, ossia Le Willi* (1843); *Il Primo navigatore* (1844); *Il Passaggio della Bersina, ossia Delvat e Alessina* (1844); *Beatrice di Gand, ovvero Un Sogno* (1845); *Armida e Rinaldo* (1845); *I Vespri Siciliani Il Pescatore di Brindisi* (1847); *L'Isolano* (1847); *Merequita e Ines, figlia dell'alchimista* (1847); *Adina, o A Promessa do Matrimonio* (1848); *Fausto* (1849); *Ondina, ossia la Fata delle acque* (1850); *Fazio* (1851); *Ali Pascià de Delvino* (1851); *La Vivandiera al campo del re di Prussia* (1852); *La Reculta in Africa* (1853); *La Gerusalemme liberata* (1853); *La Liberazione di Lisbona* (1859); *Fior di aria* (1859).

Costa, Davide, Italian nineteenth-century ballet dancer and choreographer; born c.1835. The detail and date of his death cannot be verified. Costa performed in the 1840s in various Italian theaters, among them the Teatro Carlo Felice in Genoa, the Teatro Communale in Bologna, and the Teatro Risoluti in Florence, where he appeared in Antonio Pallerino's *Il Malla per forza* in 1856. He had begun to

choreograph previous to that, however, contributing a version of the popular theme, Semiramide on the throne of Assyria, to the repertory of the Teatro Pergola in Florence, 1853, tailored to the talents of Amelia Boschetti.

Costa might have become a member of the nineteenth-century field of choreographers traveling around the theaters of un-unified Italy presenting new versions of literary and historical themes, but in 1868, he accompanied the Italian ballerina Rita Sangalli to the United States to work on the premiere of the celebrated spectacle *The Black Crook* (Niblo's Gardens, September 1866). Much has been written about this production and its sequel (or ripoff, depending on schemes of historiography), *The White Faun* (1868)—it was seminal without being particularly original, and quickly became the most popular and influential of the spectacles of French, Italian, or English origin to be presented in the United States. Little is known about the actual choreography of Costa's American works (or, for that matter, his Italian ones), but the research of Barbara M. Barker may soon change that hiatus of knowledge.

Works Choreographed: CONCERT WORKS: *Semiramide sul Trono d'Assiria* (1853); *Olimpia* (1853); *Ataliba* (1853); *Edmond Dantes, o Il Conte d'Oglaia* (1856); *La Zingara* (1857); *La Figlia smaitia* (1857); *Pelagio e Loretta l'indovina* (1859); *Megilla* (1861); *Folgore, ossia il Demone seduttore* (1861); *Il Conte di Montecristo* (1862, possibly a version of *Edmond Dantes*); *Benvenuto Cellini* (1862); *Oronos* (1864).

THEATER WORKS: *The Black Crook* (1866); *The White Faun* (1868); *Humpty-Dumpty* (1868).

Cotton, Ben, American popular entertainer of the nineteenth century; born c.1812 in Pawtucket, Rhode Island; died February 14, 1898 in New York City. Cotton was a member of a growing group of traveling clog dancers who participated in staged and honest competitions along the East Coast and the Mississippi circuit in the mid-nineteenth century. Cotton left the competitions to join the side show of Van Amburgh's Menagerie in the 1850s, then an appropriate place for a dancer to work on his own wooden stage. In that company, he had the fortune to meet George Coles, with whom he studied dance and music. As a member of Campbell's Minstrels in the 1860s, he met Billy Birch who would become his partner, and fellow "End-Man." They worked together in steamboat theaters and with Thomas Maguire's Minstrels, one of the most successful and far-touring troupes of the 1860s. They were end-men (lead dancers and joint emcees) on that troupe and introduced Cotton's most successful song, "Our Union, Right or Wrong." As the first period of minstrelsy popularity died in the 1870s, he managed theaters in New York, including the Fifth Avenue Opera Company (in Madison Square) and Wood's Museum (music hall). He became a legitimate actor in 1880 and worked in that field of entertainment until his death.

Cotton was the father of imitator and comedienne Idalene Cotton and the grandfather of dancer Nick Long, Jr.

Coulon, Anne-Jacqueline, French ballet dancer of the late eighteenth century; the birth and death dates for the dancer are not certain.

One of the most popular and celebrated dancers of the eighteenth century, Coulon was noted for her delicacy and brilliance of technique. Partnered by Jean D'Auberval and Auguste Vestris, she was assigned principal roles in Maximiel Gardel's *Le Déserteur* and *Alceste* (both 1786), and Pierre Gardel's *Le Jugement de Paris* (1793).

Coulon, Antoine-Louis, French ballet dancer and choreographer of the nineteenth century, working in London in the 1840s; born July 20, 1796 in Paris; died September 3, 1849 possibly in London. Coulon studied with his father, Jean-François, considered the most influential teacher in Paris in the early nineteenth century.

Although he performed at the Paris Opéra where his father and aunt had been so successful and created roles in Jean Aumer's *Aline* (1821) and André J. J. Deshayes' *Zemme et Azor* (1824), Coulon was better known for his work in England. From the early 1820s as a dancer, and from 1844 as ballet master, Coulon worked at Her Majesty's Theatre, London.

Coulon, Jean-François, French ballet dancer and teacher of the early nineteenth century; born 1764;

died 1836 in Paris. Trained at the school of the Paris Opéra, he made his debut with the company in 1787. Among his best known works were *Syncope*, *Reine de Mic-Mac*, performed at Versailles in 1786, and Pierre Gardel's *Les Prétendeurs* (1789), *Psiché* (1790), and *Le Jugement de Paris* (1793).

The foremost teacher in Paris between 1808 and 1830, he taught Maximilien and Pierre Gardel, Geneviève Gosselin, and Filippo, Marie, and Paul Taglioni.

Coulon was the brother of Anne-Jacqueline Coulon, also of the Paris Opéra, and the father of Antoine-Louis Coulon.

Cowen, Donna, American ballet dancer; born c.1950 in Birmingham, Alabama. Trained in Birmingham and Atlanta, she worked in the apprentice programs of the Birmingham and Atlanta Civic Ballets and the City Center Joffrey Ballet. She also studied in New York at the School of American Ballet and the American Ballet Center.

A member of the Joffrey company for most of her professional life, she has created roles in Gerald Arpino's *Secret Places* (1969), and performed in the company's revivals of Frederick Ashton's *The Dream* and John Cranko's *Pineapple Poll*. Reportedly the first native American to play the "Little American Girl" in Leonid Massine's *Parade*, she was celebrated for her remarkably successful appearance in that difficult part.

Cox, Hazel, American theatrical dancer and actress; born 1887 in Baton Rouge, Louisiana. Raised in Chicago, she moved to New York to work as a specialty dancer in *The Skylark* (1910) in which she played "Venus." Although she had danced in Chicago productions, among them the 1908 *A Stubborn Cinderella*, she found herself cast in ingenue roles in New York. Her delicate beauty and strong voice brought her roles in *Miss Jack* (1911), *Little Miss Fix-It* (1911), *The Night Birds* (1912), George M. Cohan's *45 Minutes from Broadway, The Love Wager* (1912), *The Pink Lady* (1912), the *Passing Show of 1913*, *Around the Map* (1916), and Al Jolson's vehicle *Sinbad* (1918) and the *Passing Show of 1919*. In each she danced in the popular musical comedy technique (or soft shoe) and in characterizational ballroom forms.

She also had an exhibition ballroom act in the mid-1910s on vaudeville, with Andrew Branningan.

Cox was the younger sister of dancer-comedienne Ray Cox.

Cox, Ray, American theatrical dancer and comedienne; born 1880 in Baton Rouge, Louisiana. Raised in Chicago, she attended Vassar College and worked in business before going into vaudeville. Cox's act was halfway between a concert dancer and a monologuiste—almost a precursor of the genre associated with the 1920s and Angna Enters, Rosalinde Fuller, and Ruth Draper. Her basic character was "The College Girl"; in dance, gestures, and words, Cox traced her adventures in baseball, horse race watching, driving a car, learning ballroom forms and summer sports, among other situations. Her best known acts were the baseball monologues and a 1912 specialty called "The College Girl in an Aeroplane," in which she did a monologue on the improbabilities of flying and ended the act by going up in a prop plane and taking her bows on her way down in a parachute.

Apart from her "repertoire of Original Characterizations," as her act was billed, Cox appeared in plotted productions on Broadway. Among her most successful parts were in the Lew Fields show, *The Never Homes* (1911), *The Charity Girl* (1912), *Twin Beds* (1914) and *With Flags Flying* (London Hippodrome, 1916).

Coy, Johnny, Canadian tap dancer; born John Oglivie, c.1920 in Montreal, Quebec; died November 4, 1973 in Barbados. As a young adolescent, Coy was the United States, Canadian, North American, and Western hemisphere Highland Fling champion. After studies in New York City with Ernest Carlos, he switched to tap dance and toured with Phil Spitalny's All Girl Orchestra and Ted Lewis' Band. He made his Broadway debut in *Keep Off the Grass* (1940), but was drafted by the Canadian Army shortly after its opening.

After his release from the armed service, he was booked into the Copacabaña in New York where he was seen by a Paramount studio scout. He was under contract to Paramount from 1945 to 1949, appearing in that studio's *Salty O'Rourke* (1945), *Bring on the*

Girls (1945) and *Ladies' Man* (1947), and in *Earl Carroll's Sketchbook* (1946, lent out to Republic Studios), *That's the Sport*, and *On Stage, Everyone* (lent to Universal in 1945).

The eccentric dancer made a second Broadway debut in the highly successful *Top Banana* (1952) as the choreographer of the show-within-a-show. Coy also had a concert and club career in that decade, presenting solo tap recitals in theaters and in cabarets.

Coyne, Joseph, American eccentric dancer and actor working in London after 1907; born March 27, 1867 in New York City; died February 17, 1941 in Virginia Waters, Surrey, England. Coyne had worked in vaudeville and, probably, in the chorus of a Kiralfy Brothers show, when he was discovered by Emile Agoust, who recommended him to his cousins, the juggling branch of the theatrical Agousts. Coyne made his Broadway debut in the Agousts' vehicle, *The Star and Garter* (1900), a comedy about a restaurant in which all the waiters juggle their orders. Coyne played the juvenile straight man, but also got to do the first of his many famous drunk acts.

For seven years, in fact, Coyne played the drunken Englishman character that was assigned to eccentric dancers; his skills included falling down staircases, over tables, and on top of comic leads. Like Vernon Castle, who played similar roles, it was a typecasting that obscured his other abilities, but one that brought wide recognition. He did his "Silly-ass" portrayals in George Ade's *The Night of the Fourth* (1901), the first show staged by Gertrude Hoffmann, *The Toreodor* (1902), *The Rogers Brothers in London* (1903) and *In New Port* (1904), and *The Social Whirl* (1906), before moving to London in 1907.

That season, he was cast in the best romantic lead in the early twentieth century—"Danilo" in *The Merry Widow.* By the end of its long run, he had totally reversed standard theatrical practices by changing from an eccentric dance-comic into a romantic lead. He sang in *The Dollar Princess* (1909), *The Quaker Girl* (1910), *The Dancing Mistress* (1912), *Watch Your Step* (1915), and *Katinka* (1923), before returning to comedy dancing as "Jimmy Smith" who wanted to be happy in *No, No, Nanette* (London, 1925).

Coyningham, Fred, Australian eccentric dancer working in English films; born 1909 in Sydney, Australia. Coyningham's dance act, which has been compared to the eccentric wonders of Jack Donahue and Ray Bolger, brought him to the attention of the dance director and casting office of early British sound film studios. He did high kicking, drunken slides, and befuddled pratt falls in eight successful pictures for British Lion and International in the early days of English musical films, among them Buddy Bradley's *Radio Parade of 1935* (1934), *Key to Harmony* (1934), *Ball at the Savoy* (1933), and *The Monster Boy* (1937).

Cragun, Richard, American ballet dancer associated with the Stuttgart Ballet; born October 5, 1944, in Sacramento, California. After early tap training, Cragun studied ballet locally with Barbara Briggs and performed in her Sacramento Children's Ballet, 1956 to 1960. He received further training in Canada at the Banff School of Fine Arts, where he worked with Brian Macdonald in 1960, and accepted a scholarship to attend the School of the Royal Ballet in London. He has also received private lessons from Vera Volkova, then teaching in Copenhagen.

In 1962, Cragun joined the Stuttgart Ballet, with which he is associated to this day, creating roles in many of the works of its artistic directors John Cranko and Glen Tetley. Among the Cranko ballets in which he created roles are *Eugene Onegin* (1965), *Presence* (1968), and *Initials R.B.M.E.* (1972), partially dedicated to him. His Tetley roles include *Voluntaries* (1973) and *Daphnis and Chloe* (1975). He has also become well known for partnering Marcia Haydée in classical roles both in Stuttgart Ballet productions and in guest appearances.

Craig, Sandra, Australian ballet dancer working in England; born December 7, 1942 in Adelaide, Australia. Craig was trained at the schools of the Royal Ballet and the Ballet Rambert.

A member of the latter since 1962, she has created roles in ballets by company member Christopher Bruce, among them *George Frederic* and *Living Space* (both 1969), and by Norman Morrice, including his *Hazard* (1966), *Blind Sight* (1970), and *Solo*

(1971). She has also performed in the company's repertory of works by Glen Tetley, such as his *Ziggurat, Riccercare,* and *Embrace Tiger and Return to Mountain.*

Cramér, Ivo, Swedish ballet dancer and choreographer; born March 5, 1921 in Gothenburg. Cramér was trained by Sigurd Leeder and Birgit Cullberg, with whom he danced in the early 1940s. He formed a company in 1945 in Stockholm, but merged it with Cullberg's troupe to create the Swedish Dance Theatre in 1947. He served as ballet master to companies in Lisbon and in smaller cities in Sweden before becoming artistic director of his new Dance Company (1967–1975). For that troupe and for the Royal Swedish Ballet, he has specialized in theatrical works that are based on elements of Nordic folklore, or biblical stories translated into Swedish settings, such as his popular *The Prodigal Son* (1947, 1958).

Cramér is also a successful dance director and producer of operetta and American musical comedies in Scandinavian theaters. He has, for example, done twelve different productions of the *White Horse Inn,* three of *My Fair Lady* and singles of *Pal Joey, Oklahoma, Promises, Promises,* and *Tales of Hoffman.*

Works Choreographed: CONCERT WORKS: *The Prodigal Son* (1947, revised 1958); *The Message* (1947); *Ballade* (1959); *Ballade Portugesea* (1960); *Norwegian Ballade* (c.1961); *Bluebeard's Nightmare* (1961); *Catharsis* (1962); *Fiskanena* (1971, co-choreographed with Mary Skeaping); *Good Evening, Beautiful Mask* (1971); *Peasant Gospel* (1972); *La Dansomanie* (1976, co-choreographed with Mary Skeaping after Pierre Gardel).

Crane, Dean, American aerialist, theatrical, and concert dancer; born January 5, 1932 in Denver, Colorado. Crane began his long career in a teeter board and aerial act that was featured in the Pollack Brothers', Daily Brothers', and Ringling Brothers and Barnum and Bailey Circuses. He switched to theatrical performance in 1953 with *John Murray Anderson's Almanac* and appeared as a specialty dancer and acrobat in *Fanny* (1954) and *Carnival* (1961 and 1968 revival), a circus-setting musical in which he also walked on stilts. Crane also had a successful

concert and theatrical dance career as a specialist in Orientalia. As a student and protégé of Yeichi Nimura, he was cast in a partnership with Gemze De Lappe in Nimura's *Lute Song* (1959 revival), at the Radio City Music Hall, and on frequent television appearances. He also worked with Nimura's form of exotica as a designer and maker of masks.

Cranko, John, South African ballet dancer and choreographer who worked in England and Germany through much of his career; born August 15, 1927 in Rutenberg, the Transvaal, South Africa; died June 26, 1973 on a flight to Dublin, Ireland.

Originally trained at the University of Capetown, he moved to London to attend the school of the Sadler's Wells Ballet in 1946. Although he did perform with the Sadler's Wells Theatre Ballet, notably as "Pierrot" in Mikhail Fokine's *Carnaval,* he became more interested in choreography, creating his first known works for that company. He choreographed for the Royal Ballet from its founding until 1961 when his production of *The Prince of the Pagodas* (1953) won him an invitation to become the ballet master of the Stuttgart Ballet. He built up both the repertory and the reputation of that company from an opera ballet in a middle-sized German city to an internationally known touring troupe. His Stuttgart works included full-length opera and literary ballets, such as *Romeo and Juliet* (1962 revision), *The Taming of the Shrew* (1969), and *Onegin* (1965), and abstract short works, among them *Brouillards* (1970), *Poème de l'extase* (1970), and *Initials R.B.M.E.* (1972) dedicated to his best known dancers, Richard Cragun, Birgit Keil, Marcia Haydée, and Egon Madsen.

Cranko died of a heart attack on a flight returning to Europe from a successful tour of the United States. Much of his repertory has been maintained by the Stuttgart company.

Works Choreographed: CONCERT WORKS: *A Soldier's Tale* (1942); *Children's Corner* (1946); *Beauty and the Beast* (1949); *Sea-Change* (1949); *The Witch* (1950); *Pineapple Poll* (1951); *Bonne Bonne* (1952); *Reflection* (1952); *The Shadow* (1953); *Variations on a Theme* (1954); *The Lady and the Fool* (1954); *La Belle Hélène* (1955); *The Prince of the Pagodas*

(1957); *Secrets* (1958); *Romeo and Juliet* (1958); *Antigona* (1959); *La Reja* (1959); *Sweeney Todd* (1959); *Harlequin in April* (1959); *The Catalyst* (1961); *Family Affair, Family Album* (1961); *Divertimento* (1961); *Scènes de Ballet* (1962); *Coppélia* (1962); *The Seasons* (1962); *L'Estro Armonico* (1963); *Wir reisen nach Jerusalem* (1963); *Musical Chairs* (1963); *Variations* (1963); *Swan Lake* (1963); *The Firebird* (1964); *Bouquet Garni* (1965); *Jeu de Cartes* (1965); *Onegin* (1965); *Opus 1* (1965); *Concert for Flute and Harp* (1966); *The Nutcracker* (1966); *The Interrogation* (1967); *Oiseaux Exotiques* (1967); *Quatre Images* (1967); *Holberg Suite* (1967); *Fragments* (1968); *Presence* (1968); *Kyrie Eleison* (1968); *Salade* (1968); *The Taming of the Shrew* (1969); *Brouillards* (1970); *Poème de l'extase* (1970); *Orpheus* (1970); *Cou, Coudres, Corps and Coeurs* (1970); *Ebony Concerto* (1970); *Carmen* (1971); *Into the Cool* (1971); *Initials R.B.M.E.* (1972); *−1+6* (1972); *Le Chant du Rossignol* (1972); *Aire* (1972); *Legende* (1972); *Green* (1973); *Traces* (1973).

OPERA: *A Midsummer Night's Dream* (1960).

THEATER WORKS: *Cranks* (1955); *Keep Your Hair On* (1958); *New Cranks* (1960); all London productions.

Craske, Margaret, English ballet dancer and teacher working in the United States since the 1940s; born c.1898 in Norfolk, England. Craske was trained by Enrico Cecchetti and became recognized internationally as an expert in performing and teaching his technical methods. As early as 1922, she was the illustration model in texts on Cecchetti work. Although she danced with the Diaghilev Ballet Russe and the Carl Rosa Opera Ballet Company in London, she is best known as a teacher.

Craske emigrated to the United States in the 1940s, becoming ballet master of Ballet Theatre in 1947. She taught company classes there and at the Metropolitan Opera Ballet, of which she was assistant director. Craske served on the faculty of the Ballet Theatre and Metropolitan Opera School, the Dance Department of Juilliard, and Jacob's Pillow before opening her own Manhattan School of Dance.

Although she is the country's recognized Cecchetti expert and a repository for exact precision in pure technique, her students include two of the greatest actress-dancers in America, Betty Jones and Sallie Wilson, as well as members of every major company.

Bibliography: Craske, Margaret and Beaumont, C.W. *Theory and Practice of Allegro in Classical Ballet* (Cecchetti Method) (London: 1930); Craske, Margaret and De Moroda, Derra. *The Practice of Advanced Allegro* (Cecchetti Method) (London: 1956).

Cratty, Bill, American modern dancer and choreographer; born February 28, 1951 in Cleveland, Ohio. Cratty has chosen to follow the path of the traditional American modern dancer by performing with the José Limón company while choreographing his own works. He has appeared in most of the repertory of the troupe, in many works by Limón himself, including *The Unsung, A Choreographic Offering, There Is a Time, The Traitor, Carlotta,* and *Missa Brevis,* in pieces by Limón's mentor Doris Humphrey, such as *The Shakers* and *Night Spell,* and in a piece by a fellow performer, Fred Matthew's *Solaris.* Cratty is also known for his portrayals of two very different characters, "The Standard Bearer" and "The Profiteer," in the company revival of Kurt Jooss' *The Green Table.* He has choreographed since the mid-1970s, creating works for the company and for concert and student groups across the country.

Works Choreographed: CONCERT WORKS: *Duet for Men* (1976); *Lost* (1976); *Opus No. 3* (1979); *Match* (1979); *The Man I Love* (1979); *Triumphant* (1979); *The Kitchen Table* (1980).

Crawford, Joan, American film dancer and actress; born Lucille LeSeur March 23, 1908 in San Antonio, Texas; died May 13, 1977 in New York City. She spent part of her childhood in Oklahoma where her stepfather managed a vaudeville theater. As Billie Cassin (using his last name), she made her performance debut as a chorus dancer in a Kansas City, Missouri hotel revue, c.1921. She won the first of many Charleston competitions in 1923 and was hired to dance in a show at the Hotel Oriole in Detroit, where she was seen by J.J. Shubert who engaged her for his New York production, *Innocent Eyes.* While on Broadway in that show in 1924, she worked at Harry Richman's nightclub, where she won a contract from MGM in 1925.

Despite the favorable chain of chance meetings, her film career did not begin successfully, and she spent her evenings and lay-offs doing exhibition Charleston and ballroom work in Los Angeles–area clubs. For the first ten years of her film career she danced in almost all of her motion pictures. Her first extant MGM film, for example, *Pretty Ladies* (1925), which was about the Follies, shows her as an A dancer, performing a stylized minuet. She did ballroom work in her first hit, *Sally, Irene and Mary* (MGM, 1925, the nonmusical version of the film), and in *Apache in Paris* (1926). Her Charleston can be seen in *Four Walls* (1928), *Our Dancing Daughters* (Cosmopolitan/MGM, 1928), and *Laughing Sinners* (MGM, 1931). Her best known dance performances were as Fred Astaire's first film partner in *Dancing Lady* (MGM, 1933), and the Charleston in the *Hollywood Revue of 1929* (MGM), staged by Sammy Lee. Later, she ice-danced in *Ice Follies of 1939* (MGM) and did a Charles Walters–style slink with Eugene Loring in *Torch Song* (MGM, 1953).

Her nonmusical films were considerably more successful, and, of course, reveal dramatic talents that far outweighed her Charlestons.

Crichton, Don, American theatrical and television dancer and choreographer; born during the 1940s in Thompsonville, Connecticut. Crichton received his early dance training from Helen Flanagan in Hartford, Connecticut, and from Marjorie Fielding in New York. He made his Broadway debut in the teen chorus of *Hazel Flagg* (1953), staged by Fielding's husband, Robert Alton. Following Alton to the West Coast, he was assigned the dance co-lead (with Matt Mattox) in his last film, *The Girl Rush* (Paramount, 1955). His tenure as a Jack Cole Dancer ended when the choreographer's version of the *Ziegfeld Follies of 1956* closed out of town, but it brought him back to New York, where he worked steadily on television, on *The Martha Raye Show* (NBC, 1955–1956), *The Patrice Munsel Show* (ABC, 1956–1957), *The Pat Boone Show* (ABC, 1957–1960), and *The Gary Moore Show* (CBS, 1959–1963). On the latter, he worked under Ernie Flatt, himself a former Alton assistant.

Crichton was an Ernie Flatt Dancer for many years on Broadway in *Fade Out, Fade In* (1964), and on television in *The Entertainers* (CBS, 1964) with solo billing, and on *The Carol Burnett Show* (CBS, 1967–1979).

Choreographer of *The Tim Conway Comedy Show*, Crichton has his own troupe of highly skilled tap and jazz dancers. The Don Crichton Dancers are unique among television troupes since they are all children. Their tap numbers on the Conway show are among the best dances to be seen on recent television.

Works Choreographed: TELEVISION: *The Tim Conway Comedy Show* (CBS, 1979–1981).

Cristofori, Jon, American ballet dancer; born c.1947 in Buzzard's Bay, Massachusetts. After local studies with Jane Gay, he was given a scholarship to the school of the National Ballet, Washington, D.C., and a place in its corps. He joined the apprentice program and charter company of the City Center Joffrey Ballet in 1965, becoming one of its first classical danseurs. He had a large range of roles in that young company, among them "The Boy" in Gerald Arpino's *Incubus* and "The Old Soldier" in Kurt Jooss' *The Green Table*. Although he had principal parts in Lew Christensen's *Con Amore*, George Balanchine's *Scotch Symphony*, and Anna Sokolow's *Opus '65*, he is best remembered in Arpino ballets, among them, *Night Wings*, *Olympics*, *Cello Concerto*, and the company signature piece, *Viva Vivaldi!*

Crockett, Deane, American ballet dancer; born 1906; died May 10, 1972 in Sacramento, California. Crockett received training from Mikhail Mordkin and Mikhail Fokine before moving to San Francisco as an early member of the Opera Ballet. Among the many works of William Christensen in which he performed featured roles were *Caprice Espagnol*, *In Vienna*, *Coppélia*, and *Romeo and Juliet*. He also served as personal manager in preparation for his tenure as founding artistic director of the Sacramento Ballet. With his wife, Barbara Wood Crockett, he made the essentially amateur group into a highly esteemed regional ballet company that still flourishes under her direction.

Croll, Tina, American modern dancer and choreographer; born August 27, 1943 in New York City. Croll studied dance at Bennington College with Wil-

liam Bales, Jack Moore, Martha Whittman, and Donald McKayle, while at the American Dance Festival summer sessions of 1962 and 1964, she worked under Martha Graham, José Limón, Lucas Hoving, Alvin Ailey, Ruth Currier, and Louis Horst. Later studies include work with Anna Sokolow, Merce Cunningham, Nina Fonaroff, and Robert Fitzgerald. As a member of the Dance Theatre Workshop (when it was a performing organization in the late 1960s), she appeared in dances by Jack Moore, Jeff Duncan, James Cunningham, and Art Bauman, in whose *Burlesque/Black & White* (1967) she represented the women at whom all advertising is focused. She also choreographed for Dance Theatre Workshop performances and tours, creating both solos and group pieces from 1965 to 1968. Croll has since made many popular works for dancers alone and with multimedia elements.

Cropley, Eileen, English modern dancer performing in the United States; born 1932 in London. Cropley was trained by Sigurd Leeder in England before moving to New York to accept a scholarship at the Martha Graham school. She performed with the Paul Taylor company for many years after 1966, when she created a role in his still popular *Orbs*. Among the many Taylor works in which she danced were *Piece Period*, *Agathe's Tale* (1967), in which she played the title role, *Foreign Exchange*, *Public Domain* (1969), *Big Bertha*, *Post Meridian*, *Aureole*, and *Lento*.

Cross, Wellington, American exhibition ballroom and musical comedy dancer; born c.1887 in Illinois; died October 12, 1975 in New York City. Cross left home to join the touring company of George M. Cohan's *Little Johnny Jones* in 1907. His next show, *Top O'the World*, was stranded in Winona, Minneapolis in 1909, so he joined with fellow company member, Lois Josephine, to form a dance vaudeville act. As Cross and Josephine, they performed together for almost ten years, appearing on Broadway in *The Wall Street Girl* (1912), the *Passing Show of 1913*, dancing "The Golden Stairs of Love" on a real staircase, *The Night Boat* (1920), and Ned Wayburn's *Town Topics* (1915), and presenting a series of vaudeville acts. On the Keith and Orpheum circuits, they did sketches, including their first hit, "Dying to Act," whirlwind dances, soft shoes, and song-and-patter sequences.

The act split up in 1917 when Josephine, who expected Cross to be drafted into the Army, found a new dancing partner. His call-up was delayed, however, and he took an engagement with the revue, *Words and Music* of 1917. His career continued after his release from the Army, with booking in vaudeville as a solo act, as "The Sultan of Swat," Babe Ruth's partner in 1921, and with a troupe that included Marion Saki that joined the show *Just a Minute* as a unit in 1920. His most celebrated role was as the first "Billy Early" in the popular, long-running original cast of *No, No, Nanette* (1925). He remained with the New York cast for two years and with the London production for another season, before dropping out of the industry completely to join Elizabeth Arden for thirty years. If there was a transition between Broadway stardom and the perfume business, it has not been discovered.

Cucchi, Claudina, Italian ballet dancer of the late nineteenth century; born March 6, 1834 in Monza; died March 8, 1913 in Milan. Trained at the ballet school of the Teatro alla Scala in Milan by Augusto Hus, Cucchi spent most of her performing career with that company.

From c.1854 to 1864 Cucchi worked as an itinerant ballerina, performing at La Scala, at the Paris Opéra, notably in Mazillier's *Le Corsaire* (1856), and at the Hofteater in Vienna, where she danced the title roles in many ballets of Pasquale Borri and choreographed one work of her own, *Juliska* (1858). In 1865, she performed in St. Petersburg, doing *Giselle*, *Catarina*, *Esmeralda*, and Borri's *Un Aventura di Carnevale*.

Returning to Milan after the Russian season, Cucchi was assigned principal roles in the late Romantic ballets by Borri, among them *Stella* and *Uriella* both in 1870.

Bibliography: Cucchi, Claudina. *Venti anni di paloscenio* (Rome: 1904).

Cullberg, Birgit, Swedish ballet dancer and choreographer; born August 3, 1908 in Nyköping. Trained by Kurt Jooss and Sigurd Leeder at Dartington Hall, England, in the mid-1930s, she studied ballet with Lillian Karina in Stockholm, c.1944.

In 1945, after having performed in cabaret as a dancer, she formed the Svenkadansteater with Ivo Cramer, creating her earliest extant works for the group. Her best known work, *Miss Julie* (1950) was choreographed for the touring group which she directed with Elsa Marianne von Rosen. A guest choreographer and reviver for the Royal Danish Ballet, the New York City Ballet, Ballet Theatre, and other companies from 1957 to 1967, she returned to Stockholm to direct the Birgit Cullberg Ballet in 1967. A large percentage of her stage works and most of her choreography for television was created for her troupe.

Many of her works involved strong dramatic irony and emotions, depicted in ballet technique or modern dance. Her women in particular are viable characters whose dilemmas and emotions are comprehensible to the audience.

Cullberg is the mother of dancers Niklas and Mats Ek.

Works Choreographed: CONCERT WORKS: *De Eenzame* (1945); *Hercules op de Tweesprong* (1945); *Dieren* (1946); *The Three Musketeers* (1947); *Medea* (1950); *Miss Julie* (1950); *The Stone Portal* (1950); *The Swain and the Six Princesses* (1952); *A Midsummer Night's Dream* (1956); *The Moon Reindeer* (1957); *Circle of Love* (1958); *Odysseus* (1959); *Lady from the Sea* (1960); *Eden* (1961); *The Evil Queen* (1961); *Seven Deadly Sins* (1963); *Salome* (1964); *Euridice es Tod* (1968); *Romeo and Juliet* (1969); *Bellman* (1971); *Révolte* (1973); *Report* (1976); *Rapport* (1976); *Peer Gynt* (1976); *At the Edge of the Backwoods* (1977); *Krigsdanser* (1979).

TELEVISION: *I Am Not You* (Scandinavian Television, 1966); *Red Wine in Green Glasses* (Scandinavian Television, 1970); *School for Wives* (Scandinavian Television, 1974).

Cummings, Blondell, American postmodern dancer; born c.1948 in Effingham, South Carolina. Cummings has studied with Thelma Hill, Sally Stackhouse (an expert at Limón work), Maggie Black, and the faculty of the Martha Graham school. As a freelancer, she performed with the Richard Bull Improvisational company in the late 1960s, danced in James Cunningham's *Junior Birdsmen* at the American Dance Festival of 1970, and was featured in Kai Takei's *Light, Part VI* (1971). Cummings made her debut with Meredith Monk/The House in *Juice* (1969) at the Guggenheim Museum and has performed in each of her group works since then, among them, *Needle-Brain Lloyd and the Systems Kid* (1970), *Vessel* (1971), *Education of the Girlchild* (1973), *Paris/Chacon* (1974), *Venice/Milan* (1976), and *Quarry* (1976). In the latter, her "Dictator" was a special creation of horror and grandeur within the movement confines of Monk's work.

Cummings can be seen in Yvonne Rainer's film, *Kristina Talking Pictures* (1976).

Works Choreographed: CONCERT WORKS: *Point of Reference I* (1971); *An Episode* (1975); *Point of Reference II* (1975); *Face on a Barroom Floor* (1976); *Viduo* (1976); *Cycle* (1978); *My Red Headed Aunt from Red Cheek* (1979); *Signature* (1979, directed by Niamini Mutima); *The Ladies and Me* (1979); *Poem* (1979); *A Friend* (1980); *A Friend II* (1980).

Cunningham, George, American dance director; born 1904 in New York; died May 1, 1962 in Los Angeles. Cunningham worked with Earl Carroll on the production end of the 1924 and 1925 *Vanities* before moving to Hollywood to become a dance director in early sound films. He made four musicals for MGM, including the first *Broadway Melody* (1929), a melodrama set in the Follies, but left the cinema to stage Prologs and presentation acts. Cunningham staged short variety shows for motion picture theaters, among them the Grauman's Chinese in Hollywood, until that genre died in the 1940s. He also choreographed productions for the Los Angeles Civic Light Opera, for many years the only resident theater company in the area.

Works Choreographed: THEATER WORKS: Prologs for the Fanchon and Marco West Coast Deluxe Theater Chain (1928); Prologs for Grauman's Chinese Theatre (1930–1952, intermittently).

FILM: *The Broadway Melody* (MGM, 1929); *The Hollywood Revue of 1929* (MGM); *Our Modern Maidens* (MGM, 1929); *Thunder* (MGM, 1929).

Cunningham, James, Canadian contemporary dancer and choreographer outside the conventional categories; born April Fool's Day, 1938 in Toronto, Canada. Although he had worked extensively in im-

provisational theater in Toronto with Dorothy Goulding, Cunningham did not formally study dance until he was working in London as part of the BBC Directors' Training Program. He received training from Gregg Mayer and Robin Howard in London before moving to New York to accept a scholarship to the Martha Graham school.

Cunningham's work is more closely related to his childhood in improvisational theater than it is to Graham's choreography, but, like both styles, it is a stream of images set to movement. The system of imagery works off a North American childhood—concepts of family, for example, in *Father Comes Grandly Down and Eats Baby* (1970), which shares the mental stage with pictures created in Hollywood, as in his 1972 *Treasures From the Donald Duck Collection*. Other images—both visual and aural—come from dance history, where Isadora Duncan shares title status with Walt Disney in *The First Family* (1971), and *Swan Lake*, emerges during *The Junior Birdmen* (1970), and from mythology, with god-pairing ranging from *Apollo and Dionysus* (1974) to *Isis and Osiris* (1975). The Cunningham repertory also involves a large number of anthromorphosized animals, generally in title roles, among them, *Mr. Fox's Garden* (1970), *Evelyn the Elevator* (1968), and *Lions and Roaring Tigers* (1970), and titles that sound suspiciously like commercials for America, such as *The Sea of Tranquility Motel* (1969).

His image structures create feelings of humor, consternation, and adoration, and make his company's performances exceptionally popular. Although one work was labeled immoral in Alaska, the group is especially well known and successful in residencies outside New York. Many works are actually choreographed to be performed by large groups, up to 150 nondancers, on residencies; the best known of these is *Junior Birdmen*, which is about *Swan Lake*, religious rituals, and the myths engendered by the television of his childhood.

Works Choreographed: CONCERT WORKS: *Evelyn the Elevator* (1968); *The Zoo at Night* (1969); *The Sea of Tranquility Motel* (1969); *Junior Birdmen* (1970); *Lions and Roaring Tigers* (currently includes *Mr. Fox's Garden*, *Skating to Siam*, and *Morning at the White House*) (1970); *Lauren's Dream* (1970); *Father Comes Grandly Down and Eats Baby* (1971); *The Clue in the Hidden Staircase* (1971); *The First Family: Walt Disney and Isadora Duncan* (1971); *Treasures from the Donald Duck Collection* (1972); *Everybody in Bed* (1973, co-choreographed with Lauren Persichetti); *Dancing with Maisie Paradocks* (1973); *Dances for Children* (The Creation of the World, Changing and Changing, Space Voyage, African Safari) (1973); *Apollo and Dionysus: Cheek to Cheek* (1974); *The Four A.M. Show: Isis and Osiris* (1975); *Aesop's Fables* (1976); *The Return of Mr. Fox* (1976); *North Star* (1977); *One More for the Road* (1977); *Mr. Fox Asleep* (1978); *The Well at the World's End* (1979); *Two Virgin Island Folktales* (Bru' Cock and Bru' Cockroach, Alexander and the Shepherd) (1979); *Rainbow Bridge* (1979).

THEATER WORKS: *Twelfth Night* (1960); possibly other Shakespeare productions for the Stratford (Ontario) Festival.

Cunningham, Merce, American modern and postmodern dancer and choreographer; born April 16, 1919 in Centralia, Washington. After early local training in tap dance and exhibition ballroom technique, he attended the Cornish School, Seattle, where he studied modern dance with former Martha Graham company member Bonnie Bird and music and composition with John Cage. At the Bennington School of Dance (held that summer at Mills College, Oakland, California), in the summer of 1939, he met and worked with Martha Graham who invited him to join her company as its second male soloist. While in the Graham company, he created roles in her *Every Soul Is a Circus* (1939), *El Penitente* (1940), *Deaths and Entrances* (1943), and *Appalachian Spring* (1944).

Cunningham shared a choreographic recital at Bennington with Jean Erdman and Nina Fonaroff in 1942; he presented his first solo concert in early April 1944. Between these two recitals and the formation of the Cunningham company in 1953, he and John Cage participated in the summer workshops at the Perry-Mansfield Camp (Colorado Springs, 1944), Bennington College, and Black Mountain College in North Carolina, considered the birthplace of the aleatoric (chance structure) movement in avant-garde music and dance.

His first performance group, Merce Cunningham and Dance Company, founded in 1953, included Carolyn Brown, Remy Charlip, Viola Farber, and

Paul Taylor, with Cage as musical director. Its first New York season in December 1954 was followed by more than a score of transcontinental and European tours. Almost all of the Cunningham repertory was created for his company, which at times has included Lucinda Childs, Judith Dunn, David Gordon, Steve Paxton, Yvonne Rainer, Valda Setterfield, and Gus Solomons, Jr. Those postmodernists who did not perform with the company have worked for its former members, so the Cunningham influence has pervaded that aspect of dance completely.

Cunningham's choreography itself has gone through an evolution away from formal structure toward aleatorism. His earliest works were almost indistinguishable from that of other Graham dancers-turned-choreographers. After the Black Mountain experience, however, his works took on the characteristics that make them instantly identifiable and unique. His vocabulary is interesting; it is not the Graham system of movements, with her contractions. He uses releases and many suspensions of movements but his vocabulary seems to be derived from the ballet, performed barefoot so that it expands the toe technique through contact with the stage floor.

The structure of the Cunningham repertory has undergone the most change. From the formal works of his first recitals, he went into chance structure within established works with beginnings and ends, if not middles. The pieces on which he currently works most frequently are "Events." There have actually been three series of Events, organized by place—Museum Events, Gymnasium Events, and the encompassing series, numbered from one up to the two hundreds. The pieces are constructed from segments of other repertory works by a method determined by chance. They require feats of endurance and memory from the performers and a different way of watching dance from the audience. Certain elements are common to different Events because they are derived from a finite collection of motifs and segments; there are frequently sections for two duets in unison, in canon, and out of relationship, for congruence of all performers in the penultimate segment, and a section for Cunningham himself, popularly called his "hand solo," because he now uses that part of his body most.

Probably one of the most influential choreographers in the Western dance world, he is a genuinely seminal figure whose theories and practices have inspired a new form of modernism.

Works Choreographed: CONCERT WORKS: *Seeds of Brightness* (1942, co-choreographed with Jean Erdman); *Credo in Us* (1942, co-choreographed with Erdman); *Ad Lib* (1942, co-choreographed with Erdman); *Renaissance Testimonials* (1942); *Totem Ancestor* (1942); *In the Name of the Holocaust* (1943); *Shimmera* (1943); *Triple-Paced* (1944); *Tossed as it is Untroubled* (1944); *The Unavailable Memory Of* (1944); *Spontaneous Earth* (1944); *Four Walls* (1944); *Idyllic Song* (1944); *Root of an Unfocus* (1944); *Trio* (1944); *Mysterious Adventure* (1945); *Experiences* (1945); *The Encounter* (1946); *Invocation to Vahakn* (1946); *Fast Blues* (1946); *The Princess Zondilla and Her Entourage* (1946); *The Seasons* (1947); *The Open Road* (1947); *Dromenon* (1947); *Dream* (1948); *Orestes* (1948); *The Monkey Dances* (1948); *Effusions avant l'Heure* (aka *Games*) (1949); *Amores* (1949); *Two Step* (1949); *Duet* (1949); *Ragtime Parade* (1950); *Pool of Darkness* (1950); *Before Dawn* (1950); *Waltz* (1950, two works this year with this title); *Variation* (I) (1951); *Sixteen Dances for Soloist and Company of Three* (1951); *Suite of Six Short Dances* (1952); *Excerpt from Symphonie pour un Homme Seul* (aka *Collage*) (1952); *Les Noces* (1952); *Solo Suite in Space and Time* (1953); *Suite By Chance* (1953); *Dime a Dance* (1953); *Fragments* (1953); *Septet* (1953); *Untitled Solo* (1953); *Banjo* (1953); *Minutiae* (1954); *Spring-weather and People* (1955); *Galaxy* (1956); *Lavish Escapade* (1956); *Suite for Five in Time and Space* (1956); *Nocturnes* (1956); *Labyrinthian Dances* (1956); *Changeling* (1957); *Picnic Polka* (1958); *Suite for Two* (1958); *Antic Meet* (1958); *Summerspace* (1958); *Night Wandering* (1958); *From the Poems of White Stone* (1959); *Gambit for Dancers and Orchestra* (1959); *Rune* (1959); *Crises* (1960); *Hand Birds* (1960); *Waka* (1960); *Music Walk with Dancers* (1960); *Suite de Danses* (1961); *Aeon* (1961); *Field Dances* (1963); *Story* (1963); *Open Season* (1964); *Museum Events No. 1 to 3* (1964); *Paired* (1964); *Winterbranch* (1964); *Cross Currents* (1964); *Variations V* (1964); *How to Pass, Kick, Fall and Run* (1965); *Place* (1966); *Scramble* (1967); *Rain-forest* (1968); *Gymnasium Events No. 1 to 3* (1968); *Walkaround Time* (1968); *Canfield* (1969); *Tread* (1970); *Second Hand*

(1970); *Signals* (1970); *Objects* (1970); *Landrover* (1972); *TV Rerun* (1972); *Changing Steps* (1973); *Borst Park* (1973); *Solo* (1973); *Sounddance* (1974); *Westbeth* (1975); *Rebus* (1975); *Torse* (1976); *Squaregame* (1976); *Travelogue* (1977); *New Solo* (1978); *Inlets* (1978); *Tango* (1978); *Fractions* (1978); *Exchanges* (1978); *Fielding Sixes* (1980); *Events No. 1 to 216; Unnumbered Events.*

THEATER WORKS: *The Wind Remains* (1943); *Le Piège de Méduse* (1948); *Theatre Piece* (1952, in repertory as dance work from 1960); *The Young Disciple* (1955); *The Cave at Machpelah* (1959); *The Cook's Quadrille* (1960); *The Construction of Boston* (1962).

Cuocco, Joyce, American ballet dancer; born May 7, 1953 in Jamaica Plain, Massachusetts. In Boston, she studied with Harriet Hoctor, Ana Roje, and E. Virginia Williams. When her family moved to Los Angeles, she continued her training with Irina Kosmovska, Tatiana Riabouchinska, and David Lichine. As a child, she performed extensively on television as one of the "Baby Ballerinas" on *The Danny Kaye Show* (CBS, 1966), and on the Perry Como and Ed Sullivan variety shows, as well as specials starring Debbie Reynolds.

She danced at the Radio City Music Hall under Marc Platt (c.1966–1968), then left the country to perform with the Stuttgart Ballet in Germany. In that company, she was featured in John Cranko's productions of *Eugene Onegin* and *Romeo and Juliet*, also creating roles in his *The Seasons* (1971) and dancing in *Initials R.B.M.E.*. She performed briefly with the Bavarian State Opera Ballet after Cranko's death, before returning to the United States to perform with the Pennsylvania Ballet. In that company, she has danced in the nineteenth-century classics and in the George Balanchine repertory.

Curley, Wilma, American ballet and theatrical dancer; born April 1, 1937 in Brooklyn, New York. Trained at the School of American Ballet, she performed with the New York City Ballet in the mid-1950s. She appeared in much of the company's large repertory and created roles in Todd Bolender's *Souvenirs* (1955) and Jerome Robbins' *The Concert, or the Perils of Everybody* (1956). She repeated her roles in Robbins' troupe, Ballets: U.S.A., with which she also danced in his *New York Export: Opus Jazz* (1958), *Moves* (1959), and *Afternoon of a Faun.*

Since the dissolution of that troupe, she has worked with Robbins in restaging his ballets for companies throughout the country and in Europe. The "Graziella," in the original cast of *West Side Story,* she has staged many productions of that classic musical, most frequently in Western Europe.

Currier, Ruth, American modern dancer and choreographer; born Ruth Miller on January 4, 1926 in Ashland, Ohio. Raised in Durham, North Carolina, she attended the Black Mountain College (an experimental artist community and school) before moving to New York to study with Doris Humphrey.

Currier performed for twelve years with the company for which Humphrey served as artistic director—José Limón and Dance Company—in works by Humphrey and by Limón. Among Humphrey works in which Currier created roles were *Invention* (1949), *Lament for Ignacio Sanchez Mejias* (1949), *Day on Earth* (1950), *Night Spell* (1952), and *Felipe El Loco* (1955). For Limón, she danced in the premieres of *La Malinche* (1949), *Concert Preludes and Fugues* (1950), *There is a Time* (1956), and *Missa Brevis* (1959). While in the company, she also danced in Pauline Koner's *The Visitation* (1952) and her own *Becoming* (1956), and *The Antagonists* (1955).

Currier formed her own ad hoc company in 1961, creating works for its dancers and for her students at Bennington College and Sarah Lawrence College. She currently serves as artistic director of the Limón company, which survived his tragic death in 1972. Although she has supervised the repertory and restaged works by Humphrey for the group, she has only been able to find time to create one new work, *Storm Warning* (1976).

Works Choreographed: CONCERT WORKS: *The Antagonists* (1955); *Idyll* (1955); *Becoming* (1956); *Resurgence* (1956); *Triplicity* (1956); *To Lean, to Spring, to Reach, to Fly* (1958); *Dangerous World* (1958); *Brandeburg Concerto No. 4* (1959, co-choreographed with Doris Humphrey); *Transfigured Season* (1960); *Toccata* (1960); *Places* (1961); *The Quartet* (1961); *Resonances* (1961); *A Tender Portrait* (1961); *Diva Divested* (1963); *To Wish . . . Together . . . Fearsomely* (1965); *Triangle of Strangers* (1966); *The Night Before Tomorrow* (1966); *Fantasies and*

Façades (1967); *Arena* (1967); *Phantasmagoria* (1975); *Storm Warning* (1976).

Cutler, Robyn, American modern dancer; born May 25, 1948 in Atlanta, Georgia. Trained at the Juilliard School in New York, she became a member of the José Limón Dance Company in its period of transition. As it became a viable troupe after the deaths of its great founder-choreographers, Limón and Doris Humphrey, Cutler was assigned progressively more important roles. Among her performance credits is the title role in his *La Malinche.*

Czarney, Charles, American ballet and modern dancer working in Europe; born January 4, 1931 in Chicago, Illinois. Trained at Bennington College, he also studied ballet with Benjamin Harkavy and modern dance styles with Jane Dudley and William Bales of the New Dance Group. He made his performance debut with the New York City Opera, which then used modern dancers and choreographers, and became a member of the Royal Winnipeg Ballet under Harkavy.

Czarney became a founding member of the Netherlands Dance Theatre, also a Harkavy company, appearing in his *Partita* and *Madrigalesco*, Glen Tetley's *The Anatomy Lesson* and *Pierrot Lunaire*, Job Sander's *Screenplay*, and John Butler's *Renard*. He has choreographed since early 1971, becoming best known for his abstract works to Bach.

Works Choreographed: CONCERT WORKS: *Concerto Grosso* (1971); *Sunny Day* (1972); *Brandenburg* (1973); *Brandenburg Three* (1974).

Czobel, Lisa, Hungarian concert dancer; born April 2, 1906 in Hamburg, Germany. Trained in Berlin by Bertha Trumpy and in Paris by Olga Preobrajenska, she became a member of Lisa Skoronel's concert group in Berlin. Czobel was associated for many years with the Essen Folkwang Dance Theatre of Kurt Jooss and with his emigré companies in England. Among the many roles she created for Jooss was that of the young girl forced into prostitution by the war in *The Green Table* (1932).

Exiled from Germany with Jooss, she lived and worked in Switzerland and England before emigrating to the United States in the early 1940s. She performed here with fellow exile Trudi Schoop and presented her own solo recitals from 1946 to 1949; unfortunately, the titles of her works are not known. Returning to Europe, she worked as a concert dancer in Switzerland and Germany, performing alone and sharing recitals with Alexander von Swaine.

D

Dafore, Asadata, Sierra Leonian dancer and choreographer working in the United States after 1929; born Austin Asadata Dafore Horton, August 4, 1890 in Freetown, Sierra Leone; died March 4, 1965 in New York. After studies in Germany in dance and music, he moved to the United States in the early 1930s. He worked here originally as a musician, but participated in productions of the Federal Theatre Project, among them Orson Welles' Haitian *Macbeth* and Paul Robeson's revival of *The Emperor Jones.*

For twenty years after his first successes, he presented operas and concerts of African dance and music, whether in recital form or as plotted works. For a company that included Abdul Assen, Zebedee Collins, Randolph Sawyer, and actresses Josephine Premice and Esther Rolle, he produced a repertory of eight full-evening pieces, among them, *Zunguru* (1938), *Festival at Battalakor* (1945), *The Valley Without Echo* (1975), and *Afra Ghan Jazz* (1959). He returned to Sierra Leone in 1960 to serve with the ministry of culture after independence, but was forced to move back to New York for his failing health.

Dafore's important influence on American dance has been reinforced in recent years through revivals of his group works and solos by former company members Collins and Rolle, who had become a television star, for the company of Charles Moore.

Works Choreographed: CONCERT WORKS: *Zunguru* (1938); *The Shingandi* (1941); *Africa* (1944); *Festival at Battalakor* (1945); *A Tale of Old Africa* (1946); *Festival in New Africa* (1954); *The Valley Without Echo* (1957); *Afra Ghan Jazz* (1959); *Program for Africa Dance Festival* (*Switch Dance, Batu, Eccentric, Victory Ball Dance, Ido, Conga*) (1959).

THEATER WORKS: *Macbeth* (c.1937); *The Emperor Jones* (1939, revival).

Dailey, Dan, American musical comedy and film eccentric dancer; born December 4, 1915 in New York City; died October 15, 1979 in Hollywood, California. Dailey made his Broadway reputation in two George Balanchine shows, *Babes in Arms* (1937) and *I Married an Angel* (1938), followed by *Stars in Your Eyes* (1939), staged by Carl Randall. His film roles were split between good dramatic ones and backstage musical comedies. In his best, among them *Mother Wore Tights* (Twentieth-Century Fox, 1947) and *There's No Business Like Show Business* (Twentieth-Century Fox, 1954), he played somewhat compulsive performers who combined a wild eccentric dance act with a brash personality. His "Burlington Bertie from Bow" from the former managed to evoke the silly-ass Englishmen that Vernon Castle used to play with a very personal American tap style.

Dailey's last major music dance film was *It's Always Fair Weather* (Twentieth-Century Fox, 1955). That cult film teamed him with Gene Kelly and Michael Kidd in a kind of disillusioned tribute to *Fancy Free* and *On the Town,* in which three soldiers return to New York after the war and find reality. The big dance number came near the beginning, with Kelly, Dailey, and Kidd dancing underneath the "El" in a tap dance with ash can caps. Dailey's solo, a progressively drunker dance that destroys a business/social gathering, provided him with a wonderful method for a wild, eccentric, high stepper to mature into a dramatic dancer and actor.

Daks, Nicholas, Russian ballet dancer working in the American Prolog theaters; born c.1915 in St. Petersburg. It has been impossible to verify Daks' claims for his early life but it is certainly possible that he was trained at the school of the GATOB in Petrograd before moving to Paris and the United States. Once here he joined the Metropolitan Opera Ballet, where he worked under Alexis Kosloff with whom he may have emigrated to the United States. Daks went on the Prolog circuit in the late 1920s and joined the staff of the Roxy Theater as Patricia Bowman's partner in 1930. When the Roxy's producer and Bowman moved to the new Radio City Music Hall, Daks went along as premier danseur and assistant to the producer. While working with Leonidoff on everything from bookings to color schemes and serving as mime coach and make-up designer (both tasks requiring adoption of conventional techniques to the enormous scale of the house), he partnered Bowman, Leda Anchutina, Hilda Eckler, and Eleanor Whitney

in ballet and adagio sequences. He did ballet solos until 1941 at least and appeared in mime roles for another six years after that, most notably as a "Magi" and "Santa Claus" in the annual nativity pageants.

Dale, Daphne, English ballet dancer; born 1931 in Nairobi, Kenya. After early training locally, Dale moved to London where she studied with Grace Cone and Olive Ripman.

She performed for a season with the London Festival Ballet, before moving to Rio de Janeiro, where she was featured in *Swan Lake, Les Sylphides, Prince Igor,* and Ruth Page's *Vilia,* in the title role of "the Merry Widow."

After appearing in Gene Kelly's film *Invitation to the Dance* (MGM, 1954), Dale joined the Grand Ballet du Marquis de Cuevas in Europe. She currently teaches at the school of the Geneva Opera Ballet.

Dale, Grover, American theatrical dancer and choreographer; born July 22, 1938 in Harrisburg, Pennsylvania. After early training with Lillian Jasper, he opened his own Babaloo Studio in McKeesport, continuing his own studies at Dance Masters of America conventions.

Dale made his professional debut in *Call Me Madam* (1953), choreographed by Jerome Robbins. After dancing in Michael Kidd's *Li'l Abner,* he was reunited with Robbins to play "Snowboy" in the original cast of *West Side Story* (1957), and to assist him on the first Ballets: U.S.A. tour in 1958. Additional show credits include *Green Willow* (1960), *Sail Away* (1961), *Too Much Johnson* (1964), and *Half a Sixpence* (1965). He received his first choreography credit for the musical comedy version of *Billy Budd* (1969); its one-week run was followed by a more successful project—the popular Off Broadway play, *Steambath* (1970). His next Off Broadway credits, *Pinkville* (1970), *Acrobats* and *Line* (1971), and *Jump Crow* (1972), were succeeded by a co-choreography credit on *Seesaw* (1973) and solo credits on *Molly* (1973), based on *The Goldbergs,* and *The Magic Show* (1974), for Doug Henning and his disappearing elephant.

Dale performed in two films—*The Unsinkable Molly Brown* (MGM, 1964) and the French romantic musical *Les Desmoiselles de Rochefort* (Comacio,

1967)—and in most of the television variety shows made in New York, among them *The Martha Raye Show* (NBC, 1964), *The Ed Sullivan Show* (CBS, c.1968), and *Look Up and Live* (CBS, December 1965).

Works Choreographed: THEATER WORKS: *Billy Budd* (1969); *Steambath* (1970); *Pinkville* (1970); *Acrobats* and *Line* (1971); *Jump Crow* (1972); *Seesaw* (1973, co-choreographed with Michael Bennett and Tommy Tune); *Molly* (1973); *Rachel Lily Rosenbloom and Don't You Ever Forget It* (1973); *The Magic Show* (1974).

TELEVISION: "I Love New York" television commercials (1978–).

Dale, Margaret, English ballet dancer; born December 30, 1922 in Newcastle-upon-Tyne. Trained at the school of the Sadler's Wells Ballet, Dale joined the company in the early 1940s. Among her many created roles in the company were in Ninette De Valois' *The Prospect Before Us* (1940), in Robert Helpmann's *Comus* (1941), *Hamlet* (1942), and *The Birds* (1943), and in Frederick Ashton's *The Wanderer* (1941), *Les Sirenes* (1946), *The Fairy Queen* (1946), and *Cinderella* (1948). She was featured as the "Sugar Plum Fairy" in the company production of *The Nutcracker,* the "Bride" in Ashton's *A Wedding Bouquet,* and "Swanilda" in *Coppélia.*

Since 1954, Dale has been a staff director and producer for the BBC. She has produced many live action and documentary programs, some of which were on dance, including Cranko's *Castle, on the Stuttgart,* and shows about the Royal Ballet, Netherlands Dance Theatre, and London Festival Ballet.

Works Choreographed: CONCERT WORKS: *The Great Detective* (1954).

Dale, Virginia, American film dancer and actress; born c.1918 in Charlotte, North Carolina. Dale made her professional debut with her sister, Frances, as the Paxton Sisters, an acrobatic tap and adagio act that played presentation acts' houses across the United States. The act was also extremely popular in South and Central America and was engaged frequently in clubs in Curacao. Dale accepted a contract from Columbia Pictures in 1938 to appear in the short subjects series set in universities, such as *The College*

Follies of 1938, in which she co-starred with Hal Le Roy. In 1939, however, she switched to Paramount, where she found success and considerably better roles in films starring Jack Benny and Bing Crosby. Her work in *Love Thy Neighbor* (1940), *Buck Benny Rides Again* (1940), *Las Vegas Nights* (1941), and *Dancing on a Dime* (1941) won her higher billing and more adagio, tap, and rhumba numbers, but it was her partnering of Fred Astaire in *Holiday Inn* (1942) that brought her recognition as a graceful and talented dancer.

D'Alessandri-Valdine, Blanche, French ballet dancer of the late nineteenth century; born Blanche Rostand Valdine, c.1862 in Paris; died there in July 1948. D'Alessandri-Valdine was trained at the school of the Paris Opéra by, among others, Lucien Petipa who cast her in a child's part in the London production of his *L'Enfant et les Bijoux* in 1871—her professional debut. Her first engagement as a more mature dancer (when she was seventeen) was as a soloist at the Grand Théâtre, Marseilles, in 1879. Her roles there included both "Myrthe" and "Giselle" in the company production, the latter becoming her best known part. After marrying the dancer D'Alessandri, she moved with him to the Grand Théâtre in Geneva where she appeared in *Giselle* and in interpolated dances in opera productions, most notably the local premiere of Massenet's *Hérodiade.* On a tour of the United States, in performance in New Orleans (which still had a successful French-language theater and opera), she fell though an open trap door, shattering her knee and ending her career forever.

After returning to Paris, she opened a studio where she taught Camille Bos, Maura Paiva, and Solange Schwarz, among many other dancers and teachers.

Dali, Salvador, Spanish painter and theatrical designer; born March 11, 1904 in Figueras. Originally one of a small group of Spanish Futurists, influenced by the Italian rather than French avant-garde, he became the best known surrealist painter, illustrator, and designer of his day. He has experimented with graphic design, both experimental and commercial film, notably providing dream sequences for Alfred Hitchcock's *Spellbound,* and dance scenery and costuming. Although a number of works have been described as having been influenced by his brand of surrealism, he has personally designed very few. Creating primarily for the Ballets Russes de Monte Carlo of the 1940s, he did mise-en-scène for Leonid Massine's *Bacchanale* (1939), *Labyrinth* (1941), and *Mad Tristan* (1944), André Eglevsky's *Sentimental Colloquy* (1944), Argenita's *Café de Chinitas* (1944), and in later years, Maurice Béjart's *Gala* (1961) and *Le Chevalier Romain et la dame Espagnole* (1961).

Bibliography: *The Secret Life of Salvador Dali* (New York: 1942); Déon, Michel. *The Diary of Salvador Dali* (New York: 1965), trans. of 1964 French edition.

D'Amboise, Christopher, American ballet dancer; born February 4, 1960 in New York City. The son of Jacques D'Amboise and Carolyn George (both of the New York City Ballet), Christopher D'Amboise was trained at the School of American Ballet.

Although he made his debut in the title role of *The Nutcracker* and danced it for three seasons during the early 1970s, D'Amboise did not join the company formally until 1978. He has taken featured roles in the third movement of *Symphony in C, Western Symphony,* and as an adult in *The Nutcracker.* One of the first of the second-generation of New York City Ballet members, D'Amboise has also danced in the company revival of Jerome Robbins' *Fancy Free* in 1979.

D'Amboise, Jacques, American ballet dancer and choreographer; born July 25, 1934 in Dedham, Massachusetts. D'Amboise moved to New York at age eight and, with his brother and sister, studied at the School of American Ballet. All three performed children's parts with the Ballet Society, 1946 to 1949.

D'Amboise joined the New York City Ballet in 1949, the season after it was reinstituted from Ballet Society. He has been associated with that company as a dancer and choreographer ever since. D'Amboise has created roles in a large number of works by George Balanchine, among them, *Western Symphony* (1954), *Movement for Piano and Orchestra* (1963), and the *Brahms-Schoenberg Quartet* (1966); he has also created roles in works by Frederick Ashton for the New York City Ballet, including that

of "Tristan" in his *Picnic at Tintagel* (1952). Among the many repertory roles with which D'Amboise is associated are Balanchine's *Apollo, Stars and Stripes,* and *Scotch Symphony,* Lew Christensen's *Filling Station,* and Jerome Robbins' *Afternoon of the Faun.*

D'Amboise first choreographed for the New York City Ballet in 1963, creating *The Chase.* Works which remain in the company repertory include *Tchaikovsky Suite* (No. 2) (1964) and *Sarabande and Danse II,* created for the 1975 Ravel Festival.

D'Amboise appeared in three feature films in the mid-1950s—*Seven Brides for Seven Brothers* (MGM, 1954), *Carousel* (Twentieth-Century Fox, 1956), and *The Best Things in Life Are Free* (Twentieth-Century Fox, 1956). He has danced frequently on television, performing classical pas de deux on, among others, the *Bell Telephone Hour* and the *Ed Sullivan Show.*

Works Choreographed: CONCERT WORKS: *The Chase* (1963); *Peter and the Wolf* (1964); *Irish Fantasy* (1964); *Quatouor* (1964); *Tchaikovsky Suite* (No. 2) (1964); *Prologue* (1967); *Alborada Del Gracioso* (1975); *Sarabande and Danse II* (1975); *Saltarelli* (1975).

Dana, Viola, American actress and film dancer; born Viola Flugrath, c.1898 in Brooklyn, New York; the details of her death are uncertain. Dana was a featured child performer in films before making her stage debut at age five. After appearing on stage in *When We Dead Awake* and *Rip Van Winkle,* she toured for years in the original version of *The Littlest Rebel.* In 1912, she made her Broadway debut in *The Model* (1912). Although the show was unsuccessful, it led to her engagement in the best child role of the era—"Gwendolyn" in *The Poor Little Rich Girl* (1913).

She returned to film in 1914, following the end of that play's run, to become Columbia Picture's answer to Mary Pickford. She danced in almost all of her movies, in a wide variety of styles. She did contemporary social work in most of them, including *The Innocence of Ruth* (Klein-Edison, 1916), *Threads of Fate* (Columbia, 1917), and *The Paris Tigress* (Metro, 1919), in which she did an Apache that was considered highly risqué. Dana did ballet work in *The Cossack Whip* (Edison, 1916), an exceptionally

melodramatic tale of a Russian ballerina's revenge, and ethnic danced in her contributions to American orientalia. Her Indian temple dance in *God's Law and Man's* (Columbia, 1917), Hindu solo in *Lady Barnacle* (Columbia, 1917), and Native American work in *The Million Trail* (Metro, 1920) were all highly acclaimed.

Daniass, Starr, American ballet dancer; born March 13, 1949 in Queens, New York. Daniass was trained by Natalia Branitzka and at the High School of Performing Arts and the American Ballet Center. After a season with the London Festival Ballet, she joined the City Center Joffrey Ballet with which she danced until the late 1970s. Daniass is considered by many the ideal dancer for the many repertory works of Gerald Arpino. She can shape her movements into his classical techniques or into the forms required for his contemporary views of alienation and love, as required variously in *Viva Vivaldi!, Kettentanz* (1971), *Chabriesque* (1972), *Trinity* (1970), *Reflections* (1970), and the *Sacred Grove on Mount Talampais* (1972). With the Joffrey, she has also performed in Margo Sapington's *Weewis* (1971), Alvin Ailey's *Feast of Ashes,* and Moses Pendleton's *Relâche* (1980).

Daniass has guested frequently with American and European companies, most prominently with the American Ballet Theatre long enough to do its *Sleeping Beauty.* She served as ballerina and co-director of one of the Anna Pavlova centennial companies that toured the country in 1980 with reduced reconstructions of her repertory. Daniass has also worked on television and in film, playing a seductive ballerina in *A Turning Point* and *The Love Boat.*

Daniele, Graciela, Argentinian ballet and theatrical dancer also working in the United States; born December 8, 1939, in Buenos Aires. Daniele was trained at the school of the Teatro Colón and performed with the ballet company there and at the Teatro Argentine de la Plata. After moving to New York she began appearing on Broadway in shows staged by Michael Bennett, among them *Promises Promises* and *Coco,* and other contemporary choreographers. From her debut in *What Makes Sammy Run?* (1964) to *Here's Where I Belong* and *Coco,* she worked al-

most constantly on stage, spending her rare lay-offs as a television dancer on *The Ed Sullivan Show, Bell Telephone Hour,* and on specials. Daniele began her American theatrical choreography career with New York's popular Spanish-language theaters, creating dances for *El Maleficio de la Mariposa* for the Puerto Rican Traveling Theatre's mobile stage in 1970. She has developed into one of the American and European theater's most active choreographers of both commercial and institution productions but is also known as the "queen of the industrials" for her work with the annual Miliken Breakfast shows, the highest budgeted and most artistically successful of the New York-based live commercials.

Works Choreographed: THEATER WORKS: *El Maleficio de la Mariposa* (1970); *The Most Happy Fella* (1977, revival); *A History of American Film* (1977); *Joseph and His Amazing Technicolor Dreamcoat* (1977); *Alice in Concert* (1980); *The Pirates of Penzance* (1980, Broadway revival).

Danieli, Fred, American ballet dancer and choreographer; born Alfredo Carlo Danieli, July 17, 1917 in New York City. Trained at the School of American Ballet, Danieli made his debut with the Ballet Caravan, a cooperative company of students from the school. Performing in most of its repertory, he created roles in Erick Hawkins' *Show Piece* (1937), Lew Christensen's *Filling Station* (1938), and William Dollar's *Air and Variations* (1938). Danieli also performed with the group at the New York World's Fair in Dollar's *A Thousand Times Neigh* (1939–1940) and on the South American tour of the Caravan and the American Ballet, in Balanchine's *Ballet Imperial* (actually premiered by the ad hoc New Opera Company), and Christensen's *Pastorela,* co-choreographed with José Fernandez.

After Army service, and performances in *Call Me Mister* (c.1947), Danieli rejoined Balanchine as a member of the Ballet Society. In this company, he created roles in Balanchine's *Divertimento* (1947), *Four Temperaments* (1947), in the "Sanguinic" section, *Renard* (1947), and *Divertimento* (1947), contributing an original work, *Punch and the Child,* to the season in 1947.

Retiring from performance in 1949, Danieli founded the School of the Garden State Ballet that year. That institution has fed many young dancers into the New York City Ballet, among them Gloria Govrin, Teena McConell, and Victor Castelli, and has trained many others, including Lisa Bradley, Tamara Woshiakowsky, Sharron Miller, and Stephanie Wolfe. Currently artistic director of the Garden State Ballet, Danieli has choreographed additional works for its repertory, among them *Divertimento* (1958) and the popular *Peter and the Wolf* (1958).

Works Choreographed: CONCERT WORKS: *Punch and the Child* (1947); *Divertimento* (1958); *Peter and the Wolf* (1958); *The Enchanted Piano* (1960); *The Nutcracker* (1968).

THEATER WORKS: *This Is the Army* (1944); *Where's Charley?* (1948, revival).

Danielian, Leon, American ballet dancer; born October 31, 1920 in New York City. Danielian received his early training from Mikhail Mordkin and performed with his Ballet company from 1937 to 1940. After joining Ballet Theatre, he continued his studies with Antony Tudor and Mikhail Mordkin.

A charter member of Ballet Theatre, he created roles in Anton Dolin's *Cappriccioso* and *Quintet* (both 1949), and had featured parts in the company productions of *Swan Lake* and *Les Sylphides.* A member of the Ballet Russe de Monte Carlo from 1943 to 1961, he danced in Leonid Massine's *Le Beau Danube* and *Gaité Parisienne,* Mikhail Fokine's *Les Sylphides* and *Spectre de la Rose,* and the versions of *The Nutcracker* and *The Sleeping Beauty* performed by that company.

A popular teacher, especially of men's classes, Danielian taught at the American Ballet Theatre School until 1980, serving as director from 1967 on. He presently teaches at the New York Conservatory of Dance.

Works Choreographed: CONCERT WORKS: *Confetti* (1953); *Sombreros* (1956); *Mazurka* (1958); *España* (1962).

Daniels, Billy, American theatrical dancer and film choreographer; born c.1924. Daniels made his Broadway debut in Charles Walters' *Let's Face It* (1941) as a member of the soldier chorus. He went out to Hollywood to work for Walters at the Coconut Grove nightclub and joined Paramount Studios

as a dance coach and director. Daniels specialized in staging musical and dance numbers for film comedies, especially those starring Bob Hope and/or Bing Crosby. Although Hope had had some dance training and experience, Daniels usually had to choreograph around the stars of his movies, which included Hope's *The Paleface* (1948), *Monsieur Beaucaire* (1946), and *The Road to Rio* (1947). His major dance films were Paramount's *Lady in the Dark* (1944), in which Don Loper (then a celebrated exhibition ballroom specialist) partnered Ginger Rogers, and *With a Song in My Heart* (Twentieth-Century Fox, 1952), in which he had to choreograph a multitude of choruses around the actress portraying Jane Froman after her crippling accident.

Works Choreographed: FILM: *Lady in the Dark* (Paramount, 1944); *Duffy's Tavern* (Paramount, 1945); *Masquerade in Mexico* (Paramount, 1945); *Monsieur Beaucaire* (Paramount, 1946); *The Stork Club* (Paramount, 1946); *Ladies' Man* (Paramount, 1947); *The Perils of Pauline* (Paramount, 1947); *The Road to Rio* (Paramount/Bing Crosby Enterprises/Bob Hope Enterprises, 1947); *One Touch of Venus* (Universal, 1948); *The Paleface* (Paramount, 1948); *Scared Stiff* (Twentieth-Century Fox, 1952); *With a Song in My Heart* (Twentieth-Century Fox, 1952); *The French Line* (Twentieth-Century Fox, 1953).

Daniels, Danny, American theater, film, and television dance director; born Daniel Giagni, Jr., in Albany, New York. Daniels learned tap in Albany with Jack Sternfield; after moving to Los Angeles with his family, he studied ballet with Edith Jane at the Falcon Studio. In New York, he studied ballet with Anatole Vilzak, Vincenzo Celli, and Jack Potteiger.

Daniels performed in six Broadway shows during the 1940s—*Best Foot Forward* (1941), *Count Me In* (1942), *Billion Dollar Baby* (1945), *Street Scene* (1947), *Make Mine Manhattan* (1948), and *Kiss Me Kate* (1950). *Street Scene* was staged by Anna Sokolow, whom he credits with interesting him in choreography. In November 1952 he collaborated with composer Morton Gould to create the *Tap Dance Concerto,* which he has performed frequently with symphony orchestras and has recorded on Columbia Records.

Daniels first did musical comedy choreography at the Tamiment Camp in the summers of 1954 and 1955. His first New York credit was for the *Littlest Revue,* Off Broadway, in 1956; his first Broadway show was *All American* (1962). He has staged five further Broadway shows—*Best Foot Forward* (1962), *High Spirits* (1964), *Hot September* (1965), *Walking Happy* (1966), and *I Remember Mama* (1979)—and musical comedies in London, Los Angeles, and Rome, as well as many industrials.

In his first of four films, *The Night They Raided Minsky's* (United Artists, 1968), he staged chorus numbers and comedy scenes for a c.1915 burlesque show. His other films are a political satire, *Richard* (Independent, 1972), *Tom Sawyer* (United Artists, 1972), and *Piaf* (Independent, 1975). He has also worked extensively in television, staging dances for variety shows in the 1950s and 1960s, and for many specials, including the Emmy-award-winning *Fabulous Fifties* (CBS, 1960).

Works Choreographed: CONCERT WORK: *Tap Dance Concerto* (1952).

THEATER WORKS: *The Littlest Revue* (1956); *Shoestring Revue '57* (1956); *All American* (1962); *Best Foot Forward* (1962); *High Spirits* (1964); *Ciao Rudy* (1965, Rome); *Hot September* (1965); *Walking Happy* (1966); *Love Match* (1968); *1491* (1969); *I Remember Mama* (1979).

FILM: *The Night They Raided Minsky's* (United Artists, 1968); *Richard* (Independent, 1972); *Tom Sawyer* (United Artists, 1972); *Piaf* (Independent, 1975).

TELEVISION: *The Martha Raye Show* (NBC, 1955–1956); *The Ray Bolger Show* (ABC, 1955–1956); *The Patrice Munsel Show* (ABC, 1956–1957); *The Steve Lawrence–Edie Gorme Show* (NBC, 1958); *The Voice of Firestone* (ABC, 1958–1959); *The Revlon Revue* (CBS, 1960); *The Judy Garland Show* (CBS, 1963); *The Perry Como Show* (NBC, 1964–1966, specials).

Daniels, Ron, American tap dancer, choreographer, and teacher; born August 1, 1939 in Buffalo, New York. After local training in jazz and tap with Marie Flynn-Battistoni, he moved to New York City where he continued his jazz studies with Jack Stanley, Jane Dodge, and Matt Mattox, his tap work with Stanley and Ernest Carlos, ballet with Jack Potteiger, and modern dance with Sevilla Fort. Considered one of the finest tap dancers of recent years, Daniels has

performed in clubs in all of the major resorts in the country, as a June Taylor Dancer, and on the *Ed Sullivan Show* (CBS). He tours with a lecture-demonstration on tap dance and has taught the American native technique in master classes at almost every teacher's convention in the country, at classes for ballet and theater companies, at workshops everywhere from Hong Kong to Rio de Janeiro to London and Paris, and at programs for the Lexington School for the Deaf in New York. While not teaching, Daniels stages tap routines and cabaret acts for performers in Las Vegas and Reno, Nevada, including many dance teams, and the back-ups for Ray Bolger, Tony Martin, George Burns, and dozens of staff show girls. He is also known as a choreographer and coach for beauty pageants including regional and national Miss America shows.

Danilova, Alexandra, Soviet ballerina working in Western Europe and the United States; born November 20, 1904 in St. Petersburg. Trained at the school of the Imperial/State Ballet in St. Petersburg/Petrograd, she graduated into the GATOB, where she danced in Fyodor Lopoukhov's *Dance Symphony* in 1922. A member of a concert group, The Young Dancers, she created a role in *Poème,* a very early work by George Balanchine, and toured with him to Western Europe. In Paris, they joined the Diaghilev Ballet Russe, in which company she danced in the premieres of his *Jack-in-the-Box* (1927), *The Triumph of Neptune* (1927), *Les Deux Mendicants* (1929), *La Pastorale* (1929), *Le Bal* (1929), and *Apollon Musagète* (1929), creating the role of "Terpsichore."

After Diaghilev's death, she performed with smaller companies in Paris and Monte Carlo before becoming a charter member of the Ballet Russe de Monte Carlo in 1933. With that company in the United States from 1933 to 1952, she created roles in Balanchine's *Danses Concertantes* (1944) and *Night Shadow* (1946) and in Leonid Massine's *Le Beau Danube* (1933), *Jardin Public* (1935), *Capriccio Espagnol* (1939), *Vienna—1814* (1940), and *The New Yorker* (1940). The Massine repertory revealed the charms and elegance of her performance, as well as her technical facilities. She guested with many companies in the 1940s and 1950s, among them the Slavensk-Franklin Ballet, where she created the title role in Zachary Solov's *Mlle. Fifi* (1952), and her own concert group. She was the principal ballerina and choreographer at the Metropolitan Opera in the late 1950s.

Danilova also worked on Broadway, starring in Albertina Rasch's *The Great Waltz* (1934) and in *Oh, Captain!* (1958). Her role in the film, *A Turning Point* (Twentieth-Century Fox, 1979) won her a new audience of fans.

A beloved teacher at the School of American Ballet, she has restaged productions for the student recitals, and she has co-choreographed a production of *Coppélia,* always her greatest success, with Balanchine for the New York City Ballet.

Works Choreographed: CONCERT WORKS: *Paquita* (1949); *Les Diamants* (1959); *Le Mirage* (c.1959); *Chopiniana* (1972); *Coppélia* (1974, co-choreographed with Balanchine).

Danilova, Maria, Russian ballet dancer; born 1793 in St. Petersburg; died there on January 8, 1810. Trained at the school of the Imperial Ballet by Charles-Louis Didelot, she was associated with his works throughout her tragically short career.

She created roles in all of his works choreographed between 1808 and 1810, among them *Les Amours de Vénus et d'Adonis* (1908) and *Cupid et Psyché* (1810). Danilova died of consumption at age seventeen.

Dante, Nicholas, American theatrical dancer and playwright; born Conrado Maroles in the 1940s in New York City. Dante danced with a female impersonation revue in New York City and with the ballet corps of the St. Louis Municipal Opera before becoming a Broadway gypsy. His shows ranged from the national company of Ron Field's *Applause* to a New York revival of Jerome Robbins' *Fiddler on the Roof.*

Dante's gypsy career is most memorable for the work that it inspired. He was a member of the group of Broadway dancers whose conversations and memories became the basis of the Michael Bennett musical *A Chorus Line* and served as co-author of the show's book (with James Kirkwood, Jr.). It is difficult to disavow the audience's belief that *A Chorus Line* was, in fact, the biographies of its original performers. The character of "Paul," especially, seems

to be related to Dante's own experiences as a performer with impersonation revues. His book is, however, universal in its conversational truths and perceptions.

D'Antuono, Eleanor, American ballet dancer; born 1940 in Cambridge, Massachusetts. After early training with Marie Papporella, D'Antuono studied with E. Virginia Williams at her Boston School of Ballet.

D'Antuono joined the Ballet Russe de Monte Carlo at age fourteen, the last of their "baby ballerinas." With the company she was noted for her performances in works by Leonid Massine, among them *Gaîté Parisienne,* in which she played the "Glove Seller," and *Le Beau Danube.*

After a season with The Robert Joffrey Ballet, she joined American Ballet Theatre in 1961, remaining with the company to this date. Her outstanding technique and stage presence have made her an audience favorite in pas de deux and in the classic roles, among them *Swan Lake, Giselle, La Fille Mal Gardée, Petrouchka,* and Balanchine's *Theme and Variations.* She has created roles in Dennis Nahat's *Momentum* and *Brahms Quintet* (both 1969), in Michael Smuin's *Schubertiade* (1971), and in Enrique Martinez' *Balladen Der Liebe* (1965). The section of Alvin Ailey's *The River* created for her extraordinary balance and sense of timing, "Giggling Rapids," was featured as the "impossible solo" that vanquished the elder ballerina in the film *A Turning Point.*

Da Pron, Louis, American film and television dance director; born February 3, 1913 in Herman, Indiana. Da Pron trained originally with his parents, vaudeville dancers who opened a studio in Denver, Colorado in 1921. His father had learned tap technique from famed dancer George Primrose; his mother taught ballet. With his mother, he attended summer teachers' courses in Chicago, where he studied tap with Arthur Kretlow, Tom Sheehy, and Billy Newsome.

Although he had had a brief career as a child drummer in vaudeville (from age five to eight), he was primarily a tap dancer and choreographer, inspired first by Primrose and Bill Robinson and later by Fred Astaire. In 1935, after teaching dance in Pittsburgh and Oklahoma City, Da Pron moved to Los Angeles to perform and choreograph.

After working as an assistant dance director for LeRoy Prinz at Paramount Pictures, he received his first solo choreographic credit—staging musical numbers for Ruby Keeler in *Sweethearts* (Columbia, 1940). He then moved to Universal Studio, where he worked as staff dance director from 1941 to 1947 (and freelance to 1953), specializing in staging numbers for Donald O'Connor.

In 1951, Da Pron moved to New York to work in the growing television industry, later returning to Los Angeles when taped shows began to be made there. He worked on many of the most popular hour-length variety shows on television, from the *Colgate Comedy Hour* hosted by O'Connor (NBC, 1951–1954) through the *Smothers Brothers Comedy Hour* (CBS, 1967–1968). Although Da Pron still choreographs individual specialties and acts, he currently concentrates on teaching and presenting lecture-demonstrations on the history of tap dancing.

Works Choreographed: FILM: *Sweetheart* (Columbia, 1940); *When Johnny Comes Marching Home* (Universal, 1942); *What's Cooking?* (Universal, 1942); *Get Hep to Love* (Universal, 1942); *Mr. Big* (Universal, 1943); *It Comes Up Love* (Universal, 1943); *Chip Off the Old Block* (Universal, 1944); *The Merry Monahans* (Universal, 1944); *Follow the Boys* (Universal, 1944); *Patrick the Great* (Universal, 1945); *That's the Spirit* (Universal, 1945); *On Stage Everybody* (Universal, 1945); *Something in the Wind* (Universal, 1947); *Are You With It?* (Universal, 1947); *Yes Sir, That's My Baby* (Universal, 1949); *Curtain Call at Cactus Creek* (Universal, 1953); *Walking My Baby Back Home* (Universal, 1953).

TELEVISION: *Colgate Comedy Hour* (NBC, 1951–1954); *Texaco Hour with Jimmy Durante* (NBC, 1954–1957); *Texaco Hour with Donald O'Connor* (NBC, 1954–1955); *The Perry Como Show* (NBC, 1955–1960); *The Julius LaRosa Show* (NBC, 1957); *Perry Presents* (NBC, 1959, summer replacement); *Milton Berle Starring in the Kraft Music Hall* (NBC, 1961); *Hollywood Palace* (ABC, 1964–1967); *Smothers Brothers Comedy Hour* (CBS, 1967–1968); *The Jerrry Lewis Show* (NBC, 1968–1969).

Dare, Danny, American film dance director; born c.1905. Although Dare was brought out to Hollywood to stage dances for *The Great Ziegfeld,*

MGM's biggest budget film and a tribute to Broadway's most elaborate producer, there is no evidence that Dare ever performed or choreographed on Broadway.

The success of that film, however, won him jobs as a studio dance director for Columbia for *Start Cheering* (1938), United Artists for *Lady of Burlesque* (1943), the film of a Gypsy Rose Lee novel, and RKO for the Danny Kaye vehicle *Up in Arms* (1944). Dare was best known, however, for his work at Paramount on musicals, among them *Holiday Inn* (1942) and *Star-Spangled Rhythm* (1942, ballets by Balanchine), and comedies, notably *The Road to Utopia* (1946).

Dare moved from musicals to straight dramatic and comedy assignments on staff at Paramount. An innovator in early television drama, he was blacklisted from the industry in 1953 for his participation in what seems to be his only live theater assignment, the Los Angeles political revue, *Meet the People* (1940).

Works Choreographed: THEATER WORK: *Meet the People* (1940, Hollywood Theater Alliance).

FILM: *The Great Ziegfeld* (MGM, 1936); *Three Cheers for Love* (Paramount, 1936); *Start Cheering* (Columbia, 1938); *Holiday Inn* (Paramount, 1942); *Star-Spangled Rhythm* (Paramount, 1942, ballet sequences by George Balanchine); *Lady of Burlesque* (UA, 1943); *And the Angels Sing* (Paramount, 1944); *Up in Arms* (RKO, 1944); *Here Come the Waves* (Paramount, 1945); *The Road to Utopia* (Paramount, 1946).

Darius, Adam, American mime and dancer working in Europe; born Harvey Krepets, May 10, c.1930 in New York City. Darius received dance training from Lisan Kay at the Ballet Arts Studio, from Pierre Vladimiroff at the School of American Ballet, and at the New Dance Group studio. While performing in Europe later in his career, he continued his training under Olga Preobrajenska. He does not have formal training in mime. Although he has spent some time on American unemployment, Darius has made most of his career in Europe. His first performance jobs were there, in ballet companies in the Netherlands, Sweden (Mälmo Staadteater), the International Ballet in London, the Cologne Opera, and the Royal Winnipeg Ballet.

Although he is basically a concert dancer, creating works for himself, he has choreographed for ballet and theater companies in Europe. Tremendously popular in many areas of Western Europe and in London, his work has become widely known through European television release.

Works Choreographed: CONCERT WORKS: *Antigone* (1948); *Robin Goodfellow* (1950); *Cortege* (1952); *Quartet* (c.1956); *La Boutique Fantasque* (c.1956); *Dr. Libido* (c.1956); *The Crystal Gazer* (c.1959); *The Anne Frank Ballet* (c.1959); *Jack-in-the-Box* (c.1960); *The Day the Circus Closed* (1960); *A Midsummer Night's Dream* (1961); *The Intriguer* (1961); *Girl in Paradise* (1961); *The Earth Has Patterns* (1961); *The Net* (1968); *Narcolepsy* (1961); *Death of a Scarecrow* (1969); *Vulture Umbilical* (1969); *Marylin* (1975).

TELEVISION: *Pierrot, the Wanderer* (CBS Television, 1955).

Bibliography: Darius, Adam. *Dance Naked in the Sun* (London: 1973).

Darling, May, American theatrical dancer; born May Hansen, c.1888 in Chicago, Illinois; died there March 23, 1971. Darling was a neighbor and friend of William and Florenz Ziegfeld, Jr. and Ned Wayburn (all of whom were from the Chicago area) and was trained, like them, at the Hart Conway School and the Chicago Musical College. She performed in productions by William Ziegfeld at the La Salle Theatre in Chicago and in his brother's earliest *Follies* in New York. She also had an interpretive dance act in New York, at the Hammerstein roof garden theaters, and in Chicago, and was considered one of the finest presenters of the "Spring Song" in its period of greatest popularity.

Darrell, Peter, English ballet dancer and choreographer; born September 19, 1929 in Richmond, Surrey. Trained at the school of the Sadler's Wells Ballet and by Nora Kiss, he joined the Sadler's Wells in the mid-1940s. In his ten years with that company, he created a featured role in Frederick Ashton's *Valses Nobles et Sentimentales* (1947) and danced in his *Façade*, Mikhail Fokine's *Carnaval*, and Ninette De Valois's *The Gods Go A-Begging*.

In 1957 he founded the Western Theatre Ballet with Elizabeth West, becoming director after her

death in a mountaineering accident. He choreographed extensively for that company, creating the popular *Mods and Rockers* (1963) and *Mayerling* (1963) for it. Director of the Scottish Ballet from 1969 to 1979, he staged *Herodias* (1970) and the *Tales of Hoffman* (1973), which was later revived for the American Ballet Theatre. The Scottish company has also commissioned versions of the nineteenth-century classics from him in its attempt to become the Royal Ballet of the North.

Works Choreographed: CONCERT WORKS: *Midsummer Watch* (1951); *Les Chimères* (1953); *Trio* (1953); *Fountain* (1954); *Celeste and Celesthina* (c.1954); *Magic* (1954); *Balleto da Camera* (1955); *The Gift* (1955); *The Prisoners* (1957); *The Enchanted Garden* (1958); *Chiaroscuro* (1959); *Quatre (s) Quartieres* (1959); *Sound Barrier* (c.1960); *Bal de la Victoire* (1960); *Salade* (1961); *Ode* (1961); *Non-Stop* (1962); *A Wedding Present* (1962); *The Unicorn, the Gorgon and the Manticore* (1962); *Jeux* (1963); *Mods and Rockers* (1963); *Mayerling* (1963); *Elegy* (1963–1964); *Lysistrata* (1964); *Home* (1965); *Sun into Darkness* (1966); *Lessons in Love* (1966); *Francesca* (1967); *Ephemeron* (1968); *Beauty and the Beast* (1969); *Herodias* (1970); *Giselle* (1971, after Jean Coralli and Jules Perrot); *The Nutcracker* (1972, Act II only); *Variations for a Door and a Sigh* (1972); *Othello* (1972); *The Nutcracker* (1973); *Tales of Hoffman* (1973); *La Péri* (1973); *Giselle* (1973, co-choreographed with Joyce Graeme after Coralli and Perrot); *Asparas* (1974); *The Scarlet Pastorale* (1974); *Mary, Queen of Scots* (1976); *Swan Lake* (1977, after Lev Ivanov and Marius Petipa); *Five Rocket Songs* (1978); *Cinderella* (1979); *Tristan and Iseult* (1979).

TELEVISION: *Houseparty* (BBC, 1963); *Cool for Cats* (BBC, c.1964); *A Man Like Orpheus* (BBC, 1965); *An Engagement Party* (Granada TV, c.1974).

Darsonval, Lycette, French ballet dancer; born Lycette Perron (or Perrault) on February 12, 1912 in Countances, France. Darsonval, the sister of Serge Perrault, was trained at the school of the Paris Opéra Ballet with Albert Aveline and Carlotta Zambelli.

In the Paris Opéra after 1930, she created roles in Serge Lifar's *Joan de Zarissa* (1942), *Chavallier Errant* (1950), *Phèdre* (1950), and *Suite en Blanc* (1942), in Aveline's *Elvire* (1937), and in George Bal-

anchine's *Palais de Christal* (1947). She was also featured in the title roles of *Giselle, Salome,* and *Sylvia.*

Her small troupe, La Compagnie Lycette Darsonval de l'Opéra de Paris, has toured extensively since the early 1950s.

Works Choreographed: CONCERT WORKS: *Le Nuit Venitienne* (1949); *Combat* (c.1953); *Sylvia* (1979).

Darvas, Julia, dit, Hungarian exhibition ballroom dancer and vocalist working in France and the United States; born Julia Susslar, c.1919 in Budapest, Hungary. As was proved in a complex legal battle, she was never actually Julia Darvas, but she continued to use that name professionally throughout her career. She emigrated to Istanbul as a child and became known as an actress in Turkish films, as "The Turkish Shirley Temple." In 1946, after sitting out the war in Istanbul, she teamed up with Nicholas Darvas to form an exhibition ballroom act. Although she performed as his half-sister in order to facilitate visas and create publicity, there is no evidence that they were related. They brought their extraordinary acrobatic dance act to Paris in 1947 and to New York's Latin Quarter in 1951. For ten years, they commuted across the Atlantic, presenting popular seasons of their dances in clubs across Europe.

In 1960, after Nicholas Darvas had published three how-to-beat-the-market books, Susslar revealed that she had been married for a year to someone else, and wished to move to Paris to work as a vocalist there. She also revealed that Darvas' stock-market successes had been made with their money and that she had not been paid for eighteen years. The court case, perhaps the first "palimony" suit, kept them in the headlines for months. She won and dropped out of dance to sing in clubs in New York and France for many successful seasons.

Darvas, Nicholas, Hungarian-Turkish exhibition dancer working in France and the United States; born c.1915 in Budapest, Hungary; died June 3, 1972 in Paris. Raised in Istanbul, he and fellow Hungarian refugee, Julia Susslar, teamed up into an acrobatic ballet and exhibition ballroom act. They made their joint debut in Istanbul and performed frequently in Paris after the end of World War II. Their American debut (and most of their bookings here) was at the Latin Quarter, the celebrated club that maintained

the traditions of dance teams and show girls until the mid-1960s. Darvas' act, which was reportedly staged by Julia Susslar, can best be compared to exhibition disco dancing, although it was performed to waltzes and fairly old-fashioned 1940s jazz. It involved tosses, split landings, whirlwind turns, and the spins into folds that are currently seen on *Dance Fever* (Syndicated, 1978–).

However the Darvas act was viewed, the partners' personal lives fascinated both New Yorkers and Parisians. Darvas fancied himself a stock manipulator and published three books on making it in the market. His complex legal problems with Attorney General Louis Lefkowitz are still interesting examples of the legal system as used for publicity purposes. Whether or not the books were useless, as Lefkowitz claimed, they sold well, and Darvas retired in the early 1960s.

D'Auban, John, English ballet dancer and pantomime choreographer; born c.1842 in London; died there on April 15, 1922. The D'Auban family, for almost a century, represented the best and most innovative in pantomime staging. The three children of Mme. D'Auban (1820–1867)—John, Emma (1845–1910), and Marietta (1846–1906)—were all involved in pantomime staging and production in England.

John D'Auban's first choreographic credit was a season of productions at the Alhambra Theatre in London (1865). In the next year, he switched to the Gaity Theatre, where he staged the dances for the first Gilbert and Sullivan collaboration, *Thespis, or New Gods for Old* (1868), and other shows. From 1880 to 1884 he choreographed the Christmas pantomimes at the Drury Lane Theatre, replacing a John Cormick (d.1890) who staged over a hundred shows in twenty-five years without leaving a trace of biographical information. D'Auban's best known shows for the Drury Lane were choreographed for Emma Palladino and his sisters; in his first, *La Fille de Mme. Angot*, he claimed to have invented skirt dancing in a routine for Marietta, later teaching the dance to Kate Vaughan.

Freelancing from 1884 to 1898, he worked at, among other theaters, the Opéra Comique, the Princess, the Strand, the Olympic, the Marylebone, and the Elephant; according to one source, he also staged

shows for the Théâtre de la Porte-Saint-Martin in Paris and the Alhambra Nationale in Brussels. Returning to the Drury Lane, he began a sequence of twenty-seven annual pantomimes for the Christmas season, staged alone, with his son, Ernest (1874–1941), and with Carlo Coppi, a fellow Alhambra dance director. Among the pantomimes, each based on a fairy tale overlaid with harlequinade traditions, were *Babes in the Wood* (1897), one of the best remembered, *The Sleeping Beauty and the Beast* (1900), *Ben Hur* (1903), *The White Cat* (1904), *Sinbad* (1906), and *The Sleeping Beauty* (1914).

Works Choreographed: THEATER WORKS: (Note: Christmas pantomimes traditionally open during the last week of the year, so the 1898 panto, for example, would be dated 1897.) *Thespis, or New Gods for Old* (1868); *La Fille de Mme. Angot* (1880); *The World* (1880); *Robinson Crusoe* (1880, children's dances by Katti Lanner); *Mother Goose* (1881); *Iolanthe* (1882); *Babes in the Wood* (1897, co-choreographed with Carlo Coppi); *The Forty Thieves* (1898, co-choreographed with Ernest D'Auban); *Jack and the Beanstalk* (1899, co-choreographed with Coppi and D'Auban); *The Sleeping Beauty and the Beast* (1900, with E. D'Auban); *Blue Beard* (1901, with E. D'Auban); *Ben Hur* (1902); *Humpty-Dumpty* (1903, with E. D'Auban); *The White Cat* (1904, additional dance numbers by John Tiller); *Cinderella* (1905, co-choreographed with E. D'Auban); *Sinbad* (1906, with E. D'Auban); *Babes in the Wood* (1907); *Hop O'My Thumb* (1911); *Sleeping Beauty* (1912).

D'Auberval, Jean, French eighteenth-century ballet dancer and choreographer; born Jean Bercher, August 19, 1742 in Tours, France; died February 14, 1806 in Tours, France. The son of Comédie-Française actor Étienne-Dominique Bercher, *dit* D'Auberval, the famed choreographer and teacher began his own training at the school of the Paris Opéra. After making his debut at the Opéra in 1761, he left to join the company that Jean-Georges Noverre formed in Stuttgart, Germany (c.1762–1764), also performing with Noverre in London. Unlike his mentor, however, D'Auberval was able to maintain professional ties with the Paris Opéra, performing there as a *danseur demi-charactère* and *noble* and as Maitre de Ballet with Pierre Gardel from 1773 to 1779 and from 1781 to 1783.

D'Auberval's greatest periods of creativity occurred after he left the Opéra—as ballet master of La Grand Théâtre in Bordeaux (1785-1791) and at the King's Theatre (1783-1785) and Pantheon (1791-1793) in London. Ballets choreographed in Bordeaux include *Le Ballet National* (1790), *Amphion et Thalie* (1791), and his best known work, *La Fille Mal Gardée* (1789), generally considered the oldest in the standard repertory. No matter how little current versions of this ballet resemble D'Auberval's, its status as the first extant *ballet d'action* will perpetuate its importance. His works for the London theaters, also in the *ballet d'action* style, were created for companies that included his wife, Mlle. Théodore, Gaetan Vestris, and Charles Le Picq, who brought the innovations of Noverre and D'Auberval to St. Petersburg in the 1790s. Among these works are *Pygmalion* (1784), *Télémachus dans l'Ile de Calypse* (1791), and *The Four Ages of Man* (1784), considered one of the earliest attempts to use characterization gestures to unify the ballet and social-dance movement vocabularies.

Although frequently considered important primarily as a transmitter of Noverre's innovations, D'Auberval was an important choreographer in his own right, and taught many members of the next generation of European dance experimentors, among them Le Picq, Charles-Louis Didelot, and Jean Aumer.

Works Choreographed: CONCERT WORKS: *The Pasttimes of Terpsichore* (1783); *Friendship Leads to Love* (1783); *Le Réveil du Bonheur* (1784); *Le Cocq du Village, ou la Lotterie Ingénieuse* (1784); *Orpheo* (1784); *Le Magnifique* (1784); *The Four Ages of Man* (1784); *Pygmalion* (1784); *Le Déseurteur, ou la Clémence royale* (1784); *Amphion, élève des Muses* (1789); *La Fille Mal Gardée* (1789); *Le Ballet National* (1790); *Sylvie* (1790); *Le Minuet du Volage* (may also be titled *Le Volage Fixé*) (1790); *La Foire de Smirne, ou les Amans réunis* (1790); *Télémachus dans l'Ile de Calypse* (1791); *Le Triomphe de la Folie* (1791); *Le Siège de Cythère* (1791); *La Fontaine d'Amour* (1791); *L'Amant Déguisé* (1791).

Daunt, Yvonne, English ballet and interpretive dancer also working in Paris; born c.1900 in England. Daunt was trained at the school of the Paris Opéra and performed with the company in opera divertissements in *Aida, Antar*, and *Aphrodite* there. She also had a successful career as an interpretive dancer in private recitals in Paris and London where she presented political and idealistic themes in dance. It is unfortunate that so little is known about Daunt's works. From the 1920s on, Daunt concentrated on her acting career, which led to a short period in films.

Works Choreographed: CONCERT WORKS: *Poland in Chains* (1921); *Poland Free* (1921); *Mennuet* (1921).

Davies, Marion, American theatrical dancer and comedienne; born January 3, 1897 in Brooklyn, New York; died September 22, 1961 in Beverly Hills, California. Although best known as a silent film comic and as the hostess of San Simeon, Davies was a noted Broadway dancer during the 1910s.

After making her debut in the Montgomery and Stone production of *Chin-Chin* in 1914, she was featured in four musicals, notably among them, the Princess Theater presentation, *Oh, Boy!*, and in four revues, including the *Ziegfeld Follies of 1916*, the Shakespeare and Ballet Russe edition, the elaborate *Miss 1917, Words and Music* (1919), in which she imitated Gaby Deslys, and *The Ed Wynn Carnival* (1920). Known for her imitations and stylized ballroom dances, she was too short to be a show girl as she is frequently and inaccurately described. Her most celebrated appearance, however, was in a petite version of a show-girl-style musical number—she was "Spring" in the original staging of Irving Berlin's "The Girl I Love Is on a Magazine Cover," in *Stop! Look! Listen!* (1915).

Davies, Siobhan, English modern dancer and choreographer; born September 18, 1950 in London. Trained at the London School of Contemporary Dance, she has been a member of the Contemporary Dance Theatre since its inception in 1967. She has performed in her own works, among them, *The Calm, Pilot*, and *The Sphinx*, those by Robert Cohan, including his *Eclipse* and *Stages*, and in works by Richard Alston, such as his *Behind the Piano* (1979).

Moving to New York in 1975 to study with Merce Cunningham, Davies has choreographed for com-

panies there and in London. Originally an artist, she is one of the few postmodernists working outside of New York; and she has taught both dance and composition extensively in England and Paris.

Works Choreographed: CONCERT WORKS: *Relay* (1972); *The Calm* (1974); *Celebration* (c.1974); *The Pilot* (1974); *Diary* (1975); *Night Watch* (1976, co-choreographed with Robert Cohan and Robert North); *The Sphinx* (1978); *Step at a Time* (1978); *Then You Can Only Sing* (1978); *Doublework* (1978).

Davis, Chuck, American modern dancer and choreographer; born January 1, 1937 in Raleigh, North Carolina. Davis became involved with dance for the first time while serving in the Navy and worked in nightclubs in the Washington, D.C., Bethesda, Maryland areas. After his Navy years, he attended Howard University where he became a protégé of poet and critic Owen Dodson, considered the spiritual father of the drama department there and of most conventional black theater in this country. He has performed with the dance troupes accompanying percussionist Olatunji and vocalist Mirium Makeba and with the concert groups of Eleo Pomare, Raymond Sawyer, Bernice Johnson and Joan Miller, appearing most notably in the latter's *Robot Game.*

Davis has choreographed many original pieces for his own company but is equally well known for his work in the staging of portions of rituals and dances from many areas of Africa for them. He has become an extremely popular teacher of studio and master classes for universities, artists-in-school programs, Brooklyn's John F. Kennedy Center, and sessions sponsored by the Black Theatre Alliance. His company has been sent to Europe frequently for performances in Yugoslavia, Italy, Greece, and Norway and is currently in residence at the American Dance Festival.

Davis, Robert, American ballet dancer; born March 13, 1934 in Durham, North Carolina. Davis was trained at the Washington School of Ballet under Lisa Gardinier, and at the American Ballet Theatre in New York City. He performed with a number of companies in the United States, among them, the Washington Ballet (which he later served as associate artistic director), the City Center Joffrey Ballet, and the Metropolitan Opera Ballet where he was rehearsal assistant to director Alicia Markova. In the latter company, he was unique in his ability to switch from classical ballet, most notably in the Markova production of *Les Sylphides*, to the effusive acting necessary for opera performance and atmosphere.

Davis, Sammy, Jr., American theatrical dancer and actor; born December 8, 1925 in New York City. Davis made his professional debut in his parent's vaudeville act in Columbus, Ohio in 1928. By 1930, he was a member of the Will Mastin Trio with his uncle and father, performing for fifteen years in vaudeville. In the Army Special Services unit, he began to choreograph shows.

Davis' performance in *Mr. Wonderful* (1956) was his breakthrough into the conventional forms of entertainment; it led to film work and to the cabaret bookings that now constitute most of his career. He danced in surprisingly few of his films; his slinking performance as "Sportin' Life" in the film of *Porgy and Bess* (Columbia, 1959), a similar rendition of the "Moritat" in *The Threepenny Opera* (Embassy, 1964), and his danced patter sermon on the "Rhythm of Life" in Bob Fosse's *Sweet Charity* (Universal, 1969) represent his only dance routines on commercial film. Apart from variety specials and his own *Sammy and Company* (NBC, 1975-1977) and *The Sammy Davis, Jr. Show* (NBC, 1966), his television appearances too have been primarily dramatic.

It is in nightclub work that Davis still reveals his extraordinary tap control. Since the integrating of the cabaret industry in the late 1950s, Davis has become one of the most popular performers in Las Vegas, Reno, Atlantic City, Hollywood, and New York clubs.

Dawson, Nancy, English eighteenth-century theatrical dancer; born c.1735 in London; died June 9, 1767 in London. Trained as a dancer while working in a traveling puppet troupe, Dawson joined the company attached to the Sadler's Wells Theatre in London, c.1755, as a specialty dancer and as a "Columbine" in their harlequinades. In 1757, she made her debut at Covent Garden, then also a pantomime and harlequinade theater. For the next three seasons at Covent Garden, Dawson became famous in one spe-

cialty—the hornpipe—performed in many of their productions.

Although it is not known precisely when Dawson first performed the dance, she first received specialty billing for it on May 22, 1758. In October 1759 she interpolated her hornpipe into the company's production of *The Beggar's Opera* and became permanently associated with the dance. The show ran for many seasons to the horror of rival producer David Garrick, who complained bitterly, according to a contemporary version of *The Ballad of Nancy Dawson:*

> *See how the Op'ra takes a run,*
> *Exceeding Hamlet, Lear and Lun,*
> *Though in it there would be no fun,*
> *Was not for Nancy Dawson.*

> *See Little Davy Strut and Puff,*
> *'P—on the Op'ra and such stuff.*
> *My house is never full enough,*
> *A curse on Nancy Dawson.*

In 1760, Garrick found a more efficient weapon than the curse, and hired Dawson away from Covent Garden. She performed at his Drury Lane Theatre for three seasons, in his production of *The Beggar's Opera* and the masque in his presentation of *Cymbeline* (1761).

Probably the best known performer of the period, Dawson made her reputation on this one specialty dance. It is not known whether she was capable of any other dance styles.

Bibliography: Cohen, Selma Jeanne, ed. "The Ballad of Nancy Dawson," *Dance Perspectives 26* (1966).

Day, Edith, American theatrical dancer and actress also working in London; born April 10, 1896 in Minneapolis, Minnesota; died May 2, 1971 in London. Day joined the national tour of *Dancing Around* in 1915 and returned to New York with it to become a popular musical comedy soubrette. Her roles in *Pom-Pom* (1916), *Follow Me* (1916), and *Going Up* (1917), brought her the best ingenue role of the early 1920s—the title role in *Irene* (1920). Day's charm, pleasant voice, and delicate ballroom dancing

brought her fame in that role but, apart from the popular *Wildflowers* (1923), in which she was partnered by Tyler Brooke, she could not reach major success in the United States. In London, however, she became a star, known as "The Queen of Drury Lane," for her principal roles in the four most popular American operettas presented there—*Rose Marie* (1925), *The Desert Song* (1927), *Show Boat* (1928), and *Rio Rita* (1930)—with revivals and tours of each.

Day retired in the 1930s, but returned to the stage during World War II as an ENSA volunteer and in the early 1960s, as a principal in Noel Coward's musical *Sail Away* (1962).

Day, Ernestine, American modern and concert dancer; Day is one of the "lost generation" of American dancers for whom biographies cannot be verified. She joined the Denishawn concert group that toured with Ted Shawn in 1923, presumably after studies at the Los Angeles Denishawn school. Although she appeared in an occasional work by Ruth St. Denis, most notably her group works *The Spirit of the Sea* (1924) and *In a Bunnia Bazaar* and *The Lamp* (both 1928), she spent most of her Denishawn tenure touring with Shawn and performing in his *Gringo Tango* (1924), *Bubble Dance* (1925), *General Wu's Farewell to His Wife* (1926, on the Orient tour), *Choeur Danse* (1926), *Mexican Hat Dance* (1928), *Jurgen* (1929), *Homage à Rameau* (1930), and *Bavarian Holiday* (1930), among many others. She also danced for Doris Humphrey in her early *Whims* (1926) and created her own *Drum Dance* for a program in 1930.

Although no credits can be verified for Day from 1931 to 1936, it is likely that she taught or otherwise kept in touch with her modern and concert dance colleagues since she joined the Ballet Intime in 1938, a concert dance group formed by Fé Alf, Letitia Ide, Eleanor King, and George Bockman. She also performed with the cabaret group formed by fellow Shawn dancer Jack Cole with which most of her Intime colleagues also worked.

Day, Mary, American ballet dancer and teacher; born in the first decade of the century in Washington, D.C. Associated throughout her professional life with the development of classical ballet compa-

nies and schools in the District of Columbia, Day was trained by Lisa Gardinier, a future colleague in her endeavors. She performed in Gardinier's Washington National Ballet (c.1937–1939) and her Ballet (c.1942), and co-founded the Washington School of Ballet with her in 1944. Their Washington Ballet, still thriving in the District, was founded in 1956. Day serves as director of the school and artistic director of the company.

Works Choreographed: CONCERT WORKS: *Pas de Quatorze* (aka *Hi-Spri*) (1957); *Modern Madrigal* (1957); *Schubertiana* (1958); *Ondine* (1959).

Daydé, Bernard, French theatrical designer; born February 3, 1921 in Paris. Daydé began his prolific career designing for dance productions in 1947 with his duets for *Romeo and Juliet* and *Les Sylphides* for the Metropolitan Ballet, London. He also worked extensively in Paris and London, frequently doing four or five productions for each choreographer. Some of his most successful and arresting designs were created for Maurice Béjart's *L'Etranger* (1957) and *Pulcinella* (1957), Janine Charrat's *Les Liens* (1957) and *Rencontres* (1966), Flemming Flindt's *La Leçon* (1964), with its horrifyingly stylized barre, and *The Three Musketeers* (1966), Harald Lander's *Etudes* (1956 production) and *Qarrtsiluni* (1960), and Joseph Lazzini's *La Valse* (1959) and *Prodigal Son* (1965).

Daydé, Liane, French ballet dancer; born February 27, 1932 in Paris. Trained at the school of the Paris Opéra, she actually made her professional debut at the age of ten as a "Golliwog" cake-walking in Albert Aveline's *Jeux d'Enfants*. She became an official member of the company in her midadolescence with her first major role in Aveline's *Elvire* in 1948. She performed the principal roles in the company productions of the standard repertory in versions by Aveline or by Serge Lifar. Among her many roles in Lifar's own repertory were parts in *Snow White* (1951), *Fourberries* (1952), *Le Chevalier et la Demoiselle*, and *Romeo and Juliet* (1955).

After leaving the Opéra at the end of the 1950s, she became a member of the Grand Ballet du Marquis de Cuevas for the rest of its lifetime and served as prima ballerina of the Grand Ballet Classique de France. She has guested frequently in European companies, where she is associated with the works of Heinz Rosen, and in the United States, where she made her debut in the Barstows' *Motorama of 1955*.

Dayger, John, American modern dancer; born September 9, 1948 in Bridgeton, New Jersey. Although he studied tap as a child, Dayger considers his social juke-box dancing more important to his current profession. He took his first modern dance class in the women's physical educational program at the State University of New Paltz and took a June course at the Martha Graham school in New York City. At twenty, he dropped out of college to accept a scholarship from the Graham school. Dayger has performed with a wide variety of companies and concert groups since the early 1970s, among them Lotte Gosslar's Pantomime Circus, Phoebe Neville's group, and June Lewis' company. He has appeared in Elina Mooney's *Quickening* and Cliff Keuter's *Of Us Two* and *Catulli Carmina*. Dayger is best known currently for his work with the Lar Lubovitch troupe, in which he has danced in *Whirligigs* (1971), *Social* (1971), *Cavalcade* (1980), and most of the current repertory.

Dazie, Mlle., American theatrical dancer; born Daisy Peterkin, September 16, 1884 in St. Louis; died August 12, 1952 in Miami Beach, Florida. Raised in Detroit, where her parents managed candy franchises for vaudeville theaters, Dazie studied ballet and Delsarte elocution with a Mlle. Bianchi there. She made her debut as a child in vaudeville at the Wonderland Theater, Detroit.

Dazie's first New York performance, in *Buster Brown* (1905), led to a solo engagement in Paris. When she returned a few months later, it was as "La Domino Rouge," a mysterious Russian dancer who spoke no English and performed with her face covered in a red mask. She worked masked for two years at casinos and roof theaters managed by Oscar Hammerstein, revealing her identity only to accept an engagement as prima ballerina at Hammerstein's Manhattan Opera House. Although best known as a vaudeville dance specialist, she performed as a solo or ballroom dancer in many Broadway revues, operettas, and musical comedies, among them the *Follies* of 1907 and 1908, *La Belle Paree* (1911), *Maid in America* (1915, ballet staged by Theodore Kosloff),

and *Aphrodite* (1919), with dances by Fokine. On Broadway, she was known for her innovative exhibition ballroom work, such as the "Ju-Jitsu Waltz" from the 1907 *Follies*, and character ballet roles in operetta. In vaudeville, she directed and performed in pantomimes, among them *L'Amour d'Artiste* (1909), *Pantalon* (1914), and *The Garden of Punchinello* (1916), all on the Keith circuit. Later, she performed a flash ballet specialty act, commemorated for its length—twenty-one minutes.

During the 1920s, Mme. Dazie (as she was then billed) starred in film serials, among them *The Black Panther's Cub* (Cosmopolitan Pictures/Ziegfeld Cinema Corp., 1921).

Dean, Dora, American theatrical dancer; born Dora Babbige, c.1872 in Covington, Kentucky; died January 1950 in Minneapolis, Minnesota. It is unlikely that Dean had formal training in dance before she made her first hit in *The Creole Show* (1889, Boston, also played New York). The dance that she performed in that show, a theatricalized exhibition cakewalk, made her reputation and won her engagements at vaudeville theaters and roof gardens in New York and the Northeast. The duo that she set up with Charles Johnson became the first black vaudeville team to be booked as a "class act," a financial and aesthetic determination that they shared with, among others, Anna Pavlova and her various partners. They worked together in an outstandingly popular engagement at the Madison Square Garden roof theater in 1895 but spent most of their joint careers touring Europe where they were extremely successful.

Dean returned to the United States in 1914, after the breakup of the Dean and Johnson team and marriage. For at least four years, she had a successful feature on the vaudeville circuits (both black and TOBA), among them *Dora Dean and Co.,* and *Dora Dean and Her Phantoms.* The latter included both black soloists and a "pick" chorus, and white child performers, (Seymour) Felix and (Amalia) Caire. Although she and Johnson had a "reunion" booking at Connie's Inn in 1936, she had effectively retired in the 1920s.

Dean's popularity can be attributed to many factors. One was, of course, her performing abilities—she could do a cake-walk that, because of dance technique or stage presence, was considered extraordinarily graceful and flashy. Her use of the signature song, "Have You Seen Miss Dora Dean . . ." also helped widen her public recognition as "the prettiest girl you've ever seen."

Dean, Laura, American postmodern dancer and choreographer; born December 3, 1945 on Staten Island, New York. She studied with Lucas Hoving at the Third Street Settlement in New York, took ballet classes with Muriel Stuart at the School of American Ballet, and attended the High School of Performing Arts.

It was the perfect background to become either a traditional concert dancer or a maverick, and in some ways, she accomplished both goals. Her work is personal in a way that reminds one of the concert recitalists of the 1930s, but uses the structures of the postmodern era. Dean bases her dances on a movement—walk, turn, spin—and repeats it. The element becomes a pattern which has a structure, but also begins to have an obsessive life of its own. Depending on the audience, her works are either wildly popular or abandoned by a shocked crowd.

There are few external elements in her work; she uses a noncostume of trousers and loose shirts, usually white. Her scores were frequently by composer Steve Reich, also a minimalist, but she now composes her own music. All of her works have been created for her company, except the last of this list, *Night*, which was commissioned and performed by the City Center Joffrey Ballet.

Works Choreographed: CONCERT WORKS: *Stamping Dance* (1971); *Circle Dance* (1972); *Square Dance* (1972); *Walking Dance* (1972); *Jumping Dance* (1973); *Changing Pattern Steady Pulse* (1973); *Response Dance* (1974); *Spinning Dance* (1974); *Changing* (1974); *Drumming* (1975); *Song* (1976); *Dance* (1976); *Spiral* (1977); *Music* (1979); *Tympani* (1980); *Night* (1980).

Deane, Derek, English ballet dancer; born in the 1950s in Devon. Deane began his training at the age of sixteen in Devon, but soon became adept enough to study at the Royal Ballet School in London. He joined the Royal Ballet in 1972 and has been cast in most of its repertory. His roles have ranged from the

nineteenth-century heroes, "Siegfried," "Florimund," and "Albrecht," to the principal parts in Kenneth Macmillan's full-length works, such as *Romeo and Juliet, Mayerling*, and *Manon Lescaut*. His abstractions range from George Balanchine's romantic *Serenade* to Tchaikovsky, to Macmillan's *Elite Syncopations* set to Scott Joplin rags.

Deane, Michael, American modern dancer; born November 4, 1950 in New York City. Deane was trained at the University of Colorado and by Larry Boyete and Dan Wagoner. A member of the Repertory Dance Theater of Utah in 1974, he appeared in the company revival of José Limón's *There Is a Time* and in works by his colleagues, including Lynn Wimmer's *From a Branch Nothing Cried From* and Ruth June Post's *Filligree in Five Parts*. After working with the Paul Taylor company, most notably in his *Church Yard* and *American Genesis,* he joined the Pauline Koner Dance Consort, creating roles in her *Mosaic* (1977) and *Poème*.

De Angelo, Ana Marie, American ballet dancer; born 1955 in the San Francisco area. De Angelo was trained in San Francisco and at the American Ballet Center. As a member of the City Center Joffrey Ballet, she has performed in many works by Joffrey himself, by Gerald Arpino, including his *Viva Vivaldi!* and *l'Air d'Esprit,* and in the company's revivals of works by Frederick Ashton. Her sparkling style and bravura technique have also made her a popular guest ballerina with full companies and with any of the "all-star" troupes that tour on off seasons, such as the Stars of the American Ballet and the Stars of the World Ballet, as well as the summer pick-up tribute to Anna Pavlova, called the Pendleton Festival Ballet of 1980. As well as taking Pavlova's parts in the reconstructions and revivals of the great ballerina's repertory, she choreographed a ballet herself in tribute.

Works Choreographed: CONCERT WORKS: *Le Papillon* (1980).

De Basil, Vassili, Russian tour manager and impresario; born Vasili Grigorievich Voskressensky, 1888 in Kaunas; died July 27, 1951 in Paris. De Basil, who used the title "Colonel," left Russia after the revolu-

tion, moving to Paris as a member of the staff of the Zeretelli Russian Opera Company in 1925. After working in Paris-based concert bureaus, he went to Monte Carlo in 1931 where he persuaded René Blum to accept him as co-director of the Ballet Russes de Monte Carlo, with Leonid Massine as their artistic director. After Blum left to form a rival company in 1936, and Massine joined him in 1938, De Basil was in artistic control of his Ballet Russes company, now named the Original Ballet Russe. It lasted until the 1947–1948 season, performing primarily in Western Europe.

De Beaumont, Etienne, French designer and arts patron; born March 8, 1883; died 1956. De Beaumont both produced and designed for the Soirées de Paris at the Théâtre de la Place Cigale in 1924. Associated throughout his theater career with Leonid Massine, he designed costumes for *Le Beau Danube* (1924, new sets and costumes in 1939 revival), costumes and sets for *Scuolo di Ballo* (1933), co-designed *Nobilissima Visione* with Pavel Tchelitchev (1938), and designed and wrote the libretto for *Gaité Parisienne* (1938). De Beaumont also designed two ballets for David Lichine—*Nocturne* (1933) and *Les Imaginaires* (1934).

De Bolt, James, American ballet dancer; born c.1940 in Seattle, Washington. De Bolt was trained at the Cornish School in Seattle by Mary Ann Wells and Marian Landre. After attending the University of Utah, where the dance department was headed by Willam Christensen, he joined the company of a former Wells student, Robert Joffrey. De Bolt appeared in his *Umpateedle* and Gerald Arpino's *Partia for Four* in the 1959 season and danced in Joffrey's interpolated numbers in productions of the New York City Opera later that season. In his four years with the New York City Ballet, he appeared in almost all of the large repertory of works by George Balanchine and Jerome Robbins. Following a season with the short-lived Manhattan Festival Ballet in which he danced in John Taras' *Designs with Strings* and Anton Dolin's *Pas de Deux for Four* (1966), he rejoined Joffrey in his new company based at City Center.

In the early 1970s, De Bolt brought his long experi-

ence with new and established companies to his work as principal dancer and ballet master of Den Norske Opera, then in the process of reorganization.

Debussy, Claude, French composer; born August 22, 1862 in St. Germain-en-Laye; died March 25, 1918 in Paris. Trained at the Paris Conservatoire, he was one of the most important and influential exponents of musical impressionism. Although many of the musical works that were commissioned for dance projects were never choreographed, those that were have become important elements in the international repertory. His first performed commissioned work was *Le Martyre de Saint-Sébastien* (1911) for Ida Rubinstein (choreographed by Mikhail Fokine), followed quickly by *Khamma* (1912) for its librettist Maud Allan, and *Jeux* (1913) for Vaslav Nijinsky and the Diaghilev Ballet Russe. Another score, *La Boite à Joujoux* (1913), was commissioned by the Théâtre Lyrique de Paris and performed there in 1919. It is not certain whether his piano arrangements of music from *Swan Lake* were commissioned by Diaghilev or Rubinstein; they were published without attribution.

Debussy's music has been choreographed by almost every dancer in the twentieth century, from Charles Weidman and Ted Shawn to La Meri, from Loie Fuller to James Waring, from John Cranko to Jiri Kylian. His most popular score to choreographers is unquestionably the *Prélude á l'après-midi d'un Faune,* which was set by Nijinsky (1912) and Jerome Robbins (1953), in its most important versions, and by many other dancers.

De Cahusac, Louis, French eighteenth-century librettist and historian, born c.1700 in Monauban; died 1759 in Paris. De Cahusac was commissioned to write the verse librettos for operas/ballets produced at the Académie Royale de Musique (the precursor of the Paris Opéra) and at the court theaters at Fontainbleu, Versailles, and the Théâtre Royal de Choisiel-Roi. Since the operas/ballets that were then choreographed used spoken and sung words within the dance sequences, his importance was magnified as a collaborative creator of works. Those extant titles for which choreographers are known included libretti for Jean-Baptiste François Deshayes, Antoine Laval and Laval in conjunction with his son, Michel Laval.

These extant titles include *Les Fêtes de Polimnie* (1745), *Les Fêtes de l'Hymen et de l'Amour, ou les Dieux d'Egypt* (1747), *Zorästre* (1749), *Les Amours de Tempé* (1752), and *Anacréon* (1754).

His histories of dance included statements that can be interpreted as pleas for the concepts that were later integrated into the *ballet d'action.* Although none of these books is now available, his works have been excerpted in many anthologies and contemporary histories, especially sections of *La Danse Ancienne et moderne, ou Traité histoire de la danse* (The Hague, 1954) and *Encyclopédie méthodique* (sections on dance and music, 1787–1795).

De Falla, Manuel, Spanish composer; born November 23, 1876 in Cádiz; died November 14, 1946 in Alta Gracia, Argentina. Although much of De Falla's concert music has been choreographed, only two works were created specifically for dance production. *El Amor Brujo* (1915) was presented by Pastora Imperio's troupe in the year of its creation while Leonid Massine's *Le Tricorne* was staged in 1919. The former was best known through the frequent tours of La Argentina, who included the work in her tour, while the latter has been restaged by its choreographer for Ballet Theatre, the City Center Joffrey Ballet, the London Festival Ballet, and state opera ballets across Europe.

Dégas, Hilaire Germain Edgar, French impressionist painter and sculptor; born July 19, 1834 in Paris; died there September 26, 1917. Trained at the Ecole des Beaux-Arts, he left the Salon to join the Impressionist movement as a kind of adjunct member.

Dégas' connection with dance was derived from his use of rehearsals and lessons as subjects for paintings, sketches, and sculpture. Those art works are among his best known since they are the most easily accessible. One painting, *Foyer de la Danse* (1872), has inspired many dance works, among them, Margaret Petit's *Repetition de la Danse* (1923), Agnes De Mille's *Rehearsal After Degas* (1928), Frederick Ashton's *Foyer de la Danse* (1932), and Serge Lifar's *Entre deux rondes* (1940).

De Gregory, William, American ballet dancer; born March 4, 1957 in Portsmouth, New Hampshire. De

Gregory was trained at the National Academy of Arts and by Lupe Serrano and Michael Maule. A member of the Pennsylvania Ballet since the mid-1970s, he has participated in that company's rise to prominence as one of the major out-of-New York troupes. His credits form a microcosm of the company's changing repertory, from the revivals of works by George Balanchine for which it was first known, to contemporary ballets, such as Gene Hill Sagan's *Sweet Agony,* Margo Sappington's *Under the Sun,* Rodney Griffin's *Eakin's View,* and Benjamin Harvavy's *Madrigalesco* and *From Gentle Circles.*

D'Egville Family, French dancers performing and teaching in England. The D'Egville family immigrated from Paris in the mid-1700s; the D'Egvilles, Daiguevilles, Deguevilles, et al., may have originally been Dutch or, according to one source, Maraños. The last D'Egville listed at the Paris Opéra disappeared in 1786, eighteen years after Peter D'Egville emerged in London, performing at the Drury Lane Theatre.

The English branch of the D'Egvilles is descended from Peter and his children—James Hervé, George (a child dancer with James who grew up to act at the Haymarket Theatre), Fanny (a dancer and actress at Covent Garden), Sophia (an actress at Drury Lane), a son and a daughter. The most important member of the family in the next generation was Louis Hervé D'Egville, Sr., presumably the son of James, named after Lewis D'Egville who died in childhood. Louis Hervé's son, Louis Hervé Junior, was an important teacher of ballet and social dance in London, training, among others, silent film dance director, Ernest Belcher. Another son, Geoffrey, wrote and published a textbook of social dance in 1919, reprinted in 1920 and 1929.

D'Egville, James Hervé, English ballet dancer and choreographer of the eighteenth century; born c.1770 in London; died c.1837 there. The eldest son of Peter D'Egville, he made his debut at the Royal Circus in 1782, following that with performances at the King's Theatre in works by Charles LePicq in 1783. By 1786, he was a company member of the Haymarket, London, performing with his younger brother, George.

He went to Paris to study with Jean D'Auberval, then returned to London with him to dance in his *Télémaque dans l'île de Calypso* (1791). Remaining in London, he performed for Jean-Georges Noverre at the King's Theatre, in his *Le Volange fixé, Vénus et Adonis,* and *Le Faune Infidèle* (all 1792), succeeding him as ballet master in 1793.

From then until his death, D'Egville commuted among the leading pantomime theaters of London—the King's Theatre, Drury Lane, the Royal Circus, and the Haymarket. His work ranged from harlequinades to French ballets and included national works, such as his Scottish *Mora's Harp* (1809) and his *La Fête Chinoise* (1808 after Noverre), ballets based on Italian legends, like his *Talasso et Amagahi* (1800) and *Alexander the Great* (1795), and mythological pieces, among them *Hyppomène et Atalante* (1800), and his most celebrated work, *Achille et Déidameni* (1804), which featured a male pas de deux for "Ulysses" and "Achilles" dressed as a woman, as in the legend.

D'Egville was much more than simply the first native English ballet choreographer who was able to compete with the French importations. He was an important link in the development of the *ballet d'action* from a merely popular theater structure to a cross-media format, both ballet and theater.

Works Choreographed: THEATER WORKS: *Le Jaloux puni* (1793); *Le Bon Prince* (1794); *Alexander the Great, or the Conquest of Persia* (1795); *Télémaque dans l'île de Calypso* (1799, after D'Auberval); *Hylas et Témire* (1799); *Tarare et Irza* (1799); *La Double épreuve* (1799); *Telasco et Amagahi* (1800); *Renaldo e Leonora* (1800); *Hippomène et Atalante* (1800); *Le Marriage Méxicain* (1800); *Pygmalion* (1801); *Amintas et Sylvie* (1801); *Le Jugement de Midas* (1802); *Irza* (1802); *La Coquette Villageoise* (1803); *Le Veau témerain* (1803); *Achille et Déidaminie* (1804); *Edouard III* (1805); *The Mountain Robbers, or the Terrific Horn* (1806); *Emily, or the Juvenile Indiscretion* (1807); *Caracteous* (1808); *l'Enlèvement de Déjanire* (1808); *Terpsichore* (1808); *La Fête Chinoise* (1808, after Noverre); *Don Quichotte* (1809); *Mora's Harp* (1809); *Paul et Virginie* (1810); *Drive Love Out the Door* (1815); *La Naissance de Vénus* (1826); *Le Siège de Cythère* (1827); *Zuelma* (1836); *The Swiss Nuptials* (1836).

D'Egville, Peter, French (?) ballet dancer performing in London after 1768; the details of D'Egville's birth, death, and training are not certain, but he was at least twenty years old when he arrived in London.

From 1768 to 1773 he served as premier danseur at the Drury Lane Theatre, dancing in *The Piedmontese Mountainer* in his first year; by 1772, he ran a studio in London teaching social dance. Switching to the rival Covent Garden as ballet master in 1780, he staged many pantomimes for the theater. He changed sides again in 1782, accepting a similar engagement at the King's Theatre until 1786. As ballet master of the King's Theatre, he trained the native dancers who performed in the ballets of his successor, Jean-Georges Noverre.

Works Choreographed: THEATER WORKS: *The Village Festival* (1774); *The Country Macaroni Assembly* (1775); *Boadicea, Queen of Britain* (1775); *The Humours of Newmarket* (1779); *l'Amour Jardinier* (1786); *La Fête Marriés* (1786).

De Haven, Carter, American vaudeville and musical comedy dancer, and film actor and producer; born c.1887 in Chicago, Illinois; died July 20, 1977 in Los Angeles. After touring with a Marine band as a boy soprano, he entered vaudeville as a song and dance man. Although he was successful as a solo performer, he became famous in partnership with his wife, Flora Parker, as "Broadway's Beau Ideals." They appeared together in vaudeville acts, such as *Whoops-de-Do, Dolly Dollars, All Aboard,* and *Step Lively* (1919), and on Broadway in *The Queen of the Moulin Rouge* (1908). He had an act with a company that did not include Parker in 1910, appearing in *The Girl in the Taxi* at Hammerstein's roof gardens and theaters. He also performed in a tandem dance act with comic Fred Nice in 1912 and 1913; this act was unique for him because it involved "Rube" dancing, eccentric clumsy work in country costumes, since with Parker, he always appeared as an ultrasophisticate.

He and Parker performed together in films in the mid-1910s, billed as Mr. and Mrs. Carter De Haven, in *Twin Beds* (Universal, 1916) and *His Little Roommate* (Universal, 1917). On his own, he appeared in a series of serials based on the character "Timothy Dobbs" that included *From Broadway to a Throne* (1916) and *From the Rogues Gallery* (1917) and he remained in film as a producer for First National and as a freelance director. His best known work is the Chaplin film, *Modern Times* (UA, 1926, co-directed with Chaplin), but he was responsible for at least a score of comedies. De Haven built and managed the Music Box Theatre on Hollywood Boulevard, but concentrated on film work rather than returning to live performance. He was the father of actress Gloria De Haven and film editor Carter De Haven II; De Haven III is an independent film producer.

De Haven, Gloria, American film dancer and actress; born c.1925. The daughter of Carter De Haven and Flora Parker, she made her film debut in her father's *Modern Times* (1936), co-directed with Charles Chaplin. A charming dancer and singer, she was usually cast as somebody's younger sister in a string of films for MGM. Among her most memorable appearances were in *Best Foot Forward* (1943), *Thousands Cheer* (1943), *Broadway Rhythm* (1944), *Two Girls and a Sailor* (1944), *Step Lively* (RKO, 1944), *Summer Stock* (1948), and *Three Little Words* (1950), in which she played her mother.

Although she appeared in the London production of the musical comedy, *Golden Boy,* she has concentrated on dramatic and comic performances since the early 1950s. She recently returned to dancing as Donald O'Connor's wife and vaudeville partner in a situation comedy pilot, scheduled for production in the coming seasons.

De Hesse, Jean Baptiste François, French eighteenth-century ballet dancer and choreographer; born 1705, The Hague, then capital of the Dutch Republic; died May 22, 1779 in Paris. While it is known that De Hesse trained and performed with his parents' traveling troupe in Holland and Belgium, it is not certain what techniques and styles their act involved. Their relationship with the Deshayes family troupes cannot be accurately determined at this time.

De Hesse joined the Théâtre-Italien, Paris, as a comic dancer and character mime; as he was married to Catharine Antoine, the daughter of famed "Harlequin" Thomassin, he may have inherited that part in the company's productions. He maintained an association with the Théâtre-Italien throughout his ca-

reer, serving as its choreographer/ballet master (1737 on) and its administrator (1765–1768). Works created directly for the company include *La Vallée de Montmorency* (1745); many of the ballets and pantomimes created for the childrens' troupe of Le Théâtre des Petits Appartements were later restaged for the Théâtre-Italien.

The court children's theater, located in the king's private apartments at Versaille, produced pantomimes and ballets for approximately three years. De Hesse, as ballet master, produced nineteen known works; he may have staged twenty-four pieces there altogether. These works were in the transitional form between classic ballet, pantomimes of the Italian *commedia,* and French *ballet de cours.*

Works Choreographed: CONCERT WORKS: *La Vallée de Montmorency* (1745); *Le Pédent* (1748); *Alaasis* (1748); *Érigone* (1748); *Tancrède* (1748); *Cléopâtre* (1748); *Ballet de la Paix* (1748); *L'Opérateur Chinois* (1748); *Silvie* (1749); *Zélie* (1749); *Les Amours de Ragonde* (1749); *Acis et Galatée* (1749); *Les Éléments* (1749); *Jupiter et Europe* (1749); *Le Prince de Noisy* (1749); *Les Quatre Ages de Récreation* (1749); *Les Fêtes de Thétis* (1750); *Les Bucherons, ou le Médicin du Village* (1750); *La Journée Galante* (1750); *La Guinguette* (1750); *L'Amour Piqué par un Abeille et Guéri par un Baiser de Vénus* (1750); *Vénus et Adonis* (1752); *Les Amours de Tempé* (1752); *Les Femmes* (1752); *Zémir et Azor* (1771).

De Jong, Bettie, Dutch modern dancer performing in the United States after the mid-1950s; born May 5, 1933 in Sumatra, Indonesia. She studied ballet in Sumatra and modern techniques in Holland with Jan Bronk and Max Doyes of the Netherland Pantomime Theater. Moving to New York in the mid-1950s, she studied with Martha Graham and José Limón.

She performed for Graham, playing a "Fury" in the premiere of *Clytemnestra* (1961), for Pearl Lang, dancing in her *And Joy Is My Witness, Shira,* and *Appasionata,* and for John Butler, with a role in his *Carmina Burana* (1960). In 1962, she joined the company of Paul Taylor, with whom she has danced and taught ever since. Among the many works of his in which she has created roles are his *Orbs* (1966), *Lento* (1967), *Big Bertha* (1973), and *From Sea to Shining Sea* (1965), in which she portrayed "Plymouth Rock."

De La Bije, Willy, Dutch ballet dancer; born June 1, 1934 in Leiden. Trained by Sonia Gaskell and Benjamin Harkavy, she performed with Gaskell's Ballet Recital Group before joining the Netherlands Ballet. In that company, she was assigned many featured roles in the company's *Les Sylphides* and *Giselle,* George Balanchine's *La Sonnambula,* John Taras' *Scènes de Ballet,* and David Lichine's *The Prodigal Son.*

A popular member of the Netherlands Dance Theatre from 1959 to 1970, she was featured in Glen Tetley's *Sargasso* and *The Anatomy Lesson,* Harkavy's *Nocturne* and *Recital for Cello and Eight Dancers* (1964), Job Sander's *Impressions* and Hans van Manen's *Variomatic,* among many other works. She retired from performance early to accompany her husband, Jaap Flier, to the Australian Dance Theatre of which he became artistic director in 1973. She serves there as ballet master and rehearsal director.

De La Fontaine, Mlle., French ballerina, considered the first female professional dancer; born c.1655; died c.1738. It is perhaps tragically appropriate that the woman who is considered the first female professional dancer should be little better than anonymous. Her first name, training, places of birth and death, and life after retirement are all unverifiable. The only element of De La Fontaine's existence that can be verified is her participation in Lully ballets at the Paris Opéra from *Le Triomphe de l'Amour* in 1681 to *Acis et Galathée* in 1686. She also performed in his *Persée* (1682), *Phaëton* (1683), *Roland* (1685), and *Le Temple de la Paix* (1685).

Delamaine, Henry, Specialty dancer in eighteenth-century English harlequinades; the dates and locations of his birth and death cannot be accurately determined. He made his debut as a specialty dancer in 1733 at the Goodman's Fields Theatre in London. By 1735, he was a member of the company at the Drury Lane, performing in solos in *Harlequin Grand Volgi,* and other productions; his specialties at that time included a Mason's dance, a Turkish dance, and a harlequin. After traveling to Dublin, he performed in

Paris at the Foire St. Laurent (1738 and 1739). He was billed there as "un pantomime anglais," although that does not necessarily mean that he was British, as it may have referred to the subgenre of the harlequinade. Returning to London, he worked at the Drury Lane until retiring in 1745. His specialties at this time included a Dutch clog dance and a jockey dance, *Les Maquignons.* With Mlle. Augusta, he performed in the ballets, *Les Pasteurs joyeux* and *Les Boufons de coeur.*

On retiring, he directed a children's troupe (billed as "Dutch," but again possibly referring either to nationality or to genre) that performed harlequinades.

Delamo, Mario, Cuban modern dancer working in the United States; born January 1946 in Havana. Delamo's American training came from Norman Walker and the faculties of the American Dance Theatre school and the Martha Graham School of Contemporary Dance. He performed with Alvin Ailey and Glen Tetley, most notably in the latter's *Embrace Tiger and Return to Mountain,* before joining the Graham company in the early 1970s. As a member of the troupe through the 1970s, he performed in the revivals of her personal classics of the 1950s and in the new works of the season that are known as her "renaissance," among them *Chronique, Holy Jungle, El Penitente, Adorations, Dark Meadows, The Scarlet Letter* (1975), *Seraphic Dialogues, Lucifer* (1975), *Circe, Letter to the World, Clytemnestra,* and *Equatorial* (1978). He has also served as her assistant on *Adorations* and *Lucifer,* for which he taught Rudolf Nureyev the title role for performance in the work's premiere.

De La Pena, George, American ballet dancer; born in 1957 in New York City. After studies at the School of American Ballet and the High School of Performing Arts, de la Pena continued his training with Mme. Pereyaslavec and André Eglevsky.

After performing with the Eglevsky Ballet, de la Pena joined the American Ballet Theatre in 1974. He has been assigned featured roles in George Balanchine's *Theme and Variations,* Jerome Robbins' *Les Noces,* Herbert Ross' *The Maids,* and the company productions of *La Sylphide, The Nutcracker,* and *Petroushka.*

De la Pena took a leave of absence from Ballet Theatre to play the title role in Herbert Ross' film *Nijinsky* (Twentieth-Century Fox, 1980).

De Lappe, Gemze, American ballet and theatrical dancer; born February 28, 1922 in Portsmouth, Virginia. De Lappe was trained at the Peabody Conservatory of Music and at the Henry Street Settlement before attending the High School of Music and Art in New York City. She continued her studies at the Ballets Arts School under Irma Duncan, Vitale Fokine, Yeichi Nimura, and Edward Caton.

Best known for her work with Agnes De Mille projects, De Lappe was featured in the original production of *Oklahoma* (1943) and in many revivals and touring companies. In Ballet Theatre, she had roles in her *The Harvest According* and *Three Virgins and the Devil.* She worked on revivals of *Brigadoon* and *Carousel* (three productions of each), and has toured with the De Mille Heritage Dance Theatre.

Her notable Ballet Theatre roles included character parts in Eugene Loring's *Billy the Kid* and in Antony Tudor's *Judgement of Paris.* De Lappe's best remembered non–De Mille performance on Broadway was as "King Simon of Legree" in the *Small House of Uncle Thomas* sequence in Jerome Robbins' *King and I* (1951), a role that she repeated in the film version (Twentieth-Century Fox, 1966).

De Lavallade, Carmen, American ballet and modern dancer; born March 6, 1931 in Los Angeles, California. De Lavallade studied ballet locally with Carmelita Maracchi before beginning to work with Lester Horton with whose company she performed from 1950 to 1954.

Among dances in which she created roles for Horton were his *Salome* (1950), *Another Touch of Klee* (1951), *Medea* (1951), *Liberian Suite* (1952), and *Dedication in Our Time* (1952). In the company, she began a long association with Alvin Ailey, who succeeded as director of the company after Horton's death.

Moving to New York in the mid-1950s, she worked as a freelance dancer with many established and ad hoc companies directed by Ailey, John Butler, Donald McKayle, Glen Tetley, and her husband, Geoffrey Holder. A frequent participant in the Ballet Theatre Workshop performance series (although

never a formal member of ABT), she created a leading role in Agnes De Mille's *Four Marys* (1964), as a "guest artist." Among the many dances in which she created roles as a guest artist or company member were John Butler's *Carmina Burana* (1959), *Portrait of Billie* (1962), *Catulli Carmina* (1964), and *Ceremonial* (1964), Donald McKayle's *Reflections in the Park* (1964), and Ailey's *Roots of the Blues* (1961).

After appearing in the musical *House of Flowers* (1954), De Lavallade succeeded her cousin, Janet Collins, as prima ballerina of the Metropolitan Opera (1955–1956). She later performed with the New York City Opera ballet in that capacity and as a member of the Butler troupe.

De Lavallade's first solo theatrical New York choreography credits were earned with productions for the New York Shakespeare Festival, among them, the highly praised *Les Chansons de Bilitis* (1972). For over a dozen years she has been choreographer and performer-in-residence at the Yale School of Drama, staging musical numbers in plays, musicals, and operas there, as well as acting and dancing. Among her many students at Yale is Henry Winkler who has publicly credited her with developing his sense of movement to create the gestural vocabulary of "the Fonz."

De Leporte, Rita, American ballet dancer; born c.1910 in New York City. After early training with Louis Chalif, De Leporte continued her studies at the school of the Metropolitan Opera Ballet. A protégé of Rosina Galli, she made her debut at the Met in 1922, dancing in *Lakmé, Aida,* and *The Bartered Bride,* among other operas. She was also assigned the female lead in Sammy Lee's *Skyscrapers* (1925), co-produced by Robert Edmond Jones and John Alden Carpenter at the Opera House. De Leporte retired in 1935.

Delf, Harry, American theatrical dancer, comedienne, and dramatist; born 1893 in New York City; died there February 7, 1964. Delf and his sister Juliet (1899–1962) each had imitation acts in vaudeville as children; her act was based on vocal imitations of famous political figures, but his consisted of satires of specific types of dance performers, both amateur and professional. Billed as "The Kid Romeo," he

dropped his act of parody to become a juvenile on Broadway. He appeared in *The Midnight Girl* (1914) and *The Rainbow Girl* (1917 and 1919 revival), and replaced Martin Brown (himself a future playwright) as Roszika Dolly's partner in *Hello, Broadway* (c.1915). After touring with the Proctor circuit act, World's Dancers (consisting primarily of social and exhibition ballroom teams) in 1917, he served in the military, returning to star in the musical *Jimmie* (1920) with Frances White.

Delf had written sketches and songs for vaudeville acts since the mid-1910s but did not attempt to create a play until the early 1920s. Like Brown, he dropped out of dance completely after his first successes, *The Family Upstairs* (1925), *Sunshowers* (1923), and *Atlas and Eva* (1928). He toured with a vocal act of "Songs of his own composition" on the Keith circuit, and wrote segments of the *Earl Carroll Vanities* of 1922 and 1924. He served as dean of the Lamb's Club for almost thirty years and is considered one of the inventors of that singular form of private and popular entertainment—the "Roast."

Delibes, Clement Philibert Leo, French nineteenth-century composer; born February 21, 1836 in St. Germain-en-Laye; died January 16, 1891 in Paris. Although Delibes is best remembered by dance historians for the ballets that he composed for the Paris Opéra, among them St. Léon's *Coppélia* (1870) and Mérante's *Sylvia* (1876), he was a prolific creator of scores for Paris' more popular theaters. He did scores for Les Folies Nouvelles, including his first full-length work, *Deux Sous de Charbon* (1855), and for the Opéra-Comique, among them his best known opera, *Lakmé* (1883). Both *Lakmé* and *Coppélia* remain in the repertory of ballet and opera companies throughout the world.

Deller, Florian, Austrian eighteenth-century composer; born June 2, 1729 in Drosendorf; died April 19, 1773 in Munich. Deller served as a violinist and later concert master of the court orchestra at Stuttgart from 1751. At Stuttgart, then the capitol of Wurtenberg, he worked in collaboration with the court dance master, Jean-Georges Noverre, for whom he composed many works. Among them were his *Orfeo ed Euridice* (1763), *La Mort di Licomede* (1764), and *La Mort d'Hercule* (1762).

Dell'Era, Antoinetta, Italian ballet dancer known for her performances in St. Petersburg; born December 16, 1861 in Milan; the date and place of Dell'Era's death are not certain. Dell'Era was trained at the school of the Teatro alla Scala in Milan. She was attached to the Berlin Court Opera but was much better known for her annual performances in St. Petersburg. On her visit there, she performed at an open-air operetta season, but she was invited to join the Maryinsky Theater with which she danced on later visits. The forefront of the "Italian Invasion" that inspired Russian ballet with bravura technical skills and tricks, Dell'Era left her mark permanently on Russian ballet, and on the international audience, as the first "Sugar Plum Fairy" in Lev Ivanov's *The Nutcracker* (1892).

Dello Joio, Norman, American composer; born January 24, 1913 in New York City. Like many of his colleagues in the growing world of American mid-twentieth-century composition, Dello Joio worked intimately with concert and modern choreographers. Most of his scores for dance (c.1942–1956) were created on commission from choreographers based in New York. His works include *Prairie* for Eugene Loring's Dance Players (1942), Michael Kidd's *On Stage* (1945, for Ballet Theatre although Kidd had performed with the Dance Players company), José Limón's *There Is a Time* (1956), and a trio of scores for Martha Graham—*Diversion of Angels* (1948), *Triumph of St. Joan* (1951, also used for rechoreographed *Seraphic Dialogues* after 1955), and *A Time of Snow* (1968).

Delmar, Frank and John, American theatrical and modern dancers; born c.1915 in Chicago, Illinois. The Delmar Twins, as they were billed, toured in a tandem act for more than fifteen years on the Midwestern vaudeville and Prolog circuits. Although their later publicity claimed that they had been members of *Our Gang* (for Hal Roach studios), their ages make this unlikely; they may, of course, have performed or appeared in *Our Gang* films or in rival series. Frank Delmar joined Ted Shawn and His Men Dancers in February 1937, bringing his brother along as a general understudy. From that tour to the dissolution of the company in 1940, they performed in Shawn's *O, Libertad* (1937), *Kinetic Molpai* (1937),

Dance of the Ages (1938), and *The Dome* (1940). They later toured as performers and stage managers with the play *Johnny Belinda* in 1941 before being drafted. Like the majority of their Shawn company colleagues, they were not able to create theatrical or dance careers for themselves after the end of his company.

Delpini, Carlos Antonio, Italian harlequinade dancer and choreographer working in England after 1776; born c.1740 in Rome; died January 20, 1828 in London. He had some experience in staging harlequinades before moving to London in 1776, but it cannot be determined with whom he acquired his training. Apprenticed to a commedia dell'arte troupe, Delpini became a "Pierrot" in the company of Nicolini, a famed "Arlecchino."

Although he performed as a "Pierrot" or "Clown" (as the character was called in the more assimilated English productions) in London theaters until 1788, he was known as a director of harlequinades from 1777. As a performer only, he was in the companies attached to Covent Garden, where he made his English debut in *Harlequin's Frolicks* (1776), *The Haymarket* (c.1780), and *The Royalty* (1788), and may have worked in Dublin.

As a choreographer, Delpini was an itinerant—staging harlequinades for different theaters, and, possibly, for a touring company. His productions ranged from traditional harlequinades, such as *The Life and Death of Pantaloon* (1806) to topical ones, for example, *The Impress'd Recruits, or the Seige of Belgrade* (1788, during the military engagement) and self-publicizing parodies, including *The Peasant Metamorphos'd, or Delpini's Voyage from Dublin in an Air Balloon* (1784). He also staged entertainments for George IV, both as regent and as king, although it is not known whether he received the title of Master of the King's Revels at any time.

Dance historians should not think of Delpini and his harlequinades as foreign to ballet productions; the relationship among these Italian-English spectacles and the Italian-French fair productions (both derived from traditional *commedia*) and the *ballet d'action* revolution of Noverre and Hilverding must not be overlooked.

Works Choreographed: THEATER WORKS: *The Norwood Gypsies* (1772); *The Sportsman Deceived*

(1779); *A Dutch Tea-Room* (1788); *The Impress'd Recruits, or the Seige of Belgrade* (1788); *What You Please* (1789); *The Peasant Metamorphos'd, or Delpini's Voyage from Dublin in an Air Balloon* (1889); *Don Juan, or the Libertine Destroy'd* (1789); *The Life and Death of Pantaloon* (1806).

Delroy, Irene, American theatrical dancer; born Josephine Sanders, 1898, in Bloomington, Illinois. After local classes in interpretive dance (probably within Delsarte elocution lessons), Delroy began to study ballet with Andreas Pavley and Serge Oukrainsky in Chicago, Illinois. She performed for them with the Chicago Grand Opera for two years before entering vaudeville, where she toured in an exhibition ballroom act with Charles King and in an eccentric tap act with Tom Patricola. Patricola recommended her for her first Broadway show, *Angel Face* (1919), but her dancing and charm as revealed in it brought her other engagements. She danced in each of her roles between *Angel Face* and *Top Speed* (1929), doing tap, musical comedy, or exhibition ballroom work as required by the scripts and scores in the *Frivolities of 1920,* the *Greenwich Village Follies* of 1923 and 1925, the *Vogues and Vanities of 1924,* the *Ziegfeld Follies of 1927* and musicals *'Round the Town* (1924), *Here's Howe* (1928), *Follow Thru* (1929), and *Top Speed* (1929). She specialized in roles of professional women involved in romances and athletic activities. In 1935, after a divorce, she returned to Broadway as a vocalist in the replacement cast of *Anything Goes.*

Delsarte, François, French nineteenth-century theoretician on breathing and movement; born November 11, 1811 in Solesmes; died July 20, 1871 in Paris. Originally a singer, Delsarte became a voice teacher in Paris, where he formulated his theories on rational movement and control of the body for singers. His vocal theories became extended by his protégés into formulas for declamation, acting, and dance, although he was concerned with the performance of music. The theories themselves were determined by his concept of performance as a religious ritual and were based on trinities of movement types, physical spheres, and tonalities.

Delsarte did not write a textbook of his theories or gestural system. The Delsarte manuals that prolifer-ated in the early twentieth century were written by his daughter, Anna, or by his French sponsor, the Abbé Delsolemene. His only verified American protégé was actor-director-playwright, James Steele MacKaye, who put his versions of Delsartism into practice in his theatrical productions—plays that did not involve dance. MacKaye's secretary and associate, however, was a dance and eurythmics teacher in Chicago and Denver, and a popular lecturer on the Chatauqua circuit. Ida Simpson-Serven, a second-generation Delsartist, is little known today, but had a tremendous effect on theatrical dance through her pupil, Ned Wayburn.

Most American Delsartists had no direct connection to the theorist himself. Genevieve Stebbins, the best known and most influential of the early twentieth-century teachers, claimed to have been the true prophet but no links to Delsarte himself could be verified. Since her texts have been reprinted by Dance Horizons, however, her concepts of Delsarte's theories will stand as the American version of his ideas in action.

De Luce, Virginia, American theatrical performer; born c.1930 in Newton, Massachusetts. De Luce made her debut in the conga line at the popular Manhattan club Leon and Eddie's, and followed it with tenures as a Powers model, a publicity agent for Spike Jones, and a contract ingenue at Twentieth-Century Fox. De Luce is best known for her work on Broadway where she revealed dance and vocal talents that matched what *Variety* called her "pinpointed structural appointments." She replaced Jayne Mansfield in *Will Success Spoil Rock Hunter?* and sang in *Chic* (1959), but is still best remembered for her twenty-five entrances as the "friend of the producer" in *New Faces of 1952.* Not only did she sing "He Takes Me Off His Income Tax . . . ," she undulated in a slightly different way in each of a score of progressions across the stage.

Delza, Elizabeth, American concert dancer; born c.1903 in New York City. Delza was trained at the Neighborhood Playhouse by Mary Porter Beagle, by Margot Duncan, and at the Dalcroze Institute. While teaching at the Walden School in New York City, she participated in the concert dance movement and presented recitals at the Guild Theatre. Her works were

extremely well received and until she decided to concentrate her energies on teaching, she was considered in the forefront of the innovative dance recitalists.

Delza is the sister of Sophie Delza, who left concert dance to become America's foremost native expert on traditional and contemporary Chinese dance and a pioneer in the importation of T'ai Chi Cu'uan in this country.

Works Choreographed: CONCERT WORKS: *Seven Episodes in the Book of Job* (1933); *Le Chef d'Amour* (1933); *Andante with Variations* (1933); *Pièce Brève* (1933); *Movements Perpétuels* (1933); *Siciliana* (1934); *Fughetta* (1934); *Le Tambourin* (1934); *Flammes Soubres* (1934); *Alegretto* (1934); *Valse* (1934); *Lyric Dances in the Modern Mode* (1934).

De Marco, Renée, American exhibition ballroom dancer and television choreographer; born Marguerite Verney, c.1913 in Burlington, Vermont. The niece of George Primrose, she was raised in Los Angeles, where she studied with Ernest Belcher and Theodore Kosloff. In 1929, she was working as a chorus girl at Harry Carroll's *Music Box Revue* under the name ''Marguerite Le Blanc,'' when casting director Tony De Marco hired her as his latest exhibition ballroom partner. They worked together for twelve years, appearing in cabarets including the Persian Room at the Plaza Hotel, dancing in films, such as *Three Men on a Horse* (WB, 1936), and on Broadway in *Boys and Girls Together* (1940).

The De Marcos broke up in 1941 and she continued as a solo specialty dancer, doing a waltz-tap act. She staged dances for an early television variety show, *Saturday Night Revue* (NBC, 1952–1954), before retiring.

De Marco, Sally, American exhibition ballroom dancer; born Ora Lee Allen, December 29, 1921 in Roosevelt, Utah. Trained in Los Angeles by Ernest Belcher, she worked as ''Sally Craven'' on Broadway in ballet specialty dance acts. Her engagement in *Boys and Girls Together* (1940), in which the headliners were Tony and Renée DeMarco, led to her new career. When they split during the show's run, she became his new partner.

They danced together for thirteen years primarily in nightclubs, but also in films. They were the most acrobatic of the various De Marco pairs, using the most exaggerated movements, in the style of the period.

Married to De Marco from 1944, she retired with him in 1957.

De Marco, Tony, American exhibition ballroom dancer; born 1900 in Fredonia, New York; died November 14, 1965 in Palm Beach, Florida. An amateur-contest winner, he joined Jean Bedini's Mischief Makers, c.1918, and performed in nightclubs in Chicago. With his then-partner, Helen Kromar (as ''Nina De Marco''), he danced in the *George White's Scandals of 1924* and in cabarets across the country, billed as ''The De Marcos from the National Theatre, Buenos Aires.'' When she left the act, he tried out a series of partners, including Albertina Vitak, while working as a casting director at Harry Carroll's *Music Box Revue* in Los Angeles. In 1929, he chose a chorus girl, Marguerite Le Blanc, as his new partner, renaming her ''Renée De Marco.'' They were a tremendous success on Broadway in *Girl Crazy* (1930) and *Boys and Girls Together* (1940), and in nightclubs. When he and Renée, whom he had married in 1932, were divorced in 1941, he danced with Sally Craven, as ''Sally De Marco,'' who had been a specialty dancer in *Boys and Girls Together.*

This pair was also very successful, performing in cabarets and appearing in two films, *Greenwich Village* (Twentieth-Century Fox, 1944) and *Pal Joey* (Columbia, 1957).

Whoever his partner, the De Marco dance style was unmistakable. He danced to romantic ballads, such as ''The Way You Look Tonight'' and ''Dancing in the Dark,'' and to romantic soft classics by Chopin and Liszt. To the standard ballroom dances of the period, the tangos, rhumbas, waltzes, and fox trots, he added whirlwind movements, swinging his partner to the ceiling, and syncopations. He claimed that he could partner any woman and make her look good. Among the many dancers with whom he tried out his claim were the De Marcos (Nina, Renée, and Sally), Albertina Vitak, Patricia Bowman, and Joan Crawford, with whom he danced in *The Shining Hour* (MGM, 1938).

De Mérode, Cléo, French ballet and theatrical dancer; born c.1866 in Paris; died October 17, 1966 in Paris. Known as ''la ballerina des bandeaux,'' De

Mérode began her career as a student at the school of the Paris Opéra, trained by Joseph Hanssen.

De Mérode may have been the only dancer to base her career on a hair-do. Her "bandeaux," or hair swept back over her ears into a chignon, fit her dance act, which was basically a Greek revival or interpretive dance concert. She performed at the Paris Exposition Internationale in 1900 and seemed to have been highly influenced by the other dance acts that she saw there, among them Sada Yacco and the Cambodian and Siamese dance troupes, since she included a "Danse Cambodgienne" in her act after 1901.

After the period of her greatest popularity (c.1895–1903), De Mérode performed at the Opéra-Comique and in private theatrical presentations. Her only other dance-related activity was an exhibition ballroom act in 1924, in which she was partnered by Rupert Doone.

Bibliography: De Mérode, Cléo. *Le Ballet de Ma Vie* (Paris: 1955).

De Mille, Agnes George, American ballet and theater dancer and choreographer; born 1909 in New York. De Mille was raised in Los Angeles, California, where her father worked as a film writer and producer. She was trained there by Theodore Kosloff, who ran a dance studio while acting for her uncle, Cecil B. De Mille. After attending the University of Southern California, she made her debut as a concert dancer in 1927, with characterizational dance solos, including *Jenny Loved a Sailor, Stage Fright,* and *Two Romantic Waltzes.* Her best known work from the period, *Ballet Class after Dégas,* in which she portrayed an opera dancer of the nineteenth century, was created in her second year as a recitalist. De Mille also worked in London in this style, studying with Marie Rambert and participating in West End revues as a performer and choreographer. Her *Three Virgins and a Devil,* now associated with the Ballet Theatre revivals of the early 1940s and 1970s, was created for *Why Not Tonight?* in 1934. She also danced with the Rambert and Antony Tudor companies before returning to New York as the center of activity in the late 1930s.

She had staged only one entire show, Cole Porter's *Nymph Errant* (1933) in London, but quickly made her theatrical reputation on Broadway with *Hooray for What?* (1937) and *Swingin' the Dream* (1939).

Her next show, *Oklahoma!* (1934), remains as controversial as it is popular. Much of its reputation depends on the contemporary claim that it was the "first integrated musical." It seems unlikely that it was particularly well integrated at all since its dance numbers follow the standard practices of the time and are interpolated to: introduce characters, as in "Everything's Up to Date in Kansas City," extend a suspense mechanism in a dream sequence, as in the "Laurey Makes Up Her Mind" ballet, and to lengthen scenes set at social gatherings. These practices were in use at the turn of the century and such "integrated" numbers appeared in practically every musical comedy since then. What *Oklahoma!* did have was something that was actually unique, and frankly much more interesting—it was probably the first Broadway production with music that used the acting/directing technique of severely limiting the movement vocabulary to set place and time. The steps performed in De Mille's numbers—whether authentically "cowboy" or not and whether integrated, interpolated, or dumped in for effect—are brilliantly limited and chosen to unify the characters and therefore the show.

De Mille's later Broadway credits include the classical musical comedies *Carousel* (1945) and *Brigadoon* (1947), which, like *Oklahoma!,* have been revived almost annually ever since their premieres. Less commercially successful works in which her contributions have been praised range from the period shows, *Bloomer Girl* (1944) and *Paint Your Wagon* (1951), and *110 in the Shade* (1963), the musical of *The Rainmaker* to the sexual comedies, *One Touch of Venus* (1943) and *Gentlemen Prefer Blondes* (1949). Her use of ballet dancers in her shows has brought a new look to Broadway and, of course, employment to many more performers than the ballet companies could absorb. Her use of ballet-trained dancers and elements of ballet technique in her productions, however, has also been credited with almost destroying the Broadway (and hence, economically feasible) careers of hundreds of tap dancers.

She has always balanced her Broadway career with ballet production. From the time she returned to New York from London to the very recent present, she has created new ballets and revived old ones for the Ballet Russe de Monte Carlo, Ballet Theatre, her own Heritage Dance Theatre, and the Royal Winni-

peg Ballet, Boston Ballet, and City Center Joffrey company, for which she created her most recent work, *A Bridegroom Called Death* (1978). Every member of her audience has a personal favorite—whether the cowboy comedy of adolescence and maturity, *Rodeo* (1942), or the psychological drama *Fall River Legend* (1948), or the biblical updated legends of the *Cherry Tree Legend* (1953) and *The Four Marys* (1965).

De Mille's importance currently may rely more on her abilities as a spokesperson for American dance than on her continued creativity. She has testified productively at Congressional hearings for funding of the arts and legislation that protects artists' works. She has been recognized by her peers in the dance world and by the nation itself with the Kennedy Center honor—the highest nonmilitary award in the United States. She has also written extensively on the arts and is producing a multivolume autobiography.

Works Choreographed: CONCERT WORKS: *Jenny Loved a Sailor* (1927); *Stage Fright* (1927); *Two Romantic Waltzes* (1927); *Ballet Class after Dégas* (1928); *Harvest Real* (1929); *May Day* (1929); *Ouled Naïl* (1929); *Try-out* (1929); *Julia Dances* (1930); *Armistice Day* (1931); *The Young King Danced with a Duchess* (1931); *Bourgomaster's Branle* (1931); *Cries of London* (1931); *18th Century Suite* (1931); *The Parvenues* (1931); *Theme and Variations* (1931); *Dance of Excitement* (1933); *Scherzo* (1933); *Cloggers' Cog* (1933); *American Suite* (1934); *Allegro* (1934); *Rehearsal* (1934); *Grotesque Héroique* (1934); *Rehearsal: Symphonic Ballet* (1934); *Hymn No. 2* (1934); *Witch Spell* (1935); *Dance of Death* (1935); *Incident with the Spanish Ambassador* (1935); *Mountain White* (1935); *Minuet for the Jupiter Symphony* (1935); *Plaisir d'Amour* (1935); *Night Scene* (c.1938); *Black Ritual* (1940); *Czech Festival* (1940); *Drums Sound in Hackensack* (1941); *Jesu, Joy of Man's Desiring* (1941); *Rodeo* (1942); *Tally-Ho* (1944); *Fall River Legend* (1948); *The Bitter Weird* (1953); *The Bumble Bee in the Garden* (1953); *Cherry Tree Legend* (1953); *Grande Fête de Gala* (1953); *The Rib of Eve* (1956); *Sebastien* (1957); *The Four Marys* (1965); *The Rehearsal* (1965); *The Wind in the Mountains; A Country Calendar* (1965); *A Rose for Miss Emily* (1970); *Matrix* (1973); *Texas Fourth* (1973); *Summer* (1975); *A Bridegroom Called Death* (1978).

THEATER WORKS: *Nymph Errant* (1933); *Why Not Tonight?* (1934, segments by De Mille only); *Hooray for What?* (1937); *Swingin' the Dream* (1939); *Oklahoma!* (1943); *One Touch of Venus* (1943); *Bloomer Girl* (1944, includes "The Harvest According," occasionally performed as a separate work); *Carousel* (1945); *Brigadoon* (1947); *Allegro* (1947, also directed); *Gentlemen Prefer Blondes* (1949); *Paint Your Wagon* (1951); *The Girl in Pink Tights* (1954); *Goldilocks* (1958); *Juno* (1959); *Kamina* (1961); *110 in the Shade* (1963); *Come Summer* (1969).

FILM: *Oklahoma!* (Magna, 1955).

Bibliography: De Mille, Agnes. *Dance to the Piper* (New York: 1952); *And Promenade Home* (New York: 1956); *Speak to Me, Dance With Me* (New York: 1973).

Dempster, Carol, American concert dancer and silent film actress; born January 6, 1902 in Duluth, Minnesota. Dempster was raised in Santa Maria, California and trained at the Los Angeles Denishawn school. She performed with the Denishawn concert groups in *Death and After-Life in India, Greece and Egypt* (1916) and in the company pieces, *The Spirit of the Sea* and *The Garden of Kama*. Also as a Denishawn dancer, she performed on the staircase on the Babylon set in D.W. Griffith's *Intolerance*.

After another season with Denishawn, she went to work for Griffith as an actress. She danced occasionally in Griffith films while playing professional performers, as in *Sally of the Sawdust* (1925), or nontheatrical characters, as in the tragic *Limehouse Nights* (1927). She also danced in Prologs directed by Griffith, most notably the 1922 one for the Graumman's Mayan Theater in which she tangoed with Rudolf Valentino.

Denard, Michael, French ballet dancer; born November 5, 1944 in Dresden, Germany. Trained by Solange Golovine, Yves Brieux, and Raymond Franchetti from adolescence, he spent seasons with the Ballet de la Capitale de Toulouse (1963), de l'Opéra de Nancy (1964), de Lorca Massine (1965), and de Pierre Lacotte (1966) before joining the Paris Opéra. A member of the Opéra Ballet from 1966 to the present, he has created roles there in Serge Lifar's *Istar* (1969), Roland Petit's *Schéhérézade* (1974), Michel Descombey's *Visage*, and Maurice Béjart's

Comme la Princesse Salomé est belle ce soir . . . (1970), and *l'Oiseau de Feu* (1970). He is a great favorite with American choreographers working in Europe, especially noted for his continuing works with Merce Cunningham in Paris and New York.

Denard guests frequently, performing with the American Ballet Theatre in the early 1970s in the classics as Cynthia Gregory's partner, with the Théatre du Silence in the mid-1970s, and with Petit's Ballet de Marseille, creating roles in his *Les Intermittances du coeur* and *Notre Dame de Paris* (both 1974).

Denham, Sergei, Russian ballet impresario; born 1897 in Moscow; died January 30, 1970 in New York City. Denham emigrated to the United States in 1921 (via Shanghai) and became involved in banking. He became vice president and eventually director of the Ballet Russe de Monte Carlo from 1938 to 1962, when the company was dissolved. As director, he was also responsible for transforming the Vechshlav Swoboda/Maria Yurieva studio into the Ballet Russe School in New York in 1954. During his tenure the company became an American institution and, through constant touring, brought the classical repertory to many small communities.

Dennis, Ronald, American theatrical dancer; born October 2, 1944 in Dayton, Ohio. Dennis studied locally with Etta Mosier and performed with her concert group and the Dayton Civic Ballet. After his New York debut in the Lincoln Center revival of *Show Boat,* he appeared in a wide variety of shows, including a rare revival of *Of Thee I Sing* and the national company of *Hallelujah Baby*. In 1975, he created the role of "Richie" in the original production of *A Chorus Line,* staged by Michael Bennett from its casts' memories. His monologue solo, generally known as "Gimme the ball," displayed him at his finest as the young man choosing between forms of movement. Since leaving the show after the Los Angeles run, he has begun to work extensively on television and in commercials.

Denvers, Robert, Flemish ballet dancer and teacher; born March 9, 1942 in Antwerp, Belgium. Denvers was trained by Nora Kiss and Tatiane Grantzeva. He performed with the Théâtre de la Monnaie and the Ballet du XXième Siècle of Maurice Béjart in his native Belgium, appearing in his *Choreographic Offering, Messe pour le Temps Présent*, and *Les Vainqueurs* among many other group works. Denvers has directed a dance studio in the United States since 1977 and has become one of New York's most independent teachers.

Derain, André, French theatrical designer; born June 10, 1880 in Chaton; died September 11, 1954 in Chambourcy. Derain was one of the Paris-based painters to be engaged by Serge Diaghilev to provide scenery and costume designs for his productions. From his first success, Leonid Massine's *La Boutique Fantasque* (1919), he became known as one of the few members of "Les Fauves" who could make designs in both graphics and stage work. Among his many productions were George Balanchine's *Jack-in-the-Box* (1926) and *Les Songes* (1933), Serge Lifar's *Salade* (1935) and Leonid Massine's *Mam'zelle Angot* (1947), *Les Femmes de Bonne Humeur* (1949), and *La Valse* (1950).

Derman, Vergie, South African ballet dancer working in England; born September 18, 1942 in Johannesburg. Derman was trained locally by Arnold Dover before moving to London to attend the Royal Ballet School. Apart from a year with the German Opera Ballet in Berlin (1966–1967), she has been associated with the Royal Ballet throughout her career. Although she has been described as "the ideal Bluebell Girl," with her long legs and blonde hair, she has been applauded in many roles in the classical repertory, most notably as "The Lilac Fairy" in the company's production of *The Sleeping Beauty*. Among her many roles in the contemporary repertory are parts in Kenneth Macmillan's *Valses nobles et sentimentales* (1966), both versions of his *Anastasia* (1967 in Germany, 1971 at the Royal), *The Seven Deadly Sins* (1973), *Elite Syncopations* (1974) and *Rituals* (1975), in Frederick Ashton's *The Dream* (1964) and *Jazz Calendar* (1968), and in Glen Tetley's *Field Figures* (1971).

Descombey, Michel, French ballet dancer and choreographer; born October 28, 1930 in Bois-Columbe. Trained by Lubov Egorova and at the school of the Paris Opéra, he became a member of that company

in the mid-1940s. Although he remained a dancer with the Opéra until 1963, when he was named ballet master, he began to choreograph in the late 1950s for the Opéra-Comique. He served as director of the Zurich Ballet in the early 1970s but has freelanced in recent years, notably for the Ballet Théâtre Contemporain and for troupes in Israel.

Descombey is known for his original choreography to contemporary scores, having selected music by Berio, Stockhausen, Varèse, Mayazumi, and Lalo Schifrin for recent works.

Works Choreographed: CONCERT WORKS: *Frères Humains* (1951); *Le Clochard* (1959); *L'Enfant et les Sortilèges* (1960); *Sarracenia* (1961); *Symphonie Concertante* (1962); *BUT* (1963); *Marathon* (1964); *Coppélia* (1966); *Bacchus et Ariadne* (1967); *Déserts* (1968); *Zyklus* (1968); *Spectacle Berio* (1970); a section of *Hymnem* (1970); *Suite de Bach* (1970); *Mandala* (1970); *Violostries* (1971); *The Miraculous Mandarin* (1971); *Messe en Jazz* (1972); *ES, le 8ième Jour* (1973).

Desha, American interpretive dancer; born Desha Podgorsky, c.1905 in New York City. Trained by Mikhail and Vera Fokine, she appeared in his *Casanova* (1923) as "Harlequin." Her own specialty act was a plastique performed with oversized bubbles and probably inspired by Doris Humphrey's *Hoop Dance*. Although Desha was primarily a chamber concert dancer, performing for an invited audience, she appeared on Broadway in *Music in the Air* (1932). She retired from performance altogether in 1934 and moved to Paris. Since 1950, she has taught in Bergerac, Dordogne in France.

Despite her short career, Desha is considered one of the important personalities of dance of the 1920s since she modeled for almost every personification of the art in sculpture of the period. Her portraits in marble and brass by Harriet Frishmuss are exceptionally beautiful and still celebrated as examples of the genre of public sculpture appearing in lobbies and atop buildings. To understand her position in the cycle of American dance, the reader need only go to the American wing of the Metropolitan Museum of Art in New York, where a glorious alabaster Desha greets the visitors at the entrance.

Deshayes, André Jean-Jacques, French nineteenth-century ballet dancer and choreographer working in London; born 1777 in Paris; died there in 1846. A member of the Deshayes family of touring performers, he may have studied formally in Paris, or may have been trained by his parents. He made his Paris Opéra debut, c.1792, and performed Pierre Gardel's *Le Jugement de Paris* there in 1793.

After a season in Milan (c.1798), he moved to London where the remainder of his career centered. A dancer at the King's Theatre from 1800 to 1811 and ballet master intermittently from 1821 to 1842, he was one of those responsible for maintaining the technical standards of the French ballet in London. As a dancer, Deshayes was best known for his performance of the male duet in James D'Egville's *Achille et Déidamie* (1804), dancing with D'Egville in a scene between Ulysses and Achilles *en travestie*. His revivals and original choreography for the theater company shows that he must have made frequent trips back to Paris—it reflected each change in the Opéra repertory from the *ballet d'action* to Romanticism. The original works include mythological ballets such as *l'Enlèvement d'Adonis* (1807), and the typical mid-nineteenth-century national fantasies based on novels, among them *Maisaniello* (1829, a version of *La Muette di Portici*) and *Kenilworth* (1831). His revivals ranged from *La Dansomanie* (1806), after Pierre Gardel, to *Giselle* (1842), after and with Jules Perrot.

Only one ballet remains from the period in the mid-1820s when he taught at the Academie Royale de Musique—*Zémire et Azor* (1824)—but a collection of essays is extant, *Idées générales sur l'Académie Royale de Musique, et plus specialement sur le danse*, published in Paris in 1822.

Works Choreographed: CONCERT WORKS: *La Dansomanie* (1806, after Pierre Gardel); *l'Enlèvement d'Adonis* (1807); *Psiché* (1810, after Pierre Gardel); *Figaro* (1811); *Le Prix* (1821); *La Paysanne supposée* (1821); *Alcide* (1821, co-choreographed with François Décombe Albert); *Le Signeur généreux* (1821); *Zémire et Azor* (1824); *La Somnambule* (1829); *Maisaniello* (1829); *Les Déguisements imprévus* (1829); *Kenilworth* (1831); *La Bayadère* (1831); *Faust* (1833); *Zéphir berger* (1835); *Le Rossignol* (1836); *Beniowsky* (1836); *Le Brigand de Terracina*

Beniowsky (1836); *Le Brigand de Terracina* (1837); *Le Chalet* (1838); *Giselle* (1842, co-choreographed with Jules Perrot); *La Fête des nymphes* (1842); *Alma, ou la Fille de Feu* (1842, wrote scenario and co-choreographed with Perrot and Fanny Cerrito).

De Shields, Andre, American theatrical dancer; born January 12, 1946 in Baltimore, Maryland. Trained at the University of Wisconsin at Madison, traditionally an excellent training ground for modern dancers, he worked as an actor in experimental companies in Europe and in Chicago, including The Organic Theater there.

He has performed on Broadway in two major roles—the title part in *The Wiz* (1975), choreographed by George Faison, Jr. and as one of the two men in *Ain't Misbehavin'* (1978), staged by Arthur Faria. In both, he showed how well he deserved his reputation as the best snake-hips dancer of the current generation. In his big number in *The Wiz* and in the "Reefer's Drag" in the Fats Waller show, he slunk around the stage with smooth and hypnotizing movement of the hips, feet, fingers, and torso. De Shields has staged a club act for himself and the concert dances for the vocal trio known as Formerly the Harlettes.

Deslys, Gaby, French theatrical and exhibition ballroom dancer popular in Paris, London, and New York; born c.1884 in Paris or Marseilles, France; died February 11, 1920 in Paris. The early events of Deslys' life are open to question; her own habit of prevarication and the Shubert Brothers' practice of inventing professional biographies have made it impossible to verify any relevant data.

Deslys, or "Gaby" as she was billed, made her London debut as "The Charm of Paris" in *The New Aladdin* (1909). Wildly popular from that appearance, she became successful in a singing act at the Alhambra and Palace Theatres there.

After making her American premiere in *Les Débuts de Clichine* in 1911, she was soon cast into the Shuberts' Winter Garden musical, *Vera Violette*. Celebrated for her accent, her flirtation with the audience, and her ability to model clothes, she was very successful in that show, playing a character named "Adèle de la Clôche." She had been coached for the part by Harry Pilcer; after the show closed she and he traveled to Paris as an exhibition team, specializing in whirlwinds and in a one-step called "The Gaby Glide." This dance became so popular that in her next American show, *The Honeymoon Express* (1913), they did a new number—"When Gaby did the Gaby Glide."

That show was the height of her career; she moved between musicals in London, among them, *The Belle of Bond Street* (1914) and *The Passing Show of 1915*, and New York, where she appeared in *Stop! Look! Listen!* (1915), but her fad had ended. Deslys died in Paris at the age of thirty-six.

Desmond, Florence, English musical comedy dancer and actress; born May 31, 1907 in London. Desmond was one of the few Empire Theatre ballerinas to convert to other forms of theater dancing. A student of Katti Lanner, she did Empire and pantomime dancing for eight years before receiving her first contemporary role in the revue, *On With the Dance* (1925). Although she was generally engaged for shows for her talents as an impressionist, she usually did at least one dance number in each musical comedy and, especially, revues, among them, C.B. Cochran's *Revue of 1926*, André Charlot's *Masquerades* (1930), the Savoy Follies (1932), and Noel Coward's *This Year of Grace* in London and New York (1928). She matured from juvenile to comedienne to grande dame in a series of plotted musicals dating from her pantomimes of 1916 to her last show, *If the Shoe Fits*, forty years later.

De Soto, Edward, American modern dancer; born April 20, 1939 in the Bronx, New York. Trained at Juilliard and the New Dance Group Studio, he performed with the José Limón company from 1966. Among his many roles in the troupe's large repertory were "The White Man" in Limón's *Emperor Jones*, the "Conquistador" in his *La Malinche*, "The Moor," in his *Moor's Pavanne*, and parts in his *The Winged* and Doris Humphrey's *Night Spell*. De Soto also performed with the Contemporary Dance System, a troupe made up of young dancers trained in the Limón and Doris Humphrey repertory, appearing in Anna Sokolow's *Lyric Suite* and Peter Sparling's *Little Incantations* (1974).

Desplaces, Henri, French nineteenth-century ballet dancer and choreographer; born c.1820; the exact dates of Desplaces' birth and death could not be verified. Trained at the school of the Paris Opéra, he graduated into the company, c.1840. Celebrated to this day as a *danseur noble*, he partnered many of the most famous ballerinas of his day, among them, Carlotta Grisi in *Ozai* (1847), Adele Dumilatre in *Robert Bruce* (1846), Elena Andreanova in *Robert le Diable* (1845), and Fanny Cerrito in productions in London. Desplaces worked in English theaters in the 1850s and 1860s including the Lyceum and Covent Garden. His known choreography (probably a negligible percentage of his total output) dates from his English period and includes his ballets for Fanny Cerrito, *Eva* (1855) and *La Brésilienne* (1857). He was on the staff of the Teatro Reggio in Turin in mid-1877 when he dropped out of verifiable sight.

Works Choreographed: CONCERT WORKS: *Eva* (1855); *La Brésilienne* (1857); *L'Ile Enchanté* (1864); *Nana Sahib* (1877).

Destiné, Jean-Leon, Haitian dancer and choreographer also working and teaching in the United States; born March 26, 1928 in St. Mark, Haiti. While an adolescent, Destiné worked with Lina Mathon Blanchet, organizer of the first professional Haitian dance company based on local folklore. He first performed in the United States with Blanchet's troupe and, after becoming a member of the staff of *La Nouvelle* (the Port-au-Prince paper), accepted a fellowship to study typography in New York City where he also continued his dance training and began to give recitals. After returning to Haiti, he joined Katharine Dunham's company for her Bal Negre tours in the mid-1940s. From 1948 to the mid-1960s he commuted between Haiti and the United States, organizing companies in both places, making films, and staging both recitals and festivals of folklore. Destiné's troupes have been seen to wild acclaim across North and Central America, and in the Orient and Europe. He has taught Afro-Caribbean at the New Dance Group since 1960 and has had a tremendous influence on dancers interested in the study of a specific folklore and also those whom the training in any folk process enables to create their own movement vocabularies and structures.

De Swirska, Tamara, Russian interpretive dancer and pianist; born c.1890 in St. Petersburg. Billed as "The Russian with the Soul of a Greek," De Swirska had been a concert pianist before beginning her dance career. Apart from the season in which she toured with Anna Pavlova, her concert format was the same from 1910 to the early 1930s: she alternated piano solos with her interpretations of women of antiquity. In her heyday (c.1910–1919), she was very popular on the Keith circuit, in films made for the Imperial Film Corp., and at the London Coliseum, in the *Egyptian Ballet* (1911), *The Temple Dance of Dionysius* (1914), and her most famous work, *Tanagara Suite,* a series of unconnected dances "as performed by the Women of Ancient Greece." Her importance to dance history lies not in her own work, which others did similarly, but in her connections; she was, for example, a link between the classical ballet and the opera world and introduced Mary Garden to Andreas Pavley and Serge Oukrainsky, thus hastening the formation of a ballet company in Chicago, Illinois.

Works Choreographed: CONCERT WORKS: *Prelude, Waltz and Mazurka* (1910); *Egyptian Ballet* (1910); *Le Matin* (1910); *Peer Gynt Suite* (1910); *Tanagara Suite (Meditation from Thais, The Bat, Coppélia, Pizzicato, The Bacchanale)* (1911); *Danse Coquette* (1911); *Tzardas* (1911); *Pantomime and Tziganes Dance* (1911); *Faust Ballet* (1911); *Danses Slaves* (Nuptiale, Mazurka, Danse Nationale Russe) (1911); *The Temple Dance of Dionysius* (1914); *Olympia Ballet* (1914); *Cléopâtre* (1916, possibly co-choreographed with Serge Oukrainsky); *The Soul of Chopin* (1918); *The Butterfly* (1918); *The Poisoned Flower* (1918).

De Valois, Ninette, Irish ballet dancer and choreographer in England; born Edris Stannus, June 6, 1898 in Baltiboys, Ireland. Raised in London, she was trained at the Lila Field Academy with private lessons from Enrico Cecchetti and Leon Espinosa. De Valois was known as a pantomime ballet specialty dancer at the Lyceum long before she had a career in any of the more traditional media. She also worked with the British National Opera, the (Thomas) Beecham Opera, and the Royal Opera, Covent Garden (1919, 1928), before joining her first ballet company,

the Massine/Lopoukhova troupe (1922–1923). From 1923 to 1925 she was a member of the Diaghilev Ballet Russe, hired presumably when Massine returned to that company, and dancing in his *Les Facheux*, Mikhail Fokine's *Carnaval*, and Bronislava Nijinska's *Les Biches*.

Returning to London in 1926, she opened an Academy of Dancing and began to stage and teach movement to actors at the Old Vic. A founding member of the Camargo Society, she danced in her own *Cephalus and Procris* (1931) and *The Origin of Design* (1932). The director of the Vic-Wells Ballet (later, the Sadler's Wells and after that, the Royal Ballet), she created roles in Frederick Ashton's *Les Rendezvous* (1933), *Regatta* (1931), and *A Wedding Bouquet* (1937).

Few of De Valois' ballets have been preserved; not even her most famous work, *Checkmate*, is in the active repertory of an English company. It seemed that, like so many other choreographers, her success as an administrator was in reverse proportion to her prolificacy as a choreographer, since the frequent creation of pieces of the early 1930s died down in the 1940s.

Works Choreographed: CONCERT WORKS: *Les Petits Riens* (1928); *The Faun* (1928); *Fighting the Waves* (1929); *The Picnic* (1929); *Homage aux Belles Viennoises* (1929); *Suite de Danse* (1930); *Danses Sacrées et Profanes* (1931); *The Jackdaw and the Pigeons* (1931); *Cephalus and Procris* (1931); *Job* (1931); *Fête Polonaise* (1931); *Jew in the Bush* (1931); *La Création du Monde* (1931); *Narcissus and Echo* (1932); *Rout* (1932); *Italian Suite* (1932); *Nursery Suite* (1932); *Douanes* (1932); *The Origin of Design* (1932); *The Scorpions of Ysit* (1932); *Pride* (1933); *The Birthday of Oberon* (1933); *The Wise and Foolish Virgins* (1933); *The Haunted Ballroom* (1934); *The Jar* (1934); *Bar aux Folies-Bergère* (1934); *The Rake's Progress* (1935); *The Gods Go A-Begging* (1936); *Barabau* (1936); *Prometheus* (1936); *Checkmate* (1937); *Le Roi Nu* (1938); *The Prospect Before Us* (1940); *Orpheus and Eurydice* (1941); *Promenade* (1944); *Don Quixote* (1950); *Coppélia* (1954, with Nicolas Sergeev after Cecchetti, Ivanov, and Petipa).

Bibliography: De Valois, Ninette. *Invitation to the Dance* (London: 1937); *Come Dance with Me* (London: 1957); *Step By Step* (London: 1977).

De Voie, Bessie, American theatrical dancer; born c.1888 in Mt. Clemens, Michigan. De Voie was acting in a stock company in Colorado when she was "discovered" by producer Nat C. Goodwin. She made her Broadway debut in *The Show Girl* (1902) as a chorus member, but first did ballet on stage in *Mr. Bluebeard* (1903), where she appeared in the "Fairy Ballet" and the "March of the Amazons." Joining the Rogers Brothers' company in 1904, she performed in two of their comedies—*The Rogers Brothers in Paris* (1904) and *In Ireland* (1905). After dancing in *The Dairymaids* (1907) and *The Little Cherub* (1909), she became involved in a very complicated divorce/breach of promise/conspiracy case which brought her publicity and wide public recognition. She was given much larger roles on Broadway and her own vaudeville acts after the suit was brought—among them, *Our Miss Gibbs* (1910), *Louisiana Lou* (1912), the national tour of *The Three Twins* (1910), in Bessie McCoy's part, and *Pom-Pom* (1916), and vaudeville acts with Al B. White in 1913 and Guy Livingstone in 1915.

Although she also did musical comedy techniques, including clog and pedestal work, De Voie was best known as a ballet dancer in the above shows. In one series of reviews, published before the Gould divorce case broke in the papers, she was compared to Carlotta Grisi, Fanny Elssler, Amelia Glover, and Emma Qualitz—all now recognized as excellent technicians and proponents of the Romantic era.

De Wees, Paul, Jr., American theatrical dancer; born April 19, 1910 in Pocomoke, Maryland. Pee Wee De Wees, as he was known, performed with his father's band on the Keith-Orpheum circuit as an adolescent. Leaving the family act, he toured in Gus Edwards' units during 1925, reportedly including his *Messenger Boys* act with adolescents who grew up to be Sammy Lee and Al Shaw.

De Wees did a flash dance act, an eccentric tap accentuated by his unique personal gestures. Although he did an acrobatic tap act in both of his Shubert shows, *A Night in Spain* (1927) and *A Night in Venice* (1929), it doesn't seem to have been part of his regular vaudeville and Prolog act. He went from Broadway to the Paramount/Publix Prolog circuit with his popular units, *Non-Stop to Mars* and *Jazz*

Grab-Bags. It is not known whether he injured himself or just decided to get off the circuit, but by late 1929 he had retired from dancing to perform and produce for Paramount/Publix Radio Romances.

Diachenko, Nada, American modern dancer and choreographer; born July 31, 1946 in Miami, Florida. Diachenko has studied ballet with Zena Rommett and modern techniques with Ethel Butler, Martha Graham, Merce Cunningham, Hanya Holm, and Erick Hawkins, with whom she performed for many years as Nada Reagan. Her work with Hawkins included performances in a number of his most important works, most notably the duet with him in *Here and Now with Watchers, Classic Kite Tails* (1972) and *Greek Dreams with Flute* (1973). She has also performed frequently with members of the Hawkins troupe in their own choreography, including concerts with Beverly Brown and Lillo Way and recitals of the Greenhouse Dance Ensemble, a group that at times included most of the casts of her Hawkins' creations and which she now co-directs with Way. Diachenko's teaching has included work in New York, in college residencies, and work in Berlin and London.

Works Choreographed: CONCERT WORKS: *Alighting Aloft* (1972); *Summer Settings* (1973); *Blued Spaces* (1975); *For Four* (1977); *In and Out of Sides* (1977); *Beneath It All* (1978); *Branching* (1979); *Shades of You, Shades of Me* (1979); *Structures* (1980); *To a New Place* (1981); *Avian Images* (1981).

Diaghilev, Serge, Russian impresario and arbiter of artistic taste; born Seleschev, Novgorod, Russia; died March 31, 1929 in Venice. As a law student, he moved to St. Petersburg in 1890 and became a member of an artistic circle that espoused both nationalism and experimentation in art. He was involved in graphic arts in the last decade of the century, becoming the co-founder and editor of *Mir Iskoustva* (the World of Art), a short-lived but highly influential journal. As editor of the *Annals of the Imperial Theatre* in St. Petersburg in 1899, he established standards in graphic design and typography that have never been matched. Diaghilev also served as curator and tour manager for art exhibits, among them, Russian historical portraits in St. Petersburg in 1901, and the touring collection of Russian art that traveled to Paris in 1906 with works by Alexandre Benois, Léon Bakst, Natalia Gontcharova, and Mikhail Larionov.

Although he had served as an artistic adviser of the Imperial Ballet, responsible for a revival of *Sylvia* for which he was dismissed, his reputation as an arts impresario rested on the success of his concert tours with Fyodor Chaliapin, considered the great basso voice of the time. He brought him to Paris in recital (1907) and in the opera *Boris Gudonov* (1908) to great acclaim.

The success of the Gudonov production brought Diaghilev an invitation to institute a Paris season of Russian opera and ballet in 1909. The Ballet Russe de Diaghilev, which did in fact produce operas for much of its lifespan, quickly became the most innovative and influential aspect of European artistic life. Works of dance, art, music, and even architecture were defined by their proximity to Diaghilev's personal taste and judged accordingly.

He functioned as a curator—but one with a human museum. His productions reflected the changes in the tastes of his twenty years in Western Europe, but maintained a bond to his own personal concepts of art and performance. The concept of modernity itself altered dramatically during his career, urged on or followed by him. In a general chronology, one finds in his productions: naturalism in the works of Benois with Mikhail Fokine; orientalism in Bakst; a progressive shift from the neoromanticism of *Narcisse* (1911) and *Thamar* (1913), to the early cubism of *Schéhérézade* and *Le Dieu Bleu* (1912); true cubism in the designs of Pablo Picasso, for *Parade* (1917), and Matisse and Braque; artistic neoclassicism in art in the early 1920s revivals of *The Sleeping Beauty*; Gontcharova and Larionov's "Rayonisme"; and French constructivism in the choreographic and musical neoclassical collaborations of George Balanchine and Igor Stravinsky; and true Russian constructivism in many of the last works of the company, among them Leonid Massine and Pavel Tchelichtev's *Ode*.

The choreographers that he sponsored from within the company included dancers Mikhail Fokine, Vaslav Nijinsky, Leonid Massine, Bronislava Nijinska, and George Balanchine, who, it has been reported, was hired as a choreographer who happened to be able to dance. Their own artistic ideals affected

the repertory also, although some were less able to impose themselves on Diaghilev and created *his* ballets, not their own. Although no Diaghilev choreographer can be said to have been un-avant-garde, the works of Fokine and Massine now seem less innovative, possibly because they are the most familiar, while those of the Nijinskys are devastating in their impact. Both, working independently at a ten-year interval, used the starkness and power of early constructivism, defying conventional ballet vocabulary by creating stage pictures of movement and plastiques in silences. While it is possible that Balanchine, straight from the experiments of Kasyan Goleizovky, would have revolutionized the ballet without the sponsorship of Diaghilev, it is likely that it would have taken much longer for him to do so. As a Diaghilev choreographer, his new structures and movements were fashionable in their unpopularity.

The company's actual performance history still has not been fully documented, although Nesta MacDonald's work on the tours of England and the United States are certainly informative. The company performed in Paris, occasionally touring to England and the south of Europe, dancing in Venice, Monte Carlo, and the spa areas. The commuting between Western and Eastern Europe ended with the revolution in Russia, although Diaghilev still imported dancers and ideas from the Soviet Union after that point. The infamous American tours—of South America in 1913 and of the United States and Canada in 1916–1917—were undertaken without his presence. It cannot be overemphasized, however, that the American dance, music, and artistic circles were fully aware of each infinitesimal shift in Diaghilev's artistic tastes; each was widely reported and discussed and the fact that his followers had to sail to Europe to get their information at second hand was unimportant.

Eventually, in discussing the Ballet Russe, every author has to deal with the importance of personal life on artistic creation. Diaghilev's life has been discussed with an extraordinary vocabulary of euphemisms and has been transformed into a seemingly endless series of popular scandals. All reporting on his relationships to his dancers, collaborators, and choreographers is speculative—some based on fact, some entirely romanticized. While it does not seem particularly important to dance history that he was

homosexual, it is vitally important that he could not maintain relationships—personal or professional. By turning off on people, he distributed them to every area of the dance world, creating a universal second generation of his company, ideas, and taste. In Poland, where Nijinska directed companies, to France, where for many years Serge Lifar controlled the Paris Opéra, to South America where each opera house had its resident ex-Ballet Russe-er, to England where Ninette De Valois and her protégés developed the art form, to the United States where, depending on affiliation, dancers swear by Fokine, Massine, or Balanchine, Diaghilev's protégés were vital in the development of the national form of ballet.

Bibliography: (Note: there are serious problems with many of the following works, but each gives a view of some sort to the Diaghilev reality or mythology.) Haskell, Arnold and Walter Nouvel. *Diaghilev—His Artistic and Personal Life* (London: 1935), the standard book on Diaghilev; Kochno, Boris. *Diaghilev and the Ballets Russes* (New York and London: 1971), the best general work on the company repertory; MacDonald, Nesta. *Diaghilev Observed: By the Critics in England and the United States (1911–1929)* (London and New York: 1975), the best work on the company, but only dealing with performances in English-speaking countries.

Diamond, Matthew, American modern dancer and choreographer; born 1952 in New York City. Trained at the High School of Performing Arts, he danced in the companies of three faculty members—Paul Sanasardo, Norman Walker, and Matteo, as one of his Indo-American Dancers.

A member of the Louis Falco company from 1969 to the mid-1970s, he toured extensively and created roles in his *Timewright* (1969), *Caviar* (1970), *The Sleepers* (1971), *Soap Opera* (1972), and *Avenue* (1973), and Jennifer Muller's *Rust: Giocometti Sculpture Garden* (1971) and *Tub* (1973). When she split from the Falco company, he joined Jennifer Muller and The Works, dancing in her *Speeds* (1974) and *Beach* (1976).

Concurrently to his Falco/Muller engagements, he performed with the José Limón company, with its Limón and Doris Humphrey repertory, and the Contemporary Dance System, which meshed its Hum-

phrey pieces with those by Anna Sokolow. In the former company, he was assigned feature roles in Limón's *Carlota, La Malinche,* and *The Unsung,* while in the latter, he danced in Humphrey's *Day on Earth,* a young but effective "Man," and *Night Spell,* and in Sokolow's *Steps of Silence* and *Lyric Suite.*

One of the best young dancers in the city, and described as "the ideal Performing Arts trained performer," he has choreographed for his own company since 1977. His best known work is his first, *Dead Heat* (1975), a challenge dance for two men. Diamond's other activities include teaching sessions with the University of Alabama football team under the Affiliated Artists program. He is the brother of Dance Theatre Workshop video artist Dennis Diamond.

Works Choreographed: CONCERT WORKS: *Dead Heat* (1975); *Understudy* (1977); *Escalator* (1977); *Surface* (1978); *Points and Plots* (1978); *Hot Peppers, Jazz Babies and Creoles* (1978); *Silent Film* (1979); *And . . .* (1980).

Di Belgioso, Baldassare, Italian musician and fête organizer of the sixteenth century; born c.1530 in the Piedmontale region of northern Italy; died c.1587 in Paris. Originally a musician and composer, Di Belgioso, whose name is also given as Beaujoueux, went to Paris with a troupe of Piedmontalese instrumentalists in the service of the Maréchal de Brissac.

Di Belgioso was recognized as a fête organizer, the earliest form of dance direction, while serving as a member of the personal staff of Catarina d'Medici, queen and regent of France. His best known work, perhaps the first generally known work of choreographed dance, the *Ballet Comique de la Reine* (1581), was created for her as queen and as the descendent of the family that sponsored the early Italian masques.

Works Choreographed: CONCERT WORKS: *Défense du paradis* (1572); *Ballet aux Ambassaeurs polonais* (1573); *Ballet Comique de la Reine* (1581).

Di Bona, Linda, American ballet dancer; born June 21, 1946 in Quincy, Massachusetts. After local studies with Kay Corbett and Mary Corbett Burns, she traveled to the school of the Boston Ballet, graduating into the company in 1965. Although she had

three-year tenures with the Boston and Harkness Ballets, Di Bona is best known as a freelance ballerina who has guested in almost every company in the United States and Canada. Even while with the Boston Ballet, she appeared with James Clouser in his concert program, in *The Space* and *The Soul* (both 1968). As a specialist in contemporary works, her Harkness tenure, in which she danced in Norman Walker's *Night Song* and *Ballade,* Ben Stevenson's *Three Preludes,* Brian MacDonald's *Canto Indio,* and Vincente Nebrada's *Schubert Variations* and *Percussion for Six Women,* was interrupted by guest shots in other companies for which the choreographers worked. Di Bona has also toured in pas de deux programs with Bill Martin-Viscount (c.1968–1970) and with her husband, Robert Brassel, with whom she has danced with the Ballet de Wallonie and the State Opera Ballet in Basel.

Di Chirico, Giorgio, Greek painter and theatrical designer working in Western Europe; born July 10, 1888 in Vólos. The surrealist Di Chirico was living and exhibiting in Paris in the early 1910s, the first period of collaboration between the Russian Ballet and the Western European art community, but he did not realize a dance design until 1924 when Jean Borlin choreographed *Il Giaro* for the Ballet Suédois. His only Ballet Russe production was the company's penultimate premiere, George Balanchine's *Le Bal* (1929), for which he decorated conventional ballet costume shapes with architectural motifs. Later ballet designs include productions of Serge Lifar's *Bacchus et Ariadne* (1931) and *Apollon Musagète* (1956), David Lichine's *Protée* (1938), Margarethe Wallmann's *Joseflegende* (1951), and Aurel Milloss' *Amphion* (1944) and *Galanta* (1945).

Although he was not a prolific stage designer, his paintings had a tremendous influence on choreography and mise-en-scène of the 1940s and 1950s. Elements in his style, such as the manipulation of empty space, forced classical perspectives interrupted by rounded figures, and seemingly misplaced lighting effects, found their way into many ballet productions. Works that can be said to have allusions to Di Chirico's style include Leonid Massine's *Seventh Symphony* and *Mad Tristan* (designed by Dali), and Balanchine's *La Somnambule.*

Dickson, Charles, American ballet dancer; born June 30, 1921 in Bellwood, Pennsylvania. Dickson was trained by Ruth Barnes in Altoona, Pennsylvania, in tap and ballroom work. It is uncertain with whom he studied ballet.

He made his debut in the Ballet Russe de Monte Carlo in 1938, where he created small roles in Leonid Massine's *Seventh Symphony* and *Nobilissima Visione* (both 1938). In the middle of his four-year career, he danced with the Ballet Caravan company at the World's Fair, called The Ford Ballet since it performed for the automobile pavilion, and was a founding member of Ballet Theatre. Later, he appeared in pieces by Antony Tudor, notably as a "Lover-in-experience" in the premiere of *Pillar of Fire* (1942) before being drafted into the Armed Services.

Although he did not attempt to get back into ballet performance after the war, Dickson served as the ballet master of the touring Ballet Alicia Alonso (late 1940s and early 1950s), the Borovansky Ballet in Australia (mid- to late-1950s), the London Festival Ballet (from 1961 to 1962), and the Ballet Nacional Chileno. He was the artistic director of the Ballet Municipal de Santiago in Chile before returning to the United States to become professor of performing arts at the American University in Washington, D.C. He founded the Metropolitan Ballet of Bethesda, Maryland, near the District of Columbia, in 1971.

Dickson, Dorothy, American theatrical and exhibition ballroom dancer; born Kansas City, Missouri, July 26, 1986. Dickson was trained in ballet, social, and "fancy" dance forms in Kansas City, possibly by a member of the Kretlow family. She worked on Broadway as a dancer after further studies at the Ned Wayburn Studio in New York, with featured roles in *Oh! Boy!* (1917) and *Girl O'Mine* (1918), and in the *Ziegfeld Follies of 1917* and *1918.*

Forming an exhibition dance team with Carl Hyson, Dickson performed at the Palais Royale in New York, on Broadway in *Lassie* (1920), and in hotels and casinos in London and Paris. She remained in London when the team broke up, and took leading roles in West End productions of Broadway musicals, among them, the title roles in *Sally* (1921), *Tip-Toes* (1936), *Peggy Ann* (1928), and *The Sunshine Sisters* (1933). Aside from ENSA performances and benefits, she worked as a dramatic actress from 1938 to the end of her career.

Didelot, Charles-Louis, French ballet dancer and choreographer working in London and St. Petersburg; born 1767 in Stockholm; died November 7, 1837 in Kiev. Didelot was raised in the Théatre-Italien tradition and performed under Jean D'Auberval and Jean-Georges Noverre; he brought both phases of the *ballet d'action* movement to Russia at the beginning of the nineteenth century and is generally credited with the development of "modern" ballet in that country. Didelot was born and raised in Stockholm, where his father was a performer with the Royal Opera House. Both his father and his early teacher, Louis Frossard, had been members of the Comédie-Italienne in Paris, the popular theater specializing in commedia dell-arte. Sent to Paris in 1776 to study with Jean D'Auberval, Jean-François Deshayes, and Gaetano Vestris, he performed with the Théatre Boulevard de l'Ambigu-Comique (1779). He worked under Deshayes at the Comédie-Française and the Paris Opéra in the early 1780s before returning to Stockholm in 1778.

Moving to London in 1787, he danced at the King's Theatre in the choreography of Jean-Georges Noverre, then ballet master. Among the many works in which he performed were his *Les Offrandes à l'Amour* (1787), *Les Fêtes du Temps* (1788), *Les Fêtes Provinciales* (1789), and *Annette et Lubin* (1789), partnering Mme. Guimard. From 1789 to 1791 he danced for D'Auberval in Bordeaux and London, partnering Marie-Madeleine Crespé in *Amphion, élève des muses* (1790), *Sylvie* (1790), and *La Fille Mal Gardée.*

He became a member of the Paris Opéra briefly—from August 1791 to Summer 1793—dancing with Guimard in Sébastien Gallet's *Bacchus et Ariadne* (1791), and Gardel's *Le Premier Navigateur* (1791) and *Le Jugement de Paris* (1793). He left the Opéra to join the Théâtre Nationale, which like most Opéra rivals, was soon closed down. After working in Lyon, he returned to London to become ballet master of the King's Theatre. He danced in works by Gallet, including his *Pizarre, ou la Conquête du Péron* (1797), and in his own ballets, among them,

L'Offrande à Terpsichore (1796), *La Chasse de l'Amour* (1798), and *Coustade et Alcidorie* (1798).

In 1801, he accepted an invitation to work in St. Petersburg staging ballets and opera divertissements for the company and reorganizing the school of the Imperial Theatres. Although he returned to London and Paris to work in 1812–1814, his Russian period is considered the most important professional aspect of his later life. A prolific choreographer, he created many of the cornerstones of the Russian repertory of the 19th century, among them, *Acis et Galathée* (1816), the *Prisoners of the Caucasus* (1823), and the revival of *La Fille Mal Gardée*.

A link between the popular theater and the *ballet d'action* style, Didelot was a transmitter of the French and English choreographic style to the Russian theaters. As such, he is a part of a vital chain of creative themes that cross the continent bouncing off political and cultural borders to return in different guises as "innovations" or "national styles."

Works Choreographed: CONCERT WORKS: *Pas de Deux (I)* (1786); *La Bonté du Seigneur* (1788); *Richard Coeur de Lion* (1788); *Divertissement (I)* (1789); *L'Embarquement pour Cythère* (1789); *La Métamorphose* (1795); *Pas de Deux (II)* (1796); *Pas de Deux (III) and Pas de Trois* (1796); *Pas de Deux (IV, "Polish")* (1796); *Little Peggy's Love* (1796); *Caravan at Rest* (1796); *L'Amour Vengé, ou la Métamorphose* (1796); *Flore et Zéphire* (1796); *L'Heureux Naufrage, ou les Sorcières Ecossaises* (1796); *Sappho et Phaon* (1797); *Acis et Galathée* (1797); *Laura et Lenza, ou le Troubadour* (1800); *Alonzo the Brave and the Fair Imogene* (1801); *Ken-si and Tao* (1801); *Apollo et Daphne* (1802); *Roland et Morgana* (1803); *Zéphyr et Flore* (1804); *Télémaque dans l'Ile de Calypso* (1806); *Médée et Jason* (1807, after Le Picq); *The Sea Pier* (1808, Russian title unavailable); *Don Quixote* (1808); *Divertissements (II)* (1808); *Psyché et l'Amour* (1809); *Solange Rose* (1809); *Zélis et Alcindor, ou la Fôret aux Aventures* (1809); *Laura et Henri* (1810); *L'Epreuve, ou la Jambe de Bois* (1810); *Zéphyr Inconstant puni et fixé, ou les noces de Flore* (1812); *La Reine de Golconde* (1812); *Le Bal Champêtre* (1812); *Le Pâtre et l'Hamadryade* (1813); *Une Soirée d'Eté* (1813); *La Chaumière Hongroise, ou les Illustres Fugitifs* (1813); *Les Amants Péruviens* (1813); *Kacheli* (1813); *L'Indorf et Rosalie, ou*

l'Heureuse Russe (1813); *Thamaida et Alonzo, ou l'Ile Sauvage* (1814); *Karl et Lisbeth, ou le Déserteur Malgré Lui* (1814); *Divertissement (III)* (1814); *Le Bassard d'Alger, ou le Retour du Corsair* (1814); *Zéphire et Flore* (1815); *Le Retour des Héros* (1816); *Acis et Galathée (II)* (1816); *Les Vacances dans le Seraglio* (1816); *Aline, Reine de Golconde* (1816); *Belmonté et Constance* (*The Abduction from the Seraglio*, music from opera by Mozart) (1816); *Soirée au Jardin* (1817); *Divertissement (IV)* (1817); *Nicette et Lucas, ou la Laitière Nouvelle* (1817); *Divertissement (V)* (1817); *Apollo et les Muses* (1817); *Don Carlos et Rozalba* (1817); *Théséus et Ariadne* (1817); *La Chaumière Hongroise, ou les Illustres Fugitifs* (1817); *Apollon et Pallada au Nord* (1818); *Semélé, ou la Vengeance de Junon* (1818); *Léon et Tamaida* (1818); *Divertissement VI* (1818); *Le Calife de Bagdad* (1818); *Lodoiska, ou les Tartares* (1818); *Zoraime et Zunlare* (1818); *Au Chasse* (frequently translated as *A Hunting Adventure*) (1818); *Raoul de Créquis, ou le Retour des Crusades* (1819); *La Victoire Naval* (1819); *Bazar* (1819); *Divertissement (VI)* (1819); *Raoul Barbe-Bleu* (1819, tournament and feast only); *Inès de Castro* (1820); *Robert, Ataman des Bandits* (1820); *Cora et Alonzo* (1820); *Euthyme et Eucharis* (1820); *Alcestis,* (ou la descente d'Hercule aux Enfers) (1821); *Le Jugement de Solomon* (1821); *Christophe Colomb, ou la Découverte du Nouveau Monde* (1821); *La Tempête* (1821); *Alexandre aux Indes* (1821); *Les Bandits Algériens* (1821); *Les Tableaux Vivants* (1821); *L'Offrande à l'Amour* (1822); *Toberne, ou le Pêcheur Suédois* (1822); *La Princesse de Trebizond* (1822); *Carlo, le Secrétif* (1822); *L'Oiseux feu* (also listed occasionally as *Katchei*) (1823); *Charade en action* (1823); *La Lis de Narbonne* (1823); *The Prisoner of the Caucasus* (1823, original Russian title unavailable); *Anacréon et Cupidon* (1823); *Divertissement Espagnole* (1823); *L'Abduction* (1823); *The Falcon of Prince Yaroslav of Tver, or the Promised Husband on a White Horse* (1823); *The Pirate* (1823, Russian title unavailable); *The Broken Idol* (1824); *Baba-Yaga, ou La Noce d'Ivan, Tsarevich* (1824); *Le Miroir Magique* (1824); *La Fôret Noire* (1824); *The Thunder Clap, or the Terrible Secret* (1824, Russian title unavailable); *Ruslan et Ludmilla* (1824, co-choreographed with Auguste, after Adam Glushkowsky); *Romance in Action* (1824,

Russian title unavailable, this work may be a series of tableaux vivants); *The Dream of Svetlana* (1825, Russian title unavailable); *Diadima* (1825, tableaux vivants only); *Phaédra* (1825); *Kerim-Girei* (1825); *Divertissement from Le Diable à Quatre* (1825); *The Return of Prince Pozharscky to His Estate* (1826, Russian title unavailable); *The Dream Realized* (1826, Russian title unavailable); *The Islands of Trials* (1827, Russian title unavailable); *La Fête Villageoise* (1827); *Lisette et Colin* (1827, after *La Fille Mal Gardée* of D'Auberval); *Joy of the Moldavians, or Victory* (1828, Russian title unavailable); *Dido, ou la Destruction de Carthage* (1828, with Auguste after Le Picq); *La Femme Folle* (1829, possibly a version of *La Somnambule*); *The New Woman, or the Cossack Woman* (1828); *Piramo et Thisbé* (1829).

Bibliography: Swift, Mary Grace. *A Loftier Flight: The Life and Accomplishment of Charles-Louis Didelot* (Middletown, Conn.: 1974). The above listing of concert works is based partially on the one in Swift, which is translated and adapted from one by Yuri Slominsky.

Dilley, Dorothy, American theatrical dancer; born c.1907 in the Los Angeles area. Dilley was trained by Ernest Belcher and others in Los Angeles and performed in films as a child. She joined the *Music Box Revue of 1923* on tour in Venice, California as a replacement for Harriet Hoctor. The diminutive Dilley did Hoctor-style acrobatic ballet numbers in *Kitty's Kisses* (1926) and the *Music Box Revue of 1923* but by 1927 and *Take the Air*, she was equally well known as a musical comedy ingenue. In that show, she did the contemporary popular social dances and partnered Will Mahoney ("Man with the World's Funniest Feet") in his specialties.

Dirtl, Willy, Austrian ballet dancer; born March 4, 1931. A member of a celebrated family with close connections to the Vienna State Opera, he was trained at the company's school, graduating into the troupe in 1948. For twelve years, he was a valuable member of the company with principal roles in both the nineteenth-century classics, such as *Swan Lake* and *Giselle*, and in contemporary works by Erika Hanka and Yvonne Georgi. Among his many created roles were parts in the former's *The Moor of Venice*

(1955) and *Medusa* (1957), the latter's *Ruth* (1959), and Erich Walter's *The Wanderings of Odysseus* (1965). Dirtl's cousin Gerhard overlapped his last years in the Vienna State Opera, joining the company in 1962.

Dishong, Zola, American ballet dancer; born in the late 1940s in Albany, California. Trained by Harold Christensen at the School of the San Francisco Ballet, Dishong joined the American Ballet Theatre in 1967.

In her six years with the company, she created roles in Alvin Ailey's *Sea Change* (1972) and Eliot Feld's *Eccentrique* (1972), and performed in Dennis Nahat's *Brahms Quintet* and *Ontogeny*. An extremely beautiful woman with a fluid performance line, she was ideally suited to Nahat's works and to a role in which many still remember her—the solo "Lover-in-Experience" and partner of the "Man in the House Opposite" in Antony Tudor's *Pillar of Fire*.

Dishong left Ballet Theatre to return to California; she is currently teaching at the School of the San Francisco Ballet.

Ditchburn, Ann, Canadian ballet dancer and actress; born c.1950 in Sudbury, Ontario. Ditchburn was trained at the school of the National Ballet of Canada in Toronto from her early adolescence and, apart from a leave of absence to continue her studies in London at the Dance Centre, she performed with the National Ballet until 1978. Among her many leading roles were dance parts in the contemporary repertory and dramatic ones in the Celia Franca productions of the classics. Ditchburn also staged a revue of dance works that toured briefly in Canada, and appeared at the annual Shaw Festivals. She is best known for her role as the ailing ballerina in the exceedingly melodramatic American film of 1978, *Slow Dancing in the Big City*, with choreography by, among others, Jacques D'Amboise.

Works Choreographed: CONCERT WORKS: *Listen #1* (1967); *Kisses* (1972); *Mad Shadows* (1977).

Dixon, Harland, American tandem and tap dancer, and cabaret and film choreographer; born August 10 or 17, 1886 in Toronto, Ontario; died June 27, 1969 in Jackson Heights, New York. Dixon, who claimed

to have no formal training, left Canada to become a member of George Primrose's Minstrels in 1906. From 1907 to 1909, he performed a clog dance act with Jack Corcoran in the rival Dockstadter's Minstrels, later touring with Corcoran in vaudeville.

In May 1912, Dixon met James Doyle (1889–1927), himself a Dockstadter alumnus. They worked together for eight years, forming one of the most celebrated and innovative male tandem acts of the period. After joining the touring cast of the Gertrude Hoffmann musical *Broadway to Paris* in late 1912, they were invited by dance director Ned Wayburn to appear in his *Honeymoon Express* in 1913. They performed in musical comedies and revues, among them, Ziegfeld and Wayburn's celebrated *The Century Girl* in 1916, and in vaudeville in the United States and Europe.

In late 1919, Doyle and Dixon went on tour as the leads in the national company of the Montgomery and Stone vehicle *Chin Chin*. When Fred Stone, then appearing on Broadway in *Tip Top,* broke his foot, Dixon left the tandem act to replace him. As a solo dancer, Dixon was featured in some of the most important shows of the 1920s, among them the Ziegfeld musical comedy *Kid Boots* (1923), the *Ziegfeld Follies of 1923*, in which he performed alone on stage (rare for a male in a Ziegfeld show) with a shadowgraph lighting effect, and the Gershwin's *Oh, Kay!* (1926). He returned to Broadway in 1951 with a featured role in *A Tree Grows in Brooklyn*.

Dixon went to Hollywood in 1935 to work for Warner Brothers/Vitaphone Studios. He was staff dance director for most of the "Broadway Brevities" series of two-reel musical comedy shorts, released from 1936 to 1939, and coached dances for and performed in the James Cagney vehicle *Something to Sing About* (Grand National Pictures, 1938).

Dixon's final career was as the dance director for Billy Rose's chain of cabarets, from 1940 through the mid-1950s. He also served as consultant on dance and vaudeville sequences for early live television dramatic specials, notably the Bert Lahr play *Burlesque* (on *The Prudential Family Playhouse*, CBS, 1950).

Dixon's last appearance as a dancer is believed to have occurred at the end of the limited run of the tap revival revue, *Old Bucks and New Wings*, late in 1962.

Works Choreographed: THEATER WORK: Billy Rose cabaret revues.

FILM: *I'm Much Obliged* (Vitaphone, 1936); *Rush-Hour Rhapsody* (Vitaphone/WB, 1936); *Captain Blue Blood* (Vitaphone/WB, 1937).

Dixon, Will, American theatrical and film dancer; born 1911 in Brooklyn, New York; died January 8, 1953 in New York City. After his debut in the chorus of *America's Sweetheart* (1931), he worked as the emcee at the Coconut Grove, Boston, and partnered Nina Olivette in a vaudeville dance act. He toured with the Rudy Vallee band before making his feature film debut in the *Gold Diggers of 1937* (WB, 1936). He was a featured dancer in many of the Busby Berkeley musical pictures of the 1930s, among them, *The Singing Marine* (WB, 1937) and *Ready, Willing and Able* (WB, 1937), in which he tapped across a gigantic typewriter keyboard with Ruby Keeler.

Returning to Broadway in the late 1930s, he appeared in *Hold On To Your Hats* (1939), *Higher and Higher* (1940), and created the role of "Will" in *Oklahoma!*. As such, he had the only tap solo in the show, leading the chorus in "Everything's Up to Date in Kansas City." Although he continued to make personal appearances through the 1940s, working in nightclubs and on the late Prolog circuits, he spent most of the last decade of his life writing songs.

Dlugoszevski, Lucia, American composer; born 1925 in Detroit, Michigan. After studying at the Detroit Conservatory, she moved to New York to continue her composition training under Edgar Varèse. Dlugoszevski has contributed tremendously to the aesthetic of the Erick Hawkins Company, composing scores for most of Hawkins' works. Because she frequently performs on stage, her created instruments become an element of his mise-en-scène. She was affected by the prepared instrument and *musique concrète* movement of the 1940s, but has adapted the continuum between prepared instruments and pedestrian movement to Hawkins' more theatricalized gesture system. She works often with the "Timbre Piano," prepared to return the instrument to its origin as a percussive, as well as designing new complex chimes, bells, drums, and surfaces.

Among the many Hawkins pieces to which she has contributed music are the first, *Opening of the (eye)* (1951), *8 Clear Places* (1960), and *Here and Now with Watchers* (1957), considered seminal not only for Hawkins' artistic progress but also within their collaboration.

Doboujinsky, Mstislav, Russian theatrical designer; born August 2, 1875 in Novgorod; died 1957 in New York City. Doboujinsky, who had contributed to Diaghilev's art journal, *Mir Iskoustva*, was commissioned to do the scenery and costumes for Diaghilev's productions of Mikhail Fokine's *Papillons* (1914) and *Midas* (1914). With his unique ability to make a simple tutu seem specifically invented for the movement, scale, and rhythm of each work, he was popular designing in Europe and the United States, where he designed Ballet Theatre's production of Balanchine's *Ballet Imperial* (1941), and David Lichine's *Graduation Ball* (1944). His costumes for Pavlova's *Die Puppenfee* (1915) had made him a reputation in England where he was commissioned to design costumes and sets for the Ballet Rambert's *Coppélia* and the Sadler's Wells *Nutcracker* (1937).

Dobson, Deborah, American ballet dancer working in Germany; born c.1950 in Sacramento, California. After early training locally with Barbara Crockett, Dobson attended the San Francisco Ballet School, spending her summers at the School of American Ballet in New York.

She spent her adolescence with the Sacramento Civic Ballet before joining the American Ballet Theatre in 1969. Known for her athletic prowess as well as her ballet technique, Dobson created roles in Tomm Ruud's *Polyandrion* (1973) and in Alvin Ailey's *Sea-Change* (1972), while being celebrated in his *The River*. She was featured in the company premieres of Rudi van Dantzig's *Monument for a Dead Boy* and Natalia Makarova's *La Bayadère* (1974 staging of the Kingdom of the Shades only), and in Eugene Loring's *Billy the Kid,* Frederick Ashton's *Les Patineurs*, and the Ballet Theatre production of *La Fille Mal Gardée*.

With her husband, Jonas Kage, Dobson left Ballet Theatre to dance in Europe with the Stuttgart (1974) and then the Geneva Ballets.

Docherty, Peter, English theatrical designer; born June 21, 1944 in Blackpool. Trained at the Central School of Art and Design, a center of environmental work in London, Docherty is known for his designs for two contemporary English choreographers—Peter Darrell and Eric Hynd. His productions for Hynd had been primarily for his abstractionism and have included *Le Baiser de la Fée* (1971), *In a Summer Garden* (1972), and *Mozartiana* (1973). For Darrell, however, he is best known for his sets and costumes for longer, plotted ballets, most notably his *Tales of Hoffmann* (1973) and *Mary, Queen of Scots* (1976). In the latter, his collageist tutus and set hangings were especially effective.

Dodge, Jerry, American theatrical performer; born Gerald Dodge Goodbee in 1937 in Washington, D.C.; died October 31, 1974 in New York City. After acting training and stock experience at the Cass Theater in Detroit, Dodge made his Broadway debut as one of the teen-age chorus members in the original cast of *Bye Bye Birdie* (1960). He had important roles in five major Broadway shows during his short career—*Birdie, 110 in the Shade* (1963), *George M!* (1968, as "Jerry Cohan" and as "George" in the national company), *Mack and Mabel* (1974), and as the original "Barnaby Tucker" in the first one thousand performances of *Hello, Dolly*. Dodge also acted in dramatic plays and comedies Off Broadway, as well as productions of the American Shakespeare Festival. He had begun a career as a rock musical director shortly before his death during the *Mack and Mabel* run.

Dodge, Roger Pryor, American jazz and concert dancer; born 1898 in Paris; died June 2, 1974 in New York. Dodge, known during the 1920s and 1930s as a dancer, is now thought of primarily as a collector of dance photographs and as a character who drifts in and out of the history of American jazz and ballet.

He was involved with dance during two periods of his life—the mid-1920s and early to mid-1930s. In 1925, he performed with Adolf Bolm; at some point during that year, he also danced in the chorus of the Marx Brothers' vehicle, *The Coconuts,* staged by Sammy Lee. His later role in Lee's ballet, *Skyscraper,* is considered his first major performance of

jazz combined with the more conventional techniques of ballet.

From 1935 to 1938, Dodge participated in the concert dance movement and in WPA-sponsored performances. Working with Mura Dehn, he performed solos in tap work on programs shared with José Limón and Charles Weidman or with his fellow members of the Brooklyn Museum's choreographer's workshops. The best known of these works, among them the *Jazz Toccata* (1936) and the *Black and Tan Fantasy* (1938), have been credited with "introducing" one native American dance form to another and combining tap and concert dance.

Works Choreographed: CONCERT WORKS: *St. Louis Blues* (1935); *Decadence* (1935); *Jazz Toccata* (1936); *Boogie-Woogie* (1936); *Man in the White Costume* (1936); *Dance Composition No. 2* (1937); *Black and Tan Fantasy* (1938); *The Lion Act* (1938); *Black and White Blues* (1938).

Dodworth, Allen, American nineteenth-century social dance teacher and musician; born 1817 in Sheffield, England; died February 12, 1876 in Pasadena, California. Born into a family of musicians, Dodworth arrived in the United States in 1825 with his father, Thomas, and brothers, Thomas, Charles, and Harvey. The entire family joined the Independent Band, which played at the Castle Gardens in downtown New York. Allen Dodworth played piccolo, trombone, cornet, and according to legend, played violin in the Philharmonic Society. In 1832, the family created the National Band, directed by the Dodworth patriarch; it became the most successful band in the country under his leadership and that of the youngest brother, Harvey, playing at the inaugurations of eight presidents.

Allen Dodworth split from the band in order to open a dance studio in New York in 1842. The first school was on Broome Street, but over the next thirty years, it gradually moved uptown to 681 Fifth Avenue. The Dodworth studio was the most fashionable in New York and Dodworth's conservative influence was tremendously strong. He preached courtesy and maintenance of the city's social hierarchy in his classes and textbooks. His nephew, T. George Dodworth, succeeded him in 1885 after he retired to California. The younger member of the family had directed a studio in Brooklyn, then a separate municipality.

Bibliography: Rosetta O'Neill, "The Dodworth Family." *Dance Index* (April 1943).

Doering, Jane, American ballet dancer; born c.1922 in Philadelphia, Pennsylvania. Doering was trained at the Littlefield School in Philadelphia before moving to New York to continue her training with Mikhail Mordkin and at the School of American Ballet. She performed with the early companies that were formed from SAB students, among them the American Ballet (the corps de ballet at the Metropolitan Opera) and the touring Ballet Caravan, in which she created roles in Erick Hawkins' *Show Piece* and Lew Christensen's *Filling Station* (1937). After a tour with the Littlefield Ballet, she began to work in theatrical format—Prologs and presentation act houses, including the Radio City Music Hall, and Broadway musicals such as *Early to Bed* (1943), *Are You With It?* (1945), and *Three to Make Ready* (1946).

Doering had a secondary dance career as a Spanish dancer under the stage name Dorina del Sol. She studied with Angel Cansino, touring with his troupe and working in presentation houses on her own.

Dokoudowsky, Vladimir, European ballet dancer and teacher; working in the United States; born May 31, 1920 in Monte Carlo. Dokoudowsky was trained by Olga Preobrajenska in Paris, but returned to Monte Carlo to make his professional debut with De Basil's opera season of 1936. He performed with a variety of Russian companies in Western Europe in the fertile 1937-1938 season, including Bronislava Nijinska's Polish Ballet (1937) and the Ballet Russe de Monte Carlo.

He immigrated to the United States with the latter company, performing in works by Leonid Massine, but soon switched to the (Mikhail) Mordkin Ballet and its artistic descendant, the original Ballet Theatre, of which he was a charter member. Dokoudowsky is best remembered for his work with the Original Ballet Russe, Massine's American troupe, in which he was a principal dancer. Among his many credits were both bravura and character roles in Massine's *Gaité Parisienne* and *Les Présages*, David Lichine's *Graduation Ball* (the ballet with which he was

generally associated), and company productions of *Giselle, Swan Lake*, and *Le Spectre de la Rose*.

Following his retirement from active performing, he became regisseur and ballet master for the latter Ballet Russe. As a popular teacher, he has worked with the Ballet Arts Studio since the early 1950s and the Ballet Theatre School since the mid-1960s. His affiliation with these schools allowed him to become a major influence in the maintenance of the Preobrajenska discipline and technical propriety in the United States. He has done little original choreography, but has restaged productions of parts of the classical repertory for the Ballet Arts students and for a series of union-sponsored showcases.

Dolin, Anton, English ballet dancer and choreographer; born Patrick Healey-Kay, July 27, 1904 in Slinfold, Sussex. After early training with Grace and Lily Cone, he continued his studies with Serafina Astafieva. In her concert group, he appeared in two of his earliest works—*Hymn to the Sun* and *Danse Russe* (both 1923). On recommendation from Astafieva, Dolin was hired by the Diaghilev Ballet Russe to perform in the corps of *The Sleeping Beauty* in London (1921). He joined the company proper in 1924, creating the role of "Beau Goose" in Bronislava Nijinska's *Le Train Bleu* (1924) and performing in her *Les Biches*, and Mikhail Fokine's *Spectre de la Rose* and *Daphnis and Chloe*. He danced in the West End in André Charlot productions and in the (Vera) Nemtchimova/Dolin Ballet in his own *Rhapsody in Blue* (1928) and *The Nightingale and the Rose* (1927, from the show *White Birds*. Rejoining the Ballet Russe, he created roles in George Balanchine's *Le Bal* and *The Prodigal Son* (both 1929).

A founding member of the Camargo Society, he danced in the company production of *Giselle* (1932), partnering Spessivtzeva, and in *Swan Lake* (1933). With the Vic-Wells Ballet from 1931 to 1935, he created the role of "Satin" in Ninette De Valois' *Job* (1931) and that of "Vertumnus" in Frederick Ashton's *Pomona* (1930).

From 1935 to 1948, he was involved with the (Alicia) Markova-Dolin Ballet, a company of classical works, and his own ballets. Celebrated for their performances in *Giselle*, with which they toured, they danced it in their company and as guests with companies around the world. With Ballet Theatre, in the original company, Dolin created the title role in Fokine's *Bluebeard* (1941) and roles in his own *Capriccioso* (1940) and *Quintet* (1940), playing "Paris" in both Fokine's and David Lichine's versions of *Helen of Troy* (both 1940). He played all of the principal prince roles in the classics, such as "Siegfried" in Ballet Theatre's Act II and Black Swan pas de deux, and "Florimund" in their *Aurora's Wedding*. He served as founding artistic director of the London Festival Ballet from 1950 to 1961, choreographing for the troupe. On January 1, 1981, he was knighted by Queen Elizabeth II for services to his native land and its ballet.

Works Choreographed: CONCERT WORKS: *Italian Suite* (1928); *Revolution* (1928); *Rhapsody in Blue* (1928); *Bolero* (1938); *Capriccioso* (1940); *Giselle* (1940, after Coralli and Perrot); *Quintet* (1940); *Sleeping Beauty* (1940, after Petipa, *Bluebird pas de deux* only); *Pas de Quatre* (1941, from the original Keith Lester); *Aurora's Wedding* (1941); *Sleeping Beauty* (1941, after Petipa, *Rose Adagio* only); *Romantic Age* (1942); *The Nutcracker* (1943, after Ivanov, pas de deux only); *The Nutcracker* (1946, after Ivanov, co-choreographed with Alicia Markova); *Swan Lake* (1946, after Petipa, Black Swan pas de deux only); *The Lady of the Camellias* (1947); *Ballet Divertissements* (c.1949–1950, after Petipa); *Variations for Four* (1957); *Harlequinade* (1958); *Swan of Tuonela* (1966); *Variations for Four plus Four* (1967); *Pas de Deux for Four* (1967).

THEATER WORKS: *Punch Bowl* (1925, "Albany Bound" only); *Charlot's Revue* (1926, The Pedlar and See-Saw only); *White Birds* (1927, De Valois and The Nightingale and the Rose only); *Tales of Hoffman* (1935); *The Seven Lively Arts* (1944, Scènes de Ballet only); *Song Without Words* (1945).

FILM: *Never Let Me Go* (MGM, 1953).

Bibliography: Dolin, Anton. *Divertissement* (London: 1931); *The Life and Art of Alicia Markova* (London: 1953); *Autobiography* (London: 1960).

Dolinoff, Alexis, Russian ballet dancer; born c.1900 in Astrakhan, Russia. Trained in London and Paris by Serafina Astafieva, Enrico Cecchetti, Lubov Egorova, Lydia Kyasht, and Bronislava Nijinska, he performed with the Anna Pavlova company, replac-

ing Alexander Volinine as her partner in *Christmas* (c.1924), and danced with the Ida Rubinstein and Vera Nemtchimova troupes in Paris (1928–1934). He was reunited with Nijinska in her Ballets Russes de Paris company in 1936, dancing in her production of *Les Sylphides* and Margaret Severn's *Primavera*.

Moving to the United States after that engagement, he became a member of the (Catherine) Littlefield Ballet, based in Philadelphia, Pennsylvania. He partnered Littlefield herself in *Fête Champêtre* (1936) and danced in her *Barn Dance* and *Café Society*. Dolinoff worked with the Metropolitan Opera Ballet during the 1940s before retiring to teach.

Works Choreographed: CONCERT WORKS: *Romantic Variations* (1936); *Aubade* (c.1937).

Dollar, William, American ballet dancer and choreographer born April 20, 1907 in St. Louis, Missouri. After studies and performances with Catherine Littlefield in Philadelphia, Dollar moved to New York where he continued his training with Mikhail Fokine and Mikhail Mordkin. In 1934, he became one of George Balanchine's first students at the School of American Ballet.

Associated with Balanchine for much of his career, Dollar was a member of the three companies that grew from the School—the American Ballet, Ballet Caravan, and the New Opera Company. As a principal dancer with the groups, among the many early Balanchine works in which he created roles are *Alma Mater* (1934), *Transcendence* (1934), *Concerto* (1936), which he co-choreographed, *The Bat* (1936), *Orpheus and Eurydice* (1936), *Jeu des Cartes* (1937), *Le Baiser de la Fée* (1937), *Ballet Imperial* (1941), and *Concerto Barocco* (1941), in which he performed the only male role. Dollar also performed for Balanchine in the Ballet Society and the first seasons of the New York City Ballet, in, among others, the "Melancholic" section of *Four Temperaments* (1946) and *Jones Beach* (1950), co-choreographed with Jerome Robbins. Between these companies, Dollar performed with the Ballet International in 1944 and with the Grand Ballet du Marquis de Cuevas, both in New York.

First choreographing for the cooperative company, Ballet Caravan, Dollar's primarily abstract works include *Promenade* (1936), *Air and Variation* (1938), *Juke Box* (1941), *Highland Fling* (1947), *On-*

dine* (1949), *The Duel* (1949), all for the above companies. The latter, perhaps his best known work, is a duet based on the Tancred and Clorinda stories of Tasso; originally created for Les Ballets de Paris de Roland Petit in 1949, it became a favorite with American dancers and was interpolated into the repertories of both the New York City Ballet, the Ballet Russe de Monte Carlo, and Ballet Theatre, where it is called *The Combat*.

Many of Dollar's later ballet pieces were created for Ballet Theatre or its Workshop program of concerts, among them, *Jeux* (1950), *The Leaf and the Wind* (1954), *The Parliament of Birds* (1958), and *Mendelssohn Concerto* (1958). The director of the Detroit Civic Ballet for many years, Dollar's students there have included Broadway dancer Donna McKechnie and ballet dancer Dennis Nahat.

Works Choreographed: CONCERT WORKS: *Promenade* (1936); *Concerto* (1936, co-choreographed with George Balanchine); *Air and Variations* (1938); *Juke Box* (1941); *Constantia* (1944); *Highland Fling* (1947); *Ondine* (1949); *The Duel* (1949); *Jeux* (1950, after Nijinsky); *The Five Gifts* (1953); *The Leaf and the Wind* (1954); *The Parliament of the Birds* (1958); *Angrisme* (1958); *Mendelssohn Concerto* (1958).

THEATER WORKS: *A Thousand Times Neigh* (1939–1940, production of New York World's Fair).

Dolly, Edward, Hungarian dance director working primarily in New York and London; born 1898 in Budapest, Austro-Hungary; died January 29, 1956 in Los Angeles. The younger brother of Yansci and Roszika, the famous tandem team, The Dolly Sisters, he was brought to the United States as a child and spent much of his adolescence on tour in vaudeville. His Broadway debut at seventeen in *Maid in America*, was arranged by his older sisters, for whom it is thought he arranged dance routines.

Although most of Dolly's career was spent in nonmusical-comedy direction, he did participate in the early days of British sound musicals, and served as dance director for British International Pictures from 1931 to 1932.

Works Choreographed: THEATER WORKS: *Hearts and Diamonds* (1926, London); dance routines for The Dolly Sisters (c.1915–1932).

FILM: *Let's Go Naked* (British International, 1931); *Brother Alfred* (British International, 1932).

Dolly, Yansci and Roszika, American tandem dance team; born Yanszieka and Roszieka Deutsch, October 25, 1892 in Budapest, Hungary; Yansci died June 1, 1941 in Los Angeles; Roszika died February 1, 1970 in New York. The twin Dolly Sisters were trained in ballet, eurythmics, and ballroom techniques by their mother, who was said to have been a ballerina at the Budapest Royal Opera House. As children, they performed in Budapest and Berlin music halls, where they were discovered by Gertrude and Max Hoffmann, who sponsored their immigration to the United States.

The Dolly Sisters, as they were billed throughout their careers, made their New York and American debuts in *The Maid and the Millionaire*, a summer operetta playing at the Madison Square Roof in 1907. Since they were only fifteen, however, the Gerry Society (for the protection of youth) forced them to retire or move. They therefore performed in Keith circuit vaudeville theaters in the Midwest until 1909, when they returned to New York to play the Keith Union Square. For the next three years, they performed in musical comedies, operettas, and revues, including the *Ziegfeld Follies of 1911* and *The Midnight Sons*. From 1912 to 1914, they split up; Yansci formed an exhibition ballroom team with her then-husband, Harry Fox, while Roszika performed in vaudeville and on Broadway with Martin Brown.

They reunited in 1916 for *His Bridal Night*, a typical Dolly Sisters vehicle with a plot based around the twins' mistaken identities. Their tandem act, also based on their twinship, was easily integrated into revues; among those in which they were featured were the Ziegfeld *Midnight Frolic of 1919* and the *Greenwich Village Follies of 1924*, their last American show. They performed in vaudeville in London (1920–1922) and in cabarets in Paris (1923, 1927).

A disfiguring car accident involving Yansci caused the sisters' early retirement in 1933. Roszika Dolly did not attempt a career on her own.

Each Dolly sister appeared in a single silent film alone—Yansci in *The Call of the Dance* (Kalem Corp., 1915) and Roszika in *The Lily and the Rose* (Triangle Films, 1923). The sisters were featured together in *The Million Dollar Dollies* (Screen Classics, 1918). A film about their early years in vaudeville was made by Twentieth-Century Fox in 1945; its accuracy is suspect.

Dolores, English show girl in New York; born Kathleen Mary Rose, c.1890 in London; died November 7, 1975. A cockney from the East End of London, Dolores became a model for Lucille, Lady Duff-Gordon, probably the most innovative English fashion designer of the period. As a Lucille mannequin, she performed in New York in the winter of 1918, where she was chosen to become a "Ziegfeld Girl," an A-dancer in the *Follies* and *Midnight Frolics*. As an A (the tallest category), she did not have to dance or speak on stage—Dolores became the best known performer in the show girl tradition, able to walk down a staircase with glamour and beauty at the end of a musical number. Although she was featured in the *Follies*, she is best remembered for two routines in the *Ziegfeld Midnight Frolic* (or, roof garden midnight show) *of 1919*—the "Jewel" scene in which the dancers spelled out D-E-A-R-E-S-T with the first letters of the jewels that they represented until Dolores entered as the dearest jewel of all, and in the famous bird finale, which she climaxed as "The White Peacock," with a dress whose ten-foot train was mechanically raised to become her tail.

Donahue, Jack, American eccentric dancer; born 1892 in Charlestown, Masssachusetts; died October 1, 1930 in Cincinnati, Ohio. Donahue, who did not have formal dance training, made his professional debut at age fourteen performing as a dancing shill with Prof. Zurega's Medicine Show troupe touring the Midwest. He then performed in vaudeville on the Keith circuit in a solo dance act and in an act with his wife, Alice Stewart.

The lanky Donahue became known as the best eccentric tap dancer of his time, performing in ten musical comedies and revues—*The Hitchy-Koo of 1918*, *Angel Face* (1919), the *Ziegfeld Follies of 1920, Two Little Girls in Blue* (1922, replacement cast for tour), *Molly Darling* (1922), *Be Yourself* (1924), *Sunny* (1925), *Rosalie* (1928), *Carry On* (1929), and *Sons O'Guns* (1929). Ray Bolger played Donahue in the film biography of his best known dance partner, Marylin Miller.

Donen, Stanley, American film choreographer and director; born April 13, 1924 in Columbus, South Carolina. Donen danced on Broadway in *Pal Joey* (1940), starring Gene Kelly, and in two George Ab-

bott musicals, *Best Foot Forward* (1941) and *Beat the Band* (1942). He moved to Hollywood to appear in the film of *Best Foot Forward* and remained to assist Jack Donohue, Charles Walters, and Kelly. After working for Kelly on *Cover Girl* (Columbia, 1944), he collaborated with him on *On the Town* (MGM, 1949), *Take Me Out to the Ball Game* (MGM, 1949), *Singin' in the Rain* (MGM, 1952), and *It's Always Fair Weather* (MGM, 1955)—two of the studio's best known films and two of the most underrated.

Before becoming known as a director of sophisticated comedies and suspense thrillers, he directed, but did not choreograph, some more musicals for MGM, among them, *Royal Wedding* (1951), *Seven Brides for Seven Brothers* (1954), with dances by Michael Kidd, and *Damn Yankees* (WB, 1958), choreographed by Bob Fosse. In two recent films he cast those choreographers in speaking parts, as well as employing their better known talents; Kidd played the "Boxer's father" in one section of *Movie Movie* (WB, 1978), while Fosse appeared as "The Snake" in *The Little Prince* (Paramount, 1974).

Works Choreographed: FILM: *On the Town* (MGM, 1949, co-choreographed with Gene Kelly); *Take Me Out to the Ball Game* (MGM, 1949, co-choreographed with Kelly); *Singin' in the Rain* (MGM, 1952, co-choreographed with Kelly); *It's Always Fair Weather* (MGM, 1955, co-choreographed with Kelly).

Doner, Kitty, American theatrical dancer; born September 6, 1895 in Chicago, Illinois. Doner was trained by her parents, Joe and Kitty, themselves headliners in vaudeville. Although she may have made her professional debut in their cast as early as 1900, her first known solo production in vaudeville was in 1912.

Doner had a unique combination of specialties; she was a male impersonator (or, to be more specific, a Vesta Tilley imitator) who also worked on toe. She originally performed within comedy acts, such as *A Night in the Police Station* (1912) and *The Echo* (1914), but made her New York debut in the *Ziegfeld Follies of 1914* as an eccentric dancer. She remained in New York as a favorite with audiences at the Winter Garden, the home of the Shubert Brothers' lavish musical comedies. Among her many Winter Garden

shows were *Dancing Around* (1914), *Robinson Crusoe, Jr.* (1917), and *Sinbad* (1919).

She returned to vaudeville in 1920 in an act with her brother, Ted, billed as "A League of Dance Steps." They played the Palace frequently and toured successfully for over five years. With her extraordinary eye for a popular act in a developing medium, she then moved into the Prolog field and became a headliner at the New York theaters that featured that live performance style with their films, the Mark Strand, the Capitol, and the Paramount. She became ballet master of the Roxy Theater in the 1930s and remained with it and choreographer Gae Foster for more than fifteen years.

Donn, Jorge, Argentinian ballet dancer, associated with the Ballet du XXième Siècle; born February 28, 1947, in Buenos Aires, Argentina. After local training at the school of the Ballet de le Teatro Colón, Dunn studied in Paris with Rosella Hightower and Tatiana Grantzeva.

A member of the Ballet du XXième Siècle from 1963 to the present, Donn has created roles in many of the works by director Maurice Béjart. These ballets are *Prospective: L'Art de la Barre* (1965), *Webern Opus 5* (1966), *Romeo et Juliet* (1966), *Baudelaire* (1968), *Bakhti* (1968), *Serait-ce la Mort?* (1970), *Les Fleurs du Mal* (1971), *Nijinsky, Clown of God* (1971), *Stimmung* (1972), *Golestan* (1973), *Ce que l'Amour me dit* (1974), and *Notre Faust* (1975), among others. As part of an exchange program, Donn has also performed with the New York City Ballet, partnering Suzanne Farrell in the Finale of *Vienna Waltzes*.

Since 1976, Donn has served as artistic director of the Ballet of Yantra.

Donohue, Jack, American film and theater dance director; born November 3, 1912 in New York. Donohue received his early dance training in tap and acrobatics with Jack Blue in New York; he may also have studied tap with John Lonergan at the Ned Wayburn Studio there.

Donohue performed as a dancer in seven Broadway shows from 1927 through 1931, among them, the premieres of *Good News* (1927) and *Follow Through* (1929). After serving as dance director for

three Broadway shows, Donohue went to Hollywood where he joined the staff of the Fox Film Corporation (later, Twentieth-Century Fox). He returned to Broadway as dance director of *Seven Lively Arts* (1944), *Top Banana* (1951), the revival of *Of Thee I Sing* (1952), and others.

As a film dance director, Donohue was best known as the choreographer for Shirley Temple vehicles made for Fox between 1934 and 1939. He later worked for Paramount and Metro-Goldwyn-Mayer as a staff choreographer; at the latter studio, he staged the early Frank Sinatra musicals *Anchors Aweigh* (1945) and *It Happened in Brooklyn* (1947). From the early 1950s to the present, Donohue has directed situation comedies on television and both comedies and suspense thrillers for film, but seldom worked with dance.

Works Choreographed: THEATER WORKS: *Smiling Faces, Music in the Air* (1932); *Shady Lady* (1933); *Seven Lively Arts* (1944); *Are You With It* (1945); *Top Banana* (1951, also directed); *Of Thee I Sing* (1952, revival); *Mr. Wonderful* (1956, also directed); *Rumple* (1957).

FILM: *Curly Top* (Fox, 1934); *George White's Scandals* (Fox, 1934); *Bathing Beauty* (MGM, 1934); *Music in the Air* (Fox, 1935); *Our Little Girl* (Fox, 1935); *The Littlest Rebel* (Fox, 1935); *Lottery Lover* (Fox, 1935); *Professional Soldier* (Fox, 1935); *Life Begins at 40* (Fox, 1935); *Under the Pampas Moon* (Fox, 1935); *Captain January* (Fox, 1936); *Thanks a Million* (Fox, 1936); *Louisiana Purchase* (Paramount, 1941); *You're in the Army Now* (WB, 1941); *Star Spangled Rhythm* (Paramount, 1942); *The Fleet's In* (Paramount, 1942); *The Powers Girl* (United Artists, 1942); *Girl Crazy* (MGM, 1943); *Best Foot Forward* (MGM, 1943); *Anchors Aweigh* (MGM, 1946); *Easy to Wed* (MGM, 1946); *It Happened in Brooklyn* (MGM, 1947); *On an Island with You* (MGM, 1948); *Duchess of Idaho* (MGM, 1950); *Calamity Jane* (WB, 1953); *Babes in Toyland* (Buena Vista, 1961).

Dooley, Rae, Scottish eccentric dancer and comedienne; born October 30, 1896 in Glasgow. Raised in New York, she and her two brothers were trained by Ned Wayburn who staged vaudeville acts for them. The petite comic whose eccentric shoulders seemed to perform by themselves was very popular in brat parts.

After working solo in vaudeville in an act called *Watermelon Girls*, she made her adult Broadway debut in the *Passing Show of 1917*, following it quickly with the *Hitchy-Koo of 1918*. She did her baby-talk act in six editions of the *Ziegfeld Follies*—1919, in which she did "Mandy," 1920, 1921, 1924, 1925, and the edition dated 1926—and two *Earl Carroll Vanities*. Among her many other Broadway credits were *The Bunch and Judy* (1922), with the Astaires, *The Nifties of 1922* and *1923*, both with Van and Schenk, *Sidewalks of New York* (1927), *Thumbs Up* (1934), and *Home Life of a Buffalo* (1948). She also worked in vaudeville with her husband, Eddie Dowling, an Irish tenor and songwriter.

Doone, Rupert, English ballet dancer and theater director; born Ernest Reginald Woodfield, 1903 in Redditch; died March 4, 1966 in England. Trained originally by Serafina Astafieva, he continued his studies with Leonid Massine, Mikhail Fokine, and Margaret Craske. He performed in Fokine's *Cairo* and *Hassan* in the early 1920s in London and danced in Paris in *L'Humour Masqué* (1922) and as Cléo de Mérode's partner in her dance act.

From 1923 to 1933, he performed in ad hoc and short-lived ballet companies in England and Western Europe. After touring with the Ballet Suédois (1923), he partnered Lydia Lopoukova in André Charlot *Revues* in London, danced in the play, *The Duenna* (1924), along with Aubrey Hitchins and Keith Lester, and appeared in the Nemtchimova-Dolin Ballet, the Ida Rubenstein Ballet, the Diaghilev Ballet Russe, the Camargo Society, the Ballet Club, in Susan Salaman's *Le Boxing* (1931), and the Vic-Wells Ballet where he choreographed *The Enchanted Grove* (1932).

Although he arranged dances for productions at the Cambridge Theatre in 1933, he worked primarily as a director of dramatic works for the remainder of his career, with the Group Theatre (1932–1939, 1946–1951) and at Morley College (1939–1962). He seems to have specialized in revivals of Restoration comedies and experimental plays by contemporary poets.

Works Choreographed: CONCERT WORKS: *The Marriage of Hebe* (c.1927); *The Enchanted Grove* (1932); *The Witch* (1933).

D'Or, Henrietta, Belgian or French nineteenth-century ballet dancer; born 1844 in Vienna; died March 1886 in Neuilly-sur-Seine, France. Little can be verified about the life of this dancer of the late Romantic age. She was the daughter of famed teacher Louis D'Or and was trained by him in Vienna. The only part of her life that can be verified is a brief two-year period in which she made both her Paris Opéra and Maryinsky Theatre debuts. In the former, May 1867, she partnered Louis Mérante in Lucien Petipa's *L'Uccelatore*, while in the latter, she created the principal female role in Marius Petipa's *Le Roi Candaule* (1868). It is believed that she, through her father, was involved with the Petipa family, possibly at the Théâtre de la Monnaie in Brussels.

Doraldina, American theatrical dancer and Hula specialist; born c.1893, probably in Chicago, Illinois; details of her death in c.1925 are uncertain. Although she claimed to have been born in Barcelona, Spain, it is likely that she was in fact born in or near Chicago; the trade papers said that she was born in Brooklyn, Upper Sandusky, or Pittsburgh, but such statements were frequently thrown around for effect. She was raised in California, where she worked as a stenographer in the Bay area. In her late adolescence, she moved to Spain to study classical and folk dance with Raphael Vega in Barcelona. After performing there at the Teatro Principal, she moved back to the United States.

In New York from 1916 (from which point her biography can be verified), she was hired by Ned Wayburn to appear in the acts that he staged for Reisenweber's Café, an early proto–dinner theater. Her best known dance specialties were introduced in that act, including her Hula, Larombe Shiver, and Harem Dance. She also did them in vaudeville, on the Keith circuit and on Broadway, in *Step This Way* (1916), *The Red Dawn* (1919), and *Frivolities of 1920*.

Doraldina worked on a number of silent films between 1918 and 1922, playing a South Sea islander in *The Naulahka* (Pathé, 1918) and *The Passion Fruit* (Metro, 1921), and staging routines for D.W. Griffith's *The Idol Dancer* (1920). She was replaced in Hollywood's pseudoauthentic dance routines by Ruth St. Denis and Ted Shawn, however, and returned to New York.

Although not an especially important dancer, she was a major influence on the inclusion of the Hula in the conventional repertory of the ethnic dancer and served in a similar capacity with native American work, again preceeding St. Denis and Shawn. She was also one of the few female performers to maintain control of her own career, purchasing the club in which she appeared, The Montmartre in New York.

Works Choreographed: FILM: *The Idol Dance* (D.W. Griffith, 1920).

Dorsha, American concert dancer; born Doris Bentley, c.1898 in Galesburg, Illinois. It is not known with whom Bentley studied before moving to New York where she took classes with Louis Chalif, Adolf Bolm, and Mikhail Fokine. At fifteen, she made her debut in Winthrop Ames' production of *Daughter of Heaven* at the Century Theatre. After appearing in the chorus of *Dancing Around* (1914), she performed with the Pavlova ballet at the Hippodrome (1916), toured on the Keith circuit with Brother St. Denis, and worked backup for Roshanara on tour with the Ballet Intime (billed as Joan Rhys). She also danced in Winter Garden musicals from 1918 to 1922, among them, *Sinbad, Passing Show of 1918*, and *Casanova*, and in the Rudolf Valentino film, *M. Beaucaire*. As "Dorina," she danced with the Fokine Ballet at the Lewisohn Stadium in 1927, with a featured role in *Les Elfes* and *Cléopâtre*.

From the late 1920s to the mid-1930s, Dorsha worked as a concert dancer sharing recitals with her husband, storyteller Paul Hayes, at the Art Theatre of Dance. It is difficult to determine where her concert work fit into the genre; she did some works that seem to be topical, although she avoided the allusions to the Spanish Civil War and the American social problems that existed in so many recitals. She did use a range of Orientalia, Americana, and literary themes, dancing a version of *Macbeth* in 1930. Dorsha retired from performance in 1936 to write and has since published novels and volumes of poetry.

Works Choreographed: CONCERT WORKS: (Note: in the absence of dated programs, works will be listed by year only.) *Til Eulenspiegel, The Shadowy Bird, Theatre Piece* (1929); *Bolero, Macbeth* (1930); *Tragic Tango, Shawl Tango, Futility, Fragment of an Agon, Compulsion, Let Me Also Wear such Deliberate Disguises, Street Arab* (1931); *From the Modern Scene, Challenge, Nostalgia, From the Life With* (1932); *Sarabande, Painted Desert, Dance to the Mornings* (1933); *In the Very Early Spring, This Brave World, Manhattan Serenity* (1935).

Dotson, Clarence, American eccentric tap dancer; born c.1881; died March 17, 1954 in Boston, Massachusetts. Dotson served the appropriate apprenticeship for a black tap dancer of the turn of the century, touring with feature acts until he was well known enough to stage his own solo act. He was a headliner with a solo flash act on the Keith circuit from the mid-1910s to his retirement in 1943. Dotson followed the "tapologue" format popularized by Bill Robinson and alternated tap solos with comedy routines. His dancing was the unique element of the act, not his jokes; it was enough to earn him the adoration of the audience and of his fellow performers. He did shuffles onto the stage, dressed in morning clothes as if he were going to a society wedding, and proceeded to "throw a fit," in his term for the eccentric tapping. By the time he bounced off the stage on his nonexisting pogo stick, he had shown off every eccentric dance form known to the period, and a few that he invented on the spot. After retiring in the mid-1940s, he performed occasionally in benefits for other dancers, but did not teach.

Doubrovska, Felia, Russian ballet dancer performing in Western Europe after 1920; born 1896 in St. Petersburg, as Felizata Dloujnerska; died September 18, 1981, New York City. Trained at the local school of the Imperial Ballet, Doubrovska performed with the Maryinsky company from her graduation in 1913 until 1920.

Leaving the Maryinsky for Diaghilev's Ballet Russe, she created many roles in ballets produced in that company's remaining nine years. Among these were "The Bride" in Bronislava Nijinska's *Les Noces* (1923), and featured parts in the early ballets of George Balanchine—"The Film Star" in *Pastorale* (1925), a role in his *Jack-in-the-Box* (1926), "Calliope" in *Apollon Musagète* (1928), and "The Siren" in *The Prodigal Son* (1929).

After Diaghilev's death in 1929, she performed with a series of companies formed by Ballet Russe members, among them, Nijinska's troupe, in which she was featured as "Ophelia" in her *Les Préludes* (1934), The Monte Carlo Opéra Ballet, the (Leon) Woisikovsky company, and the De Basil Ballet Russe, in which she performed the Bluebird pas de deux to great acclaim. One school and company formed by a former Ballet Russe choreographer was lasting—the School of American Ballet, begun for George Balanchine in 1934. Doubrovska and her husband, Pierre Vladimiroff, have taught at the School since that date, except for one season with the De Cuevas Grand Ballet. She also performed with the American Ballet when it was the resident company of the Metropolitan Opera, appearing in Balanchine's *Serenade, Orfeo e Eurydice*, and *Thais*.

Douglas, Ann, American concert dancer; born March 12, 1901 in Seattle, Washington. With her older sister, Germaine Ballou, she studied at her mother's studio before traveling to Los Angeles to continue her training at the Denishawn school there. A member of the Denishawn concert group from 1919 to 1926, she toured in *Julnar of the Sea* (1919, by Ted Shawn), accompanied St. Denis in her program of Music Visualizations, appearing in her *Sonata Tragica* (1923), *Waltz* (1924), *Valse à la Loie* (1924), *Second Arabesque* (1924), and in Doris Humphrey's *Soaring*, and went on the famous Denishawn tour of the Orient. Although she continued to perform primarily in the company's abstractions, she was cast in two Shawn pieces of Orientalia added during the tour—*General Wu's Farewell to His Wife* and *Impressions of a Wayang Purwa* (both 1928)—and purchased a large number of costumes in each of the stops. When she returned to the United States, she joined Ballou in a series of studios in Los Angeles, Hollywood, and Manhattan Beach, and taught until the late 1960s. For many years she and Ballou gave performances and lecture-demonstrations on Oriental dance forms in the costumes that she brought back from the Denishawn tour.

Douglas retired from teaching in 1970 to pursue a career in weaving and textile arts and is now considered a talented and innovative crafts worker and artisan.

Douglas, Helyn, American ballet dancer; born c.1945 in Dallas, Texas. After training in Stillwater, Oklahoma, Douglas moved to New York where she studied with Margaret Craske, Vincenzo Celli, Hector Zaraspe, and Maggie Black.

A season with the City Center Joffrey Ballet led Douglas to accept an engagement with the American Ballet Theatre (1968–1974). Although she performed in the company's productions of the classics, she was best known for her appearances in the works of Ballet Theatre's choreographers-in-residence. She was featured in Michael Smuin's *Pulcinella Variations* and in Dennis Nahat's *Ontogeny*; her performances in Eliot Feld's *Intermezzo* were so successful that when he formed a company, The Feld Ballet, she was asked to join him. In The Feld Ballet, she has created roles in his *The Consort* (1974) and *Half-Time* (1978), and has performed in revivals of *Intermezzo, Harbinger, Mazurka, Theatre, Cortège Parisienne,* and Glen Tetley's *Embrace Tiger and Return to Mountain.*

Douglas has performed with a group of dancers an ad hoc company. She has choreographed for them and for the Boston Ballet Competition.

Works Choreographed: CONCERT WORKS: *Three 'n Folio* (1977); *Chorihani* (1980).

Douglas, Scott, American ballet dancer; born Jimmy Hicks, June 16, 1927 in El Paso, Texas. Trained in tap and acrobatics, he performed on vaudeville at age nine. Although he had some ballet training in Texas from Karma Deane, he did not continue his studies until he was released from the Navy. Moving to California, he studied with Lester Horton in Los Angeles and with Willam Christensen in San Francisco.

In the San Francisco Ballet from 1947 to 1950, he performed in Willam Christensen's *Doctor Pantalone, Romeo and Juliet,* and the *Nothing Doing Bar,* as "weasel the bookie," and in Lew Christensen's *Jinx* and *The Nutcracker.* In 1950 he joined the American Ballet Theatre, with which he has worked since that date. A versatile dancer, popular with the company's resident choreographers, he created roles in an enormous number of new ballets, among them Edward Caton's *Tryptych* (1952), Antony Tudor's *Offenbach in the Underworld* (1956, company premiere), Herbert Ross' *Paean* (1957), and *Concerto* (1958), Kenneth Macmillan's *Journey* (1957), and Glen Tetley's *Ricercare* (1966). He was celebrated for his performance as "Pat Garrett" in Eugene Loring's *Billy the Kid,* and in Jerome Robbins' *Fancy Free.*

In the late 1950s, Douglas performed with two new companies established at the Spoleto Festival—Herbert Ross' Ballet of Two Worlds, in which he partnered Nora Kaye, and Robbins' Ballets: U.S.A.

Douglas has been associated with the works of Glen Tetley for many years and has performed for him in Ballet Theatre and in his own company. He also served as Ballet Master of the Netherlands Dance Theatre when Tetley was its Artistic Director.

Dove, Billie, American theatrical dancer and film actress; born Lillian Bohny, May 14, 1903 in New York City. Dove made her professional debut as a specialty show girl, sitting in a hoop above the *Ziegfeld Follies of 1919* but actually danced in Ziegfeld's *Sally* next season. She appeared in ingenue roles in a number of shows, notably *At the Stage Door* and *Get-Rich-Quick Wallingford,* before switching media to film.

Dove had the honor of appearing in most of the backstage musicals and melodramas produced in the early sound era, including *Polly of the Follies* (1922), *Blondie of the Follies* (1923), and *Heart of a Follies Girl* (First National, 1924). In each, she appeared as a show girl, but also was given the opportunity to work in musical comedy genre. Despite that, the image one remembers of Dove is that of her wrapped loosely in an embroidered shawl, dripping with fringe, with marcelled hair and a bracelet around her right ankle.

Dove made a large number of nonmusical films including many Tom Mix westerns and contemporary melodramas about wayward youth, before she retired in the early 1930s.

Dove, Ulysses, American modern dancer; born in Columbia, South Carolina. Trained at the University of Wisconsin at Madison and Bennington College, he performed with Kathryn Posin and José Limón at the American Dance Festival. Dove, who had been a

member of the Black Dance Theatre at Wisconsin, joined the Merce Cunningham troupe in 1970, dancing in his *Tread* (1970), *Second Hand* (1970), and many Events and repertory works. After freelancing with the Martha Graham, Pearl Lang, and Mary Anthony companies, he joined the Alvin Ailey Dance Theatre, becoming one of its most popular performers. Among the scores of works in which he has danced there are Ailey's *Hidden Rites, Night Creature*, and *Streams*, Talley Beatty's *The Road of the Phoebe Snow*, John Butler's *Portrait of Billie*, George Faison's *Suite Otis*, Louis Falco's *Caravan*, José Limón's *Missa Brevis*, Eleo Pomare's *Blood Burning Moon,* Pearl Primus' *The Wedding*, and James Truitte's *Liberian Suite*.

Frequently cast as Judith Jamison's partner, he choreographed a solo for her—*Inside* (1980).

Works Choreographed: CONCERT WORKS: *Inside* (1980).

Dowell, Anthony, English ballet dancer; born February 16, 1943 in London, England. Critics describing Dowell performances use words like "stylish," "gracious," and "superb"; fanatic audiences on either side of the Atlantic tend to agree. The training that produced these qualities was acquired with Mrs. June Hampshire in London and at the school of the Royal Ballet.

After a season dancing with the Opera Ballet at Covent Garden, Dowell joined the Royal Ballet, with which he has performed ever since. He has been featured in all of the classical male leads, among them "Albrecht," in *Giselle*, "Siegfried" in *Swan Lake*, "Florimund" (which many consider his greatest part), in *The Sleeping Beauty*, "Colas" in *La Fille Mal Gardée*, and "the Poet" in *Les Sylphides*. His contemporary created roles include "Oberon" in Frederick Ashton's *The Dream* (1964), "Beliaev" in his *A Month in the Country* (1976), and parts in *Monotones* (1965), *Jazz Calendar* (1968), *Enigma Variations* (1968), and *Meditation* (1971), as well as male leads in Antony Tudor's *Shadowplay* (1967) and Kenneth Macmillan's *Triad* (1972), *Manon* (1974), and *The Four Seasons* (1975).

Dowell has been a guest artist with most of the leading ballet companies of the world—both ad hoc troupes, such as Makarova and Co., 1980, and established companies, including American Ballet Theatre, in which he has partnered Natalia Makarova and Gelsey Kirkland to great acclaim.

Downs, Johnny, American film dancer and "All-American boy"; born October 15, 1915 in Brooklyn, New York. Downs began the first of his three film careers at age five, playing characters in biopics as children in flashback sequences. He had made four pictures before becoming a charter member of the "Our Gang" series for the Hal Roach Studio. He retired briefly at age thirteen, but returned to film in the mid-1930s as a tap dancer in adolescent musicals.

He made over a dozen films between 1936 and 1941 for Paramount, Universal, and Twentieth-Century Fox, partnering Dixie Dunbar, Eleanor Whitney, and Judy Garland in musical comedies about high school and college students getting together to put on a show. Among his best known dance appearances were in *Pigskin Parade* (Twentieth-Century Fox, 1936), *College Holiday* (Paramount, 1936), *Blonde Trouble* (Paramount, 1937), Fanchon's *Turn Off the Moon* (Paramount, 1937), and *Laugh It Off* (Universal, 1939).

Downs returned to films again in the 1950s as a comedian in Martin and Lewis pictures. He has also worked in radio and television, primarily as a game-show host. His only live theater performances were in the mid-1930s and 1940s, with featured dance roles in *Strike Me Pink* (1933) and *Are You With It?* (1945).

Doyle, Desmond, South African ballet dancer working in England; born June 16, 1932 in Capetown. Trained locally by Dulcie Howes, he performed with the University of Capetown Ballet.

Moving to England, he performed with the Sadler's Wells Ballet from 1951 on. Among the many ballets in which choreographers chose him to create roles are Frederick Ashton's *Madame Chrysanthème* (1955), *A Birthday Offering* (1956), *Ondine* (1958), *Jazz Calendar* (1968), and *Enigma Variations* (1968), John Cranko's *Sweeney Todd* (1950) and *The Lady and the Fool* (1955), and Kenneth Macmillan's *Noctambules* (1956), *The Incitation* (1960), *Symphony* (1964), *Images of Love* (1964), and *Romeo and Juliet* (1965).

Doyle served as ballet master of the Royal Ballet from 1970 to 1975.

Draper, Paul, American concert tap dancer; born October 25, 1909; Draper received what may be his only dance training at the School of American Ballet from 1935.

Draper made his professional debut as a pedestal dancer (that is, a tap dancer who works only on the top of a small pedestal—a specialty that was popular in the United States in the 1900s and in England in the 1920s) in English cine-variety shows (here called Prologs). In 1932, he moved up to a tour of the provinces in the *Sensations of 1931*. He made his New York debut in *Thumbs Up* (1934), then studied with George Balanchine at SAB.

Draper's only other show appearances were in benefit programs; he was a concert dancer in the same way that a modern recitalist was, dancing on his own with an accompanist. For many years, his musical colleague was either pianist John Coltrane or harmonica virtuoso Larry Adler. With Adler, he toured extensively, giving recitals at the traditional houses, including the 92nd Street "Y," and playing in theaters, such as the Radio City Music Hall and the Roxy. They also toured for the USO and for the State Department.

In the early 1950s, however, he and Adler were blacklisted as a result of their suit against a reactionary woman who had attempted to ban them from one performance. Adler left the country to perform in Europe; Draper remained here not dancing. Although his act was perfectly suited for television variety shows—being both popular culture and a class act, and a solo in the days of single camera live broadcasts by a handsome but mature performer—he made only one appearance, on Ed Sullivan's *Toast of the Town* (CBS, 1950), and that booking was probably as a result of Sullivan's feud with one of the columnists who supported his blacklisting.

He performed in only one film as a dance act, *Colleen* (WB, 1936), and in one as a tapping actor, *The Time of Your Lives* (UA, 1948). Recently, however, the American Dance Machine has reconstructed some of his dance routines so that a new generation can see his techniques.

His routines were truly unique as visualizations of classical music and within his tap work itself. He was a creative dancer who used eccentric and terre-à-terre movements, without the frontal attack of personality usually associated with the eccentric dancer. By performing as a recitalist, especially with a virtuoso on a so-called nonclassical instrument like the harmonica, he brought tap work to the area of choreography, rather than popular dance. While he did some characterization work, notably in *Political Speed* (1947) and *A Sharp Character* (1952), he was primarily an abstract choreographer. He is the direct ancestor—albeit without personal contact—to the current crop of tap recitalists, among them Lynne Dally, Jane Goldberg, and Pat Catterson. His style can also be seen in many of today's show tappers, in the ultracasual performance mode associated with Gregory Hines.

Works Choreographed: CONCERT WORKS: *Ad Lib Duet* (improvised with musician at performances, c.1939–); *Bye-Bye Blues* (c.1939); *Gavotte, Minuet, Tocatta in A Major* (1941); *Fantasia in C Minor* (1941); *Golliwog's Cake Walk* (1941); *The Blue Danube Waltz* (1941); *Rondo Opus 49, No. 2* (1941); *Clair de Lune* (1941); *It Ain't Necessarily So* (1941); *Intermezzo Opus 47, No. 7* (1941); *Malagueña* (1941); *Capriccio* (1942); *Astunaz* (1942); *Dance Without Music* (1942); *Blues in the Night* (1942); *Organ Grinder Swing* (1943); *Bagatelle* (1943); *Tocatta in E Flat Minor* (1945); *Partita in B. Flat* (1945); *Cancion triste y danza allegro* (1946); *Political Speech* (1947); *Alcina Suite* (1953); *On The Beat* (1953); *A Sharp Character* (1953); *On the Avenue* (1953); *The Assassin* (1953); *To His Coy Mistress* (1953); *St. James Infirmary* (1953); *French Folk Songs* (1953); *Irish Jig* (1953); *New Dance* (1954); *Sonata for Tap Dancers* (1955); *Classical Blues* (1955); *Stay With It* (1955); *Greensleaves* (1955); *Prelude in C Sharp* (1958); *Prelude in E* (1958); *Jazz Adversary* (1948); *Two Afternoons* (1958); *Allegro* (1959); *Gigue* (1962); *Solfegietto* (1962); *Tea for Two* (1962); *Chorale and Choral Prelude* (1963); *Untitled Solo* (1977, for Daniel Nagrin gala); *Tap in Three Movements for 10 dancers* (1980).

Drew, David, English ballet dancer and choreographer; born March 12, 1938 in London. He was trained at the Westbury School in Bristol and at the Sadler's Wells Ballet School. Apart from the period of his military service, he has performed with the

Royal Ballet since 1955. He has appeared in most of the repertory, with roles and variations in the company's traditional revivals of the nineteenth-century classics, and in contemporary ballets, including those by the artistic directors, Frederick Ashton and Kenneth Macmillan. His Ashton roles include "Demetrius" in *The Dream* (1964), while his Macmillan appearances range from the classical stylization of *Manon* to the jazz steps of *Elite Syncopation* (both 1974). He began to choreograph at company-sponsored workshops and has continued to create occasional ballets. His theatrical dances for the long-running musical, *Canterbury Tales* (1968), were well received by critics and admired for his ability to "jazz up" medieval forms.

Works Choreographed: CONCERT WORKS: *Separate Aspects* (1967); *Intrusion* (1969); *Waking Sleep* (1970); *St. Thomas's Wake* (1970); *Sacred Circles* (1973); *Sword of Alsace* (1973).

THEATER WORKS: *Canterbury Tales* (1968).

Drew, Roderick, American ballet dancer; born 1940 in the San Francisco Bay area; died January 27, 1970 in New York City. Trained at the school of the San Francisco Ballet, he joined the company in 1954. His featured dance roles there included parts in Lew Christensen's *Con Amore, Original Sin* (1961), *Divertissement d'Auber,* and *The Lady of Shallott.* He was a member of the National Ballet, Washington, D.C., from 1962 to 1964, dancing in the company's production of *Coppélia* and Frederick Franklin's *Homage au Ballet.* With the Harkness Ballet from 1965 to 1967, he played "The Prince" in Agnes De Mille's *Sebastien* and Mikhail Fokine's *The Firebird* and the title role in Rudi van Dantzig's *Monument for a Dead Boy.* Although a back injury threatened to abort his career, he returned to the San Francisco Ballet in late 1969 to dance in Tomm Ruud's *Mobile* (1969). The details of his death, possibly a suicide, are not known.

Dreyfuss, Anne, French modern dancer also working in the United States; born 1957 in Strasbourg, France. Dreyfuss was trained in classical ballet by Raymond Franchetti, Boris Trailine, and Nina Vyroubova, but first made a reputation for performances with Peter Goss' jazz ballet troupe. In 1978, she joined Jennifer Muller's company, The Works,

on one of its frequent European tours. Returning to the United States with her, Dreyfuss has adapted her disparate skills to Muller's combinations of contemporary societal images and traditional modern dance vocabulary.

Drigo, Ricardo, Italian nineteenth-century composer known for his work in Russia; born June 30, 1846 in Padua; died there October 1, 1930. Drigo's contributions to the dance occurred primarily during his tenure as conductor and chapel master (director of music for the Imperial Court theaters) in St. Petersburg and for the Maryinsky Theatre (c.1880–1917). As a staff composer, he wrote works for Marius Petipa and Lev Ivanov, then co-ballet masters, among them *Le Talisman* (1889) and *Les Millions d'Arlequin* (1900) for Petipa and *La Flute Enchantée* (1893) for Ivanov. His salon pieces and short orchestral works were used for divertissements by many ballerinas in the early twentieth century, causing the name Drigo to produce a shudder from many early concert and modern dancers.

Driver, Senta, American modern dancer and choreographer; born September 5, 1942 in Greenwich, Connecticut. Trained at the Ohio State University, where she began choreographing, Driver performed with the Paul Taylor company from 1967 to 1973. After dancing in his *Aureole, Private Domain, Lento, Piece Period,* and *From Sea to Shining Sea,* she formed her own company, named Harry.

She quickly became known and celebrated for the intelligence and wit of her works. Among her most popular and surprising pieces are homages to the past, such as *Board Fade Excerpt* (1975), set to a tape of the light cues from a rehearsal of José Limón's *Missa Brevis,* in a combination of formal and aleatoric-form accompaniments, *The Kschessinska Variations* (1976) in which she recites a litany of ballerinas, and *Simulcast* (1979, with Peter Anastos), a tribute and critique of the Public Broadcasting System vision of dance. Despite the specific allusions in some of her works, her movement vocabulary is unique and closer to the postmoderns than to Taylor. Each movement is chosen and timed for maximum impact, whether the variations on walks in *Running the Course* (1977), the hand solo in *Gallery* (1976), or the kiss at the end of *Sudden Death* (1977).

Works Choreographed: CONCERT WORKS: *Collection* (1966); *Dances to this Music* (1966); *Board Game Excerpt* (1975); *Two Dances from Dead Storage* (1975); *The Star Game* (1975); *Anniversary* (1975); *Melodrama* (1975); *Second Generation* (1976); *Matters of Fact* (1976); *Gallery* (1976); *Since you Asked* (1976); *Converging Lines* (1976); *Pièce d'Occasion* (1976); *In Which a Position is Taken, and Some Dances* (1976); *Sudden Death* (1977); *Running the Course* (1977); *Exam* (1978); *On Doing* (1978, collaboration with Tom Johnson); *Theory and Practice* (1979); *Crowd* (1979, collaboration with Carol Palmer); *Primer* (1979); *Simulcast* (1979, co-choreographed with Peter Anastos); *Reaches* (1980).

VIDEO: *Rough Cut* (Independent, 1980, directed by Gary Halverson).

Drylie, Patricia, Canadian ballet and theatrical dancer working in the United States; born c.1928 in Toronto. A student of Boris Volkoff, she performed in his Toronto company before moving to New York to join the Radio City Music Hall ballet corps for ten years. She left the troupe to dance with Hanya Holm's *My Fair Lady* for another seven years in New York and on the Australian and Soviet tours. Her experience on those tours and with the national companies of *Mame, Fiddler on the Roof*, and *Sweet Charity* brought her away from performance. She became one of the few successful female stage managers in the industry and performed in that capacity for the Broadway engagements of *I Do, I Do* and *Annie* and the national tours of *The Great White Hope, 1776, No No Nanette, A Little Night Music*, and Michael Bennett's *A Chorus Line*. Drylie returned to dance as a member of the Stardust Ballroom chorus in Bennett's next musical, *Ballroom*.

Du Boulay, Christine, English ballet dancer teaching in the United States; born c.1923 in Ealing, Middlesex. Du Boulay was trained at the Sadler's Wells School and with Vera Volkova, Judith Espinosa, and Anna Northcote. A member of the Sadler's Wells Ballet from 1939 to 1941 and from 1946 to 1952, she appeared in progressively larger roles in the company's productions of *The Sleeping Beauty*, in which she made her 1939 debut as "A Page," *Coppélia* and *Swan Lake*, and in Frederick Ashton's *Les Pati-*neurs, *Façade, Wedding Bouquet*, and *Daphnis and Chloe*, Robert Helpmann's *Hamlet* and *Miracle in the Gorbals*, and Ninette De Valois' *Don Quixote*. During World War II, she performed with the Sarah Gate Ballet in Dublin and with the International Ballet, London, in which she danced in Nicholas Sergeev and Mona Ingelsby's programs of contemporary works and classical divertissements.

In 1952, she and her husband, Richard Ellis, emigrated to the United States, where they had performed with the Sadler's Wells two seasons before. They established a studio in Chicago and The Illinois Ballet (1959–), at which they continue to teach.

Dubreuil, Alain, Monocan dancer working in England after 1960; born March 4, 1944 in Monte Carlo. After early training with his mother, a member of the Nouveau Ballet de Monte Carlo, he moved to England to continue his studies at the Arts Educational School.

Dubreuil performed briefly with the Irish Ballet before joining the London Festival Ballet in 1962. In that company, he danced in the revivals of the classics, notably in *Giselle* and *The Nutcracker*, and in Ninette De Valois' *The Haunted Ballroom* and Anton Dolin's *Variations for Four*. His work with the Royal Ballet has brought him acclaim in *Coppélia* and as "Oberon" in Frederick Ashton's *The Dream*.

Duddleston, Penny, American ballet dancer; born May 26, 1952 in Tacoma, Washington. Trained locally and at the School of American Ballet, Duddleston became a member of the New York City Ballet during the early 1970s.

A tall dramatic dancer with tremendous stage presence and long blonde hair, Duddleston performed in many roles in the company repertory, notably in Balanchine's *Episodes*, in the Five Dances section. In 1972, she created major roles in two important works—John Taras' revision of *The Song of the Nightingale* for the Stravinsky Festival, as "Death," and Jerome Robbins' *Watermill*, in the only featured female role.

Dudinskaya, Natalia, Soviet ballet dancer; born August 21, 1921 in Kharkov. Trained by her mother, she continued her studies at what was then the Petrograd

State Ballet School. A member of the GATOB/Kirov throughout her career, she was celebrated for her work in the classical roles, among them "Giselle," "Aurora," and "Odette/Odile." She also performed in the newer repertory, however, and created major roles in Lopoukhov's *Taras Bulba* (1940) and Chaboukiani's *Laurencia* (1939). Dudinskaya taught the *classes de perfection* at the Kirov from her retirement in 1951 to 1969.

Dudley, Jane, American modern dancer and choreographer; born April 3, 1912 in New York City. Dudley studied with Hanya Holm at her studio and with Martha Graham and Louis Horst at the Neighborhood Playhouse.

Dudley was a member of the Martha Graham Dance Company from 1937 to 1944, later performing roles with the company until the early 1970s. Among the many roles that she created in Graham's works are the "Ancestress" in *Letter to the World* (1940) and the "Sister" in *Deaths and Entrances* (1943). She has taught in Graham's School of Contemporary Dance throughout her career and served as director of the Graham-influenced Bat-sheva Dance Company in Israel from c.1967 to 1970. In 1971, she moved to London to become principal Graham technique teacher at The Place, the school of the London Contemporary Dance theatre.

In the early years of her concert dance career, Dudley was associated with the New Dance League and created many works for its recitals, among them, *The Dream Ends* (1934), *Songs of Protest* (1937), and *Cult of Blood* (1938). In 1942, she joined with fellow League and Graham company member, Sophie Maslow, and Humphrey/Weidman dancer, William Bales, to form a trio, after they had shared a recital. From then until her retirement from performing in 1944, she choreographed for the trio and the New Dance Group, at which all taught. Although some of her works are abstractions, notably *Passional* (1950), many of her best known pieces are gestural analyses of alienated family groups, among them *Short Story* (1942) and *Family Portrait* (1953).

Works Choreographed: CONCERT WORKS: *The Dream Ends* (1934); *In the Life of a Worker* (1934); *Time is Money* (1934); *Call* (1935); *Middle-Class Portraits (Swivel Chair Hero, Dream World Hero, As-*

thete, Liberal) (1935); *Song for Soviet Youth Day* (1937); *Song of Protest* (1937); *Under the Swastika (Germans, Think of Your Blood, Though We Be Flogged)* (1937); *Suite* (1937, credited either collectively to the New Dance League or to Dudley with Sophie Maslow, William Matons, and Anna Sokolow); *My Body, My Carcass* (1937); *Fantasy* (1937); *Evacuation* (1937, co-choreographed with Maslow); *Cult of Blood* (1938); *Jazz Lyric* (1938); *Nursery Rhymes* (1938); *The Ballad of Molly Pitcher* (1940); *Betrayal* (1940); *Harmonica Breakdown* (1941); *Adolescence* (1941); *Pavanne* (1941); *Skatter-brain* (1941); *Dissonance* (1941); *Gymnopédie* (1941, with Maslow); *Short Story* (1942); *As Poor Richard Says* . . . (1943, with William Bales and Maslow); *Suite (Scherzo, Loure, Gigue)* (1942, with Bales and Maslow); *Durlough* (1945, with Bales); *New World A-comin'* (1945); *The Lonely Ones* (1946); *Ballads for Dancers* (1946); *Songs for a Child* (1944); *Out of the Cradle Endlessly Rocking* (1949); *Vagary* (1949); *Passional* (1950); *Reel* (1953); *Family Portrait* (1953); *Several Brahms Waltzes* (1979); *Five Characters and Conclusion* (1979); *The Green Branch* (1979); *Suite of Four Dances* (1980).

Duell, Daniel, American ballet dancer; born August 17, 1952 in Rochester, New York. Trained originally by Hermine and Josephine Schwarz in Dayton, Ohio, Duell continued his studies at the School of American Ballet in New York.

Joining the New York City ballet in the early 1970s, Duell has performed featured roles in much of the company's repertory, partnering Patricia McBride, Heather Watts, and his wife, Kyra Nichols. He has created roles in many works by Jerome Robbins, among them *Ma Mere l'Oye* (1975), *Une Barque sur l'Ocean* (1975), the sword-play section of *A Sketch Book* (1978), and the Spring section of *The Four Seasons* (1979), which was previewed as part of *A Sketch Book*, under the title *Verdi Variations*. Duell is probably best known for his work with fellow company member Peter Martins and has created roles in his ballets, *Calcium Light Night* (1978), also performing in its preview at a concert in 1977, and *Lille Suite* (1980), performed in New York as *Tivoli*. Duell's many featured roles include Robbins' *The Goldberg Variations* and Balanchine's Emeralds sec-

tion of *Jewels*, to which a new section, a male trio-finale, was added in 1977, for him.

Duell, Joseph, American ballet dancer; born April 30, 1956, in Dayton, Ohio. Trained originally at the school of Hermine and Josephine Schwarz in Dayton, Ohio, Duell followed his older brother Daniel to the School of American Ballet and into the New York City Ballet.

After first coming to the audience's attention in the duet and male trio added to the Emeralds section of Balanchine's *Jewels* in 1976, Joseph Duell has created roles in three new works by Jerome Robbins. These include his section of *Tricolore* (1968), the Winter divertissements from *The Four Seasons* (1979), and the sword-play duet which he performed with his brother in *A Sketch Book* in 1978, known unofficially but universally as the "Dual Duell Duel."

Duffin, Matt, American theatrical dancer known for his Rag Doll act; born February 18, 1905 in Juarez, Mexico. Raised in Salt Lake City, he studied with Lars Peter Christensen and Stefano Mascagno, also serving as stage manager for the Christensen Ballet. Teaming up with Jessie Draper, he worked for the Fanchon and Marco's West Coast Prologs for two and a half years. Fanchon and her associate choreographers were fond of adagio teams and inserted such acts into each "Idea" as a unit. The Duffin and Draper act was an adagio dance in which she played a rag doll—so called because she danced as if she had no bones or structure; the standard adagio movements, lifts, and dives looked as if he were literally tossing the stuffing out of her. Even in photographs the act looks impressive, and Fanchon, a fan of simultaneous adagio acts, honored it by ensuring that they never had to share the stage with another team.

The act was also seen on the Paramount/Publix circuit (from Chicago to New York) and on Broadway in *John Murray Anderson's Almanac* (1929). After making a film in the Astoria, Queens, studio in 1927, they left for Europe, performing in London and at the Folies Bergère in Paris.

Duffin returned to films as a coach and assistant dance director for MGM.

Dukas, Paul, French composer; born October 1, 1865 in Paris; died there May 17, 1935. A distinguished composer and teacher of composition in France, Dukas is known for two ballet scores only. His *Sorcerer's Apprentice* (1897) was choreographed by Mikhail Fokine in 1916, although for most people, Walt Disney's choreography for Mickey Mouse is more memorable. His *La Péri* was created for Natasha Trouhanova for her private recital in 1911. Since its premiere, it has been restaged for many of the leading twentieth-century bravura ballerinas, among them Anna Pavlova, Olga Spessivtzeva, Alicia Markova, and Margot Fonteyn.

Duke, Vernon, Russian composer of ballets and musical comedies; born Vladimir Dukelsky, October 10, 1903 in Parafianova; died January 16, 1969 in Santa Monica, California. Duke, who used his real name until 1926, was trained by Gliere at the Kiev conservatory. After moving to Paris, he became a member of the unofficial group of Russian musicians who served as a combination claque and employment pool for the Diaghilev Ballet Russe and was commissioned to write the score for Leonid Massine's *Flore et Zéphyr* in 1924. His latter ballet scores included Massine's *Jardin Public* (1934) and Lew Christensen's *Emperor Norton* (1957).

Duke also had a successful career as a composer and songwriter for Broadway and films. His first extant show credit (and his first use of his pseudonym) was the London operetta *Yvonne* (1926), but after two more English productions he moved to New York to contribute to the *Garrick Gaities* and *Ziegfeld Follies of 1934*. In the 1936 *Follies* and *The Cabin in the Sky*, and the films *Goldwyn Follies*, *Cabin in the Sky*, and *The Lady Comes Across*, he worked with George Balanchine as dance arranger and composer. Other Broadway shows ranged from the Eddie Cantor vehicle *Banjo Eyes* (1941) to the musical version of *Sadie Thompson* (1944). His songs included the comic "I Can't Get Started" and the glorious ballads "April in Paris" and "Autumn in New York."

Bibliography: Duke, Vernon. *Passport to Paris* (Boston: 1955).

Dumilâtre, Adèle, French ballet dancer of the Romantic era; born June 30, 1821 in Paris; died there

May 4, 1909. Trained by Charles Petit at the school of the Paris Opéra, Dumilâtre, whose father was a member of the Comédie-Français, followed her sister Sophie into the company in 1840.

One of the first dancers to replace Marie Taglioni in the title role of *La Sylphide*, Dumilâtre created the role of "Myrthe, Queen of the Wilies," in the original production of *Giselle* (1841) and the title role in Joseph Mazilier's *Lady Henriette* (1844). She retired in 1848.

Dumoulin, David, French ballet dancer of the early eighteenth century. Dumoulin, whose birth and death dates are not certain, was trained at the Academie Royale de Musique and performed with that company from 1705 to 1751.

In his extraordinary forty-five years dancing, he partnered the major ballerinas of his day—Françoise Prévost, Marie de Camargo, and Marie Sallé. He took the principal male roles in the uncredited choreography of the early eighteenth century's *Roland* (1716), *Thésée* (1720), and *Les Ages* (1724), in Loyis Pécour's *Apollon Législateur* (1711), and Jean Balon's *l'Inconnue* (1720) and *Les Eléments* (1734). He danced with Camargo in the latter and in *Les Sens* (1732); he is also partially responsible for her reputation since, according to legend, by missing an entrance in a ballet, he allowed her to perform his role, showing off her elevation.

Dumoulin was the youngest of four brothers, all of whom danced at the Paris Opéra. They were Henri, also called David *l'ainé*, at the Opéra from 1695 to 1730 and ballet master of the Opéra-Comique from 1714 to 1719, François, a "Harlequin" at the Opéra in the early 1700s, and Pierre, a "Pierrot" at the Opéra whose dates correspond to David's.

Duna, Steffi, Hungarian ballet dancer and film actress; born Stephanie Berinde Le Faye, July 4, 1914 in Budapest. Duna was trained at the school of the Budapest Opera Ballet and performed with it until 1932 when she moved to London to appear in Noel Coward's celebrated revue, *Words and Music*. Her performance in it, and especially in the "Children's Hour" skit with Gertrude Lawrence and John Mills, brought her to the attention of the New York–based producers of *A Beggar's Opera* in which she made her Broadway debut. Soon after, she moved to Hollywood to begin what turned out to be a very strange film career. For some reason, the blonde and glamorous Hungarian was cast as Mexican, Spanish, gypsy, or half-caste African dancing girls in a series of melodramatic motion pictures that ranged from *Anthony Adverse* to *Waterloo Bridge*. She played those characters in musicals also, and was Mexican in *La Cucharacha* (WB, 1936), Spanish in *The Dancing Pirate* (Pioneer, 1936), and Cuban in *The Girl from Havana* (Republic, 1940) and *Way Down South* (RKO, 1939, delayed release). Strangely enough, she was a marvelous "Mexican spitfire," perfectly capable of stealing films from her better known colleagues in these unlikely roles.

Dunas, William, American postmodern dancer and choreographer, and lighting designer; born May 1, 1947 in New York. Dunas received training in ballet from Alfredo Corvino, Don Farnworth, and Mia Slavenska, and in modern dance from Paul Sanasardo, Daniel Nagrin, and Syvilla Fort.

Primarily a solo artist, he has choreographed thirty-eight works for himself and his group, The Trust. His ensemble pieces have included a trilogy, *From Fool to Hanged Man, Children's Crusade*, and *Festival of the Donkey*, for sixteen in 1972, and an opera, *The Survival of St. Joan*, in 1971, but he concentrates on evening-length solo concerts. They have ranged through the years from stark, horrifying, emotionality without motivation to collages of outer stimuli that only affect the performer and audience.

Dunas has worked in the two very important technical areas within the requirements of postmodern dance—lighting design and sound engineering. Among the projects on which he has worked are Robert Wilson's *The Life and Times of Sigmund Freud* (1969), Kenneth King's *The Celebration of Handel's Messiah Danced by Sergei Alexandrovitch* (1970), Meredith Monk's *Paris/Chaconne* (1974), the Paper Bag Player's 1975 tour, Laura Dean's *Drumming* (1975) and *Song* (1977), and Red Grooms' sets and constructions of *City Junket* (1980).

Works Choreographed: CONCERT WORKS: *A Poor Fool* (1971); *The King Is Dead* (1972); *From Fool to Hanged Man* (1972); *Our Lady of Late* (1972); *The Time of your Life* (1972); *The All the Same Faces Affair* (1972); *To Love Us Is to Pay Us* (1972); *The Children's Crusade* (1972); *Go Directly to Jail Do Not*

Pass Go (1972); *I Went with Him and she Came with Me* (1973); *They Saw the Marching Band Go 'Round the Grand Stand* (1973); *The Kids at Four* (1973); *Gap* (1973, revival); *The Great Birthday Party & Exercises for the Rocker* (1973); *Eclipse* (1973); *Five Quartets: An American Landscape* (1974); *Storey: An American Narrative* (1975); *Sightseeing U.S.A.* (1976); *Solo Dance* (1976); *Idea* (1977); *Feathers* (1978); *Dances* (1978); *The Isle of Wight* (1978); *Night Dances* (1979); *Other Dances, Other Dreams* (1980).

Dunbar, Dixie, American theater and film dancer; born Christine Dunbar, 1918 in Montgomery, Alabama. Dunbar made her professional debut at the Hollywood Restaurant in New York as a tap dancer. She appeared with Harry Richman's band at his New York club and on Broadway in *Life Begins at 8:40* (1935) before going to Hollywood with a Warner Brothers contract. She was a specialty tap and Charleston dancer in films, among them the *George White's Scandals* (Fox Films, 1935), *Idiot's Delight* (MGM, 1939) and *King of Burlesque* (Twentieth-Century Fox, 1936), but also appeared as a juvenile lead and comedienne.

Returning to Broadway in *Yokel Boy* (1939), she was raised to stardom in that show and in nightclub appearances. A headliner on the Prolog circuit with her Rhythmaires tap chorus and Les Brown and his Band of Renown, she played theaters in New York and across the country in 1940 and 1941.

Dunbar was one of the most energetic of the Broadway/Hollywood performers who toured army camps to entertain the troupes during World War II. She contracted polio on a tour and was forced to retire from performance.

Duncan, Elizabeth, American Greek revival theorist and teacher; born c.1874 in San Francisco, California; died December 1, 1948 in Tubingen, Germany. With her younger sister Isadora and their brothers, Raymond and Augustin, Duncan was initiated into the Greek revival movement by their mother. Moving to Europe with her sister, she co-founded a boarding school for her female students in Grunewald, c.1904. It was from this school that the six Duncan protégés known as the "Isadorables" were trained by Elizabeth Duncan. She opened her own school in Darmstadt in the early 1900s, presenting her groups of children in performances each year.

After returning to the United States during World War I, she moved back to Germany to form schools in Potsdam, Salzburg, and Munich, where she taught until her death. Her career was in almost direct opposition to her sister's, since she did leave many students and protégés, but had no performance skills or audience contact. The better known Duncan, whose works and technique are lost, left an image that conquered time.

Duncan, Irma, German interpretive dancer and choreographer, considered the most widely influential of the Duncan protégés; born Dorette Henrietta Ehrich-Grimme February 26, 1897 in Schleswig-Holstein, Germany; died September 20, 1978, in Santa Barbara, California. She was trained from the age of eight at the Isadora and Elizabeth Duncan school at Grunewald, making her debut as a Duncan dancer in 1905. A member of the formal company, known as the Isadora Duncan Dancers or the "Isadorables," from 1918, she directed the Duncan school in the Soviet Union from 1921 to 1930, with Western tours in 1928–1929 and 1930.

She moved to the United States in 1930, performing there as a concert dancer until the late 1930s. Although better known as an artist in her later years, she taught Duncan techniques and forms to dancers whom she considered worthy to include the material in their own repertories, serving as advisor for Julia Levien and Anabelle Gamson's Duncan revival companies in the 1970s.

Duncan's own concert and recital programs read very much like those of her mentor, with entire evenings devoted to single composers, notably Chopin, or shared among two or three Romantics. Although before 1927, she did not receive choreographic credit for her work, all pieces being created by inference by Isadora Duncan, it is possible that she staged at least parts of the two series of *Impressions of Revolutionary Russia* (c.1926). On her own in the 1930s, she was responsible for staging large-scale dances to *La Musette d'Armide* (1939), with students from the New York Lycée Français, *Iphegenia in Tauris* (1934), in the artistic community of Croton-on-Hudson, and

the famous benefit presentation of the *Ode to Joy* (1933), in the Walter Damrosch concert of the Beethoven *Ninth Symphony*.

Works Choreographed: CONCERT WORKS: (Note: no choreographic credit can be assigned to Irma Duncan absolutely before 1929.) *Famine* (1924); *Labor Harvest* (1924); *Songs in Movements and Poses* (1924); *Marche Funebre* (1925); *Chopin program* (Ballade in G Minor, Nocturne in C Major, Preludes in B Major and G Minor, Etudes in A Major, G Major (No. 11), G. Major (No. 25), Mazurkas in B flat Minor, C Major, D. Major, Polonaises in A Major, Valse in G Major, Valse Brilliante in A Major, Prelude (unidentified), Polonaise in A Major) (1925); *Schubert Marche Militaire, Gigue and Landler* (1925); *Allegro* (1926); *Symphonie Pathétique* (1926); *Impressions of Revolutionary Russia* (two series constructed of the following: *Labor Triumphant, Funeral Songs for Prisoners of Siberia, Red Prisoners in Siberia, Scenes from Childhood*) (1926); *Unfinished Symphony* (1926); *Ave Maria* (1926); *Schubert Waltzes et Ecossaises* (1928); *Dances from Iphigenia in Aulis and Iphigenia in Tauris* (1928); *Lyric Dances, Dramatic Dances* (1931); *Ode to Joy* (1933); *Liebestraum* (1937); *La Musette d'Armide* (1939); *La Marche Lorraine* (1939).

THEATER WORKS: *Iphigenia in Tauris* (1934, as play with opera score serving as incidental music).

Duncan, Isadora, American interpretive dancer and choreographer, one of the most controversial figures in the history of dance; born May 27, c.1878 in San Francisco; died September 14, 1927 in Nice. Duncan, her sister Elizabeth, and brothers Augustin and Raymond were brought up as part of the Greek revivalist movement that swept the Bay area in the mid-1870s. The amount of formal training that she had is questionable; many sources state that she worked with Marietta Bonfanti in New York while others insist that she studied with Katti Lanner in London. One not particularly reliable source mentions that she received training in improvisatory dance work with Jean Van Vlissengen, but this has not been verified.

The connection with Greek revivalism is also a question that has not been fully explored. Unlike her brothers, who adopted Hellenicism in every part of their artistic lives, she abandoned the strictures of music and format of the Greek revival movement placed on dance, and used primarily classic and Romantic music. She also split from the Greek revival movement by working in conventional proscenium theaters, although this may have been a matter of compromise, not of artistic decision.

Duncan's career itself was that of a concert dancer. After working for Augustin Daly in Chicago and New York, she traveled to Europe to perform there. She gave recitals and lecture-demonstrations on what she called "The Dance of the Future." The success of this performance, and its subsequent controversy, prompted her to open a school in Grunewald, actually directed by Elizabeth, from which her six protégés, Irma, Anna, Erika, Lisa, Maria Theresa, and Margot, came. She also opened a school in Moscow, leaving it to Irma to manage. Throughout her career, she gave recitals alone and with her children companies, visualizing musical scores for piano and full symphony orchestra.

What she actually performed has become unimportant to many who know the name of "Isadora," who for various reasons reflecting her own philosophies was usually called by her first name. Her life—with its tragedies and excesses—was known to many who had no idea what a Duncan concert looked or sounded like. Her affairs are known by every dance fan, film fan, and lover of *roman à clef*, but few know or care how or what she danced. Unfortunately, since she was a concert dancer who seems to have needed an educated and often a privately invited audience, it is unlikely that anyone will ever know her artistic identity. Critics and historians frequently admit their ignorance, but state that she was a dancer who relied on her cult of personality rather than her technique. Duncan protégés and their own disciples speak devoutly of her stage presence and powerful performance style.

What is known is threefold: she created very few works, which were performed at a surprisingly small number of public recitals; she had a definite philosophy of dance as it represented life in general and the place of women in society; and she was completely overwhelmed by her own legend.

Works Choreographed: CONCERT WORKS: (Note: this listing includes every available title from public and private concerts. Since much of her work was re-

portedly created for single performance, frequently without an audience at all, it cannot be considered a complete resume of her works.) *Orpheus* (1902); *Dance Idylles* (solos, variously including any of the following: *Bacchus et Ariadne, Primavera, Welcome to Spring* [may be the same as *Primavera*], *Berceuse, Narcisse, Romance, The Blue Danube, Dance of the Happy Spirits* [from *Orpheus*], *Pan et Echo, Musette, Tambourin, Death and the Maiden, Minuet [I] and [II]* (1901-1904); *Danses Idylles for Children (Romanesca, Entr.'acte, Rondo)* (1901-1904); *The Supplicant* (1904); *Beethoven program (Sonatas Opus 27, No. 2, Opus 13, Minuet* [unidentified], *Adagio from the Seventh Symphony, Piano Studies for the Seventh Symphony)* (1904); *Brahms Program (Waltzes Opus 52, No. 6, Opus 29, No. 15)* (1905); *Chopin Program (Waltzes Opus 64, Nos. 1 and 2, Opus 29, No. 1, Opus 70, No. 1, Mazurkas Opus 33, No. 3)* (1905); *Iphigenia in Aulis* (1905); *Knusper Waltzer* (1906); *Rosenvingel* (1906, for children's chorus); *Three National Dances (Norwegian, Slovanic, Spanish)* (1908); *Schubert Program (Marches Militaire et caracteristique)* (1909); *Six German Dances* (1909, may have been performed as early as 1905); *Dance of the Flower Maidens from Parsifal* (1911); *Two Gavottes* (1911); *Dance of the Apprentices from Die Meistersinger* (1911); *Ave Maria* (1914); *King Stephen Overture* (1914); *Schubert Unfinished Symphony* (1914); *Chopin Program II (unidentified Preludes, Etude, Impromptu, Polonaise, Mazurka, waltzes)* (1915, this may be the same program of Chopin piano pieces that Irma Duncan used); *Beethoven Fifth Symphony* (1915); *La Marseillaise* (1915); *La Rédemption* (1915); *Marche Lorraine* (1917); *Marche Slave* (1917); *Benediction de Dieu dans la Solitude* (1917); *Les Funérailles* (1917); *Marche Funèbre* (1919, may have been performed with Chopin Program II); *Trois Poèmes* (1919); *Sonate (Moonlight Sonata)* (1919); *Schubert Waltz Program* (1920); incidental dances from *Parsifal (Prelude, Régéneration de Kundry)* (1920); *The International* (1922); *Scriabin Program (Scherzo from Symphony No. 1, Idyll from Symphony No. 2, Sonata No. 4, Three Etudes)* (1922); *Funeral Scene from Gotterdammerung* (1922); *Liebestod from Tristan and Isolde* (1922); *Une Nuit sur le Mont Chauve* (1923); *Entrance of the Gods into Valhalla* (1923); *Strauss Waltz Program* (1923); *Impressions of Revolutionary Russia* (c.1926, other works performed under this title by Irma Duncan and possibly choreographed by her); *The Three Graces* (1928, possibly a version of *Primavera*).

Bibliography: Duncan, Isadora. *The Art of the Dance* (New York: 1928); *The Dance* (New York: 1909), translation of *Der Tanz de Kukunft* (Leipzig: 1903); *The Dance of the Future* (New York: 1908); *Ecrits sur la Danse* (Paris: 1927); *My Life* (New York, 1927, revised 1933); Desti, Mary. *The Untold Story* (New York: 1929); Duncan, Irma. *Isadora Duncan* (New York: 1958); *Isadora Duncan's Life in the Soviet Union and Her Last Years* (New York: 1928); *Isadora Duncan's Russian Days and Her Last Years in France* (New York: 1928); *The Technique of Isadora Duncan* (New York: 1937); Magriel, Paul David, ed. *Isadora Duncan* (New York: 1947); Steegmuller, Francis. *"Your Isadora"* (New York: 1974).

Duncan, Jeff, American modern dancer and choreographer; born February 4, 1930 in Cisco, Texas. Originally trained as a musician, Duncan was trained by Hanya Holm in Colorado and by Alwin Nikolais and Doris Humphrey in New York. He served as her assistant at the 92nd Street YMHA, and performed for her in *Poor Eddy* (1953). One of the truly great performers in the modern dance, Duncan performed in the companies of Anna Sokolow, creating roles in her *Lyric Suite* (1954), *Session '58* (1958), and *Rooms* (1955), in the "Panic" solo and later adding the "Dream" sequence to his repertory. On Broadway, he performed in Sokolow's *Red Roses for Me* (1955), in Michael Kidd's *Destry Rides Again* (1959), and Tamiris' *Plain and Fancy* (1955).

Duncan's choreography ranges from the abstract, flawlessly constructed as befits a Humphrey student, to the characterizational, such as in his best known works *Winesburg Portrait* (1963), based on a libretto by Sherwood Anderson. As in the choreography of Anna Sokolow, Duncan's dancers in that piece have to use his gestural vocabulary to create characters who are clear to the audience but a mystery to themselves.

He has choreographed for his own company, for shared recitals, for the Impetus Company of the University of Maryland at Baltimore, where he is currently in residence, and for the Dance Theatre Work-

shop, a collaborative group of dancers and a production company that manages one of the most important performance spaces in New York.

Works Choreographed: CONCERT WORKS: *Image* (1954); *Antique Epigrams* (1957); *Three Fictitious Games* (1957); *Frames* (1958); *Terrestrial Figure* (1959); *Opus 1, No. 1* (1960); *Outdoors Suite* (1960); *Il Combattimento* (1961); *Rite of Source* (1962); *Quartet* (1962); *Duet* (1963); *Trio* (1963); *Winesburg Portraits* (1963); *Revelation* (1964); *Six Bagatelles* (1964); *Diversions for Five* (1964); *Glimpse* (1965); *Summer Trio* (1965); *Canticles* (1966); *Statement* (1966); *Studies for an Ominous Age* (1966); *Preludes* (1966); *Diminishing Landscape* (1966); *Three Studies* (1967); *View* (1967); *Body Parts* (1969); *Vinculum* (1969); *Les Sirénes* (1969); *Resonances* (1969); *The Glade* (1970); *Douprelude* (1971); *Lenten Suite* (1971); *Space Test* (1971); *Shore Song* (1972); *Canticles No. 2 for Three* (1973); *View* (completed work) (1973); *Cantique de Cantique* (1973); *Pieces in May* (1974); *Phases of the Oracle* (1974); *Bach Fifth Clavier Concerto* (1975); *Contrast Suite* (1976); *Sky Paths/Places* (1977); *Quartet for Women* (1977); *The Heptasoph Pieces* (aka *Square*) (1979); *La Mesa del Brujo* (1980).

TELEVISION: *Revelation* (ABC, March 29, 1964, special); *The Joy of Bach* (PBS, December 23, 1978, special).

Duncan, Maria Theresa, German interpretive dancer; born Theresa Kruger, c.1895 in Dresden. After some dance training, possibly in a children's ballet, she entered the Isadora and Elizabeth Duncan school at Grunewald, c.1905. She remained a student of Elizabeth Duncan until 1919, when she and five other pupils were adopted by Isadora Duncan and sent to the United States on a Sol Hurok tour. As the "Isadorables," she, Irma, Anna, Margot, Erika, and Lisa performed across the country.

She returned to the United States as a solo concert dancer in the 1920s, performing as a recitalist and with a small group called the Meliconades for their Greek dances. Like her mentor, she based her works on music interpretation, but with less emotional overlay. She also arranged programs as if they were concerts, grouped chronologically, or dedicated entire concerts to Schubert or Chopin. Although she retired in the 1940s, she made a triumphant return to the concert stage in 1978, with the Isadora Duncan Heritage Dance Group. Her performance of the Adagio from the Beethoven *Seventh* Symphony was masterful for a woman of any age.

Works Choreographed: CONCERT WORKS: (This list is incomplete. It is likely that a complete chronology of her works will be compiled by Kay Bardesley within a year of this publication.) *Les Funérailles* (c.1926); *Rondo, Gavotte Gracioso* (1927); *Bacchanale* (1927); *Chopin works* (Berceuse, Valse langoureuse, Valse Brillante, Prelude, Mazurka No. 15) (1927); *Mozart Fantasia in D Minor* (1927); *Eroica Symphony* (1929); *Brandenburg Concerto No. 11* (1929); *Alceste* (1929); *The Dance of the Blessed Spirits* (1930).

THEATER WORK: *The Betrothed* (1918).

Duncan, Sandy, American theatrical dancer and actress; born February 20, 1946 in Henderson, Texas. Trained in Overton and Tyler, Texas, by Uta Ground, she made her professional debut at twelve in Dallas Civic Theater productions. In the mid-1960s, she spent time in New York City performing in revivals of classic musical comedies at the City Center, the nearest that the city comes to a repertory group. After appearing in City Center's productions of *Carousel*, *The Music Man*, *Finian's Rainbow*, and *The Sound of Music*, she did a rare dramatic role in a play, Ronald Ribman's *Ceremony of Innocence*, in 1968. Most of Duncan's Broadway credits have been in musical shows involving dance numbers and characterization. In the shows, *Your Own Thing*, *Canterbury Tales* (1969), *The Boy Friend* (1970 revival), and her vehicle, the revival of *Peter Pan* in 1979, she came to national prominence and enormous popularity.

Duncan has also appeared as a comic actress in films, on her own two situation comedies, and in a series of successful television commercials. She has toured with nightclub shows that show her dance and vocal talents since the early 1970s and currently appears in a cabaret format.

Duncan Sisters, American theatrical dancers and vocalists; Rosetta, born November 23, 1890 in Los Angeles; died December 4, 1959 in Chicago; Vivian, born June 17, 1902 in Los Angeles; date of death uncertain. The Duncans were a child act in vaudeville in

the 1910s, specializing in songs and dances that perpetuated their youth. After working in a Gus Edwards show, they made their Broadway debuts in *Doing Our Bit* in 1917. For ten years, they appeared together growing older, but remaining children in their stage characters. For this reason, they never performed sophisticated dance steps or routines, but stayed with soft shoes and fancy dancing, with Rosetta playing boy's parts. Their greatest hit was undoubtedly *Topsy and Eve* (1924), the Broadway version of the old stock company tab show of *Uncle Tom's Cabin*. They wrote most of the songs, which were so popular that they established a music publishing house, and did their dance routines, but in this production, Rosetta, as "Topsy," worked in blackface instead of her usual *travestie*. They toured extensively with this production, bringing it to London in 1928 and filming it in 1927.

For the next few years, they toured in vaudeville and wrote music for films and other performers. Their appearance in *New Faces of 1936* is believed to have been their last.

Dunedin, Maudie, Scottish specialty dancer and unit producer working in the United States; born c.1888 on tour in Australia; died April 9, 1937 in Glendale, California. Dunedin made her professional debut as a child with the family's trick bicycle acts organized by her extended family—The Incredible Dunedins, The Donegan Sisters, which also featured her on roller skates, and The Variety Girls. She toured with them until the late 1910s, performing highly successfully in England (1909, 1911, 1914) and the United States (1904–1915). Like her sisters (or possibly cousins), Florence and Queenie, she brought her husband, Harry Mallia, into the family act in the first years of their marriage. By 1920, however, Mallia had left his own vaudeville act to work as a house and circuit manager. Dunedin returned to the stage with a solo act exploiting her unique abilities on bicycles, skates, and toe shoes. That range of specialties made her extremely desirable at the New York Hippodrome, where the enormous stage floor had been augmented with rigging systems and a pool suitable for naval battles. In *Good Times* (1920), she did one toe solo on the floor and another on skates.

Although Dunedin was only in her thirties when she retired from performance, she had been on stage for three decades. She joined Mallia in production and became a manager for Prolog units on the West Coast. Her association with RKO was especially successful, lasting for more than a dozen years, and her unique experience made her expert at arranging a wide variety of specialty acts for her soloists and precision lines of dancers.

Dunham, Katharine, American modern dancer and choreographer, considered one of the founders of the anthropological dance movement; born June 22, 1912 in Glen Ellyn, Illinois. Raised in Joliet, she attended the University of Chicago where she founded a company, called alternatively Ballet Negre and the Negro Dance Group. She received her first of many fellowships to study dance cultures of the Caribbean in 1935, making it the basis of her M.A. thesis and much further research. Although she was employed as a member of the Works Progress Administration's Mid-West Federal Writers' Project, and wrote a study of cultism, she contributed one of her earliest works of choreography to the Federal Theatre Project's Chicago season in 1938.

From that time until the late 1960s, Dunham commuted between academic anthropology, becoming known as an expert on dance as a representation of religion in Caribbean cultures, and professional dance production. Her company performed from the early 1940s to the mid-1960s as a concert dance group, with regular seasons in New York and on tour, and as a unit that could be inserted whole into theatrical and film productions. They played Broadway, London, Paris, and Las Vegas frequently, with programs similar to those done in the concert halls. Her works tended to be theatricalized versions of Caribbean, American, or African cultural events—religious, sexual, or familial—but also included pure theater dance and pure anthropological presentations.

She dissolved her company in 1965 to become an adviser to the cultural ministry of Senegal, returning to the United States in 1967. She left the conventional dance world of New York that year to live and work in East St. Louis at an inner-city branch of the Southern Illinois University. There, she runs a school

attached to the university and works with neighborhood and youth groups.

Through her personal appearances and through her film work, Dunham reached many audience members across this country and the world. She is considered the major influence on that part of the American modern dance movement that uses folk and "ethnic" dances as vocabulary and background material. Her schools in New York, directed by Syvilla Fort, trained hundreds of modern and concert dancers and their theater and film colleagues. Although she withdrew from the dance world into her signature combination of political action and anthropological study, she has affected much of what is happening in a large segment of dance performance to this day.

Works Choreographed: CONCERT WORKS: (Note: some works listed below were first performed as parts of Broadway concerts, but those pieces that were created for integration or interpolation into musical comedies or revues are listed under theater works.) *Tropics* (1937); *Schulhoff Tango* (1937); *Madame Christoff* (1937); *Primitive Rhythms* (Rara Tonga) (1937); *Biguine-Beguine* (1937); *Florida Swamp Shimmy* (1937); *Lotus Eaters* (1937); *Haitian Suite* (1937); *Péruvienne* (1938); *Le Jazz Hot* (Boogie-Woogie) (1938); *Saludade da Brazil* (1938); *Spanish Earth Suite* (1938); *Island Songs* (1938); *Mexican Rhumba* (1938); *L'Ag'Ya* (1938); *A La Montanas* (1938); *Barrelhouse* (1938); *Bre'r Rabbit an' de Tah Baby* (1938); *Bahiana* (1939); *Cuidad Maravillosa* (1939); *Concert Rhumba* (1939); *Cumbancha* (1939); *Plantation Dances* (1940); *Babalu* (1941); *Haitian Suite (II)* (1941); *Honky-Tonk Train* added to Le Jazz Hot (1941); *Rites de Passage* (1941); *Tropical Revue* (1943); *Callaco* (1944); *Choros Nos. 1-5* (1944); *Flaming Youth 1927* (1944); *Para Que Tu Veas* (1944); *Havana 1910/1919* (1944); *Carib Song* (1945); *Bal Negre* (1946); *Motivos* (1946); *Haitian Roadside* (1946); *Nostalgia (Ragtime)* (1946); *Batacada* (1947); *Bolero* (1947); *C'Est Lui* (1947); *Rhumba Trio* (1947); *Floor Exercises* (1947, possibly choreographed earlier as a lecture-demonstration); *La Valse* (1947); *Octaroon Ball* (1947); *Angélique* (1948); *Blues Trio* (1948); *Macumba* (1948); *Missouri Waltz* (1948); *Street Scene* (1948); *Vercruzana* (1948); *Adeus Terras* (1949); *Afrique* (1949); *Jazz in Five Movements* (1949); *Brazilian Suite* (1950); *Los Indios* (1950); *Frevo* (1951); *Rhumba Jive* (1951); *Rhumba Suite* (1951); *Spirituals* (1951); *Caymmi* (aka *Homage à Dorical Caymmi*) (1952); *Ramona* (1952); *La Blanchisseuse* (1952); *Southland* (1952); *Afrique du Nord* (1953); *Samba* (1953); *Cumbia* (1953); *Dora* (1953); *Honey in the Honeycomb* (1953); *Incantation* (1953); *Carnaval* (1955); *Floy'd Guitar Blues* (1955); *Jazz Finale* (1955); *"Just Wild About Harry"* (1955); *New Love* (1955); *Yemana* (1955); *New Love, New Wine* (1955); *Banana Boat* (1957); *Plating Rice* (1957); *Sister Kate* (1957); *Ti'Cocomaque* (1957); *A Touch of Innocence* (1959); *Bamboche* (1962); *Diamond Thief* (1962); *Anabacoa* (1963).

THEATER WORKS: *The Emperor Jones* (1939); *Cabin in the Sky* (1940, co-choreographed with George Balanchine); *Pins and Needles* (1940, additional dances for long-running show); *Tropical Pinafore* (1939); *Les Deux Anges* (1965, Paris).

FILM: *Carnival of Rhythm* (WB, 1939, short subject); *Pardon My Sarong* (Universal, 1942); *Boote e Risposta* (Ponti-De Laurentiis, 1950); *Mambo* (Ponti-De Laurentiis/Paramount, 1954); *Green Mansions* (MGM, 1958); *The Bible* (De Laurentiis/Twentieth-Century Fox/Seven Arts, 1964, "Sodom and Gemorrah" scene only); in addition, Dunham probably choreographed her appearances in the following films for which she was not credited: *Star Spangled Rhythm* (Paramount, 1942); *Stormy Weather* (Twentieth-Century Fox, 1943); *Casbah* (Universal, 1948).

Dunn, Douglas, American postmodern dancer and choreographer; born in 1942 in Palo Alto, California. He first studied dance while a student at Princeton, working with Roland Guerard, Maggie Sinclair, and Audrey Estey at the Princeton Ballet Society. He attended the Jacob's Pillow summer courses in 1963, studying with Gus Solomons, Jr., Margaret Craske, and ethnic specialists La Meri and Matteo. After college, Dunn moved to New York to continue his training with Françoise Martinez at the American Ballet Center, but soon began to study at the Merce Cunningham studio with Judith Dunn, Viola Farber, Barbara Dilley, Margaret Jenkins, and Carolyn Brown. Graduating into the company, he created roles in Cunningham's *Triad, Second Hand, Signals,*

and *Objects* (all 1970), *Landrover* (1972), *TV Rerun* (1972), and *Changing Steps* (1973).

Although he missed the composition workshops that formed the Judson Dance Theatre, he soon became a staple of performances by Judson choreographers. He appeared in Yvonne Rainer's *Rose Fractions* (1969) and her extraordinarily influential *Continuous Project Altered Daily* (performances from 1969 to 1970). That work was the catalyst for the creation of the improvisational company, Grand Union, with which he worked from 1970 to 1976. Among the many other "classics" of the postmodern development in which he danced was Trisha Brown's *Roof Pieces* (1971).

Dunn's own choreography seems to be in reaction to the improvisational process. He communicated the process of single choreographic choice to the audience in his single performance works, in which the possible movements are visualized before the sequence is completed, and in his pieces, such as *Lazy Madge*, which evolved over a series of concerts. His performances are fascinating for the continuous play on processes and for his own dancing which seems to play with normal balance and conventional anatomy.

Although many of his works are solos, he has also choreographed in collaboration with fellow postmodernists David Gordon and Wendy Perron, and created pieces for performance with Perron, David Woodberry, Diane Frank, and Deborah Riley.

Works Choreographed: CONCERT WORKS: *One Thing Leads to Another* (1971, in collaboration with Sara Rudner); *Dancing Here (Like as Not)* (1971, in collaboration with Pat Catterson); *Co-Incidents* (1972, in collaboration with David Woodberry); *Nevada* (1973); *Time Out* (1973); *Four for Nothing* (1974); *101* (1974); *Octopus* (1974); *Part I Part II* (1975, in collaboration with Woodberry); *Gestures in Red* (1975); *Early and Late* (1976); *Lazy Madge* (1976, performed in differing versions through 1979); *Solo Film and Dance* (1977, in collaboration with filmmakers Charles Atlas and Amy Greenfield); *Rille* (1978); *Coquina* (1978); *Foot Rules* (1979); *Echo* (1979); *Relief* (1979); *Echo* (1980); *Pulcinella* (1980).

FILM AND VIDEO: *Mayonnaise—Part I* (Independent, 1972, directed by Charles Atlas); *101* (Independent, 1974, directed by Amy Greenfield).

Dunn, James, American film dancer and actor; born November 2, 1905 in New York City; died September 1, 1967 in Santa Monica, California. Although Dunn worked as a dance extra at the Paramount Studio in Astoria, Queens, he did not win a motion picture contract until after his Broadway appearances in *The Night Stick* (1927) and *Sweet Adeline* (1929).

He moved to Hollywood with a Fox Films contract and became a featured tap dancer in a series of pictures. Although he made almost a dozen musicals, he is best remembered for his work with the very young Shirley Temple, partnering her in her first feature films—*Stand Up and Cheer*, *Baby Take a Bow*, and *Bright Eyes*, in which they sang "The Good Ship Lollipop."

Dunn's career did not continue successfully, however, and he worked only infrequently until 1940 when he returned to Broadway with a principal role in *Panama Hattie*. After another period of unemployment, he was cast as "Johnny" in the film version of *A Tree Grows in Brooklyn* (1946), for Twentieth-Century Fox. He won the Academy award as best supporting actor, but became an early victim of the "Oscar curse." His later film appearances were in dramatic roles. His last known dance performance was as "Jerry J. Cohan" in the television special about George M. Cohan, *Mr. Broadway* (NBC, 1957).

Dunne, James, American ballet dancer; born c.1950 in Waldwick, New Jersey. After local training from Irene Fokine, he attended the School of American Ballet in New York. On scholarship to the Harkness House, he performed with the Harkness Youth Dancers and Ballet before they dissolved. Dunne is best known for his appearances with the City Center Joffrey Ballet in contemporary ballet, such as Margo Sappington's *Weewis* (1971) and Gerald Arpino's *Trinity*, *Sacred Grove on Mount Tamalpais*, and *Viva Vivaldi!* He left the company to work with Dennis Wayne in the charter company of *Dancers* (1977) and the Broadway show staged by Bob Fosse, *Dancin'*.

Dupond, Patrick, French ballet dancer; born March 14, 1959 in Paris. Dupond was trained by Max Bossoni and at the school of the Paris Opéra before grad-

uating into the company. He has appeared in many contemporary works in the repertory, including Grigorievitch's *Ivan the Terrible* (1977 production) and Roland Petit's *Symphonie Fantastique* (1975) and *Nana* (1976). He seems to have specialized recently in classical pas de deux. Since the mid-1970s, he has guested with many companies in Europe and the United States, generally in pas de deux in benefit performances where he has been cheered for his elevation and exuberance.

Duport, Louis Antoine, French early eighteenth-century ballet dancer; born c.1781 in Paris; died there October 19, 1854. Duport's details of birth and training have never been verified; similarities of name and possible birth date have led some to question whether he was the Louis Duport who was raised and trained in the United States by Pierre Landrin, called Duport. Lillian Moore, however, who first raised the question, was unable to solve what she called ''The Duport Mystery.'' Louis Antoine Duport first came to the public's attention in 1797 in performances with his sister Adelaide at the boulevard Théâtre de l'Ambigu-Comique, where they danced in Louis Milon's *Pygmalion*, and at the Théâtre de la Gaité. He made his Paris Opéra debut in 1801 and performed there for seven years, becoming a public favorite for his bravura jumps. He choreographed there also, producing a trio of ballets on fairly traditional themes. Duport toured extensively in Europe when he found himself unable to work within the Paris Opéra hierarchy (or to depose Pierre Gardel, depending on whose sources you believe), and performed in Vienna, St. Petersburg, Naples, and London. Since his works were based on themes that had already been choreographed frequently, he was able to adapt them easily to the demands of each new theater. His longest tenure was as co-director of the Theater am Karntnertor in Vienna from c.1820 to 1836.

Works Choreographed: CONCERT WORKS: (Note: it is unlikely that these works represented his entire canon.) *Acis et Galathée* (1805); *Le Barbier de Séville* (1806); *l'Hymen de Zéphyr, ou le Volange fixé* (1806).

Duport, Pierre Landrin, French early nineteenth-century ballet dancer teaching in the United States; born c.1762, probably in Paris; died April 11, 1841 in Washington, D.C. Duport (who is properly surnamed Landrin) was trained by Maximilien Gardel in Paris and may have performed with the Paris Opéra before leaving for the United States in 1790. He settled in Philadelphia with his wife, Irish dancer Charlotte McNeill, and two child prodigies—his daughter, Anna (later Reinagle), and a child named Louis Duport. They performed in Philadelphia, New York, Boston, Baltimore, and Georgetown as a family and connected with the Alexander Placide troupe shortly before the 1793 season. Duport retired to the District of Columbia in the 1810s and died there.

Although his was not an important family troupe in the new American tour circuit, Duport was tremendously important in terms of dance and music notation and publication. With Alexander Reinagle and other composers, he created and distributed authorized social dances. Their collaborations are some of the few sources for social dances as they were Americanized in the late eighteenth and early nineteenth centuries.

Dupré, Louis, French eighteenth-century ballet dancer and teacher; born 1697; died 1774 in Paris. After teaching in Le Mans and performing in popular theaters in Paris' fairs, he joined the company of the Paris Opéra, with which he was associated for the rest of his career.

As a performer, he is best known for his performance in the stylized wrestling dance in Lami's *Les Fêtes Grecques et Romans* in the 1733 premiere and the 1741 revival. Called ''le grand Dupré,'' he was acclaimed for his graceful style and exceptional technique as a solo *danseur noble*.

Dupré was the most celebrated teacher of his era; his students included Gaetano Vestris, Jean-Georges Noverre, Jean-Baptiste Hus, and Marianne Cochois, all innovators in choreography or performance style. Another student, and his younger brother, was Jean-Denis Dupré, who partnered Marie Sallé at the King's Theatre, London, and danced at the Paris Opéra.

Durang, Charles, American nineteenth-century dance master; born December 4, c.1794 in Philadelphia, Pennsylvania; died there 1870. Durang per-

formed with his father from early childhood until John Durang's death in 1822. He remained in theater work briefly, but by 1830 had become a dance master, or teacher, in his home town. Durang taught ballet (probably having studied himself with P.H. Hazard), theatrical forms, and social dances of the period. It is likely that he actually made his living on the latter since he began to publish a series of social dance manuals in 1848. These books, *The Ballroom Bijou* (1848, 1856), *Terpsichore or The Ball-room Guide* (1847, 1856), and *The Fashionable Casket* (1856), gave instructions on performing the actual steps of the contemporary dances, along with etiquette, music, and fashions.

Durang, John, American popular dancer of the eighteenth and nineteenth centuries; born January 6, 1768 in York, Pennsylvania; died March 18, 1822 in Philadelphia. Raised in Philadelphia, he probably received his early training from M. Roussel, a member of the Denis Ryan stock company in Philadelphia from 1783. A member of Lewis Hallam's troupes from 1784 to 1796, he performed in plays, comedies, and harlequinades. He also directed harlequinades for live performers and for marionettes.

Influenced by his work with Alexander Placide (an acrobat from the Nicolet theater in Paris who performed in New York at the turn of the century before settling in Charleston), he also worked with another Nicolet alumnus, M. Spinacuta, at Rickett's Amphitheater in Philadelphia (c.1796–1801). Both he and all of American pantomime were influenced by the performances of James Byrne of Covent Garden, London, in the 1796–1798 season. From 1800 to 1819, he managed the Chestnut Street Theatre in Philadelphia, finding time to perform and stage pantomimes for the troupe.

John Durang is generally considered the first American professional dancer. While this book eschews such competition among entries, it is likely that he was the first American (or at least native of an original colony) to base his life around the performance of the then popular dance/theater form of harlequinades and pantomimes. The fact that his preferred style of theater was so definitely derived from English culture should not be held against him. Even if another American dancer is discovered who made

his debut a year before Durang's, he would still be an important individual in American popular culture. He developed an American subgenre of political harlequinades, such as *The Western Exhibition, or the Whiskey Boy's Liberty Pole* (1797), founded a dynasty of performers and teachers, and left memoirs that demonstrate for us not only his style of performance but also the life of a performer in the new country.

As well as Charles, Durang had five additional children who followed him into the profession, listed here in chronological order of birth. Ferdinand (1796–1831), made his debut at the Chestnut Street Theatre in Philadelphia as a child dancer. He was better known, however, as a comedian in the Chatham Theatre, New York, and in T.S. Hamblin's Bowery Theatre company. Like most of his family, Ferdinand suffered from consumption and died at thirty-five of that disease. Augustus (1800–c.1840) was the most successful child performer in his family, celebrated for his portrayal of "Tom Thumb" in the Chestnut Street Theatre pantomime of that name. He too became involved in nonmusical theater, most notably at the Park Street house in New York, but left the industry to become a sailor and was lost at sea during an 1840 voyage. Charlotte (1803–1824), became a member of the Chestnut Street company at age seven. She was considered the most talented dancer of her generation, but succumbed to consumption in her adolescence. Juliet Catherine (1805–1849), worked as a specialty dancer at the Park Street Theatre in New York after childhood experience at the Chestnut Street. An 1853 census of actors described her as a celebrated portrayer of "pert Chambermaids and sprightly Pages," in other words, a talented soubrette. Aside from Charles, Catherine (c.1807–c.1860) was the only member of the family to survive until the 1853 census. Known as a vocalist, she performed under her own name and as "Mme. Busselott" in the French-language opera in New Orleans.

Works Choreographed: THEATER WORKS: *The Magic Feast* (1796); *The Country Frolic, or the Merry Haymakers* (1796); *The Independence of America* (1797); *The Western Exhibition, or the Whiskey Boy's Liberty Pole* (1797); *Harlequin Prisoner, or the Gull of the Rock* (1803); *Cinderella* (1803); *Tom Thumb*

(c.1804); Durang participated in and may have chore-ographed up to one hundred more harlequinades and pantomimes from 1796 to 1818.

Bibliography: Downer, Alan, ed. *The Memoires of John Durang* (Pittsburgh: 1967); Moore, Lillian, "John Durang," *Dance Index* (1942).

Duvernay, Pauline, French ballet dancer of the Romantic period; born 1813 in Paris; died September 2, 1894 in Mundford, England. Trained by Auguste Vestris at the school of the Paris Opéra, Duvernay made her debut with the company in 1831.

With the company from 1831 to 1836, Duvernay created roles in Coralli's *La Tentation* (1832), Filippo Taglioni's *Brézilia* (1833), and replaced Marie Taglioni in *Robert le Diable* and *Nathalie, la Laitière Suisse*.

In London, in 1833, she performed leading roles in the revivals of Aumer's *The Sleeping Beauty* and an uncredited *The Maid of Cashmere* at Drury Lane, re-turning the next season to dance Taglioni's role in *Sire Huon*. At the King's Theatre in 1836–1837 she did the Joseph Mazilier revival of *Le Diable Boiteux* and André Deshayes' *Le Brigand de Terracina*. Duvernay retired in London at the end of that season.

Dynalix, Pauline, French ballet dancer; born March 10, 1917 in Grenoble. Trained by Carlotta Zambelli at the School of the Paris Opéra, she was associated with that company throughout her career. Dynalix may have been the last woman to play the role of "Franz" en *travestie*, since, when she retired in 1957, even that company began casting men in the hero's role in *Coppélia*. Her other Opéra repertory included parts in George Balanchine's *Apollo* and in a wide variety of Serge Lifar ballets, including her best known role in *Les Mirages*.

E

Eagling, Wayne, Canadian ballet dancer working in England; born c.1950 in Montreal, Eagling was trained locally by Patricia Webster and in London at the Royal Ballet School. As a member of the Royal Ballet since 1969, he has appeared in both genres that the repertory represents—revivals and new versions of the nineteenth-century classics and contemporary works by living choreographers using an enlarged vocabulary and technique. While he remains best known for the elevation and precision that he gets into the "Bluebird" pas de deux in the final act of *The Sleeping Beauty*, Eagling has also been seen in the "Prince's role" in that ballet and in *Giselle* and *Raymonda* from the nineteenth-century Russian repertory. His other danseur roles include "Rudolf" in Kenneth Macmillan's *Mayerling*, "des Grieux" in his *Manon*, and roles in his *Elite Syncopation* (a jazzier heroicism than most) and *The Four Seasons*, and in Frederick Ashton's *Symphonic Variations* and *Monotones*.

Earle, David, Canadian modern dancer and choreographer; born September 17, 1939 in Toronto. Earle began his training in improvisational theater with Dorothy Goulding and performed with her Toronto Children's Players before studying ballet with Lucile McClure and Nancy Schwenker at the School of the National Ballet of Canada. He began his modern dance training with Yone Kvietys in Toronto and attended class with Martha Graham at the American Dance Festival in Connecticut and at her studio in New York City.

Earle became a founding co-director of the Toronto Dance Theatre in 1968 and has performed in works by his colleagues, Peter Randazzo and Patricia Beatty, and choreographed pieces for the company since that first season. Like them, he works within the Graham technique. He adds a level of theatricality derived from his work with Goulding who had a tremendous impact on both dance and theater creations by her protégés.

Works Choreographed: CONCERT WORKS: *Angelic Visitation No. 1* (1967); *Angelic Visitation No. 2* (1968); *The Recitals* (1968); *Mirrors* (1968); *Lovers* (1968); *Fire in the Eye of God* (1968); *Operetta* (1970); *A Thread of Sand* (1970); *Portrait* (1970); *Legend* (1971); *The Silent Feast* (1972); *Baroque Suite* (1972); *Boat, River, Moon* (1972); *Ray Charles Suite* (1973); *Bugs* (1974); *Atlantis* (1974); *Parade* (1975); *La Belle Epoque à Paris* (Waltz Suite, Deux Epigraphes Antiques, L'Hotel Splendide, Vignette) (1975); *Field of Dreams* (1975); *Quartet* (1975); *Fauré Requiem* (1977); *Mythos* (1977); *Courances* (1978); *Rejoice in the Lamb* (1979, in collaboration with Nancy Ferguson); *Raven* (1979); *Sweet and Low Down* (1979); *Time in a Dark Room* (1979, in collaboration with writer Graham Jackson); *Courtyard* (1980); *Akhenaten* (1980); *La Bilancia* (1980, in collaboration with Jackson); *Frost Watch* (1980, in collaboration with Jackson); *Emozioni* (1980, in collaboration with Jackson).

Eaton, Mary, American theatrical ballet dancer; born 1902 in Norfolk, Virginia; died November 10, 1948. Like her younger sister, Pearl, Mary Eaton had a successful early career as a child actor in stock companies in the Washington, D.C. area. After her New York debut as "Tyltyl" in Winthrop Ames' celebrated production of *The Blue Bird* at the Century Theater, 1915, she began to study ballet with Theodore Kosloff, then at the Ned Wayburn Studio. It is likely that she also received training in musical comedy and tap techniques at the Studio.

Her Broadway debut in *Follow Me* (1916) was followed by a tour with Adolf Bolm's Ballet Intime company, with which she danced in works by Bolm and British Indian-dance expert Roshanara. Returning to Broadway, she won tremendous acclaim as "The Gypsy Queen" in the 1919 revival of *The Royal Vagabond*, believed to have been the first time that she appeared on Broadway on point. Her specialty from then, a romantic toe dance performed almost entirely on point, *terre-à-terre*, was interpolated into her vehicles, *Kid Boots* (1923), *Lucky* (1927), *The Five O'Clock Girl* (1927), and the *Ziegfeld Follies* of 1920 through 1922; in the latter, she was featured in the famous Laceland Ballet as a "Butterfly."

Eaton made her motion picture debut in the Marx

Brothers' *Coconuts* (Paramount, 1929). Although she appeared in at least one more movie, she was unable to make a career in film or to return to the stage.

Eaton, Pearl, American theatrical dancer and film dance choreographer; born c.1906 in Norfolk, Virginia. With her siblings, including her older sister, Mary, Eaton performed in stock company productions in Norfolk, Washington, D.C., and Baltimore. When Mary moved to New York to perform in *The Blue Bird* in 1915, Pearl went with her to study with Ned Wayburn.

As a performer, Eaton was associated primarily with Wayburn shows. She performed in the choruses of tap and musical comedy dances in many of the *Ziegfeld Follies* of 1916 through 1923, with featured roles in the *Midnight Frolics* staged on the roof of the Amsterdam Theater. She was especially popular in the *Frolic* routines in the two 1919 editions, with specialties interpolated into the Knitting and Fishing numbers, each performed on stage with the audience members manipulating the props.

A protégé of Elsie Janis, Eaton moved to Hollywood to work with her at Paramount Studios. She staged three known early sound musicals—*Rio Rita* (Radio Pictures, 1929), *Paramount on Parade* (1931), and *Dance, Girl, Dance* (Invincible Picture Corp., 1933)—before retiring to work with Janis in production.

Ebbelaar, Han, Dutch ballet dancer; born April 16, 1943 in Hoorn, the Netherlands. Trained in Holland by Benjamin Harkavy and Hanny Bouman, he danced with the Netherlands Dance Theatre from 1959 to 1969, in works by Max Dooyes, Glen Tetley, and Hans van Manen. A member of the American Ballet Theatre for the 1968 to 1970 seasons, he partnered his wife, Alexandra Radius, in Steven-Jan Hoff's *Lilting Fate* (1968) and danced major roles in Enrique Martinez' *Huapango* (1969), Richard Gladstein's *Way Out* (1970), and Keith Lee's *Times Past* (1970)—all for the Ballet Theatre preview program.

With the Dutch National Ballet for the last decade, he has created roles in many new works by Hans van Manen, among them his *Daphnis and Chloe* (1972), *Adagio Hammerklavier* (1973), and *Sacre du Printemps* (1974), and by Rudi van Dantzig, including his *On the Way* (1970), *Painted Birds* (1971), and *Ramifications* (1973).

Ebsen, Buddy, American theatrical and film dancer and television actor; born Christian Rudolf, April 2, 1908 in Bellville, Illinois. Ebsen was raised in Winter Park, Florida, where he and his sister Vilma were trained by their father, C.C. Ebsen, a dance teacher (and himself a student of Louis Chalif) who then headed the Dance Masters of America. He moved to New York in the late 1920s and joined the chorus of *Whoopee* (1928), staged by Sammy Lee. In his next two shows, *Flying Colors* (1932) and the *Ziegfeld Follies of 1934*, he was partnered by his sister in an eccentric adagio act to "Shine on My Shoes" and "I Like the Likes of You," respectively.

In Hollywood, Ebsen became known as an eccentric dancer whose tap technique was accentuated by his exceptional height and extremely long hands. He danced in the *Broadway Melody of 1936* (MGM, 1935), which was his sister's last professional appearance, in the Shirley Temple vehicle *Captain January* (Twentieth-Century Fox, 1936), in the Eleanor Powell film *Born to Dance* (MGM, 1936), and in RKO's *Sing Your Worries Away* (1942), as well as more than a dozen dramatic motion pictures, notably among them, *Breakfast at Tiffany's* (Paramount, 1961). He has appeared on almost every dramatic show on television since his debut in 1952, and is known as one of the very few actors to be featured on three long-run hit series—*Davy Crockett, Indian Fighter* (a constituent part of *The World of Disney*, ABC, 1954–1956), *The Beverly Hillbillies* (CBS, 1962–1970), and *Barnaby Jones* (CBS, 1973–1980).

He has returned to the legitimate variety stage only twice since his television career took off; he played "Frank" in a New York revival of *Show Boat* in 1946 and toured with his family in vaudeville revival concerts after 1978.

Eck, Imre, Hungarian ballet dancer and choreographer; born December 2, 1930 in Budapest. Trained by Ferenc Nádesi, he performed with the Budapest State Opera from 1947 to 1960, creating his first ballets for the company in 1948.

In 1960, he founded the Sopiane Ballet, in Pécs, Hungary, for which he has choreographed most of

his canon of works. Known for his ballets to the music of Bela Bartok and other Hungarian composers, he has created abstract romantic pieces and horrifying political works, notably his *As Commanded: Hiroshima 1945* (1962).

Works Choreographed: CONCERT WORKS: *Csongor and Tünde* (1958); *Concerto to the Rainbow* (c.1960); *Divertimento* (c.1960); *Everyday Requiem* (c.1961); *As Commanded: Hiroshima 1945* (1962); *I Lived in those days* (1962); *Peasant's Revolt of 1514* (1964); *Sacré du Printemps* (1963); *Variations on an Encounter* (c.1965); *Music for Strings, Celeste and Percussion* (1966); *Ondine* (1969); *Pastoral Symphony and Seventh Symphony* (1979).

Eckl, Shirley, American ballet dancer; born during the 1920s in Pittsburgh, Pennsylvania. Trained originally by her dance master father, Frank Eckl, she continued her studies at the (Anatole) Vilzak/(Ludmilla) Schollar school.

Eckl performed with Ballet Theatre through the 1940s. Celebrated for her performance as "The Blonde" in Jerome Robbins' *Fancy Free* (1944), whose walk-on ends the ballet but obviously not the evening, she seemed to split her roles between the seductive, as in *Fancy Free* and Antony Tudor's *Undertow* (1945), and the sweet, as in Bronislava Nijinska's *Harvest Time* (1945) and Michael Kidd's *On Stage* (1945). She also appeared in Tudor's *Pillar of Fire*, Leonid Massine's *Aleko*, and the company production of *Giselle*.

Leaving Ballet Theatre in the late 1940s, she performed on Broadway, most notably in Hanya Holm's dances for *Kiss Me Kate* (1948).

Eckler, Hilda, American ballet dancer in Prolog houses; born in the 1920s, possibly in New York. Eckler's training cannot be verified but since she was considered a Patricia Bowman and Paul Haakon protégé, she may have studied with their New York teacher, Mikhail Fokine. Eckler performed at the Radio City Music Hall for more than eight years, from its opening performance to the early 1940s. She began in the ballet as a soloist and rose to première danseuse, but also did Spanish numbers with Haakon and adagio work with Leon Barté and Nicholas Daks. While a performer there, she assisted ballet master Florence Rogge and continued in that capacity after her retirement from active performance.

Eduardova, Eugenia, Russian ballet dancer and teacher; born 1882 in St. Petersburg; died December 10, 1980 in New York City. Trained at the School of the Imperial Ballet in St. Petersburg, she graduated into the Maryinsky Ballet in 1901. She was associated there with the repertory of Petipa ballets, among them his *Sleeping Beauty*, *Esmeralda*, and *Halte de Cavalrie*, which she performed on Adolf Bolm's Western European tour in 1908. She left the Maryinsky in 1917 to tour with the company of Anna Pavlova, with whom she had danced in the 1908 season, settling in Berlin in 1920.

She opened a dance studio in Berlin and served as ballet master of the Grosse Volksoper until forced to leave the country in 1935. After teaching in Paris, she emigrated to the United States where she directed another school. Among her many students here were Vera Zorina, while European protégés Alexander von Swaine, Georges Skibine, Yuri Algaroff and Natascha Yrofimova frequently scoured her classes for young Americans to take back to hire for their companies.

Edwardes, George, English early twentieth-century musical comedy producer; born October 14, 1885 in Clee; died October 4, 1915 in London. From the 1880s to the early 1910s, Edwardes produced a series of productions that formed the link between the English burlesque and the traditional musical comedy, or operetta. From *Little Jack Shepherd* (1885) to *Adele* (1914), he engaged most of the native British talent to perform, write, or stage his shows, hiring Joseph Coyne, Lily Elsie, Lottie Collins, José Collins, Ellaine Terris, and many others. He is best known for the so-called "Girl" musicals—not "girlie shows," since they had extremely decorous fully dressed female choruses, but simply a series of musicals with either the word "girl" or a woman's name in the titles. They included the celebrated *Gaiety Girl* (1893, named for the Gaiety Theatre), *The Shop Girl* (1894), *The Geisha* (1896), *A Country Girl* (1901), *The Earl and the Girl* (1903), *Madame Sherry* (1903), *The Girl on the Stage* (1906), and *The Girl on the Film* (1913).

Edwards, Hollis, American eccentric dancer; born in the 1910s; details of Edwards' probable death uncertain. In the late 1920s and 1930s, producers of Prologs and presentation acts were involved in a constant search for new acts. Many preferred to book an entire variety show organized around a central theme. Two of the most popular jobbed-in troupes were made up of performers who were, in the parlance of the industry, "lilliputians." One of the best known was eccentric dancer Hollis Edwards.

Edwards was a midget, although his troupe, Rose's Parisien Midget Follies, also included dwarfs. At thirty inches tall, his tap dancing, which was frequently compared to Bill Robinson's, was tremendously impressive on a large picture palace stage. He was even billed (c.1938) as "the little dark cloud of joy." The contemporary dramatic press, members of which delighted in denigrating publicity gimmicks, agreed that Edwards' technique, style, and articulation were outstanding for any dancer, however tall. His act consisted of three dances—a cake-walk performed with Esther Howard, a tap flash act, and an imitation of Bill Robinson, complete with hat, spats, and staircase. The only member of his troupe to be considered a specialty dancer, he was in great demand in the context of the Parisian Follies and as a soloist. An unverified newspaper report of 1938 claimed that Rose's arch rivals, the Singer Midgets (known as "The Munchkins" in the film of the *Wizard of Oz*), were trying to hire him away, but this is questionable. Singer, unlike Rose, refused to integrate his lilliputian revue, and even in 1930 it would not have been politic to hire a black Bojangles imitator and insist that he perform in white face.

Edwards, Leslie, English ballet dancer; born August 6, 1916 in Teddington. Edwards studied with Marie Rambert and at the Sadler's Wells School before making his debut with the Vic-Wells Ballet. His career has been associated with the Sadler's Wells and Royal Ballets since his 1933 debut, although he is believed also to have danced with the Rambert Ballet during the 1935 and 1936 seasons. He matured from a young *danseur noble* into one of the country's most distinguished character dancers—in the companies' *Swan Lakes*, for example, he aged gracefully from "Benno" in 1942 to "Von Rothbart." Edwards has appeared in works by all of England's major resident choreographers, among them Frederick Ashton's *Enigma Variations* (1968), Ninette De Valois' *The Rake's Progress* (1935), Robert Helpmann's *Miracle in the Gorbals* (1944), and Kenneth Macmillan's *Noctambules.*

Since retiring from performance, Edwards has served as director of the Royal Ballet's Choreographic Group and ballet master of the Royal Opera, Covent Garden. His teaching career at the Royal Ballet School has been supplemented by guest lectures and studio positions abroad.

Efrati, Moshe, Israeli modern dancer and choreographer; born December 24, 1934 in Jerusalem. Efrati began his dance studies in late adolescence at the Jerusalem Conservatory of Music. After working in the Martha Graham technique there (the prevalent modern dance work in Israel), he received a scholarship to spend a year in New York, working with her and with Louis Horst. He had performed in Jerusalem in the mid-1950s, but most of his dance career occurred after he returned from New York in 1964, when he served as charter member of the Bat-sheva Dance Company there. He performed in the Graham repertory there and in many works by other American and English choreographers in residence in Israel, among them Glen Tetley and Norman Morrice.

Much of his early choreography has been created for the Bat-sheva troupe, including his first successes, the Cain and Abel piece *Sin Lieth at the Door* (1969) and *Ein-Dor* (1970), based on the legends of Saul. He has staged new works for the Balet de Vlaadered (Flanders), among them *Nuits* (1972) and has revived his Israeli pieces there. Although he continued to make works for Batsheva, he has concentrated in recent years on the creation of collaborative works for and with the Lehakat Demama, the Demama Group of the Israeli Association of the Deaf and Mute.

Efrati has shown a tremendous ability to absorb the Graham influence and transform it within the themes of his own works. Although many of their themes are similar, his pieces with the Lehakat Demama are also influenced by American dance work, but are more closely related to the collaborative pieces of the theatrical avant-garde—using movement and visual imagery to replace the element of speech.

Works Choreographed: CONCERT WORKS: *Sin Lieth at the Door* (1969); *Ein-Dor* (1970), *Nuits* (1972); *Paths* (1973); *Until That I Awake* (1976); *David's Lament* (1976); *Textures* (1978); *After Ego* (1978); *He That Walketh Upright* (1978).

Eglevsky, André, Russian ballet dancer, trained in France, working in the United States after the 1930s; born December 21, 1917 in Moscow; died December 4, 1977 in Elmira, New York. Eglevsky was trained in Nice by Marie Nevelska, and in Paris by Lubov Egorova, Alexander Volinine, and Nicolas Legat. After emigrating to the United States, he continued his studies at the School of American Ballet in New York.

Generally considered the best *danseur noble* working in the United States in the 1940s and 1950s, Eglevsky worked with most of the European ballet companies in America between 1931 and 1951. He danced the leading roles in their productions of the nineteenth-century classics, notably *Swan Lake* and *Les Sylphides*, with the Ballets Russe de Monte Carlo (de Basil and de Blum), the Ballet International, the Original Ballet Russe, and the Grand Ballet du Marquis de Cuevas.

Performing with Ballet Theatre during much of the 1940s, he created roles in Leonid Massine's *Mademoiselle Argot* (1943), David Lichine's *Fair at Sorochinsk* (1943), John Taras' *Graziana* (1945), and his own *Sentimental Colloquy* in 1944. He was also noted for his work with the company's repertory of pas de deux, especially in *The Nutcracker* (i.e., "Sugar Plum Fairy") and Black Swan (i.e., *Swan Lake*, Act III) duets. Eglevsky's final company tenure, and probably his most creative, was with the New York City Ballet from 1951 to 1958. Taking the leading roles in the revival of George Balanchine's *Apollo* and in many of his new creations, Eglevsky danced in his *Pas de Trois* (1951), *Capricioso Brillante* (1951), *Caracole* (1952), *Scotch Symphony* (1952), *Concertino* (1952), *Western Symphony* (1954), *Roma* (1955), and *Waltz-Scherzo* (1958). Eglevsky made frequent appearances on television in pas de deux; he was also seen in a Chaplin film, *Limelight* (UA, 1955), in the *Death of Columbine* ballet.

After his retirement in 1958, he founded and directed the Eglevsky Ballet in Long Island, New York.

This company gave early performance experience to many of the principal dancers now working, among them Patricia McBride, George De LaPena, Fernando Bujones, and Sean Lavery.

Egorova, Lubov, Russian ballet dancer and teacher; born August 8, 1880 in St. Petersburg; died July 18, 1972 in Paris. Trained at the St. Petersburg school of the Imperial Ballet, she joined the Maryinsky Ballet and was featured in the ballerina roles in *Swan Lake*, *Raymonda*, and *The Sleeping Beauty*. She performed the roles of "Aurora" and "The Lilac Fairy" in the latter in the 1921 London season of the Diaghilev Ballet Russe before retiring to Paris to teach in 1923.

She taught almost every dancer in Europe at her studio, among them, André Eglevsky, Igor Youskevitch, Janine Charrat, and teachers Ethery Pagava and Solange Schwarz. Founder and director of Les Ballets de la Jeunesse in Paris, she staged productions of the Petipa classics and original works.

Works Choreographed: CONCERT WORKS: *La Flamme* (1932); *Visiones Juveniles* (1939); *Afternoon in a Park* (1939); *Raymonda* pas de deux (1951); *Aurora's Wedding* (1949, after Petipa, co-choreographed with Hans Brenaa).

Egri, Susanna, Hungarian ballet dancer and choreographer working in Italy; born February 18, 1926 in Budapest. Egri was trained at the school of the Royal Opera House in Budapest under Ferenc Nadési and Sári Bercsik, and later took classes with Harald Kreutzberg and Mary Wigman in Switzerland and Germany.

She emigrated to Italy in the late 1940s and worked for opera houses and theaters in Milan, Turin, Venice, and Florence before founding her own company in 1953. From 1949, she choreographed operas for production on RAI, Italian television; many of these were released in the United States and Western Europe as feature-length films. Aside from her choreography, and her service as director of the Academia de Danse in Turin, she finds time to work as *Dance Magazine's* Italian correspondent.

Works Choreographed: CONCERT WORKS: *Instananne* (1954); *Incontro* (1957); *The Four Seasons* (1961); *Jazz-Play* (1964).

TELEVISION: *Chagaliana* (RAI, 1954); opera series for RAI (1949–?).

Ehler, Anita, American theatrical dancer; born in Galena, Illinois. Ehler's dance training ranges from ballet classes with Finis Jhung to studies and performances with Ronn Forella. She appeared in his 20th Century Dancers in concert and in the context of his Off Broadway production, *Clown* (1977). Ehler's best remembered Broadway credit was as a member of the hard-dancing company of Bob Fosse's *Dancin'*. She had performed on the national tour before joining the Broadway cast to display her ability to work in Fosse's unique style. She can also be seen in the film of *Annie* and in a number of mini-musical commercials.

Eiko and Koma, Japanese collaborative postmodern dancers and choreographers also working in the United States; Eiko Otake, born February 14, 1952 in Tokyo, and Koma Takashi Yamada, September 27, 1948 in Niigita, Japan. Eiko and Koma, who have worked together since 1971, were trained in Tokyo by Kazuo Ohno and in Germany by Wigman disciple, Manja Chmeil. Since 1976 they have presented annual programs in New York City and are in frequent residency here. Their imagistic collages are extremely popular here for their unconventional choices of movements, stillnesses, and visual impact. They both have a presence that brings their scale of movement and individual gestures into sharp focus while their changing relationships to each other on stage move in cycles from alienation to statuary. The images that remain in memory include the willful gestures of *Fluttering Black* (1979), the flour-paste masks covered almost redundantly with blindfolds in *Fission* (part of a trilogy with works created after this edition's deadline), and the enigma of the choice of music in each work.

Works Choreographed: CONCERT WORKS: (All works choreographed in collaboration by Eiko and Koma.) *White Dance* (1976); *Fur Seal* (1977); *Before the Cock Crows* (1978); *Fluttering Black* (1979); *Fission* (1979).

Eilber, Janet, American modern dancer; born July 27, 1952 in Detroit, Michigan. Trained at the Interlochen Arts Academy where her parents taught, she continued her studies at the Juilliard School under Ethel Winter, Helen McGehee, and Mary Hinkson. On Hinkson's recommendation, she entered the apprenticeship program of the Martha Graham studio, graduating into the company in 1972.

Among the many works in which she has performed are Graham's *Holy Jungle* (1974), *Point of Crossing* (1975), *Adorations* (1975), *The Scarlet Letter* (1975), *Flute of Pan* (1978), and revivals of *Appalachian Spring* and *Seraphic Dialogues*.

Eilber has become celebrated for her guest appearances with the American Dance Machine, a repertory company of theatrical dance. Although she had never performed on Broadway, she was assigned leading roles in revivals of sequences from *Little Me* and *Cabaret*. She was cast in the dance lead of the musical, *Swing*, in January 1980 on the basis of her reviews in the Dance Machine programs, but the show died out of town. She has also played dramatic roles in film.

Eis and French, American Apache team; Alice Eis born c.1890; died December 12, 1956 in Queens, New York; Bert French born c.1884; died 1924 in New York City. Eis and French were students of Elisabetta Menzelli, who may have staged their most celebrated and infamous number—*The Vampire Dance* (1909).

Their exhibition ballroom act, performed on the early Albee circuit and in the Hammersteins' roof garden theaters, was unique since it consisted of plotted ultraromantic dance-mime-plays. They never simply danced with each other—they attacked, seduced, murdered, and hungered for each other. Their repertory included *Rouge et Noir: A Romance of Fortune* (1912), set at a gambling table, *The Dance of Fortune* (1913), an Apache that got them and William Hammerstein arrested for indecency, *The Dance of the Temptress* (1914), *Halowe'en* (1917), and *The Lure of the North* (1916), in which she, as the winter goddess, seduced him into a set piece that even *Variety* said resembled real snow. They were denounced across the country—and were incredibly popular, on tours of the United States and Europe until French's death in 1924.

Eisenberg, Mary Jane, American modern dancer and choreographer; born March 28, 1951 in Erie, Pennsylvania. Eisenberg was trained at the New School for Social Research, under Laura Foreman, and at the Martha Graham and Erick Hawkins studios. She

freelanced at the start of her career but is best remembered for her work with the Louis Falco company in the early 1970s. She was highly acclaimed for her performances in his *Caviar* (1970) and in the solo for single male or female dancer, *Ibid*. Eisenberg also performed with Falco's then associate director, Jennifer Muller, in her company recitals, creating roles in her *Nostalgia* (1971) and *Rust* (1971). She moved to the West Coast in the late 1970s and became a choreographer/member of Dance/LA. While performing in works by her colleagues, Bonnie Brosterman and Spider Kedelsky, she has created pieces for conventional presentation, such as her controversial *Close to Home* (1976), based on Diane Arbus' photographs, and ones for Event-type performance. Her *Train Station Pieces* (1980), for example, were returns to the staged and pedestrian events of the 1960s, translated to the culture and geography of Los Angeles' Union Station.

Works Choreographed: CONCERT WORKS: *Close to Home* (1976); *Apartments* (1977); *Mommy* (1978); *Train Station Piece* (1980).

Ek, Niklas, Swedish ballet and modern dancer; born June 16, 1943 in Stockholm. The son of Birgit Cullberg, Ek was trained by her and by Donya Feuer in Stockholm. He also worked and trained with Merce Cunningham in his New York Studio.

Ek is best known for his performances with the Cullberg Ballet (c.1967–1972), appearing in her *Miss Julie* and *Medea* and creating roles in her *Dionysus* (1965), *I am not You* (1966), *Coppélius* (1968), *Romeo and Juliet* (1969), and *Bellman* (1971). With the Ballet du XXième Siècle of Maurice Béjart from 1972 on, he has performed in his *Stimmung* (1972), *Marteau sans Maître* (1973), *Colestan* (1973), *I trionfi di Petracha* (1974), and *Heliogabale* (1976). He has also danced on Swedish television in Cullberg's *Peer Gynt* (1976) and *Report* (1976), and has become one of the elite group of dancers round the world to perform the role of "Death" in Kurt Jooss' *The Green Table*.

Elg, Tania, Finnish ballet dancer working in European companies and American theater; born c.1920 in Finland. Elg was trained at the school of the Finnish State Opera Ballet and performed with the Helsinki company from childhood. After further training at the Sadler's Wells Ballet School in London,

she joined the Grand Ballet du Marquis de Cuevas in 1952 and performed in that company's productions of *l'Après Midi d'une Faune* (as the elder of the nymphs), *The Sleeping Beauty*, and George Balanchine's *La Somnambule*. The beautiful, long-legged Elg also had a successful, if intermittent, career in American theater, film, and television. She appeared in many films for MGM, including the Gene Kelly vehicle, *Les Girls* (MGM, 1957), danced on television and acted on Broadway in *Tovarich* (1963) and *Strider* (1980). In between dance roles she stars on the television soap opera, *One Life to Live*.

Eline, Grace, American theatrical dancer and actress; born April 12, 1903 in Milwaukee, Wisconsin. Eline and her sister Marie were raised in New York City where they worked for the Thankhauser Studios; she was the Thankhauser Juvenile while Marie, "the Child Bernhardt of the Movies," was one of the Thankhauser Kids in a long series of shorts and serials (1910–1915). Eline's Broadway appearances included *The Prince of Bohemia* (1909), *The Jolly Bachelors* (1910), *Lady of the Slipper* (1912, on tour with Montgomery and Stone), and, as an adult, the Al Jolson vehicle *Big Boy* (1926).

Eline participated in three dance acts in vaudeville and clubs. She partnered Rudolf Valentino at Churchills and Shaney's in the 1915–1916 season, and toured with Joe Weston in an exhibition ballroom act (1917–1926). She was reunited with her sister for a series of Prologs in the late 1920s, but dropped out of theatrical work in the mid-1930s.

She was the daughter of Grace Eline (1874–1935) who designed costumes for Cecil B. De Mille films in the 1910s and 1920s, among them his biblical epics such as *The Ten Commandments*.

Ellington, Edward Kennedy "Duke," American composer; born 1899 in Washington, D.C.; died 1972 in New York City. Leader and principal composer of one of the most important and popular jazz orchestras of all time, Ellington was both classically trained and "apprenticed" in the traditions of the art form. From its tenure as guest orchestra at the Cotton Club (Uptown) in the early 1930s to the present, the Duke Ellington band has been heard by millions of jazz fans across the world.

Ellington wrote, or co-composed, almost a thou-

sand songs, mostly with Billy Strayhorn. They form a continuous history of rhythm in the Ellington era, from "Hit Me With a Hot Note [and Watch Me Bounce]" to "Mood Indigo." He also wrote many symphonic works, including a ballet score for Alvin Ailey (*The River*, 1970) and others that Ailey has since choreographed.

Elliot, Webster, American adagio dancer; born October 8, 1907 in Granite City, Illinois. According to Ned Wayburn (not necessarily a reliable source), Elliot took his Correspondence Course in Stage Dancing before studying with him in New York. With his partner he formed the adagio dance act Blanche and Elliot in 1927 to tour in Wayburn's Prolog productions. By 1931, they had moved their act from presentation theaters into cabarets in and around New York where their "hair-raising adagio" and acrobatic tricks made them extremely popular for ten years. Their most celebrated dance numbers were described both as "Martha Graham-school of interpretive dancing" and as "circus tricks"—one routine, *Deep Purple*, began with contractions in opposition and ended with a death spiral.

Elliott, Kristine, American ballet dancer; born in the late 1950s in Oakland, California. Elliott was trained at the Peninsula Ballet Theatre School in San Mateo, California. She performed with the Stuttgart Ballet briefly before joining the American Ballet Theatre in 1975.

In that company, she created a featured role in Antony Tudor's most recent work, *The Leaves Are Fading* (1975), and has performed both in contemporary works, such as Jerome Robbins' *Fancy Free*, Twyla Tharp's *Push Comes to Shove*, and Dennis Nahat's *Some Times*, and in the company's productions of the classics, among them, *Giselle, Coppélia, Swan Lake*, and *Raymonda*.

Ellis, Lucille, American modern dancer; born c.1915 in Arkansas. Raised in Chicago, she was a club dancer before joining the Katherine Dunham Company in 1939 for *Tropical Pinafore*. Among the many Dunham works in which she performed were her *Rhumba Trio, Cakewalk, Samba*, and *Jazz in Five Movements*. Ellis also served as Dunham's as-

sistant for many years and ran her second New York school.

Ellis, Richard, English ballet dancer teaching in the United States; born February 19, 1918 in London. Ellis' dance teachers included Grace Cone, Margaret Craske, Ninette De Valois, Anton Dolin, and Vera Volkova. He made his professional debut in Dolin's Coliseum Ballet and performed with the Camarago Society in the early 1930s before joining the new Sadler's Wells Ballet. He was a member of that company from 1933 to 1952 (with time off for military service), appearing in featured roles in Frederick Ashton's *Façade, A Wedding Bouquet*, and version of *Swan Lake*, Robert Helpmann's *Hamlet* (as "Laertes"), and the company's productions of *Giselle* and *The Sleeping Beauty*.

In 1952, he and his wife, Christine Du Boulay, moved to the United States where they founded a studio in Chicago. Their Illinois Ballet has continued to present concerts since the mid-1950s.

Ellis, Wendy, English ballet dancer; born in the mid-1960s in Lancashire. After local training as a child, Ellis attended the Royal Ballet School from age thirteen. As a member of the Royal Ballet since 1970, she has appeared in that company's repertory of full-length classical revivals, new plotted works requiring acting skills, and abstractions by Frederick Ashton and Kenneth Macmillan. She is considered equally adept at dancing in classical modes in *Swan Lake, Sleeping Beauty, Cinderella*, and *La Fille Mal Gardée* as she is at created movement portraits of young women in Ashton's *A Month in the Country* and *The Two Pigeons*, and Macmillan's *Romeo and Juliet*. Her abstract roles in the two directors' works include "Dora Penny" in Ashton's *Enigma Variations*, "Tuesday" and "Sunday" in his *Jazz Calendar*, and parts in *Façade, Birthday Offering*, and *Monotones*, and Macmillan's jazzy *Elite Syncopations*.

Elliston, Daisy, English theatrical ballet dancer; born August 8, 1894 in London. Elliston received her training from Adelina and Alexander Genée in London.

After her debut as a child in *The Water Babies* (1902), Elliston performed in a string of successful

musicals and operettas—all in London's West End and on tour. Among her best remembered appearances were roles in *The Merry Widow* (1908), Edward Royce's *The Dollar Princess* (1910), *The Sunshine Girl* (1912), *The Girl from Utah* (1913), *Kissing Time* (1919), *Irene* (1921), *The Street Singer* (1924), *The Desert Song* (1927), and *Rio Rita* (1930).

Ellmann, Barbara, American modern dancer and designer; born July 11, 1950 in Detroit, Michigan. Ellmann was trained in Horton technique by James Truitte. She has danced with James Cunningham and his Acme Dance company since the early 1970s, creating a variety of roles in his *Dancing with Maisie Paradocks* (1974), *The 4 A.M. Show: Isis and Osiris* (1975), *One More for the Road* (1977), and *Mr. Fox Asleep* (1978), among many others.

Currently associate director of the company, she has designed costumes and masks—very important elements in Cunningham's works—for productions since 1978, including *Alexander and the Sheep's Head* (1978), *Mr. Fox Asleep* (1978), *The Well at the World's End* (1979), *The Attic Window* (1979), and *The Rainbow Bridge* (1979). She also does graphic art, collages, and photography, and has been exhibited as a member of Ten Downtown.

Elseeta, American theatrical ballet dancer; born Helen Loder Jones, 1883 in Philadelphia, Pennsylvania; died February 23, 1903 in Newark, New Jersey. She made her debut in vaudeville at age five, and remained on the Keith circuit for the rest of her short live. She also danced on the roof garden circuit, appearing at the first Madison Square Garden and the Casino Roof. Her last performance was in *The Sleeping Beauty and the Beast* (1901), a successful pantomime presented on Broadway. Because of the restriction on children and adolescents appearing on stage in New York City, this was both her first and last Broadway show.

Billed as "The American Dancing Girl," she always appeared in red, white, and blue costumes. When she did cake-walks and struts on toe, from all publicity illustrations and written material, it seems that her claim was true—she danced barefoot on point. In the last years of her life, the finale of Elseeta's act included a unique move. She did a dance on top of a grand piano, jumped off the piano to the keyboard landing on point in unison on middle and high C, and then jumped to the floor, landing, of course, on her toes.

Although even *The Dramatic Mirror*, the early twentieth-century trade paper, said that she died "from excessive dancing," it seems from the evidence that she was killed by her second heart attack.

Elsie, Lily, English operetta star; born Lily Elsie Cotton, April 8, 1886 in Wortley; died December 16, 1962 in London. Elsie made her professional debut at age eleven and was an undisputed star of British musicals by 1901, when she played "Princess Soo-Soo" in *A Chinese Honeymoon*. The shows in which she performed fit into the categories that are now considered operetta or light opera, including the one that represents the genre for all time—Franz Lehar's *The Merry Widow* (London premiere, 1907). As the first English-language "Sonia," she introduced the great soprano arias and did the Merry Widow and Gold and Silver Waltzes. Elsie's graceful dancing and glorious voice were also featured in *Lady Madcap* (1904), *The Little Michus* (1905), *The Little Cherub* (1906), *The New Aladdin* (1908), *The Dollar Princess* (1909), *A Waltz Dream* (1911), *The Count of Luxemburg* (1911), *Mauvereen* (1916), *Pamela* (1917), and after a ten-year absence, *The Blue Train* (1927).

Elssler, Fanny, one of the most celebrated of the Romantic ballerinas of Europe; born June 23, 1810 in Gumpendorf, Austro-Hungary; died November 27, 1884 in Vienna. The daughter of the copyist and valet of Franz Josef Haydn and god-daughter to the composer, Elssler was trained at the school of the Theater an der Wein. In 1818 she joined elder sisters Anna and Thérèse as members of the Kartnertortheater in Vienna, where they worked under Jean Aumer; it is believed that she made her solo debut as "Hymen" in his *Die Hochzeit* [Wedding] *der Thetis und der Peleus*, in that season. Remaining with the company for six years, she created roles in Aumer's *Les Pages du Duc de Vendôme* (1824) and in Armand Vestris' *Eleanore* and *Bluebeard*, both in that year.

Accompanied by Thérèse, who partnered her *en travestie*, Elssler made her Teatro di San Carlo debut in July 1925. They returned to Vienna, where she per-

formed her first "Fenella," but soon began a tour that would last more than twenty-five years. After her 1833 London debut in André J.-J. Deshaye's *Faust* (1833), she performed with Marie Taglioni in *Flore et Zéphyr*. In the next year, she made her Paris Opéra debut in Jean Coralli's *La Tempête* (1834), remaining there to create roles in his *Le Diable Boiteux*, in which her famous "La Cachucha" was interpolated (1837), *Le Chatte métamorphosé en femme* (1837), and *La Tarentule* (1839), in Joseph Mazilier's *La Gypsy* (1839), and in Thérèse Elssler's *La Volière* (1838). "La Cachucha," "La Smolenska," "La Cracovienne," and "La Tarentule"—all *pas de caractère* by Thérèse and interpolated into ballets—formed much of the repertory for Elssler's next stop on her tour to the United States.

The story of Elssler's American tour has been told by historians Ivor Guest and Lillian Moore and by popular culture specialists studying the extraordinary publicity campaign that accompanied her. Also accompanying her were dancers James Silvain, as partner and ballet master, Charles Parsloe, and Pauline Desjardins; American dancers Julia Turnbull and George Washington Smith also performed with her tour group.

After performing in New York, Philadelphia, Washington, Boston, Charleston, Havana, New Orleans, and Cincinnati from 1840 to 1842, Elssler returned to Europe, where she performed at the King's Theatre, London, La Scala, and on an equally successful tour of Russia. Among the works in which she created roles in this period of her career were Jules Perrot's *Un Bal sous Louis XIV* (1843), *Le Délire d'un peintre* (1843), *La Paysanne Grande Dame* (1844), *La Esmeralda* (1847), *Odetta* (1847), and *Faust* (1848), and Marius Petipa's version of *Lida, La Laitière Suisse*, in 1848.

Elssler retired in June 1851. Her unique qualities as a ballerina seem to have centered in the emotionality and eroticism that she brought to the Romantic ballet. She avoided the more etherial characterizations of the era, concentrating on national character dances—whether in solo or pas de deux formats or extended into full-evening ballets. Elssler was the only one of the major Romantic ballerinas to reach the United States, or anywhere in the Western Hemisphere; without being overly chauvinistic, this fact must also denote her as unique. Nineteenth-century America was a prime market for Romanticism in the other arts and media and welcomed Elssler's brand of ballet.

Bibliography: Delarue, Allison, ed. *Fanny Elssler in America* (New York: 1976); Guest, Ivor. *Fanny Elssler* (London: 1970).

Elssler, Thérèse, Austro-Hungarian ballet dancer and choreographer of the Romantic era; born April 5, 1808 in Vienna or its suburb Gumpendorf; died November 19, 1878 in Merano, Italy. The older sister of Fanny Elssler, she was trained at the school of the Theater an der Wein and made her debut there in 1818. Called *"Elssler, la majesteuse,"* although current research places her at five-foot-six, Thérèse Elssler spent the first dozen years of her career partnering her sister dressed *en travestie*. She seems to have performed on point only when she and her sister were partnered by Jules Perrot at the King's Theatre, or the Paris Opéra.

Thérèse Elssler became one of Romantic ballet's few female choreographers as she continuously staged pas de deux for herself and her sister. These character dances, among them a Pas Styrien (1834), La Cachucha (1836), and a pas de châle (1840), were interpolated into the ballet or opera being performed. Her full-length ballets included *Die Maskerade* (1834) and *La Volière* for the Paris Opéra, 1838. Elssler retired from performing and choreography in 1850.

Works Choreographed: CONCERT WORKS: *Die Maskerade* (1834); Pas de deux for Paris Opéra debut (1834); *Pas Styrien* (1834); *Pas de deux and La Cachucha* (1836); *La Volière* (1838); unnamed pas de deux (1838); *Pas de Châle* (1840); *El Zapateado* (1840?, date is of publication of music); *La Smolenska* (1840).

Eltinge, Julian, American vaudeville and musical comedy dancer and female impersonator; born William Julian Dalton, May 14, 1883 in Newton, Massachusetts; died March 7, 1941 in New York City. Raised in Montana, he returned to the Boston area as an adolescent. At sixteen, he did his first female impersonation, as "Mignonette" in *Miladi and the Muskateer* for the Boston Cadet performance, dancing a cake-walk and singing in character. Eltinge's uniqueness in the vaudeville of the time was not that

he did female impersonation, it was that he did the act professionally, since throughout the nineteenth century, in America, that was considered an amateur or school performance medium. He was also considered as having a special talent since he imitated specific women of the theater, rather than "female types."

After appearing in musical comedies in Boston, notably in *The Filibusters* (1904), he moved to New York where he became celebrated as the best female impersonator and direct satirist in the business. He performed in *Mr. Wix of Wickham* (1904), the feature act *The Whole Damn Family* (1905), at the Aerial Gardens, toured Europe, reportedly under the management of Loïe Fuller, and returned to the Orpheum circuit with his own act. Among the imitations that he did in this period were two *Salomes*, based on Gertrude Hoffmann's version of Maud Allan and on Lotta Faust's version of Mary Garden, a satire of Cléo de Mérode's *Danse Cambodgienne* and *The Goddess of Incense*, a take-off on Ruth St. Denis.

When he joined (George M.) Cohan and (Sam) Harris' Minstrels in 1908, he added a new act to their performances—female impersonations based on the works of specific illustrators, among them Charles Dana Gibson and Nell Berkeley. By 1910, his part of the minstrel act included the above satires, the illustrator's characters, a new St. Denis imitation called *Cobra* and a bathing dance that was considered too risqué for many theaters.

From 1910 until his retirement in 1925, he appeared only in his own vehicles. The stage productions included *Honeymoon in June Time* (1910), *The Fascinating Widow* in which he toured from 1910 to 1914, *The Crinoline Girl* (1914-1915), *Cousin Lucy* (1915-1917), *Her Grace the Vampire* (1917), *Countess Chong* (1917-1918), *His Night at the Club* (1919-1923), *The Elusive Lady* (1922), *The Black and White Revue* (1923), and *Madame Lucy* (1925). In most, he appeared as a man who, for reasons inherent in or interpolated into the complicated plot lines, was forced to present himself as a woman for part of the action. This theme also determined his many film appearances, most of them for Jesse L. Laskey as an independent producer of his Famous Players or with Paramount. His best known films included *The Widow's Might* (Laskey Film Corp., 1917), *The Clever Mrs. Carfax* (Laskey Feature Company, 1919), *Over the Rhine* (Universal, 1918), and *Madame Behave* (Producer's Distributing Corp., 1925).

He returned to the stage twice after retirement—to appear in the show, *Nine O'Clock Revue* (1931) at Carter De Haven's Music Box Theatre in Hollywood, and to sing and dance in the Old Timers' show at Billy Rose's Diamond Horseshoe (c.1944). Although he did not appear in the film of the Rose presentation, he can be seen in the Deanna Durbin movie, *If I Had My Way* (Universal, 1940), along with fellow vaudevillians, Eddie Leonard and Sophie Tucker.

For many years, a dance could not be considered "officially introduced" to Broadway or vaudeville unless the corps of dance satirists had imitated it. The fact that Eltinge performed as a woman in most of his acts did not alter his influence on the acceptance or rejection of these dance fads. Like Gertrude Hoffmann, he determined the fate of a dance—whether social, classical or premodern—by agreeing to satirize it.

Elvin, Violette, Soviet ballet dancer working in England from the mid-1940s; born Violette Prokhorova, November 3, 1925 in Moscow. Elvin was trained at the Bolshoi Ballet school before performing in its companies in Tashkent and Moscow.

Emigrating to England in 1946, she joined the Sadler's Wells Ballet, making her debut in the Bluebird pas de deux in *The Sleeping Beauty*. She was associated with the works of Frederick Ashton, creating roles in his *Cinderella* (1948), *Daphnis and Chloe* (1951), *Homage to the Queen* (1953), and *Birthday Offering* (1956). She was featured in the company's revivals of the classical repertory, notably in *Giselle, Swan Lake*, Leonid Massine's *Le Tricorne*, and George Balanchine's *Ballet Imperial*, but also won acclaim in works by Ninette De Valois, especially in *Checkmate*, as "The Black Queen."

Emblen, Ronald, English ballet dancer; born 1933 in Port Said, Egypt. Emblen was trained at the Sadler's Wells School. After making his professional debut in Mona Ingelsby's International Ballet (c.1952), he performed with the Walter Gore concert group, the Western Theatre Ballet, and Margot Fonteyn's 1962 touring Concert Ballet before becoming a member of the London Festival Ballet. He also worked with the

Royal Ballet for two seasons before his retirement. In this complicated sequence of companies, he followed the conventional career progression of an English male dancer, taking larger and more classical roles in his twelve years of dancing. Among his best remembered roles were the character dance roles from his later career, among them "Dr. Coppelius," "Mother Simone," and the central deity in Kenneth Macmillan's *La Créâtion du Monde*. He also participated in the Jack Carter programs presented by the London Festival Ballet, most notably in his *Witch Boy* and *London Morning*.

Emery, Susan, American postmodern dancer; born in Rye, New York. Emery was trained at the State University of New York at Purchase, the major arts campus in the state university system. She has performed in the concert groups of two of her master teachers there, Kazuko Hirabayashi and Mel Wong, and in the companies that present the works of Douglas Dunn and Phoebe Neville in New York. She is, however, best known for her work with the Merce Cunningham company, with which she has danced since 1977. Among the many works that she has done for Cunningham are *Sound Dance, Summerspace, Landrover, Walkaround*, and the continuing series of *Events*.

Englund, Richard, American ballet dancer and administrator; born 1931 in Seattle, Washington. There is no evidence that Englund followed Seattle tradition and studied with Mary Ann Wells before moving East to attend college. His earliest verifiable dance training came from Antony Tudor at the School of the Metropolitan Opera Ballet, with which he danced for many seasons. Englund also performed in the corps and featured roles in Tudor works in the repertories of the American Ballet Theatre and the National Ballet of Canada.

Since 1972, he has been director of the Ballet Repertory Company, the second troupe of the American Ballet Theatre. Many of its members are now in major European troupes, although surprisingly few ever joined the parent organization. He has changed the Ballet Rep, as it is known, from a student troupe taking small bookings across the Metropolitan area to a respected company with worldwide tours.

Englund, Sorella, Finnish ballet dancer; born 1945 in Helsinki. Trained by Elsa Sylverston, she joined the State Opera Ballet of Finland in the early 1960s. Among her roles there was "Blonderlaine" in Irja Koskkinen's *Scaramouche*. A member of the Royal Danish Ballet since 1967, she has become known for her performances in that company's contemporary repertory, most notably in works by Flemming Flindt and Eske Holm, with roles in the former's infamous experimental *Triumph of Death* (1971) and the latter's *Firebird*.

Enters, Angna, American dancer-mime; born April 28, 1907 in New York City. Upon completing high school in Milwaukee, Wisconsin, Enters came to New York to study art. Within a few months, however, by the summer of 1920, she began to study dance with Michio Ito. By the summer of 1921, she was performing with Ito both as a soloist, in *En Batteau* and *Kyo no Shiki*, and as his partner, in *Genroku Hanami Odori*, among others. In the summer of 1922, Ito was hired to stage dances for Raymond Hitcock's *Pinwheel Revel*; in this revue, Enters performed several solos, including *Feline, Le Petit Berger*, and *Tribute to Gauguin*, and a rare group work, *Ecclisiastique*; some contemporary scholars believe that Enters herself created these dances, although they are credited to Ito. Enters parted company with Ito in 1923.

On Sunday, October 17, 1926, she first appeared in an entire evening of solo dance-mime performance, assisted only by pianist Madeleine Marshall. Enters toured a solo program, entitled *The Theatre of Angna Enters*, across the United States and Europe for more than thirty years; she created a repertory of more than 250 dance-mime compositions (each lasted from five to approximately thirty minutes) for her solo program, each with costume designed and music arranged by herself. She also exhibited paintings and drawings and wrote on dance for such periodicals as *Trend, Drama, Hound & Horn, The New Theater,* and *New Masses*.

Enters also wrote novels and the plays, *The Unknown Lover* and *Love Possessed Juana*; in addition, during the 1940s, she was a contract writer for MGM studios. When she retired from touring, Enters directed and taught mime for actors. Enters was

the recipient of two Guggenheim Foundation Fellowships, in 1934 and 1935. It is only recently that Enters has been rediscovered by dance and theater historians. The yet-unpublished work of Ginnine Cocuzza, on which this entry has been based, will soon provide the information with which she can be properly judged as a dance and theater artist.

Works Choreographed: CONCERT WORKS: (Note: solos arranged by year in the absence of exact concert schedules.) *Moyen Age* (1923); *Cakewalk—Charleston Blues, Contre Danse, Dance of Death, Tales of the Vienna Waltzes, Promenade, Les Sons et Les Parfums Tournent dans l'Air du Soir; A Spanish Dancer, Columbine, Cakewalk-1897, Cardinal, Habenera, Piano Music-A Dance of Adolescence, Polonaise— Dance of Death #2, Sapphic, Man His Origin is Dust, Odalisque, Der Rosenkavalier (Waltz), Second Empire, Entr'acte 1860, Rendezvous* (1926); *Entr'acte—1927, A Merry Widow, Bar Maid, In Pursuit of Art—Piano Music No. 2, Bourée, Antique à la Française, Dancing School Accompanist—Piano Music No. 3, Entr'acte—1920, Heptameron, Queen of Heaven—French Gothic* (1927); *Aphrodisiac—Green Hour, Black Magic, Blue Hour—Park Avenue, Field Day, La Sauvage Elegante, The Yellow Peril, Saturnalia—Pagan Rites, Tristan* (1928); *Commencement—Piano Music No. 4, Delsarte—With a Not Too Classic Nod to the Greeks, En Garde or the Red Heart, Inquisition Virgin—Spain 16th Century, Pavana—Spain 16th Century, 'Tis Pity She's a*, Carneval—Lorette, High Life, Odalisque—Haremlik, Antique in the English Manner—Rosetti, Ltd.* (1929); *Daunce We Praunce We, Oh the Pain of It!, Shaking or the Sheets—A Dance of Death, Contre Danse No. 2—Invention, Romance Country—Olivette, Court of Love—18th Century France, Pique-Nique—1860—Déjeuner au Bois, Webs, Narcissism* (1930); *American Ballet 1914-1916, Art d'Amour, Ikon-Byzantine, Medieval Night's Dream—Spain, Piano Music No. 5—Hurry Up It's Time!, Prelude to Dementia—Narcissism No. 2, Societé Anonyme, Stars and Stripes Forever, Auto dá Fe—Spain 15th Century, Farmer in the Dell, Flemish Saint* (1931); *Boy Cardinal—Spain 15th Century, German Angel—Reformation, Life is a Dream—Remembered Things, Peon's Heavenly Robe, Vienna Provincian—1910s, Virgin of the Fields—Mexican Cycle* (1932); *Pagan Greece, Effeminate Young Man—Amour Malade, Holy Virgin Pursued by Satan, Santa Espana del Cruz—16th Century* (1933); *Back to "Childhood," Danse Macabre—Vodvil—Let's Go to Town, David Dances before the Ark, Sevillano—Boroque Interlude* (1934); *Dama del Moche—Malaga Night—1820, Figures in Moonlight—Danse Macabre No. 2, Ishtar, Isis-Mary, Red Hot Mamma, Little Sally Water* (1935); *American Ballet No. 2—1908-1912, Deutchland Uber Alles—German Tripper, Flesh Possessed Saint—Red Malaga—1936, Mme. Pompadour—Solitude—1900, Time on My Hands—Two Modern City Women, Spain says "Salud"* (1936); *End of the World—Paris August 1914, Japan "Defends" Itself, A Modern Totalitarian Hero, T'ang—Chinese Dynastic, Venus Americana—1937, London Bridge Is Falling Down* (1937); *Balletomane—Connoisseur—Riviera Stay Away from My Door, La Cuisine Française, Impertinente-Habanera, Mr. Mozart Has Breakfast, Artist's Life, Grand Inquisitor—Spain—15th Century* (1938); *Crackpot Americana, Weiner Blut—Vienna-1939, Homage to Isadora* (1939); *Dilly Dally—Ah Sweet Mystery of Life, My First Dance—Hungarian Routine, Hollywood Horror Story, She Loves Me—She Loves Me Not* (1942); *Dilly Dally No. 2—American Primitive* (1950); *Dilly Dally No. 3, Fleur du Mal—Tango Dancer—Paris 1900, Flowering Bud, Moyen Age No. 2, Pierrot—Figures in Moonlight* (1952); *French Provincial—Chagrin d'Amour, Les Sons et les Parfums tournent dans l'Air du Soir no. 2* (1955); *Figures in Moonlight No. 2—Harlequin* (1959); *Bird in Net, Dama del Noche—Homage to Goya, Overture* (1960).

FILM: *Scaramouche* (MGM, 1952, staged *commedia dell'arte* sequences).

Bibliography: (All works by Enters; asterisked works are texts or autobiographical.) *Among the Daughters* (New York: 1955),* *Artist's Life* (New York: 1958),* *First Person Plural* (New York: 1937),* *Love Possessed Juana* (New York: 1939), *On Mime* (Middletown, Conn.: 1965),* *Silly Girl* (Cambridge, Mass.: 1944).*

Erdman, Jean, American modern dancer and choreographer; born February 20, 1917 in Honolulu, Hawaii. Erdman attended Sarah Lawrence College in

New York where she began to study with Martha Graham. A member of the Graham company from 1938 to 1943, and a frequent guest performer ever since, she created roles in *American Document* (1938), *Every Soul Is a Circus* (1959), and *Punch and Judy* (1941), but was best known as the "One Who Speaks" in *Letter to the World*, reciting the poetry of Emily Dickinson.

Erdman's choreography is also characterized by the use of the voice and verbal elements. Many of her pieces are based on mythologies or on literature, among them, *Ophelia* (1946), *The Blessed Damozel* (1952), and her best known work, *The Coach with Six Insides*, adapted from passages in *Finegan's Wake*. She has staged incidental dances for many plays and, through her Theatre of the Open Eye, has sponsored and created multimedia works, such as *Gauguin in Tahiti* (1976), and *The Shining House* (1980), based on Hawaiian mythology.

Works Choreographed: CONCERT WORKS: *Departure* (1941); *Rigaudon* (1941); *Baby Ben Says Dada* (1941); *The Transformation of Medusa* (1942); *Forever and Sunsmell* (1942); *Credo in Us, Ad Lib, Seeds of Brightness* (all 1942, all co-choreographed with Merce Cunningham); *Creature on a Journey* (1943); *Dawn Song* (1945); *Daughters of the Lonesome Isle* (1945); *Changing Moment* (1945); *Ophelia* (1946); *Passage* (1946); *People and Ghosts* (1946); *Sea Deep* (1947); *Hamadryad* (1948); *En Peregrinage* (1948); *Jazz Maze* (1948); *Four-Four Time* (1948); *The Perilous Chapel* (1949); *Festival* (1949); . . . *And a Gigue* (1949); *The Solstice* (1950); *The Fair Eccentric* (1950); *Changingwoman* (1951); *Upon Enchanted Ground* (1951); *Io and Prometheus* (1951); *Sailor in the Louvre* (1951); *The Blessed Damozel* (1952); *The Burning Thirst* (1952); *Song of the Turning World* (1953); *Broken City* (1953); *Pierrot the Moon* (1954); *Bagatelle* (1954); *Salutation* (1954); *Weather of the Heart* (1954); *Strange Hunt* (1954); *Spring Rhythms* (1955); *Duet for Flute and Dancer* (1956); *Fearful Symmetry* (1957); *Harlequinade* (1957); *Elegy* (1958); *Moments Free and Engaged* (1958); *Four Portraits* (1958); *The Road of No Return* (1959); *Now and Zen—Remembering* (1959); *Solos and Chorale* (1959); *Twenty Poems From e.e. cummings* (1960); *Dance in Five-Eight Time* (1961);

The Coach with Six Insides (1962); *Partridge in the Jungle Gym* (1964); *The Castle* (1967, co-choreographed with Jimmy Guiffre); *Encounter in the Grove* (1967); *LLove SSong DDance* (1968); *Ensembles* (1969); *Safari* (1969); *Excursion* (1969); *Voracious* (1969); *Venerable as an Island is Paradise* (1969); *Twilight Wind* (1970); *The Marathon* (1972); *Moon Mysteries* (1972); *The Silken Tent* (1974); *Rapid Transits* (1974); *Gauguin in Tahiti* (1976); *Such Sweet Thunder* (1977); *The Shining Hour* (1980).

THEATER WORKS: *Les Mouches* (1948); *The Enchanted* (1950); *Otherrman* (1954); *Hamlet* (1964); *Yerma* (1964); *Marriage on the Eiffel Tower* (1967); *The Municipal Water System Is not Trustworthy* (1968); *The King of the Schnorrers* (1970); *Two Gentlemen of Verona* (1971, Delacorte Theatre production only); *The Making of the King* (1972); *The Only Jealousy of Emer* (1973).

Erickson, Betsy, American ballet dancer; born in Oakland, California. After studying in Orinda, California, she continued her studies at the school of the San Francisco Ballet under Harold Christensen.

Erickson has been associated with the San Francisco Ballet throughout her career, performing with the company in the mid-1960s and after 1974. She has been featured in works by George Balanchine, notably his *Concerto Barocco* and *Symphony in C*, by John McFall, in his *Tealia* (live and on film) and *Quanta*, and by Lew Christensen, with solos in his *Life, Lucifer, Danses Concertantes,* and *Sinfonia*.

From 1967 to 1974, she was a member of the American Ballet Theatre. Her cool beauty and superb technique were revealed in performances in Alvin Ailey's *The River*, the company production of *Giselle*, playing "Myrthe," and Leonid Massine's *Gaîté Parisienne*, as "La Lionne." She was also celebrated for her depictions of disparate "Mother" roles—the "earthy mother of the Groom" in Jerome Robbins' *Les Noces* and the ethereal mother figure remembered by "The Accused" in Agnes De Mille's *Fall River Legend*.

Errol, Leon, Australian eccentric dancer and comic working in the United States after 1909; born July 3,

1881 in Sydney; died October 12, 1951 in Hollywood, California. A burlesque comic in his first years in the United States, he made his career breakthrough with a rag-doll act, *The Jersey Lillies*. This eccentric adagio dance act, c.1901–1911, brought him to the attention of Florenz Ziegfeld who cast him in the 1910 *Follies*. He performed in a total of six *Follies* (1911, 1913–1915), as well as *The Century Girl,* which he co-directed, and two Ziegfeld musicals, *Sally* (1920) and *Louie the 14th* (1925). He also appeared in the *Hitchy-Koos of 1917 and 1918* and directed the revue, *Words and Music* (1917). His acts in these shows usually involved his signature drunk act, generally including his celebrated fall down a staircase. Despite his Commonwealth background, he did not portray a silly-ass Englishman in the tradition of Vernon Castle; he was an American, frequently a patriotic drunk with a unique way of timing his fall to extend both the suspense and the humor.

Errol made almost a hundred films and short subjects, although many were made when he was too heavy to do even social dances on screen. Apart from his first feature films, which are still seen in retrospective series, his only extant pictures are in the *Joe Palooka* series for Monogram in the late 1940s. His early films, the motion picture version of *Sally* (First National, 1930) and the original sound *Alice in Wonderland* (Paramount, 1933), still attract viewers and fans.

Eshkol, Noa, Israeli dancer and notator; born February 28, 1927 in Safed, then Palestine. Although she did perform as a concert dancer in the 1940s and early 1950s, Eshkol is best known for her work in the codification and formulization of the notation system that now bears her name. The Eshkol (or Eshkol-Wachmann) Notation was designed for use with any kind of movement, whether choreographed, folk, or functional, and therefore has been a great importance in such nondance studies as occupational safety and labor management. In dance terms, however, the Eshkol system has been used successfully to notate works choreographed in ballet or any number of modern dance vocabularies and to facilitate the learning and maintaining of the folk and native dances of Israel's natives and immigrants.

Eshkol has written a number of textbooks in Hebrew and English, including *Movement Notation* (London, 1958, English language) which includes textual analysis and basic formulations.

Espinosa, Eduoard, English ballet dancer and theatrical choreographer; born February 2, 1872 in London; died March 22, 1950 in Worting, England. The son of Léon Espinosa, he made his debut in his father's troupe at the London Acquarium, later dancing in his *The Corsican Brothers* and *Henry VIII* in London and *The Vice-Admiral* in New York on the Casino Roof. After performing for him at the Aquacade at the Chicago World's Fair in 1893, he toured with the Henry Irving company as an actor and dancer, in the mid-1890s.

From 1896 to the early 1910s, he staged dance numbers for West End musical operettas. While research has been unable to verify his claims to have worked on thirty-five shows, it can be proved that he choreographed dances for five productions, among them *1804–1904* at the London Pavillion, *The Dancing Master* at the Empire, and the London premiere of *Chu Chin Chow*.

Espinosa was acclaimed as a teacher and became one of the founders of the Royal Academy of Dancing in 1920. He edited the periodical, *The Dancer*, from 1928.

Works Choreographed: THEATER WORKS: *Monte Carlo* (1896); *The Southern Belle* (1902); *1804–1904* (1904); *The Dancing Masters* (1913); *Chu Chin Chow* (1916).

Espinosa Family, Spanish/Dutch family of ballet and theatrical dancers working in London and Paris; the first Espinosa to perform outside of The Netherlands was Léon (1825–1904), below. His children were Edouard (1872–1922), above, Mimi (1893–1936), who was featured in Oscar Ashe productions for many years, Judith (1877–1949), prima ballerina at the Alhambra Theatre under Carlo Coppi and later one of London's most distinguished teachers, and Léa (1883–1966), who was prima danseuse at the Prince of Wales Theatre, London, and the mother of Geoffrey, who taught in London from 1935.

The Kelland-Espinosas (Evette and Edward),

known as theatrical dancers and teachers, are the son and daughter of Edouard Espinosa and Eve Kelland.

Espinosa, Léon, Dutch ballet dancer who performed in France, England, and the United States; born June 6, 1825 in The Hague; died 1903 or 1904 in London. The patriarch of the Espinosa family, he was discovered at age seven by Henri Justament who recommended him to the Paris Opéra. He studied in Paris with Jean-François Coulon, François Albert, Jean Coralli, Filippo Taglioni, Jules Perrot, and Lucien Petipa. At only four-foot-ten as an adult, he performed with Josephine Weiss' *Les Danseuses Vienoises* in Paris, then toured as a "child" with the Théâtre Gymnase, and with the Opéra-Comique.

In 1850, he traveled to New York to perform with the Ravel family troupes. After his debut at the Astor Place Opera House in *Ondine* with Celestine and Victorine Franck, he partnered Adèle Monplaisir, whom he may have known through Justament. The company, which included Paul Martinetti, Antoine and Jerome Ravel, and Flora and Julia Lehmann, performed the French Romantic ballets that were becoming familiar to New Yorkers, and added *Esmeralda* to the repertory. Since his fellow company members were related—personally or professionally—to almost every other European performing in the Western hemisphere, it is likely that this engagement added greatly to his reputation as a serious *danseur noble* despite his height.

Returning to Paris, he spent five years at the Théâtre de la Porte-Saint-Martin, dancing during the Carnaval seasons at La Scala with Amalie Ferrais. He partnered Monplaisir to Moscow in 1865, performing at the popular theater in the Isler Gardens, then switching to the Imperial Theatres in Moscow and St. Petersburg under Marius Petipa, younger brother of his teacher in Paris. In 1872, he performed in pantomimes at Covent Garden and the Crystal and Alexandria Palaces. For the next twenty years, he commuted between London, and its pantomime theaters, and Paris, where he danced and acted at the Théâtre-Historique, Folies Bergère, and de la Porte-Saint-Martin. In 1890, he returned to New York to direct shows for the old Madison Square Garden Roof Theatre. He was ballet master at the Prince of Wales Theatre, London, at the time of his death.

Esquivel, Jorge, Cuban ballet dancer; born 1950 in Havana, Cuba. Esquivel was trained at La Escuela Provincial de Ballet and La Escuela National de Arte in Havana. His instructors at the latter school included Fernando Alonso, Joaquin Banega, Anna Leontieva, Michael Giurov, and Azari Plisetski, each of whom was in residence in Cuba between 1961 and 1968.

Esquivel's performing career has all been with the Ballet Nacional de Cuba, which he joined in 1967. A principal since 1972, he has frequently partnered company founder Alicia Alonso in *Swan Lake* and *Giselle*. Among the works in which he has created roles are Alberto Alonso's *Un Retable para Romeo y Julieta* (1969), *Diogenes ante el Tonal* (1971), *A Santiago* (1972), *Viet Nam: a Lecion* (1973), and Alberto Mendéz' *Nos Veremos aver noche* and *Margarita* (1971). He has also appeared in the first Cuban casts of Plisetski's *Primer concierto* (1971) and *Canto Vital* (1973), as well as performing featured roles in his *La Avanzada*, in Balanchine's *Apollo* and *Theme and Variations*, and in Béjart's *Webern opus 5* and *Bhakti*. Cuban ballets in which he performs roles include Alberto Mendéz' *La Peri, Paso a tres* and *Plasmasis,* and Alberto Alonso's *Conjugación, Carmen,* and *Space and Movement.*

Essen, Viola, American ballet dancer; born Violeta Vassieva Colchagova, 1926 in St. Louis, Missouri; died January 1, 1969 in New York City. Essen was trained by Mikhail Mordkin and Mikhail Fokine, performing with each choreographer's New York company in the late 1930s. She was only fourteen when she danced "Myrthe" to Lucia Chase's *Giselle* in the Mordkin Ballet, but was acclaimed as the finest American performer to take the role. She was featured in *Les Sylphides* and the *Polovtsian Dances from Prince Igor* in the Fokine troupe in 1940.

A charter member of Ballet theatre, she danced in that company from the 1940 season through the 1950s. She was the first American "Caroline" in Antony Tudor's *Jardin aux Lilas* and the first "Juno" in his *Judgement of Paris*. Her featured parts ranged from Adolf Bolm's *Ballet Méchanique* to Fokine's *Carnaval*, with roles in the company's different productions of *Giselle* and *La Fille Mal Gardée*. On leave from Ballet Theatre during seasons in the 1940s

and 1950s, she danced with the Ballet International, creating roles in Simon Semenoff's *Memories*, Boris Romanoff's *Prince Goudal's Festival*, and Edward Caton's *Sebastien*, all in 1944. Essen, who was celebrated for her dramatic abilities, was featured in many theatrical productions, among them, a nightclub act with Marc Platt, a cabaret tour with Peter Birch, and appearances on Broadway in *Follow the Girls* (1944), *Hollywood Pinafore* (1945), in Antony Tudor's "Success Story" sequence, and *Along Fifth Avenue* (1949). She can also be seen in the female lead of the Ben Hecht thriller, *Specter of the Rose* (Republic, 1946).

Essex, John, English ballet dancer and publisher of the eighteenth century; born c.1680 in London; died there on February 4 or 5, 1744. It is not known where or with whom Essex was trained.

At the Drury Lane Theatre in London from 1702, Essex performed in both ballets and harlequinades. Considered by John Weaver one of London's best teachers, Essex danced in the Theatre's productions of *Apollo and Daphne* (1724), *Acis et Galatea* (1734), *Perseus et Andromache* (1736), and *The Fall of Phaeton* (1736).

Essex published and translated many French dance manuals, among them, Feuillet's *Chorégraphie For the Further Improvement of Dancing* (London: 1710), *A Collection of Minuets, Rigaudoons and French Dances* (London: 1721), *The Young Ladies' Conductor* (London: 1722), and Rameau's *The Dancing Master* (London: 1728).

Essex was the father of William Essex (flourished 1724–1742), an actor and dancer with Covent Garden.

Estópinal, Renee, American ballet dancer; born February 22, 1949 in Los Angeles, California. After local training, Estópinal continued her studies at the School of American Ballet.

Estópinal has performed with the New York City Ballet throughout the 1970s, notably in George Balanchine's *Agon*, the Ricercare section of *Episodes*, *Stars and Stripes*, and *Chaconne*. Noted for her clean line and strong performance presence, she was chosen by Jerome Robbins to dance the "Theme" in his *The Goldberg Variations* (1971).

Etcheverry, Jean-Jacques, French ballet dancer and choreographer; born 1916 in Paris. After studies with Gustave Ricaux and Nicholas Zverev, he became a member of the Nouveau Ballet de Monte Carlo in the early 1940s. From 1942 to 1944, he danced in Zverev's productions of the classics in the relative security of southern France. Following the disbandonment of the company in 1944, he formed a chamber troupe, La Compagnie de l'Oiseau Bleu, for which he choreographed *La Précaution Inutile* (1945) and *Doux Caboulet* (1945) and revived his first ballet, *La Péri* (1941).

Etcheverry worked briefly for the Ballets des Champs-Elysées before being engaged as ballet master and choreographer for the Opéra-Comique in Paris. Most of his ballets were created for that company (c.1946–c.1953) or the troupe attached to the Théâtre de la Monnaie in Brussels (c.1954–1960). With his popular works, based on literary or graphic themes, he was able to revive ballet in those two theaters which, although influential in the nineteenth century, had lost their importance.

Works Choreographed: CONCERT WORKS: *La Péri* (1941); *Chanson Sentimentale* (1945); *Doux Caboulet* (1945); *La Précaution Inutile* (1945); *Printemps* (1945); *Bourée Fantasque* (1946); *La Ballade de la Géole de Reading* (1947); *Khamma* (1947); *La Rose Rouge* (1947); *Le Cerf* (1948); *Jeux* (1948); *Jeux de Printemps* (1948, possibly same as above); *Suite Fantasque* (1948); *Etude* (1949); *Les Heures* (1949); *Paris Magic* (1949); *La Chanson du Mal Aimé* (1950); *Commedia dell'Arte* (1951); *Impromtu* (1951); *La Clef des Songes* (1952); *Gavarni* (1953); *Selection Beach* (1953); *Serenade* (1953); *Le Bal des Voleurs* (1954); *Un Ballet aux Chandelles* (1954); *Les Bals de Paris* (1954); *Candide* (1954); *Danse* (1955); *A Midsummer Night's Dream* (1955); *Miraculous Mandarin* (1955); *Opera Ballets* (1955); *Pelleas et Melisande* (1955); *Symphonie Fantastique* (1955); *Manete* (1956); *Quatre pour Quatre* (1956); *Divertissement* (1957); *La Fille de Madame Angot* (1957); *Lillian* (1957); *Pygmalion* (1957); *Quintette* (1958); *Rapsodie* (1958); *Vincti non Devicti* (1958).

Europe, James Reese, American composer; born February 22, 1881 in Mobile, Alabama; died May 10, 1919 in Boston, Massachusetts. Raised in Washing-

ton, D.C., he and his sister Mary were trained in composition, piano, and violin by Enrico Hurlei. Although his sister became known as a classical and liturgical composer, Europe moved into popular and theatrical music, maturing into one of the most influential American composers of the twentieth century. He served as musical director (i.e., orchestrator and conductor) of the two most important Broadway pairs of black composers and lyricists in the early years of the century—Bob Cole and J. Rosamond Johnson and Bert Williams and George Walker. In 1910, he formed the Clef Club, the first musicians' union in the country. He served as conductor of the Clef Club Symphony Orchestra from 1912 on, also orchestrating and composing music for the institution, which used conventional symphonic instrumentation with added mandolins and brass.

Europe's direct impact on dance came in his association with Elisabeth Marbury and her string of exhibition ballroom dancers, among them Irene and Vernon Castle. His relationship to those dance forms has been compared to Johann Strauss Jr.'s relationship to the waltz. Since he was denied royalties and credits through their franchisement agreement with Marbury, he has never been fully credited with the composition of "The Castle Hesitation" and other song scores. Europe's indirect influence is uncalculable. As the man generally believed to have institutionalized the performance of ragtime forms, he revolutionized American popular and theatrical music. As the employer and trainer of most of the next generation of black musicians, among them Noble Sissle and Eubie Blake, he extended his combination of formal composition and orchestration training and interests in the more popular forms.

Evan, Blanche, American concert dancer; born c.1913 in New York City. Evan was trained at the Neighborhood Settlement by Bird Larson and Martha Graham. Experimenting with techniques and styles, she took classes in German modern forms with Hanya Holm and Harald Kreutzberg and in ballet with Ella Dagnova. Evan gave one recital in New York in 1934 before traveling to the Soviet Union on a study trip. On her return in 1937, she participated in productions by the New Dance League and presented additional solo recitals. Her works seem to follow the two forms typical of the League choreog-

raphers (Anna Sokolow, Mirium Blecher, Si-Lan Chen, and others), presenting abstract studies in limited movement schemes or topical "monologues" about political events in Europe and the United States.

Evan wrote articles on dance and other subjects from 1933, serving at one time as an arts editor of *The Call*, one of New York's Yiddish-language newspapers. Since retiring from performance, she has taught extensively.

Works Choreographed: CONCERT WORKS: *Variations* (c.1934); *Two Studies in Despair* (Request, Demand) (c.1934); *"Spinning in the emptiness, blown by no wind in vain circles . . ."* (1934); *Impressions* (1934); *Contre Tanz* (1934); *Largo* (1934); *Hallucination* (1934); *Sostenuto* (1934); *Con Brio* (1936); *Welt und Scmerz* (Have a Duel) (1937); *An Opportunist* (1937); *On the Fence* (1937); *Redder than a Rose* (1937); *Spring Song* (1937); *Nazi or Prisoner, Dialogues* (*Guarding their Homes, In the Cell, Waiting*) (1937); *An Office Girl Dreams* (1937); *Into Action* (1937); *Opening Dance* (1939); *Variations on a Leap* (1939); *Slum Street* (1939); *From Reels to Shag* (1939); *Two Women* (*New York Nana, Parasite*) (1940); *Dream Lives On* (1947); *Death of a Loved One* (1947).

Evanitsky, Stephanie, American modern dancer and choreographer, working in aerial formats; born April 30, 1944 in Sewickley, Pennsylvania. After local tap and ballet training, Evanitsky returned to dance studies while attending the Pratt Institute in Brooklyn, New York. She took class at the Alwin Nikolais and Murray Louis studios at the Henry Street Playhouse and their own Theater Lab. With fellow Nikolais student Diane Van Berg, she developed her unique variation of modern dance forms—her Gravitational Aerodance company. During her founding directorate (1971-1979), she created a large repertory of works designed to be performed on a system of aluminum tubular scaffolding supporting trapezes with three straps to work on. The Aerodance company's first successes were presented in museums, but later works seemed to be designed for the loft performing space, a dome lighted through a ring of stained glass. Movements were performed on the scaffolding, trapezes, and straps to self-produced sounds or commissioned scores. Although Evanitsky created some du-

ets, most notably the *Silver Scream Idols* of 1972, most of her Aerodance pieces were for large groups of trained dancers.

In 1980 Evanitsky left the Multigravitation Aerodance company to form a new troupe, the Celestial Saracen.

Works Choreographed: CONCERT WORKS: *World* (1971); *Aerodance Transparent and Opaque* (1971); *Float on Slab* (1971); *Plumb Busters Get Bumped Off* (1971); *Socked Airpaste* (1971); *Helixes* (1971); *Mumsacs and Flagella* (1971); *Airspring Hoist* (1971); *Dawnseed* (1972); *Silver Scream Idols* (1972); *Altarground* (1972); *Muses* (1972); *Splat* (1972); *Sure War* (1973); *Carry* (1973); *Buff Her Blind—To Open the Light of the Body* (1974); *Inflame* (1976); *Homage to Picasso* (1976); *High Chroma Contrast* (1977); *Picasso Collage—Lovers Acrobats Clowns* (1977); *Jet Roulette* (1978); *Hot Jam* (1979); *De Carnaval* (1979); *Celestial Saracen* (1980).

Evans, Bill, American modern dance and ballet dancer and choreographer; born April 11, 1946 in Lehi, Utah. Trained by Charles Parrington and his daughter, June Parrington Park, in Salt Lake City, he continued his studies at the University of Utah under Willam Christensen, for ballet, and Shirley Ririe, for modern dance. Moving to New York, he worked with Jack Cole at the Harkness House before dancing briefly with the Chicago Opera Ballet and returning to Utah to dance and choreograph with the Repertory Dance Theatre.

He directed that company and taught at the University of Utah from 1967 to 1974, creating many of his best known pieces, such as the *Piano Rags* (1972), *Cambridge Dances* (1973), and *Hard Times* (1973). After spending two years at the Fairmount Dance Theatre, outside Cleveland, Ohio, he founded the Bill Evans Dance Company in Seattle, Washington, working there until the present.

Works Choreographed: CONCERT WORKS: *Interim* (1969); *When Summoned* (1969); *For Betty* (1970); *Tin-Tal* (1971); *Five Songs in August* (1972); *Piano Rags* (1972); *The Legacy* (1972); *Cambridge Dances* (1973); *Within Bounds* (1973); *Hard Times* (1973); *Juke Box* (1974); *Bach Dances* (1976); *Conjurations* (1977); *Barefoot Boy with Marbles in his Toes* (1977); *Astabula Rag* (1977); *Double Bill* (1978); *The New London Quadrille* (1978); *Impressions of Wil-* low Bay (1978); *What's the Story, Morning Glory?* (c.1978); *Captive Voyages* (1979).

Evans, David, American theatrical performer; born in Wilkes-Barre, Pennsylvania. Evans made his Broadway debut in *My Fair Lady* (1956) but left that fabulously successful musical to dance in *Tenderloin* (1960) and Noel Coward's *Sail Away* (1961). As a "Protean" in Jerome Robbins' *A Funny Thing Happened on the Way to the Forum* (1962), he did acrobatics, gymnastics, singing, and a little tap, while in Gower Champion's *Hello, Dolly!* (1964), he juggled plates and trays as one of the original singing waiters. Evans spent most of the later 1960s and 1970s on television and as a back-up dancer for female stars, but did take time out to appear in what many think is the ultimate Broadway musical—*Springtime for Hitler*—Alan Johnson's opening chorus number in Mel Brooks' film *The Producers*. In 1978, Evans returned to the real Broadway as a dancer in Michael Bennett's *Ballroom*.

Evdokimova, Eva, American ballet dancer working entirely in Europe; born December 1, 1948 in Geneva of American parents. Trained at the school of the Munich State Opera Ballet under Erna Gerbel, she continued her training as a private student of Maria Fay and Vera Volkova, also attending classes at the Kiov school in Leningrad, with Natalia Dudinskaya. She performed briefly with the Royal Danish Ballet, before joining the German Opera Ballet of Berlin in 1969, to dance in Hans van Manen's *Adagio Hammerklavier*, and the company's production of *Coppélia* and *Giselle*. She was a member of the Ballets Classiques de Monte Carlo in the early 1970s, but returned to Berlin where she has been featured in the works of Valery Panov, including his *Cinderella* (1977) and *Der Idiot* (1979). A favorite partner of Rudolf Nureyev, she has danced with him in the above works and in his *Sleeping Beauty* (1975) at the London Festival Ballet. Evdokimova has guested with many of the world's companies, partnering Nureyev in two of the visiting companies at the Metropolitan Opera's festival of 1980—the Berlin Ballet and National Ballet of Canada.

Everett, Ellen, American ballet dancer; born June 19, 1942 in Springfield, Illinois. Everett was trained

in Chicago by Berenice Holmes and Betty Gour, performing with the Chicago Opera Ballet from 1958 to 1964, in works by Ruth Page.

Joining the American Ballet Theatre in 1964, she created roles in works by the company's choreographers-in-residence, among them Michael Smuin's *Pulcinella Variations* (1968), Eliot Feld's *Eccentrique* (1971), and Dennis Nahat's *Mendelssohn Symphony* (1971). She was noted for her ability to bring both exceptional technical ability and warmth of characterizations to even small parts in the repertory, including the "Second Girl" in Jerome Robbins' *Fancy Free*, "Effie" in *La Sylphide*, and roles in Antony Tudor's *Jardin aux Lilas* and *Pillar of Fire*.

Everett, Tim, American theatrical dancer and actor; born c.1939 in Helena, Montana; died March 4, 1977 in New York City. Although raised in Wilmington, North Carolina, Everett moved to New York City as an adolescent and quickly became active on Broadway. He made his professional debut in the 1954 revival of *On Your Toes* as a teen-age hoofer, and played a similar role in the original cast of *Damn Yankees* (1955). After dancing as "Tom Sawyer" in the musical *Livin' the Life* (1957), he left musical comedy to create the pivotal role of the suicidal cadet in William Inge's play, *The Dark at the Top of the Stairs* (1957). Although he returned to dance occasionally, most notably as "Tommy" in the film of *The Music Man*, he spent most of the remainder of his short life in dramatic roles on stage and television. His appearance in, and direction of, June Havoc's nightmarish *Marathon '33* was especially acclaimed.

He was the elder brother of actresses Sherry and Tanya Everett. Both have had successful dramatic careers, and, in addition, the latter was a featured performer in Jerome Robbins' *West Side Story* (second cast) and the original *Fiddler on the Roof*.

Evert, Thomas, American modern dancer; born July 23, 1951 in Cleveland, Ohio. Evert was trained at the Ohio State University, which has a celebrated program in traditional modern dance forms. When he moved to New York, he augmented jazz work with Luigi and ballet with Finis Jhung, with studies at the Alwin Nikolais/Murray Louis Dance Theater Lab. He performed in the concert groups of former Nikolais dancers Phyllis Lamhut, Luise Wykell, and Richard Biles, but is best known for his work with Paul Taylor. In that popular traditional modern dance company, he has been applauded in *Airs, Book of Beasts, Cloven Kingdom, Diggity,* and *Dust*.

F

Fabbri, Flora, Italian ballet dancer of the mid-nineteenth century; born in Florence, c.1807; died after 1855. Fabbri was trained by Carlo Blasis and was named by him to "Les Pleiades de danse."

After making her debut at the Teatro la Fenice in Venice, she spent seasons at the Teatro Apollo in Rome, Teatro Comunale in Bologna, where she married dancer Luigi Bretin, and the Teatro Comunale in Padua, at which she danced in works by Antonio Monticini.

At the Paris Opéra from 1845 to the early 1850s, she was given principal roles in Mazurier's *Jerusalem*, Jean Aumer's *Zerline, ou la Corbeilles d'oranges*, Filippo Taglioni's *La Sylphide* in 1848, and Mazilier's *Paquita*, her best known role. She also danced at Covent Garden in 1846 in Bretin's *The Offspring of Flowers*, and at Drury Lane in London. In 1855, she danced in Bretin's *La Fleur Inconnue* at the Théâtre de la Porte-Saint-Martin in Paris. She retired soon after that season.

Two members of the Fabbri family also became well known dancers—her daughter Giovanni Fabbri-Bretin (flourished 1823–1845) and nephew Alessandre Fabbri (flourished 1803–1819).

Fabiani, Michele, Italian eighteenth-century ballet choreographer; born between 1730 and 1740; died October 1786 in Paris. Fabiani's training and early performance career cannot be verified. It is not actually certain whether any or all of the other Fabianis choreographing for Italian theaters in the 1760s and 1770s were related to or identical with Michele. Guiseppe Fabiani staged a production of *Semiramide* at the Teatro di San Cassiano in 1775, Camillo did a *Perseo ed Andromede* at the Teatro di via delle Pergola in Florence (1775), and Benedetto was on the staff of the Teatro Argentina in Rome from 1776 to 1782; it is geographically possible for these to have been four different people or all one.

Michele Fabiani was a member of the company of French and Italian dancers at the King's Theatre, London, in the 1780s, serving as ballet master in 1785. Among the works in which his name appeared are *Le Premier Navigateur, Les Amours Surprises,* and *Ninette à la Cour*; it is possible, but again not

verified, that these were Jean D'Auberval's versions of these popular themes.

Fabray, Nanette, American theatrical ballet dancer; born October 22, 1920 in San Diego, California. Trained by Ernest Belcher, she performed as a child in Fanchon and Marco units as "Baby Nanette." She made her Broadway debut in the revue *Meet the People* (1940), going directly into *Let's Face It* (1941), *By Jupiter* (1942), *My Dear Public* (1943), *Bloomer Girl* (1944, replacing Celeste Holm), Jerome Robbins' *High Button Shoes* (1947), *Love Life* (1948), *Arms and the Girl* (1950), and *Make a Wish* (1951). She has returned to Broadway every ten years, appearing in *Mr. President* (1962) and *No Hard Feelings* (1973).

Although most of her film roles were dramatic, she danced in Michael Kidd's *The Band Wagon* (MGM, 1953), and in "That's Entertainment" and "Triplets." From her first *Your Show of Shows* (NBC, 1950), she has performed on television almost constantly since the medium arrived.

Fadeyechev, Nicolai, Soviet ballet dancer; born January 27, 1933 in Moscow. Trained at the Bolshoi school, he has performed with the company throughout his career. Celebrated as the partner of Galina Ulanova, notably in the company's *Giselle* and of Maya Plisetskaya, he danced with the latter ballerina in Bourmeister's *Swan Lake* (1961) and Grigorovich's 1969 production of that Petipa/Ivanov ballet, in Plisetskaya's own *Anna Karenina* (1972), and Alberto Alonso's *Carmen Suite* (1967). He was considered the Bolshoi's finest "Siegfried," "Albrecht," and "Spartacus."

Fagan, Barney, American popular entertainer; born c.1851 in Boston, Massachusetts; died January 12, 1937 in Islip, Long Island. It is not known whether Fagan had had formal training in dance or earlier professional experience when he emerged in 1869 as a clogging champion. Exhibition or competitive clogging was far removed from the folk art of the South and Appalachia—it was a precursor of theatrical tap work in which the performers challenged each other to do more and better articulated individual sounds

with their wooden clogs or soles. It is possible that his competitions were actually theatricalized set-ups since he seems to have "beaten" the same person at least a dozen times. For much of the later 1800s, he integrated his dance act into productions in New York and on tour, among them a series of Harrigan and Hart shows (c.1874–1876), Gus Hill's *World of Novelties* (c.1882–1885), and his own minstrel show—the Swatman, Rice, and Fagan company. In 1891, he introduced his first individual success in a dance act, starring as "Mr. Eiffel Tower" in *A High Roller*. That dance number, which he revived frequently throughout his career, was a shipboard eccentric tap. It was a variation of a "silly-ass Englishman" dance in which the performer slipped around the stage, up and down staircases, and over furniture.

From 1894 to his retirement in 1924, he alternated between a vaudeville act with dancer Henriette Byron (his wife) and a career staging vaudeville acts and revues, including the first *Passing Show* (1894). His later theatrical work also involved his first Broadway credits as a performer in the 1922 *Stars of Yesterday* presentation act at the Palace Theater, *Sidewalks of New York*, and the original play version of *The Jazz Singer*. Fagan also wrote minstrel and vaudeville feature acts, including the famous Electric March drill of 1891, and scenarios for Metro Pictures (c.1915–1918).

Faier, Yuri, Soviet conductor; born January 17, 1890; died August 3, 1971 in Moscow. Faier was the conductor during much of the development period and triumphant eras of the Soviet ballet as conductor of the Bolshoi from the mid-1920s to the early 1960s. He was equally adept at conducting modern scores and Tchaikovsky, and was admired for his ability to adapt his rhythms to the requirements of his dancers.

Bibliography: Faier, Yuri. *Notes of a Ballet Conductor* (Moscow: 1960), French translation available (Paris: 1964).

Fairbanks Twins, American film and musical comedy dancers; born Marion and Madeleine Fairbanks, November 15, 1900 in New York City. The Fairbanks made their professional debuts in the Winthrop Ames production of *The Blue Bird* in 1910, in a cast of child actors that included Mary Eaton and members of her family. They all appeared in the "Souls of the Unborn Children" scene, but the Fairbanks' specialty, as "Sleep" and "Death" in the "Palace of the Night" won them particular notice. They appeared in more Broadway productions, including *The Piper* (1911), *Mrs. Wiggs of the Cabbage Patch* (1912), and Ames' *Snow White* (1912), before beginning to work in film.

They were Biograph Kids briefly in 1912, appearing in a serial that seems to be an upper-middle-class Our Gang. Their fame came as Thankhouser Kids, however, as the twins in a series of films and serials that featured them with a young boy and a baby girl. From 1913 to 1916 they made literally hundreds of individual films for the Thankhouser Kids series of Mutual Masterpiece Productions, among them, *Cousins* (1913), *$1000 Reward* (1914), *The Flying Twins* (1915), *The Bird of Prey* (1916), and *The Answer* (1916), the first film in which they received separate billing.

Returning to New York, they were reunited with Ned Wayburn for whom they had danced in Lew Field's shows in 1910. Their shows for Wayburn, then Ziegfeld's resident choreographer, included the *Follies of 1917, 1919* and *1918*, a series of Prologs, and the vehicle, *Two Little Girls in Blue* (1921). Cast as juvenile versions of The Dolly Sisters, they did tandem and mirror work in which they danced in parallel movements or in opposition. Among Wayburn's more innovative dance routines for them were "A Miniature" (from the *Follies of 1918*), in which they reflected each other's movements on either side of an imaginary mirror, and the Pepper and Salt dance in the "Follies Salad" opener of the *Follies of 1920*. The whole of *Two Little Girls in Blue* was one long tandem act, with the twins appearing on stage together only while dancing. The Fairbanks also performed together in *The Midnight Whirl* (1921), the *Nine O'Clock Revue* of that year, and *Oh, Kay!* (1927). They were on Broadway concurrently in 1924 when Marion was cast in Ed Wynn's *Grab Bag* and Madeleine appeared in *The Ritz Revue*. The former toured later that season in *Little Nellie Kelly*.

Faison, George, Jr. American modern dancer and choreographer; born December 21, 1945 in Washing-

ton, D.C. After receiving some dance training during his theater work in college, Faison moved to New York to continue his studies with Elizabeth Hodes, Thelma Hill, Louis Johnson, and Dudley Williams.

After a season in Hodes' Harlem Dance Company, he joined the Alvin Ailey Dance Theatre in 1966. In three years with the troupe, he created a major role in Ailey's *Masakela Langage* (1969) and performed in his *Quintet* and *Blues Suite*, Talley Beatty's *Congo Tango Palace* and *The Black Belt*, and his own *Suite Otis* (1971, as guest artist).

Faison has choreographed for his own company, the Universal Dance Experience, since the early 1970s. Among his best known creations are *Suite Otis*, to the music of Otis Redding, and *Poppy* (1971), a devastating work about drug abuse. The company has included dancers Loretta Abbott, Al Perryman, and actress Debbie Allen, who was his assistant for many years.

After appearing in *Purlie* (1968) on Broadway, Faison maintained his interest in creating works for that medium. He staged dances for *Don't Bother Me, I Can't Cope* (1972) on Broadway, *Ti-Jean and his Brothers* for the New York Shakespeare Festival, *Inner City* (1974) in Washington, D.C., and dances for *The Wiz* (1975), for which he received a Tony award. In recent years, he has concentrated on directing, rather than choreographing, productions, receiving critical acclaim for his production of Genet's *The Blacks* in 1978.

Works Choreographed: CONCERT WORKS: *The Gazelle* (1971); *Slaves* (1971); *Poppy* (1971); *Suite Otis* (1971); *The Coloureds* (1972); *Black Angels* (1972); *We Regret to Inform You* (1972); *In the Sweet Now and Now* (1974); *Reflections of a Lady* (1974); *Tilt* (1975); *Hoboes* (1976).

THEATER WORKS: *Nigger Nightmare* (1971); *The Dolls* (1971); *Don't Bother Me, I Can't Cope* (1972); *Ti-Jean and his Brothers* (1972); *Sheeba* (1972); *Everyman* (1972); *Via Galactica* (1972, Faison's only credit on this disastrous flop was as "assistant to the director," Peter Hall, who was credited with the line, "Conceived and directed by"); *The Wiz* (1975); *1600 Pennsylvania Avenue* (1976).

Falco, Louis, American modern dancer and choreographer; born August 2, 1942 in New York City. Hav-

ing studied with José Limón, Martha Graham, and Charles Weidman, and attended classes at the Ballet Theatre School, Falco joined the Limón company in 1960. In that group for ten years, he danced in Limón's *The Demon, Missa Brevis, The Winged, The Moor's Pavanne, The Exiles*, and *Psalm* (1969). He also danced with Donald McKayle, in his *Games* (1963) and *Rainbow 'Round My Shoulder*, and with an Alvin Ailey group, in his *Gillespiaana*.

Falco formed his own company in 1967–1968, for which he has choreographed extensively. He has also created works for the Boston Ballet, the Ballet Rambert, and the Netherlands Dance Theater. His pieces, which are both popular and fashionable, are usually set to commissioned scores by Bert Alcantara.

Recently, Falco has begun working in film, and was acclaimed for the dances that he staged for the motion picture, *Fame* (Twentieth-Century Fox, 1980).

Works Choreographed: CONCERT WORKS: *Argot* (1967); *Translucense* (1967); *Checkmate's Inferno* (1967); *Huescape* (1968); *Timewright* (1969); *Caviar* (1970); *Journal* (1971); *The Sleepers* (1971); *Ibid* (1971); *Soap Opera* (1972); *Avenue* (1973); *Two-Penny Portrait* (1973); *Storeroom* (1974); *Eclipse* (1974); *Tutti-frutti* (1975); *Champagne* (1976); *Hero* (1977).

FILM: *Fame* (Twentieth-Century Fox, 1980).

Fallis, Barbara, American ballet dancer; born 1924 in Denver, Colorado; died in 1980 in New York City. Raised in London, she was trained at the School of the Vic-Wells Ballet, graduating into the company in 1938.

After dancing with the Vic-Wells until 1940, Fallis returned to the United States to join Ballet Theatre. In her eight years with that company, she performed in David Lichine's *Helen of Troy* and *Graduation Ball*, in the Mobile Perpetuum solo, Frederick Ashton's *Les Patineurs*, and Antony Tudor's *Shadow of the Wind*. George Balanchine selected her to create a featured role in his 1944 *Waltz Academy*.

After a season with the Ballet Alicia Alonso, performing in her versions of the classic nineteenth-century repertory, Fallis joined Balanchine's New York City Ballet. Noted for her "Wallflower" in Ruthanna Boris' *Cakewalk*, she was featured in Balan-

chine's abstract delicacies *Valse Fantasie* (1953) and *Pas de Dix* (1955).

From her retirement to her tragically early death in 1980, Fallis and her husband, Richard Thomas, taught at their New York School of Ballet. A popular and influential teacher, she trained many dancers, including Eliot Feld, Christine Sarry, John Sowinsky, Daniel Levins, who began to choreograph for her U.S. Terpsichore company of students, and her daughter, Bronwyn.

Fanchon, American exhibition ballroom dancer, and Prolog and film choreographer; born Fanny Wolff, c.1890 in Los Angeles; date of death uncertain. Originally an exhibition ballroom dancer with her brother Marco (Mike) and Rudolf Valentino, she and Marco developed a series of Prologs, or live revues, designed to play before films at the Warfield Theater, San Francisco (1919–1920). Their Pacific Coast Golden Gate Musical Revues Corporation was developed that season to produce Prologs for a chain of West Coast theaters, and a musical comedy, *Sunkist* (1921), which reached New York in its legit house tour. Their company merged with the West Coast Theater circuit in 1925, becoming the largest Prolog chain in the state. By 1931, when they took over the Paramount/Publix chain, they ran a theater circuit that reached from Canada to Mexico with forty-seven houses.

Fanchon herself staged about half of the "Ideas," as the Prologs were known—a total of about 150 shows. Dance directors that they hired included Hollywood's Larry Ceballos, Leon Leonidoff who would later stage Prologs at the Radio City Music Hall, Jack Partington, who invented that theater's hydraulic orchestra pit, Gae Foster, later of the Roxy, and Busby Berkeley, soon to become the best known film dance director. Fanchon's Ideas frequently used double, triple, or even septuple adagio teams performing simultaneously on stage, precision lines and child tap, ballet or toe tapping specialty dancers. She employed ballet-trained soloists or teams from the Ernest Belcher school, and young dancers from the Ben and Sally Steppers Studio, which produced adagio teams by the dozens. It is estimated that more dancers were employed each year by Fanchon and Marco productions than in all of Hollywood's movie studios.

Fanchon served as dance director for a few films, but they were so widely separated in time that the credit lists do not make sense. She also produced films for Paramount, hiring Le Roy Prinz to stage dances for them. By the era of sound musicals, she was more successful as a producer for Paramount.

Fanchon's influence on the dance industry of the West Coast is incalculable. She not only employed practically every dancer west of the Rockies, but she set the tastes in dance specialty acts and team routines for over twenty years. The small precision teams of film work and the incredible popularity of adagio choreographed work can be traced to her.

Works Choreographed: THEATER WORKS: *Sunkist* (1921); *Prologs for Warfield Theatre* (1919–1920); *Prologs for Pacific Coast Golden Gate Musical Revues* (1921–1925); *Prologs for the West Coast Theatre Chain* (1925–1938).

FILM: *Fox Movietone Follies of 1929* (Fox Film Corp., 1929); *Hearts in Dixie* (Fox Film Corp., 1929); *Paddy O'Day* (Fox Film Corp., 1935); *A Night in a Music Hall* (Columbia Vanities, 1938, short subject); *A Night at the Troc* (Columbia, 1939, Vanities short subject); *Where Do We Go from Here?* (Twentieth-Century Fox, 1945); *Hit Parade of 1947* (Columbia, 1947).

Farber, Viola, American modern dancer and choreographer; born February 25, 1931 in Heidelberg, Germany. Raised in the United States, Farber studied ballet with Margaret Craske and Alfredo Corvino and modern dance with Katherine Litz and Merce Cunningham at Black Mountain College.

Farber was a member of the Cunningham Company from 1953 to 1965, creating roles in his Suite for *Five in Space and Time* (1953), *Galaxy* (1956), *Picnic Polka* (1957), *From the Poems of White Stone* (1959), *Rune* (1959), and *Crises* (1960) and performing featured parts in his *Antic Meet, Suite by Chance Minutiae,* and *Rag-time Parade,* among others. She has also danced with the companies of modern dancers Katherine Litz (1959), dancing in her *Dracula,* and Paul Taylor (c.1965–1967).

Farber founded a dance company in 1968 and has choreographed most of her works for that group. Dances created for other companies include *Surf Zone* (1966), choreographed for the Manhattan Festival Ballet, and two works, *Passengers* (1970) and

Five in the Morning (1972), for the Repertory Dance Theatre of Utah. Her works are characterized by a unique sense of humor, revealed in the movements, props, costumes, and even titles. She has choreographed both for conventional stages and for public spaces; the outdoor dances created between 1973 and 1975, among them *East 84th Street Block Party* (1973), *Bronx Botanical Gardens* (1975), and *McGraw Hill Building* (1975), are among the finest works in this urban genre.

Works Choreographed: CONCERT WORKS: *Seconds* (1965); *Surf Zone* (1966); *Excerpt* (1968); *Legacy* (1968); *Notebook* (1968); *Passengers* (1968); *Time Out* (1968); *Turf* (1968); *Duet for Mirium and Jeff* (1969); *The Music of Conlon Nancarrow* (1969); *Passage* (1969); *Pop. 11* (1969); *Pop. 18* (1969); *Quota* (1969); *Standby* (1969); *Three Duets* (1969); *Tristan and Iseult* (1969); *Area Code* (1970); *Co-op* (1970); *Curriculum* (1970); *Tendency* (1970); *Passengers* (1970); *Window* (1970); *Five in the Morning* (1971); *Mildred* (1971); *Patience* (1971); *Survey* (1971); *Default* (1972); *Dune* (1972); *Poor Eddie* (1972); *Pure Patience* (1972); *Route 6* (1972); *Passage* (1973); *Soup* (1973); *East 84th Street Block Party* (1973); *Spare Change* (1973); *Dinosaur Parts* (1974); *House Guest* (1974); *Willi I* (1974); *No Super, No Boiler* (1974); *Duet for Susan and Willi* (1975); *Bronx Botanical Garden* (1975); *Five Works for Sneakers* (1975); *McGraw Hill Building* (1975); *Brooklyn Museum* (1975); *Motorcycle/Boat* (1975); *Rainforest* (1975); *Some Things I Can Remember* (1975); *Night Shade* (1975); *Sunday Afternoon* (1976); *Lead Us Not into Penn Station* (1977); *Turf* (1978); *Dandelion* (1978); *Private Relations* (1979); *Local* (1979); *Doublewalk* (1979).

VIDEO: *Brazos River* (PBS, 1976); original choreography for television.

Faria, Arthur, American theatrical dancer and choreographer; born 1946 in Massachusetts. After local ballet training, he continued his studies in a variety of techniques with, among others, Billie Pope (African forms), Mura Dehn (American black forms), and Jack Cole (miscellaneous ethnic and exotic). After making his debut in a successful revival of *Kiss Me Kate*, he became Cole's assistant on his last productions. While working as principal dancer in *Sugar* (1972), he met Donald Saddler who was one of the

production's doctors. He left that show to assist Saddler on the revival of *Good News* in the next season. His first solo Broadway assignments were *Miss Moffat* (1977), a Bette Davis vehicle that did not last to its official opening, and the fabulously successful "new Fats Waller musical," *Ain't Misbehavin'* (1978).

Working with veteran popular entertainer Avon Long as coach, he created 1940s movement vocabularies rather than dance routines, for the five-person cast. Although the show has been performed by some of Broadway's best dancers, among them Debbie Allen, André De Shields, Alan Weeks, and Charlene Woodward, he has avoided conventional routines or numbers and has created a seamless statement of period and style to fit Waller's songs.

Works Choreographed: THEATER WORKS: *Miss Moffat* (1977, closed out of town); *Ain't Misbehavin'* (1978).

Farjeon, Annabel, English ballet dancer and critic; born 1919 in Buckleberry, Berkshires. A member of a famed literary family, she was trained in ballet at Phyllis Bedells' studio and at the school of the Sadler's Wells Ballet. A member of that company from the mid-1930s to 1940, she participated in the first performances of many important productions of the early English ballet, among them, the Wells' *Les Sylphides,* Ninette De Valois' *Le Roi Nu* (1938), and Frederick Ashton's *Cupid and Psyche* (1939) and *The Wise Virgins* (1940).

Farjeon returned to family tradition during the war years by turning to journalism as a career. At first, she reviewed dance as part of her responsibilities as literary or cultural editor for periodicals, but by 1949, she was receiving bylines as "Ballet Editor" of the *New Statesman and Nation.* She later served in that capacity for the *Evening Standard* (from 1959 on) and contributed to monthly periodicals.

Farmanyantz, Georgi, Soviet ballet dancer; born November 4, 1921 in Bezhetz. Trained at the Bolshoi School he performed in children's parts in opera and dance productions before graduating into the company in 1940. In twenty-three years with the Bolshoi Ballet, he became known as a specialist in demi-caractère roles that required flawless technique and realistic characterizations. Among his scores of roles

were heroes such as "Franz" in *Coppélia*, "Colin" in *La Fille Mal Gardée*, and "Basil" in Don Quixote, figures of comic relief, among them "The Jester" in *Swan Lake*, and glorified divertissements in which all characterization was included in choreography itself, as in the Blue Bird in the company's *Sleeping Beauty*.

After retirement in 1963, he began teaching at the Bolshoi School and in residencies around the state school system of the Soviet Union. He is considered a major factor in the continuance of the theories and practices of his own teacher, Anatole Kusnetsov, in the 1970s.

Farmer, Peter, English theatrical designer; born November 3, 1941 in Luton. Farmer has found success in productions of the full-length nineteenth-century classics, among them *Giselle, The Sleeping Beauty, Coppélia,* and *Cinderella*—each of which he has done in at least two productions. He has also done more contemporary ballets for Peter Wright (among them *Dance Macabre,* 1968, and *Namouna,* 1976), Eliot Feld, Robert Cohan, and Ben Stevenson.

Farrally, Betty, English ballet teacher of importance to the development of dance in Canada; born 1915 in Bradford. She was trained at the Torren School of Dance in Leeds. In 1938, she and Gwyneth Lloyd emigrated together to Canada where they co-founded a school in Winnipeg. After performances as a chamber group, their students were organized into the Winnipeg (now Royal Winnipeg) Ballet. Although they served as co-artistic directors until the late 1950s, Farrally was always most involved in the maintaining of high technical standards in the company and school, serving as ballet master rather than choreographer-in-residence.

Farrell, Suzanne, American ballet dancer; born August 16, 1945 in Cincinnati, Ohio. Trained originally at the Cincinnati Conservatory of Music, Farrell was one of the first Ford Foundation Scholars to the School of American Ballet to be accepted into the parent company, the New York City Ballet.

In her first years in the company, Farrell developed her ability to convey emotion to the audience until it matched her always spectacular technique. The works that Balanchine created for her in this period were split between abstractions that exploited her precision, such as the *Movements for Piano and Orchestra* (1963) and the Diamonds section of *Jewels* (1967), to the more dramatic works, in which she was frequently partnered by Jacques D'Amboise. Among those were the duet *Meditation* (1963), the final Gypsy movement of the *Brahms-Schoenberg Quartet* (1966), and especially, *Don Quixote* (1965), a rare full-evening ballet which presented her in both ballet identities.

Farrell left the company in 1969 after her marriage to soloist Paul Mejias. They joined Maurice Béjart's Ballet du XXième Siècle from 1970 to 1974, during which time she created roles in his *Les Fleurs du Mal* (1971), *Nijinsky, Clown de Dieu* (1971), and *I Triomfi* (1974), among others.

Returning to the New York City Ballet in 1974, Farrell continued her partnership with D'Amboise, notably in Balanchine's most recent work, *Schumann's Davidsbundlertanze* (1980), and began to dance with Peter Martins who had joined the company in her absence. This new partnership was the focus of new works by both Balanchine, who created *Tzigane* (1975) and revived *Chaconne* (1976) for them, and Jerome Robbins who choreographed *In G Major* (1975) and the central pas de deux of *The Four Seasons* (1979) around them. Other recent Balanchine works in which Farrell has created roles include *Union Jack* (1976), where she led a precision batterie/jig, and *Vienna Waltzes* (1977), in which she opened the final section with a solo which continually overwhelms the audience with its beauty and lush emotionality.

Farren, Fred, English eccentric dancer and ballet-spectacle choreographer; born c.1870 in London; died there May 8, 1956. Farren, who claimed not to have had formal training, made his debut as a child in a Christmas pantomime in London, playing a "Frog" in *Aladdin*. From 1886 to 1895, he was a regular member of the pantomime companies at the Olympic and Savoy Theatres of London, and performed with the Royal Italian Opera at Covent Garden in a company that included ballerina Francesca Zanfretta and acrobat Charles Lauri.

Joining the company attached to the Empire Theatre, London, he performed as an eccentric dancer

in the ballet-spectacles staged by Katti Lanner, among them *The Dancing Doll* (1905), and *Sir Roger de Coverly* (1907), and in Alexander Genée's revival of *Coppélia* (1906), playing "Dr. Coppelius." He staged at least three Empire ballets himself, among them *Cinderella* (1906), for Adelina Genée, *The Belle of the Ball* (1907), and *The Dancing Master* (1908).

Returning to performance, Farren became a constant featured player in an almost continuous series of plays, musical comedies, and pantomimes on the London stage. Among his best known shows were *Bluebell in Fairyland* (1916), *The Latest Craze* (1919), and *Angel Face* (1922), which he directed. It is likely that Farren interpolated his own specialty acts—straight-leg eccentric dancing and struts—into these shows. He may have also performed in music halls with his daughter, comedienne Babs Farren, before retiring to teach.

Works Choreographed: THEATER WORKS: *Cinderella* (1906, Alexander Genée may have choreographed the ballet variations); *The Belle of the Ball* (1907); *The Dancing Master* (1908).

Farron, Julia, English ballet dancer; born Joyce Farron, July 22, 1922 in London. After early training with Jessie Hogarth, Farron attended the Cone-Ripman School in London and accepted a scholarship to the Sadler's Wells Ballet School.

From 1936 until her retirement in 1961, Farron was associated with the Sadler's Wells Ballet and its successor, the Royal Ballet. She has created roles in a large number of ballets by Frederick Ashton, among them, *A Wedding Bouquet* (1937), *Cupid and Psyche* (1939), *Sylvia* (1952), *Rinaldo and Armida* (1955), *Homage to the Queen* (1958), and *Ondine* (1958). Other works in which she performed include Andrée Howard's *A Mirror for Witches* (1952), John Cranko's *The Prince of the Pagodas* (1957), Ninette De Valois' *Don Quixote* (1950), and Robert Helpmann's *Adam Zero* (1946). Her final created role, after retirement, was "Lady Capulet" in Kenneth MacMillan's 1965 version of *Romeo and Juliet*. Farron was also given featured roles in the Sadler's Wells and Royal Ballet productions of the classic repertory and was celebrated for her performances in *Les Sylphides, Swan Lake,* and *Giselle*.

Farron's association with the English ballet did not end with her retirement; she is an honored and popular teacher with the Royal Ballet.

Fatima, Djemille, vaudeville dancer of the early 1900s; born c.1890, possibly in Syria; died March 14, 1921 in Venice, California. Djemille, La Belle Fatima, appeared on the American scene in 1913 as a featured performer at William and Oscar Hammerstein's Victoria Theatre. Since the Hammersteins had the most fertile imaginations in the theater of the times and since their former employee was the major theatrical correspondent of the New York press, it is difficult to disprove his statement that she was an "escaped Harem dancer of the deposed Sultan of Turkey, Abdul II." There actually was an Abdul II who was deposed in 1909, but there is no way of knowing whether Djemille Fatima was employed (or owned) by him. Her function in American vaudeville was to entertain the New York and tour audience and to become a player in the continuingly successful attempts of the Hammersteins and *The New York Telegraph* to embarrass Anthony Comstock and his amateur and professional suppressors of vice. Fatima was arrested by the vice squad on Comstock's insistence, but was released when she appeared in court "dressed like a business girl." The Hammersteins sent her on tour with an act called The Tiger Lillies that consisted entirely of female headliner performers in 1917. Her personal act remained the same throughout her American career and consisted of four dances—*Dance of the Balkans, A Fantasie, The Algerian Apache as Danced 500 Years Ago,* and *Arabian Dance.*

This Fatima may have been the same person as the performer of the same name who appeared in Edison Company films and at the St. Louis World's Fair of 1904.

Fauntleroy, Fred, American vaudeville dancer; born June 29, 1894 in Gatesville, Texas. After starting his career as Little Lord Fauntleroy, Earl of Vaudeville, he worked in a child dancer act from 1898 to c.1910. Dressed, of course, in a little Lord Fauntleroy suit of velvet and lace, he presented clogging solos and sang. Fauntleroy's specialty changed drastically between 1910 and 1912—probably because he grew. When he

first appeared as an adult in vaudeville, he had transformed himself into a "Rube" dancer, appearing in exaggerated "country" clothing and slouching around the stage in a flat-foot soft shoe. Fauntleroy continued to work as a "Rube" until 1918, when he dropped from the Keith circuit; it is possible that he was drafted into the armed service in that year.

Faust, Lotta, American theatrical dancer; born February 8, 1880 in Brooklyn, New York; died in New York City, January 25, 1910. Faust made her debut in a production of *The Jack and the Bean Stalk* in 1895, in Brooklyn, which was then a municipality outside New York City. Her first Broadway show was *The Man in the Moon* in April 1899; from that production until her death, she worked constantly in New York or on tour. She was a chorus dancer in George Lederer shows, including *The Belle of Bohemia* (1900), *The Casino Girl* (1900), and *My Lady* (1900) and a specialty dancer throughout her career. Among her best remembered shows were *Sally in Our Alley* (1902), the Montgomery and Stone *Wizard of Oz* (1903), in which she introduced "Sammy," *The Girl from Vienna* (1906), *The White Hen* (1907), Lew Field's *The Girl Behind the Counter* (1907), *The Mimic World* (1908), in which she did a salome dance that was banned in Des Moines and *The Midnight Sons* (1909). In the latter, a Ned Wayburn show for Lew Field, she portrayed "Carmen, the Second," in the show-within-the-show. Her Spanish dance brought her new fame as a soloist—a genuine dance talent apart from her comic and vocal abilities.

Faust's death, just before her thirtieth birthday, shocked the theatrical community, which for many years sponsored benefit concerts in her memory.

Favors, Ronni, American modern dancer; born in the 1950s in Iowa City, Iowa. Trained at the University of Iowa and at the Interlochen music and dance camp, she moved to New York to continue her training at the American Dance Center, resident school of the Alvin Ailey Dance Theatre. After dancing with the Ailey Repertory Ensemble, she joined the Dance Theatre itself in 1978. Among the many works in which she has performed there are Ailey's *Memoria, Night Creature,* and *Revelations* and Donald McKayle's *District Storyville.*

Faxon, Randall, American modern dancer; born September 26, 1950 in Harrisburg, Pennsylvania. Faxon's training has included classes at the studios of Martha Graham, Paul Sanasardo, and Alfredo Corvino. She appeared with the Lucas Hoving company at the American Dance Festival, performing in his *Aubade II, Opus '69,* and *Satiana,* among others. Her tall strength and flexibility made her a vital member of the Gus Solomon Company/Dance, where her credits included roles in his *Urban Recreation* and *The Ultimate Pastorale.* Faxon has also danced with the Contemporary Dance system (now called the Daniel Lewis Repertory Dance Company) in revivals of works by Doris Humphrey, José Limón, and Anna Sokolow. She created a role in the latter's *Moods* (1975) and appeared in Daydream trio of her *Rooms* and sections of her *Ballade, Dreams*, and *Lyric Suite.*

Fay, Vivien, American theatrical ballet dancer; born c.1910 in San Francisco, California. Fay was trained at the Theodore Kosloff studio in San Francisco by Kosloff, Alexandra Baldina, and Julietta Mendez. She made her professional debut in a Gus Edwards vaudeville, as did so many future theatrical stars. After performing in the Los Angeles production of *Naughty Riquette* in 1926, she moved to New York to perform in *Rosalie* (1928). She did the specialties in the Earl Carroll *Vanities of 1930* and the George White *Melody* of 1933 before returning to classical ballet in 1935 playing "Katti Lanner" in Albertina Rasch's *The Great Waltz.* Between shows, she toured with Rasch's Prologs and those staged by Gae Foster of the Roxy Theater in New York.

Fay's considerable classical technique can still be seen in her specialty solo in the Marx Brothers' film, *A Day at the Races* (MGM, 1937).

Faye, Alice, American film dancer and actress; born Alice Jeane Leppert, May 5, 1915 in New York City. Faye was trained at the school managed by Chester Hale on the roof of the Capitol Theater and performed for him as a Chester Hale Girl precision dancer on tour and at the Capitol. As a seventeen-year-old cast member of the 1922 *George White's Scandals,* she met Rudy Vallee, who cast her as a vocalist on his radio show. Her duet with him in the

film *George White's Scandals* (Fox Film Corp., 1934), staged by George Hale, brought her a contract from Fox. For the first years of her film career, she was cast in Fox's backstage musical pictures and given two or three song and dance numbers in each. Typical appearances include her "Nasty Man" accompanied by five tiers of Scan-dolls in the *Scandals* of 1934, "Oh, I Didn't Know," with five tiers of Scan-dolls in the *Scandals* of 1935, the fan dance, "Foolin' with the Other Woman's Man" from *Now I'll Tell* (1934), and the military tap stolen by Shirley Temple in *Poor Little Rich Girl* (1936). As she became a star, however, she was given more dramatic roles in backstage musicals based on the traumatic lives of the stars, such as *Alexander's Ragtime Band* (1938), *Rose of Washington Square* (1939), *Lillian Russell* (1940), and *Tin Pan Alley* (1940), all choreographed by Seymour Felix, *Hello, Frisco, Hello* (1943), and her last appearance, *State Fair* (1962).

Apart from her tap and soft-shoe skills and her ability to make dance steps in almost any costume graceful, Faye was memorable for a pose that she took in almost every film. When she was shown in tights, as happened frequently, she stood with her knees pressed together, balanced on her high-heeled feet.

Fazan, Eleanor, English theatrical dancer and choreographer and director; born May 29, 1930 in Kenya. Trained at the School of the Sadler's Wells Ballet, she performed in London's West End as a specialty dancer during the 1950s. Among the shows in which she performed were *High Spirits* (1953) and *Intimacy at 8:30* (1954), as well as London Hippodrome productions during those years.

Fazan has choreographed musicals and staged incidental dances for many English shows, including *The Lily-White Boys* (1960); *The Lord Chamberlain Regrets* (1961), *Lulu* (1970), and the play *Habeas Corpus* (1973). She has also directed many musicals and revues, among them the original production of *Beyond the Fringe* (1962) and operas at Covent Garden. She is also considered one of England's most prominent experts at staging operas for television broadcast.

Works Choreographed: THEATER WORKS: *The Lily-White Boys* (1960); *The Lord Chamberlain Re-*

grets (1961); *The Broken Heart* (1962); *Lulu* (1970); *The Beggars' Opera* and *The Threepenny Opera* (1972, in repertory); *Habeas Corpus* (1973); *Twelfth Night* (1974).

Federova, Nina, American ballet dancer; born April 24, 1958 in Philadelphia, Pennsylvania. After beginning her training at the School of the Pennsylvania Ballet, Federova moved to New York to study at the School of American Ballet.

An extraordinarily mature-seeming dancer with her long legs and majestic presence, Federova began dancing with the New York City Ballet as an adolescent, creating the title role in John Taras' *Daphnis and Chloe* for the Ravel Festival in 1975. She has been cast in roles that feature her length, expressive arms, and exceptional balance, such as "Sacred Love" in Frederick Ashton's *Illuminations,* "La Bonne Fée" in George Balanchine's *Harlequinade,* "Odette" in his one-act *Swan Lake,* and the first movement of his *Brahms-Schoenberg Quartet,* and Jerome Robbins' finale to *Tricolore,* playing "Marianne," the symbol of the French Revolution.

Federova, Sophia, Russian ballet dancer; born September 28, 1879, possibly in Moscow; died January 3, 1963 in Paris. Trained at the Moscow School of the Imperial Ballet, she joined the Bolshoi Ballet in 1899. In that company until 1919, she was best known for her character roles in Alexander Gorski's revivals of the Petipa repertory, including the title roles in his *Esmeralda* and *La Fille du Pharon,* and principal parts in his *Don Quixote* and *The Goldfish.* Federova also danced in the early productions of works by Mikhail Fokine, notably his *Cléopâtre* and *Prince Igor.* She performed with Anna Pavlova's company in the 1920s before retiring in Paris.

Federovitch, Sophie, Russian theatrical designer; born December 15, 1893 in Minsk, died January 25, 1953 in London. After emigrating to England in 1920, she became associated with the works of Frederick Ashton, for whom she designed her first ballets from 1926 to 1947. Among her works for him were *A Tragedy of Fashion* (1926), *Mephisto Valse* (1934), *Nocturne* (1936), *Horoscope* (1938), *Dante Sonata* (1940), *Valses Nobles et Sentimentales* (1947), and

Symphonic Variations (1946). Her costumes for the latter are still considered among the best ballet designs of the century; they are simple, draped tunics, but each is individual enough to differentiate the three ballerinas. Federovitch also designed costumes for Andrée Howard's *La Fête Etrange* (1940) and *Veneziana* (1953, posthumous), and for many operas of the 1940s.

Fedicheva, Kaleria, Soviet ballet dancer working in the United States after 1975; born July 20, 1936 in Ust-Ijory. Fedicheva was trained at the Choreographic Institute of nearby Leningrad and became a member of the Kirov Ballet in 1955. Although celebrated for her ''Odette/Odile,'' she was best known for her work in the contemporary repertory, with roles in Igor Belsky's *Leningrad Symphony,* Konstantin Sergeyev's *The Distant Planet* and *Hamlet* (1970), Oleg Vinogradov's *Prince of the Pagodas* (1972), and Boyarsky's *Orestei* (1968).

Fedicheva emigrated to the United States in 1975. She staged a production of the third act of *La Bayadère* for the U.S. Terpsichore in that year, but has not been able to exploit her status as a defector to achieve the publicity of other former Soviet dancers.

Feigenheimer, Irene, American modern dancer and choreographer; born June 16, 1946 in New York City. Feigenheimer's actress-mother, a former student of Mary Wigman in Germany, suggested that she train under Hanya Holm in New York. She later added to her technical studies with classes from Martha Graham, Merce Cunningham, and the staff of the Metropolitan Opera Ballet School. Active in the late 1960s and 1970s, she has appeared in the concert groups of many contemporary choreographers, among them Anna Sokolow, Don Redlich, for whom she danced in *Patina Rota* (1975) and *Three Bagatelles,* Cliff Keuter, with whom she worked in *The Game Man and the Ladies* (1969), and Kathryn Posin, for whom she performed in *The Closer She Gets . . . The Better She Looks* (1968). Feigenheimer has worked in collaboration with Barbara Roan and Antony La Giglia—choreographing works with them, including the *Continuing Dance Exchange* (1973) and appearing in their own pieces.

Feigenheimer's own choreography uses a light sense of comedy and characterization with a process of repetition, an important thematic technique of contemporary postmodern dance works. She creates solos, many duets, and small group works for her excellent company, that has become very popular with audiences and critics alike.

Works Choreographed: CONCERT WORKS: *Micromaze* (1969); *Won't* (1972); *Solo* (1972); *Especially* (1972); *Parts Particles* (1972); *The Continuing Dance Exchange* (1973, in collaboration with Barbara Roan and La Giglia); *True Spirits* (1973, in collaboration with Roan and La Giglia); *45 Seconds to Spring: 15 Seconds to Winter* (1973, in collaboration with Roan); *Clearing: 1 a.m.* (1973, in collaboration with Raon and La Giglia); *Untitled Dance for Five Women* (1974); *Stages* (1974); *Dance for Four* (1975); *Travelin' Pair* (1975); *Later Dreams, Part I* (1975); *Piano Solo* (1976); *Later Dreams, Part II* (1976); *Later Dreams, Part III and IV* (1977); *Preparations* (1978); *Time Still* (1977); *Weave* (1979); *Visitors* (1979); *Inside a Whisper* (1979); *Goings* (1979); *Arena* (1979); *Red and White* (1980); *Homage* (1980).

Feld, Eliot, American ballet dancer and choreographer; born 1943 in Brooklyn, New York. Feld received his early ballet training at the School of American Ballet and, at eleven, appeared in the title role of George Balanchine's *The Nutcracker* in its first season. He also appeared as a child in the musical *Sandhog,* staged by Sophie Maslow, and with the Pearl Lang Company as an adolescent, while attending the High School of Performing Arts.

Feld joined American Ballet Theatre in 1963, dancing with that company until 1970. Then the best known of their choreographers-in-residence, he staged three celebrated works for the company, *Harbinger* and *At Midnight* (1967), and *Intermezzo* (1969), before starting his own troupe, The American Ballet Company.

For that group, which lasted until c.1973, Feld staged further works, the best received of which were *The Consort* (1970) and *The Gods Amused* (1971). Following the dissolution of that group and a brief return to ABT, he began a new company—The Eliot Feld Ballet in 1974. One of the most successful of the

New York–based small companies, the Feld Ballet performed at The Public Theater until 1979 and is renovating a movie house as its permanent home. Performing only rarely in his own works, Feld is nevertheless famous as a dancer for two featured parts—the series of duets in *Intermezzo* (1969) in which he tosses, catches, and generally plays with his partner Christine Sarry, and the crook dance in *A Footstep of Air* (1977).

Works Choreographed: CONCERT WORKS: *Harbinger* (1967); *At Midnight* (1967); *Meadow Lark* (1968); *Intermezzo* (1969); *Cortège Burlesque* (1969); *Pagan Spring* (1969); *Early Songs* (1970); *A Poem Forgotten* (1970); *Cortège Parisien* (1970); *The Consort* (1970); *Romance* (1971); *Theater* (1971); *The Gods Amused* (1971); *A Soldier's Tale* (1971); *Eccentrique* (1971); *Winter's Court* (1972); *Jive* (1973); *Tzaddik* (1973); *Sephardic Song* (1974); *The Real McCoy* (1974); *Mazurka* (1975); *Excursions* (1975); *Impromptu* (1976); *Variations on "America"* (1977); *A Footstep of Air* (1977); *Sante Fe Saga* (1977); *La Vida* (1978); *Danzano Cubano* (1978); *Half-Time* (1978); *Papillon* (1979); *Circa* (1980); *Anatomic Balm* (1980); *Scenes for the Theater* (1980).

Felix, Spanish dancer known for his participation in a production of the Diaghilev Ballet Russe; born Felix Fernando Garcia, c.1896; died 1941 in Epsom, England. Trained in the folk dances of Andalusia, Felix was a popular entertainer in Seville when he was discovered by Serge Diaghilev. The great impresario engaged him to coach Leonid Massine in the correct dance style for his new *Le Tricorne*. According to legend, he was so incensed that Massine, and not he, performed in the central role of the ballet that he went mad and was institutionalized.

It is likely that, as with Vaslav Nijinsky, the cause of his insanity will never be known and that the incident that caused its outbreak was a very late cause. Among the many dramatizations of his story is Doris Humphrey's *Felipe El Loco* (1955), created for José Limón and his company, and revived for his students at the Juilliard School in 1967.

Felix, Seymour, American theater and film dance director; born 1892; died March 16, 1961 in Los Angeles. Felix, who did not have formal dance training, made his professional debut in the child vaudeville imitation act, Felix and (Amalia) Caire, in 1907. Protégés of Ad. Newberger, they appeared in *The Mimic World* (1908) and on the Keith vaudeville circuit until 1911.

From 1918 to 1928, Felix worked as a choreographer of revues and musical comedies on Broadway. A member of the group of young choreographers known as The Big Four (Busby Berkeley, Bobby Connolly, Felix, and Sammy Lee), he staged shows for Al Jolson (*Big Boy*, 1925), Marilyn Miller (*Rosalie*, 1928), and Eddie Cantor (*Whoopee*, 1928), among many others.

Felix was the first of The Big Four to start working in film after the beginning of the sound era. He was hired by Fox Films in 1929 as Studio Dance Supervisor; his first solo credit was as dance director of *Sunny Side Up* (Fox, 1929), considered the first musical comedy written specifically for the screen. He worked as a staff director for Paramount and MGM during the 1930s, before returning to Twentieth-Century Fox, where he remained until his retirement in the mid-1950s. Although he staged a wide variety of films, he was best known for his backstage period musicals, among them *The Great Ziegfeld* (MGM, 1936), *Alexander's Ragtime Band* (Twentieth-Century Fox, 1938), and screen biographies of Lillian Russell in 1940 and Anna Held in 1953 for Fox.

Before retirement, Felix worked briefly in early television variety shows, notably the *All-Star Revue* series for NBC.

Works Choreographed: THEATER WORKS: *Some Night* (1918); *Top Hole* (1924); *The Ritz Revue* (1924); *Artists and Models of 1924* (1924); *Big Boy* (1925); *Sky High* (1925); *Gay Paree* (1925); *June Days* (1925); *Hello, Lola* (1926); *Naughty Riquette* (1926); *Peggy-Ann* (1926); *Hit the Deck* (1927); *Rosalie* (1928); *Whoopee* (1928); *Strike Me Pink* (1933).

FILM: *Sunny Side Up* (Fox Films, 1929); *Fox Movietone Follies* (Fox Films, 1929–1931 series of two-reel short subjects); *Stepping Sisters* (Fox Films, 1931, also directed); *Dancing Lady* (MGM, 1933); *Hollywood Party* (MGM, 1934); *The Girl Friend* (Columbia, 1935); *The Great Ziegfeld* (MGM,

1936); *Vogues of '38* (Twentieth-Century Fox, 1937); *On the Avenue* (Twentieth-Century Fox, 1937); *Alexander's Ragtime Band* (Twentieth-Century Fox, 1938); *Broadway Serenade* (MGM, 1939, co-choreographed with Busby Berkeley); *Rose of Washington Square* (Twentieth-Century Fox, 1939); *Lillian Russell* (Twentieth-Century Fox, 1940); *Tin Pan Alley* (Twentieth-Century Fox, 1940); *Yankee Doodle Dandy* (WB/First National Pictures, 1942, co-choreographed with John Boyle and LeRoy Prinz); *Atlantic City* (Republic, 1944); *Cover Girl* (Columbia, 1944, co-choreographed with Jack Cole, Gene Kelly, and Val Raset); *Mother Wore Tights* (Twentieth-Century Fox, 1947); *The I Don't Care Girl* (Twentieth-Century Fox, 1953).

TELEVISION: *All-Star Revue* (NBC, 1952).

Fenley, Avril Molissa, American postmodern dancer and choreographer; born November 15, 1954 in Las Vegas, Nevada. Like many of her colleagues in what is now being called the second generation of postmodern choreographers, she did not apprentice with a traditional or postmodern dancer or company. She began her training at Mills College, traditionally a center of dance education, in Northern California. Fenley works in the mode of pattern choreography, manipulating rhythmic repetitive phrases of motion and sound. Although the structures of her rhythms as heard are surprisingly straightforward—frequently series of beats in 8 arranged in an ABA format—her visual patterns are extremely complex. She frequently uses performance sounds as her score, miking the footsteps of her dancers and, in the first movement of *Mix* (1979), employing a tape delay to augment the rhythms. The scenic conception of each work is unique, adding to her reputation as one of the most important choreographers of her generation.

Works Choreographed: CONCERT WORKS: *Planets* (1978); *The Willies* (1978); *Planets (II)* (1978); *The Cats* (1978); *Red Art Screen* (1979); *Video Clones* (1979); *Mix* (1979); *Boca Raton* (1980); *Energizer* (1980).

Fenonjois, Roger, French ballet dancer; born 1920 in Paris. Fenonjois was trained at the school of the Paris Opéra Ballet under Gustave Ricaux. A member of the company since the late 1930s, he performed in principal roles in Albert Aveline's revival of *Les Deux Pigeons*, the company's productions of the classics, and Serge Lifar's *Le Chevalier et la Demoiselle*, among other works. His exceptional elevation made him a popular guest artist and partner with European ballet companies and concert groups, notably with Renée Jeanmaire's 1943 appearances. He was also a frequent visitor to South America where he settled in 1949 as ballet master of the Montevideo Opera Ballet. Although he has returned to Europe to work, most recently in the 1952–1953 attempt to revitalize the Grand Théâter de Bordeaux, he has spent most of his professional time in Lima, Peru, where he has taught since 1958.

Fernandez, Royes, American ballet dancer; born July 15, 1929 in New Orleans, Louisiana; died March 3, 1980 in New York City. He studied ballroom dance with his father and ballet with Lelia Haller, performing in her New Orleans Opera and Foxhole Ballet. After spending summers in New York at the School of American Ballet, he moved here permanently in 1946 to study with Vincenzo Celli.

Celebrated as a considerate partner and bravura technician, he performed in European companies based in New York for the first five years of his professional life. From 1946 to 1951, he danced with the De Basil Ballet Russe, in John Taras' *Camille* (1946) and the company's productions of *Aurora's Wedding* and *The Nutcracker*, in the (Alicia) Markova/(Anton) Dolin Ballet, with the Ballet Alicia Alonso, partnering her in *Spectre de la Rose, Les Sylphides*, and *Giselle*, in the Ballet du Marquis de Cuevas, and in Mia Slavenska's Ballet Variante, as her *danseur noble*.

Although he constantly toured and guested, Fernandez was a popular and valuable member of Ballet Theatre from 1951 until his retirement in 1973. Noted for his performances in the male principal roles in the company's versions of *Giselle, Swan Lake, La Sylphide, Les Sylphides* and *Petroushka*, he was equally at home with new ballets. He danced in Antony Tudor's comedies, such as his *Gala Performance*, and in the romantic tragedy, *Jardin aux Lilas*, as "Her Lover." He was chosen to perform in the company premieres of Kenneth Macmillan's *Journey* and *La Hermanas*, José Limón's *The*

Moor's Pavanne, Birgit Cullberg's *Lady from the Sea*, and Herbert Ross' *Concerto* (1958) and *Paean* (1958); his last major part in the Ballet Theatre repertory was a principal role in a new work, Dennis Nahat's *Mendelssohn Symphony*. Among the companies with which he guest-performed were the Borovansky Ballet in Australia, Margot Fonteyn's tour group of the mid-1960s, Nora Kovach and Istvan Rabovsky's Hurok company of the late 1950s, and the London Festival Ballet.

After retirement, he taught ballet at the Arts Campus at Purchase, the State University of New York, until his death from cancer. Considered by many the greatest American *danseur noble*, he was a tremendous influence on his young colleagues at Ballet Theatre and on his students.

Ferrais, Amalia, Italian ballet dancer of the nineteenth century; born 1830 in Voghera; died February 8, 1904 in Florence. Trained by Carlo Blasis and a member of his "Pleiades de Danse," she made her debut at the Teatro Reggio in Turin in 1844.

After a season at Her Majesty's Theatre in London, performing Paul Taglioni's *Les Plaisirs de l'hiver* (1849), Ferrais returned to the Teatro Reggio with a new repertory learned in London. Her performance there in Jules Perrot's *Ondine* led to an engagement at the Paris Opéra that lasted for more than ten years. At the Opéra from 1856 to 1868, she was assigned the principal roles in Joseph Mazilier's *Marco Spada* (1857), Lucien Petipa's *Sacountala* and *Graziosa* (both 1861), and Hyppolyte Monplaisir's *La Camargo* (1868) and *Brahma* (1869). Ferrais retired at the end of the 1868–1869 season.

Ferrari, Martin, exhibition ballroom dancer working in London and New York; born c.1880, possibly in southern Russia; died May 18, 1927 in Westchester County, New York. Ferrari, who claimed to have been born in a resort in southern Russia, was raised in London where he first performed. Although he was originally a pantomime dancer, with specialties in annual Christmas and Easter productions in London, Blackpool, and Manchester, he became famous as an early exponent of exhibition ballroom and adagio forms. By the time that he made his American debut in 1908, he was known as "London's leading partner" and was billed as the introducer of adagio work. While in New York he taught exhibition forms to a variety of professional and amateur students, among them Maurice Móuvet, a Brooklynite who later became known as the epitome of the French Apache dancer. Ferrari returned to London to dance at the Alhambra, the city's foremost spectacle theater. He brought a young dancer from the Alhambra, Mme. Natalie (Dumond), with him when he moved back to New York in 1914 and toured the United States with her for the next seven years. Their act included exhibition contemporary dances, such as the one-step, "exotic" specialties like the Habañera, and choreographed duets based on social forms, including their signature Phantasie Waltz and Hyacinth Trot. After Dumond's early death, he reverted to solo performing and was working as a combination specialty dancer and emcee at the Silver Slipper Club in New York when he died in 1927. Although little known by the pubiic, Ferrari was a favorite with the theatrical community, many members of whom had been coached by him in individual acts and social dance techniques.

Ferri, Olga, Argentinian ballet dancer; born 1928 in Buenos Aires. Trained by Esmee Bulnes at the Teatro Colón, she performed in her company as a child and grew up through the ranks. She was best known for her work in the principal roles in Bulnes' revivals of the Fokine repertory, including *Les Sylphides*, and of the classical ballets, among them *The Nutcracker, Swan Lake*, and *Coppélia*. In Europe from 1959 to 1962, she performed in the works of Jack Carter in many companies and media, including the Munich State Opera, Berlin State Ballet, and London Festival Ballet, as well as the German television film, *The Life and Loves of Fanny Elssler*. Ferri returned to the Teatro Colón in 1962 and after retiring from active performance, became director of the troupe. She also manages a studio in Buenos Aires and has staged the ballets of George Balanchine and Carter for her Argentinian company and students.

Fewster, Barbara, English ballet dancer and teacher; born in Bournemouth. Trained at the school of the Sadler's Wells Ballet, she spent much of her career performing with that company. She was assigned fea-

tured roles in the company's productions of the classics, and major parts in Mikhail Fokine's *Carnaval* and Ninette De Valois's *The Prospect Before Us.*

Fewster retired from performance to tour as ballet master of the Old Vic production of *A Midsummer Night's Dream* in 1954, and returned to London to become a teacher at the school of the Royal Ballet. She has served as principal of the school since 1960.

Field, John, English ballet dancer; born John Greenfield, October 22, 1921 in Doncaster, England. After early training at the Elliot Clark School in Liverpool and performances with the Liverpool Ballet Club, Field joined the Sadler's Wells Ballet in 1939.

Celebrated as a *danseur noble*, he performed in that company's productions of the classics of the ballet repertory, among them, *Swan Lake, Les Sylphides*, and *The Sleeping Beauty*, while creating roles in Frederick Ashton's *Scènes de Ballet* (1948), *Daphnis and Chloe* (1951), *Tiresias* (1951), and *Homage to the Queen* (1953).

Director of the Sadler's Wells company from 1956, Field was named co-director of the Royal Ballet in 1970. He left that position to work at La Scala in Milan (1971–1974), and on returning to England, is currently the administrator of the Royal Academy of Dancing.

Field, Ron, American theatrical dancer and choreographer; born 1934 in Queens, New York. Trained by his aunt, Stella Fields, and at the High School of Performing Arts, Field made his adult performing debut in *Gentlemen Prefer Blondes* (1949), choreographed by Agnes De Mille. He danced for Jack Cole in *Carnival in Flanders* (1953) and *Kismet* (1954) while in school.

After sharing a recital at the 92nd Street "Y," Field was invited to choreograph dances for an Off Broadway revival of Cole Porter's *Anything Goes.* The success of this production led to his Broadway shows, beginning with *Nowhere to Go but Up* (1962). He is best known for his work on two musicals— *Cabaret* (1966), for which he staged movement and the show-within-the-show, and *Applause* (1970), in which he directed the supposedly spontaneous dances for the chorus. Other productions for which his choreography was applauded include *Sherry* (1967), the

revival of *On the Town* (1971), *Zorba* (1968), and *King of Hearts* (1978). Field is also known as a successful doctor of shows in the last weeks before opening.

His non-Broadway activities include the staging of a wide variety of cabaret and nightclub acts, notably among them *AM/PM* (1971), Ann-Margaret's retrospective of theater history for Las Vegas, and *Pazazz '73*, produced at New York's Continental Baths. He choreographed dances for almost two dozen episodes of *The Ed Sullivan Show* (CBS, 1970–1971) and *Hollywood Palace* (ABC, 1967–1969), and many television specials, among them *The First Liza Minelli Special* (NBC, 1970) and the recent *Baryshnikov on Broadway* (CBS, 1980).

Works Choreographed: THEATER WORKS: *Anything Goes* (1962); *Riverwind* (1962); *Nowhere to Go but Up* (1972); *Café Crown* (1964); *Cabaret* (1966); *Sherry* (1967); *Zorba* (1968); *Applause* (1970); *On the Town* (1971, revival); *American in Paris* (1972, closed out of town); *King of Hearts* (1978); many packaged acts.

OPERA: *Ashmodai* (1976).

TELEVISION: *The First Liza Minelli Special* (NBC, 1970); *The Ed Sullivan Show* (CBS, 1970–1971); *Ed Sullivan's Broadway* (CBS, 1973, special); *Baryshnikov on Broadway* (CBS, 1980).

Fifield, Elaine, Australian ballet dancer performing in England for much of her career; born October 28, 1930 in Sydney, Australia. After local training with Elizabeth and Frances Scully, she accepted a scholarship to study at the Sadler's Wells school in 1946.

Fifield performed with the Sadler's Wells Theatre Ballet (renamed Sadler's Wells Ballet in 1955) from 1947 to 1958, creating a wide variety of roles and performing principal parts in *Les Sylphides, Coppélia, Swan Lake*, and *The Sleeping Beauty.* Among her best known roles were in works by Frederick Ashton, including his *Valses Nobles et Sentimentales* (1947), *Les Rendez-vous* (revival of 1933 work), *Madame Chrysanthème* (1955), and *A Birthday Offering* (1956). She created roles in John Cranko's *Pineapple Poll* (1951), *Pastorale*, and *Reflection* (both 1950), and in Andrée Howard's *Selina* (1948), playing the title part.

From 1964 to 1969, Fifield performed with the Australian Ballet in her native Sydney, with featured roles in Rudolf Nureyev's production of *Raymonda* and Peggy Van Praagh's revival of *Carnaval*.

Bibliography: Fifield, Elaine. *In My Shoes* (London: 1967).

Fiocre, Eugénie, French nineteenth-century ballet dancer; born July 2, 1845 in Paris; died there in 1908. Trained at the school of the Paris Opéra, Fiocre spent her performing career with the company.

Unlike most of the ballet dancers of the late Romantic era, Fiocre worked *en travestie*, playing male roles in ballets. She is best known for her creation of "Franz," the hero, or at least the partner of the heroine, in Saint-Léon's *Coppélia*, in 1870. Her other *travestie* roles include "Cupid" in *Néméa* (1864).

Fisher, Nelle, American modern ballet, theater, and television dancer and choreographer; born in the 1920s in Berkeley, California. Raised in Seattle, Washington, she was trained at the Cornish School by Sylvia Tell and Caird Leslie. After Martha Graham taught at the school, she moved to New York to work for her, dancing in *American Document* (1938) and *Every Soul Is a Circus . . .* (1939) among other works. In the mid-1940s, she shared a 92nd Street "Y" recital with Welland Lathrop, and also worked as a concert dancer in the early 1960s.

Fisher is best known, however, for her performances and choreography in theater and television. She danced in the Radio City Music Hall corps de ballet, performed in Agnes De Mille's *One Touch of Venus* (1943), and assisted De Mille on *Bloomer Girl*. Her featured dance specialty in the "Lonely Town" dream sequence in Jerome Robbins' *On the Town* (1944) led to engagements in *Make Mine Manhattan* (1948) and *The Golden Apple* (1954). She also worked at the Tamiment Camp, for Robbins and Danny Daniels, and in the Tamiris film, *Up in Central Park* (Universal, 1948). In the late 1950s, Fisher staged dances for *The Best of Burlesque* (1957, 1958), Russell Patterson's *Sketchbook of 1960*, and a revival of *The Golden Apple*.

On television, she appeared on the *Colgate Comedy Hour* (NBC, 1950-1955), *All-Star Revue* (NBC, 1950-1953), and *Your Show of Shows* (NBC, 1950-1954). She received choreography credits for *America Song* (NBC, 1948-1949), one of the first variety series, and *Melody Tour* (ABC, 1954-1955), an innovative series in which the songs and dance numbers were set in a different country each week.

Works Choreographed: CONCERT WORKS: *Period Piece* (1945, co-choreographed with Welland Lathrop); *Mad Maid's Lament* (1945); *Curley's Wife* (1945); *Tango* (1945); *El Pajarito* (1959); *The Reflections of Dobo* (1959); *Eine Kleine Nachtmusik* (1961); *Old American Song Suite* (1961); *Portraits in Pantomime* (1961); *The Comedians* (1961); *Petrouchka* (1961); *Carnival of Animals* (1961); *Concerto for Diverse Dancers* (1961).

THEATER WORKS: *Pierrot, the Prodigal* (1941, Charlestown, South Carolina); *The Best of Burlesque* (1957 and 1958 editions); Russell Patterson's *Sketchbook of 1960*; *The Golden Apple* (1962, revival).

TELEVISION: *America Song* (NBC, 1948-1949); *Melody Tour* (ABC, 1954-1955).

Fitzjames, Louise, French ballet dancer of the Romantic era; born Louise Fizan, December 10, 1809 in Paris; date and place of death cannot be verified. Trained by Auguste Vestris and Philippe Taglioni, who allowed her to share the private lessons that he gave his daughter, Marie, Fitzjames performed at the Paris Opéra from 1832 to 1846.

She replaced Marie Taglioni in the principal roles in *Robert le Diable* and *Le Dieu et la Bayadère* after the mid-1830s. Her created roles included featured parts in Philippe Taglioni's *La Revolte du Serail* (1836) and Albert's *La Jolie Fille du Gand*.

Fitzjames, Natalie, French nineteenth-century ballet dancer; born Natalie Fizan, 1819 in Paris; date and place of death cannot be verified. A protégé of Jean Aumer, Fitzjames was trained at the school of the Paris Opéra and performed with the company from 1837 to 1842.

Among her featured roles at the Opéra were the peasant pas de deux in the premiere of *Giselle* (1841), and a demicharacter part in Antonio Guerra's *Les Mohicans*, for her debut in 1837. She also performed in Aumer's *La Somnambule* and as "Fenella" in *La Muette di Portici*, her best known role.

She portrayed "Fenella," the foremost mime role in the Romantic repertory, frequently on tours of the United States and Italy. She also performed *Giselle* on her routes, becoming the first dancer to perform the role in Florence.

Fitz-Simons, Foster, American concert dancer; born c.1910 in Georgia. Fitz-Simons was trained by Phoebe Barr at the University of North Carolina and by Ted Shawn. He performed with Shawn's His Men Dancers company from 1934 to 1938, appearing in his *Sinhalese Devil Dance, Walk Together Children, The Camel Boys, Gothic,* and the three major works of the repertory—*Dance of the Dynamo* (1934), *Kinetic Molpai* (1935), and *Olympiad* (1936), a collective piece for which he choreographed his own solo, *Decathalon.* From 1939 to 1942, he toured South America and presented recitals with Miriam Winslow. Their best known works were *Landscape of Figures* (1940) and *Pavanes-Ancient, Romantic and Modern* (1941) which they co-choreographed, and his two liturgical solos, *Archangel: Michael the Watcher* and *Archangel: Lucifer the Fallen* (1940). Although, like so many later Shawn proteges, he did not become an important part of the dance world, it is believed that he remained involved in liturgical dance.

Works Choreographed: CONCERT WORKS: *Olympiad* (1936, Decathalon solo only); *On the Bayou* (1939); *Archangel: Michael the Watcher* (1940); *Archangel: Lucifer the Fallen* (1940); *Landscape with Figures* (1940, co-choreographed with Miriam Winslow); *Pavanes-Ancient, Romantic and Modern* (1941, co-choreographed with Winslow).

Flagg, Elise, American ballet dancer; born December 23, 1951 in Detroit, Michigan. Trained locally by William Dollar, Flagg continued her studies in his "alma mater," the School of American Ballet.

Dancing with the New York City Ballet throughout the late 1960s and 1970s, Flagg has been featured in George Balanchine's *Western Symphony,* in his *Ivesiana,* as the idolized figure in white, and *A Midsummer Night's Dream.* The Stravinsky Festival of 1972 brought her two major roles—the featured female part in Richard Tanner's *Octuor* and "The Mechanical Nightingale" in Taras' *The Song of the Nightingale.* With her sister, Laura, and Elyse and Bonita Borne, she danced in Balanchine's *Chaconne,* in the section added for her in 1976.

Flatt, Ernest O., American theatrical and television choreographer; born Ernest Orville Flatt, October 30, 1918 in Denver, Colorado. After local dance training, Flatt was drafted into the Army, in which he staged shows for a variety mobile unit, among them, *Five Jerks in a Jeep.* After his release he performed in a national touring company of *Oklahoma;* commuting between the coasts, he worked as an assistant to Robert Alton on *Me and Juliet* on Broadway (1953) and to Charles Walters in Hollywood.

Although Flatt has choreographed many successful Broadway musicals, among them, *Fade Out, Fade In* (1964) and the current *Sugar Babies* (1979), he is best known for his work on television variety shows. His troupe, The Ernie Flatt Dancers, has included many of television's and stage's best performers, among them, ballet dancers/company directors Ian Horvath and Richard Gain and choreographer Don Crichton. The troupe has been a staple on all shows featuring or produced by Carol Burnett since *The Garry Moore Show* (CBS, 1958–1962), on which both worked. Apart from the eleven-season *Carol Burnett Show* (CBS, 1968–1979), he has staged "Dances and musical numbers" for specials including *Carol and Company* (CBS, 1963), *Julie [Andrews] and Carol at Carnegie Hall* (CBS, 1965), *Julie and Carol at Lincoln Center* (CBS, 1971), and *Bubbles [Beverly Sills] and Burnett at the Met* (CBS, 1976).

Celebrated for the medley numbers that he stages for hour-long variety shows, Flatt's other seasonal assignments have included *Your Hit Parade* (NBC, 1954–1957), *The Garry Moore Show* (CBS, 1958–1962), *The Judy Garland Show* (CBS, 1963), *The Entertainers* (CBS, 1964–1965), and *The Steve Lawrence Show* (CBS, 1965). He also choreographed many of the Broadway musicals revised for television of the 1960s, among them *Kiss Me Kate* (NBC, 1960), *Calamity Jane* (CBS, 1964), *Annie Get Your Gun* (NBC, 1967), and *Damn Yankees* (NBC, 1968).

Works Choreographed: THEATER WORKS: *Fade Out, Fade In* (1964); *It's a Bird, It's a Plane, It's Superman* (1966); *Lorelei* (1973); *Sugar Babies* (1979).

FILM: *Anything Goes* (Paramount, 1956, dances for Mitzi Gaynor only).

TELEVISION: *Your Hit Parade* (NBC, 1954–1957); *The Garry Moore Show* (CBS, 1958–1962); *Kiss Me Kate* (NBC, 1960, special); *Julie and Carol at Carnegie Hall* (CBS, 1961); *Carol and Company* (CBS, 1963, special, also directed show); *The Judy Garland Show* (CBS, 1963); *Calamity Jane* (CBS, 1964, special); *The Entertainers* (CBS, 1964–1965); *The Steve Lawrence Show* (CBS, 1965); *Annie Get Your Gun* (NBC, 1967, special); *The Carol Burnett Show* (CBS, 1968–1979); *Damn Yankees* (NBC, 1968, special); *Julie and Carol at Lincoln Center* (CBS, 1971, special); *Bubbles and Burnett at the Met* (CBS, 1976, special).

Fleming, Bud, American theatrical dancer; born in the early 1940s in Buffalo, New York. Fleming first came to audience attention as a "Jet" in the London production of Jerome Robbins' *West Side Story* (1958) and returned to New York for roles in two popular successes and one fabulous flop—Gower Champion's *Bye Bye Birdie* (1960), Carol Haney's *Funny Girl* (1964, directed by Robbins), and *Breakfast at Tiffany's* (1966), which opened and quickly closed without a credited choreographer. Fleming also appeared as a partner of the June Taylor Dancers on *The Jackie Gleason Show*, as well as taking mime and comedy roles on that long-running television variety show.

In 1978 he was one of the dancers who came out of their new nontheatrical careers to appear in Michael Bennett and Bob Avian's choreography for the inhabitants and energy of the Stardust *Ballroom*.

Fleming, Una, American ballet and theatrical dancer; born c.1900 in the Los Angeles area of California. It is not known with whom Fleming studied before 1913 when Ernest Belcher opened his Celeste Studio in Los Angeles. She performed for him in pageants, Cecil B. De Mille films, and his school recitals before beginning a vaudeville tour from Los Angeles to New York. Despite her Belcher ballet training, Fleming worked primarily as an interpretive dancer in vaudeville and on Broadway. Her specialty dance in *The Velvet Lady* (1919) was described in a trade magazine as being "fashioned entirely of chiffon and grace," while her feather dance in *The Midnight Rounders* (1921) was considered the high point of the season for its "artistic skill and sensibility." Fleming also toured in a duet act with Joe Wilmot Niemeyer in exhibition ballroom and adagio dances in the 1920s.

Fletcher, Graham, English ballet dancer; born in the mid-1950s in Bolton, Lancashire. After local training, Fletcher became a student at the Royal Ballet School in London in 1963. He joined the company in 1968 and has performed with the senior or touring groups ever since. He is one of the young principals trained to dance with equal skill and dramatic validity in revivals of the nineteenth-century classics, the British company's own classics from the 1930s and 1950s, and in the modern repertory. In each category, he seems able to perform in a wide variety of roles—as the "Bluebird" or "Hop O'My Thumb" in *The Sleeping Beauty*, for example. He has created roles in many of the recent full-length plotted ballets by Kenneth Macmillan, including his *Mayerling* (1978) and *Isadora* (1980) and has danced in his *Anastasia*, and in Frederick Ashton's *The Dream, Daphnis and Chloe, Enigma Variations, A Wedding Bouquet*, and *A Month in the Country*. Other credits include parts in Robert Helpmann's *Hamlet*, Antony Tudor's *Dark Elegies*, and Jerome Robbins' *The Concert*.

Fletcher, John, British ballet dancer; born December 21, 1950 in Masjed-de-Sullimain, Persia. Trained at the Arts Education Trust School, he danced with the London Festival Ballet, Northern Dance Theatre, and Scottish Theatre Ballet briefly before joining the New London Ballet in 1971. He was associated with the new works by Jonathan Thorpe, John Chesworth, and Laverne Meyer in the Northern and New London companies, creating roles in Thorpe's *Tancredi and Clorinda* (1970) and Chesworth's *Games for Five Players* (1971) and in Meyer's *Schubert Variations* (1973) and *Cinderella* (1973). He also appeared in Peter Darrell's *Othello* for the Scottish Ballet. Fletcher retired from performance in 1974.

Fletcher, Tom, American popular entertainer and dancer; born May 16, 1873 in Portsmouth, Ohio;

died October 12, 1954 in New York City. After making his theatrical debut as a standby in a local performance of a traveling production of *Uncle Tom's Cabin*, in 1888, he joined Howard's Novelty Colored Minstrels as a boy vocalist, touring around Ohio, Virginia, West Virginia, and Kentucky. Although laid off after his voice changed, he returned to the stage in 1898 in *In Old Kentucky*, another traveling show. He was a vocalist, bass drummer, and dancer in Prof. J.H. Bruster's Georgia Minstrels in 1897, on the largest Southern circuits.

Although he returned to his career as a percussion instrumentalist at various times during his long life, he concentrated on dancing in the first years of the century, alternating among Minstrel tours and productions by Percy G. Williams, among them *Bergen Beach* (1898) and *Rabbit Foot* (1899–), and single-reel films with his partner, Al Bailey. He worked with Bailey on the Keith vaudeville circuit until 1907 but left to teach social dance. Fletcher returned to dance in the mid-1910s with a new partner, Abbie Mitchell. They performed together in their own act and with the New York Syncopated Orchestra, directed by her husband, celebrated composer Will Marion Cook.

After a successful career as a musician, Fletcher made his Broadway debut in 1944 in the Olsen and Johnson comedy revue, *Laffing Room Only*. He later coached ragtime dance and percussion technique in New York, working with, among other organizations, the Katharine Dunham Company.

Bibliography: Fletcher, Tom. *100 Years of the Negro in Show Business* (Albany, N.Y.: 1954, published posthumously).

Flexmore, Richard, English pantomine performer and choreographer; born 1825, possibly in London; died there in 1860. A child "Harlequin" from the age of five, he made his adult debut as "The Clown" in *The Temple of Happiness* (1849), to John Paul Bologna's "Pantaloon" and his father, Pietro Bologna's, "Harlequin." From that year until the autumn of 1852, he performed at and served as ballet master for Charles Kean's Princess Theatre in London. He staged dances and pantomime action for harlequinades, pantomimes, and dramas, among them *The Corsican Brothers* (1852) and Dion Boucicaut's *Vampire* (1852). Although he performed in harlequinades

for at least two seasons after leaving the Princess, he had begun to suffer from the tuberculosis that would kill him at the age of thirty-five.

Flexmore's "Clown" was unique since he combined the traditional *commedia* actions with imitations of his contemporary actors and dancers. He did satires of everyone from Joseph Grimaldi to Jules Perrot and integrated them into his pantomimes and harlequinades. Although best remembered for his Hornpipe, he was cast in at least two Charles LeClerq ballets, partnering his daughter Charlotte LeClerq, or Mde. Auriol, in the "Fairy-land" sequences of three pantomimes.

Works Choreographed: CONCERT WORKS: *Les Patineurs* (1849); *Dancing Mad* (1849).

THEATER WORKS: *King John, or Harlequin and the Magic Fiddle* (1849); *Queen of the Roses* (1850); *The Calife's Choice* (1850); *Alonzo the Brave, and the Fair Imogene* (1850); *The Alhambra, or the Three Beautiful Princesses* (1851); *Harlequin Billy Taylor, or the Flying Dutchman and the King of Raritania* (1851); *The Corsican Brothers* (1852); *Witikind and His Brothers* (1852); *Vampire: A Phantasm* (1852).

Flier, Frieda, American modern dancer; born c.1916 possibly in New York City. Flier studied dance with Blanche Talmud and Martha Graham at the Neighborhood Settlement, joining the Graham company in 1936. She appeared in Graham's works in concert and at the early Bennington School of the Dance sessions. Among the many works in which she performed were *Chronicle, American Lyric* (1937), *American Document* (1938), *Every Soul Is a Circus . . .* (1939), and *Letter to the World* (1940).

In line with a linkage between the Graham company and the Ballet Caravan (through the companies' mutual manager), she left the modern dance company to join Dance Players, a short-lived troupe of former Caravan performers Eugene Loring, Lew Christensen, and Michael Kidd, among others. She appeared most prominently in Loring's *Man from Midian*. Flier worked as an actress through the 1940s but returned to the dance briefly in 1954 by appearing in the film *Specter of the Rose* (Republic).

Flier, Jaap, Dutch ballet dancer and choreographer; born February 27, 1934 in Scheveringen, the Nether-

lands. Trained by Sonia Gaskell, he performed with her Ballet Recitals and Netherlands Ballets in the 1950s, with featured roles in John Taras' *Scènes de Ballet* and David Lichine's *The Prodigal Son.*

As a founding member of the Netherlands Dance Theatre, he created roles in many works by Glen Tetley, among them *The Anatomy Lesson* (1964) and *Arena* (1969), and in his own ballets. He served as artistic director from 1970 to 1973 before emigrating to Australia to direct the Dance Theatre there. Considered one of the finest dancers in the Dutch ballet, he frequently partnered his wife, Willy de la Bije, in his ballets and in the repertory of classical pas de deux.

Works Choreographed: CONCERT WORKS: *Het Proces* (1955); *De Mantel* (c.1955); *Moutore* (1956); *Peripetaia* (c.1960); *Nouvelles Aventures* (1969); *Hi-Kyo* (1971); *Elkesis* (1973); *Four Stages* (1974); *Frames, Pulses and Interruptions* (1977); *Echoi* (1979); *Episode I* (1980).

Flindt, Flemming, Danish ballet dancer and choreographer; born June 30, 1936 in Copenhagen, Denmark. Trained at the school of the Royal Danish Ballet, he graduated into the company in 1955. Among his principal roles in the company repertory were "Benvolio" in Frederick Ashton's *Romeo and Juliet,* "Nilas" in Birgit Cullberg's *Moon Reindeer,* "Don Jose" in Roland Petit's *Carmen,* and "James" in the revival of Bournonville's *La Sylphide.*

He freelanced extensively in the early 1960s, and danced with the Paris Opéra in Harald Lander's *Etudes* and Serge Lifar's *Sur un Theme* and *Les Mirages,* with the London Festival Ballet, in *Coppélia* and Anton Dolin's *Variations for Four* (1958), and with Ruth Page's company in Chicago, in her *The Merry Widow.* Returning to the Royal Danish Ballet as director in 1966, he has choreographed for that company, for the Metropolitan Opera in New York, and for Danish television. Among his best known works are *The Three Musketeers* (1966), *The Miraculous Mandarin* (1967), *Summer Dances* (1971), *Felix Luna* (1973), and *Dreamland* (1974).

Considered one of the most innovative of the younger Danish choreographers, Flindt has been able to balance his concepts of contemporary repertory with the popular Bournonville revivals that make up so much of the company's training and performance.

Works Choreographed: CONCERT WORKS: *The Three Musketeers* (1966); *The Miraculous Mandarin* (1967); *Tango Chicane* (1968); *Swan Lake* [*Act II*] (1969); *Summer Dances* (1971); *The Four Seasons* (1971); *The Nutcracker* (1971); *Triumph of Death* (1972); *Trio* (1973); *Jeux* (1973); *Felix Luna* (1973); *Dreamland* (1974); *Toreadoren* (1978, after Bournonville); *Salome* (1979).

THEATER WORKS: *The Gorgeous Bitch* (1976); *Wonderful Women* (1976).

TELEVISION: *La Leçon* (Danish television, 1963); *Le Jeune Homme à Marier* (Danish television, 1965).

Flindt, Vivi, Danish ballet dancer; born Vivi Gelker, February 22, 1943 in Copenhagen. Trained at the school of the Royal Danish Ballet, she graduated into the company in the mid-1960s. She is best known for her performances in the ballets by her husband, Flemming Flindt, among them *The Miraculous Mandarin* (1967), *Tango Chicane* (1967), *Sacre du Printemps* (1968), *Trio* (1973), and *Felix Luna* (1973), but has also danced in the company productions of the nineteenth-century classics and created the title role in Murray Louis' *Cléopâtre* in 1976.

Florodora Sextette, American six-woman chorus of the early 1900s. The musical comedy *Florodora* was written by Leslie Stuart, Ernest Boyd-Jones, and Paul Rubens from a sentimental book by Owen Hall. A year and a day after its London opening, Tom Ryley and John C. Fisher presented it at the Casino Theater, New York. During the New York production, six men and six young women took the stage to sing "Tell Me Pretty Maiden, Are There Anymore at Home Like You?" These women became known as the Florodora Sextette, the idols of New York and the epitome of chorus girls. Although many women claimed to have been in the original Sextette, the actual six were (in order of appearance from stage-right to left) Marie Wilson, Agnes Saye Wayburn, Marjorie Relyea, Vaughan Texsmith, Daisy Green, and Margaret Walker. Each of them was in her early twenties, a brunette or red-head, and an experienced chorus dancer and singer. Relyea, for example, had been acclaimed for her work in *Hotel Topsy-Turvy*

(1898) and *Mamzelle 'Awkins* (1900), while Saye Wayburn had toured with a solo dance-and-electrical-effects act staged and designed for her by her then-husband, Ned Wayburn.

The Florodora Sextette was best known, however, for nonprofessional reasons. The six were celebrated for their marriages to so-called millionaires, although two, Relyea and Texsmith, became wealthy on their own through management of their businesses. Many members of other choruses in the original or replacement casts of the New York *Florodora* also became known for nontheatrical events, among them two genuine future peeresses (Camille Clifford and Frances Belmont) and two who were memorable for their participation in murder trials (Evelyn Nesbit and Nan Patterson).

Flory, Regine, French interpretive dancer; born July 24, 1894 in Marseilles; died June 17, 1926 in Paris. If Flory had formal training in dance, she did not admit to it. Like so many interpretive dancers of the period, she claimed to have been directly inspired by nature and classical works of art.

In her short career, Flory performed mostly within French revues produced in Paris and London. Between *Avec le Sourire* (1911) and *Tu peux y aller* (1921) she was in eleven shows. Billed as "The Girl of the Golden Dress" in London, her best known specialty act was billed as *The Bas Relief*. In it she performed a *pas de Châle* with her cloth of gold skirt and shawl against a gilt background so that she seemed to blend into the backdrop and appear as a figure sculpted into it. Surprisingly, her act involved acrobatic movements on a much larger scale than most interpretive dancers. So large were her body and skirt manipulations that one could suspect that she had been influenced by Loïe Fuller.

Fokina, Vera, Russian ballet dancer; born Vera Antonova, August 3, 1886 in St. Petersburg; died July 29, 1958 in New York City. Trained at the St. Petersburg School of the Imperial Ballet, she joined the Maryinsky Ballet in 1904. She was associated throughout her professional career with the works of Mikhail Fokine, to whom she was married in 1905.

She performed in his works in student concerts in St. Petersburg, with the Maryinsky, with the Diaghilev Ballet Russe, with their concert companies in the United States and in a single solo recital in 1922. Among the hundreds of Fokine works in which she was applauded around the world were his *Schéhérézade, Daphnis and Chloe, The Dying Swan, Narcisse, Carnaval* (1910), *Firebird* (1910), and her best known solo, *The Thunderbird* (1922).

Fokine, Mikhail, Russian ballet dancer and choreographer who was highly influential in the development of so-called modern ballet in England and the United States; born April 26, 1880 in St. Petersburg; died August 22, 1942 in New York. Fokine was trained at the school of the Imperial Ballet in St. Petersburg by Platon Karsavin, Pavel Gerdt, and Nicolas Legat. Although he made the conventional debut at the Maryinsky Theatre, in the pas de quatre from *Paquita* by Petipa after Mazilier, he was soon assigned to teaching at the school from which he had graduated. He choreographed his first works for student performances, among them *Acis et Galatée* (1905), incidental dances to *A Midsummer Night's Dream* (1906), and *Le Gobelin Animée* (1907). Other works were created for charity performances, including *La Vigne* (1906), *Eunice* (1907), *The Dying Swan* (1907), and the first version of *Chopiniana* (1907).

Engaged by Diaghilev as his principal choreographer in 1909, he produced on commission the *Polovtzian Dances* and *Cléopâtre* (a revision of *Une Nuit d'Egypte*) and revived *Le Pavillon d'Armide* and a new version of *Chopiniana* retitled *Les Sylphides* for the French audience. He provided most of the Diaghilev ballet and opera dance repertory until 1914, when he quarreled with Diaghilev and left the company. During that tenure, he had produced more charity divertissements and had created works for Anna Pavlova, but his reputation rested in his ballets for Diaghilev.

From 1919, much of his work consisted of staging incidental dances for theatrical productions—whether it was his decision or the producers' requests is not known, but most of his work after that year seems to consist of remakes of *Schéhérézade, Les Sylphides,* and *Le Gobelin Animée.* There is one very interesting element in his theatrical works: although Fokine was considered the king of contention and the choreographer most likely to sue for additional

credit, he not only didn't object when Gertrude Hoffmann produced *Schéhérézade* and a Theodore Kosloff staging of the first *Chopiniana,* he actually choreographed other works for her later in their careers, among them, *Shaitan* (1921), ballets for *Hello Everybody* (1923), and *Santa Claus* (1923). Her co-producer, Morris Gest, was the producer of record and recognized sponsor of his later Broadway productions, including the famous *Aphrodite* (1919) and *Mecca* (1920). Fokine also staged ballets for the 1923 *Ziegfeld Follies* and for a London production of *A Midsummer Night's Dream* in 1924.

Those ballets of Fokine that are known date from his Diaghilev tenure; the later works seem to be saccharine from photographs and descriptions, but cannot be judged without more evidence. Many of the Ballet Russe works, however, are timeless and can be criticized on any period's merits. He set up his own critical standard in many statements, the most straightforward of which was published in a letter to *The* [London] *Times* in July 1914. The five principles stated there decry the old, Petipa styles of mise-en-scène and demand meaningful movement within the dance sequence and in background action, logically structured plots with only as much connective mime as necessary and more expressive links among dance and music and the other arts. His best interpreters were Ballet Russe dancers Tamara Karsavina, Adolf Bolm, Vaslav Nijinsky, and his wife, Vera Antonova Fokine, who created roles in most of his later works.

It is unfortunate that many students know Fokine only by his written theories and by his prejudices against other forms of dance. He genuinely disliked the works of Martha Graham and Mary Wigman and spoke out against what he considered an inartistic, badly constructed art. This position damaged his influence in the United States, which is less now than in England. Many dancers, however, were trained by him in New York, among them concert dancer Pauline Koner and theatrical ballet dancers Martha Lorber, Margaret Severn, Desha, and Claire Luce.

Works Choreographed: CONCERT WORKS: (Note: this list has been compiled with suggestions from Dawn Lille Horowitz.) *Acis et Galatée* (1905); *A Midsummer Night's Dream* (1906); *La Vigne* (1906); *Eunice* (1907); *Chopiniana (I)* (1907); *Le Gobelin Animée* (1907); *Le Pavillon d'Armide* (1907); *The Dying Swan* (1907); *Une Nuit d'Egypte* (1908); *Chopiniana (II)* (1908); *Les Quatre Saisons* (1908); *Le Bal Poudré* (1908); *Polovtzian Dances* (1909); *Cléopâtre* (1909, revision of *Une Nuit d'Egypte); Carnaval* (1910); *Schéhérézade* (1910); *l'Oiseau Feu* (1910); *Sadko* (1911); *Narcisse* (1911); *Spectre de la Rose* (1911); *Petrouchka* (1911); *Le Dieu Bleu* (1912); *Thamar* (1912); *Daphnis et Chloe* (1912); *Le Rêve* (1913); *Papillon* (1913); *Islamey* (1913); *Les Préludes* (1913); *Seven Daughters of the Mountain King* (1913); *La Légende de Joseph* (1914); *Midas* (1914); *Le Coq d'Or* (1914); *Francesca da Rimini* (1915); *Stenka Razin* (1915); *Eros* (1915); *Jota Aragonese* (1916); *The Sorcerer's Apprentice* (1916); *Les Quatre Saisons (II)* (1918); *The Moonlight Sonata* (1918); *Le Rêve de la Marquise* (1921); *Medusa* (1924); *Les Elfes* (1924); *Olé Toro* (1924); *Fra Mino* (1925); *Prologue to Faust* (1927); *Psyche* (1935); *Mephisto Valse* (1935); *Diane* (1935); *La Valse* (1935); *Bolero* (1935); *l'Epreuve d'Amour* (1936); *Don Juan* (1936); *Les Eléments* (1937); *Le Coq d'Or (II)* (1937); *Cendrillon* (1938); *Paganini* (1939); *Bluebeard* (1941); *The Russian Soldier* (1942); *Helen of Troy* (1942, choreography completed by David Lichine).

THEATER WORKS: *La Pisanelle* (1913, Paris); *Aphrodite* (1919); *Mecca* (1920); *Thunderbird* (in *Get Together*) (1921); *Shaitan* (1921, dance number for Gertrude Hoffmann); *Russian Toys* (1922, dance number for Gilda Gray); *Adventures of Harlequin* (1922, for Prolog at the Mark Strand Theatre); *Hello Everybody!* (1923, ballet sequence only); *Johanne Kresiler* (1923, incidental dances in play); *The Ziegfeld Follies of 1923* (1923, Farljando and Frolicking Gods only); *Hassan* (London, 1923); *The Return from the Carnaval* (1923); *Santa Claus* (1923, dance number for Gertrude Hoffmann); *Sweet Little Devil* (1924, interpolated dances in play); *A Midsummer Night's Dream* (1924, incidental dances in play); *The Immortal Pierrot* (1925, dance number for Martha Lorber).

Bibliography: Fokine, Mikhail. *Memoirs of a Ballet Master* (Boston: 1961).

Folett, John, The Younger, English eighteenth-century dancer and acrobat; born 1765 in London; died

there on June 12, 1799. The son of John Folett (c.1740–1790), an actor with the Haymarket and Drury Lane Theatres, Folett the Younger performed as a child with his father's troupes.

At Covent Garden from 1790 until his death, he performed in comedies and in harlequinades. Although cast in secondary roles, he was considered responsible for introducing acrobatic techniques into the portrayal of the *commedia* characters. He performed in works by James Byrne, including his *Oscar and Malvina* (1791) and in uncredited pantomimes, influencing the development of movement scales in choreography by Byrne and other harlequinade creators.

Fonaroff, Nina, American modern dancer and choreographer; born 1914 in New York City. After studying at the Cornish School in Seattle, Washington, Fonaroff returned to her native New York to become a member of the Martha Graham company. Among the many works in which she performed are Graham's *American Lyric* (1937), *American Document* (1938), *Letter to the World* (1940), *Punch and the Judy* (1941), *Death and Entrances* (1943), and *Appalachian Spring* (1944).

Fonaroff's choreographic career centered in the years 1946 to 1953, although she presented works as early as 1942. Her pieces were usually characterizational portraits, employing popular music or verbal scores, as in her best known work, *Mr. Puppet* (1947).

A former assistant in Louis Horst's composition classes, Fonaroff has taught dance and composition for many years at Bennington College, the Graham School, and in London at The Place, the London School of Contemporary Dance, which is popularly known as a Graham satellite.

Works Choreographed: CONCERT WORKS: *Theodolina, Queen of the Amazons* (aka *Little Theodolina*) (1942); *Yankee Doodle, American Prodigy* (aka *Yankee Doodle Meets Columbus*) (1942); *Hoofer on a Fiver* (1942); *Cafe Chanter, Five A.M.* (1942); *Of Tragic Gestures* (1946); *The Feast* (1946); *Born to Weep* (1946); *Of Sundry Wimmen* (1946); *Of Wimmen and Ladies* (1946, may be same work as above); *Recitative and Area* (1947); *Mr. Puppet* (1947); *The Purification* (1948); *Masque* (1949); *Requiem* (1953); *Sea Drift* (1953).

Fontana, Georges, French or Belgian exhibition ballroom dancer also working in England and the United States; born c.1900. Nothing is known about Fontana's life before 1920, when he became the staff dancer and demonstrator at the Paris café owned by his mentor of many years. In 1924, he discovered the first of his many partners at the Empire Theatre in London. With Marjorie Moss, he danced for eight years to tremendous success on both sides of the Atlantic ocean. Their engagement at London's Hotel Metropole, Café de Paris, and Kit Kat Club led to their status as "The Castles of England," while their bookings in New York brought them the accolade from *Dance Magazine* as the finest team in the United States.

When Moss retired in 1932, he teamed up with American Anna Ludmilla at the Club Montmartre in Paris and toured with her to New York that fall. In 1933, he worked with former Pavlova dancer Joyce Cole in New York, but when he returned to London in 1934, he performed with Rosita (formerly of Ramon and Rosita) with whom he stayed until 1939 when he retired. They worked at specific clubs in New York, London, and Paris in regular seasons, although the German occupation of Paris ended his French career. The team of Fontana and . . . could be found at the Montmartre, Les Ambassadeurs, the Metropole or Savoy-Plaza, and at the Central Park Casino or Versailles at any time during the years from 1924 to 1939.

Fonteyn, Margot, British ballet dancer, considered by many the finest technician of the mid- and late twentieth-century; born Margaret Evelyn Hookham, May 18, 1919 in Reigate, Surrey, England. As a child, Fonteyn studied ballet with Grace Bosustow and Nicholas Legat before moving with her parents to Shanghai in 1930; there, she worked with George Goncharov. Returning to London, she entered the Sadler's Wells Ballet School, where she studied with Ninette De Valois, the director, and Ursula Moreton. In 1936, she studied with Lubov Egorova, Olga Preobrajenska, and Mathilde Kschessinskaia in Paris.

Except for her frequent guest appearances and tours, Fonteyn has spent her entire career with the (English) Royal Ballet and its predecessors—The Vic-Wells Ballet and the Sadler's Wells Ballet. She made her Vic-Wells debut as a "Snowflake" in the 1934

production of *The Nutcracker,* then went on to create many roles in the company repertory, especially in ballets by De Valois and Frederick Ashton. Among these were De Valois' *The Haunted Ballroom* (1934), *Checkmate* (1937), and Ashton's *Le Baiser de la Fée* (1935), her first major role, *Les Patineurs* (1937), *Nocturne* (1937), and *Horoscope* (1938). She performed featured roles in Ashton's *The Lord of Burleigh* (1934), *Façade* (1935), *Judgement of Paris* (1938), and his versions of *Swan Lake, Les Sylphides, Giselle,* and *The Sleeping Beauty.*

When the company became The Sadler's Wells Theatre Ballet (later, Sadler's Wells Ballet) in 1940, Fonteyn created eight more roles in Ashton ballets— *Dante Sonata* (1940), *The Wise Virgins* (1940), *The Wanderer* (1941), *The Quest* (1943), *Symphonic Variations* (1946), for many years her best known role, *Les Syrènes* (1946), *The Fairy Queen* (1946), and *Don Juan* (1948). She also created roles in works by De Valois, including *Orpheus and Eurydice* (1941) and *Don Quixote* (1950), ballets by Robert Helpmann, among them *Comus* (1942) and *Hamlet* (1942), and in *Les Desmoiselles de la Nuit* by Roland Petit. After the retirement of Moira Shearer, Fonteyn became the undisputed principal ballerina of the company, performing featured roles in Ashton's *Tierisias, Daphnis and Chloe, Sylvia, La Peri,* and *Ondine,* Balanchine's *Ballet Imperial,* and Tamara Karsavina's revival of *The Firebird.*

Fonteyn joined the newly formed Royal Ballet as a permanent guest artist in 1959. In this company, from which she has never officially retired, she created roles in Ashton's *Marguerite and Armand* (1963), and current director Kenneth Macmillan's *Divertimento* (1964) and *Romeo and Juliet* (1965), as well as Roland Petit's *Paradise Lost* (1967). She became Rudolf Nureyev's partner after his emigration from the Soviet Union in 1962, and performed with him in his revivals of divertimentos from *Le Corsaire* (1962), *La Bayadère* (1936), *Raymonda* (1964), and *Paquita* (1967) at the Royal Ballet and on tours. With Nureyev, she has also performed with Martha Graham and Dancers in New York, creating a role in her *Lucifer* in 1975.

Fonteyn has performed with many of the world's ballet companies as a guest artist, among them the Stuttgart Ballet, where she created roles in John Cranko's *Poeme d'Extase* (1970), and the Australian Ballet, with which she toured in Helpmann's *The Merry Widow* (1976). She has toured extensively since the mid-1960s with small companies in repertories of divertimentos and pas de deux.

Fonteyn was made a Dame of the British Empire in 1959 for service to the above-mentioned companies and the Royal Academy of Dancing, of which she has been president since 1954.

Bibliography: Fonteyn, Margot. *Autobiography* (New York: 1976); Money, Keith. *The Art of Margot Fonteyn* (London: 1965); Money, Keith. *Fonteyn: The Making of a Legend* (London: 1975).

Foote, Gene, American theatrical dancer; born in Tennessee. One of the most respected chorus gypsies in New York, Foote made his Broadway debut in Michael Kidd's *Lil' Abner* in 1956. Although he has appeared in a wide variety of musicals, among them, *The Unsinkable Molly Brown* (1960), Donald McKayle's *Golden Rainbow* (1964), the celebrated flop *Bajour* (1964), *Half a Sixpence* (1965), and Ron Field's *Applause* (1970), he is best known for his work in shows choreographed by Bob Fosse. He danced in his *How to Succeed in Business Without Really Trying* (1961), *Sweet Charity* (1966), *Pippin* (1972), and *Chicago* (1973), and served as Fosse's assistant in the latter two and the film *All That Jazz.*

Foote has an additional successful career in the theater/dance; he is frequently engaged to stage national and international tours of Broadway shows. He has done many productions of *Pippin* and *Chicago* as well as the non-Fosse *I Love My Wife.* He has also directed and choreographed American musical productions for the Denmark State Theater, among them *Show Boat, Sweet Charity,* and *Annie Get Your Gun.*

Foran, Jay, American vaudeville dancer; born December 3, 1906 in North Weymouth, Massachusetts. Billed as "THE Song and Dance Man," Foran performed his own songs and original dances on the Keith circuit in his adolescence. He directed the Copley Studio of Dancing and Stage Training in Boston for three years (1925–1927), concurrently directing Prologs for Boston's Capitol Theater, one of the largest theaters left in the United States independent of an established Prolog circuit. There, Foran was responsible for staging the hour-long variety shows

that changed every other week and integrating his production ideas with the films that they accompanied.

He returned to vaudeville performance in 1928 when the Capitol was absorbed into the Paramount/Publix chain. His popular feature acts, The Rainbow Revue and Delmar's Dancing Lessons, both exploited his dance specialties—fairly conventional steps and arrangements made unique by his manipulation of timing. Foran was known as the man who could do a dance step slower or faster than anyone else in vaudeville. He retired from performance to manage Keith theaters.

Foregger, Nicolai, Soviet dance theorist and director; born April 18, 1892; died June 8, 1939 in Kuibyshev. A graduate of Kiev University in philology, Foregger worked for Alexander Tairov's innovative Kanery Theatre in 1916 and 1917. A specialist in gestural systems, he considered dance and movement a form of acting technique, not a separate art form. His first experiments were with his Theatre of Four Masks (1818–1819) with which he did reconstruction of segments of *Lazzi* from the *commedia dell'arte*. In his next group, the Mastfor (short for Masterskaya, or workshop, Foregger), he codified character types into six masks—a negative one being based partially on Serge Essenin, known to dance historians as a husband of Isadora Duncan. His productions there included the revues, *How They Organized, The Parody Show,* and his best known production, *The Dance of the Machines* (1923). His romanticization of the machine as a symbol of contemporary life involved the segmenting of a movement into short imagistic gestures and extending them through multiplication of performers. He set these precision lines of constructivist movements to American social dance music, considering both as symbols of the 1920s. He created a number of these theater pieces, among them *Historical Dances, Constructivist Hop, Dance of the Cavalry,* and *Viewing America from Leigova,* and set short after-pieces for his precision lines and his "noise orchestra" band.

After the destruction of his theater by fire in 1924, he left Moscow for tenures as dance instructor in Kharlikov (1929–1934), Kiev (1934–1936), and Kuibyshev (1938–1939). It is not known whether he created works for those state theaters.

Foregger has frequently been viewed as a master of the Soviet constructivism movement and as a major influence on the Soviet cinema, primarily through Serge Eisenstein who was his student at the Prolecult in Moscow. Although his gestural theories have been studied by theater historians, chief among them Mel Gordon, they have been ignored by dance writers.

Bibliography: Gordon, Mel. "Foregger and the Dance of Machines," *The Drama Review 65.* (March 1975).

Forella, Ronn, American theatrical dancer and choreographer. Raised in Florida, he studied tap locally and performed with Igor Youskevitch's ballet company. When he moved to New York, he was cast in dance chorus roles in almost every musical of the 1960s, among them *The Unsinkable Molly Brown* (1960), *Plain and Fancy* (1964 revival), *Promises, Promises* (1968), *Sweet Charity* (1965), *Hallelulah, Baby!* (1967), *Hot Spot* (1963), and *How Now Dow Jones* (1967). He also performed on *The Ed Sullivan Show* and the *Hollywood Palace* and in the films *Hello, Dolly!* and *Stiletto.* One of the finest tap dancers and teachers of the current generation, he has split his time among his New York studio and chamber company and a series of choreography projects that include the film of *The Little Prince* (Paramount, 1974), the syndicated *Dinah* show, and both musicals, such as *Wild and Wonderful* (1971) and straight plays, like *A Patriot for Me.* He also works extensively in Las Vegas and the country's other legal gambling resorts.

Works Choreographed: THEATER WORKS: *A Patriot for Me* (1969); *Wild and Wonderful* (1971); *Clown* (1977); nightclub acts.

FILM: *The Little Prince* (Paramount, 1974); *Those Lips, Those Eyes* (MGM, 1980).

TELEVISION: *Dinah* (Syndicated, various episodes).

Foreman, Laura, American postmodern dancer and choreographer; born c.1945 in Los Angeles, California. Foreman believes that no educational background analysis is relevant to her present work. She has choreographed since the early 1960s, but stopped actively performing toward the end of the decade when her work as chairperson of the dance department of the New School for Social Research took up much of her time. Apart from her academic work

and her continuing sponsorship of the collaborative Choreo-Concerts (that presents works by young choreographers and composers), she has staged her own works almost annually. She has been highly praised for her use of pedestrian movements—eating, brushing hair, signalling—and her manipulation of stage space.

Works Choreographed: CONCERT WORKS: *Evocations* (1961); *New Dance* (1961); *Divided* (1961); *Lyric Dances* (1961); *Last* (1962); *Sound Piece* (1962); *Improvisation Suite* (1963); *Seasonals* (1963); *Memorials* (1964); *Explations* (1964); *Freedom Suite* (1964); *Study I* (1966); *Study II* (1966); *Film Dances* (1966); *Solo Suite* (1967); *Study* (for live and film performance) (1967); *Experimentals* (1967); *A Time* (1967); *Media Piece* (1967); *Events* (1968); *Group Dances* (1968); *Pulses* (1968); *Media Dances I* (1968); *Games* (1968); *Stury* (1969); *perimeters* (1969); *Signals* (1970); *Epicycles* (1970); _____ (1970); *Events II* (1970); *glass and shadows* (1971); *Laura's Dance* (1971); *songandance (still life, songandance)* (1972); *Environments I* (1972); *Spaces* (Collage series) (1972); *Evnironments II* (1972); *SKYDANCE* (1972); *Margins* (1972); *Performance* (1973); *Spaces* (Collage series) (1973); *Locrian* (1973); *lecture-dem/ with live macaw* added to *songandance* (1973); *POSTLUDES* (1974); *à deux* (1974); *city of angels* (1974); *MONOPOLY* (1975); *PROGRAM* (1976); *HEIRLOOMS* (1977); *ENTRIES* (1978); *TINE-CODED WOMAN* (1979).

THEATER WORKS: *City Junket* (1980).

Forman, Ada, American concert and theatrical dancer; born c.1895, probably in California. Forman was a student at the Los Angeles Denishawn school from 1914 and performed with Ted Shawn's concert group (also labeled Denishawn) on its 1915–1916 tour. She was frequently engaged to partner him in exotica, such as his *Danse Javanese* (1915), exhibition ballroom work like *Dance Vogue* (1916), and abstractions, among them the *Nature Rhythms* (1915). Like so many Shawn dancers, she left him and his vaudeville engagements to get her own, thus avoiding both the requirement to bill herself as a Denishawn dancer and the necessity of a kickback. She took the Keith-Albee tour to New York where she was engaged to a series of successful Broadway revues and roof garden shows. After further studies with La Sylphe, she did the Benda mask solo in the *Greenwich Village Follies of 1922*, extending her repertory and reputation away from the Denishawn-exotic slot. Forman was highly acclaimed in London on many visits to the Rainbow Room there in the 1920s, but returned annually to New York to dance at the Palais Royale here and to appear in *Century Roof Revues*.

Fornaroli, Cia, Italian ballet dancer and choreographer; born October 16, 1888 in Milan; died August 16, 1954 in New York. Fornaroli was trained at the School of the Teatro alla Scala by Adelaide Viganó, Caterina Beretta, and Achille Coppini, and in Enrico Cecchetti's private classes. Although she had performed at La Scala in children's roles, her first major position was not there but at the Metropolitan Opera House in New York City, then in the heart of its Italianate period. After four seasons at the Met. (1910–1914), she returned to Europe to serve as prima ballerina of the Teatro Principale, Barcelona (1914 and 1916). She commuted between that theater and the Teatro Colón in Buenos Aires until 1917 when she began a long association with La Scala. For three years, she divided her time between performances at La Scala and film work for Italian studios, among them, *L'Anello di Pierro* (Caesar, 1917), *Nellina* (Caesar, 1918), *Il Castello del Diavolo* (Cinès, 1919), *I Setti Pecatti Capitali* (Caesar/UCI, 1919–1920, five-part serial), and her best remembered production, *Nanà* (Caesar, 1918). Apart from seasons in theaters in Rome and Vienna, where she and Vencenzo Celli danced at the Volksoper (1923), she remained at La Scala until 1933. Her first choreography was done for her duo performances with Celli and for La Scala, where she created early symphonic ballets.

In 1933, she directed a company in San Remo, Italy, supplying its entire repertory. With her husband, Walter Toscanini, she left Italy shortly thereafter. The success that she had as a teacher at La Scala, where she trained Atilla Radice and Teresa Legnani, led to her popular studio in New York (1943–1950), and her tenure as company teacher for the new Ballet Theatre.

Following her death in 1954, her enormous collection of eighteenth- through twentieth-century ballet libretti and materials was donated to the Dance Col-

lection, The New York Public Library, where it has contributed enormously to the American comprehension of Italian ballet and opera.

Works Choreographed: CONCERT WORKS: *I Carillion Magico* (1919); *Anina Allegra* (1920); *Thais* (1920); *Midinette* (1920); *Cupid e Schonbron* (1920); *Mahit* (1923); *Napoli* (1924); *Nerone* (1924); *Leggende di Giuseppe* (1928); *Vecchia Milano* (1928); *L'Alba di Don Giovanni* (1932); *Pantea* (1932); *The Bayadere with the Yellow Mask* (1933); *La Berceuse* (1933); *The Birds* (1933); *The Gallant Shooter* (1933); *Leggende Scandinava* (1933); *La Primavera* (1933); *The Rebellious Puppets* (1933); *Summer Concerto* (1933); *Vesuvio* (1933); *L'Historia di Pierrot* (1934).

Fort, Syvilla, American modern dancer and teacher; born c.1917 in or near Seattle, Washington; died November 8, 1975 in New York City. Fort had already worked as a dance teacher when she began to study at the Cornish School in Seattle and with Lars Frederick Christensen there. She soon joined the faculty at Cornish, where she worked with composer John Cage, who later credited her with the impetus to create his earliest aleatorically structured works.

After an early choreographic career in Seattle and Los Angeles, Fort became a member of the Katharine Dunham company, also serving as her ballet master and as head of her New York school (1948–1955). At this school, and at a later studio co-directed with her husband, tap dancer Buddy Philips, she taught most of the members of the current generations of black choreographers in conventional and anthropological modern dance and in theater. Her classes also included many of the best known practitioners of method acting, among them James Dean and Marlon Brando, although it is not known whether she had a formal association to the Actor's Studio.

Shortly before her death from cancer, Fort was glorified in a series of tributes featuring performances by those choreographers and dancers whom she influenced; among those who appeared in the program five days before her death were John Cage, many actors, the companies of Charles Moore, Eleo Pomare, Dyanne McIntyre, and the cast of *The Wiz*. The Black Theatre Alliance has also sponsored performances of the film, *Syvilla: They Dance to Her Drum* (Independent, 1978), and dance workshops in her name.

Works Choreographed: CONCERT WORKS: *Bacchanale* (c.1940); *The Drum Beat* (1942); *Mode Reve* (1942); *Danza* (1958); *Saba* (1958); *Poetic Suite* (1969).

THEATER WORKS: *Mambo-Rhumba Festival* (c.1950, co-choreographed with Buddy Philips); *The Flies* (1966); *Ododo* (1970).

Forti, Simone, American postmodernist choreographer; born c.1935 in Florence, Italy. Forti emigrated with her parents to the United States by the early 1940s and was raised in Los Angeles. She began her dance training with Ann Halprin in 1956 when she moved to San Francisco. For four years she worked with Halprin in the Dancers' Workshop in improvisational exercises and performance creations including the Nez play series. When she and then husband Robert Morris moved to New York in 1959, she studied briefly with Martha Graham and Merce Cunningham but was more influenced by her participation in Robert Whitman's early Happenings. She took Robert Dunn's famous composition classes at the Cunningham studio while performing in Happenings by Whitman and Morris, and created her own pieces at a 1960 group performance/evening at the Reuben Gallery. She did equipment pieces here and at a Yoko Ono–sponsored 1961 concert, but also began to work with people as her only structuring medium in rule games and animalist works. *Huddle*, presented on the Ono program, was an equipment piece using only human bodies, and is now considered a seminal work and an ancestor of the improvisation genre of the 1970s. Although there is a tendency to think of Forti's choreography as a series of works created within systems of control—equipment pieces, rule games, Happenings, etc.—she is also known for the extraordinary naturalness and inevitability of her movement patterns and own performance style. A Forti work always looks controlled but demonstrates a recognition of every possibility of movement of which a human can become capable with a system of choices that creates a work of beauty.

Works Choreographed: CONCERT WORKS: *Green Space* (1959); *See-Saw* (1960); *Rollers* (1960); *Slant Board* (1961); *Huddle* (1961); *Hangers* (1961); *Platforms* (1961); *Accompaniment for La Monte* [Young]*'s "2 Sounds" and La Monte's "2 Sounds"*

(1961); *From Instructions* (1961); *Censor* (1961); *Herding* (1961); *Face Tunes* (1967); *Cloths* (1967); *Song* (1967); *Book* (1968); *Bottom* (1968); *Fallers* (1968); *Sleepwalkers* (1968); *Throat Dance* (1968); *Buzzing* (1971); *Illuminations* (aka *Sheila*) (1971, ongoing project always performed with Charlemagne Palestine); *The Zero* (1974); *Crawling* (1974); *Fan Dance* (1978); *Big Room* (1975, ongoing project with composer Peter Van Riper); *Red Green* (1975); *Planet* (1976); *Estuary* (1979); *Home Base* (1979 version of *Big Room*).

Fosse, Bob, American theater and film choreographer and director; born June 23, 1923 in Chicago, Illinois. It is not known whether Fosse ever had formal dance training. From age fourteen, he appeared in burlesque, vaudeville, and nightclubs. His first "legit" work was in the national companies of *Call Me Mister* (1948) and *Make Mine Manhattan* (1949).

Fosse made his Broadway debut in the revue, *Dance Me a Song*, in January 1950. After two years of appearing in films, he returned to New York to stage dances for *The Pajama Game* (1954); the "Steam Heat" number from this show was responsible for establishing his reputation as an innovative dance director. Over the next twenty years, he choreographed eleven Broadway shows, winning six Tony awards for choreography—for *Damn Yankees* (1955), *Red Head* (1959), *Little Me* (1963), *Sweet Charity* (1966), *Pippin* (1973, also winning the Tony for best direction), and *Dancin'* (1978). His other Broadway shows included *Bells Are Ringing* (1956, co-choreographed with Jerome Robbins), *How to Succeed in Business Without Really Trying* (1961), *New Girl in Town* (1967), and *Chicago* (1975). Fosse has also performed on Broadway, notably in the 1961 and 1963 revivals of *Pal Joey*.

Fosse has appeared in five films. Under contract to MGM as a dancer, Fosse appeared in *Give a Girl a Break* (1953), *The Affairs of Dobie Gillis* (1953), and *Kiss Me Kate*, in which he danced with Ann Miller, Tommy Rall, Bobby Van, Joan McCracken, and Carol Haney in the "From this Moment On" number (1953). *My Sister Eileen* (Columbia, 1955), which he also choreographed, was his last film performance until 1974, when he performed in *The Little Prince* (Paramount, 1974). Fosse staged dances for *The Pajama Game* (WB, 1957), *Damn Yankees* (WB, 1958),

and choreographed and directed *Sweet Charity* (Universal, 1969), *Cabaret* (Allied Artists, 1972), and *All That Jazz* (Twentieth-Century Fox, 1979), and *Liza With a Z* for television (NBC, 1972). Because of differing release schedules in various media, Fosse was awarded the Triple Crown for directing (an Oscar, a Tony, and an Emmy) in 1972 for *Cabaret, Pippin,* and *Liza With a Z,* respectively. He is the only director to be so honored.

Works Choreographed: THEATER WORKS: *The Pajama Game* (1954); *Damn Yankees* (1955); *Bells Are Ringing* (1956, co-choreographed with Jerome Robbins); *New Girl in Town* (1957); *Red Head* (1959, also directed); *How to Succeed in Business Without Really Trying* (1961); *Little Me* (1962); *Pleasures and Palaces* (1965, also directed); *Sweet Charity* (1966, also directed and conceived); *Pippin* (1972, also directed); *Liza* (1974, also directed); *Chicago* (1975, also directed and wrote book); *Dancin'* (1978).

FILM: *My Sister Eileen* (Columbia, 1955); *The Pajama Game* (WB, 1957); *Damn Yankees* (WB, 1958); *Sweet Charity* (Universal, 1969, also directed); *Cabaret* (Allied Artists, 1972, also directed); *All That Jazz* (Twentieth-Century Fox, 1979, also directed and wrote screenplay).

TELEVISION: *Liza With a Z* (NBC, September 10, 1972, also directed and co-produced).

Foster, Allan K., Canadian theater and cabaret choreographer; working in the United States and Europe throughout his career; born c.1890 in Halifax, Nova Scotia; died November 2, 1937. Raised in New York, he performed in vaudeville as a child—either in a Gus Edwards act or an imitation—and became an assistant to R.H. Burnside, resident dance director of the Shubert Brothers shows at the Winter Garden Theatre. It is likely that he was a chorus boy before graduating to dance assistant.

The most acrobatically oriented of the three major toe-precision choreographers of the period—Chester Hale at the Capitol Theater, Albertina Rasch working for Ziegfeld and Foster—he first worked with a female team in 1925. The last of the three to develop a precision technique, he was the only one who retained the equine language and idiom of the genre. He had a team of "fillies" and "ponies" who did "school" routines. His sixteen-woman precision chorus, titled the Foster Girls, Foster Academy Girls,

Foster Variety Girls, and the Exponents of Rhythmic Terpsichore, worked some of the most innovative and original routines of any teams. In *The Great Temptations* (1926), they danced in precision formations on a rope spider web, while a season later, in *A Night in Spain*, they competed with The Chester Hale Girls (also cast in the extravaganza) by out-toe-tapping them in a series of military dance numbers. The team also appeared in Earl Carroll's 1926 *Vanities*, *The Circus Princess* (1927), *Breathin' Easy* (1932), *Hummin' Sam* (1933), and the Al Jolson vehicle *Bombo* (1936).

Foster brought his precision groups to Paris to compete with the English Tiller and Bluebell Girls and the American Gertrude Hoffmann acrobats. They became very popular there and worked in Paris until the Vichy government came into power. Research has revealed no film credits for Foster or appearances by his teams, although he staged many Prologs for the Paramount-Publix circuit.

Foster, Gae, American theatrical choreographer; born 1903 in Bunker Hill, California. Associated through much of her career with Fanchon and Marco's productions, she made her California debut in their Warfield Theatre presentations of 1921. It is believed that she was a member of the original Sunkist Beauties, the precision line in their *Sunkist* (1920) which toured the country until it hit Broadway in 1921. She was a Fanchon and Marco dancer through the 1920s, assisting Fanchon from 1925 when the brother and sister production team became Prolog distributors for most of the theater chains in this country and Canada. Although she was given credit on Prolog choreography after 1928, getting her name on her own precision teams, Gae's Sweet Sixteen, after that year she remained with the Fanchon and Marco production company.

In 1933 she was named dance director and production stage director of the Roxy Theater in New York, then a Fanchon and Marco chain outpost. The Gae Foster Girls were in direct competition with the Rockettes, and according to contemporary sources were the more original, interesting, and theatrical team. While the better known Rockettes, still dancing after all these years, were the supreme precision tappers, the Foster Girls, or Roxyettes, were the ultimate *schtik* dancers. Foster staged dance numbers for her sixteen or twenty-four dancers on roller skates, bicycles, unicycles, tricycles, stilts, beach balls (her specialty), polo sticks, skis, skis with roller skates, ladders, ship's rigging, scaffolding, and occasionally the stage floor. Other well-received routines included the shawl dance (May 1940), in which they manipulated fringed shawls while climbing into a pyramid, the illuminated hoop dance (February 1939), the Swiss Maid number in which they swept the stage and ended by balancing on their brooms and, a personal favorite, the May 1938 performance in which all twenty-four played tiny white pianos and then tapped on top of them. On the one occasion that she actually staged a conventional waltz for her troupe, Foster was granted a shocked headline in *Variety*.

Although best known for her work at the Roxy, Foster also staged dances for cabarets, Prolog circuits, the Million Dollar Pier in Atlantic City (1938), USO shows during the war, and ice shows. She frequently hired her former dancers to stage precision lines for Midwestern theaters, thus continuing the network of Fanchon protégés in tribute to her own mentor.

Works Choreographed: THEATER WORKS: Prologs for the Midwestern wheel of the Fanchon and Marco West Coast Deluxe Theater Corporation chain (1928–1930); Weekly Prologs for The Roxy Theater (1933–1941); Prologs for theaters in the Fanchon and Marco chain (1933–1945); *Skating Vanities* (five editions between 1943 and 1947); USO presentations (1942–1946); Cabaret shows (c.1930–1953).

The Four Step Brothers, American tap team; assembled c.1927; disassembled in the mid-1970s. Originally a trio on the permanent staff of the Cotton Club in New York, the Step Brothers became a quartet in 1938 and toured and performed successfully for the next thirty years. Two members remained throughout the act's life—Maceo Anderson and Al Williams; other dancers who were members of The Four Step Brothers included Red Gordon, Freddie James, Prince Spencer, and Flash McDonald, the latter two being in the act from 1949 to 1966. It was for many years the best known dance act in the business and the only black group to break the color barriers

then still not only in effect, but legal. Through appearances at the Radio City Music Hall (where they performed regularly for twenty years), in personal appearance shows with the then successful team of Dean Martin and Jerry Lewis, and on frequent spots on *The Ed Sullivan Show*, they became the best known tap group in the country. They also appeared in films for Universal Pictures, among them, *It Ain't Her*, *Shine on Harvest Moon*, *Greenwich Village*, and *When Johnny Comes Marching Home*.

The act itself was very important for the comprehension of tap technique and format to the general public. They institutionalized two aspects of tap popular structures—unison work and competition dances—and made them the most popular parts of their acts. The unison work consisted of one dancer (usually James or Anderson) beginning a rhythmic sequence and allowing each Step Brother to join in, maintaining the exact articulation and steps so that by the end of the sequence (about five minutes) it would be so clear that it would sound as if only one dancer was tapping. The competition dance, which was a feature of popular entertainment back in the days when the various Master Jubas were challenging each other on stage, was based on a teaching practice. In this part of the act, also known as the "lineup," the four dancers would form a line in front of the audience (frequently in one) and, in turn, do a brief dance specialty while the others maintained the rhythms by clapping or doing a simple time step. This is now the feature of the Copasetics exhibition act in concert and lecture demonstrations.

Fox, Dorothy, American dance satirist; born c.1914 in New York City. Trained in New York by Bird Larson and Martha Graham at the Neighborhood Playhouse, and at the Denishawn school by Charles Weidman, Fox continued her studies in Germany with Mary Wigman. She had a troupe for a short time in Prague and worked in Prague and Berlin cabarets before returning to New York in 1933.

For three years after 1934, Fox danced with Charles Walters as an exhibition ballroom and comedy team—both in nightclubs and within the contexts of theatrical productions, such as *New Faces of 1934*, *Fools Rush In*, and *Jubilee*. She returned to her own act as a dance satirist in 1938, working with a cabaret version of the *Chauve Souris* at the St. Moritz Hotel and on Broadway in *Sing Out the News* (1938) and *Lend an Ear* (1941). Among the characterizations that she performed in shows and nightclubs were *A Tour of Europe*, *A Day in the Life of a Chorus Girl*, and *Minuet in Jazz*.

Fox is credited with one film, *Centennial Summer*, for Twentieth-Century Fox. It is not known whether she coached dance or comedy for other Fox productions.

Works Choreographed: FILM: *Centennial Summer* (Twentieth-Century Fox, 1946).

Fox, Lisa, American postmodern dancer; born in the 1950s in the San Francisco area of California. Trained at the School of the San Francisco Ballet, she studied with David Wood and Carolyn Brown at the University of California at Berkeley and worked with Margaret Jenkins before moving to New York to attend classes at the Merce Cunningham studio. A member of the Cunningham company since 1976, she has performed in his *Travelogue* (1977), *Torse*, *Squaregame*, and other repertory works, and in his continuing series of *Events*.

Foy, Eddie, Sr., American eccentric dancer; born Edwin Fitzgerald, March 9, 1856 in New York City; died February 16, 1938 in Kansas City, Missouri. Originally an acrobatic dancer in vaudeville in the act, Foy and Flanagan, he made his Broadway debut in *Off the Earth* (1895).

On Broadway he did variations on the drunk act so popular with eccentric dancers, augmented by his real slurred speech. His work in *An Arabian Girl and the Forty Thieves* (1899) exemplifies the genre since he spent most of the show sliding down, falling off, and climbing over a staircase. Among his many other shows were *Piff! Paff! Pouf!* (1904), featuring the original English Pony Ballet, *The Earl and the Girl* (1905), *Mr. Hamlet of Broadway* (1908), *Up and Down Broadway* (1910), and *Over the River* (1912).

In 1912, he returned to vaudeville with his seven children; the act, The Seven Little Foys, lasted until the late 1920s. Eddie Foy, Jr., a machine gun tapper, was the only Foy to remain in show business.

Bibliography: Foy, Eddie, Sr. *Clowning Through Life* (New York: 1928).

Foy, Eddie, Jr., American tap dancer; born Edwin Fitzgerald Foy, Jr., February 4, 1910 in New York. Foy was trained in tap techniques by his father with whom he performed in vaudeville from age five, in the act entitled The Seven Little Foys.

Foy left the vaudeville act after fourteen years to make his Broadway debut in the Ziegfeld musical comedy, *Show Girl*, in 1929. He has appeared on Broadway regularly since then, in, among others, *Smiles* (1930), *At Home Abroad* (1935), *The Red Mill* (1945), and *The Pajama Game* (1954), playing "Hines."

Foy has performed in many films between *Present Arms* (RKO, 1932) and *Thirty Is a Dangerous Age, Cynthia* (Columbia, 1968). Among the films in which he has danced are *Yankee Doodle Dandy*, the film biography of George M. Cohan (WB, 1939), *And the Angels Sing* (Paramount, 1944), *Lucky Me* (WB, 1954), *The Pajama Game* (WB, 1957), repeating the role of "Hines," and *Bells Are Ringing* (MGM, 1960).

Foy has also appeared frequently on television. He played a tap-dancing ticket broker on the situation comedy *Fair Exchange* (CBS, 1962–1963), and has performed on many variety shows, among them, *The Dinah Shore Show* (NBC, early 1960s), *The Danny Kaye Show*, and dramatic series. In 1964, he played his father, Eddie Foy, Sr., on the television production of *The Seven Little Foys* (NBC, *Bob Hope Presents the Chrysler Theatre*, 1964).

Fracci, Carla, Italian ballerina; born August 20, 1936 in Milan. A great-great niece of Guiseppe Verdi, Fracci was trained at the school of the Teatro alla Scala. Like him, she has based her career at that historical house.

A dancer with La Scala from 1958, she has performed in principal roles in Anton Dolin's *Pas de Quatre*, in the literary ballets of Bebbe Menegatti and Louis Gai, among them, *Gli Macbeths*, *The Sea Gull*, and *Pélléas et Melisande*, and in productions of the classics staged for her. Considered the great "Giselle" of the twentieth century, she has performed that role at La Scala, and among many companies, the London Festival Ballet, the Monte Carlo Ballet, and the American Ballet Theatre, with which she filmed the ballet for European television (released theatrically in the United States). Among her other Ballet Theatre roles are "Carolina" in Antony Tudor's *Jardin aux Lilas*, the title role in *La Sylphide*, and the principal parts in *Coppélia*, *Spectre de la Rose*, José Limón's *The Moor's Pavanne* and Bournonville's *Flower Festival in Genzano*, staged for her by frequent partner Erik Bruhn. She has also performed many of these roles at La Scala, importing productions and performers from the United States.

As popular in Italy as she is in New York, she has been the topic of a television special—*An Hour with Carla Fracci* (RAI, 1973)—which has received awards at the Montreux Festival.

Bibliography: Arruga, Lorenzo. *Perché Carla Fracci* (Vicenza: 1974).

Fraley, Ingrid, American ballet dancer; born November 1, 1949 in Paris. Fraley was trained at the School of the San Francisco Ballet by Harold Christensen and members of his staff. She spent her first ten years in dance commuting between the two coasts of the United States and appearing with the San Francisco Ballet and the American Ballet Theatre (in residence at the Kennedy Center, Washington, D.C., but actually based in New York City). Her best known role from that period was performed in both companies—the woman who was carried by the male chorus in Michael Smuin's *Pulcinella Variations* (1968) with dignity, flexibility, and extraordinarily precise balance.

In 1975, when many dancers would have been retired, Fraley emerged as a première danseuse with the City Center Joffrey Ballet. Three of her roles there exploited the qualities that had made her *Pulcinella* romance so memorable, and added to her ability to maintain a frozen, slightly bittersweet smile at all times; they are "The Ballerina" in the company's production of Fokine's *Petrouchka*, his "Fiancée" in John Cranko's *Pineapple Poll*, and the heroine of the "Wallflower Waltz" in Ruthana Boris' *Cakewalk*. Her other principal parts, however, are purely abstract and reveal her fine technique; among them are roles in Frederick Ashton's *Monotones II*, Joffrey's own *Remembrances*, and Gerald Arpino's *Pas de Deux Holberg* and *Drums, Dreams and Banjos*.

Frampton, Eleanor, American concert dancer; born c.1895 in Nebraska; died October 8, 1973 in Cleveland Heights, Ohio. After attending the University of Nebraska, she opened a studio in Lincoln where her students included the young Charles Weidman. She, Weidman, and fellow teacher Helen Hewitt moved to Los Angeles to join the Denishawn school in the late 1910s. Ted Shawn arranged for her and Hewitt to put their dances into an act, "The Misses Frampton and Hewitt in The Fantastics," on the Pantages circuits, but when he quarreled with the circuit's West Coast manager over the billing of his own act, they were forced to "withdraw" theirs. They did perform it in noncircuit theaters in the Midwest, however, and their eccentric dances proved popular. It should be noted that despite Frampton's own unquestioned ingenuity and originality in her concert career, there was nothing individual about their vaudeville act; each of their specialties, *The Ghost Dance* and the *Long Legged Doll Dance* especially, had been seen in theaters since the 1890s.

Once Frampton got back to her own career, she became an ingenuous and innovative choreographer again. She created pieces for her student companies in Cleveland, where she settled for the opera and music productions of the Cleveland Institute and of her concert group at the Karamu House, a settlement which is still a center of modern dance activity in Cleveland. Although she did some satirical monologues and topical works, most of her dances were abstractions based on their accompanying musical scores. Despite her reputation, Frampton never stopped studying dance herself. By the early 1940s she published a list of teachers that included Andreas Pavley and Serge Oukrainsky, Mikhail Mordkin, Adolf Bolm, Theodore and Alexis Kosloff, and Ted Shawn.

When she retired from performance and choreography, Frampton became a dance critic for the newspaper, *The Cleveland Plain Dealer*.

Works Choreographed: CONCERT WORKS: (Note: the choreographic credits of works premiered before 1934 could not be verified with available information.) *Greeting Dance* (1934); *Etude* (1934); *Variations on a Theme of Schumann* (1934); *Scherzo and Valse* (1934); *Chopin Program* (1934); *Scriabin Prel-ude* (1934); *Valse Pro Deti* (1934); *Consonance and Dissonance* (1935); *Two Preludes* (1935); *Pictures at an Exhibition* (1935); *Rhapsodie in C* (1935); *Prelude* (1936); *Gay Promenade* (1936); *Memorials (to the Futile, to the Future)* (1936); *Fantasie in D Minor* (1936); *Three Bagatelles* (1936); *Hungarian Rhapsody* (1936); *The Road Before Us* (1936, the *Strong Fellow* section by Charles Weidman); *Miniature Variants* (1936); *Andante* (1936); *Partita in B Flat* (1937); *Variations on a Theme by Handel* (1937); *Three Satires (The Beauteous Ballerina, The Sentimental Scarf Dancer, the Mad Modern)* (1938); *Country Dance* (1938); *Suggestions Diabolique* (1949); *Colloquy for the States* (1940); *Dance Suite* (1942); *Two for Today* (1942); *Years of the Moderns* (1942).

Franca, Celia, English ballet dancer and choreographer whom many consider integral in the development of ballet in Canada; born Nita Celia Franks, June 25, 1921 in London. Franca received her earliest training at the Guildhall School of Music, then studied with Noreen Bush and Judith Espinosa. She continued her training under Marie Rambert, Antony Tudor, and Vera Volkova, then entered the Sadler's Wells Ballet where she worked with Ninette De Valois, Mary Skeaping, Harold Turner, and Peggy Van Praagh.

Franca performed with the Ballet Rambert from 1936 to 1939, creating roles in Walter Gore's *Paris Soir* (1939) and Frank Staff's *Peter and the Wolf* (1940). She was featured there in Antony Tudor's *Gala Performance*, as the "Russian Ballerina," *Jardin aux Lilas*, the *Descent of Hebe* and *Lysistrata*. With the Three Arts Ballet, she choreographed *Midas* (1949) in which she performed "His Subconscious."

With the Sadler's Wells Ballet from 1940 to 1945, she created roles in Robert Helpmann's *Hamlet* (1942), *Miracles in the Gorbals*, in Frederick Ashton's *The Quest* (1943), and in Andrée Howard's *The Spider's Banquet* (1944). She choreographed *Bailermos* while a member of the Metropolitan Ballet (1947-1949), and danced featured roles in *Les Sylphides*, *Coppélia*, *Giselle*, *Aurora's Wedding*, and *Spectre de la Rose*.

In 1951, she left England to become artistic director of the National Ballet of Canada, Toronto. She remained there as artistic director until 1974, choreographing for the company and performing in mime and character roles. Even after retiring, she continued to coach dancers and teach at the school.

Works Choreographed: CONCERT WORKS: *Midas* (1939); *Cancion* (1942); *Khadra* (1946); *Bailemos* (1947); *The Dance of Salome* (1951); *Afternoon of a Faun* (1951); *Le Pommier* (1952); production of *Cinderella, Giselle, The Nutcracker, Swan Lake*.

TELEVISION: *The Dance of Salome* (BBC, 1949); *The Eve of St. Agnes* (BBC, 1949).

France, Richard, American theatrical performer; born January 6, 1930 in Chicago. For many years Broadway's principal juvenile, France sang and danced in a number of musical comedies since his 1951 debut in *Seventeen*. His tapping was a feature of the Broadway premieres of *Wish You Were Here* (1952) and *By the Beautiful Sea* (1954), and of the London production of *Pal Joey* in 1954. When he returned to New York, he made the transition from dancing juvenile to mature leading man and vocalist on Broadway and in City Center revivals, but returned to dance as the movie star undulating with Gracielle Daniele in the Tarzan-in-a-sarong satire within *What Makes Sammy Run?* (1964).

Frances, Esteban, Spanish artist and theatrical designer; born c.1915. A prolific and versatile designer, Frances has created stylized bullfight garb for Eugene Loring's *Capitol of the World* (1954) and cleverly exaggerated toy costumes for the New York City Ballet's *Jeux d'Enfants*, choreographed variously by George Balanchine, Barbara Millberg, and Francisco Moncion in 1955. He is best known for his ability to trim a conventional ballet silhouette (of tutu or tunic and tights) until a costume representing period, place, and characterization in Balanchine's *Tyl Eulenspiegel* (1951) and the two complex longer works—*Figure in the Carpet* (1960), a stylization of the Persian view of the outside world, and *Don Quixote* (1964), with its real and fantastic creatures co-existing in Balanchine's theatrical imagination.

Franceschi, Antonia, American ballet dancer; born 1963 in Ohio. Raised in New York, she studied ballet with Margaret Craske and with the staff of the High School of Performing Arts. She entered the school of American Ballet at sixteen (unusual for that studio where most dancers enter at eight), and graduated into the New York City Ballet just before her eighteenth birthday. Although an injury kept her from appearing in the graduation performances, she soon became a valued member of the company, appearing in most of the Balanchine repertory and creating a role in Peter Martin's *Histoire du Soldat* (1980). She was also a member of the Markarova and Company troupe, where she was given solo variations in productions of *Paquita, Raymonda,* and Maurice Béjart's *Sonate*.

Franceschi is best known not as a dancer but as an actress portraying a young ballet student in the film *Fame* (Twentieth-Century Fox, 1980). Her character, "Hilary," was a wealthy teen-ager in the "School of Performing Arts," who danced on screen and also had a dramatic scene that was important to the plot progression. She chose to turn down a similar role in the television sitcom version of *Fame* in order to perform with the City Ballet.

Francis, William, English early nineteenth-century ballet dancer and teacher working in the United States; born c.1775; died 1826 in Philadelphia, Pennsylvania. Since Francis made his American debut in 1793 (the year that dance and theater exploded onto the new nation) in Annapolis, Maryland, it is possible that he had appeared in the West Indies on his route from London. He took six years to work his way up the coast to New York. During that time he performed with harlequinades and opened dance studios and halls in Savannah (c.1795), Baltimore (c.1797), and Philadelphia, where he became a member of Wignell's troupe at Rickett's Circus, the theater associated with John Durang.

Francis published dance manuals with instructions for social forms to music by Alexander Reinagle from the mid-1790s through c.1810, and probably until his death. His studio in Philadelphia was popular with socially important families and with the theatrical community. All of Durang's

children, for example, studied with him in their adolescence.

His performing career is less verifiable, although Lillian Moore attempted to create a chronology of his professional life. He was a character dancer and comic with the New Theatre company, Philadelphia, appearing in both English and French language harlequinades, c.1805 and 1806. He was believed to have suffered from gout, however, and this may have impeded his movement and the progress of his career.

Francisqui, Jean-Baptiste, French ballet dancer and choreographer working in the United States after the 1790s, born c.1760, possibly in Bordeaux; the time and place of Francisqui's death are not known. Although trained by Maximilien Gardel at the school of the Paris Opéra, Francisqui performed as a child at the Comédie-Française before making his Opéra debut in 1785. For the next ten years, he divided his career between the Opéra and the Foires St. Laurent and St. Germain, where he was an extremely popular dancer. At some point during those ten years, he is believed to have worked with Les Grands Danseurs du Roi, a company of acrobats and tight-rope walkers that included Alexander Placide and Le Petit Diable.

Francisqui emigrated to the United States in 1794, performing at first with Placide's troupe in Charleston, South Carolina in *The Bird Catcher* and *The Deserter*, later the stock repertory of all foreign dancers. He performed with the Old American Company in New York, then including John Durang, Anna Gardie, and famed actor Joseph Jefferson, in his own *Pygmalion* (1796) and *The Whims of Galatea* (1796). Francisqui taught in New Orleans until 1808, when he disappeared from verifiable existence.

Frank, Bill, American modern dancer and choreographer. Frank studied at the Henry Street Settlement before and while performing with Alwin Nikolais and Murray Louis. Among his many performance credits were roles in the former's *Imago, Galaxy, Sanctum,* and the *Vaudeville of the Elements,* and the latter's *Calligraph for Martyrs* and *Interme.* Frank presented his own elegant abstractions at the Henry Street theater in shared recitals with Louis and Phyllis Lamhut. His personal movement style with its clearly defined movements and his extraordinary stage presence was refined into a vocabulary for his pieces, as performed with his colleagues.

Works Choreographed: CONCERT WORKS: *Contours* (1962); *Pulsations* (1963); *Top Floor* (1964); *Themes* (1964); *Suite* (1966); *Many Seasons* (1966).

Frank, Dottie, American theatrical dancer and opera director; born July 8, 1941 in St. Louis, Missouri. Frank began her career as Miss Edsel but persevered to overcome that handicap. At fifteen, she made her performance debut in the St. Louis Municipal Opera revival of *Annie Get Your Gun* and began a long association with that company. She moved to New York and performed in a string of successful shows, such as *Once Upon a Mattress* (1959), *Tenderloin* (1960), *Sail Away* (1961), and *No Strings* (1962), while appearing on *The Ed Sullivan Show* and *The Garry Moore Show* as an Ernie Flatt Dancer. Frank, who now works as Dorothy Danner, has performed only rarely in the last decade, most noticably in the *New Faces of 1968*, the 1973 revival of *Irene*, and Michael Bennett's *Ballroom* (1978). She has had a successful career as an opera director, based at the St. Louis Municipal Opera but working at other theaters across the country.

Frankel, Emily, American concert dancer of the 1950s to the present; born c.1930 in New York City. Frankel studied ballet with Margaret Craske, Antony Tudor, Muriel Stuart, Ella Dagnova, and Aubrey Hitchins and modern forms with Martha Graham, Doris Humphrey, Charles Weidman, and Hanya Holm. She performed with Weidman in the late 1940s and early 1950s, most notably in his *Fables for Our Time, A House Divided,* and *And Daddy Was a Fireman.* From 1955 to 1964, she and fellow Weidman dancer, Mark Ryder, toured with a program of duets commissioned from a number of choreographers. The best remembered work from their repertory was *The Still Point* (1955), which they performed until the dissolution of the company. Frankel retired in 1966, but has returned in solo and chamber concerts occasionally since then. Her solo concerts have included Todd Bolender's *Elektra,* Norman

Walker's *Medea* and *Mahler Fifth Symphony*, and her own *Four Seasons* (1973).

Bibliography: Jackson, Teague. *Encore* (Englewood Cliffs, N.J.: 1978).

Frankfurt, Wilhemina, American ballet dancer; born December 28, 1955 in Washington, D.C. Frankfurt was trained at the Washington School of Ballet and the School of American Ballet. She has been a member of the New York City Ballet throughout her professional career and has appeared in most of its repertory of Romantic and neoclassic ballets. Her ability to communicate the intrinsic shapes of movements has been seen to great acclaim in George Balanchine's abstract *Tombeau de Couperin* (1975) and *Chaconne* (1976), and in the revivals of everything from *Divertimento No. 15* to the Five Pieces section of *Episodes*.

Franklin, Frederic, English ballet dancer working in the United States after the mid-1930s; born June 13, 1914 in Liverpool. Franklin studied locally with a Mr. Kelly before moving to London to continue his training with Nicholas Legat and Lydia Kyasht. He worked on radio as a child, and did a tap dance act at the Casino de Paris in a Mistinguett revue in 1931. Later, he danced in the corps of the Camargo Society productions of *Swan Lake* and *Coppélia* (c.1933).

After two seasons with the Dolin-Markova Ballet, he created a role in Keith Lester's *David* (1935). Associated with the Ballet Russe de Monte Carlo from 1938 to 1951 and from 1955 to 1959, he created roles in many ballets by Leonid Massine, among them *Gaité Parisienne* (1938), *Seventh Symphony* (1938), *Rouge et Noir* (1939), *Vienna—1814* (1940), *The New Yorker* (1940), *Labyrinth* (1941), and *Saratoga* (1941), and the role of "The Champion Roper" in Agnes De Mille's *Rodeo* (1942). Featured in character and demicharacter works, he also danced in the company's productions of *Coppélia* and *Swan Lake*. After guesting with the Sadler's Wells, and with the Slavenska-Franklin Ballet (1951), in which he danced in pas de deux and partnered Mia Slavenska in the premiere of Valerie Bettis's *A Streetcar Named Desire*, he returned to the Ballet Russe.

From 1959, he served as director of the Washington School of Ballet, also named director of the National Ballet Washington, from 1962. He played the senior character roles of "Dr. Drosselmeyer" in *The Nutcracker* and "Dr. Coppelius" in *Coppélia*, and choreographed and staged classics for the company. Since the disbanding of the National Ballet, he has worked as a restager of classics for the Pittsburgh Ballet and the Dance Theatre of Harlem.

Works Choreographed: CONCERT WORKS: *Etalange* (1958); *Homage au Ballet* (1962); *Danse Brilliante* (1965); *Warm Up* (1968).

Franklin, Miriam, American theatrical dancer known as "The Best Chorus Girl on Broadway"; born Miriam Frankel, c.1921, possibly in Los Angeles, California. Franklin made her professional debut at Billy Rose's Casa Manaña in Texas, but soon moved to New York to open her Broadway career in *Sing Out the News* (1938). From that show to *Let's Face It* (1941), she worked almost every day in four successful musicals, including *Yokle Boy* (1939), *Very Warm for May* (1939), *Higher and Higher* (1940), and *Panama Hattie* (1940). She married Gene Nelson (then in the ice show, *It Happened on Ice*), and moved with him to Hollywood after his military service. Although she did not appear in films, she won a tremendous reputation as a dance-team coach and choreographer there. She is considered one of the West Coast's principal stagers of industrial shows and cabaret acts.

Franklyn, Lidije, Soviet dancer working in the American theater; born Lidije Kocers, May 17, 1922. Raised in England, she studied there with Kurt Jooss (then on the faculty of Dartington Hall) and joined his Ballet in the late 1930s. After traveling to the United States with the company on its 1941–1942 tour, she elected to remain here. Of all of her many performances in a variety of styles, Franklyn is unquestionably best known for her Funeral Dance in Agnes De Mille's *Brigadoon*. The silent threnody rips apart the show's structure and progression and questions all of its simplistic virtues, but it is perhaps the most memorable moment on stage from any 1940s musicals. Franklyn has also performed in modern dance works, most notably for the Choreographer's Workshop presentations of works by Emy St. Just and Glen Tetley. She left this country for South

America, and although she has returned to coach later performers of the Funeral Dance, she has worked most prominently with companies and orchestras in Caracas, Venezuela.

Fränzl, Willy, Austrian ballet dancer; born June 5, 1898 in Vienna. Fränzl was trained at the School of the Vienna Court Opera Ballet, graduating into the company in 1914. Although he danced frequently with the company, most notably in the ballets of Josef Hassreiter, he was best known as a teacher and ballet master. He was ballet master of the Vienna Court Opera and teacher at the company school from the early 1930s, serving in those capacities for almost thirty years. Since the revival of 1957, he has been considered an expert on the reconstruction of Hassreiter's most celebrated work, *Die Puppenfée.*

Fränzl and his wife, Lucia Bräuer, are considered among Vienna's major experts in its great dance form, the waltz. They manage a school in ballroom dancing and coach performers in the State and Folk Operas and in theater performance.

French, Ruth, English ballet dancer and teacher; born 1906 in London, England. After training with Sacha Goudin and Serge Morosoff in London, French performed at the London Hippodrome in revues. She joined the Anna Pavlova Company and danced secondary ballerina roles during the late 1910s and early 1920s, among them, "Myrthe" in Ivan Clustine's version of *Giselle.* At the New York Hippodrome, she performed the Blue Bird pas de deux in Pavlova's production of *The Sleeping Beauty* in 1917. It is not known whether French remained in New York on her own or took a leave from the Pavlova company, but she was featured in Mikhail Fokine's *The Frolicking Gods* ballet interpolated into the 1922 *Ziegfeld Follies.*

After leaving Pavlova in 1925, French founded the first of a series of ballet schools in England. She choreographed divertissements for the school recitals and for the performing troupes that she trained, among them, the Versatilities, but the titles of few of these are extant. Her textbooks, *First Steps in Ballet* (1934), *Intermediate Steps* (1947), and *Advanced Steps* (1950) are well known.

Friganza, Trixie, American theatrical dancer and comedienne; born Brigit Friganza O'Callaghan, November 20, 1870 in Grenola, Kansas; died February 27, 1955 in Flintridge, California. Raised in Cincinnati, Friganza made her professional debut in Cleveland in an 1889 production of *The Prince of Pekin.* In her early shows, such as *Jupiter* (1892) and *The Man in the Moon, Jr.* (1899), she was billed as a "sylph-like dancer"; she soon grew. By the time that she became a star comic, she was more often described as *zoftig.* Her almost six-foot height and considerable girth typecast her as a comic but gave her unique opportunities to perform.

Friganza was used as a dance satirist frequently in her comic career, most often in the 1910s. She did an exhibition ballroom take-off in almost every production—as the heavily weighted member of a doomed whirlwind team, as an Apache dancer who decided to fight back, and as a recalcitrant partner in a tango or Hesitation. Her best dance satires were all interpolated into a single scene in the *Passing Show of 1912,* staged by Ned Wayburn. In the Act I finale, set in an imitation of the set from the Otis Skinner *Kismet,* she did a song, "All the World is Madly Dancing," that included satires of satirist Gertrude Hoffmann, the Apache craze, and of Anna Pavlova and her tenuous relationship with Mikhail Mordkin. Friganza ended the song with a delicate, graceful, and probably gratuitous fall back into the onstage harem pool.

Friganza left Broadway in the mid-1930s to work in film. She retired in 1939, after doing live theater in Los Angeles.

Fris, Maria, German ballet dancer; born 1932 in Berlin; died May 27, 1961 in Hamburg. Trained by Tatiane Gsovska in Berlin and by Serge Peretti in Paris, Fris was considered one of the premiere classic ballerinas in postwar Germany. She performed in a variety of companies in Germany and France, including the Berlin State Opera Ballet (People's Republic of Germany), in Gsovsky's ballet, the Weisbaden State Ballet, the Frankfurt State Opera, Janine Charrat's Ballets de France, and the Hamburg State Ballet. Her roles in each included "Odette/Odile" and "Juliet" in company versions of each, but in the Charrat troupe, she appeared in that choreographer's works, most notably her *Les Algues* (1953).

Fris committed suicide in Hamburg while in rehearsal with the State Opera Ballet, by throwing herself off a catwalk from the top of the empty theater to its stage.

Frisco, Joe, American eccentric dancer and comedian; born Louis Wilson Josephs, 1890 in Milan, Illinois; died February 16, 1958 in Hollywood or Santa Monica, California. Frisco began his career as a soft-shoe busker in Chicago, soon teaming up with Andrew Coffee to enter vaudeville as Coffee and Doughnuts. With his eccentric machine-gun tapping to "Darktown Strutters' Ball," he worked with Loretta McDermott in an extremely popular act that brought him to the attention of the Broadway producers.

He was "discovered" in 1923, a headliner by 1924, and a star until his death. The "Frisco Dance," a strut with bent knees and a tipped torso, his cigar and derby and his stutter all became popular *schtiks* for other vaudevillians. Dance halls and marathons held "Frisco" competitions to choose the best imitators of his costume and movements. Although he said of his performance style, "What Astaire is to dancing, I am to leisure," his tap technique was good enough for him to imitate his stuttering with his feet.

As a comic, Frisco was the master of the one-liners, with a repertory of jokes based on gambling and the race track.

Frohlich, Jean-Pierre, American ballet dancer; born July 14, 1954 in New York City. Frohlich was trained entirely at the School of American Ballet.

Although he made his debut with the New York City Ballet in 1964 as "Fritz" in *The Nutcracker*, his career with the company began properly in 1972 when he created the role of the "child" in Jerome Robbins' *Watermill*. Adult performances in Robbins' ballets include the company revival of *Fancy Free* in 1979 and the Autumn section of *The Four Seasons* (1979). Frohlich has also performed in much of the Balanchine repertory, notably as "Puck" in his *Midsummer Night's Dream*, the title role in *Apollo*, and in the premieres of *Le Tombeau de Couperin* (1975), and the company production of *Chaconne* (1976).

Froman, Margareta, Russian ballet dancer known for her work in Yugoslavia; born November 8, 1890 in Moscow; died March 24, 1970 in Boston, Massachusetts. Froman (or Frohmann, as it has been spelled) was trained at the Bolshoi Ballet School in Moscow, graduating into the company in 1915. She appeared with the Diaghilev Ballet Russe in its 1916 European and American performances, but returned to the Bolshoi to dance from 1917 to 1921. Among her roles there were "Aziade" in Mikhail Mordkin's *The Legend of Aziade* and featured parts in *Coppélia* and *The Sleeping Beauty*.

In 1921, she was engaged as ballet master of the Zagreb Croatian National Theatre, Opera and Ballet—a position that she held for thirty years. She choreographed a large number of ballets there, ranging from stylizations of folk themes to productions of original works to Diaghilev-commissioned musical scores. Among her many students at the school that she founded in Zagreb were Mia Slavenska (Corek), Ana Rojè, and Sonja Kastl. She emigrated to the United States in the early 1950s and taught in Connecticut until the onset of the illness that caused her death at the age of eighty.

Froman's importance in the development of ballet in Yugoslavia cannot be overstated. It is only a shame that her works have died out of the repertory of her former companies and that she did not have a chance to restage pieces for her American students.

Works Choreographed: CONCERT WORKS: *Swan Lake* (Act II) (1921); productions of the Mikhail Fokine repertory *(The Polovtzian Dances, Schéhérézade, Les Papillons)* (1922); *Pierrot* (1922); *Thamar* (1923, after Fokine); *Coppélia* (1923); *Petroushka* (1923, after Fokine); *The Gingerbread Heart* (1924); *Capriccio Espagnol* (1924); *Le Boiteau* (1927); *Raymonda* (1927); *The Humpbacked Horse* (1928); *L'Oiseau de Feu* (1928); *Le Tricorne* (1928, after Leonid Massine); *Les Noces* (1932); *The Nutcracker* (1932, sections dated 1923); *Imbrek* (1937); *Swan Lake* (full-length) (1940); *L'Après-midi d'un Faune* (1940); *The Legend of Ohrid* (1947); *Romeo and Juliet* (1949); *Ero Sonoga Svijeta* (Ero, the Joker) (c.1952).

Fuente, Luis, Spanish ballet dancer; born January 2, 1946 in Madrid. Trained in Madrid and New York by

Hector Zaraspe, he made his debut with Antonio's Ballets de Madrid, c.1961. He became a member of the charter company of the City Center Joffrey Ballet; although he missed the 1965 debut season, he created roles in Gerald Arpino's *Viva Vivaldi!* (1965) and *Fanfarita* (1968), and the company's revivals of George Balanchine's *Donizetti Variations*, Bournonville's *Flower Festival*, pas de deux, Mikhail Fokine's *Petrouchka*, and Leonid Massine's *Le Tricorne*. In October 1970, he interpolated a genuine farucca into a performance of the latter work—and was fired from the Joffrey. He danced featured roles in the classics in the National Ballet, Washington, D.C. (1970–1972), the Dutch National Ballet (1972–1973), the London Festival Ballet (1973–1974), and his own Ballet Classico in Madrid. Fuente has performed with the Joffrey company in two benefit performances since 1976, dancing *Fanfarita*, and has presented a recital of his own choreography from his Madrid Company.

Works Choreographed: CONCERT WORKS: *Four Images* (c.1975).

Fuerstner, Fiona, American ballet dancer; born April 24, 1936 in Rio de Janeiro. Raised in the Bay area of California, she was trained at the school of the San Francisco Ballet, making her debut with that company in 1952. Her progressively larger roles and assignments came in ballets by George Balanchine and Lew Christensen, among them the latter's *Jinx* and *A Masque of Beauty and the Shepherd*. After continuing her training at the School of American Ballet in New York and the Royal Ballet School in London, she joined Les Grands Ballets Canadiens, in which she performed in the classical repertory. She has been associated with the Pennsylvania Ballet (originally Opera Ballet) since the mid-1960s, where she has appeared in much of its eclectic repertory, such as Richard Rodham's *Valse Oubliée* and *Trio*, and John Butler's *Ceremony* (1968) and *Carmina Burana*, as well as revivals of Antony Tudor's *Jardin aux Lilas* and Balanchine's *Concerto Barocco* and *Symphony in C*. She now serves the company as ballet master.

Fugate, Judith, American ballet dancer, born November 23, 1956 in Hamilton, Ohio. Raised in New York, Fugate was trained at the School of American Ballet.

A charming and delicate dancer, Fugate is one of the few women to perform the leading child role in *The Nutcracker* with the New York City Ballet (called "Maria" or "Clara," depending on the season) and grow up into the company. Among her featured roles as an adult are in Jerome Robbin's *Ma Mere l'Oye*, as "Beauty," and in George Balanchine's *Valse Fantasie* and *Divertimento No.15*. Joining the company for the 1975 Ravel Festival, she performed roles in John Taras' *Daphnis and Chloe* and Balanchine's *Le Tombeau de Couperin*.

Fukagawa, Hideo, Japanese ballet dancer; born August 23, 1949 in Nagoya, Japan. Trained by Minoru Otchi in Tokyo, he made his debut with the Asami Maki Ballet there. After participating in the 1965 Varna Competition, he moved to East Berlin to continue his studies with Jurgen Schneider and perform for him with the East Berlin Comic Opera Ballet. When Schneider defected to the western part of that city, he joined him to dance with a series of German companies, among them the Stuttgart Ballet (c.1971) and the Munich State Opera Ballet (from 1973). He has guested often in France, England, and the United States in recent years, frequently performing the "Bluebird" pas de deux from *The Sleeping Beauty*.

Fuller, Larry, American theatrical dancer and choreographer; born in Rolla, Missouri. Fuller was trained locally, and in St. Louis, Missouri by Marion Ford. Moving to New York, he was cast in the City Center revival of Agnes De Mille's *Carousel*.

In 1957, two weeks after the show opened, he was chosen as swing Jet for the original production of *West Side Story*, a "swing" dancer being a group stand-by who learned everybody's lines, songs, and dance routines. Like most "swings," Fuller restaged the show in various places, among them, the Theater an der Wein in Austria and the Nuremburg State Opera House. He served as dance captain for Carol Haney's *Bravo Giovanni* (1962), and assisted her on *Funny Girl* (1964), staging the national and London companies of that hit show after her death.

In Austria to stage another production of *West Side Story* and his own *Jazz and the Dancing*

Americans (1977), he was reunited with Harold Prince who had been a producer of *West Side Story*. Prince hired him to assist Patricia Birch on the film version of *A Little Night Music* (New World Pictures, released 1979), and as choreographer for his next stage productions—*Evita* (London, 1978, New York, 1979), the extraordinary musical/opera *Sweeney Todd* (1979), and the New York City Opera presentation of *Silverlake* (1979). Fuller specializes, at least in Prince's productions, in movement groupings, rather than dance routines, and they work beautifully. In *Evita*, he made a small chorus seem like an overwhelming military presence, and brought the motif of heel stamping— as a sign of childish selfishness, as a theme in a national dance form and as a political statement—to an art of expression.

Works Choreographed: CONCERT WORKS: *Jazz and the Dancing Americans* (1977).

OPERA: *Silverlake* (1979).

THEATER WORKS: *Evita* (London, 1978); *Sweeney Todd* (1978); *Evita* (New York, 1979).

Fuocco, Sofia, Italian ballerina of the Romantic era; born Maria Brambilla, January 16, 1830 in Milan; died June 4, 1916 in Carate Lario, Lake Como, Italy. Fuocco studied with Carlo Blasis from the age of seven and is counted as a member of "Les Pléiades," the six students whom he considered the future of Italian ballet. As a ballerina of the Teatro alla Scala in Milan, she created the title role in Antonio Cortesi's production of *Gisella* (1843) and appeared in the second production of Jules Perrot's *Pas de Quatre* (1846), with Carolina Rosati, Carolina Ventu, and Marie-Paul Taglioni. Celebrated in her performances in the Cortesi repertory, she also appeared in Blasis' *Il Prestigiatori* and in Perrot's revivals of his French and English works for Milan.

At the Paris Opéra for four years after her successful debut in Mazilier's *Betty, ou la Jeunesse de Henry V* (1846), she was known as "La Pontue," for her impeccable point technique. Even in the period in which the artistic possibilities of point work were being discovered, her abilities were considered unique and her balance extraordinary.

G

Gallagher, Helen, American theatrical dancer and actress; born in 1926 in Brooklyn, New York. Trained at the School of American Ballet, she made her stage debut in the replacement cast of *The Seven Lively Arts* (c.1943). She then went into George Balanchine's *Mr. Strauss Goes to Boston* (1945), Jerome Robbins' *Billion Dollar Baby* (1945) and *High Button Shoes* (1947), and Agnes De Mille's *Brigadoon* (1947). Her grinding performance in "Gladys Bumps'" "That Terrific Rainbow" in the 1952 revival of *Pal Joey* brought her her first starring role as "Hazel Flagg" in the short-lived musical of the same name (1953).

She danced in *Guys and Dolls* (1955), *Finian's Rainbow* (1955), and replaced the ailing Carol Haney in Bob Fosse's *The Pajama Game* (1954), becoming the third person to have "Steam Heat"; She was featured in *Portofino* (1958) and his *Sweet Charity* (1966). Her part as "Nickie" and as "Charity" herself (after) 1966 brought her back to stardom, with principal roles in *Mame* (1966) and *No, No, Nanette* (1971 revival), singing "You Can Dance with Any Girl at All" to Bobby Van. Gallagher has also worked as a dramatic actress on stage and in soap operas, where she has been suffering for years as the matriarch of *Ryan's Hope* (ABC, 1974–). She appears as a dance instructor in the bittersweet film *Roseland* (Merchant-Ivory, 1977).

Gallagher, Richard "Skeets," American theatrical dancer and film comic; born Antoine Richard Gallagher, c.1891 in Terre Haute, Indiana; died May 22, 1955 in Santa Monica, California. When the studio producers of Hollywood were faced with the inevitability of sound in the late 1920s, they visited New York to scout out performers. Frequently, they chose eccentric dancers who could provide the scale of physical performance to which the audience had become accustomed with the verbal abilities that the new techniques required. Skeets Gallagher, who had come to prominence in a Keith circuit vaudeville act called *The Magazine Girl*, had appeared as a high-kicking eccentric dancer in *Up in the Clouds* (1921), *Up She Goes* (1922), *No, No, Nanette, Marjorie* (1924), *Magnolia Lady* (1924), *Rose Marie, The City Chap* (1925), and *Lucky* (1927). Although he had appeared in films made in the Astoria studios in Queens, New York, most notably in *New York* (Famous Players, 1927), he made his Hollywood debut in a W.C. Fields film, *The Potters* (Paramount, 1927). His scores of pictures included a few musicals, such as *Too Much Harmony*, exotic films like the first sound version of *The Bird of Paradise*, and comedies, such as the 1939 *Idiot's Delight* for MGM. He returned to the theater to star in *Good Night Ladies*, an infamous burlesque show that toured for four years before dying on Broadway in 1946.

In each medium, Gallagher was known for his drunk act, a traditional specialty of the eccentric dancer. His was performed on a flat floor occasionally, but was usually seen on the way down a staircase, hill, or tree.

Gallet, Sébastien, French (?) ballet dancer and choreographer working primarily in Italy, England, and Vienna; born 1753; died June 10, 1807 in Vienna. Little is known about Gallet's early life or training. Although he worked for Gasparo Angiolini at the Teatro alla Scala in Milan (c.1776–1779), he is generally considered a protégé of Angiolini's "rival" in the development of the *ballet d'action*, Jean-Georges Noverre. It is known that during one of his brief periods of power in Paris, Noverre arranged for Gallet's debut at the Paris Opéra in 1782.

Although best known for his staging (and therefore, continuance) of Noverre's works in Italy and Vienna, Gallet's own career was very successful. He served as ballet master in Turin (c.1787), Milan (1786, c.1790, 1805–1807), Naples, and Bordeaux (a stronghold of the *ballet d'action* movement) in 1796. He also choreographed at the King's Theatre, London, another center of *ballet d'action* popularity, from 1797 to 1803, and at the Burgtheater in Vienna from 1803 to 1805. Gallet's last known works were created for La Scala, shortly before his death in 1807.

Works Choreographed: CONCERT WORKS: *Mascherata* (1786); *La Forza dell'Esempio* (1786); *Il Vologeso* (1786); *Il Signore Beneficio* (1787); *Gran Gioconda—Gran Giaccona* (1787); *Bacchus et Ariadne* (1791); *La Fête Civique* (1793); *La Journée de l'Amour* (1794); *Apollon Berger* (1796); *L'Offrande à Terpsichore* (1796); *Les Circonstances Em-*

barrassantes (1796); *L'Heureux Retour* (1797); *Le Triomphe de Thémis* (1797); *Le Trompeau trompé* (1797); *Pizarre, ou la Conquete du Péron* (1797); *La Chasse d'Amour* (1798); *Constante et Alcidoris* (1798); *La Vendemmia d'Amore* (1807).

Galli, Rosina, Italian ballet dancer associated with opera companies; born 1896 in Naples; died April 30, 1940 in Milan. Trained in Naples at the school of the Teatro di San Carlo, Galli performed there and at La Scala in Milan.

In 1912, she was hired by the Philadelphia-Chicago Opera to move to the United States as principal dancer, working under Luigi Albertieri. Two years later, Guilio Gatti-Cazzaza, who had been a director at La Scala, engaged her as principal dancer of the Metropolitan Opera, of which he was then director. From 1914 to 1935, she was a constant performer in Metropolitan productions of operas choreographed by Pauline Verhoeven, and of the ballets staged at the house to replace one-act operas, among them Adolf Bolm's *Petroushka* in 1925. Ballet master from 1919 to 1935, she was responsible for the training and performances of a generation of American dancers, among them the early Ballet Theatre members Miriam Golden, Maria Karnilova, and Nora Kaye.

Galli, who represented dance to thousands of American opera aficionados, retired in 1935 at the end of the long Gatti-Cazzaza reign.

Gallini, Giovanni, Italian ballet dancer and theater manager of the eighteenth century, working in London; born January 7, 1728 in Florence; died January 5, 1805 in London. Although trained at the Academie Royale de Musique, Gallini may not have ever performed with the Paris Opéra or at a court presentation.

In England after 1753, he performed at the King's Theatre, being associated with that theater for much of his career. In his one season at Covent Garden, he danced in *The Judgement of Paris* (by or after Jean D'Auberval, 1758), but he was better known as a teacher at the theaters.

Gallini acquired the lease of the King's Theatre in 1778 and managed the building and company until his death. As manager, he was responsible for bringing Charles-Louis Didelot to London.

Galzerani, Giovanni, Italian early nineteenth-century ballet dancer and choreographer; born 1790 on the Island of Elba; died 1853 in Portolongone. Trained by Antonio Gioja, he performed and choreographed for the circuit of theaters and opera houses in Northern Italy. Although most of his works were created for the Teatro Reggio in Turin or Teatro alla Scala in Milan, he also contributed ballets to the repertories of houses in Venice (making his choreographic debut at the San Benedetto with *Gengis Khan* in 1815), Parma, Florence, Bologna, Genoa, and Naples. His attraction to ballets on classical themes through the 1820s may be related to the increasing nationalism of un-unified Italy (with its reliance on the Roman mythology), but may also be seen as a recognition of the *ballet d'action* revivals of Louis Henry in Milan. It should be noted that the use of Greek mythological plots was also a theme of Italian literature of the time.

In the 1830s and 1840s, he became involved in a movement toward grandeur and pantomime that served as a precursor to Rota and Manzotti. These ranged from the specific gestures necessary to translate Schiller into dance, as in his *Maria Stuarda* (1826), to the staged battles of *Sardanapolo* (1834), and *Gli Abencerraghi . . .* (1839).

Works Choreographed: CONCERT WORKS: *Genghizkan primo Imperatore dei Mogolli* (1815); *L'Allievo dell natura* (1817); *Mohemed Sultano di Carisme* (1818); *Grundeberga* (1818); *La Niobe* (1819); *Teodorico e Romilda* (1819); *Li Tre Fretelli* (1819); *Il Pericolo* (1819); *Amore e dovere* (1819); *Elizabetta Federove* (1819); *La Spada di legno* (1820); *Otello* (1820); *I Bianchi e i Neri, ossia la morte di Corso Donati* (1820); *Li Guidizio di Giove* (1820); *Virginia* (1822); *Cianippo* (1822); *Il Castelli di Kenilworth* (1823); *L'Oroscope* (1823); *La Pitenella perduta nella neve* (1823); *Enea nel Lazio* (1823); *Elisabetta Regina d'Inghilterra al castello di Kenilworth* (1823); *Enrico IV al passo della Marna* (1823); *L'Astuzia fortunata* (1824); *Ero e Leandro* (1824); *Il desertore per amor figliale, ossia la Spada di legno* (1824, possibly a revival of 1820 work); *La Conquista del Péru* (1824); *L'Eroe peruviano* (1825); *Oreste* (1825); *Antigone* (1825); *Francesca da Rimini* (1825); *Maria Stuarda* (1826); *La Sposa di Messina* (1826); *Il Coraro* (1826); *Buondelmonte* (1827); *Gli Adorati del fuoco* (1827); *Rosemonda* (1828); *Gli Spagnoli al*

Peru (1828, possibly revival of 1824 work); *Najazet* (1829); *La Fuga di Edoardo Stuart* (1829); *Ottavio in Eglitto* (1829); *L'Orfano di Genevra* (1831); *Irene di Borgaogna* (1833); *Monsieur de Chalumeaux* (1834); *Sardanapolo* (1834); *Ali Pascia di Giannina* (1834); *I Filibustieri* (1835); *Il Castello di Lochleven* (1837); *Ettore Fieramosca* (1837); *Il Conscritto* (1837); *Gli Abencerraghi ed i Zegrindi, ovvera La Conquista di Granata* (1839); *L'Ultimo Visconti e il primo Sforza, ovvera Milano allà meta del sec. IV* (1839); *Abou Hassan, ovver Il Califfo per un'ora* (1840); *I Tre Giobbi di Damasco* (1841); *I Paggi di Luigi XIII, ovvera La Caccia riservata* (1841); *Issipile, ovvera La Vendetta delle donne di Lenno* (1842); *La Gitana* (1844); *L'Erpina danese* (1845); *Giovanna Maillotte, ovver Il Trionfi del bel sesso* (1847); *Diavoletta* (1852); *Paquita* (1852); *Un amore impareggiabile* (1852).

Gambarelli, Maria, Italian/American theatrical ballerina; born c.1902 in Spezia, Italy. After emigrating to the United States in 1907, she entered the School of the Metropolitan Opera Ballet at age seven, studying there with Margaret Curtis and Guiseppina Bonfiglio. At age thirteen, she became a soloist in the Metropolitan Opera but after two years, she left the Met to become the principal ballerina at the Roxy Theater in New York.

The Roxy, named for impresario S.L. "Roxy" Rothafel, was a Prolog theater, presenting feature films plus forty-minute live variety shows, four times each day. For three years, Gambarelli performed solos in each Prolog; from 1918, she also performed on "Roxy's" radio show, as a vocalist of Italian folk songs. Gambarelli moved to the Capitol Theater (1922–1924) with "Roxy"; during the last two years, she served as ballet master for the Prologs, and created a troupe of precision dancers, called the Gamby Girls, that performed in Prologs for the Paramount/Publix circuit (c.1926–1931).

"Gamby," as she was known popularly, appeared in three films herself in English, as a dancer, *Hooray for Love* (RKO, 1935), *Here's to Romance* (Fox Film Corp., 1935), and *Santa Barbara Fiesta* (MGM, 1936), and in many dramatic pictures in Italy from 1937 to 1955. There is some evidence that films of her work at the Capitol and at Grauman's Theater in Los Angeles (c.1934) were used as shorts or newsreels, but they have not been located. She may also have worked as a staff dancer for MGM during the mid-1930s since research has verified that she "danced in" for Greta Garbo in her 1935 film *Anna Karenina*.

Before retiring from performance, Gambarelli had a short career as a concert dancer, creating solos and works for a small ensemble.

Works Choreographed: CONCERT WORKS: *Snowflakes* (1939); *Rhapsody in Blue* (1939); *Meditation from "Thais"* (c.1940, but possibly earlier); *Dance of Valour* (1940); *The Dying Swan* (1940); *The Merry Widow* (1940); *Valse Bluette* (1941); *Figurine* (1941); *For the Pleasure of Caesar* (1941).

THEATER WORKS: Prologs for the Capitol Theater (1923–1924); for the Paramount/Publix circuit (1931); for the Graumann's Chinese Theater (1934).

FILM: *Office Blues* (Paramount, 1930, short subject).

Gamso, Marjorie, American postmodern dancer and choreographer. Gamso has been creating works since 1970 for herself and a loosely organized company of other postmodernists, among them Scott Caywood, Sally Bowden, Jane Comfort, Carter Frank, Leslie Satin, Risa Jaraslow, and Carolyn Lord. Her group, The Energy Crisis Ensemble, is misnamed; she creates works for her dancers that exploit every possible degree of energy production with pacing games, gestural systems that govern into languages and paths that interweave into new perspectives. She has recently begun to use more external elements in her works, including film in *Gestures of Ambush* (1977), texts, as in *Appendix* (1979), and music.

Works Choreographed: CONCERT WORKS: *Octopus City* (1970); *Octopus Campsite* (1970); *Personal Bravery Test* (1971); *Decimnation* (1972); *Rotogravure* (1973); *Deed* (1973); *Waits and Measures* (1974); *As Blood Runs in the Veins* (1975); *Population Densities and Destinies* (1975); *Thread* (1976); *At Turning Points* (1976); *Framed* (1976); *A Solo and Other Matters* (1976); *Magnetic Ferry* (1977); *Gestures in Ambush: a Chain of Events in dance and film* (1977); *Indifference Intervals* (1978); *Magnetic Ferry II* (1978); *A Tale of Two Cities* (1979); *Four Observations* (1979); *Appendix* (1979); *Port of Asides* (1980).

Gamson, Annabelle, American concert dancer; born August 6, 1928 in New York City, real surname uncertain. Gamson began her dance training with Julia Levien, a student and former member of the American concert groups of both Anna and Irma Duncan. She continued with classes under Anita Zahn, and the faculties of the King-Coit School and the Katharine Dunham studio. At sixteen (as Annabelle Gold), she made her professional debut with the Dunham group at the Cafe Society Uptown, then a center for both Afro-Haitian and jazz dance. Within the next two seasons, she appeared in her first road company of Jerome Robbins' *On the Town*, as understudy for the female comic stooge role of "Lucy Schmeeler," and received her first Broadway credit in Michael Kidd's *Finian's Rainbow* (1947). She danced in his *Arms and the Girl* (1950) and in *Make Mine Manhattan* (1948) before leaving the country with her then husband to live in Paris. On her return (c.1955), she appeared once more on Broadway in the unsuccessful *Pipe Dream* (1955), and was seen often on *The Ed Sullivan Show* and the modern-dance-oriented *Lamp Unto My Feet*. She also danced occasionally with the Anna Sokolow concert group, most notably as "The Princess" in her staging of the opera, *l'Histoire du Soldat* (1956), and with elements of the American Ballet Theatre. Her only role with the company itself was as "The Cowgirl" in Agnes De Mille's *Rodeo*, but she appeared in a premiere for the Ballet Theatre Workshop, Enrique Martinez' *La Muerte Enamorada* (1957).

During the 1960s, Gamson, as she was then known, worked with opera companies and taught dance, but it was not until the Isadora Duncan "revival" of the 1970s that she returned to performance. She had lecture-demonstrations with Levien in 1972 and presented a solo concert in 1974 that integrated her Duncan pieces with her own choreography. The accuracy of the Duncan "reconstructions" cannot be gauged, but Gamson's considerable stage presence gives her audiences a genuine taste of Duncan's performance skill, if not her dance vocabulary. Her performance in *Mother* and the *Sonata Pathetique* have been especially praised.

Although she most frequently appears in solo recitals, Gamson has also presented group recitals of single performers in her or their own intimate works.

In the late 1970s, she began to include solos reconstructed from the repertories of other choreographers into her own solo recitals, including parts of Mary Wigman's *Shifting Landscape* (1979).

Works Choreographed: CONCERT WORKS: *First Movement* (1976); *Five Easy Pieces* (1976); *Portrait of Rose* (1976); *Dances of Death* (1978); *Two Dances* (1979).

García, Marta, Cuban ballet dancer; born c.1945 in Havana. Trained by Alicia and Alberto Alonso and by the faculty of the National School of Ballet, García joined the National Ballet of Cuba in the 1960s. She has inherited many principal parts in the standard repertory from her mentor, including Alonso's greatest role, "Giselle," but, following the structure of the company, has also performed in new contemporary works by native choreographers. She has been seen in works by Alberto Mendéz, Iván Tenorio, and José Parés, in whose *Bach × 11 = 4 × A* (1970) she has been especially acclaimed.

Garcia-Lorca, Isabel, American modern dancer. Garcia-Lorca is best known for her appearances with the Twyla Tharp company (c.1970–1979). Among the many Tharp works in which she has created roles are *The One Hundred* (1970), *Eight Jelly Rolls* (1971), *The Bix Pieces* (1971), and *In the Beginning* (1974), for the company, and *As Time Goes By* and *Deuce Coupe I* (both 1973), with the City Center Joffrey Ballet.

Gardel, Maximilien Léopold Philipe Joseph, French eighteenth-century ballet dancer and choreographer; born December 18, 1741 in Mannheim, then capitol of the Electoral Palatinate; died March 11, 1787 in Paris. Raised in Poland, where his father, Claude, was assistant ballet master for the court of Stanislas I (c.1742–1749), Gardel was sent to Paris to enter the Académie Royal de Danse, then the school of the Paris Opéra.

Gardel made his debut with the Opéra in 1755, remaining as a dancer and as co-ballet master of that company (with Jean D'Auberval) until his death in 1787. He is considered a conservative in the development of *ballet d'action* then being fought at the Opéra and in the London theaters, but is credited

with developing a new ballet vocabulary, including the *rond de jambe*, to fit new techniques.

Works Choreographed: CONCERT WORKS: *La Chercheuse d'Esprit* (1777); *Ninette à la Couer* (1778); *Les Graces* (1779); *La Fête de Mirza* (1779); *Mirza et Lindor* (1779, may be same as previous work); *La Rosière* (1783); *Le Déserteur* (1784); *Le Pied de Boeuf* (1786); *Le Coq du Village* (1787); *L'Oracle* (1787).

Gardel, Pierre Gabriel, French eighteenth–nineteenth-century ballet dancer and choreographer; born February 4, 1758 in Nancy, France; died October 18, 1840 in Paris. Originally trained by his father, Claude, Pierre Gardel was sent to Paris to study at the school of the Paris Opéra. He joined his elder brother Maximilien as a member of the Paris Opéra (dancing as Gardel, *le jeune*) and remained with the Opéra for his entire career, serving as a performer (1777 on), succeeding Maximilien as Maître de Ballet (1787 on), and directing the school after 1799.

Gardel has been labeled as a villain by those who follow the chronological historiography of dance since he fought against the theories of Jean-Georges Noverre and kept the Opéra in a holding pattern between classicism and the Romantic movement that overwhelmed it before his death. The ballets he staged for the Opéra were undoubtedly conservative and primarily based on mythological and historical themes, but it seems unlikely that he could have completely denied the technical and stylistic innovations that pervaded the company from the other Paris theaters.

A staunch supporter of the French Revolution, Gardel may have created his most innovative works for civic festivals. These Fêtes, Offrandes, and other occasional works were created in collaboration with artist Jacques-Louis David; they represented the ideal conjunction of political and popular entertainment forms for the two very disparate groups—the cultural socialists of the 1880s and the avant-gardists of the early 1930s—and were cited as historical precedents by the revisionist theaters of the late 1960s.

Works Choreographed: *Les Sauvages, ou le Pouvoir de la Danse* (1786); *Télémaque dans l'Ile de Calypso* (1790); *Psyché* (1790); *Le Premier Navigateur* (1791); *L'Offrande de la Liberté* (1792); *Le Jugement de Paris* (1793); *Fête Héroique pour les Honneurs du Panthéon à décerner aux jeunes Barra et Viala* (1793); *Fête pour l'inauguration des bustes de Marat et La Peletier* (1793); *Fête de la Fédération* (1794); *La Dansomanie* (1800); *Daphnis et Pandrose, ou la Vengeance de l'Amour* (1803); *Une Demi-Heure de Caprice, ou Melzi et Zénor* (1804); *Achille à Scyros* (1804); *Paul et Virginie* (1806); *Les Jeux de Paris* (1806); *Alexandre chez Apèlles* (1808); *Vertumne et Pomone* (1810); *Persée et Andromède* (1810); *L'Enfant Prodigue* (1812); *L'Heureux Retour* (1815, co-choreographed with Louis Jacques Milon); *Prosperine* (1818); *La Servante Justifée* (1818).

Garden, Mary, Scottish soprano and opera impresario in the United States; born February 20, 1877 in Scotland. Raised in Hartford, Connecticut, and Chicago, Illinois, she made her first major success in Paris, in the most dramatic way imaginable. She replaced the ailing star of the opera *Louise* in April 1900 when she fell ill during the second act. Her appearances in the premiere of Debussy's *Pelleas et Melisande* (1902) and Massenet's *Thais* brought her the attention of Oscar Hammerstein who hired her for his Manhattan Opera House in New York. After three seasons with Hammerstein, his company was dissolved and she joined the Chicago-Philadelphia troupe. In 1919, she was invited to become director of the Chicago Grand Opera. It was there that she became so influential to the development of ballet in the United States. As diva, she orchestrated the hiring of Andreas Pavley and Serge Oukrainsky as joint ballet masters, while later as director, she arranged for Adolf Bolm to replace them. Both directorships of ballet had tremendous impact on the dance in Chicago, the Midwest, and the rest of the United States.

Gardie, Anna, Dominican ballet dancer of the eighteenth century; born c.1760 in Santo Domingo; died July 20, 1798 in New York City. Little is known about Gardie's life or training before she emigrated to the United States in the early 1790s.

She made her American debut in Philadelphia in *La Forêt Noire*, her most popular presentation. From that performance in 1794 to her death in 1798, she worked primarily in New York, where she danced with the Old American Company in *Sophia de Brabant or The False Friend* (1794), *Harlequin's Anima-*

tion or the Triumph of Mirth (1795), *The Bird Catcher* (1796), the famous vehicle of her co-star John Durang, and *The Triumph of Washington, or his Return to Mount Vernon* (1797), in which she played "America."

In July 1798, Gardie was stabbed to death by her husband, a music copyist believed to have been of the French nobility, in what seems to have been a murder-suicide.

Gardinier, Lisa, American ballet dancer and teacher; born c.1896 in Washington, D.C.; died there November 4, 1958. Gardinier was trained at the studios of Louis Chalif, Ivan Clustine, and Stanislav Porta-Povitch. As a member of the Anna Pavlova touring company, she worked with Clustine and Alexander Volinine, while as dancer with *Mecca* (1922) on Broadway, she studied with Mikhail Fokine. She took class in Indian dance forms with Roshanara, although it is not clear whether she performed with her when both were members of Adolf Bolm's Ballet Intime.

She returned to Washington, D.C. in 1922 to open a school. The company that she formed—called variously the Washington National Ballet and the Washington Ballet—performed intermittently from 1937 to her death, while her school, co-directed with Mary Day, continues to this day as one of the most important dance studios in the country. Her only known choreography dates from her first company (c.1937–1939).

Works Choreographed: CONCERT WORKS: *The Dance of the Hours* (1936); *An Afternoon in Vienna* (c.1936); *Capriccio Espagnol* (c.1939).

Garland, Judy, also danced in films; born Frances Gumm, June 10, 1922 in Grand Rapids, Michigan; died June 22, 1969 in London. On their fifth or sixth time seeing Garland in her films, many of her fans realize how talented a dancer she was. She did at least one dance number in each of her twenty-seven films for MGM and, in two of her later pictures, Garland partnered Fred Astaire and Gene Kelly, as well as a quartet of great eccentric dancers—Ray Bolger, Buddy Ebsen, Jack Haley, and Mickey Rooney. Although she was seldom allowed to select a dance director from the studios' staff, she was lucky enough

to work with many of the best. Busby Berkeley and Bobby Connolly staged most of the early MGM musicals, including *Babes in Arms* and *Girl Crazy* for the former, and *The Wizard of Oz* with the latter. Charles Walters did the dances for *Presenting Lily Mars* (1942) in which he partnered her in the finale, *Ziegfeld Follies* (1945, The Interview), and *Summer Stock* (1950), among others. Most people have favorite Garland dance numbers, whether the whip dance in *Girl Crazy* (1943), the fabulous ballroom dance numbers with Fred Astaire in *Easter Parade* (1948), the waltz in *The Harvey Girls* (1949), or the complex "Somewhere There's a Someone" number in *A Star Is Born* (WB, 1954), choreographed by Richard Barstow. Many prefer the "Hallelujah" routine with male chorus in *Summer Stock*, but purists simply enjoy the glissade skips that take her and her friends down the yellow brick road.

Garrard, Mimi, American modern dancer and choreographer; born in Gastonia, North Carolina. Garrard's training includes work in ballet with Zena Rommett and in modern techniques with Alwin Nikolais and Murray Louis at the Henry Street Settlement. She performed in each one's company in the mid-1960s—in 1964, for example, she created roles in Nikolais' *Sanctum* and Louis' first major success, *Junk Dances*. She has choreographed herself since 1962, working originally in shared recitals at Henry Street and later for her own chamber company. Her work involved the synchronization of choreographed movement, music by Emanuel Ghent, and lighting designed by sculptor James Seawright. She has also done video work with Seawright, primarily for the Public Broadcasting Service, and has become known as a successor to Nikolais in intermedia experimentation.

Works Choreographed: CONCERT WORKS: *'Nn* (1962); *Images* (1962); *Cosmogonol* (1962); *Ayres* (1962); *Lady-O* (1963); *Rouleau* (1964); *Area* (1964); *Winter* (1965); *Family* (1965); *Domino* (1966); *Sketch* (1967); *Alla Marcia* (1968); *Flux* (1968); *Frieze* (1969); *Game* (1970); *Trivia* (1970); *Phosphones* (1971); *Spaces* (1971); *Dualities* (1972); *SIX, and 7* (1972); *Transaction* (1973); *Dreamspace* (1974); *Brazen* (1975); *P's and Cues* (1976); *Arc* (1977); *Vivace* (1978); *Daily Bread* (1979); *Suite* (1979); *Overcoat*

(1979); *Spaces* (1979); *Gloves* (1979); *Phases* (1980); *Elipses* (1980); *Step on a Crack* (1981); *Currents* (1981).

TELEVISION: *Capriccio for TV* (PBS, 1969); *Fantasy for TV* (CBS, 1969); *Video Variations* (PBS, 1970).

Garrett, Betty, American theatrical dancer and actress; born May 23, 1920 in St. Joseph, Missouri. Raised in New York and trained at the Neighborhood Playhouse, she made her professional debut in William Maton's *Railroads on Parade* show at the 1939 World's Fair. After working Off Broadway in *You Can't Sleep Here*, *This Proud Pilgrimage*, and *A Piece of Our Mind* (all 1940), she made her Broadway debut in the revue *All in Fun* (1940), co-starring but not dancing with Bill Robinson. After the show closed the morning after it opened, she spent the 1940s dancing and singing in Broadway revues and musical comedies, among them, *Of V We Sing* (1942), *Let Freedom Sing* (1942), in which she sang "Give Us a Viva," *Jackpot* (1944), *Laffing Room Only* (1944), and *Call Me Mister* (1946). On that revue, her best known role to this point, she sang and conga'd to "South America, Take it Away," a tribute to the aches and pains of the Latin dance craze.

On contract to MGM after her success in that show, she made four musical films—*Words and Music* (1948), a biopic about Rogers and Hart, *My Sister Eileen* (Columbia, 1955), and two Gene Kelly films, *On the Town* (MGM, 1949) and *Take Me Out to the Ball Game* (MGM, 1949), with *Call Me Mister* co-star Jules Munshin and Frank Sinatra, with whom she always ended up. Her performance as "Hildegarde Esterhazy" in *On the Town* and as a similar character in *Take Me Out to the Ball Game* established her as a feminist female comedy star.

Although she still dances and sings in cabarets in a one-woman show, Garrett is now best known for her performances on two long-running sitcoms—*All in the Family* (CBS, 1973–1976), and *Laverne and Shirley* (ABC, 1976 to the present).

Garrison, David, American theatrical performer; born June 20, 1952 in Long Branch, New Jersey. After extensive dramatic and comic experience with the Arena Stage company in Washington, D.C., he studied tap techniques with Victor Griffin. His New York–area debut came in the Brooklyn Academy of Music production of *Joseph and the Amazing Technicolor Dreamcoat* (1977), followed shortly by the Broadway staging of *A History of American Film*. In 1979, he became famous for his double performance as "Serge P. Samovar," or Groucho Marx, in the *A Night in the Ukraine* section of Tommy Tune's hit show. In the first part, *A Day in Hollywood*, he played an usher at Graumann's Chinese Theater and was called on to tap out the Hays Office in Tune's brilliant "Doing the Production Code."

Garth, Midi, American modern dancer and choreographer; born January 28, 1920 in New York City. Garth has studied composition with Louis Horst, ballet with Nanette Charisse, and modern dance technique with Sybil Shearer, Elsa Fried, and the New Dance Group. In Chicago, she performed with Shearer, studied music at the Chicago Musical College, and taught at the Hull House Settlement.

Like Shearer, she created very personal works outside the conventional categories of modern dance. She tends to use very small gestures and movements and to scale down her works so far that it is difficult to perceive how exquisitely structured they are. Her rare concerts present her works to an adoring audience, but many people, even in the dance world, have never seen any of her choreography.

Works Choreographed: CONCERT WORKS: *No Refuge* (1949); *Times Casts a Shadow* (1949); *Dreams* (1949); *Exile* (1949); *Predatory Figure* (1949); *No Refuge II* (1951); *Waking* (1951); *Dreaming* (1951); *Decisive Moment* (1951); *Ode for the Morrow* (1951); *Worship of a Flower* (1951); *Prelude to Flight* (1951); *Pastoral* (1952); *Allegro* (1952); *Hither Thither* (1952); *Tides* (1954); *Voices* (1954); *Anonymous* (1954); *Two People* (1954); *Time and Memory* (1956); *Penalty* (1956); *City Square* (1956); *A Suite of Dances* (1958); *Scerzando* (1958); *Double Image* (1958); *Sea Change* (1959); *Juke Box Pieces* (1959); *Ricardanza* (1959); *Three Tragic Figures* (1959); *This Day's Madness* (1961); *Voyages* (1961); *Versus* (1963); *Night* (1963); *Imaginary City* (1963); *Day and Night* (1965); *Other Voices* (1966); *Four Elements* (1966); *Summer* (1966); *Three Solos (Summer, plus Winter and Night)* (1967); *Warm Up* (1969); *Impres-*

sions of Our Time (1969); *Workout* (1970); *Solo for Three* (1973); *Hommage* (1973); *Solo* (1973); *Images of Our Time* (1973); *Workout for Six* (1975); *Chorale Song* (1975); *Open Space* (1976); *Trio* (1976); *Koto Song* (1978); *Images and Reflections* (1979).

Gaskell, Sonia, Lithuanian dancer considered one of the pioneers of the Dutch ballet; born April 14, 1904 in Vilkaviuskis, Lithuania; died July 9, 1974 in Paris. It is not certain with whom Gaskell trained while living in Israel (then Palestine), Paris, and Amsterdam before 1939. A noted teacher and administrator, she founded a series of companies that became ancestors of the Dutch National Ballet—the Ballet Recital Group (1949–), the Netherlands Ballet (1954–), and the Amsterdam Ballet (1959–). She served as artistic director of the Dutch National Ballet from its creation in 1961 until 1969. Most of her choreography was created for one of her earlier companies.

Works Choreographed: CONCERT WORKS: *Ragtime* (c.1954); *Atles om Een Mantel* (1954); *Sphere* (c.1956); *Sonate* (c.1956); *Allegro Barbaro* (c.1957).

Gautier, Théophile, French nineteenth-century critic and librettist for the ballet; born August 30, 1811 in Tarbes, France; died October 23, 1872 in Neuilly. Raised and educated in Paris, Gautier became a fervent supporter of the Romantic movement in art, literature, music, and the dance. He was critic of *La Presse* (1836–1854) and *Le Moniteur* (1854–1860), and a freelance essayist contributing articles to *Le Figaro*, *La Revue de Paris*, *La Revue des Deux Mondes*, and the annual *Galérie des Artistes Dramatiques de Paris*.

In many ways, Gautier's taste in dance colored what we as contemporary historians think and judge about the French Romantic era. A subjective critic in the tradition of his period, he described some movement and quite a lot of decor and atmosphere, but overlaid it with his own opinions about the performers and works. He actually seems to have had much more tolerance of the works than of the dancers, since he would excuse the most saccharine of librettos and choreography for one good solo variation.

Gautier was responsible for the libretto to *Giselle* with Vernoy de Saint-Georges, and wrote the poem,

La Mort Amoureuse, which inspired a posthumous ballet by Frederick Ashton.

Gautier's criticism has never been published in total, but C.W. Beaumont selected and translated many of his morning-after reviews of the premieres of the Romantic ballerinas in his *The Romantic Ballet as seen by Théophile Gautier* (London: 1947, reprinted by Dance Horizons, Brooklyn, New York).

Gavrilov, Alexander, Russian ballet dancer and choreographer; born 1892 in Moscow; died July 1, 1959 in Miami, Florida. Gavrilov attended the Imperial Ballet School of Moscow for two years, then trained at the St. Petersburg Academy, graduating in 1911.

Gavrilov left the Maryinsky Ballet to join the Diaghilev Ballet Russe in late 1911, remaining with that company until 1919. With the Ballet Russe, he performed many of the leading roles in the repertory and served as understudy to Vaslav Nijinsky. It is estimated that during the Ballet Russe tour of the United States, Gavrilov performed for Nijinsky in a majority of concerts.

After leaving the Ballet Russe, Gavrilov performed briefly at the Empire Theatre, London, before moving to the United States. From 1925 to 1928, he served as director and choreographer for the Ballet Moderne company, which included dancers Georgia Ingram and Maria Gambarelli, prima ballerina of the Roxy Theater. Works which Gavrilov created for this company include *Bas Relief* and *The Roguish Faun*, both in 1926. From 1929 to 1930, he was the ballet master for the Philadelphia Civic Opera Ballet. He was the first ballet master for the charter Ballet Theatre company in 1939–1941, and served in the same capacity for the Metropolitan Opera Ballet from 1949.

During the 1920s and 1930s, Gavrilov performed as a concert dancer, creating works for himself for solo programs, and for his small troupes of students. Most of his known choreography dates from these concert performances.

Works Choreographed: CONCERT WORKS: *An American Bar in Paris* (1925); *Pierrot of the Minute* (1926); *Bas Relief* (1926); *The Roguish Faun* (1926); *Alt Wein* (1928); *Manhattan Holiday* (1928); *Her Majesty's Escapade* (1928); *Grecian Rhapsody*

(1928); *Valse Romantique* (1928); *Still Life—Life Flesh* (1935); *Salomé* (1935); *Skaska* (1937); *Masquerade* (1937); *l'Après-midi d'un Faune* (after Nijinsky) (1937).

Gawlik, Roland, German ballet dancer; born September 15, 1944 in Grossenheim. Gawlik was trained at the school of the Dresden State Opera Ballet and at the Kirov School under an exchange program. One of the most popular dancers in the People's Republic of Germany, he made his debut with the Dresden State company in 1962. However, he switched after a few years to the East Berlin State Opera, where he has danced in both the Soviet and contemporary native repertories, most notably in ballets by Tom Schilling (also of Dresden in the early 1960s).

Gé, George, Russian ballet dancer and choreographer associated with the developing ballet of Finland; born Georgei Gronfeldt, June 28, 1893 in St. Petersburg; died November 19, 1962 in Helsinki. Trained in St. Petersburg by Nicholas Legat, he emigrated to Finland in 1921 to become ballet master of the Helsinki Suomanlainen Opera. His earliest known production in his fourteen seasons there was *Swan Lake* (1922), but he was also known for his original ballets, among them *Poème* (1931) and *Skydraget* (1931). He took four years off from Scandinavia from 1935 to 1939, living in France and performing with the Ballet Russe de Monte Carlo and the Folies Bergère. Gé served as ballet master of the Royal Swedish Ballet throughout the war and choreographed many works for that troupe, including his popular *Hollywood Rhythms* (1944). Returning to Helsinki in 1945, he worked with the Finnish National Opera throughout the remainder of his life. He restaged works by his mentor of his French period, Mikhail Fokine, and created original ballets, among them the romantic *The Uninvited* (1958) and *La Valse* (1958).

Works Choreographed: CONCERT WORKS: *Poème* (1931); *Den bla pätlan* (1931); *Skydraget* (1931); *Concerto* (1940); *Idolen och Slocknande Ögon* (1941); *Hollywood Rhythms* (1944); *Luabala* (1944); *Johanessnatten* (1944); *The Uninvited* (1958); *La Valse* (1958).

Geffner, Deborah, American theatrical dancer; born August 26, 1952 in Pittsburgh, Pennsylvania. Geffner was trained at the Juilliard School as a ballet dancer, but has spent most of her professional life performing in theatrical contexts. She has been applauded in the 1977 revival of *Pal Joey* and *Tenderloin* and for her portrayal of the gypsy who couldn't sing in *A Chorus Line*. During her two and a half years in that Michael Bennett show, she commuted to the Astoria studio to create the moving character of "Victoria," the Broadway dancer with more ambition than talent, in Bob Fosse's *All That Jazz* (Twentieth-Century Fox, 1979).

Gehm, Charlene, American ballet dancer; born December 14, 1951 in Miami, Florida. Gehm was trained locally by George Milenkoff and Thomas Armour and performed with the latter's regional company before moving to New York to accept a scholarship at the Harkness House. Gehm was a member of the Harkness Ballet during its last year of existence and the National Ballet, Washington, D.C., during the last years of its life. Rather than being disillusioned, she used the valuable experience that she had gained performing in *Cinderella*, *Coppélia*, *La Somnambule*, and *Pas de Dix* in her later tenures. A member of the City Center Joffrey Ballet since 1975, she became internationally known for her performance as the "Leader of the Nymphs" in the company's revival of Vaslav Nijinsky's *L'Après-midi d'un Faune* for Rudolf Nureyev. Her roles in the Joffrey Ballet's own repertory range from "Right End" in Ruthana Boris' *Cakewalk* to the abstractions of Gerald Arpino's *Suite Saint-Saens* and Margo Sappington's *Face Dances* (1976).

Geltzer, Ykaterina, Russian/Soviet ballet dancer; born November 14, 1876 in Moscow; died there December 12, 1962. The daughter of Vasilly Geltzer, German ballet master of the Bolshoi Ballet, she was trained at the Bolshoi School before joining the company in 1894. She continued her studies with Christian Johanssen when she switched to the Maryinsky troupe in St. Petersburg. That change did much more than alter her repertory, it shifted her into the mainstream of Western European and American dance touring.

At the Maryinsky itself, she was cast in principal roles in both the "old" repertory of Marius Petipa, notably in his *Raymonda* and *La Bayadère*, and in the newer works of Alexander Gorsky, including his *The Goldfish* (1903), *The Little Hump-backed Horse* (1905), and *Salambó* (1910). Her Maryinsky colleagues engaged her for their English and American performances, including bookings at the Alhambra Theatre, London, with Vladimir Tikhomirov (1911, for the Coronation Season) and the 1911 American tour of Mikhail Mordkin, on which she danced "Odette/Odile" in what may have been the country's first four-act *Swan Lake*. She returned to the Bolshoi Ballet where she remained as principal ballerina until her retirement in the 1930s. Still associated with Gorsky repertory, she also created the major role in what is popularly considered the first Soviet classic ballet, Lashcillin's *The Red Poppy* (1927).

Genée, Danish ballet dancer and teacher; born Alexander Jensen, 1850, possibly in Jutland, Denmark; died after 1919 in London, England. Genée took his pseudonym from the composer Richard Genée who sponsored him when he was young. He was engaged as a partner by the Hungarian dancer Antonia Zimmermann (a student of Gustav Grantzow) on a tour of Germany, Prussia, and Russia. He was trained on tour by Grantzow and his daughter Adèle, and in St. Petersburg by Christian Johansson and Marius Petipa.

He formed a company with Zimmermann, by then his wife, which toured to opera houses in Central Europe. On recommendation from Franz Liszt, according to an unconfirmed but plausible story, he was hired as ballet master to the Népazinháztheater in Budapest. He served in that capacity for the Cirkus Variété in Copenhagen (c.1886), the Centrallhallen Theater in Stettin during the 1890s, The Reischshallenteater in Berlin (1895), and theaters in Stockholm and in Christiana (Oslo), where his niece, Adelina Jensen, called Genée, performed with the troupe. The *Coppélia* that he revived for her at the Hofteater in Munich in 1896 was so successful that she was invited to perform with The Empire Theatre in London.

Accompanying her as teacher and personal choreographer, he settled in London, opening a school. He was credited with staging dances for her in the Empire's *Coppélia* (1906), *The Soul Kiss* (New York, 1908), *Roberto le Diable* at the Empire (1908), *The Silver Star* (Philadelphia, 1909), and *The Bachelor Belles* (Philadelphia, 1910).

Works Choreographed: THEATER WORKS: Incidental dances for Adelina Genée in the following: *Coppélia* (London, 1906); *The Soul Kiss* (1908); *Robert le Diable* (London, 1908); *The Silver Star* (Philadelphia opening of vaudeville tour, 1909); *The Bachelor Belles* (Philadelphia opening of vaudeville tour, 1910).

Genée, Adelina, Danish ballet dancer who had a tremendous impact on the development of ballet as a theatrical technique in England and the United States; born Anina Margarete Jensen, January 6, 1878 in Hinnerup, Jutland, Denmark; died April 23, 1970 in Esher, England. Trained and adopted by her uncle, Alexander Genée, and his wife, Antonia Zimmermann, Genée made her professional debut in 1888 in his *Polka à la Picarde*. For the next eight years, she performed roles in his works and revivals in the companies for which he served as ballet master—the Centralhallen Theater in Stettin (now in Poland), the Reichshallen Theater, Berlin, and Munich Hofteater. At the latter, she first danced "Swanilda" in the Genée revival of *Coppélia*, in October 1896. This portrayal led to an invitation to perform at the Empire Theatre, London, during the 1897 celebration of Queen Victoria's Jubilee.

Although she toured extensively, Genée's career was centered in England after her first Empire performances. From that date until 1907, she danced almost exclusively at the Empire in twenty of their ballet-spectacles, all but three of which were choreographed by Katti Lanner. She was the leading ballerina in each, partnered in her first three by Malvina Cavallazzi and Francesca Zanfretta, *en travestie*, performing the male supporting roles. In all of the Empire productions—by Lanner, or by eccentric dancer Fred Farren—it is likely but not yet verified that she interpolated some solo variations by her uncle into the ballets. As she became the major drawing card at the Empire, more conventional ballets were revived for her, among them *Coppélia* (1906), in her uncle's version, and *Robert le Diable* (1908).

Genée was involved also in the revival of interest in pastorales that swept England in the decade before World War I. She sponsored and choreographed three of these—*The Dryad* (1907), *Alex's Spring* (1916), and *The Pretty Prentice* (1916).

Genée's American career followed a path typical of European imported performers in all theatrical media: she made her debut in a musical comedy, *The Soul Kiss* (1908), plotted loosely enough to allow interpolations of her ballet specialties; in this case, the divertissements *The Money Basket* (said by Ivor Guest to be a variation of Alexander Genée's version of *Die Rose von Schiras*) and *The Hunting Dance*. The latter became her trademark in the United States and formed the central section of the vaudeville act that followed her next American show. This 1911 act, on the Klaw and Erlanger "class act circuit," included a divertissement, *Roses and Butterflies*, in which she was partnered by Alexis Kosloff.

Genée returned to New York in December 1912 after a brief London engagement with a series of divertissements loosely grouped together into the act *La Danse*. This act, with which she toured across the continent and in the South Pacific, included *The Hunting Dance*, the dance sequences from *Robert le Diable*, a polka from *Les Millions d'Arlequin*, and a homage entitled *La Camargo*, in which she had appeared in London. The souvenir program from this presentation represents one of the first chronological histories of ballet technique published in America.

Although she announced her retirement in 1914, she continued to perform at charity events during World War I. Her last known performance was in a hospital benefit staged at Drury Lane in June 1932. The founding president of the London Association of Operatic Dancing (the group that grew into the Royal Academy of Dancing) from 1920 and a charter member of the Camargo Society, she continued to be a major influence on English dance until her death.

Genée's impact on the uses of ballet within theatrical media was enormous; her presence in the American shows, especially, kept the ballet vocabulary on Broadway and in vaudeville houses when dance directors were discovering tap and step work. Although she might have denied the compliment, her productions have been credited with the development of eccentric and tap ballet techniques in America through her impact on Ned Wayburn and Gertrude Hoffmann.

Works Choreographed: CONCERT WORKS: (These works may have been created in collaboration with Alexander Genée.) *The Dryad* (1907); *The Money Basket* (1907, interpolated into *The Soul Kiss*); *The Hunting Dance* (1907, interpolated into *The Soul Kiss*); *Roses and Butterflies* (1911); *La Camargo* (1912); *La Danse* (Polka from *Les Millions d'Arlequin*, divertissement from *Robert le Diable*) (1912); *The Dancer's Adventure* (1915); *Alex's Spring* (1916); *The Pretty Prentice* (1916).

Bibliography: Guest, Ivor. *Adeline Genée* (London: 1958).

Gennaro, Peter, American theater and television choreographer; born 1924 in Metaire, Louisiana. Gennaro trained with Katharine Dunham from 1947 to 1948, also studying acting at the American Theatre Wing in New York.

After dancing with the touring San Carlo Opera in Chicago, Gennaro made his Broadway debut in the revue *Make Mine Manhattan* in 1948. He danced in four musicals, *Kiss Me Kate* (1948), choreographed by Hanya Holm, *Arms and the Girl* and *Guys and Dolls* (both 1950), both staged by Michael Kidd, and *By the Beautiful Sea* (1954), before joining the cast of *The Pajama Game*. In that 1954 show, he partnered Carol Haney in Bob Fosse's famous "Steam Heat" number.

Gennaro first choreographed for Broadway in 1955, staging the short-lived *Seventh Heaven*. After returning to performance, notably in *Bells Are Ringing* (1956), Gennaro co-choreographed *West Side Story* with its director Jerome Robbins. He has staged six additional Broadway musicals since then, among them, *Fiorello* (1959), *The Unsinkable Molly Brown* (1960), *Bajour* (1964), and *Annie* (1978). Since 1971, he has been producer and resident choreographer for the Radio City Music Hall.

Concurrent with his Broadway career, Gennaro became one of the best known choreographers for hour-length television variety shows. From the mid-1950s on, the Peter Gennaro Dancers were featured on, among others, *The Tonight Show with Steve Allen*, *The Red Skelton Show*, *The Polly Bergen Show*, *Your Hit Parade*, *The Andy Williams Show*, *The*

Perry Como Show, *The Judy Garland Show*, and *The Ed Sullivan Show*.

Works Choreographed: THEATER WORKS: *Seventh Heaven* (1955); *West Side Story* (1957, co-choreographed with Jerome Robbins); *Fiorello* (1959); *The Unsinkable Molly Brown* (1960); *Mr. President* (1962); *Bajour* (1964); *Jimmy* (1969); *Irene* (1973, revival); *Annie* (1978).

FILM: *The Unsinkable Molly Brown* (MGM, 1964).

TELEVISION: *The Tonight Show* (Hosted by Steve Allen) (NBC, 1954–1957); *The Red Skelton Show* (CBS, 1954–1956); *The Polly Bergen Show* (NBC, 1957–1958); *Your Hit Parade* (NBC, 1958–1959); *The Andy Williams Show* (CBS, 1959); *Bell Telephone Hour* (NBC, 1959–1968); *The Perry Como Show* (NBC, 1960–1963); *The Judy Garland Show* (CBS, 1963–1964); *The Entertainers* (CBS, 1965); *Hollywood Palace* (ABC, 1965–1966, also appeared on show); *Kraft Music Hall* (NBC, 1967–1971); *The Ed Sullivan Show* (1967–1971).

Gentry, Eva, American modern dancer and choreographer; born Henrietta Greenhood, August 20, c.1920 in Los Angeles, California. After studies with Ann Mundstok in San Francisco, she moved to New York where she continued her training with Hanya Holm, Harald Kreutzberg, Michio Ito, and Lisan Kay. At the Bennington College summer sessions, she worked with Holm, Martha Graham, Doris Humphrey, and Charles Weidman. As Henrietta Greenhood, she was a member of the Holm company in the late 1930s and 1940s, and created roles in almost every work presented in that period, among them, *A Cry Rises from the Land*, *Salutation*, *Two Primitive Rhythms*, *Trend*, *Dance of Work and Play*, *Metropolitan Daily*, *Dance of Introduction*, *The Golden Fleece*, *They Too Are Exiles*, and *Tragic Exodus*.

Although she presented a recital in 1935 in Palo Alto, California, her concert career flourished in the late 1940s and 1950s, when she was teaching at the Clark Center, the High School of Performing Arts, and the Dance Notation Bureau. She was an early experimenter in improvisation for the concert stage, presenting untitled sessions as early as 1955. She also taught improvisation techniques to dancers and actors in the 1950s and after. She was also an early

practitioner and preacher of the Pilates method of control and reconditioning, and taught that to her many students.

Works Choreographed: CONCERT WORKS: *Leisure in Dance* (1935); *Woman: Dance Cycle* (1935); *Anatomy of Melancholy* (1935); *Presto* (1935); *Lament of All Living* (1935); *So This Is Modern Dancing* (1935); *Magnolia Lady* (1948); *Good-By My Johnny* (1948); *Tenant of the Street* (1948); *Ground-hog Hunt* (1948); *Lonesome World* (1948); *Dance* (1948); *In Serenity Rejoice* (1949); *Quiet* (1949); *Dance in the Wild Wild West* (1949); *New Horizons* (1951); *The Stuff That Dance Is Made Of* (1951, lecture-demonstration); *The Birds (Prelude, The Dove, The Cuckoo, The Encounter)* (1951); *Dance of Pride . . . and of Warning* (1953); *The Sea Gives Up Its Ghosts* (1953); *Three Rhythms Circles* (1955); *Improvisatory Program* (1955); *Three Dance Themes* (1955); *The Accusers* (1956); *The Antenna Bird* (1956); *Improvisatory Program—Transformations* (1963); *Objects and Textiles* (1963); *Circus Echoes (The Parade, Zaza the Snake Enchantress, Amorpha—The Bearded Lady, Ameera—A Royal Egyptian Mummy, The Human Skeleton, Atlas—The Strong Man, Clown Act, Italian Polka, The Big Cats, Tableaux Plastiques)* (1963); *All the Dead Soldiers* (1967); *Anatomy* (1967); *Going Nowhere* (1967); *Voices* (1967); *Trumpets, Clap and Syphilis* (1967); *Three Satires in Fashion* (1967).

George, Carolyn, American ballet dancer and photographer; born September 6, 1927 in Dallas, Texas. George was a student of Willam and Lew Christensen at the School of the San Francisco Ballet before joining the New York City Ballet.

With that company, she was noted for her performances in George Balanchine's *Bourée Fantasque* and *Stars and Stripes*, both works demanding expert timing and technique. She was selected to dance in the premieres of William Dollar's *The Five Gifts* (1953), Jerome Robbins' *Fanfare* (1953), as the "Female Clarinet," and Todd Bolender's *Souvenirs*, opening the ballet as the lead "Wallflower."

After retiring from performance, George has become noted as a photographer specializing in dance. Her husband, Jacques D'Amboise, and one son, Christopher, are currently members of the City Bal-

let, while her daughters have frequently performed children's roles with the company.

Georgi, Yvonne, German concert dancer; born October 29, 1903 in Leipzig; died January 25, 1975 in Hanover. Georgi was trained by Jacques-Dalcroze and at the Wigman school in Dresden, where she met Harald Kreutzberg. She continued her studies under Viktor Gsovsky, Sigurd Leeder, and Kurt Jooss. From 1926 to 1931 she spent part of each year touring with Kreutzberg, giving recitals in Europe and the United States. Although she performed in some of his works, notably *The Angel of Annunciation*, she worked primarily as a concert dancer appearing in her own solos. During this period, she also served as ballet master in various German theaters, among them the Muenster Stadtteater (c.1924–1925), the opera house in Gera (c.1925–1926) and the Theater of the City of Hanover (1926–1931), where she choreographed *Eine Keine Nachtmusik* (c.1929), *Rococoscenes* (c.1927), and *Don Morte* (c.1928).

Georgi emigrated to the Netherlands in 1938, forming a company that performed in Scherengen and Amsterdam. She returned to Germany in the early 1950s to serve as ballet master in Dusseldorf (1951–1954) and at the Landestheater in Hanover (1954–c.1975), working concurrently as director of the dance training program. One of the most active choreographers in Germany, she was one of the few concert dancers of the 1920s who was able to work within the state ballet formulas of the 1950s and 1960s.

Works Choreographed: CONCERT WORKS: *Persisches Ballet* (1924–1925); *Der Dämon* (1925); *Barabau* (1926); *Pulcinella* (1926); *Petrouchka* (1926); *Arabische Suite* (1926); *Saudades do Brazil* (1926); *Rococoscenes* (1927); *Deutsche Danz* (1927); *De Puppernfée* (1927); *Don Morte* (1928); *Baby in Der Bar* (1928); *Prince Igor* (1928); *Remembrances of Spain* (1928); *Robes, Pierre and Co.* (1928); *Das Seltsame Haus* (1928–1929); *Kassandra* (1928); *Joseph's Legend* (1929); *Orpheus and Eurydice* (1929); *Der Fächer* (1929); *Eine Kleine Nachtmusik* (1929); *Pavane* (1930, co-choreographed with Harald Kreutzberg); *Kassandra* (1930); *Le Train Bleu* (c.1931); *Diana* (1935); *Goyescas* (1935); *Acis et Galathée* (1936); *The Creatures of Prometheus* (c.1939); *Old Dutch Dances* (1939); *Fantastic Symphony* (1939); *Festive Dances* (1939); *Souvenir* (1939); *Carmina Burana* (1940s); *Apollon Musagète* (1951); *Das Feuervogel* (1951); *Les Animaux* (1951); *Das Goldfischglas* (1952); *Die Vier Temperamente* (1952); *El Amor Brujo* (1952); *Coppélia* (1952); *Wendungen* (1953); *Pas de Coeur* (1953); *Sacre du Printemps* (1953); *Orpheus* (1955); *Human Variations* (1955); *Les Biches* (1955); *Glück, Tod und Traum* (1956); *Der Mohr von Venedig* (1957); *Le Loup* (1957); *Elektronisches Ballett* (1957); *Der Schatten* (1958); *Evolutionen* (1958); *Bacchus et Ariadne* (1958); *Agon* (1958); *Die Ballade* (1959); *The Unicorn, the Gorgon and the Manticore* (1959); *Ruth* (1959); *Königliche Spiele* (1959); *The Woman of Andres* (1960); *Bluebeard's Nightmare* (1961–1962); *Hamlet* (1961–1962); *Jeux* (1961–1962); *Passacaglia No. 1* (1961–1962); *Metamorphosen* (1962); *The Miraculous Mandarin* (1962–1963); *Suite in Four Movements* (1963); *Demeter* (1964); *Skorpion* (1973).

OPERA: *Herzog Blaubarts Burg* (Duke Bluebeards' Castle) (1953).

FILM: *Ballerina* (French Studio credit uncertain, 1950).

Bibliography: Koegler, Horst. *Yvonne Georgi* (Hanover: 1963).

Georgiades, Nicholas, Greek theatrical designer known for his work for English productions; born 1925 in Athens. Since the mid-1950s, Georgiades has become one of the best known designers in the international ballet and opera. He is considered a neobaroque specialist and has frequently been engaged to create scenery and costumes for productions of fairytale ballets, among them, Nureyev's *The Nutcracker* (London, 1968) and *Raymonda* (Zurich, 1972), Kenneth Macmillan's *Romeo and Juliet* (1965), *Swan Lakes* for Macmillan and Nureyev, and the latter's *Sleeping Beauty* (Milan, 1966).

Gerdt, Pavel, Russian ballet dancer, mime, and teacher; born December 4, 1844 in or near St. Petersburg; died August 11, 1917 in Vommala, Finland. Gerdt was trained at the St. Petersburg School of the Imperial Ballet by Marius and Jean Antoine Petipa and Christian Johansson before graduating into the Maryinsky Ballet. Celebrated as a *danseur noble* and

as a mime, he performed in almost all of the ballets by Petipa and Lev Ivanov. Members of his enormous claque could choose among performances of Marius Petipa's *The Sleeping Beauty* (1890), *Kalkalrino* (1891), *Cinderella* (1893), *Halte de Cavalrie* (1896), or *Raymonda* (1898), Ivanov's *The Nutcracker* (1892), or their *Swan Lake* (1895). As an elderly Russian audience member once said, "He was the ideal Prince Charming."

Gerdt taught at the school from which he had graduated after 1909. Among the many influential dancers who took his adagio, pas de deux, or character classes, were Anna Pavlova, Tamara Karsavina, Lydia Kyasht, Mikhail Fokine, Vladimir Tihkomirov and Alexander Gavrilov, as well as his own daughter Yelisaveta.

Gerdt, Yelisaveta, Russian/Soviet ballet dancer and teacher; born April 29, 1891 in St. Petersburg; died November 5, 1975 in Moscow. She was trained by her father Pavel and at the school of the Imperial Ballet in St. Petersburg. Graduating into the Maryinsky Ballet in 1908, she was acclaimed for her portrayals of the principal female roles of the Marius Petipa/Lev Ivanov repertory, notably as "The Sugar Plum Fairy," "Odette/Odile," and "Raymonda."

Gerdt followed her father as company teacher in 1928, forming a personal transition between the Russian and Soviet ballet styles. She taught in Leningrad until 1935 when she became a member of the faculty of the Bolshoi School in Moscow. Her students included many of the stars of the Soviet ballet, including Maya Plisetskaya, Ykaterina Maximova, Violette Boct, and Raissa Struchkova.

Germaine, Diane, American modern dancer and choreographer; born July 5, 1944 in New York City. Germaine was trained at the High School of Performing Arts in New York City. She joined the Paul Sanasardo company shortly after graduation and performed with him until 1976. Among the many works in which she performed were his celebrated *Fatal Birds*, *Metallics*, *The Path*, and *Consort for Dancers*. Germaine also performed in the companies of two choreographers associated with Sanasardo—Donya Feuer and Manual Alum—before becoming artistic director of the Sanasardo troupe and leaving

to form her own company in 1975. Although most of her works were created for her own company, Diane Germaine and Dancers, founded in 1975, she has also staged her pieces for the Norsk Opera Ballet of Oslo, the Chicago Moving Company, and the Bat-Dor and Kibbutz Dancers in Israel. Many of her best known works are segments of two cycles—the *Antipoem* series (1979–) and the many *Lulu* pieces, in which contemporary life and mores are presented as if through the experiences of Lulu, a chimpanzee. Both of the series are projected to continue through the 1982 season.

Works Choreographed: CONCERT WORKS: *Pastels* (1963); *Monody* (1963); *Trio* (1963); *Dream* (1966); *One Other* (1967); *The Moth* (1967); *The Wanderer* (1968); *Duet* (1968); *Epitaph* (1970); *Der Panther* (1971); *Remainder* (1971); *Ashes* (1972); *Stop-Over* (1972); *Among Flowers That Enclose Us* (1974); *Journal* (1974); *Playground* (1975); *For the Public Only* (1976); *Voyeurs* (1976); *Ghosts* (1978); *Wheat* (1978); *Field I* (1978); *Untitled Solo* (1978); *Archipel* (part of the *Antipoem* series) (1979); *Lulu* (1979); *Flight/Island* (1979); *It's Not the Bullet That Kills You, It's the Hole* (1980); *Hotel Nicaragua* (part of the *Antipoem* series) (1980); *The Ocean Floor & Those Who Live There* (part of the *Antipoem* series) (1980); *Ufi Ruach* (1980); *(Lulu) A Day in the Park* (1980); *(Lulu) At the Seashore* (1980); *Radiohio* (part of the *Antipoem* series) (1980); *Random* (part of the *Antipoem* series) (1980).

Gershwin, George, American composer, born September 26, 1898 in Brooklyn; died July 11, 1937 in Hollywood, California. After a half-dozen years of song writing and plugging, Gershwin had his first major success with the song, "Swanee," written for Ned Wayburn's *Demi-Tasse Revue* (1919), but made famous by Al Jolson when he interpolated it into his *Sinbad, Jr.* Gershwin contributed to ten Broadway musicals and revues, notably the *George White Scandals of 1920* to *1924*, and was sole composer of ten more, among them, *Tip-Toes* (1925), *Oh, Kay* (1926), *Funny Face* (1927), *Rosalie* (1928), *Strike Up the Band* (1930), *Girl Crazy* (1930), *Of Thee I Sing* (1931), *Let 'Em Eat Cake* (1933), and *Porgy and Bess* (1935). With his brother Ira, and other lyricists, he also contributed to a large number of films including Fred Astaire's *Shall We Dance* and *Damsel in Dis-*

tress and George Balanchine's first American picture, *Goldwyn Follies*. Although Gershwin did not become associated with any single choreographer, George White and Sammy Lee each staged more than two shows, with White doing the *Scandals* and Lee working on *Lady, Be Good* (1924), *Tip-Toes* (1926), and *Oh, Kay* (1926).

Most of Gershwin's theatrical and concert works have at one time been choreographed by someone. The best known compilation ballets are Leonid Massine's *The New Yorker* (1940), George Balanchine's *Who Cares?* (1970), and Eliot Feld's *The Real McCoy* (1974). The most famous use of an orchestral suite was *An American in Paris*, as staged by Gene Kelly for the MGM film of that name. His *Rhapsody in Blue* was the first suite to be staged. The claim to the first use of it in dance was made by many; two dance directors practically tied for first performance, and, without rehearsal schedules, must be considered co-winners. They were both Prolog choreographers, interestingly, not concert dancers—Chester Hale, who staged it for the Chester Hale Girls at the Capitol Theater, and Albertina Rasch who choreographed it for her troupe for a Publix tour—each within three weeks of its premiere. Since both had close ties to the work's commissioner, Paul Whiteman, it is possible that each had prior knowledge of the score.

Gert, Valeska, German actress and concert dancer; born Gertud Valeska, January 11, 1900 in Berlin; died 1978 in Sylt, Germany. Trained by Alexander Meisse, Gert worked with Max Reinhardt and performed in films by Ernst Pabst, notably in his *Threepenny Opera*, and Jean Renoir.

Her solo recital works, called Gert-genre, were horrifying characterizational portraits of social types, representing topical events and social conditions. These were performed at her own Berlin cabaret club, Kohlkoppec, and in concerts in Germany and in the United States during the war. She was enormously influential in the American concert dance movement during the 1930s, through pictures and descriptions in the dance and socialist press; her appearances and those of Lotte Lenya were also very important in the importation of the German film and cabaret acting styles to American dance and theater.

Works Choreographed: CONCERT WORKS: (Note: since many of these works were created for cabaret performance, the exact order of dance creation is unsure. Works created in Berlin are therefore grouped together.) *Chansonette; Nervosiat; Opus 1; Der Boxkampfer* (The Boxer); *Girl in Spring; Music Hall, Tod; Vienne—Lady—1890; Canaille; Minuett; Ballett; Diseuse; Coloratura* (pre-1933); *Strip Tease* (1936); *The Famous Pianist* (1940); *To Die* (1940); *La Tragedienne Française* (1940); *Americana (At the World's Fair, At the Microphone)* (1940).

Geva, Tamara, Soviet ballet dancer and actress working in Europe and the United States after 1924; born Tamara Gevargeyeva c.1908 in St. Petersburg. Geva was trained at the Petrograd Choreographic Institute and worked with Kasan Goleizovsky in the GATOB. With George Balanchine, then her husband, she moved to Paris where Bronislava Nijinska arranged for them to join the Diaghilev Ballet Russe. She did not remain with the company, however, but instead came to New York with the *Chauve-Souris*, in ballet solos choreographed by Balanchine. She remained on Broadway after that revue, playing seductresses and/or ballet dancers in musicals, including *Whoopee* (1928), *Three's a Crowd* (1930), *Flying Colors* (1932), and Balanchine's *On Your Toes* (1936), in the duo-roles of "Princess Zenobia" and "The Strip Tease Girl." She was reunited with Balanchine earlier when she performed in his *Errante* with the first performances of the American Ballet (1934 and 1935). The famous photograph of her posed entwined in William Dollar's arms in that ballet did much to establish the company and its repertory.

Geva's film career included appearances in three musicals—*Their Big Moment* (RKO, 1934), *Manhattan Merry-Go-Round* (Republic Studios, 1937), and *Orchestra Wives* (Twentieth-Century Fox, 1942)—and the choreography for the film of Ben Hecht's roman à clef, *The Specter of the Rose* (Republic, 1946).

Since the 1940s, she has performed notably as an actress in comedies, such as *Twentieth Century* and *Misalliance*, and in experimental productions of European dramas, among them the famous 1941 production of *The Trojan Women* and the Los Angeles production of *No Exit* in 1947.

Bibliography: Geva, Tamara. *Split Seconds* (New York: 1972).

Gibson, Albert, American tap dancer; the details of Gibson's birth cannot be verified. Born on tour with his parents' feature act, The Chocolate Box Revue, he began to perform with them as a child. His own act, the Three Chocolateers, began on the West Coast but was a favorite with New York audiences as well. In the latter trio with acrobat/tappers Eddie West and Paul Black, he brought down dozens of houses with his specialty, "Peckin'," a controlled, syncopated slow shoulder shimmy that introduced the barnyard ballroom craze. Gibson also worked in acrobatic forms, like his colleagues, and was known to make his entrance on kneedrops, flying through the air and landing on his knees. With the renaissance of interest in tap dancing in the 1970s, Gibson returned to the road with a feature act, The Generation Gap, presenting both tap and jazz dances. He was one of the "Tapologists" invited to participate in the By Word of Foot master classes in 1980.

Gibson, Ian, Scottish/Canadian ballet dancer, also working in the United States; born 1919 in Glasgow. Raised in British Columbia, he studied with Dorothy Wilson in Victoria and June Roper in Vancouver, before traveling to New York where he continued his training under Anatole Vilzak. Gibson made his professional debut with the Hollywood Bowl Ballet in 1938 in works by Aida Broadbent, Ernest Belcher, and/or Theodore Kosloff all of whom were on the Bowl staff that summer.

Gibson spent a year with the Ballet Russe de Monte Carlo, in which he danced in Marc Platt's *Ghost Town* and Leonid Massine's *Gaité Parisienne*. In two seasons with Ballet Theatre (1941–1943), he progressed from small parts in *Bluebeard* to the Bluebird pas de deux, *Spectre de la Rose*, and the title role in Eugene Loring's *Billy the Kid*. He was drafted into the Canadian Navy in 1943 and did not regenerate his career after the end of World War II.

Gielgud, Maina, English ballet dancer; born June 14, 1945 in London. Gielgud, who is the daughter of BBC producer Val and the niece of actor, John, was trained in London by Nicholas Legat, Tamara Kar-savina, and Stanislav Idzikovsky; spending her summers in Paris, she continued her studies with Olga Preobrajenska, Julie Sedova, Paul Goubé, and Lubov Egorovaa.

Gielgud performed with a series of European and French ballet companies during the 1960s, among them, the Roland Petit Ballet (1961), dancing a small solo in *España*, the International Ballet du Marquis de Cuevas, the Rosella Hightower Ballet (1963), the Grand Ballet Classique de France (1965), and Boris Tonin's Chamber company, before joining the Ballets du XXième Siècle in 1967. In that company, she has danced for Béjart in the premieres of *Beaudelaire* (1968) and in performances of *Ninth Symphony*, *Four Last Songs*, *Romeo et Juliette*, as "Queen Mab" in the visualization of Mercutio's speech, and *Le Voyage*. Gielgud's authoritarian presence and flawless technique have also been seen in many guest performances in the classics and the contemporary ballet.

Gifford, Joseph, American modern dancer; born c.1920. After graduating from the University of Michigan, Gifford moved to New York City to study at the (Doris) Humphrey/(Charles) Weidman studio. He appeared in works by each choreographed over a ten-year period from 1943, when he danced in Weidman's *Atavisms* and Humphrey's revival of *The Shakers* to 1953, when he danced in her *Poor Eddy* (1953). Between those years, he appeared in her *Music for the Theatre* (1943) and the Broadway production of *Sing Out, Sweet Land* (1944), in Helen Tamiris' show, *Up in Central Park* (1945), and in early works by José Limón (still a Humphrey/Weidman dancer then), among them, his *Western Folk Suite* (1943) and *Danzas Mexicanas* (1943).

Gifford, who was already directing the New Dance Group Studio in the early 1950s, left performance to teach but returned to New York occasionally to present works at the 92nd Street "Y" or for the company of a fellow dancer.

Works Choreographed: CONCERT WORKS: *The Frequent Hero* (1959); *L'Histoire du Soldat* (1959); *The Pursued* (1964).

Gilbert, Melvin Ballou, American nineteenth-century dance master; born April 15, 1847 in Turner,

Androscoggin County, Maine; died May 11, 1910 in Portland, Maine. Gilbert taught for over forty years in studios in Portland and Boston, Massachusetts, the latter in association with the Harvard College (Summer) School of Physical Culture. He taught a combination of exercises based on Americanized Delsarte and institutionalized Per Henrik Ling and forms based on ballroom work. Among the other dance forms that he taught were such contemporary genres as aesthetic drills, cotillions (entire evenings of social dances and games), and theatrical solos and ensembles. Gilbert served his art as editor of *The Director* (1897–1898), which is considered the first dance trade periodical in the country, and as an officer of a number of the professional organizations that sprang up in the late 1890s.

The Director was reprinted in a single volume by Dance Horizons and is a valuable source of information on the etiquette and techniques of social and theatrical dance pedagogy in the nineteenth century.

Gilmore, Ethel, American theatrical ballet dancer; born c.1890, probably in Montreal; date and place of death uncertain. Gilmore and her older sister, Rachel Amelia (called Ray), moved to New York in their adolescence with their theatrical dressmaker mother. Both studied with Mme. Elisabetta Menzelli in her New York studio, learning her combination of Viennese and Italian technique. Although Ray worked as a model as an adolescent, posing for Charles Dana Gibson, among others, there is no evidence that Ethel did the same.

Ethel Gilmore made her professional debut with the Children Theatre Company of the Carnegie Lyceum in 1902—a Lyceum, as an educational institution, could hire underage performers while a legitimate theater could not. She worked steadily through the first decade of the century, primarily in Lew Field's productions, among them, *It Happened in Norland* (1905) and *The Girl Behind the Counter* (1907), and in extravaganzas such as *Wang* (1903), *Mr. Wix* (1904), and *The Enchanted Isle* (1904). Her best remembered performances were in the ballerina roles in *Miss Innocence* (1908), a Ziegfeld production for Anna Held, and *The Soul Kiss* (1911), as Adelina Genée's replacement.

Although she was extremely successful on Broadway and in her own vaudeville ballet act, Gilmore left the theater to return to Montreal as prima ballerina of the National Grand Opera there (c.1913) to her retirement.

Gilmour, Ailes, American concert dancer; born c.1913 in New York City. Trained at the Neighborhood Playhouse, Gilmour was a charter member of the first Martha Graham company in New York. She appeared in Graham's group works during the 1930s, most notably in *Primitive Mysteries* (1931), *Bacchanale* (1931), *Ceremonials* (1931), and *Tragic Patterns* (1933). Gilmour also worked with the New Dance League's programs and with at least one of the groups in the Workers' Dance League, possibly the Red Dancers. She was both an administrator and a performer in the Workers' Dance League and directed some of its publication and free dance class programs. Gilmour was also working in slightly more conventional dance companies during the 1930s, however, including Bill Matons' Experimental Unit. She danced in most of Matons' works with female casts (and in one performance of the all-male *Dance of Work and Play*) and shared recitals with him. Like him, she disappeared at the end of the concert/political dancer era. It is hoped that more research can be done on these important figures in the development of modern and concert dance.

Works Choreographed: CONCERT WORKS: *Adam's Apple* (1936); *Holiday* (1937); *Evening of Illusion* (1937); *Who Chases Who?* (1938).

Gilmour, Sally, English ballet dancer; born 1921 in Malaya. After returning to England as a child, Gilmour studied ballet with Tamara Karsavina and Marie Rambert.

Performing with the Ballet Rambert from 1936 to her retirement, Gilmour was celebrated for her work in the ballets of Andrée Howard, among them, *Lady in Fox* (1939), in the title role, *Carnival of Animals* (1943), *The Fugitive* (1944), and *The Sailor's Return* (1947). Gilmour also created roles in Frank Staff's *Peter and the Wolf* (1940), playing the "Duck," and in Walter Gore's *Confessional* (1941), and *Winter Night* (1948). Noted for her performance in the company revival of *Giselle*, Gilmour played featured

roles in Antony Tudor's *Gala Performance* and Frederick Ashton's *Façade* that exploited her sense of comedy of style.

Gilpin, John, English ballet dancer; born February 10, 1930 in Southsea, England. Originally a child actor, frequently playing "Michael" in productions of *Peter Pan*, Gilpin received general stage training at the Arts Education and Cone-Ripman Schools in London. Ballet studies with Marie Rambert led to an engagement with her Ballet Rambert from c.1944 to 1949. In that company, he created the role of "The Rabbit Catcher" in Andrée Howard's *Sailor's Return* (1947), and danced in Antony Tudor's *The Planets*, *Descent of Hebe*, *Gala Performance*, and *Soirée Musicale*.

After seasons with Les Ballets de Paris de Roland Petit and the Grand Ballet du Marquis de Cuevas, in which he danced in a production of Balanchine's *Concerto Barocco*, Gilpin became a founding member of the London Festival Ballet. Celebrated there for his outstanding technique and stage presence, he created the leading male role in Frederick Ashton's romantic *Vision of Marguerite* (1952) and danced the male principal parts in the classical repertory, notably in *Spectre de la Rose*, *Les Sylphides*, *Coppélia*, and *Swan Lake*. Named artistic director of the company in 1962, he served in that capacity for three years before retiring. Since 1965, he has taught extensively in England and in Denmark, Japan, and Turkey.

Ginner, Ruby, English interpretative dancer involved with Greek revivalism; born c.1886 in Cannes; died February 19, 1978 in Newbury, Berkshire. Ginner had some ballet training but did not perform in that technique. She was a pioneer of the Greek revivalist movement in dance in the British Isles, and presented lecture-demonstrations and recitals of works and individual steps based on her research in Greek culture. Unlike many of her contemporaries in the movement, she made differentiations among the many disparate cultures of the individual Hellenic city-states and billed each dance accordingly. The programs that she presented—for her The Grecian Dancers (1913–) and the Greek Dance Association concert group (1923–)—were divided into three sections.

They opened with a lecture on the Greek arts and continued with demonstrations of the eight Fundamental Positions and many Expressive Movements. They, and her actual dances, were accompanied by poetry read by actress/mime Irene Mawber. Ginner's best known piece was the *Pyrric Dance* solo but her *Spartan Warrior's Dance* and *Athenian Women in Mourning* were also highly acclaimed.

Ginner continued to perform, lecture, and write on Greek dance forms long into the 1960s, outliving the popularity of her movement by more than forty years. Her books, whose contents have been outdistanced by time, are now only available from the Greek Dance Association (Imperial Society of Teachers of Dancing).

Gioja, Gaetano, Italian nineteenth-century ballet dancer and choreographer; born 1764 in Naples; died there March 30, 1826. Gioja was trained by his ballet master father Antonio (then at the Teatro San Carlo) and by Gaetano Vestris. It is presumed that he performed at the San Carlo as an adolescent, since he was known for his character work when he was named ballet master of the Teatro Reggio in Turin (c.1788). Although he was a member of the ballet at the Teatro alla Scala as late as 1790, he is better remembered as a choreographer than as a dancer.

Prolific even in comparison to his itinerant Italian colleagues, Gioja began his choreographic career at the Teatro Reggio, but soon began to work the circuit of theaters in the then separate kingdoms that made up un-unified Italy, most frequently the Teatro San Carlo in Naples, the Teatro alla Scala in Milan, the Teatro Pergola in Florence, Teatro la Fenice in Venice, and Teatro Argentina in Rome. He was known for his ballets based on the Roman and Greek mythologies—concepts that could be translated to fit the political and nationalistic feelings of each kingdom while emphasizing the history of the Italian people. His involvement with the myths of the Crusades predated those of his colleagues, many of whom did not use those themes until after unification. Gioja also created a number of works based on the nationalist themes of other countries, including a version of *Gli Esilati in Siberia* (1823), and the versions of, or separate ballets about, stories of Elizabeth I, of England, among them, *Il Conte di Essex* (1818), *Kenil-*

worth (1823), and *Elisabetta al castelo di Kenilworth* (1824).

Gioja can be credited, at least partially, with defining the pre-Romantic Italian ballet with its fascinating choice to emphasize dramatic action over bravura technique and movement. He has been called the last of the masquers, but is more accurately considered the last choreographer to be creative within the chosen definitions of the classic ballet.

Works Choreographed: CONCERT WORKS: *Sofonisba* (1789); *Felicitale Lusitua* (1793); *I Dispetti Amorosi* (1793); *Teseo Riconosciuto* (1794); *Elfrida* (1794); *Eufrusina* (1794); *Il Feudatario Paenito* (1794); *Nina, or la passa per Amore* (1794); *La Pupilia Innamorata* (1794); *Cora* (1795); *La Contadina Impertinente* (1795); *Arginia Sepulta, ovvero Lo Sdegno di Minerva* (1795); *Lo Nozze Campestri* (1795); *La Simplice Burlata* (1798); *Azen e Zulima* (1798); *La Volubile* (1798); *La Disfatti di Abderhamei* (1798); *La Disatta* (1800, possibly version of the above); *Lo Studente* (1803); *Andromeda e Perseo* (1803); *Ballo Campestre* (1804); *I Curlandesi* (1804); *Il Ritorno di Ulysse in Italia* (1804); *I Mintori Valacchi* (1804); *L'Equivoco delle muciglie* (1806); *I Sacrifice Indiani* (1806); *Saffo* (1806); *La Morte di Rolla* (1807); *Caesare in Egitto* (1807); *I Due Prigionieri* (1809); *I Morlacchi* (1809); *La Prova Generale del ballo di Giasone e Medea* (1809); *L'Eroismo dell'-amizi* (1810); *Il Trionfo di Trojano* (1810); *Gli Orazi e i Cuiriazi* (1811); *Orfeo e Eurydice* (1811); *Arsinoe e Telemaco* (1814); *I Riti Indiani* (1814); *La Casa Disabilitá* (1814); *Le Nozze di Figaro* (1814); *La Gelosio Ingegnosa* (1814); *Gundeberga* (1814); *L'Allievi dell'natura* (1815); *Macbet, Sultano di Dely* (1816); *Poltronetto* (1816); *Guidon Selvaggio* (1816); *Alfredo* (1818); *Il Conte di Essex* (1818); *Achar Gran Mogul* (1819); *Capriccio e Buon Cuore* (1819); *Penelope* (1819); *L'Insegno Supera l'eta* (1819); *Il Pelligrino* (1819); *Ottavia* (1820); *Apelle e Campaste, ovvero Generosita di Allessandro il Grande* (1822); *Il Merciavolo in Angustie* (1822); *Il due Savojardie* (1822); *La Gelosia per Equivoco* (1822); *Kenilworth* (1822); *Zoë* (1822); *I Sequci di Bacco* (1822); *Bradamente e Ruggero* (1822); *Cleopatra, regina di Siria* (1822); *Elisabetta al Castello di Kenilworth* (1822, may be revival of *Kenilworth* and/or *Il Conte di Essex*); *Gli Esilati in Siberia* (1823); *Il Trionfo dell'a-mor Filiale* (1824); *Nicola Pesce* (1824); *Otto Mesi in due Ore* (1825); *Lo Scultore* (1825).

Giordano, Gus, American jazz dancer and choreographer; born July 10, 1930 in St. Louis, Missouri. Giordano was trained at the American Theatre Wing schools, and continued his studies in classes with Katharine Dunham, Hanya Holm, and Peter Gennaro. He made his professional debut at The Roxy Theater in 1948, working in the male specialty chorus in that celebrated presentation-act house in New York. After dancing on Broadway in *Wish You Were Here* (1952), he began to present his own jazz dances in cabarets. After moving to the Chicago area where he directs a popular jazz dance studio, he became involved in choreographing for television, producing a large number of dramatic dance works for a local station, WTTW. His *Michaelangelo* (1968) and *Jazz Dance: Chicago Style* (November 1968) have been especially well received.

As well as teaching at his studio, in frequent master classes, and in guest residencies in Europe, Giordano writes articles and texts about jazz dance and sponsors a series of pamphlets and recordings to disseminate his training methods.

Works Choreographed: TELEVISION: *Requiem for a Slave* (WTTW, c.1967, special); *Michaelangelo* (WTTW, c.1968, special); *Jazz Dance: Chicago Style* (WTTW, November 1968, special); *Streetcar Dance of Desire* (WTTW, March 1969, special); *Ritual Dance* (WTTW, March 1970, special); *Call of the Drums* (WTTW, March 1971, special).

Bibliography: Giordano, Gus. *Anthology of American Jazz Dance* (Evanston, Illinois: 1975).

Gissey, Henri, French seventeenth-century theatrical designer; born c.1621; died c.1673. The son of a sculptor, he was thoroughly grounded in both the contemporary arts and the seventeenth century's revival of Roman iconography and architecture. He was appointed "Dessinateur du Cabinet du Roi" in 1660, holding that post until his death. His position, which can be translated as both designer and draftsman to the king's chambers (i.e., personal staff), gave him the royal grant to provide design schemes for all court presentations, including the ballet du cour and processionals. His best known work, *Le*

Carousel de Louis XIV (1662) was a process leading to a masque performed by humans and horses presented in honor of the birth of the Dauphin. Since the king was using the occasion to emphasize his unchallenged position as ruler of France, he directed Gissey to base the scenery, costumes, props, and hangings on the iconography of the Roman empire and himself appeared as Augustus. Gissey was succeeded by Jean Berain, *père*.

Gitelman, Claudia, American modern dancer and choreographer; born June 24, 1938 in Iola, Wisconsin. After studying ballet from childhood, Gitelman was introduced to modern dance forms by Maxine Munt and Alfred Brooks while at the summer music camp at Interlochen. As a student at the University of Wisconsin at Madison, she was able to acquire modern dance background in one of the country's best programs in German-lineage forms, from Louise Kloepper and the faculty there. She expanded her technique with American traditional modern dance pioneers Martha Graham, Louis Horst, and Helen Tamiris, and second-generation performers Lucas Hoving and Valerie Bettis, at American Dance Festival summers. As a student of Alwin Nikolais in New York after 1958, she performed in early concerts of Murray Louis' works and danced for his teacher Hanya Holm on Broadway in *Camelot*. She taught at universities throughout the 1960s until 1971, when she joined the faculty of Nikolais Dance Theater Lab, where she now serves as director of curriculum. She has also taught with Holm at her Colorado studio, at the American Dance Festival, and at summer university sessions.

Since Gitelman's first choreographic showing in 1971, she has become known as one of the most articulate and popular of the Nikolais school. Although her company's repertory also featured rare new works by Holm, her own pieces are always singled out for praise for their sensitivity to movement and situation.

Works Choreographed: CONCERT WORKS: *The Duet* (1971); *This Dance May Have a Message* (1971); *Satiezing* (1972); *Players, Players* (1972); *A Touching Piece* (1973); *Addenda* (1973); *Soundings* (1973); *Legend* (1973); *Go Suite* (1973); *Continental Harmony* (1975); *Notenbuchlein* (1975); *Lineals* (1975); *Les Folies Français* (1975); *7 Plus 14* (1975); *Blues* (1975); *Head* (1976); *Partita* (1976); *Winter Lights* (1977); *Inside Sam* (1977); *Sundy Dances* (1977); *No School Today* (1977); *A Set for Players* (1977); *Plainsong* (1978); *Wind of Knives* (1978); *Direct Direction, Projection and Whim* (1979); *Portraits* (1979); *The 29th Year* (1980); *Bag* (1980).

Giuri, Marie, Italian ballet dancer of the late nineteenth century; born c.1866 in Trieste; the date and place of Giuri's death is unsure. Trained by José Mendéz and Catarina Beretta, Giuri made her debut in Berlin in Paul Taglioni's *La Fantasca* in 1881.

Giuri's short career was spent mostly at the Teatro alla Scala in Milan, where she performed in works by Salvatore Taglioni and Pasquale Rota, but she also danced in Warsaw, where Mendéz was ballet master, and in the United States. On a tour of the East Coast, she performed *Coppélia*, the lead in which was her most successful role, *Le Bal Costumé* and *La Notta di Walpurgis* with the American Opera Company (1886 and 1887). She may also have danced with the Italian Opera Company in New York, an outgrowth of her American sponsor.

Gladstein, Robert, American ballet dancer and choreographer; born January 16, 1943 in Berkeley, California. Like so many dancers from the Bay area, Gladstein has long been associated with the school and company of the San Francisco Ballet. A company member in the mid-1960s and from 1970 to 1975, he performed in many works by Lew Christensen, among them, his *Beauty and the Beast, The Nutcracker, Lady of Shalott, Lucifer,* in the title role, and *Divertissement d'Auber.*

In the American Ballet Theatre from 1967 to 1970, he created roles in Alvin Ailey's *The River* (1970), in the Falls section, and in Eliot Feld's *At Midnight* (1967). His featured roles included parts in José Limón's *The Traitor,* Antony Tudor's *Jardin aux Lilas,* and Agnes De Mille's *Fall River Legend.*

After Gladstein retired as a dancer, he was named ballet master of the San Francisco Ballet in 1975, a position he still holds. He has also choreographed for the company.

Works Choreographed: CONCERT WORKS: *Vivaldi Concerto* (1964); *Les Désirables* (1964); *Way Out*

(1970); *N.R.A.* (1972); *Celebration* (1972); *Gershwin* (1977); *Stravinsky Cappricioso for Piano and Orchestra* (1978); *The Mistletoe Bride* (1979).

Glass, Bonnie, American exhibition ballroom dancer; born Helen Roche, c.1895, in Roxbury, Massachusetts; date and place of death uncertain. Glass had a short career as a theatrical ballet dancer, c.1910, working in the roof garden theaters of New York. She was married in 1911 to an "Oregon millionaire," Graham Glass, in a wedding that was described in both the society and theatrical newspapers. After her divorce in 1914 (an event that was also well covered in the press), she returned to the theater, this time as an exhibition ballroom dancer.

She made her second debut—as Bonnie Glass—in 1914 at Florenz Ziegfeld's Jardin de Danse, on the roof of the New York theater. Glass played there, and at two restaurants, Rector's and the Café Montmartre, in that year (1914–1915) with a partner named Bernardo Rudolf and The James Reese Europe Orchestra. Europe's band, which also accompanied the Castles, was probably the most important element in the association between exhibition work and the new ragtime craze. Rudolf, whom *The Dramatic Mirror* described as "a lengthy person utterly devoid of personality," was soon replaced by Clifton Webb—similarly tall, and then making the transformation from eccentric juvenile to glamorous dance partner. They worked well together, and played the Montmartre and on the Keith circuit very successfully, as the second team on a bill with Evelyn Nesbit and Jack Clifford.

Glass' next partner was a Rudolf with a lot of personality—Rudolf Valentino, in his first professional dance engagement. They did her specialties—the Tipperary Trot, Flirtation Waltz, Military Galop, and Cake Walk—but not the Tango with which he is associated in films. After successful club engagements and a short vaudeville tour on the Keith circuit with Valentino, she retired to marry Ali Ben Haggin, the society artist who later became known for the tableaux vivants that he staged for Ziegfeld.

Glassman, William, American ballet dancer, born February 15, 1945 in Boston, Massachusetts. After early training in tap with Esther Lyons, Kay McDermott, and the staff of the June Taylor School, he studied ballet with E. Virginia Williams and at the School of American Ballet.

He performed with Williams' New England Civic Ballet briefly before joining the American Ballet Theatre in 1963. Best known for his performance of "The Groom" in the premiere of Jerome Robbins' *Les Noces* (1965), he was noted for his works in his *Fancy Free* and *Interplay*, in Agnes De Mille's *The Wind in the Mountains* and *Rodeo*, in Eugene Loring's *Billy the Kid*, and in the company production of *La Fille Mal Gardée*.

Glauber, Lynn, American ballet dancer working in Belgium; born January 1, 1954 in Buffalo, New York. Trained locally with Stella Appelbaum, Frank Bourman, and Kathleen Crofton, she also worked with Ann Parson at the American Ballet Center.

A member of the Ballet du XXième Siècle since 1971, she has created a principal role in Maurice Béjart's *Seraphita* (1974) and danced in his *Serait-ce la Mort?*, *Romeo et Juliette*, *Bhakti*, *Les Noces*, *Offrandes Choréographique*, *Actus Tragicus*, and *Pli Selon Pli*.

Glazunov, Alexander, Russian/Soviet composer; born August 10, 1865 in St. Petersburg; died March 21, 1936 in Paris. Glazunov's many orchestral scores reveal that he was a melodist second only to Tchaikovsky in fecundity. It is unfortunate that his ballet commissions date from his least interesting compositional period, at the end of the nineteenth century. Although the works are popular and one, *Raymonda* (1898), has been parcelled out among three different ballets by George Balanchine, they are definitely not his best compositions. He was rediscovered as a dance composer in the very end of the Russian Era, when both Alexander Gorsky and Mikhail Fokine staged works to existing scores—his *Symphony No. Five* and his *Stenka Rasin* Suite.

Glenn, Laura, American modern dancer; born August 25, 1945 in New York City. Trained at the Juilliard School by José Limón and Anna Sokolow, among other working faculty members, she became a member of the Limón company while still a student. In her years with the company, from 1964 to his

death in 1972, she created roles in his series of solos, *Dances for Isadora* (1972), and performed to great acclaim in his *The Winged, Missa Brevis, Comedy, Orfeo, There Is a Time*, and *The Exiles*, and in Doris Humphrey's *The Shakers*. She staged Limón works, notably his *The Moor's Pavane*, for companies around the world, including the American Ballet Theatre, the Royal Danish Ballet, and the Royal Swedish Ballet.

A member of the Contemporary Dance System since its inception, she performed in director Daniel Lewis's *Rasaumovsky* (1975) and *And First They Slaughtered the Angels* (1975), and in the company's repertory of works by Humphrey and Sokolow. She was especially noted for her work in Humphrey's *Nightspell* and in Sokolow's *Lyric Suite, Steps of Silence*, and *Rooms,* in which she did the terrifyingly sad "The End" sequence. Her defined movements, strong encompassing stage presence, and martyred expression make her an ideal Sokolow dancer.

Since 1977, Glenn has toured with a program of solos by Humphrey, Sokolow, herself, and choreographer Barbara Roan, doing her *Closing Remarks* (1978), *Serpent Song*, and *The Return of the Red Shoes*. She has also performed in duet concerts with Gary Lund, with special success in their presentation of Limón's *The Exiles*.

Works Choreographed: CONCERT WORKS: *Stages* (1976); *The Stolen Glance* (1977); *Muse* (1978); *Figurings* (1979); *Flora Chaya* (1980).

Glière, Reinhold, Soviet composer; born January 11, 1876 in Kiev; died June 23, 1956 in Moscow. Trained in the combination of classicism and nationalism that typified the Russian musical style of the early twentieth century, Glière was most successful at creating ballet scores for the Soviet Ballet. His *Red Poppy* (for Lev Lashchilin and Vasili Tikhomirov in 1927) is considered the first classic of that national formula and is still in the active repertories of many Soviet companies. His scores are also considered the bases for the ballet repertory of the People's Republic of China, heavily influenced by the Soviet style. Other popular Glière scores include music for Nemirovich-Danchenko's *Nuits d'Egypte* (1926) and *The Bronze Horseman* for Rotislav Zakharov (1949).

Glover, Amelia, American theatrical ballet and skirt dancer; born c.1873, probably in New England; the details of Glover's death cannot be verified. Glover was trained by Malvina Cavallazzi while ballet master and prima ballerina of the Mapleson Italian Opera in New York. She made her debut with the company in 1883 as an adolescent toe dancer. Although she appeared as a ballet specialist throughout her career, partnered frequently by Ignacio Martinelli, she also worked as a skirt dancer at Koster and Bial's, the most prominent New York variety house. As a skirt dancer, she was considered a solo attraction and was frequently engaged in billing wars with Carmencita (a Spanish dance specialist there) and the latter's arch rival at the Eden Musée, La Belle Otero. It should not be thought that Glover's dances were in any way Spanish; she was simply a soloist who was compared to other soloists, most of whom did Spanish dances, rather than to ballet dancers who worked in pairs or companies. Although it cannot be verified, it is likely that she was taught the skirt dance, which became her specialty in 1891, by Letty Lind or John and Marietta D'Auban, all in the United States then to work with the Kiralfy brothers.

Gluck, Rena, American modern dancer and choreographer working in Israel; born January 14, 1933 in New York City, Gluck received the best and most appropriate training for an American dancer in the traditional modern genre—early studies with Blanche Evans, attendance at the High School of the Performing Arts and The Juilliard School—in all of which she was introduced to elements from the three streams of the genre: the works of Martha Graham, of Doris Humphrey, and of Hanya Holm. She presented a recital in New York in 1950, introducing her best remembered work, *Uprooted* (1950), before emigrating to Israel.

Gluck became a member of the Kibbutz Beit-Alpha in that new nation, working and teaching there in the 1950s. In 1964, however, she moved to Tel Aviv to become a charter member of the Batsheva Dance Company, an Israeli troupe deeply influenced by the American traditional modern dance. In its first season she was a principal dancer but she soon switched to administration, serving as rehearsal as-

sistant, director of the Batsheva IL, and assistant artistic director of the company proper.

Works Choreographed: CONCERT WORKS: *Johnny Has Gone for a Soldier* (1950); *Uprooted* (1950); *Man and His Day* (c.1958); *Moods* (c.1958); *Unfound Door* (c.1958); *Games We Play* (1965); *Woman in a Tent* (1966); *Reflections* (1968); *Time of Waiting* (1971); *Journey* (1973).

Gluck-Sandor, Senia, American concert dancer and theatrical choreographer; born c.1910 in New York City; died there March 11, 1978. Gluck-Sandor was trained at the Neighborhood Playhouse by Blanche Talmud and performed in productions there before joining the Metropolitan Opera Ballet. He toured with Adolf Bolm and danced at The New York Hippodrome, in a ballet staged by Mikhail Fokine. Although Fokine left the Hippodrome fairly quickly, Gluck-Sandor remained to become ballet master. He served in similar capacities for the Chicago Oriental Theater and the Paramount Theater in New York (in its short period of Prolog production), where he presented his first major success, *The New Yorkers* duet with Felicia Sorel. He staged interpolated dances for revues, musicals, and dramatic works, among them the first American production of Shaw's *Back to Methusalah*, editions of the *Earl Carroll Vanities*, and acts for Tex Guinan.

He had a successful concert dance career between 1926 and the death of the Federal Dance Project (Works Progress Administration), working most prominently with his Dance Centre as choreographer and producer of works by Sorel and José Limón. His best remembered works included his *Evocation of a Soul* (1926), the *Geometric Charleston* (1927), the WPA's *Eternal Prodigal* (1936), and the Dance Centre's *El Amor Brujo* (1937).

Gluck-Sandor returned to the theater with a variety of projects ranging from a one-man theater company with puppets and masks to acts for the Minsky burlesque circuit. His last role was ''The Rabbi'' of Anatevka in the original cast of *Fiddler on the Roof* (1964–) and its 1970 touring company.

Works Choreographed: CONCERT WORKS: (Note: pieces created before 1932 may have been co-choreographed with Felicia Sorel.) *A Miracle Play* (1926);

Evocation of a Soul (1926); *Mon Ecstacy* (1926); *Faun and Nymph* (1926); *Geometric Dance—Life, the Eternal Triangle* (1926); *Portrait of Madame L.* (1926); *Sea Gull* (1926); *Puppet Sarcasm* (1926); *Bedouinne* (1926); *Suite of Blues* (1926); *Hebraic Legend* (1926); *Harlem* (1926); *Primative Workshop* (1927); *Geometric Charleston* (1927); *The New Yorkers* (1929); *Picassoesque* (1932); *Petrouchka* (1932); *Salome* (1933); *The Eternal Prodigal* (1936); *El Amor Brujo* (1937); *The Yellow Poodle Peril* (1937); *Commedia (Isabella Andreini)* (1937); *American Mountain Suite* (1937); *Hamlet* (1937).

THEATER WORKS: *Cabbages and Kings* (1933); *Why Not Tonight?* (London, 1934, interpolated dances only); *Johnny Johnson* (1937); *Everyman* (1937); acts for Tex Guinan's, New York; acts for the Minsky burlesque circuit.

Glushack, Nanette, American ballet dancer; born December 31, 1951 in New York City. Glushack was trained at the School of American Ballet and performed briefly with the New York City Ballet, its sponsoring company, before joining American Ballet Theatre in 1970.

In her nine years with Ballet Theater, she performed solos in all of their company revivals of the classics, notably in *La Bayadère* (Act II), *Giselle* as ''Myrthe,'' *Swan Lake*, and *Don Quixote*. Glushack was, however, better known for her dancing in the new works of choreographers, especially in Antony Tudor's *Leaves Are Fading* (1975), Alvin Ailey's *Sea-Change* (1972) and *The River*, in which she performed with Ian Horvath in the *Meander* section, and Dennis Nahat's *Brahms Quintet, Mendelssohn Symphony*, and *Some Times*.

In 1980, Glushack left Ballet Theatre to join the Cleveland Ballet, formed by Horvath, in order to dance in more of Nahat's works. Among the many Nahat ballets in which she now performs are *Quicksilver, Celebrations, Pas de Dix*, and the *Brahms Quintet*.

Gluszkovsky, Adam, Russian ballet dancer and teacher of the mid-nineteenth century; born 1793 in St. Petersburg; died c.1870 in Moscow. Gluszkovsky was trained by Ivan Valberkh and Charles-Louis Di-

delot, in whose *Russlan and Ludmilla* (1821) and *The Black Scarf* (1831) he was given principal roles.

Ballet master of the Moscow Bolshoi from 1812 to 1839, he followed in the traditions of his mentors by staging dances and operas using Russian folk themes. Gluszkovsky, who also taught at the school of the Bolshoi, left memoires about Didelot and Valberkh's work in Russia. Unfortunately, they have not yet been translated into English or French.

Bibliography: Slominsky, Yuri, ed. *Memoires of a Ballet Master by Adam Gluszkovky* (Lenningrad: 1940).

Goddard, Paulette, Brazilian ballet dancer working in the United States from the early 1940s; born 1920 in Brazil. Goddard was trained at the School of American Ballet in New York.

Associated with the Ballet Russe de Monte Carlo throughout her career, Goddard was assigned featured roles in Ruth Page's *Frankie and Johnny*, in which she played "Nellie Bly," in Leonid Massine's *Gaité Parisienne*, in Agnes De Mille's *Rodeo*, and in George Balanchine's *Mozartiana, Danses Concertantes, Ballet Imperial*, and *Serenade*.

A popular theatrical dancer and commedienne, Goddard performed frequently on early network television, especially on the NBC series of live revue shows broadcast in the 1954 season—*Sunday in Town* and *Best Foot Forward*.

Godkin, Paul, American ballet and theater dancer; born c.1916 in Beaumont, Texas. Trained locally by Ann and Judith Spoule, he moved west to Los Angeles to study with Carmelita Maracchi, Ernest Belcher, and Theodore Kosloff, making his professional debut in the latter's *Petroushka*, c.1937. He relocated to New York to study at the School of American Ballet.

Godkin made his Broadway reputation in *Stars in Your Eyes* (1939), a Carl Randall show with a mostly ballet-trained chorus that included Jerome Robbins, Nora Kaye, Maria Karnilova, Dwight Godwin, Frederico and Alicia Alonso, and Dan Dailey. His other Broadway credits include *Great Lady* (1938), and, after serving in the Navy, Hanya Holm's *Beggar's Holiday* (1946) and Robbins' *High Button Shoes* (1947). His solo tour de force as "Willie the Weeper," the drug addict in the central segment of *Ballet Ballads* (1948), brought him fame and an engagement to perform his own works on *Chevrolet Tele-Theatre* (NBC, 1948–1949). He joined Ballet Theatre in the 1950–1951 season, dancing in Maracchi's *Circo de España*, Robbins' *Interplay*, and Agnes De Mille's *Fall River Legend*, but soon returned to the theater.

Godkin spent much of the rest of his professional life staging cabaret shows in New York and Paris, where he set a series of revues for Collette Marchand in the early 1950s. He later choreographed the musical numbers and incidental dances for the extravaganza film, *Around the World in Eighty Days* (London Films/Michael Todd, 1956), and others starring Shirley MacLaine.

Works Choreographed: FILM: *Around the World in Eighty Days* (London Films/Michael Todd, 1956); *John Goldfarb, Please Come Home* (Twentieth-Century Fox, 1964); *Gambit* (Universal, 1966).

TELEVISION: *Chevrolet Tele-Theatre* (NBC, 1948–1949, individual episodes).

Godreau, Miguel, American modern and theatrical dancer and choreographer; born October 17, 1946 in Ponce, Puerto Rico. Trained at the High School of Performing Arts in New York, where he was raised, Godreau continued his studies at the School of American Ballet and the Harkness House, under its scholarship program.

He performed with the Harkness Ballet and with Donald McKayle's recital group before joining the Alvin Ailey Dance Theatre in the mid-1960s.

Among the many works in which he created roles in that company were Ailey's *Knoxville: Summer of 1915* (1968), *Macamba* (1966), and *Streams* (1970), John Park's *Black Unionism* (1970), and Geoffrey Holder's *The Prodigal Prince* (1968), which many consider his best role. A frequent freelancer, he has danced in Michael Kidd's *Wonderworld* at the 1964 World's Fair, and Anna Sokolow's *The Question* with the American Dance Theatre in 1965. He has also had a successful acting career, with featured roles in *Golden Boy* (1964) and *Dear World* (1969), playing the "Deaf-Mute" and a part in the film, *Altered States* (WB, 1980), as the primordial devolutioned being. In London he appeared as an inserted symbolic part in the 1970 revival of *Show Boat*.

Godreau has choreographed during the 1970s, for concerts and theatrical productions, but is still better known as a performer.

Works Choreographed: CONCERT WORKS: *Us* (c.1969); *Facets* (1969); *Technique and Music, or What To Do When You Can't Do the Fifth Ballet* (1969); *Circle of the Subconscious* (1969); *Paz* (1970); *Missa Criolla* (1974).

THEATER WORKS: *Sanacho* (1979, also directed production).

TELEVISION: *Circle of the Mind* (CBS, July 1, 1969).

Godwin, Dwight, American ballet dancer and photographer; born 1913 in Fort Myers, Florida. A West Point dropout, he trained at the School of American Ballet and spent a year in London at the Sadler's Wells Ballet (c.1937). Returning to the United States, he became a member of the Ballet Caravan, a company of SAB pupils, dancing in William Dollar's *Airs and Variations*, Lew Christensen's *Charade*, and Eugene Loring's *Billy the Kid*. He danced on Broadway in Carl Randall's *Stars in Your Eyes* and Randall and George Balanchine's *Louisiana Purchase*, before becoming a charter member of Ballet Theatre.

He dropped out of live performance completely by the outbreak of the war. After it, he worked as a television cameraman, doing *The March of Time*, among other network shows, and as a freelance director of photography. He filmed dance rehearsals and performances at the Juilliard School, the American Dance Festival, and Jacob's Pillow, creating a valuable store of information on dance in the 1950s. Godwin serves as Professor of Cinematography at the University of Florida. He is married to former American Ballet and Ballet Caravan principal, Marie-Jeanne.

Goh, Cho San, Malaysian ballet dancer and choreographer working in the Netherlands and in the United States; born 1948 in Singapore. Goh was trained at the Singapore Academy of Dance, managed by his brother and sister, and continued his studies in London. He danced with the Scapino Ballet in Amsterdam, in works by Hans Van Manen, and with the Dutch National Ballet, from 1970. Much of his early choreography was created for the latter troupe, including his *Untitled* (1973), *Impressions Past* (1975), and *Introducing . . .* (1976).

Goh has been in the United States since 1977, as resident choreographer of the Washington Ballet in the District of Columbia. Extremely popular since the tours of the Dutch National Ballet, he has also contributed works to the repertories of the Pennsylvania and Houston Ballets, the Dance Theatre of Harlem, and the Joffrey and Joffrey II. His abstract ballets, such as *Variations Serieuses* (1977), *Celestial Images* (1980), and *Momentum* (1979), are in great demand for dancers and company directors.

Works Choreographed: CONCERT WORKS: *Untitled* (1973); *Impressions Past* (1975); *Introducing . . .* (1976); *Octet Plus Four* (1975); *Life in Dance* (1977); *Variations Serieuses* (1977); *Fives* (1978); *Synonyms* (1978); *Double Contrasts* (1978); *Birds of Paradise* (1979); *Arpa y Orchestra* (1979); *Variaciones Concertantes* (1979); *Momentum* (1979); *Celestial Images* (1980); *Lament* (1980); *Helena* (1980).

Goldberg, Jane, American tap dancer and choreographer, writer, and historian; born February 2, 1948 in Washington, D.C. Trained in modern dance work by Erika Thimmey, she did not discover tap as a dance technique until she was an adult, living in Massachusetts and writing for the Boston *Phoenix*. Her early tap training came from Leon Collins and Stanley Brown. She has choreographed, co-choreographed, and reconstructed works of tap improvisation and formal structure with members of the Copasetics, most frequently Buster "Brownie" Brown, his partner Charles "Cookie" Cook, and Honi Coles.

Goldberg is also a major oral historian of the tap dance of the 1940s and 1950s, recording memoirs and actual steps of the Copasetics and their colleagues. By scheduling her recitals at the traditional houses for modern and postmodern dance, the American Theatre Lab, The Dance Exchange, the Brooklyn Academy of Music, and loft theaters, she has brought it into the "mainstream" of the contemporary arts. The elements in tap work that are related to principles of postmodernism, among them improvisation, repetition, and pedestrian movements, have therefore been reintroduced to the new generation of dancers and choreographers.

Works Choreographed: CONCERT WORKS: *Years Ago It Was Heel and Toe* (1974, live performance to music and taped interviews); *Tap, Drum and Typewriter* (1975); *Dancing in the Dark* (1976, ongoing); *It's About Time* (1978, co-choreographed with Andrea Levine); *The Tapper's Tapes* (1978, in collaboration with drummer Buddy Rich); *Hebrew—Soft Shoe* (1979); *The Neighbor* (1979); *How Do You Dance* (1979); *Spain* (1979); *I Want to Be Happy* (1979); *Shake, Paddle and Roll* (1979); *Duets with Charles "Cookie" Cook* (1979, ongoing); *The Suitcase Dance* (1979, reconstruction in collaboration with Cook and Leslie "Bubba" Gaines); *Shoot Me While I'm Happy* (1979, in collaboration with Cook); *I Like to Tap, I Like to Talk* (1980).

Golden, Miriam, American ballet dancer; born January 5, 1920 in Philadelphia, Pennsylvania. Receiving her early training locally from Catherine Littlefield and Edward Caton, she joined the Littlefield Ballet in 1936. In the three seasons that she remained in that innovative native American company, she performed in Littlefield's *Café Society* and *Barn Dance* (both 1937), and in her production of *The Sleeping Beauty*.

After performing briefly with the Chicago Civic Opera, presumably with Caton, Golden joined Ballet Theatre as a charter member in 1940. Among the many works to which she brought her special combination of acting skills and ballet technique were Antony Tudor's *Gala Performance*, *Romeo and Juliet*, and *Dark Elegies*, Anton Dolin's *Romantic Age* and *Quintet*, and Mikhail Fokine's *Bluebeard* in the 1941 premiere. She was also noted for her portrayal of "Myrthe," in the company production of *Giselle*.

Goleizovsky, Kas'yan, Soviet ballet dancer and choreographer; born March 5, 1892 in Moscow; died there May 2, 1970. The son of members of the Bolshoi Opera, Goleizovsky was trained at the schools of the Imperial Theatres in Moscow and St. Petersburg. He graduated into the Maryinsky in 1909, but soon moved back to Moscow to dance with the Bolshoi. Apart from a tour to London with Theodore and Alexis Kosloff in 1910, he performed in the Soviet Union throughout his career. He stopped performing very quickly, however, and spent most of his life working outside the major state ballets. Deeply influenced by the constructivism of early Soviet theater directors, he has worked with theater companies and cabarets, including the Chauve-Souris, before forming his own Cabinet (or Chamber) Ballet in 1921. Apart from his ballet choreography, Goleizovsky had one of the few precision lines in the Soviet Union, Goleizovsky's Thirty Girls, and became an expert on the indigenous dance forms of the less Westernized republics, most notably Takjirk.

The critical view of Goleizovsky shifted frequently during and after his lifetime. He was in and out of public employment during his career, although his "exiles" to the various socialist republics became extremely valuable to his works with indigenous forms. In the West, he was lauded for his constructivist work with precision lines in the 1930s and considered passé in the 1950s. Although for many years he was known only as "Balanchine's teacher," he is now being rediscovered as a major choreographer himself.

Three factors have led to the inability of Western or Soviet researchers to acquire the titles of all of Goleizovsky's works. His problems with the Stalinist regimes led to a certain amount of dispersement of official records and programs. His works outside the Moscow/Kiev/Leningrad theaters was largely ignored during his lifetime, or was mislabeled as the work of a curator of dance forms, not a creator of new pieces. In addition, Goleizovsky's affection for miniatures and solo divertissements (or "statuettes") made it difficult to collate the titles of each individual work.

Works Choreographed: CONCERT WORKS: *L'Après-midi d'un Faune* (1919); *Salome* (c.1919); *The Tragedy of Masks* (c.1920); *Les Ephémérises* (c.1921); *Istar* (c.1921); *Daphnis et Chloé* (c.1922); *Les Préludes* (c.1922); *Suite Espagnole* (c.1923); *Liebestod* (1924); *Narcisse* (c.1924); *Joseflegende* (1925); *Theolinda, or the Remorseful Robber* (1926); *The Red Whirlwind* (1927); *Polovtsian Dances* (1933); *Sleeping Beauty* (1935); *The Fountains of Bakhchisarai* (1939); *The Two Roses* (1940); *Scriabiniana* (1942); *Leili and Majnun* (1964).

Gollner, Nana, American ballet dancer working in Europe; born January 8, 1919 in El Paso, Texas; died

August 30, 1980 in Antwerp, Belgium. After training locally with Winifred Edwards and Amet Younston, Gollner moved to Los Angeles, where she studied with Theodore Kosloff; later, she continued her professional work with Nicholas Sergeyev in London.

Gollner performed briefly with the American Ballet, then serving as the resident company of the Metropolitan Opera, before dancing with the rival Ballets Russe de Monte Carlo of Basil (1935–1936), and of René Blum (1936–1937). In the latter, she became associated with the works of Mikhail Fokine, among them, his *Les Elfes, Igrouchka,* and *Les Elements* (1937), in which she created a featured role. For the next ten years, Gollner shuttled among Ballet Theatre, the various Ballets Russes, and an English company, The International Ballet.

In Ballet Theatre from 1940 to 1941, 1943 to 1945, and 1947 to 1950, she performed in their productions of the classic repertory, especially noted for parts in *Giselle, Swan Lake* (one-act version), *Sleeping Beauty* (one-act version), *Les Sylphides, Coppélia,* and *La Fille Mal Gardée.* She created roles there in George Balanchine's *Waltz Academy* (1944), Antony Tudor's *Undertow* (1945), and Herbert Ross' *Caprichos* (1950). Moving to London in 1947, she worked with Mona Ingelsby's International Ballet, becoming the first native American to dance the full-length *Swan Lake* with her celebrated performance of the Nicholas Sergeyev revival of the Petipa/Ivanov classic.

Before retiring to teach in Belgium, Gollner returned for a season to the Metropolitan Opera Ballet in 1950 under the directorship of Antony Tudor. She performed the ballerina roles in his productions of *La Traviata, Faust,* and *Die Fledermaus.*

Golovine, Serge, Monacan ballet dancer and choreographer; born November 20, 1924 in Monaco. After early training with Julie Sedova, he studied in Paris with Carlotta Zambelli at the Paris Opéra, and with Alexander Volinine and Olga Preobrajenska at their studios. Golovine first came to prominence with the Nouveaux Ballets de Monte Carlo (1941–1946), in his performances of the Fokine classics, *Les Sylphides, Carnaval,* and *Spectre de la Rose.* He also danced the male role in the latter with the Paris Opéra Ballet

from 1946 to 1949, adding Balanchine's *Serenade* to his repertory.

From 1949 to 1961, Golovine performed and choreographed for the Grand Ballet du Marquis de Cuevas. Among the many ballets by Georges Skibine in which he created roles were *Tragedie a Verone* (1950), *l'Ange Gria* (1953), and *Pastorale* (1956); he performed in the premieres of John Taras' *Le Bal des Jeunes Filles* (1950), *Tarasiana* (1951), *Cordélia* (1952), *Une Nuit d'Été* (1952), and *Piège de Lumière* (1952), and in Leonid Massine's *Symphonie Allegorique* (1951).

Forming his own company in 1962, Les Compagnons de la Danse, he continued to choreograph for it, notably *Symphonie Classique,* and for troupes across Europe. As artistic director of the Grand Théâtre de Geneva (1963–1968), he created *l'Oiseau de Feu* (1965), *Sébastien* (1966), *Contraste* (1967), and his full-length version of *Romeo et Juliette* (1968). Retiring in 1976, he continues to teach in Geneva.

Works Choreographed: CONCERT WORKS: *Feux Rouges-Feux Verts* (1953); *Romeo et Juliette* (1955, variation only); *La Mort de Narcisse* (1958); *Symphonie Classique* (1962); *Présentation* (1964); *l'Oiseau de Feu* (1965); *Le Mandarin Merveilleux* (1965); *Sébastien* (1966); *Petite Symphonie Concertante* (1966); *Métaphore* (1966); *Opression* (1966); *Le Chant du Pavot* (1966); *Contraste* (1967); *Academia* (1967); *l'Entremonde* (1967); *Labyrinthe* (1968); *Romeo et Juliette* (1968, full-length work).

Gontcharova, Nathalia, Russian artist and theatrical designer; born June 3, 1881 in Ladyschino; died October 18, 1962 in Paris. An avant-garde Russian artist and illustrator, she became involved in theatrical design through the "Rayonisme" movement. Best known now as a ballet designer, her posters were at one time considered among the best of the Russian avant-garde.

Her designs for Diaghilev's Ballet Russe productions include Mikhail Fokine's *Le Coq d'Or* (1914), Bronislava Nijinska's *Renard* (1922, with Mikhail Larionov), *Les Noces* (1923), probably her most influential design although the starkness and simplicity of its color scheme was unusual for her, and *Une*

Nuit sur le Monte Chauve (1924). her designs for the 1926 revival of Fokine's *The Firebird* graced the programs of the Ballet Russe de Monte Carlo for many years. Later theatrical designs for Fokine include his *Ygrouchka* (1921) and *Cendrillon* (1938), Leonid Massine's *Bogatyri* (1938), and Serge Lifar's *Sur le Borsythène* (1932). She was associated throughout her professional life with Mikhail Larionov, although it is not absolutely certain whether or not they were actually married, as has often been stated.

Bibliography: Loquine, Tatiane. *Gontchorova et Larionov* (Paris: 1971).

Gonzalés, Ofelia, Cuban ballet dancer; born 1953 in Comagüez. After early studies with Vicente de la Torre, she was trained at the School of the Ballet Nacional de Cuba by Ramona de Saa, Joaquin Banegas, and Aurora Bosch. A member of the company since the early 1970s, she has been cast in featured roles in both the company revivals of the classics, notably the Valse section of *Les Sylphides*, and in the contemporary repertory. Among the latter, she has been acclaimed in Alberto Mendéz' *Tarde en la Siesta* and José Parés' *Bach × 11 = 4 × A* and *Un Concierto en blanco y negro*.

Goodman, Erika, American ballet dancer; born October 9, 1947 in Philadelphia, Pennsylvania. After training locally, Goodman accepted a Ford Foundation fellowship to continue her studies at the School of American Ballet in New York. While performing with the Boston Ballet, she worked with Muriel Stuart and Stanley Williams.

Although she has performed with the Pennsylvania Ballet, notably in Richard Rodham's *Symphonic Variations* (1962), the Boston Ballet (1963-1964), and briefly, the New York City Ballet (1965), Goodman is best known for her work with the City Center Joffrey Ballet (1967-). Among her many created roles in this company are parts in Gerald Arpino's *Cello Concerto* (1967), *Fanfarita* (1968), and *Reflections* (1971), and, as the representative of classical ballet technique, in Twyla Tharp's *Deuce Coupe I* (1973).

Goodman retired from dance performance to study acting and work toward a theater career.

Gordon, David, American postmodern dancer and choreographer; born in New York City. While studying dance at Brooklyn College (City University of New York), Gordon began to work with James Waring and performed with his concert group in *Phases* (1957), *Tableaux* (1960), and *Peripatea* (1960). He danced with the Judson Dance Theatre (after participating in the Robert Dunn composition classes), most notably in the original *Trio A* (then titled *The Mind Is a Muscle, Part I*) in January 1966. Other performances of historical note include Trisha Brown's *Roof Piece* (1971) and Yvonne Rainer's *Continuous Project—Altered Daily* (1970), which is generally considered the work that sparked the formation of the Grand Union, one of the most important single companies in dance history. He worked with the improvisational group (Trisha Brown, Barbara Dilley, Douglas Dunn, Nancy Lewis, Steve Paxton, and in some years Valda Setterfield, Becky Arnold, and Dong) throughout its existence (1970-1976).

Gordon began choreographing in Waring's composition classes at the Living Theater. His first work, and most of his canon, involved a duet with Setterfield, to whom he is married. Their performing relationship has changed over the years; in the early pieces, such as *Mama Goes Where Papa Goes* (1960), she demonstrated the fluidity of movements while he used pedestrian moves, but in more recent works, her stillness and control are shown while he floods the stage with steps and shifts. Many of the early Gordon works were related to Waring's assemblage choreographic style and used images of popular culture and nostalgic personal memories as his mentor would have done. Since the early 1970s, however, he has been working with more abstracted individual bodies to demonstrate only motion. The puns and jokes that remind one of Waring still exist, but they are related to movement, not to trimmings. His status as the most popular postmodernist may be partially related to the puns in the monologues with which he introduced works, but it is also because of the clarity and intelligence of both individual movement and structure. In *Chair*, for example, he opens the performance with a long monologue involving color names about the aleatoric process which he says that he used to create the work and closes it with an individualist

performance of the "Stars and Stripes Forever"; but as comic as those elements are, it is the movement sequence on the chairs and the variations of single performance and structure which he imposes on it that make the piece so good. Although the aleatoric manipulation of *Chair* is believed to be a put-on, Gordon has used one structuring technique associated with chance work—he often abstracts elements of one work and enlarges them into individual new dances. Frequently, the progression and interrelation of segments can be seen in the titles given to concerts—the phrase "The Matter" seems to appear in almost every title. A solo that was performed in the self-deprecating *Not Necessarily Recognizable Objectives* (1978), appears there later as a group canon and in later works as a movement motif. Gordon's use of language in his works is also attractive to the audience and a way to follow structure manipulation when movement motifs move too quickly. Many of his pieces use speeches that comment on movement, ranging from the instructions and corrections in *One Part of The Matter* (1972) to the falsified philology in *An Audience with the Pope* (1979). The fractured canon of witnesses describing a traffic accident in *What Happened* (1978) is accentuated by movements assigned to homophones of works; a particular favorite is the hand gesture denoting a crooked nose and Setterfield's glorious cackle that represents the frequently used "which" with which ("nya-ha-ha") the witnesses describe the accident which ("nya-ha-ha") they saw. There is a spoken line that accompanies the *Not Necessarily Recognizable Objectives* solo—"He can put one and one together like no one else can." Luckily for the dance audience, that describes Gordon perfectly.

Works Choreographed: CONCERT WORKS: *The Spastic Cheerleader* (1960, not publicly performed); *Mama Goes Where Papa Goes* (1960); *Mannequin Dance* (1962); *Helen's Dance* (1962); *Random Breakfast* (1963); *Honey Sweetie Dust Dance* (1963); *Silver Pieces* (1964, also called *Fragments*); improvisational performances with the Grand Union (1970–1976); *Sleep Walking* (1971); *Liberty* (1972); *The Matter* (I) (1972); *The Matter* (II) *(Oh, Yes, Men's Dance, One Part, Mannequin)* (1972); *Co-Incidents* (1972, in collaboration with Douglas Dunn); *Spilled Milk* (1974); *Spilled Milk Variations* (1974); *Chair, Alternatives I through 5* (1974); *One Act Play* (1974); *Times Four* (1975); *Wordsworth and the motor + Times Four* (1977); *Not Necessarily Recognizable Objectives* (1978); *What Happened* (1978); *In the Matter* (1978); *An Audience with the Pope, or This Is Where I Came In* (1979).

Gore, Altovise, American modern dancer and theatrical choreographer; born August 30, 1935. Trained by Syvilla Fort, she performed with Fort's concert groups in the mid-1950s, with the Alvin Ailey company in his *Gillespiana* and *Creation of the World,* and in Talley Beatty's recital group, creating roles in his *Road of the Phoebe Snow* (1959) and *Come and Get the Beauty of It Hot* (1960), both at the 92nd Street "Y."

After dancing in Donald McKayle's *Golden Boy* in London (c.1968), she became known as an actress, working on television in dramatic roles. She had staged dances and production numbers for both television specials and series and Las Vegas revues, starring *Golden Boy* star, Sammy Davis, Jr.

Gore, Walter, Scottish ballet dancer and choreographer; born August 8, 1910 in Waterside, Ayrshire, Scotland; died April 15, 1977 in Pamploma, Spain. Trained at the Italia Conti School, Gore performed with the Marie Rambert Dancers in the early 1930s.

A member of the Ballet Club and Camargo Society from 1930 to 1935, Gore created roles in works by the developers of the English ballet. He performed in the premieres of Antony Tudor's *Cross-Garter'd* (1931), *Lysistrata* (1932), *Pavanne pour Un Enfant Défunte* (1933), and *Paramour* (1934), and in Frederick Ashton's *The Lady of Shalott* (1931), *Foyer de Danse* (1932), *Mephisto Valse* (1934), and *Valentine's Eve* (1935) in the Club, and in his *Pomona* (1930), *Façade* (1931), *A Day in a Southern Port* (1931), and *The Lord of Burleigh* (1931) in the Camargo Society. Gore also performed for Ashton in the Vic-Wells Ballet in his *Regatta* (1931) and in London's West End in *Marriage à la Mode* (1930), *Magic Nights* (1932), *A Kiss in Spring* (1932), *Ballyhoo* (1932), and *How D'You Do?* (1933).

Performing with the Ballet Rambert in the 1940s, he danced in ballets by Frank Staff, among them, his *Czernyana* and *Czerny II,* by Andrée Howard, in her *The Fugitive* (1944), and in his own *Cap Over Mill* (1940), *Confessional* (1941), *Simple Symphony* (1944), and others. Although primarily a freelancer, Gore has choreographed regularly for his own Ballet (1935–1955), and for the London Ballet (1961–1963), and for companies and opera ballets in Australia, Amsterdam, Frankfurt, Oslo, and Lisbon.

Works Choreographed: CONCERT WORKS: *Valses Nobles et Sentimentales* (1936); *Valse Finale* (1938); *Paris Soir* (1939); *Confessional* (1941); *Bartlemas Fair* (1941); *Cap over Mill* (1941); *Simple Symphony* (1944); *Mr. Punch* (1946); *Concerto Burlesco* (1946); *Plaisance* (1947); *Winter Night* (1948); *Kaleidoscope* (1949); *Antonia* (1949); *Hoops!* (1949); *Birthday Suite* (c.1949); *Armida* (c.1949); *Street Games* (1953); *Romantic Evening* (c.1953); *Tancredi and Chlorinda* (c.1953); *The Gentle Poltergeist* (1953); *Classical Suite* (c.1953); *Cyclasm* (1953); *Musical Chairs* (c.1953); *La Souffrance de Martine* (c.1953); *Carte Blanche* (1953); *Jacaranda Town* (1954); *Les Saisons* (c.1954); *Giverva* (c.1954); *Pavanne for a Dead Lover* (1958); *Night and Silence* (1958); *Ljubovna Tragedi* (1959); *Don Ramiro* (c.1959); *The Light Fantastic* (1963); *The Masquers* (1965); *The Last Rose of Summer* (1971); *Embers of Glass* (1973).

Gorsky, Alexander, Russian/Soviet ballet dancer and choreographer; born August 18, 1871 in St. Petersburg; died October 20, 1924 in Moscow. Trained at the St. Petersburg school of the Imperial Ballet, he joined the Maryinsky Ballet in the late 1880s. His roles during his very brief performing career there included solos in the national dances inserted into Marius Petipa's *Raymonda* (1897) and *Ruses d'Amour* and a "Satyr" in his *Les Saisons.* He was appointed as assistant to Pavel Gerdt in the mid-1890s, but soon became better known as a choreographer than as a teacher or performer.

His first assignment was the restaging of the St. Petersburg *Sleeping Beauty* for the Bolshoi Ballet in Moscow, 1898, based on Vladimir Stepanov's notation of Petipa's 1890 production. It has frequently

been stated that his first original ballet to be produced, *Chlorinda, Queen of the Mountain Fairies,* was written out in the Stepanov notation system before it was set on Gorsky and Gerdt's students at the St. Petersburg school (1899). In 1900, he left his native city to become resident choreographer and régisseur for the Bolshoi Ballet. In his twenty-three years there, he brought the company from semiobscurity (compared to the brilliance of the Maryinsky) to world prominence, and established a technical base and style of performance that was easily adapted to the Soviet choreography. Gorsky's works are alive today because he was mature enough to create a repertory that could compromise, and wise enough to ensure that it was notated in the Stepanov system that he admired.

Like Petipa before and Goleizovsky after, Gorsky's choreography has undergone a series of reinterpretations and aesthetic reevaluations—in both the Soviet Union and the West. He has been called the last nineteenth-century choreographer, since he imposed dramatic values and elaborate productions on an era that was preparing itself for abstractions. That statement can, and has, however, been revised to say that he maintained dramatic values of truth and realism while allowing for enough visual decoration to ensure audience contact and emotional participation. Both versions are probably accurate.

The ballets themselves were primarily three-act full-evening works with definite plots and characterizations, such as his *Swan Lake* (1901), *Giselle* (1911), *Le Corsair* (1912), *Stenka Razin* (1918), and *The Nutcracker* (1919). He also created shorter works, however, including a series of character and national divertissements for the Anna Pavlova company, among them *Danse Bohémienne, Pas de Deux: En Orange, Pas Espagnole,* and her romantic *La Rose et le Papillon.* His last ballets used German late nineteenth-century scores, Richard Strauss' *Salomé* (1921), and the Venusberg music from Wagner's *Tannhauser* (1923), but most of his earlier pieces were by the trio of Russian ballet composers, Tchaikovsky, Gliere, and Glazunov.

It is surprising that so little analytic study has been made of Gorsky's works, since his versions of pieces

have affected productions in all countries with ballet companies.

Works Choreographed: CONCERT WORKS: *The Sleeping Beauty* (1898, production of version by Marius Petipa); *Clorinda, Queen of the Mountain Fairies* (1899); *Raymonda* (1900, co-choreographed with Ivan Clustine after Petipa); *The Butterfly* (1901); *La Fôret Enchantée* (1901); *The Little Humpbacked Horse* (1901); *Swan Lake* (1901); *Don Quixote* (1902); *La Esmeralda* (1903); *La Fille Mal Gardée* (1903); *The Goldfish* (1903); *La Bayadère* (1904); *Coppélia* (1905); *Fiametta* (1905, co-choreographed with Nicholas Legat); *La Fille du Pharon* (1905); *The Magic Mirror* (1905); *Robert et Bertram* (1906); *Harlequinade* (1907); *Noor et Anita* (1907); *Raymonda* (1908); *Etudes* (1909); *Salambó* (1910); *La Belle et la Bête* (1911); *The Dream* (1911, interpolated into production at the Alhambra Theatre, London); *Le Corsair* (1912); *Notre Dame de Paris* (1912); *Love Is Quick* (Russian title uncertain) (1913); *Eunice et Pétronius* (1915); *Fifth Symphony* (1916); *Stenka Razin* (1918); Divertissements for the Pavlova Company *(Danse Bohémienne, Pas de Deux: En Orange, Pas Espagnole, La Rose et le Papillon)* (1918); *The Nutcracker* (1919); *Danse de Salomé* (1921); *Chrysis* (1921); *La Bayadère (II)* (1923); *The Venusberg Grotto* (1923).

Goshen, Martita, American contemporary concert dancer; born July 24, 1948 in Montevideo, Uruguay. The daughter of a diplomat, Goshen was raised and educated in Europe and Latin America. She worked as a staff assistant in foreign affairs to the late Senator Robert F. Kennedy before returning to dance in the early 1970s. She studied briefly with José Limón and Anna Sokolow and performed with Charles Weidman's late company in his *Brahms Waltzes* and *The Unicorn in the Garden.* Since 1976 she has presented a solo repertory devoted to conservation of endangered animal species.

Works Choreographed: CONCERT WORKS: *A Day in the Life of a Whale* (1976); *At Dawn* (1978); *Where Have All the Sea Turtles Gone?* (1980).

Goss, Bick, American theatrical dancer; born in the 1940s. Goss moved to New York to dance in a series of successful musicals and celebrated flops, among them *Bajour, It's a Bird, It's a Plane, It's Superman, Little Me,* and *Ben Bagley's Shoestring Revue.* He also worked extensively on television as a member of the dance choruses of *The Ed Sullivan Show, The Entertainers,* the *Kraft Music Hall,* and the two Gene Kelly specials of the 1960s. He became known as an industrials stager in the late 1960s and worked frequently on the major shows based in New York and Las Vegas, as well as Vegas club revues. After staging dances for the memorable *I Dreamt I Dwelt in Bloomingdale's* (1970), he began to direct more frequently and eventually dropped out of dance.

Gosschalk, Kathy, Dutch ballet dancer and choreographer; born August 30, 1941 in Amsterdam. Gosschalk was trained at the Scapino Ballet School by Johanna Snoek and was given a grant to continue her studies at the Juilliard School in New York, where the faculty included Doris Humphrey, José Limón, and Margaret Craske. She returned to the Scapino troupe in 1957 but left the company in 1962 to join the Netherlands Dance Theatre for ten years. She was associated there with the works of fellow Scapino alumnus Hans van Manen, creating roles in his *Essay in Silence* (1965), *Dualis* (1967), *Three Pieces* (1968), *Situations* (1970), and *Mutations* (1970, co-choreographed with Glen Tetley). Gosschalk has choreographed for the Netherlands Dance Theatre and Scapino Ballet, but currently concentrates on verbal theater and performance.

Works Choreographed: CONCERT WORKS: *Nine Movements* (1967); *Graffiti* (1969); *Interviews* (1975).

Gotshalks, Jury, Latvian ballet dancer working in Canada and the United States; born in Riga; died July 15, 1976 in Milwaukee, Wisconsin. Trained at the school of the Latvian National Ballet, he performed with State Opera Ballet before emigrating to Canada. As a member of the National Ballet of Canada, Les Grands Ballets Canadiens, and the short-lived Montreal Ballet, he performed principal roles in each company's production of *Les Sylphides, Coppélia,* and *The Sleeping Beauty.* His other roles with the former company include Antony Tudor's *Gala*

Performance and a variety of divertissements in which he partnered Irene Apinée. He retired from performance in 1968 to teach at the University of Wisconsin and served as artistic director of the Milwaukee Ballet.

Gould, Dave, film dance director working in the United States; born March 11, 1902 in Budapest, Austro-Hungary; died June 3, 1969 in Los Angeles. Raised in Washington, D.C., Gould had a tap dance act in local theaters with his cousin, Ben Blue. He made his Broadway debut in *The Royal Vagabond* (1915) and took a job as assistant to its dance director, Julian Mitchell, who was quickly losing his hearing. After another tap act with Blue was stranded in St. Paul, Minnesota, Gould opened a dance school there. Its success brought him an offer from the Balaban and Katz chain to open a school in Chicago to train dancers for their Prologs; at this school, he taught a large number of Midwestern dancers, notable among them, Merriell Abbott who later managed precision troupes of her own. His work for the Balaban and Katz theater chain led to a similar job with the Paramount/Publix theaters, which in turn brought him to the Capitol Theater, New York, which was the originating house for MGM studio motion pictures and Prologs.

Although the trade papers announced that he had signed film contracts with both Paramount and MGM, his first films were released by RKO, which produced many of the most interesting and successful musicals during the 1930s. He won the first Oscar award for dance direction for The Carioca, in *Flying Down to Rio* (RKO, 1933), which is considered the first major Astaire and Rogers dance number. He then did the next Astaire-Rogers film, *The Gay Divorcee* (RKO, 1934), two major Eleanor Powell films, *Born to Dance* (MGM, 1936) and the *Broadway Melody of 1938* (MGM, 1937), as well as Sonje Henie vehicles, such as *Everything's on Ice* (RKO, 1939).

Works Choreographed: THEATER WORKS: *Hello Yourself* (1928); *The Little Show of 1929; Grand Street Follies of 1929; Fine and Dandy* (1930); *The Gang's All Here* (1931); *Hey Nonny Nonny* (1932); *Sham Sham Revue* (1934, Hollywood); *Sing Out the News* (1938); *Congress of Beauty* (1939,

New York World's Fair); Prologs for Balaban and Katz chain (1926–1928); Paramount/Publix chain (1929–1931); for Capitol Theater, New York (1932–1933).

FILM: *Melody Cruise* (RKO, 1933); *Flying Down to Rio* (RKO, 1933); *The Gay Divorcee* (RKO, 1934); *Hips Hips Hooray* (RKO, 1934); *Broadway Melody of 1936* (MGM, 1936); *Born to Dance* (MGM, 1936); *Broadway Melody of 1938* (MGM, 1937); *A Day at the Races* (MGM, 1937); *Breaking the Ice* (MGM, 1938); *Everything's on Ice* (RKO, 1939); *The Boys from Syracuse* (Universal, 1940); *Casanova in Burlesque* (Republic, 1943); *Lady, Let's Dance* (Monogram, 1944).

Gould, Diana, English ballet dancer; born 1913 in London, or, according to some sources, Cork, Ireland. As a student of Marie Rambert and as a member of her companies, Gould performed in the premiere performances of many early works by Antony Tudor and Frederick Ashton. As a member of the Rambert Dancers, she was in the original casts of Ashton's *A Florentine Picture, Leda and the Swan* (both 1930), and *Capriol Suite* (1931). With the Camargo Society, she created roles in *Façade* and *The Lord of Burleigh* in 1931.

The Ballet Club offered her opportunities to dance in the performances of Tudor's *Lysistrata* (1932), *Constanza's Lament* (1932), *The Planets* (1934), *Paramour* (1934), and *Atalanta of the East* (1933). According to many sources, she performed in 1933 concerts that featured the premieres of two similarly titled works by Ashton and Tudor—their *Pavanes Pour Une Infante défunte* in May and January, respectively. Gould danced in the London production of Ashton and Rambert's joint choreography for the opera *The Fairy Queen* in 1927, and may have appeared in the films on which each worked in the early 1930s.

After touring with the Markova-Dolin Ballet in 1936–1937, Gould retired from performance. Married to violinist Yehudi Menuhin, she currently teaches at their arts school in England.

Govrin, Gloria, American ballet dancer; born November 9, 1942 in Newark, New Jersey. Trained originally by Fred Danieli in New Jersey, Govrin com-

muted to New York to study with Ivan Tarasoff and at the School of American Ballet.

Throughout her long career with the New York City Ballet, Govrin was associated with the works of George Balanchine. Among the many works of his in which she created roles were *Valses et Variations* (1961), *A Midsummer Night's Dream* (1962), through which she leapt rather than danced as "Hippolyta," *Clarinade* (1964), *Harlequinade* (1964), the *Brahms-Schoenberg Quartet* (1966), *Trois Valses Romantiques* (1967), and *The Nutcracker,* in which she was the first to perform "Coffee," as a female solo in 1964. Her featured roles included parts in *Symphony in C, Firebird,* "The Leader of the Bacchantes" in the Stravinsky Festival revival of *Orpheus,* and "The Siren" in *The Prodigal Son.*

Grable, Betty, American theater and film dancer; born March 26, 1921 in St. Louis, Missouri; died July 2, 1973. It is not certain whether Grable had formal dance training before the early 1930s when she and Mitzi Mayfair teamed up in the vaudeville act, Grable and Pique. While Mayfair became a popular Broadway musical comedy performer, Grable went straight to Hollywood where she was cast in a small specialty dance part in the Astaire and Rogers film, *The Gay Divorcee* (RKO, 1934). She is the girl in the Lido who shows Edward Everett Horton how to "K-nock K-nees."

Grable became famous in the late 1930s and 1940s as "the girl with the million dollar legs," although she seldom danced more than one big number in each film. As the "queen of the pin-ups," she appeared in many wartime musicals, leading squads of tap dancers in military precision routines. Her best dance numbers can be found in *Down Argentine Way* (Twentieth-Century Fox, 1940), in a Hermes Pan pseudo-South American series of tangos and rhumbas, and in *Mother Wore Tights* (Twentieth-Century Fox, 1947), in which she does a marvelous imitation of Dan Dailey's eccentric high-kicking style.

Graham, Georgia, American modern dancer; born March 1, 1900 in Allegany, Pennsylvania. Like her sister, Martha, Georgia (or Jeordie) Graham began studying at the Los Angeles Denishawn school. She performed with the concert groups that toured with Ruth St. Denis and Ted Shawn from 1922 to 1927, and appeared in works by each choreographer. Among the many dances in which she created roles were St. Denis' *The Spirit of the Sea* (1923), *Garland Plastique* and *Waltzes* (1925), and *Sonata Tragica* (1922), which she co-choreographed with Doris Humphrey, and Ted Shawn's *In the Garden (Betty's Music Box, Valse)* (1923), *Pas de Quatre* (1925), *Bubble Dance* (1925), *Choeur Dansé* (1926), *General Wu's Farewell to His Wife* (1926), choreographed on the Oriental tour, and *Danse Sacrée* (1926). Graham left the troupe shortly after returning from the Oriental tour to teach but performed in many of her sister's early group works, including the extraordinary *Primitive Mysteries* (1931), *Ceremonials* (1932), and the *Six Miracle Plays* (1933). She was considered one of the finest teachers at the Graham school and at the Neighborhood Playhouse for many years before retiring.

Graham, Martha, American pioneer of modern dance; born May 11, 1894 in Allegany, Pennsylvania. Raised in Santa Barbara, California, Graham began her formal dance training at the Los Angeles Denishawn School at the age of sixteen. She was a member of the various Ruth St. Denis and/or Ted Shawn companies from 1916 to 1923, partnering Shawn and creating roles in his *Xochitl* (1921), *Dance* (1921), *Malagueña* (1921), *Oriental and Barbaric Suite* (1921), *Lantern Dance* (1922), and *The Princess and the Demon* (1922), in which she was partnered by Charles Weidman. She performed featured roles in St. Denis' *East Indian Suite* and in Doris Humphrey's *Soaring,* after 1921.

Leaving the Denishawn school and company setup in 1923, Graham joined the *Greenwich Village Follies of 1923* as a specialty dancer, with solos in its exotica Spanish and Indian scenes; she was especially praised in *The Garden of Kama.* Although Graham was a pioneer in the practice of presenting modern dance seasons in legitimate houses, this was a rare experience within the context of a Broadway show. Following the *Follies,* Graham taught for two years at the Eastman School of Music in Rochester, New York, where she prepared concert dances for her first solo recital in the Spring of 1926.

Graham's career may be the archetypical one in American modern dance. Beginning as a concert dancer and recitalist, she formed a school and company which still exist. Although she participated in some cooperative ventures with her contemporary colleagues—the Bennington School, for example, and shared seasons—it is possible that the communal impetus came from her manager, Frances Hawkins. Graham, basically, has survived on her own, creating enough works to mold her company's repertory to her own changing visions. With very few exceptions, notably *Primitive Mysteries* (1931), her works have also been reserved for performance by her company.

Graham's choreography may be divided very roughly into four successive style groupings. At first, she created short solo and group works for an all-female company—works that were based on styles of art (especially pre-Raphaelite) or on national characterizations. These works were not derived from Denishawn but they were typical of their period, from 1926 to the mid-1930s. The earliest works—*Maid with the Flaxen Hair, Clair de Lune, Chorale, Trois Gnossiennes, From a XII Century Tapestry,* and others—are remarkably similar to those from the repertories of the more innovative ballet companies of the time, especially the pre-Raphaelite Andreas Pavley and Serge Oukrainsky works. Both the choreography and the music to which it was set show the enormous influence of composer/writer, Louis Horst, who left Denishawn with Graham. The works extant from this period include *Primitive Mysteries,* the remarkable group dance that represents one of the masterpieces of her repertory and of the American constructivism movement, and the solos, among them *Lamentation* (1930), *Elegaic* and *Ekstasis* (1933), and *Frontier* (1935). From elements in the choreography and design of *Lamentation* and *Frontier,* and from the extraordinary Barbara Morgan photographs of Graham performing the works, those two solos have always represented a popular apotheosis of her creativity and style. *Lamentation,* performed within a hollow tube of knit fabric, reveals individual and full-body gestures in what is almost a new scale of movement. Satirized almost as often as it has been praised, this fifty-year-old work is still a vital part of the Graham repertory. *Frontier,* performed in a dress that seems to be based simply on the nineteenth-century costume, also expresses new scales of movement; the enormously wide skirt enhances all leg and torso movement, and fulfills the spiral that became a basis of Graham's movement vocabulary.

The next cycle of works was based on the presentation of universal characters; here, Graham used characters from American history, as in *American Document, Salem Shore,* and *Appalachian Spring,* from literature, as in *Letter to the World,* and religion, as in *El Penitente.* This was also the period in which Graham began choreographing for men; the first two male dancers to join the company were Erick Hawkins and Merce Cunningham.

The third cycle of choreography—the style that lasted from c.1944 until the present—was typified by Graham's reliance on two sets of interrelated thematic material—allusions and plot scenarios from Greek mythology and characterizations and emotional response systems as represented in choreography and design motifs based on contemporary American Freudian interpretations. These works tended to be based on the central female figure of the myth, or, at least, to have the action seen through the eyes of the central female figure, as in *Cave of the Heart* (based on the Medea myth), *Night Journey* (Jocasta as victim, rather than Oedipus), *Cortege of Eagles* (Hecuba), *Clytemnestra,* and *Phaedra.* Graham also created two works about Joan of Arc in this period—*The Triumph of St. Joan* (1951) and *Seraphic Dialogue* (1955)—and choreographed *Episodes* (Part I), about the conflict between Queen Elizabeth of England and Mary of Scotland, for a joint company concert of Anton Webern with the New York City Ballet. Most of these works have remained in the Graham company repertory, with the central roles played by Graham herself and by a sequence of company members, most of whom have since become choreographers, among them Ethel Winter, Yuriko, and Takaka Asawaka.

Graham's final choreographic style, so far, is a return to the characterizational abstractions of her youth. Many of these works, such as *Acrobats of God* (1960), *Adorations* (1975), and *Frescoes* (1978),

are not attached to a plot, period, or design motif; they are abstractions that use Graham's typical spiral movements and linear stage patterns.

Graham's identification herein as a pioneer of modern dance is based on an additional factor: of the fifty or so dancers who have been performing members of the Graham company since *Primitive Mysteries* at least, more than three-fourths have themselves become choreographers and company directors. They include her early dancers who maintained much of her technique and vocabulary while following their own more topical and political artistic visions, such as Anna Sokolow and Sophie Maslow; those who have maintained the interest in universal figures, primary among them, Erick Hawkins; the dancers from the Freudian period, whose works are most easily identified as "Grahamesque," among them Jean Erdman, John Butler, Yuriko, Takaka Asawaka, David Hatch Walker, Helen McGehee, Mary Hinkson, and Bertram Ross.

Two companies are frequently considered Graham satellites, or, at least, strongly Graham influenced, and have added her works to their permanent repertories—the Bat-sheva Dancers of Israel, sponsored by Graham's frequent benefactor Bathseba de Rothchild, and the London Contemporary Dance Theater, run by former Graham dancers Robert Cohan and Jane Dudley.

Graham, like her contemporary Doris Humphrey, has influenced every dancer/choreographer who ever studied at, or was a teacher from, the Bennington School of Dance, Mills College summer session, the American Dance Festival, or the Juilliard School—the past, current, and future generations of American traditional modern dance, much postmodern dance, and a large percentage of choreography in other techniques.

Works Choreographed: CONCERT WORKS: *Pomepain Afternoon* (1925, co-choreographed with Esther Gustafson); *A Serenade in Porcelain* (1925, co-choreographed with Gustafson); *Chorale* (1926); *Novelette* (1926); *Tanze* (1926); *Intermezzo* (1926); *Maid with the Flaxen Hair* (1926); *Claire de Lune* (1926); *Danse Languide* (1926); *Désir* (1926); *Deux Valses Sentimentales* (1926); *Arabesque* (1926); *Tanagra* (1926); *Flute of Krishna* (1926); *A Florentine Madonna* (1926); *Three Gopi Maidens* (1926); *Trois Gnossiennes* (1926); *A Forest Episode* (1926); *From a XII Century Tapestry* (1926); *The Marionette* (Show) (1926); *Alt-Wein* (1926); *Danse Rococo* (1926); *Bas Relief* (1926); *Gypsy Portrait* (1926); *Baal Shem* (1926); *Prelude from Alceste* (1926); *A Dream in a Wax Museum* (1926); *Portrait—after Beltran—Masses* (1926); *Contrition* (1926); *The Moth* (1926); *Three Poems of the East* (1926); *Peasant Sketches (Dance, Berceuse, In the Church)* (1927); *Tunisia: Sunlight in a Courtyard* (1927); *Lugubre* (1927); *Lucrezia* (1927); *La Cancion* (1927); *Adagio* (1927); *Rondo* (1927); *Fragilité* (1927); *Scherza* (1927); *Poeme ailé* (1927); *Revolt* (1927); *Valse Caprice* (1928); *Trouvères* (1928); *Immigrant* (1928); *Poems of 1917* (1928); *Fragments* (1928); *Resonances* (1928); *Dance (after Nietzsche)* (1929); *Three Florentine Verses* (1929); *Four Insincerities* (1929); *Cants mágic* (1929); *Two Variations (Country Lane, City Street)* (1929); *Resurrection* (1929); *Vision of the Apocalypse* (1929); *Figure of a Saint* (1929); *Adolescence* (1929); *Sketches for the People* (1929); *Danza* (1929); *Heretic* (1929); *Two Chants* (1930); *Lamentation* (1930); *Project in Movement for a Divine Comedy* (1930); *Harlequinade* (1930); *Danse* (1930); *Two Primitive Canticles* (1931); *Primitive Mysteries* (1931); *Rhapsodics* (1931); *Bacchanale* (1931); *Dolorosa* (1931); *Dithyrambic* (1931); *Serenade* (1931); *Incantation* (1931); *Ceremonials* (1932); *Offering* (1932); *Ecstatic Dance* (1932); *Prelude* (1932); *Bacchanale (II)* (1932); *Salutation* (1932); *Dance Songs* (1932); *Chorus of Youth* (1932); *Six Miracle Plays* (1933); *Elegaic* (1933); *Ekstasis* (1933); *Tragic Patterns* (1933); *Dance Prelude* (1933); *Frenetic Rhythms* (1933); *Transitions* (1934); *Phantasy* (1934); *Four Casual Movements* (1934); *Intégrales* (1934); *Dance in Four Parts* (1934); *American Provincial* (1934); *Praeludium* (1935); *Course* (1935); *Frontier* (1935, also known as *Perspectives I*); *Marching Song* (1935, also known as *Perspectives II*); *Formal Dance* (1935); *Imperial Gesture* (1935); *Panorama* (1935); *Horizons* (1936); *Chronicle* (1936); *Opening Dance* (1937); *Immediate Tragedy* (1937); *Deep Song* (1937); *American Lyric* (1937); *American Document* (1938); *"Every Soul Is a Circus . . ."* (1939); *Columbiad* (1939); *El Penitente* (1940);

Letter to the World (1940); *Punch and the Judy* (1941); *Land Be Bright* (1942); *Salem Shore* (1943); *Deaths and Entrances* (1943); *Imagined Wing* (1944); *Appalachian Spring* (1944); *Herodiade* (1944); *Dark Meadow* (1946); *Cave of the Heart* (1946); *Errand into the Maze* (1947); *Night Journey* (1947); *Diversion of Angels* (1948); *Eye of Anguish* (1950); *Gospel of Eve* (1950); *The Triumph of St. Joan* (1951); *Canticle of Innocent Comedians* (1952); *Voyage* (1953); *Ardent Song* (1954); *Seraphic Dialogue* (1955); *Clytemnestra* (1958); *Embattled Garden* (1958); *Episodes* (Part I) (1959); *Acrobats of God* (1960); *Alcestis* (1960); *Visionary Recital* (1961); *Judith (I)* (1962); *A Look at Lightning* (1962); *One More Gaudy Night* (1962); *Phaedra* (1962); *Secular Games* (1962); *Circe* (1963); *The Witch of Endor* (1965); *Part Real—Part Dream* (1965); *Cortège of Eagles* (1967); *Dancing Ground* (1967); *A Time of Snow* (1968); *The Pain of Prayer* (1968); *Lady of the House of Sleep* (1968); *The Archaic Hours* (1969); *Mendicants of Evening* (1973); *Myth of a Voyage* (1973); *Chronique* (1974); *Holy Jungle* (1974); *The Dream* (1974); *Lucifer* (1975); *Point of Crossing* (1975); *Adorations* (1975); *The Scarlet Letter* (1975); *O Thou Desire Who Art About to Sing* (1977); *The Owl and the Pussycat* (1978); *The Flute of Pan* (1978); *Frescoes* (1978); *Judith (II)* (1980).

OPERA: *Judith* (1950).

Grahn, Lucile, Danish ballet dancer of the Romantic period; born June 30, 1819 in Copenhagen; died April 1, 1907 in Munich, Germany. Trained by Auguste Bournonville at the school of the Royal Danish Ballet, she made her official debut in 1834. Associated with Bournonville throughout her Danish career, she created roles in his *Valdemar* (1835), *La Silfiden* (1836), and *Don Quixote* (1837).

She moved into the mainstream of Romantic ballet in 1838 with her debut at the Paris Opéra. For the next years, she performed in Paris where, to prove her credentials, she performed in the Taglioni original version of *La Sylphide,* and in St. Petersburg in works by Arthur Saint-Léon. In London, she participated in the *Pas de Quatre,* the famous divertissement by Jules Perrot for Grahn, Marie Taglioni, Fanny Cerrito, and Carlotta Grisi in 1845 at Her Majesty's Theatre. She also created roles in Perrot's *Eoline* (1845) and *Catarina* (1846).

Retiring from performance, Grahn became ballet master at the Opera House in Munich, where she staged dances and movement for the premiere of *Die Meistersinger von Nurmberg* in 1868, and the first separate performance of *Das Rheingold* in 1869.

Grammis, Adam, American theatrical dancer; born December 8, 1947 in Allentown, Pennsylvania. Although Grammis has danced in almost every medium available, from jazz and modern dance companies to television, he is best known for his Broadway work. He has been a "gypsy" (chorus dancer) in a wide variety of shows, most notably those in which he has played a Broadway dancer, such as *A Chorus Line* and Shirley MacLaine's 1976 vehicle at the Palace Theater. Grammis prepared for his future career as a Broadway choreographer by assisting Graciela Daniele on her recent projects, most notably the New York Shakespeare Festival's jazzed-up version of *The Pirates of Penzance* (1980).

Grandy, Maria, American ballet dancer and ballet master; born January 28, 1937 in Portland, Oregon. Trained by Jacqueline Schumacher, Igor Schwekoff, and Margaret Craske, Grandy performed with the New York City Ballet and Robert Joffrey Theatre Ballet before joining the Metropolitan Opera as a soloist.

Best known as a ballet master and company administrator, she has served in those capacities for the New York City Opera, the short-lived Brooklyn Ballet, and the Joffrey II company, of which she is now associate director.

Works Choreographed: CONCERT WORKS: *Carry Nation* (1966).

Granger, Josie, American theatrical ballet and musical comedy dancer; born 1853 in Baltimore, Maryland; died July 6, 1934 in Freeport, Long Island. Granger made her debut in a production of *The Black Crook,* c.1870, although it is impossible to verify in which presentation of this popular show she appeared. She became a member of the Tony Devere company, dancing in his presentations of operettas and extravaganzas, among them his *Humpty-*

Dumpty, in which she met the Irish eccentric dancer and comedian Pat Rooney I. In the twenty years that they toured together, she appeared in his vaudeville acts, among them his *The Miner's Bowery* and *Lord Rooney,* and, on occasion, she danced in the title role of his "Biddy the Ballet Girl." After Rooney's death in 1904, she continued touring with his company and acts for a number of years. Just before her retirement, she traveled with her oldest children, Mathilda and Pat Rooney II in the act *Two Chips Off the Old Block.* Although her elder daughter retired from the business fairly early, three of her remaining children became vaudeville headliners—Pat II, and Josie and Julia who performed as The Rooney Sisters.

Granier, Joseph, French eighteenth-century ballet dancer working in English theaters; born c.1730, possibly in Paris; died after 1774 in London. He emigrated to England with his parents as members of the Comédie-Française troupe of Francisque Moylin, another member of which was the young Marie Sallé. They made their debuts at Hallam's Booth Theatre at the Bartholomew Fair in 1740. The Masters Granier (Joseph and his younger brother Jack) also appeared in divertissements at Goodman's Fields (c.1741–1743, 1745–1746), Sadler's Wells (1746), and Covent Garden, where in 1747 he gave his first performance billed as an adult, as Joseph Granier. After working in Dublin (where he married Dutch dancer Aleda Vandersluys), and Glasgow, he returned to London to dance at Sadler's Wells. From 1751 to 1772, he performed at that theater and at Covent Garden in harlequinades and pastorales, among the latter category, *The Phophetess,* the masque *Comus* (1771), *Romeo and Juliet, Florizel and Perdita,* and *Perseus and Andromeda.* At Covent Garden, he danced in *Harlequin Skelation, Harlequin Sorceror,* and *Columbine Courtezan.*

In addition to his brother Jack, who performed at the Sadler's Wells throughout his adult career, Granier's performing family included his sister Polly and the Miss Graniers, identified by scholars as the daughters of Joseph and Jack.

Grant, Pauline, English ballet dancer and theatrical choreographer; born June 29, 1915 in Mosely, Birmingham. After studying interpretive dance forms with Ruby Ginner, she received formal ballet training from Antony Tudor and Vera Volkova. It is not known whether she ever performed in a ballet company before becoming, at age twenty-five, the ballet master of the Neighborhood Theatre, Kensington, in 1940.

After touring with the ENSA, she joined the cast of the London production of *A Night in Venice* (1944). From 1945 to the mid-1950s, she staged dances for West End musicals and operettas, among them, *Merrie England* (1945), *Picadilly Hayride* (1946), *The Babes in the Woods* (1950), and revues at the Palladium Theatre. She also worked on ice shows in the mid-1950s, and, from 1950 to 1959, served as resident choreographer for the Royal Shakespeare Company. Among her many positions with opera companies were a continuing tenure with the Festival Opera at Glyndebourne and with the English National Opera at Covent Garden.

Works Choreographed: THEATER WORKS: *Merrie England* (1945); *Can-Can* (1946, London production only); *Picadilly Hayride* (1946); *The Bird Seller* (1947); *King's Rhapsody* (1949); *Wild Violets* (1950 revival); *The Babes in the Woods* (1950); *Zip Goes a Million* (1951); *Love for Judy* (1952); Palladium Theatre Revues (1951–1955); productions at the Royal Shakespeare Company (1950–1959); ice shows including *Cinderella on Ice* and *Wildfire on Ice* (1954–1959).

FILM: *Moll Flanders* (1965).

TELEVISION: *The Julie Andrews Show* (ATV/ABC, 1972).

Grantzeva, Tatiana, Russian/French ballet dancer; born in St. Petersburg. Raised in Bulgaria and France, Grantzeva was trained in Paris by Olga Preobrajenska, Lubov Egorova, and Mathilde Kschessinskaia. Moving to New York, she continued her studies with Valentina Pereyaslavec and Elizabeth Anderson-Ivantsova.

Through much of her performing career, Grantzeva has been associated with the Ballet Russe de Monte Carlo in the United States, dancing with the company from 1938 to 1946 and from 1958 to 1962. She has been associated with the works of Leonid Massine and has brought her style and humor to roles in his *Vienna—1814, Devil's Holiday, Rouge et Noir,*

and *Gaité Parisienne,* in which she played "The Flower Girl." She also performed with the Ballet for America troupe in the Massine repertory, and with Dmitri Rostoff's Peruvian Ballet.

Acclaimed as a teacher, she has served as ballet master to the Ballet Russe de Monte Carlo, the Ballet du XXième Siècle, and various troupes of Roland Petit. She is currently the ballet master of the San Francisco Ballet.

Grantzow, Adele, German nineteenth-century ballet dancer working in Paris and St. Petersburg; born January 1, 1845 in Brunswick, Germany; died June 7, 1877 in Berlin. Trained by her father Gustav, then the ballet master of Stadtopera in Brunswick, Grantzow made her debut with the opera ballet as an adolescent. After performing with the Hanover Opera Ballet company, she moved to Paris to study with Mme. Dominique-Venettozza.

For the ten years before her death, Grantzow commuted between the Paris Opéra and the Russian theaters then under the ballet supervision of Arthur Saint-Léon. At the Moscow Bolshoi, in 1865 and 1866, she performed leading roles in Saint-Léon's *Fiametta* and *Le Poisson doré*; in St. Petersburg, she created the female lead in his *Le Lys* (1870). After her Paris Opéra debut in the 1866 revival of *Giselle,* she performed in Saint-Léon's *Néméa,* divertissements for *Don Giovanni* (1866), *La Source* (1867), and in the revival of *Le Corsaire* in 1867.

Grantzow died in Berlin after a leg amputation, complicated by typhus contracted in St. Petersburg.

Graves, Georgia, American theatrical and concert dancer working primarily in France; born c.1912 in the Los Angeles area of California. Graves was trained by Ernest Belcher and made her theatrical debut as a Belcher "Tot" at the age of five. It is possible that she also took class with Doris Humphrey at the Los Angeles Denishawn School since one of her most popular solos, *Hoop Dance,* was obviously related to (if not derived from) Humphrey's *Scherzo Waltz* (1924). She made dozens of films as a Belcher dancer and toured with his stepdaughter Lina Basquette in her vaudeville ballet act, but Graves did not rise to prominence until she left the United States to accept work in Paris. Glorified in the press as "La

Mlle. Georgia" or "La Mlle. de Georgia," she was a headliner at the Folies Bergère in Paris from 1929 until the German occupation of France. Despite the location of her engagements, Graves was never a striptease artist—she performed her *Hoop Dance* and *Bubble Waltz* in partial fleshings (unitards), but did not remove additional clothing on stage. She, and the American dance press, agreed that she was a concert dancer, albeit with a small repertory.

Gray, Diane, American modern dancer and choreographer; born May 29, 1944 in Painesville, Ohio. Trained originally by her parents at their School of Dance in Painesville, she continued her studies at the Juilliard School. A member of the Martha Graham company from the late 1960s, she created roles in her *A Time of Snow* (1968), *Archaic Hours* (1969), *Point of Crossing* (1975), and *Adorations* (1975), with additional parts in her *Chronique, Appalachian Spring, Night Journey,* and *Holy Jungle.* She also performed in works by fellow members of the company, notably in Helen McGehee's *Oreisteia* (1966) and *The Only Jealousy of Emer* in 1967.

Gray has choreographed since the late 1970s, primarily for her own company. Her best known works include *The Finger Dances* (1980) and the imaginative *Secrets of the Gibson Girls* (1978), which defines restrictions of turn-of-the-century women with a red rubber ball.

Works Choreographed: CONCERT WORKS: *Robin's Dream* (1977); *Secrets of the Gibson Girls* (1978); *Glory!* (1978); *The Arranger* (1978); *Home Burial* (1980); *The Finger Dances* (1980).

Gray, Gilda, American theatrical dancer specializing in the "Shimmy"; born c.1903, Marriana Michalska in Cracow, Poland. Raised in Milwaukee, she became a protégé of Sophie Tucker, who suggested her pseudonym. Gray's popularity coincided with the enforcement of Prohibition and she was constantly cast in musical numbers that connected the themes of sex and liquor, such as "You Can't Make Your Shimmy Shake on Tea." Primarily a cabaret performer, she appeared in very few Broadway shows. Among her stage credits were the first and only edition of the *Snapshots of 1921,* and two editions of the *Ziegfeld Follies.* She introduced her "Shimmy" in the 1919

Follies (although it had been performed earlier in Paris), as the one-step performed with vertical shoulder isolations with which she remained associated throughout her life. She had two specialty dance numbers in the *Follies of 1922*—a hula dance to "South Sea Moon," and an eccentric buck performed to the embarrassingly racist song "It's Getting Darker on Broadway," at the climax of which the stage lights were extinguished, leaving a black light set-up that made Gray and the chorus look Negroid.

Gray made an attempt at a film career in the late 1920s, but only two of her motion pictures were released—*Aloma of the South Seas* (Paramount, 1926), which tried to cash in on her hula dancing, and *Picadilly* (World Wide, 1929). She also appeared in *Rose Marie* (MGM, 1936), the Jeannette McDonald-Nelson Eddy spectacular.

Gray, Henriette Ann, American modern dancer and choreographer; born c.1914 in Missouri. Trained originally at the Lindenwood College, Missouri, Gray moved to New York to work at the Humphrey/Weidman Studio. Performing with the Concert Group attached to that studio, Gray created roles in many works by Doris Humphrey, among them, *To the Dance* (1937) and the *Passacaglia and Fugue in C Minor* (1939). Her work with Charles Weidman included performances in his *Quest* (1936), *Opus 51* (1939), and *On My Mother's Side* (1940).

When the group dissolved (c.1947), Gray began to choreograph on her own. Many of her works, among them *When Satan Hops Out* (1947), *Cartoons* (1954), and *The Ballad of the Little Square* (1954), reveal the Humphrey/Weidman influence strongly.

That influence can also be seen in Gray's extensive teaching career. At the Perry-Mansfield Camp, Colorado, from 1947 and at the New Studio Workshop, Los Angeles, from 1950, Gray has taught the fall-and-recovery theories of Doris Humphrey with the humor of Weidman. As director of the Resident Dance Company at Stephens College, Colorado (which currently controls the Perry-Mansfield Camp), Gray has taught for ten years, developing a dance program where none existed; her students there have included Fred Mathews, dancer/choreographer of the José Limón Company.

Works Choreographed: CONCERT WORKS: *When Satan Hops Out* (1947); *The Albatross* (1953); *Dance for Two* (c.1953); *Cartoons* (1954); *The Ballad of the Little Square* (1954); *Broken Flight* (1954); *To Be* (1954); *Taken with Tongues* (1954); *Saturday Night* (1954); *Grooved* (1954).

Greco, José, Spanish dancer and choreographer; born December 23, 1918 in Montorio nei Frentani, Italy. Raised briefly in Seville, and then in Brooklyn, he studied with Helene Veola. Employed originally as a specialty dancer in New York, he partnered early Ballet Theatre greats Nora Kaye and Muriel Bently at the New York Hippodrome and the nightclub La Conga respectively. La Argentinita saw him in the latter and engaged him as her partner for the two years before her death in 1945. He partnered her in her *El Amor Brujo, Bolero, Café de Chinitas,* and *Pictures of Goya.*

After her death, he returned to Spain with dancer Pilar Lopez, her sister and heir, performing in the Ballet Español in Madrid. He formed the Ballets y Bailes de España in 1949 and the José Greco Dance Company within that decade to tour the continent, Asia, and North and South America. His appearances as "local color" in Hollywood films, including MGM's *Sombrero,* Twentieth-Century Fox's *Holiday for Lovers,* Michael Todd's *Around the World in 80 Days,* and the drama *Ship of Fools,* added to his popularity, soon making him the best known Spanish dancer outside of Spain. He retired gradually during the mid-1960s, forming an educational Foundation for Hispanic Dance in 1971.

Works Choreographed: CONCERT WORKS: *Caña y Farruca* (c.1946); *Triana* (c.1946); *Polo* (c.1946); *Le Tricorne* (c.1947); *Sentimentes* (c.1948); *Old Madrid* (c.1951); *Rincon Flamenco* (1951); *Cante Jone* (c.1951); *Juerga* (c.1951); *El Cortijo* (c.1951); *Peteñeras* (c.1952); *Suite of Traditional Dances (Tientos, Alegrias, Cordoba, Mujeres de Aragon, Rumeros de la Caleta, Danza del Contrabandista Zapareado)* (1952–1953); *Anda Jaleo* (c.1956); *Tango y Sequidilla* (c.1957); *Mosaico Seciallano* (c.1956); *Tres Morilla* (c.1956); *Castellana* (c.1956); *Fantasia* (c.1956); *Los Amantes de Sierra Moreña* (c.1957); *Los Trobadores en las Calles de Cadiz* (c.1958); *Verdiales del Valle Verde* (c.1958); *Bulerias*

de Juañene (c.1959); *Fantasia del Valencia y Aragon* (c.1958); *Barcelona Suite* (1964).

Bibliography: *Gypsy in My Soul: The Autobiography of José Greco* (New York: 1977).

Greenfield, Amy, American video artist and choreographer; born July 8, 1940 in Boston, Massachusetts. Greenfield received dance training from Robert Cohan and Nina Fonaroff of the Martha Graham school and from the faculty of the Merce Cunningham studio. She was tremendously influenced by the films of Maya Deren. Greenfield has so far done all of her choreography for video or holographic presentation. She frequently performs on her pieces with Ben Dolphin, and can be seen in her *Dialogue for Camera and Dancer* (1976), *Dervish* (1976), and *Videotape for a Man and a Woman* (1979). Her video work is distributed through the Filmmakers' Collective and presented at the centers of experimental work in the United States, among them The Kitchen, Global Village, and the Cabin Creek Center.

Works Choreographed: VIDEO AND HOLOGRAPHS: (All works self-produced.) *Encounter* (1969); *Dirt* (1971); *Transport* (1971); *Lifting Scene* (1972); *Element* (1973); *Fragments: Mysterious Beginning* (1976); *Dialogue for Camera and Dancer* (1976); *Dervish* (1976); *Saskya* (1977, holograph); *Fine step* (1977, holograph); *Four Solos for Four Women* (1977); *Beach* (1979); *Videotape for a Man and a Woman* (1979).

Greenwood, Charlotte, American eccentric dancer and actress; born June 25, 1893 in Philadelphia, Pennsylvania. Greenwood studied with Ned Wayburn in the 1910s, but research has been unable to verify whether she had had previous training. She made her professional debut in the chorus of *The White Cat* (1905), then performed in a series of Rogers Brothers shows, from 1908 on. After touring in vaudeville with a pianist on the Keith circuit, she went into Wayburn's *Passing Show of 1912* and 1913, doing her own specialty act in each. Other Broadway credits include Wayburn's *Town Topics* (1915), *So Long Letty* (1916), *Linger Longer Letty* (1919), *Let 'Er Go Letty* (1921), *Letty Pepper* (1922), the *1922 Music Box Revue*, the *1924 Ritz Revue*, the

1927 edition of *Le Maire's Affaires, She Couldn't Say No* (1930), *She Knew What She Wanted* (1930), *Leading On Letty* (1935), and *Out of This World* (1950).

Her eccentric dance act, dependant on her exceedingly long legs, disproportionate arms and dead-pan expression, also worked on film, especially in her role as "Aunt Eller" in the film of *Oklahoma* (Magna, 1955).

Gregg, Mitchell, American theatrical performer; born January 15, 1921 in Brooklyn, New York. Although better known now as a vocalist, Gregg was for a decade one of Broadway's most prominent song and dance men. He actually came to public prominence in the 1949–1950 television variety show, *Music from Hollywood* (NBC), but was soon cast in Broadway musicals. He cavorted in the juvenile leads in *Music in the Air* (1961) and *Happy Hunting* (1956), and played more stylized, sophisticated roles in *Say, Darling* (1958 and 1959 revival), *The Unsinkable Molly Brown* (1960), and *No Strings* (1962). Gregg was also a leading performer with the City Center "repertory" company of musical comedy revivals of the late 1950s and 1960s, but primarily as a tenor.

Gregory, Cynthia, American ballet dancer; born July 8, 1946 in Alhambra, California. Gregory studied ballet in Los Angeles with Carmelita Maracchi, Michael Panaieff, and Robert Rosselat. At the age of fifteen, she joined the San Francisco Ballet, performing works in the classical repertory, including *The Nutcracker*.

Gregory joined American Ballet Theatre in 1965. She has remained with this company, although she has resigned three times for brief periods. Her bravura technique and prideful presence have brought her the major female roles of the classical repertory, including "Odette-Odile" (from 1967), "Myrthe" (from 1968), "Giselle" (from 1972), and "Raymonda" (in the Nureyev production, from 1975). Gregory is also associated with the modern repertory and has created roles in more lyrical works by contemporary choreographers, among them, Michael Smuin's *The Fallen Idol* (1969), Dennis Nahat's

Brahms Quintet (1969) and *Mendelssohn Symphony* (1971), Alvin Ailey's *The River* (1971), and Peter van Dyk's *Unfinished Symphony* (1972). As she developed her dramatic talents in the 1970s, she began to perform feature roles in Agnes De Mille's *Fall River Legend*, Antony Tudor's *Jardin aux Lilas, Pillar of Fire* and *Undertow*, and Eliot Feld's *At Midnight*.

Gregory has choreographed occasionally since 1973, primarily for concert groups and festivals.

Works Choreographed: CONCERT WORKS: *Bach Dances* (1973); *Solo* (1979).

Gregory, John, English ballet dancer; born April 15, 1914 in Norwich. Gregory was trained in London at the studios of Igor Schwezoff, Nicholas Legat, and Stanislas Idzikowsky. He performed in the 1941–1942 season of the Anglo-Polish Ballet there in Czeslow Konarski's *Cracow Wedding* and other works. During World War II, he appeared in ENSA productions, in the English Ballet Jooss and in Pauline Grants' chamber group, dancing the role of "Harlequin" in her *A Night in Venice* (1945).

That role became a theme for him; he played it in De Basil's Original Ballet Russe's London seasons and in Tamara Karsavina's restaging of *Les Millions d'Arlequin* in his own Harlequin Ballet, co-founded with Barbara Vernon in 1949. Their company was formed to present both new and repertory works in the "provinces," in the days before Arts Council grants, but has since offered London seasons.

Gregory is considered an expert in "Russian Classical Ballet," which in England means the technique and style performed by the Ballet Russe members who remained in London. He has written extensively on technique and teaching and has become a popular educator and coach in England and at the Academia Filarmonico in Sicily.

Grey, Beryl, English ballet dancer; born Beryl Groom, June 11, 1927 in Highgate, London. Grey's early training with Madeleine Sharpe brought her a scholarship to the School of the Sadler's Wells Ballet in 1936.

Grey performed with the Sadler's Wells, then the Royal Ballet from 1941, making her debut in the company production of *Swan Lake*. She was as-signed roles in works by many of the major choreographers of the developing English ballet. Her parts in Frederick Ashton ballets included "La Duesa" in *The Quest* (1943) and roles in *Les Sirènes* (1946), *Cinderella* (1948), *Homage to the Queen* (1953), and *Birthday Offering* (1956). In addition, she danced in Robert Helpmann's *Comus*, John Cranko's *The Lady and the Fool*, Ninette De Valois' *Checkmate*, and the company production of *The Sleeping Beauty*, playing "Aurora" and "The Lilac Fairy."

Since 1957, Grey has pursued a freelance career as a prima ballerina. Her engagements have taken her as far as the Peking Ballet in China and the Kirov, Bolshoi, Kiev, and Thilisi State Ballets in the Soviet Union, with additional performances in Sweden and Denmark. After retiring as a dancer in 1966, she was named artistic director of the London Festival Ballet, also serving as director-general of the Arts Education Trust school.

Bibliography: Gillard, David. *Beryl Grey* (London: 1977); Grey, Beryl. *Red Curtain Up* (London: 1958); *Through the Bamboo Curtain* (London: 1965).

Grey, Joel, American theatrical dancer and actor; born Josel Katz, April 11, 1932 in Cleveland, Ohio. As a child, he traveled with his father, Mickey Katz, a well-known Yiddish comic with the *Borscht-Capades*.

Grey's Off Broadway debut was in *The Littlest Revue*, 1956. It led to an engagement replacing Warren Berlinger in the Neil Simon comedy *Come Blow Your Horn*, which in turn brought him a booking as the vacation replacement for Tommy Steele in *Half a Sixpence*. After ten years in the business, he was "discovered" as the "Master of Ceremonies" in *Cabaret* (1966), a role that he repeated in the film version (AA, 1972). He won both Tony and Oscar awards for that part. Grey has also starred in three more musicals—*George M!* (1967); in the title role of *Good-time Charley* (1975), the musical comedy about the death of Joan of Arc; and in *The Grand Tour* (1979).

Although Grey has performed extensively on television and in film, most of his appearances since the 1960s have been in dramatic roles. He has, however,

danced and sung on many variety shows, and reproduced his performance in *George M* on television (NBC, 1970).

Griffin, Rodney, American theatrical and modern dancer and choreographer; born in Philadelphia, Pennsylvania. One of the few choreographers who admits that he was trained at a Fred Astaire Dance Studio, he continued his studies in Philadelphia with Nadia Chikowsky and in New York at the Martha Graham school. He performed for Donald McKayle in his Broadway shows, films, and ad hoc companies, dancing in *A Time for Singing* (1966), *I'm Solomon* (1969), and the Disney movie *Bedknobs and Broomsticks* (Buena Vista, 1970). He also restaged McKayle works for companies and replacement casts.

Griffin has choreographed since 1972 for the Theatre Dance Collection, of which he is associate director. His best known works are the hilarious *Misalliance* (1972, revised 1974), a mythological ballet about the literally misbegotten offspring of modern dance and ballet, and *Eakins' View* (1976), a very controlled movement study inspired by the early twentieth-century photographer, Thomas Eakins.

Works Choreographed: CONCERT WORKS: *Cave Paintings* (1971); *Guaranteed Pure* (1971); *The Lady Doth Protest* (1971); *Race* (1971); *Not in Your Hands* (1971); *Virginials* (1971); *Spanish Steps* (1971); *Canon* (1971); *Drawing* (1971); *Duetino* (1971); *Chamber Music* (1971); *Twelve Days of Christmas* (1971); *Winter Lady* (1971); *The Ugly Duckling* (1972); *The Nest* (1972); *Misalliance* (1971); *Tintype* (1973); *Tombmates* (1973); *Puppets* (1973); *For the Birds* (1973); *The Lovers* (1973); *Ends . . . and Odds* (1973); *Ancestral Voices* (1973); *Courtly Dances* (1973); *Mandrogola* (1973); *The Miraculous Mandarin* (1974); *Summer Lightening* (1975); *The Fool's Almanac* (1975); *Eakins' View* (1976); *Rialto* (1976); *Clean Sheets* (1976); *Three-Penny Dances* (1976); *Quiet City* (1979).

Grigoriev, Serge, Russian ballet dancer and regisseur for Ballet Russe troupes; born October 5, 1883 in Tichvin; died June 28, 1968 in London. Grigoriev was trained at the school of the Imperial Ballet in St. Petersburg and graduated into the Maryinsky Ballet in 1900. The only person connected to the Diaghilev Ballet Russe to suffer from excess modesty, Grigoriev included very little personal information in his valuable and informative work, *The Diaghilev Ballet*. It is known from other sources, however, that in his brief performing career with the Maryinsky, he was cast in characterizational and national solos in the Marius Petipa/Lev Ivanov repertory, without being denoted as a mime as such. His roles in the Diaghilev repertory were mime parts, however, and included the antagonist "Shah Shariar" in Mikhail Fokine's *Schéhérézade*, "The Russian Merchant" in Leonid Massine's *La Boutique Fantasque* and "The Emperor" in the latter's *Le Chant du Rossignol*.

Grigoriev became regisseur of the Diaghilev Ballet during its planning stages in St. Petersburg and remained in that capacity until Diaghilev's death in 1929. As such, he was responsible for the maintenance of the repertory from season to season and from theater to performance space, and for the engaging of performers both from the Russian and Soviet theaters and from Western European schools. He also served as regisseur for the De Basil Ballet Russe de Monte Carlo from its first seasons following Diaghilev's death to its end in the early 1950s. His talents and abilities within the Diaghilev organization brought him wide recognition within the industry and frequent requests to restage parts of the Diaghilev repertory for other companies, primarily in England, where he and his wife, Lubov Tchernicheva, lived after the mid-1950s.

Bibliography: Grigoriev, Serge. *The Diaghilev Ballet* (London, 1953).

Grigorovich, Yuri, Soviet ballet dancer and choreographer; born January 1, 1927 in Leningrad. Trained at the Leningrad Choreographic Institute, he continued his studies with Kasyan Goleizovsky and Alexander Pushkin. He performed with the Kirov Ballet from c.1946, specializing in the demi-caractère roles in the company productions of *Spartacus, The Stone Flower,* and *The Fountain of Bahkchisarai.* He began to choreograph while a company member, contributing a version of *The Stone Flower* in 1957 (restaged for the Bolshoi in 1959).

He switched to the Bolshoi Ballet in 1964, serving there as artistic director and principal choreographer. His works for the Bolshoi include versions of *The*

Sleeping Beauty (1965, 1973), *Spartacus* (1968), and *The Nutcracker* (1965), and original ballets including *Angara* (1976) and *Ivan Le Terrible* (1975).

Works Choreographed: CONCERT WORKS: *The Stone Flower* (1957); *Legend of Love* (1961); *The Sleeping Beauty* (1965); *The Nutcracker* (1965); *Spartacus* (1968); *Swan Lake* (1969); *The Sleeping Beauty* (1973); *Ivan Le Terrible* (1975); *Angara* (1976).

Grimaldi, Giuseppe, Italian eighteenth-century harlequinade performer working in England; born c.1713 in Genoa or Malta; died March 14, 1788 in London. The son of Jean-Baptiste Grimaldi (called Nicolini or "Gamba di Ferro"), Grimaldi immigrated to England some time before 1758, when he began performing at the King's Theatre, London.

During the next season, he joined the company attached to the Drury Lane, performing *The Millers' Dance* there, possibly choreographing it. He stayed at the Drury Lane for twenty-seven seasons until 1788. Principal Pantaloon for the company, he also served as ballet master for *Oroonoko* (1764), *The Tempest* (1764), and *Florizel and Perdita* (c.1767); he performed in *Harlequin Junior* (1783), *Here, There and Everywhere* (1884), and *Harlequin Teague*, his last show in 1886.

Apart from his performance, Grimaldi also served the Drury Lane and other London theaters by managing an apprenticeship program that taught young actors and dancers the techniques of both English and Italian pantomime.

Works Choreographed: THEATER WORKS: *Oroonoko* (1764); *The Tempest* (1764); *Florizel and Perdita* (1767).

Grimaldi, Joseph, English harlequinade performer called "The King of Clowns"; born December 18, 1778 in London; died there on May 31, 1837. Grimaldi was the son of Giuseppe Grimaldi and Rebecca Brooker, a dancer at Drury Lane who had been a pupil of Giuseppe's in the apprenticeship program. Grimaldi made his debut at age three at Drury Lane, in *Robinson Crusoe* (1781), performing at Sadler's Wells within a few weeks after that. By 1782, he was a member of the Drury Lane company, playing pages, dwarfs, cupids, monkeys, and child Pierrots.

Grimaldi played his first "Scaramouche" in 1798 in *Sylvester Daggerwood*. He developed the character by playing "drinking clowns," in *Harlequin in the Flying World* (at Sadler's Wells, 1800), before playing a clown character in *Harlequin Amulet* (1801), the most innovative production by the most celebrated harlequin of his age, James Byrne. Although he served as ballet master at Drury Lane briefly in 1805 (between the tenures of James Byrne and James D'Egville), he was best known as a performer in harlequinades and pantomimes. He worked continuously at Covent Garden and Sadler's Wells from 1806 to 1822, playing in *Harlequin and Mother Goose* (1806), with Joseph Bologna as "Harlequin," *Harlequin and Asmodeus* (1810), *Harlequin and the Forty Virgins* (1808), *The Wild Man* (1808), *Harlequin and Friar Bacon, or the Brazen Head* (1820), and *Harlequin and the Ogress* (1822).

In 1822, Grimaldi was stricken with a crippling disease, variously diagnosed (by current authors) as either polio or arthritis. Retiring in 1823, his two farewell benefit galas in 1828 were considered the greatest gathering of pantomime performers of all time.

Bibliography: Boz (Charles Dickens), ed. *The Memoirs of Joseph Grimaldi* (London: 1838).

Grisi, Carlotta, Italian nineteenth-century ballerina of the French Romantic era; born June 28, 1819 in Visinada; died May 20, 1899 in St. Jean, Switzerland. Grisi was trained at the school of the Teatro alla Scala, entering the company in 1829. In 1833, however, she met Jules Perrot with whom she performed and toured for many years thereafter. They were engaged at boulevard houses, including the Théâtre de la Renaissance in a repertory of character divertissements before she was allowed to make her Paris Opéra debut in 1941. Between her bookings and Perrot's, she danced in all of the capitals of Romanticism in Europe, but she remains famous for the roles that she created at the Paris Opéra.

It has also been curious that Grisi's reputation has not survived as well as those of her rivals, Fanny Elssler and Marie Taglioni. It seems that even with Perrot partnering her and Théophile Gautier lauding her, she simply did not have the publicity machine to maintain her name and image through history. The ballets in which she created principal roles did sur-

vive, however, longer than those of her contemporaries. Her creations include François Albert's *La Jolie Fille* [or La Rosière or Béatrice] *de Gand* (1842), Jean Coralli's *La Péri* (1843), Joseph Mazilier's *Le Diable à Quatre* (1845), *Paquita* (1846), and *Griseldis* (1848), and Perrot's *La Esmeralda* (1844) and *La Filleule des Fées* (1844). Her most famous role, however, was the title part in Coralli and Perrot's *Giselle* (1841) in which her dramatic powers brought the Romantic heroine to life and a magnificent death scene. Grisi retired in the early 1850s.

Bibliography: Lifar, Serge. *Carlotta Grisi* (Paris: 1941).

Groody, Louise, American theatrical dancer and actress; born March 26, 1897 in Waco, Texas; died September 16, 1961 in Canadensis, Pennsylvania. Trained by Ned Wayburn, reportedly by mail order and in person, Groody was a popular and vivacious dancer in Broadway musical comedies in the 1910s and 1920s. After her debut in the chorus in *Around the Map* (1915), she partnered Hal Skelly in *Fiddlers Three* (1918) and *The Night Boat* (1920), in an eccentric exhibition ballroom act. In her next show, *Good-Morning Dearie* (1921), she danced with Harland Dixon but married Oscar Shaw—a typical denouement for the period. Her biggest success was as the original Broadway "Nanette" in Vincent Youmans' *No, No, Nanette* (1925). Unlike the revival of 1971, the original gave dance specialties to the title character, who tapped and soft-shoed to "Tea for Two" and "Too Many Rings Around Rosie Will Never Get Rosie a Ring." After starring in the next Youmans musical, *Hit the Deck*, Groody retired from performance.

Grossman, Daniel Williams, American modern dancer and choreographer; born 1942 in the San Francisco Bay area. Trained by Welland Lathrop and Gloria Unti in San Francisco, he moved east to attend the American Dance Festival of 1963. As Daniel Williams, he performed with Paul Taylor for ten years, most notably in his *Orbs* (1966), *Private Domain* (1969), and *Aureole*, which he danced in New York and London with the (Rudolf) Nureyev and Friends program.

Grossman has directed his own company in Toronto, Canada, since 1973. He choreographs works of slow athleticism and tricky, quick quirks, using oversized props and empty stages to manipulate scale. Among his most popular works are *Higher* (1975), a slow duet that resembles an improvisation piece for him, a woman, a ladder, and a chair, and his solo, *Curious School of Theatrical Dancing* (1977), derived from Gregorio Lambranzi's illustrated texts of 1716.

Works Choreographed: CONCERT WORKS: *Higher* (1975); *Couples* (1975); *Triptych* (1976); *National Spirit* (1976); *Fratelli* (1976); *Curious School of Theatrical Dancing* (1977); *Bella* (1977); *Ecce Homo* (1977).

Gruber, Lilo, German ballet dancer and choreographer; born January 3, 1915 in Berlin. Trained in ballet techniques in Berlin and in modern dance by Mary Wigman, Gruber performed in Germany with an unidentified company before 1945, when she was named ballet master of the opera ballet in Greiswald. She served in a similar capacity in Leipzig before becoming ballet master of the East Berlin State Opera in 1955. With that company until her retirement in 1970, she staged the city's first *Giselle* (1966) and *Swan Lake* (1967), as well as original works.

Works Choreographed: CONCERT WORKS: *Gayane* (1955); *Coppélia* (1955); *Neue Odysee* (1957); *Lysistrata* (1959); *Romeo and Juliet* (1963); *Spartacus* (1964); *Giselle* (1966); *Ballad of Gluck* (1967); *Swan Lake* (1967).

Gsovsky, Tatiana, Soviet ballet dancer and choreographer working in Germany; born Tatiana Issatchenko, March 16, 1901 in Moscow. The daughter of a celebrated actress, she was trained at the Isadora Duncan studio in Moscow by Irma Duncan, and by Olga Preobrajenska. As ballet master of a company at Krasnoder in the late 1910s, she met Victor Gsovsky whom she married. They moved to Berlin where she became ballet master of the Berlin State Opera Ballet (1922–1945). She served in that capacity with the Staatsoper in the Eastern Zone (the People's Republic of Germany) for seven years after partition, before moving west to found the Berlin Ballet in

1955. She has also guested extensively, staging works in Munich, among them the premiere of Werner Egk's *The Nightingale*, Milan, and the Teatro Colón in Buenos Aires. Considered one of the most important figures in the German ballet, she was able to relate the innovations and experimentations of the German expressionist and modern dance studios with the conventional opera ballet genres and companies.

Works Choreographed: CONCERT WORKS: *Die Liebenden von Verona* (1942); *Pastorale* (1942); *Prinzessin Turandot* (1944); *Joan of Zarissa* (1944); *Nobilissima Visione* (1946); *Bolero* (1946); *Petrouchka* (1946); *Romeo and Juliet* (1947); *Der Nachtmittageines Faunes* (Afternoon of a Faun) (1947); *Daphnis and Chloe* (1947); *Goyescas* (1948); *Der Zauberladen* (La Boutique Fantasque) (1948); *Dornröschen* (1949); *Don Quixote* (1949); *Die Ges Chöpfe des Prometheus* (1949); *Rondo vom Goldenen Kalb* (1952); *Der Idiot* (1952); *Apollon Musagète* (1952); *Hamlet* (1953); *Der Rote Mantel* (1954); *Les Noces* (1954); *Pelléas et Melisane* (1954); *The Sleeping Beauty* (1955); *Ballade* (1955); *Juan of Zarissa* (pas de deux) (1956); *La Dame aux Camelias* (1957); *Der Letze Blume* (1958); *Agon* (1958); *Apollon Musagète* (II) (1958); *Menagerie* (1958); *Ondine* (1959); *Orpheus* (pas de deux) (1959); *Movements* (1960); *The Sleeping Beauty* (1960); *Etudes Rythmiques* (1961); *Goyescas* (1961); *Orpheus* (1961); *Illuminations* (1961–1962); *Deux Improvisations sur Mallarmé* (1961–1962); *Les Noces* (1961–1962); *Toccata for Percussion* (1962–1963); *Les Climats* (1963); *Carmina Burana* (1963); *Tristan and Isolde* (1965); *Raymonda* (1975, [Act III only], co-choreographed with Nicholas Beriosoff after Marius Petipa).

Bibliography: Gsovsky, Tatiana. *Ballett in Deutschland* (Berlin: 1954).

Guérard, Roland, American ballet dancer; born 1905 in Flat Rock, North Carolina. Raised in New York City, he studied with Mikhail Fokine there and with Adolph Bolm in Chicago. As an adolescent, he studied with Chester Hale in his free school attached to the Capitol Theater, New York, later performing there with a precision troupe.

In 1930, Guérard went to Paris to continue his studies with Alexander Volinine who, like Hale, had worked with the Anna Pavlova companies. While in Paris, he performed with Nathalie Komorova's troupe at the Folies Bergère.

He joined the Ballet Russes de Monte Carlo (de Basil) in Paris in 1932, returning with the company to New York. Associated with the ballets of Leonid Massine, he created roles in his *Jeux d'Enfants* (1932), *Nobilissima Visione* (1938), and *Vienna—1814* (1940), and danced in the American premiere of *La Boutique Fantasque*. His featured roles in this company, and in the Réné Blum Ballet Russe, included parts in *Swan Lake* (the one-act version in both troupes), *Spectre de la Rose*, *Les Sylphides*, and *Princess Aurora*.

Before retiring to teach, Guérard performed on Broadway in musicals and operettas, among them works staged by ballet choreographers—George Balanchine's *Song of Norway* (1944) and Agnes De Mille's *Brigadoon* (1947).

Guerra, Antonio, Italian nineteenth-century ballet dancer and choreographer; born December 30, 1810 in Naples; died July 20, 1846 in Neuwaldegg, Austro-Hungary. Trained by Pietro Hus in Naples, Guerra performed at the Teatro San Carlo there after 1816. He choreographed for that theater after 1827, producing *Pirra e Alcino* in that year, *Le Nosse di Bacco* (1829) and *Delitto e punizione* (1832), among others. Sponsored by Pierre Gardel, he made his Paris Opéra debut in 1836, later performing as Marie Taglioni's partner in *La Sylphide* and choreographing *Les Mohicans* (1837). At Her Majesty's Theatre, London, from 1838 to 1841, he partnered Fanny Elssler in his version of *La Gitana* and created *Le Lac des Fées* for Fanny Cerrito in 1840. For the remainder of his short life, Guerra served as ballet master of the court theaters in Vienna.

Works Choreographed: CONCERT WORKS: *Pirra e Alcindo, ossia I veriamanti* (1827); *Le Nozze di Bacco* (1829); *Rosmona* (1830); *Delitto e punizione* (1832); *Les Mohicans* (1837); *La Gitana* (1839); *Le Lac des Fées* (1840).

Guerra, Nicolo, Italian ballet dancer and choreographer; born March 2, 1865 in Naples; died February 5, 1942 in Cernobbio on Lake Como. Although he was

trained locally by Aniello Amaturo, there is no solid evidence that he performed in Naples or elsewhere in Italy before joining the Vienna Court Opera Ballet in 1896. In his five years with that company, dancing demicharacter roles in the works of Josef Hassreiter, he produced his own first ballet, *Künsterlist*, in 1898. His next tenure was one of his most prolific, serving as ballet master of the Magyar Kiralfy Opera Ballet in Budapest. From 1902 until the Hungarian participation in World War I, he created a large number of ballets for the troupe, including his celebrated productions of the Italianate *Gemma* (1904), *Maladetta* (1905), and *Psyche* (1906), and early works of Hungarian nationalism, among them *Magyar Tàncegyveleg* (1907) and *A Csodàvaza* (1908).

Guerra returned to Western Europe in 1915. He worked briefly for troupes in Paris, including the Paris Opéra, where he created a *Castor et Pollux* in 1919, and Ida Rubinstein's company, for whom he presented a new version of *La Tragédie de Salomé* (1919) and *Artémis troublée* (1922). Although he produced more works at the Paris Opéra in the mid-1920s, he concentrated his career on creative works for the Teatro alla Scala in Milan for much of the rest of his career. He served as ballet master there—a position that in his case seemed to have involved more teaching than choreography—reviving his Hungarian pieces and creating new ones in the 1930s. Although it has been said that Guerra's major importance lay in his exportation of Italian ballet techniques and styles to Hungary, it seems more likely that he was an expert, if not especially innovative, choreographer whose fame lay in his ability to integrate differing systems of movement in the stagnating Italian ballet. Unlike his contemporaries who remained at La Scala and were unable to breathe new life into the Italian ballet, once of earth-shattering importance, he emigrated to find new vocabularies and brought them back to his native genre.

Works Choreographed: CONCERT WORKS: *Künsterlist* (The Artificial Strategem) (1898); *Szerelmi Haland* (The Adventures of Love) (1902); *Müvé Szfurfnag* (The Trick of the Artist) (1903, possibly a version of *Künsterlist*); *Velencei Carnevàl* (Carnival in Venice) (1903); *A Törpe Grànàtos* (The Midget Grenadier/Soldier) (1903); *Gemma* (1904); *Alom* (Dreams) (1905); *Maladetta* (1905); *Tàncesyveleg* (Dances) (1906); *Psyche* (1906); *Magyar Tàncegyveleg* (Magyar Dances) (1907); *Tàncrèszletek* (1908, revived in Italy as *Selezione Choregraphie*, but more accurately, a suite of short dances); *A Csodàvaza* (The Miraculous Vase) (1908); *Mesecilàg* (The Kingdom of Enchantment) (1909); *Pierette Fatyola* (Pierette's Veil) (1910); *Havasi Gyopàr* (1911, revived as *Edelweiss*); *Tavasz* (Spring) (1911); *Prométheus* (1913); *Amor Jàtèkai* (The Fool of Love) (1913); *Tèli Alom* (Dream of Winter) (1914); *Pastelli Choreographici* (1915, possibly a version of *Tàncesyveleg*); *Castor et Pollux* (1919); *La Tragédie de Salomé* (1919); *Artémis Troublée* (1922); *Goyescas* (1922); *Le Diable Danse de Beffroi* (1926); *Cyre* (1927); *Supido, si Diverte* (1932); *Ellade* (1932); *Guidetta* (1932); *Passatempto e Divertimente danzati* (1936).

Guerrero, Maria, Spanish dancer working in England and Western Europe; born April 25, 1951 in Madrid. After local studies with Maria de Avila, she moved to London to continue her training with Phyllis Bedells and at the Royal Ballet School. Guerrero made her debut with the London Festival Ballet in 1967 and performed with that company for six years in its classical repertory and in contemporary works by dancers Rudolf Nureyev and Dennis Nahat. In 1973, she joined the Frankfurt Ballet where she has been given principal roles in works by John Neumeier, George Balanchine, and Alonso Catá, including the latter's *Sweet Carmen* (1975).

Guimard, Marie Madeleine, French eighteenth-century ballet dancer; born December 27, 1743 in Paris; died there May 4, 1816. It is not known where, or whether, Guimard received training in ballet technique.

She made her debut in Paris with the Comedie-Française in 1758, joining the Paris Opéra three years later. Originally an understudy for Marie Allard, Guimard performed for her in *Les Fêtes Grecques et Romaines* in 1762. In her next fourteen years at the Opéra, she performed in Antoine La Motte's *Les Triomphes des Arts* (1764), the Lavals' *Les Incas du Péron* (1766), Jean-Georges Noverre's *Les Coquetteries de Galatée* (1776), and Maximilien Gardel's

Ninette à la cour (1778), *La Fête de Mirza* (1781), and *Le Déserteur* (1788). She took a season at both the King's Theatre and Covent Garden, London, performing the Noverre and Gardel ballets.

Interest in Guimard was revived in the early part of this century by Edward Gordon Craig, not because she participated in the eighteenth-century Greek revival, but because she produced works, probably harlequinades, for private theaters in her homes in France. It is ironic that the woman who is generally considered one of the best technicians in the history of traditional ballet would be rediscovered by Craig because she was a chamber director.

Guizerix, Jean, French ballet dancer; born October 27, 1945 in Paris. Trained by Denise Bazet and Marguerite Guillaumin, he joined the Paris Opéra Ballet in 1964. Although he served his apprenticeship in the company by performing progressively larger roles in the nineteenth-century classics and works by contemporary French choreographers, he became known for his appearance in ballets by creators from the Western hemisphere. Known for the clarity of his movement and precision of his rhythm and technique, he has been cast in ballets by Brian MacDonald, including his *Variations sur un Thème simple*, and in modern and postmodern dance works by Americans Glen Tetley, John Butler, and Merce Cunningham, including the latter's *Un Jour ou Deux* (1973), considered his most successful work for a company other than his own.

Gunn, Nicholas, American modern dancer; born August 28, 1947 in Brooklyn, New York. Gunn has publicly credited a wide variety of teachers with his dance education, among them Helen McGehee, June Lewis, Stuart Hodes, and Don Farnworth. He performed with the Paul Taylor Dance Company from 1969 to 1977, the period in which that troupe flourished. Strong and gangly, like most Taylor male dancers, he seemed perfectly suited to roles in *Cloven Kingdom, Runes,* and the fast-moving *Esplanade.*

Gunnerson, Mickey, American theatrical dancer and actress; born in the late 1930s in Wilmington, North Carolina. Gunnerson made her theatrical debut in the national company of Bob Fosse's *Pajama Game* and returned to New York to dance in his *New Girl in Town* (1957), and later *How to Succeed in Business without Really Trying* (1962) and *Sweet Charity* (1964). Among her many Broadway shows for other choreographers in the 1960s were *Juno* (1959), *Greenwillow* (1960), *Tenderloin* (1960), *Kean* (1961), and *Donnybrook* (1961). Although most of her later credits were in dramatic and comedy roles on stage and television, she returned to dance performance in the ill-fated musical version of *I Remember Mama* in 1978.

Gutelius, Phyllis, American modern dancer; born in Wilmington, Delaware. Trained at the Juilliard School, her teachers ranged from Antony Tudor to Martha Graham. A member of the Graham company after 1962, she appeared in most of that troupe's repertory, especially in the late 1960s and early 1970s, when so many concerts relied on revivals of the Graham repertory. Among her many performance credits were roles in *Deaths and Entrances* as "the third sister," *Every Soul Is a Circus, Dark Meadows, Alcestis, Seraphic Dialogues* as the "Maiden," and *Diversion of Angels.*

Gutelius has also performed in the troupes of many of her fellow Graham dancers. She appeared in John Butler's Sunday morning television broadcasts, including his *The Captive Lark* (1966), in Bertram Ross' *See You Around* (1970) and *Oases* (1970), and in works by Glen Tetley, Yuriko, and Sophie Maslow.

Guthrie, Nora, American modern dancer and choreographer; born January 2, 1950 in Brooklyn, New York. Guthrie was trained by her mother, early Martha Graham company member Marjorie Mazia, and by the faculties of the Graham school and the New York University School of the Arts program in dance. She danced in the Jean Erdman company before forming her own company with Ted Rotante. Guthrie frequently stages duets for Rotante and herself and performs in his New York concerts and frequent residencies.

Works Choreographed: CONCERT WORKS: *Rooms of the House* (1974); *The Five Boons of Life* (1976);

Dances for Three Women (1977); *On and On* (1977); *Howard Beach* (1977); *Vision* (1978); *Ramkin Suite* (1978).

Guy-Stéphan, Marie, French or Spanish ballet dancer of the Romantic period; born 1818; died August 21, 1873, possibly in Paris. It is not certain where Guy-Stéphan received her ballet training.

She made her debut in 1840 in Madrid, later performing the title role in the first Spanish *Giselle* (c.1844). In Madrid, at the Teatro del Circo, she was partnered by Marius Petipa and performed in his ballets, among them *La Perle de Séville*.

In 1853, she moved to Paris to perform at the Opéra. After her debut in Mazilier's *Aelia et Mysis*, she created roles in Saint-Léon's *Néméa, ou l'Amour vengé* (1864). She also performed at the Théâtre Lyrique in *Le Lutin de la Valle* in 1853 and at the Théâtre de la Gaité.

It is difficult to determine from available evidence whether Guy-Stéphan performed interpolated Spanish dances in all her ballets or only where she was cast to take advantage of her unique talents. In *Aelia et Mysis* at least, she danced in the conventional ballet technique without recorded interpolated specialties.

Gyrowetz, Adalbert, Bohemian early nineteenth-century composer; born February 19, 1763 in Budweis (now Czechoslavakia); died March 19, 1850 in Vienna. A prolific composer talented enough to find his works occasionally credited to Mozart, Gyrowetz was kapellmeister of the Vienna court theatres during the tenures of Filippo Taglioni, Jean Aumer, and Friedrich Horschelt. His best remembered ballet scores included Jean Aumer's version of the Cherubino/Figaro story, *The Inconstant Page, or The Marriage of Figaro* (1819) and Filippo Taglioni's *La Laitière Suisse* (1821).

H

Haakon, Paul, Danish ballet and theatrical dancer working in the United States; born c.1914 in Copenhagen, Denmark. Raised first in San Francisco, where he studied with Theodore Kosloff, and then in Copenhagen, where he attended the school of the Royal Danish Ballet, he moved to London where, during a performance of *Le Train Bleu* with an Anton Dolin company, he was invited to perform with Anna Pavlova in 1929. After her death, he returned to New York, and studied with Mikhail Fokine and Mikhail Mordkin while working as a concert dancer.

Haakon was best known for his work on Broadway, dancing almost nightly from 1933 until the mid-1940s. Among his most celebrated shows were *Champagne Sec* (1933), *Music Hath Charms* (1934), Harry Losee's *At Home Abroad* (1935), in which he performed the Death in the Afternoon bullfight sequence, Agnes De Mille's *Hooray for What* (1937), *The Show Is On* (1937) with its Casanova Ballet, and *Mexican Hayride* (1944), in which he performed a famous adagio routine with Eleanore Tennis. He also worked frequently at the Radio City Music Hall, partnering Patricia Bowman. His non-Broadway theatrical ventures include a nightclub act, a USO show during the war, and the Jones Beach Parks Department production of *Florodora* in 1946.

A student at the School of American Ballet since its opening, he performed in the first public concerts of the early Balanchine company, partnering Giselle Caccialanza in *Dreams* (Les Songes). In the mid-1950s, he began performing with the Jose Greco Spanish Ballet and became its ballet master in 1960.

Hackett, Jeanette, American vaudeville dancer and precision line choreographer; born 1903, possibly in New York City; died August 16, 1979 in New York City. Although from her vaudeville debut in 1907 until the early 1940s Hackett was active in vaudeville Prologs and presentation act houses as a dance performer and choreographer, she has been forgotten by historians of that art form. That debut came in a specialty hula dance in Nora Bayes' feature act, *The Songs You Love* in the spring of 1907. Within the year, she and her brother Albert (later a celebrated playwright of the 1920s) had their own feature act

with which they toured intermittently for eight years. They also performed with other feature acts built around talented children, including Jules Garrison's newsboy act, *After the Play* (1908–1910). She toured with Harry Delmar and had a solo dance act in the late 1910s, after she had passed her eighteenth birthday and could legally perform in New York City. By March 7, 1919, when *Variety* reviewed it as a debut act, she was a veteran of more than sixteen years in vaudeville.

When not touring with her own act, which demonstrated her ability to perform in tap, ballet, jazz, and exhibition ballroom forms, Hackett trained a group of ballet and toe-tapping dancers into a series of precision lines. The lines were originally her back-up choruses, but by the late 1930s, when she was easing out of active performance, they were booked on their own in first-run houses. In 1938, for example, the Jeanette Hackett Chorus was at the Capitol Theater in Washington, D.C., and the eight Hackett Delovelies were at the Rivera in Brooklyn. Hackett also staged acts for her husband John Steele, a tenor best remembered as the singer who introduced "A Pretty Girl Is Like a Melody" in the *Ziegfeld Follies of 1919*.

Hadley, Tamara, American ballet dancer; born January 13, 1954 in San Diego, California. Hadley was trained by John Hart at the United States International University in California and continued her training in Philadelphia with Benjamin Harkavy. After performances with the San Diego Ballet, she joined the Pennsylvania Ballet in 1974. With her strong defined movements and unquestioning musicality, she is at home with the contemporary repertory of Harkavy, Hans Van Manen, and Charles Czarney as in the company's large group of works by George Balanchine. In recent years she has been assigned the principal roles in the company's productions of the nineteenth-century classics *Coppélia* and *Swan Lake*.

Haggin, Ben Ali, American artist and specialist in tableaux vivants; born James Benjamin Ali Haggin, c.1882 in New York City; died September 2, 1951 in

Tuxedo Park, New York. Famed as a "society artist," Haggin was a member of New York's social 400 who became known as a portraitist and painter of horses. Although little known now for his art work, he reached a position equal to that of a British member of the Royal Academy—respected, recognized for his ability to transmit an image, and unquestionably conservative.

Haggin's other projects, however, were slightly outside of the 400's usual sphere. He was famous for staging balls for charity—an orthodox project for the socially active—and was credited with creating the mise-en-scène for Beaux Arts Balls from 1927 to 1933 and Metropolitan Opera Ballets from 1933 to 1935, as well as other affairs. This was not a question of telling ladies which of their many gowns to wear. Haggin redesigned the place where they would be held, and staged performances (with the guests and participants of the ball as dancers) based on a theme. The Beaux Arts Ball of 1932 was built around eight episodes in an imaginary "Winter Cruise," for example, with the ballroom divided as in a Medieval procession or stations of the cross, while the Metropolitan Ball of 1934 recreated Fontainbleu for his *Le Roi S'Amuse.*

His theatrical career was very short, but extremely memorable. In 1919, Florenz Ziegfeld, Jr. decided to include tableaux vivants in his *Follies.* The genre was chosen to fit his desire to show more nudity on stage and the city's legal code's insistence that no undressed person could move on stage. Haggin solved Ziegfeld's dilemma by staging his tableaux vivants, or living pictures, in which the semidressed women were posed into a living presentation of a famous work of art. From the audience (and police) view point, the act was very simple: the curtain went up. There on stage was a painting in full human proportions made up of silent performers standing absolutely still; after a few minutes of dedicated gazing, the curtain went down.

Works Choreographed: THEATER WORKS: Tableaux vivants in the *Ziegfeld Follies* of 1919, 1920, 1921; *The Field of Ermine* (1935).

Haig, Emma, American theatrical ballet dancer; born January 21, 1898 in Philadelphia, Pennsylvania; died June 10, 1939 in Beverly Hills, California.

Haig was trained at the Sargent School of Dramatic Arts in Philadelphia and studied with Claude Alvienne and Louis Chalif in New York. From her debut in the *Passing Show of 1914*, she became one of Broadway's best known ballet dance specialists. She danced in *The Midnight Girl* and *The Whirl of the World* at the Winter Garden Theatre before joining the *Ziegfeld Follies of 1916.* In that edition, she appeared as Anna Pavlova in the Ballet Russe satire, dancing in Fokine's *Les Sylphides* and *Spectre de la Rose* straight, and in the Fanny Brice/W.C. Fields imitation of *Schéhérazade.* That Pavlova wasn't in the Ballet Russe, that she was really imitating Karsavina, and that the choreography of the Ziegfeld ballets was actually adapted from Theodore Kosloff's versions for the Saison des Ballets Russes for Lopoukhova and Baldina, did not bother a soul.

Her Ziegfeld connection continued with appearances in the *Follies of 1917* and his extravagant revue, *Miss 1917*, in which she competed with Bessie McCoy and Irene Castle for dance honors. Haig was featured in two more revues, Raymond Hitchcock's *Hitchy-Koo of 1918* and Irving Berlin's *Music Box Revue of 1920*, before switching to soubrette roles in musicals, among them, *Our Nell* (1923), *The Rise of Rosie O'Reilly* (1923), *Tell Me More* (1925), *The Girl Friend* (London, 1927), and *Silver Wings* (London, 1930). Her vaudeville career included dance acts with George White (c.1917), with Lou Lockett (1918), with the latter's ex-partner Jack Waldron (1919), and a class act with a female chorus called "Playtime" that played the Palace with Jack Benny in 1920.

Haigen, Kevin, American ballet dancer working in Europe after 1974; born Kevin Higgenbotham in Miami, Florida. Trained locally by Virginia Leigh, Haigen moved to New York to continue his studies at the School of American Ballet.

After a season with the Ballet Repertory Company, dancing the title role in the troupe's production of Loring's *Billy the Kid*, Haigen joined the American Ballet Theatre. He performed featured roles in Antony Tudor's *Pillar of Fire*, as a "Lover-in-Innocence," and *Swan Lake*; his appearance in John Neumeier's *Le Baiser de la Fée* in 1974 brought him an offer to dance for Neumeier in Europe.

He has performed ever since in Neumeier companies—in the title role in his *The Legend of Joseph* at the Vienna State Opera Ballet (1977) and creating roles in his *The Sleeping Beauty* (1978) and dancing in his *Schubert String Quartet, Mahler Fourth Symphony*, and as "Puck," in his *Midsummer Night's Dream*.

Hale, Binnie, English musical comedy star; born Beatrice Hale-Monro, May 22, 1899 in London. Like her brother, Sonnie Hale, she became a star of the West End by dancing and singing in juvenile roles in native and imported musical comedies and revues. She was the original title heroine of *No! No! Nanette!* (1925) since that highly American musical actually gave its first English performance while still on its pre-Broadway tour, and so she became the first person to soft-shoe to "Tea for Two." Her other starring credits included roles in *The Kiss Call* (1919), *Katinka* (1923), *Sunny* (1926), *Bow Bells* (1932), *The Dubarry* (1932), *Rise and Shine* (1936), *Up and Doing* (1940), *Flying Colours* (1941), *One, Two, Three* (1947, co-produced with her brother), *Four, Five, Six* (1948), and *Out of This World* (1950).

Hale, Chester, American ballet dancer and theater, Prolog, and film choreographer; born Chester Chamberlain, 1897 in Jersey City, New Jersey. While a student at the MacFadden School of Physical Culture in Chicago, Hale went to New York City on a vacation. He saw the Leon Bakst posters for the Anna Pavlova company and the Nijinsky tour of the Diaghilev Ballet Russe (both of which were in town in 1916–1917) and was inspired to audition for both on the same day. As he has said, because he was six feet tall and trained in some form of dance, he was accepted into both companies. Hale joined the Ballet Russe as a corps member and became one of the men that the ailing Nijinsky trusted to "kill" him in *Schéhérézade* and catch him after *Spectre de la Rose*. Although he returned to Europe with the Ballet Russe and appeared in Massine's *Le Tricorne*, he came back to the Western hemisphere with Pavlova and spent most of 1918 in Puerto Rico, where her international company was sitting out the war. While in both troupes, he studied with Enrico Cecchetti, earning a certificate from his private studio.

After leaving the Pavlova troupe, he formed a ballet and adagio team with dancer Albertina Vitak. They appeared together in nightclubs in New York and London and interpolated their specialties into the *Music Box Revue of 1923* and the Hassard Short *Ritz Review of 1924*.

From 1925 to 1936, Hale served as ballet master and dance director of the Capitol Theater, New York. As the keystone of the MGM film chain, the Capitol presented a new Prolog every week, sending each one out on the chain of affiliated houses with its accompanying film. It has been estimated that he staged over 1,500 Prologs for The Chester Hale Girls (a precision troupe of toe and machine gun tappers), The Capitol Ballet Corps, dance specialty performers, and stars of the accompanying films. Both his Girls and Corps worked on point, the former working in the popular technique known as toe tapping, in which the line of women did steps and kicks *sur les pointes* with metal taps attached to the point-shoe tips. Hale employed many fellow former Pavlova and Ballet Russe dancers at the Capitol, among them Beatrice Collenette, Joyce Coles, and Ella Dagnova, who taught flawless Cecchetti technique with him at the free school that he ran on the Capitol Theater roof. MGM, which sponsored the Prologs, occasionally hired him away from the Capitol to stage dance numbers for its films. Among his productions were the Jean Harlow vehicle *Reckless* (1935) and the ultimate Jeannette MacDonald/Nelson Eddy operetta, *Rose Marie* (1936), in which, if you look very closely, you can see Pavlova-dancer Hubert Stowitts as the principal dancer in the Totem Pole Dance sequence. The Chester Hale Girls can also be seen in the Marx Brothers' *The Coconuts* (Paramount, 1929), which was filmed in New York with available chorus lines and talent.

Hale also staged Broadway musicals and revues while he was working at the Capitol, among them the *Greenwich Village Follies of 1928* and the operetta, *The Red Robe*. After the end of the Prolog era, he became involved in ice show production—then an appropriate field for a former ballet dancer. He worked on *Ice Capades* until 1950, when he was released from his contract because he testified for Paul Draper in his libel suit. After his contract problem with the *Capades*, he switched to the *Ice Follies* and

staged shows for that rival organization until retiring in 1960.

Works Choreographed: THEATER WORKS: *Just Fancy* (1927); *Delmar's Revels* (1927); *Lovely Lady* (1927); *The Greenwich Village Follies of 1928; Angela* (1928); *The Red Robe* (1928); *A Night in Venice* (1929, dances for The Chester Hale Girls only); *Murder at the Vanities* (1933, straight play); *Hot Heir* (1934); *Take It or Leave It* (1936); *Viva O'Brien* (1941); Prologs for the Capitol Theater (1925–1934, 1935–1936); *Ice Capades* (1936–1950); *Ice Follies* (1951–1960).

FILM: *The Painted Veil* (MGM, 1934); *Student Tour* (MGM, 1935); *Reckless* (MGM, 1935, co-choreographed with Carl Randall); *Love While You May* (MGM, 1935); *The Night Is Young* (1935); *Rose Marie* (MGM, 1936); Chester Hale Girls appear in *Broadway Tales of the Woods* (Pathé, 1926) and *The Coconuts* (Paramount, 1929).

Hale, George, American theatrical and film choreographer; born September 6, 1900 in New York; died August 15, 1956 during an audition in New York. Raised in New York, Hale made his Broadway debut in the *Gaities of 1919*, staged by Allan K. Foster. After appearing on Broadway as a specialty dancer, notably in *Make It Snappy* (1922) and *The Rise of Rosie O'Reilly* (1928), he received his first choreography credit for films.

Most of his motion pictures were made in New York studios. The best known of them, *Glorifying the American Girl*, was about the making of the Ziegfeld Follies, but was surprisingly unsuccessful. He also worked on *Heads Up* (Paramount, 1930), Ginger Rogers' first film, and the filmed version of the *George White Scandals* (Fox Film Corp., 1934).

Returning to Broadway, Hale, who was known as "The Picker" for his taste in feminine pulchritude, staged both musical comedies and revues. Among his most important shows were the two Gershwin political shows, *Strike Up the Band* (1930) and *Of Thee I Sing* (1931), the Ethel Merman hit *Red Hot and Blue* (1936), and the ninth edition of the *Earl Carroll Vanities* (1931). He also staged the *International Ice Revue* of 1939 and was one of the first choreographers to devote himself to industrial shows, staging dozens of them in the United States, South America, and Europe.

Works Choreographed: THEATER WORKS: *Fifty Million Frenchmen* (1929); *Head's Up* (1929); *Strike Up the Band* (1930); *Girl Crazy* (1930); *The New Yorkers* (1930); *Of Thee I Sing* (1931); the *Earl Carroll Vanities* (1931); *Pardon My English* (1933); *Red Hot and Blue* (1936).

FILM: *Glorifying the American Girl* (Paramount/Publix and Famous Players/Laskey, 1929); *Head's Up* (Paramount, 1930); *Hollywood Party* (MGM, 1934); *George White Scandals* (Fox Film Corp., 1934).

Haley, Jack, American theatrical dancer; born August 10, 1899 in Boston, Massachusetts; died June 6, 1979 in Los Angeles, California. Haley was a song plugger in Philadelphia before he went into vaudeville in an act with a precision troupe; he worked with the performers (one of whom, Florence McFadden, became his wife of fifty-two years) on the Keith circuit. On Broadway, Haley was featured in *Round the Town* (1924), *Gay Paree* (1925), *Follow Through* (1929), *Free for All* (1931), and *Take a Chance* (1931), in which he introduced "You're an Old Smoothie"; after his successes in film, he returned to New York to perform in *Higher and Higher* (1940), and *Inside U.S.A.* (1948).

He worked in film from the early 1930s, debuting in the motion picture version of *Follow Thru* (Paramount, 1930). After featured roles in the Vitaphone Big V series of short subject comedies (1933–1934), he performed in musicals, among them, *Mr. Broadway* (Broadway-Hollywood productions, 1933), the Shirley Temple/Alice Faye vehicle *Poor Little Rich Girl* (Twentieth-Century Fox, 1936), in which he tapped the military finale, *Redheads on Parade* (Fox Film Corp., 1935), *Pigskin Parade* (Twentieth-Century Fox, 1936), and *Alexander's Rag-time Band* (Twentieth-Century Fox, 1938). His best remembered and loved characterization on film was as "The Tin Woodsman" in MGM's *The Wizard of Oz*. His eccentric dance number, "If I Only Had a Heart," staged by Bobby Connolly, included his specialties—his ability to handle complicated rhythms, his isolated movements, and his exceptional balance as seen in the exaggerated leanings and sways.

Haley's last performance was at the Academy Awards ceremony of 1979, when he and "Scarecrow" Ray Bolger made a presentation. Haley's son Jack Haley, Jr. was the producer of the two MGM compilation films, *That's Entertainment, I* and *II*.

Hall, Yvonne, West Indian ballet dancer working in the United States; born March 30, 1956 in Jamaica. Hall was trained at the school of the Dance Theatre of Harlem, graduating into the company in 1969. Among her many appearances in the troupe's large repertory are roles in George Balanchine's *Four Temperaments*, Glen Tetley's *Greening*, and the company's revival of *Schéhérézade*.

Haller, Lelia, American ballet dancer and teacher; born in the first decade of the century in New Orleans, Louisiana. After local training with Nina Picolette, she worked as an instructor at the Kansas City Conservatory where Sylvia Tell was principal teacher. In 1920 she moved to Paris to continue her studies at the school of the Paris Opéra, becoming a member of that company. It is believed that she also performed with the Diaghilev Ballet Russe in the mid-1920s, although this cannot be verified. She returned to the United States to work as assistant to Laurent Novikoff in his school at the Chicago Grand Opera. When she settled back in New Orleans, she opened a studio and became involved with a series of cultural organizations, most of them performing in French. She has served as ballet master with Le Petit Théâtre du Vieux Carré, Le Petit Opéra Louisanais, and the New Orleans Opera Association. Her students at her studio, at the Opéra, and at Loyola University have ranged from jazz and theater choreographer Peter Gennaro to Royes Fernandez, whom many have called the best technician ever produced in America. Both credited her with their skills and their concepts of a dancer's responsibilities to the choreographer and audience.

Bibliography: Scott, Harold George. *Lelia: The Compleat Ballerina* (Gretna: 1975).

Halprin, Ann, American modern dancer and choreographer; born Anna Schumann, July 13, 1920 in Winnetka, Illinois. Halprin's fairly traditional dance training came in classes with Margaret H'Doubler,

and at the Humphrey/Weidman Studio. After moving to San Francisco in the mid-1940s to be with her husband, architect Lawrence Halprin, she worked with Welland Lathrop, with whom she co-founded a studio and workshop series that was for many years the center of experimental activity in the Bay area. Her summer workshops (1953–) gave early training and formation to postmodernist choreographer Yvonne Rainer and composers La Monte Young, Meredith Monk, and Terry Riley. Halprin's works, generally created over a long period of time on an enormous scale, have been seen and gawked at across Europe, where she was for many years the favorite American avant-gardist, and in the United States. In recent years, however, she has become less interested in creating a project that can be seen by an audience and more involved in the experiences of its creators and performers. Her most recent "works" were a conference—the rational development of her experimental creativity.

It is difficult to describe a Halprin work since it depends so much on the vision of a single person at a particular performance. Her best known works involve the transformation of her performers into objects or animals through the adoption of individually selected gestural systems, so any given performance can be a revelation or a puzzlement. She was probably the only creator of the mid-1960s for whom nudity was a genuine artistic choice but remains known still for the (possibly contrived) furor over her *Parades and Changes* in its New York debut in 1967.

Works Choreographed: CONCERT WORKS: (Note: all works after 1964 were co-choreographed with all performers and technicians.) *The Prophetess* (1955); *Steig People* (1955); *Birds of America, or Gardens Without Walls* (1957); *The Flowerburger* (1961); *Four-Legged Stool* (1961); *Procession* (1964); *Espozizione* (1965); *Parades and Changes* (1967); *A Ceremony of US* (1969); *Animal Ritual* (1971); *Ceremony of Signals* (1971); *West/East Stereo* (1971); BOOU'LA Bo'ici bo'ee (1971); *Initiations and Transformation* (1971); *Dance by the People of San Francisco* (1976); walking tours of San Francisco; conferences on body awareness.

Hamilton, Gordon, Australian ballet dancer and choreographer working in England and Austria;

born 1918 in Sydney; died February 14, 1959 in Neuilly-sur-Seine, France. Hamilton was originally trained in Paris by Olga Preobrajenska and Lubov Egorova in whose Ballet de la Jeunesse he performed in 1939. After moving to London, he continued his studies with Marie Rambert and became a member of her troupe. He was a member of the Anglo-Polish Ballet during its brief London seasons, but was associated with the Sadler's Wells troupe, of which he was a member from 1941 to 1946. Among his roles there were parts in Ninette De Valois' *The Prospect Before Us* and in Robert Helpmann's *Miracle of the Gorbals* and *Hamlet* (1942).

He worked in France with companies associated with Roland Petit, including his Ballets des Champs-Elysées (1946–1947) and Ballets de Paris (1949–1950). When appointed ballet master of the Vienna State Opera in 1954, he retired from performance to stage productions of the classics, including a well-received *Giselle* in 1955.

Hamilton, Mitzi, American theatrical dancer; born in Chicago, Illinois. One of the most respected (and frequently employed) Broadway gypsies, Hamilton danced and sang in stock and on television before getting featured and principal roles on Broadway. Among her many credits are roles in *Applause* (also understudy to Bonnie Franklyn), Ron Field's revival of *On the Town*, Michael Bennett, Grover Dale, and Tommy Tune's *Seesaw*, Bob Fosse's *Dancin'*, the unsuccessful *King of Hearts*, and Bennett's *A Chorus Line* in which she played "Val" ("Dance 10, Looks O") in London and on Broadway.

Hamilton, Peter, American modern and theatrical dancer and choreographer; born in Trenton, New Jersey. Hamilton was an athlete and algebra teacher before he began to study at the (Doris) Humphrey/(Charles) Weidman Studio in New York. Associated with the works of Charles Weidman, he created roles in his *Inquest* (1936), *Flickers* (1940), *David and Goliath* (1945), "*A House Divided*" (1945), and *And Daddy Was a Fireman* (1941), playing "Fire" and designing the fire engine.

Hamilton danced for Weidman on Broadway in *Angel in the Wings* (1947) and performed with him at the Rainbow Room in 1940. His non-Weidman shows included *Jackpot* (1944), *The New Moon* revival, Leon Leonidoff's *Sing Out, Sweet Land* (1953) and his *Bolero*, at the Radio City Music Hall. On early television, he did thirty weeks on *The Fred Waring Show* in the 1949–1950 season.

Most of Hamilton's choreography was created for recitals in the 1940s, although he created at least one work for the 1970 Expression of Two Arts concert series. On Broadway, he staged dances for two musicals—*It's About Time* (1942) and *Beg, Borrow or Steal* (1960), winning plaudits for two numbers featuring Betty Garrett, the "Zen Is When Ballet" and "Poetry and All That Jazz."

Works Choreographed: CONCERT WORKS: *Theatrical Dances* (1942, co-choreographed with Weidman); *Sing Above All!* (1946); *Italian Concerto* (1946); *Joe Kitchener, Boy Criminal* (1946); "*We Are the Dreamers*" (1946); *Jesse James for Children Only* (1946); "*The Hollow Men*" (1946); *On, Terrible Drums!* (1946); *Lunch Hour Blues* (1947); *Dry Bones* (1947); *Prospice* (1949); *Dance for Five* (1949); *Beau Soir* (1949); *Three Antique Dancers* (1949); *Silent Snow, Secret Snow* (1949); *Images* (1970).

THEATER WORKS: *It's About Time* (1942); *Beg, Borrow or Steal* (1960).

Hammerlee, Patricia, American theatrical dancer; born November 9, 1929 in Wilmington, North Carolina. Trained at the Foster School of Dancing in nearby Columbus, she made her Broadway debut in Jerome Robbins' musical about internal politics in a ballet company, *Look Ma, I'm Dancing* (1948). For many years, Hammerlee was one of the most employable dancers on Broadway, with roles in shows staged by Robbins, including his *Miss Liberty* (1949, replacement cast) and *Call Me Madam* (1950), and Michael Kidd, among them his *Love Life* (1948). Her performance as the "Lizzie Borden" character in the wonderful "You Can't Chop Your Mother Up in Massachusetts" number in *New Faces of 1952* brought her a new career as a comic actress. Later roles allowed her to extend her range into dramatics, as in *Seventh Heaven* (1955), and satire, as in her portrayal of the charming "Elsea Chelsea" in *The Vamp* (1955), Robert Alton's satire of silent films.

Hammerstein, Oscar, American vaudeville and opera impresario; born May 8, 1847 in Berlin; died August 1, 1919 in New York City. Hammerstein, who was living in New York by the 1870s, was one of the most important figures in theatrical life of the early twentieth century. He wrote music and lyrics, staged vaudeville shows, created opera companies, and built theaters in New York. If George M. Cohan was "the man who owned Broadway," Hammerstein was "the man who invented Times Square" and transformed it into the center of American theatrical life. Among the theaters that he built were both vaudeville houses and opera houses, since he attempted valiantly to become the rival to the Metropolitan Opera. His vaudeville houses were unique since each one was built with a roof garden theater—the Victoria Theater's Paradise Roof Gardens was designed with a working farm, stream, and windmill, as well as a proscenium stage. Although his own musical comedies and operettas for the downstairs theaters were fairly conventional, he was extremely innovative in his choice of vaudeville acts and performance style for his roof gardens. He gave early breaks to both Ned Wayburn and Gertrude Hoffmann, and enabled each one to codify his and her precision dance styles. He was also a champion of the feature act format (a short variety show performed by one or two specialty dancers or singers and a small female precision chorus) which can still be seen in television variety shows after influencing Prologs, legitimate theater, and films.

Hammerstein was the grandfather of Oscar Hammerstein II (1895–1960), whose sentimental lyrics (1920–1959) resembled his. He was the father of producer Arthur Hammerstein, known for his championship of the operetta on the American stage and the presenter of *The Firefly* (1912), *Katinka* (1915), *Rose-Marie* (1924), and *Song of the Flame* (1925), among many others.

Hampton, Eric, American ballet dancer and choreographer working in Europe and the United States; born May 21, 1946 in Hackensack, New Jersey. Hampton was trained at the Interlochen Arts Academy during three summers and the last two years of high school. He studied with Antony Tudor, José Limón, Mary Hinkson, Ethel Winters, and Anna So-

kolow at the Juilliard School, and performed in works by Limón, Tudor, and Sokolow, including the latter's *Ballade* (1964).

A specialist in contemporary ballets, he performed in Europe for ten years, after joining the Netherlands Dance Theatre in 1968. In two seasons there, he created roles in many works by Hans Van Manen, including his *Squares* (1969), *Situation* (1970), and *Mutations* (1970). With the Scapino Ballet in Holland from 1970 to 1975, he was reunited with Van Manen in his *Snippers* (1970) and *Ajakaboembi* (1972) and danced in three works by Charles Czarny—his *Concerto Grosso* (1971), *Brandenburg* (1971) and *Sunny Day* (1972). He choreographed and designed productions for the company, notably his *Out of the Blue* (1972) and *Soft Floor Show* (1973). Returning to the Netherlands Dance Theatre in 1975, he danced in additional Van Manen pieces, among them *Song Without Words* (1977) and *Septet Extra*, and created roles in Jiri Kylian's *Sinfonietta* (1978), *Symphony in D* (1976), *Elegia* (1976), and *Verklachte Nacht* (1975).

Back in the United States after 1978, he worked with Scapino colleague Cho San Goh at the Washington Ballet, in the District of Columbia. He has danced in Goh's ballets there and has choreographed new works for the troupe, among them *Slow Movement* (1979), *Tchaikovsky Sketches* (aka *Glances at a Smattering*) (1979), and *Scriabin Sonata* (1979).

Works Choreographed: CONCERT WORKS: *Introduction* (1970); *Push* (1971); *Out of the Blue* (1972); *Soft Floor Show* (1973); *P.G. Suite* (1975); *Overcast* (1976); *Sleeping Beauties* (1977); *Continuing Story* (1978); *Slow Movement* (1979); *Tchaikovsky Sketches* (aka *Glances at a Smattering*) (1979); *Scriabin Sonata* (1979).

Haney, Carol, American theatrical dancer and choreographer; born December 24, 1924 in New Bedford, Massachusetts; died May 10, 1964 in New York. Haney moved to Hollywood to work in film in the late 1940s. Under contract to MGM, she danced in the background of many films, most notably in the "Bali-Boogie" number in *Wonder Man*. Also at MGM, she coached the Goldwyn Girls (a troupe of show girls hired by Samuel Goldwyn) and served as an assistant to staff dance director Jack Cole and

dancer/choreographer Gene Kelly, working and performing in the latter's *Invitation to the Dance* (1954). In the "From This Moment On" number in *Kiss Me Kate* (MGM, 1953), she danced with Bobby Van, Joan McCracken, Ann Miller, and Bob Fosse, also then a staff dance assistant.

In 1954, Fosse invited her to return to New York to perform for him in *The Pajama Game* on Broadway. She had three show-stopping numbers in that show—"Hernando's Hideaway," "Once a Year Day," and "Steam Heat," the dance with the bowler hats that is always associated with her. Haney, who was severely diabetic, injured herself while performing the show, which was her last live engagement. She continued to dance in film and on television, even after she was unable to work on stage.

She choreographed five Broadway musicals, four of them hits, including *Flower Drum Song* (1958), *Bravo Giovanni* (1962), *She Loves Me* (1963), *Jennie* (1963), and *Funny Girl* (1964). Originally scheduled to be a collaboration with Fosse, who was announced as director, Haney's choreography for the latter was completed by Jerome Robbins (credited as director) owing to her continuing illnesses.

Haney's personal style, with a choice of isolated angular movements or soft extensions, was picked up by other dancers and choreographers, and has survived her. Her participation in films as a staff dancer and as a soloist in the film of *Pajama Game* has maintained her performance for us, allowing the contemporary audience to admire her still.

Works Choreographed: CONCERT WORKS: *Flower Drum Song* (1958); *Bravo Giovanni* (1962); *She Loves Me* (1963); *Jennie* (1963); *Funny Girl* (1964).

Hanka, Erika, Austrian ballet dancer and choreographer; born in the late 1910s in Austria. Originally trained at the Wigman School in Dresden, Hanka studied ballet with Eugenie Eduardova in Berlin and with Kurt Jooss.

Hanka performed with the Jooss Ballet from 1935 until 1938 when the company left Germany. Among his works in which she performed major roles were *The Green Table, Ballade, A Ball in Old Vienna, Pavanne,* and *The Prodigal Son,* as "The Seductress." She performed at the Operahausen in Dusseldorf, Cologne, Essen, and Marburg, before be-

ing invited to stage *Joan von Zarissa* at the Vienna Staatopera in 1941. Her success with this work was so great that she was asked to remain with the theater as ballet mistress until 1958. Most of her choreography was done for the Staatopera; it included many ballet interludes for opera and operetta, and revisions of older works, ranging from *Petrouchka* to Noverre's *Les Petites Reins.*

Works Choreographed: CONCERT WORKS: *Joan von Zarissa* (1941); *Festa Romantica* (1945); *Höllische G'Schicte* (1949); *Homeric Symphony* (1950); *The Moor of Venice* (1955); *The Miraculous Mandarin* (1957); *Hotel Sacher* (1957); *Medusa* (1958).

Hanke, Suzanne, German ballet dancer; born March 30, 1948 in Alrdobern, Germany. After early training in gymnastics, Hanke studied with Annaliese Morike in Werttemberg and with Anne Wooliams at the school of the Stuttgart Ballet.

Hanke has been associated with the Stuttgart throughout her career. Since 1966, when she joined the company, she has created roles in John Cranko's *Eugene Onegin* (1969), as "Olga," and the *Taming of the Shrew* (1969), as "Bianca," with featured roles in his *Romeo and Juliet, Opus One,* and *Swan Lake.* Among the many other ballets in which she performed are Kenneth Macmillan's *The Song of the Earth* (performed in Stuttgart as *Das Lied von der Erde),* John Neumeier's *Lady of the Camilias,* John Tara's *Designs with Strings,* and the company production of George Balanchine's *La Valse* and *Apollo.*

Hanssen, Joseph, French/Belgian ballet dancer and choreographer with major careers in Brussels, Moscow, London, and Paris; born 1842 in Asnières; died July 27, 1907 in Paris. Hanssen, whose name was frequently spelled Hansen, may have been a member of the family of conductors, Charles-Louis-Joseph and Charles-Louis-Hanssen, both of whom were associated with Le Théâtre de la Monnaie in Brussels. Nothing can be verified about Hanssen's life before 1864, when he joined the Ballet company of Le Théâtre de la Monnaie—the same season that Charles Louis Hanssen became its conductor. In his thirteen seasons at that famed Brussels opera theater (intermittently on the staff until 1876, then returning for

the 1884 and 1886 seasons), he served as a solo dancer, as regisseur (from 1865) and as ballet master (from 1871). Among the choreographers under whom he performed were Henri Desplaces, Henri Justament, and Pierre Hus. During his tenure at the Théâtre, he staged two credited works—*Une Fête Nautique* (1870) and *Les Fleurs Animées* (1873); another five ballets for which no choreography credit was assigned may also be his work; these have been listed as such below.

Hanssen served as ballet master of the Moscow Bolshoi Theater from 1879 to 1884. Of major importance in the internationalization of the Russian classical ballet, he is, unfortunately, best remembered for his unsuccessful, pre-Petipa/Ivanov revivals of *Swan Lake* in 1880 and 1882. He also staged *Coppélia* for the Bolshoi in 1882.

His next career tenure brought the French/Belgian style of choreography and technique to London, where he served as ballet master at the Alhambra Theatre (1884-1887). This variety theater's productions—thematic and frequently topical extravagant ballets with singing and some dialogue—form a link between French opera ballet with its national divertissements, and the British style of ballet spectacle associated with Drury Lane pantomimes and the Empire Theatre shows. He staged nine full-length ballets, from *The Swans* (1884) to *The Seasons* (1886), for the Alhambra.

From the death of Louis Mérante to his own death in 1907, Hanssen was ballet master and principal choreographer at the Paris Opéra. Most of his choreography in this period was divertissements to be interpolated into operas, although he did create some full-length works, notably *L'Etoile* (1897), which included the role of "Zénaide"—one that provided Rosita Mauri with one of her last great roles and Carlotta Zambelli with one of her first features. His other major works include *La Ronde* (1905), with its seven variations for Zambelli, the divertissement *Ballet du Legend d'Or* (1897), after a Victor Hugo scenario, and the pageant *Danses de jadis et de naguère*, created for the Paris Universal Exhibition of 1900.

Works Choreographed: CONCERT WORKS: *Une Fête Nautique* (1870); *Les Fleurs Animées* (1873); the following five ballets cannot be definitely credited to Hanssen: *Les Belles de Nuits* (1870); *Une Fête Hon-grois* (1870); *Le Nid d'Amour* (1870); *La Moisson* (1875); *La Vision d'Harry* (1877); *Swan Lake* (1880, his 1882 revival may have included new choreography); *Coppélia* (1882); the following nine ballets were created as full-length evening works for the Alhambra Theatre and could possibly be considered theater works: *The Swans* (1884); *Melusine* (1884); *Nadia* (1887); *Algéria* (1887); *Cupid* (1886); *Le Bivouac* (1885); *Dresdina* (1886); *Nina* (1885); *The Seasons* (1886); *Pierrot Macabre* (1886); *The Tempest* (1889); *Le Rêve* (1890); *La Maladetta* (1893); *L'Etoile* (1897); *Danses de Jadis et de Naguère* (1900); *La Ronde de Saison* (1905).

OPERA: *The Beggar Student* (1884); *Black-Eyed Susan* (1884); *Ballet de Legend d'Or* (1897, in *Massidor*); *Variation* (1898, in *Thais*); *Habenera* (1900, in *El Cid*); *The Birth of the Vine* (1902, in *Bacchus*).

Harkavy, Benjamin, American ballet choreographer and teacher working in Canada, Europe, and the United States; born c.1930 in Baldwin, New York. Harkavy was trained at the school of American Ballet by Pierre Vladimiroff and Anatole Oboukhoff, and by Margaret Craske, Mme. Anderson-Ivantzova, and Edward Caton at their studios.

He performed briefly with his own concert group before being appointed artistic director of the Royal Winnipeg Ballet in 1957. He has also served in that capacity for the Netherlands Dance Theatre (1959-1969), the Harkness Ballet (1969-1970), the Dutch National Ballet (1970-1971), and the Pennsylvania Ballet (1972–). He has also contributed choreography to the Bat-Dor troupe in Israel, the City Center Joffrey Ballet, which performed his *Grand Pas Espagnol* for many seasons, and the Eglevsky Ballet. His neoclassical repertory works, such as the *Grand Pas Espagnol, Pas de Trois Classique* (c.1973), *Rococo Variations* (1968), and *Coppélia* (1978), and his romantic pieces, such as his recent *Poems of Love and the Seasons* (1979), are equally popular with his European and American audiences.

Works Choreographed: CONCERT WORKS: *Three Lyric Dances* (1956); *The Twisted Heart* (1957); *Fête Brillante* (1958); *Septet* (1959); *Primavera* (1960); *Madrigalesco* (1963); *Grand Pas Espagnol* (1963); *Recital for Cellist and Eight Dancers* (1964); *Quartet* (1964); *De Onafscheidelijken* (1965); *Le Diable à*

Quatre (pas de deux) (1966); *Rococo Variations* (1968); *La Favorita* (1969); *Four Times Six* (1969); *Aswingto* (1969); *Contrasts* (1970); *Time Passed Summer* (1974); *Continuum* (1976); *For Fred, Gene and MGM* (1976); *Four Men Waiting* (1977); *From Gentle Circles* (1977); *Signatures* (1978); *Coppélia* (1978, choreography by Petrus Bosman after Nicholas Sergeev; additional choreography for Act III only); *Poems of Love and the Seasons* (1979).

Harlan, Kenneth, American theatrical dancer and silent film star; born c.1895 in Boston or Brooklyn, New York; died March 6, 1967 in Pasadena, California. Harlan made his professional debut in his adolescence as an assistant to a hypnotist named Pauline, but soon became better known as a dancer with Gertrude Hoffmann's *Sumurun* production of 1914–1915. He worked briefly as an exhibition ballroom dancer, most notably as partner to Bonnie Glass, and appeared as a dance extra in motion pictures made at the Paramount studios in Astoria, Queens. In 1916, he was cast in a major role in D.W. Griffith's *Betsy Burgler* and decided to concentrate on film acting throughout the silent era. Among his best remembered films were First National's *Twinkletoes* (a rare dance appearance in a picture staged by Ernest Belcher), *Flames of the Yukon*, and *This Side of Paradise*, memorable mostly as F. Scott Fitzgerald's first screenplay. Although he continued to appear in films, mainly Westerns, until the mid-1940s, Harlan also worked as a restauranteur and agent after 1933. At his death in 1967, he had become a leader of the community of silent film stars who had remained in pictures in nonperforming capacities.

Harms, Rachel, American modern dancer and choreographer; born November 17, 1955 in San Francisco, California. Harms began her dance studies with Ruth Hatfield in Berkeley, California, and performed with her company. While a student at the University of California at Berkeley, she worked under David Wood and wrote dance criticism for the local newspaper. After moving to New York to study at the New York University School of the Arts' Dance Program, under Nanette Charisse, Bertram Ross, Rachel Lampert, Linda Tarnay, and Elina Mooney, she continued her training with Gabriele Taub-Darvish. Harms performed in the concert groups of many of her NYU faculty, including those directed by Lampert, Ross, and Tarnay.

The director of her own company since 1975, she has been acclaimed for the wit of her movement choices and combinations. Her *Toxic* (1980), however, displays that choreographic judgment in its portrayal of a poisonous relationship, enlivened only by attempts at communication.

Works Choreographed: CONCERT WORKS: *The Unicorn, the Gorgon and the Manticore* (1973); *de Kooning: Woman I* (1975); *Into the String* (1976); *Built on Sand* (1976); *Horse* (1976); *Sloe Gin* (1977); *On a Fair Wind Following* (1978); *Sledge* (1979); *Royal Flush* (1979); *Toxic* (1980); *Beyond These* (1980).

Harper, Lee, American modern dancer; born November 10, 1946 in Hickory, North Carolina. After studies at the North Carolina School of the Arts, Harper moved north to attend the Juilliard School, where she worked with Antony Tudor and José Limón. Later training included classes with Pearl Lang and the faculty of the Merce Cunningham studio. Harper had a unique career since she worked as an arts administrator throughout her performing tenures, serving at one time as head of the Touring Programs of the New York State Council on the Arts. Fluent in both the modern and postmodern vocabularies, her many stage appearances were roles in Pearl Lang's *Shirah* (1969) and *Piece for Brass* (1969), and Pat Catterson's *Bleecker to West 80th* and *Epilogue* (both 1970). As a member of the Alvin Ailey American Dance Theater, she appeared in Talley Beatty's *Tocatta* and Ailey's own *A Lark Ascending, Revelations*, and *Mary Lou's Mass*, among many other works of the large repertory.

Harper, Meg, American postmodern dancer and choreographer; born in the 1950s in Evanston, Illinois. Trained at the University of Illinois by former Merce Cunningham dancer Joan Skinner, she moved to New York to continue her studies at the Cunningham studio. A member of his company herself since 1967, she has performed in most of the repertory, either in concert form or as reorganized into Events. She has also appeared in works by Lucinda Childs, including her *Dance* (1979) and in Charles Atlas' live performance piece, *Wonder, Try (Sketchy*

Version) (1980). Her own choreography has been presented since 1979, in concert for herself and dancer/choreographers Andy de Groat and Gary Reigenbaum.

Works Choreographed: CONCERT WORKS: *Long Distance* (1979); *Bad Moves 3'3", Was 13, Bad Moves 26'30"* (1979).

Harris, Joan, English ballet dancer and teacher; born March 26, 1920 in London. Harris was trained by Grandison Clark and Stanislas Idzikowsky and at the Sadler's Wells School. She was one of the English dancers in the corps of the Anglo-Polish Ballet in its 1941 season and performed with the International Ballet for the next four years, with featured roles in Nicholas Sergeev's productions of the nineteenth-century classics. With the Sadler's Wells from 1945, she was cast in Alan Carter's *The Catch* (1946), Ninette De Valois' *The Gods Go-a-Begging*, and the company revival of *The Sleeping Beauty* and *Swan Lake*.

Harris served as camera assistant and ballet master for many of the English backstage ballet films of the 1950s, including The Archers' *Red Shoes* and *Tales of Hoffmann*. Returning to the concert stage, she became ballet master of the Munich State Opera in 1954 and of the Norwegian National Ballet in 1961. Since 1965, she has directed the latter company's training schools.

Harrison and Fisher, American exhibition ballroom team; Ruth Harrison born 1911 in Omaha, Nebraska; died August 12, 1974 in New York; Alex Fisher born 1911 in Czechoslovakia; died June 9, 1976 in New York. After solo careers as adolescent specialty dancers, they met in 1927 as members of the Chicago Civic Opera. They worked together as an exhibition ballroom team in vaudeville and Prologs, becoming so highly regarded that they swept the Prolog houses—in six months in 1933, for example, they played Grauman's Chinese in Los Angeles, and New York's Roxy, Capitol, Palace, and Paramount Theaters.

They appeared on Broadway in *Strike Me Pink* (1934), the Schuberts' *Ziegfeld Follies of 1936* and *1937*, and the *Priorities of 1943*, but worked primarily in nightclubs and cabarets. Known as the "Lunt and Fontanne of dance," their most celebrated rou-

tines were satires of the acting couple, *Amphitryon*, and *Taming of the Shrew*, and *Learn to Dance*, a take-off on the Arthur Murray school of dance advertisements. Harrison and Fisher became regulars at the Radio City Music Hall, with semiannual engagements from 1936 to 1958, and on television's *Ed Sullivan Show*. They also appeared in two films, *Hollywood Party* (MGM, 1934), a compendium of Prolog acts, and *Moulin Rouge* (UA, 1953).

Harrison, Ray, American modern and theatrical dancer and choreographer; born in the 1920s possibly in St. Louis, Missouri; died August 3, 1981 in Boston. Trained originally by Helene Platova, he worked with the Edwin Strawbridge Ballet in St. Louis before moving to New York to study with Hanya Holm. He was with Holm for eight years, from 1942, when she cast him in her *Ozark Set*, to 1950 when he assisted her on the Broadway show *Out of This World*. Between her tours, he danced on Broadway in *Banjo Eyes*, Agnes De Mille's *Oklahoma!*, Jerome Robbins' *On the Town, One Touch of Venus*, and Holm's *Kiss Me Kate*.

Before beginning his career as a Broadway choreographer, he worked as a concert dancer, sharing concerts with Katherine Litz and dancing in her famous *Dracula* (1959). He also served as ballet master of the New York City Opera, which used modern dance choreographers throughout the 1950s. Among his many successful theatrical productions were *Portofino* (1958), co-choreographed with Charles Weidman, *Walk-Talk* (1958), *Oh, Say Can You See* (1962), and two Rick Besoyan satires, *Little Mary Sunshine* (1959) and *The Student Gypsy* (1963). He spent two years in Yugoslavia as a state department specialist, staging musical comedies in Belgrade opera houses and teaching dance, returning to New York as a freelancer. Harrison taught at the Boston Conservatory of Music through the 1960s and 1970s.

Works Choreographed: CONCERT WORKS: *Prologue* (1958, co-choreographed with Katherine Litz); *The Last Gasp of Love's Latest Breath* (1958, co-choreographed with Litz); *Across the Memory* (1958); *Kick* (1958); *Blues* (1958); *Espial* (1964); *Jazz Suite in III* (1965).

THEATER WORKS: *Portofino* (1958, co-choreographed with Charles Weidman); *Walk-Talk* (1958); *Little Mary Sunshine* (1959, also co-directed show);

From A to Z (1960); *Oh, Say Can You See* (1962); *The Student Gypsy, or the Prince of Liedercranz* (1963).

TELEVISION: *Music '55* (CBS, 1955).

Hart, Flo, American theatrical dancer; born c.1896; died March 30, 1960 in New York City. In every edition of the *Ziegfeld Follies*, one A dancer (or show girl) became a star by virtue of her beauty. In the 1912 *Follies*, Hart was the center of attention and the visual feature. She was a celebrity, in the way that starlets were later in the century, and was invited to give her opinions and advice on all questions of etiquette and female beauty. By 1916, however, her vogue had ended and she was given (or she took) the opportunity to work as an actress in the Poli theaters' stock company, specializing in the works of Eleanor Glyn. She retired from the stage completely in the mid-1920s to become a public health nurse.

Hart, John, English ballet dancer; born July 4, 1924 in London. After initial training from Mme. Judith Espinosa of the famous family of ballet masters, Hart continued his studies at the school of the Sadler's Wells Ballet.

A member of the Vic-Wells Ballet from 1938 to 1942 and from 1946 to his retirement, Hart created roles in a number of ballets by Ninette De Valois, among them, *The Prospect Before Us* (1940), *Orpheus and Eurydice* (1941), and *Don Quixote* (1950). He also performed in the premieres of many works by Frederick Ashton, including his *Harlequin in the Street* (1938), *The Wanderer* (1941), *Sylvia* (1952), and *Homage to the Queen* (1953), and of Robert Helpmann, playing "Laertes" in his *Hamlet* (1942). Hart was especially celebrated, however, for his work in the company production of the classics, dancing in *The Sleeping Beauty* and as "Franz" in *Coppélia*.

Returning from retirement, Hart has served as the administrator of the Royal Ballet since 1975.

Hart, Margie, "The Original Show Me Girl" and American strip-tease artist; born Margaret Bridget Cox in 1916, Edgerton, Missouri. From her debut at the Rialto Theatre, Chicago, at sixteen, Hart was a burlesque star for almost thirty years. Billed as "The Poor Man's Garbo," she appeared at every house on the burlesque wheel, headlining her own revues *The Hart-Breakers* at the Old Howard in Boston. Her best remembered performance was in the short-lived Broadway production, *Wine, Women and Song* (1942), which was closed for indecency shortly after its opening. Her specialty number in the show (and in publicized court appearances) was The Victory Garden, named for her well-placed flowers. Although she starred in a film, *The Lure of the Islands* (Monogram, 1942), she was best known for her live appearances on the wheel.

Hartman, Grace and Paul, American exhibition ballroom and comedy team; Paul was born October 25, 1905 in San Francisco, California and died October 2, 1973; Grace was born c.1907 in San Francisco and died in New York before 1955. Paul, the son of Ferris Hartman, "the Ziegfeld of the West," began to work with Grace Barrett, a former Denishawn student, in the mid-1920s as a conventional exhibition ballroom team. By the mid-1930s, however, they had formulated the gimmick which they performed for many years—adagio dances that imitated specific dance teams, and those that satirized relationships among men and women. Although most of the specifically satirical dances were based on adagio or tango teams, such as the various De Marcos and Velez and Yolanda, they also did a Martha Graham take-off called *Labor and Sex* in 1939.

They danced together in cabarets, including annual visits to the Plaza Hotel in New York, and in Broadway shows, among them, *Red, Hot and Blue* (1936), *Keep 'Em Laughing* (1942), *Same Time Next Week* (1944), *Angels in the Wings* (1947), and *Ticket's Please* (1950). After his wife's death, Hartman performed a solo act in cabarets and nightclubs and appeared as "Cap'n Andy" in the 1956 revival of *Show Boat*.

Harum, Eivind, Norwegian modern and theatrical dancer working in the United States; born in the 1940s in Norway. Raised in New York City, Harum was trained at the High School of Performing Arts there, continuing his studies at the Harkness House and the Martha Graham studio. He performed with

the Harkness Ballet during its heyday, but left concert dance to appear on Broadway in *Baker Street* (1965) and the 1968 revival of *West Side Story* in which he played "Riff." In the 1970s, he commuted between appearances with modern dance companies, including the Alvin Ailey American Dance Theatre and the Graham troupe, and work on Broadway. He played "Zach," the choreographer holding auditions in *A Chorus Line*, as staged by Michael Bennett and Bob Avian, for two and a half years in the late 1970s. He is now concentrating on dramatic roles in theater productions and film.

Harvey, Cynthia, American ballet dancer; born May 17, 1957 in San Rafael, California. Raised in Navato, California, she received her early training at Miss Wanda's school there and at Christine Walton's studio. She moved to New York to enter the School of American Ballet and also studied at the American Ballet Theatre School here.

A member of Ballet Theatre from 1974, she has been featured in Baryshnikov's *Don Quixote*, Makarova's *La Bayadère*, and the company revivals of *Giselle*, as "Myrthe," Balanchine's *Theme and Variations*, Glen Tetley's *Voluntaries*, and Antony Tudor's *Leaves Are Fading* and *Jardin aux Lilas*.

Harvey, Dyanne, American modern dancer; born November 16, 1951 in Schenectady, New York. Harvey was trained originally in ballet by Marilyn Ramsey and the staff of the Schenectady Civic Ballet. Her first modern dance studies were with Pat Peterson there, before she accepted a scholarship to continue her training at the Paul Sanasardo studio in New York City.

Although she is celebrated as one of New York's most talented freelancers, Harvey has maintained close ties to two choreographers; George Faison, Jr. for whom she has danced in concert and on Broadway in *The Wiz*, and Eleo Pomare. Among her many credits in the Pomare troupe are roles in his *Radiance of the Dark, Les Desenamorades, Movements* (1971), *Missa Luba,* and *Blues for the Jungle.* Pomare's solo, *Roots,* has become her signature dance in concert with his company and in solo recitals, as it allows her to present her exceptional control and fluidity of movement and her extraordinary dramatic sense. Her

performance of *Roots* at the tribute to Syvilla Fort (a week before Fort's death) was especially strong and brought her the invitation to portray her in dance in the film, *Syvilla: They Dance to Her Music,* in a production by Eugene Little of Fort's first solo, *Bacchanale.* Harvey has also appeared with Jamaican troupes in New York and with the Brazilian Capoeiras of Bahia in concert there, dancing in the work by J.C.A. Apolo, *Capoeira du Amor.* Her theatrical performances have included work in the chorus of *Timbuktu* and acting and dancing in Ntozake Shange's *Spell #7.*

Apart from her company and theatrical ventures, Harvey has begun to present recitals of solos created or revived for her. Among her repertory are Shawneequa Baker-Scott's *Keeper of the Flame,* Ron Pratt's *Two Songs by Missy,* Charles Grant's *Blackbird,* the Fort/Little *Bacchanale,* and Pomare's *Roots* and *Hex.*

Harvey, Lillian, English film dancer and actress working in German, American, and Italian motion pictures; born January 19, 1909 in London; died July 27, 1968 in Antibes, France. Raised in Germany and Switzerland, she was trained in Charlottesburg and Berlin in both conventional ballet and theatrical toe work. Harvey made a large number of films for Fox in the 1930s, but remained best known for her motion pictures for UFA, the major German studio of that era. Among her many German films were *Heart Song* (1934), *The Blonde Dream* (1932), in which she tight-rope-walked, and *Congress Dances* (1931), with dances staged by Boris Romanoff. That film led to her American film contract.

With Fox from 1933 to 1935, she appeared in *My Weakness* (1933), *My Lips Betray* (1933), *Once a Gentlemen* (Columbia, 1934), and *Marionettes* (1933). She returned to Germany in 1935, but was soon exiled. She later made films in Italy, notably *Castelli in Aria* (Astra, 1941), and in France, among them *Schubert Serenade* (1940).

Although her career in the theater lasted until the mid-1950s, Harvey's dance work ended in the 1930s. She was an extremely popular ballet specialty dancer and actress, whose blond and delicate beauty was complemented by her exquisite technique. In her extant films, she seems to have been used as a kind of

European Harriet Hoctor, but was given more character work and many more lines than her American ballet counterpart.

Harwood, Vanessa, English ballet dancer performing in Canada; born 1947 in Cheltenham, England. Raised in Toronto, she studied with Betty Oliphant at the school of the National Ballet of Canada. A member of the company since 1965, she has specialized in the classical roles, among them "Aurora," "Odette/Odille," "Myrthe" and "Swanilda," as well as "The Girl" in Kenneth Macmillan's *Solitaire,* "La Bohemienne" in Roland Petit's *Le Loup,* and "Dona Ana" in John Neumeier's *Don Juan.*

Haskell, Jack, English dance director working in the United States. Haskell is one of the most frustrating individuals in this book since it has proved practically impossible to verify any biographical information on him. It is believed that he was an English theater and film choreographer who spent most of his short professional life in the United States, although he may well have been American or Canadian. There are gaps in his biography which I would love to fill.

Haskell first emerged in London in 1921 when he was credited with the choreography for the 1921 production of *Sally,* the famous American musical about a foundling who passes herself off as a celebrated Russian ballerina and wins a role in the *Ziegfeld Follies.* Edward Royce staged the Broadway original but it is possible that Haskell was somehow involved in the original production. He may have been a Royce protégé in his English career who was charged with the dance direction because he could reproduce his mentor's style. After a gap of six years between his last verified London credit and his first American stage one, Haskell disappeared again before emerging in Hollywood as a staff choreographer at United Artists (c.1933) and Twentieth-Century Fox. His best known film credit is enough to make him important: he staged the dances for the Shirley Temple/Jack Haley vehicle *Poor Little Rich Girl* (1936) with its marvelous military tap finale.

Works Choreographed: THEATER WORKS: *Sally* (London, 1921); *The Cabaret Girl* (London, 1922); *Hold Everything* (New York, 1928).

FILM: *Broadway Through a Keyhole* (UA, 1933); *Poor Little Rich Girl* (Twentieth-Century Fox, 1936); *This Is My Affair* (Twentieth-Century Fox, 1937); *Wake Up and Live* (Twentieth-Century Fox, 1937).

Hasoutra, American theatrical and concert dancer specializing in Oriental forms; born Ryllis Barnes, September 24, 1906 in Shanghai, China; died February 18, 1978 in New York City. Hasoutra was born of American parentage and raised in Shanghai. After returning to the United States, she performed her Oriental dances in the context of theatrical productions, among them Ed Wynn's *The Perfect Fool* (1921), *Spices of 1923,* and the *Passing Show of 1923.* Her dance specialties in these shows included *The Snake Dancer, Burma,* and her best known characterization, *The Golden Idol.*

With a colleague, Dora Duby, she toured Europe and Asia with these dances from 1926 to 1933. As in New York, she performed in Western Europe within shows, most notably at the Casino de Paris in Paris, but was able to present recitals of her specialties in opera houses in Brussels, Barcelona, and Madrid. In 1934, she presented a New York recital as a concert dancer complete with Louis Horst on the piano, not as an exotic specialty dancer. Most of her extant choreographic titles date from this recital.

When she retired from performance, she joined the United States State Department as a foreign service officer, serving from the 1940s to 1972 under her married name, Ryllis Barnes Simpson.

Works Choreographed: CONCERT WORKS: *The Snake Dancer* (introduced in a recital before 1921); *Burma* (introduced in a recital before 1921); *The Golden Idol* (introduced in a recital before 1921); *Largo* (c.1934); *Ipanema* (c.1934); *Waltz* (c.1934); *Bolero* (c.1934); *Sarabande* (1934); *Le Jongleur* (c.1934); *Prelude, Valse et Scherzo* (c.1934); *Studies from the Far East (Javanese Srimpi, Burmese Pwe Dancer, Indian Sari Dance, Marwari)* (1934).

Hasselqvist, Jenny, Swedish ballet dancer and actress; born July 31, 1894 in Stockholm. Trained at the School of the Royal Swedish Ballet, she graduated into the company in 1910. She appeared in the ballets that Mikhail Fokine restaged for the company

when he was in residence there but also worked in recitals in a series of national dances of her own (c.1918). In 1920, she joined the Ballets Suédois, dancing the female leads in many of Jean Borlin's works, including his *Jeux, Les Vierges Folles,* and *La Nuit de Saint Jean.* After another career as a recitalist (from which period, unfortunately, no titles can be verified), she returned to Stockholm to teach at the Royal Swedish Ballet and at her private studio.

Hasselqvist was also known as a silent film actress. She starred in early works of Ernst Lubitsch, including his *The Ballet Girl* (Union, 1918) and *Sumurun* (Union/UFA, 1921), and in the celebrated Swedish silent film that is considered the European equivalent of D.W. Griffith's epics, *The Gösta Berlings Saga* (Svensk Filmindutri, 1924).

Hassreiter, Josef, Austrian ballet dancer and choreographer; born December 30, 1845 in Vienna; died there on February 8, 1940. Hassreiter was trained at the school of the Vienna Court Ballet, the company with which he spent his performing and creative career.

Named soloist in 1870, he progressed to regisseur, ballet master, director of the ballet school, and teacher of the class of perfection or female company class, retiring in 1920. Among his students there was theatrical choreographer Albertina Rasch.

Best known for his ballet, *Das Puppenfee* (The Fairy Doll) (1888), which remained in the repertory of many companies until the 1960s, Hassreiter contributed many works to the company.

Works Choreographed: CONCERT WORKS: *Das Puppenfee* (The Fairy Doll) (1888); *Le Carillon* (1892); *Sonne und Erde* (Sun and Earth) (1894); *Rouge et Noir* (1894); *Columbia* (1896); *Die Perle von Iberien* (1902); *Jahreszeiten der Liebe* (Season of Love) (1911); *Little Ida's Flowers* (1916).

Hawkins, Erick, American modern dancer and choreographer; born 1909 in Trinidad, Colorado. After college, Hawkins studied modern dance with Harald Kreutzberg and continued his training at the School of American Ballet. He danced in the corps of opera ballets staged by George Balanchine at the Metropolitan Opera. He became a charter member of the Bal-

let Caravan, appearing in the premieres of most of that cooperative troupe's summer tour repertory, including Eugene Loring's *Harlequin for President* (1936), Lew Christensen's *Encounter* (1936), *Pocohontas* (1936), and *Filling Station* (1938), as "The Gangster" and his own *Show Piece* (1937).

In the first week of Caravan performances in July 1936, he was in Bennington, Vermont. Frances Hawkins (not a relation), who was the manager of both the Caravan and the Martha Graham Company, introduced him to Graham at the Summer School of Dance. He joined her company as its first male dancer. Among the many works in which he created roles were *American Document* (1938), "*Every Soul Is a Circus . . .*" (1939), *El Penitente* (1940), *Letter to the World* (1940), *Deaths and Entrances* (1943), *Appalachian Spring* (1944), as "The Husbandman," *Cave of the Heart* (1946), and *Night Journey* (1947).

He formed his own company in the late 1940s, dancing with it until 1976. Working in collaboration with composer Lucia Dlugoszewski and artists Ralph Dorazio and Ralph Lee, he creates works within a personal system of movements and of mythologies. Unlike Graham, his imagery cannot be dated, but, because it is so individual and not based on a recognized historical or psychological style, it is difficult for many to comprehend.

Hawkins has inspired many of his dancers to choreograph themselves. Among the many former and present company members who now choreograph are Beverly Brown, Nada Diachenko, Natalia Richman, Carol Conway, Nancy Meehan and Robert Yohn.

Works Choreographed: CONCERT WORKS: *Show Piece* (1937); *Liberty Tree* (1940); *Yankee Bluebritches* (1940); *Trickster Cayote* (1941); *John Brown* (1945); *Stephen Actobat* (1947); *The Strangler* (1948); *Openings of the Eye* (1953); *Here and Now with Watchers* (1957); *Sudden Snake-Bird* (1960); *Eight Clear Pieces* (1960); *Early Floating* (1962); *Spring Azure* (1962); *To Everybody Out There* (1964); *Geography of Noon* (1964); *Lords of Persia* (1965); *Naked Leopard* (1965); *Cantilever* (1966); *Dazzle on a Knife's Edge* (1966); *Tightrope* (1968); *Black Lake* (1969); *Of Love* (1971); *Angels of the Inmost Heaven* (1972); *Classic Kite Tails* (1972); *Dawn*

Dazzled Dawn (1972); *Greek Dreams with Flute* (1973); *Meditation on Orpheus* (1975); *Hurrah!* (1975); *Death Is the Hunter* (1975); *Parson Weems and the Cherry Tree* (1975); *Ah Oh* (1977); *Plains Daybreak* (1979); *Avanti* (1980).

Hay, Deborah, American postmodern dancer and choreographer; born December 18, 1941 in Brooklyn, New York. After training by her mother in children's tap work, she studied dance at the Henry Street Settlement House, home of the Alwin Nikolais and Murray Louis companies, and at the American Dance Festival summer schools. While a student at the Merce Cunningham studio, she became a member of the workshops that evolved into the Judson Dance Theatre.

Hay's choreography was at first perceived to be within the strictures of the Judson group, experimenting with aleatoric structures, sound scores or silent works, and pedestrian movements, performed by nontrained dancers entirely or by groups of differently trained individuals. The possibilities of creating pieces out of workshop-training situations became more and more important to her, resulting in a series of untitled dances that are outgrowths of classes. After a period of doing large-scale works for her previously untrained performers, she recently returned to the solo format, creating *Leaving the House* (1980), which has been perceived as a major feminist statement.

Like many of her Judson colleagues, Hay's works reflect her changing vision of her life—creating group works when communal living was important for her personal growth and returning to solos when she felt strong enough within herself to make a personal statement again. She has managed to create fascinating, hypnotic pieces out of severely limited movement vocabularies performed by dancers and other people who could not fully define each step. But many members of her audience are glad that she has returned to performing her own movements and formats.

Works Choreographed: CONCERT WORKS: *Rain Fur* (1962); *5 Things* (1962); *Rafladan* (1962, in collaboration with Alex Hay and Charles Rotmil); *City Dance* (1963); *All Day Dance* (1963); *Elephant Footsteps in the Cheesecake* (1963, in collaboration with Fred Herko); *Would They or Wouldn't They?* (1964, called *They Will* after 1964); *All Day Dance for Two* (1964); *Three Here* (1964); *Victory 14* (1964); *Hill* (1965); *No. 3* (1966); *Serious Duet* (1966); *Rise* (1966); *Solo* (1966); *Flyer* (1967); *Group I* (1967); *Group II* (1968); *Ten* (1968); *Half-Time* (1969); *20 Permutations of 2 Sets of 3 Equal Parts in a Linear Pattern* (1969); *Deborah Hay with a Large Group Outdoors* (1969); *26 Variations on 8 Activities for 13 People* (1969); *Plus Beginning and Ending* (1969); *Deborah Hay and a Large Group of People from Hartford* (1970); *20-Minute Piece* (1970); *Deborah Hay and the Farm* (the name of the communal group) (1971); *Wedding Dance for Sandy and Greg* (1972); *Circle Dances* (ongoing from 1976); *Solo Dances* (ongoing from 1976); *The Grand Dance* (ongoing from 1977 to 1979); *Leaving the House* (1980); *The Genius of the Heart* (1980); *HEAVEN/below* (1980).

Bibliography: Hay, Deborah and Donna Jean Rogers. *Moving Through the Universe in Bare Feet: Ten Circle Dances for Everybody* (Island Pond, Vermont: 1974).

Hay, Mary, American theatrical dancer; born Mary Hay Caldwell, 1901 in Fort Bliss, Texas; died June 4, 1957 in Inverness, California. Hay had already appeared in silent films for D.W. Griffith when she began to take classes at the Denishawn school in Los Angeles. She tired of the limitations that were put on her at the school, and moved to New York to study tap, musical comedy dance, acrobatics, and ballroom work with Ned Wayburn. She made her Broadway debut in the *Ziegfeld Midnight Frolics of 1918* as a specialty dancer in the tradition of Frances White and Ann Pennington (whom she was groomed to replace). Hay appeared in the *Frolics* of 1918 and 1920 and the *Follies* of 1919 before her short marriage to Griffith star Richard Barthelmess curtailed her career for two years.

Returning to Broadway in 1922 to appear in *Marjolane* (1922) and *Mary Jane McKane* (1922), she was cast by their teacher, Wayburn, into an eccentric dance team with Clifton Webb. She was slightly less than four-foot-ten and looked like a very sweet kewpie doll; he was at least six feet tall and ultra sophisticated, and their act was a straight-faced rube

whirlwind that accentuated the differences in their heights. The partnership with Webb extended her Broadway popularity and brought her principal dancing-comic roles in *Sunny* (1925) and *The Treasure Girl* (1928). She retired in 1930.

Haydée, Marcia, Brazilian ballet dancer associated with the Stuttgart Ballet; born Marcia Haydée Pereira da Silva, April 18,1939 in Niteroi, Brazil. After studies in Rio de Janeiro with Vaslav Veltchek and performances with the Teatro Municipal in 1953, Haydée accepted a scholarship to attend the school of the Sadler's Wells Ballet in London. After her studies there, and in Paris with Olga Preobrajenska and Lubov Egorova, she joined the Grand Ballet du Marquis de Cuevas in 1957.

In 1961, Haydée joined the Stuttgart Ballet, the company with which she has since been associated. She has created roles in a large number of that company's repertory, including John Cranko's *Variation* (1963), *Homage au Bolshoi* (1964), *Eugene Onegin* (1965), *Four Images* (1967), *Initials R.B.M.E.* (1972), and *Legend* (1972), Kenneth Macmillan's *Song of the Earth* (1965), and *Miss Julie* (1970), Glen Tetley's *Voluntaries* (1973) and *Algerias* (1975), and John Neumeier's *Night* (1974). She has also performed featured roles in works by the above choreographers and in the classical repertory.

Haydée has been artistic director of the Stuttgart Ballet since 1976.

Hayden, Melissa, Canadian/American ballet dancer; born Mildred Herman, April 25, 1923 in Toronto, Canada. Hayden studied locally and in New York with Anatole Vilzak and Ludmilla Schollar. She danced in the corps de ballet of the Radio City Music Hall in New York from 1943 to 1944.

Hayden joined Ballet Theatre in 1945, performing with that company from 1945 to 1949 and from 1952 to 1954. In Ballet Theatre she created roles in Jerome Robbins' *Interplay* (1945) and George Balanchine's *Theme and Variations* (1947), taking the lead role in that ballet after 1952. She performed featured roles in Balanchine's *Apollo*, Antony Tudor's *Undertow*, and William Dollar's *The Leaf in the Wind* and *The Combat*, which she performed in the New York City Ballet as *The Duel*.

Hayden joined the New York City Ballet in 1950, remaining with that company until her retirement in 1973. She created roles in many ballets, among them, Balanchine's *Caracole* (1952), *Stars and Stripes* (1958), *Episodes* (1960), *Liebeslieder Walzer* (1960), *Brahms-Schoenberg Quartet* (1966), *Glinkiana* (1967), *Choral Variations on Bach's "Von Himmel Hoch"* (1972), and *Cortège Hongrois* created as a "retirement present" for her last season in 1973. Hayden's expressive powers brought her roles in William Dollar's *Ondine* (1949), Frederick Ashton's *Illuminations* (1950), Todd Bolender's *The Masquers* (1957), Jacques D'Amboise's *Irish Fantasy* (1964), and Jerome Robbins' *The Pied Piper* (1951) and *In The Night* (1970), although she did not perform at the latter's premiere.

Hayman-Chaffey, Susanna, English modern dancer and choreographer working in the United States after 1965; born January 31, 1948 in Tenterden, Kent. Trained in London at the Royal Ballet School, in Rome with Grant Mouradoff and Olga Lepinskaya and in Brazil with Vera Kumpera, Hayman-Chaffey moved to New York to study at the Martha Graham school in September 1965.

A member of the Merce cunningham company since 1968, she has appeared in his *Tread, Crises, Second Hand, Walkaround Time, Scramble, How to Pass, Kick, Fall and Run,* and many *Events.* She left the company in 1976 to teach and study in Japan and Israel.

Haynes, Tiger, American theatrical dancer and singer; born December 13, 1907 in St. Croix, the Virgin Islands. In New York after 1919, he was a welterweight boxer before becoming a performer. As a member of the jazz trio, The Three Flames, he worked in nightclubs and on television during the 1940s, 1960s, and 1970s. He made only occasional appearances as a dancer and musical comedy performer during that time, working on Broadway in the *New Faces of 1956* and 1961 revival of *Finian's Rainbow* and playing "Lou Williams," the character based on Bill Robinson, in the Carol Burnett comedy *Fade Out, Fade In* (1964).

Since he was best known as a singer, his dancing as the "Tin Woodman" in the stage production of *The*

Wiz (1975) surprised as many people as it delighted. An eccentric dance role in all versions, this production gave him the opportunity to blend the traditional stiff-legged tap work with a tremendously sympathetic characterization.

Hays, David, American theatrical designer; born 1930 in New York City. A prolific designer on Broadway, Hays has become associated with the New York City ballet, creating scenery and costumes for many of that companies' works. His projects for George Balanchine have ranged from the naturalistic lushness of the ballroom in *Leibeslieder Walzer* (1960) and the forest in *Midsummer Night's Dream* (1962) to the glorified wing and drops of his *Stars and Stripes* (1958) and *Divertimento No. 15* (designs, 1966). Many consider *Bugaku* (1963) his most successful design for a Balanchine work, with its stark set pieces that limit and focus the vast stage space. Hays has also designed productions for ballet master John Taras, decorating his *Arcade* (1963), and for dancer Jacques D'Amboise, working on his *The Chase* (1963) and *Irish Fantasy* (1964).

Haywood, Claire, American ballet teacher; born c.1916 in Atlanta, Georgia; died September 23, 1978 in Washington, D.C. Educated at Spellman College and Howard University, she formed the Jones-Haywood School of Ballet in 1941 with Boston-born Doris Jones. Together, they maintained the school in Washington, D.C., and founded the Capitol Ballet in 1961. Among their students are a generation of black ballet dancers—those who remain in the classical field and those who moved into modern or theatrical dance. They are considered two of the most important factors in the continuing presence of trained black dancers in the American performing arts.

Hayworth, Rita, American film actress and dancer; born Marguerita Cansino, October 17, 1918 in New York City. The daughter of former Ziegfeld dancer Volga Haworth and Spanish exhibition ballroom dancer Eduoardo Cansino, she was trained by her father in his New York and Hollywood studios. She performed in her father's Prologs at the Cathay Theatre and his acts staged for Tijuana and Agua Caliente cabarets as an adolescent.

Her first film dance performances were in bit parts in Fox Film melodramas, doing exhibition ballroom numbers in the backgrounds of *Under the Pampas Moon, Charlie Chan in Egypt*, and *Dante's Inferno* (all 1935), the latter staged by her father. Under contract to Columbia Studios for most of her film career, she appeared in *Paid to Dance* (1937) as a taxi dancer before making her major reputation with musicals and dramas. Although best known for the smouldering sexuality of *Gilda*, in which she barely but effectively moved in her famous "Put the Blame on Mame," she also sang and did ballroom numbers in a few films. The most successful of these were *You'll Never Get Rich* (1941), staged by Robert Alton, *My Gal Sal* (on loan to Twentieth-Century Fox, 1942), choreographed by Hermes Pan, *You Were Never Lovelier* (1942), with its marvelous Val Raset competition tap with Fred Astaire, "Shorty George", and *Cover Girl* (1944), by Raset and Seymour Felix. She also did Spanish-style numbers in Jack Cole's *Tonight and Every Night* (1945) and *Down to Earth* (1947).

Healey, Dan, American theatrical dancer and night club comic; born November 3, 1888 in Rochester, New York; died August 31, 1969 in Jackson Heights, New York. He made his stage debut at age fourteen in a local stock company production of *The Little Outcast*, but soon became known on Broadway as a clever dancer and singer, capable of working as a juvenile or a comedy second lead. Among his many performance credits were appearances in *The World of Pleasure* (1915), *Yip!Yip!Yahank!* (1918), *Betsy* (1920), *The Sweetheart Shop* (1920), *Adrienne* (1923), *Good Boy* (1928), *Plain Jane* (1924), the *Ziegfeld American Revue*, and in a return to the stage, *This Is the Army* (1942). He had a short career as an exhibition ballroom dancer, working as a staff performer at Reisenweber's in the late 1910s, but became celebrated for his work as an emcee at cabarets. Healey produced shows for the Cotton Club in the late 1920s and managed The New Yorkers, the Ha Ha Cabaret, and the Broadway Room in the 1930s. Known as "The Night Mayor of New York" for his cabaret activities, he booked dancers into his clubs but retired from performance himself in 1925.

Healey, Eunice, American theatrical tap dancer working with swing era bands; born c.1920 in San Francisco, California. Healey worked in Fanchon and Marco West Coast units before moving to New York to tap in *Girl Crazy* in 1930. Throughout the 1930s, she divided her time between appearances as a specialty dancer in Broadway shows, among them *The Laugh Parade* (1931), *Two for the Show* (1940), *Beat the Band* (1942), and *Hold Onto Your Hats* (1940), and tours with the Benny Goodman, Glen Miller, and Artie Shaw orchestras. As a bandstand tapper, she augmented both the lead vocalists and the percussion section. She made only one film, Republic's *Follow Your Heart* (1936), but can also be seen in news footage of the Goodman and Miller orchestras.

Heater, Mary, American ballet dancer; born in the late 1910s in Seattle, Washington. Heater was trained locally by Mary Ann Wells before moving to New York to continue her studies under the staff of the (Anatole) Vilzak/(Ludmilla) Schollar school. She was an early protégé of Muriel Stuart at the new School of American Ballet and joined its students in the Ballet Caravan in its second year. As a member of that touring cooperative until its demise (1937–1940), she created roles in William Dollar's *Air and Variations*, Douglas Coudy's *Folk Dance*, Eugene Loring's *City Portrait* and *Harlequin for President*, and Lew Christensen's *Filling Station* and *Charade*. Her comic timing and charm in the later works was especially acclaimed. She performed with a number of ad hoc and short-lived companies formed by Ballet Caravan veterans before joining Ballet Theatre in 1944. Her roles there ranged from those in the Mikhail Fokine repertory that revealed her comic gifts to tragic mimed mothers in the company's production of *Giselle* and George Balanchine's *Apollo*.

Heaton, Anne, English ballet dancer; born November 19, 1930 in Rawalpindi, India. Returning to England as a child, she was trained by Janet Cranmore in Birmingham before attending the Sadler's Wells Ballet School.

Heaton was associated throughout her career with the Sadler's Wells and Royal Ballets in their various manifestations. Popular in both the classics and the new repertory of the 1940s and 1950s, Heaton created roles in many works by Ninette De Valois, among them *Promenade* and *The Gods Go A-Begging* (both 1946), and Andrée Howard, including *Assembly Ball* and *Mardi Gras* (1946), and her *A Mirror for Witches* (1952), playing "Doll." Her featured performances in the Frederick Ashton repertory include his *Valses Nobles et Sentimentales* (1947), *Madame Chrysanthème* (1955), and *Don Juan* (1948). She also danced in Kenneth Macmillan's *The Burrow* (1958) and *The Invitation* (1960), before retiring to teach in 1962.

Heberle, Thérèse, Austrian ballet dancer of the early nineteenth century, performing in Italy in the 1820s; born 1806 in Vienna; died February 5, 1840 in Naples. Heberle was trained by Frederick Horschelt at the Theater an der Wein and performed in his Kinderballet (c.1816–1821).

After a season with the Royal Italian Opera, an ad hoc company based in London, she spent the remainder of her tragically short career at the Teatro alla Scala in Milan. Since she performed as a "grotescha" in that company, it is likely that she specialized in character or demicharacter roles. Among the ballets in which she was featured were Louis Henry's *La Silfide* (1828), a version of Jean Aumer's *Le Due Zie* (1825), and Filippo Taglioni's *Danina* (1826).

Heckroth, Hein, German theatrical designer; born April 14, 1901 in Giesse; died July 6, 1970 in Alkmar. Associated through much of his career with the works of Kurt Jooss, he designed the original company productions of *The Prodigal Son* (1931), *The Big City* (1932), *Seven Heroes* (1933), *Ballade* (1935), and *Pandora* (1944), among many others. His designs for *The Green Table* (1932) are still employed in almost every new production of the work; both the characterizational costumes for the performers and the sardonic masks for the men around the table are brilliantly designed and delineated.

A pioneer in the use of technicolor design schemes, he was responsible for the art direction and ballet design for The Archers' films *The Red Shoes* (1948) and *Tales of Hoffmann* (1951). Returning to Germany, he served as resident designer for the Frankfurt Municipal Theatre.

Heinel, Anna Friedrike, German eighteenth-century ballerina, called by her contemporaries "La Reine de la Danse"; born October 4, 1753 in Bayreuth, Bavaria; died March 17, 1808 in Paris. Heinel was trained by Jean-Georges Noverre in Stuttgart and made her debut in his *Proserpine* in 1767. She worked with him in Vienna also, performing in his *Armide* and *Alceste*.

From 1768 to her retirement in 1782, Heinel performed frequently at the Paris Opéra, notably in the premieres of the magnificent operas of W.C. Gluck, *Orpheus et Eurydice* (1774), *Iphigénie en Tauride* (1779), and *Echo et Narcisse* (1779), the only one credited to a choreographer, namely Maximilien Gardel. London also celebrated her brillance of technique. At the King's Theatre (1771–1772), she performed in Vincenzo Galleotti's *Il Vaggiatori, Carnevale de Venezia*, and *Il Desertore*.

Held, Anna, French singer and dancer working in the United States at the turn of the century; born March 18, 1873 in Warsaw, Poland; died August 13, 1918 in New York City. Although known internationally as the epitome of French elegance and style and the star of a half-dozen musicals about French sexual politics, Held was born in Poland and raised in London. She made her debut in an English music hall and became well known in cabaret performance there and in Paris. She was discovered in Europe by Florenz Ziegfeld, Jr. who produced most of her American presentations. It has also been theorized that the format and dance structure of the Ziegfeld *Follies* were based on the shows that he created for her.

Held's actual dancing was probably limited by her costume, which included a famous corset that shrunk her to anywhere from sixteen to eighteen inches at the waist, and by her status in the show. She was there to be surrounded by a chorus of anonymous dancers framing her as the star. In one of her later shows, *The Parisian Model* (1906), staged by the young Gertrude Hoffmann, she actually did an eccentric dance complete with high kicks, but that was at the end of her popularity. Although she returned to Broadway in 1916 in *Follow Me*, she was unable to recapture her success of the early twentieth century.

There have always been those who believed that Held was never a successful performer but only a publicity gimmick sponsored by Ziegfeld. There is no way, however, to prove this contention and the number of critics who disagreed must be considered. She was a song and dance stylist, pressing her stage personality onto her material, but must have been able to hit the correct notes and articulate the correct number of individual steps in order to convey her interpretations.

Helliwell, Ethel, English theater and film dance director; born c.1905; details of death unknown. Helliwell and her sister Dorothy, who taught for many years in Brighton, performed in music halls as children in a tandem-style ballet act. She may have also been a Tiller precision dancer as an adolescent. By 1930, she had been hired by Lew Mangam as head of production for his cine-variety circuit (the English equivalent of Prologs, live shows presented before a feature film) and dance director for his Plaza theater. She staged precision lines and adagio routines for the Mangam-Tiller Girls and Plaza-Tiller teams for live production and early English sound films. She also worked on four French musical films in 1931 and 1932.

It is unfortunate that so little is known about Helliwell, who was as important to the development of English variety theater as Fanchon and Maria Gambarelli were in the United States.

Works Choreographed: THEATER WORKS: Cine-variety shows (or Prologs) for Lew Mangam Theatre circuit (c.1928–1933).

FILM: *Avec l'Assurance* (co-produced by British and Dominion Film Corp and unidentified French studio, 1931); *Louise* (co-produced by British and Dominion Film Corp. and unidentified French studio, 1931); *Il Est Charmant* (co-produced by British and Dominion Film Corp. and unidentified French studio, 1932); *L'Amour Chante* (co-produced by British and Dominion Film Corp. and unidentified French studio, 1932); *Man of Mayfair* (Paramount-British, 1931); *A Night Like This* (British and Dominion Film Corp, 1932); *Love Contract* (British and Dominion Film Corp, 1932); *Yes, Mr. Brown* (British and Dominion Film Corp, 1932).

Helpmann, Robert, Australian ballet dancer and choreographer and actor; born April 9, 1909 in Mount Gambler, Australia. Helpmann studied ballet with Laurent Novikoff and Harcourt Algeranoff

when they were in Australia with Anna Pavlova. After acting professionally in Sydney, he moved to London to continue his training at the school of the Sadler's Wells Ballet, later working under Tamara Karsavina in London and Olga Preobrajenska in Paris.

Throughout his English career, Helpmann alternated between dance and choreography and appearances in Shakesperean plays, for example, choreographing his ballet version of *Hamlet* in 1942 and playing the role in the Old Vic production in 1944. As a dancer at the Sadler's Wells Ballet from 1933, he created roles in many works by Ninette De Valois and Frederick Ashton, among them her *The Haunted Ballroom* (1934), *Prometheus* (1936), *The Prospect Before Us* (1940), and *Don Quixote* (1950), and his *Apparitions* (1936), *Les Patineurs* (1937), *A Wedding Bouquet* (1937), *Don Juan* (1948), and *Cinderella* (1948). He was featured as both "Prince Florimund" and "Carabosse" in *The Sleeping Beauty*, as "Dr. Coppelius" in *Coppélia* and as "Albrecht" in the company's *Giselle*. In addition, he danced the leads in his own works, including his *Comus* (1941), *Hamlet* (1942), *Adam Zero* (1946), and *Miracle in the Gorbals* (1944).

As an actor, he specialized in Shakespeare, but also performed in plays by George Bernard Shaw and directed many of the works of T.S. Eliot in London. He did very little musical theater, but directed the London production of *Camelot* in 1964. He acted in many films, among them the Olivier version of *Henry V*, but only danced in *The Red Shoes* and *The Tales of Hoffmann*, the two big ballet films of the 1950s. He co-directed and played the title role in the Nureyev film of *Don Quixote* (Continental, 1973).

In 1965, he returned to Sydney to form the Australian Ballet with Peggy Van Praagh, also serving as director of the Adelaide Festival of the Arts from 1970. He has created new works in Australia, notably *Yugen* (1965), and has restaged his Sadler's Wells work ballets for the troupe.

Works Choreographed: CONCERT WORKS: *La Valse* (1939); *Comus* (1941); *Hamlet* (1942); *The Birds* (1942); *Miracle in the Gorbals* (1944); *Adam Zero* (1946); *L'Histoire du Soldat* (1954); *The Sleeping Beauty* (1960); *Elektra* (1963); *The Display* (1964); *Yugen* (1965); *Sun Music* (1968); *Perisynthyon* (1974); *The Merry Widow* (1976, co-choreographed and directed with Ronald Hynd).

THEATER WORKS: *After the Ball* (1953); *A Midsummer Night's Dream* (1954); *Camelot* (1963, also directed show).

FILM: *The Red Shoes* (The Archers, 1948; co-choreographed with Leonid Massine).

Hemsley, Estelle, American theatrical dancer and actress; born c.1887 in Boston, Massachusetts; died November 5, 1968 in Hollywood, California. Hemsley made her professional debut as a dancer at Luna Park at Coney Island. She spent her adolescence and early maturity touring with five of the most successful black popular entertainment companies—Sisseretta Jones' *Black Patti's Troubadours*, Sid Archer's *Chocolate Drops, The Yankyana Girls*, and *The Darktown Follies*, with which she first performed on Broadway.

Hemsley's later career included successful periods on radio, including a long stint on CBS's *Pretty Kitty Kelly*, in film as Archie Savage's dance partner, and in legitimate dramas. She made her second theater debut as a dramatic actress in the Federal Theater Project's presentation of *Macbeth*, and followed it with appearances in two of the period's longest running hits—*Harvey* and *Tobacco Road*.

Hemsley, Winston de Witt, American theatrical dancer; born May 21, 1947 in Brooklyn, New York. One of Broadway's most popular dancers, he has worked constantly on stage or in clubs since his debut in Donald McKayle's *Golden Boy* in 1964. Among his many appearances were roles in Michael Bennett's *A Joyful Noise* (1966), *Hallelujah, Baby!* (1967), in which he tapped with Alan Weeks in "Feet Do Your Stuff," the Pearl Bailey cast of the long-running *Hello, Dolly!*, Gower Champion's rock version of the classic, *Rockabye Hamlet* (1976), and Bennett's *A Chorus Line* as the second "Richie." He performs with Weeks in cabarets and nightclubs, maintaining their successful partnership and dance act.

Hendel, Henriette, German nineteenth-century Greek revivalist and mime; born Johanne Henrietta Schüler, February 13, 1772 in Döbeln, Sachsen, Germany; died March 4, 1849 in Köslin. The daughter of

actors, Hendel was raised in Gotha, Breslau, and Berlin, where she studied acting with Engel. After her debut in a private performance, she toured to Mainz, Bonn, and Amsterdam in the 1790s. For ten years, she acted in Berlin, most notably in the title role of *Joan of Arc.*

Already influenced by the Rehberg drawings of Emma, Lady Hamilton, Hendel began to study archaeology after 1806 and developed a form of silent performance of themes from Greek mythology which she called "Mimischeplastik." She toured with her repertory of tableaux, among them *Niobe, The Magdalana, Hagar, Cassandra, Agrippina*, and *Ariadne*, until 1820. Although her act may have been simply a solo repertory company of great women's parts, she was considered tremendously innovative in technical theater, manipulating gas lighting and costuming to achieve what seem to have been horrifying effects.

Much of the existing research on Hendel was done by Lillian Moore for an article in the June 1956 *Dance Magazine*. Her piece is anachronistically titled "An Eighteenth Century Isadora," which seems to miss the point. Hendel was a classically trained eighteenth-century actress who chose to work without words.

Hendl, Susan, American ballet dancer; born September 18, 1949 in Wilkes-Barre, Pennsylvania. Trained at the School of American Ballet, Hendl has performed with the New York City Ballet throughout her career.

She has performed solos in much of the repertory of George Balanchine, in his *Divertimento No.15, Agon, Liebeslieder Walzer*, and *Slaughter on Tenth Avenue*, and of Jerome Robbins, notably in his *Dances at a Gathering*. She has the ability to invest conventional dance movements with a special flair and the complementary ability to make unusual steps or combinations look smoothly integrated into a work. These talents allowed her to create roles uniquely in Balanchine's *Who Cares?* (1970), with its quick *batterie* sequences set to Gershwin, and in Robbins' *The Goldberg Variations* (1971) in the group scenes and in the duet with Anthony Blum with its acrobatic quirks. Other works in which she has performed the premieres include Robbins' *Requiem Canticles II*, the finale of the 1972 Stravinsky

Festival, Alexandra Danilova's restaging of *Chopiniana* (1972), Todd Bolender's *Serenade in A*, and Balanchine's *Le Tombeau de Couperin* (1975), and *Chaconne* (1976), with an additional duet interpolated for her and Jean-Pierre Frohlich.

Hengler Sisters, American tandem team; May, born c.1884 in Brooklyn, New York, died March 15, 1952 in New York City; Flora, born c.1887 in Brooklyn, died September 7, 1965 in New York City. The daughters of Thomas M. Hengler (who, like many minstrel show stars, was both a clog dancer and songwriter), they made their debuts as children in the Hengler and (W.H.) Delehanty troupe. After Hengler's death in his early forties, the sisters premiered their tandem act in the spectacle *1492* (1893). When the Geary Society began to enforce prohibitions against child labor in the theater, the Hengler sisters accepted engagements in Europe. Their dance specialties, tandem dances in ballet, fancy dancing, and Spanish techniques, were extremely popular at the London Alhambra, and at theaters and music halls in Paris, Berlin, Vienna, Moscow, and St. Petersburg, where they were billed as "The American Beauty Sisters."

The Henglers returned to New York in 1901 to appear in their ballet tandem act and to act in *The Sleeping Beauty and the Beast* (1901). They were able to get around the Geary Society since they looked older than their real ages. After their European trip, they no longer did a child tandem act; they performed as if they were adults and were trained as such. Their ranges of dances, in both tandem and trouser (May)/female (Flora) partnership, were applauded in many of the most popular extravaganzas and musical comedies of the early twentieth century, among them *Tommy Rot* (1902), *The Runaways* (1903), *Glittering Gloria* (1904), *The Cingalee* (1904), and the series of Rogers Brothers shows. They were associated with Weber and Field shows until 1910 and had contracted themselves to Charles Frohman for a series of starring vehicles just before his death on the Titanic. By the mid-1910s, the emphasis on their vaudeville act had shifted from dance to banjo playing and singing. They retired in the early 1920s.

Henie, Sonja, Norwegian ice skater and dancer; born April 8, 1912 in Oslo; died October 12, 1969 en route

to Paris. Henie received ballet training from Love Krohn in Oslo and spent summers in London working under Tamara Karsavina. Her skating teachers included Hjordis Olsen, Oscar Holte, Martin Stixrud, and Harald Nicholson. As an amateur, she won the Norwegian National European and World Championships, with gold medals from the 1932 and 1936 Olympics.

After exhibition performances in Hollywood, Henie was given a long-term contract from Twentieth-Century Fox. In each of her Fox films, choreographed for her by Harry Losee, she had one dance number and three or four ballets on ice. In her first films, *One in a Million* (1937), *Happy Landing* (1938), and *My Lucky Star* (1938), the routines were filmed as if they were on a proscenium stage, with cameras replacing the audience. Later, however, they seemed like imitations of Busby Berkeley or Sammy Lee routines, filmed from overhead, as in *Sun Valley Serenade* (1941).

Henie sponsored and starred in a series of live shows called the *Hollywood Ice Revue* (c.1938-1946). The first three were staged by Losee, but her other dance directors included Leon Leonidoff and the great ballet choreographer, Catherine Littlefield. She frequently used classical ballets as the basis of ice dance routines, performing the *Dying Swan* in competition and exhibition in the mid-1930s and commissioning a version of *Les Sylphides* for her *Hollywood Ice Revue* of 1940.

During the 1980 Olympics, a *New York Times* poll of skaters and coaches affirmed Henie's continuing place in the annals of skating and ice dancing (now considered separate sports). She introduced most of America to the artistic and athletic possibilities of ice ballet.

Henry, Louis, French nineteenth-century ballet dancer and choreographer; born Louis Henri Bonnachon March 7, 1784 in Versailles; died November 4, 1836 in, or on the way to, Milan. Pierre Gardel sponsored Henry's training at the School of the Paris Opéra where he studied with Jacques-François Deshayes. Although Henry made his Opéra debut in 1803 and choreographed the ballet, *L'Amour à Cythère,* there shortly thereafter, most of his professional life was spent commuting between the Théâtre de la Porte-Saint-Martin in Paris (1806-c.1808,

1814-1816, c.1828-1830) and Milan's Teatro alla Scala, with short tenures at carnival theaters in Naples and Vienna.

Henry's ballets for the Théâtre de la Porte-Saint-Martin, where he performed and shared ballet master status with Eugène Hus, followed that company's traditional range from Italian-style *commedia* pantomimes to characterizational extravaganzas; over his various tenures, works included *Les Sauvages de la Floride* (1807), *Hamlet* (1816), *Le Sacrifice Indien, ou la Veuve de Malabar* (1822), and *Le Fortune Vient en Dormant* (1827). Works created for La Scala include *Otello* (1808), a *La Silfide* (1823) that preceded Taglioni's by nine years, and *Chao-Kang* (1820), a Chinese spectacular ballet that was restaged for Paris' floating Théâtre Nautique in 1834 during his tenure as ballet master there. Henry died of cholera shortly after returning to the Paris Opéra as the choreographer of a vehicle commissioned for Fanny Elssler, *L'Ile de Pirates* (1835).

Works Choreographed: CONCERT WORKS: *L'Amour à Cythère* (1804); *Deux Petits Savoyards* (1807); *Les Sauvages de la Floride* (1807); *Otello* (1808); *Hamlet* (1816); *Samson* (1816); *Le Chateau Infernal* (1817); *Chao-Kang* (1820); *Le Sacrifice Indien, ou la Veuve de Malabar* (1822); *Agnès et Fitz-Henry* (1822); *La Silfide* (1823); *Le Fortune Vient en Dormant* (1827); *William Tell* (1833); *Les Ondines* (1834); *Guillaume Tell* (1834, revival of above ballet to a different score, for the Théâtre Nautique); *La Dernière heure d'un Colonel* (1834); *L'Ile de Pirates* (1835).

Henry, Pierre, French composer; born December 9, 1927. A pioneer of the French atonal and electronic music genre (called "musique concrète"), he has worked frequently in collaboration with Maurice Béjart, creating scores for the Ballet du XXième Siècle. Among these are *Symphonie pour un Homme seul* (1955), *Le Voyage en Coeur d'Enfant* (1955), *Haut Voltage* (1956, in collaboration with Marius Conatant), *Orphée* (1958), *La Tentation de Saint-Antoine* (1967), *Messe pour le Temps Présent* (1967), *Nijinsky, Clown of God* (1971), and *Variations pour une Porte et un Soupir* (1965). The first and last works on the list above have also been choreographed by others, most notably Merce Cunningham's work on the former (1952, frequently per-

formed now without musical accompaniment) and George Balanchine's on the latter in 1974.

Henze, Hans Werner, German composer; born July 1, 1926 in Gütersloh, Westphalia. Henze was trained in the twelve-tone system in postwar Germany but also composes in a lyrical tonality and in the aleatoric form associated with American postmodern dance. Most of the dance uses of his scores have been by choreographers working in Western Europe, among them his *Third Symphony* (1950), staged by Peter Van Dyk, Erich Walter, and Glen Tetley, *Der Idiot* (1952) for Tatiane Gsovsky, *Undine* (1957) for Frederick Ashton a year later, *Tancredi* (1964) for Victor Gsovsky, and *Tristan,* which Tetley did in Paris in 1974. His music has also been heard in dance works by American traditional modern dancers, among them Marie Marchowsky's *Essay on Pigs* and Joan Lombardi's *Departure.*

Herbert, Victor, Irish-born American composer of the early twentieth century; born 1859 in Dublin; died 1924 in New York City. Originally a cellist, Herbert performed in major orchestras in Germany and Ireland before emigrating to the United States in 1886. He served as principal cellist of the Metropolitan Opera orchestra and began to write in the popular operetta format, beginning with *Prince Ananais* (1894). Two of his operettas, *Naughty Marietta* (1910) and *Sweethearts* (1913), are among the most popular in that genre in both the United States and Europe where they are regarded as stepchildren of Lehar and Kalman. Interestingly, both works were choreographed by dancers associated with the Metropolitan Opera—*Marietta* by resident ballet master Pauline Verhoeven (for years, director of the Met's children ballet) and *Sweethearts* by Charles Morgan. The operetta revivals of the 1940s in both live performance and Jeanette MacDonald/Nelson Eddy films added to the longevity of these two works. His serious operas, *Natoma* (1911) and *Madeleine* (1914), were less successful although orchestral interludes from the former are still played frequently. Herbert also wrote songs for theatrical productions of Florenz Ziegfeld, Jr. and Ned Wayburn, among them their famous Century Theater revues. His chauvinistic "When Uncle Sam Is the Ruler of the Waves" for the prewar *Century Girl* (1916), for example, accompanied a typical Wayburn tap march by squadrons of female chorus dancers on a revolving staircase. Although he will undoubtedly be remembered for the glorious "Ah, Sweet Mystery of Life," it is a mistake to ignore Herbert's more conventional, much danced to, work for the American stage.

Herget, Robert, American theatrical dancer and choreographer; born c.mid-1920s in Crete, Nebraska; died June 8, 1981 in New York City. Herget studied with Charles Weidman in New York and attended the Royal Academy of Dramatic Arts in London, where he made his professional debut in a production of *The Time of Your Life.* He danced on Broadway in Agnes De Mille's *Allegro* (1947), Jerome Robbins' *High Button Shoes* (1947), and *Lend an Ear* (1948), and on television in the *Arthur Murray* and *Kate Smith Shows,* the *Colgate Comedy Hour,* and *Your Hit Parade,* before becoming known as a choreographer himself. Like so many of his colleagues, he first staged musical numbers for shows on which he was a staff dancer, most notably *Your Hit Parade* and the *Colgate Comedy Hour.* Among the many other shows taped in New York for which he choreographed were *The Perry Como Show* (CBS, 1950–1955, intermittent episodes), *The Steve Allen Show* (NBC, 1956–1961), and occasional *Ed Sullivan Shows,* as well as specials ranging from Yves Montand's television debut to the *25th Annual Tony Awards* in 1971.

Herget's Broadway credits ranged primarily in the late 1950s and early 1960s and included incidental dances for Sean O'Casey plays to musicals like *Happy Hunting* (1956), *Mr. Wonderful* (1956), *A Family Affair* (1962), and *Something More* (1964). His best remembered individual number was unquestionably "The New-Fangled Tango" from *Happy Hunting* for which he staged a wild tango for fingers only on an overcrowded stage. He began to work more frequently in the nontraditional forms of theater in the 1970s and became famous again as an industrial and beauty pageant choreographer.

Works Choreographed: THEATER WORKS: *Happy Hunting* (1956); *Mr. Wonderful* (1956); *A Family Affair* (1962); *O'Casey Double Bill (Figuro in the Night, The Moon Shines on Kylenamoe)* (1962);

Something More (1964); industrials; beauty pageants.

TELEVISION: *Your Hit Parade* (NBC, 1950, individual episodes); *The Perry Como Show* (CBS, 1953–1955); *The Steve Allen Show* (NBC, 1956–1961); *The Ed Sullivan Show* (CBS, 1960s, occasional episodes); *25th Anniversary Tony Award Ceremonies* (CBS, 1971); *Rachel, La Cubana* (PBS, 1977, special).

Herko, Fred, American early postmodern dancer and choreographer; born c.1935 in Fredonia, New York; died October 27, 1964 in New York City. It is hard to describe Herko's career—it ended too quickly to make sense out of its ragged ends. He was basically a freelance avant-gardist, an actor involved with Off Broadway theater productions who became a member of the most influential dance composition experiments of the recent era.

In the late 1950s, Herko worked with the traditional modern dance choreographers on theatrical projects, performing in Glen Tetley's segment of *Ballet Ballads* (1960) and in Ray Harrison's *Come Play with Me* and *Little Mary Sunshine*. At the same time, however, he was involved with Diane Di Prima and the Café Cino. He also worked with the Living Theatre and began to participate in a choreography workshop led in the Theatre's building by James Waring. He became a member of the Waring Company, performing in his *Landscape* (1959), *Extravaganza* (1959), *Dromenon* and *Dithyramb* (both 1961), and *Dances Before the Wall* (1958).

Through Waring, he became a member of the Judson group, the offshoot of the Waring classes and those led by Robert Dunn. He choreographed works for Judson concerts from 1962 to 1964, creating *Like Most People, Binghamton Birdie, Villanelle,* and *The Palace of the Dragon Prince,* among others. Many members of the group created parts for him in their pieces, among them, Elaine Summers, Arleen Rothlein, and Deborah Hay, who cast him in *All Day Dance* (1963) and co-choreographed *Elephant Footsteps in the Cheesecake* with him. He still performed for Waring as well, with a memorable appearance in his *Poet's Vaudeville.*

Herko committed suicide in October 1964. The memorial concert that the Judson group staged for him marked the end of the first era of postmodernism, but inspired the next decade of experimentation.

Works Choreographed: CONCERT WORKS: *Essence of Rope* (1960); *Edge* (1962); *Once or Twice a Week I Put On Sneakers to Go Uptown* (1962); *Like Most People* (1962); *Binghamton Birdie* (1963); *Elephant Footsteps in the Cheesecake* (1963, co-choreographed with Deborah Hay); *Villanelle* (1964); *Eine Kleine Nachtmusik* (1965, posthumous).

Hernandez, Amelia, Mexican dancer, choreographer and administrator; born c.1930 in Mexico City. Hernandez studied ballet and German modern dance in Mexico City and continued her training in native dance and folklore at a Campesina (a worker's cultural encampment). She taught at the National Institute of Fine Arts but left the security of that organization to form her own folklore company. The Ballet Folklorico de Mexico is now the best known company in her native country with its own theater and school and a following in almost every city in the world. Hernandez, as director and producer of the company's repertory, generally does not list choreography credits, and arranges the steps, costumes, and accompaniment for the enormous number of works performed by her troupe.

Hérold, Louis-Joseph-Ferdinand, French nineteenth-century composer; born January 28, 1791 in Paris; died January 19, 1833 in Ternes, France. Hérold was attached to the Paris Opéra and Opéra-Comique through much of his career. He is best known for the many operas that he composed alone and in cooperation with Boieldieu and Aumer for production in the 1820s and 1830s, and for the ballets that he wrote for Jean Aumer. These scores included *Astolphe et Joconde* (1827), *La Somnambula* (1827), *Lydie* (1828), *La Fille Mal Gardée* (1828), and *La Belle au Bois Dormant* (1829).

Hertel, Peter Ludwig, Prussian nineteenth-century composer; born April 21, 1817 in Berlin; died there June 13, 1899. Hertel served the Berlin Court Opera as court composer and conductor from 1858 until shortly before his death. To dance historians, he is best known for his collaborations with Paul Taglioni on *Flik und Flak* (1858), *Sardanapol* (1865), and

Fantasca (1869), and for his arrangements for the 1864 *La Fille Mal Gardée,* many of which have been assimilated into the current editions of that score.

Hess, Sally, American modern dancer and choreographer; born March 25, 1942 in New York. Hess began her dance studies with Doris Humphrey at the 92nd Street YM-YWHA and performed the child's part in her *Day on Earth* with the José Limón company in 1952. Hess danced with the Lucas Hoving troupe in the early 1960s and performed with Ernestine Stodelle in New Haven, but she dropped out of dance for a few years before joining the Dan Wagoner troupe in 1970. Among the many Wagoner works in which she performed during those important years in his choreographic history were *A Play with Images and Walls* (1979), *Songs* (1977), *Summer Rambo, Westwork* (1972), and her favorite *Variations on "Yonker Dingle."* Hess has been choreographing since leaving the Wagoner company in 1979, contributing works to new choreographers' programs at Dance Uptown and presenting her own recitals.

Works Choreographed: CONCERT WORKS: *Overlap* (1980); *Amadeus* (1980); *Heartsongs* (1980).

VIDEO: *A Dance for Radio* (1977, WHA-National Public Radio).

Hiatt, John, American ballet dancer; born October 5, 1939 in St. George, Utah. Hiatt was trained entirely in his home state—locally by Reynolds Johnson and in Salt Lake City by Willam Christensen. He was a charter member of Christensen's Ballet West and has appeared in most of its repertory of ballets by Christensen, Lew Christensen, and George Balanchine. Among the pieces in which he has won greatest acclaim were the elder Christensen's productions of *The Firebird, Swan Lake, The Nutcracker,* and *Coppélia,* Lew Christensen's *Con Amore,* and Balanchine's *Serenade* and *Symphony in C.* He has also been applauded in ballets by the company's current artistic director, Bruce Marks, including his *A Lark Ascending.*

Hightower, Rosella, American ballet dancer; born January 30, 1920 in Ardmore, Oklahoma. After studying in Kansas City, Missouri, Hightower continued her training in New York with Vincenzo Celli, Anatole Vilzak, and Ludmilla Schollar.

Hightower's performing career can be divided between her work in the United States, with the two rival Ballets Russes and with Ballet Theatre, and her long tenure with the Grand Ballet du Marquis de Cuevas from c.1947 to 1961. In America, she performed first with the Ballet Russe de Monte Carlo (1938–1941), with featured roles in Leonid Massine's *The New Yorker* and *Rouge et Noir.* Joining Ballet Theatre in 1941, she performed in their productions of *Petrouchka, Swan Lake* and notably in the "Bluebird pas de deux" in their one-act *Princess Aurora.* Noted for her emotionality and sensuality on stage, she performed the roles of "She Wore a Perfume" in Antony Tudor's *Dim Lustre* (1943), and appeared as one of the "Lovers-in-Experience" in his *Pillar of Fire* (1942). After touring with Massine's Ballet Russe Highlights company in 1945, she joined the Original Ballet Russe, in which she performed in Edward Caton's *Sébastien* and William Dollar's *Constantia.*

Hightower left the United States to become a principal dancer with the de Cuevas company in 1947. Apart from a single season with Ballet Theatre (1955), she remained with him until retiring from performance in 1961. She became celebrated for her performances in that company's repertory, especially in John Taras' *Persephone* and *Piège de Lumière,* and contributed four ballets herself, *Henry VIII* (1949), *Pleasuredome* (1949), *Salome* (1950), and *Scaramouche* (1951).

A noted teacher of American and European dancers, she served as director of The Center for Classical Dance in Cannes, from 1960. Artistic director of the Marseilles Opera Ballet from 1969, she was recently named to a similar position with the Ballet of the Paris Opéra.

Works Choreographed: CONCERT WORKS: *Henry VIII* (1949); *Pleasuredome* (1949); *Salome* (1950); *Scaramouche* (1951).

Hilding, Jerel, American ballet dancer; born c.1955 in New Orleans, Louisiana. Hilding was trained by Lelia Haller and danced in her New Orleans Opera Ballet. His later studies included classes with Joseph Giacobbe and Jonathan Watts, director of the Jof-

frey II company. He became a member of the City Center Joffrey Ballet in 1975. Among his many roles with the senior company are "The Head Wrangler" in Agnes De Mille's *Rodeo,* the "Manager from New York" in the revival of Massine's *Parade,* and parts in John Cranko's *Jeu de Cartes,* Anna Sokolow's *Opus '65,* Moses Pendleton's *Relâche* (1980), and Gerald Arpino's *Trinity, Olympics,* and *Celebrations* (1980).

Hill, Martha, American modern dancer and teacher; born in Palestine, Ohio. Trained at the Teachers' College of Columbia University and New York University, she continued her dance studies with Martha Graham and at the Dalcroze School in New York. She performed with the Graham troupe before taking the first of many major teaching assignments, training dancers and arranging a festival at Kansas State Teachers' College. After serving in similar capacities at the University of Chicago, the University of Oregon, and the Lincoln's School, she became director of the Bennington School of the Dance (summers, 1934-1939), the first recognition of modern dance as a separate art form that could include disparate techniques. She also taught at Bennington during the conventional college sessions and at New York University.

In 1948 she became founding director of the descendent and heir to Bennington as a summer school, the American Dance Festival, then at Connecticut College, serving there until the mid-1960s. She was founding chairperson of the dance department of the Juilliard School and has remained in that position since 1951.

In her three major directorships—Bennington, the Dance Festival, and Juilliard—she has taught and influenced a good half of the participants in the traditional modern dance movement and many postmodernists. Her presence at a dance concert augers that at least performer or choreographer attended one of her schools, and she appears at hundreds of recitals each year.

Hill, Thelma, American ballet and modern dancer and celebrated teacher; born 1925 in New York; died there November 21, 1977. She was trained in tap work by Mary Brown and in ballet at the school of the Metropolitan Opera Ballet. A member of the Negro Ballet (aka Ballet Americana), she was also a modern dancer of renown, working with Alvin Ailey on many of his Broadway projects, and creating a role in the "Wading in the Water" section of *Revelations* (1960).

A founder of the Clark Center for Performing Arts, a foremost school of modern and theatrical dance in Manhattan, she was considered one of the best and most supportive teachers in New York. She also taught at the City College and Lehman College of the City University of New York. After her tragic death from smoke inhalation, she was memorialized in a series of benefit concerts and scholarship programs. The Thelma Hill Performing Arts Center in Brooklyn has become one of the most important cultural centers in that borough.

Hill Sagan, Gene, American ballet and modern dancer and choreographer, also working in Europe and Israel; born September 28, 1936 in Emporia, Virginia. Hill Sagan was trained by Michael Brigante at the Ballet Theatre School, and by Alfredo Corvino. He made his debut with the First Negro Classical Ballet in 1959. He continued to perform with unfortunately short-lived and ad hoc troupes in the New York area touring in the early 1960s, among them, Louis Johnson's concert group, the Puerto Rican Ballet, the American Festival Ballet and the recital company of Carmen De Lavallade and Geoffrey Holder.

After working in jazz troupes in Stockholm, Cologne, and Munich, he moved to Israel where he has become known as one of the country's most innovative and popular choreographers. His works for the Bat-sheva company and the Israel Classical Ballet combine classical techniques with an expressive, emotional vocabulary that delights the nation's multilingual, widespread audience. Hill Sagan has returned to the United States occasionally to stage works for the Alvin Ailey American Dance Theatre.

Works Choreographed: CONCERT WORKS: *Im Dunkeln Bluht der Blasse Lotus* (In the Mysterious Blossom of the Pale Lotus) (1971); *And After . . .* (1974); *The Burning Ground* (1975); *The Garden of Kali* (1977); *Sweet Agony* (1977); *Sunrise . . . Sunset* (1978); *Fire Sermon* (1979).

Hillman, George, American tap dancer; born c.1905 in Wilkes-Barre, Pennsylvania. Hillman was born into his parent's feature act and later formed a dance team with his younger brother. They were often booked on television in the 1950s and 1960s, most frequently on the *Ed Sullivan Show* (which loved tap tandem teams) and the *Steve Allen Show*. Hillman has performed Off Broadway as the Bill Robinson character in *Curley McDimple* (1967), and in many of the historical revues and anthology productions about black tap dancing and music, among them *On Toby* [T.O.B.A.] *Time, Suddenly the Music Starts, Stomping at the Savoy,* and the master-class program, *By Word of Foot.*

Hilverding Van Weven, Frantz Anton, Viennese eighteenth-century ballet dancer and choreographer; born November 1710 in Vienna; died there May 29, 1768. Born into a family of itinerant marionettists, Hilverding became a member of the ballet of the Vienna Burgtheater as an adolescent; he was sent by the company to Paris to study with Nicholas Michel Balthasare Blondi (c.1734–1736).

Returning to Vienna in 1737, he became ballet master of the court performances and of the Theater am Karntnerthor and Burgtheater. He produced many ballets, notably *La Fedelta sin alla Morte* (1742), and *Le Turc Généreux* (1758), for a company that included Eva Maria Violetti (Garrick), Charles Le Picq, and Gasparo Angiolini.

In 1759, Hilverding became ballet master of the Imperial Ballets of St. Petersburg and, briefly, Moscow. Remaining in Russia until 1764, he introduced the innovation of the *ballet d'action* style of choreography with his works *Amour et Psyche* (1762), *Pygmalion, ou la Statue Animée* (1763), and *Acis et Galatée* (1764).

Ceding the St. Petersburg position to his protégé, Gasparo Angiolini, Hilverding returned to Vienna in 1765. Although that year was productive, with three major works including his *Triomphe de l'Amour* and *Enéa in Italia*, he soon retired from the live theater to produce pieces for puppets.

Hilverding's importance to the development of ballet technique and choreography has only recently been rediscovered, through mentions in the works of Derra de Moroda and Marian Hannah Winter.

Works Choreographed: CONCERT WORKS: *La Fedèlta sin alla Morte* (1742); *Le Turc Généreux* (1758); *La Victoire de Flore sur Borie* (1760); *L'Asile de la Vertu* (1760); *Amour et Psyche* (1762); *Le Seigneur du village moqué* (1762); *La Vengeance du Dieu et d'Amour* (1762); *Pygmalion, ou la Statue animée* (1763); *Apollon et Daphné, ou le Retour d'Apollon au Parnasse* (1763); *Le Retour de la Déese du Printemps* (1763); *The Isle of Fools* (1763, originally performed in Russian—exact title unavailable); *Acis et Galatée* (1764); *Le Chevalier Seul* (1764); *Le Triomphe de L'Amour* (1765); *Les Amans Protèges* (1765); *Enéa in Italia* (1765).

Hindemith, Paul, German composer; born November 16, 1895 in Hanau; died December 28, 1958 in Frankfurt. Although Hindemith did a commissioned score as early as 1925 for Oskar Schlemmer's *Traidic Ballett* (1926) at the Bauhaus, he did more of his work specifically for choreographers in the late 1930s and 1940s. His most publicized score was *Nobilissima Visione* for Leonid Massine (1938), but that ballet is no longer in active repertory and the score has not been recorded. Currently, his music for George Balanchine's *Four Temperaments* (1946) and Martha Graham's *Herodiade* (1944) are in active repertories of both dance companies and orchestras. Balanchine has also staged ballets to his *Metamorphoses* (1952) and *Kammermusik No. 2* (1979). Among the other ballets created on existing Hindemith scores are Hans van Manen's *Five Sketches* (1966), Laverne Meyer's *Sextet* (1964), and Benjamin Harkavy's *Azwingto* (1969).

Hines, Elizabeth, American theatrical dancer; born c.1900 in New York City; died February 10, 1976. Hines was trained by Carl Hemmer and toured with him in *Mollie O* and *Oh, Boy*. A protégé of George M. Cohan, she made her first successes in his *The O'Brien Girl* (1921) and *Little Nellie Kelly* (1922) and went on to appear in ingenue roles in many of the most successful musical comedies on Broadway, including Dave Bennett's *Marjorie* (1924), *Peg O' My Heart* (1924), *Show Boat* (1926), and *Manhattan Mary* (1927). Except for the Jerome Kern operetta, Hines' musicals all gave her the opportunity to do theatricalized social dances as a series of Cinderellas,

playing working girls who found success and love through their innate decency and beauty. She retired in 1927.

Hines, Gregory, American tap dancer; born c.1945 in New York City. Trained by Henry Le Tang throughout his career, he made his performance debut with his older brother Maurice in the act, The Hines Kids. With their father along as Hines, Hines and Dad, they performed throughout the country until 1973. Although their only Broadway appearance was in *The Girl in Pink Tights*, with the younger team sharing the stage with Coles and Atkins, they were seen frequently on New York live television shows, most successfully on the *Ed Sullivan Show*.

Hines did not dance in the years between the dissolution of the act and his return to theater in 1978, but instead worked as a song writer and rock musician. He was cast in *The Last Minstrel Show* (1978), which did not live to reach Broadway, and was reunited with his brother in *Eubie* (1978), a tribute to composer Eubie Blake. His popularity was instant and overwhelming; his tapping was marvelous, of course, but his presentation made it special. He is an introverted tapper, who does not seem to make contact with the audience until he breaks through his concentration to reach out and grab the viewers. His style seems to involve controlled legs and torso—"hot feet," as Blake put it—but totally relaxed hands that flop without tension during his solos. When he danced with his brother, many members of the audience who remembered their tandem work on television were astounded to see how different their dance styles are now.

Following that show, for which he was nominated for a Tony award, he has starred in two Broadway productions—*Comin' Uptown* (1979), in which he played a landlord Scrooge, and *Sophisticated Ladies* (1981, delayed opening), a revue based on the music of Duke Ellington and Billy Strayhorn. Although the *Christmas Carol* update showed that he could handle lines and plots, he has become the foremost revue performer of the 1980s with his appearances in these musical tributes.

Hines, Johnny, American eccentric dancer and film actor; born c.1898 in Golden, Colorado; died October, 1970 in Hollywood, California. Hines was raised in Pittsburgh where he began his vaudeville career. He did his eccentric dances in the Keith and Orpheum circuits for almost ten years, becoming famous around the country as the man who would kick highest, furthest, and wildest in the "legomania" style of the 1910s. Between tours, he performed on Broadway in straight plays, including William Gillette's original *Sherlock Holmes*, and musicals such as George M. Cohan's *The Little Millionaire* (1911) and *The Firefly* (1912). Like most eccentric dancers, Hines was also a talented comedian and, after a long series of short films based on the popular fictional character, "Torchy," he dropped out of dance to become a star comic for First National Films. Hines averaged three films a year until the mid-1930s when he became better known as a director, writer, and producer.

Hines, Maurice, American tap dancer; born c.1947 in New York City. A professional dancer since he was five, Hines was trained by Henry Le Tang in New York. He toured with his brother, Gregory, in The Hines Kids, and with Gregory and their father, Maurice, in Hines, Hines and Dad. On Broadway in *The Girl in Pink Tights* (1954), and on television in performances on almost every variety show, including yearly on the *Ed Sullivan Show*, they danced together in impressive tap routines and extraordinary double tumbling tricks.

When the act dissolved in 1973, he began to work toward a career in what used to be called "legitimate theater," in plays and dramatic works. He took some musical parts, however, among them "Nathan Detroit" in the national company of *Guys and Dolls*, and was reunited with his brother in the revue, *Eubie* (1978), to the music of Eubie Blake. The younger Hines has been described as the ideal Broadway leading man—he can sing beautifully, speak lines, dance, and appeal to an audience. In *Eubie,* he had a tap solo, "You Got to Get the Getting While the Getting's Good," a duet with his brother to "High Steppin' Days," and a snake-hips twisting trio with his brother and Lonnie McNeil. He also took the vocal solos in many Blake tunes, among them his best remembered "I'm Just Wild About Harry." Obviously wild about Blake, he has appeared with the veteran

songwriter very frequently in past seasons—socially, in concert, and in further tributes to him.

Since leaving the show, he has returned to other areas of the theater, presenting a successful cabaret act and creating shows as well as performing in them.

Hines, Ross, American eccentric dancer; born December 10, 1899 in Oakland, California. Hines followed nineteenth-century tradition by growing up in a traveling *Uncle Tom's Cabin* show but, in his case, he defied the conventional route of a popular entertainer by switching to the very modern *Topsy and Eva*, written by its stars Vivian and Rosetta Duncan in 1923. He served that troupe as stage manager and dance specialty performer in blackface for two years. His specialty dance involved eccentric tap work performed at speeds ranging from superfast to a slow motion in imitation of film technique. After working on the Paramount/Publix circuit in theaters between Chicago and New York, he enjoyed a successful three seasons on Broadway in the *Ziegfeld's American Revue* (1926, the year in which the impresario had lost the exclusive rights to his own name and the title *Follies*), the *Ziegfeld Follies of 1927*, and the musical comedy *Here's Howe* (1928). In the latter, he worked with a partner for the first time in a celebrated role reversal Apache dance with Betty Chamberlin. In that specialty number, she seduced him and tossed him around the stage in a carefully controlled choreographed mayhem. The dance was so successful that they lifted it from the show's context and performed it in club bookings around the world, most notably in the Kit Kat Club in London and Paris' Café des Ambassadeurs. Hines and Chamberlin returned to the United States in the early 1930s to work on the Radio-Keith-Orpheum circuit of Prolog, presentation, and vaudeville houses under what seems to have been an exclusive contract. They presented their reverse Apache on each program along with her specialties in tap and acrobatic ballet, and his eccentric legomania routine with its high kicks and pace manipulations.

Hinkson, Mary, American modern dancer and choreographer; born 1930 in Philadelphia, Pennsylvania. After attending the University of Wisconsin,

Hinkson moved to New York to study with Martha Graham. She performed with the Graham company for many years after 1951, creating roles in her *Ardent Song* (1955), *Acrobats of God* (1960), *Samson Agonistes* (1962), and *Phaedra* (1969), and dancing in *El Penitente*, and *Deaths and Entrances*. Her best remembered role in the repertory was "Circe" in the work of the same name, created for her in 1963.

Hinkson has guested with the companies of many choreographers. Among other works in which she performed as a guest artist are Pearl Lang's *Chosen One* (1952), Donald McKayle's *Rainbow 'Round My Shoulder* (1959), John Butler's *Carmina Burana* (1966), Glen Tetley's *Ricercare* (1966), George Balanchine's *Figure in the Carpet* (1960), and Anna Sokolow's 1975 production of *Seven Deadly Sins* as "The Dance Anna."

She taught at the Graham school since 1951, and at Julliard and the Dance Theatre of Harlem.

Works Choreographed: CONCERT WORKS: *Make the Heart Show* (1951).

Hinton, Paula, English ballet dancer; born 1924 in Ilford. After early training with Hilda Delamare Wright, she continued her studies in London with Stanislav Idzikowsky and Audrey de Vos. She performed as "Helen of Troy" in Andrée Howard's production of *Doctor Faustus* for the Liverpool Playhouse, and won a recommendation to the Ballet Rambert. A member of that company from 1944, she began a long professional and personal association with Walter Gore, in whose *Winter Night, Antonio, Plaisance*, and *Kaleidoscope* she performed. She danced in a large number of companies from 1950 to 1969 (when she retired), among them, the London Festival Ballet (1951), the Original Ballet Russe (1952), Ballets des Champs-Elysées (1952), Walter Gore Ballet (1954), Frankfurt Municipal Opera House (1956), Edinburgh Festival Ballet (1958), London Ballet (1961), and Gulbekian Ballet (1965–1969), performing in Gore's ballets in each.

Hirabayashi, Kazuko, Japanese modern dancer and choreographer working in the United States; born in Aichi, Japan. Although trained in law at the Maiji University, she moved to New York City to study modern dance at the Juilliard School. Although best

known as a choreographer and teacher, Hirabayashi had a short career in performance with the Martha Graham company (1964) and with the Triad Theater, which she co-founded with Richard Gain and Richard Kuch in 1965. Hirabayashi's choreographic output has been created for her own company, and for her students at Juilliard (1968 to present), the State University's arts campus at Purchase, New York (1972), and more than a score of company or university assignments in the United States, Canada, Mexico, Japan, and Israel. Her intimate pieces for her own troupe and the large-scale works for Juilliard and Purchase student companies are unified by her sense of lyricism and contain gestures that illuminate individual movements, rhythms, and staged patterns.

Works Choreographed: CONCERT WORKS: *In a Dark Grove* (1964); *Water Current* (1971); *Masks* (1971); *The Stone Garden* (1971); *Untitled* (1971); *Legend* (1972); *Suite No. 1* (1972); *Black Angels* (1973); *Triste* (1973); *Night of the Four* (1974); *Moons with Lone Shadow* (1974); *The Crimson Lotus* (1974); *Duet* (1974); *Nympheas* (1975); *Silence* (1974); *Masks of Night* (1975); *Nowhere But Light* (1976); *Concerto* (1977); *Echoes* (1977); *Rounds* (1977); *Farewell* (1977); *Dark Star* (1978); *Goodbye, Porkpie* (1978); *Hat* (1978); *In a Mast* (1979); *Kurozuka* (1979); *Ebb* (1979); *Darkening Green* (1980).

Hitchins, Aubrey, English ballet dancer teaching in the United States after 1940; born c.1903 or 1906 in Cheltenham, England; died December 14, 1969 in New York City. Trained by Nicholas Legat, Lubov Egorova, and Enrico Cecchetti, he performed in Mikhail Fokine's incidental dances for *Hassan* in 1922. He was a member of Anna Pavlova's touring company from 1925 to 1930, partnering her in *Autumn Leaves*, and the *Gavotte Pavlova*. After her death, he assisted in the construction and editing of the film, *The Immortal Swan*.

Between her death in 1931 and his emigration to the United States in 1940, he performed with a series of touring troupes—The Chauve-Souris, Boris Romanoff's Romantic Ballet, the Monte Carlo Opera Ballet, and the company at the Théâtre Municipale de Caen, for which he staged *Coppélia* and *Carmen* (both 1938). He danced at the Metropolitan Opera in New York under Laurent Novikoff from 1940 to 1944, retiring from performance to open a dance studio. Returning to the Met as ballet master in 1948, he also taught at the June Taylor School and at Jacob's Pillow. In 1954, he created the Negro Dance Theatre, a short-lived company for which he choreographed. At his death in 1969, he was associated with the scholarship programs of the Harkness Ballet.

Works Choreographed: CONCERT WORKS: *Coppélia* (1938); *Carmen* (1938); *Etude Chorégraphic* (1950); *Italian Concerto* (1954).

Hobi, Frank, American ballet dancer; born 1923 in Aberdeen, Washington; died September 24, 1967 in Seattle. Trained originally by Mary Ann Wells in Seattle, Hobi moved to New York to continue his training at the School of American Ballet. Between 1941 and 1956, Hobi performed in turn with Ballet Theatre, notably in the premiere of Antony Tudor's *Pillar of Fire* in 1942, the Ballet Russe de Monte Carlo, and the New York City Ballet. In the Ballet Russe, he performed featured roles in their productions of *Swan Lake* and *Giselle* and created roles in the works of Ruthanna Boris, *Cirque de Deux* (1947) and *Quelques Fleurs* (1948). Hobi also danced in Boris' works created for the New York City Ballet, among them *Cakewalk* (1951) and *Will o' the Wisp* (1953), in the first performances of Balanchine's *La Valse* (1951), *A la Françaix* (1951), *Tyl Eulenspiegel* (1951), and *The Nutcracker* (1954), and in Jerome Robbins' *Fanfare* in 1953.

Hobi and Boris toured for two years with a concert company (c.1955–1957), in her works and classical pas de deux. After working with the Royal Winnipeg Ballet in 1957, Hobi returned to the New York City Ballet as stage manager and teacher.

Hoctor, Harriet, American theatrical ballet dancer; born 1907 in Hoosick Falls, New York; died June 9, 1977 in Arlington, Virginia. Hoctor was brought to New York at the age of twelve by her maternal aunt, Anna Kearney, who supervised her training and managed much of her performing career. She studied with Louis H. Chalif for three and a half years, and was selected to model correct ballet positions for his *Textbooks on Dance*. In 1921, she began to train with Ivan Tarasoff and remained with him through-

out her professional career. In 1922, she made her professional debut, performing in the Moth chorus of the Butterfly Ballet in *Sally* (replacement cast). For much of her career, Hoctor alternated between vaudeville tours and featured performances in Broadway shows.

Hoctor's vaudeville career began in 1922, when she joined Nelson Snow and Charles Columbus in an act involving stunt and ballroom dance, with her ballet solos; this act toured for more than a year on the Keith and Pantages circuits. In 1926, after her own signature form of acrobatic ballet had been seen on Broadway, she toured with William Holbrook in a dance act that became successful at the Palace Theater in New York, the apex of vaudeville performance. In 1930, she played the Palace with a new act, dancing with Snow and Columbus. Appearing in vaudeville and Prologs in 1933 and 1934, Hoctor toured with a twenty-women corps de ballet and symphony orchestra; her final vaudeville performances were in 1940.

After *Sally*, Hoctor always appeared on Broadway as a specialty act, a featured dance soloist in interpolated or integrated scenes. From mid-1923 until late 1925, she appeared in *Topsy and Eva* in the pants role of "Henrique;" in the Bird Dance (Act II) in that show, she introduced the backbend-on-point sequence that became her movement signature. She appeared with Holbrook in *A la Carte* (1927), and then began a long association with Albertina Rasch, whose precision dance troupe also featured acrobatic and eccentric ballet forms. She worked with Rasch in *The Three Musketeers* (1928) and *Show Girl* (1929), in which she was the featured dancer in the first ballet (Act II) set to Gershwin's *An American in Paris*. Hoctor also worked with choreographers Seymour Felix, in *Simple Simon* (1930), and George Balanchine, who created two ballets, *Words without Music* and *Night Flight*, for her to perform in the 1936 *Ziegfeld Follies*. In 1933, Hoctor appeared in *Hold Your Horses*; in this show, she received her only Broadway choreography credit, although it is believed that she at least participated in staging many of her interpolated solos in other shows.

Hoctor appeared in two films—*The Great Ziegfeld* (MGM, 1936), in which she performed a circus ballet with dogs and horses, and *Shall We Dance* (RKO, 1937), in which she partnered Fred Astaire in the final production number. She made the transition from vaudeville to cabaret work easily, appearing as "Scarlett O'Hara" in a *Gone with the Wind* ballet, at the Casa Manaña, Fort Worth, Texas, and as featured dancer and choreographer for Billy Rose's Diamond Horseshoe nightclub from 1940 to her retirement from the stage in 1945. Hoctor then taught ballet in Boston until the late 1960s.

It is important to remember that although Hoctor is now considered a symbol of acrobatic ballet of the 1920s and 30s, she was thought of as a talented, fully trained classical ballet technician by her contemporaries. Hoctor was twice voted "Prima Ballerina" in *Dance Magazine's* "All-American" poll, in 1928 and 1929.

Works Choreographed: THEATER WORKS: Flea Circus Ballet and Ballet at the Casino Theater from *Hold Your Horses* (1933): dances at Billy Rose's Diamond Horseshoe (c.1940–1945).

Bibliography: Cocuzza, Ginnine. "Harriet Hoctor," *Dance Scope 15*, 2; Ware, William. *Ballet Is Magic: A Triple Monograph [on] Harriet Hoctor, Paul Haakon and Patricia Bowman* (New York, 1936).

Hodes, Linda, American modern dancer and choreographer; born Linda Margolies, c.1933 in New York City. Trained at the Martha Graham school from age nine, she joined the Graham company in 1953. Performing as Linda Margolies or Linda Hodes (after her marriage to Stuart Hodes), she created roles in Graham's *Canticle for Innocent Comedians* (1952), *Seraphic Dialogues* (1955), as "Joan of Arc," *Acrobats of God* (1960), *Visionary Recital* (1961), *Phaedra* (1962), and *Embattled Gardens* (1963). As a freelancer, she performed with the companies of Paul Taylor, Glen Tetley, Norman Walker, and her then-husband, for whom she danced in *La Lupa* (1955).

After teaching extensively in the New York area, at the Graham school, and at Juilliard, the Neighborhood Playhouse, and the Harkness House, Hodes accepted positions coaching Graham techniques and her own work abroad. She taught at the Bat-sheva

Dance company in Israel, choreographing her popular *The Act* (1967), served as ballet master of the Netherlands Dance Theater (1970–1971), and rejoined the Bat-sheva as artistic co-director in 1972.

Works Choreographed: CONCERT WORKS: *Curley's Wife* (1959, title unverified); *Sphingi* (1959); *Suite for Young Dancers* (1960, co-choreographed with Stuart Hodes); *The Act* (1967).

Hodes, Stuart, American modern dancer and choreographer; born 1924 in New York City. Hodes studied ballet with Lew Christensen and Ella Dagnova and modern dance and composition at the Martha Graham school, while attending Brooklyn Technical High School. Among the many Graham works in which he performed from 1947 to 1958 are *Diversion of Angels* (1948), *Canticle for Innocent Comedians* (1952), *Ardent Song* (1953), and revivals of *Appalachian Spring, Every Soul Is a Circus,* and *Deaths and Entrances.* During company lay-offs, he danced on Broadway in Jack Cole's *Kismet* (1955) and the revival of Tamiris' *Annie Get Your Gun* in 1957.

Hodes has choreographed since 1950, presenting works in solo recitals and concerts with his then wife, Linda Margolies Hodes. Many of his pieces were created for his students at the High School of Performing Arts, the University of Utah, the Harkness Ballet, and the Juilliard School. Since 1972, he has served as chairperson of the dance department at the New York University School of the Arts, a program in performance and choreography that has produced many young creative artists, among them, Clarice Marshall, Debra Wanner, Valerie Hammer, and Rachel Lampert, who assisted him there for many years.

Works Choreographed: CONCERT WORKS: *Lyric Percussive* (1950); *Surrounding Unknown* (1950); *Drive* (1950); *Flak* (1950); *I Am Nothing* (1952); *No Heaven in Earth* (1952); *Musette for Four* (1952); *Murmur of Wings* (1952); *Reap the Whirlwind* (1953); *La Lupa* (1955); *Suite for Young Dancers* (1958, co-choreographed with Linda Margolies Hodes); *Offering and Dedication* (1959); *Folk Dances of Three Mythical Lands* (1959); *The Waters of Meribah* (1959); *A Good Catch* (1960); *Offering and Dedication* (1960); *Simon Says* (1960); *Salaam* (1960); *After the Teacups* (1963); *Persian Set* (1963);

The Abyss (1965); *Gymkhana* (1966); *Akimbo* (1967); *A Music of Sighs* (1967); *Persian Gymnasts* (1967); *Breugelesque* (1967); *Prima Sera* (1968); *Zig Zag* (1968); *Hocus Pocus* (1969); *Responsive Readings* (1969); *Bird of Yearning* (1969); *We* (1970); *Hear Us O Lord, From Heaven Thy Dwelling Place* (1970); *Conversation Piece* (1970); *Vocalise* (1970); *Audio-Visual* (1970); *Dance for Film/Whale/Trip* (1970); *The Honor of Your Presence is Requested* (1971); *Trace* (1971); *A Dancing Machine* (1971); *Voice Over* (1972); *I Think I Can Express* (1972); *Beggar's Dance* (1973); *A Game of Silence* (1973); *Transit Gloria* (1973); *Boedromion* (1974); *Domaine* (1974); *Bolder and Bolder* (1975); *Minutaie* (c.1980).

FILM: *Voices* (MGM, 1979).

Hoey, Iris, English dancer and musical comedy actress; born July 17, 1885 in London; died there May, 1975. An enormously popular musical comedy ingenue, Hoey danced and sang in the chorus of *The Darling of the Gods* (1903), and grew up from a "Sprite" in the 1904 premiere of *The Tempest* production to "Ariel" at its closing night. She appeared in many productions of The Gaity Theatre, including the 1906 *Geisha Girl,* and in a large number of musical comedies, including the London cast of *Oh! Oh! Delphine* (1913), *The Pearl Girl* (1913), and *Mr. Manhattan* (1916). Although she remained active in the theater until the mid-1950s, appearing in almost one hundred productions, she did few shows involving dance after the 1918 revue, *More,* but instead took straight comedy roles.

Hoff, Steven-Jan, Dutch ballet dancer and choreographer working in the United States; born June 24, 1943 in Hilversum, The Netherlands. Hoff was trained at the Academy of Dance in Amsterdam before joining the Cologne Opera Ballet in which he performed in works by John Cranko, Maurice Béjart, Harald Lander, and Leonid Massine. He moved to the United States in 1965 with a grant to study at the School of American Ballet in New York and has worked in the area ever since. As a member of the American Ballet Theatre from 1966 to 1971, he was cast in the works of Antony Tudor, including his *Undertow* and *Echoing of Trumpets,* Agnes De

Mille, Mikhail Fokine, Jerome Robbins, and Eliot Feld. Like Feld, he participated in the company's Rockefeller Foundation choreographer-in-residence program, and created *Lilting Fate* for the troupe in 1969.

Since leaving Ballet Theatre in 1971, he has taught in the New York area and has choreographed. From 1971 to 1974, he served as director of The Film and Dance Theater, a group of live performers who worked with innovative lighting and film effects. He has also created more conventional works for small ballet companies and is considered one of the finest ad hoc pas-de-deux choreographers around. His works have been seen in a number of galas and short-lived touring companies, including the Stars of the American Ballet and the Baryshnikov on Tour troupes.

Works Choreographed: CONCERT WORKS: *Lilting Fate* (1969); *In Between* (1971); *Modulations* (1971); *Space Bird* (1971); *In Black and White* (1972); *A Bench in June* (1973); *Tratto* (1973); *Distant Illusion* (1973); *Al* (1974); *Impromptu* (1978); *Airs of Spring* (1978); *Reger Pas de Deux* (1979); *Salome* (1979); *The Rendezvous* (1980); *A Strauss Festival* (1980).

Hoff, Vanda, American theatrical and interpretive dancer; born. c.1900. Although Hoff is best remembered for her unlikely name and as the first Mrs. Paul Whiteman, she was a successful specialty dancer in the late 1910s and early 1920s. She was equally adept in a variety of dance styles, ranging from interpretive to exotic, and easily able to hold a Broadway, vaudeville, or Prolog stage alone. Her best remembered appearances, apart from those with the Whiteman Orchestra, were in Ned Wayburn's *Two Little Girls in Blue* (1921) and the *Ziegfeld Follies of 1922* (not the entire run). In the latter, she simply did her Oriental dance within the context of a multispecialty procession but in the former, she was required to work alone on stage and to represent the entire Mediterranean culture. As a soloist, she was put into even greater prominence in that show since it starred The (female) Fairbanks Twins, the eccentric team of Evelyn Law and Jack Donahue, and The (male) Towson Twins. Hoff performed in nightclubs in New York, Chicago, and London with Whiteman, but was un-able to revive her solo career when their marriage broke up.

Hoffmann, Gertrude, American vaudeville dancer, Broadway and precision line choreographer, and actress; born Kitty Hayes c.1886 in San Francisco, California; died October 21, 1966 in the Los Angeles area. Hoffmann received her only formal dance training from Mme. Mindel Dreyfuss. She performed with local opera companies, among them The Tivoli, the Grand, and the Castle Square, toured with Olga Nethersole's *Sappho* (as a Spanish dancer) and danced in Eddie Foy's *Topsy Turvey* before leaving the Bay area to become a specialty dancer and producing stage manager with the original Bijou Comedy Company in its tour of the South. Her New York debut came in the musical play, *The Night of the Fourth* (by George Ade, 1901). That show, in which she may have also performed in San Francisco in 1900, featured a popular ragtime score by a Viennese immigrant conductor/composer, "Baron" Max Hoffmann, whom she married shortly after the two-week run ended.

Hoffmann was one of the first vaudeville dancers to become a choreographer in this century. Since she and Ada Overton Walker each worked on vaudeville pre-productions of their New York debuts, it is impossible to know which one created her dances first and qualified as first female dance director. For five years, Hoffmann was one of the most prolific dance directors of vaudeville acts and shows for New York's roof garden theaters and cabarets, most notably those managed by Oscar and William Hammerstein. Her first known Broadway solo choreography credit was for the Hammersteins' *Punch and Judy* (1903) for the Paradise Garden Roof Theater, which included a chorus of sixty women. Other shows of the period included *Me, Him and I* (1904), *Mollie Moonshine* (1905) for Marie Cahill, *Everybody Worked but Father* (1906), and the Anna Held vehicle, *The Parisian Model* (1906), for which she staged the first verified human xylophone act, in which, as a contemporary critic said "a whole row of girls shake out a tune with bells that they wear and then lie on their backs with their musical legs in the air, kicking out a tune."

In that show, she began her third theatrical career (the one for which she is still fondly remembered) as an imitator. That genre of vaudeville and musical comedy acts was tremendously popular in the first decades of the century for performance by men and women as their own genders or as male and female impersonators. Hoffmann was unquestionably the most popular and preeminent woman imitator and, from her satires of Eddie Foy (Sr.), Elsie Fay, George M. Cohan, and Held herself in *The Parisian Model*, to her retirement from that phase of performance in 1916, she was a headliner. For an act to be considered important, it was necessary for it to be included in the imitation acts of Hoffmann or her male (female impersonator) colleague, Julian Eltinge. Among the scores of performers whom she imitated in her acts were Eltinge (in his Gibson Girl act), Adelina Genée (in *The Soul Kiss*), Harry Lauder, Olga Nethersole, Valeska Surratt, Vesta Victoria, Hattie Williams (in *Fluffy Ruffles*), Mrs. Leslie Carter (in Belasco's *Zaza*), Eva Tanguay (who began a famous and highly remunerative feud over Hoffmann's act), George Arliss, Isadora Duncan, Alice Lloyd, Annette Kellermann, and Ruth St. Denis, of whom she created "An exact, lifelike impersonation [of *Radha*]" with music provided by "The All-Star Imperial Hindu Band." Hoffmann, who became the first female member of the Theatrical Managers' Protective Association soon after buying back her contract from the Hammersteins in 1908, considered her vaudeville imitations the prime thrust of her act, working frequently as a Hammerstein-sponsored force in the Great Vaudeville War of the first decade of the century. With the Hammersteins' blessing (and immense publicity machine), she presented imitations of acts before they were due to play at rivals' theaters, thus deflating the audience's desire to see the real thing. The first such imitation for which Hoffmann is remembered by dance historians was the celebrated impersonation of Maud Allan in *Salome* presented at Hammersteins' Paradise Garden Roof in July 1908 to forestall the Allan tour for William Morris' U.S. Amusement Co., scheduled for that fall. Hoffmann's *Salome,* which was billed as a "faithful copy of Allan's," was wildly popular in New York, where it was adored, and on tour, where it was frequently banned. It was received with enthusiastic, almost pornographic descriptions from Sam M'Kee at the *New York Telegraph,* H.T. Parker at the *Boston Herald,* and Haywood Broun in the *Morning Telegraph,* who compared her to Aubrey Beardsley but finished his review with the now classic line about packing up her costume in a handkerchief. When Hoffmann integrated her *Salome* into her own act and into revues, it was received by an earlier version of the Moral Majority. She was banned in Springfield, Massachusetts (not in Boston where Parker and the press considered her artistically valid), Cincinatti, Kansas City (Missouri *and* Kansas), and was the focus of a bill in Des Moines that made it illegal for a woman to kick to higher than 45° off the stage floor.

Her next artistic successes were produced on a larger scale but were considered a part of her imitation genre. She presented the American premiere of La Saison des Ballets Russes in 1910 in order to forestall the Diaghilev tour arranged by Oscar Hammerstein's arch rival, Otto Kahn. Although the failure of Kahn to produce a Diaghilev tour until 1916 had more to do with economics than with Hoffmann, she was for many years the only producer of the Ballet Russe repertory in the Americas. She danced in the Ida Rubinstein (mimed) roles in *Cléopâtre* and *Schéhérézade,* while the chorus of local and imported dancers did *Les Sylphides* as the curtain raiser. Although each was restaged (and possibly stolen) by Theodore Kosloff after Mikhail Fokine, there is ample evidence that Leon Bakst gave her permission to use his costume and scenery designs; he was an admirer of Hoffmann, and designed costumes for her later acts until his death. She toured with versions of her Saison des Ballets Russe until 1914, eventually integrating it into her imitation act, The Borrowed Art of Gertrude Hoffmann. She later did the same with her version of Max Reinhardt's *Sumurun,* again playing the principal mime role herself.

Her final dance-oriented career began as an outgrowth of her work with the choruses of her Broadway shows and vaudeville acts. She had staged acrobatic and diving routines for her dancers as early as 1910 and continued to do so throughout the decade as part of acts based on Annette Kellermann, Otis

Skinner's *Kismet* (which had an onstage pool), St. Denis, and Alice Lloyd. When she retired from performing herself in the late 1910s, she began a fifteen-year tenure as a precision line choreographer. The Gertrude Hoffmann Girls (more than thirty different troupes of twelve to sixteen each) used a wider variety of techniques within the precision line format than any of her contemporaries, among them single and double trapeze work, trampoline and floor acrobatics and tumbling, toe tapping, conventional tapping and rope and rigging styles (then called Spider work) that can still be seen in many circuses. They appeared in Prologs from 1922 to 1927, in Chicago-area clubs from 1924 and in Europe from 1925 to the outbreak of World War II in 1938. It has been estimated that a troupe of Gertrude Hoffmann Girls was appearing in Paris every night from 1925 to 1938. Although she occasionally set dances for Broadway or London musicals, she seemed to prefer the nightclub format which gave her routines longer slots and brought them closer to the audiences.

The Hoffmanns returned to the United States for good in 1938, followed within the year by the last of her troupes. She worked in New York for a few seasons, most notably at the Jones Beach open-air theater, but soon moved to Hollywood where her husband had found work with his fellow Broadway conductors as a studio arranger. The obviously hyperactive Hoffmann became a member of the MGM and WB stock companies and can be seen in almost fifty motion pictures in dramatic portrayals of mothers, grandmothers, housekeepers (a specialty), and nightclubbing matrons.

Hoffmann died in 1966 after a long illness. Her son, dancer/musician Max Hoffmann, Jr., had predeceased his parents by almost twenty years. A dancer, Gertrude Hoffmann Anderson, who later became a psychic and Republican National Committee member, was not related to the great dancer, choreographer, and producer.

Works Choreographed: THEATER WORKS: Productions for the Bijou Comedy Company (1901, on tour); *Punch and Judy* (1903); *Me, Him and I* (1904); *Mollie Moonshine* (1905); *Everybody Worked but Father* (1906); *The Parisian Model* (1906); *The P.M.* (1907); *Hello Everybody* (1923); *The Little Dog Laughed* (1938, London); vaudeville acts for various performers (1904–1909); The Borrowed Art of Gertrude Hoffmann (vaudeville feature act, 1905–1918); The Gertrude Hoffmann Revue (1909–1918); La Saison des Ballets Russes toured with the Hoffmann Revue (1910–1913); *Sumurun* toured with the Hoffmann Revue (1913–1915); Cabaret acts for The Gertrude Hoffmann Girls (1916–1939); Prologs for The Gertrude Hoffmann Girls (1923–1926); *Gertrude Hoffmann's Varieties* (1926–1939).

Hogan, Judith, American modern dancer; born March 14, 1940 in Lincoln, Nebraska. Hogan was trained at the Martha Graham school in New York. Before joining Graham's company, Hogan appeared in the concert groups of a number of dancer/choreographers who had themselves worked with Graham, among them Glen Tetley and Bertram Ross, for whom she performed in *Triangle* and *l'Histoire du Soldat.* As a member of the Graham troupe, she has been highly acclaimed in revivals of the classics of the 1940s, such as *Appalachian Spring* and *Letter to the World,* but has also created roles in the choreographer's later works, among them, *A Time of Snow* (1968), *Archaic Hours* (1969), *Chronique* (1974), and *Holy Jungle* (1974).

Holbrook, William, American theatrical dancer; born c.1895 in Brooklyn, New York; died August 6, 1971 in New York City. It is likely that Holbrook studied with William Pitt Rivers in Brooklyn. Holbrook's career in theater was unique since he was able to perform as a stylish and sophisticated exhibition ballroom and adagio partner and as an eccentric dancer—a combination matched only by Fred Astaire. In the *Hitchy-Koo of 1920,* he did tangos, one-steps, and glides, in full formal tails, as well as playing the forelegs of "Ethel," the period's foremost dancing horse.

Appearances in his other *Hitchy-Koos* included a ballet/adagio act with Harriet Hoctor, a beautiful dancer with exquisite classical ballet technique and an elaborately arched back, and an exhibition ballroom/adagio act with dancer/choreographer Barbara Newberry. He alternated those bookings from c.1917 to the mid-1930s, dancing with Hoctor in many of her Prolog personal appearance tours.

Holbrook staged dances for the Harvard College

Hasty Pudding shows in the 1930s, and choreographed at least two Broadway productions. He was dance director of the San Carlo Opera, an itinerant company of the 1920s, and worked with Patricia Bowman at the St. Louis Municipal Opera, a summer company. After retiring from performance, he remained on Broadway as a box office and ticket agent, living at the Lambs Club.

Works Choreographed: THEATER WORKS: *Who's Who* (1938); *Burlesque* (1946); productions for The Hasty Pudding Theatricals, Harvard College, Massachusetts.

Holden, Stanley, English character dancer; born January 27, 1928 in London. After early training as a tap dancer, he studied ballet with Marjorie Davies of the Bush-Davies School, London. After further work at the Sadler's Wells school, he joined the company in 1944, remaining with it and its successor, The Royal Ballet, until 1969.

Celebrated for his witty characterization in mime and comedy roles, Holden's repertory of parts included "Agnes, a Witch" in Andrée Howard's *Selina* (1948), "Pierrot" in John Cranko's *Harlequin in April* (1951), "Dr. Watson" in Margaret Dale's *The Great Detective* (1955), and "Mme. Simone" in Frederick Ashton's *La Fille Mal Gardée* (1960).

Since 1970, Holden has lived and taught in the Southern California area of the United States.

Holder, Christian, American ballet dancer and choreographer; born June 18, 1949 in Trinidad. Raised primarily in Trinidad, Holder traveled extensively as an adolescent with his father, Bosco Holder, and his Carribbean Dance company. While on tour and in residencies, he studied ballet at the Corona Academy State School, England, with Isabel Florence; in New York, he attended the High School of Performing Arts, also studying at the (Martha) Graham School of Contemporary Dance and at the American Ballet Center.

Holder became a member of the City Center Joffrey Company in 1966, remaining with that company until the present. He has created roles in Gerald Arpino's *Valentine* (1971), *Trinity* (1969), *Chabriesque* (1972), and *Touch Me* (1977), a solo. Other works in which he has created roles are Eliot Feld's *Jive*

(1973), Margo Sappington's *Weewis* (1971), and Michael Uthoff's *Quartet* (1968). Although best known for his work in the Arpino repertory, Holder replaced Maximillian Zomosa after his death in his dramatic roles in Joffrey's *Astarte,* and as "Death" in Kurt Jooss' *The Green Table.*

Holder has been choreographing since 1975. His works include *Five Dances* (1975), for the Joffrey Company and *Preludes for Two* (1979), for himself and Gary Chryst.

Like his father and uncle, Geoffrey, Holder is also known as a skilled costume designer; he has designed costumes for his own works and for singer Tina Turner.

Works Choreographed: CONCERT WORKS: *Five Dances* (1975, also designed costumes); *Preludes for Two* (1979, also designed costumes).

Holder, Geoffrey, Trinidanian modern dancer, choreographer, designer, and director; born August 20, 1930 in Port-of-Spain, Trinidad. Holder was trained by his brother, Bosco, and performed with his company in Trinidad. He staged three revues for the troupe, *Ballet Congo, Bal Creole,* and *Bal Negre,* before moving to New York in the early 1950s.

He performed on Broadway in *House of Flowers* (1954) and began a career as a concert dancer. Holder danced for other choreographers, notably Louis Johnson and John Butler (in whose troupe his wife, Carmen De Lavallade, was a principal), and in his own recitals. He is, however, better known currently for his theatrical work, as choreographer of *Rosalie* (1957) and *Timbuktu* (1978) and director of *The Wiz* 1975). Holder has also acted in plays and in films, notably as a Voodoo man in a James Bond thriller. He is one of the few dancers to be universally known for his commercial work, in advertisements for BWIA-Airlines and 7-Up, as "the Un-Cola man." Holder designed at least the costumes for all of his productions, if not scenery.

Works Choreographed: CONCERT WORKS: *Mal-jo* (1954); *Tobago Love* (1954); *Le Becor* (1954); *Dougla Dance* (1954); *Bele* (1955); *Banda* (1955); *To the Divine Horsemen* (1956); *Dance for Two* (1957); *Dance for Three* (1957); *The Prodigal Prince* (1957); *Danse Lorrinae* (1957); *PaPa Clown* (1959); *Yanvellou* (1959); *African Suite* (1959); *Dance for One*

(1959); *The Day of the Saints* (1959); *Yankee Dance* (1959); *Come Sunday* (1960); *Dougla Suite* (1960); *Yankee Bacchanale* (1963); *Sports Illustrated* (1963); *Suite and Light* (1967); *Bachianas Brisillias No. 5* (1967); *Pas de Deux* (1968); *Sybarites* (1968).

THEATER WORKS: *Ballet Congo* (1951); *Bal Creole* (1951); *Bal Negre* (1952); *Rosalie* (1957); *Timbuktu* (1978); cabaret and concert acts for the Supremes (1976).

Hollander, Jonathan, American modern dancer and choreographer; born June 18, 1951 in Washington, D.C. Hollander was a pianist and music student before he started taking dance classes with Eugene Loring while at the University of California at Irvine. He moved to New York City to accept a scholarship at the Merce Cunningham studio where he continued his training with Cunningham, Viola Farber, and Dan Wagoner. He has also expanded his technical studies with classes from Margaret Craske and her protégés, Diana Byer and Janet Panetta. Although he had appeared in works by Marjorie Gamso, Elaine Shipman, Twyla Tharp, and Marilyn Klaus, he gradually eased out of performance to concentrate on creating works for his Battery Dance Company. Among his best known works for live performance are *Streetmural* (1977), which is considered one of the best and most legible contemporary group works created for street performance, and the *Art of the Fugue* (1979–1980), performed with harpsichord and organ. Hollander has also worked extensively in video performance and choreography. For celebrated film maker Doris Chase, he has appeared in *Jonathan and the Rocker '76, Dance Ten* (1976), and *Fathom* (1978) and staged *Noelle* (1977) and *Emperor's New Clothes* (1977) for other performers.

Works Choreographed: CONCERT WORKS: *Waves on one Side* (1973); *Orlando* (1974); *Characters in Search of a Dance* (1975); *Camouflage* (1975); *Unmasked Ball* (1975); *Scenes in Amber* (1976); *Streetmural* (1977); *Sundial* (1978); *Slang* (1978); *A Bittersweet Bouquet* (1978); *Spire and Cube* (1979); *Life Study* (1979); *The Art of the Fugue* (1979); *Loose Joints* (1980).

VIDEO: (All videos distributed by Visualizations Gallery, New York.) *Jonathan and the Rocker '76; Dance Ten* (1976); *Streetmural* (1977); *Noelle* (1977); *Emperor's New Clothes* (1977); *Fathom* (1978); *Triptych* (1979).

Holloway, Stanley, English popular entertainer and actor; born October 1, 1890 in London; died there January 3, 1982. Holloway appeared in every media in English entertainment—music halls, cine-variety, variety (or vaudeville), legitimate theater, musical comedy, revue, film, and television—but is best known outside of Great Britain as the embodiment of the music hall. Throughout the 1920s he split his time between Lew Mangan's cine-variety circuit and West End revues, including *The Co-Optomists* of 1921 through 1926, 1929 and 1930. He also appeared in *Kissing Time* (in which he made his formal debut in 1919), *A Night Out* (1920), *The Savoy Follies* (1932), *London Rhapsody* (1938), *Up and Doing* (1940), and *Fine and Dandy* (1942), as well as ENSA shows and hundreds of benefits.

The image of Holloway that will live forever is as "Alfred Doolittle" in the live and filmed versions of George Bernard Shaw's *Pygmalion* and its musical progeny, *My Fair Lady*. He has brought the paradoxes of "Doolittle's" personality into the characterization in all of its variations—the warmth of his voice and the angularity of his East End Cockney accent are realized in his dancing with its coy shifts of weight and focus and joyous eccentricities.

Bibliography: Holloway, Stanley. *"Wiv a Little Bit o' Luck"* (New York: 1967).

Holm, Eske, Danish ballet dancer and choreographer; born March 19, 1940 in Copenhagen. Trained by Hans Brenaa at the School of the Royal Danish Ballet, he graduated into the company in the late 1950s. Known for his partnership with Anna Laekesen in the company's modern repertory, he has been acclaimed in Frederick Ashton's *Romeo and Juliet,* Roland Petit's *Cyrano de Bergerac,* as "Christian," and works by Birgit Cullberg, including her *Miss Julie.* He has choreographed for the company since 1964, contributing occasional works to its repertory, including *Tropisms* (1964), *Cicatricis* (1970) and *Chronic* (1974), to a score by his brother, Modens Winkel. Since 1975, he has also created pieces for an

experimental group in Copenhagen, Pakhus 13, occassionally collaborating with his brother.

Works Choreographed: CONCERT WORKS: *Tropisms* (1964); *Agon* (1967); *Orestes* (1968); *Cicatricis* (1970); *Firebird* (1972); *Chronic* (1974).

Holm, Hanya, German modern dancer and choreographer working in the United States after 1931; born Johanna Eckert, c.1898 in Worms, Germany. Raised in Mainz, she studied with Emile Jaques-Dalcroze in Frankfurt and Hellerau, before 1921, when she began to work with Mary Wigman. At the Wigman school, until 1930, Holm taught class and performed in Wigman's *Feier* (1928) and *Das Totenmal* (1930), for which she served as co-director. She also did her first choreography in Germany, staging dances for an open-air production of Plato's *Farewell to His Friends* in 1929 and *L'Histoire du Soldat* later in that year.

Holm came to the United States as the director of the Wigman School in New York in 1931. Although she defended Wigman admirably in the face of a dance press-inspired literary feud between her and her American modern dancer counterparts, Holm broke the bond with Wigman to open her own studio in 1936. In her first years on her own, she presented programs of dance on a recital basis and within the context of the Bennington School, in Vermont, and the Perry-Mansfield Camp in Colorado. As a choreographer, she easily became the fourth support in the development of traditional American modern dance—training dancers who have become choreographers in their own right, among them Valerie Bettis, Glen Tetley, Ray Harrison, Don Redlich, and Alwin Nikolais. Her work is abstract but includes allusions to topical events, especially the artistic Diaspora from Germany, and the vision of America that she found here. She also created works about work, pieces that brought the power of the German constructivist movement to the United States.

She was able to work successfully and creatively within the contexts of the American musical comedy, choreographing dances for conventional shows such as *Kiss Me, Kate* (1948) and *My Fair Lady* (1956), the New York/first run performance total of which equaled 3,787, and for more experimental ones,

among them, *The Insect Comedy* (1948), *The Golden Apple* (1954), and *Ballet Ballads,* her first in 1948. Although she only worked on a single film, the movie version of *The Vagabond King* (Paramount, 1956), she did a lot of work on television. In fact, her company is generally considered the first modern troupe to produce for network television, presenting *Metropolitan Daily* on NBC in May 1939. Her original work for the medium includes a *Folio* program for the Canadian Broadcasting Company and dances created for White House reception shows on *Dinner with the President* (John F. Kennedy), on CBS.

Although Holm retired from the New York studio in 1967, she still teaches occasionally at the studio of the Nikolais company, and choreographs for the troupe of Don Redlich. Living in Colorado, she has become an integral part of the artistic community there, maintaining the modern dance link with the Perry-Mansfield camp and with the universities.

Works Choreographed: CONCERT WORKS: *L'Histoire du Soldat* (Dresden, 1929); *Dances from Beyond (In Quiet Space, Drive)* (1935); *A Cry Rises Up in the Land* (1935); *Primitive Rhythm* (1935); *Salutation* (1936); *Dance in Two Parts* (1936); *City Nocturne* (1936); *Four Chromatic Eccentricities* (1936); *Festive Rhythm* (1936); *Trend* (1937); *Etudes* (1937); *Dance of Insecurity, Dance of Joy* (1937); *Dance of Introduction* (1938); *Dance Sonata* (1938); *Dance of Work and Play* (1938); *Metropolitan Daily* (1938); *Tragic Exodus* (1939); *They Too are Exiles* (1939); *The Golden Fleece* (1941); *From This Earth* (1941); *What So Proudly We Hail* (1942); *Namesake* (1942); *Parable* (1943); *Suite of Four Dances* (1943); *Orestes and the Furies* (1943); *What Dreams May Come* (1944); *Walt Whitman Suite* (1945); *The Gardens of Eden* (1945); *Dance for Four* (1946); *Windows* (1946); *Xochipili* (1948); *History of a Soldier* (II) (1949); *Ionization* (1949); *Five Old French Dances* (1950); *Prelude* (1951); *Quiet City* (1951); *Kindertotenlieder* (1952); *Concertino da Camera* (1952); *Ritual* (1953); *Temperament and Behavior* (1953); *Prelude I and II* (1954); *Presages* (1954); *Desert Drone* (1955); *Pavanne* (1955); *Sousa March* (1955); *Preludio and Loure* (1956); *Ozark Suite* (1957); *Chanson Triste* (1957); *You Can't Go Home Again* (1957); *Music for an Imaginary Ballet* (1961); *Figure of Pre-*

destination (1936); *Toward the Unknown Region* (1963); *Theatrics* (1964); *Spooks* (1967); *Rota* (1975); *Homage to Mahler* (1976); *Ravel Blues* (1980).

OPERA: *The Ballad of Baby Doe* (1956).

THEATER WORKS: *Plato's Farewell to His Friends* (Ommen, the Netherlands, 1929); *Ballet Ballads* (1948); $E = MC^2$ (1948); *The Insect Comedy* (1948); *Kiss Me, Kate* (1948, London 1951); *Blood Wedding* (1949); *The Liar* (1950); *Out of this World* (1950); *My Darlin' Aida* (1952); *The Golden Apple* (1954); *Reuben, Reuben* (1955, closed out of town); *My Fair Lady* (1956); *Where's Charley?* (London, 1958); *Christine* (1960); *Camelot* (1960); *Anya* (1965).

FILM: *The Vagabond King* (Paramount, 1956).

TELEVISION: *The Dance and the Drama* (Folio, CBC, 1957); *Pinocchio* (NBC, 1957); *Dinner with the President* (CBS, 1963).

Bibliography: Sorell, Walter. *Hanya Holm: The Biography of an Artist* (Middletown, Conn.: 1969).

Holmes, Anna-Marie, Canadian ballet dancer; born Anna-Marie Ellerbeck in 1943, Mission City, British Columbia. Trained at the British Columbia School of Dancing by Lydia Korpova and Heino Heiden, she continued her studies in London with Audrey de Vos and Errol Addison and in Leningrad under Natalia Dudinskaya.

She performed with the Royal Winnipeg Ballet, notably in Brian MacDonald's *Prothalamium,* before her tenure with the Kirov Ballet in Leningrad. Among her repertory with the Kirov were Lavrosky's *Romeo and Juliet,* the *Flames of Paris,* and *Taras Bulba,* and the company productions of *Le Corsaire* and *Giselle.* With her husband, David Holmes, she performed the Lavrosky pas de deux in guest and freelance engagements with the London Festival Ballet, Les Grands Ballets Canadiens, Het Nationale Balett of Holland, the Harkness Youth Ballet, and the Ruth Page Ballet, among many other companies, from c.1960 to 1970.

Holmes, Berenice, American ballet dancer and teacher; born c.1905 in Chicago, Illinois. Associated throughout her long and distinguished career with the developing dance in Chicago, she was trained there by Adolf Bolm. She also took classes with Harald Kreutzberg, Bronislava Nijinska, and Muriel

Stuart at the School of American Ballet. Holmes was a member of both Bolm local companies, the Chicago Civic Opera (c.1922–1924) and Allied Arts (c.1925–1929), and created the role of "Polyhymnia" in his *Apollon Musagète* in 1928. She also appeared in his *Ballet Mechanique* in its live California performance and may have been in his films.

After leaving Bolm, she began a career as a solo concert dancer, in recitals and on the Prolog circuit. Unfortunately, very few of her works are known from her concert career or from her Chicago-area companies of the late 1930s. Holmes has been considered one of the area's most influential teachers since the thirties.

Works Choreographed: CONCERT WORKS: *Chopin* (1935); *Tour de Force* (1938); *I Dream* (1948).

Holmes, David, Canadian ballet dancer and teacher; born 1928 in Vancouver, British Columbia. Trained locally at the British Columbia School of Dancing by Lydia Korpova, he danced with the Royal Winnipeg Ballet before accepting an invitation to continue his studies at the school of the Kirov Ballet under Alexander Pushkin.

At the Kirov, he learned and performed a large repertory of Soviet pas de deux, including sections of Lavrosky's *Romeo and Juliet* and *The Flames of Paris.* With his wife, Anna-Marie Ellerbeck Holmes, who had also studied in Leningrad, he performed those pas de deux with many ballet companies in Europe, Canada, and the United States, including the London Festival Ballet, Les Grands Ballets Canadiens, The Harkness Youth company, the Center Ballet of Buffalo, where Bronislava Nijinska's *Brahms Variations* and *Sleeping Beauty* were revived, and the Ruth Page Ballet.

They have taught Soviet ballet technique extensively since returning from Leningrad, presenting live demonstrations and films.

Holmes, Georgianna, American modern dancer; born January 5, 1950 in Vermont. Trained at the North Carolina School of the Arts by Pauline Koner, Duncan Noble, and Job Sanders, she continued her training with Norman Walker at Jacob's Pillow. She performed with the Louis Falco and Jennifer Muller companies through the 1970s, dancing in

Falco's *Timewright, Two Penny Portraits, The Sleepers, Storeroom, Avenue, Soap Opera,* and *Ibid,* among other works. A member of Jennifer Muller/ The Works since its split from the Falco troupe, she has created roles in *Speeds* (1974) and *Beach* (1976) and danced in the company revivals of Muller's earlier pieces. A very contemporary-looking dancer with the presence of a 1930s recitalist, she has also worked on Broadway in the short-lived rambling musical, *Dude* (1974), with Pilobolus, and in Koner's Dance Consort.

Works Choreographed: CONCERT WORKS: *Dreamers* (1975); *Island* (1975).

Homsey, Bonnie Oda, American modern dancer; born September 15, 1951 in Honolulu, Hawaii. Trained at the Juilliard School, Homsey danced with the Metropolitan Opera Ballet in the early 1970s before joining the Martha Graham dance company in 1973. She has been featured in much of the Graham repertory of older works, notably in the title role of *Phaedra,* and has created roles in her *Chronique* (1974), *Holy Jungle* (1974), *Lucifer* (1975), *The Scarlet Letter* (1975), and *Adorations* (1975).

Since 1979, Homsey has directed a new modern dance theater in Los Angeles, California, in which she has performed in works by members Will Salmon and Carl Woltz.

Works Choreographed: CONCERT WORKS: *Footfalls* (1979).

Honegger, Arthur, Swiss composer; born March 10, 1892 in Le Havre, France; died November 27, 1955 in Paris. As a member of "le Six," Honegger participated in the composition of a score for Jean Cocteau's *Les Mariés de la Tour Eiffel* in 1921 and *Skating Rink* (1922). Most of his commissioned ballet scores date from the late 1920s and early 1930s and include *Les Noces de l'Amour et de Psiché* for Bronislava Nijinksa (1928), *Amphion* for Leonid Massine (1934), *Semiraminis* for Mikhail Fokine (1934), *Jeanne d'Arc au Bucher* for Ida Rubinstein (1938), and *Cantique des Cantiques* (1938) and *La Naissance des Couleurs* (1949) for Serge Lifar. His existing scores have been used by Ted Shawn, who set a work to *Pacific 231* for His Men Dancers in 1933, Margarete Wallmann, and Susan Salaman.

Honnigen, Mette, Danish ballet dancer; born October 3, 1944 in Copenhagen. Trained at the school of the Royal Danish Ballet, she performed with that company throughout her career. Among her best remembered performances were in roles in Roland Petit's *Carmen,* Flemming Flindt's *Dreamland* (1974) and his staging of *Swan Lake,* and in Murray Louis' *Cléopâtre* (1976). She also appeared in the American film *Ballerina* (Buena Vista, 1966).

Horan, Mary, American tap dancer, born c.1908 in Cleveland, Ohio. Horan was one of the few professional dancers trained through mail-order lessons— from the Ned Wayburn Studio of Stage Dancing and a ballet studio in Chicago, probably the one named for the fictional Sergei Marinoff. When she arrived in New York, she danced in progressively larger roles in Wayburn's Prologs, among them his *Honeymoon Cruise* (1924), *Maiden Voyage* (1926), and *Varsity Show* (1927), as a tap dancer in a precision line, a solo tap Charlestoner, and a specialty toe tapper, respectively. During the late 1920s and early 1930s, she toured (as Marie Horain) with Basil Durant in a tap duet act in Prologs and with bands in presentation act houses.

Horne, Katharyn, American ballet dancer; born June 20, 1932 in Fort Worth, Texas. After local performances with the Fort Worth Civic Opera Ballet, Horne moved to New York to study with Antony Tudor and Margaret Craske. A member of the Ballet Theatre (as Catharine Horn), from 1951 to 1956, she was cast in featured roles in John Taras' *Designs with Strings,* George Balanchine's *Theme and Variations,* David Lichine's *Helen of Troy,* and the company production of *Giselle.* She was especially noted for her portrayals of disparate characters in ballets by Agnes De Mille, such as the flighty "Ranch Owner's Daughter" in *Rodeo* and the "The Mother of Accused" symbol of love and nostalgia in her *Fall River Legend.*

Horne performed with Tudor and Craske's Metropolitan Opera Ballet from 1957 to 1965, appearing in interpolated dances in opera productions. During the 1960s, she was also a member of the Manhattan Festival Ballet, one of America's longest-lived independent troupes, with a repertory of works by James War-

ing, Anton Dolin, and Ron Sequoio. She appeared in almost all of the large repertory of the small company, notably Sequoio's *Coruscare* (1967), Dolin's *Pas de Deux for Four,* and Waring's *Phantom of the Opera.*

Since retiring from performance, when the Metropolitan Opera Ballet went into its decade of decline, Horne has taught with Craske at the Manhattan School of Dance. She serves as artistic director of the Omaha Ballet.

Horschelt, Frederick, German nineteenth-century ballet dancer and choreographer best remembered for his choreography for a children's troupe; born April 13, 1793 in Cologne, then Duchy of Westphalia; died December 9, 1876 in Hamburg. The son of Frantz Horschelt, then ballet master for the troupe of his father-in-law Josef Koberwein, Horschelt was trained by his parents and grandparents, and performed with his mother as early as 1806 in the Theater an der Wein production of *The Dancing Lesson.* By 1811, he was also a dancer with the Leopoldstadtheater.

Much of Horschelt's career took place at the Theater an der Wein in Vienna, where he first worked as an assistant to Jean Aumer, then ballet master. Ballet master himself from 1816, he worked with a Kinderballett, first organized to provide intermezzi and short dance sequences for cupids, flower maidens, and pages. By the late 1810s, however, Horschelt was choreographing full ballets for the more than one hundred children, among whom were Michael Laroche and Thérèsa Heberle. After a sex scandal in which he was not implicated, the Kinderballett was disbanded and Horschelt moved to Munich where he became ballet master of the Hofteater. When he retired, leaving his position to Laroche who had followed him from Vienna, he returned to Hamburg.

Although the Kinderballett was generically unique to Vienna, which produced the only other internationally known troupe, Horschelt is considered a major choreographer and teacher of the late preclassic ballet and a major link between the popular and court theaters of Austro-Hungary.

Works Choreographed: CONCERT WORKS: *Die Eselschaut* (The Donkey Spectacle) (1815); *Das Waldmacehen* (The Forest Maiden) (1816); *Die Klein Deibin (The Little Thief)* (1916); *Chevalier Dupe auf der Jahrmarkt* (The Chevalier in the Annual Market, i.e., Fair) (1817); *Der Jahrmarkt von Krakau* (1817); *Aschenbrödel* (a version of *Cinderella*) (1817); *Der Berggeist* (The Mountain Ghost) (1818); *Der blöde Ritter* (The Stupid Horse) (1819).

Horst, Louis, American musician and teacher of dance composition; born January 12, 1884 in Kansas City, Missouri; died January 23, 1964 in New York City. Horst was a professional accompanist, playing for stock theater companies in northern California and for silent films in the San Francisco Bay area, when his fiancée, and later wife, Betty, got him a job with the Denishawn Concert Group, of which she was a member. He played for Ruth St. Denis and Ted Shawn from 1915 to 1925, leaving the company with Martha Graham to create in New York.

Horst was a very popular pianist in the 1920s and 1930s—the heyday of concert dance in New York. Probably the most consistently employed of the popular dance accompanists (others included Pauline Lawrence, Genevieve Pitrot, Sylvia Fine, and Alex North), he played for Broadway rehearsals and for concert dancers of all artistic styles. In a few weeks of the 1929 season, for example, he accompanied Graham, the Humphrey/Weidman Dancers, Tamiris, expressionist pairs Hans Weiner and Erika Thimey, and Yvonne Georgi and Harald Kreutzberg, Ruth Page, and Albertina Rasch. He also recorded modern dance exercises for disc and piano rolls for Denishawn (c.1922–1923) and ballet teacher Alexis Kosloff (c.1924), and composed scores for publications of the Perry-Mansfield Camp. Among the many dances set to his works are Graham's *Primitive Mysteries* (1931), *Frontier* (1935), *El Penitente* (1940), *Alt-Wein* (1926), and *American Provincials* (1934), Ruth Page's *Two Balinese Rhapsodies* (1929), Agnes De Mille's *Julia Dances* (1930) and *Mountain White* (1935), and Doris Humphrey's *The Pleasures of Counterpoint* (1932).

Despite his work in music, Horst's importance rests on his tenures at workshops and classes in formal dance composition. He taught these classes at the Neighborhood Playhouse (where Graham was on the

dance faculty) from 1928 to 1964, at all of the Bennington Summer Schools of Dance (1934–1945), the American Dance Festivals (1948–1963) and The Juilliard School (1958–1963). Among these institutions, he managed to train at least half of the choreographers now producing.

His ideas of teaching composition by studying preclassic musical forms, genuinely historical pieces such as *Rigaudons, Sarabandes,* and *Gigues,* and contemporary music in those forms, including the *Gymnopédies* of Erik Satie, influenced many dancers and choreographers. They ranged from Anna Sokolow, who assisted in his classes at the Playhouse but added her own vocabulary and feelings to his forms, to Meredith Monk, Yvonne Rainer, Lucinda Childs, and other members of the Judson group, who have all described attempts to thwart his formal formalizations. Lectures from his classes were published in *Pre-Classic Dance Forms* (New York: 1937, reprinted c.1965) and *Modern Dance Forms* (New York: 1960). Horst also served the traditional modern dance community as the editor of the *Dance Observer* (1934–1964), a periodical that published reviews of concerts and recitals.

Horton, Lester, American concert and modern dancer and choreographer; born January 23, 1906 in Indianapolis, Indiana; died November 2, 1953. As an art student in Indianapolis, Horton studied ballet with Mme. Theo Hawes and with Adolph Bolm (in Chicago); in 1929, he began to work with Michio Ito.

Horton may have made his professional debut with the Ito company in 1929, although he may have previously performed with the Indianapolis Civic Ballet. As a member of the Ito company, he created the secondary role in his 1929 version of *At the Hawk's Well.*

After two short-lived groups, Lester Horton and Company (1929–1930) and the Dance Repertory Group (1931), he founded the Lester Horton Dancers and Dance Theater, the organization for which he would create works until his death. Horton's own choreography reflected the influence of the short concert works of national/ethnic simplicity and romanticism that characterize the repertories of both Bolm and Ito rather than the abstract idioms of con-

temporary "modern" dance of the New York school of Graham and Humphrey.

Horton was a major influence on many of the middle generation of the traditional modern dance performers and choreographers. Among his students and company members were Joyce Trisler and James Truitte, who have restaged many of his works for contemporary dancers, James Mitchell, Bella Lewitsky, Alvin Ailey, Carmen De Lavallade, and Janet Collins.

As a result of both his presence in Los Angeles and his ability to simplify and popularize ethnic dance forms, Horton was hired to stage musical numbers for films in the mid-1940s. On staff at Universal/International, his films included *Rhythm of the Island* (1943), *Tangier* (1946), and *Bagdad* (1949).

Works Choreographed: CONCERT WORKS: *The Song of Hiawatha* (1928); *Siva-Siva* (1929); *Kootenia War Dance* (1921); *Voo-doo Ceremonial* (1932); *Takwish, the Star Maker* (1932); *Oriental Motifs* (1933); *Allegro Barbaro* (1934, with Dorothy Wagner); *May Night* (1934, with Dorothy Wagner); *Hand Dance* (1934); *Lament* (1934); *Salome* (1934, revised 1937, 1948, 1950); *Dances of the Night* (1934); *Danse Congo* (1934); *Two Arabesques* (1934); *Aztec Ballet* (1934); *Concerto Grosso* (1934); *Painted Desert Ballet* (1934); *Second Gnossienne* (1934); *Chinese Fantasy* (1934); *Bolero* (1934); *Ave* (1934); *Gnossienne #3* (1934); *Maidens* (1934); *Salutation* (1934); *Vale* (1934); *Dictator* (1935); *Passacaglia* (1935); *Pentecost* (1935); *Rain Quest* (1935); *Conflict* (1935); *Ritual at Midnight* (1935); *Tendresse* (1935); *Sun Ritual* (1935); *Rythmic Dance* (1935); *Salutation to the Depths* (1935); *The Art Patrons* (1935); *The Mine* (1935); *Flight from Reality* (1936); *Growth of Action* (1936); *Lysistrata* (1936); *Two Dances for a Leader* (1936); *Chronicle* (1937); *Prelude to Militancy* (1937); *Exhibition Dance #1* (1937); *Prologue to an Earth Celebration* (1937); *Sacre du Printemps* (1937); *Haven* (1938); *Pasaremos* (1938); *Conquest* (1938); *Departure from the Lane* (1939); *Five Women* (1939); *Something to Please Everybody* (1939); *Tierra y Libertad* (1939); *Sixteen to Twenty* (1940); *Pavanne* (1941); *Barrel House* (1947); *The Beloved* (1948); *Totem Incantation* (1948); *The Bench of the Lamb* (1949); *The Park* (1949); *A*

Touch of Klee and Delightful Two (1949); *Warsaw Ghetto* (1949); *Estilo de tu* (1950); *Bouquet for Molly* (1950); *El Rebozo* (1950); *Brown County, Indiana* (1950); *Rhythm Section* (1950); *Tropic Trio* (1951); *On the Upbeat* (1951); *Another Touch of Klee* (1951); *Medea* (1951); *Liberian Suite* (1952); *Prado de Pena* (1952); *Seven Scenes with Ballabilli* (1952); *Dedication in Our Times* (a. to Mary, Ruth and Martha; b. to Carson McCullers; c. to José Clementé Orozco; d. to Federico Garcia Lorca) (1952).

THEATER WORKS: *Tongue in Cheek* (Los Angeles, 1949, co-choreographed with Bella Lewitsky): *Girl Crazy* (Los Angeles, 1951).

FILM: *Moonlight in Havana* (Universal-International, 1942); *Rhythm of the Islands* (Universal-International, 1943); *White Savage* (Universal-International, 1943); *The Phantom of the Opera* (Universal-International, 1943); *Climax* (Universal-International, 1944); *Salome, Where She Danced* (Universal-International, 1945); *That Night with You* (Universal-International, 1945); *Frisco Sal* (Universal-International, 1945); *Shady Lady* (Universal-International, 1945); *Siren of Atlantis* (United Artists, 1948); *Bagdad* (Universal-International, 1949); *Southern Woman* (WB, 1953); *3-D Follies* (Independent, 1954).

Horvath, Ian, American ballet dancer and choreographer; born Ernie Horvath, June 3, 1945 in Cleveland, Ohio. Horvath studied tap and jazz locally, then ballet in Cleveland with Ruth Pryor and Charles Nicoll. Moving to New York, he took ballet classes with Leon Danielian and William Griffith.

A former Mouseketeer, he danced in two Broadway shows, *Fade-Out, Fade-In* and *Funny Girl*, and in many television shows as an Ernie Flatt and/or Peter Gennaro dancer; among the variety shows on which he performed were the *Bell Telephone Hour, The Ed Sullivan Show, The Entertainers,* and *The Garry Moore Show* (all 1964–1967).

In 1965, he joined the apprentice group of what became the City Center Joffrey Ballet, performing as Ian Horvath. He created roles in Arpino's *Viva Vivaldi!* (1965), and *Olympics* (1966), and Fernand Nault's version of *La Fille Mal Gardée* (1966), and danced featured roles in Arpino's *Incubus* and *Sea*

Shadows, Glen Tetley's *Games of Noah*, and Anna Sokolow's *Opus '65*.

Horvath joined American Ballet Theatre in 1967, remaining with that company until 1974. A favorite with contemporary choreographers, he created roles in a large number of ballets, among them, Alvin Ailey's *The River* (1969), Lar Lubovitch's *Three Essays* (1974), and five ballets by Dennis Nahat—*Momentum* (1969), *Brahms Quintet* (1969), *Ontogeny* (1970), *Mendelssohn Symphony* (1971), and *Sometimes* (1972). He danced featured roles in many ballets, including Jerome Robbins' *Fancy Free* ("3rd Sailor"), Eliot Feld's *Harbinger*, Tudor's *Romeo and Juliet*, and David Blair's version of *Swan Lake*.

In 1974, Horvath left Ballet Theatre to become artistic director of the new Cleveland Ballet. He has choreographed one ballet for this company, *Laura's Women* (1975), and has co-choreographed two works with Nahat, *US* (1976), and *Ozone Hour* (1977).

Works Choreographed: CONCERT WORKS: *Laura's Women* (1975); *US* (1976 co-choreographed by Dennis Nahat); *Ozone Hour* (1977, co-choreographed with Nahat).

THEATER WORKS: *Lallapalooza* (1967, New York Shakespeare Festival Mobile Theater).

Horvath, Julia, American ballet dancer; born 1924 in Cleveland, Ohio; died in a plane crash in Maryland, May 30, 1947. A tour performance of the Ballet Caravan inspired Horvath to move to New York to study at the School of American Ballet. She was a soloist with the Ballet Russe de Monte Carlo in the 1940s, performing featured roles in the company production of *Les Sylphides* and *Raymonda*, "La Lione" in Leonid Massine's *Gaité Parisienne*, and parts in Bronislava Nijinska's *Chopin Concerto* and *The Snow Maiden*. After dancing for George Balanchine on Broadway in his *Song of Norway* (1944), she was engaged as principal dancer for the Teatro Municipal in Rio de Janeiro. After a successful season there, she returned to New York to be reunited with George Starett who had just revived his ballet career after five years as a prisoner of war. In late May 1947, she and Starett were flying to Rio for a joint engagement when their plane crashed somewhere in Maryland.

Hosking, Julian, English ballet dancer; born in the mid-1950s in Cornwall. Hosking was trained at the Royal Ballet School from age eleven and graduated into the company in 1971. Hosking is one of the younger classical danseurs that the Royal Ballet is developing to appear in the traditional heroic roles such as ''Florimund,'' ''Florestan,'' ''Romeo,'' and ''Siegfried.'' He has also appeared in the passive principal roles, such as ''The Bridegroom'' in *Les Noces*, in the callow juvenile parts, including ''Lucencio'' in John Cranko's *The Taming of the Shrew*, and in the antihero roles of Kenneth Macmillan's plotted works, including ''Gordon Craig'' in his recent *Isadora*.

Houlihan, Gerrie, American modern dancer; born June 13, 1945 in Fort Lauderdale, Florida. Houlihan was trained at the Juilliard School under Antony Tudor and made her professional debut in the Metropolitan Opera Ballet, then associated with the Tudor repertory. Although she has maintained links with ballet through technique classes with Maggie Black and Marjorie Mussman, Houlihan has done most of her performing in modern dance concert groups. As a member of the Paul Sanasardo company in the late 1960s, she appeared in his *The Path, Platform, Equitorial,* and *Footnotes*, among other works. Her performances with the Lar Lubovitch company have included his *Avalanche, Les Noces,* and *Some of the Reactions of Some of the People Some of the Time Upon Hearing Reports of the Coming of the Messiah.*

Houlton, Loyce, American modern dancer and choreographer; born Loyce Johnson, c.1935 in Duluth, Minnesota. Houlton was trained at the Martha Graham school, by the New Dance Group, and by Nina Fonaroff, with whom she performed briefly.

Houlton returned to Minnesota with her husband and founded the Contemporary Dancers troupe, which evolved into The Minnesota Dance Theatre in the early 1960s.

She has choreographed for this company throughout the late 1960s and 1970s, creating such works as *Earthsong and Tactus* (1969) and *The Killing of Suzie Creamcheese*, a segment of her bicentennial event of 1976. A noted teacher and director of the affiliated school, her students include her daughter, Lise, who is currently with the American Ballet Theatre.

Works Choreographed: CONCERT WORKS: *Earthsong and Tactus* (1969); *Nutcracker Fantasy* (1971); *Ancient Air, Contemporary Air, Discontinued Spaces* (c.1973); *Carmina Burana* (c.1975); *Kaleidoscope: View of American Dance* (1976); *Song of the Earth* (1977); *Horseplay* (1977); *Wingbourne* (1977).

Hoving, Lucas, Dutch modern dancer and choreographer known for his work in the United States with the José Limón Company; born c.1920 in Groningen, the Netherlands. After training with Yvonne Georgi and performing briefly with the Dutch Opera Ballet, Hoving moved to England where he studied with Kurt Jooss at Dartington Hall. He performed with the Jooss Ballet for three seasons, traveling with them to New York where, in 1939, he first saw American traditional modern dance. Hoving returned to New York after the war to study with Martha Graham and teach at the American Theater Wing School. After performing in Broadway musicals, among them Agnes De Mille's *Bloomer Girl* (1944) and *A Kiss for Cinderella* (1945), Hoving joined the José Limón Company with which he danced for fourteen years.

In the works that Limón and Doris Humphrey created for that company, Hoving was frequently cast as the contrast to Limón; the smaller blond was generally the antagonist in the pieces, challenging the identity of the tall, dark presence that Limón portrayed on stage. In this typecasting, Hoving created the roles of ''The White Man'' in *The Emperor Jones* (1956), ''The Conquistador'' in *La Malinche* (1949), ''The Angel'' in *The Visitation* (1952), ''The Leader'' in *The Traitor*, and, in both dancer's best-known roles, ''His Friend'' (i.e., Iago) in Limón's movement-version of *Othello, The Moor's Pavanne* (1949)

While Hoving began to choreograph as early as 1950, he did not form a company until 1966 when his Dance Trio began to tour the country. Most of his work has been created for this group, featuring Nancy Lewis or Patricia Christopher and Chase Robinson, or for the many schools and conservatories at

which he has taught. Among his best known works are *Perilous Flight* (co-choreographed with Lavinia Nielsen in 1953), *Aubade* (1963), *Aubade II* (1970), and *Icarus* (1964).

Works Choreographed: CONCERT WORKS: *Three Characters* (1950); *The Battle* (1950); *Satyros* (1953); *Perilous Flight* (1953, co-choreographed with Lavinia Nielsen); *Ballad* (1955); *Time of Innocence* (1955); *Our Ladies of Sorrow* (1955); *Wall of Silence* (1961); *Suite for a Summer Day* (1962); *Parades and Other Fancies* (1962); *Strange, to Wish Wishes No Longer* (1962); *Has the Last Train Left?* (1962); *Aubade (1963); Divertimento* (c.1963); *Incidental Passage* (1964); *Icarus* (1964); *Variations on the Theme of Electra* (1966); *Satiana* (1966); *Icarus* (1964); *Variations on a Dramatic Theme* (1967); *The Tenants* (1967); *Uppercase* (1969); *Aubade II* (1970); *Opus '69* (1970); *Reflections* (1970); *Zip Code* (1971).

Howes, Dulcie, South African ballet dancer and teacher; born 1910 in Cape Province. Howes was trained in London by Margaret Craske, Tamara Karsavina, and Ella Brunelleschi. She performed there in the London season of the Anna Pavlova company but returned to South Africa in the early 1930s to found a ballet school at the University of Cape Town. Her company was known as the University of Cape Town Ballet until 1965 when it was absorbed into the state subsidy system and renamed the Cape Performing Arts Board, or the Capab Ballet.

She is considered one of the founders of the South African ballet, providing dancers for the major English troupes, among them John Cranko, Petrus Bosman, and Alfred Rodriques, and for local companies.

Howland, Jobyna, Statuesque American theatrical dancer and actress; born March 30, 1880 in Indianapolis, Indiana; died June 7, 1936 in Hollywood, California. Howland was raised in Denver, Colorado, where she was trained in plastique and Delsarte elocution techniques by Margaret Fealy and possibly by Ida Simpson-Serven, then teaching there. She did stock work on the West circuits, but moved east to accept an engagement to model in New York. She is one of the women who could accurately claim to be an original Gibson girl, since she modeled for Charles Dana Gibson at the turn of the century.

Howland, who was at least six feet tall, appeared as a dancer early in her Broadway career, notably in *The Messenger Boys* and *The Ham Tree*, but by the second decade of the century, she had been typecast as either a statuesque heroine or patsy of the Margaret Dumont genre. She was unable, or unwilling, to do the kind of eccentric dances that her fellow six-footer Charlotte Greenwood made famous, but did do dance specialties in *The Ham Tree*, an early Ned Wayburn musical based on minstrelsy, his *Passing Show of 1912* (which also featured Greenwood and the only slightly shorter Trixie Friganza), and the original play version of *The Gold Diggers* (1926, London 1927), in the Joan Blondell role. She was recognized as a fine actress and superb comedienne in her live appearances, especially in *Kid Boots* (1923) with Eddie Cantor, and in the (Bert) Wheeler and (Robert) Woolsey *Radio Revel* films for RKO.

Hoyer, Dore, German concert dancer; born December 12, 1911 in Dresden; died during the last week of 1967 in Berlin. She was trained by Gerd Palucca at Hellerau.

A recitalist during the 1930s, she created works for solo concerts and group performance. Her pieces were bitter and desolate, regarding the world with enmity and despair, and topical since her attitude reflected that of her time. The metaphors she chose to represent her feelings ranged from the mechanical in the 1930s, to the mythological in the late 1940s, and the pictorial, as in her best known later work, *Dances for Käthe Kollwitz* (1945).

Hoyer served as director of the Dresden Wigman school while she worked in Leipzig and directed productions at the Hamburg Staatsoper in the late 1940s. She also toured and created works in much of Western Europe and in South America.

Works Choreographed: CONCERT WORKS: (Note: this list is unfortunately incomplete.) *Masks* (c.1938); *Dances without Names* (c.1938); *Revolving Dance* (c.1938); *Demon Machine* (c.1938); *Dances for Käthe Kollwitz* (1945); *Bible Works* (1949); *Der Grosse Gesang cycle* (1949); *Bolero* (1953); *South American*

Journey (1957); *Between Yesterday and Tomorrow* (c.1958); *On a Black Background* (c.1958).

OPERA: *Moses und Aron* (1959).

Huffman, Gregory, American ballet dancer; born May 26, 1952 in Orlando, Florida. Trained by Edith Royal, he performed with her Orlando Ballet before moving to New York to study at the American Ballet Center.

After performing for a season with the New York City Opera, he joined the Joffrey II company (1970–1971). Graduating to the City Center Joffrey Ballet in 1972, he has performed leading roles in the company revival of *Petrouchka*, and in Eliot Feld's *Meadowlark*, Oscar Ariaz's *Romeo and Juliet*, Frederick Ashton's *Jazz Calendar*, the revival of Massine's *Le Beau Danube*, and Twyla Tharp's *Deuce Coupe II* and *As Time Goes By*.

Hughes, Michaela, American ballet dancer; born March 31, 1955 in Morristown, New Jersey. Although she has performed with other companies, most notably the Houston Ballet, Hughes is best known for her work with the Eliot Feld Ballet. She appeared in the revivals of his works from his earlier companies, such as *Harbinger* and *Cortège Parisien*, and danced in many of his new works created for his latest troupe, among them *Excursions, A Poem Forgotten, Seraphic Songs, El Salon Mexico*, and the glitzy tribute to the Gershwins, *The Real McCoy*. A member of the American Ballet Theatre since the late 1970s, she has been seen in many principal roles in the company's revivals of the classics, including "Myrthe" in *Giselle*.

Hulbert, Jack, English eccentric dancer, actor, choreographer, and director; born April 24, 1892 in Ely. With his wife and partner Cecily Courtneidge, Hulbert appeared in forty years of musicals and revues in London's West End theaters. He had a wider range of eccentric dance persona than many of his colleagues and could do Cockneys, Oxbridge types, and sophisticates, as well as the traditional silly-ass Englishman drunk act. He directed almost all of his productions after 1925 and produced many of them. Although he received choreography credits for only a small number of productions, he staged the musical numbers for Courtneidge and himself in all. His best known shows as a performer included *The Pearl Girl* (1913), *By the Way* (1925, also in New York that season), *The House That Jack Built* (1929), *Follow a Star* (1930), *Under Your Hat* (1938), and *Something in the Air* (1943).

Works Choreographed: THEATER WORKS: *Lady Mary* (1928); *Under Your Hat* (1938); *Something in the Air* (1943); *Under the Counter* (1945, New York, 1947); *Over the Moon* (1953).

Humphrey, Doris, American pioneer of modern dance; born October 17, 1895 in Oak Park, Illinois; died December 29, 1958. Humphrey, who with George Balanchine was the great abstractionist of dance, began her career as a social and fancy dancing teacher in the Chicago suburbs. Her dance training had consisted of work with Mary Wood Hinman, a Swedish folk specialist who also taught a form of eurythmics, and master classes with most of the European ballet dancers who passed through the area, among them Ottokar Bartik, a Hungarian attached to the Metropolitan Opera, and Serge Oukrainsky and Andreas Pavley of the Chicago Opera Ballet. Humphrey's career changed when she left Illinois to move to Los Angeles to train at the Denishawn school of Ruth St. Denis and Ted Shawn.

Humphrey's Denishawn tenure—as a student, company performer, and teacher—occurred at a time during which both St. Denis and Shawn were moving away from their pseudoethnic work toward the abstract, except in their own solos and directly after their Oriental tour. This abstraction manifested itself in Shawn's work somewhat later in his constructivist dances for men, but during Humphrey's time there, St. Denis began to work on a series of "Music Visualizations." Humphrey performed in many of the works presented under that catch phrase, among them *Second Arabesque* (1919), *Sonata Pathetique, Valse Caprice,* and *Valse Brilliante* (all 1922), and choreographed them herself, producing *Bourée* (1920) and *Scherzo Waltz* (1924) for the Denishawn Dancers. Humphrey's created roles in the concert groups also included "Orientalia" and "Americana," among them, St. Denis' *Three Ladies*

of the East: India and Dance of the Devidassi (both 1919), Ishtar of the Seven Gates (1922), and A Burmese Yein Pwe (1926), and Shawn's Pasquinade, a Creole Belle (1922) and Five American Sketches: Boston Fancy, 1954 (1925). In the latter work, and in many Shawn pieces, she was partnered by Charles Weidman who would become her teaching and choreographic colleague.

Following the end of the Oriental tour in 1927, Humphrey and Weidman were assigned to teach at the Denishawn franchise school in New York. For various reasons involving both artistic and political policy, they broke from the Denishawn system and set up their own New York studio, with Pauline Laurence, another former Denishawn dancer, as accompanist, designer, and manager. The Humphrey/Weidman Group, as their company was named, performed for sixteen years, until she was forced to retire owing to arthritis. Humphrey staged at least eighty-three works for the group, among them her extraordinarily innovative Water Study (1928) and Life of the Bee (1929), constructivist movement studies for a female company that preceded both Shawn's all-male pieces and Graham's abstract masterpiece Primitive Mysteries. Other Humphrey works from this period that are recognized as both masterpieces of traditional modern dance and ancestors of the innovations of modern ballet and postmodern choreography include Salutation to the Depths (1930), The Shakers (1932), New Dance (1935), With My Red Fires (1936), Passacaglia and Fugue in C Minor (1938), and the Partita in G Major (1943). The above selection from her canon includes those works that are currently restaged most frequently.

After retiring from performance, Humphrey served as artistic director of the company of José Limón, the Mexican dancer who had created roles in most of the Humphrey/Weidman concerts. For this company, with a core of dancers that included Lucas Hoving, Letitia Ide, Betty Jones, Pauline Koner, and Lavinia Nielsen, she created another repertory of innovative works, among them Night Spell (1952), Ritmo Jondo (1953), Ruins and Visions (1955), and Brandenburg Concerto No. 4 in G Major (1958). One of the few traditional modern dance pioneers able to create works for another's company, she tailored pieces to Limón's tremendous stage presence and

dramatic power, especially in Lament for Ignacio Sánchez Mejías (1947), one of the many contemporary works based on the Garcia Lorca poem, and Felipe El Loco (1955). To be totally subjective, one might say that a 1947 work for the Limón company, Day on Earth, can be considered one of the major accomplishments of the traditional modern dance, outstanding for its beauty, musicality, simplicity, and universality of concept.

Humphrey's widespread influence on modern dance can be traced to more than the power of her choreography. As a teacher at the High School of Performing Arts, the Bennington College summer workshop, and The Juilliard School, she influenced a multitude of generations of dancers and choreographers—those who remained in traditional modern dance, those who work in postmodern genres, and, to a very large extent, those who create within the technical vocabulary of ballet. Evidences of study of Humphrey's uncompromising textbook of choreography, The Art of Making Dances (published posthumously in 1959), can be found in almost every dance creator who attended any of those schools—an enormous proportion of participants in American dance.

Humphrey's uncompromising choreography is unique in the traditional modern genre as it cannot be dated. Maintaining her commitment to abstractionism, she avoided the imagery and mythology of her colleagues. Although one can occasionally make guesses based on historical taste in music, it is impossible to watch a Humphrey work and say, "this represents the typical psychological concept of this year" or "this was a popular theme in this season." Humphrey's work transcends both time and popular culture; it represents a commitment only to the music and bodies at hand and remains extant to remind us of the true art of making dances.

Works Choreographed: CONCERT WORKS: Bourée (1920); Soaring (1920); Valse Caprice (Scarf Dance) (1922); Sonata Tragica (1922, co-choreographed with Ruth St. Denis); Scherzo Waltz (Hoop Dance) (1924); At the Spring (1926); Whims (1926); Air for the G String (1928); Gigue (1928); Concerto in A Minor (1928); Waltz (1928); Papillon (1928); Color Harmony (1928); Pavanne for a Sleeping Beauty (Pavanne for a Dead Princess) (1928); Bagatelle (1928); Pathetic Study (1928); The Banshee (1928);

Rigaudon and Sarabande (1928); *Water Study* (1928); *The White Peacock* (1929); *Poème No. 1* (1929, may have been co-choreographed with Charles Weidman); *Etude No. 1* (1929, may have been co-choreographed with Weidman); *Air on a Ground Bass* (1929); *Speed* (1929); *Life of the Bee* (1929); *The Call* (1929); *Mazurka to Imaginary Music* (1929); *Jesu, Joy of Man's Desiring* (1929); *Suite (Quasi Valse, Etude No. 12)* (1930); *A Salutation to the Depths* (1930, co-choreographed with Weidman); *The Call* (1930); *Breath of Fire* (1930); *Drama of Motion* (1930); *La Valse (Choreographic Waltz)* (1930); *Descent into a Dangerous Place* (1930); *March* (Passing Parade) (1930); *Salutation* (1930); *Les Romanesques* (1930); *Scherzo* (1930); *Two Studies* (1930); *Theme and Variations* (1931); *Ritual of Growth* (1931); *The Shakers* (also titled *Dance of the Chosen,* later interpolated into *Americana*) (1931); *Dances of Women* (1931); *Burlesqua* (1931); *Lake at Evening* (1931); *Night Winds* (1931); *Tambourin* (1931); *Three Mazurkas* (1931); *Variations of a Theme by Handel* (1931); *Two Ecstatic Themes (Circular Descent, Pointed Ascent)* (1931); *String Quartet* (1931); *The Pleasures of Counterpoint* (1932); *Dionysiaques* (1932); *Suite in E* (*Prelude* section by Weidman) (1933); *Tango* (1933); *Pavanne* (1933); *Cotillion* (1933); *Rudepoema* (1934); *Credo* (1934); *Pleasures of Counterpoint, Nos. 2 and 3* (1934); *Exhibition* (1934); *Orestes* (1934); *Duo Drama* (1935); *New Dance* (1935); *Theatre Piece* (1936); *Parade* (1936); *With My Red Fires* (1936); *To the Dance* (1937); *Celebration* (1937); *Dance for Spain Solo* (1939; this was the collective name for a series of dance concerts given in 1938 and 1939); *Square Dances* (1939); *Variations* (1940); *Song of the West* (1940); *Dance "Ings"* (1941); *Decade* (1941); *Quartet* (1941); *Four Chorale Preludes* (1942); *Partita in G Major* (1942); *El Salón México* (1943); *Inquest* (1944); *Canonade* (1944); *The Story of Mankind* (1946); *Lament for Ignacio Sánchez Mejías* (1946); *Day on Earth* (1947); *Corybantic* (1948); *Invention* (1949); *Night Spell* (1951); *Fantasy, Fugue in C Major and Fugue in C Minor* (1952); *Illusions* (1952); *Ritmo Jondo* (1953); *Ruins and Visions* (1953); *Felipe El Loco* (1954); *The Rock and the Spring* (1955); *Airs and Graces* (1955); *Theatre Piece No. 2* (1956); *Dawn in New York* (1956); *Descent into the Dream* (1957); *Dance Overture* (1957); *Brandenburg Concerto No. 4 in G Major* (1958).

OPERA: *Die Gluckliche Hand* (1930).

THEATER WORKS: *Run Little Chillun'* (1933); *Swing Out, Sweet Land* (1944, co-choreographed with Charles Weidman); *Poor Eddy* (1953, incidental dances for play).

Bibliography: Humphrey, Doris. *The Art of Making Dances* (New York: 1959); "New Dance." *Dance Perspectives* (No. 25), included in *An Artist First* (Middletown, Conn.: 1972), edited and compiled from an unfinished autobiography and from correspondence by Selma Jeanne Cohen.

Hurok, Sol, Russian-American impresario; born April 9, 1888 in Pogar; died March 5, 1974 in New York City. After coming to the United States in 1906, it took Hurok only four years to put together a concert tour. He represented at various times in his career the tours of Anna Pavlova, the Duncan Dancers, Mary Wigman, Uday Shanker, La Argentinita, Martha Graham, and ballet companies that included the many Ballets Russe de Monte Carlo, the Sadler's Wells, the Bolshoi, the Kirov, the Moiseyev, the Beriokza, and the Kabuki Troupe.

Hurok's importance is derived from his longevity and from two aspects of his professional work. He was a participant, or, as some think, active negotiator in the cultural exchange program between the United States and the Union of Soviet Socialist Republics. This had both positive and negative results; the exchange programs were wonderful because they introduced audiences to different companies and styles, but Hurok, as a method of garnering publicity, inspired the American press and public with the idea that Russian and English ballet were always finer, more innovative and technically better performed than their American counterparts—an idea that probably did less for dance in America than any other, and that is still an integral part of our culture. The second element of Hurok's professional work and structure was more positive. By insisting that the concert halls and ticket bureaus across the country accept all of his clients each season, he was able to force dance companies, such as the Graham troupe and the Ballet Caravan, into bookings within communities that might not support a dance audience.

Bibliography: Hurok, Sol. *Impressario* (New York: 1946); *S. Hurok Presents* (New York: 1953).

Hurry, Leslie, English theatrical designer; born 1909 in London. A painter and illustrator, Hurry became known in the dance world for two productions that he designed for the Sadler's Wells—Robert Helpmann's *Hamlet* (1934) and the company's *Lac des Cygnes* (1943, by Nicholas Sergeev after Petipa and Ivanov). Both sets of designs revealed his strengths and difficulties. His sets for *Hamlet* and for the inside scene (Act III) of *Swan Lake*, are enormous and, in photographs, seem out of proportion to the stage area, dwarfing the dancers entirely. All contemporary descriptions mention, however, the extraordinary impact and almost startling power that the sets revealed.

Hus, Auguste I, French eighteenth-century ballet dancer and choreographer; born c.1735, possibly in Paris; his date and place of death are uncertain. This Hus is frequently called Jean-Baptiste; it is possible that he used that name in Paris.

The patriarch of the Hus family, he was trained at the Académie Royale de Musique by Dupré, and spent much of his performing career there. He left the Opéra after dancing in *Les Fêtes de Pathos* to dance at the Teatro Reggio in Turin (c.1764). After serving as ballet master of the Comédie-Italienne in Paris, a resident *commedia* troupe, he returned to the Opéra to dance in Maximilien Gardel's *Le Déserteur,* one of the standard works of the eighteenth and nineteenth-century repertory.

Auguste, or Jean-Baptiste, Hus was the father of Pietro Hus and the teacher of Pierre-Louis Stapleton, who used the name Eugène Hus to honor his mentor.

Hus, Augusto II, Italian nineteenth-century ballet dancer and choreographer; probably the son of Pietro and grandson of Auguste I, this Hus flourished between 1827 and 1853. It has proved impossible to locate verifiable birth or death dates for this member of the family.

Presumably trained by his father, Hus emerged as a ballet master of the Teatro Corigiano in Turin in 1837, creating *Eduardo II* that season. From 1839 to 1844, he served as ballet master for the Karntnerthor theater in Vienna, choreographing new works, such as *Die Geschopfe* [Creatures] *der Prometheus* (1843), and reviving his father's *Apollo und Daphne* in 1839.

Returning to Italy permanently in the mid-1840s, Hus choreographed for the Teatro Reggio in Turin and Teatro allo Scala in Milan. Among his best known works were a version of *Gustavo III, re di Svezia* (La Scala, 1846), *Zelia* (1845), and *Il Naufragio dell' Medusa* (Teatro Reggio, 1947). At La Scala, he taught the class of perfection, then including Carolina Beretta and the American ballerina Augusta Maywood.

Works Choreographed: CONCERT WORKS: *Eduardo II, ossia l'assedio di Calais* (1837); *Apollo und Daphne* (1839); *Das Schloss* [Castle of] *Kenilworth* (1840); *Der Schiffbruch der Medusa* (1842); *Pflect und Liebe* (Duty and Love) (1842); *Die Geschopfe* [Creatures] *der Prometheus* (1843); *Luise Strozzi* (1843); *l'Insidia punita* (1844); *Prometo* (1844); *Zélia* (1845); *Gustavo III, re di Svezia* (1846); *Roberto il Diavolo* (1847); *Niobe, or la Vendetta di Laton* (1847); *I collegiala* (1847); *La nozze di Zeffieo et Flora* (1847).

Hus, Eugène, Belgian ballet dancer and choreographer of the late eighteenth and early nineteenth centuries; born Pierre-Louis Stapleton in Brussels, c.1758; died there in 1822. A student of Auguste (aka Jean-Baptiste) Hus, Stapleton changed his name to honor his teacher.

Hus served as a dancer and ballet master in Lyon in 1784, producing *Le Ballon* that season, and at Le Grand Théâtre, Bordeaux in the 1780s and 1790s. In Bordeaux, traditionally a center of innovative choreography in France, Hus revived the masterpiece of the city's best known ballet master, Jean D'Auberval, and staged new ballets of his own, among them, *Les Quatre Fils Amyor* and *La Mort d'Orphée* (both in 1786) and *Tout cède à l'Amour* (1798).

Moving to Paris, Hus was the ballet master for two popular theaters—le Théatre-de-la-rue-Faydeau, for which he staged *Lise et Colin* after D'Auberval's *La Fille Mal Gardée* (1796), and le Théâtre de la Porte-Saint Martin, for which he created *Les Illustres fugitifs* and *Montbars l'exterminateur, ou les derniers Filibusters,* both in 1807.

Eugène was the founding ballet master of the Théâtre de la Monnaie in Brussels, from 1815, an opera house that produced and trained many important choreographers of the late nineteenth century. He served as ballet choreographer and mentor to Jean Petipa, his successor, thus forming a link from Dupré *le grand* and Auguste Hus to Marius Petipa and the nineteenth-century Russian ballet.

Works Choreographed: CONCERT WORKS: *Le Ballon* (1784); *Les Quatres Fils Amyor* (1786); *La Mort d'Orphée (1786); Les Muses, ou le Triomphe d'Apollon* (1793); *Lise et Colin* (1793, after D'Auberval); *Tout cède à l'Amour* (1798); *l'Apotheose de Flore* (1806); *La Joue, ou les Amours d'Eté* (1806); *Les Illustrés fugitifs* (1807); *Montbars l'exterminateur, ou les dernier Filibusters* (1807).

Hus, Pietro, French nineteenth-century ballet dancer and choreographer working primarily in Italy; born c.1770 in Paris; the date and place of his death are uncertain. It should be noted that sources which name his father, Auguste I, Jean-Baptiste generally describe Pietro as Pierre II.

Thus Hus probably studied with his father in Paris and may have performed with the Paris Opéra and with Eugène Hus (a pupil of Auguste) at the Théâtre de la Porte-Saint-Martin. In Naples by 1812, he was best known as the ballet master for the Teatros del Fondo, Santa Cecilia, and San Carlo there. A mentor of Salvatore Taglioni, Louis Henry, and Antonio Guerra, three of the most important Italian choreographers of the nineteenth-century late Romantic era, he staged more conventional ballets, primarily based on the plots of eighteenth-century works, such as *Apollo e Dafne* (1825, for the Teatro Santa Cecilia in Palermo), *Ninetta alla Corte* (1815), and *Telemaco nell'isola de Calypso* (1820).

Works Choreographed: CONCERT WORKS: *Ninetta alla Corte* (1815); *Il Ritorno di M. Deschalumeaux* (1818); *Telemaco nell'isola de Calypso* (1820); *La nozze interotte, ossia il segreto* (1822); *Apollo e Dafne* (1825); *Sofronimo e Carita, ossia il potere delle bellezza* (1826).

Hutin-Labasse, Francisque, French nineteenth-century ballet dancer celebrated for her tours of the United States; neither her birth nor death dates can be verified; it is believed that she was born in Paris and died in South America. Mlle. Hutin-Labasse, whose maiden name is not known, may have been trained at the Paris Opéra but is not believed to have performed there. She was a member of the company at the Théâtre de la Gaité before being engaged to perform in New York in 1827.

Her debut performance, in *La Bergére Coquette, or the Roaming Shepherdess,* caused a moral uproar, promoted by a newspaper and quite possibly by her own management. Although her dancing abilities have been decried by contemporary historians, she was adept enough to be booked for engagements in Philadelphia, Boston, Albany, Charlestown, and New Orleans, performing in works revived by Claude Labasse, ballet master of the Bowery Theater and her then husband. After his death, she toured the Midwest and Mississippi circuit with Joseph Barbière. It is believed that they also performed in South America, where she may have died.

Hutton, Betty, American film dancer, singer, and actress; born Betty Thornburg February 26, 1921 or 1926, in Battle Creek, Michigan. Hutton made her debut singing and dancing on street corners and performing in theaters in small towns. After working her way up to taverns in the Detroit area, she was hired as the vocalist for Vincent Lopez's orchestra. Traveling to New York with the band, she made her Broadway debut in *Two for the Show* (1941). In that show and in her next, *Panama Hattie* (1940, staged by Robert Alton), she performed a wild jitterbug, becoming known as the "Jive Girl."

Her eccentric dance and vocal style brought her a contract from Paramount Studios to jitterbug in films. Her best films, such as Preston Sturges' *Miracle of Morgan's Creek* (1944), used social dance as a characterizational device, jitterbugging to show her freedom and youth. She also appeared in conventional musical films, among them, *The Fleet's In* (Paramount, 1944), *Annie Get Your Gun* (MGM, 1950), *Somebody Loves Me* (Paramount, 1952), the biopic about Blossom Seeley, and *Let's Dance,* in which she partnered Fred Astaire. After opening the film with her usual jazz patter song, she accompanied him in a Western satire dance and in more traditional tap numbers.

It was a shock and tragedy for her many fans to learn in the 1970s that her energy and pep were the cause of a health breakdown in the late 1950s. She returned to the Broadway stage in the summer of 1980 to dance in Peter Gennaro's *Annie.*

Hyman, Prudence, English ballet dancer; born c.1910 in England. Hyman was trained by Marie Rambert.

A member of both the Camargo Society and the Ballet Club, Hyman was a participant in the development of the English ballet in the 1930s, creating roles in the early works by Frederick Ashton and Antony Tudor. Her Ashton premieres included his *The Fairy Queen* (1927, incidental dances in the opera) *Leda* (1928), *Capriol Suite* (1930), *A Florentine Picture* (1930), *Façade* (1931), *The Lord of Burleigh* (1931), *Foyer de Danse* (1931), *Mercury* (1931), and *The Lady of Shallott* (1931). If those credits were not enough to assure her place in British dance history, she also created roles in Antony Tudor's *Cross-Garter'd* (1931), *Adam and Eve* (1932), *Mr. Roll's Quadrilles* (1932), and *Lysistrata* (1932). Celebrated for her roles in the group's productions of Mikhail Fokine's *Carnaval* and *Les Sylphides,* and *The Sleeping Beauty* (final act), she danced with Les Ballets '33 in its London season, in works by George Balanchine. In the Arts Theater Ballet, the short-lived Cambridge company sponsored by John Maynard Keynes, she took the principal role in *Swan Lake* and in Keith Lester's *The Glen, Concerto,* and *De Profundis* (all 1940).

Hynd, Ronald, English ballet dancer and choreographer; born Ronald Hens, April 22, 1931 in London. Trained at the Rambert School, he performed with the company before switching to the Sadler's Wells Ballet in 1951. He was with the Sadler's Wells/Royal Ballet for nineteen years and created roles in John Cranko's *Prince of the Pagodas* (1957) and *Antigone* (1959). He danced in most of the repertory of ballets by Frederick Ashton, Cranko, and Kenneth Macmillan, and as the principal princes of the classical ballets.

Since he started to choreograph, he has created works for the touring troup and New Group of the Royal Ballet and for the London Festival Ballet, as well as for John Curry's ice show, for which he staged *La Valse Glacé* and *Winter–1895.*

Works Choreographed: CONCERT WORKS: *Le Baiser de la Fée* (1967); *Pasiphée* (1969); *Dvorak Variations* (1970); *In a Summer Garden* (1972); *Mozartiana* (1973); *Charlotte Brontë* (1974); *Orient/Occident* (1975); *Valse Nobles et Sentimentales* (1975); *The Merry Widow* (1975, co-choreographed with Robert Helpmann), *The Nutcracker* (1976); *l'Eventail* (1976); *La Valse Glacé* (1977); *Winter–1895* (1977); *La Chatte* (1978); *Papillon* (1979); *Rosalinda* (1979).

Hywell, Suzanne, English ballet dancer and choreographer; born February 15, 1944 in Tunbridge Wells. Hywell was trained at the Bush-Davies and the Royal Ballet Schools. She danced with the Western Theatre Ballet and the Northern Dance Theatre in the mid-1960s before beginning to choreograph for the latter company. Among her best known work is the philosophical *Teachings of Don Juan* (1973), which brought her to the attention of the British critics and audiences.

Works Choreographed: CONCERT WORKS: *The Clear Light* (1970); *Three-Quarter Profile* (1972); *Teachings of Don Juan* (1973).

I

İacobson, Leonid, Soviet ballet dancer and choreographer; born January 15, 1904 in St. Petersburg; died October 18, 1974 in Moscow. Trained at the Leningrad Choreographic Institute, he joined the GATOB from 1926 to 1933 as a character dancer. After dancing with the Bolshoi in Moscow for nine years, he returned to the Kirov as a choreographer from 1943 to 1970. There is some evidence that he worked as a concert dancer during the 1930s, touring with a solo recital program; if this is true, it might mean that he probably worked at the Theater International in Moscow while at the Bolshoi.

İacobson's final company, The Choreographic Miniatures, from 1970 until his death, also may have been in the concert dance style; it presented the short characterizations in dance for which he had become famous.

Works Choreographed: CONCERT WORKS: *The Golden Age* (1930, co-choreographed with Vassili Vainonen); *Tyl Eulenspiegel* (1933); *The Hunter and the Bird* (1940); *Shurale* (1941, revived 1950); *Gossips* (1949); *The Ice Maiden* (1952); *Alborado* (1953); *Spartacus* (1956); *A Blind Woman* (1959); *The Bed Bug* (1962); *New Love* (1963); *The Twelve* (1964); *Vestris* (1969); *Exercise XX* (1969); *Miniatures* (1970).

FILM: *The Bluebird* (Twentieth-Century Fox, 1976).

Ibert, Jacques, French composer; born August 15, 1890 in Paris; died February 6, 1960. The French orchestral composer worked frequently with choreographers to create new works. In general, however, the scores have lasted much longer than the ballets, most of which were not completely successful. They included Bronislava Nijinska's *Les Rencontres* (1925), Mikhail Fokine's *Diane de Pointiers* (1934), Roland Petit's *Les Amours de Jupiter* (1946), and Serge Lifar's *Escales* (1948) and *Le Chevalier Errant* (1950). Ibert also wrote music for the film ballet that Gene Kelly created for himself and Igor Youskevitch in *Invitation to the Dance* (MGM, 1954).

Ichino, Yoko, American ballet dancer; born c.1954 in Los Angeles, California. Ichino was trained in Los Angeles by Mia Slavenska and on both coasts by Margery Mussmann. After appearing with the Stuttgart Ballet, she spent most of the 1970s with the City Center Joffrey Ballet, performing primarily as Nancy Ichino. Her credits in that eclectic company include roles in the classical *Remembrances* by Joffrey and *Viva Vivaldi* by Gerald Arpino, and parts in disparate modernistic works using jazz techniques—Arpino's *Sacred Grove on Mount Tamalpais,* Twyla Tharp's *As Time Goes By,* and Jerome Robbins' *New York Export: Opus Jazz.* Although the repertory in her next company, the American Ballet Theatre, is equally eclectic, she has performed mostly in its revivals of the classics, possibly to take advantage of a formidable partnership with Fernando Bujones and her status as one of the few Americans to enter and win an international ballet competition, the Moscow event of 1977. Her Ballet Theatre appearances have included "Aurora" in *The Sleeping Beauty,* a highly acclaimed "Kitri" in the nineteenth-century *Don Quixote,* and programs of pas de deux with Bujones. Ichino also performs solos by her teacher, Mussmann, including her *Rondo* (c.1978) and *Episodes* (1977).

Ichinohe, Saeko, Japanese modern dancer and choreographer working in the United States; Ichinohe performed and toured with the Iskii Baku troupe in Japan. Her studies with Pauline Koner, when the eminent concert and modern dancer was in Japan on a residency, brought her to New York to continue her training at the Juilliard School in 1968 where she worked with Martha Graham, José Limón, Antony Tudor, and Martha Hill. She has choreographed extensively here for her own company (a part of the Asian New Dance Coalition) and for ballet troupes that range from the Joffrey II to the Syracuse, Atlanta, and Virginia Ballets. Most of her works are short, or are compilations of short segments, but a recent work, *Dance Music Landscape* (1980), allowed her to experiment with sustained images and movements in a ninety-minute piece.

Works Choreographed: CONCERT WORKS: (Note: Japanese titles have been translated by Ichinohe.) *Am Full of Tears* (1963); *Wondering* (1964); *Repen-*

tence (1965); *Leopardess* (1965); *Fire-eating Bird* (1966); *Stream* (1966); *Parting* (1966); *Waiting* (1966); *To My Beloved Child* (1966); *On a Palm* (1967); *Opus II* (1968); *Love* (1968); *Suspicion* (1968); *Quintet* (1969); *Piece in the Shape of a Pear* (1970); *Suite Hinamatsuri* (Doll Festival) (1970); *Reaction* (1971); *Megitsune* (The Fox) (1971); *Nambu Ushioi Uta* (With a Singer) (1971); *Fantasy* (1971); *Time* (1972); *Chidori* (The Plover) (1972); *Woman Who Loved Worms* (1972); *Meditation* (1973); *Toccata* (1973); *Surprise Package* (1973); *Shishimai* (Lion Dance) (1973); *Concerto Opus 24* (1974); *Evocation* (1974); *Goza* (Japanese Mat) (1974); *Luna Park* (1974); *Koku* (Empty Sky) (1974); *Riding the Wind* (1975); *Waning Moon—Morning Dew* (1975); *Miyabi* (1975); *Cakewalk* (1976); *Kenshi* (The Fighter) (1976); *Rolls! Rolls?* (1977); *Variations in the Kitchen* (1977); *Pray* (1977); *"⊟"* (The Head) (1977); *J-A-Z-P-A-N* (1977); *Hana-Zukushi* (Flowers from Japan) (1977); *Duet (Fire & Water)* (1978); *Dances for Prepared Dancers* (1978); *Yurei* (Ghost) (1978); *Kami no Yama* (Mountain of Gods) (1979); *Hitofudegaki* (Drawing with One Stroke) (1979); *Yuki* (Snow) (1979); *Willow Tree* (1979); *Op E/W-80* (1980); *Izanagi* (1980); *Gift from Japan* (1980); *Dance Music Landscape* (1980).

Ide, Letitia, American modern dancer; born in Springfield, Illinois. Ide was a graduate of the University of Chicago when she moved to New York to study at the Doris Humphrey/Charles Weidman Studio. A member of the Humphrey/Weidman Concert Group, she appeared in the premieres of many major works by the two choreographers from 1930 to 1945. Considered by many the ideal Humphrey Dancer, she brought her strength and flexibility to Humphrey's *Water Study* (1928), *The Shakers* (1930), *La Valse* (1930), *New Dance* (1935), *Lament for Ignacio Sanchez Mejias* (1946), *Invention* (1949), and *Day on Earth* (1947). With its weighted gesture and universal vocabulary of movements, "The Woman" in the latter is considered her most celebrated role and may be the most important role for a female performer in the repertory. In the Concert Group she also appeared in a large number of works by Charles Weidman, among them his *Farandole* (1932), *Memorials* (1935), and *Suite in F* (1933), and by José Limón, including his *Petite Suite* (1936). Ide appeared in many of Weidman's Broadway productions, and was especially famous for her work in his *As Thousands Cheer* (1932) and *Candide* (1933).

When Humphrey and Limón began a new company, named for him, Ide performed with it until 1952. Among her credits there were roles in Limón's *The Exiles* (1950), *The Visitation* (1952), and *The Queen's Epicedium* (1952). Ide also participated in a number of smaller troupes made up of dancers from the Humphrey/Weidman company, most notably the "Little Group" (1922?) of Ernestine Henoch-Stodelle, Ernestine King, George Bockman, and Fé Alf.

Idzikowsky, Stanislas, Polish ballet dancer and teacher raised in England where he performed; born 1894 in Warsaw. After moving to London as a child, he was trained there by Enrico Cecchetti. Idzikowsky made his professional debut at the Empire Theatre, London, where he partnered Phyllis Bedells, and her understudy Marjorie Moss. He spent four years touring the continent with Anna Pavlova (as one of her English company members) before joining the Diaghilev Ballet Russe in 1914. In that company from 1914 to 1925/26 and from 1928 to Diaghilev's death in the next year, he was cast in featured roles by each of the company's choreographers, among them Fokine's *Carnaval, Spectre de la Rose,* and *Petrouchka,* Massine's *La Boutique Fantasque* (1919), *Chant du Rossignol, Le Tricorne* (1919), and *Pulcinella* (1920), and George Balanchine's *Jack-in-the-Box* (1926). Celebrated for his elevation and precision technique, he performed the "Bluebird" pas de deux in the company's revival of *The Sleeping Princess.*

Following the dissolution of the Diaghilev troupe, he worked with the Vic-Wells Ballet in London, creating his last major role in Frederick Ashton's *Les Rendez-vous* (1933). He has contributed greatly to the developing companies in his adopted land and has helped to maintain the prevalence of the technique in which he was trained. He co-authored one of the standard texts of Cecchetti technique, *A Manual of Classical Theatrical Dancing* (London, 1922, co-authored with C.W. Beaumont), and has taught that clean style in his London studio.

Impekoven, Niddy, German concert dancer; born November 2, 1904 in Berlin. Impekoven was a child

prodigy interpretive dancer but later studied ballet with Heinrich Kroller. She performed for twenty-five years in Western Europe with her solo interpretive and characterizational dances before retiring in the mid-1930s. Her works, which are not known in enough detail to be listed, ranged from charming portraits of country maidens to solos influenced by German expressionism like the grotesque *Pretzel Puppen* (c.1924) and also included simple interpretations of music such as piano pieces by Schubert, Chopin and Bach. Impekoven's memoirs of her childhood are stirring and sometimes horrifying portraits of prodigies but do not include much information on her repertory.

Bibliography: Neddy Impekoven. *Die Geschichte eines Wunderkind* (The Cleverness of a Prodigy) (Zurich: 1955).

Ingelsby, Mona, English ballet dancer and choreographer; born 1918 in London. Ingelsby received her ballet training from Marie Rambert, Margaret Craske, and Nicholas Legat in London, and from Mathilde Kschessinskaya and Lubov Egorova in Paris.

A member of The Ballet Club from age fourteen, she was featured in the revivals of Fokine's *Papillon* and *The Sleeping Beauty,* and was understudy to Alicia Markova in Ninette De Valois' *Bar aux Folies-Bergère.*

She founded the International Ballet in 1940, creating roles in her own works and in Andrée Howard's *Twelfth Night* (1942), and performing in Leonid Massine's *Gaité Parisienne,* as the "Glove Seller."

Works Choreographed: CONCERT WORKS: *Endymion* (1938); *Amoras* (1940); *Planetomania* (1941); *Everyman* (1943); *The Masque of Comus* (1946).

Irving, Margaret, American theatrical dancer and actress; born c.1900, possibly in New England or Southern Quebec. A student of Ned Wayburn in New York City, she made her theatrical debut in his feature act, Ned Wayburn's *Girlies' Gambols* (1916), as a ballet-hula dancer on point, "Luana Lou." She went from that unique debut into specialty dance roles in *Jack O'Lantern* (1917), the *Ziegfeld Follies* of 1919, 1920, and 1923, the *Music Box Revues* of 1921, 1922, and 1924, *Manhattan Mary* (1927), *The Streets of Paris* (1929), *The Desert Song* (1927), *As Thousands Cheer* (1933), and *Hold Onto Your Hats* (1940). The exotic dances in *The Desert Song* (1927) and *Animal Crackers* (1928) brought her lasting fame on Broadway. Irving also worked in Hollywood as an actress and appeared in over fifty films, including both the "Mr. Moto" and "Charlie Chan" series of detective pictures. When she returned to Broadway in the early 1940s, she worked only as an actress.

Irving, Robert, English conductor also working in the United States; born August 28, 1913 in Winchester. Considered by many the best dance conductor now working, Irving has served as musical director for four important and very disparate companies—the Sadler's Wells Ballet, the Royal Ballet (c.1949–1958), the Martha Graham Dance Company, and the New York City Ballet (1958–present). He has been able to move from the Tchaikovsky scores of the English companies to the unique musical repertory of the American troupes, with Graham's affection for traditional American and South American modern music and Balanchine's affinity for Stravinsky. It has been said that he has conducted more twentieth-century music than any symphony orchestra director.

Isaksen, Lone, Danish ballet dancer frequently in residence in the United States and the Netherlands; born November 30, 1941 in Copenhagen, Denmark. Isaksen originally trained at the School of the Royal Danish Ballet and also studied with concert dancers Clothilde and Alexander von Sakharov in Copenhagen.

Isaksen spent a season as a soloist in the Scandinavian Ballet, founded and directed by Elsa Marianne von Rosen in 1960. After its disbandment, she moved to New York to join the Joffrey Ballet, creating roles there in Joffrey's *Gamelan* (1963), Alvin Ailey's *Feast of Ashes* (1962), and Gerald Arpino's *Incubus* (1962). When that company disbanded after its funding was withdrawn, she joined the Harkness Ballet, with which she danced until 1970. In that company, she created roles in Stuart Hodes' *The Abyss* (1965), John Butler's *After Eden* (1966), John Neumeier's *Stages and Reflections* (1968), and Milko Sparemblek's *L'Absence* (1969).

Isaksen and her husband, Lawrence Rhodes, remained in Europe after the Harkness Ballet, too, was disbanded. From 1970 to her retirement in 1971, she

performed with the Dutch National Ballet, creating a featured role in Rudolf Van Dantzig's *On the Way* (1970).

Ismailoff, Serge, Russian ballet dancer working in France and the United States; born 1912 in Moscow. Raised in Paris, Ismailoff was trained there by Olga Preobrajenska, Lubov Egorova, Nicholai Legat, and Bronislava Nijinska, in whose ballets he danced in a variety of companies. He made his professional debut in her 1932 troupe, performed in the corps of George Balanchine's Les Ballets '33 and joined De Basil's Ballet Russe (1933–1940), with which he immigrated to New York.

In that company, in the Ballet Russe de Monte Carlo (1943–1944) and Ballet International (1944), he continued his association with Nijinska, appearing in her *Danses Slaves et Tziganes* (BRMC) and *Pictures at an Exhibition* (BI). His forceful dancing and acting were also engaging in the companies' revivals of the Mikhail Fokine repertory, notably in *Le Coq d'Or, Prince Igor,* and *Schéhérézade,* as the bravura leaping "Favorite Slave."

After the demise of the Ballet International, Ismailoff opened a studio in New York City. He emerged from that semiretirement occasionally, however, to perform in cabarets, including a memorable engagement at the Russian Tea Room's café, partnering former Pavlova dancer Helen Kromar.

Istomina, Anna, Canadian ballet dancer; born Andrée Thomas in 1925 in Vancouver, British Columbia, Canada. Istomina received her early training in Vancouver in acrobatics from Jerry Mathieson, and in ballet with Charlotte del Roy, Nikolas Merinoff, and June Roper.

After a season in the corps of the Opéra Russe à Paris, Istomina joined the Ballet Russe de Monte Carlo in 1940. Associated with the works of Leonid Massine, she performed featured roles in his *Rouge et Noir, Vienna—1814, La Boutique Fantasque, Bacchanale,* and *Aleko*; in his Ballet Russe Highlights company (1945), she danced in his *Polish Festival* and *Première Polka.* She worked in South America during the late 1940s, dancing featured roles in *Giselle, Swan Lake,* and *Les Sylphides* in the Ballet de Teatro Colón in Rio de Janeiro.

Istomina was associated with the ballet of the Radio City Music Hall in the mid- and late 1950s, before retiring to teach.

Istomina, Avdotia, Russian ballet dancer of the nineteenth century; born January 6, 1799 in St. Petersburg; died there January 26, 1848. Trained by Charles-Louis Didelot in St. Petersburg, she was associated throughout her short career with his ballets. Among the many Didelot works in which she created principal roles were his *Acis et Galatée* (1816), *Le Calife de Bagdad* (1818), *Russlan et Ludmilla* (1824), and the new incidental dances for *Le Beneficant* (1829).

Ito, Michio, Japanese concert dancer and choreographer; born April 13, 1892 in Tokyo, Japan; died November 6, 1961 in Tokyo. Ito may have studied traditional dance and theater techniques in Japan before leaving for Paris in 1911. After musical training in Paris, he studied dance in Egypt and, in 1912, enrolled at the Emile Jaques-Dalcroze school in Hellerau, Germany. He left Germany at the outbreak of war, moving to Holland, and then to London, where, under the sponsorship of Lady Ottoline Morrel, he began to perform solo works. After his professional debut as a recital dancer in May 1915, he gave a series of concerts in London, culminating in his choreography and performance of *At the Hawk's Well* by William Butler Yeats, at a private performance.

In 1916, Ito emigrated to the United States where he remained until 1941. Apart from a tour with Adolph Bolm's Ballet Intime, he spent the years in America choreographing for his own company and for dance specialities interpolated into Broadway revues. Although he worked frequently on both coasts, Ito's American career can be divided between time spent primarily in New York (c.1916–1928), and on the West Coast. In his New York period he staged many plays for innovative theater groups including *Bushido* for the Washington Square Players (1916), *Tamura* (1918) and *Nuages et Fêtes* (1928) for the Neighborhood Playhouse, and *Turandot* (1929) for the Habima Players. In New York, his students included dance-mime Angna Enters and choreographers Felicia Sorel, Nimura, and Pauline Koner.

Ito's Los Angeles students included former Denishawn dancers Geordie Graham and Ann Douglas, and concert dancers Arnold Tamon and Lester Horton. There, he staged plays in Japanese for the Tokujiro Tautsui Company of Players and the Japanese Children's Theatre, as well as symphonic group concerts at the Rose and Hollywood Bowls. Ito is frequently said to have staged many Oriental dance sequences in early sound-era films, although only two such credits can be verified, most notably, his work as technical advisor on the 1933 version of *Madame Butterfly* (Paramount). He appeared in at least one additional film for Paramount—*Booloo* (1938), in which he played an African tribal chieftan.

Deported from the United States in 1941, Ito returned to Tokyo where he established a school. In Japan, he produced Prologs for Japanese movie-house chains and, after 1946, staged shows for the Fifth Air Force (Occupation Army). Before his death in 1961, Ito was involved in television production, but it cannot be determined whether he staged dances for variety shows or worked in a technical or production capacity. Ito's Tokyo school and company remained functioning until 1976, managed by his former student Ryuko Maki.

Ito's work and choreographic theories have had a revival in the United States in the last few years, sponsored primarily by Maki and her student, Satoru Shimazaki, a Japanese choreographer who lives and works in New York. Shimazaki has given recitals of Ito's reconstructed works and has included Ito's piece in concerts of his own company and repertory. He has also presented demonstrations of Ito's choreographic vocabulary—a severely limited selection of movements that he manipulated into his characterizational and abstract works.

It is likely that in the next few years Ito's work will be included in historical survey reconstruction concerts and that it will become more known to the dance audience. His theories will probably become the subject of more discussion and will take their place with those of his contemporaries—possibly dated, but very recognizable for their period and Dalcroze influence.

Works Choreographed: CONCERT WORKS: *Ave Maria* (1912); *Mai no Hagime* (Introduction of Dancing)

(1916); *Sakura Sakura* (Japanese Girl on the Cherry Hill) (1916); *Sho-Jyo* (the Spirit of Wine) (1916); *Chinese Dance* (1916); *Mangia* (Female Demon) (1916); *Gypsy Dance* (1916); *A Caprice* (1916); *Exasperation* (1916); *Fox Dance* (1916); *Pizzicatti* (1916); *Spirit Escaping from Bondage* (1916); *Marionette* (1916); *Golliwog's Cakewalk* (1917); *The White Peacock* (1918); *Wild Men's Dance* (1918); *Genroku Hanami Idori* (Japanese Spring Dance) (1918); *Bird Dance* (1918); *The Blue Flame* (1918); *Tsuru Kame* (Crane and Tortoise) (1918); *Kyo no Shiki* (Four Seasons in Kyoto) (1918); *Fujagawa Bushi* (1918); *Kappore* (1918); *Chidori no Kyoku* (Song of the Flowers) (1918); *Haru Same* (Spring Rain) (1918); *Yari no Odori* (Dance with a Spear) (1918); *Do-Jo-Ji* (1918); *Echigo-jishi* (1918); *Kembu* (Sword Dance) (1918); *Matsu-no-Midori* (1918); *Odori* (1918); *Nikki-no-Ippen* (A Page from a Diary) (1918); *Fantasie-Impromptu* (1919); *Romance and Scherzo* (1919); *En Bateau* (1919); *Gavotte* (1919); *Spanish Dances* (a. Sequidillia; b. Malaguena) (1919); *Valse Triste* (1919); *Arabesque No. 2* (1919); *The Bullfighter* (1920); *Song of India* (1920); *Siamese Dance* (1921); *Chinese Buffoon* (1921); *Mai no Hajime* (1921); *Spanish Dance* (1921); *Arabesque No. 1* (1921); *Andante Catabile* (I) (1921); *Spanish Fan Dance* (1922); *Le Petite Berger* (1922); *Spring* (1922); *Dances* from the *Pinwheel Revel (Ecclesiastique I, Jazz and Jazz, Lillies of the Field, Tropical Night)* (1922); *Japanese Spear Dance* (II) (1923); *Blue Waves* (1923); *Impression of a Chinese Actor* (1926); *Tango* (1927); *Sarabande* (1927); *Passepied* (1927); *La Joyeuse* (1927); *Hymn to the Sun* (1927); *Preludes V-X* (1927); *Caresse* (1927); *Danse Arabe* (1927); *Marche des Mirlitons* (1927); *Pair of Fans* (1927); *Single Fan* (1927); *Blue Boy* (1927); *Chinese Spear* (1927); *Danse de la Fée Dragée* (1927); *Ball* (1928); *Waltz* (1928); *Little Shepherdess* (1928, possibly the same as *Mirlitons*); *Portugese Country Dance* (1928); *Javanese Dance* (1928); *Down South* (1928); *Warrior* (1928); *Joy* (1928); *Lotus Land* (1928); *Mandarin Ducks* (1928); *Polka* (1928); *Ecclesiastique II* (1928); *Tone Poems I and II* (1928); *Faun* (1928); *Burmese Temple Dance* (1928); *Pavanne* (1928); *Sari Dance* (1928); *Persian Fantasy* (1928); *Chopin Etude* (1929); *Ladybug* (1929); *Mermaid* (1929); *Shadow* (1929); *Habañera* (1929); *Chopin Waltzes* (Op. 18, op. 64, no. 2.)

(1929); *Caucasian Dances* (1929); *New World Symphony* (1929); *Peer Gynt Suite* (1929); *Ecclesiastique III (Andante Cantabile II) (1929); Preludes IV, XI, and XV* (1930); *Polovetski Dances* (1930); *Mary Magdalene* (1931); *Sonata* (1931); *Birth of a Soul* (1931); *Tragedy* (1931); *Friendship* (1931); *Cortège* (1931); *Ecclesiastique IV* (1931); *Clair de Lune* (1933); *Dancing Girl* (1933); *Gnossienne I* (1933); *Cortège du Sardar (Caucasian Sketches II)* (1933); *Gnossienne II* (1934); *Harlequin and Columbine* (1935); *Debussy Minuet* (1936); *Orpheus* (1936); *Minuet* (1937); *Maid with the Flaxen Hair* (1937); *Blue Danube Waltzes* (1937); *Etenraku* (1937).

OPERA: *Madame Butterfly* (1927, stage director); *Orpheus* (1936, Federal Music Project); *La Traviata* (1936).

THEATER WORKS: *Bushido* (1916, also directed play and designed scenery); *The Donkey* (1918, also wrote scenario); *Tamura* (1918, also appeared in play); *At the Hawk's Well* (1918, also directed and appeared in play); *The Faithful* (1919, also directed); *What's in a Name* (1920, also designed scenery); Raymond Hitchcock's *Pin Wheel Revel* (1922, also performed and designed scenery; this production, renamed *Michio Ito's Pin Wheel Revel,* reopened for a brief run later in 1922); *Hagoromo* (Feather Mantle) and *Bu Su* (Something-Nothing) (1923, also translator and performer); *Greenwich Village Follies of 1923* (1923, choreographer of East Indian dance specialty); *The Fox's Grave* and *She Who Was Fished* (1923, also translator and performer); *Arabesque* (1925); *Goat Song* (1927); *Cherry Blossoms* (1927); *The Mikado* (1927); *L'Histoire du Soldat* (1928); *Nuages et Fêtes (Images)* (1928, also performer); *Turandot* (1929); *Samuri and Geisha* (1930); *Kage-no-Chikara* (The Shadow Man) (1930); *Matsuri* (Festival) (1930); *Koi No Yozakura* (Romance in Cherry Blossom Lane) (1930); productions of the Japanese Children's Theatre in Kabuki Plays and Dances (1932, producer, text adaptor, and director).

FILM: *No, No, Nanette* (First National, 1930, choreographer of sequence deleted from released film); *Madame Butterfly* (Paramount, 1933).

Bibliography: Michio Ito. "Omoide o Katuru: Takanoya" [Memories of Things Past], *Hikaku Bunka,* II, 57076 (Tokyo: 1956); Helen Caldwell, *Michio Ito: The Dancer and His Dances* (Berkeley, Cal.: 1977).

Ivanov, Lev, Russian ballet dancer and choreographer of the late nineteenth century, creator of two of the world's most popular ballets—*Swan Lake* and *The Nutcracker*; born February 18, 1834 in Moscow; died December 11, 1901 in St. Petersburg. Ivanov was trained at the Moscow, then at the St. Petersburg schools of the Imperial Ballet, notably by Felix Kschessinki. He joined the Maryinsky Theatre in the early 1850s, working primarily as a character dancer; his major roles included "Phoebus" in *Esmeralda* and "the Chief of the Gypsy Camp" in Saint-Léon's *Mariquita*. He served as regisseur from 1882 and as ballet master, with Marius Petipa, from 1885.

As a choreographer, Ivanov was always overshadowed by Petipa, although his work, with its scale of movement and musicality, has aged better than most of Petipa's. Two of his ballets, *The Nutcracker* (1892) and *Swan Lake* (Acts II and IV, 1895), are still in the repertories of most ballet companies throughout the world. The second act of *Swan Lake*, first of the so-called "white acts," is performed now in much of the same choreography as it was in 1895; its formations of swans and the central pas de deux have been duplicated almost exactly from the original. Two other works, *The Magic Flute* (1893, music by Drigo) and *The Awakening of Flora* (1894), are known from performances by the Anna Pavlova company.

Works Choreographed: CONCERT WORKS: *La Fille Mal Gardée* (1885, revival); *La Forêt Enchanté* (1887); *The Tulip of Haarlem* (1887); *The Beauty of Seville* (1888); *Cupid's Pranks* (1890); *Boatman's Holiday* (1891); *The Nutcracker* (1892); *The Magic Flute* (1893); *Cinderella* (1893); *Swan Lake*, Act II (1894); *Swan Lake*, Acts II and IV (1895, Acts I and III by Petipa, whole production was revival); *The Awakening of Flora* (1894); *Acis et Galathéa* (1896); *La Fille de Marbre* (1897); *Marco Bomba* (1899, after Perrot); *Sylvia* (1901, posthumous production cochoreographed or completed by Pavel Gerdt).

Bibliography: Slonimsky, Yuri. "Writings on Lev Ivanov," *Dance Perspectives 2* (1959).

Ivanovsky, Nicolai, Russian ballet dancer and teacher; born August 3, 1893 in St. Petersburg; died November 28, 1961 in Leningrad. Trained at the St. Petersburg school of the Imperial Ballet, he became a protégé of Mikhail Fokine, performing in his ballets

in school recitals, and with the Maryinsky Ballet and the Diaghilev Ballet Russe from 1912 to 1915. His credits included roles in Fokine's *Cléopâtre, Schéhérézade* and *Carnaval* and in Marius Petipa's *Don Quixote, Raymonda, Esmeralda,* and *Sleeping Beauty.*

Ivanovsky returned to Leningrad in 1915 to work with Alexander Fokine's Troitzy Theatre of Miniatures. He taught in Leningrad from 1920, becoming one of that city's most respected professors of technique, pedagogy and, surprisingly, ballroom dancing. His text on ballroom work of the sixteenth through the nineteenth centuries is a fascinating study of both the social and the geographic implications of dances' popularities.

Ives, Charles, American composer; born October 20, 1874 in Danbury, Connecticut; died 1954 in New York City. For many years, Ives' polytonality made him more attractive to choreographers than to the orchestra audience. Most of the short pieces and songs were combined to provide dance scores when only the most knowledgable musicologists knew Ives' works at all. Among the best known dances set to Ives are George Balanchine's *Ivesiana* (1954), with its nightmarish images and jarring movement patterns, Anna Sokolow's *The Question* (1956) and *Scenes from the Music of Charles Ives* (1971), Peter Martin's *Calcium Light Night* (1977), and Dennis Nahat's *Songs Our Fathers Loved* (1978), and incidental dances to the opera *Meeting Mr. Ives* (1974). The most frequently choreographed score by Ives is probably his *Variations on "America,"* which was often set by cynical choreographers who were forced to produce bicentennial pieces in the 1976 season.

Jackson, Rowena, English ballet dancer; born 1926 in Invercargill, New Zealand. Trained locally at the Lawson-Powell School, she accepted a scholarship to go to London to study at the school of the Sadler's Wells Ballet in 1946.

Joining the company in the next season, she performed in its productions of *Swan Lake* and *The Sleeping Beauty.* She was noted for her creations of roles in the works of Frederick Ashton, among them, *Homage to the Queen* (1953), *Variations on a Theme by Purcell* (1955), and *A Birthday Offering* (1956).

Returning to New Zealand with her husband, dancer Philip Chatfield, she has taught at the Wellington National School of Ballet.

Jacobi, Georges, German composer also working in France and England; born February 13, 1840 in Berlin; died September 13, 1906 in London. After studies in violin and composition in Berlin, Brussels, and Paris, he joined the orchestras of the Opéra-Comique and the Opéra. He served as conductor of the Bouffes-Parisien boulevard theater in 1869 and 1871 and served in that capacity for London theaters. He is most memorable in dance terms for his 103 scores and twenty-six years of conducting at The Alhambra Theatre, London, but also worked at the Crystal Palace exposition hall and The (London) Hippodrome, a variety house.

Jacobsen, Polle, Danish ballet dancer; born December 3, 1940 in Copenhagen. Trained at the school of the Royal Danish Ballet, he performed with the company on its American tour of 1956 as a "ballettkinder," with child roles in the Bournonville repertory. He left the company briefly to perform in state opera ballets in Germany and Switzerland, but returned in the mid-1960s. He has been able to divide his time between the Bournonville ballet that the Royal Danish Ballet keeps alive and the contemporary works that are created for its repertory, and seems as at home with the adult roles in *Napoli* as he is in the modernist floor-centered movements of Flemming Flindt.

Works Choreographed: CONCERT WORKS: *De Blâ Ojne* (Blue Eyes) (1975).

Jago, Mary, English ballet dancer working in Canada; born 1946 in Henfield, England. Trained at the Royal Ballet School, she made a brief debut at the Royal Opera's Ballet before emigrating to Toronto to work with the National Ballet of Canada. Best known for her performances in the company's repertory of classics, she has taken the principal roles in *Coppélia, The Sleeping Beauty,* and *La Bayadère.* Her contemporary roles include a lead in Ann Ditchburn's *Mad Shadows* and a part in the company revival of Antony Tudor's *Offenbach in the Underworld.*

James, Janice, American ballet dancer; born February 14, 1942 in Salt Lake City, Utah. James was trained with Willam Christensen and Bene Arnold, but before joining their Ballet West, she danced in the corps of the New York City Ballet (1963–1964). Since joining Ballet West in 1965, she has been acclaimed in most of its large repertory of ballets by Christensen and Balanchine. Her partnership with Tomm Ruud brought audience adoration in both pas de deux and in the principal roles of the company's *Cinderella, The Nutcracker, Swan Lake,* and *Coppélia.* James has proven, however, that she can dance in the calm technical requirements of Balanchine's cool abstractions, such as *Concerto Barocco,* as well as the effusions of the pas de deux repertory.

James, Leon, American theater, film, and social dancer; born c.1920 in New York City. James was a fairly conventional, upwardly mobile young man with a college degree, a wife, and a secret life. He was also the Harvest Moon champion and the "King of the Savoy Ballroom." James, who was considered one of the finest Lindy Hoppers in the country, appeared in the primarily social form professionally in nightclubs, theatrical productions, television, and films. His credits include engagements at the Latin Quarter, Cafe Society, the Cotton Club (Uptown, Downtown, Hollywood), College Inn, and the Florentine Gardens in Los Angeles. Bookings at all of the most important presentation act houses included the Roxy, Palace, Paramount, Loew's State (Brooklyn),

Strand, and the Radio City Music Hall. He appeared in most of the musicals and revues that featured dance specialties in the late 1930s, among them *Knickerbocker Holiday* (1938), the *Hot Mikado* pictures (1939), *Blackbirds of 1939, Hellzapoppin',* and *Sons o'Fun* (1941). His films ranged from the Marx Brothers' *Day at the Races* (MGM, 1937), to the filmed revues, *Hellzapoppin'* (WB, 1941) and *Meet the People* (MGM, 1944).

Jamison, Judith, American modern dancer who may be the United States' most widely recognized dancer, both here and abroad; born May 10, 1944 in Philadelphia, Pennsylvania. Jamison studied ballet locally with Marion Cuyjet, Nadia Chilkovsky, and Juri Gottschalk, and tap and jazz techniques with Delores Brown, John Jones, and Johnny Hines. Moving to New York, she has continued her ballet training with Patricia Wilde and studied traditional modern and Horton techniques with Dudley Williams and Paul Sanasardo.

Unquestionably, Jamison is best known as a dancer with the Alvin Ailey Dance Theatre, with which she has performed from 1965. In *Cry*, the solo that Ailey created for her in 1971, she seems to represent both the American dance experience and the more general life of the American woman. Among the many other works by Ailey in which she has created roles are his *Maskela Langage* (1969), *Choral Dances* (1971), *Mary Lou's Mass* (1971), *The Lark Ascending* (1972), *Passage* (1978), and *The Mooche* (1975). She is also widely praised for her featured performances in his *Revelations*, in Janet Collins' *Spirituals*, and in Talley Beatty's *The Road of the Phoebe Snow*. Jamison served as a company director during Ailey's medical leave of absence in 1979–1980.

A popular guest artist, Jamison has appeared frequently in benefits, galas, and single appearances with many companies, among them the Swedish Royal Ballet, the Cullberg Ballet, the Vienna State Opera, the Harkness Ballet, and American Ballet Theatre, as well as performances with ad hoc companies such as the United States Dance Company, formed with Jamison, John Parks, and her then husband Miguel Godreau. Jamison has also acted extensively in the New York area, in musical productions and in Shakespeare plays.

Jaques-Dalcroze, Emile, Austro-Hungarian composer and theorist with a tremendous influence on German modern dance; born Jakob Dalkes, July 6, 1865 in Vienna; died July 1, 1950 in Geneva, Switzerland. Jaques-Dalcroze's contribution to dance came as a result of a training exercise that he developed to help teach music through the perception of rhythm in movement. He established the Institute for Applied Rhythm in Hellerau in 1911, where he trained a generation of German, Austrian, and Swiss dancers and musicians. His direct students included Marie Rambert, Mary Wigman, Hanya Holm, and Yvonne Georgi. Since he had an indirect influence on anyone who worked with any of them, he can be said to have affected almost everyone in dance today.

Unlike Delsarte, whose philosophies were never directly imparted to dancers, Jaques-Dalcroze accepted dancers as students. The Dalcroze schools in many cities around the world now teach his theories and methods to children and adults; among the former students at the New York studio is this author.

There has been a revival of interest recently in Jaques-Dalcroze's own compositions, most of which were written for large chorus, although it is not known whether anyone has choreographed a dance to his work. His staging techniques on the multitiered stage floor at Hellerau have also come under close study.

Jaraslow, Risa, American postmodern dancer and choreographer; born March 22, 1947. Jaraslow attended Bennington College and continued her dance training in New York with Viola Farber, Dan Wagoner, and Merce Cunningham at the Cunningham studio. She has performed with the New Haven Dance Ensemble, in Sara Rudner's *Dancing* (1975) and *May's Dances* (1976), Wendy Rogers' *Evidence* (1977) and in shared recitals with Rudner, Rogers, Wendy Perron, Rosalind Newman, and Nancy Lewis over the last seven years. Jaraslow's own works have been performed at many New York loft theaters and in some of the city's most important dance festivals, including the Roxanne Foundation's

own *Dancing in Series* (1979) and the Museum of Modern Art summer-garden programs of that summer. Like her colleagues in Roxanne (Wendy Perron, Dana Reitz, and Susan Rethorst), she works her choreography around the study and manipulation of patterns of movement and timing in dense works for solo dancer or small group.

Works Choreographed: CONCERT WORKS: *Oysters* (1973); *Raindance* (1974); *South Street* (1974); *Point Lobos First Visit* (1975); *Stardust* (1977); *Surfacing* (1978); *Five and Dime* (1978); *Plain Crossing* (1978); *A History of "Walking" and "Cowgirls" from Plain Crossing* (1979); *Mayweed* (1979); *Roundelay* (1979); *Daily Rushes* (1980); *Rites of Passage: Part I, Ceremonies for the Sand* (1980, continuing project).

Jarnac, Dorothee, American theatrical dance comic; born 1922 in Sacramento, California. Jarnac studied ballet in Los Angeles with Ernest Belcher, Carmelita Maracchi, and Bronislava Nijinska, and modern dance in New York with Hanya Holm and Martha Graham. She performed with the Hollywood Ballet at the Hollywood Bowl and appeared in *Meet the People* (1940) before joining the national tour of *Bloomer Girl* (replacing Joan McCracken) and moving with the show to New York. Her Broadway credits include featured dancer status in *Heaven on Earth* (1948), *Tickets Please* (1950), and *The Littlest Revue* (1956). Jarnac also performed frequently at the Cafe Society (both Uptown and Downtown branches) with vocalist Hope Foy, reviving the solos that had made her reputation in their theatrical contexts.

Jarnac's best known pieces were a letter dance (from *Heaven on Earth*) in which she danced out a piece of correspondence, complete with punctuation, a chair number in which she portrayed the angst of love to "Do Nothing 'Til You Hear from Me" without leaving her seat, and a solo predating Alwin Nikolais (a fellow Holm student) in which she worked inside a five-foot rubber band, dressed in a hooded leotard.

Jarrott, John, American exhibition ballroom dancer; born c.1893 in Jacksonville, Florida; died June 15, 1955 in New York City. Of the lives covered in this book, Jarrott's may have been the most tragic. Even without reading into the euphemisms with which he described his childhood, there is a feeling that all of the social and artistic forces surrounding the dance world conspired to destroy him. Jarrott was raised on the steamboat circuit of the Mississippi, his father a professional gambler, his mother the director of a "pleasure establishment." After his abandonment and her suicide, Jarrott was "adopted" by a former heavyweight boxer who toured in a theatricalized fight act, using the adolescent as a tap-dancing bait. At fifteen, he was hired by "horseman" August Reilley to dance in the cabarets that he controlled in the Chicago area; at one, Ray Jones' Cafe, he and Louise Greuning introduced The Grizzly Bear, for which he became famous. From 1912 to 1920, Jarrott was the most popular and well-reputed exhibition ballroom dance partner in the business. He worked with Greuning, Benna Hoffman, Louise Alexander, Vera Maxwell, Josephine Kimball, Ivy Sawyer, Josephine Harriman, Joan Sawyer, Mae Murray, Louise Whiting, and Josephine Howard, to whom he was briefly married. Among the dances with which he was credited as inventor or introducer were the Grizzly Bear, the Turkey Trot, and the Yankee One-Step.

When he died at Bellevue Hospital in 1955, it was revealed that Jarrott had been addicted to drugs since 1923. From the polite statements that appeared in the theatrical press in the high point of his career, stating that he had missed a performance or a train, that he was ill, that he was incapacitated, it seems likely that he had been an addict for the greater part of his life, perhaps since as early as 1912, when he was working for Reilley. He survived somehow until he was sixty-three, but Jarrott, the most sophisticated and innovative dancer of the period, had been dying throughout his life. Able to perform for only a short period, he left a major legacy of dances that have become a part of the culture, if not the repertory, of America.

Jarvis, Lilian, Canadian ballet dancer; born 1931 in Toronto. Jarvis was trained by Mildred Wickson and Boris Volkov in Toronto. On a study trip to England in 1950, she appeared in the West End while continuing her training. On returning to Toronto, she became a charter member of the National Ballet of

Canada, and its first native principal. Her "Odette/ Odille," "Swanilda," and "Sugar Plum Fairy" set the standard for Canadian bravura dancing for many years and brought the excitement of contemporary productions of the classics to the country through live and televised performance. Her versatility was shown in the company's repertory evenings, in which she appeared in abstractions by Gwynneth Lloyd and Arnold Spohr, dramatic works by Grant Strate, and the revivals of Antony Tudor's *Jardin aux Lilas* and John Cranko's *Pineapple Poll*, possibly the most disparate works in any company's schedule.

Jasinsky, Roman, Polish ballet dancer working in the United States after the mid-1930s; born June 23, 1912 in Warsaw, Poland. Jasinsky was trained at the Polish State Ballet School by Bronislava Nijinska, with whom he performed in Warsaw, and in Paris as a member of the Ida Rubinstein Ballet, c.1928.

He performed in two companies associated with the works of Leonid Massine—the ballet of the Teatro alla Scala, which Massine directed in 1932, and the Ballets Russes de Monte Carlo (1933–1948). In the latter, he created roles in his *Union Pacific* and *Jardin Public* (both 1935), and *Choreatium* (1933) and performed in his *Les Présages* and *Symphonie Fantastique*, and in Nijinska's *Variations* and *Les Comediens Jaloux*. Jasinsky also danced with Les Ballets, 1933, creating roles in George Balanchine's *Mozartiana, Les Songes, Errante,* and *The Seven Deadly Sins*. In the original Ballet Russe (1946–1947), he danced in David Lichine's *Francesca da Rimini* and *Graduation Ball*.

Jasinsky has served as artistic director of the Tulsa (Oklahoma) Civic Ballet since 1957, and has choreographed for that group.

Works Choreographed: CONCERT WORKS: *Mozartiana* (1957); *Polka Mazurka* (1957); *A Polish Tribute to Oklahoma* (1977).

Jeanmaire, Zizi, French ballet and theatrical dancer born April 29, 1924 in Paris. Trained at the school of the Paris Opéra, she joined the company in 1939, performing in the Lifar repertory. When he was suspended from the Opéra for collaboration with the Vichy regime, she danced for him in the Nouveau Ballet de Monte Carlo, creating roles in his *La Péri, Aubade,* and *Pygmalion* (1946). With the De Basil Ballet Russe de Monte Carlo in 1947, she performed in David Lichine's *Prodigal Son* and *Les Sylphides,* and Boris Kniaseff's *Piccoli* (1947).

From 1948 to the present, she has been associated with the companies and productions of Roland Petit, whom she met while working on the *Soirée de la Danse* series in 1944. She has created roles in almost every work that he has done since that year, in his Ballet de Paris (1948–1953), Ballets Roland Petit (1956–1960), Ballet de Marseilles (during the late 1970s), in his films and television programs, and in a series of revues. Among the many ballets in which she performed were his *La Nuit* (1956), *Valentine* (1956), *Rose des Vents* (1958), *Cyrano de Bergerac* (1959), *Rain* (1960), *La Chaloupée* (1961), and *Symphonie Fantastique* (1975), in which she returned to the Paris Opéra.

Her revues include *The Girl in Pink Tights* (1953), *Patron* (1959), *Lasilla* (1963), and seven years of productions at the Casino de Paris (1970–1977). She made her film debut in Petit's choreography for *Hans Christian Andersen,* later appearing as an actress and featured dancer in his *Anything Goes* (Paramount, 1956), *Folies Bergère* (Independent, 1956), and *Black Tights*. Her television revues, primarily for the French Radio-television network, include *Show Zizi* (1963), *Les Chemins de la Création* (1965), *Show Zizi Jeanmaire* (1967), and *Zizi!* (1969).

Extraordinarily popular both within and outside France, Jeanmaire has managed to link her stardom in theater to a continuing presence in the ballet.

Jeffries, Stephen, English ballet dancer; born June 24, 1951 in Reintelm, West Germnay. Trained at the Royal Ballet School, he entered the Royal Ballet in 1969. He was known originally for his performances in the contemporary repertory and was cast in the classical male principal roles only in the late 1970s. He has been applauded in Joe Layton's *The Grand Tour* (1971), Kenneth Macmillan's *Ballade, Isadora* and *The Poltroon* (1972), Peter Wright's *El Amor Brujo,* and David Drew's *Sword of Alsace* (1973), as well as the company revival of Richard Helpmann's *Hamlet*.

Jenkins, Margaret, American postmodern dancer and choreographer; born c.1944 in San Francisco, California. Trained as an adolescent by Welland Lathrop, Jenkins attended the Juilliard School, where she studied with José Limón and Martha Graham, and the University of California at Los Angeles, where she danced with Al Huang. Returning to New York in 1964, she taught at the Merce Cunningham Studio and worked with him restaging works for European companies.

In New York through the 1960s, she danced with the companies of Gus Solomons, Jr., James Cunningham, Twyla Tharp, for whom she created roles in *Cede Blue Lake* (1965), *Unprocessed* (1965) and *Re-Moves* (1966), and Viola Farber, with whom she performed in *Notebook, Quota, Passage*, and *Excerpt*.

She has choreographed since 1969, mostly for her own company in the Bay area. Her works are postmodernist abstraction in the Merce Cunningham tradition and are considered both highly original and stimulating.

Works Choreographed: CONCERT WORKS: *Leeway* (1969); *Equal Time* (1976); *Lapinsky* (1976); *Story* (1976); *About the Space in Between* (1977); *Video Songs* (1977); *Copy* (1978); *Interferences II for Seven* (1978); *Into Three* (1978); *Red, Yellow, Blue* (1978); *Invisible Frames* (1980); *Straight Words* (1980).

Jenner, Ann, English ballet dancer; born March 8, 1944 in Ewell, Surrey. Trained by Marjorie Shrimpton in Balham, she continued her studies at the school of the Royal Ballet.

In the Royal Ballet from 1961, she has created roles in Frederick Ashton's *Jazz Calendar* (1968) and in Kenneth Macmillan's *Marguerite and Armand* (1963). Celebrated for her performances in the principal roles in *La Fille Mal Gardée* and *Coppélia*, she has also performed in the company productions of *Cinderella, Giselle,* Ashton's *Symphonic Variations* and *The Dream*, and Antony Tudor's *Shadowplay*.

Jensen, Svend Erik, Danish ballet dancer and mime; born September 1, 1913 in Copenhagen, Denmark. Jensen was trained at the school of the Royal Danish Ballet and has performed with that company throughout his career.

Jensen's association with the Royal Danish Ballet is not only one of tenure, but also one of artistic image and repertory. He has created roles in the contemporary works which the company commissioned, among them, Harald Lander's *Etudes* (1948) and *The Sorceror's Apprentice* (1940), and Bjørn Larsen's *The Dethroned Lion Tamer* (1944). But Jensen is equally well known for his mime roles in the works of August Bournonville, which the company has kept alive since the nineteenth century, including *A Folk Tale* and *Kermesse in Bruges*.

Jerrell, Edith, American ballet dancer; born Edith Jerchower, c. 1938 in the Bronx, New York. Trained at the Metropolitan Opera Ballet School and at the High School of Performing Arts, she has listed among her most important influences Antony Tudor, Margaret Craske, Valentina Pereyeslavec, and Yeichi Nimura. A member of the Metropolitan Opera Ballet for ten years, she appeared in interpolated dances in many opera productions and in ballets staged specifically for the company. Her major credits ranged from *Les Sylphides* to a trio of Tudor ballets, *Echoing of Trumpets, Concerning Oracles*, and *Hail and Farewell*. Jerrell worked as ballet master for a number of short-term opera companies, including the Sante Fe Opera (open only during the summer months), and for the City Center Joffrey Ballet.

Jhung, Finis, American ballet dancer and teacher; born May 28, 1937 in Honolulu, Hawaii. After local training in tap, acrobatics, and ballet, Jhung attended the University of Utah, where he studied with Willam Christensen.

Jhung joined the San Francisco Opera Ballet in 1960, performing featured roles in Lew Christensen's *Variations de Ballet, Con Amore, Danses Concertantes, Caprice,* and Balanchine's *Symphony in C*. He then moved to New York to perform with The Robert Joffrey Ballet (1962-1964); after the company's demise, he, along with many of the dancers, joined the Harkness Ballet for its brief existence. Among the many dramatic works in which he was

featured in the company's repertories were Gerald Arpino's *Incubus* and *The Palace*, Francisco Moncion's *Pastorale*, Donald Saddler's *Koshare* and *Dreams of Glory*, and Brian McDonald's *Time Out of Mind* and *Capers*.

Since his retirement as a performer, Jhung has become one of New York's most popular ballet teachers.

Jillana, American ballet dancer; born Jillana Zimmerman, in 1934 in Hackensack, New Jersey. After early studies with Emily Hadley, she continued her training at the School of American Ballet.

From her performances with Ballet Society, Jillana was associated with the New York City Ballet for most of her performing career. After gaining her first important part in the trio (second waltz) in Balanchine's *La Valse* (1951), she created many roles in the Balanchine works, among them *Capriccio Brillante* (1951), *Liebeslieder Walzer* (1960), *Midsummer Night's Dream* (1962), as "Helena," and *Don Quixote* (1965), as "The Duchess" in the horrifying court scene. Among the many works in which she performed featured roles were his *Serenade, Apollo, The Nutcracker,* and *Divertimento No. 15.* Also in her repertory were created roles in works by Jerome Robbins, among them *The Pied Piper* (1951) and *Quartet* (1954), and the female role in his *Afternoon of the Faun.*

For one season (1957–1958), she performed with Ballet Theatre, dancing in the company's productions of *Les Sylphides* and as "The Mother" in Agnes De Mille's *Fall River Legend.* She created roles in two Ballet Theatre Workshop productions during that season too, in Enrique Martinez's *La Muerte Enamorada* (1957) and Herbert Ross' *Ovid Metamorphoses* (1958).

Since retiring from performance, Jillana has served the City Ballet as a traveling judge recommending students outside New York for Ford Foundation scholarships to the School of American Ballet. A popular teacher and frequent adjudicator for regional ballet conferences, she currently serves as artistic director of the San Diego Ballet in California.

Joffrey, Robert, American ballet dancer and choreographer; born Abdullah Jaffa Bey Khan, December 24, 1930 in Seattle, Washington. Joffrey studied ballet and character dancing locally from the age of eight; at twelve, he began to train with Mary Ann Wells. In 1948, he moved to New York and studied ballet with Alexandra Fedorova and at the School of American Ballet, and modern dance with Gertrude Shurr and May O'Donell.

Joffrey's short performance career began in Seattle, Washington, with a solo concert of his own works. In 1949, he danced as a soloist with Roland Petit's Ballets de Paris during the company's New York season. From 1950 to 1952, he performed with the May O'Donell Concert Group in many works, among them, *Dance Sonatas #1 and 2.* He served on the dance faculty of New York's High School of Performing Arts from 1950 to 1955 and of the American Ballet Center (1953–), the official school of the various Joffrey companies.

Joffrey choreographed works for graduation performances at the High School of Performing Arts, including *Umpateedle* (1952). He also participated in the early Choreographers' Workshops that year. His earliest company, the Robert Joffrey Ballet Concert, gave its premiere concerts at the 92nd Street YM-YWHA in New York in 1954; works created for that company included *Le Bal Masque* and *Pas de Déèses,* the signature piece for many Joffrey companies. From 1955 to 1964, he toured with a group of dancers, among them Gerald Arpino, Brunhilda Ruiz, John Wilson, and Beatriz Thompkins, creating works for them.

In 1965, following the dissolution of the Robert Joffrey Ballet, Joffrey instituted an apprentice group to perform his works and those of Arpino, Glen Tetley, and Anna Sokolow. This group of young dancers, who included Lisa Bradley, Robert Blankshine, John Jones, Dennis Nahat, George Ramos, Margo Sappington, Michael Uthoff, and Maximilliano Zomosa, formed the nucleus of the City Center Joffrey Ballet, his current company.

This organization, which has become one of America's major ballet companies, produces new choreography by Arpino and revivals of works by Frederick Ashton and Leonid Massine. Joffrey has been able to take the time to create very few ballets for the company—*Remembrances* (1973), the bicentennial work *Beautiful Dreamer* (1975), and perhaps

his best known work, *Astarte* (1967). Images from that mixed-media ballet were featured on the covers of national general-interest and news magazines throughout the 1967–1968 season.

Joffrey has worked extensively as an opera choreographer, particularly in the 1960s, at the New York City Opera. He is best known for his work on American operas performed live or on television; among those which he has staged are *Susannah* (1959), by Carlisle Floyd, Douglas Moore's *The Wings of the Dove* (1961), and Marc Blitzstein's *Regina* (1959).

Works Choreographed: CONCERT WORKS: *Persephone* (1952); *Umpateedle* (1952); *Scaramouche* (1952); *Le Bal Masque* (1954); *Pas de Déèses* (1954); *Harpsichord Concerto in D Minor* (1955); *Pierrot Lunaire* (1955); *Workout* (1956); *Kaleidoscope* (1957); *Le Bal, Within Four Walls* (1957); *Gamelan* (1962); *Astarte* (1967); *Remembrances* (1973); *Beautiful Dreamer* (1975).

THEATER WORKS: *Love's Labours Lost* (1965).

TELEVISION: *Griffelkin* (NBC, Opera Theatre, 1955).

Johanssen, Christian, Swedish ballet dancer who performed and taught in Russia; born May 20, 1817 in Stockholm, Sweden; died December 12, 1903 in St. Petersburg. Johanssen was trained at the school of the Royal Swedish Ballet, and in Copenhagen by August Bournonville. He made his debut with the Royal Swedish Ballet in 1837, partnering Marie Taglioni. In 1841, he was engaged by the Maryinsky Theater in St. Petersburg as a principal dancer. At the theater from 1841 to 1869, he performed roles in *La Gitane* and in works by Marius Petipa and Lev Ivanov.

Retiring from performance in 1860, he served as principal teacher at the school of the Imperial Ballet until his death. Among the dancers whom he trained were Mathilde Kschessinskaia, Olga Preobrajenska (perhaps the most important Russian emigré teacher in the 1920s in Paris), Pavel Gerdt, and his daughter Anna (1860–1917), who taught at the school herself from 1899.

Johansson, Anna, Russian nineteenth-century ballet dancer; born 1860, possibly in St. Petersburg; died there 1917. Trained by her father, Swedish dancer

Christian Johansson, at the School of the Imperial Ballet where he taught, she graduated into the Maryinsky Ballet in 1878. In her twenty years in the company, she performed many of the principal roles of the classical repertory, among them "Emma" in Lev Ivanov's *La Tulipe d'Haarlem*, "Titania" in his *Midsummer Night's Dream*, and the title role in Marius Petipa's *Esmeralda*. One of her pupils, Tamara Karsavina, described her dancing as flawless, graceful, and beautifully shaped and phrased, an epitaph that explained the devotion that so many had to the memory of her performance in the latter role—that of her debut and of her greatest fame.

After retiring from performance, Johansson succeeded her father on the faculty of the Imperial School. As well as Karsavina, her pupils there included Lubov Egorova, herself a great teacher whose studio fed dancers to the Ballets Russe de Monte Carlo and Paris Opéra for many years.

Johansson, Ronny, Swedish concert dancer; born 1891 in Riga, Latvia, of Swedish parents. Originally trained as a linguist, Johansson returned to her parents' native Stockholm in the early 1910s. She began her dance training there under Heinrich Kroller, a ballet dancer (and later ballet master of many German state operas) with an interest in the expressionist dance movement. She began touring with a solo program in 1914, presenting character studies and folk motif works. By 1920, she was so popular in Central Europe that her photographs were included in the famous German cigarette card series on concert dance. Johansson made her United States debut in 1925, with a series of concerts on a route that stretched "from New York to Minneapolis" (traditionally the center of Swedish immigration in the United States). She taught at the Denishawn school in New York (and possibly the one in Boston) on that trip, and began a professional relationship with Adolf Bolm, for whom she later guested. Her American recitals of the 1920s and 1930s (1925, 1928, 1931, 1938–1939) were frequently shared with diseuses and monologuistes such as Rosalinde Fuller, and with pioneers of concert and modern dance who were then considered characterizational mimes, among them, Charles Weidman.

Johansson taught in Stockholm from the early 1930s, serving with the Royal Dramatic Theatre after the mid-1940s.

The list of concert works below does a disservice to Johansson. It has been estimated that she maintained a repertory of more than a hundred works, each a solo. The following list of verified titles that lasted in her repertory is woefully inadequate, but at least it gives an idea of the range and scope of her performance.

Works Choreographed: CONCERT WORKS: *Paderewski Menuett* (c.1916); *Moments Musicales* (c.1916); *Gavote Joyeuse* (1917); *Scherzo* (1917); *An der Frühling* (To the Dawn) (1917); *Allegro Moderato* (c.1925); *Norland Scherzo* (c.1925); *Greig Waltz* (c.1925); *The Elf* (c.1925, possibly created as early as 1914); *Serenade* (c.1925); *Strauss Waltz* (c.1925); *Mazurka* (c.1925); *Rustic Dance* (c.1925); *Allegro Energetico* (c.1929); *Bach Andante and Allegretto* (c.1929); *Alla Marcia* (c.1929); *Twilight Meeting* (c.1938); *Folk Moods (Swedish, Czech, Slovakian, Argentine)* (c.1938, it is possible that a series of Folk Moods was included in programs as early as 1917); *Old Gnome* (c.1938); *Dynamic Improvisations* (c.1938); *Caprichos* (c.1938); *Play at Dawn* (c.1939); *Night Voices* (c.1938); *Dance at Evening* (c.1938); *Days Work* (c.1939, includes *Home and Its Production, Harvest Machine Clatter, Assembly Line, Speed up*).

Johns, Jasper, American artist and designer; born 1930 in Alandale, South Carolina. Johns serves as artistic director of the Merce Cunningham Dance Company, contributing visual elements for Cunningham works. Among the pieces in which his set pieces and costumes can be seen are *Walkaround Time* (1968), *Second Hand* (1970), *TV Rerun* (1970, changed somewhat at each performance), and *Borst Park* (1972). His paintings and graphics can be seen in most American and European museums, and in the lobby of New York State Theatre.

Johnson, Carole, American modern dancer; born in Jersey City, New Jersey. Trained at the Juilliard School in ballet and modern dance techniques, Johnson performed with Cleo Quitman before joining the Eleo Pomare Dance Company in 1965. In that troupe she appeared in many of the dramatic female roles for which Pomare is noted, among them segments in *Gin, Woman, Distress* (1967), *Serendipity* (1966), *Black on Black* (1971), *I Am a Witness, To a Cleaner's Wife,* and his well known *Blues for the Jungle* (1966). Johnson has been noted also as one of the most politically active dancers, able to represent the arts in the city's bureaucracy, including work with the Park Department's Dancemobile, the New York State Council on the Arts, and the Harlem Cultural Council, of which she was dance representative. She edited *FEET* (a periodical about black choreographers and companies) in New York and in Cleveland, where she worked with the Karamu House.

Johnson, Julie, American exhibition ballroom and theatrical dancer; born Juliette Henkel, 1903; died 1973 in Los Angeles, California. A student of Ned Wayburn, she appeared in choruses of his Prologs and vaudeville feature acts before 1926. During that season, she turned down a part in his *Palm Beach Girl* to form an exhibition ballroom team with her future husband, George Murphy. They had a clean-cut "collegiate" type of act, in contrast to the tango and Apaches that were just going out of fashion. Their dance acts, staged for them by Billy Pierce, were booked into George Olsen's nightclub circuit, where they also did a version of Moss and Fontana's Apache routine. They appeared in the London company of *Good News* (which was an Olsen show), where they did the "Varsity Drag"; in London, they also worked at three celebrated nightclubs—the Café de Paris, the Kit Kat Klub, and the Mayfair Hotel. Returning to New York, they were booked into the Central Park Casino for three years but also appeared on Broadway in *Hold Everything* (replacement cast), *Shoot the Works* (1931), and *Of Thee I Sing* (replacement).

Although she performed live in Los Angeles, she did not enter films with Murphy. Johnson retired in the mid-1930s, and was soon debilitated by arthritis.

Johnson, Kurt, American theatrical dancer and actor; born October 5, 1952 in Pasadena, California. Johnson was trained locally and at the Los Angeles Community College before moving east. After West Coast regional plays and a trio of musicals at the

Goodspeed Opera House in Connecticut, he has appeared in New York productions as a dramatic actor and as a dancer. He played *A Chorus Line's* choreographer "Zach" in both coasts and danced in Gower Champion's *Rockabye Hamlet* and the Equity Library Theater's memorable revival of *Follies*. His film roles have been primarily dramatic, for example, his "David Barnum" in *The Fan* (RSO, 1981) partnered Lauren Bacall in a show-within-the-film before he was murdered.

Johnson, Louis, American ballet, theater, and modern dancer and choreographer; born 1930 in Statesville, North Carolina. Originally a gymnast, he was given ballet training by Clare Hayward in her Washington, D.C. school and at the School of American Ballet in New York. As an SAB student, he appeared with the New York City Ballet in the original cast of Jerome Robbins' *Ballade* (1952).

Johnson made his Broadway debut later that year as a featured dancer in the 1952 revival of *Four Saints in Three Acts*. His later performance credits included *My Darlin' Aida* (1952), *House of Flowers* (1954), Bob Fosse's *Damn Yankees* (1955, repeating the role in the film, WB 1958), *The World's My Oyster* (1956), Agnes De Mille's *Kwamina* (1961), and *Hallelujah Baby* (1967). Celebrated for his Broadway choreography of *Purlie* (1970), he is also well known for his work with Off Broadway companies, staging dances for the original production of *Black Nativity* in 1961, for the New York Shakespeare Festival's *Electra* in the park in 1969, and for many productions of the Negro Ensemble Company, among them *The Song of the Lusitania Bogey* (1968), *Kongi's Harvest* (1968), and *God Is a (Guess What?)* (1968). His many opera assignments include *Aida* for the Metropolitan Opera (1976) and the production of *Treemonisha* that revived Scott Joplin's reputation forever in 1975.

Since the premiere of his *Lament* in 1953, Johnson has been known as a concert choreographer in New York and as an adjunct to his many teaching jobs. Among his best known works are *Jazz Study* (1965) and *Youth in the Ghetto* (1967), for the HarYou dance troupe, *Forces of Rhythms* (1974), a popular work piece in the Dance Theatre of Harlem repertory, and *Echoes of Spain* (1977), for the New York

Ballet Hispanico. His ballets are in the repertories of the Brooklyn Ballet, the Washington (D.C.) Ballet, the Alvin Ailey Dance Theatre, and the company at Howard University, where he has been on the faculty since 1977.

Works Choreographed: CONCERT WORKS: *Lament* (1953); *Whisk* (1953); *Spiritual Suite* (c.1954); *Kindergarten* (c.1954); *Variations* (1955); *Georgia* (1963); *Shades of Brown* (1963); *What a World* (1963); *Afternoon in the Park* (1965); *Jazz Study* (1965); *First Sin* (1965); *Youth in the Ghetto* (1967); *And the Beat Goes On* (1969); *Ode to Martin Luther King* (1969); *Forces of Rhythm* (1974); *Pickaninny Fairy* (1975); *When Malindy Sings* (1976); *Echoes of Spain* (1977).

THEATER WORKS: *Black Nativity* (1961); *The Song of the Lusitania Bogey* (1968); *Kongi's Harvest* (1968); *God Is a (Guess What?)* (1968); *Electra* (1969); *Purlie* (1970); *Lost in the Stars* (1972); *Changes* (1974).

FILM: *Cotton Comes to Harlem* (UA, 1970); *The Wiz* (MGM, 1979).

Johnson, Mel, Jr. American theatrical dancer; born April 16, 1949 in New York City. Among his acting work, Johnson has danced more dramatically in theatrical contexts since his professional debut in an Off Broadway *Hamlet* in 1972. He was a member of the quartet of Pullman car porters who performed their functions in tap dance in *On the Twentieth Century* (1979) and revived his reputation as a skilled hoofer in *Eubie* (1979). Johnson combined his dance, vocal, and acting skills in *Shakespeare's Cabaret* in 1980.

Johnson, Nancy, American ballet dancer; born 1934 in San Francisco, California. Trained at the school of the San Francisco Ballet, Johnson's performing career was, like so many of her Bay area colleagues', wound into those of the Christensen brothers—Willam, Lew, and Harold. She studied with the latter two at the school of the San Francisco Ballet and appeared in many works by the middle brother after graduating into the company. Her best known of many roles in the San Francisco Ballet included the "Sugar Plum Fairy" in the company's *Nutcracker* (and in Willam's version for his University of Utah Ballet), "Terpsichore" in George Balanchine's

Apollo, and principal parts in *Con Amore* and *A Masque of Beauty and the Shepherd*. After a number of tours with her husband, dancer Richard Carter, she settled in Northern California to teach and to direct the San Diego Ballet. Since retiring from the dance world, after developing her company into a major troupe with its own Balanchine-based repertory, she has worked in orchestra administration.

Johnson, Pamela, American ballet dancer; born in Chicago, Illinois. After local training with Andre Comiacoff, she entered the Richard Ellis/Christine Du Boulay School and performed with their Illinois Ballet. A member of the original apprentice group of the City Center Joffrey Ballet, she performed with the company from 1966 to 1972. Although she was seen and applauded in Ruthanna Boris' *Cakewalk*, Frederick Ashton's *Façade*, and George Balanchine's *Donezetti Variations*, she is best remembered for her work in the many works by Gerald Arpino in the company repertory. Among her Arpino credits are *Night Wings, Cello Concerto, Confetti, Solarwind, A Light Fantastic*, and the troupe's first success, *Viva Vivaldi!* Johnson left the Joffrey Ballet to perform briefly with the American Ballet Theatre.

Johnson, Raymond, American modern dancer and choreographer; born 1946 in New York City. Johnson was trained at the Henry Street Settlement House by Alwin Nikolais and members of his company. He performed with the Nikolais dancers himself from 1963 to 1969, creating roles in his *Sanctum* (1964), *Tower* (1965), *Limbo* (1967), and many other works. Johnson also danced in concerts of works by fellow company members, including *Go Six* (1969) and *Junk Dances* (1969) by Murray Louis, and by independent choreographers Rudy Perez, in his *Lot Piece Day/Night* (1971), and Rod Rogers, performing in his *Dances in Projected Space* (1969).

He has choreographed for his own companies since the early 1970s, forming both a solo and a group recital series. His solo concerts include pieces by Perez, James Waring, who created the extraordinary imaginary tight-rope walking *Feathers* for him in 1973, and his own *Three Faces, Black Dance*, and others. His six-person troupe has performed his works and

Waring group pieces across the country in concerts and residencies.

Works Choreographed: CONCERT WORKS: *Solo (I)* (1964); *Solo (II)* (1965); *Duet (I)* (1966); *Untitled Solo* (1966); *Rock Suite* (1966); *Six Little Dances* (1969); *Solo (III)* (1969); *Study E* (1970); *Duet (II)* (1970); *Cycles* (1971, co-choreographed with Sara Shelton); *Ambit* (1971); *Solo (IV)* (1971); *Pillow Dance* (1971); *Phase* (1972); *Ingame* (1972); *While They're Away* (1972); *Duet (III)* (1972); *Two Plus One* (1972); *Jeremy Bummer's Own Private Show* (1972); *Three Faces* (1972); *Tuesday's Tempered Terpsichore* (1973); *Landmark* (1973); *Black Dance* (1973); *Sugar Cane* (1974); *As the World Turns Out* (1976); *Chamber* (1976); *Threshold* (1976); *Corridor* (1976); *Wolfman* (1977); *Flapjack* (1977); *Untitled Work to Eubie Blake* (1977); *Atrium* (1978); *Run for Your Life* (1979); *Untitled Children's Program* (1979).

Johnson, Virginia, American concert dancer and television choreographer; born c.1910, probably in Southern California; died February 7, 1969 in Lincroft, New Jersey. Raised in the Los Angeles area, she gave one known recital there in 1940 before moving to New York. During the 1940s, she functioned as a concert dancer presenting recitals of her own works as solos or for small companies. Although her style was consistently compared to that of Martha Graham, there is no evidence that she ever studied directly with her. The most likely link between them was the Bennington School of Dance's presence at Mills College in California in the summer of 1939.

Johnson staged dances for a single Broadway show, *Mexican Hayride* (1944), and for seasons of operettas at the St. Louis Municipal Theater, which for many years maintained the operetta tradition in America. She was one of the most prolific dance directors of early television production, responsible for many of the most popular live shows in the early 1950s.

Works Choreographed: CONCERT WORKS: *Call to Dance* (1940); *Serenade* (1940); *California Tango* (1940); *The World's Children* (1940); *American Primitive* (1940); *Phantasm* (1940); *Heroic Purpose* (1942); *The Eternal Heroine* (1942); *Trilogy* (1946);

The Invisible Wife (1949); *Within These Walls* (1949); *Crisis* (1949).

THEATER WORKS: *Mexican Hayride* (1944); Productions for the St. Louis Municipal Opera (1946–1949).

TELEVISION: *The Ken Murray Show* (CBS, 1950–1953); *The Jo Stafford Show* (CBS, 1954–1956); *The Arthur Murray Show* (Dumont, 1952–1953; NBC, 1953–1957).

Johnstone, Justine, American theatrical dancer; born c.1895. "The most beautiful blonde in America," as she was frequently billed, was a model for artist Harrison Fisher before she made her Broadway debut as a show girl in the *Folies Bergère* (1911). She appeared in revues, including the *Ziegfeld Follies of 1915* and *1916*, and in musical comedies, among them Irving Berlin's *Stop! Look! Listen!* (1915), *Betty* (1916), and the celebrated Jerome Kern opus for the Princess Theater, *Oh, Boy!* (1917). During the run of that show, she and colleague Billie Allen opened a nightclub together in what is now the Sardi building on Shubert Alley. Their Little Club featured a jazz band, live entertainment, and a team of society dancers recommended by Elizabeth Marbury (manager of the Princess and New York's principal ballroom booker). Johnstone's professional relationship to Marbury, other than her participation in Princess productions, is unclear.

Johnstone left the theater in 1920 to make silent dramatic films. In 1921, she moved with her then husband to London, where he served as manager of the Covent Garden. Toward the end of the 1920s, she became involved in medical work and in 1931, co-published the medical paper on continuous-drip intravenous feeding dosages that revolutionized the treatment of syphilis, producing the celebrated "Five day cure."

Jolson, Al, American theatrical vocalist, actor, and dancer; born Asa Yoelson, March 26, 1886 in St. Petersburg, Russia; died October 23, 1950 in San Francisco, California. Although most people think that the extent of Jolson's dance ability was the way he managed to get down on one knee to sing "Mammy," he was at one point in his career considered a talented eccentric dancer. In his first shows, all produced by the Shubert Brothers at their Winter Garden Theater, he worked in blackface playing a servant of the principal character. Following the tradition of the period, the male and female servants on stage were entitled to two specialty numbers—one satirizing their masters and the other referring to a popular contemporary dance style. By the time he was cast into *The Honeymoon Express* (1913), he was still playing a servant but was now to everyone but the Shuberts the undisputed star of the show. His songs there, "The Spaniard Who Blighted My Life" and "Who Paid the Rent for Mrs. Rip Van Winkle When Rip Van Winkle Was Asleep," involved some dance movements (mostly lecherous ones), and references to popular forms, but began a new format for him, that of the observer of human foibles. The better known persona, the overly sentimental devoted son, was his most popular but it seems that he worked against it for much of his career; except in the celebrated sound film, *The Jazz Singer* (1927), he played cynics on the stage and on the screen throughout his career. And for him, the best way to portray that view of life was in stylized dance movement.

Jones, Betty, American modern dancer; born 1926 in Meadville, Pennsylvania. Raised in Albany, New York, she studied locally with Evelyn Blevins, spending summers at Jacob's Pillow where she worked with Ted Shawn and Alicia Markova. Moving to New York, she continued her training with Anatole Vilzak, Aubrey Hitchins, Margaret Craske, and Antony Tudor—all in ballet technique. It was not until after she had performed on Broadway in Agnes De Mille's *Bloomer Girl* (1947) that she became involved in modern dance, joining the José Limón company in that year. She remained with Limón until his death in 1972.

In the small Limón company, she created roles in almost all of the repertory. She was seen and applauded in Doris Humphrey's *Fantasy and Fugue* (1952), *Ritmo Jondo* (1953), *Ruins and Visions* (1953), *Airs and Graces* (1955), and *Night Spell* (1951), and in Limón's *Concerto in D Minor* (1948), *La Malinche* (1949), *Symphony for Strings* (1955), *Concerto Grosso* (1959), and her best remembered

credit, *The Moor's Pavanne* (1949), in which she played "His Wife," the Desdemona character. If she had done nothing else in her career, she would still be acclaimed for her exquisitely characterized portrayal of the victim in that popular and magnificent work.

Jones also performed for Ruth Currier, a fellow company member, in her *The Antagonist* (1958) and *A Tender Portrait* (1961).

Since 1964, Jones has performed with a duo company, Dances We Dance, with Fritz Ludin. They have toured extensively and are now in residence in Honolulu, Hawaii. She has also choreographed for the Hawaii Dance Theater of the University of Hawaii and has reconstructed works of Humphrey and Limón for her students there.

Works Choreographed: CONCERT WORKS: *Of Heads, Hands and Other Things* (1972).

Jones, Bill T., American postmodern dancer and choreographer; born February 15, 1952 in Bunnell, Florida. Jones was trained in the dance and theater programs of the State Universities of New York at Binghamton and Brockport. He studied various techniques with Percival Borde, Pat Taylor Frye, Lois Welk, and Senta Driver, as well as improvisation techniques with Richard Bull and the touring seminars of Contact Improvisation. Like many postmodernists, he has performed only in his own works and in those of his collaborators, Arnie Zane and Sheryl Sutton. Although he had presented concerts for more than five years, his duet and solo concert with Sutton in 1979 brought him into his greatest public and critical prominence, ratifying the allegiances of his fervent fans. His tremendously exciting stage presence works with the complicated structures of his choreography, which uses accumulation techniques with movements and verbalizations. In his duets created collaboratively with Zane, he uses his personal technique to accentuate their uses of support and the Contact-derived balance work.

Works Choreographed: CONCERT WORKS: *Negroes for Sale* (1973); *Track Dance* (1974); *Pas de Deux for Two* (1974, in collaboration with Arnie Zane); *Across the Street* (1975, in collaboration with Zane); *Everybody Works/All Beasts Count* (1976); *WhosedebabedoIbabedoll?* (1977, in collaboration with Zane); *De Sweet Streak to Loveland* (1977); *The Runner Dreams* (1978); *Stories, Steps and Stomps* (1978); *Progresso* (1979); *Echo* (1979); *Naming Things Is Only the Intention to Make Things* (1979); *Floating the Tongue* (1979); *Monkey Run Road* (1979, in collaboration with Zane); *Blauvelt Mountain* (1980, in collaboration with Zane); *Sissyphus, Act I and II* (1980); *Open Spaces* (1980); *Tribeca, Automation, Three Wise Men, Christmas* (1980).

Jones, Inigo, English seventeenth-century architect, theatrical designer, and master of masques; born 1573 in London; died there in 1652. An early master of perspective drawings and detailed renderings, Jones had made at least one study visit to Italy before 1603, when he received his first credit as "inventor" of The Masque of Blackness. Through the Jacobean and Carolingian eras, he created mise-en-scène for two masques every year—for Twelfth Night (January 6th) and Shrovetide—in collaboration with Ben Jonson (to 1631) and other poets, and occasional masques to celebrate weddings, entries, and political events. Although he was an enormously influential architect of both public and domestic buildings, his fascination for historians lies in these masques.

A multidimensional theatrical form, a masque was performed and viewed on many levels. It was literally multidimension, with Jones' ability to manipulate perspective to create three-dimensional objects within painterly wing-drop systems inside a room that was also designed in the Pallatinate style of focus manipulation. All vocal and danced actions were performed "fronting the state," facing the king or highest-ranking member of the audience, in formations that either followed the actual lines of the room or the angle of forced focus. Jones designed scenery, costumes, hangings, and effects within a system of iconography that took into account the Elizabethan microcosm theory of representing the court hierarchy in similar stages of nature and what is now considered the Platonic system of imagery that believed that visual elements were more communicative than language. In each masque, the poet created a system of images based on the plot's mythological basis and on the event that commissioned the performance, that had to be translated into visual elements that did not risk insult to the king by ignoring the microcosm.

The masques, which did not have credited choreographers, frequently included dances based on popular social forms and those based on characterizations ranging from national dances to grotesqueries, represented by acrobatics. A large amount of the movement was limited by the iconographic costuming, however, and it is safe to say that only certain groups of performers worked in more than "stately processions."

Because both Jones and Jonson were important in other areas of their careers, their masques are among the best documented productions in the history of theater. The Yale University Press editions of Jonson's masques include his glosses and notes with commentary by Stephen Orgel. Roy Strong's books on Jones (London: 1973, with Orgel) and on court-sponsored performances are of tremendous importance to the understanding of these performances, as are articles published in the *Journal of the Warburg and Courtauld Institutes*. Only by redesigning the masques themselves, however, can one find information on the choreography of the productions and begin to understand Jones' contribution to the form and the restrictions that its creators put on each other and themselves.

Jones, John, American ballet dancer and choreographer; born 1937 in Philadelphia, Pennsylvania. Trained at the JudiMar School in Philadelphia while in high school, he commuted to New York to study at the School of American Ballet and the school of the Metropolitan Opera Ballet. He performed with four ballet companies of major standing in the late 1950s and 1960s—Jerome Robbins' Ballets: U.S.A. (1958–1959, 1961), the charter City Center Joffrey Ballet (1965–1967), the Harkness Ballet (1967–1968), and the first seasons of the Dance Theatre of Harlem. He created roles in Robbins' *Moves* (1959), *Events* (1961), and *New York Export: Opus Jazz* (1959). With the Joffrey apprentice group and company, he danced in the premieres of Anna Sokolow's *Opus '65*, Eugene Loring's *These Three* (1966), and Gerald Arpino's *Nightwings* and *Olympics* (both 1967). He performed in George Balanchine's *Jazz Variants* (1961) as a guest artist and in his repertory with the Dance Theatre of Harlem.

Jones returned to Philadelphia to work with the Arthur Hall Afro-American Dance Ensemble and Contemporary Dance Theatre Company of Philadelphia, but commutes to New York to work with the American Dance Machine. He has choreographed for the American Dance Machine and the Pennsylvania Ballet, creating *Eight Movements for Ragged Time* for it in 1973, and the Alvin Ailey American Dance Theatre.

Works Choreographed: CONCERT WORKS: *Two Bats* (1966); *Balafon* (1966); *Eight Movements in Ragged Time* (1973); *Nocturne* (1974).

Jones, Marilyn, Australian ballet dancer; born February 14, 1940 in Newcastle, New South Wales. Trained in Australia by Peggy Van Praagh, she moved to London to continue her studies at the Royal Ballet School, dancing with the company briefly in 1957.

Jones danced first with the Borovansky Ballet (c.1959–1961), then with the Australian Ballet in 1971, when she became director of the National Theatre Ballet School in Melbourne. Among her many roles with the company were featured parts in John Cranko's *Romeo and Juliet* and Frederick Ashton's *The Dream* and the company productions of *La Fille Mal Gardée* (by Ashton), *The Merry Widow* (by Ronald Hynd and Robert Helpmann), and *Raymonda* (by Rudolf Nureyev). She currently serves as artistic director of the Australian Ballet.

Jones, Susan, American ballet dancer; born June 22, 1952 in York, Pennsylvania. Jones was trained at the Washington School of Ballet in the District of Columbia. After an apprenticeship with the City Center Joffrey Ballet, she joined the American Ballet Theatre where she performed throughout the 1970s. Jones performed in almost all of the company's eclectic repertory, with roles in works by Agnes De Mille, Eugene Loring, George Balanchine, John Neumeier, and the troupe's choreographers-in-residence. She is best known for her unique ability to bring dramatic life and validity to her roles, whether symbolic, as "The Accused as a Child" in De Mille's *Fall River Legend*, comic, as "The Cat" in *Sleeping Beauty*, imitative-ethnic, as in the national dances in *Swan Lake, Coppélia, Raymonda,* and *Don Quixote*, or period-American, as in Loring's *Billy the Kid*.

469

Jones is known also for her roles that, for other performers, could disappear into the chorus movement on stage. Among these is the "Peasant Girl" in the company's production of *Swan Lake,* generally a throwaway part which she made into a memorable piece of acting at each performance.

Jooss, Kurt, German ballet and expressionist choreographer; born January 12, 1901 in Wasseralfingen, Wurtemburg, Germany; died May 22, 1979 in Heilbronn, West Germany. Jooss was trained by Rudolf von Laban at the National Theater, Manheim, traveling with him to Hamburg in 1922 to become his principal dancer and assistant. As director and ballet master of the Münster (Westphalia) Stadttheater from 1924 to 1927, he formed his first company, the Neue Tanzbühne. In Essen from 1927 to 1933 he became director of the Folkwang Schule and its Dance Theater, and ballet master of the Essen Opera House. His best known work, *The Green Table* (1932), was created there.

When the National Socialist Party came to power in 1933, Jooss was ordered to expel all Jews from his company. He refused and fled to Holland, moving to England in 1934, and establishing the Jooss School in Dartington Hall, Devon, with dancer Sigurd Leeder. Ironically, he was interned in England as an "enemy alien" in 1939, before he could establish himself as a choreographer for the ENSA, the English equivalent of the USO. The Jooss Ballet was finally reorganized in England in 1943.

Before returning to Germany after the war, he spent time with the Chilean State Ballet, directed by former company members, Lola Botka and Ernst Uthoff. Back in Essen, he reorganized the company as the Folkwong Tanz-Theater from 1951 to 1953, also serving as ballet master of the Dusseldorf Opera, staging the *Fairie Queen* there in 1959. Jooss retired in 1968, but has restaged productions since that time for companies in Europe, South America, and the United States.

Jooss' works themselves combined ballet technique with that of the German expressionists school of Laban. They were distinguished by their content, with its recognition of topical problems, their structures, and their vocabularies, which were very wide and flexible. In *The Green Table,* for example, the different characters use a variety of movement systems; the partisan's vocabulary is one of the modern dance, while the angularity of "Death" (considered by many the greatest test of a character dancer) is derived from the German constructivist school of the 1920s.

Jooss' works are still popular in the United States, if not in Germany. *The Green Table* is in the repertory of scores of companies here, ranging from the José Limón Company to the Cleveland Ballet, which put on the work in its third year of precarious existence. The City Center Joffrey Ballet performs it, along with *The Big City* (1932) and *A Ball in Old Vienna* (1932).

If this entry alludes to *The Green Table* more than to Jooss' other works, it is not just because it remains his best known ballet. It is a work that is contemporary whenever there is a present or remembered state of war against life or ideas.

Joplin, Scott, American composer; born November 24, c.1868 in Texarkana, Texas; died April 1, 1917 in New York City. The principal composer of the Mississippi genre of rags, Joplin went through periods of obscurity and rediscovery during and after his lifetime. The most recent and longest-lasting era of reevaluation and discovery was the result of the film, *The Sting,* which used arrangements of his most celebrated rags, among them "The Entertainer" and "Elite Syncopation." Joplin's pieces were syncopation in four-four time, with a regular beat in the base, unlike the East Coast rags, such as those by Eubie Blake, which are considerably more complex.

Joplin wrote song rags for publication in sheet music and piano rolls specifically for social dance. Others, such as "The Pineapple" rag that was printed with lyrics, were designed for theatrical performance and popular vocalizing. Most of the choreographers who have used his pieces have mixed the genres indiscriminately.

The ballets that use Joplin music include James Waring's *Eternity Bounce* and a number of sections of his other works, Barry Moreland's *Prodigal Son* (1974), and Kenneth Macmillan's *Elite Syncopation* (1974). Louis Johnson staged the dances for the first production of Joplin's opera, *Treemonisha,* in 1972. Although for a few years after the release of *The*

Sting it seemed as if every choreographer was planning a ballet to Joplin's rags, very few have remained in the repertories of their companies.

Josephine, Lois, American exhibition and musical comedy dancer; born c.1890 in Boston, Massachusetts. The daughter of an original member of the George M. Christy Minstrels, Josephine grew up on tour circuit. Her own first show, *Top O' the World*, got stranded in Minnesota in 1909. While sitting out the winter there, she paired up with fellow company member, Wellington Cross, to create a vaudeville act that would last for eight successful years. Cross and Josephine toured with a series of acts that featured their comic abilities, their singing and their whirlwind dances. One show, "Dying to Act" (c.1902), was so popular that they were able to survive following Sarah Bernhardt in a variety format. They also performed on Broadway, dancing and acting in the *Passing Show of 1913,* the Princess Theater musical, *O, I Say!* (1913), Ned Wayburn's *Town Topics* (1915), and their last show together, *Go To It* (1916), at the Princess.

The act split up in 1917 when Cross was expected to be drafted. Josephine joined dancer Tyler Brooks to create a new act, "An Artistic Treat," that played until 1919. She was featured in George M. Cohan's *Mary* (1920), when she shattered her ankle and was forced into early retirement.

Joyce, Jack, English eccentric dancer; born Harry Hall, November 5, 1898 in Ashton, Lancashire. Joyce, whose left leg was amputated at age ten, had a brief career in English music halls before accepting an engagement on the Keith-Orpheum circuit in the United States. For seven years, he performed his act of singing, monologues, and tap dancing on the circuit and in musical comedies, most notably *Poppy* (1920). He also had a successful American career in Prologs on the Paramount/Publix circuit out of Chicago and Fanchon and Marco's West Coast Deluxe circuit out of Los Angeles. His best known act in this period was in a Fanchon and Marco Idea—his "zylophenia," in which he tapped out a rhythmic pattern that was reproduced in the percussion section.

Joyce returned to England in the early 1930s with his American wife, Prolog dancer Madeleine Villere,

where he performed for more than twelve years. His eccentric technique did not integrate into an exhibition act with Villere, but they shared billing in their English presentation act.

Juba. See **Lane, William Henry.**

Jude, Charles, French ballet dancer; born July 25, 1953 in My Tho, Cochin China (now Vietnam). Raised in France after that country withdrew from Indo-China, he was trained by Alexander Kalioujny in Nice. He joined the Opéra-Comique in the early 1970s and the Paris Opéra shortly thereafter, becoming celebrated for his performances in the classic male roles of the Romantic repertory. He has danced "Albrecht," his most acclaimed role, as a guest artist with many companies around the world, including the American Ballet Theatre.

Judson, Stanley, English ballet dancer. Trained in London at the studios of Enrico Cecchetti and Stanislav Idzikowsky, Judson performed with the Anna Pavlova company in England in 1927. Considered one of the first British *danseurs nobles,* he performed the principal roles in early English productions of the nineteenth-century classsics and the Fokine repertory, among them, *Spectre de la Rose* for the Camargo Society and "Cavalier of the Sugar Plum Fairy" and "Franz" for the first seasons of the Vic-Wells Ballet. He understudied Anton Dolin and took featured roles in productions of the (Alicia) Markova/Dolin Ballet 1935 season, including their celebrated *Giselle,* and danced with Blum's Ballet Russe de Monte Carlo later that season in his Fokine roles.

Judson staged the (London) *Hollywood Ice Ballets* for English ice dancer, Belita, and moved with her to the United States. He worked on both *Ice Capades* and *Ice Follies* here before returning to the United Kingdom as director of the Cork Ballet in Ireland.

June, English theatrical ballet dancer; born June Howard Tripp, June 11, 1901 in Blackpool, England. Trained locally by a Madame Claire, she continued her studies in London under Lila Field, in a class that included Ninette De Valois. As a child, she performed in the corp and as a soloist in the London

production of *Snowflakes* by the Anna Pavlova company (c.1911), taking class with the ballerina during the run. Moving to Paris, possibly with the company, she worked under Ivan Clustine and performed at the Folies Bergère.

June returned to London to serve as understudy for Phyllis Bedells at the Empire Theatre, in ballets by Fred Farren, Willie Warde, and others, and began to train under Serafina Astafieva. Shortly thereafter, she switched to theatrical dance formats, going into the cast of *The Passing Show* (1914); *Watch Your Step* (1915); *Buzz-Buzz* (1918); and *London, Paris and New York* (1920), as a specialty dancer.

Between 1921 and her retirement in 1936, she played soubrette/dance leads in many British musical comedies, among them *Little Nellie Kelly* (1923); *Happy-Go-Lucky* (1926); *Fanfare* (1932); *Here's How!* (1934, replacement cast), and *The Town Talks* (1936).

Bibliography: June. *The Glass Ladder* (London: 1960).

Junger, Esther, American modern dancer and theatrical choreographer; born c.1915 in New York City. After a very brief period as a demonstrator at the Denishawn school in New York, Junger studied dance with Bird Larson at the Neighborhood Playhouse in New York. She danced with Larson's company and, after the death of her mentor, with the New World Players (a dancers' cooperative) and Senia Gluck-Sandor's Dance Centre, performing in his *Petrouchka* and *El Amor Brujo*.

In 1931, Junger began to work at the Humphrey/Weidman Studio, possibly on recommendation from José Limón, a fellow student who had been in the Gluck-Sandor productions. She danced in Doris Humphrey's works and in Charles Weidman's theatrical presentations, among them *Life Begins at 8:40* (1935). She also danced in the Russell Markert production of *2036* at the Radio City Music Hall, interpolating her own solo, *Scientific Creation,* into the work.

Junger's own choreography was created primarily for her annual solo recitals in 1930, 1932, 1935, and 1939. The first concert, sponsored by the New World Dancers, featured *Go Down Death,* which was to remain one of her best known works. Other notable dances include *Closed in Cities* (1932); *Variations on a Tango* (1935); *Bach Goes to Town,* first performed at a TAC Cabaret night in 1939, and the *Heartbroken Bolero* (1941). The four pieces that she choreographed during her summer as one of the first Bennington Choreographic Fellows, in 1937, *Dance for the People, Festive Rites, Ravage,* and *With Hats* from the *Opus for Three and Props* (created with the other Fellows, Limón and Anna Sokolow), were revived for her concerts.

During the early 1940s, Junger worked frequently as a choreographer for musical comedies and plays on Broadway. Among her best known productions were the original production of *Dark of the Moon* (1945), cabarets for Billy Rose's Diamond Horseshoe (1946 and 1947), and the 1947 to 1949 editions of the Ringling Brothers and Barnum and Bailey Circuses. Her works frequently employed modern and concert dancers; *Dear Judas* (1947), for example, used Tony Charmoli, later known for his extensive work on television, Beatrice Seckler, and Emy St. Just in its chorus.

Junger retired as a choreographer in the early 1950s—or was unable to obtain work. It is unfortunate that none of her work has been revived so that it could be viewed and judged. Her work must have been especially creative for her to have been given the Bennington Fellowship in its first year as independent choreographer—not attached to the Humphrey/Weidman or Graham companies.

Works Choreographed: CONCERT WORKS: *Go Down Death* (1930); *Bolero* (1930); *Toward the Light* (1930); *Ballad of a Nun* (1930); *Caprice* (1930); *Criticism: Destruction and Appreciation* (1930); *Inertia* (1930); *Conscience* (1930); *A Mourner* (1930); *Vers la Flamme* (1932); *Berceuse* (1932); *A Moment's Inertia* (1932); *Song for the Dead* (1932); *La Preciosité* (1932); *Soap Box* (1932); *Closed in Cities* (1932); *At a Tea* (1932); *Woman in Yellow* (1932); *Animal Ritual* (1935); *Festival* (1935); *Variations on a Tango* (1935); *Untimely* (1935); *Archaic Figure* (1935); *Relegated to the Past* (1935); *Festive Rites* (1937); *Dance for the People* (1937); *Ravage* (1937); *Opus for Three and Props* (1937, *With Hats* section staged alone, other sections co-choreographed with José Limón and Anna Sokolow); *Dada In Nachtmusik* (1938); *Bach*

Goes to Town (1939); *Torch Song* (1940); *Judgment Day* (1940); *Stage Characters* (1940); *Cinema Ballerinas* (1940); *And We'll Waltz* (1941); *Heartbroken Bolero* (1941); *High Yaller* (1941).

THEATER WORKS: *Black Narcissus* (1942); *Dark of the Moon* (1945); *Dear Judas* (1947); cabarets for Billy Rose's Diamond Horseshoe (1946–1947); Ringling Brothers and Barnum and Bailey Circus (1947–1949).

Jurrilëns, Henny, Dutch ballet dancer; born February 21, 1949 in Arnhem. Trained at the Arnhem Municipal Conservatory by Winja Morova, and later by Sonja Arova, Jurrilëns performed briefly with the Norwegian National Opera Ballet before joining the Dutch National Ballet in 1973. Celebrated for her sensitivity to modern styles, she has appeared in featured roles in many works by Toer van Schayk, including his *Pyrric, Dances* and *Eight Madrigals,* by Hans van Manen, among them his *Metaphors* and *Adagio Hammerklavier,* and by Rudi van Dantzig, in his *Ginastera* and *Ramifications*.

Justament, Henri, Nineteenth-century choreographer for popular theaters in Western Europe; there is no solid data on Justament's birth, death, or training; nevertheless, since his work is so important, he is included herein.

Justament served as ballet master of the Théâtre de la Monnaie in Brussels (1861–1864), then moved to Paris to serve in the same capacity at the Théâtre de la Porte-Saint-Martin in 1866 to 1867. In 1868, he worked at the Théâtre des Variétiés, switching to the Paris Opéra in 1869, to choreograph dances for *Faust*. After creating dances for the Théâtre de la Gaité (c.1870–1876), he moved to London to work at the Alhambra (1876–1877), before returning to the Porte-Saint-Martin.

Works Choreographed: THEATER WORKS: (Note: these could also be listed as concert works.) *Les Filles du Ciel* (1861); *Le Magicien* (1861); *Les Contrabandiers* (1861); *Les Fils de l'Alcade* (1861); *Un Bal Travesti* (1862); *Le Joueur de Binion* (1862); *Les Songes* (1862); *Le Royaume des Fleurs* (1863); *Flamma* (1863); *Les Amadryades* (1864); *l'Etoile de Messine* (1864); *Nymphes Amazones* (1864); *Les Parisiens à Londres* (1866); *La Revue* (1867); *La Tour de Nesles* (1867); *Le Bossu* (1867); *Salvator Rosa* (1868); *La Comédie Bourgeoise* (1868); *Faust* (1869); *Gilbert Danglars* (1870); *La Chatte Blanche* (1870); *Le Bourgeois Gentilhomme* (1876); *M. de Pourceaugnac* (1876); *Orphée aux Enfers* (1877); *Le Voyage dans la Lune* (1879); *Cendrillon, Faerie* (1879); *Royaume de Nôel* (1880); *l'Arbre de Nôel* (1880); *La Biche au Bois* (1881); *Les Chevaliers du Brouillard* (1881); *Le Petit Faust* (1882).

K

Kâge, Jonas, Swedish ballet dancer who worked in the United States and Germany; born 1950 in Lidingǒ, Sweden. After early training from his mother, he entered the school of the Royal Swedish Ballet.

As a member of the company, he performed the title role in Kenneth Macmillan's *Romeo and Juliet* in 1969. Erik Bruhn then recommended him for an engagement with the American Ballet Theatre in New York with which he danced from 1971 to 1974. His partnership with Martine van Hamel in Dennis Nahat's *Some Times* (1972) was so successful that he performed with her in several company premieres, such as Antony Tudor's *Shadowplay* and Glen Tetley's *Gemini,* and in Eliot Feld's *Intermezzo.* He also danced in Antony Tudor's *Leaves Are Fading* and in Peter Darrell's revival of *Tales of Hoffmann,* taking the title role.

Kâge and his wife, Deborah Dobson, left Ballet Theatre for the Stuttgart in 1974, performing there in works by Tetley, among them the premiere of his *Greening* (1974). He has been with the Geneva Ballet since 1976.

Kahn, Hannah, American modern dancer and choreographer. Trained at Juilliard, under Anna Sokolow, José Limón, Kazuko Hirabayaski, and Daniel Lewis, she performed with Lewis' company, the Contemporary Dance System, since its early seasons. She created a role in Sokolow's *Moods* (1974) and performed in the company revivals of her *Rooms, Ballade, Lyric Suite,* and Doris Humphrey's *Day on Earth* and *Night Spell.* Kahn also danced in Lewis' *Rasaumausky* and *And First They Slaughtered the Angels* (1975).

She has shared a small company with Dalienne Majors since the late 1970s, creating many works for the group and for Majors to perform. Among her most acclaimed works were the solos *Spill Quell* (1974), *Dashes and Bolt* (1979), and *Ring* (1980), to a delicate Debussy quartet.

Works Choreographed: CONCERT WORKS: *Spill Quell* (1974); *Pulling Through* (1974); *The Rambler, The Grumbler* (1974); *One Thistle and a Rose* (1974); *Aviary Pulse* (1976); *Britten Suite* (c.1977); *Glint* (1977); *Passage* (1977); *Dashes and Bolt* (1979); *Add* (1980); *Ring* (1980).

Kahn, Robert, American modern dancer; born May 31, 1954 in Detroit, Michigan. Kahn was one of the first dancers to be trained at the New York University School of the Arts program directed by Stuart Hodes. After a season with the José Limón company, he joined the Paul Taylor troupe from 1975 to the present. He has appeared in almost every work in that company's continuing repertory from the rushes movement in *Esplanade* to the low comedy of *From Sea to Shining Sea* to the controlled motion of *Runes.*

Kahn, Willa, American modern dancer; born May 4, 1947 in New York. After ballet training with Mia Slavenska, she studied modern dance forms with Paul Sanasardo. As a member of the Sanasardo company from 1959, she appeared in most of his canon of works, such as *Two Movements for Strings, Metallics* (1964), *Excursions* (1966), *Fatal Birds, The Path, Platform,* and *Equitorial.* She has also danced with the concert groups of Sanasardo dancers, Diane Germaine, with whom she performed in *Recurring Dream,* and Manual Alum, for whom she appeared in *Palomas, Night Bloom, The Offering,* and many other pieces.

Kai, Una, American dancer and ballet master; born March 7, 1928 in Glenridge, New Jersey. After early training with Vera Nemtchimova, Kai began to take class with George Balanchine at the School of American Ballet.

A member of the Ballet Society from 1948, and a charter member of the New York City Ballet until 1960, Kai performed feature roles in Jerome Robbins' *The Cage,* Antony Tudor's *La Gloire,* and Frederick Ashton's *Picnic at Tintagel.* From 1956, when she was appointed ballet master, Kai has frequently staged works by Balanchine for companies in the United States and abroad.

Kai has also served as ballet master of The Robert Joffrey Ballet during the early 1960s and of the New Zealand Ballet from 1973 to 1976.

Kain, Karen, Canadian ballet dancer; born 1952 in Hamilton, Ontario. Trained at the school of the National Ballet of Canada by Betty Oliphant, she has

performed with the company since 1969. Known for her performances in the nineteenth-century classics, she has taken the principal roles in Frederick Ashton's production of *La Fille Mal Gardée,* Erik Bruhn's *Swan Lake,* and the company productions of *Giselle* and *The Sleeping Beauty;* her appearances in these roles with Rudolf Nureyev in his New York season made her well known throughout the dance world. Her nonclassical appearances include roles in van Dantzig's *Collective Symphony* and Kenneth Macmillan's *Elite Syncopations.*

Kain has also performed as a guest with the Ballet National de Marseilles, in director Roland Petit's *Nana* and *Les Intermittences du Coeur,* with the Makarova and Company troupe in 1980, and with ballet companies across Canada and America. She has been the subject of a photojournal and CBC special.

Kajiwara, Mari, American modern dancer; born in 1952 in New York, New York. After beginning her dance training as a child with Aurora Hodgin as part of the Teachers' College community program, Kajiwara continued her studies at the High School of Performing Arts.

After a season performing with Glen Tetley's ad hoc company in 1969, Kajiwara joined the Alvin Ailey Dance Theatre, with which she has remained until the present. An audience and choreographers' favorite, she has created roles in Ailey's *Archipelago* (II) (1971), *Hidden Rites* (1973), and the second version of *Feast of Ashes* (1974), and Jennifer Muller's *Crossword* (1977). Her many featured roles include parts in Ailey's *Revelations, Mary Lou's Mass, Blues Suite, Choral Dances, Streams and Myth,* and company repertory works by Talley Beatty, John Butler, Rael Lamb, and Joyce Trisler. Three of her best known featured roles are in pieces by Donald Mc-Kayle—*Blood Memories, Rainbow Round My Shoulder*—and by Beatty, *The Road of the Phoebe Snow.*

Kalioujny, Alexander, Czech-born ballet dancer and teacher working in France; born April 15, 1923 in Prague. Trained by Olga Preobrajenska, he made his professional debut with the Nouveau Ballet de Monte Carlo in 1946 during Serge Lifar's directorship. He returned to the Paris Opéra with Lifar in 1947 and danced there for seven years, with featured roles in Lifar's *Le Chevalier et la Demoiselle, Zadig,* and *Prince Igor,* and George Balanchine's *Palais de Crystal* (1947), among other ballets. As Zizi Jeanmaire's partner, he appeared on Broadway in *The Girl in Pink Tights* (1953), but returned to France to dance with the Opéra and with Jean Babilée's troupe, notably in his *Balance à trois* (1955). Since retiring, he has taught in Nice.

Kane, Helen, American theatrical singer and dancer; born Helen Schroeder, August 4, 1904 in New York City; died there September 26, 1966. A student of Ned Wayburn (and probably of other tap teachers in the New York area), Kane danced in vaudeville and in Prolog units before she made her Broadway debut in *A Night in Spain* (1927), a Shubert Brothers extravaganza. She was then considered the mid-1920s' answer to Ann Pennington. In her next show, a backstage musical called *Good Boy* (1928), she introduced the song "I Wanna Be Loved By You," and the voice for which she was known. Within two years she had become so well known as "The Boop-Boop-a-Doop" girl that the characterization had become institutionalized. In *Paramount on Parade* (1930), for example, Elsie Janis wrote her a song entitled the "Helen Kane's School Days" for a scene in which she taught a class "what did Cleopatra say when her Caesar rode away—Pooh-Pooh-pa-Do." However it was spelled, Kane's scatting became more important to her performances than her dancing although that film included her tapping as well. She left film for a period to return to vaudeville and presentation acts as a dancer but eventually gave in to the inevitable and became a voice.

Kane, Marjorie, American film dance star of the early sound era; born April 28, 1909 in Chicago, Illinois. Kane was trained by Merriell Abbott in Chicago and made her professional debut in a Balaban and Katz theater Prolog. After moving to Los Angeles with the West Coast touring company of *Good News,* in which she played the Zelma O'Neal specialty dancer role, she entered films. Her motion picture credits cover the transitional sound era in which musical films were being made in both plotted and revue formats. In the eighteen months in which musical films were the most popular forms of early sound pictures, Kane made seven movies—*The Dance of*

Life (Paramount, 1929) and *The Great Gabbo* (Sono Art/World Wide, 1929) for Cecil B. De Mille, *Border Romance* (Tiffany, 1930), *Sunny Skies* (Tiffany, 1930), *Be Yourself* (UA, 1930), *Let Us Be Gay* (MGM, 1930), and *Night Work* (RKO, 1930). Her act, an eccentric tap performed in barely adolescent clothing, was not particularly unique, but Kane was obviously able to take direction and work hard.

The last mention of Marjorie Kane in a West Coast or industry paper mentioned her "mysterious disappearance." It is not known whether this refers to an unexpected retirement or to a crime.

Karalli, Vera Alexeyevna, Soviet ballet dancer and silent film actress; born August 8, 1889 in Moscow; died November 16, 1972 in Baden, Austria. Trained at the school of the Bolshoi Ballet, she performed with the company after 1906. She was featured in Mikhail Fokine's *Le Pavillion d'Armide* there and with the Diaghilev Ballet Russe in 1909. Karalli also performed with the touring companies of Mikhail Mordkin and Anna Pavlova during the 1910s.

Retiring from live performance, she became one of the first stars of the Soviet silent film industry. Of her many films, only one seems to be about dance—*The Dying Swan,* which was described as being about "a ballerina suffocated by a sculptor who wanted to make a statue of her."

Later, she served as ballet master of the State Opera in Bucharest, Rumania, from c.1930 to 1937.

Karavaeff, Simon, Russian eccentric dancer; born c.1893 in St. Petersburg; died March 15, 1972 in New York City. Karavaeff was rejected from the St. Petersburg School of the Imperial Ballet owing to a congenital deformity of the hands, so he studied dance at private studios and with the cast of The Aquariam Gardens, where he worked. According to one source, he worked under Theodore Thomas, an American entertainer who was on the staff of the Gardens in the early 1900s. Karavaeff toured on the European music-hall circuit as an adolescent until one evening in 1919 when he was engaged for the same benefit performance as Anna Pavlova. She hired him as her partner for her 1920–1921 American tour.

Like most of her tour company, he decided to remain in the United States and was soon cast in the *Ziegfeld Follies of 1922* and *1923* as a Russian and tap specialty dancer. Reportedly on the advice of Will Rogers, he combined his two specialties into what is known as Russian tap work. That technique had been performed infrequently in the past, notably by Ida Forcyne and by Ivan Bankoff, but Karavaeff was still able to parlay it into a solid reputation. He did his *kazatkes* in tap shoes in the *Follies, A la Carte* (1927) and in the French Casino (c.1927, 1930) and The Russian Kretchma, a 14th Street cabaret in imitation of the original *Chauve-Souris* (1935–1939). He also appeared on Broadway in the 1943 *Chauve-Souris* season, interpolating his own specialties and the skit, "A Russian Sailor in New York."

His cabaret work led to a second career as an emcee in New York nightclubs.

Karinska, Barbara, Russian couturière and costumer associated with the works of George Balanchine; born October 3, 1886 in Russia. A costume constructor known for her structured bodices and graceful tutu skirts, Karinska first made ballet costumes in 1932 when she was hired to build dresses for Balanchine's *Cotillion,* after designs by Christian Bérard. After moving to New York in 1938, she became the foremost expert in constructing ballet costumes in the United States. Working primarily with Balanchine, she has designed costumes for his *La Valse* (1951), *Capriccio Brilliante* (1952), *Scotch Symphony* (1952), *Valse Fantasie* (1953), *Divertimento No. 15* (1956), *Stars and Stripes* (1958), *Liebeslieder Walzer* (1960), *Bugaku* (1963), *A Midsummer Night's Dream* (1962), *Brahms-Schoenberg Quartet* (1966), *Who Cares?* (1970), and *Scherzo à la Russe* (1972). Her costumes for *The Nutcracker* (1954) and *Jewels* (1967) may be her most influential; every shape and structure of tutu is used to differentiate character and role and to accentuate the movements.

Karinska has also designed costumes for the Metropolitan Opera and for film, sharing an Oscar for best costumes with Dorothy Jeakins for *Joan of Arc* (RKO, 1948). She has received many awards in the dance and theater communities and has been honored with exhibits at major museums.

Karinska is semiretired now; Karinska, Ltd. is managed by designer Ben Benson, formerly associated with the modern dance companies of Emily Frankel and with Broadway shows.

Karnakoski, Kari, Finnish ballet dancer; born c.1920 in Helsingfore, Finland. Trained in Paris with Olga Preobrajenska, he performed with Bronislava Nijinska's Polish National Ballet in the late 1940s. Moving to the United States, he studied with Mikhail Mordkin and performed in his Ballet company, with a featured role in his *Voices of Spring* and *Giselle*.

A charter member of Ballet Theatre, he was noted for his work in Andrée Howard's *Death and the Maiden*. He also spent seasons with the Ballet Russe de Monte Carlo, in the revival of *Prince Igor*, and in Nijinska's *Chopin Concerto*, and in Ballet International, creating the role of "The Prince" in Edward Caton's *Sebastien* (1944).

Karnilova, Maria, American ballet dancer, theater dancer, and actress; born August 3, 1920 in Hartford, Connecticut. Karnilova was trained at the Metropolitan Opera Ballet School under Rosina Galli; she also studied ballet with Mikhail Fokine, Antony Tudor, Edward Caton, and Anton Dolin, and Wigman technique with Hanya Holm in New York. Karnilova performed as a member of the Metropolitan Opera Children's Ballet, in Victor Dandré's Opera Company in Caracas, and with the American Ballet troupes of Fokine and Mikhail Mordkin at free Lewissohn Stadium concerts in the summer of 1936.

Karnilova was a founding member of Ballet Theatre and danced with that company from 1939 to 1948, from 1955 to 1956, and in 1959. Among the ballets in which she performed featured roles were Tudor's *Jardin aux Lilas* and *Gala Performance*, Eugene Loring's *Billy the Kid*, Fokine's revival of *Carnaval* and new *Bluebeard*, and Agnes De Mille's *Three Virgins and a Devil* and *Tally-Ho*.

Karnilova danced with the Metropolitan Opera from 1952 to 1953, performing in the ballet sequences of *Manon, La Traviata, Alceste,* and *Die Fledermaus*. She was a member of Jerome Robbins' Ballet U.S.A. (1958–1961), dancing roles in his *New York Export: Opus Jazz* and *The Concert*.

Karnilova's theatrical performing career has run concurrent to her work in ballet companies. She is generally associated with shows staged by Robbins, and has danced in his *High Button Shoes* (1948), danced and acted as "Tessie Tura" in *Gypsy* (1959), and as "Golde" in *Fiddler on the Roof* (1964). Other Broadway shows in which she has danced include

Stars in Your Eyes (1938), in a chorus that included Robbins, Alicia Alonso, and Nora Kaye, *Call Me Mister* (1946), *Two's Company* (1952), *Bravo Giovanni* (1962), *Zorba* (1968), *Gigi* (1973), and *God's Favorite* (1974). She also performed in the film, *The Unsinkable Molly Brown* (MGM, 1964), and on many television programs, among them, *The Fabulous Fifties* (CBS, 1960), choreographed by Danny Daniels.

Karsavina, Tamara, One of the great Russian ballerinas of the early twentieth century and the first modern ballerina, working primarily in St. Petersburg, Paris, and London; born March 9, 1885 in St. Petersburg, Russia; died May 26, 1978 in London. The daughter of Platon Karsavin, she was trained at the St. Petersburg school of the Imperial Ballet by Pavel Gerdt, Theodore Kosloff (on leave from the Odessa school at which he usually taught), and Enrico Cecchetti. She made her Maryinsky Theater debut in 1902, with later featured roles in *Giselle, The Nutcracker, La Bayadère,* and *Swan Lake*.

In the trio of Russian ballerinas who both publicized and defined ballet in the early twentieth century, Karsavina was the least able to be placed in a human-interest or general-consumption category. Kschessinskaia was the noblewoman and Pavlova was the swan, but Karsavina was just a magnificent dancer. Her reputation now, however, and probably in the future, will be greater than that of the other two, since she was the only one with taste in vehicles that resemble that of the present. She was the first ballerina of modern music and of modern art, and as such will survive.

Karsavina's importance is based primarily on her work with Diaghilev's Ballet Russe from 1909 to 1919 and irregularly until 1920. Among the many seminal works in which she created leading roles are Mikhail Fokine's *Les Sylphides* (1908, as *Chopiniana*), *Cléopâtre* (1909), *L'Oiseau de Feu* (1910), *Narcisse* (1911), *Petroushka* (1911), *Le Dieu Bleu* (1912), *Tamar* (1911), *Daphnis and Chloe* (1912), and *Papillion* (1914), Vaslav Nijinsky's *Jeux* (1913), and Leonid Massine's *Le Tricorne* and *Pulcinella* (1920).

She, Pavlova, and Danish ballerina Adelina Génee are considered the patrons of the English ballet companies. Her residence in London would have assured her influence, even without her frequent coaching of

younger dancers and advising on revivals. She served as vice-president of the Royal Academy of Dancing from its formation until 1955, but maintained her influence until her death.

Her influence in the United States is also great, although not directly an effect of her presence. In fact, she toured only once in America, as part of a Chicago-based tour organized by Adolf Bolm in 1924. The impact, however, of the Diaghilev Ballet Russe began shortly after its Paris debut and did not depend on the actual presence of it or its dancers. Theater and fashion magazines publicized Karsavina as a modern, intelligent woman and as a dancer from 1909 to her death. Her repertory too was known, through illustrations in the press and through descriptions. This author has, in fact, made a study of one Karsavina costume, the tutu from *The Firebird,* and its influence on Broadway costuming and has found similar structures and designs as late as 1919, in a set of gowns for the Dolly Sisters in a Hawaiian number in a *Ziegfeld Midnight Frolic.*

Bibliography: Karsavina, Tamara. *Theatre Street* (London: 1930); *Ballet Technique* (London: 1956); *Classical Ballet: The Flow of Movement* (London: 1962). The two latter volumes are reprinted from *The Dancing Times.*

Karstens, Gerda, Danish ballet dancer; born July 9, 1903 in Copenhagen. Trained at the school of the Royal Danish Ballet, she joined the company in 1923 after the traditional apprenticeship in children's character roles in the repertory of ballets by August Bournonville. From 1921 to 1956, she matured from feature roles and variations in works by Bournonville and his predecessor, Gasparo Angiolini, to full-scale characterizations of witches and crones. "Madge" in *La Sylphide* was her best known role, but she also appeared in Bournonville's *Napoli, Far from Denmark,* and *A Folk Tale,* and in Angiolini's *Loves of a Ballet Master.*

Kasatkina, Natalia, Soviet ballet dancer and choreographer; born July 7, 1934; place of birth uncertain. Trained at the school of the Bolshoi Ballet by Sulamith Messerer and Maria Kazhukova, she performed with the Bolshoi from 1953. A celebrated character dancer, her best known role was as "Phrygia" in the company production of *Spartacus.*

With her husband, Vassili Vasiliov, she has choreographed since the 1960s for the Kirov Ballet, the Bolshoi, and the Nemirovich-Danchenko Theater.

Works Choreographed: CONCERT WORKS: *Vanina Vanini* (1962); *Heroic Poem, or Geologists* (1964); *Sacre du Printemps* (1965); *Preludes and Fugues* (1968); *Gayané* (1970); *Creation of the World* (1971); *Seeing the Light* (1974).

Kasper, Michael, American postmodern dancer and choreographer; born c.1952 in Newark, New Jersey. After studies in dance at George Washington University, Kasper returned to the New York area to continue training with Richard Thomas, Barbara Fallis, and Zena Rommett in ballet and Susan Klein and Dan Wagoner in modern forms. He has performed in set works for a number of contemporary modern dance choreographers, among them Twyla Tharp, Barbara Roan and Irene Feigenheimer, Billy Seigenfeld, and Jennifer Donahue, as well as free or improvisational groups led by Kei Takei, Roan, and Stuart Pimsler. As well as setting works of his own company, he is a performer/member of Free Association, a Washington, D.C.–based improvisation group.

Kasper himself works in many levels of conventional choreography and improvisatory work. Some company works are completely set, while others, among them the Movement Journal Pieces (*Ladenheim, Ukran, Flurry,* and *Martell* [1981]), are improvised from limitation and choices set by Kasper. Those works, which are among his most highly acclaimed, are built from "journal entries" of pedestrian movements recorded to reflect a set time span.

Works Choreographed: CONCERT WORKS: *The Run Dance* (1973); *Jamf* (1973); *Riisager I* (1973); *Ladenheim* (1974); *Riisager II* (1975); *Kathy's Solo* (1976); *Jeremiah* (1976); *Ukran* (1977); *Flurry* (1978); *Homestead Bronco* (1978); *Rough Beach* (1978); *Solo No. 1* (1978); *Solo No. 2* (1979); *Opera (Puccini)—Dance of Love and Death* (1980); *Solo No. 3* (1980); *The Harris Duet* (1980).

Kastl, Sonja, Yugoslavian ballet dancer and choreographer; born July 14, 1929 in Zagreb. Kastl was trained locally by Margaret Frohman and Ana Roje and continued her studies in Western Europe with Olga Preobrajenska, Nora Kiss, and Mary Skeaping.

She became a member of Frohman's Zagreb State Opera Ballet, performing featured and principal roles in the classics, *Swan Lake* and *Coppélia,* and in ballets by her mentor and by Pio and Pina Mlaklar. After staging interpolated dances for opera productions, notably the Zagreb productions of *Andréa Chenier* and *Pique Dame* in the 1959–1960 season, she succeeded Frohman as director of the Zagreb State Opera Ballet.

Works Choreographed: CONCERT WORKS: *Simfonia o Mrtvom Vojniku* (Symphony of Dead Soldiers) (1958, co-choreographed with Nevenka Bidjin).

Kavan, Albia, American ballet dancer; born c.1917 in Chicago, Illinois. Trained locally, possibly by Adolf Bolm, she performed with Ruth Page and Bentley Stone before moving to New York to enter the School of American Ballet. She danced with the American Ballet at the Metropolitan Opera corp and with the Ballet Caravan, a company of Balanchine students that toured the country in the late 1930s. Performing in most of the cooperative repertory, she was acclaimed for her comic and dramatic sense and her technique in Eugene Loring's *Harlequin for President* (1936) and *Yankee Clipper* (1937), and Erick Hawkins' *Show Piece* (1937).

After partnering Paul Haakon in vaudeville and Prolog presentations, she joined Ballet Theatre in 1943. Her roles there included featured parts in Antony Tudor's *Pillar of Fire* and *Gala Performance,* Mikhail Fokine's *Bluebeard* and Balanchine's *Waltz Academy.* With the (Anton) Dolin/(Alicia) Markova Ballet from 1945 to 1947, she performed in Bronislava Nijinska's *Fantasia* and the company's repertory of pas de deux and divertissements.

Kay, Hershy, American composer and arranger; born November 17, 1919 in Philadelphia, Pennsylvania; died December 2, 1981 in Danbury, Connecticut. Trained at the Curtis Institute in Philadelphia, Kay played cello in orchestras of Broadway musicals while writing song arrangements for nightclub acts. His first solo Broadway orchestra engagement, for Jerome Robbins' and Leonard Bernstein's *On the Town* (1944), led to further musical comedy and dance projects. Like his colleague, Genevieve Pitrot, Kay combined these two aspects of music orchestra-tion to double success, with Bernstein's *Candide* becoming one of the most popular scores in Broadway and symphony repertories. Among his best remembered arrangement of music for dance performance are the scores for Herbert Ross' *The Thief Who Loved a Ghost* (1950, from von Weber), Ruthanna Boris' *Cakewalk* (1951, from Louis Moreau Gottschalk), Jerome Robbins' *The Concert* (1956, from Chopin), and Joe Layton's *The Grand Tour* (1971, based on show music by Noel Coward). He remains best known for his work with George Balanchine's Americanizations of classical ballet, such as his *Western Symphony* (1954), *Stars and Stripes* (1958), and *Who Cares?* (1970); he also worked with him on the American Bicentennial tribute to Great Britain, *Union Jack.*

Kay, Lisan, American concert dancer; born Elizabeth Hathaway, May 4, 1910 in Conneaut, Ohio. Trained by Andreas Pavley and Serge Oukrainsky at their Chicago studio, she performed with their Chicago Civic Opera Ballet and concert group before accepting a scholarship to the International Congress of Dance in England, 1930. She met Yeichi Nimura there and became his partner in their European and American tours, until the mid-1940s. Kay appeared in all of his duets, such as *Chi'En and the Spring Maiden* (1931), *Figures of Earth* (1936), and *Sleeve Dance* (1936), and in his *Lute Song* on Broadway (1946). She also presented solo concerts of her own works mixed with his until 1943. From its formation in the late 1930s, Kay was on the faculty of the Ballet Arts Studio in New York City.

Works Choreographed: CONCERT WORKS: *Mu-Lan Goes to War* (c.1943); *Moorish Fantasy* (c.1930); *Invocation* (c.1943); *Rhumba Rhythm* (c.1943); *Query and Conclusion* (c.1943); *Sky Scrapes* (c.1960).

Kaye, Danny, American actor, singer, dancer, and satirist; born David Daniel Kominsky, January 18, 1913 in Brooklyn, New York. Kaye made his theatrical debut in 1933 with a dancing act, The Three Terpsichoreans (Kaye, Dave Harvey, and Kathleen Young), in Utica, New York. For five years, he toured with a series of revues and acts, among them A.B. Marcus' revue *La Vie Paree,* a dance act with Nick Long, Jr., and the one-night *Sunday Night Va-*

rieties. After working for Max Liebman at Camp Tamiment, he made his Broadway debut in Liebman's *Straw Hat Revue* (1939). An engagement at La Martinique in New York, and Broadway appearances in *Lady in the Dark* (1940) and *Let's Face It* (1941) led to a long-term film contract with Samuel Goldwyn. He did at least one dance number in each film and in some, such as *Wonder Man* (1945), *Knock on Wood* (1954), and *White Christmas* (1954), he appeared in different dance styles to fit split characterizations. He occasionally did a conventional dance-romance duet, such as "The Best Things Happen When You're Dancing" with Vera-Ellen in *White Christmas,* but more frequently did theatrical numbers within the context of "shows," as in the "Bali Boogie" nightclub routine with her in *Wonder Man* (with Carol Haney somewhere behind his left ear) or the title number in the vaudeville flashback in *Knock on Wood.*

The truly memorable Danny Kaye numbers, however, were the satires written for him by Sylvia Fine. These were interpolated into his shows and films and recorded in slightly longer versions. Many of these numbers referred to dance, such as "Manic-Depressive Pictures Presents" from *Up in Arms* (1944), "Pavlova" from the Martinique act and "Choreography," the Martha Graham-in-a-leotard satire in *White Christmas.* Fine, who played piano for concert dancers in her early career, was an excellent dance satirist.

To realize the full effect of Kaye's and Fine's routines, this entry should be read out loud very very quickly. Get It? Got It? Good.

Kaye, Nora, American ballet dancer; born Nora Koreff, January 17, 1920 in New York City. Trained as a member of the Children's Ballet of the Metropolitan Opera, Kaye also studied with Mikhail Fokine and danced in the corps of his 1935 Ballet company.

After dancing with the Metropolitan as an adult, Kaye joined the Ballet Theatre in its founding year, 1940. With that company from 1940 to 1950, 1953 to 1959, and currently as a director, she became famous for her dramatic portrayals of her heroine/victims of ballets by Antony Tudor, among them, his *Goya Pastoral* (1940), *Pillar of Fire* (1942, with "Hagar"

being her greatest role), *Dim Lustre* (1943), and the company revivals of *Offenbach in the Underworld, Gala Performances,* and *Jardin aux Lilas.* Although she did not create the role, she was similarly celebrated for her work as "The Accused" in Agnes De Mille's *Fall River Legend.*

With the New York City Ballet in the 1951 and 1953 seasons, she danced in the company premiere of George Balanchine's *Pas de Trois* (1951) and the first performances of Jerome Robbins' *The Cage* (1951), playing "The Novice," and *Ballade* (1952), and Antony Tudor's *La Gloire* (1952). When she returned to Ballet Theatre, she had her own repertory within the company, dancing in the Tudor and De Mille works and in the nineteenth-century classics, *Giselle* and *Swan Lake.* Kaye also performed in the ballets by Herbert Ross, her third husband, among them, *Paean* (1957), *Concerto* (1958), and *Dialogues* (1959). They formed a company, Ballet of Two Worlds, in 1960 for a European tour; with it, she performed in his *Persephone* (1960) and *The Dybbuk* (1960).

Kaye retired in 1961, but has returned to Ballet Theatre to serve on its board of directors.

Kaye, Pooh, Puerto Rican-American postmodern dancer and choreographer; born March 28, 1951 in San Juan, Puerto Rico. After moving to New York to attend Cooper Union, Kaye studied dance and composition with many of the most innovative participants of the postmodern dance movement, among them, Trisha Brown, Steve Paxton, Robert Dunn, David Woodberry, and Mary Overlie. Working with Simone Forti, she performed in many of her pieces, among them, *Red Green* (1975) and *Planet* (1976), creating her own roles within the context of the work. Kaye has also performed with the companies of Douglas Dunn, Liz Pasqual, and Joan Jonas, for whom she created the role of "the child" in *The Juniper Tree* in 1978.

For the last five years, Kaye has created works for performance in New York and in Holland, where she presented *Untitled* at a Symposium of Art and Architecture in 1980.

Works Choreographed: CONCERT WORKS: *Coming Out* (1975); *Three Minutes on a Revolving Stage* (1976); *Bad Dogs* (1976); *Brooding Bluffs* (1977); *Oh*

(1978); *Thick as Thebes* (1978); *Rampant Heights* (1979); *Zizi* (1980); *Home Stories* (1980); *Camptown* (1980); *Wild Girl* (1980); *Untitled* (1980).

Keane, Fiorella, English ballet dancer and teacher working in the United States after the late 1950s; born c.1930 in Rome, Italy; died June 9, 1976 in New York. Raised in England, she attended the Royal Academy of Dancing and the school of the Sadler's Wells Ballet. Keane was a member of both the Sadler's Wells and Royal Ballets, dancing featured roles in the companies' productions of the classics. After touring the United States with the Royal Ballet, she decided to return to work and live in New York.

She taught at the Juilliard School from 1959, participating in the collaborative choreography for *Gradus Ad Parnassum* in 1962. Popular with her students, but a firm disciplinarian, she served as ballet master of the Alvin Ailey Dance Theatre from the mid-1960s to 1974, and of the American Ballet Theatre. She was expected to spend her third year with the latter company when she died very suddenly just before the summer season opened.

Keeler, Ruby, American tap dancer; born August 25, 1910 in Halifax, Nova Scotia. Keeler studied tap and acrobatic dance with Jack Blue in New York.

Keeler worked as an adolescent at Texas Guinan's New York nightclub, and made her "legit" debut in the chorus of *The Rise of Rosy O'Reilley* in 1923. She appeared in four Broadway musical comedies between 1927 and 1929, before moving to Hollywood. These were *Bye-Bye Bonnie* (1927), *Lucky* (1927), *The Sidewalks of New York* (1927), and *Show Girl* (1929), her only Florenz Ziegfeld production.

With her then-husband, Al Jolson, Keeler moved to Los Angeles in 1930 after the success of his *The Jazz Singer,* the 1927 "talkie" melodrama. She may have appeared in late silent or transitional sound films in 1930–1932, but her first credited film appearance was as the understudy chorus girl "Peggy Sawyer" who, in *42nd Street* (WB, 1933), was told to "go out there and come back a star." She appeared in three more Busby Berkeley extravaganzas for Warner Brothers—*Gold Diggers of 1933, Footlight Parade* (1933), and *Dames* (1934). In each, she and Dick Powell played the juvenile leads in backstage musicals, surrounded by enormous sets and large choruses magnified with mirrors and camera effects.

Keeler made a film per year from 1934 to 1940, when she retired from motion pictures after *Sweetheart* (also called *Sweetheart of the Campus*), choreographed by Louis Da Pron for Columbia Pictures (released 1941).

Keeler's tap style, with her angular movements and extraordinary sound articulation, and her presence in the Berkeley films, made her a cult figure in the 1960s. After many university and museum film festivals, Keeler returned to Broadway to appear in a revival of *No No Nanette* (1971), supervised by Berkeley.

Keen, Elizabeth, American modern dancer and choreographer; born in Huntington, New York. Keen received her early training at the Adelphia University Children's Theater program (under Hanya Holm) and at the Preparatory Division of the Juilliard School. Her teachers as an adolescent and adult have included Karel Shook, William Griffith, Barashkova, Robert Denvers, James Truitte, and Dalcroze instructor, Mita Rom. She performed with the Mary Anthony company, the Helen Tamiris–Daniel Nagrin troupe, in which she performed in Tamiris' *Womansong* (1960), and with concert groups of Judith Dunn, Rudy Perez, Katherine Litz, and James Waring. She did a season with Paul Taylor, dancing in his *Insects and Heroes* (1961), *Junction, Rebus,* and *Three Epitaphs*. She began choreographing in 1962 and formed her own company eight years later. Her works are performed to music but do not copy the rhythmic structures of the scores; she frequently molds movements and rhythms to the individual dancers. Keen frequently uses dramatic vignettes interpolated into her abstract pieces, most popularly in two works based on noncontemporary dance forms—*Quilt* (1971), a nonverbal theater piece, and *A Polite Entertainment for Ladies and Gentlemen* (1975) to songs of Stephen Foster. Keen has also worked extensively with theater companies, staging and choreographing plays and musicals for institutional theater companies, among them the American Shakespeare

Festival, the Williamstown Playhouse, the Lenox Arts Center, and the Kennedy Center.

Works Choreographed: CONCERT WORKS: *Dawning* (1962); *Sea Tangle* (1962); *The Perhapsy* (1962); *Match* (1962, with Gus Solomons, Jr.); *Bird Poem* (1963); *Blinkers* (1963); *Reins* (1963); *Formalities* (1963); *Suite in C Minor* (1965); *Red Sweater Dance* (1965); *One X Four* (1965); *Scanning* (1967); *Short Circuit* (1967); *Stop Gap* (1967); *Rushes* (1967); *Attics* (1967); *Recipe* (1967); *Sub-Sun* (1968); *Point* (1969); *Poison Variations* (1970); *Parentheses* (1971); *Quilt* (1971); *Mini-Quilt* (1971); *Amalgamated Brass* (1972); *Tempo* (1972); *The Unravish'd Bride* (1972); *Onyx* (1973); *Dancing to Records* (1973); *Enclosure Acts* (1973); *Seasoning* (1974); *Pale-Cool, Pale-Warm* (1974); *A Polite Entertainment for Ladies and Gentlemen* (1975); *Line Drawing* (1975); *Rainbow Tonight* (1976); *A Fair Greeting* (1977); *The Last Snack* (1977); *Carmina Burana* (1977); *Continuum* (1978); *The Forget-Me-Not* (1978); *Garlic and Sapphires* (1978); *Slash* (1979); *Ruins* (1979); *Quadrille* (1980); *King David* (1980).

THEATER WORKS: *Hamlet* (1969); *Everyman* (1970); *The Mother of Us All* (1972); *Anna K* (1972); *The Freedom of the City* (1974); *Polly* (1975); *The Kitchen* (1976); *U.S.A.* (1977); *My Mother Was a Fortune Teller* (1978); *Swamp* (1978); *Jane Avril* (1980).

Kehlet, Niels, Danish ballet dancer; born September 6, 1938 in Copenhagen. Trained at the school of the Royal Danish Ballet with Karl Merrils, Hans Brenaa, and Vera Volkova, he graduated into the company in 1957. His later studies include classes with Nora Kiss, Michael Rekhikov, and Ter Stepanova.

His roles with the Royal Danish Ballet included "Gennaro" in Bournonville's *Napoli,* "Colas" in Frederick Ashton's *La Fille Mal Gardée,* and parts in Bournonville's *Flower Festival at Genzano,* Juan Corelli's *Chant pour un Temps Nouveau,* and Birgit Cullberg's *Cain and Abel, Miss Julie, Moon Reindeer,* and *Flirtation in the Chicken Run.* He currently performs mime roles in the company's productions of the classics and is celebrated for his portrayal of "Madge" in Bournonville's *La Sylphide.*

Kehlet has guested extensively, dancing Bournon-ville and Cullberg roles with the Grand Ballet du Marquis de Cuevas, the London Festival Ballet, the American Ballet Theatre, and the Frank Schaufuss Chamber Ballet.

Keil, Birgit, German ballet dancer; born September 22, 1944 in Kowarchen, Sudetenland, Germany. Trained at the school of the Werttemberg State Theatre Ballet and at the Royal Ballet School in London, she has been a member of the Stuttgart Ballet throughout her professional life.

She danced in most of the John Cranko repertory, including parts in his productions of *Giselle, Swan Lake, Romeo and Juliet, Eugene Onegin, Carmen,* and the *Taming of the Shrew,* and created roles in his original works, *Scènes de Ballet* (1961), *Opus 1* (1965), *Jeu de Cartes* (1965), *The Seasons* (1971), and *Initials R.B.M.E.* (1972), which was partially dedicated to her. Keil also performed in the premieres of Glen Tetley's *Voluntaries* (1973), *Daphnis and Chloe* (1975), *Greening* (1975), and *Sacre du Printemps* (1974), in Kenneth Macmillan's *Lady of the Camelias* (1978), and in Jiri Kylian's *Return from Strange Land* (1975) and *Nuages* (1976). As a guest artist, she danced in Eliot Feld's *Impromptu* with his New York–based company in 1976.

Keith, Jens, German ballet dancer and choreographer; born 1898 in Stralsund; died July 23, 1958 in West Berlin. Trained by Rudolf von Laban, he performed with his Neue Tanzbühne Münster and created his first works there.

Keith performed with the Berlin Staatsoper in the late 1920s before being named ballet master of the state opera theater in Essen from 1930. He also toured with his own concert group in the early 1930s, creating new works for a troupe that included Liselotte Köster and Daisy Spies.

From 1945 until his death, he served the Berlin Municipal Opera as ballet master and choreographer. Much of his known choreography, including his controversial *Legend of Joseph* (1948), was created for the Berlin company.

Works Choreographed: CONCERT WORKS: *Tales from the Vienna Woods* (late 1930s); *Pavane* (late 1930s); *Gypsy Dance* (late 1930s); *Sinfonie in Weis*

(late 1930s); *Cock in the Basket* (originally *Hahn im Korb*) (late 1930s); *Trisch-Trasch Polka* (late 1930s); *Harlequinade* (1940); *The Unhappy Lover* (1945); *The Three-Cornered Hat* (1947); *The Legend of Joseph* (1948); *Chiarina* (1950); *The White Rose* (1951).

Kellermann, Annette, Australian specialty swimmer and dancer; born July 6, 1888 in Sydney, New South Wales; died November 5, 1975 in Southport, Australia. Kellermann began her championship swimming career as therapy from infantile paralysis. After winning amateur competitions in Australia, she moved to London. Originally a distance swimmer in England, she went commercial and created a diving and dancing act at the London Hippodrome. She made her American debut at the White Circus Amusement Park in Chicago in 1907 and her vaudeville debut at Proctor's 5th Avenue Theatre shortly thereafter. Her American act consisted of two dance specialties, the *Mirror Ballet* and the *Diavolo Dance,* and her diving numbers, which ranged from the now-conventional swan to some tricks that began prone on the board or balancing on the neck. While studying with Luigi Albertieri, she appeared with her act on the Keith circuit and in *The Big Show* (1913) at the Hippodrome. Kellermann also swam and dove in four American films, *Neptune's Daughter* (1914), *A Daughter of the Gods* (1916), and *Queen of the Sea* (1918), all for William Fox, and *What Women Love* (First National, 1920), a five-part series.

As her success as a swimmer became international, she became more and more involved with presenting herself as a dancer. She added a ballet version of *Undine* in 1913, certainly an appropriate choice, and performed *The Dying Swan* once at a benefit staged by Daniel Frohman at the Metropolitan Opera House in 1917. Kellermann also worked with publisher Bernarr MacFadden to promote both dance and swimming in his physical culture magazine and publications. Her own *The Body Beautiful* (c.1917) and a series of articles in his periodicals proclaimed her "The Perfect Woman and the Form Divine."

Kellermann's career as a performer ended in the early 1920s. She returned to Australia where she staged charity water pageants, especially to raise funds for polio victims. She was founder of the Theatrical Unit of the Australian Armed Forces and was cited frequently for service to the armed forces.

Kelly, Desmond, Rhodesian ballet dancer; born January 13, 1942 in Penhalonga, Southern Rhodesia. Trained by Ruth French, he performed with the London Festival Ballet from 1959 to 1964, in the company's productions of *Les Sylphides, Swan Lake, The Nutcracker,* and *Spectre de la Rose.* After a brief tenure with the New Zealand Ballet, he performed with the National Ballet, Washington, D.C., in the late 1960s. He took the principal roles there in the classics and in George Balanchine's *Night Shadow, Pas de Dix,* and *Serenade.*

A principal of the Royal Ballet (of England) since 1969, he has become associated with the company's modern repertory, celebrated for his work in Glen Tetley's *Field Figures* (1970) and *Laborinthus* (1972).

Kelly, Ethel Amorita, American theatrical ballet dancer; born 1894 in Providence, Rhode Island. Kelly was trained by Karl Warwig, then teaching in New York City. Before her Broadway debut in *A Winsome Widow* (1912), Kelly distributed photographs of herself posed on point on the tip of a champagne bottle; for this reason, she was known as the "Champagne danseuse." Kelly's best remembered specialty dances were seen in the *Ziegfeld Follies of 1912,* the *Follies of 1913,* in which she was featured in The Bacchante in a "black silk bathing suit and a branch of grapes," and the *Passing Show of 1914.*

Kelly, Gene, American tap dancer, film dancer, and choreographer; born August 23, 1912 in Pittsburgh, Pennsylvania. Kelly studied tap and social dance locally, and ran dance studios in Pittsburgh and Johnston, Pennsylvania, from 1931 to 1937.

Kelly made his Broadway debut as a dancer in *Leave It to Me* (1938), later performing as the table tap dancer, "Harry," in the play *The Time of Your Life* in 1939. The title role in *Pal Joey* (1940) brought him to prominence and led to a film contract with MGM. Before leaving for Hollywood, Kelly staged dances for *Best Foot Forward* in 1941. In 1958, he returned to Broadway to direct the musical *Flower Drum Song.*

He has appeared in almost forty films, dancing in almost all of them. He has worked for many of the choreographers on staff at MGM, including Robert Alton (*Ziegfeld Follies,* 1946 and *Words and Music,* 1948), Jack Donohue, who staged *Anchors Aweigh* (1946), and Jack Cole, dance director of *Summer Stock* (1950) and *Les Girls* (1957). Kelly first received an on-screen choreography credit for *On the Town,* the 1949 film version of the Broadway show. It is possible, however, that he staged his own musical numbers for previous films. He staged tap numbers, romanticized social dances, a show-within-a-show, and a half-hour ballet in *An American in Paris* (MGM, 1951). In the next year, he created more tap dances, including the "Gotta Dance" tap ballet, in *Singin' in the Rain* (MGM, 1952). The opening sequence in *It's Always Fair Weather* (MGM, 1954) was a soft-shoe trio (for Kelly, Dan Dailey, and Michael Kidd) that included cabrioles performed with garbage can lids. Kelly's ability to integrate "found" objects into his choreography, as seen to great advantage in that film, has always been an integral part of his work, and a reason for its popularity.

His next film, *Invitation to the Dance* (MGM, 1954), was a three-part motion picture without spoken dialogue. The first sequence, "Circus," was a melodrama danced by Kelly, Claire Sombert, and Igor Youskevitch. The next section, "Ring Around the Rosy," featured American film dancers, including Tommy Rall, ballet dancers, among them Youskevitch, Tamara Toumanova, and Diana Adams, and a large dance chorus. The third sequence, the best received of the three, was performed by Kelly, his then-assistant Carol Haney, and animated figures by Hanna-Barbera.

He has also directed musical and dramatic films, among them, *Hello Dolly* (Twentieth-Century Fox, 1968) and *The Cheyenne Social Club* (National-General, 1970).

Kelly has appeared frequently on television, especially between 1958 and 1970. He has danced on most of the major variety shows, and acted on a short-lived situation comedy based on the Bing Crosby film, *Going My Way* (ABC, 1962). Kelly has choreographed his own specials for television over the years; notable among these have been *Dancing Is a Man's Game,* an *Omnibus* segment broadcast in 1958, that

compared movements necessary for dance forms and athletics, and his *New York, New York,* danced by Kelly, Haney, Carol Lawrence, and Jules Munshin, his co-star in *On the Town* and *Take Me Out to the Ballgame.*

Kelly's relaxed athleticism has made his dancing and choreography tremendously popular in America and overseas. His films are extremely innovative in their early uses of pedestrian (but choreographed) movement, integrating so-called normal movements, such as walking, kicking, and conventional manipulation of props, into obviously stylized dance forms.

Works Choreographed: CONCERT WORKS: *Pas des Dieux* (1960, Paris Opéra Ballet).

THEATER WORKS: *Nights of Gladness* (1940, Billy Rose's Diamond Horseshoe); *Best Foot Forward* (1941).

FILM: *On the Town* (MGM, 1949, also co-directed); *An American in Paris* (MGM, 1951); *Singin' in the Rain* (MGM, 1952, also co-directed); *Brigadoon* (MGM, 1954); *It's Always Fair Weather* (MGM, 1954, also co-directed); *Invitation to the Dance* (MGM, 1954, public distribution in 1956, also directed).

TELEVISION: *Dancing Is a Man's Game* (*Omnibus,* NBC, 1958, special); *New York, New York* (CBS, 1966, special); *Jack and the Beanstalk* (NBC, 1967, special, also directed).

Kelly, Paula, American modern dancer and actress; born c.1944 in Jacksonville, Florida. Raised in New York City, she attended the High School of Music and Art, continuing her training at the Juilliard School. Kelly had a very successful short career as a modern dancer, appearing in many works by Pearl Lang, including her *Tongues of Fire* (1968), Donald McKayle, among them his *District Storyville,* and Anna Sokolow, for whom she danced at Juilliard and as a company member in *The Question, Session for Six,* and *Time Plus.*

Although she had appeared frequently as a television dancer while at Juilliard, performing on Harry Belafonte, Sammy Davis, Jr., and Gene Kelly specials, she waited to make her Broadway debut in the unfortunately short-lived *Something More!* (1964). When she moved briefly to Las Vegas to work at Caesar's Palace and appeared in Juliet Prowse's pro-

duction of *Sweet Charity* there, she was invited to appear in her role ("Helene") in the London production and the film version—all staged by Bob Fosse.

Kelly had always worked as a straight actress, but after the success of her performances in Paul Sills' Story Theater production, *Metamorphosis*, she began to ease out of dance work. Although she has occasionally appeared as a dancer, most notably in Michael Kidd's television production of *Peter Pan* (1977), she has more frequently played dramatic roles in film and television and on stage.

Kelton, Gene, American theatrical performer; born October 21, 1938 in Flagstaff, Arizona. Kelton performed in many of the most successful dance shows on Broadway in the 1960s, among them Michael Kidd's *Destry Rides Again* and *Subways Are for Sleeping* (1961), Ernest Flatt's *Fade Out–Fade In* (1964), and Ron Field and Michael Bennett's *Applause* (1970), as well as others with shorter runs such as *Here's Love* (1963), *Skyscraper* (1965), and *Dear World* (1969), the musical version of *The Madwoman of Chaillot*. He returned to Broadway in 1978 in Michael Bennett's *Ballroom*, after a successful second career as a lighting designer for shows and club acts. Kelton can still be seen in two popular films that are frequently included in repertory series—Bob Fosse's *Damn Yankees* and Eugene Loring and Hermes Pan's *Silk Stockings*.

Kempe, William, English late sixteenth-century actor and dancer; the details of Kempe's birth and death are unknown but he has frequently been described as "young" at the time of his death, c.1607. Kempe's existence can be verified as early as 1586, when he was a member of the Earl of Leicester's Men (acting company) on its Danish tour. He is best known for his participation in The Lord Chamberlain's Men, the company in which Richard Burbage and William Shakespeare were principal members. It has been theorized by Shakespearean scholars that Kempe was principal "short" comic for the company and that he created the roles of "Dogberry," "Bottom," "Lance," "Costard," and one of the "Dromios."

Kempe is considered a dancer because of a publicity gimmick. He was the star of a 1599 media event—a progression, using only steps from a Morris dance, from London to Norfolk in nine days.

Kennedy, Merna, American theatrical dancer and actress in silent and sound films; born c.1909 in the Los Angeles area of California; died December 20, 1944 in Los Angeles. Trained locally by Ernest Belcher, she made her debut in one of the many child ballerina acts that he staged for Fanchon and Marco's West Coast De Luxe Prolog circuits. It is likely that she also appeared in Belcher's film choreography before being "discovered" at the age of fifteen by Charles Chaplin. Her role as the victimized tight-rope walker in his *The Circus* (Universal, released 1928) marked the beginning of her adult career. She was under contract to either Universal or First National through the remainder of her short life and appeared in more than a dozen films, primarily melodramas, but among them the musicals *Broadway* (Universal, 1931) and Al Jolson's *Wonderbar* (First National, 1933).

Kent, Allegra, American ballet dancer; born August 11, 1937 in Santa Monica, California. After training in Los Angeles with Bronislava Nijinska, Kent continued her studies at the School of American Ballet in New York.

Kent joined the New York City Ballet in 1953 and remains a principal with the company, although she has performed rarely since 1978. Although there has been a tendency to typecast Kent retroactively into those parts requiring absolute, superhuman flexibility (especially her many Balanchine roles), she actually performed a wide range of parts from the dramatic to the comic. Although her first major role, the "Idol" in *The Unanswered Question* section of *Ivesiana* (1954), was inhumanly unemotional, Kent performed in many characterizational parts, notably "The Girl" in Francisco Moncion's *Pastorale* (1957). She is best known, however, for her work in Balanchine's abstract ballets, among them, *Divertimento No. 15* (1956), *Stars and Stripes* (1958), the *Brahms-Schoenberg Quartet* (1966), and the concerto in *Episodes* (1959), considered by many the ultimate Kent part since it requires isolation of almost every part of her body.

Kent was also known for her performances in the works of Jerome Robbins, with featured roles in his *The Cage* and *Afternoon of a Faun*, and parts in the premieres of his *Dances at a Gathering* (1969) and *Dumbarton Oaks* (1972).

Kent, Helen, American modern dancer and choreographer; born December 30, 1949 in New York City. Kent was trained at the University of Wisconsin at Madison, where she studied with modern dancers of the Hanya Holm lineage, such as Louise Kloepper and Anna Nassif. When she returned to New York, she continued her studies with James Waring and the faculties of the Martha Graham studio and the Alwin Nikolais/Murray Louis school. As a member of the Louis troupe after 1971, she appeared in his repertory and in the videotapes that he created to show Dance as an Art Form. Kent formed her own company in 1978, in collaboration with dancer/mime Carlo Pellegrin and composer Robin Batteau. In Vertigo, she has worked in improvisational forms and has created much of its repertory alone or in collaboration with Pellegrin.

Works Choreographed: CONCERT WORKS: *Bruised Suite* (1977); *No School Today* (1978); *Indigo* (1978, continuous project); *Afterwords* (1978, choreographed by Vertigo); *The Comedian* (1980).

Kent, Linda, American modern dancer; born September 21, 1946 in Buffalo, New York. Trained locally by Seenie Rothier and Stella Applebaum, Kent continued her studies on scholarship to Jacob's Pillow (1963), before attending Juilliard. In the Dance Program at the Juilliard School, Kent studied with José Limón who cast her into his revival of *Tonantzintla* in 1968, and with Thelma Hill.

Joining the Alvin Ailey Dance Theatre just prior to her graduation in 1968, Kent created roles in his *Quintet* (1968), *Knoxville: Summer of 1915* (revised version, 1968), *Threnodies* (1969), *The Lark Ascending* (1972), and danced in his *Blues Suite, Revelations, Choral Dances, Flowers,* and *Hidden Rites.* Her other noted roles in the company included parts in Talley Beatty's *The Road of the Phoebe Snow,* Pauline Koner's *Poeme,* and Pearl Primus' *The Wedding.*

Kent has danced with the Paul Taylor Dance Company since 1975. She has performed in his *Three Epitaphs, Private Domain, Runes,* and *Esplanades,* and took major roles in the premieres in his *Diggity* (1979) and *Sacre du Printemps* (1980).

Kern, Jerome, American theatrical composer; born January 27, 1885 in New York City; died there November 11, 1945. Recognized as the "father" of the modern musical comedy, Kern worked primarily in plotted shows. Apart from his two revues, Ziegfeld and Dillingham's *Miss 1917* and the (Raymond Hitchcock) *Hitchy-Koo of 1920,* and dozens of topical commissioned numbers, he created scores and songs for intimate shows and extravagant operettas from 1912 to 1939. The former genre, with which he is most popularly associated, was the house style of the Princess Theatre from 1914 to 1918. Since the house was owned and managed by Elizabeth Marbury, Kern and his collaborators, Guy Bolton and P.G. Wodehouse, integrated social dance numbers for her exhibition ballroom dancer clients into each show. They were sometimes placed in a cabaret or party setting, but were more often eased into pedestrian movement patterns.

Kern's operettas were as large as could fit into a theater and an audience's imagination. *Sally* (1920), *Sunny* (1925), and *Show Boat* (1927) each placed dance numbers within theatrical settings, but ranged in technique from enlarged social dance forms to ballet. For the latter show, Sammy Lee used dances from the cake-walk to the waltz to show changes of period and emotion.

Late Kern is associated by dancers with Fred Astaire and Ginger Rogers since the celebrated team found great success in the film of *Roberta* (RKO, 1935) and *Swing Time* (RKO, 1936), a score created specifically for the screen. The "Smoke Gets in Your Eyes" duet from the former and "Swing Time Waltz" from the latter are considered among the finest works designed for the dancers.

Bibliography: Boardman, Gerald. *Jerome Kern* (New York: 1981); Ewen, David. *The World of Jerome Kern* (New York: 1960).

Kersley, Leo, English ballet dancer; born 1920 in Watford. Trained by Stanislas Idzikowski and Marie Rambert, he performed with the Rambert company in the late 1930s. From 1941 to 1951, he appeared with the Sadler's Wells and Sadler's Wells Theatre Ballets, creating a wide variety of roles in ballets by Robert Helpmann, Andrée Howard, Anthony Burke, and Ninette De Valois, as well as dancing in the company's troupe revivals of the classics. His creation credits include "The Grave-Digger" in Helpmann's *Hamlet* (1942), "The Master of Ceremonies"

in Howard's *Assembly Ball* (1946), "The Shepherd" in De Valois' *The Gods Go-A-Begging* (1946), and roles in Burke's *The Vagabonds* (1946) and *Parures* (1948), Howard's *Mardi Gras* (1946), and De Valois' *The Haunted Ballroom* (1947).

Kersley left England to teach in the Netherlands and the United States, but returned in 1959 to open a studio in Essex with his wife, Janet Sinclair. They have written extensively on dance, technique, and pedagogy for publication in a variety of British dance periodicals. Their *Dictionary of Ballet Terms* (1953) is still used at many schools and studios.

Kessler, Dagmar, American ballet dancer also working in Europe; born November, 1946, in Merchantsville, Pennsylvania. After early training with Thomas Cannon (danseur of the Littlefield Ballet in its prime), she entered the school of the Pennsylvania Ballet, graduating into the company in 1965. She appeared in many of that company's revival of works by George Balanchine, most notably his *Scotch Symphony*, and in the wide range of pas de deux and divertissement. She left the company in 1966 to perform with the Hamburg State Opera Ballet and the London Festival Ballet. She has been cast in progressively larger roles in the latter company, culminating in the principal parts of "Giselle," "Aurora," and "Cinderella." Since the mid-1970s she has divided her performance time among the London Festival and companies in the United States, most notably the Pittsburgh Ballet, and has taught extensively.

Kessler Twins, German ballet and theatrical dancers; born Alice and Ella Kessler, c.1938 in Leipzig, now People's Republic of Germany. The Kesslers were trained at the school of the Leipzig State Opera Ballet until 1952 when they joined their defecting father in Dusseldorf. When they found themselves unable to adapt their technique and style to the Dusseldorf company, they formed a nightclub act and made their joint debut at the Dusseldorf Palladium. For the next six years, they presented their dance act at the Paris Lido where they fit in beautifully in Miss Bluebell's choreography, and in London, before making their United States debut in 1958. After a successful engagement at the Persian Room of the Plaza Hotel, they were booked onto *The Ed Sullivan Show*, where they became extremely popular. The Kesslers, who retired in the early 1960s, were probably one of the last tandem acts in show business. They used all of the tricks of tandem work and adapted them to their ballet training, their fabulous acrobatics, and the individual limitations of nightclubs and television.

Keuter, Cliff, American modern dancer and choreographer; born 1940 in Boise, Idaho. Keuter began his dance training in San Francisco as a member of Welland Lathrop's workshop. After moving to New York, he studied with Helen Tamiris and Daniel Nagrin, performing in Tamiris' *Rituals* and *Versus*, and in Nagrin's *The Man Who Did Not Care* and *American Journey*. Classes with Paul Taylor led to a two-season stint with his company dancing in *Agathe's Tale* as "Raphael," *Lento, Scudorama, Public Domain*, and *Private Domain*. Apart from a few performances with Paul Sanasardo and appearances in works by his company members, Keuter has danced in his own pieces since forming his company in the mid-1960s. Keuter does dances about relationships, choice, and usually, indecision. His concerts are very popular but he has talked about disbanding the company since 1979.

Works Choreographed: CONCERT WORKS: *Collapse of Tall Towers* (1963); *Entrances* (1963); *Atsumori* (1964); *As It Was, Love* (1965); *After a While, Love* (1965); *A Cold Sunday Afternoon, A Little Later* (1966); *The Orange Dance* (1966); *Now What, Love* (1966); *White Shirt* (1966); *Cross-Play* (1966); *Hold* (1966); *Beyond Night* (1967); *Eight* (1967); *Small Room* (1968); *Dangling Man* (1968); *Three-Sided Peach Viewed Variously Three Hours of the Day of the Plastic Garment Bag* (1968); *The Game Man and the Ladies* (1969); *Letter to Paul* (1969); *Dream a Little Dream of Me, Sweetheart* (1969); *Sunday Papers* (1970); *Three Four Four Plus One* (1970); *Twice* (1970); *Now Is the Hour in the Wild Garden* (1970); *Crown Blessed* (1970); *Bread, and the Proudest Man Around* (1970); *A Snake in Uncle Sammy's Garden* (1970); *Amazing Grace* (1971); *Gargoules* (1971); *Wood* (1971); *Old Harry* (1971); *Poem in October* (1971); *If You Want Meditation, You Have to Work for It* (1971); *Fall Gently on Thy Head* (1971); *New Baroque* (1972); *I Want Somebody, Yes I Do* (1972);

Match (1972); *Hold III* (1972); *Poles* (1972); *Passage* (1972); *Cui Bono* (1972); *A Christmas Story* (1972); *Unusual in Our Time* (1973); *Musete di Taverni* (1973); *Plaisirs d'Amour* (1973); *Visit* (1973); *Restatement of Romance* (1973); *The Murder of George Keuter* (1975); *Voice* (1975); *Burden of Vision* (1975); *Station* (1975); *Field* (1975); *Of Us Two* (1975); *Table* (1975); *Tetrad* (1976); *Interlude* (1976); *Third Crossing* (1978); *Catulli Carmina* (1978); *Day Before Easter* (1978).

Kholfin, Nicolai, Soviet ballet choreographer; born November 23, 1903. The details of Kholfin's training are not verified although it is believed that he studied in the evening ballet classes that sprang up after 1919 in Moscow and other large cities. He joined Viktorina Krieger's Moscow Art Theatre Ballet in the early 1930s and first choreographed for the troupe in 1933, when he created the celebrated *The Rivals,* based on the *La Fille Mal Gardée/La Precaution Inutile* theme. He staged one further work for Krieger, *The Gypsies* (1937), before working with state theaters in the Asian Soviet. He served as ballet master for the state companies in two Soviet republics in Asia—the Kirghiz Theatre Ballet, for which he staged *Anar* (1940) and others, and the Turkmenistan State Opera, where he worked in the local folk media.

Kholfin returned to Moscow at the end of World War II and staged two comic works for the Stanislavsky/Nemirovich-Danchenko Theatre Ballet (the successor of Krieger's Art Theatre), *Doktor Albolit* (1948) and *Veselyi Obermanshchkik* (1949). He remained in Moscow as a teacher and ballet master, but occasionally staged works in other state or people's opera ballets within the Soviet block nations.

Works Choreographed: CONCERT WORKS: *The Rivals* (1933, Russian title unavailable); *The Gypsies* (1937); *Anar* (1940); *Francesca da Rimini* (1947); *Doktor Abolit* (1948); *Veselyi Obmanshchkik* (The Gay Deceivers) (1949); *Khaidushka pesen* (The Song of Khaidushka) (1953).

Kholkov, Boris, Soviet ballet dancer; born 1932 in Moscow. Trained at the Bolshoi Ballet School by Asaf Messerer, he was associated with the Bolshoi company through his career. Although he performed in most of the repertory, he was best known for his principal roles in the company's productions of the classics. He danced all of the major nineteenth-century roles in the 1950s and early 1960s, among them "Siegfried," "Basil," "Albrecht," and charming "Princes" in *The Nutcracker, Sleeping Beauty,* and *Cinderella.* Considered for many years the best partner in the company, he was selected frequently to perform with Galina Ulanova in *Giselle, Cinderella,* and *Chopiniana,* notably her last Bolshoi appearance.

Kidd, Michael, American ballet dancer and theater and film choreographer; born Milton Gruenwald, August 11, 1917 in New York City. Kidd enrolled in the School of American Ballet while a chemical engineering student at the City College of New York. After studying with Muriel Stuart, Ludmilla Schollar, and Anatole Vilzak, and performing with the American Ballet as a corps member, he joined the Ballet Caravan tour as a backstage technician. Using the names Michael Grey, Michael Forrest, and finally Michael Kidd, he performed with the Caravan in Eugene Loring's *Billy the Kid* and *City Portrait.* Following the Caravan's engagement at the 1940 World's Fair, he joined Loring's Dance Players, creating a major role in *The Man from Midian.* A soloist with Ballet Theatre from 1942 to 1947, he danced in the premieres of Antony Tudor's *Dim Lustre* (1943) and *Undertow* (1945) and in his own *On Stage* (1945), with featured roles in Jerome Robbins' *Fancy Free,* Tudor's *Pillar of Fire,* and the title role in Fokine's *Petroushka.*

Kidd deserted ballet for Broadway in 1947. He was the first person to win four Tony awards in any category, and the first to win four successive awards, for *Guys and Dolls* (1950), *Can-Can* (1953), *Li'l Abner* (1956), and *Destry Rides Again* (1959). His other successful musicals include *Finian's Rainbow* (1947), *Here's Love* (1963); *Skyscraper* (1965), and *The Rothschilds* (1970). His cinema credits include the motion picture version of *Guys and Dolls* (MGM, 1955) and two of the most popular dance films of all time, *The Bandwagon* (MGM, 1953), with its wonderful *Girl Hunt* movement satire of hard-boiled detectives, and *Seven Brides for Seven Brothers* (MGM, 1954), built around the competition polka at the barn raising. He staged the frantic finales of two Danny Kaye vehicles, *Knock on Wood* (Paramount,

1954), set during a satire of the Polovtsian Dances, and *Merry Andrew* (MGM, 1958), placed at the circus, the chorus line of *Star* (Twentieth-Century Fox, 1969) and the *"Baxter's Beauties"* sequence of *Movie Movie* (WB, 1978). Kidd has acted in the Dynamite Hands section of that film, as a burned out choreographer in *Smile* (UA, 1975), and as a Yiddish theater veteran in *Actor* (PBS, 1977).

Works Choreographed: CONCERT WORKS: *Finian's Rainbow* (1947); *Hold It* (1948); *Love Life* (1948); *Arms and the Girl* (1950); *Guys and Dolls* (1950); *Can-Can* (1953); *Li'l Abner* (1956); *Destry Rides Again* (1959); *Wildcat* (1960); *Here's Love* (1963); *Ben Franklyn in Paris* (1964); *Skyscraper* (1965); *Breakfast at Tiffany's* (1966, closed out of town); *Subways Are for Sleeping* (1967); *The Rothschilds* (1970); *Cyrano* (1973).

FILM: *Where's Charley* (WB, 1952); *The Bandwagon* (MGM, 1953); *Knock on Wood* (Paramount, 1954); *Seven Brides for Seven Brothers* (MGM, 1954); *Guys and Dolls* (MGM, 1955); *Merry Andrew* (MGM, 1958); *Hello Dolly!* (Twentieth-Century Fox, 1969); *Star* (Twentieth-Century Fox, 1969); *Movie Movie* (WB, 1978, staged dances for *"Baxter's Beauties"* sequence, appeared in Dynamite Hands segment).

Killeen, Madelyn, American theatrical dancer; born c.1905 in New York City. Killeen was a Wall Street secretary when she began to study with Alexis Kosloff and acrobatics specialist Theo Creo. She made her debut with the Yiddish Art Theater but soon moved uptown to the Music Box Theater on Broadway. In the 1923 *Music Box Revue*, she served as a "swing girl" for The Fairbanks Twins and danced in the chorus. Killeen was a specialty dancer in the *Greenwich Village Follies* of 1924, the musical *Mercenary Mary*, and the *Earl Carroll Vanities* of 1925. Her numbers ranged from "fancy dancing" to stylized social dances, but she was best known for her acrobatic Black Bottoms.

Kimball, Christina Kumi, American theatrical dancer; born in Otsu, Japan. Kimball was trained at the High School of Performing Arts in New York City and took ballet classes at the Harkness House and the Dance Theatre of Harlem. She performed with the Alvin Ailey American Dance Theatre and George Faison's Dance Experience before leaving concert work for theater, beginning with productions staged by Ailey and Faison. Her strong appearance as the "Tornado Eye" in Faison's choreography for *The Wiz* (national tour and Broadway) was especially admired. She has also been acclaimed for her dance work on television, most notably on *Positively Black*, in Louis Johnson's film of *The Wiz*, and Bob Fosse's *All That Jazz*, and on Broadway in Gower Champion's *A Broadway Musical*.

Kinch, Myra, American modern dancer and choreographer; born c.1903 in Los Angeles, California; died November 20, 1981 in Bonita Springs, Florida. After graduating from the University of California at Los Angeles, she danced at the Coconut Grove and for Fanchon and Marco's West Coast De Luxe Theatres, performing in Prologs. She went to Germany in 1932 to work with Max Reinhardt, touring Eastern Europe and the United States with his company; there is also evidence that she performed in solo recitals in Czechoslovakia during the tours.

Returning to Los Angeles, she performed in films, among them *The Lives of a Bengal Lancer* (Paramount, 1935), and became director of the dance unit of the local Federal Theatre Project. As such, she choreographed historical productions for the Golden Gate International Exposition and for concert tours.

After the mid-1940s, she worked primarily on the East Coast, associated during each summer with the school at Jacob's Pillow. From 1940 on, she staged pageants for the Williamsburg reconstruction project. She also taught in New York and its suburbs until her retirement in 1967.

Kinch's choreography runs the gamut from the abstract and serious to the satirical and hysterically funny. Her best known work, *Giselle's Revenge* (1953), in which Albrecht gets his, is the fantasy of every balletomane gone sour, while her *Tomb for Two* (1957) reveals the real fate of *Aida*.

Works Choreographed: CONCERT WORKS: *American Exodus* (1937); *Album Leaves (Ballet 1840, Spanish 1890, Skirt Dance 1900, Greek Dance 1915)* (1937); *Coronation* (1937); *Introduction to Movement* (1938); *American Holidays* (1938); *Let My People Go* (1938); *Sarabande for the Erudite* (1938);

Waltzes Nobles et Sentimentales (1939); *Love in the Snow* (1946); *Romance* (1947); *Amerindian Suite* (1948); *Entrances and Exists* (1948); *Fatima from Sarasota* (1948); *Song of Sabia* (1948); *The Six Mrs. Tudors* (1949); *Of Dreadful Magic* (1949); *The Angels of Puno* (1950); *El Reboso* (1950); *Modinha* (1950); *The Grape Gatherer* (1950); *Along Appointed Sands* (1951); *The Bird Watcher* (1951); *The Tower of Rage* (1952); *Giselle's Revenge* (1953); *Wherever the Land Is* (1953); *The Wind Is West* (1955); *Salade* (1955); *Variations on a Variation* (1955); *Sundered Majesty* (1955); *Magnolias for Three* (1956); *The Bajour* (1956); *Sad Self Hereafter Kind* (1956); *Tomb for Two* (1957); *You Unfurl the Fan* (1957); *Sound of Darkness* (1958); *Beautiful Dreamer I* (1958); *Mr. Mitten* (1959); *A Waltz Is a Waltz Is a Waltz* (1960); *The First Togetherness* (1960); *Ah, Psyche, Vex'd Am I* (1961); *Mystic Trumpeter* (1961); *Beautiful Dreamer II* (1961); *Acquaintance with Grief* (1963); *Synkopto* (1964); *Fragments Re-Assembled* (1965); *Concerto Grosso* (1967); *Shakespeare Haiku* (1969); *The Devil's Tattoo* (1970); *Sappho Synkopto* (1971).

THEATER WORKS AND PAGEANTS: *The Common Glory* (1949); *Faith of Our Fathers* (1951); *Festival of Faith* (1954); *The Founders* (1957).

King, Bruce, American modern dancer and choreographer; born February 10, 1925 in Oakland, California. King's academic dance studies at the University of California at Berkeley and New York University were balanced by studio work with Hanya Holm, Merce Cunningham, Martha Graham, Alwin Nikolais, and the staff of the Metropolitan Opera Ballet School. He appeared with the Nikolais company at the Henry Street Settlement in his company works, among them *Opening Suite, The Committee,* and *The Invulnerables,* and in productions for the children's theater. A member of the Merce Cunningham company from 1955 to 1959, he danced in his *Septet, Banjo, Labyrinthian Dances,* and *Nocturnes.* Other performance credits include roles in Sophie Maslow's *From the Book of Ruth* (1964), Katherine Litz's *Loving Couples* (1978), and John Parks' *Forest* (1978)—in each case King shared recitals with his fellow choreographers and appeared in their works on the programs. King also worked in some theatrical productions including a national tour with Gypsy Rose Lee (c.1958), *Li'l Abner* (1959, cast as "Available Jones"), and performance in the *Broadway Jazz Ballet* company that was sent to Germany in 1961 on a concert tour.

King began to present his own choreography in recitals shared with fellow dancers in the Nikolais and Cunningham companies. He has been able to divide his career between choreography and teaching, frequently by being named choreographer and artist-in-residence at universities of educational programs. His work for children is better known at present than his excellent concert work, which has been described as being in the forefront of the young creators of traditional modern dance forms.

Works Choreographed: CONCERT WORKS: *A Door Stands Open* (1954); *Gingerbread Man* (1954); *Figures Caught* (1957); *March* (1957); *Cowboy's Lament* (1958); *Waltz for Fun* (1958); *Bird Dance* (1958); *Running Figure* (1959); *Five Short Dances* (1960); *Children's Suite* (1961); *Cadillac Industrial* (1962); *Street Song* (1963); *Themes: Desert, Sky, City* (1963); *Cloud* (1964); *Ghosts: Falling, Calling Mad, Exiled, Lost, Adrift* (1965); *Miraculous Garden* (1966); *Overture* (1966); *Omens and Departures* (1967); *Catacombs* (1967); *Walk in Splendor* (1968); *Autumn* (1969); *Echoes* (1969); *Parable* (1970); *Rondo Toward Death* (1971); *After Guernica* (1971); *Vigil* (1972); *Bamboo* (1973); *Leaves* (1974); *Swarm* (1974); *Oranges and Lemons* (1974); *Jazz Set* (1976); *Gen. Booth Enters into Heaven* (1976); *Autumn* (1977); *Hidden Ancestors* (1978); *Entrances* (1978); *Tunnel* (1979); *Winter Harvest* (1979); *Earth Song* (1979); *Pattern* (1980).

King, Charles, American musical comedy and film star of the early twentieth century; born October 31, 1889 in New York City; died January 11, 1944 in London. It is difficult to understand how King could have been forgotten by audiences after his death; from his Broadway debut in *The Yankee Prince* (1908) to his last show, *Sea Legs* (1937), he was the embodiment of a musical comedy actor. He could sing any music and, in fact, introduced some of the most famous songs of his period, and could do tap, soft shoe, and exhibition ballroom dance work without difficulty. It is unsure whether any musical com-

edy performer, with the possible exception of Alfred Drake, had the versatility necessary to be cast in featured roles in English-derived operettas, such as *The Slim Princess* (1911) and the 1913 revival of *The Geisha;* in revues, among them *The Mimic World* (1908, with his sister Nellie), *The Passing Show of 1913,* and Ziegfeld and Dillingham's *Miss 1917,* in which he serenaded the beautiful chorus with the glorious ballad, "The Land Where the Old Songs Go"; and plotted musicals. Among the classics of the latter genre, King appeared in *Watch Your Step* (1914), George M. Cohan's *Little Nellie Kelly* (1922), *No Foolin'* (1926), *Hit the Deck* (1927), *Present Arms* (1928), and *The New Yorkers* (1930). Among the hundreds of songs that he introduced were ballads and patters by Jerome Kern, Irving Berlin, George Gershwin, Cohan, Rudolf Friml, Vincent Youmans, and Cole Porter, including "Happy Days Are Here Again" and "Sometimes I'm Happy."

King was also an early musical star of sound films, with the hero role in the original *Broadway Melody* (MGM, 1929), *The Hollywood Revue* (MGM, 1929), *The Girl in Show* (MGM, 1929), and *Chasing Rainbows* (MGM, 1930). In *Broadway Melody*, he was the first of many to sing "Singin' in the Rain."

King also worked on vaudeville, from the act with his sisters Mollie and Nellie to presentation houses in the later 1930s. He was in London to perform with the USO when he died of a heart attack in 1944.

King, Dottie, American theatrical ballet dancer; born c.1900, possibly in Rochester, New York; died March 15, 1923 in New York City. It is not certain whether King was her real name or not; at the time of her death, her legal name was Dorothy Keenan. King made her professional debut in the 1907 season in vaudeville in an act with Louisa Marshall, who, according to many sources, was in fact her sister. Marshall and King were for many years the best known eccentric ballet tandem and specialty act in the business, with successful coast-to-coast seasons on the circuits and a European tour in 1909. Among their specialties were tangos, bullfight dances, and ethnic pieces based on South American characterizations— all performed on point. They joined a musical, *The Golden Crook,* in 1910, integrating their dances into the plot. King did her first conventional ballet work

in that show, as prima ballerina of the Grand Ballet de la Lune.

From 1912 to 1916, King worked solo in operettas and musical comedies. She did not appear on the New York stage (probably because she was under age, although this is unsure), but toured the country with the shows. In 1916, she returned to vaudeville in her own act, *The Ballet Divertissement,* on the Keith circuit, but within the year she had teamed up with Charles Grohs in an exhibition ballroom act.

At the height of her popularity as an exhibition ballroom dancer, King was found dead in her 57th Street apartment. Her murder has never been solved, although after the murder of a suspect's alibi-er, many people considered his release a miscarriage of justice. Her death became the basis for S.S. Van Dine's celebrated *Canary Murder Case* (New York: 1927), in the popular "Philo Vance" series. Unlike her fictional counterpart, however, King did not perform in the *Ziegfeld Follies*; it is also unlikely from available evidence that she, like the "Canary," supplemented her dance earnings with blackmail.

King, Eleanor, American concert and modern dancer and choreographer; born 1906 in Middletown, Pennsylvania. After studying locally with Clair Tree Major, she moved to New York to work with Doris Humphrey and Charles Weidman at their studio. She has also received training in mime with Etienne Decroux, and in Oriental dance forms of Japan, Sri Lanka, and Bali.

A charter member of the Humphrey/Weidman Concert Group, she was privileged to create roles in many of the early works of those pioneering choreographers. Her performances for Weidman were in the premieres of *The Conspirator* (1930) and *The Happy Hypocrite* (1930), while her many created roles for Humphrey included *Water Study* (1929), *Life of the Bee* (1929), *The Shakers* (1932), *The Pleasures of Counterpoint* (1932), and *Suite in F* (1933).

King began to choreograph in "The Little Company," consisting of herself, Ernestine Henoch (Stodelle), Letitia Ide, and José Limón; her first solo credits came from another small company of concert dancers—among them Fé Alf, George Bockman, Sybil Shearer, and William Bales—the Theatre Dance Group. She then worked extensively as a con-

cert dancer and with a company of her own in Seattle, Washington (c.1948). Other works were created during teaching engagements at the University of Arkansas, the Toankunst Dansschool, Rotterdam, and the College of Sante Fe, New Mexico. The dances reveal her debt to Humphrey's teachings on choreography and structure and her interest in Asian forms and techniques.

Works Choreographed: CONCERT WORKS: *Polonaise, Rondeau, Badinerie* (1932, co-choreographed with José Limón); *American Folk Suite (Hoe Down, Horn Pipe)* (1936); *Peace, An Allegory* (1936); *Festivals* (1936); *Song of the Earth* (1936); *Dance from an Old World* (1937); *Icaro* (1937); *Renascence* (1937); *Parodisms* (1937, with Elizabeth Calman); *Two Characters of the Annunciation* (1941); *Song for Heaven* (1941); *A Saint and the Devil* (1941); *Roads to Hell* (1941); *Novella* (1942); *Brandenburg Concerto No. 2 in F* (1942); *Beasts and Saints* (1942); *Ode to Freedom* (1943); *To the West* (1944); *Ascendence* (1944); *Moon Dance* (1945); *Etruscan Soliloquy* (1947); *Afternoon in Crete* (1947); *Partita No. 6 in E Minor* (1947); *She* (1948); *Agonistae* (1949); *Triumph of Man* (1949); *Dance for the Spring* (1949); *Concerto for Harpsichord* (1950); *Transformations* (1950); *Invocation* (1951); *Soliloquy in the Morning* (1951); *Dance in the Afternoon* (1951); *Four Visions* (1952); *Ceremony of Carols* (1953); *I Grionfi di Petrach* (1954); *Who Walk Alone* (1955); *Byrantiou* (1955); *Korinthiakas* (1955); *Archias* (1955); *Three Ritual Figures from Hellas* (1956); *The Temptation of Saint Anthony* (1956); *Hogaromo* (1957); *Theatre of the Imagination* (1959); *Images Japonaises* (1959); *Rhapsodic Suite* (1959); *Duets for Dance and Piano* (1959); *Miracles* (1959); *Elegy and Tocatta* (1959); *Gilgamesh, Babylonian Dance, Play* (1960); *Passacaglia* (1962); *Burlekaniana* (1962); *Evening* (1962); *Hanivia* (1963); *Nuna-da-vt-sun-yi* (1963); *Salutation* (1963); *Synthesis* (1967); *Kancharo Rin* (1967); *e.e. cummings Poems* (1969); *Dance in Japan, Kagura, Saran-Bushi, Tabaruzaka, Hogoromo* (1969); *Symphonic Etudes* (1969); *Three Poems* (1969); *Three Lamentations of Jeremiah* (1970); *St. Francis* (1970); *The Waves* (1970); *Angel Concert* (1970); *Fundamentals of Resting* (1970); *Night Song—Day Cry* (1971); *Vivace, Fifth Ode* (1971); *The Medium Addresses the kami* (1971); *Dolorosa* (1978); *Salpiri* (1978); *A Fantasy on T'ai Chi* (1978); *Wha . . . i, Whai . . . o* (1978); *Anthropoi Kai gymnaikes* (1978).

Bibliography: King, Eleanor. *Transformations. A Memoir: The Humphrey/Weidman Era* (New York: 1977).

King, Kenneth, American postmodern dancer and choreographer; born April 1, 1948 in Freeport, New York. King became involved with the Judson Dance Theater while a student at Antioch College. He has created works since 1964, when he staged *cup/saucer/two dancers/radio* for himself and Phoebe Neville. A King dance work is a unique experience, an assemblage of movement, visuals, and a constant stream of puns in every medium. Words and linguistic references sneak up on the audience which thinks that it is only watching something on stage, but King's actual movements are also fascinating and show a tremendous range of gestures, scales, and isolations. One of the pleasures of a Kenneth King performance is in the program. He uses typography with the same sense of freedom found in his movements— he can make the same impact with a full cap placed carefully in the middle of a word as he can with a sudden pose and stillness on stage. King, who frequently lectures while dancing, occasionally uses an alter ego as collaborator for a specific work; the audience has been introduced to Pontease Tyak, Custodian of the Trans Himalean Society for Interplanetary Research, Mater Harry, Joseph D. Davadese, and Paeter Nostraddos while learning about their friends, acquaintances, and theories of philosophy. He has the imagination to spring his cast of characters on the audience and the contact and presence to make it vital.

Works Choreographed: CONCERT WORKS: *cup/saucer/two dancers/radio* (1964); *Spectacular* (1965); *Self-Portrait: Dedicated to the Memory of John Fitzgerald Kennedy* (1965); *m-o-o-n-b-r-a-i-nwithSuperLecture* (1966); *Blow-Out* (1966); *Camouflage* (1966); *Print-Out: (CELE((CERE))-BRATIONS: PROBElems & SOULutions for the dyEYEing: KING)* (1967); *A Show* (1968); *Being in Perpetual Motion* (1968); *exTRAVEL(ala)ganza* (1969); *Conundrum* (1969); *Phenomenology of Movement* (1969); *Secret Cellar* (1970); *Carrier Pigeon* (1970); *Christmas Celebration* (I) (1970); *INADMISSLE-*

ABLE EVIDENTDANCE (1971); *Perpetual Motion for the Great Lady* (1971); *Christmas Celebration* (II) (1971); *Simultimeless Action (The Dansing Jewel, The Great Void)* (1972); *Solstice Event* (1972); *Christmas Celebration* (III) (1972); *Metagexis* (1973); *Patrick's Dansing Dances* (1973); *Mr. Pontease Tyak* (1973); *INADMISSLEABLE EVIDENTDANCE* (II) (1973); *Praxiomatics (The Practice Room)* (1974); *Time Capsule* (1974); *High Noon (A Portrait-Play of Friedrich Nietzsche)* (1974); *The Telaxic Synapsulator* (1974); *The Ultimate Expose* (1975); *Battery* (1975); *Battery (Part 3)* (1976); *RAdeoA.C.tiv-(ID)ity* (1976–1978, ongoing project); *Video Dances* (1977); *Labyrinth* (1977); *RAdeoA.C.tiv(ID)ity* (1978, final version); *Dance S(p)ell* (1978); *Worl(l)d (T)raid* (1978–); *The Run-in Dance* (1978); *WORD RAID* (1978); *SPACE CITY* (1980); *Blue Mountain Pass* (1980); *CURRENCY* (1980).

Bibliography: King frequently publishes scripts from his works under his name and those of his pseudonymous alter egos. A complete list of these to 1978 can be found in Sally Banes, *Terpsichore in Sneakers* (Boston: 1979).

King, Mazie, American eccentric toe dancer; born c.1880; King was not formally trained in ballet. When King made her New York debut as the principal specialty dancer of Leonard and Gilmore's *Hogan's Alley* in 1896, she had already been in the theater for most of her young life. She toured with Leonard and Gilmore shows until 1906, but took off time in 1898 to work in New York's roof gardens, traditional homes for eccentric toe dancers. It should be noted that even compared to roof garden dancers Elseeta and Annabella, she was considered a spectacular performer, able to do more, jump further, and land better on toe than the others. Her most popular specialty at this point was similar to Elseeta's—she jumped from tables to the floor, landing in perfect fifth position on point.

After the 1908 death of John Leonard (who was by then her husband), she joined the revue, *The Mimic World,* as the imitator of Bessie Clayton. She then began a successful period of four years in which she commuted between vaudeville and Broadway, where she appeared in a number of Lew Fields musical comedies including *The Hen-Pecks* and *The Midnight Sons.* In vaudeville, she had an act billed as "The World's Greatest Novelty Toe Dancer," but her greatest fame in this period actually came from a publicity gimmick of April 8, 1911. She walked down the thousands of steps of the Metropolitan Tower, New York, *on point.* The media event got so much publicity that she was forced to repeat the gimmick in every city that she visited, walking down the stairs of the highest building that her press agent could find.

King also walked down steps on stage, appearing in Ned Wayburn's Magic Staircase sequences in *The Passing Show of 1913* and *The Escalade* as imported to the Hippodrome Theatre, London. The latter, however, marked the end of her legitimate career, since, when she returned to the United States, she invaded vaudeville with a series of successful feature-length class acts. These fifteen- to twenty-minute sequences, generically known as *The Spirit of Spring,* featured her in ballets and exhibition ballroom dances, as partnered by Tyler Brooke or Ted Doner. Mazie King and Her Terpsichorean Beauties were the most popular dance feature act in vaudeville from 1913 to 1917, when she retired, and her feats on point continued to delight and surprise her audiences. In 1916, the act included films of her footwork projected in back of her live performance; unfortunately, these reels have never been found.

King, Mollie, American theatrical dancer and film actress; born c.1898 in New York City. King made her theatrical debut in a child act with her older sister, Nellie, and brother Charles. The Three Kings toured extensively until 1905, when she dropped out of the team to work as a child actress on Broadway. Mollie King played Maxine Elliot's daughter in a number of plays, including her dramatic debut in *Her Own Way,* but returned to musicals in 1911 in *A Winsome Widow.* For the next ten years, she split her time between Broadway musicals and film serials, in which she fought off perils and danger in Pathe's *The Seven Pearls* (1917), *Mystery of the Double Cross* (1917), *Women Men Forget* (1919), and *Greater than Love* (1920). Her Broadway appearances included an imitation of Laurette Taylor in *The Passing Show of 1913,* and dance/singing roles in *The Belle of Bond Street* (1914), *Nobody Home* (1915), and *Blue Eyes* (1921). Although her film work made her less impor-

tant as a stage performer than her brother, she was still well known on Broadway as the "most beautiful ingenue" and a superb actress.

King, Nellie, American theatrical dancer; born c.1895 in New York City; died July 1, 1935 in West Palm Beach, Florida. King toured with her older brother, Charles, and younger sister, Mollie, as The Three Kings. She is best remembered for her partnership with her brother, however, in vaudeville and in the *Mimic World of 1909* as child imitators. Illness forced her retirement at a very early age and caused her death at forty.

Kiralfy, Bolossy, Austro-Hungarian nineteenth-century ballet master and exposition producer; born c.1848 in Posen (now Poland); died March 7, 1932 in London. The Kiralfy Family was a Polish popular entertainment troupe working in Hungary when Bolossy was born, but the troupe was forced to leave the country shortly thereafter, settling in Brussels after touring extensively in Western Europe. Bolossy and his older brother, Imre, emigrated to the United States in 1869 to be followed eventually by all of their extant siblings. The Kiralfy Brothers (Bolossy and Imre as artistic directors, Charles and Arnold Georg as managers) became associated with Niblo's Gardens in New York as producers of revivals of the ballet-spectacles of the 1870s, among them *The Black Crook, Dolores, The Water Queen,* and two works "borrowed" from La Scala, *Sieba* and *Excelsior.* After Bolossy and Imre quarreled in 1885, Bolossy founded an amusement park on the Palisades overlooking the Hudson River (on the New Jersey side), where he produced spectacles in an enormous arena. In many shows, such as *King Solomon, or the Destruction of Jerusalem,* he was able to manipulate scale so successfully that the audience genuinely believed that they saw the destruction of an entire city. He frequently brought entire expositions on tour with him, setting up permanent facilities in Paris, Toronto, and the Orient. Many productions maintained the curious contact with European ballet titles, such as Toronto's *A Carnival of Venice* (1903), but others were topical, among them, the Louisiana Purchase Spectacle at the St. Louis World's Fair of 1904 and the Pocohantas Expositions in Jamestown in 1907.

From 1900 to 1907, he also worked with Barnum and Bailey, designing mobile productions to be performed in the ring as part of the side shows for that circus. He revived *Belkis* and *The Water Queen* for Barnum and Bailey, and produced one of his best remembered spectacles, *Around the World in 80 Days.*

Bolossy Kiralfy retired in 1912 and lived in both the United States and England, where he was reunited with his brother. His children, Nona and Alexander, performed in vaudeville as The Kiralfy Kiddies in the 1910s and 1920s.

Kiralfy, Imre, Austro-Hungarian nineteenth-century ballet master and exposition producer; born c.1845 in Posen (now Poland); died April 27, 1919 in Brighton, England. The Kiralfy Family, consisting of the popular entertainer parents and children Imre, Bolossy, Charles, Arnold Georg, and Emilie, left Hungary in the late 1840s for Western Europe (and religious freedom). They became very popular in Belgium and Germany. Imre, Bolossy, and Emilie left their family troupe in 1869 to emigrate to the United States, where eventually their siblings would join them. For fifteen years, Imre and Bolossy worked together to produce, direct, write, and design spectacular presentations of shows based on historical or literary events. They worked at first in conjunction with Niblo's Gardens but soon left to produce for Barnum and Bailey. For both organizations, they varied the staple diet of falls of cities and disasters, to create spectacle productions of nineteenth-century ballets, among them Manzotti's *Excelsior* and *Sieba,* and versions of *The Water Queen* (popular in New York since the 1860s) and *Belkis.*

When the brothers quarreled in 1885, Imre began to work in an even larger scale, presenting Expositions involving hundreds of performers such as *America* (1893, Chicago), *The Fall of Babylon* (1889, revival), and *The Grand Naval Spectacle* (1898). After his move to London, he worked at Earl's Court, staging more spectacles (with an English colonialist political bias), among them, *China, or the Relief of the Legations* (1901) and *Empire of India and Ceylon* (1896). When he opened his own "Great White City" at Shepherd's Bush, he designed not only individual productions, but entire expositions with dozens of buildings and arenas. These were also based on the

British view of history, and included Franco-British, Sino-British, Japanese-British, Latin-British, Anglo-American, Coronation and Jubilee Expositions. He purchased Steeplechase Park on Coney Island (Brooklyn, New York) in order to assemble a similar "White City" in the United States, but was unable to do so because of the outbreak of World War I. His English dream was destroyed as Shepherd's Bush became a munitions factory shortly before his death in 1919.

Kirkland, Gelsey, American ballet dancer; born 1953 in Bethlehem, Pennsylvania. Kirkland, and her older sister Johnna, moved to New York to study at the School of American Ballet. Both joined the New York City Ballet as adolescents.

As a member of the company, Kirkland performed in much of the repertory of ballets by George Balanchine, including his *Concerto Barocco, Symphony in C, Stars and Stripes, Tchaikovsky Pas de Deux,* and the *Rubies* section of *Jewels.* She has also performed in many works by Jerome Robbins, creating roles in his *Goldberg Variations* (1971), *Scherzo Fantastique* (1972), and *Four Bagatelles* (1974). Other premieres in which she performed included ballets by her colleagues, among them John Clifford's *Reveries* (1969), in which she danced with her sister, and *Symphony in E flat* (1972), and Richard Tanner's *Concerto for Two Solo Pianos* (1971).

Kirkland joined the American Ballet Theatre, reportedly to partner Mikhail Baryshnikov. In that highly publicized partnership, she danced in John Neumeier's *Hamlet Connotations*, Robert Weiss' *Awakening*, Balanchine's *Theme and Variations,* and an entire repertory of pas de deux. She has also participated in successful partnerships with Ivan Nagy, in *La Sylphide, Giselle,* and Weiss' *A Promise,* and with Antony Dowell in the classics.

Since the late 1970s, Kirkland has worked as a freelancer, accepting invitations for guest performances and short-term company work. An organizer of the dancer's strike at Ballet Theatre, she has been in and out of the company frequently in the last two years.

Kirkland, Johnna, American ballet dancer; born February 14, 1950 in Bethlehem, Pennsylvania. After studying interpretive dance locally, Kirkland moved to New York with her family, including sister Gelsey. There, both entered the School of American Ballet. Johnna Kirkland performed child roles with the New York City Ballet, playing roles in *The Nutcracker* and in the premiere of Balanchine's *A Midsummer Night's Dream* in 1962, before joining the company in 1965.

In the New York City Ballet, she danced featured roles in Balanchine's *Raymonda Variations, Four Temperaments, Tchaikovsky Suite #3,* and *Who Cares?,* and Robbins' *Goldberg Variations.* She created roles in many works staged by New York City Ballet dancers experimenting in choreography; these works included Richard Tanner's *Octandre* (1971), Lorca Massine's *Four Last Songs* (1971), and the following ballets by John Clifford: *Fantasies* (1969), *Reveries* (1969), *Sarabande and Danse I* (1970), and *Kodály Dances* (1971).

Kirkland left the New York City Ballet with Clifford to form the Los Angeles Ballet in 1974. With that company, she has created roles in seventeen Clifford ballets, among them *Les Amants, The Red Back Book* (1974), *Symphony* (Saint-Saens), *Von Suppe Bouffe* (1974), *Dvorák Serenade, Prokofiev Violin Concerto, Serenade in A* (Stravinsky), *Sitar Concerto, Zolotoye Concerto* (1975), *Introduction and Allegro, Rhapsody in Blue* (1976), *Das Hammlische Leben* (1977), *Rococo Variations, Transcendental Etudes* (1978), and *La Fête d'Rameau* (1980).

Kirkwhite, Iris, English theatrical ballet dancer; born c.1900 in London; died there October 22, 1975. Kirkwhite was trained by her sister, Sylvia Fenwick, a former Pavlova company dancer; it should be noted that research has been unable to determine whether the family name was Kirkwhite (occasionally, Kirk-White) or Fenwick or neither.

Kirkwhite performed her specialty, a pizzicato waltz in a form of toe tapping, in the London productions of *The Blue Mazurka* (1925), *Sunny* (1926), and the *André Charlot 1928 Revue.* With Errol Addison, she danced in the Moonlight Ballet in Albertina Rasch's *Rio Rita* (1930).

After opening and directing a dance school with her sister, she came out of retirement to arrange the

dances for Bertram Montague Christmas panto-mimes from 1942 on.

Kirov, Ivan, American performer; born 1928 in Newark, New Jersey. Originally a championship swimmer, Kirov was chosen to play the role of "André Sanine," the male dancer in *The Specter of the Rose* (Republic, 1946). As trained by Tamara Geva, who choreographed the dance numbers in the film, he was able to combine his own athletic skills with the film's camera tricks to present an extremely dramatic final dance of madness, culminating in a leap through a window. He did not attempt to continue his ballet career after the release of the film.

Kirsch, Carolyn, American theatrical performer; born May 24, 1942 in Shreveport, Louisiana. After local training, Kirsch moved to New York City to continue her studies at the Ballet Russe studio. She made her Broadway debut in 1963 after her height made a ballet career unsatisfactory. Since that debut in Bob Fosse's *How to Succeed in Business Without Really Trying,* she has appeared in many of the most popular Broadway shows of the 1960s and 1970s, including Fosse's *Sweet Charity* (1966). Among the shows that displayed her dance talents were two attempts to do "French farces," *Folies Bergère* (1964) and *La Grosse Valise* (1965), and conventional Broadway musicals *Skyscraper* (1965), *Hallelujah Baby* (1967), and *Dear World* (1969). Kirsch danced in Michael Bennett's *Promises, Promises* (1968), *Coco* (1969), and *A Chorus Line,* in which she played "Sheila" on tour and on Broadway.

Kirsova, Helene, Danish ballet dancer who worked in France and Australia; born Ellen Wittrup, c.1911; died February 22, 1962 in London. Trained by Lubov Egorova, she performed with the Ballet Russe de Monte Carlo until 1936, creating a role in Mikhail Fokine's *Don Juan* (1936). She danced in the company revivals of Fokine's Diaghilev Ballet Russe repertory, in among other works *Les Sylphides, Carnaval,* and *Petroushka,* and in Leonid Massine's *Choreartium* and *Les Présages.* After performing with the Taddeo Woizikovski Ballet in 1936, she moved to Australia where she founded the company that became the Australian National Ballet. Between that event and her retirement in 1947, she choreographed for her company, doing revivals of Fokine's *Les Sylphides* and original works.

Works Choreographed: CONCERT WORKS: *Faust* (1941); *Cappriccio* (1942); *Vieux Paris* (1942); *Revolution of the Umbrellas* (1943); *Harlequin* (1944); *Peter and the Wolf* (1946); *Waltzing Mathilda* (1946); *A Dream and a Fairy Tale* (1947).

Kirstein, Lincoln, American writer and company manager; born May 4, 1907 in Rochester, New York. Originally an art historian and novelist, Kirstein became involved in ballet as a spectator, not as a performer. He reviewed dance and theater presentations for the *Horn and Hound,* which he co-founded, and, on a trip to Europe, ghosted Romola Nijinsky's biography of her husband. It was on that trip that he first met George Balanchine, whose emigration to the United States he sponsored.

Kirstein also supported a School of American Ballet for Balanchine, originally in Hartford, Connecticut under the sponsorship of a local museum, but later in New York, where it still exists. The company of that school, the American Ballet, was in residence at the Metropolitan Opera during the late 1930s, while a non-Balanchine troupe, the Ballet Caravan, toured the country. That company, a cooperative with works by Lew Christensen, William Dollar, Douglas Coudy, and Eugene Loring, was based on his taste in art, more than his preferences in dance. The choreographers created works in mural structure, in a physicalized representation of the murals that he sponsored in public buildings and museums.

Since the end of World War II, in which he served as a conservationist, he has sponsored the Balanchine companies—The Ballet Society (1946–1948) and its outgrowth, the New York City Ballet (1948 to the present). Although the Society was a membership organization that sponsored private subscription presentations, the City Ballet is considered the most publicly accessible of all companies, in residence at the City Center, and later the New York State Theatre, with its subsidized ticket prices. Kirstein is currently the general director of the company and, with Balanchine, still molds its artistic vision.

Although he stopped writing formal criticism in the late 1930s, he has been an important writer in

dance and the other arts since leaving college. He was the founding editor of *Dance Index* from 1942 to 1948, molding that periodical into a monograph series that is still cited as the best in the history of dance publications. His promotional articles for the Ballet Caravan and New York City Ballet are considered classics of dance criticism and of public relations on the arts. Although many of his earlier books and pamphlets have since been repudiated as overly prejudiced against other forms of dance, others remain useful texts on dance history, among them, *Dance* (1935), which has frequently been reprinted, and *Movement and Metaphor* (1970), which was one of the first works to treat dance as a metaphoric and iconographic system, rather than a story-telling device. A collection of all of his dance criticism has been planned for publication within the next few years.

Bibliography: Kirstein, Lincoln. *Blast at Ballet: A Corrective for the American Audience* (New York: 1938); *The Classic Ballet* (New York: 1952, in collaboration with Muriel Stuart); *Dance* (New York: 1935); *The New York City Ballet* (New York: 1974); *Nijinsky Dancing* (New York: 1975); *Thirty Years with the New York City Ballet* (New York: 1978).

Kitahara, Hideteru, Japanese ballet dancer and choreographer; born November 12, 1940 in Lsesaki-Shi. Kitahara was trained at the School of the Tokyo Ballet, graduating into that company in the early 1960s. After continuing his studies in the West with Alexandra Danilova and Frederick Franklin and with Soviet guest teacher Sulamith Messerer, he became the principal male dancer of the Tokyo Ballet. Among his roles were the heroic parts of the classics, and featured solos and partnering work in the contemporary repertory of Felix Blaska. Artistic director of the troupe, he staged the company's productions of *Cendrillon, The Nutcracker,* and *The Sleeping Beauty* in the 1970s.

Kitchell, Iva, American concert dancer and dance satirist; born Emma Baugh, March 31, 1912 in Junction City, Kansas. Using the name of her adoptive parents, Kitchell spent a summer at the camp that Andreas Pavley and Serge Oukrainsky ran in Michigan and performed for them in the Chicago Grand

Opera Ballet. Although most of her roles were conventional ballet variations and solos, she did a comedy one in their *La Fête à Robinson.* She also performed in the presentation acts at Chicago-area Balaban and Katz Theaters, and at the Radio City Music Hall before a triumphant European club tour brought her to the attention of American book agents. In her twenty years as a concert dancer in the United States, she was most frequently engaged as part of a package offered by musical agents, one that in the early 1940s included Fritz Kreisler, Arthur Rubinstein, Ballet Theatre, and the Don Cossack Chorus. Kitchell, who was frequently compared to both Victor Borge and Anna Russell, also appeared on Broadway in a one-woman show and produced her own Carnegie Hall concert in 1946.

Her solos included satirical comments on contemporary life, such as *The Broken Appointment* (1940), *Salesman* (1941), and *Maisie at the Movies* (1943), and specifically directed take-offs on dance genres. Her *Ze Ballet,* "assisted by The Imperial Invisible Ballet" (1940), *Oriental Dance by an Occidental Girl* (1941), *Bacchanale (As seen at the Opera)* (1949), and *Soul in Search* (1947), were well-received allusions to the Ballet Russe de Monte Carlo, Ruth St. Denis, Pavley and Oukrainsky, and Martha Graham, respectively. The latter, especially, was extremely popular and brought her national recognition.

Kitchell retired in 1961. Her range and the accuracy of her satires have never been equaled.

Works Choreographed: CONCERT WORKS: (Note: some works dated 1940 may have been created earlier for performance in Europe.) *The Broken Appointment* (1940); *The Chorus Girl* (1940); *Shoes in Three Parts* (1940); *Petite Danse* (1940); *Ze Ballet* (1940); *Can-Can* (1940); *Yes? No?* (1940); *Me-Ow* (1940); *Something Classic (Scarf Dance, Garland Dance)* (1940); *Before the Wall* (1940); *The Salesman* (1941); *First Appearance, or When I Was Eight* (1941); *Three Sisters* (1943); *Oriental Dance by an Occidental Girl* (1943); *The Dilligent Char* (1943); *Romance* (1943); *Maisie at the Movies* (1943); *The Gentlemen Friend of the Lady in Pink . . . and the Lady in Blue* (1943); *Wrote a Letter to Her Lover* (1944); *Dance No. 1* (1944); *Mineral, Vegetable and Animal* (1944); *Quarrel* (1944); *Two Horrid Dances (Toothache, Quarrel)* (1945); *Sonatina Rococco* (1947); *The Vert*

Brothers: Intro and Extro (1947); *Going Up* (1947); *Soul in Search* (1947); *The Tale of a Bird, Starring Iva Kitchellova and Ivan Kitchelloff* (1949); *Lament for a Wilted Lily* (1949); *Carmen Kitchell from Kansas* (1949); *Obsession* (1949); *Bacchanale (As Seen at the Opera)* (1949); *Many Me's (Spontaneous, Desperate, Industrious, Introspective, Synthesis)* (1949); *Chanteuse-Dansuese* (1949); *The New Hat* (1949); *Coloratura* (1953); *Pseud—Voodoo* (1953); *Psychochondriac* (1953); *Valse Triste* (1954); *Dance and Encore* (1956); *Fantasy for Body and Piano* (1957); *Gift Wrapped* (1957); *Scherzo-Kinetic* (1958).

Kivett, Ted, American ballet dancer; born December 21, 1942 in Miami, Florida. Kivett was trained locally by Thomas Armour and George Milenoff. He joined the American Ballet Theatre in 1961 and performed with it for more than fifteen years. Kivett had what may be the prototypical Ballet Theatre career: he matured into progressively larger roles in both the classical and contemporary repertory and was frequently chosen for new works. Both he and his then wife Karena Brock were members of the unofficial company that worked with its choreographers-in-residence, bringing him roles in new ballets by Eliot Feld, Dennis Nahat, and Michael Smuin, for whom he danced in *Gartenfest* (1968). He appeared in most of the company's "American" ballets, most notably *Fancy Free,* but became an audience favorite with his partnering of Cynthia Gregory and Eleanor D'Antuono in bravura pas de deux. A *Don Quixote* with D'Antuono, for example, was one of the few things ever to have been encored at a Ballet Theatre performance, while his *Gladzunov Pas de Deux* with Gregory made her into a star. He danced all of the nineteenth-century starring roles, "Siegfried," "Albrecht," "Colas" and especially "Franz," but was frozen out of the repertory when Ballet Theatre suffered its Russian invasion of 1974.

Since leaving Ballet Theatre, Kivett has performed with the Pennsylvania Ballet and became artistic director of the Milwaukee Ballet.

Klekovic, Patricia, American ballet dancer; born c.1935 in Chicago, Illinois. Trained by Edna McRae, in whose Fine Arts Ballet she performed as an adolescent, and by Ruth Page, she has performed in the Chicago Lyric Opera Ballet for much of her career. Among the many Page works in which she has danced are *Camille* (1957); *Die Fledermaus* (1962), *Alice* (1970), and *Romeo and Juliet* (1968); she was assigned the female lead in each. Her other Page ballets include *Concertino pour Trois, Carmina Burana, Revenge, Carmen,* and *Bullets or Bon-Bons.*

Klekovic has also performed with the Radio City Music Hall ballet, under the directorship of Marc Platt, and with the Pittsburgh Ballet Theatre from c.1970 to 1972.

Kloepper, Louise, American modern dancer; born c.1910 in Washington, D.C. Raised in Tacoma, Washington, she studied ballet with Mary Ann Wells in nearby Seattle. In 1929, she moved to Germany to study with Mary Wigman for two years. After returning to the United States, she taught and danced for Hanya Holm, who had come from Germany to open a Wigman studio in New York. Among the many Holm works in which she performed were *Trend, Dance of Introduction, Tragic Exodus, They Too Are Exiles, Metropolitan Daily, The Golden Fleece,* and the lecture-demonstration that was given frequently on tour.

A Bennington fellow for the summer of 1938, she choreographed many works for herself and fellow concert dancers.

Works Choreographed: CONCERT WORKS: *Idyll* (1936, co-choreographed with Jane Dudley); *Study in Suspension* (1937); *Romantic Theme* (1938); *Statement of Dissent* (1938); *Earth Saga* (1938).

Kniaseff, Boris, Russian ballet dancer and choreographer in France after 1924; born July 1, 1900 in St. Petersburg; died October 6, 1975 in Paris. Trained in St. Petersburg by Lydia Nelidova and Kasyan Goleizovsky, he emigrated to France in 1924, where he worked as a freelance ballet dancer. Among the projects with which he was associated in Paris were the Vendredis de la Danse recital series, the 1925 Exhibition des Artes Décoratifs, and the Bronislava Nijinska Ballet.

He formed his own company, Les Ballets de Boris Kniaseff, in 1931, creating pieces for it within his combination of ballet technique and plastique, among them *Le Rendez-vous Manqué, Jeux d'Au-*

tomne, and *Tziganes.* After serving as ballet master of the Opéra-Comique in Paris from 1932 to 1934, he concentrated on teaching there, in Athens, Geneva, Lausanne, and South America.

Kniaseff had the same kind of influence on French and Swiss ballets that Pavley/Oukrainsky or the Kosloffs had in the United States—conventional technique with unique methods of training augmented by especially interesting mise-en-scène work in plastiques and tableaux.

Works Choreographes: CONCERT WORKS: *Aux Pieds des Pyramides* (1924); *Au Temps des Tartares* (1930); *Le Rendez-vous Manqué* (1930); *Vision Antique* (1930); *Rhapsodie Poètique* (1930); *Rêverie Lunaire* (1930); *Scherzo* (1930); *Verso l'Oriente* (1930); *Arabesques* (1930); *Schumanianne* (1930); *Légende de Beriozkha* (1930); *Tziganes* (1931); *Piccoli* (1947); *Etudes Symphoniques* (1948).

Knott, Amanda, English ballet dancer; born 1945 in Sawbridge. Although trained at the Royal Ballet School, she was associated with the Ballet Rambert for most of her dance career. She actually made her professional debut with the Teatro Italiano di Ballet, a company of English dancers touring Italy, but joined the Rambert troupe in 1964. In that company she was considered a specialist in the Rambert's contemporary repertory of works by Glen Tetley and Norman Morrice. She also choreographed herself for the troupe in the mid-1960s.

Knott retired in 1971, after a performance on tour of her best known role, the homage to female decision making, Norman Morrice's *Solo.* She has since made a career for herself in the theater as an actress.

Works Choreographed: CONCERT WORKS: *Singular Moves* (1966); *Mechos* (c.1967).

Kobeleff, Konstantine, Russian ballet dancer working in the United States; born 1885 in St. Petersburg; died August 7, 1966 in New York. Trained at the School of the Imperial Ballet in St. Petersburg, he became a member of the Maryinsky Ballet in 1903. After six years performing featured solos in the Marius Petipa repertory, he joined the Diaghilev Ballet Russe in its first three seasons, appearing in Mikhail Fokine's ballets. After returning briefly to St. Petersburg in 1914 (possibly for reasons that had to do with his visa, rather than his artistic life), he joined the

touring Anna Pavlova company as a soloist. One of the most versatile members of that troupe, he appeared in her classical and romantic works and in the national pieces, based on stylized Indian fables.

He arrived in this country with the Pavlova troupe—not, as has been said, the Ballet Russe—and decided to remain here. Like most of his fellow refugees from Diaghilev and Pavlova, he was offered the choice of an opera company in the Midwest or a Prolog circuit in the East. He selected the latter, and joined the staffs of the Mark Strand and Paramount Theaters in New York. He opened a studio in New York in 1924 with the slogan, "the type of dancing you will eventually need." It was successful through the 1920s and early 1930s, but he merged it with the Albertina Rasch school in the early 1940s, replacing her as director during her Hollywood employment. Kobeleff did not retire until 1960.

Kochno, Boris, Russian poet, writer, and librettist; born January 3, 1904 in Moscow. Kochno became secretary to Serge Diaghilev shortly after emigrating from the Soviet Union in 1923. He wrote libretti for many operas produced by Diaghilev, including that for Igor Stravinsky's *Mavra* (1922), and for the following ballets: Bronislava Nijinska's *Les Facheux* (1924), Leonid Massine's *Zéphire et Flore* (1925), *Les Matelots* (1925), and *Ode* (1928), in collaboration with designer Pavel Tchelitchew, and George Balanchine's works, *La Pastorale* (1926), *La Chatte* (1927), *The Gods Go-A-Begging* (1928), *Le Bal* (1929), and *The Prodigal Son* (1929).

He worked with his colleagues from the Diaghilev Ballet Russe on later projects also. As artistic advisor of the Ballet Russe de Monte Carlo in its founding, he wrote libretti for Massine's *Cotillion* and *Jeux d'Enfants* (1932). He worked with Balanchine on the pieces for Les Ballets 33. After the end of World War II, he collaborated with Roland Petit, as co-founder of the Ballets des Champs-Elysées and created libretti for his *Les Forains* (1935), *Le Bal des Blanchisseurs* (1946), *Prais* (1964), and many others. Although he is too clever a writer to impose himself on the choreographers, one can recognize certain characteristics of a Kochno libretto. They seem generally to deal with death, frequently as a seductive attractive force, and frequently use movement as a metaphor for the acceptance of death. The Ballets 33 works, and even

some Balanchine pieces on which he was not a collaborator, show this thematic material, for example his early *Errante* (1933) and later *La Valse* (1951).

As well as his libretti and poetry, Kochno is the author of a valuable (but untranslated) history of dance (Paris: 1954), and works on the Diaghilev productions.

Bibliography: Kochno, Boris, *Le Ballet en France du quinzième siècle à nos jours* (Paris: 1954); *Diaghilev and the Ballets Russes* (New York: 1970); *Hommage à Diaghilev* (Paris: 1972).

Koesun, Ruth Ann, American ballet dancer; born May 15, 1928 in Chicago, Illinois. While training locally with Edna Lucille Baum, Walter Camryn, and Bentley Stone, Koesun spent her summers in New York working with Vechslav Swoboda. After performing briefly with the Chicago Opera Ballet and Chicago-based San Carlo Opera, Koesun joined Ballet Theatre in 1945 and remained with that company for twenty years.

In these years, Koesun's beauty, acting ability, and techniques were put to use in a large percentage of the repertory. She was equally noted for her lush and melodious performance as "The Ballerina of the Prelude" in the company production of *Les Sylphides*, as the victim of her environment in Herbert Ross' *Caprichos* (1950), and Donald Saddler's *This Property Is Condemned* (1957), both previewed in Ballet Theatre Workshops. She created roles in Agnes De Mille's *Fall River Legend* (1948), playing "The Accused as a Child," in Antony Tudor's *Shadow of the Wind* (1948), and in Herbert Ross' *The Thief Who Loved a Ghost* (1950), *Paean* (1957), *Ovid Metamorphoses* (1958), and *Concerto* (1958). Koesun's best known role, however, was probably that of the "Mexican Sweetheart" (doubling as "The Mother") in Eugene Loring's *Billy the Kid*. Partnered by John Kriza in the title role, she performed at the White House and on television (*Omnibus*, CBS, 1953).

A frequent performer in trade shows and industrials, Koesun also worked in nightclubs with Kriza during Ballet Theatre lay-offs.

Köhler-Richter, Emmy, German ballet dancer and choreographer working in the People's Republic of Germany; born February 9, 1918 in Gera. Köhler-Richter was trained in Berlin by Tatiana Gsovsky and Mary Wigman. She performed in Opera Ballets in Bonn, Berlin, and Leipzig before the outbreak of World War II, spending much of the 1940s in Switzerland. She served as ballet master for three of the most active postwar state operas—Cologne, Basle, and Weimar—before returning to Leipzig as choreographer-in-residence, since the mid-1950s. Most of her works date from her second tenure in Leipzig, and consist of revivals of nineteenth-century classics, both common, like *The Sleeping Beauty*, and rare, like *The Daughter of Castille*. She has created works within the artistic style of the Soviet ballet, most notably her extremely popular *Sklaven* (1961), based on the Spartacus story, but has also staged fairy tales for her company.

Works Choreographed: CONCERT WORKS: *The Daughter of Castille* (1960); *Dornroschhen* (1960); *Legend of Love* (1961); *Sklaven* (1961); *Abraxas* (1962); *Maskarade* (1962); *Till Eulenspiegel* (1965); *Schwanenessee* (Swan Lake) (c.1970); *Der Rowdy under Der Mädchen* (The Young Lady and the Hooligan) (1972).

Kölling, Rudolf, German ballet dancer and choreographer; born February 9, 1904 in Hanover; died May 5, 1970 in Münster. Trained by van Laban and Mary Wigman, he performed at the Berlin State Opera Ballet of Max Terpis, who frequently used Hellerau alumni. He was, for example, featured in Terpis' *Don Morte* (1926), with Harald Kreutzberg and Dorothea Alon. He danced and choreographed for the German Opera House in Berlin (1934–1944) and in the Metropol Theatre in East Berlin after it. In 1949, he staged *Sacre du Printemps* for the Bavarian State Opera, and commuted among the many German opera houses in Bavaria, Weimar, and Münster until his retirement in the mid-1960s.

Works Choreographed: CONCERT WORKS: *Apollo und Dafne* (1936); *Die Gaunerstreiche der courasche* (1936); *Der Stralaver Fischzug* (1936); *The Rivals* (c.1939); *Legends of a Hungarian Village* (c.1939); *Sacre du Printemps* (1949).

Kolpakova, Irina, Soviet ballet dancer; born May 22, 1933 in Leningrad. Trained at the Leningrad Choreographic Institute by Agrippina Vaganova, she performed with the Kirov Ballet throughout her career.

Among her many celebrated roles are the title role in *Cinderella*, "Aurora" in the company production of *The Sleeping Beauty*, "Giselle," "Raymonda," and "Masha" in *The Fountain of Bakhchisarai*. She has also performed to great acclaim in newer works, among them Yuri Grigorovich's *The Stone Flower* (1957), Belsky's *Coast of Hope* (1959), and Kasatkina and Vasiliov's *Creation of the World* (1971).

Komar, Chris, American postmodern dancer and choreographer; born October 30, 1947 in Milwaukee, Wisconsin. A music student at the University of Wisconsin at Madison, he became interested in dance performance. While teaching at the University of Wisconsin at Milwaukee, he worked with the Milwaukee Ballet until 1970 when he moved to New York to study with Merce Cunningham. A member of the Cunningham company since 1971, he has created roles in his *Rebus* (1975), *Torse* (1976), and *Travelogue* (1977), and has participated in almost one hundred *Events*. Although the structure of Cunningham's collagist *Events* is aleatoric, many regulars in the audience have come to expect and hope that the manipulation of segments of past repertory will include a quartet for Komar, Robert Kovich, and two women in unison and canon.

Kondratieva, Maria, Soviet ballet dancer; born February 1, 1934 in Leningrad. Trained at the Bolshoi School, she spent her career with the company, which she joined in 1952. She was best known for the fragility and delicacy of her presentations of characters in the Soviet production of the fairy-tale ballets, *Cinderella* and *The Sleeping Beauty*, but she was also capable of demonstrating real drama on stage in Maia Plisetskaya's *Anna Karenina*. Her "Giselle," "Juliet," and "Muse of Creation" in Lavrosky's *Paginini*, revealed the power of her acting ability and physical composure.

Koner, Pauline, American concert dancer and choreographer; born 1912 in New York City. Koner received training in ballet from Mikhail Fokine, in Spanish dance with Angel Cansino, and his own expressionist techniques from Michio Ito. She danced with the Fokine Ballet in the mid-1920s, also touring with Ito. From 1930 to c.1949 she worked as a concert dancer, giving solo recitals in New York and elsewhere. Among the many works that she created for herself were *Upheaval* (1931), *Two Laments: For the Living, for the Dead* (1931), *Spanish Impressions* (1931), and *Jitterbug Sketches* (1945).

In 1949, she joined the José Limón company as a permanent guest artist, performing in works by him and by Doris Humphrey. For Humphrey, she danced in the premieres of *The Story of Mankind* (1949), *Lament for Ignácio Sánchez Mejías* (1949), *Felipe el Loco* (1952), and *Ritmo Jondo* (1953); for Limón, she created roles in *La Malinche* (1949), *The Visitation* (1952), *The Exiles* (1952), and *The Moor's Pavanne* (1949), in the "Emilia" character. She also choreographed for the company, alone and in cooperation with Limón.

Since leaving the Limón troupe, she has choreographed for students and for her Dance Consort (1975 to the present).

Works Choreographed: CONCERT WORKS: *Jeux d'eau* (1930); *Nilamani* (1930); *Allegretto* (1930); *Blue Flame* (1930); *Mara Gitana* (1930); *Altar Piece* (1930); *Rustique* (1930); *Despair* (1930); *Sonata in F Sharp, No. 4* (1930); *Visions* (1930); *Triana* (1930); *Exotique* (1931); *Dance in Religious Mood* (1931); *Two Laments: For the Living, for the Dead* (1931); *At the Fair* (1931); *Barbaresque* (1931); *A Love Poem* (1931); *Without Rhyme or Reason* (1931); *Upheaval* (1931); *Spanish Impressions* (1931); *Waltz Momentum* (1934); *Bird of Prey* (1934); *Russian Rhythms* (1934); *Cycle of the Masses* (1934); *Three Funeral Marches* (1934); *Dances of Longing* (1934); *Ya-lel* (1934); *Chassidic Dance* (1934); *Prelude in American Style* (1939); *Song in the Slums* (1939); *Legenda* (1939); *Three Soviet Songs* (1939); *Among the Ruins* (1939); *Surrealists* (1939); *Mothers of Men* (1945); *Ballerina* (1945); *Love Song* (1945); *Judgement Day* (1945); *In Memoriam* (1945); *Jitterbug Sketches* (1945); *It Ain't Necessarily So* (1945); *Song of the Prairie* (1946); *Out of This Sorrow* (1946); *Woe Unto Them* (1946); *It Might as Well Be Spring* (1946); *Amarares Adventure* (1951); *Suite* (1951); *Deep Song* (1951); *Cassandra* (1953); *Concertino in A Major* (1955); *The Shining Dark* (1958); *Solitary Song* (1963); *Dance Symphony* (1963); *The Farewell* (1963); *Elements of Performing* (1963); *Poème* (1968); *Solitary Song* (1975); *A Time of Crickets*

(1976); *Mosaic* (1977); *Cantigas* (1978); *Untitled Work* (1979).

Koren, Serge, Soviet ballet dancer; born September 9, 1907 in St. Petersburg; died June 17, 1968 in Moscow. Koren was considered one of the ideal Soviet dancers for his consummate skill and for the fact that he was a dancer at all. He began his studies in the evening classes organized in Leningrad for those who had not been able to take advantage of the tzarist system of education. He was transferred to the GATOB school and graduated into the GATOB/Kirov company in 1927. He bagan his extraordinary string of character roles with the Kirov, presenting dance and dramatics in *Taras Bulba, Heart of the Hills,* and *Partisan Days*, and continued it with the Bolshoi Ballet after 1942. His best remembered roles there include "Espada" in the Bolshoi's *Don Quixote*, "Mercutio" in *Romeo and Juliet*, and the "dastardly capitalist, Li Shung-fu" from *The Red Flower*. After retiring in 1960, Koren taught and served as ballet master for the Bolshoi.

Korty, Sonia, Russian ballet dancer and teacher; born Sophia Ippar, October 25, 1892 in St. Petersburg; died December 1, 1955 in Salzburg, Austria. Korty was trained by Alexandra Federova and Eugenia Sokolova in St. Petersburg, presumably as a private student in their studios. She was a member of the Diaghilev Ballet Russe in the last seasons of the company's life and performed with the Opéra-Comique in Paris as a specialty dancer and soubrette. Described by a contemporary critic as the "last Russian *demi-caractère* danseuse," she was undoubtedly the last ballet dancer to base her career on her success as "Fenella." That role, in the *Dumb Girl of Portici* or *Maisanello*, was considered the prime test of a dramatic dancer in the nineteenth century, but fell into disuse as a vehicle.

In the late 1930s, she staged ballets for companies in Baden-Baden and Göttinger, and served as ballet master for the Royal Opera of Flanders in Antwerp, Belgium. Following an engagement in a similar capacity in Essen in the 1940s, she retired to act, without dance steps, in the Austrian operetta theaters. She taught at the Mozartium conservatory in Salzburg until her death in 1955.

Works Choreographed: CONCERT WORKS: *Die Kermes [market-fair] von Delft* (1937); *The Wise and Foolish Virgins* (1940).

Kosloff, Alexis, Russian ballet dancer, working in England and the United States after 1910; born c.1885 in Moscow. The descendent of Imperial Theater violinists, Kosloff was trained at the Moscow school of the Imperial Theaters. After graduating, he joined his older brother, Theodore, at the Maryinsky Theater in St. Petersburg.

While it cannot be determined whether Alexis Kosloff performed with the Diaghliev Ballet Russe on their 1909 tour, it is known that he joined Theodore and his wife, Maria Alexandra Baldina, in the company that Tamara Karsavina put together for performances in London (1910). In that season, he played "Hilarion" in *Giselle*, did the solo *Danse Bouffon*, and partnered Karsavina in the "Sugar Plum Fairy" pas de deux from The *Nutcracker*. In 1910, he went to the United States with the family of his own wife, Italian-born and Russian-trained dancer Juliette Mendez, to perform on the Orpheum circuit under their class act policy. After partnering Adelina Genée in her act, he joined the company which Gertrude Hoffmann assembled for her Saison des Ballets Russes on Broadway and on the Keith circuit (1911–1912).

Returning to London to dance in his brother's production of *Schéhérézade*, Kosloff remained in Europe to work with Karsavina. An extraordinarily handsome dancer, Kosloff also seems to have been an especially talented partner, in demand for many ad hoc and established seasons of Russian dance. After performing in the London production of *Chu Chin Chow*, staged by Eduoard Espinosa, Kosloff returned to New York where he was hired to choreograph it and other shows for the Shubert Brothers, among them, *Sinbad* (1918) and a production of *Peter Pan* (1917).

Appointed principal mime for the Metropolitan Opera in 1922, Kosloff remained in the New York area for the rest of his performing career. A popular teacher throughout the 1920s and 1930s, Kosloff was one of the first dancers to record lessons on piano rolls, publishing a series of

barre exercises and divertissements with Ampico in 1926.

Kosloff, Theodore, Russian ballet dancer and choreographer working in England and the United States after 1910; born c.1881 in Moscow; died November 2, 1956 in Los Angeles. The son and grandson of violinists with the Imperial Theaters, Kosloff was trained at the Imperial Ballet School in Moscow, notably with Vassili Tikhomirov. After graduating in 1898, he was assigned to perform with the St. Petersburg company.

Leaving the Maryinsky to perform with Diaghilev's Ballet Russe in 1909, Kosloff began ten years of almost constant touring. He performed with Tamara Karsavina's ad hoc company in London and then took a group from that company to the United States. With that group, among them his wife, Maria Alexandra Baldina, his brother, Alexis, and Alexis' wife, Juliette Mendez, he toured on the Orpheum vaudeville circuit, performing divertissements from the Russian and Diaghilev repertory, including *Le Mirroir Magique* (after Petipa), *Salambô*, and a duet, *Autumn Bacchanale*, that may have been related to the similar work of the Pavlova company. In 1911, the group joined up with Gertrude Hoffmann to perform in her Saison des Ballets Russes at the Winter Garden Theater and on vaudeville; although the press ran stories about Hoffmann meeting the Kosloffs as they got off the boat, there is no evidence that they had returned to Europe between American engagements. This season, which included Kosloff's versions of *Schéhérézade* and *Les Sylphides* (for thirty-six women and four men), toured for almost a year, after which Kosloff returned to London where he performed at the Coliseum with Baldina.

The next American tour, with a group that included the family, Anatole Bourman, and Natasha Rambova, ended in Los Angeles, where Kosloff became a member of the Cecil B. De Mille stock company, making his debut as "Guatemo," an Aztec warrior, in the Geraldine Farrar vehicle, *The Woman God Forgot* (Artcraft, 1917). He spent the years between 1915 and 1926 commuting between the American coasts—to Broadway for the *Passing Show of 1915* and *The Awakening*, and to Hollywood, where he played decadent European noblemen in *Forbidden Fruit, The Affairs of Anatole, Fool's Paradise, Adam's Rib,* and *Triumph* from 1921 to 1924.

His only dancing appearance in the eleven films that he made for De Mille, apart from a few tangos with dissatisfied wives, was in his last movie, *Madame Satan* (MGM, 1930), in which he played the lead danseur of the *Ballet Méchanique*, staged by Adolf Bolm, performed during a party on a dirigible. Acquiring stock in Paramount Studios and Los Angeles real estate, Kosloff became Americanized and opened franchised dance studios across the country.

It is difficult to determine a list of choreographic credits for Kosloff; his only official credits are for his theatrical ventures. Although he served as "choreographic director" and ballet master of the tour companies, their repertory was primarily by either Marius Petipa or Mikhail Fokine. The listing below includes all credited work as well as unassigned pieces from the touring repertory, and later works created for school recitals.

Works Choreographes: CONCERT WORKS: *Salambô* (1910); *Autumn Bacchanale* (1910); *Adagio Romantique* (1913); *Ecsasie d' Amour* [sic] (1913); *The Romance of the Infanta* (1933); *Divertissements (Khorovod, Canzonetta, Boyarishnaya)* (1933); *Shingandi* (1933); *Petrouchka* (1939).

THEATER WORKS: *Come Over Here* (London, 1913); *The Peasant Girl* (1915); *Maid in America* (1915, ballet sequences only); *The Passing Show of 1915; The Awakening* (1918).

Kosminsky, Jane, American modern dancer; born c.1944 in Jersey City, New Jersey. Kosminsky began her modern dance training at the Hanya Holm school in New York, expanding her styles and techniques at the High School of Performing Arts from which she graduated in 1960, and the Juilliard School. Kosminsky performed in the companies of many of her PA teachers, among them May O'Donnell and Norman Walker, for whom she danced in *Meditations of Orpheus* (1963), *Baroque Concerto, Prussian Blue* (1961), and *Testament of Cain*, among many other works. As a member of the Paul Taylor Company from 1966 to 1972, she appeared in many of his most popular repertory pieces, including *Orbs, Aureole, Junction,* and *Three Epitaphs.*

With Bruce Becker, with whom she had danced as early as 1961 (in a Juilliard dance workshop), she formed a chamber dance company called 5 by 2 in 1972. The group, now called 5 by 2 Plus, performs and presents lecture-demonstrations across the country. Its repertory includes works by the pioneers of modern dance, including Helen Tamiris who was Becker's aunt, the major figures of traditional modern dance, among them Taylor, Merce Cunningham, and José Limón, and contemporary choreographers, such as Marcus Schulkind, Kathryn Posin, Moses Pendleton and Becker. Kosminsky is considered one of the most versatile dancers in the full range of modern dance idioms, as well as a popular teacher in New York and in residencies.

Kotchetovsky, Alexander, Russian ballet dancer and teacher working in the United States in ballet and theater; born 1889 in Moscow; died March 3, 1952 in Houston, Texas. Kotchetovsky was trained at the Bolshoi School in Moscow, graduating into the company in the mid-1900s. He appeared in progressively larger solos in Alexander Gorsky's productions of the nineteenth-century classics before leaving Russia to join the Diaghilev Ballet Russe as a mime. (There is some question as to whether he was the Kotrokowsky who appeared in the Karsavina/Kosloff family production at the London Coliseum in 1911, but no doubt as to his importance in the Diaghilev productions.) He appeared in almost every work by Mikhail Fokine and Vaslav Nijinsky, and became best known for his "Moor" in *Petrouchka* and in unnamed characters in the former choreographer's national works. Apart from his participation in his then brother-in-law Nijinsky's London season of 1914, in which he appeared in his solo *Danse Orientale* and in a condensed and probably plagiarized version of Fokine's *Carnaval*, he was with the Ballet Russe from 1911 to 1914 and again in 1925.

In Russia during World War I, he served as ballet master in Petrograd and Kiev. He somehow received permission to work in the same capacity for the Vienna State Opera, entering Austria at a time when other Russian dancers were attempting to escape. He moved back to Paris in 1918, but left again for the United States as a member of the Chauve-Souris troupe. His popularity in the *Javanese Spear Dance*

and *Dance of the Wooden Soldiers* in that show brought him offers from American producers to remain as a Prolog director and teacher. He joined the staff of the Paramount Theater from 1923 to 1925, but after a brief trip to Europe became a freelance Prolog stager for the next four years.

In 1930, Kotchetovsky moved to Houston to open a dance studio there. His school was one of the most important in the Southwest and for many years fed students into the Ballet Russe de Monte Carlo. He was an extraordinarily popular teacher and most beloved by the people of Houston—for his artistic contributions and for his decision to honor his adopted country as a graveyard shift pipefitter and by contributing his salary to the American World War II efforts.

Kovach, Nora, Hungarian ballet dancer; born 1931 in Satoraljaujhely, Hungary. Trained in Budapest by Ferenc Nádesi and in Leningrad by Agrippina Vaganova, she performed with the ballet of the Budapest State Opera until 1953. In that year, with her husband, István Rabovsky, she defected from East Berlin where they were touring to the West to rendezvous with impresario Sol Hurok. They performed together in pas de deux and the classics with the London Festival Ballet for a season, and then toured the United States with a chamber ballet company, playing concert halls and Las Vegas nightclubs. They currently teach in upstate New York.

Bibliography: Kovach, Nora and István Rabovsky. *Leap Through the Curtain* (London: 1955).

Kovich, Robert, American postmodern dancer; born January 17, 1950 in San Jose, California. Trained at Bennington College under Judith Dunn, he has been a member and regular performer of the Merce Cunningham company since 1973. He has performed in most of the company's large continuing repertory, and created roles in *Torse* (1976) and *Travelogue* (1977). In Cunningham's *Event* series, he frequently appears in slow duet sequences or in male group dances where he is noted for his control of movement and performance style.

Kozlov, Leonid, Soviet ballet dancer working in Western Europe and the United States since 1979;

born c.1947 in Moscow. Kozlov was trained at the Bolshoi and performed with the Ballet until his defection in 1979. He was acclaimed in the principal roles in the company's productions of *Swan Lake, Giselle, La Bayadère, Don Quixote,* and *The Stone Flower,* as well as in parts in the contemporary choreography of Yuri Grigorovich and Vladimir Vasiliev. Since leaving the Soviet Union, he and his wife, Valentina Kozlov, have performed in North and South America and in Europe. They made their American debut with the Maryland Ballet in pas de deux from *La Bayadère* and *Don Quixote* and have presented those bravura showpieces in guest appearances with many American troupes, the London Festival Ballet, and the Ballet Internacional de Caracas. In late 1980, they were appointed artistic directors of the Classic Ballet Company of New Jersey.

Kozlov, Valentina, Soviet ballet dancer working in the West after 1979; born c.1954 in Moscow. Trained at the Bolshoi school, she danced with the company from 1973 to her defection in 1979. She was assigned leading roles in the Bolshoi's productions of *Swan Lake, La Bayadère, Sleeping Beauty, Don Quixote, Pinocchio, Giselle, Romeo and Juliet,* and *The Stone Flower,* where she was noted for her "Mistress of the Copper Mountain." She and her husband, Leonid, defected in September 1979. They have performed pas de deux programs and company repertories with the Maryland Ballet (where they made their United States debuts), the Ballet Internacional de Caracas, the London Festival Ballet, and the Classic Ballet of New Jersey. They currently serve as artistic directors of the latter company.

Krassovska, Nathalie, Soviet ballet dancer performing in Western Europe and the United States; born June 1, 1918 in Petrograd. The daughter and granddaughter of Bolshoi soloists, she received early training from her mother, Lydia Krassovska Egorov, and continued under Olga Preobrajenska in Paris. She danced with the Ballets Russe de Paris, a short-lived company that featured the performances and choreography of American, Fokine-trained dancer, Margaret Severn. As a member of Réné Blum's Ballet Russe in 1936 and 1937, she danced in Fokine's *Les Sylphides, Carnaval, Spectre de la Rose, Schéhérézade,* and *L'Epreuve d'Amour,* all restaged for the troupe. Traveling to the United States with the Ballet Russe de Monte Carlo in 1938, she became popular in the works of Leonid Massine, among them *Vienna-1814* (1938), *Le Tricorne, Le Beau Danube,* and *The Snow Maiden.* Other performance specialties in that company included "Swanilda" in *Coppélia,* and principal roles in Balanchine's *The Night Shadow,* Anton Dolin's *Pas de Quatre,* and the company productions of *Swan Lake, Giselle,* and *The Nutcracker.*

After retiring from performance, she settled in Dallas, Texas, where she formed the Ballet Jeunesse, teaching and choreographing for her young protégés.

Works Choreographed: CONCERT WORKS: *Pizzicato* (c.1964); *Dance of the Hours* (1964); *Chopiniana* (1964); *España* (1970); *Liliana* (c.1974); *The Romantic Dream* (c.1974).

Kraul, Earl, Canadian ballet dancer; born 1929 in London, Ontario. Kraul is considered by many the first native ballet star to base his entire career in Canada. He was trained by Betty Oliphant and Celia Franca and joined their National Ballet of Canada as a charter member in 1951. He specialized in the principal roles of the classical repertory, among them "The Poet" in *Les Sylphides,* "Albrecht," "Siegfried," "Franz," "Florimund," the "Cavalier of the Sugar Plum Fairy" in *The Nutcracker* and the "Enchanted Prince" in *The Sleeping Beauty.* He also worked in the company's contemporary repertory, however, and could bring tremendous presence and validity to both comic roles, as in *Offenbach in the Underworld,* and drama, in Antony Tudor's *Jardin aux Lilas* and *Dark Elegies.*

Krauss, Carol-Rae, American modern dancer; born April 17, 1950 in Hammond, Indiana. Krauss began to study dance seriously in New York after graduating from Barnard College, She worked under, and now performs with, Jennifer Muller, augmenting this work with ballet classes with Maggie Black. As a member of the Contemporary Dance System (now called the Daniel Lewis Dance Repertory Company) from 1970, she has taken roles in revivals of Anna Sokolow's *Steps of Silence* and *Lyric Suite* and Doris Humphrey's *Day on Earth,* as the "older Woman." With her height and defined movements, she resembles Humphrey in performance.

In Muller's company, The Works, she has created

roles in *Speeds* (1974), *Beach* (1976), and *Clowns* (1977).

Krauss, Gertrud, Austrian concert dancer considered one of the founders of the Israeli modern dance; born May 6, 1903 in Vienna; died November 23, 1977 in Tel Aviv, Israel. Trained originally as a pianist, Krauss began to study dance as a musician at the Vienna State Academy, and as the staff accompanist for concert dancer, Eleanore Tordis.

She performed herself as a concert dancer from the late 1920s on, frequently working solo, but also creating pieces for a company that included Fritz Berger (Fred Berk) and others. Among her best remembered projects from this period were the incidental dances to the play, *The Last Days of Mankind* (1932) and repertory works *Songs of the Ghetto, The City Waits,* and *Guignol* (all 1930–1932). After a tour of Palestine, as it was then known, Krauss decided to emigrate there in 1935, remaining in Israel until her death. She choreographed for a group there, the Gertrud Krauss Dancers, produced large-scale works in the 1940s, and collaborated with the Habima Theatre on productions of *Sabbatai Zvi, Peer Gynt,* and *A Midsummer Night's Dream.*

As a teacher, Krauss is generally considered responsible in part for the training of the modern dancers in Israel, notable among them Gideon Avrahami, Ze'eva Cohen, and David Ben-Ehud. The modern dancers remaining in Israel today and those performing in the United States all praise her training as a combination of interpretative and improvisational work and traditional German expressionist techniques.

Works Choreographed: CONCERT WORKS: *The Strange Quest* (c.1930); *Songs of the Ghetto* (c.1930); *Spanish Dance* (1931); *Guignol* (1931); *The Young Russian* (c.1931); *The City Waits* (1932); *Song of a Fool* (1933); *Allegro Barbaro* (c.1942); *Death and the Maiden* (1945); *Dream of a Creation* (c.1947); *The Fallen Angel Tavern* (1950).

THEATER WORKS: *The Last Days of Mankind* (1932); *Sabbatai Zvi* (c.1947).

Kretlow, Arthur, American dance master and theatrical performer; born c.1895 in Chicago, Illinois; died October 18, 1968 in Los Angeles, California. The son of Louis Kretlow, he was a member of the sixth generation of Kretlows teaching social dance in the United States. His father was considered one of the stalwarts of the "modern dance movement" of social dance teachers and creators who attempted to liberate ballroom forms from the strictures of costume, music, and etiquette of the late nineteenth century. The younger Kretlow taught for his father but left the world of ballroom and social dance to do a flash act in vaudeville. After performing in Ned Wayburn's Capitol Theater Prologs in 1918 and 1919, he returned to Chicago to dance in and coach dancing for the Balaban and Katz circuit of local Prolog houses. He remained with the theaters when they were taken over by the Paramount/Publix chain but took time off from his theatrical career to appear with Boris Novikoff's Russian Grand Opera Ballet company.

Kretlow returned to teaching in the 1930s, contributing, as did his parents, to the developing dance fields in America.

Kreutzberg, Harald, German concert dancer; born December 11, 1902 in Reichenberg, Austria (now Czechoslovakia); died April 25, 1968 in Muri, Switzerland. Originally a graphics designer, Kreutzberg was employed in layout on a fashion magazine when he began to study with Mary Wigman in Dresden.

In 1922, he joined the Hanover Ballet directed by Max Terpis, following him after three years to the Berlin Staatsoper, where he partnered Yvonne Georgi. Also in 1925, he was cast by Max Reinhardt in his production of *Turandot* (as a play), creating the characterization of the "Jester" which made him famous. With his Reinhardt reputation, he was able to arrange a concert tour of the United States in 1927, sharing recitals with Tilly Losch. From 1930 to 1939 and from 1947 to the mid-1950s, he toured Western Europe and the United States with Georgi and in solo programs.

Kreutzberg's specialty was solo performance, deeply dramatic works of legible characterization. Some were based on known entities from mythology or literature, but most were representations of invented personalities, each with a deep involvement with an emotion, demonstrated in movement, gesture, and shape.

Works Choreographed: CONCERT WORKS: (Note: this list, unfortunately, may represent less than half

of Kreutzberg's complete output.) *Kuyawiak* (1927); *March* (1927); *Gothic Dance* (1927); *Revolt* (1928); *Three Mad Figures* (1928); *Four Little Figures* (1928); *Spanish Impressions* (1929); *The Angel of Last Judgement* (1929); *The Spirit of Evil* (1929); *Romantic Dance Scene* (1929); *Flag Dance* (1929); *The Jubilate* (1930); *King's Dance* (1930); *Polonaise* (1930); *In the Twilight* (1930); *Variations* (1930); *Persian Song* (1930, co-choreographed with Yvonne Georgi); *Angel of the Annunciation* (1930); *Waltz* (1932); *The Hangman's Dance* (1932); *Gloria in Excelsis Deo* (1932); *The Cripples* (1932); *Petrouchka* (1932); *Three Miniatures in the Spanish Style* (1932); *Dance of the Moon* (1933); *Pièta* (1936); *Soldier of Fortune* (1936); *King's Dance* (1937); *Barcarole* (1937); *The Romantic* (1937); *Dance Through the Streets* (1937); *Orpheus' Lament for Eurydice* (1937); *Vagabond's Song* (1937); *Greek Theater: Scenes from the Oresteia of Aeschelus* (1937); *Tango at Midnight* (1937); *The Merry Pranks of Tyl Eulenspeigel* (1937); *Choral* (1939); *Night Song* (1939); *Hungarian Dances* (1939); *Four Little Etudes* (1947); *Evocation of the Evil One* (1947); *Li-Tai-Po* (1947); *Night Terror* (1947); *In ¾ Time* (1948); *The End of Don Juan* (1948); *Trois Morceaux Caracteresque* (1948); *Song of the Stars* (1948); *From an Old Calendar* (1948); *Variations on "Ah Du Lieber Augustin"* (1948); *Notturno* (1948); *Job Expostulateth with God* (1948); *Jolly Trifles* (1948; *The Guardian of the Realm of Shades* (1953); *Moira Ton Mykenon* (1956); *The Angel Lucifer* (1960).

Krevoff, Sammy, American ballet and vaudeville dancer; born August 28, 1910 in New York City. Krevoff was trained by Ivan Tarasoff in New York City. He made his vaudeville debut at the age of two as a circus dancer and clown. After six years with circuses and traveling carnivals, he appeared in a number of Gus Edwards' "kiddie" acts on the Keith circuit as a specialty dancer. His act at this point in his career was a combination of tap work and "infant imitations," a subgenre that forced the audience to watch children doing take-offs of established artists—Krevoff specialized in doing Nijinsky as a baby *Spectre de la Rose,* and also appeared in satires of the Castles, Maurice Mouvet and Florence Walton, and The (Pat) Rooneys.

As an adult, Krevoff worked on most of the American and Canadian Prolog circuits, among them the Paramount/Publix route in the Midwest, Fanchon and Marco's West Coast Deluxe Theaters from San Diego to Victoria, and the Capitol Theater MGM circuit out of New York City. He was especially popular at the Capitol, which traditionally used the most ballet work in its shows, and partnered its resident ballerina Maria Gambarelli and its ballet-based Chester Hale Girls. By the 1930s, however, Krevoff had been discovered by the studio that sponsored the Capitol's productions and became an MGM stock company player.

Although comparatively little is known about Krevoff, and no information can be verified at all on his parents, who were reportedly also ballet dancers, he is a fascinating representation of the professional uses that a performer could make of ballet technique in the United States. A detailed study of his career would be useful for all researchers.

Krieger, Viktorina, Soviet ballet dancer and critic; born April 9, 1893 or 1896, in St. Petersburg. A member of a respected Russian theatrical family, the daughter of Vladimir Krieger and Nadezhda Bogdanovskaya-Krieger was trained at the Bolshoi school while her parents were on the staff of the private Korsh Theatre, Moscow. After graduating in 1910, she entered the Bolshoi Ballet where she became noted for her performances as "Swanilda," "Kitri," and "Lise" in the Gorsky productions of the nineteenth-century classics, and in the rare presentations of opera incidental dances by Mikhail Fokine, among them his *Prince Igor* in 1916. Krieger appeared with the Anna Pavlova Company in 1921, with her Bolshoi partner, Laurent Novikoff; although her bravura technique and dramatic attacks were in contrast to Pavlova's softer style, the latter ballerina decided not to share her company bookings with Kreiger. She did remain in the United States, where her association with Pavlova had ended, to work with Mikhail Mordkin in a dance act on the Criterion Theatre and East Coast Prolog circuit, notably in *The Doll [or Toy] Shop* (1921), a version of *Puppenfee,* and a *Bacchanalia* by Mordkin.

She returned to the Soviet Union with him, touring in his repertory briefly before rejoining the Bolshoi in

1925. Between 1927 and 1929, she performed there while organizing and directing the Moscow Arts Theatre of Ballet, a touring company dedicated to creating new repertory of more naturalistic ballets. Her most famous roles in the new company were in the works of Kholfin, including the "Lise" character in his *The Rivals* (1933), and "Zarema" in *The Fountains of Bakhchisarai*, one of the few pieces to become part of the Soviet heritage. Her troupe was absorbed into the Lyric Theatre, now named for its founders Konstatin Stanislavsky and Vladimir Nemirovich-Danchenko.

Although she danced with the Bolshoi through the 1940s, eventually leaving her ballerina roles for character parts, she was also well known as a writer and critic. She is now considered a major journalist on dance and other cultural news and serves as director of the Bolshoi Theatre Museum.

Bibliography: Krieger, Viktorina. *Moil Zapiski* [My Notes] (Moscow: 1930); a translation of Krieger's memoirs is expected in the near future.

Kriza, John, considered by many the best representative of the native American ballet; born January 15, 1919 in Berwyn, Illinois; died August 18, 1975 in Naples, Florida. After early training with Mildred Parchal, Kriza studied in Chicago with Walter Camryn, Bentley Stone, and Ruth Page of the Chicago Civic Opera Ballet, performing with them from 1937 to 1939.

Moving to New York, Kriza became a charter member of Ballet Theatre, the company with which he remained until his death. Perhaps the most versatile dancer in the company's history, Kriza performed in the classics, among them, *Les Sylphides, Giselle,* and *La Fille Mal Gardée*, and created roles in new works from 1942 to 1963. Associated with the works of Jerome Robbins, he created the role of "The Second Sailor" in his *Fancy Free* (1944), and featured parts in *Interplay* (1945) and *Facsimile* (1946). Equally adept at performing in the dramatic works of Antony Tudor, he danced in the company premieres of his *Pillar of Fire* (1942), *Dim Lustre* (1943), as "It Was Spring," *Undertow* (1945), *Shadow of the Wind* (1948), and *Offenbach in the Underworld* (1956), in the comic role of "His Imperial Presidency." Among his other created roles were "The Pastor" in Agnes De Mille's *Fall River Legend* (1948), "Sebestien" or the "The Ballerina's Partner," in Michael Kidd's *On Stage* (1945), and parts in Leonid Massine's *Mademoiselle Angot* (1943), Balanchine's *Waltz Academy* (1944), Bronislava Nijinska's *Harvest Time* (1945), Bentley Stone's *L'Inconnue* (1963), and Herbert Ross' *Paean* (1957) and *Concerto* (1958). Kriza's best remembered roles were "The Boy in Green" in Frederick Ashton's *Les Patineurs* and the title role in Eugene Loring's *Billy the Kid,* which he danced on stage for over twenty years and portrayed on television (*Omnibus*, CBS, 1963).

During Ballet Theater layoffs, Kriza danced on Broadway in *Panama Hattie* (1941) and *Concert Varieties* (1944), and worked in nightclubs with dancer Ruth Ann Koesun.

After his formal retirement from performing in 1966, Kriza served as assistant to the director of American Ballet Theatre until his drowning.

Kromar, Helen, American ballet and exhibition ballroom dancer working under many different names; born c.1905, reportedly in New York City. It is not certain with whom Kromar first studied ballet since, in order to take advantage of the free classes given by Anna Pavlova at the Hippodrome Theater, she had to swear that she had never before taken a lesson. It is a sad testimony to the credulity of the great ballerina and to the desperation for American young dancers to be associated with a Russian company that few if any of her students at the Hippodrome told the truth about their former training. Kromar, as Elena Kromariovskaia (more or less), joined the Hippodrome ballet within a week of her first lesson from Pavlova. She joined the Pavlova company officially at the end of the run of *The Big Show*.

Unfortunately, soon after, she and the rest of the Pavlova company were stranded in Puerto Rico for much of World War I, so she had few opportunities to perform publicly with her. She did do some private performances with the remainder of the American contingent, among them Hubert Stowitts, Joseph Levine, and Chester Hale. When the Pavlova company returned to the United States in the early 1920s, she left the troupe. Within the year she had changed her technique and professional name. As "Nina De Marco," she became the first partner in the famous

succession of those who danced with Tony De Marco in his exhibition ballroom act. They appeared in nightclubs, cabarets, and theaters for nine years until she left him in California where he quickly found a new partner, who became "Renée De Marco."

Kromar returned to New York where she taught for Chester Hale at his own free school atop the Capitol Theater. Unfortunately, her habit of changing her name to suit her latest performance style makes it impossible to determine whether she retired to teach or embarked on a completely new career in dance. Kromar/Kromariovskaia should not be confused with Helen Kramer, who performed with the Ballet Russe de Monte Carlo as Elena Komarova.

Kronstam, Henning, Danish ballet dancer; born June 29, 1934 in Copenhagen. Trained at the school of the Royal Danish Ballet, he has served as a member of the company since 1952.

He has created roles in many ballets, among them, Frederick Ashton's *Romeo and Juliet* (1955), Flemming Flindt's *The Three Musketeers* (1966) and *Dreamland* (1974), and Birgit Cullberg's *Moon Reindeer* (1957), his first international success. Featured in leading roles in the continuing Bournonville repertory, notably that of "James" in his *La Sylphide*, Kronstam has also performed in the company's George Balanchine revivals, including his *Four Temperaments*, *Apollo*, *Danses Concertantes*, and the adagio movement of the *Symphony in C*.

Kronstam currently serves as director of the school at which he was trained.

Krupsa, Dania, American theatrical and ballet dancer and choreographer; born August 23, 1923 in Fall River, Massachusetts. After touring the United States and Europe as "Dania Darling, Child Ballerina," she returned to America where she studied with Catherine Littlefield, Aubrey Hitchins, and Syvilla Fort. She danced in The Littlefield Ballet, as a Chester Hale Girl in Frank Fay's vaudeville act, at the Radio City Music Hall, and with the Chauve-Souris of 1943 before joining the national company of *Oklahoma* as the "Dream Laurey." When she played that role on Broadway in 1945 to 1946, she began to work for the show's choreographer, Agnes De Mille. Krupsa assisted De Mille on *Allegro*, *Gentle-*

men Prefer Blondes, and *Paint Your Wagon*, and Michael Kidd on *Can-Can*. After working as stand-by and replacement dancer for Zizi Jeanmaire in Roland Petit's *The Girl in Pink Tights*, she received her first solo choreography credit for the *Shoestring Revue* (1955). Among her later Broadway shows were *The Most Happy Fella* (1956), *The Happiest Girl in the World* (1961), *Fiorello* (1962), *Her First Roman* (1968), and *Rex* (1976), Richard Rogers' last work.

Works Choreographed: CONCERT WORKS: *Pointes on Jazz* (1960).

THEATER WORKS: *Shoestring Revue* (1955); *The Most Happy Fella* (1956); *The Happiest Girl in the World* (1961); *Fiorello* (1962); *Regatino* (Rome, 1963); *That Hat* (1964); *Her First Roman* (1968); *A Report to the Stockholders* (1975); *Rex* (1976).

Kschessinskaia, Mathilde, Russian ballet dancer of the turn of the twentieth century; born August 31, 1872 in Ligovo; died December 6, 1971 in Paris. The daughter of character dancer Felix Kschessinski, Kschessinska (or, correctly, Kschessinskaia) was trained at the St. Petersburg school of the Imperial Theatre by Lev Ivanov and Christian Johansson. At the Maryinsky Theatre from 1890, she was assigned feature principal roles in most of the Marius Petipa repertory, dancing "Kitri" in *Don Quixote*, and the title roles in *Esmeralda* and *The Sleeping Beauty*. She created roles in his *Les Saisons* and *Les Millions d'Arlequin* (both 1900) and in Ivanov's *Le Réveil de Flore* (1894). Supposedly the first Russian dancer with bravura-enough technique to perform the sequence of thirty-two *ronds de jambes fouetté* with which Zucchi had dazzled St. Petersburg, Kschessinska was named prima ballerina absolute in 1895.

Unlike her fellow principals at the Maryinsky, Kschessinska spent only one season with the Diaghilev Ballet Russe—the 1911–1912 London season. She revived her role as "Aurora" in Petipa's *Sleeping Beauty* with the pas de deux *Aurore et le Prince*, performed with Nijinsky, and danced with him in Fokine's *Le Carnaval* and *Pavillion d'Armide*. She also appeared in a shortened version of *Swan Lake*, credited to Petipa, but in fact after Ivanov.

Retiring from performance, Kschessinska moved first to the Côte d'Azur in 1920 and to Paris in 1929 where she opened a studio. Although rumored to

yield tremendous influence in Russia, and in Paris with the emigré community, Kschessinska was not as important an influence on Western dance as her colleagues, Anna Pavlova and Tamara Karsavina. Because of her marriage and financial position, or because she was not as interested in prolonging the art form, she did not reach and inspire younger dancers the way that the other two did throughout their careers.

Kubala, Michael, American theatrical dancer; born in Redding, Pennsylvania. Kubala's training ranges from ballet classes with Yurek Lazowski and Galina Razoumova to jazz work with Ronn Forella. Although his Broadway debut, *A Broadway Musical*, was a famous flop, he was much luckier in his later engagements. In *Dancin'* (1978), he demonstrated his abilities to shape his body into Bob Fosse's personal movement vocabulary in a dazzling variety of techniques—ballet, jazz, tap, acrobatics, and mime. His dance and vocal skills and regional acting experience brought him a principal role in the 1980 musical, *Woman of the Year*.

Kuchera, Linda, American ballet dancer; born January 28, 1952 in Monongahela, Pennsylvania. Kuchera was trained at the Washington School of Ballet and the American Ballet Center. After work in the corps of the New York City Opera Ballet and apprenticing with the Joffrey II company, she joined the American Ballet Theatre in 1973. The versatile Kuchera has been applauded in roles in the company's traditional mixture of revived classics, currently among them, *Swan Lake*, *Raymonda*, *Don Quixote*, *The Nutcracker*, and *La Bayadère*, and modern works. She has adapted her own technique and presence to the diverse stylization necessary for Jerome Robbins' *Les Noces*, Twyla Tharp's *Push Comes to Shove*, and Antony Tudor's lyrical *Leaves Are Fading*.

Kunsell, Maurice, American dance director of the early sound era; Kunsell's studio biography cannot be verified and it is not sure whether he was in fact an Englishman who arrived in Hollywood in 1926 to work for Cecil B. De Mille. Many of his early film credits were actually for De Mille, either for his own production company, or for one of the most celebrated early sound films, *The Great Gabbo*, for a conglomeration of independent studios. Kunsell joined the directing staff of United Artists in 1929 when all studios were expanding their stables of directors and choreographers, and worked on two memorable films—the Fanny Brice vehicle *Be Yourself* (1930) and the musical extravaganza *Puttin' On the Ritz* (1930). He probably also worked on the studio's series of short musical films, although these credits cannot be verified. Kunsell later taught in Hollywood.

Works Choreographed: FILM: *The Angel of Broadway* (De Mille Pictures, 1927); *Be Yourself* (UA, 1930); *The Great Gabbo* (Sono Art and World Wide Pictures, Inc., 1930, delayed release); *Puttin' on the Ritz* (UA, 1930).

Kurgapkina, Ninel, Soviet ballet dancer; born February 13, 1929 in Leningrad. Trained at the Leningrad Choreographic School, she performed with the Kirov Ballet from the late 1940s. A Kirov ballerina from the late 1950s to her retirement in 1972, she was celebrated for her performances in the company's productions of the Russian and Western European classics, among them *Giselle* and *Swan Lake*. Considered a living repository of the Kirov style, she became director of her alma mater, the Leningrad Choreographic School, after retirement.

Kurylo, Eduoard, Polish ballet dancer teaching in the United States; born c.1885 in Warsaw; died c.1940 in New York City. Trained at the school of the Imperial Ballet in Warsaw, he became a member of that company in the mid-1900s, soon graduating to the principal roles in the classical repertory. Having studied with Enrico Cecchetti in Warsaw, he was frequently invited to partner Russian ballerinas in their Western European engagements. For example, he danced with Lydia Kyasht in her *Water Nymph* ballet at the Empire Theatre (April 1912) and with Anna Pavlova in London a few months later, replacing the ailing Laurent Novikoff. Kurylo emigrated to the United States in 1915, although he maintained close professional ties with English ballet. He partnered Pavlova again in 1916 in New York (probably as a replacement for her usual "Cavalier") and taught at her

Hippodrome Free School during *The Big Show* run. He opened his own studio in 1916, teaching there until the early 1940s. Kurylo, or De Kurylo as he was also billed, was a popular social dance teacher and coach and frequently staged "unique" versions of popular dances for exhibition ballroom and theatrical teams unable to invent their own variations on the one-step, two-step, and tango.

Kyasht, Lydia, Russian ballet dancer working in England and the United States in the 1910s; born Lydia Kyashkt, March 25, 1885 in St. Petersberg; died January 11, 1959 in London. Trained at the school of the Imperial Ballet in St. Petersburg by Pavel Gerdt, Kyasht made her Maryinsky Theater debut in 1902.

One of the few female Russian dancers to make a successful transition from the Imperial Theaters to the popular stage in the West, Kyasht left St. Petersburg for London in 1908. She was the principal ballet dancer at the Empire Theatre there from 1908 to 1913, performing in Fred Farren's *Sylvia* (1911), and *New York* (1912), Adolf Bolm's divertissements *The Princess and the Slave, Carnaval,* and *Valse Idyllie* (1910), and four productions of her own. These four—*The Water Nymphs* (1912), *First Love* (1912), *Titania* (1912), and *The Gamble* divertissement (1913)—proved that she had successfully mastered the unique idiom of that theater, mixing sentimentality and bravura technique.

Enormously popular in the United States, where the revisionist *Modern Dance Magazine* praised her (with Nijinsky and Lopoukhova) as the most innovative of the Russians, she appeared in the Winter Garden revue, *The Whirl of the World* (1914) and toured with partners Eduoard de Kurylo and Bolm. Returning to England, she performed with Leon Kellaway in a revue, *A la Russe,* which toured extensively in the early 1920s, with her solos and pas de deux. One of the most interesting of her recital pieces was created

for that revue; it was a version of *Spectre de la Rose* in which she played "the Rose," not the dreamer.

Kyasht opened a school in London in 1935; a troupe of dancers trained there performed as the Kyasht Ballet in the 1940s in her works.

Works Choreographed: CONCERT WORKS: *Spectre de la Rose* (1924); *Sylvia* (1939); *Ballerina* (1940); *Cinderella* (1941); *Heraldic* (1942).

THEATER WORKS: *The Water Nymphs* (1912); *First Love* (1912); *Titania* (1912); *The Gamble* (1913).

Bibliography: Kyasht, Lydia. *Romantic Recollections* (London: 1929).

Kylian, Jiri, Czech ballet dancer and choreographer; born March 21, 1947 in Prague. After early training in acrobatics, he studied at the ballet school of the National Theatre and at the Prague Conservatory with Zora Semberova. He polished his technical skills and performance abilities in a year at the school of the English Royal Ballet.

Best known as a choreographer of seamlessly constructed abstract works, Kylian began to create works for a company while a member of the Stuttgart Ballet in the early 1970s. He was named co-artistic director of the Netherlands Dance Theatre in 1975, and promoted in 1978. Most of his extant works were created for that troupe, and were first seen in the United States during its tour. The enthusiastic reception of the pieces has made them standard repertory works throughout Western Europe, and in the United States.

Works Choreographed: CONCERT WORKS: *Blanc Haut* (1974); *Stoolgame* (1975); *Torso* (1975); *Verklate Nacht* (1975); *Newers* (1975); *Return from a Strange Land* (1975); *Cathedrale Engloutte* (1975); *Elegia* (1976); *Nuages* (1976); *Symphony in D* (1976); *November Steps* (1977); *Sinfonietta* (1978); *Symphony in Psalms* (1978); *Rainbow Snake* (1978); *Intimate Letters* (1979); *Msa Glagosaja* (1979).

L

Laban, Rudolf von, Slovakian pioneer of modern dance and dance notation; born Rudolf Laban de Varaljas, December 15, 1879 in Pozsony (now Bratislava, Czechoslovakia); died July 1, 1958 in Weybridge, England. Although Laban was probably the most influential European modern dancer, little is known about his actual choreography. He staged at least one touring revue, c.1905–1906, in which he performed in North Africa and the Mediterranean ports. In the period between returning to Germany (c.1907) and establishing his first school in Munich (c.1910), he performed as a recitalist, presenting his own solos in concert; the titles of these works cannot yet be verified.

As a teacher, he shaped the German and Austro-Hungarian modern dance movements of the 1910s through 1930s. Mary Wigman was a student at the Munich school and Kurt Jooss studied with him in his Stuttgart studio, after the Swiss period during World War I. He inspired the movement choirs popular in the early 1920s, for schools and amateurs. He established the Institute of Choreography in Würzburg in 1925 and became director of the Berlin State Opera five years later. Titled extant works date from this period, when he created dances for his student groups in concert and in festivals; his *Gaukelei*, for example, was created for the 1930 Dance Congress. During this period, he began an association with the Bayreuth Festival that continued until he was forced into exile in the late 1930s.

Although he originally joined Jooss at Dartington Hall, he left that arts school after the war and established an Art of Movement Studio in Manchester, England, in 1946. The codification of Labanotation, his most lasting accomplishment, was completed in England from the establishment of the studio until his death in 1958.

Labanotation, or Kinetographic Laban, and Effort/Shape notation are systems of writing down both movements and the energy necessary to perform them. This distinguishes it from other dance notation systems, which denote shape and direction only, and enables it to be used for nonperformance purposes, including physical and emotional diagnosis and rehabilitation, industrial efficiency studies, analysis of historical movement, and the kinaesthetic studies grouped popularly under the phrase "body language."

The two major centers of research into Laban's systems are in Jooss' Folkwangschule in Essen, Germany, and in the Dance Notation Bureau and Laban Institute for Movement Studies in New York City. The latter two, with branches at universities across the country, have insured that Labanotation and Effort/Shape have become the most prevalent dance language in the Western hemisphere.

Works Choreographed: CONCERT WORKS: *Don Juan* (1929); *Green Clowns* (1929); *Pageant of Crafts and Industries* (1929); *Gaukelei* (1930); *Prince Igor* (1930).

Bibliography: Laban, Rudolf von. *The Mastery of Movement* (London: 1950); *Principles of Dance and Movement Notation* (London: 1956); *Choreutics* (London: 1966); Hutchinson, Ann. *Labanotation: The System of Analyzing and Recording Movement* (New York: 1954, 1970).

Lacotte, Pierre, French ballet dancer and choreographer; born February 3, 1932 in Chatou. Trained at the school of the Paris Opéra under Gustave Ricaux, he performed with the company from 1946 to 1955. Since then, he has performed and choreographed primarily for his own companies—the Ballet de la Tour d'Eiffel and Les Ballets de Pierre Lacotte. Among his best known original works are *La Nuit est une sorcière* (1956), *Gosse de Paris* (1955), *Intermède* (1966), and *Platée*. He has become a popular revival stager, creating ballets "after Filippo Taglioni" for companies and guest artists; for example, his *La Sylphide* of 1972 was set for the Paris Opéra and taken on tour by Rudolf Nureyev.

Works Choreographed: CONCERT WORKS: *Gosse de Paris* (1955); *La Nuit est une sorcière* (1956); *Solstice* (c.1958); *Such Sweet Thunder* (1959); *Elegie* (1962); *Hotel des Etrangers* (1962); *Simple Symphonie* (c.1962); *Interemède* (1966); *La Sylphide* (after Filippo Taglioni); *Le Papillon* (1975, after Marie Taglioni); *Coppélia* (1977); *Platée* (1977).

TELEVISION: *Hamlet* (French Radiotélévision, 1977).

Laemmle, Carla Rebecca, American film ballet dancer; born October 20, 1909 in Chicago, Illinois; date and place of death uncertain. The daughter of film producer Carl Laemmle, she was raised in Chicago, where she studied with Professor Jacobsen, and in Los Angeles, where she was trained by Ernest Belcher; reportedly, she studied with Anna Pavlova while the ballerina was making *The Dumb Girl of Portici* for Universal, (c.1915). After working in operetta in Los Angeles, she became a specialty dancer in films, primarily those produced by Universal. Her best remembered dance number was interpolated into *King of Jazz*, a Universal filmed revue. It was an eccentric ballet tap, although it is believed that she also performed in more conventional ballet. Laemmle also appeared in the original *Dracula* (Universal, 1930), and in the MGM revue, *Hollywood Party* (1930), staged by Albertina Rasch.

Laerkesen, Anna, Danish ballet dancer; born March 2, 1942 in Copenhagen. Trained by Edite Feifere Frandsen, c.1954 to 1959, she entered the school of the Royal Danish Ballet at the advanced age of seventeen. Graduating to the company during the next season, she became internationally famous for her portrayal of the title role in the company revival of Bournonville's *La Sylphide*. Apart from her roles in the classics, which include *Swan Lake, Giselle,* and *The Nutcracker*, she is known for her performances in Frederick Ashton's *Romeo and Juliet*, Flemming Flindt's *The Three Musketeers* (1966), and Birgit Cullberg's *Moon Reindeer* and *Lady from the Sea*. As a guest artist/member, she performed in Eliot Feld's early troupe, the American Ballet Company, in his *Romance* (1971), *Intermezzo,* and *Early Songs*.

Lafon, Madeleine, French ballet dancer; born 1924 in Paris; died there on April 6, 1967. Trained at the school of the Paris Opéra, she continued her studies at the studios of Boris Kniaseff, Alexander Volinine, and Lubov Egorova. Lafon was associated with the Paris Opéra throughout her short life, performing with the company from the late 1940s. She created the female lead in the fourth movement of George Balanchine's *Le Palais de Crystal* (1947) and the principal role in Victor Gsovsky's *La Dame aux Camilias*, and Serge Lifar's *Mirages* (1947). Her major roles included Lifar's *Suite en Blanc* and *Divertissement*, and Juan Corelli's *Le Combat de Tancrède et Clorinde*. She taught at the school at which she had been trained after 1963.

La Fosse, Edmund, American ballet dancer; born July 30, 1953 in Beaumont, Texas. Trained locally with Marsha Woody, he moved to New York to continue his studies with David Howard, Finis Jhung, and Maggie Black.

La Fosse performed with the National Ballet, Washington, D.C., for the last seasons of its existence, with featured roles in Ben Stevenson's *Cinderella*, John Cranko's *Jeu de Carte*, and George Balanchine's *The Prodigal Son*. He joined the Eliot Feld Ballet in its first season in 1974. He has created roles in Feld's *Mazurka* (1975), *Danzano Cubano* (1978), and his best known role, the popular solo performed with a walking stick in *A Footstep of Air* (1977), and has performed in most of the company's repertory. In 1979–1980, La Fosse appeared in the so-called male ballet lead in Bob Fosse's *Dancin'* on Broadway.

La Fosse, Robert, American ballet dancer; born December 9, 1959 in Beaumont, Texas. After local training with Marsha Woody and summers spent at New York's School of American Ballet, he joined the American Ballet Theater in 1977. Among his many performance credits in the company are roles in the company productions of *The Nutcracker, Swan Lake, Don Quixote,* and *The Sleeping Beauty*, and revivals of George Balanchine's *Prodigal Son*, Jerome Robbins' *Fancy Free*, Agnes De Mille's *Rodeo*, Frederick Ashton's *Les Rendez-vous*, and Antony Tudor's *Jardin aux Lilas*. With additional training in tap and jazz from Ron Abshire, La Fosse sat out the Ballet Theatre strike in Bob Fosse's *Dancin'* in what is generally known as the "unemployed ballet" role.

La Gai, Louisa, French ballet dancer and pantomimist working in the United States; born c.1897 in Paris. La Gai was trained at the Paris Opera by Leo Staats and Albert Aveline. It is not known whether she ever made her debut with the company. She first appeared in the United States in 1910 in a feature

vaudeville act, *The Carnival of Roses*. She remained on the class act circuits for three years with a variety of acts, such as *Les Vanities de la Danse* (c.1912) and *Danses d'Amour* (1913). Her tour brought her to Berkeley, California, where she became a member of the staff of the Greek Theater and University. She taught pantomime and staged dance-dramas for her students for at least a dozen years, becoming a major influence on Hubert Stowitts, among others. La Gai returned to the popular theater in 1914 in a dance act with Quinten Tod that included her *Homage to Camargo* and *The Peacock Pantomime*.

Laine, Doris, Finnish ballet dancer; born February 15, 1931 in Helsinki. Laine was trained at the school of the Finnish National Ballet and with Anna Sevenskaya and Anna Northcote in London. As a member of the Finnish National Ballet throughout the 1950s and 1960s, she appeared in the company productions of both the Russian and Soviet classics, including *Esmeralda*, *Swan Lake*, *Giselle*, *Coppélia*, *Don Quixote*, *The Sleeping Beauty*, *The Fountain of Bakhchisarai* and *The Stone Flower*. She is also known for her work in the dramatic ballets of Birgit Cullberg and for the pas de deux programs with which she toured the Soviet Union, Western Europe, and the United States.

Laing, Elizabeth, American ballet dancer; born 1959 in New York City. A second generation member of the American Ballet Theatre, she was trained by her parents, Kelly Brown and Isabel Mirrow, in Phoenix and at the School of American Ballet. After joining Ballet Theatre in 1977, she was overshadowed by her older sister, Leslie Browne, but brought her own fame to her new professional name. In her three years in the company, she has appeared most frequently in the new repertory of revivals by Natalia Makarova and Mikhail Baryshnikov of nineteenth-century full-length ballets, in featured roles and variations. Laing has also been seen in the more contemporary repertory of works by Antony Tudor and Agnes De Mille.

Laing, Hugh, English ballet dancer working in the United States after 1940; born Hugh Skinner, June 6, 1911 in Barbados, the West Indies. Moving to England to continue his art training, Laing began to study ballet in London with Margaret Craske and Marie Rambert in 1932.

In his English and American careers, Laing has been associated with the works of Antony Tudor. In the Ballet Club, an experimental company that existed from 1933 to 1937, he created roles in Tudor's *Atlanta of the East* (1933), *The Planets* (1934), *Descent of Hebe* (1935), *Jardin aux Lilas* (1936), and *Dark Elegies* (1937); during this time, he also performed for the Ballet Club's other major innovator, Frederick Ashton, dancing in his *Valentine's Eve* (1935) and in his theatrical production, *The Flying Trapeze* (1935). The short-lived London Ballet offered him the opportunity to perform in the premieres of further Tudor works, among them *Soirée Musicale* (1938) and *Gala Performance* (1938).

Laing emigrated to the United States in 1940, joining Ballet Theatre in its first season. Here again, he danced featured roles in the growing Tudor repertory, with parts in the above works revived for Ballet Theatre, and in *Goya Pastoral* (1940), *Romeo and Juliet* (1943), *Dim Lustre* (1943), *Undertow* (1945), *Shadow of the Wind* (1948), and *Nimbus* (1950). His performance as "The Man from the House Opposite" in *Pillar of Fire* (1942) won him the reputation as one of the best dramatic dancers in ballet, a status that he upheld in productions of Leonid Massine's *Aleko* (1942), Agnes De Mille's *Tally-Ho* (1944), and the company's *Giselle*.

As a member of the New York City Ballet from 1950 to 1952, Laing performed both dramatic and abstract roles, among them, the title role in George Balanchine's *The Prodigal Son*, and parts in Ashton's *Illuminations*, Jerome Robbins' *Age of Anxiety*, and Tudor's new works, *Lady of the Camelias* (1951) and *La Gloire* (1952). He starred in the dance role of "Harry Beaton" in the Gene Kelly film of *Brigadoon* (MGM, 1954) before retiring from dance performance to pursue a career in photography.

Lair, Grace, American television dancer; born c.1920 probably in New York City; died January 5, 1955 in Cleveland, Ohio. Lair performed as a tap dancer for most of her short life. She made her theatrical debut at five (going by her approximate date of birth) and

continued until shortly before her death. Despite all of her presentation act, Prolog, Broadway, and cabaret credits, however, Lair is best remembered for a piece of advertising trivia—she was the tap-dancing Coca-Cola bottle on early live television. In 1953–1955, she came on in the commercial breaks of variety shows and tap-danced across the stage dressed in a very large Coke bottle. Although she was not the first live tapping ad (that honor went to Floria Vestoff, the original Old Gold cigarette box), she was, for many years, the most famous.

Lalande, Michel, French late seventeen-century composer; born December 15, 1657 in Paris; died June 18, 1726 in Versailles. The one-time master of the King (Louis XIV)'s music and director of the Royal Chapel was associated with opera-ballets in the late seventeenth century. From his first known dance score, for *La Sérénade* (1682), to his last, *Les Eléments* (1725), he was noted for his abilities to bring national character into the mythological and pastoral plots of the works, using both movement and sung texts. Three of his works, *Le Ballet de la Jeunesse* (1686), *Les Eléments*, and *La Noce de Village* (1700), became the bases for later ballets of the next two centuries, with the latter plot lasting well into the 1900s. Little of his dance music is now known; however, much of his church music is extant.

Lamb, Gil "Slim," American eccentric dancer working in theater and film; born c.1920 in Minneapolis, Minnesota. Lamb was trained as a band musician, not in dance techniques. He worked in a dance band in his late adolescence before making his theatrical debut in a pantomime act directed by Fred Corway. For many years he worked on the Fanchon and Marco circuit of presentation act houses, becoming a headliner at their Roxy Theater in New York. His extremely eccentric act involving dance, harmonicas, and suspension of disbelief, led to his Broadway specialty debut in the Al Jolson vehicle, *Hold Onto Your Hats* (1940), which in turn brought him to the attention of the Paramount Studio casting office. Considered Paramount's answer to Ray Bolger (under contract to MGM), he was cast as a specialty dancer and as a comic in the studio's military musicals. His roles in *Star Spangled Rhythms* (1942) and *The Fleet's In* (1942), were similar—a sailor friend of

the hero who finally breaks into a dance three-quarters of the way through the film. After a few more Paramount pictures, he returned to Broadway as "Ichabod Crane" in Anna Sokolow's *Sleepy Hollow* (1948). In 1950, however, he moved back to California to star in a series of two-reeler comedies about the character "Slim." In such films as *Pardon My Wrench* (1953), *Baby Makes Two* (1952) and *Fresh Painter* (1953), he played a young man whose legs, arms, and emotions constantly interfered with his job and romances. Lamb retired from performance in the late 1950s to concentrate on his second career as a developer and inventor of props for theater, film, and television, but returned to the stage in the veteran's vehicle *70-Girls-70* in 1971.

Lamb's presentation act routines were probably the most eccentric of any solo dance performer. The basic specialty fitted into the category that *Variety* called "tapologues," a dance act punctuated by introductory patter and jokes. Lamb, however, went much further than the conventional tap-dancing comic. Some routines involved satires of nursery rhymes as written, composed, or danced by everyone from Vincent Youmans to a bebopping teen-ager, while others included swallowing tricks with cigarettes and harmonicas. The latter was a complicated *schtik* involving an offstage harmonica virtuoso (Tommy Stafford) and an onstage nut who ate harmonicas and "hummed" his critical opinions. By 1938, when he began to introduce Stafford for an onstage solo, he had further complicated the act by grading the instruments by size and talking his way through an entire menu of harmonicas ranging from full length to miniatures. Unfortunately, his film routines were generally standard (in other words, spectacular) eccentric dances using legomania techniques, but no harmonicas.

Lambert, Constant, English composer and conductor; born August 23, 1905 in London; died there August 21, 1951. Member of a well-known artistic family, Lambert was trained at the Royal College of Music. At twenty, he was commissioned by Serge Diaghilev to compose a ballet, *Romeo and Juliet* (1926), for Bronislava Nijinska. He worked with Frederick Ashton to create scores for many of his earliest ballets, composing *Pomona* (1930), *Rio Grande* (1932, to a libretto by Sacheverell Sitwell),

and *Horoscope* (1958) and arranging music for *Les Rendez-vous* (1933) and *Les Patineurs* (1937), the latter two still existing in the repertories of many companies in England and the United States.

Conductor of both the Camargo Society and the Vic-Wells and Sadler's Wells Ballets, he orchestrated scores for works by its choreographers, among them Ashton, Ninette De Valois, arranging the score for her *The Prospect Before Us* (1940), and Robert Helpmann, modernizing the Purcell pieces for his *Comus* (1942). Lambert also wrote works for the theater and the concert stage and served as music critic for *The Sunday Referee*.

Lambert, Hugh, American theater and television dancer and choreographer; born in New York City. Lambert studied dance and acting at the American Theatre Wing on his G.I. Bill funds. He appeared on Broadway as a chorus and specialty dancer in Donald Saddler's *Wonderful Town* (1952), *Hazel Flagg* (1953), Michael Kidd's *Can-Can* (1953), the *Ziegfeld Follies of 1957*, and a large number of industrials. At the end of the decade he began working for Carol Haney as her assistant, serving in that capacity on the *Flower Drum Song* (1958) and on television shows.

Although Lambert has worked in many media, he is best known for his choreographic work on television specials. He worked on episodes of *The Ed Sullivan* Show and staged variety shows for many of the best known vocalists of our time, among them, Perry Como, Bing Crosby, and Frank Sinatra.

Works Choreographed: THEATER WORKS: *Don't Shoot, We're British* (1961).

TELEVISION: *The Ed Sullivan Show* (CBS, c.1959, c.1963); *Ol' Blue Eyes Is Back* (NBC, 1973 special); Specials for Perry Como (NBC, various dates); Bing Crosby (CBS, NBC, various dates).

Lamhut, Phyllis, American modern dancer and choreographer; born November 14, 1933 in New York City. Lamhut was trained by Alwin Nikolais and Murray Louis at the Henry Street Playhouse and performed in the company of each. She appeared in almost every Nikolais work of the 1960s, notably his *Imago* (1963), *Sanctum* (1964), *Tower* (1965), and *Tent* (1968). Among the many Louis pieces in which she has danced are *Junk Dances* (1966), *Proximities* (1969), and *Interims* (1966).

She has contributed choreography to Henry Street recitals since the early 1960s, but did not form a company until 1970. Most prolific toward the end of the decade, she toured with her troupe and created many works. She frequently uses irony in her works and manipulates the audience's expectations accurately. Her use of sounds, influenced by her work with Nikolais, is especially interesting as she employs devices of repetition, volume parabolas, and shock effects. The humor in her choreography and mise-en-scène belies her adept games with structures.

Works Choreographed: CONCERT WORKS: *Nostalgia* (1950); *Incantation of Greed* (1951); *Annoyous Insectator* (1952); *Theme and Variations* (1953); *Periphery of Armor* (1953); *Cameo* (1953); *Lady of the Aviary* (1954); *Interlude* (1954); *Hex* (1955); *Clock* (1955); *Gemini* (1955); *Loreli* (1955); *Two Dances* (1955); *Stick Figure* (1956); *Sleep* (1956); *Lament* (1956); *Tragedienne* (1956); *Ritual* (1956); *Reverie* (1957); *Excursion* (1957); *Coif* (1957); *Suite* (1957); *Willow* (1957); *Trifoliate* (1957); *Unmirrored* (1958); *Hands* (1959); *Lavella* (1959); *Cebrina* (1959); *Ceremonial* (1959); *Pastel* (1960); *Herald* (1961); *Fanfare* (1961); *Portrait* (1961); *March* (1961); *Trilogy* (1962); *Tocsin* (1962); *Puppet* (1962); *Group* (1963); *Shift* (1963); *Recession* (1963); *Touch Dance* (1963); *Computer Piece* (1964); *Three Dance Movements* (1965); *Ostinatp* (1965); *Fickle Idol* (1965); *Viols* (1966); *Monody* (1966); *Incidentals* (1966); *Come on and Trip* (1967); *Space Time Code* (1969); *Big Feature* (1970); *Extended Voices* (1970); *House* (1971); *Area I* (1971); *Field of View* (1971); *Act I* (1971); *Congeries* (1972); *Scene Shift* (1972); *Two Planes* (1972); *Dance Hole* (1972); *Terra Angelica* (1973); *Z Twiddle* (1973); *Off Track Dancing* (1973); *Medium Coelli* (1974); *Late Show* (1974); *Country Mozart* (1974); *Untitled Piece* (1975); *Solo with Company* (1975); *Hearts of Palm* (1975); *Conclave* (1975); *A Bicentennial Celebration* (1976); *Brainwaves* (1976); *Disclinations* (1978); *Dryad Essence* (1978); *Mirage Blanc* (1979); *Guerrero* (1979); *Musical Suite* (1979); *Passing* (1980).

Lamont, Deni, American ballet dancer; born May 28, 1932 in St. Louis, Missouri. Lamont was trained locally and at the School of American Ballet.

A member of the Ballet Russe de Monte Carlo from 1951 to 1958, Lamont performed frequently in

works by Leonid Massine, among them, *Harold in Italy* and *Gaité Parisienne*, and in Ruthanna Boris' *Cirque de Deux*. In 1959, he joined the New York City Ballet, remaining with that company until the present. Although Lamont has performed in George Balanchine's abstractions, including his *Symphony in C* and *Stars and Stripes*, he is best known in character roles. Among the many roles in which he has danced in his twenty years with the City Ballet are the searching man in the *Eternal Question* section of Balanchine's *Ivesiana*, "Pierrot" in his *Harlequinade*, also performing in the title role, "Sancho Panza" in *Don Quixote*, both "Candy Cane" and "Tea" in *The Nutcracker*, and a featured part in his tribute to the Gershwins, *Who Cares?* He has also appeared in Gloria Contreras' *Panamericana* section (1960), John Taras' *Piège de Lumière*, Merce Cunningham's *Summerspace*, and Jerome Robbins' *Watermill*.

Lamour, Dorothy, American film actress, vocalist, and dancer; born December 10, 1914 in New Orleans, Louisiana. After becoming Miss New Orleans in 1931, Lamour was awarded a contract from Vitaphone and appeared in many short subjects for that dying studio. Best known for her long series of musical pictures for Paramount, she became famous for the many films in which she was semidressed in a sarong. These ranged from the melodramatic, such as *The Jungle Princess* (1936), *Hurricane* (UA, 1937), *Her Jungle Love* (1938), and *Aloma of the South Seas* (1941), to the hysterical, as in the *Roads to Singapore* (1940), *Zanzibar* (1941), *Morocco* (1942), and *Bali* (1952). Her glorious voice frankly overwhelmed her dancing, but each exotic or comic film included at least one dance sequence, whether a nautch or, in the *Road* films, a tap number with Bing Crosby and Bob Hope.

Lamour phased herself out of films in the 1960s, but has performed frequently on stage since then, most notably in *Hello Dolly!* in New York and on tour.

Lampert, Rachel, American modern dancer and choreographer; born December 4, 1948 in Morristown, New Jersey. Raised in Brooklyn, she studied ballet there before attending Mount Holyoke College where she was introduced to modern dance forms. She continued her studies at New York University's School of Arts, studying ballet with Nanette Charisse, and modern dance with Jean Erdman, Gladys Bailin, and Stuart Hodes, whose assistant she was for many years.

She formed her own company in 1975, with dancer-choreographers who had also attended N.Y.U., among them Clarice Marshall and Holly Harbinger. Her pieces are frequently very funny, using images of childhood and games in the perception of a fairly egocentric youngster. Audience favorites include *Issue* (1975), a dance story about a child watching her parents split, *Home* (1976), which uses the structure of a baseball game, and *Doing the Dance* (1977), the movement equivalent of the Nichols and May "Pirandello" skit. Her works have been created primarily for her company, but also appear in the repertories of the Connecticut and San Antonio Ballets and Naomi Sorkin's solo concerts. She has staged dances for *The Misanthrope* and the Public Theatre, and an original musical, *The Vagabond Stars*, for the Berkshire Theatre Festival.

Works Choreographed: CONCERT WORKS: *Going Nowhere* (1971); *Divertimento* (1971); *Oval* (1974); *Edge* (1975); *Issue* (1975); *Brahms Variations on a Theme by Handel* (1976); *Daguerrotype* (1976); *Odyssey Before Brunch* (1976); *The Frog Princess* (1976); *Turn* (1976); *Bloody Mary Sunday* (1976); *Home* (1976); *Coasting* (1977); *Doing the Dance* (1977); *In Memory of the Lonesome Pine* (1978); *Traffic* (1978); *Dark Dreams and Endings* (1979); *Solo Suite* (1979); *Prelude at the End of a Day* (1979); *Cliff Walking* (1980); *Mirror* (1980); *After the Fact* (1980); *Me and Beethoven* (1980).

THEATER WORKS: *The Misanthrope* (1978); *Now That We're Rolling* (1979); *The Vagabond Stars* (1980).

Lancaster, Mark, English artist and designer working in the United States; born in Yorkshire, England. The celebrated British painter became associated with the Merce Cunningham company in 1973 when he worked with Jasper Johns to develop designs for Cunningham's *Un Jour or Deux* in Paris. Since emigrating to the United States in 1974, he has continued to work with Cunningham and succeeded Johns as

artistic advisor (and hence resident artist) for Cunningham's company in 1981. He has designed sets, costumes, props, and other elements for both video and live Cunningham works, among them *Westbeth* (1974, video), *Sounddance* (1975), *Rebus* (1975), *Squaregame* (1976), *Video Triangle* (1976), *Fractions* (1977, videotape and live version a year later), *Tango* (1978), and *Duets* (1980). He has also worked on many Events staged in those six years and has designed multiple-use costumes for that unique Cunningham dance form.

Landa, Anita, English ballet dancer; born 1929 in Las Arenas, Vizcaya, Spain. She had a brief career in Spanish dance, including an engagement with La Esmeralda's troupe in London, c.1948. As a member of the Alicia Markova/Anton Dolin Ballet in the next season, she became part of the newly formed London Festival Ballet. Her best remembered roles were those that involved both bravura technique and characterizations, such as "The Dreamer" in Fokine's *Spectre de la Rose* and "The Ballerina" in his *Petroushka*, but she also appeared in contemporary works created for the company, such as David Lichine's *Symphonic Impressions* and Michael Charnley's *Symphony for Fun*. Landa retired at the start of the 1960s.

Landé, Jean Baptiste, French eighteenth-century ballet dancer and teacher; born c.1690 in France; died February 26, 1748 in St. Petersburg. Landé performed in Paris and Dresden, possibly in connection with the productions of Rainaldi Fossano in the fair theaters and operas. In 1734, he moved to St. Petersburg to work with Fossano at his studio there and, after four years, they founded an orphanage school that formed the basis of the Imperial school system and eventually became the School of the Imperial Ballet. Together, they were responsible for the training of the first generation of Russian dancers in French ballet techniques.

Lander, Harald, Danish ballet dancer and choreographer; born Alfred Bernhardt Stevnsborg, February 25, 1905 in Copenhagen; died there September 14, 1971. Trained at the school of the Royal Danish Ballet by Christian Christensen and Hans Beck, he joined the company in 1923. On trips to the United

States during the 1920s, he continued his studies with Ivan Tarasoff, Adolf Bolm, and the Cansinos.

Associated with the Royal Danish Ballet from 1929 to 1951, as ballet master since 1932, he performed principal and character roles in the Bournonville repertory as maintained by Beck, notably in *Napoli* and *Far from Denmark*. His choreography from this period included *l'Apprenti Sorcier* (1940), *Boléro* (1934), *La Valse* (1940), and *The Phoenix* (1946).

Lander resigned in 1951, moving to Paris to become ballet master of the Opéra in 1953 and director of the school from 1959 to 1963. He staged his Danish repertory there, including his very popular *Etudes* (1948), and created new divertissements for *Oberon* and *Un Bal Masqué*. *Etudes* is in the repertories of many companies across the Western dance world, and is currently performed by the London Festival Ballet and the American Ballet Theatre. Set to orchestrations of Czerny études, the ballet opens with a demonstration of the five basic positions performed by five very young dancers, and amplifies them with every bravura combination possible. Just as the audience begins to think that they have seen every step known to man, the chandeliers come down, the lights go up, and Lander's versatility is proven again.

Works Choreographed: CONCERT WORKS: *Gaucho* (1931); *Tata* (1932); *Battles of the Goddesses* (1933); *Football* (1933); *Diana* (1933); *Boléro* (1934); *A Day in Tivoli* (1935); *Svinedrengen* (1936); *The Seven Deadly Sins* (1936); *Den Lille Havfrue* (The Housewife of Lille) (1936); *Thorvalden* (1938); *La Valse* (1940); *L'Apprenti Sorcier* (1940); *Napoli* (1941, after Bournonville); *Le Pays de Cognac* (1942); *Printemps* (1942); *Fête Polonaise* (1942); *Vaaren* (1942); *Qarrtsiluni* (1942); *The Loves of a Ballet Master* (1942, after Galleotti); *Quasi une Fantasie* (1944); *The Phoenix* (1946); *Etudes* (1948); *Homage à Bournonville* (1949); *The Nutcracker* (1950, after Lev Ivanov); *Les Indes Galantes* (1952, co-revived with Albert Aveline and Serge Lifar); *Les Fleurs* (1952); *La Sylphide* (1953, after Bournonville); *Printemps à Vienne* (1954); *Concerto aux Etoiles* (1956); *Vita Eterna* (1959); *Yara* (1960); *Les Victoires de l'Amour* (1962); *Un Roi Kristian II* (1965).

TELEVISION: *Pas de Trois Cousines* (Danish television, 1970).

Lander, Margot, Danish ballet dancer; born August 2, 1910 in Copenhagen; died there July 18 or 19, 1961. Trained at the School of the Royal Danish Ballet under Vera Volkova and others, she joined the company in 1925 and performed there for twenty-five years. Celebrated for her "Swanilda" in the company production of *Coppélia*, she was also featured in the revivals of Mikhail Fokine's *Spectre de la Rose* and *Les Sylphides*, in Bournonville's *Napoli* and in Harald Lander's *Swan Lake*. Among the many Lander works in which she created roles are *l'Apprenti Sorcier* (1940), *Qarrtsiluni* (1942), *Printemps* (1942), and *Etudes* (1948), one of the most demanding ballerina roles of the contemporary repertory.

Lander, Toni, Danish ballet dancer working in Europe and the United States after the mid-1950s; born Toni Pihl Petersen, June 19, 1931 in Copenhagen. Trained by Leif Oernberg and at the School of the Royal Danish Ballet, she continued her studies in Paris with Olga Preobrajenska and Lubov Egorova.

Performing with the Royal Danish Ballet in 1948, she was featured in *Etudes*, by her then-husband, Harald Lander. She left Denmark with him to dance with the Paris Opéra in his *Pas de Deux Romantiques*, *Printemps*, and *Valse Triste*. In Paris, she performed in John Taras' ballet of Françoise Sagan's *Les Rendez-vous manqués* (1958). Traveling to London, she performed with the London Festival Ballet in *Etudes*, Bournonville's *Napoli*, and Fokine's *Les Sylphides*.

Lander joined the American Ballet Theatre in 1965, dancing with the company until the early 1970s. As well as *Etudes* and *Les Sylphides*, she was assigned principal roles in the company's productions of Bournonville's *La Sylphide* and *Flower Festival in Genzano*, Leonid Massine's *Gaité Parisienne*, as "the Glove Seller," Antony Tudor's *Jardin aux Lilas*, and José Limón's *The Moor's Pavanne*. She left Ballet Theatre with her husband, Bruce Marks, when he was named artistic director of Ballet West in Salt Lake City, Utah. She has taught and coached for this company, also restaging Bournonville ballets for the young dancers.

Lane, Lupino, English theatrical dancer and comic; born June 16, 1892 in London; died there November 10, 1959. A member of the famed Lupino clan, Lane was an acrobatic dancer and comedian specializing in Cockney underdog parts. He was best known for an elaborate drunk act in which he attempted to walk across the stage, but slid into splits and fell over his toes. Among his most successful shows were *Afgan* (1919, New York, 1920), the *Ziegfeld Follies of 1920*, *Silver Wings* (1930), and *Me and My Girl* (1935). He choreographed one show in which he did not appear, *Puss-Puss* (1921), but was generally considered to have created his own routines in other shows.

Works Choreographed: THEATER WORKS: *Puss-Puss* (1921).

Lane, Maryon, South African ballet dancer working in England after 1947; born February 15, 1931 in Melmouth, Republic of South Africa. After early training in Johannesburg with Pauline Stokes, Lane accepted a scholarship to the school of the Sadler's Wells Ballet.

Performing with the Sadler's Wells Ballet, and its successor, the Royal Ballet, throughout her career, Lane has been associated with the works of Kenneth Macmillan, performing in his *Laiderette* (1954), *Danses Concertantes* (1955), *House of Birds* (1955), *Noctabules* (1956), *Solitaire* (1956), *Agon* (1958), and *Diversions* (1961). Lane created roles in Frederick Ashton's *Les Rendez-vous* and *Valses Nobles et Sentimentales* in 1947 and has performed in his *Mme. Chrysanthème*, *Les Patineurs*, and *A Birthday Offering*. After dancing in the premieres of John Cranko's *Children's Corner* (1948) and *Pineapple Poll* (1951), she took part in his productions of *The Shadow* and *Beauty and the Beast*.

Since retiring from performance, Lane has taught at the London Ballet Centre and the school of the Royal Ballet.

Lane, William Henry, American popular entertainer who performed as Juba; born c.1825 in what was already part of the United States, according to one source, east of the Mississippi; died 1852 in England. Nothing is known about Lane's early life or training; it has only recently been verified that he was in fact at least one of the people performing under the pseudonym of "Juba."

The earliest verified mention of Lane occurred on July 8, 1844, when he performed in a challenge dance act with John Diamond (1823–1857); these fixed

challenges had been a stock part of Diamond's act since 1841 at least, and were called Jim-a-Long Josey. On this occasion, Lane performed as Master Diamond (probably because he was shorter than John Diamond), but in later advertisements he was identified as Master Juba.

In 1845, as Juba, Lane was a specialty dancer with the Georgia Champion Minstrels. From 1846 to 1848, he performed his specialty act with (Charles) White's Ethiopian Serenaders at White's Melodeon in New York.

Lane, as Juba, traveled to London with (Gilbert Ward) Pell's Serenaders in the Spring of 1848, performing at Vauxhall Gardens that June. They, and he, were exceptionally popular in London, and were booked solidly until 1851, when it is believed that the Serenaders left after playing Cremorne Gardens. Lane remained in England, dying there in 1852.

Two elements have made Juba interesting to dance historians Marian Hannah Winter, Steven Johnson, and others. The first, simply, is that Lane was black but that he was successful in what was generally an all-white entertainment medium, the minstrel show. The second element is that, until recently when the existence of a multitude of Jubas was recognized, it seemed possible to trace the development of the act over its ten-year span. Now, one can simply say that the Juba act, as performed by Lane and others, involved an eccentric dance that featured a straightened inside support leg—an eccentric feature that can be traced to John Diamond. Although Lane performed as a female impersonator in London, there is no evidence that the character, "Lucy Long," was part of his rather than Pell's act.

Lang, Harold, American ballet and theatrical dancer; born c.1924 in Daly City, California. After studying at the local branch of the Theodore Kosloff Studio, he continued his training with Willam Christensen at the school of the San Francisco Opera Ballet.

Moving to New York, he danced with the Ballet Russe de Monte Carlo (1941–1943), with featured roles in Leonid Massine's *Le Beau Danube* and *La Boutique Fantasque*. Switching to Ballet Theatre in 1943, he created the role of "the First Sailor" in Jerome Robbins' *Fancy Free* (1944), and a feature part in his *Interplay* (1945), and in George Balan-

chine's *Waltz Academy* (1944). He also performed in the company premiere of David Lichine's *Graduation Ball*, and in productions of Massine's *Aleko* and Mikhail Fokine's *Carnaval*.

Lang left Ballet Theatre to play the juvenile lead in Jerome Robbins' *Look Ma, I'm Dancing* (1948), a musical that many thought was about company director, Lucia Chase. Among the many other famous musicals in which he was cast was in the juvenile and/or dance lead in *Kiss Me Kate* (1948), staged by Hanya Holm, Robert Alton's *Pal Joey* revival (1952 and 1954), Balanchine's *Mr. Strauss Goes to Boston* (1945), the *Ziegfeld Follies of 1957*, and *Once Upon a Mattress* (1960). His appearance in the 1959 revival of Robbins' *On the Town* made him the first, and so far only, person to play principal roles in both that musical and its ballet source, *Fancy Free*. He also performed on television in variety series and specials, and on Broadway in nonmusical productions, among them the 1955 revival of Saroyan's *The Time of Your Life*.

Lang, Maria, Swedish ballet dancer; born March 21, 1948 in Stockholm. Trained at the school of the Royal Swedish Ballet, she danced with that company from 1965 to 1974, notably in *The Firebird*, considered her best.

She performed with the Royal Winnipeg Ballet for a season, then joined the Australian Ballet in 1974. With that company, she has been featured in Robert Helpmann's production of *The Merry Widow*, in the Cranko version of *Romeo and Juliet*, and the company revivals of Frederick Ashton's *Les Deux Pigeons* and *Monotones*.

Lang, Pearl, American modern dancer and choreographer; born Pearl Lack, May 29, 1922 in Chicago, Illinois. Raised in Chicago, she studied with Nicholas Tsoukalas and in the Federal Dance Project directed by Ruth Page before moving to New York to work with Martha Graham. In the Graham company from 1941 to 1955, she created roles in *Punch and the Judy* (1941, as Pearl Lack), *Deaths and Entrances* (1943), *Appalachian Spring* (1944), *Dark Meadow* (1946), *Night Journey* (1947), *Diversion of Angels* (1948), *Canticle for Innocent Comedians* (1952), *Ardent Song* (1954), and *Adorations* (1975), for which she returned to the company. She took over the Graham

roles in two early works—"Three Marys" in *El Penitente* and "The Wife" in *Appalachian Spring*—and has performed her solos in concert in the 1970s. Lang also had a successful theater career, serving as Agnes De Mille's assistant and dancing in her *One Touch of Venus* (1943), *Carousel* (1945), and *Allegro* (1947), for Michael Kidd in *Finian's Rainbow* (1947, as "Susan") and for Helen Tamiris in *Touch and Go*.

She has choreographed, since the early 1950s, for her own company and for students at Jacob's Pillow and the American Dance Festival. Her works are frequently based around a theme, although only a few have plots. The pieces seem sometimes to be about movement as a force, as a statement of emotion and as sentiment itself. Her *Shirah* (1960), and the Chassidic pieces, among them the two versions of *The Dybbuk*, make movement a representation and a cause of faith and joy. Lang frequently uses dancers from other technical backgrounds in her company, including ballet dancers Bruce Marks, William Carter, and Alexander Minz, and theatrical performers Kevin Carlisle and Paula Kelly, as well as a stock of highly trained dancers from a Graham background similar to her own.

Works Choreographed: CONCERT WORKS: *Song of Deborah* (1949); *Legend* (1951); *Moonsong* (1952); *Ironic Rite* (1952); *Windsong* (1952); *Rites* (1953); *And Joy Is My Witness* (1955); *Juvenescence* (1956); *Three at a Phantasy* (1956); *Persephone* (1957); *Nightflight* (1958); *Black Marigolds* (1960); *Shirah* (1960); *Sky Chant* (1960); *Apassionada* (1962); *Broken Dialogues* (1963); *Shore Bourne* (1964); *Remembered Fable* (1965); *Piece for Brass* (1969); *Tongues of Fire* (1969); *Sharjuhm* (1971); *The Encounter* (1972); *Two Passover Celebrations* (1972); *Moonways and Dark Tides* (1972); *"At This Point in Time . . ."* (1974); *The Possessed* (1975); *Prairie Steps* (1975); *Plain Song* (1975); *Kaddish* (1977); *I Never Saw Another Butterfly* (1977); *Roundelays* (1977); *Icarus* (1978); *Cantigas Ladino* (1978); *Noches Noches* (1979).

THEATER WORKS AND PAGEANTS: *Judith* (1956); *Miriam's Song* (1959); *Sabbath Song* (1959); *Three Chassidic Dances* (1962); *Murder in the Cathedral* (1966); *Song of Deborah* (1968); *Had Gadyo* (1973); *Prayers at Midnight* (1973).

TELEVISION: *Parable for Lovers* (*Look Up and Live*, CBS, 1956); *Rites* (*Look Up and Live*, CBS, 1956); *And Joy Is My Witness* (*Frontiers of Faith*, CBS, 1957); *Prayer to the Dark Bird* (*Directions*, ABC, 1966); *Two Songs in Dance* (*Directions*, ABC, 1970).

Langford, Bonnie, English child star and tap dancer; born 1965 in Twickenham, England. Langford began her dance studies with her mother, Barbette Palmer, and made her professional debut with her precision children troupes in pantomimes. She has continued her training at the Arts Educational School and the children's division of the Royal Ballet School. After many years playing animals, jewels, and flowers in pantomimes, she made her ballet debut as a "Marionette" in Rudolf Nureyev's production of *Don Quixote* for a London engagement of the Australian Ballet. She was "Bonnie Butler" in Joe Layton's musical stage version of *Gone With the Wind*, while making frequent appearances on English television as a modernized Shirley Temple–type hoofer. Her most popular characterization on stage has been the youngest metamorphosis of "Baby June" (Hovack) in the musical *Gypsy* (in the Angela Lansbury revival of 1977). She opened the marvelous show with the first version of "Let Me Entertain You" as a second-rate Temple imitation, enlivened with her extraordinary energy and talent.

Lanner, Josef Franz Karl, Austrian nineteenth-century composer; born April 1801 in Oberdöbling; died April 14, 1843 in Vienna. As the Kapellmeister of a Regimental ensemble, Lanner composed more than two hundred waltzes, landler, polkas, and marches. An influence on, and rival to, the Strauss family, he may be more correctly thought of as the Viennese Sousa, writing occasional pieces for both court and military entertainments. Like the Strausses, however, he wrote both original melodies and adaptations of popular and folk tunes within the strictures of the dance and musical forms. His music is as easy to listen to and as complex to analyze as his rivals' and deserves its continuing popularity.

After Lanner's early death, he was succeeded by his son, Auguste, who was to have an even shorter life, dying at age twenty-one. Lanner's daughter,

Katti, perhaps the most influential female choreographer of the nineteenth century, is discussed below.

Lanner, Katti, Austrian ballet dancer and ballet and theatrical choreographer working in England after 1875; born September 14, 1829 in Vienna; died November 15, 1908 in London. The daughter of waltz composer, Josef Lanner, she was trained in Vienna at the Court Opera School of Ballet, where she studied with Pietro Campilli. She made her debut at the Court Opera in August 1845, performing an anonymous pas de deux inserted into Antonio Guerra's *Angelica*. Her career at the Court Opera progressed rapidly in the 1840s and 1850s; she performed her first "Fenella" in *La Muette de Portici* in August 1847 and her first "Myrthe" in the June 1852 revival of *Giselle*. In July 1854, she was chosen by Auguste Bournonville to perform a featured role in his revival of *The Toreodor*.

Lanner left Vienna for Berlin in 1856, where she performed her first "Giselle" in December. Over the next eight years, she performed in court operas and state theaters across Germany, ending in a two-year tenure at the Hamburg State Theater, where she did her first credited choreography, including *Uriella, der Daemon der Nacht* (The Demon of the Night) (1862) and *Die Rose von Sevilla* (The Rose of Seville) (1862). Her later tours took her to London, where she was ballet master of the opera company at Her Majesty's Theatre, and the United States, where she performed at Niblo's Garden (c.1871–1874) and served as ballet master of the Stadttheater of New York. In New York, she also worked with Augustyn Daly on at least one production, his August 1873 *A Midsummer Night's Dream*.

Lanner retired from performing in 1875–1876, accepting the joint assignments of ballet master of Her Majesty's Theatre (c.1877–1881) and director of its National Training School, a system of free scholarships to young English women who then became "indentured" to perform with the operas produced at the Theatre. Her importance as a choreographer came from her work with this company and, from 1887, with the Empire Theatre, London.

The thirty-six productions that Lanner staged for the Empire Theatre were thematic revues with ballets, chorus sequences, interpolated dance numbers ranging from eccentric clog work, for Willie Warde among others, to romantic pas de deux, for dancers including Emma Palladino, Maria Guiri, Enrico Cecchetti, and Luigi Albertieri, and the three ballerinas most associated with her—Francesca Zanfretta, Malvina Cavallazzi, and Adelina Genée. As staff ballet master and choreographer, she was able to work consistently with the design team, headed by C. Wilhelm, and the composers to create productions that are considered the height of English popular theater. The manipulation of theatric material, especially, was a contribution of Lanner and Wilhelm to the progress of musical theatre in England.

Works Choreographed: CONCERT WORKS: *Uriella, der Daëmon der Nacht* (The Demon of the Night) (1862); *Die Rose von Sevilla, oder Ein Abend bei Don Bartolo* (1862, possibly a pantomime version of *Il Barbiere de Seville*); *Sitala, das Gaukler-Mädchen* (The Juggler) (1863); *Asmodeus, oder Der Sohn des Teufels auf Reisen* (The Son of the Devil on a Trip) (1863); *Azrael* (1873); *Ahmed* (1874); *Les Nymphs de la Forêt* (1877); *Une Fête de Pêucheurs à Pausilippe* (1877); *Les Papillons* (1878, possibly a version of divertissement produced for United States tour).

THEATER WORKS: *A Midsummer Night's Dream* (1873, incidental dances only); *Dilara* (1887); *The Sports of England* (1887); *Rose d'Amour* (1888); *Diana* (1888); *The Duel in the Snow* (1889, co-choreographed with Paul Martinetti); *Cléopâtre* (1889); *The Paris Exhibition* (1889); *A Dream of Wealth* (1889); *Cécile* (1890); *Dolly* (1890); *Orfeo* (1891); *By the Sea* (1891); *Nisita* (1891); *Versailles* (1892); *Round the Town* (1892); *Katarina* (1893); *The Girl I Left Behind Me* (1893); *La Frolique* (1894); *On Brighton Pier* (1894); *Faust* (1895); *La Danse* (1896); *Monte Christo* (1896); *Under One Flag* (1897); *The Press* (1898); *Alaska* (1898); *Round The Town Again* (1899); *Sea-Side* (1900); *Les Papillions* (1901); *Old China* (1901); *Our Crown* (1902); *The Milliner Duchess* (1903); *Vineland* (1903); *High Jinks* (1904); *The Dancing Doll* (1905); *The Débutante* (1906); *Sir Roger de Coverly* (1906).

Lany, Jean-Barthélemy, French eighteenth-century ballet dancer and choreographer; born March 29, 1718 in Paris; died there on March 29, 1786. The son of Jean Lany, Jean-Barthélemy was trained by him

and may also have studied at the Académie Royale de Danse. Lany, *le jeune*, made his debut with the Paris Opéra in c.1740; after working in other Paris theaters and in Berlin, he returned to the Opéra and remained with the company primarily as a comic and character dancer until his death.

During 1743 Lany left the Opéra to perform and choreograph for a company of actors and dancers at the Foire St. Laurent—a group that formed the nucleus of the Opéra Comique. The satirical ballets created for this company by Lany, Louis Dupré, and according to some sources, Marie Sallé, combined the developing classical ballet technique with the formats of the Italian *commedia* and French fair popular performers. The best known of these ballets, *L'Ambingu de la Folie, où le Ballet des Dindons* (1743), was a direct satire of Rameau's *Les Indes Galants* (1743), still a popular work in the repertory of the Paris Opéra.

When the Foire St. Laurent company was suppressed at the end of the season, Lany took some of his dancers, including his sister Madeleine and Jean-Georges Noverre, to Berlin where he served as ballet master to the court of Frederick the Great for four years.

Lany returned to Paris and the Opéra in 1747 as assistant to Louis Dupré, then Maître de Ballet. Still dancing in 1765, he created roles in Jean Baptiste Deshayes' *Les Amours du Tempé* and the Lavals' *Silvie* in that year. His own works for the company included *Les Fêtes d'Amours et de l'Hymen* (1748), *Les Surprises de l'Amour* (1757), and *Les Paladins* (1760).

Lany's students and protégés, who included Noverre, Maximilien Gardel, and Jean D'Auberval, formed the ballet during the transition period between the classic and romantic eras in France and England.

To this day the ideal of a comic dancer, Lany's importance as a choreographic influence and teacher still needs to be investigated.

Works Choreographed: CONCERT WORKS: *Le Coq du Village* (1743, co-choreographed with Louis or Jean Dupré Jean Marie Sallé); *L'Ambigu de la Folie, où le Ballet des Dindons* (1743, co-choreographed with Louis Dupré and possibly Marie Sallé);

Catone in Utica (1744); *Armino* (1745); *Pygmalion et Psyche* (1745); *Adriano in Siria* (1745); *Demofoönte, Re de Tracia* (1746); *Les Fêtes d'Amour et de l'Hymen* (1748); *Platée* (1749); *Zoroästre* (1749); *La Guirlande, où Les Fleurs Enchanteés* (1751); *Les Surprises de l'Amour* (1757); *Les Paladins* (1760).

Lany, Louise-Madeleine, French eighteenth-century ballet dancer; born 1733 in Paris; died there in 1777. Daughter of Jean Lany and sister of Jean-Barthélemy, she was trained at the school of the Paris Opéra, then the Académie Royale de Musique. Apart from a brief tenure in Kassel working for her brother, she remained at the Opéra from 1744 until her retirement in 1767.

A popular dancer of delicacy and brilliant technique, she was given featured roles in many works at the Opéra and in court performances, among them *Les Amours de Tempé* (1752), and Antoine and Michel Laval's *Anacréon* (1754), *Amneris* (1762), and is *La Coquette trompée* (1752).

Lapzeson, Noemi, Argentinian modern dancer and choreographer also working in the United States and England; born June 28, 1940 in Buenos Aires. Lapzeson was trained locally in eurythmics and in ballet by Ana Stelamn. She moved to New York to attend the Juilliard School and, after returning briefly to Argentina, to study at the Martha Graham school. A member of the Graham company from 1961 to 1968, she was cast in many roles in which her strength enabled her to play archetypical parts suitable to much older performers, among them "Joan the Martyr" in *Seraphic Dialogues* and "The Pioneer Woman" in *Appalachian Spring*. Other credits included Graham's *A Time of Snow* (1968), *Cortege of Eagles*, *Secular Games*, and *Diversion of Angels*, and roles in works by fellow performers, such as Richard Kuch's *The Brood* (1968, based on Brecht's *Mother Courage*) and Bertram Ross' *Holy Holy, Triangle, Untitled*, and *Break-Up* (all 1966). In 1968, she left New York to work with the London Contemporary Dance Theatre, which was then considered a Graham satellite troupe. She taught there, choreographed, and performed in works by its co-directors, Robert North and Robert Cohan. Her solo in a wheelchair in Co-

han's *People Alone* (1971) was cited by critics for special commendation.

Works Choreographed: CONCERT WORKS: *Cantabile* (1971); *One Was the Other* (1972); *Conundrum* (1972).

Larionov, Mikhail, Russian painter and designer; born May 25, 1881 in Tiraspol; died April 10, 1969 in Fontenay-aux-Roses, France. A futurist painter and, with Nathalie Gontcharova, the principal designer in the "Rayonisme" movement of theatrical design, he is best known for his work on productions of the Diaghilev Ballet Russe. His Diaghilev works included Leonid Massine's *Soleil de Nuit* (1915), *Kikimora* (1916), and *Les Contes Russes* (1917), Taddeo Slavinsky's *Chout* (1921), which he supervised, and both the Nijinska original and Lifar revival of *Renard* (1922, 1929).

Bibliography: Larionov, Michel. *Diaghilev et les Ballets Russe* (Paris: 1970); Loquine, Tatiana. *Gontcharova et Larionov* (Paris: 1971).

Larkin, Moscelyne, American ballet dancer; born 1925 in Miami, Oklahoma. After early training with her mother, Eva Matlogova, she moved to New York to work under Mikhail Mordkin, Anatole Vilzak, and Vincenzo Celli. A member of the Original Ballet Russe from 1941 on, she was known for her performances in the company's productions of Mikhail Fokine's *Paganini* and *Les Sylphides* and Leonid Massine's *Le Beau Danube*, *Symphonie Fantastique*, and *Les Présages*. The style and purity of technique which she brought to George Balanchine's *Concerto Barocco* and *Night Shadow* could also be seen in her comedy roles in Agnes De Mille's *Rodeo* and David Lichine's *Graduation Ball*. She repeated many of her roles for the Ballet Russe de Monte Carlo after 1948, adding performances in that troupe's versions of *Swan Lake* and *Giselle*. With the Alexandra Danilova tour of 1956, she was featured in Balanchine's *Cotillion* and created a role in Michael Maule's *The Carib Peddler*.

After ballet performances at the Radio City Music Hall, she and her husband, Roman Jascinsky, left New York to found the Tulsa Civic Ballet and School. She was reunited with fellow Ballet Russe dancers, Yvonne Chouteau, currently with the Oklahoma City Civic Ballet, and Maria and Marjorie Tallchief, for the Oklahoma Indian Ballerina Festival of 1967.

La Roy, Rita, Canadian vaudeville dancer and film actress working in the United States; born Ina La Roi Stuart, c.1909, either in Paris, as she has stated, or in British Columbia. The details of La Roy's early life, as promulgated in Hollywood fan magazines, are so fantastic as to be denied credence. It is likely that she was trained by her mother in or near Vancouver, but less probable that her mother was a ballerina from the Paris Opéra who had eloped with the illegitimate son of a Scottish earl. La Roy emigrated to the United States in the mid-1920s and began a two-year engagement on the Pantages and Orpheum theater circuits out of Seattle and Tacoma, Washington. Three of her solo dance specialties were especially popular along the Pacific Coast circuits—the grotesque *Frog Dance*, her version of the *Peacock Dance* (a standard in vaudeville since 1915), and her unique *Cobra Dance*, in which her feet and legs were tied together underneath a stylized snake skin so she could undulate only with her torso. Her appearances in the Los Angeles–area vaudeville and Prolog houses led to a contract with Paramount Films in 1927. She appeared in dozens of short subjects as a specialty dancer, including her own series of seven-minute films. Her feature appearances were limited to the many musical revues that the studio put out in their early sound era and to cameos in Cecil B. De Mille biblical orgies, most notably in the 1933 *Song of Songs*. La Roy's contralto voice worked against her acting style and she was dropped from the studio roster at the end of her contract.

Larsen, Gerd, Norwegian ballet dancer working in England from 1938; born February 20, 1921 in Oslo, Norway. After moving to London to study with Margaret Craske, the celebrated expert on Cecchetti technique, Larsen performed with Antony Tudor in his short-lived London Ballet. She performed "La Fille de Terpsichore" (the French Ballerina) in the original production of *Gala Performance*, and roles in his

Soirée Musicale, Judgement of Paris, Dark Elegies, and *The Planet.*

Dancing with the Sadler's Wells Ballet in Ashton's *Persephone* (1961) and in his *Les Patineurs* and *Nocturne,* Larsen developed into a highly dramatic dancer, noted for her mime and characterizations. Since retirement, she has served as senior company teacher for the Royal Ballet, training younger dancers in those rare performance arts.

Larsen, Niels Bjørn, Danish ballet dancer, mime, and choreographer; born October 5, 1913 in Copenhagen, Denmark. Larsen was trained at the school of the Royal Danish Ballet, entering the company in 1933.

After spending two seasons with Trudi Schoop's company, perfecting his mime work in her *Want Ads* and *Fridolin on the Road,* he returned to the Royal Danish Ballet in 1937. Celebrated for his performance as "Dr. Coppelius" and for his characterizational work in the Bournonville repertory, he has also been featured in Leonid Massine's *Symphonie Fantastique,* Harald Lander's *Qarrtsiluni,* and Frederick Ashton's *Romeo and Juliet.*

As ballet master of the Royal Danish Ballet from 1951 and director from 1961 to 1965, he created many ballets, among them the popular *Tivoliana* (c.1957) and *Til Eulenspigel* (1954). He also served as director of the Pantomime Theater of the Tivoli Gardens from 1966. As well as teaching and choreographing in Denmark, Larsen and his daughter, Dinna Bjørn, spent the 1979–1980 Bournonville Centennial year touring with a fascinating presentation and lecture-demonstration of nineteenth-century mime techniques.

Works Choreographed: CONCERT WORKS: *Til Eulenspiegel* (1954); *Vision* (1957); *Tivoliana* (1957); *Columbine og Anderumpan* (1958); *Peter and the Wolf* (1959).

La Rue, Grace, American theatrical performer of the early twentieth century; born c.1883; died March 12, 1956 in Burlingame, California. A staple of Broadway productions for almost twenty years, La Rue first came to critical acclaim in the *Blue Moon,* a popular 1906 musical at the Casino Theater. After appearing in the first two editions of the Ziegfeld

Follies, 1907 and 1908, she returned to musicals in *Molly May, Mme. Troubadour* (both 1910), and the popular *Betsy* (1911). For much of the rest of her career, she alternated between vaudeville tours and specialty acts in Broadway's annual revue series, most notable the *Hitchy-Koo of 1917,* the *Greenwich Village Follies of 1928,* and the celebrated *Music Box Revue of 1922.* In that edition of the Irving Berlin revue, she was the focus of two musical numbers in which the scenery and costume designers stole the show from her. Actually, both of her specialty numbers used the same *schtik*—a costume that grew until it became an element of scenery. The second one, "Crinoline Days," used a stage elevator to enlarge her skirt until it filled the stage.

Laskey, Charles, American modern, ballet, and theatrical dancer; born c.1911 in Montclair, New Jersey. One of the most versatile performers in dance, Laskey was a featured modern and ballet technician with a healthy Broadway and film career. Originally trained at the New York Denishawn School under Doris Humphrey and Charles Weidman, he performed with the Humphrey/Weidman Group from 1928 to 1932, with featured roles in the premieres of her *The Shakers* (1931) and *Lysistrata* (1930), and his *The Happy Hypocrite* (1931). Laskey also danced with the Neighborhood Playhouse group led by Bird Larson and with the Dance Centre company of Senia Gluck-Sandor, most notably in the latter's *Salome* and *Petrouchka* (both 1931).

Laskey became one of George Balanchine's first American students and featured dancers in 1934. As the principal male dancer of the American Ballet, Laskey created important roles in most of Balanchine's early American works, among them, *Serenade* (1934), as the soloist in the Elegy section, *Alma Mater* (1934), as "The Hero," in *Errante* (1935, first American performance), *Reminiscence* (1935), *Dreams* (1935, U.S. premiere), *Transcendence* (1935), *Mozartiana* (1935), *Concerto* (1936), *The Bat* (1936), and *The Triumph of Bacchus and Ariadne* (1948) for the later company, Ballet Society. In Ballet Caravan, a cooperative company made up of American Ballet members, Laskey performed in Lew Christensen's *Encounter* (1936) and William Dollar's *Promenade* (1936).

Also serving as Balanchine's principal male performer, Laskey partnered Vera Zorina in many of her film and stage vehicles, among them, *I Married an Angel* (1938) and *Louisiana Purchase* (1940) on Broadway. Their films together include *Goldwyn Follies* (MGM, 1937), *On Your Toes* (MGM, 1937), *I Was an Adventuress* (Twentieth-Century Fox, 1940), and *Louisiana Purchase* and *Star Spangled Rhythm* (Paramount, 1941). Laskey also worked for other Broadway choreographers with ballet backgrounds, among them Agnes De Mille, in the national company of *Oklahoma* (1940), and Albertina Rasch, in the revival of *Marinka* (1945).

Last, Brenda, English ballet dancer; born April 17, 1938 in London. Trained originally by Miss Biddy Pritchard, she continued her studies at the school of the Royal Ballet.

A member of the Western Theatre Ballet from 1957, she has performed in works by Peter Darrell, among them his *A Wedding Present*, and in a revival of Fokine's *Carnaval*. In the touring company of the Royal Ballet, she created roles in Frederick Ashton's *Sinfonietta* (1967) and *The Creatures of Prometheus* (1970), and in Joe Layton's *The Grand Tour* (1971), with featured roles in Ashton's *Les Deux Pigeons* and *Coppélia*. She also danced for Ashton as "The Black Berkshire Pig" in his film *Tales of Beatrix Potter* (EMI, 1971).

Last has served as ballet master of the New Group of the Royal Ballet since 1974.

Lathrop, Welland, American concert dancer and choreographer on the West Coast; born 1906 in upstate New York; died February 24, 1981 in San Francisco, California. Originally an art student in Rochester, New York, he received some dance training from Lore Feja, a Mary Wigman student, while teaching in the design department of the Cornish School in Seattle, Washington. By the early 1930s, he was choreographing at the Cornish School for a company that included Maxine Cushing and Nina Fonaroff.

He left Seattle to study at the Neighborhood Playhouse in New York with Martha Graham and Louis Horst, whose assistant he became. He danced with the Graham company from 1938 to 1945 while pre-

senting recitals alone and with Nelle Fisher. Among his best known works of the period were the *Drawing Room Comedy* (1943), *Festival Dances for the Revival of Spring* (1943), and *Wine Song from Poems by Li Po* (1945). After dancing on Broadway in Jerome Robbins' *On the Town* (1945), he moved to San Francisco where he taught until his death thirty-five years later. He ran his own studio until 1964, also teaching at San Francisco State University from 1956; after retiring from dance, he taught art there.

Teaching on his own, and in workshops with Ann Halprin, Lathrop had a tremendous influence on the development of a separate modern dance style on the West Coast. Among his many students were Cliff Keuter and Nancy Meehan; dancer-choreographers who worked at the Halprin-Lathrop workshops include James Waring, Yvonne Rainer, and Trisha Brown.

Works Choreographed: CONCERT WORKS: *Chorale* (1933); *Adagio* (1933); *Ballade* (1933); *Earth Song* (1933); *Andante con Moto* (1933); *Agitato* (1933); *Suite (Allegro, Folk Song, Vivo)* (1933); "*Quos Ego . . .*" (1933); *Dances in Miniature* (1935); *Suite in the American Style* (1935); *Exodus* (1935); *Dances Based on Stephen Foster Melodies* (1935); *Three Characters for a Passion Play* (1941); *Prelude* (1941); *Two American Portraits (The Puritan, Johnny Appleseed)* (1941); *This Is My Birthday* (1941); *Idyll—About a Little Man* (1941); *Drawing Room Comedy* (1943); *Harlequin* (1943); *Festival Dances for the Revival of Spring* (1943); *Legend of the Navaho* (1945); *Wine Songs for Poems by Li Po* (1945); *Jacob* (1949); *Partita in D Major* (1950); *Cantos on "The Chinese Flute"* (1951); *Cry* (1952); *The Enchantment of Alonzo Quixano* (1955); *Do Not Go Gentle into That Good Night* (1958); *The Thing That Wasn't There* (1958); *Winter Song for Spring* (1961); *L'Histoire du Soldat* (1961).

Latimer, Lenore, American modern dancer; born July 10, 1935. Latimer was trained at the Juilliard School in New York. While maintaining an extensive teaching career through which she has trained students at the Third Street Music School, the Clark Center for the Performing Arts and Bard College, Latimer has performed with a wide variety of modern dance companies and concert groups. She has ap-

peared with the José Limón company in his *Missa Brevis*, with Anna Sokolow's group in her *Lyric Suite* and *Déserts*, and with the Dance Theatre Workshops troupe in Art Bauman's *Approximately 20 Minutes* (1970), Jeff Duncan's *Resonances, Statement,* and *Winesburg Portrait*, Deborah Jowitt's *Palimpest* (1969), and Frances Alenikoff's *Apples in Eden's Expressway* (1970).

Lauchery, Etienne, French nineteenth-century choreographer working in Germany; born September 1732 in Lyon; died January 5, 1820 in Berlin. It is not certain with whom Lauchery studied in Lyon before accepting an engagement to join the ballet troupe in Mannheim, the cultural capital of the Palatinate. While Mannheim was never an especially important dance capital, as court dancing master, Lauchery was a member of the staff that included the famous Mannheim orchestra. He served in a similar capacity for the Court theater of Kassel (capital of Westphalia) from 1764 to 1772, presenting, among other ballets, his celebrated *Les Arts Protégés par le Genie de la Hesse* (1769). A congratulatory work in praise of his employer, the latter included many of the elements that, depending on chronological biases, can be seen as typical of masques or *ballets d'action*. After further tenures in Mannheim, where he overlapped Wolfgang Amadeus Mozart's engagement as court musician, and in Kassel, he worked in Berlin from the late 1780s until his death in 1820.

Although Lauchery has never been studied in detail, his extant titles (comprising less than one-tenth of his estimated output), are fascinating. He seems to have worked in every contemporary genre, creating pieces on mythology, Roman history, tales of the Crusades, and village pastorales, as well as topical pageants in praise of his employers. Even apart from the link to the Mannheim orchestra, it seems obvious that an analysis of Lauchery's choreography could tell us a great deal about the process and business of producing works on demand in the eighteenth and early nineteenth centuries.

Lauchery was the father of Albert Lauchery (born 1779 in Mannheim; died 1853 in Berlin) who was noted for his performances with the Berlin Court Opera in works by his father and by Antoine Titus. He taught at the school attached to that company from the very early 1800s until his death in 1853, turning out three generations of dancers for the German and European ballet.

Works Choreographed: CONCERT WORKS: *Acis et Galatéa* (c.1764); *Achilles und Ulysses auf der Insel Scyros* (c.1766); *Les Arts Protégés par le Génie de la Hesse* (1769); *La Foire du Village Hessoie* (1772); *Médée et Jason* (1772); *Roger dans l'Île d'Alcide* (1772); *L'Embarquement pour Cythère, ou le Triomphe de Venus* (1775); *La Descente d'Hercule aux Enfers* (1780).

Laurel, Kay, American film and theatrical dancer; born Kay Leslie, c.1897 in Pittsburgh, Pennsylvania; died during the Spring of 1925 in Paris, France. Laurel was the original of the persistent legend of the *Follies*—she really was a switchboard operator before becoming an "A" dancer, a Ziegfeld-picked show girl. She appeared in the roof garden's *Midnight Frolics* of 1915 to 1918 and the *Follies* of 1916 through 1918, performing primarily in the tableaux staged by Ben Ali Haggin and in the large multi-chorus numbers staged by Ned Wayburn. In the 1915 *Frolics*, for example, she was "The Spirit of Peace," while in the 1918 *Follies* (after the United States abandoned peace to enter World War I), she depicted "France" in the "Parade of Our Allies."

Despite her blonde beauty, her film performances were in "ethnic" roles; her most successful motion pictures were *The Valley of the Giants* (Famous Players/Laskey, 1919) and *The Lonely Heart* (Pickford Productions–Famous Players/Laskey, 1920), in both of which she played Native Americans. She left Hollywood in 1921, perhaps because of her casting difficulties, to enter into vaudeville as a solo ballroom specialist and vocalist. Her act was unsuccessful, however, and she began to work with stock companies on the East Coast while appearing in New York–made film serials. It has never been determined what she was doing in Paris when she died under suspicious circumstances, but it has been suggested that she was there attempting to enter the exhibition ballroom field.

Laurencin, Marie, French theatrical designer and artist; born c.1885 in Paris; died there June 9, 1956. Laurencin's textural pastels were popular in Paris when Serge Diaghilev asked her to design costumes for Bronislava Nijinska's *Les Bîches* in 1924. Her

costumes for two characters—the tunic for the androgynous "La Garçonne" and the seemingly conventional dress, pearls, and cigarette holder for the hostess at the imaginary party—were controversial and popular. While pursuing a successful career in art, she also designed Leonid Massine's *Les Roses* (1924) and Roland Petit's *Le Déjeuner sur l'Herbe* (1945), both based on street clothes rather than the conventional ballet silhouettes.

Lauret, Jeannette, French ballet dancer working in the United States after the mid-1930s; born c.1910 in France, possibly in Paris. Trained at the school of the Paris Opéra, Lauret performed with the Opéra-Comique before joining the Ballet Russe de Monte Carlo (De Basil) in 1936. Associated with the works of Leonid Massine, she was featured in his *Nobilissima Visione* and *Seventh Symphony*, and in Mikhail Fokine's *Don Juan* and *Schéhérézade*.

A member of Ballet Theatre after 1949, she was known for her performance as "Zobeida" in that company's production of *Schéhérazade*, and as "Eleanore" in Fokine's *Bluebeard*. She also performed in the works of Antony Tudor, being especially noted for her work in his *Judgment of Paris* and other comic ballets.

After retiring from performance, Lauret taught in the Stamford, Connecticut area.

Laval, Antoine Bandiéri , French eighteenth-century ballet dancer and choreographer; born 1688 in Paris; died there October 20, 1767. Trained at the Academi Royal de Musique, Laval made his Paris Opéra debut in 1706. Among the works in which he danced there were Louis Pécour's *Apollon Legislateur* (1711) and Jean Balon's *l'Inconnue* (1720) and *Les Eléments* (1721).

Named ballet master in 1739, Laval staged many works for the Opéra both alone and with his son, Michel Jean Laval. Among his solo assignments were *Anacreon* (1754), an influential work with a libretto by Cahusac, *Les Festes de l'Hymen et de l'Amour* (1747), and *Zélisca* (1746). Their joint credits include many ballets, notably *Les Indes galantes* (1765), and intermezzi presented at the court theaters of Versailles and Fontainebleu.

Works Choreographed: CONCERT WORKS: (Note: only those titles marked with an asterisk were choreo-graphed alone; all others were jointly credited to Antoine and Michel Laval.) *Les Fêtes d'Hébé* (1744); *Zélisca* (1746)*; *l'Année galante* (1747)*; *Les Festes de l'Hymen et de l'Amour* (1748)*; *Les Hommes* (1753); *Les sibarites* (1753); *Anachréon* (1754)*; *Daphnis et Eglée* (1753)*; *Le Triomphe du temps* (1761); *Alphée et Aréthuse* (1762); *Amneris* (1762) *Le Dormeur eveillé* (1765); *Le Triomphe de Flore* (1765); *Thésée* (1765); *Zénis et Almasis* (1765); *Palmire* (1765); *Les Sauvages* (1765); *Prologues des Indes galantes* (1765); *Les Incas du Péron* (1765); *Prologues des Amours des dieux* (1765); *La Fée Urgele* (1765); *Thétis et Pélée* (1765); *Erosine* (1765); *Silvie* (1765).

Laval, Michel Jean, French eighteenth-century ballet dancer and choreographer; born c.1725 in Paris; died there in 1777. The son of Antoine Bandiéri Laval, he was trained at the school of the Paris Opéra and performed with the company from 1740. Since so many of the works in which he was cast as a principal were produced in the latter part of his career, he may have been a mime specialist or character dancer.

Laval is best remembered for his many ballets choreographed for the Opéra and for court performances. Most of them were co-created with his father, but in the 1770s, after Antoine's death, he received solo credits for four works.

Works Choreographed: CONCERT WORKS: (Note: only those titles marked with an asterisk were choreo-graphed alone; all others were jointly credited to Antoine and Michel Laval.) *Les Fêtes d'Hébé* (1740); *Les Hommes* (1753); *La Coquette trompé* (1753)*; *La Naissance d'Osiris* (1754)*; *Le Triomphe de temps* (1761); *Alphée et Aréthuse* (1762); *Amneris* (1762); *Le Dormeur éveillé* (1765); *Le Triomphe de Flore* (1765); *Thésée* (1765); *Zénis et Almasis* (1765); *Palmire* (1765); *Les Sauvages* (1765); *Prologues des Indes galantes* (1765); *Les Incas de Péron* (1765); *Prologues des Amours des dieux* (1765); *La Fée Urgele* (1765); *Thétis et Pélée* (1765); *Erosine* (1765); *Silvie* (1765); *La tour enchantée* (1770)*; *Arglé* (1770)*; *Castor et Pollux* (1770)*; *Bacchus et la Minéide* (1773)*.

Lavarre, Marie, American theatrical dancer; born Marie Lavarre Marcelle, c.1890 in Calais or Le Havre, France. The daughter of Jo-Jo, The Dog-

Faced Boy and Mlle. Marcelle (of the Trained Cockatoos), both of Barnum's Circus troupe, Lavarre performed as a child with her mother. After working in a dance act in which she performed on a revolving ball (c.1910–1912), she made her Broadway debut in *Trop Moutard* (1913). After studying at the Ned Wayburn Studio of Stage Dancing, she was cast as a specialty dancer in Wayburn's *Town Topics of 1915*. She also danced on Broadway in *Splash Me* (1916) before returning to vaudeville. Her dance specialties included the acrobatic ball act, a soft-shoe routine staged for her by Wayburn, and a stepping dance, a semieccentric routine with off-rhythm balances and poses.

After 1917, Lavarre performed primarily as a vocalist.

Lavery, Sean, American ballet dancer; born August 16, 1956 in Harrisburg, Pennsylvania. Following his local studies, Lavery continued his ballet training with Barbara Fallis and Richard Thomas at the New York School of Ballet. After seasons with the San Francisco Ballet and The Frankfurt Ballet, Lavery was invited to join the New York City Ballet.

The tall dancer, who has exceptional stage presence for his age, has taken on many of the principal roles in the large Balanchine repertory, in *Symphony in C, Serenade, Concerto Barocco*, and many others. Since joining the company in the 1977–1978 season, he has created roles in dancer Jean-Pierre Bonnefous' *Pas Degas*, in *Tricolore* (May 1978), and Peter Martins' *Pas de Deux* from *A Sketch Book* (June 1978). Partnering Karin von Aroldingen, also a tall blond dancer from the Frankfurt Ballet, he performed in the premieres of George Balanchine's *Kammermusik No. 2*, an exceptionally difficult work in a dense canon of constant movements, and the romantic opening sequence of *Vienna Waltzes*, set to Strauss' *Tales of the Vienna Woods*.

Lavrosky, Leonid, Soviet ballet dancer and choreographer; born June 18, 1905 in St. Petersburg; died November 27, 1967 in Paris. Trained at the school of the Imperial Ballet in St. Petersburg, Lavrosky participated in the celebrated and/or infamous presentation of Fyodor Lopoukhov's *Dance Symphony* in 1922.

Known as a choreographer, Lavrosky served as artistic director of the Leningrad State Opera Theatre (c.1934), State Academic Theatre (1937–1944) and Mary Theatre, producing his earliest works, among them *Fadetta* (1930), *Katarina* (1935), and his revival of *La Fille Mal Gardée* (1937).

Moving to Moscow, he served as principal choreographer of the Bolshoi there (c.1944–1956, and 1960–1964), and as director of the Moscow School of Choreography. His popular *The Red Poppy* (1949), *Paganini* (1960), and *Night City* (1961) were created in Moscow. Lavrosky, probably the best known Soviet choreographer of his time, died in Paris where he was touring with a group of students from the school of choreography.

Works Choreographed: CONCERT WORKS: *Fadetta* (1930); *Katarina, the Serf Ballerina* (1935); *La Fille Mal Gardée* (1937); *Prisoner of the Caucasus* (1938); *Romeo and Juliet* (1940); *Giselle* (1944); *Raymonda* (1945); *The Red Poppy* (1949); *The Stone Flower* (1954); *Paganini* (1960); *Pages from a Life* (1961); *Night City* (1961).

Lavrosky, Mikhail Leonidovich, Soviet ballet dancer; born 1941 in Tbilisi. The son of Leonid Lavrosky, he was trained at the school of the Bolshoi Ballet in Moscow and performed with that company from 1961 on.

He has created roles there in Kasyan Goleizovsky's *Leili and Mejnun* (1964), and Grigorovich's *Legend of Love* and *The Nutcracker* (1966). Partnering Natalia Bessmertnova, he has performed the principal roles in the company's productions of all the classics, among them, *Giselle, Don Quixote, Cinderella,* and *Swan Lake.*

Law, Evelyn, American theatrical dancer known for the height of her hitch kick; born 1904 in Brooklyn, New York. After studying ballet locally with Katherine Constantine and William Pitt Rivers, she received tap and eccentric dance training from Ned Wayburn and took acrobatic classes with Jack Blue.

In Law's short career as a specialty dancer, from 1918 until her retirement in 1930, she appeared in many Broadway musical comedies and revues, including two *Ziegfeld Follies* (1922 and 1924) and the *Midnight Frolics of 1923*. She performed her trade-

mark—a hitch kick forward that reached to ten inches above her head—in each of her plotted shows, among them, *Two Little Girls in Blue* (1922), in which she was swung into a whirlwind by Jack Donahue, *Louie the Fourteenth* (1924), *Betsy* (1926), and *A Night in Venice* (1929). In her Ziegfeld shows and in the *Greenwich Village Follies of 1928*, she was given dance numbers that exploited her ability to perform her acrobatic specialty, notably in the Wayburn routine in the 1922 edition, appropriately titled "There's Something About Me They Like."

Law also worked as an exhibition ballroom dancer, partnered by Arthur Murray in 1924, and in films. She appeared in short subjects made by The Leventhal Music Film Corp., in 1922, among them, *Valse Ballet* and *High Kicking* (both shown at the Capitol Theater in 1922), and in feature films, *Potash and Perlmutter* (Samuel Goldwyn Productions, 1923) and *The Great White Way*, a backstage musical set at the *Follies* (Cosmopolitan Pictures, 1924).

Lawrence, Carol, American theater and television dancer, actress, and singer; born Carol Maria Laraia, September 5, 1932 in Melrose Park, Illinois. Trained by Edna MacRae in nearby Chicago, she was a member of the Chicago Opera Ballet in her adolescence. Moving to New York, she made her professional debut in the *Borscht Capades of 1951*. After doing a club act at Leon and Eddie's, she received her first Broadway credit for the *New Faces of 1952*, later performing in the film version. She appeared in the national tour of *Me and Juliet* (1954), the replacement cast of *Plain and Fancy* (1955), *Shangri-La* (1956), and the 1957 *Ziegfeld Follies* before doing her best known and remembered role, "Maria" in the original production of *West Side Story*. Despite more than twenty subsequent years of starring on stage, film, and television, she is still associated with her luminous performance in that part from 1957.

While on Broadway in the above and in *Saratoga* (1959) and *Subways Are for Sleeping* (1961), she appeared frequently on television—on variety shows filmed in New York. Since then, she has acted in dramatic roles, notably in the Play of the Week's production of *The Dybbuk*, and in musical shows. They have ranged from a presentation of *The Enchanted Nutcracker* (ABC, 1961, special), in which she danced "the Sugar Plum Fairy" and played a dramatic role, to the *NBC Follies* (1973, special), as "The Goddess of the Moon," to commercials for instant coffee.

Lawrence, Pauline, American modern dancer, designer, musician and manager; died July 16, 1971 in Stockton, New Jersey. Lawrence went to work for the Denishawn School in Los Angeles, California, as a class accompanist, but took dance classes there. After conducting for Doris Humphrey's vaudeville tour, she performed on Denishawn tours from 1923 to 1926, creating roles in Ted Shawn's *The Feather of the Dawn* (1923), *Five American Sketches: Boston Fancy, 1854* (1924), *The Bubble Dance* (1925), and *General Wu's Farewell to His Wife* (1926), and in Humphrey's *Whims* (1926). After the Oriental tour, she, Humphrey, and Charles Weidman worked at the Denishawn school in New York; she was resident pianist, costumer, and business manager. When the three split from Denishawn in 1929, she remained in those capacities for the Humphrey/Weidman Concert Group and studio. For example, she played for and designed Humphrey's *The Shakers* in 1930, and created costumes for her *Water Study* (1928), *The Pleasures of Counterpoint* (1932), *Rudepoema* (1931), *Theme and Variations* (1934), *Credo* (1934), *New Dance* (1935), *Theatre Piece* (1936), *With My Red Fires* (1936), *To the Dance* (1937), *Race of Life* (1938), *Song of the West* (1940), *Four Choral Preludes* (1942), *El Salon* (1943); *Lament for Ignacio Sanchez Mejias* (1947), *Day on Earth* (1947), *Night Spell* (1951), *Ruins and Visions* (1953), *Felipe el Loco* (1954) and many others. She also managed the Humphrey/Weidman company and organized many cooperative dance benefits and seasons. With Frances Hawkins, the Graham company manager, she is considered responsible for the organizing and unionization of concert and modern dancers in the late 1930s.

Lawrence designed for and managed the José Limón company after its founding in 1945 with Humphrey as artistic director. For Limón, to whom she was married from 1941, she created costumes for *La Malinche* (1949), *Performance* (1961), *Concerto in D Minor* (1963), *There Is a Time* (1966), *The Winged* (1972), *The Traitor* (1954), *The Exiles*

(1950), *The Visitation* (1952), and more than a score of others. Her best known work was the four costumes for *The Moor's Pavanne* (1949), which not only helped to delineate the characters and emotions of the participants in the tragedy, but also assist in the creation of the dance movements themselves by continuing and extending the dance shapes and efforts.

Although she was, to the best of my research, one of the first women to conduct in vaudeville, she was unable to continue that phase of her multifaceted career. She was, however, a tremendously important design influence on the traditional modern dance, as innovative in costuming as Jean Rosenthal was in lighting, and was a force for improvements in the economic and artistic status of the performing and creative dancer in this country.

Lawson, David, American theatrical dancer; born in Glen Cove, New York. Lawson traveled into New York City to study tap with Bob Audy and Linda Davin and jazz dance with Michael Shawn, Tony Stevens, Phil Black, Mary Jane Houdina, and acrobatics specialist Charles Kelly. After extensive stock and regional theater experience, Lawson appeared on Broadway in dance/singing roles in Gower Champion's *Rockabye Hamlet* (1976) and the highly acclaimed Angela Lansbury revival of *Gypsy*. Lawson can be seen in two Patricia Birch extravaganza musical films, *Sgt. Pepper's Lonely Heart's Club Band* and *Grease*.

Lawson, Joan, English ballet dancer, writer, and teacher; born 1907 in London. Trained with Margaret Morris and Serafina Astafieva, she danced with the (Vera) Nemtchimova/(Anton) Dolin Ballet (c.1933–1934). After teaching privately, she became a member of the advisory council on education for the armed services during World War II. She directed the course for teachers at the Royal Academy of Dancing from 1947 to 1959 and taught at the Royal Ballet Society from 1963 to 1971, specializing in mime and character work.

An editor of *The Dancing Times* from 1940 to 1954, she has published many texts and popular books on the dance, among them *Mime* (New York: 1957) and *A History of Ballet and Its Makers* (New York: 1964).

Bibliography: Lawson, Joan. *Ballet in the U.S.S.R.* (London: 1945), *"Job," and "The Rake's Progress"* (London: 1949); *Mime, The Theory and Practice of Expressing Gesture* (New York: 1957); *Dressing for the Ballet* (London: 1958); *A History of Ballet and Its Makers* (New York: 1964).

Layton, Joe, American theater and ballet choreographer; born Joseph Lichtman, May 3, 1931 in New York. Trained by Joseph Levinoff and at the High School of Music and Art, he made his Broadway debut in *Oklahoma*, before going into the Army to work in Special Services. He performed on Broadway in Jerome Robbins' *High Button Shoes* (1947) and *Miss Liberty* (1949), Agnes De Mille's *Gentlemen Prefer Blondes* (1949) and Donald Saddler's *Wonderful Town* (1953), before making his debut as a choreographer with *Once Upon a Mattress* in 1959.

Among his many successful shows were *The Sound of Music* (1959), *No Strings* (1962), which he also choreographed, *George M!* (1968), in which he had to revive George M. Cohan's dance routines for Joel Grey, and *Clams On the Half-Shell* (1975), the revue for Bette Midler in which she emerged from a giant clam shell to the jungle beats of "Oklahoma!" He was acclaimed for his handling of stars on television specials also, including the *Mary Martin Easter Show* (c.1958), a *Diana Ross Show* (NBC, 1977), and the Barbra Streisand musicals, *My Name Is Barbra, Color Me Barbra,* and *The Belle of 14th Street*. Layton has staged musicals away from Broadway also, notably the musical version of *Gone With the Wind* in Tokyo (1969) and London (1972).

In the early 1970s, Layton became known as a ballet choreographer for the first time, contributing two works on Oscar Wilde—*Double Exposure* for the City Center Joffrey Ballet and *O.W.* for the Royal (both in 1972).

Works Choreographed: CONCERT WORKS: *Grand Tour* (1971), *Overtime* (1971); *Double Exposure* (1972); *O.W.* (1972).

THEATER WORKS: *Once Upon a Mattress* (1959); *The Sound of Music* (1959); *Greenwillow* (1960); *Tenderloin* (1960); *Sail Away* (1961); *No Strings* (1962); *The Girl Who Came to Supper* (1963); *Peterpat* (1965); *Drat the Cat* (1966); *Sherry!* (1967); *George M!* (1968); *Dear World* (1968); *Scarlett* (1969, produced as *Gone with the Wind* in London,

1972); *Two by Two* (1970); *Clams on the Half-Shell* (1975).

FILM: *Thoroughly Modern Millie* (Universal, 1967).

TELEVISION: *The Mary Martin Easter Show* (NBC, 1958); *The Gershwin Years* (CBS, 1960); *My Name Is Barbra* (CBS, 1965); *Color Me Barbra* (CBS, 1966); *The Belle of 14th Street* (CBS, 1967); *Diana Ross Special* (NBC, 1977).

Lazovsky, Yurek, Polish ballet dancer; born October 29, 1917 in Warsaw; died July 6, 1980 in Los Angeles, California. After local studies with Mme. Balichevsky, Lazovsky continued his training in Paris with Olga Preobrajenska and Lubov Egorova. He performed in works by Bronislava Nijinska in her Warsaw Opera Ballet and Ida Rubinstein Ballet, before joining the Ballet Russe de Monte Carlo (1935–1941, 1944–1945). In that company, he was associated with the works of Leonid Massine, performing in his *La Boutique Fantasque, Scuola di Ballo*, and *Gaité Parisienne*, and George Balanchine, dancing in his *Cotillion* and *Mozartiana*. He also worked with Massine in his Ballet Russe Highlights company (1945–1946), creating roles in his *Premier Polka, Polish Festival, Russian Dance, At the Dentist*, and *Dancing Poodles*. Between tenures in the Ballet Russe, Lazovsky was a member of Ballet Theatre, with roles in Mikhail Fokine's *Russian Soldier* (1942) and in Agnes De Mille's *Three Virgins and a Devil*, the title role of which he repeated in the 1975 Ballet Theatre gala.

Since retiring, Lazovsky enjoyed an extensive teaching career, working at the Metropolitan Opera Ballet School, the Juilliard School, American Ballet Theatre, its second company Ballet Repertory, and the High School of Performing Arts, among others.

Works Choreographed: CONCERT WORKS: *Gopak* (1945); *Strange Sarabande* (1945, co-choreographed with Massine); *Oberek* (1960); *Carnaval* (1969, after Fokine, two versions staged in that year).

Lazzini, Joseph, French ballet dancer and choreographer, also working in Italy and Belgium; born c.1927 in Marseilles. Lazzini performed at the San Carlo Opera House in Naples before becoming ballet master of the Opéra Ballet in Liège, Belgium. His works for that theater, the Grand Théâtre de Toulouse (c.1958), and the Marseilles Opera House made him an extremely controversial figure in European dance. He has also worked for his own short-lived troupe, the Théâtre Française de la Danse (1968), the Ballet Royal de Wallonie, and, recently, the Israeli Classical Ballet. He frequently worked around elaborate space-consuming stage designs by graphic artists, among them Alexander Calder and Bernard Daydé.

Works Choreographed: CONCERT WORKS: *Till Eulenspiegel* (1954); *Symphonie Classique* (1955); *Spleen* (1955); *Remords* [sic] (1955); *Le Prisonier* (1955); *Ode des Ruines* (1955); *Le Chausseur Maudit* (1955); *Sous le Chapiteau* (1956); *Romeo et Juliette* (1956); *Orgeuils* (1956); *Le Bouffon Amoreux* (1956); *Joue de Vacances* (1956); *La Chatte* (1957); *Homage à Jerome Bosch* (1961); $E = MC^2$ (1964); *The Miraculous Mandarin* (1965); *Eppur e muove* [sic] (1965); *Ecce Homo* (1968); *La Fille Mal Gardée* (1977); *The Nutcracker* (1978).

LeClercq, Tanaquil, American ballet dancer; born October 2, 1929 in Paris, France. Raised in New York City, LeClercq was trained at the School of American Ballet and performed as an adolescent with Ballet Society. With that company, the versatile dancer created roles in George Balanchine's *The Four Temperaments* (1946), *Symphonie Concertante* (1947), *Elégie* (1948), and *Orpheus* (1948), John Taras' *The Minotaur* (1947), and Merce Cunningham's *The Seasons* (1947).

LeClercq was a member of the New York City Ballet from its first performances, dancing the roles from Ballet Society until her retirement in 1956 after contracting polio on a European tour. There is a recognizable ''LeClercq'' role in many works that remain in the company repertory. They showed off her quickness and attack, as in Balanchine's *Caracole* (1952) and *Western Symphony* (1954), and concurrent languorous extensions, as in her role in the second movement of his *Symphony in C.* She was frequently cast as a contemporary woman, as in Jerome Robbins' *Age of Anxiety* (1950), as a symbolic representation of seduction, as aggressor, as in Frederick Ashton's *Illuminations* (1950), or as victim, as in Balanchine's *La Valse* (1951). In those eight years, she created other major roles in Balanchine's *Bourée Fastasque* (1949), *Valse Fantasie* (1953), *Ivesiana* (1954), and *Divertimento #15* (1956), in Jerome Rob-

bins' *The Pied Piper* (1951), and the duet which many consider his most important work, *Afternoon of a Faun* (1953).

LeClercq currently teaches at the school of the Dance Theatre of Harlem.

Lecompte, Eugenie Anna, Belgian ballet dancer of the Romantic era; born Eugenie Martin c.1798 in Lille, then Belgium; died c.1850 in the United States, possibly in Philadelphia. The sister of Jules Martin, Lecompte was trained in Lille and Paris, making her Paris Opéra debut in 1826. Although she did not make that large an impact on Paris audiences, she obviously made a successful debut since she spent the next eight years on a touring schedule that rivals the Elsslers'. In 1828, she performed at the King's Theatre, London, in Anatole's *Hassan et le Calife* and *Phillys et Mélibée* (both 1828) partnered by Auguste Bournonville. She spent a season in Barcelona before joining the Théâtre de la Monnaie, then under Jean Petipa, to perform in Eugene Hus' *Cendrillon* (1830). She then returned to London to dance with the King's and Haymarket Theatres, notably in François Albert's *The Enchanted Ring* (1832).

In 1837, she and her brother began a series of tours of North America that would continue intermittently to her death. From their debut at New York's historic Park Theatre to the Mississippi circuit (from St. Louis to New Orleans), and in the major cities of the Northeast, including Boston and Philadelphia, the Lecompte-Martin troupes were popular and enormously influential. They brought almost the entire stock repertory of the Romantic era with them—Taglioni's *La Sylphide,* D'Auberval's *Fille Mal Gardée* (probably in the Gardel version), *La Bayàdere* and *Nathalie, La Laitière Suisse*—and employed almost every ballet-trained dancer in the country. They also imported dancers from Europe, among them, Jean Petipa and his younger son Marius, in 1839. Both she and Martin performed with Fanny Elssler on the 1841–1842 stretch of her American tour.

Although Lecompte returned to Europe at least once in 1843 to perform *Robert le Diable* in London, and possibly in St. Petersburg, she settled in the United States.

Lederer, George W., American theatrical director and producer; born 1861 in Wilkes-Barre, Pennsylvania; died October 8, 1938 in Jackson Heights, Queens, New York. Originally a stage manager, he produced almost forty musical shows on Broadway, reviving many of them in London. Many of his shows introduced major innovative elements to the musical stage. *The Passing Show* (1894) is generally considered the first revue, that is, a musical show without even the pretense of plot. Like its descendents, the Shuberts' *Passing Shows* in the 1910s, this "revue" reviewed the past theatrical season with additional allusions to politics and society.

For his *Casino Girl* (1900), Lederer was credited with introducing The Original English Pony Ballet to Broadway. This extraordinarily influential troupe was a precision team, trained by John Tiller in London, who arrived in New York for the show and stayed. Although it is not true that all line work derives from Tiller, it can be said that the arrival of this troupe urged the adoption of that style of theatrical dance on the Broadway dance directors.

His *Madame Sherry* (1910) is memorable for its use of the song, "Every Little Movement Has a Meaning All Its Own," during an onstage Delsarte class. This song became the theme for American Delsartists, among them, Ted Shawn, who used it as the title of his book on the theorist.

From *The Princess Nicotine* (1893) to *The Girl in The Spotlight* (1920), Lederer had a major influence on the American musical theater, its habits, and tastes in dance direction.

Lee, Dixie, American theater and film dancer and vocalist; born Wilma Wyatt, November 5, 1911 in Harriman, Tennessee; died November 1, 1952 in Los Angeles, California. Lee entered the theater in the traditional manner of her day—she won a Charleston and singing competition in Chicago and performed briefly in local Prologs. She then joined the national tour of *Good News* and appeared in it on Broadway in 1928.

One of the most popular dance and singing stars of the transitional film era, she appeared in almost all of the musical pictures presented by Fox Films in the early sound period, among them, *The Fox Movietone Follies* (1928), *Happy Days* (1929), *Harmony*

at Home (1929), *Let's Go Places* (1929), *Why Leave Home?* (1929), and *Cheer Up and Smile* (1930). Her marriage to Bing Crosby in 1930 slowed the progress of her career, but she returned to films briefly before retiring in 1935. Her last pictures, *Manhattan Love Song* (Monogram, 1934), *Redheads on Parade* (Fox, 1935), and *Love in Bloom* (Paramount, 1935), showed her gift for comedy and her own crooning style.

When Lee died of cancer three days before her forty-first birthday, she had been out of films for almost fifteen years, but her fans remembered her stage and film personality and mourned her loss.

Lee, Elizabeth, American ballet dancer; born in Los Angeles, California. Trained locally with Harriet De Rea, and in New York by Barbara Fallis and Richard Thomas, Lee has been associated throughout her career with choreographer Eliot Feld.

She was a member of his American Ballet Company from 1969 to 1971, creating roles in his *A Poem Forgotten* (1970), *The Consort* (1970), *Early Songs* (1970), *Cortège Parisien* (1970); *Romance* (1971), and *Theatre* (1971). A member of the American Ballet Theatre in 1968 to 1969 and 1971 to 1973, she also danced in Feld works, *Intermezzo* (1969) and *Eccentrique* (1971), and performed in works by Ballet Theatre's other choreographers-in-residence, Michael Smuin, for whom she danced in *Pulcinella Variations*, and Dennis Nahat.

When Feld established a new company, the Feld Ballet, she joined as performer and as his assistant. In the new company, she created a role in his *Sephardic Song* (1974) and performed in his revivals. A popular teacher, she has worked in the Outreach programs at the Feld company school and Nahat's Cleveland Ballet school.

Lee, Gypsy Rose, American strip-tease artist and theatrical dancer; born Rose Louise Hovick, January 9, 1914 in Seattle, Washington; died April 26, 1970, in Beverly Hills, California. Trained locally by her mother and a Professor Ballard, she performed in the "Just Sisters" act after Spring 1917 in Seattle with her sister (actress June Havoc). They toured on the Pantages and Keith-Albee-Orpheum circuits (1917–1929) in a series of feature acts, including "Baby June and Her Pals," and "Dainty June and her Newsboy Songsters," performing the latter at the Roxy Theater in New York in 1928. After Havoc left the act, Lee toured in the acts "Madame Rose's Baby Blondes" and "Rose Louise and Her Hollywood Blondes." During a performance of the latter (Kansas City, 1929), Lee made her debut as a strip tease, having been coached by Tessie, the Tassel Twirler.

Lee made her New York debut (as a strip-tease artist) in *Yetta Lostit from Monte Carlo*, produced by Billy Minsky, on April 1, 1931. She did her signature slow strip on Broadway in revues and musicals, such as *Hotcha* (1932), *Ziegfeld Follies of 1936* (1935–1937), *George White Scandals of 1937, Billy Rose's Casino de Paree* (1938), *I Must Have Someone* (replacement cast, 1939), *The Streets of Paris* (1940), *Du Barry Was a Lady* (replacement cast, 1940), *Star and Garter* (1942) and *Gay New Orleans* (1943. She was also a great success in burlesque (1929–1934), vaudeville (1938–1940, 1951–1955), and in one-woman shows in nightclubs and cabarets.

Her act was toned down considerably when she appeared in films as Louise Hovick: *You Can't Have Everything* (Twentieth-Century Fox, 1937). As Gypsy Rose Lee, she was featured in *Stage Door Canteen* (United Artists, 1943), *Belle of the Yukon* (RKO, 1944), *Doll Face* (Twentieth-Century Fox, 1945, based on her play, *The Naked Genius*), *Wind Across the Everglades* (WB, 1958), *Screaming Mimi* (Columbia, 1966), *The Stripper* (Twentieth-Century Fox, 1962), and *The Trouble with Angels* (Columbia, 1966).

She also appeared on television as talk-show hostess and performer, stressing her intelligence and wit, not her dance talents.

Bibliography: Lee, Gypsy Rose. *Gypsy* (New York: 1955). The musical comedy, *Gypsy* (book by Arthur Laurents, lyrics by Stephen Sondheim), was based on this autobiography.

Lee, Katharyn, American theatrical ballet dancer; born Kathryn Lee Scales, September 1, 1926 in Danton, Texas. Lee received most of her early training in Texas—from Inez Keith Elmore in Sherman and from Maria Domina and Alexander Oumansky in Fort Worth. While in California, she also worked with Ernest Belcher as a youngster. As an adolescent

prima ballerina at the Dallas Starlight Operetta, she was discovered and sent to an audition for the School of American Ballet. Her studies there were helpful to her career, as was the favor of auditioner Leonid Massine who cast her in principal roles in his *Daphnis and Chloe* sequence in (Vincent) *Youman's Ballet Review* (1944) and the New Opera production of *Helen Goes to Troy.* Lee was seventeen when she made her first Broadway hit as principal dancer of *Laffin' Room Only* in 1944. In the next ten years, she alternated between Broadway shows and frequent engagements as soloist and principal of the Radio City Music Hall corps de ballet, where she remained until 1958. Her dance and speaking roles in her Broadway shows grew in each engagement from specialities with bit parts in Agnes De Mille's *Allegro* (1948) and *Are You With It?* (1949). Her duet with Bill Calahan, ''Lucky in the Rain,'' was considered the high point of *As the Girls Go* (1949) and her movement and dialogue and dramatic portrayal of a dancer in *Maggie* (1953) was singled out for critical acclaim. Lee also performed frequently on television in the 1950s, both as a dancer and as a panelist on talk and game shows.

Lee, Keith, American ballet dancer and choreographer; born in the Bronx, New York. Trained at the High School of Performing Arts, he worked with the Harkness Youth Ballet before joining the American Ballet Theatre in 1969.

In Ballet Theatre until 1974, he was best known for his role in the opening sequence of Alvin Ailey's *The River* (1970). He also created roles in Lar Lubovitch's *Scherzo for Massah Jack* (1973) and *Three Essays* (1974), and performed in the company productions of *Petrouchka* and *The Sleeping Beauty.*

While in Ballet Theatre, he began to choreograph, contributing *Times Past* (1970) to the company's repertory. He has since choreographed and directed for two companies—The Ballet of Contemporary Art (1973) and the Capitol Ballet Company in Washington, D.C. (1978–).

Works Choreographed: CONCERT WORKS: *Times Past* (1970); *Our Saving Grace* (1973); *Conversation with Lotus* (1980).

Lee, Mary Ann, American eighteenth-century ballet dancer; born 1823 in Philadelphia, Pennsylvania; died, perhaps there, in 1899. Lee, like many of her native-born colleagues, was trained by Paul H. Hazard, perhaps the most influential teacher in North America in the nineteenth-century. She made her debut in Philadelphia in *The Maid of Cashmere* (1937), a version of *La Bayadère*, and performed in *La Sylphide* there and in Baltimore before moving to New York in 1839.

Her New York debut was in *La Bayadère*, in a version by Jules Martin and/or Charles Labasse, in 1839. In New York, she studied with James Sylvain (then traveling in America with Fanny Elssler's tour company) who taught her works from the Paris Opéra repertory. In 1844, she moved to Paris to study with Jules Perrot and Jean Coralli, but there is no evidence that she ever danced with the Opéra.

Returning to the United States, she formed a touring company of her own, with George Washington Smith as her partner. They presented the first American *Giselle* in 1846 (in Boston) and introduced productions of *La Jolie Fille de Gand, La Fille du Danube*, and *La Muette di Portici*, to the East Coast and Midwestern states.

She and Smith deserve more than chauvinistic praises—they brought a repertory to the United States, preparing audiences for fifty years of touring ballet. They were more than just American-born and -trained dancers; they were performers who chose to remain in the United States and develop its audiences for acceptance of the European techniques, styles, and forms.

Lee, Sammy, American theatrical and film dance director; born Samuel Levy, c.1890 in New York. Lee, who claimed to have no formal dance training, made his performing debut as an amateur at Miner's Bowery Theater, New York, in 1905. Within a few months, he had been cast as a member of Gus Edwards' child vaudeville act, The Messenger Boys, along with Bert Wheeler, Groucho Marx, and Al Shaw. He toured the United States and Europe in vaudeville in another child act, Irene Lee's Candy Kids, from 1907 to 1908. He also performed in vaudeville in a flash dance act with eccentric dancer, Al Shaw, a former Messenger Boy. A dance act with Ruby Norton led Lee to his first Broadway performances in *The Firefly*, in December 1912.

After performances in San Francisco and London, Lee staged his first Broadway show, *The Gingham*

Girl, in August 1922. A member of The Big Four group of young Broadway choreographers, Lee staged twelve more shows before moving to film work in California. These included Gershwin musical comedies, *Lady, Be Good* (1924), *Tip Toes* (1925), and *Oh, Kay* (1926), Irving Berlin's third *Music Box Revue* (1923), the Marx Brothers' *The Coconuts* (1926), and two of the best known shows of the 1920s, *No, No, Nanette* (1925) and *Show Boat* (1927). Between shows, Lee collaborated with composer John Alden Carpenter and designer Robert Edmond Jones to create the ballet *Skyscraper*, performed once in 1926 at the Metropolitan Opera House.

In Hollywood, Lee staged dance numbers in short subjects and feature-length motion pictures, primarily for MGM and Fox Film Corporation. Most of his movie credits were either on filmed revues or on backstage musicals. The former included his first feature film, the *Hollywood Revue* (MGM, 1929), *New Faces of '37* (RKO, 1937) and two series of shorts—*Fox Movietone Follies* (1934–1935) and *Novel Musical Miniatures* for MGM in 1936. The backstage (and backset) musicals included *The King of Burlesque* (1935) and *365 Nights in Hollywood* (1934), both for Fox Film Corporation.

Works Choreographed: CONCERT WORKS: *Skyscraper* (1926).

THEATER WORKS: *The Gingham Girl* (1922); *The Music Box Revue of 1923* (1923); *Sweet Little Devil* (1924); *Lady, Be Good* (1924); *No, No, Nanette* (1925); *Tip Toes* (1925); *The Coconuts* (1926); *Queen High* (1926); *The Ramblers* (1926); *Oh, Kay* (1926); *Betsy* (1926); *Rio Rita* (1927, with Albertina Rasch); *Show Boat* (1927); *Cross My Heart* (1928).

FILM: *Hollywood Revue* (MGM, 1929, with Albertina Rasch); *It's a Great Life* (MGM, 1929); *Children of Pleasure* (MGM, 1930); *On The Set* (MGM, 1930); *The Woman Racket* (MGM, 1930); *Adorable* (Fox Films, 1933); *Dancing Lady* (MGM, 1933, with Edward Prinz); *It's Grand to be Alive* (Fox Films, 1933); *Jimmy and Sally* (Fox Films, 1933); *I Loved You Wednesday* (Fox Films, 1933); *Ring Up the Curtain* (Fox Films, 1933, uses Albertina Rasch sequences from *The March of Time*); *My Lips Betray* (Fox Films, 1933); *365 Nights in Hollywood* (Fox Films, 1934); *Transatlantic Merry-Go-Round* (Reliance, 1934, with Larry Ceballos); *The King of Burlesque* (Fox Films, 1935); *Ali Baba Goes to Town* (Twentieth-Century Fox, 1937); *The Life of the Party* (RKO, 1937); *New Faces of '37* (RKO, 1937); *Hullabaloo* (MGM, 1940); *Chasing Rainbows* (MGM, 1940); *Hit the Ice* (Universal, 1943); *Meet the People* (MGM, 1943); *Cairo* (MGM, 1942); *Carolina Blues* (Columbia, 1944); *Two Girls and a Sailor* (MGM, 1944); short subject series—*Fox Movietone Follies* (Fox Films, 1934); *Novel Musical Miniatures* (MGM, 1936).

Lee, Sondra, American ballet and theatrical dancer; born Sondra Lee Gash, September 30, 1930 in New York. Lee was trained as a child at the school at the Metropolitan Opera, and later continued her studies with Edward Caton and Nanette Charisse. Associated with both the musical comedies and the ballets of Jerome Robbins, she made her Broadway debut as "The Playmate" in his *High Button Shoes* (1947). Her next role, in which many will always see her, was "Tiger Lily" in his musical version of *Peter Pan* (1954). Her later Broadway shows include *Hotel Paradisio* (1957), *Street Scene* (1959), and *Hello, Dolly!* (1964), as "Minnie Fay." While in her twenties, she was a regular on an early variety show, *Starlit Time* (Dumont, 1950), partnering Sam Steen.

Between the two periods in which she worked on Broadway, she lived and performed in Europe. A member of the Ballet de Paris, under Roland Petit in 1958, she also danced with Robbins' Ballet: U.S.A. and Herbert Ross' Ballet of Two Worlds, both at the Spoleto Festival in Italy. While in Europe, she danced with the John Butler Company, in his *Album Leaves* (1959), and appeared in Fellini's *La Dolce Vita*.

Leeder, Sigurd, German modern dancer and teacher; born August 14, 1902 in Hamburg. A student of Rudolf von Laban in Hamburg, he performed with fellow student Kurt Jooss, with whom he was associated throughout his career. They toured together as "Two Male Dancers," then worked together at the Essen Folkwangschule after 1927. His career paralleled Jooss' through their exile from Germany and the establishment of the Ballet Jooss in England.

In 1947, Leeder opened a school in London at which he taught for a dozen years. He also taught in Chile, for Jooss Ballet members Ernest Uthoff and

Lola Botka (c.1960), and in Herisau, Switzerland, after 1965.

Works Choreographed: CONCERT WORKS: *Sailor's Fancy* (1943); *Nocturne* (1952); *Allegro Maestoso* (1959).

Lefèbre, Jorge, Cuban ballet dancer and choreographer working in Europe; born in Havana. Lefèbre was trained in Havana by Alberto and Alicia Alonso. In 1956, he moved to New York to continue his studies in ballet with William Dollar, and in jazz with Matt Mattox and Luigi. He first performed in Europe with Katharine Dunham's company in France and Italy, but by 1961 became a member of Maurice Béjart's Ballet du XXième Siècle. He has performed with that company since, most notably in Béjart's *Actus Tragicus* (1969) and the company's unique production of Leonid Massine's *Parade*, but has also left frequently to guest-teach and choreograph with other troupes, among them, the People's Republic of Germany State Ballet in Berlin and the Ballet de Wallonie (Belgium) for which he staged his best known work, *Edipe Roi* (1970). Lefèbre returned to Cuba and the Alonsos to restage that work for his mentors and the young Jorge Esquival, in 1975.

His literary ballets, with the depth of emotion that may be adapted from that of Bèjart, are very popular with both audiences and dancers. *Edipe Roi*, for example, is more than seventy-five minutes long, but seldom fails to maintain a receptive audience with its powerful imagery and movements and internalized sound score.

Works Choreographed: CONCERT WORKS: *Edipe Roi* (spelling alters by place of performance) (1970); *Salomé* (c.1971); *La Dame aux Camillas* (1980).

Legat, Nadine De Briger, Russian ballet dancer and teacher in London; born c.1895 in St. Petersburg. De Briger was trained at the Bolshoi Ballet school in Moscow, but performed with both the Bolshoi and the St. Petersburg Maryinsky Ballet, with increasingly larger solos in the nineteenth-century repertory. With Nicholas Legat, whom she married in the late 1910s, she appeared in ballets at The Coliseum Theatre, London (1915, 1925), most notably in an early version of *Coppélia* on their second engagement. They left the Soviet Union again in 1920 for tours of Berlin, Paris, and London and did not return.

De Briger Legat taught at her husband's London studio and founded a boarding school of dance in Kent after his death. She is considered one of the best ballet pedagogues in England and has written extensively on the training of dance teachers.

Legat, Nicolai, Russian ballet dancer and teacher; born December 27, 1869 in St. Petersburg; died January 24, 1937 in London. The grandson of Constance Lede and son of Gustave Legat was trained at the school of the Imperial Ballet in St. Petersburg. His teachers included his father (a Swede who had been a member of the Bolshoi Ballet), Pavel Gerdt, and Christian Johanssen, before he graduated into the Maryinsky Ballet in 1888. He was considered one of the finest partners in the company, able to support Vera Trefilova and/or Mathilde Kschessinskaia, and was cast in a cross section of heroes in the Marius Petipa and Lev Ivanov repertory, most notably in the first cast premiere of the latter's *Nutcracker* (1892), and revivals of the former's *Esmeralda*. He choreographed ballets with his younger brother Serge, and succeeded Petipa as a ballet master of the company in 1903, becoming director of the attached school shortly thereafter.

Legat performed in London in 1915 and 1925 with Nadine De Briger, whom he married in the late 1910s. His popularity there enabled him to settle permanently in England in the mid-1920s, after an aborted tenure with the Diaghilev Ballet Russe. His students in Russia and England together equal most of the performers of classical ballet in England and Western Europe of the first half of this century, among them, the teachers Olga Preobrajenska, Lubov Egorova, Agrappina Vaganova, Julie Sedova, and Adolf Bolm, and the dancers Tamara Karsavina, Vaslav Nijinsky, Bronislava Nijinska, Margot Fonteyn, Alexandra Danilova, Anton Dolin, and André Eglevsky.

Works Choreographed: CONCERT WORKS: *The Fairy Doll* (1904, co-choreographed with Serge Legat).

Bibliography: Gregory, John. *Heritage of a Ballet Master* (Brooklyn, N.Y.: 1977).

Legat, Serge, Russian ballet dancer; born 1875 in St. Petersburg; died there, 1905. With his older brother, Nicolai, Legat was trained at the school of the Impe-

rial Ballet in St. Petersburg, most notably with Christian Johanssen and Pavel Gerdt. After graduation, he joined the Maryinsky Ballet, where he danced from 1894 to 1905. A fierce rivalry with his brother for the principal roles in the Marius Petipa and Lev Ivanov repertory resulted in the common belief that Serge was the better stylist, more able to maintain the nobility of his "princes" and other heroes within the technical feats and theatrical practices of the choreography. Like his brother and father, he began to teach early in his performing career and is remembered today as an influence on Vaslav Nijinsky.

As with all young suicides, people have tried to justify Legat's death at twenty-nine. The reasons that have been put forward range from the rivalry with Nicolai and a failing marriage to Petipa's daughter Maria to his inability to function artistically and politically during the Duma Revolution.

Works Choreographed: CONCERT WORKS: *The Fairy Doll* (1904, co-choreographed with Nicolai Legat).

Legnani, Pierina, Italian nineteenth-century ballet dancer, famous in London and St. Petersburg for her bravura technique; born 1863 in Milan; died 1923. Trained by Catarina Beretta at the Ballet School of the Teatro alla Scala, she made her debut with the company in the late 1880s.

Performing at the Alhambra Theatre, London, intermittently from 1888 to 1897, she danced featured roles in many of their ballet pantomimes, among them, Carlo Coppi's *Aladdin* (1892) and *Victoria and Merrie England* (1897), in which she played the "Genius of Britain" and "the May Queen."

Her annual seasons of performances in St. Petersburg were marked by the impact that her technique had on both the local dancers and the members of the audience. Her best known specialty, a sequence of thirty-two rhythmic *ronds de jambes fouettés*, that was originally seen in *Aladdin*, was interpolated first into Marius Petipa's *Cinderella* (1893), and then into the finally successful revival of *Swan Lake* that he and Lev Ivanov staged in 1895. Legnani was also featured in Petipa's *The Talisman* (1895), *La Perle* (1896), *Raymonda* (1898), and *Les Ruses d'Amour* (1900).

The sequence of *fouettés* has deteriorated into a choreographic cliché for most frequent ballet goers, but it is important to remember the extraordinary impact that the *enchaînement* originally had. It is also important to imagine the bravura technique that Legnani must have offered to her choreographers, Coppi, Ivanov, and Petipa. It allowed them in *Swan Lake* and *Raymonda*, among many others, to manipulate characterizations within the technical boundaries.

Lehmann, Adelaide, nineteenth-century dancer working and touring in the United States; born c.1830 in France; died 1851 in New York.

The Lehmann Family, which may have been French or Swiss, toured the United States in the mid-1840s to the 1860s. Adelaide, the most promising of the four sisters of the younger generation (Adelaide, Flora, who had a solo career with other touring companies in the 1850s, Julia, and Mathilde), was assigned leading roles in the family productions of *Comus* and *The Spirit of the Air* in 1848. She and the family joined with members of the Ravel family to perform on the Mississippi circuit, St. Louis to New Orleans, and in New York from 1849 to 1851. During a performance in 1851, Adelaide Lehmann was fatally burned by a gas light.

Like those of her colleagues, Emma Livry and Clara Webster, Lehmann's death created an outpouring of grief for the loss of a promise of the future.

Leland, Sara, American ballet dancer; born Sara Leland Harrington, August 2, 1941 in Melrose, Massachusetts. Leland studied ballet from the age of five with E. Virginia Williams, first locally, then at the School of the New England Civic Ballet (later Boston Ballet). She made her dance debut with the New England Civic Ballet in Williams' *Don Quixote Pas de Deux*, and later created the "Juliet" role in her *Young Loves* (1957).

Leland joined the Robert Joffrey Ballet in 1959, performing featured roles in Francisco Moncion's *Pastoral* and Balanchine's *Pas de Dix* with that company. She performed Joffrey's choreography for *Carmen, La Traviata,* and *The Merry Widow* with the corps de ballet of the New York City Opera (1959–1960).

In 1960, Leland joined the New York City Ballet, remaining with that company to the present. Her first

role creation was in Moncion's *Les Biches* section of the 1960 Jazz Concert program. She has created roles in Balanchine's *Jewels* (1967, "Emeralds"), *PAMTGG* (1971), *Gaspard de la Nuit* (1973), and *Union Jack* (1976). During the 1972 Stravinsky Festival, she created roles in his *Lost Sonata, Symphony in Three Movements*, and *Choral Variations on Bach's "Von Himmel Hoch."*

Leland is generally associated with the choreography of Jerome Robbins, for whom she has created roles and served as assistant and regisseur. Among the Robbins ballets that she performed at their premieres are his *Dances at a Gathering* (1969), *The Goldberg Variations* (1971), *Scherzo Fantastique* (1972, on the same Stravinsky Festival program as the *Lost Sonata* and *Violin Concerto*), and *An Evening's Waltzes* (1973), as well as the revival of *The Concert* in 1971.

Lemaitre, Gerard, French ballet dancer associated with the Netherlands Dance Theatre; born December 8, 1936 in Paris. Trained at the school of the Théâtre Chatelet, he performed with the senior company there, the Ballet Marigny, and Roland Petit's Ballet de Paris, in his *Les Belle Damnées* and *La Chambre*, among others.

With the Netherlands Dance Theatre since 1960, he has been featured in the works of guest choreographers, John Butler, in his *Carmina Burana*, and Anna Sokolow, in her *Dreams*. He has been cast in principal roles in ballet pieces by each of the company's successive ballet masters, appearing in Benjamin Harkavy's *Le Diable à Quatre* and *Recital for Cello and Eight Dancers* (1964), Glen Tetley's *The Anatomy Lesson*, and Hans Van Manen's *Dualis, Metaphors* (1965), *Point of No Return, Situations* (1970), *Three Pieces* and *Opus Lemaitre*, choreographed and named for him in 1972.

Works Choreographed: CONCERT WORKS: *Concerto en Sol* (1977).

Leno, Dan, English eccentric dancer and comic; born George Galvin, December 20, 1860 in St. Pancras, London; died October 31, 1904 in London. Leno made his professional debut as "Little George, the Infant Wonder Contortionist and Posturer." By 1880, he had become known as a champion clog dancer, winning competitions in the provinces. He made his debut at The Drury Lane in 1888, remaining at the theater until his death at forty-three. Although he was known for his "dame" parts, playing the elderly women/comics in Christmas pantomimes, such as "Mother Goose" (1903) and "The Widow Twanky" in *Aladdin* (1896), he also did other dance/comedy specialties. Leno did patter songs and movements characterizations in his skits in music hall, among them, "The Beefeater" and "The Railway Guard."

Incredibly popular in England, his image was franchized into Dan Leno tea services, ink wells, and plates. Although he performed in New York in 1897, appearing at Hammerstein's Olympia, he was never as well received here. Leno was hospitalized in 1901, but returned to The Lane for a single pantomime, *Mother Goose*, in 1903.

Leonard, Eddie, American soft-shoe dancer and minstrel show performer; born Lemuel Gordon Toney, October 18, 1875 in Richmond, Virginia; died July 29, 1941 in New York City. Leonard worked in a steel mill before making his debut as an amateur at Putnam's Music Hall. John L. McGrawa of the Baltimore Orioles introduced him to George Primrose who hired him to perform with the Primrose and (Billy) West Minstrel Shows. He developed his unique soft-shoe style while a minstrel performer and maintained it in his vaudeville appearances from 1910 to 1939. He appeared in a Broadway vehicle, *Roly-Poly Eyes* (1919), and in many cabarets and nightclubs over his fifty-year career. He danced very slowly with explicit articulation and rhythm. He can still be seen dancing to his signature song, "Ida, Sweet as Apple Cider," in the Deanna Durbin movie, *If I Had My Way* (Universal, 1940).

Considered one of the major figures in the early vaudeville era, Leonard was a dearly loved performer until the year of his death, making his last appearances at the Diamond Horseshoe in late 1939. The songs that he wrote, among them "Ida," "Goo-Goo Eyes," and "Roly-Poly," will live after him, as will soft-shoe work as a separate tap dance form.

Bibliography: Leonard, Eddie. *What A Life, I'm Telling You* (New York: 1934).

Leonidoff, Leon, Prolog producer; born January 1, 1899 in Bendery, Bessarabia (Rumania). Leonidoff

was a medical student in Geneva when he became interested in the theater. He worked with a company in Lausanne before joining the Isbe Russe of Georg Piteoff (also Pityov), then on a European tour. When that tour ended in New York in 1921, he accepted the invitation of S.L. Rothafel to join the production staff of his Capitol Theater. After a brief tenure with Famous Players/Canada, Leonidoff eventually worked for all of "Roxy" Rothafel's motion picture palaces—the Capitol, the Roxy, and the most famous of all, the Radio City Music Hall.

From opening day, December 1932, to his retirement on August 1, 1974, Leonidoff produced and directed more than six hundred shows for the Music Hall, each including dance numbers for The Rockettes and corps de ballet. He did not stage the dance numbers himself; his choreographers at the three theaters included Maria Gambarelli, Gae Foster, Leonid Massine, and Florence Rogge. He did, however, exercise complete control over the plots, mise-en-scène, and structure of each show. The Music Hall Prologs, which were the best known of his or any other career, ranged in theme from plugs for accompanying films, such as *Mickey's* [Mouse] *Circus* of 1938, to advertisements for its host city, among them *Manhattan* (1940), *East Side, West Side* (1938), and *Little Old New York* (1957). Prologs were based on motifs of pastorale imagery, spring and fall, notably *The Enchanted Forest* (1934) and the *Flower Parade* (1938), with its ultraviolet light effects. Leonidoff was the originator of the four annual pageants interpolated into Prologs at Thanksgiving, Christmas (the famous Nativity scene), Easter (the parade of Calla Lillies), and the Jewish High Holidays.

Apart from his work at the Music Hall, Leonidoff also staged World's Fair presentations, ice shows, and expositions. It was estimated at his retirement that he had staged a grand total of five thousand shows for theaters and public spectacles.

Works Choreographed: THEATER WORKS: (Note: Leonidoff produced but did not choreograph the following.) Prologs for the Capitol Theater, New York (c.1921–1925); Prologs for the Famous Players theater circuit, Canada (1925); Prologs for the Roxy Theater, New York (c. 1926–1930); Prologs for the Radio City Music Hall (1932–1974); *Virginia* (1937); productions for the 1939–1940 New York World's Fair; *It Happened on Ice* (1940); productions for the 1964 New York World's Fair, including *Wonderworld*; productions for Expo '67.

FILM: *When You're in Love* (Columbia, 1937); *Sunny* (RKO, 1941).

Léotard, Jules, French acrobat of the nineteenth-century; born August 1, 1830 in Toulouse; died 1870 in Paris. Léotard made his debut in Paris in 1859 at the Cirque d'Hiver. His act, called *Zampillaerostation*, was performed on three hanging (or "flying") trapezes. The act remained consistent throughout his performing career in Europe and in the United States until 1868, when he toured with the Ravel family's act.

Two elements made Léotard unique and brought him a reputation wider than that usual for a circus performer. One was his ability to exploit the song, "The Man on the Flying Trapeze," as his theme. The other was his costume—a full-length outfit in wool—which took his name. Every time any dancer puts on a leotard or unitard, he or she continues the acrobat's fame.

Bibliography: Léotard, Jules. *Mémoires* (Paris: 1860).

Lepeshinskaya, Olga, Soviet ballet dancer; born September 28, 1916 in Kiev. Trained at the school of the Bolshoi Ballet, she performed with that company from 1933 to 1963. In those thirty years, she created roles in Igor Moiseyev's *Three Fat Men* (1935) and Rotislav Zakharov's *Cinderella* (1945), with featured roles in the company productions of *Coppélia, Swan Lake, The Nutcracker,* and *Don Quixote.* Since retiring from performance, she has taught extensively in the Soviet Union and in The People's Republic of Germany.

Le Picq, Charles, French eighteenth-century ballet dancer and choreographer working in Italy, London, and St. Petersburg; born 1744 in Naples; died 1806 in St. Petersburg. A student of Jean-Georges Noverre in Stuttgart from 1761 to 1764, Le Picq is considered a protégé of his in the *ballet d'action* "war" of European dance of the early nineteenth-century.

Le Picq's emergence as a choreographer occurred over the 1770s in the opera houses of Italy; he created mythological ballets for the Teatros de

San Benedetto in Venice (1771 and 1772), Reggion-Ducale di Milano (1772), and di San Carlo in Naples (1774).

At the King's Theatre, London from 1782 to 1783 and 1784 to 1785 (replaced by Jean D'Auberval in the middle season), Le Picq became known as an extraordinary actor, as well as dancer, especially in his performances with Mme. Rossi. Many of the ballets which he created for the King's Theatre sound like revivals or restagings of Noverre's works; among these are *Il Ratto delle Sabine* (1782), *Les Epouses persannes* (1783), and *Semiraminis* (1784); however, it is impossible to judge originality at this chronological distance.

In St. Petersburg from 1786 to 1798, between Gasparo Angiolini and Charles-Louis Didelot in the continuum of Western European ballet masters, Le Picq restaged Noverre's *Medée et Jason* (1789) and choreographed ballets, among them *La Bergère* (1790), *Didone abbandonata* (1795, possibly a revival of Noverre's work), *Les deux Savoyards* (1795), and *Les Amours de Bayard* (1798).

Le Picq sponsored the publications of, and may have translated, Noverre's *Lettres sur le Danse* in Naples and St. Petersburg. His discipleship to Noverre is unquestionable, but many historians wish that more had been written about his own theories and practices of choreography; since his influence, at least geographical, was so similar to that of the protégés of Franz Anton Hilverding, more specific information on Le Picq could enable us to distinguish between the two great innovators of the *ballet d'action*.

Works Choreographed: CONCERT WORKS: (Note: any and all of the works listed below might be properly labeled "after Noverre"; sufficient evidence does not exist to prove or disprove their originality.) *Gli Amati protetti dall'amore* (1771); *Il Sacrifizio d'Iphigenia* (1772); *Armida* (1772); *Aminta e Clori* (1774); *Il Ratto delle Sabine* (1782); *Le Tutore trompé* (1783); *Les Épouses persannes* (1783); *La Bégueule* (1783); *The Loves of Alexander and Roxanne* (1783); *La Dame benifaisance* (1783); *Sémiraimis* (1784); *La Partie de chasse d'Henri IV* (1784); *Il Convito degli dei* (1785); *Le Jugement de Paris* (1785); *A la plus sage* (1785); *Il Convitato di Pietra* (1785); *Macbeth* (1785); *La Bergère* (1790); *Les Amours d'été* (1795); *Didone abbandonata* (1795); *La*

Belle Arsène (1795); *Les Deux Savoyards* (1795); *Les Amours de Bayard* (1798); *Tancrède* (1798).

Leporska, Zoya, Russian-American ballet dancer, theatrical choreographer, and actress; born 1918 in Nikolaevsk-on-Amur, Siberia. After emigrating to Seattle, Washington, in 1925, Leporska began her dance training. She studied ballet with Gertrude Weinzurl at the Cornish School in Seattle, with Jersie Merris in Portland, and with Fanchon Collon in Berkeley, California. After moving across the Bay, she continued her training with the various directors of the San Francisco Opera ballet—Serge Oukrainsky, Adolm Bolm, and Willam Christensen. As a member of Christensen's San Francisco Opera Ballet, she appeared in *Les Sylphides* and his *A Roumanian Wedding* and *Romeo and Juliet*. She moved to New York in 1942 and, while performing with Lew Christensen in Dance Players, studied with Anatole Vilzak, Vera Nemtchimova, Edward Caton, and Igor Schwetzoff. For the first time, she expanded her training into concert/ethnic work with Yeichi Nimura and Arthur Mahoney, jazz with Jon Gregory and Matt Mattox, and into modern dance forms with Charles Weidman, Doris Humphrey, and Louis Horst. She performed with the new Ballet Theatre company after 1942, and joined George Balanchine's corps for the New Opera Company in 1943. After dancing in the Ballet International, with roles in *Swan Lake*, and Caton's *Sebastien*, she toured with the Foxhole Ballet and partnered Mahoney in his Spanish concert group. From 1948 to 1952, she was a member of Mata and Hari's pantomime company and performed with them live on television.

Although she guested with Charles Weidman's Theatre Dance Company frequently in the 1950s, she spent most of her performing time in theatrical productions. As assistant to Bob Fosse, she danced in *Pajama Game* on Broadway and in the national, English, and Las Vegas companies, before working with him on the MGM movie (1954). She had the same range of work in his *Damn Yankees* (1955–1957) and danced for him in *New Girl in Town* (1957). Her restaging and supervision work for Fosse led her to a new career—choreographing Broadway shows for out-of-town productions. It has been estimated that she has done more than three dozen productions of shows for summer theaters, opera companies, and

national touring shows. However, she also performed in "first-run" shows and continued to work as a choreographic assistant for Carol Haney and Joe Layton.

Leporska is now considered as a talented and innovative opera choreographer, known for her work on new operas, such as *Summer and Smoke* and *Before Breakfast*, and on revivals of lost works, among them, the New York City Opera's production of Erich Korngoldt's *Der Tote Stadt* in 1975. She continues to act and can be seen being terrorized in the recent thriller *Night Hawks*.

Works Choreographed: OPERA: *Summer and Smoke* (1971); *Before Breakfast* (1980).

FILM: *Untamed Youth* (WB, 1958).

Lepri, Giovanni, Italian ballet dancer of the nineteenth-century; born c.1825; died c.1890. Lepri was trained by Carlo Blasis, possibly at the school of the Teatro alla Scala. After making his debut in 1848 at the Gran Teatro Communale, Bologna, Lepri performed at the Teatro Carlo Felice, Genoa, partnering Giovanna King in Antonio Monticini's *Margherita di Danimarca* and *La Vendetta di Medea*. Throughout the 1850s, he commuted among theaters in Bologna and Turin, in both of which he danced in Antonio Cortesi's *La Belle Fanciulla di Gand*, and *La Gerasalem Liberata*, and La Scala in Milan. He partnered Amalia Ferrais in Guiseppe Rota's *I Bianchi ed i Negri* (the ballet version of *Uncle Tom's Cabin*) and in Cortesi's *Gerusalem Liberata*, in Turin and Milan. At some point before returning to La Scala in 1861, he worked in Florence where he taught the young Enrico Cecchetti.

After twenty years at La Scala, in works by Rota, Pasquale Borri, and Paul Taglioni, Lepri performed in the United States in *Castles in Spain* with his wife Amalia at Niblo's Gardens in New York. It is believed that he died while in the United States, c.1890.

The position of Lepri in the late Romantic era is difficult to determine. He is known today, but mostly as a kind of conduit—the Blasis student who taught Cecchetti and made a link between the two most important schools of Italian ballet.

Lerner, Judith, American ballet dancer; born December 30, 1944 in Philadelphia. Lerner studied at the American Ballet Center, the American Ballet

Theatre School, and the studio of Nico Charisse. After a season with the Eglevsky Ballet on Long Island, she joined Ballet Theatre, with which she performed in the 1960s. Although she appeared in featured roles and solos in almost all of the company's large repertory, she is best remembered for her appearances in the ballets of Antony Tudor, notably as the "Episode in His Past" in his *Jardin Aux Lilas*, and of Agnes De Mille. Among her many De Mille credits were parts in *A Wind in the Mountains* (1965), "The Mistress" in *The Four Marys* (1965), and "Her Mother" in *Fall River Legend*. Lerner retired from dance to become a hospital nurse.

Leroux, Pauline, French nineteenth-century ballet dancer; born August 20, 1809 in Paris; died there in 1891. Leroux was trained at the school of the Paris Opéra and spent most of her professional life with the company.

A featured dancer at the height of the French Romantic era, she is remembered for creating roles in three of the movement's best known works—Filippo Taglioni's *Nathalie, ou la Laitière Suisse*, premiered in 1832 and performed in various versions throughout the nineteenth-century, his *La Révolte au Sérail* (1833), and Jean Coralli's *Le Diable Boiteux* (1836).

Le Roy, Hal, American theater and film dancer; born John LeRoy Schotte, c.1912 in Memphis, Tennessee. Without formal dance training, Le Roy moved to New York to work in the theater. After a successful vaudeville solo act, he was engaged to dance in *The Gang's All Here* (1931). After its three-week run, he went into the *Ziegfeld Follies* of 1931, the last edition produced by Ziegfeld. While partnering Mitzi Mayfair in that show, he was hired to make a series of musical short subjects for Warner Brothers/Vitaphone in their New York studios. He made a total of eighteen shorts, with Mayfair, Dixie Dunbar, June Allyson, and Toby Wing (the "Young and Healthy Girl" from the Busby Berkeley films), among them, *Tip Tac Toc* (1932), *Wash Your Step* (1936), *The Knight Is Young* (1938), and *Public Jitterbug No. 1* (1939). Le Roy's eccentric style, always performed at whirlwind pace, was perfect for these shorts.

During the 1930s, he commuted between Broad-

way shows, among them *Strike Me Pink* (1933), *Thums Up* (1934), and *Too Many Girls* (1939), and feature films, such as *Harold Teen* (WB, 1934), *Wonder Bar* (WB, 1935), and the RKO motion picture of *Too Many Girls* (1940). After another decade of stage performances and vaudeville and cabaret tours, Le Roy made what is believed to have been his last performance in 1956, playing "Frank," the song and dance man in the 1956 revival of *Show Boat*.

Information on Le Roy's film career was derived from the writings of Leonard Maltin, in his *The Great Movie Shorts* (New York: 1972) and "Hal Le Roy," *Film Fan Monthly*, No. 180 (April 1972).

Le Roy, Ken, American theatrical dancer; born Kenneth Kopfenstein, August 17, 1927 in New York City. Le Roy and his sister, who uses the professional name Gloria Le Roy, were trained at the Neighborhood Playhouse.

Le Roy worked on Broadway almost steadily from 1939 to the mid-1960s. Among his many dance credits were parts in *The American Way* (1939), *Morning Star* (1940), *Oklahoma* (1943), as a chorus dancer and as understudy to "Will Parker," *The Firebrands of Florence* (1945), Agnes De Mille's *Carousel* (1945), her *Brigadoon* (1947), as one of the sword dancers, Jerome Robbins' *Call Me Madam* (1950), the 1952 revival of *Pal Joey, Paint Your Wagon* (1951), Bob Fosse's *The Pajama Game* (1954), his *Damn Yankees* (1955), and *West Side Story* (1957), as "Bernardo," leader of the Sharks. As far as research can determine, he is the only Broadway gypsy to have performed in the original casts of both *Oklahoma* and *West Side Story*. After playing "Bernardo" in New York and London, he took a featured part in *I Can Get It for You Wholesale* (1962), believed to be his last dance credit.

Leskova, Tatiana, French ballet dancer working in North and South America; born 1922 in Paris. Born of Russian parents, Leskova was trained in the studios of Lubov Egorova, Boris Kniaseff, and Anatole Oboukhoff. She danced in Egorova's Ballet de la Jeunesse and in the Paris Opéra-Comique in the late 1930s, but emigrated to the United States with the Original Ballet Russe in 1939. In her six years with that troupe, she was cast in featured roles in George Balanchine's *Balustrade*, David Lichine's

Graduation Ball, and the company's production of *Aurora's Wedding*.

Leskova has worked in Rio de Janeiro since 1945. She founded a Ballet Society in 1948 and became director of the Teatro Municipale Ballet two years later. Although the companies were staffed with imported Americans and Europeans at first, Leskova was soon able to train her students sufficiently to create a "home-grown" troupe.

Leslie, Caird, American ballet dancer; born c.1900 in Des Moines, Iowa; died February 8, 1970 in New York City. Raised in Seattle, he moved to New York to study with Adolf Bolm in the late 1910s, performing in his *Le Coq d'Or* and *Petrouchka* at the Metropolitan Opera. After dancing at the Roxy Theater in New York in an early Prolog, he joined Bolm's Ballet Intime, partnering Ruth Page and Margit Leeraas in his *Pavanne, Fantasie Chinoise, Irish Dance,* and *Deception*. Leslie also worked for Bolm on the Allied Arts tour of Tamara Karsavina in 1924, dancing with her in *Elopement*.

Deciding to live and work in Paris so that he might learn choreography, and because it was the traditional path for young Americans seeking enlightenment, Leslie moved there in 1925 to study technique with Nicholai Legat. There is inconclusive evidence that he received composition training in Germany before presenting a solo recital at the Berlin Deutsches Kunstlertheater in 1930. That concert led to a season in Paris as a solo dancer.

Leslie returned to Seattle to teach at the Cornish School from 1935 to c.1950, when he founded the Ballet Center studio in New York. An apocryphal story that can be traced to a single Seattle paper tells that in his gala return recital at the school, he harangued the audience for fifteen minutes because they applauded a performance which he considered under par. It can be hoped that the story is true and that his work with Bolm and adventures in Europe brought him a stringent sense of values. Leslie was considered a very important teacher on the West Coast in his fifteen years at the Cornish School in Seattle, one whose classes would not deviate from perfection.

Works Choreographed: CONCERT WORKS: *Pierrot Lunaire* (1930); *Sarcasm* (1930); *Despair at Night* (1930); *Polka* (1931); *Mercury* (1931); *First and Sec-*

ond *Mazurkas* (1931); *Dance of Terror* (1931); *Aragonanza* (1931); *Two Mexican Dances: Las Espuelas and Jarab Tapitio* (1931); *Cape Dance* (1931); *The Temptation of St. Jean* (1932); *Two Dances in Ancient Styles* (1932); *Three Dances on Hungarian Themes* (1932).

Leslie, Earl, American exhibition ballroom dancer and musical comedy performer; born Earl Leslie Kulp, c.1900. A club dancer in his adolescence, he made his professional debut in the replacement cast of *The Velvet Lady* (1919); during the tour and layoffs, he studied ballet with company member Una Flemming. He appeared as a dancing juvenile in *Vanity Fair* (1919), the London production of *League of Notions* (1921), and *A Midsummer's Mad Caps* (1922), and performed at the Casino de Paris in New York as a Joe Frisco imitator. Cast into *Innocent Eyes* (1924) as a juvenile, he was assigned to dance an Apache with the French boulevard star, Mistinguett.

She invited him to return to Paris with her to partner her in the Moulin-Rouge revues (1924–1933). He did variations of the Apache dances, including her Valse Renversant, created for her and Maurice Chevalier, in productions such as *Paris en Fête* (1925), *Mees* (1926) and *Beaucaire* (1926). In 1933, Leslie married Argentinian/Spanish singer, Carmen Morales, and moved with her to Buenos Aires where he managed the Casino after 1935.

Celebrated as "Mistinguett's American," he, and Gaby Deslys' partner, Harry Pilcer, were responsible for introducing American dance styles to Paris—among them, the Charleston, Black Bottom, and Texas Tommy.

Leslie, Fred, *fils,* English theatrical dancer, later acting in New York; born May 19, 1881 in London. The son of Fred Leslie of the Gaiety Theatre, he made his theatrical debut in a walk-on part at that theater. His professional life really began, however, in 1901, when he was cast as an eccentric specialty dancer in *Love Birds.* For the next twenty years, he commuted across the Atlantic ocean, playing comic roles and doing eccentric specialties in *Tea Time* (New York, 1904), *Lady Madcap* (New York, 1905), *The Dairymaids* (London, 1908), *The Merry Widow* (London, 1908), *Princess Caprice* (London, 1912; New York, 1913). *Dancing Around* (New York, 1914), *Made in England* (London, 1915), *The Miller's Daughter* (London, 1916), *Theodore and Co.* (London, 1917), and a half-dozen Andre Charlot revues. By 1933, he had stopped dancing and worked only as a comic and dramatic actor in New York, where he appeared in many plays by Noel Coward. Although Leslie did his father's specialty in historical sequences in some shows, he was best known for his own very different style. One of the few English machine-gun tappers, he worked with speed and articulation, where his father had played with the audience and the floor.

Leslie, Fred, *pere,* English nineteenth-century theatrical dancer; born 1855 in Notting Hill, London; died December 7, 1892 in London. Leslie made his theatrical debut in 1878 in the local theater's production of *Paul Pry*, and worked almost constantly until his death at thirty-seven. After a season at a French-language operetta house in residence at the Alhambra, he became a permanent member of the theater's usual inhabitants—the English burlesque company that presented parodies (literally, burlesques) of operas, artistic dramas, and topical events. He made his American debut in *Mme. Favart* in 1881 and became as popular on this side of the Atlantic as he was in London. His greatest successes came in both cities as a member of the Gaiety Theatre in London (and on tour in New York). He appeared in principal comic roles in the troupe's first major successes, *Monte Christo, Jr., Miss Esmeralda,* and *Ruy Blas (or the Blase Roue),* and added to their financial and artistic merits.

Because the Gaiety presented English burlesque in both cities, the American critics and audiences (who didn't understand all the topical jokes) were more influenced by the performers' dance specialties than by the artistic possibilities of the genre. Like Letty Lind, who became known for her skirt dancing, Leslie became a celebrity for his dance specialty—a clog routine in which he played with gravity and with the audience's expectations. He almost fell, slid, tumbled, and went too far, but was under so much physical control that he could manipulate the audience into a combination of tension and apprehension, winning them over to his act.

Leslie, Joan, American film dancer; born Joan Agnes Theresa Sadie Brodell, January 26, 1925 in

Detroit, Michigan. Leslie joined the Brodell sister act when she was two and a half, and performed with her siblings in vaudeville and nightclubs until she was thirteen. A bit part in *Camille* (MGM, 1936) led to a series of movie appearances and a contract with Warner Brothers that lasted for most of her short professional life. She made her studio debut in *Nancy Drew, Detective* (1940), but went on to perform in most of its musical films, among them, *Yankee Doodle Dandy* (1942), *Thank Your Lucky Stars* (1943), *The Sky's the Limit* (1943, on loan to RKO), and *Rhapsody in Blue* (1945). Her dances with James Cagney (in *Yankee Doodle Dandy*) and Fred Astaire (in *The Sky's the Limit*) brought her to greater prominence, even though the latter is generally considered the weakest of Astaire's films for RKO.

Leslie was the defendant in one of Hollywood's most turbulent contract disputes. As usual in film, she lost her contract and reputation, despite the legal ruling in her favor.

Lesser, Felice, American modern dancer and choreographer; born May 28, 1953 in Norwalk, Connecticut. Trained locally and at Barnard College, Lesser founded her New York–based company in 1975. She works frequently with twentieth-century and experimental scores on which she sets abstractions. Lesser has also used musicians on stage as frequently as possible—to help the musical presentation and as scenery and prop elements. Her choreography has been compared to a "living mobile" with moves in response to an outside element but with a unity and integrity of its own.

Works Choreographed: CONCERT WORKS: *Triptych* (1973); *Like Horses on a Roundabout* (1964); *Dichterliebe* (1974); *Rose, Liz, Printemps* (1974); *Roulette* (1975); *Arabia Felix* (1976); *The Bach Pieces* (1977); *Duet for Two Old Friends* (1977); *Jazz Ten* (1977); *Shutters* (1977); *Six Short Pieces for Two Flutes and Four Dancers* (1977); *Berg Violin Concerto* (1978); *Bits and Pieces* (1980); *Quintet* (1980).

Lester, Keith, English ballet dancer and ballet and theater choreographer; born April 9, 1904 in Guildford, England. Trained in London by Serafina Astafieva, Nicholai Legat, and Anton Dolin, he made his debut in the Basil Dean production of *Hassan* (1923), with dances by Mikhail Fokine.

In 1931, he partnered Spessivtseva in performances of Fokine's *Carnaval* and *Schéhérézade* at the Teatro Colón. Engagements with the (Alicia) Markova/(Anton) Dolin Ballet (1935) and the London Ballet followed. In that company, he performed in Antony Tudor's *The Planets* and *Gala Performance*. He served as founding director of the Art Theatre Ballet in 1940, choreographing *Concerto, The Glen, Perseus,* and *De Profundis* for the troupe.

Lester also had an extensive career as a theatrical dance director, staging dances for the Shakespeare production in the Regent's Park Open Air Theatre in the 1930s, and for the London Windmill Theatre from 1945 to 1970. That institution, a cabaret-style theater with variety acts, was famous for the precision fan dances that Lester staged for its long-run productions.

Lester has been principal teacher at the Royal Academy of Dancing since 1965.

Works Choreographed: CONCERT WORKS: *David* (1935); *Pas de Quatre* (1936); *Grande Valse Finale* (1937); *Fore and Aft* (1937); *Death in Adagio* (1937); *Le Pas des Déèses* (1939); *Concerto* (1939); *The Glen* (1940); *Perseus* (1940); *De Profundis* (1940).

THEATER WORKS: dances for productions at The Open Air Theatre, Regent's Park, London, (1937, 1938, 1939); productions at the London Windmill Theatre (1945–1970).

Levans, Daniel, American ballet dancer and choreographer; born Daniel Levins on October 7, 1953 in Ticonderoga, New York. Raised in New York City, he received his dance training at the High School of Performing Arts and at the New York School of Ballet with Richard Thomas and Barbara Fallis. He maintained his link with Thomas and Fallis throughout his career.

Levans joined Eliot Feld's American Ballet Company in 1969, creating roles in his *A Poem Forgotten* (1970), *The Consort* (1970), *The Gods Amused* (1971), and *Romance* (1971). He performed the principal male role in *At Midnight* in that company and in Ballet Theatre from 1971 to 1974. In Ballet Theatre, he created roles in Feld's *A Soldier's Tale* (1971) and *Eccentrique* (1971), and in Alvin Ailey's *Sea-Change* (1972). Noted for his character work, he was assigned featured roles in Agnes De Mille's *Rodeo,* Eugene Loring's *Billy the Kid* (in the title role), and

in Antony Tudor's *Dark Elegies, Romeo and Juliet,* and *Undertow.*

Leaving Ballet Theatre in 1974, he joined the New York City Ballet for a single season, changing the spelling of his last name, and performing in George Balanchine's *Western Symphony.* With injuries to his leg, Levans has not performed regularly with a company since 1975, but he has danced with the New York City Opera in Patricia Birch's "Starry-Eyed" duet in the 1978 revival of *Street Scene.* Co-artistic director with Richard Thomas of the U.S. Terpsichore company, Levans has choreographed many abstract works for its dancers, among them *Caprice* (1975), *Italian Concerto* (1976), and *Concert Waltzes* (1978), which was restaged for Ballet Theatre in 1980.

Levans played "Arnold," the obnoxious choreographer-in-residence, in *A Turning Point* (Twentieth-Century Fox, 1977), and one of the "Burger-Palace Boys" in *Grease* (Paramount, 1978). The latter led to an engagement with Patricia Birch as her assistant on *Sgt. Pepper's Lonely Heart's Club Band* (Paramount, 1979). He received his only theatrical choreography credit for the Gerald Boardman revival of *Oh, Boy!* in 1979.

Works Choreographed: CONCERT WORKS: *Caprice* (1975); *Canciones Amatorias* (1975); *Why Not?* (1976); *Italian Concerto* (1976); *Concert Waltzes* (1978); *Actuations* (1978); *Valse Scherzo* (1980).

THEATER WORKS: *Oh, Boy!* (1979, revival).

Levashev, Vladimir, Soviet ballet dancer; born January 23, 1923 in Moscow. Levashev was trained at the Bolshoi school, appearing in children's roles with the company while a student. After graduating, he joined the Bolshoi where he became known as an excellent dancer and mime. His roles ranged from the classics of the character repertory, among them, "Hilarion," "Von Rothbart," "Carabosse," and "Drosselmeyer," the antagonists of *Giselle, Swan Lake, The Sleeping Beauty,* and *The Nutcracker* respectively. Levashev also performed in the Soviet canon of popular ballets, appearing frequently as the villain in Grigorovich's version of *The Stone Flower.*

Levey, Ethel, American eccentric dancer and vocalist; born November 22, 1881 in San Francisco, California; died February 27, 1955 in New York. Married briefly to George M. Cohan, she made her Broadway debut with him in his *The Governor's Son* (1901), staged and/or doctored by a number of choreographers, among them Ned Wayburn. She did her eccentric dance, with its quick changes of focus and position in ragtime jazz, in his *Running for Office* (1903), and his *Little Johnny Jones* (1904), before moving to London where she spent most of her performing life.

A star of music halls primarily as a vocalist, she danced in earlier London revues and musicals. In *Hullo, Ragtime!* (1912) and *Hullo Tango!* (1913), she did both her signature dance and exhibition ballroom works; while in *Three Cheers* (1916) and *Here and There* (1917), she relied on her charming soft-shoe work.

Lewis, Daniel, American modern dancer and choreographer; born in New York City. Lewis was trained at the High School of Performing Arts and at the Juilliard School, where he studied with Anna Sokolow, José Limón, and Ruth Currier, among others.

A member of the José Limón Company from 1963 to 1972, and assistant to Limón after 1966, he performed in most of the repertory by Limón and Doris Humphrey, including the *Choreographic Offering* (1962), created for him at Juilliard, *The Winged* (1968), *The Unsung* (1972), and *The Moor's Pavanne.* He remained with the company for one season after Limón's death, staging his works for companies in Sweden, Denmark, and Israel.

In 1972, he formed a company of choreographers, then called the Contemporary Dance System. Now titled the Daniel Lewis Repertory Company, the members perform each other's works and those of Humphrey, Limón, and Anna Sokolow, who is resident choreographer. He has danced in Humphrey's *Night Spell* and *Day on Earth,* and in Sokolow's *Lyric Suite, Steps of Silence,* and *Rooms,* as well as the premiere of member Matthew Diamond's *Dead Heat.* Among the many dancer choreographers who have been members of the troupe are Diamond, Hannah Kahn, Jim May, Lorry May, Carol-Rae Krauss, José Coronado, Peter Sparling, Kathryn Posin, Teri Wecksler, and Laura Glenn.

A very popular teacher, he has served on the faculty of Juilliard since his own graduation and has

given master classes in Limón technique at many universities and studios.

Works Choreographed: CONCERT WORKS: *Washed* (1966); *The Minding of the Flesh Is Death* (1967); *Man Made* (1968); *Irving the Terrific* (1972); *My Echo, My Shadow and Me* (1974); *And First They Slaughtered the Angels* (1974); *No Strings* (1974); *Rasamovsky* (1975); *Proliferation* (1976); *Cabbage-Patch* (1976); *Beethoven Trio* (1978); *Beethoven Sextet* (1978); *Life and Other Things* (1978); *Mostly Beethoven* (1979); *There's Nothing Here of Me but Me* (1980).

THEATER WORKS: *Nefertiti* (1977, closed out of town); *Feathertop* (1980).

Lewitsky, Bella, American modern dancer and choreographer; born 1915 in Llano del Rio, California. Raised in the Mojave Desert in her parents' Utopian community, she moved to Los Angeles as an adolescent to study with Lester Horton. She performed in his Dance Theatre for fourteen years, creating roles in his *Lysistrata* (1936), *Prelude to Militancy* (1937), *Exhibition Dance No. 1* (1937), *Pasaremos* (1938), *Tierra y Libertad* (1939), *A Noble Comedy* (1940), *Barrel House* (1947), *The Beloved* (1948), *The Park* (1949), and *El Robozo* (1950), among many others.

After Horton's death, she taught extensively at the University of Southern California and the California Institute of the Arts, as its first dean of dance. She has choreographed for her own solo concerts and for her company since 1964; it was not until recently, however, that she created works frequently for regular seasons. Her pieces frequently use dehumanizing costumes, often by former company member Rudi Guernrich, that extend movements until they seem to reach across the stage. Although she uses conventional forms, her sense of scaled movements and of theatrical gesture makes her works very popular in the California dance and arts community.

Works Choreographed: CONCERT WORKS: *Trio for Saki* (1966); *Kinaesonata* (1969); *On the Brink of Time* (1969); *Orrendas* (1969); *Pietas* (1971); *Ceremony for Three* (1972); *Scintilla* (1972); *Game Plan* (1973); *Bella and Brindle* (1973); *Five* (1974); *Spaces Between* (1974); *Voltage Controlled Oscillator* (1975); *Greening* (1976); *Pas de Bach* (1976); *Inscape* (1977); *Recesses* (1979); *Suite Satie* (1980).

Lichine, David, Russian ballet dancer and choreographer in the United States after the early 1930s; born October 25, 1910 in Rostov-on-Don, Russia; died June 26, 1972 in Los Angeles. Raised in Paris, he received his early training from Lubov Egorova and Mathilde Kschessinska and continued his studies with Bronislava Nijinska, performing for her in the Ida Rubinstein Company in the late 1920s.

Lichine was associated with the Ballet Russe de Monte Carlo throughout his career—as a dancer and as a choreographer. He created roles in Leonid Massine's *Les Présages* (1933), *Le Beau Danube* (1933), *Choreartium* (1933), and *Beach* (1933), and George Balanchine's *Cotillion* (1932) and *Bourgeois Gentilhomme* in the same year. Featured in the revival of Nijinsky's *Afternoon of a Faun* and the Bluebird pas de deux from *Princess Aurora,* he also danced in the premieres of his own *Protée* (1938), *The Prodigal Son* (1939), and *Graduation Ball* (1940).

While traveling to choreograph works for European and American companies through the 1940s, 1950s, and 1960s, Lichine performed in film, appearing in *Something to Shout About* (Columbia, 1943), *Sensations of 1944* (UA), *Make Mine Music* (Walt Disney, 1946), with Tatiana Riabouchinska in the Two Silhouettes pas de deux, and *An Unfinished Dance* (MGM, 1947). He staged works for La Scala, the Royal Opera House in Amsterdam, the Borovansky Ballet in Australia, his own company in Paris, the London Festival Ballet, the Grand Ballet du Marquis de Cuevas, and many other troupes. Settling in Southern California, he and his wife Tatiana Riabouchinska formed the Ballet Society of Los Angeles, with which he worked and taught until his death.

Although Lichine's works are not all revived frequently, some, such as *Graduation Ball* and *Helen of Troy* , have never been out of the repertories of companies in America and Europe. They are popular with dancers and with audiences and may never be allowed to lapse.

Works Choreographed: CONCERT WORKS: *Nocturne* (1933); *Les Imaginaires* (1934); *Le Pavillion* (1936); *Francesca da Rimini* (1937); *The Gods Go A-Begging* (1937); *The Amourous Lion* (1937); *Protée* (1938); *The Prodigal Son* (1939); *Graduation Ball* (1940); *Fair at Sorochinsk* (1943); *Helen of Troy*

(1943); *Cain and Abel* (1946); *Orpheus* (1948); *La Rencontre* (1948, also called *The Sphinx); La Création* (1948); *Infanta* (1949); *Le Coeur de Diamant* (1949); *Valse Caprice* (1949); *The Enchanted Mill* (1950); *Harlequinade* (1950); *Symphonic Impressions* (1951); *Concerti* (1952); *Corrida* (1956); *New World Symphony* (1956); *The Nutcracker* (1957); *Vision of Chopin* (1959); *Images Choréographiques* (1962).

Liepa, Maris, Soviet ballet dancer; born July 27, 1936 in Riga, Latvia. Originally a vocal student at the Riga Theater of Opera·and Ballet, he attended classes at the Choreographic Institute of Riga and was hooked. He moved to Moscow in 1953 to study at the Choreographic Institute there, but returned to Riga to make his debut.

He did move back to Moscow, however, to perform with the Stanislavsky and Nemirovich-Danchenko Theater there from 1956 to 1960, with featured roles in the company productions of *Le Corsaire, Schéhérézade,* and *Esmeralda.* With the Bolshoi Ballet from 1960, he has been assigned leading roles in Leonid Iacobson's production of *Spartacus,* and the company's *Don Quixote, Les Sylphides,* and *Giselle.* Frequently partnered by Natalia Bessmertnova, in the classics, he staged a revival of *Spectre de la Rose* (after Mikhail Fokine) for them. His created roles include a principal part in Vladimir Vasiliev's *These Enchanting Sounds . . .* (1978). An extremely handsome man, Liepa has done nondancing roles in dramatic films.

Lifar, Serge, Russian ballet dancer and choreographer working in France since 1929; born April 2, 1905 in Kiev. Trained by Bronislava Nijinska in Kiev, he joined the Diaghilev Ballet Russe on her recommendation in 1923. While a company member, he continued his studies with Enrico Cecchetti, Nicholai Legat, and Pierre Vladimiroff. Among the many works in the Ballet Russe repertory in which he created roles were Nijinska's *Les Facheux* and *Le Train Bleu* (both 1924), Leonid Massine's *Les Matelots* (1925) and *Ode* (1928), George Balanchine's *La Chatte* (1927), *Le Bal* (1929), and two of the most important title roles of the twentieth century—his *Apollon Musagete* (1928) and *The Prodigal Son* (1929).

Lifar served as director of the Paris Opéra Ballet from Diaghilev's death in 1929 to his own retirement in 1958. He choreographed an enormous number of works for his company during those thirty years, appearing in the principal roles in most until the mid-1950s. Among his best known pieces were *Bacchus et Ariadne* (1931), which he performed with Olga Spessivtseva, *Icare* (1935), *David Triomphant,* and *Alexandre le Grand* (both 1937), *Istar* (1941), *Les Mirages* (1944), *Phaedre* (1950), *Daphnis et Chloe* (1948), and *Roméo et Juliette* (1955). He was also known for his "Albrecht" in the company's production of *Giselle,* a role that he performed at his farewell benefit in 1956.

His tenure with the Opéra was broken twice. During the 1938–1939 season, he staged works for the Ballets de Monte Carlo, notably the *Homage à Diaghilev.* From 1945 to 1947, he was suspended from the Opéra for collaboration with the Nazis under the Vichy regime. He spent his sentence with the Nouveau Ballet de Monte Carlo, for which he created *Aubade, La Péri,* and *Nautéos.*

Lifar has written frequently of his life and vision of history. He is still an important influence on French dance, but has never been considered a major artistic force in the rest of the ballet world.

Works Choreographed: CONCERT WORKS: *Le Renard* (1929); *Les Créatures de Prométhée* (1929); *Prélude Dominical* (1931); *L'Orchestre en Liberté* (1931); *Bacchus et Ariadne* (1931); *Sur le Borysthène* (1932); *Jeunesse* (1933); *La Vie de Polichinelle* (1934); *Giration* (1934); *Salade* (1935); *Prélude de l'Après-midi d'un Faune* (1935); *Icare* (1935); *Harnasie* (1936); *Le Roi Nu* (1936); *Jurupary* (1936); *Promenade dans Rome* (1936); *David Triomphant* (1937); *Alexandre le Grand* (1937); *Oriane et le Prince d'Amour* (1938); *Le Cantique des Cantiques* (1938); *Aenéas* (1938); *Adélaide* (1938); *Homage à Diaghilev* (1939); *Entre deux Rondes* (1940); *Pavanne* (1940); *Sylvia* (1941); *La Princesse au Jardin* (1941); *Le Chevalier et la Demoiselle* (1941); *Boléro* (1941); *Istar* (1941); *Joan de Zarissa* (1942); *Les Animaux Modèles* (1942); *L'Amour Sorcier* (1943); *Prière* (1943); *Le Jour* (1943); *Suite en Blanc* (1943); *El Amor Brujo* (1943); *Plein Chant* (1943); *Guignol et Pandore* (1944); *Syrinx* (1944); *Allégresse* (1944); *Sospiro* (1944); *Sérénité* (1944, attributed to Lifar, but questionable); *Le Défilé* (1945); *Méphisto Valse* (1945);

Prière (1946, uncertain whether this is different from the 1943 version); *Salomé* (1946); *La Nuit sur le Mont Chauve* (1946); *Aubade* (1946); *Chota Rostaveli* (1946); *Les Mirages* (1947); *Pavanne pour une Enfant Défunte* (1947); *Zadig* (1948); *Escales* (1948); *La Mort du Cygne* (1948); *Lucifer* (1948); *L'Ecuyère* (1948); *Roméo et Juliette* (1948); *La Naissance des Couleurs* (1949, some sections by Irene Popard); *Endymion* (1949); *Septuor* (1950); *Passion* (1950); *L'Inconnue* (1950); *Le Chevalier Errant* (1950); *Phèdre* (1950); *Dramma Per Musica* (1950); *Les Eléments* (1950); *La Pierre Enchantée* (1950); *L'Astrologue dans le Puits* (1951); *Blanche-Neige* (1951); *Fourberies* (1952); *Les Indes Galantes* (1952, second and fourth entries, others by Aveline and Lander); *Variations* (1953); *Cinéma* (1953); *Grand Pas* (1953); *L'Oiseau de Feu* (1954); *Nautéos* (1954); *Pas et Lignes* (1954); *Rondo Capriccioso* (1954); *Les Noces Fantastique* (1955); *Roméo et Juliette* (1955, new version); *Apollo* (1956); *Quasimodo* (1956); *Divertissement du Roi* (1956); *Chemin de Lumière* (1957); *Eternel Amour* (1957); *L'Indécise* (1957, with Népo); *Le Martyre de Saint Sébastien* (1957); *Hamlet* (1957); *Le Bel Indifférent* (1957); *Pas et Lignes* (1958); *Symphonie Classique* (1958); *Daphnis et Chloe* (1958); *Nuages et Fêtes* (1958); *Toi et Moi* (1958); *Francesca da Rimini* (1958); *Duetto* (1958); *L'Atlantide* (1958, with Skibine); *L'Amour et Son Destin* (1958, with Parlić); *Homage à Garnier* (1960); *La Dame de Pique* (1960, with Grunberg); *Bonaparte à Nice, 1796* (1960); *Constellations* (1969); *Le Grand Cirque* (1969).

Bibliography: Lifar, Serge. *Le Manifeste du Chorégraphe* (Paris: 1935); *Traité de Danse Académique* (Paris: 1947); *A l'Aubade de mon destin chez Diaghilev* (Paris: 1949); *Vestris, Dieu de la Danse* (Paris: 1950); *Les Trois graces du XX^e Siècle* (Paris: 1958); *Ma Vie* (Paris: 1965).

Lightener, Winnie, American theatrical dancer; born September 17, 1901 in Greenport, New York; died March 5, 1971 in Sherman Oaks, California. Like so many featured dancers of the 1920s, she was claimed as a student by both Ned Wayburn and Jack Blue, the two major theatrical dance teachers in New York at the time.

Lightener was a tap and "musical comedy" (or soft-shoe) dancer who also worked as a singer and as a straight man to comic Chick Sales. Her presence in the *George White's Scandals* of 1922 to 1924 alone could prove that she was an expert dancer. It should also be noted that she was chosen to introduce the Gershwins' "I'll Build a Staircase to Paradise," which, with its verses intact, is a musical comment on the advertisements of dance studios that learning to dance would bring love, beauty, and financial security and on the antidance fundamentalist movement that accompanied the dance craze.

As well as her George White shows, Lightener was featured on Broadway in both editions of the *Gay Paree* revue (1925 and 1926) and in *Harry Delmar's Revels* (1927), a vaudeville act.

Limón, José, Mexican modern dancer and choreographer, working in the United States after 1930 and associated throughout his career with the choreography of Doris Humphrey and Charles Weidman; born January 12, 1908 in Culicán, Mexico; died December 2, 1972 in Flemington, New Jersey. Limón, whom many consider the greatest performer in the history of modern dance, came to the United States to study art. In 1930, however, he started taking classes at the Humphrey/Weidman Studio.

As a member of the Humphrey/Weidman Group from 1930 to 1945, Limón created roles in almost the entire company repertory. He performed in Weidman's Broadway shows, notably in *As Thousands Cheer* (1932) and *Life Begins at Eight-Forty* (1934), and in many of his concert works, among them, *Gymnopedia* (1931), *Dance of Sports* (1932), *Exhibition Piece* (1933), *American Saga* (1935), *Opus 51* (1939), and *On My Mother's Side* (1940). The Humphrey pieces in which he created roles in this company included *The Shakers* (1931), *Suite in F* (1933), *New Dance* (1935), *Theatre Piece* (1936), *To the Dance* (1937), and *Passacaglia and Fugue in C Minor* (1939).

When in 1945, he founded his own company, Humphrey became its artistic director. Among the new works in which he created roles for his company's repertory were her *Lament for Ignacio Sanchéz Mejiás* (1947), *Day on Earth* (1947), and *Felipe El Loco* (1955).

Limón began to choreograph while a Humphrey/Weidman student, collaborating with Eleanor King on *Suite in B Minor* and *Mazurka* (both 1931) and

with Letitia Ide on *Greeting* and *Nostalgic Fragment* in 1935. As a member of Bill Maton's New Dance League–sponsored Experimental Dance Unit, he probably choreographed solos and group dances during the group's 1934–1935 season of invitational concerts. His first solo choreographic credit seems to be for *Cancion y Danza*, in 1932. Although he choreographed works throughout the 1930s and early 1940s, his most prolific periods were during the 1950s and 1960s when he did more than over thirty-five works for his company and for his students at The Juilliard School.

Limón was especially noted during this period for the multitude of works that he staged for the core group of performers that made up his company. Among the many celebrated works that he created for these dancers—Lucas Hoving, Betty Jones, Pauline Koner, and Lavinia Nielsen—were *La Malinche* (1949), *Exiles* (1950), *Emperor Jones* (1956), *The Apostate* (1959), and his currently best known work, *The Moor's Pavanne* (1949). That work, in the repertory of many ballet and modern dance companies throughout the world, is a retelling of *Othello* by four characters—"The Moor," "His Wife," "His Friend" (i.e., Iago), "His Friend's Wife"—through a brilliantly controlled system of gestures and poses. Other well-known Limón works employ a large number of dancers. Among these are his works created at Juilliard and the American Dance Festival, such as *Missa Brevis* (1958), *A Choreographic Offering* (1962), *MacAbner's Dance* (1967), and *The Winged* (1968), a series of solos and group sections for men.

It is difficult to explain why Limón was considered such a magnificent performer without resorting to clichés. He was capable of extraordinary audience communication with almost infinitesimal gestures and of enormous movements without a feeling of effort. He had the stage presence to embue any movement with riveting power and the choreographic sense to control his body and face to manipulate the audience into watching what he meant them to see.

Works Choreographed: CONCERT WORKS: *Suite in B Minor* (1931, co-choreographed with Eleanor King); *Mazurka* (1931, co-choreographed with Eleanor King); *Scherzo and Two Preludes* (1932, collectively credited to Limón, Ernestine Henoch, Letitia Ide, and Eleanor King); *Polonaise, Rondeau, Boninerie* (1932, co-choreographed with Eleanor

King); *Tango Rhythms* (1932, co-choreographed with Ernestine Henoch); *Cancion y Danza* (1932); *Greeting* (1935, co-choreographed with Letitia Ide); *Nostalgic Fragment* (1935, co-choreographed with Letitia Ide); *Hymn* (1936); *Petite Suite* (1936); *Danza de la Muerte* (1937); *Danzas Mexicañas (Sarabande for the Dead, Interlude, Hoch! Viva! Ave!)* (1939); *Chaconne* (1942); *We Speak for Ourselves* (1943); *Western Folk Suite* (1943); *El Salon Mexico* (1943); untitled or unidentified work for Special Services group (1944); *Concerto Grosso* (1945); *Three Ballades* (1945); *Song of Songs* (1947); *La Malinche* (1949); *Corybantic* (1949); *The Moor's Pavanne* (1949); *Exiles* (1950); *Concert, Preludes and Fugues* (1950); *Sonata No. 4* (1950); *Tonantzintla* (1950); *Antigonà* (1950); *Los Cuatro Soles* (1951); *The Visitation* (1952); *El Grito* (1951); *The Queen's Epicedium* (1952); *Don Juan Fantasia* (1953); *Ode to the Dance* (1954); *The Traitor* (1954); *Scherzo* (1955); *Symphony for Strings* (1955); *King's Heart* (1956); *There Is a Time* (1956); *Emperor Jones* (1956); *Blue Roses* (1957); *Serenata* (1957); *Dances* (1958); *Missa Brevis* (1958); *The Apostate* (1959); *Tenebrae* (1959); *Barren Sceptre* (1960, co-choreographed with Pauline Koner); *Sonata for Two 'Cellos* (1961); *The Moirai* (1961); *Performance* (1961); *I, Odysseus* (1962); *A Choreographic Offering* (1962); *Concerto in D Minor* (1963); *The Demon* (1963); *Two Essays for Large Ensemble* (1964); *My Son, the Enemy* (1965); *Variations on a Theme by Paganini* (1965); *The Winged* (1966); *Psalm* (1967); *MacAbner's Dance* (1967); *La Piñata* (1968); *Comedy* (1968); *The Legend* (1968); *The Unsung* (1970); *Waldstein Sonata* (1971, premiered posthumously in 1975); *Revel* (1971); *Dances for Isadora* (1971); *Carlotta* (1972); *Orfeo* (1972).

Lind, Letty, English nineteenth-century theatrical skirt dancer; born Letitia Rudge, December 21, 1862 in Birmingham; died August 27, 1923 in London. A member of a theatrical family, Lind made her debut at the age of four as "Little Eva" in a Theatre Royal, Birmingham, production of *Uncle Tom's Cabin*. She performed with that theater and with Hengler's Circus throughout her adolescence before making her first appearance at the Gaiety Theatre in 1887. Lind's career is still associated with the Gaiety and Drury Lane major burlesque companies in England, British

burlesque being a satirical form more like American spectacles or Gilbert and Sullivan operettas than the American burlesque. She worked at the Gaiety from 1887 to 1894, appearing in *Monte Christo* (1887), performing in *An Artist's Model* (1895), *A Greek Slave* (1895), and *The Girl from Kay's* (1902). She is best remembered in England for her work in *The Geisha* (1897), considered by many historians the most typical Daly Theatre musical.

In her English and American tour performances, Lind presented her own variety of skirt dancing—a form now thought of as a precursor to Loie Fuller, but at the time recognized as a unique dance genre. Lind's variety of the skirt dance, developed with John D'Auban who staged different forms for other performers in the genre, was a continuous spiraling of movement with the skirt lifted in both hands to accentuate the changing shapes. The dance ended when she was lying on the floor, covered by the skirt.

Linden, Anya, English ballet dancer; born Anya Eltenton, January 2, 1933 in Manchester. Raised during World War II in Los Angeles, California, she studied ballet with members of the Kosloff clan, among them Theodore Kosloff, Alexandra Baldina, and possibly Josefina Mendez. She attended the Sadler's Wells School after returning to England and graduated into the ballet company in 1951. Associated throughout her career with that troupe, she appeared in Nickolai Sergeev's production of *Giselle* and in the contemporary repertory, with featured roles in Frederick Ashton's *Symphonic Variations*, Robert Helpmann's *Hamlet*, John Cranko's *Prince of the Pagodas* (1957), and Kenneth Macmillan's *Agon* and *Noctanbules*. In a rare guest appearance outside the classical repertory, she danced "Anna II" to Cleo Laine's "Anna I" in the Western Theatre Ballet's *Seven Deadly Sins*.

Lindgren, Robert, Canadian ballet dancer working in the United States from the early 1940s; born 1923 in Victoria, British Columbia. Lindgren received his early training in Victoria at Dorothy Wilson's School of Elocution and Russian Ballet, later studying with June Roper in Victoria or Vancouver.

A member of Ballet Theatre in 1943, he performed in Leonid Massine's *La Boutique Fantasque*, as "the American Boy," in Antony Tudor's *Romeo and Juliet*, and in Eugene Loring's *Billy the Kid*. He switched to the Ballet Russe de Monte Carlo at the end of that season, remaining with that New York–based company until 1951. Among the many works in which his performances were celebrated with the Ballet Russe were *Les Sylphides, Schéhérézade*, in Nijinsky's role of "the Golden Slave," Agnes De Mille's *Rodeo*, as "the Champion Roper," and George Balanchine's *Danses Concertantes, Mozartiana*, and *Night Shadow*. Lindgren ended his company career in Balanchine's New York City Ballet, dancing in his *Square Dance* and *Western Symphony*.

Like many ballet dancers of the period, Lindgren spent time in the choruses of many Broadway musicals, notably Robert Alton's *Me and Juliet* and Helen Tamiris' *Up in Central Park* and *Plain and Fancy*. He also worked extensively on early television variety shows in the 1950s, most of which were broadcast live from New York, most frequently on Max Liebman's *Your Show of Shows* (NBC, 1949–1954).

Retiring from performance, he and his wife, Sonya Tyven, opened a studio in Phoenix, Arizona, during the late 1950s. He currently serves as dean of the North Carolina School of Arts.

Lindsay, Earl, American dance director; born c.1894 in Philadelphia, Pennsylvania; died May 12, 1945 in Miami Beach, Florida. Lindsay worked as an actor in stock companies and local theatrical groups during his childhood and adolescence. He had a flash dance act on the Keith circuit from c.1912 until the outbreak of World War I, and after 1920, in which he astounded the vaudeville audiences with his eccentric steps and leaps across the stage. Lindsay had a secondary career adapting exhibition ballroom acts from vaudeville to cabaret scale, primarily for acts engaged at Maxim's (New York), the first club to stage coordinated shows instead of assembling them out of disparate acts. His staff position at Maxim's lead to a similar job in Los Angeles at a Hollywood club, which in turn brought him to the attention of studio heads. He was one of the East Coast dance directors hired in Hollywood when sound films became popular, although he was one of the few without Broadway experience. Most of his transition-period

films were short subjects, but he worked on at least three features, among them, *The Dance of Life* for Paramount and *Happy Days* for Fox Film Corp., starring Ann Pennington. A staff coach at Paramount, he coordinated dance solos for the studio's featured and contract players and organized a precision line, The Earl Lindsay Girls, which toured extensively.

Lindsay lost his sight in 1939. As his film career ended, he began to work in transitional live forms, such as expositions and aquacades, becoming extremely successful at his third career.

Works Choreographed: THEATER WORKS: stage shows at Maxim's, New York (c.1921–1928); Prologs for independent film theaters in Los Angeles (1929–1931); Prologs for Grauman's Mayan and Chinese Theaters (c.1927–1934, intermittently); personal appearance routines for The Earl Lindsay Girls (c.1928–1939).

FILM: *Sweetie* (Paramount, 1929); *The Dance of Life* (Paramount, 1929); *Happy Days* (Fox Film Corp., 1929); short subjects for Fox Film Corp. (1929–1935).

Linn, Bambi, American ballet and theatrical dancer; born Bambina Linnemeier, April 26, 1926 in Brooklyn. Linn studied ballet with Mikhail Mordkin and Agnes De Mille and modern dance at the Neighborhood Playhouse.

Linn made her stage debut in 1943 as "Aggie" in Agnes De Mille's *Oklahoma*. She played the title role in a revival of *Sally* in 1948 before joining Ballet Theatre, where she was featured in *Petroushka*, and in the De Mille repertory.

Although she appeared in many more Broadway shows, among them, *Great to Be Alive!* (1950), *Carousel* (1954), *Red Head* (1960), and *I Can Get It for You Wholesale* (1962), she was better known in her television work with Rod Alexander during the 1950s. Together they appeared on almost every variety show taped in or broadcast live from New York, including *The Kate Smith Show* (NBC, 1948), *Your Show of Shows* (NBC, 1952–1954), *Ding Dong School* (CBS, 1956), *The Seven Lively Arts* (CBS, 1959), and Max Liebman's specials (c.1954–1961).

She returned to concert ballet in the last years of the decade, dancing "Eve" in John Butler's *In the Beginning* (1959), and performing in Herbert Ross' *Dialogues* that year. She repeated her role as the "Dream Laurey" in the film of *Oklahoma* (Magna, 1955), and assisted Alexander on the choreography for his *Carousel* and *The Best Things in Life Are Free* (both Twentieth-Century Fox, 1956).

It was Linn's versatility that made her the representative of dance for so many in the theater and television audience. Every Saturday night, on whatever show, she and Alexander performed brilliantly in a different mode with the appropriate technique. The demise of live variety shows left most of the Broadway/ballet combination dancers unemployed and limited the need for such versatile performers.

Lippincott, Gertrude, American traditional modern dancer and choreographer and educator; born c.1913 in St. Paul, Minnesota. Lippincott's life seems to be a continuing process of educating herself so that she can better train her students. After intensive academic studies at the Universities of Chicago and Minnesota, she began a series of visits to the East Coast and to Europe to continue her training with the best available teachers. She worked with Wigman students Jan Veen (in the United States) and Leslie Burrowes (in London), and Pavlova student Ella Dagnova, and participated in the first year of the Bennington School of the Dance, where she took classes with Martha Graham, Doris Humphrey, and Charles Weidman. Although Lippincott was geographically separated from the mainstream of the American modern dance movement, she was nonetheless an important part of it.

She spent much of her career in Minneapolis with the University of Minnesota Dance Group and her own Modern Dance Group of Minneapolis (from 1937). Her productions were concurrent with her extensive teaching experience at the University, making her native twin cities part of the developing dance movement. She also did editorial work with two of the most influential periodicals of the dance—*The Dance Observer* (1945–1957) and *Impulse*.

Works Choreographed: CONCERT WORKS: *A Minnesota Saga* (*To Minnesota, Dance of the Indian Women and French Voyageurs, Dance of the Immigrants, Dance of the Workers*) (1939); *Dance of Formal Introduction* (1940); *Refugees* (1940); *Jazz*

(1940); *Interlude* (1940); *Initiation* (1940); *Negro Lament* (1940); *Statement for Peace* (1940, co-choreographed with R. Hatfield); *Premonition of Disaster, Affirmation, Battle Hymn of a Patriot, Figure of Bereavement, Affirmation, Panic—1940, Ode to Freedom, Re-Affirmation* (1940); *Modern Rhythms* (1941); *Pavana de Nuestros Tiempos* (1941); *Diary for Europe* (1941); *Panic—1941* (1941); *Dance to Open the Second Half of the Program* (1941); *Dance of Celebration* (1941); *American Scenes (Kentucky Mountains, Lament for the South, Song of the Range, The City)* (1941); *Medieval (Kyrie Eleison)* (1941); *And They Came to America* (1941); *And They Came to the Prairie* (1944); *It Will Be Night* (1944); *I Shall Look for You* (1944); *Jazz Baby—1925* (1944); *Blues* (1944); *The Rivals* (1944); *Incantation* (1946); *Hot Sunday* (1946); *Invitation* (1946); *Tragic Lullaby* (1946); *Young Girl in a Garden* (1946); *Light in the Spring* (1946); *There Is a Passage* (1947); *The Devil Is Loneliness* (1947); *Ki Yippee Yay* (1947); *Three Indecisions* (1947); *Dance of the Quick and the Dead* (1948); *Deidre of the Sorrows* (1948); *Duo* (1948); *La Danse des Morts* (1949); *Madman's Wisp* (1949); *A Full Moon in March* (1950); *Night Piece* (1950); *Fanatic* (1950); *Three Excursions for Dancer and Pianist* (1953); *The Wild Wild Women* (1953); *Madonna della Rosa* (1957); *Requiem in Honor of Doris Humphrey* (1959); *Evening Hours* (1959); *Calendar* (1960); *Entangled Enclosure* (1961); *Figures on an Altar Panel* (1961); *Mater Dolorosa* (1961); *Sea Drift* (1961); *Character on an Aimless Journey* (1961); *Lost in the Past Life* (1961); *Portraits from Facade* (1961); *Studies in Movement* (1961); *Ghosts of the Heart* (c.1961); *Tree of Sins* (c.1961); *Decoration Day* (c.1961); *Homage to Horst* (1964).

Littlefield, Caroline, American ballet dancer and teacher; born c.1882; died May 7, 1957 in Red Bank, New Jersey. Nothing is known about her life before her marriage to James Littlefield, then in the early motion picture industry (which was centered in the New Jersey/Philadelphia area). She became a super and then soubrette with the Philadelphia Opera Company after training from the company's ballet master, Romulus Carpenter.

She founded a school in Philadelphia to provide dancers for the opera, becoming the director of the opera ballet at the Philadelphia Civic Opera in 1925. Among her students at these institutions were Nelson Eddy, Lucille Bremer, and her children—Catherine, Dorothie, Carl (1915-1966), and James. Except for the last, who became a songwriter, her children became dancers inextricably caught in the development of a twentieth-century ballet in Philadelphia.

Littlefield, Catherine, American ballet and theater dancer and choreographer, a pioneer in the American ballet; born September 16, 1904 in Philadelphia, Pennsylvania; died November 19, 1951 in New York City. Trained by her mother, Caroline, she continued her studies in New York with Luigi Albertieri and possibly Ivan Tarasoff and in Paris with Lubov Egorova and Leo Staats. Littlefield managed to crowd many successful careers into her short life—as a ballet dancer, a ballet choreographer to be remembered, a theatrical dance director, and a teacher, who died at forty-seven.

From 1925, when she returned to the United States, until 1935 when her company was founded, Littlefield commuted regularly between her position with the Philadelphia Civic and Grand Opera companies and her work in New York, dancing in the Ziegfeld musicals, *Sally* (1933), *Kid Boots* (1934), and *Louie the Fourteenth* (1925), and teaching ballet at the Roxy Theater.

She created the Littlefield Ballet and its repertory between 1935 and the early 1940s—a short life for a company, but one that gave it enough time to become a major factor in American dance. She choreographed many works, among them American pieces such as *Barn Dance* and *Café Society*, and revisions of the classics, including the first native American *Sleeping Beauty*. She also put on dances for operas in Philadelphia, Chicago, and Hollywood, staging large-scale ballets in the Hollywood Bowl while there in 1939.

Littlefield's third career was as a theatrical choreographer. She staged dances for the *American Jubilee* presentation at the 1940 World's Fair and for Broadway musicals, *Hold Onto Your Hats* (1940), *A Kiss for Cinderella* (1942), *Follow the Girls* (1945),

and *Sweethearts* (1947). Littlefield somehow also choreographed most of the ice shows traveling around the country between 1940 and 1951, including *It Happens on Ice* (1940), that featured a *Swan Lake*, and the 1941-1951 Sonja Henie *Hollywood Ice Revues*. She was the choreographer on *The Jimmy Durante Show* (NBC, 1949-1951) at the time of her tragic death.

Works Choreographed: CONCERT WORKS: *The Minstrel* (1935); *The Snow Queen* (1935); *Die Puppenfee* (1938); *Daphnis and Chloe* (1936); *Poème* (1936); *Fête Champêtre* (1936); *Bolero* (1936); *Classical Suite* (1937); *The Rising Sun* (1937); *Let the Righteous Be Glad* (1937); *Barn Dance* (1937); *Sleeping Beauty* (1937, sometimes performed as *Aurora's Wedding*); *Viennese Waltz* (1937); *Terminal* (1937); *Ladies' Better Dresses* (1938); *Café Society* (1938); *Moment Romantique* (1938); *The Vacant Chair* (1939); *Fantasia* (1945).

THEATER WORKS: *American Jubilee* (1940 World's Fair performances); *Hold Onto Your Hats* (1940); *Crazy with the Heat* (1940); *A Kiss for Cinderella* (1941); *Follow the Girls* (1945); *Sweethearts* (1946).

ICE SHOWS: *It Happens on Ice* (1940); *Hollywood Ice Revue* (1941-1951); *Stars on Ice* (1942); *Hats Off to Ice* (1944); *Ice Time* (1948); *Howdy, Mr. Ice* (1948).

TELEVISION: *The Jimmy Durante Show* (NBC, 1949-1951).

Littlefield, Dorothie, American ballet dancer; born c.1908 in Philadelphia; died August 16, 1953 in Evanston, Illinois. After early training with her mother, Caroline, she continued her studies in Paris under Lubov Egorova. She taught at the School of American Ballet in its first season, while dancing with the Ballet Russe de Monte Carlo in the company productions of *Aurora's Wedding* and *Schéhérézade*.

A member of her sister's Littlefield Ballet, she created roles in *Bolero* (1936), *The Sleeping Beauty* (1937), as the "Fairy of Hope," *Classic Suite* (1937), and *Barn Dance* (1937), among others. She also performed with the Chicago Civic Opera and in Prologs at the Roxy Theater in the late 1930s. As a theatrical dancer, she worked in her sister's *American Jubilee* at the 1940 World's Fair and in her *Hats Off to Ice*

(1945). She served as ballet master to the company of Balanchine's *Song of Norway* in 1946 and choreographed revues for the Martinique Hotel's cabaret later that year.

Litz, Katharine, American modern dancer and dance humorist; born c.1918 in Denver, Colorado; died December 19, 1978 in New York City. After local training with Martha Wilcox, Litz moved to New York to work with Doris Humphrey and Charles Weidman. Among the many works in which she created roles for them were Humphrey's *New Dance* (1935), *Theatre Piece* (1936), *With My Red Fires* (1936), and the *Song of the West* (1940), and Weidman's *Opus 51* (1938) and *Flickers* (1941). She also danced on Broadway, although not for Weidman. She appeared in Agnes De Mille's *Oklahoma* (1943) and *Carousel* (1945), and contributed *Susannah and the Elders* to *Ballet Ballads* (1948).

Litz made her debut as a choreographer at the 92nd Street Y in 1948. Her works are frequently satirical—of situations and of the audience's expectations of movements. She could drop a conventional gesture into a work and then shape the choreography around it until it reached its totally illogical conclusion. The paradoxes and puns legible in her titles also show up in her choreography.

Works Choreographed: CONCERT WORKS: *Impressions of Things Past* (1948); *How I Wasted Time and Now Time Doth Waste Me* (1948); *Four Studies* (1949); *Daughter of Virtue* (1949); *Fire in the Snow* (1949); *Suite for a Woman* (1949); *Blood of the Lamb* (1950); *All Desire Is Sad* (1951); *Songs of Joy* (1951); *That's Out of Season* (1951); *Three Women* (1951); *Celebrations* (1951); *Pastorale* (1951); *One Death to a Customer* (1951); *The Glyph* (1951); *Chorales for Spring* (1952); *Twilight of a Flower* (1952); *Bound by House and Kin* (1952); *Super Duper Jet Girl* (1953); *Brief Song* (1953); *Garden of Doubts* (1953); *Madame Bender's Dancing School* (1954); *Excursion* (1954); *The Lure* (1954); *Summer Cloud* (1954); *The Story of Love from Fear to Flight* (1954); *The Enchanted* (1956); *Summer Idyl* (1956, co-choreographed with Ray Harrison); *Intrigue* (1956, co-choreographed with Harrison); *archie and mehitabel* (1956, co-choreographed with Harrison);

Courting the Spell (1958, co-choreographed with Harrison); *In Terms of Time* (1958, co-choreographed with Harrison); *Prologue* (1958, co-choreographed with Harrison); *The Last Gasp of Love's Latest Breath* (1958, co-choreographed with Harrison); *Dracula* (1959); *The Fall of the Leaf* (1959); *And No Birds Sing* (1959); *Transitions* (1961); *Poetry in Motion* (1963, co-choreographed with Paul Taylor); *What's the Big Idea 321* (1964); *Sell Out* (1964); *To Be Continued* (1964); *Fatima* (1965); *Continuum* (1965); *Solo with People* (1965); *Ballet with Furniture* (1965); *Spectacle* (1965); *The Nerve of Some People* (1965); *Stop, Look and Listen I'm Not Just a Number* (1968); *Sermon* (1968); *Harangue and Inner Thoughts* (1969); *Adaptations V* (1969); *Fandango* (1969); *Big Sister* (1969); *Evolutions* (1969) *Adaptations XI* (1970); *The Dress* (1971); *Accumulations* (1971); *The Vision* (1971); *Score* (1972); *Mabel's Dress* (1972); *Marathon* (1972); *In the Park* (1973); *Echo* (1973); *Territory* (1974); *They All Came Home Save One Because She Never Left* (1974); *Baroque Suite* (1975); *Straining at the Leash* (1975); *Women* (1976); *Plane of Tolerance* (1976); *Homage to Lillian Gish* (1977); *The Car That Went with Motor 88 Miles* (1978).

THEATER WORKS: *Susannah and the Elders* (section of *Ballet Ballads,* 1948).

Livry, Emma, French nineteenth-century ballet dancer; born Emma-Marie Emarot in Paris, in September 1841; died July 26, 1862, in Neuilly, France. Livry, whose mother, Célestine Emarot, had performed minor roles at the Paris Opéra, was trained by Mme. Dominique-Venettozzo, then the foremost teacher for women in Paris. She made her Opéra debut at age sixteen in October 1858, performing the lead and title role in Marie Taglioni's vehicle, *La Sylphide.* After Taglioni came to see her dance, Livry became her protégé.

In her short career, Livry created roles in Joseph Mazillier's *Herculanum* divertissements (1859), and in Lucien Petipa's interpolations into the opera *La Reine du Saba* (1862), but was best known for her performances in *Le Papillon* (1860), commissioned by Marie Taglioni and choreographed by her with her father, Filippo.

During a rehearsal of *La Muette di Portici* in November 1862, Livry was badly burned in an accident involving the easily combustible gas lighting commonly used in theaters at that time. She died eight months later; her death was not only a personal horror, but also a national tragedy for the late Romantic ballet of France.

Lland, Michael, American ballet dancer; born Holland Stoudenmire in 1925 in Bishopville, South Carolina. Studying ballet in Bishopville with Margaret Fostoer and at the University of South Carolina, Lland spent his summer vacations at the School of American Ballet.

He made his professional debut on Broadway in *Song of Norway* (1944), choreographed by George Balanchine. After performing with the Ballet of the Teatro Municipal de Rio de Janeiro, directed by Igor Schwezoff, he returned to New York to join Ballet Theatre. In that company for five years, he participated in many of the Ballet Theatre Workshop programs, creating roles in Herbert Ross' *Paean* (1957) and *Ovid Metamorphoses* (1958), and in Enrique Martinez's *The Mirror* (1958). Although a snapped Achilles tendon interrupted his career, he performed featured roles in the company's repertory of classical revivals to great acclaim. In the New York City Ballet from 1960 to 1962, he was assigned many principal roles in Balanchine works, notable among them, his *Square Dance* and *La Valse.*

Since retiring from performance, Lland has taught extensively in the United States and abroad, serving as ballet master of the Ballet Classico de Mexico and the American Ballet Center.

Lloyd, Gweneth, English ballet choreographer and teacher working in Canada; born 1901 in Eccles, Lancashire. Lloyd studied interpretive dance styles at the Liverpool College of Physical Training and with Ruby Ginner at her studio in London. She emigrated to Canada after teaching briefly in London, and co-founded a school in Winnipeg with Betty Farrally. Their Canadian School of Ballet there and in Toronto gave birth to the Royal Winnipeg Ballet, the country's first regularly producing ballet company.

Lloyd served as artistic director of the Royal Winnipeg through its early years and contributed many works to its repertory. Her pieces ranged from Canadian imagery, from *The Shooting of Dan McGrew* (1950) to *Shadow in the Prairie* (1952), to abstractions and comedies, such as *Finishing School* (1942) and *The Wise Virgins* (1942). It is unfortunate that so few of her ballets remained in the Winnipeg repertory, but a film of *Shadow on the Prairie* exists to remind us of the early years of Canadian ballet.

Works Choreographed: CONCERT WORKS: *The Wise Virgins* (1942); *Finishing School* (1942); *Chapter Thirteen* (1947); *Romance* (1947); *Visages* (1949); *The Shooting of Dan McGrew* (1950); *Shadow on the Prairie* (1952); *Parable* (1953); *Arabesque* (1953); *Rondel* (1954).

Lloyd, Maude, South African ballet dancer working in England in the late 1920s and 1930s; born August 16, 1908 in Cape Town, South Africa. Trained in London by Marie Rambert, she performed with the Rambert Dancers and Ballet Club in works by Frederick Ashton and Antony Tudor. For Tudor, she performed in the premieres of *Cross-Garter'd* (1931), *Mr. Roll's Quadrilles* (1932), *The Planets* (1934), *The Descent of Hebe* (1935), *Jardin aux Lilas* (1936), as the first "Caroline," *Dark Elegies* (1937), and *Soirée Musicale* (1938). Her created roles in Ashton's works include *A Florentine Picture* (1930), *La Péri* (1931), *Façade* (1931), *Mercury* (1931), *The Lady of Shalott* (1931), *The Lord of Burleigh* (1931) and *Valentine's Eve* (1935).

With her husband Nigel Gosling, she writes under the pseudonym "Alexander Bland," for *The Observer* and both trade and consumer periodicals.

Lokelani Lei, Princess, American vaudeville dancer specializing in Hawaiian dances; born c.1898 in San Francisco, California; died there on April 18, 1921. Lokelani Lei, whose full name was Elizabeth Jonica Lei Lokelani-Shaw, was a member of a Scottish-Irish-Hawaiian theatrical family. She made her professional debut with the family troupe, called variously The Shaw Family, Shaw's Hawaiians, and Jonica's Hawaiians, at the Panama Exposition in San Francisco. She traveled with the family until 1917, when she formed her own group for the remainder of her short life. Described by *Variety* as a "nacreous" dancer, she was probably more accurate than most performers at presenting the Hula and other dance forms of Hawaii.

The family troupe continued to tour until the mid-1920s. Lokelani Lei's youngest sibling left the company to become famous dancer/vocalist Wini Shaw.

Lombardi, Joan, American modern dancer and choreographer; born November 18, 1944 in Teaneck, New Jersey. Although she had taken dance classes locally as a child, she did not return to formal dance training until she was a graphic designer working in New York City. She studied ballet at the American Ballet Center with Richard Thomas and modern dance with Mary Hinkson and Paul Sanasardo.

She was a member of the New York City Opera Ballet, dancing in John Butler's *Catulli Carmina* and *Cinderella*, when she began performing with Sanasardo's dance troupe. She danced in his *Fatal Birds* (1977), *Footnotes*, and *Time No More* and in *Era* and *Roly-Poly* by company member, Manuel Alum. Since 1977, she has served as assistant artistic director to Sanasardo while presenting concerts for her own dance company. Most of her choreography has been done for her own company concerts, frequently shared with Vic Stornant's troupe, although she has staged dances for student companies at Lehman College, City University of New York, and Skidmore College.

Works Choreographed: CONCERT WORKS: *Time Squared* (1972); *Portrait* (1974); *Segaki* (1975); *Sanctuary* (1975); *Again and Again and Again* (1975); *Echoes of Time* (1976); *All the Way Around and Back* (1976); *Threads* (1976); *Googie's Foxtrot* (1977); *Departure* (1977); *Revolving Door* (1978); *Chiaroscuro* (1978); *Zones* (1977); *Melancholy* (1979); *Everything as it moves, here and there, now and then makes stops* (1979); *Fore Gather* (1980); *Midnight Museum* (1980).

Lommel, Daniel, French-Belgian ballet dancer; born March 26, 1943 in Paris. Raised in Liege, Belgium, he was trained by Joseph Lazzini there before returning to Paris to study with Nora Kiss. He performed in

the corps of the Grand Ballet du Marquis de Cuevas (c.1962) and in Janine Charrat's troupe, where he appeared in her *Nana et Valentin, Zone Interdit,* and *Le Massacre des Amazones,* and in Serge Lifar's *Suite en Blanc.* After a season with the Hamburg State Opera Ballet, performing in Peter van Dijk's *Romeo and Juliet* and *Abraxas* and in revivals of George Balanchine's *Four Temperaments* and *Symphony in C,* he joined the Ballet du XXième Siècle in 1967. A valuable member of that troupe for over a dozen years, he has been featured in most of Maurice Béjart's new ballets and revivals, including his *Bhakti* (1967), *La Messe pour le Temps Present* (1967), *Nijinsky, Clown of God* (1971), *Le Chant du Compagnon Errant* (1973), *Le Marteau sans Maitre* (1975), *Pli Selon Pli* (1975), *Erotica, Sacre du Printemps, Symphonie pour un Homme Seul, Les Fleurs du Mal, Golestan,* and *Romeo et Juliet,* in which he portrayed "Mercutio." Since 1977, he has served as assistant artistic director of the company.

Long, Avon, American soft-shoe dancer, singer, and actor; born June 18, 1910 in Baltimore, Maryland. It is not certain whether Long had dance training before he made his debut on the Black vaudeville circuit, touring in Connie's *Hot Chocolates* (1934). His reputation was made when he starred as "Sportin' Life" in the revival of the Gershwins' *Porgy and Bess* in 1942. After dancing on Broadway in *Very Warm for May* (1939), he was cast in *Memphis Bound* (1945), in which his soft shoe served as contrast to Bill Robinson's tapping. Among his many other show credits are featured roles in Katharine Dunham's *Carib Song* (1945), *Beggar's Holiday* (1946), the revivals of *Green Pastures* (1951), and *Shuffle Along* (1952), *Ballad of Jazz Street* (1959), *Ain't Supposed to Die a Natural Death* (1971), the beginning of his second career, *Don't Play Us Cheap* (1972), *Other Voices, Other Rooms* (1973), and *Bubblin' Brown Sugar* (1975), in which he took the audience on an imaginary tour of Harlem to Billy Wilson's dance direction.

Long made his film debut in 1937 in Republic Studio's *Manhattan Merry-Go-Round* (1937), and was featured in *Centennial Summer* (Twentieth-Century Fox, 1946), and *The Romance of the High Seas* (WB, 1948); when his career was revived in the early 1970s,

he was cast in *The Sting* (Paramount, 1973) and *Harry and Tonto* (Universal, 1974) in nondancing roles. Most of his television appearances have been related to his acting, or to his performance as "Sportin' Life."

Long, Nick, Jr., American theatrical dancer; born c.1906; died August 31, 1949 in New York City. Born on tour with his parents, Italian dialect comedian Nick Long, Sr. and imitator Idalene Cotton, he made his debut with them in Saginaw, Michigan, doing a parody of his father's act. His Broadway debut came in 1913 in their *Things That Count.* After studies with Ned Wayburn in New York, he began his adult Broadway career in Wayburn's *Lady Butterfly,* partnering Janet Stone in a popular eccentric dance act. He astounded audiences with his machine-gun tapping and elegant partnering in *Lollipop* (1924), *Kitty's Kisses* (1926), *Say When* (1928), *Manhattan Mary* (1927), *She's My Baby* (1928), *Louisiana Purchase* (1940), and the *Artists and Models of 1943.* Long also appeared in London in C.B. Cochran shows, most notably his *Monte Carlo Follies* in 1943. His best remembered stunt in these shows was introduced in *Oh, Please* (1926), in which he leapt over the heads of ten chorus girls.

After a film career, in which he appeared in MGM's *Broadway Melody in 1936* and *King of Burlesque,* he returned to New York to work in presentation act houses and Prolog theaters, frequently working as a performing emcee at the Capitol in the 1930s.

Loper, Don, American ballet and exhibition dancer, art director, film choreographer, and fashion designer; born c.1906 in Toledo, Ohio; died November 22, 1972 in Santa Monica, California. Loper made his professional dance debut as a member of the Chicago Grand Opera, under the directorship of Andreas Pavley and Serge Oukrainsky. He alternated between tenures with the Oukrainsky companies and work with his parent's department store in Toledo before moving to New York to dance on Broadway. After appearing in two revues, *One for the Money* (1939) and *Very Warm for May* (1939), he went to London to work at the Dorchester Hotel with his partner Beth Hayes. The partnership with Hayes ended in London, but he met a former Powers model

there who became his new colleague in England, Paris, and the United States. With Maxine Barrat, he appeared on Broadway in *All in Fun* (1940), and in frequent engagements at the Radio City Music Hall and the Copacabana. At the latter cabaret he began working as a "hyphenate," choreographing, directing, and designing club acts and performing in his popular exhibition ballroom act.

He moved to Hollywood to partner Ginger Rogers in *Lady in the Dark* and appeared with Barrat in *As Thousands Cheer*. After working with Sonja Henie in *It's a Pleasure*, he signed a contract with Metro-Goldwyn-Mayer to serve as art director, costumer, and fashion consultant, eventually becoming the arbiter of fashion taste in Hollywood film and real life. Although he was actually very conservative in his taste in street and evening clothes, he is remembered as a kind of proto-Ray Arghyan, creating sequined evening gowns for screen wear.

Lopoukhov, Andrei, Soviet ballet dancer; born August 8, 1898 in St. Petersburg; died May 23, 1947 in Leningrad. Trained at the school of the Imperial Ballet, Lopoukhova performed with the Maryinsky/GATOB/Kirov Ballet throughout his career. Celebrated as a character dancer, he created the role of "Mercutio" in Lavroksi's *Romeo and Juliet* (1940). He also taught character works and left a textbook on the subject written in association with Shiriaiev and Bacharov.

Lopoukhov, Fyodor, Soviet ballet dancer and choreographer; born October 17, 1886 in St. Petersburg; died January 28, 1973 in Leningrad. Trained at the school of the Imperial Ballet, he joined the Maryinsky Theater in 1896.

Primarily a choreographer, Lopoukhova was a founder of the Maly Academic Theater of Opera and Dance, artistic director of the school of the Kirov, and director of the Leningrad Choreographic Institute. A charter director of the Evening of Young Ballet in 1921, he was considered an avant-garde choreographer.

Works Choreographed: CONCERT WORKS: *The Dream* (1916); *Firebird* (1921); *Dance Symphony* (1922); *The Sleeping Beauty* (1922); *Renard* (c.1926); *The Nutcracker* (1929); *The Ice Maiden* (1927); *The Bolt* (1931); *The Bright Source (The Bright Stream)* (1935); *Taras Bulba* (1940); *Pictures from an Exhibition* (1963).

Lopoukhova, Lydia, Russian ballet dancer who performed in London from the early 1930s; born October 21, 1891 in St. Petersburg; died June 8, 1981 in England. Trained at the St. Petersburg school of the Imperial Ballet by Enrico Cecchetti, she joined the Maryinsky Ballet in 1907. Her most celebrated role in that company was "Swanilda" in *Coppélia*, which she danced with Alexander Volinine. Leaving Russia in 1910, she performed with Diaghilev's Ballet Russe until 1929, creating roles in Leonid Massine's *Les Femmes de Bonne Humeur* (1917), *Parade* (1917), as one of the "Acrobats," and *La Boutique Fantasque* (1919), and performing in Fokine's *Carnaval* and the company production of *The Sleeping Princess*. A frequent guest artist and tour performer, she also danced in the premieres of Massine's *Le Soleil de Nuit* (1915) and *Le Beau Danube* (1924), at the Soirées de Paris.

A founding member of the Camargo Society, she created roles in Frederick Ashton's *Façade* (1931), *A Day in a Southern Port* (1931), and *The Rio Grande* incidental dances (1941). In that prolific year, she also performed with the Vic-Wells Ballet dancing "Swanilda" and Ninette De Valois' *Cephalus and Procris* (1931). With her husband, John Maynard Keynes, she founded the Arts Theatre Club in Cambridge, England (c.1936–1940).

Lopoukhova also worked in theatrical ventures, among them the Shubert's operetta, *The Rose Girl* (1921, New York), in gypsy dances staged by Mikhail Fokine, and the London production of *Comus: A Masque*.

Lorber, Martha, American ballerina working in theatrical productions; born c.1901 in Brooklyn, New York. After local training in Brooklyn, possibly with William Pitt Rivers, she moved to New York City to continue her studies with Alexis Kosloff. She joined his company at Oscar Hammerstein's Manhattan Opera House in 1917 and appeared with him in *The Wanderer* (1919). While with the company and the alternative opera troupe, she studied with and understudied Ekaterina Galante, who recommended that

she work under Mikhail Fokine when he relocated in New York. After partnering Kosloff in *Chu Chin Chow* (1918), she joined Fokine's company of ballet dancers in his theatrical productions of exotica. She was the lead dancer in the Bacchanales of his *Mecca* (1920), *Aphrodite* (1920), and the *Ziegfeld Follies of 1923* and *1924*.

Lorcia, Suzanne, French ballet dancer; born December 18, c.1902 in Paris. Lorcia's teachers at the school of the Paris Opéra included Carlotta Zambelli. Her twenty-two years at the Opéra (1928–1950) overlapped Serge Lifar's tenure there and she appeared in many of his ballets, including his *Les Créatures de Prométhée* (1929), *Salade* (1935), *Le Roi Nu* (1936), *Alexandre le Grand, Aneus, Bolero,* and *Guignol et Pandore*. She was cast in Zambelli's roles in classics restaged by her former partner Albert Aveline, most notably his *Sylvia* and *Les Deux Pigeons*. After retiring in 1950, she taught at the school where she had been trained.

Lord, Carolyn, American modern dancer and choreographer; born c.1942. Lord studied dance at the University of Chicago and in New York with Vincenzo Celli and the faculties of the Merce Cunningham studio. She has performed in works by William Dunas, Twyla Tharp, Steven Witt, Charles Stanley, and Kenneth King, as well as in productions by the Playhouse of the Ridiculous. Her own works included mostly solos until the mid-1970s, when she produced group works ranging from the outlandish *Mystic Writings of Paul Revere* to the austere *Night Fragments*. Her solo full-length evenings have attracted much attention from the press and the curious audience captivated by her bravura.

Works Choreographed: CONCERT WORKS: *Zoomorphic* (1970); *Black Dress* (1971); *765-4-321* (1971); *Rokudan* (1971); *Building Piece/Party* (1971); *The Secret Life of Rosie Miller* (1972); *The Stream Has Shown Me My Semblance True* (1972); *The Devil's Revenge and Other Essays* (1972); *The Theory and Practice of Miss America* (1973); *Brahms-Handel Variations* (1973); *Beethoven Op. 101* (1973); *Reflections on the French Revolution* (1973); *A Child's History of Paradise* (1973); *Song* (1974); *The Terrible Fate of an Ill-Begotten Muse*

(1974); *The Mystic Writings of Paul Revere* (1975); *The Absolute and the On-Going; Dance Sketches* (1975); *Night Fragments* (1976); *Liszt B Minor Sonata* (1976); *Mozart Sonata* (1976); *Summerdancing* (1976); *Soft Barricade Winter Sports* (1977); *Simple and Exotic Dances* (1977); *Fantasy* (1978); *My House/Rated X* (1978); *Fantasy Variations* (1979); *Jane Avril Ascending* (1979); *Moonbeam* (1979); *Spy/Counterspy* (1979); *Water in Winterlight* (1979); *An Affair of Quality* (1979).

Loring, Eugene, American ballet dancer and ballet, theater, and film choreographer; born Le Roy Kerpestein, 1914 in Madison, Wisconsin. Raised in Milwaukee, he did his first choreography for a theater production, c.1934. He moved to New York to study at the new School of American Ballet in 1935, where he worked with George Balanchine and Pierre Vladimiroff.

With the American Ballet, he danced in the premieres of Balanchine's *Alma Mater* (1934) and *Reminiscence* (1935); with the Ballet Caravan, a cooperative troupe of American Ballet members, he created roles in William Dollar's *Promenade* (1936), Douglas Coudy's *Folk Dance* (1937), Erick Hawkins' *Show Piece* (1937), and Lew Christensen's *Filling Station* (1937). His own best known work, *Billy the Kid*, was created for the 1938 season, following his *Harlequin for President* (1936) and *Yankee Clipper* (1937).

A charter member of Ballet Theatre, he danced the title role in Anton Dolin's *Peter and the Wolf* and his own *Great American Goof* on the same night in 1940. After acting for the *Goof's* scenarist, William Saroyan, in *The Beautiful People* (1941), he formed Dance Players, with Lew Christensen, Janet Reed, and Michael Kidd, among other dancers. Following the company's season of performances in his *The Man from Midian, Prairie,* and *The Duke of Sacramento,* Loring followed his *Beautiful People* co-star Gene Kelly to MGM. He acted in *National Velvet* (1944) as a jockey, and in *Torch Song* (1954) as a dance director, while staging dances for many musical films, notable among them *Yolanda and the Thief* (1945) for Fred Astaire, and *Meet Me in Las Vegas* (1956), *Silk Stockings* (1957), and other Cyd Charisse films. Loring's specialty, as seen in *Yolanda*, the Lucile Bremer dance numbers in *Ziegfeld Follies* (1946),

and *The 5000 Fingers of Dr. T.* (1952), seems to have been dream sequences that turn into nightmares.

Loring also staged dances for Charisse's television appearances and cabaret acts. His Broadway career, emerging after his film work, including the stage presentation of *Silk Stockings* (1955) and the 1958 edition of *Ice Capades*.

Loring is also celebrated as a teacher. His American School of Dance was for three decades the most important school of dance in Hollywood, teaching ballet and all of the techniques necessary for film and television work. He retired from that school in 1974 to become the first chairperson of dance at the newest campus of the University of California, at Irvine.

Works Choreographed: CONCERT WORKS: *Harlequin for President* (1936); *Yankee Clipper* (1937); *Billy the Kid* (1938); *City Portrait* (1939); *The Great American Goof* (1940); *The Man from Midian* (1942); *Prairie* (1942); *The Duke of Sacramento* (1942); *The Sisters* (1966); *These Three* (1966).

THEATER WORKS: *Carmen Jones* (1943); *Silk Stockings* (1955); *Ice Capades of 1958.*

FILM: *Yolanda and the Thief* (MGM, 1945); *Ziegfeld Follies* (MGM, 1946, dance numbers for Lucile Bremer only); *The Petty Girl* (Columbia, 1950); *The Toast of New Orleans* (MGM, 1950); *Deep in My Heart* (MGM, 1954); *Meet Me in Las Vegas* (MGM, 1956); *Silk Stockings* (MGM, 1957, Hermes Pan credited for Satire dance numbers); *Funny Face* (Paramount, 1957, Pan credited for Astaire dance numbers); *The 5000 Fingers of Dr. T.* (Columbia, 1952).

TELEVISION: *The Capital of the World* (*Omnibus*, NBC, December 6, 1953, performed by Ballet Theatre in concert after 1954); *Crescendo* (*Dupont's Show of the Month*, ABC, 1957); *Meet Cyd Charisse* (*Startime*, NBC, 1959, special).

Lorraine, Jeanne, American comedienne and theatrical dancer; born Jean O'Rourke, 1912 in Roxbury, Massachusetts; died August 22, 1969 in Hollywood, California. After working as a solo act in local theaters, she became the female member of Jeanne, John, and Joe, a dance trio on the presentation theater circuit in the Northeast. In 1936 she met and began to work with a former circus acrobat, Roy Rognan, in a comedy-dance act. They did dialogue that was compared to Burns and Allen routines, a solo tap dance each, and a series of satirical debuts based on exhibition ballroom forms, Apaches, and gymnastic adagio numbers. From 1936 to 1943 they toured with the Benny Goodman and Lawrence Welk Orchestras at the major presentation houses and on Broadway in *Laughter Over Broadway* (1939). In February of 1943, they flew to Europe as a member of a USO tour that included actress Tamara and singer Margaret Froman. Their plane, the Yankee Clipper, crashed in the water outside of Lisbon. Rognan was drowned in the crash. Although Lorraine was injured, she returned to the USO tour after a period of mourning and continued her career as a solo comedienne.

Lorraine, Vyvyan, South African ballet dancer performing in England; born April 20, 1939 in Pretoria, South Africa. Trained in Durban by Faith de Villiers, she continued her studies at the school of the Royal Ballet.

A member of the Royal Ballet from 1958, she created roles in Frederick Ashton's *Monotones I* (1965), *Jazz Calendar* (1968), and *Enigma Variations* (1968), as "Isobel." She has also performed the principal roles in *Les Sylphides, La Bayadère,* and *The Sleeping Beauty.*

As a member of the Royal Ballet's New Group, she created a role in a new pas de deux by Ashton, *Siesta* (1972).

Losch, Tilly, Vienese ballet and theatrical dancer and actress; born November 15, c.1904 in Vienna; died December 24, 1975 in New York. Trained at the school of the Vienna State Opera, she performed as a child in ballets by Josef Hassreiter. Associated for many years with the companies of director Max Reinhardt, she performed in his *The Green Flute* (1926) and both danced in and staged his *Jedermann* (1927), *Danton's Death* (1927), and *A Midsummer Night's Dream,* with which she toured the United States.

After performing in recitals with Harald Kreutzberg, who had been a colleague in the Reinhardt company, she moved to London, where she made her musical revue debut in *This Year of Grace* (1928). She introduced "What Is This Thing Called Love?"

in the 1929 *Wake Up and Dream,* before moving to New York to partner Fred Astaire in *The Band Wagon* (1931). In Paris, she created the role of the dancing "Anna" in the George Balanchine production of Brecht and Weill's *The Seven Deadly Sins,* as part of the Ballet '33 season, dancing that and the leading female role in his *Errant* in the Paris and London seasons.

Losch had her own ballet company in London briefly, creating works for her dancers, but soon left England to work in Hollywood. Her film appearances were all as seductive dancers—in *The Good Earth, The Garden of Allah,* and *Limelight.* She coached dances for the film, *Duel in the Sun* (Selznick Productions, 1946).

Works Choreographed: CONCERT WORKS: *Streamline* (1943); *Everyman* (1935).

FILM: *Duel in the Sun* (Selznick Productions, 1946).

Losee, Harry, American concert dancer and film choreographer; born c.1900 in Dayton, Ohio; died in early 1963. Losee was a student at the Los Angeles Denishawn School, performing on the 1920 tour in Ted Shawn's *Javanese Shadow Play* and other dances.

It is not certain what Losee's career was like in the 1920s. Although he was described as a "celebrated concert dancer," programs exist for only one recital in 1928. In 1922, however, he modeled for photographs of his dances, which may have been from a specific program.

There is no question, however, about his activities from 1933 to the early 1940s. After dancing at the Radio City Music Hall, and being reunited with Ruth St. Denis for a concert of religious works, he staged musical numbers for *Keep Moving* (1934), and moved to Hollywood with a contract from Fox Films. He was best known for his choreography for Fox's Sonja Henie vehicles, among them, *Thin Ice* (1937), *My Lucky Star* (1938), and *Iceland* (1942), although he also worked with Hermes Pan on *Shall We Dance* (1937), on loan to RKO. The Sonja Henie connection brought him choreography credits for her live ice shows of 1936 to 1941, as well as non-Henie ice acts for the Coconut Grove in Hollywood.

Works Choreographed: CONCERT WORKS: (All titles from 1927 recitals; no detailed information of dating available.) *Satyricon, Jarabe, Rhapsody, Dance Motif, Impromptu, Dweller Upon the Threshhold, Boodadjir, The Desert, Medieval Motif, Symphony of a City* (c.1927).

THEATER WORKS: *Keep Moving* (1934); *Hollywood Ice Revues with Sonja Henie* (1936–1941); *Ice-a-Poppin'* (1940).

FILM: *Shall We Dance* (RKO, 1937, co-choreographed with Hermes Pan); *Happy Ending* (Twentieth-Century Fox, 1937), *Thin Ice* (Twentieth-Century Fox, 1937); *You Can't Have Everything* (Twentieth-Century Fox, 1937); *One in a Million* (Twentieth-Century Fox, 1937); *My Lucky Star* (Twentieth-Century Fox, 1938); *Second Fiddle* (Twentieth-Century Fox, 1939); *Iceland* (Twentieth-Century Fox, 1942).

Louis, Murray, American modern dancer and choreographer; born November 4, 1926 in New York City. Trained by Alwin Nikolais at the Henry Street Settlement, he has been associated with the older choreographer's works throughout his career. Among the many Nikolais works in which he performed are *Imago* (1963) *Sanctum* (1964), *Tower* (1965), *Galaxy* (1966), and *Tent* (1968).

Many of the elements which made him the ideal Nikolais dancer are visible in his own choreography, notably his ability not only to perform isolations of limbs and muscles, but also to focus the audience's attention on those miniscule movements. He had choreographed for his own company, of Nikolais dancers and their joint students, since the mid-1950s. Although the two companies are now separated, Louis and Nikolais still share a studio and school. Louis still dances with his company, for which he has created most of his works—in its own season and in cooperation with Rudolf Nureyev in various theaters. His works, which to a unique degree built their movements on his own performance style, are characterized by humor in step combinations and in mise-en-scène.

Works Choreographed: CONCERT WORKS: *Opening Dance* (1953); *Little Man* (1953); *Antechamber* (1953); *Star-cross'd* (1953); *Affirmation* (1954); *For Remembrance* (1954); *Courtesan* (1954); *Family Al-*

bum (1954); *Martyr* (1954); *Triptych* (1954); *Piper* (1955); *Court* (1955); *A Dark Corner* (1955); *Monarch* (1955); *Polychrome* (1955); *Man in Chair* (1955); *Figure in Grey* (1955); *As the Day Darkens* (1955); *Small Illusions* (1955); *Frenetic Dances* (1955); *Belonging to the Moon* (1955); *Suite* (1956); *Incredible Garden* (1956); *Reflections* (aka *Harmonica Suite*) (1956); *Corrida* (1956); *Journal* (1957); *Entr'Acte* (1958); *Odyssey* (1960); *Calligraph for Martyrs* (1962); *Facets* (1962); *Interims* (1963); *Suite for Divers Performers* (1963); *Transcendencies* (1964); *Landscapes* (1964); *Junk Dances* (1964); *A Gothic Tale* (1964); *Chimera* (aka *Charade*) (1966); *Choros I* (1966); *Concerto* (1966); *Illume* (1966); *Go Six* (1967); *Proximities* (1968); *Intersection* (1968); *Personae* (1971); *Continuum* (1971); *Disguise* (1971); *Hoop-la* (1972); *Dance as an Art Form* (1972); *An Index . . . (to Necessary Neuroses)* (1973); *Porcelain Dialogues* (1974); *Schéhérazade* (1974); *Geometrics* (1974); *Moments* (1975); *Catalogue* (1975); *Glances* (1976); *Ceremony* (1976); *Cléopâtre* (1976); *Déja Vu* (1977); *Schubert* (1978); *Vivace* (1978); *The Canarsie Venus* (1978); *Figura* (1978); *Afternoon* (1979); *Five Haikus* (1979); *November Dance* (1980); *The City* (1980).

Louther, William, American modern dancer also working in Israel and Great Britain; born January 22, 1942 in Brooklyn, New York. After local tap lessons from Kitty Carson, he attended the High School of Performing Arts, where he worked under May O'Donnell and Gertrude Schurr. At the Juilliard school, he worked with Antony Tudor, Louis Horst, and Martha Graham. He performed with O'Donnell's concert group, like so many of his fellow P.A. alumni, and with the early Alvin Ailey troupe, in which he danced in Ailey's *Hermit Songs,* Talley Beatty's *Road of the Phoebe Snow,* and Anna Sokolow's *Rooms.* With the Martha Graham company after 1965, he danced in *Circe, Secular Games, Witch of Endor, Diversion of Angels,* and *Cortege of Eagles,* among many other repertory works. As a freelancer, he danced in Ernie Flatt's *Fade Out-Fade In* (1964), in Herbert Ross' company at the Spoleto Festival (1960), and in Donald McKayle's television specials and live performances of *Wilderness* and *Brave New World* (1967).

When Louther joined the London Contemporary Dance Theatre in 1969, he was described as a Graham "missionary," but instead of simply teaching her technique and repertory, he choreographed himself and performed in works by his English colleagues, most notably in Robert Cohan's *Side Scene* and Brian Moreland's *Kontakion.* He later served as artistic director of the Bat-sheva Dance Company in Tel-Aviv (1972-1974) and the Welsh Dance Theatre (1974-1976), before founding his own English company, the Dance and Theatre Corporation. His most successful works range from the satire of Graham known as *Divertissement in the Playground of the Zodiac* (1972) to the sensitive study of Vaslav Nijinsky, *Voices* (1980).

Works Choreographed: CONCERT WORKS: *Mantle* (1968); *Vesalii Icones* (1970); *Divertissement in the Playground of the Zodiac* (1972); *Prologues* (1976); *Plaintiff Events* (1976); *Mirror* (1978); *Voices* (1980); *I Am Women* (1980).

Love, Bessie, American theatrical dancer and silent film star; born in Midland, Texas. A student at the Ned Wayburn Studio of Stage Dancing in New York, Love performed in Fanchon and Marco productions in Los Angeles before entering films. Her West Coast training came from Ernest Belcher, who was both a film dance director and the ballet teacher most frequently recommended by Fanchon to improve the skills of her performers.

Originally a juvenile in dramatic two-reelers and featured films, Love was the star of three innovative backstage musicals of the early sound era—*Sally of the Scandals* (Fox Film Corp., 1928), the first *Broadway Melody,* actually a melodrama, but one in which Love, as "Hank," and Anita Page danced in the "Follies," and Larry Ceballos' *Hollywood Revue* of 1929.

Love came out of retirement in 1968 to play the mother of Isadora, Elizabeth, Raymond, and Augustin Duncan in the film, *The Loves of Isadora* (Universal, 1969).

Love, Edward, American theatrical dancer and actor; born June 29, 1952 in Toledo, Ohio. Love was trained at the Ohio State University, considered by many a major center of modern dance education in

the Midwest. Since moving to New York, Love has performed with the Alvin Ailey American Dance Theater. Many Ailey company choreographers have used him as a Broadway dancer. His roles have included "The Pusher" in Donald McKayle's *Raisin,* "The Tinman" in George Faison's *The Wiz,* both "Butch" and the larger role of "Richie" ("gimmie the ball") in Michael Bennett and Bob Avian's *A Chorus Line,* and a variety of dance parts in Bob Fosse's *Dancin'.*

Love has also had a successful career as a dramatic actor in New York Off Broadway productions, in film, and on television, where he appears regularly in the soap opera, *The Edge of Night.* He has been highly acclaimed for his performances in two productions for the New York Shakespeare Festival's Public Theater presentations of new plays, among them *Ti-Jean and His Brothers* and Ntozake Shange's *Spell #7.*

Løvenskold, Herman, Norwegian nineteenth-century composer associated with August Bournonville in Denmark; born July 30, 1815 in Holdensjarnbruk, Norway; died December 5, 1870 in Copenhagen. Raised in Copenhagen, he was a member of the Court theater and chapel throughout his professional life. His first ballet score, written at thirty, was for August Bournonville's new staging of *La Sylphide* in 1836; it has completely overtaken the Schneitzhoeffer music of the French original 1832 production by Filippo Taglioni and is generally thought of as the first score of that name. After further studies in Vienna and with a maturing style, he returned to Copenhagen where he composed music for Bournonville's *New Penelope* (1847) and *Fantasies* (1836, multiple composers). His opera *Turandot* (1854), which provided music for a number of exotic dancers of the 1890s, has occasionally been revived by contemporary American companies interested in alternative versions of standard repertory works.

Lubovitch, Lar, American modern dancer and choreographer; born Larry Lubovitch, 1943, in Chicago, Illinois. Lubovitch began his dance training while an art student at the University of Iowa and continued his studies at the Juilliard School under Antony Tudor, Anna Sokolow, and Helen McGehee. Through-

out the 1960s, he worked as a lighting designer for Louis Falco and, occasionally, the Alvin Ailey troupes, while dancing with Pearl Lang and the eclectic Manhattan Festival Ballet. He founded his company in 1968 and, apart from works staged for ballet companies, has created most of his dances for it ever since. Although for many years Lubovitch was known for his titles, among them *Some of the Reactions of Some of the People Some of the Time Upon Hearing Reports of the Coming of the Messiah* (1971), *The Time Before the Time After After the Time Before* (1972) and *Variations and Fugue on the Theme of a Dream* (1970), or for the seeming irrelevancies of his collagistic images, such as the references to *Gone with the Wind* in *Scherzo for Massah Jack* (1973), he has since become celebrated for his use of movements. His more recent works, set to minimalist scores by Steve Reich and Philip Glass, are more involved with patternings and groupings of dancers in abstract shapes than in ideas or verbal humor.

Works Choreographed: CONCERT WORKS: *Blue* (1968); *Freddie's Bag* (1968); *The Journey Back* (1968); *Incident at Lee* (1969); *Transcendent Passage* (1969); *Unremembered Time-Forgotten Place* (1969); *Ecstacy* (1970); *Variations and Fugue on the Theme of a Dream* (1970); *Sam Nearly Dead Man* (1970); *Clear Lake* (1971); *Social* (1971); *Some of the Reactions of Some of the People Some of the Time upon Hearing Reports of the Coming of the Messiah* (1961); *Whiligogs* (1971); *Joy of Man's Desiring* (1972); *The Time Before the Time After After the Time Before* (1972); *Scherzo for Massah Jack* (1973); *Chariot Light Night* (1973); *Three Essays* (1974); *Zig-Zag* (1974); *Avalanche* (1975); *Rapid Transit* (1975); *Session* (1975); *Girl on Fire* (1975); *Les Noces* (1976); *Marimba* (1976); *Exultate, Jubilate* (1977); *North Star* (1978); *Scriabin Dances* (1978); *Up Jumps* (1979); *Cavalcade* (1980).

Lubovska, Desirée, French/Mexican interpretive dancer of the early twentieth century; born, according to a publicity release, on January 1, 1900 in Paris, France, although other sources estimate her birth at c.1895–1898 in Mexico City, Mexico. A protégé of Dictator Portifiro Diaz, she made her professional debut in Mexico City in 1912.

Between 1915 and 1923, when she retired, Lubovska performed a series of solos and group dances in various media. She toured for many years in vaudeville, primarily on the Keith/Orpheum "Class Act" circuits, and interpolated her act into the opening number of the revue, *Everything,* at the New York Hippodrome in 1918; her status was such that she opened the revue, in Part I—*The Beginning of the World,* which ran an outstanding thirty-seven weeks. There is some evidence that she was involved in Florence Noyes' circuit of lecturers on health, physical culture, and American Delsartism.

The Lubovska act, in which she was billed as the "Originator and Foremost Creator of Egyptian Angles in Dance; Originator of Interpreting Types of Art in That of Dance; America's Greatest Dramatic Interpretive Artist, in her Original Impressionistic Dance," was very successful. Whatever her level of historic authenticity, Lubovska's visual sense seems to have been highly developed; her works had definite color schemes (rare in vaudeville), with some in stark black and white, notably the *Gavotte Grotesque* (1916), and others in bright tints with elaborate accompanying charts of "Egyptian color symbolism." Although from their title, her works seem to be similar to those of Ruth St. Denis and Ted Shawn, it seems more likely that she was in fact a mime-monologuiste, in the tradition of Rita Sangalli and Gertrude Hoffmann.

Works Choreographed: CONCERT WORKS: *Gavotte Grotesque* (1916); *Egyptian Maids Preparing a Tomb* (1916); *Egyptian Dance of Morning* (1916); *Coolie Kuang Hua* (1916); *Soul of Vanity—Peacock Dance* (1916); *Madame Diablo* (1918); *Creation* (1918, presumably the Hippodrome dance from *The Beginnings of the World*); *Sahara* (1918); *Story of Egypt* (1919); *Spirit of Russia* (1919); *Olympic Dance* (1921); *La Nuit* (1921); *Tibetian Dance* (1921); *Mannequin Parisienne* (1921); *Orientale* (1921); *Incense Dance* (1921); *Autumn* (1921); *An Athenian Rite* (1923).

Lucci, Michelle, American ballet dancer; born April 26, 1950 in Buffalo, New York. Lucci's training has been acquired at the Banff School of the Arts in Canada and at the studios of Robert Joffrey and Edward Caton in New York City. After a season with the Royal Winnipeg Ballet, Lucci became a member of the Pennsylvania Ballet in 1969. She has performed in the company's versions of the shorter classics and in its large Balanchine repertory, but has also become known for her appearances in the troupe's contemporary works, most notably, Benjamin Harkavy's *Time Past Summer* and Hans Van Manen's *Adagio Hammerklavier.*

Luce, Claire, American theatrical dancer; born October 15, 1903 in Syracuse, New York. Trained at the New York Denishawn School, c.1920-1923, and with Mikhail Fokine, Luce made her professional debut with the Russian Opera Ballet (a Sol Hurok pick-up company) in 1921. From 1923 to 1926, she appeared on Broadway as a featured dancer and musical comedy star in, among other shows, *Little Jesse James* (1923), *Dear Sir* (1924), *The Music Box Revue of 1924,* which was one of the most dance oriented of all the annual revues, *No Foolin'* (1926), the *Ziegfeld American Revue* (1926, replacing that season's *Follies*), and *The Scarlet Page* (1929). In 1932, she starred as "Mimi" in the original production of *The Gay Divorce,* becoming Fred Astaire's first partner since the retirement of his sister, Adele. With Astaire, she introduced "Night and Day" to New York and London. After dancing in three more successful shows—*Vintage Wine* (1934), *The Gay Deceivers* (1935), and *Follow the Sun* (1936)—she began to work in straight dramas and in the classics. She created the role of "Curley's Wife" in the original stage production of *Of Mice and Men* in 1937, and went on to act in productions of Shakespeare on stage, film, and television. Luce is also well known for her participation in spoken arts recordings over the last twenty years.

Lüders, Adam, Danish ballet dancer working in the United States after 1975; born February 16, 1950 in Copenhagen, Denmark. Trained at the school of the Royal Danish Ballet, he performed with that company in the Bournonville repertory and in their productions of *Swan Lake, The Nutcracker,* and George Balanchine's *Night Shadow.*

He later worked with the London Festival Ballet for two seasons, dancing in their productions of *Swan Lake* and *The Nutcracker,* and in Maurice

Béjart's *Webern Opus 5*. Joining the New York City Ballet in 1975, he has performed there ever since his debut in Balanchine's *Brahms-Schoenberg Quartet*. He has since danced in many works by Balanchine, including *Stars and Stripes,* his *Nutcracker* and *Swan Lake, Chaconne* and *Kammermusik No. 2* (1978), an intensely difficult work with complex rhythmic structures that proved that Lüders could handle the Balanchine style of dancing. Returning to the style in which he was trained, Lüders has also won acclaim in Stanley Williams' presentation of *Bournonville Divertissements* for the City Ballet.

Ludin, Fritz, Swiss modern dancer working in the United States after 1963; born 1934 in Switzerland. Trained in Vienna by Lia Schubert and in Paris by Victor Gsovsky, Ludin worked in Stockholm before joining the José Limón company for a Far Eastern tour in 1963.

As a member of the Limón company from then until Limón's death, he was assigned featured parts in his *Missa Brevis, The Traitor, The Winged, There Is a Time, Psalm,* and *A Choreographic Offering.* He also performed in Ruth Currier's *The Antagonists* (1958) and *Triplicity* (1956).

Currently a member of Dances We Dance, with fellow Limón dancer Betty Jones, he performed in works by Martha Wittman, including her *Journey to a Clear Plane* (1961), *On Dancing* (1971), and *Untitled Solo* (1973), and in excerpts from Limón's *There Is a Time* and *Missa Brevis.* The duo company is currently in residence at the University of Hawaii, where both teach. Ludin has choreographed for the Hawaiian company.

Works Choreographed: CONCERT WORKS: *Form* (1977); *Divertimento* (1977).

Ludlow, Conrad, American ballet dancer; born March 31, 1935 in Hamilton, Montana. Ludlow received his training from Willam and Harold Christensen at the School of the San Francisco Ballet, graduating to the company in 1953.

After two seasons in San Francisco, Ludlow joined the New York City Ballet in 1956, performing with the company until 1972. Associated almost entirely with the works of George Balanchine, Ludlow danced principal roles in many of his abstract ballets of the 1960s. Among the works in which he created roles were the *Danzas Sinfonia* section of *Panamerica* (1960), the *Tchaikovsky Pas de Deux* (1960), *The Figure in the Carpet* (1960), *Liebeslieder Walzer* (1960), *A Midsummer Night's Dream* (1962), as "Titania's Cavalier," the *Emeralds* section of *Jewels* (1967), and the *Tchaikovsky Suite #3* (1970). Ludlow also performed the title role in *Apollo* and *danseur* roles in the *Tchaikovsky Piano Concerto No. 2* (then called *Ballet Imperial*), *Symphony in C,* and *Divertimento No. 15.*

Since his retirement in 1972, Ludlow has served as director of the Oklahoma City Ballet.

Ludmilla, Anna, American ballet dancer working in operas, ballet companies, and revues; born Jean Cahley, c.1903 in Chicago, Illinois. Ludmilla was trained in Chicago by the ballet masters of the Chicago Grand Opera, Andreas Pavley and Serge Oukrainsky, and after 1921, Adolf Bolm. In London in the 1930s, she continued her studies under Nicholai Legat and Serafina Astafieva. Ludmilla was principal dancer of the Chicago Grand Opera under the regimes of Pavley and Oukrainsky and of Bolm; for the former, she danced in their *Afternoon of a Faun, Pastorale,* and divertissements, while for the latter in the early 1920s, she performed in *Petrouchka,* as "The Ballerina," and in opera ballets to *La Juive* and *Cléopâtre.*

She left the Opera to perform on Broadway in Fred Stone's *Tip Top* (1921) and *Tangerine* (1921). Ludmilla then went to Paris, was discovered there by John Murray Anderson, and hired to perform—on Broadway—in his *Greenwich Village Follies* of 1924 to 1926. In the summer between the last two editions of that "intellectual revue," she was reunited with Bolm for the South American tour of his Ballet Intime. Following the *Follies* of 1926, she returned to Paris to dance at the Folies Bergère as a toe specialist, and with the Ida Rubinstein Company as a conventional ballerina. There is a persistent, but unverified, story that she was hired to join the Diaghilev Ballet Russe in July, 1929, but did not arrive in Monte Carlo until after Diaghilev's death.

Ludmilla moved to London, where she performed until 1931. She partnered Keith Lester in the *Intimate Revue* (May, 1930), Anton Dolin in *Alf's Button*

(late 1929), *Pomona* (1930), and his Coliseum Theatre season (December, 1930), and Leon Woizikowsky in his ballet season of Massine works (early 1931). In the Dolin season, she danced in an early, obscure Balanchine pas de deux, *Jack and Jill* (1930), that fit her personal style. With each, she performed in a ballet-technique, romantic adagio dance that was popular at the time; it has been described as an Apache on point, but probably resembled the early works of George Balanchine more than the psychological thrillers of the French Apache dancers.

In her next career, returning to New York, she partnered Georges Fontana after the split with his England partner, Marjorie Moss. Although they were billed as an exhibition ballroom team, his style had always included point work adagio dances. She retired in 1932 to teach in Indianapolis, Indiana. By 1950, however, she was living in Panama and teaching ballet technique there. Margot Fonteyn, who resides in Panama when not working and touring, frequently studies with Ludmilla there.

Luigi, American jazz dancer and teacher; born Eugene Louis Facciuto, March 20, 1925 in Steubenville, Ohio. Facciuto spent his G.I. Bill funds on classes with Edith Jane at the Falcon Studio in Hollywood. Jane's work in tap and ballet were augmented with studies with Adolf Bolm, Bronislava Nijinska, Edward Caton, and Eugene Loring, all of whom were then teaching on the West Coast. An automobile accident made a performing career in film difficult, but he found frequent employment as an assistant to the choreographer on films in Hollywood, working with, among others, Le Roy Prinz (head dance director at Paramount), Ernest Flatt, and Robert Alton. He performed, coached, and choreographed for a multitude of productions for hotel clubs in Las Vegas and Reno, Nevada before moving east to New York. He has taught jazz dance since the early 1950s, developing a series of exercises and studies that have been presented in master classes at hundreds of studios and teacher conferences. It has been estimated that more than 70 percent of all dancers working in the conglomerate jazz style have studied with Luigi or used his exercises as taught by another. The sequence that opens each class is frequently used by dancers who cannot get to class and want a complete warm-up in a limited space. His own choreography has usually been seen in lecture-demonstrations, but he occasionally presents recitals by selected groups of students at festivals and multiple concert series. His textbooks and recordings are sold through his studio to teachers around the world.

Lukom, Yelena, Soviet ballet dancer; born May 5, 1891 in St. Petersburg; died there February 27, 1968. Lukom was trained at the school of the Imperial Ballet in St. Petersburg, most notably by Mikhail Fokine. She is considered the first ballerina of the Soviet era, although she had eight years of success at the Imperial Theater before the revolution. A member of the Maryinsky/GATOB/Kirov for an extraordinary thirty years, Lukom had the three basic ingredients of ballet performance—technique, musicality, and stage presence. She could easily adapt to the dying Imperial style with its arbitrariness and artifices and to the developing Soviet genres with their theatrical realism in contrast to the bravura technical requirements. It should be noted that some works, most notably *Giselle,* remained in her repertory throughout her career and that, with the possible exception of Fokine's *Chopiniana,* she may never have appeared in nonplotted ballet.

Lukom was also known for her pas de deux in both genres and especially for the lifts and throws that she and her partner, Boris Shaivrov, popularized in the coda sections of their duets. Western balletomanes tend to be snobbish about the "Soviet acrobatic" style of ballet partnering, but there is no question that audiences find it inspiring and effective much in the way that the early French Romantics first beheld point work.

When she retired from performance in 1941, she taught and directed rehearsal and repertory for the Kirov Ballet.

Lully, Jean Baptiste, French composer; born November 28, 1632 in Florence; died March 22, 1687 in Paris. Considered the founder of the French opera, Lully began his career as a popular entertainer and strolling player. By 1645, however, he entered the service of the Mlle. de Montpelier, shifting his allegiance to Louis XIV, and by 1662, becoming music master to the royal family.

In the 1660s he collaborated with Molière to create productions that meshed comedy dialogue with music and movement, among them *Le Mariage forcé* (1664) and *Le Bourgeois Gentilhomme* (1670). In 1671, after he had managed to obtain exclusive rights to produce opera productions in Paris, he created a series of works, then called operas but now considered the first ballets, including *Le Triomfe de l'Amour* (1681) and *Le Temple de la Paix* (1685),

Lumbye, Hans Christian, Danish composer known as the "Strauss of the North"; born May 2, 1810 in Copenhagen; died there March 20, 1874. Lumbye composed music for ballets by August Bournonville fairly early in his career, producing music for many of his works with local or Italian settings, such as *Napoli* (1842), *La Ventana* (1854), *Far from Denmark* (1860), and *The Life Guards at Amager* (1871). His score for Bournonville's *Konservatoriet* (1849) has survived with the ballet and is occasionally played in concert. Lumbye is best known for his popular dance music, written for his Copenhagen-based private orchestra. Like the Strauss family, the Lumbyes (Hans Christian and his sons Karl and Georg) maintained a repertory of musical works based on both folk and popular dances.

Lund, Gary, American modern dancer and choreographer; born in Climbing Hill, Iowa. He began his dance training in Colorado with Hanya Holm and has continued it with classes with Nancy Hauser, Oliver Bostock, Don Redlich, Viola Farber, Billy Seigenfield, and James Cunningham. After moving to Minneapolis in 1973, he began to perform with the Nancy Hauser company while teaching at her studio and the local school system. He has participated in two important collaborative duet companies—with Ric Rease, with whom he worked in Minneapolis, and with Laura Glenn in their New York–based Two's Company. They dance together in José Limón's *The Exiles* (her signature piece), and works by Don Redlich, and themselves.

Works Choreographed: CONCERT WORKS: *Crel* (1975); *Countenance* (1976); *Ranger 15:14* (1977, in collaboration with Bruce Drake and Steven Potts); *Short Subjects* (1978); *Terranulius Wright* (1978); *A Half Bubble Off* (1979); *It Could Of Happened Like This* (1979); *A Bad Day* (1980); *Day Dream* (1980); *To Be First* (1980).

Lupino, Stanley, English theatrical dancer and actor, director, and author; born May 15, 1894 in London; died there June 10, 1942. A member of the Lupino family of actors, father of actress/director Ida Lupino and cousin of Lupino Lane, he began his career as an acrobat. Unlike Lane, however, he was famous as a "man-about-town" comic, rather than an eccentric. He did musical comedy dance and song numbers as the hero of London shows, including *Suzette* (1917), *Arlette* (1917), *His Girl* (1922), Ned Wayburn's *Jig Saw* (1920), *Dover Street to Dixie* (1923), *Naughty Riquette* (1926 in New York) and *The Nightingale* (1972). From 1928 until his death, he wrote librettos and directed his shows, frequently in collaboration with actor-dancer-producer Laddie Cliff. Like his cousin, he was generally believed responsible for his dance routines although he never received a dance direction credit.

Bibliography: Lupino, Stanley. *From the Stocks to the Stars* (London: 1934).

Lupone, Robert, American theatrical dancer and actor; born in the 1950s in Northport, Long Island. Although when he was a student at the Juilliard School, he was known as a ballet *danseur,* Lupone has become celebrated as a Broadway dancer and actor. He made his Broadway debut in the 1968 revival of Jerome Robbins' *West Side Story* as "A-Rab" and followed it with an appearance in Noel Coward's *Sweet Potato* later that year. After dancing in both the stage and film versions of *Jesus Christ Superstar,* he was cast as the first "Zach," the onstage choreographer and protagonist of Michael Bennett's *A Chorus Line* (1975). In that role, he questions the auditioners (whose responses are the monologues and songs) and leads the climactic "One." Since leaving the show, he has had the leads in two unfortunately unsuccessful musicals, *Nefertiti* (1977, closed out of town) and *Swing* (1980). He has become known as a talented dramatic actor since early in his career, with one of his most notable roles in the American premiere of Sam Shepherd's *The Tooth of Crime.*

Lyman, Peggy, American modern dancer; born 1950 in Cincinnati, Ohio. Although she is now associated in the minds of dance audiences with the repertory of the Martha Graham company, Lyman began her training and career in ballet with classes with Myrl Laurence and David McLain in Cincinnati. She performed with the latter's company (now The Cincinnati Ballet), with the City Center Joffrey Ballet (as an apprentice), and with the corps de ballet of the Radio City Music Hall after moving to New York. Despite these credits, and her participation in Gower Champion's very Broadway musical *Sugar* (1972), she became one of traditional modern dance's most highly regarded and employed performers. As a member of the Graham company, she has been seen in new works, such as *Chronique* (1974), *Holy Jungle* (1974), *Adorations* (1976), and *Flute of Pan* (1978), and in revivals of the classics of the 1940s and 1950s. She was honored to have been chosen to recreate Graham's performances in her early solos, *Lamentation* (the moving dance performed inside a tunnel of fabric) and *Frontier.* Lyman also works as a guest dancer in other small concert groups of contemporary choreographers, such as William Badulato, Kathryn Posin, Peter Sparling, and Murray Spalding, for whom she appeared in *The Traced* in 1978.

Works Choreographed: CONCERT WORKS: *Shadow* (1976); *The Sag* (1978).

Lynn, Rosamond, American ballet and modern dancer; born December 31, 1944 in Palo Alto, California. Lynn studied ballet on the East Coast with William Griffith, Vincenzo Celli, Richard Thomas, and Patricia Wilde before making her professional debut with the ballet corps of the Philadelphia Lyric Opera in 1964. As a member of the American Ballet Theatre, she appeared in both the company's revivals of the full-length classics, such as *Swan Lake* and *Giselle,* and in the contemporary repertory, such as Jerome Robbins' *Les Noces.* She left Ballet Theatre, however, to dance in the entirely contemporary repertory of the Alvin Ailey American Dance Theatre. Among her many performance credits there are roles in Talley Beatty's *Tocatto* and Ailey's own *A Lark Ascending* (1972), *Revelations,* and *Mary Lou's Mass.*

Lynne, Gillian, English ballet dancer and theatrical choreographer; born Gillian Pyrke, 1926, in Bromley, Kent, England. Trained at the Arts Education Trust School, she performed with the Sadler's Wells Ballet from 1943 to 1951. She created the role of "Daughter" in Robert Helpmann's *Adam Zero* (1946), and parts in Frederick Ashton's *Les Sirènes* (1946), *Don Juan* (1948), and *Daphnis and Chloe* (1951); she was featured in Ashton's repertory also, performing in his *Les Patineurs, Symphonic Variations, A Wedding Bouquet,* and *Cinderella.*

In 1951, she became a staff dancer at the London Palladium, performing in ballets by Pauline Grant. She danced in the West End in *Can-Can* (1954), *Becky Sharp* (1959), and *New Cranks* (1960), before becoming a choreographer on her own. Among her many English productions are *England Our England* (1962) and *Love on the Dole* (1970), while on Broadway, she choreographed *Roar of the Greasepaint, The Smell of the Crowd* (1965) and *How Now Dow Jones* (1968). Her films have included *Man of La Mancha* (UA, 1972), and *Half a Sixpence* (Paramount, 1968). She has recently become famous for her choreography for Miss Piggy on *The Muppet Show* (ATV, 1976–).

Works Choreographed: CONCERT WORKS: *The Owl and the Pussycat* (1961); *Collages* (1963); *Breakaway* (1970).

THEATER WORKS: *England Our England* (1962); *Round Leicester Square* (1963); *Roar of the Greasepaint, The Smell of the Crowd* (1965); *Pickwick* (1965); *How Now Dow Jones* (1968); *Love on the Dole* (1970); *Tonight at 8* (1971); *Ambassador* (1971); *The Card* (1973).

FILM: *Half a Sixpence* (Paramount, 1968); *Man of La Mancha* (UA, 1972).

TELEVISION: *The Muppet Show* (ATV, 1976–).

Lyon, Annabelle, American ballet dancer; born January 8, c.1915 in New York City. Lyon was trained by Mikhail Fokine and Alexandra Fedorova, and at the School of American Ballet, as a charter member of the company. She had performed with the Fokine Ballet in 1934, in his *Les Sylphides* and *Schéhérézade,* but became better known for her work in the Ameri-

can Ballet, the first Balanchine company in the United States.

Among the many early Balanchines in which she danced were *Serenade* (1934), in the Valse section in the original production, *Reminiscence* (1935), *The Bat* (1936), and *The Card Party* (1937). As a member of the Ballet Caravan, a company of American Ballet dancers, she created roles in Eugene Loring's *Harlequin for President* (1936), William Dollar's *Promenade* (1936), and Douglas Coudy's *The Soldier and the Gypsy* (all in the first season in 1936). She can also be seen with the American Ballet in Balanchine's film, *The Goldwyn Follies* (MGM, 1937).

An early member of Ballet Theatre, she created the role of the "Youngest Sister" in Antony Tudor's *Pillar of Fire* (1942) and danced in his *Jardin aux Lilas* and *Dark Elegies*. She was also in the first cast of Fokine's *Bluebeard* (1941) and repeated her role in *Les Sylphides* for him. Other roles with the company include major parts in Massine's *Aleko,* Agnes De Mille's *Three Virgins and a Devil,* and Eugene Loring's *The Great American Goof* and *Billy the Kid.*

Before retiring from performance, she danced on Broadway in Agnes De Mille's *Allegro* (1947) and *Carousel* (1948).

Lyon, Genevieve, American interpretive and exhibition ballroom dancer; born c.1893 in Chicago, Illinois; died Spring 1916 in Denver, Colorado. In 1910, Lyon was chosen as the most perfect example of American beauty in a competition sponsored (or staged) by a Chicago-area sculptor and Hotel. She modeled for many artists in Chicago and New York, and her beautiful face can still be seen on many American art nouveau nymphs, goddesses, and caryatids on public buildings across the country. Her first theatrical performances were seen in New York when she interpolated her interpretive dances into the symbolic play, *Daughters of Dawn* in 1912. She appeared in the operetta *The Count of Luxemburg* (1912) and the *Varieties* of 1913 on Broadway, but left the stage to become a ballroom dance demonstrator at Shanley's, New York. Her partner there was John Murray Anderson whom she married in 1914. They toured as ballroom dancers and modeled for the illustrations in Troy Kinney's early textbook of social dance for almost a year, but in the fall of 1914, Lyon contracted tuberculosis and they were forced to move to the Southwest for her health. By winter of that year, she was too ill to perform at all, and, although Anderson continued to dance in Flagstaff, Arizona and Denver, Colorado, Lyon could not work. She died at the age of twenty-three.

M

Mabry, Iris, American modern dancer and choreographer; born c.1920 in Clarksville, Tennessee. After spending summers at the Bennington College School of Dance, she continued her studies in dance and composition at the Neighborhood Playhouse in New York. A 1943 audition winner at the 92nd Street Y, she presented her first recital in 1946.

Mabry specialized in choreographing solos for herself with piano accompaniment. Her works tended to use small, limited vocabularies of movement, repeated and varied to create entire languages for her to perform.

Works Choreographed: CONCERT WORKS: *Litany* (1946); *Witch* (1946); *Dreams* (1946); *Sarabande* (1946); *Scherzo* (1946); *Bird Spell* (1946); *Rally* (1946); *Cycle* (1946); *Blues* (1946); *Rhapsody* (1947); *Allemande* (1947); *Doomsday* (1947); *Counterpoint* (1948); *Lamb of God* (1948); *The Magic Cauldron* (1953); *Appassionata* (1954); *Entr'acte* (1954); *Cabaret* (1955).

MacDonald, Brian, Canadian ballet dancer and choreographer; born May 14, 1928 in Montreal. MacDonald was a music critic for the *Montreal Herald* when he began his short performing career in 1951. After two seasons in the Canadian National Ballet, he suffered an arm injury which ended his dancing.

Founder of the Montreal Theatre Ballet in 1956, he worked with the Royal Winnipeg Ballet from 1958 on. He served as artistic director of the Royal Swedish Ballet from 1964 to 1966 and of the Harkness Ballet from 1967 to 1974. He is currently director of the Montreal-based Les Grands Ballets Canadiennes. Most of his choreography has been created for the company with which he was employed at the time, although he has also contributed dances to the repertories of the Paris Opera Ballet and the City Center Joffrey Ballet.

Works Choreographed: CONCERT WORKS: *The Darkling* (1958); *Les Whoops-de-Doo* (1959); *A Court Occasion* (1961); *Time out of Mind* (1962); *Aimez-vous Bach?* (1962); *Capers* (1963); *Prothalamion Pas de Deux* (1963); *Pas D'Action* (1964); *While the Spider Slept* (1965); *Skymning* (1966); *Cucurucu* (1966); *Firebird* (1966); *Octet* (1966); *Rose Latulippe* (1966); *Song without Words* (1966); *Tchaikovsky* (1967); *Zealous Variations* (1967); *Canton Indio* (1967); *Ballet High* (1970); *The Shining People of Leonard Cohen* (1971); *Voices from a Far Place* (1971); *Star-Crossed* (1973); *Several Occasions* (1973); *Cordes* (1973); *Diabelli Variations* (1974); *The Lottery* (1974); *Rags* (1975); *Romeo and Juliet* (1975); *Double Quartet* (1978); *Remembranza* (1978).

Mack, Charles, American popular entertainer; born Charles E. Sellers, November 22, 1887 in White Cloud, Kansas; died January 11, 1934 near Mesa, Arizona. Mack made his professional debut in a "Tom" show (a shortened theatricalized version of *Uncle Tom's Cabin*) touring West from Kansas. He met his future partner George Searcy (Moran) in Astoria, Oregon, when their tour routes overlapped, and traveled east with him. Although they both appeared in *Over the Top* (1917) on Broadway, they did not develop their joint act, Two Black Crows, until four years later. That celebrated Moran and Mack routine was basically a rube act, based on rural jokes about worms and cows, in which they dressed in countrified tramp outfits. Their importance to dance and popular culture historians does not lie in their actual comic lines, but in the way that they aligned their comic and dance timing into a unified act. They drawled verbally and visually, making a legible connection between their jokes and their dancing.

Mack and Moran appeared together in their Two Black Crows act in the *Ziegfeld Follies* of 1920 and 1925, Earl Carroll's *Vanities* of 1926 and 1928, George White's *Scandals* of 1925, the *Passing Show of 1921* and the *Greenwich Village Follies* of 1924 and 1926. They worked together in their earliest films for Paramount/Famous Players-Laskey, *Two Flaming Youths* (1927) and *Why Bring That Up?* (1929), but quarrelled and were reunited only shortly before Mack's death. In Moran's absence, his role was taken by Jon or Bert Swor.

Charles Mack was killed in an automobile accident involving his partner and the director/producer, Mack Sennett.

MacLaine, Shirley, American film dancer and actress; born Shirley Beatty, April 24, 1934 in Richmond, Virginia. MacLaine was trained at the Washington School of Ballet by Lisa Gardinier and Mary Day, performing in the latter's children's ballets. She moved to New York in 1950, soon after getting a job in the City Center revival of *Oklahoma.* After appearing in *Me and Juliet* (1953), she was cast as a chorus girl and understudy in Bob Fosse's *The Pajama Game* (1954). She went on for the ailing Carol Haney later that year and on her third night in the part was seen by a film executive.

Although that felicitous chance brought her an immediate film contract, she did not dance on screen until 1960, when she did Hermes Pan's *Can-Can* for Twentieth-Century Fox. She has danced in very few of her comedies and thrillers, namely *Two for the Seesaw* (UA, 1962), in which she played a modern dancer, *What a Way to Go* (Twentieth-Century Fox, 1964), *John Goldfarb, Please Come Home* (Twentieth-Century Fox, 1964), and *Gambit* (Universal, 1966), the latter two of which were choreographed by Paul Godkin, and Fosse's *Sweet Charity* (Universal, 1969). Although she played a former ballet dancer in the backstage melodrama, *A Turning Point* (Twentieth-Century Fox, 1977), she did not dance on screen.

MacLaine has appeared very frequently on television, from the mid-1950s when she was a staple on *The Chevy Show,* to the notably unsuccessful sitcom, *Shirley's World* (ABC, 1971). Her specials for CBS since 1974 have all been well received. They have been staged by Alan Johnson but frequently use her favorite dance sequences from her old shows, including the "Steam Heat" number from *The Pajama Game.*

MacLeary, Donald, Scottish ballet dancer; born August 22, 1937 in Glasgow. Trained locally by a Miss Grant, he continued his studies at the school of the Sadler's Wells Ballet.

Throughout his career, MacLeary has performed with the Royal Ballet and its predecessors, the Covent Garden Opera Ballet and the Sadler's Wells Theatre Ballet. Celebrated for his partnership with Svetlana Beriosova, he has danced the principal roles in the company productions of *La Bayadère, Swan Lake,* and *Romeo and Juliet,* and has created roles in

Kenneth Macmillan's *Danses Concertantes* (1955), *The Burrow* (1958), *Diversions* (1961), and *Images of Love* (1964), and in John Cranko's *Antigone* (1962).

MacLeary has served as ballet master of the Royal Ballet since the mid-1970s.

Macmillan, Kenneth, Scottish ballet dancer and choreographer working in England; born December 11, 1929 in Dunfermline, Scotland. Trained in the school of the Sadler's Wells Ballet, he performed with the company from 1947 on. He created the title role in Margaret Dale's *The Great Detective* (1953) and performed in John Cranko's *The Lady and the Fool* and *Children's Corner,* in Frederick Ashton's *Cinderella, Façade,* and *Les Rendez-vous,* and in George Balanchine's *Ballet Imperial.*

Best known as a choreographer, Macmillan first created works for the Sadler's Wells. He served as director of the Deutsche Opera Ballet in Berlin (c.1966–1970) and of the Royal Ballet (1970 to the present, currently co-director) in England; his choreography also appears in the repertory of the Stuttgart Ballet, and the American Ballet Theatre, the Western Theatre Ballet, and many other companies.

His most celebrated works include the full-length revivals of the classics, *Swan Lake* and *The Sleeping Beauty,* and full-evening original works such as his *Romeo and Juliet* (1965), *Anastasia* (1971), and *Manon* (1974), all created for his principal dancers at the Royal Ballet. Shorter works range from the dramatic, such as *The Burrow* (1958) and *Cain and Abel* (1968), to the abstractions *Danses Concertantes* (1955), *Valses Nobles et Sentimentales* (1966), and *The Four Seasons* (1975).

Works Choreographed: CONCERT WORKS: *Somnambulism* (1953); *Laiderette* (1955); *Danses Concertantes* (1955); *House of Birds* (1955); *Fireworks* (1956); *Noctambules* (1956); *Solitaire* (1956); *Valse Eccentrique* (1956); *Winter's Eve* (1957); *Journey* (1958); *The Burrow* (1958); *Agon* (1958); *Le Baiser de la Fée* (1960); *The Invitation* (1961); *Diversions* (1961); *The Seven Deadly Sins* (1961); *Le Sacré du Printemps* (1962); *Symphony* (1963); *Creation du Monde* (1964); *Divertimento* (1964); *Images of Love* (1964); *Romeo and Juliet* (1965); *Concerto* (1966); *Das Lied von der Erde* (1966); *Las Hermanas* (1967); *Sphinx* (1968); *Cain and Abel* (1968); *Valses Nobles*

et Sentimentales (1966); *Olympiad* (1969); *Swan Lake* (1969); *Checkpoint* (1970); *Miss Julie* (1970); *Anastasia* (1971; a one-act version had been performed in 1967); *The Poltroon* (1972); *Side Show* (1972); *Ballade* (1972); *The Sleeping Beauty* (1973); *Pavanne* (1974); *Elite Syncopations* (1974); *Manon* (1974); *The Four Seasons* (1975); *Requiem* (1976); *Rituals* (1976); *The Four Seasons* (1976); *6.6.78* (1978); *My Brothers, My Sisters* (1978); *Playground* (1979); *La Fin du Jour* (1979).

TELEVISION: *Turned Out Proud* (BBC, 1955, special).

Madsen, Egon, Danish ballet dancer associated with the German Stuttgart Ballet; born August 24, 1942 in Ringe, Denmark. Trained by Thea Jolles, Birger Bartholin, and Edite Frandsen, he performed with the Copenhagen Tivoli Theatre and Marianne von Rosen's Scandinavian Ballet before joining the Stuttgart in 1961. A member of the company ever since, he performed in much of the John Cranko repertory, with leading roles in his *Jeu de Cartes, Eugen Onegin, The Nutcracker, The Taming of the Shrew, Poème de l'Exstace* (1970), *Brouillards* (1970), and *Initials R.B.M.E.* (1972) in which he was "E." He has created roles in Kenneth Macmillan's *Song of the Earth* (1960) and *Requiem* (1976), in Glen Tetley's *Daphnis and Chloe* (1975) and *Pierrot Lunaire,* and in John Neumeier's *Lady of the Camilias* (1978), as a very romantic "Armand."

Works Choreographed: CONCERT WORKS: *L'Histoire du Soldat* (1977).

Magallanes, Nicholas, Mexican ballet dancer working in the United States from childhood; born May 31, 1919 according to the New York City Ballet (other sources put his birth date at November 27, 1922), in Camargo, Chihuahua, Mexico; died May 1, 1977 in Merrick, Long Island. After moving to New York at age five, he saw his first ballet performance (Aida Broadbent at the Metropolitan Opera) while in high school and began to study at the School of American Ballet.

Associated throughout his career with the companies and works of George Balanchine, Magallanes made his debut with the Ballet Caravan's presentation of *A Thousand Times Neigh* at the New York World's Fair. He performed for him with the New Opera Company (a one-performance group in New York), in the premiere of *Ballet Imperial* (1941), and participated in the South American tour of the American Ballet and Ballet Caravan, dancing in *Fantasia Braileira* and *Concerto Barocco*. Between Balanchine companies, he danced with the Littlefield Ballet on its 1942 tour, and performed progressively larger parts with the Ballet Russe de Monte Carlo (1953-1956), doing "Siegfried" in *Swan Lake,* "The Poet" in Balanchine's *La Somnambule,* and "The Head Wrangler" in Agnes De Mille's *Rodeo.* On layoffs, he danced on Broadway in *The Merry Widow* (1943) and *Song of Norway* (1944), staged by Balanchine, and in Ruth Page's *Music in My Heart* (1947).

From the founding of the Ballet Society to his death, Magallanes was a mainstay of the Balanchine companies. The list of works in which he created roles includes *Orpheus* (1948) and *Don Quixote* (1965), in the revival of which he gave his last performance. In many ways, he and his fellow *Orpheus* principals—Maria Tallchief, Tanaquil LeClerq, and Francisco Moncion—represented the New York City Ballet company. They had technique, emotive abilities to communicate dramatic meaning and musical phrasing, and tremendous stage presence, but did not look like the traditional—i.e., European—ballet dancers. Cast in almost every ballet in the repertory, Magallanes created major roles in Balanchine's *Sylvia pas de deux* (1950), *La Valse* (1951), *Caracole* (1951), *Metamorphoses* (1952), *Valse Fantasie* (1953), *Opus 34* (1954), *The Nutcracker* (1954), as the "Sugar Plum Fairy's Cavalier," *Western Symphony* (1954), *Allegro Brilliante* (1956), *Divertimento No. 15* (1956), *Square Dance* (1957), *Episodes* (1959), *Liebeslieder Walzer* (1960), and *Midsummer Night's Dream* (1962). Equally at home in the works of Jerome Robbins, he danced in the first performances of *The Guests* (1949), *The Cage* (1951), and *The Pied Piper* (1951).

Mahler, Donald, American ballet dancer. Trained by Margaret Craske and Antony Tudor, he has been associated for much of his career with the Metropolitan Opera Ballet, of which they were directors. As an observer at the Leningrad Choreographic Academy, he worked with Natalia Dudinskaya. Mahler was a

member of the Met Ballet from 1961 to 1975, working as a mime for opera productions toward the end of that tenure. He created a major role in Antony Tudor's *Concerning Oracles* in 1965 and was featured in the American performances of his *Echoing of Trumpets*. After accepting an engagement as ballet master of the Zürich Opera House from 1975 to 1977, he returned to the Met as ballet master. He is responsible for dance sequences in opera productions and for the group's tours of more conventional ballet repertory.

Mahler, Roni, American ballet dancer; born 1942 in New Rochelle, New York. Trained at the Ballet Russe School in New York City, she performed with the company from 1960 to 1962, creating roles in Frederick Franklyn's *Tribute* (1960) and dancing in *The Nutcracker* and *Swan Lake*. In the National Ballet, Washington, D.C., she danced in Franklyn's *Rhythms in Three, Hommage au Ballet,* and *Danse Brilliante,* and in Valerie Bettis' *Early Voyager,* Lew Christensen's *Con Amore,* and George Balanchine's *Four Temperaments, Pas de Dix,* and *Serenade.*

As a member of Ballet Theatre from 1963 to 1970, she leapt across the stage in *Les Sylphides, Grand Pas Glazunov,* and *Coppélia.* Her strong stage presence and fabulous extensions made her a popular dancer with the audience and choreographers. While in all three companies, she performed on television, notably in James Starbuck's dances for *Sing Along with Mitch.*

Mahler retired to teach in the early 1970s. Chairperson of dance at Kansas State University, and a frequent participant in Dance Caravans, she also coaches at the Cleveland Ballet.

Mahoney, Will, American eccentric tap dancer; born William James Fitzpatrick, February 5, 1894 in Helena, Montana; died February 9, 1967 in Melbourne, Australia. After making his debut in a tandem act with his stepbrother (whose surname was Mahoney), he toured with a medicine show in his adolescence. The specialties that he developed in that show lasted throughout his professional life, on Broadway in the *Scandals of 1924* and the *Vanities of 1925* and *1928,* in London in *Radio New York* (1935) and *Laugh Round-Up* (1939), and in a single film, *The Entertainer* (Columbia, 1934). His act, called *Why Be Serious,* consisted of songs and topical jokes and two dance *schtiks.* The first happened during a machine-gun tap solo—at a point in the dance, he began to fake a pratt fall, leaning over into a gravity-defying pose. He held that lean until he had taken off his coat, wadded it into a ball, and placed it on the floor at the place where his head would hit the floor when (or if) he finally let go and dropped to the ground. The second trick was also a tap dance, but one that was performed on top of a xylophone as he tapped out "The Stars and Stripes Forever."

Mahoney did the act across the United States, through Europe, and in Australia from 1925 to 1958, when he retired to Australia where he had performed successfully in the past. The man billed as the possessor of "The World's Funniest Feet" emerged from retirement only to appear at benefit performances.

Maiorano, Robert, American ballet dancer; born August 29, 1946 in Brooklyn, New York. Trained at the School of American Ballet, Maiorano became a member of the New York City Ballet in 1962.

Although he has performed in a wide variety of roles there, Maiorano is unquestionably best known for his performances in two works of Jerome Robbins, works that many consider his masterpieces—*Dances at a Gathering* (1969) and *The Goldberg Variations* (1971). Maiorano created roles in these two abstract works and in Robbins' *Watermill* (1972) and *Requiem Canticles II* (1972), as well as in works by John Taras—*Shadow'd Ground* (1965) and *Concerto for Piano and Winds* (1972)—and Lorca Massine, for whom he danced in *Four Last Songs* (1971) and *Ode* (1972).

Maiorano has written two children's books about ballet.

Maiorov, Genrik, Soviet ballet dancer and choreographer; born September 6, 1936 in Ulan-Ude. Trained at the Kiev State Conservatory, he performed with the Lvov Theater (1957–1959). Returning to Kiev, he danced there from 1960 to 1967, then serving with the Leningrad Maly, choreographing full-length works and miniatures. He currently serves as director of the Yshevtchenko State Academic Opera and Ballet Theater in Kiev.

Works Choreographed: CONCERT WORKS: *We* (1969); *Poem at Sunrise* (1973); *Cippollino* (1974).

Majilton, Alfred Henry, American nineteenth-century acrobat and dancer; born c.1830 in either Philadelphia, Pennsylvania, or London; died June 18, 1901 in Philadelphia. The patriarch of the enormous Majilton family troupe was a member of many of the European companies touring around the United States. He was a "Jocko," in the celebrated pantomime that was in the repertory of almost every troupe. He began playing the Brazilian Ape as a child in the Martinelli, Zanfretta, and Blondin companies and revived the work in his own family troupe.

Majilton was paralyzed in a fall at the London Coliseum in 1859. He coached his children, Charles, Marie, and Alfred, in the act and became a choreographer for other acrobatics and ballet acts. A contemporary review in a trade paper described the Majiltons as using every acrobatic, juggling, and dance trick in the world, and each was called "the Family's patented specialty," so it is not known how many of the troupe's technical secrets were revealed in Majilton's classes for young performers.

Makarova, Natalia, Soviet ballet dancer working in the West from 1970; born November 21, 1940 in Leningrad. Trained by Natalia Dudinskaya at the Leningrad Choreographic School and the Ballet Club of the Young Pioneers, she performed with the Kirov Ballet from 1959 to 1970. Among her best-received roles were in Lavrosky's *Romeo and Juliet,* the company's production of *Chopiniana,* and "Maria" in Zacharov's *The Fountain of Bakhchisarai.*

Makarova defected from the Kirov on September 4, 1970. Since that date, she has performed extensively in Europe and the United States. Associated with the American Ballet Theatre since 1970, she has become famous for her performances in the nineteenth-century classics, especially in *Giselle.* Her other principal roles include Antony Tudor's *Romeo and Juliet,* and the company productions of *Les Sylphides, La Sylphide,* and *Swan Lake.* She has created roles in Jerome Robbins' *Other Dances* (1978) and John Neumeier's *Epilogue* (1975). For Ballet Theatre, she has also staged a production of *La Bayadére*—full-length in 1980 and the Kingdom of the Shades scene only in 1974.

Makarova has also performed frequently with the Royal Ballet in London, in *Giselle, Swan Lake,* and in works by Ashton and Tudor, and with a multitude of other companies on a guest-star basis. Disagreeing with the artistic policies of Mikhail Baryshnikov, the new director of Ballet Theatre, she formed a new troupe, called Makarova and Company, which had a successful season on Broadway in 1980.

Malo, Gina, American theatrical performer working in the United States and in Europe; born Janet Flynn in the mid-1910s in Cleveland, Ohio; died November 30, 1953 in New York City. As Janet Flynn, she was a scholarship student at the Albertina Rasch studio in New York and made her professional debut as an Albertina Rasch Girl in the *George White's Scandals of 1926.* Later that year, she traveled to Paris with a Rasch team of precision ballet dancers to appear at the Moulin Rouge there. She liked Paris and remained there to act and dance in *Broadway* (a popular play) and the French version of *The New Moon.* In 1930, Flynn was discovered in that show by an American producer and was hired as "Gina Malo, the famous French chanteuse" to replace Lita Damita in *Sons O'Guns.* With the connivance of Rasch, who was also the choreographer of that popular show, Flynn/Malo got away with the masquerade for more than four months and was the subject of a score of articles about her charming French accent and marvelous grasp of English. Despite the publicity that accrued from the revelation that she was "merely" an American, she chose to continue her career in Europe and became known as the star of British productions such as *Victoria and Her Hussars, Why Not Tonight?,* Rasch's *The Cat and the Fiddle,* and Balanchine's *On Your Toes.* She also worked as a dramatic and comic actress in films and live performances, most notably in the Katharine Cornell troupes.

Maloney, Daniel, American modern dancer and choreographer; born in the 1950s in Philadelphia, Pennsylvania. Maloney was trained in traditional American modern dance forms at the Ohio State University and at the studios of Mary Anthony, Pearl Lang, and Martha Graham. He freelanced extensively after moving to New York and could be seen in performances of the Anthony and Lang companies, and concert groups of Joyce Trisler, for whom he did *Dance for Six,* Joy Boutilier, for whom he danced in *Lines for Lewis Carroll* (1968), Jeff Duncan, Sophie

Maslow, and Ethel Winter, among many others. As a member of the Martha Graham company since 1972, he has been applauded for his physical and dramatic strengths in her *Clytemnestra, Diversion of Angels, Acrobats of God, Holy Jungle* (1974), *Point of Crossing* (1975), *Adorations* (1975), and *Lucifer* (1975). His own choreography ranges from montages of recognizable images in a whirl of action to more Grahamesque emotional studies. Among his best received works have been the solo, *The Maker* (1977), *Percussion Suite* (1979), with its instrumental movement patterns, and the montages *Minstrel Show* and *Getting Off* (both 1979), with characters from nineteenth-century theater forms and hitchhiking cultures.

Works Choreographed: CONCERT WORKS: *Far Glances* (1974); *Renascent Vision* (1974); *The Master* (1977); *Power* (1977); *The Maker* (1977); *Minstrel Show* (1979); *Getting Off* (1979); *Percussion Suite* (1979); *In a Looking Drop* (1979); *Distant Echoes* (1979); *Buster* (1979).

Mandia, John, American ballet dancer; born c.1935 in New York City; died August 11, 1970 in Berkeley, California. Trained at the School of American Ballet, Mandia performed with the New York City Ballet for much of his career. He appeared in most of the company's repertory through the 1950s and 1960s, from the classic abstractions of George Balanchine to the comedies of Todd Bolender and Jerome Robbins. His Robbins credits included the Bassoon specialties in *Fanfare,* "The Intruder" in *The Cage,* and roles in *The Concert* (1956) and *Ballade* (1952). He appeared in Bolender's *Souvenirs* (1955) as "The Man" in the Bedroom Affair scene and in the New York City Ballet production of *The Still Point.* He worked with Bolender in the Cologne Opera Ballet when the latter was ballet master there, and frequently traveled to companies in Europe and the United States to stage productions of *The Still Point,* as he was doing when he died of a heart attack.

Mangan, Francis, American presentation act and cine-variety producer in the United States and England; born c.1885, possibly in Wilkes-Barre, Pennsylvania; died January 6, 1971 in Teaneck, New Jersey. It is not certain exactly how Mangan became involved in theater production. He was a scene painter and designer when he was hired to stage acts for the Mark Strand Theatre and Roof Garden, which traditionally engaged artists or architects as producers. After two seasons there, he expanded his producing to create presentation acts for the Majestic, the most important vaudeville house in Brooklyn (which was legally, but not economically, a part of New York City). He was also involved in production for Victor Herbert, and staged a large number of tab (shortened) shows and feature acts based on his operettas packaged for tours.

In 1926, Mangan was engaged as the director of production for the Plaza Theatre, London, on the basis of his American shows. For thirteen years, he staged cine-variety shows (containing feature films and live performance) for the Plaza and its chain of houses in the provinces. He subcontracted precision teams from the Tiller schools and sent Mangan-Tiller and Plaza-Tiller girl teams with his shows, but engaged Ethel Helliwell to choreograph the actual routines. His success in England brought him invitations to stage cine-variety shows in Dublin, Barcelona, Rome, and Paris, where they were called revues. Mangan returned to the United States after the German occupation of France endangered his theaters, and became an early television producer, working primarily on variety shows.

At his death in 1971, it was announced that he was writing an autobiography. Unfortunately, it has not been published. It would be fascinating.

Mangrove, American postmodern choreographic collective. The San Francisco–based company was formed by Byron Brown, John Le Fan, Jim Tyler, and Curt Siddal who had worked together in a 1975 Contact Improvisation session at the Center Space. Although Siddal had been in one of the original Contact Improvisation groups taught by Steve Paxton in 1972 and Brown had worked with Pilobolus (a nonimprovisatory collective), the original group created a new set of structures and improvisations. The group, which included Ernie Adams, Charles Campbell, Rob Faust, and Ric Rease, travels and teaches across the United States and Canada with four or more members of its full eight-man company. It has become very popular as an all-male group and is gen-

erally considered one of the best and most influential improvisatory companies not under the direct control of the Contact Improvisation organization. Like many improvisatory companies, Mangrove does not title its creations, or even consider them individual works.

Manning, Jack, American tap dancer, choreographer, and teacher; born April 1897 in Brooklyn, New York; details of his death are uncertain. Manning was raised on the vaudeville circuit by his mother, a vocalist, and his sisters, The Hall Twins. He made his formal dance debut as a specialty shepherd in Lew Wallace's production of *Ben-Hur* in 1916 and joined the chorus of the Shuberts' *The World of Pleasure* (1916), starring Moon and Morris. He trained the chorus for the tour and began the double career that he maintained for five years—dancing in a show, serving as assistant stage manager in New York, and as managing director on tour. He served in those capacities on the *Passing Show of 1917,* Gus Edwards' *Song Revue* (1918), *Monte Christo, Jr.* (1919), also dancing with Adelaide and Hughes, and the Sigmund Romberg operetta *Magic Melody* (1919).

His solo choreographic credits included *What's in a Name* (1920), the *Greenwich Village Follies* of 1920 through 1926 and various Gallagher and Sheehan productions for vaudeville. He opened a tap studio in 1926 where his students included Richard and Edith Barstow and Georges Fontana. He also taught tap work at Dance Masters of America conventions for a dozen years following 1927. Considered the principal teacher of nonprofessional tap dancers in the country, he is estimated to have taught master classes to more than fifty thousand dance masters.

Works Choreographed: THEATER WORKS: *What's in a Name?* (1920); *The Greenwich Village Follies of 1920* (tap numbers only); *Silks and Satins* (1920); *Greenwich Village Follies of 1921* (tap numbers only); *Greenwich Village Follies of 1922* (tap numbers only); *Greenwich Village Follies of 1923* (tap numbers only); *Greenwich Village Follies of 1924* (tap numbers only); *Greenwich Village Follies of 1925;* vaudeville productions for Gallagher and Sheehan.

Bibliography: Howard, Ruth Eleanor. *Jack Manning: A Biography* (New York: 1936).

Manning, Katharine, American modern dancer and teacher; born c.1910; died August 13, 1974 in Chicago, Illinois. A student at the Denishawn school in New York when it was directed by Doris Humphrey and Charles Weidman, she became a member of the original Humphrey/Weidman Concert Group, appearing in the premieres of some of their most important early works. Among the many pieces that have become part of the living history of dance in which Manning created roles are Humphrey's *Water Study* (1928), *Life of the Bee* (1928), *The Shakers* (1930), *New Dance* (1935), *Theatre Piece* (1936), *With My Red Fires* (1936), and *Passacaglia and Fugue in C Minor* (1938), and Weidman's *Happy Hypocrite* (1931), *Color Harmony* (1930), *Candide* (1933), *Quest* (1936), and *Opus 51* (1939).

When she retired from performance she became a noted teacher of dance at the University of Chicago where she served as director of the program, then considered part of women's physical education.

Manning, Sylvia, American modern dancer. Manning was trained at the New York Denishawn school by Doris Humphrey and Charles Weidman. When they split from Denishawn to form their own company, she went with them, becoming a charter member of the Humphrey/Weidman Group.

Among the many works in which she performed were Humphrey's *Air for the G String* and *Color Harmony,* and Weidman's *Americana, School for Lovers,* and *The Happy Hypocrite.* A member of the New Dance League and a director of movement for the Children's Theater of the Federal Theatre Project, she also performed in at least one recital with Gene Martel, another Humphrey/Weidman dancer. Her one extant piece of choreography dates from their 1937 joint concert.

Works Choreographed: CONCERT WORKS: *Heroic Pilgrimage* (1937).

Mansfield, Portia, American dancer, choreographer, and educator; born Portia Mansfield Swert, November 19, 1887 in Chicago, Illinois; died January 29, 1979 in Carmel, California. Mansfield, who used her mother's name professionally, studied dance at Smith College, where she met director/teacher Charlotte Perry, with whom she shared most of her pro-

fessional activities. Among her dance teachers were Louis Chalif, Luigi Albertieri, and the staff of the Dalcroze Institute and School in New York. After teaching social dance in Omaha and Chicago, she and Perry moved to Colorado where they founded a series of camps and summer schools. Although some of the camps were purely athletic and equestrian, their most memorable project was the Perry-Mansfield School of the Theatre and Dance (c.1913–1957) in Colorado, and, briefly, in Carmel-by-the-Sea, California. Mansfield sponsored a group of students in a vaudeville feature act, *Squirrels and Girl* (c.1923) and *Rhythm and Color* (c.1924) on the Keith Circuit, for which she choreographed all works and taught at the camp, but its lasting importance lay in the guest teachers that they imported from the East Coast, such as Doris Humphrey, Hanya Holm, Charles Weidman, and Helen Tamiris.

Among Mansfield's many other projects followed in Winter months were a doctorate in cultural anthropology and dance, for which she wrote a dissertation on the Native Mexican Conchero Indians, and an innovative series of films depicting both human and equestrian movement. The concert works below date from her vaudeville company—her administrative and educational activities preclude much choreographic work in her later years.

Works Choreographed: CONCERT WORKS: *Rhythm and Color Dances (Unfinished Symphony, Chanson Arabe, Prelude, Op. 23, No. 5, Episode du Carnaval, Les Preludes, Country Gardens)* (1924); Additions to vaudeville program included: *Saturnalia* (1925); *Romantic Anglers* (1925); *Is Happiness Sin?* (1925); *Picnic Day in Holland* (1925); *From an Etruscan Screen* (1925); *Hymn of Joy* (1925); *The Sculptor's Dream* (1925); *Valse Fantasie* (1925); *Dutch Love* (1925); *The Silver Hoop* (1925); *Trepak* (1925); *Castillian Tango* (1925); *Bolero* (1926); *Komanstai* (1926); *The Fall of Babylon* (1926); *Squares and Diagonals* (1926); *Two Preludes* (1926); *Ouiji* (1926); *Pia and Francette* (1926).

Manzotti, Luigi, Italian mime and choreographer of ballet spectacles; born February 2, 1835 in Milan; died there March 15, 1905. Originally trained as a dance-mime, Manzotti created his first work in 1858.

This piece, *La Morte di Masaniello,* based on the same theme as *La Muette di Portici*—the destruction of Pompei—used spectacular staging and scenic effects to portray "realistically" the events in its plot.

These staging techniques were also used for the major body of his cannon of works—those ballets created for La Scala, Milan, between 1881 and 1897, among them *Excelsior* (1881), *Amor* (1886), and *Sport* (1897). These works, and the contemporary ones staged for theaters in Turin and Rome, were restaged across Europe and affected staging techniques in London, especially in the pantomime theatres of Drury Lane, Convent Garden, and the Empire. The early musical comedies in the United States, notably those produced in Chicago, were also strongly influenced by Manzotti's use of spectacular effects with variety structure.

Works Choreographed: *La Morte di Masaniello* (1858); *Il Moro delle Achille* (c.1860); *Cleopatra* (c.1865); *Gallileo Gallilei* (1873); *Pietro Micca* (1873); The Dance of the Hours divertimento from *La Gioconda* (1875); *Excelsior* (1881); *Sieba* (1886); *Amor* (1886); *Rolla* (1887); *Narenta* (1887); *Sport* (1897); *Rosa d'Amore* (1899).

Maracchi, Carmelita, Uruguayan concert dancer and ballet teacher working throughout her career in the United States; born 1911 in Montevideo, Uruguay. Raised and trained in the Los Angeles area of California, she made her debut there as a concert dancer. There is no evidence from the extant works from her repertory that she used any more Spanish themes than other concert dancers of the period, although her allusions may have been less political. Alone, partnered by Paul Godkin, or with her small company of female dancers, she presented recitals from 1930 to c.1950.

Maracchi has become one of the most important and influential pure ballet teachers on the West Coast, with Cynthia Gregory as one of her most successful students.

Works Choreographed: CONCERT WORKS: *Piece en forme de Habañera* (1932); *Reflets dans l'Eau* (1932); *Dance of the Shadows of Evil* (1932); *Etude Satyrique* (1932); *Dance with Green Gloves* (1932); *Form in Sound and Movement* (1935); *Carlotta Grisi: in*

Retrospect (1935); *Cante Hondos* (1935); *Farucca* (1935); *Primitive Study* (1935); *Spain Cries Out* (1937); *Tango Introspective* (1937); *Live for the One Who Bore You* (1937); *Two Caprices* (1937); *Pavana* (1941); *Another Goyescas* (1941); *Madrigal* (1941); *Jota and Synthesis* (1941); *Romanza* (1941); *Zambra* (1941); *Flamenco* (1941); *Sonata* (1945); *Gavotte Vivace* (1945); *Suite of Moments Musicales* (1945); *The Nightingale and the Maiden* (1945); *Another Fire Dance* (1945); *Portrait in Raw España* (1945); *Suite in D Minor* (1950); *E Minor Suite* (1950); *Les Adieux* (1950); *Rondo, Opus 28* (1950); *Chaconne* (1950); *Sonata in A Flat Major* (1950); *Klavierstucke* (1950); *Circo de España* (1951).

Marbury, Elisabeth, American agent, producer, and Democratic Committee-woman; born June 19, 1856 in New York City; died there January 22, 1933. Marbury was one of the most influential social and political personalities of her day. Her theatrical and dance ventures, which concern us here, lasted through the 1930s, and have had a lasting influence on the business and even the scheduling of performance in New York. Marbury was foremost an extremely successful literary and theatrical agent; her first venture, as business representative for Frances Hodgson Burnett's popular play, *Little Lord Fauntleroy,* continued to bring her income until her death. She also represented British writers, among them, George Bernard Shaw and Oscar Wilde, and the entire French Society of Authors.

Marbury's dance ventures fell into two categories. In the 1910s, she managed Vernon and Irene Castle, their school, cabaret, and franchise operation. Despite their tremendous success, and the version of their business relationship in Irene Castle's autobiography, Marbury and the Castles were frequently at odds. With Anne Morgan (daughter of J.P.), she opened the Strand Theater Roof Garden in 1913, as a setting for amateur dance competitions. While Morgan, who was known for her interest in the working and leisure conditions of the poor and the business woman, may have believed that the Strand was a safe and healthy place for young people to dance, it is likely that Marbury was in the operation for very different reasons. Each time she was having problems

making the Castles sign their contracts, she would select a Strand competition winner and set her up with a professional exhibition ballroom dancer as partner, and announce to the world in general and the New York press in particular, that she had discovered "The New Castles." Since she put each of her new discoveries under personal commitment contracts, she soon controlled the engagements and tours of almost every exhibition ballroom team in the United States.

As producer and founder of the Princess Theater (1912–1919), she was able to insert her teams into the intimate musical comedies written for her by Jerome Kern, Roy Bolton, and P.G. Wodehouse. Their shows, which had a tremendous influence on the development of American musical comedy, were all set in the present, in realistic settings representing upper-middle-class suburbia, so the interpolation of these dances did not hurt their artistic integrity or popularity.

Marbury also produced some recitals of concert dancers in the late 1920s, among them Angna Enters, Harald Kreutzberg, Yvonne Georgi and Michio Ito, although in some cases, historians believe that she simply lent her mailing list to the choreographers in question. She was, however, a major factor in the passage of the Sunday concert law which allowed performances of dance and music recitals in New York City despite the Blue Laws that then banned theatrical productions. Her clout was related more to her political activities, as Democratic National Committeewoman and a power behind Governor Al Smith, than the artistic leaning of the New York State Assembly. Ironically, after she lost interest in production, her Princess Theater was sold to the International Ladies' Garment Workers Union and, as The Labor Stage, became one of New York's most important concert dance houses.

Marchand, Colette, French ballet and theatrical dancer; born 1925 in Paris. Marchand was trained at the school of the Paris Opéra, studying with Albert Aveline.

After a season with the Paris Opéra Ballet and performances with the Metropolitan Ballet, notably in Serge Lifar's *Romeo and Juliet,* Marchand joined the

Ballets de Paris de Roland Petit. Associated throughout her ballet career with Roland Petit, she danced in his *L'Oeuf à la Coque, Les Demoiselles de la Nuit, Carmen, Ciné-Bijou,* and *Deuil en Vingt Quatres Heures.*

Marchand has frequently performed in Paris revues, among them *Two on the Aisle* (1951) and *Plein Fue* (1954), and in films, including John Houston's celebrated *Moulin Rouge* (MGM, 1953).

Marchiolli, Sonja, Yugoslavian ballet dancer working in the Netherlands; born May 1, 1945 in Zagreb. Trained at the school of the Zagreb State Ballet, she graduated into the company in 1965. After only two years, however, she moved to the Netherlands to dance with Het National Ballett. She has performed there in the company's repertory of works by George Balanchine, with roles in his *Serenade* and *Four Temperaments* and by its choreographers-in-residence, Rudi van Dantzig and Hans van Manen. For the former she has danced in *Ramifications, Blown in a Gentle Wind* (1975), *Four Last Songs,* and *About a Dark House* (1978), while for the latter, she has worked in the celebrated Adagio *Hammerklavier* in 1973.

Marchowsky, Marie, American modern dancer and choreographer; born c.1919 in New York City. Trained in ballet by Ella Dagnova, she studied at the Martha Graham studio, graduating into the company in 1934. Among the many works in which she performed in her six years with the company were *American Provincials* (1934), *Panorama* (1935), *Chronicle* (1936), *American Lyric* (1937), *American Document* (1938), and *"Every Soul Is a Circus. . ."* (1939).

During her Graham tenure, she had a successful concert career, presenting solo recitals and sharing concerts with other members of the American Dance Association and New Dance League. She continued to present occasional recitals in New York through the 1950s while teaching in California, then moved to Canada to direct the Toronto Dance Theatre in her choreography.

Works Choreographed: CONCERT WORKS: *Invocation* (1943); *There Will Be Tomorrow* (1943); *Children of the Sun* (1943); *Vivace* (1945); *Image of Obsession* (1945); *Dearly Beloved* (1945); *Dilemma of the Inept One* (1945); *Night Music* (1945); *Odalisque* (c.1952); *Pompes Funebre* (c.1953); *Dance Hall Caprice* (1953); *Ebb Tide* (1953); *Femme Traquée* (1953); *Pastoral Fragments* (1953); *Age of Unreason* (1953); *Journey Through a Dream* (1953); *Seascape* (1956); *Primitive Suite* (1956); *Demimondaine* (1956); *Festive Rhythm* (1957); *Arena* (1957); *Camera Eye* (1957); *Age of Unreason* (1960); *Four Amiable Follies* (c.1960); *Prelude* (1961); *Encounters* (1961); *La Vox Humaine* (1961); *One City Block* (1961); *Whoever—Whatever* (1973); *Celebration of Youth* (1975); *Ancient Voices of Children* (1977); *Essay on Pigs* (1977).

Margot, American exhibition ballroom dancer; born Marjorie Smith, c.1910 in New York City. Margot, who also performed as Margot Love and Margot Webb, studied ballet with Vivian Roberts at the Harlem YMCA and with Louis Chalif. After she had performed extensively as an adolescent, she made her professional debut in the chorus of Leonard Harper's *Harlem Nights*, at the Caton Inn, Brooklyn, in early 1932. She danced in Harper's *Sepia Rhythms* and *Creole Revue* shows until late 1933, when she had a featured dance role in a Ralph Cooper unit in Philadelphia. Her fan-dance solo was coached by Harold Norton, who was then touring with the unit in his own solo, featuring a spear dance. At Cooper's suggestion, they became partners in an exhibition ballroom act.

They danced together for ten years, playing the Black Prolog circuit and performing in nightclubs. Among their most memorable bookings were at the Grand Terrace, Chicago, and the Plantation Club, New York, where they worked in revues staged by Clarence Robinson. Robinson (c.1900–1979), for whom there is not enough solid information to fill the entry that he so obviously deserves, also staged the Cotton Club Revue with which they toured in Europe, 1938. The act itself was strictly within the conventional confines of exhibition ballroom work, with the stylized waltzes, one-steps, and tangos of the genre. Robinson staged spectacular entrances for Margot, floating down staircases in her partner's arms, but Norton staged the dances themselves.

Margot and Norton danced together until 1942, and then again from 1945 to her retirement in 1947.

Between bookings, each worked as a solo, he with his spear dance and she as an eccentric ballet dancer, showing her toe work at the Apollo.

Although Margot had been forgotten by historians and the entire field of black exhibition ballroom dancing has been ignored, historian Brenda Dixon-Stowell has been working on an as yet unpublished book on Margot which should illuminate both the subject and her genre and art.

La Belle Marie, American vaudeville dancer generally considered the first native strip-tease artiste; born Marie Gilliam, c.1882 in Ashtabula, Ohio; died August 21, 1935 in Clementon, New Jersey. La Belle Marie spent most of her childhood and adolescence on tour with her parents, trapeze acrobats with the Dan Berry, John Robinson, and Ringling Brothers circuses. In preparation for her later billing, "America's Most Versatile Artist," she danced on point on horseback, on both slack and tight ropes, and on her parents' trapeze riggings. She left their act in 1908 and joined a Philadelphia-based company titled The Crackerjacks, as the specialty dancer. Her acts there ranged from a fancy-dancing duet with comedian Billy Hart to a version of the popular Salome solo, billed as The Terpsichorean Dream. She left that troupe to form a duet act with Hart, best remembered for their extremely popular plotted feature act, *The Circus Girl*. It should be noted that they were billed as Marie and Billy Hart from 1910 to 1917, although they were only married for the first two years. In *The Circus Girl*, she played the cornet, did an eccentric toe dance, a singing act with a cockatoo, and a slack wire number that included a strip from a tutu to full fleshings (unitard). No less an authority than Ann Corio has labeled La Belle Marie an early strip-tease artiste on the basis of this routine.

She performed for at least three years after Hart's retirement in 1917, working up a barefoot tight-wire dance act to jazz accompaniment in 1918. She became more and more involved with musical performance, however, and gave up dance for a choir and band.

Marie-Jeanne, American ballet dancer; born Marie-Jeanne Pelus, 1920 in New York City. It is not certain with whom she studied before continuing her training at the newly founded School of American Ballet from 1934. She danced in the corps of the American Ballet at the Metropolitan Opera and performed with the Ballet Caravan, a cooperative troupe of Balanchine students. Her credits in that company, all created roles, included Douglas Coudy's *Folk Dance* (1937), Erick Hawkins' *Show Piece* (1937), William Dollar's *Air and Variations* (1938), Lew Christensen's *Filling Station* (1938), and Eugene Loring's *Yankee Clipper* (1937) and *Billy the Kid* (1938), as the first "Mexican Sweetheart." In the combined American Ballet and Ballet Caravan Latin American tour of 1941, she had the honor of creating the principal female roles in two of Balanchine's greatest hits, *Ballet Imperial* and *Concerto Barocco*.

After a season with the Ballet International, in which she danced the premiere of Dollar's *Constantia* (1944), and André Eglevsky's *Sentimental Colloquy* (1944), she joined the Ballet Russe de Monte Carlo. In that company, she was assigned principal roles in *Les Sylphides*, Balanchine's *Baiser de la Fée* and *Night Shadow*, Todd Bolender's *Seraglio*, and Ruthanna Boris' *Commedia Balletica* (1949). She returned to the Balanchine company, the Ballet Society, to dance in the premiere of his *The Triumph of Bacchus and Ariadne* (1948), but remained with the Grand Ballet du Marquis de Cuevas (an outgrowth of the Ballet International) until her retirement in 1954.

Markert, Russell, American theater and Prolog dance director; born August 8, 1900 in Jersey City, New Jersey. Markert studied tap and acrobatic dance as an adult with Thelma Entwistle in Brooklyn, New York.

Markert made his Broadway debut as a chorus dancer in the 1923 edition of *Earl Carroll's Vanities*, also serving as assistant dance director to Dave Bennett. He staged dances for Broadway musical comedies, notably the Marx Brothers' *Animal Crackers* (1928), but also worked in Prologs, the genre in which he became famous. Markert staged his first precision troupe, The Sixteen Missouri Rockettes, for the Skouras Brothers' Missouri Theater in St. Louis, in 1925. This team toured on the Balaban and Katz and the Publix Theater circuits as the Sixteen American Rockettes from 1925 to 1928, appearing on Broadway in 1928 in *Rain or Shine*. From 1928 to

1932, he staged dances for a troupe known as the Roxyettes for the Roxy, managed by S.L. ("Roxy") Rothafel; when "Roxy" took over the management of the Radio City Music Hall, just before its opening in December 1932, Markert brought his troupe along. He staged weekly Prologs for the renamed Rockettes for thirty-nine years, retiring in 1971.

Markert staged dances for two early sound films. The first of these, *King of Jazz* (Universal, 1930), is considered one of the most innovative of the transitional sound era—a revue format featuring bandleader Paul Whiteman that includes solo and duet dance acts, and two large numbers, a ballet version of *The Rhapsody in Blue*, and a reproduction of a Prolog for Publix, entitled *The Melting Pot*.

Works Choreographed: THEATER WORKS: *George White's Scandals* (1924); *Rain or Shine* (1928); *Animal Crackers* (1928); *George White's Music Hall Varieties* (1933); *Ice Capades* (1940); *Holiday on Ice* (1952); Prologs for Missouri Theater, St. Louis (1925); Publix Theater and Balaban and Katz Theater chains (1926–1928); Roxy Theater, New York (1928–1932); Radio City Music Hall, New York (1932–1971).

FILM: *The King of Jazz* (Universal, 1930); *Moulin Rouge* (Twentieth-Century Fox, 1934).

Markham, Pauline, English pantomime performer working in the United States after 1867; born Pauline Margaret Hill, in the East End of London; died March 20, 1919 in New York City. Markham is believed to have made her professional debut as "Oberon" in a Manchester Theatre in 1865. She moved to London to work at the Queen's Theatre, where she was hired to tour the United States with Lydia Thompson's pantomime troupe. After performing here in Thompson's production of *Ixion, the Man in the Moon* and the rest of the company's repertory, she remained to play "Stalacta" in the 1868 revival of *The Black Crook* in New York. Apart from one return engagement in London playing Her Majesty's Haymarket in 1875, she performed in New York and on American tours until her retirement in 1893. Among her best known shows were *Chow Chow* (1872) at Wood's Museum, parts in early American productions of *H.M.S. Pinafore* and *East Lynne*, and more *Black Crooks*, including her final one at Tony Pastor's in 1897.

Considered the most beautiful woman in the United States, with "the arms that Venus De Milo lost," she had a very successful, if short, career here. Although she was probably not as technically sound as her Italian predecessors in *The Black Crook*, she was well received here in that spectacle and in later tours of melodramatic plays. Her carefully euphemistic memoirs were published in New York in 1871; at least one source claimed that they were actually written by Richard Grant White of the *Century Magazine* and father of architect Stanford White. They are currently out of print.

Markó, Iván, Hungarian ballet dancer; born 1947 in Ballasagyarmatom, Hungary. Markó was trained at the Budapest State School of Ballet, graduating into the State Opera Ballet in 1967. Although acclaimed in his native land for his performances in works by Imre Eck and György Lörinc, he is better known in western Europe for his work with the Ballet du XXièmè Siècle of Maurice Béjart. A guest with that company since 1972, he has appeared in Béjart's *Le Marteau sans Maitre* (1973), *Seraphita* (1974), and many other ballets.

Markova, Alicia, English ballet dancer who, with Anton Dolin, performed in England and the United States during the 1930s and 1940s; born Lillian Alicia Marks, December 1, 1910 in London. Markova received her early training at the Thorne Dance Academy, performing in pantomimes as a child from 1920. Her studies with Serafina Astafieva, which brought her to Diaghilev's attention, were followed by training from Enrico Cecchetti, Julie Sedova, Bronislava Nijinska, Nicholai Legat, and Vincenzo Celli.

As Markova, she danced with the Diaghilev Ballet Russe in its last four seasons, notably in the premiere of *Le Chant du Rossignol* (George Balanchine, 1926), in the title role. Her other major roles were as dolls in Mikhail Fokine's *Petrouchka* and in Leonid Massine's *La Boutique Fantasque*.

Returning to England, she participated in the first seasons of The Camargo Society and the Vic-Wells

Ballet, the companies credited with the establishment of a modern English ballet. Among the many roles that she created in those seasons were Ninette De Valois' *Cephalus and Procris* (1931), *The Haunted Ballroom* (1934), *Narcissus and Echo* (1932), and *The Rake's Progress* (1935), Antony Tudor's *Lysistrata* (1932), and Frederick Ashton's *Façade* (1931), *Rio Grande, High Yellow* and *Foyer de Danse* (all 1932), *Les Masques* (1933), and *The Lord of Burleigh* (1931), perhaps her best known vehicle at that time.

From 1935 to 1955, she and Anton Dolin performed together in a series of American companies, among them the Ballet Russe de Monte Carlo (1938–1941), the Original Ballet Russe (1946), and Ballet Theatre. She created roles in works by Massine, notably in his *Seventh Symphony* (1938), *Rouge et Noir* (1939), and *Aleko* (1942), by Antony Tudor, in the title role of his *Romeo and Juliet* (1943), and by Dolin.

The Markova–Dolin company itself was in existence from 1935 to 1937 and from 1947 to 1951, although they performed together under other managements. The company's repertory included ballets by Dolin, including his *Water-Lily* (1935) and *La Dame aux Camilias*, by John Taras (*Camille*, 1946), and Rosella Hightower (*Henry VIII*, 1947), as well as many pas de deux. They also performed together in the revue *Seven Deadly Arts*, in his *Scènes de Ballet* (1944) and in countless productions of *Giselle*, both performers' specialty, in their own, and other productions.

Markova worked as a freelance ballerina from 1953 to her retirement ten years later. With Sadler's Wells, the London Festival Ballet, the Grand Ballet du Marquis de Cuevas, and American Ballet Theatre, she danced the principal roles in *Giselle, Swan Lake, La Sylphide*, and *Les Sylphides*, partnered by Dolin or Eric Bruhn. Since retirement, she has taught for the school of the Royal Ballet and in master classes and coaching sessions around the world.

Bibliography: Dolin, Anton. *Markova—Her Life and Art* (London: 1953); Markova, Alicia. *Giselle and I* (London and New York: 1960).

Markovic, Vera, Yugoslavian ballet dancer; born 1931 in Zagreb. Markovic was trained by Ana Roje and Margaret Froman, in whose Zagreb National Ballet she performed after 1945. Markovic was cast in principal roles in Froman's *Romeo and Juliet* and *The Legend of Ohrid*, considered her most influential works, and was principal dancer when her mentor retired and was replaced by Pino and Pia Mlakar and Dmitri Parlić. Among her roles for the company's later ballet masters were parts in the Mlakar's *Devil in the Village* and Parlić's *Classical Symphony*.

Marks, Bruce, American ballet dancer and choreographer; born January 31, 1937 in Brooklyn, New York. Trained as an adolescent at the Metropolitan Opera Ballet School under Antony Tudor and Margaret Craske, Marks attended the High School of Performing Arts and The Juilliard School in New York. He performed in both the Metropolitan Opera ballet corps and in the Pearl Lang Dance Company between c.1955 and 1960, appearing in Tudor's incidental dances for *Alceste* (1960), and in Lang's *Nightflight, Black Marigolds, Persephone,* and *And Joy Is My Witness.*

Joining American Ballet Theatre in 1961, he performed with the company for ten years, returning occasionally as a guest artist to partner Carla Fracci and Cynthia Gregory. Marks created roles in Jerome Robbins' *Les Noces* (1965), and Eliot Feld's *At Midnight* (1967), and performed in the company premieres of Harald Lander's *Etudes* and José Limón's *The Moor's Pavanne* and *The Traitor*. Celebrated for his "Prince Siegfried" in *Swan Lake*, he danced that role in the David Blair production for Ballet Theatre and became one of the few Americans to perform it as a guest artist in European companies. Marks was, according to many sources, the first American to be named principal dancer with the Royal Danish Ballet, with which he performed from 1971 to 1976.

Named artistic Director of Ballet West, an established company in Salt Lake City, Utah, Marks has created works for that company and revived his European ballets. Among his works in the current repertory are *Dichterliebe* (1972), *Inscape* (1977), and *The Lark Ascending* (1977).

Works Choreographed: CONCERT WORKS: *Dichterliebe* (1972); *Asylum* (1974); *Songs of the Valley*

(1976); *Don Juan* (1976); *Inscape* (1977); *The Lark Ascending* (1977); *Sanctus* (1978); *Pipe Dreams* (1979).

Marks, Rita, American theatrical dancer; born c.1908; died November 11, 1976 in Hollywood, Florida. Marks made her professional debut at the age of sixteen after studies with Ned Wayburn and Jack Blue, both tap and acrobatics teachers in New York. She went from the chorus of *No, No, Nanette* (1925 New York, after lengthy pre-Broadway tour) into an engagement as a specialty dancer in *Yes, Yes, Yvette* (1927). Growing into ingenue status, she appeared in many of the most successful productions of the period, among them *Good News* (1927), the *Grand Street Follies* of 1928 and 1929, the operetta *New Moon* (1928), the 1932 production of *Show Boat*, and the Jerome Kern/Oscar Hammerstein, Jr. collaboration, *Music in the Air* (1932), with its famous singing in the swing sequence.

Marmein, Irene, American concert dancer; born c.1900 in or near Chicago, Illinois; died September 9, 1972 in Schenectady, New York. With her sisters, Miriam and Phyllis, Marmein began her studies with their mother, Anna Egleton, who staged many of their early productions. They continued their training at a variety of ballet studios, including that of Luigi Albertieri in New York City. From 1915 on, the Marmeins worked in both vaudeville and the concert field. They were on the Keith circuit as a class act in 1915 and headliners by 1919. Their program included the range of dances typical of the nonballet class act (and, therefore, identical to that of Denishawn), with Egyptian, Indian, Chinese, constructivist, and historical-social numbers. They were best known for their dances which, in description, seem to be music visualizations or movement choirs, in which they created shapes on stage with the three bodies in tandem. Their "Drama-dances" were also popular and are believed to have introduced that format of dance, mime, and representational performance into vaudeville, if not the concert field.

Irene Marmein, who had taught in Chicago as an adolescent, was the first of the sisters to drop out of performance to teach. She also worked as a director of dramatic productions and opera in upstate New York, where she ran the family school.

Works Choreographed: CONCERT WORKS: (Note: since there is no evidence to determine which Marmein staged the dances in their vaudeville and concert act, they will be listed under each member of the family. The listing, unfortunately, reflects only a portion of their large canon of works.) *Egyptian Nights* (1919); *Noah's Ark* (1919); *Vanity Fair* (1919); *The Dance of Shiva* (pre-1926); *Suite after Watteau* (c.1926); *A Chinese Porcelain* (1926); *The First Kiss* (1926); *Infernal Dance* (1926); *Industry* (aka *The Spirit of Modern Industry*) (1927); *Reingold* (1927); *Florentine Incident* (1927); *Flore et Zephyr* (1927); *Tocatta and Fugue in D Minor* (1928); *His Maiden Voyage* (1928); *Invitation to the Valse* (1928); *Argument* (1928); *New York Architecture* (1928); *The Bourgeois Gentleman* (1937, choreographed by Irene and Phyllis Marmein only).

Marmein, Miriam, American concert dancer; born c.1898, possibly in the Chicago, Illinois area; died August 17, 1970 in Schenectady, New York. Trained by her mother, Anna Egleton, she continued her studies with Luigi Albertieri in New York City. The Marmein Dancers (Miriam, Irene, and Phyllis Marmein) were one of the most important dance acts on the vaudeville and concert circuit in the 1910s and 1920s. They presented the popular Orientalia and exotica that the audiences had been trained to want by the Denishawn tours, but preceded St. Denis and Shawn in two genres—music visualizations and constructivist works about labor, industry, and contemporary arts. They choreographed their trios communally until the late 1920s, after which Miriam Marmein presented works for an additional twenty years. She maintained her interest in abstractions, but also added humorous pieces to her canon, among them, *With a Terpsichorean Bow to Mrs. Erskine* (1931) and *Chef d'Orchestre* (1936). She worked as a concert dancer, participating in shared recitals and the panels at the Dance Congress of 1936.

Marmein joined her sisters in Schenectady to teach at their studio there. She also taught in New York City and in Massachusetts until the early 1960s.

Works Choreographed: CONCERT WORKS: (Note: since there is no evidence to determine which Mar-

mein staged the dances in their vaudeville and concert act, they will be listed under each member of the family. Works created after 1928 were choreographed by Miriam Marmein alone.) *Egyptian Nights* (1919); *Noah's Ark* (1919); *Vanity Fair* (1919); *The Dance of Shiva* (pre-1926); *Suite after Watteau* (c.1926); *A Chinese Porcelain* (1926); *The First Kiss* (1926); *Infernal Dance* (1926); *Industry* (aka *The Spirit of Modern Industry*) (1927); *Reingold* (1927); *Florentine Incident* (1927); *Flore et Zephyr* (1927); *Tocatta and Fugue in D Minor* (1928); *His Maiden Voyage* (1928); *Invitation to the Valse* (1928); *Argument* (1928); *New York Architecture* (1928); *La Ballerine* (1929); *The Young Satyr* (1929); *The Fountain* (1929); *Satan's Prelude to Job* (1931); *Vicarious Romance* (1931); *Tennysonial Idyll* (1931); *Sketches for an American Dance* (1931); *That Affair in Naxos* (1931); *With a Terpsichorean Bow to Mrs. Erskine* (1931); *Impressions of a Tennis Champion* (1931); *Ritual* (1931); *The March* (1932); *Modern Ballerina* (1932); *Pierrot Encounters the Doctor* (1936); *Marine Fantasy* (1936); *March, Prelude, Idyll* (1936); *Medicine Man* (1936); *Rhapsody* (1936); *Chef d'Orchestre* (1936); *'Tis Love* (1937); *La Peri* (1937); *Behold the Glory* (1942); *Death to the First Born* (1948); *And So to Bed* (1948); *Legend of St. George* (1948); *Windy Mountain* (1948); *Wisdom Tooth* (1948); *The Golden Calf* (1948); *Frankincense* (1948).

Marmein, Phyllis, American concert dancer; born c.1903, possibly in the Chicago, Illinois area. Phyllis Marmein was trained by her mother, Anna Egleton, and at the Luigi Albertieri studio and School of American Ballet in New York. She joined the vaudeville and concert dance act of her sisters, Irene and Miriam, and toured with them from 1915 to 1928. She also worked on her own in the 1930s, presenting works as a concert dancer in shared programs in New York City. Her own work, like the communal choreography that she did with her sisters, emphasized national dances and constructivist visualizations of music, visual themes, as in *New York Architecture* (1928), one of their most controversial works, and abstractions and studies of movement as multiplied and changed by multiplicity of performers.

After retiring from the tour circuit, she moved to Schenectady to teach ballet. She became a local tele-vision personality while directing the upstate regional company, the Schenectady Civic Ballet.

Works Choreographed: CONCERT WORKS: (Note: since there is no evidence to determine which Marmein staged the dances in their vaudeville and concert act, they will be listed under each member of the family. The listing, unfortunately, reflects only a portion of their large canon of works.) *Egyptian Nights* (1919); *Noah's Ark* (1919); *Vanity Fair* (1919); *The Dance of Shiva* (pre-1926); *Suite after Watteau* (c.1926); *A Chinese Porcelain* (1926); *The First Kiss* (1926); *Infernal Dance* (1926); *Industry* (aka *The Spirit of Modern Industry*) (1927); *Reingold* (1927); *Florentine Incident* (1927); *Flore et Zephyr* (1927); *Tocatta and Fugue in D Minor* (1928); *His Maiden Voyage* (1928); *Invitation to the Valse* (1928); *Argument* (1928); *New York Architecture* (1928); *Russian Dance* (1937, choreographed by Phyllis Marmein only); *Russian Peasant* (1937, choreographed by Phyllis only); *Five Women* (1937, choreographed by Phyllis only); *Individual* (1937, choreographed by Phyllis only); *Festival Dance* (1937, choreographed by Phyllis only); *Two Wives* (1937, choreographed by Phyllis only); *The Bourgeois Gentleman* (1937, co-choreographed with Irene Marmein only).

Marshall, Clarice, American postmodern dancer and choreographer; born December 31, 1951 in Berkeley, California. Marshall was trained at the dance program of New York University's School of the Arts, where she currently teaches, and at the Merce Cunningham Studio. Among her teachers were Margaret Craske, Nanette Charisse, Viola Farber, Gus Solomons, and Nancy Meehan, with composition work with David Gordon, Meredith Monk, Yvonne Rainer, and Trisha Brown. She has performed in many concert groups and performances for members of the New York–based postmodern choreographers, including David Gordon, Pat Catterson, Stephanie Skura, and Rosalind Newman, and has participated in similarly experimental theatrical productions such as the Performance Garage's *Marilyn Project* (1976) and *Dog Shots in Indirection* (1978). Her earliest professional choreography was created in collaboration with Debra Wanner for the New York Dance Collective, of which both were founding members. Her own works have also been highly acclaimed for their

demonstrations with viable structures of her large and acute movement vocabulary.

Works Choreographed: CONCERT WORKS: *White Dance* (1974, in collaboration with Debra Wanner); *Paintings Nos. 1, 2, 3, 4* (1976, in collaboration with Wanner); *Draw* (1977, in collaboration with Wanner); *Bridges and Boundaries* (1978, in collaboration with Wanner); *Black Tongue/Running* (1978); *Deltas* (1978); *Come and Part* (1979); *Solo for a Wall* (1980); *Furl* (1980); *Twined* (1980, in collaboration with Mark Taylor).

THEATER WORKS: *Dog Shots in Indirection* (1978).

Marshall, Larry, American theatrical dancer and singer; born April 3, 1944 in Spartanburg, South Carolina. Trained at the New England Conservatory of Music, Marshall is equally talented, and employable, as a singer and as a dancer. Marshall has performed in most of the successful rock musicals on Broadway, among them the replacement casts of *Hair* and *Two Gentlemen of Verona*, and the premiere productions of Tom O'Horgan's *Inner City Mother Goose* (1971) and Gower Champion's *Rockabye Hamlet* (1976), in the title role. He has also worked in somewhat more conventional productions of Shakespeare at the Public Theatre and in the musically traditional shows, *A Broadway Musical* (1978) and *Comin' Uptown* (1979), playing the "Ghost of Christmas Past" to Gregory Hines' "Scrooge."

Despite his variety of credits, Marshall is best known for his portrayal of "Sportin' Life," still one of the finest dance/vocal parts in the American musical theater. He was hired to understudy his mentor (and father-in-law) Avon Long in that part for the 1966 national tour of *Porgy and Bess*, has sung it in concert, and played it on Broadway in the Houston Opera production of 1976, to great critical acclaim and audience adoration.

Marsicano, Merle, American modern dancer and choreographer; born Merle Petersen, c.1920 in Philadelphia, Pennsylvania. Trained in ballet techniques by Ethel Philipes, she performed with the Philadelphia Opera Company in the mid-1930s, dancing in the incidental dances within opera productions of that experimental company. She continued her ballet training with Mikhail Mordkin and studied modern dance forms with Ruth St. Denis, Wigman-student Erna Wassell, and Martha Graham, and composition with Louis Horst.

Basically a concert dancer, she began to present solo concerts in Philadelphia. From 1952 until the mid-1970s, she gave regular concerts in New York, creating new works almost annually. Her dances are abstractions of emotions, clarified through her management of gesture until each is completely legible.

Works Choreographed: CONCERT WORKS: *Dolorosa* (1949); *Manead* (1952); *Idyll* (1952); *Waltz* (1952); *Three Dances* (1952); *Figure of Memory* (1954); *Fantasy* (1954); *Mask* (1954); *Images* (1954); *Green Song* (1954); *Souvenir* (1955); *Il n'y a plus de raison* (1958); *Mysteries of the Summer Solstice* (1958); *Enigma* (1958); *Way Out* (1960); *Time Out of Season* (1960); *Queen of Hearts* (1970); *Caprice* (1962); *Elizabethan Mood* (1962); *Gone!* (1962); *Images in the Open* (1962); *Carnival of Imagined Faces* (1962); *The Long Gallery* (*Formal Appearances, Without Words, Edge, Nocturne*) (1963); *Yellow Night* (*Dance for Three, for Four, for One, for Five*) (1965); *Fantasy II* (1967); *How Calm the Hour Is* (1967); *March* (1967); *The Beauties* (1967); *Eyes of Mauve* (1967); *Design for Black* (1968); *Dreams of Celeste* (1968); *Dark Angel* (1970); *Infantasy* (1970); *Amphibian Memories* (1970); *These Three* (1970); *Les Belles Eccentriques, or the Nothing Doing Bar* (1970); *She* (1972); *Certain Places, Certain Times* (1975); *Disquieting Muses* (1976); *On the Half Shell* (1976); *They Who Are Not Named* (1976).

Martinelli Family, French acrobats, harlequinade performers, and ballet dancers performing in the United States, mid- and late nineteenth century. Despite a lineage that is complicated even by nineteenth-century theatrical family standards, the Martinellis can be traced back to two brothers—Julian (1821–1884) and Philippe (c.1819–1872). These French acrobats developed a harlequinade act in which Julian performed as the "clown" and Philippe as "Harlequin." With their sister Bella and Philippe's ward (and second wife) Desirée, they emigrated to the United States where they made their debuts in 1846 in Niblos Gardens, New York. Like most of the harlequinade families touring the country then, they found that it was easier to merge productions with

their colleagues, so the Martinelli Family joined forces with the (Gabriel) Ravel Troupe. At various points in the nineteenth century, the combined or separate troupes also included members of the (Gabriel) Ravel-Monplaisir company, the Lehmann family, and the Marzetti acrobats. From 1857 to the mid-1860s, the troupe merged with that of Blondin, the celebrated tightrope walker, and his equally famous rival, Marietta Zanfretta. The troupe's productions between 1846 and the 1870s were French harlequinades performed in English, such as *Seven Dwarfs* (c.1862), *Esther* (1858), *Humpty-Dumpty Abroad* (c.1861), and *My Wife* (c.1870); when the family was merged with the Ravels, they performed in the latter company's repertory, including *The Star of the Rhine* and *Jocko, le Singe du Brésil*.

Many of the second generation of the family (the first born in the United States) remained with the family troupe, although a daughter of Julian became a member of the Monplaisir company. The most celebrated members of that generation were Julian's sons Paul and Alfred, Philippe's son Albert, and Ignacio Martinelli, who was the son of Philippe and Desirée.

To facilitate comprehension, brief professional biographies of the most important family members follow.

Julian Martinelli (1821–1874) was considered the greatest of all nineteenth-century "Clowns," and worthy successor to Grimaldi. He retained that character through his professional life, supplanting the "Clowns" in the Ravel, Marzetti, and Monplaisir families in performance. His best known vehicles were *Humpty-Dumpty Abroad* (c.1861), *Raoul* (c.1858–1870), and *Seven Dwarfs* (1870). He was also a master of the suspended rings, working with his brother Philippe on the rings during the intervals between sections of their theatrical presentations. Julian and his wife, Adèle (I) had three children who performed with the family—Pauline, Paul, and Alfred.

Pauline Martinelli-Grossi was the "Columbine" of the family productions until the company merged with the Monplaisir Ballet Troupe. She joined that organization as a ballet dancer, touring with it in this country and in Europe. Her daughter, La Belle Gabrielle, was a vaudeville ballet specialist in the 1900s and 1910s.

Alfred Martinelli was the "Pantaloon" of the family productions through his father's lifetime. He joined with his brother, Paul, to perform in the United States and Europe in *Robert Macaire*, the French boulevard drama which can be seen in the film *Les Enfants du Paradis*. He became famous for his performance in the title role of that presentation and performed it throughout his life.

Paul Martinelli was the most celebrated member of the second generation of the family. He made his debut as a tightrope walker during the family's merger with the Blondin and Zanfretta troupes in the 1850s. Paul played Gabriel Ravel's son in many of the family's productions, including *Jocko, le Singe du Brésil*. As an adult, he was considered the rival of his father and uncle and his Ravel mentor, as a "Harlequin" and in contemporary comedies. The undisputed leader of the family troupe by the 1870s, he produced pantomimes for the Théâtre-Comique in New York and brought the troupe back to Europe for a successful tour (c.1878–1890). Among his own productions were *Nick-Nack* (1870), *My Wife* (c.1880), and *A Terrible Night* (1904).

The original leader of the family troupe, Philippe, had three children in the profession, Albert, Adèle (II), and Ignacio.

Albert Martinelli was the "Harlequin" of the company between his father and his cousin, Paul. Although he remained with the company until the late 1860's he seems to have retired by 1870. There is a possibility that he switched to the Marzetti family troupe, however, and remained in New York.

Adèle Martinelli-Mathieu was the daughter of Philippe and his ward, Desirée. Although she was adopted by Desirée's second husband, she, her mother, and her stepfather remained with the family troupe. She and her younger brother (entry for Ignacio follows) made their debuts as children in 1872 in a series of specialty dances performed within the productions and in entr'actes. She inherited "Columbine" from Julia Lehmann as an adolescent, but retired in her early twenties.

Other members of the family included actresses/dancers Josephine and Clara Martinelli, who performed with Paul's troupe in the 1890s. The Martinelli Brothers of the early 1900s were a son of Alfred and a series of partners, each of whom was

called Joe Sylvester. They were considered the finest comedy tumbling team (or teams) in vaudeville from 1903 to the mid-1910s. An adopted member of the family, Medric Robillard, called Louis Martinelli, was the only person from the French Canadian family branch to enter the entertainment business. Before his death in 1903, he was considered a talented comic.

Martinelli, Ignacio, American theatrical dancer; born c.1865 in Argentina or Baltimore, Maryland; date of death (after 1919) uncertain. The son of Philippe Martinelli and Desirée Martinelli-Mathieu of the celebrated pantomime clan, he made his debut with the family tour. He and his younger sister Adèle (II) worked together on the stationary rings and in an exhibition ballroom act. After growing up in the family productions, from the "Child Adonis" in *Le Roi Carrott* (1871) to the adult "Jocko" in 1890, he made his Broadway debut in *The City Directory* (1890) playing the first of many ballet masters. He taught ballroom dance on stage in at least five shows. He did not, however, appear in the dancing school scene in *Madame Sherry* (1910, in which "Every Little Movement" was introduced), but did do an Apache dance with Dorothy Jardon. Although his best remembered Broadway part, that of "Alan" in *Babes in Toyland* (1903), was a vocal one, he played dancers, barbers, and flirtatious husbands with dance sequences in almost two dozen shows, mostly for Julian Mitchell. His specialties were not connected to his family's in anything but performance skill, but he did provide the clan with its best known individual member of the twentieth century and ended its century of American appearances in style.

Martinez, Enrique, Cuban ballet dancer and choreographer working in the United States since the 1940s; born 1938 in Havana, Cuba. Trained by Alicia Alonso, he performed with her Pro-Arte Ballet in Havana before coming to the United States to study with Igor Schwezoff. A member of Ballet Theatre from 1946, he was featured in Jerome Robbins' *Fancy Free* and *Interplay,* and Agnes De Mille's *Three Virgins and a Devil.* He toured with the Ballet Alicia Alonso from 1949 to 1950, in *Apollo, Cop-*

pélia, Afternoon of a Faun, and *Les Sylphides,* but returned to Ballet Theatre for the next ten years.

In his second tenure with Ballet Theatre, he created roles in Edward Caton's *Tryptych* (1952), De Mille's *Sebastien* (1957), and Erik Bruhn's *Festa* (1957). A frequent participant in the Ballet Theatre Workshop programs, he performed in Kenneth Macmillan's *Winter's Eve* (1957), and his own *La Muerte Enamorata* (1957). He left the company to perform with Alonso's Ballet de Cuba in 1959, and became ballet master of the Bellas Artes Ballet in Mexico in 1964. Martinez returned to Ballet Theatre in 1968 as regisseur; he restaged productions of *Coppélia* and *La Fille Mal Gardée* for the company in 1968 and 1972, respectively.

Works Choreographed: CONCERT WORKS: *Sinfonia Latino-Americana* (1950); *Tropical Pas de Deux* (1951); *La Muerte Enamorata* (1957); *The Mirror* (1958); *Electra* (1963); *Fiesta* (1964); *Concerto Romantiques* (1965, also performed as *Balladen der Liebe*); *Huapango* (1969).

Martins, Peter, Danish ballet dancer and choreographer associated with the New York City Ballet since 1969; born October 27, 1946 in Copenhagen, Denmark. Trained at the School of the Royal Danish Ballet, Martins performed with the parent company from 1965 to 1969. Celebrated for his performances in the Bournonville repertory, Martins also danced the title role in George Balanchine's *Apollo.* Replacing an injured dancer in this part during a City Ballet tour, he was invited to join the company in New York.

Except for performances with the Royal Danish Ballet in Copenhagen and on tour during the Bournonville celebrations, Martins has danced and choreographed for the New York City Ballet ever since. He has taken parts in much of the company's repertory, notably in Balanchine's *Agon,* in the central pas de deux, the Diamonds section of *Jewels, Serenade, Concerto Barocco,* and the second movement of *Symphony in C.* Two partnerships have given him featured roles in new ballets. That with Kay Mazzo brought them roles in two Balanchine works for the Stravinsky Festival in 1972, *Stravinsky Violin Concerto* and *Duo Concertante,* and in the Gold and Silver Waltz section of his *Vienna Waltzes*

in 1978. The celebrated partnership with Suzanne Farrell, after her return to the company in 1974, came to the forefront during the Ravel Festival of 1975, with new ballets *In G Major* and *Tzigane*. Martins has since created roles in the four new Balanchine works, *Chaconne* (1976), *Union Jack* (1976), famed especially for his performance in the finale with a cigarette hanging out of his mouth, *Vienna Waltzes,* and *Schumann's Davidsbundlertanze* (1980).

Martins' first choreography was created during a lay-off concert in 1977. This work, *Calcium Light Night,* was taken into the repertory of the City Ballet in 1978. Three later works, the *Pas de Basque* from *Tricolore* (1978), *Sonate di Scarlatti* (1979), and *Lille Suite* (1980), were created for the company, while a fifth, *Five Easy Pieces,* was choreographed for a benefit performance and has been danced by the company.

Works Choreographed: CONCERT WORKS: *Calcium Light Night* (1977); *Pas de Deux* from *A Sketch Book* (1978); *Pas de Basque* from *Tricolore* (1978); *Sonate di Scarlatti* (1979); *Five Easy Pieces* (1980); *Lille Suite* (1980, performed in New York as *Tivoli*).

Martlew, Gillian, English ballet dancer; born c.1935. Trained at the Rambert School, she was associated with the Rambert Ballet throughout her career. She joined that troupe in time for its transition between productions of the classics, in which she did character roles, and the contemporary repertory. She was cast in many early ballets by Norman Morrice, including his *Two Brothers* (1958), in Frederick Ashton's *Persephone,* John Cranko's *Variations on a Theme,* and in the company revival of Antony Tudor's *Gala Performance.*

Martlew retired in 1964 to enter a convent.

Martynuk, Nusha, American modern dancer and choreographer; born February 2, 1953 in Elmira, New York. Martynuk was trained at Temple University in Philadelphia and performed with the Zero Moving Company there before moving to New York City to join the Alwin Nikolais troupe. She danced in his most recent works, including *Arporisms, Gallery, Talisman,* and *Guignol,* while presenting concerts of her own choreography. Her works have been described as "dazzling," "sensitive," and "exhilarat-ing," with special acclaim given to her solos. She frequently shares concerts with Carter McAdams, also of the Nikolais company, for whom she choreographs and in whose works she dances.

Works Choreographed: CONCERT WORKS: *Transcience* (1973); *A.C.M. Annotated* (1975); *Toy Giraffe and Other Animals* (1976); *Tea and Crackers* (1976, co-choreographed with Martha Hansen); *One Two Many* (1976); *Octet-One* (1976); *Figure Drawings: Nude in Blue* (1976); *Changelings* (1976); *Space* (1976); *One Woman One* (1976); *Solar Time* (1977, co-choreographed with Tim Maloney); *Loosing the Albatross* (1977); *Alighting* (1978); *Reeling* (1978); *Children of the Third Eye* (1979, in collaboration with Osvaldo Rodriguez, Joan Finklestein, and Robert Sherman); *For the Non-Believers* (1979); *Small Changes* (1979); *Repeating on Change* (1979); *Patternset* (1980); *Fast Dance Goodbye* (1980).

Maslow, Sophie, American modern dancer and choreographer; born in New York City. Maslow was trained at the Neighborhood Playhouse, in composition by Louis Horst, and in dance by Blanche Talmud and Martha Graham. She joined the Graham company in 1931, remaining with it for twelve years.

In that time, she created roles in almost every Graham work, among them, *Tragic Patterns* (1933), *American Lyric* (1937), *"Every Soul Is a Circus . . ."* (1939), *Letter to the World* (1940), and *Deaths and Entrances* (1943), in which she danced with Graham and Jane Dudley as "the Sisters."

While in the Graham company, Maslow became involved with the New Dance League, and choreographed for its recitals. Among her works for these concerts were *Prelude to a May First Song* (1935) and *Women of Spain* (1937). In 1942, after a recital shared with Dudley and Humphrey/Wiedman company dancer William Bales, they decided to form a dance trio company. For the next twelve years, Maslow choreographed for the trio and its outgrowth, the New Dance Group (the term actually refers to the school of the trio which took its name from the outgrowth of the New Dance League). Among her best known dances from this period are the Americana works, *Dust Bowl Ballads* (1941), and *Folksay* (1942), and early works on Jewish themes, including *The Village I Knew* (1949). Since Dudley's

retirement in 1954, Maslow has choreographed for the New Dance Group and for her own company, many of whose members were trained at the State University of New York at Purchase in the dance department headed by Bales. Many of these works too had Jewish themes, among them, *Ladino Suite* (1969), and *Neither Rest nor Harbor* (1968), her version of *The Dybbuk,* the classic play of the Yiddish theater.

Maslow has also staged opera, notably for the New York City Opera Company which, in the 1950s, frequently hired modern dancers as choreographers, and theatrical productions, among them, *Three Wishes for Jamie* (1956) and *The Machinal* (1960). She is also noted for her incidental dances created for the annual Hanukkah Festivals (actually, Israel Bond rallies) produced in New York from 1955 to 1967.

Among the many dancer/choreographers who have worked with Maslow in the New Dance Group and her own companies are Donald McKayle, Carmen De Lavallade, Julie Arenal, Jeff Duncan, Ethel Winter, Ross Parkes, and Val Quitzow.

Works Choreographed: CONCERT WORKS: *Themes for a Slavic People* (1934); *Two Songs about Lenin* (1934); *Death of Tradition* (1934); *Challenge* (1934, co-choreographed with Lily Mehlman and Anna Sokolow); *May Day March* (1936); *Prelude to a May First Song* (1935); *Suite* (1937, credited variously to the New Dance League or to Maslow, Jane Dudley, William Matons, and Anna Sokolow); *Ragged Hungry Blues* (1937); *Runaway Rag* (1937); *Women of Spain* (1937); *Evacuation* (1937, with Dudley); *Mountain Shout* (1941); *Sarabande, Gigue, Bourée* (1941); *Exhortation* (1941); *Melancholia* (1941); *Gymnopédie* (1941, with Dudley); *Dust Bowl Ballads* (1941); *Folksay* (1942); *Llanto* (1944); *Fragments of a Shattered Land* (1945); *Suite (Scherzo, Loure, Gigue)* (1945, with Dudley and William Bales); *Partisan Journey* (1945); *Inheritance* (1945); *Champion* (1948); *The Village I Knew* (1949); *Four Sonnets* (1951); *The Snow Queen* (1953); *Sonnets* (aka *Three Sonnets*) (1953); *Prologue* (1953); *Suite: Manhattan Transfer* (1954); *Celebration* (1954); *Anniversary* (1956); *The Diamond Backs* (1958); *Three Sonatas* (1958); *Rain Check* (1958); *Poem* (1963); *Collage '66* (1966); *Episodia* (1969); *Ladino Suite* (1969); *Neither Rest nor Harbor* (1968); *Country Music* (1971);

Touch the Earth (1973); *Such Sweet Thunder* (1975); *Songs for Women, Songs for Men* (1975); *The Fifth Season* (1976); *The Decathelon Etudes* (1976); *Theme and Variations* (1979); *Voices* (1980).

OPERA: *The Dybbuk* (New York City Opera, 1951); *The Golem* (New York City Opera, 1962).

THEATER WORKS: *The Sand Hog* (1954); *Three Wishes for Jamie* (1956); *The Machinal* (1960); *The Big Winner* (1974).

Mason, Jack, American dance director; born c.1885; died May 8, 1938 in New York City. Mason worked as chorus coach for Weber and Fields, and for Lew Fields when he decided to produce on his own, before he became a member of the Winter Garden Theater staff. That theater, which still stands on Broadway, was owned and operated by the Shubert Brothers for the production of musical comedies (frequently starring Al Jolson) and revues, including the *Passing Shows* series. While staging vaudeville acts for dancers, singers, and especially comics, he coached and choreographed for the Shubert shows and their touring versions.

In the mid-1920s, Mason became known as a cabaret producer in London and New York, again, being involved in the production of acts for dancers, vocalists, and comedians.

Mason, Monica, South African ballet dancer performing in England from 1958; born September 6, 1941 in Johannesburg, South Africa. Mason received her earliest training in Johannesburg from Ruth Ingelstone, Reina Berman, and Frank Staff, in whose company she danced as an adolescent. Moving to England, she continued her studies at the school of the Royal Ballet with Barbara Fewster.

Mason has danced with the Royal Ballet throughout her career, performing in both the company's classical repertory and in contemporary works. She has created roles in many works by Kenneth Macmillan, among them, his *The Rite of Spring* (1962), *Manon* (1974), *Elite Syncopations* (1974), *The Four Seasons* (1975), and *Rituals* (1975). Noted also in the classical ballets for which the company is famous, she has danced principal roles in *Giselle, Raymonda, La Bayadère*, and *Swan Lake*. A sub-specialty in which she has been acclaimed is performance in

works by major American choreographers, among them, Jerome Robbins, for whom she worked in *Dances at a Gathering,* and George Balanchine's abstract *Ballet Imperial* and *Serenade.*

Massine, Leonid, Russian ballet dancer and choreographer working in Europe and the United States after 1914; born August 8, 1895 in Moscow; died March 15, 1979. Trained at the Moscow school of the Imperial Theatre, he performed with the Bolshoi Ballet briefly before joining the Diaghilev Ballet Russe in 1914. With Diaghilev from 1914 to 1921 and 1925 to 1928, he studied with Enrico Cecchetti while performing lead roles in the repertory and developing as a choreographer. As a dancer, he created the title role in Mikhail Fokine's *Legend of Joseph* (1914). He also danced in many of his own works of the period, among them, in the early years, *Les Femmes de Bonne Humeur* (1915), *La Boutique Fantastique* (1919), *Le Rossignole* (1919), and the extraordinary *Parade* (1917), in which he used movements and gestures from the circus and the cinema against a cubist background (by Picasso) and score (by Satie). After touring as a dancer and creating ballets for the Soirées de Paris series of concerts, he rejoined Diaghilev in his constructivist period, to create the masterpieces of the genre, *Le Pas d'Acier* (1927) and *Ode* (1928), which was one of the first works to merge human and nonhuman "performers."

After leaving Diaghilev for the second time, Massine worked in the London theater, staging dances for C.B. Cochran revues. He did Prologs in New York, as the first ballet master of the Radio City Music Hall, where he staged a *Sacre du Printemps* in 1930. Returning to Europe, he staged works for the Ida Rubenstein company, and began to work for the Ballet Russe de Monte Carlo (De Basil) in 1932. He served as ballet master for both the De Basil and Blum rival Ballets Russes, creating many of his most memorable works for the two companies. Since he did revivals for each, it is difficult to judge affiliation by works, but, as a rule of thumb, the works created from 1932 to 1938 were done for De Basil, among them the controversial *Choreartium* (1933), while those choreographed in New York from 1938 to 1941 were made for Blum; that list includes his *Gaité Parisienne* (1939), perhaps his most popular

work, *Seventh Symphony* (1938), and *Rouge et Noir* (1939). He staged *Aleko* for the new Ballet Theatre in 1943 and *Mad Tristan* for the Ballet International (1944) before forming his own Ballet Russe, the Ballet Russe Highlights company, for which he choreographed a large number of works in 1945 and 1946.

Although he returned to the United States to restage his canon, he worked primarily in Europe after the late 1940s. As a freelancer, he created for the Sadler's Wells and Ballets des Champs-Elysées. He formed the Ballet Europa for the 1960 festival in Nervi, choreographing many pieces for that occasional troupe.

Massine's works can be found in the repertory of many companies in Europe, among them the Royal Ballet, Ballet de La Scala, and Grand Ballet du Marquis de Cuevas, and in the United States, where the City Center Joffrey Ballet has staged productions of *Parade* and *Pulcinella*, and the American Ballet Theatre and Cleveland Ballet retain productions of *Gaité Parisienne*. He is also known through his performances in film—as the evil spirits in *The Tales of Hoffmann* (The Archers, 1941) and as the charming "Grisha" in *The Red Shoes* (The Archers, 1946). In the latter film, he is seen in both stage personae, as the charmer that he portrayed in *La Boutique Fantastique* and as the manipulative fanatic of later works.

Works Choreographed: CONCERT WORKS: *Le Soleil de Nuit* (1915); *Contes Russes* (1916, additional dances added until 1919); *Les Meninas* (1916); *Les Femmes de Bonne Humeur* (1917); *La Boutique Fantastique* (1919); *Parade* (1919); *Le Tricorne* (1919); *Pulcinella* (1920); *Le Rossignole* (1920); *Cimarosiana* (1924); *Mercure* (1924); *Salade* (1924); *Scuolo di Ballo* (1924); *Crescendo* (1925); *Les Matelots* (1925); *Zephiré et Flore* (1925); *Les Facheux* (1927); *Le Pas d'Acier* (1927); *David* (1928); *Ode, or Meditation at Night on the Majesty of God as Revealed by the Aurora Borealis* (1928); *Amphion* (1931); *Belkis, Regina di Saba* (1932); *Beach* (1933); *Choreartium* (1933); *Les Présages* (1933); *Union Pacific* (1934); *Le Bal* (1935); *Le Bal du Pont du Nord* (1935); *Symphonie Fantastique* (1936); *Bogatyri* (1938); *Gaité Parisienne* (1938); *Nobilissima Visione* (1938); *Seventh Symphony* (1938); *Bacchanale* (1939); *Capriccio Es-*

pagnole (1939); *Rouge et Noir* (1939); *The New Yorker* (1939); *Vienna-1814* (1939); *Labyrinth* (1941); *Saratoga* (1941); *Aleko* (1942); *Don Domingo* (1942); *Jeux d'Enfants* (1943); *Mademoiselle Angot* (1943); *Daphnis et Chloe* (1944); *Mad Tristan* (1944); *Moonlight Sonata* (1944); *Reverie Classique* (1944); *Rowlandson Comic Ballet* (1944); *At the Dentist* (1945); *Bohemian Dance* (1945); *Dragon Fly* (1945); *BumbleBee* (1945); *Pavanne* (1945); *Premiere Polka* (1945); *Polish Festival* (1945); *Russian Dance* (1945); *Leningrad Symphony* (1945); *Clair de Lune* (1945); *Contre Dances* (1945); *Scherzo* (1945); *Strange Sarabande* (1945); *Vision* (1945); *Les Arabesques* (1946); *Capriccio* (1948); *Clock Symphony* (1948); *Le Peintre et son Modèle* (1949); *Concertino* (1950); *Platée* (1950); *Sacre du Printemps* (1950); *La Valse* (1950); *Donald of the Burtheus* (1951); *The Seasons* (1951); *Laudes Evangelii* (1952); *The Dryads* (1954); *Harold in Italy* (1954); *Resurrection and Life* (1954); *Vergines Savie e Folli* (1954); *Hymn to Beauty* (1955); *Usher* (1955); *Divertimento* (1956); *Mario and the Magician* (1956); *Ballade* (1958); *Petrouchka* (1958, after Fokine); *Don Juan* (1959); *Bal des Voleurs* (1960); *Barbiere di Siviglia* (1960); *La Commedia Umana* (1960); *Fantasmi al Grand Hotel* (1960); *Les Noces* (1966).

Bibliography: Massine, Leonid. *My Life in Ballet* (London: 1960).

Massine, Lorca, European ballet dancer and choreographer; born Leonid Lorca Massine, July 25, 1944 in New York City. The son of Léonid Fedorovich Massine, he was trained by his father and by Yves Brieux and Victor Gsovsky in Paris. He appeared as "the Prince" in his father's French television production of *The Nutcracker* and as "Puck" in his incidental dances for Benjamin Britten's *A Midsummer Night's Dream* (1960) before creating his own company in 1964.

He has choreographed extensively for his company (1964 to 1967), the Ballet du XXième Siècle (1968–1970) and the New York City Ballet, where he staged *Printemps* (1972), *Ode* (1972), and restaged *Four Last Songs* (created originally for the School of American Ballet workshop). Since leaving that company, he has freelanced as a choreographer, creating *Fantasie Sérieuse* for the American Ballet Theatre in

1980, and *Vendetta* for Makarova and Company later that year.

Works Choreographed: CONCERT WORKS: *European Windows* (1964); *Focus* (1964); *Metamorphosis* (c.1965); *Just Feelings* (c.1965); *Exutoire* (c.1966); *Chant* (c.1966); *Adagio* (c.1967); *Andante* (1967); *Sienna* (1967); *Sketches of Spain* (1967); *Animal Farm* (1967); *La Herse* (1968); *Xième Symphonie* (1968); *Les Quatre Fils Amyon* (1970); *Four Last Songs* (1970); *Printemps* (1972); *Ode* (1972); *Esoterik Satie* (1978); *Fantasie Sérieuse* (1980); *Vendetta* (1980).

Masters, Gary, American modern dancer and choreographer. Masters was trained at the Juilliard School, where he studied with José Limón, Anna Sokolow, Antony Tudor, and Hanya Holm. He danced with the Ethel Winter company, the Pennsylvania Ballet, most notably in George Balanchine's *Four Temperaments*, and the Limón company, where he has been seen in *A Choreographic Offering, There Is a Time,* and *The Winged* by Limón, and Doris Humphrey's *The Shakers* and *Brandenburg Concerto*, among many other repertory works. He has choreographed since 1968 for companies across the United States. Currently he serves as associate director, choreographer, and principal for the (Fred) Mathews/Masters Dance Company, in cooperation with Mathews, a fellow Limón company member.

Works Choreographed: CONCERT WORKS: *Echoes* (1968); *Mask* (1969); *Places* (I) (1971); *Celebration* (1972); *Untitled Solo* (1975); *Triptych* (1975); *Places* (II) (1975); *Quest* (1976); *Tribute to Limón* (1977); *Summer Spill* (1978); *Tabuh Tạbuhan* (1979); *Scapegoat* (1979); *Bolero* (1980); *Concerto for Paris* (1980).

Mastin, Will, American tap dancer; born c.1879; died a few days before March 1, 1979 in the Los Angeles area of California. Little can be verified about Mastin's dance career before his military service in World War I. It is believed that he made his professional debut in his early childhood and toured extensively as a member of a "pick" (Pickaninny) chorus in one or more black musical shows. His first headlining act was his own *Holiday in Dixieland*, (c.1913–1916). After he was demobilized, he formed a partnership with Sam Davis (Sr.) that lasted for

more than forty years. Their first act, *Shake Your Feet* (c.1919), was a tap flash duet, to which they returned occasionally throughout their careers. For many years between 1920 and 1928, however, they worked with a feature act, called *Holiday in Dixieland*, that included their duet and a female chorus. They also worked in a short-term feature act called *Struttin' Hannah from Savannah* (c.1926) and at one point interpolated their duets into an early 1930 edition of *Connie's Hot Chocolates*. Davis' son, Sammy Davis, Jr., joined the duet act in 1929 as a child specialty tapper, and by 1933 they performed as Will Mastin's Gang, featuring Little Sammy. From 1936 to the duet's retirement in 1958, they were the Will Mastin Trio, probably the most successful nonunison act in black or white popular dance. Sammy Davis Jr.'s growing personal popularity was an important factor in the trio's continued bookings, of course, but Mastin's own dancing remained impressive.

After retiring from the act in 1958, he occasionally appeared with Sammy Davis Jr. in his nightclub and television engagements. He died at one hundred years of age in 1979.

Mata and Hari, German dance satirists and mimes; born Mata Krantz and Otto Ulbrecht, in the mid-1910s in Germany. As Ruth Mata and Eugene Hari, they studied ballet with Alexandra Federova and Elizabeth Anderson-Ivantzova, modern techniques with Rudolf von Laban and Mary Wigman, and pantomime with Trudi Schoop. Both members of the Schoop troupe, they decided to remain in New York after performing here on tour.

In New York, they performed on Broadway in *The Straw Hat Revue* (1939), a compilation of Tamiment shows, and *Laffing Room Only* (1944), and in many nightclubs and cabarets, notably sharing a gig at the Martinique with Straw Hat-colleague Danny Kaye. On television, they were semiregulars on *Your Show of Shows* (NBC, 1950–1954) and appeared on most of the other variety shows of the 1950s and early 1960s.

They also worked as concert dancers as a duo, and with a small company that included Zoya Lamporska and Swen Swenson. Among their best-known works were *Circus Spotlights* (1939, from *Straw Hat Revue*), including *Hindu Fakir*, a satire on

the works of Jack Cole, *The Psychoanalyst* (1933), *Marionettes Theater* (1953), and *Carnegie Hall* (1946), in which they satirized the musicians and the audience at the bastion of classical music. They opened a studio in 1962 and gradually shifted out of performance.

Mata Hari, Dutch concert dancer and possibly spy; born Margarete Gertruida Zelle, August 7, 1876, probably in Leeuwarde, the Netherlands; executed October 15, 1917 at the St. Lazare Prison, France. Mata Hari, whose pseudonym was derived from a single Malaysian word meaning "the Eye of the Dawn," was raised in the Netherlands, but spent some time as an adult in Dutch Indo-China; it was said during her life that she was born in Java and dedicated to a temple there by her Bayadère mother, but it is unlikely that this biography was more than a press release that became part of the popular tradition.

Mata Hari made her debut as a dancer at a soirée held at the Musée Emile Etienne Guimet, a collection and study center of Asian art in Paris. Her dances there and at a series of private performances included *The Princess and the Magic Flower, The Invocation to Siva*, and *The Legend of the Black Pearl*. She also performed at the Olympia Théâtre in Paris (Winter, 1905–1906), in Berlin (1907), and in Egypt. Her debut at the Folies Bergère in Paris in July 1913 is believed to have been her last public appearance.

Executed as a spy for Germany against England and France, there is no way of knowing whether she was guilty of anything; there is, however, considerable evidence that her trial was used in France as a popular rallying point against Germany and the neutrality of the Netherlands. Contemporary and 1920s and 1930s English books on her—all "proving her guilt"—include language that is distinctly xenophobic and anti-Semitic.

Mata Hari has been the subject of many novels and films, as well as one musical comedy—*Ballad for a Firing Squad* (1968, closed out of town).

Mathé, Carmen, English ballet dancer also performing in the United States; born Margaretha Matheson, November 3, 1938 in Dundee, Scotland. Trained at the Cone-Ripman School and with Margaret Craske

(with whom she still trains), she performed with the Grand Ballet du Marquis de Cuevas in the late 1950s. She moved to New York in the early 1960s, joining Ballet Theatre for the 1962 season. Her greatest successes came on her return to London to join the Festival Ballet for the next eight years. Although she was associated with her featured roles in *Les Sylphides, The Nutcracker, Petrouchka, The Sleeping Beauty*, and Bournonville's *Napoli*, she was also cast in more contemporary works, including John Taras' de Cuevas piece, *Designs with Strings*, and Jean Babilée's *l'Amour et son Destin*.

Mathé danced principal roles with the English-accented National Ballet, Washington, D.C., for the last years of its existence (c.1970–1975). Her "Aurora" was especially celebrated. Since the company's demise, she has performed and taught in Chicago.

Mathews, Fred, American modern dancer and choreographer. Matthews was trained at Stephens College in Colorado and Bennington College under Harriette Ann Gray (in whose Colorado company he performed), Ruth Currier, Martha Wittman, Jack Moore, Ruthanna Boris, and Viola Farber. He performed with the José Limón company in the 1970s, taking major roles in his *Carlotta, A Choreographic Offering, La Malinche, The Exiles,* and *The Winged*, and in Doris Humphrey's *The Shakers* and *Brandenburg Concerto*. Mathews appeared in the role of "The Moor's Friend" in Limón's Othello quartet, *The Moor's Pavanne*, with the Limón troupe, and with Rudolf Nureyev's chamber company in London. He choreographs for the Limón company and for a troupe that he co-directs with a colleague, Gary Masters, but his works can be found in the repertories of troupes across the United States and Canada. His pieces, the best known of which remain *Solaris* (1976) and *Lunaris* (1977), have made him a popular choreographer.

Works Choreographed: CONCERT WORKS: *In the Night of Minds* (1969); *Circus* (1969); *Pas Bleu* (1969); *Celebrations* (1970); *La Fête Solaire* (1970); *Rite* (1970); *Trois Etudes* (1971); *Quartet* (1971); *Rhapsody* (1972); *Etude* (1973); *The Keepers* (1974); *Chasm* (1974); *Quietus* (1974); *A Siege of Herons* (1975); *Aubade* (1975); *Sang-Froid* (1975); *Solaris* (1976); *Lunaris* (1977); *Oceanus* (1978); *The Seasons* (1978); *Spectrum* (1979).

Mathis, Bonnie, American ballet dancer; born September 8, 1942 in Milwaukee, Wisconsin. After local training with Roberta Rehberg and summer lessons at the Bentley-Stone school in Chicago, Mathis moved to New York to attend the Juilliard School, to study with Antony Tudor and Betty Jones.

After dancing with the corps de ballet of the Radio City Music Hall, she joined the Harkness Ballet, performing there in Alvin Ailey's *Feast of Ashes*, Jerome Robbins' *New York Export: Opus Jazz* and Benjamin Harkavy's *Madrigalesco* and *La Favorita*. Becoming a member of the American Ballet Theatre in 1971, she created roles in Lar Lubovitch's *Scherzo for Massah Jack* (1973) and *Three Essays* (1974), with featured parts in Antony Tudor's *Pillar of Fire,* Agnes De Mille's *Fall River Legend*, and Alvin Ailey's *The River*. Noted for her cool performance of the "Desdemona" character in José Limón's *The Moor's Pavanne* (a part created by Betty Jones), she did that role in Ballet Theatre and in The Ballet of Contemporary Art in 1973.

Mathis left Ballet Theatre to join the charter company of Dancers, founded and directed by Dennis Wayne with whom she had performed frequently at festivals and galas. After one season with Wayne, she became a member of the Netherlands Dance Theatre, performing in works by Rudi van Dantzig and others.

Matons, William, American concert and modern dancer and choreographer; perhaps the most important of the lost concert dancers from the 1930s, Matons was born at some time during the late 1910s, possibly in New York. Little is known about his training except that, by 1934, he was expert enough as a dancer and teacher to head the Experimental Unit of the New Dance League.

In that capacity, he ran a loosely organized company of male dancer-choreographers, including Roger Pryor Dodge, Charles Weidman, who taught the company classes, José Limón, Kenneth Bostock, and Lee Sherman. Although they were members of the Humphrey/Weidman Group, the relationship between the two organizations has not been accurately determined. Matons' own choreography, or the amount of it that is known, can be divided into three distinct categories—so disparate that it was often doubted whether the same person staged all of it. He

created concert solos and group dances within the then traditional range of social-political characterizational portraits, such as *Demagogue* (1935) and *Letter to a Policeman in Kansas City* (1937). He staged pageants for political organizations in New York, among them the Lenin Memorial and Peace Pageants in 1937. Matons, however, also choreographed productions for the 1939–1940 New York World's Fair, among them the *Railroads on Parade* presentation, and nightclub routines for himself and fellow leaguer Ailes Gilmour.

More research needs to be done to determine Matons' connections with the concert and modern dance movements, and his influence on Weidman and Limón.

Works Choreographed: CONCERT WORKS: *Demagogue* (1935); *Dance of Sports* (1935, co-choreographed with Kenneth Bostock and José Limón); *Crossroads* (1935); *Mad Figure* (1935); *Traditions* (1935, co-choreographed with Charles Weidman); *Dance of Death* (1935); *Ivory Tower* (1935); *Lynch* (1935); *Today We Live (Fed, Unfed)* (1936); *Rhumba* (1937); *College Graduate* (1937); *Autumn Rhapsody* (1937); *Success Game* (1937); *Follow the Flag* (1937); *Two Russian Folk Dances* (1937); *Fascist Dictator* (1937); *Private Estate* (1937); *Dance of Death* (1937).

THEATER WORKS: *Shadows over Harlem* (1939); *Railroads on Parade* (1939–1940); *Dances for Calypso Troubadours* (1940).

Matray, Ernst, Hungarian actor and director working in Hollywood as a choreographer; born Erno Siblatt Matray, c.1891 in Budapest, Austro-Hungary. An actor associated with Max Rheinhardt productions in Germany, he created the role of "The Hunchback" in *Sumurun* and a major part in *The Miracle*, touring with both to the United States in 1911. During his German career, he also worked in an experimental cabaret with Ernst Lubitsch and directed Prologs for UFA film productions.

Matray accepted an appointment as a staff dance director at MGM in 1936, probably on recommendation from Lubitsch. Since the UFA Prologs were his only known dance-related works, he may have taken the job simply to get out of Germany with a work permit. At MGM until the mid-1950s, he soon became known as a dialogue director, but still staged dances for his films. Although many of his directo-

rial assignments were social dances of historical periods, as in *Pride and Prejudice* (1940), there is no real pattern to his film work. The films range from Jeanette MacDonald–Nelson Eddy operettas, like *Bittersweet* (1940), to Judy Garland vehicles, such as *Presenting Lily Mars* (1943).

Works Choreographed: CONCERT WORKS: *Bittersweet* (MGM, 1940); *Pride and Prejudice* (MGM, 1940); *Waterloo Bridge* (MGM, 1940); *The Chocolate Soldier* (MGM, 1941); *I Married an Angel* (MGM, 1942); *White Cargo* (MGM, 1942); *Presenting Lily Mars* (MGM, 1943); *Higher and Higher* (RKO, 1943); *Step Lively* (RKO, 1944).

Matthews, Jessie, English star of musical comedies and films; born March 11, 1907 in London. Matthews studied with Buddy Bradley after his arrival in England; it is not certain with whom she received her basic dance training. After stints in the choruses of the *Music Box Revue* (1923) and *Charlot's Revue of 1924* in New York and London, she worked as understudy to Gertrude Lawrence. Performances in three more revues, each with slightly larger parts and billing, led her to stardom in a long series of musical comedies, many with songs by Rogers and Hart. In *One Damn Thing after Another* (1927), she introduced "My Heart Stood Still," topping that in 1930, when she sang "Dancing on the Ceiling," in *Evergreen*.

Her dancing in these shows, and in *Wake Up and Dream* (1929), *Hold My Hand* (1931), *Come Out to Play* (1940), *Wild Rose* (1942), and *Maid to Measure* (1948), many of which were staged by Bradley, brought her worldwide acclaim. Even contemporary audiences, who tend to have difficulties with the plots of her shows, applaud her specialty movements—the wide sweeps of the leg into a hitch kick that grazes her ears. The movement can also be seen in her films, among them *Out of the Blue* (British International, 1931), *The Mid Shipmaid* (Graumont, 1932), and *Evergreen* (Graumont, 1933).

Ironically, her critically best received film was the one in which she did the least dancing—the movie version of J.P. Priestly's *The Good Companions* (Graumont/Welsh Pictures, 1933).

Bibliography: Matthews, Jessie. *Over My Shoulder* (London: 1974).

Mattox, Matt, American theater, film, and television dancer and choreographer; born Harold Mattox, August 18, 1921 in Tulsa, Oklahoma. After moving to San Bernardino, California, in the mid-1930s, Mattox studied ballet with Ernest Belcher and Nico Charisse, jazz with Jack Cole, and tap with Louis Da Pron.

Mattox's first Broadway appearance was as a dancer in *Are You With It?* in 1945. He later appeared in *Carnival of Flanders* (1953), *The Vamp* (1955), and the 1956 edition of the *Ziegfeld Follies* which closed out of town. For Broadway, he choreographed *Say Darling* (1958), *Jennie* (1963), *What Makes Sammy Run?* (1964), and two shows that did not reach New York.

He was equally well known as a dancer in film. After making his debut in the chorus of *Yolanda and the Thief* (MGM, 1945), choreographed by Eugene Loring for Fred Astaire, he also appeared in *'Til the Clouds Roll By* (MGM, 1946), *Gentlemen Prefer Blondes* (Twentieth-Century Fox, 1953), *The Band Wagon* (MGM, 1953), and, playing "Caleb," *Seven Brides for Seven Brothers* (MGM, 1954).

Mattox worked extensively for television in the late 1950s and 1960s. He staged dances and appeared on variety shows, including *The Patti Page Show* (ABC, 1958–1959), and *Bell Telephone Hour* (NBC, 1963–1966), and on many specials, among them, *Arias and Arabesques*, one of the earliest CBS Young People Arts programs, and the *U.S. Steel Hour* productions of *Tom Sawyer* (1961) and *Huck Finn* (1962).

Mattox, considered one of the outstanding jazz teachers, has taught at The Place, in London, since 1970.

Works Choreographed: THEATER WORKS: *Say Darling* (1958); *Pink Jungle* (1959, closed out of town); *A Short Happy Life* (1961, closed out of town); *Jennie* (1963); *What Makes Sammy Run?* (1964).

TELEVISION: *The Patti Page Show* (ABC, 1958–1959); *United States Steel Hour* specials (CBS, 1960–1962, irregularly scheduled); *Bell Telephone Hour* (NBC, 1963–1966); *Arias and Arabesques* (CBS, 1963, special).

Mauk, Linda, American eccentric dancer; born c.1900 in Columbus, Ohio. Raised in Chicago, Illinois, she studied there at the Andreas Pavley/Serge Oukrainsky school and the Ned Wayburn Studio (probably with anonymous assistant teachers at both) before beginning to work as a specialty dancer at the Rainbow Gardens there. She was discovered by Elsie Janis at that outside *thé dansant* garden and given a letter of recommendation to C.B. Dillingham who cast her in the *Ziegfeld Follies of 1923*. For the next five years, Mauk (who also performed just as Linda) alternated between Broadway appearances in *Sunny* (1925) and *The Sidewalks of New York* (1927), among other shows, and tours as a specialty dancer with the Marx Brothers in their vaudeville acts.

Maule, Michael, South African ballet dancer in the United States from the mid-1940s; born October 31, 1926 in Durban, South Africa. After local training, Maule moved to New York to study with Vincenzo Celli, an expert teacher of Cecchetti technique. Making his debut in *Annie Get Your Gun* on Broadway (dancing Helen Tamiris' choreography), Maule joined Ballet Theatre in 1947.

After touring with Alicia Alonso for a season, Maule became a member of the New York City Ballet, where he performed in much of the company repertory. He became associated with the works of Jerome Robbins, created roles in his *The Cage* (1951) and *Fanfare* (1953), and danced in the company revival of his *Interplay*. Maule also performed for Robbins in his *Ballets: U.S.A.*, notably in his *Moves* (1958), one of the few ballets designed to be danced in silence. In a second tenure with Ballet Theatre in 1958, Maule danced in many works by Herbert Ross, among them, *Concerto* and *Paean*.

Retiring in 1960, Maule has taught for many years at the National Academy of Dance, a private school in Illinois.

Mauri, Rosita, Spanish ballet dancer of the late nineteenth century, performing in France and Italy; born September 15, 1856 in Rens, a suburb of Barcelona; died 1923 in Paris. After her debut in Majorca in 1866, Mauri performed with the Teatro Principale of Barcelona until 1871. She toured as a principal dancer in Vienna and Berlin before presenting a series of performances during the carnival seasons at the major Italian opera houses, among them, Teatro

Reggio di Turino where she danced in Luigi Manzotti's *Rolla* in 1876, and Milan's Teatro alla Scala where she was presented in Hyppolyte Monplaisir's *Le Figlie di Chéope* (1875) and *Le Semiramide di Nord* (1874), and in Paul Taglioni's *Ellinor* and *La Fantasca*, both in 1877.

In 1878 she made her Paris Opéra debut. Best known for her brilliant mime work as "Fenella" in *La Muette di Portici*, which she performed for the first time in 1879, she created roles in an enormous number of major ballets by the Opéra's ballet masters. For Louis Mérante, she took roles in *Korrigane* (1880), *La Farrandole* (1883), *Yedda* (1885), *Les Deux Pigeons* (1886), and *Sylvia* (1892). Josef Hanssen staged many works for her at the Opéra including *La Tempête* (1889), *Le Rêve* (1890), *La Maladetta* (1893), and *l'Etoile* (1897), which featured both her last major role and Carlotta Zambelli's first.

Maximova, Ykaterina, Soviet ballet dancer; born February 1, 1939 in Moscow. Trained at the Bolshoi Ballet School with Elizaveta Gerdt, she has performed with the company throughout her professional career.

Among her best known featured parts were "Marie" in Yuri Grigorovich's *The Nutcracker* (1966), and "Katerina" in his *The Stone Flower*, and the principal roles in his *Spartacus* and the company productions of *Les Sylphides* (as *Chopiniana*), and *Giselle*.

Maxwell, Carla, American modern dancer and choreographer; born c.1948. Trained at the Juilliard School under Anna Sokolow and José Limón, she joined the Limón company in 1965. Among her many featured roles were the title one in his *Carlotta* (1972), one of the solo *Dances for Isadora* (1971), and parts in *La Malinche, Comedy, The Moor's Pavanne, The Winged*, and *There Is a Time*, and in Doris Humphrey's *The Shakers* and *Brandenburg Concerto No. 4*. She also danced in works by Ruth Currier, who became company director after Limón's death, and by company alumnus Louis Falco, including his *Translucence* and *Checkmate's Inferno* (both 1967), and *Caviar* (1970).

Maxwell toured during the beginning of the decade with her then-husband Clyde Morgan, performing in his *Triptych* (1970), her own *Function* (1970), and Limón's duet, *The Exiles*. Her later choreographic works were created for her own recitals and for the Limón company, for which she is artistic director.

Works Choreographed: CONCERT WORKS: *Function* (1970); *Improvisations on a Drama* (1970); *A Suite of Psalms* (1973); *Homage to José* (1974); *Place Spirit* (1975); *Aadvark Brothers, Schwartz and Columbo Present Please Don't Stone the Clowns* (1976); *Blue Warrior* (1976).

Maxwell, Vera, American theatrical and exhibition ballroom dancer; born c.1892 in New York City; died there May 1, 1950. Maxwell began her career as a member of a Ned Wayburn feature act, *The Broilers of 1908*. She may have grown, however, since in most of her Broadway shows she was cast as a show girl, a height category taller than that of a Broiler. Many of these shows were staged by Wayburn, including *Mr. Hamlet of Broadway* (1909), and her last shows, the *Ziegfeld Follies of 1917, The Century Girl*, and *Miss 1917*. Maxwell appeared in two musical comedies, *The Pink Lady* and *The Winsome Widow* (both 1911), and in a record eight editions of the *Ziegfeld Follies*, 1909 through 1916. Maxwell also had a successful career as an exhibition ballroom dancer. She toured with Wallace McCutcheon in 1913 and presented a series of concerts and vaudeville tours with John Jarrott, considered the best ballroom partner of the period. They worked together from 1915 to 1916, eschewing his Turkey Trots for the newly popular Fox Trot, the Congo Tango, and their invention, the Three-in-One.

When she stopped performing as a show girl, Maxwell opened cabarets in New York (Reisenweber's Paradise) and Paris; although she performed her ballroom act there for opening weeks and special occasions, she had stopped dancing for many years when she formally announced her retirement in 1928.

Maxwell was frequently described as "The Most Beautiful Girl in the World." While this was a fairly standard approbation from press agents and artists, it is quite likely that she really was the most appropriate choice for the judgment. With her blonde hair and dark eyes, she was extraordinarily attractive and was able to transcend the stiffness of the period's poses, costumes, and hairdressing to create an

image that continues to win her the beauty contest of memory.

May, Pamela, English ballet dancer; born May 30, 1917 in Trinidad. Trained by Ninette De Valois at the Sadler's Wells school, May performed for her in her Vic-Wells Ballets throughout her career.

Celebrated for her performances in the De Valois and Frederick Ashton repertories, May created roles in the following De Valois ballets: *Checkmate* (1936), as "The Red Queen," *The Prospect before Us* (1940), *Prometheus* (1936), and *Orpheus and Eurydice* (1940). Her many performance credits in Ashton works include *Les Patineurs* (1937), *A Wedding Bouquet* (1937), *Horoscope* (1938), *Dante Sonata* (1940), *The Wanderer* (1941), *Symphonic Variations* (1946), and *Cinderella*, in which she played the "Fairy Godmother."

Retiring from performance, May has taught at the Royal Ballet for many years.

Mayer, Ruth American ballet dancer; born in Teaneck, New Jersey. Mayer received her early training locally with Helen Bettis before continuing her dance education at the Ballet Theatre School.

Mayer has been a member of the American Ballet Theatre since 1969. Her first featured role was "Leto" in the company revival of George Balanchine's *Apollo*. This mime role, which showed off her acting ability and long red hair, led to a series of "mother" parts, in *Giselle* and Agnes De Mille's *Fall River Legend*. She has also taken important roles in Peter Darrell's *Tales of Hoffmann*, and in Mikhail Baryshnikov's productions of *The Nutcracker* and *Don Quixote*.

Mayfair, Mitzi, American theatrical dancer; born c.1910 in Fulton, Kentucky. Raised in St. Louis, Missouri, she received some dance training there from a member of the Clendenen clan of ballet masters.

Mayfair made her Broadway reputation with her performance in the *Ziegfeld Follies of 1931* as Hal Le Roy's dance partner in his tap and exhibition ballroom numbers. They also worked together in a long series of filmed musical shorts for Warner Brothers from 1931 to 1934. Her other Broadway shows include *Take a Chance* (1932), *Calling All Stars* (1934),

At Home Abroad (1935), and *The Show Is On* (1936), with progressively larger roles, and less dancing, in each.

She worked in feature films from 1939 to the late 1940s but was best known as one of the "Four Jills in a Jeep," starlet performers for the USO during the war. She and other women appeared in variety shows and promotional films to promote savings bonds and to raise morale.

Mayo, Virginia, American theater and film dancer and actress; born Virginia Jones, November 30, 1922 in St. Louis, Missouri. Trained by her aunt in her School of the Theatre in St. Louis, she made her professional debut as a dancer with the Municipal Opera there. As the dancing partner of the duet of men who performed as "Pansy, the Performing Horse," she worked in vaudeville, on Broadway in *Banjo Eyes* (1941) and at Billy Rose's Diamond Horseshoe, where she was discovered and offered a contract by Samuel Goldwyn Studios.

Under that contract, she was a Goldwyn Girl in the Danny Kaye vehicle, *Up in Arms* (1944), and partnered him as co-star of his next four films, *The Kid from Brooklyn* (1946), *The Secret Life of Walter Mitty* (1947), *A Song Is Born* (1948), and *Wonder Man* (1945), a personal favorite. Switching to Warner Brothers, she appeared in many comedy and dramatic roles, but in surprisingly few dance sequences. One of her last dancing roles was in *Painting the Clouds with Sunshine* (WB, 1950), an elaborate but unsuccessful operetta in technicolor. Her best nonmusical role, and perhaps the best of her career, was undoubtedly that of the flyer's unhappy wife in *The Best Years of Our Lives*.

Phasing herself out of films in the mid-1950s, she began a thirty-year career in summer professional theater. Although her last dancing role was in the 1977 tour of *Good News*, she is still performing throughout the country to packed houses of people who remember and love her from her films.

Maywood, Augusta, American ballet dancer of the Romantic era; born 1824 in Albany, New York; died 1876 in Vienna. The daughter of stock company actors, Maywood was raised in Albany, where her parents were working. She was trained by P.H. Hazard

in Philadelphia, as were almost all of this generation of American ballet soloists. Maywood made her debut in December 1837 in Philadelphia, dancing in *Le Dieu et La Bayadère* with a fellow Hazard student, Mary Anna Lee. During that season, she also performed her first *La Sylphide* in Philadelphia.

Moving to France, she studied with Jean Coralli and Joseph Mazilier before making her Paris Opéra debut in 1839. She then interrupted her triumphant season by eloping with dancer Charles Mabille to Lyon and Lisbon, where she performed his version of *Giselle* and *La Gypsy*. When the marriage broke up, she accepted engagements in Vienna, where she was partnered by Pasquale Borri in *Giselle*, and Budapest, where in 1847 she did her first choreography, *Légyott ázalarcosbálban*.

From 1848 to her retirement in 1862, she performed at the opera houses of Italy, dancing in Trieste, Rome (at the Teatro di Apollo), and Milan, where, at La Scala, she danced in Guiseppe Rota's ballet based on *Uncle Tom's Cabin, I Bianchi ed i Negri*. Married to opera impresario Carlo Gardini, she coached at his theater after her retirement.

Works Choreographed: CONCERT WORKS: *Légyott ázalarcosbálban* (Rendez-vous at a Fancy-Dress Ball) (1847).

Mazilier, Joseph, French ballet dancer and choreographer of the Romantic era; born Guilio Mazarini, March 13, 1801 in Marseilles; died May 19, 1862 in Paris. Although trained at the school of the Paris Opéra, Mazilier made his debut at the Théâtre de la Porte-Saint-Martin in the early 1820s. In that boulevard theater, he performed leading character roles in F.A. Blache's *Jocko, le Singe de Brésil* (1825), probably the most influential work of the Romantic popular theater, and Jean Coralli's *Lisbell* (1825), *Gulliver* (1826), *La Visite à Bedlam* (1826), *La Neige* (1827), *Léocaide* (1828), and *Les Artistes* (1829), among others.

Joining the Paris Opéra, he created roles in many of the most important works of the period, in Taglioni's *La Sylphide* (1832) and *La Fille du Danube* (1836), Coralli's *Le Diable Boiteux* (1836) and *La Tarentule* (1839), and Antonio Guerra's *Les Mohicans* (1837). His status as the creator of the leading male roles in the two most influential (and most fre-

quently plagiarized) ballets of the Romantic era—*Jocko, le Singe de Brésil* and *La Sylphide*—surely qualifies Mazilier as the most versatile dancer of the century.

Ballet master from 1839, he staged ballets in the nationalist/Romantic style, combining conventional Romantic themes with national-derived dance motifs, as in *La Gypsy* (1839), *Paquita* (1846), *Le Corsaire* (1856), *Marco Spada* (1857), and *Les Elfes* (1856).

Works Choreographed: CONCERT WORKS: *La Gypsy* (1839); *Le Diable Amoureux* (1840); *Lady Henriette, ou la Servante de Greenwich* (1844); *Le Diable à quatre* (1845); *Paquita* (1846); *Betty* (1846); *Griseldis, ou les cinq sens* (1848); *Vert-Vert* (1851); *Orfa* (1852); *Jovita, ou les Boucaniers* (1853); *Le Corsaire* (1856); *Marco Spada, ou la Fille du Bandit* (1857); *Les Elfes* (1856); *Aélia et Mysis* (1853).

Mazurier, Charles, French ballet dancer in the popular theaters of France; born 1798 in Lyon; died February 4, 1828 in Paris. Trained in Lyon, he made his debut there as a *danseur comique et de caractère* in 1820, dancing as a Polichinelle in an unidentified *ballet d'action*. The success of this performance led to his engagement at the Théâtre de la Porte-Saint-Martin, one of the most important of the Boulevard theaters of Paris. He made his debut there in the role of *Polchinel vampyr* (1823) by Frédérick-Auguste Blache. From that season until his death at the tragically young age of thirty, he performed in Blache's Porte-Saint-Martin comic ballets, melodramas, and satires, among them, *Jean-Jean* (1824) which he co-choreographed, and the theater's most famous and influential production, *Jocko, le Singe de Brésil* (1825). His work in productions by Jean Coralli includes parts in his *Lisbell* (1825), *Les Monsieurs de Pourceugnac* (1826), *Gulliver* (1826), *La Visite à Bedlam* (1826), and *La Neige* (1827), which some sources claim that he helped choreograph.

Mazzo, Kay, American ballet dancer; born January 17, 1946 in Chicago, Illinois. After studies with Bernardene Hayes in Chicago, Mazzo continued her training at the School of American Ballet in New York.

After dancing for a season with Jerome Robbins' Ballets: U.S.A., notably in his *Afternoon of a Faun*, Mazzo joined the New York City Ballet with which she continues to dance. As well as *Afternoon of a Faun*, she has danced in many works by Robbins, including his *Dances at a Gathering* (1969), and *In the Night* (1970). She has also performed in a variety of works by George Balanchine, including revivals of his *Serenade, Apollo, Orpheus, La Valse, Swan Lake, Square Dance*, and *Liebeslieder Walzer*. Her created roles in the Balanchine repertory include parts in *Don Quixote* (1965), *Tchaikovsky Suite #3* (1970), *PAMTGG* (1971), *Schéhérazade* (1975), and *Union Jack* (1976). Her partnership with Peter Martins led Balanchine to create two works for them during the Stravinsky Festival of 1972—the second duet in the *Stravinsky Violin Concerto* and *Duo Concertante*—and to insert duets for them into *Vienna Waltzes* (1978), in the *Gold and Silver Waltz* section, and *Schumann's Davidsbundlertanze* (1980).

McAdams, Carter, American modern dancer and choreographer; born December 31, 1951 in Bloomingfield, Connecticut. McAdams worked with Bill Evans in Fairmount, Ohio, and in Seattle, and danced with Elizabeth Keen in New York before joining the Alwin Nikolais troupe in 1978. He has appeared in almost all of the group works in the current Nikolais repertory, including his *Gallery, Arporisms,* and *Talisman,* while presenting his own pieces in concerts shared with Nusha Martynuk.

Works Choreographed: CONCERT WORKS: *Won't You Deal the Cards Again* (1978); *Dusk Shiftings* (1979).

McBride, Patricia, American ballet dancer associated throughout her career with the New York City Ballet; born August 23, 1942 in Teaneck, New Jersey. After local ballet studies with Ruth Vernon, McBride continued her training at the School of American Ballet. Although she made her professional debut with the (André) Eglevsky Ballet in Long Island in 1958, her career has been fulfilled almost entirely at the New York City Ballet.

McBride has been able to combine perfection of technique with an exciting performance style to become a favorite with the audience and with ballet masters George Balanchine and Jerome Robbins. She has the ability to take chances with her balance and play with the music in the company's standard repertory works, such as Balanchine's *Serenade, Concerto Barocco, Symphony in C, Western Symphony, Divertimento No. 15, Agon,* and *Tchaikovsky Piano Concerto*. She has created roles in almost every work choreographed for the company in the last twenty years. Partnered by Edward Villella, she performed in the premieres of Balanchine's high-speed *Tarantella* (1964), *Harlequinade* (1965), *Brahms-Schoenberg Quartet* (1966), and the *Rubies* section of *Jewels* (1967), and of Robbins' *Dances at a Gathering* (1969). Other Robbins works in which she has created roles are *In the Night* (1970), in the terrifyingly emotional third duet, *An Evening's Waltzes* (1972), *The Dybbuk* (1974), *Introduction and Allegro for Harp* (1975), *Chanson Madécasses* (1975), *The Four Seasons* (1979), and *Opus 19: The Dreamer* (1979). The many Balanchine ballets to which she has brought her precision and musicality include *Who Cares?* (1970), *Divertimento from Le Baiser de la Fée* (1972), considered one of the most difficult works in the repertory, *Coppélia* (1974, co-choreographed with Alexandra Danilova), *Pavanne* (1975), the Pearly King and Queen pas de deux in *Union Jack* (1976), and *Vienna Waltzes* (1977).

Married to Jean-Pierre Bonnefous, she has performed in many of his works created for guest performances and their small off-season concert group, among them, his *Othello,* choreographed for the Louisville Ballet, 1980.

McCarthy, Patricia, American theater and film dancer; born Patricia Cook, 1911; died January 25, 1943 in New York City. Cook made her most successful early dance appearances as a member of the McCarthy Sisters, a 1920s tandem act. With her entry into the act, it became the foremost Charleston single-gender duet in the business. They danced together (in unison) in the *George White Scandals of 1927* and on the Keith circuit before making their communal film debuts in short subjects filmed at the Warner Brothers studio in Brooklyn. Although Dorothy McCarthy (the remaining member of the real sister act) retired early, Cook accepted a contract from the studio for work in Hollywood. She appeared in many

films for WB/Vitaphone, but not, it seems, in movies staged by Busby Berkeley.

McCarthy Sisters, American theatrical dance team; The McCarthy Sisters consisted originally of Margaret and Dorothy McCarthy, who made their Broadway debuts in *The Last Waltz* (1921). Engaged as rivals to The Fairbank Twins (who had opened in *Two Little Girls in Blue* a week earlier), they did a juvenile tandem act that depended more on their dance technique than on their mirror and opposition posing. They worked together in the Eddie Cantor vehicle, *Make It Snappy* (1922) and in the *Music Box Revue of 1922/23*, but by the time they joined the *George White Scandals of 1927*, Margaret had been replaced by Patricia Cook (called McCarthy). She and Dorothy danced together as tandem flappers in the *Scandals* and in dozens of short subjects filmed in the WB studios in New York before they split, leaving Cook to her own motion picture career. The McCarthys were the only tandem team to make the transition between the tandem style of musical comedies and revues of the 1910s and early 1920s and the roaring twenties style later in the decade. They maintained some of the formats and poses of tandem work, but adapted it to the new rhythms and social dances of the Flapper era.

McCauley, Jack, American theatrical dancer and actor; born c.1902 in New York City. Although it only seems that McCauley has been on Broadway every day of the twentieth century, he did perform almost constantly from his debut in 1923 to the end of the successful run of *Gentlemen Prefer Blondes* (opened 1949). He was an athlete and varsity track star before he made his professional debut in the play *Nerves* in 1923. After another straight play, the stage version of the melodrama *White Cargo* (1924), he began his long musical career as "Tom Trainor" in the cast of *No, No, Nanette!* (1925). Dancing with Una Munson, he introduced many of the songs that are still popular, among them, "Tea for Two." Averaging a successful show every two years, he appeared in juvenile roles until the mid-1930s and in character roles for fifteen years after that. He was a baritone, unlike most juveniles who were high tenors, and so was easily cast into such musicals as *Queen High*

(1926), *Just a Minute* (1928), *Of All Things* (1930), *Hey Nonny Nonny* (1932), *Take a Chance* (1932), *At Home Abroad* (1935), *Present Arms* (1938), *Keep Off the Grass* (1940), and *Snookies* (1941). In revues and comedies, he was usually a stooge, especially when appearing with Abbott and Costello in *The Streets of Paris* (1939) and with Milton Berle in the *Ziegfeld Follies of 1943*. As a mature performer, he was cast in two of the most popular musicals of the late 1940s—Jerome Robbins' *High Button Shoes* (1947), in which he sang "Papa, Won't You Dance With Me" with Nanette Fabray, and *Gentlemen Prefer Blondes*, in which he played "Lorelie Lee's" sugar daddy.

McCoy, Bessie, American theatrical dancer and singer; born Elizabeth McAvoy in 1888; died August 16, 1931 in Bayonne, France. McCoy made her theatrical debut in the vaudeville act of her mother, Minnie McAvoy, and stepfather, Billy McCoy. Her older sister, also in the family act, became a noted toe dancer in the 1910s. McCoy had all of the traditional abilities of a female performer of her period—she could sing well as a mature character and in imitation of childhood, she could speak lines, and she could perform on point gracefully enough to be considered a versatile dancer. In her second Broadway show, her abilities came together with a song that became associated with her and she became a star. In this show, *The Three Twins* (1908), there was no special reason for a song about nightmares, but it was interpolated for her. "The Yama-Yama Man" had a frightening verse and a silly chorus, but it allowed McCoy to show off her high kicks accentuated by her costume, a stylized one-piece pierrot costume with a ruff and cone-shaped hat. For the rest of her career, McCoy was known as the Yama-Yama Girl and included elements of the song or costume in many of her later acts.

She appeared in two successful shows, *The Echo* (1910) and the *Ziegfeld Follies of 1911*, before retiring briefly during her marriage to writer Richard Harding Davis. After his death, she returned to Broadway to appear as Bessie McCoy Davis in *Miss 1917*, the Ziegfeld/Dillingham revue at the Century Theater that was unkindly known as "the widow's show." She did the only engagement as a specialty

dancer divorced from the "Yama-Yama" presence in the 1919 *Greenwich Village Follies,* in which she appeared as the traditional porcelain and lace images of ballet. She retired following her next show, Morris Gest's *Midnight Whirl* (1919).

McCracken, Joan, American theater and film dancer and actress; born December 31, 1922 in Philadelphia, Pennsylvania; died November 1, 1961 in New York. Trained originally by Catherine and Dorothie Littlefield, McCracken accepted a scholarship to the School of American Ballet in New York, where she performed in the corps of the American Ballet. After dancing with the Littlefield Ballet on tour in 1937, she joined the Dance Players company of Eugene Loring and Lew Christensen, dancing "the Mexican Sweetheart/Mother" in Loring's *Billy the Kid.* She was also a Rockette for a season before getting her big break on Broadway as "The Girl who Falls Down" and a Can-Can girl in the Dream Ballet in *Oklahoma!* in 1944. She also danced for Agnes De Mille in *Bloomer Girl* (1944), and for Jerome Robbins in *Billion Dollar Baby* (1945) before accepting a contract from MGM. Her films included *Hollywood Canteen* (WB, 1945), *Good News* (MGM, 1947), and *Kiss Me Kate* (MGM, 1953), in which she danced with Bobby Van in the "From This Moment On" sequence, also featuring Ann Miller, Buzz Miller, Carol Haney, and Bob Fosse.

She danced with Fosse, who was then her husband, in *Dance Me a Song* (1950) on Broadway, and in cabaret. Her last dance role was in *Me and Juliet* (1953), in which she was partnered by Buzz Miller. Following that show, she was forced to retire with a heart condition, although she acted in many dramatic productions until her death in 1961.

McDermaid, Suzanne, American modern dancer; born c.1950 in Los Angeles, California. McDermaid was trained at the University of California, at Los Angeles, and at the Alwin Nikolais studio in New York.

She has performed with the Nikolais troupe since the early 1970s, creating roles in his *Guignol* (1977), *Arporisms* (1977), and *Gallery* (1978), among many others, and performing in his divertissement pro-

grams in selections from *Somniloquy, Triad,* and *Vaudeville of the Elements.*

McDonald, Gene, American modern dancer; born in the late 1930s in Chicago, Illinois. McDonald was trained at the Goodman School of Drama in Chicago and at the Juilliard School in New York, where he studied with Martha Graham, José Limón, and Doris Humphrey.

He danced with the concert groups of Helen McGehee and Pearl Lang, appearing in her *Falls the Shadow Between,* and joined the Graham company in 1958. His roles with Graham include "King Hades" in *Clytemnestra* (1958), "Darnley" in her section of *Episodes* (1959), "Admetus" in *Alcestis* (1961), and roles in *Acrobats of God, Cortege of Eagles,* and many repertory works. He began teaching in the early 1960s at the Graham school and at the Neighborhood Playhouse, which was traditionally a Graham outpost.

McDonald, Ray, American theater and film dancer; born c.1925 in Boston, Massachusetts; died February 20, 1959 in New York City. After working with his sister Grace in vaudeville, he made his Broadway debut with her in *Babes in Arms* (1937), as one of the teen-age stars of that early Balanchine musical. They moved to Hollywood to repeat their roles in the MGM film of the same name. Although she returned to stage work, he remained in Hollywood with an MGM contract. As a member of the studio's stable of teen-age feature players, he appeared in a number of Mickey Rooney films, among them *Babes on Broadway* and *Life Begins for Andy Hardy.* His other MGM films included *Born to Sing* (1942), *Park Avenue* (1946), and *Crazy in the Heat.* Unfortunately, McDonald's film career did not continue as successfully as it began, and he found himself unable to return to live performance. He committed suicide at the age of thirty-five.

McDowell, Norman, Irish ballet dancer and designer; born September 26, 1931 in Belfast, Northern Ireland; died July 4 (or 6), 1980 in London. McDowell was trained in London by Molly Lake and the faculty of the Sadler's Wells School. Associated

throughout his career with the ballets of Jack Carter, he performed in and designed productions for him with the London Festival Ballet, the Ballet Workshop at the Mercury Theater, and the Ballet der Lade Landen. Although he was noted for his portrayals of the heroes of the nineteenth-century classical ballet, in particular for his "Franz" and "Siegfried," he is best remembered for his work with Carter. As well as performing, he designed costumes and sets for his *Stagioni, L'Homme et sa Vie, Living Image, Ouverture, Impromtu for Twelve, Pavana Interrumpida, Paysage Triste, London Morning, Lulu, Shukumei, De Ontgoochelden,* and *The Witch Boy* (1956), in which he created the title role in workshop performances. He designed, but did not appear in, Carter's famous historical tributes, *Adeline Plunkett in Paris* and *The Life and Death of Lola Montez,* and many productions of the classics for Carter, Ben Stevenson, and other English choreographers.

McFall, John, American ballet dancer and choreographer; born in Kansas City, Missouri. Trained at the school of the San Francisco Ballet, he graduated into the company in 1965. He has appeared as all of the heroes of classical ballet, including the "Prince" in Lew Christensen and Michael Smuin's *Cinderella,* the "Cavalier" in Christensen's *Nutcracker,* and "Romeo" in Smuin's *Romeo and Juliet.* McFall has also become a comic of note in the company known for his "Mac" in Christensen's *Filling Station,* and "Alain" in the company's revival of *La Fille Mal Gardée.*

McFall has become one of the company members to experiment with choreography and has set five works for the troupe. Most are abstractions that portray phases and variations of relationship within dancers and musical scores.

Works Choreographed: CONCERT WORKS: *Tealia* (1973); *Garden of Love's Sleep* (1976); *Beethoven Quartets* (1977); *Quanta* (1978); *Cyrano* (1979).

McFarland, Beulah, American theatrical dancer and "Ziegfeld Girl"; born c.1898 in Des Moines, Iowa; died August 8, 1964 in Los Angeles, California. McFarland, whose life seems typical of every show girl, moved to New York to join the company of the *Ziegfeld Follies* of 1918. In that and the next three editions, she was ogled in the A-dancer numbers as a bird, a flower, a section of New York City, a piece of a bride's trousseau, a jewel, and a soft drink in the 1919 "glorification" of Prohibition, "You Don't Need the Wine to Have a Wonderful Time When They Still Make Those Beautiful Girls." Her most celebrated representation of a "Beautiful Ziegfeld girl" was as one of the members of the living curtain in the 1922 *Ziegfeld Follies.* In that extraordinary scene, she and Eva Brady were placed in the front of the curtain, with jeweled garters attaching them to the velvet, and rose with it as the *Follies* began.

Mc Gehee, Helen, American modern dancer and choreographer; born 1921 in Lynchburg, Virginia. Trained at the Randolph-Macon Women's University, she moved to New York to continue her studies at the Martha Graham school. Among the many Graham works in which she created roles were her *Night Journey* (1947), *Canticle for Innocent Comedians* (1952), *Clytemnestra* (1958), *Acrobats of Gods* (1960), *Alcestis* (1960), *Phaedra* (1967), and *Cortege of Eagles* (1967). She has taken Graham's own roles in many of her works, and has performed in almost all of the repertory.

A 92nd Street Y audition winner in 1951, she shared a recital with Ronne Aul that season. She has choreographed for her own ad hoc companies and for her students in Virginia and at the Juilliard School. Her best known works include *The Only Jealousy of Emer* (1967), based on the Yeats play, and the *Oreisteia,* choreographed for the Greek Theatre in Ypsilanti, Michigan. Her pieces are not all based on literature; many involve the universal themes associated with Graham's protégés, especially her Mexican folklore works, *La Intrusia* (1952) and *El Retablo de Maese Pedro* (1969).

Works Choreographed: CONCERT WORKS: *Undine* (1951); *Suspended Path* (1951); *The Pit* (1951); *La Dame à la Licorne* (1951); *Metamorphoses* (1951); *Outside* (1951); *The Man with a Load of Mischief* (1951); *Someone to Play With* (1951); *La Intrusia* (1952); *I Am the Gate* (1957); *Incursion* (1962); *Nightmare* (1963); *After Possession* (1965); *Yarn* (1965); *Doxasticon* (1965); *Men with the Blue Guitar*

(1966); *Oreisteia* (1966); *The Only Jealousy of Emer* (1967); *Ceremony of Remembrance* (1969); *El Retablo de Maese Pedro* (1969); *Changes* (1978).

McKayle, Donald, American modern dance, television, and theatrical performer and choreographer; born July 6, 1930 in New York City. McKayle was trained at the Martha Graham school, the New Dance Group Studio, and by Karel Shook. He performed in works by Sophie Maslow and William Bales in Dance Group concerts and in Anna Sokolow's *Lyric Suite* (1954) and *Rooms* (1955), among other pieces, during her New York residence in the mid-1950s. He danced in *House of Flowers* (1954) and served as dance captain for *West Side Story,* while appearing on television, both on modern dance sequences of Sunday morning shows and on prime-time variety programs.

McKayle's choreographic career has been divided successfully among concert, dance, theater, and television. He had a company in the 1960s in New York for concerts here and in Europe, and formed a troupe in Los Angeles from his Inner City studio, but has worked primarily for pick-up recital groups. His best known pieces include *Games* (1951), considered one of the best of the street-life depictions in dance, *Her Name Was Harriet* (1952), a tribute to Harriet Tubman, *Rainbow 'Round My Shoulder* (1959), a chain-gang dream created for a group that included Mary Hinkson and Charles Moore and now in the repertory of the Alvin Ailey Dance Theatre, and *District Storyville* (1962), also in the Ailey repertory, a popular piece about coming of age in the New Orleans jazz and prostitution era.

His Broadway shows range from the Sammy Davis, Jr. vehicle, *Golden Boy* (1964) to the biblical *I'm Solomon* (1969), and the unfortunately unsuccessful *Dr. Jazz* (1975), which seemed to many like an outgrowth of *District Storyville.* He has also staged dances for films, including two Disney movies, *Bedknobs and Broomsticks* (Buena Vista, 1970) and *Charlie and the Angel* (Buena Vista, 1972), and the very dramatic, *The Great White Hope* (Twentieth-Century Fox, 1969), about the tragic heavyweight champion, Jack Johnson.

On television he has done everything from the 1970 Oscar presentations to the feminist prime-time spe-cial, *Free to Be You and Me* (ABC, 1974), and from *Bill Cosby Shows* to the pilot for *Good Times* (CBS, 1974). He has been associated as choreographer, director, or producer with most of the Black educational/variety series on network or syndicated television since the late 1960s, including both *Soul* and *TCB* (both NBC, 1968), the series *And Beautiful* (Metro-Media, 1969), and the *Black Omnibus* (Metro-Media, 1973). He has also staged cabaret and nightclub acts for many singers, notably Harry Belafonte, and has himself recorded songs and story narrations.

Works Choreographed: CONCERT WORKS: *Exodus* (1948); *Saturday's Child* (1948); *Creole Afternoon* (1948); *Games* (1951); *Her Name Was Harriet* (1952); *Nocturne* (1952); *The Street* (1954); *Prelude to Action* (1954); *Four Excursions* (1956); *Muse in the Mews* (1958); *Out of the Chrysalis* (1958); *Rainbow 'Round My Shoulder* (1959); *Legendary Landscape* (1960); *They Called Her Moses* (1960, possibly a revival of *Her Name Was Harriet*); *District Storyville* (1962); *1-2-3 Follow Me* (1962); *Arena* (1963); *Blood of the Lamb* (1963); *Reflections in the Park* (1964); *Workout* (1964); *Daughters of the Garden* (1965); *Black New World* (1967); *Incantation* (1968); *Winderness* (1968); *Burst of Fists* (1969); *Barrio* (1972); *Songs of the Disinherited* (1972); *Migrations* (1972); *Sojourn* (1972); *Album Leaves* (1976); *Blood Memories* (1976).

THEATER WORKS: *Golden Boy* (1964); *A Time for Singing* (1966); *I'm Solomon* (1969); *Raisin* (1974); *Dr. Jazz* (1975); nightclub acts (c.1956–1962, c.1976–present).

FILM: *The Great White Hope* (Twentieth-Century Fox, 1969); *Bedknobs and Broomsticks* (Buena Vista, 1970); *Charlie and the Angel* (Buena Vista, 1972).

TELEVISION: *The Ghost of Mr. Kicks* (CBS, 1963, Repertory Workshop special); *Baseball Ballet* (*Exploring,* NBC, 1963, special); *Amahl and the Night Visitors* (NBC Opera, 1963 [Note: each live broadcast of this popular opera had new choreography]); *Fanfare* (CBS, 1965); *Jazz-Dance, U.S.A.* (NET, 1965, special); *The Strolling Twenties* (CBS, 1965, special); *Ten Blocks of the Camino Real* (NET, 1966, special); *The Ed Sullivan Show* (CBS, 1966–1967, segments of episodes); *The Bill Cosby Special* (NBC,

1967); *Soul* (NBC, 1968); *TCB* (NBC, 1968); *The Second Bill Cosby Special* (NBC, 1968); *The Sounds of Summer* (PBS, 1969, special); *The Leslie Uggams Show* (CBS, 1969); *Dick Van Dyke and the Other Women* (CBS, 1969, special); *And Beautiful* (Metro-Media, 1969, series); *The 43rd Oscar Awards Ceremony* (NBC, 1970, special); *Yesterday, Today and Tomorrow* (CBS, 1970, special); *The Super Comedy Bowl* (CBS, 1971, special); *A Funny Thing Happened on the Way to a Special* (ABC, 1972); *The New Bill Cosby Show* (CBS, 1972-1973); *Angelitos Negros* (Metro-Media, 1973, special); *Free To Be You and Me* (ABC, 1974, special); *Good Times* (CBS, 1974-1978, occasional episodes); *Minstrel Man* (CBS, 1977, special).

McKechnie, Donna, American theatrical dancer; born 1946 in Pontiac, Michigan. Raised in Sylvan Lake, Michigan, outside of Detroit, she had some local dance training before moving to New York to study at the Ballet Theatre School.

On Broadway, McKechnie began with a part in the chorus line of *How to Succeed in Business without Really Trying* (1961), then graduated to *The Education of Hyman Kaplan* and Michael Bennett's *Promises, Promises* (both 1968). In his *Company* (1970), she was a member of the three-woman chorus that sang "You Could Drive a Person Crazy." Bennett, who had been her dance partner on the television show, *Hullaballo* (NBC, 1965-1966), cast her as "Cassie," the chorus dancer who didn't make it in Hollywood, in his *A Chorus Line* (1975) and gave her the show's only set piece, the dance solo, "The Music and the Mirror." Although "Cassie" did not bring her starring roles in further shows, McKechnie did not have the bad luck of her character. She returned to Hollywood as a known quantity, dancing "The Music and the Mirror" on the *Kraft 75th Anniversary Special* (CBS, January 24, 1978) as an honored alumna of the chorus.

Since she left *A Chorus Line,* she has worked in cabaret and as a nonmusical actress.

McKenzie, Kevin, American ballet dancer; born 1954 in Burlington, Vermont. After early training in tap, acrobatics, and ballet, McKenzie entered the Academy of the Washington Ballet in 1967.

With the National Ballet, Washington, D.C., he was featured in the company productions of *Les Sylphides, The Nutcracker,* and *The Flower Festival in Genzano,* after Bournonville. Joining the City Center Joffrey Ballet in 1974, he danced in Frederick Ashton's *The Dream, Monotones,* and *Jazz Calendar,* in George Balanchine's *Square Dance,* and in Robert Joffrey's *Remembrances* and *Pas des Déèses.*

McKenzie switched to the American Ballet Theatre in 1979 to dance the classics and has so far performed in the company productions of *Les Sylphides, La Sylphide,* Balanchine's *Theme and Variations,* Harald Lander's *Etudes,* and many pas de deux. A frequent guest artist with American companies, and a member of an ad hoc troupe with Martine van Hamel and Naomi Sorkin, among others, McKenzie has begun to choreograph for small groups of ballet-based dancers.

Works Choreographed: CONCERT WORKS: *Essay* (1977).

McLain, David, American ballet choreographer and teacher; born in Arkansas. He was a music student at the University of Arkansas when he became involved with dance; within a few months, he had moved to New York to study at the School of American Ballet, the Ballet Russe School, and the American Ballet Center. He taught for Robert Joffrey at the latter school, and performed briefly in his troupe.

After serving as a company teacher for Sandra Severo in Detroit and Barbara Weisberger in the Pennsylvania Ballet, he accepted a position with the Dayton Ballet after its founders, Josephine and Hermene Schwartz, had retired. Since 1966, he has been the artistic director of the Cincinnati Ballet Company and chairperson of the dance department of the Cincinnati College Conservatory of Music. Much of his choreography has been created for his company there.

Works Choreographed: CONCERT WORKS: *Night Soliloquies* (1961); *Sons of Silence* (1956); *Concerto* (1968); *Antiche Arie e Danze* (1968); *Romanza* (1968); *D*i*l*e*m*m*a*n*s M*o*d*e*r*n*e* (1969); *12 × 9 in 5* (1969); *Winter's Traces* (1971).

McLain, Susan, American modern dancer; born April 27, 1953 in New Haven, Connecticut. McLain's

training in traditional modern dance forms includes work with May O'Donnell, Norman Walker, Paul Sanasardo, and the faculty of the Martha Graham school. Like many Graham company members, McLain first appeared in the concert groups of Graham's former dancers. She performed, for example, with Larry Richardson, Diane Gray, for whom she danced in Robbins' *Dream,* and Pearl Lang, with whom she appeared in *The Possessed, Moorings and Dark Forest,* and *At That Point in Time and Place.* She joined the Graham company during its enlargement of both membership and repertory after the success of the mid-1970s, and has been in most of Graham's revivals and additions to the canon. Her work in *Seraphic Dialogues, Appalachian Spring,* and *Adorations* has been especially acclaimed.

McLerie, Allyn Ann, American ballet and theatrical dancer and actress; born December 1, 1926 in Grand'Mere, Quebec, Canada. McLerie received her dance training in New York, studying ballet with Vera Nemtchimova, Edward Caton, and Agnes De Mille, and modern dance techniques with Yeichi Nimuri, Hanya Holm, Martha Graham, and Syvilla Fort. After dancing in the corps of the San Carlo Opera Company in 1942, she was cast in De Mille's *One Touch of Venus* (1943), in the ballet "Venus in Ozone Heights." She succeeded Sono Osato as "Ivy" in Jerome Robbins' *On the Town* and created the role of "Amy" in the Ray Bolger hit, *Where's Charley?* (1948), staged by George Balanchine. During the 1950s, she alternated working with Ballet Theatre and dancing for Jerome Robbins on Broadway in *Miss Liberty* (1949) and *West Side Story* (1957); her other shows include the London productions of *Bells Are Ringing,* and the New York original cast of *Dynamite Tonight* (1967). She made her film debut in *Words and Music* (MGM, 1948), singing "Mountain Greenery" to Perry Como, then repeated her Broadway role in the film of *Where's Charley?* (ABC, 1951). Much of the rest of her stage, film, and television appearances have been in dramatic roles.

McLoed, Anne, American modern dancer; born December 20, 1944 in Carbondale, Illinois. After at-tending Bard College, McLoed transferred to the University of California at Los Angeles, where she worked with Gloria Newman. As did many of her UCLA colleagues, she moved to New York in the early 1970s to study at the Alwin Nikolais/Murray Louis studio. She has been a member of the Louis company since 1972 performing as Anne McLoed or, briefly, as Anne Ditson. Among the many works in which she has been given featured roles are his *Hoopla, Personae, Cléopâtre II* (duet extrapolated from ballet), *Go Six, Ceremony* (1977), *Schéhérézade, Catalogue* (1975), *Glances,* and *Schubert.*

She has also taught Louis technique and repertory extensively in this country and abroad.

McRae, Edna, American ballet dancer and teacher; born Chicago, Illinois, c.1898. McRae, originally trained in folk and interpretive forms, took advantage of Chicago's identity as a major center of European dance and opera in the late 1910s and early 1920s. She studied with and taught for Andreas Pavley and Serge Oukrainsky and with Adolf Bolm when each was associated with the Chicago Grand Opera.

McRae opened her own Chicago studio in 1923, while performing with Bolm's Allied arts troupe. She taught there full time until 1964 and supervised the curriculum for years after. Anxious to provide the best possible training for the school, she continued her own dance education almost until retirement. She studied with most of the Anna Pavlova dancers in the United States, notably Chester Hale and Ella Dagnova, and traveled to Europe to work under Nicholai Legat and Phyllis Bedells in London and Lubov Egorova, Olga Preobrajenska, and Vera Trefilova in Paris.

Mears, Elizabeth, American ballet and theatrical dancer; born 1903 in Chicago, Illinois. The daughter of actor/manager John Henry Mears, she was trained by the ballet masters of the Chicago Civic Opera, Adolf Bolm, Andreas Pavley, and Serge Oukrainsky. Her exquisite technique and line can be seen in the photographs and film stills that illustrate the Sergei Marinoff Home-Study Course in Russian Classical Dancing, a pseudonymous mail-order ballet

school that contemporary sources believed she ghost-wrote.

Mears moved to New York in 1925 to enter the chorus of *Mercenary Mary* (1925). She appeared in the chorus of *The Dream Girl* later that year and took solos and featured roles in her later Broadway shows, among them *The Girl Friend* (1926) and *Judy* (1927). An ingenue in both Broadway and Chicago productions at the end of the decade, she appeared in her father's tours in 1933 and 1934. Mears retired from performance in 1934, but continued her writing career.

Meehan, Danny, American theatrical dancer, actor and songwriter; born c.1932 in White Plains, New York; died March 29, 1978 in New York City. Meehan was trained at the American Academy of Dramatic Arts and first performed in military entertainments. He served an acting apprenticeship Off Broadway while dancing on live television shows, and made his Broadway debut in the short-lived *Whoop-Up* in 1958. His best remembered Broadway appearance was as the soft-shoe expert, "Eddie Ryan" who taught Fannie Brice everything she knew in *Funny Girl* (1964).

By the mid-1960s, Meehan was splitting his time between Broadway, where he danced in *Cabaret* and acted in *Ulysses in Nighttown* (1974), *The Poison Tree* (1976), other plays, and nightclubs where he performed his own songs. His frequent, extended engagements at the Bon Soir and Village Vanguard made him a New York favorite as dancer and vocalist. Meehan died of cancer at the age of forty-seven.

Meehan, John, Australian ballet dancer; born May 1, 1950 in Brisbane, Australia. After early training with Patricia Macdonald, he continued his studies at the school of the Australian Ballet under Cecil Kellaway, Margaret Scott, and guest teacher Vera Volkova. A member of the company from 1970, he was featured in Glen Tetley's *Gemini,* Frederick Ashton's *Façade,* John Cranko's *Lady and the Fool* and *Eugene Onegin,* and the Rudolf Nureyev production of *Don Quixote.* In the Ronald Hynd ballet of *The Merry Widow,* he played the male lead, "Danilo," partnering Margot Fonteyn. A popular

guest artist in many international companies, he has performed with the American Ballet Theatre in 1977 and from 1979 to 1980, with principal roles in that troupe's versions of *Don Quixote, The Nutcracker,* and *The Sleeping Beauty.*

Meehan has stated that he hoped to move into theatrical and film performance, and has played an aging ballet dancer on *The Love Boat* (ABC, 1979).

Works Choreographed: CONCERT WORKS: *Adagio for Strings* (c.1978); *Serenade for Tenor, Horn and Strings* (c.1979); *Le Retour* (1980).

Meehan, Nancy, American modern dancer and choreographer; born c.1940 in San Francisco, California. Meehan was trained locally by Ann Halprin and Welland Lathrop before moving to New York to study at the Martha Graham school. She performed with Erick Hawkins through the 1960s and early 1970s, creating roles in his *Geography of Noon* (1964), *Black Lake* (1968), and *Eight Clear Pieces* (1969), among others.

Meehan has choreographed for her own company for eleven years. Her best known work, *Whitip* (1971), is a series of stage crossings performed in silence, which reveals new schemes and even dimensions of movement possibilities.

Works Choreographed: CONCERT WORKS: *Hudson River Seasons* (1970); *Whitip* (1971); *Live Dragon* (1972); *Bones Cascades Scapes* (1973); *Split Rock* (1974); *Yellow Point* (1974); *Grapes and Stones* (1975); *Threading the Wave* (1976); *Ptarmigan Wall* (1977); *White Wave* (1978); *How Near* (1979); *One Eye's Higher Than the Other* (1979); *Seven Women* (1980).

Mehlman, Lily, American concert dancer; born c.1903, possibly in New York City; the details of her life after 1940 are uncertain. Trained at the Neighborhood Playhouse by Blanche Talmud and Martha Graham, she performed with Graham's company in the mid-1930s. Among the many works in which she created roles were *Tragic Patterns* (1933), *Celebration* (1934), *American Provincials* (1934), *Course* (1935), *Panorama* (1935), and *Horizons* (1936).

A member of the New Dance League, Mehlman presented solo and group dances at League recitals

and concerts shared with other dancers. She choreographed characterizational profiles, such as the *Four Portraits* (1939) and *Social Scenes* (1935), and dances of protest with allusions to the Spanish Civil War and conditions in the United States.

Works Choreographed: CONCERT WORKS: *Defiance* (1934); *Death of a Tradition: Challenge* (1934, credited collectively to Mehlman, Sophie Maslow, and Anna Sokolow); *Social Scenes (Fatherland, In the Beginning)* (1935); *Song of Affirmation* (1937); *Spanish Woman (Lullaby for a Dead Child, No Passaran)* (1937); *Harvest Song* (1937); *Girl* (1937); *Idol* (1937); *Americana* (1939); *Death from the Skies* (1939); *Four Portraits (Esthete, De Luxe, Espagnole, Patriotic Matron)* (1939); *Go Down Ol' Hannah and Poor Harold* (1939); *Mene Mene Teckel* (1939).

Meister, Hans, Swiss ballet dancer also working in the United States; born October 13, 1937 in Schaffhausen-an-Rhin. Meister was trained at the nearby Zurich Opera Ballet school and appeared in adolescent roles in opera divertissements. He continued his studies at the Paris studio of Mme. Rousanne and at the Royal Ballet School in London, before joining the National Ballet of Canada in 1957. He was assigned progressively larger roles in that company's productions of the classics and its revivals of works by Frederick Ashton and Antony Tudor, but sprang to stardom with a series of pas de deux concerts and appearances with Galina Samtsova across Canada and the United States. Meister was the principal danseur of the Metropolitan Opera Ballet in its late prime, in the mid-1960s. His roles ranged from appearances in party or orgy scenes in various operas to principal danseur parts in *Les Sylphides,* Hans Brenaa's revival of Bournonville's *La Ventana,* Joseph Lazzini's *Miraculous Mandarin,* and Antony Tudor's *Echoing of Trumpets.* After he left the Met, he went to Leningrad to study with Alexander Pushkin and to perform with the Kirov Ballet as a guest. An illness required his retirement from active performance, after which he became director of the Zurich company where he had begun his long career.

Mekka, Eddie, American theatrical dancer and actor; born c.1953 in either Marpoot, Armenia, or Worcester, Massachusetts. Raised in Worcester, he was a gymnast before first receiving theater training at the Boston Conservatory of Music. He studied dance in New York with Phil Black.

After performances in stock productions of musical comedies, he was cast as one of the acrobats in Dennis Nahat's *Jumpers* (1974), doing his intricate dance and gymnastics choreography and speaking lines. His appearance in the one-week run of *The Lieutenant* (1975) won him a Tony nomination for best actor. Since 1976, he has co-starred as "Carmine Ragusa," the social dance teacher, in the television sitcom *Laverne and Shirley* (ABC, 1976–). For the 1977 season, he also appeared as choreographer "Joey De Luca" in the show's spin-off, *Blansky's Beauties* (ABC).

Melendez, Jolinda, American ballet dancer; born November 17, 1954 in New York City. Melendez was trained by Thalia Mara at her National Academy of Ballet; she also spent a brief amount of time in Leningrad studying at the Kirov school.

Melendez has been a member of the American Ballet Theatre since 1972. She has progressed from solo roles, among them "second swan," "third shade," and "first willi," to principal roles in Ballet Theatre's large repertory of revived classics, among them *Swan Lake, La Bayadère*, and *Giselle.* Melendez has also been featured in the *Meander* section of Alvin Ailey's *The River,* exploiting her long legs, and in Frederick Ashton's *Les Patineurs,* showing off both her balance and her sense of comedy.

Méndez, Alberto, Cuban ballet dancer and choreographer; born April 8, 1939 in Pinar del Río, Cuba. Méndez was trained at the Escuelo Nacional de Ballet by Alicia and Fernando Alonso, Joaquin Banegas, Aurora Bosch, and Azari Plisetski.

Méndez's career as a dancer, and most of his choreography, has been involved with the Ballet Nacional de Cuba, with which he has danced since 1960. He has performed featured roles, primarily character parts, in Alicia Alonso's restagings of *Giselle, Swan Lake, The Sleeping Beauty,* and *La Fille Mal Gardée,* and company productions of *La Bayadère* and *Don Quixote,* as well as in the works of the contemporary repertory, such as José Pareš' *Bach × 11 = 4 × A* and *Concierto en Blanco y Negro.*

Méndez's choreographic career is also based primarily around his company, the Ballet Nacional. The winner of three first prizes for choreography from the Varna competition (in 1970, 1974, and 1976), Méndez has created over a score of ballets for the company repertory. He is also known for his occasional anniversary spectacles and pieces choreographed for student theater groups, ministerial celebrations, and state-supported educational institutions, among them, the Instituto Cubano del Arte e Industria Cinematografico.

Works Choreographed: CONCERT WORKS: *Plásmasis* (1970); *Nos veremos ayer noche, Margarita* (1971); *Del XVI al XX* (1972); *Tarde en la Siesta* (1973); *Los Cheverines* (1973); *Tiempos de soledad* (1973); *El río y el bosque* (1973); *La bella Cubana* (1973); *Paiseje blanco* (1973); *Nuestra América* (1973); *Velada XIII Aniversario de la Victoria de Playa Giron* ("La Maquinaria") (1974); *Homenaje al XIV Aniversario de lo CDR* (1974); *Mujer* (1974); *Historia del ballet* (1975); *Paso a dos* (1975); *Velada cultural XXII Aniversario del Asalto al Cuarte Moncada* (1975); *Polonesia* (1975); *. . . de los olas* (1975, co-choreographed with G. Herrera); *El son entero* (1975); *Los enseño a ser fuertes* (1975); *Cinco Canciones Vietnamitas* (1976); *El duo de siempre* (1976); *Paso a tres* (1976); *Velada XV Aniversario de la Victoria de Playa Girón* (II) (1976); *Safeta Amó* (1976); *Velada "Amancer de Victorias" por el XXIII Aniversario del asalto al Cuartel Moncada* (1976); *Valse* (1976); *La Perí* (1976); *Juventad* (1977); *Sinfonía para estudeintes* (1977); *El en Jardin* (1977); *Trois pas de deux* (1977); *Corpografía* (1977); *Canción para la extraño flor* (1977); *El futuro nacio en octubre* (1977); *Muñecos* (1978); *Cascañueces* (1978); *Cantata del hombre cotidiana* (1978); *Ad Libitum* (1978); *Rara Avis* (1979).

Méndez, Josefina, Cuban ballet dancer; born c.1940 in Havana. Méndez was trained at the Sociedad Pro-Arte Musical by Alberto and Alicia Alonso and José Parés. Her career has been associated with Alonso's Ballet de Cuba and Ballet Nacional de Cuba, of which she has served as ballerina and artistic director. Méndez shared many of the classical roles with her mentor, including her productions of *Giselle, Coppélia,* and *Swan Lake.* Her bravura technique, strength, and presence were acclaimed in those parts by critics and enthusiastic audience members in Cuba and on the company's frequent tours. Her credits in the contemporary repertory include "Jocasta" in José Lefebre's *Edipo Rey,* a principal part in Parés' *Un Concierto en Blanco y Negro,* and "Taglioni" in Alonso's version of the *Pas de Quatre.* While there is a tendency in America to think of the new Cuban generation of Cuban ballerinas as tributes to Alonso's training and their own patriotism, there is no question that Méndez's skills and performance integrity could win her principal roles anywhere.

Mendez, Juliette, Italian/Russian ballet dancer and teacher working in the United States after 1910; born c.1886 in Milan. Raised in Moscow, Mendez was trained at the local school of the Imperial Theater and taught there briefly after her graduation. Although it cannot be determined exactly when they were married, Mendez's career was associated with that of Alexis Kosloff from 1910 when he was playing "Hilarion" in *Giselle* at the Coliseum in London with Tamara Karsavina, and she was in Olga Preobrajenska's company doing *Swan Lake* at the Hippodrome.

In 1911, they, with his brother Theodore and in-law Maria Alexandra Baldina, were members of the company of dancers performing in Gertrude Hoffmann's Saison des Ballets Russes in New York and on tour. The Kosloff clan performed and toured across America for many years after that. In Los Angeles after 1917, she served as a staff dance teacher at the Laskey Studios. She had retired by 1920 to teach in the school that Alexis ran in New York and those that her brother-in-law directed in Los Angeles and San Francisco. Mendez served as a ballet master of the Mikhail Mordkin company in the late 1930s and in the same capacity for the first few years of Ballet Theatre.

Ménéstrier, Claude-François, S.J., French seventeenth-century arranger and chronicler of fêtes; born 1631 in Lyons; died 1705 in Paris. Ménéstrier, a French Jesuit priest, is in a strange position in dance history—he is the principal, if not the only, source for his own creations. He arranged both public and private fêtes in Turin, then a principality of France in

what is now northern Italy. The Savoie Court in Turin had traditionally been sponsors of fêtes and public masques, as staged by Compte Aglié San Martino. Ménéstrier is known as the major source of information on his works, through his valuable books *Traité des Tournants, Joustes, Carousels et autre Spectacles publiques* (Lyons: 1669), and *Des ballets anciens et modernes selon les règles du théâtre* (Paris: 1682).

Mengarelli, Julius, Swedish ballet dancer; born 1920 in Stockholm; died 1960 in Västanvik. Trained at the School of the Royal Swedish Ballet, he graduated into the company in the early 1940s. Celebrated for his performances in the contemporary repertory, he created roles in Birgit Cullberg's *Miss Julie* (1950) and *Medea* (1950), and in Ivo Crámer's *The Prodigal Son* (1958). In a famous partnership with Elsa Marianne von Rosen, he also danced in revivals of the Fokine repertory.

Mengarelli, Mario, Swedish ballet dancer; born January 1925 in Stockholm. The younger brother of Julius Mengarelli, he was also trained at the School of the Royal Swedish Ballet and a member by the mid-1940s. He inherited his brother's role in Birgit Cullberg's *Miss Julie,* partnering Gert Anderssen, and created roles in Antony Tudor's *Echoing of Trumpets* (1963) and Birgit Akesson's *Sisyphus* (1957). He performed with the company until 1971, becoming known as a talented mime and character actor.

Menotti, Gian-Carlo, American composer; born July 7, 1911 in Cadegliano, Italy. Educated in the United States, Menotti has made a major contribution to this country's contemporary opera and concert stage. His *Amahl and the Night Visitors*, presented annually on television during the 1950s and at almost every school sometime around Christmas, is one of the most commonly known operas in America.

Menotti has written scores on commission from the International Ballet du Marquis de Cuevas (Edward Caton's *Sebastien,* 1944), the Martha Graham troupe (her *Errand into the Maze,* 1947) and the New York City Ballet (John Butler's *The Unicorn, the Gorgon and the Manticore,* 1956). The latter

work has been choreographed by many other dancers for American and European companies.

The Spoleto Festival, which Menotti founded in 1958, has sponsored dance performances in each year of its existence. It has also seen the premieres of three important American choreographers' companies— Jerome Robbins' Ballets: U.S.A., Herbert Ross' Ballet of Two Worlds, and Eliot Feld's American Ballet Company.

Menzelli, Elisabetta, Prussian ballet dancer, choreographer and teacher; born c.1860 in Bresslau, Prussia (now Wroklaw, Poland); died c.1929 in Los Angeles, California. Trained at the school of the Opera Ballet in Bresslau where her mother served as wardrobe mistress, Menzelli continued her studies under Jeanette Köhler and Paul Taglioni. She and her sister, Elena, worked as child ballet dancers in Berlin, with Pasqualli's Kinderballett and in the Hamburg Stadtopera premiere of Verdi's *Il Trovatore*, and in the Volkstadterater in St. Petersburg, where she claimed to have studied with Marius Petipa.

At sixteen, Menzelli was named to the company of the Imperial Theater in Vienna, where she performed the role of ''Fenella'' for the first time; the featured mime role in *Maisanello* (or *The Dumb Girl of Portici*, as it was alternatively titled) was to become her most famous characterization. She performed ''Fenella'' and other roles on a tour of the United States, timed to coincide with the centennial celebrations of Philadelphia. After playing Niblo's Garden in New York and a Midwestern tour with a German opera company, Menzelli joined the Italian Opera Company, directed by Col. Charles Mapleson.

Injured in a trap-door malfunction in 1880, while with Mapleson's troupe, Menzelli returned to Europe where she served as ballet master for an Italian company in Tiflis. Emigrating to the United States in 1904, she opened a school in New York where she taught ballet technique until 1923. Her students there included her protégé, called Lola Menzelli, who had a short career as an opera dancer, and many vaudeville and theater dance performers, among them, the Eaton sisters—Mary and Pearl—and the Fairbanks Twins. Announcing her retirement in 1923, she

moved to Los Angeles where, after the briefest vacation, she began to teach again at the McAdam Normal School.

Menzelli, Lola, American ballet dancer; born c.1898 in Vienna; died March 11, 1951 in Chicago, Illinois. Menzelli made her professional debut at the age of four in a children's role in the German-language opera in New York, and continued to work as a German-language actress until 1912. From the age of eight, the dancer, whose real name is not known, studied with Elisabetta Menzelli, who adopted her and gave her her surname. She danced for her mentor in New York City recitals and performed in the ballet divertissements in Weber and Field musical productions, such as *The Man with Three Wives* (1913). She also toured with Stafford Pemberton, a vaudeville ballet dancer who was a student of the elder Menzelli's and gained a reputation as an excellent ballerina. Although she was hurt by her height (less than five feet from photographs), she had a successful career in vaudeville and variety in the Americas and Europe, where she was a special favorite. In 1914, she married Senia Solomonoff (then of the Metropolitan Opera Ballet). They toured together for fifteen years and retired to the Florida area where he staged ballets and pageants for the St. Petersburg Ballet. Their daughter performed as Marya Saunders.

Mérante, Louis, French nineteenth-century ballet dancer and choreographer; born July 23, 1828 in Paris; died July 17, 1887 in Courbevoi, France. Originally of Italian parentage, Mérante was trained by Lucien Petipa in Paris. He made his Paris Opéra debut in the mid-1850s, later creating roles in Petipa's *Rilla* (1885), Joseph Mazilier's *Marco Spada* (1859), and Marie Taglioni's *Le Papillon* (1860).

Named ballet master in 1853, Mérante continued many well-known late Romantic ballets, each emphasizing national dances rather than spirits and willies. At least two of his works, *Sylvia* (1876) and *Les Deux Pigeons* (1886), were revived frequently in France and across Europe.

Works Choreographed: CONCERT WORKS: *Gretna Green* (1853); *Hulda, leggenda islanders de secolo*

VIII (1854); *Sylvia, ou la Nymphe de Diane* (1876); *La Fandango* (1877); *Yedda* (1879); *La Korrigane* (1880); *La Fanadole* (1883), *Les Deux Pigeons* (1886); *Les Jumeaux de Bergane* (1886).

Mercado, Hector, American modern and theatrical dancer; born January 12, 1949 in New York City. Mercado studied in New York with his uncle Jaime Rogers, and later with Finis Jhung while attending the High School of Performing Arts.

A member of the Alvin Ailey Dance Theatre from 1970 to 1975, he created roles in Ailey's *Flowers* (1971), *Archipelago (I)* (1971), *Choral Dances* (1971), *The Lark Ascending* (1972), and *Hidden Rites* (1973). His many featured roles in the company include parts in Ailey's *Blues Suite, Revelations, Streams,* and *Mary Lou's Mass,* John Butler's *According to Eve,* Donald McKayle's *Rainbow 'Round My Shoulder,* and the revival of Ted Shawn's *Kinetic Molpai.*

Mercado has performed extensively on network television for the last fifteen years, on the *Kraft Music Hall* and the *Ed Sullivan Show,* among many others, and has danced and acted on the Latino Télévicion productions, including *Realidades,* broadcast over WNET in 1977. His film appearances include *Slow Dancing in the Big City* (UA, 1979), choreographed by Jacques D'Amboise, and *Hair* (UA, 1979), with dances by Twyla Tharp.

Although his Broadway career started with two celebrated flops, *1600 Pennsylvania Avenue* (1976), and *Dr. Jazz* (1975), Mercado became famous from his portrayal of "Judas" in Vinette Carroll's musical, *Your Arms Too Short to Box with God* (1977), choreographed by Talley Beatty. Mercado's extraordinary acrobatics and jumps, the most exciting of which was shown in slow motion in the show's television commercial, won him enormous admiration. Mercado was also seen as "Bernardo" in the Broadway revival of *West Side Story.*

Mercier, Margaret, Canadian ballet dancer; working in Canada, England, and the United States; born 1937 in Montreal, Canada. After early training locally with Eleanor Moore Ashton, Mercier continued her studies at the school of the Sadler's Wells Ballet,

with Ursula Moreton, Lydia Kyasht, Winifred Edwards, and Ailene Phillips.

Performing with the Royal Ballet from 1954 to 1958, she was selected for featured soloist and principal roles in *Swan Lake* and *The Sleeping Beauty*. She returned to Montreal to work with Les Grands Ballets Canadiens in 1958, dancing in that company's repertory of classics, notably *The Sleeping Beauty, The Nutcracker,* and the *Don Quixote* pas de deux, and in Edward Caton's *Pas de Deux Classique*.

Messel, Oliver, English artist and theatrical designer; born January 13, 1905 in Cuckfield; died July 13, 1978 in Bridgetown, Barbados. Since his first productions for C.B. Cochran's annual *Revues,* Messel was considered the ideal English designer, celebrated for his uses of color with conservative naturalistic scenery. His most successful ballet productions, among them David Lichine's *Francesca da Rimini* (1937), Robert Helpmann's *Comus* (1942), Frederick Ashton and Ninette De Valois' *Sleeping Beauty* (1946), and Ashton's *Homage to the Queen* (1953), were all based on nineteenth-century perspective systems, as depicted in Messel's glorious watercolor techniques. The most memorable of these, the postwar *Sleeping Beauty,* has been copied, adapted, and alluded to in almost every subsequent production of that ballet, especially in the curving lines of the architectural motifs. Messel's textbook on design and presentation techniques is still a valuable book, making up in technical information what it now lacks in contemporary aesthetics.

Bibliography: Messel, Oliver. *Stage Designs and Costumes* (London: 1934).

Messerer, Asaf, Soviet ballet dancer and choreographer; born November 6, 1903 in Vilna. Trained at the Theater of the Working Youth and the Moscow school of the Bolshoi Ballet, he performed with that company from 1921 to 1954. In that extraordinary thirty years, he danced in the company's productions of *The Red Poppy, The Nutcracker,* the Zakharov version of *Fountains at Bakhisarai,* as "Chieftain in Nurali," and in *The Sleeping Beauty,* in the Bluebird pas de deux variation.

Ballet master for the Bolshoi from 1942, he staged productions of the classics and choreographed the famous pas de deux, *Spring Waters* (1959).

Considered one of the first Soviet dancers to combine exceptional technical bravura with legible and expressive mime work, he was chosen to tour outside the country in the 1940s. He has also worked in Western Europe as a guest ballet master, notably at the Théâtre de la Monnaie, in Brussels.

Works Choreographed: CONCERT WORKS: *Schumanianna* (1924); *The Sleeping Beauty* (1936, co-choreographed with Chekrygin); *Swan Lake* (1937); *La Fille Mal Gardée* (1945); *Swan Lake* (1956, co-choreographed with Radunsky); *Spring Waters* (1959); *A Bashkir Dance* (1959); *Ballet School* (1962).

Meyer, Laverne, Canadian ballet dancer and choreographer; born February 1, 1935 in Guelph, Ontario. Trained in Canada by Boris Volkoff, he continued his studies at the school of the Sadler's Wells and Rambert Ballets. He spent some time at the Martha Graham school in New York in the mid-1960s.

A founding member of the Western Theatre Ballet from 1957, and ballet master from 1964, he choreographed for the company. Much of his choreography was created for the Northern Dance Theatre, Manchester, of which he served as an artistic director.

Works Choreographed: CONCERT WORKS: *The Web* (1962); *Meeting Places* (1969); *Brahms Sonata* (1969); *The Trojans* (1969); *Silent Episode* (1970); *Pas de Cinq* (1970); *Pas de Trois* (1970); *Introduction Piece* (1971); *Schubert Variations* (1973); *Cinderella* (1973).

Milberg, Barbara, American ballet dancer; born c.1930 in New York. Trained at the School of American Ballet, Milberg made her debut with Ballet Society in 1947.

A charter member of the New York City Ballet, Milberg performed in works by George Balanchine, among them *Apollo, Divertimento No. 15, Roma,* and *Agon,* as half of the tandem Galliarde section in the 1957 premiere performance. She also danced in Lew Christensen's *Jinx,* in Frederick Ashton's *Illuminations,* as "Profane Love," and in sections of *Jeux d'Enfants,* choreographed by Balanchine, Francisco Moncion, and herself, in 1955.

Milberg left the City Ballet to perform with Jerome Robbins' Ballets: U.S.A. through its short life (1958-1959, 1961-1962). She danced in most of the company's small repertory of Robbins' work, among them *New York Export: Opus Jazz, The Concert,* and *Moves.*

Milhaud, Darius, French composer born September 4, 1892 in Aix-en-Provence; died June 22, 1974 in Geneva. Milhaud had studied at the Paris Conservatoire and had served with the French consulate in Rio de Janeiro when he returned to Paris in 1919 and became involved with the experimental group of composers known as Les Six (Louis Durey, Georges Auric, Arthur Honegger, Francis Poulenc, and Germaine Tailleferre, with poet Jean Cocteau). He composed ballets to Cocteau's libretti for Les Ballets Suedois, among them *Le Boeuf sur le Toit* (1920), *L'Homme et son Désire* (1921), *Les Mariés de la Tour Eifel* (1921, with Auric, Honegger, Poulenc, and Tailleferre), and *La Création du Monde* (1923), which remains his best known concert work. After the success of those works, choreographed by Jean Borlin, he was commissioned to create scores for Leonid Massine's *Salade* (1924, Paris Opéra), Bronislava Nijinska's *Le Train Bleu* (1924, Diaghilev Ballet Russe), George Balanchine's *Les Songes* (1933), and Roland Petit's *La Rose des Vents* (1958). Milhaud also wrote incidental music to plays and liberetti by Paul Claudel, and works for symphonic orchestra, many of which have been choreographed by contemporary dancers.

Miller, Ann, American tap dancer; born Lucille Ann Collier, April 12, 1919 or 1923 in Chireno, Texas. Miller studied ballet locally in Houston, Texas, and began nightclub work in her adolescence. After engagements at the Bal Tabarin in San Francisco and at the Casanova Club in Hollywood, she was offered a contract at RKO studios. Although she was occasionally loaned out to other studios, Miller spent most of her movie life at RKO (1936-1940), Columbia (1941-1946), and MGM (1948-1956). She occasionally played a dramatic role but is unquestionably best known for her tap solos in films for each studio, among them, *New Faces of 1937* (RKO), *Hit Parade of 1941* (Republic), *Revellie with Beverly* (Columbia, 1943), *Jam Session* (Columbia, 1944), *Small Town Girl* (MGM, 1952), *Hit the Deck* (MGM, 1955), and *The Great American Pasttime* (MGM, 1956). Although many of her fans prefer her dances with Fred Astaire to "It Only Happens When I Dance with You" from *Easter Parade* (MGM, 1948), to any of her tap work, others adore her "Shaking the Blues Away" number with her signature tap fouéttés. Other well remembered Miller routines include the "Prehistoric Man" number in *On the Town* (MGM, 1949) and the wonderful "From This Moment On" sequence from *Kiss Me Kate* (MGM, 1953), with most of the studio's contract dancers. A new generation of fans, who discovered her in the *That's Entertainment* films, have followed her to Broadway, where she has starred in the burlesque extravaganza, *Sugar Babies,* since its opening in 1979. Unlike her Broadway debut, when she did the "Mexiconga" in the *George White Scandals of 1939,* her *Sugar Babies* numbers include her unique tap dancing. Miller has also appeared live in summer-stock tours of most of the great female vehicles of the musical theater, including *Panama Hattie, Can Can,* and *Mame.*

Bibliography: Miller, Ann. *Miller's High Life* (New York: 1972); *Taps on Tap* (New York: 1980).

Miller, Buzz, American theater and film dancer; born Vernal Miller, 1928 in Snowflake, Arizona. After attending Arizona State College, Miller became a Jack Cole Dancer in 1948. He made his professional debut with Cole, dancing in his *Magdelena* in Los Angeles and in New York (c.1948). After working with the Cole Dancers in nightclub bookings, he returned to Broadway to dance in the 1952 revival of *Pal Joey.* Parts in *Two's Company* (1952) and *Me and Juliet* (1953) led to his performance in *The Pajama Game* (1954), in which he partnered Carol Haney and the black bowler hats in "Steam Heat." He can also be seen with her in the film version (WB, 1957).

For many years after that, he split his time between Broadway shows—*Bells Are Ringing* (1956), *Redhead* (1959), *Hot Spot* (1963), *Funny Girl* (1964), and *Moondreamer*—and concert dance, working with Roland Petit's Ballets de Paris in his *La Chambre,*

with Herbert Ross' *Festival of Two Worlds,* Petit's *An Evening with Zizi Jeanmaire,* Carmen De Lavallade's *Portrait of Billie,* John Butler's *Villon* and *The Unicorn, the Gorgon and the Manticore* and Bertram Ross' *Ballet* (1968). He has also directed plays, choreographed operas, and danced in dozens of industrials.

Miller, Flournoy, American popular entertainer of the early twentieth century; born c.1887; died June 6, 1971 in Hollywood. Miller wrote, directed, produced, and appeared in many of the most influential and popular black revues and musical comedies of the 1920s and 1930s on Broadway. He had a successful career as a stand-up comic, but started his career as a dancer. He and Aubrey Lyles (died 1932) had a complex act involving dialogue, competition dance sequences, and a staged fight that required expert skill in the acrobatics and balancings used by adagio teams. Although many historians consider Miller important because he was the first black popular star who did not use dance on stage, it is vital to remember that he had begun his career in that genre.

Miller's first writing credit dates from 1908, but most of his work was done in the late 1920s and 1930s, when he produced *Shuffle Along* (1932, also 1952 revival). He did his nondance act in *Great Day* (1929), the *Blackbirds of 1930,* the *Harlem Cavalcade* (1942), and at the Palace Theater.

Miller, Freda, American composer and pianist for modern dancers; born c.1910; died May 25, 1960 in New York City. Miller was considered second only to Louis Horst as the principal pianist and accompanist for the traditional modern American dance pioneers. She also composed music for members of that generation, most notably, for Pauline Koner, whose *Amorous Adventure* she wrote, Hanya Holm and Charles Weidman, for whom she set music for the James Thurber pieces, *Fables for Our Time* and *The Courtship of Arthur and Al.* Other choreographers for whom she played and composed or arranged included Helen Tamiris and John Butler.

After Miller's death in 1960, a scholarship fund was set up by her friends and a series of Freda Miller Memorial Concerts presented at the 92nd Street YMHA, where she had so often played.

Miller, Jane, American ballet dancer; born March 19, 1945 in New York City. Miller was trained at the School of American Ballet in New York. After dancing with the newly formed Pennsylvania Ballet, she joined the National Ballet, Washington, D.C., where she soon became recognized as a versatile and talented performer. She was cast in the leads of a wide variety of repertory works, from the revival of Doris Humphrey's *The Shakers* to Frederick Franklyn's classical *Hommage* and Mikhail Fokine's *Les Sylphides.* As a guest with the Harkness Ballet, she appeared in Valerie Deakin's *Masque of the Red Death* and Vicente Nebrada's *Circle of Love,* two dramatic ballets in which she excelled.

In the late 1970s, following the death of its founder, she became co-artistic director of the Eglevsky Ballet on Long Island, New York. This chamber ballet, which presents frequent concerts on Long Island and in New York City, sponsors a school and performances that are recognized as preparation sessions for the younger soloists and principals of the country's major ballet troupes.

Miller, Joan, American modern dancer and choreographer; Miller's training in dance included classes with José Limón, Martha Graham, Betty Jones, Doris Humphrey, Louis Horst, and Perry Brunson. She performed with the single-season American Dance Theatre with Rudy Perez, Rod Rogers, and in Ruth Currier's concert group in her *The Antagonists* and *Tocatta,* among other repertory works. Miller formed her Chamber Arts/Dance Players troupe in 1969, the year that she became involved with the new degree program in dance at Lehman College, City University of New York. Her company is currently in residence at the Bronx college campus. Miller's works have been highly praised for their clean and inventive movement patterns and legible montages of images in dance and words.

Works Choreographed: CONCERT WORKS: *Robot Game* (1969); *Pass Fe White* (1970, Part I only); *Improvisations on a Theme by Rudy Perez* (1970); *Plus Four* (1970); *Pulp* (1970); *Blackout* (1971); *Pass Fe White* (1971, Part II); *Memplayfus* (1971); *Plus Six (II)* (1971); *Pass Fe White* (1972, Part III); *Route* (1972); *Mix* (1972); *Plus or Minus* (1972); *Homestretch* (1973); *Thoroughfare* (1973); *Escapades*

(1974); *Pass Fe White* (1974, Part IV); *Sponge* (1974, Part I); *Sponge* (1975, Part II); *Soulscape* (1977); *Brassy* (1979); *Lyric Dance No. 1* (1979); *Thoroughfare II* (1980).

Miller, Marian, American interpretive toe dancer; born c.1905 in Cincinnati, Ohio. Miller had a short but fascinating career in the early 1920s in which she investigated every possible theatrical use of classical ballet technique. Unlike her contemporary Marilyn Miller (with whom she is often confused), Miller seldom appeared in the then conventional persona for a ballet dancer—complete with blonde curls, white organdy, and rosebuds. Billed as an interpretive dancer, she was more likely to appear in a jazz gown, Pierrot outfit, or a Faun suit. She appeared in one plotted musical, *Good Morning Dearie* (1923), at the end of her career, but found that her singular solos worked better in revues such as Irving Berlin's *Music Box Revues* of 1920, 1921, and 1922, the Hippodrome extravaganzas of 1920 and 1921, and the roof garden shows of the Winter Garden Theater, *The Century Rounders*. Miller can still be seen in a toe-Black Bottom in the early Samuel Goldwyn film, *The Girl with the Jazz Heart* (Goldwyn Productions, 1920).

Miller, Marilyn, American theatrical ballet dancer; born c.1898 in Findlay, Ohio; died April 7, 1936 in New York. Miller made her stage debut at age five with her parent's act, redubbed The Columbian Trio for her appearance. She toured with the act, later called *The Five Columbians* and *A Bit of Dresden,* for ten years until she was "discovered" by a scout for the Shubert Brothers, probably Harry Pilcer or Melville Ellis, and hired for the *Passing Show of 1914.*

"The Dresden Doll of Dance," as she was known, appeared in the *Passing Shows of 1914, 1915,* and *1917* and the Shubert's *Show of Wonders* (1916) and *Fancy Free* (1918), before defecting to Florenz Ziegfeld's *Follies.* She also danced for Ziegfeld in three of his most lavish musical comedies, *Sally* (1920), *Sunny* (1925), and *Rosalie* (1928). Partnered by Jack Donahue, Miller was the best known ballet specialty dancer and musical comedy performer on Broadway.

Unable to make the transition to Hollywood, Miller died very young but already passé at the age of thirty-eight.

Miller, Patricia, South African ballet dancer working in England; born 1927 in Pretoria. Trained with Dulcie Howes, she performed with her University of Capetown Ballet.

Moving to England, she joined the Sadler's Wells Theatre Ballets in 1947. In that company, she became associated with the works of John Cranko, creating roles in many of his early works, among them, *Children's Corner* (1948), *Beauty and the Beast* (1949), *Pastorale* (1950), *Harlequin in April* (1951), *Reflection* (1952), and *The Lady and the Fool* (1954). She also danced in Michael Somes' *Summer Interlude* (1950), and in the company's productions of the classics.

Miller returned to South Africa in the mid-1950s to open a dance studio in Capetown.

Millman, Bird, American theatrical dancer and tightrope walker; born Jennadean Engelmann, October 20, 1895 in Canon City, Colorado; died there August 5, 1940. "The Genée of the Air" was born and trained in the Grand Melbourne Circus by her aerialist parents, Dyke and Genevieve Millman, and joined their act. She made her debut in a 1909 production at the Hippodrome, the only indoor theater in New York with an aerial ballet and swimming pool. For much of the rest of her career, she commuted among bookings in vaudeville, on Broadway, and in the Barnum and Bailey circus. She danced on tightrope in the latter institution in the 1913–1915, 1917, and 1918 seasons, joining the merged Ringling Brothers and Barnum and Bailey Circus for the 1919 and 1920 seasons. The Millman Trio was booked on the Keith and Orpheum circuits from 1906 to 1924, although billing was changed to Bird Millman and Her Company in 1915.

Millman danced on her tightrope on point on Broadway. She appeared in three editions of the roof garden *Ziegfeld Midnight Frolics* (1915, August 1916, October 1916), and in the *Greenwich Village Follies of 1921*—performing her own act in each show. Millman also appeared in a five-part serial film, *Deep Purple* (World, 1915).

615

After retiring in 1924, she moved to a ranch in Colorado, which she managed. She was posthumously elected to the American Circus Hall of Fame in 1961.

Milloss, Aurel, Hungarian ballet dancer and choreographer working in Italy and Western Europe; born Aurel Milloss de Milholy, May 12, 1906 in Ozora, Hungary. Milloss was trained in ballet techniques by Nicola Guerra, Victor Gsovsky, and Enrico Cecchetti, and in German expressionist dance by von Laban and Mary Wigman. Since his tenure with the Berlin State Opera from 1928 to 1936, he has served as ballet master or resident choreographer for almost every opera house in Europe, working with, among others, companies in Breslau, Dusseldorf, Budapest, Rome (1938–1945 and 1966–1969), the Teatro alla Scala in Milan (1946–1951), the State Operas of Cologne (1960–1963), and Vienna (1963–1966, 1971–1974), and the Teatros di Rio de Janeiro and Sao Paulo. Among his best known ballets are his versions of *Pulcinella* and *Joseph's Legend* (both 1933), works to scores by Stravinsky including *Apollo* (1941), *Sacre du Printemps* (1941), *Capricci alla Stravinsky* (1943), *Jeu de Carte* (1948), *Orpheus* (1948), and *Renard* (1958), and his national pieces, such as *Sonntagsesärdas* (1933), the gypsy *Pusata-Zigeuner* (1934), *Intermezzo Ungherese* (1941), *Ungheria Romantica* (1941), *Hungarica* (1956), and *Vienna si Diverte* (1957).

He staged theater works in Berlin, Budapest, and Milan and operettas in the standard repertory of almost every position. His Italian films include the 1965 *Guerra e Pace* and the Hollywood extravaganza, *Quo Vadis* (MGM, 1951).

Works Choreographed: CONCERT WORKS: *Der Bestegte Fakir* (1932); *Pulcinella* (1933); *Joseph's Legend* (1933); *Parkballett* (1933); *Deutsche Taenze* (1933); *The Creatures of Prometheus* (1933); *Sonntagsesärdas* (1933); *Das grosse Los* (1933); *Silvana* (1934); *Keline Wiener Parade* (1934); *Coppélia* (1934); *Pusata-Zigeuner* (1934); *Der Tanzgeist* (1934); *Das Zirkusliebchen* (1934); *Auf der Mondscheinredaktion* (1934); *Kuruc Fairy Tale* (1935, co-choreographed with Rezsó Brada); *Antikes Tanzbild* (1935); *Capriccio espagñol* (1935); *Aeneas* (1937); *The Jar* (1939); *Le Donne di Buon Amore* (1939); *La Camera dei disegni* (1940); *Apollo* (1941); *The Rite of Spring* (1941); *Intermezzo Ungherese* (1941); *Ungheria Romantica* (1941); *La Tarantola* (1942); *Alomjáték* (1942); *The Miraculous Mandarin* (1942); *Follie viennesi* (1943); *La Rosa del sogno* (1943); *Deliciae Populi* (1943); *Capricci alla Stravinsky* (1943); *La Stelia del circo* (1944); *Don Juan* (1944); *Amphion* (1944–1945); *Visione nostalgica* (1945); *L'Isola eterna* (1945); *La Dama del Camelie* (1945); *Allucinazioni* (1945); *L'Allegra piazzetta* (1945); *Danza di Galanta* (1945); *La Follia di Orlando* (1947); *Invito alla danza* (1947); *Le Portrait de Don Quichotte* (1947); *Bolero* (1947); *Evocazioni* (1947); *Rhapsody in Blue* (1948); *Marsia* (1948); *Jeu de Cartes* (1948); *Orpheus* (1948); *Terszili Katicza* (1949); *Ballade sans Musique* (1950); *Chout* (1950); *La Soglia del tempo* (1951); *Tirsi e Clori* (1951); *Mystére* (1951); *Riflessi nell'oblio* (1952); *Coup de Feu* (1952); *Fantasia brasileira* (1954); *Passacaglia* (1954); *Indiscrezioni* (1954); *La Valle dell'innocenza* (1954); *La Sonata dell'angoscia* (1954); *Cangaceira* (1954); *La Vedova di Efeso* (1955); *Ciaccona* (1956); *Hungarica* (1956); *Creation du Monde* (1956); *Idillio campestre* (1956); *Saltimbanchi* (1956); *Sogno romantico* (1956); *Estro arguto* (1957); *The Prodigal Son* (1957); *Moses* (1957); *Mirandolina* (1957); *Vienna si Diverte* (1957); *Rappresentazione d'Adamo ed Eva* (1957); *Renard* (1958); *L'Allegra Piazetta* (1958); *Sei danze per Demetra* (1958); *Der Dämon* (1958); *Memorie dall'-Ignoto* (1959); *Stasera la Bella Otero* (1959); *Hellenikon* (1959); *Petit ballet en rose* (1959); *Danze e contraddanze* (1959); *Allegrie brasiliane* (1959); *Il Cimento dell'allegria* (1960); *Treize Chaises* (1960); *Par Flux et Marée* (1960); *Wandlungen* (1960); *L'Homme et son Désir* (1963); *Salade* (1963); *Estro Barbarico* (1963); *Déserts* (1965); *Les Jambes Savantes* (1965); *Divagando con Brio* (1967); *Jeux* (1967); *Ricercare* (1968); *Estri* (1968); *Tautologos* (1969); *Reláche* (1970); *Hommage . . . à Couperin* (1970); *Raremente* (1971); *An die Zeiten* (1972); *Dedale* (1972); *Panta Rhei* (1972); *Per Aspera* (1973); *Visage* (1973); *Relazioni Fragili* (1974); *Rivolta di Sisofo* (1977).

THEATER WORKS: *Auferstehung* (1930); *A Roninok Kinese* (1936); *A Gyémantpatak Kisasszony* (1936); *A Csodatükör* (1937); *Le Bourgeois gentilhomme* (1937); *Fekete Mária* (1937); *Aminta* (1939); *Il Poeta*

fanatico (1941); *El Nacimiento del hombre* (1948); *Elletra* (1956); *Ippolito* (1956); *Ifigenia in Tauride* (1957).

FILM: *Oltre l'amore* (1940); *Quo Vadis* (MGM, 1951); *Guerra e Pace* (Paramount, 1956).

Mills, Florence, American theatrical dancer; born January 25, 1895 in Washington, D.C.; died November 1, 1927 in New York City. Details of Mills' training are not known, but there were many dance teachers in the Washington area training black dancers in musical comedy work and fancy dancing. The petite dancer with a facile, seamless style made her Broadway debut in the replacement cast of Sissle and Blake's *Shuffle Along* in 1921. She quickly became an audience favorite in that show and in the *Plantation Revue* (1922, called *Dover Street to Dixie* in London, 1923), *Dixie to Broadway* (1924), and *Blackbirds* (London, 1926). It is tragic that Mills died so young, before she could be filmed or recorded so that we of the current age could understand her talent and attraction. We have only photographs and a song, reportedly written about her death, Andy Razaf and Blake's "Memories of You."

Milon, Louis Jacques Jesse, French eighteenth-nineteenth-century ballet dancer and choreographer; born 1766, possibly in Paris; died November 25, 1845 in Neuilly, France. Milon, a protégé of Pierre Gardel, was trained at the school of the Paris Opéra and spent his professional life with that company.

After his Paris Opéra debut in 1787, he taught at the school from 1789 and choreographed after 1799. From 1800 to 1826, he served as associate Maître de Ballet with Pierre Gardel. His ballets were primarily pastorals, such as *Le Carnaval de Venice, ou la Constance à l'Epreuve* (1816), *Les Noces de Gamache* (1822), and *l'Epreuve Villageouise* (c.1818), or based on mythological subjects, as *Héro et Lyandre* (1799), *L'Enlévement des Sabines* (1811), and *Le Retour d'Ulysse* (1807).

Works Choreographed: CONCERT WORKS: *Héro et Lyandre* (1799); *Pygmalion* (1800); *Le Retour d'Ulysse* (1807); *L'Enlévement des Sabines* (1811); *Nina, ou La Folle par Amour* (1813); *Le Carnavale de Venice, ou la Costance à l'Epreuve* (1816); *Les Sauvages de la Mer de Sud* (1816); *Zéloïde, ou les Fleurs enchantees* (1818); *l'Epreuve Villageouise* (c.1818); *Clari, ou la Promesse de Mariage* (1820); *Les Noces de Gamache* (1822); *Luca e Laurette* (1832).

Mineo, John, American theatrical dancer; born in New York City. Mineo was trained at the High School of Performing Arts in New York. He made his professional debut as "Baby John" in the national company of Jerome Robbins' *West Side Story,* and first appeared on Broadway in that role in the show's second run (1960). Mineo, who has been called "the ultimate gypsy" and "the most versatile man on Broadway," appeared in a long string of successful musical comedies from his 1960 debut for most of the theater's most innovative choreographers. His credits include performances for Gower Champion, Carol Haney, Ron Field, and Patricia Birch in *Bye Bye Birdie, The Music Man, Flower Drum Song, Hello Dolly, George M!, The Rothchilds, On the Town* (Ron Field's revival), *Sugar, Over Here,* and *A Chorus Line.* He is, however, best known as a dancer at ease with the unique vocabulary of Bob Fosse and has danced to popular acclaim in his *Pippin* (1972) and *Dancin'* (1978).

Minkus, Leon, Austrian nineteenth-century composer; born Aloisius Ludwig Minkus, 1827 in Vienna; died there 1907. As Inspector of Music to the Imperial Theatres of St. Petersburg, and composer-in-residence of the Maryinsky Theatre, Minkus had a veritable monopoly on choreographic commissions. A particular favorite composer of Marius Petipa, himself a choreographer-in-residence, he wrote the music for his *Don Quixote* (1869), *Le Papillon* (1874), *La Bayadère* (1877), *La Fille de Neige* (1879), and *Kalkabrino* (1891), among many others.

Even critics who like Minkus' music tend to describe it in terms more appropriate for patent medicine; it is "soothing," "ingratiating," and "regular." The second-act music for *La Bayadère* especially has become a symbol of a particular genre of dance music—one that has kept people away from the respect that they might otherwise have for ballet choreography as a musical art. There is no question,

however, that Minkus was the perfect composer-in-demand and, as such, a probable partner for his choreographic collaborators.

Minnelli, Liza, American theater and film dancer and actress; born March 12, 1946 in Los Angeles, California. Minnelli was trained at the High School of Performing Arts in New York City. After making her stage debut in the 1963 revival of *Best Foot Forward,* she won a Tony award for her performance in the title role of *Flora, the Red Menace* (1965). Apart from replacing Gwen Verdon briefly in Bob Fosse's *Chicago,* her other stage appearances have been in concerts, including the touring *Liza* (1974–1975) and the plotted *The Act* (1977).

Although she actually made her film debut in her parents' *In the Good Old Summertime* (MGM, 1949), directed by Vincente Minnelli and starring Judy Garland, she became known as an actress in a series of dramatic motion pictures. She has danced in only two films—Bob Fosse's version of *Cabaret* (ABC/Allied Artists, 1972) and *New York, New York* (UA, 1977). In the former, she showed her ability to handle Fosse's complicated rhythms and strenuous body isolations, while in the latter, although most of the dance numbers were eliminated from the final edit, one could see her talent in performing period social and theatrical dance styles.

Minnelli appeared almost constantly on television in the 1960s and early 1970s, with seven performances on *The Ed Sullivan Show,* three *Kraft Music Halls,* and guest shots on her mother's variety series. Her own specials—*Liza* (NBC, June 29, 1970) and *Liza with a Z* (NBC, September 10, 1972)—were extremely popular, the latter winning her the triple crown of musical theater, as best actress in a musical on television, as well as on stage and in film.

Minnelli, Vincente, American theatrical designer and stage and film director; born February 28, 1913 in Chicago, Illinois. Although he began his career as a child actor in Midwest stock companies, he soon left acting for design to join the staff of the Balaban and Katz Prolog circuit. He moved to New York in 1930 to serve in a similar capacity with the Paramount, then a Prolog house. His first Broadway credits came from a specialty set designed for the *Earl Carroll Vanities* of 1931, but within the season he received a full design credit for sets and costumes for *The Du-Barry* (1932). For the next seven years, he worked both in Prolog houses and on Broadway, serving as designer and tableaux director for the Paramount until 1933 and as art director of the Radio City Music Hall for the next three years. His Broadway credits included *At Home Abroad* (1935), the *Ziegfeld Follies of 1936, The Show Is on* (1936), *Hooray for What?* (1937), and *Very Warm for May* (1939). He added directing to his usual sets, costumes, and lighting work for the last three shows. Although he almost returned to Broadway in 1967 with *Mata Hari* (closed in Washington, D.C., prior to Broadway opening), he is best known for his films for MGM. From his film debut with *Cabin in the Sky* (1943) to his final MGM picture, the melodramatic *Sandpiper* (1965), he became known for his stylish movies, whether they involved music or not. Among the many choreographers with whom he worked were Gene Kelly, who staged *The Pirate* (1948) and *An American in Paris* (1951), Eugene Loring, who did *Yolanda and the Thief* (1945), and Michael Kidd, whose dance numbers for *The Bandwagon* (1953) are among his finest. Minnelli's other film favorites include *Meet Me in St. Louis* (1944), *Til' the Clouds Roll By* (1945, Judy Garland sequence only), *Madame Bovary* (1949), *Brigadoon* (1954), *Kismet* (1965), *Bells Are Ringing* (1960), and the original screen musical, *Gigi* (1958).

Bibliography: Minnelli, Vincente. *I Remember It Well* (New York: 1974).

Minns, Al, American Lindy Hopper; born c.1920 in Newport News, Virginia. The son of a guitarist, Minns began dancing at social functions as a child. He won the Harvest Moon Ball (a social and exhibition ballroom competition sponsored by a New York newspaper) in 1938 and became a member of the Savoy Lindy Hoppers, a professional group of dancers who had performed at the celebrated Savoy Ballroom. His specialty was the group dance named for its home town, The Big Apple. Minns did a series of lecture demonstrations with Mura Dehn and Leon James, among them the History of Jazz Dance pro-

gram which demonstrated the themes of Marshall and Jean Stearns' *Jazz Dance* (New York: 1964, 1980).

Minty, Jeanette, English ballet dancer; born c.1931 in London. One of the stars of the London Festival Ballet in its early prime, Minty was trained at the Sadler's Wells School and performed briefly with the International Ballet before joining the Festival in 1953. She enchanted audiences in London and on tours with her portrayals of the younger heroines of the ballet repertory, most notably "Juliet" in the Oleg Briansky *Romeo and Juliet,* "Swanilda," and "The Sugar Plum Fairy" but was also seen to advantage in contemporary works by Jack Carter and Anton Dolin.

Minz, Alexander, Soviet character dancer and mime; born c.1938 in Leningrad; Minz was trained at the Leningrad Choreographic Institute by Valentin Shylkov and Abdurham Kumysnikov, graduating in 1960. He was a member of an operetta theater in Karelia for two years before joining the Kirov Ballet in 1962. In his ten years with the company, he was featured in the "Spanish" variations in the classics, such as *Swan Lake, Don Quixote,* and *The Sleeping Beauty,* and taught mime and character work.

Minz left the Soviet Union in 1972, spending a year in Italy before moving to New York to teach at the American Ballet Theatre School. He has been cast in mime roles in the Ballet Theatre productions of *The Nutcracker, Don Quixote,* and *La Bayadère* (by Kirov alumni, Baryshnikov and Makarova), and in Pearl Lang's *The Possessed* (1975).

Miramova, Elena, Russian ballet and theatrical dancer working in the United States; born c.1905 in Tsaritsyn, Russia. Miramova was trained at the Cornish School in Seattle, Washington, possibly by Mary Ann Wells, who had just begun teaching there. Although her ambition then was to be an actress, she went on the Northwest Pantages vaudeville circuit with a ballet class act at age sixteen. Despite additional training with Adolf Bolm in Los Angeles, she worked primarily as a dramatic actress from 1922 to the late 1930s, appearing most notably in the Los Angeles productions of *A Bill of Divorcement* and *Sister Beatrice* and in the Broadway versions of *The Affairs of Anatol, The Two Mrs. Carolls,* and her best known role, the ballerina in the stage version of *Grand Hotel.* Miramova also wrote plays and screenplays, among them the extravagantly romantic Russian *Dark Eyes.*

Miranda, Carmen, "The Brazilian Bombshell"; born Maria do Carma Miranda da Conha, February 9, 1914 in Portugal; died August 5, 1955 in Beverly Hills, California. Raised in Rio de Janeiro, Brazil, she did nightclub and personal appearance tours when she was discovered by Lee Shubert. The Shubert Brothers were attempting to break ASCAP (the licensing organization for composers and lyricists) and were promoting Latin American (unaffiliated) music heavily when Sonja Henie recommended Miranda to them as a dancer noted for her samba, maxixa, and marcha. She was cast in *The Streets of Paris* (1939) and given a celebrated solo specialty, "The South American Way." It, and she, quickly became the most imitated act in the country, turning up as Imogene Coca's "Souse American Way" in her Martinique Café act and as Betty Garrett's "South America, Take It Away" in *Call Me Mister* (1946). After her second Broadway appearance, doing the samba "Ella diz que tem" in *Sons O'Fun* (1941), she accepted a contract from Twentieth-Century Fox in the 1940s. Most of her films featured her as a representative of her South American heritage and frequently, as in *Down Argentine Way* (1940), *Week End in Havana* (1941), and *That Night in Rio* (1941), she was the only authentic Latino thing about the pictures. She was also used in show-within-a-show sequences in Fox films, most memorably in Busby Berkeley's color extravaganza, *The Gang's All Here* (1943).

Despite her genuine talent for performing Latin American social dances in their authentic forms and in more theatricalized styles, Carmen Miranda was best known for her head-dresses. Berkeley, and other directors, dressed her in fruit and decorated her musical sequences in bananas, apples, and cherries in various super-human proportions, turning her into a gigantic sight gag.

Miranda died of a heart attack at forty-one, shortly after taping a segment of *The Jimmy Durante Show* in 1955. Her talent, or at least her image, lives on.

Mirk, Sharoch, American ballet dancer performing in Europe; born in the 1950s in Westport, Connecticut. After local training with Jeanne de Bergh in Westport, she began to commute to New York to attend class at the School of American Ballet. When her family moved to London, she continued her training at the Royal Ballet School. After working at Maurice Béjart's MUDRA center, she joined his Ballet du XXième Siècle, where she performed in his *Notre Faust, Héliogabale, Dichterliebe, Ce Que l'Amour Me Dit, Duo,* and *Romeo et Juliette,* as "Queen Mab."

Mistinguett, French popular and theatrical dancer and singer; born Jeanne Bourgeous, c.1877 in Anghien et Montmorency, outside Paris; died January 5, 1956 in Bougival, France. It is difficult to verify the order of her early performances, but it is likely that she made her Paris debut at either the Trianon or the Casino de Paris shortly before 1895, as a vocalist. Considered one of the greatest performers of the French twentieth-century popular theater, she was primarily a vocalist who used dance and movement to designate characters for her songs. She did do two major dance acts, however, the Valse chaloupé (c.1910) and La Valse Renversant (c.1913). The former was an early Apache, a duet with Max Dearly in which the male dancer flung the female around into tango holds and passionate embraces. Props for the dance included cigarettes hanging out of his mouth, and in some versions, hers, and a knife with which one stabs the other, again depending on the version. The second specialty developed for her and Maurice Chevalier, then her partner, was also an Apache but one in which the two partners were equalized. A longer routine, it involved reversals of movements with both the man and woman taking turns leading the dance and dramatic action.

Following the split from Chevalier, she hired American Earl Leslie as her dance partner. He introduced Broadway Glides, Black Bottoms, and tangos into the act, although her Apaches remained her best known specialties.

Bibliography: *Mistinguett* (Paris: 1952), published in London as *Mistinguett: The Queen of the Paris Night* (1954).

Mitchell, Arthur, American ballet dancer and choreographer; born March 27, 1934 in New York City. Trained at the High School of Performing Arts and the School of American Ballet, he danced with Donald McKayle's chamber company in *The Street* (1954), *Nocturne,* and *Games,* before joining the New York City Ballet in 1956. The first black dancer to be a full-time, full-contract member of the company, he was also one of the most popular. In his twelve years with the company, he danced in most of the repertory of works by George Balanchine, Jerome Robbins, John Taras, and Todd Bolender. Although his Robbins' pieces, *Interplay* and *Afternoon of a Faun,* were popular, he is best remembered for his work in the Balanchine canon. He created a role in his *Agon* (1957), in the pas de deux section which many consider the most important, influential, and devastating duet in the repertory, and in his *Figure in the Carpet* (1960), *Modern Jazz Variants* (1960), *A Midsummer Night's Dream* (1962, as "Puck"), *Clarinade* (1964), *Don Quixote* (1965), *Ragtime* (1966), *Trois Valses Romantiques* (1967), and *Requiem Canticles (I)* (1968). It has to be emphasized that he was a completely conventional staff dancer, neither a star nor a symbol, in Balanchine's *Four Temperaments, Western Symphony, Ivesiana, Divertimento No. 15, Bugaku, Slaughter on Tenth Avenue,* and *Stars and Stripes.*

In 1968, inspired by the general public reaction to the assassination of the Reverend Martin Luther King, Jr., civil rights and peace activist, Mitchell began the three-year process that created the Dance Theatre of Harlem and its school. He directs the company, serves as its spokesman in press interviews, television appearances, and fund-raising cocktail parties, and choreographs for it, but no longer dances himself. Although, like all young companies, it has had problems creating a viable repertory, the company includes some of the best dancers in the United States and presents them well. The educa-

tional programs of the company and school have been tremendously important to all children in the city school system and to the neighborhood around the headquarters.

Works Choreographed: CONCERT WORKS: *Rhythmetron* (1968); *Convergences* (1968); *Ode to Otis* (1969); *Concerto for Jazz Band and Orchestra* (1971, co-choreographed with Balanchine); *Fête Noire* (1971); *Tones* (1974).

Mitchell, James, American ballet and theatrical dancer; born February 29, 1920 in Sacramento, California. Mitchell studied and danced with Lester Horton, performing in his *Sacre du Printemps* (1937) and *Conquest* (1939).

Mitchell moved to New York in the early 1940s. His Broadway debut, in 1944, was as a dancer in *Bloomer Girl*, choreographed by Agnes De Mille, with whom Mitchell's long career would often be associated. He has also danced for her in *Brigadoon* (1947) and *Paint Your Wagon* (1951) on Broadway, and in *Fall River Legend* and *Rodeo* in Ballet Theatre and the Agnes De Mille Dance Theatre. Mitchell's non-De Mille Broadway shows include *Livin' the Life* (1957) and *Carnival* (1961).

Mitchell's many films have included dance roles, notably *The Band Wagon* (MGM, 1953), in which he played the original choreographer of the title show-within-a-show, *Oklahoma* (Magna, 1955), and *A Turning Point* (Twentieth-Century Fox, 1977). Mitchell has performed frequently on television, primarily in dramatic roles.

Mitchell, Julian, American dance director of the turn of the century; born 1854, possibly in New York; died June 24, 1926 in Long Branch, New Jersey. It is not certain whether Mitchell had any dance training. He performed at Niblo's Garden in the 1870s but soon gave up dance for dance direction. He worked for Charles Hoyt, for Weber and Fields, and for Montgomery and Stone; he choreographed the original *Babes in Toyland* (1903), and staged the first eight *Ziegfeld Follies* (1907 to 1915), as well as the 1924 edition. Mitchell, who became gradually deaf from c.1900 to 1910, was the model for the character "Julian Marsh," the dance director who, ruined by the Depression, suffers a heart attack after staging "Pretty Lady," the fictional revue of *42nd Street*. From his first show, *The Maid and the Moonshine* (1886) to his last, *Sunny* (1925), he created dances for almost all of the major performers on Broadway, among them, his sometime wife, ballet dancer Bessie Clayton. He is generally considered the most prolific dance director on Broadway, although Ned Wayburn, his arch rival and successor as Ziegfeld's house choreographer, and Edward Royce, the Shuberts' house dance director, both equal his record.

Works Choreographed: THEATER WORKS: (Note: Mitchell directed and choreographed all shows unless otherwise noted.) *The Maid and the Moonshine* (1886); *An Arabian Girl and Forty Thieves* (1887); *A Trip to Chinatown* (1891); *A Black Sheep* (1896); *At Gay Coney Island* (1897); *The Glad Hand* (1897); *The Idol's Eye* (1897); *Pousse-Café* (1897); *The Con-Curers* (1898); *Hurley-Burely* (1898); *The Fortune Teller* (1898); *Cyranose de Bric-a-Brac* (1898); *Catherine* (1899); *The Three Dragoons* (1899); *Helter-Skelter* (1899); *An Arabian Girl* (1899); *Whirl-a-Gig* (1899); *The Singing Girl* (1899); *The Princess Chic* (1900); *Fiddle-Dee-Dee* (1900); *The Girl from Up There* (1901); *Hoity-Toity* (1901); *Twirly-Whirly* (1902); *The Wizard of Oz* (1903); *Babes in Toyland* (1903); *It Happened in Norland* (1904); *Wonderland* (1905); *About Town* (1906); *The Parisien Model* (1906); *The White Hen* (1907); *The Tattoed Man* (1907); *Follies of 1907; The Girl Behind the Counter* (1907); *Hip! Hip! Hooray!* (1907); *The Merry Widow Burlesque* (1908); *The Soul Kiss* (1908); *Follies of 1908; Miss Innocence* (1908); *Follies of 1909; The Silver Star* (1909); *Follies of 1910; The Bachelor Belles* (1910); *The Pink Lady* (1911); *Ziegfeld Follies of 1911; A Winsome Widow* (1912); *The Count of Luxembourg* (1912, choreographed only); *Ziegfeld Follies of 1912; Eva* (1912, choreographed only); *Ziegfeld Follies of 1913; Queen of the Movies* (1914, choreographed only); *Papa's Darling* (1914); *Fads and Fancies* (1915); *Ziegfeld Follies of 1915; Around the Map* (1915, choreographed only); *Miss Springtime* (1916); *Hitchy-Koo of 1917; The Rainbow Girl* (1918); *The Kiss Burgler* (1918); *The Girl Behind the Gun* (1918, choreographed only); *The Velvet Lady*

(1919); *The Royal Vagabond* (1919); *The Midnight Whirl* (1919); *As You Were* (1920, choreographed only); *Mary* (1920); *The O'Brien Girl* (1921); *The Perfect Fool* (1921); *The Blue Kitten* (1921); *Daffy Dill* (1922); *Molly Darling* (1922); *The Yankee Princess* (1922); *Little Nelly Kelly* (1922); *Our Nell* (1922, choreographed only); *The Rise of Rosie O'Reilly* (1923); *Ziegfeld Follies of 1924*; *The Chocolate Dandies* (1924); *The Grab* (1924); *Sunny* (1925, choreographed only).

Mitchell, Lucinda, American modern dancer; born February 18, 1946 in Takoma Park, Maryland. After academic training at Smith College (a member of the Five College group that has long featured modern dance work), she moved to New York City to continue her studies at the Martha Graham school. After dancing with the concert groups of Bertram Rose, for whom she appeared in *New Math* (1970), and Kazuko Hirabayashi, she joined the Graham company in 1972. Although she has appeared in almost every work in the large Graham repertory, she is best known for her portrayals of young girls, frequently foci of plot tension in pieces such as *Seraphic Dialogues, Deaths and Entrances, Phaedra,* and *Clytemnestra.* Other works in which she has won acclaim include the revivals of *Appalachian Spring* and *Night Journey.*

Mladova, Milada, American ballet dancer and film performer; born Milada Mráz, c.1918 in Oklahoma City, Oklahoma. Mladova was trained locally by Fronie Asher before continuing her studies in New York with Edward Caton and Aubrey Hitchens. Visits to Paris and Los Angeles gave her the opportunities to work under Olga Preobrajenska and Bronislava Nijinska, respectively. Mladova was a member of the Ballet Russe de Monte Carlo after 1939. Among her many roles there were parts in Marc Platt's *Ghost Town,* Leonid Massine's *Nobilissima Visione, Gaité Parisienne, Bacchanale,* and *The New Yorker,* Agnes De Mille's *Rodeo,* and George Balanchine's *Jeu de Cartes* and *Serenade.* She created a role in Frederick Ashton's *Devil's Holiday* in her first season with the company.

Mladova also enjoyed a successful career in theater and film. She appeared on Broadway in *The Merry Widow* and *The Man Who Came to Dinner* and presented her nightclub act throughout the 1940s and early 1950s, most notably in engagements at the Waldorf Astoria in New York. Her film appearances included Lester Horton's *Atlantis,* Marc Platt's *The Eternal Melody* (a tribute to Sol Hurok), and the Cole Porter biopic, *Night and Day.*

Mlakar, Pia and Pino, Yugoslavian ballet dancers and joint choreographers; Pia born Pia Scholz, December 28, 1908 in Hamburg, Germany; Pino born March 2, 1907 in Novo Mesto, Slovenia, now Yugoslavia. Each was trained by Rudolf von Laban and Elena Poljakova in Belgrade, where they met and married. During the 1930s and early 1940s, they performed in opera ballets in Darmstadt, Dessau, Zurich, and Munich. Returning to Yugoslavia after the end of the German occupation, they taught in Ljubljana, near Pino's birth place in Central Slovenia.

Although his first major choreographic credit, *Un Amour du Moyen Age* (1932), was created alone, and as such won a medal at the 1932 competition of the International Archives of Rolf de Maré, they have worked together since then. Among their best known works are *Der Teufel im Dorf* (the Devil in the Village), staged for the Zurich State Theatre in 1935 and restaged for Belgrade in 1955, the *Josefslegende* (1941) for the Bavarian State Opera Ballet, and *The Little Ballerina* (1947) for the Ljubljana State Ballet. Their daughter, Veronika, known for her performances with the American Ballet Theatre in the mid-1960s, made her debut in the latter.

Works Choreographed: CONCERT WORKS: (All works jointly choreographed.) *Un Amour du Moyen Age* (1932, Pino Mlakar only); *Der Teufel im Dorf* (1935); *Prometheus* (1935); *Josefslegende* (1941); *Verklungene Feste* (1941); *The Little Ballerina* (1947); *Jeu de Cartes* (1953); *Legend of Ohrif* (1978).

Mlakar, Veronika, Yugoslavian ballet dancer who has performed in Western Europe and the United States since the early 1950s; born December 8, 1935 in Zurich, Switzerland. The daughter of Pia and Pino Mlakar, then with the Zurich State Opera, she was trained by them in Zurich and in Ljubljana, Yu-

goslavia, where they directed the State Opera Ballet School. Her other teachers at that school included Mlle. Jowanolc and Lydia Visijakova.

Mlakar made her debut with the Munich State Opera in 1952; in four years there, she created the role of the "Unicorn" in Heinz Rosen's *La Dame à la Licorne* (1953), and performed in *Coppélia* and Cranko's *Jeu de Cartes*. With Roland Petit's company and Les Ballets de Paris, she performed in that choreographer's *La Chambre, The Lady in the Moon, Contrepointe*, and *Le Loup*, and in Maurice Béjart's *Prometheus*.

Moving to the United States in 1958, she performed first with the Chicago Opera Ballet in works by Ruth Page, and then with the American Ballet Theatre. In the latter company, she created the role of the "Bride's Mother" in Jerome Robbins' *Les Noces* (1965) and was featured in Antony Tudor's *Pillar of Fire* as "Hagar," *Dark Elegies, Echoing of Trumpets*, and *Jardin Aux Lilas*. Her dramatic style and cogent characterizations were also seen in the company's production of Birgit Cullberg's *Miss Julie*.

Moccia, Jodi, American modern dancer; born October 24, 1954 in New York City. Trained, like so many of the nation's best dancers, at the High School of Performing Arts, Moccia worked with Alvin Ailey in the Mini-Met (technically, the Metropolitan Opera's concert and chamber opera production wing) production of *Four Saints in Three Acts*. A member of the Ailey Dance Theatre since 1974, she has appeared in much of that company's repertory, most notably in his The *Lark Ascending, Night Creatures, Suite Otis*, and *Blood Memories*.

Møllerup, Mette, Danish ballet dancer; born November 25, 1931 in Copenhagen. After private studies with her aunt, Asta Møllerup, she entered the school of the Royal Danish Ballet. Soon after graduating into the company in 1950, she became known for her versatility and style. Her credits came from roles in the company's revivals of ballets by August Bournonville to its productions of George Balanchine's *Symphony in C, La Somnambule*, and *Apollo*. Before retiring in 1969, she also danced in

Birgit Cullberg's *Medea* and in Alfred Rodrigues' *Blood Wedding*.

Moiseyev, Igor, Soviet ballet and folk dance choreographer; born January 21, 1906 in Kiev. Trained at the Bolshoi school and the Moscow Institute of Choreography, Moiseyev danced with the Bolshoi company from 1924 to 1936, when he was appointed ballet master. He created the title role in Kasyan Goleisovsky's *Joseph the Beautiful* (1925) and danced in the company productions of his *Salammbo* and *The Red Poppy*.

In 1936, he established a folk dance festival which later assembled into a permanent group, with a school in cooperation with the Bolshoi's. The Moiseyev Folk Dance Troupe, extremely popular in the Soviet Union and abroad, has toured in the United States under Sol Hurok management. Although most of the company repertory is made up of actual folk dances, Moiseyev has choreographed some works, and has also staged full-evening ballets for other companies, among them his *Spartacus* (1958) for the Bolshoi.

Works Choreographed: CONCERT WORKS: *The Football Player* (1930, co-choreographed with Lev Lashchilin); *Salammbo* (1932); *Three Fat Men* (1935); *Anait* (1940); *Spartacus* (1958); *Seven Girls* (1958); *Poetry of Emotions* (1969).

Moncion, Francisco, Dominican/American ballet dancer associated with the works of George Balanchine for over forty years; born July 6, 1922 in La Vega, the Dominican Republic. After emigrating to the United States as a child, he was raised in New York City. Moncion was an airplane mechanic when he saw *The Goldwyn Follies* (1938), with appearances by the American Ballet staged by George Balanchine. That performance, and articles by Lincoln Kirstein, who was then a critic for *New Theatre* and *New Masses*, led him to the School of American Ballet where he became a student of Balanchine. He made his debut in the premiere of *Ballet Imperial* (1941).

After serving in the armed forces, he became a member of the Ballet International, his only non-Balanchine affiliation, where he created the title roles in Edward Caton's *Sebastien* and Leonid Massine's

Monk

Mad Tristan (both 1944). He danced for Balanchine on Broadway in *The Merry Widow* (1943) and *Song of Norway* (1944).

Since 1946, when he first performed with the Ballet Society, to the present season, he has been a consistent dancer in Balanchine's works, creating roles in two dozen of his ballets and participating in more. In Ballet Society, he appeared in the premieres of the *Four Temperaments* (1946, in the third variation), *Divertimento* (Haieff) (1947), *The Triumph of Bacchus and Ariadne* (1948), and *Orpheus* (1948), playing "The Dark Angel" until 1979.

His position in the City Ballet can best be explained by the cast list for the company's first performance under that name: he danced the male role in *Concerto Barocco*, "The Dark Angel," and partnered Tanaquil LeClerq in the adagio movement of the *Symphony in C*. Since then, he has created roles in Balanchine's *The Firebird* (1949), memorable in the duet with Maria Tallchief, *La Valse* (1951), as the "Death" figure who dances with and claims LeClerq, *Bayou* (1952), *Opus 34* (1954), *The Nutcracker* (1954), as "Coffee," *Ivesiana* (1954, *In Central Park*), *Episodes* (1959), *The Figure in the Carpet* (1960), *A Midsummer Night's Dream* (1962), *Don Quixote* (1965), as "Merlin," but also playing the title role to great acclaim, the *Emeralds* section of *Jewels* (1967), and *Pulcinella* (1972), co-choreographed with Jerome Robbins. He also danced in the premieres of Todd Bolender's *Capricorn Concerto* (1948), William Dollar's *Ondine* (1949), John Cranko's *The Witch* (1950), Frederick Ashton's *Picnic at Tintagel* (1952), Ruthanna Boris' *Kaleidoscope* (1952), Jacques D'Amboise's *Tchaikovsky Suite No. 2* (1969), and John Taras' *The Song of the Nightingale* (1972).

Moncion has also appeared in many of the works of Jerome Robbins, performing the theme in his *Goldberg Variations* and creating roles in *Age of Anxiety* (1950), the horribly anxious third duet in his *In the Night* (1970), and the male role in *Afternoon of a Faun* (1953). In that work, he partnered Tanaquil LeClerq without emotional contact, as the most detached of the couples, or rather, trio of two dancers and a mirror, who have performed this duet.

Although he is considered one of the most versatile performers in the company, able to partner any dancer, however short or tall, and do pure technical feats or dramatic readings, there is a "Moncion" ideal role in the choreography of both Balanchine and Robbins. Roles that require stage presence without large actions or that demand stillness (such as "The Dark Angel" and "Death"), that require a depth of emotion (as in Balanchine's *The Prodigal Son* or Robbins' *In the Night*), or coolness and a very modern control (as in *Age of Anxiety*, the *Faun*, and *Don Quixote*), were frequently created for him.

Associated as he is with the New York City Ballet, and currently the only charter member who is still dancing, Moncion has had a secondary career as a performer on television, in cultural or religious programs staged by both ballet and modern dance choreographers. For example, he danced in Pearl Lang's *Black Marigolds* (WCBS, 1962) and in his own *Song of the Soul* (WCBS, 1964) on *Camera Three*. He has also choreographed for the City Ballet and other companies, and is expected to return to creating ballets, should he ever decide to retire from dancing for Balanchine.

Works Choreographed: CONCERT WORKS: *Passepied from Castor and Pollux* (1950); *Jeux d'Enfants* (1950, contributed section to work co-choreographed with George Balanchine and Barbara Millberg); *Pastorale* (1957); *Panamerica* (1959, section III only); *Honneger Concerto* (1966); *Night Song* (1966).

TELEVISION: *Song of the Soul* (WCBS-TV, November 15, 1964, special).

Monk, Meredith, American postmodern dancer, choreographer, and composer; born November 20, 1943 in New York City. Monk studied composition at Sarah Lawrence College with Bessie Schoënberg and Judith Dunn; her experiences in Louis Horst's classes at the American Dance Festival were typical of a future postmodernist, being blasted for attempting to create a dance about the earth with her arms pointing to the sky. She studied dance technique at the Merce Cunningham and Martha Graham studios and worked with the pantomime classes of Mata and Hari.

Her works have often been described as operas of the future—elaborately produced compositions for voices and movement based on scenarios and librettos. Although only one work is titled *Education of*

the Girlchild (1973), all of her pieces relate to that theme, with music, movement, and visual imagery creating a continuing stream of dances about general and very specific childhood. Although some elements can be related to her own childhood—among them the mother singing on the radio and the very American diaspora concept of European and Biblical ancestors being equally distant—her works can also be called statements for all women, and indeed all of her audience.

Her career has been fairly straightforward. Recognized as a member of the Judson Group, although she appeared almost entirely in her own works, she collaborated for a time with Kenneth King, notably on *Duet with Cat's Scream and Locomotive* (1966). Her group, The House, was formed at the end of the 1960s, and most of its members have performed with her ever since. She uses trained dancers, among them, Lanny Harrison, Blondell Cummings, and Tone Blevins, nontrained ones, such as physicist Daniel Sverdlik, and vocalists. Although all perform in the striking finales of her pieces, she frequently sets movement patterns that equalize their abilities in the body of her works. She has employed film sequences in some pieces, among them *Title: Title* (1969) and *Quarry* (1976), but manipulated scale and timing in the preset videos and films in the same way as she does in live performance, to integrate each element.

The scale manipulation can be seen in her use of props, in detail, or as children's drawings, in her choice of theaters, renting the vast expanse of the La Mama Annex and limiting the perception of space with Tony Giovanetti's expert lighting, and in her orchestration of vocal music. The chorale in *Quarry*, a fugue for solo and group voices, is as effective as her quiet solo at its opening. Her ability to focus the audience's attention is so finely tuned that in *Quarry*, she placed scenes in the center and at corners and edges of the performance space, creating a theatrical stage that resembled a page of Talmud commentary. Although she tends to integrate her own character into the action of each work, *Education of the Girl-child's* second part allows the audience to see her alone on stage. That solo, which is one of the greatest acting jobs in the dance repertory, forces her to grow from an aged woman, the matriarch of her own fam-

ily, into a young girl; she moves down a ramp toward the audience, becoming youthful, strong, and alive in a transition of imperceptible steps and stages.

Most of her music is composed for her dance pieces, but she has also presented concerts and made recordings of independent scores. Her works, primarily for vocalists, range from solos, such as *Our Lady of Late*, to massive chorales, as in the one that ends *Quarry*. Her music has been used by other choreographers as prepared scores, including William Dunas, who staged a dance to *Our Lady of Late*, and Merce Cunningham, who has set Events to her works, a recognition of her prominence in the experimental music community.

Works Choreographed: CONCERT WORKS: *Troubadour Songs* (1962); *Vibrato* (1962); *Me* (1963); *Timestop* (1963); *Diploid* (1964); *Break* (1964); *Cartoon* (1965); *The Beach* (1965); *Radar* (1965); *Relâche* (1965); *Blackboard* (1965); *Portable* (1966); *Duet with Cat's Scream and Locomotive* (1966); *16 Millimeter Earrings* (1966); *Excerpt from a Work in Progress* (1967); *Goodbye/St. Mark's/Windows* (1967); *Blueprint* (I) (1967); *Overload* (I) (1967); *Blueprint* (II) (1967); *Blueprint/Overload* (1967); *Blueprints III to V* (1968); *Co-op* (1968); *Title: Title* (1969); *Tour: Dedicated To Dinosaurs* (1969); *Untidal: Movement Period* (1969); *Tour 2: Barbershop* (1969); *Intermission Events* (1969); *Juice* (1969, performed in three concerts, November through December); *Tour 4: Lounge* (1969); *The Beach* (II) (1969); *Needle-Brain Lloyd and the System's Kid* (1970); *Tour 5: Glass* (1970); *Tour 6: Organ* (1970); *Tour 7: Factory* (1970); *Key* (1970); *Vessel* (1971); *Tour 8: Castle* (1971); *Black Room* (1972); *Our Lady of Late* (1972); *Education of the Girlchild* (1972, solo section only); *Education of the Girlchild* (1973, complete work); *Paris* (1973, in collaboration with Ping Chong); *Chacon* (1974, in collaboration with Ping Chong); *Roots* (1974, in collaboration with Donald Ashwander); *Small Scroll* (1975); *Anthology* (1975); *Quarry* (1976); *Venice/Milan* (1976, in collaboration with Chong and performed with *Paris* and *Chacon*); *The Plateau Series* (1977); *Recent Ruins* (1979).

Independent Scores: *Candy Bullets & Moon* (1967, voice, electric organ, electric bass, drums; collaboration with Don Preston); *Blueprint; Overload/Blueprint 2* (1967, solo voice with Echoplex & tape); *A*

Raw Recital (1970, solo voice and electric organ; vocal duets and electric organ); *Key: an album of invisible theatre* (1970–1971, solo voice and electric organ, vocal quartet, percussion, jew's harp; Increase Records); *Plainsong for Bill's Bojo* (1971, electric organ for "Bojo" by William Dunas); *Our Lady of Late* (1973, solo voice and wine glass); *Our Lady of Late* (1974, solo voice, wine glass, percussion; Minona Records); *Fear and Loathing in Gotham* (1975, solo voice and piano for *Fear and Loathing in Gotham* by Ping Chong); *Songs from the Hill* (1976–1977, unaccompanied solo voice); *Tablet* (1977, four voices, piano four-hands, two soprano recorders); *Vessel Suite* (1978, three voices, electric organ four-hands); *Dolmen Music* (1979, six voices, cello, percussion); *Songs from the Hill/Tablet* (1979, four voices, piano four-hands, two recorders, jew's harp; Wergo Spectrum Records); *Dolmen Music* (1980–1981, six voices, piano, violin, cello, percussion; ECM/Warner Bros. Records); *Turtle Dreams* (1980–1981, four voices, two electric organs).

Monkman, Phyllis, English theatrical ballet dancer; born January 8, 1892 in London; the date of her death is uncertain. Trained by Mme. Sismondi, presumably a member of the theatrical and acrobatic family of that name, Monkman made her debut in children's parts in pantomimes at The Prince of Wales Theatre, c.1904. As an adolescent and adult, she was given featured roles and specialty dancer status in many productions at The Gaiety Theatre, among them, *The Belle of Mayfair* (1907), *The Quaker Girl* (1910), *The Monte Carlo Girl* (1912), and *The Girl on the Train* (1910). She served as principal danseuse at the Alhambra Theatre from 1913 to 1916, dancing in *5064 Gerrard* with Harry Pilcer, and in *Keep Smiling!*

Among her many other successful West End musicals were *See-Saw* (1912), *The Sunshine Sisters* (1930), and the first three editions of *The Co-Optomists* (1921–1923), and the 1929, 1930, and 1935 productions. Following these shows, she retired from dancing but remained on stage as a comedienne.

Monplaisir, Hyppolyte, French ballet dancer and choreographer of the nineteenth century, performing in Brussels, Italy, and the United States; born Hyppolyte (or Ippolito) Georges Sornet in 1821 in Bordeaux; died July 10, 1877, in Besane-il-Brianza, in the Piedmontale (then part of France). It is not certain where Monplaisir received his first training, although if, as has been surmised, he had been a dancer with the Théâtre de la Monnaie in 1839, he would have worked with Victor Bartholomin, later his father-in-law. In the early 1840s, he studied with Carlo Blasis at the Teatro alla Scala, where he married Adèle Bartholomin. A celebrated *danseur noble* while at La Scala, he partnered her, Fanny Elssler in *Giselle*, Marie Taglioni, Lucille Grahn, and Carolina Rosati.

In 1847, the Monplaisirs accepted an engagement to perform in the United States with Victor Bartholomin's French Ballet Company. For two years after the troupe's October debut at the Broadway Theatre, New York, they toured with a repertory of works by Bartholomin and Monplaisir, among them the elder man's *L'Almée* and *Les Deux Roses*, Monplaisir's *Azelia, the Syrian Slave*, and Jules Perrot's *l'Illusion d'un Peintre* and *Esmeralda*. After Adèle left her husband to perform with the Ravel family, Monplaisir became ballet master for Laura Keane's Varieties Theatre in New York.

Returning to La Scala in 1861, Monplaisir became ballet master and staged many new works for the company, among them, *Benvenuto Cellini* (1861), *La Devâdâcy* (1866), *Estella* (1866), and *Lorelay* (1877). A leader in the Egyptian revival movement in Italian art, architecture, and music (especially noted in opera), Monplaisir created many such ballets, among them *La Figlie di Chéope* (1871), *Giulio Cesare* (1874), and his own version of *l'Almea* (1872), about the opening of the Suez Canal.

Works Choreographed: CONCERT WORKS: *Azelia, the Syrian Slave* (1847); *Une Nuit à Venice* (1848); *Folette, or the Enchanted Pill* (1848); *Les Follets des Alpes* (1848), possibly same as above; *Benvenuto Cellini* (1861); *Cristoforo Colombo* (1861); *Nostrodomas* (1861); *Terpsichore in Terce* (1863); *La Devâdâcy* (1866); *Mélina* (1866); *Estella* (1866); *Brahma* (1869); *Tra la veglia e il sunne* (1869); *La Camargo* (1869); *La Semiramide del Nord* (1869); *La Figlie di Chéope* (1871); *La Sirène* (1872); *l'Almea* (1872); *Giulio Cesare* (1874); *Lorelei* (1877, also spelled Lore-Lay).

Montalbano, George, American ballet dancer; born c.1948 in Brooklyn, New York. A graduate of the High School of Performing Arts, Mantalbano continued his training with Nathalie Branitzka and at the American Ballet Center. A member of the apprentice group that became the charter City Center Joffrey Ballet, Montalbano appeared with that company in Jerome Robbins' *Moves,* Gerald Arpino's *Olympics,* Mikhail Fokine's *Petrouchka,* and Kurt Jooss' *The Green Table,* succeeding Maximiliano Zomosa in the pivotal role of "Death." Montalbano was also a charter member of the new Eliot Feld Ballet in 1974. Among the many Feld works in which he appeared were his *Harbinger, Cortège Parisien, At Midnight, The Real McCoy,* and *Sephardic Song.*

Monte, Elisa, American modern dancer and choreographer; born May 23, 1949 in New York City. Monte made her professional dance debut in a revival of Agnes De Mille's *Carousel* and worked for that choreographer in later productions. She danced with Pilobolus in *Molly's Dead* and guested with Pearl Lang and Lar Lubovitch, but is best remembered for her work with the Martha Graham company. Among her many Graham roles were in revivals of *Seraphic Dialogues, Clytemnestra,* and *Appalachian Spring.* Monte also danced with, and served as co-director of, the Marcus Schulkind company, taking roles in his *Ladies' Night Out, Circular Ruins,* and *Affestuoso,* among many others. Her own company performs works by herself, by Schulkind, and by contemporary choreographers ranging from Cliff Keuter to Sara Rudner.

Works Choreographed: CONCERT WORKS: *Treading* (1979); *Pell Mell* (1980).

Montez, Lola, celebrated entertainer who toured extensively in Europe and the United States in the mid-nineteenth century; born Maria Delores Gilbert, 1818, in Limerick, Ireland; died January 16, 1861 in Jamaica, Queens, New York. Since it is difficult to determine which of Montez's many biographies and autobiographies are accurate, one can only guess about her training. She probably had some general training in social dance, which, during her adolescence, included turnout, the five basic positions, and traditional ballet postures. According to most sources, she traveled in India, learning some nautch works, and in Spain, studying dance forms there.

Whatever her background, by the 1840s she was performing in Europe as a Spanish dancer. Extraordinarily popular, even in a period that idolized female dancers, she toured to great acclaim and packed houses in England, Dresden, Paris, Munich, and in various cities in Italy. In Munich, then capital of Bavaria, she became involved in a scandalous affair with its king, Ludwig I. While the consequence of the relationship to European history was exaggerated in many contemporary sources, there is no question that, for the remainder of her career, that affair was the mainstay of her reputation.

The difference that her relationship with Ludwig made to her press reception was tremendous. In New York, her next major step on the tour, what had been conventional descriptions of her dances changed. An 1841 review in one paper reviewed her *La Tarentule* (an adaption of the Coralli vehicle for Fanny Elssler) as a strip tease, with her literally snapping her garters at the audience.

Her tour to the United States was disappointing to the audiences, who probably expected something much more exciting, and to the box office, but she chose to remain there. She settled for a time in California, then returned to the New York area, dying in seclusion in Jamaica, then a conservative residential area of Queens.

Although Montez's career as a dancer seems almost irrelevant to her biography, she did have a fairly large repertory. She performed primarily in solos, both those derived from the then standard repertory, such as the *La Tarentule, La Tyrolienne,* and *La Crakovienna,* and unique ones, such as her *Spider Dance.* She also worked her specialties, stylized Spanish dances, into full-length works, among them George Washington Smith's *Un Jour de Carnaval à Séville* (1852) and an uncredited work from the same year that may be by Smith, *Diana and the Nymphs.*

Montez has been the central character in a large number of works created in dance forms. They range from Pasquale Borri's *Lola Montez,* created four years after her death, to Edward Caton's work of the same name in 1946 or Jack Carter's in 1954. Montez has also been a topical reference/character in novels, plays, and films, notably in Max Ophuls' *Lola Mon-*

tez, released in 1955. Her own writings, basically etiquette and beauty manuals, were reprinted in 1969 as a historical curiosity.

Montgomery, David, American eccentric dancer; born April 21, 1870 in St. Joseph, Missouri; died April 20, 1917 in Chicago. Montgomery was a member of Haverly's Minstrels in the 1880s and 1890s before working with Fred Stone in an *Uncle Tom's Cabin* in St. Joseph in 1894. They teamed up to become the most famous eccentric dance duo in vaudeville and musical theater. After touring on the Keith circuit and in England, they were cast into *The Girl Up There* (1901). Their next show was their most celebrated—*The Wizard of Oz* (1903), which in pre-Garland days was a vehicle for the ''Scarecrow'' (Stone) and ''Tin Woodsman'' (Montgomery). They toured that presentation until 1906, when they opened in *The Red Mill* which, again, they traveled with for three years. Montgomery and Stone were starred in three more shows, *The Old Town* (1909), *The Lady of the Slipper* (1912), and *Chin-Chin* (1914), before his death.

Athough he does not seem to have appeared in a film, remnants of his dance style exist in every performance of the *Wizard of Oz,* including Jack Haley's portrayal in the MGM film. The stiff-legged eccentricities, balance tricks, and heel spins that we now associate with the character were developed by Montgomery for the original performances.

Moon and Morris, British tandem dance team, also working in the United States; born George Moon and Daniel Morris, c.1895 possibly in Nottinghamshire. The foremost tandem team of the early twentieth century was assembled over two years of experimentation and ten years of rehearsals. They met while appearing in a provincial production of the pantomime *Red Riding Hood* in December 1905, and first worked as a tandem team while playing ''The Ugly Step-Sisters'' in the next Christmas' presentation of *Cinderella.* They toured together for five years in music hall companies and, while working as comics, developed their tandem dance acts, which depended on absolute accuracy and precision of movement. By 1911, when they made their United States debut, they had honed the act until they moved together as one unit. They were engaged by J.J. Shubert to per-

form in Winter Garden musicals and revues, among them *The Whirl of the World* (1914) and the *Passing Show of 1912.* In the latter, they worked with Ned Wayburn (dance director of the production) who was tremendously impressed with the tandem techniques and adopted them into his own choreographic work vocabulary.

It is not absolutely certain what happened to Moon and Morris after 1917, when they announced that they were returning to England to serve in the military. Morris' name cannot be verified in any further appearances in music halls, variety, or the legitimate stage. It is likely, however, that George Moon remained in the industry to become a comedian. A man of the correct age, named George Moon and showing a striking resemblance to the dancer, was featured on a British television show of the late 1950s, although no mention of a previous career was found in that man's publicity.

Mooney, Elina, American modern dancer and choreographer; born in Washington, D.C., Mooney, who has also performed as Elina Cross, studied and performed with Helen Tamiris and Daniel Nagrin, Charles Weidman (for whom she danced in *Brahms Waltzes*), Don Redlich, Paul Sanasardo, Marion Scott, and Cliff Keuter. She, Scott, and Keuter, who had all been with Tamiris in the early 1960s, formed a trio company in the late 1960s, in which she danced in Scott's *Concerto for 3, Jibe,* and *Tabloid,* and Keuter's *The Game Man and the Ladies.* She first choreographed for the Scott trio, creating a solo, *Reprise,* for a 1968 recital program. Since then she has staged works for a variety of cooperative companies and shared concerts in and outside of New York. Her works, like her personal performance style, are noted for their deliberateness, allowing the dancers to appear to be improvising while creating logical movement patterns. Many of her pieces seem to be task related, especially *If You Get There Before I Do* (1973), which is about crossings and the manipulations of perspective, but still have delicacy and grace in their choice of movements.

Works Choreographed: CONCERT WORKS: *Reprise* (1968); *Play Dance* (1970); *Figure* (1970); *Hard Edge* (1970); *Sawing-in-Half Dance* (1971); *Region* (1971); *Prints* (1971); *Night Garden* (1972); *Dejeuner sur l'Herbe* (1972); *Rope Dance* (1973); *Duet* (1973);

Odori (1973); *If You Get There Before I Do* (1973); *Eliza* (1974); *Pageant* (1974).

Mooney, Gypsy, American theatrical dancer; born c.1892 in New York City. Mooney made her professional debut in *The Merry-Go-Round* (1908), as a specialty act with her older sister, Julie. They worked together in two feature acts produced by Gus Edwards—his celebrated *School Days* (1909) and *Song Revue* (1911)—interpolating their own act into his variety formats. Although her sister was primarily a "Pony" (the shortest category of dancer on Broadway), Gypsy Mooney was a soloist throughout her adult career and had the stature to uphold her position. She left Edwards in 1915 to become a feature dancer in six successive Ziegfeld revues—the *Follies* of 1916 and 1917 and the *Midnight Frolics* of 1915 through 1917. While studying at the Ned Wayburn studio, she developed from a vaudeville tap soloist into a very glamorous dancer capable of social dance routines, vocal solos, and the flirtatious numbers typical of the *Frolics*.

Mooney, Julie, American theatrical dancer; born 1888 in New York City; died there March 6, 1915. Billed as "The Smallest 'Pony' on Broadway," Mooney was one of the many five-foot-or-under tap or soft-shoe dancers who appeared in musical comedies and revues from 1893 to 1920; unlike most, however, Mooney was not a permanent member of a troupe or Pony Ballet, but was instead a freelancer. She appeared in four dozen different parts as a chorus pony in *Piff, Paff, Pouf* (1905), at one point partnering members of the Original English Pony Ballet who were in the production as a unit. She danced in *The Earl and the Girl* (1905), *His Majesty* (1907), *The Merry-Go-Round* (1908), and Ned Wayburn's feature act, *The Rain-Dears* (1908), before teaming up with her younger sister, Gypsy, to join Gus Edwards' *School Days* (1909) and *Song Revue* (1911).

Moore, Charles, American modern and theatrical dancer; born c.1938 in Cleveland, Ohio. Moore was trained at the Karamu House in Cleveland under Eleanor Frampton. After moving to New York, he was honored to study with the three pioneers and champions of the anthropological modern dance movement—Asadata Dafore, Katharine Dunham, and Pearl Primus. He danced with Dunham for eight years, primarily on tour, and appeared on Broadway frequently in the late 1950s and early 1960s, most notably in the Lena Horne vehicle, *Jamaica* (1957), *Carmen Jones* (1959 revival), and *Kwamina* (1961). Moore also performed with the concert groups of Geoffrey Holder, Donald McKayle, and Alvin Ailey, creating roles in the early signature works of the latter two—Ailey's *Blues Suite* (1958) and McKayle's *Rainbow 'Round My Shoulder* (1959).

While teaching in his Brooklyn Center for Ethnic Studies, Moore has directed a company dedicated to the performance of dances derived from African forms as reconstructed or as choreographed by himself. The Moore troupe has also reconstructed the works of Asadata Dafore, or rather the African forms as interpreted by Dafore, and performs ten of them frequently to a new generation of fans. His best know solo is Dafore's ostrich dance, *Awassa Astrige,* which shows the power and control that he maintains over his body and the audience. Like Dunham and Primus, Moore is also adding Caribbean forms to his repertory and teaching them at the Brooklyn school.

Works Choreographed: CONCERT WORKS: *Fast Agbekor* (1970); *Spear Dance* (1970); *Antelope* (1970); *Poro Mask Dance* (1970); *Moon Dance* (1971); *Sacred Forest* (1974); *Souvenir d'Haiti* (1974); *Takai* (1976); *Three Spirits* (1976); *Siychi* (1976); *Congo* (1978); *Tyi Wara* (1978); *Le Masque du Force* (1980); *Royal Dahomey Court Dance* (1980).

Moore, Geoff, English experimental choreographer; born December 28, 1944 in Wales. Moore, who does not have formal dance training, studied at the Leeds College of Art, then the center of multimedia work in England. He has created pieces of dancers and actors working within systems of verbal and visual imagery since the late 1960s, for the company, Moving Being. Although many works for the company are considered collaborative and do not include specific choreographer or direction credits, the list below includes those pieces for which he was denoted creator in the contemporary press.

His works are frequently based on literary works, fragmenting their structures within his own formats of movement, graphics, films, and scripts. Some in-

volve specific references to their bases, such as his *Dream Play* (1975) and *Oedipus Rex—A Complex Oedipus* (1977; others are more generalized, with allusion systems based on more than one work or genre.

Works Choreographed: CONCERT WORKS: *Remembered Motion* (1968); *Package Deal* (1969); *Three Pieces* (c.1970); *Phoenix* (1973); *Dream Play* (1975); *Life Masque* (1975); *Death Kit* (1975); *Oedipus Rex—A Complex Oedipus* (1977).

Moore, Gladys, American theatrical ballet dancer; born c.1892 in St. Louis, Missouri. Moore joined the Gertrude Hoffmann company in 1909, touring with her Saisons des Ballets Russes dancers and studying with its ballet master, Theodore Kosloff. Hoffmann cast her in her revue, *The Mimic World* (1909), for the Shuberts, in which she imitated Adelina Genée. Her parodies on the Danish ballerina's divertissements and music were extremely popular and she was engaged to repeat them in vaudeville acts and roof garden performances. Moore was the principal specialty dancer in a number of Lew Fields musicals staged by Ned Wayburn, including *The Wife Hunters* (1911) and *The Hen-Pecks* (1911). She shared principal ballet dancer specialist status in their *The Midnight Sons* (1909) with many of the best toe dancers on Broadway that season, including Mazie King, Maybelle Meeker, and Mme. Marvelous Miller.

Moore returned to vaudeville in 1913 but retired after an injury to her ankle in 1914. It is believed that she was the Gladys Moore of Denver (where she retired) who became a character actress and stock player in silent films of the late 1910s and early 1920s.

Moore, Jack, American modern dancer and choreographer; born March 18, 1926 in Monticello, Virginia. Moore studied dance with Doris Humphrey and composition with Louis Horst, later serving as his assistant at the Neighborhood Playhouse. His work with Anna Sokolow included a role in her Broadway production, *Red Roses for Me* (1955). With Katherine Litz, he danced in *Summer Cloud* (1954) and *Excursion* (1954).

Moore, who was honored as the winner of the first Doris Humphrey Memorial Fellowship to the American Dance Festival (1960), presented his choreography in concerts of the Contemporary Dance Productions from 1961 and shared recitals with Marion Scott and Erin Martin later in the decade. He is a founder of the Dance Theatre Workshop and as such has helped all choreographers by providing a place for rehearsal and performance.

His choreography itself has been described as "Sokolow with puns." The works frequently include both verbal and visual humor but treat life as a system of confrontations—with other people and with inanimate objects. His *Rocks* (1967), for example, uses references to rocking (back and forth), rocks (as centers of performance), and the hymn "Rock of Ages." A more recent work, *Love Songs for Jason Mayhew* (1975), is overtly about a specific relationship, but still includes his signature visual puns accentuated with suspended motions and expressions, still a "vaudeville of the mind" and eye.

Works Choreographed: CONCERT WORKS: *Esprit de Corps* (1951); *Clown '51* (1951); *Somewhere to Nowhere* (1957); *The Act* (1957); *The Greek* (1958); *Cry of the Phoenix* (1958); *Area Disabled* (1959); *Figure '59* (1959); *Songs Remembered* (1960); *Intaglios* (1960); *Target* (1961); *Opticon—a Vaudeville of the Mind* (1962); *Excursions* (1962); *Erasure* (1962); *Chambers and Corridors* (1963); *Vintage Riff* (1965); *Assays* (1965); *Parsley All Over the World* (1965); *Four Elements in Five Movements* (1966); *Figure '66* (1966); *Vintage Riff No. 2* (1967); *Brew* (1967); *Rocks* (1967); *Five Scenes in the Shape of an Autopsy* (1968); *Puzzle* (1969); *Tracks* (1969); *Tracings* (1969); *Residue-Variants 1, 2, 3, 4* (1969); *Fantasie pour deux* (1971); *Ode* (1971); *Blueprint:Gardenstrip* (1972); *Three Odes* (1972); *Ghost Horse Rocker* (1973); *Tracks and Side Tracks* (1974); *Nightshade* (1974); *Garden of Delights* (1974); *Landscape for a Theater* (1974); *Resume* (1975); *Love Songs for Jason Mayhew* (1975); *Four Netsukes* (1976).

Moore, James, American ballet dancer; born December 12, 1930 in Muncie, Indiana. After spending his early adolescence touring with his brother in a tap dance vaudeville act, he studied ballet at the (Bentley) Stone/(Walter) Camryn School in Chicago and the Metropolitan Opera school in New York, under Antony Tudor and Margaret Craske.

After dancing in the Ruth Page/Bentley Stone Ballet in Chicago, he joined Jerome Robbins' Ballets: U.S.A., appearing in his *Events, Moves,* and *3 × 3*. Since the company's disbanding, he has assisted Robbins on many new and revived productions, including his *Les Noces* (1965) for the American Ballet Theatre. He served as ballet master of Ballet Theatre (1966-1972) and director of the Royal Swedish Ballet in the mid-1970s, freelancing since then.

Moore, Lillian, American ballet and concert dancer, and historian; born 1911 in Chase City, Virginia; died July 29, 1967 in New York City. Trained originally by Mikhail and Vitale Fokine, she continued her technical studies at the School of American Ballet. As a member of the American Ballet, she performed at the Metropolitan Opera in the choreography of George Balanchine until 1938 and of Boris Romanoff from 1939 to 1942. In 1940, she also performed with the (Vitale) Fokine Ballet in the *Polovtsian Dances from Prince Igor* and *Les Sylphides,* taking the Valse and Prelude solos.

Moore also had a successful but intermittent concert career, presenting solo recitals of works based on incidents in dance history, such as *Terpsichore* (1934), *The Amazon* (1942), *30 Years in a Dancer's Life* (1947), and *Tentative Tango* (1952). She taught dance technique at the High School of Performing Arts and at the American Ballet Center, where she also served as director of its apprentice program. That program evolved into the charter company of the City Center Joffrey Ballet.

In a related career, Moore became a prolific writer on subjects in American and Danish dance history. She wrote frequently for the dance press and for reference books, but also submitted articles to consumer magazines. Her specialty was the European ballet tours of the nineteenth century, but her pieces ranged from monographs on Currier and Ives to a technical manual on Bournonville. Her articles on dance in America have been collected into two volumes—*Artists of the Dance* (New York: 1938, reprinted 1978) and *Images of the Dance* (New York: 1965).

Works Choreographed: CONCERT WORKS: *Terpsichore* (1934); *Stage Fright* (1934); *Danse Macabre* (1934); *Ondine* (1934); *Bohemian Polka* (1934); *Amazon* (1934); *Spring Ecstacy* (1934); *Introduction to the Ballet (La Sylphide, Crakovienne, The Debutante,* and earlier works) (1942); *Thirty Years in a Dancer's Life, 1880-1910* (1947); *Up in the Attic* (1952); *Audition for the Amateur Hour* (1952); *Fortuna Gallop* (1952); *Tentative Tango* (1952); *Children's Games* (1953); *Bavariana* (1956); *Tarantella* (1956).

Morales, Hilda, American ballet dancer; born June 17, 1946 in the Bronx, New York. Raised in Santurce, Puerto Rico, Morales received her first training from Ana Garcia. She received a Ford Foundation scholarship to the School of American Ballet and appeared with its sponsor, the New York City Ballet, as an apprentice, a "Snowflake" in *The Nutcracker.* She became a member of the Pennsylvania Ballet in 1965. Although she appeared in most of the troupe's Balanchine repertory, most notably in *Serenade, Allegro Brillante* and *Concerto Barocco,* she was also cast in much of its contemporary works, including John Butler's *Ceremony* (1968), *Villon,* and *Journeys* (1970).

Morales' New York appearance as the "Acid Queen" in Fernand Nault's *Tommy* (1971) led to a wider national reputation and an invitation to perform with the American Ballet Theatre from 1972-1973. She has performed the entire range of ballets in that intensely eclectic company, from Ailey's *The River* to Baryshnikov's version of *The Nutcracker,* from *Les Sylphides* to *La Sylphide,* and especially the works of Antony Tudor, with roles in his *Jardin aux Lilas* and *The Leaves Are Fading.*

Moran, George, American popular entertainer; born George Searcy, 1882 in Elwood, Kansas; died August 1, 1949 in Oakland, California. Moran was best known for his partnership with Charles Sellers, called Mack, in the act Two Black Crows. They developed it over four years between 1917, when they both appeared in *Over the Top,* and 1921. The act was seen in vaudeville, on Broadway in editions of all of the major revues, including *Ziegfeld Follies, Vanities, Scandals, Passing Shows,* and *Greenwich Village Follies* from 1920 to 1928, and in film. Searcy Moran appeared in two early Mack and Moran films, *Two Flaming Youths* (Paramount/Famous Players-

Laskey, 1927) and *Why Bring That Up?* (Paramount/Famous Players-Laskey, 1929), but left the act shortly thereafter. He acted on his own as straight man to W.C. Fields in *My Little Chickadee* and *The Bank Dick* and acted in Westerns and occasionally comedies for Universal Studios. Because the act was performed in black face, Searcy could be replaced as "Moran" easily, and was in the late 1920s and early 1930s. He attempted to resurrect the Mack and Moran routines with a new partner after Mack's death in 1934 but was unsuccessful.

Mordente, Anthony, American ballet dancer and theatrical choreographer; born 1936 in New York. Trained locally in tap techniques by Nellie Cook, he studied with Don Farnworth, then at the Chalif School, before entering the High School of Performing Arts. Mordente quickly became expert at ballet, starring in all three annual recitals before graduating in 1954; among the works in which he created roles at PA were Robert Joffrey's *Umpateedle* (1954) and Lillian Moore's *Children's Games* (1952), which he also performed at Jacob's Pillow in 1953. Since he was five-foot-three, he could not get employment in a conventional ballet company, so he became *premier danseur* of the ballet of Radio City Music Hall in the spring of 1955; he did work frequently at Ballet Theatre Workshop performances, dancing in Joffrey's *Workout* and Job Sanders' *Streetcorner Royalty* in 1956.

After working with Danny Daniels at Tamiment Camp in the Summer of 1956, Mordente gave up on ballet and became a Broadway specialty dancer. He played "Lonesome Polecat" in *Li'l Abner* (1956), staged by Michael Kidd (also a short ballet dancer who turned Broadway choreographer), but left that show to create the role of "A-rab" in Jerome Robbins' *West Side Story* in 1957. He toured with the show in that part, but played "Action" in Robbins' filmed version of 1962.

Although he has staged two musicals for Broadway—*How Do You Do I Love You*, which closed out of town in 1967, and *Here's Where I Belong* (1968), the musical version of *East of Eden*—as well as the London production of *Bye Bye Birdie* in 1962, Mordente is better known for his work on television. His troupe, The Tony Mordente Dancers, has performed on a multitude of specials and on four variety series,

among them *The Jimmy Dean Show* (ABC, 1965–1966), *The Jim Nabors Hour* (CBS, 1969–1971), and *The Sonny and Cher Comedy Hour* (CBS, 1971–1974). His *That's Life* (ABC, 1968–1969), although short-lived, was considered one of the most innovative comedies on the screen, meshing the conventional sitcom format with musical comedy techniques. Since 1975, he has directed mostly taped comedy for television, notably for the MTM production, *Rhoda* (CBS, 1975–1979).

Works Choreographed: THEATER: *Bye Bye Birdie* (London, 1962); *How Do You Do I Love You* (1967, closed out of town); *Here's Where I Belong* (1968).

TELEVISION: *The Jimmy Dean Show* (ABC, 1965–1966); *That's Life* (ABC, 1968–1969); *The Jim Nabors Hour* (CBS, 1969–1971); *The Sonny and Cher Comedy Hour* (CBS, 1971–1974).

Mordkin, Mikhail, Russian ballet dancer and choreographer working in the United States after the mid-1920s; born December 21, 1880 in Moscow; died July 15, 1944 in Milbrook, New Jersey. Trained at the Imperial School of Ballet in Moscow, he graduated into the Bolshoi Ballet in 1899. He participated in 1909 Diaghilev Ballet Russe season, but left the company to tour with Anna Pavlova. He came to the United States with her, performing in *Coppélia, La Fille Mal Gardée*, and the famous *Autumn Bacchanale*, and remained there to tour with an ad hoc company called the All-Star Imperial Russian Ballet, the second or third company by that name.

After returning to the Bolshoi in 1912 and serving briefly as ballet master, he settled in New York in the mid-1920s. He had a company of Ballet Russe dancers in the 1926–1927 season, including Hilda Butsova, Felia Doubrovska, and Nicholas Zverev, and one of American students in the mid-1930s. The latter troupe is considered the basis of Ballet Theatre since its artistic director, Lucia Chase, and many of its members were Mordkin dancers. As well as Chase, his American students included Patricia Bowman, Paul Haakon, Leon Danielian, Viola Essen, Lucille Bremer, and Michael Arshansky, now better known as a ballet make-up artist.

Unlike his colleague and compatriot, Mikhail Fokine, he left a large number of students but little or no repertory. Even those works that were taken into the early Ballet Theatre repertory have been forgot-

ten completely. For many years, however, he was considered the equal of Fokine and the better of Balanchine and must be respected for that status.

Works Choreographed: CONCERT WORKS: *Coppélia* (1911); *Song of Love* (1912); *Anitra's Dance* (1912); *Polka Xylophone* (1912); *La Tzigane* (also performed as *The Gypsy*) (1912); *Danse Variations* (1912); *Bacchanale (I)* (1912); *A Night in Madrid* (1926); *Divertissements (Russian Gypsies, The Butterfly, Egyptian Dance, Wanyka-Tanyka, Trepak, Pas de Bouquets, Norwegian Dance, Danse Classique, Souvenir of Moscow, Lesguinska, Melodie Hebraic)* (1926); *Carnival* (1926); *A Caucassian Dance* (1926); *The Seagull* (1926); *Hungarian Rhapsody* (1926); *Italian Beggar* (1926); *The Phoenix* (1926); *The Dream of the Prince (The Enchanted Lake, The Festival in the Palace of the Prince)* (1927, this was Mordkin's *Swan Lake*); *Aziade* (1927); *Bow and Arrow* (1927); *Snow Maiden* (1927); *Spinning Top* (1927); *Gopak* (1927); *Souvenir of Roses* (1927); *Dance of Brittany* (1927); *Forest Murmurs* (1935); *Ave Maria* (1935); *Mazurka* (1935); *Spring Fantasy* (1936); *The Goldfish Bacchanale (II)* (1936); *Giselle* (1936); *Blind Fortune* (1937); *Hymn to the Sun* (1937); *Slavonic Dance* (1937); *Waltz-land* (1937); *Temple Dance* (1937); *Bird of Paradise* (1937); *Russian Humoresque* (1937).

Moreland, Barry, Australian ballet dancer and choreographer working in England; born 1943 in Melbourne, Australia. After training at the Australian Ballet School and performing with the company, Moreland moved to London to continue his training with the faculty of the London School of Contemporary Dance. Best known as a choreographer, he has created works for the Contemporary Dance Theatre, with which he also performed, the London Festival Ballet, the New London Ballet, the Welsh Dance Theatre, and the Australian Ballet. Although his most celebrated works are in popular styles with ragtime and jazz accompaniments, Moreland is considered one of the most innovative of the new English abstractionists.

Works Choreographed: CONCERT WORKS: *Noctural Dances* (1970); *Summer Games* (1970); *The Troubadours* (1971); *Kontakion* (1972); *Dvorak Variations* (1973); *Summer Solstice* (1973); *Infinite Pages* (1973); *Intimate Voices* (1974); *The Prodigal Son (in ragtime)* (1974); *Sacred Space* (1974); *Tryptich* (1975); *Dancing Space* (1976).

Moreton, Ursula, English ballet dancer; born March 13, 1903 in Southsea; died June 24, 1973 in London. Moreton was trained by Enrico Cecchetti and Tamara Karsavina at their studios in London, and studied and taught with Ninette De Valois from the mid-1920s on. After dancing with Karsavina in 1920 in London, she appeared with the Diaghilev Ballet Russe in England and Western Europe. While teaching for De Valois at her Academy of Choreographic Arts, she appeared with the early English ballet companies—the Camargo Society and the charter Vic-Wells troupe. She performed in the premiers of a dozen early De Valois ballets, among them *Les Petits Riens* (1928), *Hommages aux Belle Viennoises* (1929), *La Création du Monde* (1931), *Narcissus and Echo* (1932), and the quartet of her best known works, *A Haunted Ballroom, The Rake's Progress, The Prospect Before Us,* and *The Gods Go A-Begging.* In those early troupes, she also danced in Frederick Ashton's *The Lord of Burleigh, Le Baiser de la Fée* (1935), *Rio Grande,* and the musical comedy, *High Yellow* (1932) and in company productions of the Mikhail Fokine repertory.

Moreton retired from dancing in 1946 to teach and co-direct the Sadler's Wells Theatre Ballet. She served as principal of the Royal Ballet School from 1952 to 1968, establishing the studio as both a center of dance activity in England and as a recognized academic secondary school.

Morgan, Clyde, American modern dancer and choreographer; born c.1945 in Cincinnati, Ohio. Trained at the State University of Ohio, at Cleveland, and at Bennington College, Morgan studied with Anna Sokolow and José Limón before joining their companies in the mid-1960s. He created roles in Sokolow's *Time + 7* and *Déserts* in 1967 and performed in Limón's *A Choreographic Offering, Missa Brevis, Comedy, The Traitor, Legend,* and *The Exiles,* for which he was best known. He also danced in company member Louis Falco's *Checkmate's Inferno* (1967), *Timewright* (1969), and *Ibid* (1971) and toured with his then-wife Carla Maxwell in *The Exiles,* Morgan's own *Tryptich* (1970), and Daniel Nagrin's *With My Eye and With My Hand.*

He has been director of the Danza Contemporeana de Universita Federale da Bahia in Brazil since the mid-1970s, creating new works for the troupe which he has trained.

Works Choreographed: CONCERT WORKS: *Tryptich* (1970); *The Traveller* (1971); *Chorinhos* (1977, sections III and IV only); *Visao e una espada nua* (1977); *Dancas de Natal* (1977); *Artikulation* (1977); *Rythmetron* (1977); *Betheleheum* (1978); *Aquacimento* (1978).

Morgan, Earnest, American modern dancer; born December 3, 1947 in Waihjwa, Hawaii. While a student at Northwestern University, near Chicago, he studied dance with Gus Giordano, Ed Parish, and Jene Sugayo. After performing with the Giordano troupe, he moved to New York, where he joined the Paul Taylor Company. Among the many Taylor works in which he was singled out for critical acclaim were *Lento, Agathe's Tale, Port Meridian, Foreign Exchange, Public Domain, Churchyard, Book of Beasts, Fetes,* and *Three Epitaphs.*

Morishita, Yoko, Japanese ballet dancer; born December 7, 1948 in Hiroshima. Originally trained at the Tachibana Ballet School, she continued her studies with Asami Maki in Tokyo, performing in her company in the late 1960s. There she first performed the ballerina roles in the company productions of the classics, including *Swan Lake, Sleeping Beauty, The Nutcracker, Coppélia,* and *Giselle.*

Morishita has worked frequently as a guest artist in the United States and London, notably as Fernando Bujones' partner in the Black Swan pas de deux. Her performances with the American Ballet Theatre in 1977 and with the London Festival Ballet in 1979 were especially successful.

Morlacchi, Giuseppina, Italian nineteenth-century ballet dancer working in the United States after 1867; born 1843 in Milan; died July 24, 1886 in Billerica, Massachusetts. Morlacchi was trained at the school of the Teatro alla Scala, by Augusto Hus and his wife Salvina Calversi. She made her professional debut at the Teatro Carlo Felice in Genoa, however, in Jules Perrot's *Faust.* Benjamin Lumley, proprietor of Her Majesty's Theatre, London, invited her to perform

with his company in 1857, 1858, 1860, 1862, and 1866; she worked for his rivals—Covent Garden in 1859 and Drury Lane in 1859–1860.

In October 1867, she performed in New York for the first time in *The Devil's Auction* at the Banvards' Opera House, and on tour. She and her company toured with her own *Seven Cardinal Passions, The Seven Dwarfs, Tale of Enchantment, The Black Crook,* and *The Tempest* until 1872, when she accepted an engagement to perform in *The Scouts of the Prairie* with Buffalo Bill (Cody) and Texas Jack Omohundro. She played "Dove Eye" for two seasons and married Texas Jack in 1873. From 1873 to her retirement in 1880, she alternated between tours with her own repertory of European opera/ballets, such as *Achmed, La Bayadère,* and *The French Spy,* and his Western melodramas, among them, *Scouts of the Prairie, Life on the Border,* and *Texas Jack and the Black Hills.*

After the death of Texas Jack, Morlacchi retired to teach in Lowell, Massachusetts.

Morrice, Norman, English ballet dancer and choreographer; born September 10, 1931 in Agua Dulce, Vera Cruz, Mexico. Trained at the school of the Ballet Rambert, he performed with the company from 1952, becoming associate director in 1966 and co-director in 1970.

In 1977, he was appointed director of the Royal Ballet, for which he has choreographed frequently. Other companies for which he has staged works include the Rambert and the Bat-sheva in Israel.

Works Choreographed: CONCERT WORKS: *Two Brothers* (1958); *Hazana* (1959); *The Wise Monkeys* (1960); *A Place in the Desert* (1961); *Conflicts* (1962); *The Travelers* (1963); *Cul de Sac* (1964); *The Realms of Choice* (1965); *The Tribute* (1965); *Side Show* (1966); *The Betrothal* (1966); *Hazard* (1967); *Rehearsal* (1968); *1-2-3* (1968); *Them and Us* (1968); *Pastorale Variée* (1969); *Blind-Sight* (1969); *The Empty Suit* (1970); *Solo* (1971); *That Is the Show* (1971); *Isolde* (1973); *Fragments from a Distant Past* (1976); *The Sea Whispered Me* (1976); *Smiling Immortal* (1977).

Morris, Lenwood, American modern dancer; born c.1925 in Philadelphia, Pennsylvania. Morris was associated throughout his performing career with Kath-

arine Dunham. After studying with her and Syvilla Fort, he joined her company in 1943. He danced with her throughout the 1940s and served as ballet master and her assistant on theatrical productions and film appearances. Among the many repertory works in which he performed were *Puberty Ritual, Nanigo, l'Ag'Y'a, Rhumba Trio,* and *Flaming Youth.*

Morris, Margaret, English theatrical and interpretive dancer and choreographer; born March 10, 1891 in London. Trained originally by John D'Auban in ballet and theater dance forms, she then studied with Raymond Duncan, learning his theories of Greek movement. She had a successful theatrical career for more than sixteen years, making her debut as a specialty dancer in a Christmas pantomime in Plymouth, England. Moving to London, she performed in Ben Greet's productions, among them his *Midsummer Night's Dream* (1901). She choreographed incidental dances for Marie Brena's revival of *Orpheus* (1910), the Herbert Tree production of *Henry VIII* (1911) and *Aspacia's Statue* (1911), and Granville Barker's *Iphigenia in Tauris* (1914).

She opened studios in 1909 and 1918, working on her own movement theories, derived from Duncan's and those of Rudolf Steiner. By 1925, she had left theatrical dance to work as a dance therapist.

Works Choreographed: THEATER WORKS: *Orpheus* (1910); *Henry VIII* (1911); *Aspacia's Statue* (1911); *The Little Dream* (1912); *Iphigenia in Tauris* (1914).

Bibliography: Morris, Margaret. *My Life in Movement* (London: 1970).

Morris, Marnee, American ballet dancer; born April 2, 1946 in Schenectady, New York. After studies with Phyllis Marmein and Vladimir Dokoudovsky, Morris continued her training at the School of American Ballet in New York.

Morris joined the New York City Ballet in 1961, remaining with the company for almost twenty years. Associated with the works of George Balanchine, she performed featured roles in his *Apollo, Symphony in C, Prodigal Son, The Nutcracker, Divertimento No. 15, Stars and Stripes, Episodes, Tarantella,* and *Jewels,* dancing the female solo in the *Rubies* section. Among the ballets in which she created roles for him are *Don Quixote* (1965), *Trois Valses Romantiques* (1967), *Tchaikovsky Suite #3* (1970), *Coppélia*

(1974), and the *Symphony in Three Movements,* probably her best known role, created for the Stravinsky Festival in 1972.

Morrison, "Sunshine Sammy," American tap dancer and child actor; born Frederick Ernest Morrison, 1914 in New Orleans, Louisiana. Morrison, who performed as "Sunshine Sammy" or as "Booker T. Morrison," was the son of a specialty dancer on the Black burlesque and tap show circuit. He made his film debut in 1919 as a member of the Hal Roach stock company, appearing in Harold Lloyd silents. The star of his own "Sunshine Sammy" series of one-reelers in 1921, he is best known as the senior member of the first *Our Gang* films, when he was eight. He appeared in twenty-eight short subjects in the series before going into vaudeville in 1924. His act in the mid-1920s was staged by Bill Robinson— the only choreography for which the great "Bojangles" was officially credited. He also toured with Ethel Waters' *Harlem Hollywood Revue* on the TOBA circuit in a tandem tap act with Sammy Williams. Morrison returned to films in the late 1930s as a Dead End, or East End, Kid, playing "Scruno" in that series of films until 1945.

Mosconi Brothers, American tap dancers and teachers; Louis Mosconi born 1895 in Philadelphia, Pennsylvania; died August 1, 1969 in Hollywood, California; Charles Mosconi born c.1898 in Philadelphia; died there February 27, 1972. The Mosconis were trained by their father and eventually took over his Philadelphia studio. They toured their own tap act on the Keith circuit from 1907, when they appeared in the local theaters only, to the late 1930s, but also appeared with Bessie Clayton in her feature act and appeared in Shubert Brothers and Ziegfeld revues from 1915 to 1920. Their specialty, which was later adopted by the Nicholas Brothers, Louis Da Pron, and Donald O'Connor, was deceptively simple sounding. They "ran up the wall." This maneuver, which they did concurrently on opposite walls, is best known in O'Connor's performance in the "Be a Clown" number in *Singin' in the Rain*; the Mosconis ran up the walls to head height and performed back flips to the center of the stage.

After easing out of performance at the end of the vaudeville era, they both taught tap dance. Charles

managed his father's school in Philadelphia, while Louis commuted between there and Hollywood.

Mosolova, Vera, Russian ballet dancer and teacher; born April 19, 1875 possibly in or near Moscow; died January 29, 1949 in Moscow. Mosolova was trained at the Bolshoi school in Moscow and spent much of her professional life with that company. She performed with the Maryinsky Ballet in St. Petersburg for six years around the turn of the century, at the end of the Petipa era. In the first years of the 1900s, she returned to Moscow where she was associated with the works of Alexander Gorsky who had preceded her from St. Petersburg to Moscow in 1898. She danced the principal roles in many of his productions of the nineteenth-century classics, among them *Raymonda, Le Corsair, La Esmeralda*, and *The Sleeping Beauty*, and appeared with Ykaterina Geltzer in his *Dance Dream* at the Alhambra Theatre, London, in the 1911 Coronation season.

Mosolova became a member of the faculty of the Bolshoi School within four years of her retirement. In her more than twenty years at the school, she taught the first Soviet generation of dancers and the choreographers who would branch out from the conventional ballet field, among them, Igor Moiseyev and Asaf Messerer. Another student, Sulamith Messerer, a Bolshoi ballerina and herself a teacher from the 1940s, has recently introduced Mosolova's methods to her New York students.

Moss, David, American composer and improvisatory performer; born January 21, 1949 in New York City. After training and professional work in percussion and ethnomusicology, Moss began his first collaborative processes involving dance as a musician with Bill Dixon and his Dixon/(Judith) Dunn Ensemble. He is best known as a dance composer and collaborator for his work with Steve Paxton. They began to perform together in duet formats—concurrently improvising rather than choreographing set scores—in 1975. They have organized their performances into a series of continuing projects—Spanner (1975–1976) and Backwater/Twosome (1977–). In both, the sight of Moss, encaged in his structure of Western orchestral instruments, Eastern traditional gongs and bells, invented and pedestrian drums and

sonic sculptures, augments the fluidity of Paxton's dancing.

Moss, Majorie, English ballet and exhibition ballroom dancer; born c.1895, possibly in London; died February 3, 1935 in Palm Springs, California. Moss was trained by Katti Lanner and Malvina Cavallazzi and performed for them at the Empire Theatre as a member of the corps, a soloist, and understudy and replacement for Phyllis Bedells. In the early 1920s, she teamed up with Georges Fontana to create one of the most popular European exhibition ballroom teams of all time. Performing together from 1924 to 1932, they designed a series of highly dramatic dances using adagio and acrobatic techniques as well as contemporary rhythms and costumes for effect. They commuted across the Atlantic from 1924 to 1931, appearing at the Hotel Metropole in London (and running the *thé dansant* there), at the Café de Paris and Kit Kat Club in London, and at the Central Park Casino in New York City. They were in New York frequently enough to be named the best dance team in America in 1930.

Moss retired from the team in 1932 when she was married to Edmund Goulding, then directing in Hollywood. She died of tuberculosis three years later.

Moss, Paula, American modern dancer and actress; born in the 1950s in San Francisco, California. Moss received a BA in dance from the University of California at Irvine and performed in student companies there. Among the groups with which she danced in the early 1970s were the Afro-American Dance Theatre, Agnes De Mille's American Heritage Dance Theatre, and the Frank Ashley company in New York. Moss participated in the New York Shakespeare Festival presentation of Ntozake Shange's *For Coloured Girls Who Have Considered Suicide When the Rainbow Is Enuf*, as "The Lady in Green," and choreographed its Public Theater and Broadway productions.

Works Choreographed: THEATER WORKS: *For Coloured Girls Who Have Considered Suicide When the Rainbow Is Enuf* (1976).

Mossetti, Carlota, English theatrical ballet dancer; born September 23, 1890 in London. Mossetti was

trained at the school attached to the Alhambra Theatre, London, where she made her debut in 1908 in *Paquita*. Throughout her career at the Alhambra, she worked *en travestie*, playing men's parts in ballets.

She was associated with the Empire Theatre, London, for many years, playing trouser parts there in Fred Farren's *Sylvia* (1911), in which she partnered Lydia Kyasht, Edouard Espinosa's *Europe* (1914), Farren's *The Vine* (1915), and Alfred Majilton's *Pastorale* (1915). After seven years, in which her activities remain unknown, she opened a studio in London where she trained precision troupes for work in pantomimes and cine-variety shows. Among the shows in which her troupes performed were *Angelo* (1923) and *Lilac Time* (1922), for which she also received choreography credit.

Works Choreographed: THEATER WORKS: *Lilac Time* (1922); *Angelo* (1923).

Motte, Claire, French ballet dancer; born December 21, 1937 in Belfort, France. Trained at the school of the Paris Opéra Ballet by Carlotta Zambelli and Serge Lifar, she spent her career at that theater. Among the many ballets in which she has created roles are Michel Descombey's *Bacchus et Ariadne* (1967), Lifar's *Chemin de la Lumière* (1957), and Roland Petit's *Turangalila* (1968). She danced with Jean-Pierre Bonnefous in Juan Corelli's *Lament* and was assigned featured roles in George Balanchine's *Le Palais de Cristal* and Georges Skibine's *La Péri*. Motte retired in January 1979.

Moulton, Charles, American postmodern dancer and choreographer; born July 13, 1954 in Minneapolis, Minnesota. Moulton's studies with Merce Cunningham led to appearances in his company, in performances of repertory works and of Events. He was influenced by Cunningham's experiments with structures (which were becoming institutionalized into the differentiated categories of works) but has adopted a range of vocabularies unique to the contemporary dance world. Moulton's works use pedestrian movements and elaborate tap routines to express structures that involve accumulation and elaborate series of step sequences. His works are among the most popular and critically acclaimed of postmodernists,

partly because his use of objects and taps produces such articulate patterns.

Works Choreographed: CONCERT WORKS: *300–300–300–400* (1975); *Phytonoze with Three Teams and Two Balls* (1977); *Three Person Precision Ball Passing* (1979, continuous choreographic project); *Dance Form Demonstration* (1979); *Thought Movement Motor* (1980); *Three Piece Motor Ingrams* (1980); *Motor Fantasy* (1980); *Motor Set Changes and Nine Person Precision Ball Passing* (1980).

Mounsey, Yvonne, South African ballet dancer working in the United States during the 1940s and 1950s; born c.1921 in Pretoria, South Africa. After local training, Mounsey studied in Paris with Olga Preobrajenska and Lubov Egorova before moving to New York to work at the School of American Ballet.

Mounsey spent the 1940s touring the United States with the Ballet Russe de Monte Carlo (from 1939), and its rival, the Original Ballet Russe. In both companies, she performed featured roles in their productions of the classic repertory, notably *Les Sylphides, Swan Lake,* and *Giselle*. In 1949, she joined the New York City Ballet, remaining with them for ten years. A dramatic dancer, Mounsey performed in the companies plotted and abstract ballets, notably in the revival of Balanchine's *The Prodigal Son* as "The Siren," and as "The Queen" in Jerome Robbins' *The Cage* (1951). Mounsey's created roles in the company repertory included Robbins' *Age of Anxiety* (1950), *Fanfare* (1953), as "The Harp," *Quartet* (1954), *The Concert* (1956), Balanchine's *La Valse* (1951), and *The Nutcracker* (1954), as "Hot Chocolate," and their joint venture, *Jones Beach* (1950).

Returning to South Africa in 1959, Mounsey was a founder of the Johannesburg Ballet.

Mouradoff, Grant, Soviet ballet dancer working in France, Italy, and the United States; born Yrant Mouradoff, c.1915 in Tiflis. On the recommendation of Mikhail Mordkin, who visited Tiflis in 1928, Mouradoff left the Soviet Union to study with Olga Preobrajenska in Paris. He performed with the Folies Bergère and the Paris Opéra (at one point concurrently), but joined the Monte Carlo Ballet in 1936 and emigrated to the United States with its successor, the Ballet Russe de Monte Carlo. His leading roles in

Mikhail Fokine's *Don Juan, Les Sylphides*, and *Schéhérézade* brought him a reputation for dramatic performance that made him a popular member of the Metropolitan Opera ballet and mime contingent under Boris Romanoff during the 1940s and 1950s. He was equally adept at dancing in the ballet divertissements and at menacing or rescuing the opera's heroines in dramatic mime sequences. Mouradoff also worked with the New York City Opera, choreographing for that smaller company in the 1950s.

In between his opera engagements, Mouradoff formed a chamber company called The Foxhole Ballet, designed to tour overseas for Special Services and the USO, during World War II. He staged two works for the company, *Circus* (1945) and *The Garden Party* (1945), and danced in Aubrey Hitchins' *Century Bouquet* (1945) and Boris Romanoff's *A Czech Village* (1945). It is believed that Mouradoff settled in Italy in the 1960s, becoming known for his staging of operas and industrials there.

Works Choreographed: CONCERT WORKS: *Circus* (1945); *The Garden Party* (1945); *Dance Studio Workout* (1945).

Mouvet, Maurice, American exhibition ballroom dancer; born 1888 in Brooklyn, then a separate municipality; died 1927 in Lausanne, Switzerland. Mouvet, raised in Paris from the age of twelve, started to dance professionally at Maxim's while working there as an assistant doorman. He toured Western Europe before making his first major success with the exhibition-style Apache dance. Billed as a French dancer, and "the originator of the Apache," he and then partner, Madeleine, came to New York to perform at Louis Martin's Café de Paris. After performing with Madeleine in the Broadway show *Peggy* (1911), and briefly with Joan Sawyer in cabaret, Mouvet was introduced to Florence Walton by Florenz Ziegfeld. As Maurice and Florence Walton, they rivaled the Castles in popularity and general recognition, performing together in *Over the River* (1912), *The Whirl of Society* (1912), and *Hands Up* (1915), with vaudeville and European tours between shows.

After Walton's retirement in 1921, Mouvet worked with partners Leonora Hughes, actress Barbara Bennet, and society dancer Eleanora Ambrose—all primarily in Europe. With Ambrose, Mouvet managed a cabaret in Paris from 1926 until his death from tuberculosis in 1927.

Moylan, Mary-Ellen, American ballet dancer; born 1926 in Cincinnati, Ohio. Raised in Florida, she was trained by Alice Young in St. Petersburg before moving to New York to accept a scholarship at the School of American Ballet. She performed in the premiere of George Balanchine's *Ballet Imperial* (1942), before joining the Ballet Russe de Monte Carlo. She was celebrated there for her work in the Balanchine repertory, dancing in his *Serenade, Concerto Barocco, Night Shadow,* and *Danses Concertantes,* and in Ruthanna Boris' *Quelque Fleurs.* During the early 1940s she was featured in Balanchine's *Rosalinda* on Broadway, and his *Pas de Trois for Piano and Two Dancers,* created for a benefit performance in 1942.

She danced with Francisco Moncion on Broadway in Balanchine's *The Chocolate Soldier* (1947) and in the performances of the Ballet Society, creating roles in Balanchine's *Four Temperaments* (1946) and *Divertimento* (1947). A member of the Ballet Theatre from 1950, she was featured in David Lichine's *Helen of Troy,* John Taras' *Designs with Strings,* Anton Dolin's *Pas de Quatre,* Fokine's *Les Sylphides,* Balanchine's *Theme and Variations,* and the company productions of *Swan Lake* and *Giselle.* Considered one of the best American-trained dancers of the 1940s and 1950s, she served as solo ballerina of the Metropolitan Opera in the mid-1950s before retiring.

Muller, Jennifer, American modern dancer and choreographer; born October 16, 1949 in Yonkers, New York. Muller was trained at the Juilliard School, New York City, and performed while a student in the companies of Pearl Lang, creating a role in *Shirah* (1960), Sophie Maslow, and Manuel Alum. She joined the José Limón company in 1963, performing in his *Missa Brevis, The Winged, Comedy,* and *The Moor's Pavanne.*

In 1968, she began to perform with the company of a fellow-Limón dancer, Louis Falco. She danced in the premieres of his *Timewright* (1969), *Huescape* (1968), *Caviar* (1970), *Sleepers* (1971), and *Soap Opera* (1972), becoming associate director of his troupe. She also choreographed for that group, creating her *Rust-Giocometti Sculpture Garden* and *Nostalgia* for it in 1971.

Since 1975, she has directed her own company—Jennifer Muller and The Works—and has choreographed for it, and for the Netherlands Dance Theatre and Repertory Dance Theatre of Utah. Among the dancer/choreographers who regularly perform with The Works are Carol-Rae Krauss, Georgianna Holmes, and Matthew Diamond.

Works Choreographed: CONCERT WORKS: *Rust-Giocometti Sculpture Garden* (1971); *Nostalgia* (1971); *Sweet Milkwood and Blackberry Bloom* (1971); *Tub* (1973); *Speeds* (1974); *Biography* (1974); *Stateroom Winter Pieces* (1974); *Four Chairs* (1974); *Clown* (1974); *An American Beauty Rose* (1974); *Sleepers* (1975); *Beach* (1976); *Predicament for Five* (1977); *Mondrian* (1977); *Lovers* (1978).

Mumaw, Barton, American modern and concert dancer and choreographer; born Barton Sensenig, Jr., c.1912 in Hazelton, Pennsylvania. Mumaw left Eustis, Florida, where he was raised, to study with Ted Shawn during the last years of the Denishawn companies. He created roles there in his *Fingals' Cave Overture* (1929), *Pacific-231* (1919), *Job* (1931), *Rhapsody* (1931), and *Song of the Millers*, and Ruth St. Denis' *Angkor-Vat* (1930). When Shawn formed his later company, called TS and His Men Dancers, Mumaw was its second principal, capable of taking Shawn's roles and of performing in the solos that Shawn created for him. Throughout the company's short life (1934–1940), he performed in *Worker's Songs of Middle Europe* (1933), *The French Sailor* (1933), *Fetish* (1933), *Labor Symphony* (1934), *O Libertad* (1937, including *Olympiad*), *Dance of the Ages* (1938, including *Kinetic Molpai*), and *The Dome* and *Jacob's Pillow* (1940). He began to choreograph solos for himself within Shawn works—the *Banner Bearer* in *Olympiad*, for example, and a section of *Jacob's Pillow Concerto.*

Mumaw worked as a concert dancer throughout the 1940s, presenting recitals of Shawn's and his own solos. In the 1950s, however, he also worked in national and Broadway companies of *Annie Get Your Gun* (in the Daniel Nagrin role of "Wild Horse"), Hanya Holm's *The Golden Apple, Out of This World*, and in the incredible 2,717 performances of *My Fair Lady.*

Works Choreographed: CONCERT WORKS: *Banner Bearer* section of *Olympiad* (1937, by Shawn and other members of His Men Dancers); *Bouree* (1940); section of *Jacob's Pillow Concerto* (1940, by Shawn and other members of His Men Dancers); *God of Lightning* (1938); *Sonata Scarlatti* (1941); *War and the Artist* (1941); *Earth Forces* (1941); *Prelude to the 35th Cantata* (1946); *Rhapsody* (1948); *La Cathedrale Engloutie* (1948); *Vienna Dance No. 2* (1948).

Munson, Ona, American musical comedy star; born June 16, 1894 in Portland, Oregon; died February 11, 1955 in New York City. Munson made her vaudeville debut at age four on the Northwest circuit that stretched between the United States and Canada. After a brief tour with her own "Baby dancer" act, she joined the first of many Gus Edwards' Kiddy acts, with which she traveled for ten years. A second act of her own, with which she appeared from age eighteen, brought her the title role in a tour of the Gershwins' *Tip-Toes* (1925) and of *No, No, Nanette.* She actually toured in the national company of the latter before it became a Broadway hit, later replacing the earlier "Nanette" (Louise Groody) on Broadway. Her portrayal of "Nanette" and her singing of "Tea for Two" made her an ingenue star for the remainder of her musical career and brought her starring roles in *Manhattan Mary* (1927), *Hold Everything* (1928), in which she introduced "You're the Cream in My Coffee," *Pardon My English* (1933), *Hold Your Horses* (1933), and *Petticoat Fever* (1935). She also acted in straight plays, most notably in the 1935 revival of *Ghosts*, before becoming a film actress.

For most film goers, Munson's later career consisted of one role, that of "Belle Watling," the lady of pleasure with the heart of gold who donated her ill-gotten gains to Melanie Wilkes and the starving of Atlanta in the American epic, *Gone with the Wind.* However, she actually made more than a dozen films ranging from melodramas to Westerns, and appeared frequently on television. Munson commited suicide in 1955 after a long debilitating illness, but her beauty can still be seen through the padding and makeup that transformed her into the flashy "Belle" in the most popular film ever made.

Murphy, George, American song and dance man, former senator, and publicist; born July 4, 1902 in New Haven, Connecticut. The son of a celebrated colleagiate track coach, Murphy dropped out of Yale

to become a floor manager of a dance hall in Newark, New Jersey. He was a Frisco imitator before meeting Julie Johnson, his future wife, and joining her dance act. They formed an exhibition ballroom team and toured with George Olsen's band on his nightclub circuit. Murphy also did a comedy act on the circuit with Olsen's brother-in-law, Jack Shutta.

They appeared in the London cast of *Good News*, dancing the "Varsity Drag," and performed in London cabarets. Returning to New York, they joined the casts of *Hold Everything* and *Of Thee I Sing* and were engaged by the Central Park Casino for three years. He was cast as a soloist in *Roberta* (1933) before moving to Los Angeles to enter film.

Murphy was under contract to MGM for much of his performing career, cast in secondary musical roles in, among others, *For Me and My Gal* (1943) and *Two Girls on Broadway* (1940). Lent out to other studios, he made *Rise and Shine* (Twentieth-Century Fox, 1941), *The Powers Girl* (UA, 1943), and *The Navy Comes Through* (WB, 1942), as well as dramatic roles in military films. When he retired from performance, he served as a public relations manager for MGM, and directed two industry promotion groups, the Motion Picture Industry Council and the Academy of Motion Pictures Arts and Sciences. He was also a promotional advisor for Technicolor, Inc., a fact that emerged during his campaigns for the United States Senate. A Republican for many years, and producer of the party's national conventions, he served as senator from California for one term.

Bibliography: Murphy, George and Victor Lasky, *"Say . . . Didn't You Used To Be George Murphy?"* (privately printed, 1970); only the first part is relevant to his theatrical career.

Murray, Arthur, American exhibition ballroom dancer and entrepreneur; born Arthur Murray Teichmann in 1896 in New York City. Trained at Castle House—the school, cabaret, and dance hall run by Irene and Vernon Castle—Murray opened his first dance studio in Asheville, Georgia, in 1919. From then through the 1930s, he opened new franchised schools and sold mail-order dance lessons with an advertising campaign that is still part of the national psyche and vocabulary. The heroine of "80 days ago they laughed at me . . ." and the hero of "How could I go to the party when they knew I couldn't dance" could meet at an Arthur Murray studio and find happiness, love, and financial security. The ads, and radio and television campaigns, worked of course since they promised that the new dancer would succeed in every capitalist, small-town American way.

With his wife Katharine (b.1897 in Jersey City, New Jersey), he hosted a twenty-year radio show, and a television show that at times ran on each of the four commercial networks from 1950 to 1957. The methods that they used to get America to believe that "to put a little fun into your life, try Dancing!" occasionally got the franchising system investigated by the press. The Murrays retired from the studio franchise system in 1964.

Works Choreographed: TELEVISION: *The Arthur Murray Party* (ABC, 1950–1951, 1951–1952; Dumont, 1950–1951, 1952–1953; CBS, 1952–1952, 1953–1954, 1956–1956; NBC, 1953–1955, 1957).

Murray, Julian, "Bud," American film dance director; born November 21, 1888; died November 1, 1952 in Los Angeles, California. Murray worked as an office boy for George M. Cohan's New York Office before making his professional debut in Cohan's *45 Minutes from Broadway* (1906). He became known as an eccentric dancer on Broadway in *Playing the Ponies* (1908), where he delighted the audience in the Act II finale set in Luna Park (Coney Island), *The Girl of My Dreams* (1911), and a long series of Shubert Brother shows for the Winter Garden Theater, including *The Whirl of Society* (1912), *Maid in America* (1915), *The World of Pleasure* (1915), the *Passing Shows* of 1916 and 1917, *Doing Our Bit* (1918), and *Monte Cristo, Jr.* (1919). Murray went out to Hollywood to work as a coach and dance director with the Hal Roach Studio, becoming responsible for the dance numbers and training of the two hundred-plus *Our Gang* comedies. Although he returned to Broadway occasionally, he worked almost entirely in film after the 1920s, staging dances and teaching at the studio schools and at his own studio in Hollywood.

Works Choreographed: THEATER WORKS: *The Great Magoo* (1932, play).

FILM: *Our Gang* comedies (Hal Roach Studio, 1922–1944); intermittent credits on more than 220 films.

Murray, Mae, American theatrical dancer and silent film star; born Marie Koenig, May 10, 1893 in Portsmouth, Virginia. "The Girl with the Bee-Stung Lips" was a cabaret dancer when she made her Broadway debut as Irene Castle's temporary replacement in the Irving Berlin show, *Watch Your Step*, probably in February 1915. She was then cast into the *Ziegfeld Follies of 1915* (considered the first of the "typical" *Follies* and definitely the first to be truly a revue), in which she played the ingenue of the "film-within-a-show," as directed from the boxes by Ed Wynn. She danced in this show with George White and Ann Pennington.

Moving to Hollywood, Murray became one of the most famous actresses on the screen—celebrated both for her beauty and for her extravagant lifestyle. Best known for her performance in the title role of the silent version of *The Merry Widow* (MGM, 1925, dances by Ernest Belcher), she did not survive the transition to sound films, although she had done lines on Broadway. In the more moralistic American newspapers, her downfall in Hollywood was quoted as a lesson in ethics.

Murray, Michelle, American modern dancer; born in the early 1940s in Tuskegee, Alabama. Murray began her dance training at the Tuskegee Institute (where both her parents taught) and continued it at the Juilliard School under Martha Graham, José Limón, and Alfredo Corvino. Although she performed in a number of musical comedies, including the 1967 *Hal-*

lelulah Baby and an engagement as Geoffrey Holder's partner at the Olympic Théâtre, Paris, she is best known for her performances with the Alvin Ailey Dance Theatre. Among the many works in which she has danced are Ailey's *Streams, Quintet* (1968), and *Masekela Langage* (1969), Holder's *The Prodigal Prince*, and Talley Beatty's *Congo Tango Palace* and *Come and Get the Beauty of It Hot*.

Musette, American vaudeville dancing violinist; born Marguerita Theresa Flowers, c.1895 in New England. From 1912 to 1919, she was universally acclaimed as North America's foremost dancing violinist in vaudeville and in Broadway's roof garden theaters. Unlike many of her competitors, she was both a talented violinist and a graceful dancer. The act itself was artistically unified since she selected equally charming and sentimental scores to play and dance. Musette left her act by 1921 to become an opera singer.

Musgrove, Traci, American modern dancer; born February 7, 1948 in Carlysle, Pennsylvania. After academic dance studies at Southern Methodist University in Texas, she moved to New York for professional training with Yuriko, Richard Kuch, Lucas Hoving, and the faculty of the Martha Graham school. Early in her New York career, she performed with former Graham company members Yuriko and Pearl Lang, appearing in the latter's *Shore Bourne, Piece for Brass, Sharjuhn* (1971), and *Shirah*, among other works. In the mid-1970s, she joined the Graham troupe and won acclaim in her performances in Graham's *Night Journey, Secular Games*, and *Diversion of Angels*, among many credits in the large repertory.

N

Nabokov, Nicholas, Russian/American composer; born April 17, 1903 in Lubcha; died 1978 in New York City. Trained in Western Europe, Nabokov began his association with dance with his oratorio for the Leonid Massine ballet, *Ode, or Meditation at Night on the Majesty of God, as Revealed by Aurora Borealis,* for the Diaghilev Ballet Russe (1928). He emigrated to the United States in 1934, but spent much of the postwar years in Berlin where he directed cultural organizations for the United States and West German governments. His Americanization was honored in music with *Union Pacific* for Massine and the Ballet Russe de Monte Carlo (1933, ballet premiered a year later). His most controversial score was the music that he wrote for George Balanchine's full-length dramatic ballet of *Don Quixote* (1965). Since he and Balanchine worked from the plot of the book, not from the romanticization that nineteenth-century choreographers imposed on the story, they were mistakenly accused of undermythicizing the hero and robbing the ballet of its sentimentality.

Bibliography: Nabokov, Nicholas. *Old Friends and New Music* (Boston: 1951).

Nadezhdina, Nadezhda, Soviet ballet dancer and folk dance expert; born June 3, 1908 in St. Petersburg; died in 1979 on tour in Germany. Trained at the Leningrad Choreographic Institute, she performed with the Bolshoi Ballet in Moscow, specializing in character roles. While perfecting her character and national dance techniques, she became interested in the choreographic possibilities in the genuine Russian folk dances from the nations that make up the Soviet Union. She founded the Beryozhka Dance Ensemble in 1948, serving as its director until her death. The company, whose name means Birch Tree, was all female until 1961, but currently numbers more than sixty women and more than twenty men. Although it is assumed that Nadezhdina created the company's repertory, it is unsure whether she is officially credited as choreographer of any individual works.

Nadja, American interpretive dancer also working in Paris; born in the first years of this century in San Francisco, California; died March 15, 1945 in New York City. Nadja, who occasionally performed under her real name, Beatrice Wanger, was trained at the Florence Flemming Noyes school in New York City. She taught in New York and London before moving to Paris in 1924 to perform as an interpretive and exotic dancer. She made her French debut in Cora Laparcie's production of *Lysistrata* at the Théâtre Mogador, in October 1924, but within two months, gave a recital of her own dances set to poems by Dante Gabriel Rosetti and G. Constant Lounsberry at the Théâtre Esotérique. Her recitals over thirteen years in Parisian private theaters and popular revues presented a surprisingly small number of titled works and, according to her report, a different improvisation every performance. She described her theories of dance as being the "re-collecting of rhythm" (phrase published in English in a Paris program), in three forms, ranging from objective concentration to subconscious creation and inspiration.

After returning from Paris in 1937, she taught at the Albertina Rasch studio in New York City.

Works Choreographed: CONCERT WORKS: *Poèmes Vécus* (1924, in collaboration with poet G. Constant Lounsberry); *Songs of Brahma* (1924); *Trois Danses* (*Valse, Orientale, Danse de Tambourin*) (1925); *Dance Indone* (1926); *Danse Mystique* (1926); *Chant Hindoue* (1926).

THEATER WORKS: *Lysistrata* (1924); *Babylone* (1925).

Nagrin, Daniel, American modern and theatrical dancer and choreographer; born May 22, 1917 in New York City. Nagrin received his early basic dance training and performance experience with the Experimental Dance Unit, under Bill Matons, with classes taught by Charles Weidman, and The Dance Unit, directed by Anna Sokolow, in whose *Façade—Expositione Italiana* (1938) he appeared. He also studied ballet with Elizabeth Anderson-Ivantzova and Edward Caton, and modern dance techniques with Martha Graham, Hanya Holm, and Helen Tamiris.

Tamiris, to whom he was then married, cast him in her *Liberty Song* (1942), a modern dance concert in cabaret, and in her musical comedy productions. He performed in and assisted her on *Up in Central Park* (1945), *Annie Get Your Gun* (1946), in which his solo

in "I'm an Indian Too" astounded the audience with its power, *Inside U.S.A.* (1948), *Touch and Go* (1949), *Bless You All* (1950), and *Plain and Fancy* (1955). His non-Tamiris show, *Lend an Ear* (1948), was also a success that cemented his reputation as one of Broadway's finest dancers. He staged the dances for a jungle musical film, *His Majesty O'Keefe* (WB, 1954), and afterwards partnered Miriam Pandor in the dance numbers in *Just for You* (Paramount, 1952).

Nagrin co-directed the Tamiris-Nagrin Company and Workshop in the 1960s, dancing in her late works and creating a solo repertory for himself. His works are character studies in movement, defined by costume, poses, and manipulation of real and imaginary props. His characters fight against the world, frequently losing with grace, as in *Strange Hero* (1948), and sinking under outside and inner pressure, as in his later literary works, *The Fall* (1978) and *Jacaranda* (1979). The last work, his most recent to date, may represent a new part of a long career—one that continues into the 1980s—solos with less emphasis on movement and more on the interpretation of a libretto, in this case by famed playwright Sam Shepard. This collaboration, the cooperation of two protectors of the American myths of independence and heroism, should prove important to both dance and theater.

Works Choreographed: CONCERT WORKS; *Private Johnny Jukebox* (1942); *"Landscape with Three Figures, 1859"* (1943); *Spanish Dance* (1948); *Strange Hero* (1948); *Man of Action* (1948); *Dance in the Sun* (1950); *The Ballad of John Henry* (1950); *Faces from Walt Whitman* (1950); *Man Dancing* (1954); *Tom O'Bedlam* (1954); *Progress* (1957); *Indeterminate Figure* (1957); *Three Happy Men* (1958); *Jazz, Three Ways* (1958); *The Boss Man and the Snake Lady* (1958); *With My Eye and with My Hand* (1958); *A Dancer Prepares* (1958); *For a Young Person* (1958); *Dance in the Sun* (1959); *An Entertainment* (1960); *An American Journey* (1960); *Two Improvisations* (1962); *The Man Who Did Not Care* (1963); *In the Dusk* (1965); *Not Me, But Him* (1965); *Path* (1965); *A Gratitude* (1965); *In Defense of the City* (1965); *Why Not* (1965); *The Peloponnesian War* (1968); *The Image* (1971); *Duet* (1971); *The Ritual* (1971); *Polythemes* (1971); *Wind I* (1971); *Rondo* (1971);

Mary Annie's Dance (1971); *Rituals of Power* (1971); *Songs of the Times* (1972); *Fragment: Rondo I and II* (1972); *Ritual for Two* (1972); *Ritual for Eight* (1972); *Quiet Dance I, II* (1972); *Wounded Knee* (1972); *Sea Anemone Suite* (1972); *Hello-Farewell-Hello* (1973); *Steps* (1973); *Untitled* (1974); *Jazz Changes* (1974); *Sweet Woman* (1974); *Nineteen Upbeats* (1975); *The Edge Is Also a Center* (1975); *Ruminations* (1976); *Someone* (1977); *Untitled (II)* (1977); *Time Writes Notes on Us* (1978); *The Fall* (1978); *Getting Well* (1979); *Jacaranda* (1979).

FILM: *His Majesty O'Keefe* (WB, 1954).

Nagrin, Lee, American modern dancer and choreographer, actress, and artist: born June 3, 1929 in Seattle, Washington. An Off Broadway director/producer and artist, Nagrin began to participate in dance performance in 1972 when she joined Meredith Monk as a member of The House. She has performed in most of Monk's works since that date, among them *Education of the Girlchild* (1973), *Paris/Chacon* (1974), *Venice/Milan* (1976), *Small Scroll* (1975), *Quarry* (1976), and *Recent Ruins* (1978). With Margaret Beals, she co-created *Stings*, based on the poetry of Sylvia Plath (1975), and has choreographed and directed works that will soon be performed together as a quatrain.

Works Choreographed: CONCERT WORKS: *Stings* (1975, co-created with Margaret Beals); *Sky Fish* (1979); *Bird Devil* (1980).

Nagy, Ivan, Hungarian ballet dancer working in the United States after the mid-1960s; born April 28, 1943 in Debrecen, Hungary. After early training with his mother, Viola Sarkozy, Nagy attended the school of the Hungarian Opera Ballet where he studied with Ferenc Nadesi, Irene Bartos, and Olga Lepeshinskaya. Graduating into the company, he created the title role in Viktor Fulop's *Marius* (1964), danced in opera ballets in *Faust, Aida, La Traviata*, and *Samson and Delilah*, and was assigned featured roles in the company productions of the nineteenth-century classics.

After the Varna competition of 1965, Frederick Franklin, who had been a judge, invited Nagy to come to the United States to perform with his National Ballet in Washington, D.C. He danced with

the National in Franklin's productions of the classics and in his *Dance Brilliante* (1965) and James Starbuck's *Legend of the Pearl* (1966). Switching to the American Ballet Theatre in 1968, he created roles in Michael Smuin's *The Eternal Idol* (1969), Alvin Ailey's *The River* (1970), and Dennis Nahat's *Brahms Quintet* (1969), in all of which he partnered Cynthia Gregory. Considered one of the best partners in the company, he danced with her, with Gelsey Kirkland, and with Natalia Makarova in the company's *Swan Lake, Les Sylphides, La Sylphide, Coppélia, La Fille Mal Gardée, Giselle*, and Makarova's *La Bayadère* (1974 version).

Nagy retired in 1978.

Naharin, Ohad, Israeli modern dancer; born 1955 on the Kibbutz Mizra, Emech' Izräl. Naharin was trained at the studio of the Bat-sheva Dance Company and spent the years 1967–1977 in the United States continuing his studies at the Martha Graham school. A member of the Graham company in its "renaissance" season in 1976, he appeared in the revival of her *Diversion of Angels* and in the new work, *Adorations* and *Lucifer*. During that year, he was also a member of the amplified corp for the José Limón company revival of that choreographer's *Missa Brevis* (1977). After performing with the Ballet du XXième Siècle in Brussels, most notably in Maurice Béjart's *Raga* and *Petrouckha*, he returned to Israel to join the Bat-Dor troupe. Among his credits in that modern dance company are roles in Mirali Sharon's *Hymn to Israel*, Yehuda Maor's *Desert Poem*, and Rudolf van Dantzig's *Couples*.

Nahat, Dennis, American ballet dancer and choreographer with a concurrent career as a theatrical choreographer; born February 20, 1944 in Detroit, Michigan. Nahat began his ballet studies when his parents' insurance coverage included an offer of free lessons with adagio dancer turned American Cecchetti expert, Enid Ricardeau. When the offer ran out, he played piano for classes and cleaned her studio. After high school and performances with Detroit's Civic Ballet, he moved to New York to attend the Juilliard School.

Although he studied ballet at Juilliard with Antony Tudor, his tenure there was more distinguished for his work with modern dance pioneers, José Limón, with whom he worked extensively, and Anna Sokolow. For Sokolow, he created roles in *Odes* (1965), *Session for Six* (1965), and *Ballade*, performing the latter with the American Dance Theater in March, 1965.

On recommendation from Tudor, Nahat was named an apprentice to what would become the City Center Joffrey Ballet, serving as a charter member of that company. There, he created roles in Sokolow's *Opus '65*, and Arpino's *Olympics* and *Viva Vivaldi!*, and taught at the American Ballet Center. After an injury, he left the Joffrey company to perform on Broadway in Bob Fosse's *Sweet Charity*.

Nahat joined American Ballet in 1968, performing there on a full-time basis until 1974, and as a guest principal to the present. Generally considered the best actor in American dance, and typecast in an international array of gypsies, courtiers, witches, and devils, his technical ability was largely ignored, although he performed featured roles in the Tudor repertory and the classics. His best-remembered created role was the *Riba* section of Alvin Ailey's *The River* (1969); other parts include the title roles in Fokine's *Petrouchka* and De Mille's *Three Virgins and A Devil*, "Mercutio" in Tudor's *Romeo and Juliet*, and both male roles in Limón's *The Moor's Pavanne*.

The last of Ballet Theatre's choreographers-in-residence of the late 1960s and early 1970s, Nahat created four ballets for the company—*Momentum* (1968), *Brahms Quintet* (1969), *Mendelssohn Symphony* (1970), and *Some Times* (1972). His *Ontogeny* (1970), created for the Royal Swedish Ballet, was also performed by Ballet Theatre. Other than these works, a version of the Grand Pas de Dix from *Raymonda* staged for the Hartford Ballet, directed by fellow Joffrey charter-member Michael Uthoff, and works created for Juilliard student productions, all of Nahat's ballet works have been choreographed for The Cleveland Ballet, of which he became associate director in 1975. Among the works that he has created for this company are the *Contra Concerti*, dedicated to Limón (1977), *Quicksilver* (1980), and *Celebrations* (1980). His works are known for their abstract delicacy and musicality and for the ingenuity of their structural formats. Abstract ballets, they do

not exploit the dramatic or comedic qualities that characterized his performance career.

Nahat has also worked extensively in theater forms, although his commitment to the Cleveland company has cut back on his Broadway career. Many of his Broadway, Off, and Off Off Broadway shows were staged for the New York Shakespeare Festival and Public Theater, among them, the Broadway and London versions of the musical *Two Gentlemen of Verona* (1971), *Pericles* (1974), and the cult favorite *Lotta, or The Best Thing Evolution's Ever Come Up With* (1973). His other theater credits include the staging of the dances for the opera *Meeting Mr. Ives* for Tanglewood's Lenox Art Center (1975), and the brain activity acrobatics for the Tom Stoppard play, *Jumpers* (1974).

Works Choreographed: CONCERT WORKS: *Momentum* (1968); *Brahms Quintet* (1969); *Ontogeny* (1970); *Mendelssohn Symphony* (1970); *Mendelssohn Quintet* (1971); *Some Times* (1972); *US* (1976, co-choreographed with Ian Horvath); *Grand Pas de Dix* (1976); *Suite Charactéristique* (1976); *Things Our Fathers Loved* (1976); *In Concert* (1977); *Contra Concerti* (1977); *The Gift* (1977); *Ozone Hour* (1977, co-choreographed with Ian Horvath); *Slavonic & Hungarian Dances* (1978); *The Nutcracker* (1979); *Textura* (1979); *Quicksilver* (1980); *Celebrations* (1980).

OPERA: *Meeting Mr. Ives* (1975).

THEATER WORKS: *Two Gentlemen of Verona* (1971, "dances staged by" credit on Broadway programs, conventional credits for national and London companies); *Lotta, or The Best Thing Evolution's Ever Come Up With* (1973); *Jumpers* (1974, credit technically for "acrobatics and tumbling"); *Pericles* (1974).

FILM: *A Turning Point* (Twentieth-Century Fox, 1977, "Anna Karenina" ballet).

Nassif, Anna, American modern dancer and choreographer; born August 17, 1933 in Rowlesburg, Virginia. Nassif spent a season in New York City studying with Martha Graham, Louis Horst, Nina Fonoroff, and Erick Hawkins. She then attended the University of Wisconsin at Madison, where she worked under Louise Kloepper, one of the first students of Mary Wigman and Hanya Holm to teach at the university level in the United States. During a research term abroad, Nassif worked under Wigman herself, and took classes from ballet teachers Nora Kiss, Anton Dolin, and Felia Doubrovska, and experts in Flamenco and historical dance forms. Nassif has taught at the University of Wisconsin, Madison, throughout her long career and has been, with Kloepper, a major influence on the shaping of dance in the Midwest and on her many students, performers, and advisees, among them Don Redlich, John Wilson, Bob Beswick, and Beth Soll. An extremely prolific choreographer, she has also worked extensively in nondance capacities with the celebrated theater and film programs in Madison. In her work, and in the influence she has had, Nassif has emerged as one of the later figures of the traditional modern dance, willing to experiment with movement, structure, and media, but maintaining the tradition of composition as a form of dance expression.

Works Choreographed: CONCERT WORKS: *Composition for Three Groups* (1962); *Time Mass* (1963); *Five Dances* (1963); *The Highway* (1963); *Danced Concerto* (1963) *Dance Sequences for Mental Health Film* (1963); *Dance for Two Figures with Red Scarf* (1964); *Six Little Dances* (1964); *Six Dances for Five Figures* (1964); *Meditations on Ecclesiastes* (1965); *Black and White Solo* (1965); *Dance for One Figure and Two Objects* (1965); *Two Duets in Shades of Blue* (1965); *Composition for Ten Figures in Shades of Red* (1965); *Four Studies* (1965); *Composition for Thirteen Figures in Black, Gold and White* (1965); *Duet in Six Moods* (1965); *Variations* (1965); *Four Systems* (1965); *Untitled Duet* (1965); *New Untitled Solo* (1965); *Durations I* (1965); *Durations II* (1965); *Tryptique* (1966); *Solo* (1966); *Les Noces* (1966); *New Dance for 13 Figures, Film Sequence, Sound, Three Objects and Film Collage* (1966); *Group Dance in Four Movements* (1966); *Dance for One Figure, Four Objects and Film Sequence* (1966); *Struwwelpeter* (1966); *Dance Drama #1* (1967); *Dance Drama #2 for 13 Figures in 12 Parts with Words, Poetry, Percussion and Film Sequences* (1967); *Variation on Two Duets* (1967); *Five Group Studies for 13 or More Figures, with Props, Sound, Poetry and Music (A Work-in-Progress)* (1967); *Variation on Solo in Black and White* (1967); *Variation on Composition for Three Groups* (1967); *Six Short Pieces for One*

Male Figure Assisted by Two Female Figures (1967); *Dance Drama for Large Group in 13 Parts with Words, Poetry, Syllables, Percussion and Objects* (1967); *Improvisatory Piece for One or More Figures with Props and Slides* (1967); *Controlled Study Using Indian Movement Material for One Female Figure in Four Roles with Photography* (1967); *Study for One or More Figures in Ten Sections in Black and White with Music, Poetry, Photography* (1967); *Indian Goddess, Dance Drama No. 3 for Female Figure* (1968); *Krishna, Dance Drama No. 6* (1968); *Three Changing Points in Space Time, Dance Drama No. 4* (1968); *Raja, King of the Dark Chamber, Dance Drama No. 5* (1968); *Malbec, A Riddle* (1968); *Nine Moods* (1968); *Two Absurd Dance Plays with Props* (1968); *Kaleidoscope, Solo for Female Figure* (1969); *Dance Drama No. 7 in Four Acts—I: The Creation; II: Duet with Coffin and Cradle (Birth to Death Sequences); III: The Warriors; IV: Death and Re-incarnation* (1969); *Three Changing Points in Space Time* (1969); *Human in Search of the Divine* (1969); *Figure in Motion with Drums* (1969); *Theatre Piece No. 1, Dancing Figure Performing Two Roles, One Mythical and One Real* (1969); *Theatre Piece No. II Meanwhile* (1969); *Metamorpha* (1969); *Untitled Solo—24 Activities* (1970); *Absurd Dance Play for Soloist and Group* (1970); *Mass Ritual Theatre Piece No. 3 for Solo Figure with Photography* (1970); *Camino Real* (1970); *16 Dramatic Sketches, Theatre Piece No. 5* (1970); *Ecology in the Forest, Theatre Piece No. 6* (1970); *Meditations on Ecclesiastes* (1970); *Godmother, Time and Numbers* (1970); *Synthesis, Touch and Feel* (1970); *Life Against Death, Breathing and Tension* (1970); *Persian Sketches in Black and White* (1970); *Composition for One Figure in Many Places and Spaces, Theatre Piece No. 7* (1971); *Absurd Dance for Soloist, Sculpture and Dresses, Theatre Piece No. 8* (1971); *A Spanish Collage, Epic I* (1971); *Choreographic Epic Theatre Piece, A Mythological Construction in Eight Episodes* (1971); *Heroic Episode, Don Quixote and Sancho Panza Historical Episode, Cave-man Oxen, Wheel, Writing, Inventions, The Way of St. James, Saints and Sinners, Beggars and Kings, Inquisition, Ferdinand and Isabella, Columbus, Poet's Vision of Nature, Human Relationships, Gypsy* (1971); *Romantic Episode, Man and Woman in Rooms* (1971); *Arabic Music and Dance*

Episode, A Night Visit to Granada (1971); *Dramatic Episode, Women of Spain, Past, Present, Future, including Saint Therese, Mad Juana La Loca and Jacqueline Onassis* (1971); *International Episode, Twentieth Century Spain or Any Other Place* (1971); *Psychological Episode, Dream of Lovers of Teruel, Don Juan, James Bond, and All Their Girl Friends* (1971); *Festive Episode, Seville: Circus, Horse Fair, Religious Procession, Virgin Mary Floats, Gypsy Houses, Improvised Dance, Id, Ego, Superego (Bull, Matador, Spectators, Bulls, Picodores, Baderilleros, Matador, Peons, Mourners, Lovers)* (1971); *Mass Ritual, Choreographic Epic Theatre Piece No. 2* (1971); *Entrance and Opening Statements with Tubes* (1971); *Kyrie* (1971); *Genesis: Primitive Fire, Cult Rhythm, Olatunji* (1971); *Bible Stories: The Pipes of Trinity College* (1971); *Gloria* (1971); *Epistle* (1971); *Gospel—Judith* (1971); *Sermon—Job* (1971); *Credo* (1971); *Offertory* (1971); *Sanctus* (1971); *Our Father* (1971); *Agnus Dei* (1971); *Communion* (1971); *Blessing* (1971); *Dismissal—The 1960s* (1971); *Hallelujah* (1971); *Time and Numbers with Acceleration and Deceleration* (1972); *Expression of Opposites* (1972); *Coliseum Piece—Space-Time Cycle* (1972); *Fire, Flood, Olive Tree* (1972); *Collect* (1972); *Hymn to Saint Cecilia* (1972); *Process Composition* (1972); *Cycle* (1972); *Arc* (1972); *English Suite, A Multi-Sensory Experience* (1972); *Now What Is Love* (1972); *Circle of Stones* (1972); *Prelude by Bach* (1972); *Sonnets by Chance* (1972); *The Virtuous Wife* (1972); *Honky Chateau* (1972); *Experimental Dance Drama* (1972); *Orfeo* (1973); *Vibrations, A Kinetic Event* (1973); *Whiskey Place and Wild Like Wine* (1973); *Pluto and Persephone* (1973); *Solo for Video Tape* (1973); *L'Histoire du Soldat* (1974); *Haydn Concerto—Composition for Solo and Group in a Familial Situation* (1974); *The Exciting Wilson Pickett* (1974); *Dance Sequences—Four Saints in Three Acts* (1974); *Places and Spaces* (1974); *Shakti, An Intermedia Event* (1974); *Dance and Mime Sequences—Portrait of Karl Whitaker* (1974); *Realizations* (1974); *Word [Movement] Slide Interlude* (1974); *Interlude* (1974); *Les Noces* (1974); *Meditations on Ecclesiases* (1974); *Shakti* (1975); *Bicentennial Pieces (Fourth of July, American Salute, I Pity the Poor Immigrant)* (1975); *Dance Suite* (1975); *Music Hall Suite* (1975); *Coup de Brass* (1975); *Duet for Two*

(1975); *Tryptich* (1976); *Americana Suite* (1976); *Six Intermedia Pieces* (1976).

Natalie, Mlle., Russian-born American exhibition ballroom dancer also working in England; born Natalie Dumond c.1895 in Odessa; died in summer of 1922 in New York City. Dumond, who did not use her surname professionally, was born in Russia of French and Irish parents but emigrated to the United States at the age of two. She was trained in Buffalo, New York, by Emilie Kiralfy and had a successful local career as a child ballerina. After her family moved to London, she attended the free school attached to the Alhambra Theatre ballet corps. Although she did perform with the ballet, she found more success as the adagio and exhibition ballroom dance partner of Martin Ferrari there. They came to the United States together in 1914 and toured their act for the next seven years. That act was carefully arranged to provide each with personal specialties; they did social and choreographed ballroom numbers, Ferrari's signature adagios, and Dumond's own rose-petal ballet solos. She was also occasionally engaged as a solo specialty ballerina, most notably in the Hippodrome Theatre's extravaganza, *Good Times* (1920). Natalie Dumond died in the polio epidemic of 1922.

Naughton, Harry, Australian ballet and theatrical dancer also working in England; born c.1930. Naughton appeared in the Australian premiere of *Oklahoma* before moving to London to continue his training at the Royal Ballet School. While in England, he danced with the Old Vic's celebrated production of *A Midsummer Night's Dream* and in the West End productions of the American musicals, *Plain and Fancy* and *Bells Are Ringing*. He is best known for the choreography of the musical *Valmouth* (1960).

Nault, Fernand, Canadian ballet dancer and choreographer; born December 27, 1921 in Montreal. After local studies with Maurice Marenoff and Elizabeth Leese, Nault continued his training in New York with Edward Caton, Margaret Craske, and Antony Tudor. After a season at the Radio City Music Hall, he joined Ballet Theatre in 1944. He remained with

that company for eleven years as a dancer, serving as ballet master from 1958 to 1965. Among the many works in which he created roles there were George Balanchine's *Theme and Variations* (1947), Eugene Loring's *The Capital of the World* (1953), Edward Caton's *Triptych* (1952), and Bronislava Nijinska's *Harvest Time* (1955). He played "Hilarion" in *Giselle*, "Von Rothbart" in *Swan Lake*, "Alias" in *Billy the Kid*, and "Mme. Simone" in *La Fille Mal Gardée*.

Nault served as artistic director of the Louisville (Kentucky) Civic Ballet in the 1960s and was named artistic director of Les Grands Ballets Canadiens in 1965, a post which he still holds. Much of Nault's choreography has been created for those two companies.

Works Choreographed: CONCERT WORKS: *Claytonia* (1960); *The Lonely Ones* (1960); *Iskushenye* (1960); *Giosco* (1961); *Latin American Symphoniette* (1961); *Cyclic* (1962); *The Sleeping Beauty* (1963); *Roundabout* (1962); *Carmina Burana* (1962); *Pas d'Eté* (1966); *La Lettre* (1966); *Hip and Straight* (1970); *Tommy* (1970); *Coppélia* (1971); *Cantique* (1974).

Neagle, Anna, English theatrical dancer and actress; born Florence Marjorie Robertson, October 20, 1904 in London. As Marjorie Robertson, she danced in the choruses of André Charlot's *1924 Revue*, the London production of *Rose Marie* (1925), the Charlot 1926 show, *The Desert Song* (1927), *The Trocadero Cabaret* (1927–1928), *This Year of Grace* (1928), and *Wake Up and Dream* (1929), in which she made her New York debut. With her next show, *Stand Up and Sing* (1931), she adopted the pseudonym "Anna Neagle" and moved into the legitimate theater as a stage actress. Although she performed in ENSA variety shows, she did not return to the musical stage in London until 1965, when she began a five-year run of the show *Charlie Girl*, staged by Alfred Rodrigues. Her last song and dance appearance was as "Sue Smith," in the revival of *No, No, Nanette* (1973), the role played by Ruby Keeler in New York.

Neagle is an example of the myopia of this book since, away from the dance, she is one of England's

most beloved actresses, known throughout the country for her portrayals of historical characters in plays and films.

Neal, Frank, American theatrical dancer and artist; born c.1917 in Palestine, Texas; died May 8, 1955 in Astoria, Queens, New York. Neal studied with Katharine Dunham while a student at the Art Institute of Chicago and appeared with her on tour in her concert repertory, in *Stormy Weather* (1943) and on Broadway in *Carmen Jones* (1945). His Broadway credits also included Jerome Robbins's *On the Town* (1944) and *Peter Pan* (1954) and Michael Kidd's *Finian's Rainbow* (1947), for which he served as dance captain. Neal continued his art work, participating in the Americraft cooperative and designing costumes for productions by Talley Beatty's concert groups and for the American Negro Theatre. Neal was killed in a massive auto crash and pile-up in Astoria, Queens, on Mother's Day, 1955.

Nearhoof, Pamela, American ballet dancer; born May 12, 1955 in Indiana, Pennsylvania. Nearhoof was trained at the American Ballet Center, school of the City Center Joffrey Ballet with which she has spent her professional life. A member of the company since 1971, she has appeared in almost every work by the resident choreographer, Robert Joffrey, and Gerald Arpino. Her roles in works by guest choreographers range from parts in Frederick Ashton's *The Dream* to Anna Sokolow's *Opus '65*, Jerome Robbins' *Interplay*, and Twyla Tharp's *Deuce Coupe II*.

Neary, Colleen, American ballet dancer; born May 23, 1952 in Miami, Florida. After local studies, Neary continued her training at the School of American Ballet in New York.

Neary followed her older sister, Patricia, into the New York City Ballet, performing with that company during the 1970s. Like her sister, Neary was associated with the solo woman part in Balanchine works such as the *Tchaikovsky Piano Concerto*, the first movement of the *Brahms-Schoenberg Quartet*, and the *Rubies* section of *Jewels*. Among her created roles in Balanchine ballets were in his *Cortège Hon-*

grois (1973), *Coppélia* (1974, co-choreographed with Alexandra Danilova), *Gaspard de la Nuit* (1975), and *Kammermusik II* (1978). Neary also created roles in John Clifford's *Kodály Dances* (1971), Richard Tanner's *Concerto for Two Solo Pianos* (1971), Lorca Massine's *Ode* (1972), and Jacques D'Amboise's *Sinfonietta* (1975) and *Sarabande et Danse II* (1975).

In 1979, Neary left the New York City Ballet to dance and teach for her sister, Patricia, artistic director of the Geneva Ballet.

Neary, Patricia, American ballet dancer working in Europe after 1968; born October 27, 1942 in Miami, Florida. After training with Georges Milenoff and at the School of American Ballet, Neary performed for a season with the National Ballet of Canada.

Neary joined the New York City Ballet in 1960. In her eight years with the company, she performed in the "extra women" parts in Balanchine works, parts that require perfect balance, precise timing, and expansive movements. The solo role which he created for her in the *Rubies* section of *Jewels* (1967), for example, includes an acrobatic exiting sequence and a pas de cinq in which parts of her body were supported by four chorus men in turn. Neary also performed featured roles in Balanchine's *Apollo, Concerto Barocco, Symphony in C, The Prodigal Son, Ivesiana, Don Quixote*, and *Divertimento No. 15*, as well as John Taras' *La Guirlande de Campra* (1966), and Merce Cunningham's *Summerspace* (1966).

Leaving the company in 1968 to work in Europe, Neary has staged Balanchine works for many ballets there. She has served as ballet master of the German Opera Ballet (1971–1973), and as director of the Geneva Ballet (1973–).

Nebrada, Vicente, Venezuelan ballet dancer and choreographer; born March 31, 1932 in Caracas, Venezuela. Nebrada was trained locally at the school of the Ballet Nacional de Venezuela and the Liceo Andrés Bello.

Although Nebrada performed in France with Janine Charrat and with Roland Petit's Ballets de Paris, he is best known for his work with New York–based companies. He danced with the Robert

Joffrey Theater Ballet in the late 1950s, notably in the premiere of Dirk Sanders' *Yesterday's Papers* in 1959. Associated with the various Harkness Ballets as dancer and ballet master, he choreographed many works for their New York seasons, among them, *Percussion for Six Men* (1972), *Percussion for Six Women* (1973), and the duet, *Memories* (1974).

Since 1975, he has been the director and principal choreographer of Le Ballet du Nouveau Monde International de Caracas. For this troupe, he has restaged his Harkness works and choreographed new ballets, among them *Lento a Tempo e Appassionato* (1978).

Works Choreographed: CONCERT WORKS: *Cain* (1967); *Sebastien* (1972); *Shadows* (1972); *Percussion for Six Men* (1972); *Percussion for Six Women* (1973); *Schubert Variations* (1973); *Memories* (1974); *La Luna y los Hijos que Tenier* (1975); *Nos Valses* (1978); *Lento a Tempo y Appassionato* (1978).

Nedejdin, Serge, Russian ballet dancer also teaching in the United States; born Serge Ossipov, c.1880 in St. Petersburg; died July 22, 1958, possibly in Cleveland, Ohio. Although he followed tradition by receiving his basic training at the School of the Imperial Ballet in St. Petersburg, he transferred to the drama program soon after joining the Maryinsky Ballet in 1898. He performed with Alexander Fokine's Theater of Miniatures as a dancer/actor/mime before leaving Russia to work in Constantinople and Paris as a film director. He returned to ballet after arriving in the United States in the early 1920s, and taught in New York (at the studio of Alexander Gavrilov) and Houston, before settling in Cleveland. From 1932 until shortly before his death he ran a studio and chamber company in Cleveland, producing a number of students who performed with the Ballet Russe de Monte Carlo, including Lorand Andahazy, and possibly Julia Horvath. Although most of his works for his company were national dances, he also produced a *Tennis Dance* that resembled Nijinsky's *Jeux*, *A Lake of Swans* (1937), and a tribute to Cleveland, *Lake Front Stadium* (c.1936).

Neels, Sandra, American postmodern dancer; born September 21, 1942 in Las Vegas, Nevada. Trained in ballet by Nicolas Vasilief and Richard Thomas, she attended classes at the Merce Cunningham studio in New York City. Neels was a member of the Cunningham company for over a dozen years, appearing in many of his most celebrated works of the late 1960s and early 1970s. Among her credits were performances in the premieres of *Variations V* (1965), *How to Pass, Kick, Fall and Run* (1965), *Rainforest* (1968), *Changing Steps* (1973), and *Excerpts* (1974).

Neglia, José, Argentinian ballet dancer; born 1929 in Buenos Aires; died October 10, 1971 in an air crash over Argentina. Trained in Buenos Aires by Irina Borovska and Maria Ruanova, he performed with the Teatro Colón there throughout his short career, from 1947 to 1971. Among his best remembered roles were the principal male part in George Balanchine's *Mozart Concerto*, the title role in Jack Carter's *The Witch Boy*, and "Roderick" in the premiere performance of Leonid Massine's *Usher* (1955).

Nelidova, Lydia, Russian ballet dancer and teacher; born 1863 in Moscow; died there 1929. Trained at the school of the Bolshoi Ballet in Moscow, she spent much of her performing career with that company. From the mid-1880s to the 1890s, she appeared in productions of Marius Petipa's full-evening ballets, most notably in *La Esmeralda* in 1893. She guested in London in Katti Lanner's *Faust* (the Empire Theatre, 1895), but did not attempt to make a career for herself in the West.

Nelidova resigned from the Bolshoi, for reasons that may never be understood, and opened a private studio in Moscow. Despite the competition of the Imperial schools, the studio was successful and her students there included many members of the Diaghilev Ballet Russe, most notably Vera Nemtchimova. Nelidova's daughter, also named Lydia, joined the Ballet Russe for its 1912 seasons and was best known for her roles as Vaslav Nijinsky's partner in his *l'Après-midi d'un Faune* and in Mikhail Fokine's *Le Dieu Bleu*.

Nelson, Gene, American theater and film dancer; born Eugene Berg, March 24, 1920 in Seattle, Washington. Raised in Santa Monica, California, Nelson

made his professional debut in Sonja Henie's *It Happened on Ice* of 1940, staged by Harry Losee. He moved to New York with her 1941 edition, where he met and married Miriam Franklin, known as "The Best Chorus Girl on Broadway." After military service and performances in *This Is the Army*, he returned to New York to appear in the musical revue, *Lend an Ear* (1948). He accepted a contract from Warner Brothers in 1950 and appeared in almost a dozen musicals about backstage characters bursting into song, among them, *Lullaby of Broadway* (1951), *She's Back on Broadway* (1953), and *Tea for Two* (1950). His performance as "Will Parker" in the film of *Oklahoma* (Magna, 1955), led to his engagement in that part in the 1958 City Center revival of that musical.

Nelson dropped out of dance in the mid-1950s to direct and act in television dramas, but reemerged as a musical star to play "Buddy" in Hal Prince's *Follies* (1971).

Nemetz, Lenora, American theatrical dancer and actress; born c.1950 in Pittsburgh, Pennsylvania. Nemetz was trained at Andrea's Dance School and other local studios. She made her Broadway debut as a "Kit Kat Klub Girl" in Ron Field's *Cabaret* at age twenty, but returned home to work at the Pittsburgh Playhouse for further training and experience. In 1975, she served as standby for both of the female leads, Gwen Verdon and Chita Rivera, in Bob Fosse's *Chicago*. She went on for Verdon in a highly publicized period of previews but danced on stage longest in Rivera's role in the second season of the run. Since *Chicago*, she has danced in *Workin'* (1979), toured with Peter Allen's concert/musical *Up in One*, and presented her own nightclub act.

Nemtchimova, Vera, Russian ballet dancer also performing and teaching in Western Europe and the United States; born 1899 or 1903 in Moscow. Nemtchimova was trained privately by Vera Nelidova and Elizabeth Anderson-Ivantzova. She joined the Diaghilev Ballet Russe in 1915, becoming known for her appearances in the repertory of works by Leonid Massine, including his *Soleil de Minuit* (1915), *Pulcinella* (1920), *Les Matelots* (1925), *Le Tricorne, Zéphir et Flore* (1925) and *La Boutique Fantasque*. She also performed in Bronislava Nijinska's *Les Tentations de la Bergère* (1924) and *Les Bîches* (1924), in her most celebrated role as "La Dame en Bleu."

Toward the end of the Diaghilev era, Nemtchimova left the Ballet Russe to form a troupe with Anton Dolin, performing in his *The Nightingale and the Rose, Revolution,* and *Rhapsody in Blue*, in Nicholas Zverev's *Rondo Capriccioso*, and in chamber productions of Mikhail Fokine's *Les Sylphides* and *Spectre de la Rose*. She performed in C.B. Cochran's 1927 revue with Mikhail Mordkin and in her own Ballets Russes in 1930 before returning to Eastern Europe to dance with the State Ballet of Kaunas, Lithuania, under Zverev's direction.

Nemtchimova emigrated to the United States with René Blum's Ballet Russe de Monte Carlo, creating a major role in Fokine's *L'Epreuve d'Amour* (1937) and doing featured roles in the company productions of *Coppélia* and *Les Sylphides*. She guested in one-act and full-length productions of *Swan Lake* with both Ballet Theatre and the Original Ballet Russe before retiring to teach in her celebrated studio at The Ansonia Hotel in New York City.

Neri, Gaetano, Italian nineteenth-century ballet dancer and choreographer also working in the United States; born December 14, 1821 in Milan; died 1852 in Philadelphia, Pennsylvania. Neri was trained by Carlo Blasis at the school attached to the Teatro alla Scala. He became a member of that company, but also guested and choreographed for the Teatro Carigniano in Turin and the Teatro Grande di Brescia in the late 1840s.

In 1848, he and his frequent La Scala partner, Giovana Ciocca, accepted an invitation from Thomas Hamblin to perform in New York City. They made their debuts together at the Park Theatre, but soon had to vacate to make way for the Monplaisir Ballet Troupe. For the next two years, Neri, Ciocca and the American dancer George Washington Smith formed an uneasy trio that presented carefully balanced ballets at the Bowery Theatre, New York. At least three of the pieces, *The Abduction of Nina* (1848), *Les Jardiniers* (1849), and *Les Tyrolienes*

(1849), were by Neri, although each evening of performances included solos by Smith. His last dance work was as Lola Montez's partner at the Bowery in Smith's *Betty, The Tyrolian* (1851).

Neri died in Philadelphia in 1852 after almost a year's illness. It is impossible to speculate about the impact he might have had on American dance, but one can suggest that he could have choreographed for at least fifteen more years, either working with Smith to expand the popularity of ballet or in a rivalry that could have had the same effect.

Works Choreographed: CONCERT WORKS: *Il Furioso nell'Isola di San Domingo* (1846, interpolated sequences); *Elvina* (1847, interpolated sequences); *The Abduction of Nina* (1848); *Les Jardiniers* (1849); *Les Tyroliennes* (1849).

Nerina, Nadia, South African ballet dancer working in England after 1946; born October 21, 1927 in Capetown, South Africa. After early training in Capetown with Dorothea McNair and Eileen Keegan, Nerina moved to England to study at the school of the Sadler's Wells Ballet.

As a member of the Sadler's Wells Theatre Ballet (1946) and Ballet Company (1947–), she performed frequently in the ballets of Frederick Ashton, among them *Cinderella* (1948), *Homage to the Queen* (1953), *Variations of a Theme by Purcell* (1955), and *Birthday Offering* (1956); she was particularly noted for her portrayal of "Lise," the heroine and title role of *La Fille Mal Gardée* in his 1960 version. Nerina danced the title role in Robert Helpmann's *Elektra* in 1963 and performed frequently in his *Miracle in the Gorbals*, before retiring in 1966.

Nesbit, Evelyn, American theatrical and exhibition ballroom dancer; born 1884 in Tarentum, Pennsylvania; died January 18, 1967 in Santa Monica, California. Nesbit left her native suburb of Pittsburgh with her mother to work as a model in Philadelphia, primarily for stained-glass designer Violet Oakley. Shortly after coming to New York in 1901, she became one of the city's most popular artists' models. Although she was best known for her appearance in Charles Dana Gibson's *The Eternal Question* (a profile view of "The Gibson Girl," in which her swirls of hair form a question mark around her face), she also worked for illustrators Nell Brinkley and George Grey and photographers Rudolf Eichenmeyer, Joel Feder, and Otto Sarony.

Under personal contract to producer George Lederer, she made her professional stage debut as the gypsy "Vashti" in *The Wild Rose* (1902). Her later shows were all produced by Lederer and included *Tommy Rot* (1902), *Sally in Our Alley* (1902), and *A Girl from Dixie* (1904). She was not, contrary to popular opinion, a member of the celebrated Double Octette vocal group in his *Florodora*, but was in a replacement cast of the dancers who appeared in back of them. It is incorrect to assume that Nesbit's identification as a performer was euphemistic: she had a specialty in each show and was known as an articulate interpretive dancer.

Nesbit is best known, however, for her role in the murder of architect Stanford White by her then-husband, Harry Thaw. It is impossible for a New Yorker to be objective about White; he and his architectural firm transformed the city into a Beaux Arts showcase. It seems, in fact, that no one can be objective about the shooting during a performance of *Mamzelle Champagne* in the Madison Square Garden roof theater. Whatever happened, Thaw, who had been consistently described as a wastrel representing the worst in American youth, was lionized as the defender of a husband's honor, and both White and Nesbit were slandered.

While Thaw, who was eventually freed, was under observation, Nesbit began a successful vaudeville career. Her act (c.1913–1927), consisted of a pantomime (or short story told without words, but with music and gestures rather like an imitation silent film) and three or four exhibition ballroom dance numbers, performed with her partner, Jack Clifford. Her pantomimes were all based on wronged women in bohemian situations, ranging from *Mariette, La Vie Bohemienne* (1914) to *A Roseland Fantasy* (1917). The dances included the Clifford Trot, the Nesbit Tango, In Der Nacht (a waltz), Rouli Rouli (a French sailor dance), the Argentine Tango, the Argentine Polka, and the Evelyn Fox-Trot. Although most of their appearances were on the Keith and Proctor circuits, they also worked in London in the

revue, *Hullo Ragtime* (1916). She was described in *Variety* as "One of the Biggest Draws" in vaudeville, and was engaged frequently for performances. At one time early in their partnership, she and Clifford needed to use the rivalry set-up to get an audience, working in stage competitions with another dance team (Clifton Webb and Bonnie Glass), but soon they were able to get bookings on their own.

She had a short film career, making silent serials about wronged women for William Fox, among them *Redemption* (1917), *Woman Woman* (1910), *Threads of Destiny* (1919), and *Fallen Idol* (1919), in which she played a Hawaiian princess and did her only screen hula. By the mid-1920s, however, she had begun to slip from the industry. She made occasional appearances as an exhibition dancer but was unable to move back into musical comedy. She served as technical adviser on the film, *The Girl in the Red Velvet Swing* (Twentieth-Century Fox, 1955), and advised the writers of articles on the case. At her death at age eighty-one she had become a noted teacher of sculpture in Hollywood, showing a remarkable ability to create works of art in a style similar to that of Stanford White.

Nettles, Gene, American theatrical dancer; born in the 1930s in Jackson, Mississippi. Nettles studied jazz with Walter Nicks at the Katharine Dunham studio in New York City in the summer of 1948 and at the School of American Ballet after 1949. He toured to Paris with the Ruth Page Ballet in 1950 and remained there to work with the Folies Bergère and to serve as ballet master of the Théâtre des Capucines (c.1950 and 1951). After returning to New York via Lee Sherman's Italian musicals, he began to work frequently on television variety shows and in national and European companies of Broadway musicals. Nettles was in the original cast of *My Fair Lady* but returned to Europe to stage television shows in Norway, including the local version of *Your Hit Parade*, *Slagerparaden*. A frequent commuter from Europe, he has taught tap in the United States, Norway, and France.

Neumann, Natanya, American modern dancer and choreographer; born 1924 in New York City; died

there April 1974. Trained at the School of American Ballet and at the Martha Graham school, Neumann joined the Graham company after graduating from Barnard College. In the company, she created roles in her *Dark Meadow* (1946), *Night Journey* (1947), and *Diversion of Angels* (1948).

A 1946 audition winner at the 92nd Street Y, she presented a recital there in 1947. Concerts in 1951 and 1955 seem to be her only other productions of her own works. Neumann taught throughout the 1950s and 1960s at the Neighborhood Playhouse, the Graham School, the Juilliard School, and the American Dance Festival.

Works Choreographed: CONCERT WORKS: *Questing Flight* (1947); *One Returned* (1947); *In the Village of . . .* (1947); *Ardent Prelude* (1951); *A Time to Love* (1955); *Ingenious Dalliance* (1955); *Nocturne* (1955).

Neumeier, John, American ballet choreographer working in Germany; born February 24, 1942 in Milwaukee, Wisconsin. While attending Marquette University, he studied ballet with Sheila Reilly. He then continued his studies at the Stone-Camryn school in Chicago and worked with modern dancer Sybil Shearer in Evanston, Illinois. After working at the Royal Ballet School in the early 1960s, he joined the corps of the Stuttgart Ballet, where he began to choreograph.

His works have almost all been created in German companies—the Stuttgart (1963-1969), the Frankfurt Ballet (1969-1973), and the Hamburg State Ballet (1973–present). Many have been restaged for American companies. He is one of the most successful American choreographers in Germany because he creates works for the German taste, with an emphasis on internal meaning, symbolism, and intellectualization rather than abstract movements. He is best known for his reinterpretations of works, among them his *The Nutcracker* (1971), his *Le Baiser de la Fée* (1972), *Swan Lake* (1976), and *Hamlet Connotations* (1976) which distills the Shakespearean tragedy into a quartet.

Works Choreographed: CONCERT WORKS: *Aria da Capo* (1966); *Haiku* (1967); *Die Befragung* (1967); *Of Innocence and Experience* (1967); *The Only Adventure of the Princess* (1967); *Separate Journeys* (1968);

Stages and Reflections (1968); *Frontier* (1969); *Rondo* (1970); *The Firebird* (1970); *Brandenburg 3* (1970); *Unsichtbare Grenzen* (including Rondo [II], Aria da Capo [II], Frontier) (1970); *Parade* (1971); *Romeo and Juliet* (1971); *The Nutcracker* (1971); *The Rite of Spring* (1972); *Don Juan* (1972); *Daphnis and Chloe* (1972); *Bilder I, II, III* (1972); *Le Baiser de la Fée* (1972); *Desir* (1973); *Scriabin* (1973); *Nacht* (1974); *Meyerbeer/Schumann* (1974); *Die Stille* (The Silence) (1975); *Trauma* (1975); *Mahler Third Symphony* (1975); *Epilogue* (1975); *Petrushka Variations* (1976); *Swan Lake* (1976); *Hamlet Connotations* (1976); *Ein Sommernachtstraum* (A Midsummer Night's Dream) (1977); *StreichQuintett C-Dur von Franz Schubert* (1977); *Joseph's Legend* (1977); *Fourth Symphony* (1977); *Ariel* (1977); *The Sleeping Beauty* (1978); *Kameliendame* (The Lady of the Camelias) (1978); *Elegie* (1978); *Vaslaw* (1979); *Songfest* (1979); *Age of Anxiety* (1979); *Don Quixote* (1979); *Lieb und Leid und Welt und Traum* (Love and Suffering and World and Dream) (1979).

Neville, Phoebe, American postmodern dancer and choreographer; born September 28, 1941 in Philadelphia, Pennsylvania. Neville began her dance studies in her late adolescence with Joyce Trisler and Daniel Nagrin. She was involved with three of the most important collaborative producing organizations for young choreographers in recent years—the Clark Center for the Performing Arts (now a celebrated studio of various techniques), Studio Nine (c.1961), and the Judson Dance Theatre. She performed in works by Carolee Schneemann, Meredith Monk, and Kenneth King, most notably in the latter's *cup/saucer/two dancers/radio* (1964), striding across the room on point in curlers and a girdle. Neville's own works delight her constant audience with their selective movements and intimate scale. She works in a pace that is reminiscent of the determined balances of T'ai Chi, presenting rituals of despair and self-determination.

Works Choreographed: CONCERT WORKS: *Of the Dark Air* (1962); *Remnant* (1963); *Terrible* (1966); *Move* (1966); *Ragaroni* (1966); *Dance for Mandolins* (1966); *Mask Dance* (1967); *Eowyn's Dance* (1967); *Nova* (1968); *Light Rain* (1968, in collaboration with Philip Hipwell); *Edo Wrap* (1969, in collaboration

with Hipwell); *Ninja* (1969); *Caryatid* (1969); *Termination* (1969); *Terminal* (1970, in collaboration with Nicki Goodman); *Untitled Duet* (1970); *Memory* (1971, solo); *Memory* (1972, group format); *Night Garden* (1972); *Triptych* (1972); *Panels I and II; Triptych* (1973); *Panel III; Passage in Silence* (1973); *Solo* (1973); *Cartouche* (1974); *Ladydance* (1974); *Canto* (1974); *Oracles* (1975); *Mosaic* (1976); *Tigris* (1977); *Oran* (1977); *Passage* (1978); *Overcast* (1979); *Sandweaving* (1979); *Dodona* (1980).

Newberry, Barbara, American theatrical dancer and choreographer; born April 12, 1910 in Boston, Massachusetts. Newberry studied at the Metropolitan Opera Company Ballet School, under Rosina Galli, as a member of the children's chorus. She later studied tap and acrobatics at the Merriell Abbott Studio in Chicago.

Newberry made her professional debut as an adolescent in the replacement cast of *Penrod* in 1918. Her adult performances included featured dance roles in *Ziegfeld's American Revue* (1926), *Betsy* (1926), *Golden Dawn* (1927), *Show Boat* (replacement cast, 1929), and two musical comedies in which she co-starred with Carl Randall, *A Little Racketeer* (1932) and *Pardon My English* (1933).

With Randall, Newberry staged the dances for the stage version of *The Gay Divorce* in New York (1932) and London (1933). Remaining in London, she co-directed the *Monte Carlo Follies* (1933) at the Dorchester Hotel, and performed in *Love Laughs* (1935). Newberry's solo choreographic credits include two seasons of Prologs for the Balaban and Katz chain of Midwest theaters (1927–1928) and the Broadway show *Take a Chance* (1932).

Works Choreographed: THEATER WORKS: *The Gay Divorce* (1932, co-staged by Carl Randall); *Take a Chance* (1932); *Monte Carlo Follies* (1933); Prologs for the Balaban and Katz chain (1927–1928).

Newman, Claude, English theatrical and ballet dancer; born April 20, 1903 in Plymouth, England; date of death uncertain. Trained by Phyllis Beddells and Mikhail Fokine, he made his debut in Fokine's incidental dances to *A Midsummer Night's Dream* (1924). He performed frequently in London's West End theaters, partnering Jessie Matthews in *One*

Damn Thing after Another (1927), *Wake Up and Dream* (1929), and *Evergreen* (1930), and dancing solo in the London production of *Tip Toes* (1928). He also worked at the Trocadero in London and in cabarets in New York while with shows on Broadway.

As a ballet dancer, Newman performed with the Vic-Wells and Sadler's Wells Ballets from 1931 to 1939, dancing in Ninette De Valois' *The Rake's Progress* (1935) and in the company productions of *Coppélia* and *The Nutcracker*. After the war, he served as a ballet master and principal mime to the Wells, and as a teacher and coach at the Royal Academy of Dancing. He also worked with the latter as a kind of traveling regisseur, adjudicating at examinations and giving master classes and lecture demonstrations to schools in the British Commonwealth countries.

Newman, Rosalind, American modern dancer and choreographer; born November 12, 1946 in Brooklyn, New York. Originally trained by Marjorie Mazia in Brooklyn, Newman continued her studies with Merce Cunningham, Viola Farber, and Martha Graham in whose company Mazia had danced. She has also worked under James Waring, Richard Thomas, and at the University of Wisconsin, Madison, with Don Redlich.

Returning to New York, she performed for Farber, as a charter member of her company, Kathryn Posin, Dan Wagoner, and Twyla Tharp, for whom she participated in the first performances of *Dancing in the Streets of Paris and London . . .* (1969). She began to choreograph in April, 1972 with *Anne and Susan*, forming her company in 1974. She has since created many works for her troupe, which has included choreographers Stormy Mullis and Clarice Marshall and critic Tom Borek. Her popular concerts display her ability to work with props and her extraordinary inventiveness with pedestrian movements.

Works Choreographed: CONCERT WORKS: *Anne and Susan* (1972); *Chapter II* (1973); *Chapter III* (1973); *Orange Pieces* (1974); *Flakes* (1975); *Free Fall* (1975); *Octoberrun* (1975); *Dances, Strange and Familiar, Antique and New, Festive and Otherwise* (1976); *Moorings* (1976, co-choreographed with Tom Borek); *Topaz* (1976); *New Berlin Dances* (1977);

||||| (1977); *Cairn* (1979); *Necessary Adventure* (1979); *Juanita* (1980); *Rope Works* (1980).

Newmar, Julie, American theater, film, and television performer; born Julia Newmeyer, August 16, 1935 in Los Angeles, California. Trained in ballet technique by Bronislava Nijinska and Carmelita Maracchi, Newmar made her professional debut with the Los Angeles Philharmonic at the Hollywood Bowl. She worked as a dance coach for Universal Studies in the early 1950s, but her appearance in *Seven Brides for Seven Brothers* (MGM, 1954) brought her recognition and work as a performer. Michael Kidd, who had staged the dances for *Seven Brides*, hired her to play "Stupefyin' Jones" in the musical comedy version of *Li'l Abner* on Broadway (1956); she later repeated the characterization on film (Paramount, 1959).

Newmar's extraordinarily long legs and expansive movements have also been seen in the stage (1958) and film (Twentieth-Century Fox, 1960) versions of *The Marriage-Go-Round* and on many television shows, among them, *My Living Doll* (ABC, 1964–1965) and *Batman* (ABC, 1966–1968).

Newton, Joy, English ballet dancer; born 1913 in Wimbledon. Trained by Ninette De Valois, Newton performed in her Vic-Wells and Sadler's Wells Ballets in the 1930s. Among her credits were principal roles in the company's productions of *The Nutcracker* and *Coppélia* and De Valois' *The Rake's Progress* (1935), as "The Ballad Singer," *Job*, and *The Gods Go A-Begging*. While serving as ballet master of the Sadler's Wells, she continued to appear in demicharacter roles, including "The Princess Royal" or "Queen" (depending on production) in *Swan Lake*. She was the founding director of the Turkish Ballet School in Istanbul after the war, and a popular faculty member of the Royal Ballet School in the 1960s.

Newton-Davis, Billy, American theatrical dancer and singer; born April 16, in the 1950s in Cleveland, Ohio. Like so many Clevelanders, Newton-Davis began theatrical training and work at the Karamu House. After graduating from Ohio State University, he moved to New York to continue his studies at the

Alvin Ailey American Dance Theatre school and the Alwin Nikolais/Murray Louis Dance Lab, and with choreographers George Faison, Louis Johnson, and Billy Wilson. His Broadway roles have included Wilson's *Bubblin' Brown Sugar*, the Sammy Davis, Jr. revival of *Stop the World, I Want to Get Off!*, and the rock musical *Gottu Go Disco*. He has also been seen Off Broadway and in pre-Broadway musicals, such as *Miss Truth* at the Kennedy Center, Washington, D.C.

Newton-Davis has two other theatrical careers. He is a popular back-up vocalist, working frequently for singer Gloria Gaynor, and has his own nightclub song and dance act that has been seen at the Copacabana in New York and the Improvisation in Hollywood, among many other cabarets.

Nicholas Brothers, American tap dance team; Fayard (born c.1918) and Harold (c.1921) were both born in New York City but began their careers in Philadelphia dancing with their parents' orchestra on radio. The Nicholas Brothers worked in both black and white nightclubs throughout their careers and danced on Broadway in George Balanchine's *Babes in Arms* (1937), *St. Louis Woman* (1946), the *Ziegfeld Follies of 1936*, and *Sammy* [Davis, Jr.] *on Broadway* (1963). They were regulars at the downtown Cotton Club, the Apollo, and Ken Murray's Blackouts in Hollywood. They are best known for their film dance sequences for Twentieth-Century Fox. Although seldom given lines to speak, they were seen in dance scenes interpolated into the films, most of which were choreographed by Nick Castle. They did their own numbers in the big band backstage musicals, like *Sun Valley Serenade* (1941) and *Orchestra Wives* (1943), and in Broadway backstage musicals like *Tin Pan Alley* (1940), *The Great American Broadcast* (1941), *Stormy Weather* (1943), and their debut, *The Big Broadcast of 1936*. The ultimate Nicholas Brothers' number may be the one interpolated into *Stormy Weather*: they work on a double staircase and tap up and slide down their steps. That number also includes their specialty—the jumps into splits over each other's heads that still seem impossible everytime they are seen.

The Nicholases were rediscovered in the late 1970s in the light of compilation films. They created a lec-ture-demonstration to go with screening of their old movies and have toured it on college campuses where they are adored. Harold Nicholas has also had a solo career as a tap dancer and drummer.

Nicholas, Bryan, Cuban-American theatrical dancer; born in Havana, Cuba. After stock work in Florida, where he was raised, and the New York metropolitan area, Nicholas began an almost unbroken stream of dance credits. He appeared in Miguel Godreau's *Sancochio* at the Public Theater downtown, and has been applauded on Broadway in Gower Champion's *Irene* revival, Bob Fosse's *Pippin*, the unsuccessful *King of Hearts*, and the very popular Sandy Duncan revival of *Peter Pan*. He was reunited with the individualist style of Fosse in the revue, *Dancin'*.

Nicholoff, Michael, American ballet dancer; born July 28, 1896 in Boston; died July 30, 1971 in Columbia, Pennsylvania. Nicholoff began his studies at the dance studio of Lilla Viles Wyman where his mother was pianist and accompanist. He later continued his training under Ivan Clustine as a member of the Anna Pavlova company. Nicholoff joined the troupe on tour in 1917, remaining with it for nine years. During one lay-off, however, he took time out from his work with Pavlova to partner an even more demanding woman, Mistinguett (who had just lost her partner, Earl Leslie) in Paris.

When he returned to the United States in 1926, Nicholoff opened a studio in Hartford, Connecticut, where he taught for six years. He moved to Baltimore, Maryland, in 1934, teaching there until he retired in the mid-1960s. He was involved in opera productions in Boston, Hartford, and the Baltimore/Washington area.

Nichols, Kyra, American ballet dancer; born July 2, 1958 in Berkeley, California. After early training with her mother, Sally Streets, a former New York City Ballet company member, Nichols moved to New York to study at the School of American Ballet.

Since joining the New York City Ballet in 1976, she has performed featured roles in many works by Jerome Robbins, notably his *In the Night*, and by George Balanchine, who has used her lyrical line and flawless technique in his *Agon, Ballo de Regina,*

Concerto Barocco, Cortège Hongrois, Divertimento No. 15, Symphony in C, and *Who Cares?* Robbins has cast her into three new works—his section of *Tricolore* (1978), the *Verdi Variations* part of *A Sketch Book* (1978), and the enhancement of the latter, the *Spring* section of *The Four Seasons* (1979).

Nickel, Paul, American ballet dancer; born 1941 in Detroit, Michigan; died June 24, 1975 in New York City. Nickel was brought to New York as a young child and trained entirely at the School of American Ballet. He made his debut as a dancer at the age of twelve playing the child "Billy" in the telecast version of Eugene Loring's *Billy the Kid* (*Omnibus,* CBS, 1953). He then created the title role in George Balanchine's *The Nutcracker* in February of 1954.

Nickel joined the New York City Ballet in 1959, performing featured roles in Balanchine's *Seven Deadly Sins* (revival), *Stars and Stripes,* and *The Figure in the Carpet.* He was also one of the few ballet dancers to perform in Martha Graham's section of *Episodes,* creating the role of the "Herald" in 1959.

In 1961, Nickel joined the American Ballet Theatre, with which he remained until his death. He performed many roles, among them "Gurn" in *La Sylphide,* "Hilarion" in *Giselle,* and "Garrett" in *Billy the Kid.* A favorite with choreographers, Nickel created roles in many works at ABT, including Bentley Stone's *Gardenfest* (1968), and Dennis Nahat's *Momentum* (1968).

After retiring from performance, Nickel served as assistant stage manager for ABT until his death from leukemia.

Nielsen, Augusta, Danish nineteenth-century ballet dancer; born Feburary 20, 1822 in Copenhagen; died there on March 29, 1902. The daughter of an attendant at the Royal Theatre, Nielsen was trained at the school of the Royal Danish Ballet.

In the company, Nielsen was assigned to replace Lucille Grahn in her principal roles, among them, the title role in *La Sylphide* from 1839. She created roles in Auguste Bournonville's *Toréadoren* (1840) and in François Lefebre's *Nymphen Cloris ved Dianas Hof* (1846), as the "Goddess Diana." Her most popular dances were two national divertissements, *La Cracovienne* and *La Lithuanie.*

Nielsen performed briefly at the Paris Opéra, after training from Jules Perrot, in Lucien Petipa's incidental dances to *La Juive.* She also worked at Her Majesty's Theatre, London, in her national dance repertory before retiring in 1848.

Niemeyer, Joe Wilmot, American tap dancer known as "Lone Star Joe"; born c.1893 in Galveston, Texas; died September 27, 1965 in Santa Monica, California. Niemeyer grew up in Galveston in a theatrical family. His father managed the local vaudeville theater and his mother, then retired, had been May Smith of the celebrated Smith Sisters. After making his debut in his father's theater, he moved to New York to begin a fifteen-year almost continuous performance career on Broadway. He was a specialty eccentric dancer in *Top of the World* (1907), *Prince for Tonight* (1909), *Golden Girl* (1909), and *Miss Nobody from Starland* (1910) before becoming a member of the Lew Fields stock company and being cast in his musical comedies. His best remembered Fields show, *A Lonely Romeo* (1919), which included almost a dozen eccentric dance solos, brought him to the attention of George M. Cohan who cast him in his next three musicals, *Mary* (1920), *The O'Brien Girl* (1921), and *Little Nellie Kelly* (1922).

Niemeyer also had a successful career in vaudeville. In the 1910s his nickname, "Lone Star Joe," gave way to another one, "Lonely Romeo," since he had a reputation for losing his partners after a single tour, working successively with Nina Payne, Alice Eis, in her *Shadow of Pajai,* and Una Fleming. The partnership with Fleming was successful and longlasting, however, and they worked together in vaudeville and on the Publix Prolog circuit until the mid-1920s.

Nijinska, Bronislava, Russian ballet dancer and choreographer; born January 8, 1891 in Minsk; died February 22, 1979, in Pacific Palisades, California. Nijinska's parents, Tomas Nijinsky and Eleanora Berenda, were ballet dancers who, at the time of her birth, toured Poland and Russia with a small group of itinerant performers. Nijinska, and her brother Vaslav, were enrolled in the Imperial Ballet School in St. Petersburg; her teachers there included Enrico Cecchetti, Mikhail Fokine, and Nicholai Legat. In

1908, she graduated from the school and joined the Maryinsky company. While in that company, she danced many solo roles in the classical repertory, including the Gold and Silver Variations in *The Sleeping Beauty* (Act III) and the Cygnets in *Swan Lake*.

In 1909, Nijinska joined Diaghilev's Ballet Russe while on leave from the Maryinsky company. In the Ballet Russe, she created roles in Fokine's *Le Carnaval* (1910), and Nijinsky's *l'Après-midi d'un Faune* (1912), and danced featured roles in Fokine's *Petrouchka, Les Sylphides*, and *Prince Igor*.

Nijinska returned to Russia during the First World War, teaching in St. Petersburg and Kiev. Her first choreographic works date from this period.

Nijinska returned to the Diaghilev Ballet Russe in 1921 as choreographer, the only woman to work for Diaghilev in that capacity. Among the works that she created in this company were the abstract *Les Noces* (1923), and the satires of contemporary social mores, *Les Biches* (1924), *Le Train Bleu* (1924), and *Roméo et Juliette* (1926).

In the next five years, she did new ballets for a number of European and South American companies, among them, the Ida Rubinstein Ballet, for which she created *Boléro, Le Baiser de la Fée*, and *La Valse*, the Russian Opera of Paris, and her own Théâtre de Danse, in Paris.

In 1931, Nijinska choreographed Max Reinhardt's *Tales of Hoffmann* in Berlin; three years later, she was asked to stage the dances for his American film version of *A Midsummer Night's Dream*. This was to be Nijinska's only commercial film.

From 1935 through the early 1950s, she choreographed for a multitude of ballet companies in Europe and the United States. These included the Ballet Russe de Monte Carlo, the (Alicia) Markova–(Anton) Dolin Ballet, the Polish National Ballet, Ballet Theatre in its charter seasons, the American Ballet Russe de Monte Carlo, for which she choreographed *Ancient Russia* (1943), and the Ballet International, which performed her *Pictures at an Exhibition* (1944) and *Brahms Variations* (1944). In 1945, she returned to Ballet Theatre, choreographing more works for that company, among them, *Harvest Time* (1945) and *Schumann Concerto* (1951).

In the 1960s, Nijinska's choreography was given retrospectives and revivals in the United States and Europe. Her neoclassical, abstract works were as popular with contemporary audiences as they had been at their premieres.

Works Choreographed: CONCERT WORKS: *La Tabatière* (1914); *Etude* (1920); *The Three Ivans* (1921, from *The Sleeping Beauty*, Act III), *Le Rénard* (1922); *Les Noces* (1923); *Les Biches* (1924); *Les Facheux* (1924); *Les Tentations de la Bergère* (1924); *Le Train Bleu* (1924); *Roméo et Juliette* (1926, in collaboration with George Balanchine), *Une Nuit sur le Mont Chauve* (1926); *Impressions de Music-Hall* (1927); *Boléro* (1928); *La Bien Aimée* (1928); *Le Baiser de la Fée* (1928); *La Princess Cygne* (1928); *Nocturne* (1928); *Les Noces de l'Amour et de Psyche* (1928); *La Valse* (1929); *Aubade* (1929); *Les Variations* (1932); *Les Comediens Jaloux* (1932); *Hamlet* (1932); *Les Cents Baisers* (1935); *Danses Slaves et Tziganes* (1936); *La Légende de Cracovie* (1937); *Concerto de Chopin* (1937); *Le Chant de la Terre* (1937); *La Fille Mal Gardée* (1940, after D'Auberval); *Ancient Russia* (1943); *Pictures at an Exhibition* (1944); *Brahms Variations* (1944); *Harvest Time* (1945); *Rendez-vous* (1945); *In Memoriam* (1949); *Schumann Concerto* (1951).

THEATER WORKS: *Tales of Hoffmann* (1931).

FILM: *A Midsummer Night's Dream* (WB, 1934).

Nijinsky, Vaslav, Russian ballet dancer and choreographer, considered the greatest male dancer of the twentieth century. Despite the brevity of his career (which lasted less than one dozen years), he is remembered as an extraordinary technician and an innovative choreographer; born February 28, 1890 in Kiev; died April 8, 1950 in London. His parents, Tomas Formich Nijinsky and Eleanora Berenda, were both dancers; his sister, Bronislava Nijinska, was a dancer with the Ballet Russe and, like her brother, a choreographer who extended the dramatic possibilities of ballet technique.

Nijinsky entered the Imperial School of Dancing, St. Petersburg, in September 1900. In his seven years at the school, he studied with Nicholai and Serge Legat, Pavel Gerdt, Mikhail Oboukhov (from 1902), and Enrico Cecchetti (after 1907). He performed in school demonstrations from 1905, when he appeared

in *Acis et Galatea*, choreographed by Mikhail Fokine, and, in March 1906, he danced the role of "Chief Elf" in Fokine's staging of incidental music from *A Midsummer Night's Dream*. His reputation grew while he was still a student after he began to perform in ballet divertissements interpolated into opera productions at the Maryinsky Theatre, among them Fokine's incidental dances from *Don Giovanni* and his *Eunice*. After graduation (April 29, 1907), he partnered leading dancers Tamara Karsavina, Mathilde Kschessinskaia, and Anna Pavlova in leading roles in the classical repertory, including *Giselle*, Petipa's *The Hunchbacked Horse, The Magic Mirror, Paquita, Le Roi Candaule, Le Talisman*, Fokine's *Le Pavillon d'Armide* and revised *Chopiniana*.

Nijinsky was introduced to Western European fame in the first performance of Serge Diaghilev's Ballet Russe, May 19, 1909. He was with this company for less than seven years, but performances in Paris, London, Spain, the United States, and South America spread his reputation throughout these countries' intelligentsias. In that Paris debut, he performed featured roles in the revised *Le Pavillon d'Armide* and the "Princesse enchantée" section of *Le Festin* (now known as the Bluebird pas de deux). In the European performances, as in Russia, he created roles in the ballets of Mikhail Fokine, among them *Spectre de la Rose* (1911), *Petrouchka* (1911), *Narcisse* (1911), and *Le Dieu Bleu* (1912).

He was dismissed from the service of the Imperial Theatres in June, 1911, after an incident described at the time as "scandalous." Nijinsky's refusal to wear the prescribed costume, omitting the long trunks, caused the management to drop his contract. Sources differ as to the veracity of Anatole Bourman's contention that this rift with the Imperial Theatres was precipitated by Diaghilev in order to free him from the long-term contract.

Nijinsky's early ballets, choreographed between his dismissal from the Imperial Theatres and his break with Diaghilev, *L'Après-midi d'un Faune, Jeux*, and *Sacre du Printemps*, were characterized by their uses of movement vocabularies derived from Archaic Greek art and contemporary sports rather than the fashionable reliance on conventional ballet and Orientalesque techniques. The contemporary au-

diences rejected all three ballets, preferring to see Nijinsky in Fokine's more romantic works.

Nijinsky's 1913 marriage to Romola de Pulszky caused a rift with Diaghilev which separated him from the repertory and creative possibilities that he had found with the Ballet Russe. In February 1914, he made his first attempt to create a separate company in the image of Diaghilev's. He signed a contract with Alfred Butt of London's Palace Theatre (Pavlova's London base) to produce ballets for a six-week season. Nijinsky hired thirty-two dancers, among them his sister, Bronislava Nijinska, and her husband Alexander Kotchetovsky, to perform in *Spectre de la Rose, La Princesse enchantée*, and *Les Sylphides*. It is not known whether Fokine gave (or was asked for) permission to dance his choreography for the first two ballets; *Les Sylphides* was billed as having revised choreography by Nijinsky himself, and the order of its individual segments is distinctly different from Fokine's original. This season was cut short by his illness, and the Nijinskys' return to Budapest.

As a Soviet enemy alien, he was interned in Austro-Hungary during World War I; during this period of forced retirement, he worked on a system of dance notation with which he hoped to conserve his choreography. He was released from Austro-Hungary through the intervention of Otto Kahn of the Metropolitan Opera Company and the Metropolitan Musical Management Bureau, who wanted him to join the American tour of the Ballet Russe, then in progress. On April 12, 1916, Nijinsky made his New York premiere at the Metropolitan Opera House, performing his leading roles in *Petrouchka, Spectre de la Rose, Prince Igor* and *Schéhérézade*. His reconciliation with Diaghilev did not last long, however, and on May 6, 1916, after Kahn had returned Diaghilev to Europe, Nijinsky was installed as artistic director of the Ballet Russe United States tour.

He planned two new ballets for the Ballet Russe engagements—*Valse Mephisto*, set to music by Liszt, and *Tyl Eulenspiegel*, to the orchestral suite by Richard Strauss, both of which were designed and co-scripted by Robert Edmond Jones. Only *Tyl Eulenspiegel* was performed in public, October 23, 1916. The Ballet Russe tour "under the direction of Vaslav

Nijinsky'' lasted from October 30 through February 24, 1917, and presented the company's standard repertory (e.g., *L'Après-midi d'un Faune, Narcisse, Petrouchka, Schéhérézade, Spectre de la Rose, Les Sylphides*); despite the repertory's slant toward Nijinsky's starring roles, he did not actually perform in many of the tour's fifty engagements. He was generally replaced by Alexander Gavrilov, although this fact was frequently not announced to the audiences.

Nijinsky and the company returned to Europe for the spring of 1917. The second South American tour began on July 4; it was to end with his final public performance. While on this tour, the rumors of his imminent mental breakdown became persistent. Before the return to Europe, where Nijinsky was diagnosed as a paranoid schizophrenic, he performed at a gala to benefit the French and English Red Cross in Montevideo, dancing solos to Chopin.

Nijinsky is believed to have danced only once more in front of an audience—at a Red Cross benefit in Switzerland, March 14, 1918. He danced what may have been an improvised solo set to Chopin piano music.

Between this performance and his death in April 1950, Nijinsky the dancer became subjugated to the created myth. Rumors of his complete cure were distributed at intervals in 1921, 1928, 1937, 1940, 1945, 1948, and 1950, just before his death. Romola Nijinsky's biography of her husband excited public interest in the 1930s, interest that still has not died.

Nijinsky, his performance style and choreography, were popularized by theatrical and fashion magazines in the United States. His personal life was theatricalized through American films. Although the frequently announced filmed biography of Nijinsky has only now been made, two *roman-à-clef* had been released—*The Mad Genius* (WB, 1931), a John Barrymore vehicle that attempted to cash in on both the Nijinsky/Diaghilev mythicized relationship and its similarities to the plot of his earlier *Svengali*, and *The Specter of the Rose* (Republic, 1946), written, produced, and directed by Ben Hecht, from his short story. Nijinsky's own performance technique and style were never filmed, so all attempts to define his status as a dancer objectively can be viewed only through a montage of photographs, drawings, satires, and contemporary reviews. His status as the continuing image of ballet, and, more specifically, male dancing, is still being created.

Works Choreographed: CONCERT WORKS: *L'Après-midi d'un Faune* (1912); *Jeux* (1913); *Sacre du Printemps* (1913); *Tyl Eulenspiegel* (1916); works planned or partially choreographed: *"Bach piece"* (set to piano music from *The Well-Tempered Clavier, The English Suites*, etc.) (1912–1913); *The Legend of Joseph* (1913); *Valse Mephisto* (1916); *Les Papillons de Nuit* (Fall 1917).

Bibliography: Beaumont, C.W. *Vaslav Nijinsky* (London: 1943); Bourman, Anatole. *The Tragedy of Nijinsky* (London: 1937); Buckle, Richard. *Nijinsky* (London: 1971); Krasovskaya, Vera. *Nijinsky* (New York: 1979); Magriel, Paul David, ed. *Nijinsky* (New York: 1947); Niehaus, Max. *Nijinsky* (Munich: 1961); Nijinsky, Romola de Pulsky. *Nijinsky* (London: 1933); *The Last Years of Nijinsky* (New York: 1952); Nijinsky, Vaslav. *The Diary of Vaslav Nijinsky* (New York: 1936); Reiss, Francoise. *Nijinsky* (New York: 1960).

Nikitina, Alice, Russian ballet dancer working in Western Europe; born 1909 in St. Petersburg. Trained at the St. Petersburg School of the Imperial Ballet, she left the country before graduating. She performed in Vienna in the French revue *Oh! Que! Nu!!* (1919), and with Boris Romanoff's company in Berlin before joining the Diaghilev Ballet Russe in 1923. Known for her absolute balance, she was frequently cast in the new ballets by choreographers influenced by constructivist denials of characterization and conventional ballet grace in favor of geometric postures. Frequently partnered by Serge Lifar, she appeared in Leonid Massine's *Zéphyr et Flore* (1925), Bronislava Nijinska's *Roméo et Juliette* (1926), and George Balanchine's *La Chatte* (1927), *Apollon Musagète* (1928), and *Le Bal* (1929).

Lifar also partnered her in Balanchine's duets for C.B. Cochran's 1930 revue in London, among them, *Night, Luna Park* (aka *Freaks*), and *Piccadilly*, and in a single-performance venture called Les Ballets de Serge Lifar (during an off-night from the Cochran revue). She presented a solo recital for herself in Paris in 1932, dancing pieces by Nijinska such as *Le Cirque, Gavotte Russe*, and *Leçon de Danse*. After returning to London to appear in Les Ballets '33, she

joined the Ballet Russe de Monte Carlo in revivals of the Diaghilev repertory.

Nikitina made her operatic debut in a Palermo production of *Rigoletto* in 1938. Although her "Gilda" was well received, she was not able to repeat her dance success in opera, perhaps because World War II cut back on Italian- and German-language productions in England. She began to teach dance in Paris at the end of the war.

Bibliography: *Nikitina, by Herself* (London: 1959); *nb.*, although the book was published in 1959, its discussion ends at 1940.

Nikolais, Alwin, American modern dancer and choreographer, composer, and designer; born November 25, 1912 in Southington, Connecticut. Originally a silent film accompanist and puppeteer, he began to study dance with Hanya Holm, whose assistant he became. He choreographed for the Federal Theatre Project in Hartford, Connecticut, and for an ad hoc group there in the late 1930s and 1940s, moving to New York in 1948 to become director of the theater and dance programs at the Henry Street Playhouse.

At Henry Street for almost twenty years, he was able to develop his concert concept of total theater, in which one mind creates movement to sounds and defines both through the design elements. In his best known works, this results in a performance of elements—dancers transformed into their costumes, reshaped by side lighting, unscaled head-dresses, and set pieces for which they provide the movement and structure. The works are abstractions to the ultimate degree, with no genders, no characterizations, and no plot situations.

Although, or possibly because, he uses his dancers as movements rather than personalities, many of them have become choreographers themselves. It is interesting that none of the dancers, among them, Murray Louis, Phyllis Lamhut, Beverly Blossom, and Carolyn Carlson, works in his style. His total theater concept has had an influence on dance in general, however, introducing lighting effects that were quickly adopted by almost every designer and choreographer in concert or theatrical dance, and promoting the genre of performance in which dancers are dehumanized by design elements. Nikolais also helped promote absolute abstraction as a genre, as did

Merce Cunningham, by denying finally the adage that for every two individuals on stage, a relationship had to exist.

Works Choreographed: CONCERT WORKS: *Eight Column Lines* (1939, co-choreographed with Truda Kaschmann); *American Greetings* (1940); *The Jazzy "20's"* (1940); *Opening Dance* (1941); *American Folk Themes* (1941); *Pavanne:1941* (1941); *Evocation* (1941); *War Themes (Rumor Monger, Complacent One, Defeatist, Terrorist)* (1942); *Metamorphosis* (1942); *Popular Theme* (1942); *Dramatic Etude* (1948); *Extrados (Focus towards Faith, Submission to Faith, Focus towards Self)* (1949); *Opening Suite* (1950); *Heritage of Cain* (1951); *Invulnerables* (1951); *Committee* (1952); *Vortex* (1952); *Masks, Props and Mobiles (Aqueouscape, Noumenom Mobilius)* (1953); *Forest of Three* (1953); *Kaleidoscope* (1953); *Farm Journal* (1953); *Village of Whispers (Web, Glade, Tournament)* (1955); *Kaleidoscope (II, Discs, Pole, Box, Skirts, Bird, Hiop, Straps, Capes)* (1956); *Prism* (1956); *The Bewitched* (1957); *Runic Canto* (1957); *Mirrors* (1958, improvised) *Cantos (of Energy, of Things Wary, of Things Frivolous, of Things of Night, of Two Not Together, of Two Together, of Things Flowing)* (1958); *Allegory* (1959); *Totem* (1960); *Stratus and Nimbus* (1961); *Illusions* (1961); *Imago* (1962); *Sanctum* (1964); *Tower* (1964); *Galaxy* (1965); *Vaudeville of the Elements* (1965); *Somniloquy* (1967); *Premiere* (1967); *Triptych* (1967); *Scrolls* (1967); *Tent* (1968); *Echo* (1969); *Structures* (1970); *Scenarios* (1971); *Foreplay* (1971); *Grotto* (1973); *Kyldex I* (1973); *Scrolls (II)* (1974); *Cross Fade* (1974); *Temple* (1974); *Tribe* (1975); *Styx* (1976); *Triad* (1976); *Guignol* (1977); *Arporisms* (1977); *Gallery* (1978); *Castings* (1978); *Aviary* (1978); *Cent Dom* (1980).

THEATER WORKS: (Note: this list includes children's theater projects.) *The Sabine Women* (1936); *World We Live In* (1937); *Fable of the Donkey* (1947); *Lobster Quadrille* (1949); *Shepherdess and the Chimneysweep* (1949); *Sokar and the Crocodile* (1950); *Starbeam Journey* (1951); *Indian Sun* (1951); *Merry-Go-Elsewhere* (1952); *St. George and the Dragon* (1953); *Legends of the Winds* (1954).

TELEVISION: *Finials* (*The Steve Allen Show*, NBC, March 22, 1959); *Web* (*The Steve Allen Show*, NBC, May 17, 1959); *Kites* (*The Steve Allen Show*, NBC,

May 31, 1959); *Pavanne* (*The Steve Allen Show*, NBC, September 28, 1959); *Ritual* (*The Steve Allen Show*, NBC, October 19, 1959); *A Time to Dance* (WGBH, Fall 1959); *Seascape* (*The Steve Allen Show*, NBC, December 28, 1959); *Noumenon Mobilius (II)* (ATV–Granada Television, December 15, 1962); *Limbo* (CBS, 1968, special); *The Relay* (BBC, 1971, special).

Bibliography: Siegel, Marcia B. "Nik," *Dance Perspectives 48.*

Niles, Doris, American concert and ballet dancer working in Europe; born c.1904 in California. Niles had studied with Mme. Arriaza locally before she moved to New York to work with Mikhail and Vera Fokine. She continued to perform with the various Fokine companies in the early 1920s and was a member of the corps in his 1924 New York concerts. Niles took advantage of her frequent performance tours of Europe to continue her studies there with a variety of teachers, among them Alexander Volinine, Vera Trefilova, Cia Fornaroli, and Vicente Escudero. In 1921, however, she was expert enough to have been engaged as a specialty and ballet dancer at the Capitol Theater, New York's principal Prolog house. She appeared in her own Orientalia numbers, among them *Spear Dances* and "unusual Hindu solos," but also performed in the ballets staged there by then resident choreographer Alexander Oumansky. For the American premiere of *The Cabinet of Dr. Caligari*, for example, she did one of her specialties and appeared in his *Woodland Ballet* (1921). Niles remained at the Capitol until 1925, dancing every week alone, in ballets by Oumansky, Maria Gambarelli, and Chester Hale, and in duets with Leon Leonidoff. Her theatrical career also included appearances at S.L. Rothafel's new theater, The Roxy (1927) and on his radio show, *Roxy's Gang* (NBC Blue, 1927).

Niles' better known career had its beginning in the 1926 trip that she made to Seville, Spain, to expand her training and repertory in Spanish classical and folk dance under José Otero. Although she had presented a recital in New York in 1924, her new Spanish repertory made her famous in the United States and Europe. After returning to Spain in 1928, she began a ten-year series of concerts and theater appearances in France, England, and Spain that lasted until World War II. Although she is considered a Spanish-dance

specialist, Niles, and her partner, Serge Leslie, had one of the largest concert dance repertories of the period. She did her Spanish numbers, among them, *España Cani* (1926), *Alegrias* (1928) and *Albrada del Graciosa* (1938), conventional ballets, such as the *Legends of the Forest* (1928), and *Ballet Bleu* (1931), characterizational ballets, including the popular *Roses of the South* and *Mme. Dubarry* (both 1928), and national dances from India, Cambodia, China, Japan, and the generalized Orient—in other words, a repertory very much like that of Denishawn.

She presented her enormous repertory in recitals and within the context of French variety programs, notably at the Paramount Theatre, Paris (1928) and the various houses controlled in France by English entrepreneur Francis Mangan. She staged full-company ballets for her theatrical presentations, such as *Cameos* (1931), *Les Forces Errantes* (1935), and *Les Ambulants* (1939). The almost constant recital tours of Europe ended in Brussels in 1939–1940, when she and Leslie were forced to return to the United States.

Although she presented a recital in Los Angeles in 1947, she did not continue the scope of her career here. Niles' extraordinary range and performance style have now been forgotten by most Americans and Europeans, and she and Leslie are known only for their extraordinary private collection of dance books and manuscripts.

Works Choreographed: CONCERT WORKS: (It should be noted that the works below were occasionally credited to Niles and her sister, Cornelia Niles, or to Niles and Leslie.) *Dancing Waves* (1924); *Gratitude* (1924); *Wind Dance* (1924); *Classical Suite* (1924); *Character Suite* (1924); *Suspiro Gitana* (1924); *España Cani* (1926); improvised Spanish dances (1926–retirement); *Saint Joan* (1927); *Granada Suite* (1927); *Southern Roses* (solo, 1927); *Danse Gitana* (1927); *Legends of the Forest* (1927); *Cherry Tree Fête* (1927); *Divertissements de l'Opéra* (1928); *Marigolds* (1928, also titled *Black Marigolds* and *Marigolds of India*); *Street Dancers of India* (1928); *Fandanguitto de Huelva* (1928); *Mme. Dubarry* (1928); *Black Eyes* (1928); *Hat Dance* (1928); *Memories of the Ballet* (1928); *Alegrias—Paso Doble* (1928); *Patrio Anadaluz* (1928); *Roses of the South* (full company, 1928); *Danse Orientale* (1929, may have been work from Capitol Theater repertory); *Ballet Bleu* (1931); *Cameos* (1931); *Grand Pas Bril-*

lante (1932); *La Danseuse de Cambodge [Cambodia]* (1932); *Lisebesfreund* (1932); *Glinka Mazurka* (1932); *Les Charmes de la Danse* (1935, title uncertain); *Bolero* (1935); *Peintures Vivantes* (1935); *Au Clair de la Lune* (1935); *Sarachi* (1935); *The Raven* (1935); *Les Forces Errantes* (1935); *The Mongolian Priestess* (1936); *La Castiliana* (1936); *Pierrot Salutant* (1936); *Deux Danses Japonaises* (1936); *Can-Can 1900* (1936); *Marionettes Echapées* (1938); *Caprice Nocturne* (1938); *Mamorie de l'Arena* (1938); *The Unfinished Polka* (1938); *Le Cid* (1938); *Soirée dans Granade* (1939); *Poissons d'Or* (1939); *Albrada del Gracioso* (1939); *Les Ambulants* (1939).

THEATER WORKS: Solos for self in The Capitol Theater Prologs (1921–1925); Solos for self in The Roxy Theater Prologs (1927).

Niles, Mary Ann, American theatrical dancer; born May 2, 1938 in New York City. Niles was trained at a Miss Finchley's Ballet Academy. After partnering Bob Fosse in his early club dates, she made her Broadway debut in *The Girl from Nantucket* in 1945, and has worked in musicals ever since. Among her many appearances have been parts in *Call Me Mister* (1946), *Make Mine Manhattan* (1948), *Dance Me a Song* (1950), *The Shoe String Revue* (1955, replacing Chita Rivera), Donald Saddler's *Shangri-La* (1956), *La Plume de Ma Tante* (1958), Gower Champion's *Carnival* (1961), *Flora, the Red Menace* (1965), Fosse's *Sweet Charity* (1966), and the revivals of *No, No Nanette* (1971) and *Irene* (1973).

Nillo, David, American ballet dancer; born c.1910 in Baltimore, Maryland. Originally an athlete, Nillo studied ballet with Estelle Deni and Edith Joesting in Baltimore, performing with each teacher's concert groups, and in Chicago with Bentley Stone, Laurent Novikoff, and Kurt Graff. There, he danced with the Page-Stone Ballet, the (Grace and Kurt) Graff Ballet, and Page's Federal Theater Project in Chicago.

Coming to New York, he performed with the Ballet Caravan at the World's Fair before becoming a charter member of Ballet Theatre. With that company until the war, he created roles in Anton Dolin's *Quintet* (1940) and *Romantic Age* (1942), and was featured in the repertory's most important character roles, "The Blackamoor" in *Petrouchka* and "Alias" in Eugene Loring's *Billy the Kid*.

After the war, he did not attempt to rejoin the ballet, but worked in nightclubs, cabarets, and early television with his own dance troupe. He was a featured performer in *Call Me Mister* (1948) on Broadway and has recently choreographed touring productions of musicals and operettas, including versions of *The Student Prince* (c.1973) and *My Fair Lady* (c.1976).

Nimura, Yeichi, Japanese concert dancer working in the United States; born March 25, 1897 in Suwa; died April 3, 1979 in New York City. Nimura was trained in the disciplines that are popularly grouped under the headings of Judo and Ju-Jitsu as part of his spiritual education in Japan. After moving to New York to study mathematics at Columbia University, he became interested in dance and continued his training with a wide variety of teachers, among them, former Pavley-Oukrainsky dancer Katherine Edson, Russian emigrés Ivan Tarasoff and Konstantine Kobeleff (each of whom taught ballet, interpretive dance, and ballroom work), and Angel and Elisa Cansino. He was a house tango demonstrator in New York cabarets in the mid-1920s, but made enough of a reputation with his *Sword* and *Spear Dances* to be cast as a specialty dancer in a number of productions. These ranged from Michio Ito's revues, such as *Ching-a-Ling* (closed out of town, 1928) to the musical shows *A Night in Venice* (1929), *Broadway Nights* (1929), and *Taza* (1930). It was his participation in downtown productions, however, that influenced his career, most notably his dancing in the Neighborhood Playhouse's *Israel* and *Prince Igor* (1928), and the League of Composers' *Pas d'Acier* (1931), staged by Edwin Strawbridge.

Although he remained in touch with the New York theater and worked intermittently but successfully as a Prolog director for the Roxy Theater and the Radio City Music Hall, Nimura was best known for his concert programs. Alone, with Lisan Kay (Elizabeth Hathaway) and sharing a recital with Pauline Koner, he presented works based on his Oriental experiences and beliefs. Unlike Ito, who did dances based on other national forms, Nimura created with legibly Japanese pieces or pure abstraction. He established the Ballet Arts Studio in New York in the late 1930s, and taught there, with Kay, for the remainder of his career. Their repertory was based on the pieces that he had created in the 1930s. He did not set pieces

again until 1960. Although he coached Oriental movement throughout his career, specializing in setting vocabularies, rather than dances, for actresses and opera singers, he received full choreographic credit only on one Broadway show, *Lute Song* (1946).

Works Choreographed: CONCERT WORKS: *Sword Dance* (pre-1927); *Spear Dance* (pre-1927); *Life Perpetual* (1930); *Le Chat Hommé* (1930); *Javanesque* (1930); *Wizard Cat* (1930); *The Earth in a Drum* (1930); *Oriental Themes* (*Ceremony, Chi'En Niu and the Spring Maiden, Java*) (1931); *Modern Forms* (*Neko, Ambush*) (1931); *Poème Chinois* (1935); *Céleste sur le Voile Lactré* (1935); *Primeaval* (1936); *Figures of Earth* (1936); *Cleavage* (1936); *Creature Conservations* (a series of untitled solos) (1936); *Figments of Shadow* (1936); *Arabian Nights* (1936); *Sleeve Dance* (1936); *Prelude in the Form of a Dance* (1937); *Etude* (1937); *A Rain in Yedo* (1937); *Hara no Umi* (Lullaby) (1937); *Wind Rhythms* (1937); *Allegro Barbaro* (1937); *Spear Episode* (1937); *Sword Ritual* (1937); *The Dream of General Sang* (1937); *Urvasi* (1937); *Nagare* (1960); *Pas de Deux after Ondine* (c.1962); *Ros Homon* (1962); *Tropic Etudes* (1963); *A Changing Wind* (1963).

THEATER WORKS: Prologs for the Roxy Theater (c.1935, 1937–1938); Prologs for the Radio City Music Hall (1940); *Lute Song* (1946).

Nirska, American concert and theatrical dancer; born c.1905 in Akron, Ohio. The dancer, who was part Russian and part Ojipwa Native American, has never revealed her real name. Raised in New York, she studied ballet with Luigi Albertieri, Ivan Tarasoff, and probably, Albertina Rasch. After making her theatrical debut as a dancer in the *Greenwich Village Follies* of 1923, she was cast in a specialty "Indian" number in Rasch's famous operetta, *Rose-Marie*. She remained with the show through its New York run and danced in it for three years in London before going off on her own as a solo concert dancer in Europe.

Nirska developed her most celebrated number in 1928, while performing in clubs on the French Riviera. The solo, *The Butterfly Ballet*, lasted throughout her forty-year career and never lost either its impact or its popularity. A spiritual descendent of the solos created and performed by Loie Fuller

(c.1891–1925), Nirska's *Butterfly Ballet* was danced within 340 yards of silk attached to bamboo spines. Most of her performances were on European and American tours with her own revue and cabaret troupes, but she occasionally returned to the United States to appear within the contexts of theatrical productions, among them the 1935 edition of the Earl Carroll's *Sketchbook* and more than a score of engagements at the Radio City Music Hall, from 1935 to 1953. She was a regular headliner at the New York Latin Quarter in 1950 and danced in what is believed to be her last performance with the thirty-five pounds of the *Butterfly Ballet* costume in the 1955 production of *Arabian Nights* at the Jones Beach outdoor theater.

Noblet, Lise, French ballet dancer of the Romantic era; born November 24, 1801 in Paris; died there September 1852. Trained at the school of the Paris Opéra, she made her debut there in 1818.

In her twenty-three years with the company, she created many roles, most notably, that of "Effie" in Taglioni's *La Sylphide* (1832). Her other featured roles included "Fenella" in Aumer's *La Muette di Portici* (1828), considered the most important female mime role in the Romantic repertory. Company revivals of Jean Baptiste Blache's *Mars et Vénus* and Aumer's *Astolphe et Joconde* (1827) and *La Belle aux Bois Dormant* (1829) also featured Noblet's elegant style.

At the King's Theatre, London, Noblet performed Emilie Biggottini's roles in Milon's *Nina* (1821) and D'Auberval's *Le Page Inconstant* (1824) to great acclaim.

Noguchi, Isamu, American sculptor and theatrical designer; born Isamu Gilmour, November 7, 1904 in Los Angeles, California. The son of poet Yone Noguchi and Leonie Gilmour, he was raised in Yokohama, Japan, until his adolescence. While a medical student at Columbia he began to work with sculptors Onorio Ruotolo and Gaston Borglum. He may have met choreographer Michio Ito at the latter's Connecticut home in 1923. Noguchi's Guggenheim fellowship in 1927 sent him to Paris, where he worked as an apprentice and stone-cutter for Brancusi, who had a major effect on his sculpture and designs. He

gave his first one-man show in New York in 1924 and presented his first exhibition of abstractions in 1927.

Celebrated around the world for his sculpture, landscaping, and domestic designs of objects and lamps, Noguchi has become equally famous for his theatrical designs. He had been involved in dance work since the early 1930s if only as a member of the appreciative audience and employer of dancers as models. For example, his head of Angna Enters is now in the collection of the American Wing, the Metropolitan Museum of Art. His best known dance designs were created for Martha Graham over a long period that lasted from 1935 for her *Frontier*, to 1967 with her *Cortege of Eagles* (1967), and included work for her *Appalachian Spring* (1944), *Cave of the Heart* (1946), *Night Journey* (1947), *Diversion of Angels* (1948), *Seraphic Dialogues* (1955), *Embattled Garden* (1958), *Acrobats of God* (1960), and *Circe* (1963). He also designed two productions of the Ballet Society—Merce Cunningham's *The Seasons* (1947) and George Balanchine's *Orpheus* (1948), which is still performed by the New York City Ballet in the original Noguchi sets and costumes.

Nordi, Cleo, Finnish ballet dancer and teacher; born 1899 in Kronstadt, Russia. Nordi was trained by Nicholai Legat in nearby St. Petersburg and by George Gé in Helsingford. Although she is considered an expert at maintaining the purity of ballet technique, she first worked as a "plastiqueist," a specialist in interpretive dance forms and vocabularies, with Anna Pavlova. She also appeared, however, in Pavlova's company repertory, for example, in *Chopiniana, Mazurka*, and *Autumn Leaves*, where her plastique background could enable her to form graceful backgrounds for the ballerina assoulata.

One of the most highly regarded teachers in London, she has served on the faculty of the Sadler's Wells Ballet School, modern dance companies and her own studio. She was still giving classes as of July 1979.

North, Alex, American composer and accompanist for concert and modern dancers; born December 4, 1910 in Chester, Pennsylvania. Trained at the Curtis Institute and the Juilliard School, North became a principal composer and pianist for concert dancers

through the members of the New Dance League. He played for its members, and composed and arranged works for Lily Mehlman, Jane Dudley, and Anna Sokolow, whose *Ballad in a Popular Style, Slaughter of the Innocents, Façade*, and *Song of the Semite* he wrote. North also composed music for Hanya Holm, notably for her *The Golden Fleece* and *What Dreams May Come*. North's scores for modern dancers and choreographers also included Martha Graham's *American Lyric* and Valerie Bettis' *Streetcar Named Desire*. North is best known to the general public for his extraordinary scores for documentary and dramatic films, including the atmospheric *Death of a Salesman* and the beautiful fugue in *Who's Afraid of Virginia Woolf?*

North, Robert, American modern dancer and choreographer working in England; born June 1, 1945 in Charleston, South Carolina. North was trained in England at the London School of Contemporary Dance. Returning to New York, he studied and worked with Martha Graham, but then went back to London where he has worked ever since. A member/ choreographer of the London Contemporary Dance Theatre since 1969, he has created many works for that Graham-technique-oriented group. Although many of his works are solo assignments, he has participated in many joint choreographic ventures with ballet dancers, such as Lynn Seymour and Wayne Sleep, and with modern dance choreographers, among them Noemi Lapzeson, Richard Alston, and Siobhan Davies.

Works Choreographed: CONCERT WORKS: *Brian* (1972); *One Was the Other* (1972, co-choreographed with Noemi Lapzeson); *Troygame* (1974); *Dressed to Kill* (1974); *Still-Life* (1975); *David and Goliath* (1975, co-choreographed with Wayne Sleep); *Running Figures* (1975); *Gladly, Sadly, Badly, Madly* (1975, co-choreographed with Lynn Seymour); *Reflection* (1976); *Night Watch* (1977, co-choreographed with Micha Bergese, Robert Cohan, and Siobhan Davies); *The Annunciation* (1979); *January to June* (1979); *The Water's Edge* (1979); *Scriabin Preludes and Studies* (1979).

Notara, Darrell, American ballet dancer; born c.1933 in Chicago, Illinois. Notara was trained in Chicago by Bentley Stone and Walter Camryn.

A member of Ballet Theatre during the 1950s, he created a major role in Agnes De Mille's *Sebastien* (1957), and was featured in character roles in Birgit Cullberg's *Miss Julie*, Herbert Ross' *Caprichos*, De Mille's *Rodeo*, David Lichine's *Graduation Ball*, and Jerome Robbins' *Fancy Free*. Notara left Ballet Theatre to work on Broadway in a series of musicals, notably in Bob Fosse's *How to Succeed in Business without Really Trying*, from 1961.

Novack, Cynthia, American improvisatory dancer and choreographer; born September 6, 1947 in Cincinnati, Ohio. After local training in St. Louis, Missouri, she studied Graham technique with David Wood at the University of California at Berkeley and worked under Margaret Jenkins, Viola Farber, and Merce Cunningham at courses in California and New York. She has also studied non-technique-oriented forms such as Contact Improvisation, Skinner Releasing, and Effort-Shape notation. While a teacher at the State University of New York at Brockport, she began to work with Richard Bull, then chairperson of the program in dance. With Peentz Dubble, they formed the Improvisation Dance Ensemble, now based in New York City. She maintains her links with academic dance, but performs and choreographs with the improvisational group.

Works Choreographed: CONCERT WORKS: (Note: titles after *The Conspirators* by the Improvisation Dance Ensemble [Richard Bull, Peentz Dubble, and Cynthia Novack].) *Brief Lives* (1975); *Waiting* (1975); *Countdown* (1975); *Dance Concert* (1975); *The Next Voice* (1976); *The Longest Dance* (1976, in collaboration with Richard Bull); *Bicentennial Vaudeville* (1976); *Transformations* (1976, *Forecast* section co-choreographed with Susan Foster); *Synchrony* (1977); *One Week at a Time* (1977, ten improvisational concerts in collaboration with Susan Foster); *Déjà Vu* (1977); *Running Time* (1977, in collaboration with Bull and filmmaker Bill Rowley); *Telepathic Duet* (1977, in collaboration with Foster); *All in a Week* (1978, four improvisation concerts with Foster); *The Conspirators* (1978); *Crossovers* (1978); *Story Dance* (1978); *Making Contact* (1978); *Touch and Go* (1979, by Dubble and Novack only); *Trilogy* (1979); *Prologue* (1979); *Slow Blues* (1979); *Solo Set* (1979); *Telltale* (1979); *Cityscape* (1979); *De-tective Story* (1979); *Elisions* (1979, by Novack only); *Suite* (1979); *La Parole* (1979); *Groupdance* (1979); *Recursions* (1980); *Three Sets* (1980); *Relay* (1980); *Onagainoff* (1980); *Soundings* (1980); *My Story* (1980).

Novak, Nina, Polish ballet dancer; born 1927 in Warsaw, Poland. Trained at the Ballet School of the Warsaw Opera, notably by Jan Cleplinsky, Novak came to the United States to perform with the Polish Representative Ballet at the national exhibit at the New York World's Fair (1939–1940). She remained in the United States, working with Bronislava Nijinska and performing in summer stock with Paul Haakon until 1948 when she joined the Ballet Russe de Monte Carlo.

With the Ballet Russe, she created a role in Tatiana Chamie's *Birthday* (1949), and won acclaim in featured roles in *The Nutcracker* pas de deux, *Le Beau Danube, Coppélia*, Balanchine's *Ballet Imperial*, and Massine's *Le Beau Danube* and *Gaîté Parisienne*.

Living in Caracas, Venezuela, Novak formed a company in the early 1970s, Ballet Classico de Nina Novak, for which she restaged productions of the classics and pas de deux.

Noverre, Jean-Georges, French eighteenth-century ballet dancer and choreographer, considered the great theorist of the *ballet d'action* movement; born April 29, 1727 in Paris; died October 19, 1807, in St. Germain-en-Laye, France. Trained in Paris by Jean-Denis and Louis Dupré, Noverre made his performance debut with the harlequinade and ballet company of the Foire St. Laurent during the summer of 1743, in works co-choreographed by Louis Dupré, Jean-Barthélemy Lany, and possibly Marie Sallé. While his theoretical and practical innovations did not emerge until the 1750s, it is likely that he was drastically affected by his work with these three reformers.

Noverre's career was not discernedly different from those of his less innovative contemporaries; he was, basically, an itinerant ballet master, although one with less connection than usual to the Paris Opéra, then the focus of European dance. From Paris, he followed Lany to the Berlin court of Frederick the Great, dancing in his *Armino* (1745) and in other ballets. It is believed that Noverre's first solo

appointment as Maître de Ballet was in Marseilles (c.1748–1749); his earliest known work, *Les Fêtes Chinoises*, was choreographed either for this company or for the opera in Lyon in 1750. That work, as revived for the Paris Opéra-Comique (the successor to the Foire St. Laurent group), gave him his first European reputation as an innovator and brought him his first invitation to stage *ballets d'action* in London.

In understanding Noverre's career, and the spread of his theories, it is important to remember that London, artistically and theatrically, was at this time a colony of Paris. Even the chauvinists of the London theater audiences expected to see a stream of new works choreographed and performed by French dancers. Noverre's London tenures at the Drury Lane (c.1755–1756) and, more importantly, at the King's Theatre (c.1781–1794), were jobs as ballet master to primarily French-trained dancers, among them Jean D'Auberval, Mlle. Théodore, and Gaetan Vestris.

Between periods of employment in London, periods in which he formulated his theories of choreography, mime, performance, and mise-en-scène, Noverre served as ballet master in Lyon (c.1758–1759), and at the opera house and court theatres of Wurtenburg-Teck in Stuttgart. In residence there from 1760 to 1767, Noverre's company included dancer/choreographers Angiolo Vestris, Jean D'Auberval, and Charles Le Picq; the latter two were to establish the *ballet d'action* style in England, Russia, and finally, Paris. From Stuttgart, Noverre moved to Vienna, where he staged ballets and social dance performances for the French-language Burgtheater, the German Theater an der Kärntnerthor, and the Court festivities. Noverre's sole period of employment by the Paris Opéra, in 1776, was sponsored by then Queen Marie Antoinette, who had performed in Noverre's court festivities as a member of the Austro-Hungarian royal family.

Noverre's importance to the development of ballet as a technique and of choreography as a theatrical art does not rely on his own dance works, which have not and probably cannot be successfully reconstructed. Noverre's reputation as an innovator is based on his theories as published in his *Lettres sur la Danse et sur les Ballets* (probably written in London,

but published from Lyon in 1759), and *Lettres sur les Arts Imitateurs en général et sur la Danse en Particulier* (published in 1807). The former volume was widely translated and reprinted throughout Europe; it is probably the most generally read work of dance theory to this day. The second volume, which included a reprint of the original *Lettres*, is less well known, but in many ways is more interesting and innovative. That volume includes, as the responsibility of a ballet master, theories and practical advice on mise-en-scène and architectural acoustics, and one of the earliest known treatises on sight lines and audience focus as a choreographic phenomenon.

Works Choreographed: CONCERT WORKS: *Les Fêtes Chinoises* (c.1750, also performed as *Les Métamorphosées Chinoises*); *Cythère Assiegée* (1754); *La Fontaine de Jouvence* (1754); *Les Matelots* (1755); *Les Réjoissances Flamandes* (1755); *La Provençale* (1755); *The Lilliputian Sailors* (1755); *La Toilette de Vénus, ou les Ruses de l'Amour* (1757); *L'Amour Corsaire, ou l'Embarquement pour Cythère* (1758); *L'Impromptu du Sentiment* (1758); *Les Jalousies, ou les Fêtes du Serail* (1758); *Les Jaloux sans Rival* (1759); *Les Caprices de Galathée* (c.1758); *Les Récrues Prussienes* (1758); *Les Fêtes du Vauxhall* (1759); *Renaud et Armide* (1759); *La Descente d'Orphée aux Enfers* (1759); *Le Jugement de Paris* (1759); *La Mort d'Ajax* (1759); *Le Bal Paré* (1759); *La Mariée du Village* (1759); *Admète et Alceste* (1761); *Amors Sieg uber die Kaltsinnigkeit* (Love's triumph over indifference) (1761); *Die Unverhoffte Zusammenknuft* (The Unforeseen marriage or alliance) (1761); *La Mort d'Hercule* (1762); *Les Fêtes Persanes* (1762, may be same work as *l'Epouse Persane); Psyche et l'Amour* (1762); *Medée et Jason* (1762); *Orpheus and Eurydice* (1762); *Der Sieg des Neptun* (the Victory or triumph of Neptune) (1762); *Der Glückliche Schiffbruch* (the Fortunate Shipwreck) (1763); *Le Triomphe de l'Amour* (1763); *Hypermnestra* (1764); *Der Tod des Lykomedes* (the Death of Lycomede) (1764); *Das Fest des Hymnaus* (the Feast of Hymenaius) (1766); *Der Ruab der Proserpine* (the Rape of Proserpine) (1766); *Diane et Endymion* (1761); *Antoine et Cléopâtre* (1761); *Les Amours d'Henry IV* (1761); *Les Danaïdes* (1761); *Alexandre* (1761); *Ballet Hongrois* (1765?); *Enée et Lavinia* (1766); *Pyrrhus et Polixene* (1766); *Le Tem-*

ple du Bonheur (1766); *Pyramus und Thisbe* (1767); *L'Apotheose d'Hercule* (1767); *Les Petits Riens* (1767); *Der Kleiner Weinleser* (the Little Wine merchant, litt. Vintager) (1768); *Les Bagatelles* (1768); *Thelmire* (1768); *Donchischott* (1768, possibly divertissement); *La Fête des Matelots* (1769); *La Foire Persane* (1769); *Roger et Bradamante* (1771); *Der Gerächte Agamemnon* (the Righteous Agamemnon) (1771); *Die Fünf Sultaninen* (the Five Sultana; but note that in the 1770s, ''Sultaninen'' was the European word for a Turkish gold coin) (1771); *Die Wascherinnen con Cythère* (the Laundresses of Venus) (1771); *La Kermesse Hollandaise* (1771); *La Jalousie* (1772); *Les Brutalités inutiles* (1772); *Le Marriage double* (1772); *Die Quelle der Schönheit und der Hässlichkeit* (the Source of Beauty and Ugliness) (1772); *Iphigenie en Tauride* (1772); *Thésée, ou la Noce Précoce* (1772); *Les Vendages de Tempé* (1772); *Ballet Episodique* (1773); *Adèle de Ponthieu* (1773); *Die Aufnahne des Sancho Panza in der Insel Barataria* (the Reception of Sancho Panza on the Island of Barataria) (1773, may be section of larger work on *Don Quixote*); *Das Unterbrochene Gluck* (the Interrupted luck or happiness) (1773); *Sémiramis* (1773); *Acis et Galateé* (1773); *Vénus et Adonis* (1773); *Les Amours d'Énée et Didon, où Didon Abandonée* (1773); *Die Italiensche Schaeffer* (the Italian Shepherd) (1773); *Les Graces* (1773); *Der Schaeffer Gattung* (possibly misspelling of Gattin [spouse] since title as given means the Species of Shepherd) (1773); *Gli Orazi e gli Curiazi* (1773); *Apelles et Campaspe, où le Triomphe d'Alexandre soi-même* (1773); *Flora* (1774); *Ballo des Amore* (1774); *Ballo Olandese* (1774); *La Statue Animata* (1774); *Das Strassburische Fest* (1774); *Gli Amori de Venere, ossia la Vendetta di Vulcano* (1774?); *Eurthyme et Eucharis* (1774); *Gl' Incidenti, ossia La Dilegneza di Luna* (1775); *La Festa di Villagio* (1775); *Galeas, Duc de Milan* (1775?); *Ritiger e Wenda* (1775?); *Hymenée et Chryseus* (1775?); *Belton et Eliza* (1775?); *Le Premier Age de l'Innocence, où la Rosière de Salency* (1775); *Weiss und Rosenfarb* (White and Red-dyed) (1776); *l'Amore Nascoto sotti i Fiori* (1776); *Die Wöhltätige Fee* (the Beneficient fairy) (1778); *Annette et Lubin* (1778); *Don Quichotte* (1780, may be revision of earlier work); *The Prince of Wales Minuet* (1781, first public performance in 1782); *Les Amans Réunis* (1782); *Le Triomphe de l'Amour Conjugal* (1782); *The Emperor's Cossack* (1782); *Le Temple de l'Amour* (1782); *Apollon et les Muses* (1782); *Les Offrandes a` l'Amour* (1787); *Les Fêtes du Tempé* (1788); *Les Fêtes Provençales* (1789); *Les Folies d'Espagne* (1789); *Les Époux du Tempé* (1793); *Pas de Trois et de Quatre* (1793); *Vénus et Adonis* (1793); *Le Faune Infidel* (1793); *Iphigenia in Aulide* (1793); *Les Noces de Thétis* (1793); *Adelaide, où la Bergère des Alpes* (1794); *l'Union des Bergères* (1794); *La Serva Padrone* (1794).

OPERA: *l'Olimpiade* (1761); *Il Matrimonio per Concorso* (1766); *Alceste* (1767); *Paride e Élena* (1770); *Armide* (1777); *Roland* (1778); *Il Re Teodoro in Venezia* (1787); *La Locandiera* (1788); *Guilio Sabino* (1788); *Il Disertore* (1789); *La Vendemmis* (1789); *La Vittoria* (1794); *I Contadini Bizzani* (1794).

Novikoff, Laurent, Russian ballet dancer associated with the companies of Anna Pavlova; born August 3, 1888 in Moscow; died June 18, 1956 in New Buffalo, Michigan. Trained at the Moscow school of the Imperial Ballet, Novikoff performed with both the Moscow Bolshoi and the Maryinsky in St. Petersburg before joining the company that traveled to Paris with Serge Diaghilev in 1909. He left Diaghilev at the end of that season to partner Anna Pavlova in the companies with which she toured from 1910 to her death in 1931. With Pavlova throughout that time (except for the war years and brief seasons in 1919 and 1920), he danced with her in many works, among them, *Souvenir d'Espagne* (1912), *Amarilla* (1912), *The Fauns* (1921), and *Ajanta's Frescoes* (1923).

During World War I, Novikoff returned to Russia where he worked with the Opera in Moscow. He freelanced for two years after returning to England after the war—partnering Phyllis Bedells in cabaret performances in 1920. He partnered Tamara Karsavina in London from 1919 to 1920, and performed with her in benefits in 1921, in her *Pantaloon* (by J.M. Barrie), and in excerpts from *Sylvia* and *The Firebird*.

Novikoff directed a series of schools in London and Chicago between 1928 and 1932, including the school attached to the Chicago Civic Opera Company from 1929 to 1930. In 1941, he was named ballet master of the Metropolitan Opera, a position which he held until his retirement in 1945. Novikoff's

only known choreography can be divided into two types: divertissements for the Pavlova company (c.1923) and solos for himself created, presumably, for cabaret performances in Chicago (c.1930).

Works Choreographed: CONCERT WORKS: *An Old Russian Folk Lore* (1923); *Don Quixote* (1924, Act I and Prologue after Gorsky); *Grand Pas Hongrois* from *Raymonda* (1927, after Petipa); *Bolero* (1930); *Oceans* (1930).

Noyes, Florence Flemming, American interpretative dancer and theorist in the Greek revival movement; born 1871 in New York City; died there in 1928. Raised in Cambridge, Massachusetts, she was trained at the Emerson College of Oratory where she was given lessons in the American Delsarte system of gestures. She studied dance with Lucia Gale Barber, an important leader in the Greek revival movement in the Boston area. Although she gave two recitals for which, unfortunately, we do not have programs, Noyes was best known as a teacher and lecturer on her own concepts of Greek and universal dance.

Believing that rhythm was a representation of nature and the key to dance, she set up a series of schools and summer camps where she promoted free movement and contact with one's personal rhythms and dance vocabularies. She opened her New York studio in 1912 and established camps in Peterborough, New Hampshire, and in locations in Connecticut. She staged masques for her students there, among them the mythological dances, *Pan and the Mortal* (1914), *Ceres* (c.1916), *Ariadne on Naxos* (c.1918), and *Jason and the Argonauts* (1921). She published her lectures in the volume *Rhythm and the Basis of Art and Education* (New York: 1926), and edited the periodical, *Rhythm*, from 1926 to her death in 1928.

The Noyes camp still exists under the directorship of Valeria Ladd, who has edited Noyes' later writings for publication. Although she claimed that her Greek work, unlike Isadora Duncan's, had a technique and could be retained after her death, none of her choreography has been seen outside her camps.

Nuchtern, Jeanne, American modern dancer and writer; born November 20, 1939. After ballet studies with Margaret Craske, Nuchtern began working with the faculty of the Martha Graham school. As a member of the Graham company, she appeared in much of the repertory and created roles in *Cortege of Eagles* and *Dancing Ground* (both 1967). Many of her noncompany performances were with the concert groups of former Graham dancers, among them Sophie Maslow, Yuriko, and Bertram Ross, for whom she appeared in *Break-Up* (1966). Nuchtern also worked for Yuriko in the 1965 revival of *The King and I*, which she restaged. Since retiring from performance, she has written extensively on dance, most notably as a critic for the *Soho Weekly News*.

Nureyev, Rudolf, Soviet ballet dancer, considered the most widely recognized international dance star; born March 17, 1938 near Irkutsk. Originally trained in folk dance techniques in The Young Pioneers, the Soviet equivalent of the Boy Scouts, Nureyev entered the Leningrad Choreographic School in 1955. After graduating into the Kirov Ballet, he performed leading roles in the company's classical repertory, notably in *La Bayadère, Le Corsair, Don Quixote, Laurencia, The Sleeping Beauty*, and *Swan Lake*.

Nureyev defected to France in June 1961 after a Paris performance on the Kirov's European tour; one week later, he danced the role of "Prince Florimund" in the Robert Helpmann production of *The Sleeping Beauty* with the International Ballet du Marquis de Cuevas in Paris. His professional relationship with the Royal Ballet of England, of which he remains a "permanent guest artist," began with his February 1962 performance in Frederick Ashton's *Poème Tragique*, at a Royal Academy of Dancing benefit gala organized by his frequent partner, Margot Fonteyn. His American live performance debut occurred on March 19, 1962, when he danced in the Grand Pas de Deux from *Don Quixote* with Ruth Page's Chicago Opera Ballet in New York; he had made his U.S. television debut on the January 19, 1962 broadcast of the *Bell Telephone Hour*, as partner to Maria Tallchief.

His first years as an ex-Soviet proved prophetic. His career in Western Europe has been one of constant freelancing, with many different companies, creating roles and reviving the Soviet and Russian repertories. He has performed with the Western Ballet Theatre, the Ballet of the Teatro alla Scala, the Dutch National Ballet, the Ballet du XXième Siècle, the Martha Graham Company, the National Ballet of

Canada, the Paris Opéra Ballet, the Boston Ballet, the American Ballet Theatre, and the companies mentioned above, among many others.

He has presented seasons in New York and London under the inclusive title, Nureyev and Friends, with a repertory of short ballet and modern dances by Americans Paul Taylor, Glen Tetley, and Murray Louis, and Dutch choreographers, Toer Van Schayk and Rudi Van Dantzig.

He has also had a successful subcareer staging productions of full-length ballets, such as *Raymonda* (for the Royal Ballet small company in 1964, the Ballet of the Zurich Opera in 1972, and Ballet Theatre in 1975), and *Don Quixote* (for the Ballet of the Vienna State Opera in 1966 and The Australian Ballet in 1970). He has created different versions of Fokine's *Spectre de la Rose* for German television, and live presentations of *La Bayadère, Swan Lake, The Sleeping Beauty, Tancredi*, and *The Nutcracker*.

Twenty-five years after his first successes, Nureyev remains the most popular and widely recognized dancer around the world. His image is known wherever there is a dance company, fashion magazine, or even a movie house. He also remains a brilliant performer, still able to dance whatever is required of him by classical and modern choreographies.

Works Choreographed: CONCERT WORKS: *Le Spectre de la Rose* (1963); *La Bayadère* (1963, after Petipa and Chabukian); *Raymonda* (1964, 1965, 1972, 1975, after Petipa); *Swan Lake* (1964, after Ivanov and Petipa); *The Sleeping Beauty* (1965, after Petipa); *Tancredi* (1966); *Don Quixote* (1966, 1970); *The Nutcracker* (1969).

TELEVISION: *Le Spectre de la Rose* (Frankfurt Independent Television, 1962, special).

Bibliography: Bland, Alexander, ed. *Nureyev, An Autobiography with Pictures* (London: 1962); *The Nureyev Image* (New York: 1976); Percival, John. *Nureyev: Aspects of The Dancer* (New York: 1975).

Nuyts, Jean, Belgian ballet dancer; born 1949 in Antwerp. Nuyts was trained at the Jeanne Brabants studio in Antwerp and performed with her Ballet of Flanders. After a short tenure with the Nederlands Dans Theater, he joined the Ballet du XXième Siècle in 1974. Apart from a year with the San Francisco Ballet (performing and staging works by Maurice Béjart), he has danced in Béjart's Belgian company since that year. He has appeared in most of his large-scale ballets, such as *Boléro, Notre Faust, Roméo et Juliette, Ninth Symphonie, Offrandes*, and the *Dichterliebe*, in which he played the "Man in Black."

O

Oakie, Jack, American theater and film dancer and actor known as "The King of the Triple Takes"; born Lewis Delaney Offield, November 12, 1903 in Sedalia, Missouri; died January 23, 1978 in Northridge, California. It is difficult to explain Oakie's popularity to a contemporary audience unused to physical eccentricities; he seems only to be a dancing version of Fatty Arbuckle. But Oakie was, for the first fifteen years of his long career, a musical comedy film star, capable of handling complicated tap routines with ease and a reflection of personality that was not revived until Gene Kelly. Oakie made his Broadway debut in George M. Cohan's *Little Nellie Kelly* (1922) after Midwest tours on small vaudeville circuits. He moved up from the chorus to dance specialty status in *Innocent Eyes* (1923), *Artists and Models of 1925*, and *Peggy-Ann* (1927), and partnered Lulu McConnell (later a celebrated radio comedienne) in her vaudeville act.

Oakie moved to Hollywood in 1927 and soon received the first of many contracts from Paramount. He made more than fifty films for that studio, among them most of their early sound musicals. Two years after his debut in *Finders Keepers* (1928), he was popular enough to serve as on-screen emcee in the studio's revue/advertisement *Paramount on Parade* (1930). During the next decade, he was featured or starred as lead dancer and comic as a student, sailor, or unemployed musician in *Million Dollar Legs* (1932), *If I Had A Million* (1932), *Close Harmony* (1929), *Too Much Harmony* (1933), *College Humour* (1933), *College Rhythm* (1934), and *The Collegiates* (1935). Other films from later in his career ranged from father roles in Universal's teen films such as *The Merry Monahans* (1940), to dramatic ones, as in *The Call of the Wild* (1935), to nosy neighbor ones in Doris Day/Rock Hudson comedies. To modern audiences he is best known as "Napolini, Il Duce of Bacteria," ally of Chaplin's *The Great Dictator* (1940), although this is his least typical role.

Oakie made frequent television appearances in the 1950s and remained on radio until the end of that decade, but began to retire as early as 1954.

Oboukhoff, Anatole, Russian ballet dancer also performing and teaching in the United States; born 1896 in St. Petersburg; died February 24, 1962 in New York. Oboukhoff was trained at the school of the Imperial Ballet, graduating into the Maryinsky Ballet in 1913. His graduation performance included a *Chopiniana* in which he partnered Olga Spessivtseva. He portrayed the romantic heroes of the nineteenth-century repertory from 1913 to 1920, when he left the Soviet Union to tour with Boris Romanoff's Ballet Romantique in Europe and South America. On his return from the Teatro Colón, he joined the Diaghilev Ballet Russe for its last seasons.

Oboukhoff came to the United States with the Ballet Russe de Monte Carlo, with which he danced in *Les Sylphides, Giselle, Swan Lake*, and Mikhail Fokine's *Petrouchka* and *l'Epreuve d'Amour*. He served as ballet master of the De Basil Ballet Russe and taught at the School of American Ballet from 1940 until shortly before his death.

O'Brien, Shaun, American ballet dancer and mime; born November 28, 1925 in New York City. Trained at the School of American Ballet, O'Brien performed briefly with the Grand Ballet du Marquis de Ceuvas and with the touring company of Alicia Alonso before joining the New York City Ballet.

Although O'Brien danced in abstract ballets, performing in the premieres of Jerome Robbins' *Age of Anxiety*, Frederick Ashton's *Illuminations*, and George Balanchine's *Pas de Dix*, he is best known for his character work in the company's full-evening ballets. Perhaps the only dancer in the world to be celebrated for his performance as "Drosselmeyer" in *The Nutcracker*, O'Brien has also been highly praised in his unusual interpretation of the character of "Dr. Coppelius" in the Balanchine/Alexandra Danilova production of 1974. Other works in which his character roles have been noted included Birgit Cullberg's *Medea* (revived for the City Ballet in 1958), Jacques D'Amboise's *The Chase* (1963), Balanchine's *Harlequinade* (1965), and Balanchine and Robbins' *Puncinella* (1972), co-created for the Stravinsky Festival.

La Belle Oceana, American nineteenth-century ballet dancer; born c.1835 in the Midwestern United States; date and place of death unknown. Although contemporary newspapers proclaimed her name to be Oceana Smith, La Belle Oceana was the daughter of a Mrs. Bennie, and daughter or granddaughter of

W.H. Bennie, considered one of the best pantomimists in the country. It is likely that she received some training from her family, or from other members of the troupe.

La Belle Oceana made her debut as a child in 1844, doing imitations of Fanny Elssler in Fort Levenworth, Kansas. Although the family troupe was best known for its performances on the Mississippi circuit (St. Louis, Missouri to New Orleans, Louisiana), it is probable that the Kansas booking was part of the family's tour. For the next seven years, she danced with the troupe in progressively larger parts in productions of Romantic ballets; she did her first *La Fille du Danube* in 1845 and her first *Fille Mal Gardée* in 1847. She replaced Emilie Baron at Thomas Placide's Theatre Vanitiés in the early 1850s and traveled on the Mississippi circuit throughout the decade.

The last known mention of La Belle Oceana occurred in 1864; she was then touring in *Mazeppa* with her horse, Black Bess. It is not sure whether she was performing on horseback or on a conventional stage.

O'Connor, Donald, American vaudeville and film dancer; born August 28, 1925 on tour in Chicago. O'Connor's parents were former Barnum and Bailey acrobats who had a flash family act on the Keith circuit in vaudeville. He danced with the act and, with his older brothers, worked as a specialty dancer in a 1937 film, *Melody for Two* (Warner Brothers). Under contract to Paramount, he made a number of films as a child, most notably, *Sing You Sinners* (Paramount, 1938), and *On Your Toes* (WB, 1939), as Eddie Albert as a young man. After another bout with vaudeville, he became a Universal Studios contract teen-ager—for fourteen years. Although best known for his nondance films, the *Francis, the Talking Mule* series, he made a number of musicals for Universal, mostly choreographed by Louis Da Pron. They included *Mister Big* (1943), *The Merry Monahans* (1944), *Patrick the Great* (1945), and a personal favorite, *Curtain Call at Cactus Creek* (1950).

He made four dance films in the 1950s, beginning with the film that is most people's favorite, *Singin' in the Rain* (MGM, 1952). Playing "Cosmo," Gene Kelly's pianist and sidekick, he tapped in the fabulous "Moses Supposes" tongue-twister routine and

stole the film with "Be a Clown." That film best represents O'Connor's unique ability to portray a rather plaintive manic character while dancing. His other films of the period, *Call Me Madam* (Twentieth-Century Fox, 1953), *There's No Business Like Show Business* (Twentieth-Century Fox, 1954), and *Anything Goes* (Paramount, 1956), gave him dance solos and duets, but allowed him to develop as a singer, sharing songs with Ethel Merman.

O'Connor took parts in film and television in the 1960s and 1970s which required dramatic and comic abilities, but little dancing. Two projects of the 1980–1981 seasons, however—a comedy pilot and a Broadway musical—brought his dancing back to an appreciative public, tantalized by glimpses of him in the two *That's Entertainment* films.

O'Curran, Charles, American film dance director; born c.1915. Surprisingly little is known about O'Curran's early life. When he was given his first studio dance direction and coaching contract from Universal in 1946, he was described as a "Broadway performer" but no stage credits can be verified for him. After a year with Universal, he joined the staff of RKO where he worked on *If You Knew Suzie* (1947) and *Honeymoon* (1948), among other films. O'Curran is best known, however, for his long tenure at Paramount Pictures as choreographer and director. He worked on pictures ranging from *The Road to Bali* (1952) to *G.I. Blues* (1960), and staged dance numbers for Bing Crosby, Bob Hope, Dorothy Lamour, Betty Hutton, Betty Grable, Patti Page, and Elvis Presley.

He was also known as a brilliant creator of cabaret acts for vocalists in the Hollywood area, in Las Vegas, and in Reno. He has staged acts for many of the performers on whose films he worked.

Works Choreographed: FILM: *If You Knew Suzie* (RKO, 1947); *Honeymoon* (RKO, 1948); *The Miracle of the Bells* (RKO, 1948); *Somebody Loves Me* (Paramount, 1951); *The Road to Bali* (Paramount, 1952); *King Creole* (Paramount, 1958); *G.I. Blues* (Paramount, 1960); *Bells Are Ringing* (MGM, 1960); *Girls! Girls! Girls!* (Paramount, 1962).

O'Dea, Sunnie, American theatrical dancer; born Marthandrew Bonini, c.1912 in Pittsburgh, Pennsyl-

vania. O'Dea worked on the Orpheum circuit in a children's act before joining the Stars of Tomorrow troupe at the age of twelve. In that touring feature act, she partnered Hal Le Roy in a tap sequence that dazzled the audience with its speed and articulation. O'Dea dropped out of the entertainment industry briefly (probably to attend high school) and studied ballet in Pittsburgh with Frank Eckl. Her many Broadway performances were, however, as a tap dancing soubrette, flirting with the hero and audience alike while performing a tap and soft-shoe solo, and in social dance–based duets and chorus numbers. She split her time between revues, including the *Ballyhoo of '32* and the Earl Carroll *Vanities* of that season, and musical comedies, among them, *Walk a Little Faster* (1932), *Strike Me Pink* (1933, in which she was reunited with Le Roy), and *Let's Face It* (1941). She also appeared in straight romantic plays before leaving Broadway for Hollywood and a contract at Universal Studios. Most of her films were forgettable military musicals of the 1941 genre, such as *In the Navy* (Universal, 1941), *Sing Another Chorus* (Universal, 1941), and *Moonlight in Hawaii* (Universal, 1941), but she did appear in one Fred Astaire picture for Columbia, *You'll Never Get Rich* (1941).

O'Denishawn, Florence, American theatrical dancer; born Florence Andrews, c.1900. Raised in Southern California, she was trained at the Los Angeles Denishawn school. As a member of the various Denishawn concert groups from 1915 to 1918, she appeared in the group version of Ruth St. Denis' *The Peacock*, Ted Shawn's *Dog Dance* (1915), and their collaborative *Death and After-Life in Egypt, Greece and India* (1916). After changing her name to O'Denishawn, she purchased solo dances from Shawn and began to work in Chicago-area clubs as a specialty dancer. She was seen there by Raymond Hitchcock who hired her for his *Hitchy-Koos of 1920* and *1922*. In these revues and in the *Ziegfeld Follies of 1921*, she did solos within the Denishawn tradition of Orientalia, but with less reliance on costuming and more on dance movements. Her "Legend of the Cyclamen Tree" in the *Follies* was considered the hit of the season for its delicacy and grace although she was rooted to the stage floor throughout and could move only her torso and arms.

Apart from her Broadway work, O'Denishawn also appeared in vaudeville with the act of Nelson Snow and Charles Columbus. These two dancers were considered among the best ballet specialists in the country, but their act also included adagio works for two and three performers. From their schedules, it would seem that O'Denishawn alternated in the act with Harriet Hoctor, whom many consider the best acrobatic ballet dancer of the period.

O'Denishawn retired in the mid-1920s after an injury on stage. She can still be seen in her glorious dance acts in photographs, however, and can be recognized as the model for Harriet Frishmuth's statue of Papillon, which still stands on the top of a building in Minneapolis.

O'Donnell, May, American modern dancer and choreographer; born 1909 in Sacramento, California. O'Donnell studied locally with Estelle Reed, with whose chamber group she performed, and with Martha Graham in New York. A member of the Graham company from 1932 to 1938 and 1944 to 1952, she created roles in her *Tragic Patterns* (1933), *Celebration* (1934), *American Provincials* (1934), *Panorama* (1935), *American Lyric* (1937), *Appalachian Spring* (1944), *Herodiade* (1944), *Dark Meadow* (1946), and *Cave of the Heart* (1946), among many others.

She returned to the Bay area in 1938 to organize the San Francisco Dance Theatre with Gertrude Shurr. In collaboration with José Limón, she toured across the country between 1941 and 1943, performing in her *On American Themes, Praeludium*, and *War Lyrics*.

Retiring from performance after her second Graham tenure, she taught at the High School of Performing Arts and at a studio co-founded with Shurr. After her first solo recital in 1945, she gave concerts of her own choreography throughout the 1950s and in the late 1970s. Her works employ the measured movement and pacing of Graham's, but with more human character, freed from the strictures of universality.

Works Choreographed: CONCERT WORKS: *Of Pioneer Women (Sarah Goes a Courtin', Markers on the Trail, Jubilation for a Frontier)* (1937); *Running set* (1939); *So Proudly We Hail (Cornerstone, Hymn, Tunes, Of Pioneer Women, Our Rivers Our Cradles,*

Dance Set, Epilogue from Cornerstone) (1940); *On American Themes (Curtain Raiser, . . . this story is legend, Three Inventories of Casey Jones)* (1941, possibly co-choreographed with José Limón); *Dance Theme Praeludium: Dance Theme and Variations* (1941); *Suspension* (1943); *Celtic Ritual* (1949); *Forsaken Garden* (1949); *Horizon Song* (1949); *Jig for a Concert* (aka *Fanfare in Jig Time*) (1949); *Act of Renunciation* (1952); *Dance Sonata, No. 1* (1952); *Magic Ceremonies* (1952); *The Queen's Obsession* (1952); *Ritual of Transition* (1952); *Spell of Silence* (1952); *Dance Concerto* (1954); *Legendary Forest* (1954); *Incredible Adventure* (1955); *Lilacs and Portals* (1956); *Second Seven: The Drift, The Threshold* (1956); *Dance Sonata, No. 2* (1956); *Dance Energies* (1958, work continued to be revived through 1974); *Figure of the Individual* (1958); *Dance Sonatinas (Polka Sonatina, Song Sonatina, Cowboy Sonatina)* (1958); *The Haunted* (1959); *Sunday Sing Symphony* (1961); *Dance Scherzos* (1962); *The Pursuit of Happiness* (1977); *Vibrations* (1978); *Homage to Shiva* (1980).

Offenbach, Jacques, French nineteenth-century composer of operettas; born 1819 in Deutz, Germany; died 1880 in Paris. There are questions about the legal name of the composer, who took his pseudonym from the family's most recent place of national origin in Offenbach am Mainz. Trained at the Paris Conservatory, he played in the orchestra of the Opéra-Comique and served as conductor of the Théâtre François in the 1850s. He composed almost a hundred operettas and pantomimes for theaters in Paris and London, most frequently for his own Théâtre Comte, Les Bouffes-Parisiennes. Following the traditional structure of the period, he included dance music sequences in each of his operettas, his single ballet, *Le Papillon* (1860), and in his two grand operas. His best remembered single segment of music is the Quadrille from *Orphée aux Enfers* (1858), because it was associated with the quartet of Can-Can dancers who performed to it at the theaters of the Moulin Rouge. Many twentieth-century ballets have been set to music from existing Offenbach scores, among them the following: *La Belle Hélène* (1955, by John Cranko), *Barbe-bleu* (1941) and *Helen of Troy* (1942) for Mikhail Fokine, (1954) . . . *in the Underworld* for Antony Tudor, and Leonid Massine's *Gaité Parisienne* (1938).

Ohman, Frank, American ballet dancer; born January 7, 1939 in Los Angeles, California. Trained at the school of the San Francisco Ballet by Harold Christensen and at the School of American Ballet in New York, he performed with the New York City Ballet during the 1960s and early 1970s.

He performed in almost all of the repertory of works by George Balanchine, including his *Four Temperaments, Western Symphony, Allegro Brillante, Agon, Episodes*, and *Slaughter on Tenth Avenue*. He created roles for Balanchine in *Don Quixote* (1965), *Trois Valses Romantiques* (1967), *PAMTGG* (1971), and *Who Cares?* (1970), where his casual style enlivened the "Biding My Time" dance routine. Ohman has frequently performed in works by fellow dancers, among them Jacques D'Amboise's *Irish Fantasy* (1964) and *Prologue* (1967), and John Taras' *Concerto for Piano and Winds* for the 1972 Stravinsky Festival.

Although he still performs with the company, especially in *Who Cares?*, Ohman now serves as ballet master for the New York Dance Theater and for companies in New Jersey.

Olenewa, Maria, Russian ballet dancer and teacher in South America; born c.1900 in Moscow. Trained at the Moscow studio of Lydia Nelidova, she moved to Paris in 1917 and performed with the company of Maria Konznetzova at the Théâtre des Champs-Elysées. She joined the Anna Pavlova tour in Paris and performed with her in the United States and South America until the early 1920s. After dancing with the Vienna Opera, she moved to Buenos Aires to direct the training of the pick-up corps de ballet for Leonid Massine. She remained in South America for the remainder of her career.

She founded the school of the Teatro Municipale in Rio de Janeiro in 1927, also serving as ballet master to the theater. In 1943, she moved to Sao Paulo to become head of the ballet school there until 1957, when she opened a private studio.

Olenewa is generally considered a major factor in the development of classical ballet training and performance in South America.

Works Choreographed: CONCERT WORK: *Evocation of Two Periods* (1959).

Oliphant, Betty, English ballet dancer associated with the National Ballet of Canada since the early 1950s; born 1918 in London. Trained in London by Tamara Karsavina and Laurent Novikoff, she performed with the Ballet Rambert and in West End musicals and Christmas pantomimes before moving to Toronto in 1949. She was named ballet master of the National Ballet of Canada in 1951 and director of the school in 1967. In those capacities, she has taught almost every dancer to emerge from Canada's east coast. Oliphant currently serves as associate artistic director of the company.

Oliver, Thelma, American theatrical dancer; born in Los Angeles. The daughter of Cappy Oliver of the Lionel Hampton Orchestra, Oliver was raised in Los Angeles where she studied ballet. Her work with Lavinia Williams' folklore school in Haiti (to which she was given a scholarship in 1959) brought her to the attention of Yma Sumac, who engaged her for a tour to South America and the Soviet Union in 1960. When she returned to the United States, she moved to New York City where she became known as an actress and appeared in the celebrated 1961 production of *The Blacks, Fly Blackbird,* and the New York Shakespeare Festival's *Tempest.* After replacing Diana Sands in The Living Premise company, she returned to dance as a member of Donald McKayle's concert troupe, with a major role in *District Storyville.* Oliver played an important part in the original cast of Bob Fosse's *Sweet Charity* in 1966 but has since concentrated on dramatic roles.

Oliveros, Pauline, American composer; born 1932 in Houston, Texas. Oliveros was brought into the group of composers working with the Merce Cunningham company through her association with David Tudor. Her music for live electronic performance has become a controversial and popular element of many Cunningham Events, using existing scores as a background for dance. Her most memorable score for a repertory work, *Canfield* (1969), is an eighty-minute work performed by musicians of the company during the dance and manipulation of physical elements. Al-

though it is difficult to employ existing scores written for live electronic performance, Manual Alum used her music in his popular company work, *Palomas.*

Olivette, Nina, American theatrical dancer; born Nina Lachmann, c.1908 in New York City; died there February 21, 1971. Born into a vaudeville and theatrical family, Olivette made her theatrical debut with Violet Carlsman as the Lachmann Sisters, a tandem act. She made her adult debut as a specialty dancer in *Frank Fay's Fables,* a 1922 feature act and revue, and followed it with roles in the George Gershwin musical *Sweet Little Devil* (1924). Olivette did her unique combination of acrobatic ballet and adagio work and musical comedy dance in the 1925 musical, *Captain Jinks,* and in a number of Broadway operettas. After a brief retirement, she reemerged as a star vocalist.

Olrich, April, English ballet dancer and actress; born April Penrick in 1931 in Zanzibar, East Africa (now Tanzania). The daughter of an English diplomat, she was raised and trained in Paris, where she worked with Lubov Tchernicheva, and Buenos Aires, where she studied with Irina Borowska. At the age of thirteen, she was hired as a member of the Original Ballet Russe (on tour in Santiago, Chile). Among her many roles in that company were variations in *Aurora's Wedding,* Edward Caton's *Sebastien* and *Cain and Abel.* After a season off in which she continued her studies in Paris with Olga Preobrajenska, she joined the Sadler's Wells Ballet for four years. In the seasons between 1950 and 1954, she was cast in featured roles and solos in the company's production of *The Sleeping Beauty, Swan Lake,* and *Giselle,* and performed in Andrée Howard's *Veneziana* (1953) and Frederick Ashton's *Sylvia* and *Façade.*

Her charming stage presence and reliably precise technique made her transition to theatrical performance easy. She danced in Alfred Rodrigues' *Pay the Piper* (1954, London) and acted in stage and television productions of Shakespeare. Olrich returned to the United States as the dance specialist member of the cast of the South African revue, *Wait a Minim* (London, 1964, New York, 1966).

O'Neal, Christine, American ballet dancer; born Christine Knoblauch, February 25, 1949 in St. Louis,

Missouri. After local training and work in the St. Louis Municipal Theater, she joined the corps of the National Ballet, Washington, D.C., where she appeared in Frederick Franklin's stagings of the nineteenth-century classics. Although she performed in the classical repertory with the American Ballet Theatre also, her tenure there was more noticeable for her work in the ballets of Antony Tudor. She created a role in his lyrical *Leaves Are Fading* (1974) and took the principal role of "Hagar" in his *Pillar of Fire* in 1976, becoming one of the few dancers to portray that intensely dramatic role. O'Neal left Ballet Theatre to join the chamber company called Dancers. Her parts in that touring group have included the principal role in Todd Bolender's *The Still Point*, which many consider second only to "Hagar" in its impact, and in David Anderson's *The Entertainers*.

O'Neal, Zelma, American musical comedy dancer; born Zelma Ferne Schrader in the late 1890s, in Rock Falls, Illinois. Schrader made her vaudeville debut in a popular sister act with Bernice O'Neal and borrowed the latter's name when she hit Broadway by storm as "Flo, the Varsity Drag Girl," in *Good News* (1927). O'Neal not only went down on her heels and up on her toes but sang and danced to the "Varsity Drag." She also got to sing the title song in that collegiate musical. After repeating her role in the London production of 1928, she returned to New York to play similar dancing parts in the contemporary musicals, *Follow Thru* (1929) and *The Gang's All Here* (1931). Although she did one more show in London and New York (*Jack O'Diamond* and *Swinging Along*, respectively), O'Neal's career really consisted of a single spectacular dance number.

O'Neill, Sheila, English theatrical dancer; born May 5, 1930 in Dulwich, London. Educated at the Arts Education Trust school, she made her West End debut in the London production of *Song of Norway* in 1949. Specializing in British revues and in London restagings of Broadway musicals, she appeared in featured roles in *Brigadoon* (1949), *Paint Your Wagon* (1953), *Jokers Wild* (1954), *Kismet* (1957), *One of the Eight* (1961), *Six of One* (1963), *Sweet Charity* (1972), in the title role, and *Applause* (1972), performing the title number. She has danced in almost every television variety show, and has appeared in Gillian Lynne's film of *Half a Sixpence*.

Orcutt, Edith, American modern dancer; born c.1918; died March 25, 1973 in New York City. A student at the Doris Humphrey/Charles Weidman studio, she became an early member of their Concert Group in performances in New York, on tour, and at the Bennington School of the Dance. Among the many works in which she created roles were Humphrey's *New Dance* (1935), *With My Red Fires* (1936), *Theatre Piece* (1936), *Race of Life* (1938), and *American Holiday* (1938), and Weidman's *Quest* (1937) and *The Happy Hypocrite* (1938). Orcutt continued to work with the Humphrey/Weidman group until she retired from performance in the mid-1940s.

O'Reilley, Terry, American experimental theater and postmodern dance performer; born June 27, 1950 in Niagara Falls, New York. While performing and collaborating with the Mabou Mines (theater company) since 1972, he has taken classes and workshops with postmodernists Simone Forti, Barbara Dilley, Cynthia Hedstrom, Meredith Monk, and Trisha Brown. He has also worked with Contact Improvisation experimentor Steve Paxton. Most of O'Reilley's dance performances have been improvisations, but he has also appeared in works by his teachers, most prominently Trisha Brown's *Line Up* (1977) and the revival of *Planes*.

The Original English Pony Ballet, English precision dancers working in the United States; assembled in London in 1899; dissolved 1915 in New York City. The actual original Original English Pony Ballet was assembled by John Tiller for performances in George Lederer's *The Man in the Moon* (March 1899) on Broadway. Five members of the OEPB were from the Tiller school in London—Elizabeth Hawman, Beatrice Liddell, Seppie McNeil, Dorothy Marlowe, and Ada Robertson—while the other three were trained at his Manchester school and were probably from the North of England—Martha Edmund, Carrie Polz, and Nellie Wilke. They were not employed as a unit in England, but were each team leaders, sent to New York as a kind of advertisement for Tiller and his schools.

Instead, however, the eight decided to split from the patriarchal Tiller system and to institute themselves as a specialty act. They negotiated their own contracts and refused to pay Tiller his usual one-third of their salaries. They also managed to get choreography credit for their own numbers interpolated into shows, with routines listed as "by the OEPB" or by its resident choreographers, Marlowe and Robertson. When members retired, Hawman and Marlowe sent to England for their own younger sisters, so by the 1910s, the team looked more visually unified than it had originally.

The performance history of the OEPB was typical of any dance specialty act, whether solo or octette. After their successful engagement in *The Man in the Moon*, they interpolated their numbers into *Mr. Bluebeard* (1902), *Piff, Paff, Pouf* (1906), *Wang* (1904 revival), *Fantana* (1905), *The Pink Hussar* (1907), *The Midnight Sons* (1910), and a series of vaudeville acts. Their numbers ranged from conventional precision team dances to a group "Yama-Yama" in imitation of Bessie McCoy, to "The Pocket Pederevskiettes" (in *The Midnight Sons*) in a pre-Busby Berkeley act with rolling pianos, to a roller skating number, to their usual childhood act with hoops, parasols, or pets. Their most famous dance sequence was in *Piff, Paff, Pouf*, in which Dorothy Marlowe staged a dance, "The Ghost That Never Walked," to be performed in "radium-encrusted gowns" before black curtains.

Although it was not the first set of five-foot-and-under British precision dancers to perform in New York, the Original English Pony Ballet soon became a part of American theatrical lore. The claim of being "a member of the original English Pony Ballet," was a natural for imitation in song and skit, most notably by the very tall Nora Bayes in "I'm all that's left of the first Pony Ballet" (1906, written by Irene Franklyn) and in Fanny Brice's "I'm a daughter of an original member of the original English Pony Ballet" in her vaudeville act.

The original members and their younger sisters toured until 1915, when they retired en masse.

Orio, Diane, American ballet dancer; born February 9, 1947 in Newark, New Jersey. Orio was trained at the School of American Ballet and the American Ballet Center, the studios of the New York City Ballet and the City Center Joffrey Ballet, respectively. She joined the Joffrey troupe in 1968 and has worked with it as dancer or ballet master throughout her career. Among her many performance credits were roles in the company's revivals of ballets by Leonid Massine and Frederick Ashton, including the former's *Le Beau Danube* and the latter's *The Dream* and *Façade*. She appeared in the early successes of the company—Anna Sokolow's *Opus '65* and Ruthanna Boris' revived *Cakewalk*, and in works created by Gerald Arpino for the dancers, such as his *Incubus* and *The Sacred Grove on Mount Tamalpais*. Orio became ballet master of the company in the mid-1970s.

Orlando, Mariane, Swedish ballet dancer; born June 1, 1934 in Stockholm. Orlando was trained by Vallborg Franck and at the school of the Royal Swedish Ballet; she received scholarships to attend summer classes with Mme. Roussane in Paris, for two years. A member of the Royal Swedish Ballet from the late 1940s, she has appeared in principal roles in both the classical and contemporary repertory. Her performances with Caj Selling in *Giselle, Swan Lake,* and *Spectre de la Rose,* are described in the ways that nineteenth-century ballerinas were praised, as "gracious," "moving," and "delicate," but, in the works of Birgit Cullberg and Birgit Akesson, she can be a true representative of her time— sharp and ultracool in *Miss Julie,* tormented in *Medea,* and starkly moving in *Sisyphus.*

Orlik, Vanya, Russian ballet and theatrical dancer working in the United States; born 1898 in Russia; died July 4, 1953 in Alexandria, Virginia. After training under Charles and Albert Bekefi in St. Petersburg, he emigrated to Berlin where he performed in a variety of cabarets. He moved to the United States with *The Bluebird Revue,* a 1931 answer to the *Chauve-Souris,* that was not as successful as its rival. Orlik was best known in this country as the lead dancer and dance director of the Don Cossack Chorus, a choir that performed in full ethnic costume with balalaikas. Since the chorus was booked into concerts through classical music agencies, including both Sol Hurok and Columbia Artists Management,

it survived much longer than any theatrically based chorus of the 1930s. Orlik retired in the mid-1940s after working with the USO in the United States and Western Europe.

Orlikowsky, Wazlaw, Soviet dancer and choreographer working in Western Europe; born November 8, 1921 in Kharkov. Orlikowsky was trained by Vladimir Preobrajensky. The details of his Soviet performing career are uncertain.

Moving to Germany and Switzerland, he served as ballet master for companies in Munich and Oberhausen before joining the Stadttheater in Basel. Many of his ballets were created for the company there, among them, *Dorian Gray* (1966) and *The Prince of the Pagodas*; others were made for the London Festival Ballet and the Vienna Staatopera.

Works Choreographed: CONCERT WORKS: *The Prince of the Pagodas* (1961); *Daphnis and Chloe* (1961); *Walpurgisnacht* (1963); *Swan Lake* (1963); *The Sleeping Beauty* (1963); *Peer Gynt* (1963); *Giselle* (1963); *The Fountain of Bakhchisarai* (1965); *Dorian Gray* (1966); *Swan Lake* (1965, co-choreographed with Jack Carter); *Swan Lake* (1965, co-choreographed with Vladimir Bourmeister); *Le Corsair* (1975).

Orloff, Nicholas, Soviet ballet dancer performing in the United States after the late 1930s; born 1914 in Moscow. Raised in Paris, he was trained there by Olga Preobrajenska and Victor Gsovsky. After performing briefly with the Ballet Russe de Monte Carlo in 1938, he began a decade of dancing alternatively for the Original Ballet Russe and Ballet Theatre. Among the works in which he danced were Fokine's *Bluebeard* (ABT), David Lichine's *Graduation Ball* (OBR), and each troupe's *Fille Mal Gardée* and *Giselle*. With the Grand Ballet du Marquis de Cuevas (c.1950), he danced in *Giselle* and did the title role in Fokine's *Petrouchka* to great acclaim. Returning to the United States, he appeared on Broadway in the 1955 revival of Balanchine's *On Your Toes* and the original production of *Pipe Dreams* later that year.

Ormiston, Gale, American modern dancer and choreographer; born April 14, 1944 in Liberal, Kansas.

Originally an architecture student at the University of Texas, he moved to New York to study and work with Alwin Nikolais. An expert performer in Nikolais' "total theater," he has danced in his *Imago, Vaudeville of the Elements, Tent* (1968), *Echo* (1969), and many others. He has choreographed since the early 1970s, frequently creating works for fellow Nikolais/Murray Louis dancers, Luise Wykell and Richard Biles.

Works Choreographed: CONCERT WORKS: *RePLAY* (1972); *Convergeance* (1972); *Ascents* (1973); *Take Three* (1973); *ODDyssey* (1973); *Creiteria* (1976); *Syzygy* (1976); *Sequitur* (1976); *Icarus* (1977); *Requiem* (1977); *Garden* (1977).

Orr, Terry, American ballet dancer; born March 12, 1943 in Berkeley, California. Like so many dancers from the Bay area, Orr was trained at the school of the San Francisco Ballet. He performed with the company from 1959 to 1965, with featured roles in Lew Christensen's *The Nutcracker, Fantasma, Divertissement d'Auber*, and *Jeu des Cartes*, and in Willam Christensen's *Con Amore*. In San Francisco, he also directed a company, Ballet '62.

Orr became a member of the American Ballet Theatre in 1965, remaining with the company to the present. Associated throughout his career with the works of Ballet Theatre's then choreographers-in-residence, he created roles in Eliot Feld's *At Midnight* (1967), Michael Smuin's *Pulcinella Variations* (1968) and *Schubertiade* (1971), and Dennis Nahat's *Mendelssohn Symphony* (1971) and *Brahms Quintet* (1969), with featured roles in Feld's *Harbinger* and *Theatre*, Smuin's *Gartenfest*, and Nahat's *Ontogeny*. He was celebrated for his portrayals of the heroes, or antiheroes, in Eugene Loring's *Billy the Kid* and Agnes De Mille's *Rodeo*, two of the company's most popular works.

After serving as rehearsal assistant for the company since the early 1970s, Orr was named ballet master in 1980.

Osato, Sono, American ballet and theatrical dancer; born August 29, 1919 in Omaha, Nebraska. Osato was trained by Adolph Bolm, Berenice Holmes, and Lubov Egorova. She was a member of the Ballet

Russe de Monte Carlo through the 1930s, performing in the company's productions of the classics and in David Lichine's *Prodigal Son*, Leonid Massine's *Union Pacific* and *Symphonie Fantastique*, and George Balanchine's *Cotillion*. In Ballet Theatre from 1941 to 1943, she was noted for her created roles in Antony Tudor's works, *Pillar of Fire* (1943), as a "Lover in Experience," and *Romeo and Juliet* (1943), opening the ballet as "Rosalind."

Osato was also known for her work on Broadway. After appearing in the dream ballet in Agnes De Mille's *One Touch of Venus* (1943), she starred as "Miss Turnstiles" in Jerome Robbins' *On the Town* (1944). Her other dramatic credits include roles in *Ballet Ballads* (1948), Valerie Bettis' *Peer Gynt* (1950), and the revue, *Once Over Lightly* (1955). She danced in one film, *The Kissing Bandit* (MGM, 1947).

Bibliography: Osato, Sono. *Distant Dances* (New York: 1980).

Osbourne, Aaron, American modern dancer; born October 16, 1947 in Lakeview, Oregon. Trained at the Juilliard School by José Limón, Antony Tudor, Anna Sokolow, and other members of the celebrated faculty, he continued his studies at the studios of Merce Cunningham, Maggie Black, and the Dance Theatre Workshop. Osbourne has enjoyed a successful career as a freelance modern dancer, working with the concert groups of many of New York's choreographers. Among the works in which he has danced are Jack Moore's *Rocks*, Jeff Duncan's *Resonances*, and Frances Alenikoff's *Apples in Eden's Expressway* (1970—all of the latter, at Dance Theatre Workshop concerts), Hava Kohav's *Footfall* and Lar Lubovitch's noted piece, *The Time Before The Time After After The Time Before* (1975). Osbourne has also been a member of the José Limón company since 1970. His roles in the company include "The White Man" in his *The Emperor Jones*, the title role in his *Orfeo*, and parts in *The Unsung*, *The Winged, There Is a Time*, and other repertory works.

Oscard, Paul, American ballet dancer, Prolog choreographer and architect; born c.1888; died November 12, 1959 in Hollywood, California. Trained at the Beaux Arts Académie in Paris as an architect, he moved to New York in the late 1910s where he studied dance with Adolf Bolm and with both Theodore and Alexis Kosloff. He became involved in Prolog production as a scenic artist (scene painter) at the Rivoli Theater, New York, but soon became the house's dance director and producer. His shows there led to his engagement at the Paramount Theater in 1925 where he remained for almost a dozen years. That house got out of Prologs very early in the period but he stayed there as booker and designer of presentation acts. He later staged acts for nightclubs in New York and Los Angeles, at the Casa Manaña in Texas, and at the Dorchester Hotel in London. He also worked as a dance coach and designer in film.

Oscard is a fascinating figure in the development of Prologs and presentation acts in this country. Although he was a member of a family deeply involved in theatrical industry reporting, nothing has been written on his life or works.

Works Choreographed: THEATER WORKS: Prologs for the Rivoli Theater, New York (c.1919–1924), including *Carnaval Espagnole* (1919) and *At the Mill* (1920); Prologs and presentation acts at The Paramount Theater, New York (c.1925–c.1936); shows at the Casa Manaña, Texas (1938); shows and club acts for the Dorchester Hotel, London (1938–1939, 1945–1948).

Osipenko, Alla, Soviet dancer; born June 16, 1932 in Leningrad. Trained at the Leningrad Choreographic school, she was a member of the Kirov Ballet from 1954 to 1971. Celebrated as the first "Mistress of the Copper Mountain" in Yuri Grigorovitch's *The Stone Flower* (1959), she danced principal roles in Leonid Ĭakobsen's *Fantasia*, Igor Belsky's *Coast of Hope*, and Chabukiani's *Othello*.

Osserman, Wendy, American modern dancer and choreographer; born 1942 in New York City. Osserman received training in ballet at the Ballet Russe School and the Ballet Arts school, and in modern dance with Muriel Manning and Bonnie Bird at the Martha Graham school, and with Betty Jones and José Limón—all in New York. She attended summer

courses with Tamiris and Daniel Nagrin (1959 and 1960), Valerie Bettis (1961, 1965), and the American Dance Festival of 1963, with Christmas sessions with Hanya Holm. Later training includes work with Thelma Hill at the Clark Center, Matt Mattox at The Place, and with ethnic specialists Luis Olivares, Jean-Leon Destiné, and Charles Moore.

Osserman's professional experience is equally varied. She has performed with the Hellenic Chorograma in Athens in 1964 and Alice Condolina's troupe in New York and Europe (c.1965–1970), with theatrical presentations, such as the 1974 production of *The Housewives' Cantata*, and with dance projects of Frances Alenikoff, Valerie Bettis and Kai Takei, appearing in her *Light, Part IX*.

Although she has choreographed since 1968, performing her works in New York and Greece, she has been most prolific in the last few years. Since 1975, she has provided the repertory for her dance company, creating abstractions, studies of relationships, and pieces based on group emotional experiences. Among the latter is her best known, a dance production of *I Never Saw Another Butterfly* (1977), based on the writings of the child victims of the Terezin Camp.

Works Choreographed: CONCERT WORKS: *Trojan Women* (1968); *Hippolytus* (1968); *Siblings* (1970); *U-47* (1970); *Sextet* (1971); *Cycladic* (1971); *Solo* (1971); *Trio* (1972); *Quartet* (1973); *Two Duets* (1974); *Septet* (1975); *Solo, Trio, Quartet* (1975); *Duet for Joyce and Joan* (1976); *Still Me* (1976); *Dream Animal* (1976); *Heavy Light* (1976); *New Quartet* (1976); *Flight In, Flight Out* (1976); *Me Strong Me Scared* (1976); *Double Entendre* (1976); *I Never Saw Another Butterfly* (1977); *Medieval Pieces* (1977); *Family Ties* (1978); *Rizes* (1979); *One Million* (1979); *The Whole Horizon Retreats* (1980); *Two Sisters/Two Brothers* (1980).

Ostergaard, Solveig, Danish ballet dancer; born January 7, 1939 in Skjern. Trained at the school of the Royal Danish Ballet, she performed with that company throughout her career. Famed for her technique and stage presence, she could carry a ballet, as "Swanilda" in *Coppélia*, or stop a show, as "Rosalind" in Frederick Ashton's *Romeo and Juliet*. She was also known for her performances in Kenneth Macmillan's *Solitaire*, Harald Lander's *Etude*, Flemming Flindt's *The Private Lesson* and *Felix Luna*, Mikhail Fokine's *Spectre de la Rose*, and the works by the two American choreographers-in-residence in 1972, Bruce Marks' *Dichterliebe* and Eliot Feld's *Winter's Court*.

La Belle Otero, Spanish popular entertainer of the late nineteenth century; born Augustina Carolina Iglesias, in 1868 in Valga, Galician Spain; died April 10, 1965 in Nice, France. Of all of the performer-courtesans of La Belle Epoch, La Belle Otero is the most likely to have only used the description "dancer" as a euphemism. Unlike Cléo de Mérode, who was a member of the Paris Opéra and a celebrated soloist, or Liane de Pougy, noted for her concert work, she did not even list titles of her Spanish dance specialties on programs. She made her professional debut as a cabaret dancer sometime before 1880 in Spain and was discovered while dancing in a Marseilles club in 1889 by an American entrepreneur. That man, Ernest Jurgens, was in Europe trying to find a performer for his New York theater, Eden's Museum, as a rival for Carmencita, then a regular at Koster and Bial's. She made her American debut in October 1890, billed as an "Illegitimate daughter of" almost every degree of European nobility.

Her performance career took her on a number of European tours that reached north to Copenhagen and east to St. Petersburg. She had regular seasons in London and Paris, most notably at the Alhambra and Empire Theatres in the former and the Cirque d'Eté and Le Bal Tabarin in the latter. Her acts were generically known as *Une Fête* or *Un Soir à Séville* and ranged from plotted musicals to programs of songs and dance solos.

Bibliography: Lewis, Arthur H. *La Belle Otero* (New York: 1967).

Oukrainsky, Serge, Russian ballet and opera dancer and choreographer working in the United States; born Leonide Orlay de Carva, 1886 in Odessa, Russia; died November 1, 1972 in Hollywood. Educated and raised in Paris, Oukrainsky studied ballet with Ivan Clustine (beginning in his mid-twenties), making his performing debut as a mime in the Ida Rubenstein productions of *Salome* and *Istar* in 1913. He

later performed incidental dances in a Hindu play season at the Théâtre Femina in Paris and toured Europe as a concert dancer.

In 1913, he joined the Anna Pavlova Company as Serge Oukrainsky, on recommendation from Clustine. In his three years with Pavlova, he had featured roles in Clustine's *Valse Triste, Pas de Trois*, and *Flora's Awakening*, and created his own solo in the *Persian Dance*. In 1916, he and fellow Pavlova company member Andreas Pavley left the company tour to remain in the United States. At first they worked in Indianapolis, performing at a James Whitcomb Riley Festival in that city with a pick-up company that included a very young Ruth Page. Within the year, however, they moved to Chicago where they began a long association with the Chicago Grand Opera and its featured soprano (and, after 1919, director), Mary Garden.

By 1919, the Pavley-Oukrainsky Ballet had become an official component of the Chicago Grand Opera, with Oukrainsky serving as ballet master and providing incidental dances for the company's repertory of operas. Following the practice of the time, the Ballet not only performed within the operas—as temple dancers in *Aida, Cléopâtre*, and gypsies in *Carmen, The Jewels of the Madonna*, and *Il Trovatore*, among others—but also maintained a repertory of one-act ballets to be performed after short operas, such as *Pagliacci* and *Cavalleria Rusticana*.

These short ballets, among them *Boudour* (1920), *The Birthday of the Infanta* (1922), and *La Fête a Robinson* (1922), choreographed collaboratively with Pavley, formed the nucleus of the repertory of the Ballet company, which began to tour as a separate entity in 1917. The fifteen long ballets, excerpts from opera incidental dances (choreographed solely by Oukrainsky), and shorter divertissements that made up the repertory were mostly designed by Oukrainsky, working as Orlay de Carva. Whether the creative intellect behind the repertory was Oukrainsky's alone, or part of the collaboration with Pavley, it resulted in a group of dances that are in many ways archetypical of the state of dance in America in the 1920s. The vision of the repertory managed to combine those of Pavlova, with her romanticizing, and Denishawn, with their theatricalizations of other peoples' religious and social beliefs.

The Pavley-Oukrainsky Ballet reflected both Pavlova in *Will-O'-the-Wisp* (1917), *Nymphs at Play* (1922), and *In a Garden* (1925), and Denishawn in *Egyptian Temple Procession* (1917), *Syrian Temple Dance* (1922), and *Temple of the Sun* (1922).

While Pavley toured with the company and concert groups, Oukrainsky taught and choreographed in California. He served as Ballet Master for the opera companies in Los Angeles (1926-1928) and San Francisco (1928-1930, 1937-1938), and staged ballets for symphonic concerts at the Hollywood Bowl, among them, the expressionist *Les Eléments* (1935). He taught and coached extensively within the film community, but received credit for only three feature films, among them the Delores Del Rio films *The Red Dancer of Moscow* (Fox Films, 1928) and *Revenge* (UA, 1928). Also in 1928, Oukrainsky created a live ballet that could tour with filmed backdrops, called *Videballeton*.

After Pavley's death in 1931, Oukrainsky broke all remaining ties with the Chicago Opera, and remained in Los Angeles, teaching and coaching opera. While serving on the board of governors of AGMA, he found time to design for local opera productions but does not seem to have choreographed after 1935. While it is unlikely that Oukrainsky's choreography could ever be reconstructed, his costumes and design sketches have been preserved by the Archives of the Performing Arts in San Francisco.

Works Choreographed: CONCERT WORKS: (Please note: no solo credit can be assigned absolutely before 1930. Those dances that are probably by Oukrainsky alone are marked with an asterisk. All others must be considered collaborations with Andreas Pavley.) *Cymbal Dance** (1916); *Algerian Dance** (1916); *Persian Dance** (1916); *A Ball Game* (1917); *Scène Dansant** (1917); *Vagabond Dance* (1917); *Mazurka* (1917); *Romance* (1917); *Slave Dance* (1917); *Minuet Récamier* (1917); *The Bird and the Serpent* (1917); *Valse Triste* (1917); *L'Ephème* (1917); *La Sylphide* (1917); *Hungarian Dance* (1917); *Mirror Dance* (1917); *Will-O'-the-Wisp* (1917); *Bacchanale* (1917); *An Egyptian Temple Procession* (1917, may be sequence from *Aida*, if so, by Oukrainsky alone); *Spanish Suite* (1917); *Bohemian Dance* (1917); *Pastoral* (1917); *Hymn to Joy* (1917); *Prélude l'Après Midi d'un Faune* (1919); *L'Arlesienne* (1920); *Danse du*

Printemps (1920); *La Camargo* (1920); *Siamese Dance* (1920); *Flying Leaves* (1920); *Adagio Classique* (1920); *Pierrot's Shadow* (1920); *Habañera* (1920); *Torch Dance* (1920); *Boudour* (1920); *The Dance of the Hours* (1922); *Syrian Temple Dance** (1922); *A Cruxificion** (1922); *Nymphs at Play* (1922); *Valse Classique* (1922); *Rondo Capriccioso* (1922); *Largo* (1922); *Victory Dance* (1922); *The Bee* (1922); *Anitra's Dance* (1922); *Bal Mobile* (1922); *Trianon* (1922, short version); *Lieberswalzer* (1922); *The Frog* (1922); *The Chase* (1922); *The Powder Puff* (1922); *La Fête à Robinson* (1922); *Danse Macabre* (1922); *The Birthday of the Infanta* (1922); *The Gates of Redemption* (1922); *The Captive Princess* (1922); *Dance Poem* (1922); *The Temple of the Sun* (1922); *Gypsy Camp* (1922); *The Temple of Dagon* (1922); *Trianon* (1923, full-length ballet version); *Japanese Ballet* (1923); *Les Fleurs du Mal* (1924); *In a Garden* (1925); *Three Grecian Studies* (1925); *White Mazurka* (1925); *In Knighthood Days* (1926); *Bourée* (1926); *Titiana* (1926); *A Night in Granada* (1927); *Kloris and Roosje* (1927, possibly by Pavley alone); *The Legend of the Sun* (1927); *Au Claire de Lune* (1927); *Cubist Dance** (1927); *Blue Danube* (1927); *Czardas* (1927); *Ballet Romantique* (1927); *Pizzicato* (1928); *The Naughty Bustles* (1928); *Rebellion* (1928); *Videballeton** (*Grecian Bacchanale, Snow Bird, Futuristic Town, East Indian Dance, Gypsy Scene*) (1928, choreography and film by Oukrainsky); *Idol Dance* (1931); *Dance, Marionette, Dance* (1931); *The Death of a Lunatic* (1931); *Flirtation 1870* (1931); *Algerian Dance* (1931); *The Aztec Sacrifice* (1934); *Les Eléments* (1935).

FILM: *The Red Dancer of Moscow* (Fox Films, 1928); *Revenge* (UA, 1928); *Noah's Ark* (WB, 1929).

Oumansky, Alexander, Russian ballet dancer and Prolog choreographer working in the United States; born in Kremenchuk, Russia, probably in the early 1890s. Oumansky left Russia with a boys' choir and was raised in New York City. He toured with the Ballet Russe under Vaslav Nijinsky's directorship and performed for many years with the Metropolitan Opera Ballet under Alexis Kosloff and Boris Romanoff. Although he later returned to ballet as a teacher, Oumansky spent much of the 1920s and 1930s as one of America's foremost Prolog dance directors. He was expert at creating these thirty-minute variety shows for motion picture palaces and tours, and was capable of thinking up new routines for the two dance choruses (ballet and tap) and soloists each week. He was staff dance director or producer for the major chain theater, "Roxy" Rothafel's Capitol in New York, for four years, and worked extensively at the most important independent houses (i.e., without chains) in the country, among them the Fox in Washington, D.C., the Albee/Broadway, and Graumann's Chinese in Hollywood, where his shows rivaled the footsteps in cement for interest. Oumansky also worked frequently in London where he restaged *Rio Rita* and served as a staff dance director and coach for Gainsborough Pictures and British International. His own dance act, in the so-called American style of male solowork, was tremendously popular in London cabarets and Cine-Variety (Prolog) houses.

His importance as a theatrical figure has been equaled by his work as a ballet teacher. He had a New York studio throughout his Prolog career and later managed the staff school for RKO. Since retiring from theatrical forms, he has taught in Oregon, California, and Hawaii, where he still runs a studio. Oumansky is the father of Valentina Oumansky, a modern dance choreographer based in the Los Angeles area.

Works Choreographed: THEATER WORKS: Prologs for the Capitol Theater, New York, Graumann's Chinese Theater, Hollywood, The Fox, Washington, D.C.; productions for the Hollywood Bowl.

Overlie, Mary, American postmodern dancer and choreographer; born 1946 in Terry, Montana. After local studies in ballet with Harvey Jung (in nearby Bozeman), she moved to San Francisco where she came into contact with Yvonne Rainer and Barbara Dilley at a Grand Union performance. She arrived in New York City in 1972 and continued to work with Rainer, Dilley, and Steve Paxton in improvisation and performance. Overlie returned to ballet classes in recent years with Diana Byers, the Cecchetti teacher who works extensively with postmodernists on alignment. She was a member of the five-woman improvisational collaborative, Natural History of the American Dancer company, from 1972 to 1975, but left to

present her own choreography in performance. Her solo concerts and improvisations in 1976 brought her a following that remains with her, attracted by her ability to chose and subvert movements into flows of shapings and rhythm. When her works began to get larger, using up to fifteen dancers in *Hero* (1979), she became better known but did not lose her tight control over the performers' and audiences' perceptions of the movement.

Overlie teaches at the School for Movement Research, of which she is a founding member, and the New York University School of the Arts Experimental Theater wing. She has worked with the Mabou Mines theater group on two productions—*The Saint and the Football Player* (1976), and the marvelous portrait of Collette, *Dressed Like an Egg* (1977).

Works Choreographed: CONCERT WORKS: *Adam* (1976); *To Be Announced* (1976); *Wash* (1976); *Small Dance* (1976); *Glass Imaginations* (1976, improvisation program in window of the Holly Solomon Gallery); *Glassed Imaginations II* (including named segments *Kuwait, Chinese Clouds, Flies, Circles I Have Known, Two By, Blind Bird Comes to Speak, One Four*) (1977, indoor program); *Window Pieces* (1977); *Cartoon Coordinations* (1977, improvisation program); *Possibility of Personal Failure* (1977); *Flower Garden* (1977, improvisation program);

Painter's Dream (1978); *The Figure* (1978); *Paper Waltz* (1979); *Hero* (1979); *Wallpaper* (1980); *Swan* (1980); *Literary Duet* (1980).

THEATER WORKS: *The Saint and the Football Player* (1976); *Dressed Like an Egg* (1977).

Oyra, Jan, Polish theatrical dancer working in England; born Jan Wojcieszko, March 8, 1888 in Warsaw; date and place of death uncertain. In the popular theater in Warsaw with his acrobat parents, he emigrated to England in the early 1910s, making his London debut at Daly's in *A Waltz Dream* (1911). A role and specialty number in *The Girl in the Film* at the Gaiety Theatre brought him on his first of many tours of the United States in 1913.

Oyra had an acrobatics and concert dance act in London cabarets and music halls, and worked his specialties into musical comedies, among them *Vanity Fair* (1916), *Airs and Graces* (1917), and *The Beauty Spot* (1917). With his partner, Catherine Galliarde, he performed adagio and Apache dances at the Casinos de Paris in Paris and in New York. They remained on Broadway to work in two Shubert shows in the late 1920s—*A Night in Paris* (1926) in which he did a knife throwing act, and the *Artists and Models of 1927*.

Oyra returned to London to teach acrobatics and circus techniques.

P

Packer, Myrna, American postmodern dancer and choreographer; born April 23, 1953 in Rye, New York. Packer studied at the Steffi Nossen studio as an adolescent and was lucky enough to have Ze'eva Cohen as a camp counselor at age fifteen. She attended Bennington College, where she continued her training with Judith Dunn, Martha Wittman, and Jack Moore, and participated in early Contact Improvisation workshops with Steve Paxton. Moving to New York City, she danced for Cohen and performed in Cohen's solo concert repertory. She danced in Art Bauman's Movement Project in his *Dance for Women*, and in the Nimbus choreographers' *Oaks* and *Banana Peel* (by Erin Martin), *Sympathetic Vibrations* and *Caprice for a Sunday Afternoon* (by Alice Tierstein), and *Netskes* (by Jack Moore). Since 1977, Packer has performed with Harry Streep's Third Dance company and has choreographed alone and in collaboration with Art Bridgeman.

Works Choreographed: CONCERT WORKS: *Rites* (1977); *July 20th, Jefferson Gorge, Vermont* (1978, in collaboration with Art Bridgeman).

Padow, Judy, American postmodern dancer and choreographer; born January 10, 1943 in Brooklyn, New York. Padow studied composition with Ann Halprin, Yvonne Rainer, and Trisha Brown, ballet with Don Farnworth, and Merce Cunningham technique with Barbara Dilley.

Padow has performed in works by postmodern choreographers Trisha Brown, Yvonne Rainer (creating roles in her *Rose Fractions*, 1969), and Lucinda Childs. As a member of the Childs company from 1973 to 1979, she created roles in her *Calico Mingling* (1973), *Interior Drama* (1977), *Melody Excerpt* (1977), and *Dance* (1979). Padow has also performed with the improvisation collaboratives Natural History of the American Dancer company in 1972, and Contact Improvisation Workshop (1976–1978).

Padow began choreographing in 1968 and formed her present company in 1974. She now choreographs primarily for her group and for students at the Leonard Davis Center of the City College, City University of New York at which she is artist-in-residence.

Padow's works, especially her nine *Solos* (variously, 1976–1980), employ the manipulation of movement scale, rhythm, and repetition that characterize the American postmodern choreography, but her use of suggested emotions in the gestural system makes her work unique. Her ability to analyze and encapsulate movement has enhanced her writings on choreography and dance, which have been published in the United States and in France.

Works Choreographed: CONCERT WORKS: *The Board Dance* (1968); *Two Minute Dance* (1968); *Self-Portrait* (1969); *Circle Dances* (1969); *Audience Participation* (1969); *Solo* (1969); *Group Dance* (1969); *Accumulation for Five People with Props* (1969); *The Circle Dance* (1969); *Two Dances* (1969); *The Clump* (1970); *Duets* (1970); *Disintegrations* (1970); *Corridor* (1970); *High Speed Runs* (1970); *Trio* (1970); *Dances* (1970, co-choreographed with Batya Zamir); *Solos* (1971); *Dancing* (1971); *Performance* (1971, with Sara Rudner and Suzanne Harris); *Body Kinetics* (1971); *Dancing (II)* (1971, with Suzanne Harris); *Solos & Duets* (1972, with Batya Zamir); *Repeat* (1975); *Indian Summer* (1975); *Panorama* (1975); *The Snake Dance* (1975); *Threes* (1975); *Jamming* (1975); *The Drift* (1975); *Solo Patterning* (1975); *Ensemble* (1977); *Quartet in Unison* (1977); *Cameo* (1977, sections 1–6), *Cameo* (1977, sections 1–10); *Pages of a Waltz* (1978); *Mix* (1979); *Two-Way Play* (1979); *Native Dancer* (1979); *Triple Prime* (1980); *Surface Incidents* (1980); *Remote Sensing* (1980).

Pagava, Ethery, French ballet dancer; born November 13, 1932 in Paris, France. Trained by Lubov Egorova, she performed as a child with the Ballets de la Jeunesse in 1937, and made at least one appearance as an adolescent with Roland Petit in his Ballets des Champs-Elysées. In that company from 1945 to 1947, she created roles in his *Les Forains* (1945), *Les Amours de Jupiter* (1946), and *Le Déjeuner sur l'Herbe* (c.1947).

Pagava danced with the Grand Ballet du Marquis de Cuevas in the 1950s, notably in their production of Balanchine's *La Somnambule (Night Shadow)* and Serge Lifar's *Noir et Blanc*. Her featured works included Massine's *Le Beau Danube*, Georges Ski-

bine's *A Tragedy in Verona*, as "Juliet," *Les Sylphides*, and *La Fille Mal Gardée*.

A freelance ballerina since the 1960s, Pagava has performed throughout France and Europe.

Works Choreographed: CONCERT WORKS: *La Cage* (1971).

Page, Annette, English ballet dancer; born December 18, 1952 in Manchester, England. Trained at the school of the Sadler's Wells Ballet, Page spent her entire performing career with that company and its successor, the Royal Ballet. Celebrated for her technique and precision of movement, she was given principal roles in both companies' productions of the classics of the ballet repertory—*Giselle, Coppélia, Swan Lake, Cinderella*, and *La Fille Mal Gardée*. Page created roles in Alfred Rodrigues's *Ile Sirenes* (1952) and *Cafe des Sports* (1954), and in Kenneth Macmillan's *Danses Concertantes* (1955), and was noted for her performances in Celia Franca's *Khadra* and Robert Helpmann's *Miracle in the Gorbals*.

Page, Ashley, English ballet dancer; born August 9, 1956 in Rochester, Kent. Trained at the school of the Royal Ballet, he joined the company in 1975. He created a role in Frederick Ashton's *Rhapsody* (1980) and was assigned featured and principal parts in Kenneth Macmillan's *Gloriana, Fin du Jour*, and *Elite Syncopations*. A frequent participant in the company workshop performances of new choreography, he has danced in Robert North's *Troy Games* and Michael Batchelor's *Ego*.

Page, Lucille, American theatrical dancer; born in the early 1920s, possibly in California. After a successful debut in a Los Angeles *Kiddies' Revue* at age nine, Page developed a series of acts based on widely disparate techniques. In 1933, she was booked as a tap dancer on the same Radio City musical bill as Paul Draper (also making his house debut), but within a year she was being touted as New York's best exotic specialist in the *Earl Carroll Vanities*. She did a rube (exaggerated country) act with Buster West in the George White *Scandals* of 1934, was billed as America's best acrobatic dancer two years later, and in 1939 was engaged as a ballet stylist. Her association with Gae Foster (a former *Kiddies' Revue*

dancer working as dance director at the Roxy) brought her engagements as a roller-skate dancer in *Skating Vanities* (1943) and as an ice dancer in *Hats Off to Ice* (1944). Throughout the late 1930s and 1940s, she and West toured the major presentation act houses with their rube and eccentric duets and personal solos—his eccentric taps and her acrobatics.

Page, Ruth, American ballet dancer and choreographer; born March 22, 1905 in Indianapolis, Indiana. Page received dance training from ballet dancers passing through her native Indianapolis, among them the Anna Pavlova Company's Andreas Pavley and Serge Oukrainsky, who left the tour to teach and cast her in their Hoosier Festival Ballet. She went to Chicago with them, where she joined up with Adolf Bolm instead. When he succeeded Pavley/Oukrainsky as ballet master of the Chicago Opera, she appeared in a leading role in his *The Birthday of the Infanta* (1919) and toured with his Ballet Intime, and Allied Arts company. Traveling to Buenos Aires to appear in his *Coq d'Or* (1925), she became a pick-up member of the Diaghilev Ballet Russe.

Page has been associated with opera ballet through most of her career, performing with the Metropolitan Opera (1926–1928) before rejoining Bolm for the premiere of his *Apollon Musagète* (1928). After touring as a concert dancer briefly in the beginning of the 1930s, she returned to Chicago where she has worked ever since. She served as ballet master of the Ravinia Park, a summer encampment of the Chicago area, from 1929 to 1933, staged a work for the 1933 Chicago Century of Progress Exhibition, ran the ballet company of the Chicago Opera Company (1934–1937), the Federal Theatre of Chicago (1937–1939), her own Ballets Americains (1950), which was basically a tour group, and the Chicago Lyric Opera (1954–1955). She has been associated with the Chicago Opera Ballet in various capacities since 1955.

Although Page's career sounds complicated, she has been a consistent influence in the Chicago area since the early 1920s, promoting dance as a collaborative art to the city, its citizens, and its other cultural institutions.

Works Choreographed: CONCERT WORKS: *The Flapper and the Quarterback* (1926); *Peter Pan and the Butterfly* (1926); *Creole Dances* (1927); *The Snow*

is Dancing (1927); *Ballet Scaffolding* (1928); *Barnum and Bailey* (1928); *Coquette–1899* (1928); *The Shadow of Death* (1928); *Moonlight Sailing* (1928); *Diana* (1928); *Blues* (1928); *Oak Street Beach* (1929, originally titled *Sun Worshippers*); *Etude, op. 10, no. 3* (1929); *Japanese Print* (1929); *Two Balinese Rhapsodies* (1929); *St. Louis Blues* (1929); *Iberian Monotone* (1930); *Garçonette* (1930); *Pre-Raphaelite* (1930); *Incantation* (1930); *Modern Diana* (1930); *Cinderella* (1931); *L'Histoire du Soldat* (1931, co-choreographed with Jacques Cartier and Blake Scott); *La Valse* (1931); *Pavane* (1931); *Giddy Girl* (1931); *Cuban Night* (1932); *The Expanding Universe* (1932); *Largo* (1932); *Vagabond* (1932); *Tropic* (1932); *Three Humoresques (I—Giddy Girl rev., Spanish Girl, Patriotic Finale)* (1932); *Possessed* (1932); *Humoresques (II—Giddy Girl, Spanish Girl, Gigue, Berceuse, Patriotic Finale)* (1932); *Jungle* (1933); *Lament* (1933); *Morning in Spring* (1933); *Mozart Waltzes* (1933); *My Sorrow Is My Song* (1933); *Resurgence* (1933); *La Giuablesse* (1933); *Songs* (1933); *Shadow Dance—Homage to Taglioni* (1933); *Rustic Saint's Day* (1933); *Pendulum* (1933); *Variations on Euclid* (1933); *Country Dances* (1933, co-choreographed with Harald Kreutzberg); *Promenade* (1933, co-choreographed with Kreutzberg); *Arabian Nights* (1934, co-choreographed with Kreutzberg); *Bacchanale* (1934, co-choreographed with Kreutzberg); *Hear Ye! Hear Ye!* (1934); *Gold Standard* (1934); *Body in Sunlight* (1935); *Love Song* (1935); *Fresh Fields* (1935); *Fugitive Visions* (1935); *Valse Mondaine* (1935); *Night Melody* (1935); *An American in Paris* (1936); *Hicks at the Country Fair* (1936, co-choreographed with Bentley Stone); *An American Pattern* (1937, co-choreographed with Stone); *Buenos Dias, Señorita* (1938, co-choreographed with Stone); *Frankie and Johnny* (1938, co-choreographed with Stone); *Gavotte* (1938, co-choreographed with Stone); *The Story of a Heart* (1938); *Delirious Delusion* (1938); *Night of the Poor* (1939, co-choreographed with Stone); *Three Shakespearean Heroines* (1939); *Scrapbook* (1939); *Guns and Castanets* (1939, co-choreographed with Stone); *Liebestod* (1939, co-choreographed with Stone); *Saudades* (1939, co-choreographed with Stone); *Zephyr and Flora* (1939); *Catarina, or the Daughter of the Bandit* (1940); *Songs of Carl Sandburg* (1940); *Les Incroya-*

bles (1941, co-choreographed with Stone); *Park Avenue Odalisque* (1941); *Spanish Dance in Ballet Form* (1941), *Chopin in our Time* (1941); *Anyone* (1943); *Rebecca, who slammed doors for fun and perished miserably* (1943); *We were very tired, We were very merry* (1943); *Death in Harlem* (1944); *Adonis* (1944); *Dances with Words and Music* (1942–1945, including *Anyone, Rebecca, who slammed doors for fun and perished miserably* and *Death in Harlem*); *Les Petits Riens* (1946); *The Bells* (1946); *Harlequinade* (1948, co-choreographed with Stone); *Billy Sunday* (1948); *Dance of the Hours* (1949); *Beauty and the Beast* (1949); *Revanche (Revenge)* (1951); *Beethoven Sonata* (1951); *Impromptu au Bois* (1951); *Villa (The Merry Widow)* (1953); *Triumph of Chastity* (1954); *El Amor Brujo* (1954, originally titled *Spectre of Love*); *Daughter of Herodias* (1954); *Susanna and the Barber* (1956); *Die Fledermaus* (1958); *Camille* (1959); *Carmen* (1960); *Pygmalion* (1961); *Concertino pour Trois* (1961); *The Nutcracker Suite* (1965); *Combinations* (1965); *Bullets and Bon-Bons* (1965); *Carmina Burana* (1965); *Mephistophela* (1966); *The Jar* (1966); *Bolero '69* (1968); *Romeo and Juliet* (1969); *Alice in the Garden* (1970); *Alice* (1971); *Catulli Carmina* (1973).

THEATER WORKS: *Music in My Heart* (1947); *Minnie Moustache* (1954); *The Dream* (1958).

Pagent, Robert, American ballet and theater dancer; born December 12, in the 1920s in Pittsburgh, Pennsylvania. Pagent was trained in Chicago by Laurent Novikoff and Berenice Holmes, performing for them in the Chicago Grand Opera Ballet. He studied with Lubov Egorova and Olga Preobrajenska in Paris when a member of the Ballet Russe de Monte Carlo and with Pierre Vladimiroff and Anatole Oboukhoff in New York. His modern dance training came at the studios of the Humphrey/Weidman Concert Group and of Valerie Bettis.

A member of Ballet Theatre during the 1940s, he was noted for his performance in Agnes De Mille's *Rodeo*, Leonid Massine's *Le Beau Danube*, and Bronislava Nijinska's *Chopin Concerto*. He returned to the company in the 1950–1951 season to dance in De Mille's *Fall River Legend* and to repeat his *Rodeo* role. His De Mille connection was even stronger on Broadway, where he appeared in her *Oklahoma*

(1943), *Carousel* (1945), as "The Boastswain" in the Waltz and the "Dream Billy" in the ballet sequence, and *One Touch of Venus* (1943), again with a featured role in the dream ballet. He danced for Jerome Robbins in *Miss Liberty* (1949), *Call Me Madam* (1950), and *Two's Company* (1952), and appeared in the 1947 revue, *Angel in the Wings*, starring The Hartmans.

Pagent choreographed for television and live industrials during the 1950s and 1960s, notably on the monthly *Bell Telephone Hour*, but returned to musical comedy to stage revivals of Broadway hits at the Jones Beach Theatre.

Works Choreographed: THEATER WORKS: *Carousel* (1954, after De Mille); *Carousel* (1973); *Finian's Rainbow* (1977).

TELEVISION: *The Bell Telephone Hour* (NBC, intermittently, 1958–1963).

Pagliero, Camilia, Italian mime working in Vienna; born March 13, 1859 in Castel Rosso; died May 12, 1925 in Lovrano. After a short career as a demi-character soloist, she became celebrated as a principal mime. In that capacity, she created the role of *Die Puppenfee* (1888) in Josef Hassreiter's best remembered ballet. With the Vienna Court Opera Ballet, she also performed in other Hassreiter ballets and in works by Nicola Guerra, to whom she was married, including his *Kunsterlist* (1898). When he moved to Budapest to become ballet master of the Magyar Kiralfy Opera Ballet, she taught there, becoming, according to many sources, the consolidation of the Italian bravura technique in that city. She coached Ida Rubinstein in the late 1910s when Guerra was working in Paris, but is believed to have retired shortly thereafter.

Paige, Brydon, Canadian ballet dancer and choreographer; born in the 1920s in Vancouver, British Columbia. Trained by Kay Ambrose, he appeared in local theater productions before joining the charter company of Les Grands Ballets Canadiens in 1953. Although he appeared in the classical repertory, notably as "Franz" in *Coppélia*, and in the contemporary ballets of Eric Hyrst, among them, his *Sea Gallow* and *Premiere Classique* (both 1959), he was best known for his character work. Among his roles were "Il Dottore" in Ludmilla Chiriaeff's tribute to the commedia *Farces*, "Le General" in Lichine's *Graduation Ball* and arch villains "Von Rothbart" and "Kotschei."

Paige has contributed original choreography to the company with which he danced throughout his career. Many of his pieces are based on literary themes, including his well known *Médée* (c.1965), or on the national "excuses" for ballet movement such as *La Espagnole* (1963) and *Follies Française* (1960). Paige serves the company as resident choreographer and as rehearsal director.

Works Choreographed: CONCERT WORKS: *Follies Française* (1960); *Bérubée* (1960); *La Espagnole* (1963); *Quartuor* (1963); *Three Sisters* (1965); *Médée* (c.1965).

Palladino, Emma, Italian ballet dancer working in Italy, the United States, and England; born c.1860 in Milan; died April 13, 1922 in London. Daughter of dancer Andrea Palladino, she was trained by Giovanni Casati at the Ballet School of the Teatro alla Scala, Milan. She is believed to have performed at La Scala as an adolescent.

In New York with the Mapleson Opera Troupe (c.1878), she was hired to perform with the Italian opera company in ballets staged by Katti Lanner at Her Majesty's Theatre in London. In 1881, she joined the ballet company attached to the Alhambra Theatre, then directed by A. Bertrand. After seven years commuting between the Alhambra and freelance work in opera ballet, she joined the Ballet of the Empire Theatre, London.

The five ballet productions that Palladino performed at the Empire—*Diana* (1888), *A Dream of Wealth* (1889), *Dolly* (1890), *The Paris Exhibition* (1891), and *Nisitia* (1891)—were all staged by Katti Lanner for the company of English and Italian dancers. They employed conventional bravura ballet technique for the soloists and musical comedy staging effects for the corps.

Palladino retired in Munich in 1899 after performances there and, according to some sources, in Moscow. Although forgotten by historians for many years, Palladino was rediscovered in correspondence among Ivor Guest, Edouard Espinosa, and Richard Buckle (as editor) in the English periodical *Ballet* in

1947. Espinosa, calling her "the complete Palladino," praised her as a beautiful dancer of precise technique and radiant presence.

Pallerini, Antonia, Italian ballet dancer of the nineteenth century; born June 25, 1790 in Pesaro; died January 11, 1870 in Milan. Trained at the school of the Teatro alla Scala by Gaetano Gioja, she spent her professional life with that theater.

Associated primarily with the works of Salvatore Vigano, she created the leading roles in his *Prometeo* (1813), *Otello* (1818), *I Titani* (1819), *Allessandro nelle Indie* (1821), and *Didone* (1821). She was considered the ideal performer for his combinations of conventional Romantic ballet technique and expert mime work.

A member of a distinguished theatrical family, she was either the mother or the aunt of Antonio Pallerini.

Pallerini, Antonio, Italian ballet dancer and choreographer of the nineteenth century; born 1819 in Milan; died there in 1892. Trained at the school of the Teatro alla Scala, he was associated with that theater throughout his performance career.

As a choreographer, Pallerini worked the entire circuit of northern Italian theaters, working at opera houses in Parma (Teatro Stocchi), Turin (Teatro Reggio), Brescia (Teatro Grande), and Rome (the Teatro di Apollo). Many of his works, among them *Aasvero* (1871) and *Ondina* (1869), were created for La Scala and then produced at the other theaters; some ballets, however, were created uniquely for the Teatro Reggio, among them *Le Grotta di Adelbergo* (1868), considered one of the most influential of the early Italian spectacle-genre of ballets.

Works Choreographed: CONCERT WORKS: *Unsogno* (1862); *l'Annello infernale, ossia Folgore* (1862); *l'Ambiziosa* (1863); *Attia* (1863); *Actea* (1864); *La Grotta di Adelbergo* (1868); *Ondina* (1869); *Amore e Arte* (1870); *Aasvero* (1871); *Le due gemelle* (1873); *Semiramide* (1875); *Nerone* (1877).

Palmer, Leland, American theatrical, film, and television dancer, choreographer, and actress; born June 16, 1940 in New York. Raised in Los Angeles, she began to study dance at age nineteen at the American

School of Dance there. She worked as a secretary in the school while studying with Eugene Loring, Bella Lewitsky, Carmen De Lavallade, John Butler, and David Winters. Returning to New York, she continued her training with Richard Thomas, Nanette Charisse, Donald McKayle, Jaime Rogers, and Alvin Ailey.

Palmer has had at least three concurrent careers in dance since the early 1960s. She has been an assistant choreographer to Michael Bennett (in summer stock and on Broadway with *A Joyful Noise*, and *How Now Dow Jones*), Grover Dale, Ron Field (for the summer series starring The Manhattan Transfer), Hugh Lambert (for the *Dinah Shore Summer Show*), and Bob Fosse, for whom she worked on *Pippin* and the film *All That Jazz*.

As a dancer, she has appeared in Loring's Dance Players company in Hollywood, in the touring company of *Little Me* (1953), and in New York in *Bajour* (1964), Bennett's *A Joyful Noise* (1967), *Your Own Thing* (1968), which provided her first major recognition, *Hello Dolly* (1968 cast), *Dames at Sea*, and Fosse's *Pippin* (1973). She also appeared in *A Chorus Line* and *Hold Me* in Los Angeles. Her dance appearances on television range from 1961 to the present and include numbers on *Glen Campbell's Goodtime Hour* (1970), the *Manhattan Transfer Summer Series* (1975), the 1975 Democratic Telethon, the *Dinah Shore Summer Series* (1976), and many sitcoms. She can be seen in the film *Valentino* (Twentieth-Century Fox, 1977), and in Fosse's *All That Jazz* (Twentieth-Century Fox, 1979).

Palmer also works as a choreographer, creating dance routines for individual performers, and industrials and commercials.

Paltenghi, David, English ballet dancer; born 1919 in Bournemouth; died February 4, 1961 in Windsor. Trained by Antony Tudor and Marie Rambert, he performed with the London Ballet in the late 1930s.

From 1941 to 1947, Paltenghi was a member of the Sadler's Wells, creating roles in Robert Helpmann's *Hamlet* (1942), *Comus* (1941), *Adam Zero* (1946), and the *Miracle in the Gorbals* (1944), and in Frederick Ashton's *The Quest* (1943) and *The Fairy Queen* (1946). Featured in *Les Sylphides*, he also danced in Ninette De Valois' *Promenade* (1944). In his last

years as a dancer he worked with the Ballet Rambert, performing in his own *The Eve of St. Agnes* (1950), and in the company productions of the classics.

As well as his concert choreography, Paltenghi worked in film staging the mime sequences in the Olivier film of *Hamlet* and background dances for the Alfred Hitchcock film *Stage Fright* in 1949. He appeared in Gene Kelly's *Invitation to the Dance* (MGM, 1952) as a character dancer and mime.

Works Choreographed: CONCERT WORKS: *The Eve of St. Agnes* (1950); *Prismatic Variations* (1950); *Fate's Revenge* (1951); *House of Cards* (1951); *Canterbury Prologue* (1951).

FILM: *Hamlet* (Two Cities, 1948); *Stage Fright* (WB, 1949).

Pan, Hermes, American motion picture dance director; born Hermes Panagiotopulos, 1913 in Memphis, Tennessee. Raised in Nashville, he worked as a Charleston dancer in Nashville and New York. He moved to Los Angeles in 1931 and taught dance at a private studio. After serving as dance director for a stock company, he became a camera dance assistant to Le Roy Prinz on Prologs, to Dave Bennett on the *Nine O'Clock* Revue, and to Dave Gould on the RKO films *Flying Down to Rio* (1931), and *The Gay Divorcee* (1934).

When Gould switched to MGM, Pan took over his position as staff dance director for RKO studios, inheriting the Fred Astaire/Ginger Rogers series of musical films. About half of his total output at RKO and other studios featured Astaire or Rogers, or both. He choreographed most of the co-starring films, beginning with *Top Hat* (RKO, 1935) and continuing through *Shall We Dance* (RKO, 1937, with Harry Losee) and *Swing Time* (RKO, 1936) to *The Barkleys of Broadway* (MGM, 1949, with Robert Alton). Everyone has a favorite Pan routine for Rogers and Astaire; mine are the romantic exhibition ballroom numbers, "Cheek to Cheek" and the "Swing Time Waltz," and the tap competitions from *Top Hat*. His Astaire films included *Damsel in Distress* (RKO, 1937), with dance numbers with Burns and Allen, *Second Chance* (Paramount, 1940), with the fast-talking and fast-dancing Betty Hutton, *Lovely to Look At* (MGM, 1952), *Silk Stockings* (MGM, 1957, with Eugene Loring), and *Finian's Rainbow*

(WB, 1968). He also staged dances for Astaire's NBC television specials in the late 1950s.

Pan also choreographed social dance numbers for Ginger Rogers in her comedy vehicles, *In Person* (RKO, 1935), *Bachelor Mother* (RKO, 1939), and *Roxie Hart* (Twentieth-Century Fox, 1942). Among his many other successful films were *Mary of Scotland* (RKO, 1936), for which he staged an Elizabethan masque, *Sun Valley Serenade* (Twentieth-Century Fox, 1941), with specialty numbers by Sonja Henie and the Nicholas Brothers, *Porgy and Bess* (Goldwyn/Columbia, 1959), and filmed musicals of successful shows like *The Flower Drum Song* (Hunter-Fields/Universal, 1961), and *Can-Can* (Twentieth-Century Fox, 1960).

Works Choreographed: FILM: *Top Hat* (RKO, 1935); *In Person* (RKO, 1935); *Roberta* (RKO, 1935); *I Dream Too Much* (RKO, 1935); *Follow the Fleet* (RKO, 1936); *Swing Time* (RKO, 1936); *Mary of Scotland* (RKO, 1936); *Shall We Dance* (RKO, 1937, co-choreographed with Harry Losee); *Damsel in Distress* (RKO, 1937); *Carefree* (RKO, 1938); *The Story of Vernon and Irene Castle* (RKO, 1939); *Bachelor Mother* (RKO, 1939); *Second Chance* (Paramount, 1940); *Rise and Shine* (Twentieth-Century Fox, 1941); *That Night in Rio* (Twentieth-Century Fox, 1941); *Weekend in Havana* (Twentieth-Century Fox, 1941); *Sun Valley Serenade* (Twentieth-Century Fox, 1941); *Moon Over Miami* (Twentieth-Century Fox, 1941); *Roxie Hart* (Twentieth-Century Fox, 1942); *Springtime in the Rockies* (Twentieth-Century Fox, 1942); *Footlight Serenade* (Twentieth-Century Fox, 1942); *My Gal Sal* (Twentieth-Century Fox, 1942); *Coney Island* (Twentieth-Century Fox, 1943); *Sweet Rosie O'Grady* (Twentieth-Century Fox, 1943); *Irish Eyes Are Smiling* (Twentieth-Century Fox, 1944); *Pin Up Gal* (Twentieth-Century Fox, 1944); *Billy Roses' Diamond Horseshoe* (Twentieth-Century Fox, 1945); *Blue Skies* (Paramount, 1946); *The Barkleys of Broadway* (MGM, 1949, "Shows with Wings On" sequence); *Three Little Words* (MGM, 1950); *Let's Dance* (Paramount, 1950); *Lovely to Look At* (MGM, 1952); *Hit the Deck* (MGM, 1955); *Silk Stockings* (MGM, 1957, Fred Astaire numbers only); *Porgy and Bess* (Goldwyn/Columbia, 1959); *Can-Can* (Twentieth-Century Fox, 1960); *The Flower Drum Song*

(Hunter-Fields/Universal, 1961); *The Pink Panther* (Blake Edwards, Mirisch, 1964); *Finian's Rainbow* (WB, 1968).

TELEVISION: *An Evening with Fred Astaire* (NBC, 1958, special); *Another Evening with Fred Astaire* (NBC, 1959, special); *Astaire Time* (NBC, 1960, special); *Think Pretty* (NBC, 1960); *The Bell Telephone Hour Valentine's Day Special* (NBC, 1961).

Panaieff, Michel, Russian ballet dancer working in the United States from the mid-1930s; born January 21, 1913 in Novgorod, Russia. After early training in Belgrade, Panaieff continued his studies in Paris with Alexander Volinine, Boris Kniaseff, and Lubov Egorova.

After a season with the Belgrade Opera, he joined the Ballet Russe de Monte Carlo in 1936, moving with the company to the United States. Among the many works in which he was given featured roles were Mikhail Fokine's *Don Juan, L'Epreuve d'Amour, Les Elfes,* and *Les Elements,* and Leonid Massine's *Rouge et Noir, Seventh Symphony*, and *Capriccio Espagñole,* as well as George Balanchine's *Aubade* and the company productions of *Swan Lake* and *Les Sylphides.*

Panaieff has taught in the Los Angeles area since the mid-1950s, also directing a small company and coaching period and national dances for MGM studios, notably, the 1957 *The Brothers Karamazov.*

Panko, Thomas, American theatrical dancer and choreographer. After being in Michael Kidd's *Can-Can* (1953), and *Li'l Abner* (1956), Panko began to work as an assistant and frequent performer for Oona White, for whom he has served on *The Music Man* (stage and film), *Take Me Along, Irma La Douce, Half a Sixpence, Mame,* and *Ilya Darling.* On his own, he has served as dance director for the television series *The Roaring '20s,* most of which was set inside a speakeasy (the Charleston Club) during a performance of some sort, and has choreographed Broadway shows. He is also known as a doctor for musicals in trouble on the road.

Works Choreographed: THEATER WORKS: *Golden Rainbow* (1968); *One for the Money* (1972).

TELEVISION: *The Roaring '20s* (ABC, 1960–1962).

Panov, Galina, Soviet ballet dancer working in the United States and Western Europe after 1974; born Galina Ragozina, 1949 in Archangel. Raised in Perm, she was trained at the Academy of Dance there, continuing her studies with Galina Ulanova from the age of eighteen. A member of the Kirov Ballet from 1970 to 1974, she performed roles in the classical repertory, notably *The Nutcracker* and *The Sleeping Beauty*, and in the Soviet works, such as *The Bronze Horseman* and Kasatkina and Vassiliov's *Creation of the World* (1971).

She and her husband, Valeri, defected in 1974 after a period of forced unemployment. They guested for a time, performing their own pas de deux and interpolating their versions of the classical principal parts into companys' productions. Settled into the Berlin Opera Ballet, where he is ballet master, she has performed major roles in his *Cinderella* (1978) and *The Idiot* (1979).

Panov, Valeri, Soviet ballet dancer and choreographer whose attempt to emigrate became an international diplomatic incident; born March 12, 1938 in Vitebsk. Originally trained in Vilna, he continued his studies with Agrippina Vaganova in Leningrad.

After making his debut at the Maly Theatre Ballet in Leningrad in 1957, and his reputation with performances of *Petroushka*, he switched to the Kirov Ballet, with which he appeared from 1964 to 1972. Featured in classical roles such as the "Bluebird" in *The Sleeping Beauty* and solos in *The Nutcracker* and *Le Corsaire*, he created roles in Leonid Iacobson's *Land of Miracles* (1967), and the title role in Constantin Sergeev's *Hamlet* (1970).

His attempt to emigrate to Israel in 1972 led to his dismissal from the Kirov and two years of enforced unemployment. The outpouring of support from Western balletomanes, especially in England and the United States, finally enabled him and his wife Galina to leave the Soviet Union for Israel. Although his participation in the Israeli dance has been minimal, he has performed and choreographed in North America and Europe since his arrival. During their first year in the West they did frequent guest performances with companies in America such as the San Francisco Ballet, in Canada, and in England, but managerial problems and the dated quality of their

repertory caused difficulties. Panov's work with the West Berlin Opera Ballet since 1978 has repaired his reputation as a performer and choreographer who can contribute to the artistic development of a company. His *Der Idiot* (1979), based on the Dostoyevsky novel and performed successfully on tour in America with Rudolf Nureyev, has been very well received, making him a name as a respected choreographer, not just a political victim.

Works Choreographed: CONCERT WORKS: *Heart of the Mountain* (1976); *Sacre du Printemps* (1977); *Cinderella* (1977); *Der Idiot* (1979); pas de deux and divertissements for duet performances with Galina Panov.

Pardue, Bessie, English precision-line choreographer also working in the United States; born c.1880 in London. Pardue was trained by Katti Lanner in her London studio and may have had some professional connection with the John Tiller School there. Her first professional precision team, the Eight High Steppers (c.1905), consisted primarily of her female relatives. Like the Tillers of England, the High Steppers all lived and toured together under adult supervision and close chaperoning. The success of the original High Steppers was so great that she began to train other teams of eight young "ponies" (women under five feet) for the Keith vaudeville circuit. Each of them was named for a flower, such as the Eight English Rosebuds, Eight Daisies, Eight Little Roses, and the Eight Forget-Me-Nots.

Paredes, Marcos, Mexican ballet dancer and costume designer working in the United States after the early 1960s; born in Aguacalientes, Mexico. Paredes was trained at the Academía de la Danza in Mexico City. He performed with two Mexican companies—Ballet Contemporaneo and the Ballet Classico de Mexico—before joining the Denver Civic Ballet. Performing in works by Enrique Martinez in that company, among them his *La Fille Mal Gardée* and *Electra*, he was invited to join the American Ballet Theatre, of which Martinez was regisseur.

In Ballet Theatre, he created roles in Eliot Feld's *At Midnight* (1967) and *Harbinger* (1967), in Michael Smuin's *Schubertiade* (1971), and in Baryshnikov's revival of *The Nutcracker* in 1976. Known for his

mime roles, he has been featured in *Petrouchka* as "the Chief Coachman," Glen Tetley's *Sargasso*, and Rudi van Dantzig's *Monument for a Dead Boy* and *La Sylphide*. His performance as "Carabosse," in Ballet Theatre's production of *The Sleeping Beauty*, was seen nationally on Public Television.

A member of the United Scenic Artists, Paredes has designed costumes for ballets by Michael Smuin, including his *Gartenfest* and *The Eternal Idol*, and for many pas de deux.

Parés, José, Puerto Rican ballet dancer and choreographer working in Cuba; born December 11, 1926 in Humacao, Puerto Rico. Parés was trained in New York City at the Ballet Arts School by Edward Caton and Margaret Craske. He taught in Puerto Rico briefly before beginning a long association with the companies of Alicia Alonso—the Ballet de Cuba, Ballet de Alicia Alonso, and Ballet Nacional de Cuba. He has also taught with the Ballet du XXième Siècle, the Berlin Opera, and in a multitude of guest engagements and master classes around the world.

Works Choreographed: CONCERT WORKS: *Un Concierto en Blanco y Negro* (1953); *Narcissus e Echo* (1958); *Coppélia* (1973); *Excercises sur les Études Symphoniques de Schumann* (1974); *La Fille Mal Gardée* (1978).

Paris, Carl, American modern dancer; born c.1950 in Trenton, New Jersey. Paris studied and performed with Pearl Lang, Eleo Pomare, and Olatunji before joining the Alvin Ailey Dance Theatre in the mid-1970s. His fluidity and strength of movement have made memorable his performances in Ailey's *Echoes in Blue, Blood Memories*, and *The Lark Ascending*, and in George Faison's *Lovers' Prayer* section of *Suite Otis*.

Park, Merle, Rhodesian ballet dancer working in England after the mid-1950s; born October 8, 1937 in Salisbury, Rhodesia. Trained in Salisbury, and at the Elmhurst Ballet School in Camberley, she continued her studies at the school of the Sadler's Wells Ballet.

Park, a beautiful dancer with strong technique and inherent lyricism, has performed with the Royal Ballet throughout her career. Best known for her work in the company's popular repertory of the classics,

she has danced the principal roles in *La Fille Mal Gardée, Coppélia, Cinderella, La Bayadère, Swan Lake*, and *The Sleeping Beauty*, which she did on satellite television hook-up in 1978. She has created roles in Antony Tudor's *Shadowplay* (1967), as "Celestial," in Frederick Ashton's *Jazz Calendar* (1968) and *The Walk to Paradise Garden* (1972), and in Kenneth Macmillan's *Elite Syncopations* (1974).

Parker, Flora, American vaudeville and film dancer; born September 1, 1891 in Perth Amboy, New Jersey; died c.1950 in Los Angeles, California. Parker made her Broadway debut at the age of eleven in *The Telephone Girl* (1901) and did not stop performing for thirty years. Her next show was *Mr. Bluebeard* (1903), the Eddie Foy, Sr. vehicle which was playing during the infamous Iroquois Theater fire in Chicago. After meeting and marrying Carter De Haven, she toured with him in vaudeville acts, billed as Mr. and Mrs. Carter De Haven, "Broadway's Beau Ideals." Among their appearances together were the Broadway shows, *The Queen of the Moulin Rouge* (1908), *The Girl and the Wizard* (1909, De Haven appeared only briefly), and *Hanky-Panky* (1912), and the vaudeville acts, *Whoops-de-Do* (c.1910), *All Aboard* (1913), and *Step Lively* (c.1916).

She danced in one film as a soloist, *The Mad Cap* (Universal, 1916), and appeared with De Haven in a series of other comedies with music, among them his "Timothy Dobbs" serials (Universal, 1916–1918) and *Twin Beds* (Universal, 1916).

It is unfortunate that so few of Parker's film appearances involved only social dancing, since she was considered a major dance star of vaudeville. With De Haven, she performed in straight exhibition ballroom work, characterizational and plotted pieces, such as seduction one-steps and arguing hesitations, and in conventional musical comedy duets in soft shoe. Like her daughter, Gloria De Haven, who played her in the film *Three Little Words* (MGM, 1950), she is known to the film audience as a fine comedienne, not as a specialty dancer.

Parker, Howard, American theatrical performer; born August 3, 1933 in Tampa, Florida. Parker has had a variety of theatrical careers, ranging from management of his own musical group, The Establish-

ment, to songwriting, but he has occasionally emerged from music to perform as a dancer. He made his dancing Broadway debut in *Once Upon a Mattress* (1959), after appearing in its Off Broadway run earlier that year. After receiving dance specialty billing in *Juno* (1959), he went to work for *The Red Skelton Show* as its dance lead for over seven years. While in Hollywood, where the show was taped, he appeared in two Bob Fosse motion pictures—*Pajama Game* and *How to Succeed in Business Without Really Trying*. Parker returned to dance in 1978 as a member of the chorus of regulars in Michael Bennett's imaginary Stardust *Ballroom*.

Parker, Madeleine; American theatrical and ballet dancer also performing as Mira Dimina; born c.1909 in New York City; died December 1936 on tour in Australia. Parker was trained in New York by Russian ballet dancers in residence there, among them Theodore Kosloff, Ivan Tarasoff, and Mikhaïl Fokine, before joining the Fokine Ballet in the mid-1920s. Like most of her American colleagues then, she was in her adolescence when she left Fokine for theatrical roles on Broadway and in London, where she replaced Mary Eaton in *The Five O'Clock Girl*. Parker left the theater to dance in Bronislava Nijinska's interpolated sections of the Max Reinhardt film of *A Midsummer Night's Dream* (WB, released 1934), and remained to appear in more conventional musical pictures. She joined the Ballet Russe de Monte Carlo in Los Angeles on Nijinska's recommendation and performed in her *Les Cents Baiser* with that company. Dancing as "Mira Dimina," she also appeared in solo roles in *Les Sylphides* and Leonid Massine's *Choreartium, Les Présages*, and *Symphonie Fantastique*. She had been publicized by the company as a native star, especially admired for her charm in demicharacter roles, but died tragically young on an Australian tour.

Parkes, Ross, Australian dancer working in American modern dance; born June 17, 1940 in Sydney, Australia. Parkes studied ballet in Sydney with Valrene Tweedie and in London with Audrey De Vos before moving to the United States to accept a scholarship at Martha Graham's School of Contemporary Dance. He joined the Graham company in the mid-

1960s, but left to pursue a freelance career that included performances with Graham dancers Bertram Ross, Helen McGehee, and Sophie Maslow. Associated closely with the works of John Butler, he created roles in Butler's pieces for a variety of companies, ranging from the Pennsylvania Ballet, where he was in *Villon* (1968), to the Carmen De Lavallade concert group, where he partnered her in *The Captive Lark* and *Portrait of Billie*. He was also associated with the Mary Anthony Dance Theater since 1966 as a dancer in her works, most notably in *In the Beginning* (1969), and as a choreographer for her company. He rejoined the Graham company in 1972 to perform dramatic roles in her *Acrobats of God, Clytemnestra, Chronique* (1974), *Adorations* (1975), and *Point of Crossing* (1975), and to serve as associate artistic director.

Works Choreographed: CONCERT WORKS: *Tides* (1974); *1.2.3.4.5* (1974).

Parkinson, Georgina, English ballet dancer; born August 20, 1938 in Brighton. Following studies at the Audrey Kepp school in Brighton, Parkinson continued her training at the school of the Royal Ballet.

Graduating to the Royal Ballet in 1954, she has created roles in Frederick Ashton's *Monotones II* (1966), and *Enigma Variations* (1968), and performed in his *La Fille Mal Gardée*. A strikingly beautiful performer with tremendous stage presence, she has been featured as ''The Mysterious Stranger'' in Bronislava Nijinska's *Les Biches*, as ''Rosaline'' in Kenneth Macmillan's *Romeo and Juliet*, and as ''Myrthe'' in *Giselle*.

Parks, John, American modern dancer and choreographer; born 1946 in the Bronx, New York. A graduate of the High School of Performing Arts, Parks attended American Dance Festival summer sessions and the Juilliard School, where he studied with José Limón and Anna Sokolow. At Juilliard, he performed in Sokolow's famed 1964 revival of *Session for Six*; with her company he created roles in her *Time Plus Seven* and *Déserts* in 1967. He also performed with the recital groups of Mary Anthony, Donald McKayle, and musician Bavatunde Olatunji, before joining the Alvin Ailey Dance Theatre in 1970.

His Ailey credits include the premier performances of his *Choral Dances, Flowers*, and *Mary Lou's Mass*, all in 1971, and featured roles in his *Revelations,* John Butler's *Carmina Burana*, Joyce Trisler's *Dance for Six*, and the company revival of Ted Shawn's *Kinetic Molpai*.

Since leaving the Ailey company, Parks has performed on Broadway in *The Wiz* (also in the film version) and has worked unceasingly as a freelance guest artist. Famed for his striking stage presence and articulate shapings of all scales of movements, he has performed with Rod Rodgers, dancing in his *Harambee* (1970) and *Eidolons*, Katherine Litz (*Loving Comments*, 1978), Sun Ock Lee, and the Movement Black Dance Repertory Theatre co-founded with his wife, designer/dancer Judith Dearing. Much of his choreography has been for that group, although his *Black Unionism* was created for the Ailey company in 1970.

Works Choreographed: CONCERT WORKS: *Trilogy (It Happens Every Day, A Woman's Way, The Man's the Klan)* (1969); *Black Unionism* (1970); *The 14 Stations of the Cross* (1973); *Nubian Lady* (1973); *You and the Ladies* (1976); *Forest* (1978); *Rā* (1978).

THEATER WORKS: *God's Song* (1977).

Parlić, Dimitrije, Yugoslavian ballet dancer and choreographer; born October 23, 1919 in Salonika, Greece. Trained at the school of the Belgrade Opera, he performed with the company after 1938, serving as choreographer after 1949.

In 1958, he became ballet director of the Vienna Staatsoper, succeeding Erika Hanka; he had worked with the company in the early 1940s, and on guest leaves. He has served in a similar capacity with the National Ballet of Finland (after 1971) and with companies in Zagreb and Edinburgh. Parlić's works that are known in the West date primarily from the 1950s, and were created for his company in Belgrade. More recently, he has created full-evening literary ballets including *Anna Karenina* (1973), *The Golem* (1974), and *Katerina Ismailova* (1977), a ballet of the opera.

Works Choreographed: CONCERT WORKS: *The Gingerbread Heart* (1951); *Romeo and Juliet* (1955); *La Reine des Iles* (1956); *La Chaconne* (1957); *The Miraculous Mandarin* (1957); *Symphony in C* (1959); *The Birthday of the Infanta* (1962); *Swan Lake*

(1970); *Anna Karenina* (1973); *Bacchus et Ariadne* (1974); *The Golem* (1974); *Katerina Ismailova* (1977); *Between Dream and Reality* (1977).

Parnova, Lisa, Russian-born American concert dancer; born c.1903; died September 3, 1969 in New York City. Parnova was raised in New York City, where she studied with Mikhail Fokine. In 1925, she moved to Germany to perform with the Cologne Opera Ballet in works by Hans Strohbach. She presented concerts of her own solos in Cologne in 1927 and 1928 and continued her career as a recitalist after returning to New York in 1930. She was unique in the period since she used ballet techniques, including toe work, but functioned professionally and socially as a concert dancer. If it were not for performance photographs showing her on point, there would be no reason even to think that she worked in ballet techniques, since she performed in the traditional concert dance theaters (the Guild, the Labor Stage, etc.), appeared at the "correct" benefits (for refugees of the Spanish Civil War), and presented concerts only on Sunday. Although she danced alone most frequently, she also worked with partners, Edwin Strawbridge (1929–1935), Igor Mileradoff (c.1939), and Barton Mumaw (c.1941–1944).

Parnova served as director of dance at the Neighborhood Playhouse from the early 1930s. In the mid-1950s, she left the city to found a Dance Education Centre in Westport, Connecticut.

Works Choreographed: CONCERT WORKS: *Indescher Tanz* (1927); *Russian Fantasy* (1927); *Zigeumertanz* (Gypsy dance) (1927); *Zwei Walzer* (1927); *Liebesfreud* (1928); *Jota Navarra* (1928); *Tanz ohne Musik* (1928); *Slavish Rendezvous* (1930); *Prelude and Etude* (1930); *Paris* (1930); *Wind on the Plain* (1930); *Garden in the Rain* (1930); *Waltz* (1930); *Modern Dancers* (1930); *Fire Dance* (1930); *Summer Days* (1930); *Mazurka* (1930); *A la Taglioni* (1930); *Gallop and Polka* (1931); *Refugee* (1931); *Idea of Evolution* (1931); *Spring Comes to Earth* (1931); *Three Songs* (1931); *Author's Dance* (1931); *Le Plus que Lente* (1931); *Individualist* (1931); *Earth Bound* (1933); *Effevescence* (1933); *Geres* (1933); *Abirato* (1933); *Burlesco* (1933); *Saudades do Brasil* (1933); *Comments on the Ballet (Classicism, Romanticism, Modernism)* (1934); *Les Petits Reins* (1935); *Youth* (1935); *The Afternoon of the Faun* (1935); *Tales from the Vienna Woods* (1935); *Light and Shade* (1935); *Fancy Skater* (1935); *Gavotte* (1939); *Pastorale* (1939); *Ballet Suite* (1939); *The Melting Pot* (1939); *Three Diagonal Dance Forms* (1939); *Muse* (1939); *Caprice* (1939).

Passloff, Ailene, American postmodern dancer and choreographer; born October 21, 1931 in New York City. Passloff participated in the Robert Dunn workshops that evolved into the Judson Dance Theatre. She created works, notable among them the 1963 *Boa Constrictor*, and performed in the pieces of Remy Charlip, including the solos, *April and December* (1965), and James Waring, dancing in his *Salute* in 1967. Passloff also participated in productions of the Judson Poet's Theatre, creating dances for Madeleine Renaud in 1964.

While teaching at Bard College, Passloff has created works for recent recitals. The 1978 recital, her first concert in many years, showcased her dance and choreographic students there. Unlike many of her colleagues in the workshops, she has stayed in formal choreography—of postmodern, nonformally constructed works, rather than improvisational or contact techniques.

Works Choreographed: CONCERT WORKS: *Prism* (1950); *Duologue* (1951); *Wind Song* (1953); *Intruders* (1956); *At Home* (1957); *Dust* (1957); *Sarabande* (1959); *Tea at the Palaz of Hoon* (1959); *Arena* (1959); *A Dance of Sleep* (1959); *Cypher* (1960); *Strelitzia* (1960); *Battle Piece* (1960); *Structures* (1960); *Foam* (1960); *Phantoms on the Mudflats* (1961); *Rosefish* (1961); *Pagoda* (1961); *Asterisk* (1962); *Glacier* (1962); *A Salute to the New York's World's Fair* (1963); *Pavilion* (1963); *Tier* (1963); *Boa Constrictor* (1963); *Fandango* (1963); *A Dozen Dances* (1963); *Unholy Picnic* (1964); *Thanksgiving Dance for Joanna and Burt* (1964); *Belissa in the Garden* (1964); *Bench Dance* (1964); *Men's Dance* (1965); *Spanning* (1966); *Waterwork* (1966); *Crossover* (1966); *Dance from "Molly's Dream"* (1967); *Fauna* (1967); *A Spike of Grain Bursts from Some Lips* (1969); *Tarosh* (1969); *Hopes and Fears* (1969); *Moving Day* (1969); *Hans* (1970); *A Dream Under a Black Hat* (1971); *Struggle in the Doorway* (1972); *Events from a Nightmare* (1972); *Entangle-*

ments (1974); *Emergence* (1975); *Footsteps in the Snow* (1978); *. . . With the Moon* (1978); *Dreams of Small Battles* (1978); *Claim* (1978); *Conservations* (1978); *Duet for Lyndy [Rieman] and Dan [O'Neill]* (1978); *Conversations with a Dog in a Long, Long Dream* (1978).

THEATER WORKS: *A Full Moon in March* (1958); *For Madeleine Renaud* (1964); *Pomegranada* (1966); *Aunt Mary* (1967); *Untitled Play* (1968, co-choreographed with Remy Charlip); *Song of Songs* (1969, co-choreographed with Charlip); *Encounters* (1969); *The Last Triangle* (1969); *Aurora* (1975).

Patricola, Tom, American tap dancer; born c.1893 in New Orleans; died January 1, 1950 in Pasadena, California. Raised in Italy, he spent his adolescence in the United States touring with his father's band; both he and his sister were then considered singers. After fifteen years on the Keith-Orpheum circuit, in the family act and in his own *The Dancing Pool*, he was engaged to perform in the *George White Scandals of 1923*, his first of five editions. The heavy dancer, called in one review "elephantine," did tap specialties and imitation acts (generally of Ziegfeld stars) in all five *Scandals*, and in the musical *Hold Your Horses* (1937).

Patricola made two feature films—*Married in Hollywood* (Fox Film Corp., 1929) and *One Mad Kiss* (Fox Film Corp., 1930)—and a series of comedy shorts, but returned to vaudeville with his own acts. He also worked at Billy Rose clubs, including the Diamond Horseshoe in 1939.

Patterson, Helen, American eccentric ballet dancer; born c.1903. Patterson, whose father served in the Navy, was raised in more than a dozen places across the country so it is impossible to verify with whom she studied ballet before joining the free classes that Anna Pavlova directed on the roof of the Hippodrome Theatre, New York, in 1916. She appeared with the Pavlova company at the Hippodrome in *The Big Show*, dancing as a Fairy in Pavlova's *The Sleeping Beauty*. She left Pavlova, however, to become featured dancer in the musicals *Follow the Girl* (1918) and *Little Blue Devil* (1919). Patterson also brought her extraordinary ability to do both ballet and toe tapping to the Keith and Orpheum circuits

and to Fanchon and Marco's West Coast productions in California, where she starred in their version of *Sunny*. After fifteen years of performing (a very long career for a toe tapper), Patterson began to appear regularly in films choreographed by her West Coast teacher Maurice Kunsell.

Patterson, Joy, American tap dancer working in film; born c.1926; died March 23, 1959 in Santa Ana, California. Patterson was one of the best tappers in the group of talented dancing and singing adolescents on contract to Universal Studios in the 1940s. Her machine-gun tap solos were featured in the *Collegians* series of short subjects, but she also danced in the long series of B musicals that the studio churned out. After retiring from performance in the late 1940s, Patterson worked for *Daily Variety* at its Los Angeles office.

Patterson, Yvonne, Australian ballet dancer working in the United States and Europe; born 1916 in Melbourne. Raised in the United States, she was trained originally by Chester Hale at his free school in New York and made her professional debut as a Chester Hale precision dancer. After continuing her studies at the School of American Ballet, she participated in projects and companies associated with its alumni— the American Ballet at the Metropolitan Opera, the Ballet Caravan, and the film, *The Goldwyn Follies*. She went on the Latin American tour of the combined companies, creating her first of many roles in a William Dollar ballet, *Juke Box* (1941), and returned to go into Balanchine's *Rosalinda* (1942). Patterson performed with the American Concert Ballet, a short-lived chamber company made up of SAB-related dancers in Dollar's *The Five Gifts* (1943) and appeared in Edward Caton's *Sebastien* (1944) and Dollar's *Constantia* with the Ballet International. She continued to dance in works by Balanchine and in the Original Ballet Russe in New York and the Grand Ballet de Monte Carlo in Europe but added roles in the companies' nineteenth-century repertories and the works of Mikhail Fokine and Leonid Massine.

Paul, Mimi, American ballet dancer; born February 3, 1942 in Nashville, Tennessee. Raised in the Wash-

ington, D.C. area she studied eurythmics with Evelyn LaTour and dance at the Washington School of Ballet.

Paul made her professional debut with the Washington Ballet in 1957, performing with the company until 1960 in Mary Day's *Ondine* (1959), and Frederick Franklin's staging of Act II of *Swan Lake* (1960). After further studies at the School of American Ballet, she joined the New York City Ballet in 1960. In her seven years with the company, Paul performed in almost every work by George Balanchine in the repertory, notably in *Apollo, Concerto Barocco, Four Temperaments, Symphony in C, Western Symphony, Divertimento No. 15, Episodes,* and *Bugaku.* She created roles in his *Don Quixote* (1965), *Jewels* (1967), dancing the melancholic pas de deux with Francisco Moncion in the *Emeralds* section, and *Glinkaiana* (1967), in the divertissement now called *Valse Fantasie.*

Leaving the City Ballet in 1967, Paul became a principal with American Ballet Theatre in order to perform in their production of the classic repertory. She danced the featured roles in *Giselle* after 1970 and *Swan Lake* from 1971, and performed in the company revival of Leonid Massine's *Gaîté Parisienne.* The piquant dancer created roles in Dennis Nahat's *Momentum* (1968), *Brahms Quintet* (1969), and *Ontogeny* (1971).

Paul has taught at the North Carolina School of the Arts since retiring from performance in 1974.

Paulli, Holger Simon, Danish nineteenth-century composer; born February 22, 1810 in Copenhagen; died there December 23, 1891. Paulli was one of the most important figures in Danish nineteenth-century musical life. He served as concert master and/or conductor of the Court Orchestra in Copenhagen from 1828 to 1883, and helped to found the Chamber Music Society and the Copenhagen Conservatory of Music. In his capacity at the Court Theatres in Copenhagen, he conducted and composed for August Bournonville. The Royal Danish Ballet's maintenance of the Bournonville ballets has kept his music alive and in the repertories of ballet orchestras around the world. Although like most composers around Bournonville he was forced to collaborate or share credits with many of his colleagues, he is be-

lieved to have created large portions of *Napoli* (1842, including the Tarentule finale), *Konservatoriet* (1849), *Kermesse in Bruges* (1851), and *Flower Festival at Genzano* (1858), composing the celebrated pas de deux in the latter.

Pavinoff, Rovi, Australian ballet dancer; born Phil Marks, c.1920 in Melbourne. Trained locally and at the school of the Sadler's Wells Ballet, he performed briefly with the Ballet Rambert in the late 1930s before joining the Anglo-Polish Ballet during the war. In Mona Ingelsby's International Ballet, he created roles in Harold Turner's *Fête en Bohème* (1941) and Ingelsby's own *Planetomania* (1941), with major featured roles in *Coppélia* and *Swan Lake.*

Pavinoff returned to Australia in 1951 to form his own company, choreographing original works and reviving the classics for touring performances.

Works Choreographed: CONCERT WORKS: *Les Elfes* (1951); *Boulevards du Quartier* (c.1952); *Suite en Rose* (1955).

Pavley, Andreas, Dutch ballet dancer and choreographer working in England and the United States as a Russian; born Andreas Hendrikus Theodorus van Dorp de Weyer, November 1, 1892 in Batavia, Java; died June 26, 1931 in Chicago, Illinois. Raised in Amsterdam, Pavley received his first formal dance training with Emile Jaques-Dalcroze in Geneva (c.1909–1911). He created his first choreography, a pageant based on Beethoven's *Prometheus* ballet, for students at the University of Amsterdam, before traveling to Paris in 1911. There, and in London, he studied with Ivan Clustine and Enrico Cecchetti.

After moving to London in 1912, Pavley (as Andreas de Weyer) collaborated on a ballet, *The Gate of Life,* with artist Avild Rosencrantz, later performing it and a solo, *Death and the Maiden,* in a London recital early in 1913. Following this concert, he auditioned to become a member of the company being assembled to perform with Anna Pavlova on her next American tour. Now dancing as Andreas Pavley, he remained with Pavlova for three years, performing solos in Clustine's *The Fairy Doll* and in the Pavlova tabloid versions of the classics. Pavley served as the model for Pavlova's partner in Malvina Hoffmann's statue of *Autumn Bacchanale,* but it cannot be deter-

mined accurately whether he ever performed in that capacity on stage.

After the 1916 American tour, Pavley and Pavlova dancer Serge Oukrainsky decided to remain in the United States, working first in Indianapolis, Indiana, and later in Chicago. Through the intervention of dancer/musician Tamara de Swirsky and soprano Mary Garden, the leading singer (and, after 1919, the director) of the Chicago Grand Opera, Pavley and Oukrainsky became associated with the company, then considered one of the most important opera companies in America. The Pavley-Oukrainsky Ballet company and school, with the financial and social backing of the Opera, flourished in Chicago, on tour, and in summer bookings in Los Angeles.

The enormous influence that the Pavley-Oukrainsky school and company had on Chicago and on all of American ballet is just now beginning to be appreciated. Among their company members were Ruth Page (also performing with them in Indianapolis), Edward Caton, Edris Millar, Ruth Pryor, Sylvia Tell, and Eleanore Flaige. Dancers who studied with them on a permanent basis, or in master classes, include almost everyone west of the Great Lakes area, among them, Doris Humphrey, Arthur Corey, Leon Varkas, and Delores del Rio.

Pavley's position in the company seems to have been primarily that of a performer and director. As he and Oukrainsky shared choreography credits for most of the company's repertory, it is difficult to determine who was responsible for the individual work, although one can tentatively assign credit to each choreographer for his own performance solos. Pavley, probably the most widely known and recognized ballet dancer based in the United States, led the full company and small concert groups on tours throughout the country on the Keith-Orpheum circuit—either alone or with the San Carlo or Manhattan Opera Companies.

Pavley died in Chicago on June 26, 1931, the day on which the company's first Paris performances were being arranged. Although it is still impossible to determine exact factual data, it seems likely that, victimized by a blackmail attempt, he committed suicide. For many years after his death, dance, art, and physical culture magazines were filled with the controversy surrounding his death—either mourning

him as a martyr to dance, or presenting detailed analytic explanations proving that his death was accidental. It is unlikely that the actual details will ever be known.

Works Choreographed: CONCERT WORKS: (Note: no solo credit can be assigned absolutely after 1913. Those dances which are probably by Pavley alone are marked with an asterisk.) *Prometheus** (1909); *The Gate of Life* (1912, in collaboration with artist Avild Rosencrantz); *Death and the Maiden* (1912); *Demon Dance** (1916); *Dance of a Gypsy** (1916); *The Sacrilege** (1916); *Cymbal Dance* (1916); *A Ball Game* (1917); *Dutch Dance** (1917); *Mazurka* (1917); *Romance* (1917); *Slave Dance* (1917); *Minuet Récamier* (1917); *The Bird and the Serpent* (1917); *Valse Triste* (1917); *L'Ephème* (1917); *La Sylphide* (1917); *Hungarian Dance* (1917); *Mirror Dance* (1917); *Will-O'-the-Wisp* (1917); *Bacchanale* (1917); *An Egyptian Temple Procession* (1917, may be sequence from *Aida*); *Spanish Suite* (1917); *Bohemian Dance* (1917); *Pastorale* (1917); *Hymn to Joy* (1917); *Prelude L'Après-Midi d'un Faune [sic]* (1919, by Pavley-Oukrainsky, after Nijinsky); *L'Arlesienne* (1920); *Danse du Printemps* (1920); *La Camargo* (1920); *Siamese Dance* (1920); *Flying Leaves* (1920); *Adagio Classique* (1920); *Pierrot's Shadow* (1920); *Habañera* (1920); *Torch Dance** (1920); *Boudour* (1920); *The Dance of the Hours* (1922); *Syrian Temple Dance* (1922); *A Cruxificion* (1922); *Nymphs at Play* (1922); *Valse Classique* (1922); *Holland Dance** (1922); *Rondo Capriccioso* (1922); *Largo* (1922); *Victory Dance* (1922); *The Bee* (1922); *Anitra's Dance* (1922); *Bal Mobile** (1922); *Trianon* (1922, short version); *Liebeswalzer* (1922); *The Frog* (1922); *The Chase* (1922); *The Powder Puff* (1922); *La Fête à Robinson* (1922); *Danse Macabre* (1922); *The Birthday of the Infanta* (1922); *The Gates of Redemption* (1922); *The Captive Princess* (1922); *Dance Poem* (1922); *The Temple of the Sun* (1922); *Gypsy Camp* (1922); *The Temple of Dagon* (1922); *Trianon* (1923, full-length ballet version); *Japanese Ballet* (1923); *Les Fleurs du Mal* (1924); *The Garden Dance* (aka *In a Garden*) (1925); *Three Grecian Studies* (1925); *White Mazurka* (1925); *In Knighthood Days* (1926); *Bourée* (1926); *Titiana* (1926); *A Night in Granada* (1927); *Kloris and Roosje** (1927); *The Legend of the Sun* (1927); *Au Claire de Lune* (1927); *Cubist Dance*

(1927); *Martyr** (1927); *Blue Danube* (1927); *Czardas* (1927); *Ballet Romantique* (1927); *Pizzicato* (1928); *The Naughty Bustles* (1928); *Rebellion* (1928); *Christmas Eve** (1929).

Pavloff, Michel, Russian ballet dancer and nightclub manager; born c.1891 in Kiev; died May 14, 1981 in New York City. Originally an opera student, he migrated to Paris in 1911 to continue his training. Although it is not certain whether he ever sang onstage, he became well known as an opera mime and actor. He joined the Diaghilev Ballet Russe in 1916 in London and in his thirteen years with the company became its principal *demicaractère* dancer and comic. Among his credits were roles in the premieres of *Les Femmes de Bonne Humeur* (Leonid Massine, 1917), *La Boutique Fantasque* (Massine, 1919), *The Sleeping Princess* (1921), and Bronislava Nijinska's *Les Noces* (1923).

Following the death of Diaghilev in 1929, he became manager and part owner of the Casanova nightclub in Paris. At the time of the German invasion of Paris he emigrated to the United States with the help of former Diaghilev dancer Chester Hale, and assisted him briefly in his nightclub and ice show ventures here. He served at various times as stage manager of most of New York's most popular cabarets, among them El Morocco and the Copacabaña. In his later life, he emerged from retirement occasionally to assist in the presentation of exhibits dedicated to Diaghilev and his artistic collaborators and in the restaging of Ballet Russe productions, including the City Center Joffrey Ballet's *Parade* of 1973.

Pavlova, Anna, Russian ballet dancer touring in Europe, England, and the United States after 1910, still considered, fifty years after her death, the ideal female dancer; born January 31, 1881 in St. Petersburg; died January 3, 1931 in the Hague, The Netherlands. Trained at the St. Petersburg school of the Imperial Theatres, Pavlova made her debut as a child, and danced her first important role in Petipa's *The Two Stars*. By her graduation performance in 1898, she was considered a finished dancer, capable of creating characters without diluting the purity of her technique. While at the Maryinsky Theatre, she participated in tours to Moscow with Mikhail Fokine in 1907 and Western Europe in 1908 with Adolf Bolm. In 1908, she performed in Germany and Paris with Serge Diaghilev in the troupe that was considered the Ballet Russe.

Pavlova had created important roles by Fokine before the Diaghilev tour, among them, in his *The Swan* (known as "The Dying Swan" and remembered as Pavlova's most persistent dance image), his *Le Pavillon d'Armide*, and *Chopiniana*—all in 1907. She had done her first *Swan Lake* on the Bolm tour in 1908, and her first full-length production in the next year. But whether as an active decision or as an inevitable career move, Pavlova left Diaghilev to spend the rest of her life touring.

It may be that Pavlova became the world-famous image of dance because she was not a part of a company and because her personality overwhelmed any possible publicity value that could be given to her choreographers. She also seems to have overwhelmed her repertory; the recognition factor that Pavlova maintained throughout her career as The Dance, The Swan, The Epitome of Movement, did not carry over to it. Apart from *The Swan*, known from photographs more than performance, her repertory was not identifiable in contemporary descriptions. Pavlova became a piece of iconography, not just a dancer and not completely the head of a work-producing company.

Pavlova was in fact responsible for part of her repertory; she was credited with the choreography for fourteen known works, from *Le Papillon* (1910) to *Masquerade* (1926). The best known of these, *Snowflakes* (1915, after Ivan Clustine), *Dragonfly* (1915), and *Autumn Leaves* (1919), fit the limitations of the repertory in total. They were sentimental studies of movement-in-nature as related to ballet techniques.

Part of the Pavlova mystique was the extent of her tours—she performed regularly not only on the New York-Philadelphia-Boston circuit but throughout the United States. She and her company extended their tours to South America, actually sitting out most of World War I there, and to Australia.

The company was not, of course, a cohesive unit. She performed regularly with four partners—Mikhail Mordkin (1909-1911), Laurent Novikoff (from 1911–), Alexander Volinine (from 1914–), and Pierre Vladimiroff (1927-1931). Two sets of com-

pany members were responsible for spreading Pavlova's concept of dance and concurrently the technical training from Enrico Cecchetti to America and the other "outreaches" of the contemporary world. Many of the European dancers left the company to remain in the United States, among them, Mordkin, Novikoff, Serge Oukrainsky and Andreas Pavley (settling in Chicago), Muriel Stuart, Joyce Coles, Beatrice Collenette, and Ella Dagnova. In addition, the Americans who joined the company and then returned to the U.S. were generally very influential in various dance forms, including Hubert Stowitts (known as a performer and artist) and Chester Hale, the most important Prolog stager on the East Coast. It is important to note that most of the Pavlova returnees worked in theatrical and popular dance, not in classical or opera ballet.

The Pavlova image was also spread through her film appearance in Universal Studio's silent motion picture version of *The Dumb Girl of Portici* in 1916, and through her many newspaper publicity interviews. Pavlova on dance, fashion, health, and physical culture was a staple of journalism, especially on the Hearst chain, for many years. Pavlova was also the most imitated person in the arts, with the possible exception of Vaslav Nijinsky. Some satire of Pavlova appeared in almost every edition of the major Broadway revues from 1910 to 1930 and in many of the plotted musical comedies in London. During her life and for many years after her death, she was the subject of a multitude of poems and artistic tributes in the dance and popular press.

Works Choreographed: CONCERT WORKS: *Le Papillon* (1910); *La Rose Mourante* (1910); *Blue Danube* (1911); *Snowflakes* (1915); *La Naissance du Papillon* (1912); *Dragonfly* (1915); *California Poppy* (1916); *Rondino* (1916); *La Danse* (1918); *Autumn Leaves* (1919); *Three Wooden Dolls* (1920); *Christmas* (1920, co-choreographed with Ivan Clustine and Alexander Volinine); *Japanese Butterfly* (1923); *Masquerade* (1926).

Bibliography: Lazzarini, John and Roberta. *Pavlova* (New York: 1981), includes one of the most comprehensive Pavlova bibliographies of published works available; Magriel, Paul, ed. *Pavlova: An Illustrated Monograph* (New York: 1947); Svetlov, Valerian. *Anna Pavlova* (Paris: 1922). (Note: memoirs by Algeranoff, Oliveroff, Oukrainsky, Stier, and Volinine should be consulted but not accepted as unbiased sources.)

Pavlova, Nadeshda, Soviet ballet dancer; born 1956 in Tsheboksari. Trained at the school of the Perm State Ballet, she performed with that company until 1975, when, after winning an International Ballet Competition, she was assigned to the Bolshoi Ballet. There, she has performed in Grigorovich's *Spartacus* and *The Legend of Love*, and in the company's productions of *Giselle, Romeo and Juliet,* and *The Stone Flower.*

Pavlova, who was very popular in the United States when she toured with a "Young Stars of the Russian Ballet Troupe," danced in the Soviet-American film flop, *The Blue Bird* (Twentieth-Century Fox, 1976).

Paxton, Steve, American postmodern dancer and choreographer; born in Tucson, Arizona. Paxton, who was a tumbler in high school, studied modern dance locally with two Martha Graham–trained instructors—Sister Jean of the order of The Teachers of the Children of God, who also taught a Cecchetti class, and Frances Smith Cohen of the Jewish Community Center. He attended the Connecticut summer classes of the American Dance Festival in 1959, where he studied technique with José Limón and Merce Cunningham, and composition with Louis Horst and John Cage. He began working with Robert Rauschenberg and Robert Dunn shortly thereafter and did not return to Tucson. For a few years in the late 1950s and early 1960s, Paxton seemed to follow a fairly traditional path: he attended Juilliard and performed in new works by Limón, including his *Missa Brevis* (1958) and *Tenebrae, 1914* (1959). He freelanced with James Waring productions at the Living Theater and a miscellany of pick-up jobs, including a Buzz Miller jazz piece for the Sunday morning television show *Look Up and Live* (1962).

His work with Robert Dunn led to his participation in the Judson Dance Theater, for which he created many works. He performed in the dances of his colleagues at Judson also, most notably in the extraordinary *Trio A* (1966), by Yvonne Rainer, that one critic considers the touchstone of postmodernism. Paxton

also became a frequent participant in collaborative projects with artists, most frequently with Rauschenberg, while performing at Judson and with the Merce Cunningham company. He was considered one of the major figures in postmodernism and one of the finest performers in any dance genre.

It is difficult to avoid chronological historiography when discussing Paxton. The piece that focused him in the genre in which he currently choreographs was not considered seminal at its premiere. *Satisfyin' Lover* (1967) was a work for the audience—a large group of people walked across the stage, stopping occasionally in their progression from stage right to left. It was perhaps the ultimate form of pedestrian movement, abstracting even the act of performance from dancers. The intense theatricality of his other contemporary works, among them the dance in an inflatable tunnel setting/costume/function used in *Music for Words Words* (1963) and *Physical Things* (1966), and the sexual allusionary motifs found in *Somebody Else* (1967) and *Beautiful Lecture* (1968), obscured his work with pedestrian features of dance. It may have been his participation in the Grand Union improvisatory sessions and concerts that freed him from theatrical elements and allowed the evolution of his current work. In 1972, during a Grand Union residency, he began to work publicly in duet formats with sharing of support and movement among performers as thematic material and vocabulary. Contact Improvisation (always capitalized) was officially named and presented in a New York concert late that year. Since then, it has become a recognized genre in itself—one that has spawned a number of companies working in duet and group formats. Contact Improvisation concerts, which generally do not include differentiated, titled works, deny choreography credits as a limitation, so Paxton's creativity may seem to have ceased in the 1970s. It is now a form of dance, as well as a liberating experience for performers and students, but is no longer Paxton's work, or even a franchised system of choreography.

While teaching extensively and occasionally performing with Trisha Brown, Paxton has returned to solo improvisation for public recitals. He has cumulatively titled his concerts *Backwater: Twosome* (1977–) but each is a different simultaneous improvisation as performed by percussionist David Moss and Paxton. They work together as concurrent performer and accompanist, but the musician does not necessarily also follow the dancer. The combination is exciting, since Moss, caged in a rectangle of drums, bells, and tubes, is frequently more active as a performer than Paxton. While improvisation sessions cannot be judged or described, Paxton's performances are always exciting. He has a unique sense of balance and is able to sustain movements and integrate them while in poses that would, in a more theatrical context, seem to defy gravity.

Works Choreographed: CONCERT WORKS: *Proxy* (1961); *Transit* (1962); *English* (1964); *Words Words* (1964, in collaboration with Yvonne Rainer); *Left Hand David Hayes* (1963); *Music for Words Words* (1963); *Afternoon* (1963); *Flat* (1964); *First* (1964); *Title Lost Tokyo* (1964); *Jag ville görna telefonera* (I Want the Telephone) (1964); *Section of a New Unfinished Work* (1965); *The Deposits* (1965); *Section of a New Unfinished Work (augmented)* (1966); *A.A.* (1966); *Earth Interior* (1966); *Physical Things* (1966); *Improvisation with Trisha Brown* (1966); *Satisfyin' Lover* (1967); *Love Songs* (1967); *The Sizes* (1967); *The Atlantic* (1967); *Somebody Else* (1967); *Some Notes on Performance* (1967); *Walkin' There* (1967, also titled *Audience Performance #1*); *State* (1968); *Untitled Lecture* (1968); *Beautiful Lecture* (1968); *Audience Performance #2* (1968); *Salt Lake City Deaths* (1968); *Smiling* (1969); *Lie Down* (1969); *Pre-history* (1969); *With Rachel, Suzi, Jeff, Steve & Lincoln* (1970); *Roman Newspaper Phrase* (1970); *Niagara Falls At* (1970); *Intravenous Lecture* (1970); *St. Vincent's Hospital At* (1971); *Collaboration with Wintersoldier* (1971); *Magnesium* (1972, considered the first performance titled Contact Improvisation); *Benn Mutual* (1972, in collaboration with Nita Little); Contact Improvisations (1972, ongoing); *Dancing* (1973, ongoing); *Air* (1973); *With David Moss* (1974, ongoing); *Roaming (Aroma)* (1974); *Scribe* (1976); *Backwater: Twosome* (1977, ongoing collaboration with David Moss); *Solos* (1977, ongoing); *The Reading* (1978); *Come to Pass* (1979).

Payne, Nina, American interpretive dancer working in theaters in the United States and France; born c.1885 in Louisville, Kentucky. Payne was raised in Seattle, Washington, where she began her training in

Delsarte elocution and interpretive dance with Daniel Doré. She made her professional debut in 1910 with a vaudeville tour that brought her east to New York. Her repertory did not consist of the traditional short abstractions based on Romantic piano music but was instead a series of one-woman plotted pantomimes, among them *La Danse de Robe de la Nuit* (c.1910), *La Somnambule* (1911), and *Cléopâtre en Masque* (1911). By 1915, however, she had created a repertory of short works for vaudeville and for interpolation in revues and roof garden shows, including her Cubist sensation, *Pen Point Prance*, performed in a fabulous painted bodysuit and head-dress. Her works from 1915 to 1920 included that dance, *The Cameo Waltz*, the satirical *Cleopatre Cakewalk*, her first piece of exotica, *East Indian Juggler*, and *A Spanish Dancer's Concept of "The Spring Song."*

In 1921, she took a vacation to Paris, where she worked briefly as Harry Pilcer's partner in his Pré Catalan ballroom act. She then brought her own solo act to that famed Paris café, and, after its success, to the Olympia Théâtre and the Folies Bergère. She was a staple at the latter for eight years.

Pearson, Jerry, American modern dancer and choreographer; born March 17, 1949 in St. Paul, Minnesota. Pearson studied and performed with Nancy Hauser locally before moving to New York to dance in the Murray Louis company in repertory works (1973–1977). Since 1975, he has presented works in recitals shared with his wife, Sara Pearson. In their cooperative choreography, they avoid the standard male-female pas de deux format and instead create works for two equal but different bodies performing in abstracted physical relationships.

Works Choreographed: CONCERT WORKS: (Note: unless otherwise noted, all works by Jerry and Sara Pearson.) *Exposures* (1975); *Morning Dances* (1976); *Magnetic Rag* (1978); *Andante* (1978); *Nocturnal Excavations* (1978); *The Disease Suite* (1978, Jerry Pearson only); *Vampire Dance: A Personal Melodrama* (1978, Jerry Pearson only); *Secrets of Sleep* (1979); *Under the Spell* (1980); *Chemical Dependencies* (1980).

Pearson, Sara, American modern dancer and choreographer; born April 22, 1949 in St. Paul, Minnesota. Pearson consistently uses her married name in performance. Like her husband and colleague, Jerry Pearson, she was trained by Nancy Hauser in Minneapolis and performed in her company. After moving to New York she danced with the Murray Louis troupe from 1973 to 1976, and later as a guest artist. Although she presented a work of her own choreography in 1974, she has worked most prominently with Pearson in creating a cooperative repertory for performance. Their witty duets have proven very popular with audiences at their New York recitals and on tour.

Works Choreographed: CONCERT WORKS: (Note: all works co-choreographed by Jerry and Sara Pearson.) *Amnesia* (1974, Sara Pearson only); *Exposures* (1975); *Morning Dances* (1976); *Magnetic Rag* (1978); *Andante* (1978); *Nocturnal Excavations* (1978); *Secrets of Sleep* (1979); *Under the Spell* (1980); *Chemical Dependencies* (1980).

Pearson, Scott, American theatrical performer; born in Milwaukee, Wisconsin. After making his professional debut as the dancer "Curley" in the Johnny Desmond tour of *Oklahoma*, Pearson moved to New York where he was cast in *Irma La Douce* (1960). After dancing for Bob Fosse in *How to Succeed in Business Without Really Trying* (1961) and for Michael Bennett in *A Joyful Noise* (1966), he expanded his professional scope outside of dance into dramatic roles. He returned to conventional Broadway dance, however, as the choreographer "Zach" in Bennett's innovative musical *A Chorus Line*, playing that role in the national touring and Broadway companies.

Peck, Andé, American modern dancer. Trained at Bennington College, he has become one of New York's most important modern and postmodern freelance dancers, with performance credits in a variety of major companies. His first New York appearances were with Dance Theater Workshop's group concerts, in which he danced in Kathryn Posin's *Guidesong* (1969) and the New York premiere of *Rocks*, by his Bennington teacher, Jack Moore. He has worked with Viola Farber throughout the 1970s, and has been seen in her *Turf* (1978), *Dinosaur, Parts, Night Shade, Dune, Passage, Co-op, Survey*, and the outside pieces, *Bronx Botanical Garden* and

Brooklyn Museum. With Lucinda Childs since 1977, he has been able to work in her studies of repetition and rhythmic patterns, including her *Melody Excerpt* and *Radial Courses.*

Pécourt, Louis, French seventeenth-century ballet dancer and choreographer; born August 10, 1653 in Paris; died there April 22, 1729. Trained by Henri-François Beauchamp, Pécourt was associated with the Paris Opéra throughout his career.

He performed there in operas by Lully, among them, *Le Triomphe de l'Amour* (1681) and *Le Temple de la Paix* (1685). Ballet master himself from 1687 to 1703, his choreographed works included *Achille et Polixene* (1688), *Le Palais de Flore* (1689), performed at Le Petit Trianon, and *Apollon Législateur* (1711), which provided David Dumoulin with his first major role. Like Beauchamp, he sponsored the dance script experiments of Raoul-Auger Feuillet, who notated his ballets.

Works Choreographed: CONCERT WORKS: *Achille et Polixene* (1688); *Le Palais de Flore* (1689); *Apollon Législateur, ou le Parnasse réformé* (1711).

Pelt, Joost, Dutch ballet dancer; born September 29, 1950 in Amsterdam. Trained at the Academy in Rotterdam, he performed with the Nederlands Dans Theater through much of the 1970s. Best known in contemporary works, he was acclaimed in the company's production of John Butler's *Carmina Burana* and in new works such as Gerhard Bohers' *Unterwegs* (1976) and Jonathan Taylor's *Deranged Songs* (1976). Pelt has also performed with the Royal Winnipeg Ballet in its contemporary repertory of ballets by Fernand Nault.

Pemberton, Stafford, American early twentieth-century ballet dancer; born Stafford Penigberton, c.1897 in Virginia. Originally an athlete, he studied ballet with Elisabetta Menzelli in New York. He first performed professionally as a ballet dancer as Gertrude Hoffmann's partner in her 1913–1914 tours. He played "Shiek El Mahdi" in her *Zobedie's Dream*, partnered her in her duet version of *Spring Song* and interpolated his own plastique solos into the program. He also put his solos, generally about woodland creatures and fauns, into Ned Wayburn's

Town Topics (1915) and the *Passing Show of 1914.* One of his last dance engagements was as a principal danseur with a fascinating ballet company in vaudeville—Ruth Thomas' troupe that played at the Palace Theatre in 1917. He partnered Thomas and soloist La Sylphe in all four dances—*The Nymphs, Song Without Words, The Yellow Feather,* and *The Stolen Idol.* There are many interesting elements to this company, not the least of which is that there is no available information on Thomas in any dance or vaudeville source.

Pemberton dropped out of sight after the 1916 Thomas engagement. It is not known whether he dropped completely out of dance.

Pendleton, Moses, American modern dancer and choreographer; born March 28, 1949 in Lyndonville, Vermont. Pendleton was trained by Alison Chase while a student at Dartmouth College. In 1971, he founded Pilobolus with fellow student Jonathan Wolken, and has performed and choreographed with the partially collaborative group ever since. He has become expert at creating shapes with the people and props that make up the Pilobolus company, whether humorous sight gags as in *Untitled* (1975) and *The Detail of Phoebe Struchan* (1980), or abstractions named for (but not necessarily based on) biological phenomena. He has choreographed alone for himself, in collaboration with the entire company (at the time of each work's creation), and with his mentor, Chase.

Works Choreographed: CONCERT WORKS: *Walklyndon* (1971, choreographed by Pilobolus); *Anaendrom* (1971, choreographed by Pilobolus); *Ocellus* (1972, co-choreographed with Robert Morgan Barnett, Michael Tracy, and Jonathan Wolken); *Monkshood* (1974, choreographed by Pilobolus); *Ciona* (1975, choreographed by Pilobolus); *Lost and Found* (1976, choreographed with Alison Chase); *Lost in Fauna* (1976, choreographed with Chase); *Molly's Not Dead* (1978, choreographed by Pilobolus); *Shizen* (1979, choreographed by Chase); *The Detail of Phoebe Struchan* (1980); *Rélâche* (1980).

Penney, Jennifer, Canadian ballet dancer working in England after 1963; born April 5, 1946 in Vancouver, British Columbia, Canada. After studying with

Gwynneth Lloyd and Betty Farrally (founders of the Royal Winnipeg Ballet), she continued her training at the School of the Royal Ballet in London, 1962.

Performing with the Royal Ballet from 1963 to the present, she has become associated with the repertory of its director, Kenneth Macmillan. She has created roles in his *Anastasia* (1971 version), *The Four Seasons* (1975), *Elite Syncopations* (1974), and *Manon* (1974), also dancing in his *Song of the Earth* and *Seven Deadly Sins*. Featured in the classical repertory for which the company is famous, she has performed to great acclaim in *Swan Lake, The Sleeping Beauty,* and *La Fille Mal Gardée*. Her lyrical style and gifts for musicality have brought her to prominence in revivals of Frederick Ashton's *A Wedding Bouquet, Daphnis and Chloe,* and *Symphonic Variations*, and in Jerome Robbins' *Dances at a Gathering* and *Afternoon of a Faun.*

Pennington, Ann, American theatrical dancer; born December 23, 1894 in Camden, New Jersey; died November 4, 1971 in New York. Pennington was trained by Ned Wayburn and Jack Blue—both noted teachers of tap work, acrobatics, and musical comedy dancing.

Billed as "the girl with the dimpled knees," she could easily have been called "the girl with the open torso," since in almost every dance routine in every show, she moved into the same positions, climaxed in a lunge toward her right foot. Pennington was basically a revue dancer, and was considered one of the best and most versatile. She performed in eight editions of the *Ziegfeld Follies* (1913–1918, 1923–1924), and five editions of the *George White Scandals* (1919–1921, 1926–1928). Although known for the Black Bottom that she introduced in the 1926 *Scandals*, her specialty dances ranged from the buck-and-wing, in the 1914 *Follies*, to the Hula, danced in "I Left Her on the Beach at Honolulu" in the *Ziegfeld Follies of 1916*. White's dance partner in the early *Follies*, she was a staple in his *Scandals* throughout the 1910s and 1920s, performing songs by the Gershwins, and by Da Sylva, Brown and Henderson. She also worked in three musical comedies—*Jack and Jill* (1923), Cole Porter's *The New Yorkers* (1936), and *Everybody's Welcome* (1931), and came

out of retirement in 1943 to tour with *The Student Prince.*

Although she made three feature films, and a large number of short subjects, Pennington never really made a success of her movie career. Two of her transitional era musicals, however—*The Goldiggers of Broadway* (WB, 1929), the first of the series, and *Happy Days* (Fox Film Corp., 1929)—are considered among the best of the genre and have been preserved.

Pennison, Marleen, American modern dancer and choreographer; born August 26, 1951 in New Orleans, Louisiana. Pennison was trained at the University of Southern Louisiana. She has performed with a number of New York-based projects since moving north in 1974, among them Barbara Roan's *Blue Mountain Paper Parade* (1974), Rudy Perez's Dance Theater, and Ping Chong's *Fear and Loathing in Gotham*, playing all of the victims in the 1980 work. She has taught movement for actors since coming here and has been director of the movement program at the Stella Adler studio in New York since 1977. In recent years, she has done some choreography for theater productions, including an industrial and a union revue, but she creates most of her characters and plotted sequences in dance performance. Pennison is one of the few contemporary dancers working in characterizational forms and creating theater pieces into short stories of movement. Her works are frequently set in the literary South, the New Orleans of fantasies and disappointments. Her works are beautifully realized statements of a life seen in vignettes, as if an imagination, not a history, were telling the stories.

Works Choreographed: CONCERT WORKS: *The Keeper* (1972); *Bethena* (1973); *Don't Step on the Pavement Cracks* (1973); *One Dance in the Shape of a Couple* (1975); *A Little Bit of Honey's* (1975); *Bethena After* (1977); *In Absentia* (1977); *River Road Sweet* (1977); *The Mute* (1978); *Porch Song* (1978); *Fat Monday* (1978); *Tante Jeanne* (1978); *Hurricane Warning* (1978); *Flatfoot* (1979); *Girlfriend* (1979); *Mother and Child* (1979); *The Commonplace* (1979); *Dialogues for a Woman and a Chair* (1980).

THEATER WORKS: *Take Care* (1980, revue for the Hospital Workers' Union, Local 1199, New York);

Busy Signal (1980, play written and directed by Pennison).

FILM: Lindy sequence in industrial film for Philip Morris Industries.

Percassi, Don, American theatrical dancer; born January 11, c.1948 in Amsterdam, New York. Percassi made his Broadway debut in *High Spirits* (1964), and followed it with half a dozen musical comedies, among them, *Walking Happy* (1966), *Coco* (1969), *Molly* (1973), and Gower Champion's twenties period pieces, *Sugar* (1972) and *Mack and Mabel* (1974). A member of the London revival company of *West Side Story*, he appeared as "Shake" and "A-rab," at various times in the run.

Percassi created the role of "Al" in the original cast of *A Chorus Line*.

Peretti, Serge, French ballet dancer and teacher; born in Paris. After training at the school of the Paris Opéra, he performed with that company throughout his career. He appeared in the Prince Charming roles in the nineteenth-century repertory and created roles in many works by Serge Lifar, including his *Salade* (1929), *Le Chevalier et la Demoiselle* (1941), and *Joan da Zarissa* (1942). He became ballet master in 1944 but staged only one work, *The Call of the Mountain*, before retiring to teach at the school at which he had been trained.

Works Choreographed: CONCERT WORKS: *The Call of the Mountain* (1945).

Pereyaslavec, Valentina, Soviet ballet dancer, teaching in New York after 1949; born 1907 in the Ukraine. After graduating from the Bolshoi Ballet School in Moscow in 1926, she joined Asaf Messerer and Vladimir Ryabster's troupe in Kharkov. She performed her first "Swanilda" and "Kitri" there. In the State Ballet in Sverdlovsk, she appeared in the premiere of Iakobson's *Lost Illusions* (1936), but, during a tour of the larger Soviet cities, she "defected" to Leningrad to continue her studies with the celebrated teacher of that city, Agrippina Vaganova. After her training, she returned to the Ukraine as a member of the State Ballet at Lvov in 1940.

After the German invasion of that Southwestern area, she was deported and sentenced to work in factories in Leipzig. At the end of the war, she taught dance and organized small troupes in the liberation army and refugee camps in which she lived. She was allowed to enter the United States in 1949, and, after a false start in this country working at another factory, she moved to New York to teach. Her students at Tatiana Semenyonova's studio included Nora Kaye and John Kriza; they recommended her to Lucia Chase who arranged for her to become the company teacher of Ballet Theatre. She has taught at the Ballet Theatre School since 1951 and is considered one of the most important influences on the continuing Soviet tradition in the American Ballet Theatre, and on her students in other companies.

Perez, Rudy, American modern dancer and choreographer; born November 24, 1929 in New York City. Perez began dance studies in his early twenties, taking classes from the faculty of the eclectic New Dance Group and the Martha Graham school. As a student at the Merce Cunningham Studio, he participated in productions and shared concerts of the Judson Dance Theatre, and presented his first extant work, *Take Your Alligator (Coat) with You* in 1963. He did a few performances for other choreographers, most notably the extraordinary Beverly Schmidt-Blossom concert where the male chorus included Perez, Steve Paxton, and Kenneth King, but appeared primarily in his own works with his two companies—The Rudy Perez Dance Theatre and, after 1978, the Men's Coalition. His best known works were set for the former company which at times included choreographers Barbara Roan, Anthony La Giglia, John Moore, and Raymond Johnson. They range from the horrifyingly stark solos, such as *Countdown* (1966), in which the most energetic movement made is the lifting and smoking of a cigarette, to the group pieces that experiment with the widest possible variety of locomotions, as in the hopping in *Lot Piece Day/Night* (1971), the roller skating in *Transit* (1969), or in a combination of the two themes, the devastating walk in a straight line that reveals the character's pressure in *Coverage* (1970).

In 1978, Perez began to work with a group of eight men in a semiimprovised format. Although the first

works that he created for his Men's Coalition included roles for women (Roan and Elyssa Paternoster) and for male dancers outside the group, including La Giglia, he soon began to work more easily within the confines and freedom of his new company. Perez is also known for his works for large groups of trained and untrained dancers, especially those created for university groups at Marymount Manhattan College in New York or at residencies across the country.

Works Choreographed: CONCERT WORKS: *Take Your Alligator (Coat) with You* (1963); *Thumbs* (1963, co-choreographed with Elizabeth Keen); *Field Goal* (1965); *Countdown* (1966); *Monkey See, Monkey Wha?* (1966); *Bang, Bang* (1966); *Center Break* (1967); *Topload-Offprint* (1968); *Loading Zone* (1968); *Loading Zone-Revisited* (1968); *Re-Run Plus* (1968, a version of *Monkey See, Monkey Wha?*); *Transit* (1969); *Outline* (1969); *Match* (1969); *Arcade* (1969); *Annual* (1970); *Prefix: Grand II* (1970); *Round-Up* (1970); *Coverage* (1970); *Monumental Exchange* (1971); *Lot Piece Day/Night* (1971); *New Annual* (1971); *Asparagus Beach* (1972); *Salute to the 25th* (1971); *Thank You, General Motors* (1971); *Steople People* (1971); *Lot Piece/Lawn* (1972); *Walla Walla* (1972); *Running Board for a Narrative Quadrangle* (1973); *Americana Plaid* (1973); *Pedestrian Mall* (1974); *Parallax* (1975); *Colorado Ramble* (1975); *System* (1976); *Update* (1976); *Rally* (1976); *. . . Just for the Sake of It* (1977); *According to What, or Is Dancing Really About Dancing?* (1978); *Rally* (1979); *All Things Considered* (1979); *Point of Departure* (1980); *Take-Stock* (1980); *Plain Sight-Revisited* (1980).

Perrault, Serge, French ballet dancer; born c.1920 in Paris. Trained in Paris by Victor Gsovsky, he joined the Paris Opéra Ballet in 1946 and the Metropolitan Ballet in London in 1947.

In 1948, he began performing with Roland Petit's Les Ballets de Paris, the company with which he is generally associated. He performed for Petit in his *Le Loup, Les Demoiselles de la Nuit,* and *L'Oeuf à la Coque,* creating roles in his *Deuil en 24 Heures* (1948) and *Carmen* (1949), as "the Toreador."

Perrault partnered Tamara Toumanova (playing Pavlova) in the film tribute to Sol Hurok, *Tonight We Sing* (Twentieth-Century Fox, 1935).

Perron, Wendy, American postmodern dancer and choreographer; born October 8, 1947 in the Bronx, New York. Perron began her training with Irina Fokine and studied at the Martha Graham school from the age of fifteen. As a member of the Trisha Brown company, she appeared in the masterpiece of accumulation process, *Line-Up* (1977). She has choreographed since 1969, presenting both solos such as *A Piece of the Wind* (1969), *Thin Air* (1974), *Swan Dive* (1978) and *Untitled Solos* (1980), and group dances. Throughout her career she has occasionally collaborated with other Brown dancers to create works for individual performance, among them, *Blueberry Rhyme* (1973), co-choreographed with Rosalind Newman after photographs of another dancer (Marjorie Gamso), *Choreolympics* (1975), with Stephanie Woodward, *Dancing on View* (1975), with Sara Rudner, Risa Jaroslow, and Wendy Rogers, and *Hands and Giants* (1978), with Susan Rethorst. With her interest in the collaborative processes, it is not surprising that Perron uses accumulation as a choreographic technique since it relies on trust among the creator and performers. Accumulations, adjuncts, support work and signaling also appear in Perron's works; although one solo, *Daily Mirror,* which is an accumulation over a lengthy period of time "reported" in performance, brings the choreographic process into view for the audience, despite the presence of only a single performer.

Perron's incisive vision of dance has made her a valuable dance critic on the staffs of *Dance Magazine,* the *Village Voice,* and the *SoHo Weekly News.*

Works Choreographed: CONCERT WORKS: *A Piece of the Wind* (1969); *Olympic for Three* (1970); *Family Album* (1971); *Winter Pieces* (1972); *Shorts* (1972, also titled *Duet*); *Skippoff* (1973); *Blueberry Rhyme* (1973, in collaboration with Rosalind Newman after photographs of Marjorie Gamso dancing); *Oath* (1973); *Forest* (1973); *A Small Sarabande* (1974); *Flowering Bones* (1974); *Thin Air* (1974); *The Rise and Fear of October* (1975); *Head Ache* (1975, in collaboration with its performers); *Choreolympics*

(1975, in collaboration with Stephanie Woodward); *Dancing on View* (1975, in collaboration with Sara Rudner, Risa Jaroslow, and Wendy Rogers); *BMW* (1975); *Equinox/Solstice/Equinox/Sifting* (1975); *Sky Report* (1975); *Spring Equinox* (1976); *Veldt* (1976); *The Daily Mirror* (1976); *Pool* (1976, in collaboration with Beth Soll); *Beads* (1977, in collaboration with Woodward and Peter Zummo); *The Four-Way Daily Mirror* (1977); *Hands and Giants* (1978, in collaboration with Susan Rethorst); *Big Dog* (1978); *Swan Dive* (1978); *Quarters* (1978); *Flying or Falling* (1978); *Series of Lies* (1979); *Three-Piece Suite* (1980); *Big Dipper* (1979); *Toward a Woman-Centered University* (1980); *Untitled Solo* (1980).

Perrot, Jules Joseph, French nineteenth-century ballet dancer and choreographer, perhaps the foremost male figure of the Romantic ballet; born August 18, 1810 in Lyons, France; died August 24, 1892 in Paramé, France. Perrot, whose father was a technician at the Grand Théâtre in Lyon, studied locally and may have performed with the company as an adolescent. Arriving in Paris in the mid-1820s, he studied with Auguste Vestris while performing at the Théâtre de la Gaité. In this popular theater, he performed the leading roles in satires of Frederic-Auguste Blache works created for Charles Mazurier at the Théâtre de la Porte-Saint-Martin. Among the pieces in which Perrot performed were *Polichinel avalé par la baleine* (1823, believed to have been his Paris debut), and *Sapajou* (1825), one of many satires of Mazurier's best known vehicle, the monkey comedy, *Jocko, le Singe du Brésil*. Since the satires required even better jumps and stage presence than the originals, the Théâtre de la Porte-Saint-Martin hired Perrot away from the Gaité when Mazurier left the company. He performed for four seasons in Jean Coralli's ballets, among them *Léocadie* (1828) and *Les Artistes* (1829), before making his Paris Opéra debut in 1830.

Perrot's Paris Opéra career was tortured, even for that theater. Whether voluntarily or through his inability to function within the Opéra bureaucracy, Perrot became the first of the great freelance choreographers, and, some think, the first choreographer with a modern career. His desirable qualities were surprisingly simple: he had the ability to create works that reflected the cultural interests of his audience and that enhanced the individual technical gifts of his performers.

Perrot's career as a choreographer can be considered in two ways—divided by theater for which he worked or by the Romantic ballerina with whom he danced. He partnered Marie Taglioni in his brief tenure at the Paris Opéra, in the divertissements from *Robert le Diable* among other works. In 1834, in Naples, he met Carlotta Grisi, then with the Teatro alla Scala.

Perrot's career was connected to Grisi's for more than ten years. After creating *La Nymphe et le Papillon* for her (Vienna Karntnertor, 1836), he returned to London, where he had danced in 1830 and from 1833 to 1836, and set *Zingaro* for them to perform at the Paris Théâtre de la Renaissance (1840). As ballet master of Her Majesty's Theatre (formerly the King's Theatre), he staged many of his best known Romantic works. Presented in other European theaters and brought to America by touring companies, they were among the most widely known works of the Romantic era, among them, *Ondine* (1843), *Le Délire d'un Peintre* (1843), *La Esmeralda* (1844), *Catarina* (1846), and *Lalla Rookh* (1846). One divertissement, *Pas de Quatre* (1845), choreographed for Marie Taglioni, Carlotta Grisi, Fanny Cerrito, and Lucille Grahn, became perhaps the best known single work of the period, although it was performed by its original cast only four times. Like so many Romantic ballets, depictions of the event brought its fame to those who could never see the performances.

After creating individual ballets in Milan and Paris in the late 1840s, Perrot went to St. Petersburg. There, from 1851 to 1858, he revived ballets, bringing the repertory to Russia where it remained extant longer than in France, and created new works, among them, *Le Angustie [Angst] d'un maître de ballet* (1851), and *Marko Bomba* (1854).

Freelancing in Italy and in cities in Germany/Austro-Hungary, he restaged his own repertory and staged a few new works, notably, *Odetta, o la Demeza di Carlo VI, re di Francia*, in Bologna, 1854. Perrot retired in the early 1860s, leaving a large repertory and a transformed European ballet.

Works Choreographed: CONCERT WORKS: *La Nymphe et le Papillon* (1836); *Zingaro* (1840); *Giselle* (1841, co-choreographed with Jean Coralli); *Le Pécheur napolitain* (1842); *Le Double Cachucha* (1842); *Alma* (1842); *L'Aurore* (1843); *Un Bal Sous Louis XIV* (1843); *Ondine, ou la Naide* (1843); *Pas de Deux* (1843, for Fanny Elssler and Fanny Cerrito); *Le Délire d'un Peintre* (1843); *La Esmeralda* (1844); *Zélia, ou les Nymphes de Diane* (1844); *La Paysanne Grande Dame* (1844); *Éoline* (1845); *Kaya* (1845, co-choreographed with Louise Weiss); *La Bacchante* (1845); *Pas de Quatre* (1845); *Diane* (1845); *Catarina, où la Fille du Bandit* (1846); *Lalla Rookh* (1846); *Le Jugement de Paris* (1846, generally known as *Pas des Déèsses*); *Les Éléments* (1847); *Les Quatre Saisons* (1848); *Faust* (1848); *La Filleule de Fées* (1849); *Le Angustie d'un maître de ballet* (1851); *La Guerre des Femmes, ou les Amazones du XIXe Siècle* (1852); *Gizelda, ou les Tziganes* (1853); *Marko Bomba* (1854); *Odetta, o la Demenza di Carlo VI, re di Francia* (1854); *Armide* (1855).

Bibliography: Slonimsky, Yuri. "Jules Perrot," *Dance Index 4*, 12.

Perry, Ronald, American ballet dancer; born March 17, 1955 in New York City. Trained at the school of the Dance Theatre of Harlem, Perry has performed with the company through most of his career. Among the many works in which he has performed leading roles are Arthur Mitchell's *Holberg Suite* and *Biosfera*, Talley Beatty's *Caravanserai*, and Geoffrey Holder's *Dougla*. He has performed the male role in Jerome Robbins' *Afternoon of a Faun* and George Balanchine's *Bugaku* and *Allegro Brillante*. In 1980, he was given the role "Siegfried" in the company's production of *Swan Lake* (Act II). Perry joined the American Ballet Theatre late in 1980.

Persichetti, Lauren, American modern dancer and choreographer; born March 21, 1944 in Philadelphia, Pennsylvania. After dance training at Sarah Lawrence College, she worked under Elizabeth Keen, Tina Croll, Phoebe Neville, and Meredith Monk. Persichetti was principal dancer and associate director of the Acme Dance Company ("We deliver") for ten years. She co-choreographed five works with director James Cunningham, among them *Lauren's Dream* (1970), *Everybody in Bed* (1972), and *Apollo and Dionysus: Cheek to Cheek* (1974), and appeared in his *A Clue in the Hidden Staircase, Junior Birdsmen,* and *Dancing with Maisie Paradocks*, among many others. In all of the repertory, she was acclaimed for her sane portraits of maniacal characters in their collages of images.

Since leaving the Acme company, she has concentrated on choreography for theatrical production. She has choreographed for three Off Off Broadway shows and co-authored a musical and movement adaptation of Kenneth Graham's *The Wind in the Willows* (with Howard Harris and Lauren Kaplan, for production in 1981).

Works Choreographed: CONCERT WORKS: *Lauren's Dream* (1970, co-choreographed with James Cunningham); *Everybody in Bed* (1972, co-choreographed with Cunningham); *Apollo and Dionysus: Cheek to Cheek* (1974, with Cunningham); *Isis and Osiris: The 4 A.M. Show* (1975, co-choreographed with Cunningham); *Aesop's Fables* (1976, co-choreographed with Cunningham).

THEATER WORKS: *SoHo Promenade* (1977); *Monsieur de Pourceaugnac* (1978); *Southern Comfort* (1979).

Peters, Delia, American ballet dancer; born May 9, 1947 in Brooklyn, New York. Trained at the School of American Ballet, Peters made her New York City Ballet debut at age eleven as a child in the company premiere of Birgit Cullberg's *Medea*.

As an adult, she has become associated with the works of Jerome Robbins, for whom she has danced in *The Concert, Dances at a Gathering, The Goldberg Variations*, and *Ma Mère l'Oye*, among many other ballets. The company's Stravinsky and Ravel Festivals brought her to prominence in Richard Tanner's *Octuor* (1972) and George Balanchine's *Le Tombeau de Couperin* (1975), respectively.

Petersen, Kirk, American ballet dancer; born December 10, 1949 in New Orleans, Louisianna. After local tap and acrobatics training, Petersen studied ballet with Lelia Haller and performed with her Ballet Jeunesse and New Orleans Opera Ballet. A schol-

arship to the Harkness School of Ballet led to a position with the Harkness Youth Dancers. After dancing with the junior company, in Vicente Nebrada's *Percussion for Six* and *Schubert Variations*, and in Ben Stevenson's *Theme of Youth*, he was promoted to the Harkness Ballet. In the latter company, he danced featured roles in Stevenson's *Bartok Concerto* and Walter Gore's *A Light Fantastic*. Petersen followed Stevenson to the National Ballet, Washington, where he created the role of the "Jester" in his *Cinderella*—the role that brought him to national prominence.

After the dissolution of the National Ballet, Petersen joined American Ballet Theatre as a principal dancer. His roles with Ballet Theatre included the *Riba* section of Alvin Ailey's *The River*, and parts in Jerome Robbins' *Fancy Free*. A leader of the dancers' strike against Ballet Theatre in 1979, Petersen was dropped from the company as one of Mikhail Baryshnikov's first actions as artistic director.

Peterson, Marjorie, American theatrical dancer and actress; born c.1897 in Houston, Texas; died August 19, 1974 in New York City. Peterson was trained at the Houston Academy of Dancing; when she made her New York debut in the 1923 *Greenwich Village Follies*, she was billed by the producers as "a student of Ted Shawn." There is no evidence that she was a member of any of the Denishawn companies, although she may have been a private student of his; it may, of course, have been the producers' attempt to link her with their past specialty dancers, Florence O'Denishawn and Martha Graham, who had actually been Shawn students.

Her *Follies* specialty was not an exotic dance, as theirs' had been; it was an eccentric number performed in a boy's "Rube" outfit, titled "The Rain Beam." She was a specialty dancer in two more shows—*Annie Dear* (1924) and the Earl Carroll's *Vanities of 1925*—before giving up eccentric acts to become one of Broadway's best ingenues. She sang and danced as sweet heroines in some of the period's operettas on Broadway, among them *The Red Robe* (1928) and *Countess Maritza* (1926), and also worked for the Shubert Brothers in musical comedies and straight plays. Her last major dance role was in the 1930 *Prince Chu-Chang*, where she partnered Barry Lupino, but she continued to appear on Broadway as a comedienne through the 1950s.

Petipa, Jean, French ballet dancer and choreographer in Paris, Brussels, and St. Petersburg; born 1787 in Paris; died in St. Petersburg in 1855. The details of Petipa's early life and training cannot be verified until 1815, when he served as principal dancer at the Théâtre de la Porte-Saint-Martin under Jean-Baptiste Blache. After Blache's troupe had performed at the Théâtre de la Monnaie in Brussels, Petipa was invited to return there as a dancer and assistant to ballet master Eugène Hus (c.1819). He made his company debut in that year in Blache's *Almaviva et Rosine* and choreographed divertissements interpolated into *La Caravanne du Caire*. After Hus' death in 1822, he became ballet master, creating *Frisac* and *Le Cinq Juillet* for the company in 1825. He left the Théâtre de la Monnaie in 1831, and worked in theaters in Lyon, Marseilles, and Bordeaux.

In 1839, Eugénie Anna Lecompte, who had danced with the Monnaie troupe in 1830, invited Petipa and his younger son Marius to perform with her in the United States; they danced in *La Tarentule* (after Coralli) and *Marco Bomba* (after Mazilier) on that tour. Returning from the trip, he went back to Brussels for five years. In 1845, he retired to St. Petersburg to teach at the Imperial Ballet School.

He was the father of Lucien and Marius Petipa, each of whom made major contributions to nineteenth-century ballet.

Works Choreographed: CONCERT WORKS: *La Caravanne du Caire* (1819, interpolated divertissements only); *La Kermesse* (1819); *Frisac, ou la Double Noce* (1825); *Le Cinq Juillet* (1825).

Petipa, Lucien, French ballet dancer, considered one of the greatest dancers of the Romantic period; born December 22, 1815 in Marseilles; died July 7, 1898 in Versailles. The son of Jean Petipa, he was raised and trained in Brussels, where his father served as ballet master for the Théâtre de la Monnaie.

Petipa made his Paris Opéra debut in 1839, partnering Lucille Grahn in *La Sylphide* by Filippo Tag-

lioni. Throughout his performance career, he was known as one of the best partners in the Romantic ballet; he was paired with Carlotta Grisi in *Giselle, La Péri,* and *Le Diable à Quatre,* with Fanny Cerrito in Taglioni's *Orfa,* with Adèle Dumilatre in Coralli's *Eucharis,* and with Adelina Plunkett in *La Péri* for her 1845 debut. Between 1843 and 1857 he created principal or character roles in almost every ballet choreographed at the Opéra, among them Jean Coralli's *La Péri* (1843) and *Eucharis* (1844), Joseph Mazilier's *Paquita* (1846), *Jovita* (1853), and *Les Elfes* (1856), Perrot's *La Filleule des Fées* (1849), and Cerrito's own *Gemma* (1854). In London too he was known as an ideal partner, working with Grisi at Drury Lane and with Marie Taglioni on tour in England and Ireland.

As a choreographer, Petipa's reputation has been lost in the aura that is attached to his brother, Marius. He staged interpolated dances for the first Paris performances of many operas, among them Verdi's *Don Carlos* (1867) and Wagner's *Tannhauser* (1861). His controversial "Venusberg" scene in the latter is frequently cited as an example of problems of choreographing for the Opéra in the Second Empire. From 1860 to late in his life, Petipa taught the *classe de perfection* at the Paris Opéra.

Works Choreographed: CONCERT WORKS: *Rilla, ossia la Fato di Provenza* (1855); *Sacountala* (1858); *Graziosa* (1861); *Le Roi d'Yvetot* (1865); *Namouna* (1882).

OPERA: *Les Vespres Siciliana* (1855); *Tannhauser* (1861); *La Reine de Saba* (1862); *Don Carlos* (1867); *Hamlet* (1868).

Petipa, Marie Surovschikova, Russian nineteenth-century ballet dancer; born 1836; died March 1882 in Pytigorsk, the Caucasas. Trained at the school of the Imperial Ballet in St. Petersburg, she performed with the Maryinsky Theatre throughout her short career. Married to Marius Petipa, then ballet master of the company, she created roles in many of his early Russian works, among them, *Le Marché des Innocents* (1859), *Le Merle Blanc* (listed in English-language studies as *The Blue Dahlia*) (1860), *La Belle de Lebanon* (1863), and *La Danseuse Ambulante* (1865). In the 1861–1862 season, she performed at the Paris

Opéra, partnered by her brother-in-law Lucien Petipa, in her husband's *Marché des Innocents* and in Joseph Mazilier's *Le Diable à Quatre.* Petipa was also well known for her portrayal of "Aspacia," the heroine of *La Fille du Pharon.*

Petipa, Marius, French ballet dancer and choreographer credited with the development of the classical ballet in Russia at the end of the nineteenth century; born March 11, 1818 in Marseilles; died July 14, 1910 in Girzuf, the Crimea. The son of Jean Antoine Petipa, and younger brother of Paris Opéra idol Lucien, he studied with his father and made his adult debut in Brussels' Théâtre de la Monnaie in Pierre Gardel's *La Dansomanie* (c.1831).

From that date to his employment in St. Petersburg, Petipa's career was split between tours and performances with his father, notably to the United States in 1839, and solo engagements. As principal danseur in Nantes (c.1838), he is said to have choreographed his first ballets, although there is not enough firm evidence that he staged them or that they had not been previously created by another ballet master. After the American tour, he worked at the Grand Théâtre de Bordeaux, where he revised or staged four Romantic ballets, *La jolie Bordelaise, l'Intrigue amoureuse, La Langue des Fleurs,* and *La Vendange,* all between 1840 and 1844. At the Teatro del Circo, Madrid, he choreographed works that combined the French Romantic format with the Spanish academic dance-form techniques, among them *Carmen et son Torero, La Perle de Séville,* and *La Fleur de Grenade.*

Following an engagement at the Paris Opéra where his older brother was the most popular and celebrated danseur of the day, Petipa toured to St. Petersburg, with a standard repertory of *Giselle, Catarina, Le Délire [or Illusion] d'un Peintre,* and *Esmeralda.* He was hired to serve as assistant to Jules Perrot, then succeeded him in 1862. Most of Petipa's known ballets date from his service to the St. Petersburg Imperial Theatre and Maryinsky company. His fifty-odd ballets and dozen restagings changed the repertory and, therefore, technique of the Imperial Theatres and all of Russian ballet. What is generally known as Russian Ballet is actually the technique de-

veloped to perform these works by a French ballet master trained in Brussels.

His reputation as a choreographer has undergone at least two revisionist reinterpretations already. At the turn of the century, Mikhail Fokine and his followers denounced the Petipa repertory as old fashioned, as it undoubtedly is, and badly structured; he was also reviled during the era of early Soviet choreography for his constricted movement vocabulary and cross-cultural borrowings. His reputation survived both those revisionist periods because his works lend themselves to bravura performances and use pleasant music. He is scheduled for a period of popularity in the early 1980s, due to revivals by Mikhail Baryshnikov, now director of the American Ballet Theatre, but will probably undergo an era of reconsideration soon thereafter. The growing realization that many of the freest and most musical passages in the repertory, especially in *Swan Lake*, are actually by Lev Ivanov may bring about an era in which the Petipa ballets are not performed at all.

Works Choreographed: CONCERT WORKS: *Carmen et son Toréro* (c.1845); *La Perle de Séville* (c.1845); *L'Aventure d'une Fille de Madrid* (c.1846); *La Fleur de Grenade* (c.1846); *La Laitière Suisse* (1849, after Taglioni); *l'Etoile de Grenade* (1855); *Le Papillon, La Rose et le Violet* (1857); *Un Marriage desous la Régence* (1858); *Le Marché des Innocents* (1859); *La Somnambule* (1859); *Le Merle Blanc* (1860); *Terpsichore* (1861); *La Fille du Pharon* (1862); *La Belle de Lebanon* (1863); *La Danseuse Voyageant* (1865); *Titania* (1866); *Florida* (1866); *La Slave* (1868); *Le Roi Candaule* (1868); *Don Quixote* (1869); *Trilby* (1870); *Les deux Etoiles* (1871); *La Péri* (1872); *Camargo* (1872); *Oberon* (1872); *Le Papillon* (1874); *La Fete du Printemps* (1874); *Russlan et Ludmilla* (1874); *Les Bandits* (1875); *l'Aventure de Péléus et Thétis* (1876); *A Midsummer Night's Dream* (1876); *La Bayadère* (1877); *Roxane, ou la Belle de Montenegro* (1878); *Ariadne* (1878); *La Fille de Neige* (1879); *Frisac, ou la Double Noce* (1879, after Jean Antoine Petipa); *Mlada* (1879); *La Fille du Danube* (1880, after Taglioni); *Le Roi de Lahore* (1881); *Zoraya* (1881); *Nuit et Jour* (1883); *Pygmalion* (1883); *Lalla Rookh* (1884); *The Magic* (1886); *The King's Decree* (1886); *Les Offrandes à l'Amour* (1886); *La Vestale* (1889);

The Talisman (1889); *Les Caprices du Papillon* (1889); *La Belle au Bois Dormant* (1890); *Nénuphar* (1890); *Kalkabrino* (1891); *La Sylphide* (1892, after Taglioni); *Casse-Noisette* (1892); *Le Réveillant du Flore* (1894); *Swan Lake* (1895, Acts I and III only); *Halte de Cavalrie* (1896); *La Perle* (1896); *Bluebeard* (1896); *Raymonda* (1898); *Robert le Diable* (1899, after Taglioni); *Ruses d'Amour* (1900); *Les Quatres Saisons* (1900); *Harlequinade* (1900); *Les Elèves de M. Dupré* (1900); *Le Miroir Magique* (1903).

Bibliography: Moore, Lillian, ed. *Russian Ballet Master: The Memoirs of Marius Petipa* (London: 1968).

Petit, Margaret, American theatrical ballet dancer and choreographer; born Margaret Pettibone, c.1904 in Seattle, Washington; details of Petit's death in France cannot be verified. Supporting herself as an artists' model, she studied at the Seattle Cornish School with Mary Ann Wells who had recently arrived from Wisconsin.

Petit moved to New York in 1919, still in her adolescence, to continue her studies with Luigi Albertieri, Ivan Tarasoff, and Mikhail Fokine. She appeared in *What's in a Name* (1920) and the *Greenwich Village Follies of 1921*. A specialty dancer in revues that glorified their designers rather than their composers, she was featured in both editions of the *Pin Wheel Revue of 1922*—the one produced by Raymond Hitchcock uptown, and the one by Michio Ito downtown—and in *Sweet Little Devil* (1923). She staged her own dances for the *Pin Wheel Revue*, among them, *The Masked Bacchantes*, and *La Répétition de la Danse*, a presentation of Degas' paintings of the Paris Opéra rehearsals that predates De Mille's by five years. Unlike many specialty dancers, Petit staged musical numbers that involved other performers; the Degas piece, for example, featured Angna Enters.

Petit returned to Seattle briefly in 1924 to present a concert of her own works. Unfortunately, no program or review of this concert can be located. The only dance from the program that is known is a *Waltz* staged for dancer Margery Williams, a Cornish student who also performed on Broadway.

Moving to Paris in 1926, Petit retired from per-

formance. Her daughter, Leslie Caron, became famous as a French ballet dancer before moving to the United States to work in films and live theater.

It is tragic that so little information on Petit's choreography can be located, since, from all available evidence, she was a major theatrical talent. This entry was written with the assistance of Gininne Cocuzza, who unearthed part of the material while doing research on Enters.

Works Choreographed: CONCERT WORKS: *Waltz* (c.1924).

THEATER WORKS: *The Pin Wheel Revue* (1922, *La Répétition de la Danse* and *The Masked Bacchantes* only).

Petit, Roland, French ballet dancer and choreographer; born January 13, 1924 in Villemomble, France. Trained at the school of the Paris Opéra by Gustave Ricaux and Serge Lifar, he graduated into the company in 1940. Associated with the Lifar repertory, especially with his *l'Amour Sorcier*, he also performed in the chamber companies of Marcelle Bougat and Janine Charrat. In the Ballets des Champs-Elysées from 1945 to 1948, he created a major role in her *Jeux de Carte* (1946) and in his own *Les Forains* (1945), *Le Bal des Blanchisseuses* (1946) and *Les Amours de Jupiter* (1946).

He left that company to form Les Ballets de Paris de Roland Petit in 1948, and worked with various groups under that generic title. A prolific film choreographer in the 1950s, he worked primarily with Leslie Caron in *Daddy Long Legs* and *The Glass Slipper*, and with his wife, Zizi Jeanmaire, who appeared in his *Hans Christian Andersen* and *Black Tights*. He has also staged revues for Jeanmaire, notably at the Casino de Paris which he directed from 1970 to 1975.

Since 1972, he has served as artistic director of the Ballets de Marseilles. Almost all of Petit's concert choreography has been created for his own companies. His artistic style has been described as typically French; while that seems like a meaningless statement, it is actually fairly accurate. His choreography and mise-en-scène are unquestionably within the scale and artistic definitions that have been typical of French graphics and staged works since the 1940s and the Cocteau experimental films. While many of his later ballets are based on literature such as *Pelléas et*

Mélisande (1969), *Nana* (1976), and *Marcel Proust Remembered* (1980), others are based on artistic developments in the other arts, especially in popular music.

Works Choreographed: CONCERT WORKS: *Saut du Tremplin* (1942); *Paul et Virginie* (1943); *Orphée et Eurydice* (1944, co-choreographed with Janine Charrat); *La Jeune Fille endormie* (1944, co-choreographed with Charrat); *Ballet Blanc* (1944); *Le Rossignol et la Rose* (1944); *Un Americain à Paris* (1944); *Guernica* (1945, co-choreographed with Charrat); *Fables de la Fontaine* (1945); *Mephisto Valse* (1945); *Guernica* (1945); *Les Forains* (1945); *Le Rendez-vous* (1945); *Le Poète* (1945); *Le Déjeuner sur l'Herbe* (1945); *La Fiancée du Diable* (1945); *Les Amours de Jupiter* (1946); *Le Jeune Homme et la Mort* (1946); *Le Bal des Blanchisseuses* (1946); *Treize Danses* (1947); *Les Demoiselles de la Nuit* (1948); *Que le Diable l'emporte* (1948); *L'Oeuf à la coque* (1949); *Carmen* (1949); *Pas d'action* (1949); *Ballabile* (1950); *Chaises Musicales* (1950); *Croque de Diamants* (1950); *Le Loup* (1953); *Ciné-Bijou* (1953); *Deuil en 24 Heures* (1953); *Lady in the Ice* (1953); *Belle au Bois Dormant* (1953); *Les Belles Damnées* (1955); *La Chambre* (1955); *La Nuit* (1956); *Valentine* (1956); *La Peur* (1956); *Contre-pointe* (1958); *Rose des Vents* (1958); *La Dame dans la Lune* (1958); *Cyrano de Bergerac* (1959); *Ballets des Electrons* (1960); *Rain* (1960); *La Chaloupée* (1961); *Mon Truc en Plume* (1961); *Scaramouche* (1961); *Tarantelle, etc.* (1961); *Palais de Chaillot* (1962); *Maldorer* (1962); *Le Violon* (1962); *Rapsodie Espagnole* (1962); *Quatre Saisons* (1963); *La Silla* (1963); *Gourmandises, etc.* (1963); *Notre Dame de Paris* (1965); *Adage et Variations* (1965); *Eloge de la Folie* (1966); *Paradis Perdu* (1967); *24 Préludes* (1967); *Formes* (1967); *La Voix Humaine* (1968); *Turangalila* (1968); *L'Estasi* (1968); *Pelléas et Mélisande* (1969); *Kraanerg* (1969); *Allumez les Etoiles* (1972); *Pink Floyd Ballet* (1972); *La Rose Malade* (1973); *Debussy* (1973); *Bizet'ism* (1974); *Intermittences du Coeur* (1974); *Jeux d'Enfants* (1974); *Prologue* (1974); *Schéhérézade* (1974); *L'Arlesienne* (1974); *Septentrion* (1975); *Coppélia* (1975); *La Symphonie Fantastique* (1975); *Benedictiones* (1975); *The Nutcracker* (1976); *Mouvances* (1976); *La Nuit Transfigurée* (1976); *Nana* (1976); *Bleu, Variation pour un Danseur* (1977); *A la*

Mémoire d'un Ange (1977); *Fascinating Rhythm* (1977); *La Dame de Pique* (1978); *La Chauve-Souris* (1979); *Marcel Proust Remembered* (1980).

THEATER WORKS: *Musical Chairs* (1950); *ZIZI au Music-Hall* (1957); *Patron* (1959); *La Silla* (1963); *Revue de Roland Petit* (1970); *ZIZI Je t'Aime* (1972, "La Veuve Rusée").

FILM: *Hans Christian Andersen* (RKO/Goldwyn, 1951); *Daddy Long Legs* (MGM, 1954); *The Glass Slipper* (MGM, 1954); *Anything Goes* (Paramount, 1955); *Folies Bergère* (Films Around the World, 1956); *Black Tights* (1960).

Petroff, Paul, Danish ballet dancer working in the United States after the mid-1930s; born Paul Eilif Petersen in 1908 in Elsinore, Denmark. Trained by Katja Lindhart at the school of the Royal Danish Ballet, Petroff performed with the Opera de Monte Carlo in the early 1930s.

For much of his performing career, Petroff danced with the Ballet Russe de Monte Carlo, creating roles in Leonid Massine's *Jeux d'Enfants* (1932), *Choreartium* (1933), *Union Pacific* (1935), and *Jardin Public* (1935), and in Mikhail Fokine's *Paganini* (1939). His featured roles included the male principal roles of *Swan Lake* and *Les Sylphides*, among other classics.

With his wife, Nana Gollner, Petroff has directed a touring company and a studio in Brussels.

Pettit Sisters, American theater and film tandem act; Lillian, born September 21, 1910 in Gackle, North Dakota; Luella, born there December 12, 1911. Raised in the Los Angeles area, the Pettits were trained at the Fanchon and Marco–sponsored dance schools in the area. Their act was probably staged for them by Fanchon herself or by Ben and Sally of the Stepper School in Long Beach. They appeared in films as children, most notably in *Sally* (First National, 1925), but spent most of their professional lives on Fanchon and Marco's Prologs circuit doing their tandem and harmony act in their Ideas.

Philippart, Nathalie, French ballet dancer; born c.1926 in Bordeaux, France. Trained by Lubov Egorova and Tatiana Gsovsky, she made her debut in the Irene Lidova's *Soirée de Danse* series in 1944.

With the Ballets des Champs-Elysées and Ballets de Paris, she was noted for her performances in Roland Petit's *Le Rendez-vous, Les Forains,* and *Le Jeune Homme et La Mort*, which she frequently danced on tour with her husband, Jean Babilée. Additional roles included principal parts in *La Sylphide, Pas de Quatre,* and Janine Charrat's *Jeu de Carte,* and Babilée's *l'Amour et Son Amour.*

Phillips, Ailne, Irish ballet dancer working in England; born 1905 in Londonderry. Trained by Lydia Kyasht and Ninette De Valois, she made her debut with the Royal Carl Rosa Opera (then directed by her mother in London) in dance sequences in *Faust, Carmen,* and *Romeo and Juliet.*

She danced with De Valois' Vic Wells company throughout the 1930s, with featured roles in Frederick Ashton's *Pomona, The Lord of Burleigh,* and *Les Rendez-vous,* and in De Valois' *The Birthday of Oberon* (1933), *The Wise and Foolish Virgins, The Gods Go-a-Begging,* and *The Rake's Progress.* After dancing with Mona Ingelsby's International Ballet in Nickolai Sergeev's productions of the classics, she worked as De Valois' assistant, teaching for her and restaging her ballets for other companies.

Phipps, Charles, American modern dancer; born November 23, 1946 in Newton, Massachusetts. Phipps' training ranges from the Ballet Theatre School to the studios of Martha Graham and Merce Cunningham. For much of the 1960s and early 1970s, Phipps was one of New York's hardest working freelance modern dancers. That particular breed of contemporary performers is able to adapt to the individual techniques and personal styles of different choreographers and genres. Among his many credits were roles in Pearl Lang's *Shirah* (1969) and *Piece for Brass,* Lucas Hoving's *Opus '69* (1970) and *Aubade II,* and Louis Falco's *Timewright* and *Caviar* (1970). He appeared in works by those choreographers in the same dance festival in one busy weekend in 1970.

Pianowski, Mieczyslaw, Polish ballet dancer also working in the United States; born 1890 in Warsaw; died March 30, 1967 in Amarillo, Texas. He was trained at the School of the Warsaw Grand Opera

Theatre Ballet under Enrico Cecchetti, Alexander Gilbert, Argut Berger, and Jan Walczak. On recommendation from Cecchetti, he joined the Diaghilev Ballet Russe in 1915. In three years with the company he appeared in many works by Mikhail Fokine, including his *Tamar* and *Cléopâtre*. He performed with the Anna Pavlova company from 1917–1918 (joining on tour) for thirteen years as a dancer, assistant to Ivan Clustine, and ballet master. After Pavlova's death, he staged ballets in Riga, Latvia, and at the operas in Belgrade and Warsaw until the mid-1930s. An active member of the Polish underground, he was captured by the German army of occupation and sent to a camp. Released at the end of World War II, he emigrated to the United States to teach in Boston (c.1946), Seattle (c.1946), and Amarillo, Texas (c.1957–1967).

Works Choreographed: CONCERT WORKS: *A Polish Wedding* (1921); *Amarilla* (1933); *Invitation to the Dance* (1933); *Flora's Awakening* (1934); *Snowflakes* (1934, after Clustine).

Picasso, Pablo, Spanish artist and occasional theatrical designer; born October 23, 1881 in Malaga; died April 8, 1973 in Mougins, France. Picasso's dance designs were created primarily during his Cubist period, in the late 1910s and 1920s. Associated with the Diaghilev Ballet Russe through the entrepreneur's own experiments with French Cubism, and through his marriage to a Ballet Russe member, he designed and collaborated with the choreographer on Leonid Massine's *Parade* (1917), *Le Tricorne* (1919), *Pulcinella* (1920), and *Mercure* (1924). He also worked on the sets of *Cuadro Flamenco* (1924) and enlarged a painting to serve as the cyclorama for Bronislava Nijinska's *Le Train Bleu* in the same year.

He was established as the foremost artist in the West by the time he returned to ballet design with his sets and costumes for Roland Petit's *Le Rendez-vous* (1954) and Serge Lifar's production of *L'Après-midi d'un Faune* (1960).

His association with dance was analyzed in William Liberman's issue of *Dance Index* (Volume 5, no. 11) and in Douglas Cooper's study of *Picasso Theatre* (Paris and New York: 1967).

Pierce, Billy, American dance teacher and choreographer known as "the oracle of Tapology"; born c.1891 in Purcelville, Virginia; died April 10, 1933 in New York City. One of the most important forgotten men of the 1920s, Pierce was an editor of two of the major black newspapers of the country—*The Washington* [D.C.] *Dispatcher* and *The Chicago Defender*—as well as a dance teacher and choreographer. He made his performing debut in the early 1920s at the Pekin Theatre, Chicago, and staged tap shows on the Black circuit. Moving to New York in the late 1920s, he ran an elevator before opening his dance studio. Among his many students there were the Astaires, the Eatons, Ruby Keeler, George Murphy and Julie Johnson, Ann Pennington, and Florence Mills. He was credited with only one Broadway show, *Walk a Little Faster* (1932), but is generally thought to have contributed to at least a score more. At his tragically early death at the age of forty-two, both the trade and general newspaper obituaries described him as the "creator and progenitor" of the Charleston and Black Bottom.

However important his dance career may have been, one should not overlook Pierce's editorial and journalistic career. He contributed to the development of the reputations of both newspapers, both in arts coverage and in general editorial stature. He was active in rallying support among New Yorkers for the defense in the Scotsboro case at the time of his death.

Pietri, Frank, American theatrical performer; born July 6, 1934 in Ponce, Puerto Rico. Like so many other talented Broadway dancers, Pietri first came to notice in the whip chorus of Michael Kidd's *Destry Rides Again* in 1959. He appeared almost constantly on Broadway since that success, with dance specialties and roles in Kidd's *Wildcat* (1960), *Nowhere to Go But Up* (1962), *What Makes Sammy Run?* (1964) *Golden Rainbow* (1968), Michael Bennett's *Promises, Promises* (1968), his *Seesaw* (1973, co-choreographed with Grover Dale and Tommy Tune), and *Ballroom* (1978). In between shows he performed frequently on television variety series and specials, taped in both New York and Hollywood, among them those staged by Bennett, Ernest Flatt, Alan Johnson, and Bob Fosse. He has also toured and appeared in New York clubs in his own one-man show.

Pilarre, Susan, American ballet dancer; born May 13, 1947 in Brooklyn, New York. Trained at the

School of American Ballet, Pilarre graduated into the New York City Ballet and has performed with it throughout the 1970s.

Associated with the works of George Balanchine, Pilarre has danced for him in *Agon, Divertimento No. 15*, the *Scotch Symphony, La Source,* and *Stars and Stripes*, among many other ballets. She was chosen to perform in the premiere of his *Who Cares?* (1970) and *Le Tombeau de Couperin* (1975), as well as Lorca Massine's *Four Last Songs* (1971).

Pilcer, Harry, American exhibition ballroom and theatrical dancer; born c.1886 in New York City; died January 14, 1961 in Paris. Without formal dance training, Pilcer made his New York debut at Blaney's Theatre in *The Bad Boy and the Teddy Bears* (1907). After touring on the Keith circuit, he began a long series of Broadway shows for the Shubert Brothers with *Hello, Paris!* (1911). In his next show, *Vera Violette* (1911) he was assigned to help Ned Wayburn coach his co-star, French star Gaby Deslys. Their partnership was so successful that he went with her to Paris to dance in clubs during the summer. Returning to New York, they went into the Wayburn show, *The Honeymoon Express* (1913), better known as the joint vehicle for Al Jolson and Fanny Brice; Pilcer closed that show with the exhibition number, "When Gaby Did the Gaby Glide." His next Broadway show, *The Belle of Bond Street* (1913), led to an engagement in London at the Palladium with Miss Teddie Gerrard and a reconciliation with Deslys in Paris. He acted in *Stop! Look! Listen!* (1918), an all-star Irving Berlin show, but then left the United States to open a club in Paris. His cabaret and studio there remained successful until the German occupation, when he returned to the United States to retire.

Pilcer was the elder brother of Elsie Pilcer, also an exhibition ballroom dancer, who was George Raft's partner in the 1920s.

Piletta, Georges, French ballet dancer; born February 13, 1945 in Paris. Piletta was trained by his mother, Anna Stéphane, before entering the school of the Paris Opéra. A member of the company since 1963, he has specialized in the works of contemporary choreographers, among them Felix Blaska, for whom he danced in *Arcana* (1973), and Roland Petit.

Among the many works by the latter in which he has performed are *Turganalila* (1968) and *Kraanerg*.

Pinnock, Thomas, Jamaican modern dancer and choreographer; born October 15, 1942 in Kingston, Jamaica. Pinnock was trained in Kingston by Eddy Thomas and Neville Black and performed in each one's workshop company. On an early trip to New York, he continued his training at the New Dance Group Studio and the Martha Graham school. He performed with Talley Beatty on his first professional visit here and with Rod Rodgers in the 1970s. He has also served as a guest artist with the National Dance Theater of Jamaica and the Africa-Reggae Dance Theater Expressions. His theatrical appearances have included roles in the Henry Street Settlement's New Federal Theater's production of *Princess Too Tall* (1979) and a role in the Broadway musical *Reggae* (1980). Pinnock has presented concert works with the Jamaican National Dance Theater and his New York–based company, Choreo-Mutation. A recognized expert on rasta-reggae, he has staged and consulted on theatrical productions based on that Jamaican form of music.

Works Choreographed: CONCERT WORKS: *Ballot* (1971); *Desperate Silences* (1972); *Moments Remembered* (1974); *Homosapiens; Two Halves* (1974); *Tenement Rhythms* (1975); *Speng and Spar* (1976); *Insights* (1976); *Stickers and Steppers* (1977); *Utterances* (1977); *Problem Times* (1979); *Make a Joyful Noise* (1980).

THEATER WORKS: *Exlanitation* (1978, premiered in Kingston).

Pinska, Klarna, Ukrainian-born Canadian-American concert dancer; born c.1906 in Krilowitz, the Ukraine. Pinska, whose stage name was adapted from Charna Pachapinsky, was raised in Winnipeg, Manitoba, from childhood. She first saw Ruth St. Denis in a Winnipeg vaudeville theater and, after moving to San Francisco with her family, decided to study with her on seeing *Death and After-Life in Egypt, Greece and India* in nearby Berkeley. In the absence of scholarships, she worked as St. Denis' personal maid in exchange for classes at the Denishawn school in Los Angeles and performed in cabarets in a program of works rented from Ted Shawn. Although she taught at the Denishawn

schools in Los Angeles and New York, she performed only rarely with the concert Denishawn groups, most notably in the 1930 Lewisohn Stadium concert presentation of St. Denis' *A Buddhist Festival*. It has been suggested that her absence from the Denishawn programs was due to St. Denis and Shawn's well-known quota system regarding Jewish dancers.

Following the disolution of Denishawn as a company and school, Pinska had a successful career as a recitalist presenting her own works in concerts in New York and California. Her students at the Dance Center in New York included José Limón and Jerome Robbins. Her titles are similar to those of her fellow concert dancers trained in New York City by Denishawn refugees Martha Graham and Doris Humphrey, and include *Ritmos Españole, Sanctification of the Candles,* and *Western Glances at the Orient* (all 1937). She retired from performance to become a shipyard riveter in Marin, California, during World War II, but has taught dance throughout her life. Pinska reemerged into modern dance in 1976 when she staged a program of reconstructions of works by St. Denis and Shawn for the Joyce Trisler Dance Company. This popular program has been repeated frequently on both coasts.

Works Choreographed: CONCERT WORKS: (Note: it is unlikely that this listing represents Pinska's entire canon of works.) *Diabolique* (c.1935); *Prologue* (1937); *Waltz Trifles* (1937); *Barbarosa* (1937); *Folklore* (1937); *Ritmos Españole* (1937); *Sanctification of the Candles* (1937); *Dissonent Eyes* (1937); *Cathedral Glass* (1937); *Space and Form in Classicism* (c.1937); *Fugue with Code* (1937); *Western Glances at the Orient* (1937); *Woodcuts* (1937).

Piper, John, English artist and theatrical designer; born 1903 in London. The celebrated painter used his brush technique and sense of color in the scenery, costumes, and lighting that he designed for productions of the Sadler's Wells Ballet. The decor, as presented in performance, still looked like a watercolor, with depth created by perspective and by shading. These designs, among them sets for Frederick Ashton's *The Quest* (1949), Ninette De Valois' 1948 revival of *Job,* and John Cranko's *Harlequin in April* (1951) and *The Shadow* (1953), were each distinguished by an enlarged single element that represented the choreography in static art. The tree that overwhelmed the set in *Job* exemplified Piper's sense of design scale.

Piro, Frank "Killer Joe," American jive dancer and teacher; born c.1920, probably in Brooklyn, New York. Piro had been a plastic designer before he began his military service as a Seaman, First Class, in the Coast Guard during World War II. He was obviously a talented social dancer before the 1940s, and a winner of many Harvest Moon Ball competitions, but he was not "discovered" until he appeared on the dance floor at the Stage Door Canteen. His "jive" act at the New York and Hollywood Canteens brought him to national prominence for its eccentricities, its raw energy, and its experimentation with the forms that became known as the jive. Working primarily with nontrained dancers (among them, actress Shirley Booth), he was able to spin, toss, twirl, and dip his partners into a wild dance routine.

Piro went "pro" in the late 1950s when the Palladium Dance Hall on Broadway hired him as teacher and master of ceremonies. He directed a studio in New York for many years and was in demand at master classes and teacher conventions.

Pitot, Genevieve, American pianist, composer, and dance music arranger; born c.1920 in New Orleans, Louisiana. Pitot had two successful careers as a musician in the dance world of the 1930s through the 1950s. She is known as the composer of a multitude of works for Helen Tamiris, among them *Adelante, As in a Dream, Bird of Paradise, Liberty Song, How Long Brethren* (arranged), *Toward the Living,* and *Walt Whitman Suite,* for Donald Saddler, Agnes De Mille, and Charles Weidman, whose *Candide* she wrote. She also accompanied Tamiris, Weidman, and many other concert and modern dancers at recitals and benefits throughout the 1930s and 1940s. Pitot's second career was as dance arranger for Broadway musicals. That little understood job involved the orchestration of themes from the songs written for the show and the enlarging and rearranging of them in order to fill musical time to fit the choreographer's needs. Pitot worked on shows by Jerome Robbins, Michael Kidd, Tamiris, Hanya

Holm, and Donald Saddler, among them *Miss Liberty, Call Me Madam, Destry Rides Again, Can-Can, Inside U.S.A., Kiss Me Kate,* and her rare failure, *Shangri-La.*

Pitrot, Antoine Bonaventura, French eighteenth-century ballet dancer and choreographer; born c.1725 in Marseilles; died after 1792, possibly in Milan. Pitrot was trained at the school of the Paris Opéra and made his debut there in 1744.

Unlike so many of his contemporaries, Pitrot did not remain at the Opéra. Instead, he choreographed for the Comédie-Italienne—the Paris-based company that presented Italian-style commedias and Harlequinades. Among the many ballets and pantomimes that he created for that company were *Les Amants introduits dans le Sérail* (1759) and earlier versions of the preclassic standards *Télémaque dans l'île de Calypso* and *Les Oiseleurs* in the same year. Pitrot, whose scandals (but not performances) were well documented by the gossips and authorities of his time, also performed in Vienna, Dresden, Parma, and Milan. He served as ballet master for the King's Theatre, London, creating ballet intermezzi for their commedia-based plays and Harlequinades, such as *Ulysses dans l'île de Circe, The Tempest, L'Embarras du Choix,* and *La Bouquetière du Village,* all in 1774.

Pitrot was not, as some contemporary sources have claimed, a *ballet d'action* innovator because he adapted well from his more inventive colleagues. By choosing to work outside of the Opéra, which was then a conservative influence, he selected the path of "creating" the *ballet d'action* style of pure choreography from the popular theater and Harlequinades of the innovative comedies.

Works Choreographed: CONCERT WORKS: *Les Amants introduits dans le Sérail* (1759); *Télémaque dans l'île de Calypso* (1759); *Les Oiseleurs* (1759); *La Chaconne* (1759); *La Dispute des faunes et des bergers paru les Hamadryades* (1759); *Vénus et Adonis* (1759); *On ne s'avise jamais du tout* (1761); *Ulysse dans l'île de Circe* (1761); *La Fée Urgele, ou ce qui plait aux dames* (1765); *The Tempest* (1774); *L'Embarras du Choix* (1774); *La Bouquetière du Village* (1774); *Les Faunes vainqueurs* (1775); *Pirame et Thisbé* (1775); *Ballets des Fleurs* (1775); *Le Bal Masque* (1775); *Alessandro e Timoteo* (1780).

Pitts, Bryan, American ballet dancer; born February 5, 1952 in Winston-Salem, North Carolina. Trained at the school of the American Ballet, he performed in Lorca Massine's *Four Last Songs* (1970) and Richard Tanner's *Octandre* (1971) in graduation recitals before joining the New York City Ballet.

He performed in those ballets and created a role in Jerome Robbins' *Scherzo Fantastique* (1972) in his first year with the company. Among the other ballets in which he performed were George Balanchine's *Who Cares?, Symphony in C,* and many others. While a member of the City Ballet, Pitts performed at the Metropolitan Opera in the mime role of "Tadzeo" in the American premiere of Benjamin Britten's opera *Death in Venice.* He left the company in 1977 to join the Los Angeles Ballet, a new institution founded by fellow City Ballet dancer John Clifford.

Plá, Mirta, Cuban ballet dancer; born c.1940 in Havana, Cuba. Associated throughout her career with the great Cuban ballerina Alicia Alonso, Plá was trained by her and by Fernando Alonso, Mary Skeaping, and José Perés.

Plá made her performing debut with the Ballet Alicia Alonso in 1953, dancing with that company and with the Ballet Nacional de Cuba after its founding in 1962. Celebrated for her portrayal of "Myrthe" in Alonso's production of *Giselle* (both live and in the 1963 film), Plá served as her understudy, learning her roles in *Les Sylphides* and *La Fille Mal Gardée,* both of which she now performs. Famed for her work in the contemporary Cuban repertory, notably in Alberto Méndez's *Plasmosis* (1970), Plá is probably, after Alonso, the best known ballet dancer outside of Cuba, having won medals at the Varna and Paris Competitions of 1964, 1966, 1970, and 1972. Plá currently teaches at the Ballet Nacional.

Placide, Alexandre, French tightrope dancer, pantomime performer, and choreographer; born c.1750, possibly in France; died 1812 in New York City. A member of Jean-Baptiste Nicolet's Grands Dasnseur du Roi troupe of tight and slack rope dancers from 1770, he was paired with Paolo Redigé, as Le Petit

Diable, in a series of specialty acts and entr'actes. As well as touring with Nicolet and regular seasons in Paris, he and Redigé performed in London at the Sadler's Wells Opera House, an Italian-style pantomime theater, in 1779 and subsequent summers.

With acrobat Laurent Spinacutta and soubrette Suzanne Taillande, *dit* Mme. Placide, he brought the troupe to the Western hemisphere, landing in Santo Domingo in 1791. In New York, at the John Street Theatre in 1792, he, and especially Spinacutta, had a tremendous influence on the young native pantomime dancer, John Durang. They traveled down the East Coast from New York to Boston to South Carolina, where Placide managed the Charleston Theatre from 1800 to 1812, spending summers at the Vaux-Hall Garden there, and touring to Richmond, Virginia. After losing a duel to the singer Louis Douvillier for the hand of Taillande, she married the vocalist and Placide married actress/singer Charlotte Wrighten. They worked together in the South Carolina/Virginia circuit until 1812 when his Charleston Theatre burned down. Although he took on the management of the Olympic Theatre in New York, he died during its first season.

Four of Placide's children became members of the profession. Thomas (1805 to 1877) was celebrated as the manager of Placide's Varieties Theatre in New Orleans, one of the most successful theaters in the United States in the mid-nineteenth century. He had made his professional debut at the Park Street Theatre, New York, in 1828, but was never as well known as a performer as he was as a manager. Caroline, born 1798 in Charleston, danced professionally as a child at Alexander Placide's theaters but switched to comedy and became a member of the celebrated Lyceum Theatre company, New York. Henry, born 1799 in Charleston, was the best known member of his generation—a famed comic actor in New York and London. Jane, born 1804 in Charleston, made her debut as a child dancer, but acted in dramatic and comedy roles by the age of sixteen. She was a successful ingenue in both the French- and English-language theaters and operas in New Orleans in the 1830s and 1840s.

Works Choreographed: THEATER WORKS: *Americana* (1798); *Elutheria* (1789).

Plasikowski, Serena, American ballet dancer working in concert and theatrical forms; born c.1902 in West Hartford, Connecticut. Plasikowski was trained locally by Helen Way and Mrs. T. Windsor and continued her studies in New York City under Claude M. Alvienne. She made her debut at the age of three as Baby Serena in a local theater's benefit program. After twelve years as the local benefit and gala ballet star, and sponsor of her own assemblies, she joined the Anna Pavlova Company. She appeared in the Corps of the touring troupe in the United States, Central and South America, and Europe, with small solos and variations in *Amarilla*, *Valse Danube*, and other divertissements.

Plasikowski returned to the United States to join the *Greenwich Village Follies of 1920*, using the name ''Cyrena Dahl'' and claiming to be a French sculptor. This professional lie was appropriate since the John Murray Anderson revue was considered the most intellectual and artistic of the annual shows. Her additional theatrical credits included the *Music Box Revue of 1922* and a number of Prologs staged by Anderson on the Paramount/Publix circuit in the mid-1920s.

Platt, Marc, American ballet and theatrical dancer and choreographer; born Marcel Le Plat in 1914 in Seattle, Washington. Like so many dancers from Washington State, Platt was trained by Mary Ann Wells in Seattle.

Moving to New York, he joined the De Basil Ballet Russe de Monte Carlo in 1938, switching to the Massine-Blum rival company in 1939. Associated with the works of Leonid Massine, he created roles in his *Jardin Public* (1935) and *Nobilissima Visione* (1938), and was featured in his *Bacchanale*, *Seventh Symphony*, *Symphonie Fantastique*, *Gaité Parisienne*, and *The New Yorker*. As Mark Platoff he choreographed his first work for the Ballet Russe, *Ghost Town* (1939), to a rare commisioned ballet score by Richard Rogers.

His abilities to create believable characters within the confines of ballet vocabularies also brought him fame on Broadway and in film. As Marc Platt, he danced in George Balanchine's *The Lady Comes Across* (1941), David Lichine's *Beat the Band* (1942),

and in Agnes De Mille's *Oklahoma* (1943) as "Curley" in the Dream Ballet. His films were made primarily for Columbia Studios where he was under contract, and included *Tars and Spars* (1943), *Tonight and Every Night* (1945), and *The Eternal Melody* (1948). On loan to Metro, he participated in one of the most popular musical films ever—Michael Kidd's *Seven Brides for Seven Brothers*, in which he played "Daniel."

Platt served as stage producer and director for the Radio City Music Hall in New York throughout the 1960s, staging the theater's spectacles and some of the dance numbers for the ballet corps.

Works Choreographed: CONCERT WORKS: *Ghost Town* (1939).

THEATER WORKS: (All works for the Radio City Music Hall.) *The Lovers* (1962); *Classical Symphony* (1965); *An Imperial Ballet* (1965); *Marionette Theatre* (1966); *The Spice of Life* (1966); *Winterset* (1966).

Plisetskaya, Maya, Soviet ballerina; born November 20, 1925 in Moscow. Trained at the Bolshoi School by Yelisaveta Gerdt, she has been associated with the Bolshoi Ballet throughout her career. The best known Soviet ballet dancer in the West, and generally considered the ideal example of the Bolshoi style of performance and choreography, she has toured extensively and has appeared frequently on film. Her fabulous extensions and exciting stage presence have been seen and applauded at the premieres of Grigorovich's *The Stone Flower* (1954) and *Swan Lake* (1972), Moiseyev's *Spartacus* (1958), Alberto Alonso's *Carmen Suite* (1967), and the company productions of *Don Quixote* and *Raymonda*. Her own *Anna Karenina* (1972), although a vehicle for herself, has entered the company repertory. The niece of Asaf Messerer, she is the sister of Azari Plisetski, a Soviet dancer and choreographer known for his work coaching and choreographing in Cuba.

Works Choreographed: CONCERT WORKS: *Anna Karenina* (1972).

Plunkett, Adeline, Belgian ballet dancer of the Romantic era; born March 3, 1824 in Brussels; died November 1910 in Paris. Trained in Paris by Jean-Bap-

tiste Barré, Plunkett performed at Her Majesty's Theatre, London, in 1843 and 1844. She was featured there in Jules Perrot's *Esmeralda* and *Ondine* and played a principal "Willi" in the English premiere of *Giselle* in 1843. At the Drury Lane in 1844, she took the principal role in Albert's *Le Corsaire.*

At the Paris Opéra from 1845, she created roles in Jean Coralli's *Ozai* (1847), Charles Mabille's *Nisidia* (1848), Mazilier's *Vert-Vert* (1851), and Arthur Saint-Leon's *l'Enfant prodigue* (1851). After a season at the Teatro de Fenice in Venice performing Pasquale Borri's *La Giocoliera* (1855), she spent the remainder of her career at the Teatro di Apollo in Rome, dancing in Borri's *Birenne* and Guiseppe Rota's *Una silfide a Pekino* and *Zaide.* Plunkett retired in 1861.

Poelvoorde, Rita, Belgian ballet dancer; born February 23, 1951 in Anvers. Trained by Jeanne Brabands, she performed in her Ballet du Koninklijke Vlaamse and with the Netherlands Dance Theatre.

In 1971, Poelvoorde joined the Ballet du XXième Siècle with which she has performed ever since. Among the many works by Maurice Béjart in which she has created roles are *Le Marteau sans Maitre* (1973) and the *Dichterliebe* (1979). She has danced in featured roles in his *Romeo et Juliette, Ah, Vous dirai-je Maman?, Farah, I Trionfi di Petracha, Le Molière Imaginaire,* and *Pli Selon Pli,* a section of which was included in the film *Je t'aime, Tu danses* (1974). She is very popular in her Béjart roles for her precise dance technique and almost casual and childlike performances.

Poliakova, Jelena, Russian ballet dancer teaching in Yugoslavia and Chile; born 1884 in St. Petersburg; died July 25, 1972 in Santiago. Poliakova was trained at the St. Petersburg School of the Imperial Ballet, graduating into the Maryinsky Ballet in 1902. She performed with that company for more than a dozen years, primarily in such Marius Petipa ballets as *The Sleeping Beauty, La Esmeralda,* and *Paquita,* and also appeared with the first season of the Diaghilev Ballet Russe.

Best known as a teacher, she had some students in St. Petersburg, among them Alice Nikitina, before

accepting an engagement in Belgrade (c.1920). She was a member of the first separate ballet company of the Belgrade National Opera, appearing in Russian works revived by Claudia Issachenko, and a company teacher. Her students there included almost every member of that company and its Zagreb neighbor, among them Ana Roje and Dimtrije Parlic, each of whom would later head a Yugoslavian troupe. She emigrated to Chile in the late 1940s and taught in Santiago with the National Ballet of Chile. The dance archives of the Teatro Municipale in Santiago were enriched by her donation of materials on the German, Russian, and Yugoslavian ballet.

Pomare, Eleo, American modern dancer and choreographer; born October 22, 1937 in Cartegena, Colombia. Raised in New York, he attended the High School of Performing Arts, studying with May O'Donnell, Louis Horst and José Limón.

He had already formed a chamber company and presented recitals when he was given a fellowship to train with Kurt Jooss in Essen. In Europe from 1961 to 1964, he studied in Essen and choreographed for the National Ballet of Holland and the Scapino Ballet. Since returning to the United States, he has choreographed for his own company in recital and on the Dancemobile, a traveling truck stage that tours the streets of New York in the summertime. Although his best known works are solos—*Narcissus Rising* (1968), the portrait of a doomed motorcycle gang member, for himself, and *Roots* (1972), for Lillian Coleman but now associated with Dyanne Harvey—he has created many large-group pieces for his company, that has included choreographers Shawneequa Baker-Scott, John Parks, Carole Johnson, and Frank Ashley. The most celebrated of those is his *Blues for the Jungle* (1962), a scenario of the kind of summer that the Dancemobile and its fellow touring theaters are supposed to avert, and still popular in each revival.

Works Choreographed: CONCERT WORKS: *Cantos for a Monastery* (1959); *Encounter* (1959); *Wind and Quicksand* (1959); *Construction in Green* (1959); *Rites* (1960); *En Rondeau* (1960); *Not Now* (1960); *Alienations* (1961); *Blues for the Jungle* (1962); *Missa Luba* (1965); *Serendipity* (1966); *Junkie* (1966); *Climb* (1966); *Gin, Woman, Distress* (1967); *Les De-*

senoradas (1967); *Up Tight* (1967); *Narcissus Rising* (1968); *Radiance of the Dark* (1969); *Movements for Two* (1970); *Movements* (I) (1971); *Black on Black* (1971); *Roots* (1972); *Descents and Portals* (1974); *Hushed Voices* (1974); *Transplant II* (1974); *Movements II* (1975); *De la Tierra* (1975); *The Queen's Chamber* (1976); *Sextet* (1976); *Tetramin* (1976); *Hex* (1977); *Cantos* (1977); *'Nother Shade of Blue* (1977); *Blood-Burning Moon* (1978); *Fall-Out* (1978); *Fallscape* (1979); *Sombras* (1980); *Covenant* (1980).

Ponomarynov, Vladimir, Soviet ballet dancer and teacher; born July 22, 1892 in St. Petersburg; died May 21, 1951 in Budapest. Trained at the school of the Imperial Ballet in St. Petersburg, he performed with the Maryinsky Theatre for most of his short dance career, spending the 1910 season with the Diaghilev Ballet Russe.

Although he created the role of "Old Montague" in the Lavrosky production of *Romeo and Juliet* (1940), he has been known primarily as a teacher since the early 1920s. Among the male dancers whom he has trained are many of the choreographers of the 1940s–1960s, among them Rotislav Zakharov, Mikhail Lavrosky, Vakhtang Chabukiani, and Konstantin Sergeev.

Pontois, Noella, French ballet dancer; born December 24, 1943 in Vendôme. Trained at the school of the Paris Opéra, she has performed with the company throughout her career. Best known for her work in the classics, she performed the lead in the premiere of Pierre Lacotte's *La Sylphide* (1972, after Taglioni) and in the company's productions of *Les Sylphides*, *The Sleeping Beauty*, and *Giselle*. A frequent guest artist abroad, she danced in Natalie Makarova's production of *La Bayadère* with the American Ballet Theatre and has performed with the Vienna State Opera and the Boston Ballet.

Poole, David, South African ballet dancer working in England after the mid-1940s; born September 17, 1925 in Capetown, South Africa. After training at the Ballet School of the University of Capetown, Poole moved to England to continue his studies.

Poole performed with the Sadler's Wells Theatre Ballet from 1947 to 1955, creating roles in many of

the early works of John Cranko, among them, his *Trisch-Tratsch* (1947), *Sea Change* (1949), *Beauty and the Beast* (1949), *Pineapple Poll* (1951), *Reflection* (1952), and the *Lady and the Fool* (1954). He also danced in the premieres of Alfred Rodrigues' *Blood Wedding* (1953) and *Café des Sports* (1954), Kenneth Macmillan's *Danses Concertantes* and *House of Birds* (1955), and George Balanchine's *Trumpet Concerto* (1950).

After a season with the Ballet Rambert, Poole returned to Capetown in 1959 to choreograph for the University Ballet Company. Since then, he has restaged *The Sleeping Beauty* for the group and created *The Square* (1962).

Works Choreographed: CONCERT WORKS: *Coppélia* (1956, after Sergeev); *The Square* (1962); *The Sleeping Beauty* (1963, after Ashton and Sergeev, based on the original Petipa production).

Poole, Dennis, American ballet dancer; born December 27, 1951 in Dallas, Texas. After local training, he accepted a scholarship to the Harkness School. From 1970 to 1975, he performed in classical works staged by Frederick Franklin and Ben Stevenson and contemporary ballets by Stevenson, Vicente Nebrada, and other European choreographers in a series of short-lived companies—the Harkness Ballet, the National Ballet, Washington, D.C., and the Chicago Ballet of 1975. After starring as "Romeo" in Ruth Page's Shakespearean ballet in 1975, he joined the City Center Joffrey Ballet in which he has become known as a dancer capable of pure classicism and cool stylizations. His parts at the Joffrey Ballet include roles in Jerome Robbins' *New York Export: Opus Jazz*, Frederick Ashton's *Monotones II*, and Gerald Arpino's *Reflections*, *Pas d'Esprit*, and *Pas de Deux Holberg*.

Popova, Nina, Soviet ballet dancer and teacher working in the United States after 1940; born October 20, 1922 in Novorossisk. Raised in Paris, she was trained by Olga Preobrajenska and Lubov Egorova, with whose Ballet de la Jeunesse she performed. She emigrated to New York in 1939 to join the Original Ballet Russe and continued her studies with Anatole Vilzak and Anatole Oboukhoff here. Throughout the 1940s, she performed in New York–based companies, including the Original Ballet Russe, Ballet Theatre, the Ballet Russe de Monte Carlo, and the touring Ballet Alicia Alonso. She was associated with the works of David Lichine and Leonid Massine in all companies, dancing in the former's *Graduation Ball* and in the latter's *Aleko*, *Le Beau Danube*, and *Gaité Parisienne* as the "Leader of the Can-Can," but also danced featured and solo roles in the troupes' versions of *Aurora's Wedding*, *Giselle*, and *Swan Lake*. Popova worked with fellow Ballet Theatre alumnus James Starbuck in his dance routines for *Your Show of Shows* (NBC, 1949–1954), performing in his dance satires for Imogene Coca and in the "straight" numbers set into the variety format of the program.

As an honored member of the ballet faculty of the High School of Performing Arts in New York, she contributed to the training of almost every dancer and actor to pass through those halls from 1954 to 1967. Popova followed that impressive record with seven years as founding director and principal teacher of the Houston Ballet and Ballet Academy in Texas.

Portapovitch, Anna Knapton, Russian ballet dancer teaching in the United States; born Anna Knapton c.1890; died December 11, 1974 in West Roxbury, Massachusetts. Trained at the school of the Imperial Ballet in St. Petersburg, she performed with both the Anna Pavlova company and the Diaghilev Ballet Russe. Since all of her extant Ballet Russe credits use her married name (or some variant of it), it is likely that she had performed in the Imperial Ballet of Poland in Warsaw previously. From 1914 to 1920, she and her Polish husband, Stanislas Portapovitch, appeared in featured solos and variations in the Fokine repertory with the Diaghilev company and with the Nijinsky tour of 1916–1917. They returned to New York in 1919 to open a studio. Knapton-Portapovitch taught there for fifty-five years, retiring only a few months before her death in the mid-1970s.

Portapovitch, Stanislas, Polish ballet dancer teaching in the United States; born c.1890 in Warsaw; died before 1974 in West Roxbury, Massachusetts. The dancer, whose name is more properly spelled Potopowicz, was trained at the school of the Imperial Ballet in Warsaw and was engaged from there to tour in

the Anna Pavlova company and the Diaghilev Ballet Russe. His repertory in the latter company is unsure, since even the most reliable sources on that company seem to combine his credits and existence with that of his Russian wife, Anna Knapton Portapovitch. Since he was noted in later years for his reconstructions of works by Mikhail Fokine, including his *Chopiniana*, *Spectre de la Rose*, *Schéhérézade*, *Petroushka*, *Carnaval*, and *Prince Igor*, it is likely that he appeared in those ballets. Similarly, his revivals of the Pavlova repertory, including *The Magic Flute*, *Puppenfee*, *Amaryllis*, and *Pas Twardoski*, point to his participation in the productions of these ballets. He was the first person to produce *Horse with the Hump on His Back* in the United States in 1924, but it is not sure whether he based it on the Petipa version of 1895 or the Gorski piece of 1901.

Portapovitch and his wife returned to the United States after the Diaghilev London season of 1919 to open a studio in New York City. At her death in 1974, she was described as his widow, although it is unsure exactly when he died. In New York, he was best known as an opera choreographer, working with chamber and private companies as well as the Metropolitan Opera. He also staged and published divertissements for school recitals that ranged from European folk festivals to a ballet, *Pocohontas* (c.1927).

Porter, Cole, American musical comedy composer; born June 9, c.1891 in Peru, Indiana; died October 15, 1964 in Santa Monica, California. Porter began composing songs at Yale University. Among his earliest works was a tribute to Mikhail Mordkin for a fraternity show, "When I Used to Lead the Ballet." He scored some of the most popular shows on Broadway, and some of the most infamous flops, among them, *Fifty Million Frenchmen* (1929), *The Gay Divorce* (1932), *Anything Goes* (1934), *Red, Hot and Blue* (1936), *Panama Hattie* (1940), *Mexican Hayride* (1944), *Around the World in 80 Days* (1946), *Kiss Me Kate* (1948), *Can-Can* (1953), and *Silk Stockings* (1955). He would be remembered in dance circles if only for one song—his "Begin the Beguine" from *Jubilee*, 1935, named for a South American ballroom form, was performed by June Knight and Charles Walters in the original show, and most memorably in a speeded-up version by Fred Astaire and Eleanor Powell in the MGM *Broadway Melody of 1940*.

Porter wrote a score for the Ballet Suédois—*Within the Quota* (1923), staged by Jean Borlin. The music was later used by Keith Lee for his *Time Past* (1971).

Bibliography: Kimball, Robert, and Brendan Gill. *Cole* (New York: 1971).

Porter, Jean, American film dancer and actress; born December 8, 1924 in Cisco, Texas. After a long career in vaudeville as a baby and child hoofer, Porter was hired as a member of the MGM stock company of teen-agers. Even in that extraordinary group that included Judy Garland, Mickey Rooney, and Nancy Walker, Porter (at four-foot-eleven) was the shortest and, some believed, the best tap dancer. She was the female dance lead in *Babes on Broadway* (1942), *Bathing Beauty* (1944), *Betty-Co-Ed* (1946), *Two Blondes and a Red-Head* (1947, as the redhead), *Little Miss Broadway* (1947), *Andy Hardy's Blonde Trouble* (1948), and other teen musicals. Her career was damaged by the blacklisting of her husband, Edward Dmytryk, but was not revitalized as his was after his recantation in 1951. However, she has appeared occasionally in dramatic roles in his 1950s films, among them, *The Left Hand of God*.

Porter, Marguerite, English ballet dancer; born c.1956 in Doncaster. After local training, she entered the Royal Ballet School for two years before joining the Royal Ballet. Porter has appeared in the principal roles in the company's productions of the nineteenth-century classics, most notably in *The Sleeping Beauty*, *Swan Lake*, *Giselle*, and *Cinderella*, and in the Royal's director's plotted contemporary works, such as Frederick Ashton's *A Month in the Country* (1976), *The Dream, The Two Pigeons, A Wedding Bouquet,* and *Daphnis and Chloe*, and Kenneth MacMillan's *Mayerling* and *Manon*. Porter's sense of humor in characterizations was revealed when she brandished her cigarette holder in Bronislava Nijinska's *Les Biches*.

Posin, Kathryn, American modern dancer and choreographer; born March 23, 1945 in Butte, Montana. Posin was trained at Bennington College by Jack

Moore, and in New York by Maggie Black and the faculty of the Merce Cunningham studio. She was a member of the Valerie Bettis and Anna Sokolow companies, dancing in the latter's *Odes, Rooms,* and *Time + 7,* and appeared in many concerts of the Dance Theater Workshop group of choreographers. In the mid-1960s, for example, she danced in Jack Moore's *Five Sequences in the Shape of an Autopsy* and Jeff Duncan's *Winesburg Portraits, Diminishing Landscape, Canticles,* and *Statement.* She has presented her own choreography since 1967 for her company and for both ballet and modern dance troupes. She works primarily in abstractions, but has added a satirical edge to many works, such as the portrait of commercials, *The Closer She Gets . . . The Better She Looks* (1968). She has also staged musical numbers for theatrical productions, including Andre Serban's highly acclaimed *Cherry Orchard* for the New York Shakespeare Festival (1977).

Works Choreographed: CONCERT WORKS: *Anecdote* (1965); *Call* (1967); *Block* (1968); *The Closer She Gets . . . The Better She Looks* (1968); *40 Amp Mantis* (1968); *A: Arm, B: Yellow, Blue Leg* (1968); *Guidesong* (1969); *Days* (1971); *Three Countrysides* (1971); *Flight of the Baroque Airship* (1971); *The Black Dance* (1971); *The White Dance* (1972); *Prism* (1972); *Subway* (1972); *Tunnel Lights* (1972); *Summer of '72* (1972); *Grass* (1973); *Ladies in the Arts* (1973); *Ghost Train* (1973); *Bach Pieces* (1973); *Port Authority* (1973); *Getting Off* (1973); *Nuclear Energy I* (1974); *Children of the Atomic Age* (1974); *Nuclear Energy II* (1974); *Nuclear Energy III* (1975); *Street Song* (1975); *Waves* (1975); *Light Years—Four Plays for a Quarter* (1976); *Tales from the Dark Wood* (1976); *Soft Storm* (1977); *Saks Fifth Avenue Suite* (1977); *Clear Signals* (1978); *Close Encounters of the Third Kind* (1978); *Apache* (1979); *Windowsill* (1979).

THEATER WORKS: *Salvation* (1971); *A Dream Out of Time* (1972); *The Cherry Orchard* (1977); *The Tempest* (1979).

Potts, Nadia, English ballet dancer working in Canada; born April 20, 1948 in London. Raised in Toronto, she was trained at the school of the National Ballet of Canada, which she joined in 1966. Among her many roles in the company were the "Nocturne" and "Valse" solos in *Les Sylphides*, "Aminta" in John Neumeier's *Don Juan*, and "Nikiya" in the company's production of *La Bayadère*. She has also taken the principal roles in the classical repertory, being especially noted for her work in the Erik Bruhn production of *La Sylphide*.

Poulsen, Aage, Danish ballet dancer; born July 4, 1943 in Copenhagen. Poulsen was trained at the School of the Royal Danish Ballet and graduated into the company in the mid-1960s. After coming to prominence in the 1970s, Poulsen became associated with the current surge in popularity of the nineteenth-century works of August Bournonville, still in the company's repertory. His prowess in Bournonville technique was augmented by his ability to work in an even earlier style, with his solos in the only extant work by Bournonville's predecessor, Angiolini's *Whims of Cupid and the Ballet Master.* He has also been acclaimed in performances in a more contemporary repertory, most notably in works by Birgit Cullberg.

Pourfarrohk, Ali, Iranian ballet dancer and teacher; born in Kermanchah, Iran. Trained at the Royal Conservatory of Music and Drama in Teheran under William Dollar, he moved to New York to continue his studies with Antony Tudor and Margaret Craske at the school of the Metropolitan Opera Ballet. He was a member of the American Ballet Theatre from 1959 to 1963, dancing in the company's classical and contemporary repertory, and of the Harkness from its first season in 1964. In the latter troupe, he was cast in Brian Macdonald's *Capers*, Alvin Ailey's *Ariadne* and *Feast of Ashes*, and in Georges Skibine's *Pas d'Action*.

A popular teacher for both ballet and modern dancers, he served as ballet master for the Alvin Ailey Dance Theatre during the 1970s before returning to Iran to become director of the National Ballet in 1976.

Powell, Eleanor, American theater and film tap dancer; born c.1912 in Springfield, Massachusetts; died February 11, 1982, Beverly Hills, California. After studying acrobatics and interpretive dancing locally, she worked in Gus Edwards productions at

Atlantic City during the summers of 1924, 1925, and 1926. It was not until she was in New York, appearing in *The Co-optomists* on the Ziegfeld Theater Roof (1928), that she began to study tap dance with Johnny Boyle of the Jack Donahue Studio, then and for many years the best teacher in town. Although she also worked with Donahue, it is more likely that she learned her *terre-à-terre* style from Boyle, who worked very close to the floor, than from Donahue who was an eccentric dancer.

As her tap style became more famous, her parts got progressively larger, in *Follow Through* (1929), *Fine and Dandy* (1930), *George White's Music Hall Varieties* (1932), and *At Home Abroad* (1935). She was soon discovered by Hollywood and brought out to the West Coast to make the film, *The George White Scandals* (Fox Film Corp., 1935). For the next fifteen years, she made musical films for MGM—first starring in musical comedies, then appearing in dance cameos. Her best remembered films featured her casual dances, that seem to be improvised on the spot during a rehearsal, and her elaborate production numbers, ranging from the fabulous "Begin the Beguine" on a black glass floor in the *Broadway Melody of 1940* (MGM) to the incredible ritual drum dance in *Rosalie* (1936, MGM), in which she piqué-tap-turned down a series of drum heads.

Powell became a cult figure because of her technical ability. Unlike most film stars of the 1930s and 1940s, she was known for her lack of temperament. She was the mascot and titular editor of the "Young Dancers" section of *Dance Magazine*. On retiring from film, Powell became a producer of religious programming for television.

Powell, Lillian, American theatrical dancer; born c.1904, probably in or around Los Angeles, California. Powell was trained at the Denishawn school in Los Angeles and was for a number of years the prize pupil and performer in the works of Ruth St. Denis and, especially, Ted Shawn. She was the female principal of the Shawn troupes when economics required the Denishawn concert groups to split into two tour routes, and played the title role in the extravagant feature act, *Julnar of the Sea*, on the 1919–1921 engagements. She also toured with a solo act on the West Coast Pantages circuit, but split with Denishawn (reportedly over kickbacks to Shawn for arranging her tour) and moved to New York City to present her solos in Prologs and revues there. In the early and mid-1920s, when every Broadway revue required at least one exotic dancer, she appeared in at least one edition of many of the major annuals, including the *Greenwich Village Follies* (replacement and tour cast) and the *Music Box Revues*. Her Prolog engagements included work as a specialty or premiere dancer at the Rialto Theater (an independent house), and houses on the MGM, Paramount Publix, and Balaban and Katz circuits.

Powell, Ray, English ballet dancer; born March 20, 1925 in Hitchin, England. Trained at the school of the Sadler's Wells Ballet, he entered the company in 1941.

Celebrated for his character roles, he performed in the premieres of Frederick Ashton's *The Quest* (1943), *Homage to the Queen* (1953), and *Madame Chrysanthème* (1955), Ninette De Valois' *Promenade* (1943) and *Don Quixote* (1950), and Andrée Howard's *Veneziana* (1953). He was also assigned character roles in the company's productions of the classics, becoming famous for his portrayal of "Carabosse" in *The Sleeping Beauty*.

Ballet master of the Australian Ballet since 1960, he has choreographed for the company and has staged their productions of *Swan Lake*.

Works Choreographed: CONCERT WORKS: *Sweet Echo* (1953); *One in Five* (1960); *A Fool's Tale* (1961).

Powell, Robert, American modern dancer; born 1939 in Hawaii; died October 24, 1977 in New York. Raised in New York, he attended the High School of Performing Arts and studied with May O'Donnell, Gertrude Schurr, and Alfredo Corvino. A member of the Martha Graham company from 1958 on, he created roles in her *Acrobats of God* (1960), *Alcestis* (1960), *One More Gaudy Night* (1961), *Cortege of Eagles* (1967), and *Archaic Hours* (1974), and performed in repertory works. As a freelancer, he danced in John Butler's *Carmina Burana* (1959) at the New York City Opera, Fernand Nault's *Bitter*

Rainbow (1964), and in Glen Tetley's *Pierrot Lunaire* (1962). He rejoined the Graham company in 1973 as rehearsal director, serving as associate director from 1974 until his death in 1977.

Preger, Marianne, American postmodern dancer; born c.1925 in Brooklyn, New York. Trained by May Atherton while at college, she was a student of Jean-Pierre Barrault in Paris when she began to work with Merce Cunningham there in 1949. A member of the Cunningham company from 1950, she participated in many of his most innovative works of the period in which he was experimenting with aleatoric structure. Her credits, as Marianne Preger and Marianne Simon, include his *Septet, Banjo, Galaxy*, and *Suite for Five in Space and Time* (1956), considered a seminal dance work of the mid-twentieth century.

Preisser, June, American theater and film dancer; born c.1926 in New Orleans, Louisiana. Without formal training, she began her long theatrical career as the blonde member of The Preisser Sisters, an acrobatic dance act in local houses. With her sister Cherry (c.1924–1964), she did her eccentric tumbling acts in the *Ziegfeld Follies of 1934* and *1936* and on world tours in 1932 and 1935. They were frequently booked into the Radio City Music Hall and made more than twenty appearances on the Orpheum circuit. When her sister retired in 1937, she began to work alone as an acrobatic tap specialist on Broadway in *You Never Know* (1938) and at cabarets and clubs. After a highly successful personal appearance tour at the Loew's presentation houses and a second Broadway solo in *Count Me In* (1942), she was offered a movie contract with MGM.

As a member of MGM's stable of contract teenagers, she appeared in dozens of musical films, beginning with *Babes in Arms*. She was the blonde vamp in most of the Andy Hardy series, trying in vain to win Mickey Rooney away from Judy Garland (in the musicals) or Ann Rutherford. Although she occasionally made "adult" films, such as *Gallant Sons* (MGM, 1941) and *Sweater Girl* (Paramount, 1942), she was best known as a "girlfriend" of Andy Hardy, Henry Aldrich, or similar adolescent swains. After the end of her MGM contract, she joined Mono-

gram Pictures and appeared in many of its backstage mysteries, among them *Death on the Downbeat* (1943), *Murder in the Blue Room* (1943), and *Babes in Swing Street* (1944).

Preisser retired from films at the end of the 1940s and opened a string of dancing schools in the Los Angeles area.

Preobrajenska, Olga, Russian ballet dancer teaching in Paris; born Olga Preobrajenskaia, January 21, 1870 in St. Petersburg; died December 27, 1962 in Sainte-Mande, France. Preobrajenska was trained at the School of the Imperial Ballet in St. Petersburg by Christian Johanssen and Enrico Cecchetti. A member of the Maryinsky Ballet from 1890 to 1917, she appeared primarily in principal roles in the Marius Petipa repertory of pastorale comedies that required charm and reactions to realistic situations. As well as those parts, among them "Lise" and "Swanilda," Preobrajenska performed in Petipa's *Esmeralda* (in the title role of a gypsy), *Paquita, The Talisman, Raymonda,* and *Harlequinade*, and in Lev Ivanov's *Acis et Galathée, Camargo*, and *La Fille du Mikado*.

A teacher in the state ballet faculty from 1917 to 1920, she moved to Berlin (c.1921–c.1924) and Paris to train Western European dancers in her private studios. It would be impossible to list all of Preobrajenska's students without compiling a register of every company in Europe. They included the ballet stars, such as Igor Youskevitch and Margot Fonteyn, and the company directors and teachers, including Georges Skibine and Serge Golovine, through whom she influenced most of the next two generations of ballet and its performers.

Preobrajensky, Vladimir, Soviet ballet dancer; born January 21, 1912, probably in Leningrad. Trained at the school of the Kirov Ballet, he joined the company in 1931. After three seasons there performing featured roles in the classics, he spent five years with the Kiev ballet. He joined the Bolshoi in 1943 as Olga Lepechinskaya's partner, dancing with her in Lavrosky's *Walpurgis Night* and *The Stone Flower*, and in the company productions of *Swan Lake, Les Sylphides*, and *Giselle*.

Since retiring from performance in 1963, Preobra-

jensky has worked as a concert manager for the company.

Prévost, Françoise, French ballerina of the eighteenth century; born 1680, possibly in Paris; died in Paris, 1741. Trained at the Academie Royale de Musique, she made her debut at the Paris Opéra in 1699 in Lully's *Atys*. There for thirty years, she replaced Subigny as principal female dancer and was herself replaced by Marie Sallé and Marie Camargo. As well as her performances there in works of Lully, Rameau, and the Lavals, she participated in private and court presentations partnered by Blondy.

Price, Ellen, Danish ballet dancer of the early twentieth century; born 1878 in Copenhagen; died there in 1968. The daughter of Carl and granddaughter of James Price, she was trained at the school of the Royal Danish Ballet.

Because the company had maintained its repertory of ballets by August Bournonville, Ellen Price was assigned many of the roles that were created by her great-aunt, Juliette Price. These principal parts included both the title role and "Effie" in *La Silfiden,* and parts in *Konservatoriet, Flower Festival in Genzano*, and *Kermesse in Bruges*. She was featured in the ballets of Hans Beck, among them *Pierrette's Veil* (1911) and *The Little Mermaid* (1909). The latter ballet not only made her reputation and Beck's, but also inspired a statue that, for many tourists, represents Copenhagen. Price retired early in 1913.

Price Family, English family troupe of popular theater performers working in Denmark after the eighteenth century. By the end of the eighteenth century, the Price family had settled in Copenhagen at the Morskabsteater (literally Fun-Theater), a fair booth in the Tivoli. Although family techniques had at times included horseback riding and slack and tightrope walking, the nineteenth century Prices, Adolph and James, worked in the harlequinade theater. The children and grandchildren of both actors were members of the Royal Danish Theater and Ballet. Adolph, the "Pierrot" of the troupe, was the father of Juliette, Valdemar, Amalie, and Sophie, all of whom performed with the ballet; James, a celebrated "Harlequin," was the father of Julius, who left the

Royal Danish Ballet in 1855 to serve as principal danseur with the Vienna Court Opera, Mathilde and Carl, and was the grandfather of ballerina, Ellen Price.

Price, Juliette, Danish ballet dancer of the nineteenth century; born August 13, 1831 in Copenhagen; died there on April 4, 1906. Trained privately with August Bournonville, Price made her debut at the Royal Danish Ballet in his *Konservatoriet* (1849). Associated throughout her career with his ballets, she created roles in *Far from Denmark* (1860), *Psiche* (1850), *Valdemar* (1853), *Flower Festival in Genzano* (1858), and *Kermesse in Bruges* (1851). An enormously popular dancer and ideal Bournonville performer, Price retired in 1866 after injuring herself on stage.

Price, Valdemar, Danish ballet dancer of the nineteenth century; born September 1, 1836 in Copenhagen; died there on January 4, 1908. Trained privately by August Bournonville with his sisters Juliette and Sophie, he made his Royal Danish Ballet debut in 1857. Although he danced frequently in works by Bournonville, he did not receive featured roles until 1866, when his performance of "King Svend" in the revival of *Valdemar* was received with enthusiasm by the Copenhagen audience. From then until his retirement in 1901, he was cast in the principal male roles in the Bournonville repertory, creating roles in his *The Ordeal of Theyn* (1868), *Cort Adeler in Venice* (1870), *The King's Volunteers at Amager* (1871), and his last ballet, *From Siberia to Moscow* (1876).

Priest, Josias, English seventeenth-century theatrical choreographer associated with the operas of Henry Purcell; born c.1640, possibly in London; buried April 20, 1734 in London. It is believed, but cannot be verified, that Priest was a member of a family associated with music performance or printing. His first known performance credit was in *St. Martin Mar-All* (1667), presented at the Lincoln's Inn Field's theater.

The research of Selma Jeanne Cohen has shown that Priest opened an unlicensed dance school in 1669. By 1673, however, he had become principal of a licensed school in Chelsea, and, in 1689, the "Gen-

tlemen'' of that school performed in the premiere of Henry Purcell's *Dido and Aeneas*.

Despite the fame of that presentation, Priest should not be considered a choreographer of operas or a dance director for amateurs. He was the resident dance director of The United Company (a combined troupe made up of members of The Duke's Company and The King's Company), at least from 1690. There is some evidence, although no complete verification, that he was with the King's troupe before the uniting of the two in May, 1682. He and Purcell were engaged to create dances and music for many United Company presentations; although only verified productions are listed below, it is possible that Priest worked on all forty-two plays for which Purcell provided extant scores.

Works Choreographed: THEATER WORKS: *Macbeth* (1673); *Calisto, or The Chaste Nymph* (1675); *The Prophetess, or The History of Dioclesian* (1690); *King Arthur, or The British Worthy* (1691); *The Fairy Queen* (1692); *The Indian Queen* (1695).

OPERA: *Dido and Aeneas* (1689).

Bibliography: Cohen, Selma Jeanne. ''Theory and Practice of Theatrical Dancing.'' In Fletcher, Ifan Lyrle, ed. *Famed for Dance* (New York: 1960).

Primus, Pearl, American pioneer of the anthropological modern dance movement; born c. November 1919 in Trinidad, British West Indies. Raised in the United States from the age of two, she was trained at the New Dance Group Studio, with Charles Weidman and with La Belle Rosette, a specialist in Caribbean dance forms who taught occasionally in New York. Primus' first dance performances were at the Café Society, a cabaret that catered to the political and intellectual elite in New York and was one of the first clubs to be integrated in both cast and audience. Her appearances with the Teddy Wilson Band were tremendously popular and won her a national reputation, via an article in *Life* magazine that featured action photographs of her. Her first study trip to Africa came in the midst of her cabaret career and although she resumed performances at Café Society after her return, her focus shifted to the possibilities of combining anthropoligically analyzed movements with the modern dance vocabularies.

From 1944 to 1951, and again in the early and late 1960s and 1970s, Primus choreographed works for a company of dancers. In between her periods of creating works for audiences, she taught in colleges and schools in both arts and urban studies programs, using dance to train her students in both African and American anthropologies. Although most of her best known works relate to anthropological research (which led to a Ph.D. in African and Caribbean studies), she has also choreographed pieces about American life, including her celebrated *Strange Fruit* (1945), *The Negro Speaks of Rivers* (1944), based on the poem by Langston Hughes, and *Michael, Row Your Boat Ashore* (1979), about the horror of the Birmingham, Alabama, church bombings.

Works Choreographed: CONCERT WORKS: (Note: this listing includes works premiered in Café Society performance.) *Solos for Performance at the Cafe Society (Strange Fruit, Our Spring Will Come, Jim Crown Train, Ague, African Ceremonial, Afro-Haitian, Play Dance, The Negro Speaks of Rivers, Study in Nothing, Rock of Daniel)* (c.1944); *Shouters of Sabo* (1945); *Sometimes I Feel Like a Motherless Child* (1945); *Hard Times Blues* (1945); *To One Dead* (1946); *Trio* (1946); *Dance of Strength* (1946); *Dide-Dide* (1946); *Dark Rhythms* (1946); *No Shoes* (1946); *Two Moana* (1946); *Dance of Beauty* (1946); *Dance of Dahomey* (1946); *Rookombey* (1947); *Santos* (1947); *Legend* (1947); *Shango* (1947); *Caribbean Carnival* (1948, performed with *Rookombey);* ''*Everybody Loves Saturday Night*'' (1949); *Invocation* (1949); *Go Down Death* (1949); *American Folk Dance* (1949, changing elements); *Fanga* (1949); *Prayer* (1950); *Yurubo People* (1950); *Egbo Escapade* (1950); *The Initiation* (1950); *Benis Woman's War Dance* (1950); *Fanti Dance of Fishermen* (1950); *Excerpts from an African Journey* (1951); *Impinyuza* (1951); *Royal Ishadi* (1951); *Kalenda* (1953); *La Jablesse* (1954); *Mr. Johnson* (1955); *Castillian* (1957); *Temne* (1958); *Ibo* (1958); *Earth Magician* (1958); *Unesta* (1958); *Mtimi* (1959); *Whispers* (1960); *Story of a Chief* (1960); *Naffi Tombo* (1960); *Zo Kengal* (1960); *Kwan* (1960); *The Wedding* (1961); *To the Ancestors* (1962); *The Man Who Would Not Laugh* (1962); *Mangbetu* (1963); *Zebola* (1963); *Life Crisis* (1963); *Anase* (1965); *Hi Life* (1965); *Patch Work Quilt* (1967); *Fertility Dance* (1967); *Pleasure Song* (1967, may have been choreo-

graphed before this date); *Song for Tomorrow* (1967); *Echoes in the Night* (1967); *Dance of Lights* (1970); *In Honor of a Queen Mother* (1975); *Dance of Tattles* (1979, may have been choreographed before this date); *Michael, Row Your Boat Ashore* (1979).

Prinz, John, American ballet dancer; born May 14, 1946 in Chicago, Illinois. After receiving classical training at the School of American Ballet, Prinz joined the New York City Ballet. Noted for his performances in the revival of Frederick Ashton's *Illuminations* and the *Emeralds* section of Balanchine's *Jewels*, Prinz brought precise technique and stage presence to many works in the repertory. He created roles in ballets by many of his fellow dancers, among them Jacques D'Amboise's *Prologue* (1967), and *Tchaikovsky #2* (1969), John Clifford's *Stravinsky Symphony in C* (1968), and a role in Jerome Robbins' celebrated *Dances at a Gathering* in 1969.

From 1970, Prinz performed with American Ballet Theatre, although his eight years there were disrupted by major injuries. He danced in the company's productions of the classics and in Michael Smuin's *Schubertiade*, Robbins' *Fancy Free*, and both the one-act and complete versions of *The Sleeping Beauty*. After his attempt to start a ballet company in Chicago fell through, Prinz joined the Cleveland Ballet as ballet master in 1980. Within the year, he returned to New York to teach at the American Ballet Theatre school.

Prinz, LeRoy, American film dance director; born July 14, 1895 in St. Joseph, Missouri. Prinz studied contemporary ballroom forms with his father, dance master E.A. Prinz, but never performed professionally as a dancer. Details of his early life have been obscured by promotional material from the Hollywood studios, but it is known that he served in World War I as a member of Edward Rickenbacher's Flying Tigers air squadron and, after the war, staged student revues at Northwestern University. One commonly published story about Prinz that cannot be confirmed is that he was discovered at Northwestern by Al Capone who hired him to stage cabaret acts at the nightclubs that he owned and/or controlled in Chicago and Havana.

In 1930, Prinz went to Hollywood to work for Cecil B. De Mille as a production assistant. It is believed that his recommendation came from Elsie Janis, the World War I–era troop entertainer who was then a musical production supervisor and songwriter at Paramount. It is not known how Prinz made the career switch from De Mille's assistant to dance director; his first solo credit was assigned for the De Mille film *Squaw Man* (MGM, 1931). In his twenty-five years as a film dance director, Prinz was primarily associated with two studios—Paramount (1931–1941), and Warner Brothers (1942–1957). He retained his connection with De Mille, staging orgies for him in *The Sign of the Cross* (Paramount, 1932), but became known for four disparate dance direction tasks—social dance scenes, as in the George Raft vehicle *Bolero* (Paramount, 1934), tropical numbers for Dorothy Lamour, in *Road* pictures, large chorus routines as in *The Big Broadcasts* of 1936 and 1938 (both Paramount), and the World War II all-star revues, *Thank Your Lucky Stars* (WB, 1943) and *This Is the Army* (WB/First National Pictures, 1943). Prinz is also known for his work on Warner Brothers' many theatrical biography films, contributing to the songwriter "biopics" on George M. Cohan, George Gershwin, and Cole Porter (*Yankee Doodle Dandy, Rhapsody in Blue*, and *Night and Day*, respectively), and to *The Eddie Cantor Story* and *Helen Morgan Story* (1956, 1957). Prinz's last film assignment was *South Pacific* (Twentieth-Century Fox, 1958).

Works Choreographed: FILM: *Squaw Man* (MGM, 1931); *The Sign of the Cross* (Paramount, 1932); *Too Much Harmony* (Paramount, 1934); *Bolero* (Paramount, 1934); *College Rhythm* (Paramount, 1934); *Search for Beauty* (Paramount, 1934, with Jack Haskell); *Mrs. Wiggs of the Cabbage Patch* (Paramount, 1934); *You Belong to Me* (Paramount, 1934); *All the King's Horses* (Paramount, 1935); *The Big Broadcasts of 1936* (Paramount, 1935); *Show Boat* (Universal, 1936); *Artists and Models* (Paramount, 1937); *Champagne Waltz* (Paramount, 1937); *High, Wide and Handsome* (Paramount, 1937); *Waikiki Wedding* (Paramount, 1937); *The Buccaneer* (Paramount, 1938); *College Swing* (Paramount, 1938); *Every Day's a Holiday* (Paramount, 1938); *Give Me a Sailor* (Paramount, 1938); *Tropic Holiday* (Paramount, 1938); *The Road to*

Singapore (Paramount, 1938); *Too Many Husbands* (Columbia, 1940); *Aloma of the South Seas* (Paramount, 1941); *The Road to Zanzibar* (Paramount, 1941); *Yankee Doodle Dandy* (WB/First National Pictures, 1942, with John Boyce and Seymour Felix); *The Desert Song* (WB, 1943); *The Hard Way* (WB, 1943); *Las Vegas Nights* (Paramount, 1943); *Thank Your Lucky Stars* (WB, 1943); *This Is the Army* (WB/First National Pictures, 1943, with Robert Sidney); *Rhapsody in Blue* (WB/First National Pictures, 1945); *Night and Day* (WB/First National Pictures, 1945); *The Time, The Place and The Girl* (WB, 1946); *Escape Me Never* (WB, 1947); *It's a Great Feeling* (WB, 1947); *Look for the Silver Lining* (WB, 1949); *My Dream Is Yours* (WB, 1949); *Tea for Two* (WB, 1950, with Edward Prinz); *The West Point Story* (WB, 1950); *I'll See You in My Dreams* (WB, 1951); *On Moonlight Bay* (WB, 1951); *Starlight* (WB, 1951); *April in Paris* (WB, 1952); *The Jazz Singer* (WB, 1952); *She's Working Her Way Through College* (WB, 1952); *All American Girl* (Universal, 1953); *The Eddie Cantor Story* (WB, 1956); *The Helen Morgan Story* (WB, 1957); *South Pacific* (Twentieth-Century Fox, 1958).

Prior, Candace, American modern dancer; born January 25, 1951 in New York City. Prior began her studies with Steffi Nossen and continued in college and at the Martha Graham and Merce Cunningham studios. Best known and admired for her work with choreographers who deal with verbal, visual, and movement syntaxes, she has been a valuable member of Raymond Johnson's troupe. She appeared in his works, such as *Black Dance*, and his revivals of ballets by James Waring, including his *Feathers* and *Mazurka*. She has also performed in many works by Elizabeth Keen, among them her *The Forget-Me-Not* (1978) and with James Cunningham's Acme Dance Company. She is adept and perfect in Cunningham's montages of effects and jokes, able to appear straight-faced as an image of his fantastic imagination or glorified into a fabulous creature.

Prokofiev, Serge, Soviet composer; born April 23, 1891 in Sonzowska; died March 5, 1953 in Moscow. Prokofiev wrote scores for dance performance from his youth, when he was considered an atonal avant-gardist, to his later years, when he was revered for his ability to mesh lyrics with Soviet social realism. His first dance score, *Ala and Lolly*, was not seen publicly until Max Terpis staged it for the Berlin State Opera in 1927, but his next three were created for the Diaghilev Ballet Russe and were not only produced, but were publicized as marvels of the avant-garde. These ballets ranged from the nationalist *Chout* (1915, staged by Taddeo Slavinsky and designer Mikhail Larionov in 1927) to the constructivist *Pas d'acier* (1927, for Leonid Massine) and *Prodigal Son*, which, with the Balanchine choreography and Georges Roualt designs, was rightly judged a masterpiece. He composed a ballet for Serge Lifar at the Paris Opéra in 1932 before returning to the Soviet Union, but *Sur le Borsynthène* was not a success. Prokofiev's trio of full-length plotted ballets for the Soviet-influenced company in Brno, Czechoslovakia, and the Bolshoi Ballet—*Romeo and Juliet* (1938), *Cinderella* (1945), and *The Stone Flower* (1954)—are still in the repertories of most troupes in the Soviet Union and other countries of Eastern Europe.

His ballet dance scores and music from concert works have been used by hundreds of choreographers in every country where ballet is performed. There are scores of productions of *Romeo and Juliet* alone and almost as many of *Cinderella* and *Peter and the Wolf*. A brief survey of works to concert scores reveals Mikhail Fokine's *A Russian Soldier* (1942, for Ballet Theatre) set to selections from the film score to *Lieutenant Kijé*, Antony Tudor's satire of ballerina rivalry set to the *Classical [5th] Symphony* (1938), Eliot Feld's debut ballet, *Harbinger*, set to the G major Piano concerto, and Jerome Robbins' *An Evening of Waltzes* (1973), using sections from Prokofiev ballet and opera scores.

Prokovsky, André, French ballet dancer working in England from the late 1950s; born January 13, 1939 in Paris. Trained by Lubov Egorova, Nicholas Zverev, and Nora Kiss, he performed briefly with Les Ballets de Jean Balibée (1953), de Janine Charrat (1955), and de Roland Petit (1956). In the London Festival Ballet from 1957 to 1960, he performed in Anton Dolin's *Variations for Four*, in David Lichine's *Graduation Ball*, and in the company productions of Bournonville's *Napoli*.

He spent two years with the International Ballet du Marquis de Cuevas from 1960 to 1962, with featured roles in Edward Caton's *Sebastien*, in Serge Lifar's *Suite en Blanc*, and in John Taras' *Piège de Lumière*. On recommendation from Taras, he joined the New York City Ballet for two seasons, creating roles in George Balanchine's *Pas de Deux and Divertimento* (1965), and *Brahms-Schoenberg Quartet* (1966), and Jacques D'Amboise's *The Chase* (1963) and *Irish Fantasy* (1964).

In London after the mid-1960s, he performed with the London Festival Ballet (1966–1973) in Peter Darrell's *Othello* (1974) and Jack Carter's *Pythoness Ascendent* (1974), dancing in both with his wife, Galina Samtsova. With her, he founded the New London Ballet, for which he has choreographed.

Works Choreographed: CONCERT WORKS: *Vespri* (1973); *Piano Quartet No. 1* (1974); *Soft Blue Shadow* (1976).

Prowse, Juliet, South African film and club dancer; born September 25, 1936 in Bombay, India. Raised in Durham, South Africa, she was trained in ballet there and performed with the Johannesburg Festival Ballet before moving to London in the mid-1950s. After spear carrying with the London Festival Ballet, she joined the chorus of the London Palladium. In England, she appeared in the London production of Jack Cole's *Kismet* and danced for him in *Gentlemen Marry Brunettes* (MGM, 1955), filmed there. Prowse danced at La Nouvelle Eve in Paris, the Teatro Madrid, and in an Italian musical revue, in which she was seen by Hermes Pan.

When Pan was preparing to choreograph *Can-Can* for Twentieth-Century Fox, he recommended her for the secondary dance role in the film. As the lead Can-Can dancer, she became famous and moved to the United States to work.

Although known for that role and similar seductive parts in film comedies, including one with Elvis Presley, the long-legged Prowse is best known for her performances in cabarets in America's gambling/tourist areas—Las Vegas, Reno, and Atlantic City. She has played Vegas almost annually since arriving in this country.

Psota, Ivo, Russian ballet dancer working in the United States and Czechoslovakia; born May 1, 1908 in Kiev, the Ukraine, Russia; died February 16, 1952 in Prague. Raised in Prague, he attended the ballet school of the National Theater there, later continuing his training with Olga Preobrajenska and Lubov Egorova.

Psota, whose first name has been spelled variously as Ivan, Vania, and Jean, served as ballet master of the National Opera of Brno, Czechoslovakia, from 1926 to 1932, 1937 to 1940, and again from 1950. In between those tenures, he performed with the Ballet Russe de Monte Carlo, creating roles in Leonid Massine's *Le Beau Danube* and *Scuola di Ballo*, both in 1933. He was featured in Massine's *La Boutique Fantasque, Choreartium,* and *Soleil de Nuit,* and in the company's production of *Schéhérézade*.

For the company in Brno, he has choreographed many operas and ballets, among them *Romeo and Juliet* (1938), *Slavonica* (1941), and *Prince Igor* (1952).

Works Choreographed: CONCERT WORKS: *Romeo and Juliet* (1938); *Slavonika* (1941); *Yara* (1946); *Prince Igor* (1952).

Puck, Eva, American theatrical dancer; born 1892 in Brooklyn, New York; died October 24, 1979 in Grenada Hills, California. Puck made her vaudeville debut at the age of three in a successful act with her older brother Harry. They worked together until 1912 and from 1916 to 1921 in a feature act of songs and dancing. As a child, she (like Adele Astaire) made a success of playing mature women in sophisticated situations and dances but, as she grew older (but not taller), she added ingenue characterizations to the act. Her dance specialties included a Highland Fling (performed with her brother's Harry Lauder imitation), a doll waltz, and a changing series of exhibition ballroom numbers with Harry Puck. During her short-lived first marriage to a vaudeville manager with the Hammerstein office, she retired from the act, which her brother continued with Mabelle Lewis.

After four more years with Harry (1916–1921), she found a new partner, Sammy White. Together they were a tremendously successful musical comedy dance lead team, appearing in a large number of revues and plotted shows. Among their best remembered productions were *Mary* (1920), the original *Irene* (1924), *Melody Man* (1924), the *Greenwich Vil-*

lage Follies of 1922 and *1923*, and *The Girl Friend* (1926), in which she introduced the Rogers and Hart classic, "Blue Room." Their most celebrated characterizations were as "Ellie" and "Frank" in *Show Boat* (1927), singing and cake-walking to "Life Upon the Wicked Stage," "Under the Bamboo Tree," and "Goodbye My Lady Love." They did these parts for many seasons before returning to vaudeville and Prologs. Puck retired in the early 1930s.

Puck, Harry, American theatrical dancer; born 1893 in Brooklyn, New York; died January 28, 1964 in Metuchen, New Jersey. Puck and his younger sister Eva worked in vaudeville from c.1898 to c.1918 as "The Child Wonders," "The Two Pucks," and "Sunshine and Shadow" on the Keith circuit. Their acts over this period changed with the shifting tastes in dance and songs, of course, but seem to have maintained the same format with vocal solos, exhibition dances, and travesties of popular stage figures. Frequently, he did the imitations of, for example, Harry Lauder, while she did a dance specialty that was somehow related—in that case, a Highland Fling. From 1912 to 1916, when his sister had retired from the act, he worked with Mabelle Lewis in his old format.

Puck had a brief but successful career as a juvenile lead in musical comedy, partnering Marie Saxon in *My Girl* (1924) and *Merry Merry* (1921). After his last show, *Three Little Girls* (1931), he retired from performing to go into production. He was on the staff of the Shubert Brothers office for six years before moving to Hollywood and a job with Paramount Pictures. He worked with his brother Larry in his management agency and also produced industrial shows for many years. He had written songs since the 1910s and in later years concentrated entirely on his musical career.

Pugni, Cesare, Italian nineteenth-century composer; born c. 1805 in Milan; died January 26, 1870 in St. Petersburg. Pugni wrote the first of his more than three hundred ballets for the Teatro alla Scala in 1823—Gaetano Gioja's *Il Castello di Kenilworth*. He is generally associated with the ballets by Jules Perrot, having scored music for his *Ondine* (1843), *Eoline* (1845), the celebrated *Pas de Quatre* (1845), *Catarina* (1846), and *Faust* (1845). Pugni also composed ballets for Arthur Saint-Léon, Joseph Mazilier, and Marius Petipa, for whom he did *Le Corsaire* (1858) and *Le Roi Candaule* (1868). The pas de deux from the former is his only ballet music still in the current repertory.

Purcell, Henry, English seventeenth-century composer; born 1659 in London; died there November 21, 1695. As composer-in-residence to a royal orchestra (the King's violins) and organist of Westminster Abbey, Purcell wrote a large number of occasional pieces for orchestra and keyboards. His dance music was composed for dramatic productions of The United Company (a conglomerate of two theater companies in London), now divided in terminology between stage-spectacles, such as *King Arthur, or the British Worthy* (1691) and *The Fairy Queen* (1692), and incidental music for plays, including *Timon of Athens* (1694), *Abdelazer* (1695), and *The Mock Marriage* (1695). It is believed that they, like his opera *Dido and Aeneas* (1689), were staged by Josiah Priest, also associated with the united companies.

Modern choreographers have used primarily his theater scores. Such works were especially popular in the 1930s and 1940s, when Purcell was being challenged in England by Benjamin Britten. They were staged by major choreographers in England and the United States and include Frederick Ashton's *Dances for "The Fairy Queen"* (1927), Ninette De Valois' *The Birthday of Oberon* (1933), Antony Tudor's *Suite of Airs* (1937), Robert Helpmann's *Comus* (1937), and José Limón's *The Moor's Pavanne* (1949) and *The Queen's Epicidium* (1953).

Pushkin, Alexander, Soviet ballet dancer and teacher; born September 7, 1907 in Mikulino, Prussia; died March 20, 1970 in Leningrad. Trained in Leningrad at the forerunner of the Choreographic Institute, he spent his performing career with the GATOB/Kirov Ballet (c.1925–1953). Like his pupils, he was known for a phenomenal ability to leap which enabled him to take principal roles in *The Sleeping Beauty* ("Blue Bird"), *La Esmeralda* ("Acteon"), and other ballets that had series of interpolated bravura solos and duets. Pushkin was not only a jumper, however, and was acclaimed for his unified portrayals of the heroes in *Swan Lake, Les Sylphides* (with the "Poet" counting as a characterized hero in

the Soviet version), and *The Fountains of Bakhchisarai.*

Despite the length of his dancing career, Pushkin is best known as a teacher of male students at the Leningrad Choreographic Institute. From 1932 to his death, he trained the dancers who are now considered typical of the Kirov style, which is actually derived from his personal abilities and preferences. Among them are defectors Rudolf Nureyev, Mikhail Baryshnikov, and Valeri Panov, all of whom have been able to parlay their own leaps into success.

Q

Qualter, Tot, American theatrical dancer; born Marguerite Qualters, 1895 in Detroit, Michigan; died March 27, 1974 in New York City. A member of a theatrical family, Tot Qualter was one of five family members working on Broadway in the 1920s. She worked originally with her twin, Fritzie (Gertrude), in a dance act, but left to make her Broadway debut in *The Winsome Widow* (1912). She moved out of the chorus in *Chin-Chin* (1915), in which she partnered Fred Stone in a brief specialty number. Qualter, and her sisters Cassie and Fritzie and sister-in-law Stella, were under contract to Florenz Ziegfeld between 1916 and 1921, appearing in the *Follies* of 1916, 1920, and 1921, and in *The Century Girl* (1916) and *Miss 1917*. Although she served as understudy to Fanny Brice, she seldom performed her solos but, instead, worked as a swing show girl and specialty dancer. Her best known dances of this period were shimmies, and her great specialty songs were introduced in Shubert Brothers shows in 1919 to 1922, among them *Move On* (1919), where she did "How I Killed the Shimmy in the West" and the *Passing Show of 1921*, in which she was "Miss Rattle," who has a "Rattling Good Time."

R

Rabovsky, István, Hungarian ballet dancer; born 1930 in Szeged, Hungary. Trained at the Budapest State Opera Ballet School by Ferenc Nádasi, he spent some time in Leningrad, studying with Agrippina Vaganova. As a principal dancer with the Budapest State Opera, best known for his performance in Mikhail Fokine's *Spectre de la Rose*, he was assigned to make a concert tour of Eastern Europe in 1952, with his wife Nora Kovach. While in East Berlin in 1953, they defected to West Berlin where Sol Hurok contracted them to perform under his management.

They danced first with the London Festival Ballet, in a repertory of classical pas de deux. In 1954, they toured the United States for Hurok, performing in concert halls and at the Sahara in Las Vegas. Rabovsky and Kovach performed frequently on *The Ed Sullivan Show*—a showcase both for Cold War politics and for ballet—and with the Judy Garland tour in 1956. They currently teach in upstate New York.

Bibliography: Kovach, Nora and István Rabovsky. *Leap through the Curtain* (London: 1955).

Radice, Atilla, Italian ballet dancer; born January 8, 1914 in Taranto. Radice was trained by Enrico Cecchetti and Cia Fornaroli at the school of the Teatro alla Scala. Radice was associated with La Scala for much of her performing career, and danced in the works of the company's ballet masters Aurel Milloss, Margarete Wallmann and Boris Romanoff. Her Romanoff credits include his *El Amor Brujo, Carmina Burana* and *Hommage à Schubert*; among the many Milloss works in which she has performed are his *Petroushka, Sacre du Printemps, Bolero, Le Quattro Stagione, Daphnis ed Chloe,* and *Ungarica.*

After a bad review developed into a scandal that involved two ballerinas, two journalists, and a duel, Radice moved to Rome. She served there as director of the Ballet School of the Opera House from 1957 until her retirement.

Radius, Alexandra, Dutch ballet dancer; born July 3, 1942 in Amsterdam. Trained by Nel Rooss, she made her debut with the Netherlands Ballet in 1957. A member of the Netherlands Dance Theatre from 1959 to 1969, she created roles in Hans van Manen's *Symphony in Three Movements* (1963), *Metaforen* (1965), and *Five Sketches* (1966), the latter two with her husband, Han Ebbelaar.

They joined the American Ballet Theatre, dancing with that company from 1968 to 1970. She was known for her charming performances in *Coppélia, Les Sylphides,* Harald Lander's *Etudes,* and Balanchine's *Theme and Variations,* but partnered her husband in the premiere of Stephen-Jan Hoff's *Lilting Fate* (1969). With the Dutch National Ballet after 1970, she danced in van Manen's *Twilight* (1972), *Adagio Hammerklavier* (1973), *Sacre du Printemps* (1974), and *Quintet* (1974), and in Glen Tetley's *Mythical Hunters.*

Radojevic, Danilo, Australian ballet dancer currently performing in the United States; born September 8, 1957 in Sydney, Australia. Radojevic was trained locally with Marion Walker and Jeffrey Kahn.

As a member of the Australian Ballet, he was cast in the title role when Eugene Loring restaged his celebrated *Billy the Kid* for the company. He also danced the "Blue Boy" in Frederick Ashton's *Les Patineurs,* the "Bluebird" in the company production of *The Sleeping Beauty,* and the "Pontevedrian Dancer" in the Robert Helpmann ballet of *The Merry Widow.*

Since joining the American Ballet Theatre in 1978, Radojevic has come to national attention as "The Golden Idol" in Makarova's production of *La Bayadère.* He has also performed in the company's production of *Giselle,* in the peasant pas de deux, *The Nutcracker,* and *Don Quixote.*

Radunsky, Alexander, Soviet ballet dancer and choreographer; born August 2, 1919 in Moscow. Trained at the school of the Bolshoi Ballet, he performed with the company from 1933 to 1962.

Celebrated as a mime and character dancer, he was featured as "Capulet" in Lavrosky's *Romeo and Juliet* (1940), as "Dr. Coppelius" in the company's production of *Coppélia,* and in a principal role in *The Little Hunchbacked Horse* (1960).

Radunsky retired in 1962 to become chief choreographer of the Red Army Song and Dance Ensemble.

Works Choreographed: CONCERT WORKS: *The Little Stork* (1937); *Svetlana* (1939); *The Crimson Sails* (1942); *The Little Hunchbacked Horse* (1960).

Raft, George, American theatrical and social dancer and film star; born in New York City; died November 24, 1981 in Hollywood. Raft, who did not have formal dance training, emerged as the winner of Charleston competitions in the early 1920s.

Famed for his triple-time Charleston, he worked as a taxi-dancer at Churchill's New York, where the tango expert was Rudolf Valentino. After a vaudeville act with Eva Shirley, and a triple act, Pilso, Douglas, and Raft, on the Paramount/Publix circuit, Raft went to work as a featured dancer at Texas Guinan's El Fey Club in 1924. In 1925 and 1926, he partnered Elsie Pilcer who had followed her older brother, Harry, to Paris to perform in his club there. His Broadway debut, *Padlocks of 1927*, with Guinan led to a job on the film *Queen of the Night Clubs* (WB, 1929), with and reportedly about her. After that film, made in New York, he moved to Hollywood where he made films almost until his death. Rightly known for his participation in the gangster-based films *Scarface* (UA, 1932), where he first used the coin toss that would become his trademark, and *Some Like It Hot* (UA, 1959), he also performed as a dancer in musical films for Paramount, among them *Bolero* (Paramount, 1934), *Dancers in the Dark* (Paramount 1932), and *Midnight Club* (1933). Since some of his action films are among the best ever made in Hollywood, and his musicals among the worst, he has been much better known as an actor in dramatic roles.

Rainer, Yvonne, American postmodern dancer and choreographer also working as a film maker; born 1934 in San Francisco, California. Rainer began her dance training in New York with Edith Stephens, Syvilla Fort, and the staff of the Martha Graham school. In 1960, however, she returned to San Francisco to work with Ann Halprin's workshop program, on recommendation from Simone Forti. When she moved back to New York, she appeared in Forti's task pieces *See-Saw* (1960) and *An Evening of Dance Constructions* (1961), took classes at the Merce Cunningham studio, and performed for James Waring in his *Dromenon* (1961), *Dithyramb* (1962), *At the Hallelujah Gardens* (1963), *Bachanale* (1963), and *Musical Moments* (1964). As a Cunningham studio student, she took Robert Dunn's composition classes and, in their second year, was one of the organizers of the Judson Dance Theater. She has become a symbol of the Judson movement in the press, partially because she participated in so many of the concerts. She created a large number of works for Judson and performed at almost every recital in works by Steve Paxton, Carolee Schneemann, Philip Corner, Judith Dunn, Lucinda Childs, Aileen Pasloff, Dick Higgins, Robert Morris, and David Gordon. Rainer also presented works in concerts that were not sponsored by Judson (Memorial Church, Dance Theater, or Poet's Theater) but were popularly associated with the group of choreographers and artists, such as the Once Festival of 1964, Café Cino, Nine Evenings: Theater and Engineering (1966), and the season of modern and postmodern dance recitals at the Billy Rose Theater, New York, in 1969. There was a Rainer company after the end of the Judson presentations, for which she choreographed *Continuous Project—Altered Daily* in 1970. When she decided to avoid choreography, its cast formed themselves into the Grand Union (with which she did not actually perform). Rainer has detached herself from dance increasingly over the 1970s in favor of film directing. Her new works are well known and admired in the experimental film field and have been given frequent showings in New York City. Although many of her admirers were disappointed when she dropped out of dance, they had to recognize her desire for more artistic control and her choice of a more appropriate medium.

Rainer's choreography itself dates from 1961 to the early 1970s. She created her first extant works for James Waring's composition workshops at the Living Theater in 1961, *The Satie Spoons* and *The Bells*. Her canon uses all of the elements that are now considered a part of postmodernist choreography—aleatoric structuring using a form of chance mechanism, repetition, and game or task work. Her aleatoric work was frequently based on grids or charts that determined the individual elements and performers within each work, or each performance of a work. Repetition and patterning could be perceived within the chanced structure. Her task dances ranged from locomotion games of getting from one place to another to mechanical manipulations, as in *Carriage Discreteness* at the Theater and Engineering program. Her best known work and, according to Sally Banes, the most significant single piece of the

genre, was the section of *The Mind Is a Muscle* known as *Trio A*. The four-and-a-half-minute dance was originally performed as a trio of simultaneous solo performances by Rainer, David Gordon, and Steve Paxton in January 1966. It is an extremely difficult yet sublimely logical series of movements that are perceived as being primarily circular and spiraling. It moves constantly and seems to be very dense. *Trio A* is unquestionably nongenderal and has been performed by men and women as solos or group pieces. It has been adapted in many different ways—as a more balletic work for Peter Saul, as a demonstration in learning a dance with Rainer and Becky Arnold, and as a continuous performance. The most controversial performance was perhaps the most irrelevant to the work—the press at the Judson Flag Show of 1970 focused on the nudity of the performers wearing the American flag, not on the work being danced. *Trio A* has also been adapted into other dancers' choreography, almost in the way that allusions are made in contemporary ballets to the Cygnet quartet of *Swan Lake*.

Works Choreographed: CONCERT WORKS: *Three Satie Spoons* (1961); *The Bells* (1961); *Satie for Two* (1962); *Three Seascapes* (1962); *Grass* (1962); *Dance for 3 People and 6 Arms* (1962); *Ordinary Dance* (1962); *We Shall Run* (1963); *Words Words* (1963, in collaboration with Steve Paxton); *Terrain* (1963); *Person Dance* (1963, a section of *Dance for Fat Man, Dancer and Person*); *Room Service* (1963, in collaboration with sculptor Charles Ross); *Shorter End of a Small Piece* (1963); *At My Body's House* (1964); *Dialogues* (1964); *Some Thoughts on Improvisation* (1964); *Check* (1964); *Part of a Sextet* (1964); *Incidents* (1965, in collaboration with Larry Loonin); *Part of a Sextet no. 2* (1964, now known as *Rope Duet*); *Part of Some Sextets* (1965); *Waterman Switch* (1965); *Partially Improvised New Untitled Solo with Pink T-Shirt, Blue Bloomers, Red Ball, and Bach's Tocatta and Fugue in D Minor* (1965, usually referred to as Untitled Solo); *The Mind Is a Muscle, Part 1* (*Trio A*) (1966); *The Mind Is a Muscle* (1966); *Carriage Discreteness* (1966); *Convalescent Dance* (1967); *Untitled Work for 40 People* (1968); *The Mind Is a Muscle* (1968, final version); *Performance Demonstration no. 1* (1968); *North East Passing* (1968); *Rose Fractions* (1969); *Performance Fractions for the West Coast* (1969); *Continuous Proj-*

ect—Altered Daily (1970); *WAR* (1970); *Grand Union Dreams* (1971); *Numerous Frames* (1971); *In the College* (1972); *Performance* (1972); *Inner Appearances* (1972); *This Is the Story of a Woman Who . . .* (1973); *Kristina (for a . . . novella)* (1974).

FILM: *Lives of Performers* (1972); *Film About a Woman Who . . .* (1974); *Kristina Talking Pictures* (1976).

Bibliography: *WORK 1961–1973* (Halifax, Nova Scotia and New York: 1974).

Raines, Walter, American ballet dancer and choreographer; born August 16, 1940 in Braddock, Pennsylvania. Raines was trained in tap and acrobatics by the Wrayettes, two local teachers in nearby Pittsburgh who had been in vaudeville. He later continued his studies at the School of American Ballet.

After dancing for a season with the Pennsylvania Ballet, he joined the Stuttgart company in 1963. In five years there, he was featured in John Cranko's *The Catalyst, Onegin*, and *Jeu de Cartes*, and the company production of *Les Sylphides*.

A charter member of the Dance Theatre of Harlem, Raines performed in works by company director Arthur Mitchell, among them, *Fête Noir, Holberg Suite*, and *Rhythmeton*, and in the Balanchine repertory. He retired in 1975 but remains associated with the school and company as a teacher.

Raines has choreographed a few concert works, and the premiere of Michael Tippett's opera, *The Ice Break* (1977).

Works Choreographed: CONCERT WORKS: *Haiku* (1973); *After Corinth* (1975).

OPERA: *The Ice Break* (1977).

Rall, Tommy, American ballet, theatrical, film, and television dancer; born December 27, 1929 in Kansas City, Missouri. Rall made his debut in a tap and acrobatics acts in the Pacific Northwest before moving to Hollywood where he studied with David Lichine and Carmelita Maracchi. On recommendation from Lichine, he spent the 1943–1947 seasons with Ballet Theatre in New York, dancing in his *Graduation Ball*, among other works.

Although he did a specialty act on Broadway in Ken Murray's *Blackouts* in 1944, he returned to Ballet Theatre, not performing on Broadway again until

Jerome Robbins cast him in the juvenile/dance lead in his *Look Ma, I'm Dancing* (1948). He also worked for Robbins in *Miss Liberty* (1949) and *Call Me Madam* (1950), and for Gower Champion in *Small Wonder* (1948). Donald Saddler's *Milk and Honey* (1961) gave him his best part as "David," probably the most challenging juvenile lead in the conventional Broadway musical.

Rall had a very successful film career, especially during the last gasp of movie musicals of the 1950s. After his featured debuts in *Give Out Sisters* (Universal, 1942) and *Mr. Big* (Universal, 1943), both Louis Da Pron films, he returned to Hollywood in 1953 to play "Bill" in the film of *Kiss Me Kate*, partnering Ann Miller in the "From This Moment On" routine, with Joan McCracken, Bobby Van, Carol Haney, and Bob Fosse. Rall went from that film into Michael Kidd's *Seven Brides for Seven Brothers* (MGM, 1954), as one of the all-singing, all-dancing brothers, and into Fosse's *My Sister Eileen* (Columbia, 1955). His other featured film roles include Gene Kelly's *Invitation to the Dance* (MGM, 1954), Kidd's *Merry Andrew* (MGM, 1958), and *Funny Girl* (Columbia, 1968), as "Siegfried" in the satire of *Swan Lake*. On television, he has performed on most of the variety series and specials, and staged dances for *The Faye Emerson Show* (NBC, 1951–1953).

Ralov, Borge, Danish ballet dancer and choreographer; born 1908 in Copenhagen, Denmark. Trained at the school of the Royal Danish Ballet, he has been associated with the company throughout his career. Celebrated for his work in the Bournonville repertory, especially for his performances as "The Ballettmeister" in *Konservatoriet* and as "Gennaro" in *Napoli*, he has also taken the roles of "The Baron" in George Balanchine's *La Somnambule*, "Albrecht" in *Giselle*, and the title role in *Petrouchka*.

Ralov has choreographed since 1934 for the company and currently teaches at the school at which he was trained.

Works Choreographed: CONCERT WORKS: *The Widow in the Mirror* (1934); *The Four Temperaments* (1939); *Afternoon of the Faun* (1941, after Nijinsky); *Toly Med Posten* (Twelve for the Mail Coach) (1942); *Kurtisanan* (The Courtesan) (1953).

Ralov, Kirsten, Danish ballet dancer and choreographer; born Kirsten Gnatt, 1922 in Baden, Austria. Trained at the school of the Royal Danish Ballet, she performed with that company from 1940 until 1962. She created the role of "Rosalind" in Frederick Ashton's *Romeo and Juliet* (1955), and performed in Leonid Massine's *Le Beau Danube*, in Mikhail Fokine's *Petrouchka*, as "The Ballerina," and *Chopiniana*. Reflecting the artistic aims of the company, she also specialized in principal roles in the maintained Bournonville repertory, among them, "Teresina" in *Napoli*, "Birth" in *A Folk Tale*, "Eleanore" in *Kermesse in Bruges*, and "Victorine" in *Konservatoriet*.

Currently the rehearsal mistress of the company, she has also choreographed works for its dancers.

Works Choreographed: CONCERT WORKS: *Kameliadamen* (La Dame aux Camelias) (1960); *Doren* (The Door) (1962).

Rambert, Marie, Polish ballet dancer of tremendous importance to the development of the British ballet of the twentieth century; born Myriam Rambert, February 20, 1888 in Warsaw. Trained at the Jacques-Dalcroze school in Geneva, and later at Hellerau, she studied ballet under Enrico Cecchetti. She was hired to assist Vaslav Nijinsky on his *Sacre du Printemps* and teach eurythmics to his cast.

She opened a studio in London in 1920, which developed into the Marie Rambert Dancers in 1926. The troupe performed in films, in ballets commissioned from Frederick Ashton. After working with the Ballet Club from 1930, she formed the Ballet Rambert from 1935 to the present. The company has gone through two distinct phases of artistic policy; until the early 1970s, its repertory included productions of the classics scaled to the small troupe and theater, and revivals of Ashton pieces. After the mid-1970s, however, the company performed works by modern ballet choreographers, such as Glen Tetley, Jonathan Taylor, John Chesworth, Norman Morrice, and Christopher Bruce. The Rambert also sponsored choreographic and design workshops, and a yearly series of school matinees.

Rambert herself has had a tremendous influence on the emerging ballet in England, and, through her friendship with Lincoln Kirstein, in the United

States. Her choreography, however, was not particularly innovative and has never been revived. She commissioned major works, supported important dancers, and inspired later developments.

Works Choreographed: CONCERT WORKS: *Leda* (1928, co-choreographed with Frederick Ashton).

Bibliography: Rambert, Marie. *Quicksilver* (London: 1972).

Rambova, Natacha, American ballet dancer, film designer, and writer; born Winifred Shaunessy, 1897 in Salt Lake City, Utah; died June 6, 1966 in Pasadena, California. Raised in Europe, she was trained privately in Paris, reportedly by Ivan Clustine, and in London where she joined the Kosloff company at the Coliseum Theatre. She returned to the United States with the troupe that included Theodore Kosloff, his wife Alexandra Baldina, Alexis Kosloff, his wife Juliette Mendez, and Anatole Bourman, in the former Kosloff's versions of *Les Sylphides* and *Spectre de la Rose*.

A resident stage and film designer for Alla Nazimova, she designed her celebrated *Camille* (Metro, 1921), co-starring Rudolf Valentino. As the last ex-Mrs. Valentino, she was billed as "The best-dressed, most envied woman in the world." Retiring from the film world in the late 1920s, she lived in Europe, and became an expert in Egyptian religious iconography. According to one obituary, she had also worked as a crime reporter, a stage actress, and a film producer.

Rameau, Jean Phillipe, French composer; born September 25, 1683 in Dijon; died September 12, 1764 in Paris. The successor of Jean Baptiste Lully in the development of the French opera, he became composer of the King's Chamber by 1745. Among the many opera-ballets which he created for performance at the court theaters of the Académie Royal de Musique are *Les Indes Galantes* (1735), probably the best known score of the century, *Les Fêtes d'Hébé* (1739), *La Fête de l'Hymen et de l'Amour* (1747), *Zais* (1748), and *Pygmalion* (1748).

Rand, Sally, American strip-tease artist; born Helen Gould Beck, February 2, 1904 in Elkton, Hickory County, Missouri; died August 31, 1979 in Glendora, California. Rand made her professional debut in a

Kansas City cabaret before joining Gus Edwards' *School Days* act of adolescent vaudeville talents. She worked as a web dancer in a side act in the Ringling Brothers and Barnum and Bailey circus, but joined a burlesque wheel by 1931. Although she actually did her specialty in the very early 1930s, she became famous at the 1936 World's Fair in Chicago. After making her entrance to the fairway dressed as Lady Godiva, she became the featured dancer at the Streets of Paris booth.

Rand's act was performed to Debussy's *Clair de Lune* and its finale was set to the Chopin *Valse in C Sharp Minor*. Her specialty, which was performed in the same style, timing, and technique throughout her career was—"Fan-tastic." Proving her axiom that "the Rand is quicker than the eye," she manipulated two seven-foot pink ostrich feather fans to conceal most, but never all, of her body, revealing most, but never all. Apart from a Bubble Dance, with seven-foot covered hoops, and a new set of fans, suitable to her *Dance of the Peacock* (c.1948), she stayed with her specialty in her *Fanciful Revues* and cabaret performances until her retirement in 1970.

Her last known performance was in June 1979, three months before her death, in a publicity appearance for *Sugar Babies*, a Broadway musical about burlesque that includes a tribute to Rand and her fans.

Randall, Carl, American theatrical dancer and choreographer; born February 28, 1898 in Columbus, Ohio; died September 16, 1965 in New York. Randall was trained by his dance master parents in Columbus, and performed briefly on the Midwest vaudeville circuits while attending Ohio State University there.

Randall's career on Broadway was unique since he was able to perform as an eccentric dancer in revues and as a juvenile lead in musical comedies. In the *Follies* of 1916, he performed *Les Sylphides* and *Le Spectre de la Rose* straight to offset Fanny Brice and Bert Williams' satires of Vaslav Nijinsky. His revue career, which included performances in the *Ziegfeld Follies of 1915*, 1916 and 1920, *The Midnight Frolics of 1922*, the *Greenwhich Village Follies of 1922* and the *Music Box Revue of 1924* (September 1923), led to vaudeville performances on the Keith and

Orpheum circuits in a solo and in a ballroom/comedy flash act with Emma Carus, the famous husky-voiced overweight star of Broadway and early East Coast comedy films, in 1916. In the mid-1920s, Randall toured in a duo act with theatrical and ballroom dancer Barbara Newberry, who later became his choreographing partner.

Randall was one of Broadway's top juveniles for almost twelve years. A juvenile—the character who gets the girl and gets to sing both comic and romantic ballads—with more-than-the-normal adequate dance technique was in great demand, and Randall played featured roles in many of the Shubert Brothers' best remembered musicals and operettas, among them, *Sonny* (1921), *Sunny Days* (1928), *Pardon My English* (1933), and in his best known part, *Countess Maritza* (1929).

Randall received his first solo choreographic credits for the three annual revues that he staged for Mistinguett in the Casino de Paris, Paris, from 1923, although he had earlier received partial credit for nonballet numbers in the *Greenwich Village Follies of 1922*. In November 1932, he and Newberry collaborated on *The Gay Divorce*, the stage version of the Fred Astaire vehicle, and later re-created it for a London run. While in London, they staged revues for the Dorchester Hotel (1933–1934). Returning to New York, Randall concentrated on staging dances for live revues and musical comedies, with a brief one-year tenure in Hollywood, coaching and partnering Jean Harlow in *Reckless* (MGM, 1935), and other films. Among his Broadway shows were *The Little Show of 1935, Knickerbocker Holiday* (1938), and *Stars in Your Eyes* (1939), with a chorus that included Alicia Alonso, Nora Kaye, and Jerome Robbins, and *Louisiana Purchase* (1940). In the mid- and late 1940s, Randall was associated with the New York City Opera, as its resident choreographer and ballet master, staging dances for, among others, *Carmen, La Traviata*, and *The Bartered Bride*.

Works Choreographed: THEATER WORKS: *Greenwich Village Follies of 1922*; *The Gay Divorce* (1932, co-choreographed with Barbara Newberry); *Monte Carlo Follies* (1933, London); *The Little Show of 1935* (1935); *The Illustrators' Show* (1936); *Swing to the Left* (1938); *Knickerbocker Holiday* (1938); *Stars in Your Eyes* (1939); *Louisiana Purchase* (1940, ballets staged by George Balanchine); *High Kickers* (1941); revues for the Casino de Paris (1923, 1924, 1925).

FILM: *Reckless* (MGM, 1935, co-choreographed by Chester Hale, also performed as self); *You're a Sweetheart* (Universal, 1937).

Randazzo, Peter, American modern dancer also working in Canada; born January 2, 1943 in Brooklyn, New York. Randazzo's training came from ballet teachers, such as Mme. Swoboda, Antony Tudor, and Robert Joffrey, and from the traditional modern dancers, among them Martha Graham, José Limón, and Donald McKayle. He was a member of the Graham company for six years, appearing in revivals of many works and in the premiere performances of *Phaedra* (1962), *Part Real—Part Dream* (1965), *Cortege of Eagles* (1967), and *Dancing Ground* (1967). After visiting Toronto to set a work, *Fragments*, for the New Dance Group of Canada in 1967, he remained to co-found the Toronto Dance Theater in 1968. He has performed in the works of his colleagues, David Earle and Patricia Beatty, and has choreographed and performed for that company since its foundation, presenting a large number of popular works based on the Graham technique. His *Voyage for Four Male Dancers* (1969), *Prospect Park* (1971), and *A Flight of Spiral Stairs* (1973) have been especially popular in performance in Canada, the United States, and England.

Works Choreographed: CONCERT WORKS: *Fragments* (1967); *Aftermath* (1968); *Trapezoid* (1968); *Voyage for Four Male Dancers* (1969); *Encounter* (1969); *Suncycle* (1969); *Untitled Solo* (1970); *Continuum* (1970); *I Had Two Sons* (1970); *Visions for a Theater of the Mind* (1971); *Prospect Park* (1971); *Starscape* (1971); *Dark of the Moon* (1971); *The Amber Garden* (1972); *The Last Act* (1972); *Three Sided Room* (1972); *Figure in the Pit* (1973); *A Flight of Spiral Stairs* (1973); *A Walk in Time* (1973); *Mythic Journey* (1974); *The Letter* (1974); *L'Assassin Menacé* (1975); *Nighthawks* (1976); *Recital* (1977); *A Simple Melody* (1977); *The Light Brigade* (1979); *Moving to Drumming* (1980); *Duet Untitled* (1980).

Randolph, Elsie, English musical comedy dancer and actress; born December 9, 1904 in London. Ran-

dolph appeared in four musicals, among them, *The Girl for the Boy* (1919), before being teamed with Jack Buchanan. Following the custom of the time, the dainty and petite Randolph danced with Buchanan, who, at six-foot towered at least nine inches over her. The most successful of their many shows, *Sunny* (1926) and *Stand Up and Sing* (1931), allowed them to perform their own specialties and to work together in a romantic encounter duet. Her charm and reliable technique brought her success as a solo performer in such hit musicals as the 1930 version of *The Co-Optomists* and *The Wonder Bar* (1930).

Rapp, Richard, American ballet dancer; born in Milwaukee, Wisconsin. After studies with Ada Artinian and Ann Barzel, he moved to New York to continue his training at the School of American Ballet. A member of the New York City Ballet since 1958, he is best known for his portrayal of the title role in George Balanchine's *Don Quixote* (1965, first official performance), but has appeared in almost all of the company's enormous repertory. He created roles in Balanchine's *Who Cares?* (1970), John Taras' *Shadow'd Ground* (1965), and Willam Christensen's *Octet* (1958), and has performed in the company's production of Antony Tudor's *Dim Lustre*, in the "He Wore a White Tie" section. Among the scores of Balanchine ballets in which he has danced are *Agon, Divertimento No. 15, Ivesiana, Serenade*, and *Western Symphony*. Rapp has recently added an extensive teaching schedule to his performance work.

Rasch, Albertina, Austrian ballet dancer, working in the United States after 1911 as a ballet, theater, and film choreographer; born 1896 in Vienna; died October 2, 1962 in Los Angeles, California. Rasch was trained in ballet technique at the School of the Royal Opera House, Vienna, probably by Josef Hassreiter; she also studied Dalcroze technique although it has been impossible to verify whether she was enrolled at the Jaques-Dalcroze school in Hellerau. It has been suggested that Rasch may have performed or studied with the Weisenthal Sisters.

Rasch made her professional debut as a child (age seven) with the Royal Opera House Ballet. At fifteen, she left Vienna and immigrated to the United States. Two equally plausible reasons have been given for her move to the United States. She is said to have come either at the invitation of R.H. Burnside to become prima ballerina of the New York Hippodrome Theatre, or, under the sponsorship of Otto Kahn, to become leading *danseuse* of the Century Opera House. Either way, Rasch spent the next seven years as a ballet dancer and choreographer with American opera companies—The (New York) Century Opera (1913-1914), the Chicago Opera (1914-1915), the American Opera Company, in Los Angeles (1915-1916), for which she staged the premiere of H.W. Parker's *Fairyland* in 1915, and Geraldine Farrar's All-Star Ellis Opera (1916-1918). In 1920, she toured in vaudeville on the Keith circuit with a company of three dancers, before returning for two years to Austria, where she worked in silent films.

Returning to New York in 1923, she opened a school to train the troupes of ballet specialists to be known as The Albertina Rasch Dancers. These troupes performed in vaudeville, in Prologs for the Mark Strand and Paramount/Publix Prolog circuits, and on Broadway. From 1925 to 1938, Rasch divided her time among Broadway and London shows, films, and ballet companies. These companies, known variably as Ballet Classique and The American Ballet, were presented in symphonic concerts at Carnegie Hall (1925), New York's Lewisohn Stadium (1927, 1932), and the Hollywood Bowl. The repertory for these companies, which represents the only concert dance titles that can be verified, was split between conventional ballet and Rasch's symphonic jazz style, performed primarily on point but with angular movements and an emphasis on irregular rhythms. Rasch's best known ballet in this style was her *Rhapsody in Blue*, choreographed for vaudeville performance with the music's commissioner, the Paul Whiteman Orchestra. A version of this ballet, restaged for camera, can be seen in the Albertina Rasch Dancers Specialty Act in the Paul Whiteman film, *King of Jazz* (Universal, 1930). Since George Gershwin himself performed in the scene, the footage has been carefully preserved and appears in many film history compilation movies.

Rasch's theatrical choreography career was unquestionably successful. Considered one of Broadway's most innovative dance directors, she staged musical numbers in over twenty shows, revising

many for their London runs. After making her choreographic debut with the *George White Scandals of 1925*, she went on to stage dances for three major Ziegfeld musical comedies of the 1920s—*Rio Rita* (1927), *The Three Musketeers* (1928), and *Show Girl* (1929)—and his last *Follies* in 1931. Other well-remembered musicals on Broadway included *The Band Wagon* (1931), with Fred Astaire and Tilly Losch, *The Great Waltz* (1935), and the revolutionary *Lady in the Dark* (1941).

Rasch went to Hollywood in 1929 with her husband, composer Dmitri Tiomkin. Like him, she spent most of her professional career at the MGM studios, where she staged dances for feature-length films and the MGM Colortone Novelties (1929–1933), considered by many cinema historians to be the most innovative and unique live-action shorts ever produced in Hollywood. Rasch's feature film career, beginning in 1926 with the original *Broadway Melody* (MGM, 1926), included the typical filmed revues of the early sound era and the sophisticated integrated musical plays of the 1940s. Her work appeared in some of the best known films of the 1930s, among them Howard Hughes' *Hell's Angels* (The Caddo Co., 1930), the Jeanette McDonald/Nelson Eddy vehicles, *The Girl of the Golden West, New Moon, Naughty Marietta*, and *Sweethearts* (all for MGM), and Eleanor Powell's *Rosalie* (MGM, 1937), and *The Broadway Melody of 1940*. Rasch was considered the most demanding choreographer in Hollywood in terms of both technique and rehearsals. She could, however, produce surprisingly simple numbers using pedestrian movements or basic dance steps. Her title number from Ernst Lubisch's 1934 version of *The Merry Widow* is frequently cited as both a triumph of the Hollywood view of German constructivism and as a structurally unifying scene for the film script, but it is one of the most uncomplicated dances that she ever created. A chorus of dancers simply waltzed around a mirrored room to the "Merry Widow," but in Rasch's view of Parisian seduction and elegance, the dancers are organized by dress, fan and wig color, so that the double clichés of the waltz steps and music are diffused into a mobile kaleidoscope.

Although Rasch remained a member of the MGM staff for many years, she dropped out of choreography after the mid-1940s, working only as a movement coach at the studio. She died at age 75 after a very long illness.

Works Choreographed: CONCERT WORKS: *Carnaval* (1925); *Invocation* (1925); *Prelude* (1925); *Badinage* (1925); *Air de Ballet* (1925); *In a Village of Tscheko-Slovakia* (1925); *Chinoise* (1925); *Chopin Waltzes (Ecossaise, Valse Brilliant, Etude, Adagio, Mazurka, Valse)* (1925); *Slavic Dances* (1925); *Old Vienna* (1925); *Zuni Indian Snake Dance* (1925); *Rhapsody in Blue* (1925); *Fiesta* (1932); *Cakewalk* (1932); *Today* (1932); *Divertimento No. 10* (1932).

THEATER WORKS: (New York if not otherwise noted.) *George White Scandals of 1925* (1925); *Rio Rita* (1927); *Lucky* (1927); *LeMaire's Affairs* (1927); *My Princess* (1927); *The Three Musketeers* (1928, credit was "ensembles by"); *Show Girl* (1929); *Sons o' Guns* (1929); *Three's a Crowd* (1930); *Wonder Bar* (1931); *The Band Wagon* (1931); *Ziegfeld Follies of 1931* (1931); *The Cat and the Fiddle* (1931); *The Laugh Parade* (1931); *Face the Music* (1932); *Smiling Faces* (1932); *Bally-Hoo of 1932* (1932); *Walk a Little Faster* (1932); *Wild Violets* (London, 1933); *The Great Waltz* (1935); *Jubilee* (1935); *Very Warm for May* (1939); *Boys and Girls Together* (1940); *Lady in the Dark* (1941); *Marinka* (1945); seven editions of the Ringling Brothers and Barnum and Bailey Circus (1941–1947/8).

FILM: *The Broadway Melody* (MGM, 1926); *The Hollywood Revue* (MGM, 1929); *Why Bring That Up?* (Paramount, 1929); *Deception* (UA, 1930); *Devil-May-Care* (MGM, 1930); *DuBarry, Woman of Pleasure* (UA, 1930); *Free and Easy* (MGM, 1930); *Hell's Angels* (The Caddo Co., 1930); *Lord Byron of Broadway* (MGM, 1930); *Our Blushing Brides* (MGM, 1930); *The Rogue Song* (MGM, 1930); *East Lynne* (Fox Films, 1931); *New Moon* (MGM, 1931); *March of Time* (MGM, 1931); *Broadway to Heaven* (MGM, 1933); *Going Hollywood* (MGM, 1933); *The Merry Widow* (MGM, 1934); *After the Dance* (Columbia, 1935); *Naughty Marietta* (MGM, 1935); *The King Steps Out* (Columbia, 1935); *Rosalie* (MGM, 1937); *The Girl of the Golden West* (MGM, 1938); *The Great Waltz* (MGM, 1938); *Sweethearts* (MGM, 1938); *Idiot's Delight* (MGM, 1940); *New Moon* (MGM, 1940, co-choreographed with Val Raset);

Broadway Melody of 1940 (MGM, 1940); *Colortone Novelties* (MGM, 1929–1933).

Raset, Val, Russian dancer and American film choreographer; born c.1910; died July 26, 1977 in the Los Angeles area of California. Raset's real name is not known, and for that reason it is impossible to verify his claim that he was a member of the Diaghilev Ballet Russe and the Anna Pavlova company. It should be noted that most dancers who made that double claim and ended their careers in the American theater had joined the companies in the United States in the 1916–1917 season.

Raset's first film credit was as one of the choreographers working on the MGM film, *Camille* (1936), which, like most Greta Garbo vehicles, went through at least two changes of dance direction. He assisted Albertina Rasch on *New Moon* (MGM, 1940) and was offered a contract by Columbia Studios in 1942. Most of his film credits were motion pictures created for Rita Hayworth, who was that studio's reigning musical star. The fact that he shared credits means that he was the staff dance director, responsible for staging all musical numbers involving groups, but, since his collaborators were all working on at least one other film at the time, one can assume that some of the musical numbers that reached the screen were actually Raset's.

He dropped out of musical films in the mid-1940s to concentrate on dramatic works and became a noted director of action and police shows on television. He was a staff director on *Kojak* at the time of his fatal illness.

Works Choreographed: FILM: *Camille* (MGM, 1936); *New Moon* (MGM, 1940, co-choreographed with Albertina Rasch); *My Gal Sal* (Twentieth-Century Fox, 1942); *You Were Never Lovelier* (Columbia, 1942); *Hello, Frisco, Hello* (Twentieth-Century Fox, 1943); *Cover Girl* (Columbia, 1944, co-choreographed with Seymour Felix); *Tonight and Every Night* (Columbia, 1945, co-choreographed with Jack Cole).

Rassine, Alexis, Lithuanian ballet dancer working in England after the 1930s; born Alexis Rays, July 26, 1919 in Kaunas, Lithuania. Trained in Cape Town, South Africa, and in Paris, where he worked with Olga Preobrajenska, Rassine's career was based primarily in England.

He performed briefly with the Ballet Rambert (1938) and the Anglo-Polish Ballet (1940), before joining the Sadler's Wells Ballet in 1942. In that company until the late 1950s, he created roles in Robert Helpmann's *Hamlet* (1942), *The Birds* (1942), *Miracle in the Gorbals* (1944), and *Adam Zero* (1946), in Ninette De Valois' *Promenade* (1944) and *Don Quixote* (1950), and in Frederick Ashton's *The Quest* (1943), *Les Sirènes* (1946), *Homage to the Queen* (1953), and *The Beloved* (1957). Celebrated for his performance in the Bluebird pas de deux in *The Sleeping Beauty*, he appeared in featured roles in the company's *Giselle, Swan Lake, La Sylphide, Les Sylphides, Coppélia*, and De Valois' *Checkmate*.

Ratner, Anna, American theater and film dancer; born c.1892 in the Los Angeles area; died July 2, 1967 in Chicago. It is not known with whom Ratner studied, but by 1912 she had mastered a wide variety of dance techniques. As a member of the Essenay Studio stock company, she did Spanish solos, ballet divertissements in butterfly and swan costumes, Chinese dances, one-woman theatrical chorus lines, and every kind of social dance in the background on the studio's films. She can still be seen tangoing, fox trotting and one-stepping in the ballroom scenes of Charlie Chaplin's pictures and in Mexican and American Indian imitation ethnicities in the saloons of Bronco Billy Westerns. In the early 1920s, Ratner worked as a band dancer (then a popular means of employment for a soloist) with Paul Ash in the Chicago-area theaters on the Balaban and Katz chain.

Rauschenberg, Robert, American artist and theatrical designer; born October 22, 1925 in Port Arthur, Texas. A participant in the Black Mountain workshops, Rauschenberg collaborated frequently with Merce Cunningham, designing, among others, *Antic Meet* (1958), *Summerspace* (1958), *Winterbranch* (1964) and *Travelogue* (1977). His works for other choreographers include Paul Taylor's *Three Epitaphs* (1956) and *Images and Reflections* (1958), and Trisha Brown's *Glacial Decoy* (1979).

Rauschenberg worked with Steve Paxton and Alex Hay on projects for the Nine Evenings: Theater

and Engineering (1966), and in other projects and performance exhibits of the Judson Dance Theatre group.

Ravel Family, three generations of French ballet and tightrope dancers performing in Europe and in the United States. Members of this family, which married into most of the ballet and popular dance families of Europe, performed from the mid-1700s to the end of the nineteenth century. It would probably take a five-volume tome to explicate completely the lives, performances, and tours of the family, so this entry will only scratch the surface with brief precis.

François I, the first to adopt rope dancing as a profession, worked in France throughout the eighteenth-century, dying at ninety-four. Of his sons, Gabriel I was the best known performer and worked briefly with Les Grands Danseurs du Roi in Paris. His children—Gabriel II (1810-18?), Antoine (1812-18?), Jerome (1814–1890), François II (1823–1880), and Angelique (1813–1895)—all performed on rope in the nineteenth century. Gabriel II, originally the best dancer, was injured while performing on stilts and later concentrated on mime work. François II, who was married to Yrca Matthias, was an exceptional rope worker and also integrated his specialty into the ballet repertory of the Romantic era. Jerome, who was credited with most of the family's choreography, François, and Gabriel brought the family to the United States frequently after 1832, performing in New York and on Sol Smith's Mississippi circuit.

The Ravel troupe in Ameria, although working in the popular theater techniques, included many of the best ballet dancers in the country, among them the Roussets, the Lehmann sisters, Paul Brillant, and Miss and Master (Henry) Wells, who presented *Giselle* with the troupe in 1847.

Although many dance historians have begun projects on the Ravels, none have been completed to this day. It is accepted that the complete research will enlighten us about their techniques and repertory and about the entire popular theater/ballet differential of the nineteenth century.

Ravel, Maurice, French composer; born March 7, 1875 in Cibourne; died December 28, 1937 in Paris. Although Ravel wrote only five complete scores spe-cifically for dance productions, he became posthumously one of the most popular dance composers of the twentieth century. The five works, all created for Paris-based troupes, were *Ma Mère l'Oye* (1912) for Leo Staats and the Théâtre des Arts, *Adelaïde, ou le Langage des Fleurs* (1912) for Ivan Clustine's recital performance at the Théâtre du Chatelet, *Daphnis et Chloe* (1912) for Mikhail Fokine and the Diaghilev Ballet Russe, and *Boléro* (1928) and *La Valse* (1929) for Bronislava Nijinska and the Ida Rubenstein group. He also contributed a one-minute *Fanfare* to Jeanne Dubost's *L'Eventail de Jeanne* in 1928 and did orchestrations of other composers' works for ballet companies. Many of Ravel's ballet scores are presented in conjunction with concert works to create longer musical backgrounds for modern choreographers. George Balanchine added *La Valse* as an afterpiece to *Valses Nobles et Sentimentales* (which Trouhanova had presented as *Adelaïde*) for his 1951 nightmare, while John Cranko concocted his 1966 *Beauty and the Beast* (a segment of *Ma Mère l'Oye*) score out of the 1912 suite. *Boléro*, thanks to Hollywood, has sexual implications to the modern audience, but has most frequently been staged as a Spanish rhapsody, most notably by Serge Lifar, La Argentinita, Nijinska, and Maurice Béjart.

Ravel was honored in 1975 with a festival staged by the New York City Ballet as part of an international centenary celebration. The company revived Balanchine's *La Valse* and commissioned new works from him, Jerome Robbins, John Taras, and Jacques D'Amboise. Of these, Balanchine's *Tzigane* and *Le Tombeau de Couperin* and Robbins' *Ma Mère l'Oye* and [Piano Concerto] *In G Major* have remained popular works in the repertory.

Ravelle, Ray, American theatrical dancer and radio personality; born Otto Frances Wess, c.1914; died March 18, 1969 in Youngstown, Pennsylvania. Ravelle made his dance debut as Gene and Fred Kelly's partner in a vaudeville and cabaret act in their local area of western Pennsylvania in the late 1930s. While one Kelly became a star and the other a celebrated teacher, Ravelle moved into production. During World War II, he produced and staged a series of Special Service shows called *Reveille with Ravelle*. Ravelle later became a personality on KDKA-Pitts-

burgh, one of the country's first popular radio stations.

Ray, Jimmy, American theatrical dancer; born August 22, 1905 in New York City. Ray was a competitive Charleston dancer in Chicago when he was discovered by Abe Lyman and engaged for his Frolics Café for eighteen months. He moved West to work as a dancer in Lyman's clubs in the Los Angeles area and remained to work in Prologs. As a Charleston specialist-emcee, he performed in more than a dozen Fanchon and Marco units, ending his West Coast career with performances in Los Angeles' only unaffiliated Prolog house—the celebrated Grauman's Chinese, which had its own production team headed by George Choo. Ray made his Broadway debut in 1929 in *Hello, Yourself,* an archetypical musical about collegiates putting on a show. After its three-month run, he was engaged as an "Americain danseur" for the Café Ambassadeur in Paris, which was still enthralled by American social and theatrical dance forms. Ray, who was still only twenty-five, returned to the United States to work on John Murray Anderson's Paramount/Publix circuit out of Chicago.

Rayet, Jacqueline, French ballet dancer; born June 26, 1932 in Paris. Trained at the school of the Paris Opéra, she graduated into the company in 1946. Rayet has been considered a specialist in contemporary ballets from the early years of her career. She has appeared in many works by Serge Lifar during his' tenure at the Paris Opéra, among them his *Blanche-Neige* and *Daphnis et Chloe,* and has also performed in works by George Balanchine and Roland Petit there, including the former's *Palais de Cristal* and the latter's *Turnagalila.* As a guest with the Hamburg State Opera Ballet she created roles in many works by Peter van Dijk, most notably his pas de deux *Unfinished Symphony* (1957), and the contractist classical romances of his *Romeo et Juliette* and *Daphnis et Chloe.*

Reader, Ralph, English theatrical choreographer and producer; born William Henry Ralph Reader, May 25, 1903 in Somerset, England. It is not known whether Reader had formal dance training in England before coming to the United States in 1918. He made his professional debut in the chorus of *Charles* in 1923, later performing in *The Passing Show of 1924,* the Jolson vehicle *Big Boy* (1925), *June Days* (1925), and on the Keith vaudeville circuit.

Reader's first choreography credit was earned for the 1925 edition of the *Artists and Models* revue series. His ability to move large and small choruses around the revue and book-show stage brought him further New York credits for directing *Gay Paree* (1926), *Yours Truly* (1927), *Take the Air* (1927), and the 1928 *Greenwich Village Follies.*

Returning to London where he maintained most of his professional career, he staged both live shows and films, averaging at least two shows per year until the early 1950s. Reader's best known professional London shows, *The Cochran Revue of 1930, Tommy Tucker* (1931), and *Babes in the Wood* (1938), among many others, used American theatrical techniques and traditional English, Tiller-troupe formats.

Reader was also well known for his producing and staging of benefit performances—over 145 productions for the Royal Albert Hall, including twenty-two consecutive Rememberance Festivals from 1940 on, and over thirty years of *The Gang Show.* This annual production is a benefit for the London area Boy Scouts, who perform in each show. Reader was granted an MBE in 1941 and a CBE in 1957 for his work staging, writing, and producing the shows.

Reader staged dances for early English film musicals, among them, *Good Night Darling* (British International, 1933) and *First a Girl* (Gaumont-British Lion, 1935), for Jessie Matthews. He performed in films in England and in the United States, including a role in Chaplin's *Limelight* (UA, 1952), and on British radio and television regularly from 1939 through to 1963.

Works Choreographed: THEATER WORKS: *Artists and Models of 1925* (1925); *Gay Paree* (1926); *Yours Truly* (1927); *Take the Air* (1927); *Greenwich Village Follies of 1928* (1928); *Merry Merry* (London, 1929); *Hold Everything* (London, 1929); *Dear Love* (London, 1929); *Silver Wings* (London, 1930); *The Cochran Revue of 1930* (London, 1930); *Artists and Models of 1930* (New York, 1930); all further shows are London: *Sons O'Guns* (1930); *Song of the Drum* (1931); *Tommy Tucker* (1931); *The Hour Glass*

(1931); *Crest of the Wave* (1931); *Babes in the Wood* (1938); Remembrance Festivals (1940–1963); *The Gang Show* (1932–1966, live version); Productions for ENSA (1939–1945).

FILM: *Lord Chamber's Ladies* (British International, 1932); *Good Night Darling* (British International, 1933); *First a Girl* (Gaumont-British International, 1935); *The Gang Show* (Herbert Wilcox, 1937).

Reams, Le Roy, American theatrical performer; born August 23, 1942 in Covington, Kentucky. Reams was trained at the University of Cincinnati and the Cincinnati Conservatory complex's dance studio which offers ballet and jazz techniques. Shortly after moving to New York, he was cast into a small skating and important dance role in Bob Fosse's *Sweet Charity*. When not appearing in his own cabaret act, Reams has been cast in larger but similar Broadway musicals. Always given plot importance as well as flashy dance numbers, he has partnered Lauren Bacall as her hairdresser/confidante in *Applause* (1970) and Carol Channing as her underage beau in the 1974 *Lorelei*. Since 1980, he has been tapping down Broadway in a more sympathetic version of the Dick Powell role in Gower Champion's *42nd Street*.

Rédigé, Paulo, French eighteenth-century rope dancer and acrobat; neither his birth nor death dates can be verified. Rédigé, the son of Jean Rédigé who had a tableaux theater on the Boulevard du Temple, made his debut in 1779 at the Foire St. Germain. Billed as Le Petit Diable, he performed as a tight and slack rope dancer and tumbler with Jean-Baptiste Nicolet's Grand Danseurs du Roi troupe. With his colleague, Alexander Placide, he worked in London intermittently from 1781 to 1789, probably at the Sadler's Wells Theatre. His specialty in 1785 was to "sommersault over two men on horseback each with a lighted candle."

Although Rédigé was unquestionably the most famous Petit Diable on the ropes, there were two others of that professional name—a child, Petit Petit Diablo, who performed with a Spanish troupe that Nicolet booked to replace Placide and Rédigé during one of their London trips, and a tumbler who emigrated to the United States after 1789.

Redlich, Don, American modern dancer and choreographer; born August 17, 1933, in Winona, Minnesota. While attending the University of Wisconsin at Madison, he studied with Margaret H'Doubler and with Louise Kloepper, who had been an early member of Hanya Holm's company. When he graduated, he moved to New York to study with Holm, also working under Doris Humphrey and Helen Tamiris. As a member of the Holm company, he created roles in her *Ionization* (1949), *Concertino da Camera* (1952), *Temperamental Behavior* (1953), *String Quartet No. 2* (1952), and *Imaginary Ballet* (1961), also dancing in her APA Phoenix production of *The Golden Apple*, in 1954. Among his other performance credits were Doris Humphrey's *Passacaglia and Fugue* at the American Dance Festival in 1951 and her *The Rock and the Spring* in 1955, Jeff Duncan's *Winesburg Portrait* (1963), Tamiris' *Plain and Fancy* on Broadway (1955), and television appearances with Rod Alexander.

Redlich has choreographed since the late 1950s, primarily for his concert group, but also for students at the University of Wisconsin. He has created many solos for himself, notably the popular *Passin' Through* (1959) and *Mark of Cain* (1958), duets for himself and Gladys Bailin, among them *Alice and Henry* (1966) and group pieces. His company has also been privileged to premiere the most recent works by Hanya Holm, including her *Rota*.

Works Choreographed: CONCERT WORKS: *Idyl* (1958); *Three Figures of Delusion* (1958); *Electra and Orestes* (1958); *The Zanies* (1958); *Flight* (1958); *Mark of Cain* (1958); *Passin' Through* (1959); *Eventide* (1959); *Earthling* (1963); *Four Sonatas* (1963); *Fragments in Jazz* (1963); *Cross-Currents* (1964); *Salutations* (1964); *Duet* (1964); *Concertino de Printemps* (1964); *Forgetmenot* (1965); *Eight and Three* (1965); *Oddities* (1965); *Pocourante* (1966); *Set of Five Dances* (1966); *Commedians* (1966); *Trumpet Concerto* (1966); *Alice and Henry* (1966); *Couplet* (1966); *Air Antique* (1966); *Two Some* (1967); *Runthrough* (1967); *Struwelper* (1967, co-choreographed with Anna Nassif); *Cahoots* (1967); *Tyro* (1967);

Tabloid (1968); *Slouching Toward Bethlehem* (1968); *Untitled* (1968); *Jibe* (1969); *Tristran and Isolt* (1969); *Tristram, Isolt and Aida* (1970); *Stigmata* (1971); *Tristram, Isolde, Aida, Hansel and Gretel* (1971); *Implex* (1971); *Estrange* (1971); *Harold* (1972); *Opera* (1972); *She Often Goes for a Walk Just After Sunset* (1972); *Everybody's Doing It* (1973); *Three Bagatelles* (1974); *Patina* (1974); *Traces* (1975); *Lake of Fire* (1976); *Finistere* (1977); *Threnody* (1979); *One Guiding Life* (1979).

THEATER WORKS: *Thieves' Carnival* (1955); *Age of Anxiety* (1960); *Wozzeck* (1970); *The Ride Across Lake Constance* (1972).

Redpath, Christine, American ballet dancer; born January 19, 1951 in St. Louis, Missouri. Redpath was trained in New Jersey at Fred Danieli's School of the Garden State Ballet, and in New York at the School of American Ballet.

As a member of the New York City Ballet, she created roles in many ballets in the early 1970s, among them Jerome Robbins' *An Evening's Waltzes* (1973), and the George Balanchine–Alexandra Danilova revival of *Coppélia* (1974). Redpath was noted for her work in the premieres of ballets staged by her fellow dancers, including Richard Tanner's *Concerto for Two Solo Pianos* (1971) and *Octandre* (1971), Lorca Massine's *Printemps* and *Ode* (both 1972), and Jacques D'Amboise's *Saltarelli* (1974) and *Sinfonietta* (1975). Among the many Balanchine works in which her forceful dancing and expert technical abilities were featured were *Scherzo à la Russe*, *Symphony in C*, *Western Symphony*, the *Emeralds* section of *Jewels*, the *Brahms–Schoenberg Quartet*, and especially, the *Symphony in Three Movements*, created for the Stravinsky Festival in 1972.

Reed, Janet, American ballet dancer; born September 15, 1920 in Central Point, Oregon. Reed began her training with Willam Christensen in Portland, Oregon, then continued it in New York with Vincenzo Celli and Antony Tudor. She performed with the San Francisco Ballet in the late 1930s, dancing in Christensen's *Roumanian Wedding Festival* in 1939 and becoming the first American to star in a full-length production of *Coppélia*.

In Ballet Theatre from 1942 to 1947, Reed created roles in company productions of Antony Tudor's *Dim Lustre* (1943), and *Undertow* (1945), of Michael Kidd's *On Stage* (1945), and in Jerome Robbins' *Fancy Free* (1944), as the second girl featured in the central pas de deux. After dancing in Robbins' *Look Ma, I'm Dancing* on Broadway in 1948, Reed joined the New York City Ballet, with which she was affiliated until 1960. There, she performed in Robbins' *The Pied Piper* (1951), and *Ballade* (1952), and in Todd Bolender's *Jinx*, in 1949, and *Creation of the World* (1960). Her many roles in ballets by George Balanchine included parts in *Bourée Fantasque* (1949), *Pas de Deux Romantique* (1950), *The Nutcracker* (1954), creating the solo role of the "Marzipan Shepherdess," and *Ivesiana* (1954). Reed served as ballet mistress of the company from 1958 to 1964.

Reeder, George, American theatrical dancer; born July 15, 1931 near Ontario, California. After moving down to Los Angeles, Reeder began his distinguished career as dance-in for Ricardo Montalbán. Within two years, however, he had risen to chorus dancer in two of MGM's best dance films, *The Best Things in Life Are Free* and *Singin' in the Rain*, and had made his stage debut in *Off All Things* at the (Hollywood) Century Theater, 1950. In 1952, he moved to New York and made his Broadway debut at the other Century Theater, this time in *Buttrio Square*. He was in *Three Wishes for Jamie* (1952) and the dance lead in *Hazel Flagg* (1953) before joining the dance specialty chorus in Michael Kidd's *Li'l Abner*. Before leaving dance for comic roles, Reeder was a whip-cracking cowboy in Kidd's *Destry Rides Again* (1969), an acrobatic Protean (the only chorus) in Jerome Robbins' *A Funny Thing Happened on the Way to the Forum* (1962), and lead dancer of the Carol Haney production numbers of the Ziegfeld Follies in *Funny Girl* (1964), later playing the male dramatic lead, "Nick Arnstein."

Like many of his colleagues, Reeder successfully combined a career on Broadway with one dancing on New York–based television of the 1950s and 1960s. He was one of the original *Your Hit Parade* dancers, but was most frequently seen on the shows staged by Ernest Flatt, such as *The Garry Moore Show*. Reed-

er's most memorable television appearance, however, was on crutches. After an onstage injury in 1957, he married Christy Petersen (also of Ontario, *Your Hit Parade*, and *Li'l Abner*), live, coast to coast, on the popular game show, *Bride and Groom*.

Reese, Gail, American modern dancer; born August 13, 1946 in Queens, New York. Reese was a student of Syvilla Fort. She made her professional debut with Cleo Quitman's concert troupe and soon became a member of Talley Beatty's company, at the ANTA Festival of Modern Dance, in which she won acclaim for her energetic performances in *The Road of the Phoebe Snow* and *Come and Get the Beauty of It Hot*. When Beatty dissolved his group, she joined the Alvin Ailey American Dance Theatre, where she repeated her Beatty roles. Among her many credits in the new company repertory were Beatty's *Tocatto*, and Ailey's own *A Lark Ascending* (1972), *Mary Lou's Mass, Blues Suite*, and *Revelations*.

Regay, Pearl, American theatrical dancer; born c.1902 in New York City. A student of Ned Wayburn and John Lonergan, she made her professional debut in Prologs for the Capitol Theater in 1919. She was extremely popular for two seasons for her jazz dance act, billed as "Terpsichore Meets Syncopation." Touring with Roy Sheldon's Syncopators, a five-man jazz band, she did acrobatic specialties in syncopated rhythms. Her ragged contortions devastated the audience in *Hello, Alexander* (1920) before she dropped out of performance.

Regnier, Patrice M., American modern dancer and choreographer; born March 3, 1953 in Minneapolis, Minnesota. After studying at the Interlochen music camp during summers in her adolescence, she moved to New York to attend the Juilliard School, graduating in 1975. She performed with José Limón shortly before his death and has also been seen in works by Anna Sokolow and Elizabeth Keen. When Regnier founded the Rush Dance Company in her last year at Juilliard, it was her third concert group. She had worked with the New Improvisational Co. in Long Beach, California, in 1972, and had co-founded The Body Electric in New York in 1973. She choreographs most frequently in collages of plots with

graphic and sound images reinforcing settings and characterizations. More recently, she has also begun to do pieces about movement itself, working with opposition and balance as compositional forms, rather than metaphor for personality shifts. Her works and company are very popular in performances and residencies in the United States, the Virgin Islands, and Western Europe, where they fill the enormous stages of nineteenth-century opera houses with forceful dancing.

 Works Choreographed: CONCERT WORKS: *Adam and Eve* (1967); *An Evening of Dance* (1969); *Intellect Sequence I* (1969); *On Five* (1970); *In Heat I* (1971); *Howtown* (1971); *Water Music* (1971); *Men's Trio* (1972); *In Heat II* (1972); *Les Femmes* (1973); *Wizard of Oz* (1973); *Bovary* (1974); *Blinky Learns to Spell* (1975); *Don't Look Back* (1975); *The Lake* (1975); *Peer* (1975); *Bernard I* (1976); *Bernard II* (1977); *Convictions I* (1977); *Convictions II* (1978); *Concerto for Catherine* (1978); *Elasticity* (1979); *First Solo* (1979); *Presenting the Board* (1979); *Crisis* (1980); *Flick and Flack* (1980); *Reaction* (1980).

Reich, Steve, American composer; born 1936 in New York City. Trained in electronic music composition and performance techniques, Reich has also been influenced by the repetition formulas of non-Western music. Many choreographers have chosen to use his scores for works that involve repetition of movement patterns within barely perceptible changes of tone and pace. They range from Nikolais dancers Phyllis Lamhut, who used his score for her *House*, and Raymond Johnson, whose *Black Dance* and *Three Faces* are to Reich, to Lar Lubovitch who chose Reich music for the two works, *Cavalcade* and *Marimba*, that represented his shift from traditional American modern dance to the adoption of experiments made by the postmodernists. The choreographer whose dances are most associated with Reich is Laura Dean (who has since begun to use only her own compositions); two of her Reich collaborations, *Drumming* and *Square Dance*, are considered classics of her choreographic style and content.

Reid, Albert, American modern and postmodern dancer; born July 12, 1934 in Niagara Falls, New York. Trained at Stanford University in California,

Reid moved to New York to continue his training under Alwin Nikolais, Merce Cunningham, and Margaret Craske. Reid performed with three of America's most influential choreographers at the time when each was developing the style with which he or she is now associated. He worked with Nikolais in 1959 when he was translating his television experience onto the concert stage. He appeared in many seminal works, including his celebrated *Imago* (1963). Reid was associated with Yvonne Rainer at the time of her Judson Dance Theatre experiments, notably in her *Terrain* (1963). Among the many works of Merce Cunningham in which he performed were some that are considered watersheds of his choreography and the progress of postmodern dance itself. His credits include appearances in the premieres of *Winterbranch* (1964), *How to Pass, Kick, Fall and Run* (1965), *Place* (1966), *Scramble* (1967), *Rain Forest* (1968), and the early Events.

Reid has himself choreographed since the early 1970s. His works relate closely to Cunningham's, with depiction of movement itself as a major theme.

Reiman, Elise, American ballet dancer and teacher; born c.1910 in Terre Haute, Indiana. Reiman was trained by Adolf Bolm in Chicago, and performed in his various companies from c.1927 to c.1932. She appeared in his *Ballet Méchanique* on stage (and may have performed it in the film, *The Mad Genius*), and is, probably, the only person to have danced in both the original *Apollon Musagète* by Bolm (1928) and George Balanchine's better known version (premiered six weeks later).

She became a charter student of Balanchine's School of American Ballet and an original member of the American Ballet, appearing in the premiere of *Serenade* (1934), and most of the company's repertory. After appearing in Balanchine's dances for *The Goldwyn Follies* and his opera divertissements at the Metropolitan, she played "Terpsichore" in his *Apollo.*

Reiman returned to the concert stage to join the Ballet Society, where she created roles in Balanchine's *Four Temperaments* and *Divertimento*. She has served on the faculty of the School of American Ballet for many years, and still teaches scholarship classes there during summer months.

Reinking, Ann, American theatrical dancer; born November 10, 1949 in Seattle, Washington. Trained in Seattle, by Mary Ann Wells, she followed tradition by moving to New York to continue her studies at Robert Joffrey's American Ballet Center. Reinking, however, switched her focus to Broadway and auditioned for a role in the chorus of *Coco* (1969). Her next part, in *Pippin* (1972), began an association with choreographer Bob Fosse that has brought her many of her best roles, among them, parts in *Chicago* (1975) and the revue *Dancin'* (1978). She has also been featured in the 1940s-style musical *Over Here* (1974), staged by Patricia Birch, *Goodtime Charley* (1975), a musical comedy about the martyrdom of Joan of Arc, and *A Chorus Line*, in which she followed Donna McKechnie as the second "Cassie." Reinking also appears in Fosse's film, *All That Jazz* (Twentieth-Century Fox, 1980) and struts her stuff in a well-received commercial for a jazz radio station.

Reisinger, Julius Wenzel, Austrian ballet choreographer; born c.1827, possibly in Vienna; died 1892, possibly in Prague. Little is known about Reisinger who is remembered now as the man who did not make a success out of the first production of *Swan Lake*. There is no way to know how bad the original production was, or alternatively, how maligned Reisinger has been.

It is believed that Reisinger was a ballet master in Leipszig in the late 1860s, serving in the same capacity for the Bolshoi Ballet from 1873 to 1878, then moving to Prague. His known works were created in Moscow.

Obviously, research needs to be done on Reisinger. At the very least, it might be interesting to know what constituted a bad choreographer in the 1870s.

Works Choreographed: CONCERT WORKS: *Cinderella* (1871); *Kashchei* (1873); *Stella* (1875); *Swan Lake* (1877).

Reiter-Soffer, Domy, Israeli ballet dancer and choreographer; born July 17, 1943 in Tel Aviv. Reiter-Soffer was trained in Israel by Mia Abramova, Rena Gluck, and, among other visiting choreographers, Anna Sokolow. He left at age seventeen to work in Western Europe, studying with Vera Volkova in Copenhagen and with Audrey de Vos in London. He

had performed with the Israel Opera Ballet since the end of the 1950s and continued dancing in England, working with the Irish National Ballet and the London Dance Theatre. He also acted in London, primarily with the Royal Court Theatre, as he had in Israel, when he appeared in *The Bluebird* with The Habimah.

Reiter-Soffer began to choreograph in 1961 for a cooperative group of Opera Ballet members. Although much of his work has been created for the Israel Opera Ballet or the Bat-Dor troupe, he has also worked for American companies, such as the Ballet Theatre Repertory group and the Maryland Ballet, and for groups in England and Ireland. Some of the Israeli pieces refer to his Sefardic heritage, notably his *Song of Deborah* (1972), to a score of songs that he arranged himself, but he is basically an abstract choreographer within the general style of "modern ballet," using a wide vocabulary of conventional techniques, folk elements, pedestrian movement, and steps that are associated with the traditional American modern dance. He returned to the Irish National Ballet Company (now The Irish Ballet) in 1974 as resident choreographer and eventually as artistic director.

Works Choreographed: CONCERT WORKS: *Flowers* (1961); *Encounters* (1961); *Moods* (1962); *Cul-de-Sac* (1963); *Serafino* (1964); *Olympics '67* (1967); *Caprice* (1967); *The Messenger* (1967); *Quarto de Sonata* (1969); *I Shall Sing to Thee in the Valley of the Dead, My Beloved* (1971); *Song of Deborah* (1972); *Phases* (1972); *Mirage* (1972); *Children of the Sun* (1973); *Timeless Echoes* (1973); *Women* (1974); *Jingle-Rag, Jingle-Tag* (1974); *Loveraker* (1975); *Other Days* (1975); *Yerma* (1975); *Romances* (1976); *Journey* (1977); *Chariots of Fire* (1977); *Shadow Reach* (1978); *Elusive Garden* (1978); *Visitors of Time* (1978); *Night Spells* (1978); *Phantasmagoria* (1978); *Timetrip Orpheus* (1979); *The House of Bernada Alba* (1979); *Equus: The Ballet* (1980).

Reitz, Dana, American postmodern dancer and choreographer; born October 19, 1948 in Rochester, New York. Reitz had originally planned to be a concert musician, but an exchange program to Japan gave her the impetus to explore other performance arts. She studied dance and theater at the University of Michigan and at a summer American Dance Festival before moving to New York City where she has continued her training with Elaine Summers, Andre Bernard (anatomy), Maggie Black, and the staffs of the New York School of Ballet, the Alwin Nikolais studio, and the Merce Cunningham studio. Her performance credits range from work with James Cunningham in *Junior Birdsmen* (1970) and a tour with Laura Dean and Steven Reich to a role in the opera *Einstein on the Beach* (1976). She has also been seen in Wendy Perron's *4-Way Daily Mirror* (1977), Elaine Summers' *Birchforest* and *Confrontations* (1978), and Andrew De Groat's *Get Wreck* (1978).

Reitz' own choreography employs pre-prepared elements, such as films and videos, and "Blueprints of action" that bring focus to movement possibilities but allow for personal improvisation. One is always conscious of phrases of movements, rather than individual steps, as the elements with which a work is constructed for a performance or into a permanent creation. Works are frequently re-created for a different number of individuals or for a performance space that can change both the dancers and the audience's perception. *Phrase Collection*, for example, included versions for solo, trios, and fifteen dancers in planned gardens, casual park spaces, and theaters. Reitz has had a tremendous influence on performers and audiences alike in the United States and Europe.

Works Choreographed: CONCERT WORKS: *Vidase* (1969); *Comment* (1970); *Passage* (1970); *Three Piece Set* (1974); *Georgia* (1974); *Grounded* (1974); *Brass Bells* (1974); *The Price of Sugar* (1975); *Dances for Outdoor Space* (1975); *Steps* (1975); *A Collaboration in Vocal Sound and Movement* (1975, with vocalist Joan La Barbera); *Desert* (1977, in collaboration with artist Dave Gearey and composer Pierre Ruiz); *Journey: Moves 1 through 7* (1977); *Journey for Two Sides: A Solo Dance Duet* (1978); *Pilot 5* (1978, in collaboration with David Woodberry, Nancy Lewis, and Kenneth King); *Phrase* (1978); *Phrase Collection* (1978, 2 through 5 only); *Between 2* (1979); *Phrase Collection* (1979, Versions 6, 7, 8 through 10, and 11, performed in different concerts); *Phrase Collection* (1979, solo edition); *4 Scores for Trio* (1980); *Single Score, Working Solo* (1980); *Double Scores* (1980).

FILM: *Once Again* (1974); *Footage* (1975); *Branches* (1975); *Airwaves* (1975); *Three Locations* (1975); *The Erotic Signal* (1978, section of film by Walter Gutman); *Mobile Homes* (1979, section of film by Rudy Burckhardt).

VIDEO: Untitled video project with Phil Niblock (1973); *Two Sides: A Solo Dance Duet for Two Monitors* (1978).

Remington, Barbara, Canadian ballet dancer working in England and the United States; born 1936 in Windsor, Ontario. Trained in Detroit, Michigan, by Sandra Severo, Remington continued her studies at the School of American Ballet in New York and at the Royal Ballet School in London.

After a year in the corps de ballet of American Ballet Theatre (1958), Remington joined the Royal Ballet (1959–1962). Noted for her "Lilac Fairy" in their production of *The Sleeping Beauty*, Remington also performed featured roles in *Les Sylphides* and, as "The Fairy Godmother," in *Cinderella*. Returning to the United States, she spent another season with Ballet Theatre, before joining the City Center Joffrey Ballet in 1966. Among her many notable parts in the company's repertory are "Venus" in Ruthanna Boris' *Cakewalk*, and featured roles in George Balanchine's *Scotch Symphony* and *Pas de Dix*, and Bournonville's *Konservatoriet*.

Renault, Michel, French ballet dancer; born January 1927 in Paris. Trained at the school of the Paris Opéra, he graduated into the company in 1944. Among the many works in which he created roles are Serge Lifar's *Mirages* (1947), *Nautéos* (1954), and *Romeo and Juliet* (1955), John Cranko's *La Belle Helène* (1955), and in the third movement of George Balanchine's *Palais de Cristal* (1947). He also danced principal and featured roles in Lifar's productions of the classics.

Renault left the Opéra in the early 1960s to work in nightclubs, staging adagio dance numbers. He has since returned to the Opéra to teach.

Rencher, Derek, English ballet dancer; born June 6, 1932 in Birmingham, England. After early dance training in Birmingham with Janet Cranmoore, Ren-

cher moved to London to attend the Royal College of Art. While in the city, he studied ballet with Barbara Vernon, Jill Gregory, George Goncharov, and Igor Schwekoff.

Performing with the Sadler's Wells Ballet and the Royal Ballet throughout his career, Rencher has danced in many productions of the classic repertory and in contemporary ballets. He appeared in many of the early John Cranko works, among them the *Fledermaus Ballet* (1957), and in Frederick Ashton's *Persephone* (1961), *The Dream* (1964), *Jazz Calendar* (1968), *A Month in the Country* (1976), and *Enigma Variations* (1968), his first celebrated character role. He was "Terrestial" in the premiere of Antony Tudor's *Shadowplay* (1967), "Paris" in Kenneth Macmillan's *Romeo and Juliet* (1965), and "Nicholas II" in his 1971 *Anastasia*. More recently, Rencher's "Von Rothbart" in the Royal Ballet's *Swan Lake* has won him great acclaim.

Still involved in art, Rencher has designed costumes and sets for some revivals of the classical repertory, including a *Swan Lake* for the Philadelphia Ballet in the early 1960s.

Repole, Charles, American theatrical dancer and singer; born March 24, 1947 in Brooklyn, New York. Raised on Long Island, Repole studied at Hofstra University. His first Broadway jobs were as stand-by to Joel Grey in *George M*; he also worked with Grey in a "Me and My Shadow" number in his cabaret act and stage-managed his club dates. His first principal role was as "Eddie" in the Goodspeed Opera revival of *Very Good Eddie* in 1975. His fast footwork, pleasant singing voice, and stage presence make him ideal for revivals of 1920s musicals, dependent as they were on a single transcendent performance. He has been acclaimed by audiences at Jones Beach as "Og," the leprechaun in *Finian's Rainbow* (1977, revival) and at Goodspeed and on Broadway as "Henry Williams" in *Whoopee* (1978, revival).

Rethorst, Susan, American postmodern dancer and choreographer; born June 17, 1951 in Washington, D.C. Trained in Washington by Erika Thimey, she continued her dance studies at Bennington College with Judith Dunn and Steve Paxton, considered two

of the most influential teachers in improvisation styles, and with Jack Moore and Martha Wittman. Workshops with Simone Forti have been especially important to the development of Rethorst's creative skills.

In the four years that she has choreographed for live performance in New York she has become well known for the skill and intelligence of her work. In her solo creations and collaborations with Pooh Kaye, she shows an ability to make dances that can interest the audience with both structure and movement combinations.

Works Choreographed: CONCERT WORKS: *Straws* (1977); *Ferry* (1978, duet); *Steps* (1978); *Ferry* (1978, quartet); *Catwalk* (1978); *Long Sleepless Afternoons* (1979, solo); *Rampart Heights* (1979, in collaboration with Pooh Kaye and Yoshiko Chuma); *Long Sleepless Afternoons* (1979, quintet); *Separate Tables* (1979); *Swell* (1980); *Long Sleepless Afternoons (II)* (1980); *Camptown* (1980, in collaboration with Pooh Kaye); *The Plunge* (1980); *The Life of the WASP* (1980).

Revene, Nadine, American ballet dancer; born in the 1920s in New York City. Trained by Helen Platova, she made her professional debut in the musical *Call Me Madam*. After dancing in the corps of the New York City Opera (then choreographed by Carl Randall), she joined the American Ballet Theatre, where she was cast in roles in which her ability to create characterizations was important. She appeared as "The Mother of the Accused" in Agnes De Mille's *Fall River Legend*, as a "Lover-in-Experience" in Antony Tudor's *Pillar of Fire*, and as the "First Passer-By" in Jerome Robbins' *Fancy Free*, as well as abstract parts in George Balanchine's *Theme and Variations* and Kenneth Macmillan's *Concerto* (1958). After a season in the New York City Ballet, she joined with colleagues William Carter, Charles Bennett, and Lois Bewley to form the First Chamber Dance Quartet. A member of the Quartet for its first seasons, she returned as a guest artist frequently in the 1960s. Revene performed with the Bremen State Opera Ballet in Germany, most notably in a highly acclaimed "Odette/Odille," and returned to perform and teach with the Pennsylvania Ballet.

Revene has developed into one of New York's most popular teachers.

Reyes, Eva, Cuban or American exhibition Latin ballroom dancer; born c.1915; died March 20, 1970 in Miami, Florida. With her partner Raul, Eva Reyes was one of the best known Rhumba specialists in the Western hemisphere. They were the house dance team at the Club Havana in New York in the 1940s but also performed regularly at the Copacabaña. Reyes made her Broadway debut in *Mexican Hayride* (1944) but spent more of her career in presentation act houses touring with orchestras, including those of Benny Goodman and Vincent Lopez.

Reynolds, Gregory, American modern dancer and choreographer; born July 18, 1952 in Washington, D.C. Reynolds was trained locally with Batya Haller and Erika Thimey. After moving to New York to continue his studies, he joined the Paul Taylor Company in 1973 where he created roles in *Churchyard* and *American Genesis*. He returned to the Washington area to choreograph for his own chamber group which has traveled extensively in the United States and Europe.

Works Choreographed: CONCERT WORKS: *Luminous Flux* (1976); *The Passion According to Mary* (1976); *Equinox* (1978).

Reynolds, Marjorie, American film dancer and actress; born Marjorie Goodspeed, August 12, 1921 in Buhl, Idaho. Raised in Los Angeles, Reynolds studied ballet with Ernest Belcher and became one of his "Ballet Tots," with appearances in more than a score of silent films. She can be seen, for example, in the Ramon Navarro silent version of *Scaramouche*, as one of the child members of the commedia troupe. Reynolds also studied with Frank Egan (who ran a film-acting school for children in Hollywood) and with Danny Dare, who taught at the Paramount Studio school. She made her adult film debut as Marjorie Moore in *Wine, Woman and Song* (Paramount, 1939), playing the ballerina daughter of a burlesque queen, but was unable to get other roles involving dance. After more than forty-two Westerns, however, she was cast as Fred Astaire's dancing partner

in the still popular Irving Berlin film, *Holiday Inn* (Paramount, 1942), and became a part of the American communal psyche forever as the beautiful blonde to whom Bing Crosby crooned "White Christmas." Reynolds danced in three more Paramount musicals, *Star Spangled Rhythms* (1942), *Dixie* (1943), and *Bring on the Girls* (1945), before another period of more dramatic roles.

Reynolds is known to an early generation of television viewers as the long-suffering wife in the television comedy, *The Life of Riley* (NBC, 1953–1958).

Rhodes, Lawrence, American ballet dancer, born November 24, 1939 in Mount Hope, West Virginia. Raised in Detroit, Rhodes took up tap for four years; at age fifteen, he began to study ballet, working with Violette Armand of the School of Theatrical Arts. He later moved to New York to train at the School of the Ballet Russe de Monte Carlo, and also with Stanley Williams and Robert Joffrey.

Rhodes became a member of the corps de ballet of the Ballet Russe de Monte Carlo in 1958, remaining with that company for two seasons. From 1960 to 1963, he was a member of The Robert Joffrey Ballet, creating roles in Gerald Arpino's *Incubus* (1962) and Brian Macdonald's *Time Out of Mind* (1962), and dancing for Joffrey with the New York City Opera. With the disbanding of the Joffrey company in 1963, he joined the Harkness Ballet as principal dancer and co-director (1969–1970). Among the many ballets in which he created roles were Stuart Hodes' *The Abyss* and John Butler's *After Eden* (1967), which he performed with his wife, Lone Isaksen, and Lar Lubovitch's *Unremembered Time—Forgotten Places* and *Andantino Cantabile* (both 1969).

For the next two years, Rhodes performed with the National Dutch Ballet, creating roles in Rudolf van Dantzig's *On the Way* in 1970. Before devoting himself entirely to a freelance career, Rhodes was associated with the Pennsylvania Ballet (1972–1976) and the Eliot Feld Ballet (1974–1976). As a freelancer, he has worked with both ballet and modern dance companies, partnering Naomi Sorkin in Paul Sanasardo's *Andante Cantabile* (1976) and *Of Silent Doors and Sunsets* (1977).

Rhodes officially retired in 1978; he has choreographed one work for the Joffrey II Company—*Four Essays* (1971)—and has been expected to spend more time creating new works.

Works Choreographed: CONCERT WORKS: *Four Essays* (1971).

Rhodin, Teddy, Swedish ballet dancer; born 1919 in Stockholm. Rhodin was a student at the school of the Royal Swedish Ballet before graduating into the company in the mid-1930s. In his more than two dozen years there he became one of Sweden's most popular dancers. He was capable of a wide variety of roles— from the doomed antihero of Birgit Cullberg's *Miss Julie* to the tourist-class seducer of Leonid Massine's *Gaité Parisienne* to the nobility of the Mary Skeaping version of *Swan Lake*—all roles that he revived for his farewell season in 1964. Although most of his choreography has been for opera productions, he staged one ballet, *Arabesque* (1960), for the Royal Swedish Ballet. Since retiring in 1964, he has taught extensively in Stockholm and Mälmo.

Works Choreographed: CONCERT WORKS: *Arabesque* (1960).

Riabouchinska, Tatiana, Soviet ballet dancer; born May 23, 1917 in Petrograd. Riabouchinska was trained in Paris by Mathilde Kschessinskaia and Alexander Volinine.

After a season with the Chauve-Souris, she joined the Ballet Russe de Monte Carlo in 1932. Associated with the works of Leonid Massine, she created roles in his *Jeux d'Enfants* (1932) and *Les Présages* (1934) and danced in his *Le Beau Danube* and *Beach*. Celebrated for her performances as the "Ballerina of the Prelude" in Mikhail Fokine's *Les Sylphides*, she appeared in his *Spectre de la Rose* in the Ballet Russe and Ballet Theatre.

With her husband, David Lichine, she performed frequently as a guest artist in American and European companies, and in the Walt Disney film, *Make Mine Music*. Their silhouette duet is still considered one of the finest accomplishments in combining live dance with animation.

Ricarda, Ana, American concert and Spanish dancer and choreographer; born c.1925 in San Francisco,

California. Ricarda was trained in ballet technique by Minnie Hawkes in Washington, D.C., Nicholai Legat in London, and Lubov Egorova in Paris. She began her Spanish-dance studies with La Argentina and continued them in New York with La Argentinita, Vicente Escuerdo, and La Quica. While a member of the Markova/Dolin troupe in New York, she attended ballet class with Vincenzo Celli.

Ricarda was first able to combine her dance interests as a solo dancer with the Metropolitan Opera, appearing in productions of *Carmen* and other operas. She became known in ballet circles for her reconstructions of Fanny Elssler's Spanish specialties (originally staged by Therese Elssler), among them *La Cachucha* and *Pas Espagnol*. In 1949, she joined the Grand Ballet du Marquis de Cuevas, for which she danced and choreographed. Among her best known ballets are *Bolero 1830*, a 1953 solo for Alicia Markova, *Del Amor y de la Muerte* (1950), *Le Tertulia* (1952), and *La Chanson de l'Eternelle Tristesse* (1957), all for the de Cuevas company.

She has taught in London, coaching dances for the Royal Ballet and its school, and has staged dances for companies around the world.

Works Choreographed: CONCERT WORKS: *Pas Espagnol* (1945, originally performed as part of *Suite of Romantic Dances* by Vincenzo Celli, Anton Dolin, and Ana Ricarda); *Del Amor y de la Muerte* (1950); *Le Tertulia, ou Les Deux Rivales* (1952); *Doña Ines de Castro* (1952); *Bolero 1830* (1953); Untitled work for the Sao Paolo centenary (1954); *Serenade* (1955); *La Chanson de l'Eternelle Tristesse* (1957); *Divertimento Espagnol* (1967); *California Legend* (c.1971); *La Esponta* (1971).

Riccoboni, Francesco, Italian *commedia* performer and choreographer working in Paris in the eighteenth century; born in Mantua in 1707; died 1772 in Paris. Riccoboni moved to Paris in 1716 with members of his family, a *commedia* troupe led by his father Luigi, known as "Lelio," for his most popular character. The troupe also included Francesco's mother, Elena Balletti, considered second only to Isabella Andreiani for both performance skills and intelligence, and Thomassin (Antonio Vincentini), one of the first tragic clowns.

Riccoboni was raised in Paris and trained to become a member of the troupe, which had settled there. As a performer (c.1726–c.1750), he inherited his father's role of "Lelio," the male lover.

Less is known about Riccoboni as a choreographer. He was employed by the Théâtre-Italien throughout his life but also worked at the Foire St. Laurent in the booth theaters. He is most important as one of the strongest links between the Paris Opéra and the fair theaters; in the connections between those two rival institutions, the *ballet d'action* was conceived and brought to the stage. Riccoboni had an especially strong influence on Marie Sallé, herself a fair performer as a child, and on Thomassin's son-in-law, Jean-Baptiste-François De Hesse.

Richard, Don, American ballet dancer; born c.1945 in Houston, Texas; died December 25, 1967 in combat in Vietnam. A member of the Houston Youth Ballet, he accepted a scholarship to the American Ballet Center in New York. A member of the second apprentice groups of the Robert Joffrey–sponsored school, he joined the City Center Joffrey Ballet in its second year. Among his many performance credits in his single year of professional dance were parts in Gerald Arpino's *Ropes, Viva Vivaldi!*, and *Olympics*, and Anna Sokolow's *Opus '65* created for the original apprentice group.

It is ironic that Richard became a victim of the forces that Sokolow recognized as the potential destroyers of her alienated youth, class of '65. He allowed one commitment to override another and was killed in combat in the chronological center of the long Vietnam "police action."

Richardson, David, American ballet dancer; born March 2, 1943 in Middletown, New York. Trained at the School of American Ballet, Richardson performed briefly with the American Ballet Theatre before joining the New York City Ballet.

As a company member, he has created roles in George Balanchine's *Tombeau de Couperin* (1975) and Jerome Robbins' *The Four Seasons* (1979). His featured roles range from the *Ricercare* section of Balanchine's *Episodes* to his *Who Cares?*, Robbins' *Circus Polka*, playing the "Ringmaster," and

"Mother Ginger" in *The Nutcracker*. The two latter parts are appropriate ones since Richardson is well known as the ballet master who picks and trains the children from the School of American Ballet for performances in Balanchine's *The Nutcracker, A Midsummer Night's Dream, Don Quixote*, and *Coppélia*, and Robbins' *Circus Polka*. As such, he has been seen annually on news broadcasts that cover *The Nutcracker* selection process and plug the upcoming season.

Richardson, Larry, American modern dancer and choreographer; born January 6, 1941 in Minerva, Ohio. Richardson was trained at Ohio State University, a home of traditional modern dance in the Midwest, and continued his studies in New York with Louis Horst and José Limón. He performed in the Pearl Lang company in the late 1960s and early 1970s, most notably in her *Shore Bourne* and *Tongues of Fire* (both 1968), before forming his own company, but he had been choreographing since 1965. Among his most popular and effective works are *Kin* (1974) on the Book of Job, *Mondrianesque* (1971), which uses prop manipulation to form images of the style of the cubist painter, and *Chasm* (1968), which uses a basketball as a sound motif.

Works Choreographed: CONCERT WORKS: *Erebus* (1965); *Fusion* (1966); *Capriccio* (1967); *Tenebris* (1967); *New Antioch* (1967); *Air Stroll* (1968); *Psycho-Static* (1968); *Crotalistria* (1968); *Chasm* (1968); *The Walking Wounded* (1970); *Mondrianesque* (1971); *Tribute* (1971); *Epoch* (1971); *Santa Claus* (1971); *The Chameleons* (1972); *Stomping Grounds* (1973); *Kin* (1974); *Rounds* (1975); *The Heart's Rialto* (1976); *Because I Am Flesh* (1978); *Symphony In Yellow* (1979); *In Time of Roses* (1980).

Richman-Graniella, Natalie, American modern dancer; born 1947 in Murfreesboro, Tennessee. Raised in Indiana, she began her dance training in children's classes in Purdue. Richman also studied at Interlochen (an arts camp), the Perry-Mansfield camp in Colorado, and at Jacob's Pillow. At the Boston Conservatory of Music she received professional training from Jan Veen. As Natalie Richman, she performed with the Erick Hawkins company during the 1970s, creating roles in *Classic Kite Tails* (1972) and *Greek Dreams with Flute* (1973). She has also danced in the concert groups and cooperative troupes of fellow Hawkins dancers, including Beverly Brown, Lillo Way, Robert Yohn, and Nada Reagan-Diachenko.

Ridout, Danita, American modern dancer; born in Baltimore, Maryland. Ridout was trained in dance, music, and acting in her native Baltimore, with formal training at the Peabody Conservatory. After studies in New York with Joyce Trisler, Eleo Pomare, and the staff of the American Dance Center, she joined the Alvin Ailey Dance Theatre in 1978. She has performed in featured roles in much of that company's universally popular repertory of standard works, including Ailey's *Night Creatures* and *Revelations*, Rael Lamb's *Butterfly*, and most notably as the child hooker in Donald McKayle's *District Storyville*. Ridout's small body with its beautifully defined movements and enormous stage personality has also been seen in many new works, among them Ailey's *Memoria* (to Trisler) and *Phases* (1980), and Kathryn Posin's *Later That Day* (1980).

Riggs, Ralph, American theatrical dancer; born c.1885 on tour in St. Paul, Minnesota; died September 16, 1951 in New York City. Riggs made his debut as "Eliza's Baby" in his mother's touring presentation of *Uncle Tom's Cabin* in 1885. As he grew older, he toured with her troupe, The Rose Stillman Stock Company and Dramatic Exposition, appearing in the title roles of the *Prince and the Pauper* and *Little Lord Fauntleroy*, and as a variety of tearful children, juveniles, and grandparents. He also worked for his father's troupe, the Boston Lyric Opera, in the operettas of Gilbert and Sullivan.

His second career began in the 1910s, in a partnership with his wife Katharine Witchie. Their adagio act, with balletic overtones, was featured in *The Enchantress* (1911), *All Aboard* (1913), the *Passing Show of 1919*, and in Albert de Courville productions at the London Hippodrome. Their appearances in continental music halls and cabarets brought him the epithet, "The American Nijinsky," and a wide reputation for his leaps and partnering. After Wit-

chie retired in the late 1920s, Riggs began a solo career on Broadway. He appeared as a comic in many of the century's best musicals, among them, *Of Thee I Sing* (1931) and its sequel, *Let 'Em Eat Cake* (1933), *The Show Is On* (1936), Balanchine's *Louisiana Purchase* (1940), and *Oklahoma* (1943), playing "Carnes" ("Ado Annie's" father) in the original cast. He appeared frequently in that and similar comic heavy roles in revivals and had just returned from playing "Arvide" in the national tour of *Guys and Dolls* when he died. Witchie survived him by sixteen years, dying on April 19, 1967.

Works Choreographed: THEATER WORKS: *The Blond Sinner* (1926).

Riisinger, Knudage, Danish composer; born March 6, 1897 in Kunda, Estonia; died December 26, 1894 in Copenhagen. Riisinger's contemporary scores have been very popular with Danish and Swedish choreographers. Among the many scores that he wrote on commission were *Qarrtsiluni* (1942), for Harald Lander and later choreographed by Roland Petit, the arrangements of Czerny exercises for Lander's *Etudes* (1948), and *Moon Reindeer* (1957) and *The Lady from the Sea* (1960) for Birgit Cullberg.

Rinker, Kenneth, American modern and postmodern dancer and choreographer; born 1945 in Washington, D.C. Rinker began studying dance in his late adolescence at the University of Maryland. After graduation, he continued his training in New York with Charles Wiedman, Erick Hawkins, Merce Cunningham, and Igor Youskevitch. After performing briefly with the Ethel Butler Company, Rinker moved to Berlin, where he founded a Dance Ensemble with composer Sergio Cervetti in 1969. In Berlin, he began choreographing works for the Ensemble, among them *Prisons* and *Zinctum*, both 1969.

Returning to New York in 1971, he joined the Twyla Tharp company as its first male dancer. Staying with the company until 1976, and returning occasionally for guest appearances, he has created roles in Tharp's *The Bix Pieces* (1971), *Deuce Coupe I* (1973), *Sue's Leg* (1975), *Give and Take* (1976), *In the Beginnings* (1974), and *Oceans Motion* (1975).

Rinker returned to choreography after leaving the Tharp company—creating solos for himself, among them the remarkable *Alberti-Bass, Alberti-Bounce* (1975), and for dancers in a series of workshops. His works, with their postmodern structural formats and exceptional verbal and gestural puns, are more typical of a direct Cunningham student and/or protégé than of Tharp.

Works Choreographed: CONCERT WORKS: *Prisons* (1969); *Zinctum* (1969); *Raga II* (1971); *Melodies* (1972); *Alberti-Bass, Alberti-Bounce* (1975) *40 Second/42nd Variations* (1979).

Ritz Brothers, American very eccentric theater and film dancers; Al Joachim (born August 27, 1903, died December 23, 1965 in New Orleans), Jimmy Joachim (born 1905), and Harry Joachim (born May 22, 1908), all born in Newark, New Jersey. Raised in Brooklyn, two of the brothers were involved in a vaudeville dance act before they decided to team up—Al with Al Van and Vera Audrey and Harry with Lorraine and Ritz. Their first brothers act was as The Collegians, a straight vocal teaming in close harmony and blazers.

Their comedy acts on stage and in film involved a large amount of dance. They did satires of vaudeville acts, including a precision tap dissolving into chaos, and of dance genres, among them a take-off on George Balanchine's Water Nymph Ballet (from *The Goldwyn Follies*) that dissolved into chaos. In fact, all of their routines—dance or verbal—sooner or later ended with the brothers, led by Harry, destroying the traditional formulations and structures of a theatrical genre, each other, and most of the scenery. They were more physical, and a bit madder, than the Marx Brothers but have been considered for some reason less universal than their older colleagues. Their new generation of fans, however, disagree and go out of their ways to track down one of the Ritz Brothers films for Fox or Universal. Of these, the best known is unquestionably *The Goldwyn Follies* (Samuel Goldwyn Productions/Twentieth-Century Fox, 1938), a compilation film built around a vague backstage plot in which the Ritzes deflate everything seen on the screen. Their more successful pictures range from *Anchovy Adverse*, a 1933 short for Educational Film Exchange, to Fox's musical vehicles for

Sonja Henie such as *One in a Million* (1937), to their own satires, among them *The Three Musketeers* (1939), *Pack Up Your Troubles* (1939), *Never a Dull Moment* (Universal, 1943), and *Argentine Nights* (Universal, 1940), in which they costarred with the Andrews Sisters.

The Ritzes appeared occasionally on television in the early 1950s although that medium did not seem able to contain them. Their annual Las Vegas engagements from 1945 to Al's death in 1965 were always successful, as were their tours of resort hotels.

Rivera, Chita, American theatrical dancer; born Delores Figueroa del Rivero, January 23, 1933 in Washington, D.C. Rivera left a scholarship to the School of American Ballet to join the chorus of a road-show production of Jerome Robbins' *Call Me Madam* (c.1952), later dancing in the replacement casts of Michael Kidd's *Guys and Dolls* and *Can-Can*. She appeared in the original casts of *The Shoestring Revue* (1955), *Seventh Heaven* (1955), *Mr. Wonderful*, and *Shinbone Alley* (1957), before starring as "Anita" in the original 1957 production of Robbins' *West Side Story*. For many years, she alternated starring roles in hit musicals and flops that won her personal glory, among them Gower Champion's *Bye Bye Birdie* (1960), *Zenda* (1963), *Zorba* (1968), *Bajour* (1964), and Bob Fosse's *Sweet Charity* (1967) and *Chicago* (1975). Like her *Chicago* co-star Gwen Verdon, she is considered an ideal Fosse dancer, with long legs and flexible shoulders. Rivera has also appeared in film and on television as an actress.

"Shark" Rivera married "Jet" Antony Mordente during the *West Side Story* run. Their daughter, Lisa Mordente, has appeared on Broadway and television as a dancer/comedienne and received her first choreography credit for *The End* (UA, 1978).

Rivers, Max, English theater and film dance director; born December 12, 1890; the details of Rivers' death are not certain. Rivers began his long theatrical career as a call boy at the Royal Theatre, Holborn. After touring in a satirical ballroom act in variety, he became known as a dance director of productions for C.B. Cochran. His 1923 and 1924 *Co-Optomists* were especially successful. Rivers also worked in early sound films in England for London Film and British Lion. His greatest importance to the development of theatrical dance in England, however, lies in his school established in London in the late 1920s.

Works Choreographed: THEATER WORKS: *The Co-Optomists* of 1923 and 1924, possibly later editions; *Folies-Bergère of 1926*; *The White Horse Inn* (1937, New York).

FILM: *Looking on the Bright Side* (Associated Talking Pictures, 1932); *Bright Lights of London* (London Film Productions, 1933); *Cleaning Up* (British Lion, 1933).

Roan, Barbara, American modern dancer and choreographer; trained at the University of Wisconsin at Madison, which has been traditionally a station of Hanya Holm students such as Louise Kloepper and Don Redlich, she continued her studies with Nina Fonaroff and ballet teachers Maggie Black and Alfredo Corvino. Her work at the Erick Hawkins Studio brought an involvement with fellow student Rod Rodgers, for whom she danced in the mid- and late 1960s, notably in *Tangents* (1968). She has also performed for Elizabeth Keen and Rudy Perez, appearing in his *Transit* (1969) and *Lot Piece Day/Night* (1971).

Roan's own creations are unique. She choreographs parades for large groups of dancers, props, and generally inanimate objects. Her creations relate to both the mural structure that Hawkins worked with in the Ballet Caravan and the pedestrian movement format of the postmodernists. Like an improvisation specialist, she does some specifically titled works, such as *The First Annual American Dance Festival Opening Day Parade* (1977) and *The Festival Foot Foolery Parade* (1978), and some series of pieces, generically called *Woolworths* or *October Parades*. The parades frequently seem to display elements of a generalized American culture, such as the 1971 *October Parade* about brass bands, Coca-Cola, and small towns, but some use the format to handle the imagery of an author's specific vision, as in her marvelous version of *One Hundred Years of Solitude* (1977).

Works Choreographed: CONCERT WORKS: *Dog Run Entrance* (1967); *Prefix* (1968); *Driz . . . zle*

(1968); *Pause* (1969); *Ocean* (1969); *Woolworths I, II* (both 1970); *Woolworths III* (1971); *Blue Mountain Paper Parade* (1971); *The October Parade* (1971, annual performances to the present); *Department of Parks and Recreation* (1972); *Waystation/Truckers Only* (1972); *True Spirit* (1972); *True Spirits* (1973, co-choreographed with Irene Feigenheimer and Anthony LaGiglia); *The Continuing Dance Exchange* (1973, co-choreographed with Feigenheimer and La Giglia); *45 Seconds to String* (1973, co-choreographed with Feigenheimer); *Landmark* (1974); *Woolworths IV* (1974); *Nightwatch* (1974); *Range* (1975); *Juggler* (1975); *The Return of the Red Shoes* (1975); *Time Still* (1976); *One Hundred Years of Solitude* (1977); *The First Annual American Dance Festival Opening Day Parade* (1977); *The Festival Foot Foolery Parade* (1978); *Annual Parades for National Dance Week* (1978–1980) *Serpent Song* (1979); *Rider* (1979).

Robbins, Jerome, American ballet dancer and choreographer, and theatrical director and choreographer; born Jerome Rabinowitz, October 11, 1918 in New York City. Robbins first studied modern dance at classes sponsored by the New Dance League, possibly with William Matons, then learned ballet technique from Ella Dagnova (a former Pavlova dancer and student of Enrico Cecchetti), Helene Platova, and Eugene Loring.

Robbins made his debut as a dancer in a production of Senia Gluck-Sandor and Felicia Sorel at the Dance Centre in 1937. He worked on Broadway in *Great Lady* (1939) and *Keep Off the Grass* (1940, his first professional contact with George Balanchine). While dancing at the Tamiment Camp during the summers of 1938 through 1941, he earned a featured role in the New York production of *The Straw Hat Revue* (1939), a spin-off from a summer production. His successful Tamiment partnership with Anita Alvarez brought him early fame from their appearances at Theatre Action Committee Cabarets in New York.

Before graduating to choreography on Broadway, he joined Ballet Theatre in 1940, creating roles in David Lichine's *Helen of Troy* (1942) and Antony Tudor's *Romeo and Juliet* (1943). With *Fancy Free* (1944), in which he also danced, he became famous as an American ballet choreographer. That ballet, which is still in Ballet Theatre's repertory, was the basis of his first show choreography credit, *On the Town* (1944), which also told the story of three sailors on leave. Since those two successes, his life has been one of commuting between ballet and theater.

He created two more ballets for ABT—*Facsimile* (1946) and *Summer Day* (1947)—before returning to Broadway for a prolific period. His Broadway shows, which include some of the most successful in history as well as those that are generally considered the best, date from 1945's *Billion Dollar Baby* to *Fiddler on the Roof* in 1964, his last original production. The list includes *High Button Shoes* (1947), with its fabulous Mack Sennett ballet sequence, *Look Ma, I'm Dancing* (1948), considered a *roman à clef* about Lucia Chase, *Miss Liberty* (1949), *Call Me Madam* (1950), *The King and I* (1951), with its extraordinary Small House of Uncle Thomas sequence in which the Siamese slaves and wives act out *Uncle Tom's Cabin, Two's Company* (1951), *Wonderful Town* (1953), and *Peter Pan* (1954), a vehicle for Mary Martin. After co-choreographing *Bells Are Ringing* with Bob Fosse (1956), he conceived, directed, and co-choreographed (with Peter Gennaro) the show that many consider his masterpiece, *West Side Story* (1957). The opening sequence of the show, repeated and developed in the film version, is one of the most exciting theatrical experiences in media: it grows from pedestrian movement to superhuman dance bravura before dialogue is added.

Although many consider *West Side Story* his best, his next show is the one that others think the highest achievement. In *Gypsy*, which is about dance and vaudeville life as a framework for emotions, he created an opening in which one act is seen in different guises and techniques. The audience knows, even before the characters, that the act, the child version of "Let Me Entertain You," will never make it, but it is staged so that we care about the performers. The difficulties in directing and choreographing *Gypsy* were augmented since the show is structured without a single heroine; the audience is shifted from "June" to "Louise" all in the first act, only realizing at the very end that the heroine is the villain and victim "Rose."

The end of the show, "Rose's Turn," which has no dance movements at all, may be the best-staged musical number of all time.

After experimenting with drama and actor workshops, Robbins returned to Broadway to stage and direct *Fiddler on the Roof* (1964), which after its fifth birthday became the longest-running show. *Fiddler* was based on Yiddish-language tales that inspired both nostalgia for the "Old Country" and gratitude for an earlier generation's decision to emigrate to the United States. In this show again, his task was to handle the audience's emotions, not to stop the show with production numbers. The Act I finale, a wedding scene that is the show's nearest thing to a conventional dance sequence, excites the audience with pure performance skill.

Robbins' experience on the film of *West Side Story* (UA, 1961) did not lead to future commitments. He has also not worked extensively on television, although his production of *Peter Pan* for that medium was rerun annually after its 1955 premiere.

Robbins' ballet career has been equally successful; he has choreographed for very few companies, but is quite prolific. As associate choreographer and then ballet master of the New York City Ballet, he has augmented the Balanchine repertory with many works. In his early days with the company, he created socially conscious works with political overtones, such as *The Guests* (1949), *Age of Anxiety* (1950), and *The Cage* (1951), about a nonhuman civilization which destroys aliens. He left the City Ballet in the late 1950s to form a new company, Ballets: U.S.A., for which he choreographed two works that reverted to his Ballet Theatre style—*New York Export: Opus Jazz* and *3 X 3* (both 1958)—and one extraordinary ballet, *Moves* (1961), performed in nonbravura, nonballetic movements to absolute silence.

Returning to the City Ballet in the early 1960s, he took a long period to produce his next work, the abstract, romantic *Dances at a Gathering* (1969), the first in a series of ballets set to piano music by Chopin. The next one, *In the Night* (1970), is on a smaller scale than *Dances* but is equally effective. Its third duet is considered by many a microcosm of Robbins' later works—movements that work brilliantly to depict a relationship that works only on its own level. Interrupting the series of Romantic ballets were two that expanded his vocabulary of steps and the audience's sense of scale and time—the complete *Goldberg Variations* (1971) and *Watermill* (1972). Other works which he has created recently for the company include *Dybbuk* (1974), his version of the frequently choreographed Ansky masterpiece of the Yiddish theater, which has been getting progressively more abstract in passing seasons' revisions, *In G Major* (1975), which introduced the Suzanne Farrell/Peter Martins partnership, and *A Sketch Book*, a recent compilation of unfinished works that range from a romantic pas de deux to a study of eighteenth-century male etiquette and training.

Works Choreographed: CONCERT WORKS: *Fancy Free* (1944); *Facsimile* (1946); *Pas de Trois* (1947); *Summer Day* (1947); *The Guests* (1949); *Age of Anxiety* (1950); *Jones Beach* (1950, co-choreographed with George Balanchine); *The Cage* (1951); *The Pied Piper* (1951); *Ballads* (1952); *Afternoon of a Faun* (1953); *Fanfare* (1953); *Quartet* (1954); *Fireball Mail* (1954); *The Concert* (1956); *New York Export: Opus Jazz* (1958); *3 X 3* (1958); *Moves* (1961); *Events* (1961); *Dances at a Gathering* (1969); *In the Night* (1970); *The Goldberg Variations* (1971); *Watermill* (1972); *Scherzo Fantastique* (1972); *Circus Polka* (1972); *Dumbarton Oaks* (1972); *Requiem Canticles (II)* (1972); *An Evening's Waltzes* (1973); *A Beethoven Pas de Deux* (1973, now called *Four Bagatelles*); *Four Pas de Deux* (1973, choreographed for four couples as a gala); *Dybbuk* (1974, called *Dybbuk Variations* after November 1974); *In G Major* (1975); *Introduction and Allegro for Harp* (1975); *Ma Mère l'Oye* (1975); *Une Barque sur l'Ocean* (1975); *Chansons Madécasses* (1976); *A Sketch Book* (*Fencing Dances and Exercises, Solo* and *Verdi Variations* only, 1978); *The Four Seasons* (1979, includes *Verdi Variations* as *Spring* pas de deux); *A Suite of Dances* (1979, a revision of *Dybbuk Variations*); *Opus 19: The Dreamer* (1979).

OPERA: *The Tender Land* (1954).

THEATER WORKS: *On the Town* (1944); *Concert Varieties* (1945, included ballet *Interplay*); *Billion Dollar Baby* (1945); *High Button Shoes* (1947); *Look, Ma, I'm Dancing* (1948, co-directed with George Abbott); *That's the Ticket* (1948, closed out

of town); *Miss Liberty* (1949); *Call Me Madam* (1950, also directed); *The King and I* (1951); *Two's Company* (1952); *The Pajama Game* (1954, also co-directed); *Peter Pan* (1954, also directed); *Bells Are Ringing* (1956, directed and co-choreographed with Bob Fosse); *West Side Story* (1957, conceived, directed, and co-choreographed with Peter Gennaro); *Gypsy* (1959); *A Funny Thing Happened on the Way to the Forum* (1962, Jack Cole was choreographer of record, but was replaced out of town, before much of the score (as performed on Broadway) was written); *Funny Girl* (1964, Robbins was co-director of record, but is believed to have taken over the choreography after the fatal illness of Carol Haney); *Fiddler on the Roof* (1964).

FILM: *West Side Story* (UA, 1961, choreographed and co-directed with Robert Wise).

TELEVISION: *Ford 50th Anniversary Show* (1953); *Peter Pan* (NBC, three live telecasts 1955, 1956, 1960).

Roberts, Eddie, American tap dancer and teacher; born 1918; died April 24, 1966 in the New York City area. After ballet studies with Constantine Kobeleff, he began to take class with Jules Stone at the age of twelve. He matured from student to assistant to colleague during his almost thirty-year professional relationship with Stone and succeeded him as the most popular tap teacher at conventions and conferences around the country.

Roberts, June, American child vaudeville ballerina; born c.1902 in, according to her publicity, a trunk on tour with her parents' troupe, Will H. Roberts & Co. Probably the best known child ballerina of the early twentieth century, Roberts was one of the few to have formal dance training, having studied at the age of four with Claude M. Alvienne. Her actual debut was at the age of three, as a monologuist, but she is not known to have danced professionally until she was five.

By 1911, she had her own act, featuring her famous toe dance jumping to and from tables in imitation of Mazie King. At her most successful, Roberts led a troupe of dancers, including her father as mime and her younger sister; although the evidence is not conclusive, this troupe seems to have been based on

Adelina Genée's and may have been used by the Keith circuit management as an advance publicity gimmick. It certainly seems likely that Roberts' *The Doll Maker's Dream* and *The Evolution of Terpsichore* were either plagiarisms of, or previews to, Genée's *Coppélia* and *La Danse*, respectively. Roberts' last known booking was as the principal soloist in May Tully's pageant, *The World Dances*, in Atlanta (1916).

Roberty, Robert, English theatrical ballet dancer; born c.1895 or as many as five years later in London; died c.1918 in Belgium. Roberty was trained by Serafina Astafieva in London and may have also studied with Eduoard Espinosa. Roberty's first known appearance was in Astafieva's *Theban Nights* (1915), a ballet that she produced for the Empire Theatre as a student recital. Later descriptions celebrated his extraordinary ability to perform conventional and trick pirouettes, and there is evidence that he must have been a talented partner since he did extensive performance work with Ninette De Valois.

All of Roberty's verifiable appearances were within the context of theatrical presentations. He partnered Lady Constance Stewart-Richardson at the Empire in 1915 in her *The Wilderness*, and performed in the musicals *Destiny* (1916), *The Cup of the Season* (1916, The Prince of Wales), and *Theodore and Co.* (1917), at the Gaiety. It is possible that the *Danse d'Anitra* that he performed in 1916 was part of Derra De Moroda's *Peer Gynt Suite*, premiered in the same year.

In October 1918 the English trade papers announced that Roberty was fatally ill in a military hospital in Belgium, a victim of the Western front of World War I. It is not certain whether he actually died in 1918 or early in 1919.

Robinson, Bill "Bojangles," American theatrical dancer known as "The King of Tapology"; born Luther Robinson, May 25, 1878 in Richmond, Virginia; died November 25, 1949 in New York. Robinson, who claimed to have no formal training, first appeared on stage as a child in the tap show extravaganza, *The South Before the War* (c.1887). From c.1896 to 1907 and from 1909 to 1914 he toured on the Keith Southern vaudeville circuit with famed

singer George Cooper in a series of short variety acts, among them, "Going to War," "Looking for Hanna," and "A Friend of Mine."

After Cooper's death, Robinson (with his long-time agent, Marty Forkins) developed the first of over twenty black variety and cabaret acts with which he played the Cotton Club, the Marigold Gardens, and the black theater circuit that stretched from the Apollo Theater in New York to the Alcazar in San Francisco. He took time out from the variety circuit to perform in four Broadway shows—*Lew Leslie's Blackbirds of 1927*, joining the cast three weeks after its opening, *Brown Buddies* (1930), *The Hot Mikado* (1939), and *Memphis Bound* (1945). Although he was not credited as choreographer, it is possible that he interpolated his own staged acts into the shows. The only actual Robinson choreography credit that historians have been able to discover was for a vaudeville act for "Sunshine Sammy" Morrison, an *Our Gang* member (1925).

It is possible that he interpolated his own routines into his films. Among these were *From Harlem to Heaven* (Independent, 1929), *Dixiana* (RKO, 1930), *In Old Kentucky* (Fox Film Corp., 1935), *The Big Broadcast of 1936* (Paramount, 1935), *Stormy Weather* (Twentieth-Century Fox, 1943), the film in which one can best see his dance style, and the four films in which he performed with Shirley Temple, *The Little Colonel* (Fox Film Corp., 1935), *The Littlest Rebel* (Fox Film Corp., 1935), *Rebecca of Sunnybrook Farm* (Twentieth-Century Fox, 1938), and *Just Around the Corner* (Twentieth-Century Fox, 1938).

Both major guilds of tap dancers currently performing, The Hoofers and The Copasetics, have declared Robinson the greatest tap dancer of all time.

Robinson, Chase, American modern dancer; born in the 1940s in Florida. Robinson began his dance training at Florida State University and continued it at American Dance Festival summer sessions in the early 1960s and at the Merce Cunningham and Martha Graham studios in New York. He performed with three major companies in the 1960s—the troupes of Lucas Hoving, Martha Graham, and Merce Cunningham. For the former, he appeared in *Aubade* (1963), *Icarus* (1967), *Suite for a Summer Day, Flight,* and *Has the Last Train Left?* (1964). With Graham, he danced in *Cortege of Eagles* and *Dancing Ground* (both 1967), while his Cunningham credits include performances in *Rainforest, How to Pass, Kick, Fall, and Run, Second Hand,* and the early Events.

Rock, William, American theatrical dancer; born c.1875 in Indiana; died June 27, 1922 in New York City. Raised in St. Louis, Missouri, where he pushed candies at the Olympic Theater, he performed in vaudeville as a singer before joining Richard Carle's company in 1902. In Carle's Chicago and New York productions, he played Oriental characters—the exact phrase then was "Chinee depictor"—and did specialty dances with Orientalish movements. From 1904, when he made his Broadway debut in *The Forbidden Land,* to 1913, he worked with Maude Fulton in a series of vaudeville dance acts. Their Broadway shows included *The Bourgomeister* (c.1906), *The Orchid* (1907), and *The Candy Shop* (1909). Their first specialty acts were derived from his "depictions," but toward the end of their partnership, they worked in a unique mode: they did exhibition ballroom work and then did the same dances in the styles of specific Broadway personalities and general types. In 1911, for example, they did dances straight and then as Bostonians and Quakers.

In 1916, he began a partnership with Frances White. According to some sources, he discovered her in Seattle and sponsored her move to New York. However the relationship began, it turned into an extremely successful act. They appeared together in two editions of the *Ziegfeld Follies* (1918 and 1919), and in many of his *Midnight Frolics,* as well as the *Hitchy-Koo of 1917.* This second partnership was more oriented toward eccentric dance, especially since White was more than six inches shorter than Rock.

Rock staged dances for at least two Broadway musical comedies and scores of vaudeville acts, for White, Fulton, members of Carle's companies, and other performers.

Works Choreographed: THEATER WORKS: *Top O'the World* (1910); *Let's Go* (1918); vaudeville acts for himself and Maude Fulton; vaudeville acts for himself and Frances White.

Rode, Lizzie, Danish ballet dancer; born 1933 in Copenhagen. Rode was trained in the school of the Royal Danish Ballet and spent her professional life in that company. Her technical prowess and comedic control allowed her to split her time between the company's Bournonville repertory, with roles in *La Sylphide* and *Kermesse en Bruges*, and its contemporary ballets. Her credits in the latter ranged from Birgit Cullberg's stark *Miss Julie* and *Medea*, to David Lichine's *Graduation Ball*, with its giddy adolescent lovers. She choreographed one work for the company, *Ballad in D* (1961), and now serves it as ballet master.

Works Choreographed: CONCERT WORKS: *Ballad in D* (1961).

Rodgers, Richard, American composer; born June 28, 1902 in New York City; died there December 29, 1979. Rodgers was one of the most longlasting of all American musical comedy composers; in fifty years he created scores for more than forty shows in New York and London, as well as films and television programs. All but three of his shows were written with Lorenz Hart (*Poor Little Rich Girl* [1920] to *Beat the Band* [1942]) or Oscar Hammerstein II (*Oklahoma* [1943] to *The Sound of Music* [1959]). One Broadway sage has said that there are Hart people and Hammerstein people and that while they might meet, they should never get involved, but Rodgers was able to work with both lyricists to create a canon of song that still astounds and attracts a worldwide audience.

Rodgers did compose one score specifically for ballet, Marc Platt's *Ghost Town* (1939), but his major contribution to dance is his theatrical scores. The waltzes in *Carousel* (1945) and *Cinderella* (CBS, March 3, 1957 and February 22, 1965 specials) have been occasionally choreographed for television but most of his music has only been staged in context. His shows used remarkably few individual choreographers, considering the scope of his career. The first Rodgers and Hart show, *Poor Little Rich Girl* (1920), was a Ned Wayburn production for Lew Fields but most of their earliest shows, such as the Columbia University productions and the *Garrick Gaieties of 1925* and *1926*, were staged by Herbert Fields who became better known as a librettist with Cole Porter and Vincent Youmans. From *Peggy-Ann* (1926) to

On Your Toes (1938), they worked almost exclusively with the members of The Big Four, engaging Busby Berkeley, Bobby Connolly, Seymour Felix, and Sammy Lee to stage at least two shows each. George Balanchine had a monopoly in the late 1930s and did dances for *On Your Toes* (1936), *Babes in Arms* (1937), *I Married an Angel* (1938), and *The Boys from Syracuse* (1938), while Robert Alton did the last Rodgers and Hart collaborations, *Too Many Girls* (1939), *Higher and Higher* (1940), *Pal Joey* (1940), and *By Jupiter* (1942).

Agnes De Mille became famous for her work on the early Rodgers and Hammerstein musicals—*Oklahoma* (1943), *Carousel* (1945), and *Allegro* (1947)—which she also directed. These all had dream sequences but were considered integrated shows. Other choreographers who have worked with Rodgers include Jerome Robbins, whose "Small House of Uncle Thomas" sequence in *The King and I* (1951) is considered one of the finest single musical numbers of all time, Carol Haney, who did the dances for *Flower Drum Song* (1958), and Joe Layton, who staged *The Sound of Music* (1959).

It would take a volume to list the Rodgers' songs that have been tapped, slinked, and waltzed to. From "Dancing on the Ceiling" misinterpreted by Jessie Matthews in *Evergreen* to "Ten Cents a Dance" for Ruth Etting in *Simple Simon*, he has written music for songs in praise of dance as a medium for romance and living. Personal favorites could be listed forever, but mention should be made of a rare Richard Rodgers song that actually describes a dance routine—"At the Roxy Music Hall," from *I Married an Angel*—and of the score for *Slaughter on Tenth Avenue*, which has been abstracted from its place in *On Your Toes* and interpolated into the repertory of the New York City Ballet.

Rodgers, Rod, American modern dancer and choreographer; born in Detroit, Michigan. Rodgers was brought up in a family of popular entertainers and learned tap styles at an early age. He had done club and resort work when he left the Detroit area to move to New York. He established a company at the Clark Center of the Performing Arts in New York which has become not only an important producing body but also a major civic force. An organizer of

the Dancemobile (the only surviving institution of the great mobile arts movement of the late 1960s), he has consistently presented concerts and workshops for that organization since its founding. He has worked closely with the Mobilization for Youth and Har-You Act (Harlem Youth Action Bill) block and community organizations, and cultural archives such as the Institute of Jazz Studies at Rutgers University.

Rodgers' works are primarily abstractions, experimenting with movement, visual elements, and produced sound. Two of his best known works, *Tangents* (1968) and *Rhythm Ritual* (1972), use props to create the sound score, and relate both to similar practices in forms of African ritual dance and in French experimental *musique concrète*. These two works are frequently performed in programs directed for street performance. He has also worked with real and imaginary space limitations, as in his *Dances in Projected Space* (1970), which uses slides, and the duet *Box* (1972), in which one dancer deals with a real cage while the other performs in psychic bonds.

Works Choreographed: CONCERT WORKS: *Inventions II* (1964); *Two Falling* (1965); *Percussion Suite* (1965); *Oscillating Figures* (1965); *Trajectories* (1966); *Folk Suite* (1966); *Quest* (1966); *The Conjuring* (1968); *Tangents* (1968); *News Recall* (1968); *Dance Poems . . . Black, Brown, Negro* (1968); *Assassination* (1969); *Schism* (1969); *Sketches for Projected Space* (1969); *Early Dances* (1969); *Harambee* (1970); *Now Nigga* (1970); *Dances in Projected Space* (1970); *Box* (1972); *Shout* (1972); *In Hi-Rise Shadows* (1972); *Rhythm Ritual* (1972); *Work Out* (1973); *Need to Help* (1973); *Love Flower* (1974); *Vuca* (1974); *Intervals I* (1975); *Intervals II* (1976); *Visions . . . of a New Blackness* (1976); *Jazz fusions* (1978, continuing improvisations with musicians); *Soft Days . . . Secret Dreams* (1978).

THEATER WORKS: *Historical Tableau* (1969); *Down in the Valley* (1969); *Black Cowboys* (1970); *Prodigal Sister* (1974).

Rodham, Richard, American ballet dancer and choreographer; born September 2, 1939 in West Pittston, Pennsylvania. After local studies, Rodham continued his training under two women with important influences on American dance—Barbara Weisberger, founder of the Pennsylvania Ballet, and E. Virginia Williams, founder of The Boston Ballet. He moved to New York to take classes at the School of the American Ballet and graduated into the New York City Ballet in 1960. In three years with the company, he appeared in a large number of ballets by George Balanchine, among them, *Agon, Don Quixote*, and *Midsummer Night's Dream*, and in the revival of Antony Tudor's *Dim Lustre*, in the "It Was Spring" solo.

Rodham returned to Weisberger as ballet master and principal dancer of the Pennsylvania Ballet in 1963, appearing in that company's Balanchine repertory, in its productions of the classics, and in John Butler's *Villon*. He choreographed occasionally for the troupe, and revived pieces that he had created for workshops in New York.

Works Choreographed: CONCERT WORKS: *Encounter* (1963); *Pas de Deux* (1963); *Ballade* (1963); *Pas de Poisson* (1966); *Trio* (1968); *Gala Dix* (1968); *In Retrospect* (1973); *The Class* (1978).

Rodolphe, Jean-Joseph, Eighteenth-century Austro-Hungarian composer; born October 17, 1730 in Strassbourg; died August 18, 1812 in Paris. Rodolphe joined the Orchestra of the Stuttgart Court Opera in 1760 where he came in contact with court choreographer Jean-Georges Noverre. He composed a number of operas and divertissements for Noverre, among them *Medée et Jason* (1762), *Le Mort d'Hercule* (1762), *Psiche et l'Amour* (1762), and *Hypermnestre* (1766), and for Etienne Lauchery at the court theater in Kassel, including his *Apollon et Daphne* (1764) and *Titon et l'Amore* (1767). Rodolphe later served with the Paris Opéra orchestra, where again he worked with Noverre and taught at the Paris Conservatory.

Rodrigues, Alfred, South African ballet dancer and choreographer working in England after the mid-1940s. Trained locally by Dulcie Howes and Cecily Robinson, he moved to London to perform with the Sadler's Wells Ballet in 1947. Noted for his character roles, he also choreographed ballets for the company and dances for West End revues. Among his shows are the Joyce Grenfell revues, *Penny Plain* (1951), and *Grenfell Requests the Pleasures* (1956), and the long-running musical comedy *Charlie Girl* (1965).

Works Choreographed: CONCERT WORKS: *Ile des Sirenes* (1950); *Blood Wedding* (1953); *Café des Sports* (1954); *Cinderella* (1955); *The Miraculous Mandarin* (1956); *Saudades* (1956); *Le Renard* (1961); *Jabez and the Devil* (1961).

THEATER WORKS: *Penny Plain* (1951); *Pay the Piper* (1954); *Grenfell Requests the Pleasure* (1956); *Airs of a Shoestring* (1956); *Charlie Girl* (1965).

Rodriguez, Zhandra, Venezuelan ballet dancer; born March 17, 1947 in Caracas, Venezuela. Originally trained at Nena Coronil's school in Caracas, she continued her studies at the Interamerican School of the National Ballet of Venezuela, with Ady Addor and Anna Istomina. With the National Ballet, she performed in William Dollar's *Constantia, The Combat*, and *Divertimento*, and in the *Don Quixote* pas de deux.

Rodriguez danced with the American Ballet Theatre from 1968 to 1974. Although she performed in most of the company's revivals of classics, most notably in *Coppélia* and *The Sleeping Beauty* (1974, one-act version), she was best known for her work in more modern ballets. She created roles in Dennis Nahat's *Mendelssohn Symphony* (1971) and *Some Times* (1972) and performed in his *Brahms Quintet*; she also danced in works by the company's other choreographers-in-residence in the early 1970s, Michael Smuin's *Pulcinella Variations* and Eliot Feld's *Harbinger* and *At Midnight*. With her fast movements and extraordinary balance, she made her first hit in the Giggling Rapids solo from Alvin Ailey's *The River*, performing it from 1969 to 1974.

Leaving Ballet Theatre, she performed in works by John Neumeier in the Hamburg Opera Ballet, among them *Third Symphony* (1975) and *A Midsummer Night's Dream* (1977), playing "Hippolyta" and "Titania." In 1975, she returned to Venezuela to join the new International Ballet de Caracas, in which she danced in new works and revivals by Vicente Nebrada, most notably his *Ombras*.

Roess-Smith, Julie, American postmodern dancer; born July 28, 1947 in Brooksville, Florida. Roess-Smith was trained at the Merce Cunningham Studio by the choreographer himself, Viola Farber, and Dan Wagoner. A member of the Cunningham Company since 1973, she has appeared in his Events, his video pieces, such as *Westbeth*, and his live company repertory, most notably in *Travelogue* (1977), *Rebus, Summerspace, Torse, Signals, Squaregame,* and *Sounddance*. She has also performed in the concert works of colleagues Sandra Neels and Susanna Hayman-Chaffey.

Rogers, Ginger, American theater and film dancer and actress; born July 16, 1911 in Independence, Missouri. Raised in Virginia, she was trained by her mother. After winning a series of Charleston competitions, she went into vaudeville as the star of Ginger and Her Red Heads in 1925. Billed as "The John Held Girl," after the popular cartoons of long-legged flappers with wide smiles, she also danced in an act, Ginger and Pepper, with her first husband. Her John Held act, which lasted longer than the marriage, involved baby talking, and with that specialty she replaced Helen Kane (the Betty Boop voice) as the featured singer with Paul Ash's Orchestra at the Brooklyn Paramount. That engagement brought her her first Broadway roles in *Top Speed* (1929), which featured New York's fastest eccentric tappers, Harland Dixon and Johnny Boyle, and included a chorus boy named Hermes Pan. Her starring role in the stage version of *Girl Crazy* (1930) was staged primarily by George Hale, but one number was reputed to have been choreographed by a colleague, Fred Astaire.

That show brought her to the attention of a talent scout who offered her the first of her many Hollywood contracts. Apart from the acting and comedy roles in which she excelled, Rogers had two successful musical film series. Her first, for Vitaphone/WB, was as a comic and dancer in the *Golddiggers of 1933* and *42nd Street*, both staged by Busby Berkeley. In the latter, as "Anytime Annie, who never said no but once and that time, she didn't hear the question," she is integral to the plot, but doesn't have a dance solo. In the *Golddiggers* film, the best of the series, she opens the action with "We're in the Money" in Pig Latin and taps in all of her other numbers.

Her next series of musical films paired her with Astaire, who was making his film debut. Their first appearance dancing together in "The Carioca" se-

quence in *Flying Down to Rio* (RKO, 1933), won its dance director the first choreography Oscar, and won them a devoted following that has not waned to this day.

The Rogers/Astaire partnership lasted through two studios and half a dozen dance directors, and it represents musicals at their best for much of the American and European audience. The structure of the films was remarkably similar, allowing for their tap competition dances, their exhibition ballroom seduction dances, and solos for each. Every person who has seen one of the films has a favorite number—whether the "Night and Day" from *The Gay Divorcee* (RKO, 1934), or the "Cheek to Cheek" in *Top Hat* (RKO, 1935), or the rehearsal dance in *The Barkleys of Broadway* (MGM, 1949). Personal soft spots include the "Swing Time Waltz" from the movie of the same name (RKO, 1936), and the tap competition from *Follow the Fleet* (RKO, 1936).

Rogers' nonmusical films include some of the funniest comedies of the 1930s through 1950s, among them, *Bachelor Mother* (RKO, 1939) and *Monkey Business* (Twentieth-Century Fox, 1952), and topical dramas in the 1950s and 1960s. No matter how well received her acting was, however, she will always be remembered for her musical comedies, as the most musical and most comical of them all.

Rogers, Jaime Juan, American modern and theatrical dancer and choreographer; born in Puerto Rico. Rogers was raised in New York City and trained at the High School of Performing Arts. He attended Juilliard briefly but left to join the touring cast of *West Side Story.* For many years, Rogers worked concurrently on Broadway, where he appeared in specialty dance roles in *Flower Drum Song, Bravo Giovanni* (both by Carol Haney), and the 1966 revival of *Annie, Get Your Gun,* and on the concert stage, where he was known for his performances in the works of Donald McKayle, among them *District Storyville,* as "little Lou," and *Bursts of Fists* (1969). After assisting McKayle on *Golden Boy* (and appearing as "Lopez"), Rogers choreographed one show for Broadway, *The Education of H*y*m*a*n K*a*p*l*a*n* (1968), and a number of successful revues and musicals in Japan. Working with McKayle also brought him into television choreography and

direction, beginning with performances on Sammy Davis, Jr. specials, and culminating with successful work on the *Andy Williams Show* (NBC, 1969–1971), *The Dean Martin Show* (NBC, 1972–1975), *Sonny and Cher* (CBS, 1976–1977), and many specials. He currently works primarily in dramatic work as a television director and producer.

Works Choreographed: THEATER WORKS: *The Education of H*y*m*a*n K*a*p*l*a*n* (1968); productions in Japan.

TELEVISION: *Hullabaloo* (NBC, 1965–1966); *The Andy Williams Show* (NBC, 1969–1971); *The Dean Martin Show* (NBC, 1972–1975); *The Sonny and Cher Show* (II) (CBS, 1976–1977); specials for Sammy Davis, Jr., Soupy Sales, and others; productions in Japan.

Rogge, Florence, American presentation act choreographer; born 1904 in Detroit, Michigan. The list of Rogge's dance teachers sounds like a complete register of dance masters of New York and includes Theodore Kosloff, Luigi Albertieri, Michio Ito, Konstantin Kobeleff, Ella Dagnova, and Margarete Wallmann. She became a soloist at the Roxy Theater, working under Gae Foster. After four years there, she became the ballet master and choreographer of ballet routines at the new Radio City Music Hall from 1932 until her retirement in 1952. Unlike Foster who handled all of the dance in the Roxy shows, in the theater's hierarchy Rogge was responsible only for ballet work and collaborated with Rockettes director Russell Markert and general producer Leon Leonidoff. The Music Hall's hierarchy was based on that developed at the Capitol Theater and the first "Roxy" Rothafel houses.

Most of Rogge's pieces were ballets based around visual themes, such as flowers, the seasons or pieces of music. She did a *Rhapsody in Blue*, like every other line choreographer of the period, but was best known for her *Snowflakes* and *Undersea Ballets*.

Works Choreographed: THEATER WORKS: Ballet sequences in presentation acts at the Radio City Music Hall (1932–1952).

Rognan, Roy, American theatrical dancer; born c.1909; died February 22, 1943 in the waters outside Lisbon. Rognan made his professional debut as a

child roustabout and acrobat in circuses in the American Midwest; it is not known whether his parents were also involved in circus performance. By 1936, he had switched genres and had developed a tap act in vaudeville and on the presentation (or Prolog) theater circuits. He met, married, and formed a partnership with Jeanne Lorraine who had previously been in vaudeville as a member of Jeanne, John, and Joe. Together, they became one of America's best known comedy dance acts. On the presentation circuit and with the Benny Goodman or Lawrence Welk Orchestras, they presented their own tap solos and a series of satirical ballroom numbers, including their celebrated Blue Danube Waltz, which began straight and ended as a gymnastic comedy of impossible positions.

Their appearances on tour and in *Broadway in Laughter* on Broadway brought them many offers from producers of live and filmed performances. In 1943, however, they, like many of their colleagues, gave up a season to tour Europe with USO teams. The plane in which they were flying to Europe crashed outside of Lisbon. Most of those aboard, among them Jeanne Lorraine and Margaret Froman, were injured, but Rognan was lost at sea.

Rohan, Sheila, American ballet dancer; born November 20, 1947 on Staten Island, New York. Rohan's training ranges from classes with the strict Cecchetti protégé, Vincenzo Celli, to the popular Maggie Black, to modern dancer James Truitte, who teaches Lester Horton work. A member of the Dance Theatre of Harlem since the late 1960s, she has performed in the company's revival of ballets by George Balanchine, including his *Agon* and *Concerto Barocco*, and in the contemporary works by William Dollar, including his *Mendelssohn Concerto* (1976), and artistic director Arthur Mitchell, among them his *Fun and Games* (1971) and *Rhythmetron*.

In 1978, she began to perform with the Contemporary Chamber Dance Group of Nanette Bearden, where she has danced in works by Bearden and by Keith Lee.

Roje, Ana, Yugoslavian ballet dancer; born 1909 in Split, Yugoslavia. Roje received her ballet training from Nicholai Legat, whose assistant she later became. She performed for him with the Yugoslav State Ballet in Zagreb before moving to the United States with the Ballet Russe de Monte Carlo in 1938. Returning to Yugoslavia during World War II, she taught and danced in Zagreb and Split, in *Giselle, Romeo and Juliet*, and Oskar Harmos' *Fifth Symphony*.

Roje is well known as a teacher of the Legat system, having worked at the Ballet Russe de Monte Carlo School (from 1954), the Bermuda Ballet Festival (from 1959), and in England, where she served as the president of the Society of Russian-style Ballet Schools.

Roll, Eddie, American theatrical dancer and director; born in the late 1930s in Cincinnati, Ohio. Roll taught dance in Cincinnati before moving to New York to break into Broadway performance. Although his debut show, *By the Beautiful Sea* (1954), was a critical success and financial failure, six of his next seven musicals were among the century's best. From that show he made annual changes and danced as a farmer in Tamiris' *Plain and Fancy* (1955), a baseball player in Bob Fosse's *Damn Yankees* (1955), and a Cockney in Hanya Holm's *My Fair Lady* (1956). Roll left that show to become the original "Action" in the dancing gang of Jets in Jerome Robbins' *West Side Story*, playing that important role in New York and London. For the London run, he danced that part and staged Robbins' choreography for the English cast. Later shows ranged from the nostalgic *Sophie* (1963) to the World's Fair spectacle *To Broadway with Love* (1964) to a comedy role in *The Man of La Mancha* (1965). During these runs, he also acted and directed in straight plays and comedies and became a regular performer on almost every television variety and dramatic show of the 1950s and 1960s.

Romanoff, Dimitri, Russian ballet dancer working in the United States from the mid-1920s; born 1907 in Tzaritzin, Russia. Raised in Japan and California, Romanoff was trained by Theodore Kosloff in Los Angeles. After studying with Adolf Bolm, he performed for him and Michio Ito at the Hollywood

Bowl. On the West Coast, he also worked for Serge Oukrainsky, then based in Hollywood, and for José Fernandez.

Moving to New York, Romanoff joined the (Mikhail) Mordkin Ballet (1937-1940), creating roles in his *Trepak, The Goldfish, Dionysus,* and *Voices of Spring,* as the "Boy in Green." Like many fellow Mordkin company dancers, he became a charter member of Ballet Theatre in 1940. Associated for many years with that company as a dancer and as a regisseur from 1947, Romanoff created parts in Eugene Loring's *The Great American Goof* (1940), and Antony Tudor's *Romeo and Juliet* (1943) and *Shadow of the Wind* (1948). He also took featured roles in Tudor's *Dark Elegies* and *Jardin aux Lilas,* and in the company productions of *Bluebeard, Aurora's Wedding* (a one-act version of *The Sleeping Beauty*), and *Naughty Lisette* (Romanoff's revision of *La Fille Mal Gardée*).

Since retiring from Ballet Theatre, he has taught in the Los Angeles area of Southern California.

Works Choreographed: CONCERT WORKS: *Naughty Lisette* (1943, after D'Auberval).

Romanov, Boris, Russian ballet dancer and choreographer who worked in Europe, South America, and the United States; born March 22, 1891 in St. Petersburg; died January 30, 1957 in New York City. Trained at the St. Petersburg school of the Imperial Ballet by Nicholai Legat, he performed with the Maryinsky Ballet after graduation.

A celebrated character dancer with the Maryinsky (1909-1910, 1914-1921) and with the Diaghilev Ballet Russe, he bagan to choreograph in 1913 in Paris. His *La Tragédie de Salome* was performed there with a cast that included Serge Oukrainsky in his first role, and also in London by the Ballet Russe. He also staged the Stravinsky opera, *Le Rossignol* (1913), on the Western European engagement. Returning to Russia, he served as ballet master of the Maryinsky (1917-1921) and staged ballets and cabarets for the Letni Theater Minotaur and the Chauve-Souris, two experimental companies.

After 1921, Romanov traveled in Western Europe, working for the Romantic Ballet (1921-1925), La Scala (1925), and the Teatro Colón (1928), and in the United States, where he accepted an engagement with the Ballet Russe de Monte Carlo. From 1938 to 1949, when he retired, he was associated primarily with the Metropolitan Opera Ballet, staging productions of *Tannhauser, Boris Godounov, Carmen,* and *La Traviata,* among many others. He also worked with two short-lived companies in the mid-1940s, serving as ballet master of de Cuevas' Ballet International (1944), and the touring Foxhole Ballet (1946). In these troupes, and as a freelance teacher, he influenced generations of American ballet dancers, most of whom are now themselves teaching or directing companies.

Works Choreographed: CONCERT WORKS: *La Tragédie de Salome* (1913); *Andelusiana* (1922); *Prince Goudal's Festival* (1922); *Petrouchka* (1926); *At a Ball* (1927); *The Champions* (1928); *Pulcinella* (1928); *An Interrupted Festival* (1931); *Chout* (1932); *L'Amour Sorcier* (1932); *Volti la Laterna* (1934); *Madona Purita* (1934); *Balilla* (1935); *The Conflicts of the Spirits* (1940); *A Midsummer Night's Dream* (1944); *Harlequinade* (1956).

OPERA: *Le Rossignol* (1913).

Ron, Rachamin, Egyptian/Israeli modern dancer; born November 15, 1942 in Cairo, Egypt. Raised in the Galilee, Ron was a folk dancer before he began modern dance training with Gertrude Krauss and Rena Gluck. Like most Israeli dancers, he acquired both experience and additional technical education from the many American choreographers who worked or gave master classes in the country. Ron joined the Bat-sheva Dance Company at its founding in 1963. Apart from a period of study in the United States in the Martha Graham company, he has performed with that Israeli company throughout his career. He has performed major roles in the Graham repertory in both countries, notably in her *Plain of Prayer* (1968), *Cortege of Eagles,* and *Circe* in New York and *Diversion of Angels* in Tel Aviv. His Israeli performance credits for further American classics of the traditional modern dance include roles in Jerome Robbins' *Moves,* Talley Beatty's *The Road of the Phoebe Snow* and *Come and Get the Beauty of It Hot,* José Limón's *La Malinche* and *The Exiles,* and Glen Tetley's *Mythical Hunters.*

Rooney, Mickey, American film and stage dancer and comic; born Joe Yule, Jr., September 23, 1920 in Brooklyn, New York. Rooney made his vaudeville debut in his parents' act, Joe Yule and Nell Carter; he joined it as a midget, but later was billed as a child hoofer. He entered film in 1926 as the winner of a contest to choose a child actor to portray "Mickey MacGuire," a popular newspaper serial character who became the hero of two-reel comedies. Although he had his first major success in Warner Brothers' 1934 film of *A Midsummer Night's Dream* (directed by Max Reinhardt with choreography by Bronislava Nijinska), he remains best known for his pictures for MGM (1934-1948). The first and last were versions of the Eugene O'Neill play *Ah, Wilderness* (MGM, 1935, 1948 as *Summer Holiday*) and in between were melodramas such as *Captain Courageous* (1937), *Boys Town* (1938), *Men of Boys Town* (1941), *National Velvet* (1944), *Young Tom Edison* (1940), and fifteen "Andy Hardy" films (1937-1946). His best remembered musical appearances were as young hoofers partnering, and falling in love with, Judy Garland in *Babes in Arms* (1939), *Strike Up the Band* (1940), *Babes on Broadway* (1941), and *Girl Crazy* (1943)—dance versions of their roles in the Hardy series. In each, they tap danced at least once and showed the importance of good vaudeville training in their timing, attack, and precision.

As Rooney grew older, if not taller, he was cast most frequently as a comedian, although often given a chance to dance on screen. The dramatic gifts that he revealed in straight roles gave way to the fast-paced comedy of his television series characters, "Mickey Grady" (ABC, 1964-1965) and "Mickey Mulligan" (NBC, 1954-1955). In 1979, he was returned to public attention in two disparate roles that revealed his range—a serious one in the suspense film, *The Black Stallion*, and a vaudeville triumph in his Broadway debut in *Sugar Babies* (1979-), a tribute to burlesque.

Rooney, Pat (I), Irish eccentric dancer and comic, working in the United States; born in Birmingham, England, 1844; died 1891 in New York City. The patriarch of the celebrated Irish family moved to the United States at the age of nineteen. He not only was Irish by place of national origin, but also worked in the vaudeville genre of "Irish dialect" comedy. His theme songs included "Biddy the Ballet Girl," a ballad which seems to be a direct precursor of the "Sadie Salome" and "Becky from Babylon" songs that Fanny Brice made famous—about the emigrant girl who tries to transform herself into an exotic or ballet dancer, but gets recognized by a member of the audience who knew her when. His acts, ranging from *The Letter Carrier, Pat's Wardrobe*, and *Lord Rooney*, to *The Miner's Bowery*, lasted throughout his American career, and were popular in every booking.

Rooney and his wife, dancer Josie Granger, had five children—Katherine, Mathilda, Pat (II), Josie, and Julia—all of whom performed in vaudeville. Although all were young when he died, they each included imitations of his eccentric dance style and characteristic voice in their own acts.

Rooney, Pat (II), American eccentric dancer and comic; born July 4, 1880 in New York City; died there September 9, 1962. Rooney made his debut in 1897 in Atlantic City with the vaudeville act of his mother, Josie Granger. By 1904, he was a headliner in his own act with his wife, Marion Bent (c.1880-1940), whom he had met when both were featured in *Mother Goose* (1903). They worked together for more than forty-five years in vaudeville and other media. Among their most popular acts were *Make Yourself at Home* (1906), *Hotel Laughland* (1909), *Simple Simon Simple* (1909), *The Yiddisher Gazatsky (kasatke)* (1910), *Love Birds* (1921), and *Rings of Smoke*, a forty-six-minute act in which they toured from 1919 to the mid-1920s. They also danced together in a series of film comedies for Universal Studios, among them *The Belle and the Bell Hop* (1916) and *I'll Get Her Yet* (c.1918). Pat Rooney III (1903-1929) made his debut in the popular act, *Twenty Minutes with Pat and Marion* (1919), and was himself signed to become a headliner in 1926.

Rooney performed almost constantly until his death in 1962. After the death of vaudeville, the family medium, he went into Prologs and presentation acts co-starring in 1933 with Pat Rooney IV. He was a popular star of cabarets and nightclubs, among them Billy Rose's Diamond Horseshoe. After almost fifty years, he returned to Broadway in 1952 as "Arvide Abernathy," the understanding mission director

in *Guys and Dolls*, to introduce the song, "More I Cannot Wish You."

Rooney Sisters, American theatrical dancers; Josie Rooney born 1892 in New York City; Julia Rooney born there in 1893. The younger daughters of Pat Rooney (I) and dancer Josie Granger, they made their debuts in their parents' vaudeville troupe. They danced with the family, which then consisted of their mother, brother Pat Rooney (II), and older sisters Katherine and Mathilda, until 1905 when they formed a duet act. They were members of *The Woodland Nymphs* that year, and toured with their own twelve-minute cake-walk act on the Orpheum circuit in the United States and in European cabarets from 1906 to 1913.

Although Josie retired from dance performance to concentrate on other areas of the theater, Julia toured with Walter Clinton in an exhibition ballroom act until 1925.

Roope, Clover, English ballet dancer and choreographer; born 1937 in Bristol. Roope was trained at the Royal Ballet School, but spent a year with the Sadler's Wells before joining the Royal Ballet in 1957. She was cast both in solos in the company's full-length nineteenth-century ballets and in the 1930s repertory, most notably in Frederick Ashton's *Façade* and Andrée Howard's *La Fête Étrange*. She joined the Western Theatre Ballet in 1960, appearing in much of that troupe's commissioned repertory, including Walter Gore's *Street Games*, Ray Powell's *One in Five*, and Kenneth Macmillan's *Valse Eccentrique*. She was given a two-year fellowship to continue her studies in the United States, to expand both her performance and her choreographic vocabulary. After studying at the studios of Martha Graham, Jóse Limón, Margaret Craske, Antony Tudor, and Helen McGehee, she appeared in the latter's *After Possession* (1965) and partnered Christopher Lyall in a pas de deux concert at Jacob's Pillow.

Roope's choreographic career has followed the traditional route for English dancers in the 1960s. She created her first pieces for a Sunday Ballet Club workshop, *Le Farceur* (1958), a work for university students, staged interpolated dances for a Shakespearean repertory group (the Bristol Old Vic), and

then became as useful as a choreographer to her company as she was as a performer. Most of her late work has been created for the Western Theatre Ballet, with which she still dances.

Works Choregoraphed: CONCERT WORKS: *Le Farceur* (1958); *Sleight of Hand* (1960); *Rencontre Imprévue* (1962); *Spectrum* (1967); *Point of Contact* (1970); *Disenchanted* (c.1973).

THEATER WORKS: production of Shakespearean plays for the Bristol Old Vic (1960).

Rosati, Carolina, Italian ballet dancer of the nineteenth century; born Carolina Galletti, December 13, 1826 in Bologna; died May 1905 in Cannes, France. Trained by Carlo Blasis in Milan, she made her debut at La Scala in 1846. In six years with that company, she was best known for her work in Giovanni Casati's *Abd-el-Kadar* (1846) and Pasquale Borri's *Zoloë* (1852). Her three seasons at Her Majesty's Theatre, London, brought her roles in the *Pas de Quatre*, in the replacement cast, in *Les Quatres Saisons* (1848), dancing with Carlotta Grisi, Marie Paul Taglioni, and Fanny Cerrito, and in Paul Taglioni's *Fiorita* (1848) and *La prima ballerina* (1849).

At the Paris Opéra after 1853, she was assigned principal roles in Mazilier's *Jovita, Le Corsaire,* and *Marco Spada.* She brought *Jovita* with her tour repertory to St. Petersburg in 1859, 1862, and 1863; in the middle season, she created the leading role of "Aspacia" in Marius Petipa's *La Fille du Pharon* (1862).

Rose, Jurgen, German theatrical designer; born August 25, 1937 in Bernberg. Rose's dance career has long been associated with the production of John Cranko. From his 1962 Stuttgart *Romeo and Juliet* and full-length ballets *Swan Lake* (1963) and *Eugene Onegin* (1965) to his abstractions, *Poème d'Extase* (1971) and *Initials RBME* (1972), Rose's designs have always fitted Cranko's requirements. His full-length pieces were detailed and stylish while the abstract pieces did not restrain either movement or the audience's imagination.

Rose's work for other choreographers has been primarily full-length plotted ballets and included a *Baiser de la Fée* and *Daphnis and Chloe* for John Neumeier, a *Nutcracker* and *Cinderella* for Celia

Franca, and the Royal Danish Ballet's 1974 revival of *Romeo and Juliet*.

Rose, Mitchell, American modern dancer and choreographer; born September 4, 1951 in Boston, Massachusetts. Rose was the first dance major at Tufts University and, like so many of his colleagues there, had no dance training before beginning his studies with Grisela White. Later, New York–based training has included work with Hanya Holm, Gladys Bailin, Alwin Nikolais, Martha Wittman, Mel Wong, Kathy Kramer, and the faculties of the Merce Cunningham and Viola Farber studios. Although he has danced with Jerry and Sara Pearson's company as the third person in the duet and trio repertory, he has spent most of the six years since forming his own company in tours, concerts, and residencies with it. His works for The Mitchell Rose Dance Company (now the Dance/Theatre/Etcetera) seem to form a continuing history of contemporary culture in movement, musical collages, and exceptionally vivid visual images. Although most of his pieces are for solo, duet, or quartet, some of his works were created for his chamber company and require only its six members. His many solos and duets have proven him a master of that genre with its self-limitation and challenges.

Rose composes or arranges music for many of his works, among them *uhd* (1971), *The History of Man* (1972), *18 Beginnings* (1975), *hay, hay, hay* (1977), and *Hue and Cry* (1978). He also serves as lighting designer for his company, for Martha Bowers, Catherine Turocy, and the New York Baroque Dance Company.

Works Choreographed: CONCERT WORKS: *Nightwall* (1970); *Shadows* (1971); *Elements* (1971); *uhd* (1971); *The History of Man* (1972); *What You Want* (1972); *lenz es tu* (1972); *The Bohr Theory* (1973); *D'Artagnan in Marseilles* (1973); *Inhabitants of Jupiter and Their Nightmares* (1973); *Following Station Identification* (1973); *18 Beginnings* (1975); *Low Art Motion* (1975); *Apples Are Cheap* (1975); *Plurals* (1975); *Danncei [sic]* (1975); *A Roll of Danish Dimes* (1976); *Swamp* (1976); *Dutiful Beamer* (1976); *When Insane, Do as the Sane Do* (1977); *Poo-tee-weet?* (1977); *hay, hay, hay* (1977); *Bon Voyage, Cheryl and Walter* (1977); *Prelude* (1977); *In a Sentimental Mood* (1978); *L'Enfant Terrible* (1978); *Not a Bed of Roses* (1978); *Low Art Motion '78* (1978); *Hue and Cry* (1978); *P's and Q's* (1978); *To Them, the Brave* (1979); *What Baby Baby Nice Nice Nice* (1979); *Sales Presentation of Choreography for Popular Musical Artists as Presented at the Third Annual Convention of Rock 'n' Roll Managers, February 25, 1969* (1979); *Fox Trot* (1980); *The Elements* (1980); *ZZ* (1980).

Rosen, Heinz, German ballet dancer; born July 3, 1908 in Hanover; died December 25, 1973 in Munich. Trained with Kurt Jooss, Rosen performed with the Jooss Ballet from 1933 to c.1946, with featured roles in his *The Green Table, A Ball in Old Vienna,* and *Impressions of a Big City.*

Rosen served as ballet master of the Basel State Opera from 1946 to 1951 and of the Munich State Opera from 1959 to 1969. Among the many works that he created for those companies and as a freelance choreographer are *Aubade* (1961), *Les Noces* (1962), and *Trionfi di Afrodite* (1960), which included productions of Carl Orff's *Carmina Burana* and *Catulli Carmina.*

Works Choreographed: CONCERT WORKS: *Le Bourgeois Gentilhomme* (1949); *l'Indifférent* (c.1949); *Danza* (1960); *Trionfi di Afrodite* (1960); *Ivan von Larissa* (1960); *Aubade* (1961); *Les Noces* (1962); *Le Renard* (1962); *The Moor of Venus* (1963).

Rosenthal, Jean, American lighting designer for dance and theater; born March 16, 1912 in New York City; died there May 1, 1969. Trained as a dancer and scenic artist at the Neighborhood Playhouse by Martha Graham and Blanche Talmud, she became production supervisor (i.e., a combination lighting designer, technical director, and production stage manager) for the Federal Theatre Project under Orson Welles and John Houseman, working on their *Black Macbeth, Horse Eats Hat*, and on *The Cradle Will Rock*, co-sponsored by Minna Curtiss (1938).

Rosenthal's connection to dance began in the early 1940s, through Curtiss, who is Lincoln Kirstein's sister, and through Frances Hawkins, who managed both the Martha Graham company and the Ballet

Caravan and was an organizer of the American Dancer Association and the dance unionizing movement. Rosenthal served as production supervisor for all of Hawkins' companies—the Graham troupe (1949–1957), Balanchine's Ballet Society, The New York City Ballet (1948 until her death), and Robbins' Ballets: U.S.A. As well as designing lighting for the two companies' productions, she was responsible for creating the tree in *The Nutcracker*. Her major contribution to dance lighting designs came in her interest in the white-light concept of using unjellied lighting equipment to define shapes of space on stage, thereby adding to the choreography, rather than just coloring it.

Rosenthal also worked her magic of light on Broadway, designing Robbins' *King and I* (1950), *West Side Story* (1957), *A Funny Thing Happened on the Way to the Forum* (1962), and *Fiddler on the Roof* (1964), Hanya Holm's *Kiss Me Kate* (1948), Bob Fosse's *Redhead* (1959), and Michael Kidd's *Destry Rides Again* (1959).

Roshanara, English dancer specializing in Indian and Asian performance styles; born Olive Craddock, January 1894 in Calcutta; died July 14, 1926 in New York. The daughter of an Irish officer in the British Army in India, she was trained in local dance forms as a child and adolescent. Moving to London in 1910, she was recommended by Loie Fuller to perform as a specialty dancer in Oscar Ash's production of *Kismet*; according to many contemporary sources, she also worked as an extra in the Ballet Russe's production of *Schéhérézade* in 1911 in London, although she may have performed in the Kosloff version in that season instead.

After traveling between New York and Europe from 1913 to 1917, Roshanara settled in the United States in 1916. She performed as a solo specialty act on the Keith vaudeville circuit in 1916, then joined with Adolf Bolm and Michio Ito on the Ballet Intime tours of 1917 and 1918. Assisted by Mary Eaton and Blanche Talmud (both as students), she performed a repertory of Indian and Oriental dances and scenes, among them, *Harvest Dance* (1917), *A Hindu Fantasy* (1917), and *A Moon Flower* (1918). Her non-ethnic works were theatrical answers to World War I

and included *Camoflage, The Field of Honor,* and *After the War* (1917).

As well as dancing and choreographing, she seems to have served as a freelance expert on India for theatrical productions in New York, among them Winthrop Ames' *The Green Goddess* (1920), for which she received credit as the costume designer. While there is no way to judge the authenticity of her work, there is no question that her presence in New York as a performer, as a writer on Indian dance as both a valuable technique and as an exercise, and as a teacher lent enormous weight to productions of dances and plays set in India. There is growing evidence that her work at the Neighborhood Playhouse made her a major influence on the many concert dancers trained there by her or by Talmud, in terms of both the professional life of the concert dancer and the value of isolated movements, especially of the hands, in their choreography.

Works Choreographed: CONCERT WORKS: *The Nautch* (1910); *Dagger Dance* (1911); *Incense Dance* (1911); *Radha* (1911); *The Snake Dance* (1911); *Burmese Dances (Kayar Than—The Ancient Court Dance of Greeting, Modern Butterfly Dance)* (1917); *The Field of Honor* (1917); *A Hindu Fantasy* (1917); *Harvest Dance—the Golden Winnow* (1917); *East Indian Folk Dances* (1917); *Marwari Village Dance* (1917); *On the Way to the Temple* (1917); *After the War* (1917); *Camoflage* (1917); *A Burmese Boat* (1918); *A Moon Flower* (1918).

Rosita, American exhibition ballroom dancer; born c.1910, probably in the United States, but reportedly in Cuba. Either Rosita or her successor Renita was born Mary-Jane Louisa Hanrick, but sources differ as to her identity. With her partner, Ramon (Reachi), Rosita performed in Hollywood-area clubs before signing a joint contract with MGM (1933–1934) and First National/Warner Brothers (1934–1937). Although they appeared in more than a dozen short subject and feature films, they are unquestionably best remembered as the art deco team in the "Lullaby of Broadway" number in the *Golddiggers of 1935*. In 1935, however, she and Reachi split up. He joined forces with Renita to work in New York clubs, while she teamed up with Georges Fontana, a Euro-

pean exhibition ballroom dancer who had worked extensively in New York. They performed together until 1939, when he retired.

Rosita was unique in the later era of exhibition ballroom work in her ability to adapt to different forms and styles. With Reachi she was the ultimate sultry Hispanic, while with Fontana she was a European sophisticate capable of exquisitely dramatic adagio work. It is not known which if any of the Rositas who later performed in the New York area was the one of this entry. She may have been the dancer who performed with Caesar in a Cuban team at Leon and Eddie's in the Spring of 1942 or with Deno at the Belmont-Plaza that August, or she may have been the singer who worked in the late 1950s and early 1960s with two guitarists.

Ross, Bertram, American modern dancer and choreographer; born November 13, 1920 in Brooklyn, New York. Associated through much of his career with the company and school of Martha Graham, he began to study with her in the early 1950s, joining the company in 1953. Among the many Graham works in which he created roles in his almost twenty-five years in the company were *Canticle for Innocent Comedians* (1952), *Seraphic Dialogue* (1955), *Clytemnestra* (1958), Part I of *Episodes* (1959), *Acrobats of God* (1960), *Alcestis* (1960), *Phaedra* (1962), *Cortege of Eagles* (1967), *Lady of the House of Sleep* (1968), and *Archaic Hours* (1969). He also danced in works by fellow company members, among them, Sophie Maslow, partnering Carmen De Lavallade in her *Israeli Suite* (1963).

Ross has choreographed since 1964, presenting his first recital at the 92nd Street Y in 1965. Although he created works fairly regularly since that date, his most prolific periods were from 1965 to 1968, when he was sharing recitals with fellow Graham dancers, and after 1978, when he directed his own group.

Works Choreographed: CONCERT WORKS: *Untitled* (1964); *Triangle* (1965); *Breakup* (1965); *Holy, Holy* (1965); *If Only* (1966); *Reveal Me and Sing* (1968); *Solo* (1968); *L'Histoire du Soldat* (1968); *Oases* (1970); *See You Around* (1970); *Trio* (1970); *A Small Book of Poems* (1971); *Still Life* (1971); *New Math* (1972); *Nocturne* (1978); *Rencounters* (1978); *How*

Fair How Fresh Were the Roses (1978); *Theater Piece* (1978); *Totem* (1978); *Las Mujeres Sefardicas* (1978); *Four Preludes* (1980); *Threads* (1980); *Vanya: Three Poems* (1980); *Dear Friend and Gentle Heart* (1980).

Ross, Herbert, American ballet, theater, and film choreographer and director; born May 13, 1927 in Brooklyn, New York. Raised in Miami Beach, Florida, he returned to New York to study dance with Doris Humphrey, Helen Platova, and Caird Leslie. He appeared in six Broadway shows—*Follow the Girls* (1944), Agnes De Mille's *Bloomer Girl* (replacement cast, 1944), *Laffing Room Only* (1944), *Beggar's Holiday* (1946), Jerome Robbins' *Look Ma, I'm Dancing* (1948), and Tamiris' *Inside U.S.A.* (1948)—before beginning to work in ballet, reversing the usual route. After he injured his ankle on *Inside U.S.A.*, he began to create pieces for Ballet Theatre Workshop programs, which then admitted theater performers to its recitals.

Ross created all of his ballets during the 1950s and early 1960s, for Ballet Theatre and for his own company, the Ballet of Two Worlds, set up for a European tour. Among his best known works are *Caprichos* (1950), based on Goya etchings of war, the abstract *Paean* (1958), *Concerto* (1958), and *The Maids* (1958), which is still occasionally revived for performance by Ballet Theatre.

His Broadway choreography began with the musical version of *A Tree Grows in Brooklyn* (1951), and continued with *I Can Get It for You Wholesale* (1962), *Tovarich* (1963), *Do I Hear a Waltz?* (1965), *On A Clear Day You Can See Forever* (1965), and *Kelly* (1965), which was memorable as the show that, at that time, lost the most money in the fewest performances. He also staged club acts for many performers and a 1956 water revue for Esther Williams. He staged dances for episodes of *The Bell Telephone Hour* in 1959, 1963, and 1964, and of the *Hallmark Hall of Fame* in the late 1950s.

Known now as the director and producer of successful comedies and thrillers, he began his film career as a choreographer for *Carmen Jones* (Twentieth-Century Fox, 1954). His other dance films have included *Inside Daisy Clover* (WB, 1966), *Funny Girl* (Columbia, 1968), and *Doctor Doolittle* (Twentieth-

Century Fox, 1967). As an independent producer affiliated with Twentieth-Century Fox, he produced and directed the successful *A Turning Point* (1977) and the less well received *Nijinsky* (1980).

Works Choreographed: CONCERT WORKS: *Caprichos* (1950); *Ballet d'Action* (1951); *The Thief Who Loved a Ghost* (1951); *Paean* (1958); *The Maids* (1958); *Tristan* (1958); *Concerto* (1958); *Ovid Metamorphoses* (1958); *The Exchange* (1959); *Serenade for Seven Dancers* (1959); *Angel Head* (1959); *Rashomon* (1959); *Dark Song* (1959).

THEATER WORKS: *A Tree Grows in Brooklyn* (1951); *The Gay Life* (1961); *I Can Get It for You Wholesale* (1962); *Tovarich* (1963); *Anyone Can Whistle* (1964); *Do I Hear a Waltz?* (1965); *On a Clear Day You Can See Forever* (1965); *Kelly* (1965); *Hot Spot* (1965); Esther Williams water revue (1956); club acts for various performers.

FILM: *Carmen Jones* (Twentieth-Century Fox, 1954); *The Young Ones* (Vitalita, 1961); *Inside Daisy Clover* (WB, 1966); *Funny Girl* (Columbia, 1968); *Doctor Doolittle* (Twentieth-Century Fox, 1967); *Summer Holiday* (WB-British, 1968).

TELEVISION: *The Hallmark Hall of Fame* (NBC, 1959, single episode); *Bell Telephone Hour* (NBC, episodes in 1959, 1963, and 1964).

Ross, Shirley, American film dancer and vocalist; born Shirly Gaunt, January 7, 1915 in Omaha, Nebraska; died March 27, 1975. Raised in Los Angeles, she made her professional debut as a band singer, working at Graumann's Chinese Theater in Prologs and with the Phil Harris Band. While working as a rhumbaist at the Beverly Wilshire with the Gus Arnheim Orchestra, she was discovered by Lorenz Hart and Richard Rogers who arranged for her to get a film contract. Ross sang and danced in almost a dozen Paramount film musicals, including *What Price Jazz*, *100% Pure*, *Wakiki Wedding*, *Blossoms of Broadway*, and the 1937 and 1938 editions of the *Big Broadcast* revues. In the latter, she entered motion picture history as the woman to whom Bob Hope first sang "Thanks for the Memories." Between films, Ross appeared in the Los Angeles production of *Anything Goes* (1935) and on Broadway in *Allah Be Praised* (1944) and *Higher and Higher*

(1940). Although neither show lasted long, she equalled her film success by introducing the author's favorite Rogers and Hart ballad, "It Never Entered My Mind."

Ross retired in 1944 but emerged occasionally to tour with Hope.

Rosson, Keith, English ballet dancer; born January 24, 1937 in Birmingham, England. After local training under Mary Deverson, he moved to London to attend the Royal Ballet School. He made his debut with the Covent Garden Opera Ballet, but joined the Royal Ballet within the year. As a member of that company in its early years, he appeared in Leonid Massine's revival of his *The Good-Humoured Ladies*, in Fokine's *Petrouchka* (as "The Blackamoor"), and in Frederick Ashton's *La Valse*, *Daphnis et Chloe*, *Persephone*, and *Les Rendezvous*. Rosson left England during the 1970s to perform and teach with the Johannesburg PACT, but returned to work with the Northern Dance Theatre.

Rota, Giuseppe, Italian ballet and spectacle choreographer of the nineteenth century; born in 1822 in Venice; died 1865 in Turin. Rota's claim of being entirely self-taught cannot be disproved.

Through his short career, Rota, who may never have danced professionally, staged ballets and spectacles in theaters in central and northern Italy. Among the companies for which he choreographed his "azioni mimo-danzati" were Milan's Teatro Cannobiana and Teatro alla Scala, Teatro la Fenice in Venice (c.1857), Teatro Communale in Bologna in that same year, Teatro di Apollo in Rome (1859–1862), and Turin's Teatro Reggio (1860). Most of the works, however, were staged originally or restaged at La Scala, among them, his *I Bianchi ed I Neri* (1853), based on *Uncle Tom's Cabin*, *Diana* (1854), *Il Conte di Montecristo* (1856); *La Contessa di Egmont* (1861); and *La Maschera, or le Notte di Venezia* (1865). These literary ballets, ancestors of Manzotti's spectacles which affected performance in Italy, Europe, England and the United States, were extremely popular in their day. Although based on conventional ballet technique, the "azioni," which have been accurately compared to Classic Comics, were

more like the American tab show melodramas than opera ballets—condensing plot action while magnifying the mise-en-scène.

Works Choreographed: CONCERT WORKS: *Anna di Masovia* (1852); *La Forza dell'amicizia, o I Due Sergenti* (1852); *Gli Amori di Armida e Rinaldo* (1853); *I Bianchi ed I Neri* (1853); *Un Fallo, o Il Fornaretto* (1853); *Il Giuocatore* (1853); *Sangranella (di P. Tcinese)* (1853); *Diana* (1854); *Ida Badoer* (1854); *Clelia* (1854); *Delia* (1854); *Il Trionfi dell'inocenza* (1855); *Un Ballo nuovo* (1856); *Il Conte di Montecristo* (1856); *Carlo il Gistatore, ossia 1812* (1857); *Il Sogna dell'esule* (1857); *Cléopâtre* (1859); *Giorgio il Negro* (1859); *Il Pontoniere* (1859); *Zaide* (1860); *Lo Spirito maligno* (1860); *Il Genio del Mare* (1861); *La Contessa di Egmont* (1861); *Elda e Dielma* (1862); *Velleda* (1864); *La Maschera, or le Notte di Venezia* (1865).

Rotardier, Kelvin, West Indian modern dancer and choreographer, working in the United States from 1961; born January 23, 1936 in Port-of-Spain, Trinidad. He performed with The Little Carib Theatre of Trinidad, winning fellowships to study with Sigurd Leeder in London (1960) and with James Truitte and Alvin Ailey in New York, from 1961. He performed with the companies and recital groups of many choreographers, among them Geoffrey Holder, Donald McKayle, and Pearl Primus, before joining the Alvin Ailey Dance Theatre in 1964.

Remaining with the company until 1976, he has created roles in many Ailey works, among them his *Knoxville: Summer of 1915* (1968), *Masekela Langage* (1968), *Streams* (1970), *Archipelago* (1971), *Choral Dances* (1971), *Mary Lou's Mass* (1971), *Feast of Ashes* (1974), and *Night Creatures* (1975). His featured roles include Ailey's *Hidden Rites, Blues Suite,* and *Revelations,* Talley Beatty's *Congo Tango Palace,* John Butler's *Portrait of Billie,* Pearl Primus' *The Wedding,* and the revival of Lester Horton's *The Beloved.*

Works Choreographed: CONCERT WORKS: *Changeling* (1970); *Child of the Earth* (1971).

Rothlein, Arlene, American modern dancer and actress; born 1939 in Brooklyn, New York; died November 20, 1976 in New York. Raised in New York and educated at Erasmus and Brooklyn College, Rothlein studied dance at the New Dance Group and the Merce Cunningham studios. Associated throughout her short life with the dance and theater productions of James Waring, she was a member of his company during the 1960s, creating roles in his *Poet's Vaudeville* (1963), *Double Concerto* (1964), *At the Café Fleurette* (1968), *Spill* (1967), and *An Eccentric Beauty Revisited* (1970), and in John Herbert McDowell's *Dance in Two Rows* (1970).

Her wit and beauty were also a major feature in the Judson Poet's Theatre presentations of the *Poor Little Match Girl* (1968), for which she won an Obie (the Off and Off Off Broadway award for excellence), *Peace* (1969), and the original and all four revivals of Gertrude Stein's *What Happened.* Her own theater pieces included *Aunt Mary* (1970) and *Lines of Vision* (1975).

Rotov, Alexis, Russian dance satirist and theatrical performer working in the United States; born c.1906 in Russia or Georgia. Raised in New York from early childhood, he began his dance studies in a settlement house on the Lower East Side; from his descriptions, it seems likely that his training came from Irene Lewisohn or Blanche Talmud at the Neighborhood Playhouse. In 1916, he talked his way into a meeting with Anna Pavlova backstage in New York. On her recommendation, he started to study with Luigi Albertieri, then teaching pure Cecchetti technique there. His later ballet training came in classes with Ivan Clustine and Mikhail Fokine locally and with Olga Preobrajenska in Paris. Rotov began his professional dance career as a member of the Mikhail Mordkin Ballet (1926–1927), but because of his diminutive height, soon switched to Prologs and presentation house solo acts. His first dance acts were presented at the Mark Strand Theater, New York, which was in 1928 controlled by Russian ballet dancers such as Anatole Bourman and Sonia Serova. For the next twenty years, he performed his solo satires in presentation houses in New York (including a record nine appearances at the Roxy), in Prolog theaters across the country, in cine-variety clubs in Paris, such as the Gaumont-Palace, and on European tours of music halls. In the 1940s, he began to appear more often in the contexts of theatrical works, among them George

Balanchine's *Dream with Music* (1944), but still presented his dances in nightclubs, presentation houses such as the Radio City Music Hall, and television variety shows. He also became known for his performances in operetta revivals in New York, St. Louis (where the Municipal Opera is the center of continuing operetta popularity in the United States), and across the country.

Rotov's act itself consisted of three or four solo characterizations in dance of the excesses of dance or theatrical personalities. Among the most popular over the years were "The Torreador," "Portrait of a Continental Officer Waltzing," and "East Indian Snake Charmer" in which he whistled up a chain of weiners.

Roudenko, Lubov, Bulgarian ballet dancer working in the United States; born in the mid-1910s in Sofia, Bulgaria. Trained in Paris by Lubov Egorova, she moved to the United States with the Ballet Russe de Monte Carlo in 1936. In that company, she was associated with the works of Leonid Massine, creating roles in his *The New Yorkers* (1940), *Vienna—1814* (1940) and *Gaité Parisienne* (1938) and dancing in his *Seventh Symphony* and *Le Beau Danube*. She was featured in the original cast of Agnes De Mille's *Rodeo* (1942) and replaced the choreographer in the main role of "the Cowgirl." Roudenko also performed in the company's production of the *Polovtsian Dances*, *Giselle*, and George Balanchine's *Jeu de Carte*.

She left the Ballet Russe to dance on Broadway in *Nellie Bly* (1945) and Helen Tamiris' *Annie Get Your Gun* (1946).

Rousanne, Mme., Russian ballet teacher in Paris; born Rousanne Sarkissian, 1894 in Baku (Azerbaian); died March 19, 1958 in Paris. Rousanne was a law student in Moscow when she became interested in studying ballet. Much has been made of the fact that she was too old to begin performing professionally; no one has ever explained why she was unable to fulfill her ambitions in law.

After leaving Russia in the mid-1920s, she continued her studies with Vera Trefilova, Ivan Clustine, and Alexandre Volinine—at the time, the best possible training that anyone, professional or hopeful,

could obtain. She herself taught in Paris from 1928 to her death. Almost every European dancer who wished to perfect his or her technique or wanted to work out a specific problem attended her strict classes.

Roux, Aline, French ballet dancer and choreographer; born August 22, 1935 in Brest. Roux was trained at the Ecole Normale Supérieure d'Education Physiques and with Karin Waehner. A Fullbright Fellowship to the United States brought her to the University of Kansas. On her return, she performed for Waehner and formed her own troupe, Rythme et Structure, in 1969. Roux also teaches in Paris, and is known as one of the few people in Western Europe to teach the composition class associated with the traditional American modern dance.

Works Choreographed: CONCERT WORKS: *Volutes* (1968); *Psalmos* (c.1970); *Hymnen* (c.1970, co-choreographed with Michel Descombey, Alain Deshayes, Jacques Guarnier, and Norbert Schmucki).

Rowe, Marilyn, Australian ballet dancer; born August 20, 1946 in Sydney, Australia. After early training with Frances Lett, she attended the Australian Ballet School, graduating into the company in 1965. Rowe has performed with the Australian Ballet throughout her career. Celebrated for her performances in the company's productions of the classics, she has been seen in *Giselle, Don Quixote, Raymonda, La Fille Mal Gardée, Cinderella,* André Prokovsky's *Anna Karenina,* Garth Welch's *The Firebird,* and George Balanchine's *Ballet Imperial.*

Rowell, Kenneth, Australian theatrical designer also working in England; born c.1922 in Melbourne. Although raised in his native land, Rowell began his designing for dance career in London. He worked frequently for Walter Gore, Michael Charnley and Kenneth Macmillan, then considered the rising second generation of English choreographers. Among his many London productions were Gore's *Carte Blanche* (1953) and *Light Fantastic* (1953), Macmillan's *Baiser de la Fée* (1960), and Charnley's celebrated *Alice in Wonderland* (1953). After returning to Australia in the mid-1960s he designed the Australian Ballet's full-length *Coppélia* (1960), *Giselle*

(1965), and *The Sleeping Beauty* (1973). Rowell's work was ideal for the fairly conservative British and Australian tastes in ballet design but he was considered an expert at creating sets that gave a feeling of depth without using conventional perspective. His *Alice in Wonderland*, with references to Tenniel, was considered especially expert.

Royce, Edward, English choreographer and director in England and New York; born December 14, 1870 in Bath, England; died June 15, 1964 in London. Originally a scene painter for English theaters, Royce followed his father into pantomime and musical comedy acting in the late 1890s. From 1903 to 1935, he was the foremost director/choreographer of musical comedies on either side of the Atlantic.

Royce's career was unique on Broadway, if not in the West End, for his ability to skip back and forth between the different styles of contemporary shows. He staged conventional musicals for George Edwardes in London, among them his first *The Earl and the Girl* (1903), and *The Beauty of Bath* (1906), and innovative revues, notably *The Century Girl* (1916), which employed a double-revolve massive staircase and platform systems, and almost every dancer in New York. His American musicals ranged from the intimate Princess Theater shows such as *Oh, Boy!*, *Leave It to Jane*, and *Going Up* (all in 1917), to the enormous Ziegfeld musical extravaganzas, *Sally* (1920) and *Kid Boots* (1923). He was celebrated for his two Ziegfeld *Follies*, although those editions (1920 and 1921), coming directly after Prohibition, were actually less spectacular than usual, and for his operettas, staged at The Mayan Theater in Los Angeles in 1932. Royce's only unsuccessful venture, in fact, was his short film career; although under contract to the Fox Film Corp. for four years, he produced only two features, *Married in Hollywood* and *The Dollar Princess*, and one edition of the Movietone Follies (all 1929).

Works Choreographed: THEATER WORKS: (Note: Royce directed, as well as choreographed, every show after *Havana*, unless otherwise noted.) *The Earl and the Girl* (London, 1903); *The Catch of the Season* (London, 1904); *The Talk of the Town* (London, 1905); *The Beauty of Bath* (London, 1906); *My Darling* (London, 1907); *Havana* (London, 1908); *Our Miss Gibbs* (London, 1909); *The Dollar Princess* (London, 1909); *The Girl in the Train* (London, 1910); *A Waltz Dream* (London, 1911); *Peggy* (London, 1911); *The Count of Luxembourg* (London, 1911); *Gypsy Love* (London, 1912); *The Doll Girl* (New York, 1913, choreographed only); *The Marriage Market* (1913); *The Laughing Husband* (1914); *Bric-a-Brac* (London, 1915); *Betty* (1916); *The Century Girl* (1916, additional scenes and musical numbers staged by Leon Errol and Ned Wayburn); *Have a Heart* (1917); *Oh, Boy!* (1917); *Leave It to Jane* (1917); *Kitty Darlin'* (1917); *Going Up* (1917, co-staged with Robert Milton); *Oh, Lady! Lady!* (1918); *Rockabye Baby* (1918); *The Canary* (1918); *Oh, My Dear!* (1918, co-staged with Robert Milton); *Come Along* (1919); *She's a Good Fellow* (1919); *Apple Blossoms* (1919); *Irene* (1919); *Lassie* (1920); *Ziegfeld Follies of 1920*; *Kissing Time* (1920); *Sally* (1920); *Ziegfeld Follies of 1921*; *The Love Letter* (1921); *Good Morning Dearie* (1921); *Orange Blossoms* (1922); *The Bunch and Judy* (1922); *Cinders* (1923); *Kid Boots* (1923); *Annie Dear* (1924); *Louie the 14th* (1925); *The Merry Malones* (1927); *She's My Baby* (1928); *Billie* (1928); *Rose of Flanders* (1934, revival); *Princess Ida* (1934, revival); *Fritzi* (London, 1935).

FILM: *Married in Hollywood* (Fox Film Corp., 1929); *The Dollar Princess* (Fox Film Corp., 1929); *Fox Movietone Follies* (Fox Film Corp., 1929, short subject).

Rubin, Pedro, Mexican theatrical and exhibition ballroom dancer and precision team choreographer; born c.1900 in Mexico; died April 17, 1938 in Mexico City. Rubin emerged in the mid-1920s as an exhibition ballroom dancer in Mexico City, Rio de Janeiro, Havana, Buenos Aires, and London, where he was a staff performer and demonstrator at the Kit Kat Club in 1925. He brought his repertory of social, exhibition ballroom, and theatrical dances to North American vaudeville in 1926 as a headliner on the Keith and Orpheum circuits in the mainland United States. His repertory included genuine Spanish classic and folk dances, most notably the Jota Aragonesca, Latin American ballroom work such as the Rhumba Cubana and the Spanish, Argentinian, and Brazilian tangos, and theatricalized forms, including his signature number, the Spanish Charleston, done with cas-

tanets. While not on the vaudeville stage, Rubin worked the New York to Havana circuit as a club dancer and demonstrator. He also coached performers in New York theater, as a member of the loosely organized "staff" of specialty performers who worked occasionally for Florenz Ziegfeld. His only known Broadway appearance was as a specialty dancer in *Rio Rita* (1927), staged by Albertina Rasch.

In 1929, Rubin ceased performing (probably because of an injury or the illness that eventually killed him at thirty-eight) and worked as a ballet master and precision team dance director. It is likely that he apprenticed with Rasch while working with her on *Rio Rita* and was hired on her recommendation as ballet master of the Roxy and Palace Theater teams. His own group, The Pedro Rubin Girls, toured on the Paramount/Publix circuit for many seasons and appeared in a feature act or Prolog unfortunately titled *Spic and Spanish* (1930).

Rubinstein, Ida, Russian dancer and mime working in Paris; born c.1885 in St. Petersberg; died September 20, 1960 in Venice. Rubinstein studied recitation and mime with Veronine Vestoff and dance with Mikhail Fokine, who staged a *Salome* solo for her in 1907. She first came to public attention in the early seasons of the Diaghilev Ballet Russe as the principal mime/heroine of Fokine's *Cléopâtre* and *Schéhérézade*. The extraordinarily beautiful Rubinstein was especially noted for the entrance in the former, when she was carried in and stripped slowly of her veils. From 1911 to 1936 she commissioned and appeared in a series of mime-dramas with scores, libretti, and designs by Paris' neoimpressionists, among them, Gabriel d'Annunzio, Claude Debussy, Florenz Schmidt, André Gide, and Leon Bakst. Among the most memorable works from her first period of productions were the controversial *Le Matyre de Saint Sébastien* (1911, choreographed by Fokine), which was placed on the Catholic Church's register of banned productions at least partially because Rubinstein was Jewish, and the d'Annunzio/Fokine *La Pisanelle* (1913), in which she was smothered to death under a pile of roses. Her second prolific era was from 1928 to 1935, when she sponsored a ballet company for Bronislava Nijinska. Her Ida Rubinstein Ballet also included ballets by Leonid Massine.

She is a controversial figure in dance history since, for some reason, she has always been thought of as a bad dancer. There are no such statements in the contemporary press. On the contrary, the French journalists seemed to be uniformly in love with her, if not with her taste in art forms, and consistently gave her glowing personal reviews.

Rudner, Sara, American postmodern dancer and choreographer; born 1944 in Brooklyn, New York. Rudner studied ballet with Mia Slavenska, Margaret Black, and Richard Thomas; her modern dance training included classes with Paul Sanasardo, and Merce Cunningham and Carolyn Brown at the Cunningham Studio.

Rudner's first company position was with Paul Sanasardo from 1964 to 1966; she created roles in his *Excursions*, *The Animal's Eye*, and *Fatal Birds*, all in 1966. She later performed briefly with Pilobolus and with Lar Lubovitch (both in 1975–1976).

From 1966 to 1974, and in subsequent guest appearances, Rudner performed with the Twyla Tharp Dance Company (now Foundation). She created roles in almost all of Tharp's works choreographed between 1966 and 1973, among them, her *Re-moves*, *One Two Three* (both 1966), *Generation* (1968), *Eight Jelly Rolls* (1971), *The Bix Pieces* (1971), *Deuce Coupe I* (1973), *As Time Goes By* (1973), and in the film *Hair* (UA, 1979).

Rudner has been choreographing since 1971. Her works, for her own companies and for the Lar Lubovitch group, are more consistent in their postmodern structures than Tharp's and have attracted wide attention and an almost fanatic following. Among the most innovative of the current generation of postmodernists, she uses repetition, manipulation of phrases, stage spacing and paths, and timing.

Works Choreographed: CONCERT WORKS: *One Thing Leads to Another* (1971, co-choreographed with Douglas Dunn); *Boa* (1975); *Yes* (1975); *Dancing May's Dances* (1976); *One Good Turn* (1976); *Session* (1976); *Some "Yes" and More* (1976); *Wendy's Solution* (1976); *As Is* (1977, as group work, performed as solo after 1980); *Layers* (1977, performed with above *As Is/Layers*); *November Duets/Molly's Suite* (1977; in collaboration with Wendy Rogers);

Thirty-Three Dances (1977); *Modern Dances* (1979); *Palm Trees and Flamingoes* (1980).

Ruiz, Brunhilda, American ballet dancer; born 1936 in Puerto Rico. Ruiz, who attended the High School of Performing Arts, became a charter member of the Robert Joffrey Ballet in 1955.

From that year to her retirement in 1972, Ruiz was primarily involved with Joffrey's various projects— the Robert Joffrey Ballet (1955–1964), the New York City Opera Ballet (1957–1961), and the City Center Joffrey Ballet (1968–1972). In those companies, she created roles in Joffrey's *Le Bal Masque* (1954), *Harpsichord Concerto in D Minor* (1955), *Pierrot Lunaire* (1955), and *Gamelan* (1962), Arpino's *Ropes* (1961) and *Incubus* (1962), Brian MacDonald's *Time Out of Mind* (1962), and Alvin Ailey's *Feast of Ashes* (1962).

Between tenures with Joffrey companies, she was a member of the Harkness Ballet from 1964 to 1968. In that short-lived company, she performed featured roles in many ballets, among them, John Butler's *A Season in Hell* and *Sebastian,* and in Joffrey's *Pas de Déesses.*

Ruiz came out of retirement briefly in 1977 to perform in *El Banquiné de Angeliton Negros,* a Realidades production on WNET and Latino Television.

Russell, Francia, American ballet dancer; born January 10, 1938 in Los Angeles, California. Trained locally and at the School of American Ballet, Russell spent much of her performing career with the New York City Ballet.

Known now for her restaging and coaching of works by George Balanchine, she performed many featured roles in his ballets while with the company. Celebrated for her portrayal of "The Princess of the West Indies" in his *Figure in the Carpet* (1960), she also danced in his *Apollo, Divertimento No. 15, Agon,* and *Stars and Stripes.*

In 1973, Russell and her husband Kent Stowell were named co-directors of the Frankfurt Opera Ballet. In Germany, she taught and staged revivals of Balanchine's ballets; one of her students there, Sean Lavery, became a principal in the New York City Ballet after he left Frankfurt. Since 1978, they have been directors of the Pacific Northwest Ballet in Seattle, Washington.

Russell, Paul, American ballet dancer; born March 2, 1947 in Amarillo, Texas. Raised in Hartford, Connecticut, he studied with Joseph Albano of the Hartford Ballet, and at the School of American Ballet and the Dance Theatre of Harlem School.

Graduating to the latter company, he danced featured roles in productions of *Le Corsaire,* John Taras' *Designs for Strings,* Louis Johnson's *Forces of Rhythms,* and was assigned principal roles in the George Balanchine repertory, performing in *Concerto Barocco* and *Agon.* Joining the Scottish Ballet in 1978, he danced in the company's production of *Swan Lake* and in Stuart Sebastien's *The Aftermath,* Peter Farrell's *Othello,* and William Dollar's *The Combat.*

Russell's elegance and bravura technique won him a place in the San Francisco Ballet in the Fall of 1980, where he has performed in Michael Smuin's *Mozart's C Minor Mass.*

Ruud, Tomm, American ballet dancer and choreographer; born May 25, 1943 in Pasadena, California, or in Afton, Wyoming, where he was raised. Ruud attended the University of Utah, where he studied ballet with Willam Christensen and performed in his company. He has since received training in modern dance and improvisation from Shirlie Ririe and Joan Woodberry.

Ruud has been associated with the companies of Willam and Lew Christensen throughout his career. As a charter member of Willam's Ballet West (1963–1975), he performed featured roles in the company productions of *Giselle, Paquita,* and *The Firebird,* and in Christensen's *Nothing Doing Bar.* A dancer-choreographer with the San Francisco Ballet since 1975, he has danced to great acclaim in Lew Christensen's *Ice Maiden.* His other roles in the company include major parts in co-director Michael Smuin's *The Eternal Idol, Mozart's C Minor Mass,* and *Romeo and Juliet.*

Although he staged one work for the American Ballet Theatre, *Polyandrion,* in 1973, Ruud has created most of his ballets for the companies with which

he danced. Among his best known works are *Mobile* (1969) and an enlarged and complex revision of it, *Trilogy* (1978).

Works Choreographed: CONCERT WORKS: *Mobile* (1969); *Polyandrion* (1973); *Statement* (1977); *Trilogy* (1978); *Richmond Diary* (1979); *Introduction and Allegro* (1980).

Ruvolo, Danny, American theatrical dancer; born c.1957 in East Rockland, Long Island; died November 17, 1978 in an auto crash. Ruvolo was one of the last child tap prodigies in show business, and showed all of the promise that his early start foresaw. He worked on television from the age of five, making his adult debut in the Zero Mostel revival of *Ulysses in Nighttown* in 1974. He appeared in a duet of musicals that had long pre-Broadway tours and short runs, *Rex* (1976) and *Lorelei*, and traveled in the national company of *Pippin*, before returning to Broadway as "Ray" in *A Chorus Line*. He had been in the show for eighteen months (also serving as assistant stage manager) and was about to begin filming in a featured role in Bob Fosse's *All That Jazz* when he was killed.

Ryan, Charlene, American theatrical dancer, known as "the last Broadway show girl"; born c.1948 in Amityville, New York. Ryan studied ballet with Maria Yurievna Swoboda and jazz forms with Luigi. At her height of five-foot-nine, Ryan is unquestionably qualified as a show girl; she won her sobriquet for her ability to create individual characterizations within the structures of that category, making her roles more important than her legs. She has appeared in some flops, including her debut show, *Never Live over a Pretzel Factory* (1964), but has also been seen and acclaimed in a wide range of roles in many successful shows. She slinked as a hostess in the Fan-Dango Ballroom in Bob Fosse' *Sweet Charity* (1966, and film version), did the tango as a model in Michael Bennett's *Coco* (1969), high-kicked as the prisoner "Go-to-Hell Kitty" in Fosse' *Chicago* (1975), and just stood there as the whip-cracking "Gymnasia" in the 1972 revival of *A Funny Thing Happened on the Way to the Forum*. Ryan has also danced for Bennett as "Sheila," the show girl trying to be a hoofer in national and Broadway companies of *A Chorus Line*.

Ryan, Peggy, American film dancer and actress; born Margaret O'Rene, August 28, 1924 in Long Beach, California. Ryan made her theatrical debut in her parents' vaudeville and Prolog act, The Dancing Ryans, at the age of three. For the next nine years, she worked with them in Fanchon and Marco Ideas and Pantages units while appearing in Education Pictures' *Baby Burlesks*. After some short subjects for MGM, where she was the third child song and dance star after Deanna Durbin and Judy Garland, she switched to Universal where she made almost two score of musicals in eight years. She appeared in one film classic, the 1940 *The Grapes of Wrath*, while on loan to Twentieth-Century Fox, but is remembered for her performances in a string of fourteen Universal musicals, most staged by Louis Da Pron. While Garland and Mickey Rooney were extolling small-town values at MGM, Ryan and Donald O'Connor were playing show business brats for Universal, and demonstrating their marvelous tapping ability in each film. The Ryan/O'Connor/Da Pron triumvirate sparkled through *Mister Big* (1943), *When Johnny Comes Marching Home* (1944), *Follow the Boys* (1944), *The Merry Monahans* (1944), and *Patrick the Great* (1945), among a score of others.

While not making films, Ryan joined her then husband, Ray McDonald, in the vaudeville and exhibition ballroom act that he had done with his sister, Grace. She also worked extensively on television in the late 1940s and 1950s and was, by chance, a guest on the June 1948 premieres of the two most popular shows of early television—*The Toast of the Town* (the Ed Sullivan show) and Milton Berle's *Texaco Star Theater*. After settling in Honolulu in the 1950s, she became entertainment director of the Royal Hawaiian Hotel and appeared on many television shows filmed locally. She was last seen on the screen as "Jenny" (McGarrett's Secretary) on the long-running *Hawaii Five-O*.

Ryder, Mark, American modern dancer and choreographer; born in the 1920s in Chicago, Illinois.

Raised in New York City, he was trained at the Neighborhood Playhouse when it was a Martha Graham–based school. After military service, he joined the Graham company in which he danced in *Dark Meadow* (1946), *Errand into the Maze* (1947), *Night Journey* (1947), and *Diversion of Angels* (1948). Ryder joined with Emily Frankel to form a duet touring company in 1950 and performed with her until 1960. Their repertory included Todd Bolender's *At the Still Point* (1955), and his own duets and solos, *And Jacob Loved Rachel* (1953), *Rejoice, O Maiden* (1953), *Poet's Journey* (1960), and many others. Since the disbandment of the company, Ryder has taught at Goddard College in Vermont, where his students have included choreographer Marcus Schulkind.

Works Choreographed: CONCERT WORKS: *Chaos and Counterpoint* (1952); *The Misfits* (1952); *And Jacob Loved Rachel* (1953); *Biography of Fear* (c.1953); *The Ballad of the False Lady* (c.1953); *Die, You Bastard Die* (1953); *Haunted Moments* (1953); *Rejoice, O Maiden* (1953); *Brandenburg Concerto no. 3* (1958); *A Knight Errant* (c.1960); *Fête Champêtre* (1960); *Three Dances from a Musical Comedy* (1960); *Poet's Journey* (1960).

THEATER WORKS: *Chucky Jack* (1957).

S

Sabo, Roszika, American ballet dancer; born December 5, 1917 in Chicago, Illinois. After local studies with John Petri, she moved to New York to continue her training with Vincenzo Celli, Edward Caton, and Antony Tudor. After seasons with the San Carlo Opera here and the Radio City Music Hall, she joined Ballet Theatre as a charter member. Among her many credits in her six years there were "Nemesis" in Tudor's *Undertow* (1945) and roles in Jerome Robbins' *Interplay*, Anton Dolin's *Pas de Quatre*, and the company productions of *Les Sylphides* and *Swan Lake*. She appeared in the classics while in the Original Ballet Russe (1946–1947) and the Alicia Markova/Anton Dolin tours of 1946 to 1948. Sabo appeared in supporting roles in Dolin's stagings of pas de deux and played "Jane Seymour" in Rosella Hightower's *Henry VIII* (1946).

Sacchetto, Rita, Austrian concert dancer and mime; born 1879 in Monaco di Baviera; died 1959 in Nervi, outside Genoa, Italy. The daughter of a Venetian and a Viennese musician, Sacchetto was trained as a dancer in Munich, making her debut as a concert dancer in 1906. From 1907 to 1909, she performed across Europe, in Vienna, Budapest, Berlin (then the center of German concert performance), Dresden, Amsterdam, Hanover, and Madrid. Her repertory, all self-choreographed, consisted of abstract works, such as the *Sarabande*, the Brahms *Liebeslieder Walzer* (nos. 4, 6, and 10), a program of Chopin waltzes, and characterizational mime pieces, among them *Krinoline* and *l'Amourette d'un Pierrot*.

During the 1909 and 1910 seasons, Sacchetto performed with the Metropolitan Opera in New York, in her own solos interpolated into operas, including *Cavalleria Rusticana, Don Pasquale*, and the American premier of *Il Maestro di Capella*. She also danced with the ballet company attached to the Met in concert and in David Costa's pantomime, *l'Histoire d'un Pierrot*.

Returning to Europe, she taught briefly in Munich before moving to Italy where she became involved with silent film production. Sacchetto acted and directed film in Italy (and, according to some sources, in Denmark) throughout the silent era and into the 1930s.

Works Choreographed: CONCERT WORKS: (Note: these titles are derived from the listing of repertory in a 1911 program, and are all dated c. 1910.) *Toreodor ed Andalouse; Kastagnetten; Caprice Espagnole; Tanz Nr.III: Śarabande; Menuett aus den d-moll Quartet* (Minuet from the D Major Quartet); *Menuett aus den Divertissment; Aus den Gifilden der Serligen* (From the Realm of the Blessed, from *Orpheus and Eurydice*, by C.W. Gluck); *Tarantella; Liebeslieder Walzer; Fruhlingsstimen* (Dawn); *Valse Brillante; Valse* (by Josef Lanner); *Sirenenzauber* (The Magical Siren); *l'Amourette d'un Pierrot; Loin du Bal; Rhapsode* (Liszt); *Das Intellektuelle Erwachen der Frau* (The Intellectual Awakening of Woman); *Simonetta.*

Saddler, Donald, American ballet dancer and theatrical choreographer; born January 24, 1920 in Van Nuys, California. Saddler was trained in Los Angeles by Carmelita Marrachi before moving to New York to work with Anton Dolin and Antony Tudor. In Ballet Theatre from 1940 to 1943 and 1946 to 1947, he danced in Tudor's *Romeo and Juliet, Jardin aux Lilas*, and *Gala Performance*, as "Benno" in the company's *Swan Lake* and as "Alias" in Eugene Loring's *Billy the Kid*. He left Ballet Theatre in 1947 to succeed Paul Godkin in Jerome Robbins' *High Button Shoes*, and followed his performance in that show with featured dance numbers in *Dance Me a Song* (1950), which also featured Bob Fosse and Joan McCracken, and Tamiris' *Bless You All* (1950), a Jules Munshin/Pearl Bailey political revue.

Saddler's first Broadway choreography credit was earned on *Wonderful Town* (1953), followed quickly by *John Murray Anderson's Almanac* (1953). He then worked in Italy, staging dances for *Tobia La Candida Spia* (1954), *La Patrona di Reggio di Luca* (1955), *Bueno Notte Bettina* (1956), and *l'Adorabile Guilio* (1957), returning to New York to choreograph the fabulous flop *Shangri-la* in 1956. After staging *When in Rome* in London (1959), he moved back to Broadway to do *Milk and Honey* (1961), *Sophie*

(1963), *Morning Sun* (1963), *No No Nanette* (1971), which featured Ruby Keeler's tap numbers and a dance routine on beach balls, and *Tricks* (1973). Saddler is also well known as a choreographer and production supervisor for industrials and for gala performances and benefits.

He has choreographed three films—*By the Light of the Silvery Moon* (WB, 1953), *Young at Heart* (WB, 1954), and *The Main Attraction* (Seven Arts, 1963)—and two American variety television shows—*Holiday Hotel* (ABC, 1950), and the *Bell Telephone Hour* (NBC, 1961–1964), as well as shows for Italian television.

Saddler has returned to the concert ballet occasionally to stage works for the Robert Joffrey Ballet and the Harkness Ballet.

Works Choreographed: CONCERT WORKS: *Blue Mountain Ballads* (1948); *This Property Is Condemned* (1959); *Dreams of Glory* (1961).

THEATER WORKS: *Wonderful Town* (1953); *John Murray Anderson's Almanac* (1953); *Tobia La Candida Spia* (Rome, 1954); *La Patrona di Reggio di Luca* (Rome, 1955); *Bueno Notte Bettina* (Milan, 1956); *Shangrila* (1956); *l'Adorabile Guilio* (Rome, 1957); *When in Rome* (London, 1959); *Milk and Honey* (1961); *Sophie* (1963); *Morning Sun* (1963); *No No Nanette* (1971); *Tricks* (1973).

FILM: *By the Light of the Silvery Moon* (WB, 1953); *Young at Heart* (WB, 1954); *The Main Attraction* (Seven Arts, 1963).

TELEVISION: *Holiday Hotel* (ABC, 1950); *Bell Telephone Hour* (NBC, 1961–1964).

St. Clair, Sallie, American nineteenth-century ballet dancer; born 1842, possibly in Philadelphia, Pennsylvania; died January 23, 1867 in Buffalo, New York.

St. Clair spent most of her tragically short career with the stock company attached to the Bates Theater, St. Louis, Missouri. As a dancer with that company, she performed pas seuls, pas de Mélanges, and productions of *Giselle* (after 1855), *La Vivandière*, and *La Bayadère*. St. Clair died of consumption in 1867 after a long illness.

St. Clair, Yvonne, American theatrical dancer; born 1914 in Seattle, Washington; died there September 22, 1971. It is possible that St. Clair was actually born in Vancouver, British Columbia, across the Canadian border. St. Clair performed in vaudeville as a child and adolescent in a dance act with her sister Irma on the Pantages circuit. After touring theaters in Washington and British Columbia, they were hired to perform in Prologs produced by Fanchon and Marco in San Francisco.

St. Clair remained on the Fanchon and Marco circuit as a solo specialty dancer, performing throughout California and the West Coast. After she turned eighteen, she also danced in Hollywood clubs, among them Ciro's and Earl Carroll's nightclub. She appeared in more than a dozen musicals at MGM, most released between 1935 and 1938, among them Bronislava Nijinska's *A Midsummer Night's Dream* (WB, 1934), *The Great Ziegfeld* (MGM, 1936), the Marx Brothers' *A Night at the Opera* (MGM, 1935), and *Anna Karenina* (MGM, 1935), parts of which were choreographed by Margarete Wallmann and Chester Hale.

After retiring from performance in the late 1930s, St. Clair became an aeronautical engineer.

St. Denis, Ruth, American concert, interpretive, and exotic dancer; born Ruth Dennis, January 20, 1880, 1877 or 1878 in New Jersey; died July 21, 1968 in Hollywood, California. St. Denis studied Delsarte elocution techniques with her mother, considered a devotée of Genevieve Stebbins' form of Delsartism; she later studied ballet briefly with Marie Bonfanti, but denied any influence from the Italian ballerina. As an adolescent, she worked for David Belasco, whose productions influenced her tremendously. Every element in her later work—the opulence, the reliance on exotic locales and scenarios, and the scale of movement and emotional communication—is derived from Belasco's international repertory of melodramas.

The story is frequently reported that while on tour with the Belasco production of *DuBarry* (1904), St. Denis saw a specific poster for Isis cigarettes and was inspired with the desire to dance the spirit of Egypt. It is more likely that, inspired by the craze for Egyptiana that had pervaded architecture and commercial art in the early twentieth century, she used the Belasco techniques of realism in staging to create a dance persona. Her first dance creation, however,

was not about Isis (although works about Isis were done in later years), but *Radha*, first performed in 1906. After a vaudeville tour, she presented *Radha*, *Incense*, and *The Cobras* as a dance concert, to great acclaim. She took it to Europe in July for three years, with successful performances in Berlin, Vienna, and London.

Returning to the United States, she finally produced *Egypta*, which, with a Japanese saga, *O-Mika*, she toured in vaudeville. In 1914, she teamed up with Ted Shawn, a concert and exhibition ballroom dancer, to tour and to create a school, called Denishawn, in Los Angeles. The Denishawn school and concert groups had their greatest successes in the late 1910s and the 1920s. She and Shawn toured with dancers who included Martha Graham, Doris Humphrey, Charles Weidman, and future film stars Louise Brooks and Carol Dempster. They taught at schools in Los Angeles and New York, managed franchised schools in Boston, Rochester, Albany, and other major cities, sold piano rolls printed with exercises, and printed dances in word-notes.

The repertory of the Denishawn tours was by St. Denis and Shawn; her canon included full-length works based on real or created mythologies of female gods, such as *Julnar of the Sea* and *Ishtar of the Seven Gates*, short pieces on Spanish, Japanese, Indian, or Egyptian national types, among them the *Nautch* series, *O-Mika*, and *Kuan Yin*, exhibition ballroom work, and her true innovation—music visualizations. The latter works were interpretive pieces based on classical music, generally piano scores. It is likely that the music visualizations, recognizable in the listing of works since they are named for their scores, were the real "Denishawn influence" lauded as the impetus for Graham and Humphrey—the inspiration for their own abstract choreography.

Denishawn broke up in the early 1930s after the young choreographers left the company to work on their own. St. Denis became increasingly involved with religious dance, presenting a *Masque of Mary* (1934) and founding The Society of Spiritual Arts that year. She taught extensively in New York and elsewhere, and established a school, Natya, with La Meri in 1940.

It is hard to be objective about Denishawn, as an artistic force or as a social phenomenon. The works with which St. Denis has been primarily associated are typical examples of American cultural imperialism, the adoption of individual elements of a culture without a thorough knowledge of that world. Her music visualizations, which were genuine artistic innovations even though they were derived from Delsartism, were almost ignored by the audiences and booking agents.

A major research project on St. Denis has been completed by Suzanne Shelton, for Doubleday books; it was published in summer 1981. Although Shelton takes a different view of St. Denis' conceptions of alien cultures, it should provide an important interpretation of her life and work.

Works Choreographed: CONCERT WORKS: (Note: this listing, which is as complete as possible but may be superseded by that in the Shelton study, is based partially on *The Professional Appearances of Ruth St. Denis and Ted Shawn—A Chronology and an Index of Dances, 1906–1932*, by C.L. Schlundt [New York: 1962]). *Radha* (1906); *Incense* (1906); *The Cobras* (1906); *The Nautch* (1908); *The Yogi* (1908); *A Shirabyoshi* (1908); *Egypta (Tamboura, Veil of Isis, Dance of Day)* (1910); *The Lotus Pond* (1910); *Dance of the Rosebuds* (1913); *Blue Flame* (1913); *The Impromptu* (1913); *O-Mika (O-Mika Arranging Flowers, Poetess of Nippon)* (1913); *Champagne Danse* (1914); *The Scherzo Waltz* (1914); *La Marquise* (1914); *Chitra Hunting* (1914); *Danse Impromptu* (1914); *The Garden of Kama* (1915); *A Lady of the Genroko Period* (1915); *O-Mika Arranges Her Flowers and Starts for a Picnic* (1915); *The Spirit of the Sea* (1915); *Death and After-Life in India, Greece and Egypt* (1916, co-choreographed with Ted Shawn); *Dance with Scarf* (1916); *Dance of the Royal Ballet of Siam* (1918); *An Indian Temple Scene* (1918); *Jeptha's Daughter* (1918); *Greek Scene* (1918); *Dance of Theodora* (1918); *Nautch II* (1918); *Rosamund* (1918); *The Spirit of Democracy* (1918); *The Vision of Yashodhara* (1918); *Syrian Sword Dance* (1918); *At Evening* (1919); *Coolan Dhu* (1919); *Dancer from the Court of King Ahasuerus* (1919); *Kuan Yin* (1919); *Egyptian Suite* (includes sections of *Death and After-Death*) (1919); *Street Nautch Dance* (1919); *The Street of Dancers* (1919); *Three Ladies of the East* (1919); *Little Banzo* (1919); *J'ai Pleuré en Reve* (1919); *Music Visualizations*

(1919, including, at various times, *Danse, First and Second Arabesque, Floods of Spring, Gavotte, Hungarian Dance No. 6, Impromptu [II], Intermezzo No. 1* and *No. 3, Opus 119, Intermezzo No. 3, Polonaise, Prelude No. 4, Prelude, Valse Oubliée, Rigaudon, Romance, Schottische, Sonata Pathétique, Two Waltzes, Valse Brilliante, Vizione veneziana, Waltz No. 15*); *Soaring* (1919, co-choreographed with Doris Humphrey); *Sappho* (1921); *Poetess of the Thirteenth Century* (1921); *The Beloved and the Sufi* (1921); *Hymn to the Sun* (1921); *Impressions of a Japanese Tragedy* (1921); *Ancient Greece Suite* (1921); *Persian Suite* (1921); *Siamese Suite* (1921); *East Indian Suite* (1922); *Japanese Suite* (1922); *Liebestraum* (1922); *The Three Apsarases* (1922); *Street Nautch* (1922); *Music Visualizations* (*Liebestraum, Waltz Opus 33, No. 15, Greek Veil Plastique*) (1922); *Impressions of a Japanese Story-Teller* (1923); *Ishtar of the Seven Gates* (1923); *The Spirit of the Sea* (1923, group version); *Cupid and Psyche* (1923); *Dance, O Dance, Maidens Gay* (1923); *Sonata Tragica* (1923, co-choreographed with Doris Humphrey); *Vision of the Aissoua* (1924); *Music Visualizations* (*Allegro risoluto, Valse à la Loie, Schubert Waltzes*) (1924); *Queen of Heaven* (1925); *Dance of the Volcano Goddess* (1925); *American Sketches I* (1925, co-choreographed with Ted Shawn); *Love Crucified* (1925); *Music Visualization: Garland Plastique* (1925); *The Singer* (1926); *Suite for Violin and Piano* (1926); *A Burmese Yein Pwe* (1926); *A Yein Pwe* (1926, co-choreographed with Doris Humphrey, may be same work as above); *Dances from the Oriental Tour* (*Festival of Sarawati, In the Bunnia Bazaar, Invocation to the Buddha, Javanese Court Dancer, The Soul of India*) (1926); *Dances from the Oriental Tour* (*A Legend of Pelee, Dance of the Red and Gold Saree*) (1927); *Dances from the Oriental Tour* (*The Batik Vendor, Black and Gold Sari, Three Coolie Girls*) (1928); *The Lamp* (1928); *Dances Inspired by the Oriental Tour* (*Burmese Dance, Japanese Wisteria Dance, A Figure from Angkor Vat, Kwannon, A Tagore Poem*) (1929); *Prophet Bird* (1929); *Scarf Dance* (1929); *Waltz* (1929); *Dojoji* (1929); *A Buddhist Festival* (1930); *Nautch Dance Ensemble* (1930); *Dance Balinese* (1931); *Modern Nautch* (1931); *Solome* (1931); *Unfinished Symphony* (1931, co-choreographed with Klarna Pinska); *The Proph-*etess (1931); *Balinese* (1933); *Masque of Mary* (1934); *Adventures of Marco Polo* (1941); *A Color Study of the Madonna* (1946); *Buddhist Nun* (1949); *Gregorian Chant* (1950); *Three Poems in Rhythm* (1951); *Freedom* (1955); *To a Chinese Flute* (1957).

Bibliography: St. Denis, Ruth. *Lotus Light* (Privately published, 1932); *An Unfinished Life* (New York: 1939); Suzanne Shelton, *Divine Dancer* (Garden City, N.Y.: 1981).

Saint-Léon, Artur, French nineteenth-century ballet dancer and choreographer of the Romantic era; born September 17, 1821 (or as many as seven years earlier) in Paris; died there September 2, 1870. Raised in Stuttgart, Saint-Léon was trained by his father, then ballet master of the court theater of the Duchy of Würtenberg-Teck; later, as an adult, he studied with François Décombe Albert in Paris.

Although reputed to have had extraordinary technique and, especially, elevation, Saint-Léon's performing career was characterized by his reliance on what could be called a specialty act: he played the violin while dancing onstage in, for example, his own *Tartini, il Violonista* (1848) and *Le Violon du Diable* (1849). An itinerant like so many of his contemporaries, he worked in Munich (c.1835), Brussels (c.1838), Milan, and Vienna before moving to London to dance for Jules Perrot in 1842. In London, he created roles in Perrot's *Ondine* (1843) and *La Esmeralda* (1844), married Fanny Cerrito, and began to choreograph for her. Although the association with Cerrito lasted only until 1851, his reputation for creating Romantic ballets to fit the individual technical needs of the dancer remained with him.

He taught the *classe de perfection* for the Paris Opéra from 1851 to 1859, staging works for his students and for the Théâtre Lyrique in Paris. He also spent three productive seasons at the Teatro da San Carlos in Lisbon, creating Romantic ballets that included *Saltarello* (1854), later revived across Europe, *Lia, la Bayadère* (1854), and *Bailados Allegoricas* (1855).

Saint-Léon succeeded Jules Perrot as ballet master in St. Petersberg from 1858 to 1869 while also working at the Paris Opéra; he created both conventional French Romantic ballets, such as *Les Nymphs et le Satyr* (1861) and *Théolinde, l'orpheline* (1862), and

works based on Russian folklore, among them *Ko-niob Gorbunok* (The Little Humpback Horse, in 1864), during this time.

As Maître de ballet at the Paris Opéra from 1863 to 1870, Saint-Léon produced more works of the late Romantic era, combining the more fictionalized worlds of spirits with recognizable European folk-lores. His last, and best known work, *Coppélia*, is still considered the masterpiece of late Romanticism.

Works Choreographed: CONCERT WORKS: (Note: Saint-Léon frequently retitled works of revivals; whenever possible, the renamed works have been listed with their originals, not as new works.) *La Vivandièra ed il Postiglion* (1843, included *Il Re-dowa*, performed by Cerrito as a solo); *La Fille de Marbre* (1847); *Tartini, il Violonista* (1848); *l'Anti-Polkista ed i Polkamanie* (1848); *Stella, ou les Con-trabandiere* (1850); *Le Violon du Diable* (1849); *Pâquerette* (1851); *Le Lutin de la Vallée* (1852); *Le Danseur du Roi* (1852); *La Rosière* (1854); *Saltarello* (1854); *Lia, la Bayadère* (1854); *Ensaio Geral, o Las Aflições de Zeferina* (1855); *Bailados Allegoricas* (1855); *Sataniel* (1855); *Os Saltimbancos* (1856); *Me-teora* (1856); *Stradella* (1856); *Bailados Chinese* (1856); *Graziella, ou la Querelle amoureuse* (1860); *La Perle de Séville* (1861); *Les Nymphs et le Satyr* (1861); *Les Tribulations d'une répétition générale* (1862); *Théolinde, l'orpheline* (1862); *Diavolina* (1863); *Néméa* (1864, also performed as *Salamandra* and *Fiametta*); *Konick Gorbunok* (The Little Hump-back Horse) (1864); *La Source* (1866); *La Fiancée* Valaque (1866); *Le Poisson doré* (1867); *Le Basilic* (1869); *Le Pâtre et les Abeilles* (1869); *Le Lys* (1869); *Coppélia* (1870).

OPERA: *l'Africaine* (1864).

Sakharoff, Clothilde von Derp and Alexander, Ger-man concert dancers; Clothilde Sakharoff born Clothilde von der Planitz, 1892 in Berlin; died Janu-ary 11, 1974 in Rome; Alexander Sakharoff born Al-exander Zuckermann, May 26, 1886 in Mariupol, Russia; died September 2, 1963 in Sienna, Italy. Clothilde von Derp gave her first solo recital at age fifteen, performing untitled dances to works of Rich-ard Strauss, Frederick Chopin, and Franz Schubert. She studied mime at the studio attached to Max Reinhardt's theater and performed in his productions of *Sumurun* and *Songe d'une Nuit d'Été* in Germany and London. Alexander Sakharoff was an art stu-dent in Paris when he began working in movement forms. Originally trained as an acrobat and single trapeze artist in Munich, he gave his first recitals there in 1910, presenting solos based on mythological concepts and iconography. They met at a ball dedi-cated to the works of Richard Strauss, at which he performed to *Ariadne auf Naxos* and she worked to *Rosenkavalier*, and began to tour together in recitals of their joint choreographies. After their marriage in 1919, von Derp ceased to use her own professional name and billed herself "Clothilde Sakharoff."

Their concerts included from a dozen to a score of short solos, performed alternately by each, culmi-nating in a duet. All programs claimed that their works were choreographed jointly, although Alexan-der Sakharoff claimed full credit for the design of the pieces and their elaborate costumes. They produced a large number of short works from 1920 to the late 1930s, but seem to have frozen their repertory during their forced unemployment period during World War II. After they ended their tours in the early 1950s, they did a small amount of individual chore-ography and opened a dance studio in Rome, with summer classes in Sienna.

The Sakharoff's works were more like American concert dance pieces than the German expressionist solos of Wigman, Palucca, and Holm. They created easily legible characterizations, clothed in elaborate iconographies with appropriate gestural systems.

Works Choreographed: CONCERT WORKS: (Note: all works jointly choreographed by Clothilde von Derp Sakharoff and Alexander Sakharoff unless oth-erwise noted; dates as of first known performances.) Recital solos (1910–1920, by Alexander Sakharoff); Recital solos (1907–1920, by Clothilde von Derp); solo to *Ariadne auf Naxos* (1919, by Alexander Sakharoff); solo to *Der Rosenkavalier* (1919, but possibly earlier, by Clothilde von Derp); *Visions du Moyen Age* (1920); *Du Temps du Grand-siècle* (1920); *Danse du "Passe-Joli"* (1920); *Le Petit Berger* (1920); *May Day Danse* (1920); *Visione del quartocento* (1922); *Gavotte* (1922); *Caprice du Cirque* (1922); *Chinoiserie* (1922); *Poème Printanier* (1922); *Humoresque* (1922); *Chanson Negre* (1922); *Pavane Royale* (1923); *Golliwog's Cake Walk* (1923);

Danse Sainté (1923); *Danseuse de Delphes* (1923); *Valse Romantique* (1923); *Valse Rouge* (1923); *Danse del'Epervier* (1926); *Minuet du Bourgois Gentilhomme* (1926); *Moria Blues* (1926); *D'Apres Goya, No. 1* (1926); *Danse de la Joie d'un Mystère du XVe Siècle* (1926); *Plein Bonheur* (1926); *Valse* (1926); *Le Martyre de Saint-Sébastien* (1930); *Berceuse de l'Oiseau de Feu* (1930); *Prelude et Fugue* (1930); *Prélude* [Scriabin] (1930); *Parfait Bonheur* (1930); *Le Printemps* (1930); *D'Après Goya, No. 2* (1933); *Bourée Fantasque* (1933); *Papillon* (1933); *Invocation à Aphrodite* (1933); *Danse Sombre* (1933); *Sur l'Ocean* (1933); *Jeune Fille au Jardin* (1933); *Farfalla* (1934); *Danse du Destin* (1937); *Prelude à l'Après-Midi d'un Faune* (1937); *Troisieme Nocturne* (1939); *Danse de Coré du Poème Choréographique* (1939); *La Maya y El Ruisena* (1953, by Clothilde Sakharoff).

Saki, Marion, Japanese-American theatrical ballet dancer; born Marion Hatsaki Sakakibara, c.1902 in Tokyo. The daughter of actor Gitsuo Sakakibara, she was raised in New York from the age of four. Originally trained by Claude Alvienne, one of the few classical ballet teachers to acept vaudeville and theater children into his classes, she studied with Ivan Clustine as the youngest member of the Anna Pavlova Company performing at the New York Hippodrome in 1916.

Although she received publicity in the New York and trade papers as a student in the free school that Clustine and Pavlova had set up on the Hippodrome roof, she had in fact performed there as a ballet specialty dancer before Pavlova's engagement. She was also in two later Hippodrome shows, *Cheer Up* (1917) and *Everything* (1918). Saki toured on the Keith Circuit in a dance and singing act, returning to New York to perform in *Little Nellie Kelly* (1922). After another vaudeville tour, she danced in *Polly* (1929) and *Land of Smiles* (1934).

Salaman, Susan, English ballet dancer and choreographer; born c.1910. Salaman, about whom little can be verified, served the Ballet Club as stage manager and costumer while contributing works to its repertory. Her best remembered ballets are the trio of works based on the movement patterns of sports—*Le Rugby* (1930), *Le Cricket* (1930), and *Le Boxing* (1931)—and the two collaborations with Andrée Howard, the second version of *Our Lady's Juggler* (1933), and *Mermaid* (1934). After a breakdown in 1935, she dropped out of dance completely, depriving the developing English ballet of a talented choreographer and performer.

Works Choreographed: CONCERT WORKS: *The Tale of a Lamb* (1929); *Our Lady's Juggler* (1930); *Le Rugby* (1930); *Le Cricket* (1930); *Le Boxing* (1931); *Waterloo and Crimea* (1931); *The Garden* (1932); *Our Lady's Juggler* (1933, in collaboration with Andrée Howard); *Mermaid* (1934, in collaboration with Howard); *Circus Wings* (1935).

Saland, Stephanie, American ballet dancer; born January 12, 1954 in Brooklyn, New York. Saland was trained at the School of American Ballet before graduating to the New York City Ballet.

As a member of the company, Saland has performed in most of its repertory, notably in "Swanilda" and the title role of the George Balanchine/Alexandra Danilova revival of *Coppélia*. Her beauty, dramatic talents, and expansive gestures have brought her prominence in Jerome Robbins' *Dances at a Gathering*, *The Four Seasons*, and *In the Night*, while her ability to kid herself has been invaluable in his *Fancy Free*.

Sallé, Marie, French eighteenth-century ballet dancer and choreographer, a pioneer of the *ballet d'action* movements in Paris and London; born 1707 in France (?); died July 27, 1756 in Paris. The daughter of a tumbler, Sallé worked in harlequinades as a child. She danced Mlle. Prévost's female lead in a Paris Opéra revival of Campra's *Les Fêtes Venitiennes* in 1721, but it is likely that this was a specialty act—a child dancing at the Opéra being notable for her age, not for the incipient technique that she might possess. With her father's troupe, Sallé went to London to perform at John Rich's Lincoln's Inn Field (1725–1727), in a series of uncredited pantomimes, among them *La Matelot Français et sa Femme* (1725), *Pan et Syrinx* (1726), and *Les Amours de Damon et Climène* (1727).

Her Opéra debut as an adult took place in September 1727 in the Lavals' *Les Amours des Dieux*, in

which she was partnered by David Dumoulin. From that performance to her retirement in December 1739, Sallé commuted between the Opéra and the theaters of London. At the Opéra, where she was in competition with Marie Camargo, she performed works by the Lavals, among them *Castor et Pollux* (1737) and *Les Fêtes d'Hébé, ou les Talents Lyrique* (1739), and created the leading role in Rameau's *Les Indes Gallants* (1734).

In London, she performed in ballets and in a revival of *The Beggar's Opera* in 1728. She was also given a chance to choreograph in London, where the theatrical bureaucracy was less structured than in Paris. Her credited works, which probably represent fewer than half of her complete canon, include *Pygmalion* (1733), possibly the touchstone of the *ballet d'action* movement, *Bacchus et Ariadne* (1733), and *Terpsichore*, the prologue to the Handel opera, *Pastor Fido* (1734).

In 1743, Sallé was involved with the choreography of satirical ballets for the company at the Foire St. Laurent, the group that formed the nucleus of the Opéra-Comique. One of these works, *L'Ambigu de la Folie, ou le Ballet des Dindons*, was a satire of her Opéra vehicle, *Les Indes Gallants* (1734).

Sallé's contribution to the development of the *ballet d'action* may never be fully understood. It is likely that her roots in popular theater and fair entertainment may prove to be a key to the understanding of the *ballet d'action's* acceptance by the ballet audience—a key that was not considered at the time by the great theorists of the movement.

Works Choreographed: CONCERT WORKS: *Pygmalion* (1733); *Bacchus et Ariadne* (1733); *Le Masque Nuptial, ou les Triomphes du Cupidon et d'Hymen* (1733); *Terpsichore* (Prologue to *Pastor Fido*) (1734); *Alcina* (1735); *Le Coq du Village* (1743, co-choreographed with Louis Dupré and Jean-Barthélemy Lany); *L'Ambigu de la Folie, ou la Ballet des Dindons* (1743).

Salsberg, Germaine Merle, Canadian modern dancer and choreographer also working in the United States; born July 22, 1950 in Toronto, Ontario. After working in radio as a child, she studied modern dance with Patricia Beatty and the staff of the Dance Group of Canada. She moved to New York where she ex-

panded her technical expertise with training in tap and jazz dance with Charles Kelly and Bob Audy. A member of the Toronto Dance Theatre from 1970, she appeared in many works by company directors Beatty, David Earle, and Peter Randazzo, among them her *Study for a Song in the Distance* (1970), and *Hot and Cold Heroes* (1970), and Earle's *Operetta* (1970) and *A Thread of Sand.* Fellow performer Barry Smith cast her into his *Coronation* (1969), *Lady Fox* (1969), *Lacemakers* (1970), *Third Awakening* (1972), and *Midnight Faun* (1974) in Toronto.

Salsberg moved to New York in the mid-1970s. She shares concerts with Smith and continues to perform in his works, among them *Filligree* (1977) and *Meadow Ring* (1978), but her own choreographic style has changed from the Grahamesque work she had done in Toronto. Her work in Matthew Diamond's *Understudy* (1978) introduced her to the choreographic uses of the American techniques of tap, jazz, and ballroom dance. She began to study with Kelly and integrated her newly discovered talents into her works, most notably *Hey Girl* (co-choreographed with Smith), *Album* (1978), set in the 1940s, and the popular *Trouble in Paradise* (1980), for five dancers, a mannequin, and records from the big band era.

Works Choreographed: CONCERT WORKS: *Untitled Solo for Live Musicians and Single Dancer* (1968); *Between Two Waves and the Sea* (1970); *Funeral for Nellie Rubine* (1971); *Hey Girl* (1977, co-choreographed with Barry Smith); *Album* (1978); *Trouble in Paradise* (1980).

Saltonstall, Ellen, American postmodern dancer and choreographer; born November 2, 1948 in Exeter, New Hampshire. While in college, Saltonstall attended the summer American Dance Festival in 1970, where she studied with Clay Taliaferro, Meredith Monk, Cecily Dell, and James Cunningham. At the University of California at Berkeley, she studied Graham technique under David Wood and Merce Cunningham technique under Carolyn Brown. Since moving to New York, she has worked with Peter Saul, Alfredo Corvino, and the late Barbara Fallis in ballet. A licensed therapeutic masseuse, she has studied effort-shape and observation techniques with Irmgard Bartinieff and kinetic awareness with Elaine Summers.

A member of the cooperative Among Company, she danced in works by colleagues Wendy Rogers, Ann Darby, Joyce Morgenroth, and Carolyn Brown, including Brown's *House Party* (1974) and *Bunkered for a Bogey* (1973). Wendy Rogers cast her in *Super Magnolia* (1973), *Cat's Cradle* (1973), *Exposure* (1975), and *Gull's Meadow* (1973), and has collaborated with her in *Ceremony of the Wren* (1974). Saltonstall also worked with the Elaine Summers Dance and Film Company (1973–1974) on the *Energy Changes* series, and other works. Among the many celebrated dances in which she has performed as a guest artist are Sara Rudner's *Boa* (1975), Twyla Tharp's incidental dances in *Hair*, Helen Alexander's *No. 14 for Ellen* (1975), and Nina Wiener's *Palindrome* (1975), the latter two being solos created for her.

After the dissolusion of the Among Company, for which she had choreographed, Saltonstall created works for herself and for recitals.

Works Choreographed: CONCERT WORKS: *Sweet Potato* (1973); *Hors d'Oeuvre* (1974); *Buttermilk* (1974); *Ceremony of the Wren* (1974, co-choreographed with Wendy Rogers); *Untitled Quartet* (1975); *Pas de Foie Gras Duet* (1976); *Duet for Susan and Joyce* (1976); *Solo for the Persian Line* (1976); *Restless Roquefort* (1977, co-choreographed with Peggy Spina); *Oriental Dance* (1977); *Fresh Fruit* (1978); *Ivories* (1979, co-choreographed with Spina and Martha Andrew).

Salvioni, Guglierma, Italian nineteenth-century ballet dancer; born 1842 in Milan; date and place of death uncertain. Salvioni was trained at the school of the Teatro alla Scala, from which she graduated in 1856. She performed in the works of Raefele Rossi at La Scala and other theaters in northern Italy in 1862, becoming known for her performance in his *La Capricciosa* (c.1862). She was one of the Italian ballerinas engaged by the Paris Opéra for their assurance in point technique (the contemporary critical phrase translates as "points of steel") and replaced Adele Grantzow there for the role of "Naila" in Artur Saint-Léon's *La Source* (1866). After traveling with him to St. Petersburg, she created the central role in his *The Little Goldfish* (1867). She ended her known career as a member of the Vienna Court Opera Ballet in the 1870s, where she began her tenure by performing in Filippo Taglioni's late ballet, *Sardanolpol*, in 1869.

Salz, Barbara, American modern dancer and choreographer; born October 29, 1950 in Brooklyn, New York. Beginning at the Brooklyn studio of former Graham dancer Marjorie Mazia, she continued her dance training in a dazzling variety of techniques, ranging from ballet with Zena Rommett and Vera Nemtchimova to modern dance forms with Merce Cunningham, Murray Louis, Gladys Bailin, and James Waring. She began to choreograph at the University of Colorado, gaining prominence for *Saucerful of Secrets* (1970). Salz has been a member of the Multigravitation Aerodancc Company since 1973, performing on the structures of ropes that constitute its "stage," in works by former artistic director Stephanie Evanitsky and in pieces that she co-choreographs with Kay Gainer and Bronya Weinberg.

Works Choreographed: CONCERT WORKS: *Saucerful of Secrets* (1970); *Muses of the Mast* (1980); *Decade* (1980); *Craneworks* (1980).

Salzedo, Leonard, British ballet conductor and composer; born September 24, 1921 in London. Trained at the Royal College of Music, Salzedo served as conductor and musical director of three British dance companies—the Ballet Rambert (1966–1972), the Scottish Theatre Ballets (1972–1974), and the New London Ballet (1974–). Choreographers in each company commissioned scores for him, among them, *The Fugitive* (1944) and *Mardi Gras* (1946) for Andrée Howard, *The Witch Boy* (1956) and *Agrionia* (1964) for Jack Carter, and *The Realms of Choice* (1965) and *Hazard* (1967) for Norman Morrice, who also used extant music for other dance works.

Samtsova, Galina, Soviet ballet dancer working in Canada and England from the 1960s; born March 17, 1937 in Stalingrad. Trained at the Kiev Choreographic Institute by Natalia Verekundova, she entered the Kiev Ballet where she was featured in *Swan Lake* and *Le Corsaire*.

In the National Ballet of Canada from 1960 to 1964 she was featured in John Cranko's production of *Romeo and Juliet* and the company's revivals of

Giselle, Swan Lake, and Zachary Solov's *Allegresse.* With the London Festival Ballet, she danced in Jack Carter's *The Witch Boy.*

She and her husband, Andre Prokovsky, founded the New London Ballet in the early 1970s. Among the many ballets in which she has performed with the troupe are Carter's *Pythoness Ascendent* (1973), and Prokovsky's *Piano Quartet No. 1* (1974).

Sanasardo, Paul, American modern dancer and choreographer; born September 15, 1928 in Chicago, Illinois. Originally trained as an artist, Sanasardo studied dance in Washington, D.C., with Erika Thimey, and in New York with Antony Tudor, Mia Slavenska, and at the Martha Graham school.

Sanasardo performed with the Anna Sokolow company from 1953 to 1957, dancing in the first cast of her magnificent *Rooms* (1955), and on Broadway in her incidental dances for *Red Roses for Me.*

Since 1957, Sanasardo has performed and choreographed primarily for his own companies—the Sanasardo/(Donya) Feuer Company (1957–1963), and the Sanasardo Company (1963). Both his abstract and his characterizational works tend to experiment with manipulation of scale of movement, ranging from tight, almost autistic solos about alienation to lush romantic duets. His dancers, who come from all dimensions of dance, have included Sara Rudner, Laura Dean (both uncompromising postmodernists), Manuel Alum (who served for a time as associate director), and ballet freelancers Noami Sorkin, William Carter, and Lawrence Rhodes, for whom (in different combinations) he has created *Andantino Cantabile* (1976), *Triad*, and *Of Silent Doors and Sunsets* (both 1977).

Works Choreographed: CONCERT WORKS: *Excursions for Miracles* (1961, in collaboration with Donya Feuer); *Metallics* (1963); *Of Human Kindness* (1963); *Opulent Dream* (1963); *Laughter After All* (1964); *The Animal's Eye* (1966); *Cut Flowers* (1966); *An Earthly Distance* (1966); *Excursions* (1966); *Fatal Birds* (1966); *Two Movements for String* (1966); *Three Dances* (1967); *The Descent* (1968); *Pain* (1969); *Footnotes* (1970); *Sightseeing* (1971); *The Path* (1972); *Shadows* (1973); *The Amazing Graces* (1974); *The Platform* (1974); *A Sketch for Donna* (1974); *A Consort for Dancers* (1975); *A Memory Suite* (1975); *Pearl River* (1975); *Sketches for Nostalgic Children* (1975); *Abandoned Prayer* (1976); *Andantino Cantabile* (1976); *Of Silent Doors and Sunsets* (1977); *Triad* (1977).

Sand, Inge, Danish ballet dancer; born July 6, 1928 in Copenhagen; died there February 8, 1974. Trained at the school of the Royal Danish Ballet, she graduated into the company in 1946. Celebrated for the charm, strength, and bravura of her "Swanilda" in the company's production of *Coppélia*, she was also noted for her performances in George Balanchine's *Night Shadow*, David Lichine's *Graduation Ball*, and the "Mazurka" solo of *Les Sylphides*. Her ability to work in the standard European repertory, the company's contemporary works, and its Bournonville ballets made her a local favorite. She also toured with a chamber concert group in the United States and South America in the late 1950s.

Sand served as ballet master of the Copenhagen Ballet Theatre and assistant director of the Royal Danish Ballet before her death from cancer in 1974.

Works Choreographed: CONCERT WORKS: *Liv i kludene* (Rags Come Alive) (1964).

Sand, Monique, French ballet dancer working in Germany and the Netherlands; born June 24, 1944 in Dakar, Senegal. Trained in Toulon at the Ecole de Danse Taneëff, she made her debut at the Opera Ballet there. She performed for a season with the Geneva Opera Ballet before joining the Hamburg State Opera in 1966. With that troupe and with the Dutch National Ballet after 1970, she danced in the works of Peter Van Dyk, including his *Pinocchio* (1969), Glen Tetley, in his *Chronochromie* (1971), Hans Van Manen, in his *Adagio Hammerklavier* (1973), considered by many her best role, and Toer Van Schayk, in the premiere of his *Before, During and After the Party* (1972).

Sandanato, Barbara, American ballet dancer; born July 22, 1943 in Harrison, New York. After studies with Lorna London, a charter member of the American Ballet, she followed her teacher to become a student at the School of American Ballet. She appeared with the Radio City Music Hall corps de ballet at age sixteen and performed briefly with the New York

City Ballet before Barbara Weisberger invited her to join the new Pennsylvania Ballet in 1964. Among her many roles in the company's large repertory were almost all of the revivals of works by George Balanchine, including his *Pas de Dix*, *Concerto Barocco*, *Allegro Brillante*, *Donizetti Variations*, and *Symphony in C*, and contemporary works by John Butler, such as his *Villon* (1967) and *Ceremony* (1968), and by Richard Rodham, in his *Gala Dix* and *Mignon*. With her husband, Alexei Yudenich, she has guested frequently in American companies and with the National Ballet of Canada.

Sanders, Dirk, Dutch ballet dancer and choreographer; born Dirk Hans Van Hoogstraten, 1933 in Djakarta, Indonesia. After early training in Essen with Kurt Jooss, he continued his studies in Paris with Nora Kiss. He performed in small French ballet companies during the 1950s, dancing in Maurice Béjart's *The Taming of the Shrew* and *Haut Voltage* for his Ballets de l'Etoile, in Pierre Lacotte's *Gosses de Paris* in his Ballets de la Tour Eiffel, Janine Charrat's *Les Liens* in her troupe, Jean Balilée's *Divertimento*, *Sable*, and *Balance à Trois* in his company, and Roland Petit's *Pistols at Dawn* (1961) in his Ballets de Paris. After dancing in New York with the Petit troupe, he was engaged as Mary Martin's partner for her 1959 television special and concert tour.

He has also worked on French television and has choreographed for the Ballet Théâtre Contemporain de France.

Works Choreographed: CONCERT WORKS: *L'Echelle* (1956); *L'Emprise* (1957); *Balletino* (1957); *Maratona di Danza* (1957); *L'Arbre Rouge* (1957); *Hotel de L'Esperance* (c.1959); *HOPOP* (1972); *Pas Dansés* (1972, co-choreographed with René Golaird); *Whiskey-Cola* (1973).

Sanders, Job, Dutch ballet dancer and choreographer working in the United States from the late 1930s; born in Amsterdam. Raised in New York, he studied with Alexander Gavrilov and Anatole Oboukhoff. Sanders made his debut as a "Satyr" in George Balanchine's *Orpheus* (1948) for the Ballet Society.

Shortly thereafter he joined the Ballet Russe de Monte Carlo where he performed in Balanchine's *Ballet Imperial* and *Raymonda Divertissements*, with featured roles in Ruthanna Boris' *Quelque Fleurs*, Fokine's *Schéhérézade*, and the company production of *Swan Lake*. With Ballet Theatre from 1953 to 1956 he created the role of "The Proud Matador" in Eugene Loring's *Capitol of the World* (1953), and was featured in Antony Tudor's *Jardin aux Lilas*, Balanchine's *Theme and Variations*, and Agnes De Mille's *Rodeo*. He also appeared with the Chicago Opera Ballet in Ruth Page's *Revenge*, *El Amor Brujo*, and *The Merry Widow*, and with the Netherlands Dance Theatre. His Broadway credits include the Bette Davis vehicle *Two's Company*, the 1956 revival of *Carousel*, and the original production of *Gentlemen Prefer Blondes*. He has choreographed extensively since 1956 when he created *Streetcorner Royalty* for a Ballet Theatre Workshop performance. His works appear in the repertories of the Washington Ballet, the Pennsylvania Ballet, the Netherlands Dance Theatre, the Opéra-Comique, and the Ballet Classico de México, for which he has served as artistic director from 1971.

Works Choreographed: CONCERT WORKS: *Streetcorner Royalty* (1956); *Cheri* (1956); *The Careless Burghers* (1957); *Bachianas Brasileiras* (1958); *Contretemps* (1958); *Les Violents* (1959); *Troubadour* (1960); *The Taming* (1962); *Wedding Cake* (1964); *Danses concertantes* (1964); *Errata* (1965); *Screenplay* (1966); *Pour Les Oiseaux* (1967); *Impressions* (1967); *Fugitive Visions* (1970).

Sandow, Eugen, Nineteenth-century performer and physical culturist known as "The Mighty Monarch of Muscle"; born April 10, 1867 in Königsberg, Germany; died October 13, 1925 near London. While a student of anatomy in Brussels, Sandow met and formed a partnership with Professor Atilla. They created a competition act using both "artistic" and gymnastic poses that became very successful in the amateur circuits of Holland and Belgium. Their first theatrical engagement, at the Paleis voor Volksvlyt in Amsterdam, led to a booking at the Crystal Palace in Sydenham, England. The act ended when Atilla was injured, and Sandow moved to Paris, where he became popular as an artists' and anatomists' model.

In Paris, he created a new act with an itinerant circus dancer, François, in which they recreated harlequinade scripts with added acrobatics and strong-man work. He returned to the competition act format after Atilla's recovery and became a regular in London's classier music halls, among them The Royal Aquarium (1889), where he and Atilla beat Samson, The Alhambra (1890), The Royal Music Hall (1890), where they were joined by Goliath, and the London Pavillion. Sandow first performed in the United States in 1893, making his debut at the Casino Theater (roof garden), New York, in June. In August, he was seen by a very young Florenz Ziegfeld, Jr., at the Trocadero, Chicago, and began a professional association with him that led to Ziegfeld's first management credit—the American tour of the Sandow Trocadero Vaudeville Company (1893–1894). This troupe, which also included conventional acrobats and a variety of vocal acts, presented the strength and artistic image of Sandow as a physical culturist. Accompanied by a musical score by his long-time associate Martinus Sieveking, Sandow presented his body in a series of poses and transitions designed to demonstrate his musculature before the act's climax, the lifting of a platform on which were a dozen girls from the audience, Sieveking, and his piano.

Although he continued to present theatrical exhibitions in England until 1910, Sandow, who settled in London in 1894, worked primarily as a teacher and educator after his American tour. He established his first school (technically a club) in London in 1894 and within ten years had two hundred in Great Britain alone. *Sandow's Magazine of Physical Culture* was published in London from 1899 to 1907 and in Boston in the early 1900s. His books became progressively more scientifically oriented and ranged from *Strength and How to Obtain It* (London: 1907) through *The Construction and Reconstruction of the Human Body: A Manual of the Therapeutics and Exercise* (London: 1907) to *Life Is Movement: The Physical Reconstruction and Regeneration of the People* (London: 1919). His Creative Institute in London also published manuals of exercises that eventually became part of the armed forces training.

It is unfortunate that so few sources of information exist on Sandow's theatrical career; this entry was written with the assistance of Gininne Cocuzza from contemporary sources. Sandow's own writings can occasionally be found in the physical education libraries of universities that were created before the turn of the century.

Sangalli, Rita, Italian nineteenth-century ballet dancer performing in the United States in the 1860s; born in Antegnate, Italy, August 20, 1849; died November 3, 1909 in Arcellasco. Sangalli was trained at the school of the Teatro alla Scala under Augusto Hus, and made her debut with the company in December 1864 in *Flik e Flok* by Paul Taglioni.

After two seasons at La Scala, in Taglioni's *Azaele* and *Leonilda*, she performed at Her Majesty's Theatre, London, in incidental dances to the repertory of the Royal Italian Opera season.

Sangalli was engaged to perform *The Black Crook* at Niblo's Garden Theatre in September 1866, and traveled to Boston with it, *Cinderella*, and *Bluebeard*. From 1868 to 1879, Sangalli and her company toured with *Humpty-Dumpty, Hickory Dickory Doc, The Tempest*, and her own version of *Flik e Flok*; they also performed with the Fisk Grand Opera House in *Les Hugenots*, and *La Bohémienne*. In the winter of 1870, they toured to California on a circuit of Tom MacGuire theatres, dancing *The Black Crook* at every stop.

Returning to Europe, she danced in England, performing *Puella, the Fairy and the Evil Genie*, and *The Sylph of the Glen* at The Alhambra Theater in 1871. She made her Paris Opéra debut in 1872 in *La Source* and created the title role in *Namouna* (1880). Sangalli retired in 1881.

Sankovskaya, Ykaterina, Russian nineteenth-century ballet dancer; born c.1816 in Moscow; died there 1878. Trained at the Bolshoi School in Moscow, she spent most of her professional career in that company. From 1836 to her retirement in 1854, she appeared in the principal roles of the Gluszokowsky repertory of original ballets and revivals of works by Didelot. She took the title roles in the Moscow premieres of much of the French repertory, including *La Sylphide, Giselle, Esmeralda*, and *La Fille du Danube*. Although these productions were basically

plagiarisms (unlike Titus' new versions in St. Petersburg), Sankovskaya brought a new, transforming aspect to the ballets. She was considered one of the great actresses of the nineteenth century, able to bring dramatic truth to the hackneyed plots of the Romantic era.

After retiring from performance, she taught ballroom dance in Moscow.

Santley, Joseph, American theatrical and exhibition ballroom dancer; born January 10, 1889 or 1892 in Salt Lake City, Utah; died August 8, 1971 in Los Angeles, California. Santley, who survived four different theatrical careers to become one of the most important performers on stage and one of the great American ballroom innovators, made his debut at age four as "Little Eva" in a touring *Tom* (that is, *Uncle Tom's Cabin*) show. After five years as the star of boys' melodramas such as *Billy the Kid* and *Lucky Jim*, Santley made his Broadway debut in *The Queen of the Moulin Rouge* (1908). Although Ned Wayburn claimed to have discovered and taught him, it cannot be determined whether Santley ever had formal dance training.

In his second career, still in his adolescence, Santley worked as one of Broadway's most successful male juveniles. In *A Matinee Idol* (1910), *Judy Forgot* (1910), *The Never-Homes* (1911), and *When Dreams Come True* (1913), he played the hero who sang love songs and partnered the heroine in contemporary social dances. When he outgrew juvenile status, Santley made a career out of the social dance scenes; with his partner, Ivy Sawyer, he appeared in thirteen musicals and revues over the next dozen years, among them three of the famous Princess Theater shows: *Oh Boy!* (1917), *She's a Good Fellow* (1919), and *Oh, My Dear!* (1918). With Sawyer, Santley also became the first recognizably American ballroom dancer to be credited with developing social dance forms; their specialty dance in *When Dreams Come True*, for example, was published in instruction manuals as *The Santley Tango* and was copyrighted as such.

Retiring from the stage after *Just Fancy* (1927) closed, Santley worked in film for another dozen years as a character actor cast primarily in gangster roles. Although he received film credits for writing, production, and direction, no choreography credits have been located.

Santlow, Hester, English theatrical and ballet dancer of the eighteenth century; born c.1690, probably in the London area; died January 15, 1773 in London. In the early 1700s, before 1706, Santlow was a student of René Cherrier under an indentureship system in which he received one-half of her salary. In 1706, she made her debut at Drury Lane in divertissements that he choreographed for her.

After acting and dancing at the Queen's Theatre, Haymarket, notably in *Hamlet* and the comedy, *Love for Love*, Santlow joined the company attached to Drury Lane; she remained with that theater until her retirement. She danced in ballets, including John Weaver's *The Loves of Mars and Venus* in 1717, and in pantomimes, among them *Harlequin Women*, in 1720. Santlow retired in 1733 after the death of her husband, Drury Lane manager Barton Booth.

While Santlow was undoubtedly a skilled dancer, her fame and reputation rested on her abilities as a comic actress in verbal and pantomimed presentations. She is remembered as a performer who was able to transcend the differentiations among the theatrical forms of her period.

Sapiro, Dana, American ballet dancer; born January 2, 1952 in New York City. Sapiro was trained at the American Ballet Center, the official school of the City Center Joffrey Ballet. She graduated into the company in 1970 and was cast into roles in a large part of the repertory. She created roles in two works by Gerald Arpino, including *Reflections* (1971) and *Trinity* (1970), which some consider his most telling portrayal of contemporary romance. Her other company credits include roles in Arpino's *Cello Concerto*, Todd Bolender's *Time Cycle*, and the company revivals of Mikhail Fokine's *Petrouchka*, Leonid Massine's *Le Tricorne*, John Cranko's *Pineapple Poll*, and Ruthanna Boris' *Cakewalk*.

Sappington, Margo, American ballet and theatrical dancer and choreographer; born July 30, 1947 in

Baytown, Texas. Sappington began her dance studies locally and continued them in Houston with Emmamae Horn, and in New York at the American Ballet Center, the school of the various Joffrey companies.

Sappington became an apprentice of what would soon become the City Center Joffrey Ballet, and a charter member of that company (1965–1966). In that first company season, she created roles in Eugene Loring's *These Three* (1966), performed in Anna Sokolow's *Opus '65*, and Gerald Arpino's *Viva Vivaldi!* (1965). Leaving the Joffrey company to appear and choreograph for Broadway productions, she later returned to stage her own works for the company, among them *Weewis* (1971), and *Mirage* (1977). Her popular concert works have also been performed by the Harkness Ballet (*Rodin, Mise en Vie*, 1974), the Pennsylvania Ballet (*Under the Sun*, 1976), and others.

After appearing in *Sweet Charity* and *Promises, Promises*, Sappington staged the musical numbers for and performed the nude pas de deux in the first New York production of *Oh, Calcutta!*, in 1969. She has since staged the London and Los Angeles productions, a film, and restaged a New York revival of that show, and has provided incidental dances for two Circle-in-the-Square revivals—*Where's Charley?* in 1974 and *Pal Joey* in 1976.

Works Choreographed: CONCERT WORKS: *Weewis* (1971); *Rodin, Mise en Vie* (1974); *Juice* (1975); *Tactics* (1976); *Face Dancers* (1976); *Under the Sun* (1976); *Mirage* (1977); *Medusa* (1978); *Juice II* (1979).

OPERA: *Death in Venice* (1974, U.S. premiere).

THEATER WORKS: *Oh, Calcutta!* (1969, restaged 1976); *Where's Charley?* (1974, revival); *Pal Joey* (1976, revival).

Sari, George, Italian ballet dancer and actor; born c.1900. Sari was trained privately by Enrico Cecchetti in his Turin studio. After performing with the Teatro Constanzi in Rome, Cecchetti recommended him to Anna Pavlova as a character dancer for her company. He toured with her in the mid-1920s playing sorcerers and high priests, leaving her during layoffs to work with Mikhail Mordkin.

Sari also had a successful career on the "speaking stage," as his advertisements read. He worked with Nahum Zemach's company in Los Angeles, notably playing the title role in his production of *The Dybbuk*. Sari also taught on the West Coast, frequently using Norma Gould's studio in Los Angeles.

Sarry, Christine, American ballet dancer associated throughout her career with the works of Eliot Feld; born 1946 in Long Beach, California. After local studies with Valerie Silver and Carmelita Maracchi, she continued her professional training in New York with Richard Thomas and Barbara Fallis.

After performing with The Robert Joffrey Ballet, Sarry joined the American Ballet Theatre, remaining with that company from 1964 to 1970 and returning to it from 1971 to 1974. In Ballet Theatre, she performed featured roles in *Coppélia* and in Agnes De Mille's *Rodeo*, but became best known for her work with the company's choreographers-in-residence: Dennis Nahat, for whom she danced in *Some Time* (1972), and Eliot Feld. In her first tenure with Ballet Theatre, she created roles in his *Harbinger* and *At Midnight* (both 1967).

Sarry left Ballet Theatre to join Feld's groups, American Ballet Company (1969–1971) and the Eliot Feld Ballet (1974–). In the first company, she created roles in his *A Poem Forgotten, Cortège Parisien*, and *Early Songs* (all 1970), *Romance* and *Eccentrique* (1971), and in his *Intermezzo* (1969). In the latter work, her best known part, she was partnered by Feld in a series of high-tossing duets.

With The Feld Ballet, Sarry has performed in his *Variation on "America"* and *A Footstep of Air* (1977), *Half-Time* (1978), and *Anatomic Balm* (1980).

Sarstadt, Marian, Dutch ballet dancer; born July 11, 1942 in Amsterdam. Trained by Nora Kiss and Audrey De Vos, she made her debut in Johanna Snoek's Scapino Ballet in 1957. She performed "the Ballerina" in *Petrouchka* and "La Coquette" in George Balanchine's *Night Shadow* with the Grand Ballet du Marquis de Cuevas in the 1960–1961 season before joining the Netherlands Dance Theatre for ten years. Noted for her work in contemporary ballets, she was cast in principal roles in Glen Tetley's *Mythical*

Hunters, Benjamin Harkavy's *Recital for Cello and Eight Dancers*, and Hans Van Manen's *Dualis and Metaforen*. She retired in 1972 to return to the Scapino Ballet as ballet mistress.

Satie, Erik, French composer; born May 17, 1866 in Harfleur, France; died July 1, 1925 in Paris. Little known until 1910, Satie became a major influence on the l'Ecole d'Acceuil and "Les Six," the group of French composers which included Georges Auric, Louis Derez, Arthur Honneger, Darius Milhaud, Francis Poulenc, and Germaine Tailleferre, each of whom wrote at least one ballet score.

Satie wrote four scores specifically for ballet productions: *Parade* (Leonid Massine, 1917), *Relâche* (Jean Borlin, 1924), *Mercure* (Massine, 1924) and *Jack-in-the-Box* (Balanchine, 1926). As a personal favorite and representation of his theories, Satie was frequently cited by both of the major composer/composition teachers in the dance world, Louis Horst and John Cage. For this reason, it has been estimated that his *Gymnopédies* (1888) may be the most frequently choreographed works; most students at the Neighborhood Playhouse and the Judson group have set at least one dance to the second *Gymnopédies*. Among the many choreographers who have staged dances to Satie are Frederick Ashton (*Monotones*, 1965), Martha Graham, Yvonne Rainer, and Merce Cunningham, who has created dance works to (or at least, concurrent with) his *Monkey Dances* (1948), *Two Steps* (1949), *Rag Time Parade* (1950), and *Second Hand* (not in public performance, 1970).

Sauget, Henri, French composer; born Jean-Pierre Poupard, May 18, 1901 in Bordeaux. A student of Charles Koechlin and protégé of Erik Satie, Sauget wrote many work ballet scores on commissions from choreographers working in France. Among his works were *Les Roses* (1924), *David* (1928), and *Les Saisons* (1951) for Leonid Massine, *La Rencontre* (1928) for David Lichine, *Le Dernier Jugement* (1951) for Janine Charrat, *Le Caméléopard* (1956) for Jean Babilée, *Cordelia* (1952) for John Taras, and *Die Kameliendame* (1957) for Tatiane Gsovsky. He has created scores frequently for Serge Lifar and Roland Petit,

including *La Nuit* (1930) and *Les Mirage* (1947) for the former, and *Paul et Virginie* (1943, also titled *Image à Paul et Virginie*) and *Les Forains* (1945) for the latter.

Saul, Peter, American ballet and modern dancer; born February 10, 1936 in New York City. Saul was trained by Margaret Craske, a recognized expert in the Cecchetti technique, and Antony Tudor and Merce Cunningham. He performed with Tudor's Metropolitan Opera Ballet and the American Ballet Theatre, where he danced in works by Tudor and George Balanchine. Saul also participated in modern and postmodern dance productions, including works by Yvonne Rainer for the Judson Dance Theatre, and danced with the Merce Cunningham company in the mid-1960s in *Place* and *How To Pass, Kick, Fall and Run*. Saul teaches at Cornell University in upstate New York, where he reputedly gives a pure Cecchetti class.

Sawyer, Geneva, American dance director for films; I don't know anything about Sawyer's life, but suspect that she was born in the mid-1910s and died shortly before 1944. Sawyer was a staff dance director at Twentieth-Century Fox, assigned to choreograph dance routines for conventional films and those featuring the studio's child star, Shirley Temple. One-third of those films were co-credited to Nick Castle, who survived her by almost thirty years and named his daughter for her. However inappropriate it may be to include in a biographical dictionary an individual for whom no biography exists, it is important to recognize the accomplishments of this woman, who created extraordinarily good results in her films.

Among the most interesting of her assignments were *The Bluebird* (1939), *Blood and Sand* (1941), and *Stormy Weather* (1943). In the former—the first sound film of the Metterlinck play—she created pseudo–folk dances for Temple, movement patterns for Gale Sondergaard and Leon Errol as the "cat" and "dog," and choreography for an extremely strange scene set in the land of unborn children, with most of Fox's contract children in a neoclassic masque. She staged Spanish dances and a bullfight

for *Blood and Sand* and worked with Cotton Club director Clarence Robinson to adapt the stage specialties of the Nicholas Brothers, the Katharine Dunham Dancers, and Bill Robinson to the screen in *Stormy Weather*.

Works Choreographed: FILM: (All films released by Twentieth-Century Fox.) *Love and Hisses* (1937, co-choreographed with Nick Castle); *Pig Skin Parade* (1937, co-choreographed with Castle); *Little Miss Broadway* (1938, co-choreographed with Castle); *Hold That Co-Ed* (1938, co-choreographed with Castle); *Sally, Irene and Mary* (1938, co-choreographed with Castle); *Just Around the Corner* (1938); *Up the River* (1938); *The Boy Friend* (1939, co-choreographed with Castle); *The Bluebird* (1939); *Down Argentine Way* (1940, co-choreographed with Castle); *Young People* (1940); *Blood and Sand* (1941); *Stormy Weather* (1943, co-choreographed with Clarence Robinson); *Jitterbugs* (1943).

Sawyer, Ivy, English exhibition ballroom dancer working in the United States after 1916; born c.1896 in London, England. Trained at Stedman's Academy in London, Sawyer made her debut as "the Doormouse" in a pantomime of *Alice in Wonderland* at the Prince of Wales Theatre in December 1909. Growing quickly, she played "Alice" in that production during the next Christmas season of 1910–1911.

By June 1912, Sawyer was proficient enough in classical technique to perform with the Diaghilev Ballet Russe in its London season, presumably as an unbilled extra or corps member, since her name does not appear on programs. She was billed as an "English ballerina from the Ballet Russe" on music hall programs from 1913 until 1915, when she emigrated to the United States.

In New York, teamed with former juvenile, Joseph Santley, she performed in eleven Broadway musical comedies, among them, the Princess Theater's celebrated *Oh, Boy!* (1917), and shows including the 1921 and 1923–1924 editions of Irving Berlin's *Music Box Revue*. In both kinds of production, they did exhibition ballroom work, notably one-steps and tangos; in the revues, the dance numbers merely visualized the songs while in the plotted musical comedies, Santley and Sawyer played the "friends of the hero

and heroine" type of characters, with two or three specialty numbers of their own.

Sawyer, Joan, American exhibition ballroom dancer; born 1890 in Cincinnati, Ohio. Raised in El Paso, Texas, Sawyer made her debut as "Little Eva" in a Southwest touring production of *Uncle Tom's Cabin* (c.1895). It is not known whether she had formal training in dance in Texas before 1907 when she joined the replacement cast of The *Vanderbilt Cup* on Broadway. She performed in the chorus of two additional shows, *The Merry-Go-Round* (1908) and *The Pink Lady* (1911), before author Jeanette Glider introduced her to Maurice Mouvet, an exhibition dancer who had recently returned to New York from Paris.

Although Sawyer's tenure as one of Mouvet's many partners was short, she retained the identity of an exhibition ballroom career. From 1913 on she performed one-steps, tangos, and Maxixes as the first woman to be the featured, leading member of a ballroom team. After holding the euphemistic position of "Society dancer" (i.e., demonstrator) at New York roof garden theaters and cabarets for eighteen months, Sawyer purchased control of The Persian Garden's cabaret. She thereby became the first woman to manage a dance roof as well as a dance act. In one publicity release, Sawyer claimed to have also been the first woman to own a restaurant, although this cannot be verified. Partnered by John Jarrott, Joseph C. Smith, and Quentin Tod, Sawyer popularized dances at her cabaret and patented a system of teaching social dances at home.

Sawyer also had a vaudeville career as a pantomimist, producing so-called "ballets d'action" at the Palace and on the Keith circuit; her performances at the Palace in 1915 and 1916 were part of a publicity campaign/rivalry with Adelaide and Hughes, and, like all such rivalries, added to the popularity of both acts. A fervent Suffragist, Sawyer spent the summer of 1915 motoring from New York to San Francisco for the cause.

In 1916, Sawyer signed a long-term contract with William Fox to perform and coach social dance scenes for Fox Films' silent movies. Apart from a brief return engagement at New York's Casino de

Paris in 1921, Sawyer remained in film for the rest of her professional life.

Saxon, Marie, American theater and film dancer; born Marie Saxon Landry, 1904 in Laurence, Massachusetts; died November 12, 1941 in Harrison, New York. Saxon was a member of a family that contributed greatly to the popular theater of her times. Her father managed two theaters in Laurence, while his mother managed a vaudeville house in East Haddam, Connecticut, and her sister was one of the few female orchestra leaders in vaudeville. After her father's death, she toured with her mother, actress Pauline Saxon, in a sister act on the Keith circuit. After performing with two George Choo feature acts, *The Little Cottage* and *The Dancing Honeymoon*, she made her Broadway debut in the chorus of *Battling Butler* (1923). At this point, she began to study with Claude Alvienne.

For five years she was one of the most successful and popular ingenues on Broadway, dancing in the *Passing Show of 1923, My Girl* (1924), *The Ramblers* (1926), and *Upsa-Daisy* (1928). As the heroine of *Merry Merry* (1925) she became beloved as the epitome of a girl who comes to New York to become a "Merry merry," the contemporary affectionate name for a chorus dancer. Saxon was also one of the few ingenues who wrote about the requirements of that role type, publishing articles on the importance of realistic acting even for non-specialty dancers. Saxon appeared in a few early film musicals, most notably *The Broadway Hoofer* (Columbia, 1930), but was forced by a debilitating illness to retire early.

Sayre, Jessica, American modern dancer and choreographer; born August 13, 1949 in Cleveland, Ohio. Sayre began her dance studies at the Colorado College summer session directed by Hanya Holm and continued them with Ernestine Stodelle in New Haven while a member of the first co-educational graduating class of Yale University. After additional training at the Alwin Nikolais/Murray Louis studio in New York City, she joined the Nikolais company in 1973. Among the many works in which she has performed are his *Sanctum, Guignol, Triad, Styx* (1976), and *Arporisms* (1977).

While performing and teaching for Nikolais, she began to present concerts of her own choreography and to participate in the various shared recital programs available in New York. Her theatrical choreography has been created for a wide range of institutions, from the Yale University Divinity School, for which she staged a production of Michael Posnick's *Bubber* (1976), to the Bloomingdale House of Music Orchestra's presentation of *Amahl and the Night Visitors* (1980). She has also worked with the Living Theatre in Paris, where she created movement patterns for its *Prometheus* in 1978.

Works Choreographed: THEATER WORKS: *Bubber* (1976); *Prometheus* (1978).

Schaefer, Richard, American ballet dancer; born December 27, 1952 in Denver, Colorado. Schaefer received his early training in Dallas, Texas, from Lorraine Cranford. After dancing with the Dallas Civic Ballet, he continued his studies at the School of the National Ballet in Washington, D.C. A member of the American Ballet Theatre since 1972, he was known at first for his performances in the company's contemporary repertory, with roles in Alvin Ailey's *The River*, Glen Tetley's *Voluntaries*, and Twyla Tharp's *Push Comes to Shove*. When Ballet Theatre changed its policy toward revivals of the classics, however, Schaefer began to be featured more prominently in nineteenth-century roles in the company's *Swan Lake, La Bayadère, The Nutcracker*, and *Don Quixote*.

Schanne, Margarethe, Danish ballet dancer; born November 21, 1921 in Copenhagen. After local training, Schanne attended the Ballet School of the Royal Danish Ballet.

Performing with the Royal Danish Ballet from 1942 to 1966, she was celebrated for her ability to work within the confines of the Bournonville technique in the revivals of his works. She was especially noted for her roles in *La Sylphide* (a picture of her in the title role appeared on a postage stamp in 1959), and *La Ventana, Napoli, A Folk Tale*, and *Far from Denmark*.

On a leave of absence in 1946 she danced with the Ballet des Champs-Elysées in Paris, with featured roles in Roland Petit's *Les Amours de Jupiter* and his *Lac des Cygnes*. Returning to the Royal Danish Bal-

let, she continued to perform in the Bournonville repertory and created roles in new works, among them, Nils Bjørn Larsen's *Drift* (1964), Kirsten Ralov's *La Dame aux Camillias* (1960), and Hans Brenaa's *Stemninger* (1964). She has also danced featured roles in stagings of works by George Balanchine, notably his *Symphony in C, Night Shadow,* and *Serenade,* to great acclaim.

Schaufuss, Frank, Danish ballet dancer; born December 13, 1921 in Copenhagen, Schaufuss was trained at the School of the Royal Danish Ballet.

After guesting briefly in London with the Metropolitan Ballet, and in Paris with Roland's Petit's Ballet de Paris, Schaufuss returned to Copenhagen to perform with the Nils Bjørn Larsen Ballet in 1940. For the next thirty years, Schaufuss danced with the Royal Danish Ballet, creating the role of "Mercutio" in Frederick Ashton's *Romeo and Juliet* (1955) and performing in a wide variety of company revivals. Among the works in which he was assigned principal roles were Leonid Massine's *Le Beau Danube,* Birgit Cullberg's *Miss Julie,* and David Lichine's *Graduation Ball.*

On retiring from the company, he and his wife, Mona Vangsaae, opened a studio in Copenhagen, the Danish Academy of Ballet.

Works Choreographed: CONCERT WORKS: *Idolon* (1953); *Opus 13* (1959); *Garden Party* (1963).

Schaufuss, Peter, Danish ballet dancer performing in Denmark, Canada, the United States, England, and France; born April 26, 1946 in Copenhagen. The son of Frank Schaufuss and Mona Vangsaae, he was trained, as were they, at the School of the Royal Danish Ballet.

After performing in the Bournonville repertory as a child, he grew up into the principal roles in his *La Sylphide* and *Napoli.* He danced in his *Flower Festival at Genzano* with the National Ballet of Canada, also performing in the company productions of *The Nutcracker* and the *Don Quixote* pas de deux. After appearing with the London Festival Ballet, notably in Frederick Ashton's *Romeo and Juliet* and Dennis Nahat's *Mendelssohn Symphony,* he joined the New York City Ballet. Although he performed in much of the repertory, with featured roles in George Balanchine's *Symphony in C, Scotch Symphony, La Somnambula,* and *Cortège Hongrois,* he created roles in *The Steadfast Tin Soldier* (1975), and in the Ravel Festival's *Rhapsodie Espagnole* and John Taras' *Daphnis and Chloe,* both in 1975.

An itinerant guest artist in the late 1970s, with the Royal Danish Ballet, the National Ballet of Canada, and the American Ballet Theatre, among other companies, Schaufuss joined Roland Petit's Ballet Nationale de Marseille in 1980. Featured as "Johann" in Petit's *The Bat,* Schaufuss created a leading role in his new *Phantom of the Opera* (1980).

Schilling, Tom, ballet dancer and choreographer of the People's Republic of Germany; born January 23, 1928 in Esperstadt, Germany. Schilling was trained at the school of the Dessau State Opera Ballet and with Mary Wigman, Dore Hoyer, and Olga Ilyina. For the first ten years of his career, he performed with the State Ballets in Dresden, Leipzig, and Weimar, beginning to experiment with his choreography in each tenure. As ballet master of the Dresden State Opera Ballet and the East Berlin Comic Opera, he has become recognized as one of the People's Republic's most innovative choreographers. He has staged productions of the Soviet repertory and of original works for his companies and as a guest choreographer for companies in France, Belgium, and Norway.

Works Choreographed: CONCERT WORKS: *Gayane* (1953); *The Flames of Paris* (1954); *The Fountains of Bakhchisarai* (1958); *Snow White* (1956); *Abraxas* (1957); *The Nightingale* (1958); *Moor of Venice* (1958); *Swan Lake* (1959); *The Stone Flower* (1960); *The Seven Deadly Sins* (1962); *The Sleeping Beauty* (1963); *Symphonie fantastique* (1967); *Aschenbrödel* (1968); *La Mer* (1968); *Der Doppelganger* (1969); *Ondine* (1970); *Match* (1970); *Fancy Free* (1971); *Romeo and Juliet* (1972); *Die Schwarze Vogel* (Black Bird) (1975); *Ballettogramme* (1976); *Erfinding der Liebe* (The Invention of Love) (1976); *Revue* (1977); *Swan Lake* (1978).

Schlemmer, Oskar, German expressionist artist, director, and choreographer working with the Bauhaus; born September 4, 1888 in Stuttgart; died April 13, 1943 in Baden-Baden. Schlemmer first wrote

about dance as an artistic genre in 1912 and, after a number of preliminary sketches, created *Triadic Ballet* for a 1922 performance at the Bauhaus art school and community. His choreographic experiments, which have been called movement for sculptures, were carried out with the facilities and students of the Bauhaus. *Figural Cabinet*, in fact, was originally created for a Bauhaus student's ball and was added to the Bauhaus touring repertory six years later. His other experiments of the 1920s included a series of short pieces, each built around a specific visual element, such as the *Dance of Wings*, the *Hoop Dance*, and the *Stick Dance*, the illustration from which is well known.

Works Choreographed: CONCERT WORKS: *Untitled duet* (1916, considered a preliminary sketch for the *Triadic Ballet*); *Triadic Ballet* (1922); *Figural Cabinet* (1922, first public performance in 1928); *Dances for the Experimental Stage* (*Space Dance, Form Dance, Gesture Dance, Dance with Wings, Toy Block Dance, Metal Dance, Glass Dance, Hoop Dance, Stick Dance*) (1926–1929).

OPERA: *Renard* (1929); *Rossignol* (1929).

Bibliography: Scheyer, Ernest, "The Shapes of Space: The Art of Mary Wigman and Oscar Schlemmer," *Dance Perspectives 41*; Schlemmer, Oskar, Laszko Moholy-Nagy, and Farkas Molnár. *The Theater of the Bauhaus* (Middletown, Conn:, 1961).

Schmidt-Blossom, Beverly, American modern dancer and choreographer; born c.1940 in Chicago, Illinois. After studies at Roosevelt University and Sarah Lawrence College, she was awarded a Fulbright scholarship to continue her training at the Mary Wigman school in Berlin (c.1962).

As Beverly Schmidt, she was a principal dancer with the Alwin Nikolais company for ten years, performing in his productions for the Henry Street Playhouse and for television. Her first recitals were at Henry Street in collaboration with fellow company members Phyllis Lamhut and Murray Louis. Although she uses his "total theater" concept to justify her creation of all the elements in her works—notably both live performance and film—she uses existing music or commissioned scores, frequently by Philip Corner or by Nikolais himself. Many of her works

are solos, among them *Black Traveler* (1961), *Piano-Dance* (1964), *My Bag* (1980), and her double-image solos with film, *The Seasons* (1963) and *Poem for the Theatre #6* (1964).

After teaching at Sarah Lawrence while working in New York, she joined the faculty of the University of Illinois at Urbana, where she has created many of her most recent works.

Works Choreographed: CONCERT WORKS: *Evil Eye* (1955); *Styx* (1955); *Six Miniatures* (1955); *Beginning* (1955); *Mobile* (1955); *Rite* (1956); *Gigues I and II* (1956); *Caprice* (1956); *Hymn* (1956); *Rag* (1956); *Premonitions* (1956); *Magma* (1956); *Two Characters* (1956); *Droll Figure* (1956); *Idyll* (1957); *Crest* (1959); *Wanderhythm* (1959); *9 Points in Time* (1960); *Aire* (1961); *Black Traveler* (1961); *Erg* (1961); *Caper* (1961); *Pindaric* (1962); *Momentos (Three Dances)* (1962); *Prelude to a Masked Event* (1962); *Chamber Dances* (1962); *Everybody* (1963); *All* (1963); *The Seasons* (1963); *Piano-Dance* (1964); *With Gladys, et al.* (1964); *Scene:Unresolved* (1964); *Eagle Sketches (Rocking Chair Dance)* (1964); *Poem for the Theatre #6* (1964); *Florence, Italy* (1965); *Waltz* (1965); *Three October Dances* (1965); *Yes, Live Happily* (1966); *Movement Loops* (1967); *A Rehearsal for Michaelangelo* (1968); *Depot Soup (collage)* (1968); *Dances for Kaleidoscope* (1968); *Patterns* (1969); *Yaxkin* (1970); *Corolla* (1970); *The Beginning of a Revolting Solo* (1971); *A Long Walk* (1971); *Dog* (1972, first version); *Requiem* (1972); *Moonlight Sonata* (1973); *Movement Loops with Bumbershoots* (1974); *I Look Back . . . I* (1974); *Flashback (An Affair with the Dance)* (1974); *Blue 1970* (1974); *Kitsch* (1975); *Dog* (1976, second version); *Celebrant* (1977); *One, Too* (1977); *Coda (Sorceress)* (1977); *Souvenir* (1977); *Questus Inquietus (Huh?)* (1977); *Vivaldi Trio* (1978); *Memory* (1978); *Old Woman in Blue Suede Shoes* (1978); *Signal* (1978); *Brahms Walk* (1978); *Sands* (1978); *Rollercoaster* (1979); *Ballroom* (1979); *My Bag* (1980); *Gemini* (1980).

Schneitzhoeffer, Jean-Madeleine, French nineteenth-century composer; born c.1785; died 1852 in Paris. Schneitzhoeffer was tympanist and *chef du chant* (chorus master) at the Paris Opéra in the early 1800s.

As a member of the musical staff he was expected to produce ballet scores on demand and was responsible for four complete works and for divertimenti in more than a dozen more. He was considered adept at composing music for pastorale ballets set in mythical or real countries in Europe, unlike the Orientalists who succeeded him. He did the music for François Albert's *Le Séducteur du Village* (1818), Jean Coralli's *La Tempête* (1834), André Jean-Jacques Deshayes' *Zémire et Azor* (1834), and the work for which he is remembered, Filippo Taglioni's *La Sylphide* (1832). Although his work is seldom used for revivals of that long-lasting ballet (since most choreographers use the Løvenskold music written for August Bournonville), it is extant in score and was once recorded. It is unkind, but not invalid, to say that Schneitzhoeffer represents a composer-on-demand who would not be remembered today were it not for the coincidence of his having written a score for a historically important ballet.

Schoënberg, Bessie, German modern dancer and teacher working in the United States; born December 27, 1906 in Hanover, Germany. Raised in the United States, she studied with Martha Hill at the University of Oregon before moving to New York to continue her training with Martha Graham at her school and at the Neighborhood Playhouse. As a student at the latter, she participated in Irene Lewisohn's orchestral dramas and concerts, dancing on one occasion in Humphrey's *String Quartet* (Bloch) (1931) and in Benjamin Zemach's *Tocatta and Fugue in D Minor*, with Albert Schweitzer playing the organ. She was a member of Graham's company in 1931, appearing in the premieres of her *Primitive Mysteries, Ceremonials,* and *Project in Movement for a Divine Comedy.*

One of the most influential composition teachers in the modern dance field, she was associated, both as a student and as Hill's assistant, with the Bennington School of Dance throughout its existence. She taught at Sarah Lawrence College for over thirty years, serving as head of the Dance Department from 1941. On her thirtieth anniversary at the school, some of her many students put on a recital for her; among the dancer/choreographers participating were Lucinda Childs, Meredith Monk, Lanny Harrison, Elizabeth Keen, Ted Striggles, Lauren Persichetti, and Carolyn Adams.

Schollar, Ludmilla, Russian ballet dancer also teaching in the United States; born c.1888 in St. Petersburg; died July 10 (or 11), 1978 in San Francisco, California. Schollar (or Shollar, as her name is occasionally spelled) was trained at the School of the Imperial Ballet in St. Petersburg and graduated into the Maryinsky Ballet in 1906. After dancing in works by Mikhail Fokine at the Maryinsky, she began to commute between that company and the Diaghilev Ballet Russe, performing in Paris and London. Her roles in the two institutions at this time included parts in Fokine's *Carnaval, Petrouchka, Papillon, Pavillon d'Armide,* and *Schéhérézade* and in Vaslav Nijinsky's *Jeux* (1913). She served as an army nurse during World War I but was able to return to a dance career in 1917. She performed with the GATOB/Kirov until 1921, when she returned to the Diaghilev company to perform in Bronislava Nijinska's *Les Fâcheux* (1924), and in the "White Cat" and "Enchanted Princess" variations in *The Sleeping Princess.*

After Diaghilev's death, she appeared with three interrelated companies of former Ballet Russe associates, the Ida Rubinstein Ballet, the (Tamara) Karsavina/(Anatole) Vilzak troupe, and the Nijinska company, before emigrating to the United States to teach at the Ballet Theatre School and the studio in New York that she shared with Vilzak. In 1965, they moved to the Bay area in California to work with students at the school of the San Francisco Ballet.

Schooling, Elizabeth, English ballet dancer; born 1919 in London. One of the earliest native dancers to fulfill her professional career entirely within England, Schooling was trained by Marie Rambert and was a member of her companies, the Ballet Club and Ballet Rambert. She appeared in early works by the company's trio of choreographers—Antony Tudor, Andrée Howard, and Agnes De Mille. Her Tudor credits include his *Descent of Hebe* and *Judgment of Paris* (as the original "Venus," 1938), while her Howard parts range from roles in *Ma Muse S'Amuse*

to "The Chantelaine" in her *La Fête Etrange*. She danced for De Mille in her theatrical ventures, creating the second-entering "Virgin" in her *Three Virgins and a Devil* in *Why Not Tonight?* (1934, London).

Schooling performed in West End musicals and operettas for many years after she retired from ballet.

Schorer, Suki, American ballet dancer; born March 11, 1939 in Cambridge, Massachusetts; raised in the Bay area of California, Schorer studied at the School of the San Francisco Ballet with Harold Christensen.

After performing for one season with the San Francisco Ballet, Schorer joined the New York City Ballet in 1959 and has been associated with that company ever since. Noted for the precision of her technique, Schorer created roles in Balanchine's *The Figure in the Carpet* (1960), *Raymonda Variations* (1961), *Pas de Deux and Divertissement* (1965), *Don Quixote* (1965), and the *Emeralds* section of *Jewels* (1967); she also performed to great acclaim in the *Rubies* section. Dancing until the early 1970s, Schorer performed in Balanchine's *Apollo, Concerto Barocco, Symphony in C,* the *Brahms-Schoenberg Quartet, Western Symphony, Ivesiana,* and in her best remembered comedy roles, *Tarantella* and *Stars and Stripes*.

Since retiring, Schorer has directed the lecture-demonstration program of the New York City Ballet, presenting dancers in exercises and excerpts from the repertory to students at New York-area public schools.

Schulkind, Marcus, American modern dancer and choreographer; born February 21, 1948 in New York City. Schulkind attended Goddard College in Vermont but transferred to the Juilliard School for his final year of formal education. He performed with the companies of Martha Graham (during her absence), Lar Lubovitch, Kathryn Posin, with whom he performed in *Colors*, and Pearl Lang, for whom he appeared in *Piece for Brass* (1969), *Shirah*, and repertory works. For his own company, founded in 1975, he has choreographed many works that are noted for their uses of balance and falls, with changing scales and speeds of movement. Among the troupe's most popular repertory pieces are the solo, *Fragments* (1979), choreographed for Schulkind by Daniel Nagrin, and the pair of social works, constructed of solos, *Ladies' Night Out* (1974) and *Gentlemen's Night at Home* (1980).

Works Choreographed: CONCERT WORKS: *Ladies' Night Out* (1974); *Lambert* (1976); *Onus* (1976); *A Piece of Bach* (1976); *Affetuoso* (1977); *Job* (1977); *Of Talliesin* (1977); *Earth Song* (1979); *And the Dawn Surprises No-One* (1979); *Gentlemen's Night at Home* (1980); *Pell Mell* (1980); *Mummers* (1980).

Schurman, Nona, Canadian modern dancer working and teaching in the United States; born in the 1910s in Oxford, Nova Scotia. Schurman was a graduate of McGill University when she visited New York to study at the Doris Humphrey and Charles Weidman studio. She became a member of the Humphrey/Weidman concert group in 1939 and appeared in Humphrey's *Song of the West, The Shakers,* and *Four Chorale Preludes*, Charles Weidman's *Flickers* (1941) and *And Daddy Was a Fireman*, and early works by José Limón, including *Western Folk Suite* (1943) and *Danzas Mexicanas* (1945). Schurman taught for many years at the New Dance Group Studio, the 92nd Street YM-YWHA (where Humphrey was director of the dance program), and the High School of Performing Arts.

Schwarz, Solange, French ballet dancer; born 1910 in Paris. The daughter of Jean Schwarz, a celebrated teacher in Paris, she was trained at the school of the Paris Opéra Ballet. She performed with the Opéra for much of her career, from 1930 to 1933 and from 1937 until her retirement in 1957. Best known for her "Swanilda" in *Coppélia*, she created major roles in Serge Lifar's *Entre Deux Rondes* (1940) and *Alexandre le Grand* (1937) and appeared in his *Le Chevalier et la desmoiselle* and *Les animeux modèles*, among many others. She performed as a guest artist with the Opéra-Comique, with which she had danced in the 1930s, Maurice Béjart's Ballet de L'Etoile and the Grand Ballet du Marquis de Cuevas.

After retiring from performance, she taught for many years at l'Ecole du Conservatoire Nationale de

Musique et de Déclamation, France's equivalent of New York's High School of Performing Arts.

Schwezoff, Igor, Russian ballet dancer and teacher; born 1904 in St. Petersburg. Trained at the School of the Imperial Ballet by Pavel Petroff and Asaf Messerer, Schwezoff moved to Paris to work with Olga Preobrajenska and Bronislava Nijinska. He performed for Nijinska in the Paris Opéra-Comique (1931) and her own company (1934), before moving to Amsterdam where he did his first choreography for a revival of Max Reinhardt's *The Miracle* and his own *Emperor Jones.*

In the Original Ballet Russe in 1939, Schwezoff created a featured role in David Lichine's *Graduation Ball* (1940). He formed a company in Brazil for which he continued to produce versions of the classic repertory and taught extensively in South America. Since the 1950s he has taught regularly in New York and Washington, D.C.

Bibliography: Schwezoff, Igor, *Borzoi* (London: 1957).

Scott, Judith, American choreographer and video artist; born March 20, during the 1920s in Chicago, Illinois. While pursuing an academic education in dance and video production, Scott studied dance with Alwin Nikolais and Murray Louis, composition with Anne Halprin, and technique with Zena Rommett and Raoul Gelabert.

Although she danced professionally since the early 1960s and worked in video and television production, she did not combine her careers until the mid-1960s in Chicago. Since 1973, she has presented live outdoor works and video choreography through her Experiments in Interactive Arts. Among her works created on tape are *Airport Piece/New London* (1973) at the Waterford Airport, and *Airport Piece/Newark* (1973), set on a DC-8. Her best known live works are *Rosarium* (1976), performed inside at the American Theatre Lab for a group of women, *Collections for the Spirit* (1978), in collaboration with artist Ralph Lee, puppeteer Eric Bass, Dennis Valinski and Bob Milnes, and *Summer Dances in the Streets* (1980), performed at five locations in lower Manhattan, beginning at the Louise Nevelson Plaza. Like Nevelson,

Scott is an artist who is able to combine media in unique ways into a new form of private communication based on public events.

Works Choreographed: CONCERT WORKS: *Deca Dance* (1973); *Gym Piece-Barnard* (1975); *Rosarium* (1976); *Colby College Snow/Museum Piece* (1977); *Up from the Streets* (1977); *Collections for the Spirit* (1978, in collaboration with Ralph Lee, Eric Bass, Dennis Valinski, and Bob Milnes); *Sky Sculpture Event* (1979, in collaboration with Howard Woody); *Springtime Salute to Dance* (1980); *Summer Dances in the Streets* (1980).

Video: *Untitled collaborations with Elsa Tambellini* (1973); *Airport Piece/New London* (1973); *Airport Piece/Newark* (1973); *Coast Guard Piece—New London* (1974); Video versions of live performance works.

Scott, Margaret, English ballet dancer teaching in Australia; born 1922 in Johannesburg, South Africa. Scott was trained in London by Marie Rambert and by the faculty of the Sadler's Wells School. After appearing in the Wells' wartime concerts in 1941, she joined the Ballet Rambert in 1943. A versatile dancer with tremendous presence and power, she danced "Odille" in the company's one-act *Swan Lake* and "The Hen" in Andrée Howard's *Carnival of Animals.* Among her other Rambert credits were roles in Antony Tudor's *Gala Performance* and *Judgment of Paris* and the company's *Les Sylphides.* After touring to Australia with the Rambert she decided to remain there to teach. She has served for many years as director of the Australian Ballet School.

Scott, Marion, American modern dancer and choreographer; born c.1922 in Chicago, Illinois. Scott studied with Martha Graham and Louis Horst at Bennington in 1941, and with Doris Humphrey and Charles Weidman at their New York studio. As a Humphrey/Weidman concert dancer, she performed in the premieres of Weidman's *Quest* (1936), and *And Daddy Was a Fireman* (1943), and served as Humphrey's teaching assistant.

Scott made her formal choreographic debut as a 92nd Street Y audition winner in 1948 and has presented many concerts since then. She was a founding

member of the Choreographers' Workshop series of recitals, which presented pieces by dancers who wanted to try out single titles without the pressure of producing entire concerts. Many of her own works, notably The *Afflicted Children* (1953), a dance treatment of the popular contemporary theme of the Salem witch trials, were presented at the Workshop performances. She has also shared recitals with Don Redlich (1964) and with Cliff Keuter and Elina Mooney (1967), setting up a national tour with them.

An influential teacher at the High School of Performing Arts, Scott has also taught at the Tamiris/Nagrin Studio and at Jacob's Pillow. She currently teaches dance and composition at the University of California at Los Angeles.

Works Choreographed: CONCERT WORKS: *Pastorale* (1940); *Salute* (1940); *Museum Piece* (1948); *As the Wind* (1948); *Dangerous Crossing* (1948); *The Tower of Bable* (1949); *The Afflicted Children* (1953); *Animal Courtship* (1955); *Bacchanale* (1955); *The Tenderling* (1956); *Hymn* (1957); *Undercurrents* (1958); *From the Sea* (1960); *From the Rocks* (1960); *Night Quest* (1960); *Three Energies* (1961); *Dilemma* (1962); *Rapt Moment* (1962); *Aftermath* (1963); *Couplet* (1964); *Going* (1964); *Haiga* (1964); *Psalm* (1965); *Matrix* (1965); *Jump! Jump!* (1966); *Breakpoint* (1966); *Concerto for Three* (1967); *Life Begins on Childhood Wings* (1968); *Abyss* (1971); *Sevenfold* (1972); *A Celebration for Percussion and Dance* (1974); *He That Has Time to Mourn Has Time to Mend* (1974); *Mysterium* (1975); *Trans* (1976); *Invitation* (1978).

Seckler, Beatrice, American modern dancer; born c.1910 in Brooklyn, New York. Trained at the Neighborhood Playhouse, she studied with Michio Ito and with Doris Humphrey and Charles Weidman at their studio. A Humphrey/Weidman dancer from 1935 to c.1942, she created roles in his *Lynch Town* and *Flickers*, playing "Flower of the Desert," and her *New Dance, Theatre Piece,* and *The Shakers*. Seckler also participated in recitals with fellow company members Dorothy Bird (better known as a Martha Graham dancer) and José Limón, dancing in his *Concerto* (1941). She and Lee Sherman, in their performances at the Roxy Theater, New York, of *Du-*

Barry Was No Lady and *Why Don't You Do Right?* (1943), were a great success.

Although she retired to teach in the 1940s, she emerged occasionally to perform for Sophie Maslow's annual Hannukah Festival presentations and to dance with Anna Sokolow. She was privileged to create roles in Sokolow's *Lyric Suite* (1954) and *Rooms* (1955), as the original performer of the solo, "Escape."

Sedova, Julie, Russian ballet dancer and teacher; born March 21, 1880 in St. Petersburg; died 1969 in Cannes, France. Sedova was trained in St. Petersburg at the school of the Imperial Ballet, graduating into the Maryinsky Theatre in 1898. She appeared in principal roles and solos in the works of Marius Petipa and Lev Ivanov, specializing in stereotypical national solos. A typical role was "Gamsatti" in Petipa's *La Bayadère*, the princess who seduces the hero away from the heroine through her Oriental wiles. She also appeared with Mikhail Mordkin's All Star Imperial Russian Ballet, a touring company, in the United States and Canada in its 1911 season, playing "Swanilda" and doing the divertissements that he choreographed for her: *Melancholia, Danse Orientalia,* and *Variations Classique*.

After leaving Russia in 1917, she settled in Nice, where she trained many future members of the Paris Opéra and the various touring Ballets Russe, among them, Serge Golovine, Georges Skibine, and Elizabeth Carroll of Ballet Theatre.

Segara, Ramon, American ballet dancer; born November 26, 1939 in Mayaguez, Puerto Rico. Segara was trained in New York City by Valentina Pereyaslavec, Anatole Vilzak, André Eglevsky, and George Chaffee, in whose chamber ballet and lecture-demonstrations he performed as a student. A member of the Ballet Russe de Monte Carlo in the late 1950s, he appeared in progressively larger roles in Leonid Massine's *Le Beau Danube* and *Gaité Parisienne* (maturing in three years from "A Soldier" to "The Peruvian"), Edmund Novak's *Slavonic Dances*, Leon Danielian's *Sombreros* (1958), and the company productions of *Coppélia* and *The Nutcracker*. With the New York City Ballet in the early 1960s, he performed in classical roles, as in George Balanchine's

Divertimento No. 15, in abstractions, such as his *Four Temperaments*, and in dramatic portrayals, including that of "Noah" in the televised opera, *Noah and the Flood* (CBS, June 14, 1962). Noted for his partnering and bravura style, he guested with a large number of companies, among them the Pennsylvania Ballet (in Balanchine's *Donizetti Variations* and the *Le Corsaire* pas de deux) and the Deutsche Opera in Berlin, in the 1965 revival of Marius Petipa's *Entrée*.

A popular and demanding teacher, he has served as ballet master of both modern dance and classical companies around the world, including the Alvin Ailey American Dance Theatre, the Hamburg State Opera Ballet, the Ballet Hispanico of New York, the Ballet Teatro de San Juan, and the Ballet Teatro Puertorriqueño.

Seigenfeld, Billy, American modern dancer; born October 15, 1948 in Mount Vernon, New York. Seigenfeld was trained at the Alwin Nikolais/Murray Louis studio in New York. He has worked with many of the most prominent choreographers and in companies of the contemporary creators of traditional American modern dance, among them Phyllis Lamhut, for whom he danced in *Congeries*, Elina Mooney, Irene Feigenheimer, Barbara Roan, Cliff Keuter, for whom he appeared in *Match*, and Don Redlich. A member of the Redlich company for much of his career, he has been applauded in the choreographer's *Jibe, Slowly Towards Bethlehem, Etrange, Patina, Rota, Traces,* and *Three Bagatelles*.

Works Choreographed: CONCERT WORKS: *Scenes of Childhood* (1972); *His Mistress Mine* (1973); *Planting* (1973); *Two Songs for Throwing Time* (1974); *Nest* (1975); *Antaean* (1976); *Mound* (1976); *Severance* (1977); *Severance II* (1978); *Pockets* (1979); *Quartz Contentment* (1980).

Seigneuret, Michele, French ballet dancer; born 1934 in Paris. Seigneuret was trained by Jeanne Schwarz in Paris. Associated throughout her career with the companies of Maurice Béjart, she was a member of his Ballets de l'Etoile (from 1954) and his troupe at the Ballet du Théâtre de la Monnaie in Belgium. She created roles in almost all of his early ballets, notably among them his *Symphonie pour un Homme seul* (1955), *Sonate à Trois* (1957), and *Orphée* (1959).

Sekh, Yaroslav, Soviet ballet dancer; born 1930 in the Ukraine. Sekh is frequently cited as a brilliant dancer who could never have been trained, or even have been in a ballet audience, in tzarist Russia. He discovered dance as a member of a worker's school (the equivalent of a union cultural education program) in Lvov, and was invited to apply for entrance in the school of Lvov Opera Ballet. He had been a performer with the Opera for two years when he entered the Bolshoi School in Moscow (1949) for two years. When he graduated into the Bolshoi Ballet he soon became known as its superlative character dance specialist, noted for his credibility in the national dances that proliferated in nineteenth-century ballets. His Spanish dances in *Swan Lake* and *Raymonda* were especially noted. He has also danced in the roles in which character development affects the plot progression of the entire work, such as "Mercutio" in *Romeo and Juliet* and the title role in Mikhail Lavroski's *Paginini* (1960).

Selden, Elizabeth, European concert dancer and writer working in the United States; born c.1895. Raised in Western Europe and the United States, she studied dance with Rudolf von Laban, Mary Wigman, and the Weisenthal sisters in Germany and Switzerland. Although she gave recitals in New York and in California, her real importance lay in her lectures and essays on the analytics of "free," or interpretive, and "modern," or German expressionist dance. Her two books, *Elements of a Free Dance* (New York: 1930) and *The Dancer's Quest* (Berkeley, Cal.: 1936), deserve reprinting if only for their attempts to create definitions for dance forms.

Works Choreographed: CONCERT WORKS: *The High Priests' Dances* (pre-1932); *Two Bagatelles* (pre-1932); *Moonlight Sonata* (1932); *Pulse of the Deep* (1932); *Temple Maid's Dance* (1932); *The Last Messenger* (1932); *Passive-Active* (1932); *Hymn to the Day* (1932).

Self, Jim, American postmodern dancer and choreographer; born March 6, 1954 in Greenville, Alabama. Raised in the Evanston/Chicago area of Illinois, Self studied at the Ruth Page Ballet School, the Chicago Dance Center, and the Columbia College Dance Center, for which he did early performance

and choreography. Since moving to New York, he has studied at the Merce Cunningham studio.

In Chicago, Self performed with the collective choreographic companies, MoMing Collection and Huperbody Marching Band (1975). Since arriving in New York, he has performed with Kenneth King, in his *RAdeoA.C.tiv(ID)ity* (1976) and as a member of the Merce Cunningham Dance Company, in his *Torse, Exchange,* and *Locale*, in repertory, and Events.

In Chicago, working with MoMing, and in New York, Self has choreographed solos for himself to be performed in theaters or, more frequently, in studios and museums, among them the Cloud Hands Studio in Chicago, the Walker Art Center in Minneapolis, and the downtown branch of the Whitney Museum in New York. The popularity of his works is due both to the facility with which he handles the postmodern formats of repetition and closely focused movement and to the humor which he incorporates in his choreography.

Works Choreographed: CONCERT WORKS: *Miami Beach* (1973); *Transverse* (1974); *Friday Night at MoMing* (1974); *Tuscaloosa* (1974); *Xanadu* (1975); *Self-Studies 1 to 12* (1975); *More of the Same in a Different Place Twelve Times* (1975); *White on White* (1976); *Scraping Bottoms* (1976); *Side Walks* (1977); *Up Roots* (1977); *Silent Partner/Changing Hands* (1980, in collaboration with writer Richard Wlovich); *Marking Time* (1980); *A Domestic Interlude* (1980).

Semenoff, Simon, Latvian ballet dancer working in Western Europe and the United States after the mid-1930s; born November 25, 1908 in Liepaja, Latvia. Trained at the school of the Latvian National Ballet in Riga under Alexandra Federova, he performed with the company while Mikhail Fokine was ballet master.

Semenoff left Latvia in the early 1930s to study mime at the school run by director Max Reinhardt. He performed in Reinhardt's productions and staged dances from his 1934 *Merchant of Venice*. After a season touring with the Woizikovsky Ballet, he joined the Blum Ballet Russe de Monte Carlo in the mid-1930s, dancing in Leonid Massine's *Rouge et Noir* and *Aleko*.

In the United States after 1941, he joined Ballet Theatre, and was reunited with Fokine for whom he danced in *Russian Soldier* (1942) *Carnaval, Petrouchka,* and *Bluebeard.* He was noted for his work in Massine's *Aleko, Don Domingo de Don Blas* (1942), and *Mademoiselle Angot* (1943), and David Lichine's *Helen of Troy.*

After retiring, Semenoff opened a series of dance studios in California and Connecticut, and took a job as a tour manager for Hurok Attractions.

Works Choreographed: CONCERT WORKS: *Memories* (1944); *Gift of the Magi* (1945).

Semyonova, Marina, Soviet ballet dancer; born June 12, 1908 in St. Petersburg, full maiden name unknown. Trained by Agrippina Vaganova, she was associated through the first part of her career with the GATOB company which she joined in 1923. For twenty years after 1930, she performed with the Bolshoi Ballet in Moscow, where her roles included "Odette/Odile," "Aurora," "Nikya," "Raymonda" in the Alexander Gorsky version, and "Giselle."

A teacher after the mid-1920s, she taught the *classes de perfectionement* and company classes for the Bolshoi after the mid-1940s.

Sequoio, Ron, American ballet dancer and choreographer; born in Texas. After local training he continued his studies in New York with Margaret Craske while performing in *The Happiest Girl in the World* (1961). He choreographed for a small company for recital and for the Manhattan Festival Ballet, of which he was artistic director (1964–1966). This troupe, with a repertory by Anna Sokolow, James Waring, and Sequoio, was short-lived but had a great impact on the development of the mixed-genre companies of later years. He contributed to productions at the New York City Opera, notably the controversial *Prince Igor* of 1969, and freelanced extensively.

Works Choreographed: CONCERT WORKS: *The Wind's Bride* (1962); *Legend of Lovers* (1963); *Moods* (1963); *The Stone Image* (1963); *Last of Earth* (1963); *Clytie* (1964); *Passage Enchanté* (1964); *Pas de Trois* (1965); *Adagietto* (1965); *Rondo* (1965); *Schubertiade* (1966); *Rondo for Seven* (1966); *First Reflection* (1967); *Dark Psalters* (1967); *Devamagari* (1967); *Allegro Largo* (1967); *Cinq Poèmes Hindou*

(1967); *Coruscare* (1968); *Da Capo 20* (1968); *Variations on a Rococo Theme* (1968).

Sergava, Katherine, Russian ballet dancer and American musical comedy actress; born c.1918 in Tiflis, Russia. Sergava studied ballet in Paris and London with Mathilde Kschessinskaia, Lydia Kyasht, and Julietta Mendez, also working with the latter in Los Angeles. After acting on the London stage, she was cast into a series of films made in London for American film studios, among them *Bedside* (WB, 1934), *Cock of the Air* (RKO, 1934), and *Eighteen Minutes* (Pathé, 1935). She came to the United States to further her film career, but continued to dance with the Mordkin Ballet (1938) and its descendant, the Ballet Theatre, of which she was a charter member. Her roles in the latter company included Mordkin's *La Fille Mal Gardée*, and the company productions of *Les Sylphides* and *Pas de Quatre*, in which she played "Cerrito." In the Ballet Russe de Monte Carlo in 1941, she was cast in Leonid Massine's *Choreartium* and *Les Présages*, and in David Lichine's *Graduation Ball*.

Following that engagement, Sergava undertook a tour for the USO, winning the accolade "the Ballerina Pin-up" and more popular fame than she had ever had as a film actress. Her recital program for the G.I. concerts included a solo staged for her by Agnes De Mille, *Jesu, Joy of Man's Desiring*. De Mille hired her for the original cast of *Oklahoma* as "Ellen," the chorus girl who dances the part of "Laurey" in the dream ballet. She did over one thousand performances in that part before moving into Jerome Robbins' *Look Ma, I'm Dancing* (1948), in which she portrayed a Russian ballerina, "Tanya Drinksaya."

Sergava became a member of the Actor's Studio and concentrated on dramatic roles for much of the remainder of her career. She did dance once more, however, to replace Lotte Lenya in the successful New York presentation of *The Threepenny Opera* in 1956. Since then, she has performed extensively in and outside New York's theaters.

Sergeev, Konstantin, Soviet ballet dancer and choreographer; born Febuary 20, 1910 in St. Petersburg. After private lessons with Simon Semenoff and ballet classes in night school, Sergeev entered the school of the Leningrad Choreographic Institute. He made his debut in a touring ensemble directed by Josef Kschessinsky but soon became a member of the Kirov Ballet. In that company, he created roles in Lavrosky's *Romeo and Juliet* (1940), as "Romeo," and in Leonid Iacobson's *Shurale* (1950), with featured parts in Zakhoarov's *The Bronze Horseman* and Fenster's *Tara Bulba*. He frequently partnered Galina Ulanova and his wife, Natalia Dudinskaya, in *Giselle*.

Sergeev choreographed for the Kirov and remounted productions of the classics of the European and Russian repertory.

Works Choreographed: CONCERT WORKS: *Cinderella* (1946); *Raymonda* (1948); *Swan Lake* (1950); *Path of Thunder* (1958); *A Distant Planet* (1963); *Hamlet* (1970); *Levsha* (1976).

Sergeev, Nikolai, Russian ballet dancer, teaching and staging works in Western Europe; born September 15, 1876 in St. Petersburg; died June 23, 1951 in Nice, France. Sergeev was trained by Pavel Gerdt, Marius Petipa, and Christian Johanssen at the school of the Imperial Ballet in St. Petersburg. He appeared in many Petipa works as a member of the Maryinsky Ballet, including *The Sleeping Beauty, Swan Lake* (Petipa acts only), and *Les Elèves de Dupré* (1907). He retired from performance in 1904 to serve as a regisseur of the Maryinsky and became *régisseur générale* in 1914, recording works in the Stepanov notation system. He emigrated from the Soviet Union in 1918, traveling through Istanbul and Marseilles to Paris. After 1921, he worked as a freelance restager of the nineteenth-century repertory for companies in France and England, among them the Diaghilev Ballet Russe, with which he produced the 1921 *Sleeping Princess* in London, the Camargo Society, for which he staged *Giselle* (for Olga Spessivtseva and Anton Dolin), and the Sadler's Wells Ballet, where he reconstructed *Giselle, Coppélia, Casse-Noisette,* and a *Lac des Cygnes*. He served as ballet master for the International Ballet, London, and staged *Coppélia, Swan Lake, Giselle*, and *Sleeping Beauty* for that company. Aside from the Petipa revivals, he staged *La Fille Mal Gardée* after Ivanov for the Riga Opera in 1922 and a *Coppélia* with Ninette

De Valois, after Ivan Clustine and Ivanov in 1954 for the Sadler's Wells Ballet.

Sergievsky, Oleg, Russian ballet dancer working in the United States; born August 21, 1911 in Kiev. Sergievsky was trained by Bronislava Nijinska at her school in Kiev before he emigrated to France, where he studied with Olga Preobrajenska. After moving to Bridgeport, Connecticut, he continued his studies there with Irene Comer and with Mikhail Fokine in New York City. He performed in Fokine's companies in the New York area, working concurrently in cabarets and nightclubs on recommendation of fellow Fokine student, Paul Haakon. He appeared in the corps of most of the Russian ballets in the country between 1941, when he joined the Metropolitan Opera Ballet under Boris Romanoff, and 1946, when he rejoined the Ballet Russe de Monte Carlo. In between he was with the charter company of Ballet Theatre, where he performed in Eugene Loring's *Great American Goof* and Adolf Bolm's *Peter and the Wolf*, and the Original Ballet Russe, in which he danced in David Lichine's *Graduation Ball* and Leonid Massine's *Les Présages* and *Symphonie Fantasque.*

Sergievsky taught in Manhattan, Jackson Heights, Queens, and Milford, Connecticut, from 1950 on.

Serrano, Lupe, Mexican ballet dancer working in the United States after 1949; born December 7, 1930 in Santiago, Chile. Raised in Mexico City, she studied there with Nelsy Dambré, performing in Dambré's ballet troupe as an adolescent. She made her debut at age thirteen with the Ballet de Palacio de Bellas Artes in a presentation of Mikhail Fokine's *Les Sylphides.*

Serrano performed with the Ballet Alicia Alonso and the Ballet Russe de Monte Carlo in the United States, in featured roles in the nineteenth-century classics in both companies. Her exact and exciting technical brilliance brought her to fame in the classics in Ballet Theatre also. Joining that company in 1951, she performed both "Myrthe" and the title role in *Giselle,* "Odette" in the one-act and complete versions of *Swan Lake,* and many pas de deux. She danced in the premieres of many contemporary works, created for the company and for the Ballet Theatre Workshop series, among them, Eugene Loring's *The Capital of the World* (1953), Agnes De Mille's *Sebastien* (1957), Birgit Cullberg's *Lady from the Sea* (1960), and Herbert Ross' *Concerto* and *Ovid Metamorphoses* (both 1958).

Constantly employed as a guest artist, in the full-length classics and in pas de deux, Serrano also performed with the Metropolitan Opera Ballet in the 1958 and 1959 seasons, notably in Antony Tudor's *Hail and Farewell* and Alexandra Danilova's *Les Diamants* (both 1959). Serrano retired from performance after fifteen years with Ballet Theatre.

Setterfield, Valda, English ballet and theatrical dancer working in the United States as a postmodernist. After training at the Italia Conti school (a pre-professional studio of dance and theater) in London, she took ballet classes with Marie Rambert and Audrey De Vos. She appeared in London and provincial pantomimes and in Donald Saddler's American-style touring musical shows in Italy before emigrating to the United States in 1958. Her first job here was as a costume assistant to Pauline Lawrence, so she took classes with the José Limón company and participated in the 1960 to 1962 American Dance Festivals. She had also begun to work with James Waring in his occasional concerts, in which she appeared in his *Tableaux* and *Peripatea* (both 1960) and in his productions with the Living Theater. Through Waring she became a student at the Merce Cunningham studio and a member of the Cunningham company from 1960 to 1961 and 1965 to 1975. Among the many repertory works in which she performed were *Aeon* (1963), *Place* (1966), *How to Pass, Kick, Fall and Run* (1965), and *Changing Steps* (1973), as well as early Events.

Setterfield is best known at present for her performances in the works of David Gordon and his Pick-Up company. In their duet appearances together, whether characterizational as in *Random Breakfast* (1963) or abstract as in *Chair* (1974), they work together in a comic coupling complete with set roles and reactions. The straight-faced Setterfield, who was once described as "miming with a British accent," moves serenely through Edwardian athletic poses in *One Part of the Matter* (1972) and fractured voice reports in *What Happened* (1978). In the Gordon scheme of costuming, she is frequently dressed in

white tailored shorts or black rugby shirts that make her look like a physical education teacher suffering through a required master class. Gordon also uses Setterfield's voice for comic effect, most delightfully in the commentary about his own solo in *Not Necessarily Recognizable Objectives* (1978) when she deflates his every polemic. She can also be seen in the Yvonne Rainer film, *Lives of Performers* (1972).

Severn, Margaret, American ballet and concert dancer and choreographer; born 1901 in Birmingham, Alabama. Severn first studied interpretive dance in Denver, Colorado, where she was raised by her mother, the crusading suffragist psychologist, Dr. Elizabeth Severn. At the age of nine she moved to London, where she was trained at the school of Léon and Edouard Espinosa, later founders of the Royal Academy of Dancing. After a solo recital at London's Hotel Savoy in 1914, she moved to New York where she studied ballet with Luigi Albertieri, Vincenzo Celli, and Mikhail Fokine, and took classes at the local Denishawn school. For the next four years, Severn worked as a freelancer in a wide variety of techniques and specializations. She performed as a ballet dancer with the Metropolitan Opera, where she made her debut in *Aida* at age fifteen. She worked as a soloist with Ruth St. Denis in her March 1917 New York recitals, although, since she was never listed as a company member, she may have been hired as a pick-up dancer or to replace an injured company member. She also appeared in Broadway shows, among them *Linger Longer Letty* (1919) and *As You Were* (1920), before becoming a recognized soloist with her featured performances in the *Greenwich Village Follies of 1920.*

In this edition of the innovative design-oriented revue, Severn performed both barefooted and on full point. Her specialty in the show, and throughout her concert dance career, was defined by a design element—her use of characterizational masks by W.T. Benda. Wearing Benda's masks, or those of her own design, Severn toured on the Keith and Orpheum vaudeville circuits and on the less organized concert tour routes in the United States and Europe for over twenty years. Using the wide variety of dance techniques at her disposal, she became able to create human personas for extended mime dramas or for the quick-change series of twelve dances that were included in most performances under the collective title, *Mask Portraits.*

Although best known as a solo concert dancer, Severn had a successful career as a ballet dancer and choreographer, creating works for the final 1934 season of the Ballets Russes de Ida Rubinstein and Ballets Russes de Paris in 1935–1936, serving as ballet master for the latter company's 1936 tours. She received choreographic credit for three full-length works performed in the company's 1936 season—*Rhapsodie, Suite Caucasienne,* and *Bolero*—and may also have restaged their productions of *Les Sylphides* and the *Polovtsian Dances.*

Severn served as founding president of The Dancers' Club and was active in the unionization of concert and ballet company dancers in the late 1930s. During the 1940s, she taught ballet and characterizational movement to both dancers and actors, while associated with Walter Armitage revivals of Elizabethan drama. She danced in theatrical productions and in her own solo recitals until 1945.

Works Choreographed: CONCERT WORKS: *Korean Warrior Dance* (1920); *Ballet Egyptian No. 4* (1920); *The Silly Doll Tries a Greek Dance* (1920); *Bacchanal* (1920); *The Golden Dragon* (1920); *Japonaise* (1920); *Primavera* (1920); *March Funèbre* (1920); *Valse, Scherzo and Etude* (1930); *Frenzy* (1930); *In the Hall of the Mountain King* (1930); *Valse Brilliant* (1930); *Hungarian Ballade* (1930); *Maroushka* (1930); *Fool's Dance* (1930); *To the Sea* (1930); *From A Wandering Iceberg* (1930); *A.D. 1620* (1930); *Moonlight Sonata* (1930); *Gossip* (1930); *Prelude* (1931); *Ecos Sevillianos* (1931); *Shriek* (1931); *Hurdy-Gurdy* (1931); *Poem from "The Rolling Pearl"* (1931); *The Dagger* (1931); *Two Mazurkas* (1931); *The Pink Lady* (1931); *El Baturo* (1931); *Rhapsodie* (1931, solo); *Nocturne* (1931); *Harlequin* (1931); *Various Devils* (1931); *Rhapsodie* (1936, group work); *Suite Caucasienne* (1936); *Bolero* (1936); *Green Pickle Waltz* (1940); *Feline Adventures* (1940); *Impromptu* (1940); *Romance and Caprice* (1940); *Romance* (1940); *Butterfly* (1940); *Hungarian Ballade* (1940); *Conflict and Resolution* (1940); *Revolutionary Etude* (1945); *Dance of the Rose* (1945); *Vixen and Shrew* (1945); *Sketches* (1945); *Sonatine* (1945); *Waiting* (1945); *The Enchanted Dove* (1945); *Show Business* (1945).

Seymour, Lynn, English ballet dancer; born Lynn Springbett, March 8, 1939 in Wainwright, Alberta, Canada. Trained as a child in Vancouver, British Columbia, by Jean Jepson and Nicolai Svetlanov, Seymour continued her studies in England at the school of the Royal Ballet.

Joining the Royal Ballet from 1957 to 1965, she became associated with the works of Kenneth Macmillan, creating roles in his *The Burrow* (1958), *The Invitation* (1960), *Le Baiser de la Fée* (1960), *Symphony* (1963), *Images of Love* (1964), and *Romeo and Juliet* (1965). Moving with Macmillan to the (West) Berlin State Opera Ballet (1965–1966), she danced in the premieres of his *Concerto* (1966) and the first version of *Anastasia* (1967).

After returning to the Royal Ballet in 1970, she continued to create roles in Macmillan ballets, including the full-length version of *Anastasia* (1971), *Side Show* (1972), *Seven Deadly Sins* (1974), and *Rituals* (1975). She also danced in Jerome Robbins' *Dances at a Gathering* and *The Concert* and in Frederick Ashton's *A Month in the Country* (1976) and *Five Brahms Waltzes in the Manner of Isadora Duncan* (1976), a series of solos which she performed frequently in guest appearances since their creation.

An extremely popular dramatic dancer who can look totally modern or seem to be intrinsically attached to a historical period, Seymour has frequently been invited to perform with other companies—from American Ballet Theatre, in which she has performed the classics, to the Alvin Ailey Dance Theatre, with which she created the role of "The Woman" (generally believed to represent Janis Joplin) in Ailey's *Flowers* (1971). Often experimenting in nonclassical techniques, Seymour co-choreographed a work with Robert North of the London Contemporary Dance Theatre—*Gladly, Sadly, Madly, Badly* (1975). Seymour retired from ballet in 1980 to perform as an actress and rock musician.

Works Choreographed: CONCERT WORKS: *Gladly, Sadly, Madly, Badly* (1975, co-choreographed with Robert North).

Seymour, Nelse, American nineteenth-century eccentric dancer; born Thomas Nelson Sanderson, June 5, 1835 in Baltimore, Maryland; died February 2, 1875 in New York City. Seymour, whose mother is reported to have made the actual flag about which the "Star Spangled Banner" was written, was considered one of the finest eccentric dancers of the nineteenth century, as well as an expert at the satires of ballet and theatrical dance that were interpolated into contemporary minstrel shows. He made his debut with the Dan Rice Minstrel Company in 1860 but three years later joined the company with which he would be forever associated—Dan and Jerry Bryant's troupe in New York City. Apart from a tour of Western Europe with the (George) Christy Minstrels in 1868, he spent all of his short professional life with the Bryants. With that company of comedians doing both Irish and Black clichés and slurs, he worked primarily in silent acts, doing legomanic routines in male and female attire. One contemporary critic stated that Seymour "could kick higher than any man living," and his imitations of the European ballerinas working at Niblo's, the Park, and the Bowery, were considered hysterically funny.

Seymour died of Bright's disease less than a week after his last performance in the Bryant company.

Shabelevski, Yurek, Polish ballet dancer working in Western Europe and the United States after the mid-1920s; born 1910 in Warsaw, Poland. Shabelevski was trained at the ballet school of the National Theater of Warsaw by Bronislava Nijinska, with whom he worked at the Teatre Wielki, Warsaw, and the Ida Rubinstein Company in Paris in 1928.

An original member of the Ballet Russe de Monte Carlo, he created roles in Leonid Massine's *Scuola di Ballo* (1933), and *Union Pacific* and *Jardin Public* (both 1935), also performing in Massine's *La Boutique Fantasque*, Nijinska's *Les Noces*, and Mikhail Fokine's *Schéhérézade* and *Carnaval*. A charter member of Ballet Theatre in 1940, he danced the role of "Colin" in the Mikhail Mordkin/Nijinska version of *La Fille Mal Gardée* to great acclaim.

During the 1950s, Shabelevski performed and taught in South America. He has served as ballet master of the New Zealand Ballet since 1967.

Shabelska, Maria, Russian ballet dancer also teaching in North and South America; born c.1899 in St. Petersburg; died May 14, 1980 in Brattleboro, Vermont. Trained at the school of the Imperial Ballet in

St. Petersburg, she joined the Diaghilev Ballet Russe after her graduation recital. Although she appeared in most of the company repertory of the seasons 1915 to 1918, she is best remembered for her performance of "The Little American Girl" (after Fanny Brice) in Leonid Massine's *Parade*. With her husband, Alex Yakovleff, she spent most of the 1920s performing at the Teatro Colón, Buenos Aires, or teaching with him at the Ned Wayburn Studio of Stage Dancing in New York City. They continued to commute between Buenos Aires and New York until his death sometime in the 1930s, when she began to work with the Detroit Civic Opera as ballet master and resident choreographer; Shabelska dropped out of dance shortly thereafter and became a factory supervisor. It has been suggested that she began that line of work as a "Rosie the Riveter" during World War II.

Shaler, Eleanor, American theatrical dancer and dance satirist; born in the first years of the century in Indianapolis, Indiana. Shaler, who was a friend and neighbor of Ruth Page, studied along with Page with Andreas Pavley and Serge Oukrainsky after they left the Pavlova company to teach in Indianapolis. After graduating from Vassar College, Shaler moved to New York City to work as a dance parodist, pursuing her ballet studies as a basis for satires on the classics, and to work on more contemporary forms. Her best known numbers were "Working with a Scarf," interpolated into the *Garrick Gaieties of 1926* and "Tally-Ho," which she did in *The Manhatters* (1927). Although she was the dance headliner of two more revues, *Pardon My English* (1932) and *Clo-Clo* (1934), she became better known as a novelist by the mid-1930s with the *roman à clef, Wake and Find a Stranger*, her most popular work. Shaler also worked as a reviewer for the Hays Office, the film-rating tyranny of the 1930s.

Shapero, Lillian, American concert dancer and choreographer associated with the Yiddish-language theater; born c.1910 in New York City. Trained at the Neighborhood Playhouse by Blanche Talmud, Louis Horst, and Martha Graham, Shapero performed with Graham in many of her early works. Notable among them were her *Primitive Mysteries* (1931), still considered one of the masterpieces of traditional modern dance, *Ceremonials* (1932), the *Six Miracle Plays* (1933), *Tragic Patterns* (1933), and *Intergrales* (1934).

Shapero also worked as a concert dancer with recitals of her own works in 1935 through 1940, and as a choreographer for the Yiddish theater in New York. Her concert works included topical solos depicting political and social conditions in New York and Europe, among them her *Two Dances of Unrest* (1936), *Proletarian Songs* (1937), *We Are the Living* (1939), and her most famous piece, *No Pasaran* (1938). She also staged movement for oratorios, chorale performances, and celebrations for social/political organizations, such as the *Tzvei Bruder* (Two Brothers) (1936), *A Bunt mit a Stachke* (performed in English as *To Strengthen the Bond*) (1937) for the Freiheit, *New Fields* (1940), and annual Artef (Workers' Theater Group) anniversary concerts.

Shapero was associated with two of the major Yiddish-language theater companies in New York—the Artef (Workers' Theater Group) and Maurice Schwartz' Yiddish Art Theater. She staged movement and national dances for many important productions, including Schwartz' *Yoshe Kalb* (1933), and *Three Cities* (1938), and the Artef's *East Side Professor*.

Works Choreographed: CONCERT WORKS: *Tragic Carnaval* (1935); *Beggars' Dance* (1936); *Wanderers' Dance* (1936); *Salutations* (1936); *Lyric Fragments* (1936); *Once Upon a Time* (1936); *Two Dances of Unrest* (1936); *Blues* (1936); *Street Scene* (1936); *Prelude* (1937); *Demagogue* (1937); *Proletarian Songs* (1937); *Trilogy (Patriotism, Casualty List, Drums Again)* (1937); *Crisis* (1937); *Purim Shpiel* (1937); *Song of the Harvest* (1937); *Peasant Girl* (1937); *Jingoist* (1937); *No Pasaran* (1938); *We are the Living* (1938); *Songs of the People* (1939); *On a Folk Theme* (1939); *Workaday Songs* (1939); *Women of Spain* (1939); *Chorale* (1939); *Mazel-Tov* (1939); *. . . And in Those Days* (1939); *Young America* (1939); *We Are the Living* (1939).

ORATORIOS AND CHORALES: *Tzvei Bruder* (1936); *A Bunt Mit a Stachke* (1937); *One-Sixth of the Earth* (1937); *New Fields* (1940).

THEATER WORKS: *Yoshe Kalb* (1933); *The Water Carrier* (1937); *East Side Professor* (1938); *Three Cities* (1938).

Shaw, Brian, English ballet dancer; born Brian Earnshaw, June 28, 1928 in Huddersfield, Yorkshire. After early training locally with Mary Shaw, he continued his training with Nickolai Sergeev and Ailine Philips at the school of the Sadler's Wells Ballet.

Performing with the Sadler's Wells and Royal Ballets since his debut in 1944, he has created roles in many of the most important works of the great English choreographer, Frederick Ashton. These include Ashton's *Symphonic Variations* (1946), *Tiresias* (1951), *Sylvia* (1952), *Homage to the Queen* (1953), *Birthday Offering* (1956), *Ondine* (1958), *Monotones* (1966), and *Enigma Variations* (1968), and revivals of his *Les Patineurs* and *Scènes de Ballet*. Shaw's other celebrated performances range from "Franz" in *Coppélia*, the title role in *Petrouchka,* the "Bluebird" in *The Sleeping Beauty*, and parts in John Cranko's *Bouche-Bouche* (1952) and *The Shadow* (1953).

Shaw, Oscar, American musical comedy star of the early twentieth century; born Oscar Scwartz, 1889 in Philadelphia, Pennsylvania; died March 6, 1967 in Little Neck, New York. Shaw sang and danced on Broadway for almost thirty straight years from his debut in the chorus of *The Mimic World* (1908) to *Petticoat Fever* in 1935. He was the juvenile lead in everything from *The Kiss Waltz* (1911) and the *Passing Show of 1912* to *Two Little Brides* (1912) and *Two Little Girls in Blue* (1920), in which he partnered the Fairbanks Twins. His best known shows included Jerome Kern's intimate musicals, *Very Good Eddie* (1915), *Leave It to Jane* (1917), and *Good Morning Dearie* (1920), and the Gershwin shows, *Oh, Kay* (1926) and *Of Thee I Sing* (1932). Although he performed social dances in every show and specialty one-steps in many, his only ballet work was done in London where he was in the Alexis Kosloff *Rose d'Ispahan* and *The Opium Den* with Phyllis Monkman at the Alhambra Theatre.

Shaw also worked in films, playing a boxer in the ultimate backstage/locker-room movie, *The Great White Way* (Cosmopolitan, 1924), and playing the singing hero in *Upstage* (MGM, 1926), *Going Crooked* (Fox Films, 1927), *Marianne* (MGM, 1930), and *The Coconuts* (Paramount, 1929). For many

years after his retirement from Broadway in the mid-1930s, he could be heard on radio.

Shaw, Wini, American theatrical and film dancer and torch singer; born Winifred Lei Momi Lokelani-Shaw, February 25, 1910 in San Francisco, California. She made her professional debut as the youngest member of The Shaw Family, a Hawaiian dance act. She made the switch to Broadway in more conventional technique, however, doing musical comedy work and belting out torch songs in *Rain or Shine* (1928). In her next shows, her singing began to overwhelm her dance work, as she replaced Ruth Etting in *Simple Simon* and Helen Morgan in the *Ziegfeld Follies of 1931*. Her success on Broadway and as a band vocalist brought her a Hollywood contract from Warner Brothers. Her best remembered film appearance was as the doomed "Gold-digger" who lived and died the "Lullaby of Broadway" in Busby Berkeley's *Gold-Diggers of 1935* (First National/Vitaphone, 1935). Other celebrated performances included *Sweet Adeline* (1935), Al Jolson's *The Singing Kid* (1936), and *In Caliente* (1935), in which she sang the song for which she was dubbed "The Woman in the Red Dress."

Shaw made her last dance appearances as a member of Jack Benny's *Five Jerks in a Jeep* (a USO troupe in Europe). From the mid-1940s, she worked almost exclusively as a torch singer.

Shawn, Ted, American concert dancer and choreographer; born October 21, 1891 in Kansas City; died January 9, 1972 in Orlando, Florida. Shawn received dance training from Hazel Wallack in Denver, and from Norma Gould, his first partner. After teaching in Los Angeles, he toured with Gould in 1914. On that series of performances, he met and married Ruth St. Denis, a more established concert dancer whose repertory included works inspired by Oriental cultures. Shawn's early works, which were mostly exhibition ballroom works and abstract pieces influenced by Gould's choreography, merged with St. Denis' to produce the Denishawn style.

Shawn and St. Denis managed the Denishawn schools, in residence at the studios in Los Angeles and New York, and the concert tours across the

United States and in Asia. His own choreography of this period was very like hers, with its Orientalism and abstractions, but he added elements of Greek mythology to offset her interests. Together they produced what may be the ultimate Denishawn work—*Death and After-Life in India, Greece and Egypt* (1916).

Toward the end of the Denishawn era, however, Shawn became involved in the German modern dance movement through the participation of Margarete Wallmann at the Los Angeles school. Their *Orpheus Dionysus* (1930), which was created in Germany, brought him into the mainstream of Dalcrozean choreography, and that element of his work revitalized him as a creative artist. His later work for an all-male company was constructivism at its most objective. Although his works had such titles as *Worker's Songs of Middle Europe* (1931) and *Labor Symphony* (1934), they were not political pieces but were, rather, abstractions about energy and force. While it is a shame that his prejudices made him unable to create such works for the women of the Denishawn troupe, there is no question that these works for the Ted Shawn and His Men Dancers group were among the best of the American branch of the German expressionist movement.

The latter group was established at a farm in Becket, Massachusetts, called Jacob's Pillow. His theater and school at Jacob's Pillow, open during the summer, became a favorite performance spot for ad hoc companies and individual dancers who wanted to try out a choreographic urge. The school there enabled young students to work with the performers as well as resident faculty.

A prolific author, Shawn published books on St. Denis, on touring, on education, and on François Delsarte.

Works Choreographed: CONCERT WORKS: *A French Love Waltz* (1911); *Diana and Endymion* (1912, co-choreographed with Norma Gould); *Cymbal Dance* (1914); *Dagger Dance* (1914); *The Joy of Youth* (1914); *Grecian Suite* (1914); *Oriental Suite (Zuleika, Poem of Love)* (1914); *Modern Dances* (aka *Dances of Today*) (1914); *Oureida* (1914); *Rondo Capriccio* (1914); *Vintage Dance* (1914); *Earth Cycle* (1914); *Pipes of Pan* (1914); *Waltz Al-Fresco and Lu-Lu Fandango* (1914); *Mazurka Matinée* (1914); *Tao-Tao* (1914); *Springtime Idyll* (1914); *Hawaiian Ballet* (1915); *South Sea Ballet* (1915); *Nature Rhythms* (1915); *Ancient Egypt* (1915); *Valse Directoire* (1915); *St. Denis Mazurka* (1915); *The Legend of Joseph* (1915); *The Lord is My Shepherd* (1915); *Arabic Suite* (1916); *Sculpture Plastique* (1916); *Savage Dance* (1916); *Inventions and Fugues* (aka *Bach's Inventions*) (1917); *Botticelli* (1917); *Love Waltz* (1918); *Danse de Medici* (1918); *The Willow* (1918); *Flamenco* (1919); *Japanese Spear Dance* (1919); *Julnar of the Sea* (1919); *Miriam, Sister of Moses* (1919); *Three-Part Invention, No. 4* (1919); *Gnossiene, No. 1* (1919); *Two-Part Invention, No. 4* (1919); *Serenata Morisca* (1919); *Frohsinn* (1920); *Javanese Shadow Play* (1920); *Les Mystères Dionysiaques* (1920); *Two Chopin Mazurkas* (1920); *Spring Beautiful Spring* (1921); *The Abduction of Sita* (1921); *Le Contrebandier* (1921); *A Church Service in Dance* (1921); *Invocation to the Thunderbird* (1921); *Malaguena* (1921); *Pierrot Forlorn* (1921); *Scherzo Waltz* (1921); *Cappriccioso* (1921); *Spanish Suite I* (1921); *Pastorale* (1921); *Street Nautch* (1921); *Sita* (1921); *Xochitl* (1921); *Juba* (1921); *Ecossaise* (1921); *Spanish Suite II* (1922); *Cowboy* (1922); *Maskowski Waltz* (1922); *Siamese Ballet* (1922); *Flamenco Dances* (1923); *Tales from the Vienna Woods* (1923); *Pasquinade* (la Belle Creole) (1923); *Invitation* (1923); *Cuadro Flamenco* (1923); *American Sketches (Boston Fancy—1854, The Crapshooter, Around the Hall)* (1924); *Death of Adonis* (1924); *Gringo Tango* (1924); *Ballerina Real* (1924); *Voices of Spring* (1924); *Choeur Dansé* (1925); *Spanish Suite III* (1925); *Straussiana* (1925); *Valse Denishawn* (1925); *Pas de Quatre* (1925); Dances from the Oriental Tour *(Impression of a Wayang Purwae, Cosmic Dance of Siva, Danse Cambodienne, General Wu's Farewell to His Wife, Momijii-Gari, Sinhalese Devil Dance)* (1926); *Spanish Suite IV* (1926); *Allegresse* (1926); *Gladzunov Waltz* (1927); *Valse de Concert* (1927, possibly same as above); *Mazurka de Salon* (1928); *Pulcinello* (1928); *Ballade, Opus 47* (1929); *Death of a Bull God* (1929); *Fingal's Cave Overture* (1929); *Idyll* (1929); *Ramadan* (1929); *Shawl Dance* (1929); *Temple Dancing Girl* (1929); *Pacific: 231* (1929); *Baba Jaga*

(1930); *Homage à Rameau* (1930); *The Divine Idiot* (1930); *Brahms, Opus 79, No. 2* (1930); *Group Dance for Male Ensemble* (1930); *Osage-Pawnee Dance of Greeting* (1930); *Metal Fantasy* (1930); *Scarf Plastique* (1930); *Orpheus Dionysus* (1930, cochoreographed with Margarete Wallmann); *Souvenir of Bavaria* (1930); *Dance of Greeting, Dance of the Redeemed* (1931); *The Camel Boys* (1931); *Pièces Froides* (1931); *Stick Nautch* (1931); *Worker's Songs of Middle Europe* (1931); *Rhapsody Op. 119, no. 4* (1931); *Zuni Indian Ghost Dance* (1931); *O Brother Sun and Sister Moon* (1931); *Job, a Masque for Dancers* (1931); *Charlie's Dance* (1933); *Two Part Invention, No. 4, Three Part Invention, No. 12* (1933); *Doxology* (1933); *John Brown Sees the Glory* (1933); *Los Embozados* (1933); *Negro Spirituals I and II* (1933); *Sixth Prelude from the Well-Tempered Clavichord* (1933); *Kankakee at Cannes* (1933); *Archipenkesque* (1933); *French Sailor* (1933); *March Wind* (1933); *Fetish* (1933); *Pleasantly Satirical Comment* (1933); *A Church Service in Dance II* (1934); *Dance of the Threshing Floor* (1934); *Dayak Spear Dance, Hopi Eagle Dance, Maori War Haka, Ponca Indian Dance* (1934); *Variations on a Theme of Diabelli* (1934); *Dynamo* (1934); *Pioneer's Dance* (1934); *Primitive Rhythms* (1934); *Labor Symphony* (1934); *Hound of Heaven* (1935); *Brother Bernard, Brother Lawrence, Brother Masseo* (1935); *Mouvement Naif* (1935); *A Dreier Lithograph* (1935); *Danza Afro-Cubana* (1935); *Noche Triste de Montezuma* (1936); *O Libertad* (1936, included *Jazz Decade, Kinetic Molpai* and *Olympiad*, by Shawn and members of the His Men Dancers Co.); *Finale from the New World Symphony* (1936); *The 49ers* (1936); *Symphony No. 40* (Mozart) (1937); *March of the Veterans of Foreign Wars* (1938); *Pierrot in the Dead City* (1938); *Dance of the Ages* (1938); *The Persians* (1939); *The Dome* (1940, included *Excursions into Visible Song* and *Jacob's Pillow Concerto*, with sections by Fred Hearn); *Free Fantasia for Capes* (1940); *God of Lightning* (1940); *Jesu, Joy of Man's Desiring* (1940); *Toccata and Fugue in D Minor* (1940); *Mongolian Archer* (1941); *Hellas Triumphant* (c.1941); *Valse Brillante* (1941); *Polka Militaire* (1941); *Mountain Whippoorwill* (1944); *Gypsy Rondo-Bout Town* (1946); *Minuet for Drums* (1948); *Dreams of Jacob* (1949); *Song of Songs* (1951); *Siddhas of the Upper Air* (1964).

Bibliography: Shawn, Ted. *Ruth St. Denis: Pioneer and Prophet* (Los Angeles: 1920); *Dance We Must* (Pittsfield, Mass.: 1940); *Every Little Movement* (Pittsfield, Mass.: 1945); *One Thousand and One Night Stands* (Garden City, N.Y.: 1960).

Shearer, Moira, English ballet dancer and actress; born Moira King, January 17, 1926 in Dunfermline, Scotland. Raised in Ndola, Rhodesia, where she studied with Ethel Lacey, Shearer returned to England to continue her training with Nicholai Legat.

After a season with Mona Ingelsby's International Ballet, she joined the Sadler's Wells Ballet in 1942. She created the title role in Frederick Ashton's *Cinderella* (1948) and leading parts in his *The Quest* (1943), *Symphonic Variations* (1946), *The Fairy Queen* (1946), and *Don Juan* (1948); she also performed in his *Les Patineurs, Façade,* and *A Wedding Bouquet.* Among her many other celebrated performances were appearances in the premieres of Ninette De Valois' *Promenade* (1943), Leonid Massine's *Clock Symphony* (1948), Robert Helpmann's *Miracle in the Gorbals* (1944), and Andrée Howard's *Le Festin de l'Araignée* (1944). These roles, and her performances in the nineteenth-century classics, led to Shearer's film career as an actress who played dancers.

Best known for her portrayal of the suicidal ballerina in *The Red Shoes* (The Archers, 1948) with choreography by Helpmann, and of a similar character in *The Story of Three Loves* (MGM, 1953), choreographed by Ashton, she also acted in *Tales of Hoffmann* (London Films, 1951) and *The Man Who Loved Redheads* (British Lion, 1955). The latter was an appropriate title for her final film since her worldwide popularity, based on her talent as a dancer/actress, was heightened by the effect of her auburn hair in the newly developed English color-film industry.

Shearer, Sybil, American modern dancer and choreographer; born c.1918 in Toronto, Canada. Raised in Newark, New Jersey, she was trained at the Humphrey/Weidman Studio and also studied ballet with Muriel Stuart. A Humphrey/Weidman Concert Dancer in the late 1930s, she created roles in Doris Humphrey's *Race of Life* and *American Holiday* (both 1938) and Charles Weidman's *Quest* (1936),

Promenade (1936), and *The Happy Hypocrite*. With fellow Concert Group members George Bockman and Katherine Litz, and the New Dance Group's William Bales, she formed the Theatre Dance Company, choreographing her earliest extant work, *A Fable*, for it in 1938. Shearer also worked for Agnes De Mille, performing in her small touring company, in De Mille's *Rehearsal: Dance Group* and *Night Scene*, and assisting her on the revival of *Three Virgins and a Devil*.

Despite her rather conventional dance background, Shearer soon became a maverick. From her first solo concert in 1941 to the present, she has evolved into almost an interpretive dancer in the tradition of the turn-of-the-century Greek revivalists. Her choreography is very personal, using allusions in movement and in titles that seem to use conventional body and English language in a personal code. The visual and practical aspects of her choreography are also unusual. She abandoned New York, the center of both concert and modern dance, for Northbrook, Illinois, home of the National College of Education, a private college at which she is artist-in-residence. She tends to perform cycles of short pieces, listed numerically or by epigram—leaving connective matter for the audience to interpolate at will.

Shearer is still named consistently as one of the great modern dance performers. Those fortunate enough to have seen her work describe her balance and extensions with awe. Since she has chosen to remove herself from the home of the modern dance audience, however, most members of the generation now choreographing have never seen her performance or one of her works.

The list below of her choreographic works is probably incomplete since her concerts tend to include pieces of works that are later performed under different titles.

Works Choreographed: CONCERT WORKS: *A Fable* (1938); *The Battle of Carnival and Lent* (1939); *In a Vacuum* (1941); *In the Cool of a Garden* (1941); *In Thee Is Joy* (1943); *Oh, Lost* (1943); *Property* (1943); *Spanish Reversal* (1943); *Prologue* (1944); *Vanity— or the Pulse of Death* (1944); *Oh Ye of Little Faith* (1945); *No Peace on Earth* (1945); *Sarabande* (1945); *In the Garden* (1947); *Pastoral* (1947); *One Blocking's Worth Two in the Bush* (1947); *The Adaptability of Man* (1947); *Pale Pasts* (1947); *O Sleeper of the Land of Shadows, Wake, Expand* (1947); *Is It Night?* (1947); *Let the Heavens Open That The Earth May Shine* (1947); *Recital pieces (Sonata in A Major, Sonata in D Major* [both Scarlatti], *Sonata in A Major* [Schubert], *Sonata in E Flat* [Mozart], *Cappriccioso, Presto, Rumanian Dances, Etude in A Flat)* (1948); *Recital of Numbered Dances, One through Eight* (1949); *Once Upon a Time* (1951); *Shades Before Mars* (1953); *Snow Melts in the Heart* (1956); *Mysterium Tremendum* (1956); *Part I, II, III* (1959); *Toccata for Percussion* (1959); *Fables and Proverbs* (1960); *In the Shell Is the Sound of the Sea* (1961); *The Reflection in the Puddle Is Mine* (1963); *Wherever the Web and Tendril* (1964); *Afternoon, Evening and the Next Day* (1971); *Toujours le Dimanche* (1971); *It's None of Those Blues* (1972); *Popular Thoughts, Unpopular Thoughts* (1972); *Ticket to Where?* (1972); *A Sheaf of Dreams* (1976).

Sheina, Svetlana, Soviet ballet dancer; born December 26, 1918 in Odessa. Trained at the Leningrad Choreographic Institute, she joined the Leningrad Maly Theater after graduation in 1938. A principal dancer of that company, she appeared in its productions of the nineteenth-century classics and in contemporary works that reflect views of Soviet life translated into dance. Recognized as an expert at the delicate art of balancing realistic acting and the exaggerated scale of any theatrical performance, she was selected to create roles in Boris Fenster's *Youth* (1949) and *Twelve Months* (1954). She has served as *repiteur* of the Maly since 1959.

Shelest, Alla, Soviet ballet dancer; born February 26, 1919 in Smolensk. Trained in Leningrad, she performed with the Kirov Ballet throughout her career. Considered the best actress of her generation of ballerinas, she was acclaimed in both the traditional repertory and contemporary works. Her "Juliet" was especially celebrated, as was her *Swan Lake*, in which the differentiation between her "Odette" and her "Odile" was considered exemplary. She was cast in the leading female roles in much of the Kirov's growing Soviet repertory, including parts in Chabukiani's *Heart of the Hills*, Anisimova's *Gayane*, and Lev Iakobsen's *Spartacus*. She toured Western Europe

and England in a program including the "Balcony" pas de deux from *Romeo and Juliet* and a program of waltzes to Soviet and Western composers. It is not certain whether she choreographed these short works for herself and her partner, Kostantin Shatilov. After retiring from performance in the late 1960s, she became ballet master of the Kirov.

Shellman, Eddie, American ballet dancer; born May 10, 1956 in Tampa, Florida. Shellman's training ranges from courses at Lehman College, City University of New York, to work at the Alvin Ailey American Dance Center. A member of the Dance Theatre of Harlem since 1975, he has been seen in the company's productions of Geoffrey Holder's *Bélé*, and Robert North's *Troy Game*, with roles in the large Balanchine repertory, most notably in *Four Temperaments* and *Agon*. His leaping in the Nijinsky role of "The Golden Slave" in the revival of Mikhail Fokine's *Schéhérézade* was acclaimed by critics and enthusiastic audiences alike.

Shelton, Sara, American modern dancer; born December 7, 1943 in New York City. Trained at the Henry Street Settlement by Alwin Nikolais and Murray Louis, she has been a member of each choreographer's company. Originally she performed for Nikolais, appearing in his *Tent* (1968), the *Vaudeville of the Element*, and many other works. She joined the Murray Louis troupe when it split from Nikolais and danced in Louis' *Intersection, Junk Dances*, and *Proximities*. Shelton has also appeared in the concert groups of fellow Nikolais/Louis dancers, among them, Bill Frank and Raymond Johnson.

Sherman, Hal, American eccentric dancer; born in the early 1900s in Boston, Massachusetts. After amateur performances in Boston, Sherman began to develop his characterization and act on the Keith vaudeville circuit. He made his Broadway premiere in the *Music Box Revue* of 1922–1923 and, following his success, the edition of the next season. His character was a pathetic tramp who wore oversized shoes and an enormous overcoat. His dancing began slowly but transformed him into a strong, self-possessed character who was capable of any kind of dance but chose to tap. He worked occasionally on Broadway in his silent act, most notably in *Good Boy* (1928),

but spent most of the 1930s in Europe where he added comic monologues to his act—tapologues done in seven different languages, suitable to the place of performance. He returned to the United States in 1938 and became the lead dancer and straight man of Olsen and Johnson's comedy classic, *Hellzapoppin'*. During his long stay with the show, he became one of the first dancers to be featured in a new medium, when he tapped on NBC's hour of daily television on May 17, 1938 in a live broadcast from the studios in Rockefeller Center.

Sherman, Lee, American modern dancer and theatrical choreographer; born c.1915 in Brooklyn, New York. Sherman was trained in ballet by Nina De Marco, who as Helen Kromar had been a Pavlova company member. He received modern dance training in the Federal Dance Theater under Berta Ochsner and William Matons, and at the Humphrey/Weidman Studio from Charles Weidman and José Limón.

His first Weidman work was *Candide*, staged for the Federal Theater Project in 1933. From that date until the mid-1940s, he performed regularly with the group, with roles in Weidman's *Marionette Theater, Opus 51*, and *American Saga* (1935, his first created role), and in Doris Humphrey's *Square Dances, The Shakers, Decade, Dance "ings"*, and *Song of the West* (1940), creating a part in the Desert Gods section. During the 1930s, he also danced in Ochsner's *Fantasy* (1939) and in Matons' *March of Time* (1937).

Sherman also worked extensively in theater and cabaret. He performed with Weidman at the Rainbow Room and with fellow Humphrey/Weidman dancer Beatrice Seckler at the Roxy Theater, sharing concert recitals with her. His first credits for choreographing shows were earned at the Tamiment Camp in 1941, to which he returned frequently until 1953. After staging dances for a Special Services Unit of the Army during the war, he worked on *Alive and Kicking* (1948), staging tap numbers while Jack Cole did the ethnic dances, and on *Make Mine Manhattan* (1948). Apart from its other virtues, that show had an incredible male dance chorus that included future choreographers Tony Charmoli, Danny Daniels, Bob Fosse, Peter Gennaro, and Ray Harrison. Since the 1950s, Sherman has commuted between Broadway,

Rome, and London, staging musicals and revues. His work on television includes early American variety shows and European entertainment specials.

Works Choreographed: CONCERT WORKS: *Jazz Trio* (1943); *DuBarry was No Lady* (1943); *Effervescent Blues* (1943, co-choreographed with Beatrice Seckler); *Why Don't You Do Right?* (1943, co-choreographed with Beatrice Seckler); *Nevertheless, Come Back* (1943); *The Ballad of Frankie and Johnny* (1946).

THEATER WORKS: *Nellie Bly* (c.1943, Special Service Unit); *Alive and Kicking* (1948, credited with numbers not performed by the Jack Cole Dancers); *Make Mine Manhattan* (1948); *Alvaro Piutosta Coisara* (1954, Rome); *Catch a Star* (1955); *Five Past Eight* (1957, London).

FILM: *Bal Tabarin* (Republic, 1952); *Serenade of Texas* (Republic, c.1953).

TELEVISION: *The Arthur Murray Show* (ABC, 1950; Dumont, 1951–1952); *Colgate Comedy Hour* (NBC, 1950–1955, irregularly scheduled); *The Vic Damone Show* (CBS, 1956–1957).

Sherman, Maxine, American ballet and modern dancer; born in Pittsburgh, Pennsylvania. Sherman was trained at the school of the Pittsburgh Ballet, and at the School of American Ballet in New York City. She was a member of the Pittsburgh Ballet, an acclaimed professional troupe with a classical and contemporary repertory, but joined the Alvin Ailey American Dance Theatre in New York where she performs in the traditional and Horton modern dance technique. Among the many company works in which her grace, agility, and dignity have been applauded are Ailey's *Memoria, Revelation*, and *Phases* (1980), Rael Lamb's *Butterfly*, Talley Beatty's *Toccata*, and Margo Sappington's *Medusa*.

Sherwood, Gary, English ballet dancer; born September 24, 1941 in Swindon. Sherwood was trained at both the Sadler's Wells and Royal Ballet schools before joining the ballet attached to the Royal Opera at Covent Garden. Celebrated for his performances in the featured solos in the nineteenth-century repertory, he danced with almost all of England's ballet troupes in the 1960s: the Royal Ballet touring group, the Western Theatre Ballet, the London Festival Ballet, and finally, the Royal Ballet itself in 1967. In that time, he had performed most of the roles in the Petipa and Ivanov repertory, in each company's versions, and had, for example, matured from a "Fairy's Cavalier" to the "Bluebird" and "Prince Florestan" in *The Sleeping Beauty*. He created roles in each company, notably Norman Morrice's *The Tribute* (1964) in the touring Royal, Peter Darrell's *Sun into Darkness* (1966) in the Western Theatre Ballet, and Joe Layton's *The Grand Tour* (1971) in the Royal Ballet, but is equally known for his work in ballets by Frederick Ashton, including his *Les Rendez-Vous*, and by Kenneth Macmillan, such as his *Blood Wedding*.

After retiring from performance, Sherwood became ballet master of the Ballet Rambert.

Shimazaki, Satoru, Japanese modern dancer and choreographer working in the United States after 1971; born c.1947 in Sapporo, Japan. Trained at the Michio Ito Studio in Tokyo by Ryuko Maki, he moved to New York to continue his studies at the Martha Graham school, the Merce Cunningham Studio, and the private ballet classes of Maggie Black.

He is equally well known in New York for his own choreography and for the recitals of Ito's works that he has staged in the last two years. His company performed many of Ito's short concert works and a lecture-demonstration of his movement vocabulary in concerts through the 1979–1980 season and have included Ito numbers in the later recitals.

Works Choreographed: CONCERT WORKS: *Geki-Sei* (1976); *Child Is Father to the Man* (1976); *Get* (1976); *Beethoven—Opus 110, Third Movement* (1977); *Dance for a Summer Evening* (1977); *Bartók Dances* (1978); *Golliwog's Cakewalk* (1978); *Children's Corner Suite* (1979, including the *Golliwog's Cakewalk*); *Nocturnal III* (1980); *Nocturnal IV* (1980); *Nocturnal V* (1980).

Shook, Karel, American ballet dancer and teacher; born August 8, 1920 in Renton, Washington. Shook was trained originally at the Cornish School in Seattle and later studied at the School of American Ballet in New York with Anatole Oboukhoff and Pierre Vladimiroff. He danced with the Ballet Russe de Monte Carlo in works by Leonid Massine, including his *Nobilissime Visione, Gaité Parisienne*, and *Jardin Public*. He served as assistant ballet master and prin-

cipal mime for the company toward the end of his tenure there. During his Ballet Russe period, he performed in George Balanchine's Broadway operettas, *Song of Norway* (1944) and *The Chocolate Soldier* (1947).

Shook taught ballet at the Katharine Dunham School in New York (c.1952–1954), the June Taylor Studio (home of the precision chorus on *The Jackie Gleason Show*), and the Netherlands Ballet (1959–1968), before returning to New York to help Arthur Mitchell found the Dance Theatre of Harlem. Artistic co-director with Mitchell, he has choreographed pas de deux for the company and has helped keep the performance level of that still young company up to its high standards.

Shorter, Beth, American modern dancer; born in New York City. Trained at the High School of Performing Arts, she performed with the Negro Ensemble Company before joining the Alvin Ailey Dance Theatre. Among the repertory works in which she has been applauded are Ailey's *Feast of Ashes, Choral Dances, Night Creatures, A Lark Ascending*, and *Blood Memories*, and Donald McKayle's *District Storyville*. Shorter left the Ailey company in late 1980 for an engagement in Bob Fosse's *Dancin'* on Broadway.

Shurr, Gertrude, American modern dancer and teacher; born c.1920 in Riga, Latvia. Raised in the Pacific Northwest, she was educated at the San Francisco State College and University of Oregon before moving to New York to study at the Denishawn school with Doris Humphrey and Charles Weidman. While they were on tour with the Denishawn company, she taught at the school. She continued her studies with Martha Graham at the John Murray Anderson School of Theatre.

She was a charter member of the Humphrey/Weidman Group, and an early member of the Graham company, while assisting the latter choreographer at Bennington and the Neighborhood Playhouse. Among the many Graham works in which Shurr created roles were *Heretic* (1930), *Primitive Mysteries* (1931), *Bacchanale* (1931), *Tragic Patterns* (1933), *American Provincials* (1934), *Panorama* (1935), *Horizons* (1936), and *American Lyric* (1937).

After retiring from performance, she taught extensively at colleges across the country, most notably the summer sessions of the University of Utah, called the "Bennington of the West," and the High School of Performing Arts in New York. In the 1940s through 1960s, she directed a New York studio with fellow Graham dancer May O'Donnell.

Shurr's position is very important in the development of a flexible modern dance technique. Unique if only for her participation in two of the masterpieces of the early modern dance—Humphrey's *Water Study* (1928) and Graham's *Primitive Mysteries* (1931)—she has taught at least one-third of the dancers working in the traditional modern dance idiom today.

Sibley, Antoinette, English ballet dancer; born February 27, 1939 in Bromley, Kent. Sibley was trained at the Arts Educations Trust school and the school of the Royal Ballet.

Sibley entered the Royal Ballet in 1956 and has performed with that company throughout her career. She has become famous for her extraordinarily successful partnership with Antony Dowell, beginning with their performances as "Titania" and "Oberon" in Frederick Ashton's *The Dream* (1964). Other Ashton ballets in which she has created roles include *Monotones* (1966), *Jazz Calendar* (1968), *Enigma Variations* (1968), and *Meditation* (1971). She has also performed in the premieres of Kenneth Macmillan's *Symphony* (1963), *Anastasia* (1970), *Triad* (1972), *Pavanne* (1974), and *Manon* (1974). She has been featured with Dowell in the company productions of *Swan Lake, La Fille Mal Gardée, The Sleeping Beauty*, George Balanchine's *Ballet Imperial*, and Ashton's *Les Deux Pigeons, Daphnis and Chloe*, and *Symphonic Variations*.

Simon, Victoria, American ballet dancer; born 1939 in New York City. Trained at the (New York) High School of Performing Arts and the School of American Ballet, Simon made her debut at age fourteen as a "Candy Cane" in the premiere of George Balanchine's *The Nutcracker*.

Associated with Balanchine as an adult, she performed with the New York City Ballet from 1958 through the 1960s and early 1970s. Celebrated for her

grace and technical brilliance, especially in the opening solo in *Raymonda Variations* (1961), she was given featured roles in many Balanchine ballets, including *La Somnambule, La Valse, Divertimento No. 15*, and *The Nutcracker*, in which she played "Hot Chocolate."

Since retiring from performance, Simon has staged Balanchine works for many foreign and American companies, including *Donizetti Variations* for the City Center Joffrey Ballet (1966), *Concerto Barrocco* for the Cleveland Ballet (1978), and the 1976 revival (without caller) of *Square Dance* for the City Ballet itself.

Simone, Kirsten, Danish ballet dancer; born July 1, 1934 in Copenhagen. After private training from age three, she entered the school of the Royal Danish Ballet where she studied with Vera Volkova and Gerda Karstens, and joined the company in 1951. Celebrated for her performances in the Bournonville repertory, she was assigned principal roles in his *Napoli, La Sylphide, A Folk Tale, Kermesse in Bruges*, and *The King's Volunteers on Amager*. She also danced the leads in the company's *Swan Lake, Sleeping Beauty, Giselle*, Roland Petit's *Cyrano de Bergerac*, Frederick Ashton's *Romeo and Juliet*, and George Balanchine's *Apollo, Bourée Fantasque*, and *Four Temperaments*. Still a member of the Royal Danish Ballet, she now plays principal mime roles in Bournonville works.

Simons, Ton, Dutch experimental choreographer; born in Beesel, The Netherlands. Simons left art school to enter the Rotterdam Dance Academy from which he received a grant to study at a variety of American modern dance studios. Since returning to The Netherlands, he has been associated with the Rotterdam Werkcentrum Dans-company as performer and choreographer. He has presented his works in New York regularly since 1978, using American dancers.

Strongly influenced by Merce Cunningham's experiments in the aleatoric structure of single dances and entire presentations, he has created evenings of works, such as the recent *Countermix* (1980), that combine elements and sections of existing repertory works to form new pieces. He has also used these structural configurations in single works, as in his *Sleeve* (1979), in which performers work concurrently with similar movement patterns in disparate rhythms and speeds.

Works Choreographed: CONCERT WORKS: *While* (1973); *Chantal Meteor* (1973); *31 Simple Steps* (1975); *Domino* (1975); *Two Evenings I* (1976); *Throw Wood/At Green* (1977); *Two Evenings II-Video* (1977); *Jumble* (1978); *Two Evenings III-Icon* (1978); *Sleeve* (1979); *Two Evenings IV-Fieldpiece* (1979); *Kameubel Kamendelmoes* (1979); *Commonplace Quintet* (1980); *Countermix* (1980).

Simpson-Serven, Ida, American teacher of Delsarte movement theories in the late nineteenth century; born c.1850s; died c.1896 in Chicago, Illinois. Simpson-Serven was a student and associate of James Steele MacKaye, director, producer, author, and one of the few genuine students of François Delsarte. She worked with him until 1884, teaching Delsarte theories of elocution and movement to the actors in his theatrical company in New York. Since Genevieve Stebbins was a member of the company then, it is likely that Simpson-Serven taught her also. In 1884, the illness of a Winfield S. Serven (possibly husband or child) forced her to leave New York for Denver, Colorado, which was then one of the few places in the United States considered safe for consumptives. Once in Denver, she joined the faculty of O.E. Howell's Conservatory of Music, but by 1888 she was a teacher at the University of Denver, and in 1890, the principal of the Denver Conservatory. Between 1886 and 1889, she also taught Delsarte theories at the Denver Chautauqua—the only Delsartist (first or second generation) to work at a genuine Chautauqua. At the annual summer encampments for moral education (at which both lectures and concerts were given), she had classes of children, adults, and business women, and also staged aesthetic drills, plays, and masques, as well as giving solo recitals of her own. She moved to Chicago in 1893, presumably after the recovery of Serven, where MacKaye was then working. In Chicago, she taught at the Hart Conway School of Dramatic Arts, where her students included Ned Wayburn and William (if not Florenz, Jr.) Ziegfeld. Although she was listed as a member of the faculty of the Conway school when it announced

its merger with the elder Florenz Ziegfeld's Chicago Musical College, she died before the opening of the combined schools.

Although one of the first MacKaye students to teach Delsartism in the West and an important influence through her Chautauqua work, Simpson-Serven has been almost completely forgotten. However, the discovery of a notebook containing her complete system of exercises and a table of differences between her and Stebbins in the MacKaye papers at Dartmouth has made a study of her work vital.

Sinceretti, Francis, French ballet dancer; born July 18, 1942 in Grasse. Sinceretti was trained in Nice by Serge Golovin and Victor Gsovsky. He performed briefly with the opera ballets in Nice, Toulon, and Geneva before joining the Hamburg State Ballet in 1966. In that company, and the Dutch National Ballet, he danced in works by the trio of choreographers who are in the forefront of European modern ballet—Peter van Dijk, Rudolf van Dantzig, and Hans van Manen. Among his many roles were the former's *Pinocchio* (1969), van Dantzig's *Ramifications*, and van Manen's well-known *Adagio Hammerklavier* (1973) and *Sacre du Printemps*.

Sinden, Topsy, English theatrical dancer; born December 15, 1878; the date and place of Sinden's death are uncertain. Trained by Malvina Cavallazzi and Katti Lanner at the free school of the Empire Theatre, London, she performed there after 1884 in *The Paris Exhibition, Cecilia, Dolly*, and *Cinderella*—all staged by Lanner. A principal dancer at the Gaiety Theatre, she was featured in productions of *Cinder-Ellen Up Too Late, In Town, A Gaiety Girl*, and *The Shop Girl*. Her specialty dance act, an eccentric solo, could easily be interpolated into the Chinoiserie musicals that were popular in London at the turn of the century, among them, *The Yakima* (1897) and *San-Toy* (1899).

A popular principal boy (the female performer who plays the hero) in pantomimes, Sinden worked extensively at the Brittania and other theaters until 1912. She came out of retirement to give a benefit performance in 1927; nothing can be verified about her life after that date.

Singer's Midgets, Hungarian vaudeville troupe performing in the United States after 1914. The first Singer troupe, the Royal Lilliputians, was engaged by Oscar Hammerstein in 1914 to perform at his Victoria Theater. As always, Hammerstein's motives were involved with the constant feuds among vaudeville producers, and his Midgets were set up in competition with those of his rivals, among them, Picolo's (male) Midgets and the troupe then touring as "The Genuine Original Royal Hungarian Lilliputians." Singer's Royal Lilliputians company had been assembled in Budapest but many of their acts were created for them in New York, not imported from Europe. The first feature act, staged by Ned Wayburn and designed by Joseph Urban, was rightly described as the Ziegfeld *Follies* of Lilliputian revues. Individual specialty acts included an elephant trainer, a staged boxing match, singers, two eccentric dancers, Adelaide and Carl Wilkens, the acrobatic Altholff Sisters, and toe dancer Dorothy Hermann.

Between that troupe and the company of the 1930s, more than a hundred talented Singer Midgets toured the United States in troupes of twenty. They remained under the Wayburn auspices for five years, but soon became independent stars of the Prolog circuits. Since they always had a self-sufficient feature act, they could be booked as a unit on the Pantages, Balaban and Katz, and Paramount/Publix circuits. They were especially popular in Fanchon and Marco's units in the late 1920s and 1930s.

The most famous Singer Midgets were the troupe that appeared as "The Munchkins" in Bobby Connolly's film *The Wizard of Oz* (MGM, 1938). Although no individual credits were given, it is known that three Singer specialty performers can be seen in the Munchkin scenes—Ruthie Robertson, John Leal, and Billy Curtis, who played "The Lord Mayor." The three toe dancers who represented "The Lullaby League" were not midgets, however, but young students of Ernest Belcher.

Singleton, Trinette, American ballet dancer; born November 20, 1945 in Beverly, Massachusetts. After local studies with Harriet James, Singleton moved to New York to train at the American Ballet Center. She joined the apprentice group of what became the

City Center Joffrey Ballet, soon becoming a charter member of the company.

Singleton remained with the Joffrey company from 1965 to 1969, and returned to it in 1973. In the company, she created roles in many Gerald Arpino ballets, among them *Viva Vivaldi!* (1965), *A Light Fantastic* (1968), and *The Poppet* (1969), and the title role in Robert Joffrey's *Astarte*, 1967. Her role as the "Goddess" in that multimedia ballet made her into more than a dancer with the company: she became its symbol, featured on posters, t-shirts, and a *Time* magazine cover.

Siretta, Dan, American theatrical dancer and choreographer; born 1940 in Brooklyn, New York. Siretta was trained at the High School of Performing Arts and the Juilliard School, with additional tap studies with Jimmy Trainor. He danced on Broadway in many successful shows, among them, *Fiorello* (1959), *Sail Away* (1961), *Mr. President* (1962), *Hello, Dolly!* (1964) and *Coco* (1969), and dozens of television commercials and industrial shows.

In 1975 he was hired by the Goodspeed Opera House in East Haddam, Connecticut, to choreograph for their continuing series of revivals of musical comedies from the 1910s and 1920s. He has become well known for his work on these shows, and for his ability to mesh the Broadway choreographic style of the 1960s with the requirements of older scripts and scores.

Works Choreographed: THEATER WORKS: *Louisiana Purchase* (1975, revival); *Very Good Eddie* (1975, revival); *Going Up* (1976, revival); *Whoopee* (1978, revival); *The Five O'Clock Girl* (1980, revival).

Sizova, Alla, Soviet ballet dancer; born September 22, 1939 in Moscow. Raised in Leningrad, she attended the Leningrad Choreographic School and joined the Kirov Ballet in the late 1950s. A delicate dancer with bravura technique and a tender stage presence, she is considered one of the few great "Auroras" of the ballet world. Apart from her highly acclaimed performance in *The Sleeping Beauty* on stage and in the Moscofilm of 1965, she was known for her roles as "the Girl" in Belsky's *Leningrad Symphony*

and her "Ophelia" in Sergeev's *Hamlet*. Sizova surprised her adoring public in the late 1960s when she began to choose to portray stronger, more resolute characters; she may be one of the few dancers able to transform herself both into "Aurora" and into the implacable "Myrthe" of *Giselle*.

Skelly, Hal, American eccentric dancer and comic; born May 31, 1881; died June 16, 1934 on tour in West Cornwall, Connecticut. From the time he learned to walk and his Broadway debut in 1918, Skelly appeared in almost every imaginable form of popular entertainment in America. Chronologically, his pre-Broadway credits began with an engagement as one of The Flying Christies (elephant jumpers) and included stints in Dr. Rucher's Famous All-Star Comedians Company and Medicine Show, a tour of *The Time, The Place and The Girl*, Norris & Rowe's Dog and Pony Show, A.M. Zinn's Musical Comedy Company and Conservatory, Mortimer Singer's operetta troupes, Jos. E. Howard's Burlesque show, Lew Dockstader's Minstrels, and the road company of *So Long, Letty*. At one point he was also a first baseman with the Boston Braves and a fight manager. Once he hit Broadway, however, he stuck. Skelly brought his eccentric comedy and dance routines to a dozen musical comedies between *Fiddlers Three* (1918) and *Melody* (1933). In most, he did an eccentric soft-shoe dance and an exhibition ballroom number, most successfully with Louise Groody in *Fiddlers Three, The Night Boat* (1920), and the road company of *No, No, Nanette*. His exceptionally long feet and slightly ironic expression made him a very popular feature of his musicals and made his success in the play, *Burlesque* (1927), understandably a delight to his colleagues. He repeated his role in *Burlesque* in the film version (called *The Dance of Life*) and was expected to enjoy a successful career in motion pictures when he was killed in an automobile accident.

Skibine, Georges, Russian ballet dancer and choreographer working in the United States after the late 1930s; born January 30, 1920 in Yasnaya Poliana, the Ukraine; died January 14, 1981 in Dallas, Texas. The son of Boris Skibine, formerly of the Diaghilev

Ballet Russe, he received his early training in Brussels before moving to Paris to work with Olga Preobrajenska, Lubov Egorova, Serge Lifar, and Alexander Volinine.

After working at the Bal Tabarin (Cabaret), and performing with the Ballets de la Jeunesse and de Paris, all within a few months in 1937, Skibine joined the Ballet Russe de Monte Carlo for its 1938–1939 New York season. Associated with the works of Leonid Massine, he danced with that Ballet Russe, the Original Ballet Russe, and Ballet Theatre in Massine's *Seventh Symphony, Gaité Parisienne, Nobilissima Visione,* and *Aleko,* creating the title role in the latter as a charter member of Ballet Theatre in 1940. He was also noted for his performances in Ballet Theatre's productions of *Swan Lake* (Act II only), *Princess Aurora, Les Sylphides,* Anton Dolin's *Bluebeard,* David Lichine's *Helen of Troy,* and Mikhail Fokine's *Petroushka.*

Skibine danced and choreographed for the Grand Ballet du Marquis de Cuevas (1947–1956), the Paris Opéra Ballet (1957–1962), and the Dallas Civic Ballet, of which he was director at his death. His dramatic ballets, frequently choreographed for his wife, Marjorie Tallchief, and Rosella Hightower, are very popular in Europe but have not been seen often in America. The best known of them include *The Prisoner of the Caucasus* (1951), *Les Fâcheuses Rencontres* (1959), *Ombres Lunaires* (1960), and *Les Bandar Log* (1969). He recently revised *Schéhérézade* and *Les Indes Galantes* for his Dallas company.

Works Choreographed: CONCERT WORKS: *Tragedie à Verone* (1950); *Annabel Lee* (1951); *The Prisoner of the Caucasus* (1951); *L'Ange Gris* (1953); *La Reine Insolente* (1954); *Le Retour* (1954); *Idylle* (1954); *Achilles* (1955); *Romeo and Juliet* (1955); *Le Prince du Désert* (1955); *Pelléas et Mélisande* (1957); *Concerto* (1958); *Isoline* (1958); *L'Atlantide* (1958, co-choreographed with Lifar); *Daphnis et Chloe* (1959); *Les Fâcheuses Rencontres* (1959); *Conte Cruel* (1959); *Clair de Lune* (1959); *Divertimento* (1960); *Ombres Lunaires* (1960); *Metamorphoses* (1961); *Pastorale* (1961); *Marines* (1961); *Les Noces* (1962); *Danses Brèves* (1963); *Bacchus et Ariadne* (1964); *The Four Moons* (1967); *The Firebird* (1967); *La Péri* (1967); *Les Bandar Log* (1969); *Carmina Burana* (1970); *Cantata Profana* (1971); *Gloria* (1974); *Schéhérézade* (1975); *Les Indes Galantes* (1976); *American Tarentella* (1976).

Skinner, Laurie Dawn, American ballet and theatrical dancer; born in Omaha, Nebraska. Skinner performed with the Omaha regional ballet company and the Frankfurt Ballet before moving to New York to study jazz dance with Bob Audy, Phil Black, and Charles Kelly. She toured with the national companies of Bob Fosse's *Pippin* and *Dancin'* and can be seen in his film, *All That Jazz.* Her Broadway principal roles have included "Contact" in *Gottu Go Disco,* "The Stepdaughter" in *The Act,* a specialty in *Dancin',* and both "Sheila" ("Everything Is Beautiful at the Ballet") and the principal dance role of "Cassie" in Michael Bennett and Bob Avian's *A Chorus Line.*

Sköld, Berit, Swedish ballet dancer; born 1939 in Stockholm. Sköld was trained at the school of the Royal Swedish Ballet, graduating into the company in 1956. Although she also performed in the classical repertory, Sköld was best known for a trio of contemporary dramatic roles—"The Mistress of the Copper Mountain" in the company's production of Yuri Grigorovitch's *The Stone Flower* in 1962, the title role in Birgit Cullberg's *Lady from the Sea,* and the female principal in Antony Tudor's short, elegant version of *Romeo and Juliet.*

Skorik, Irene, French ballet dancer; born Irène Beaudemont, January 27, 1928 in Paris. Skorik was trained by Carlotta Zambelli, Olga Preobrajenska, Victor Gsovsky, Lubov Egorova, and Boris Kniaseff. As a dancer with Les Ballets des Champs-Elysées from 1945 to 1960, she performed in *La Sylphide* (her greatest success) and in works by Roland Petit and Serge Lifar, creating a role in the latter's *Chota Rostaveli* (1946). She performed in Petit's Ballets de Paris in 1950, then began a series of short engagements in companies around Germany and Switzerland. Performing *La Sylphide* and the standard classical repertory in many of her companies, she also created roles in Victor Gsovsky's *Hamlet* (1950) and *La Legende de Joseph* (1951) with the Munich

Opera, Vaslav Orlikovsky's *Prince of the Pagodas* in Basel (1961), and Tatiana Gsovsky's *Etudes* (1961) and *Fleurenville* (1956) with the Berlin Stadtopera.

Skoronel, Vera, Swiss modern dancer; born May 28, 1909 in Zurich; died March 24, 1932 in Berlin. Skoronel studied in Dresden with Mary Wigman and in Mannheim with Rudolf von Laban—the two foremost teachers of the German expressionist modern dance movement. She opened a dance studio in Berlin with Bertha Trumpy (c.1926) and formed her dance group in the late 1920s. The few extant titles of her choreography date from the group's appearances at German dance congresses and festivals (1929 and 1930). Skoronel died at the age of twenty-three—too young to have made a full contribution to the burgeoning modern dance in Europe, but old enough to have created works that revealed her promise.

Works Choreographed: CONCERT WORKS: *Rhythms Marteles* (c.1929); *Tans der Gedenpole* (Dance of Opposition) (1930); *Kaleidoskopic (Klare, Folge, Schillerndes Speil—Clarity, Succession, Lecture on Schiller)* (1930).

Slavenska, Mia, Yugoslavian ballet dancer working in the United States after the mid-1930s; born Mia Corak, 1914, in Slavonski-Brod, Yugoslavia. Slavenska began her studies at the Zagreb Opera Ballet school and performed with the company from 1930 to 1933. She continued her training in Paris with Olga Preobrajenska and Lubov Egorova and in New York with Bronislava Nijinska and Vincenzo Celli.

In the United States after 1938, Slavenska was a member of the Ballet Russe de Monte Carlo, creating roles in Leonid Massine's *Bogatyri* and *Capriccio Espagnole* (both 1939), *Vienna—1814* (1940), and was featured in his *Gaité Parisienne*, and in the company's *Giselle, Swan Lake, Coppélia, The Nutcracker,* and *Pas de Quatre*. With Frederick Franklyn, she directed a series of touring companies from 1848 to 1954. She created a solo, *Salome,* for herself for her Ballet Variante in 1948, and created the celebrated role of "Blanche" in Valerie Bettis' *Streetcar Named Desire* (1952), her best known part. From the disbandment of the Slavenska-Franklyn Ballet to her retirement in 1958, she danced with the Metropolitan Opera Ballet in works and opera divertissements by Zachary Solov.

Slavenska has taught at the Fort Worth Civic Ballet from 1958, at her own school from 1962, and at the University of California at Los Angeles from 1971.

Works Choreographed: CONCERT WORKS: *Salome* (1948).

Slavinsky, Taddeo, Polish ballet dancer; born 1901 in Warsaw, Poland; died January 22, 1945 in New Zealand. Slavinsky, whose first name is variously spelled Thaddeaus and Thaddeo, was trained at the school of the Warsaw Opera Ballet.

Slavinsky performed with Diaghilev's Ballet Russe from 1921 until 1929, creating roles in Leonid Massine's *Les Matelots* (1925) and performing in his *La Boutique Fantasque, Les Femmes de Bonne Humeur,* and *Pulcinella,* and in Bronislava Nijinska's *Les Biches* and *Tentations de la Bergère*. He co-choreographed one work for the company, *Chout,* in collaboration with designer Mikhail Larionov in 1921.

After Diaghilev's death in 1929, Slavinsky appeared with many of the companies organized by former Ballet Russe dancers, notably among them, the Ballets Nijinska, dancing in her *Les Biches, Variations, Les Commediens Jaloux,* and *Bolero,* and the Ballets Russes de Paris, where he was featured in Mikhail Fokine's *Polovtsian Dances* in 1935. He left Europe to work with the Borovansky Ballet in Australia and was teaching in New Zealand at the time of his death.

Slayton, Jeff, American modern dancer; born September 5, 1945 in Richmond, Virginia. Slayton first studied with Viola Farber while attending Adelphi University in 1967, then followed her to the Merce Cunningham Studio where she was teaching. He performed with the Cunningham Company, most notably in early Events and his *Rainforest, Variations V, Scramble,* and *How to Pass, Kick, Fall and Run*. He also appeared in most of the repertory of the Viola Farber company since the early 1970s, including her *Three Duets, Tendency, Survey, Co-op, Turf,* and

Dune. Slayton and Farber have been married since 1971.

Sleep, Wayne, English ballet dancer; born July 17, 1948 in Plymouth, England. Trained at the school of the Royal Ballet, he has performed with the company since 1966. Associated with the ballets of Frederick Ashton, he has created roles in *Jazz Calendar* (1968), as "Saturday's Child," *Enigma Variations* (1968), and *A Month in the Country* (1976). He has frequently been chosen by Kenneth Macmillan to perform in the premieres of his works, among them, *Manon* (1974), *The Sleeping Beauty* (1973), *The Four Seasons* (1975), *Anastasia* (1971), and *Elite Syncopations* (1974). An actor in dance and verbal theater, he has brought his exceptional gift for comedy to the role of "Puck" in Ashton's *The Dream* and to the walk-on of "The Notary's Clerk" and the *travestie* role of "Mme. Simone" in his *La Fille Mal Gardée.*

Sleep has been seen often in feature films, ranging from the Royal Ballet's *Tales of Beatrix Potter* (EMI, 1970) in which he played "Tom Thumb" and "Squirrel Nutkin," to *The Great Train Robbery*, a nondancing movie, in which he played a Victorian thief.

Small, Robert, American modern dancer and choreographer; born December 19, 1949 in Davenport, Iowa. Small was raised in Moline, Illinois, and was trained at the University of California at Los Angeles where he danced in the company of faculty member Gloria Newman. He moved to New York in 1971 to study with Murray Louis and the Alwin Nikolais/Louis studio here. Among the many Louis works in which he has danced as a company member are *Caligraph for Martyrs, Hoopla, Porcelain Dialogue* (1974), *Cleopatre II* (extrapolated duet), *Go Six, Schéhérézade,* and *Schubert.*

While performing with Louis, Small has presented concerts of his own choreography alone in recitals and in shared evenings with Diane Boardman. Many of his best known works are solos, among them, *Solo* (1978), the work of that name (1978), *Send* (1980), *Crest* (1980), and *Musings* (1979), in all of which his physical control and purity of dance imagery have been acclaimed. His group pieces range from the satirical, such as *Watermelon* (1980), to the abstract,

among them, *Variations on a Place/Theme* (1978), *Divertimento* (1977), and *Boundaries* (1980).

Works Choreographed: CONCERT WORKS: *Bach to Bach* (1976); *Fascia* (1976); *Two Alone* (1977); *Divertimento* (1977); *Tight, Down, Light* (1977); *Minerva* (1978); *I'm Confessin'* (1978); *Solo* (1978); *Variations on a Place/Theme* (1978); *Musings* (1979); *Send* (1980); *Crest* (1980); *Tuber Tales* (1980); *Boundaries* (1980); *Carousel* (1980); *Watermelon* (1980).

Smith, Barry, Canadian modern dancer and choreographer also working in the United States; born February 6, 1946 in Toronto, Ontario. After studies at the school of the National Ballet of Canada from the age of sixteen, he started modern dance training with Patricia Beatty at her New Dance Group of Canada. He performed with that troupe and with its outgrowth, the Toronto Dance Theatre, from its founding in 1968. His appearances with the company in works by its founding directors revealed his sinuous strength and dramatic stage presence, especially in such theatrical works as David Earle's *A Thread of Sand*, Peter Randazzo's *Dark of Moon* (1971) and *Voyage for Four Men* (1969), and Beatty's *Hot and Cold Heroes* (1970). He began to choreograph himself in 1968, creating a duet, *Akrata*, to music by Xenakis. After staging *Fishers of Mermen* (1968) for the Toronto Futz Festival, he did his first work for the Toronto Dance Theatre, *Coronation* (1969). Among his Canadian works, his *Lacemakers* (1970), with its ritualist circular movements in a range of small scales, the gothic *Third Awakening* (1972), and the athletic *Runners* (1974) have proved controversial. After moving to New York in 1975, he dropped out of choreography while performing for Pearl Lang (in her *Prairie Steps)* and Martha Graham, for whom he created roles in *Lucifer* (1975), *The Scarlet Letter* and *Point of Crossing* (all 1975). Since 1976, he has created works for recitals shared with fellow Dance Theatre alumna Germaine Merle Salsberg, in whose pieces he frequently performs. His ritualistic movements and structures have been well received here, and his solos, *Buffalo Soldier* (1976) and *Rainbow Mountain* (1979), and group pieces, among them, *Filligree* (1977), *Meadow-Ring* (1978) and *Electric Twilight* (1980), are all critically acclaimed. The duets on the joint programs, including his *Bridge*

of Glass (1979) and their *Hey Girl* (1978), are especially popular.

Works Choreographed: CONCERT WORKS: *Akrata* (1968); *Fishers of Mermen* (1968); *Coronation* (1969); *Lady Fox* (1969); *Lacemakers* (1970); *Third Awakening* (1972); *Midnight Faun* (1973); *Runners* (1974); *Buffalo Soldier* (1976); *Galliard* (1976); *Filligree* (1977); *Hey Girl* (1978, co-choreographed with Germaine Merle Salsberg); *Meadow-Ring* (1978); *Rainbow Mountain* (1979); *Bridge of Glass* (1979); *Electric Twilight* (1980).

Smith, Frank, American ballet dancer; born c.1950 in Hamlet, North Carolina. Smith received his dance training at the North Carolina School of the Arts and the School of American Ballet.

Smith has been a member of the American Ballet Theatre since 1970. He has always been associated with the works of American choreographers, with featured roles in many of the ballets by Eliot Feld, notably *Eccentrique*, by Alvin Ailey, with parts in *The River* and *Sea-Change*, and Glen Tetley's *Sacre du Printemps*. He has been acclaimed for his performance as "Pat Garrett" in Eugene Loring's *Billy the Kid* and as "Lorenzo" in Mikhail Baryshnikov's *Don Quixote*.

Smith, George Washington, American nineteenth-century ballet and harlequinade dancer and choreographer; born c.1815 in Philadelphia, Pennsylvania; died February 18, 1899 there. Smith was trained in Philadelphia, probably by P.H. Hazard, whose female students he partnered frequently, and possibly by John or Charles Durang. After performing in Philadelphia during the mid- to late 1830s, he was hired to join the touring company that Fanny Elssler engaged in America. During the two years of touring he continued his studies in ballet technique with James Sylvain. Since Sylvain had also worked in harlequinades in London, he may have been the one who taught Smith the gestural vocabulary and technical skills necessary to perform both or either style of dance.

The ballet side of his career took precedence during the 1840s. He toured with Hazard pupil Mary Ann Lee in 1845, performing *Giselle, La Fille du Danube* and *La Jolie Fille du Gand*. In 1847, he partnered Julia Turnbull at the Bowery Theatre, New York, in her best known role, *The Naiad Queen* (probably by Jules Martin, 1847), *Giselle*, and *Nathalie, La Laitière Suisse*. They added *The Bohemian Girl* and *The Magic Flute* (a divertissement unrelated to the opera) in the next year when they were in competition with the touring Giovanna Ciocca. In 1851, he staged the ballet dance season for Lola Montez, creating *Un Jour de Carneval à Séville, Diana and the Nymphs*, and a *Pas de Matelot* for her.

Although he performed in *La Péri* with Lucile Dulcy-Barre in 1851, he had concentrated his career on the harlequinade after the late 1840s. One of the last great "Harlequins," Smith created pantomimes for companies in Philadelphia and toured extensively. Unlike the classical *commedia*-derived productions of the London theaters, or the political satires produced by Durang, Smith's presentations were a combination of fairy tale, pantomime, and working-man melodrama, among them *Mose's Dream*, which seems to say that if strength and fortitude don't reap rewards, then fairy godmothers will provide.

Although his works, like most in popular theater, have been lost, a Currier and Ives print of the transformation scene in *The 40 Thieves* (1867) shows the enormous scale of the productions. Smith also staged *The Black Crook* in 1868 and 1882; his versions were among the most elaborate and most extravagant of the many revivals of that work.

Works Choreographed: CONCERT WORKS: *Un Jour de Carneval à Séville* (1851); *Pas de Matelot* (1851); *Diana and the Nymphs* (1851); *Betty, la Tyrolienne* (1852); *La Maja de Séville* (1853); *La Belle d'Andeleuse* (1853).

THEATER WORKS: *Harlequin Toad in the Hole* (1846); *Robin Red-Breast* (1849); *The Sleeping Beauty* (1849); *Mose's Dream* (1856); *The Seven Sisters* (1859); *The Forty Thieves* (1867); *The Black Crook* (1868); *The Black Crook* (1882).

Smith, Joseph, C., American theatrical dancer and choreographer; born 1878 in Philadelphia, Pennsylvania; died December 22, 1932 in New York. Smith studied ballet and acrobatics with his father, George Washington Smith. He worked as a circus rider from the age of five, and later as an exhibition roller skater

and as an acrobat and mime in his father's harlequinade troupes.

As a solo eccentric dancer, as a ballroom specialist, and as an actor/vocalist, Smith had an extensive and successful career on Broadway between 1893 and the mid-1910s—between *Little Christopher Columbus* (1894) and *Very Good Eddie* (1915). Among the many shows in which he appeared were *A Country Girl* (1902), *Humpty-Dumpty* (1907), in which he played "Harlequin," and the *Ziegfeld Follies of 1907*, in which he was featured as an exhibition ballroom dancer, performing an Apache (possibly for the first time on Broadway), a Maxixe, and a Whirlwind with Dorothy Jardon. With Louise Alexander, Smith toured in vaudeville with the ballroom dances from 1906 to c.1911, and as actors with Mlle. Dazie's pantomime company, 1912.

Smith received full or partial choreography credits for over a dozen musical comedies and operettas on Broadway, most of them from 1897 to 1904 and from 1910 to 1914. In between, he staged exhibition ballroom sequences and acts for roof gardens and cabarets. He is generally credited with staging the first floor shows in New York at the Café Maxim in 1910. Although his primacy here may be a matter of semantics, he was certainly one of the first exhibition dance innovators to demand and receive staging credit for his dance act, rather than relying on the publicity value of claiming to have originated single steps. Among his many shows were *The Girl From Paris* (1896), *Queen of the Moulin Rouge* (1908), *Peggy from Paris* (1903), *The Girl from Montmartre* (1912), and the original production of *The Vagabond King* in 1901.

Smith opened a School of Theatrical Dance and Dramatic Arts in New York in 1913. Among his many pupils and coachees were Valeska Surratt and Mae Murray.

Works Choreographed: THEATER WORKS: *The Girl from Paris* (1896); *The French Maid* (1897); *The Vagabond King* (1901); *The Show Girl* (1902); *Peggy from Paris* (1903); *The Southerners* (1904); *Queen of the Moulin Rouge* (1908); *Madame Sherry* (1910); *Jumping Jupiter* (1910); *Bouffe Vanities* (1911); *A Certain Party* (1911); *The Girl from Montmartre* (1912); *1000 Years Ago* (1914); Café Maxim floor shows (1910–1914).

Smith, Lois, Canadian ballet dancer; born October 8, 1929 in Vancouver, British Columbia. Trained locally with Mara McBirney, she also studied in Los Angeles with Eugene Loring.

Smith performed with the National Ballet of Canada throughout her career, dancing the principal roles in that company's productions of the classics, notably *Swan Lake* and *The Sleeping Beauty*. Known for her technique and line, she was cast in the leads in *La Sylphide, Les Sylphides*, and George Balanchine's *Serenade*.

Smith has directed a school in Toronto, Canada, since her retirement in 1969.

Smith, Oliver, American scenic designer and company director; born February 13, 1918 in Wawpawn, Wisconsin. Co-director of the American Ballet Theatre from 1945 to 1980, he is known as a designer of ballets and musical comedies. After his debut as a dance designer with *Saratoga* (1941), for the Ballet Russe de Monte Carlo, he became famous for his next two projects: sets for Agnes De Mille's *Rodeo* (1942) and sets and costumes for Jerome Robbins' *Fancy Free* (1944). The designs for these two works, although seemingly very different, are quite similar and representative of his style: each uses a skeleton set (with only the most necessary prop items created realistically) which is skewed out of perspective and seems to float in the air above the stage. Smith's other dance works include De Mille's *Fall River Legend* (1948), probably his best known design, Robbins' *Interplay*, and Balanchine's *Waltz Academy*.

His designs for musical comedies are generally realistic, although they use limited color schemes and some altered perspectives. Although now best known for the black and white "Ascot Gavotte" number from *My Fair Lady* (1956) and the descending ramp for the title song in *Hello, Dolly!* (1964), he has designed sets for the following: *On the Town* (1944), based on *Fancy Free*, Robbins' *Million Dollar Baby* (1945), and *Look, Ma, I'm Dancing* (1948), De Mille's *Brigadoon* (1947), *West Side Story* (1957), *Flower Drum Song* (1958), and *The Sound of Music* (1958), and the stage version of *Gigi* (1974). His films include *Oklahoma* (Magna, 1955), *Porgy and Bess* (Columbia, 1959) and two motion pictures that typify the color sense and scale of MGM musicals of the

1950s—*The Band Wagon* (1953), which has three shows-within-a-film, a ballet performance, and a Times Square arcade, and *Guys and Dolls* (1955), with a different arcade, and two very different styles of production numbers all within the nonrealistic design scheme of Damon Runyon's Broadway.

Smith, Queenie, American ballet and theatrical dancer; born September 8, 1902 in New York City; died August 5, 1978 in Los Angeles, California. Smith was trained as a child in the school of the Metropolitan Opera Children's Ballet by Malvina Cavallazzi, Rosina Galli, and Pauline Verhoeven. She made her adult professional debut replacing the ailing Galli in *Aida* (1916).

After three years at the Met, Smith retired from ballet to work on Broadway. She starred in twelve Broadway musicals between *Roly Poly Eyes* (1919) and *Every Thursday* (1934), among them *Sitting Pretty* (1924), *Hit the Deck* (1925), and *The Street Singer* (1929). Her performance in the title role of the Gershwins' *Tip Toes* (1925) was notable for her dancing and singing, and for the fact that the four-foot-ten Smith could sing a lyric about wanting to look up to "a boy of five foot six or seven."

She went into films in 1935 and worked steadily in that medium and on television for the next forty-two years. By her death in 1978, she was so well known as a mother, and then grandmother, in television sitcoms that only her obituaries reminded her fans that she had been a dancer.

Smok, Pavel, Czech ballet dancer and choreographer; born October 22, 1927 in Levoča, Czechoslovakia. Trained at the Prague State Conservatory, he performed with the Army Ensemble from 1952 to 1955, before becoming ballet master to companies in Usti, Labem (1958–1960) and Ostrava (1960–1963).

A founder of the Prague State Ballet and ballet master there from 1964 to 1970, he choreographed many works for the company, among them *Rossiniana* (1961), *Frescoes* (1966), *Intimate Letters* (1969), and *Glagolitic Mass* (1969). Moving to Switzerland in 1970, he served as ballet master to the Basel Ballet for three years, before becoming a freelancer. He is best known in the United States as an opera choreographer, having staged dances for *Jenufa* for the American Opera Center and *The Bartered Bride* for The Metropolitan Opera.

Works Choreographed: CONCERT WORKS: *Rossiniana* (1961); *Frescoes* (1966); *Intimate Letters* (1969); *Glagolitic Mass* (1969); *The Servant of Two Masters* (1970); *Sinfonietta* (1971); *Celestial Ocean* (1973); *Brain Ticket* (1973).

Smoller, Dorothy, American theatrical ballet dancer; born c.1901 in Memphis, Tennessee; died December 10, 1926 in New York City. Raised in the Los Angeles area, Smoller was trained in ballroom styles by Tom Rector who engaged her as his partner for a tour of the Orient in 1915. On her return to California, she became an apprentice member of the Anna Pavlova Company, with which she toured to New York to perform in *The Sleeping Beauty* at The Hippodrome. As is usual with Americans in the Pavlova company, there is no way to determine training previous to work with the star and ballet masters. When Pavlova returned to Europe, Smoller and her sister opened a studio in Washington, D.C., but she left teaching shortly thereafter to perform on Broadway. She was a featured ballet dancer in at least eight musical comedies and revues between *Seesaw* (1919) and *The Fantastic Fricasee* (1922), including the popular *What's In a Name?* (1920), *Up in the Clouds* (1921), and *The Hotel Mouse* (1922). In 1923, however, she was forced to leave New York for Colorado and a tuberculosis sanitarium. Although it was announced that she had been cured and would soon return to Broadway, Smoller committed suicide in 1926, leaving notes in which she explained that she was afraid of the long death that tuberculosis then meant to its victims.

Smuin, Michael, American ballet dancer and choreographer; born October 13, 1938 in Missoula, Montana. Smuin was trained by Willam Christensen while attending the University of Utah; moving to San Francisco, California, he continued his studies with Lew Christensen at the school of the San Francisco Ballet.

A member of the company from 1957 to 1962, he performed featured roles in Lew Christensen's *Divertissement d'Auber, Danza Brilliante, Filling Station, Lady of Shallott,* and *Beauty and the Beast.* After

touring with his wife, Paula Tracy, in an adagio dance act and performing in *Little Me* on Broadway, Smuin joined the American Ballet Theatre in 1966. In that company he performed in Leonid Massine's *Gaité Parisienne* as "The Peruvian," in *Coppélia, La Fille Mal Gardée,* Alvin Ailey's *The River,* and Jerome Robbins' *Fancy Free.* One of Ballet Theatre's choreographers-in-residence, he created many works for the company, including *The Catherine Wheel* (1967), *Gartenfest* (1968), *Pulcinella Variations* (1968), *The Eternal Idol* (1969), and *Schubertiade* (1970).

Smuin returned to the San Francisco Ballet in 1973 to become co-artistic director with Lew Christensen. He choreographed extensively for that company, creating many well-received works, among them, *Shinju* (1975), *Scherzo* (1977), *Q. a V.* (1978), and *A Song for Dead Warriors* (1979). His full-length ballets, *Cinderella* (1973, with Christensen), *Romeo and Juliet* (1976), and *The Tempest* (1980), have proved popular with the local audience. *Romeo and Juliet* was a hit with the nationwide television audience as well.

Works Choreographed: CONCERT WORKS: *Vivaldi Concerto* (1958); *The Circle* (1966); *The Catherine Wheel* (1967); *Gartenfest* (1968); *Pulcinella Variations* (1968); *The Eternal Idol* (1969); *Schubertiade* (1970); *Harp Concerto* (1973); *Cinderella* (1973, co-choreographed with Lew Christensen); *Mother Blues* (1974); *Shinjū* (1975); *Songs of Mahler* (1976); *Romeo and Juliet* (1976); *Medea* (1977); *Scherzo* (1977); *Mozart's C Minor Mass* (1978); *Q. a V.* (1978); *A Song for Dead Warriors* (1979); *Duettino* (1979); *The Tempest* (1980).

THEATER WORKS: *Sophisticated Ladies* (1981 delayed opening, co-choreographed and directed with Donald McKayle and Henry Le Tang).

Snyder, Gene, American theater and Prolog choreographer; born Gene Le Du, 1908 in Richmond, Virginia; died April 15, 1953 in New York City. After performances in vaudeville in the Midwest and work at S.L. "Roxy" Rothafel's Capitol Theater, he became an assistant to the producer. When he built his next Prolog palace, Snyder became dance director of The Roxy Theater in 1930. He moved with "Roxy" to his Radio City Music Hall in 1932 to become director of the precision team, the Rockettes. For seventeen years, Snyder staged dance numbers for the Rockettes, creating their signature control kicks, and also directed the Revue Tours (1936–1937) sponsored by the theater. Snyder served as choreographer for two Broadway musicals, *At Home Abroad* (1935) and *Yokel Boy* (1939), and worked on films, including *Top of the Town* (Universal, 1936) but remained best known for his work in Prologs.

Works Choreographed: THEATER WORKS: *At Home Abroad* (1935); Prologs (called cine-varieties) for The Empire Theatre, London (1936); Radio City Music Hall Revues (1936–1937); Radio City Music Hall Prologs (1938–1949); *Yokel Boy* (1939).

FILM: *The Collegiates* (Universal short subjects, c.1935–1938); *Top of the Town* (Universal, 1936).

Soares, Janet Mansfield, American modern dancer and choreographer; born in Attleboro, Massachusetts. Soares was trained at the Juilliard School where she served as assistant to Louis Horst. While teaching at Juilliard and at Barnard College, she has maintained a successful choreographic career. Her popular abstractions have been presented frequently at the Dance Uptown programs at Barnard and at the Dance Theatre Workshop for companies that include both students and recognized choreographers. Among her best known works of recent seasons are *Singing Low Songs . . . and Even Thinking . . . Dancing* (1974), *Bennett's Folly* (1978), dedicated to her Volunteer Lawyers for the Arts advocate, and *Bentwood Pieces* (1974), with its acclaimed duet that alters subtly when performed by some of New York's best dancers, among them Matthew Diamond, Leigh Warren, and Pierre Barreau.

Works Choreographed: CONCERT WORKS: *Trio* (1961); *Barefoot* (1961); *When the Bough Breaks* (1961); *Dear Luella* (1961); *Solo* (1961); *Stay Not Among the Wicked, But Let Us to New England Go* (1961); *Family Portrait* (1961); *Chimera* (1964); *Z6508 TIMES* (1968); *SKIN/deep* (1969); *Bentwood Pieces* (1974, two versions in the same year); *Singing Low Songs . . . and Even Thinking . . . Dancing* (1974); *Risks and Pleasures* (1975); *Cameo* (1976); *Temporary Quarters* (1977); *Bennett's Folly* (1978);

Madcaps and Lullibies (1978); *Step After Nine* (1979); *Images in Red* (1980); *Catch Phrase* (1980); *One on One* (1980).

Sobotka, Ruth, American ballet dancer and costume designer; born 1925 in Vienna; died June 18, 1967 in New York. Trained at the Carnegie Institute of Technology in Pittsburgh, Pennsylvania, where her father taught architecture, Sobotka continued her dance education at the School of American Ballet.

Sobotka joined the Ballet Society in 1947, performing with it and the New York City Ballet until the mid-1950s. She danced in the company revivals of Antony Tudor's *Time Table,* Lew Christensen's *Jinx,* and Jerome Robbins' *Interplay,* and created a major role in Balanchine's *Tyl Eulenspiegel* in 1951. While in the NYCB, she designed the costumes for productions by ballet master John Taras (*Arcade,* 1963), and fellow dancer Francisco Moncion, dressing his *Pastorale* (1957) and *Les Biches* (1960) for the City Ballet, and his *Night Song* (1966) for the National Ballet.

She also designed productions for Erick Hawkins (*Lords of Persia,* 1965), Kazuko Hirabayashi (*In a Dark Grove,* 1964), and Richard Rodham (*Pas de Poisson,* 1966), as well as television dramas and films. Her last credited performance as a dancer was with the company of choreographer-designer James Waring in 1960 at the Living Theater, where she appeared in his *In the Mist* and *Pyrrhus.*

Sodi, Pietro, Eighteenth-century Italian ballet dancer and choreographer working in Paris, Berlin, Vienna, London, and the United States; born c.1716 in Rome; died c.1776 in Charleston, South Carolina. It is not certain where or with whom Sodi was trained before he made his London debut in 1742.

Perhaps the most mobile of even the itinerent eighteenth-century ballet masters, Sodi spent the years between 1744 and 1774 touring Europe for one-year tenures at both opera houses and popular theaters. In France, for example, he performed and choreographed at the Paris Opéra (1749, 1774) and at the Comédie-Française (1745, 1752, 1753–1755) and the Theatre-Italien (1747, 1755–1757, 1758–1761). Sodi was a major figure in the linkage between the Opéra,

which was still in the early phase of development of ballet technique and form, and the French and Italian popular theatrical forms. Sodi also served as ballet master in Berlin, replacing Jean-Bathélemy Lany in 1747 and 1748, in Vienna, where he danced for Gasparo Angioli, and at the Teatro San Samuele in Venice before spending a solid five years in London (1761–1766). In that period, one of his most prolific, he created many pastoral ballets, such as *The French Country Gentlemen* (1761) and *The Pleasures of Spring* (1762).

In 1774, Sodi accepted an invitation to tour the East Coast of the United States. After performing in New York, Philadelphia and Baltimore, he settled in Charleston where he died in c.1776.

Works Choreographed: CONCERT WORKS: *Les Cors de Chasse* (1745); *Le Prince de Salerne* (1746); *Les Fetes Galantes* (1747); *Les Nouveaux Caractères de la Danse* (1747); *Cinna* (1748); *Les Enfants Bücherons* (1752); *Le Jardin des Fées* (1752); *La Gasse* (1754); *La Noce* (1754); *Impermestre* (1757); *l'Isola Disabilita* (1757); *Il Marcato di Malmantile* (1758); *La Cocaigne, ou les Jours Gras de Naples* (1759); *l'Amour Vainqueur de la Magic* (1760); *The Hungarian Gambols* (1761); *The French Country Gentlemen* (1761); *Harlequin Sorceror* (1762); *The Pleasures of Spring* (1762).

Sokolova, Eugenia, Russian ballet dancer; born 1850 in St. Petersburg; died there in 1925. Trained at the school of the Imperial Ballet, she appeared in ballets by Artur Saint Léon. Her student debut, and first created role, was in Marius Petipa's *L'Amour Bienfaiteur* in an 1868 school recital. As a member of the Maryinsky Ballet from 1869 to 1886, she appeared in more Petipa ballets, including his *Fille du Pharon, Don Quixote, Le Corsaire, Esmeralda,* and *Offrandes à l'Amour* (1886). She taught after her retirement for almost twenty years, training many of the most celebrated Russian ballerinas, as well as the first generation of Soviet stars of the GATOB.

Sokolova, Lydia, English ballet dancer; born Hilda Munnings, March 4, 1896 in Leyton, Essex, or Wanstead, London; died February 16, 1974 in Sevenoaks. Sokolova was trained at the Stedman's Academy in

London, later taking advantage of the presence in London of Mikhail Mordkin, Ivan Clustine, and Anna Pavlova to take classes and rehearsals with them. Although she may have participated in Stedman pantomimes in or around London, her first ballet company performances were with Mordkin's Imperial Russian Ballet in London and on tour in the United States (1911–1912). On her return to London, she performed with the Kosloff family troupe at the London Coliseum, partnering Alexis Kosloff.

Sokolova is best remembered as a member of the Diaghilev Ballet Russe. She maintained her links with that troupe from 1913 to 1929. She was the first English dancer to have a permanent contract with Diaghilev, although British performers may have appeared with the company in its London seasons as extras or swing dancers. It has been estimated that Sokolova appeared in more repertory works than anyone else in the company, with the exception of Tamara Karsavina. Whether that is true or not, Sokolova's name can be found in programs for Mikhail Fokine's *Narcisse, Carnaval* (as "Columbina" and "Papillon"), *Cléopâtre, Daphnis et Chloe, Spectre de la Rose*, and *Petrouchka*, Leonid Massine's *Sacre du Printemps* (1920), *Contes Russe* (1916), *Les Matelots, Le Tricorne, Cimarosiana*, Vaslav Nijinsky's *Till Eulenspeigel* (1916, on the American tour), Bronislava Nijinska's *Les Biches* (1924) and *Le Train Bleu* (1924), and George Balanchine's *Le Bal* (1929) and *Barabau*. She was considered one of the great comediennes of ballet, with technical brilliance and dramatic timing and style.

Although she retired after Diaghilev's death in 1929, she emerged to partner Leon Woizikovsky in their Ballet Russe repertory for his London company season in 1935 and appeared with the Royal Ballet in a mime role in the 1962 revival of Massine's *Les Femmes de Bonne Humeur.*

Works Choreographed: CONCERT WORKS: *The Silver Birch* (1942).

Bibliography: Sokolova, Lydia. *Dancing for Diaghilev* (London: 1960).

Sokolow, Anna, American pioneering modern dancer and concert and theatrical choreographer; born February 22, 1913 or February 9, 1915 in Hartford, Connecticut. Sokolow moved to New York as a child with her mother, a founding member of the International Ladies' Garment Workers Union. In New York, she studied with Bird Larson, then began to take classes in dance and composition at the Neighborhood Playhouse, whose program was directed at this time by Martha Graham and Louis Horst. While studying with Graham and Blanche Talmud, Sokolow assisted Horst in his Pre-classic Dance Forms classes.

Sokolow joined the Graham company in 1930, staying with the group until 1939, when she left the United States. Among the many Graham works in which Sokolow created roles were *Primitive Mysteries* (1931), *Tragic Patterns* (1933), *American Provincials* (1934), and *American Lyric* (1937). While a company member, she began to work with a collective group of Graham and Humphrey/Weidman dancers which came to be known first as the New Dance League and then as the New Dance Group. Like her League colleagues, Lily Mehlman, Si-lan Chen, Jane Dudley, and others, Sokolow became involved in the promotion of dance as a medium of political communication and education. Her best-known dances of the period—choreographed for her own recitals, for Dance League concerts, and for the performing group, the Dance Unit—had titles and themes that revealed their involvement with both domestic politics—poverty, bigotry, and industrialization—and the pacifist view of European and North African affairs. Sokolow's choreographed works revealed her special interest in the Spanish and Italian civil problems, particularly in such pieces as the ironic *Excerpts from a War Poem* (1937) and *Façade-Expositione Italiana* (1939). Her American works showed characterizations of women surviving in cities, as in *Impressions of a Dance Hall* (1935), and people being destroyed by factories, as in her extraordinary *Strange American Funeral* (1935), about a man killed in a metal melt-down.

In 1939, Sokolow accepted the invitation of the Mexican government to choreograph and teach there. She remained in Mexico until 1943, and commuted between there and New York for an additional number of years. Two works from this period remain extant: her *Homage to Garcia Lorca* (1940), which

includes the *Lament for the Death of a Bullfighter,* and the *Mexican Retablo* (1949).

Sokolow's choreography in the 1950s, 1960s, and 1970s, created for her own companies, for groups in Mexico and Israel, and for the Juilliard Dance Ensembles, are less specifically topical but still maintain a political involvement. Her works can be generally divided into two rough groupings: those that allude to specific historical situations and those that perceive the general compulsions, fears, apathies, and desires of the "anonymous" people of today. In the first group can be found her *Dreams* (1961), a horrifying view of concentration-camp life, and *Ellis Island* (1976), a tribute to her parents and to all the other immigrants who entered America through the port of New York. The other, better known, works are considered among the best depictions and analyses of contemporary life in any medium or art. Although every critic and audience member has one or two works that he or she finds most affecting— whether they can be called the most beautiful or the most horrific—certain pieces are generally considered classics of twentieth-century art, among them, *Lyric Suite* (1953), *Steps of Silence* (1968), and *Rooms* (1955). The latter work, a series of solos and group conjunctions of solos, has been revived frequently since its premiere—both the entire suite of dances and the solos, especially "Escape," that are included in many repertories—and never seems to lose its impact. More surprisingly, those works that allude specifically to the dress and habits of alienated youth in certain periods, such as the *Session* and *Opus* series, also survive in the repertories of many companies.

Sokolow has had a successful theater career, concurrent to her work as a concert dancer and choreographer. Associated with both Broadway musicals and Off Broadway and institutional shows, her credits range from the WPA revue, *Sing for Your Supper* (1937), to the original productions of the plays *Camino Real* (by Tennessee Williams, 1953), *Red Roses for Me* (1955), and *The Brig* (1971). Her musical shows include the original productions of *Hair* (1968), and the American operas *Street Scene* (1947) and *Regina* (1949). She has been choreographer-in-residence for the American Youth Theater (1941), ANTA (1957–), and the original Lincoln Center Repertory company.

Two of Sokolow's most successful operas were first produced as Broadway shows—Kurt Weill's *Street Scene* (1947), with its "Moon-Faced, Starry-Eyed" duet-romance, and Marc Blitzstein's *Regina* (1949), based on Lillian Hellman's *The Little Foxes*. She has also staged new productions and revivals of many American and European modern repertory works, among them Carl Orff's *The Moon* (1956), Elie Siegmeister's *A Cycle of Cities* (1979), and Kurt Weill's *The Seven Deadly Sins*, in the United States, Holland, and Israel.

As a choreographer, teacher, and lecturer, Sokolow has had wide influence on young dancers in America and abroad, especially in Mexico, Israel (where she has worked with Inbal, Bat-sheva, and the Habima Theater), the Eastern European countries, and Japan. The dancers whom she has sponsored for dance studies in the United States range from Ze'eva Cohen to Kei Takei; each now directs a company in New York. As a choreographer and teacher at the Juilliard School's dance department, Sokolow has inspired many dancers and choreographers in both modern dance and ballet. In one revival at Juilliard, for example (the 1965 cast of her revised *Session for Six*), five of the dancers Martha Clarke, Ze'eva Cohen, Paula Kelly, Dennis Nahat, John Parks, and Michael Uthoff now serve as directors or choreographers-in-residence for companies ranging from Pilobolus and a solo repertory company to the Cleveland and Hartford Ballets. Among the many others who have created roles in Sokolow works, or have been members of her company, are Tony Azito, Jeff Duncan, Jim and Lorry May, Laura Glenn, Hannah Kahn, Julie Arenal, Jack Moore, Raymond Cook, Don Redlich, and Donald McKayle.

Works Choreographed: CONCERT WORKS: *Pre-classic Suite (Sarabande, Gavotte, Gigue)* (1933); *Romantic Dances (Illusion, Désir)* (1933); *Prelude and Chorale* (1933); *Histrionics* (1933); *Salutation to the Morning* (1933); *Jazz Waltz* (1933); *Homage to Lenin* (1933); *Folk Motifs (Song, Dance, Legend)* (1933); *Death of a Tradition* (1934); *Challenge* (1934, collectively choreographed with Sophie Maslow and

Lily Mehlman); *Pioneer Marches* (1935, choreography credited collectively to the Dance Unit); *Strange American Funeral* (1935); *Impressions of a Dance Hall* (1935); *Speaker* (1935); *We Remember* (1935, choreography credited collectively to the New Dance League); *Inquisition 1936* (1936); *Opening Dance* (1937); *Case History, No.___* (1937); *Excerpts from a War Poem* (1937); *Ballad in a Popular Style* (1937); *War-Monger* (1937); *Four Little Salon Pieces (Début, Élan, Reverie, Entr'acte)* (1937); *Suite of Soviet Songs (Sailors' Holiday, Defend Our Lord, Lullaby, Sailors' Chorus)* (1937); *Façade-Expositione Italiana* (1939); *The Exile* (1939); *Entre Sombras anda el Fuego* (1940); *Los Pies de Pluma* (1940); *Don Lindo de Almeria* (1940); *Sinfonia de Antigonia* (1940); *La Maderugadel Panadero* (1940); *El Ranacuajo Pasedor* (1940); *Homage to Garcia Lorca (Lament on the Death for a Bullfighter* frequently performed as separate work) (1940); *Siete Canciones España* (1940); *Prelude* (1944); *Madrid 1937* (1944); *Side Street* (1944); *Mama Beautiful* (1944); *Songs of a Semite (Visions:* a. of Ruth and Naomi, b. of Mirium, c. At the Wall, d. Fantasy—Confusion of Dreams, e. Deborah, March of the Semite Women) (1944); *Dos* [Bach] *Preludios* (1945); [Chopin] *Preludios y Mazurkas* (1945); *Danzas sobre Temas Ruses* (1945); *Kaddish* (1945); *A Summer's Day* (1947); *Divertimento* (1947); *Mexican Retablo* (1949); *La Vida es Fandango* (1949); *The Dybbuk* (1951); *A Short History and Demonstration in the Evolution of Jazz* (1953); *Lyric Suite* (1953); *L'Histoire du Soldat* (1954); *Rooms* (solos *Escape* and *Panic* performed as separate works) (1955); *Primavera* (1955); *Poem* (1956); *Le Grand Spectacle* (1956); *Opus '58* (1958); *Session for Eight* (1958); *Dreams* (1961); *Opus '60* (1961); *Musical Offerings* (1961); *Opus '62* (1962); *Four Jazz Suites* (1962); *The Treasure* (1962); *Suite No. 5 in C Minor for 'Cello* (1963); *Opus '63* (1963); *The Question* (1964); *Session for Six* (1964); *Forms* (1964); *Ballade* (1965); *Odes* (1965); *Time Plus Six* (1966); *Night* (1966); *Deserts* (1967); *Memories* (1967); *Time Plus Seven* (1968); *Tribute to Martin Luther King* (1968); *Steps of Silence* (1968); *Echoes* (1969); *Magritte, Magritte* (1970); *The Dove* (1970); *Where . . . To* (1970); *Scenes from the Music of Charles Ives* (1971); *A Short Lecture and Demonstration on the Evolution of Ragtime as Presented by Jelly Roll Morton* (1972); *Three Poems* (1973); *In Memory of No. 52346* (1973); *Come, Come Travel with Dreams* (1974); *Friendships* (1974); *Song* (1975); *Ride the Culture Loop* (1975); *Dreaming* (1975); *Moods* (1975); *Song of Songs* (1976); *Ellis Island* (1976); *Caprichos* (1976); *The Holy Place* (1977); *Songs Remembered* (1978); *Question and Answer* (1978); *Homage to Scriabin* (1979, full-length full-company work); *Homage to Scriabin* (1979, solo); *Homage to Gertrud Kraus* (1979); *Asi es la Vida en Mexico* (1979).

OPERA: *The Moon* (1956); *The Tempest* (1957); *The Seven Deadly Sins* (1967, later productions in 1978); *Huckleberry Finn* (1971); *Alexander, the Hashmonai* (1979); *A Cycle of Cities* (1979).

THEATER WORKS: *Valley Forge* (1934); *Noah* (1935, co-choreographed with Louis Horst); *Panic* (1935); *Sing for Your Supper* (1937); *You Can't Sleep Here* (1941); *The Great Campaign* (1947); *Street Scene* (1947); *Regina* (1949) (both first produced as Broadway shows, now considered operas); *Camino Real* (1953); *Madame, Will You Walk?* (1953); *Red Roses for Me* (1955); *Metamorphosis* (1957); *On Baile's Strand* and *The Death of Cuchulain* (1959); *Hair* (1968, original Public Theater production); *Act Without Words* (1970); *The Brig* (1971); *Pinkville* (1971); *The Wings* (1979).

TELEVISION: *Three Conversations in a City* (*The Perry Como Show*, NBC, 1959); *The Song of Songs* (*Look Up and Live*, CBS, 1959); *The Celebrations* (*Look Up and Live*, CBS, 1967); *Queen Esther* (WPIX, 1980).

FILM: *Bullfight* (Independent Production, 1956); *A Moment in Love* (Independent Production, 1957).

Solar, Willie, American eccentric dancer and comic; born 1891 in Hartford, Connecticut; died December 17, 1957 in New York City. A former boy tenor, he made his first hit as the "Teddy Bear" who accompanied Julia Sanderson in her song, "Bessie and Her Little Brown Bear," in 1907. He introduced his signature song, "Abba Dabba Honeymoon" in 1908 in the Gus Edwards' *Country Kid's* act, with which he toured for two seasons.

Solar maintained his "country kid" image in a series of rube acts in vaudeville, as a solo performer and in a dance act with Alice Rogers. His specialty

consisted of performing every movement in social dance satires just a little bit wrong, as if he were a country rube who had learned the steps from mail-order lessons. His other dance specialty was introduced in his next show, *Get Rich Quick Wallingford*. Although this 1912 satire of boy's literature was also a "rube" characterization, he originated his new act in a scene in which he was introduced to real society. Basically, Willie Solar became famous by falling down staircases.

Whether he was drunk, clumsy, or naive in character, or simply showing off in a vaudeville act, Solar fell down staircases in London shows, including *Hullo Ragtime* (1912) and the famous *Escalade, or The Magic Staircase* (1913) staged by Ned Wayburn for the London Hippodrome. He also did his specialty on Broadway in *The Midnight Frolics* (1915), *The Century Girl* (1916), another Wayburn show with a staircase set, and *Ladies First* (1919). He was a headliner in English music halls and on the American Keith and Orpheum circuits from 1912 to 1937. Solar also performed in Russia, where he learned the Kazatke which he added to his act, in Cairo, Paris, and Copenhagen.

After a brief retirement, he returned to the stage in the old-timers edition at Billy Rose's Diamond Horseshoe in 1943, and made his film debut in the Fox motion picture about that nightclub.

Solino, Louis, American modern dancer; born February 7, 1942 in Philadelphia, Pennsylvania. Solino was trained by May O'Donnell, José Limón, Mary Anthony, and Gertrude Shurr. Considered one of the finest contemporary performers of the traditional American modern dance, he has appeared with many of the choreographers and companies working in that living medium. He has danced as a company member or freelancer with Mary Anthony, Art Bauman, John Butler, Deborah Jowitt, Sophie Maslow, and Glen Tetley, but is best known for his work with the José Limón company. He was given the antagonist parts, the Lucas Hoving roles, in many of the small-scale Limón works, among them the Judas in *The Traitor* and the Iago in *The Moor's Pavanne* (neither being the character's name). He also danced in Limón's abstractions, among them *A Choreographic Offering, The Unsung, The Winged*, and *There Is a Time*. He

has been asked to stage Limón work, especially *The Moor's Pavanne*, for many companies in the United States and has guested frequently in the Limón repertory.

Solomons, Gus, Jr., American modern dancer and choreographer; born August 27, 1940 in Boston, Massachusetts. Although he studied jazz and tap dance as a child, Solomons did not continue his training until he was an architecture student at the Massachusetts Institute of Technology, from which he graduated in 1961. During his studies there, he took classes in Mary Wigman technique with Jan Veen (Hans Weiner) at the Boston Conservatory of Music, and in ballet with E. Virginia Williams.

Solomons became a member of the Donald McKayle company in 1961, creating a role in McKayle's *Legendary Landscape* (1961), and performed with the companies of modern dance choreographers Joyce Trisler, Flower Hujer, Pearl Lang, and Paul Sanasardo, before joining the Martha Graham company in 1965. He remained with the Graham group only one season, creating the role of "Samuel" in her *The Witch of Endor* (1965).

A member of the Merce Cunningham company from 1964 to 1968, he created roles in many of his important works, among them *Winterbranch* (1964), *Variations V* (1965), *How to Pass, Kick, Fall and Run* (1965), *Place* (1966), and *Rainforest* (1968), before, like all Cunningham dancers, he left to choreograph on his own.

Possibly the last person to have a true concert dance career, Solomons began to choreograph for himself and small groups for solo and shared recitals at the 92nd Street YMHA and the Clark Center for the Performing Arts, both in New York. The Gus Solomons Company Dance, as it is called, founded in 1969, has included dancer/choreographers Margaret Beals and Dianne McIntyre as well as Solomons students from Bard College, UCLA, and the California Institute of Arts. Like the crossword puzzles that he creates for the Off Off Broadway trade paper *Other Stages*, his works frequently include allusions to mathematics and architecture, but may involve references to contemporary culture, as do *The Son of Cookie Monster* (1972), and *Draft Alteration* (1969).

As can be seen, his titles, as well as his choreography, frequently employ paradox and quixotic scores, decor, and gestural systems.

Solomons has worked extensively in video, both as a choreographer and as an artist.

Works Choreographed: CONCERT WORKS: *Construction II* (1959); *Etching of a Man* (1960); *Fogrum* (1962); *Match* (1962); *Rag Caprices* (1962); *Fast* (1963); *Kinesia for Women and a Man* (1963); *Four Field of Six* (1964); *The Ground Is Warm and Cool* (1964); *Construction II & 1/2* (1964); *Simply This Fondness* (1966); *Ecce Homo* (1967); *Kinesia for Five* (1967); *Neon* (1967); *Notebook* (1967); *City-Motion-Space-Game* (1968); *Two Reeler* (1968); *Christmas Piece* (1969); *Draft Alteration* (1969); *Obligato '69 N.Y.* (1969); *Phreaque* (1969); *We don't know only how much time we have . . . We don't know only how much time we have . . .* (1969); *cat. #CCS70-10/13 NSSR-GSJ9M* (1970); *A Dance in Report Form/A Report in Dance Form* (1970); *Quad* (1970); *Warm-up Piece* (1970); *On Par* (1971); *Patrol* (1971); *Pyrothonium* (1971); *Title Meet* (1971); *Urban Recreation/The Ultimate Pastoral* (1971); *Beet-can Conserves* (1972); *Grandular Dilemma and a Vision* (1972); *The Gut-Stomp Lottery Kill* (1972); *Masse* (1972); *Pocketcard Process No. 2* (1972); *The Son of Cookie Monster* (1972); *Brill-o* (1973); *Decimal Banana* (1973); *Par/Tournament* (1973); *Yesterday* (1973); *Chapter One* (1974); *Molehill* (1974); *A Shread of Prior Note* (1974); *Stoneflesh* (1974); *Statements of Nameless Root—Part I, Observation* (1975); *Steady Work* (1975); *Ad Hoc Transit* (1976); *Conversation* (1976); *Forty* (1976); *Statements of Nameless Root—Part II, Conclusions* (1976); *All but One* (1977); *Bone Jam* (1977); *Boogie* (1977); *Acrylic-flake Diagram* (1978); *Psycho Motor Works* (1978); *Signals* (1978); *make me no boxes to put me in . . .* (1979); *Wide Wide World of Sports and Dance* (1978); *Dance Is a 5-letter Word* (1979); *Stepchart* (1979); *Steps-progressive Pieces* (1980); *NŌZ* (1980).

THEATER WORKS: *Joan* (1972).

TELEVISION: *Construction II 1/2* (NBC, 1964).

Solov, Zachary, American ballet dancer and opera choreographer; born c.1923 in Philadelphia, Pennsylvania. Solov's early training included classes in ballet with Catherine and Dorothie Littlefield, tap with Ernest Carlos, modern dance with Hanya Holm and Doris Humphrey, and after traveling to Europe, technique work with Olga Preobrajenska. While performing in the 1940s, he studied at the School of American Ballet and at Mme. Anderson-Ivantzova's studio in New York. Solov actually made his professional debut on a children's radio show at the age of eleven, and worked in a nightclub trio called The Three Tip Tappers, at fifteen. In 1939, he joined the Littlefield Ballet, with which he danced in Catherine Littlefield's *Café Society, Barn Dance*, and *The Sleeping Beauty*. After the American Ballet Caravan tour of Latin America in 1941, he joined Eugene Loring's Dance Players, in which he danced as "Alias" in *Billy the Kid* and staged his first extant work, *Ethan Frome* (1942). After working at the Roxy Theater, he entered military service, returning to New York to join Ballet Theatre, in which he performed in George Balanchine's *Theme and Variations*, Antony Tudor's *Dark Elegies*, and Jerome Robbins' *Interplay* and *Fancy Free*. Solov has directed two chamber companies—the Ballet Sextette (1954), with a membership that sounds like the history of dance in the 1950s (André Eglevsky, Melissa Hayden, Nora Kaye, Hugh Laing, Maria Tallchief, and Patricia Wilde), and a Ballet Ensemble (1961).

Despite these activities, however, Solov is best known for his work with opera companies. He was ballet master at the Metropolitan Opera Company during the 1950s and a choreographer there until very recently, staging ballet and social dance sequences in the traditional repertory and operettas.

Works Choreographed: CONCERT WORKS: *Ethan Frome* (1942); *Mademoiselle Fifi* (1952); *Vittorio* (1954); *Soirée* (1955); *The Golden Apple* (1955); *Chez Tchaikovsky* (1961); *Invitation to the Dance* (1961); *Alegresse* (1961).

Soloviev, Yuri, Soviet ballet dancer; born August 10, 1940 in Leningrad; Soloviev was trained at the Leningrad Choreographic School before joining the Kirov Ballet in the late 1960s. From live performances, appearances in Soviet ballet films, and international reputation, Soloviev has been credited (or blamed) with the returning emphasis on elevation in judging a Kirov male dancer. His extraordinary elevation has been cheered in the nineteenth-century bravura roles,

such as "Siegfried" in *Swan Lake* and "The Blue Bird" in *The Sleeping Beauty*, but has also garnered applause and critical approval in the Soviet repertory of ballets. Among the works in which his special abilities have been featured are Grigorovich's *The Stone Flower*, Belsky's *Leningrad Symphony*, Ĭakobson's *Land of Miracles*, and *Creation of the World* (1971), the ballet by Nathalia Kasatkina and Vladimir Vasiliov that was for many seasons considered the most "modern" piece in the repertory.

Somes, Michael, English ballet dancer; born September 28, 1917 in Horsley, Gloucestershire, England. After early training with Katherine Blott in Weston-super-Mare, he continued his studies with Phyllis Beddells and Eduoard Espinosa, and entered the school of the Sadler's Wells Ballet on scholarship.

The premier danseur of the early English ballet, Somes was celebrated for his nobility, stage presence, and brilliant technique. As a measure of his importance to the developing art form there, one need only look at the immense list of works in which he performed. In the ballets of Frederick Ashton alone, he created roles in the following: *Horoscope* (1938), *Harlequin in the Street* (1938), *Cupid and Psyche* (1939), *Dante Sonata* (1940), *The Wise Virgins* (1940), *The Wanderer* (1941), *Symphonic Variations* (1946), *Les Sirènes* (1946), *The Fairy Queen* (1946), *Scènes de Ballet* (1948), *Cinderella* (1948), *Daphnis and Chloe* (1951), *Tiresias* (1951), *Sylvia* (1952), *Homage to the Queen* (1953), *Rinaldo and Armida* (1955), *La Péri* (1956), *Birthday Offering* (1956), *Ondine* (1958), *Raymonda* (1959), and *Marguerite and Armand* (1963). In many of these works, and in the revivals, he partnered Margot Fonteyn.

Retiring in 1961, he became a director of the Royal Ballet, also teaching and performing in mime roles.

Works Choreographed: CONCERT WORKS: *Summer Interlude* (1950).

Sorel, Felicia, American concert dancer and theatrical choreographer; born 1904 in New York; died September 7, 1972 in Las Vegas, Nevada. Sorel had ballet training from Mikhail Fokine, German modern dance studies with Mary Wigman, and some Spanish-dance lessons from Vicente Escudero.

A concert dancer in the late 1920s and early 1930s, Sorel worked with her then-husband, Senia Gluck-Sandor, in a series of recital seasons under the inclusive title, Dance Centre. The actual Dance Centre, as a company, lasted from 1931 to 1933, presenting full-evening concerts of "ballets" that used both classical-ballet-trained and modern dancers. Sorel performed the leading female roles in each production, among them, *Petrouchka* (1931), *Tempo* (1932), *Afternoon of a Faun* (1932), and *El Amor Brujo* (1931, 1933), but did not receive choreography credits. Her own works were presented at the Dance Centre Sunday evening recitals of 1933 and 1934, and were also included in a series of programs by Paul Whiteman's Orchestra in 1933. She presented concerts on her own in the Spring of 1935, at the Labor Stage, but then became involved in the Opera Division of the WPA Music Project, of which she was named director.

Concurrent to her concert career, Sorel worked at the Radio City Music Hall in an adagio/characterization dance team with Demetrios Vilan. With Vilan, she also performed at the Ann Arbor (Michigan) Arts Festival in 1935, where she did her first credited theatrical choreography—*The Ugly Runts*. Most of her theater works were staged before 1948 and ranged from individual numbers interpolated into *Pins and Needles* (1939 and 1940 revisions) to the large spectacular musicals that she choreographed for the Theatre Guild, such as Marc Connelly's *Everywhere I Roam* and *Our Honor and Our Strength* (both 1939). Sorel also staged *The Pirate* for Alfred Lunt and Lynn Fontanne (1942) and black revivals of *La Belle Hélène* (1941) and *Lysistrata* (1946).

Works Choreographed: CONCERT WORKS: *A Miracle Play* (1926, co-choreographed with Senia Gluck-Sandor); *Dressing Room of a Dancer, 18th Century* (1926); *Bedouine* (1926); *Portrait of Mme. L* (1926); *Harlem* (1926, co-choreographed with Gluck-Sandor); *Commercially Sponsored* (1933); *Two Deadly Virtues* (1933); *Mountain Blues* (1933); *American Negro Blues* (1939); *St. James Infirmary Blues* (1939); *Frankie and Johnny* (1941); *Rhumba* (1941); *Mexican Suite* (1941); *Appalachian Blues* (1941); *St. Louis Blues* (1941); *Primitive American Rituals* (1943).

THEATER WORKS: *Cabbages and Kings* (1933, co-choreographed with Gluck-Sandor); *Up to the Stars* and *The Ugly Runts* (1935, co-choreographed with Demetrios Vilan); *Land of the Living* (1938); *Ameri-*

can Varieties (1939); *Everywhere I Roam* (1939); *Our Honor and Our Strength* (1939); *Jeremiah* (1939); *Pins and Needles* (1939, 1940, additional dance numbers interpolated into long-run show); *La Belle Hélène* (1941, theatrical presentation of operetta); *Johnny Doodle* (1942); *The Pirate* (1942); *Henry VIII* (1946); *Lysistrata* (1946).

TELEVISION: *The Dybbuk* (*Studio One*, CBS, June 1, 1949).

Sorkin, Naomi, American ballet dancer; born October 23, 1948 in Chicago, Illinois. Raised in Chicago and Milwaukee, where her father's string quartet was in residence, Sorkin was trained in both ballet and modern dance by some of the great iconoclasts of America, among them, Sybil Shearer, Eric Braun, Bentley Stone and Walter Camryn, Carmelita Maracchi, and Maggie Black. After working with Ruth Page's Chicago Opera Ballet as an adolescent, she moved to New York to join the American Ballet Theatre. Cast in both classical and contemporary works, she was featured in the company's productions of *Swan Lake, La Fille Mal Gardée, Giselle*, and *Les Sylphides*, and appeared in works by José Limón, including his *The Moor's Pavanne*. Sorkin was cast in the ballets by all of Ballet Theatre's choreographers-in-residence, Michael Smuin, Eliot Feld, and Dennis Nahat, and has appeared in each one's later company.

When Smuin became artistic director of the San Francisco Ballet in 1973, Sorkin moved to the West Coast with a group of Ballet Theatre dancers and appeared with that company for a season. She returned to New York to join the new Eliot Feld Ballet, dancing in his *Intermezzo, Sephardic Songs*, and others. Sorkin also appeared in the first seasons of Nahat's Cleveland Ballet, creating the ballerina roles in his *In Concert* (1977) and reviving her roles in the pieces that he had created in Ballet Theatre.

Since 1978 she has been one of the world's few successful freelance ballerinas. She appears with ballet companies, modern dance troupes, including that of Paul Sanasardo for whom she created *Andante Cantabile* (1977) and *Of Silent Doors and Sunsets* (1977), and her own solo dance recitals. She has commissioned works from Anna Sokolow (*Solo for Anne Frank, Scriabin Solo*), Rachel Lampert (*Solo Suite*),

and other choreographers. Her studies in Duncan technique have brought even more lyricism to her extraordinarily flexible body and performance style. Her large number of fans, many of whom have followed her to their first modern dance concerts, argue to choose their favorite Sorkin role, dance sequence, or individual movement. Although some acclaim her graceful backbends and port de bras, others remember her ability to make infinitesimally small movements in Nahat ballets legible to the fans in standing room.

Sorkin's participation in performances by companies and concert groups across the spectrum of performance techniques and styles has made her a unique figure in American dance. Her ability to perform brilliantly in each of these genres has brought her back to the forefront of her chosen field.

Sorokina, Nina, Soviet ballet dancer; born May 13, 1942 possibly in Moscow. Trained at the Bolshoi school in Moscow, she graduated into the Bolshoi Ballet, where she has spent her entire career. Although her flawless technique and artless characterizations have made her popular in the younger ballerina heroic roles of the classics, most notably as "Masha" in *The Nutcracker* and "Kitri" in *Don Quixote*, she is best known for her work in the Soviet repertory. Sorokina is considered a master of the art of delineating a Soviet heroine in dance and making her actions both beautiful and believeable in that system of dramatic validity that is unnecessary in Western ballet. Among her best known credits in that repertory are Natalia Kasatkina and Vladimir Vasiliov's *Sacre du Printemps, Poème Heroique*, and *War and Peace*, Asafiev's *Flames of Paris*, and Grigorovich's *Assel*.

Soto, Merián, American modern dancer and choreographer; born January 8, 1954 in San Juan, Puerto Rico. After local training (which she now considers irrelevant to her present work), she moved to New York City to study at the New York University School of the Arts under Nanette Charisse in ballet and Bertram Ross in Graham technique and composition. Although she has concentrated on the presentation of her own choreography, she has also performed in the works of others, among them, Elaine

Summers, Rachel Lampert, for whom she danced in *Brahams Variations, Home,* and *Attic,* and Linda Tarnay, for whom she appeared in *Voice of the Whale, Ocean,* and *You Are My Sunshine.* Her own work deals with the synthesis in rhythm of her personal imagery into a legible ritual.

Works Choreographed: CONCERT WORKS: *Danilo* (1975); *Presencias* (1978, in collaboration with poet Marisol Villamil); *Son Galán Galán* (1979); *El Agua Viva* (1979); *Puerta* (1979); *Son Montuno en Remojo* (1979); *Noches de Santiago* (1980); *Desilusión* (1980, in collaboration with mime Rafael Fuentes); *Sueño de Malanga* (1980); *Flor de Caimito* (1980).

Soudekeine, Serge, Russian artist and theatrical designer working in France and the United States; born 1883; died August 13, 1946 in Nyack, New York. Considered one of the century's finest scenic artists, Soudekeine was associated with dance and opera productions from the early 1910s. He designed *La Tragédie de Salomé* (1913) for Diaghilev (although there is evidence that he worked for the Ballet Russe before that date as a scenic artist, rather than a designer), and staged a large number of works by Ivan Clustine for private performance and for the Pavlova company, including his *Puppenfée* (1914) and *Coppélia* (1923). In the United States he worked on the scenes for Adolf Bolm's *Petrouchka* at the Metropolitan Opera (1925), with costumes by a young Vincent Minnelli, and designed most of the Mordkin Ballet repertory, among them his *La Fille Mal Gardée, Giselle,* and *Trepak.* His Ballet Theatre productions included Bronislava Nijinska's *Fille Mal Gardée* (1941) and Leonid Massine's *Moonlight Sonata* (1944).

Soudekeine was a staff designer at many of the theaters operated by S.L. "Roxy" Rothafel, including the Roxy Theater and the Radio City Music Hall.

Southern, Georgia, American popular entertainer, toe dancer, and ecdysiast; born Hazel Eunice Finklestein, in the late 1920s in Dunganon, Georgia. Southern made her theatrical debut at the age of four in an Atlanta-area stock company with her uncle, John Diamond. She was a member of the vaudeville act John Diamond and Company until she was twelve, by which time she was an accomplished acrobatic and barefoot toe dancer. A year later, she went into burlesque, making her debut at the Bijou Theatre in Philadelphia. Minsky saw her there and cast her into his New York productions at The Republic but she considered the Old Howard Theater in Boston her "alma mater." For most of the 1940s, she alternated between performances at nightclubs such as Billy Rose's Casino de Paris and Leon and Eddie's and worked in burlesque shows, including Michael Todd's *Star and Garter* (1942) and slightly lesser productions such as the Howard's *Peek-a-Vue.* Southern was noted as an extremely fast dancer. Working at top speed to rags, she did high fast kicks and shook her head and fabulous gold-red hair into circles. She did strip, but only after she had danced for the audience.

Bibliography: Southern, Georgia. *My Life in Burlesque* (New York: 1973).

Sowinski, John, American ballet dancer associated with the work of Eliot Feld; born 1947 in Scranton, Pennsylvania. After early training locally at the Sutton Dance Studio, he accepted a scholarship to attend the School of American Ballet in New York.

Throughout his career, Sowinski has commuted among the companies of Eliot Feld and, between their existences, the American Ballet Theatre. In Ballet Theatre, he created roles in Feld's *At Midnight* and *Harbinger* (both 1967) and *Intermezzo* (1969), and in Michael Smuin's *Pulcinella Variations* (1968). When Feld founded the American Ballet Company, Sowinski joined to perform roles in his *A Poem Forgotten, The Consort, Early Songs,* and *Cortège Parisien* (all 1970), and *Romance* (1971).

Returning to Ballet Theatre, when Feld's company disbanded, Sowinski performed in company revivals of Bournonville's divertissements from *Napoli* and Ashton's *Les Patineurs.* He created roles in Lar Lubovitch's *Scherzo for Messiah Jack* and Tomm Ruud's *Polyandrion* (both in 1973) but left the company to join the new Feld Ballet in 1974. In that group, he has performed in most of the Feld repertory, repeating his most celebrated role in *Intermezzo,* and dancing in the premiers of *Tzaddik* (1974), and *Scenes from a Theatre* (1980).

Soyer, Ida, American modern dancer; born 1909; died July 4, 1970 in the Hamptons, New York. The

"maiden" name of the dancer, who was married to the artist, Moses Soyer, cannot be verified; she was known by her married name throughout her entire performance career. Soyer was a member of Helen Tamiris' concert group from its inception in 1931 to the choreographer's switch to Broadway work in 1944. She appeared in almost every work that Tamiris created for a dancer other than herself in that period, among them the *Triangle, Woodblock*, and *Cymbal Dances* (1930–1933), *Olimpus Americanus* (1932), *Mourning Ceremonial* (1932), *Song of the Open Road* from the *Walt Whitman Suite* (1934), *Towards the Night* (1934), especially the third and fifth sections, *Cycle of Unrest* (1935), *These Yearnings, Why Are They?* (1940), and *Liberty Song* (1942), premiered at The Rainbow Room. Soyer also appeared as a guest artist in the recitals of her contemporary dancers and young choreographers, most notably in Dorothy Barret's *Last Spring* (1938).

Sparemblek, Milko, Yugoslavian ballet dancer and choreographer; born December 1, 1928 in either Zagreb or Farnavas, Slovenia, Yugoslavia. Trained at the school of the Zagreb Opera Ballet under Ana Roje, he graduated into the company in 1949. After performing there for three seasons he joined the Ballets de Janine Charrat in Paris for two years, and the Milovad Moskovitch Ballet de Paris until 1958. He was associated for many years with Ludmilla Tcherina, in whose company he performed for three years, and for whom he staged his best known work, *Les Amants de Teruel* (1960). Among the other companies for which he has served as ballet master are the Ballet du XXième Siècle (1963–1964), the Metropolitan Opera Ballet in New York (c.1973–1975), and the Gulbekian Ballet in Lisbon (in the early and mid-1970s). He has also choreographed for French television since the mid 1960s.

Works Choreographed: CONCERT WORKS: *L'Echelle* (1957, co-choreographed with Dirk Sanders); *Quatuor* (1957); *Les Amants de Teruel* (1960); *La Baque* (1964); *Wagner, ou l'Amour fou* (1965); *The Seven Deadly Sins* (1968); *l'Absence* (1969); *Passacaglia* (1970); *The Miraculous Mandarin* (1971); *Ancient Voices of Children* (1972); *Symphony of Psalms* (1972); *Le Combat de Tancréde et Clorinde* (1973); *Opus 43* (1973); *Oedipus Rex* (1978).

FILM: *Les Amants de Teruel* (Independent, 1961).
TELEVISION: *Phédre* (French Télévision, 1968); *Jeanne d'Arc* (French Télévision, 1968); *Miroir à Trois Faces* (French Télévision, c.1967–1969).

Sparling, Peter, American modern dancer and choreographer; born June 4, 1951 in Detroit, Michigan. After attending the Interlocken Arts Academy as an adolescent, he moved to New York to study at the Juilliard School with José Limón, Helen McGehee, and Anna Sokolow; as a student, he played the male role in Doris Humphrey's *Day on Earth*. He apprenticed with the Martha Graham company, joining the troupe in the early 1970s. Among the works in which he performed there were her *Chronique, Adorations, Lucifer* (1975), *Shadows*, and *Flute of Pan* (1978).

Sparling has presented concerts of his own choreography since 1973. He created many works for his small ad hoc company, but has recently been working in the solo genre, producing *Hard Rock, What She Forgot He Remembered*, and *Sitting Harlequin* in 1979, in a concert called "Solo Flight."

Works Choreographed: CONCERT WORKS: *Divining Rod* (1973); *Little Incantations* (1974); *Three Farewells* (1977); *A Thief's Progress, or The Lantern Night* (1978); *Excursions of Chung Kuei* (1978); *Nocturnes for Eurydice* (1978); *Once in a Blue Moon* (1978); *Suite to Sleep* (1978); *Harald's Round* (1979); *Hard Rock* (1979); *What She Forgot He Remembered* (1979); *Elegy* (1979); *Sarabande* (1979); *Sitting Harlequin* (1979); *In Stride* (1979); *The Tempest* (1980); *Orion* (1980); *Landscape with Bridge* (1980).

Spears, Warren, American modern dancer and choreographer; born May 2, 1954 in Detroit, Michigan. Trained at Cass Tech, Detroit's arts public high school, he moved to New York to study at Alvin Ailey's American Dance Center. Spears was a member of the Ailey Repertory Ensemble in 1974 before graduating into the senior company, the Alvin Ailey Dance Theatre. Among the many works in which he was assigned featured roles were Ailey's *Night Creatures, Streams*, and *Revelations*, Talley Beatty's *The Road of the Phoebe Snow*, George Faison's *Gazelle*, Louis Falco's *Caravan*, Donald McKayle's *Blood Memories* and *Rainbow 'Round My Shoulder*, and James Truitte's *Liberian Suite*.

A popular teacher and guest performer, he has choreographed occasionally for his ad hoc chamber group.

Works Choreographed: CONCERT WORKS: *Tears* (1977); *Late Summer* (1978); *Summer House* (1979); *Just Friends* (1980).

Spies, Daisy, German ballet dancer and choreographer; born December 29, 1905 in Moscow. Trained by Julian Algo, she joined the ballet of the Berlin State Opera in 1924. Associated with the works of Jens Keith, she danced with him at the Berlin Opera and performed in his concert group in the late 1930s. She also choreographed for that group, contributing *Traumwalzer* (Dream Waltz) and *Freitagszauber* (Friday Fascination) to the repertory.

From 1951, she performed and choreographed with the East Berlin State Opera, creating the company production of *Aschenbrödel* (1951). She also worked with the Hamburg Operetta Theatre, choreographing productions of Strauss and Lehar, before retiring to teach at the Wigman school in Berlin.

Works Choreographed: CONCERT WORKS: *Traumwalzer* (Dream Waltz) (late 1930s); *Freitagszauber* (Friday Fascination) (late 1930s); *La Valse* (1951); *Aschenbrödel* (1951); *Der Bekehrte Speiser* (literally, The Altered Dish) (1953); *Das Recht Des Herrn* (The Rights of Man) (1953).

Spohr, Arnold, Canadian ballet dancer and choreographer; born c.1919 in Rhein, Saskatchewan. Raised in Winnipeg, Spohr was trained in London at the Royal Academy of Dancing and privately with Audrey de Vos. Although he returned to London in the 1946–1947 season to partner Alicia Markova in John Taras' *Where the Rainbow Ends*, he has performed and choreographed in Canada since the mid-1940s. He danced with the Winnipeg Ballet in its earliest form in Gwenneth Lloyd's *The Planets* (1944), *Finishing School, Concerto*, and *Chapter Thirteen* and in the company production of *Les Sylphides*. He has contributed works to the company's repertory, among them, *Ballet Premiere* (1951) and *Intermède* (1951), and performed in them in the 1950s.

Spohr has served as director of what is now the Royal Winnipeg Ballet since 1958. Building on what Lloyd created, he has been with the company during its years of growth from the Canadian equivalent of a regional ballet troupe into an internationally recognized company.

Works Choreographed: CONCERT WORKS: *Ballet Premiere* (1951); *Intermède* (1951); *The E Minor* (1959).

Spurlock, Estelle, American modern dancer; born May 9, 1949 in Roselle, New Jersey. Spurlock was trained at the Boston Conservatory of Music by Sonja Wilson and James Truitte. A member of the Alvin Ailey Dance Theatre since 1971, she has been applauded and adored by audiences around the world in her multitude of roles in the company's large repertory. Although she has appeared in pieces by many different choreographers, most notably Truitte and Talley Beatty, she is best known for her performances in works by Ailey himself, among them his *The Lark Ascending, Night Creatures, Echoes in Blue, Suite Otis*, and *Blues Suite*. Her "Black Beauty" portrayal in *The Mooche* and her performance in the extraordinarily moving solo, *Cry*, have brought her a wide reputation as a dramatic and theatrical dancer.

Staats, Leo, French ballet dancer and choreographer; born November 26, 1877 in Paris; died there on February 15, 1952. Trained at the school of the Paris Opéra by Louis Mérante and others, Staats spent much of his professional life with the Opéra. He joined the company in 1893, partnering Rosita Mauri and Carlotta Zambelli in the ballets and opera divertissements of Jóseph Hanssen. Staats served as ballet master intermittently from 1909 to 1936, teaching at the school at which he had himself been trained throughout his later life. Among his many works for the company were original ballets, such as *Les Abeilles* (1917), an early use of Stravinsky's *Scherzo Fantastique*, and *Taglioni chez Musette* (1920), opera divertissements for *Namouna* (1908), *Javotte* (1909), *Henry VIII* (1909), and *Bacchus* (1909), among others, and revivals of classical works from the Opéra's past, including *Les Deux Pigeons* (1912) and *Sylvia* (1919).

Works Choreographed: CONCERT WORKS: *Contes de ma Mère l'Oye* (1912); *Les Abeilles* (1917); *Tag-*

lioni chez Musette (1920); *Cydalise et la Chèvre* (1923); *Soir de Fête* (1925); *La Peri* (1931).

Staff, Frank, South African ballet dancer and choreographer who worked in England for much of his performing career; born June 15, 1918 in Kimberly, South Africa; died May 7, 1971 in Bloenfontein. Staff was trained in London at the Rambert School, graduating to the Ballet Rambert in the mid-1930s.

Staff created roles in works by Frederick Ashton in that company, among them *Mephisto Valse* (1934), and *Valentine's Eve* (1935), and in the Vic-Wells Ballet, including *Harlequin in the Streets* (1938 version) and *Cupid and Psyche* (1939). In both companies he was featured in the ballets of Antony Tudor, such as his *Jardin aux Lilas* and *Gala Performance*. The troupes also gave him experience as a choreographer, with two ballets, *The Tartans* and *Czernyana*, dating from this period. Returning to the Rambert, he created *Enigma Variations* (1940), *The Seasons, Peter and the Wolf* (all in 1940), and *Czerny II* (1941), for the company.

In South Africa from 1953 until his death, he choreographed for Ballets in Cape Town, Johannesburg, and the Free Orange State.

Works Choreographed: CONCERT WORKS: *The Tartans* (1938); *Czernyana* (1939); *Enigma Variations* (1940); *The Seasons* (1940); *Peter and the Wolf* (1940); *Czerny II* (1941); *The Lover's Gallery* (1947); *Fanciulla delle Rose* (1948); *Frankie and Johnny* (1950); *Transfigured Night* (1955); *Romeo and Juliet* (1956); *Raka* (1967).

THEATER WORKS: *Wait a Minim* (1966).

Stanley, Charles, American postmodern dancer, choreographer, and designer also working in experimental theater forms; born c.1940; died September 17, 1977 in an automobile crash on Vancouver Island, Vancouver, British Columbia. Stanley's dance training came in work with Barbara Gardner, Carolyn Lord, James Waring, Phoebe Neville, and Marion Sarach. His skills as an actor and designer brought him to the attention of the postmodernist pioneers in New York, many of whom also participated in theatrical productions of the Café Cino and Living Theater. He created dance and art works for the Judson Dance Theatre, alone or in collaboration with De-

borah Lee, from 1966, among them, *Exclamations in a Great Space* and *Black and White and Sparkle Plenty* (1966). For the next seven years, Stanley choreographed a stream of dance works that did indeed "sparkle plenty." Like Waring, he meshed visual, aural, and dance elements to create canvases of images from the past to refocus the present. Despite his output, which was surprisingly large for a postmodernist, Stanley eased out of dance in order to work more frequently in theatrical productions. He managed the Café Cino after the suicide of its founder and acted in early productions of Joe Chaikin and Tom Eyen. Stanley was a founding member of The Talking Band, and has been credited with much of that poetry/theater troupe's early artistic development.

It is appropriate to the diversity of his importance that his 1972 Obie (Off-Broadway theater award) was given for his entire work, and was not limited to participation in a single presentation, genre, or art form.

Works Choreographed: CONCERT WORKS: *Exclamations in a Great Space* (1966, in collaboration with Deborah Lee); *Black and White and Sparkle Plenty* (1966); *Lola Montez* (1967); *A Scarlet Pastorale* (1967); *Opening July Fourth* (1967); *A Postcard from the Volcano—A Comic Postcard* (1971); *Eroica! An Anti-Fascist Rally* (1971); *Oboe Rampant* (1971, in collaboration with musician/composers John Herbert McDowell and Bert Lucarelli); *Past Image* (1972); *Domination of Black* (1972); *The Stream Has Shown Me My Semblence True* (1972, in collaboration with Carolyn Lord); *Highways* (1972); *Highways and Byways* (1972); *Le Roi Soleil* (1972); *A Personal Landscape* (1972); *Caligula* (1973); *The Great American Pinball Machine* (1973); *Thursday Nights at the Fights* (1973); *The 20th Century Limited* (1974); *Words and Images* (1974); *The Kalevala* (1975–1976, ongoing project, a production of The Talking Band [then, Sybille Hayn, Ellen Maddow, Tina Shepard, Margo Lee Sherman, Stanley, Arthur Strimling, Paul Zimet, and composer Elizabeth Swados]).

Starbuck, James, American ballet and theatrical dancer and television choreographer; born c.1916 in either Albuquerque, New Mexico, or Denver, Colo-

rado. Raised in the Bay area of California, he studied with Adolf Bolm and performed in juvenile roles in the Ballet Moderne's *Salomé* in Berkeley in 1934. He danced with the San Francisco Opera Ballet from 1935 to 1938, in works by Willam Christensen.

Moving to New York in 1939, he danced with the Ballet Russe de Monte Carlo in Marc Platt's *Ghost Town*, Leonid Massine's *Gaité Parisienne* and *Seventh Symphony*, Agnes De Mille's *Rodeo* as the "Champion Roper," and Mikhail Fokine's *Carnaval*. He danced on Broadway in George Balanchine's *The Song of Norway* (1944) and Tamiris' *Fanny* (1954) but spent summers performing and choreographing at the Tamiment Camp in the Poconos. His Broadway staging credits include *Peep Show* (1950), *Oh Captain* (1958), and *A Thurber Carnival* (1960).

By 1950, however, he was involved in a newer medium. Starbuck was not the first television choreographer, but he was one of the first to take advantage of the technical possibilities involved in the new art form. He was the expert at staging dance scenes of any scale and scope for the live variety shows of the 1950s and the taped ones of the 1960s. Best known for his dance numbers for *Your Show of Shows* (NBC, 1950–1954), which was his fourth seasonal assignment, he staged conventional musical comedy numbers, satires of ballets for Imogene Coca (whose "Faun" spent an afternoon rather unlike Nijinsky's), ballets for the resident corps, and dance backgrounds for the satires of films and plays. He also helped to stage comedy numbers, such as the broken Bavarian clock sketch and the satire of *Carmen*. Starbuck also had an interesting assignment in his dance numbers for the all-musical *Sing Along with Mitch* (NBC, 1960–1966) that had to be performed on the small amount of stage left over from the choir.

Works Choreographed: CONCERT WORKS: *Le Point* (1956); *Mal de Siècle* (1958); *The Comedians* (1961).

THEATER WORKS: Productions at Tamiment Camp (1945–1948); *Peep Show* (1950); *Oh, Captain* (1958); *A Thurber Carnival* (1960, credited as associate director); cabaret acts.

FILM: *The Court Jester* (Paramount, 1956).

TELEVISION: *Variety Showcase* (CBS, 1946); *Admiral Broadway Revue* (NBC, 1949); *Inside U.S.A.* (CBS, 1949–1950); *Your Show of Shows* (NBC, 1950–1954); *Shower of Stars* (CBS, 1955); *The Frankie Laine Show* (CBS, 1958–1960); *Arthur Murray Dance Party* (NBC, 1958–1960); *The Big Record* (CBS, 1957–1958); *Sing Along with Mitch* (NBC, 1960–1966).

Starett, William, American ballet dancer; born October 18, 1956 in Palm Springs, California. Starett's training includes work with Benjamin Reyes, Vera Volkova, and David Howard. After working with the Royal Winnipeg Ballet and the American Ballet Theatre, in corps and featured roles in each company's productions of the classics, he joined the City Center Joffrey Ballet in 1977. Although he has been cast in that troupe's eclectic repertory of neoclassical and protomodernistic ballets by Gerald Arpino, he has become well known for his roles in the troupe's revivals of works by celebrated English choreographers. Among these are Frederick Ashton's *The Dream, A Wedding Bouquet,* and *Jazz Calendar,* and John Cranko's *Brouillards,* in which he does both national styles and conventional ballet steps.

Starzer, Josef, Austro-Hungarian eighteenth-century composer also working in Russia; born 1716 in Vienna; died there April 22, 1787. Starzer served as court composer-in-residence in St. Petersburg from 1760 to 1770, but his first extant ballet scores date from his return to the imperial courts of Vienna. His importance to dance (which far outweighs his reputation in music) results from his tenures that corresponded to those of court ballet masters Jean-Georges Noverre and Gasparo Angiolini. Among the best remembered scores are those for Noverre's *Diane ed Endymion* (1770), and the historical pageants *Roger ed Bradamante* (1771) and *Adele de Pointheiu* (1773).

Stebbins, Genevieve, American teacher of Delsarte-derived movement theories and elocution; born March 7, 1857 in San Francisco, California; the details of Stebbins' death cannot be verified at this time. Stebbins left the Bay area in 1875 to move to New York City to become an actress. In 1877, she enrolled in James Steele MacKaye's school and apprenticeship program in New York, where she studied the movement, color, and elocutionary theories that he had learned from François Delsarte. It has never

been determined accurately whether she studied directly with MacKaye or, equally possibly, with Ida Simpson-Serven, who taught his company classes. She acted in MacKaye's production in her own name and as "Agnes Loring," but broke with him in the early 1880s. There is no evidence to verify her claim that she traveled to Paris in 1881 to study Delsarte's manuscripts before returning to New York as a French-trained Delsartist, but Percy MacKaye's claims that she simply stole his father's exercises are not true. In fact, a contemporary comparison between her exercises and those taught at the MacKaye school prove that hers are very different; whether they are closer to or further away from Delsarte's is questionable. Another contemporary source suggested that she simply made hers up.

Whatever their validity, her exercises soon made Stebbins the most recognizable member of the "American Delsartist" community of rivals. Her matinees and books were extremely popular and were distributed through mail-order houses across the country. In a strange way, her de-Christianized Delsartism (a far cry from the originator's theories based on the Trinity as the center of all valid life) was even more popular than the direct descendants' genuine Delsartism, since her style corresponded with the Greek revivalism that was then growing in the American cities.

Stebbins' place in the prehistory of American modern dance has been secured through her influence on Ruth St. Denis, as delineated by Suzanne Shelton. She is also important because of the wide distribution of her books, but she should not be considered the only source of American Delsartism.

Steinberg, Rise, American modern dancer; born December 19, 1949 in New York City. Steinberg was trained at the High School of Performing Arts and the Juilliard School, both of which taught traditional modern dance technique and choreography. She has been a member of the José Limón company since shortly after graduation from Juilliard, and has performed principal roles in much of its repertory of works by Limón, Doris Humphrey, and company members Fred Mathews and Bill Cratty. Among her many credits are roles in Limón's *A Choreographic Offering, There Is a Time, The Winged, Orfeo,*

Missa Brevis, and *Concerto Grosso,* Humphrey's *The Shakers,* Mathews' *Solaris* (1976), and Cratty's *Kitchen Table* (1980).

Stepanek, Gael, American modern dancer and choreographer; born April 1, 1951 in Jackson Heights, Queens, New York. Raised in California, she studied dance at the State University at San Jose and at the University of Colorado before moving to New York to continue to train with Merce Cunningham, Erick Hawkins, Zena Rommett, and Alwin Nikolais, Murray Louis, Phyllis Lamhut, and Gladys Bailin at the Nikolais/Louis Lab. She also took master choreographic workshops with Anna Sokolow in 1977 and 1978. Stepanek has taught extensively at her own studio and at the school of the Mimi Garrard Dance company with which she performed from 1975. She has presented concerts of her choreography since 1974, becoming respected for the inventiveness with which she blends movements from disparate cultures and styles into her ingeneous structures.

Works Choreographed: CONCERT WORKS: *Mercurial Jive* (1973); *Ruined Castles* (1973); *In the Name of My Father* (1973); *Subject to Change without Notice* (1974); *Upon a Time Once* (1975); *Alone* (1975); *Untitled Voyage* (1976); *Le Danser* (1976); *Portrait of Three* (1976); *Downtown Blues* (1977); *Magic* (1978); *Cube Queue* (1979); *Helix* (1979); *Where Have I Known You Before* (1979); *An April Fool* (1980); *Tight Squeeze* (1980); *Persona* (1980); *Nancy's Solo* (1980); *Room with a View* (1980); *Sky Above Clouds* (1980).

Stevenson, Ben, English ballet dancer and choreographer working in the United States after 1969; born John Stevens, April 4, 1937 in Portsmouth, Hampshire, England. After early training with Mary Tinkin, he attended the Arts Education School in London. He danced with the Sadler's Wells Ballet, the Royal Ballet touring company, and the London Festival Ballet, performing featured roles in the classics of the repertory, *Giselle, Swan Lake,* and *Les Sylphides.* After working in West End musicals for five years, he returned to the London Festival as a choreographer, staging his first *The Sleeping Beauty* for them in 1968.

Always associated with revivals of classics, he

served as director of the Harkness Youth Dancers in the late 1960s, then as co-director of the National Ballet, Washington, D.C., from 1971 to 1974, staging a *Sleeping Beauty* and *Cinderella* there. He spent a season with the Chicago Opera Ballet before accepting the position of director of The Houston Ballet, for which he currently choreographs. With that growing company, he directs the associated school, and creates both new works and new revivals.

Works Choreographed: CONCERT WORKS: *The Sleeping Beauty* (1968); *Cinderella* (1970); *L* (1971); *Courante* (1973); *Three Preludes* (1974); *The Nutcracker* (1976); *Bartók Concerto* (1977); *Elegie* (1978); *Pas de Deux: Britten* (1979); *Four Last Songs* (1980).

Stevenson, Hugh, English theatrical designer; born 1910 in London; died there December 16, 1946. After making his dance design debut at twenty-two with Sara Patrick's *Unbowed* (1932), he began a successful collaboration with Antony Tudor which resulted in his well-remembered designs for *Pavanne pour une Infante Defunte* (1933), *The Planets* (1934), *Gallant Assembly* (1938), and *Gala Performance* (1938). Tudor's *Jardin aux Lilas* (1936) is still usually performed in Stevenson's costumes, to retain their Edwardian feel and restrictions and to avoid having to limit the performances by overlaying them with period pedestrian movements.

Stevenson's other dance productions included Keith Lester's *Pas des Déèsses* (1939), Andrée Howard's *The Fugitive*, and two early British productions of the classics—Ballet Rambert's *Giselle* (1945) and the Vic-Wells' *Swan Lake* in 1934.

Stewart-Richardson, Lady Constance, Scottish interpretive dancer; born Lady Constance Hay-Mackenzie of Cromartie in 1883; died November 24, 1932 in London. Stewart-Richardson (her married name) was a celebrated athlete and suffragist before she saw a recital by Isadora Duncan. After that concert in 1909, she became an interpretive dancer herself who, like Duncan, had grandiose schemes for combining her theories on dance with her concept of an ideal educational system. She performed and toured to raise money for such a school but, unlike Duncan, was never able to establish one.

Her concert career began in London in 1910. She gave annual recitals of her own dances, in which she interpreted music and legends, but the artistic merit of her choreography was lost in the scandal caused by a member of the nobility dancing barefoot in diaphanous gowns and scarves. Although most of her English appearances were at recitals, she was engaged occasionally at The Empire, the most pretentious of the London variety houses. Her works for that theater included *Judith* (1915) and *The Wilderness* (1915), in which she was partnered by Robert Roberty. In the United States, she appeared at Hammerstein theaters and went on two extraordinary tours with Gertrude Hoffmann and Mdlle. Polaire (in 1913) and Evan Burrows-Fontaine (in 1917). Although her 1913, 1915, and 1917 tours were successful, her 1919 week at The Palace (keystone of the Keith circuit) was an unmitigated disaster, and was cited as an example of a "Flop" for many years thereafter. It is unlikely that its failure had much to do with Stewart-Richardson, however; New York was thoroughly bored with interpretive dance by 1919.

When she returned to England in 1917, she taught dance to factory workers; this reinstated her in the favor of society but ended her English concert career. When the Palace flop ended her American career, she left performance altogether to fight for educational reforms.

Works Choreographed: THEATER WORKS: *Before Dawn* (1913); *Humoresque* (1913); *Judith* (1915); *The Wilderness* (1915).

Stone, Bentley, American ballet dancer and choreographer; born 1908 in Plankington, South Dakota. Trained by Margaret Severn and Luigi Albertieri in New York, Stone continued his studies with Laurent Novikoff as a member of the Chicago Opera Ballet and with Marie Rambert as a guest performer with the Ballet Rambert (c.1937). Returning to the United States, he became a performer, choreographer, and teacher for a succession of companies in Chicago, including the Federal Theatre Project, the (Ruth) Page/Stone Ballet and the Chicago Civic Opera. He danced principal roles in some classics, among them, *Les Sylphides* and *Spectre de la Rose* but was best known for his performances in his own and Ruth

Page's ballets, notably, *The Merry Widow, Daughter of Herodias, Susanne and the Barber* as "Figaro," and *Frankie and Johnny* (1938).

With Page and his colleague Walter Camryn, Stone has been a tremendous influence in the ballet of the Midwest.

Works Choreographed: CONCERT WORKS: *Rhapsody in Blue* (1934) *Mercure* (1936); *Tonight the Ballet* (1937, tentative title); *An American Pattern* (1938); *Frankie and Johnny* (1938, co-choreographed with Ruth Page); *Liebestod* (1939, co-choreographed with Page); *Casey at the Bat* (1939); *Mosaic* (1941); *Darkness at Dawn* (1942); *Zephyr and Flora* (1943, co-choreographed with Page); *Caballero Stone in Five Inauthentic Dances* (1943); *A Little Night Music* (1947); *Les Enfants Perdus* (1951); *The Little Match Girl* (1954); *The Wall* (1956); *Cours de la Reine* (1960); *L'Inconnue* (1963); *Les Biches* (c.1964); *Celebration* (c.1967).

Stone, Dorothy, American musical comedy dancer and actress; born June 3, 1905 in Brooklyn, New York; died September 24, 1974. The daughter of Fred Stone and Allene Carter, she made her debut with them in *Stepping Stones* (1923) at the age of sixteen. She appeared with her parents in *Criss Cross* (1926) and as a solo specialty dancer in *Three Cheers* (1929) and *Show Girl* (1929), in which she replaced Ruby Keeler. After another show with her parents, *Ripples* (1930), she accepted an engagement at the London Palladium, where she met Charles Collins, her future dance partner and husband. They worked together as an exhibition ballroom team in cabarets and in Prologs, and danced together in *The Gay Divorce* (1933), replacing Luce and Astaire, *Sea Legs* (1937), *Hooray for What* (1938), *The Life of the Party* (1942), and revivals of *The Gay Divorce* (1941) and *The Red Mill* (1945), her father's success from 1906. She and Collins returned to club work before retiring.

Stone, Fred, American eccentric dancer and comedian; born August 19, 1873 in Valmost or Longmont, Colorado; died March 6, 1959 in Hollywood, California. Raised in Wellington and Topeka, Kansas, Stone made his debut in an acrobatics act with his brother Edward (died c.1903), and later worked as a clog dancer. Working in an *Uncle Tom's Cabin* in 1894 in St. Joseph, Missouri, he came into contact with David Montgomery, a former Haverly's Minstrel. From their vaudeville debut in 1896 to Montgomery's death in 1917, they were the best known team in the business.

Their shows together included *The Girl Up There* (1900), *The Red Mill* (1906), *The Old Town* (1910), *The Lady in the Slipper* (1912) and *Chin-Chin* (1914). Their most famous production was the original theatrical version of *The Wizard of Oz* (1903), in which he played the "Scarecrow" as an eccentric dancer. After his partner's death, he starred alone in *Jack O'Lantern* (1917) and *Tip Top* (1920), before appearing with his daughter, Dorothy, in *Stepping Stones* (1923), the title for which became the family trademark. He danced with his other stepping Stones, daughters Paula and Carol and son-in-law Charles Collins, in *Ripples* (1930) and *Smiling Faces* (1932). Stone's wife, Allene Carter (died August 13, 1957) appeared in many of his Montgomery and Stone shows, notably as "The Lunatic" in *Wizard of Oz* and in all of the family revues.

Stone's later productions included *Jaykawker* (1934), *Lightnin'* (1938), and the original production of *You Can't Take It With You* (1945). He repeated his role in the latter in the film version. In 1917, he had starred in a series of adventure comedies for Famous Players/Jesse Laskey/Paramount, including *Johnny Get Your Gun* and *Under the Top*.

Stone's childhood circus and acrobatics background gave him flexibility and special talents that most eccentric dancers lacked. He did a boxing match dance in *The Red Mill* with ease, while he had a particularly difficult trick in *The Lady and the Slipper*. He had to catch on to the fringe of the house curtain and let himself be lifted to the proscenium arch.

Although Stone never officially retired, he did not make public appearances after Carter's death and died two years later. It is believed that he lost his sight gradually over the last fifteen years of his life, but he continued to make cabaret and nightclub appearances and to work on radio.

Apart from Dorothy, who became a musical comedy star in her own right, Stone and Carter's daughters entered other areas of show business. Carol be-

came a noted dramatic actress, creating roles in *Dark of the Moon, The Skin of Our Teeth*, and *They Knew What They Wanted*, among many other important American plays. Paula had a short career in musical theater, appearing in *Ripples, Smiling Faces*, and *The White Horse Inn* (1936), worked in film, notably in the Paramount *Hopalong Cassidy*, and radio, with three talk shows in the 1950s, before becoming a theatrical producer in New York and London.

Bibliography: Stone, Fred. *Rolling Stone* (New York: 1945).

Stornant, Vic, American modern dancer and choreographer; born March 7, 1947 in Lansing, Michigan. After university studies with Dixie Durr, he moved to New York to continue his training with Hanya Holm, Phyllis Lamhut, Paul Sanasardo, May O'Donnell, and Zena Rommett. Stornant has been able to combine an active choreographic career with his standing as one of New York's most popular freelance modern dancers, in performance with the companies and concert groups of Lamhut, Mimi Garrard, Erin Martin and Jack Moore, Jeff Duncan, Diane Germaine, and Diane Boardman. He has taught extensively in studios and schools in Brooklyn and Manhattan and in residencies and master classes in cooperation with the Lamhut troupe and the Dance Theatre Workshop.

He has choreographed for theater productions of new plays and performance pieces, ranging from the Classic Theatre revival of *A Country Gentleman* to a new work for a chorus and the 1978 Theater for the New City Halloween Parade. His concert works, primarily for his own troupe, are noted for their wit and uses of imaginative movement and literary allusions.

Works Choreographed: CONCERT WORKS: *Radio Fantasy* (1969); *Vesare* (1970); *Living Sculpture as Human Art* (1971); *Vesare Revisited Through a Camera* (1972); *Pegar* (1972); *Chronus* (1973); *He— She Duet* (1974); *L'Eau et Les Rêves* (1974); *Choreographed Poem* (1975); *Palimpsest Wall* (1975); *Little Murders* (1975); *Film Solo* (1976); *Ambivalence* (1976); *Resignation* (1977); *Some Times Here, Sometimes There* (1977); *Dragon* (1978); *Smorgasbord* (1978); *Deranged Divertissement* (1979); *Gold* (1980); *To Succeed* (1980); *Anaglypta* (1980); *Glass* (1980); *Concerto #4* (1980); *Concerto #5* (1980).

THEATER WORKS: *The Most Happy Fella* (1976, revival); *Love Letters to George, To Whom It May Concern* (1976); *A Country Gentleman* (1978, revival); *Theater for the New City* [Greenwich] *Village Halloween Parade* (1978).

Stowell, Kent, American ballet dancer and choreographer; born August 8, 1939 in Rexburg, Idaho. Trained by Willam Christensen at the University of Utah, Stowell performed with his company there and with Lew Christensen's San Francisco Opera Ballet from 1957 to 1962.

During the 1960s, Stowell was a member of the New York City Ballet, where he performed principal roles in the works of Jerome Robbins, notably his *Interplay*, and George Balanchine. Among the many Balanchine works in which he danced were *Don Quixote, Symphony in C, Divertimento No. 15, Agon, Stars and Stripes*, and two ballets created for him—the second movement of the *Brahms-Schoenburg Quartet* (1966) and the third section of *Trois Valses Romantiques* (1967).

Stowell performed with the Munich State Opera from 1970 to 1972 before he was named director of the Frankfurt Opera Ballet in 1973. Among the works that he choreographed for that company were *Ragtime* (1974) and the *Prokofiev Violin Concerto* (1977). In 1978, Stowell and his wife, Francia Russell, returned to the United States to become directors of the Pacific Northwest Ballet in Seattle, Washington. His choreography for that company included *Kareria* (1980), *Deranged Dances* (1980), and full-length versions of *Coppélia* and *Swan Lake*.

Works Choreographed: CONCERT WORKS: *Ragtime* (1974); *L'Heure Bleu* (1976); *Prokofiev Violin Concerto* (1977); *Over the Waves* (1978); *Symphonic Impressions* (1978); *Symphony No. 5* (1978); *Coppélia* (1978); *Daphnis and Chloe* (1979); *Kareria* (1980); *Deranged Dances* (1980).

Stowitts, Hubert Julian, American ballet dancer and artist; born c.1893 in California; died there, c.1954. Educated at the University of California at Berkeley, he was performing in pageants by Louisa La Gai at the Greek Theatre there in 1915 when he was hired by Anna Pavlova to tour with her company. He replaced Serge Oukrainsky in the company as principal

exotic dancer and costume designer, creating garments for her touring version of *The Dumb Girl of Portici* (c.1916), and *La Péri* in which he also danced. He toured with the company until 1928 when he moved to Java to paint.

Returning to the United States in the early 1930s, Stowitts left dance to pursue his career in art. His last known performance was as the featured dancer in the Indian War Dance sequence in the film *Rose-Marie* (MGM, 1936, choreographed by fellow American Pavlova alumnus, Chester Hale).

Strate, Grant, Canadian ballet dancer and choreographer; born 1927 in Cardston, Alberta. After studying at the Laine Mets Moderne Dance Studio in Edmonton, he attended the University of Alberta. He left academics, however, to join the National Ballet of Canada in 1951. Noted for his intelligent portrayals of the character roles in the classical repertory, Strate has also choreographed extensively for the company and for his students at York University in Toronto.

Works Choreographed: CONCERT WORKS: *Ballad* (1958); *Arctic Spring* (1960); *House of Atreus* (1963); *Electra* (1964); *Le Pécheur et son Ame* (c.1965); *Tracings* (1978).

Strauss, Johann II, Austrian composer; born October 25, 1825 in Vienna; died there June 3, 1899. The Strauss family of composers all created music based on dance rhythms, but Johann II, called "The Waltz King," became known around the world for his contributions to the genre. His waltzes were not a simple piece of dance music in three-four time, however; they were complex structures involving four or five themes in at least three different rhythms, including a conventional waltz and a landler. Very few choreographers use entire Strauss waltzes although George Balanchine became a notable exception, when he staged one as the opening of *Vienna Waltzes*.

Although Strauss, like his French contemporaries, inserted dance variations perforce into his operas and operettas, he wrote only one complete ballet score. His *Cinderella* (published posthumously) was choreographed by Josef Hassreiter for the Vienna Court Opera in 1908. The list of choreographers who have used his concert works is enormous and ranges from Balanchine to Ted Shawn (both of whom set pieces to the *Legends of the Vienna Woods*), and from Leonid Massine to David Lichine; Massine's *Le Beau Danube* (1924) and Lichine's *Graduation Ball* (1940) are among each choreographer's most popular works. Almost every concert dancer in Central Europe and the United States has staged a dance to at least one Strauss work; the Americans frequently used the regularity and pleasantries of the waltzes to offset their anger and ironies.

Strauss, Sara Mildred, American concert dancer and teacher; born 1896 in New York City; died July 7, 1979 in Wilmington, Delaware. Although she later claimed that she was self-taught, Strauss at least attended classes with Marietta Bonfanti and Florence Flemming Noyes. Her long career was divided into periods of work in concert dance and in teaching theatrical forms. The first took up her early life; she was teaching and writing about her theories of art and dance as early as 1916, when she published *The Dance and Life* (Brooklyn: 1916). Her most prolific period was in the late 1920s, the early years of the concert dance movement, when she choreographed a series of recitals of her "Independent Dance," performed without accompaniment or libretto. Her works from this period, among them *Formlessness, Consciousness*, and *Realization* (all 1928), *Space Limitation* (1933), and the *Studies* series (1930), were considered tremendously innovative and influential although her concert works have been almost forgotten. Strauss would have been an important part of the period even without the contributions of her original choreography since, as chair of the Concert Dancers' League, she was primarily responsible for the passage of the Sunday Concert bill that legalized performances of dance despite the New York City blue laws.

Strauss had a concentrated theater career in the early 1930s; she taught at a studio above the Ziegfeld Theatre and staged numbers in a Shubert *Ziegfeld Follies*, a musical, and a film. It was her movement for actors courses at the American Academy of Dramatic Arts that made her reputation in the theater world. Through her classes have come many of the

finest stage and film actors in the country, many of whom credit her with teaching them how to breathe, move, and act on stage.

Works Choreographed: CONCERT WORKS: *Formlessness* (1928); *Consciousness* (1928); *Evolution* (1928); *Realization* (1928); *Lyrical* (1929); *Sensual* (1929); *Artificial* (1929); *Modern* (1929); *Future* (1929); *Studies in a Modern Dance Symphony* (First study developed on an oblique movement, second study on horizontal and perpendicular movements, third study on movements in triangles) (1930); *Space Limitation* (1933).

THEATER WORKS: *The Ziegfeld Follies of 1934; Calling All Stars* (1934); *America Sings* (1934).

FILM: *Sweet Surrender* (Universal, 1935).

Stravinsky, Igor, Russian composer; born June 18, 1882 in Oranienbaum; died April 6, 1971 in New York City. Stravinsky was both the preeminent figure in twentieth-century composition for ballet and a seminal force in the mainstream of experimentation in concert music. Throughout his career, he wrote ballet scores that reflect shifts in compositional forms and vocabularies, but that are equally suited for dance performance by the musically educated artist. Serge Diaghilev commissioned early ballet works on the basis of two concert scores, the *Scherzo Fantastique* and *Fireworks;* appropriately these were included in the 1972 Stravinsky Festival sponsored by the New York City Ballet. Stravinsky's scores for Diaghilev are among his most frequently choreographed—*The Firebird* (1910, for Mikhail Fokine), *Petroushka* (1911, for Fokine), *Sacre du Printemps* (1914, for Vaslav Nijinsky), *Le Chant du Rossignol* (1920, for Leonid Massine), *Pulcinella* (1920, for Massine), and *Le Noces* (1923, for Bronislava Nijinska)—and have been produced by every contemporary ballet company that can afford the production costs.

Although his *Apollon Musagète* was first choreographed by Adolf Bolm in performance at the Library of Congress, Washington, D.C. (1928), it also marked the beginning of a collaboration between Stravinsky and George Balanchine that would have a tremendous effect on the development of the American ballet. From the Balanchine staging of *Apollo* in 1928 to Stravinsky's death, and beyond in a continuing series of posthumous productions, all the Balanchine/Stravinsky works were steps in the emergence of abstraction as the prevalent artistic image in ballet. *Apollo* and *Agon* (1957) are generally considered the two monuments to the collaboration and the major works created during Stravinsky's lifetime, but the list of artistic successes and audience favorites is longer. It would have to include *Orpheus* (created for the Ballet Society in 1948 and included in the first performance of the New York City Ballet), *Momentum pro Gesualdo* (1960), rewritings of pre-Renaissance madrigals that are generally performed with *Movements for Piano and Orchestra* (1963) to emphasize each one's manipulation of its small chorus, the *Rubies* section of *Jewels* (1967), with its rare uses of pedestrian movement, *Requiem Canticles,* dedicated to the memory of the assassinated Martin Luther King in 1968 (and to Stravinsky himself in a 1972 version by Jerome Robbins), and the extraordinary trio of works from the 1972 festival—*Duo Concertante, Symphony in Three Movements,* and *Violin Concerto.*

Surrounding the collaboration with Balanchine are works for other choreographers, and, of course, uses of existing scores. These include Nijinska's *La Baiser de la Fée* (1928) and the opera *Renard* (1922), Kurt Jooss' production of the opera *Persephone* in 1934, Robbins' *The Cage* (1951), *Dumbarton Oaks* (1972, occasionally titled *A Little Musical*), and *Scherzo Fantastique* (1972), John Taras' *Ebony Concerto* (1960) and *Arcade* (1963), and Kenneth Macmillan's *Danses Concertantes* (1956), *Agon* (1958), *Sacre du Printemps* (1962), *Side Show* (1972), and *Olympiad* (1968).

Bibliography: Stravinsky, Igor. *Chronicle of My Life* (London: 1936); *Memories and Commentaries* (London: 1960); *Expositions and Developments* (London: 1962); *Dialogues and a Diary* (New York: 1963).

Strawbridge, Edwin, American concert dancer; born c.1900 in York, Pennslyvania; died October 19, 1957 in New York City. Although he had taken social dance classes as a child, Strawbridge did not receive professional training until he was in his early twen-

ties, when he was a law student. He auditioned for Adolf Bolm and became a replacement in Bolm's Ballet Intime, while he was also studying with Luigi Albertieri and with eurythmics expert Florence Flemming Noyes. Bolm invited him to accompany the troupe to Chicago on his second tour a year later and cast him in his *The Birthday of the Infanta*.

Primarily a concert dancer after 1926, although he partnered Ruth Page on an Oriental tour in 1928, he gave yearly recitals in New York. His best known works were his version of the popular *White Peacock* (1929), which was a regular in all male and female recitalist's programs, *Prelude at the Heroic Portals of the Sky* (1932), *The Voice of the People* (1937), and the first American performance of *Pas d'Acier*. This 1931 presentation of the League of Composers allowed him to use a cast that included Yeichi Nimura and a young Pauline Koner in his mechanistic dance forms. Although he remained in the concert field, sharing recitals and tours with Lisa Parnova, he began to work more and more with children's theater, which was considered a professional field in the 1930s. As the director of Junior Programs, Inc., he presented full-length children's ballet from 1933 to c.1948.

Strawbridge is an interesting figure since he seems to resist categorization. Don McDonagh lists him as a "Founder of Modern Dance," alphabetically between Doris Humphrey and Helen Tamiris. He was not a founder in the sense of creating a lineage, nor was he a member of the mainstream of experimental male concert dancing, as represented by the Matons/Limón/Weidman triad from the Dance Unit. He connected with some tremendous innovations, but remains one of the few people from the recital movement who left it for conventional, nonlegitimate, theater.

Works Choreographed: CONCERT WORKS: *Fantastic Fricasse* (1923); *Allegro Barbaro* (1929); *The White Peacock* (1929); *Prelude to Revolt* (1929); *Dance for Victory for Male Ensemble* (1929); *The Eagle* (1929); *The Sea* (1930); *March* (1930); *Vagabond* (1931); *Driver of the Storm Winds* (1930); *Poème Satanique, Prélude, Etude* (1920); *Youth* (1931); *Delusion* (1931); *New Visions* (1931); *Pas d'Acier* (1931); *Prometheus* (1931); *I Danced with a Mosquito* (1931); *David and Goliath Impressions*

(1931); *Heroic Hymn* (1931); *Harlequin Dance* (1932); *Polka from The Bartered Bride* (1932); *Les Petits Riens* (1932); *Prelude at the Heroic Portals of the Sky* (1932); *Pyrrhic Dances* (1932); *Dance of Olaf* (1932); *Pastorale* (1933); *Space Moods* (1933); *Histories* (1933); *Orestes and the Furies* (1933); *Night Winds* (1936); *Burlesca* (1936); *Idyll and Romanza* (1936); *The Voice of the People* (1937); *Afternoon of a Faun* (1937).

THEATER WORKS: *Pinocchio* (1936); *The Cat and the Mouse* (1936); *The Little White Donkey* (1936); *In Theatre Street* (1936); *The Princess and the Swineherd* (1938); *Daniel Boone* (1941); *Christopher Columbus* (1942); *Simple Simon* (1948); *Pecos Bill* (1953).

Streep, Harry, III, American postmodern dancer and choreographer; born July 31, 1951 in Summit, New Jersey. One of the most talented of the newest generation of American choreographers, Streep is representative of those innovators who have never been trained in traditional modern dance. He studied with Griselda White while a student at Tufts University in Medford, Massachusetts, and performed with the Boston City Dance Theater (1973–1975), an improvisational troupe. As a member of the student company at the Harvard Summer School of Dance, he performed in Martha Gray's *Hockey Scene* and *Rabbit Row*, in which he recently toured Belgium.

Streep has been highly praised as a dancer for his ability to hold the audience's attention during his lengthy solos and for the articulation of his movements. He has created works for his Third Dance Theater since 1977. Among his best known works are *Third* (1977), a full-company work, *Suggestions* (1979), *Uh-Oh!* (1980) for The Cambridge School, *Whisper* (1980) for the Dance Kaleidoscope company in Indianapolis, *The Destination and Instinct of Ants* (1980), and *My Job* (1980). He frequently restages sections of his works, as he did for *Third*, which was originally a solo for himself but has also been performed by a female, Martha Bowers; *Underline* (1978), the first half of which has been done as a solo; *Suggestions*, also transformed into a solo; and *Personal Objects*, a segment of *The Destination . . .*, which was favorably received as a separate work.

The brother of actress Meryl Streep and husband of May Kinkead, he has participated in many theatrical productions. He staged dances for two plays at the New York Shakespeare Festival, Thomas Babe's *Taken in Marriage* (1979), and Dereck Walcott's *Rememberances* (1979), and set movement for a feature film, *You Better Watch Out* (Independent, 1980).

Works Choreographed: CONCERT WORKS: *Third* (1977); *Still* (1977); *Underline* (1978); *Suggestions* (1979); *Licks* (1979); *When* (1979); *This Is Life* (1979); *Uh-Oh!* (1980); *Whisper* (1980); *The Destination and Instinct of Ants* (1980); *Personal Objects* (performed as a separate work); *My Job* (1980); *Take Care* (1980).

THEATER WORKS: *Taken in Marriage* (1979); *Rememberances* (1979); *Confessional of a Reformed Romantic* (1979).

FILM: *You Better Watch Out* (Edward Pressman Productions, 1980, unreleased as of December 31, 1980).

Strickler, Fred, American modern dance and tap choreographer; born August 5, 1943 in Mt. Clemens, Michigan. Raised in Columbus, Ohio, Strickler first studied tap technique, from 1954 to 1961, with Jimmy Rawlins, the father of Lynn Dally, his current partner. As an adolescent, he also studied ballet there with Jorge Fastung from 1957 to 1961. He attended Ohio State University, taking master classes with Judith Dunn and performing in Anna Sokolow's revival of *Odes*. At Ohio State, Strickler did his first choreography, *Trio for Piano, Space and Dancer* (1965), for which he also wrote the score. Strickler was a student of Louis Horst and Lucy Venable at the 1963 American Dance Festival; there he performed in Lucas Hoving's *Icarus*, and in the filmed revivals of José Limón's *Brandenburg Concerto* and *Passacaglia and Fugue*, and in Doris Humphrey's *The Shakers*.

After moving to Los Angeles, Strickler became a member of the Bella Lewitsky Company in January 1968. In the company from 1968 to 1975, he created roles in her *Pietas, Orrendas, Ceremony for Three, Game Plan, Scintilla,* and *Kinaesonata.*

In 1974, Strickler joined the collective company Eyes Wide Open Theater, for which he choreographed both modern dance and tap works. In 1979,

with Lynn Dally, he founded the Jazz Tap Percussion Ensemble for which he constructed *Cadenza, Waltz* and *Jam with Honi Coles.*

Works Choreographed: CONCERT WORKS: *Trio for Piano, Space and Dancer* (1965); *Bags and Things* (1969); *Pomander* (1972); *Solo for Fred* (1974); *Tanzan Sprites* (1974); *Los Angeles Stories* (1974); *Near Duck* (1974); *While Waiting for the Muse* (1977); *Ember* (1978); *Cadenza, Waltz* (1979); *Jam with Honi Coles* (1979); *Untitled* (1980).

FILM: *Lipstick* (Twentieth-Century Fox, 1976).

Striggles, Theodore, American modern dancer, attorney, and arts administrator. Educated at Stanford University and Harvard Law School, Striggles moved to New York to join the highly esteemed law firm of Paul, Weiss, Rifkind, Wharton, and Garrison. As a dancer he is best known for his work with the Acme Dance Company, where he dances in works by James Cunningham. Cunningham's pieces of theater usually include movement and vocal performance of both linguistic and visual puns. Striggles brought his straight-faced appearance and strong technique to Cunningham's *The Cue in the Hidden Staircase* (1971), *Junior Birdsmen* (1970), and *Dancing with Maisie Paradocks* (1974), among many others. He has also danced with the companies of Pearl Lang, Tina Croll, and Elizabeth Keen in whose *Poison Variations* (1970) and tribute to Stephen Foster, *A Polite Entertainment for Ladies and Gentlemen* (1975), he created roles.

Striggles has worked with his firm's Civic Arts Program, advised many dance companies and support organizations, and served as director of the Volunteer Lawyers for the Arts. He was executive director of the New York State Council on the Arts' dance program in 1979.

Stroganova, Nina, Danish ballet dancer working and teaching in the United States; born Nina Rigmor Strøm, October 21, 1919, in Copenhagen. Trained locally by Jenny Moller, Stroganova later studied in Paris with Olga Preobrajenska and in New York with Bronislava Nijinska, Mikhail Mordkin, and Anatole Vilzak. After performing with the Ballet de l'Opéra Comique in Paris, Stroganova emigrated to the United States (c.1937).

A soloist with the Mordkin Ballet in New York from 1937 to 1940, she created roles in his *The Goldfish* (1939) and *Voices of Spring* (1940) and performed in his revival of *Giselle*. With other members of the Mordkin company, she became a charter member of Ballet Theatre in 1940. In two seasons with that company, she created roles in Adolf Bolm's *Peter and the Wolf* (1940) and in Anton Dolin's *Quintet* and *Capriccioso* (both in 1940) and performed featured roles in the classical repertory and in Antony Tudor's *Dark Elegies*.

Stroganova performed with the Original Ballet Russe from 1942 to 1950, with featured roles in a wide variety of ballets, among them *Swan Lake, Les Sylphides, Spectre de la Rose*, the company revivals of Fokine's *Petrouchka* and *Carnival*, and of Massine's *Les Présages*.

Struchkova, Raissa, Soviet ballet dancer; born October 5, 1921 in Moscow. Struchkova was trained at the Bolshoi school and created the title role in *The Baby Stork* (Popko, Pospekhin, and Radunsky, 1937) while a student there. Graduating into the company in 1944, she performed both the Act II and Act III pas de deux from *Swan Luke* at her final school recital. Her exceptionally strong point work and fabulous elevation were soon revealed in her performances as "Lise" in *La Fille Mal Gardée*, "Cinderella," "Odette/Odille," "Aurora," "Juliet," and the heroines of Soviet classics, *Flames of Paris, The Red Poppy*, and *The Stone Flower*.

Although the Western audience frequently confuses the styles, Struchkova also excelled in a dance medium that was separate from the Bolshoi's repertory. She and her husband, Alexander Lipauri, toured with a program of pas de deux that resembled the American theatrical adagio more than the conventional Soviet repertory. She was lifted, thrown, and hoisted from one impossibly graceful position to another in Lipauri's *Moskowski Waltz* and *Spring Waters*.

Stuart, Muriel, English ballet dancer teaching in the United States; born Muriel Stuart Popper, 1903 in South Norwood. Stuart was one of the English children chosen to be trained by Anna Pavlova and Ivan Clustine in the 1910s. She performed with the Pavlova company from 1916 to 1926, appearing in her *Autumn Leaves* and the company productions of *Coppélia, Puppenfee, Chopiniana, Amarilla*, and the *Rhapsodie Hongroise*. She elected to remain in the United States, like so many of her colleagues from the Pavlova and Diaghilev companies. Since her former partner, Mikhail Nicholoff, was in Hartford, Chester Hale and Ella Dagnova were in New York, and Beatrice Collenette was teaching in Los Angeles, she settled in San Francisco to teach. She had studios in the Bay area, Chicago, and Southern California before moving to New York in 1937 to become associated with the School of American Ballet.

Stuart has served on the faculty of that school, now considered the training studio of the New York City Ballet, since its first New York season. She takes the class of young women who, in the curriculum of the school, have just made the decision to leave public school to concentrate on a possibility of a ballet career. She brings them technique and musicality and shows them how to judge and learn from their own bodies and perceptions. Her former students have appeared with every company in the country. It is inconceivable that her current and future protégés will fail to follow in their footsteps.

Bibliography: Stuart, Muriel and Lincoln Kirstein. *The Classic Ballet: Basic Technique and Terminology* (London: 1953).

Stukolkin, Timofei, Russian ballet dancer; born c.1829 in St. Petersburg; died there in 1894. It is not certain at which school of the Imperial Ballet Stukolkin began his training, but he was associated with the St. Petersburg one when he joined the Maryinsky Ballet shortly before 1850. It is believed that he was a student of Jean-Antoine Petipa there.

Although originally a versatile dancer in the large Russian repertory of imported French ballets, Stukolkin soon became associated with character roles. He played "Dr. Coppelius" in Marius Petipa's 1884 production, believed to have been the first staged in Russian, and created the two major character roles in the Petipa repertory—"The Fakir" in his *La Bayadère* (1877) and "Catalabutte" in *The Sleeping Beauty* (1890). He was also the first "Drosselmeyer,"

the protagonist in Lev Ivanov's *The Nutcracker* (1892). Stukolkin appeared in the original production of *Swan Lake* (by Julius Reisinger) but did not take the role of "Von Rothbart" until the Ivanov/Petipa version was presented.

Sugihara, Sara, American postmodern dancer and choreographer; born November 21, 1953 in Boston, Massachusetts. Originally trained as a musician, Sugihara has studied dance forms with Jennifer Muller, Sarah Stackhouse, Merce Cunningham, Dan Wagoner, Richard Kuch, and Richard Gain. She formed her company, Fresh Dance, in 1974 and has performed with it in the United States and Europe. Other works have been created for the Ballet Rambert in London, the Kibbutz Dance Company, and the Australian Dance Theatre. She has written scores for many of her works, among them, *Inertia, bébé*, and *nights*, all of which have been recorded, and for theatrical productions.

Works Choreographed: CONCERT WORKS: *Chambre à Deux* (1975); *Window* (1976); *Couches* (1977); *Sleeping Birds* (1977); *thataway* (1977); *F* (1978); *Gathering Water* (1978); *bébé* (1978); *Intentional Veer* (1979); *Inertia* (1979); *nights: stargazer* (1979); *nights: toss* (1979).

Sullivan, Ed, American columnist and television personality who had tremendous influence on American tastes in dance; born September 28, 1902 in New York City; died there October 13, 1974. Sullivan got his first newspaper job with the *Portchester* [New York] *Item*, and after positions with the *Hartford* [Connecticut] *Post,* the *New York Evening Mail, The* [New York] *World*, and *The Morning Telegraph* (a racing paper), he went to work with Bernarr Mac-Fadden's *New York Graphic*. He did his first emceeing in charity performances in the 1920s as a public relations challenge to gossip columnist Walter Winchell, who had left *The Graphic* to work for *The Mirror*. From the mid-1920s to 1948, he became gradually better known as a personality and columnist for *The* [New York] *Daily News*, appearing as emcee of benefits, presentation house feature acts, such as the *Gems of the Town* at the Paramount Theater, New York, and of the *News'* Harvest Moon Balls. On his

radio show (CBS, 1931–), he introduced Jack Benny and Broadway greats Irving Berlin and Florenz Ziegfeld to the audiences.

By 1948, Sullivan was the logical choice for CBS' new variety show, scheduled to premiere on June 20, 1948. *The Toast of the Town* (as it was originally named) and *The Ed Sullivan Show* "owned" Sunday night until June 1971 with weekly, hour-long presentations. It is difficult for anyone alive in those twenty-three years to believe that there is a generation that may not understand Ed Sullivan jokes and would not recognize the origin of the phrase "rrrr-Really big shew." The myths surrounding the Sullivan show were myriad and probably true; he had almost negative stage presence and terrible diction, but he was the best known personality on television. The show had other distinctions also; it was the most consistently integrated production on television until the mid-1970s and the one, strangely enough, that presented the most "high culture" to the American audiences.

The Ed Sullivan Show, which was credited with keeping acrobatics, accordions, and ventriloquism alive, also introduced ballet and opera to most of its audience. In the decades when cultural programming was scheduled inconveniently, the *Sullivan Show* on Sunday evening had an enormous, captive audience. He presented most of the native opera singers of the 1950s and 1960s, including Marian Anderson (in her 1952 television debut), Roberta Peters, Jan Peerce, Richard Tucker, Risë Stevens, and Robert Merrill (about whom the famous "I should now like to prevent the singer . . ." mistake was made). The dance acts that he presented ranged from entire Soviet ballet companies to Canadian Cloggers to winners of the Harvest Moon Balls. He scheduled performances from Rudolf Nureyev, Edward Villella (a particular favorite on the show), adagio teams, acrobats, precision lines, and hundreds of tap dancers. He had a special affinity for black tap dance teams, among them The Clark Brothers, Cook and Brown, Coles and Atkins, and the trio (Gregory and Maurice) Hines, Hines and Dad. The show had a resident dance chorus for every year of its existence, among them the Ernie Flatt, Hugh Lambert, and Peter Gennaro Dancers.

Sultzbach, Russell, American ballet dancer; born August 13, 1952 in Gainesville, Florida. Sultzbach studied locally with Edith Royal and in New York at the American Ballet Center.

After performing briefly with the Joffrey II, he graduated into the City Center Joffrey Ballet in 1971. An authoritative dancer with bright red hair, he quickly took on featured roles in the company's repertory. He created roles in works by Gerald Arpino, among them *The Sacred Grove on Mount Tamalpais* (1972) and the controversial *The Relativity of Icarus* (1974), and by Eliot Feld, *Jive* (1973), and Joe Layton, *Double Exposure* (1972). His flair for drama won him further roles in the company productions of Frederick Ashton's *The Dream* and Oscar Araiz's *Romeo and Juliet,* in which he danced "Mercutio."

Sultzbach joined the Milwaukee Ballet during a Joffrey Company lay-off and decided to remain with it in 1980.

Summers, Elaine, Australian-American postmodern dancer and choreographer, video artist, and filmmaker; born February 20, 1925 in Perth, Australia. Raised in Boston, Summers was trained in art before beginning dance studies with Merce Cunningham, Martha Graham, and Robert and Judith Dunn. A member of Dunn's composition classes, she performed and choreographed with its artistic descendent, the Judson Dance Theatre. Interested throughout her career in mixed-media events that combine live performance with video art, she has participated in many experimental projects in both media. Her *Fantastic Gardens* (1964, at Judson) is considered one of the first mixed-media works created as a dance concert performance. She is also credited with the earliest 3-D dance video, made for Cable Arts Foundation, and with choreography for both of WNET-NY's Video Artists-in-Residence—Stan Vanderbeek and Nam June Paik.

Unlike many of her Judson colleagues who now work in video, Summers does not mesh her elaborate media creations with pedestrian movements. Instead, she choreographs highly tuned, minimal, but legible dance movements that could stand on their own, dance creations structured within themselves and their own time frames. She has become more involved in the placing of the work as a whole; her cho-

reography and video are attuned to the performance space, whether a found location such as a museum or public park, or a theatrical design, as in her use of the reconstruction of a Gordon Craig set from the Moscow Art Theatre.

Admired as a choreographer and celebrated as a mixed-media artist, Summers is also known as a community activist for the dance. She has co-sponsored economic workshops and is a participant in and catalyst of the annual SoHo Loft Dance Festivals.

Works Choreographed: CONCERT WORKS: (Note: this list includes all works involving live performers. The titles may refer to the entire piece or to the filmed background. Works in which no live performers participate are listed under film or video.) *Instant Chance* (1962); *Newspaper Dance* (1962); *Dance for Lots of People* (c.1963); *Execution Is Simply Not* (1963); *Dance for Carola* (1963); *Suite* (1963); *Walking Improvisations* (1963); *Film Dance Collage* (1963); *Country Houses* (1963); *Fantastic Gardens* (1964); *Tumble Dance* (1965); *Suspended Ring* (1965); *Theatre Piece For Chairs and Ladders* (1965); *Dressing and Undressing* (1965); *To Steve with Love* (1965); *Balancing Solo* (1965); *The Closer She Gets . . . The Better She Looks* (1968); *White Wind Dance* (1968); *Jazz for a Lake and Trees* (1971); *Floating Dance for Two on a Raft on a Lake* (1971); *Celebrations in a City Place* (1971); *Energy Changes (I)* (1971); *Without Permission, Perhaps Next Monday* (1971); *Conversations form a Long Train Ride* (1971); *City Light Signals* (1972); *Energy Changes: Bell Progressions* (1972); *Energy Changes (II)* (1973); *Intermediate Events* (1974); *Open Field Dance* (1974); *One and One and One and One* (1974); *City Corners and Rivers for Rivers* (1974); *Energy Changes (III)* (1975); *All Around Buffalo* (1975); *Illuminated Workingman* (1975); *Come and Go and Come Again* (1976); *Solitary Geography* (1976); *Geography for One or More* (1976); *Windows in the Kitchen* (1977); *Energy Changes (IV)* (1978); *Confrontation* (1978); *Alexandra* (1978); *Tumble Dance for Any Number* (1979); *Crow's Nest* (1980); *One and One and One and One and One and One* (1980, may be a version of *One and One and One and One*).

FILM AND/OR VIDEO: *Walking Dance for Any Number* (1968, no production information available); *Without Permission* (1971); *City People Moving*

(1971); *Iowa Blizzard '73* (1973); *Two Girls Downtown Iowa* (1973); untitled work with Stan Vanderbeek (WNET-TV, 1974); untitled work with Nam June Paik (WNET-TV, 1974).

Sumner, Carol, American ballet dancer; born February 24, 1940 in Brooklyn, New York. Since graduating from the School of American Ballet, Sumner has performed with the New York City Ballet for almost two decades.

Associated throughout with the works of George Balanchine, she has performed in his *Apollo, Agon, Concerto Barocco, Divertimento No. 15, Four Temperaments, Stars and Stripes*, and *Western Symphony*, among other ballets. He selected her for major parts in the premieres of his *Raymonda Variations* (1964), *Harlequinade* (1965), *Don Quixote* (1965), *La Source* (1969 additions), *Divertimento from "Le Baiser de la Fée"* (1972), and *Le Tombeau de Couperin* (1975).

Sunshine, Marion, American vaudeville and Broadway dancer and songwriter; born Mary Tunstall Ijames, 1894 in Louisville, Kentucky; died January 25, 1963 in New York City. Sunshine made her theatrical debut at age seven in the melodrama, *Two Little Waifs* (1901) with her sister, Claire Lillian, who used the name Florenz Tempest. As Tempest and Sunshine, they entered vaudeville in 1904 and danced together until 1916. Among their Broadway productions as a duo were *Captain Nemo* (1908), the *Follies of 1907* (Tempest legally, Sunshine possibly with some illegal performances in New York), the Irving Berlin show *Stop, Look and Listen* (1916), and *The Midnight Revue* (1916). They also worked together in the acts *The Round of Roses* (c.1910) and *A Broadway Bouquet* (1916), and appeared together in a film, *Sunshine and Tempest* (Rialto Star Features, 1915).

As a solo specialty dancer, Sunshine was cast in Gertrude Hoffmann's *Broadway to Paris* (1913), *The Beauty Shop* (1914), *The Red Widow* (1916), *Going Up* (1917), *The Girl from Home* (1920), and *The New Dictator* (1921). While her own musical comedy dance work was not as well received as the sisters' tandem act, she was considered one of the best soubrettes on Broadway.

She gradually shifted from performing songs to writing them, becoming one of the first female performers to join ASCAP. When she died at the age of seventy, only a few old fans remembered that the highly respected songwriter had been a vaudeville star.

Sutherland, Paul, American ballet dancer; born 1935 in Louisville, Kentucky. Raised in Fort Worth, Texas, he studied there with Ross Hancock before moving to New York to work with William Dollar, who was then at the Ballet Theatre School.

After a season each in the corps of the Royal Winnipeg Ballet and American Ballet Theatre, he joined the American Ballet Center Company (soon renamed The Robert Joffrey Theater Ballet). In that company, he was given featured roles in Francisco Moncion's *Pastorale*, Gerald Arpino's *Partita for Four* and *Sea Shadow*, and Joffrey's own *Pas des Déesses*.

Rejoining Ballet Theatre in 1964, he performed in the company premieres of Agnes De Mille's *The Four Marys*, Glen Tetley's *Sargasso*, and David Blair's staging of *Swan Lake*, and was featured in Dollar's *The Combat*, Mikhail Fokine's *Les Sylphides*, and George Balanchine's *Theme and Variations*.

Throughout the 1970s, Sutherland danced for the new Joffrey company, the City Center Joffrey Ballet. He performed *danseur noble* roles in Arpino's *Kettentanz*, Balanchine's *Square Dance*, and John Cranko's *Pineapple Poll*.

Suzuki, Dawn, Canadian modern dancer working in the United States; born in the 1940s in Slocan, British Columbia. Suzuki was trained at the Canadian branch of the Royal Academy of Dancing and at the arts center in Bamff before attending the University of Toronto. She moved to New York to study at the Martha Graham school, but served an informal apprenticeship in the concert groups of Yuriko, Bertram Ross, and Pearl Lang before joining the Graham company in 1968. In the Graham company she has been acclaimed in both the frequent revivals of the classics of the Graham repertory, and the new works of the 1960s and 1970s. Among the latter, she has performed major parts in *A Time of Snow* (1968), *Plain of Prayer* (1968), *Lady of the House of Sleep* (1968), *Archaic Hours* (1969), *Cortege of Eagles*, and *Part Real, Part Dream*.

Sverdlik, Daniel Ira, American performer associated with the works of Meredith Monk; born August 8, 1942 in Queens, New York. Sverdklik, who is a physicist, has no formal dance training.

He has participated in many works by Meredith Monk since her *Juice* in 1969. He plays patriarchs, refugees, dictators, and other archetypes in her dance and music pieces, frequently as the only male performer. Although technically an "untrained dancer," he has been able to capture her movement and vocal style to create full characters or symbols, as she requires.

Svetlova, Marina, French ballet dancer; born May 3, 1922 in Paris. Named for Valeri Svetloff, the Russian dance critic, she was born Yvette von Hartmann. Svetlova was trained in Paris at the studios of Vera Trefilova, Olga Preobrajenska, and Lubov Egorova.

After performing in an Ida Rubinstein spectacle, Svetlova joined the Original Ballet Russe in 1939, with featured roles in Leonid Massine's *Symphonie Fantastique* and David Lichine's *Protée*. She performed with Ballet Theatre for a season, notably in Fokine's *Spectre de la Rose*, before accepting an engagement that stretched out until 1950 with the Metropolitan Opera Ballet. After dancing in the Met's productions of *La Traviata, Aida, Carmen*, and other operas, she did guest appearances with the Irish National Ballet and the London Festival troupe.

On retiring from performance, Svetlova became chairperson of the Ballet Department at the University of Indiana at Bloomington.

Swain, Eve, American ballet dancer; born c.1895; died November 1, 1947 in Sarasota, Florida. Swain was trained at the school of the Metropolitan Opera Ballet by Malvina Cavallazzi and Pauline Verhoeven. She made her professional debut at Carnegie Hall, in the corps that framed Adelina Genée in her concert there in 1911.

From 1913 to 1914 she was the first American-born and trained dancer to attain the position of *première danseuse* at the Metropolitan Opera. She danced in *Hamlet, Faust*, and *Les Hugenots*, among many other operas, in choreography by Verhoeven.

Leaving the Metropolitan in 1915, she danced with the Philadelphia-Chicago Grand Opera Ballet that season before retiring.

Swan, Paul, American interpretive dancer; born 1883 in Ashland, Illinois; died February 1, 1972 in Bedford Hills, New York. Raised in Nebraska, Swan attended art school in Chicago before he moved to New York to study with Mikhail Mordkin. Reportedly, a portrait series that he painted of Alla Nazimova gave him the money needed to travel to Greece, where he studied Hellenic dance and culture. Returning to New York as "Iolaus," he gave a series of Greek revival recitals in New York, performed in a production of *Lysistrata* (c.1913), and worked at Hammerstein's Victoria Theater in Gertrude Hoffmann's class act slot. He was frequently compared to Ted Shawn then, although he did not make Shawn's compromises and perform in social and exhibition ballroom dances. A story has been traced to a single source in a color supplement (not a particularly reliable source in 1914, or ever) that when Ruth St. Denis married the then little-known Shawn in 1914 and announced hyperbolically that she was marrying the "most beautiful man in the world," the public assumed that she was marrying Swan.

He retired in 1930 to paint and do sculpture, but reemerged in 1940 to give the first in what turned out to be a series of regularly scheduled recitals in studio 90 of the Carnegie Hall Building. These concerts, which were annual in the early 1940s and weekly by 1947 to 1953, presented Swan as a solo performer, artist, and lecturer on philosophy and aesthetics. Unfortunately, few programs remain (if, in fact, programs were printed for each concert), but all extant work titles are listed below.

Swan also worked extensively in silent films, acting for Cecil B. De Mille in the original *Ten Commandments* (Paramount/Famous Players-Laskey, 1923), and in Five Star Featurettes and serials in the late 1910s.

Works Choreographed: CONCERT WORKS: *Pierrot's Serenade* (pre-1914); *The Passing of Summer* (pre-1914); *The Quest of the Soul* (pre-1914); *The Confessions of a Chinese Idol* (pre-1914); *Le Cygne* (1914); *Narcissus* (1914); *Rubyat* (1917); *Dances of the Wind* (1917); *To Heroes Slain* (1917); *The Sphinx* (1917);

The Device (1947); *The House That Jack Built* (1947); *Poems of Paul Swan* (1947, a solo dance); *The Elements* (1947); *Greek Legend* (1947); *Far, Far Away* (1947); *Oriental Dance* (1947); *In Chinese Masks* (1947); *Persian Poem* (1947); *Juggler at le Cirque* (1947); *Triumph of Spirit over Matter* (1947); *Chinese Theatre* (1947); *The Temptation* (1947); *Musical Lines* (1947); *The Tightrope Walker* (1947); *Fourteen Verses of Omar Khayam* (1947); *The Nightingale and the Rose* (1947); *Bon Jour* (1947); *French Rustic* (1947); *Game of Tennis* (1947); *New Poems with Movement* (1947); *London Suite* (1947); *Chinese Temple Dance* (1947); *Ancient Poem* (1959); *Three Pierrot Pieces* (1959); *Bacchanale in the Desert* (1959).

Swensen, Swen, American theatrical dancer; born January 23, 1932 in Inwood, Iowa. Trained by Mira Rostova and at the School of American Ballet, Swensen performed frequently on Broadway. Among the many shows in which he has danced are *Great to Be Alive* (1950), *Bless You All* (1950), *As I Lay Dying* (1952), *Ulysses in Nighttown* (1958), Michael Kidd's *Destry Rides Again* (1959), *Wildcat* (1960), *The Golden Apple* (1962), *Little Me* (1962), Michael Bennett's first show, *A Joyful Noise* (1966), Donald Saddler's revival of *No, No, Nanette* (1972), *Molly* (1973), and *I Remember Mama* (1979), staged by Danny Daniels. His eccentric style and high kicks have also been seen in the film *What's the Matter with Helen?* and on many television variety shows, notably *Your Show of Shows*, on which he was a semiregular, and the *Ed Sullivan* and *Perry Como* shows.

Swoboda, Vecheslav, Russian dancer and teacher working in Western Europe and the United States after the early 1920s; born c.1892 in Moscow; died August 23, 1948 in New York. Trained at the school of the Imperial Ballet in Moscow, he performed with the Bolshoi after 1910, notably as a partner of Ykaterina Geltzer. After dancing for Bronislava Nijinska in the Diaghilev Ballet Russe and the Ida Rubinstein Ballet, he joined the San Carlo Grand Opera in 1926, an itinerant troupe which then featured Maria Yurievna as *première danseuse*. They were married and offered positions with the Chicago Grand Opera in the late 1920s.

In New York by 1931, they opened a school which was unaffiliated with a company. Their studio merged with the Chalif School in 1936 and remained solvent and successful after his death in 1948.

Swor, Bert and John, American popular entertainers; Bert, born 1878 in Paris, Tennessee; died November 30, 1943 in Tulsa, Oklahoma; John, born April 7, 1883 in Paris, Tennessee; died July 15, 1965 in Dallas, Texas. Bert and John Swor were the oldest of four brothers who appeared in minstrel shows in the early years of the twentieth century. Unlike Jim and Will (the younger Swor brothers), Bert and John worked together for much of their professional lives, touring as "End-men" in the Dockstader, the Honey Boy Evans, and the Al. G. Fields Minstrel troupes. As "End-men," they did comedy routines and step dances in rhythm in the minstrel shows, developing an act that was halfway between conventional minstrelsy and the innovations of tandem theatrical dancing.

The Swors worked separately occasionally in their careers. Each was, for example, a replacement "Moran" in the celebrated Mack and Moran, The Two Black Crows, act, during quarrels between Charles E. "Mack" Sellers and George "Moran" Searcy. In addition, Bert worked on Broadway in *Loose Ankles* (1931) and John toured in a Black Crow–type act with Frank Conroy, as Swor and Company. They were reunited on radio in the late 1930s, as stars and hosts of NBC's *Bicycle Party*. After Bert's death, John worked extensively in live theater and played "Cap'n Andy" on the television series, *Show Boat*.

La Sylphe, American acrobatic ballet dancer; born Edith Lambelle, c.1900 in New York City. Because of the Gerry Society's injunctions against children performing on the New York stage, La Sylphe made her professional debut as a ballet dancer at the age of six in London. She performed in Europe for four years, appearing in music halls in London, Paris, Brussels, and Milan. Returning to the United States in 1910, she was one of many interpretive and ballet

dancers who performed Salome solos. While she was not the youngest (she was three years older than Amalia Caire) to participate in the trend, she was billed as "the nubile Salome revealing her remorse in an exotic dance." After six more years in vaudeville, she became old enough to qualify for performance on Broadway. La Sylphe was the featured ballet dancer in the first three editions of the *George White Scandals of 1919, 1920*, and *1921*. In each, she was considered the "class act" dancer (in contrast to Ann Pennington's more popularist styles) with solos ranging from a "Scandalous One-Step" and "A Vampire" to "The Spider Ballet."

She taught ballet, adagio work, and acrobatic exhibition forms in New York from 1921 until the early 1940s.

Sylvain, James, English nineteenth-century ballet dancer known as the partner, on a freelance basis, of the major Romantic ballerinas; born James Sullivan in England c.1810; died April 12, 1856 in London. The brother of actor Barry Sullivan, Sylvain made his debut as an adolescent in an 1819 Drury Lane pantomime. A second pantomime part led to a job with Jean-Baptiste Hullin's company, then in residence at Drury Lane, with which he toured for the next four years. In 1823, the tour performed in Bath; during his stay there, he arranged a divertissement from *La Bayadère* for Clara Vestris Webster, the young dancer-daughter of the Theatre Royal's manager. Still billed as James Sullivan, he performed for two seasons at the King's Theatre, London (1824–1826), during which time Jean Aumer served as ballet master.

Possibly under Aumer's sponsorship, Sullivan moved to Paris where he performed in ballets by Frederic-Auguste Blache at the Théâtre de l'Ambigu-Comique. From 1831 to 1833 he was a member of the Paris Opéra, at which he changed his name to Sylvain, or, occasionally, Silvain.

Returning to London, he worked at a series of pantomime theaters, among them Drury Lane (1833) and Covent Garden (1834–1836, 1848), until 1840, when he was hired to accompany Fanny Elssler to the United States. On the tour, he partnered her in *Giselle, La Bayadère*, and *Pas Styrien*. Replaced by Jules Martin toward the end of the two-year tour, he established a small company of American-based dancers, including Julia Turnbull and Josephine Petit-Stéphan. Lillian Moore, in her study of the Elssler tour, has also suggested that while Sylvain was in New York, he coached Turnbull and Mary Ann Lee in the European Romantic repertory.

Sylvain's reputation as a partner was consolidated when, between 1844 and 1846, he toured with Elssler, and performed with Lucile Grahn at Drury Lane, and Carlotta Grisi at Her Majesty's Theatre, London.

Although no choreographic credits can be found for Sylvain, two instances of his staging French repertory works for English theaters are known. It is not sure exactly how, in two years at the Opéra, he managed to become known as an expert of that Romantic repertory. In 1844, he staged *The Revolt of the Harem* for Adelaide Plunkett and Clara Webster, the ballet during which she was fatally burned. In 1846, he was hired to stage *Paquita* for Carlotta Grisi in London.

Sylwan, Kari, Swedish ballet dancer; born 1940 in Stockholm. A private pupil of Lilian Karina, she joined the Royal Swedish Ballet in 1959. Although she has performed in works by other choreographers, she is best known for her portrayals of strong, disturbed women in the ballets of Birgit Cullberg. Among her characterizations in Cullberg's innovative works are "Elida" in *The Lady from the Sea*, "Eve" in *Eden*, and the title role in *Miss Julie*. Sylwan left the Royal Swedish Ballet to join Cullberg's own ballet company when it was founded in the mid-1960s.

T

Taglioni, Carlo, Italian eighteenth-century choreographer and patriarch of the Taglioni clan; born c.1750 in Turin; the details of Carlo Taglioni's death, after 1800, have not been verified. Known for his work as a dancer in Venice, he was able to perform in both the *"serie"* and *"grotechi"* modes, as, in modern equivalents, a *premier danseur* and a character dancer known for elevation and precision of movement. The works that are known, probably numbering less than one-fourth of his output, seem to follow the traditional range of the period. It cannot be determined whether the choreographic skill of his sons was reflected in his own work for the Teatro Argentina in Rome and theaters in Siena and Udine. Taglioni was the father of Guiseppa, Louisa I, Salvatore, and Filippo Taglioni, all of whom had careers in dance. His granddaughters, Maria and Louisa II, grandson Paul, and great-granddaughter, Marie Paul, were stars and creators of the Romantic era.

Works Choreographed: CONCERT WORKS: *Il Villano Rincivilito, o sia Il Barone Molletta di Rocca Antica* (1790); *Li Due dindaci, ossia La Vendemmia* (c.1790); *La Scuola olandese, ossia L'Amante in statua* (1796); *La Sposa Rapita* (1796); *La Piazza di Pasilipo in Napoli* (1797); *La Recluta con inganno* (1797); *Li Sposi contenti* (1797); *La Villegiratura alla moda* (1797).

Taglioni, Filippo, Italian ballet dancer and choreographer best known for his works for his daughter, famed Romantic ballerina, Marie Taglioni; born November 5, 1777 in Milan; died February 11, 1871 in Lake Como. The son of dancer Carlo Taglioni, Filippo was trained in Paris by Jean-François Coulon. Although he performed briefly at the Paris Opéra, notably in Pierre Gardel's *La Dansomanie* in 1800, he became known as a choreographer and ballet master for theaters in Northern Europe and England.

Taglioni's five major tenures were at the Theater Royal, Stockholm (c.1800–1894), the Court and Opera theaters of Vienna (c.1804–1809 and c.1821), the Court Theater of the Duchy of Westphalia at Kassel (c.1809–1814), Her Majesty's Theatre, London (intermittently, 1834–1851), and the Imperial theaters in Warsaw (c.1848–1853). In between, he served as his daughter's private ballet master and choreographer-in-residence.

Generally credited with developing his son and daughter as dancers, Taglioni staged ballets for Marie that exploited her abilities to dance effortlessly on point. These ballets, created for the Paris Opéra and the King's Theatre, also caught the aesthetic elements of Romanticism so that, although they were occasional vehicles, they are considered symbols of an artistic era. The works, especially *Le Dieu et la Bayadère* (1830), *Robert le Diable* (1831), *La Sylphide* (1832), *Gustave III* (1833), *La Fille du Danube* (1836), *l'Ombre* (1839, premiered in St. Petersburg), and *La Péri* (1843), were performed in authentic and plagiarized versions across Europe and in America by resident and touring companies throughout the century. Unfortunately, since the extant versions of these works are not Taglioni's, or cannot be authenticated as his, it is impossible to judge his choreographic skills.

Works Choreographed: CONCERT WORKS: *Dansomania* (1804); *Zerline et Gorano* (1805); *Atalante et Hippomène* (1805); *Divertissement Orientale* (1807); *Les Masques* (1810); *Paul et Rosette* (1811); *La Fête Indienne* (1811); *Les Mines de Valachie* (1818); *Ladoisca* (1821); *Joconde* (1821); *Marguerite, Reine de Catanea* (1822, the pas de châle from this work was frequently performed as a separate ballet); *La Reception d'une Jeune Nymphe à la Cour* [in some sources, *le Temple*] *de Terpsichore* (1822); *Rinaldo d'Asti* (1823); *Nathalie, Laitière Suisse* (1823); *Le Réveil de Vénus* (1824); *La Glaive et la Lance* (1825); *Zémire et Azor* (1825); *Les Vendanges* (1825); *Les Meuniers* (1826); *Les Sortilèges de l'Amour* (1826); *Le Soirée d'un Rajah* (1826); *Une Fête à la Campagne* (1827); *Les Filets de Vulcain* (1827); *Le Carnaval de Venise* (1827); *Flore et Zéphire* (1830); *Le Dieu et la Bayadère* (1830); *Les Jeunes Pensionnaires* (1831); *La Sylphide* (1832); *Gustave III* (1833); *Sire Huon* (1834); *La Chasse des Nymphes* (1834); *Le Pouvoir de la Danse* (1834); *Brézilia, ou la Tribe des femmes* (1835); *Le Minuet de Cour* (1835); *Mazila* (1835); *La Fille du Danube* (1836); *Miranda* (1838); *l'Ombre* (1839); *Aglaë, ou l'été de l'amour* (1841); *La Gitana* (1841); *Yetta, Reine des Elfrides* (1842); *Herta, ossia*

il Lago delle Fata (1842); Satanella (1842); La Péri (1843); Clemenza di Valois (1842); Coralia (1847); Théa (1847); Orithia (1847); Fiorita et la Reine des Elfrides (1848), but possibly a version of Yetta; Electra (1849); La Prima Ballerina (1849); Les Plaisirs de l'hiver (1849); Les Métamorphoses (1850); Les Grâces (1850); L'Ile des amours (1851); La Bouquetière (1856); Alphéa (1857).

OPERA: Robert le Diable (1831); La Juive (1835); Les Hugenots (1836).

Taglioni, Louisa, Italian nineteenth-century ballet dancer working in France; born 1823 in Milan or Naples; died in Naples in 1893. The daughter of Salvatore Taglioni, she is often called Louisa II, to distinguish her from her aunt. Trained by her father and, following family tradition, by Jean-Baptiste Coulon, she performed at the Paris Opéra in the mid-1800s. Among her many credits in the home of the French Romantic era were principal roles in Jean Perrot's Catarina, ou la fille du Bandit, Lalla Rookh, and Le Jugement de Paris (1846, known in English as Pas de Quatre), and in Fanny Cerrito's Gemma (1854). After she retired to Naples, she became director of a ballet studio there.

Taglioni, Marie, French ballerina and major figure of the Romantic era; born April 23, 1804, Stockholm, Sweden; died April 22, 1884, in Marseilles. Trained primarily by her father, Filippo, and by Jean-François Coulon, Taglioni is one of very few dancers credited with creating a unique performance style. Although she was neither the first to perform on point nor the earliest example of the etherealism of the Romantic era, she was the epitome of the combination of strength and delicacy that embodied the persona of the Romantic ballet heroine.

Taglioni made her debut at the Vienna theater at which her father was serving as ballet master in 1822 in his la Récéption d'une Nymphe à la Cour [au Temple] de Terpsichore. She danced for him in Vienna and Stuttgart in his Zémire et Azor (1825), Le Soirée d'un Rajah (1826), and Danisia, ou le Singe de Brésil (1826), before making her Paris Opéra debut in 1827 in a pas de deux interpolated into Le Sicilien.

It was appropriate that she should make her Opéra debut in an interpolated specialty by her father since, instead of adjusting her style to accommodate the company's performances, she would impose her technique and vision of ballet on it. She was one of the few persons—choreographer or performer—ever able to accomplish that feat, and, within ten years of her debut, when she left for St. Petersburg, she had done it. The Taglioni repertory, consisting of her father's Flore et Zéphire (1830), La Fille du Danube (1836), Nathalie, La Laitière Suisse (1832), and, especially, La Sylphide (1832), became the standard ballets of the period, and works that other dancers had to perform to create reputations of their own.

The next ten years of Taglioni's career—also her last—were spent touring and maintaining her reputation in a rivalry with Fanny Elssler, the representative for the Romantic theorists of the sensuality of the ideal woman. She participated in the celebrated performance of Perrot's Pas de Quatre in 1845, but it may have been that work which froze her persona for the audience. Taglioni retired in 1848. She choreographed, or supervised the rehearsals of, a ballet, Le Papillon (1860), for her protégé, Emma Livry, after her debut in La Sylphide persuaded her that the younger dancer could perform her style and technique of the Romantic ballet. Although a teacher and inspector of classes at the Paris Opéra until 1870, she did not choose another protégé to continue her performance style.

Works Choreographed: CONCERT WORKS: Le Papillon (1860, possibly co-choreographed with her father).

Taglioni, Marie Paul, German ballet dancer of the late nineteenth century; born October 27, 1833 in Berlin; died August 27, 1891 in Neu-Aigen, Austro-Hungary. The daughter of Paul Taglioni and Amalia Galster, she was trained by her father in Berlin and London. She first performed publicly in London in her father's Théa, ou la Fée aux fleurs in 1848 at Her Majesty's Theatre. Following her season there, with additional performances in Jules Perrot's Les Quatre Saisons (1848), she performed in Vienna and at the Berlin Court Opera. There too she was known for her appearances in the ballets of her father, among them Flik und Flok, Sardanapolo, and La Fantasma.

Taglioni, Paul, Austrian ballet dancer and choreographer who worked in Berlin, London, Milan, and Naples during the mid-nineteenth century; born January 12, 1808 in Vienna; died January 6, 1884 in Berlin. The son of Filippo Taglioni, he studied with his father and with Antoine-Louis Coulon in Paris.

Taglioni made his debut in 1824 in a pas de deux with his sister Marie in Stuttgart, and continued to partner her for five years there and at the Paris Opéra. Named ballet master to the Royal Opera House in Berlin in 1829, he met and married the dancer Amalia Galster there, and choreographed many works for her. They performed together on a tour of the United States, making their debut in New York in a performance of *Le Sylphide* in May 1839. It is not known whether Taglioni staged their productions of *Sylphide, Le Bal Masqué, Le Dieu et la Bayadère, Ondine,* and *Nathalie.*

The Taglionis also worked in London, where Paul served as ballet master of Her Majesty's Theatre in the 1840s and early 1850s. They returned to Berlin, then moved to Milan where he became ballet master at the Teatro alla Scala. Many of his best known Romantic ballets, among them, *Le Stelle* (1862), *Théa* (1867), and *Léonilda* (1867), were created for that theater.

It is important to remember that Paul Taglioni was as important to the aesthetic of the late Romantic era as his father had been to the early one. He defined its ethics and technical requirements, and forms an artistic link between the early Romantic ballets of the Paris Opéra and the spectacles of La Scala in the 1880s.

Works Choreographed: CONCERT WORKS: *La Nouvelle Amazone* (1830); *La Foire du Village* (1832); *Liebeshändel (the Love Quarrel)* (1836); *Le Pauvre Pêcheur* (1835); *Ondine* (1836); *La Fille aux Roses* (1836); *Coralia* (1847); *La Fée aux Fleurs* (1848); *Electra, ou la Pléiade Perdue* (1849); *La Prima Ballerina* (1849); *Les Métamorphoses* (1850); *l'Ile des Amazones* (1851); *Alphéa* (1853); *Les Joyeux Mousquetaires* (1855); *Ballanda* (1855); *Morgano* (1857); *Catarina* (1860); *Ellinor* (1861); *Le Stelle* (1862); *Flik e Flok* (1863); *Sardanapolo, re di Assiria* (1867); *Théa, o la Fata dei Fiore* (1867); *Léonilda* (1867); *Don Parasol* (1869); *La Fantasma* (1869); *Miliataria*

(1872); *I due Soci* (1872); *Madelina* (1876); *Un Heureux Evénement* (1878); *Don Quixote* (1886).

Taglioni, Salvatore, Italian nineteenth-century ballet dancer and choreographer; born 1789 in Palermo; died 1868 in Naples. The younger son of Carlo, Salvatore was trained by him and Jean-Baptiste Coulon in Paris. His Paris Opéra debut was made in a pas de deux with his sister, Louisa (I). As a dancer he worked primarily in France, at Lyons and Bordeaux, but he returned to Italy in 1812 to found a school in Naples with Louis Henry. Although he choreographed throughout northern Italy, most of his better known works were created for the Teatro Reggio in Turin, Teatro San Carlo in Naples, or Teatro alla Scala in Milan. Most of his enormous output were historical dramas, translated into dance and employing elements of spectacle and pageantry. In this manner he was aesthetically different from his better known brother, Filippo, but closer to the eventual national style of Italian ballet.

Taglioni's daughter, Louisa (II) (1823–1893), was best known as a dancer for her performances at the Paris Opéra; his son, Fernando, was a composer.

Works Choreographed: CONCERT WORKS: *Atalanta ed Ippomene* (1817); *Il Principle Fortunio, ossia Le Tre melarence* (1817); *La Conquista di Malacca, ossia I Portoghesi nell' India* (1819); *Otranto liberata* (1820); *Il Narciso corretto* (1820); *Il Natale di Venere* (1822); *Il Seduttore* (1822); *La Premosa mantenula* (1822); *Sespstri* (1823); *Attide e Cloe* (1823); *Tippoo-Saeb* (1823); *Bianca di Messina* (1824); *L'Ila di Achille* (1826); *Pietro di Portogallo* (1827); *Pelia e Mileto* (1827); *Euticho della Castgna, ossia La Case disabilita* (1827); *Il Paria* (1827); *Il Flauto incanto* (1828); *Amore filosofo* (1828); *Il Serto di alloro* (1828); *Le Montagne russe* (1830); *La Prigione di Dario, ossia Peilia e Mileto* (1830); *Le Convulsioni musicali* (1832); *La Festa do ballo in machera* (1832); *Il Collegiale in vacanza* (1832); *Romanow* (1832); *L'Ombra di Tsi-Ven, ossia La Constanza premiata* (1833); *I Saraceni in Sicilia* (1834); *Il Ritorno di Ulisse* (1836); *Amore e Psyche* (1837); *Le Nozze campestri* (1837); *Los Notte di un proscritto* (1838); *Faust* (1838); *Il Perdono* (1839); *Smore alla prova* (1839); *L'Assed di Sciraz, ossia L'amprematerno* (1839); *Il*

Duca di Ravenna (1840); *Basilio III, Demetriovitz* (1840); *Un Episodio della capagna di Constantina* (1840); *Marco Visconti* (1841); *La Foresta d'Hermanstadt* (1841); *Le Nozze di Romanow* (1841); *La Zingara* (1842); *Le Avventure di Don Chiscotte* (1843); *Gugliermo di Provenza* (1846); *Margherita Pusterla* (1846); *L'Eroe cinese, ossia fedeltà e clemenza* (1846); *Bradamante e Ruggiero* (1849); *I Candiano* (1849); *Il Ritorno di Alfonso d'Aragona della guerra d'Otranto* (1850); *La Stella del mariano* (1851); *Bassora, ossia Il Fantasma d'Arafat* (1852); *Olfa* (1853); *Anacreonte* (1853); *Hulda* (1854); *L'Araba* (1854); *Noama* (1855); *Zilmè, o la Dea delle dovizie* (1855); *Isaura, ossia La Protettadelle Fate* (1856); *Lady Enrichetta, o la Fantesca di Greenwich* (1856); *Il Figlio dello Shah* (1861).

Taillande-Douvillier, Suzanne, French ballet dancer of the early nineteenth century performing in Paris and the United States after 1792; born c.1778; died August 30, 1826 in New Orleans, Louisiana. Taillande's training is not known; she may have studied at the school of the Paris Opéra. It is also not certain how or where she became involved with Alexander Placide, of the Grands Danseurs du Roi company, but she did, and in 1792, she came with him to the United States as Mme. Placide.

The soubrette of the troupe, Taillande played "Columbine" in *The Restoration of Harlequin* and *Harlequin Protected by Cupid*, "Collette" in *The Old Soldiers*, and the title role in *La Belle Dorothée*—all in the first weeks of the troupe's New York season. She also played "Columbine" for John Durang's Harlequin in the company's *The Birth of Harlequin* in 1792, and for Placide in *Harlequin Balloonist* later that season. The troupe moved south to Charleston where they performed in works by Noverre and Maximilien Gardel and presented her *Echo et Narcisse* (1796). In New Orleans, singer Louis Douvillier challenged Placide to a duel over Taillande. When it ended with both alive, Taillande (although known as Mme. Placide) married Douvillier and for the rest of her life was known as Taillande-Douvillier. Unfortunately, as is often the case, much of the publicity and coverage of Taillande-Douvillier referred to the duel, not to her further choreography.

Works Choreographed: CONCERT WORKS: *Echo et Narcisse* (1796).

Tait, Marion, English ballet dancer; born October 7, 1950 in London. Trained at the Royal Ballet School, Tait has performed with the Royal Ballet or its touring company since 1968. Among her roles with the company are a principal part in the premiere of Jack Carter's *Shukemei* (1975), "Swanilda" in *Coppélia*, and roles in the revivals of John Cranko's *Brouillards* and the smaller company's production of *Aurora's Wedding*.

Takei, Kei, Japanese postmodern dancer and choreographer working in the United States; born 1946 in Tokyo. Takei studied locally at the Sakai Bara School and the Kaitani Ballet Studio before moving to New York in 1966 to attend the Juilliard School. At Julliard she worked with Anna Sokolow. She also studied with Trisha Brown and Alwin Nikolais in New York and with Ann Halprin in San Francisco.

Takei founded the Moving Earth Company in 1969, for which company she has created most of her choreography. Takei's major work, a multipart epic collectively entitled *Light*, has been performed progressively and in repertory since 1969. Her works—both choreography and mise-en-scène—are among the most imaginative and innovative of any at the present time. The later parts of *Light*, especially, can both shock and inspire an audience with their controlled steps, imagery, and decor manipulation.

Works Choreographed: CONCERT WORKS: *Voix/Ko-E* (1968); *Light, Part I* (1969); *Lunch* (1970); *Light, Part II* (1970); *Light, Part III and IV* (1970); *Light, Part V* (1971); *Light, Part VI* (1971); *Light, Part VII* (1973); *Light, Part VIII* (1974); *After Lunch* (1975); *Light, Part IX* (1975); *Light, Part X* (1976); *Light, Part XI* (1976); *Light, Part XII* (1976); *Light, Part XIII* (1977); *Light, Part XIV* (1979); *Light, Part XV* (1980).

Taliaferro, Clay, American modern dancer and choreographer; born April 5, 1940 in Lynchburg, Virginia. Taliaferro began his dance training with Jan Veen while a student at the Boston Conservatory of Music. A member of the José Limón company for

many years, and assistant artistic director in the mid-1970s, he was celebrated for his strong performances in Limón's *The Winged, The Unsung, There Is a Time, The Exiles,* and *The Moor's Pavanne,* in the "Othello" part. As a freelancer, he also danced with Lotte Goslar's Pantomime Circus, in her *Clown and Other Fools* (1969) and *Splendor in the Grass* (1972), and in Rodney Griffin's *Misalliance* (1972) as "The Groom" and representative of traditional modern dance.

Taliaferro choreographs for his students in residencies at various universities and for The Dance Trio, a company he formed with Carol Warner and Lynda David. His group works include *Other Recent Jogging Deaths* (1978) for the University of Montana, *The Purple Moment* (1979) for students at the Rhode Island College, and *Dancing Woman* (1980) for his former colleagues of the Limón company.

Works Choreographed: CONCERT WORKS: *Ivesound* (1977); *Behold Yourself Therein* (1977); *Dance in F.M.* (1978); *Other Recent Jogging Deaths* (1978); *The Purple Moment* (1979); *Earthlight* (1980); *Dancing Woman* (1980).

Tallchief, Maria, American ballerina who for many years was the symbol of the ballet to live audiences and television viewers; born Betty Marie Tallchief, January 24, 1925 in Fairfax, Oklahoma. Tallchief and her sister Marjorie were raised in Los Angeles where she studied with Ernest Belcher and Bronislava Nijinska, performing for both at the Hollywood Bowl.

Considered one of the greatest ballerinas, both technically and as a dance actress, ever developed in the United States, Tallchief became one of the Ballet Russe de Monte Carlo's four Native American stars in the early 1940s. In that company she performed in Leonid Massine's *Gaité Parisienne,* Mikhail Fokine's *Schéhérazade,* and George Balanchine's *Serenade,* and *Ballet Imperial,* creating the leads in his *Danses Concertantes* (1944), and *Night Shadow* (1946). Married to Balanchine during the late 1940s and early 1950s, she accompanied him to the Paris Opéra where she repeated her role in *Serenade* and danced in his *Apollo.*

When they returned to the United States to create the Ballet Society and the New York City Ballet, she became the best known dancer in that starless company. Between 1947 and 1965 (when she left the company), she created roles in most of the Balanchine repertory, among them, *Four Temperaments* (1946), *Orpheus* (1948), *The Firebird* (1949), *Bourée Fantastique* (1949), *Capriccio Brillante* (1951), *Á la Françaix* (1951), *Swan Lake* (1951), *Caracole* (1952), *Scotch Symphony* (1952), *The Nutcracker* (1954, as the first "Sugar Plum Fairy"), *Allegro Brillante* (1956), and *The Gounod Symphony* (1958). Partnered by Nicholas Magallanes, Francisco Moncion, or André Eglevsky, she was an elegant, brilliant technician with tremendous presence and audience contact. She was able to preserve those qualities in her many performances on television, on *Omnibus,* the *Hallmark Hall of Fame,* and *The Ed Sullivan Show,* and in films, among them *Presenting Lily Mars* (MGM, 1943), and *Million Dollar Mermaid* (MGM, 1953), in which she played Anna Pavlova and danced the "Dying Swan."

After she retired from the City Ballet, Tallchief, who had guested frequently during the 1950s, performed as a freelancer in the United States and Europe, creating the title role in Peter Van Dyke's *Cinderella* (Hamburg, 1965). She resides in Chicago where she has performed with the Opera Ballet and has restaged Balanchine's works for her students. Her attempt to create a ballet company there has now been successful.

Tallchief, Marjorie, American ballet dancer performing in Europe after the mid-1950s; born October 19, 1927 in Fairfax, Oklahoma. Raised in Los Angeles, she received her ballet training from Ernest Belcher, Bronislava Nijinska, and David Lichine, later continuing her studies with Olga Preobrajenska and Lubov Egorova.

Tallchief was a member of Ballet Theatre from 1944 to 1947, creating roles in Nijinska's *Harvest Time* (1945), Simon Semenoff's *Gift of the Magi* (1945), and Antony Tudor's *Undertow* (1945). Her featured parts included solos in Lichine's *Graduation Ball,* Michael Kidd's *On Stage,* and the company production of *Giselle.* Switching to the Ballet Russe de Monte Carlo in 1945, she was featured in Anton

Dolin's *Pas de Quatre* and William Dollar's *Constantia*. In the rival Original Ballet Russe (c.1946–1947), she was assigned roles in George Balanchine's *Concerto Barocco* and *La Somnambula*, John Taras' *Designs with Strings*, and Leonid Massine's *Le Beau Danube*.

Performing in Europe after 1947 with Le Grand Ballet du Marquis de Cuevas, she created roles in works by her husband, Georges Skibine, among them *Annabel Lee* (1951), *The Prisoner of the Caucasus* (1951), *l'Ange Gris* (1952), and *Idylle* (1954). She also danced in the company's productions of the classics and was reunited with Bronislava Nijinska, who featured Tallchief in her *Boléro*, *Les Biches*, and *Chopin Concerto*. For the next eight years, she commuted between Chicago where she performed in opera ballets by Ruth Page, and Paris where she danced in ballets by Serge Lifar and Skibine. Before retiring, she created roles in the latter's *Conte Cruel* (1960) and *Pastorale* (1961).

Talmud, Blanche, American concert dancer; born c.1900, probably in the New York area. Talmud made her professional debut as a member of the Roshanara back-up chorus in Adolf Bolm's Ballet Intime performances of 1917. She began teaching at the Neighborhood Playhouse in the early 1920s and performed in a number of Alice Lewissohn productions. In 1931, she danced in the Doris Humphrey and Charles Weidman productions of music by Ernst Bloch, including Humphrey's *String Quartet*. Talmud taught at the Playhouse at least into the 1940s.

Talvo, Tyyne, Finnish ballet dancer and choreographer; born 1919 in Helsinki. Talvo has been associated throughout her career with the companies of her husband, Ivo Cramer—his Dance Company of 1945, Swedish Dance Theatre (c.1947), and Ny Norsk Ballet and Dance company of the 1970s. In the latter company, which was founded in 1968, she has performed in her own *The Hill of the Winds* (c.1970), *Bright Night* (1972), *As Time Passes . . .* (1975), and other works.

Works Choreographed: CONCERT WORKS: *Sauna* (1968); *The Hill of the Winds* (c.1970); *Carvings* (1970); *Bright Night* (1972); *As Time Passes . . .* (1975); *Among Pucks and Trolls* (1976).

Tamblyn, Russ, American film dancer and actor; born December 30, 1934 in Los Angeles, California. A champion tumbler and acrobat, Tamblyn made his film debut as an adolescent in *The Boy with Green Hair* in 1948. Although celebrated as a dancer, especially by current audiences who were brought up on his films for MGM, Tamblyn danced in comparatively few motion pictures. His dramatic pictures included Westerns, Biblical epics, exposes of teen-age life, and *Peyton Place* (Twentieth-Century Fox, 1957), in which he played the good boy, "Norman."

His five musical films were spectacular and his exuberant performances made him memorable as a dance star. In Michael Kidd's *Seven Brides for Seven Brothers* (MGM, 1954), he played the youngest brother and integrated his acrobatic skills into the performances of the ballet and jazz-trained dancers who played his brothers. *Hit the Deck* (MGM, 1955) was a more conventional musical film, but in the Western, *The Fastest Gun Alive* (MGM, 1956), he did a Kidd-style dance with two shovels as partners, barres, and props. His dance work in *Tom Thumb* was dwarfed by the special effects that made him look three inches tall, but nothing could cloud his performance in *West Side Story* (Twentieth-Century Fox, 1961). As "Riff," the leader of the Jets, in Jerome Robbins' film, he dies halfway through the film, and leaves a noticeable gap. He can be seen, however, in the Jets' opening sequence, again using tumbling techniques within a ballet/jazz format, and in the dance at the gym in Robbins' stylized jitterbugging.

Tamblyn dropped out of film to pursue a career in art, becoming known for his sculpture, collages, and video art. He has performed recently in independent films made by vocalists.

Tamiris, Helen, American modern dancer and theatrical choreographer; born Helen Becker, April 24, 1905 in New York City; died there August 4, 1966. Tamiris studied ballet as a member of the children's chorus of the Metropolitan Opera Company and, as an adolescent and adult, with Mikhail Fokine. She studied modern dance at the Neighborhood Playhouse (c.1918–1920) before it became associated with the theories and teachings of Louis Horst. Before beginning her career as a concert dancer, she ap-

peared in at least one Broadway show, the *Music Box Revue of 1924* (renumbered "of 1925," after January of that year).

Although generally accepted as one of the major figures of American modern (now considered "traditional modern") dance, Tamiris' career followed the pattern of a concert dancer; she created works for herself and a small, primarily female, company to be performed on solo or shared programs, before branching out onto Broadway. Tamiris was also one of the most vital supporters of the organization of modern and concert dance, working for the Dance Repertory Theater (1930–1932), the American Dance Association, and the WPA's Federal Dance Project.

Tamiris made her concert debut on October 9, 1927 with a program of solos, including her *Florentine, Portrait of a Lady, Impressions of the Bullring*, and *Circus Sketches*. The first of her continuing series of dances based on traditional American music, the *Negro Spirituals*, was introduced in January of the next year. Her concert career (c.1927–1944) consisted almost entirely of short works created for herself or her company in conjunction with those of her contemporaries—Martha Graham, Doris Humphrey, and the choreographers of the New Dance League and Group, among them Sophie Maslow, Lily Mehlman, and Anna Sokolow. Tamiris' works, however, were not choreographed for other companies and, until shortly before her death, were not taken into the repertories of other groups. There have been attempts recently to reconstruct some of her most important works, among them the *Negro Spiritual* series (variously, 1928–1942), *How Long, Brethren?* (1937–1942), *Cycle of Unrest* (1935), and the sections of the *Walt Whitman Suite* (1934), especially *Salut au Monde* and *I Sing the Body Electric*.

Separate from her concert work was a successful Broadway choreography career. Tamiris' first theatrical works were created for experimental groups; her first four works, for example, were staged for the Provincetown players, the Group Theater (with performers who included John Garfield and Clifford Odets), and the Federal Theatre Project. After 1944, however, with only two exceptions, she worked on commercial productions, revues, and musical comedies, many of which were among the most successful shows on Broadway at the time, such as *Annie Get Your Gun* (1946) and *Plain and Fancy* (1955), each of which she also staged in London. Tamiris' shows are notable also for the caliber of dancers in their casts: apart from Daniel Nagrin, Tamiris' husband and Broadway assistant, her dancers included Lidija Franklyn, Joseph Gifford, George Bockman, Dorothy Bird, J.C. McCord, Pearl Lang, Valerie Bettis, Rod Alexander, Claude Marchant, Talley Beatty, and Pearl Primus.

Works Choreographed: CONCERT WORKS: *Florentine* (1927); *Melancholia* (1927); *Portrait of a Lady* (1927); *Circus Sketches* (1927); *The Queen Walks in the Garden* (1927); *Three Kisses* (1927); *Two Poems* (1927); *Impressions of the Bull Ring* (1927); *Tropic* (1927); *Amazon* (1927); *Subconcious, 1927* (1927); *Moods Diverse (Gayety, Perpetual Movement, Country Holiday, Hypocrisy)* (1928); *American Moods (Harmony in Athletics)* (1928); *Two Spirituals (Nobody Knows de Trouble I See, Joshua Fit de Battle ob Jericho)* (1928); *20th-Century Bacchante* (1928); *Prize Fight Studies* (1928); *Rhythm Paysan* (1928); *American Serenades I and II (aka Sonatine for Radio I and II)* (1929); *Swing Low, Sweet Chariot* added to *Negro Spirituals* (1929); *Popular Rhythms* (1929); *Dance of the City* (1929); *Revolutionary March* (1929); *Sentimental Dance* (1930); *Dirge* (1930); *Triangle Dance* (1930); *Woodblock Dance* (1931); *Olympus Americanus (Basking in the Sun, Prairie Ritual, Tempo, Dance to Hermes and Aphrodite, The Races, Triumphant)* (1931); *Mirage* (1931); *South American Dance* (1931); *Dance of Exuberance* (1931); *Triangle Dance, Part II* (1931); *Cruxificion* (1931); *Mourning Ceremonial* (1931); *Dance for a Holiday* (1931); *Transition* (1932); *Manad* (1932); *Eroica* (1932); *Composition for Group* (1932); *Git on Board, Go Down Moses* and *Little Chillen'* added to *Negro Spirituals* (1932); *Gris-Gris Ceremonial* (1932); *Walt Whitman Suite (Salut au Monde, Song of the Open Road, I Sing the Body Electric, Halcyon Days)* (1934); *Toward the Night (I—Freedom, II—Dance of War, III—Elements, IV—War, V—Work and Play)* (1934); *Group Dance* (1934); *Cycle of Unrest (Protest, The Individual and the Mass, Affirmation, Camaraderie, Conflict)* (1935); *Dance of Escape* (1935); *Flight* (1935); *Mass Study* (1935); *Harvest (Sycophants, Middle Ground, Maneuvers)* (1935); *Momentum (Unemployed, SH!—, SH!—Le-*

gion, *Nightriders, Diversion, Disclosure)* (1936); *Salut au Monde* (1936, new version of this section only); *Wade in De Water* added to *Negro Spirituals* (1937); *How Long, Brethren? (Picken' Off the Cotton, Upon de Mountain, Railroad, Scottsboro, Sistern an' Brethren, Let's Go to de Buryin', How Long, Brethren?)* (1937, note: sections of *Negro Spirituals* and *How Long, Brethren?* may have been interpolated into each other's programs after this year); *Two Diversions* and *Code* added to *Momentum* (1938); *My Call Is the Call of Battle* (1939); *Last Spring* (1940); *In the Court (Pavanne, Love's Song, Masks)* (1940); *In the Village* (1940); *Kentucky Gal* (1940); *These Yearnings, Why are They?* (1940); *Floor Show (We Present, Sister Act, Très Très Elégante, Honky Tonk, Orientale, Seventh Girl from the Left, Dumb Show, Four Torches, Finale)* (1940); *Song of Today* (1941); *As in a Dream* (1941); *Withdrawal* (1942); *The Vanished* (1941); *Vain Portrait* (1941); *Duality* (1942); *Return* (1941); *Liberty Song (What a Court Hath Old England, My Days Have Been So Wondrous Free, Bunker Hill, Ode to the Fourth of July)* (1941); *Good-Will Mission* (1942); *Waterfront Serenade* (1942); *Bayou Ballads (Suzette, When Your Potatoe's Done, Pity Poor Mlle. Zizi, Little Carnaval)* (1942); *No Hidin' Place* and *Little David* added to *Negro Spirituals* (1942); *Ode to Stalingrad* (1943); *Spanish Dance* (1944); (Note: no concert works created between 1944 and 1957); *Memoir* (1957); *Dance for Walt Whitman* (1958); *The Vine or the Tree* (1958); *Women's Song* (1960); *Memoir (II)* (1960); *Once Upon a Time . . .* (1961); *Arrows of Desire* (1963); *Rituals* (1963); *. . . Versus . . .* (1963).

THEATER WORKS: *Fiesta* (1929); *Gold Eagle Guy* (1934); *Trojan Incident* (1938); *Adelante* (1939, sections, including *Lady with a Fan,* added to concert repertory); *It's up to You* (1943, Prolog for U.S. Department of Agriculture, performed in Skouras Theatre, Washington, D.C.); *Marianne* (1944, closed on pre-Broadway tour); *Stove Pipe Hat* (1944, closed on pre-Broadway tour); *The People's Bandwagon* (1944, campaign presentation for FDR reelection); *Up in Central Park* (1945); *Annie Get Your Gun* (1946, London 1947); *Park Avenue* (1946); *The Great Campaign* (1947, directed only); *The Promised Valley* (1947, Utah Centennial Celebration); *Inside U.S.A.* (1948); *Touch and Go* (1949); *Great to Be Alive* (1950); *Bless You All* (1950); *Flahooley* (1951); *Carnival in Flanders* (1953); *By the Beautiful Sea* (1954); *Fanny* (1954); *Plain and Fancy* (1955, London 1956).

FILM: *Up in Central Park* (Universal/International, 1948).

Tanguay, Eva, Canadian-American vaudeville "cyclonic" dancer; born August 1, 1878 in Marbleton, Quebec; died January 11, 1947 in Hollywood, California. Raised in Massachusetts, Tanguay acted as a child in a variety of dramatic and musical roles, most notably as "Cedric Errol, Little Lord Fauntleroy," for five years. It is not certain when she made her New York debut, but her first legal appearance, over the age at which the Gerry Society could deny a youth labor license, was in *A Hoo-Doo* (1896), in which she played the "Fiji King's Daughter." She went on to perform in many Broadway shows, among them *My Lady* (1901), *The Chaperons* (1902), *The Office Boy* (1903), *The Sun Dodgers* (1912), *Miss Tabasco* (1914), and the tour of *The Blonde in Black* (1904).

Most of Tanguay's enormous popularity came from her vaudeville appearances. Her stage presence (the only modern performer whose presence could be compared to Tanguay's is Bette Midler) could not be contained in a plotted show; alone on the vaudeville stage, she could transform the theater. Certain elements of her performance remained constant throughout her career: the white tights that began as shocking and ended a trademark, the enormous hats, the flamboyant costumes, including one made entirely of dollar bills and another decorated with new pennies, and the signature tunes. Her songs were generally simple airs in standard song format with self-conscious lyrics, including "Please Don't Forget Me When I'm Gone," "You Can't Lose Me," "And Still They Call Me Crazy" and, of course, "I Don't Care." In the latter, especially, she was imitated by every performer, male or female, on the vaudeville or roof garden circuits, especially those managed by the booking agents with whom she was then feuding. Her rivalry with Gertrude Hoffmann was covered in intimate detail in both trade and general readership newspapers. Both sang "I Don't Care" and bought up their own contracts.

Tanguay was unable to condense her performance style to fit the medium of film. She worked in vaudeville until her retirement in the 1930s.

Tanner, Richard, American ballet dancer and choreographer; born October 28, 1948 in Phoenix, Arizona. After early training with Robert Lindgren in Phoenix, Tanner studied with Willam Christensen while attending the University of Utah.

Choreographing his first works for Christensen's company, Tanner took a small group of dancers on tour to California. There, he was seen by George Balanchine who invited him to stage one of the pieces for the School of American Ballet Workshop. That work, *Concerto for Two Solo Pianos*, led Tanner to a brief career with the New York City Ballet.

Recently, Tanner has begun staging works for the small company led by City Ballet principal Peter Martins, collaborating with him on the first version of *Calcium Light Night* (1977).

Works Choreographed: CONCERT WORKS: *Theme and Variations* (1966); *Koche #453* (1969); *Trois Pièces* (1969); *Concerto for Two Solo Pianos* (1970); *Octandre* (1970); *Octuor* (1972); *Calcium Light Night* (1977, co-choreographed with Peter Martins).

Tapps, Georgie, American tap dancer; born Mortimer Ambrose Bender, November 6, 1920 in Brooklyn, New York. Trained by John Lonergan and Alexis Yakovlev at the Ned Wayburn Studio in New York, Tapps made his debut at the Texas Guinan nightclub as an adolescent. He performed in *Americana* (1932), and worked as a specialty dancer in vaudeville before getting his best remembered part in *I'd Rather Be Right*, in 1937. During the rehearsals for that show, its star, George M. Cohan, taught Tapps his old routines, trusting him to continue a style that had existed since the turn of the century.

Although he replaced Gene Kelly in the title role of *Pal Joey* in 1942, Tapps was best known for his cabaret and Prolog work. In the latter, performing at motion picture palaces throughout the 1940s, he did solo work tapping to pieces of classical music, among them *The Fire Dance* (c.1936), the Chopin *Prelude in A*, which he performed at the White House in 1936, and Ravel's *Bolero*. Tapps and His Dancers worked extensively in Europe and England in the 1950s and early 1960s; his best known cabaret show there was *United Notions* (1957). Working on both American and European television in the 1950s, Tapps made his debut on *The Toast of The Town* on CBS in 1953.

After retiring for almost twenty years, Tapps returned to the stage in Los Angeles in a show, *There Comes a Time* (1979), that was renamed for its only performer—*Whatever Happened to Georgie Tapps?*.

Works Choreographed: CONCERT WORKS: *Bolero* (c.1933); *La Comparisita Tango* (1934); *Fire Dance* (1936); *Prelude in A* (1936).

THEATER WORKS: *Born to Dance* (1961, cabaret); *United Notions* (London, 1957); *There Comes a Time* (1979, renamed *Whatever Happened to Georgie Tapps?*).

Taras, John, American ballet dancer and choreographer working in both the United States and Europe; born April 18, 1919 in New York City. Taras was trained originally by Mikhail Fokine and made his ballet debut in a Fokine touring company in c.1938. He later continued his studies with Mme. Anderson-Ivantzova and at the School of American Ballet. Moving into the mainstream of native American ballet, he appeared with the so-called Ford Ballet (members of the Ballet Caravan who appeared at the Ford Motor Company exhibit at the 1939–1940 World's Fair), the (Catherine) Littlefield Ballet (in her *Barn Dance, Café Society*, and others) and the combined American Ballet and Ballet Caravan tour of Latin America, his first performing experience with the works of George Balanchine.

He performed in ballets by Balanchine and by Anton Dolin with Ballet Theatre as well as featured solos in the company's Fokine and/or Mikhail Mordkin productions of the nineteenth-century classics. He choreographed his first ballet for that troupe, *Graziana* (1945), for Diana Adams and the company's American corps. Although he staged ballets in the United States over the next few seasons, creating *Tchaikovsky Waltz* for the (Alicia) Markova/Dolin Ballet (1946), *Camille* for Markova and Dolin to dance with the Original Ballet Russe (1946), and *The Minotaur* (1947) for Ballet Society, he spent most of the next ten years choreographing in Europe, for the Ballets des Champs-Elysées (among them *Devoirs des Vacances*, 1949), the Monte Carlo

Opera, and the Grand Ballet du Marquis de Cuevas, including most of his output such as *Cordelia* (1951) and *Piège de Lumière* (1952).

Taras returned to the United States in 1959 as ballet master of the New York City Ballet. Although he has choreographed for the company, most notably for its Stravinsky and Ravel Festivals, he spends much of his time staging works of his own and of Balanchine for European companies. His reconstruction of *Apollo*, for example, is in the repertories of the Dutch National, the Royal (British), the Royal Danish, and dozens of American ballets. Taras has also been engaged to maintain or revive the status of European companies, serving as interim ballet master of the Paris Opéra Ballet in 1969 on sabbatical from the New York City Ballet.

Works Choreographed: CONCERT WORKS: *Graziana* (1945); *Tchaikovsky Waltz* (1946); *Camile* (1946); *The Minotaur* (1947); *Designs with Strings* (1948); *Elégie* (1948); *Persephone* (1948); *D'Amour et d'eau fraiche* (1949); *Réparateur de Radio* (1949); *Devoirs des Vacances* (1949); *Persephone (II)* (1950); *Le Bal de Jeunne Filles* (1950); *Cordelia* (1951); *Tarasiana* (1951); *Scherzo* (1952); *Piège de Lumière* (1952); *Scènes de Ballet* (1954); *La Fôret Romantique* (1955); *Fanfares pour un Prince* (1955); *Suite New-Yorkaise* (1955); *Les Baladins* (1955); *Rideau Rouge* (1955); *Le Rendez-vous Manqué* (1957; Acts I and III only); *Soirée Musicale* (1957); *L'Ile Cruel* (1957); *Octet* (1958); *Variaciones Concertantes* (1960, section of *Panamerica*, other sections choreographed by Balanchine, Francisco Moncion, and Gloria Contreras); *Ebony Concerto* (1960); *Arcade* (1960); *Fantasy* (1963); *Shadow'd Ground* (1965); *Jeux* (1966); *Haydn Concerto* (1968); *Guirlande de Campra* (1969); *Dolly Suite* (1971); *The Song of the Nightingale* (1972); *Concerto for Piano and Winds* (1972); *Scènes de Ballets* (1972); *The Song of the Nightingale* (1974); *Sacre du Printemps* (1974); *Dohnyiana Suite* (1974); *Daphnis and Chloe* (1975).

THEATER WORKS: *Where the Rainbow Ends* (1957, London).

Tarasoff, Ivan, Russian ballet dancer teaching in the United States after 1915; born 1878 in Moscow; died September 11, 1954 in New York City. Trained at the Moscow school of the Imperial Ballet, Tarasoff performed with the Bolshoi Ballet in unspecified works by Marius Petipa until 1907, when he took a position as ballet master of the Oslo National Theatre. There is no evidence to verify his claim that he performed with the Diaghilev Ballet Russe, although there is some circumstantial proof that he worked on one of the Adolf Bolm tours in 1908 or 1909.

Tarasoff emigrated to the United States to become ballet master of the Boston Grand Opera, then the home company of Maggie Teyte. He staged incidental dances for the opera repertory and, following the practice of the time, short ballets to replace one-act operas, among them *Le Bal Masqué* (1916). In New York from 1919 to his death, he directed a famous studio of Russian ballet from 1920 to 1949. He taught primarily theatrical dancers, including Mary, Pearl, and Doris Eaton (who also studied with him at the Ned Wayburn Studio), Harriet Hoctor, and Anna Robena. His casual relationship with the Wayburn studio was formalized in 1920, when he was named head ballet teacher, but that job did not last. Tarasoff and his wife, Olga, also taught extensively at Dance Masters of America conventions and normal courses.

There is no firm evidence that the Nicolai Tarasov of the Soviet ballet is Ivan's son, as has been stated in reference books, but it is possible. Tarasoff and Olga had a daughter, Margit, who taught in New York after her parents' deaths.

Tashamira, Yugoslavian concert dancer working in the United States during the 1930s and 1940s; born Vera Milcinovic c.1910 in Zagreb. Tashamira was trained in Zagreb by Margaret Frohman and later continued her studies at the Dalcroze Institute in Hellerau. After working with the Tanz Buhne in Hamburg, she moved to New York where she resided from the late 1920s on. Her American career was split between her work with Slavic folk dance groups, including the Jugoslovenski Venae, and her concert dance performances. She functioned as a recitalist for many years, presenting solo concerts in the traditional New York theaters and supplementing her income with appearances on Broadway in *The Little Shows* (1929 and 1930) and operettas set in mythical Balkan countries.

Although she continued to present recitals through

the 1940s, her most prolific period corresponded with the era of concert dance. She became active in the American Stanislavsky groups and taught movements for actors in a number of New York–area theater schools.

Works Choreographed: CONCERT WORKS: *Ornament* (1929); *Moods (Fear, Sorrow, Courage, Joy)* (1929); *Hindu Sounds* (1929); *Formata* (1929); *Mooche* (1929); *West End Blues* (1929); *Birth* (1929); *Moderne* (1933); *Opening Dance* (1933); *Religious Theme—The Covered Face* (1934); *Crystal "an it wanted to breathe"* (1934); *Romantic Interlude* (1934); *Beyond Night* (1934); *Children of the Sun* (1934); *Whim* (1934); *New York Pastel* (1934); *Cycle of Escape* (1934); *In Croation Melodies* (1934); *Prélude Romantique* (1936); *Valse* (1936); *Mystique de la Nuit* (1936); *Negro Spirituals* (1936, six individual dances performed in groups of three); *Jazz Harlem Americain* (1936); *Caprice* (1936); *Rhymes Sun Slaves* (1936); *Covered Face* (1938); *Poem of My Mountains* (1938); *Stama* (1938); *Kolo* (1938); *Invitation to the Dance* (1939); *My Native Land (Memories, Realization, It Shall Live)* (1939); *Harlem Belle* (1939); *My Red Umbrella* (1939); *Song of Excitation* (1941); *The Dance of the White Gown* (1941); *Yugoslavian Dance* (1944, full evening of folk dances); *Miserlou* (1948); *Rhapsodie Rumana* (1948); *Pastorale* (1950); *Summertime* (1960); *The Golden Angel* (1960); *Desire* (1960); *Swinging Shepherd Blues* (1960).

Taverner, Sonia, English ballet dancer working in Canada; born 1936 in Byfleet. Taverner was trained at the Elmhurst School and at the Sadler's Wells Ballet School. She performed with the Wells corps for one season before her family emigrated to Canada in 1956. Settling in Winnipeg, she joined Gwynneth Lloyd's new Royal Winnipeg Ballet, where she danced for more than a decade. Taverner has performed principal roles in almost all of the repertory, as it changes in each successive phase in the company's artistic development. She appeared in the revivals of the nineteenth-century classics in the 1950s, notably in Anton Dolin's production of *Giselle*, and in new works by Canadian and American choreographers, such as Fernand Nault's *Carmina Burana* and *Gehane*, Benjamin Harkavy's *Fête Brillante* (1957),

and Brian MacDonald's *Aimez-vous Bach?* and *Pas d'Action*.

Taverner's range of performance styles and roles was based at least partly on her unique stage presence which combined an exuberant bravura with a mature line and grace. The combination brought her guest engagements in nineteenth-century works across Canada and the United States, notably in *Swan Lake* in Boston and Montreal, and in many appearances with orchestras.

Taylor, Brenda, English ballet dancer; born 1934 in London. Taylor was trained at the Sadler's Wells Ballet School and graduated into the troupe in 1951. In her ten years with the company (during which time it was transformed into the Royal Ballet), she became celebrated for her performances in the "cooler" principal roles of the classical repertory, among them "The Lilac Fairy" in *The Sleeping Beauty* and "Myrthe" in *Giselle*, neither of which has human emotions. Taylor also appeared in roles in the contemporary English repertory in the companies and their touring divisions.

Taylor, Burton, American ballet dancer; born August 19, 1943 in White Plains, New York. After local training with Alexandra Alland, Taylor attended the Ballet Theatre School in New York, where he worked with Leon Danielian and William Griffith. He has since studied with Maggie Black and Robert Denvers at their New York studios.

Taylor's full-time company career has been very straightforward—with American Ballet Theatre (1962–1968) with featured roles in the classical repertory, and with the City Center Joffrey Ballet from 1969 to the present, with a three-year absence owing to injury. At the Joffrey he had principal roles in Joffrey's own *Pas des Déèsses*, Gerald Arpino's *Cello Concerto*, and company revivals of John Cranko's *Pineapple Poll* and Frederick Ashton's *The Dream*.

Many of his best known works, however, have been done on a guest-artist basis. As a touring partner of Carla Fracci, he has performed in Europe in principal roles in the major nineteenth-century classics, notably in the revival of *Raymonda* that was staged for them in 1976 at the Teatro San Carlo. With Anna Maria de Angelo, he has danced across

Europe, on a successful Far East tour, with the National Ballet of Mexico, in *Swan Lake, Coppélia*, and *Giselle*, and with the North Carolina School of the Arts, in Hans Brenaa's *La Sylphide* (1980).

Taylor, Jonathan, English ballet dancer and choreographer; born May 2, 1941 in Manchester, England. Trained at the Royal Academy of Dancing in London, Taylor spent a season with the National Ballet of Holland before joining the Ballet Rambert. With the company during its transition from a classical to a modern ballet repertory, he danced in both sets of works, but was best known for his performances in the contemporary ballets. He had featured roles in the company premieres of Glen Tetley's *Ziggurat* (1967), *Embrace Tiger and Return to Mountain* (1968), and *Rag Dances* (1971), and in Norman Morrice's *Realms of Choice* (1965) and *Blind Sight* (1969). Much of his choreography was created for Rambert's dancers.

Taylor also worked in the West End, creating dances for the musical productions of *Cockie* (1973) and *The Good Companions* (1974). His frequent guest appearances and choreographic gifts to the Australia Dance Theatre brought him to accept the position of artistic director in 1977.

Works Choreographed: CONCERT WORKS: *'Tis Goodly Sport* (1970); *Listen to the Music* (1972); *Star's End* (1975); *Deranged Songs* (1976); *Almost an Echo: A Celluloid Dream* (1976); *Flibbertigibbet* (1977); *The Wedding* (1978).

THEATER WORKS: *Cockie* (1973); *The Good Companions* (1974).

Taylor, June, American theatrical dancer and television choreographer; born c.1919 in Chicago. Trained at the Merriell Abbott School in Chicago from the age of ten, Taylor made her professional debut at thirteen in the chorus of the *George White Scandals*, Chicago edition. She performed with The Chez Paree Adorables act for two years until, at age seventeen, she left the United States to perform in hotels and cabarets in England, with the Ted Lewis Band. In 1938, at nineteen, she contracted tuberculosis and had to stop performing for two years.

Taylor returned to the theater as a choreographer with a troupe of six precision dancers working in local nightclubs around Chicago. While touring around the country, she met comic Jackie Gleason in 1946 when both were performing at a club in Baltimore.

Taylor's troupe made its television debut on one of the medium's earliest variety shows—*The Toast of the Town* (CBS, 1948), the first Ed Sullivan show—as The Toastettes. After performing for the first time as the June Taylor Television Dancers, on a Summer replacement show named *Broadway Spotlight* (NBC, 1949), she was reunited with Gleason on the last two seasons of the *Cavalcade of Stars* on the Dumont network (1950–1952). Although the comedy spot, *The Honeymooners*, began on the *Cavalcade*, it has never been certain whether Taylor staged Art Carney's dance/*schtik* for that famous show. When Gleason left Dumont to get his own show on CBS, Taylor went with him. She was choreographer of record on the Saturday-night *Jackie Gleason Show* throughout its screen life (1952–1959, 1962–1970), on his *American Scene Magazine* (CBS, 1962), and on his many specials.

The Taylor signature routine, popularized through the Gleason shows, lasted approximately three minutes. In each musical number, thirty-two matched female dancers performed tap, soft-shoe, or jazz dances in a straight line, culminating in the famous overhead shot of a circular formation. Although this format was a specialty of the Gleason show, and to many dance fans one of its most memorable elements, it was developed on a short-lived but very innovative Dorsey Brothers vehicle, *Stage Show* (CBS, 1954–1956), which used the so-called "I am a camera" technique in which the live show was filmed as if by a member of the audience, entering and leaving the theater and changing its focus. This technique allowed the overhead shot to combine both nostalgia (with its overtones of the Busby Berkeley films) and voyeurism.

Although unquestionably celebrated for her television work, and known for twenty years as "the lady who owns Saturday night," Taylor also staged precision routines for theaters, nightclubs, and cabarets in the United States and South America. For five years during the 1960s, she also served as choreographer for the productions of musical comedies staged at Jones Beach, New York, among them the *Pleasure Island* (1961) and *Around the World in 80 Days* (1963).

Works Choreographed: THEATER WORKS: *Pleasure Island* (1961); *Around the World in 80 Days* (1963); *Mardi Gras* (1966); acts for night-clubs in the New York and Florida areas (1946–); routines for the Miami Dolphin Cheerleaders (1977–).

TELEVISION: *The Toast of the Town* (CBS, 1948–1949); *Broadway Spotlight* (NBC, Summer 1949); *Cavalcade of Stars* (Dumont, 1950–1952); *The Jackie Gleason Show* (CBS, 1952–1959, 1962–1970); *Stage Show* (CBS, 1954–1956); *Jackie Gleason's American Scene Magazine* (CBS, 1962); *The Dom DeLuise Show* (CBS, Summer 1968).

Taylor, Mark, American modern dancer and choreographer; born April 26, 1953 in Wichita Falls, Texas. Taylor began his dance training at Swarthmore College with Patricia Wittyck Boyer and continued his studies in New York with Melissa Hayden. He has been a member of the Hannah Kahn troupe, appearing in her *Glint*, and of the Rosalind Newman company, with whom he performed in *New Berlin Dances* (1977), *Dances, Strange and Familiar, Antique and New, Festive and Otherwise* (1976), *Glen Island Casino* and |||| . Taylor also performed, in a solo and duet program with Nancy Rosensweig in works by Newman (*Parade for Solo Dancer*) and Clarice Marshall (*Twined*, 1980), as well as their own pieces. Most of his exciting choreography has been in the solo format, although he has started to prepare a series of works for a larger group.

Works Choreographed: CONCERT WORKS: *Cow Path Reel* (1979); *Volte Faccia* (1979); *The Hurricane Whirl* (1980).

Taylor, Paul, American modern dancer and choreographer; born July 20, 1930 in Alleghany County, Pennsylvania. Taylor attended the Juilliard School in 1952 and 1953, where he performed in works by, and studied with, Martha Graham, Doris Humphrey, José Limón, Margaret Craske, and Antony Tudor.

Taylor was a member of the Merce Cunningham company in 1954, performing in his *Septet* and *Fragments*. He danced with the Martha Graham company form 1955 to 1960, with featured roles in her *Clytemnestra* and *Embattled Garden* (1958), *Alcestis* (1960), and *Phaedra* (1962), and in George Balanchine's section of *Episodes* (1959), a joint performance of the Graham company and the New York City Ballet.

Taylor has choreographed since 1954. From 1954 to 1956, he participated in the Dance Associates programs, contributing choreography. The first performances of the Paul Taylor Dance Company were in 1957; he has created over fifty works for that group, among them, *Aureole* (1962), *Scudorama* (1963), *Private Domain* (1969), *Big Bertha* (1970), *Esplanade* (1975), and *Airs* (1978). Dancers in this company have included Laura Dean, Bettie de Jong, Viola Farber, Jane Kosminsky, Marian Sarach, Twyla Tharp, Dan Wagoner, and Daniel Williams Grossman, all of whom are currently choreographing for their own companies.

Works Choreographed: CONCERT WORKS: *Jack and the Beanstalk* (1954); *Circus Polka, Little Circus* (1955); *The Least Flycatcher* (1956); *4 Epitaphs* (1956, later *3 Epitaphs*); *Untitled Duet, Troupes* (1956); *Obertura Republicana* (1956, co-choreographed with Remy Charlip, Marian Sarach, David Vaughan, and James Waring); *The Tower* (1957); *Seven New Dances* (1957); *Rebus* (1958); *Images and Reflections* (1958, full company); *Option* (1960); *Images and Reflections* (1960, as duet); *Meridian* (1960, trio); *Meridian* (1960, full company); *Tablet* (1960); *The White Salamander* (1960); *Fibers* (1960); *Insects and Heroes* (1961); *Junction* (1961); *Tracer* (1962); *Aureole* (1962); *Piece Period* (1962); *La Negra* (1963); *Poetry in Motion* (1963, co-choreographed with Katherine Litz); *Scudorama* (1963); *Party Mix* (1963); *The Red Room* (1963); *Duet* (1964); *9 Dances by Corelli* (1965); *Post Meridian* (1965); *From Sea to Shining Sea* (1965); *Orbs* (1966); *Agathe's Tale* (1967); *Lento* (1967); *Public Domain* (1968); *Private Domain* (1969); *Duets* (1969); *Churchyard* (1969); *Foreign Exchange* (1970); *Big Bertha* (1970); *Book of Beasts* (1971); *Fêtes* (1971); *Guests of May* (1972); *American Genesis* (1973); *Sports and Follies* (1974); *Quartet* (1974); *Esplanade* (1975); *Runes* (1975); *Cloven Kingdom* (1976); *Polaris* (1976); *Images* (1977); *Dust* (1977); *Aphrodisiamania* (1977); *Airs* (1978); *Diggity* (1978); *Nightshade* (1979); *Profiles* (1979); *Sacre du Printemps* (1980).

Taylor-Corbett, Lynne, American theatrical and modern dancer and choreographer; born in Denver, Colorado. Trained locally by Constance Garfield, she moved to New York to continue her studies at the School of American Ballet. Her first dance jobs in-

cluded a stint with Ann Corio's *This Was Burlesque*, a tour with Jaime Rogers, and a knife-throwing act in Quebec. Returning to New York to work with James Truitte, she was accepted as a member of the Alvin Ailey Dance Theatre. Taylor-Corbett also performed on Broadway in the 1966 revival of *Oklahoma*, Michael Bennett's *Promises, Promises*, and the ill-fated *La Strada*, in which she worked with Rodney Griffin.

Taylor-Corbett and Griffin were among the founders of the Interboro Ballet, which soon changed its name to the Theatre Dance Collection. Taylor-Corbett choreographed for that company's own dancer/members and for guests, including fellow *Promises* alumna, Donna McKechnie.

Works Choreographed: CONCERT WORKS: *Flowers for Departed Children* (1972); *Double Solitude* (1973); *Kinetics* (1973); *Odd Man Out* (1974); *Diary* (1975); *Legacy* (1976); *Semantically Speaking* (1977).

Tcherepnin, Alexander, Russian composer working in Western Europe and the United States; born 1899 in St. Petersburg; died 1977 in Paris. Trained by his father, Nicolai, he created scores for ballet performance from the early 1920s to the late 1940s. He was responsible for what may be Anna Pavlova's most experimental score, *Ajanta Frescoes* (1920), but did most of his dance work in postwar France, where he composed *Le Déjeuner sur l'herbe* for Roland Petit (1945), *Chota Roustaveli* for Serge Lifar (1946), and *La Femme et son ombre* for Janine Charrat in 1948.

Tcherepnin's work with dance music fits in neatly among that of his father, who was known as the arranger of rather conventional scores for the Diaghilev Ballet Russe in its early years, and those of his sons, Serge (1941–) and Ivan (1943–), whose work with tapes and live electronic performance has led to associations with the Merce Cunningham Dance Company.

Tcherepnin, Nicolai, Russian composer and conductor; born May 15, 1873 in St. Petersburg; died June 26, 1945 in Issy-les-Miulineaux, France. A student of Rimsky-Korsakov, Tcherepnin was a staff conductor at the Maryinsky Theater when Serge Diaghilev invited him to join the Ballet Russe Paris season of 1909. He remained with the company until 1914, conducting performances and arranging music to fit choreographic needs. He composed *Le Pavillon d'Ar-*

mide for Mikhail Fokine in 1907 from themes suitable to the Crusade plot, and participated in the composition of his *Cléopâtre* in 1909. Most of his solo dance scores were created after returning to the West in 1922, although Fokine staged his *Narcisse* in 1912. His most popularly seen works for dance were probably *The Romance of a Mummy* (1924) with which Anna Pavlova toured for seven years, and *The Goldfish*, which Mikhail Fokine staged as a vehicle for Patricia Bowman at the enormous Lewissohn Stadium in New York. He was the father of Alexander Tcherepnin, and the grandfather of Serge and Ivan Tcherepnin.

Tcherina, Ludmilla, French ballet dancer and film actress; born Monique Tchemerzina, October 10, 1924 in Paris. Trained at the school of the Paris Opéra, she performed there at various times in her career; in her first period with the Opéra, she created the role of "Juliet" in Serge Lifar's ballet *Romeo and Juliet* (1942). She danced with the Opéra de Marseilles and with the Nouveaux Ballet Russes de Monte Carlo, where she created roles in Lifar's *Mephisto Valse* (1946). Returning to the Paris Opéra, she performed the principal part in the revival of *Le Martyre de Saint Sébastein*, which was created originally for Ida Rubinstein. With her own company, she danced in the stage version of Milko Sparemblik's *Les Amants de Teruel* (1959); she appeared as a guest artist in *Giselle* with many troupes in different countries.

Tcherina is also known as a film actress and dancer. From her roles in *The Red Shoes*, and *The Tales of Hoffmann*, she won a film contract with Universal Studios. Although she appeared in the films of *The Sign of the Pagan* and *Oh, Rosalinda*, she never became a popular performer in the American medium. Her best-received cinema roles were in the European films *The Lovers of Teruel* and *La Belle que Voila*.

Tcherkas, Constantine, Russian ballet dancer also working in Western Europe; born c.1903 in St. Petersburg; died January 7, 1965. Tcherkas was trained with Enrico Cecchetti, Nicholai Legat, Lubov Egorova, and Olga Preobrajenska in St. Petersburg and Paris. He performed with the Diaghilev Ballet Russe in its final six years and was given solos in

Leonid Massine's *Zéphyr et Flore* and *Les Femmes de Bonne Humeur*, George Balanchine's *La Chatte*, and the company production of *The Sleeping Princess*. Tcherkas worked in both London and Paris after Diaghilev's death in 1929. He performed in the West End production of C.B. Cochran's *1930 Revue*, in Balanchine's *Luna Park* sequence, and with the Camargo Society. In Paris, he worked at the Opéra for four years before being named ballet master of the Théâtre de l'Opéra-Comique.

Tcherkassky, Marianna, American ballet dancer; born 1955 in Glen Cove, Long Island, New York. Raised in Washington, D.C., she was trained by her mother, Lillian, a former dancer with the de Cuevas companies, and at the Washington School of Ballet. A Ford Foundation Scholarship to the School of American Ballet in New York led to a season with the (André) Eglevsky Ballet there.

A member of the American Ballet Theatre since 1970, Tcherkassky has performed to great acclaim in both classical works and new abstract ballets. Her roles in the company's revivals of the classics have included "Swanilda" in *Coppélia*, "Giselle," and the principal female parts in *La Sylphide, Les Sylphides, La Bayadère*, and *Spectre de la Rose*. Although she is generally cast as a young innocent, as in Rudi van Dantzig's *Monument for a Dead Boy*, Peter Darrell's *Tales of Hoffmann*, and Baryshnikov's version of *The Nutcracker*, she can also play with her technique. In the trio section of Dennis Nahat's *Some Times*, for example, she used her long legs and expansive movements to perfection in a cool, not innocent, performance.

Tchernicheva, Lubov, Russian ballet dancer; born September 17, 1890, in St. Petersburg; died March 1, 1976, in Richmond, England. After training at the Imperial Ballet school in St. Petersburg, Tchernicheva joined the Maryinsky company in 1908.

In 1911, Tchernicheva, with her husband, regisseur Serge Grigoriev, joined Diaghilev's Ballet Russe and remained with that company until it was dissolved in 1929. Among the many ballets in which she created roles were Leonid Massine's *Les Contes Russes* (1919), *La Boutique Fantasque* (1920), *Les Femmes de Bonne Humeur* (1920), and *Pulcinella* (1923), Bronislava Nijinska's *Les Biches* and *Les Facheux*

(both 1924), and the four early works of George Balanchine, *Jack-in-the-Box* (1927), *The Triumph of Neptune* (1927), *The Gods Go A-Begging* (1929), and as "Polyhymnia" in *Apollon Musagète* (1929). Her featured roles included "Zobeide" in Fokine's *Schéhérézade*, "The Miller's Wife" in Massine's *Le Tricorne*, and parts in *Petrouchka, Les Sylphides*, and *Carnaval*—all by Fokine.

The ballet mistress of the Diaghilev company from 1926, Tchernicheva served in that capacity for the Ballet Russe de Monte Carlo (1932–1937) and the Original Ballet Russe (1952). She and Grigoriev supervised the revivals of Fokine works from the Diaghilev repertory in England, including the 1957 Royal Ballet production of *Petrouchka*.

Teer, Barbara Ann, American actress, director, playwright, and producer who began her theatrical career as a dancer; born June 18, 1937 in East St. Louis, Illinois. Teer began her training at the local dance school directed by her aunt. She also studied with Mary Wigman in Germany and with Alwin Nikolais, Syvilla Fort, and Matt Mattox in New York before joining the early Alvin Ailey company. Her performances as a dancer include concerts and tours with Ailey, the *Pearl Bailey Dance Revue* (touring company), Louis Johnson's concert group, and Agnes De Mille's short-lived musical *Kwamina* (1961), for which she served as dance captain.

Teer has also made an important contribution to theater in the New York area. She served as director of workshops at the Harlem School of the Arts (1967–) and co-founded the Group Theatre Workshop that became the foundation of the Negro Ensemble Company. It would be impossible to list all of her accomplishments as an actress, writer, director, filmmaker, and representative of the arts as an individual artist and as producer of the National Black Theatre.

Works Choreographed: THEATER WORKS: (Note: although Teer should probably list herself as choreographer for all of her theater works, she has taken that credit only once.) *Sojourney into Truth* (1976).

Tell, Sylvia, American ballet dancer; born Sylvia Siebenthal, c.1903 in Chicago. Trained by Andreas Pavley and Serge Oukrainsky at their studio in Chicago, then affiliated with the Chicago Grand Opera,

869

she moved to New York to perform at the Metropolitan Opera in 1918 under Adolf Bolm. Tell returned to Chicago's opera house in the next season as première danseuse, dancing in concert works by Pavley and Oukrainsky, and in their opera divertissements. There is some evidence that she also performed with Arthur Corey in his private recitals in Chicago, although this cannot be verified.

Tell concentrated on teaching ballet after 1924, becoming the principal ballet master in three important institutions—the Horner Institute in Kansas City, Missouri (c.1924–1927), The Cornish School in Seattle, Washington (c.1927–1932), and The Chicago Musical College (from 1932 until her retirement).

Tempest, Florenz, American vaudeville and theatrical dancer; born Claire Lillian Ijames, c.1891 in Richmond, Virginia; date and place of death unknown. With her younger sister Mary (Marion Sunshine), she made her debut in *The Two Little Waifs* in 1901. They entered vaudeville in 1904 as Tempest and Sunshine, although the younger sister could not legally perform in New York commercial theater until 1910. Tempest was the "boy" in all nontandem work for the duo, and eventually used that characterization in her own acts. Her first big success, however, was as a female, as "The Candy Kid" in the 1908 extravaganza, *Captain Nemo*. The solo vaudeville acts that she sponsored—not performing alone on stage, but dancing without Sunshine—included *College Town* (1913), *Our American Boy* (1914), *One of the Boys* (1915), and *The Collegiates* (1919). Reunited with Sunshine after the latter outgrew the Gerry Society's age restrictions, she danced in *The Midnight Revue* (1916) in a female-female tandem act that was augmented for performances at Castle House cabaret when the Castles were on tour. Their act can be seen in the film, *Sunshine and Tempest* (Rialto Star Features, 1915).

Tempest's last known appearance was in the vaudeville bill headlined by the Marx Brothers in 1920. A notice that she planned to change her name to avoid confusion with actress Marie Tempest could make one believe that she was planning to enter the more legitimate branches of theater. If she did change her professional name, it could explain why no credits can be found for her after 1920.

Temple, Shirley, American film dancer and actress; born April 23, 1928 in Los Angeles. At age three, Temple began studying tap dance at a local children's studio where she was "discovered" and cast in the first of ten short films for Educational Films—eight *Baby Burlesks* and two *Frolics of Youth* (1932–1933). In 1934, under contract to Fox Film Corporation, she began studying dance at Ernest Belcher's Celeste School of Dance.

Between the ages of six and twenty-one, Temple made thirty-five films, the first twenty-two of which involved dance. Her dance specialty numbers were generally her machine-gun tap solos, although many of her best remembered scenes were duets with James Dunn, Buddy Ebsen, Jack Haley, and especially, Bill Robinson. Temple films were staged by Fox Film Corporation (later Twentieth-Century Fox) staff dance directors Jack Donohue, Nick Castle, and Geneva Sawyer, although it is possible that Robinson staged their duets in *The Little Colonel* (1935), *The Littlest Rebel* (1935), *Rebecca of Sunnybrook Farm* (1938), and *Just Around the Corner* (1938).

Temple retired from films in 1949 and later served as Ambassador to Ghana and United States Chief of Protocol.

Tennant, Veronica, English ballet dancer working in Canada; born 1946 in London. Trained originally at the Cone-Ripman School there, she studied with Betty Oliphant after emigrating to Toronto, Canada.

Tennant has performed with the National Ballet of Canada since 1963. She is best known for her principal roles in the company productions of the classics, among them, *La Sylphide, Les Sylphides, Cinderella*, and *Giselle*, and in Frederick Ashton's *The Sleeping Beauty* and John Cranko's *Romeo and Juliet*. Her cool performing style and flawless technique have also been highlighted in more recent works, including Roland Petit's *Kraanerg* and *Le Loup*, John Neumeier's *Don Juan*, as "Dona Ana," and Eliot Feld's *Intermezzo*.

Terabust, Elisabetta, Italian ballet dancer; born Elisabetta Terabust Maglie, August 5, 1946 in Varese. Trained by Atila Radice at the school of the Rome Opera Ballet, she performed with the company from 1963, becoming its prima ballerina. She rose to

prominence in productions of *Giselle, La Sylphide*, Bronislava Nijinska's *Les Biches*, and George Balanchine's *Symphony in C*, as well as contemporary ballets by Aurel Milloss. In 1977, after considerable guesting, she joined Roland Petit's Ballet in Marseilles. Her Petit ballets have included his *Casse-Noisette, Coppélia, Carmen, l'Arlesienne,* and *Notre Dâme de Paris*. Despite her long tenures with those companies, Terabust finds time to work frequently as a guest artist, partnering Rudolf Nureyev and seconding internationally known female ballet stars, including Natalie Makarova in her chamber ballet in 1980.

Ter-Arutunian, Rouben, Romanian-Soviet theatrical designer working in the United States throughout his career; born July 24, 1920 in Tbilis, the Union of Soviet Socialist Republics. Raised in Western Europe, he was trained at the Hollenzollern Oberreal Schule in Berlin and the Ecole des Beaux Arts in Paris.

Known for his ability to work equally well in detailed realistic roles and in ultra-abstractions, he has designed sets and costumes for ballet, modern dance, and Broadway. His theatrical productions range from Bob Fosse's *New Girl in Town* (1957) and *Redhead* (1959), to *Goodtime Charley* (1975), which was staged out of town by Dennis Nahat and on Broadway by Oona White. He has designed productions of Shakespeare on television as well as George Balanchine's presentation of the Stravinsky opera, *The Flood* (CBS, 1962).

His dance productions have included Todd Bolender's *Souvenirs* (1955), which is a satire of the 1920s, abstract sculptures for scenery in Glen Tetley's *Pierrot Lunaire* and *Sargasso* (1965), casually draped cycloramas for Jerome Robbins' *An Evening's Waltzes* (1973) and Nahat's *Some Times* (1972), the coloring book drops in for Balanchine's *Union Jack* (1976), and the beautiful series of sets for his *Vienna Waltzes* (1977), in which the foliage of each set piece lifts to form the next sequence's decor with its roots.

Bibliography: Ter-Arutunian, Rouben. "In Search of Design," *Dance Perspectives 28* (1966).

Terekoff, Miguel, Uruguayan ballet dancer; born in the 1910s in Montevideo, Uruguay. Trained at the school of the Uruguayan National Ballet, he joined the Original Ballet Russe in the early 1940s. A talented character dancer, he was known for his performances of "The Father" in David Lichine's *The Prodigal Son*, "The Stranger" in John Taras' *Camille*, and "The General" in Lichine's *Graduation Ball*. A premier danseur with the Ballet Russe de Monte Carlo in 1954, he performed comedy and character roles in the Leonid Massine repertory, notably *Gaité Parisienne* and *Le Beau Danube*.

Terekoff serves as artistic director of the Oklahoma Ballet and, under its affiliation agreement, chairperson of the Ballet Department of the University of Oklahoma. He has restaged the Ballet Russe de Monte Carlo repertory and contributed new works to his company.

Works Choreographed: CONCERT WORKS: *The Nutcracker* (1963); *The Four Moons* (1967, co-choreographed with Rosella Hightower, Roman Jasinsky, and Georges Skibine); *Bodas de Sangre* (1979); *Don Quixote* (1979); *Tumbleweeds* (1979).

Terpis, Max, Swiss ballet choreographer; born Max Pfister, March 1, 1889 in Zurich; died there March 18, 1958. The man who was described as the connective tissue between the German ballet and modern dance movements was trained as an architect before he discovered dance. He studied with Mary Wigman in Dresden in the 1920s and was named ballet master of the Hanover Opera in 1924. Throughout his tenure there and at the Berlin State Opera (1924–1930), he engaged modern and concert dancers for his companies, among them Yvonne Georgi, Alex Andre von Swaine, and Harald Kreutzberg, as well as the so-called "Berlin generation" that included Daisy Spies and Rolf Arco. He also integrated elements from his Wigman training in his choreography for the ballet companies, most notably in his *Don Morte* (1926) and *Die Fünf Wunsche* (1929).

Terpis traveled to Milan to stage ballets for the Teatro alla Scala in 1931, including his *One Thousand and One Nights* (1931, Italian title uncertain) and *Rondo Veneziano* (1931). Although he returned to his Berlin post, he was dismissed from the State Opera shortly after the Kristalnacht. He remained in Berlin as director of a private studio but was exiled to Switzerland by the late 1930s. He taught in Basel, and served briefly as ballet master of the German-

language Municipal Opera there but concentrated on opera production for the remainder of his life. His opera career was as innovative as his dance work and he was considered one of the most progressive director/producers in the postwar European era.

Works Choreographed: CONCERT WORKS: *Der Leierkasten* (The Barrel-organ) (1924); *Das Unheimliche* (The Eerie One) (1924, co-choreographed with Harald Kreutzberg); *Don Morte* (1926); *The Saved* (1927); *Prometheus* (1927); *Die Fünf Wunsche* (Five Wishes) (1929); *Die Nachtlichen* (The Clear Night) (c.1929); *One Thousand and One Nights* (1931); *Rondo Veneziano* (1931); *Mythologoische Trilogie (Orpheus Lysios, Kirke, Niobe)* (1936).

Bibliography: Terpis, Max. *Tanz und Tanzer* (Zurich: 1946).

Tetley, Glen, American modern dancer and choreographer; born February 3, 1926 in Cleveland, Ohio. A drop-out from medical school, Tetley began studying with Hanya Holm in the mid-1940s. He danced for her and assisted her as choreographer for the Broadway shows, *Kiss Me Kate* (1948) and *Out of This World* (1950). Through the 1950s, he improved his performance ability by studying with Antony Tudor and Margaret Craske and by dancing with a wide variety of modernists. Among them were John Butler, for whom he danced on television in the broadcasts of *Amahl and the Night Visitors* (NBC, 1951, et al.) and at the New York City Opera in *Carmina Burana* (1959), Pearl Lang, for whom he created a role in *And Joy Is My Witness* (1955), and Jose Limón, when he replaced Lucas Hoving in *The Moor's Pavanne*. His performances with the Martha Graham company, in her *Embattled Garden* (1958) and *Clytemnestra* (1959), were followed by a year in the American Ballet Theatre, playing "Alias" in Eugene Loring's *Billy the Kid* and dancing in Antony Tudor's *Pillar of Fire* and *Jardin aux Lilas*, and a season with Jerome Robbins' Ballets: U.S.A. in Robbins' *Moves, The Concert,* and *Events*.

As choreographer, Tetley has contributed works to the repertories of many ballet and modern dance companies, among them, the Netherlands Dance Theatre, of which he was artistic director in the 1970s, the Bat-sheva Dance Theatre, the Royal Ballet (England), the Ballet Rambert, the Munich State Opera, and the Hamburg State Opera. Many of his best known works employ innovative scenic elements, generally by Rouben Ter-Arutunian, which offset the emotionality of his movements. His *Pierrot Lunaire* (1962), *Sargasso* (1964), and *Ricercare* (1966) all deal with relationships that seem to be specific people with individual problems, but which, from the mise-en-scène, become universal. Other works are based on movement systems themselves, notably the popular *Embrace Tiger and Return to Mountain* (1968), which uses balance exercises from the Tai Chi.

Works Choreographed: CONCERT WORKS: *Richard Cory* (1948); *Daylights Dauphin* (1949); *Birds of Sorrow* (1962); *Gleams in the Bone House* (1962); *How Many Miles to Babylon* (1962); *Pierrot Lunaire* (1962); *The Anatomy Lesson* (1964); *Sargasso* (1964); *Fieldmass* (1965); *Mythical Hunters* (1965); *The Game of Noah* (1965); *Lovers* (1966); *Ricercare* (1966); *Chronochromie* (1966); *Tehilim* (1966); *Dithyramb* (1967); *Ziggurat* (1967); *Freefall* (1967); *Circles* (1968); *Embrace Tiger and Return to Mountain* (1968); *Arena* (1969); *Field Figures* (1970); *Imaginary Film* (1970); *Mutations* (1970); *Rag Dances* (1971); *Small Parades* (1972); *Threshold* (1972); *Laborintus* (1972); *Strophe-Antistrophe* (1972); *Stationary Flying* (1973); *Voluntaries* (1973); *Gemini* (1973); *Tristan* (1974); *Sacre du Printemps* (1974); *Daphnis and Chloe* (1975); *Alegrias* (1975); *Greenleg* (1975); *Contradances* (1979); *Tempest* (1979).

Tharp, Twyla, American modern dancer and choreographer; born July 1, 1941 in Portland, Indiana. Tharp began tap lessons at the age of four in Los Angeles. Moving to New York to attend college, she studied ballet with William Griffith, Margaret Craske, Richard Thomas, and Barbara Fallis, and jazz with Luigi. She trained in modern dance with Carolyn Brown (in Merce Cunningham technique), Paul Taylor, and in classes at the Martha Graham studio.

Tharp performed with the Paul Taylor Dance Company from 1963 to 1965, creating a role in his *Scudorama* (1963). In 1965, she formed her own company, known variously as Twyla Tharp and Dancers and Twyla Tharp and (names of individual

dancers). Although Tharp was originally an abstract choreographer, influenced by the works of Yvonne Rainer, Steve Paxton, and the other members of the Judson Dance Theater group that included her then husband, Robert Huot, her works since c.1970 have diverged sharply from the postmodern dance genres. She has drastically limited her movement vocabulary and has dropped task-dance procedures. During this period, she has become enormously popular; she is probably the most widely known modern dance choreographer, second only to Martha Graham. This popularity and public recognition came in part from her works for ballet companies, in part from her creations of solos and duets for well-known dancers, ice skaters, and sports figures, and also from a highly successful publicity campaign.

Although most of Tharp's works have been choreographed for her own company, she has also staged works for American Ballet Theatre—*Push Comes to Shove* (1975) and *Once More, Frank* (for the Summer 1976 benefit program only)—and for the City Center Joffrey Ballet Company—*As Times Goes By* (1973), *Deuce Coupe I* (1973) and *II* (1975), and *Happily Ever After* (1976), among others.

Works Choreographed: CONCERT WORKS: *Code Blue Lake* (1965); *Unprocessed* (1965); *Stage Show* (1965); *Tank Dive* (1965); *Jam* (1966); *One-Two-Three* (1966); *Removes* (1966); *Twelve Foot Change* (1966, the latter was renamed *Yancey Dance*); *Disperse* (1967); *Forevermore* (1967); *Three Page Sonata for Four* (1967); *Generation* (1968); *One Way* (1968); *Excess* (1968); *Idle* (1968); *Surplus* (1968); *After "Suite"* (1969); *Group Activities* (1969); *Medley* (1969); *Dancing in the Streets of Paris and London, Continued in Stockholm and Sometimes Madrid* (1969); *11 Minute Excerpt* (1970); *Hour's Work for Children* (1970); *Pymffyppmfyonm Ypf* (1970); *Rose's Cross-Country* (1970); *The Fugue* (1970); *The One-Hundreds* (1970); *Eight Jelly Rolls* (1971); *Mozart Sonata, K. 545* (1971); *Torelli* (1971); *The Bix Pieces* (1971); *The History of Up and Down, I and II* (1971); *The Raggedy Dances* (1972); *Deuce Coupe I* (1973); *As Time Goes By* (1973); *In the Beginnings* (1974); *Push Comes to Shove* (1975); *Sue's Leg* (1975); *The Double Cross* (1975); *Deuce Coupe II* (1975); *Ocean's Motion* (1975); *Give and Take*

(1976); *Once More, Frank* (1976); *Happily Ever After* (1976); *Cacklin' Hen* (1977); *Mud* (1977); *The Hodge Podge* (1977); *Country Dances* (1977); *Half the One Hundreds* (1977); *Baker's Dozen* (1979); *Chapters and Verses 1903* (1979); *Three from* [the film] *Hair* (1979); *Brahms' Paganini* (1980); *When We Were Young* (1980).

FILM: *Hair* (United Artists, 1979).

TELEVISION: *Dance and the Wide Receiver* (ABC, *Omnibus*, June 15, 1980).

Theilade, Nini, Danish ballet dancer; born 1916 in Java. After receiving her first dance lessons from her mother, Theilade studied ballet in Denmark and in Paris with Lubov Egorova. She was also trained in modern and characterizational dance by Harald Kreutzberg with whom she worked in a Salzburg production of *Everyman*.

Theilade performed in Max Reinhardt productions, among them his *Midsummer Night's Dream* on stage (1933) and film (WB, 1934), and *The Eternal Road* on stage in New York. She also toured as a concert dancer before joining the Ballet Russe de Monte Carlo, in which she created roles in Leonid Massine's *Seventh Symphony* (1938), *Nobilissima Visione* (1938), and *Bacchanale* (1939), and her own *Les Nuages* (1940).

Theilade moved to South America in the early 1940s and taught in Brazil for many years before returning to Denmark to open a school in Svendborg in 1970.

Works Choreographed: CONCERT WORKS: *Psyche* (1936); *Cirklen* (1938); *Les Nuages* (1940); *Concerto* (1950); *Kalkbillede* (1968).

Théodore, Mlle., French eighteenth-century ballet dancer associated with the works of Noverre and D'Auberval; born Marie-Madeleine Crépé, October 6, 1760, in Paris; died September 9, 1798 in Audenge, France. A student of Jean-Barthélémy Lany, Mlle. Théodore made her debut with the Paris Opéra in 1775 or 77. One of the first dancers whose career was based primarily around her prowess in the *ballet d'action* style, she was featured in many works by Jean-Georges Noverre and her husband Jean D'Auberval at the Opéra and in London; she created

roles in Noverre's *The Emperor's Cossack* (1782) and D'Auberval's *Le Réveil du Bonheur* (1784), among many others. She is best remembered as a dancer as the first "Lise" in D'Auberval's production of the original *La Fille Mal Gardée* in Bordeaux (1789), but is also known as a political and philosophical figure in prerevolutionary France.

Thesmar, Ghislaine, French ballet dancer; born March 18, 1943 in Beijing, China. Thesmar was trained at the Paris Conservatoire and at the studios of Solange Schwarz, Peggy Van Praagh, Marie Rambert, and Yvette Chauvire.

She danced with the International Ballet du Marquis de Cuevas in 1961 before joining Les Ballets de Pierre Lacotte, her husband and the choreographer with whom she is most frequently associated. She has created roles in many Lacotte's original works, among them, *Hôtel des Etrangers* (1962), *Intermèdes* (1965), and *La Proie* (1967), and his revivals of the classics, most notably his *La Sylphide*, as presented on television in 1972, and with the Paris Opéra and The Boston Ballet.

Thesmar also performed in the premieres of Georges Skibine's *Les Noces* (1962) and Nicholas Zverev's *Sérénade* (1962) for the Cuevas company, Roland Petit's *Formes* (1967) and *Schéhérézade* (1974), Brian MacDonald's *Variations Diabelli* (1974), and George Balanchine's *Chaconne* from *Orpheus* (1975) at the Paris Opéra.

She has performed as a guest artist with many companies, including the New York City Ballet, and at benefits and galas.

Thibon, Manon, French ballet dancer; born 1944 in Paris. Trained at the school of the Paris Opéra, she has performed with that company since she graduated from the school in the late 1950s. A remarkably versatile dancer, she brings an easy technique and performance style to roles in the company productions of the classics, especially to the dual role of "Odette" and "Odile" in *Swan Lake*, and to "Giselle." She has danced in character and abstract roles in Maurice Béjart's *La Damnation de Faust* and *Les Noces*, Serge Lifar's *Le Grand Cirque* (1969), *Suite en Blanc*, and *Les Mirages*, Roland Petit's *Themes et Variations* (1965) and *Turangalila* (1968), and George Balanchine's *Scotch Symphony*, *Le Palais de Cristal*, and *Four Temperaments*.

Thimey, Erika, German concert dancer performing and teaching in the United States; born in the 1910s in Itzehoc, Germany. Thimey was trained by Mary Wigman in Dresden and performed with her there. She moved to the United States in 1932 to teach at the Chicago North Shore Conservatory where she met former Wigman dancer Jan Veen (Hans Weiner). They formed a duet recital company and toured together through the 1930s. Thimey moved to Washington, D.C., in 1941 and has taught there ever since. She managed her own studio and taught for many years at Howard University, as director of its celebrated Dance Group. She has been a tremendous influence on the dance in the area and, through her work at Howard, on black dancers and choreographers across the country.

Thomas, Olive, American theatrical dancer and film actress; born Olive Duffy, c.1900 in Pittsburgh, Pennsylvania; died September 10, 1920 in Paris, France. Although Thomas had received training at the Ned Wayburn Studio of Stage Dancing, she was not considered a specialty dancer until she made her theatrical debut in the Spring, 1915 edition of the *Ziegfeld Midnight Frolic*. She appeared in all of the 1915 and 1916 editions of the midnight roof garden show, and in the 1916 *Ziegfeld Follies*. Her best known specialty was as "The Central Park Girl" in the March, 1916 *Frolic*. She was also a popular artists' model and can still be seen on the mural adorning the lobby of the New Amsterdam Theater on 42nd Street.

Thomas became a film star very quickly in the 1918 season, appearing in movies made in New York and in Hollywood. After appearing in a series of feature films for Triangle, including the popular *Betty Takes a Hand* (1918) and *Madcap Madge* (1918), she became one of the first contract players at the new Selznick Studio. She starred in a half-dozen successful films for Selznick, among them *Upstairs and Down* (1919), *Youthful Folly* (1919), *The Woman Game* (1920), *The Flapper* (1920), and the posthumous *Everybody's Sweetheart* (1920). In each, she

performed at least one social dance, while in *The Flapper* and *Footlights and Shadows* (1920), she also did a simplified theatrical soft shoe.

Although the exact details of her death may never be known, the reports following the events of September 1920 seem to prove that she commited suicide by drinking a tincture of mercury following a drug-related trauma. It is not certain whether she was involved in the use of drugs herself or whether, as Kenneth Anger suggested, she was fronting for her husband, Jack Pickford. One of the most persistent rumors along 42nd Street is that Thomas' ghost haunts the New Amsterdam and that the figure of a beautiful flapper can still be seen there—dancing.

Thomas, Richard, American ballet dancer; born in Kentucky. Thomas studied with Bronislava Nijinska in Los Angeles and at the School of American Ballet.

Thomas danced on Broadway in *Million Dollar Baby* (1945) and in Ballet Theatre, before joining the New York City Ballet. Although he took featured roles in most of the company repertory, he was best known for his character roles in Todd Bolender's *Souvenirs* (1955), Balanchine's duet for him and his wife, Barbara Fallis, in *Jeux d'Enfants* (1955), Jerome Robbins' *The Concert* (1956), and *The Nutcracker*, in which he played the original "Drosselmeyer."

One of the most popular teachers and coaches in New York, he has worked at the American Ballet Center and his own New York School of Ballet, and has served as company teacher for the American Ballet Company (the first Eliot Feld Ballet) and the U.S. Terpsichore. Although his son and namesake is now better known as a dramatic actor, he danced on Broadway as a child. His daughter, Bronwyn, is currently a freelance ballet dancer but frequently works with the U.S. Terpsichore.

Thomas, Ruth, American theatrical ballet dancer of the early twentieth century; of the number of people in this book who seem to exist in name only, Thomas, about whom no biographical information can be verified, is one of the most interesting. It is not known where or with whom Thomas was trained; one reference in a single promotional article men-

tioned her past experience with "the Russian ballerina," but it is not known with which, if any, of the touring or New York–based groups she might have worked. She can be found in the dance ensemble of the Cole Porter musical, *See America First* (1916), but within the year had persuaded the Keith management to allow her to present a ballet feature act at its Palace Theater in New York. This troupe, which also included Pemberton Stafford and La Sylphe, presented four short ballets (all by Thomas), ranging from the Grecian *The Nymph* and the abstract *Song Without Words* to the exotic *Yellow Feather* and *The Stolen Idol*. Although no Keith or other circuit credits can be found for Thomas after the end of the ballet tour in 1918, she may have continued her theatrical career for a few more years. In 1924, she was still advertising in the program of the National Vaudeville Artists' annual benefit.

Thome, Michael, American theatrical dancer; born July 24, 1951 in Salt Lake City, Utah. After local training in the Utah center of both ballet and modern dance studies, Thome moved to New York City. His work in the 1970s had been split between shows that require period movement and dance styles, such as *Rogers and Hart* (1975) and the revivals of *No No Nanette* in 1971 and *Good Times* in 1974, and new and innovative musicals. The latter category included the cult favorite *Different Times* (1972) and Michael Bennett's *A Chorus Line*. In Broadway and national companies of that show, he has played two roles: "Don," an auditioning dancer, and "Zach," the onstage choreographer.

Thompson, Clive, West Indian–American modern dancer; born October 20, c.1940 in Kingston, Jamaica. Thompson studied locally with Ivy Baxter before moving to New York in 1960 to study at the Martha Graham School of Contemporary Dance.

Performing with the Graham company from 1961 to 1966, he created roles in her *One More Gaudy Night* (1961), *Secular Games* (1962), and *Circe* (1963). He has also performed with members of the Graham company in their own choreographic recitals, creating the male roles in Yuirko's *Life of a Tree* (1963), *Flowers with Me* (1963), *Wind Drum*

(1965), *Night Fantasy* (1967), *Wanderers* (1967), and *Strange Landscape* (1968), and dancing featured roles in John Butler's *Carmina Burana* and Pearl Lang's *Shirah*.

Thompson has been a member of Alvin Ailey's Dance Theatre from 1965 to 1967 and from 1970. In that company, he has created roles in Ailey's *Myth* (1971), *The Lark Ascending* (1972), *Hidden Rites* (1973), *Black, Brown and Beige* (1976), and *Three Black Kings* (1976), among others. His many featured roles include company revivals of José Limón's *Missa Brevis*, Pearl Primus' *The Wedding*, and Shawn's *Kinetic Molpai*.

Thompson, Lydia, English pantomime performer credited with introducing the economic possibilities of female choruses to America; born February 19, 1836 in London; died there November 1908. Thompson made her theatrical debut in the title role of *Little Flaxen-hair* (c.1852) at His Majesty's Theatre, Haymarket, London, and remained on the stage for almost fifty years. She was a pantomime actress and occasionally a specialty dancer working with the St. James Theatre, in *Little BoPeep* (1855) and the Prince of Wales, in *Magic Toys* (c.1859). Her specialties included a Highland dance, presumably a fling, and a Shadow dance, which she did in the *Magic Toys*.

When Thompson first brought her troupe of pantomime performers to the United States in 1867, she was following the example of her first professional management, since His Majesty's was run by Mme. Celeste, then known as the first actress-manager to cast herself as "Harlequin" but known in the Americas as a traveling ballerina. Thompson brought the companies over in 1867–1868, 1872–1873, and 1887–1888, to great popular acclaim. Billed here as "The British Blondes," because of their flaxen wigs, she and her company, including Pauline Markham, Rose Coghall, and Eliza Weathersbey, presented a repertory of pantomimes which were called burlesques here since they burlesqued, or made fun of, specific productions. The current usage of that word to denote shows in which the female performers wear very little is also applicable to Thompson's production, so the interchanging of the word's meaning was inevitable. The repertory included such British standards as *Sinbad the Sailor* (for 1868 tour), *The Swan and Edgar* (for 1867), *The Forty Thieves* (1870), *Robinson Crusoe* (for 1877), and *A Bric-à-Brac Shop* (for the 1892 tour). Since it is unlikely that the American audiences picked up the contemporary British allusions in the rhymed librettos and lyrics, one can understand why attention was paid to costuming rather than to plot analysis. The troupe's best known piece was *Ixion, The Man in the Moon* (1868), a mythological work with a large pick-up female chorus.

Between and after American engagements, Thompson continued her pantomime career with regular seasons at London theaters and tours as far east as Russia. She was associated with the Lyceum and Royalty Theatre in London, where she presented her own versions of the standard calendar of pantomimes.

While there is no question that Thompson had a major effect on American theatrical costuming and staging, it is a shame that her influence has been downgraded recently. Many historians now say that she just happened to be the English pantomime performer who toured the United States in the right year to influence theatrical practices. They forget, however, that most intercontinental theatrical revolutions happen by chance when one actor/manager happens to be able to fund, plan, and promote a tour. Thompson was more than a typical English pantomime artist with good timing; she was spectacular enough to overcome differences in language and allusionary systems to promote a visual effect when language failed to reach her audience.

Thorogood, Alfreda, English ballet dancer; born August 17, 1942 in Lambeth, London. Thorogood was trained by Vera Volkova and George Goncharov before she entered the Royal Ballet School. She joined the Royal Ballet touring company in 1960 and was given roles in that company's *Swan Lake* and *Sleeping Beauty*, and the revival of Frederick Ashton's *The Two Pigeons*. She created roles in Geoffrey Cauley's *Symphonie Pastorale* (1969) and *Beginning* (1969), and in Antony Tudor's *Knight Errant* (1968). After joining the Royal Ballet proper in 1970, she was featured in the principal female roles of the classic repertory. Her "Swanilda" and "Aurora" were especially lauded. Thorogood also

danced in the Royal Ballet's productions of George Balanchine's *Agon,* Jerome Robbins' *Dance at a Gathering*, and Kenneth Macmillan's *Elite Syncopations* and *Mayerling*.

Thorpe, Jonothan, English ballet dancer and choreographer born October 12, 1943 in Birmingham. Thorpe was trained by Harold Turner and Errol Addison at the school of the Royal Ballet in London. He performed in Germany at the Essen home of the Kurt Jooss Company, where he was featured as the "Standard Bearer" in *The Green Table*, and at Erich Walter's Deutsche Opera am Rhein in Dusseldorf.

Returning to England in 1969, he joined the Northern Dance Theatre as a dancer and became the ballet master after 1972. He has performed in many works by Laverne Mayer there, including his *Brahms Sonata, Silent Episodes,* and *the Web*, and in John Chesworth's *Games for Five Players* and the company revival of Andrée Howard's *Death and the Maiden*. Much of his own choreography has been created for the Northern Dance Theatre.

Works Choreographed: CONCERT WORKS: *Tancredi et Clorinda* (1970); *Quartet* (1971); *The Wanderer and his Shadow* (1972); *Part Exchange* (1973); *A Woman's Love* (1974); *Stamping Ground* (1975); *Triptych* (1975); *Spring Song* (1976); *Big Fellatootssqoodgeand Nora* (1976); *Game Piano* (1978); *Metamorphosis* (1979); *Madame Butterfly* (1979).

Tihmar, David, American ballet and theatrical dancer and choreographer; born Ernest George Snodgrass, 1910 in Blair, Oklahoma; died April 16, 1971 in Oklahoma City, Oklahoma. Tihmar was trained in acting in Los Angeles (by Maria Ouspenskaya and Max Reinhardt, among others) and in dance by Bronislava Nijinska. After moving to New York, he exprimented in different dance styles in studies with Ram Gopal, José Fernandez, Harald Kreutzberg, and Vincenzo Celli. He began his professional life as a contract player with Warner Brothers and MGM, and can be seen in the Reinhardt/Nijinska *Midsummer Night's Dream* and in musicals starring Eleanor Powell, Grace Moore, and Jeanette McDonald. He joined the Adolf Bolm Ballet in 1931, possibly after dancing for him in the film, *The Mad Genius* (WB, 1930). He appeared in Bolm's revival of the dance number from that film, *Ballet Méchanique*, at the Hollywood Bowl in 1931, and with Bolm in the San Francisco Opera Ballet.

After he moved to New York Tihmar joined the Ballet Russe de Monte Carlo with which he danced for four seasons, most notably in the company productions of *Giselle* and *Princess Aurora* and in Agnes De Mille's *Rodeo*. After a tour with British actress Anna Neagle for Canadian War Relief, he did military service and returned to work on Broadway. He did what was an almost compulsory stint as "Chambers," the lead male ballet-trained dancer in De Mille's *Oklahoma*, appearing with almost every other available dancer in *Follow the Girls* (1944), and also worked in *Finian's Rainbow* (1947).

Returning to ballet, he toured with Mia Slavenska, partnering her in pas de deux from *Romeo and Juliet* (by Tudor), *Coppélia,* and *Swan Lake*, and dancing with her in his own *Belle Star* (c.1949). He divided the remainder of his career between choreographic stints at theaters outside New York and presentations at New York recitals. He also staged one Broadway revue, the *New Faces of '56*, and a number of aquacades. He was the director of the Highland Park Music Fair (c.1949–1954), The Paper Mill Playhouse, and the Oklahoma City Lyric Theatre where he was working when he died of a heart attack.

Works Choreographed: CONCERT WORKS: *Belle Star* (c.1949); *Petite Suite* (c.1949); *Spirituals* (c.1949); *American Ballad* (c.1950); *Flight of the Bumblebee* (c.1950); *The Wanderer* (c.1960); *II Samuel: 6,14* (c.1960); *White Witch of Jamaica* (c.1960); *Cass Carter: Federal Marshall* (c.1960).

THEATER WORKS: *New Faces of '56* (1956); productions for the Highland Park Music Fair (c.1949–1954); productions for The Paper Mill Playhouse (c.1949, 1955–1958); productions for the Oklahoma City Lyric Theatre (c.1960–1971); *Aquacade of 1960; Aquacade of 1961; Aquacarnival* (1962).

Tikhomirov, Vassili, Soviet ballet dancer and teacher; born March 30, 1876 in Moscow; died there June 20, 1956. Trained at the school of the Bolshoi Ballet, he was associated with that company throughout much of his career. A *danseur noble* with the company from 1893, he performed the principal roles in *Raymonda, Esmeralda* and other nineteenth-cen-

tury classsics. He partnered his wife Ykaterina Geltzer in many performances, but also toured with Anna Pavlova in 1914. He taught from very early in his life, but became director of the school as late as 1925. Among the many dancers whom he taught were Pavlova partners Mikhail Mordkin, Alexander Volinine, Laurent Novikoff, Ivan Tarasoff, and both Theodore and Alexis Kosloff. Since all of these men worked and taught in the United States, we could say that Tikhomirov' technique and style live here.

Works Choreographed: CONCERT WORKS: *La Bayadère* (1923, with Alexander Gorski); *The Red Poppy* (1927, with Lev Lashchillin); *The Red Poppy* (1933); *The Sleeping Beauty* (1934, after Petipa).

Tiller, John, English teacher associated with the development of precision-line choreography; born c.1852 in Manchester; died October 22, 1925 in New York City. Tiller opened a dance studio in Lancashire in 1886, eventually running schools in London and Manchester. These studios trained dancers into eight-, twelve-, or sixteen-women precision teams, using musical comedy or tap techniques. The teams were booked into pantomimes, music halls, and musicals. By 1912, there were Tiller Girl teams performing in Paris, Bordeaux, Australia, Austria, Turin, Glasgow, throughout England, and in the United States.

The most influential individual Tiller troupes were the team that moved to New York to perform in *The Casino Girl* and remained as The Original English Pony Ballet, the Sunshine Girls on the Canadian and American Orpheum circuit in the mid-1910s, and the Tiller Girls de Paris, which was booked almost permanently into the Folies Bergère. It should be remembered that Tiller did not generally stage the teams' actual dance routines, but only trained the performers. The French and English dances were staged by each show's dance director, while the American team work was created by Dorothy Marlowe (for the Original English Pony Ballet) and Mary Read-Clark, for the miscellaneous troupes.

Tilley, Vesta, English music hall dancer and male impersonator; born Matilda Alice Powles, c.1864 in Worcester, England; died September 16, 1952 in London. Raised in Gloucester, where her father was manager of a variety hall (using the name of Harry Ball), she made her debut as "The Great Little Tilley" at age four. Using that name, or "The Pocket Sims Reeves" (after the songwriter), she used the *schtik* of wearing boys' clothing as early as 1869, wearing an evening or sailor suit. For many years, she also did female characterizations, such as old ladies, but she was far better known for her male impersonations.

In music halls and pantomimes, Tilley was also known for the range of her male characters. Her "people," each of whom was identified in song and distinguished through dance steps, included "Algy, the Picadilly Johnny," "Dick Wittington" (her most celebrated principal boy), "A Policeman's Duty," "The Bold Militiaman," "The Midnight Son," and "Monte from Monte Carlo." She began a two-year farewell tour in 1919 which ended with a gala benefit in London in 1921. Although not particularly popular outside of England, "Our Tilley," was probably the best known music hall performer of her time.

Bibliography: *Recollections of Vesta Tilley by Lady De Freece* (her married name) (London: 1934).

Timofeeva, Nina, Soviet ballet dancer; born July 11, 1935 in Leningrad. Trained at the Leningrad Choreographic Institute, she performed briefly at the Kiev Ballet before joining the Bolshoi company in Moscow in 1956.

With that company, where she has performed most of her career, she created roles in Oleg Vinogradov's *Asel* (1967), and performed in his *Cinderella*, Grigorovich's *Spartacus*, and Nina Anisimova's *Gayane*, as well as the company productions of *Swan Lake* and *Giselle*.

Tip, Tap and Toe, American tap dance trio; this popular act (c.1934–1951) originally consisted of dancers Sammy Green, Teddy Frazier, and Raymond Winfield; after 1939, Winfield was replaced by Freddie James. Although they had worked together since the early 1930s, Tip, Tap and Toe first became generally popular with their appearances in the 1935 *George White's Scandals*. Although they were engaged at the Uptown and Downtown Cotton Clubs, they worked primarily on white presentation act and vaudeville circuits. Their basic act was a triple-challenge tap

dance performed on an oval platform, but for a number of occasions, they adapted their piece into a plotted format. At the Radio City Music Hall Christmas program of 1939–1940, for example, they did "Special Delivery," with one performer playing the doorman of a Fifth Avenue department store and the other two appearing as delivery men, carrying in their platform and props. The original trio were seen in their standard act in *You Can't Have Everything* (Twentieth-Century Fox, 1937), staged by Carl Randall.

Winfield had a brief career of his own, after his solo debut at the Paramount Theater, New York, on the bill with the Vincent Lopez Orchestra in early 1939. Later that spring he teamed up with a male dancer to do a platform competition act, billed as Winfield and Ford.

Tippet, Clark, American ballet dancer; born in Parsons, Kansas. After local studies, Tippet continued his training in New York at Thalia Mara's Academy of Ballet.

Tippet joined the American Ballet Theatre in 1972 and remained with the company for seven years, creating roles in Antony Tudor's *Leaves Are Fading* (1975) and Twyla Tharp's *Push Comes to Shove* (1976). His many featured roles included Glen Tetley's *Sphinx, Gemini,* and *Sacre du Printemps*, Dennis Nahat's *Brahms Quintet* and *Some Times*, and the company productions of *Coppélia* and *The Nutcracker*.

After leaving Ballet Theatre, Tippet performed with the Cleveland Ballet, in Nahat's works, the Maryland Ballet, and the (André) Eglevsky Ballet—all within six months. He currently freelances as a guest artist.

Titus, Antoine Danché, French nineteenth-century choreographer known for his work in Berlin and St. Petersburg; born c.1800, possibly in Paris; the details of Titus' death, sometime after 1846, cannot be verified. Titus contributed at least one ballet, an early version of *La Laitière Suisse* (1823), to the repertory of the Théâtre de la Porte-Saint-Martin in Paris before accepting the position of Ballet Master to the Berlin Court Opera in 1824. It was not unusual for a choreographer from the popular French theaters to be offered an engagement at the German court houses, but it seems to point to evidence that Titus had created more than the one ballet.

His German career consisted primarily of restagings of the company repertory and the classics of the international *ballet d'action*. When he was hired as co-ballet master to the Bolshoi Theatre, St. Petersburg, however, he began to create more original works. With his colleague, Alexis Scipion Blache, he brought the French ballet technique and the Paris popular performance style to Russia, creating a foundation for the Russian Romanticism of Ivanov and Petipa. He did stage his own versions of the Paris Opéra repertory occasionally, presenting a *Giselle* in 1842, a *La Sylphide* in 1835, and a *La Révolte au Sérail* in 1836, but is also remembered for his original work. His work ranged from the mythological ballets popular in Italy, such as *Caesar in Egypt* (1834), to Orientalia, including *Kia-Kung* (1832), to Russian historical and folk themes, as in his *Dve Volshebnitzy* (Two Sorcerers) (1846), *Ivan Susanin* (1836), and *Russlan et Ludmilla* (1842).

Titus' work and reputation have lapsed into obscurity. This is unfortunate since, like the members of the Blache family, he combined backgrounds in the popular theater with tenures at the more traditional ballet houses. It is hoped that a thorough study of his work will soon be made.

Works Choreographed: CONCERT WORKS: *La Laitière Suisse* (1823); *Kia-Kung* (1832); *Maskarad v Teatro* (1834); *Caesar in Egypt* (1834); *La Sylphide* (1835); *La Révolte au Sérail* (1836); *Dikii Ostrov* (1837); *Giselle* (1842); *Dve Tetki, ili Nastoiahchii, Proshedshii veka* (Two Aunts, past and present) (1845); *Dve Volshebnitzy* (Two Sorcerers) (1846).

OPERA: *Ivan Susanin* (1836); *Russlan et Ludmilla* (1842).

Tobias, Roy, American ballet dancer; born 1927 in Philadelphia, Pennsylvania. After local studies, presumably at the Littlefield Ballet School, Tobias joined Ballet Theatre from 1943 to 1947, creating the role of "The Boy Who Plays the Piano" in Michael Kidd's *On Stage* (1945).

After a season with the Grand Ballet du Marquis de Cuevas, Tobias joined Ballet Society and the New York City Ballet. In eleven years with the company

he became one of its most popular dancers with his exceptional elevation and constant smile. He created roles in most of the Balanchine ballets of the 1950s, among them, *A la Françaix* (1951), "The Toy Soldier" solo from the party scene of *The Nutcracker* (1954), *Roma* (1955), *Pas de Dix* (1955), *Divertimento No. 15* (1956), and the second pas de trois in *Agon* (1957). In the works of Jerome Robbins, he performed featured roles in *Age of Anxiety, The Cage*, and *Interplay*, as well as created roles in *The Pied Piper* (1951) and *Fanfare* (1953). Tobias also performed in the premieres of works by his fellow dancers, among them Todd Bolender's *The Miraculous Mandarin* (1951), *The Filly* (1953), and *Souvenirs* (1955), and Francisco Moncion's *Pastorale* (1957) and *Choros No. 7* (1960).

Tobias left the company in 1960 and spent many years teaching in Japan. From 1963 to 1965, however, he danced with the Théâtre d'Art du Ballet in Paris, notably in their revivals of Fokine ballets.

Tod, Quentin, English actor and theatrical dancer; born c.1887 in Devonshire, England. Tod made his acting debut in *Nero*, following that production with a series of appearances in plays by George Bernard Shaw, among them *Captain Brassbound's Conversion, You Never Can Tell*, and *Fanny's First Play*. His dance studies were acquired in the London studios of Enrico Cecchetti and Malvina Cavallazzi, for whom he performed at The Empire in *Christmas Eve*. Tod came to New York with *Fanny's First Play* in 1911, but remained as an exhibition ballroom dancer. He was interpolated into the musical, *The Laughing Husband* (1914), and spent the remainder of that year dancing with Louisa La Gai in San Francisco, New York, and on the vaudeville circuit in her *Danses d'Amour* act. In 1915, Elizabeth Marbury engaged him to partner her latest protégé, Helen Clarke, in a series of productions at the Princess Theater, New York. They worked together in *Nobody Home* (1915), *Very Good Eddie* (1915), and *Love O'Mike* (1917), in a celebrated trio with Clifton Webb. He was considered the most stylish dancer on Broadway, in the press' unofficial competition between him, Webb, and Vernon Castle.

Tod returned to England after the close of *Oh, My Dear* to enter the ambulance service during World War I.

Todd, Thelma, American film dancer and comedienne; born July 29, 1905 in Lawrence, Massachusetts; died December 16, 1935 in Santa Monica, California. Every era of Hollywood seems to require a blonde bombshell—Todd was the representative of that persona for the transitional sound era. She was nineteen when she was named Miss Massachusetts in a beauty contest and won a "scholarship" to the Paramount studio school. In the eleven years she spent making films, she made over forty short subjects, including items in comedy series with Zasu Pitts and Patsy Kelly, and more than fifty features. She made the transition from silent to sound films with no difficulty since her voice matched her seductive film presence. Todd is best known now for two films, the original *Maltese Falcon* (WB, 1931) and the Marx Brothers' *Monkey Business* (Paramount, 1931), in which she did not dance. However, from her earliest pictures, *Fascinating Youth* (Paramount, 1926) with the so-called "debutantes" (or studio contractees) of 1926 and *Vanishing Venus* (First National, 1927), to her last, *After the Dance* (Columbia, 1935) and *The Bohemian Girl* (MGM, released 1936), she used her dancing ability to augment her seductions. As was required from her successor, Jean Harlow, it was necessary for Todd to dance on screen to complete the characterization of the seductive bombshell.

Todd is one of those Hollywood figures who is remembered for the manner and mystery of her death. Less than a month after she had successfully prosecuted an extortion case in which a fan had threatened her life if she would not pay him to leave her alone, she was found dead. Although the case was officially closed with a verdict of suicide, it was believed for many years that she was murdered by a friend or relative of the jailed extortionist or that she was caught in the middle of a bootleg war involving the restaurant to which she left her name in Santa Monica. It has never been explained how she could have committed suicide in her car two hours before she was last seen alive.

Toguri, David, Canadian theatrical dancer and choreographer working in London; born c.1940 in Van-

couver, British Columbia. After studying there with Boris Volkoff, he moved to London where he danced in many British revues and American exports, including *Flower Drum Song* (1960), *Six in One* (1963), and *Charlie Girl* (1965).

He has choreographed musical numbers for *What a Way to Run a Revolution* (1971), *The Island of Majesty* (1972), *The Marquis of Keith* (1974), *Cole* (1974), and many productions of Shakespeare plays in Stratford, Ontario. His television projects have included the well-received and very popular series, *Rock Follies*.

Works Choreographed: THEATER WORKS: *What a Way to Run a Revolution* (1971); *The Island of Majesty* (1972); *The Marquis of Keith* (1974); *Cole* (1974); incidental dances for productions at Stratford, Ontario.

TELEVISION: *Rock Follies* (Thames/ATV, 1976).

Tomal, George, American ballet dancer; born October 21, 1924 in Chicago, Illinois. After local training under John Petri, Tomal moved to New York where he continued his studies with Igor Schwezoff, Antony Tudor, Margaret Craske, Valentina Pereyaslavec, and Yurek Lazowski. He had as varied a career in ballet as was possible in the 1940s and 1950s and performed in every medium available. As a member of Ballet Theatre from 1947 to 1949 and from 1954 to 1960, he appeared in the classical repertory but made his true mark in such contemporary works as Valerie Bettis' *A Streetcar Named Desire*, Herbert Ross' *Ovid Metamorphosis* (1958), and William Dollar's *Angrisme* (1958). He alternated ballet performances there and with Schwezoff's chamber troupe with tours with mimes Mata and Hari, while taking time out for Broadway shows, such as Albertina Rasch's late operetta *Marinka* (1945), the comedy revue *Pardon Our French* (1950), and the Jones Beach extravaganza *Arabian Nights* (1955). His television appearances included cultural series, such as *Omnibus, The Bell Telephone Hour,* and *The Ed Sullivan Shows*, but he also appeared on Max Liebman comedies, most notably *Your Show of Shows*.

Tomal began teaching early in his performance career, for Schwezoff and as ballet master of the International Dance School, New York, and the New Jersey Ballet Company, which he co-founded. He has also worked extensively in opera choreography and production in the New York–New Jersey area.

Tomasson, Helgi, Icelandic ballet dancer, performing in the United States since 1961; born 1942 in Reykjavik, Iceland. Tomasson started his dance lessons locally in the Westman Islands, then, at age nine, began formal ballet training at the National School of Reykjavik. During his adolescence, he spent summers in Copenhagen, studying and working at the Tivoli (Garden) Pantomime Theater. In the United States, he has studied with Anatole Oboukhoff and Stanley Williams, the latter at both the American Ballet Center and the School of American Ballet.

After performances with the Tivoli Pantomime Theater and Ballet, from age fifteen, Tomasson moved to New York to join the Robert Joffrey Ballet in 1961, creating a featured role in Gerald Arpino's *Incubus* (1962). With the dissolution of the early Joffrey company, Tomasson moved, with much of the group, to the Harkness Ballet. In that company, he met his wife, talented Harkness dancer Marlene Rizzo, and created roles in John Butler's *A Season of Hell* (1967), John Neumeier's *Stages and Reflections* (1968), and Benjamin Harkavy's *La Favorita* (1969).

In 1970 Tomasson became a member of the New York City Ballet, where he presently dances. As a solo variation dancer and the frequent partner of Patricia McBride, he has created roles in most of the works choreographed for the company by its ballet masters, George Balanchine and Jerome Robbins. His Robbins' creations include *The Goldberg Variations* (1971), *Dybbuk Variations* (1974, revised as *Suite of Dances* in 1980), and two works from the Ravel Festival, *Chansons Madecasses* and *Introduction and Allegro*, in 1975.

His created roles in Balanchine works include *Symphony in Three Movements* (1972), *Coppélia* (Balanchine and Danilova, 1974), *Union Jack* (1976), and *Vienna Waltzes* (1977).

Tomaszewski, Henryk, Polish dancer and mime; born November 20, 1925 in Poznan. Trained at the Cracow Ballet Academy under Ivo Gall, he performed with the Wroclaw Ballet in the company's productions of the Soviet standard repertory, *The Fountain of Bakhchisarai* and *The Red Poppy*.

Although he continues to contribute works to the Royal Danish Ballet, notably *Bagage* (1969), and the Dutch National Ballet, for whom he staged *Before Five Years Passed* (1972), he creates most of his pieces for his own Polish Mime Theatre, which was founded in 1955. Writing his own scripts and producing his own works, he creates full-evening concerts of movement and characterizational pieces. Neither conventional pantomimes nor the avant-garde experiments of Grotovski's theater, he sets his pieces on available texts, such as *Wozzeck* and *The Overcoat*, or on his observations.

Works Choreographed: CONCERT WORKS: *Bagage* (1969); *Before Five Years Passed* (1972); *Novemberhachstraum* (c.1972); *Gilgamesz* (c.1974); *Pit and Bolster* (c.1976).

THEATER WORKS: (Exact dates unavailable.) *Jeskela; The Detective; The Book; Jacob and the Angel* (all mid-1960s); *The Kernel and the Shell* (c.1970); *Luna Park* (c.1972).

Tomlinson, Mel, American ballet dancer; born January 3, 1954 in Raleigh, North Carolina. Tomlinson was trained at the North Carolina School of the Arts and performed with its resident company, the Agnes De Mille Heritage Dance Theater, in 1973. He has frequently appeared in his best known role, that of the "Head Cheerleader" in De Mille's *Texas Fourth*, since leaving the company, most notably in the Kennedy Center Award presentations of 1980. A member of the Dance Theatre of Harlem since 1974, he has been cast in almost every work in the large repertory of ballets by George Balanchine, such as *Agon* and *Concerto Barocco*, and by choreographers who include Glen Tetley and Robert North. He has taken principal roles in the company's recent revivals of *Swan Lake* and Mikhail Fokine's *Schéhérézade*.

Tompkins, Beatrice, American ballet dancer; born in the 1910s. A member of a theatrical family, Tompkins originally studied ballet to augment her acting training. After classes at the School of American Ballet, she became a member of the Ballet Caravan in which she danced in Eugene Loring's *Billy the Kid* (1939) and *City Portrait* (1939), and William Dollar's *Air and Variations*. She also performed in two other SAB-related companies—the Ford Ballet,

made up of Caravan and other dancers employed by the Ford Motor Company at the 1939–1940 World's Fair, and the American Ballet Caravan, a combined American Ballet and Ballet Caravan troupe established for a tour of Latin America. When Tompkins moved to northern California to be with her husband, Hal Keith (an NBC director considered a major innovator in the presentation of cultural events in live broadcast), who was stationed there, she performed with the San Francisco Ballet. She then toured with the Ballet Russe de Monte Carlo, with roles in the company's Balanchine repertory of *Mozartiana* and *Ballet Imperial*.

As a charter member of the Ballet Society and the New York City Ballet, she created roles in George Balanchine's *Four Temperaments* (1946, first theme), *Divertimento* (1947), the American *Symphony in C* (third movement), *Orpheus* (1948), and *Jones Beach* (1950, co-choreographed with Robbins), in Jerome Robbins' *Age of Anxiety* (1950), in Ruthanna Boris' *Cakewalk* (1951), as one of the "Endmen," and in Antony Tudor's *La Gloire* (1952). Although she had started to teach at the School of American Ballet in 1950, she left the City Ballet to join the newly formed Robert Joffrey Ballet in 1954. Among her many roles in that troupe were parts in his *Umpateedle, Harpsichord Concerto* (1955), *Pierrot Lunaire, A la Gershwin* (1959), and *Le Bal Masqué* (1955). Tompkins taught at the Joffrey school, the American Ballet Center, since 1960.

Torrence, Edna, American theatrical dancer; born c.1912 in Chicago, Illinois, or vicinity. Torrence studied with most of the available studios in Chicago, including the Andreas Pavley and Serge Oukrainsky school of the Chicago Grand Opera and the acrobatics and social dance classes of Tom Sheehy and Arthur Kretlow. She made her Broadway debut as one of the more sultry exotic dancers in *The Desert Song*, along with acrobat Pearl Regay and specialty ballerina Margaret Irving. Most of her professional career was centered in vaudeville and Prologs, however, in an acrobatic adagio and ballroom team with her younger brother, Johnny. They toured until 1928 at least, on the Keith circuit and the Balaban and Katz, Paramount/Publix, and Fanchon and Marco Prolog houses. Their most popular acts included a variety of

Maxixes, adagio duets, and satires of beboppers doing the newer dances, such as The Big Apple and The Lindy.

Toumanova, Tamara, Russian ballet dancer working in the United States after the early 1930s; born in 1919, according to legend, in a railroad car somewhere in Eastern Europe. Raised in Paris, she was trained by Olga Preobrajenska from the age of five, making her debut at seven in a benefit concert at the Trocadero.

After performing with the Paris Opéra Ballet, creating a role in Yvonne Franck's *L'Eventail de Jeanne,* she joined the Ballet Russe de Monte Carlo in 1932. She created roles there in Leonid Massine's *Jeux d'Enfants* (1932) and in George Balanchine's *Cotillion, La Concurrence,* and *Le Bourgeois Gentilhomme,* all in that year. In the next season, she performed in the premieres of his *Les Songes* and *Mozartiana* for Les Ballets '33.

Toumanova moved to New York with the Ballet Russe de Monte Carlo in 1933, where she was reunited with Massine and danced in his new *Jardin Public* (1935), *Union Pacific* (1934), and *Symphonie Fantastique* (1936), as "The Beloved." She performed Balanchine's *Balustrade* (1941) with the Original Ballet Russe, pas de deux with the Denham Ballet Russe de Monte Carlo, and Massine's *Moonlight Sonata* with Ballet Theatre (1944). In that company, she also created a role in Bronislava Nijinska's *Harvest Time* (1945) and danced in *Giselle, Swan Lake,* and the *Nutcracker* pas de deux.

Returning to Paris, she performed in a premiere of Balanchine's *Palais de Crystal* (1947, known in English as *Symphony in C*), and *Le Baiser de la Fée* (1947) with the Paris Opéra. In that company, she also performed in the premiere of Serge Lifar's *Phèdre* (1952) and danced in his productions of *Giselle* and *The Nutcracker.* With the Teatro alla Scala in 1956, she danced in Margarete Wallmann's *The Legend of Joseph* (1956) and her own *L'Epoque Romantique.*

Always esteemed as a dramatic dancer, she has acted in films since retiring from ballet. She played Anna Pavlova in the film homage to Sol Hurok, *Tonight We Sing* (Twentieth-Century Fox, 1953), danced in the movie biography of Sigmund Romberg, *Deep in My Heart* (MGM, 1955), and in Gene Kelly's *Invitation to the Dance* (MGM, 1954). She danced and acted ballerinas in suspense films by Alfred Hitchcock, *Torn Curtain* (Universal, 1966), and Billy Wilder, *The Private Life of Sherlock Holmes* (Mirisch, 1970).

Works Choreographed: CONCERT WORKS: *L'Epoque Romantique* (1956).

Toumine, Nesta, English ballet dancer and teacher associated with the development of ballet in central Canada; born Nesta Williams, c.1912 in England. Raised in Ottawa, Canada, where she studied with Gwendolyn Osbourne, she returned to England to continue her training under Margaret Craske and Nicholai Legat. She worked with Olga Preobrajenska and Lubov Egorova in Paris in the mid-1930s.

She made her debut in the London musical, *The Golden Toy* (1932), directed by Ninette De Valois and performed with the Carl Rosa Opera Company in England and Ireland. As Nesta Williams, she was a member of the Ballets Russes de Paris, a short-lived company in the mid-1930s, with a repertory by Bronislava Nijinska and Margaret Severn. While performing with the Ballet Russe de Monte Carlo in the United States, primarily in the Massine repertory, she married mime/designer Sviatoslav Toumine, and used her married name for the remainder of her career.

Returning to Ottawa in 1946, she opened the Classical Ballet Studio in 1949 and its company in 1958. She has served as director of its successor, the Ballet Imperial de Canada, since 1965. Although she has created original works for the company, she is best known for her stagings of the Mikhail Fokine repertory, both the popular works such as *Les Sylphides* and *Spectre de la Rose* and the more unusual pieces, among them *Les Elfes* and *L'Epreuve d'Amour.*

Works Choreographed: CONCERT WORKS: *Gymnopédies* (c.1960); *Mozartiana* (1961); *The Seasons* (1962).

Touron, Patrice, French ballet dancer associated with the Belgian company of Maurice Béjart since 1972; born c.1954 in Dakar, French Senegal. Touron was trained in Bordeaux, where he was raised, and continued his studies at Rosella Hightower's studio

and center in Cannes. His roles in Béjart's Ballet du XXième Siècle repertory have been primarily archetypical characters, whether *commedia* personae in *Molière* and the solo *Clair de Lune*, or superhuman characters such as "The Chosen One" in his *Sacre du Printemps*, "Death" in *I Trionfi* and the "Archangel/Devil" in *Notre Faust*. He has also appeared in Béjart's *Spectre de la Rose* and *Dichterliebe* and played "Tybalt" in his *Romeo et Juliette*.

Toye, Wendy, English ballet dancer and theatrical choreographer; born May 1, 1917 in London. A student of Marie Rambert, Toye began dancing with the Camargo Society in 1930, creating a role in Frederick Ashton's *Pomona* in that year, and dancing in the corps of *High Yellow*, which Ashton co-choreographed with Buddy Bradley. As a member of the Vic-Wells Ballet, she danced in Ashton's *Les Petits Riens, Les Deux Pigeons*, and the corps of *Job*. She also danced briefly with the Markova-Dolin company in 1934, but became more involved with theatrical choreography and performance.

After dancing in *Ballerina* (1933), *The Golden Toy* (1934), and *Tulip Time* (1935), she received her first major choreography credit on *These Foolish Things* (1938). Among her best known shows were *Little Dog Laughed* (1939), *Panama Hattie* (1943), *Bless the Bride* (1947), which she also directed, the nonmusical version of *Peter Pan* in New York (1950), *Robert and Elizabeth* (1964), and the 1971 revival of *Show Boat* (1971). She is considered an expert at working with period styles in movements and making them seem theatrical to the contemporary audience.

Works Choreographed: THEATER WORKS: (All London credits.) *Cross-Garter'd* (1937); *These Foolish Things* (1938); *Black and Blue* (1939); *The Little Dog Laughed* (1939); *Black Velvet* (1939, also performed in show); *Who's Taking Liberty* (1939); *Black Vanities* (1941); *Gangway* (1941); *It's about Time* (1942); *Best Bib and Tucker* (1942); *Hi-De-Hi* (1943); *Strike a New Note* (1943); *The Lisbon Story* (1943); *Panama Hattie* (1943); *Jenny Jones* (1944); *Strike It Again* (1944, also performed in show); *Gay Rosalinda* (1945); *Follow the Girls* (1945, also performed in show); *Big Ben* (1946, also directed); *The Shepherd Show* (1946, also directed); *Bless the Bride*

(1947, also directed); *Tough at the Top* (1949, also directed); *Peter Pan* (New York, 1950); *And So to Bed* (1951, also directed); *Wild Thyme* (1955, also directed); *Lady at the Wheel* (1958, also directed); *Virtue in Danger* (1963, also directed); *Robert and Elizabeth* (1964, also directed); *On the Level* (1966, also directed); *Show Boat* (1971, revival, also directed); *Stand and Deliver* (1972, also directed show).

Tracy, Michael, American modern dancer and choreographer; born February 1, 1952 in Florence, Italy. Tracy was trained at Dartmouth College by Ray Cook and Alison Chase before joining Pilobolus in 1974. With that company, which was founded by former Dartmouth students Moses Pendleton and Jonathan Wolken, he has performed and choreographed works within the acrobatic vocabulary. Tracy is known within the group (where identities are frequently masked in the impersonalized formations) as its finest comedian and has come to be recognized by the audience as such.

Works Choreographed: CONCERT WORKS: *Walklyndon* (1971, choreographed by Pilobolus); *Ocellus* (1972, co-choreographed with Robert Morgan Barnett and Moses Pendleton); *Monkshood* (1973, choreographed by Pilobolus); *Ciona* (1974, choreographed by Pilobolus); *Untitled* (1975, choreographed by Pilobolus); *Molly's Not Dead* (1978, choreographed by Pilobolus); *Tendril* (1979, cochoreographed with Georgiana Holmes).

Tracy, Paula, American ballet dancer; born 1939 in San Francisco, California. Trained at the school of the San Francisco Ballet, she performed with the company from 1956 to 1962, creating a role and performing the Can-Can in Lew Christensen's *Emperor Norton* (1957). She also danced there in Christensen's *Original Sin* and *Lady of Shallot*, and in George Balanchine's *Concerto Barocco*.

Leaving the company, she and her husband, Michael Smuin, toured as an adagio team in cabaret. They appeared on Broadway in *Little Me* (1962); she performed alone on Broadway in *No Strings* (1962) and can be seen fleetingly in the hilarious "Springtime for Hitler" number in the Mel Brooks film, *The Producers*.

Tracy joined the American Ballet Theatre in 1966, to appear in the classical repertory and create roles in Smuin's *Pulcinella Variations*, Eliot Feld's *A Soldier's Tale*, playing the "Whores" with Sallie Wilson, and Dennis Nahat's *Mendelssohn Symphony* (all in 1971). She returned to the San Francisco Ballet when Smuin was named co-artistic director in 1973. Still dancing with the company to great acclaim, she has created roles in Smuin's *Songs of Mahler* (1976), *Mozart's C Minor Mass* (1978), and *Shinju* (1978). A brilliant comedienne, she has been applauded in her roles in Lew Christensen's *Filling Station* and Willam Christensen's *Nothing Doing Bar*.

Trailine, Boris, French ballet dancer and teacher; born June 13, 1921 in Lemmos, Greece. Trained by Julie Sedova, Ivan Clustine, and Nicholas Zverev in Paris, he performed with the Ballet de Cannes in southern France. From 1943 to 1950, he was a member of the Nouveau Ballet de Monte Carlo, performing in the standard repertory and in Serge Lifar's *Chota roustaveli* (1946) and *Dramma per musica* (1950). As a freelance partner of Tamara Toumanova and Yvette Chauviré, he performed in *Les Sylphides, Giselle, Spectre de la Rose*, and *Swan Lake* across Europe, also dancing at the Munich State Opera in Marianne von Rosen's ballets, among them, *La Dame et le Licorne* (1953).

After the death of Alexandre Volinine in 1955, Trailine directed classes in his studio, teaching there until 1970.

Trailine, Helen, French ballet dancer; born October 6, 1928 in Bombas, Lorraine. Trailine was trained by Julie Sedova, Lubov Egorova, and Olga Preobrajenska. Trailine is best known for her performances with the alternative French ballet companies of the 1940s and 1950s—the Nouveau Ballet de Monte Carlo (1946), under Serge Lifar, Les Ballets des Champs-Elysées (1949–1950), directed by Roland Petit, Les Ballets Janine Charrat, with a repertory of Aurel Milloss, Maurice Béjart, and Charrat, and the French Ballet Russe de Monte Carlo. She was celebrated for the power and precision of her work in the classics, *Giselle, Lac des Cygnes*, and *The Nut-cracker*, but was chosen to create roles in Charrat's *Electre* (1960) and Béjart's *Haut Voltage* (1956).

Travolta, John, American film dancer and television actor; born February 18, 1954 in Englewood, New Jersey. Travolta studied tap dance with Fred Kelly from the age of five and added jazz classes with JoJo Smith and Henry Le Tang as an adult performer. After stock work, he made his professional dance debut as "Keinicke" in the national company of *Grease* and moved to Broadway in *Over Here!* (1974), choreographed by Patricia Birch, who had also choreographed *Grease*. He made some horror films in Hollywood and became a teen-age idol for his portrayal of the conceited and somewhat idiotic "Vinnie Barbarino" on *Welcome Back Kotter* (ABC, 1975–1980), before coming to national prominence in a duet of dance films. The first, *Saturday Night Fever* (Paramount, 1977), is considered the keystone of public acceptance of disco dancing as a life style and theatrical form. Travolta's dancing (coached by Smith) was integrated into the story about a young man who finds fulfillment in a disco, but it was the poster showing him in a stark white suit in the center of an empty disco floor that made him famous and gave a symbol to the period. Travolta's next film was an enlargement of *Grease* (Paramount, 1978), choreographed by Birch. He played the hero, "Danny Zukko," instead of his role from the national company, and was given additional songs and dance numbers because of the success of *Saturday Night Fever*. Unfortunately, as he performed them, the dances themselves were updated from the authentic 1950s styles to a theatricalized style reminiscent of both the "Greaser" period and of disco.

Trecu, Pirmin, Spanish ballet dancer working in England; born Pirmon Aldabaldetrecu, 1930 in Saraus, Spain. A refugee from his home in the Basque region at the outbreak of the Spanish Civil War, Trecu was raised in London where he studied at the Sadler's Wells Ballet School. A member of the Sadler's Wells Ballets from 1947 to 1961, he appeared in many early works by John Cranko, including his *Sea Change, Pastorale* (1950), *Reflection, The Lady and the Fool* (1954), and *The Prince of the Pagodas* (1957). Other

credits include roles in Andrée Howard's *Selina*, Michael Somes' *Summer Interlude*, and Frederick Ashton's *Ondine* (1958). The role of "The Boy" in Howard's *La Fête Etrange* was considered his best and most illuminating portrayal. After an injury, Trecu retired from performance to teach in Lisbon.

Trefilova, Vera, Russian ballet dancer; born 1875 in St. Petersburg; died July 11, 1943 in Paris. Trained at the St. Petersburg school of the Imperial Ballet, Trefilova was a member of the Maryinsky Theatre from 1898 until 1910. She danced in the principal roles in the repertory of nineteenth-century ballets by Lev Ivanov, including his *Tulip of Haarlem, Graziela* (1901), and *Swan Lake*, and by Marius Petipa, among them his *La Bayadère, Sleeping Beauty, Fille du Danube*, and *Raymonda*.

After leaving the Maryinsky under circumstances that have been described as political but may have had more to do with a rivalry with Mathilde Kschessinskaia, Trefilova taught in St. Petersburg. She moved to Paris where she offered a solo recital of pieces that she may have choreographed, and opened a studio. Her major performances after leaving Russia were the Diaghilev revivals of *Sleeping Beauty* in London (1921). Her ability to recapture "Aurora's" youth in the first act and her pathos in the second act were ecstatically admired throughout her career, but many English critics believed that her third act, including the celebration and grand pas de deux, was especially magnificent.

Trisler, Joyce, American modern dancer and choreographer; born in 1934 in Los Angeles, California; died October 13, 1979 in New York City. Trisler studied with Lester Horton and performed with his Dance Theatre as an adolescent, creating roles in his *Seven Scenes with Ballabilli, Prado de Pena,* and *Dedication in Our Times* (all 1952).

After Horton's death, Trisler moved to New York to attend the Juilliard School. There, she studied with Antony Tudor and created roles in works by her teachers Donald McKayle (*Out of the Chrysalis*, 1958), Anna Sokolow (*Session '58*), and Doris Humphrey, for whom she danced in *The Rock and the Spring* (1955), *Descent into the Dream* (1956), and *Dawn in New York* (1956).

From the mid-1950s through the 1960s, Trisler worked as a freelance performer in the established and ad hoc companies of John Wilson and Alvin Ailey, and in concerts at the 92nd Street YMHA, dancing for James Truitte (in *Bagatelle*, 1960, and *Variegations*, 1958), and in her own works. She also performed with the Valerie Bettis group in the 1965 concerts of the American Dance Theatre, a cooperative venture among traditional modern dancers and choreographers. One of the foremost experts in the teachings and choreography of Lester Horton, she supervised the reconstruction of his *The Beloved* for the Alvin Ailey Dance Theatre.

Although a prolific choreographer, Trisler was occasionally better known for her revivals of the works of Horton and, after 1977, of Ruth St. Denis and Ted Shawn. Her group, Danscompany, frequently performed the Denishawn repertory for entire seasons in New York and on tour without featuring her own works.

Trisler also choreographed extensively for opera companies, among them the New York City, San Francisco, and Boston Operas, and for theatrical productions. She was especially well known for her work on the New York Shakespeare Festival productions in the Delacorte Theater in Central Park each summer from 1967 to 1971. Her Broadway shows, unfortunately, were uniformly unsuccessful.

Works Choreographed: CONCERT WORKS: *Playthings of the Wind* (1956); *Journey* (1958); *The Pearl* (1958); *Place of Panic* (1958); *Bewitched* (1959); *Theater Piece* (1959); *Bergamesca* (1960); *Bronx Zoo Cantata* (1969); *Dance for Percussion* (1960); *Nite Life* (1960); *Primera Cancion* (1960); *Brandenberg Concerto* (1961); *Eccosaises* (1961); *Ballroom* (1964); *Dance for Six* (1964); *Rite of Spring* (1974); *Soliliquy of a Bhiksuni* (1974); *Four Temperaments* (1975); *Little Red Riding Hood* (1975); *Four Against the Gods* (1976); *Fantasies and Fugues* (1978); *By Dawn's Early Light* (1979); *Concerto in E* (1979).

OPERA: *King Arthur* (1968); *Beatrix Cenci* (1973); *Death in Venice* (1975); *The Good Soldier Schweik* (1976).

THEATER WORKS AND INCIDENTAL DANCES: *Everyman Today* (1958); *Put It in Writing* (1963); *Titus Andronicus* (1967); *Henry IV* (1968); *Romeo and Juliet* (1968); *Peer Gynt* (1969); *La Strada* (1969); *Look*

to the Lillies (1970); *Timon of Athens* (1971); *Great Scott!* (1971); *Ambassador* (1972).

Trouhanova, Natalia, Russian dancer working in Paris; born 1885 in Kiev; died August 25, 1956. Trouhanova was an interpretive dancer in Russian private performances before she moved to Paris. There are various theories about her training, ranging from spiritual inspiration to a revolt from ballet, but the one that seems most plausible is that she was a student of Veronine Volinine (I), who taught plastique in both St. Petersburg and Moscow in the 1880s through the 1900s.

In Paris, she created a career for herself similar to that of Ida Rubenstein. She commissioned scores and mise-en-scéne from leading composers, poets, and artists and presented recitals of two to four of these short pieces. Although Ivan Clustine, with whose studio she was affiliated, is generally credited with the choreography of the best remembered concert, it is likely but unverifiable that she created all of her solos and many of the earlier recitals. The Clustine concert is considered her most important, although it came very late in her career; in that evening she presented the premieres of Vincent D'Indy's *Istar of the Seven Gates*, Paul Dukas' *La Péri*, Florenz Schmitt's *La Tragédie de Salomé*, and Maurice Ravel's *Adelaide*. Her partners for these ballets, Theodore Cherer-Bekefi and Leo De Carva (Serge Oukrainsky), both had important influences on the development of theatricalized ballet in the United States.

Trouhanova also presented solo concerts of untitled works set to piano or chamber music, arranged as musical recitals in chronological order. Her other productions were similar to the evening described above, and included an early version of *La Tragédie de Salomé* (1907), set to the opera music by Richard Strauss, *The Miracle* (1912), *Nebuchadnezzar* (1913), *Les Sylphides* (1913), and *Narkiss* (1913), performed at Deauville.

Trouhanova retired in 1914. It is not certain why she was in Moscow at the time of her death since she lived in Paris and the south of France through her retirement.

Trouson, Marilyn, American ballet dancer working in England; born September 30, 1947 in San Francisco, California. She studied with Meriem Lanova in San Francisco before moving to London to continue her training at the Royal Ballet School in 1964.

As a member of the Royal Ballet, Trouson has performed in Frederick Ashton's *Jazz Calendar* (1968) as "Sunday's Child," in his *Lament of the Waves* (1970), and in the 1971 version of Kenneth Macmillan's *Anastasia*, as well as the company's large repertory of nineteenth century classics. She also performed with the Stuttgart Ballet during the mid-1970s.

Truitte, James, American modern dancer and choreographer; born 1925 in Chicago, Illinois. As a premed student at UCLA, Truitte studied ballet with Janet Collins and Carmelita Maracchi, Dunham technique with Archie Savage, and modern dance with Lester Horton. He joined the Horton Dance Theatre, remaining there as a dancer until Horton's death and as a teacher until c.1959.

In the Horton company, Truitte created roles in his *Another Touch of Klee* (1951), *Media* (1951), *Seven Scenes with Ballabilli* (1952), *Liberian Suite* (1952), and *Dedication in Our Times* (1952), and performed the male role in *The Beloved*. Truitte also performed featured roles in the Horton company works of Alvin Ailey and joined the Ailey Dance Theatre when he moved to New York in 1960. For Ailey, he created roles in *Gillespiana* (1960), performed in his *Revelations*, and staged company reconstructions of Horton's *Liberian Suite*.

Truitte is as well known as a teacher as he is as a choreographer. Among the schools at which he has taught Horton and his own techniques are the Ailey School of American Dance, the Clark Center for the Performing Arts in New York, and the University of Cincinnati Conservatory of Music, from 1970 to the present.

Much of Truitte's choreography has been created for recitals, for himself and fellow Horton dancer Joyce Trisler, at the 92nd Street YMHA. His works have been restaged recently for the Cincinnati Ballet. After assisting Horton on the film, *South Sea Woman*, Truitte staged dances for one film, *The Sins of Rachel Cade* (Twentieth-Century Fox, 1961).

Works Choreographed: CONCERT WORKS: *Introduction to the Dance* (1955); *Mirror, Mirror* (1956);

With Timbrel and Dance Praise His Name (1958); *Two Spirituals* (1958); *The Duke's Bard* (1958); *Variegations* (1958); *Bagatelles* (1960); *Guernica* (1971).

FILM: *The Sins of Rachel Cade* (Twentieth-Century Fox, 1961).

T'Sani, Nolan, American ballet dancer; born February 4, 1950 in Coral Gables, Florida. Trained at the School of the San Francisco Ballet and the School of American Ballet, T'Sani graduated to the New York City Ballet during the early 1970s.

One of the most highly regarded younger dancers in the company, he took featured roles in George Balanchine's *Concerto Barocco, Symphony in C* (adagio movement), *Brahms-Schoenberg Quartet,* and *Tchaikovsky Pas de Deux.* The 1975 Ravel Festival brought him three major roles in premiered works by Jerome Robbins (*Une Barque sur l'Océan*) and by Balanchine (*Gaspard de la Nuit* and *Rhapsodie Espagnole*).

T'Sani left New York to become the director of the Capital City Ballet in Sacramento, California.

Tucker, Bert, American theatrical dancer; born Albert Edward Tucker, February 5, 1905 in Hartford, Connecticut. Trained by Billy Pierce, he worked at the Oriental Theatre in Chicago with the Paul Ash Orchestra (actually jazz band) on the Balaban and Katz circuit. His own act, Kitchen Kabaret, was an eccentric flash dance in which he did high kicks and balancing tricks. Tucker appeared on Broadway in the designer's revue, *Le Maire's Affairs* (1927), but soon returned to the Prolog circuit and to tours with Ash, who is little known now but was then one of the influential band leaders and stagers of band and orchestra acts.

Tudor, Antony, English ballet dancer and choreographer who worked in the United States after 1940; born William Cook, April 4, 1908 in London, England. Trained by Marie Rambert, he continued his studies with Pearl Argyle, Harold Turner, and Margaret Craske. He joined the Ballet Rambert in 1930, creating roles in Frederick Ashton's *Façade* (1931), *The Lord of Burleigh* (1931), and *Les Rendez-vous* (1933), and in his own early works, among them, *Cross-Garter'd* (1931), *Lysistrata* (1932), and *The Planets* (1934). With the London Ballet in this pe-

riod, he also began a long career choreographing incidental dances for operas, almost all of which were standard repertory works.

Tudor emigrated to the United States to head what was then the English branch of the new Ballet Theatre company in 1940. Within a season, the three branches had combined and he had emerged as the company's most important choreographer. His works of this period were dramatic and generally based around the psychological conflicts of a single character—"Hagar" in *Pillar of Fire* (1942) and "The Transgressor" in *Undertow* (1945), for example. Many of them were set in an indeterminant period specified by the designer as Edwardian; others were mythologically based, mixing contemporary and ancient movement vocabularies. Frequently a single movement or style of gesture defines the central character—the tense hand to neck movement of "Hagar," for example.

During a season in which Ballet Theatre was not performing at all, he and the dancers associated with his works—Hugh Laing, Diana Adams, and Nora Kaye—left to join the New York City Ballet. Although he choreographed two new works there—*Lady of the Camilias* (1951) and *La Gloire* (1952)—he did not mesh into the company; his ballets used primarily his dancers. He has also set works for the Royal Swedish Ballet (1948–1949 and 1963), his students at the Juilliard School, and the dancers of the Metropolitan Opera Ballet, where he staged more productions of the nineteenth-century opera repertory.

His work has been highly influential in the United States, where he has spent most of the last forty years. Two elements of his style especially can be seen in the choreography of his dancers and students. The use of dramatic gesture, while it was not unique to him, was invested with a new importance during the period of his presence at Ballet Theatre. His use of contemporary psychological theory and iconography was as influential in the ballet as Martha Graham's was in the traditional modern dance. The constricted movement scales created for "Hagar," the paralyzing gestures of grief in *Dark Elegies,* and the tragically futile and noncommunicative social graces of *Jardin aux Lilas* and *Dim Lustre*—all have inspired audiences and dancers.

Although it has not proved of as much importance

as his concert career, Tudor also worked in theater and film in London. He staged incidental dances for plays and musicals in the West End and a musical number for the Rambert Dancers (the women of the Ballet troupe) for an early sound film, *In a Monastery Garden*. Tudor also worked extensively on television, creating dance numbers for BBC productions from 1937 to 1939.

Works Choreographed: CONCERT WORKS: *Cross-Garter'd* (1931); *Mr. Roll's Quadrilles* (1932); *Constanza's Lament* (1932); *Lysistrata* (1932); *Adam and Eve* (1932); *Pavanne Pour une Infante Defunte* (1933); *Atalanta of the East* (1933); *Paramour* (1934); *The Legend of Dick Whittington* (1934, as an interlude in T. S. Eliot's *The Rock*); *The Planets* (1934); *The Descent of Hebe* (1935); *Jardin aux Lilas* (1936); *Dark Elegies* (1937); *Suite of Airs* (1937); *Gallant Assembly* (1937); *Judgment of Paris* (1938); *Soirée Musicale* (1938); *Gala Performance* (1938); *Goya Pastoral* (1940); *Time Table* (1941); *Pillar of Fire* (1942); *The Tragedy of Romeo and Juliet* (1943); *Dim Lustre* (1943); *Undertow* (1945); *Shadow of the Wind* (1948); *The Dear Departed* (1949); *Nimbus* (1950); *Lady of the Camilias* (1951); *Les Mains Gauches* (1951); *Rondé du Printemps* (1951); *La Gloire* (1952); *Trio Con Brio* (1952); *Exercise Piece* (1953); *Little Improvisations* (1953); *Elizabethan Dances* (1953); *Britannia Triumphs* (1953); *Offenbach in the Underworld* (1954); *La Leyenda de José* (1958); *Hail and Farewell* (1959); *A Choreographer Comments* (1960); *Gradus Ad Parnassus* (1962); *Fandango* (1963); *Ekon Av Trumpeter* (Echoes of Trumpets) (1963); *Concerning Oracles* (1966); *Shadowplay* (1967); *Knight Errant* (1968); *Divine Horseman* (1969); *Continuo* (1971); *Sunflowers* (1971); *Cereus* (1972); *The Leaves Are Fading* (1975); *Tiller in the Fields* (1978).

THEATER WORKS: *The Happy Hypocrite* (1936, "Performers at Garble's Open-air Theatre''); *To and Fro* (1936, Prelude and Symphonie Russe only); *Seven Intimate Dances* (1938, two only of set given as a curtain raiser to Gogol's *Marriage*); *Johnson over Jordan* (1939); *Hollywood Pinafore* (1945, "Success Story" only); *The Day Before Spring* (1945).

FILM: *In a Monastery Garden* (British International Films, 1932).

TELEVISION: *Paleface* (BBC-TV, January 7, 1937); *Hooey* (BBC-TV, February 2, 1937); *Fugue for Four Cameras* (BBC-TV, March 2, 1937); *After Supper* (BBC-TV, March 2, 1937); *Dorset Garden* (BBC-TV, April 13, 1937); *Boulter's Lock 1908–1912* (BBC-TV, June 29, 1937); *Douanes* (BBC-TV, July 5, 1937); *Excerpts from Relache* (BBC-TV, July 8, 1937); *Siesta* (BBC-TV, September 6, 1937); *Portsmouth Point* (BBC-TV, September 6, 1937); *High Yellow* (BBC-TV, September 14, 1937); *Full Moon* (BBC-TV, October 25, 1937); *Tristan and Isolda* (Act II) (BBC-TV, January 24, 1938); *Wien* (BBC-TV, April 5, 1938); *The Emperor Jones* (BBC-TV, May 11, 1938); *Master Peter's Puppet-Show* (BBC-TV, May 29, 1938); *Cinderella* (BBC-TV, December 13, 1938); *The Tempest* (BBC-TV, February 5, 1939); *The Pilgrim's Progress* (BBC-TV, April 7, 1939).

Bibliography: Percival, John and Selma Jeanne Cohen. "Antony Tudor," *Dance Perspectives, 17* and *18* (1963).

Tudor, David, American composer and musician associated with the Merce Cunningham company; born 1926 in Philadelphia, Pennsylvania. After studies with Stefan Wolpe, Tudor began to work with Morton Feldman and John Cage in the late 1940s. Tudor, who has been called the "Merce Cunningham orchestra," is considered one of the major practitioners of live electronic music performance, specializing in the works of Cage, Feldman, Gordon Mumma, and his own compositions. He has performed with the Cunningham company since 1953 and can be seen at Events at the back or side of the stage surrounded by tables of tapes and equipment. Tudor is also known as a pioneer in the performance of prepared instruments, aleatoric musical scores, and the Western contemporary uses of the bandaneon. His own creations for the Cunningham company include the score for *Rainforest* (1968), *Changing Steps* (1973), composed in collaboration with Cage and Mumma, and an untitled collaborative work with Robert Rauschenberg.

Tune, Tommy, American theatrical dancer and choreographer; born February 28, 1940 in Wichita Falls, Texas. Raised in Houston, he worked in many stock and college productions before making his Broadway debut in Michael Bennett's first show, *A Joyful Noise* (1966). Tune moved to Hollywood where he danced in the film of *Hello, Dolly!* and assisted the choreographers of *The Dean Martin Show* and *Dean*

Martin Presents The Golddiggers. He took on various short-term jobs, such as staging the Adolph Zucker 100th Birthday Party and the MGM Float for the 1971 Macy's Thanksgiving Day Parade.

His success as a tap dancer in the film version of *The Boy Friend* led to his return to Broadway in Bennett's *Seesaw* (1973), which he also co-choreographed. In the second act of that musical, Tune stopped the show dead cold tapping in wooden clogs down a staircase into a stage filled with balloons in "It's Not How You Start But How You Finish." His six-foot-six-inch frame seemed even taller since he tapped with Baayork Lee, who is barely five-foot. After doing a one-man show, appropriately enough about Ichabod Crane, he staged dances for the Off Broadway production of *The Club* (1978), Eve Merriam's musical about members of a Victorian men's club that was performed by an all-women cast.

His work on the 1978 musical, *The Best Little Whorehouse in Texas*, brought him wide recognition as an innovator. The dance number performed by a precision troupe of cheerleaders, accompanied by mannequins, competed for shock and entertainment value with the musical routine in which the football team changes from their game outfits into their cowboy uniforms, tapping out rhythms in spikes, socks, bare feet, and boots. His most recent show, *A Day in Hollywood/A Night in the Ukraine* (1980), also involved innovative staging techniques, especially in the first half of the production. In "Hollywood," he choreographed a nostalgic trip through the famous dancers of film history, using only disembodied feet, and staged a marvelous number in which a group of ushers tapped out the film censorship code.

Works Choreographed: THEATER WORKS: *See-Saw* (1973, co-choreographed with Michael Bennett and Grover Dale); *The Club* (1978); *The Best Little Whorehouse in Texas* (1978); *A Day in Hollywood/A Night in the Ukraine* (1980, co-choreographed with Thommie Walsh, also directed).

Turnbull, Julia, American ballet dancer considered one of the earliest American-trained Romantic ballerinas; born on tour June 18, 1822 in Montreal, Canada; died September 11, 1887 in Brooklyn, New York. The daughter of J. D. Turnbull, a melodrama writer and actor, she was raised in Albany, New York, where her parents managed a stock company.

Turnbull became a member of the stock company at the famous Park Theater in New York in 1834, continuing her dance training with Eugénie Lecompte and Jules Martin of the company. In her first major work, *The Sisters* (1839, possibly staged by Martin), she apppeared with Mary Ann Lee, another American-trained dancer. Within the year, Turnbull had been invited to perform with Fanny Elssler's touring company, in which she danced and studied with James Sylvain. When he formed his own small company in 1841, she partnered him in divertissements from the Paris Opéra repertory.

From 1844 to 1850, she worked with Jules Martin's companies at the Bowery Theater, New York, and on the Mississippi circuit, in his versions of *The Bohemian Girl* (1844), *The Naiad Queen* (1847), her most celebrated role, *Giselle* (1847), in which she was partnered by George Washington Smith, and *Nathalie, la Laitière Suisse* (1848). Always known as a mime, Turnbull became a legitimate (i.e., verbal) actress after 1850, most notably with the Olympic Theater in New York.

Turner, Harold, English ballet dancer and choreographer; born December 2, 1909 in Manchester, England; died July 2, 1962 during a rehearsal at Covent Garden in London. Trained locally by Alfred Haines, Turner performed in his chamber company before he moved to London to study and dance with Marie Rambert. With the Ballet Club, he partnered Tamara Karsavina in a performance of Fokine's *Spectre de la Rose* in 1930, and he danced with the Ballet Club in early works by Frederick Ashton, including his *Nymphs and Shepherds* (1928), *Leda* (1928), and *Capriol Suite* (1930).

With the Vic-Wells Ballet, he created roles in Ashton's *Le Baiser de la Fée* (1935), *Les Patineurs* (1937), and *A Wedding Bouquet* (1937), and in Ninette De Valois' *The Rake's Progress* (1935) as "The Dancing Master," which was one of his most celebrated roles. He was also noted for his performance as "The First Red Knight" in her *Checkmate* and in the Bluebird variation in the company production of *The Sleeping Beauty*.

Turner also danced in principal parts with the International Ballet, creating roles in Mona Ingelsby's *Everyman* (1943) and *Planetomania* (1941). His characterizational abilities came to the fore in the Sadler's Wells Ballet's performances of Leonid Massine's *Clock Symphony* (1948), *La Boutique Fantasque* and *Le Tricorne*. He retired in 1950 to teach at the schools of the Sadler's Wells and Royal Ballet.

Works Choreographed: CONCERT WORKS: *Serenade* (1940); *Fête en Bohème* (1941).

Turney, Matt, American modern dancer; born c.1930 in Americus, Georgia. Trained at the University of Wisconsin and at the Martha Graham school in New York, she joined the Graham company in 1951 and continued to dance for her until 1972. Among the many works in which she created roles were Graham's *Ardent Song* (1954), *Seraphic Dialogue* (1955), *Clytemnestra* (1958), *Embattled Garden* (1958), *Visionary Recital* (1961), *Part Real—Part Dream* (1965), and *Phaedra* (1969). She has also danced in recital of choreography by colleagues Bertram Ross and Robert Cohan, for whom she performed in *Praises, The Pass*, and *Quest* (all 1960).

Turpine, Oleg, Russian ballet dancer; born November 17, 1920 on a ship off the coast of Istanbul. Turpine was trained in Paris by Lubov Egorova.

Upon moving to the United States, he joined the Original Ballet Russe in 1938, where he created the role of "Abel" in David Lichine's *Cain and Abel* (1946). With Ballet Theatre in the early 1940s, he was featured in *Spectre de la Rose, Les Sylphides*, Leonid Massine's *Symphonie Fantastique* and *Choreartium*, and Lichine's *Francesca da Rimini*. He also performed *Les Sylphides* in the Markova-Dolin company that toured the United States in the 1947–1948 season. After a season with the Ballet Russe de Monte Carlo, creating a role in Tatiana Chamié's

Birthday (1949), he rejoined Ballet Theatre for the remainder of his performing career.

Now a teacher, Turpine served as ballet master of the National Ballet, Washington, D.C., during its brief lifetime (c.1966–1974).

Tyven, Gertrude, American ballet dancer; born 1924 in Brooklyn, New York; died there February 13, 1966. Tyven was trained by Eugene Slavin and Vecheslav Swoboda at the latter's school in New York; she used the name Svobodina until 1946 in tribute to her teacher.

Performing with the Ballet Russe de Monte Carlo throughout her career, she danced featured roles in the company's revivals of *Swan Lake, The Nutcracker*, and *Les Sylphides*, and in Leonid Massine's *Le Beau Danube, Gaîté Parisienne*, and *Rouge et Noir*. She also was assigned leading roles in George Balanchine's *Danses Concertantes* and *Ballet Imperial*.

After her retirement from dancing in 1959, Tyven taught at the Ballet Russe school until 1963.

Tyven, Sonia, American ballet dancer; born c.1925 in New York City. Like her sister Gertrude, she was trained by Mme. Swoboda and by Igor Schwezoff. She performed with the Ballet Russe de Monte Carlo as Sonia Taanila with featured roles in George Balanchine's *Symphony in C*, Ruthanna Boris' *Quelque Fleurs*, and Leonid Massine's *Seventh Symphony*. Always noted for her comic touch, Tyven was cast in a variety of roles in Massine's *Gaîté Parisienne*. After touring with Alexandra Danilova's company, notably in her divertissements, she joined the New York City Ballet where she again performed in both abstract classical ballets, such as *Symphony in C* and *Allegro Brillante*, and in works that allowed her to reveal her abilities as a comedienne, such as Lew Christensen's *Con Amore* and Balanchine's *Western Symphony* and *Stars and Stripes*.

U

Uchida, Christine, American ballet dancer; born April 20, 1952 in Chicago, Illinois. Uchida received her professional training in New York at the School of American Ballet and the American Ballet Center.

Dancing with the City Center Joffrey Ballet during the early 1970s, Uchida created featured roles in Eliot Feld's *Jive* (1973), Gerald Arpino's *Chabriesque* (1972) and *Sacred Grove on Mount Tamalpais* (1972), and Twyla Tharp's *Deuce Coupe I* and *As Time Goes By* (both 1973). After touring for a year with the ill-fated musical *I, Odyssey* (called *Homer, Sweet Homer* during its brief stay on Broadway), she joined the Twyla Tharp company, with which she has danced ever since. In that company, she has created roles in Tharp's *From Hither and Yon* (1976), *Mud* (1977), *Baker's Dozen* (1979), and *And When We Were Very Young* (1980), and has performed in her repertory, notably in *Sue's Leg* and *Country Dances*.

Ulanova, Galina, Soviet ballerina; born January 8, 1910 in St. Petersburg. Ulanova was trained by her mother, Maria Romanovna, and at the school of the Petrograd State Ballet under Vaganova.

She spent the first half of her career at the Kirov Ballet (1928–1944), where she created the role of "Marie" in Zakharov's production of *The Fountains of Bakchisarai* (1933), and performed the principal roles in the classical repertory. After guesting with the Bolshoi Ballet in Moscow, she joined that company in 1944 and remained with it until her retirement in 1962. There, she danced at the premieres of new works by Lavrosky, among them, *The Red Poppy* (1950) and *The Stone Flower* (1954), but was better known for her performances in *Swan Lake, Raymonda, Don Quixote*, and especially *Giselle*. Her portrayal of "Giselle" is considered by many the most perfectly danced and creatively acted of the century; it can affect an audience more than any play. Many dancers of the West consider her the great figure of the contemporary ballet.

Ulanova was seen on tour frequently during her career; she made films of *Giselle* which were released commercially in England and the United States.

Ullate, Victor, Spanish ballet dancer; born May 9, 1947 in Saragossa, Spain. Ullate was trained by Maria de Aville and Hector Zeraspe. He performed with the classic Spanish dance troupe of Antonio before joining the Ballet du XXième Siècle in 1968. A member of the company since that year, he has created roles in the Maurice Béjart's *Farah* (1973), *Nijinsky, Clown of God* (1971), *Golestan* (1973), and *Notre Faust* (1975), and has danced in his *Romeo and Juliet* as "Mercutio," *Bhakti, Le Corsaire*, and *Ni Fleurs, Ni Couronnes*.

Ulrich, Johann, German contemporary modern dancer and choreographer; born August 3, 1944 in Osterode. Trained at the Cologne Institute of theatrical dance, he performed briefly with the Cologne Opera Ballet before founding the experimental Tanz Forum in 1971. Apart from a few pieces created for the Cologne and Bavarian State Opera Ballets in the mid-1970s, he has created works exclusively for his company, both alone and in collaboration with Jurg Barth. His pieces range from imagistic works based on literary or musical allusions, as in his tributes to *Lewis C* (1970) and *Für Maurice Ravel* (1975), to movement works set to lyrical scores from the past and present repertory.

Works Choreographed: CONCERT WORKS: *Lewis C.* (1970); *Touch* (1971); *Ballett fur Theater* (1973); *The Four Seasons* (1973); *Lyrische Suite* (1974); *Des Knaben Wunderhorn* (1974); *Sinfonietta* (1975); *Für Maurice Ravel* (1975); *Ein Requiem* (1976); *Walzertraum* (1977); *Tango* (1978); *Der Blaue Manetl* (The Blue Coat) (1979); *Paul in Kino, zu Hause und Unterwegs* (Paul at the Movies, at Home and on the Way) (1979).

Uris, Victoria, American modern dancer; born November 28, 1949. Trained at the New York University School of the Arts, she studied with Nanette Charisse, May O'Donnell, Viola Farber, Stuart Hodes, and Rachel Lampert. Among her many company credits are performances with a group comprised of fellow SOA students, the New York Dance Collective, with which she danced in works by Debra Wanner, Clarice Marshall, Rachel Lampert, Livia Drapkin, and Polly Sherer. After dancing with the companies of Norman Walker, O'Donnell, and Rosalind Newman, she joined the Paul Taylor troupe in

1975. She has appeared in many of the repertory works in that popular company, most notably in *Big Bertha, From Sea to Shining Sea, Images*, and *Aphrodisimania*, in which she enchanted the audience as "The Snake Lady."

Urmiston, Kenneth, American theatrical performer; born August 6, 1929 in Cincinnati, Ohio. From 1950, when he made his Broadway dance debut in *Make a Wish*, to the present, Urmiston has appeared in many of the most popular and most acclaimed musical comedies ever presented in New York. In chronological order, they include the Phil Silvers' comedy *Top Banana* (1951), Michael Kidd's *Guys and Dolls, John Murray Anderson's Almanac* (1953), Kidd's *Can-Can* (1953), *Silk Stockings* (1955), *Oh, Captain* (1958), Bob Fosse's *Bells Are Ringing* (1956), *Redhead* (1959), *Tenderloin* (1960), *We Take the Town* (closed out of town, 1963), *Lovely Ladies, Kind Gentlemen* (1970), Michael Bennett's *Follies* (1971), Fosse's *Pippin*, and Bennett's *Ballroom* (1978). His characterizations ranged from a callous television dancer in the first named show to a cynical denizen of the Stardust Ballroom, and included French Apaches and Japanese tea-house regulars as well as a surprisingly disparate collection of dancers in his many backstage musicals. Most of his shows used musical comedy jazz and tap forms, but he has also worked in Kidd's stylizations for *Guys and Dolls*, Fosse's angularity in *Pippin*, and Bennett's tricks of timing and pace in both the flashbacks of *Follies* and the off-focus dancing of *Ballroom*.

Usher, Graham, English ballet dancer; born May 23, 1938 in Beverley, Yorkshire; died Feburary 3, 1975 in London. Trained at the Sadler's Wells Ballet School, he performed with the Royal Ballet throughout his career. From 1955 to 1970, he followed an almost classic progression from bravura variations, as in *The Sleeping Beauty* and Frederick Ashton's *Les Patineurs*, to principal roles in the lighter full-length classics, such as "Franz" in *Coppélia* and "Colas" in *La Fille Mal Gardée*, to such typical Romantic heroes as "Florimund" and "Albrecht."

Usher retired in 1970 owing to failing health.

Uthoff, Ernst, German ballet dancer and choreographer working in Chile from 1941; born December 28, 1904 in Duisburg, Germany. Uthoff was trained by Sigurd Leeder and Kurt Jooss in Germany, joining the Jooss Ballet in 1930.

With Jooss' company, he created many of the most important roles in its repertory, among them, the "Standard Bearer" in *The Green Table* (1932) and the "Libertine" in *Impressions of a Big City* (1932). In these roles, and in parts in Jooss' *The Mirror, The Seventh Heroes, A Ball in Old Vienna*, and *Pavanne on the Death of an Infanta*, he was able to create vital characterizations with few gestures but with a powerful stage presence.

After extensive touring with the Jooss Ballet, Uthoff and his wife, Lola Botka, left the company in 1941 in Santiago, Chile, to found and direct the Ballet Nacional de Chile. Co-artistic director until 1976, he choreographed for the company and taught its dancers, creating the country's first professional ballet. Their son, Michael, performed in the United States for many years and is now artistic director of the Hartford Ballet in Connecticut.

Works Choreographed: CONCERT WORKS: *Alotria* (1957); *Carmina Burana* (1957); *The Prodigal Son* (1964).

Uthoff, Michael, Chilean ballet dancer and choreographer working in the United States from 1965; born November 5, 1943 in Santiago, Chile. After studies with his parents, Ernst Uthoff and Lola Botka, former Ballet Jooss dancers and founder/directors of the Ballet Nacional de Chile, Uthoff moved to New York to attend the Juilliard School. At Juilliard, he studied with Antony Tudor, José Limón, and Anna Sokolow, for whom he performed in the revised *Session for Six* (1964).

Uthoff became a charter member of the City Center Joffrey Ballet in 1965, creating roles in Gerald Arpino's *Olympics* (1966) and performing in company productions of Jerome Robbins' *Moves*, Arpino's *Incubus* and *Viva Vivaldi!*, and Kurt Jooss' *The Green Table*, in which he played the role created by his father, "The Standard Bearer."

After leaving the Joffrey company in 1969, Uthoff became a member of the First Chamber Dance Company (c.1970–1973) for which he danced and choreographed. In 1973, he became artistic director of the Hartford (Connecticut) Ballet. Much of his choreography has been created for this company, includ-

ing his well-known *Aves Mirabele* (1974), *Tom Dula* (1976), and a version of *The Prodigal Son* (1978).

Works Choreographed: CONCERT WORKS: *In the Glen* (1967); *Quartet* (1968); *The Pleasure of Merely Circulating* (1969); *Tenderplay* (1969); *Windsong* (1969); *Promenade* (1970); *Reflections* (1970); *Dusk* (1971); *Concerto Grosso* (1972); *Peter and the Wolf* (1972); *Danza Quatro* (1972); *10 Seconds and Counting* (1972); *Marosszek Dances* (1973); *Brahms Varia-* *tions* (1973); *Cantata* (1974); *Pastorale* (1974); *Duo* (1974); *Aves Mirabele* (1974); *Primavera* (1975); *Antumalal* (1975); *Panuelitos* (1976); *Tom Dula* (1976); *Mir Ken Geharget Veren* (1976); *Unstill Life* (1977); *Songs of a Wayfarer* (1977); *The Nutcracker* (1977); *Souvenirs* (1977); *White Mountains Suite* (1977); *Bach Cantata #10* (1978); *Patrasolifutracatramerifu* (1978); *Prodigal Son* (1978); *Mulheres* (1979); *A Little Dance* (1980); *Romeo and Juliet* (1980); *Déjeuner sur l'Herbe* (1980).

V

Vachon, Ann, American modern dancer and choreographer; born September 1, 1938 in Washington, D.C. Vachon's long career in dance has been divided evenly between performance and choreography. She presented her first work, *Strange Dreams*, in a Contemporary Dance Production Center at the 92nd Street YM-YWHA in 1959 and her next, *Cloudburst*, there in the following season. Between then and 1971, however, she did not produce works at all, but instead danced with the José Limón company in its repertory of works by Limón and Doris Humphrey. Among the works in which she performed were Humphrey's *The Shakers* and Limón's *A Choreographic Offering, Missa Brevis, There Is a Time*, and *Dances for Isadora*, in which she danced the "Primavera" solo. Vachon returned to choreography in 1971, while she continued to perform for Limón. When she left the company in the late 1970s to teach at the University of Pennsylvania, she had earned a reputation for thoughtful pieces based on both pedestrian and choreographic movements in ingenious patterns.

Works Choreographed: CONCERT WORKS: *Strange Dreams* (1959); *Cloudburst* (1960); *Resoundings* (1971); *Changling* (1972); *Quest* (1973); *Concerto Grosso* (1974, after Limón); *Womanways* (1975); *The Light Fantastic* (1975); *Amin's Dream* (1976); *Six Poems* (1976); *Three Epicycles* (1977); *First Walking Dance* (1977); *From the Notebooks of Leonardo da Vinci* (1977); *The Telling* (1978); *Chufa* (1979); *In the Blue* (1979); *Changes* (1979); *Stone Sycle* (1979, in collaboration with Karen Bamonte); *Bedtimestory* (1980).

Vainonen, Vassili, Soviet ballet dancer and choreographer; born February 21, 1901 in St. Petersburg; died March 23, 1964 in Moscow. Trained at the school of the Imperial Theatres, he joined GATOB as a character dancer. First choreographing for an Evening of Young Ballet (the Soviet version of a recital), he presented his *Moszokowski Waltz* in c.1924. His first major recognition came from the controversy surrounding his production of *The Golden Age* (1930), which was considered the first example of the acrobatic style that has come to be as-

sociated with the Bolshoi company. He staged works for the Kirov and Bolshoi theatres and, in 1950, served as ballet master of the State Opera Ballet of Belgrade.

Works Choreographed: CONCERT WORKS: *Moszokowski Waltz* (c.1924); *The Golden Age* (1930); *The Nutcracker* (1934); *Raymonda* (1938); *Partisan Days* (1937); *Militza* (1947); *Mirandolina* (1949); *The Little Humpbacked Horse* (1949); *The Cost of Happiness* (1952); *Gayanne* (1957).

Valberkh, Ivan, Russian early nineteenth-century ballet dancer and choreographer; born 1766 in St. Petersburg; died July 14, 1819. After studying in St. Petersburg with Gasparo Angiolini, Valberkh continued training with his successor, Charles Le Picq, and performed in his revivals of Noverre ballets. By 1794, he was named inspector of the St. Petersburg Bolshoi Theatre and director of its affiliated ballet school. Valberkh remained in St. Petersburg for the remainder of his career, except for the 1807–1808 season when he was invited to reorganize the Moscow Bolshoi training system.

Valberkh's ballets can be divided into two styles: melodramatic works based on contemporary fiction, and patriotic spectacles created during the Russian campaigns of the Napoleonic Wars. Beginning with *The New Werther* in 1799, the early works include *Count Castelli, or the Criminal Brother* (1804) and *The American Heroine, or Perfidy Punished* (c.1807) (Russian titles unavailable). The patriotic ballets, all created around 1812, have translated titles ranging from *The New Heroine, or the Woman Cossack* and *The Russians in Germany, or the Consequences of Love for the Motherland* to *A Russian Village Fête*, co-choreographed with folk specialist Auguste Poireau.

Works Choreographed: CONCERT WORKS: (Note: Russian titles unavailable for all works.) *The New Werther* (1799); *Clara, or the Resort to Virtue* (c.1802); *Bianca, or Marriage Out of Revenge* (1803); *Count Castelli, or the Criminal Brother* (1804); *The American Heroine, or Perfidy Punished* (c.1807); *Romeo and Juliet* (1809); *The New Heroine, or the Woman Cossack* (c.1812); *Love for the Motherland*

(1812); *A Cossack in London* (1812); *The Russians in Germany, or the Consequences of Love for the Motherland* (1812); *A Festival in the Allied Armies' Camp at Monmartre* (1812); *Russia's Victory, or the Russians in Paris* (1812); *A Russian Village Fête* (1812, co-choreographed with Auguste Poireau).

Valentine, Paul, American theater and film dancer; born William Wolf Daixel, March 23, 1919 in New York City. Trained by Mikhail Mordkin, Valentine made his professional debut with the Ballet Russe de Monte Carlo in 1933, dancing as "Valodia [Val or Vasya] Valentinoff." He used that name on Broadway in *Virginia* (1937), *Sons o' Fun* (1941), and *Follow the Girls* (1944). After the latter show's two-year run, he moved to Hollywood to dance in *Out of the Past* (RKO, 1947), *Love Happy* (UA, 1949), and *Something to Live For* (Paramount, 1952).

He returned to Broadway as Paul Valentine to take featured roles in *Wish You Were Here* (1952) and *Oh, Captain* (1958). He also staged acts for his wife, Lili St. Cyr, and for other ecdysiastic performers.

Valentino, Rudolph, Italian dancer and film idol; born Rodolpho Gugliemini, May 6, 1895 in Castellana, Italy; died August 23, 1923 in New York. In the eight years between his arrival in the United States in 1913 and his first stardom after the release of *The Four Horsemen of the Apocalypse* in 1921, Valentino supported himself as an exhibition ballroom and film dancer. As a demonstration dancer (which was not then a euphemism for gigolo) he taught dances to unescorted women in New York and Los Angeles clubs, sharing his Tait's engagement in the latter city with the brother and sister team, Fanchon and Marco. His first known movie appearance was as a background dancer in the third episode of Irene Castle's serial, *Patria* (International Film Services, 1916), filmed in New York.

In Hollywood, too, he appeared in films as a dancer before rising to stardom; his Apache in *A Rogue's Romance* (Vitaphone, 1919) is frequently included in compilation movies about him or the silent film era. The motion picture that made him a star, *The Four Horsemen of the Apocalypse* (Metro, 1921), included a celebrated, and still fabulously sexy, sequence in which he seduced Alice Terry during a tango. He became an idol with *The Sheik* (Laskey-Paramount, 1921) and with his final four films. While it is difficult to judge Valentino as an actor without an emotional feeling for his times, one can easily see what a good dancer he was. He brought a sense of drama and the specifics of each plot into the dances and, even without reference to correct film scores, enveloped the viewer in the rhythm of the music.

Van, Bobby, American theatrical dancer; born Bobby Stein, December 6, 1930 in New York City; died July 31, 1980 in Los Angeles, California. The son of vaudevillian Harry King, Van claimed to have had no formal dance training. After a short career as a jazz musician, Van made his Broadway debut in *Alive and Kicking* (1950), and followed that show with *Red, White and Blue* (1950) and the 1954 revival of *On Your Toes*.

Van was under contract to MGM during the 1950s, performing as a specialty dancer in an Esther Williams vehicle, *Skirts Ahoy!* (1952), and as a dancing actor in *Because You're Mine* (1952), *The Affairs of Dobie Gillis* (1953), and *Kiss Me Kate* (1953). In the latter he partnered Joan McCracken in "From This Moment On" that also featured Hollywood's finest—Ann Miller, Carol Haney, and Bob Fosse. His "Hippity-hoppity Hop" in *Small Town Girl* (1953), in which he bounced in rhythm for the entire five-minute dance number, was featured in the second *That's Entertainment*. He returned to film in the early 1970s as a USO performer in the musical remake of *Lost Horizons*.

Van's career was revived in 1971 when he starred in the revival of *No, No, Nanette*. His tap dancing and charm won the audience over to his character. Van also performed frequently on television—hosting game shows, dancing and singing on variety shows, and starring in a musical special with his wife, Elaine Joyce, in 1973.

Vance, Norma, American ballet dancer; born Norma Kaplan, May 1927, in New York City; died in a crash of a private plane which is believed to have occurred on April 15, 1956. A student of Maria Yurievna-Swoboda and Mikhail Mordkin as an adolescent, Vance performed with a variety of ad hoc companies,

among them, the New York Philharmonic Children's Concert series troupe (at age nine) and the Mia Slavenska concert group (1944–1945).

Vance joined Ballet Theatre in 1946, performing with the company until 1952; she was on medical leave from Ballet Theatre and was expected to rejoin it at the time of her death. Among the works in which she created roles for Ballet Theatre were William Dollar's *Jeux* (1950), but she was best known for her featured roles in the Antony Tudor repertory, dancing the "French Ballerina" in *Gala Performance* and the "Youngest Sister" in *Pillar of Fire*.

Van Dantzig, Rudi, Dutch ballet dancer and choreographer; born August 4, 1933 in Amsterdam. Van Dantzig was trained by Sonia Gaskell and performed with her chamber company and her Netherlands Ballet, in David Lichine's *La Creation* and Leonid Massine's *La Boutique Fantasque*. A charter member of the Netherlands Dance Theatre, and a dancer with the Dutch National Ballet, he has served as artistic director of the latter company since 1971.

A prolific choreographer of dramatic pieces, he has created works for his Dutch companies and has restaged them for troupes around the world, among the Ballet Rambert, the Harkness Ballet companies, American Ballet Theatre, and the Bat-Dor Dance Company. His most popular works, such as *Monument for a Dead Boy* (1965), *Romeo and Juliet* (1967), and *Blown in a Gentle Wind* (1975), are bittersweet romances told in a free vocabulary of ballet and modern dance movements.

Works Choreographed: CONCERT WORKS: *Night Island* (1955); *Tij en ontij* (Time and Untimeliness) (1956); *Giovinezza* (1959); *Vergezixht* (Perspective) (1960); *Jungle* (1961); *Monument for a Dead Boy* (1965); *Romeo and Juliet* (1967); *Moments* (1969); *Epitaph* (1969); *The Ropes of Time* (1970); *Onderweg* (On the Way) (1970); *Painted Birds* (1971); *Après-visage* (1972); *Ramifications* (1973); *Couples* (1974); *Movements in a Rocky Landscape* (1974); *Are Friends Delight or Pain?* (1974); *Collective Symphony* (1975, co-choreographed with Van Manen and Van Schayk); *Blown in a Gentle Wind* (1975); *Ginastera* (1976); *Orpheus* (1977); *Vier Letzte Liede* (Four Last Songs) (1977); *Gesang de Junglinge* (Ode to Youth) (1977); *About a Dark House* (1978); *Ulys-* ses (1979); *Life* (1979, co-choreographed with Van Schayk).

Van den Berg, Atty, Dutch ballet dancer also working in the United States as a choreographer and theatrical dancer; born in the late 1910s in Amsterdam. Van den Berg was trained locally by Lili Green before moving to England to join the Ballet Jooss (then in exile from Germany). She toured with Kurt Jooss for three seasons and appeared in his *Green Table, Strauss,* and *The Big City,* among others, before emigrating to the United States in 1939. Although she made her recital debut in a joint recital with Marthe Kreuger (also a recent refugee), she gave her first solo concert soon after. She worked on Broadway, however, in the two major dance-oriented musicals of the early 1940s—*One Touch of Venus* (1943) and *On the Town* (1944)—before returning to the concert field in the 1946 season as a participant in the first Choreographer's Workshop in November of that year.

Works Choreographed: CONCERT WORKS: *Jota* (1941); *Victory Dance* (1941); *Lorsque Tout est Fini* (1941); *Lyrical Dance Movements* (1942); *Gavotte* (1942); *City Life* (1942); *The Prodigal Daughter* (1942); *l'Aspettado l'Amante* (1942); *Chorale* (1943); *Prelude* (1943); *The Jolly Maiden and the Old Hag* (1943); *In Memory of a Beloved Brother* (1946); *Triumph of Ignorance* (c.1947).

Van Dijk, Peter, German ballet dancer and choreographer; born August 21, 1929 in Bremen. Raised in Berlin, he studied with Tatiana Gsovsky, ballet master of the Berlin State Opera, and later continued his training with Boris Kniaseff.

Van Dijk (whose name is sometimes spelled Van Dyk) made his debut in the (East) Berlin State Opera Ballet in 1946. In four years with that company and two seasons with the Municipal Opera, he was assigned featured roles in Leonid Massine's *La Boutique Fantasque,* the company revival of Mikhail Fokine's *Prince Igor,* and the company's production of *The Sleeping Beauty,* in which he danced the Bluebird variation.

Although he served as ballet master at the Weisbaden Opera from 1951 to 1952, and began to choreograph there, he took some time to continue his training and performance career in Paris, where he

danced with the Ballets de Janine Charrat (1952–1954), in her *Les Langues* (1953), *Le Cygne Noir*, and *Geste Pour un Génie*. Next, he joined the Paris Opéra, with which he created roles in Serge Lifar's *Les Noces Fantastique* (1955), and *Chemin de Lumiere* (1957), as well as dancing in his productions of the classic repertory.

As ballet master and director of the Hamburg State Opera from 1960 to 1974, Van Dijk created a large repertory of works, ranging from full-length classics, such as *Swan Lake* (1963), to more modern pieces set to the works of German Romantic composers. His symphonic ballets are among his best received in Germany and abroad. Since 1974, he has served as ballet master of the Ballet du Rhin in Strasburg, for which he has choreographed his most recent ballets.

Works Choreographed: CONCERT WORKS: *Pelléas et Melisande* (1952); *Symphonie No. 3* (Henze) (1952); *Portrait d'un Maudit* (1956); *The Unfinished Symphony* (Schubert) (1957); *Spirale* (1958); *The Scarf* (1959); *Turangîla* (1960); *La Peau de Chagrin* (1960); *Scènes de Ballet* (1962); *Swan Lake* (1963); *Sinfonia* (1965); *Poème* (1965); *Pinoccio* (1969); *Suite Lyrique* (1973); *Cinderella* (1974); *Pour la Danse pour Schubert* (1978).

Van Dyke, Jan, American modern dancer and choreographer; born in Washington, D.C. Van Dyke's training in the Washington area included classes with Heidi Pope, Ethel Butler, and the staff of the Washington School of Ballet, while her studies in New York involved work with the Martha Graham and Merce Cunningham studios. While serving as an administrator for arts festivals in the Washington-Baltimore area and as director of the Dance Project in the capital she began to create works for solo and company concerts. Her use of music as correlated background sound and as a coordinated allusionary system has always fascinated critics and audiences. Whether she selected composers whose works, and even names, represent a period and its belief, such as John Philip Sousa or Johann Strauss (for the *Big Show* and *Waltz*, respectively), or used a piece of contemporary music created for a recording session, she has always been able to choose the exactly appropriate score for her movement vocabulary and structure.

Works Choreographed: CONCERT WORKS: *Diversion* (1965); *Canto* (1966); *Six Sections of Orange* (1967); *Dream Forcing* (1967); *Solitude's Dance* (1967); *Rose Garden* (1968); *Camp Lilies* (1968); *Sisters* (1968); *Jungle Peaches* (1968); *Hot Sleep* (1968); *I Am Waiting* (1969); *One Potato, Two . . .* (1969); *Backwater* (1969); *Three Ringling* (1970); *Park Dance* (1970); *Going On* (1970); *Two* (1970); *Duet I* (1971); *Duet II* (1971); *Benches On and Off* (1971); *Bird* (1971); *Ready* (1971); *Big Show* (1973); *Waltz* (1973); *Park Dance II* (1973); *U.S. Lions* (1974); *Ceremony I in Six Acts* (1974); *Ella* (1974); *Paradise Castle* (1975); *Ceremony II with Roses* (1976); *Silence* (1976); *Elly's Dance* (1976); *The Story of Twilight* (1976); *Fleetwood Mac Suite* (1977); *No Name* (1977); *A Dance Parade* (1978); *The Passenger* (1978); *Variations on a Theme* (1978); *A Dance in Two Spaces* (1979); *Two Dances in One Space* (1979); *Looping the Circling* (1980); *Stamping Dance* (1980); *Untitled Duet* (1980); *Double Times* (1980).

Vane, Daphne, American ballet dancer; born 1918. A charter student at the School of American Ballet, she danced at the Radio City Music Hall until the American Ballet began performances in 1935. A member of that company at the Metropolitan Opera House, she was in the premieres of George Balanchine's *Mozartiana* and *Orpheus and Eurydice*, and in the first American performances of his *Errante* and *Apollo*, as "Calliope."

Vane went to Hollywood to dance in the "Romeo and Juliet ballet" in Balanchine's *The Goldwyn Follies* but returned to New York to play a featured role in his Broadway musical, *Keep Off the Grass* (1940), before retiring.

Vangsaae, Mona, Danish ballet dancer; born April 29, 1920 in Copenhagen. Vangsaae received her professional training at the school of the Royal Danish Ballet and has performed with that company for most of her career.

An intensely lyrical dancer, she has been featured in many of the ballets of August Bournonville that

remain in the company repertory, among them, *Konservatoriet, La Ventana*, and *Napoli*. She has also performed in the European classics, including Fokine's *Chopiniana* and *Giselle*, and in George Balanchine's *La Somnambule*. Vangsaae created the title role in Frederick Ashton's *Romeo and Juliet* in 1955 and the part of "Aili" in Birgit Cullberg's *Moon Reindeer* (1957).

Van Hamel, Martine, Dutch ballet dancer, working in Canada and the United States after 1963; born November 16, 1945 in Brussels, Belgium. The daughter of a Dutch diplomat, she studied in Copenhagen, Java, The Hague, Caracas, and Toronto, Canada, where she worked with Betty Oliphant.

After performing with the National Ballet of Canada and the City Center Joffrey Ballet, Van Hamel joined the American Ballet Theatre in 1971. Performing with that company until the present, she has danced in its revivals of *Giselle, The Sleeping Beauty, Swan Lake*, and especially the Rudolf Nureyev production of *Raymonda*. Popular with modern choreographers for her ability to invest movements with both shape and dramatic meaning, she danced in the premieres of Dennis Nahat's *Some Times* (1972), Twyla Tharp's *Push Comes to Shove* (1975), and Glen Tetley's *Gemini* (1977).

A frequent guest artist for foreign and American companies, and a popular performer at benefits and galas, Van Hamel has choreographed solos for herself, among them *Syrinx*, danced to a live performance by Jean Pierre Rampal at a concert for the Performing Arts Research Center of The New York Public Library.

Works Choreographed: CONCERT WORKS: *Syrinx* (1978).

Van Hoecke, Micha, Belgian ballet dancer and choreographer; born 1945. Although trained by Olga Preobrajenska in Paris, he worked as an actor for many years before beginning his concert career as a member of Maurice Béjart's Ballet du XXième Siècle. He appeared in almost all of the Béjart repertory during the 1960s, most notably in his *Tales of Hoffmann, A la Recherche de Don Juan, Ninth Symphony*, and *Romeo and Juliet*. His choreography has been based on literary sources but employs many Béjart-like staging devices. Van Hoecke also participates in productions of Mudra, the dance school sponsored by Béjart.

Works Choreographed: CONCERT WORKS: *Le Fou* (1971); *Les Mariés de la Tour Eiffel* (1972); *The Diary of Samuel Pepys* (1974).

Van Manen, Hans, Dutch Ballet dancer and choreographer; born Nieuwer Amstel, in the Netherlands, July 11, 1932. Trained by Sonia Gaskell, he performed with her Ballet Recital in 1951 and with the Netherlands Ballet from 1952, where he created his first works. After two years with the Roland Petit Ballet in Paris, where he studied with Nora Kiss, he joined the Netherlands Dance Theatre in 1960, where he was subsequently artistic director from 1961 to 1971.

Much of his choreography has been done for the Netherlands Dance Theatre in his ten-year tenure, although he has restaged many of his works for other companies, including the Pennsylvania Ballet, the Royal Ballet (of England), and the Munich State Opera Ballet. Many of his pieces are abstractions set to modern music, often by Stravinsky, such as his *Symphony in Three Movements* (1963), *Sacre du Printemps* (1974), *Dumbarton Oaks* (1978), and *Ebony Concerto* (1976).

Works Choreographed: CONCERT WORKS: *Feast Ordeal* (1957); *Symphony in Three Movements* (1963); *Opus 12* (1964); *The Man in the Trapeze* (c.1964); *Essay in Silence* (1964); *Metaphors* (1965); *Five Sketches* (1966); *Dualis* (1967); *Squares* (1969); *Snippers* (1970); *Situation* (1970); *Mutations* (1970, with Glen Tetley); *Grosse Fugue* (1971); *Keep Going* (1971); *Tilt* (1972); *Daphnis and Chloe* (1972); *Twilight* (1972); *Adagio Hammerklavier* (1973); *Septet Extra* (1973); *Opus Lemaître* (1973); *Assortimento* (1974); *Quintet* (1974); *Sacre du Printemps* (1974); *Valses Nobles et Sentimentales* (1975); *Four Schumann Pieces* (1975); *Collective Symphony* (1975, co-choreographed with Van Dantzig and Van Schayk); *Ebony Concerto* (1976); *Songs without Words* (1977); *Five Tangos* (1977); *Octet Opus 20* (1977); *Grant Trio* (1978); *Dumbarton Oaks* (1978); *Live* (1979).

Van Praagh, Peggy, English ballet dancer credited with helping in the development of an Australian ballet; born September 1, 1910 in London. Trained by Margaret Craske, Tamara Karsavina, and Vera Volkova, she performed with the Ballet Rambert from 1933 to 1938, creating roles in Antony Tudor's *The Planets, Dark Elegies* (1937), and *Jardin aux Lilas* (1936), in the part of "An Episode in His Past." Her major roles included Susan Salaman's *Circus Wives* (1935) and Frederick Ashton's *Mephisto Valse* (1934) and *Valentine's Eve* (1935). She served as director of the short-lived London Ballet but returned to dancing with the Sadler's Wells in 1941. Although celebrated for her delicate comedy and bravura technique in *Coppélia* and Ashton's *Les Patineurs*, she dropped out of performance to become producer and ballet master of the company in 1946 and associate director in 1952.

Van Praagh emigrated to Australia in the early 1960s, working with the Borovansky Ballet and the Australian Ballet itself (1963–1974 and 1977–1979). She has brought her uncompromising view of ballet both as a performance art and as a choreographic discipline to Australia and has frequently been honored by that country for her contributions to the development of the company.

Bibliography: Van Praagh, Peggy. *How I Became a Dancer* (London: 1954); Van Praagh, Peggy and Peter Brinson. *The Choreographic Art* (London: 1963).

Van Schayk, Toer, Dutch ballet dancer, choreographer, and designer; born September 28, 1936 in Amsterdam. Van Schayk studied with Sonia Gaskell while receiving training in painting and sculpture at the Academy of Art in The Hague from c.1958 to 1965. A member of the Netherlands Ballet, he created roles in, and designed for, many works of Rudi Van Dantzig, among them *Monument for a Dead Boy* (1965), *Après-Visage* (1972), and *Movement in a Rocky Landscape* (1974).

He has choreographed alone and in collaboration with Van Dantzig for the Dutch National Ballet, creating *Past Imperfect* (1971), *Eight Madrigals* (1975), *Dansen II* (1977), and *Faun* (1978), among others.

Works Choreographed: CONCERT WORKS: *Past Imperfect* (1971); *Before, During and After the Party* (1972); *The Art of Saying Good-Bye* (1973); *Fanfare to Europe* (1973); *Eight Madrigals* (1975); *Collective Symphony* (1975, co-choreographed with Van Dantzig and Van Manen); *Eerste Lugtige Plaatsing* (First Aerial Station) (1976); *Dansen II* (1977); *Faun* (1978).

Varkas, Leon, American ballet dancer; born c.1925 in Nebraska. There are areas of omissions or questions in Varkas' biography; according to all reports, he was born in Nebraska but raised in Europe. Trained in Paris and London with Nicholai Legat and Vera Trefilova, he made his debut with an operetta theater in Moscow in 1933. He also performed with a state revue theater in 1934 before returning to the United States to dance with the (Mikhail) Mordkin Ballet. He created roles in his *Voices of Spring* and *Giselle* and in Bronislava Nijinska's staging of *La Fille Mal Gardée*. A charter member of the Ballet Theatre, he re-created his role in *Fille Mal Gardée* and danced in Mikhail Fokine's *Les Sylphides*. He also worked with the ballet company of the Metropolitan Opera before serving in the armed forces during the war. From available evidence, it seems that he did not return to performance after the war.

Varone, Douglas, American modern dancer and choreographer; born November 5, 1956 in New York City. Raised on Long Island, Varone studied tap locally before attending the State University of New York's arts campus at Purchase. Among the many dancers and choreographers with whom he studied at the SUNY arts campus were Aaron Osbourne, Carole Fried, Kazuko Hirabayashi, Mel Wong, Royes Fernandez, Will Glassman, and Roseanne Servalli. Later studies included classes with ballet teachers Maggie Black and Zena Rommett. He participated in the school's revival of Martha Graham's *Diversion of Angels* and danced in the production of Doris Humphrey's *The Shakers* and *Passacaglia and Fugue*, which he also performed as a member of the José Limón company. His first professional engagement was with Limón's troupe, where he danced in Limón's *Choreographic Offering, There Is a Time,* and *The Traitor*, in Kurt Jooss' *The Green Table*, and in Murray Louis' *Figura* (1978). Varone has also

danced in the concert groups of fellow Limón company dancers, most notably in Matthew Diamond's *Diamonds*, where he did *Points and Plots, Surface*, and *Hot Peppers, Jazz Babies and Creoles*. Since the mid-1970s, he has been a member of the Lar Lubovitch troupe and has appeared in most of the choreographer's works, creating roles in his popular *Marimba* (1976) and *Cavalcade* (1980).

Varone has presented two programs of choreography, both as part of the Clark Center for Performing Arts' new artist series.

Works Choreographed: CONCERT WORKS: *Mendet* (1978); *Fortress* (1980); *Parallels* (1980); *Ain't Nothing That Keeps Us Here* (1980).

Vasiliev, Vladimir, Soviet ballet dancer; born April 19, 1940 in Moscow. Trained at the Bolshoi school, he has performed with that company for most of his professional life. One of the most popular and most acclaimed *danseurs nobles* in the Soviet dance, he has created roles in Grigorovich's *Spartacus* (1968), *The Nutcracker* (1966), *The Sleeping Beauty* (1973), and *Angara* (1976), as well as Lavrosky's *Paganini* (1960) and *Pages of Life* (1961), and Kasyan Goleizovsky's *Leili and Melshnun* (1964). He has toured Western Europe in a program of pas de deux and divertissements with his wife, Ykaterina Maximova.

Works Choreographed: CONCERT WORKS: *Icarus* (1971).

Vaughan, Kate, English theatrical dancer; born c.1850, probably in London; died February 21, 1903 in Johannesburg, South Africa. Vaughan was coached by Mrs. Conquest of the Grecian Theatre, London, before making her earliest known appearances at the Court Theatre in *In Re:Becca* (1872). She made her first personal success in *Magic Toys* at the Adelphie Theatre (1874) and performed her first roles at Drury Lane and The Princess Theatre later that season. Vaughan was best known for her work with the Gaiety Theatre, the center of English burlesque, which was a form that fell between spectacle and pantomime with topical overlays. She was the specialty dancer in *Little Don Caesar de Bazan* (1876), in which she was partnered by Edward Terry and Edward Royce, Sr., *Esmeralda* (1879), *Robin Hood, Lalla Rookh,* and *Amy Robsart,* among many

other burlesques. While she did not invent skirt dancing, she was credited with popularizing and institutionalizing that form of popular theatrical dance. Her first dance roles used ballet and skirtwork, the latter generally in exotic or foreign characterizations, but by the height of her popularity, she interpolated her skirt waltzes into most of the Gaiety productions. She also toured with a solo act (described as a "monologue dansant") called *How It Happened* in the 1880s and 1890s.

Vaussard, Christiane, French ballet dancer; born 1923 in Neuilly-sur-Seine, France. Vaussard was trained at the school of the Paris Opéra Ballet before joining the company in 1940. Her teachers there included the legendary ballerina, Carlotta Zambelli, with whom she was frequently compared. Vaussard's credits included the revival of Zambelli's roles in *Les Deux Pigeons* and *Giselle*, and newer ballets by George Balanchine and Leonid Massine. Her contemporary repertory included roles in many ballets by Serge Lifar, including his *Le Chevalier Errant* (1950), *Firebird* (1954), and *Pas de Quatre* (1960) and *Variations*. After retirement, she followed her mentor to become a member of the faculty of the Paris Opéra school.

Vazem, Ykaterina, Russian late nineteenth-century ballet dancer; born January 13, 1848 in Moscow; died 1937 in Leningrad. Vazem was trained at the St. Petersburg School of the Imperial Ballet, from which she graduated in 1876. She appeared in many works by Marius Petipa in the 1860s through 1880s, replacing Maria Surovshchikova as his favorite native dancer. It is possible that the choreographic quirks that developed in his works were related to her specific abilities—balance that could withstand changes of focus, quick *batterie* movements, and low attitudes. Among the many ballets that he choreographed around her were *Le Corsair* (*Le Slave*) (1868), *Le Papillon* (1874), *Les Bandits* (1875), *La Fille du Neige* (1879), and *La Bayadère* (1877); the latter has remained in the repertories of companies in the Soviet Union, Western Europe, and the Western hemisphere.

In 1884, Vazem retired from performance to teach at the school where she had been trained. Her pres-

ence there assured that the next generation—which included Anna Pavlova, Tamara Karsavina and most of the Diaghilev Ballet Russe—could, if necessary, perform in Petipa's ballets. Vazem's autobiography, *Memories of a Ballerina of the St. Petersburg Bolshoi Theatre* (Leningrad: 1937), is currently being translated into English and may soon be published here.

Vecheslova, Tatiana, Soviet ballet dancer; born 1910 in St. Petersburg. The daughter of Kirov company teacher Yevgenia Snietkova, she was trained at the Petrograd school (later called the Choreographic Institute) and performed with the GATOB/Kirov Ballet throughout her long career. A dramatic ballerina of the Kirov for over twenty-five years, she took the principal female roles in the entire range of the company repertory, from the 1931 and 1935 versions of *Esmeralda* (after Petipa and by Agrippina Vaganova, respectively) to the great roles of the Soviet ballet, "Zarema" in *The Fountain of Bakhchisarai*, "Manije" in Vakhtang Chabukiani's *Heart of the Hills* (1938), and "Pascula" in his *Laurencia* (1939).

Although her sense of dramatic timing and proportion was instinctive and unique, she was able to transmit much of her technique and performance style to her many pupils at the Kirov and its school.

Veen, Jan, Austrian concert dancer working in the Boston area after the late 1920s; born Hans Weiner in 1903 in Vienna; died June 8, 1967 in Boston, Massachusetts. Trained originally at the Vienna Conservatory of Music, he continued his studies with von Laban and Mary Wigman at their studios. He performed with Yvonne Georgi in Gera before 1925, when he moved to Shanghai to teach and choreograph. Sol Hurok met him there and sponsored his emigration to the United States, where he remained for forty years.

In New York and in Boston, Veen opened studios and undertook concert engagements, alone and with Erika Thimey. On the faculty of the New England Conservatory, he staged dances for the Boston Pops concerts and the Boston Grand Opera. Although his early works, created in Shanghai, were clearly within the conventional German expressionist style, his American pieces were more like the traditional American modern dance, ranging from new works to preclassic music to older dances to contemporary scores.

Works Choreographed: CONCERT WORKS: *Suite of Dances* (1926); *Dance Dimension* (1926); *Page Dance* (1926); *Chant Hindou* (1926); *Flemmish Suite* (1927); *Grotesque* (1927); *Cymbal Dance* (1927); *Preludium* (1927); *Judgment* (1927); *Humoresque* (1927); *Chinese Sword Dance* (1929); *The Dance of Shiva* (1927); *Rhapsody Negre* (1933); *Monotones I and II* (1933); *Persian Ballet* (1933); *Foolish Virgins* (1933); *Overture and Eight Dances* (1933); *In Winged Measure* (1933); *Largo* (1933); *Malaguena* (1933); *El Amor Brujo* (1934); *A Night in Venice* (1934); *Pictures at an Exhibition* (1934); *Rumanian Wedding* (1936); *Hollywood Div-O-tissement* (1937); *Les Petits Riens* (1938); *The Incredible Flutist* (1938); *Theme and Variations on Contemporary Dance in Relation to the Fine Arts* (1938); *Suite of Old Court Dances* (1938); *Valesquerias* (1939); *Symphonic Suite* (1940); *Man with a Moustachio* (1941); *Cross-Currents* (1941); *Hudson River Legend* (1944); *Romantic Waltz* (1945); *Dance in the Streets* (1945); *Three Minor Vices* (1945); *Naragansett Bay* (1947); *Timeless Legend* (1947); *Gayane Suite* (1948); *Witch Dance* (1948); *Hora Stacatto* (1948); *Study with Tambourines* (1948); *Spasmodic Space* (1948).

Venable, Lucy, American modern dancer, notator, and teacher. After graduating from Wellesley College, Venable moved to New York to study with Doris Humphrey and José Limón. She danced in Humphrey's *Poor Eddy* (1955) and in Limón's *El Grito* (1952), *Ode to the Dance* (1954), *The Shining Dark* (1956), *Missa Brevis* (1959), and *I, Odysseus* (1962). For fellow Limón company member Ruth Currier, she appeared in *Neophyte* (1952), *Tender Portrait* (1961), *Places* (1961), and *Quartet* (1961), and for Pauline Koner, she performed in the premiere of *Concertino in A Major* (1958).

As a Labanotator, she served on the board of directors of the Dance Notation Bureau for many years, directing its training program in New York and at the Ohio State University.

Vera-Ellen, American theater and film dancer; born February 16, 1921 in Cincinnati, Ohio. Trained originally at the Hessler Dancing School in her native Cin-

nia. Vernon made his professional debut at the age of three (or even earlier) in minstrelsy with his interlocutor-father. In the late 1930s, he regularly brought his father out of the audience at the Palace to join him in his own act. Vernon worked steadily in vaudeville (on the Keith circuit), Prologs, and presentation acts until the mid-1950s, but in the late 1940s he also began to work in film. Under contract from Twentieth-Century Fox, he appeared in both musicals, such as *Alexander's Ragtime Band* (1938) and *Reveille with Beverly* (1943), and more than two dozen Westerns. His last film was *What a Way to Go* (1964), one that claimed to show every contract comic on the Fox lot. His vaudeville act over the twenty years of his greatest popularity (mid-1930s to mid-1950s) included four specialties—a straight soft shoe, imitations, a dull monologue enlivened by an ecdysiast (Ginger Sherry) who was visible to the audience but not to him, and his best known *schtick*, an imitation of a very long, very skillful strip in which he removed absolutely nothing.

Verso, Edward, American ballet, television, and theater dancer; born October 25, 1941 in New York City. Verso studied with Vincenzo Celli while attending the New York High School of Performing Arts.

Verso went into the cast of Jerome Robbins' *West Side Story* on Broadway after graduating from Performing Arts and later appeared in the film version. Between projects, he toured with Robbins in his Ballets: U.S.A. company, creating a major role in his *Events* (1961). Through the 1960s, he alternated work in ballet companies with performances on Broadway and on television. He danced in the American Ballet Theatre, creating roles in Robbins' *Les Noces* (1965) and in Eliot Feld's *Harbinger*, and performing in Robbins' popular *Fancy Free* and *Interplay*, and Antony Tudor's *Dark Elegies*. With the City Center Joffrey Ballet, he danced in Robbins' *New York Export: Opus Jazz, Interplay*, and *Moves*, in Leonid Massine's *Le Tricorne* and *Pulcinella*, and in revivals of Frederick Ashton's *Façade* and *Les Patineurs*. He was also a principal dancer in Eliot Feld's American Ballet Company, repeating his role in *Harbinger*.

On Broadway, he performed in *Oh, Captain*

(1958), *I Can Get It for You Wholesale* (1964), and *On a Clear Day You Can See Forever* (1965). He worked on most of the television variety shows that were filmed in New York, among them *The Garry Moore Show* (CBS, 1958–1967, intermittently) and *Hullaballoo* (NBC, 1965–1966). In Los Angeles, he has performed on many specials and on the Osmond Family series.

A popular teacher of both jazz and classical ballet, Verso has served as an artistic director of the Festival Dance Theatre in New Jersey and the Hollywood Ballet Theatre in California, for which he currently choreographs.

Works Choreographed: CONCERT WORKS: *Night Dreams* (1970); *Concerto Grosso* (1970); *An Evening of Jazz* (c.1974); *Rags* (1980); *Gaité Parisienne* (1980).

Vervenne, Frans, Dutch ballet dancer; born June 16, 1945 in Amsterdam. Trained at the Scapino Ballet Academy, he has performed with the Netherlands Dance Theatre for most of his professional life. He is best known for his articulate performances in the works of Hans Van Manen, especially *Dualis* (1967), *Situation* (1970), and *Grosse Fuge* (1971), and the company's other contemporary choreographers, among them Rudi Van Dantzig, Toer Van Schayk, and Glen Tetley. He has created works for that and other Western European companies.

Works Choreographed: CONCERT WORKS: *Interludes* (c.1971); *Goodbye, P.A., Goodbye* (1973); *Sunflower* (1974).

Vesak, Norbert, Canadian ballet dancer and choreographer; born October 22, 1936 in Vancouver, British Columbia. Trained by Margaret Craske, Vera Volkova, Pauline Koner, Geoffrey Holder, and La Meri, Vesak danced in Canada through the 1940s, primarily in opera companies. He has choreographed for many opera troupes in Canada and the United States, among them the Metropolitan Opera in New York and the San Francisco Opera. His concert works have been created primarily for ballet companies in Canada, among them the National Ballet and the Royal Winnipeg Ballet.

For many years, Vesak has been the director of the

National Association of Regional Ballet's Craft of Choreography Conferences, where he teaches composition to young dancers and company directors.

Works Choreographed: CONCERT WORKS: *The Ecstacy of Rita Jo* (1971); *Butterflies Can't Live Here Anymore* (1972); *What to Do 'Til the Messiah Comes* (1973); *A Time of Windbells* (1973); *Blue Is the Color of My True Love's Bag* (1973); *The Good Morrow* (1974); *Whispers of Darkness* (1974); *In Quest of the Sun* (1975); *The Grey Goose of Silence* (1975); *The Gift to Be Simple* (1977); *Belong* (1979); *Meadow Dances* (1980).

Vessel, Anne Marie, Danish ballet dancer; born May 1, 1949 in Copenhagen. Trained at the school of the Royal Danish Ballet by her father, Poul Vessel, and by Vera Volkova and others, she became a member of the company in 1967. Like her father, she was noted for her performances in the nineteenth-century classics of the French/Russian repertory, dancing "Swanilda" in *Coppélia* and "Clara" in *The Nutcracker*. In the Danish Bournonville canon, she was featured in his *Flower Festival in Genzano, La Ventana, Kermesse in Bruges*, and *The King's Volunteers on Amager*.

Vessel, Poul, Danish ballet dancer; born 1914 in Copenhagen. Trained at the school of the Royal Danish Ballet, he graduated into the company in the early 1930s. Celebrated for his dance and mime work in the revived Bournonville and Angiotti repertory, he was chosen to create the role of the "Duke of Verona" in Frederick Ashton's *Romeo and Juliet* (1955). He served as regisseur of the company during the 1940s and 1950s.

Vestoff, Floria, American theatrical dancer; born 1920, possibly in Europe, possibly in New York City; died March 18, 1963 in Hollywood, California. Vestoff was the daughter of Genrik and Jennie Vestoff and the great-grand-niece of the Veronine Vestoff who had taught plastique in St. Petersburg in the 1890s. At the time of her professional debut in the 1930s, her mother was running the family dance school in New York where she was trained.

Originally a tap dancer in nightclubs, Vestoff made her professional debut at the Latin Quarter in New York, and followed that booking with engagements at the Astor Hotel Roof, the Café Mirador, El Morocco, and the Paramount Theater. She was the original tapping Old Gold cigarette box in the popular live television commercial of the late 1940s and early 1950s, and staged dances for the *Ted Mack Family Hour*.

After retiring from dancing, she remained in the television field as a song and comedy writer.

Works Choreographed: TELEVISION: *Ted Mack Family Hour* (ABC, 1951).

Vestoff, Valodia, Russian theatrical dancer working in the United States; born c.1902 in Moscow; died September 5, 1947 in New York City. The nephew of Veronine Vestoff, who was teaching in New York through most of his life, Valodia and his brother Genrik emigrated to the United States as adolescents. He made his professional debut in the New York Hippodrome production of *Happy Days* in 1919, soon following it with appearances in *Heigh Ho* (1922), *Allez-Oop* (1927), *Katja* (1926), two editions of the Shuberts' *Artists and Models* revue, two *Passing Shows*, and the *Greenwich Village Follies* of 1921 and 1922. In each, he performed both as a ballet dancer and in more American theatrical dance forms. He was one of the most popular Prolog dancers of the 1920s and a regular at the Capitol. After his last Broadway show, *Anything Goes* (1936), he retired to teach. It is not certain whether he formed his own school or became a teacher in the studio run by his brother and sister-in-law. He was credited as the teacher and first partner of his niece, Floria.

Vestoff, Veronine, Russian ballet dancer teaching in the United States; born c.1880 in St. Petersburg; died c.1930 in New York City. Vestoff was trained privately by his father, who taught plastique in St. Petersburg, and at the School of the Imperial Ballet there. It is uncertain whether he was a member of one of the Imperial Theatres before joining the Anna Pavlova/Mikhail Mordkin American tour of 1910. He remained in the United States to perform with Adelina Genée's traveling company and served as her ballet master. Vestoff taught in the Berkeley area of

California after the mid-1910s and may have trained Hubert Stowitts there to prepare him for his performance with Pavlova.

After moving east to New York in the early 1920s, Vestoff opened a studio in conjunction with Sonia Serova, who taught interpretive dance and classical ballet. He taught conventional classes and mail-order lessons. For the latter, he developed the Vestograph, a system of printing film footage of dances in order to teach individual movements as well as steps in combinations. Among his many students at the school and in teachers' training courses were his nephew and grand-niece, members of the Barstow family, and Dance Masters Leo Kehl, of Madison, Wisconsin, and Frank Eckl of Pittsburgh, Pennsylvania.

Vestris, Armand, French nineteenth-century ballet dancer and choreographer known for his work in London; born 1786 in Paris; died May 17, 1825 in Vienna. Armand studied with his father Auguste Vestris, and grandfather, Gaetano, and made his debut with them when he was four years old.

Although he worked extensively in Italy, notably in Padua's Teatro Nuovo, Vestris is best known for his work at the King's Theatre, London (1810–1816). During this period, he danced and created ballets, among them *Le Troubador* (1813), *Mars et l'Amour* (1815), and *Caesar's Triumph over the Gauls*, a cantata staged in the Summer of 1815 to celebrate the Battle of Waterloo.

Other known works of Vestris' date from Padua, (*Astolfo e Gioconda*, 1820), and his tenure at the Vienna Staatsoper from 1822 until his death in 1825.

In 1813, Vestris married Eliza Bartholuzzi, an Italian dancer and vocalist with the company. She would become famous after his death as Mme. Eliza Vestris-Matthews. She was the manager of four London theaters—the Olympic (1836–1839), the Theatre Royal, Covent Garden (1839–1842), the Royal Lyceum (1844–1855), and The City of London (1855–1857).

Works Choreographed: CONCERT WORKS: *Anacréon, ou l'Amour fugitif* (1810); *Ildamor et Zuléma* (1811); *Le Troubadour* (1813); *Le Calife voleur* (1814); *Le Petits Braconniers* (1815); *Le Prince Troubadour* (1815); *Mars et l'Amour* (1815); *Caesar's Triumph over the Gauls* (1815); *Gonzalve de Cordaue* (1816); *l'Amour et le Poisson* (1816); *Emmeline* (1816); *Astolfo e Gioconda* (1820); *Zélis* (1823); *Eleanore* (1824); *Bluebeard* (1824).

Vestris, Auguste, called **Vestr'Allard**, French nineteenth-century ballet dancer and choreographer, considered the major virtuoso dancer of his generation; born March 27, 1760 in Paris; died there December 5, 1847. The son of Marie Allard and Gaetano Vestris, and trained by his father, he made his Paris Opéra debut, according to legend, at the age of twelve in *Les Cinq Variations* in 1772.

Vestris performed with the Opéra from then, or from his formal debut in 1773, until his retirement in 1816, later teaching company classes from 1821 until 1826. Among his many roles there were *danseur noble* parts in Noverre's *Les Petits Reins* (1778, revival) and *Les Caprices de Galatée* (1780, revival), and Maximilien Gardel's *Le Chercheuse d'Esprit* and *La Rosière* (both 1783) and *Le Coq du Village* (1783).

Vestris worked with his father at the King's Theatre, London, from 1780 to 1781 and again in 1784 and 1786. Best known for his partnering of Mme. Baccelli, he also contributed two ballets to the company's repertory—*Le Premier Navigateur* (1786), a revival of the Maximilien Gardel work, and *Les Folies d'Espagne* (1791). He served as ballet master himself during the 1791 and 1815 seasons.

Vestris retired from the Paris Opéra after, appropriately enough, a September 1816 performance of *l'Enfant prodigue*. He came out of retirement at least twice, the last time to dance a Minuet de Cour with Marie Taglioni. Among the Opéra dancers who took his *classe de perfectione* from 1821 to 1826, were choreographers Jules Perrot, August Bournonville, and Charles-Louis Didelot.

Works Choreographed: CONCERT WORKS: *Le Premier Navigateur* (1786, after Maximilien Gardel); *Les Folies d'Espagne* (1791); *François Ier à Chambord* (1830).

Vestris, Gaetano Apolline, Italian/French eighteenth-century ballet dancer and choreographer called "le dieu de la danse." The son of ballet master

Tomasso Vestris, he performed in Florence before moving to Paris to study with Louis Dupré. He made his Paris Opéra debut in 1748, remaining with the company until 1782.

Vestris and his sister, Teresa (1726–1808), performed primarily in the works of the Lavals. He served as co-ballet master with Jean D'Auberval and was given the position alone from 1760 to 1766, between Jean-Barthélemy Lany and Jean-Georges Noverre. As director of the Opéra's school, he trained not only his son and grandson but a generation of French dancers.

Vestris' most prolific period as a choreographer occurred between 1791 and 1793, when he served as ballet master to the King's Theatre, London. Among the works that he created there were *Ninette à la Cour* (1781), after Maximilien Gardel, *La Mort d'Hercule* (1791), and *La Fête de Seigneur* (1791). Contemporary evidence suggests that this Vestris was not only the best technically equipped dancer of his generation, but that he was also a technical innovator. There is a growing feeling that he did not simply perform choreography, but instead developed the necessary steps. It is unfortunate that the lack of visual records, and the legend of Vestris conceit, must hamper the current historian's ability to determine the extent to which his technique affected the choreography of his time.

Works Choreographed: CONCERT WORKS: *Ninette à la Cour* (1781); *La Mort d'Hercule* (1791); *l'Amadriade* (1791); *La Capricieuse* (1791); *La Fête du Seigneur* (1791).

Victor, Eric, American concert and theatrical tap dancer; born c.1920. Although Victor was born in the United States, he was raised and educated in Western Europe. He is believed to have made appearances at the Bal Tabarin in Paris before returning to the United States at the outbreak of World War II. Although a dance role in *Oklahoma!* fell through when he broke his leg, he began to get a New York reputation in the mid-1940s from well received appearances in unsuccessful shows like *My Dear Public* and *Sadie Thompson*, and from recitals. His first New York solo concert (shared with folk singer Susan Reed) introduced his most popular works, *Masks and Versatilities* and *The Dictator* (both

1944), in which he presented characterizations through the seemingly unnarrative medium of tap work. He returned to Broadway in the late 1940s, most notably as Valerie Bettis' partner in Tamiris' "Tiger Lily" number in *Inside U.S.A.* (1948), but eschewed recitals for solo presentations at nightclubs. The bearded Victor was capable of technical feats for which he was compared to Astaire and Kelly (among them his extraordinary tapping leap from the stage floor to a piano), but he added political commentary in words and dance, which made him practically unemployable in the 1950s. No record of a television appearance can be found and even *The Dictator*, once considered one of the major dance works of the twentieth century, was not preserved in film or tape.

Viganó, Salvatore, Italian nineteenth-century ballet choreographer, composer, and dancer; born March 25, 1769 in Naples; died August 10, 1821 in Milan. Viganó was trained in ballet by his parents, Onorato Viganó and Maria Ester Boccherini, and in musical composition by his maternal uncle, Luigi Boccherini. Throughout his short, intensive career, he composed or arranged much of the scores for his ballets. Soon after his debut in a skirt role in his father's company in Rome, he moved to Madrid (where Italian ballet dancers were frequently engaged) in 1788. With his Spanish wife, Maria Medina, he toured France, England, Brussels, and Venice, where Onorato was in residence at the Teatro alla San Samuele. His first credited choreography was produced on tours—*La Figlia mal custodia* (a version of Jean D'Auberval's *La Fille Mal Gardée*) in Venice in 1793 and *Riccardo Cuor di Leone, VI Re d'Inghilterra* at the Vienna Hofoper in 1795. Later works, created for performance in a variety of houses in every city on the ballet map of the nineteenth-century, tended toward the historical, with central themes that glorified the deeds of a hero or tragic heroine, similar to motifs in literature and music. These works were especially popular in Austria and Italy, where the "great man" theories of history were being lived in reality, and his tenures in Vienna (1799–1803) and Milan (1813–1821) were among the most successful and most productive of his career. It is interesting to read Viganó's titles as a guide to his canon of works: it seems more like the reading list of an early nineteenth-century adolescent

who iş fascinated by kings and heroics. Along with his facilities with music, Viganó is remembered as the choreographer/commissioner of Beethoven's ballet score, *The Creatures of Prometheus* (1813).

Works Choreographed: CONCERT WORKS: *La Figlia mal custodia* (1793, after D'Auberval); *Riccardo Cuor di Leone, VI Re d'Inghilterra* (1795); *Raul, Signore di Crequi, o sia La Tirannide repressa* (1797); *Giorgio, Principe della Servia* (1798); *Divertimento campestre* (1804); *Caio Marzio Coriolano* (1805); *Gomes nell' isola Cristina* (1805); *Sammete e Tamiri* (1805); *Gli Strelizzi* (1809); *Il Semplice e la vanarella* (1810); *Il Barbiere di Villafranca* (1810); *Un Equivoso* (1812); *Clotilde, duchessa di Salerno* (1812); *Il Noce di Benevento* (1812); *L'Alunno della guimenta, ossia Ippotoo vendicato* (1812); *Le villanelle bizzarre* (1813); *Prometeo* (1813); *Samandria liberata, ossia I Serviani* (1813); *Il Nuovo Pigmalione* (1813); *Gli Ussiti sotto a Maumburgo* (1815); *Numa Pompilio* (1815); *Il Sindaco vigilante* (1815); *Mirra, o sia La Vendetta di Venere* (1817); *Psammi, re d'Egitto* (1817); *La Scuolo del villaggio* (1818); *Otello, o sia Il Moro di Venezia* (1818); *Dedalo* (1818); *La Vestale* (1818); *La Spada di Kenneth* (1818); *Bianca, o sia Il Perdono per sorpresa* (1818); *I Titani* (1820); *Cimene* (1820); *Alessandro nell' Indie* (1820); *Le Sabine in Roma* (1821); *Giovanna d'Arco* (1821); *Didone* (1821).

Vikulova, Sergei, Soviet ballet dancer; born November 11, 1937 in Leningrad. The grandson of Alexander Gorsky, he was trained at the Vaganova School in Leningrad and joined the Kirov Ballet in 1956. Since then, he has become known for his stylish performances in the classics. Among his best received roles are "Solor" in *La Bayadère*, "The Prince" in *The Nutcracker*, "Siegfried" in *Swan Lake*, and "The Bluebird" in *The Sleeping Beauty*.

Vilan, Demetrios, Greek concert and theatrical dancer in the United States from the age of three; born c.1908 in Smyrna, Greece. Raised in Pittsburgh, Pennsylvania, Vilan studied ballet there with Karl Heinrich. He continued his training at the New York Denishawn School (c.1926) and performed with St. Denis and Shawn on the tour of George Wintz' *Ziegfeld Follies* in 1926 and 1927.

From the early 1930s, Vilan split his career between concert dance recitals and jobs partnering female ballet dancers. As a recitalist, he worked in Greece (1933) and occasionally in New York. As a partner, he seems to have been constantly employed with Felicia Sorel in the Dance Centre, taking the title role in *The Prodigal Son* (1931), and at the Radio City Music Hall (1933–1935), with Patricia Bowman at the Roxy Theater, in the late 1930s, and partnering Vera Zorina in the ballet sequence of *On Your Toes* (1936), in the choreography of George Balanchine.

Works Choreographed: CONCERT WORKS: (Note: all works listed below were created before Vilan's only New York recital in 1933; their dates of original choreography are not known.) *Prelude; Sacré et Profane; Ballade; Impromtu; Spanish Mood; Entrée du Grec; Vampire; Blues; l'Homme Abandonné; Soudanesque; Valse; Crime, Dope, Art, Labour; Poème de Tagore; Revolte.*

Villella, Edward, American ballet dancer and choreographer who represents to many people the ballet as a career for Americans; born January 10, 1937 on Long Island. Raised in New York City, he attended the High School of Performing Arts and trained at the School of American Ballet. His reputation as an archetypical American who just happened to become famous in ballet is based in part on his degree from the Maritime College of the City University of New York.

Villella has always been considerably more, however, than a symbol used to alleviate the fears of parents who felt ambivalent about the study of ballet. Throughout his career as a live performer, he was always a great dancer, with technique, stage presence, and a unique power to draw the audience into watching him. Featured in most of the company repertory, he danced in George Balanchine's *Symphony in C, Scotch Symphony, Western Symphony, Donizetti Variations, Swan Lake, La Source, The Nutcracker, Agon, Stars and Stripes*, and the two Ballet Russe revivals, *Apollo* and *The Prodigal Son*, which became his best known and best received roles. His twelve premieres in Balanchine works include *The Figure in the Carpet* (1960), *Electronics* (1961), *A Midsummer Night's Dream* (1962), *Bugaku* (1963); *Tarantella* (1964), *Harlequinade* (1965), *The Brahms-Schoen-*

berg Quartet (1966), the Rubies section of Jewels (1967), Glinkiana (1967), Symphony in Three Movements (1972) and Schéhérazade (1975). He danced in most of those roles with Patricia McBride who could match his ability to do impossible steps extremely quickly, while looking as if it were merely fun. He danced with her in Jerome Robbins' Afternoon of a Faun and Dances at a Gathering (1969), but worked alone on stage for much of his controversial Watermill (1972).

He first choreographed for the City Ballet, creating Narkissos in 1966, but has made most of his dances for television. That medium has added to his tremendous popularity since he performed frequently on The Ed Sullivan Show, The Bell Telephone Hour, Omnibus, and other shows in the 1960s, with McBride and Violette Verdy.

Again, the fact that he spoke with a thick New York accent and looked, as one columnist said, "like a method actor playing a punk," popularized ballet as an art and possible career to the broad television audience. He served as a Commissioner of Cultural Affairs for the City of New York, but left this post with complaints about bureaucracy. He is currently artistic director of the Eglevsky Ballet on Long Island, a company that performs as a completed unit but which is also well known for training dancers who later join the City Ballet or Ballet Theatre.

Villella is not only one of the best known American dancers, but one who did not leave his home company to indulge in constant guesting. Although, like most City Ballet members, he left the company years after he stopped dancing, he left his stamp not only on the audience but on the repertory itself.

Works Choreographed: CONCERT WORKS: Narkissos (1966); Shostakovitch Ballet Suite (1972); Shenandoah (1972); Gayane Pas de Deux (1972); Salute to Cole (1973); Sea Chanties (1974); Preludes, Riffs and Fugues (1980).

TELEVISION: Harlequin (CBS, 1974, special); Dance of the Athletes (CBS, 1976, special); Little Women (NBC, 1976, special).

Vilzak, Anatole, Russian ballet dancer and teacher. Trained at the school of the Imperial Ballet in St. Petersburg, he succeeded Vaslav Nijinsky as principal dancer in the Maryinsky Theatre.

Vilzak left Russia to join the Diaghilev Ballet Russe in 1921, creating roles in Bronislava Nijinska's Les Biches and Les Facheux in 1924 with that company. He also danced in Nijinska's works in the Ida Rubinstein Ballet, among them Le Bien-Aimée, Bolero (1928), and La Valse (1929), and in her own Ballets Nijinska, 1932.

After dancing and serving as ballet master with the Ballet Russe de Paris, he traveled to the United States with the Ballet Russe de Monte Carlo in 1935. He has been associated with the American Ballet (George Balanchine's first U.S. company) and the School of American Ballet (now the New York City Ballet's school) since then, and is considered one of the country's most influential teachers.

Vinogradov, Oleg, Soviet ballet dancer and choreographer; born August 1, 1937 in Leningrad. Trained in Leningrad at the Vaganova Institute, he made his professional debut with the Novosibirsk Opera, where he began to choreograph. He was appointed ballet master of the Leningrad Maly Ballet in 1972, choreographing Yaroslavna (1974) there, and of the Kirov State Ballet Theater from 1978. His works range from unconventional reworkings of the classics to original plotted pieces, and have been seen with the Bolshoi, Maly, and Kirov Ballets.

Works Choreographed: CONCERT WORKS: Cinderella (1964); Romeo and Juliet (1965); Aselle (1967); Gorjanka (1968); Two (1969); La Fille Mal Gardée (1970); Prince of the Pagodas (1972); Yaroslavna (1974).

Violette, Eva Maria, Austrian ballet dancer who also performed in London; born Eva Maria Veigel, February 29, 1724 in Vienna; died October 16, 1822 in London. Violette, who used the French translation of her surname professionally, was trained by Franz Anton Hilverding in Vienna and performed for him with the Imperial Ballet at the Kartnertor theater from the age of ten. A favorite of Empress Maria Theresa (a sponsor of the Court Theater), she was invited to perform at the King's Theatre in London. After an English court intrigue, she switched to the Drury Lane Theatre, where she became an audience favorite in roles in pastoral ballets, including The Vintener, The Turkish Pirate, or the Descent on the

Grecian Court, and *The German Camp*. After marrying actor/manager David Garrick in 1749, she retired from performance.

Violino, Terry, American theatrical dancer; born in the late 1930s in New York City. There are some Broadway dancers who became important because of their appearances in individual shows and others who are memorable for the quantity of their credits. Violino, the son of a theatrical milliner, managed to qualify under both categories. After his debut in the 1952 revival of *Pal Joey* (starring Bob Fosse), he spent many years in Hanya Holm's *My Fair Lady*. His 1960s credits include some of the most successful shows of the decade, as well as some of its most memorable flops, among them (chronologically), *The Unsinkable Molly Brown* (1960), *Mr. President* (1962), *We Take the Town* (1963, closed out of town), *Cafe Crown, Bajour*, and *What Makes Sammy Run?* (all 1964), *Funny Girl* (1965), *Ilya Darling* (1967), *Zorba* (1968), *Coco* (1969), and *Gantry* (1970). He has appeared in many shows staged by Michael Bennett, including *Promises, Promises* (1968), and *Ballroom* (1979). Violino also performed extensively on television, most notably as an Ernie Flatt Dancer.

Vita, Michael, American theatrical performer; born 1941 in New York City. Vita made his professional debut as one of the teen-agers in *Bye Bye Birdie* (1960) and has been appearing on stage ever since. For twenty years he has alternated between club acts, most memorably in *Jacques Brel Is Alive and Well and Living in Paris*, and Broadway shows. Among the latter credits are *Golden Rainbow, Cyrano* (1973), Bob Fosse's *Sweet Charity* (1967) and *Chicago* (1975), and Michael Bennett's *Promises, Promises* (1968) and *Ballroom* (1978). In the latter, he appeared as a tango specialist in the romantic musical set in the Stardust Ballroom and provided atmosphere for Bennett's bittersweet romance.

Vitak, Albertina, American ballet and theatrical dancer; born c.1898 in Chicago, Illinois. Vitak was trained in Chicago by Hazel Sharp and in New York by Mikhail Fokine. She performed with Fokine at the Hippodrome in 1921 and in his "Frolicking Gods" and "Farlandjiando" ballets in the *Ziegfeld Follies of 1923*. Partnered by Chester Hale, she danced in the "Fountain of Youth" scene in the *Music Box Revue of 1925, Peg O' My Dreams*, and the *Ritz Revue of 1925*. Among her other Broadway appearances were *Le Maire's Affaire of 1926, Flying Colors* (1932), *Walk a Little Faster* (1932), and *Annina* (1933), in which she danced with Paul Haakon.

She performed with the Fokine Ballet in his presentations of *Schéhérazade* and *Les Sylphides* before retiring in 1934. After that season, she remained in the dance world as a critic for *The American Dancer* and as a teacher and lecturer.

Vladimiroff, Pierre, Russian ballet dancer and teacher; born 1893 in St. Petersburg; died November 25, 1970 in New York City. Trained at the St. Petersburg school of the Imperial Ballet, he performed at the Maryinsky Theatre from 1911, primarily in the roles left vacant by Vaslav Nijinsky. He partnered Spessivtseva in *Giselle* and created roles in Mikhail Fokine's *Francesca di Rimini* and *Eros*, both in 1915. Between Maryinsky engagements, he performed with the Diaghilev Ballet Russe in 1912, 1914, and 1921, when he played "Florestan, Prince Charming" in Diaghilev's London production of *The Sleeping Beauty*, partnering Spessivtseva, Vera Trefilova, and Vera Nemtchimova.

He lived in Western Europe permanently after the mid-1920s, and toured as partner to Tamara Karsavina, and Anna Pavlova (1928–1931), also dancing with Mikhail Mordkin's European Ballet.

After emigrating to the United States, Vladimiroff taught at the School of American Ballet from 1935, when it was founded for George Balanchine's arrival in New York, until his retirement in 1967. As a teacher there, he has trained most of the New York City Ballet members who are over thirty, and members of almost every ballet company in the country.

Vladimirov, Yuri, Soviet ballet dancer; born January 1, 1942 in Kosteroovo. Trained at the Bolshoi School, he graduated into the company in 1962. With his exceptional stage presence and almost brash bravura technique, Vladimirov has become one of the Bolshoi's most popular performers and a representative of its theatrical style. He has danced in the com-

pany productions of the nineteenth-century classics, but is better known for his work in the Soviet pas de deux repertory and in contemporary ballets such as Yuri Grigorovitch's *Ivan the Terrible* (1975) and Vladimir Vasiliev's *Icarus*. He frequently partnered his wife Nina Sorokina in pas de deux in the Soviet Union and in concert for appreciative foreign audiences.

Vlassi, Christine, French ballet dancer; born June 5, 1938 in Paris. Trained at the school of the Paris Opéra, Vlassi was one of the last students of Carlotta Zambelli. After graduating into the company in 1952, she was soon assigned featured roles in the classics, including *Les Sylphides*, for which she was well known, and in the contemporary ballets that use the ballet vocabulary, such as George Balanchine's *Palais de Cristal* and Serge Lifar's *Suite en Blanc*. Her roles in the works of the modern French repertory include principal parts in many ballets by Atillo Labis, among them, *Entrelacs* (1963), *Arcades* (1964), and *Romeo et Juliette* (1967), Roland Petit's *Turangalila*, and dramatic works by Maurice Béjart.

Vodehnal, Andrea, American ballet dancer; born 1938 in Oak Park, Illinois. Raised in Houston, Texas, Vodehnal studied there with Alexander Kotchetowsky and Tatiana Semenova. After additional coaching from Alexandra Danilova, she joined the Ballet Russe de Monte Carlo in 1957, where she appeared in company productions of *Swan Lake, Les Sylphides*, and *Giselle*, in which she danced as "Myrthe." Her performances in contemporary ballets included George Balanchine's *Ballet Imperial*, Leon Danielian's *España*, and Frederick Franklin's *Tribute*. A charter member of Franklin's National Ballet, Washington, D.C., she appeared in principal roles in his *Homage au Ballet* and *Coppélia*, in Balanchine's *Serenade*, Valerie Bettis' *Early Voyagers*, and Georges Skibine's *La Péri*. She won audience and critical acclaim in dramatic roles in the above and in principal parts in the classical repertory that combine technical expertise with acting ability, such as "Odille," and "Myrthe." Her range of roles made her a valuable member of the Houston Ballet after 1974. As well as the classical roles, to which she has added "The Sugar Plum Fairy" and "Aurora," she

has performed in Ben Stevenson's *Bartok Concerto* and *Four Last Songs* and in Cho San Goh's *Variaciones Concertantes* and *Interventions*.

Vogeler, Sara, American postmodern dancer and choreographer. At the Erick Hawkins studio as a trainee and apprentice from 1974 to 1977, she continued her studies in jazz with Jon Devlin and Lee Becker-Theodore, ballet with Nanette Charisse, and Contact Improvisation with David Woodberry.

She performed for Hawkins dancers Beverly Brown, in *Life Is a Drop of Pond Water* (1975), and Kristen Peterson, in *Song Wants to Be the Light* (1977) and *Such Dusk* (1977), and in works by Elaine Summers, Andy De Groat, his *Angie's Waltz* (1978), and Pauline De Groot in Amsterdam. With Woodberry, she has danced in his *Body Wave* (1978), *Leverage* (1979–1980) on a tour of Western Europe, *Dance to Sunset* (1979), *Running Waves* (1979), *Invisable Line* (1979), *Desert* (1980), and the 1980 production of *Nijinsky Suicide Health Club*.

Vogeler has choreographed herself since 1974, and her works since 1977 have been well received in performance in New York and Europe. She creates solos dances for herself to be performed with readings of her own poetry. She teaches improvisation techniques and modern therapy and centering systems in New York and while on tour in Western Europe.

Works Choreographed: CONCERT WORKS: *Mandala* (1974, in collaboration with Lynne Feigenbaum); *Branch* (1975); *Cockatoo* (1976); *Lightning Bug* (1977); *Temple Dance* (1977); *Fish* (1978, in collaboration with David Woodberry); *Cross Currents* (1979); *The Poet as Dancer* (1979, to score of own poetry); *Lies Through Love, Section I* (1980); *Lies Through Love, Section II* (1980); *"Nightscape"* (1980); *Circles and Lines* (1980); *Dutch Truths* (1980).

Volinine, Alexander, Russian ballet dancer; born September 17, 1882 in Moscow; died July 3, 1955 in Paris. Trained at the Moscow School of the Imperial Theatres by Vassili Tikhomirov, Volinine joined the St. Petersburg company after graduating in 1901.

A member of the first company of Diaghilev's Ballet Russe, Volinine, with Lydia Lopoukhova, was

hired to perform in New York by Charles Frohman. They danced in his *The Echo* (August 1910), and performed *Les Sylphides* and divertissements from the Russian repertory at the Globe Theater in New York. After partnering Ykaterina Geltzer at the Metropolitan Opera, he toured in vaudeville with the All-Star Imperial Russian Ballet (c.1911) and with Adelina Genée's production, *La Danse* (c.1912).

Volinine joined the Anna Pavlova Company in 1914, remaining with her tours until 1927. He partnered her in many ballets and divertissements, among them, her two-act *Raymonda* (1915), *Snowflakes* (1915), and *Giselle* (1920).

Retiring to teach in 1928, he opened a studio in Paris, where he trained, among many others, André Eglevsky, Roland Guerrard, and Renée Jeanmaire. Most of his known choreography was created for school recitals, but three earlier works (c.1915) seem to have been interpolated into the Pavlova concerts. He was also asked to restage both Pavlova works and standards of the Russian repertory; for example, he revived *Giselle* for the Royal Danish Ballet in 1946.

Works Choreographed: CONCERT WORKS: *The Bow and Arrow Dance* (c.1915); *Sad Pierrot* (c.1915); *Variations Brilliantes* (1915); *Divertissements* (Passepied, Valse Champêtre, Libellule, Danse Tyrolienne, Tango, Chinoiseries, Louis XV, Danse Orientale, Tarentella, Poème, Valse Sentimentales, Arlequinade, Cake-walk, Petite Chinoiserie, Gopak, Mazurka, Danse Egyptienne, Polka, Pizzicato) (1939).

Bibliography: Volinine, Alexander. "My Dance of Life," *The Dance* (January–May 1930). There is no evidence that this autobiography was ever published.

Volkova, Vera, Soviet ballet dancer and teacher working in London and Copenhagen since the 1940s; born 1904 in St. Petersburg; died May 5, 1975 in Copenhagen, Denmark. Trained by Maria Romanova and Agrippina Vaganova, she performed with the GATOB but left a tour of the Far East to remain in Shanghai, along with George Goncharov. She taught in Goncharov's studio there, but moved with her English husband to Hong Kong and London, where she worked with Mona Ingelsby's International Ballet.

Volkova opened a studio in Knightsbridge and quickly became one of London's most popular and most influential teachers. She taught for a year at the Teatro alla Scala in Milan but left for Copenhagen where she became artistic advisor to the Royal Danish Ballet from 1951 until her death in 1975.

Vollmar, Jocelyn, American ballet dancer; born November 25, 1925 in San Francisco. Trained by Willam and Harold Christensen at the school of the San Francisco Opera Ballet, she has been associated with that company first in the 1947 and 1948 seasons, with roles in Adolf Bolm's *Mefisto*, Willam Christensen's *Farranda, Coppélia, Sonata Pathétique*, and classical pas de deux.

After performing as a guest with Ballet Society, she joined Ballet Theatre, where she danced in Balanchine's *Theme and Variations*, Frederick Ashton's *Les Patineurs*, and the company production of *Swan Lake*. She also performed with the Grand Ballet du Marquis de Cuevas in Europe and the Borvcansky Ballet in Australia before returning to San Francisco. In her second tenure there, she created roles in Lew Christensen's *Lady of Shallott* (1958) and *Fantasma* (1963), and was cast in the ballerina roles in Balanchine's *Concerto Barocco* and Christensen's *Beauty and the Beast* and *Sinfonia*. She retired in 1972 after a final performance of her most famous role in San Francisco—the "Sugar Plum Fairy" in his production of *The Nutcracker*.

For six years after retiring from performance, Vollmar taught the young dancers at the San Francisco Ballet. It is to be hoped that her technical strength and precision will be inherited by the next generation.

Von Grona, Eugene, German concert dancer working in the United States; born c.1908. Von Grona was trained in Germany in (Per Henrik) Ling gymnastics and the German expressionist work of Mary Wigman. He emigrated to the United States in 1926 under the management of Sol Hurok to introduce America to "Absolute Dance," his term for a combination of music visualizations and constructivist machine dances. Although his first American recital included many abstractions based on Romantic scores, his first major successes were the *Ballet Méchanique* that he staged at The Roxy Theater (1927) and the

shorter work, *The Factory*, from the first recital. For most of his early career, he worked successfully within theatrical formats, ranging from frequent engagements at The Roxy and at "Roxy" Rothafel's Radio City Music Hall, to work on Broadway in *Let 'Em Eat Cake* (1933), which he co-choreographed, *Vincent Youman's Ballet Revue* (1936, Boston), and *Blackbirds of '39.*

His concert career included almost annual solo and duet recitals in New York until 1934, when he founded a company to present his group works. The short-lived First American Negro Ballet appeared in its own concerts, with symphony orchestras, and at the Dance Congress, but was unable to garner a permanent audience. By 1941, Von Grona dropped out of dance to concentrate on work in directing and dramatic production in collaboration with Edwin Piscator. In 1976, however, he returned to the concert stage, performing his own *Epic in Jazz.*

Works Choreographed: CONCERT WORKS: (Note: works dated 1927 may have been choreographed earlier in Germany.) *Chopin Prelude* (1927), *La Plus que Lente* (1927); *Nocturne* (1927); *Sonate No. 9* (1927); *Narcissus* (1927); *Caprice Moderne* (1927); *Marche* (1927); *Second Hungarian Rhapsody* (1927); *The Factory* (1927); *Danses Negres (The Golliwog's Cakewalk, Pierrot Noire)* (1927); *Ballet Méchanique* (1927); *The Spirit of Labour* (1928); *Two Roads* (1932); *Valse d'Amour* (1932); *Harlem Impressions* (1932); *Revolutionary* (1932); *Victory of Labour* (1932); *Swastika* (1935); *Children of the Earth* (1937); *Garden of Weeds* (1937); *Lullaby* (1937); *Dodging a Divorcée* (1937); *Sunday Morning: Town and Country* (1937); *St. Louis Woman* (1937); *Air for the G String* (1937); *The Firebird* (1937); *Epic in Jazz* (1976).

THEATER WORKS: *Let 'Em Eat Cake* (1933, co-choreographed with Ned McGurn); *Vincent Youman's Ballet Revue* (1936, out of town only); *Blackbirds of '39.*

Von Reinhold, Calvin, Canadian theater, film, and television performer also working in England and the United States; born Calvin von Reinhold Lutz, January 17, 1927 in Regina, Saskatchewan, Canada. Raised in Vancouver, British Columbia, he was trained in dance by Kay Armstrong. After moving to London, he continued his studies in ballet with George Goncharov and Anna Northgate, in jazz with Matt Mattox and in ethnic forms with Ram Gopal.

A West End dancer from 1952, he specialized in London productions of Broadway musicals, among them, *Call Me Madam* (1952), *Wish You Were Here* (1953), and *Pal Joey* (1954). He moved to Broadway itself in 1958. While in London, he danced for and appeared in Jack Cole's *Gentlemen Prefer Brunettes* (UA, 1955) and staged dances for the British independent television network, Associated Redifusion. On Broadway itself, he was cast in *Say Darling* (1958) and *No Strings* (1962), performing between runs at the Radio City Music Hall.

Works Choreographed: TELEVISION: *The Vera Lynn Show* (Associated Redifusion, 1956–?); *Youth Takes a Bow* (Associated Redifusion, 1956–?).

Von Rosen, Elsa Marianne, Swedish ballet dancer and choreographer; born April 21, 1927 (or 1924) in Stockholm. Trained at the school of the Royal Ballet, von Rosen spent a year in Copenhagen studying the Bournonville repertory. After performing with the Oscars Teatrum in Stockholm and her own Swedish Ballet (1950), notably in Birgit Cullberg's *Miss Julie* (1950), von Rosen joined the Royal Swedish Ballet. In that company, she danced the principal roles in the company's productions of the classics of the nineteenth-century repertory, and in works by Leonid Massine (*Gaité Parisienne* and *Le Tricorne*), Birgit Cullberg (*Medea*), and Harald Lander, for whom she created *The Woman in Rhapsody*. She also choreographed for the Ballet, creating *Prometheus* in 1958 and *Helios* in 1960. A freelance choreographer since 1960, she has staged new works for the Royal Swedish Ballet, among them *Irene Holm* (1960) and *The Virgin Spring* (1964), and has restaged ballets for companies in Scandinavia, England, and Russia. An innovative choreographer, she is known for the subtlety of her dramatic gestures and for her experiments with music, employing everything from Swedish Romantic symphonists to Emerson, Lake, and Palmer.

Works Choreographed: CONCERT WORKS: *Prometheus* (1958); *Helios* (1960); *Irene Holm* (1960);

The Virgin Spring (1964); *Jenny von Westfalen* (1965); *Don Juan* (1967); *Romeo and Juliet* (1972); *Utopia* (1974); *A Girl's Story* (1975).

Von Rottenthal, Irmgard, Austrian interpretive dancer; born 1890 in Moslovena, Hungary. Von Rottenthal was trained in Vienna, possibly in social dance forms only, and by Rita Sacchetto in Paris. After marrying an American editor and settling in Chicago, she began to perform in private recitals and with the Chicago Symphony Orchestra in interpretive solos. She appeared in a musical play in Montreal's His Majesty's English Language Theatre (*Lady Luxury*, 1914), and in an American film, *Midnight at Maxim's* (Kalem, 1915), but otherwise worked entirely in concerts.

Works Choreographed: CONCERT WORKS: *Woodland Legend* (1913); *Symphonic concert (Barcarole, Song Without Words, Peer Gynt Suite, Meditation from "Thais")* (performed together in 1913, possibly choreographed previously); *Dance of the Dark Ages* (1914); *Love's Waltz* (1914); *The Temptation of Eve* (1914); *The Gold Fish* (1914); *Nature Dances (Dance and the Sea, Sea Mist, Snow Flurry)* (1914); *Paderewski Minuet* (1914); *Aubade* (1914); *Printainiere* (1914); *Serenade Coquette* (1914); *The Flatterer* (1914).

von Swaine, Alex Andre, German concert dancer; born December 28, 1905 in Munich. Von Swaine was trained at Eugenie Eduardova's ballet studio in Munich and may have also had formal work in *plastique*. Although he produced solos for himself as early as 1920, among them his celebrated and frequently revived *De Profundis*, he worked primarily as an actor in the 1920s. His best known role in that period was as a member of Max Reinhardt's company, playing "Puck" in his 1926 *Midsummer Night's Dream*. Like so many of Reinhardt's dancer/actors, he found it difficult to work within the confines of a conventional company, and although he occasionally became a member of a German state opera ballet or an Italian theater, he toured more frequently as a concert dancer. He created pieces for himself and his female partner (Darja Collin in the early 1930s, and later Lisa Czobel) based on characterizations in movement, images of contemporary life, and like many American concert dancers, studies of folk work. Many of his works from the late 1930s, such as *The Outcast, Le Damné, Lamentation,* and *Le Destérade*, were solo struggles with life and the environment, frequently represented by a brilliantly manipulated prop or garment. His repertory also included comic interpretations of historical types, however, among them *Minuet, Cavalier à la Mode*, and *The Haymaker*. He performed a *l'Après-midi d'un Faune* (credited to Eduardova) and his own *Petrouchka* in the late 1930s, although it is likely from available evidence that the latter was a solo.

While one can never accurately determine motivations from the past, it seems that von Swaine joined traditional ballet companies when he needed to take time off from touring to renovate his repertory. His most important tenures were with the Berlin Deutsche Stattsoper under Max Terpis' directorship, and with La Scala, where he performed in works by Lizzie Maudrik. It is not known how good his conventional ballet technique was, but since he partnered La Scala ballerina Attila Radice, it was probably excellent.

Through the mid-1950s, von Swaine toured with what was basically his 1940s repertory, but also taught. Since the late 1950s he has been associated with the Etudios das Belles Artes in Mexico City.

Works Choreographed: CONCERT WORKS: *Allegro Tragico* (c.1920); *De Profudis* (c.1920, revived frequently); *Farucca* (pre-1937); *Resoluto* (pre-1937); *Nocturne* (pre-1937); *Czardas* (pre-1937); *Valse Classique* (pre-1937); *La Damné* (pre-1937); *Murmillos de l'Alhambra* (pre-1937); *The Hungarian Soldier* (1937); *Caprichos* (1937); *Lamentation* (1937); *Le Fleuve Enchanté* (1937); *Petrouchka* (1937); *Reverie* (1937); *Danse du Dervische* (1937); *Galop* (1937); *Danse Populaire* (1937); *Le Faucheur* (1937); *Laendler* (1937); *Le Destérade* (1938); *Minuet* (1938); *The Outcast* (1938); *Farucca* (1938); *Capricios* (1939); *Cavalier à la Mode* (1939); *The Haymaker* (1939).

Vosseler, Heidi, American ballet dancer; born 1914 in Philadelphia, Pennsylvania. Trained at the School of American Ballet, she participated in the first per-

formances of the American Ballet, dancing in the El-egie section of George Balanchine's *Serenade* and in his *Alma Mater* (both 1934). She worked with the American Ballet in productions of the Metropolitan Opera and in the film, *The Goldwyn Follies*. Her Broadway credits included Balanchine's *On Your Toes* (1938), *I Married an Angel* (1938), as Vera Zorina's understudy and chorus dancer, and *The Boys from Syracuse* (1939).

Vosseler toured with the combined American Bal-let and Ballet Caravan in 1941, dancing in *Concerto Barocco* and *Ballet Imperial*. While on that tour, she married tap dancer Paul Draper (also a student at the School of American Ballet), who was then perform-ing in cabarets in Latin America.

Vyroubova, Nina, Russian ballet dancer working in France; born June 4, 1921 in Gourzoff, the Crimea, Russia. Trained by her mother Irène Vyroubova, and by Olga Preobrajenska, Tatiana Gsovsky, and Lu-bov Egorova, she made her debut with a Chauve-Souris company in 1939. She performed with a variety of French companies in the 1940s, among them the Ballet Russe de Paris (1940), the Ballets des Champs-Elysées, in which she created a role in Roland Petit's *Les Forains* (1945), and Ballets de Paris. In the Paris Opéra from 1949 to 1956, she created roles in works by Serge Lifar, among them his *Blanche Neige* (1951), *Les Noces Fan-tastique* (1955) and *Hamlet* (1959). She danced in ballets by Ana Ricardu with the Grand Ballets du Marquis de Cuevas, including her *Inez de Castro* (1952) and *Chanson de l'éternel tristesse* (1957). Since 1962, she has worked as a guest artist in various companies in Europe and the United States.

W

Wagner, Frank, American theatrical dancer, teacher, and choreographer; born in St. Mary's, West Virginia. Wagner was trained at the Katharine Dunham studio in New York and at the American Theater Wing school. He also took modern dance class with José Limón, Anna Sokolow, Hanya Holm, and Charles Weidman, and studied ballet with Helena Platova and Ella Dagnova. While teaching at the International Dance School for the last thirty-five years, he has been associated with a wide variety of theatrical forms. Wagner was first known for his work with intimate revues—for summer camps like Green Mansions and Tamiment, and for ten years of Julius Monk shows at the Plaza Nine in New York City. More recently, however, he has become famous for his work with enormous extravaganzas, most notably those for the Radio City Music Hall. Wagner has been able to use both formats and scales of performance with equal skill.

Works Choreographed: THEATER WORKS: *I Feel Wonderful* (1954); *Ziegfeld Follies of 1961* (closed out of town after a long tour, tap numbers); *How to Steal an Election* (1962); *New Faces of 1968*; *Snow White and the Seven Dwarfs* (1979, Radio City Music Hall and lengthy tour); *Manhattan Showboat* (1980); productions for Green Mansions (late 1950s); productions for Tamiment Camp (late 1950s); productions for Julius Monk (c.1958–1971, for Plaza Nine); many industrials.

Wagoner, Dan, American modern dancer and choreographer; born July 31, 1932 in Springfield, Massachusetts. Wagoner was trained by Ethel Butler and Mary Day in Washington and at the Martha Graham school in New York. A member of the Graham company from 1958 to 1962, he created roles in her *Clytemnestra* (1958), *Espisodes I* (1959), *Alcestis* (1960), *Visionary Recital* (1961), *Phaedra* (1962), and *Samson Agonistes* (1962).

After performing briefly with Merce Cunningham, he joined the company of Paul Taylor, dancing in the premieres of his *Junction* (1961), *Insects and Heroes* (1961), *Pieces, Period* (1962), *Scudorama* (1963), *Orbs* (1966), and *Dances* (1965). As a freelancer, he guested with John Butler, dancing in his *Carmina Burana* in 1960, and with Viola Farber, performing in her *Notebook* (1968) and *Passage* (1969).

Wagoner has choreographed for his own company since 1969, touring frequently and giving recitals in New York. His works are mostly abstract, but all deal with emotions among people or between a dancer and an object that defines space and function. He has also worked with Al Camines' Judson's Poet's Theatre in New York.

Works Choreographed: CONCERT WORKS: *Flag Dance* (1968); *Dan's Rum Penny Supper* (1968); *Duet* (1968); *Le Jardin de Monsieur McGregor* (1969); *Brambles* (1969); *Night Duet* (1969); *Westwork* (1970); *Iron Mountain* (1971); *July 13* (1971); *Cows and Ruins* (1971); *Numbers* (1972); *Changing Your Mind* (1972); *Dance* (1972); *Broken Hearted Rag Dance* (1973); *Meets and Bounds* (1973); *A Sad Pavanne for These Distracted Times* (1973); *Taxi Dances* (1974); *Summer Rambo* (1975); *A Dance for Grace and Elwood* (1976); *Songs* (1976); *"George's House"* (1976); *Allegheny Connection* (1977); *Green Leaves and Gentle Differences* (1978); *Variations on "Yonker Dingle"* (1978); *A Play with Images and Worlds* (1979); *Seven Tears* (1979); *Lila's Garden Ox* (1980).

Walczak, Barbara, American ballet dancer; born c.1940 in New York City. A student of Phyllis Marmein, Walczak continued her training with Muriel Stuart at the School of American Ballet and performed with the Ballet Society as an adolescent.

A member of the New York City Ballet during the 1950s, she was assigned featured roles in George Balanchine's *Scotch Symphony, Bourée Fantasque, Mazurka from "A Life for the Tsar," Roma,* and the *Pas de Dix,* in which she created one of the brilliant variations. Like so many other seemingly staid Balanchine dancers of the fifties, she won acclaim as a comic in his *Western Symphony.* She also created roles in the works of her colleagues, among them, Francisco Moncion's section of *Jeux d'Enfants* (1955) and Willam Christensen's *Octet* (1958).

Walczak was a frequent guest artist, and participated in two major touring troupes—André Eglevsky's company, in which she performed in *Les*

Sylphides and many pas de deux, and the Ballet Alicia Alonso, where she danced with Alonso in *Swan Lake* and *Coppélia*.

Walker, Ada Overton, American theatrical dancer and choreographer, believed to be one of the first women to receive a formal dance direction credit; born 1880 in New York; died there October 10, 1914. Walker, who probably did not have any formal training, toured for many years with the companies of Sisseretta Jones (known as "Black Patti"). During the last years of the nineteenth century, she was a specialty dancer with the (Bert) Williams and (George) Walker troupe of comics. After she married Walker (1873–1911), she performed with their company for a dozen years. She received credit for the dances in all of the Williams and Walker shows to be performed on Broadway—the only shows that had formal credits printed on their programs—*Sons of Ham* (1900), *In Dahomey* (1902), *Abyssinia* (1906), and *Bandana Land* (1908). She probably staged her own specialty, a stylized cake-walk, the chorus numbers, and some of the Williams and Walker comedy sequences.

The company broke up after Walker's death in 1911. Williams (1874–1922) went on to become one of the period's great song stylists and comics. Overton-Walker died in 1914, and had not worked on Broadway since 1911.

Works Choreographed: THEATER WORKS: *Sons of Ham* (1900); *In Dahomey* (1902); *Abyssinia* (1906); *The Red Moon* (1907); *Bandana Land* (1908); *The Smart Set* (1911).

Walker, David Hatch, Canadian ballet and modern dancer, associated with the Martha Graham company after 1970; born David Hatch, 1949, in Edmonton, Alberta. After local studies with Ruth Carse, he accepted a scholarship to the School of the National Ballet of Canada where he worked with Eugen Valukin. He left Canada to join the Ballet Rambert in London (1968–1969), with which he performed featured roles in revivals of Antony Tudor's *Dark Elegies* and Glen Tetley's *Embrace Tiger and Return to Mountain*.

Hatch Walker moved to New York to study with Martha Graham in 1970 and joined her company within the year. He has performed most of the principal male roles in company revivals of Graham works, among them *Diversion of Angels, Clytemnestra, Seraphic Dialogues, Night Journey*, and *Appalachian Spring*, in which he played "The Revivalist." His created roles in Graham works included *Chronique* and *Jungle* (both 1974), and *Adorations* (1975).

Hatch Walker choreographs and dances for the Asakawalker company, which he directs with his wife, fellow Graham dancer, Takako Asakawa. Among the works which he has created for Asakawa to perform are *Fantasy I* (1970), *Vision* (1978), *The Golden Door* (1978), and *Time Unseen* (1970).

Works Choreographed: CONCERT WORKS: *Time Unseen* (1970); *Fantasy I* (1970); *The Farewell* (1975); *Ritual* (1976); *Ecstasis* (1977); *Vision* (1978); *The Golden Door* (1978); *Rhapsody* (1980).

Walker, Norman, American modern dancer and choreographer; born June 21, 1934 in New York City. A graduate of the High School of Performing Arts and a student of Robert Joffrey and May O'Donnell, he typified the ability of a PA dancer to perform and choreograph in both ballet and modern techniques. After performing with the companies of O'Donnell, Pearl Lang, and Yuriko, Walker formed his own troupe in the early 1960s. Partnered by Cora Cahan in his own works, he frequently performed at the 92nd Street Y and at Jacob's Pillow. Until the 1970s, in fact, he seemed to choreograph primarily solos and duets, although he did stage larger pieces for students at the Pillow. Walker is also known for his television choreography, especially the work *Reflections* (CBS, 1963, special), which was presented on one of the first Repertory Workshops.

His works have been created and revived for many ballet companies, among them the Boston Ballet, Bat-sheva Dance Company, and Harkness Ballet, of which he was a resident choreographer. A student from the Harkness, Dennis Wayne, revived many of Walker's solos for himself in his Dancers company.

A popular teacher, Walker has worked at the High School of Performing Arts and currently serves as chairperson of the Department of Performing Arts at Adelphi University, just outside New York City. His

department there has a famous artists-in-residence program and has produced many working performers in all aspects of theater and dance.

Works Choreographed: CONCERT WORKS: *Four Cantos* (1956); *Variations from Day to Day* (1957); *Crossed Encounter* (1960); *Baroque Concerto No. 1* (1961); *Cowboy in Black* (1961); *In Praise of . . .* (1961); *A Passage of Angels* (1961); *Prussian Officer* (1961); *Clear Songs After the Rain* (1962); *Reflections* (1962); *Enchanted Threshold* (1963); *Figures and Masks* (1963); *Meditations of Orpheus* (1963); *Baroque Concerto No. 2* (1963); *The Testament of Cain* (1964); *Schéhérazade* (1964); *Ritual and Dance* (1964); *The Night Chanter* (1965); *Illuminations* (1965); *Contrasts* (1965); *Trionfo di Afrodite* (1965); *IIXIIXII* (1966); *Elogiés* (1966); *A Certain Slant of Light* (1966); *The Sybil* (1966); *Night Song* (1966); *Untitled I and II* (1967); *Calendar* (1967); *Baroque Concerto No. 3* (1967); *Drifts and Dreams* (1967); *A Broken Twig* (1967); *Ceremonials* (1967); *Suite* (1968); *Song* (1968); *As Quiet As . . .* (1968); *Evocation* (1968); *Duet* (1968); *Portrait of . . .* (1969); *Kleediscopic* (1969); *Baroque Concerto No. 4* (1969); *Homage to Jacob's Pillow* (1969); *Nocturne* (1969); *Three Psalms* (1969); *The Lovers* (1969); *Baroque Concerto No. 5* (1970); *Baroque Concerto No. 6* (1971); *Heaven Within the Mountain* (1971); *Three Psalms* (1971); *Sky-Well* (1971); *The Dark Backwards* (1971); *Summer Flight* (1971); *Suite for Sixteen* (1972); *Serendipitous Seraphin* (1972); *Fantasy Variations* (1972); *Season of Flight* (1972); *Baroque Concerto No. 7* (1972); *Fifth Symphony* (1973); *Moon Fern Mid Solar Wind* (1973); *Gloria* (1973); *Prelude* (1973); *Lazarus* (1973); *piece for piece* (1973); *Songs of a Wayfarer* (1973); *Pavanne for a Solo Dancer* (1973); *Medea* (1974); *Autumn Dialogues* (1974); *Mosaics* (1974); *Nocturnes* (1975); *Le Bal Masqué* (1975); *Fighting the Waves* (1975); *Celestial Circus* (1975); *First Raptures* (1975); *Rossiniana* (1975); *Knoxville* (1976); *Prelude to a Summer's Evening* (1976); *Echoes from the Tempest* (1976); *The Arc of Angels* (1977).

Walker, Ron, American cabaret dancer and choreographer; born in the 1940s in Los Angeles, California. Walker began ballroom dance classes at sixteen and decided to continue his studies in ballet locally with Michael Panaieff and Valentin Frohman and in jazz dance with Luigi in New York. He has taught and coached extensively in Las Vegas since the 1960s but has also worked as a unit dance director for the Tibor Rudas theaters and clubs in Paris, including the famous Lido, and in Bangkok, Australia, Singapore, Barcelona, and Milan.

Wall, David, English ballet dancer; born March 15, 1946 in Chiswick. After early training in Windsor, he entered the school of the Royal Ballet in 1956. Graduating into the Royal Ballet touring company (1964–) and senior company (1970–), he created roles in Antony Tudor's *Knight Errant* (1968), Frederick Ashton's *Sinfonietta* (1967) and *The Creatures of Prometheus* (1970), and Kenneth Macmillan's *Manon* (1974, as "Lescaux" but now playing "Des Grieux"), *Elite Syncopations* (1974), *Rituals* (1975) and *Mayerling* (1977). He is well known for his work in the company productions of the classics, among them *Raymonda, The Nutcracker, Swan Lake*, and *Cinderella*, and in the contemporary abstractions of Glen Tetley and Jerome Robbins, dancing in the former's *Voluntaries* and the latter's *Dances at a Gathering* and *Afternoon of a Faun*.

Wallace, Earl, American dance director and teacher of the early twentieth century; born c.1880, possibly in the Los Angeles area of California; the details of Wallace's death cannot be verified. Two dance forms associated with Hollywood films of the 1930s were developed by Wallace in his Los Angeles–area studios in the 1920s—adagio team work and living statues. The adagio form, popular in the United States between 1925 and 1935, should not be confused with the ballet pas de deux; it was more like exhibition pair figure skating. He specialized in staging teams for Prolog units managed by Fanchon and Marco, who frequently hired teams for their "Ideas." Fanchon, and her choreographers, used at least one adagio team in each Idea and, in some, staged simultaneous adagio acts for two, three, four, or, in one case, six teams. Wallace specialized in male-female teams, ranging from "America's Youngest Adagio Dancers" (his daughter Earlyne,

age nine, and John Samma, age eleven), to a score of interchangeable teen-age teams. For Fanchon, he staged trick adagio acts, such as the underwater team for The Mermaid Idea or the concurrent teams that appeared in Busby Berkeley's Chains Idea.

Wallace's other specialty is also associated with Berkeley. He staged living statues, living fountains, and poses for photographs and live performance. The fountain was a special audience favorite—with young women replacing statues and caryatids underneath a shower of colored water—and was quickly adapted to film use. He also taught more conventional dance techniques, among them acrobatics and tap work. Among his students were his teams and actress Betty Grable.

Wallace, Paul, American theatrical and television dancer; born 1939 in Encino, California. A dancer with Fanchon and Marco Prolog units from the age of five, Wallace was trained by film dance directors Nick Castle and Louis Da Pron. Through his adolescence, he played juvenile delinquents in film, and a clean-cut neighbor on *Father Knows Best* (CBS, 1954, NBC, 1955–1959), and tapped on television variety specials and series, among them the *Colgate Comedy Hour, The Jimmy Durante Show*, and the *Eddie Cantor Television Anniversary Show*.

Wallace is best known for his performance of "Tulsa," the tap-dancing juvenile in Jerome Robbins' *Gypsy* (1959); he repeated his performance in the film (UA/Mirisch Prods., 1961). His soft-shoe number, "All I Need Now Is the Girl," was the climax of the plot of the first act (breaking up the vaudeville act), and the only conventional dance number in the show. While on Broadway in that show, he appeared frequently on *The Ed Sullivan Show*. Wallace has staged industrials and commercials since the mid-1960s, and has become one of the most popular teachers of tap and jazz in Los Angeles.

Wallmann, Margarete, Austrian ballet and concert dancer, choreographer, and opera director; born July 22, 1904 in Vienna. Wallmann studied ballet with Eugenia Eduardova in Berlin and Olga Preobrajenska and Mathilde Kschessinskaia in Paris, and was trained in German modern dance by Mary Wigman. A child prodigy ballet dancer, she joined the Charlottenburg Opera Ballet as a young adolescent, also performing with the Berlin Municipal Opera and Bavarian State Opera under Heinrich Kröller. While touring in Switzerland, she saw Mary Wigman perform and decided to study with her in order to join her concert group. A member of the company in the mid-1920s, concurrently with Hanya Holm and Ruth Abrahamowitsch, she received a Wigman teaching certificate. She established a Wigman "twin" school in Berlin in 1927 and managed it until 1932.

Her first company was a group of soloists with whom she performed at the Third German Dance Congress in 1930. The *Orpheus Dionysus* that she presented there was performed by Ted Shawn (owing to a dancer's last-minute injury), who invited her to return to the United States with him. She taught Wigman work at the Denishawn school in New York that winter, becoming the first licensed teacher of the German technique in the United States. She was a major influence on Shawn in the period in which he made the transition from the highly romanticized ethnicities of the 1920s to the expressionist abstractions of the 1930s.

In 1931, she began the association with the Salzburg Festivals that would last until 1937 and which brought her into the forefront of opera production. She worked there with Max Reinhardt, collaborating with him on a *Faust*, and with Bruno Walter and Arturo Toscanini. In 1934, she was appointed ballet director of the Vienna State Opera (to 1937), where she supervised the academy and created new ballets, including *Fanny Elssler* (1934), *Der Liebe Augustin* (1936), and *A Christmas Tale* (1936).

Leaving Germany in 1936, she began a period of traveling from opera house to theater that would last throughout her career. She went to Hollywood in 1935 but only created (or received credit for) two dance sequences. One was in an unreleased color short on Mexican folklore, memorable only because it featured Marguerita Cansino (Rita Hayworth); the other was a ballet scene in *Anna Karenina* (MGM, 1935) for Greta Garbo, which, according to verified sources, actually featured Maria Gambarelli's legs.

She worked in Italy after 1935, associated with the Teatro alla Scala from 1936, where she choreo-

graphed a new version of *Gli Uchelli* and an original work, *Antiche danze e arie*. From 1937 to 1948, she was the ballet master of the Teatro Colón in Buenos Aires, where she supervised the staging of works by Fokine, Balanchine, and Massine, and choreographed her own works. Many of these pieces, such as the *Bachianas Brasilias No. 5* (1943), *Tierra* (1945), and *La Cuidad de las Puertas de Oro* (1947), are based on Latin American themes.

She returned to Italy and La Scala in 1949, but by 1952 was involved in a new career—directing opera productions. Known at first for her successful productions for Maria Callas, she became a frequent guest director at all of the major opera houses in the world. Her last known staff position was in 1976, when she was resident director at the Opera de Monte Carlo, but it is believed that she is living in Italy again. Among the operas for which she staged premieres were Darius Milhaud's *David* (1955) and Francis Poulenc's *Dialogues des Carmélities* (1957).

Wallmann's choreography is especially interesting because she has been able to maintain elements from her performance work and to integrate them into her own style. Her mass groupings on stage in dance and opera can be traced to her work with Wigman, while her ability to focus movements on individuals can be said to derive from her early work in the Vienna court ballet.

Works Choreographed: CONCERT WORKS: *Orpheus Dionysus* (1930); *Das jungste Gericht* (The Last Judgment) (1931); *Fanny Elssler* (1934); *Oesterreichische Bauernhochzeit* (An Austrian Peasant Wedding) (1934); *Gli Ucchelli* (The Birds) (1936); *Der liebe Augustin* (1936); *Weihnachts Marchen* (Christmas Tale) (1936); *Tschaikovsky Fantasy* (1936); *Antiche danze e arie* (1937); *Coppelia* (1937); *Josephslegende* (1937); *Daphnis et Chloe* (1938); *Georgia* (1939); *La Boutique fantasque* (1939); *La Valse* (1939); *Oriane et le Prince d'Amour* (1939); *Offenbachiana* (1940); *Cuento de Abril* (1940); *Panambí* (1940); *La Infanta* (1941); *El sombrero de tres picos* (1941); *Les patineurs* (1941); *Salomón* (1942); *Aubade* (1942); *Bachianas Brasilias No. 5* (1943); *Quartetto* (Haydn, Op. 33, no. 3) (1943); *Quartetto* (Schubert, *La merte y donlo*) (1943); *Apurimac* (1944); *Chasca Nahui* (1944); *Tierra* (1945); *Porto Felice* (1945); *Vidala* (1946); *Passacaglia* (1947); *Pe-*

ter and the Wolf (1947); *La Cuidad de las Puertas de Oro* (1947); *Jeanne au Bucher* (1947); *L'Histoire du soldat* (1948); *I Pini di Roma* (1948); *Jeu de Cartes* (1948); *Le Bourgeois Gentilhomme* (1948); *La Giara* (1949); *Passacaglia* (new version) (1949); *L'Amore stregone* (*El Amor Brujo*, Love, The Magician) (1949); *Firebird* (1949); *Swan Lake* (1949); *Les Sylphides* (1950); *Schéhérézade* (1950); *Sleeping Beauty* (1950, with Beatrice Appleyard); *La Legende di Giuseppe* (1951, new version); *Vita dell'uomo* (1951); *Bottega fantastica* (1951, new version), *Il Fiume Innamorato* (River of Love) (1953); *Salzburger Divertimento* (1954); *La Danse des Morts* (1954); *Persephone* (1955); *Mystère de la Nativité* (1960).

THEATER WORKS: *Faust* (1933); *El Grande Teatro del Mundo* (1933, both for Max Reinhardt).

FILM: *Anna Karenina* (MGM, 1935, additional choreography by Chester Hale); untitled material for short subjects (MGM, 1935); *La Hosteria del caballeto blanco* (Unidentified studio, Buenos Aires, 1937); *Donde mueren las palabras* (Unidentified studio, Buenos Aires, 1937).

TELEVISION: Productions of opera for RAI (1953–1958).

Bibliography: Wallmann, Margarete. *Les Balcons du Ciel* (Paris: 1976).

Walsh, Thommie, American theatrical dancer and choreographer; born in Buffalo, New York. Walsh, who also performs as Thomas, appeared in a number of shows after his arrival in New York City, among them, *Rachel Lily Rosenbloom, and Don't You Forget It* (1978) and Michael Bennett and Tommy Tune's *Seesaw*, but was then engaged for the national company of *Applause*. Another dancer on that tour, Nicholas Dante, was a member of the writing team of Bennett's *A Chorus Line*, and Walsh was cast in a major role in the show's original cast. His character, ''Robert Charles Joseph Henry Mills, III,'' or ''Bobby,'' is the only one in the show who has a full name, and the only dancer who appears in street clothing. He also has one of the most memorable monologue-songs in the central montage, ''If Troy Donahue could be a movie star . . . I could be a choreographer,'' and a classic autobiographical one-liner—''Suicide in Buffalo is redundant.'' Since leav-

ing *A Chorus Line* after its Los Angeles run, he has worked as a choreographer, collaborating as an associate to Tommy Tune on *Best Little Whorehouse in Texas*, and receiving a solo credit for *The 1940's Radio Hour* (1979).

Works Choreographed: THEATER WORKS: *The 1940's Radio Hour* (1979); *A Day in Hollywood/A Night in the Ukraine* (1980, co-choreographed by Tommy Tune).

Walters, Charles, American theater dancer and theater and film choreographer; born 1913 in Pasadena, California. As an adolescent dancer with the Fanchon and Marco West Coast Deluxe Theatre Corporation's Prolog units, he was trained at the schools that Fanchon sponsored in the Los Angeles area—Ernest Belcher's Celeste School of Dancing and Ben and Sally's Stepper Studio in Long Beach, the school that turned out adagio teams by the dozens in the 1920s and 1930s. After moving to New York to work on Broadway, he became well known for his exhibition and comedy dance routines with Dorothy Fox (1934-1938), Vilma Ebsen (1938-1940), and Mitzi Mayfair (1940-1942). He appeared in many of the most popular musicals on Broadway during those years, among them, *Parade* (1935), Robert Alton's *Jubilee* (1935), his *Between the Devil* (1937), and George Balanchine's *I Married an Angel* (1938).

Walters' first Broadway choreography credit was received for sections of *Sing Out the News* (1938), but his period of greatest popularity as a dance director was in the 1941 and 1942 seasons when he worked on *Let's Face It* (1941), *Banjo Eyes* (1941), and *The Lady Comes Across* (1942).

On Gene Kelly's recommendation, Walters moved to Hollywood to join the dance direction staff of MGM in 1942. By the time he retired from that studio in 1965, he had choreographed over a dozen musical comedies and directed an equal number of non-dancing, nonsinging comedies. The most underrated of MGM's dance directors, he is best remembered for his work on the studio's musical films for Judy Garland, among them, *Girl Crazy* (MGM, 1943, the finale only staged by Busby Berkeley), *Presenting Lily Mars* (MGM, 1947), in which he performed and partnered her, *Meet Me in St. Louis* (1944), *The Harvey Girls* (1945), *Easter Parade* (1948), which is still

broadcast every year on many networks, and *Summer Stock* (1950), as well as her tribute to the inventor of the safety pin in *Ziegfeld Follies* (1944), and many of her tours and live acts.

Walters' other memorable films include *Dubarry Was a Lady* (1943), in which he danced with Betty Grable, two early Leslie Caron movies, *Lili* (1953) and *The Glass Slipper* (1955), *High Society* (1956), his last musical, and *The Barkleys of Broadway* (1949), the last Astaire and Rogers film.

Works Choreographed: THEATER WORKS: *Sing Out the News* (1938, partial credit only); *Let's Face It* (1941); *Banjo Eyes* (1941); *The Lady Comes Across* (1942); *St. Louis Woman* (1946).

FILM: *Girl Crazy* (MGM, 1943, finale by Busby Berkeley); *Dubarry Was a Lady* (MGM, 1943); *Presenting Lily Mars* (MGM, 1943); *Meet Me in St. Louis* (MGM, 1944); *Ziegfeld Follies* (MGM, 1944, "The Interview" sequence only); *Her Highness and the Bell Boy* (MGM, 1945); *Weekend at the Waldorf* (MGM, 1945, dream sequence only); *The Harvey Girls* (MGM, 1945); *Summer Holiday* (MGM, 1946); *Good News* (MGM, 1947); *Easter Parade* (MGM, 1948); *The Barkleys of Broadway* (MGM, 1949); *Summer Stock* (MGM, 1950); *Lili* (MGM, 1953); *The Glass Slipper* (MGM, 1955); *High Society* (MGM, 1956).

Walton, Florence, American exhibition ballroom dancer; born 1891 in Wilmington, Delaware; died January 7, 1981. Walton made her professional debut in the Lew Fields show, *The Girl Behind the Counter*, in 1907. Within the year, she was a featured soloist on Broadway in *Miss Innocence* (1908), in which she played a Spanish dancer. After touring in vaudeville, she was in rehearsal for *The Pink Lady* (1912) when Florenz Ziegfeld, Jr. introduced her to exhibition tango and Apache specialist Maurice Mauvet, whose partner had just retired from his act. As partners, billed as Maurice and Florence Walton, they became world famous—second only to the Castles in popularity and general recognition.

Like the Castles, much of the pair's publicity value depended on nonperformance elements. Dressed by Lucille (Lady Duff-Gordon), Walton, like Irene Castle, became a symbol of a fashionable professional woman. When Mouvet and Walton were actually set

up in a publicity rivalry with the Castles, the comparison was primarily one between the Castles as typical Americans and Mouvet and Walton (both of whom were born in the United States) as exotic Europeans.

After divorcing Mouvet in 1920, Walton moved to Paris, where she performed with Leon Leitrin in cabaret (1920-1926). In 1923, as performer/managers of the Marigny Théâtre, in Paris, Walton and Leitrin set up a publicity rivalry with Mouvet and his then-partner, Leonora Hughes.

Walton performed briefly as a tango soloist before her retirement in 1934.

Wanner, Debra, American postmodern dancer and choreographer; born June 13, 1953 in Sacramento, California. Wanner had some background in Creative Movement as a child, but began her professional dance training as a student at the New York University School of the Arts Dance Program under Stuart Hodes, Nanette Charisse, and Rachel Lampert. She has worked frequently with fellow SOA alumni in the New York Dance Collective, Dance Transit (a student company), and in collaboratives choreographed with Clarice Marshall. Her own works have been acclaimed for her interesting uses of partial movements and energies within fuller gestures, and for the wide vocabulary of body shapes that she and Marshall use in their improvisations.

Works Choreographed: CONCERT WORKS: *Knit* (1972); *Laughbath* (1974); *Somebody's* (1974, in collaboration with Clarice Marshall); *The White Piece* (1974, in collaboration with Marshall); *Paintings 1, 2, 3, 4* (1976, in collaboration with Marshall); *Malachite* (1976); *Intramural* (1976); *Draw* (1977, in collaboration with Marshall); *Bridges and Boundaries* (1978, in collaboration with Marshall); */Calico//August/Moon//Dance* (1979); *Young Blood* (1980).

THEATER WORKS: *123* (1980).

VIDEO: *Paintings 5* (1976, in collaboration with Marshall).

Ward, Charles, American ballet and theatrical dancer; born 1952 in Los Angeles, California. Ward studied locally with Stanley Holden and Gene Marianaccio, and in Houston with Michael Lland, while performing with the Ballet there.

Ward joined the American Ballet Theatre in 1972,

and remained with the company for six years. He created roles in Alvin Ailey's *Sea Change* (1972), Lar Lubovitch's *Scherzo for Massah Jack* (1973), and Antony Tudor's *Leaves Are Fading* (1975), and was featured in the company premieres of Glen Tetley's *Gemini* and *Sacre du Printemps*. With the company, he also danced in *Giselle, La Bayadère*, and *Swan Lake*.

Ward left the company in 1978 to create the role that is generally called (not billed officially) the "male ballet lead" in Bob Fosse's *Dancin'* on Broadway.

Ward, Dorothy, English theatrical dancer and actress; born c.1885 in Birmingham. Ward danced in local pantomimes before moving to London to appear in George Edwardes' revues and musicals, among them *A Waltz Dream* (1908), *Havana* (1908), and *The Girl on the Film* (1913). Her New York appearances included *Phoebe of Quality Street* (1921), in which she made her American debut, and the Shuberts' *The Whirl of New York* (1921), where she became famous for introducing "Molly on a Trolly, by Golly, with You." Despite the range of her London and Broadway appearances, she remained best known as a pantomime star, performing, for example, for eighteen years in The (London) Alhambra's Christmas pantomimes. Because of her height, her shapely legs, her dance abilities, and her glowing voice, she was always cast as a "Principal boy," the hero of the pantomime plot. The boy, whether "Aladdin," "Dick Wittington," or "Jack," was always played by a woman in trousers in the tradition that began in English harlequinades and burlesques.

By the mid-1930s, Ward left pantomime to return to London revues, notably *Stop-Go!* (1935) and *Meet Me Victoria* (1944). She was also known for her work with ENSA and for her stirring renditions of "We're Going to Hang Out Our Washing on the Siegfried Line."

Warde, Willie, English eccentric dancer and choreographer; born 1857 in Great Yarmouth; died August 18, 1943 in London. Warde made his debut at age two in *Young and Older Stagers*, working in the provinces until 1877 when he played his first "Harle-

quin'' in London. He joined the Gaiety Theatre company that year and performed with it for thirty years as an eccentric dancer specializing in drunken falls, and as a verbal comic.

Warde's freelance career included performances as ''Coppelius'' and ''Hilarion'' in the A. Bertrands' productions at The Empire Theatre in 1884, and an eccentric dance in Katti Lanner's *Round the Town* there in 1892. In 1905, he created the roles of ''Harlequin'' in James M. Barrie's playlet, *Pantaloon*, repeating that characterization frequently in revivals.

It is difficult to determine which shows Warde actually choreographed at the Gaiety. The list of verified credits below probably represents less than a fifth of the complete number.

Works Choreographed: THEATER WORKS: *A Gaiety Girl* (1893); *The Shop Girl* (1894); *Little Jack Shepherd* (1895); *The Geisha* (1896); *The Quaker Girl* (1910).

Waring, James, American ballet, modern, and theater dancer and choreographer of tremendous importance to the development of postmodern dance; born November 1, 1922 in Alameda, California; died December 2, 1975 in New York City. Raised in the San Francisco Bay area, he first studied ballet and plastique with Raoul Pausé in Oakland before crossing the Bay to continue his training at the San Francisco Ballet School and in Welland Lathrop's composition workshops. After moving to New York, he studied at the School of American Ballet with Muriel Stuart and Anatole Vilzak, and with Merce Cunningham and John Cage who were then teaching modern dance and music at SAB.

Although there is a tendency to think of Waring as a prolific choreographer, there were many years when he could not afford to present more than one concert. He choreographed for his company—an ad hoc contingent that at various times included Yvonne Rainer, David Gordon, Arlene Rothlein, Valda Setterfield, Deborah Hay, Fred Herko, and ballet dancer Christopher Lyall—for his students at the Indian Hill summer camp, for small ballet and modern dance companies, and for theater productions. His concert works, all of which tended to slip in between categories, could be straightforward ballets with dancers doing beautiful movements, like the abstract

solo, *32 Variations in C Minor* (1973), or they could be montages of allusions to film, Victorian songs, popular culture, and private mythologies. A dancer who arrived in New York too late to work with him once made a piece to a score made up of Waring titles; a similar list could include *Little Kootch Piece* (1955), *Dances Before the Wall* (1957), *Dromenon: Concert for Music, Dancers and Lights, dedicated to Ruby Keeler* (1961), *At the Hallelujah Gardens* (1963), *The Phantom of the Opera* (1966), *Well . . . Actually* (1967), *A Waltz for Midnight Comedians* (1968), *Pumpernickle and Circumstances* (1969), *Twelve Objects from Tender Buttons* (1972), or a personal favorite, *At the Café Fleurette* (1968), subtitled ''a Garland of Songs and Dances for Vernon and Irene Castle'' which included a homage to Jeannette MacDonald and Nelson Eddy.

Waring's theater pieces were created for the major experimenters of the late 1950s—the Living Theatre, Diane Di Prima, and the Café Cino—and for the Judson Poet's Theater. The productions included Di Prima's *Monuments for the Café Cino* (1958), the Living Theatre's presentation of *Love's Labor* (1959) with Viola Farber, Fred Herko, and Valda Setterfield as ''Venus,'' and *The Poor Little Rich Girl* (1968) for Al Carmines' Judson Poet's Theater.

He also taught classes for the Living Theatre—company movement for actor sessions and a series of composition workshops. These classes, for a group that included David Gordon, Setterfield, Herko, Rothlein, and Rainer, set the stage (or space) for the developing Judson Dance Theater and, therefore, for the postmodern movement. It would be difficult to underestimate Waring's impact on dance and theater in New York in the late 1950s and 1960s—the time that inspired and challenged these most influential innovations in both arts. It is unfortunate that so few of his works have been maintained, but his importance is undeniable.

Works Choreographed: CONCERT WORKS: *Luther Burbank in Santa Rosa* (1946); *Duet* (1949); *The Wanderers* (1951); *The Prisoners* (1952); *Pastorale* (1953); *Lamento* (1953); *Burlesca* (1953); *Freaks* (1954); *Three Pieces for Solo Clarinet* (1954); *Intrada* (1955); *Largo* (1955); *Little Kootch Piece* (1955); *Jeux d'enfants* (1955); *Duettino* (1956); *Adagietto* (1956); *Pieces and Interludes* (1956); *Fantasy and*

Fugue in C Major (1956); *Suite* (1956); *Obertura Republicana* (1956, co-choreographed with Remy Charlip, Marian Sarach, Paul Taylor, and David Vaughan); *Phrases* (1956); *Humoresque* (1957); *Poeta Nascitur* (1957); *Ornaments* (1957); *Dances Before the Wall* (1957); *Octandre* (1958); *In the Mist* (1959); *Pyrrhic* (1959); *Corner Piece* (1959); *Extravaganza* (1959); *Peripatea* (1960); *Tableaux* (1960); *Gossoon* (1960); *Landscape* (1960); *Lunamble* (1960); *A Swarm of Butterflies Encountered on the Ocean* (1960); *Dromenon; Concert for Music, Dancers and Lights, dedicated to Ruby Keeler* (1961); *Little Kootch Piece Number Two* (1962); *Two More Moon Dances, with Radio Music as an Overture* (1962); *Dithyramb* (1962); *Exercise* (1962); *Bacchanale* (1963); *At the Hallelujah Gardens* (1963); *Divertimento* (1963); *Poet's Vaudeville* (1963); *Double Concerto* (1964); *Stanzas in Meditation* (1964); *Rondo in A Minor and Fugue in C Major* (1964); *Panacea* (1964); *Three Symphonies* (1965); *Tambourine Dance* (1965); *Musical Moments* (1965); *In Old Madrid* (1965); *Andante Amoroso and Adagietto* (1965); *Munuet, Gigue and Finale* (1965); *Three Dances from Triumph of Night: Scenes for a Masque* (1965); *La Serenata in Maschera: to Pietro Longhi* (1965); *March: to Johann Joachim Kandler* (1966); *The Phantom of the Opera* (1966); *Mazurkas for Pavlova* (1966); *Northern Lights* (1966); *Good Times at the Cloud Academy* (1966, co-choreographed with Deborah Lee and Irene Meltzer); *Arena* (1967); *Salute* (1967); *Musical Banquet* (1967); *Well . . . Actually* (1967, co-choreographed with Remy Charlip and John Herbert McDowell); *Spell* (1968); *Winter Circus* (1968); *Amethyst Path* (1968); *A Waltz for Midnight Comedians* (1968); *At the Café Fleurette* (1968); *An Oriental Ballet* (1968); *Seven Poems by Wallace Stevens* (1968); *Polkas and Interludes* (1968); *Revision of Mazurka for Pavlova* (1969); *Dance Scene, Interlude and Finale* (1969); *Spookride* (1969); *Beyond the Ghost Spectrum* (1969); *Purple Moment: to Joan Blondell* (1969); *Pumpernickle and Circumstance* (1969); *Amoretti* (1969); *Variations on a Landscape* (1971); *An Eccentric Beauty Revisited* (1972); *Twelve Objects from Tender Buttons* (1972); *Thirty-two Variations in C Minor* (1973); *Feathers* (1973); *Moonlight Sonata* (1974); *Scintilla* (1974); *A New Life* (1975).

THEATER WORKS: *Noh Play* (by Paul Goodman) (1948); *Monuments* (1958); *Madrigal of War* (1959, directed); *Love's Labor: An Eclogue* (1959); *Murder Case* (1963); *The Poor Little Rich Girl* (1968, directed).

Warner, Gloria, American theatrical dancer; born 1915 in New York City; died June 8, 1934 in Los Angeles, California. A student of Ned Wayburn's studio, she made her stage debut at the age of five, performing as Gloria Kelly. Her tapping and singing brought her to the attention of the casting office at Warner Brothers' Brooklyn studio and a contract to appear in short subjects. Her scores of film credits included a dance specialty in the 1927 *School for Romance* and a continuing role in the Lou Holtz comedy series. As Gloria Warner, she appeared on Broadway in *Hotcha* and *Take a Chance* (both 1932) before moving to Hollywood to work there. She was soon too ill, however, to work at Warner Brothers and died at nineteen of leukemia.

Warren-Gibson, David, American theatrical dancer; born in Detroit, Michigan. Warren-Gibson studied with Ronn Forella and performed with his Second Century Dancers in New York. Although he was seen with the Contemporary Ballet Company, he has performed most frequently in theatrical media. The six-footer has been featured in Bob Fosse's *Dancin'* and in the segment from that show chosen to represent Broadway on Julie Andrews' *Invitation to the Dance* (CBS, 1980, special). Other television engagements have ranged from back-up dancing on a Racquel Welch special to discoing on a *Don Kirschner Rock Concert* (NBC, late night special).

Waters, Elizabeth, American modern dancer; born c.1920. A student of Hanya Holm, Waters performed as a member of the Holm group in its early prime. Among the many works in which Holm created roles for the troupe were *Dance in Two Parts, Salutation, Two Primative Rhythms, Trend, Dance of Work and Play, Dance Sonata, Metropolitan Daily, Dance of Introduction* and *Tragic Exodus*. While a member of the Holm group, she toured with a small company of her own, Dancers en Route, which included Linda Locke, Alwin Nikolais, and

Ray Mahon (all Holm dancers), which crossed the country with Waters' works.

Works Choreographed: CONCERT WORKS: *They Do Not Accept the Verdict* (1942); *Try, Try Again* (1942); *Rites for Rejoicing* (1942).

Waters, Sylvia, American modern dancer. A graduate of Juilliard, Waters has also studied at the New Dance Group and Ballet Arts Studios and at the Martha Graham School of Contemporary Dance.

Associated with the companies of Alvin Ailey throughout her career, Waters was a member of his Dance Theatre from 1968 to 1976. Among the many works in which she created roles are Ailey's *Masakela Langage* (1968), *Choral Dances* (1971), and *Hidden Rites* (1973). She was assigned featured roles in his *Blues Suite, Quintet,* and *The Lark Ascending,* Talley Beatty's *The Black Belt,* Pearl Primus' *The Wedding,* and Norman Walker's *Clear Songs After Rain.*

Waters has served as the artistic director of the Alvin Ailey Repertory Dance Ensemble, known as "Ailey II," since it was founded in 1976.

Watt, Nina, American modern dancer; born April 6, 1951 in Petoskey, Michigan. Raised in Palm Springs, California, she studied with a number of celebrated teachers who commuted from nearby Los Angeles, among them Angiola Sartorio and David Lichine. She spent summers working with Bella Lewitsky and traveled up the coast to take class with Gene Marinaccio. While a student at the University of California at Los Angeles, she met José Limón who invited her to study with him in New York. A member of the Limón company since 1972, she was able to work with the great choreographer for a year before his death in December of that year. Among the many repertory works in which she has been cast are Limón's *A Choreographic Offering, There Is a Time, The Winged, Orfeo, Carlotta, Missa Brevis,* and the "Primavera" solo in his *Dances for Isadora* (Duncan), with additional parts in Doris Humphrey's *Shakers,* Kurt Jooss' *The Green Table* (as the doomed "Young Girl"), and company member Fred Matthew's *Solaris* (1976).

Watts, Heather, American ballet dancer; born September 27, 1953 in Los Angeles, California. Trained at the School of American Ballet, she has been asso-

ciated throughout her career with the New York City Ballet.

Watts has created roles in four of the ballets by fellow dancer Peter Martins—*Calcium Light Night* (1977), *Pas de Deux* from *A Sketch Book* (1978), *Sonate di Scarlatti* (1979), and Lille Suite *Tivoli* (1980)—and has danced with his off-season troupes on tour. Known equally for her dramatic characterizations and technical prowess in works by Jerome Robbins, she has performed in his *Goldberg Variations, In the Night,* and in both the preview and the premiere of his Winter section from *The Four Seasons* (1979, performed as a divertissement in *A Sketch Book* in 1978). Her roles in the Balanchine repertory have included the Second Movement (Adagio) of *Symphony in C, Concerto Barocco, Symphony in Three Movements,* and *Episodes*; in Spring of 1980, she danced in the first performance of his most recent work, *Schumann's Davidsbundlertanze,* partnered by Martins.

Watts, James A., Australian dance satirist working in England and the United States; born c.1890 in Melbourne, Australia; died October 5, 1961 in London. Watts was an opera student in Italy when he discovered that he was more successful at satirizing sopranos than at supplanting the local tenors. Until the end of his long career, he included an imitation of the contemporary prima donna in his acts.

His dance satires began developing in 1911 in Paris, when he first performed as Pavlova. He was engaged as an imitator at the London Coliseum and at the Hippodrome, where he was featured in Ethel Levy's *Hullo, Ragtime* (1912). He first performed in the United States on the Keith and Orpheum vaudeville circuits imitating Pavlova (with Mikhail Mordkin), Nellie Melba, and contemporary actresses; his Maud Allan act was considered second only to Gertrude Hoffmann's in accuracy and humor. Watts' best remembered American performances were in the 1919–1921 editions of the *Greenwich Village Follies.* In his first, he portrayed "Anna Fallova" (by then, partnered by "Sissinsky" rather than "Mudkin") and a very acquisitive "Marguerite" from *Faust.* In his last edition he was teamed with Joe E. Brown, with whom he toured in vaudeville for many seasons.

Returning to England in the mid-1920s, he per-

formed in "Dame" roles in pantomimes until retiring in the late 1940s. He maintained his act in music halls and club presentations, but there is no evidence that he performed it on film or television.

Watts, Jonathan, American ballet dancer; born John Leech, November 8, 1933 in Cheyenne (Fort Warren), Wyoming. Spending his adolescence in San Francisco and New York, he attended the High School of Performing Arts, first as a drama major, then as a dance student, working with Robert Joffrey. He has also trained with Stanley Williams at the American Ballet Center and the School of American Ballet.

From high school, Watts joined The Robert Joffrey Ballet, performing the director's *Pas de Déèsses, La Fille Mal Gardée, Scaramouch, Le Bal Masque,* and *Umpateedle,* which he had danced at its premiere at high school. He also worked for Joffrey as a member of the corps of the New York City Opera in the late 1950s.

Watts is best known for his work with the New York City Ballet from 1955 to 1960. In those years, he created roles in Balanchine's *Pas de Dix* (1955), *Donizetti Variations* (1960), and in three of his seminal works of the decade—*Agon* (1957), *Episodes* (1959, the "Symphony" section of Part II), and *Liebeslieder Walzer* (1960).

After two years teaching and performing in Cologne, Germany, primarily for the Atadtische Opera at which he created the title role in Gise Firtwangler's *Daphnis and Chloe,* Watts returned to New York. He served as director of the apprenticeship program for the City Center Joffrey Ballet, and as founding director of its company, the Joffrey II, for which he has frequently choreographed. He has taught at many American university dance programs, including the SUNY arts campus at Purchase, New York, and the Indiana University School of Music.

Works Choreographed: CONCERT WORKS: *Album Leaves* (1970); *Marcello Concerto* (1971); *Schumann-Opus 6* (1972); *Evening Dialogues* (1974, revision of *Opus 6*).

Wayburn, Ned, American dance director; born Edward Claudius Weyburn, March 30, 1874 in Pittsburgh, Pennslvania; died September 2, 1942 in New York City. Wayburn (who adopted the misspelling of his surname in 1896), was raised in Chicago and trained there at the social dance studio of A.E. Bournique and the Hart Conway School of Dramatic Arts, where he worked with a first-generation student of Per Henrik Ling (T.H. Monstery) and a second-generation Delsartist (Ida Simpson-Serven). His first theatrical engagements were as a pianist specializing in ragtime versions of the classics, coupled with jobs as stage manager for touring troupes. His first professional dance direction credit came for the show, *By the Sad Sea Waves* (1899) for which he also wrote music and performed as "Gregory, the Rag-Time Butler." He got involved in staging feature vaudeville acts in the first decade of the century and while his colleagues believed that he was stepping down from Broadway to vaudeville, the format became important in his later work. When he returned to full-length musical comedies and revues, he quickly became one of Broadway's most popular and highly acclaimed dance directors, creating musical numbers for more than one hundred productions until 1923. He worked primarily in New York, but also did shows for the intimate La Salle Theater in Chicago and the enormous London Hippodrome.

Although 90 percent of his full-evening productions were plotted musical comedies for Lew Fields, the Shuberts, and others, he is best remembered for his work on annual revue series. He did the first two Shubert *Passing Shows* of 1912 and 1913 (plotted satirical revues of past seasons) and won his reputation for working well with large choruses for the Act I finale of the 1913 edition, with forty-eight women and a double revolving staircase on a set that was designed to look like the Capitol steps. His work on the *Ziegfeld Follies* of 1916 to 1919, 1922 and 1923, and the *Midnight Frolics* of those years was consistently praised by the critics for his imaginative use of stage space and his ability to work in all of the contemporary techniques—musical comedy or fancy dancing, tap dancing, ballet, eccentric ballet, acrobatic ballet, toe tapping, straight (or curved) acrobatics, exhibition ballroom work, and national dances. He divided the large *Follies* choruses by height and techniques into smaller groups of eight to sixteen so that he could fill any area of the stage with dancers. Wayburn is generally credited with developing the Delsarte-derived "Ziegfeld walk," with which the

show girls moved down the long staircases in elaborate costumes.

Wayburn received dance direction credit for one motion picture, *The Great White Way* (Cosmopolitan, 1924), part of which is set at a *Follies* (actually a *Frolics*) rehearsal, and he also appeared in that film as the show's choreographer. He was involved with radio work and had been announced as the host for a new television show, *The Search for Beauty*. It was supposed to premiere on December 7, 1941, but was never rescheduled after the cancellation of entertainment broadcasting on that day.

When he wasn't planning a Broadway production or working on a Prolog, Wayburn ran his studios in New York and Chicago. Young men and women, children, and family troupes came from across the country to study with Wayburn and, with his influence, to enter vaudeville or Broadway. He also ran a mail-order dance studio and published notated dances and exercises for each of the theatrical techniques. His *Art of Stage Dancing* (New York: 1925), basically a commercial for his studios, was recently issued in a photoreprint edition.

Works Choreographed: THEATER WORKS: *By the Sad Sea Waves* (1899); feature acts for Klaw and Erlanger Circuit (1900–1908); *The Night of the Fourth* (1901); *The Governor's Son* (1901); *The Hall of Fame* (1902); *Miss Simplicity* (1902); *The Billionaire* (1902); *Mr. Bluebeard* (1903); *The Rogers Brothers in London* (1903); *Mother Goose* (1903); *A Little Bit of Everything* (1904); *The Rogers Brothers in Paris* (1904); *Humpty-Dumpty* (1904); *The Pearl and the Pumpkin* (1905); *The Ham Tree* (1905); *The Rogers Brothers in Ireland* (1905); *The White Cat* (1905); *The Time, the Place and the Girl* (1907); *The Rogers Brothers in Panama* (1907); feature acts for Headline Vaudeville Productions (1908–1913); *The Honeymoon Trail* (1908); *Li'l Mose* (1908); *The Mimic World* (1908); *The Girl Question* (1908); *The Girl at the Helm* (1908); *Mdlle. Mischief* (1908); *Mr. Hamlet on Broadway* (1908); *Havana* (1909); *The Golden Girl* (1909); *The Midnight Sons* (1909); *The Rose of Algeria* (1909); *The Girl and the Wizard* (1909); *The Belle of Brittany* (1909); *Old Dutch* (1909); *The Goddess of Liberty* (1909); *The Jolly Bachelors* (1910); *The King of Caledonia* (1910); *The Prince of Bohemia* (1910); *The Yankee Girl* (1910); *Tillie's Nightmare* (1910); *The Summer Widowers* (1910); *The Paradise of Mahomet* (1911); *The Hen Pecks* (1911); *Sweet Sixteen* (1911); *Love and Politics* (1911); *The Heart Breakers* (1911); *Hullo Paris* (1911); *A la Broadway* (1911); *The Never Homes* (1911); *The Wife Hunters* (1911); *The Passing Show of 1912* (1912); *The Military Girl* (1912); *Broadway to Paris* (1912); *The Sun Dodgers* (1912); *The Honeymoon Express* (1913); *The Passing Show of 1913* (1913); *Are You There?* (1913); *Hullo Tango* (London, 1913); *The Honeymoon Express* (1914); *Dora's Doze* (1914); *The Ham Tree* (1914); *Hello Broadway* (1914); *She's In Again* (1915); *Ziegfeld Midnight Frolics* (1915); *Splash Me* (1915); *Town Topics* (1915); *Ziegfeld Follies of 1916; The Century Girl* (1916); *Ziegfeld Midnight Frolics* (1916); *Zig Zag* (London, 1917); *Ziegfeld Follies of 1917; Miss 1917; Ziegfeld Midnight Frolic* (1917); *Box O'Tricks* (London, 1918); *Ziegfeld Follies of 1918; Ziegfeld Midnight Frolic* (1918); *Ziegfeld Midnight Frolic and Nine O'Clock Frolic* (1918); Prologs for the Capitol Theater (1919–1921); *Joy Bells* (London, 1919); *Ziegfeld Follies of 1919; Ziegfeld Midnight Frolic* (1919); *The Night Boat* (1920); *Ziegfeld Midnight Frolic (The Girls of 1920); The Ed Wynn Carnival* (1920); *Oui Madame* (1920); *The Poor Little Ritz Girl* (1920); *Hitchy-Koo of 1920; Jimmie* (1920); *Vogues and Vanities of 1920; Town Gossip* (1921); *Two Little Girls in Blue* (1921); *Little Kangaroo* (1922); *Ziegfeld Follies of 1922*; Prologs for the Headline Vaudeville Productions (1923–1932); *Lady Butterfly* (1923); *Ned Wayburn's Demi-Tasse Revue of 1923; Ned Wayburn's Song Scenes of 1923; Ned Wayburn's Moonlite Show* (1923); *Ziegfeld Follies of 1923; Carmen: An Operatic Fantasie* (1925); *Palm Beach Night* (1926); *Smiles* (1930).

FILM: *The Great White Way* (Cosmopolitan, 1924).

Wayne, Dennis, American modern and ballet dancer; born Dennis Wendelken, July 19, 1945 in St. Petersburg, Florida. Raised in New York, he attended the High School of Performing Arts where he studied with Norman Walker, Gertrude Shurr, David Wood, and May O'Donnell. He performed with Walker and Paul Sanasardo's dance companies before joining the Harkness Ballet in its first season.

He is best known for his work with the City Center Joffrey Ballet from c.1970 to 1975. In that troupe, he was featured in Joe Layton's *Double Exposure*, Gerald Arpino's *Solarwind, Secret Places*, and *Sacred Grove at Mount Tamalpais*, Benjamin Harkavy's *Grand Pas Espagnol*, and the company revival of Leonid Massine's *Le Beau Danube*. He was a member of the American Ballet Theatre briefly in 1976, dancing in the Nureyev production of *Raymonda* and in Eugene Loring's *Billy the Kid*.

He formed a new company, Dancers, in 1978 which was built around his own repertory of ballet and modern dance duets and group works. While he does not choreograph for the troupe, the repertory is definitely tailored to his own abilities, and features the Norman Walker piece, *Lazarus*, and John Butler's *After Eden*.

Weathersby, Eliza, English nineteenth-century theatrical dancer also working in the United States; born 1849 in London; died March 23, 1887 in New York City. After her debut in 1865 at the Alexander Theatre, Bradford, and performances at the Strand Theatre in London, Weathersby made the first of her many visits to the United States as a member of Elisa Holt's Burlesque troupe. When that company disbanded soon after landing (a fate that befell a large number of companies imported to the United States in the 1860s), she joined Lydia Thompson's troupe which was then presenting *Sinbad the Sailor* at Niblo's Gardens in New York. From arriving in the United States in 1867 and the foundation of her own troupe in 1877, she commuted between New York and London either with Thompson or in a rival organization of British burlesquers. She left Thompson after the engagement at Niblo's to form The Beautiful Blondes for a California tour managed by Thomas Maguire, a producer who manipulated his way into the history of dance in this country through setting up rivalries between English dance troupes, Italian ballerinas, and occasionally, American circuses. The Beautiful Blondes opened in San Francisco a week before Thompson's troupe, but after the intense rivalry directed (and probably invented) by Maguire, she rejoined Thompson to tour in *Paris, or the Apple of Discord* (1870). From 1871 to 1875, she made two roundtrips across the Atlantic with

Thompson, although in 1873 she took a month off from her employer to perform at Wallack's Theater in New York. In 1876, she returned to New York alone to star as "Gabriel" in the successful premiere of *Evangeline*, in which she co-starred with Nat Goodwin. They were married in 1877, and for the remainder of her life, produced burlesques and spectacles together for The Weathersby-Goodwin Froliques. Their most popular productions were *Those Bells* (1884) and frequent revivals of *Evangeline*.

Weaver, John, English seventeenth–eighteenth-century ballet master and choreographer, known for the scope of his critical and historical essays; born July 21, 1673 in Shrewsbury; died there September 1760. The son of a dancing master, he performed at the Drury Lane and Lincoln's Field Inn theatres of Colley Cibber in the 1700s and 1730s. Very few of his choreographed ballets are extant or even known by title. Those that are known date from these years and were created primarily for the resident companies of the Cibber theaters; they include *The Union* (1707), *The Tavern Bilkers* (1702), and *The Loves of Mars and Venus* (1717).

Weaver is better known for his writings on dance, ranging from the straight standard dance manuals, such as the *Small Lecture in Time and Cadence* (1706) and *Anatomical and Mechanical Lectures* (1721), and his translation of Feuillet's *Chorégraphie*, to the historical, which included *Mimes and Pantomimes* (1728) as well as a *History of Dancing* (1707).

A major treatise on Weaver has been written by Richard Ralph, which should increase our knowledge of his choreography and writings a thousandfold.

Works Choreographed: CONCERT WORKS: *The Tavern Bilkers* (1702); *The Union* (1707); *Orpheus and Eurydice* (1717); *The Loves of Mars and Venus* (1717); *Perseus and Andromache* (1730); *The Judgement of Paris* (1733).

Weaver, Marjorie, American film dancer and actress; born March 12, 1913 in Crossville, Tennessee. Weaver began her dance training by winning a contest that brought her a scholarship to study in New York, at the Ned Wayburn studio there. A contract to Fox Film Corporation (later Twentieth-Century

Fox) brought her to Hollywood where she was cast as independent business and sales women who loved to dance in a series of films set in the present. As with many of her colleagues, Weaver used her dancing ability to portray the intelligence of her characters in the face of danger in everything from the sound remake of *Sally, Irene and Mary* to the crime melodramas *Michael Shane, Private Detective, Man at Large*, and *Murder over New York*. Although best known for these, and for her performance as "Mary Todd" in the Henry Fonda classic, *Young Mr. Lincoln*, Weaver was actually cast as a theatrical dancer occasionally in pictures for Paramount and Universal in the mid-1940s, most notably in *Pardon My Rhythm* (Universal, 1944).

Webb, Clifton, American theatrical dancer and film actor; born Webb Parmalee Hollenbeck, November 19, 1891 in Indianapolis, Indiana; died October 13, 1966 in Beverly Hills, California. Webb's training cannot be verified, although many of the teachers who worked in New York in the 1910s, ranging from Ned Wayburn to Claude Alvienne, claimed to have taught him dance techniques.

Since his film characters were physically tight and constricted, it is hard to remember that on Broadway, Webb was a loose-limbed eccentric dancer. Always in complete control of his body, he was able to shape it and to maintain impossible poses. A versatile performer, he did every kind of dance from soft shoe, in *The Little Show*, to an Apache that ends in disaster in the famous "Moanin' Low" sequence in the same production; in *Vogues and Vanities*, one of his rare Wayburn shows, he did a solo that was billed as a Cubistic Dance, in inhuman positions against a Bakstian background. In the 1910s, when he was very young, he did an eccentric dance act with Mary Hay who was approximately a foot shorter than he. This dance act was what is known as a "Hick dance," in which they wore outlandishly unfitted costumes and shlumphed around the stage.

In his shows, Webb introduced songs by the Gershwins, Cole Porter, and Arthur Schwartz. It is likely that he choreographed dance solos to those songs for himself in his shows—*Dancing Around* (1914), *Town Topics* (1915), *See America First* (1916), *Vogues and Vanities of 1920, Treasure Girl* (1928), *The Little Show* (1929), *Three's a Crowd* (1930), *Flying Colors* (1932), *As Thousands Cheer* (1933), and *You Never Know* (1938).

Webb-Dawson, Elida, American theatrical dancer and choreographer; born c.1898; died May 1, 1975 in New York City. It is unlikely that Webb-Dawson had formal training in theatrical dance although she may have studied social forms. Her first verifiable appearance was in *Shuffle Along* (replacement cast), the celebrated Eubie Blake and Noble Sissle musical comedy that was produced by Flournoy Miller. Her only Broadway choreography credit came from another Miller show, *Running Wild* (1921). In that production, which is generally associated with the introduction of the theatrical Charleston, she staged all musical and dance specialties and chorus numbers. It should be noted that among the male chorus were tap dancers Pete Nugent and Derby Wilson, and future choreographer Sammy Dyer. Webb-Dawson's prolific dance direction career consisted primarily of staging presentation and club acts for black Prolog theaters and cabarets, including The Plantation and Connie's Inn. It is likely that she also staged acts for her husband, Garfield ("Strutter") Dawson, who performed regularly until his retirement in 1973.

Webb-Dawson had the longest career of any black female choreographer of her era; this was, unfortunately, not a guarantee of more than one show. Unable to support herself as a dance director, she worked for Ethel Waters as a personal secretary, dresser, and assistant for many years.

Works Choreographed: THEATER WORKS: *Running Wild* (1921); club acts for The Plantation (1925–); club acts for Connie's Inn (1933–).

Weber, Diana, American ballet dancer; born January 16, 1945 in Passaic, New Jersey. Weber was trained at the Ballet Theatre School, graduating into the company in 1962.

Since then, she has performed featured roles in *Swan Lake, Giselle*, and the remainder of the company's classical repertory. Associated with the works of Michael Smuin, she created roles in his *Pulcinella Variations* (1968) and *Schubertiade* (1971), and per-

formed in his *Gartenfest*. Her other Ballet Theatre creations include Eliot Feld's *Harbinger* (1967) and Robert Gladstein's *Way Out* for a 1970 Workshop.

Weber left Ballet Theatre in 1973 to join the San Francisco Ballet to which Smuin had been named co-director. In that company, she has performed in his *Romeo and Juliet* and *Scherzo*.

Webster, Clara Vestris, English ballet dancer of the early Romantic era; born in the Fall of 1821 in Bath, England; died December 17, 1844, in London. The daughter of Benjamin Webster I (a former student of Peter D'Egville and Gaetano Vestris, who was then ballet master/manager of the Theatre Royal in Bath), she was named Vestris, although there is no evidence that he formally stood as godfather. By 1840, she had already performed extensively in Bath and Dublin and had toured Northern England with Fanny Cerrito and Antonio Guerra. She had performed a remarkable amount of the ballerina touring repertory by that date, having learned Cerrito's solos and character duets while dancing in James Sylvain's version of *La Bayadère* in Bath in 1843.

A member of the ballet company at the Drury Lane—and expected to be England's first native Romantic ballerina—she performed featured roles in the London productions of *Le Corsaire* and *Lady Henrietta* in 1844. She was assigned the secondary role in Sylvan's production of the *Revolt of the Harem* in December 1844. During a performance in mid-December, her costume caught fire and she died on the seventeenth. Tragically, neither her death nor that of Emma Livry in 1867 led to any movement to improve the working conditions of dancers.

Webster, David, English impresario and arts administrator; born 1903 in Dundee, Scotland; died 1971 in London. Webster became associated with the development of the English cultural scene as chairman of the Liverpool Philharmonic, a volunteer post that he held while he was running a local department store. With the influx of money and talent into London at the end of World War II, Webster was named administrator of the Royal Opera House (Covent Garden) in London, a post that he held from 1945 to 1970. In that capacity, he managed both the Royal Opera and the Royal Ballet, bringing both to world prominence in presentations of repertory classics and new works. Although nominally the manager of the house only, Webster also arranged world tours for his companies and is considered co-responsible with Sol Hurok for the position that the Royal Ballet holds in foreign countries.

Weeks, Alan, American theatrical dancer; born in Queens, New York. Weeks made his Broadway debut in the short-lived boxing musical, *The Body Beautiful* (1958). His fabulous tap work and singing voice made his later career considerably more successful. Week's tapping has been heard and seen in *Funny Girl* (1964), *George M!* (1968), *Billy* (1969), *The Fig Leaves are Falling* (1969), *The Wiz, Rockabye Hamlet* (1976) as "Claudius," *Ain't Misbehavin'* (in which he did "The Viper Drag"), and more than a dozen Off Broadway productions. In *Hallelujah Baby!* (1967) he sang "Feet Do Your Stuff" with Winston DeWitt Hemsley (as "Tip and Tap"); he and Hemsley still perform together frequently in cabarets. Weeks has also appeared in a number of black action thrillers, including *Shaft* and *Black Belt Jones*, and on television, primarily in police shows.

Weidman, Charles, American pioneer of traditional modern dance as a concert and theatrical technique; born in Lincoln, Nebraska, on July 8, 1900 (date given alternatively as July 22, 1901); died July 15, 1975 in New York. After local studies with Eleanor Frampton, Weidman moved to Los Angeles to work at the Denishawn school of Ruth St. Denis and Ted Shawn.

As a dancer in the various Denishawn companies and concert groups, Weidman frequently replaced Shawn in his leading roles in, among others, *Xochitl* (from 1921) in which he partnered Martha Graham. He created roles in many repertory works by Shawn, including *Pierrot Forlorn* (also titled *Ne Rien Plus*) in 1921, the Thoth and Horus duet from the *Egyptian Ballet* (1922), the *Crapshooter* and *Boston Fancy: 1854*; sections from *Five American Sketches* (1924), and three works from 1926 that were inspired by the Denishawn Oriental tour—*General Wu's Farewell to His Wife, Singhalese Devil Dance*, and *Momijii Gari*.

Also on the tour, he created a role in *Whims*, a work by Denishawn dancer, Doris Humphrey, with whom he would collaborate for many years.

After the tour, in 1927, Weidman and Humphrey were assigned to teaching positions at the New York Denishawn school. After detaching themselves from the Denishawn system, they opened their own studio, the home for sixteen years of the Humphrey/Weidman Group and school. Although his early work was within the conventional style of traditional modern and concert dance, he soon specialized in producing concert works about current life and emotions that could be interpolated into theatrical performances.

Weidman may have entered the field of Broadway dance direction in order to give employment and funding to himself and his dancers, as historians and critics have suggested, but it soon became obvious that he was tremendously gifted at that medium. In his shows *Americana* (1932), *As Thousands Cheer* (1932), *Life Begins at 8:40* (1934), *Sing Out, Sweet Land* (1944), *The Littlest Revue* (1955), and others, he was able to mix techniques and to manipulate dancers' musical rhythms and decor to produce a wide variety of effects, from the topical satires of *As Thousands Cheer* to its charming 1910 dances set to "Easter Parade," and from the tropical congas of *Life Begins at 8:40* to its almost conventional love duel that featured José Limón fencing. Weidman also used humor as an effect in his concert choreography, especially in his autobiographical pieces, *On My Mother's Side* (1940) and . . . *And Daddy Was a Fireman* (1941), in his satires of other media, notably in *Flickers* (1940), and in his works set to short stories by James Thurber, among them, *Fables for Our Time* (1948) and *The War Between Men and Women* (1959).

After Humphrey's retirement, Weidman continued to create works for a series of concert groups entitled the Weidman Theatre Dance Company. Between group works, he collaborated with artist Mikhail Santaro in concerts of solos generically called *The Expression of Two Arts*. Although the collaboration did not continue long, Weidman's interest in the solo form did; his last work, as tribute to Humphrey, Graham, and his Denishawn training, punfully titled *Visualizations, or From a Farm in New Jersey* (1974), was a series of solos. Many of

Weidman's later group works were in an abstract style similar to that in which he had collaborated with Humphrey in his concert dance period. These late pieces, *Brahms Waltzes, Op. 39* (1971), *Easter Oratorio* (1972), and *Bach's St. Matthew Passion* (1973), have been labanotated and frequently revived since their creation.

Weidman had a wide influence on dancer/choreographers through his work at the Humphrey/Weidman studio and as the teacher of the Experimental Unit of male dancers sponsored by the Federal Dance Theatre during the 1930s. His protégés have become famous in modern dance, notably José Limón and Beatrice Seckler, and in theater, film, and television choreography, among them, Esther Junger, Bill Matons, Peter Hamilton, and Lee Sherman. He is often credited with opening the fields of theater and opera choreography to modern dancers and, although he was not the first to work in those media, his ability to work within the strictures of the media made the modern dancer attractive to producers and impresarios.

Works Choreographed: CONCERT WORKS: *A Japanese Actor* (1928); *Nuages et Fêtes* (1929); *On the Steppes of Central Asia* (1929); *A Passion [Savanorola] and Compassion [St. Francis]* (1929); *Study* (1929); *Americanisms (Prelude, Ringside, Cowboys)* (1929); *Singhalese Drum Recital* (1929); *Leprechaun* (1929); *Rhythmic Patterns of Java* (1929); *Ein Heldenleben* (1929, possibly co-choreographed with Doris Humphrey); *Rumanian Rhapsody No. 1* (1929); *Scherzo* (1929); *Etude No. 2* (1929); *Minstrels* (1929); *Marionette Theatre* (1930); *Two Studies* (1930, No. 2 only co-choreographed with Humphrey); *Sacre du Printemps* (1930); *Commedia* (aka *Burlesca*) (1930); *Danse Profane* (1930); *The Tumbler of Our Lady* (1930); *Three Studies (Diffidence, Annoyance, Rage)* (1930); *The Conspirator* (1930); *La Puerto del Vino* (1931); *Music of the Troubadours* (1931, co-choreographed with Blanche Talmud); *The Happy Hypocrite* (1931); *Piccoli Soldati* (1931); *Gymnòpédie* (1931); *Alcina Suite (Introduction, Pomosa et Allegro, Pantomime, Minuet)* (1931); *Danza* (1932); *Steel and Stone* (1931); *Dance of Sport* (1932, co-choreographed with José Limón and William Matons as Experimental Dance Unit); *Dance of Work* (1932, co-choreographed with

José Limón and William Matons as Experimental Dance Unit); *Studies in Conflict* (1932); *Farandole* (1932); *Kinetic Pantomime* (1934); *Memorial to the Trivial* (1934); *Affirmations* (1934); *The Christmas Oratorio* (1934); *Duo-Drama* (1935); *American Saga* (1935); *Quest* (1936); *Atavisms* (1936); *Promenade* (1936); *A Cult Ballad* (1937); *Air Raid Blues* (1938); *This Passion* (1938); *Studies in Technique for Men* (1938); *Opus 51* (1938); *On My Mother's Side* (1940); *Flickers* (1940); *War Dance for Wooden Indians* (1941); *The Happy Farmer* (1941, co-choreographed with Peter Hamilton); *Portraits of Famous Dancers* (1941); . . . *And Daddy Was a Fireman* (1941); *Theatrical Dances (Snow Fall, Penguin)* (1942, co-choreographed with Lee Sherman); *The Dancing Master* (1943); *Rumba to the Moon* (1943); *La Comparsa* (1943); *Park Avenue Intrigue* (1943); *Promenade* (1943); *Imitations and Satires* (included various short sketches and dances) (1943); *The Heart Remembers* (1944); *Dialogue* (1944); *Three Antique Dances* (1945); *"A House Divided"* (1945); *David and Goliath* (1945); *Fables for Our Time* (1948); *Rose of Sharon* (1949); *Memorial Program in Honor of Doris Humphrey* (untitled lecture-demonstration) (1959); *The War Between Men and Women* (1959); *A Song for You* (1961); *King David* (1963); *Danse Russe* (1963); *Dialogue and Situation* (1963); *Saints, Sinners and Scriabin* (1963); *Jacob's Wedding* (1964); *Brahms Waltzes, Op. 39* (1971); *Diabelli Variations* (1972); *Easter Oratorio* (1972); *In the Beginning (Steps in the Snow, Cathedral, The Maid with Flaxen Hair)* (1973); *Bach's St. Matthew Passion* (1973); *Visualizations, or From a Farm in New Jersey* (1974).

THEATER WORKS: *Lysistrata* (1929); *Hamlet* (1931, players sequence only); *Americana* (1932); *As Thousands Cheer* (1932); *A School for Husbands* (1933); *Life Begins at 8:40* (1934); *Star Dust* (1943); *Spoon River Anthology* (1943); *The New Moon* (1944, revival); *Sing Out, Sweet Land* (1944); *If the Shoes Fits* (1946); *The Barrier* (1950); *The Littlest Revue* (1955); *Waiting for Godot* (1956); *Portofino* (1958, co-choreographed with Ray Harrison).

Weinberg, Bronya, Polish modern dancer working in the United States; born November 8, 1944. Raised in New York City after moving there at the age of five, she performed with the New Poor Theatre of Amer-

ica (English language) in the early 1970s, before joining the Multigravitational Aerodance Group in 1972. After performing and teaching with the company that uses both modern dance and trapeze techniques, she became co-artistic director in 1980 and has co-choreographed with her fellow directors.

Works Choreographed: CONCERT WORKS: *Muses of the Mast* (1980); *Decade* (1980); *Craneworks* (1980).

Weiner, Nina, American postmodern dancer and choreographer. Weiner, whose father was at one time stage manager for Lester Horton's Dance Theatre, was trained originally by Bella Lewitsky. She performed for Twyla Tharp, notably in her *Medley, Juice* (both 1969), and *Dance Coupe* (1974), but works in a completely different mode herself. Weiner's works are involved with isolated movements for individual parts of the body, especially focusing on the arm and upper torso. She also works brilliantly with movement equivalencies rather than Tharp's oppositions, creating mobile balancing acts for her dancers by devising sets of movements for the arms and legs that continually remold each other in new human flexibilities.

Weisberger, Barbara, American ballet dancer and company administrator; born Barbara Linshen c.1926 in Flatbush, New York. Weisberger began her training at the age of five in Brooklyn in classes with Marian Lehman, later crossing the East River to study at the School of American Ballet and at the Metropolitan Opera Children's Ballet School under Margaret Curtis. After her parents moved to Wilmington, Delaware, she began to commute to Philadelphia to study with Catherine Littlefield. She performed in a small local company directed by Mary Binney Montgomery while attending the University of Delaware and followed her mentor's example by directing her own small company and school in Wilkes-Barre, Pennsylvania, in the late 1940s.

Weisberger's accomplishment, recognized throughout the country, is the creation and continuance of the Pennsylvania Ballet. It began as a small school and troupe known as the Philadelphia Ballet, but was actually the corps of the Philadelphia Lyric Opera. As dance and ballet became decentralized in the

1960s, Weisberger was able to enlarge her scales of production and budgets until the present company opened its charter season in 1964 as a fully professional group with a repertory of works by George Balanchine (always a sponsor of the organization), and by contemporary American and European choreographers.

Weiss, Josephine, Austrian ballet dancer and choreographer; born in 1805 in Austria; died December 18, 1852 in Vienna. A dancer and ballet master at the Karntnertor and Josephstadter court theatres of Vienna, Weiss was best known for her choreography and management of a children's ballet, Les Danseuses Vienoises (c.1843–1848).

The troupe performed in Josephstadt and toured extensively with successful seasons in London and Paris. In December 1846, Weiss brought the troupe to the United States to perform in New York and Philadelphia, and on Sol Smith's Mississippi circuit of theaters from St. Louis to New Orleans. Weiss' choreography for the children used many of the devices developed in popular theater, among them, stylized reflection acts, as in her *Les Sauvages et le Miroir* (1845) in which half of the dancers mimicked the others from behind a scrim, and wreath dances, such as *Les Pas des Fleurs* (1845).

Weiss died in Vienna shortly after the troupe was dissolved. Her career was particularly interesting because of how she was perceived by critics and entrepreneurs. Smith's correspondence, for example, mentions that he and most of the Mississippi assumed that the children were mistreated and were pleased, but surprised, to discover that they were well kept and well fed. Smith also mentioned that Weiss, although "virtuous" in other ways, used swear words backstage—a strange comment about a choreographer.

Works Choreographed: CONCERT WORKS: *Les Pas des Fleurs* (1845); *Les Sauvages et le Miroir* (1845); *Pas de Hongrois* (1845); *Polka de Paysan* (1845); *Allemande* (1846); *La Grande Mazurka* (1846); *Galloppée des Drapeaux* (1846).

Weiss, Robert, American ballet dancer; born March 1, 1949 in New York City. Trained at the School of American Ballet, Weiss has performed with the New York City Ballet since the late 1960s.

As a company member, he has performed in most of the large repertory, with featured roles in Balanchine's *Symphony in C, Stars and Stripes, Donizetti Variations, Tarantella,* the *Brahms-Schoenberg Quartet,* and *Valse Fantasie,* and in Jerome Robbins' *The Concert* and *Dances at a Gathering.* He has created roles for Balanchine in his *Symphony in Three Movements* (1972), *Coppélia* (1974), in the *Discord and War* section, and *Ballo della Regina* (1978), and for Todd Bolender in *Serenade in A* for the Stravinsky Festival in 1972.

As a choreographer, Weiss has provided occasional pas de deux for former company member Gelsey Kirkland.

Works Choreographed: CONCERT WORKS: *Awakening* (1975); *A Promise* (1975).

Welch, Elizabeth, American theatrical dancer, actress, and singer working in London; born February 27, 1908 in New York City. Although best known as a vocalist and actress, Welch is always remembered as a dancer for introducing the song, "Charleston," on Broadway. Her performance in that became the image of the song, and eventually, of the era.

After making her debut in *Running Wild* (1923), introducing that celebrated song, she appeared in New York in *The Chocolate Dandies* (1924), *Blackbirds of 1928,* and the replacement cast of *The New Yorkers* (1931), in which she sang "Love for Sale." From 1933 to the present, she performed in London, appearing in Cole Porter's *Nymph Errant* (1933), *Let's Raise the Curtain* (1936), *Sky High* (1942), *Happy and Glorious* (1944), *Tuppence Coloured* (1947), *Penny Plain* (1951), *Pay the Piper* (1954), the English version of *Pippin* (1973), and many other shows. Welch returned to New York in 1980 to appear in *Black Broadway,* a retrospective concert.

Although she was a favorite on English radio and television, she made few movies. She can still be seen, however, in the Paul Robeson film, *Big Fella* (Fortune Films, 1937).

Welford, Nancy, American theatrical dancer; born c.1905 in New York City. The second vocalist-dancer daughter of English actors Dallas and Ada Welford, she made her professional debut playing their babies and infants in touring melodramas. Like her sister Christina (best remembered for her dance

specialties in the 1919 and 1920 *George White Scandals*), she had a short but very successful career as a Broadway dancer and ingenue. Her charm, soprano voice, petite beauty, and machine-gun hoofing made her an audience favorite in *Cinders* (1923), *Twinkle-Twinkle* (1926), *Lady Do* (1927), and *Rain or Shine* (1928).

Wells, Bruce, American ballet dancer; born January 17, 1950 in Tacoma, Washington. Trained locally by Patricia Cairns and in New York at the School of American Ballet, Wells performed with the New York City Ballet during the early 1970s.

In that company, he created a major role in Jerome Robbins' *The Goldberg Variations* (1971) and John Taras' *Concerto for Piano and Winds* (1972), and performed in George Balanchine's *Agon* and Robbins' *An Evening Waltzes*.

Since leaving New York, Wells has been associated with the Boston Ballet.

Wells, Doreen, English ballet dancer; born June 25, 1937 in Walthamstow. After studies at the Bush-Davies School, she entered the Sadler's Wells School and graduated into the company Theatre Ballet in 1955 and the Wells proper in 1956. She danced with that company and the touring and London sections of the Royal Ballet throughout her career, but left England occasionally to partner Rudolf Nureyev in his productions of the nineteenth-century Russian classics, most notably in his *Raymonda* at the 1964 Spoleto Festival.

Wells also performed principal roles in the English productions of the classics, including "Aurora," "Swanilda," and "Lise." Her roles in the contemporary repertory reflected her style as well as easy technique and included parts in Frederick Ashton's *Sinfonietta* and *Les Rendez-vous*, Kenneth Macmillan's *Danses Concertantes*, and Joe Layton's *The Grand Tour*. Wells retired in 1974.

Wells, Mary Ann, American ballet teacher; born c.1895 in Appleton, Wisconsin; died January 11, 1971 in Seattle, Washington. The most influential teacher in the Pacific Northwest, Wells began to teach at the Cornish School in Seattle in 1916. Unfortunately, no one has ever been able to verify Wells' own dance training and too little is known about her

adolescence to determine where she could have studied classical ballet technique. In her almost fifty years of teaching in Seattle, she produced many dancers of note and fame in the American ballet and theater. Among them are theatrical ballerina and choreographer of the 1920s Margaret Petit, television dancer and choreographer William Weslow, *Seven Brothers* stars Marc Platt and Tommy Rall, each of whom also had successful careers in ballet, and ballet directors Richard Englund, Robert Joffrey and Gerald Arpino. She was the hub of the so-called "Seattle connection," of the 1960s and 1970s, training young dancers who moved to New York to join Joffrey's company.

Wengerd, Tim, American modern dancer; born January 4, 1945 in Boston, Massachusetts. After studying with Elizabeth Waters in Albuquerque, New Mexico, he attended the University of Utah and performed with the Utah Repertory Dance Theatre. After dancing with its professional descendant, the Repertory Dance Theatre, for three years, he became a member of the Martha Graham company in New York.

As a Graham dancer, he has created roles in *Holy Jungle* (1974), *Lucifer* (1975), *Point of Crossing* (1975), *Adorations* (1975), *The Scarlet Letter* (1975), and *O Thou Desire Who Art About to Sing* (1977). Among his many repertory roles are "Theseus" in her *Phaedre* and "The Husbandman" in *Appalachian Spring*.

Wengerd has choreographed since his 1979 debut recital.

Works Choreographed: CONCERT WORKS: *Sun Dance* (1979); *Dorian Horizon* (1979).

Weslow, William, American ballet, theater, and television dancer; born 1925 in Seattle, Washington. Weslow was trained locally by Mary Ann Wells and in New York by Edward Caton, Anatole Vilzak, Vera Nemtchimova, and George Balanchine.

One of the most successful of the tripartite dancers of the 1950s and 1960s, Weslow worked extensively, and concurrently, on Broadway, in both major ballet companies and on television. As well as performing at the Radio City Music Hall, he danced in Tamiris' *Annie Get Your Gun* (1946) and *Plain and Fancy* (1955), Jerome Robbins' *Call Me Madam* (1950), and

Donald Saddler's *Wonderful Town* (1952), among many musicals. On television in the 1950s, he was featured in many Max Liebman series and specials and was a regular member of *Your Hit Parade*rs, the six-person dance chorus on the long-running NBC musical show (1950–1958).

Weslow was a member of Ballet Theatre from 1949 to 1952, where he performed in the company's productions of the classics and modern repertory, notably in Frederick Ashton's *Les Patineurs*. In the New York City Ballet through most of the 1950s, he was assigned featured roles in George Balanchine's *Four Temperaments, Native Dances, Pas de Dix, Divertimento No. 15, La Valse*, and *Stars and Stripes*, in Ashton's *Illuminations*, and in the premiere of Willam Christensen's *Octet* (1958).

After retiring from performance, Weslow became a masseur and therapist, celebrated for his ability to mend the aching bodies of his former colleagues.

West, Buster, American theatrical dancer and comic; born c.1905. West made his professional debut in his parents' vaudeville act in 1909. For the next fifteen years, the family, John, Virginia, and Buster, were headliners with their comedy and eccentric dance act; Buster West was especially acclaimed for his Russian tap work. After making his Broadway adult debut in the *George White's Scandals* of 1916, he toured Europe with his solos, becoming a regular at the Café Ambassadeur in Paris. He returned to New York to appear in an almost constant stream of musical shows and presentation act engagements. Among his greatest successes were editions of the *Scandals* and the *Earl Carroll Vanities*, the operettas *White Horse Inn* and *The Red Mill*, and comedies *Follow the Girls* and *The Pajama Game* (replacement and national "Hines"). With his wife, Lucille Page, he danced frequently in presentation act houses, including the Radio City Music Hall, the Palace, and the Paramount. Throughout his long and distinguished career, he was known for two *schtiks*—a scream that was described as a "dying French auto horn" and a unique kick performed from the knee down in both directions and a circle.

West, Elizabeth, English ballet dancer and choreographer; born 1927 in Alassio: died on Valtournanche,

the Italian Alps, September 28, 1962. Trained originally by Edouard Espinosa, she also studied dance and drama at the school of the Bristol Old Vic. While West was best known for her production of incidental dances for Shakespearean productions for the Bristol Old Vic and the Stratford upon Avon company, she also danced in the West End in *Salad Days*. She choreographed for the Western Theatre Ballet, a company that she co-founded with Peter Darrell in 1957. West was killed in a mountaineering accident while she was climbing the Italian Alps.

Works Choreographed: CONCERT WORKS: *Black-Eyed Susan* (1955); *Pulcinella* (1957); *Peter and the Wolf* (1957).

Westbrook, Frank, American modern and theatrical dancer and television choreographer; born c.1920 in Jackson, Mississippi. It is not certain which route Westbrook took to studies with Charles Weidman, but he was a member of the (Doris) Humphrey/Weidman Concert Group in the mid-1940s and appeared in dozens of repertory works including Weidman's *Inquest* and *And Daddy Was a Fireman* (1943). He also performed with the Edwin Strawbridge troupe and with Felicia Sorel's Studio Workshop before leaving the modern and concert field for Broadway. After performing in a short-lived musical called *Jackpot* (1944), Westbrook was fortunate enough to appear in five shows staged by some of the medium's most successful guests from the ballet world—Agnes De Mille's *One Touch of Venus* (1943) and *Allegro* (1947), Jerome Robbins' *On the Town* (1944), *The Day Before Spring* (1945) with ballets by Antony Tudor, and Michael Kidd's *Love Life* (1948). Although he occasionally participated in the Choreographers' Workshop programs as creator or performer, he concentrated his career in the theater and the new entertainment medium—television.

Through the 1950s, Westbrook staged dances for television variety shows that were broadcast live from New York studios, among them, some of the popular music–based productions. His work for the *Paul Whiteman/Goodyear Revue* (ABC, 1949–1952), *Kate Smith Hour* (NBC, 1951–1953), and *Voice of Firestone* (ABC, 1954–1956) were especially well received by critics and the growing audience alike. Like many of his colleagues in the new field of choreogra-

phy for television, he moved into directing, rather than returning to dance. In 1974 he was still active in commercial and entertainment broadcasting in Los Angeles and Chicago.

Works Choreographed: CONCERT WORKS: *The Lovers' Wood* (1947); *Waltzes* (1947); *Vertigo* (1951).

TELEVISION: *The Paul Whiteman/Goodyear Revue* (ABC, 1949–1952, full season only); *The Big Big Revue* (CBS, 1950); *The Kate Smith Hour* (NBC, 1951–1953); *The Schlitz Pulitzer Prize Playhouse* (CBS, 1951–c.1954, intermittent episodes); *The Martha Wright Show* (ABC, 1954, also titled *The Packard Showroom*); *The Voice of Firestone* (ABC, 1954–1956).

Westerdijk, Lenny, Dutch ballet dancer; born February 14, 1946 in Amsterdam. Trained by Karel Poon, Westerdijk has spent much of his career commuting between the Netherlands Dance Theatre, with which he danced from 1965 to 1968 and from 1969 to 1972, and the Ballet Rambert in London (1968–1969, 1972 on). He has become known for his performances in the works of Glen Tetley in both companies, with roles in Tetley's *Mythical Hunters* and *Embrace Tiger and Return to Mountain*. His Dutch repertory has included parts in Charles Czarney's *Concerto Grosso*, Job Sander's *Screenplay* (1966), and Hans Van Manen's *Square, Grosse Fuge*, and *Opus Lemaitre*.

Works Choreographed: CONCERT WORKS: *5-4-3-2-1* (1976).

Westergard, Lance, American modern dancer and choreographer; born in Poughkeepsie, New York. Westergard was trained at the Juilliard School by Antony Tudor, Anna Sokolow, and José Limón, among others. He has performed with a wide variety of groups, ranging from Eliot Feld's American Ballet Company, in which he appeared in Feld's *Harbinger* and *Early Songs*, to Lottie Goslar's Pantomime Circus, to the lyrical modern dance companies of Manuel Alum and Kazuko Hirabayashi. Westergard is best known for his work with Kathryn Posin's troupe, of which he was associate artistic director. He danced in almost all of her repertory, including her *Tunnel Lights* (1972), *Bach Pieces* (1973), *Waves* (1975), *Soft Storm* (1977), and *Clear Signals* (1978).

Westergard left the Posin troupe to pursue the development of his own choreographic career with his New York Dance Ensemble.

Wheeler, Pearl, American dancer and costumer associated with the Denishawn companies; born c.1890 in California; died 1964 in Hollywood, California. A student at the school of Ruth St. Denis and Ted Shawn in Los Angeles from the mid-1910s, she joined the Denishawn tours between 1918 and 1927. Among the many works by the choreographers in which she danced were St Denis' *Dance of the Royal Ballet of Siam* (1918), *Egyptian Suite*, and *Vision of the Aissoua* (1924). She went on the Oriental tour but was not cast in any of the new works that were created on it. As a costume designer and constructor, Wheeler worked on almost every St. Denis work created after the mid-1920s, including the solo, *White Jade*, and the group work, *The Lamp* (1928).

After the disbanding of the grandiose scheme for the continuation of Denishawn, Wheeler moved back to Los Angeles from New York where she had moved with St. Denis. She served as a consultant on Oriental decor and dance for MGM, which, for some reason, could not hire a genuine Oriental in California, and rented her own belongings to studios for their film productions. Wheeler also taught ballet and exotic dance in the Los Angeles area and staged revivals of works by St. Denis and Doris Humphrey at the Hollywood Bowl in the summer of 1935.

Works Choreographed: CONCERT WORKS: *The Planet* (1935).

White, Alice, American film dancer and comedienne known as "The Pout"; born c.1912 in Patterson, New Jersey. White was raised in Los Angeles as an adolescent and worked as a script girl before she broke into film performance. Her life formed the reality of the legend of a script girl getting in front of the camera to test a new lens and being discovered, by chance, by directors and studio executives. She had, however, been a student of Ernest Belcher for many years prior to her discovery and was trained in ballet and the popular theatrical dance styles required for film performance. Although her first picture, *Sea Tiger* (First National, 1927), was a melodrama, she was best known for her starring appearances in back-

939

stage musicals of the early sound era. Under her five-year contract to First National/Vitaphone, she was the all-dancing, all-singing star of *Man Crazy* (1927), *The Girl from Woolworths* (1929), *Broadway Babies* (1929), and *A Show Girl in Hollywood* (1930). White is best remembered as the first "Lorelie Lee," in Anita Loos' *Gentlemen Prefer Blondes* (Paramount/Famous Players-Laskey, 1928). She attempted to break her studio contract (to negotiate for better films) and was punished in a unique fashion: her last two films for First National were released without her name used in publicity or credits even though she had the starring role in each.

It is not certain why White, who was at one time second only to Clara Bow in popularity, had such a short career in films. Her attempt to buck the studio certainly didn't help, and her reputation as "the star of more court appearances than films" probably worked against her. She was cast in a few comic roles in the mid-1930s and toured throughout that decade with a dance trio act on the Loew's theater circuit, but never regained her star status.

White, Frances, American theatrical dancer; born c.1898 in Seattle, Washington; died February 24, 1969 in Baldwin Hills, Los Angeles. Discovered in Seattle by dancer William Rock, she moved to New York to become his partner in vaudeville and on Broadway. From her debut at The Palace on May 1, 1916 to her retirement, she was a headliner. The five-foot hoofer appeared in the *Ziegfeld Follies of 1916* but was better known for her performances in the *Ziegfeld Midnight Frolics of 1916, 1917,* and *1918,* where she was an undisputed star. She was featured in the numbers that were euphemistically known as flirtation dances in which she and her female chorus did songs about knitting or fishing on stage and cajoled the men in the audience into holding onto their props. White was also known as a Black Bottom expert in competition with Gilda Gray and Ann Pennington. She appeared as a specialty dancer in the *Hitchy-Koos of 1917* and *1918* and in English revues, such as Ned Wayburn's *Joy-Bells.*

Although she performed for a few wonderful seconds in *The Great Ziegfeld* (MGM, 1936), White had retired in the 1920s. She continued to appear on the Keith circuit after ceasing her Broadway activities in 1920, but did not lengthen her career by many years. White was the heroine of many of the best stories about the battles between the sexes on Broadway in the 1910s and 1920s, most notably in her status as the first ex–Mrs. Frank Fay, but it is not certain whether these activities helped or hurt her career.

White, George, Canadian/American tap dancer, producer, and songwriter; born 1890 in Toronto; died October 11, 1968 in Hollywood, California. After dancing in a vaudeville act with Ben Ryan, he made his Broadway debut in *The Echo* (1910) as a specialty dancer and actor. He played the juvenile/dance lead in three Winter Garden musicals—*The Whirl of Society* (1912), *The Pleasure Seekers* (1913), and *The Midnight Girl* (1914)—and appeared in the *Ziegfeld Follies* of 1911 and 1915 and Ziegfeld's *Miss 1917.*

In 1919, he produced the first of a long series of George White's *Scandals. The Scandals* (1919–1939) differed from the *Follies* since they had better music—by various combinations of George Gershwin, Ira Gershwin, Ray Henderson, B.G. Da Sylva, and Lew Brown—fewer performers, and far less elaborate settings. Except for White himself, the two series shared dance acts, notably the singular talents of Ann Pennington (who introduced The Black Bottom in the 1926 edition and did tap and hula numbers in the 1919–1921 and 1926 and 1928 shows), and Tom Patricola whose "elephantine grace" was featured in the 1923 to 1928 editions. White also directed shows outside of the *Scandals* series, among them *Running Wild* (1923), *Manhattan Mary* (1927), in which he himself performed, *Flying High* (1930), and *George White's Music Hall Varieties* (1932). He worked as production supervisor or co-producer on the filmed scandals—*George White's Scandals* (Fox Film Corp., 1934), *George White's 1935 Scandals* (Fox Film Corp., 1935), and *George White's Scandals* (RKO, 1945), as well as appearing as himself in the Warner Brothers biopic of George Gershwin—*Rhapsody in Blue* in 1945.

White was considered one of the best tap dancers of his day—a machine-gun noneccentric tapper who could partner the best female dancers, such as Ann Pennington, and could hold the stage on his own.

White, Glenn, American ballet dancer; born August 6, 1949 in Pittsburgh, Pennsylvania. White was trained at the American Ballet Center, graduating' into the City Center Joffrey Ballet in 1969. He has developed into a mature, versatile performer in his eleven years with the company and has been acclaimed in principal roles in almost the entire repertory. His appearances in works by Gerald Arpino include *Trinity, Confetti, Reflections, Solarwind, Kettentanz, Suite Saint-Saens, Air d'Esprit*, and *Celebration* (1980). He has also been cast in the company's revival of the Diaghilev Ballet Russe repertory, most notably as "The Charlatan" in its *Petrouchka*, and in new works by guest choreographers, among them Moses Pendleton's *Relâche* (1980) and Jiri Kylian's *Return to the Strange Land*.

White, Oona, Canadian theatrical dancer and film choreographer, in England and the United States; born March 24, 1922 in Inverness, Nova Scotia. Raised in San Francisco, California, she studied with Freida Marie Shaw and at the school of the San Francisco Ballet. She worked as a choreographic assistant to Michael Kidd for many years, dancing for him in *Finian's Rainbow* (1947) and *Guys and Dolls* (1950), and staging the 1955 City Center revivals of both. She also danced on Broadway in Anna Sokolow's *Regina* (1949), Kidd's *Arms and the Girl* (1950), and Eugene Loring's *Silk Stockings* (1955).

As a choreographer, she worked on the London production of *Fanny* (1956) and the Broadway productions of *The Music Man* (1957), *Take Me Along* (1959), *Irma La Douce* (1960), *Half a Sixpence* (1965), *Mame* (1966), *Ilya Darling* (1967, the musical of *Never on Sunday*), *1776* (1969), *Gigi* (1973), and the New York production of *Goodtime Charley* (1975), a musical comedy about the death of Joan of Arc. She repeated her choreography of *The Music Man* for the film version (WB, 1962) and staged the movie versions of *Bye Bye Birdie* (Columbia, 1963) and *Oliver* (Columbia, 1968).

Works Choreographed: THEATER WORKS: *Fanny* (1956, London production only); *The Music Man* (1957); *Whoop-Up!* (1958); *Take Me Along* (1959); *Irma La Douce* (1960); *Let It Ride* (1961); *I Had A Ball* (1964); *Half a Sixpence* (1965); *Mame* (1966, London 1969); *Ilya Darling* (1967); *1776* (1969); *70,*

Girls, 70 (1971); *Gigi* (1973); *Billy* (London production only); *Goodtime Charley* (1975).

FILM: *The Music Man* (WB, 1962); *Bye Bye Birdie* (Columbia, 1963); *Oliver* (Columbia, 1968).

White, Sammy, American theatrical dancer and actor; born 1895; died March 3, 1960 in Beverly Hills, California. "Funny-foot" White, so-called because of his complicated step work, made his vaudeville debut in an act with Lou Clayton (later Jimmy Durante's partner). They worked together on the Keith circuit until 1918, when he made the first of three appearances in the Shubert's revue, the *Show of Wonders*, followed by the *Passing Shows* of 1919, 1920 and 1921. In 1921, he became Eva Puck's vaudeville and Broadway dance partner, working with her in the *Greenwich Village Follies of 1922* and *1923, Melody Man* (1924), *The Girl Friend* (1926), and the original *Show Boat* (1927) as "Frank" and "Ellie." Although their act included exhibition ballroom work, he remained best known for his footwork in tap solos.

After the breakup of his act (and marriage) with Puck, he moved to Hollywood to partner Marion Davies in *Cain and Mabel* (Cosmopolitan, 1936). Apart from playing "Frank" in frequent revivals of *Show Boat*, White worked in films and television for the remainder of his career. Playing agents, gamblers and gangsters, he worked constantly in melodramas and comedies.

Whitener, William, American ballet dancer and choreographer; born August 17, 1951 in Seattle, Washington. Trained locally, presumably by Mary Ann Wells, he moved to New York to continue his studies at the American Ballet Center, the official school of the City Center Joffrey Ballet.

After performing briefly with the New York City Opera, he joined the Joffrey company in 1970. His principal credits in that company included parts in Benjamin Harkavy's *Grand Pas Espagnole* in 1972 and Twyla Tharp's *As Time Goes By* (1973). After leaving the Troupe to perform on Broadway in Bob Fosse's *Dancin'*, he joined Tharp's own group. He has danced in much of her active repertory, creating roles in her *Baker's Dozen* (1979) and *3-5-0-0* (1979), the concert version of dances from the film *Hair*.

He has choreographed occasionally since 1978, when he contributed *Boomfallera* to the Joffrey II Company. Other works have been created for the Ice Theatre of skater John Curry.

Works Choreographed: CONCERT WORKS: *Boomfallera* (1978); *Quatrefoil* (1979); *Night and Day* (1980).

Whiting, Jack, American theatrical dancer and actor; born June 22, 1901 in Philadelphia, Pennsylvania; died February 14, 1961 in New York City. "Smiling Jack," as he was occasionally called, attended the University of Pennsylvania and participated in Mask and Wig Club shows there. He made his professional debut in the *Ziegfeld Follies of 1922*, possibly through the recommendation of dance director Ned Wayburn who had staged Mask and Wig shows in the late 1910s. He sang and danced juvenile and comic roles in over two dozen successful Broadway musicals, among them *Cinders* (1923), *The Ramblers* (1926), *Yes, Yes, Yvette* (1927), *Hold Everything* (1928), *America's Sweetheart* (1931), *Hooray for What* (1937), *Walk with Music* (1940), *Beat the Band* (1942), and two shows of the 1950s, *Hazel Flagg* (1953), and *The Golden Apple* (1954). Most of his dance numbers were variations on popular social dances, but he tapped in London productions of *Anything Goes* (1935), *Rise and Shine* (1936), and *On Your Toes* (1937) in which he was the hoofer "Phil Dolan." Among the hundreds of songs that he introduced were Lorenz Hart and Richard Rodgers' range of love songs from the jaunty "I've Got Five Dollars" to the haunting "Ship Without a Sail."

Whiting also performed in film in England, where he made *Sailing Along* for Great British Pictures (1937), and in Hollywood, where he danced in Warner Brothers' *Life of the Party* (1930), Paramount's *Give Me a Sailor* (1938), and First National's early sound pictures, *College Lovers* (1930), *Top Speed* (1930), and *Men of the Sky* (1931).

Whitney, Eleanor, American film tap dancer; born 1917 in Cleveland, Ohio. Whitney claimed to have been trained by Bill Robinson himself and is believed to have been a student of Johnny Boyle in Hollywood. In the two years of her performance career, Whitney did not make many important films, so it is difficult now to understand why her status in film dance led to her being called "the next Eleanor Powell." Her dance style itself was unique and made her tremendously popular. A combination of Powell and Claire Luce, she managed to be a machine-gun tapper, as was typical of Boyle's students, while remaining extremely seductive. One trade paper even compared her allure favorably to Jean Harlow, whose dancing efforts lacked tap technique and facility. The three films in which she danced solos are all from Paramount: *Rose Bowl* (1936), *Blonde Trouble* (1937), the film version of *June Moon*, and *Turn Off the Moon* (1937), produced by Fanchon. Whitney also performed live in promotional appearances on Fanchon's Prolog circuit.

Wiesenthal Sisters, Austrian early twentieth-century concert dance team. Although five Wiesenthal sisters existed and were trained at the school of the Vienna Court Opera Ballet, the concert dance performances were generally given by Grete (the best known), Elsa, Berthe, and Marthe, without Gertrud. They were never interchangeable, but were frequently cast successively in productions of the Kinderballett and opera. Grete (followed by Elsa and Berthe) also appeared in presentations of independent theaters, including productions by Hugo von Hofmannstall and Max Reinhardt.

The dance style of the Wiesenthals, in solos, duets, and trios, is still remembered fondly in Vienna. They were neoromanticists of the era, if not the style, of von Hofmannstall and Richard Strauss, but were popularly associated with the waltzes of Edwards and the two Johann Strausses, especially the "Blue Danube." The duets, for Elsa and Berthe, were among the most popular individual dances and were choreographed in mirror imagery, with the two dancers reflecting each others' impressionist movements.

Bibliography: Rudolf Huber-Wiesenthal, *Die Schwestern Wiesenthal* (The Wiesenthal Sisters) (Vienna: 1934).

Wigman, Mary, German modern dancer and choreographer, considered by many the most influential creator of the German expressionist movement; born Mary Wiegmann, November 13, 1886 in Hanover;

died September 18, 1973 in Berlin. Trained originally by Emile Jaques-Dalcroze in Hellerau and Dresden, she began to work with Rudolf von Laban in 1913 and studied with him in Ascona, Switzerland, and in Munich.

She made her debut as a recital dancer, c.1914, and as a concert dancer and choreographer in 1919. Successful performances in Zurich and Hamburg led her to open her own school in Dresden. Among her first students there were Yvonne Georgi, Gert Palucca, Vera Skoronel, and Harald Kreutzberg—almost the entire first generation of German concert dancers. By 1925, her students included Ruth Abrahamowitsch, Hanya Holm, with Margarete Wallmann in the dance company and Tilly Losch as a frequent guest student. Her students performed as a company and toured Western Europe through the 1930s, performing in London after 1928 and touring the United States as a Hurok troupe in 1930. Although she performed at the Berlin Olympics of 1936, her school was closed under the National Socialist regime and she became a teacher at the Leipzig Music Academy. She returned to Berlin in 1948 to reopen the school which, once again, became the focus for the German modern dance movement. As well as her works for her own students and companies, she worked frequently in various operà houses in Germany, notably staging productions of operas by Gluck in Leipzig and Mannheim and a famous joint performance of Carl Orff's *Carmina Burana* and *Catulli Carmina* in Mannheim in 1955.

Wigman's choreography itself was created primarily in two genres—solo and group dances, which ranged from works for small companies to the large movement choruses for which she became known. These works, such as *Choric Movement* (1929) and *Totenmal* (1930), used dancers as elements of a mass movement, not as conventional performers. Her solos and group works used limited movement vocabularies based on shifts of weight and thrust and on eventual shapes, rather than transitional poses. She became known in the United States especially for works that employed single movements or patterns almost compulsively, as in her *Two Monotonies: Restrained and Turning* and *Vision IV: Witch Dance* (both 1926), which used revolving as their motifs.

It is almost impossible to overestimate Wigman's influence. Family trees of dance that begin with her stretch throughout the current modern dance in its expressionist, traditional American, and postmodern branches. Although many of her direct disciples were concert dancers whose works were lost when they stopped dancing, others worked in films, in repertory companies that maintained active and older works, and in television. Through Hanya Holm alone, she has influenced her students Alwin Nikolais, himself the root of a modern dance style and family, Don Redlich, Glen Tetley, and many Broadway and West End choreographers. Through Wallmann, she introduced expressionist forms to Ted Shawn, who in turn influenced the traditional branch of American modern dance.

Works Choreographed: CONCERT WORKS: (Note: this listing is partially based on the chronology in Sorrell's *The Language of Dance*.) *Witch Dance Without Music* (1914); *Lento* (1914); *A Day of Elves* (1914); Untitled Dances to recitations from Nietzsche (1916); *The Tumbler of Our Lady* (1917); *Marche Orientale* (1918); *Scherzo* (c.1918); *Serenade* (1918); *Yaravi* (1918); *Estatic Dances* (1918); *Prayer* (1918); *Sacrifice* (c.1918); *Idolation* (c.1918); *Temple Dance* (c.1918); *Four Hungarian Dances* (c.1918); *Eroica* (c.1919); *Waltz* (c.1919); *Polonaise* (1920); *Dance Suite (Prelude, Play Waltz, Allegro con Brio)* (1920); *Four Dances Based on Oriental Motifs* (1920); *Arabesque, Soaring, Center* (1920); *Dances of the Night (Shadow, Dream)* (1920); *Dance Suite II (Intermezzo, Minuet, Farandole)* (1920); *The Spook* (1920); *Vision* (1920); *Dance Rhythms I (Triste, The Call)* (1920); *Dance Rhythms II (Song of the Sword, Lament, Zañacueca)* (c.1920); *Suite in Old Styles (Polonaise, Gavotte, Sarabande, Rigaudon)* (c.1920); *Danish Suite* (c.1920); *Spanish Suite (Canción, Allegro airolo, Malagueña)* (c.1920); *Two Dances of Silence* (c.1920); *The Cry, The Road* (c.1920); *Variations on a Heroic Theme* (c.1920); Romance and Seguidilla added to *Spanish Suite* (c.1922); *Appassionata* (1923); *Two Dance Songs* (1923); *Dance Dance Rhythms* (1923); *Celebrations (I—Greetings, Spell, Consecration, Chant)* (c.1921); *Danse Macabre* (c.1922); *Grotesque* (c.1922); *Two Dance Rhythms (II)* (c.1922); *Flight* (c.1922); *The Seven Dances of Life (Prelude, Dance of the Longing, Dance of Love, Dance of Lust, Dance of Sorrow, Dance of the De-*

mon, Dance of Death, Dance of Life) (c.1922–1923); March (1923); Polonaises Nos. 1 and 2 (1923); Rhapsody (II) (1923); Silhouettes (1923); Final Dance of Rhapsody (1923); Alla Marcia, All' Improvisato, Allegretto zingarese (c.1924); Three Elegies (1924); Visions No. I to III (1925); Ceremonial Figure (1925); A Dance Fairy Tale (1925); Masked Figure (1925); Spectre (1925); Festival Prelude (1926); Rhapsodic Dance (1926); Two Monotonies: Restrained and Turning (1926); Vision IV: Witch Dance (1926); Suite of Russian Folk Songs and Rhythms (1926); Dance of Death (1926); Hymns in Space (1926); Ceremonial Figure (II) (1926); Festival Prelude (1926); Celebration II (1927); Dance Song (1927); Bright Oscillations (With a Big Verse, Tender Flowing, Playful) (1927); Vision V: Dream Figure (1927); Ballad (I) (1927); Vision VI: Ceremonial Figure II (1927); Ghostly Figure (1927); Vision VIII: Study for Totenmal (1928); Shifting Landscape (Invocation, Seraphic Song, Dance of Night, Pastoral, Festive Rhythm, Dance of Summer, Swinging) (1929); Choric Movement (1929); Three Gypsy Dances (1929); Dances of Grief (1930); Totenmal (1930); Sacrifice (Song of the Sword, Dance for the Sun, Death Call, Dance for the Earth, Lament, Dance into Death) (1931); The Road (1932); Heroic Chord (1932); Nocturnal Song (1932, co-choreographed with Margarete Wallmann); Dream (1932); Women's Dances (Wedding Dance, Maternal Dance, Lament for the Dead, Dance of Silent Joy, Prophetess, Witch Dance [II]) (1934); Hymnic Dances (Paean, Song of Fate, Road of the Supplicant, Moon Song, Dance of Fire, Dance of Homage) (1935); Lament for the Dead (II) (1936); Untitled Festival of Youth performance (1936); Autumnal Dances (Hunting Song, Dance of Remembrance, Blessing, Windswept, Dance with Stillness) (1937); Ballet (II) (1938); Play (1938); Dance of the Queen of Light, Dance of the Queen of Night (c.1939); Three Dances for Polish Folk Songs (c.1939); Be Calm, My Heart (1942); Rejoice My Heart (1942); Carmina Burana (1943); Three Choric Studies of the Misery of Time (Escape, Those Seeking, In Loving Memory) (1946); Orpheus et Eurydice (1947); Choric Studies (Those Waiting, The Homeless, Grievance and Accusation) (1952); Farewell—Sarabande (1953); Lament for Orpheus (1953, possibly from Orpheus et Eurydice, 1947); Estatic Rhythm (1953); Maenad's Rhythm (1953); Choric Scenes (The Prophetess, The Temple, The Street, Twilight, Resounding Steps, Dance, The Road) (1955).

Bibliography: Sorrell, Walter. The Mary Wigman Book (Middletown, Conn.: 1975); Sorrell, ed. The Language of Dance (Middletown, Conn.: 1966); Wigman, Mary. Deutsche Tanzkunst (Dresden: 1935, partially translated and included in The Mary Wigman Book).

Wilde, Patricia, Canadian ballet dancer working in the United States after 1943; born July 16, 1928 in Ottawa, Canada. After local studies with a Miss G. Osborne, Wilde continued her training with Dorothie Littlefield in Philadelphia and at the School of American Ballet in New York. She made her debut in New York with the American Concert Ballet, a one-performance company that featured works by Todd Bolender and Mary-Jane Shea. After one season with the Ballet International, she danced with the Ballet Russe de Monte Carlo from 1945 to 1949, performing in Balanchine's Concerto Barocco, Agnes De Mille's Rodeo, and Ruthanna Boris' Cirque de Deux (1947).

As a member of the New York City Ballet during the 1950s, Wilde became one of its best known dancers. Her precise technique and fabulous stage presence made her uniquely useful to the company and won her roles in most of the new works of that decade. Among these were Balanchine's La Valse (1951), Swan Lake (1951), Caracole (1952), Opus 34 (1954), Ivesiana (1954), Pas de Trois (1955), Divertimento No. 15 (1956), Waltz-Scherzo (1958), Native Dancers (1959), and Raymonda Variations (1961); she brought romance and comedy to her parts in his Scotch and Western Symphonies, respectively, in 1952 and 1954. While in the company, Wilde also created roles in Boris' Cakewalk (1951) and Kaleidoscope (1952).

After retiring from performance, Wilde taught at the Harkness House where she directed their scholarship program. From 1969 to the present, she has served as director of the Ballet Theatre School in New York.

Wilder, Marc, American film dancer; born May 1, 1929 in Italy. Raised in the Los Angeles area, he was trained in the Jack Cole workshop at Columbia Studios. He danced for Cole in Kismet on Broadway

(1953), and in many films and cabaret performances. Among his film assignments were parts in *The I Don't Care Girl* (Twentieth-Century Fox, 1953), Eugene Loring's *Meet Me in Las Vegas* (MGM, 1956), partnering Cyd Charisse, *The Tender Trap* (MGM, 1955), and *Can-Can* (Twentieth-Century Fox, 1960), as Shirley MacLaine's partner in the Garden of Eden dance sequence. He has also worked in Las Vegas as a partner for female vocalists, among them Mitzi Gaynor, Debbie Reynolds, and Sheree North.

Wilhelm, Charles, English theatrical designer; born William John Charles Pitcher, March 21, 1858 in Northfleet, Kent; died 1925 in London. Known for his exquisite drawings and detailed iconographic systems, Wilhelm designed costumes, sets, and special effects for pantomimes and ballets in London theaters, especially those staged by Katti Lanner.

Although he did a great deal of freelance work, his career was basically divided between tenures at the Drury Lane Theatre (1868–1892) and The Empire (1887–1919). At the former he created designs for Lanner's *Aladdin* (1885) that are now housed in the Victoria and Albert Museum. At the latter, he created more than a score of ballets, notably *The Press* (1898) and *Rose d'Amour* (1888). In both of those, he employed a system of iconography, adapting symbols of nationality, emotions, and contemporary life as decorative motifs and as structures by themselves. For example, in *The Press*, some of the choruses were decorated with the trade symbols of the specific London newspapers, but others were transformed into representations of newsprint, ink, and other things in his protohuman costumes.

Wilhelm's other assignments included *Nero* (1889) and *Venice* (1891) at the Olympia, the pantomimes *Cinderella* (1893), *Santa Claus* (1894), and *Robinson Crusoe* (1895) at the Lyceum, shows at the Crystal Palace, and the original Savoy Theatre productions of Gilbert and Sullivan's *Princess Ida* (1884), *The Mikado* (1885), and *Ruddigore* (1887).

Williams, Andrès, Cuban ballet dancer; born 1952 in Havana. Williams was trained entirely at the school of the Ballet Nacional de Cuba and has performed with that company since 1970. Although he has danced in Alicia Alonso's productions of the nineteenth-century classics, his strength and powerful dramatic style have been seen more frequently in the company's contemporary repertory, most notably in Azari Plisetski's *Canto Vital*, Alberto Mendéz' *Paso à Tres*, and many pieces by compatriot Iván Tenorio, including *Ritmicas* and *Euologias de la Danza*.

Williams, Dudley, American modern dancer; born August 1938 in New York City. A graduate of New York's High School of Performing Arts, Williams has studied tap dance, ballet (primarily with Antony Tudor at the Metropolitan Opera Ballet school and Juilliard), jazz, and a variety of modern dance techniques.

While at Performing Arts, he and fellow student Eleo Pomare formed a small company, the Corybantes, that performed locally in New York. Later he performed with the companies of May O'Donnell, creating roles in her *Theme and Variation* (1956), Hava Kohav, and Donald McKayle. From 1961 to 1968 he was a member of the Martha Graham company, performing featured roles in her *Acrobats of God, Clytemnestra, Diversion of Angels, Dancing Ground*, and *Embattled Garden,* and creating roles in her *Cortege of Eagles* (1967), *A Time of Snow* (1968), and *Lady of the House of Sleep* (1968).

As a member of the Alvin Ailey Dance Theatre from 1963 to the present, he has created a large number of roles in Ailey's *Reflection in D* (1962), *Streams* (1970), *Choral Dances* (1971), *Mary Lou's Mass* (1971), *A Song for You* (1972), *Night Creature* (1975), *Three Black Kings* (1976), and his rare male solo, *Love Songs* (1972), which is one of the most popular works in the company repertory. Williams also performed featured roles in the company productions of Ailey's *Blues Suite, Revelations,* and *Hermit Songs*, Talley Beatty's *Black District*, Louis Falco's *Caravan*, Donald McKayle's *Rainbow 'Round My Shoulder*, Kathryn Posin's *Later That Day* (1980), and John Jones' *Nocturnes* (1974). Still a performing member of the company, Williams has served as an assistant ballet master since 1974.

Williams, E. Virginia, American ballet dancer and teacher; born in the 1930s in Melrose, Massachusetts. Trained by Geraldine Cragin, a former Harriet Hoctor protégé, and Dana Sieveling, she worked with the San Carlo Opera (in Boston) before forming a con-

cert group in the late 1950s. That group was transformed into the New England Civic Ballet in 1958, which in 1963 was renamed The Boston Ballet.

The Boston Ballet has become one of the country's most important and innovative small companies in the 1960s and 1970s, commissioning new works and sponsoring a competition for young choreographers.

Williams has restaged productions of the classics for the company and serves as a dance director for Sara Caldwell's opera productions.

Williams, Hattie, American musical comedy performer; born 1872 in Boston, Massachusetts; died August 17, 1942 in the Bronx, New York. It is unlikely that Williams had training beyond the Delsarte elocution classes that were popular in New England in the 1880s; these, however, frequently involved interpretive and national dance styles as well as the study of gestures. She made her professional debut in a local production (or possibly a pre-Broadway tour) of the spectacle *1492*, and traveled to New York in it. A popular performer throughout her long career, Williams worked constantly from 1895 to 1915, when she retired from the business. She began in dance roles in atmostpheric pieces like *Thrilby* (1895) and moved on to soubrette parts in a series of Gus and Max Rodgers vehicles, such as *The Rodgers Brothers in Washington* (1901) and *The Rodgers Brothers at Harvard* (1902). She moved on to specialty roles with dance solos in *The Girl from Maxim's* and *The Girl from Montmartre, The Little Cherub* (1906), *Decorating Clementine* (1910), and *The Doll Girl* (1913), in which she did her most celebrated Spanish-dance solo. Her best known performance was in the title role of *Fluffy Ruffles* (1908), in which she appeared in an Alec Guinness–like repertory of characterizations of dancers, suffragists, chauffeurs, and vocalists. Williams' last role was as Ethel and John Barrymore's butler in J.M. Barrie's playlet, *A Slice of Life* (1915), after which she retired.

Williams, Sammy, American theatrical dancer and actor; born Salvatore Gualiamo, 1948 in Trenton, New Jersey. After local training, Williams made his professional debut as the swing "School Boy" in Gower Champion's *The Happy Time* in 1969. For most of the early 1970s, Williams worked on tour (notably in Michael Bennett's *Seesaw*) and in indus-

trials, and lived on unemployment. His activities brought him into the group of hard-core "Gypsies" whom Bennett interviewed as background to his *Chorus Line*. Williams claimed that his training and credits were the origin of the monologue and song for "Mike," who discovered his talents in his sister's dance class, but Bennett cast him in the more demanding role of "Paul." That character is, depending on the audience's attitudes, the (or one of the) protagonists of *A Chorus Line*, the dancer whose activities finally move the choreographer "Zach" to personal involvement and whose tragedy gives the cue for the celebrated song, "What I Did for Love." Williams was given the Tony award in 1976 for his ability to show the lay audience that dance and performance were worth loving. After leaving the Broadway company, Williams appeared as "Paul" in Los Angeles for two years. He has concentrated on acting, rather than dance, in recent seasons.

Williams, Stanley, English ballet dancer performing in Denmark from 1934 and teaching in the United States since 1964; born 1925 in Chappell, England. Educated and raised in Denmark, Williams was trained at the school of the Royal Danish Ballet from 1943, notably by Vera Volkova.

As a member of the Ballet, he created the role of "The Poet" in Borge Ralov's *Kurtisanen* (The Courtesan) in 1953, and was featured in Birgit Bartholin's *Romeo and Juliet*, Leonid Massine's *Symphonie Fantastique*, and Emille Walborn's *Dream Pictures*. Noted for his work in the Bournonville repertory that was maintained by the company, he performed in *Far from Denmark, La Sylphide*, and *Konservatoriet*.

Working in New York since 1964 at the American Ballet Center and, currently, the School of American Ballet, Williams has become one of the city's most popular and most influential teachers. Students at SAB, the New York City Ballet, and many other dancers take his classes regularly when they are in town. Williams has staged Bournonville works and excerpts in the United States since the renewal of interest in that nineteenth-century choreographer, among them, the *Bournonville Divertissements* for the New York City Ballet in 1977.

Willis, Mary, English ballet and theater dancer; born November 15, 1945 in Wimbledon, England. Trained

locally by Letty Littlewood, she attended the Arts Educational School in London and studied ballet with Errol Addison and jazz with Tony Mordente.

A member of the Ballet Rambert from 1964, she performed in Frederick Ashton's *Façade* and when the company switched from the classics to modern works, she created roles in David Toguri's *Inochi* (c.1971). Willis also performed extensively in London's West End in the premiere of *Half a Sixpence* (1963) and in the London productions of the Broadway musicals *Flower Drum Song* (1960), *Bye Bye Birdie* (1961), and *The Music Man* (1961).

Wilson, Billy, American theatrical dancer and choreographer; born April 21, 1935 in Philadelphia, Pennsylvania. Wilson was trained by Karel Shook, Walter Nicks, and Antony Tudor. He performed with the Philadelphia Ballet Guild and on Broadway in the 1956 revival of *Carmen Jones*, and in *Bells Are Ringing* (1956), *Jamaica* (1957), and the London company of *West Side Story*. He remained in Europe to work with the National Ballet of the Netherlands and to stage productions of Broadway musicals in Rotterdam. In 1960, he was invited to create the title role in Serge Lifar's *Othello* in Monte Carlo.

When he returned to the United States in the early 1970s, he taught in New England where he served as director of the Dance Theater of Boston. He has also staged musical numbers for the local Public Broadcasting Service station's children programming and for musicals on Broadway, most notably *Bubblin' Brown Sugar* (1976) and the 1976–1977 revival of *Guys and Dolls*.

Works Choreographed: THEATER WORKS: *Bubblin' Brown Sugar* (1976); *Guys and Dolls* (1976, revival); *Eubie* (1978, co-choreographed by Henry Le Tang).

TELEVISION: *Zoom* (WGBH-TV, syndicated on PBS, 1976–1981).

Wilson, John, American modern dancer and composer; born 1927 in Los Angeles, California. Wilson's musical training, at the University of Southern California, the Juilliard School, the Dalcroze Institute in Geneva, and the Tanglewood summer program in conducting, was augmented by his dance studies with Katharine Dunham, Henriette Ann Gray, and Robert Joffrey. Wilson both danced in

and accompanied Gray's troupe, the Robert Joffrey Ballet, and the Harkness Ballet. Often, he partnered his wife, Brunhilda Ruiz, a principal performer with each.

Wilson is, however, better known as a modern dancer and choreographer. He worked with Joyce Trisler for many years, sharing a concert group that produced both of their works and occasionally creating scores for her pieces, most notably the popular *Bronx Zoo Cantata* (1960). After the dissolution of the Trisler/Wilson troupe, and some years of teaching music full time, he became a member of the original Dance Theater Workshop, which was then a performing as well as a producing institution. He appeared in works by his colleagues Jeff Duncan (among them, his *Vinculum* and *Diminishing Landscapes*), Kai Takei (performing in her *Lunch*, 1969), and Deborah Jowitt (including her *Black and White and True Blue*, 1968, and *Palimpsest* 1970), and presented his own pieces on shared recitals.

Works Choreographed: CONCERT WORKS: *Balloons* (1960); *Rhapsodies* (1960); *The Commuter* (1969); *Act Without Words* (1960); *Domestic Suite* (1961); *Songs of Ives* (1961); *The Seasons* (1962); *Songs of Faure* (1962); *Tiddly-winks* (1962); *Poe-Pour-Ri* (1964); *Networks* (1965); *First Excursion* (1966); *Chorales* (1969); *Scene-Dreams (America)* (1970); *Ecossaises* (1978); *Impromptu for Eurydice* (1978); *Bacchianas Americanus* (1978); *Eulalie/Ulalume* (1979); *Flies* (1979); *Lear Limmerick* (1980).

Wilson, Sallie, American ballet dancer renowned for her performances in dramatic works; born April 18, 1932 in Fort Worth, Texas. Trained locally by Dorothy Edwards, she moved to New York in 1948 to study with Margaret Craske.

She joined Ballet Theatre for the 1949–1950 season but left to perform with the Metropolitan Opera Ballet under Antony Tudor, also appearing in his chamber company at Jacobs' Pillow (1951). She returned to Ballet Theatre in the spring of 1954, performing featured roles in the classical repertory, notably as "Myrthe" in *Giselle*, and in Tudor's *Dim Lustre, Gala Performance, Judgement of Paris, Jardin aux Lilas*, and *Pillar of Fire*. During this tenure, she created roles in three ballets by Herbert Ross, *Concerto, Metamorphoses*, and *Paean* (all 1958).

During Ballet Theatre's two-season lay-off in 1958

to 1960, she performed with the New York City Ballet, creating roles in George Balanchine's section IV and VIII of *Panamerica* (1960), and Martha Graham's part of *Episodes* (1959). She was assigned featured roles in Balanchine's *Apollo, Four Temperaments, Stars and Stripes,* and *Western Symphony,* and in Jerome Robbins' *The Cage, Fanfare,* and *The Pied Piper.*

When Ballet Theatre was reorganized in 1960, she assumed the principal roles in the Tudor repertory, becoming famous for her portrayal of "Hagar" in his *Pillar of Fire.* Her performance as "The Accused" in Agnes De Mille's dramatic *Fall River Legend,* and the "Emilia" character in José Limón's *The Moor's Pavanne,* were equally celebrated. She has created an especially large number of roles in her twenty-five years with Ballet Theatre, among them, parts in Alvin Ailey's *The River* (1971), and *Sea-Change* (1973), Michael Smuin's *Schubertiade* (1970), Jerome Robbins' *Les Noces* (1965), and Glen Tetley's *Sargasso* (1964). Wilson has also made roles in the standard repertory into her specialties, such as "The Chief Nursemaid" in *Petrouchka* and a solo in *Les Sylphides.*

Winchell, Walter, American vaudeville dancer turned columnist; born April 7, 1897 in New York City; died February 20, 1972 in Los Angeles, California. "Mrs. Winchell's little boy," as he called himself, made his theatrical debut as an usher at the Imperial Theater in New York at the age of twelve. Shortly after beginning to work there, he and a fellow usher, George Jessel, formed a duet act. With Jack Wieber, they were booked into Gus Edwards' *Song Revue* as the Imperial Trio. After two years with Edwards, he left male acts to team up with Ballroom dancer Rita Green for a "bench" act of the type associated with Burns and Allen in which a man taps across the stage, sees a woman on a bench, and begins a flirtation in comedy, song, and dance. After military service, he and Green toured on the Keith, Albee, and Pantages circuits until 1921. He began to submit gossip items and jokes to the Keith-Albee house organ, *The Vaudeville News,* and in 1922, he left performance for his first newspaper staff job there. Winchell became known for his work on Bernarr MacFadden's *The* [New York] *Evening Graphic,* where he also served as drama critic, and on *The* [New York] *Mirror,* where he worked from 1929 until its demise in 1963. His columns, "Your Broadway and Mine," "Things I Never Knew Til' Now," and "My Girl Friday," also ran in syndication (through the *Mirror*) in short-lived papers such as *The World-Herald Tribune* and in MacFadden's dance magazines. On radio on Sunday nights, he announced items from his columns to "Mr. and Mrs. America and all the ships at sea."

In both his professional dancing and his radio work, Winchell was known for speed and stacatto delivery. He was a machine-gun hoofer, relying on the number of articulated sounds for effects, not the grace of his leg work, and he followed that pace in his announcements. From contemporary reviews, however, it would seem that his writing was considerably more interesting than his dancing. He is still remembered for the idioms that he contributed to the English language, although only a few words—"bundle from Heaven," "blessed event," "plugolas," and "phftt"—are in contemporary use. The connection between Winchell and the announcements of births was memorialized in a lyric to "Shuffle Off to Buffalo," the celebrated production number in *42nd Street* (WB, 1933 and Broadway, 1980)—"We don't know when to expect it, but it's a cinch Winchell knows." He was probably better known, however, for announcing divorces, or "Reno-vations," which was previously considered in bad taste.

In his later years, Winchell became a mere gossiper with dangerous political views, such as his campaign against polio vaccinations on the grounds that they were Communist inspired; however, his earlier columns can still be read for information about casting and productions. He can still be found in thinly disguised portraits in literature ranging from the cynically sympathetic character in Damon Runyon to the dangerous and vindictive villain of *Sweet Smell of Success.* It is, however, very difficult to obtain his columns without visiting the morgues of dead newspapers. None of the biographies listed below includes copies of those columns.

Bibliography: Mosedale, John. *The Men Who Invented Broadway* (New York: 1981); Lyle, Stuart. *The Secret Life of Walter Winchell* (New York: 1957); Thomas, Bob. *Winchell* (New York: 1971).

Winfield, Hemsley, American concert dancer; born c.1907 in Yonkers, New York; died January 15, 1934 in New York City. In his twenty-seven years of life, Winfield accomplished a tremendous amount and tantalized historians with his promise. It is impossible to say what might have happened in the progression of concert-dance development or in the integration of the dance in the United States, but many people have speculated that he might have effected major changes.

He developed as a dancer in the midst of the Harlem Renaissance, the son of a librettist who helped him adapt his literary sources into dance dramas. He formed the Negro Art Theater Dance Group (also billed as the Bronze Ballet Plastique) in 1931, staging a large number of short concert works for himself and a company that included the very young Archie Savage. These works seem to be abstractions, but his best known accomplishments were three plotted works—*Wade in the Water* (1932), *Salome* (1933), *De Promis' Lan'* (1933), and the choreography for the opera *The Emperor Jones* (1934), presented at the Metropolitan Opera. Winfield died of pneumonia shortly after that production. An annual Hemsley Winfield award is given in Brooklyn, New York as part of the Celebration of Men in Dance of the Thelma Hill Performing Arts Center.

Works Choreographed: CONCERT WORKS: *Plastique* (c.1931); *Song Without Words* (1931); *Sundown* (1931); *Creation of Man* (1931); *Rhythm-Rhythm* (1931); *Life and Death* (1931); *Four Spirituals* (1931); *Mood Indigo* (1931); *Laughter* (1931); *Festival* (1931); *Fear* (1931); *Wade in the Water* (1932); *Salome* (1933); *De Promis' Lan'* (1933).

OPERA: *The Emperor Jones* (1934).

Wing, Toby, American film dancer; born Martha Virginia Wing, July 14, 1915 in Richmond, Virginia. The daughter of a Paramount Studios executive, she made her film debut at age eight, worked for three years, retired, and returned to Hollywood at sixteen to become a Mack Sennett bathing beauty. After a few years at the Sennett Studio, where she did social dances on screen but was basically a show girl, she was given specialty dance numbers in Samuel Goldwyn's *The Kid from Spain* (1933), an Eddie Cantor vehicle. Although she danced in motion pic-

tures for another seven years, she continues to be best remembered for her next film—Busby Berkeley's *Forty-Second Street*. She can be seen in many Berkeley dance numbers in various Warner Brothers/Vitaphone films, but her appearance in white with her platinum hair reflecting on the glossy black floor in *Forty-Second Street* is still a very special Art Deco image. It is sad in a way that, although she could tap with the best of them, she remains famous for just lying there, staring up at Dick Powell and embodying the ideal of his song, "Young and Healthy."

After another half-dozen films for Paramount, among them *College Rhythm* (1934) and *Murder at the Vanities* (1934), she retired. Her only stage appearances were promotional performances in Prologs until 1938, when she was cast in her one Broadway show—Cole Porter's *You Never Know* (1938).

Winslow, Miriam, American concert dancer; born c.1915 in Beverly, Massachusetts. Winslow was trained at the studio directed by Berthe, Francesca, and Gloria Braggiotti in nearby Boston (which also served briefly as a Denishawn franchise school in the early 1920s), and took over management of the studio from her mentors at the age of fifteen. Later training included studies in Flamenco and classical Spanish dance under Bautisto Baznela and Fransquillo, and some work with Ted Shawn. Winslow had already presented at least one local concert in Boston when she made her New York recital debut in 1937 with a suite of *Dances to Old Music*. Her second concert in 1938 was even more successful, so that when she teamed up with Foster Fitz-Simons to give concerts in New York and South America, the dance world expected tremendous results. Although their tours and performances were extremely successful, they did not work together long and by 1943, Winslow was presenting solo recitals again. She returned to South America to teach in Buenos Aires until the early 1960s. On retirement, she gave up dance in favor of graphic and plastic arts. It is unfortunate that so little is known about Winslow's character studies and abstractions and little of it can be distinguished from the other concert dance works of the period. She deserves much further study.

Works Choreographed: CONCERT WORKS: *Little Women* (1934); *Jota* (1934); *Dances to Old Music*

(1937); *Sports Intermezzo* (1938); *Boy Crusader* (1938); *Leprechaun* (1938); *Valses* (1938); *Zingara* (1938); *Largo* (1938); *Frail Woman* (1939); *Chrono* (1939); *Hornpipe* (1939); *Landscape with Figures* (1940, co-choreographed with Foster Fitz-Simons); *Magnificat* (1940); *New England Portrait: 1640* (1940); *Pavanne-Ancient, Romantic and Modern* (1941); *For the Very Young* (1943); *Three Sorrows* (1948); *Salut au Monde* (1948).

Winter, Ethel, American modern dancer and choreographer; born June 18, 1924 in Wrentham, Massachusetts. Winter attended Bennington College where she studied dance with Martha Hill and Martha Graham. In 1945 she moved to New York to join the Graham company.

Winter's first of many created roles in Graham works was as a "Follower" in the New York premiere of *Appalachian Spring* in 1945; in 1965, she replaced Graham herself as "The Bride." Among the other Graham works in which she created roles are *Dark Meadow* (1946), *Night Journey* (1947), *Seraphic Dialogue* (1955), *Clytemnestra* (1958), *Episodes, Part I* (1959), *Alcestis* (1960), *Phaedra* (1962), and *Cortege of Eagles* (1967).

Apart from her work with the Graham company itself, Winter has also created roles in the works of fellow Graham dancers, among them Yuriko, for whom she created "The Bride" in *The Ghost* (1960). She has created roles in many of the annual Hannukah festivals staged by Sophie Maslow (1955–c.1969) and premiered the part of "Chana" in *Neither Rest nor Harbor*, Maslow's version of *The Dybbuk*.

She choreographed for her own ad hoc company recitals and for the Bat-sheva Dance Company of Israel.

Works Choreographed: CONCERT WORKS: *Driftwood* (1955); *Suite for Three* (1964); *En Dolor* (1964); *Night Forest* (1964); *The Magic Mirror* (1964); *Fun and Fancy* (1964); *Tempi Variations* (1969); *Two Shadows Passed* (1969); *An Age of Innocence* (1970); *Promise* (1971); *In Praise of Music* (1972).

Witchie, Katharine, American theatrical ballet dancer; born c.1890 in Minneapolis, Minnesota. It is not known with whom Witchie studied ballet and the form that was then called "fancy dancing." She made her debut in the local light opera company and was engaged as featured dancer in the musical, *Miss Nobody from Starland* (1911). In that and her next show, *The Enchantress* (1912), she worked as a solo ballerina, but from then on she augmented her ballet dances with exhibition ballroom work with Ralph Riggs (a member of *The Enchantress* company). Witchie and Riggs performed together in New York in *All Aboard* (1913), *Princess Pat* (1916), and the *Passing Show of 1919*, in London in Albert de Courville extravaganzas at his Hippodrome Theatre, and in Paris and Brussels at the local music halls. Their specialties ranged from a Harlequin and Columbine piece done in flawless ballet technique and partnering positions, a Ballroom Tango (introduced in *All Aboard*) and their best known social dance, The Futurist Maxixe, all performed in the generic act, Dance Divertissements. They were probably the most popular American ballet and adagio team in Europe and rivaled Maurice Mouvet (born in Brooklyn) and Harry Pilcer as exhibition ballroom stars there. Riggs was billed as "The American Nijinsky," but the star of the act was Witchie, whose placement was unwavering and whose presence delightful. Witchie retired in the late 1920s, after performing for almost twenty years. Riggs' later career is described in detail in his entry.

Woizikovski, Leon, Polish ballet dancer and choreographer also working in the United States; born c.1899 in Warsaw; died there February 27, 1975. Woizikovski was trained at the school of the Imperial Polish Ballet and at Enrico Cecchetti's studio in Warsaw. He was a member of the Diaghilev Ballet Russe from 1915 until the impresario's death in 1929, appearing in works by each of the company's successive choreographers-in-residence—Mikhail Fokine, Vaslav Nijinsky, Leonid Massine, Bronislava Nijinska, and George Balanchine. Among the many works in which he created roles were Massine's *Las Meninas* (1916) and *Le Tricorne* (1919), Nijinska's *Three Ivans* section of *The Sleeping Princess* (1921), *Les Noces* (1923), *Les Biches* (1924), and *Le Train Bleu* (1924), and Balanchine's *Barabau* (1925)

and *The Prodigal Son* (1929). He also danced in Fokine's *Petrouchka, Schéhérézade,* and *Les Papillons* and took the Nijinsky role in his *L'Après-midi d'un Faune.*

After Diaghilev's death, Woizikovski appeared with a number of Russian emigré companies, including the Anna Pavlova group, the Ballet Russe de Monte Carlo, in which he danced in Massine's *Les Présages* and *Choreartium* (both 1935) and Balanchine's *Cotillion* and *Le Concurrence* (both 1932), and his own troupe. That organization, called Les Ballets de Woizikovski on tour and The Coliseum (Theatre) Ballet in London, lasted from 1934 to 1936. He revived Fokine's *Les Sylphides, Petrouchka,* and *Carnaval* for it and staged his own version of *L'Amour Sorcier.* After rejoining the Ballet Russe de Monte Carlo long enough to enter the United States, he formed a company, The Polish Ballet, to perform at the New York World's Fair of 1939. Most of his choreography was presented in New York, although works may have been created for his English or touring companies.

Woizikovski taught for the Ballet Russe de Monte Carlo and at his own New York studio until 1945, when he returned to Poland to direct the opera ballet school. Although he worked in Western Europe staging productions of the Fokine repertory for many years, most notably in England, and served as ballet master for a number of troupes, among them Massine's Ballet Europe and the London Festival Ballet, he concentrated his career in his native land.

Works Choreographed: CONCERT WORKS: *El Amor Brujo* (c.1935); *L'Amour Sorcier* (1935); *Les Deux Polichinelles* (1935); *Allegory* (1935); *During the Ball* (1936); *Country Wedding* (c.1938); *A Fairy Tale* (c.1938); *Eine Kleine Nachtmusik* (c.1939).

Woizikovski, Sonia, Polish/American ballet dancer; born 1919 in London. The daughter of Leon Woizikovski and Helene Antonova, who were both members of the Diaghilev Ballet Russe, she was raised and trained in London, Paris, and New York with Lubov Egorova, Carlotta Brianza, Ludmilla Schollar, and her parents. She made her professional debut in her father's Coliseum Ballet in London and joined him in New York in his Polish Ballet at the World's Fair. A charter member of Ballet Theatre, she was featured in the works of Mikhail Fokine (her uncle-in-law) and Mikhail Mordkin. She joined the Ballet Russe de Monte Carlo where she was cast in David Lichine's *Le Beau Danube* and George Balanchine's *Jeu de Cartes,* but left to work with The Foxhole Ballet, a small company that was formed originally as a USO entertainment unit. On tour with that troupe, she appeared in ballets by its founder, Grant Mouradoff, including his *Garden Party* and *Circle,* and partnered him in classical pas de deux.

Before retiring to teach, Woizikovski went back on tour, this time as the featured dancer, "The Girl Who Falls Down," in the national company of Agnes De Mille's *Oklahoma!*

Wolenski, Chester, American modern dancer and choreographer; born in the early 1940s in Bayonne, New Jersey. Wolenski, who occasionally used the spelling Cieslciew for his first name, was trained by Betty Osgood at Henry Street, by Carl Morris, and at the Juilliard School. He performed with the Juilliard Dance Ensemble in the mid- and late 1950s, appearing in Doris Humphrey's *Dawn in New York* (1956), *The Race of Life,* and *Theatre Piece,* and in José Limón's *Variations on a Theme,* and *There Is a Time, King's Heart,* and *The Emperor Jones* (all 1956). For the next ten years, he danced in the repertories of a variety of companies and concert groups in the New York area, among them Bill Frank's *Contours* (1962), *Pulsations* (1963), and *Many Seasons* (1966), Jack Moore's *Assays* (1965), and Anna Sokolow's *Lyric Suite* (opening solo), *Time + 7,* and *Deserts* with her mid-1960s troupe. Since leaving New York, Wolenski has been a valued member of the faculty of the Krannert Center of the Performing Arts at the University of Illinois.

Wolken, Jonathan, American modern dancer and choreographer; born in Pittsburgh, Pennsylvania. As a student of Alison Chase at Dartmouth, Wolken cofounded Pilobolus with Moses Pendleton in 1971. Since then, he has performed and choreographed for that troupe which has won fans around the world with its structures made of acrobatics and modern dance forms. It is generally believed that Wolken,

who once worked with his scientist father, is responsible for the company's extraordinary titles, most of which are little known words for biological phenomena.

Works Choreographed: CONCERT WORKS: *Walklyndon* (1971, choreographed by Pilobolus); *Anaendron* (1971, choreographed by Pilobolus); *Ocellus* (1972, choreographed with Robert Morgan Barnett and Michael Tracy); *Pilobolus* (1972, co-choreographed with Pendleton, Barnett, Lee Harris, and Stephen Johnson); *Pseudopodia* (1974); *Monkshood* (1974, choreographed by Pilobolus); *Ciona* (1975, choreographed by Pilobolus); *Renelaugh on the Randan* (1977); *Molly's Not Dead* (1978, choreographed by Pilobolus).

Wonder, Tommy, American theatrical and club dancer; born Tommy Wunder, March 7, 1914 in Havre, Montana. Raised in Los Angeles, he worked as a child in dramatic films. His first dance acts were exhibition ballroom and soft-shoe numbers performed with a life-sized doll; he performed with the doll originally in 1924 Prologs featuring the Paul Ash band, but did the act as late as 1944.

For most of his long career, Wonder commuted between Broadway shows and Hollywood films and personal appearances. His first engagements on the East Coast were for the duo act he shared with his sister Betty (born August 25, 1912). They worked together in vaudeville, in the *George White Scandals of 1931, The Little Racketeer* (1932), and on an extended tour of Europe. When he returned to Hollywood in the late 1930s, he became a member of the unofficial stock company of teen-age dancers who were featured in a string of college musicals, among them *Dance, Charlie, Dance* (WB, 1937), *Thrill of a Lifetime* (Paramount, 1938), *Freshman Year* (Universal, 1938), and *Sally, Irene and Mary* (Twentieth-Century Fox, 1938). His nonmusical films included *Gangster's Boy* (Monogram, 1938) and *Calling Dr. Kildare* (MGM, 1939).

Wonder returned to the East in 1940. He partnered Nadine Gae in a number of club acts, at the Roxy Theater, and on Broadway in *Two for the Show* (1940). He also appeared in *Banjo Eyes* (1941), the *Ziegfeld Follies of 1943*, and many supper-club and cabaret acts. Frequent engagements at the Waldorf-Astoria in the late 1940s and 1950s with Gae, Margaret Banks, and the doll led to a new era of popularity for the celebrated dancer.

Wong, Mel, American postmodern dancer and choreographer; born December 2, 1938 in Oakland, California. Originally and concurrently an artist, Wong received his varied training in California from Ann Halprin of the San Francisco Dancers' Workshop and Harold Christensen of the San Francisco Ballet, and in New York at the American Ballet Center, the New York School of Ballet, the School of American Ballet, and the Merce Cunningham studio.

A member of the Cunningham company from 1968 to 1972, he performed in Museum and Gymnasium Events on tour and in the film of *Ghiradelli Square*. He has choreographed since 1970 and has directed his own company since 1975. The Wong company performed his full-evening mixed media works which combined his visual pieces with the movement sense honed through his work with Cunningham. He has created works for public spaces, among them his early *Dance for One Mile* on the streets and *Subway Piece* underground (both 1970), for museum performance, including his *Catalogue 34* (1973), and for production in the American Theatre Lab and Dance Umbrella series. Among his experiments in dance forms are works for objects, such as the two Cubiculo dances for trays filled with water and for melting wax sculptures (both 1971), and "booklet dances," in which instructions given to the dancers represent the dance itself.

His graphic art works and sculptures have been exhibited separately in museums across the country, and in conjunction with live performances.

Works Choreographed: CONCERT WORKS: *Dance for One Mile* (1970); *Subway Piece* (1970); *Continuing Dance Project* (1971); *Water Walk* (1971); *Wax Walk* (1971); *Ramp Walk* (1971); *Zip Code* (1972); *Catalogue 34* (1973); *Four or Five Hours with Her* (1974); *Watertown* (1974); *Rocktown* (1975); *A Town in Three Parts* (1975); *Bath* (1975); *Wells* (1976); *Breath* (1976); *C-10-20-W* (1976); *Glass* (1976); *Quick Run* (1977); *Envelope* (1977); *Trees* (1977); *I Was Flying the Other Day* (1977); *Winds* (1978); *Harbor* (1978); *The Organization, Performed by the Organization: We Are Looking for the Letter*

York, she worked at the (Murray) Louis/(Alwin) Nikolais Dance Theatre Lab with Louis, Nikolais, Hanya Holm, Phyllis Lamhut, and Beverly Schmidt-Blossom.

She has performed with the Gale Ormiston Company, in his *Replay, Convergence, Passed Tango,* and *Sequitor,* and with the Murray Louis troupe as "The Lady on the Beach" in his *Canarsie Venus* (1978). Her choreographic career since 1971 has included productions for her own company only. Many of her works are allusions to works of art, notably her *Maillol, We Salute You!* (1973), *Palette* (1977), *The Nevelson Room* (1977), *Two for Giaco-metti* (1977), *Dali's Gala* (1978), and *By Way of Paul Klee* (1979), among others.

Works Choreographed: CONCERT WORKS: *Twoing* (1971); *Nest* (1973); *N.Y.C. Promenade* (1973); *Tracking* (1973); *Maillol, We Salute You!* (1973); *Pardon Me, But Haven't We . . .* (1973); *Labyrinth* (1974); *Anoles* (1974); *Reciprocity* (1974); *Cervidae* (1975); *Habitat* (1975); *The Game* (1976); *Palette* (1977); *The Nevelson Room* (1977); *Two for Giaco-metti* (1977); *Filigree* (1977); *Dali's Gala* (1978); *Around Rousseau* (1978); *By Way of Paul Klee* (1979); *Gallery* (1979); *Duet* (1979); *After Goldilocks* (1980); *Arachnida* (1980); *Ursidae* (1980).

Y

Yakovleff, Alexander, Russian ballet dancer and choreographer working in the United States after 1915; born during the late 1890s in Leningrad. Reportedly trained at the school of the Imperial Ballet in Leningrad, Yakovleff was on tour in Japan when he hooked up with the traveling Anna Pavlova company. He came to New York with that troupe but left it in Buenos Aires. While working there, he formed a troupe of the Pavlova and Ballet Russe dancers who were stranded in South America during the first World War, among them his future wife, Maria Chabelska, and Americans Ivan Tchourakoff (Chester Hale) and Elena Kromariovskaia (Helen Kromar, now better known as Nina De Marco).

He commuted between Buenos Aires and New York throughout the 1920s, teaching and choreographing in South America and staging ballets for Broadway revues in New York. Among the shows in which he staged interpolated ballets were the *Greenwich Village Follies of 1922*, the *Ziegfeld Follies of 1923*, for Lina Basquette, and *The O'Brien Girl* (1921) in which he danced as an Indian prince. In New York, he assisted the aging Luigi Albertieri in his Cecchetti classes and taught ballet at the studios of Ned Wayburn and Louis Chalif.

Yakovleff formed a small ballet company in the late 1930s, which included Vasya Valentinoff (one of the many pseudonyms of Paul Valentine) and Basquette, as a guest artist.

It is not certain when or where Yakovleff retired.

Yarborough, Sara, American modern and ballet dancer; born 1950 in New York City. Yarborough began her dance studies with her mother, former Katharine Dunham company member Lavinia Williams, in New York and in Haiti where she was raised. Returning to New York, she continued her training at the School of American Ballet and on scholarship at the Harkness Ballet School.

Yarborough's career has been split between the Alvin Ailey American Dance Theatre and tenures with ballet companies. For Ailey, with whom she has danced from 1971–1975 and from 1977, she has created roles in his *La Mooche* (1974) and performed featured roles in almost the entire repertory, notably in his *Hidden Rites, The Lark Ascending,* and *Revelations,* and the company revival of Dunham's *Choros.*

After performing with the Harkness Ballet from 1967 to 1971, with a featured role in the premier cast of Brian MacDonald's *Time Out of My Mind* (1970), she joined the City Center Joffrey Ballet from 1975 to 1976. There she created a role in Margo Sappington's *Tactics* (1976) and performed featured parts in Gerald Arpino's bicentennial work, *Drums, Dreams and Banjos* and the company revival of Kurt Jooss' *A Ball in Old Vienna.* Yarborough had been expected to join American Ballet Theatre in 1976 but this never took place and she rejoined the Ailey company.

Yohn, Robert, American modern dancer and choreographer; born in the 1940s in Fresno, California. Yohn began his training there with Marion Bigalow at Fresno State College. Moving to New York in 1963, he continued his training at the New Dance Group Studio under William Bales, Judith Dunn, Sophie Maslow, and Joyce Trisler. He has also taken classes in ballet with Don Farnworth and Leon Danielian, and in jazz with Charles Kelley.

Since 1967, Yohn has been known for his performances with the Erick Hawkins company. He danced for Hawkins for nine years, creating roles in most of his repertory, most notably in *Classic Kite Tails* (1972) and *Greek Dances with Flute* (1973). He and the other dancers in *Classic Kite Tails*—Beverly Brown, Carol Conway, Nada Reagan, Natalia Richman, and Lillo Way—formed a separate company, the Greenhouse Dance Ensemble, while they were working for Hawkins. Yohn has staged works for this group and for his own dance company.

Working with his own ideas above the Hawkins derivation, Yohn shows an interest in religious dance that is unusual for the current day. His sacred dances, among them *The Man They Say* (1971) and *The Trinity Mass* (1973), have been performed on Sunday afternoon local television broadcasts in the New York area.

Works Choreographed: CONCERT WORKS: *The Prodigal* (1968); *The Sword* (1969); *Nicene Creed*

(1969); *Christmas Concerto* (1969); *Abraham* (1970); *Fanfares* (1970); *Hand of Love* (1970); *The Man They Say* (1971); *A New Virgin of an Old Tale* (1971); *Pilgrimage* (1973); *Upon the Mountains of Spices* (1973); *The Trinity Mass* (1973); *Collect* (1973); *Sanctus* (1973); *In the Beginning of Creation* (1973); *Day in the Lee of April* (1974); *Chimera* (1974); *Sundering Echo* (1975); *Three Songs* (1975); *Fall Down in Brown November* (1976); *Cruciform* (1977); *Temperance Songs* (1977); *Bridge into August* (1977); *Leaves from Path* (1977); *Catch Off* (1977); *Go Tell the Baby's Father* (1978); *Point of Contact* (1978); *A Day for Dancing* (1978); *Wind and Fire* (1979); *Four Auguries* (1980); *Wind Moves* (1980).

York, Lila, American modern dancer; born November 29, 1948 in Syracuse, New York. Trained at the studios of Martha Graham, Paul Sanasardo, and Paul Taylor, she has been a member of the Taylor company since 1973. Associated with all the company favorites, she has been applauded for her energy and presence in his *Runes, American Genesis, Piece Period, Polaris, Three Epitaphs,* and *Sacre du Printemps,* among other works.

Young, Gayle, American ballet dancer; born November 7, 1938 in Lexington, Kentucky. Young received his original ballet training with Dorothy Pring while attending the University of California at Berkeley. He moved to New York in the late 1950s to continue his studies at the Ballet Theatre School.

After performances with The Robert Joffrey Ballet, notably in Job Sanders' *Contretemps*, the New York City Ballet, and Bob Fosse's Broadway show *Redhead*, Young joined American Ballet Theatre, with which he dances to this day. He has participated in many Ballet Theatre Workshop presentations while in the company, including William Dollar's *Concerto* (1963), Enrique Martinez' *Electra* (1963) and *Concerto Romantique* (1965), and Ron Sequoio's *Le Passage Enchanté* (1964). Among the company productions in which he has created roles are Agnes De Mille's *The Wind in the Mountain* (1965), Michael Smuin's *Schubertiade* (1971), and Dennis Nahat's *Brahms Quintet* (1969). Celebrated for his dramatic abilities, he has performed featured roles in much of the Antony Tudor repertory, frequently partnering Sallie Wilson in Tudor's *Pillar of Fire* and *Dark Elegies*.

Young, Ronald, American theatrical dancer; born c.1945 in Tulsa, Oklahoma. Raised in the farm community of Miami, Oklahoma, Young began performing on the Four-H Club and women's church social circuit. As a music major at the University of Tulsa, he studied ballet with John Hertel. Later studies included work with Harry Asmus at the June Taylor School and with Paul Draper and Nanette Charisse. Incredibly, Young got his first chorus job on his second day in New York; after auditions with Gower Champion, he was a dancing waiter in *Hello, Dolly!* for two and a half years. Young also danced in *Mame* (1966), *George M!* (1968), *The Boy Friend*, and *A Chorus Line* (London) before concentrating on roles with lines and solo songs. He has been heard in the original cast of *MASS*, in the film of *Hair* (in a role that he described as "Token WASP on a trip") and the forthcoming film of *Annie*, in which he returns to his roots as a dancing butler.

Youshkevitch, Nina, Russian ballet dancer and teacher; born December 7, during the 1920s in Odessa. Raised in Paris, she studied with Leo Staats, Olga Preobrajenska, and Lubov Egorova.

Throughout the 1930s Youshkevitch was associated with the companies and choreography of Bronislava Nijinska; she performed in her *Les Biches, Variations*, and *Baiser de la Fée* in the two Ballet Russe companies in 1934. In the Polish National Ballet, she created roles in Nijinska's *Chopin Concerto* (1937), *Apollo Through the Ages* (1937), *Le Rappel* (1937), and *Le Chant de la Terre* (1937— also performed as *Das Lied von der Erde*). She also danced during this period, with the Ballet Russe de Monte Carlo (De Basil), in which she performed roles in the classics for which she became famous—leads in *Les Sylphides, Auroras' Wedding, Swan Lake, Carnaval*, and *The Firebird*.

From 1942 on, she lived and worked in the United States, performing at the Metropolitan Opera in Laurent Novikoff's works, and playing "Aurora" for the San Francisco Russian Opera in the first American full-length *Sleeping Beauty* (1945). She re-

tired from performance after a concert tour through Canada in 1946. A popular teacher, she took over classes for Nijinska in her Los Angeles studio and also worked at the Perry-Mansfield Camp during the summers. Since 1973, she has had a studio in New York. Most of her choreography was created for each of the companies for which she has served as artistic advisor—the Ballet Workshop Co., the Wayne State University Company, and the Sioux City Civic Ballet.

Works Choreographed: CONCERT WORKS: *The Infinite* (1951); *Light and Shadow* (1953); *In a Garden* (1953); *La plus que lente* (1968); *Song Without Words* (1968); *Les Cinq Petites Variations* (1969); *The Nutcracker* (1968); *The Nightingale and the Rose* (1969).

Youskevitch, Igor, Russian-born ballet dancer working in Western Europe and the United States; born March 13, 1912 in Piryatin, Youskevitch was raised in Belgrade. Although it seems as if Youskevitch was born for ballet, he was once known as the "miracle dancer" because he didn't begin his dance training until after he had been a member of the Yugoslavian Olympic athletic team at the 1932 Games. He began his studies with Xenia Grunt and continued his training in Paris with Olga Preobrajenska. Youskevitch danced with a variety of Paris-based companies of former Diaghilev dancers including Bronislava Nijinska and Leon Woizikovsky's troupes, before coming to the United States with the Ballet Russe de Monte Carlo in 1938. He performed with that company until his (American) military service and with the Ballet Theatre and short-lived troupes from 1946 until his retirement in 1962. Best known for his excellent partnering and technique, he excelled in pas de deux in all of the above companies, and with the Ballet Alicia Alonso. Among his longer ballets were George Balanchine's *Theme and Variations* and *Apollo* (both considered ideal Youskevitch vehicles), Nijinska's *Snow Maiden* (1942) and *Schumann Concerto* (1951), Antony Tudor's *Shadow of the Wind* (1948) and *Romeo and Juliet*, Valerie Bettis' *Streetcar Named Desire*, and Leonid Massine's *Les Présages, Helen of Troy, Seventh Symphony, Rouge et Noir, The New Yorker,* and *Gaité Parisienne.* He also performed frequently on television as Alonso's

partner and as the *danseur noble* in Gene Kelly's *Invitation to the Dance* (MGM, 1954).

Since retiring, Youskevitch has taught in New York City, Massapequa, Long Island, and Austin, Texas. His students, many of whom are professional dancers or teachers, frequently follow him from studio to studio to continue their training in pure movement and performance styles.

Youskevitch, Maria, American ballet dancer; born c.1946 in New York. Trained originally by her parents, Igor Youskevitch and Anna Scarpova, she continued her studies with Ludmilla Schollar. She performed with the Metropolitan Opera Ballet and with her father's Ballet Romantique before joining the American Ballet Theatre in 1967. In her seven years with the company, she appeared in most of the large eclectic repertory, with roles in the many productions of the classics and in American works. Audiences have seen her in Agnes De Mille's *Rodeo,* Eugene Loring's *Billy the Kid,* Antony Tudor's *Dark Elegies,* Frederick Ashton's *Les Patineurs,* and productions of *Swan Lake, Les Sylphides, La Sylphide,* and *Etudes.* Youskevitch left Ballet Theatre to work with The Maryland Ballet, a growing company with a repertory of works by both ballet and modern dance choreographers.

Yuan, Tina, Chinese modern dancer and choreographer working in the United States; born c.1950 in Shanghai. Raised in Taiwan, Yuan moved to New York to study at the Juilliard School and also took classes at the Martha Graham studio. She joined the Alvin Ailey Dance Theatre, performing in Ailey's *Three Black Kings, Night Creature, Revelations,* and *Feast of Ashes,* in Talley Beatty's *The Road of the Phoebe Snow,* in Pearl Primus' *The Wedding,* and in James Truitte's *Liberian Suite,* among many other works. She created roles in Janet Collins' *Canticle of the Elements* (1974) and Jennifer Muller's *Crossword* (1977), in the Ailey repertory and in Yuriko's *Events I* and *II* as a guest in her group.

Yuan is the founder and co-director of the East-West Contemporary Dance Company, a traditional modern dance troupe for which she choreographs with Richard Ornellas of the Mary Anthony company. She is also a director of the Chinese Dance

(1978); *You See It All Started Like This* . . . (1978); *Door 1, Door 2, Door 3* (1978); *Epoxy* (1979); *Salt* (1979); *Windows* (1979); *Peaks* (1979); *Phones* (1980); *Streams* (1980); *Wings-Arc* (1980); *Untitled* (1980); *Bouncing* (1980); *Kiezelstenen* (1980); *Imprint* (1980); *Palms* (1981).

Wood, David, American modern dancer and choreographer. Wood became a member of the Martha Graham company in 1954 and has served as regisseur since 1965. Among the many Graham works in which he created roles are *Ardent Song* (1954), *Clytemnestra* (1958), as "the Messenger of Death," *Acrobats of God* (1960), *Alcestis* (1960), *Phaedra* (1962), and *Cortege of Eagles* (1967). He also danced for Tamiris on Broadway in her *Plain and Fancy* (1955), and for the New York City Opera when Charles Weidman was resident choreographer. Wood has been a popular teacher at the High School of Performing Arts in New York, the Graham school, the American Dance Festival, and in many cities abroad, and has choreographed intermittently since 1957 for concert groups. Currently associated with the Bay Area (of California) Repertory Dance Theatre, he has created pieces for the company since 1977.

Works Choreographed: CONCERT WORKS: *Country Style* (1957); *Episodes for Three Poems of the Haiku* (1960); *Danza* (1960); *The Initiate* (1961); *The Sea Years* (1962); *Circa 1500* (1964); *Along Corridors* (1968); *Mama Bakes Cookies, Daddy Drinks Beer* (1974); *Conversation Pit* (1975); *The House of Bernarda Alba* (1975); *Pre-Amble* (1975); *In the Glade* (1977); *Today and Tomorrow* (1977).

Woodard, Charlene, American theatrical dancer and actress. Woodard was trained at the Goodman School of Drama in Chicago. She made her Broadway debut in the revival of *Hair*, later appearing in the filmed version of 1978. Other appearances, including engagements with the national company of *Don't Bother Me, I Can't Cope*, led to her role in the "new Fats Waller musical," *Ain't Misbehavin'* in 1978. In Arthur Faria's staging she was given the show's only conventional tap solo and was able to make it represent all of theatrical dance in its context. She also sang in the show in New York, on tour, and in London.

Woodard, Stephanie, American postmodern dancer and choreographer; born 1948 in New York City. Woodard began her dance training with local ballet classes in Middlebury, Vermont, and continued her studies at college and at the Merce Cunningham studio in New York. She also earned a degree in World Music for her study of Javanese Court dance forms. Her performing experience has included engagements with Kenneth King (*Battery*, 1976), Wendy Perron, Alvin Lucier, and David Gordon's Pick-Up Company with which she danced in *Not Necessarily Recognizable Objectives*. She has created since 1969, working primarily in collaborative modes with composer Peter Zummo and other dancer/choreographers. Although he is not always listed as a choreographer, she considers Zummo a collaborator on each of her works. Many of her creations are full-evening pieces, although one is designed to last throughout the day, *Out on the Serein* (1979), and three were composed to traverse the night. A trio of the works involve real time: *Sifting* and *Sky Report* (both 1975) were designed for performance at the solstice and equinox respectively, while *Searching for Bodies of Water* (1978) was created for Woodard and Zummo to dance at the summer solstice in New York while a collaborator, Eva Karczag, performed it in Australia during the concurrent winter solstice.

Woodard has also written about dance and contemporary performance, notably for the *Cleveland* [Ohio] *Plain Dealer*, the *Contact* [Improvisation] *Quarterly* and two New York papers, the *Soho Weekly News* and the *Village Voice*.

Works Choreographed: CONCERT WORKS: (Note: all works were created in collaboration with Peter Zummo, as well as with those performers listed). *Dance for* (number of performers) (1969–ongoing to 1974); *Music for* (number of performers) (1969–ongoing to 1974); *Hallelujah, Bananas* (1974); *Frame of Mind* (1975); *A Night at the Races* (1975, in collaboration with Zummo and Wendy Perron); *Sifting* (1975); *Sky Report* (1975, in collaboration with Zummo and Perron); *Black and Light* (1976); *Veldt* (1976, in collaboration with Zummo and Perron); *Conclusive Evidence of Life on Mars* (1976); *The Trombone That Devoured Cleveland* (1977); *Beads* (1977, in collaboration with Zummo and Perron); *June Forth* (1977); *Tall Tree* (1977, in collaboration

with Zummo and Eva Karczag); *With Ease She Darts These Bees and Sees: with E's, C's, D's, B's and C's* (1978, in collaboration with Zummo and Ellen Webb); *Searching for Bodies of Water* (1978); *Out on the Serein* (1979, in collaboration with Zummo, Karczag, and Webb); *The Rest Is History* (1979, in collaboration with Zummo and Webb); *Dance of the Central Plains* (1979); *Whipp's Ledge* (1980); *Weather Watch* (1980); *Travelogue* (1980); *Special English* (1980–ongoing project).

Woodberry, David, American postmodern dancer and choreographer; born 1948 in Lexington, Massachusetts. Trained at the Merce Cunningham studio, and in class with Kenneth King, Daniel Lepkoff, Barbara Dilley, and Douglas Dunn, Woodberry worked with Steve Paxton in the developing Contact Improvisation techniques.

He has participated in three of the most widely acclaimed dance/theater creations of the last decade—the Contact Improvisation performance tours of 1972 to 1980, Douglas Dunn's continuing presentations of *Lazy Madge* (1976–1978), and the Robert Wilson/Philip Glass opera, *Einstein on the Beach* (1976). Other performances have included five years of collaborative work with the Tropical Fruit Company (1970–1975), Kenneth King's *Praxiomatics* (1974), Barbara Dilley's untitled works of November 1974, Dunn's *Four for Nothing* and *Octopus* (both 1974), Judy Padow's *Snake* (1975), and Lucinda Childs' *Reclining Rondo* (1976).

Although Woodberry has adopted many of the considerations of contact work—the consciousness of weight, the reliance on trust of one's own body and one's collaborators, the speed and seeming danger of movements—he uses preconstructed formats in a throwback to traditional dance forms. His best known work, *The Nijinsky Suicide Health Club* (1976, ongoing to 1980), has become very popular in performances in The Kitchen, as it uses the obstacles built into the performance space to add to the challenges of trust in movement. His work has been described as "suicidal" and "dangerous"; he seems to use larger movements at a more personal pace and speed than other choreographers in, or from, contact work.

Although much of his work is credited choreography, he has also collaborated with Dunn, Paxton, and dancer Sara Vogeler.

Works Choreographed: CONCERT WORKS: *Catch the Wind* (1970); *Today* (1972); *How's Your Body/Playtime* (1972); *Empty Whispers* (1973, in collaboration with Mary Fulkerson); *Park Piece* (1974); *Dasan* (1974, ongoing to 1975); *Part One, Part Two* (1975, in collaboration with Douglas Dunn); *Discreet Street* (1975); *Flight* (1975); *Untitled* (1975); *Nijinsky Suicide Health Club* (1976, ongoing to 1980); *Body Wave* (1978); *Leverage* (1978–1980); *Fish* (1978–1980, in collaboration with Sara Vogeler); *Dance to Sunset* (1979); *Running Waves* (1979); *Invisible Line* (1979); *New Dances* (1980); *Desert* (1980); Contact Improvisation Performance Tours in collaboration with Steve Paxton (1972–).

Wood-Crockett, Barbara, American ballet dancer; born c.1925, probably in the San Francisco Bay area in California. An early member of the San Francisco Ballet, she was cast in progressively larger roles in the repertory of works by Willam Christensen, among them, his *Impromptu, In Vienna, Romeo and Juliet, Coppélia,* and *Swan Lake.* She moved to the capitol of California in the early 1950s with her husband, Deane Crockett, to become principal dancer and eventually co-artistic director of the Sacramento Civic Ballet. After his death in 1972, she became the solo director of the growing company. She is very active in the regional ballet movement and has become known for her liberality in teaching both ballet and modern dance techniques to her company and students. Among them is her daughter, Leslie Crockett.

Woodin, Peter, American modern dancer; born August 27, 1949 in Tucson, Arizona. In some ways, Woodin owes his professional career to the co-educational movement in the late 1960s. Since his alma mater, Wesleyan University, did not offer dance, it sent its students to nearby Connecticut College which had a thriving modern dance program. He began to study dance with Martha Myers both during the school year and at the American Dance Festivals during the summer. A member of the Festival company during its twenty-fifth anniversary celebrations, he

was assigned leading roles in many of the revivals of works presented in past summers. He took the Charles Weidman role in Doris Humphrey's *New Dance* and appeared in her *With My Red Fires*, Weidman's *Flickers*, and José Limón's *Emperor Jones*.

After graduation, Woodin worked with the company of Lucas Hoving (with whom he had studied at an American Dance Festival), performing in his *Satiana* and *Prodigal Son* (1979). He spent a season with the Utah Repertory troupe (1971–1972) dancing in works by Donald McKayle and Tim Wengerd, and returned to New York to appear with Gus Solomons Company Dance in his *Brill-o* (1973). Woodin became internationally known for his work with the Alvin Ailey Dance Theatre (1973–1980). He appeared in almost all of the group works in the repertory, most notably in his *Night Creature, Revelation, Myth*, and the Guibiloso section of *Streams,* and in Donald McKayle's *Rainbow 'Round My Shoulder*.

Wooliams, Anne, English ballet dancer and teacher also working in Germany and Australia; born August 3, 1926 in Folkestone, Kent. Wooliams studied with Judith Espinosa and the faculty of the Bush-Davies School in London from the age of three and a half. Later, in her adolescence, she continued her training under Vera Volkova. She performed with small English or London-based companies in her twenties, including the Lydia Kyasht troupe, the London Ballet, and the Russian Opera Ballet (a very short-term company of the 1942 season), as well as appearing in The Archers' *Tales of Hoffmann* and *The Red Shoes*.

Wooliams' teaching career was of much greater importance than her performances. She taught for Volkova in Florence and Chicago before joining the faculty of the Essen Folkwang from 1958 to 1963. John Cranko, a Volkova student himself, asked her to become director of the school of his Stuttgart Ballet in 1963 and cast her into mature roles in his plotted ballets, among them "Lady Capulet" in *Romeo and Juliet* and "The Queen Mother" in *Swan Lake*. She succeeded Cranko as artistic director of the Stuttgart Ballet and staged his works for companies across Europe, but left Germany for Australia in 1976.

Workman, Jenny, American ballet dancer; born c.1920 in Ames, Iowa. Trained by Marion Venable in Washington, D.C., she was known for her performances in Ballet Theatre in the 1940s and 1950s. Associated with the works of Agnes De Mille, she performed in the company premiere of her *The Harvest According* and replaced the choreographer in her *Rodeo*. She created roles in Herbert Ross' *Caprichos* (1950), Carmelita Maracchi's *Circo de España* (1951), and Edward Caton's *Tryptich* (1952), and was assigned featured roles in Antony Tudor's *Pillar of Fire* and Fokine's *Les Sylphides*.

Wright, Belinda, English ballet dancer; born Brenda Wright, January 18, 1927, in Southport, England. Wright received ballet training locally with Dorothea Helliwell of the famous English stage family and also studied tap dance and voice. She performed in pantomimes in Southport before continuing her technical training in Paris with Olga Preobrajenska and Rosanne Crotton. She may also have worked with Marie Rambert before joining her Ballet Rambert in 1945.

Wright's twenty-year performance career carried her among English companies, including the Ballet Rambert (1945–1949) and the London Festival Ballet (1951–1954, 1955–1957, 1959–1962), and European groups, including Roland Petit's Ballet de Paris (1949–1951) and the Grand Ballet du Marquis de Cuevas (1954–1955). Partnered frequently by John Gilpin, Wright performed in the classic repertory, notably in *Giselle* and *Swan Lake* in each company, as well as in newly created works. She performed in the premieres of many works, among them Petit's *Les Forains* (1945) and *Les Demoiselles de la Nuit* (1948), Frederick Ashton's *Vision of Marguerite* (1952), in the title role, and Vladimir Bourmeister's *The Snow Maiden* (1959).

Wright, Peter, English ballet dancer and choreographer; born 1926 in London. Trained by Kurt Jooss in England, he performed with the Ballet Jooss in its 1945–1946 season. Joining the Sadler's Wells Ballet shortly thereafter, he created a major role in John Cranko's *Pastorale* (1951). He served as ballet master of the Edinburgh International Ballet in 1958, the Stuttgart Ballet after 1961, has frequently freelanced,

and worked as the ballet master of the BBC, with Margaret Dale's documentary and production unit; he is currently associated with the Royal Ballet and its touring programs.

Works Choreographed: CONCERT WORKS: *Under Canvas* (1956); *A Blue Rose* (1957); *The Great Peacock* (1958); *Musical Chairs* (1959); *Trial* (1961); *The Mirrow Walkers* (1963); *Quintet* (1963); *Designs for Dancers* (1964); *Summer's Night* (1964); *Ballet to This Music* (1965); *Namouna* (1967); *Danse Macabre* (1968); *Arpège* (1974); *El Amor Brujo* (1975); *Summertide* (1976); *Coppélia* (1979).

Wright, Rebecca, American ballet dancer; born December, 5, 1942 in Springfield, Ohio. Wright studied ballet locally with Josephine and Hermine Schwartz, and in Columbus, Ohio, with Jorg Fasting before moving to New York to continue her training at the American Ballet Center, the school of the City Center Joffrey Ballet.

Wright joined the Joffrey company in 1966 and remained there until 1975. With the company, she created roles in Gerald Arpino's *Confetti* (1970, perhaps her best known part), in Joe Layton's *Double Exposure* (1972), and Margo Sappington's *Weewis* (1971). Her featured roles included parts in Arpino's *Viva Vivaldi!*, *Valentine*, and *Animus*, and in the company's revivals of Frederick Ashton's *Façade*, Mikhail Fokine's *Petrouchka*, Leonid Massine's *Three-Cornered Hat*, and Jerome Robbins' *Interplay*.

Leaving the Joffrey company in 1975, she joined American Ballet Theatre in order to perform roles in the classics that were progressively taking over ABT's repertory. She has performed roles in the company's productions and revivals of *Coppélia, The Sleeping Beauty, Don Quixote, The Nutcracker,* and *Swan Lake* in subsequent years.

Wright, Rose Marie, American ballet and modern dancer; born 1949 in Pittston, Pennsylvania. Wright studied ballet with Barbara Weisberger in Wilkes-Barre, Pennsylvania, and in Philadelphia. Her first performance experience was gained with Weisberger's Pennsylvania Ballet, in which she was a corps member from 1963 to 1967.

Wright moved to New York in 1967 to study with Richard Thomas and Barbara Fallis and the New York School of Ballet. In 1968, she became a member of the Twyla Tharp company, with which she still dances. She has created roles in most of Tharp's company repertory, including her *Medly* (1969), *Eight Jelly Rolls* (1971), *The Bix Pieces* (1971), *Deuce Coupe I* (1973), *Sue's Leg* (1975), *Give and Take* (1976), and *When We Were Very Young* (1980). Wright has also supervised the reconstruction and revivals of early Tharp works for the company.

Wyatt, Joseph, Trinidanian ballet dancer working in the United States; born January 23, 1950 in Trinidad, West Indies. Trained at the school of the Dance Theatre of Harlem, he graduated into the company in 1973. He has gradually been cast in progressively larger roles in the vast repertory, most notably in Geoffrey Holder's *Bélé,* Robert North's *Troy Game,* and the company revivals of *Swan Lake* and *Schéhérézade.*

Wyckoff, Bonnie, American ballet dancer; born November 20, 1945 in Natick, Massachusetts. Raised in Boston, she was trained at E. Virginia Williams' school of the Boston Ballet and graduated into the company in 1967. In her five years with the company, she was cast in increasingly larger solos in the company's productions of the nineteenth- and twentieth-century classics and in a variety of parts in works by Agnes De Mille, including her *Rodeo.* She continued her association with the De Mille repertory in the Royal Winnipeg Ballet (1973–), repeating her popular portrayal of "The Cowgirl." Her roles in that Canadian company ranged from solos in abstract ballets by Oscar Araiz and John Neumeier, in the former's *Mahler 4* and *Family Scenes* and the latter's *Pictures,* to comic roles by Araiz and De Mille.

Wykell, Luise, American modern dancer and choreographer; born November 22, 1942 in Chicago, Illinois. After studying as an adolescent with Rosalie Lyga at the Chicago Musical College, she continued her training at the University of Wisconsin at Madison (1967–1970), where the faculty included Louise Kloepper, Anna Nassif, Don Redlich, Viola Farber, and Chester Wolenski. When she moved to New

York, she worked at the (Murray) Louis/(Alwin) Nikolais Dance Theatre Lab with Louis, Nikolais, Hanya Holm, Phyllis Lamhut, and Beverly Schmidt-Blossom.

She has performed with the Gale Ormiston Company, in his *Replay, Convergence, Passed Tango,* and *Sequitor,* and with the Murray Louis troupe as "The Lady on the Beach" in his *Canarsie Venus* (1978). Her choreographic career since 1971 has included productions for her own company only. Many of her works are allusions to works of art, notably her *Maillol, We Salute You!* (1973), *Palette* (1977), *The Nevelson Room* (1977), *Two for Giaco-* *metti* (1977), *Dali's Gala* (1978), and *By Way of Paul Klee* (1979), among others.

Works Choreographed: CONCERT WORKS: *Twoing* (1971); *Nest* (1973); *N.Y.C. Promenade* (1973); *Tracking* (1973); *Maillol, We Salute You!* (1973); *Pardon Me, But Haven't We . . .* (1973); *Labyrinth* (1974); *Anoles* (1974); *Reciprocity* (1974); *Cervidae* (1975); *Habitat* (1975); *The Game* (1976); *Palette* (1977); *The Nevelson Room* (1977); *Two for Giacometti* (1977); *Filigree* (1977); *Dali's Gala* (1978); *Around Rousseau* (1978); *By Way of Paul Klee* (1979); *Gallery* (1979); *Duet* (1979); *After Goldilocks* (1980); *Arachnida* (1980); *Ursidae* (1980).

Y

Yakovleff, Alexander, Russian ballet dancer and choreographer working in the United States after 1915; born during the late 1890s in Leningrad. Reportedly trained at the school of the Imperial Ballet in Leningrad, Yakovleff was on tour in Japan when he hooked up with the traveling Anna Pavlova company. He came to New York with that troupe but left it in Buenos Aires. While working there, he formed a troupe of the Pavlova and Ballet Russe dancers who were stranded in South America during the first World War, among them his future wife, Maria Chabelska, and Americans Ivan Tchourakoff (Chester Hale) and Elena Kromariovskaia (Helen Kromar, now better known as Nina De Marco).

He commuted between Buenos Aires and New York throughout the 1920s, teaching and choreographing in South America and staging ballets for Broadway revues in New York. Among the shows in which he staged interpolated ballets were the *Greenwich Village Follies of 1922*, the *Ziegfeld Follies of 1923*, for Lina Basquette, and *The O'Brien Girl* (1921) in which he danced as an Indian prince. In New York, he assisted the aging Luigi Albertieri in his Cecchetti classes and taught ballet at the studios of Ned Wayburn and Louis Chalif.

Yakovleff formed a small ballet company in the late 1930s, which included Vasya Valentinoff (one of the many pseudonyms of Paul Valentine) and Basquette, as a guest artist.

It is not certain when or where Yakovleff retired.

Yarborough, Sara, American modern and ballet dancer; born 1950 in New York City. Yarborough began her dance studies with her mother, former Katharine Dunham company member Lavinia Williams, in New York and in Haiti where she was raised. Returning to New York, she continued her training at the School of American Ballet and on scholarship at the Harkness Ballet School.

Yarborough's career has been split between the Alvin Ailey American Dance Theatre and tenures with ballet companies. For Ailey, with whom she has danced from 1971–1975 and from 1977, she has created roles in his *La Mooche* (1974) and performed featured roles in almost the entire repertory, notably in his *Hidden Rites, The Lark Ascending,* and *Revelations,* and the company revival of Dunham's *Choros.*

After performing with the Harkness Ballet from 1967 to 1971, with a featured role in the premier cast of Brian MacDonald's *Time Out of My Mind* (1970), she joined the City Center Joffrey Ballet from 1975 to 1976. There she created a role in Margo Sappington's *Tactics* (1976) and performed featured parts in Gerald Arpino's bicentennial work, *Drums, Dreams and Banjos* and the company revival of Kurt Jooss' *A Ball in Old Vienna.* Yarborough had been expected to join American Ballet Theatre in 1976 but this never took place and she rejoined the Ailey company.

Yohn, Robert, American modern dancer and choreographer; born in the 1940s in Fresno, California. Yohn began his training there with Marion Bigalow at Fresno State College. Moving to New York in 1963, he continued his training at the New Dance Group Studio under William Bales, Judith Dunn, Sophie Maslow, and Joyce Trisler. He has also taken classes in ballet with Don Farnworth and Leon Danielian, and in jazz with Charles Kelley.

Since 1967, Yohn has been known for his performances with the Erick Hawkins company. He danced for Hawkins for nine years, creating roles in most of his repertory, most notably in *Classic Kite Tails* (1972) and *Greek Dances with Flute* (1973). He and the other dancers in *Classic Kite Tails*—Beverly Brown, Carol Conway, Nada Reagan, Natalia Richman, and Lillo Way—formed a separate company, the Greenhouse Dance Ensemble, while they were working for Hawkins. Yohn has staged works for this group and for his own dance company.

Working with his own ideas above the Hawkins derivation, Yohn shows an interest in religious dance that is unusual for the current day. His sacred dances, among them *The Man They Say* (1971) and *The Trinity Mass* (1973), have been performed on Sunday afternoon local television broadcasts in the New York area.

Works Choreographed: CONCERT WORKS: *The Prodigal* (1968); *The Sword* (1969); *Nicene Creed*

(1969); *Christmas Concerto* (1969); *Abraham* (1970); *Fanfares* (1970); *Hand of Love* (1970); *The Man They Say* (1971); *A New Virgin of an Old Tale* (1971); *Pilgrimage* (1973); *Upon the Mountains of Spices* (1973); *The Trinity Mass* (1973); *Collect* (1973); *Sanctus* (1973); *In the Beginning of Creation* (1973); *Day in the Lee of April* (1974); *Chimera* (1974); *Sundering Echo* (1975); *Three Songs* (1975); *Fall Down in Brown November* (1976); *Cruciform* (1977); *Temperance Songs* (1977); *Bridge into August* (1977); *Leaves from Path* (1977); *Catch Off* (1977); *Go Tell the Baby's Father* (1978); *Point of Contact* (1978); *A Day for Dancing* (1978); *Wind and Fire* (1979); *Four Auguries* (1980); *Wind Moves* (1980).

York, Lila, American modern dancer; born November 29, 1948 in Syracuse, New York. Trained at the studios of Martha Graham, Paul Sanasardo, and Paul Taylor, she has been a member of the Taylor company since 1973. Associated with all the company favorites, she has been applauded for her energy and presence in his *Runes, American Genesis, Piece Period, Polaris, Three Epitaphs,* and *Sacre du Printemps,* among other works.

Young, Gayle, American ballet dancer; born November 7, 1938 in Lexington, Kentucky. Young received his original ballet training with Dorothy Pring while attending the University of California at Berkeley. He moved to New York in the late 1950s to continue his studies at the Ballet Theatre School.

After performances with The Robert Joffrey Ballet, notably in Job Sanders' *Contretemps,* the New York City Ballet, and Bob Fosse's Broadway show *Redhead,* Young joined American Ballet Theatre, with which he dances to this day. He has participated in many Ballet Theatre Workshop presentations while in the company, including William Dollar's *Concerto* (1963), Enrique Martinez' *Electra* (1963) and *Concerto Romantique* (1965), and Ron Sequoio's *Le Passage Enchanté* (1964). Among the company productions in which he has created roles are Agnes De Mille's *The Wind in the Mountain* (1965), Michael Smuin's *Schubertiade* (1971), and Dennis Nahat's *Brahms Quintet* (1969). Celebrated for his dramatic abilities, he has performed featured roles in much of the Antony Tudor repertory, frequently partnering Sallie Wilson in Tudor's *Pillar of Fire* and *Dark Elegies.*

Young, Ronald, American theatrical dancer; born c.1945 in Tulsa, Oklahoma. Raised in the farm community of Miami, Oklahoma, Young began performing on the Four-H Club and women's church social circuit. As a music major at the University of Tulsa, he studied ballet with John Hertel. Later studies included work with Harry Asmus at the June Taylor School and with Paul Draper and Nanette Charisse. Incredibly, Young got his first chorus job on his second day in New York; after auditions with Gower Champion, he was a dancing waiter in *Hello, Dolly!* for two and a half years. Young also danced in *Mame* (1966), *George M!* (1968), *The Boy Friend,* and *A Chorus Line* (London) before concentrating on roles with lines and solo songs. He has been heard in the original cast of *MASS,* in the film of *Hair* (in a role that he described as "Token WASP on a trip") and the forthcoming film of *Annie,* in which he returns to his roots as a dancing butler.

Youshkevitch, Nina, Russian ballet dancer and teacher; born December 7, during the 1920s in Odessa. Raised in Paris, she studied with Leo Staats, Olga Preobrajenska, and Lubov Egorova.

Throughout the 1930s Youshkevitch was associated with the companies and choreography of Bronislava Nijinska; she performed in her *Les Biches, Variations,* and *Baiser de la Fée* in the two Ballet Russe companies in 1934. In the Polish National Ballet, she created roles in Nijinska's *Chopin Concerto* (1937), *Apollo Through the Ages* (1937), *Le Rappel* (1937), and *Le Chant de la Terre* (1937— also performed as *Das Lied von der Erde*). She also danced during this period, with the Ballet Russe de Monte Carlo (De Basil), in which she performed roles in the classics for which she became famous—leads in *Les Sylphides, Auroras' Wedding, Swan Lake, Carnaval,* and *The Firebird.*

From 1942 on, she lived and worked in the United States, performing at the Metropolitan Opera in Laurent Novikoff's works, and playing "Aurora" for the San Francisco Russian Opera in the first American full-length *Sleeping Beauty* (1945). She re-

tired from performance after a concert tour through Canada in 1946. A popular teacher, she took over classes for Nijinska in her Los Angeles studio and also worked at the Perry-Mansfield Camp during the summers. Since 1973, she has had a studio in New York. Most of her choreography was created for each of the companies for which she has served as artistic advisor—the Ballet Workshop Co., the Wayne State University Company, and the Sioux City Civic Ballet.

Works Choreographed: CONCERT WORKS: *The Infinite* (1951); *Light and Shadow* (1953); *In a Garden* (1953); *La plus que lente* (1968); *Song Without Words* (1968); *Les Cinq Petites Variations* (1969); *The Nutcracker* (1968); *The Nightingale and the Rose* (1969).

Youskevitch, Igor, Russian-born ballet dancer working in Western Europe and the United States; born March 13, 1912 in Piryatin, Youskevitch was raised in Belgrade. Although it seems as if Youskevitch was born for ballet, he was once known as the "miracle dancer" because he didn't begin his dance training until after he had been a member of the Yugoslavian Olympic athletic team at the 1932 Games. He began his studies with Xenia Grunt and continued his training in Paris with Olga Preobrajenska. Youskevitch danced with a variety of Paris-based companies of former Diaghilev dancers including Bronislava Nijinska and Leon Woizikovsky's troupes, before coming to the United States with the Ballet Russe de Monte Carlo in 1938. He performed with that company until his (American) military service and with the Ballet Theatre and short-lived troupes from 1946 until his retirement in 1962. Best known for his excellent partnering and technique, he excelled in pas de deux in all of the above companies, and with the Ballet Alicia Alonso. Among his longer ballets were George Balanchine's *Theme and Variations* and *Apollo* (both considered ideal Youskevitch vehicles), Nijinska's *Snow Maiden* (1942) and *Schumann Concerto* (1951), Antony Tudor's *Shadow of the Wind* (1948) and *Romeo and Juliet*, Valerie Bettis' *Streetcar Named Desire*, and Leonid Massine's *Les Présages, Helen of Troy, Seventh Symphony, Rouge et Noir, The New Yorker,* and *Gaité Parisienne.* He also performed frequently on television as Alonso's

partner and as the *danseur noble* in Gene Kelly's *Invitation to the Dance* (MGM, 1954).

Since retiring, Youskevitch has taught in New York City, Massapequa, Long Island, and Austin, Texas. His students, many of whom are professional dancers or teachers, frequently follow him from studio to studio to continue their training in pure movement and performance styles.

Youskevitch, Maria, American ballet dancer; born c.1946 in New York. Trained originally by her parents, Igor Youskevitch and Anna Scarpova, she continued her studies with Ludmilla Schollar. She performed with the Metropolitan Opera Ballet and with her father's Ballet Romantique before joining the American Ballet Theatre in 1967. In her seven years with the company, she appeared in most of the large eclectic repertory, with roles in the many productions of the classics and in American works. Audiences have seen her in Agnes De Mille's *Rodeo*, Eugene Loring's *Billy the Kid*, Antony Tudor's *Dark Elegies*, Frederick Ashton's *Les Patineurs*, and productions of *Swan Lake, Les Sylphides, La Sylphide,* and *Etudes.* Youskevitch left Ballet Theatre to work with The Maryland Ballet, a growing company with a repertory of works by both ballet and modern dance choreographers.

Yuan, Tina, Chinese modern dancer and choreographer working in the United States; born c.1950 in Shanghai. Raised in Taiwan, Yuan moved to New York to study at the Juilliard School and also took classes at the Martha Graham studio. She joined the Alvin Ailey Dance Theatre, performing in Ailey's *Three Black Kings, Night Creature, Revelations,* and *Feast of Ashes,* in Talley Beatty's *The Road of the Phoebe Snow,* in Pearl Primus' *The Wedding,* and in James Truitte's *Liberian Suite,* among many other works. She created roles in Janet Collins' *Canticle of the Elements* (1974) and Jennifer Muller's *Crossword* (1977), in the Ailey repertory and in Yuriko's *Events I and II* as a guest in her group.

Yuan is the founder and co-director of the East-West Contemporary Dance Company, a traditional modern dance troupe for which she choreographs with Richard Ornellas of the Mary Anthony company. She is also a director of the Chinese Dance

Company of New York, which meshes Chinese-Taiwanese gesture vocabularies with the formats of traditional modern dance.

Works Choreographed: CONCERT WORKS: *Suite of Taiwanese Dances* (1972); *The Peacock* (1972); *Martian Dances* (1972); *Dances of the Border Provinces* (1972); *Legend of the White Snake Lady* (1972); *Trilogy* (1975).

Yurievna-Swoboda, Maria, Russian ballet dancer teaching in the United States; born during the late 1890s in St. Petersburg. Trained privately by Lydia Nelidova, she entered the Moscow Bolshoi company at the age of fifteen. Little is known about her life or career before 1926 when, according to reports, as the premiere danseuse of the San Carlo Grand Opera, she met and married Veschslav Swoboda.

Together they emigrated to the United States to perform with the Chicago Grand Opera but soon moved to New York in 1931 to open a studio. After the death of her husband in 1948, she kept the school open until 1954, when it became the official affiliated school of the Ballet Russe de Monte Carlo and she was named company teacher.

Yuriko, American modern and theatrical dancer and choreographer; born Yuriko Kikuchi, in San Jose, California on February 2, 1920. Raised in Japan, Kikuchi (known professionally as Yuriko) studied at the school of Konami Ishil in Tokyo and performed with her company. When she returned to the United States, she became a member of Dorothy Lyndall's Junior Dance Company in Los Angeles and performed with the University of California at Los Angeles Dance Group until 1941. Interned outside of Phoenix, Arizona, at the outbreak of World War II, she taught dance locally but left Arizona when she was released from internship to travel to New York to study with Martha Graham.

She joined the Graham company in 1944 and remained with the group until 1967, but has performed as a guest artist to the present. In that company, she created roles in Graham's *Appalachian Spring* (1944), *Imagined Wing* (1944), *Cave of the Heart* (1946), *Diversion of Angels* (1948), *Canticle for Innocent Comedians* (1952), *Ardent Song* (1954), *Cly-*temnestra* (1958), *Embattled Garden* (1958), *Cortege of Eagles* (1967), and *Equatorial* (1978), and currently performs the Graham roles in *Appalachian Spring* and other works.

On leave from the Graham company, she created the role of "Eliza" in the "Small House of Uncle Thomas" sequence in Jerome Robbins' *The King and I* on Broadway (1951–1954) and in the 1956 film. She has re-created the choreography for many revivals of the show in the United States and Europe, and received solo choreography credit for the 1977 Broadway revival. She was also featured in the ballet-within-a-show in Carol Haney's *Flower Drum Song*, 1958.

As the winner of the annual audition, she presented a solo recital at the 92nd Street YMHA in New York in 1946. She formed a company in 1960 and has presented dance concerts regularly in New York and abroad since then. Her works combine the influences of Martha Graham and Japanese theater; they tend to involve relationships or solitude as themes.

Works Choreographed: CONCERT WORKS: *Stubborn* (1944); *Earth Primative* (1944); *Troubled Hour* (1944); *Images* (1945); *Thin Cry* (1945); *The Gift* (1945); *Young Memories* (1946); *Shut Not Your Doors* (1946); *Tale of Seizure* (1947); *Perpetual Notions* (1949); *Incident* (1949); *Servant at the Pillars* (1949); *Suite* (1949); *Four Window* (1954); *. . . where the Roads . . .* (1954); *Shochikubai* (1960); *A Fool's Tale* (1960); *In the Glory* (1960); *The Ghost* (1960); *The Cry* (1963); *Three Dances* (1963); *Flowers for Me* (1963); *Life of a Tree* (1963); *Colors of the Heart* (1963); *Conversations* (1964); *The Trapped* (1964); *Remembrance* (1964); *. . . and the Wind* (1964); *Wind Drum* (1965); *Forgotten One* (1965); *Wanderers* (1965); *Three Dances* (1965); *Tragic Memory* (1966); *Celebrations* (1966); *Five Characters* (1967); *Strange Landscape* (1968); *Dances for Dancers* (1968); *Moss Garden* (1968); *Shadowed* (1968); *Night Fantasy* (1968); *Spirit of the Ink* (1970); *Events I* (1970); *Quintet* (1971); *Events II* (1971); *Events III* (1972); *Moments* (1978); *City Square* (1978); *Epitaphim* (1978).

THEATER WORKS: *The Emperor's Nightingale* (1958); *The King and I* (1977, revival).

Zakharov, Rotislav, Soviet ballet dancer and choreographer; born September 7, 1907 in the Astrakhan. Trained at the school of the Petrograd State Ballet, he danced briefly in Kiev before joining the GATOB.

Best known as a choreographer of dramatic works (melodramatic perhaps by current standards), Zakharov served as artistic director of the Moscow Bolshoi from 1936 to 1939 and as director of the school from 1946 to 1949. He currently teaches at the Lunachevsky State Institute for the Theatre Arts in Moscow.

Works Choreographed: CONCERT WORKS: *The Fountain of Bakhisarai* (1934); *Lost Illusions* (1935); *The Prisoner of the Caucasus* (1938); *Don Quixote* (1940, co-choreographed with Kasyan Goleizovsky); *Taras Bulba* (1941); *Cinderella* (1945); *Mistress into Maid* (1946); *The Red Poppy* (1949); *The Bronze Horseman* (1949); *Under Italian Skies* (1952); *Ivan Susanin* (1959).

Zambelli, Carlotta, Italian ballet dancer associated with the Paris Opéra; born November 4, 1875, in Milan; died there January 28, 1968. Trained at the school of the Teatro alla Scala by Angela Vago, Adelaide Viganò, and Cesare Coppini, Zambelli performed as a child in Luigi Manzotti's spectacles, *Excelsior* and *Amor.*

In the summer of 1894, Zambelli was offered a contract to perform with the Paris Opéra. After additional training in Paris with Miguel Vasquez and Joseph Hanssen, she made her company debut in December. With the exception of a season in St. Petersburg, Zambelli was to spend the remainder of her professional life at the Opéra.

In the thirty-six years that she danced there, she created roles in the works of all of the Opéra ballet masters and guest choreographers. After her first major role as "Hélène" in Henri Justament's *Faust* (1894), she performed in many ballets by then ballet master Joseph Hanssen, among them, *Le Cid* (1900), the Habañera of which was filmed and shown at the Photo-Cinéma Théâtre at the Paris Exposition Internationalle, *Bacchus* (1902), and *La Ronde de Saisons* (1905). She created roles in many of the works by Leo Staats during his early tenure at the Opéra, including *Namouna* (1908), *España* (1911, co-choreographed with former ballerina Rosita Mauri), and his famed *Les Abeilles* (1917). She also danced premiere performances of works by Ivan Clustine, notably his *La Roussalka* (1911), by Bronislava Nininska, in her *Impressions de Music-hall* (1927), and those staged by Zambelli's constant partner, dancer Albert Aveline.

After her retirement in 1930, Zambelli became the teacher of the *classes de perfection* at the Opéra, a position that she held until 1955.

Bibliography: Guest, Ivor. Carlotta Zambelli, *Revue de la Société d'Histoire du Théâtre*, Vol. 21, no. 3, translated and reprinted in *Dance Magazine* (February–March 1974).

Zamir, Batya, American postmodern dancer and choreographer; born in Brooklyn, New York. Zamir was a member of the Alwin Nikolais troupe for many years, performing in *Somniloquy, Tent, Tower,* and other works for bodies within structural scenery and costumes. Her own work is related to his—inhumanly abstract and entertaining. Since 1969, she has worked on suspended soft sculptures designed by her husband, Richard Van Buren, which serve as single trapezes. She and her dancers can hang or work from them, can climb into them, and can use them to frame their bodies.

Unlike her colleagues in the postmodern-aerial dance movement, she enjoys the theatricality of the medium and does not work to thwart the audience's circus reactions. In the eleven years that she has worked in the air, she has managed to create new effects for her trained and untrained performers, adults and children.

Works Choreographed: CONCERT WORKS: *Releases I* (1969); *Carrys* (1969); *Prances* (1969); *Crawls* (1969); *Releases II* (1969); *Shadow Slot Follows* (1969); *Slot Changes* (1969); *Laying Down Rolls* (1969); *Gravity Falls* (1969); *Duet and Solo Concert Works* (1970); *Trio Release* (1971); *Trio Exchange* (1971); *Individual Turns* (1971); *Circle Exchanges* (1971); *Slot Exchanges* (1971); *Direction Changes* (1971, solo and group duet versions); *Untitled Improvisations* (1971); *Dancing Solo* (1973); *Off the*

Wall (1973); *Prelude to Botticelli's Revenge, or Scar Baby and the Two Dicks* (1974); *On and Off the Wall, and Between the Columns* (1974); *Saturday Morning on Sunday Afternoon* (1974); *Improvised Concert* (1975); *Rebound* (1976); *Sweet Sensations* (1977); *Air Lines* (1977); *Swivel Piece* (1978); *Out of the Blue* (1980); *Music for Zen Meditation* (1980); *Coming and Going* (1980); *Mat Dance* (1980); *Duet on Floor* (1980); *Air Lines for Kids* (1980).

Zane, Arnie, American post modern dancer and choreographer; born September 26, 1948 in the Bronx, New York. Zane was not trained in the traditional dance techniques. He has choreographed and performed since 1974 in collaboration with Bill T. Jones in a company entitled the American Dance Asylum. His duets with Jones use the smooth experimentations with unconventional support and reflective movements that are popularly associated with Contact Improvisation work, and are especially popular. Their bodies and styles of performance complement each others with Jones' length working well with Zane's tightly coiled movements, in the powerful body language typical of a short actor.

Works Choreographed: CONCERT WORKS: *Self-Portrait* (1974); *Pas de Deux for Two* (1974, in collaboration with Bill T. Jones); *Across the Street* (1975, in collaboration with Jones); *Whosedebabedolbabedoll?* (1977, in collaboration with Jones); *Crux* (1978); *More Dogs and People Dancing* (1979); *Monkey Run Road* (1979, in collaboration with Jones); *Pieman's Portraits* (1980); *Blauvelt Mountain* (1980, in collaboration with Jones).

Zanfretta, Francesca, Italian ballet dancer who performed primarily in English pantomimes and ballet spectacles; born 1862 in Milan; died June 4, 1952 in London. After training with Ernestine Vantiès (ballet) and Louis Rouffe (mime), Zanfretta made her debut at the Deutschestheater in Prague (c.1878). She also danced at the Théâtre de la Monnaie in Brussels before making her London debut at Covent Garden, presumably with the Royal Italian Opera Company which was then in residence.

Although now the home of the Royal Ballet, Covent Garden was the center of pantomime and Italian Opera at the close of the nineteenth century. The Royal Italian Opera, headed by Col. Charles Mapleson, was then the base of such famed Italian ballet technicians and mimes as Malvina Cavallazzi and Emma Palladino, as well as eccentric dancer Fred Farren and acrobat Charles Lauri, who later became Zanfretta's husband.

Zanfretta remained in English theater for the rest of her performing career, working at The Prince of Wales Theatre (c.1891), and at The Empire, the most famous and innovative center of ballet spectacle outside of Italy. At The Empire, Zanfretta performed as a *danseuse-mime*, as both a bravura female technician and an actor working *en travestie* to create male characters. Among her many Empire credits were Katti Lanner's *Faust* (1895), in which she played "Mephistopheles" to Cavallazzi's title role, her *The Press* (1898), a spectacle that directly influenced many of America's musical comedy creators, and Léon Espinosa's *Europe* (1915), her last part before retirement.

Zanfretta taught in London for many years, bringing the Italian technique to English dancers and, through dance director Ernest Belcher, to Hollywood.

Zanfretta, Marietta, Italian tightrope dancer of the nineteenth century; born c.1837 in Venice; died March 1898 in New York City. Zanfretta was trained by her parents, who were tightrope performers in the Piedmontale region of northern Italy.

After working at Franconi's Theatre in Paris as an adolescent, Zanfretta toured the United States with the Carine troupe, making her New York debut in 1858 at Niblo's. Rightly celebrated for her ability to do point work on a tightrope, she performed with the Martinelli and Manzetti family troupes and with a company that she formed with her daughter and adopted sons. It is so difficult even to imagine anyone being able to perform her specialty that one tends to rationalize around it, to develop elaborate schemes involving forced perspectives and audience perceptions. From all contemporary evidence, however, it would seem that Zanfretta actually did dance on her toes on a tightrope above the stage at the climax of each ballet. One additional piece of evidence exists to disprove the idea that she faked her performance: she challenged Blondin to a tightrope

competition during his American tour. Blondin, who had danced his way across Niagara Falls, backed down and defaulted.

Zaraspe, Hector, Argentinian ballet dancer and teacher; born 1931 in Tucumán, Argentina. Zaraspe was trained in ballet by Esmee Bulnes and in Spanish dance forms by Callejas in Buenos Aires, before performing with the Teatro Colón (c.1949–1952). He started a school in Buenos Aires in 1951 but left it to work with Antonio in Madrid in c.1954.

He has been living and teaching in the New York area since the mid-1960s, on staff at the American Ballet Center and at the Juilliard School. He has also coached ballet dancers in Spanish and other character works.

Although the names of his Spanish films are not available, his three dance direction credits from Hollywood include at least one that was made in Spain— *Spartacus* (Universal, 1960).

Works Choreographed: CONCERT WORKS: *Bolero* (1979); *Debussyana* (1979).

FILM: *John Paul Jones* (WB, 1959); *Spartacus* (Universal, 1960); *55 Days at Peking* (Allied Arts, 1963).

Zastro, Roy, American vaudeville dancer; born May 8, 1905 in Milwaukee, Wisconsin. One of the few whites who ever had a presentation that was recognized as a "flash act," Zastro first appeared in vaudeville in the early 1920s in The City Chap act. This dance routine, the opposite of a "Rube" act, presented him as a sophisticated Manhattanite in top hat and tails. The act, which was related to the "silly-ass Englishman" genre, required him to parade around the stage in his immaculate garb and begin to do a ballroom step (alone, with an imaginary partner). As the act progressed, the waltz hesitation movements got larger and larger until they turned into a legomania, or acrobatic, high-kicking flailing dance—a "flash act" because its impact depended on its eccentric steps and boisterous presentation.

Zastro did his City Chap act in vaudeville and Prologs throughout the 1920s and early 1930s. There is some evidence that he also worked as a conventional eccentric dancer on the Paramount/Publix circuit in the mid-1930s, although the person billed as "formerly of The City Chap" may have been a Zastro imitator.

Zemach, Benjamin, Russian/American concert dancer and theatrical choreographer; born c.1900 in Bialystock, Russia. A member of the Moscow Habima, of which his brother Nahum was director, Zemach was trained by Konstantin Stanislavsky and Yvgeny Vakhtangov, leaders in the Soviet avant-garde theater movement. Zemach also received training at the Moscow Dalcroze Institute and may have studied biomechanics, under Vsevolod Meyerhold.

When the Habima left the Soviet Union in the late 1920s, Zemach emigrated to New York with his brother. Both became involved with the Artef (Workers' Theater Group); in addition, Zemach taught and choreographed for the arts program of the International Ladies' Garment Workers and the Labor Stage, creating dances for the original production of *Pins and Needles* (1938).

His concert dance career was split between New York where he had recitals in 1929, 1931, 1936, and 1940–1941, and the West Coast where he staged plays for the Actors' Lab and the Pasadena Playhouse and served as a dialogue coach at RKO Studios. His most acclaimed works use the angularity and physical impact of Russian constructivism within their topical and social mise-en-scène. Most were based on Eastern European Jewry, although in the late 1930s he became involved in Palestinian folk culture.

Although Zemach's directing work overwhelmed his career, he did produce some dance pieces in the early 1970s, while he was serving as Director of Dance and Drama at the University of Judaism in Los Angeles.

Works Choreographed: CONCERT WORKS: *Der Badchen* (the Jester/Troubadour) (1929); *Beggar's Dance* (1929); *Three Generations* (1929); *The First Quarrel* (1929); *Dance Eccentrique* (1929); *Jacob's Dream* (1929); *The Fallen Angel* (1931); *On the Earth* (1931); *The Funeral March* (1931); *Cheder* (1931); *The People and the Prophet* (1931); *Chapter of the Psalms* (1931); *The Menorah* (1934); *Revolutionary* (1934); *Lullaby* (1934); *Tocatta in D Minor* (1934); *The Worker on the Soil* (1934); *On the Theme of Benjamin the Third* (1936); *Contrition* (1936); *Kaddish* (1936); *Joys* (1936); *Abstract* (1936); *At the Well*

(1936); *Palestinian Folk Songs* (1936); *The Mowers Dance on the Soil* (1936); *Farewell to Queen Sabbath* (1936); *Cain and Abel* (1942); *Wandering* (1942); *Vision of the Dry Bones* (1942); *Kol Kora* (1971); *Hora* (1971).

THEATER WORKS: *Lag-Boy-mer* (1929); *100,000* (1936); *The Outlaw* (1937); *Pins and Needles* (1938, original production included two dance sequences that were dropped in later editions: *The General Is Unveiled* and *Men Awake*); *The Eternal Road* (1940).

FILM: *She* (RKO, 1933); *The Last Days of Pompei* (RKO, 1933).

Zhadnov, Yuri, Soviet ballet dancer; born November 29, 1925 in Moscow. Trained at the school of the Bolshoi Ballet, he has performed with that company throughout his career. Known for partnering Galina Ulanova in the classics, he danced with her in *Giselle, The Bronze Horseman, Romeo and Juliet*, and many other works. They appeared together in the Mosfilm production of *Romeo and Juliet* (1956). Since 1972, he has been the director of the Moscow Classic Ballet Ensemble.

Zide, Rochelle, American ballet dancer; born April 21, 1938 in Boston, Massachusetts. Zide was trained by Harriet Hoctor, the foremost acrobatic ballet dancer of the 1920s and 1930s, who was then running a studio in Boston. Later studies in New York brought her to the attention of Tatiana Chamie, Elizabeth Anderson-Ivantzova, Frederick Franklin, Leon Danielian, and Robert Joffrey. She performed with the Ballet Russe de Monte Carlo in the mid-1950s, appearing in Danielian's *Sombreros* (1956), Leonid Massine's *Gaité Parisienne* and *Le Beau Danube*, Ruthanna Boris' *Cirque de Deux*, and the company productions of *Coppélia* and *Swan Lake*. As a member of the Robert Joffrey Ballet from 1958 to its disbanding in 1962, she danced in his *A la Gershwin* and *La Fille Mal Gardée* and in George Balanchine's *Square Dance*. During that period, she also participated in ballet workshop productions by unaffiliated choreographers, such as Thomas Andrew and Dirk Sanders, who frequently shared concerts with Joffrey's chamber troupe. She worked for Joffrey as a member of the New York City Opera Ballet (1962–1964) and as ballet master for his new

City Center Joffrey Ballet (c.1965–1968). Zide has also worked extensively on television as an Ed Sullivan dancer and as a frequent performer on ballet specials.

Since retiring from performance, Zide has taught at many universities and studios in the New York area and has also worked with the Dance Notation Bureau in its preservation projects.

Ziegfeld, Florenz, Jr., "The Great Glorifier," and American theatrical producer; born March 15, 1867 in Chicago, Illinois; died July 22, 1932 in New York. The son of Florenz Ziegfeld, Sr., founder of the Chicago Musical College, he had no formal training in theater or dance although he may have attended social dance classes at the fashionable studio of A.E. Bournique.

Ziegfeld was undoubtedly one of America's great entrepreneurs: the products he sold were entertainment and his own reputation. He produced fifty-one shows on Broadway, among them, nineteen editions of the *Follies*. The *Ziegfeld Follies* were not the only annual revue on Broadway, were not the most witty, the best staged, or the best choreographed, but they were then, and forever, the image of Broadway and its musical productions. It is easier to describe the *Follies* in generalities, but it is important to remember that the series extended from 1907 to 1931—a period in which popular music, lyrics, choreography, set design, lighting design, the audience's attitude toward censorship, and the legal status of theaters all changed drastically. The first *Follies* were not in fact revues but were musical comedies; even the later Ziegfeld editions had themes and some internal plotlines. They were all involved with the presentation of female dancers and male comics, the women as solo stars and as glorified but anonymous members of a stratification of choruses. The Ziegfeld Girls themselves, the A chorus, were not dancers at all; they moved down, or on one occasion, up, the elaborate staircases and platforms to frame the soloists.

The *Follies* were staged by only five dance directors—Herbert Gresham (editions of 1907–1909), Julian Mitchell (1907–1913, 1915, 1924), Edward Royce (1920–1921), Albertina Rasch (1927, titled *The American Revue*, and 1931), and Ned Wayburn, who choreographed the 1916–1919, 1922 and 1923 *Follies*

and all of the early *Midnight Frolics* at the roof garden. Mitchell and Wayburn did much of the best work in their long and prolific careers for the *Follies*, with their combined editions including most of those that are considered the "ultimate Follies."

The typical *Follies*, if one can be chosen, would have to be one of Wayburn's, since he happened to be Ziegfeld's favorite at the time when the producer's finances, his list of available stars, and the activities of his competitors combined to force him into creating the most elaborate, most expensive, and best written editions. Although experts and fans can argue for weeks to choose their favorite editions, most would select the 1916 *Follies*, with sketches and production numbers based on the Shakespeare Tercentenary and the tour of the Diaghilev Ballet Russe, the 1919 edition, in which most of the jokes were about Prohibition, or the 1922 *Follies*, considered the most elaborately designed, which had two different dance numbers created to exploit the newly formulated black-light effect. Its major Act II production number, "Laceland," employed more than forty female dancers in five differentiated choruses, with two toe dancers and one acrobatic soloist. The *Midnight Frolics*, produced with fewer performers on a much smaller stage, were also imaginatively presented.

Ziegfeld produced four other revues, *The Century Girl* (1916) and *Miss 1917*, on the revolving stage at the Century Theatre, and two pseudo-Follies, *No Foolin'* (1926) and *The American Revue* (aka *Palm Beach Girl*) (1927), which he put on during the years when he had sold the rights to the title *Ziegfeld Follies*. He also presented elaborately designed and staged musical comedies, among them, *Sally* (1920) and *Kid Boots* (1923) for Marilyn Miller, *Rio Rita* (1927), staged by Rasch, *Rosalie* (1928), the Eddie Cantor vehicle *Whoopee* (1928), and the original *Show Boat* (1927).

Bibliography: Cantor, Eddie and David Freedman. *Ziegfeld, the Great Glorifyer* (New York: 1934); Higham, Charles. *Ziegfeld* (Chicago: 1972); Carter, Randolph. *The World of Florenz Ziegfeld* (London: 1974).

Zimmermann, Gerda, German ballet dancer also working and teaching in the United States; born March 26, 1927 in Cuxhaven, Germany. After studies with Erika Kluetz in Hamburg, she enlarged her range of techniques with training in modern and ethnic forms with Ursula Knalevsky and Jan De Reuiter. Zimmermann performed with the Rheinische Opera in Dusseldorf for four years and the Ballet of the Landestheater, where she worked under Yvonne Georgi, a concert dancer who had become known as a ballet choreographer in postwar Germany. From 1951 to 1960 she appeared in more than forty different Georgi ballets, including her celebrated productions of *Carmina Burana, Four Temperaments, Apolon Musagète, Evolution, Les Sylphides, Orpheus and Eurydice,* and *Bacchus and Ariadne*, as well as dance divertissements in operas and operettas.

After moving to the United States in 1960 to work in the traditional American modern dance, she studied with Donald McKayle, José Limón, Alwin Nikolais, and Martha Graham company dancers Bertram Ross, Helen McGehee, Yuriko, Ethel Winter, Mary Hinson, and Patricia Birch. She also trained with Zena Rommett (in ballet), Luigi (in jazz), and took composition seminars with Louis Horst, Katharine Litz, and Joan Skinner. She has presented concerts of her own works in Europe and the United States for her Kammertanz Theatre, New Reflections Dance Theatre, and Dance Gallery/Charlotte at the University of North Carolina. Her many group works have been staged for professional and student companies in North Carolina and Wisconsin. Her score of solos were presented as recitals throughout the United States in concerts and university residencies from 1964 on. She has become a major influence in the areas of the country where she has taught, bringing the German expressionist dance structures into academic dance, through both modern and ballet techniques.

Works Choreographed: CONCERT WORKS: *Phases and Faces* (1964); *Lot's Wife* (1964); *Zeremonie in Blau* (1965); *Hindernesse* (1965); *Traumend* (1965); *The Joy of a Malicious Spirit* (1965); *Requiem* (1965); *Dance Suite à la Swingle* (1967); *Emanations* (1967); *Concerto* (1967); *Contrasts* (1967); *Sidewalk Interlude* (1968); *Other Dreams—Other Faces* (1968, solo version); *Obsession* (1969); *Cycle* (1969); *Apokatastase* (1969); *Continuum* (1970); *Episode I* (1970); *Salute to a Gorgon* (1970); *Reflections* (1971); *Other Dreams—Other Faces* (1971, group version); *Silhouettes in Orange* (1971); *Von A Bis E* (1972); *Contrasts* (1972); *Synopsis* (1972); *Strahlunden* (1972); *Charade* (1972); *Lollapalooza* (1974); *Peitho*

(1974); *Chimera* (1974); *Luna Park I* (1975); *Arachne* (1976); *Earthbound Glow* (1977); *Suite à la Hee-Haw* (1976); *A Choice* (1977); *Suite in Black and White* (1977); *Metamorphosis* (1978); *The Claw of the Butterfly* (1978); *Fantasy Island* (1978); *Fragments* (1980); *Luna Park II* (1980); *Heaven Tree* (1980); *A Sunshine Day* (1980); *Illusion* (1980); *Human Variations* (1980).

Zomosa, Maximiliano, Chilean/American ballet dancer; born February 28, 1937 in Valparaiso, Chile; died January 10, 1969 in Woodbridge, New Jersey. Zomosa was a medical student when he decided to train seriously for a career in dance. He studied with Ernst Uthoff (Jooss and ballet techniques), ballet with Elena Poliakova, and modern dance with Hans Frellig.

Zomosa performed with the Chilean National Mime Theater and the Chilean National Ballet between 1960 and 1964, dancing featured roles in Birgit Cullberg's *Medea, Miss Julie*, and *Eden*, and performing the role that became his best known, "Death" in Kurt Jooss' 1932 *The Green Table*.

In 1965, while on a Fulbright grant to study in the United States, Zomosa joined the apprentice group that would become the City Center Joffrey Ballet. In the group and company, he created roles in Arpino's *Viva Vivaldi!* (1965), *Olympics* and *Nightwings* (1966), *Elegy* (1967), and *The Clowns* (1968). His presence and dramatic power were undeniable in his two signature roles with the Joffrey ballet—"Death" and the enthralled worshiper in *Astarte* (1967).

Zompakos, Stanley, American ballet dancer; born May 12, 1925 in New York City. Trained at the School of American Ballet, he made his professional debut in the corps of the New Opera Company, a one-performance company for which George Balanchine staged *Ballet Imperial* (1941). He performed with the Ballet Russe de Monte Carlo until 1954, appearing in the company's repertory of Balanchine works, including *Mozartiana, Concerto Barocco,* and *Danses Concertantes*, in Leonid Massine's *Gaîté Parisienne* and Ruthanna Boris' *Cirque de Deux* (1948). Although he danced in works by Balanchine in the New York City Ballet, most notably in *La Valse*, he won greater acclaim in ballets by Frederick

Ashton, among them *Illuminations* and *Picnic at Tintagel*, and by Jerome Robbins, for whom he danced in *Quartet, Ballade, The Pied Piper,* and *Age of Anxiety*. After retiring from performance, Zompakos began a lengthy and successful teaching career in New York.

Zorina, Vera, Norwegian ballet dancer and actress working on Broadway and in film during the 1930s and 1940s; born Brigitta Hartwig in Berlin, Germany, on January 2, 1917. Zorina was trained in Paris by Olga Preobrajenska, in Berlin by Victor Gsovsky, and in London by Nicholai Legat and Marie Rambert. After arriving in the United States, she studied at the School of American Ballet in New York.

After making her debut as an actress with Max Reinhardt in his *Midsummer Night's Dream* (1929) and *The Tales of Hoffmann* (1931), Zorina became a member of the Ballet Russe de Monte Carlo in 1932. In four years with that company, she was featured in many classical works, among them *Aurora's Wedding* and the one-act version of *The Sleeping Beauty*.

Her beauty, ballet technique, and sense of comedy brought her to Broadway and Hollywood as an actress and dancer. Her Broadway shows, staged by George Balanchine, involved both straight comedy scenes and dance sequences; in the first, *On Your Toes* (1937), for example, she played a dancer and performed in Broadway-style dance numbers, stylized ballet exercise sessions, and in two specialties, *The Princess Zenobia Ballet*, a satire of the Ballet Russe de Monte Carlo style, and the famous *Slaughter on Tenth Avenue*, which provided both a devastatingly effective dance scene and a plot-related climax to the show. Her other Broadway musicals were *I Married an Angel* (1938) and *Louisiana Purchase* (1940), and the revue, *Dream with Music* (1944).

The dance sequences that Balanchine created for her films were less integrated into the movie structures but they were still effective and enjoyable. In the *Goldwyn Follies*, their first, she appeared in two sequences—the jazz versus ballet version of *Romeo and Juliet*, and the nymph ballet—which were shown as part of a backstage plot. Their other films, all for MGM, included versions of *On Your Toes* (1939) and *Louisiana Purchase* (1941), and the original films, *I*

Was an Adventuress (1940), *Star-Spangled Rhythm* (1942), and *Follow the Boys* (1944).

Since retiring from dance, Zorina has performed as a narrator for oratorios, and has directed opera and produced records, among them, a compilation of dance music.

Zoritch, George, Russian ballet dancer working in the United States after the mid-1930s; born June 6, 1917 in Moscow. After studies with Paul Petroff in Kowno, Lithuania, he moved to Paris where he continued his training with Olga Preobrajenska, Leonid Massine, Anatole Vilzak, and Nikolai Sergeev. In New York after the mid-1930s, he worked with Bronislava Nijinska, Muriel Stuart, Igor Schwezoff, Maria Bekefi, and Katharine Dunham. He made his debut with the Ida Rubinstein Company in 1933 and spent seasons with the posthumous Pavlova troupe and the Bronislava Nijinska Ballet.

Zoritch joined the Ballet Russe de Monte Carlo (De Basil) in 1936 in New York. He was associated there with the works of Leonid Massine, for whom he created roles in *Jardin Public* (1935) and *Symphonie Fantastique* (1936), and danced in *Les Présages* and *Choreartium*, and in David Lichine's *Cimarosiana*. With the Serge Denham Ballet Russe de Monte Carlo from 1938 to 1943, he created roles in Massine's *The New Yorker* (1940) and was featured in Frederick Ashton's *Devil's Holiday* and George Balanchine's *Serenade* and *Concerto Barocco*. For the remainder of his performing career, he alternated between Broadway performances, in *Pardon Our French* (1949), *Louisiana Purchase* (1948), and Balanchine's *Rosalinda* (1946), and work in ballet companies, among them the Ballet Variante where he partnered Mia Slavenska (1947–1948), and the Grand Ballet du Marquis de Cuevas (1951–1954), in which he danced in Rosella Hightower's *Scaramouche*, Georges Skibine's *Tragedie en Verona*, and revivals of *Spectre de la Rose* and *Quatre Saisons*. He also worked at the Radio City Music Hall and appeared as a specialty dancer in Warner Brothers' backstage films, *The Unfinished Dance, Look for the Silver Lining*, and *Night and Day*.

Zoritch has taught extensively in Hollywood since 1957 and in Phoenix, Arizona, after 1975, and as a guest teacher.

Zucchi, Virginia, Italian nineteenth-century ballet dancer in St. Petersburg after 1885; born February 10, 1849 in Parma, Italy; died 1930 in Nice, France. Trained privately in Milan by Giuseppe Ramaccio and Lodovico Montini, Zucchi made her professional debut with a troupe of touring child performers. Her formal ballet debut in Varese in 1864 led to performances at the Teatro di Borgognissanti in Florence, Trieste's Teatro Communal, Turin's Teatro Reggio, and Teatro Balboa, where she performed in 1869 in the revival of Perrot's *La Esmeralda*, and La Scala where she danced in the 1883 revival of Manzotti's *Excelsior*.

In 1885, Zucchi made her first visit to St. Petersburg, touring with a production of Joseph Hanssen's *Le Voyage dans la Lune*. At the Imperial Theater, she performed in Marius Petipa's *Le Roi l'a Dit* (1886) and the revival of *La Fille du Pharon*. Zucchi's performances in St. Petersburg had an enormous impact on many members of the audience, among them, Serge Volkonsky and Alexandre Benois, both of whom have written that her season first excited them about the possibilities, rather than limitations, of ballet technique.

When she returned from Russia, Zucchi performed in a Drury Lane pantomime in London. In this work, *Robinson Crusoe*, staged by John D'Auban in 1893, she was partnered by Luigi Albertieri. Zucchi retired from performing in 1899. Her nieces Maria and Virginia II each had successful career as dancers—Maria in Italy and Virginia at the Teatro Colón in Buenos Aires.

Zullig, Hans, German ballet dancer associated with the Ballet Jooss; born February 1, 1934 in Rorschach. Zullig was trained at the Folkwangschule in Essen and followed his teachers, Kurt Jooss and Sigurd Leeder, when they emigrated to England. He performed with the Ballets Jooss from 1935 to 1947, creating roles in Jooss' *Company at the Manor* (1943) and *Pandora* (1944), Leeder's *Sailor's Fancy* (1943), and his own *Le Bosquet* (1945). His roles in the company included "The Young Workman" in Jooss' *The Big City*, "The Young Soldier" and "The Profiteer" in his *Green Table*, and featured roles in his *A Ball in Old Vienna, Ballade,* and *Johann Strauss, Tonight*. He remained in England for two

Was an Adventuress (1940), *Star-Spangled Rhythm* (1942), and *Follow the Boys* (1944).

Since retiring from dance, Zorina has performed as a narrator for oratorios, and has directed opera and produced records, among them, a compilation of dance music.

Zoritch, George, Russian ballet dancer working in the United States after the mid-1930s; born June 6, 1917 in Moscow. After studies with Paul Petroff in Kowno, Lithuania, he moved to Paris where he continued his training with Olga Preobrajenska, Leonid Massine, Anatole Vilzak, and Nikolai Sergeev. In New York after the mid-1930s, he worked with Bronislava Nijinska, Muriel Stuart, Igor Schwezoff, Maria Bekefi, and Katharine Dunham. He made his debut with the Ida Rubinstein Company in 1933 and spent seasons with the posthumous Pavlova troupe and the Bronislava Nijinska Ballet.

Zoritch joined the Ballet Russe de Monte Carlo (De Basil) in 1936 in New York. He was associated there with the works of Leonid Massine, for whom he created roles in *Jardin Public* (1935) and *Symphonie Fantastique* (1936), and danced in *Les Présages* and *Choreartium*, and in David Lichine's *Cimarosiana*. With the Serge Denham Ballet Russe de Monte Carlo from 1938 to 1943, he created roles in Massine's *The New Yorker* (1940) and was featured in Frederick Ashton's *Devil's Holiday* and George Balanchine's *Serenade* and *Concerto Barocco*. For the remainder of his performing career, he alternated between Broadway performances, in *Pardon Our French* (1949), *Louisiana Purchase* (1948), and Balanchine's *Rosalinda* (1946), and work in ballet companies, among them the Ballet Variante where he partnered Mia Slavenska (1947–1948), and the Grand Ballet du Marquis de Cuevas (1951–1954), in which he danced in Rosella Hightower's *Scaramouche*, Georges Skibine's *Tragedie en Verona*, and revivals of *Spectre de la Rose* and *Quatre Saisons*. He also worked at the Radio City Music Hall and appeared as a specialty dancer in Warner Brothers' backstage films, *The Unfinished Dance, Look for the Silver Lining*, and *Night and Day.*

Zoritch has taught extensively in Hollywood since 1957 and in Phoenix, Arizona, after 1975, and as a guest teacher.

Zucchi, Virginia, Italian nineteenth-century ballet dancer in St. Petersburg after 1885; born February 10, 1849 in Parma, Italy; died 1930 in Nice, France. Trained privately in Milan by Giuseppe Ramaccio and Lodovico Montini, Zucchi made her professional debut with a troupe of touring child performers. Her formal ballet debut in Varese in 1864 led to performances at the Teatro di Borgognissanti in Florence, Trieste's Teatro Communal, Turin's Teatro Reggio, and Teatro Balboa, where she performed in 1869 in the revival of Perrot's *La Esmeralda*, and La Scala where she danced in the 1883 revival of Manzotti's *Excelsior*.

In 1885, Zucchi made her first visit to St. Petersburg, touring with a production of Joseph Hanssen's *Le Voyage dans la Lune*. At the Imperial Theater, she performed in Marius Petipa's *Le Roi l'a Dit* (1886) and the revival of *La Fille du Pharon*. Zucchi's performances in St. Petersburg had an enormous impact on many members of the audience, among them, Serge Volkonsky and Alexandre Benois, both of whom have written that her season first excited them about the possibilities, rather than limitations, of ballet technique.

When she returned from Russia, Zucchi performed in a Drury Lane pantomime in London. In this work, *Robinson Crusoe*, staged by John D'Auban in 1893, she was partnered by Luigi Albertieri. Zucchi retired from performing in 1899. Her nieces Maria and Virginia II each had successful career as dancers—Maria in Italy and Virginia at the Teatro Colón in Buenos Aires.

Zullig, Hans, German ballet dancer associated with the Ballet Jooss; born February 1, 1934 in Rorschach. Zullig was trained at the Folkwangschule in Essen and followed his teachers, Kurt Jooss and Sigurd Leeder, when they emigrated to England. He performed with the Ballets Jooss from 1935 to 1947, creating roles in Jooss' *Company at the Manor* (1943) and *Pandora* (1944), Leeder's *Sailor's Fancy* (1943), and his own *Le Bosquet* (1945). His roles in the company included "The Young Workman" in Jooss' *The Big City*, "The Young Soldier" and "The Profiteer" in his *Green Table*, and featured roles in his *A Ball in Old Vienna, Ballade,* and *Johann Strauss, Tonight*. He remained in England for two

years after leaving the company, dancing with the Sadler's Wells Theatre Ballet (1948–1950) with roles in the company's revivals of *Les Sylphides* and *Carnaval* and in Ninette De Valois' *The Gods Go-A-Begging* and Andrée Howard's *Selina* (1948).

He returned to Essen, however, in 1950 to help in the reforming of the Ballets Jooss and remained there as dance and principal company teacher. For many years he worked simultaneously with Jooss at the Folkwangschule and at the Dusseldorf State Opera Ballet. After five years spent with fellow Jooss member Ernst Uthoff in Santiago, Chile, he became director of the dance program at the Folkwangschule.

Works Choreographed: CONCERT WORKS: *Le Bosquet* (1945); *Fantasie* (1957); *Avners auf Balletmasterens Luner* (*Cupid and the Loves of the Ballet Master*) (1958).

Zverev, Nicholas, Russian ballet dancer and choreographer; born c.1888 in Moscow; died June 28, 1965 in St. Raphael, France. Trained at the school of the Imperial Ballet in Moscow, Zverev performed with Diaghilev's Ballet Russe from 1912 to 1926. Celebrated for his character performances, he created roles in Leonid Massine's *La Boutique Fantasque* (1920), *Parade* (1971), as one of the "Acrobats," and *Pulcinella* (1923), and in Bronislava Nijinska's *Les Facheux* (1924) and *Les Biches* in the same year. He was also featured in character roles in Mikhail Fokine's *Schéhérézade* and *Petrouchka*.

After Diaghilev's death in 1929, Zverev began a long career as ballet master of a string of companies in Europe and the United States. Among the companies for which he taught and choreographed were the Kaunas Opera in Lithuania (1930–1936), the Ballet Russe de Monte Carlo in New York (1936–1945), the Théâtre des Champs-Elysées (1951), the Théâtre de la Monnaie in Brussels (1952), and the Teatro Colón in Buenos Aires (1957–1960); he also taught at Boris Kniaseff's Academie de Danse de Lausanne in Switzerland. Although much of his choreography was in fact restagings of works from the Bolshoi or Ballet Russe repertory, he also created original pieces in the 1930s.

Works Choreographed: CONCERT WORKS: *Raymonda* (1933, after Marius Petipa); *The Sleeping Beauty* (1934, after Petipa); *Les Fiancailles* (1935); *Islamey* (1935); *Daphnis and Chloe* (1948, with Serge Lifar and Mikhail Fokine); *Serenade* (1963).